*Art in Rome in the Eighteenth Century*

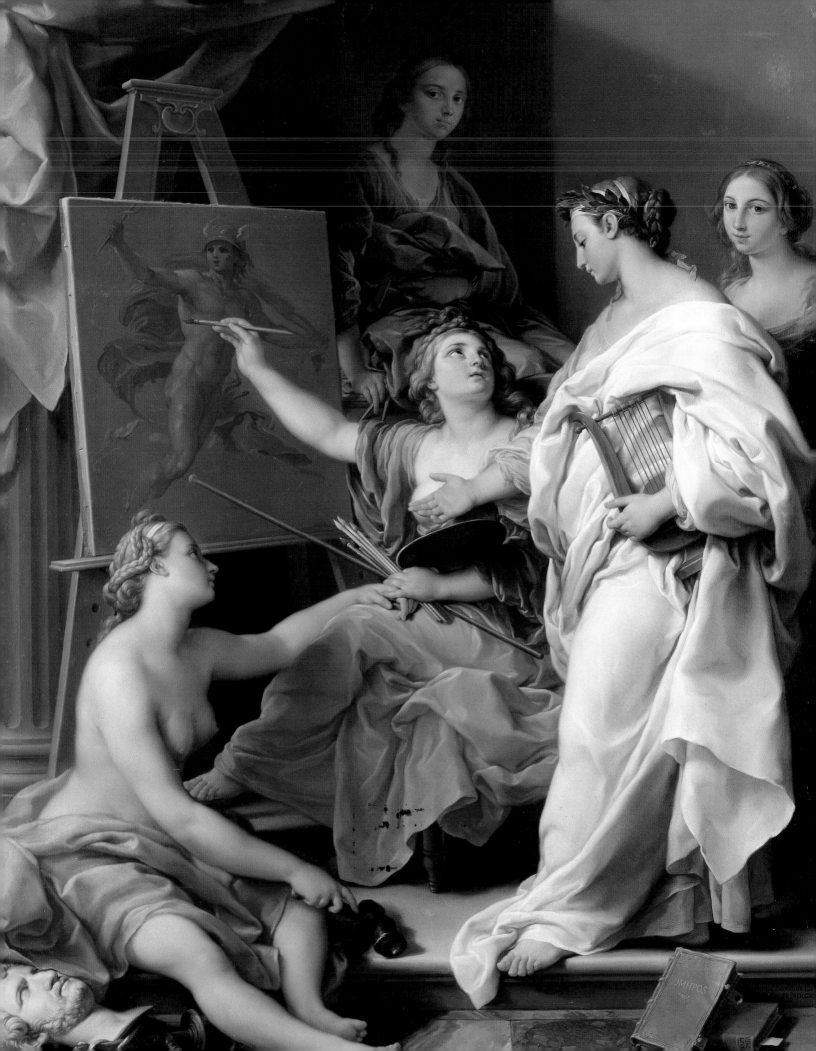

# ART IN ROME

## IN THE EIGHTEENTH CENTURY

Edited by Edgar Peters Bowron and Joseph J. Rishel

MERRELL

*in association with*

Philadelphia Museum of Art

Paperback published by Philadelphia Museum of Art, Box 7646, Philadelphia, PA 19101

Hardback first published in 2000 by
Merrell Publishers Limited
42 Southwark Street
London SE1 1UN
www.merrellpublishers.com

Distributed in the USA and Canada by Rizzoli International Publications, Inc., through St. Martin's Press, 175 Fifth Avenue, New York, New York 10010

Text © 2000 Philadelphia Museum of Art
Compilation © 2000 Philadelphia Museum of Art

Library of Congress Cataloging-in-Publication Data
Art in Rome in the eighteenth century / edited by Edgar Peters Bowron and Joseph J. Rishel.
   p. cm.
   Catalog of an exhibition held at the Philadelphia Museum of Art, Mar. 16–May 28, 2000, and The Museum of Fine Arts, Houston, June 25–Sept. 17, 2000.
  Includes bibliographical references and index.
  ISBN 1-85894-098-2 (cloth)
  ISBN 0-87633-136-3 (pbk.)
  1. Art, Italian – Italy – Rome – Exhibitions. 2. Art, Modern – 17th–18th centuries – Italy – Rome – Exhibitions. I. Bowron, Edgar Peters. II. Rishel, Joseph J. III. Philadelphia Museum of Art. IV. The Museum of Fine Arts, Houston.
N6920 .A7 2000
709′.45′63207474811–dc21        00-024655

British Library Cataloguing-in-Publication Data
Art in Rome in the eighteenth century
1. Art, Italian – Italy – Rome – Exhibitions
2. Art, Modern – 17th–18th centuries – Italy – Rome – Exhibitions
3. Architecture – Italy – Rome – History – 18th century – Exhibitions
I. Bowron, Edgar Peters
  709.4′5632′09033

Printed and bound in Italy

Jacket/cover illustrations:
Front: Giovanni Paolo Panini, detail of *Interior of an Imaginary Picture Gallery with Views of Ancient Rome*, 1756–57 (cat. 275)
Back (hardback only): *The Oceans' Coach*, 1716 (cat. 62)
Frontispiece: Pompeo Batoni, *Allegory of the Arts*, 1740 (cat. 162)

ISBN 0 87633 136 3 (paperback)
ISBN 1 85894 098 2 (hardback)

*Coordination—Philadelphia*: Publishing Department of the Philadelphia Museum of Art: George H. Marcus, Director of Publishing; Jane Watkins, Senior Editor; Nicole Amoroso, Catalogue Bibliographer; Jane Boyd and Vanessa J. Silberman, Catalogue Coordinators

*Coordination—London*: Matthew Taylor, Project Manager; Dr Helen Langdon, Consultant Editor; Lucinda Hawksley, Editorial Administrator; Michael Bird, Susan Haskins, Celia Jones, Kim Richardson, Iain Ross, Eleanor van Zandt, Copyeditors; Avril Bardoni, Kate Clayton, Jenny Coates, Stella Cragie, Tom Geddes, Judith Hayward, Simon Knight, Pamela Marwood, Jenny Marsh, Shelley Nix, and Helen Stevenson, Translators

*Design*: Matthew Hervey
with the assistance of Tom Dalton, Steven Raw, and Kate Ward

This book accompanies the exhibition
*The Splendor of 18th-Century Rome* at:

Philadelphia Museum of Art
March 16–May 28, 2000

The Museum of Fine Arts, Houston
June 25–September 17, 2000

The exhibition *The Splendor of 18th-Century Rome* was organized by the Philadelphia Museum of Art and The Museum of Fine Arts, Houston, with generous funding from the National Endowment for the Arts and the National Endowment for the Humanities, and an indemnity from the Federal Council on the Arts and the Humanities.

In Philadelphia, the exhibition is made possible by the generous support of ADVANTA and American Water Works Company.

Major support was provided by The Pew Charitable Trusts, the Connelly Foundation, the Teresa and H. John Heinz III Foundation, The Women's Committee of the Philadelphia Museum of Art, the Robert Montgomery Scott Endowment for Exhibitions, Helen B. Alter, and other generous individuals; in-kind support was provided by IBM Corporation. NBC 10 WCAU is the media sponsor. US Airways is the official airline.

# Contents

# International Honorary Committee

# Organizers of the Exhibition

# Organizing Committee

# Lenders to the Exhibition

AUSTRALIA
*Melbourne*
National Gallery of Victoria

AUSTRIA
Private collection (1)
*Vienna*
Graphische Sammlung Albertina
Kunsthistorisches Museum

CANADA
*Montreal*
Canadian Centre for Architecture
Montreal Museum of Fine Arts
*Ottawa*
The National Gallery of Canada
*Quebec*
Musée de la Civilisation, Fabrique
Notre-Dame de Québec
*Toronto*
The Art Gallery of Ontario

DENMARK
*Copenhagen*
Det danske Kunstindustrimuseum
Statens Museum for Kunst
Thorvaldsens Museum

FRANCE
Private collections (2)
*Angers*
Musée des Beaux-Arts
*Chartres*
Musée des Beaux-Arts
*Compiègne*
Musée Antoine Vivènel
*Lyon*
Musée des Beaux-Arts
*Montpellier*
Musée Fabre
*Paris*
Collection Frits Lugt, Institut
Néerlandais
Institut de France, Musée Jacquemart-
André
Musée du Louvre
*Rouen*
Musée des Beaux-Arts
*Valence*
Musée des Beaux-Arts
*Versailles*
Musée National des Châteaux de
Versailles

GERMANY
Private collection (1)
*Bayreuth*
Neues Schloss
*Berlin*
Staatliche Museen zu Berlin
Stiftung Archiv der Akademie der
Künste
*Dessau*
Anhaltische Gemäldegalerie Dessau
*Dresden*
Staatliche Kunstsammlungen Dresden
*Düsseldorf*
Kunstmuseum Düsseldorf im Ehrenhof
*Frankfurt am Main*
Städelsches Kunstinstitut
*Gotha*
Schlossmuseum
*Munich*
Bayerisches Nationalmuseum
Bayerische Staatsgemäldesammlungen
*Nürnberg*
Germanisches Nationalmuseum
*Potsdam*
Stiftung Preussischer Schlösser und
Gärten, Berlin-Brandenburg
*Stuttgart*
Staatsgalerie Stuttgart

IRELAND
*Dublin*
National Gallery of Ireland

ITALY
Private collections (12)
*Ascoli Piceno*
Pinacoteca Civica di Ascoli Piceno
*Bologna*
Roberto and Titti Franchi
Pinacoteca Nazionale
*Cantalupo*
Vincenzo Camuccini
*Fano*
Pinacoteca Civica di Fano
*Florence*
Galleria Palatina di Palazzo Pitti
Galleria degli Uffizi
*Lucca*
Museo Nazionale di Palazzo Mansi
*Matelica*
Chiesa di San Filippo Neri

*Milan*
Gabinetto dei Disegni dell'Accademia
di Belle Arti di Brera
*Naples*
Museo di Capodimonte
Museo Nazionale di San Martino
*Padua*
Musei Civici
*Piacenza*
Istituto Gazzola di Piacenza
*Pistoia*
Biblioteca Capitolare Fabroniana
*Rome*
Accademia Nazionale di San Luca
Associazione Bancaria Italiana,
Palazzo Altieri
Biblioteca Casanatense
Chiesa di Santa Francesca Romana
(Santa Maria Nova)
Chiesa di Santa Maria dell'Orazione e
Morte
Chiesa di Santa Maria in Vallicella
(Chiesa Nuova)
Gabinetto Comunale delle Stampe
Galleria Borghese
Galleria Corsini
Galleria Nazionale d'Arte Antica,
Palazzo Barberini
Istituto Nazionale per la Grafica
Fabrizio Lemme, Fiammetta Luly-
Lemme
Museo del Palazzo di Venezia
Museo di Roma
Obra Pia, on deposit at The Spanish
Embassy to the Holy See
Carlo Odescalchi
(from Chiesa dei SS. Apostoli)
Pinacoteca Capitolina
Principe Aldobrandini
Principessa Pallavicini
*Senigallia*
Palazzo Comunale
*Turin*
Musei Civici di Torino
*Tursi (Matera)*
Cattedrale di Muro Lucano
*Vatican City*
Biblioteca Apostolica Vaticana
*Venice*
Musei Civici Veneziani, Museo Correr
*Vetralla*
Chiesa di Sant'Andrea

NETHERLANDS
   *Amsterdam*
      Rijksmuseum
   *The Hague*
      Koninklijk Kabinet van Schilderijn
      Mauritshuis

POLAND
   *Warsaw*
      The Royal Łazienski Museum

PORTUGAL
   *Lisbon*
      Museu Nacional dos Coches, Lisbon
      Museu de São Roque, Santa Casa da
         Misericórdia de Lisboa

RUSSIA
   *Moscow*
      State Pushkin Museum of Fine Arts
   *St. Petersburg*
      The State Hermitage Museum

SPAIN
   *Sotogrande*
      Mrs. Juliet M. E. Hambro

SWEDEN
   *Stockholm*
      Nationalmuseum

SWITZERLAND
      Private collection (1)
   *Lausanne*
      Musée Cantonal des Beaux-Arts
   *Mendrisio*
      Massimo Martino Fine Arts & Projects
   *Zürich*
      Kunsthaus Zürich

UNITED KINGDOM
      Her Majesty Queen Elizabeth II
      Private collections (8)
   *Bakewell*
      The Duke of Devonshire, Chatsworth
   *Barnard Castle, Durham*
      The Bowes Museum
   *Birmingham*
      Birmingham Museums and Art
         Gallery
   *Calne, Wiltshire*
      Trustees of The Bowood Collection,
         Bowood House
   *Cambridge*
      The Fitzwilliam Museum
   *Edinburgh*
      National Gallery of Scotland
   *Glasgow*
      Glasgow Museums
   *Ickworth*
      Ickworth House and The National Trust

*London*
   The British Museum
   Chaucer Fine Arts, Ltd.
   Colnaghi
   Philip Hewat-Jaboor
   Holyrood Palace, Royal Collection
      Trust
   Sir John Soane's Museum
   Derek Johns
   National Gallery
   National Portrait Gallery
   Trinity Fine Art, Ltd.
   Victoria and Albert Museum
   Walpole Gallery
*Longniddry, East Lothian*
   The Earl of Wemyss and March
*Norwich*
   Norfolk Castle Museum
*Romsey, Hampshire*
   Lord Romsey, Broadlands
*Sevenoaks, Kent*
   Chevening Estate
*Stamford, Lincolnshire*
   The Burghley House Collection
*Wakefield, West Yorkshire*
   The National Trust, Nostell Priory,
   St. Oswald Collection
*Wells-next-the-Sea, Norfolk*
   The Earl of Leicester, Holkham Hall
*Windsor*
   Eton College Library
   Windsor Castle, Royal Collection

UNITED STATES
      Private collections (4)
      Robison Collection
   *Baltimore*
      The Walters Art Gallery
   *Boston*
      Boston Athenaeum
      Museum of Fine Arts
   *Brunswick, Maine*
      Bowdoin College Museum of Art
   *Cambridge, Massachusetts*
      Fogg Art Museum, Harvard
         University Art Museums
   *Chicago*
      Vincent Buonnano
      The Art Institute of Chicago
   *Cleveland*
      The Cleveland Museum of Art
   *Detroit*
      The Detroit Institute of Arts
   *Fort Worth*
      Kimbell Art Museum
   *Greenville, South Carolina*
      Bob Jones University Collection
   *Hartford*
      Wadsworth Atheneum
   *Houston*
      The Museum of Fine Arts, Houston

      The Sarah Campbell Blaffer
         Foundation
   *Indianapolis*
      Indianapolis Museum of Art
   *Kansas City*
      The Nelson-Atkins Museum of Art
   *Los Angeles*
      The Getty Research Institute for the
         History of Art
      The J. Paul Getty Museum
      Los Angeles County Museum of Art
   *Minneapolis*
      The Minneapolis Institute of Arts
   *New Haven, Connecticut*
      Yale Center for British Art
   *New York*
      Avery Architectural and Fine Arts
         Library, Columbia University
      Cooper-Hewitt National Design
         Museum, Smithsonian Institution
      The Ivor Foundation
      The Metropolitan Museum of Art
      Pace Master Prints
      The Pierpont Morgan Library
      Malcolm Wiener
   *Philadelphia*
      Philadelphia Museum of Art
   *Pittsburgh*
      Dr. Alfonso Costa
      Carnegie Museum of Art
   *Ponce, Puerto Rico*
      Museo de Arte de Ponce
   *Providence*
      Museum of Art, Rhode Island School
         of Design
   *Richmond*
      Virginia Museum of Fine Arts
   *St. Louis*
      The Saint Louis Art Museum
   *San Francisco*
      The Fine Arts Museums of San
         Francisco
   *Sarasota*
      The John and Mable Ringling Museum
         of Art
   *Toledo*
      The Toledo Museum of Art
   *Washington, D.C.*
      The Corcoran Gallery of Art
      National Gallery of Art
      The Woodner Collections (on deposit
         at the National Gallery of Art)
   *Worcester, Massachusetts*
      Worcester Art Museum

*This book is dedicated to the memory of Anthony Morris Clark*

# Preface

When the twenty-one-year-old Benjamin West set sail from Philadelphia in 1760 bound for Rome and his education as an artist, the youthful painter may not have envisioned his glory days as president of the Royal Academy in London thirty-two years later, but he ensured by his voyage that his work would bear the stamp of exposure to the greatest combination of influences—from Antiquity, the Renaissance, and the art of his contemporaries—to be had anywhere in the Western world.

It is an honor for two American museums to present this panoramic view of one of the most profoundly international "art scenes" of any century, just as this exhibition of eighteenth-century Rome ushers in a new century in our respective cities, and, in the case of Houston, a new museum building. Even for generations now accustomed to the contemporary wonders of air travel, telefax, and e-mail, let alone digital imagery transmitted by satellite, the visit to a great international exhibition where works of art made in Rome but now separated by oceans or continents rejoin each other briefly in our presence is a dazzling experience. For their sympathy with the profound scholarly and public purposes of this project, and their willingness to part with treasured objects on its behalf, we are enormously grateful to some 200 lenders in sixteen countries. Without the wholehearted support of the Italian Ministry of Culture, the Hon. Giovanna Melandri, and her distinguished associates Prof. Dott. Mario Serio, Direttore Generale, Ufficio Centrale per i Beni Archeologici, Architettonici, Artistici e Storici at the ministry, and Prof. Dott. Claudio Strinati, Soprintendente, Soprintendenza per i Beni Artistici e Storici di Roma, this project which has depended so deeply on the enthusiastic cooperation of so many museums, churches, and collections in Italy, would never have been possible. We are profoundly grateful to them, and to their courteous and helpful colleagues in the official Italian cultural community at all levels.

The panoply of generous sponsors and contributors to this project is as substantial

and diverse as the exhibition itself. To the National Endowment for the Humanities, which supported essential years of research and preparation with a planning grant, followed by a handsome grant for implementation, we have been grateful from the start. The NEH has been very generously joined by a mix of public and private support from The Pew Charitable Trusts, the Theresa and H. John Heinz III Foundation, the Connelly Foundation, Helen B. Alter, and several anonymous individuals, The Women's Committee of the Philadelphia Museum of Art, the Robert Montgomery Scott Endowment for Exhibitions, and the National Endowment for the Arts. An indemnity from the Federal Council on the Arts and the Humanities will assist substantially with insurance costs. To our corporate sponsors goes a particular vote of thanks for not only supporting this major cultural endeavor for the year 2000, but for helping to spread the word to a broad audience through their own marketing and media outreach. Advanta and American Water Works Company have taken the lead in corporate sponsorship of this project in Philadelphia, and IBM Corporation has assisted with in-kind support. NBC 10 WCAU is the media sponsor in Philadelphia, and US Airways is the official airline.

This exhibition and the accompanying catalogue have been long in the making. In June 1991 a group of friends met for a weekend in the house of Stefano Susinno in San Casciano dei Bagni (in Tuscany) to outline a long-discussed exhibition that would survey all the arts made in Rome through the eighteenth century. With Susinno as host, the party consisted of Ann Percy, Liliana Barroero, Edgar Peters Bowron, and Joseph Rishel. A car trunkful of books had been borrowed from the University of Rome and in a leisurely fashion, befitting the place and the season and very much the subject at hand, essential ideas emerged that would govern the specific selection of the exhibition. Inclusions and rejections were debated, but a remarkable consensus was soon formed as to what made Roman art Roman, in that most polyglot and cosmopolitan city. For drawings and paintings a core of ten figures was established, those artists who by collective agreement were at the center of picturemaking in eighteenth-

century Rome, and who it was felt must be given the largest representation in the show. They were Carlo Maratti, Pier Leone Ghezzi, Corrado Giaquinto, Pompeo Batoni, Giovanni Paolo Panini, Anton Raphael Mengs, Angelika Kauffmann, Pierre Subleyras, Jacques-Louis David, and Giuseppe Cades. It will be quickly noted that of these ten, one is German, one Swiss, and two French, while the others are from places that marked them in the Papal States as "foreign"—from Venice, Naples, and Lucca—with only one artist born in Rome: Pier Leone Ghezzi. This demonstrated early on one of the exhibition's central premises: Rome, like Paris in the nineteenth century and New York in the twentieth, acted as a magnetic center for the training, making, and export of art and artistic ideas.

That small group of friends was sharply aware of their bias toward painting and drawing, and it was soon decided that it was necessary to be sufficiently ambitious to include the other arts, which played an equally critical role in the Roman artistic dominance of the eighteenth century. John Pinto, from Princeton University, was recruited to select objects and write about architecture; Malcolm Campbell, from the University of Pennsylvania, was asked to form a selection on printmaking with, inevitably, Giovanni Battista Piranesi as the star. The decorative arts must clearly be given a proportionately large presentation and we quickly turned to the long-established expertise of the connoisseur/scholar Alvar González-Palacios, whose research and publications in this field have established a new level of insight. Dean Walker from the Philadelphia Museum of Art gallantly accepted responsibility for sculpture in the show, one of the least researched yet central aspects of Roman artistic production.

Nearly all of these people had been attracted to the subject of eighteenth-century Rome through the scholarship and hugely engaging personality of Anthony Morris Clark, who by the time of his untimely death in 1976 had made this area very much his own "campo," winning over established scholars and students alike to the delights and demands of Settecento Roman studies. Ann Percy, with Ulrich Hiesinger, had published in 1980 Clark's drawing collection, which had been bequeathed to the Philadelphia Museum of

Art by his estate. Pete Bowron as Clark's literary executor edited his essays and in remarkably swift order published Clark's proposed book on Batoni, left only in note form at his death. Three other colleagues soon became central to the organization of the show: Christopher M. S. Johns, from the University of Virginia, who had already demonstrated his particular skill at balancing archival investigations with achieved monuments through his work first on the patronage of Pope Clement XI Albani and then Antonio Canova; Ornella Francisci Osti, whose knowledge and nimble wit were required to select and evoke the personalities who truly characterized the sophistication of that place at that moment; and Jon Seydl, who moved to Philadelphia as a graduate student at the University of Pennsylvania in 1994 and was hired as the coordinator of the complex business of loan negotiations and as overall exhibition coordinator. Seydl has played a vital role in the entire enterprise and has provided the illustrated chronology. Jennifer Vanim in the European Painting

Department has been in charge of gathering all images required for this book, a trying job that she has done perfectly.

From that first meeting in 1991 it was clear that as many colleagues as possible must be involved in the project, much in the spirit of Clark's energetic and encompassing interests, but also to reflect fairly the completely international aspect of Roman studies at the present moment. The large number of contributing authors writing here—some sixty-nine scholars writing in nine different languages—amply suggests the burgeoning and diverse growth of the field. We owe them all a great debt of thanks.

The organizing team of the exhibiton has depended daily on the kindness of a wide array of colleagues and friends: diplomats, scholars, librarians, art packers, translators, editors, installation designers, and preparators. We have attempted to name some of these people in the acknowledgments at the end of this book, but it would be remiss of us not to single out the efforts of the Senior

Registrar of the Philadelphia Museum of Art, Irene Taurins, for her deft maneuvering of such a varied and large number of objects across the seas and a continent. Carl Brandon Strehlke in Philadelphia and Florence has also been an essential friend of the project since its conception, helping to shape its organization and attending to many critical details.

Finally, at the turn of the millennium which is, of course, the Jubilee year of Rome itself, we very much hope that this exhibition will be received in the spirit of this celebratory moment, a spirit that prompted the making of much that is on view here.

*Anne d'Harnoncourt*
The George D. Widener Director
Philadelphia Museum of Art

*Peter C. Marzio*
Director
The Museum of Fine Arts, Houston

# Foreword

Few cities in the world have experienced such tumultuous and significant changes over the centuries as Rome. From bucolic village, kingdom, republic, capital of an empire, seat of the papal court and center of Christendom, to kingdom once again, Rome is now capital of a modern republic as well as the administrative base for one of the world's largest religions. Yet in the popular imagination and in fact, Rome has maintained a remarkable continuity for two and a half thousand years during its evolution from a settlement on the Palatine to the capital of the Italian state. Rome's perpetual ability to regenerate itself, to foster cosmopolitan and innovative societies, and to seek and attract the finest talents in many fields of human endeavor, has always accorded the city huge historical and artistic importance. Whether the ancient Roman's *caput mundi*, Goethe's "Haupstadt der Weltangelangt," or—as the popular cliché would have it—the place to which all roads lead, Rome's heritage has inspired and fascinated generations of artists and architects, both native and foreign.

At the beginning of the last century, the art of Italy was best understood, almost to the exclusion of all other aspects, for its achievements during the Renaissance in Tuscany. Only in the 1920s, when a small group of Italian and German scholars began to reconsider Italian art of the sixteenth and seventeenth centuries, did Rome regain center stage as a center of creativity and patronage. Following the Second World War these interests blossomed into a full-scale reevaluation of the art of the Counter-Reformation, which elevated Rome over Florence, Venice, Milan, Naples, and other Italian centers in terms of culture, political power, and artistic production.

Seventeenth-century studies found fertile ground in Germany, Italy, Great Britain, and America, and burgeoned, evolving with tremendous vitality through publications, restorations of works of art, and exhibitions. Just as this exhibition opens in Philadelphia, for example, an equally ambitious and innovative show will take place in Rome, examining the influence of the seventeenth-century critic, antiquarian, and tastemaker Giovan Pietro Bellori (1613–1696). It was Bellori who, through his artistic friendships and his *Vite de'*

*pittori, scultori et architetti moderni*, did much to establish in the modern mind the basic concept of Roman art as the product of a long and constant deference to, and defense of, the doctrines of ideal beauty, the antique as *the* model of excellence, and the Grand Manner.

Inevitably, twentieth-century interest in seventeenth-century Roman art led to curiosity about the artistic activities of the city in the aftermath of the Baroque. In many instances, however, such studies still deferred to the apparently more heroic (more "modern" for some) doings of the seventeenth century, a view exemplified in Rudolph Wittkower's canonical survey *Art and Architecture in Italy 1600–1750*. Although he thrust his interest in the seventeenth century forward into the Settecento, there is a noticeable lack of interest in the Roman art and artists subsumed under the rubric "Late Baroque." But in 1959, the year after Wittkower published the first edition of his magisterial book, an extraordinary exhibition devoted to *Il Settecento a Roma* was held in Rome at the Palazzo delle Esposizioni, the cavernous Renaissance Revival exhibition hall erected on via Nazionale in 1878–82, which laid the foundation for a new appreciation of this splendid chapter in the city's artistic history.

Organized by the "Associazione Amici dei Musei di Roma" under the leadership of Emilio Lavagnino, Nolfo di Carpegna, Carlo Pietrangeli, and a host of Italian and European scholars, the show contained 2,656 items, including paintings, sculpture, drawings, prints, books, manuscripts, maps, plans, musical scores, historical documents, medals, furniture, decorative arts, and tapestries. More than 600 paintings alone composed an extraordinary survey of the pictorial efforts of nearly every Italian, British, French, German, and Scandinavian painter resident, however briefly, in the Eternal City in the eighteenth century. There were omissions, of course (Pietro Bianchi, Vincenzo Camuccini, the subject paintings of Pier Leone Ghezzi), but as a survey the exhibition was remarkable and encompassed such well-known pictures as Batoni's double-portrait of the *Holy Roman Emperor Joseph II and His Brother Leopold I, Grand Duke of Tuscany* in Vienna (cat. 172) and those obscure as a landscape by the little-known Scottish painter George Augustus

Wallis, who went to Rome in 1788 as the protégé of Lord Warlock.

The critical fortunes of many of the artists featured in the 1959 exhibition followed a familiar pattern. Their works, acclaimed by contemporaries and generally admired throughout much of the eighteenth century, were censured and eventually neglected in the nineteenth, only to be gradually revalued and appreciated once again after 1900. From the 1950s, Roman eighteenth-century art found increasing appeal among European museums, collectors, and connoisseurs, who recognized its quality and value. In the 1960s and 1970s, in part owing to the influence and enthusiasm of the American scholar and museum director Anthony Morris Clark (1923–1976), art museums in the United States bought (often incredibly cheaply) exceptionally fine works from the period, and even a few American art historians were encouraged to concentrate their studies in this historical period.

Unfortunately for the average museum visitor, eighteenth-century Rome remains terra incognita, and the work of even its finest painters, sculptors, and architects, strange and unfamiliar, with the possible exception of Giovanni Battista Piranesi and Giovanni Paolo Panini. It is difficult to see fine examples of their work in the original outside Rome and even there, the closure of the Villa Borghese (until recently), the Museo di Roma, and the Settecento collections of the Palazzo Barberini—not to mention the vagaries of access to Roman churches and palaces—has meant that Roman Settecento painting, sculpture, and decorative art, even in the city of their origin, are difficult to appreciate except for the most persistent and privileged observer.

Nonetheless, the scholarship devoted to Roman Settecento art has developed rapidly in scope and sophistication since the 1959 exhibition. During the past four decades, an astonishing amount of information has been published on a wide range of individual artists, patrons, collectors, and institutions such as the Accademia di S. Luca, and the boundaries of the field have been enlarged in many directions. Gradually, our understanding of what happened in the arts in Rome during this period is increasing. A number of important Roman painters, for example—Pompeo

Batoni, Jan Frans van Bloemen, Giuseppe Cades, Felice Giani, Jakob Philipp Hackert, Hendrik Frans van Lint, Andrea Locatelli, Anton Raphael Mengs, Giovanni Paolo Panini, Pierre Subleyras, Francesco Trevisani, and Gaspar van Wittel among them—have been the subject of authoritative scholarly monographs or catalogues raisonnés. One might wish that the work of these artists were admired a little more for its intrinsic aesthetic quality, often wondrous state of preservation, and historical merit than strictly for its proximity to or remoteness from Neoclassicism, however: David's *Oath of the Horatii* (1784; Musée du Louvre, Paris), the textbook example of the Neoclassical style, represents neither the goal nor the pinnacle of nearly a century's effort on the part of dozens of painters in eighteenth-century Rome, but the interest of too many writers on the period continues to hinge upon this proposition.

This is not to deny the significance of Neoclassicism, the dominant movement in European art and architecture in the late eighteenth century and early nineteenth. In fact, renewed attention to the new Neoclassical ideas of "noble simplicity and calm grandeur," notably the work of Anton Raphael Mengs, Antonio Canova, and Jacques-Louis David, has furthered the notion of Rome's importance as an artistic center throughout the eighteenth century, even and perhaps especially in the fields of architecture and the decorative arts. This interest, prompted by the writings of Mario Praz just after the war, was the subject of a vast Council of Europe exhibition in London in 1972, *The Age of Neo-Classicism*. The degree to which Rome served as the crucible for Neoclassicism, in spite of the pan-European nature of the movement and its efflorescence in London, Paris, Berlin, Stockholm, and St. Petersburg, remains striking.

The art of Settecento Rome, in all of its ideological forms and stylistic inflections, was fervently embraced by Anthony Morris Clark, to whom this catalogue and exhibition are dedicated. Having gone to Europe from Harvard just after the war as a painter, he fell in love with Rome and became a joyous and passionate advocate of both the city and its cultural and artistic achievements in the eighteenth century. Clark returned to America after several years in Rome with firm beliefs about the importance that Roman eighteenth-century art and culture held for Europe as a whole. His first exhibition on the subject, which he organized in 1957 at the Museum of

Art, Rhode Island School of Design, was entitled *The Age of Canova*. A decade later, relishing his skills (and growing international reputation) as a provocative impresario of all things Roman and Settecento, he organized with John Maxon and Italo Faldi a landmark survey, *Painting in Italy in the Eighteenth Century: Rococo to Romanticism* (1970; Chicago, Minneapolis, and Toledo; catalogue edited by Joseph Rishel and Anselmo Carini), in which he presented to a larger audience his strong Roman predilections. The present exhibition is, in a variety of ways, a continuation of Tony Clark's work, particularly since so many ideas presented here (and so many of the people involved in the research and writing for this project) can be traced directly to his generous scholarship, ample gifts for friendship, and enthusiasm for the Roman Settecento.

Thanks to Clark's efforts and those of several other scholars of his generation, notably Giuliano Briganti, Andrea Busiri Vici, Italo Faldi, Olivier Michel, and Sir Ellis Waterhouse, the view that Rome declined as an artistic center in the late seventeenth century and the eighteenth has been reevaluated. A look around the walls of this exhibition should expunge any doubt about the aesthetic quality of Roman art and architecture in the eighteenth century. Surely, in this assemblage of works drawn from around the globe, it should be possible to understand why, throughout the eighteenth century, nearly every European artist of significance made a pilgrimage to Rome to study its artistic heritage and to view at firsthand the latest productions of its painters, draftsmen, sculptors, printmakers, architects, and craftsmen.

Our purpose here is thus both confirmational and subversive. We profoundly believe that the artistic creations of eighteenth-century Rome are worth examining, if only for the enormous aesthetic pleasure they provide. The accounts of foreign visitors to the city are filled with details of the delight, even rapture, they experienced when viewing the latest efforts of the city's leading artists. Tourists' itineraries at the time often included visits to artists' studios, where, pleased by the works on view, they commissioned paintings and other works of art. Among the criteria of selection for the works in the exhibition, artistic quality has always remained at the forefront, and nothing would please the organizers more than if our visitors were to respond to what they see in Philadelphia and Houston with the same unabashed enthusiasm as their

British, French, German, and Russian predecessors seeing these works for the first time in Rome some two hundred years ago.

But in an exhibition of such size, scope, and expense we also felt it necessary—in the spirit of Tony Clark's pioneering enthusiasms—to challenge certain accepted beliefs and values about the history of later Italian art (not to mention the history of modern Europe) and aggressively to promote Rome as one of the liveliest cultural and artistic centers in eighteenth-century Europe, the preeminent international school of art, and the place where new ideas were most often hatched, nurtured, developed, and launched into international circulation. In other words, we have sought to reinforce Clark's belief that in the eighteenth century "Rome was still the greatest European city, the most artistically wealthy city, and the Mecca both of every young artist and of every cultivated person."

From the start it was our intention to view Settecento Rome and its artistic achievements not solely through the eyes of the British Grand Tourist or, say, a *pensionnaire* at the French Academy at Rome, but to examine less familiar subjects. In both the essays and the individual entries in this catalogue, we have asked our contributors not only to remind us of the often dazzling artistic significance of the works at hand but also to examine them in the light of the most recent research and of the interests of scholars around the world. Thus, the reader of this catalogue will be introduced to the Accademia dell'Arcadia, the Concorso Clementino (a student competition in the Accademia di S. Luca named in honor of Pope Clement XI), church restoration and urbanism, pietism and hagiography, the Chinea and Lateran *possesso* festivals, archaeology, the Accademia del Nudo, Roman libraries and museums, canonization and beatification *apparati*, questions of iconography, liturgy, and theology, the revival of early Christian art, ephemeral architecture, patronage and collecting, aristocratic families and the clerical élite, and political and economic issues, to mention but a few of the subjects examined by the authors in this panoramic survey of eighteenth-century Roman art and architecture. Goethe, in his rambles around the "hub of the world," found that "in every corner there are magnificent things which are almost never mentioned." We are pleased to illuminate a few of them.

*Edgar Peters Bowron and Joseph J. Rishel*

# Contributing Authors

KAS Katrin Achilles-Syndram, *Staatliche Museen zu Berlin*

SA Sergej Androsov, *The State Hermitage Museum, St. Petersburg*

LA Luciano Arcangeli, *Ministero per i Beni Culturali e Ambientali, Rome*

AB Andrea Bacchi, *Università di Trento, Italy*

MB Malcolm Baker, *Deputy Head of Research, Victoria and Albert Museum, London*

MGB Maria Giulia Barberini, *Curator, Museo del Palazzo di Venezia, Rome*

LB Liliana Barroero, *Dipartimento di Studi Storico-artistici, Archeologici e sulla Conservazione, Università di Roma Tre, Rome*

CB Charles Beddington, *London*

SB Sylvain Bellanger, *Curator, 19th-Century European Painting, The Cleveland Museum of Art*

SBE Silvana Bessone, *Directora, Museu Nacional dos Coches, Lisbon*

DB David Bindman, *Professor of the History of Art, University College London*

DEB Dilys E. Blum, *Curator of Costume and Textiles, Philadelphia Museum of Art*

EPB Edgar Peters Bowron, *The Audrey Jones Beck Curator of European Art, The Museum of Fine Arts, Houston*

MLB Melissa L. Bryan, *Visiting Assistant Professor, Rochester Institute of Technology*

EC Emilia Calbi, *Dipartimento delle Arti Visive, Università degli Studi di Bologna*

MC Malcolm Campbell, *University of Pennsylvania, Philadelphia*

RJC Richard J. Campbell, *John E. Andrus III Curator of Prints and Drawings, The Minneapolis Institute of Arts*

MTC Maria Teresa Caracciolo, *Chargée de recherche, C.N.R.S. Université Lille*

VC Victor Carlson, *Senior Curator, Prints & Drawings, Los Angeles County Museum of Art*

AC Allan Ceen, *Professor of History of Architecture, The Pennsylvania State University, Rome Program*

IC Irene Cioffi, *London*

ANC Angela N. Cipriani, *Accademia Nazionale di San Luca, Rome*

JC Jeffrey Collins, *Assistant Professor of Art History, University of Washington, Seattle*

PC Philip Conisbee, *Senior Curator of European Paintings, National Gallery of Art, Washington, D.C.*

FC Fintan Cullen, *University of Nottingham*

CF Chiara Felicetti, *Predazzo, Italy*

PF Peggy Fogelman, *Associate Curator, Sculpture & Works of Art, The J. Paul Getty Museum, Los Angeles*

OFO Ornella Francisci Osti, *Rome*

DGA Donald Garstang, *Colnaghi, London*

AGP Alvar González-Palacios, *Rome*

DG Dieter Graf, *Bibliotheca Hertziana, Max-Planck-Institut für Kunstgeschichte, Rome*

SG Stefano Grandesso, *Rome*

JH James Harper, *Department of Fine Arts, Trinity College, Hartford, Connecticut*

SH Seymour Howard, *Research Professor, University of California at Davis*

CMSJ Christopher M. S. Johns, *Professor of Art History, University of Virginia, Charlottesville*

CJ Catherine Johnston, *Curator of European Art, The National Gallery of Canada, Ottawa*

JKB John Kenworthy-Browne, *London*

EK Elisabeth Kieven, *Bibliotheca Hertziana, Max-Planck-Institut für Kunstgeschichte, Rome*

PK Patrick Kragelund, *Director, Kunstakademiets Bibliotek, Copenhagen*

SL Sylvain Laveissière, *Conservateur en chef au Département des Peintures, Musée du Louvre, Paris*

RL Rossella Leone, *Museo di Roma*

ALB Anna Lo Bianco, *Soprintendenza Beni Artistici e Storici di Roma*

TJMCC Thomas J. McCormick, *Professor Emeritus, Wheaton College, Massachusetts*

JPM J. Patrice Marandel, *Curator, European Painting and Sculpture, Los Angeles County Museum of Art*

FM Frank Martin, *Deutsche Forschungsgemeinschaft, Bonn*

OM Olivier Michel, *Paris*

VHM Vernon Hyde Minor, *Professor of Art History and Humanities, The University of Colorado at Boulder*

JM Jennifer Montagu, *Warburg Institute, London*

TM Teresa Morna, *Museu de São Roque, Lisbon*

MO Magnus Olausson, *Associate Professor and Senior Curator of the Royal Castle Collection, Nationalmuseum, Stockholm*

AOC Anna Ottani Cavina, *Professore, Università degli Studi di Bologna*

FP Fiorella Pansecchi, *Rome*

AP Ann Percy, *Curator of Drawings, Philadelphia Museum of Art*

JP John Pinto, *Howard Crosby Butler Memorial Professor of the History of Architecture, Princeton University*

ALP Anne L. Poulet, *Russell B. and Andrée Beauchamp Stearns Curator of European Decorative Arts and Sculpture Emerita, Museum of Fine Arts, Boston*

JR Joseph J. Rishel, *The Dennis and Gisela Alter Senior Curator of European Painting and Sculpture before 1900, Philadelphia Museum of Art*

SPVR Simonetta Prosperi Valenti Rodinò, *Università della Tuscia, Viterbo*

SR Steffi Roettgen, *University of Munich*

PR Pierre Rosenberg, *Président-Directeur, Musée du Louvre, Paris*

SMCR Stella (Margaret Camp) Rudolph, *Florence*

IS Isabella Schmittmann, *Munich*

AS Almuth Schuttwolf, *Kustos Schlossmuseum, Gotha, Germany*

JLS Jon L. Seydl, *European Painting and Sculpture before 1900, Philadelphia Museum of Art*

SS Stefano Susinno, *Dipartimento di Studi Storico-artistici, Archeologici e sulla Conservazione, Università di Roma Tre, Rome*

RV Roberto Valeriani, *Rome*

DW Dean Walker, *Henry P. McIlhenny Senior Curator of European Decorative Arts and Sculpture, Philadelphia Museum of Art*

SW Stefanie Walker, *Assistant Professor, Bard Graduate Center for Studies in the Decorative Arts, New York*

DHW David H. Weinglass, *Professor of English, University of Missouri-Kansas City*

RW Robert Wolterstorff, *Director, Victoria Museum, Portland, Maine*

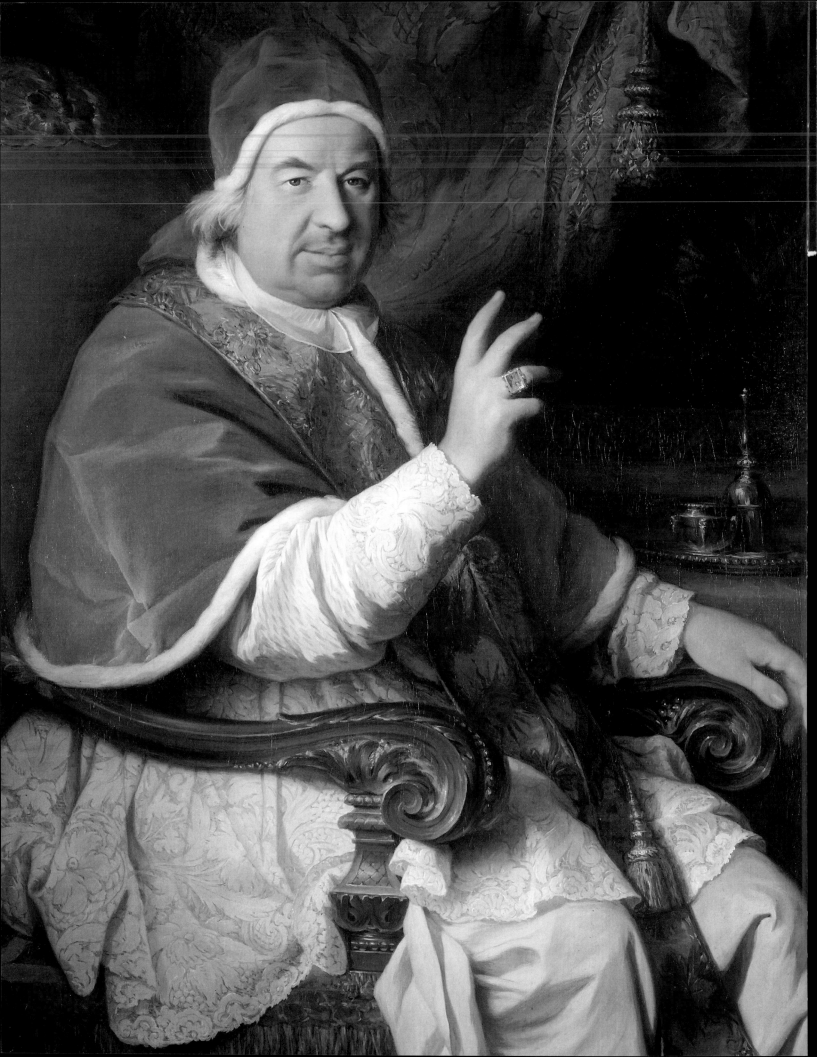

# The Entrepôt of Europe: Rome in the Eighteenth Century

## CHRISTOPHER M. S. JOHNS

Living in the shadow of the Baroque has not been easy for eighteenth-century Roman art. Long judged by aesthetic, formal, and iconographic categories invented to describe, classify, and explain the art of the seventeenth century, Roman art of the Settecento (the Italian designation for the eighteenth century) has often been relegated historically to a secondary, inferior position. This attitude has been especially true of non-Italian scholarship and is more frequently encountered in the history and criticism of painting and sculpture than of architecture and printmaking. Indeed, the magnificent scale and urbanistic ambition of such monuments as the Spanish Steps (cat. 19) compare favorably to such Baroque architectural initiatives as the Piazza Navona, while the astonishingly high quality and fame of the prints of Giovanni Battista Piranesi (see *Prints* section of the Catalogue) overshadow the achievements of the previous century.

With sculpture and especially painting, always celebrated in the canon of art-historical scholarship and teaching, it is a different story, however. The emphasis on Baroque art in the Western canon is in large part historically determined. The nepotistic, aggressive, and aggrandizing building and decorative programs of the seventeenth-century papal families and their associates provided myriad opportunities for painters and sculptors that were not nearly so numerous in the next century. And there was certainly no dearth of talent. Such names as Caravaggio, the Carracci, Guido Reni, Domenichino, Pietro da Cortona, Gianlorenzo Bernini, Claude Lorrain, Nicolas Poussin, Salvator Rosa, Giovanni Battista Gaulli, and many others feature prominently in most major museum collections and still fetch enormous sums when their works infrequently appear on the art market. Of their Settecento successors, only Pompeo Batoni and Antonio Canova are well known today, and they are certainly not so highly esteemed as their illustrious Baroque predecessors. But in their own time these now neglected eighteenth-century artists were household names all over Europe.

What historical process has all but effaced their memory from the western cultural consciousness? As Sir Joshua Reynolds predicted in his *Discourses on Art*, the names of Batoni and Anton Raphael Mengs, his contemporaries, soon fell into the same oblivion where the painters of the previous generation (Sebastiano Conca, Placido Costanzi, Francesco Fernandi, *called* Imperiali, and Agostino Masucci) now reside.[1] In fact, we might add to Reynolds's mean-spirited list every painter and sculptor included in the present exhibition, with the sole exception of Canova. I believe that much of the "oblivion" populated by Roman eighteenth-century artists has been constructed on ignorance of the art itself, a problem the present exhibition will partly resolve. The relative rarity (outside Italy) of the cultural production of eighteenth-century Rome is the culprit in this case. More insidious is the modernist prejudice against all academically inspired art, which was considered compromised and tainted by the institutions that helped to create it. But in a postmodern world, the championship of "originality" over "rationality" is no longer in play, and we may finally revisit the art of eighteenth-century Rome and evaluate it on its own terms.

There are many problematic aspects of the historiography of the art of the Baroque and of the eighteenth century that have tended to minimize the distinctiveness and historical importance of the latter while trumpeting the accomplishments of the former. In addition, patterns of scholarship of eighteenth-century art have tended to spotlight Venetian painting while denigrating (or largely ignoring) contemporary painting at Rome. The history of eighteenth-century sculpture before Canova's definitive move to Rome in 1780 has largely been the history of French sculpture, and only in recent years has British and Italian sculpture received much scholarly attention outside Italy.[2] Fortunately, architecture and printmaking have helped keep Roman art in the canon, but only in a relatively limited way. Thus, one of the goals of the present exhibition is to present eighteenth-century Rome and its cultural production as part of an art-historical "period" unto itself. Similarly, greater emphasis on historical importance, as opposed to mere aesthetic preference, is necessary to

separate Venice from the Eternal City in the contemporary art-historical imagination. But historical significance is augmented by this exhibition's desire to present works of art of very high quality to an American public, a goal readily attained because of the high standards of eighteenth-century academic instruction and the period's extremely competitive market. To achieve this goal, some conceptual problems must first be addressed.

The two major historiographical problems confronting a sustained reconsideration of eighteenth-century Roman art are the long-standing popularity of Settecento Venetian painting, above all among the British, and the traditional status in art-historical literature of the eighteenth century as an appendage to or afterthought of the Baroque. Public and private collections in Great Britain have long preserved many splendid examples of works by artists of the Serene Republic of Venice. This phenomenon has marginalized Rome in the abbreviated survey books of eighteenth-century Italian art and in the few galleries devoted to the period. This pattern has been widely repeated by American museums and private collections. Arguably, the view paintings of Antonio Canaletto have impressed themselves on the consciousness of scholars and art lovers even more than the Grand Tour portraits of Batoni as the characteristic examples of Settecento Italian painting.[3] While undeniably important and often of exceptionally high quality, Venetian *vedute* enjoyed very little aesthetic or intellectual prestige in the eighteenth century and their popularity was a sore point to many historical painters. The genre of history painting, however, was not undergoing an identity crisis in Rome as it was in contemporary France, primarily because it still had a flourishing foreign market and continued to enjoy tremendous prestige (and numerous commissions) in Rome, throughout Italy, and beyond the Alps. Many painters in Rome received impressive commissions from Grand Tourists for mythological, historical, allegorical, and religious subjects, but this pattern of patronage has been relatively unappreciated because of the mania for portraits and painted views as the "typical" acquisitions from contemporary artists by privileged visitors to Rome. Mengs's *Augustus and Cleopatra* of c. 1759, commissioned by Sir Richard Colt

Hoare for his estate at Stourhead, is a good example.[4] Sculptors of various nationalities also received important commissions from visitors for works besides potboiling portrait busts, although these were also popular. John Flaxman's celebrated *Fury of Athamas*, commissioned by the eccentric Frederick Hervey, Earl of Bristol and Bishop of Derry, is a monumental sculpture that could only have been commissioned in Rome, despite the fact that both sculptor and patron were English.[5] Such was the cultural influence of the entrepôt of Europe.

Another problem facing a more positive evaluation of art in eighteenth-century Rome is chronological in nature. Academic curricula, especially in the United States, rarely include courses on the eighteenth century except as add-ons or afterthoughts to surveys of the Baroque. My own undergraduate exposure to the Italian eighteenth century was less than three lectures in a semester course that spent almost a month on Bernini and, alas, this situation is not much improved two decades later. And even when an independent course on the eighteenth century is in place, its chief focus is France and Britain; the coverage afforded Italy is limited almost entirely to Venice and, perhaps, a Grand Tour portrait by Pompeo Batoni. Because the post-Renaissance, pre-modern curriculum extensively privileges the seventeenth century, few textbooks seriously consider the Settecento.[6] Indeed, the chronological bifurcation of the eighteenth century in Rudolf Wittkower's otherwise splendid *Art and Architecture in Italy 1600 to 1750* has done much to inhibit reconsideration of the Settecento as an independent era.[7] The year 1750 means nothing, art-historically speaking, to Italy. Wittkower's treatment of Italian architecture of the first half of the century is, predictably, excellent, but his discussion of painting and sculpture is no more than cursory. Fifty years of the Roman school of painters are represented by only four objects, one painting each by Conca, Marco Benefial, Giovanni Paolo Panini, and Batoni. The rather atypical *Achilles and Chiron* from the Uffizi represents the œuvre of the century's most famous painter. One cannot help but come to the conclusion that its date, c. 1746, was the deciding factor for its inclusion. Thus, the chronological constraints of Wittkower's influential book, widely used even today as a textbook for Baroque surveys, have hamstrung attempts to study the Settecento as a discrete century. Another frequently encountered textbook, Julius S. Held and Donald Posner's *17th- and 18th-Century Art: Baroque Painting, Sculpture, Architecture*, devotes a chapter to the Italian Settecento, but only two Roman works, a Batoni portrait and Mengs's *Parnassus* from the Villa Albani, are very briefly considered.[8] In fact, the subtitle "Baroque" tells the story—this book also makes the fundamental assumption that the Italian eighteenth century is a Baroque afterthought, a quiet art-historical eddy, of interest only to specialists and lovers of Venice.

Given the fact that the pedagogy of art history demands taxonomic categories into which the art of a period may be placed, it is important to note that Roman art of the first sixty years of the Settecento cannot be organically positioned in any canonical period designation. This phenomenon has also worked against the integration of eighteenth-century art into the teaching narratives of post-Renaissance Italian art. Since the Rococo is an admittedly problematic stylistic designation for much of the era's cultural production, given the general perception, however erroneous, that it is an exclusively French and south German phenomenon, the Italian word *barocchetto* has been substituted. This has had a highly negative influence on the critical reception of early Settecento Roman art. The Italian suffix *-etto* signifies diminution; thus, *barocchetto* essentially means "little Baroque." Given the notion of grandeur of scale as one of the compellingly positive qualities of Seicento Baroque art, the "little" version of this style can only be interpreted as being inferior and essentially derivative. The same may be said of the less pejorative but still condescending term "Late Baroque." Moreover, like the traditional descriptions of the French Rococo, Italian *barocchetto* implies an art of easy grace, charm, and "feminine" elegance.[9]

Although grace, charm, and elegance are accurate and helpful words to describe much early Settecento Roman art, our culturally determined prejudice reacts negatively against such formal characteristics, which we tend to gender as feminine. Gender stereotyping deeply, if subconsciously, colors our reaction to and reception of Baroque and eighteenth-century art. In gendered language, the Baroque is either dynamic and triumphant or rational and balanced, depending on what type of Baroque art is under consideration, while such terms as coy, suave, and decorative are employed to characterize the art and architecture of most of the following century. In a largely unintentional but nonetheless real way, *barocchetto* has marginalized and stigmatized pre-Neoclassical art in accordance with the broader stream of phallocentric cultural critique. Once it is acknowledged as biased and arbitrary, such a term can no longer be instructively employed in period narratives. For my purposes, "eighteenth-century art" is sufficient to describe the period, since it can never fit comfortably into any preexisting art-historical categories, and I believe it would be counterproductive to attempt to invent a new designation.

A final problem confronting a more balanced evaluation of the artistic achievements of Settecento Rome is the dearth of "big name" artists, especially in comparison to the "giants" of the seventeenth century. With few exceptions, even the names of the leading artists of the Roman school in the age of the Enlightenment are known outside Italy only to specialists. In the art-historical canon today Rome has no rival to Canaletto, Tiepolo, Hogarth, Gainsborough, Watteau, Fragonard, David, or Goya. The paucity of high-profile artists, in terms of the modern art market, has not only reinforced the traditional scholarly neglect afforded the period but has inhibited more public-oriented attempts to familiarize a broader audience with cultural practitioners who were highly acclaimed in their own time. This neglect has been followed in both the market, where few Settecento Roman paintings and drawings attract significant attention, and, predictably, in the collecting patterns of many major museums. While such prominent institutions as the Metropolitan Museum of Art, the Philadelphia Museum of Art, and the Los Angeles County Museum of Art, among others, have acquired pictures by Batoni, Giuseppe Bartolomeo Chiari, Mengs, and others in recent years, major Roman painters are still either underrepresented or ignored altogether in many American and British museums. It is significant and telling that Washington's National Gallery of Art declined to acquire Batoni's spectacular Grand Tour *Portrait of William Knatchbull-Wyndham* (cat. 169), even though the gallery has no picture by Batoni in its collection and in spite of remarkable recent public interest in the Grand Tour and its images. That a supposedly representative national collection would spurn such a picture is evidence of an enduring prejudice against eighteenth-century Roman art that the present exhibition hopes to overcome.

A particularly fruitful strategy for reassessing Roman art of the Settecento entails a reconsideration of the notion of the "foreign" artist. What does the adjective "foreign" actually mean in the context of eighteenth-century Rome? This question has two major aspects: whether or not non-Roman Italian artists should be considered "aliens" and whether or not this designation should be extended to transalpine artists who spent most or all of their careers working in the papal city. Canova, Batoni, Alessandro Galilei, and Piranesi, among others, are examples of the first group, while Pierre Subleyras, Gavin Hamilton, Angelika Kauffmann, and Charles-Louis Clérisseau, among many others, fit the

second case. Historically, very few important artists were actually of Roman origin, but because of the remarkable degree of cosmopolitanism during the eighteenth century, Rome was of crucial significance not only as a cultural site but also as the promoter of a vigorous school for artists of widely different nationalities; being from Venice or Paris makes an artist no less "Roman" in consequence. Unfortunately, many artists who are Roman in this context are considered only in the narratives of "national" schools, a phenomenon fueled in scholarship by the acutely nationalistic world view of the nineteenth and twentieth centuries. The encyclopedic, school-oriented impulse of most modern museums (above all the Musée du Louvre and the national galleries of Great Britain and the United States) has also facilitated the "repatriation" of many artists who should be interpreted primarily in a Roman context. The present exhibition ably demonstrates a viable school that is both Roman and international. Indeed, few in the eighteenth century would have seen this as a contradiction.

The lack of appreciation for the *romanismo* of numerous foreign painters, sculptors, and architects of the eighteenth century is closely related to the mistaken notion that artists came to Rome only in order to study antiquities, ruins, and the monuments of the High Renaissance and early Baroque periods. While Rome's historical attractions—including the Belvedere Courtyard, which displayed world-famous classical sculptures such as the *Apollo* Belvedere and *Laocoön*, Raphael's famed murals in the Vatican Stanze, and the ceiling frescoes in the Palazzo Farnese by Annibale Carracci and his students—were all but irresistible, it should also be noted that many foreign artists were also prominent members of the Accademia di S. Luca and were active in the attempt to attract both local and visiting patrons.[10] Surprisingly, their competition with established local artists caused much less friction than might be imagined, evidence of a broad consensus of the cosmopolitan nature of the art world in Settecento Rome. Such an attitude stands in sharp contrast to the nationalistic howls of protest from most British and French artists when a choice commission was awarded to a foreigner.

To an artist working in eighteenth-century Rome, the practice of making art in London, Berlin, Madrid, St. Petersburg, or even Paris must have seemed parochial in comparison. In Rome, on the other hand, some of the most spectacular public and private commissions of the century went to artists who were neither Roman nor even Italian (although the distinctions are of relatively little consequence, as noted above). That four of the twelve colossal

Apostle statues in St. John Lateran were executed by French sculptors is a case in point. Pietro Stefano Monnot received the prize commissions for the *Saint Peter* and *Saint Paul* directly from Pope Clement XI, while the more famous Pierre Legros provided *Saint Thomas* and *Saint Bartholomew* (fig. 1). The nave of St. John Lateran became a spectacular museum of contemporary sculpture representing the work of artists from many regions of both France and Italy.[11] The construction of two Roman churches, S. Claudio dei Borgognone and SS. Nome di Maria, by the French architect Antoine Derizet, is another noteworthy example. Similarly, even a relatively unknown British painter such as William Kent could receive a modest commission for a ceiling fresco in the Belgian national church, S. Giuliano dei Belgi, while the prominent Gavin Hamilton enjoyed considerable patronage from visiting tourists. John Parker, primarily known as a landscape painter, also provided an altarpiece for the church of S. Gregorio al Celio, the type of commission one would not expect a Protestant painter to receive, Jacobite though he was. Several objects in the present exhibition owe their origins to Roman commissions to foreign artists; while the context is usually acknowledged, the strength of the local art economy in Rome is generally downplayed in favor of the Old Master/antiquities connection as the only one of real interest in the history of Italian patronage. Foreign artists who stayed in Rome for a few months, a few years, or a lifetime were well aware of the vitality of the modern school of art flourishing all around them. The fact of their presence is an eloquent testimony to the ubiquity of professional opportunity not always found in the more restricted art economies of their native places.

The considerable professional benefits accorded foreign artists in the Roman market should be weighed in relation to the advantages that accrued to established practitioners, despite the increase in competition that came with the newcomers. It is undeniable that the presence of so many foreign, transalpine artists in the papal capital helped attract larger numbers of Grand Tourists, but it is even more significant that their presence encouraged connoisseurs, amateurs, aesthetes, and modest collectors to venture southward, people who might not have made the trip had it not been for the established community of sympathetic compatriots they expected to find there. Such visitors could not but be a boon to the local artists.

Social class is an important issue in this context. The large majority of those we designate "Grand Tourists" were exactly that—grand, wealthy, socially well connected, and

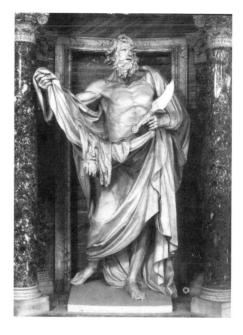

Fig. 1 Pierre Legros II, *Saint Bartholomew*, 1705–12, marble; St. John Lateran, Rome

often even politically influential. These élite visitors often included in their entourage culturally and intellectually prominent figures, usually from the middle classes, who helped enrich the Roman milieu. King Louis XV and his remarkably accomplished mistress, Madame de Pompadour, believed that an extended trip to Italy was absolutely essential to the cultural and intellectual formation of a young, parvenu aristocrat who was to become the "arts czar" of mid-eighteenth-century France; Pompadour's brother, the Marquis de Vandières (later the Marquis de Marigny), was the king's choice for the powerful post of Surintendant des Bâtiments du Roi (surveyor of the king's buildings). His cultural tutelage in Italy, in the company of the academic critic Charles-Nicolas Cochin and the architect Germaine Soufflot, reflects the widely held belief that an extended experience of Italy and especially Rome was vital to Europeans of social, political, cultural, and intellectual ambition. This belief fueled the mania for the Grand Tour, which will be discussed in due course, but it is important to remember that middle-class amateurs and intellectuals usually accompanied their more privileged patrons, and that these people greatly contributed to Rome's artistic and intellectual development. One last case in point is the Rococo painter Jean-Honoré Fragonard, who came to Rome in the entourage of the wealthy bourgeois Jean-Claude Richard, the abbé de Saint-Non. Fragonard executed some of his finest drawings for Saint-Non's *Voyage pittoresque* and some of his most accomplished

landscape paintings in Rome and its environs, above all at Tivoli (cat. 348).[12]

In the final analysis, many bourgeois members of the eighteenth-century cultural élite gravitated to the Eternal City and either found permanent employment—for instance, Johann Joachim Winckelmann, who became Cardinal Alessandro Albani's librarian at the famed Villa Albani, seen here in the view painting by Jakob Philipp Hackert (cat. 229)—or remained long enough to enrich significantly the cultural life of the city, such as J. W. von Goethe and Angelika Kauffmann, among others. My point here is that the presence of such luminaries, both aristocratic and middle-class, did much to enliven and even define the character of Roman cultural production in all media. Panini's close connections to the French Academy (he was the brother-in-law of Nicolas Vleughels, the director) and his position as professor of perspective there constitute just one of many examples of the advantages enjoyed by Roman artists because of the city's international milieu. Thus, it is ultimately impossible (and unhelpful) to separate the native from the foreign. Both elements were necessary to make Rome what it was: the cynosure of eighteenth-century European cultural life.

## BAROQUE AND SETTECENTO ROME: CONTINUITY AND INNOVATION

In recognizing the critical and historical factors that have relegated Roman art of the eighteenth century to an inferior position vis-à-vis the Seicento Baroque, it is necessary to keep in mind the many essential links—stylistic, iconographical, pedagogical, political, spiritual, social—between the two centuries. Conversely, there are also highly significant innovations and new departures that absolutely justify the consideration of the Settecento Romano as a discrete art-historical "period." Among the societal factors that remain relatively constant are the dual functions of the papacy as both a sacred and a secular institution, the slow ebb of the political and spiritual influence of Rome and the Catholic Church in Europe, and the growing global reputation of the Eternal City as the cradle of Western culture and civilization. While the present exhibition acknowledges and makes visually manifest many of the connections of *ancien régime* Roman art to its glorious past, it is the essential differences between the two centuries that are necessarily underscored.

As Francis Haskell has ably demonstrated, popes, their relatives, and a relatively small number of noble Roman families dominated art and architectural patronage in Rome and the Papal States during the seventeenth century.[13] Cultural competition among families of reigning popes and those of past pontiffs, along with others who aspired to see one of their own occupy the throne of Saint Peter, was the defining characteristic of Baroque art patronage, and it continued to be important in the following century, if to a much lesser degree.[14] The phenomenon of unabashed nepotism that made the lavish scale of familial patronage possible during the Seicento, however, was radically altered in the atmosphere of reform and greater accountability promoted by a new breed of pontiffs at the dawn of the Enlightenment. Indeed, nepotism was so thoroughly entrenched in the Roman way of doing things that it took widespread European disapproval to provoke a vigorous response to what was generally perceived as a crisis of public confidence.

On June 22, 1692, Pope Innocent XII Pignatelli promulgated a bull abolishing the enrichment of papal relatives by rewarding them with highly lucrative but egregiously untaxing ceremonial offices and the placement of family members in sensitive financial positions in the Curia that facilitated corruption and venality. Surprisingly, the bull was highly effective for most of the eighteenth century, a phenomenon that may be largely attributed to the emergence of the reforming *zelanti* faction of cardinals in the Sacred College. The *zelanti* were literally those zealous for the interests of the pope and the states of the Church, as opposed to those who favored broad concessions to the Catholic dynasties. Several Settecento popes sympathized with *zelanti* aims of political independence from the Catholic dynasts of western Europe and a thorough reform of the spiritual mission of the Church. The *zelanti* astutely recognized the relationship between nepotism and foreign influence, and they worked tirelessly for its suppression. Their triumph was complete with the election of Cardinal Gian Francesco Albani of Urbino in November 1700 as Pope Clement XI. As a cardinal, he had authored Innocent XII's bull of suppression of nepotism.[15] A new era had dawned in the history of papal art patronage.

Beginning with Clement XI, in the aftermath of the abolition of nepotism, a new attitude emerged that emphasized cultural initiatives as glorifications of the institution of the papacy, rather than as propaganda for individual papal families—the traditional role of culture. This development was connected to Counter-Reformation notions of the *Ecclesia Triumphans*, but it was understood less as a celebratory act than as a rationalistic justification of the continued secular role of the papacy in European society. Increasingly, Settecento popes used culture and art patronage to appeal to the good opinion of Catholic (and even Protestant) Europe, promoting the role of the institution as a guardian of monuments and works of art that were almost universally regarded as fundamental to Western traditions. As responsible caretakers, the popes initiated an unprecedented program of restoration, focusing both on early medieval churches such as S. Clemente and S. Maria Maggiore (cat. 9), buildings rich in Paleochristian associations, and on the monumental legacy of ancient Rome, including such undertakings as the raising of the column of Antoninus Pius and, under Pope Benedict XIV, a major restoration of the Colosseum. While these projects have often been labeled "heavy-handed" by modern scholars, they were considered circumspect and even scientific by contemporaries. Indeed, compared with many Renaissance and Baroque renovations, the eighteenth-century initiatives were remarkably restrained.

Closely connected to the increasingly rationalistic emphasis in the restoration of both pagan and Christian monuments in Rome was the papal encouragement of scholarship.[16] Scholars had always been a major presence in Rome and had often been supported and encouraged by the popes (many of whom were intellectuals in their own right), but a much more active promotion of scholarship, especially in the context of pontifically sponsored academies, characterizes the eighteenth century. Clement XI and Benedict XIV enjoyed a European reputation as scholars, and the strong financial support for research and publication in such diverse fields as archaeology, ecclesiology, and the natural sciences did much to foster a more sympathetic view of the papacy among Europe's cultural élite. The most famous instance of this new international intellectual regard is Voltaire's enthusiasm for Benedict XIV, with whom he corresponded, somewhat to the pope's embarrassment. All in all, consistent papal support for scholarship did much to promote Rome as a center of intellectual tolerance and relatively free inquiry, a fact that has been largely overlooked by many modern scholars who wish to portray Rome as obscurantist and priest-ridden. In comparing the freedom of expression possible in Rome with that of Paris of the *philosophes*, Goethe claimed that France was stifling and that in Rome even a pope could be publicly criticized (up to a point) without fear of reprisal.[17]

Prospero Lambertini (later Pope Benedict XIV), while still archbishop of Ancona, wrote a letter to Giovanni Gaetano Bottari, one of Italy's leading scholars and a confidant of the Corsini family and Pope Clement XII, stating the vital importance of scholarship to papal

rule. His words later set the tone for his own pontificate: "The duty of a Cardinal, and the greatest service he can render to the Holy See, is to attract learned and honest men to Rome. The Pope has no weapons or armies; he has to maintain his prestige by making Rome the model for all other cities."[18] As pope, Benedict did everything in his power to bring eminent scholars to Rome and to facilitate the publication and circulation of their works, even when these publications were thought to be in conflict with Church orthodoxy and in the face of often intense conservative opposition. The official Roman rehabilitation of the reputation of Lodovico Antonio Muratori, Italy's most celebrated scholar and the founder of the discipline of Italian medieval history, was among the Lambertini pontiff's most notable achievements.

Lambertini also encouraged scholarship by establishing a number of informal academies to complement the large number of such intellectual entities already existing in Rome. These included a revival of Giovanni Ciampini's celebrated Accademia Fisica-Matematica, which had lapsed earlier in the century; another group dedicated to the study of Church history that met in the convent of the Oratorians near the Chiesa Nuova, where Cardinal Baronius had written the *Annals* during the Counter-Reformation; and an academy for the study of antiquities that met on the Capitoline Hill, supposedly to revive the tradition of Livy. Benedict XIV was careful to associate leading cardinals and patricians with these new academies; for example, Cardinal Portocarrero was the protector of an academy devoted to religious rites and ceremonies (no inconsiderable thing, given the mania for historical precedent so crucial to the claims of both the Church and the long-established, absolutist Catholic dynasties), while the Gran Conestabile Lorenzo Colonna served as protector of the academy of ancient studies, the forerunner of the Accademia Pontificale d'Archaeologia established later in the century. The most important academies were the Accademia di S. Luca for artists and the Accademia dell'Arcadia for writers and poets, but there were myriad others. Rome's leading scholars, including Nicola Maria Antonelli, Giuseppe Bianchini, Giovanni Gaetano Bottari, Niccolò Panzuti, and Antonio Baldani, were associated with Benedict's scholarly efforts. Benedict XIV was truly called the "scholar's pope," a sobriquet coined by no less a personage than Montesquieu; his Rome valued the life of the mind highly, a phenomenon that had a considerable influence on the pope's art patronage.

In addition to supporting scholarship, many Settecento popes were eager to establish libraries and render existing ones more accessible. Early in the century Cardinal Girolamo Casanate founded the famous Biblioteca Casanatense, near the church of S. Ignazio, with strong pontifical encouragement from Clement XI. The cardinal's full-length portrait statue by Pierre Legros still adorns the Great Hall of the library. The Albani pope also helped promote the establishment of the Biblioteca Lancisiana in the hospital complex of S. Spirito in Sassia in 1714, a scholarly resource of enormous value initiated by Clement's physician, Giovanni Maria Lancisi.[19] Clement XII and his nephew Cardinal Neri Corsini employed the scholar Bottari to restructure their important library in the Palazzo Corsini in Trastevere, and Benedict XIV was personally responsible for saving for Rome the vast collection of books and incunabula belonging to Cardinal Pietro Ottoboni by purchasing the lot for the Vatican Library. In this treasure trove are the remarkable series of caricatures of notable contemporaries by Pier Leone Ghezzi (cats. 352–56).[20] Many pontiffs also encouraged bequests to the papacy of books and works of art as part of a campaign to raise the public profile of the institution, rather than the traditional practice of currying official favor, although that less altruistic motive continued in a more subtle fashion. The learned Marchese Alessandro Gregorio Capponi is a case in point. In 1746 he left his impressive collection of pagan and Paleochristian antiquities to the Museo Kircheriano (so called after the Jesuit polymath Athanasius Kircher, who helped establish this important collection in the Vatican Palace in the seventeenth century), and he also bequeathed his famous library to the Vatican Library. Capponi's advanced cultural orientation is seen to advantage in his innovative tomb memorial in S. Giovanni dei Fiorentini (fig. 2), designed in the early 1740s by the prominent expatriate French sculptor René-Michel (*called* Michel-Ange) Slodtz. The restraint of the ensemble, its relatively small, even intimate scale, and the emphasis on such classicizing elements as the flattened obelisk and the use of a medallion portrait of the deceased instead of a "real" representation of the aristocrat anticipate many elements of Neoclassical funerary monuments.[21] Subsequent pontiffs, especially Pius VI Braschi, continued earlier programs of support for the Vatican Library and encouraged the establishment of smaller, private libraries with greater access to the international community of scholars. The most important of this group was the splendid library assembled by Cardinal Alessandro Albani at his sumptuous villa outside the Porta Pia. The fact that one of Europe's best-known scholars, Winckelmann, was the cardinal's librarian assured it of international celebrity.

Fig. 2 René-Michel (*called* Michel-Ange) Slodtz, monument to the Marchese Alessandro Gregorio Capponi, 1745–46, marble; S. Giovanni dei Fiorentini, Rome

The importance of the papacy to the intellectual life of eighteenth-century Rome and Europe was fundamental, and, complemented by the vitality of various expatriate communities, a picture of an intellectually ambitious European capital emerges that directly contradicts such recent scholarly assertions as those of Hanns Gross, whose book *Rome in the Age of Enlightenment: The Post-Tridentine Syndrome and the Ancien Régime* claims that Rome was in a precipitous decline during the Settecento. This book, the only one of its kind in English, has unfortunately perpetuated many of the outmoded stereotypes of Rome as enervated, reactionary, and backward, especially in terms of its cultural and intellectual life. The diagnosis that the city was suffering from "post-Tridentine syndrome," whatever that may be, is yet another instance of the unfair, ahistorical, and inappropriate comparison of the eighteenth century to the era of the Counter-Reformation (initiated at the Council of Trent in the sixteenth century, from which the term "post-Tridentine" derives). The chapters on art and architecture are marred by factual inaccuracies and a dependence on out-of-date secondary sources, while the characterization of Rome's intellectual life as stilted, limited, and derivative is simply erroneous.[22] The chapters on Rome's economic life paint a bleak, if more accurate, picture, but no one questions the validity and vitality of contemporary French art, culture, and intellectualism in an era in which the Bourbon monarchy actually achieved bankruptcy in 1788, a dismal prospect visited on the States of the Church

only by the Napoleonic invasion of 1797–98. The point here is that economic lassitude and an essentially precapitalist society have rarely been major impediments to artistic and intellectual life.[23] In this regard, eighteenth-century Rome was no exception, and it should be judged on its own terms rather than by the standards of modern bourgeois liberalism.

The dual role of the Roman popes as the spiritual leaders of international Roman Catholicism and the secular rulers of an extensive domain in central and northeastern Italy makes the context of Roman art unique. It also endangered the papacy politically because these two roles were often in conflict, and at no time was this more apparent than in the eighteenth century. Art and culture, like other forms of politics, became hotly contested arenas as a result. While it is true that the popes had always employed culture as a tool of statecraft, it was not always true that the papacy lacked military and political clout. The eighteenth-century papal army and police force, unlike their predecessors, were often inadequate even for domestic purposes. The continuing evolution of the Catholic nation states (France, Spain, Portugal, Piedmont, Naples, and the Habsburg empire) increasingly precluded real papal influence outside Italy. Papal prerogatives and pretensions were often in conflict with the growing nationalist spirit characteristic of the last phase of eighteenth-century absolutism, so there were myriad points of contention between the pontiffs and the secular rulers. In fact, Catholic sovereigns did everything in their power to limit or eliminate papal authority in their dominions (an authority that had shaken thrones in the not-so-distant past), even though the moral authority and traditional privileges they enjoyed were ultimately inseparable from those of the Church. This interconnectedness was clearly seen during the Revolution and its aftermath, when both throne and altar shook and fell, and not only in France.

Painfully aware of declining political influence and increasingly attacked as an obscurantist spiritual force by certain aspects of Enlightenment discourse, the Settecento pontiffs increasingly turned to cultural promotion and patronage of the arts as a political strategy. And even though such a program was of limited practical influence in European affairs, it completely transformed Rome in its own, and in international, perception. For this reason if for no other, Roman Settecento art and culture have to be evaluated in a separate context from that of the seventeenth century.

The decline of nepotism in the papal administration had a decisive effect on art patronage in Rome, as has been noted.

Similarly, the emergence of the *zelanti* faction of cardinals in the Sacro Collegio radically altered the politics of the Curia. The result of both trends is that eighteenth-century popes (elected by a majority of the cardinals) were very different kinds of men from many of their Renaissance and Baroque predecessors. The throne of Saint Peter was occupied by a succession of relatively modest men of good character who were much more interested in preserving the status quo (which meant continuing to enjoy the many immunities, prerogatives, and privileges on which much of their authority and most of their income were based) than in expanding their secular domain or improving their family's social and financial status, with the partial exception of Pope Pius VI at the end of the century. Eighteenth-century popes were especially interested in showcasing the city of Rome as a museum of the Western tradition, and it was in this notion of commonality, rather than political particularism or nascent nationalism, that the city's rulers placed their trust. Indeed, who would dare attack such an international city? Or at least that was the thinking until the anticlerical occupation by the French and the establishment of the short-lived Roman republic in 1798. The ensuing systematic sack of the city's museums, churches, and palaces ended the century of cosmopolitanism as surely as the sack of 1527 ended the High Renaissance.[24] The papacy was eventually restored, but its cultural authority never recovered. Eighteenth-century popes, usually affable, mild, and benevolent, ultimately could do nothing to avoid being drawn into European conflicts, despite official positions of neutrality, and this was their undoing.[25] But the cultural initiatives of these underestimated popes gave Rome and the entire *ancien régime* a brilliant twilight it might not otherwise have enjoyed.

Eight men occupied the Holy See during the eighteenth century, beginning with Clement XI Albani in 1700 and ending with Pius VI Braschi, who died a political prisoner in France in 1799. These pontificates ranged in length from about three years (Innocent XIII) to almost a quarter of a century (Pius VI); the average was about twelve years. Thus, there was relative stability and continuity in policy compared with earlier periods (with the exception of the Jesuit issue, which will be addressed in due course), although many of the conclaves (the papal election process) were excessively long because of the increased interference of the distant Catholic rulers who wished to exclude candidates unfavorable to their views, even if they were unable to influence the election of a candidate in their direct interest. All Settecento popes were compromise candidates, and only the Albani family

exercised decisive influence in the elections for the entire century. The first few weeks of the conclaves were almost always indecisive because no serious canvassing could be initiated without the presence of foreign cardinals, usually the representatives of the courts, from fear of provoking the Catholic monarchs. While every eighteenth-century pope was well educated, highly cultivated (the exception here is the monkish Benedict XIII Orsini), and moderately conservative, their pontificates usually had very distinctive characteristics. It is in the cultural initiatives and patterns of art patronage that Settecento popes left their most conspicuous mark on the city of Rome, and understanding something of the character of these undertakings is crucial to a comprehensive reassessment of Roman art and architecture at the end of the *ancien régime*. The following brief survey attempts to contextualize many of the objects in the exhibition and to help explain why Rome exercised such profound cultural influence on contemporary Europe.

## CLEMENT XI ALBANI (1700–1721)

Gian Francesco Albani of Urbino was elected pope in the highly troubled conclave of 1700, an election that was overshadowed by Europe's greatest crisis since the Thirty Years' War—the death of the childless King Charles II of Spain. There was a general expectation of a continental dynastic war to determine the succession, since there were claimants from both Bourbon France (the eventual King Philip V) and Habsburg Austria (the Archduke Charles). Clement XI's relative youth (he was fifty-one when elected) and *zelanti* political proclivities were deemed essential for the new pope at such a trying time. Despite Clement's efforts, the War of the Spanish Succession devastated large areas of the Papal States and northern Italy and brought papal political influence to its nadir. This calamity was occasioned by the fact that Clement had initially backed the Bourbon claimant but was forced to declare for the Archduke Charles after the emperor threatened to occupy Rome in 1709. Thus, the pope was trusted by neither party and the peace treaties ending the conflict in 1713 and 1714 were highly unfavorable to papal interests.[26]

Albani assiduously employed cultural politics to help bring the pontifical position to European notice and consideration. Paintings such as *The Allegory of the Reign of Clement XI* in the Museo di Roma, which is sometimes erroneously attributed to Giuseppe Chiari, often employed papalist iconography to celebrate European peace treaties (such as those of Utrecht and Rastatt that concluded the

Spanish war) and underscored the spiritual role of the pope as a mediator, an office that in practice was much less efficacious. The Museo di Roma picture shows the pope and a female personification of Ecclesia worshiping at the altar of peace, while the Virgin and Child above oversee the expulsion of a personification of war from the scene. Clement XI similarly used the arts to encourage the formation of a Holy League of Catholic rulers to expel the Ottoman Turks from the Balkans, hoping a common enemy would heal the wounds of Christian conflict and revitalize the unifying papal role in European affairs. One example among many of this type of papal propaganda is a drawing by the architect Giuseppe Marchetti, who in 1716 won the second-class Concorso Clementino in architecture (a student competition in the Accademia di S. Luca named in honor of Clement XI) with a design for a triumphal arch for the Capitoline Hill that was to celebrate a Christian victory over Islam.[27] Luckily for Albani, a great victory was gained over the Turks at the Battle of Peterwardein in Hungary, but the Catholic triumph was short-lived, since the Spanish declared war on the Habsburgs in the same year, 1716, hoping to capitalize on their old enemy's weakness in the aftermath of the Turkish war.

Despite Clement XI's signal failures in foreign policy and the political crisis occasioned by the War of the Spanish Succession, his pontificate was remarkable for the range of its cultural initiatives and the new emphasis on the papacy as a venerable institution. Many of these undertakings were directly connected to the flowering of Paleochristian studies, an intellectual movement that sought to restore equanimity to a parlous era by holding up the early Church in all its supposed simplicity as a panacea for modern ills. Early Christian interests prompted an unprecedented attention to the restoration and embellishment of many of Rome's oldest churches, and many medieval mosaics were more sensitively restored than at any time in their previous history. The famed apse mosaic in S. Clemente, the site of a major Clementine intervention, is a case in point, and the large ceiling fresco executed by Chiari for the venerable basilica also celebrates another aspect of the Early Christian revival—the glorification of the early martyrs, especially the papal ones.[28] *Saint Clement in Glory* is not only an apotheosis of the martyred first-century pontiff but also honors his long-suffering namesake, who had undergone his own kind of martyrdom during the War of the Spanish Succession.

While it would not be appropriate here to compile an exhaustive list of all the artistic endeavors of the various Settecento pontiffs,

especially since the chapters on art and culture in Ludwig von Pastor's *History of the Popes* does this admirably, certain projects should be considered. As has been mentioned, the greatest single initiative of Clement XI was the decoration of the nave of St. John Lateran with twelve colossal marble statues of the Apostles, accompanied by large oval paintings of a dozen Old Testament prophets.[29] Benedetto Luti's *Isaiah*, represented in the exhibition by the splendid *modello* (cat. 243), is an outstanding representative of this group of paintings in the restrained tension of the pose and the broad monumentality of the draperies. In addition, the elegant stucco surrounds of each painting, in the form of palm fronds, are of exceptionally high quality and represent an underexplored but very significant aspect of Settecento cultural production. Stucco artists were also effectively employed in the decoration of the Albani funerary chapel in S. Sebastiano fuori le Mura.

Albani was also an important promoter of Roman urbanism, ordering the creation of the spacious Piazza Bocca della Verità, the partial clearing of the Piazza della Rotonda (the Pantheon), and the construction of a superb fountain, as well as the building of Alessandro Specchi's *Porto di Ripetta* (cat. 33) on the Tiber, a public monument combining architectural distinction with economic utility. Albani's greatest contribution to Rome's urban fabric, however, was his pursual of lapsed projects for the Spanish Steps, the Trevi Fountain, and a new sacristy for St. Peter's, all of which are visually documented in the present exhibition.[30] Although none of these undertakings was completed in his lifetime, all three were realized by the end of the eighteenth century. The Spanish Steps and the Trevi Fountain are still two of the city's most popular and beloved monuments. Had Clement XI not pursued these projects, Rome's modern appearance might be remarkably different today.

## INNOCENT XIII DE' CONTI (1721–1724) AND BENEDICT XIII ORSINI (1724–1730)

The death of Clement XI on March 19, 1721, ended one of the papacy's most controversial and troubled eras. Political and spiritual problems of European importance, however, continued into the pontificate of Albani's successor, Innocent XIII. A fat, jolly, even-tempered, and peace-loving man, Pope Innocent was the first pontiff to address openly the mounting wave of criticism of the Society of Jesus, having formed a highly unfavorable opinion of their activities while he was papal nuncio (ambassador) in Lisbon. Only his

Fig. 3 Agostino Cornacchini, *Equestrian Monument to the Emperor Charlemagne*, 1720–25, marble; St. Peter's, Vatican City

death in 1724 prevented a more concerted offensive against the society, delaying any papal attack on the order until the pontificate of Clement XIV. Reflecting a greater sense of political accountability inherited from the Albani pontificate, Innocent XIII put Cardinal Giulio Alberoni on trial for treason for his role in the breakup of the Holy League alliance in 1716.[31] Although Alberoni was acquitted, he retired temporarily from political life and his trial established an important precedent.

The brief reign of Innocent XIII was not characterized by remarkable cultural initiatives, but he continued to oversee projects inherited from the Albani pontificate, including the completion and installation of Agostino Cornacchini's colossal equestrian *Charlemagne* (fig. 3) in the left side of the narthex of St. Peter's and the continuing work on the mosaic decorations of the Baptismal and Presentation Chapels in the basilica.[32] In 1723 Innocent XIII ordered the beginning of construction on both the façade of St. John Lateran and the Spanish Steps on the Pincio, but his death delayed the façade project for several years.[33] One important accomplishment of Innocent's patronage was the execution of the two grand *acquasantierre* (holy water stoups), one each for the first two pilasters flanking the nave of St. Peter's, polychrome marble monuments that give a sense of scale to the immense church while simultaneously maintaining the human relationship of the visitor to the sublime scale of the architecture. The work of the sculptors Cornacchini, Francesco Moderati, Giuseppe Lironi, and

Fig. 4 Pier Leone Ghezzi, *The Final Session of the Lateran Council*, 1725, oil on canvas; North Carolina Museum of Art, Raleigh

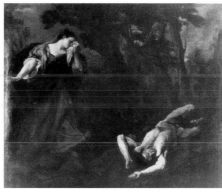

Fig. 5 Marco Benefial, *modello* for *Saint Margaret of Cortona Discovering the Body of Her Lover*, c. 1728–32, oil on canvas; Galleria Nazionale d'Arte Antica, Rome, Palazzo Barberini

Giovanni Battista Rossi, they were largely complete by 1724 and still amaze and delight visitors; indeed, they are among the most popular attractions in the entire church.

The severe and ascetic Dominican friar Pietro Francesco Orsini was seventy-five years old when he became Pope Benedict XIII in May 1724, much against his personal desires. As archbishop of Benevento, he led an exemplary life but had tended to delegate the details of administration to subordinates, many of whom were unworthy of his trust. Chief among these was Niccolò Coscia, whom he brought to Rome and elevated to the purple in the teeth of the vigorous protests of the Sacred College. Until Benedict's death in 1730, Coscia set a new standard for corruption, graft, greed, and cronyism. Indeed, Romans complained of a *sede vacante* (the term applied to papal interregnums) because the pope refused to attend to his responsibilities as a ruler, preferring to perform only ecclesiastical functions. The naive and diplomatically inexperienced Benedict XIII left everything to Coscia. As a result, a concordat (a formal treaty between the papacy and a secular power) with Piedmont, achieved with an unprecedented amount of bribery of Coscia and his "Beneventan gang" (a cohort of corrupt cronies who attached themselves to Orsini while he was still archbishop of Benevento and who followed him to Rome for greater

spoils), severely damaged papal prestige and interests. Coscia's campaign against the elevation of Monsignor Lorenzo Bichi to the cardinalate, even though it was customary to elevate papal nuncios to important Catholic courts, so infuriated King John V of Portugal that the monarch expelled all papal subjects from his dominions and closed the nunciature. This action arguably influenced the growth of anticlericalism, especially anti-Jesuitism, in a traditionally staunchly Catholic kingdom. Even at the Lateran Council of 1725, the most important conference of bishops of the eighteenth century, memorialized in Pier Leone Ghezzi's monumental *The Final Session of the Lateran Council* (fig. 4), Coscia's venality seriously compromised papal interests.[34]

As a deeply observant friar, it is unsurprising that Benedict took great interest in religious affairs, especially ceremonies, and one of his canonizations, that of Saint Margaret of Cortona in 1728, prompted some of the century's greatest religious art.[35] In 1729, in a chapel dedicated to the new saint in the civic church of Rome, S. Maria in Aracoeli on the Capitoline Hill, Marco Benefial installed two pictures of intense spirituality in which two events of the saint's life are portrayed in a highly naturalistic manner more closely related to genre painting than to traditional hagiographic glorification. In *Saint Margaret of Cortona Discovering the Body of Her Lover* (fig. 5)

and *The Death of Saint Margaret of Cortona*, a new eighteenth-century vision of religious experience may be seen that underscores a "you are there" sensibility for the life of this reformed "fallen woman" that is remarkably prescient of such nineteenth-century artists as Gustave Courbet. Saint Margaret of Cortona, a woman who, in the thirteenth century, lived openly as a nobleman's mistress and who became a Franciscan penitent after his murder, was a notable caretaker of the sick and poor. Her canonization, along with numerous others, reflects the eighteenth century's increasing emphasis on the utility of the religious life and the virtues of asceticism, as well as rationalist opposition to the contemplative orders, which were viewed by many as socially useless. During the French Revolution the contemplative orders were the first to go, while nursing and teaching orders were tolerated for much longer.

The Beneventan connections of Benedict XIII created a great professional opportunity for the architect Filippo Raguzzini, who was continually employed in Rome during the Orsini pontificate and who designed one of the city's most charming squares—the Piazza di S. Ignazio. Although the pontiff had little direct influence in the commission, Raguzzini's association with Coscia and others undoubtedly was crucial to his selection. Creating a highly decorative space in front of the stark, monumental Baroque façade of the seventeenth-century Jesuit church, Raguzzini erected a small, pavilion-like building with irregular cornices and surfaces and beveled the edges of two flanking buildings to create one the most overtly Rococo spaces in the city, rivaled only by the view of the undulating, highly ornamented façade, sometimes attributed to Giuseppe Sardi, of the nearby church of S. Maria Maddalena.[36] In addition, Raguzzini executed

a number of ecclesiastical commissions, including the diminutive, almost hyper-elegant, façade of the church of S. Filippo Neri in via di Monserrato, a building now unfortunately in ruinous condition.

In the final analysis, the short reigns of Innocent XIII and Benedict XIII had a relatively limited impact on Roman art and culture, despite a few notable achievements. Part of this evaluation is based on the aggressive building programs and numerous, sustained cultural initiatives of the two following pontificates, reigns that not only revived the ambitious cultural policies of such earlier pontificates as that of Clement XI but that also witnessed the flowering of Rome as a cultural cynosure of unrivaled international significance. The dramatic infusion of foreigners into Rome from the 1730s radically altered Roman art and culture. If there ever had been a "Late Baroque," it was dead by 1730.

## CLEMENT XII CORSINI (1730–1740)

The aged Cardinal Lorenzo Corsini, scion of a distinguished Florentine family, inherited a bleak financial and political situation when he became Pope Clement XII on July 12, 1730. One of his first acts was to set up a series of courts of inquiry to punish Cardinal Coscia (who had been excluded from the conclave) and the "Beneventan gang" of the previous pontificate; Coscia was given a ten-year prison sentence and had to forfeit a large part of his ill-gotten fortune. Much of Corsini's waning energy (he suffered terribly from gout and was blind by 1732) was spent in trying to repair the damage caused by six years of governmental neglect under Benedict XIII. The increasing demands and insults of the Catholic powers continued apace. In 1731, on the death of the last Farnese ruler, the Duchy of Parma and Piacenza was seized by Spain and presented to the son of King Philip V and his Italian wife, the ruthless and intelligent Elisabetta Farnese, without reference to the issue of papal investiture that had been observed for centuries. This is only one example of the bitter war between absolutism's claims to total power within a realm and the universal, spiritual authority that had been claimed by the papacy for centuries. Similarly, the traditional papal role as mediator in conflicts between Catholic states fell into open contempt, as when the Republic of Genoa insolently spurned the offer made by Clement XII to mediate in the republic's conflict with its rebellious Corsican subjects.

Rome's severest trial, however, was during the War of the Polish Succession, which broke out in 1733. This dynastic war resembled, *mutatis mutandis*, the War of the Spanish Succession during the reign of Clement XI, pitting France and Spain against the Habsburgs and their German allies, with Italy as one of the chief theaters of conflict. Again, the territory of the Papal States was violated with impunity by the warring armies, since it stood between the belligerents and the territory of the Kingdom of Naples. The inhabitants of the Marches and Umbria suffered acutely from the depredations of the maneuvering armies. Clement XII was helpless to resist the intrusions or to mediate the conflict and, at the war's conclusion in 1738, massive territorial changes occurred in Italy without the pope's consent. The king of Spain was especially punitive towards the papacy, successfully demanding recognition of his son's new title as king of the Two Sicilies and major concessions of a financial and ecclesiastical nature, such as the gift of benefices (clerical appointments with stipulated incomes that could often be held by members of the laity and were frequently used to reward supporters or curry favor) previously enjoyed by the pope.[37] In addition, the ambitious Queen Elisabetta Farnese forced Clement to name her eight-year-old son Don Luis as archbishop of Toledo, and bullied the pope into making him a cardinal the next year, despite canonical impediments to such an elevation in effect since the Council of Trent. There were even challenges to traditional papal competence in purely religious matters, such as the Parlement of Paris's refusal to register the decree of canonization of Vincent de Paul,[38] since the papal document praised the new saint's resistance to the early Jansenists (the Parlement was a stronghold of the banned ideology).[39] Only the direct intervention of Cardinal Fleury, Louis XV's prime minister, annulled the Parlement's decree; Fleury was one of the few statesmen of the period sympathetic to papal interests.

On a final note of challenge to papal authority, the first lodge of freemasons appeared in Rome in 1735. This group, which stressed "natural" morality over Christian dogma and encouraged the secret collaboration among individuals of widely different spiritual beliefs, grew in importance as the century progressed and posed a major threat to the papacy's system of government. Clement XII's encyclical *In eminenti* of 1738 condemned freemasonry and the Roman lodge was closed, but the problem did not go away.

Limited by his age and infirmities from too active a role in papal government, Clement XII relied heavily on the judgment and energy of his nephew Cardinal Neri Corsini. Neri was one of the most politically acute and culturally ambitious cardinals of the eighteenth century, and his activities as an art patron gave a certain splendor to Corsini's otherwise deeply

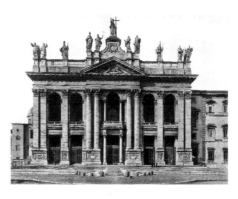

Fig. 6 Alessandro Galilei, façade of St. John Lateran, Rome, 1731–36

troubled pontificate. Among the many artistic, urbanistic, and architectural projects initiated during the Corsini pontificate and with the direct or indirect involvement of the pope and Neri Corsini, the most notable are the erection of the façade for St. John Lateran (1731–36), the building of the Palazzo della Consulta in the Piazza del Quirinale (1732–38), the construction of the sumptuous Palazzo Corsini in Trastevere (1732–55), and the execution of the splendidly restrained Corsini Chapel in St. John Lateran (1732–35). These undertakings made major contributions to the embellishment of the city and to the imposition of an almost Neoclassicizing monumentality that largely rejected the *fantasia* and *bizzarria* of much Roman architecture of the previous generation, above all the style represented by Raguzzini in the Piazza di S. Ignazio. Both the Lateran façade and the Palazzo della Consulta had a significant impact on the city: the former was a major site of pilgrimage on Rome's southern boundary and the latter continued the development of the piazza in front of the primary papal residence during the Settecento, the Palazzo del Quirinale.

The idea of providing the Lateran basilica, the pope's church as bishop of Rome and the second most important church in the city, with a worthy façade goes back at least to the reign of Innocent XII, when the basilica's arch-priest, Cardinal Benedetto Pamphili, left a legacy of 60,000 *scudi* for its construction. Seriously considered during the Albani pontificate (it even was the subject of a Concorso Clementino in architecture), it was delayed in favor of completing the decoration of the nave. Innocent XIII had shown keen interest in the project, but it was a decade later that the final decision was made and an architect selected. The severe, monumental, and colossal two-story façade was designed by the Florentine Alessandro Galilei, a fellow countryman of the pope and Cardinal Corsini (fig. 6). The *campanilismo* (the practice of favoring people from

Fig. 7 Alessandro Galilei, Corsini Chapel, St. John Lateran, 1732–35; general view

one's own home town, that is, those who live near the same church tower or campanile) manifested in the choice irritated many local architects. The sobriety of the structure and its commanding travertine figures of Christ, the two Saint Johns, and other saints atop the pediment were judged a universal success and refocused attention on the architectural achievements of Michelangelo and Bramante. Indeed, the style has been labeled "neo-Cinquecento," and it certainly has strong affinities to much Renaissance architecture.[40] As a symbol of the pope's episcopal authority, the façade must also be judged a resounding triumph.

Since the sixteenth century the chief papal tribunal, the *sacra consulta*, and the office of the secretary of briefs (a glorified amanuensis to the pope who usually became a cardinal) had been housed in a dilapidated and inadequate building next to the Palazzo Rospigliosi, near the Palazzo del Quirinale. Clement XII decided to raze the old structure and commissioned Ferdinando Fuga to design a new palace. The interior of the Palazzo della Consulta has been completely remodeled, but the imposing horizontal façade, composed of two low storeys and articulated by three portals, looks much as it did in the Settecento.[41] The imposing escutcheon of the Corsini family, flanked by graceful travertine genii sculpted by Pietro Benaglia, is still visible. This restrained, elegant structure has a commanding view of the dome of St. Peter's, and its progressive design was perhaps partly intended to represent a new dedication to more efficient papal administration, a goal that was, alas, largely unrealized.

The Corsini family already possessed a splendid palace in Florence, but Cardinal Corsini also required a large Roman residence, and his choice was the Palazzo Riario, across the street from the Villa Farnesina. The palace, formerly inhabited by Queen Christina of Sweden, was bought from the Riario family for 70,000 *scudi*, and immediately underwent a major interior renovation and the provision of a large, highly reductive façade by Fuga. As imposing in its own way as the Lateran façade by Galilei, the Palazzo Corsini façade also bears an affinity to Renaissance domestic architecture, especially to such buildings as the Palazzo Cancelleria in Rome and to the Palazzo Strozzi in Florence. The chief alteration of the interior was the provision of a capacious library for Neri's notable collection of books, replete with a series of ceiling frescoes representing various aspects of philosophy and pedagogy. Giovanni Gaetano Bottari, the leading Roman representative of Jansenist thinking and one of Italy's most prominent intellectuals, served the Corsini as librarian. The Corsini palace was the largest papal residence built in Rome until the Palazzo Braschi was constructed in the last quarter of the century. Its magnificent gardens were one of the major attractions for the city's élite visitors.[42]

The single monument that best embodies the artistic sensibility of the middle decades of the eighteenth century and that most clearly foretells the rise of Neoclassicism in the 1760s is probably the Corsini family chapel in St. John Lateran (fig. 7). The construction and decoration of papal chapels had not played a major role in Roman art since the seventeenth century, the superbly modest Albani chapel in S. Sebastiano fuori le Mura that had been completed in 1712 notwithstanding. The grandeur, elegance, and restraint of Galilei's design are perfectly complemented by the tasteful combination of materials—bronze, marble, and stucco. Designed as a Greek cross with an exceptionally high ceiling and lighted by a small cupola, one enters the chapel from the left side-aisle of the basilica. On the chapel's altar is a mosaic copy of Guido Reni's *Ecstasy of Saint Andrew Corsini*, a tribute to the family's most illustrious ancestor. To the left is the tomb of Clement XII with a bronze figure of the pontiff executed by Giovanni Battista Maini flanked by marble allegories sculpted by Carlo Monaldi. Neri Corsini's funerary monument, also designed by Maini, is on the opposite wall and includes an especially fine allegory of religion next to the representation of the deceased cardinal. The corners of the chapel are articulated with classicizing niches containing statues representing the cardinal virtues. *Temperance* is by Filippo della Valle, *Prudence* by Cornacchini, *Justice* by Lironi, and

*Fortitude* by Giuseppe Rusconi. *Temperance*, represented in the exhibition by the terracotta *modello* (cat. 158), with its quiet languor and suave insouciance, helped establish the sculptor as a leader of the generation of artists who would see the rise of Neoclassicism.[43] Indeed, it is one of the finest accomplishments of the Roman school of sculpture between Bernini and Canova.

## BENEDICT XIV LAMBERTINI (1740–1758)

The damaged prestige and declining political fortunes of the papacy had a partial recovery during the long pontificate of Benedict XIV, a seasoned diplomat and administrator who had been archbishop of both Ancona and Bologna before his election as pope after the lengthy conclave of 1740. Unlike Clement XII, who was a strong advocate of culture and scholarship but who was no scholar himself, Benedict XIV enjoyed a pan-European reputation as a canonist, Church historian, and general man of letters. Among his correspondents were some of the leading figures of the European Enlightenment, including Montesquieu, Catherine II, and Frederick II. Voltaire dedicated his play *Mahomet* to the pope and wrote to him frequently, although Benedict was justifiably wary of praise from this quarter.

Benedict's primary concern was with the rehabilitation of the papacy's political reputation, and he wished to adapt the Church to the realities of modern circumstances. To this end, he made impressive concessions to the Catholic powers, believing it better to concede as much as possible in order to preserve the essentials of the faith. An example of his relative liberalism was the papal recognition of the royal title for the margrave of Brandenburg, usually called the king of Prussia, a designation that had been tenaciously resisted by Benedict's immediate predecessors. In addition, he distanced the pontifical court from that of the Stuart Old Pretender, the so-called James III, whose claims to the British throne had been supported by the Holy See since Clement XI established the Stuarts in Rome at the beginning of the century.[44] The attempts at rapprochement with the Hanoverian dynasty made by Benedict XIV intensified after the victory over the Jacobites at the Battle of Culloden in 1746, and made it much easier for British travelers in the states of the Church. Its impact on the flowering of the Grand Tour was considerable. Deeply scholarly and very hard-working, the Lambertini pope was easily the most illustrious of the Settecento. Horace Walpole, the British resident in Florence, char-

acterized him as "a censor without severity, a monarch without favorites and a pope without a nephew, a man whom neither wit nor power could spoil."

The Lambertini pontificate, like those before it, also had to intervene in the tiresome Jansenist controversy in France. After the temporary exile of the archbishop of Paris, Christophe de Beaumont, by the Parlement of Paris, Louis XV asked the pope for yet another letter of condemnation of the heresy. The archbishop had ordered priests not to administer the sacraments to unrepentant Jansenists or to any who rejected the bull *Unigenitus*, even if the sacrament in question were extreme unction. Since Jansenism still had many sympathizers in the Parlement, the edict of exile was not surprising. As an indication of the moderation and pliability of Benedict XIV, he issued the encyclical *Ex omnibus* in 1756, reaffirming *Unigenitus* as both the law of the Church and the law of France, but allowed the sacraments to be administered to recusants unless they could be identified as "public sinners," a caveat that gave the king some leeway in punishing opposition. To celebrate the papal intervention, Cardinal Domenico Corsini commissioned Batoni for a history painting of the event as a present for the pope. *Benedict XIV Presenting the Encyclical "Ex omnibus" to the Comte de Choiseul* of 1757 (cat. 168) is one of Batoni's most important history paintings and underscores the growing importance of scenes of contemporary history in Settecento art. Accompanied by a personified Ecclesia at left and a female figure of Divine Wisdom at right, the entire scene is watched over by Peter, Paul, and the dove of the Holy Spirit on a cloud at the upper right. The most remarkable aspect of the picture, however, is its naturalism, seen in the veracity of the portrait of the papal protagonist, the emphatic legibility of the text of the encyclical, and the minute visual description of the costumes. Choiseul's portrait is imaginary, as is the elegant pavilion seen beyond the balcony in the Vatican gardens, perhaps a reference to the Coffee House at the Palazzo del Quirinale, where the encyclical was actually presented to the ambassador.[45]

Benedict XIV continued urban beautification initiatives inherited from the pontificate of Clement XII, including much of the actual construction of the Trevi Fountain. His major project, however, was the restoration of the basilica of S. Maria Maggiore and the erection of a grand new façade. The most important church in Rome dedicated to the Virgin Mary, the basilica had long been associated with Christian victories over paganism and with major dogmas related to the Virgin's role as the Mother of God. Ferdinando Fuga, who had

attained prominence during the Corsini pontificate, was selected as architect. The interior of the basilica was regularized, including the provision of bases for the nave columns that standardized the elevation of these spoils from ancient buildings. Small, shallow side-chapels were provided along the flanking walls, adorned with altarpieces by major Roman painters, including Batoni's oval *Annunciation* and works by Placido Costanzi, Stefano Pozzi, and others. In addition, the famous Early Christian mosaics above the nave walls and the grand apse mosaic by Giacopo Torriti of 1295 were restored, while Fuga also provided a grand porphyry baldachin above the high altar. Francesco Mancini's splendid *Nativity*, his masterpiece, was placed in the apse below the imposing thirteenth-century mosaic. Benedict's attention to S. Maria Maggiore was prompted not only by the church's decayed condition but also by the fact that it was a major site of pilgrimage and one of the most important buildings in Rome with early Church associations. While many would now find the restoration heavy-handed, few at the time thought it anything but a respectful refurbishment of a venerable Paleochristian basilica.[46] Fuga's highly innovative design for the façade (cat. 9) stacks two deep loggias, creating a narthex below and a gallery above. One of the requirements of the commission was that the medieval façade mosaic be preserved and left visible by the new structure; thus, the open gallery above provided an ideal solution and indicates a remarkable sensitivity to preexisting monuments. Carlo Fontana had earlier rebuilt the façade of S. Maria in Trastevere (1702–4) with the same stipulation—to preserve the pre-existing façade mosaic. The cost of the S. Maria Maggiore project was over 300,000 *scudi*, much of which was supplied by moneys collected from the lottery, which had been restored by Clement XII after its suppression by the moralizing Benedict XIII.

The other major renovation of a hallowed Paleochristian basilica undertaken by Benedict XIV was the reconstruction of the church of S. Croce in Gerusalemme (1741–44), reputedly built at the command of the Christian Empress Helena, the mother of Constantine, in the fourth century. The basilica was especially sacrosanct owing to the importance of its relics—it possessed a relatively large fragment of wood believed to be part of the True Cross brought back from Palestine by Saint Helena. The architects selected for the renovation were Domenico Gregorini and Pietro Passalacqua, the former being a protégé of Cardinal Pietro Ottoboni and the latter serving as Gregorini's collaborator in several minor details of the design,

including door and window frames.[47] The unusually dynamic façade, consisting of concave and convex elements that recall Borromini, is articulated by a large central opening crowned with an oval window. The surface is divided into three parts by engaged composite pilasters on exceptionally high bases, the ensemble crowned by a balustrade with travertine figures of saints and angels. The façade is, in fact, only a screen for a spacious oval vestibule that forms one of the most unusual and airy spaces in Rome. The interior renovation included the provision of a new ceiling and a baldachin over the high altar, as at S. Maria Maggiore, and the construction of new walls around the nave that screen the pre-existing walls, which had to be preserved. New windows allowed for additional lighting for what is still a very dark interior. The Neapolitan painter Corrado Giaquinto was commissioned to paint a large fresco, *The Holy Cross in Glory*, which was completed in 1744–45, along with two frescoes of Old Testament subjects on the curved wall of the apse. The restoration by Benedict XIV of S. Croce in Gerusalemme fitted in well with general pontifical goals of glorifying the Church's Paleochristian inheritance and enhancing the city's beauty for less spiritually motivated foreign visitors.

Although the restorations at S. Maria Maggiore and S. Croce in Gerusalemme were the most significant contributions made by Benedict XIV to Roman art and architecture, he was by no means limited to those initiatives. The Lambertini pontificate was one of the great eras of church construction, which comprised both complete renovations and the building of new churches. Fuga's eerily imposing S. Maria della Consolazione e Morte, behind the Palazzo Farnese; the small, engaging church of the Bambino Gesù, also by Fuga; and the raising of the German collegiate church, S. Apollinare, are only three of the most important examples. The pope provided 15,000 *scudi* from his privy purse to pay for Fuga's high altar baldachin in S. Apollinare, and despite his coolness towards the Stuarts, he gave 18,000 *scudi* for the cenotaph of Queen Maria Clementina Sobieski in St. Peter's, a monument designed by the architect Filippo Barigioni with figures by the prominent Academy sculptor Pietro Bracci.[48]

The Sobieski cenotaph was only one of the sculptural projects in St. Peter's supported by the pope, either through contributions or encouragement to other potential patrons. The Founders series, initiated by Clement XI to adorn the many niches of the colossal piers of the basilica with statues of the founders of the religious orders, continued under Lambertini. Among the statues to make their

Fig. 8 *Boy Struggling with a Goose*, Hellenistic, c. 180 BC, marble; Musei Capitolini, Rome

debut during the pontificate of Benedict XIV were *John of God* and *Teresa of Avila* by Filippo della Valle, *Vincent de Paul* by Bracci, and the justly celebrated *Bruno Refusing the Miter*, completed in 1744, by the French artist Slodtz. Slodtz's success in the highly competitive Roman art market—he executed the Capponi monument previously discussed (fig. 2) while he was working on the *Bruno*, among many other projects—and his influential position in the Accademia di S. Luca are strong evidence of the international character of Roman patronage and the city's importance for the development of contemporary European, and not just Italian, art.

In addition to his activities in church restoration and urbanism, Benedict XIV was also a major promoter of Roman museology. His chief focus in this respect was the Musei Capitolini, which had been established as the first publicly accessible museum in Europe by Clement XII. The Capitoline Hill, the site of the city's legendary foundation in AD753, was rich in historical associations and, following Michelangelo's brilliant intervention in the Cinquecento, had become one of Rome's chief attractions . The Lambertini pope was particularly assiduous in procuring antiquities for the museum, including numerous objects bought from the impecunious Francesco III d'Este, Duke of Modena, who was selling off his collections from the splendid Renaissance villa at Tivoli. The pontiff was motivated by a desire to keep the sculptures in Rome, and he reconfirmed previous papal edicts against export of works of art that were largely effective,

modern preconceptions notwithstanding. In 1741 Benedict acquired the famed Hellenistic genre group *Boy Struggling with a Goose* (fig. 8) and presented it to the Musei Capitolini; it is still one of the museum's most popular objects.

At the instigation of the cardinal secretary of state (the pope's prime minister) Silvio Valenti Gonzaga, Lambertini decided to establish a picture gallery at the Museo Capitolino to complement the collection of antique statues. Begun in 1747 and expanded in 1752, Benedict's Pinacoteca Capitolina housed a number of important pictures purchased from private collections, often to prevent their export. These included paintings from the collections of Cardinal Pio da Carpi and the Sacchetti family (the latter was especially rich in Venetian Renaissance and Bolognese Baroque works). In total, the pope bought over two hundred paintings for the museum, some of which are still highlights of the collection. Pietro da Cortona's *Rape of the Sabine Women*, one of the most famous pictures in Rome in the eighteenth century, is among the notable examples. Benedict's picture gallery was an important precedent for the Pinacoteca Vaticana, established in the early nineteenth century by Pope Pius VII Chiaramonti.

Benedict XIV also concerned himself with the further development of a number of small museums (properly called cabinets and usually limited to a single room) in the Vatican Palace that had been neglected in earlier pontificates. Chief among these was his revival of the moribund project for a museum of Christian antiquities, a project initiated by the polymath Francesco Bianchini under Clement XI. He appointed the learned Francesco Vettori as curator (Vettori presented his outstanding collection of Paleochristian artifacts to the museum in appreciation), and the new museum flourished. The pope purchased the collection of Cardinal Gaspare Carpegna, which largely comprised objects from the catacombs that had been published by the Early Christian scholar Filippo Buonarotti, and also added Cardinal Alessandro Albani's collection of imperial coins, bought for 12,000 *scudi*, to the collection. Other groups of objects were also added by bequest, including the extensive numismatic collection of Clement XII. The scholars Scipione Maffei and Giovanni Gaetano Bottari encouraged the pope in his efforts on behalf of the Paleochristian museum as an aid to the sacred sciences, where scholars were freely admitted. This museum, like the Capitoline, was an important precedent for the ambitious expansion of the papal collections later in the century.[49]

Considering his contemporary reputation as a ruler of moderate views who had a cautious appreciation of Enlightenment thought,

it is perhaps surprising to learn that Benedict XIV was a rigorous moralist and as ardent a defender of the Ecclesia Triumphans as any of his Counter-Reformation predecessors. In his jubilee bull of 1749 the pope outlined the major benefits that would accrue to pilgrims to Rome the following year, citing above all a pilgrimage as the opportunity to witness the splendor of the capital of Christendom. His characterization of the triumph of Christian over pagan Rome would have satisfied even such ascetic popes as Sixtus V and Innocent XI:

> Here [at Rome] we see the former rule of superstition buried in oblivion … we see the sanctuaries of false gods razed to the ground … how the monuments of tyrants lie prostrate in the dust … how the precious works intended for the honouring of Roman pride are used for the embellishment of churches; how the memorials erected in thanksgiving to heathen deities for the subjugation of provinces, now, purged of their godless superstition, bear on their summits … the victorious symbol of the unconquerable cross.[50]

It is always important to remember that the flowering of antiquarian culture in eighteenth-century Rome had a Christian subtext, and that the seemingly profane interests of scholars, collectors, patrons, and visitors usually recognized the importance of antiquity in the Christian frame of reference outlined in Benedict's jubilee bull.

The pope's intervention at the Colosseum, long used as a quarry, a barracks, a manufactory for saltpeter, or a secluded spot for illicit rendezvous, is a case in point. Many eighteenth-century pontiffs had attempted, with varying degrees of success, to preserve the monument. Lambertini transformed the site into a martyrological shrine (a notion that had earlier manifested itself in a proposal by the architect Carlo Fontana to build a martyrological basilica inside the amphitheater) by erecting inside the building a large cross and small chapels dedicated to the Stations of the Cross. During Lent the newly established Confraternity of the Lovers of Jesus and Mary led penitents through the Stations every Friday and Sunday. Dedicating the Colosseum to the sufferings of Christ and the martyrs, the famous preacher Leonardo da Porto Maurizio harangued immense crowds, proclaiming the sacredness of the site. In 1756 Cardinal Guadagni celebrated a mass in the Colosseum in which several thousand people participated.[51] So much for the notion of religious indifference in Settecento Rome.

Benedict's pietistic interests also extended to hagiography. As a young cleric he had been

active in canonization processes and had been entrusted by Clement XI with the cases of Catherine of Bologna and Pope Pius V Ghislieri, who were canonized in 1712. His activities earned him the title Promotor Fidei from Clement XI. While archbishop of Ancona he published a treatise on beatification and canonization that is still used, and as pope he continued the scrutiny of the list of saints to remove legendary figures and to make hagiography as scientific as possible. Given Lambertini's interests in hagiography, it is surprising that there was only one canonization ceremony in his long pontificate. On the feast of Saint Peter and Saint Paul (June 29) in 1746, Benedict XIV proclaimed five new saints.[52] Two of these, Camillo de Lellis and Caterina de' Ricci, inspired two of the finest religious paintings of the century. Pierre Subleyras's *Saint Camillo de Lellis Saving the Sick of the Hospital of Spirito Santo from the Floodwaters of the Tiber in 1598* (cat. 287) depicts the founder of the Camillans and patron saint of hospitals and the chronically ill bearing a lame man from a dormitory hall in the hospital of S. Spirito in Sassia to escape rising flood waters. Painted in warm earth colors and with a keen eye to naturalism seen also in works by Benefial, the dignity and plastic quality of the figures elicited praise from Canova. Commissioned from the Camillans (also known as the Fathers of the Good Death) as a present for the pope, Subleyras's picture quickly became one of the most admired modern works in Rome.[53] The French painter's other canonization canvas, *The Mystic Marriage of Saint Caterina de' Ricci*, was commissioned by the Dominicans, the august order to which the new saint belonged, as a present for the pope. Unlike the frank naturalism of the *Camillo de Lellis*, this painting is suffused with an apparitional light of divine intensity, while the saint, in her white Dominican habit, kneels before the Risen Christ, who proffers a ring.[54] The golden light and the metaphysical transcendence are appropriate to the subject and are far removed from the mundane empiricism of the Camillian offering to the pope. These two works are a good example of academic notions of decorum that governed different types of pictures and that must caution against connoisseurship as a sole means of determining attributions and dates of eighteenth-century paintings.

Despite the continuing decline of papal political influence in Europe and the increased pressure brought to bear by the Catholic dynasts against ecclesiastical privileges and influence in an increasingly secularized society, the pontificate of Benedict XIV must be considered the high point of the Settecento papacy. Respected by many of the *philosophes* and even some Protestants, Benedict's contri-butions to Roman cultural and artistic life were highly remarkable. It is unfortunate that there is no sustained study of his art patronage. But the relative tranquillity of Rome during the Lambertini reign was to be shortlived; the problem of the Jesuits, in incubation since the reign of Innocent XIII, was soon to dominate papal affairs and have a profound impact on both art and culture.

## CLEMENT XIII REZZONICO (1758–1769) AND CLEMENT XIV GANGANELLI (1769–1774)

Shortly after the election of the Venetian Cardinal Rezzonico, bishop of Padua, as Pope Clement XIII, the Portuguese court began a determined campaign against the Society of Jesus, ultimately calling for the complete suppression of the order. This scabrous issue dominated both the Rezzonico and the Ganganelli pontificates. There were numerous reasons for the war on the Jesuits: their supposed wealth; their control over the upper levels of the educational system in most Catholic countries; their arrogance; and the fact that so many Jesuits were confessors to sovereigns, positions that gave them considerable political influence. But their greatest sin was the fact that they represented an international power (and a spiritual one at that) with allegiance to a "foreign" sovereign—the pope. Such a force was unacceptable to both absolutist rulers and progressive Enlightenment ideology. Voltaire was one of their leading and most effective critics. Short, fat, and indecisive, Clement XIII was nonetheless tireless in his defense of the society and resisted all attempts to force its suppression. In 1765 he promulgated the constitution (a position paper, as opposed to a bull or a brief) *Apostolicum pascendi munus* as an undisguised defense of the Jesuits and as praise for their efforts on behalf of the Church. The tenacity of Clement XIII roused the ire of most of the Catholic courts and, in turn, Portugal, France, Spain, Naples, and Parma expelled the Jesuits from their territories and colonies and confiscated their property, which was not nearly so extensive as they had hoped. Rezzonico's combative attitude also lost the papacy its territorial enclaves in France (Avignon and the Venaissin) and the Kingdom of Naples (Benevento and Ponte Corvo). Although these territories were temporarily restored to the pope after the suppression of the Jesuits, loyalty to the society cost the papacy dearly.

Rezzonico's pro-Jesuit sympathies, however, had a profound influence on the visual arts, both positive and negative. In 1765, the same year in which he published the constitution in support of the society, he ratified

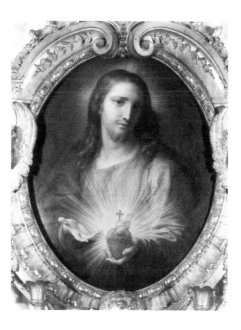

Fig. 9 Pompeo Batoni, *The Sacred Heart of Jesus*, c. 1765-67, oil on copper; Il Gesù, Rome

the cult of the Sacred Heart of Jesus, a devotion closely associated with the Jesuits since the early eighteenth century. Sacred Heart images showing Jesus holding the heart, which is encircled by a crown of thorns, topped with a small cross and radiating light, appeared everywhere in Europe and the colonies. The archetypal image, *The Sacred Heart of Jesus* (fig. 9), a small oil on copper painting by Pompeo Batoni commissioned by Monsignor Domenico Calvi for the mother church of the Jesuits, Il Gesù, soon became widely disseminated.[55] In addition to its ubiquity in Jesuit (and many other) churches, ephemeral representations of the image on canvas, paper, and other cheap materials led penitential processions and heightened a form of devotion that ran counter to much Catholic Enlightenment sensibility, recalling mystical Baroque devotions of the seventeenth century. A large Sacred Heart banner was set up in the interior of the Colosseum near Benedict XIV's Stations of the Cross, an act that scandalized the ambassadors of the Bourbon courts and Portugal. Significantly, Sacred Heart images were removed from churches in countries where the Jesuits were suppressed almost as soon as the places were occupied by the secular authorities. Such was the power of images.

The early years of the Rezzonico pontificate witnessed the culmination of the competition between Batoni and Mengs in the realm of portraiture, a friendly rivalry seen to great advantage in their official portraits of Clement XIII. Batoni's three-quarter-length portrait in the Palazzo Corsini in Rome (fig. 10) represents the corpulent Clement standing beside a

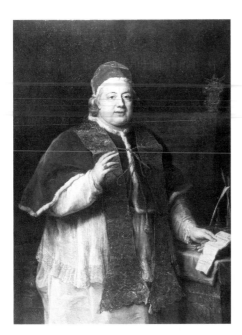

Fig. 10 Pompeo Batoni, *Clement XIII Rezzonico*, c. 1760, oil on canvas; Palazzo Corsini, Rome

desk holding a paper, rather timidly offering his benediction to the beholder. The soft pink flesh of the face and hands and the rather shy glance perfectly embody the character of the pontiff as described by contemporaries. The warm hues and soft lighting underscore the mood of benevolent paternalism that permeates the image.[56]

Mengs's seated portrait of Clement XIII, now in the Pinacoteca Nazionale, Bologna (cat. 255) also represents the pontiff in three-quarter length but the mood is entirely different. Evenly and rather coldly lit, the image is much more formal and forceful. The splendor of the throne and vestments, which are carefully rendered according to pattern, texture, and color, gives the pope a sense of aloof dignity absent in the more humanized portrait by Batoni. Romans were little interested in portraiture except for the necessary papal images (usually commissioned after an accession and often copied for diplomatic distribution), and the market was dominated by foreigners. But the naturalism and emphasis on physiognomic likeness seen in both Batoni's and Mengs's portraits of Clement XIII help underscore the vast differences between the papal form of monarchy and the dynastic model prevalent elsewhere in Catholic Europe, except Spain.

Although Clement XIII was not as culturally ambitious as his two immediate predecessors, he did enjoy the fruits of their labor when he dedicated the completed Trevi Fountain in a ceremony that took place on May 20, 1762. He also visited the newly completed Villa

Albani in the summer of 1763. His antiquarian interests were hamstrung by a misdirected sense of modesty; he ordered nude statues in the Vatican to be covered, and even Cardinal Albani supposedly draped the genitals of statues in his own collection during the pontifical visitation. Clement XIII even went so far as to employ the painter Stefano Pozzi to continue Daniele da Volterra's work of painting over several passages of nudity in Michelangelo's *Last Judgment* in the Sistine Chapel. Winckelmann, who had been appointed commissioner of antiquities by the pope, remarked on Clement's prudery: "This week the *Apollo*, the *Laocoön*, and the other statues in the Belvedere are going to have lattens [thin sheets of metal] tied on to them by means of wires fastened round their hips; I suppose the same thing will happen to the statues in the Capitol [the Musei Capitolini]. Rome could hardly have had a more asinine government than the present one."[57] Clement XIII did, however, make a few remarkable donations to the Vatican and Capitoline collections, notably the famed *Dove Mosaic* (fig. 11) purchased from the estate of Cardinal Giuseppe Alessandro Furietti and a number of antique statues excavated at Hadrian's Villa.

The most important contribution to Roman art and culture by Rezzonico was his support and encouragement of Giovanni Battista Piranesi, the most favored artist at the pontifical court. Several of the Venetian artist's works were dedicated to the pope or to members of the Rezzonico family, including the world-famous *Della magnificenza ed architettura de' Romani*, published in 1761. Like Mengs, Piranesi was honored by a papal title of nobility—membership in the order of the Golden Spur (Speron d'Oro). The pope's nephew Giovanni Battista Rezzonico commissioned his fellow Venetian to oversee the renovation of the church of S. Maria del Priorato in the papal nephew's capacity as grand prior of the order of Saint John of Malta. The highly imaginative façade, the expressive and inventive use of architectural ornament in the interior, and the profoundly visionary high altar all make Piranesi's only executed building a memorable one.[58] In many ways, the church on the Aventine Hill is a monument to the architect and to the idea of Roman grandeur and magnificence as much as it is a glorification of the Maltese order, and Piranesi chose to be buried there. The high favor shown Piranesi by Clement XIII and his family partly help to revise the perception of the Venetian pontiff as indifferent to art and culture.

The Jesuit controversy that had been brewing for over a decade finally came to a head during the reign of Pope Clement XIV Ganganelli. In order to achieve election,

Fig. 11 *Dove Mosaic*, Roman, first century BC; Musei Capitolini, Rome

Cardinal Lorenzo Ganganelli had to assert his belief that a pope could suppress a religious order if he thought its continued existence deleterious to the peace of the Church. In response to the intense pressure placed on him by the Catholic courts to suppress the society, the pope vacillated, acquiescing only in 1773 to promulgate the bull of suppression, *Dominus ac redemptor*. The papal suppression was greeted enthusiastically by progressive opinion in Europe, and not only in Catholic countries. Ganganelli's public image became that of a benevolent and liberal old man whose humble origins (his father had been a surgeon) were to his advantage as the Vicar of Christ. In a popular print the pope was shown on horseback in the Roman Campagna with a remarkable degree of informality that signaled a move away from the pomp of the past. More typical is the intelligent severity seen in Christopher Hewetson's marble bust of the pontiff now in the Victoria and Albert Museum (cat. 130). Traditionalists and especially the *zelanti*, however, were stunned by the suppression of the Jesuits, recognizing in it an admission of the subordinate status of the papacy to the secular monarchies that did not bode well for the future, especially in light of the increasing attacks on Church doctrine, practices, and privileges that framed a major part of Enlightenment discourse.

The health of Clement XIV was undermined by the anxiety of the Jesuit question and the ultimate realization that the suppression had done little to improve the position of the papacy in relation to the Catholic states, other than the promises of Naples and France to return occupied papal territories. Ganganelli died only thirteen months after *Dominus ac redemptor* was published. Such a short and profoundly troubled pontificate would normally not be propitious for cultural and artistic patronage, but the major initiative of Ganganelli's reign forever altered the papacy's

relationship to art. Urged on by his treasurer, Cardinal Gian Angelo Braschi, Clement XIV initiated the systematization of the Vatican collections that eventually became the Museo Pio-Clementino (named for Braschi, who became Pius VI in 1775, and his predecessor Clement XIV, who had initiated the vast undertaking). The dazzling museological display now arrayed in the large halls and chambers of the Vatican Palace took much of its definitive form in the last three decades of the century, and many of the embellishments and displays there were originally proposed by Clement XIV and Cardinal Braschi. The reorganization of the existing collections into a more coherent whole and the acquisition of prized objects to be displayed in the newly constructed wings captured the imagination of Europe and made it more difficult than ever to export important works of art and antiquities, much to the chagrin of the hordes of privileged tourists who wished to augment their collections. Clement's motivation was undoubtedly an appeal to the historical and cultural traditions of the papacy for the benefit of influential visitors to Rome, a notion embodied in Mengs's famous fresco *The Allegory of History* on the ceiling of the Sala dei Papiri (fig. 12).[59] A pragmatic benefit, however, was the preservation and display of significant components of the cultural patrimony. Assuming the curatorship of its patrimony in so systematic a fashion set an example for other nations (notably France and Great Britain) and aroused the admiration of Europe. France's envy resulted in the sack of the museum during the occupation of 1798–99, the culmination of cultural hostilities over a century old.

## PIUS VI BRASCHI (1775–1799)

The short, parlous pontificate of Clement XIV was followed by a much longer and even more disastrous reign, that of Pius VI Braschi, the Ganganelli pontiff's former treasurer. Overcoming the intense opposition of the Portuguese, Braschi emerged as a compromise candidate after an exceptionally long conclave. Although in his late fifties when elected, he reigned for twenty-four years, the longest pontificate since the quarter-century of rule attributed to Saint Peter. While the Jesuit question had been the defining feature of the two previous pontificates, it was the French Revolution and its aftermath in Italy that made Pius VI's reign so difficult, and the chief events of the period may be conveniently divided into two parts—the period before 1789 and the period from 1789 until Pius's death in 1799. Difficulties with France would also be the plague of Pius VI's successor, Pius VII Chiaramonti.

Braschi's fiscal policies and blind adoration of his nephew Luigi Braschi Onesti (later Duke of Nemi), led to an unfortunate recrudescence of nepotism and a number of embarrassing scandals, the most important of which was Luigi's acquisition of 12,000 acres of land in the Pontine marshes that had been drained at government expense. Initially hailed as an enlightened project in the spirit of the physiocrats, much of the actual economic benefit of the draining accrued to the papal nephew. Greatly enriched by his connection to the pontiff, Duke Luigi employed the architect Cosimo Morelli to construct a grand new palace near the Piazza Navona, an extremely expensive undertaking that became the talk of the town.[60] Morelli's expansive staircase and massive façade are imposing in the extreme, and the Palazzo Braschi was the last of its type to be built in Rome by a papal family. Despite his good looks (he was popularly acclaimed *il bel papa*) and initial popularity, the widespread approbation of the new pope was severely compromised by the favoritism shown to his unworthy nephew. It was only Pius's deposition and death in exile at the hands of revolutionary France that rehabilitated his reputation.

Before the outbreak of revolution in France in the spring of 1789, Pius VI had already been confronted with some serious political challenges, above all from the Habsburg Empire and the Grand Duchy of Tuscany. After the death of the pious Empress Maria Theresa in 1780, her son Joseph II ruled alone, and he had very different ideas concerning the role of the pope and the Church in his dominions. In a policy usually called Josephinism by historians, the emperor began the systematic subordination of the administration of ecclesiastical properties and endowments to the secular authorities. He greatly limited the pope's ability to interfere in internal affairs, even in such religious issues as divorce and the promulgation of bulls, briefs, encyclicals, and constitutions. Many religious establishments were suppressed and their revenues confiscated. By 1782 the situation was so acute that Pius took the momentous step of actually going to Vienna to meet the emperor. Although hailed as a great breakthrough in relations between the empire and the Holy See, in fact little of a substantial nature was accomplished. Only the emperor's death in 1790 brought about a temporary amelioration of the situation.[61]

The Grand Duke Leopold, the younger brother of Joseph II, also sought to obtain greater mastery over the Church in Tuscany and to limit the power of the pope to intervene in Tuscan disputes. Interestingly, both Joseph and Leopold are represented in a double portrait by Batoni painted in commemoration of their brief visit to the papal capital (cat. 172).

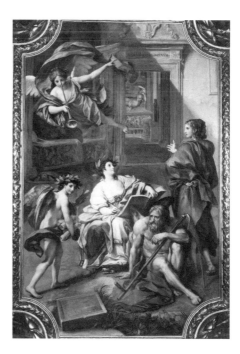

Fig. 12  Anton Raphael Mengs, *The Allegory of History*, 1772, fresco; Musei Vaticani, Vatican City, Sala dei Papiri

Working through the bishop of Pistoia, Scipione de'Ricci, Grand Duke Leopold attempted to secularize much of the ecclesiastical administration and even summoned a council of bishops to address the issue of reducing papal influence. The resulting Synod of Pistoia passed radical decrees enhancing the power of bishops at the expense of that of the pope.[62] When the people of nearby Prato heard a rumor that the synod had decided to curb popular "superstition" by removing the famed relic of the Virgin's girdle from the cathedral, three days of rioting ensued, culminating in the sack of the episcopal palace. The grand duke had to send troops to restore order. All things considered, the systematic and coordinated attacks on papal authority by Austria and Tuscany, coming in the wake of the suppression of the Jesuits at the insistence of the Bourbon powers and Portugal, left the Holy See in an isolated position to face the challenges posed by the French Revolution.

Rome's initial response to events in France in 1789 and 1790 was cautious and highly guarded. Only in mid-1790, when the convention passed the Civil Constitution of the Clergy (a law that made the Church a department of state and allowed the people to elect their own bishops without reference to the pope), was Pius forced to condemn it. As the revolution became more radical, the position of the Church became untenable, and the massive persecutions of nonjuring clergy plunged France headlong into civil war by

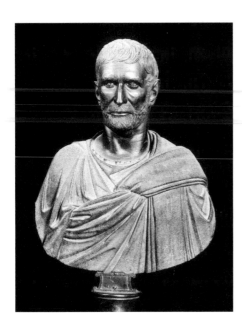

Fig. 13 *The Capitoline Brutus*, Roman, c. 140 BC, bronze; Musei Capitolini, Rome

late 1792. The papal enclaves of Avignon and the Venaissin were occupied, never to return to Roman rule. The crisis became so acute after the execution of Louis XVI and Queen Marie-Antoinette that Italy was invaded and the pope forced to declare war on France.

General Napoleon Bonaparte's attack on the Papal States in 1796 detached the legations of Bologna, Ferrara, and Ravenna from the pope and joined them to the newly created Cisalpine Republic, the capital of which was Milan. Shortly afterwards, Bonaparte penetrated further into papal territory and forced the pontiff to accept the Armistice of Bologna, which resulted in the humiliating Treaty of Tolentino signed the next year. To save Rome from occupation, Pius agreed to pay France 15,000,000 *scudi* in gold, to disarm his troops, to allow the French free passage through his territories to attack Naples, and accepted the unprecedented cultural properties clause calling for the cession of a hundred works of art, to be chosen by French commissars. The inclusion of a cultural spoliation clause in a peace treaty was shocking to moderate European opinion, but the pope had no choice but to agree. Eventually, many of the most famous works of art in Rome went to Paris, but only the *Capitoline Brutus* (fig. 13), so beloved of the revolutionaries, was specifically named in the treaty.[63] The next year, using the pretext of the assassination of the French General Léonard Duphot during an anti-French riot, French troops occupied Rome, deposed the pope and established the short-lived Roman republic. The octogenarian pontiff, confused and ill, was carted off to

France, where he died in Valence on August 29, 1799. The precarious military situation in Rome and the spoliation of the museums and churches effectively ended the age of the Grand Tour, and not even the restoration in 1814 could return Rome to its undisputed position as cultural capital of Europe. Although defeated in war at Waterloo in 1815, France triumphed over Rome in the culture wars, and European art was forever changed.

In spite of serious financial and political crises during most of his pontificate, Pius VI nonetheless pursued an ambitious program of new building, urban beautification, and augmentation of the papal art collections, although he was a much less active patron of contemporary Roman painters and sculptors than many of his Settecento predecessors. The fact that Antonio Canova received no papal commission from 1780 until the fall of the papacy eighteen years later is telling in this context, although it should be pointed out that the Venetian sculptor was not elected a member of the Accademia di S. Luca until 1800, owing to professional jealousy. Braschi's most important ecclesiastical commission was for the building of a grand new sacristy for St. Peter's, a project that had been under consideration since the reign of Clement XI. The project was entrusted to the architect Carlo Marchionni, the designer of the Villa Albani, and work began in 1776, less than a year after Pius VI's election. The new sacristy was dedicated in 1784. The pope doubtless hoped to leave a personal mark on Rome's most important church, but he also encouraged a stylistic eclecticism in Marchionni's design that embraces the neo-Cinquecento currents seen in Galilei's Lateran façade (the source of which is ultimately Michelangelo) and the full-blown Baroque elements attributable to Carlo Maderno. Significantly, both stylistic trends are seen in St. Peter's itself, and Marchionni was careful not to violate the architectural integrity of the entire complex.[64] The political dimension of the stylistic choices is also important, for in an era of decreased papal influence, Pius and Marchionni consciously recall grander eras of the past associated with such pontiffs as Julius II, Leo X, and Paul V. This staggeringly expensive project did much to further the disarray in papal finances, but the pope was undeterred.

The Braschi pope was also a major contributor to the embellishment of the city of Rome, a phenomenon encouraged by the enormous increase in the popularity of the Grand Tour in the last quarter of the century. Pius's major addition to the urban fabric was the erection of three Egyptian obelisks at important focuses in different parts of the city. The first obelisk was placed in the square in front of the

Palazzo del Quirinale in 1786, facing Clement XII's Palazzo della Consulta and enhancing the façade of the major papal residence. Long a symbol of Roman triumph over Egypt and, subsequently, Christian triumph over paganism, obelisks served as important reference points for visitors and were often aligned with other obelisks, forming a legible urban grammar. The Quirinale obelisk was set up in conjunction with the famed *Horse Tamers*, believed by many to be Greek sculptures by Praxiteles, helping to draw attention to one of the city's celebrated antiquities.[65] The Quirinale project elicited one of the most splendid decorative objects of the entire eighteenth century—the silver gilt inkstand with the obelisk and *Horse Tamers*, studded with semiprecious stones, commissioned by Marchese Ercolani from the metalsmith Vincenzo Coacci as a gift for Pius VI (cat. 82). In 1789 Pius ordered the elevation of an obelisk at the top of the Spanish Steps in front of the church of SS. Trinità dei Monti, a reassertion of papal authority in an area of the city long identified with French interests. Finally, in 1792, an obelisk was raised in the square in front of the Palazzo Montecitorio, a papal administration building and key landmark near the column of Marcus Aurelius. Had not problems with France intervened, it seems clear that Pius would have continued such projects as a conscious use of ancient monuments to glorify the papal present.

Braschi's most ambitious undertaking, however, was the vast expansion of the papal museum complex in the Vatican Palace that he began during the pontificate of Clement XIV. Named the Museo Pio-Clementino, this institution made a significant contribution to the formation of modern museums in the following century and immediately became one of the wonders of Europe. Employing the architects Michelangelo Simonetti and, later, Pietro Camporese, Pius VI created a monumental museum worthy of Rome's cultural heritage. In a remarkably systematic fashion, Pius had important ancient works assembled from sites all around the city, consolidating many previously neglected and isolated works under one roof. In addition, the excavations in progress everywhere in the city and its environs were carefully monitored, and the papacy reserved the best finds for the new museum. The great expense of these excavations gave rise to the practice of speculative collaboration. Such archaeological entrepreneurs as the Britons Gavin Hamilton, Thomas Jenkins, and Robert Fagan and the Italians Nicola Lapiccola and Domenico de Angelis, among many others, applied for excavation licenses from the Reverenda Camera Apostolica (the financial office of the papal administration), agreeing to

submit their discoveries to official scrutiny. The excavators shared the expenses with the landowners where the digs took place and sometimes even with art dealers, restorers, and wealthy amateurs interested in such enterprises. The Pio-Clementino's appropriation of the best works available fueled a market for pastiches composed of less important fragments, and a number of dealer–restorers rose to prominence in the art market as a result. Vincenzo and Camillo Pacetti, Pietro Pacilli, Giuseppe Angelini, Giuseppe Franzoni, and many others prospered in the manic market for antiquities.[66] Moreover, many of the works of art reserved for the Museo Pio-Clementino were in need of restoration, so there was no dearth of work for those willing to do it. Much of the decline in sculptural patronage for new works in the last quarter of the Settecento was offset by the huge demand for antique restorations.

In addition to the extensive architectural additions to the Vatican Palace and the restructuring of existing spaces to house the horde of objects selected for public display, Pius VI also commissioned a number of new works to decorate the galleries. These included sculptural *stemme* (coats-of-arms) that everywhere in the architecture proclaimed the pope's munificence, and ceiling paintings, such as Tommaso Maria Conca's *Triumph of Apollo*, which was executed on the ceiling of the Sala delle Muse. A lively sketch drawing of the composition is included in the exhibition (cat. 339). Important objects from Roman churches were gathered in the new museum, often over the vigorous protests of their former proprietors. The colossal porphyry sarcophagus of the Emperor Constantine's daughter Santa Costanza, brought from the eponymous church, is a notable case in point. The unprecedented collection of ancient statues of various animals, assembled impressively in the Sala degli Animali, quickly became a public favorite.[67] Indeed, the entire museum became the focal point of visitors to Rome and was even the site of the "accidental" meeting of Pius VI and King Gustav III of Sweden, a cultural and diplomatic event celebrated in Bénigne Gagneraux's commemorative painting (fig. 14).[68] All things considered, the Museo Pio-Clementino must be seen as the most significant manifestation of the cult of antiquity in eighteenth-century Rome, and its conception was fundamental to the museum mentality that now informs the relationship between the typical tourist and the Roman patrimony.

From an institutional perspective, it could be argued that the papacy was the most tenacious and successful promoter of visual culture in eighteenth-century Europe. With

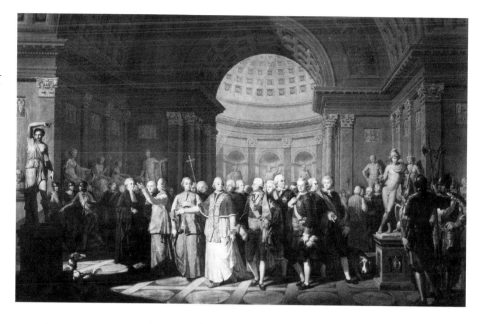

Fig. 14 Bénigne Gagneraux, *Pius VI Braschi and King Gustav III of Sweden Touring the Museo Pio-Clementino*, 1785, oil on canvas; Nationalmuseum, Stockholm

an artistic patrimony unmatched in both quantity and quality in contemporary Europe, it became essential to the popes to be seen as responsible curators of the works of art in their dominions, especially since Europe viewed Rome as the cultural cradle of western civilization. The promotion of culture through scholarship, museology, urban beautification, and an aggressive program of art and architectural patronage increasingly came to be seen as one of the chief responsibilities of the popes. In addition, support for such cultural institutions as the Accademia di S. Luca, the Accademia dell'Arcadia, the Virtuosi al Pantheon, the various libraries, and the informal private academies helped integrate Rome and the papacy into the broader current of European intellectualism. The rise of the Grand Tour and the birth and dissemination of Neoclassicism similarly positioned Rome on the center stage of Europe, helping to create the cosmopolitanism so essential to the pope's redefined role in European affairs. The papacy's keen advocacy of all forms of culture was the single most significant factor in making eighteenth-century Rome the entrepôt of Europe.

## TALES OF THE CITY: DAILY LIFE IN SETTECENTO ROME

By 1700 Rome's population had reached approximately 135,000; it grew to about 175,000 by the early 1790s, after which period the population fell dramatically as a result of the French invasions and the suppression of the papal government. Throughout the

century Rome was the second largest city in Italy, smaller only than Naples and larger than Turin, Venice, Milan, and Florence.[69] At any given time, especially after mid-century, the local population was augmented by the influx of tourists and pilgrims, so that many neighborhoods, above all the area around the Piazza di Spagna and via del Corso (Rome's most fashionable street), were crowded and uncomfortable. Many modern ideas about life in Rome in the Settecento come from the myriad travel accounts published by tourists, many of which were deeply unsympathetic to the city's customs, mores, and form of government. Contradicting these dyspeptic views are sympathetic descriptions and diary accounts penned by more tolerant foreigners and the Romans themselves. A balanced evaluation of such contradictory evidence is essential to understanding Rome's peculiar character, and any attempt to describe daily life there in the eighteenth century must take into account the habits of the people, the cultural and spiritual impact of religion, and the social hierarchy of the inhabitants. The picture that emerges is radically different from that of any other contemporary European capital. Indeed, Rome was, and still is, unique.

Settecento Rome was ruled, politically and socially, by a clerical gerontocracy. Ecclesiastical government permeated every aspect of daily life; religion was not only a spiritual exercise but produced the rhythm of the days. Sundays and feast days were holidays, and one of the frequent Enlightenment criticisms of the city was that it lost economic productivity because of the numerous feast days, when many types

of labor and almost all forms of commerce were forbidden. The households of the popes and the leading cardinals employed large numbers of people, some Roman and others who were family dependants who were brought to Rome (or came on their own, hoping for employment) from the popes' places of origin. Few members of the upper echelon of the Church knew exactly how many people they actually employed, and petty forms of fraud against employers by their dependents were commonplace and expected, partly as a compensation for very low wages. These petty peculations were augmented by the ubiquity of *mancie* (tips), often for the most perfunctory of services, from members of the household and especially from visitors and suppliants. Failure to provide the expected *mancia* could have dire consequences for those unfamiliar with the system.

The households of the nobility were also very much at the mercy of their servants, whose numbers far exceeded the requirements for domestic labor. Foreign visitors to aristocratic residences frequently commented on the large numbers of people, in and out of livery, simply hanging about, all expecting a tip. A defining feature of Roman life was the relative informality of social relations among all classes of society, a phenomenon also remarked upon by more class-conscious foreign visitors. The Roman nobility varied in social prestige and degrees of antiquity; some families claimed very ancient (even mythological) origins, such as the Colonna, the Orsini, and the Conti, while others were relative newcomers who owed their status to the election of an ancestor as pope. These included the Barberini, the Borghese, the Albani, the Altieri, and many others. Since most noble families lived in well-established palaces built and decorated in earlier periods, the culturally ambitious focused on the development of their collections and the establishment of informal salons that had both intellectual and social functions. These noble palaces were the meeting places of the clerical hierarchy, the patriciate, and privileged visitors to the city. It was quite common to see a number of cardinals, bishops, and other ecclesiastics enjoying card parties and excursions to the theater (especially the famous Teatro Argentina), but a pope was almost never seen in this context, unless it was a formal diplomatic reception. The integration of the clerical and patrician hierarchies in Rome was complete; to be sure, few noble families did not have relations well placed in the papal Curia.

The easy, informal interaction between the clerics and the laity predictably led to problems, some real, others imagined. The "decline" in public morality was a leitmotiv of contemporary sermons, edicts, diaries, and letters. Even so prominent a figure as Cardinal Alessandro Albani became a subject of social scandal because of his losses at card parties. An entry in Valesio's *Diario di Roma* dated October 14, 1729, recounts Albani's loss of 2,000 *scudi* (a very large sum) to an Umbrian nobleman while gambling at an evening salon held at the palace of the Principessa di S. Bono. Such misfortunes doubtless had an impact on his collecting activities. Another Valesio diary entry of January 21, 1730, repeats the rumor that losses at the gaming table had forced the cardinal to sell two antique cameos to someone at the French Academy for 700 *scudi*.[70]

An anonymous pamphlet sent to Pope Benedict XIII in 1724 denounced the spread of social *conversazioni* (the Italian name for evening parties that prominently featured conversation, gaming, and light refreshments), blaming them for most of the ills of contemporary Roman society:

> Until now it has been the habit, and it increased greatly in the last pontificate [Innocent XIII], that every evening many, many prelates, including bishops and archbishops, go to conversation parties hosted by women, and they make the rounds to six or more palaces in an evening, consuming almost the entire night, either in games of chance or in watching others play cards in a fashion that can only cause scandal …[71]

The text goes on to argue that this social practice is a great impediment to sacred duties and that it ought to be curtailed. While the monkish Benedict XIII may have been sympathetic to the complaint, there was little he could do about it, and the *conversazione* continued to grow in social importance as the century progressed.

Clerical influence was also deeply felt among Rome's middle and professional classes. The various papal bureaucracies required large numbers of clerks, lawyers, and scribes, and these men formed the majority of the city's bourgeoisie. So clerical was the tone of government that even many laymen donned the garb of an *abbate* (the Italian version of the French *abbé*, a person in minor orders supported by a clerical income) in order to blend in better with their colleagues and superiors. Similarly, many widowed or unmarried women of all social classes either took minor orders as nuns or at least dressed in a modified habit. Such self-fashioning was unique and did much to give Rome its clerical tone.

Unfortunately, many who donned clerical garb did not follow the prescribed manner of living. A large proportion of those involved in the ecclesiastical bureaucracy were not actually fully ordained priests and often did not behave in a priestly manner. Monsignor Pittoni, a relatively high official in the papal household, is a case in point. Valesio's *Diario di Roma* recounts that Pittoni died on the morning of April 4, 1729. His younger brother the painter Flavio Pittoni had to bring charges against the deceased's natural son Vincenzo Onori, who was arrested with the cleric's valuables in his possession. The dénouement of this squalid story occurred at Pittoni's funeral in S. Maria Maggiore, where he held a canonry (an official of the basilica's chapter who had few duties but usually received a substantial income from the church's investments), when a wit characterized the dead prelate as "a priest who never said Mass, a canon who never sat in the church's choir, a bishop who never carried a mitre and a father who never had a wife."[72] Clerics who led irregular lives had always been the subject of gossip, but the greater moral critique of the eighteenth-century Church by society made such incidents more public and helped to discredit the institution.

By far the largest number of Romans belonged to the urban working class or else were a part of the city's unemployed poor. Workers included innkeepers, shopkeepers, grocers, coopers, blacksmiths, policemen (called *sbirri*, a type of paid thug who was universally detested), and the large body of artisans employed in construction and the luxury trades. Visitors often remarked on the large number of idle poor and the ubiquity of beggars, attributing their presence to bad government and widespread sloth. In fact, beggars were an accepted part of daily life and reveal Rome's tolerant attitudes towards those less fortunate. In a Christian society that valued good works as an essential component of salvation, beggars performed a valuable social function in allowing the faithful to give alms, and were usually found near the entrances to churches. Pompeo Batoni enjoyed a considerable reputation as a pious almsgiver, and the city's mendicants used to wait daily for him to emerge from church, requesting a small coin. Rather than take steps to end mendicancy (many beggars were members of religious orders), which would never have occurred to the government, it was carefully regulated: Clement XI, for example, issued a decree in 1718 forbidding begging inside the churches and within ten feet of their portals.[73]

Beggary and the desire to alleviate the distress of the poor encouraged the formation of several new lay confraternities, associations of a paraliturgical character devoted to the pursuit of Christian charity and good works among the disadvantaged. One of the most important was the Arciconfraternità

dell'Immacolata Concezione, whose patron was Saint Ivo, the advocate of the poor. Centered on the church of S. Carlo ai Catinari in a working-class neighborhood, this arch-confraternity became a sort of free legal aid society to the poor. Members of the Confraternità di S. Eligio visited the sick and brought them food and comfort, while the Arciconfraternità della Pietà de' Carcerati visited prisoners and assisted their families, all the while calling for greater awareness of the role of poverty in the formation of criminals in society, ideas that echo those of Cesare Beccaria and contemporary Enlightenment ideology.[74] In sum, far from indicating a backward and priest-driven urban culture, eighteenth-century Rome embodied the ideas of its religion and should be judged accordingly.

Because of a clement climate, popular life in Settecento Rome centered on cafés and informal meetings in the city's many squares. Not only were these piazzas popular places of rendezvous, conversation, business transactions, and gentle exercise, but their fountains provided water for personal consumption and cleaning. The busy life of a Roman piazza was frequently commented upon by visitors and is seen to advantage in Aureliano Milani's *Festival in the Piazza della Bocca della Verità*, showing a large square in front of the venerable basilica of S. Maria in Cosmedin that had been regularized and given a new fountain during the reign of Clement XI.[75] Piazzas were also the sites of public executions and whippings, events that attracted large crowds who, unlike their counterparts at penal spectacles in Britain, usually prayed for the victim and offered assistance to his (and rarely her) relatives. Vendettas among the lower orders were not uncommon; the preferred tool of assassination was a knife with a long, narrow blade (much like the modern stiletto). And although the criminal code of papal Rome allowed the death penalty for a long list of offenses and whippings for a host of others, in practice drastic punishments were relatively rare. Commuting death or banishment sentences allowed the popes to show Christian mercy to the malefactors and set an example of charity and forgiveness. Having such laws on the record, however, allowed the government to be ruthless when it felt threatened, or when the crime was egregious or the criminal recidivist.[76]

Artists and architects, both Roman and foreign, were a vital part of the urban tapestry. Artists' studios were popular attractions and the more successful practitioners employed many part-time laborers, especially porters, janitors, and lower-level studio assistants. Prominent artists often became wealthy and were socially identified with the upper middle class. Many lived in the area around the Piazza

di Spagna and the Piazza del Popolo, and the via del Babuino, which connects the two squares, was (and still is) famous for its art galleries and antiquarian shops. Artists of all nationalities mingled freely and became integral parts of the larger community, although the French, because of the institution of the French Academy, were often somewhat more isolated and were viewed by the Romans as rather clannish. In this cosmopolitan artistic world artists were friends, rivals, habitués of the same cafés and *trattorie* (family-style eating houses), often members of the same academy and not infrequently related by marriage. When the Welsh landscape painter Thomas Jones arrived in Rome in the autumn of 1776, he immediately went to the Café Anglais in the Piazza di Spagna (with its famed murals by Piranesi) and fell in with William Pars, Jacob More, John Robert Cozens, and many others, including non-Britons. Artists of various nationalities witnessed one another's marriages and stood as godparents to one another's children, such as the painter Stefano Pozzi and the sculptor–restorer Giovanni Angeloni. The Tyrolese painter Cristoforo Unterperger married Filippo della Valle's daughter, while Panini's son Giuseppe wed the architect Fuga's daughter. Panini himself was the brother-in-law of Nicolas Vleughels, director of the French Academy at Rome. There were four Pozzis in the Accademia di S. Luca—the painters Stefano and Giuseppe, Andrea the sculptor, and the engraver Rocco. Agostino Masucci and his son Lorenzo were both members and attended meetings together. Panini held a professorship at the French Academy, while the Florentine painter Benedetto Luti became the teacher of Domenico Piastrini of Pistoia and taught the English painter William Kent. Rocco Pozzi engraved the works of his cousin Pietro Bracci.[77] Understanding these familial and professional networks and not underestimating the power of amity or enmity in Rome's artistic culture are absolutely essential to even a basic comprehension of how things worked. In sum, artists and the art industry (for such it was) occupied an important social and economic niche in Settecento Rome, and the cultural and artistic cosmopolitanism characteristic of the era began at a fundamental personal level.

The most conspicuous intersection of popular and official life in eighteenth-century Rome was that of the festival. These urban events, replete with fireworks, street performances, processions, ephemeral architectural displays, and the distribution of food and wine, enlivened the Roman year in a way similar to the celebrated Carnival, a week-long event leading up to the beginning of the

Lenten season of penance and abstinence.[78] The Chinea ceremony, the ritualized payment of the feudal dues of the Kingdom of Naples (as a vassal of the pope) in the form of a bag of gold borne on the back of a white donkey (the chinea), took place until 1787, when Naples refused to continue to recognize its status as a papal fief. Held in either the Piazza Ss. Apostoli or the Piazza Farnese, the focal point of the Chinea was a large ephemeral *macchina* (construction with movable parts) often designed by leading architects and put together at considerable expense. The Colonna family, representatives of the Kingdom of Naples, coordinated the activities. The general appearance of the Chinea *macchine* is preserved in fine engravings that were distributed widely as publicity for the event and for the Colonna family. Louis Le Lorrain's *The Temple of Minerva* (cat. 13) of 1746 and Nicola Michetti's *Jupiter and Minerva in the Forge of Vulcan* (cat. 17) are two excellent examples of the iconographical complexity and inventiveness of the Chinea engravings. The prints, often produced before the construction of the *macchine* themselves, are highly mediated and were scrutinized as works of art in their own right. They were often used as cultural favors and mounted in luxurious frames, although the vast majority of their audience never saw the actual constructions on which the prints were supposedly based. As John Moore, the leading historian of the Chinea, has written: "Prints lent the individual imagination a structure on which to fashion a mental image, a structure nuanced by education and common cultural codes, and necessarily altered by personal experience."[79] The actual festivals were, of course, an important part of Rome's self-presentation to Europe and to its own citizens, a form of participatory spectacle that integrated rulers and ruled in a highly organic manner.

In addition to the strongly politicized festival of the Chinea, Rome enjoyed the Lateran *possesso* (literally the pope's taking possession of the basilica of St. John Lateran as bishop of Rome), a cavalcade in which a newly elected pontiff traversed the city from the Palazzo del Quirinale to the Lateran, underscoring his authority as both head of the Universal Church and as the local episcopal authority. Each *possesso* included a large, ephemeral triumphal arch erected somewhere on the Sacra Via in the Roman forum under which the cavalcade passed (cat. 7). The Farnese family, in its capacity as representatives of the Dukes of Parma, was responsible for the cost of the arches, since Parma was technically a papal fief (although a hotly debated one as the century progressed, and the dukes were increasingly disinclined to acknowledge papal suzerainty) and the arches were a traditional

part of their feudal dues to their papal overlords. The highly classicizing arch erected for the *possesso* of Pius VI in 1775 is a typical example, and the engravings made after the ephemeral arches, like those for the Chinea *macchine*, were widely circulated.[80]

The Braschi cavalcade was vividly described by an eyewitness, Dr. John Moore, who published a three-volume account of his Grand Tour in 1792. As a guest of Prince Giustiniani, he viewed the procession as it ascended from St. John Lateran to the Capitoline Hill on the way back to the Quirinale. In order of procession he lists the Horse Guards, the Swiss Guards, the Roman nobles and their retainers, archbishops, bishops, and canons followed by the cardinals and finally the pope, mounted on a white mule. Once atop the Capitoline, the pontiff was given the keys to the city by the senator of Rome, the leading lay magistrate; after having assumed episcopal authority at the Lateran, the pope claimed secular power at the Palazzo dei Conservatori (City Hall). After descending the Capitoline Hill, Pius was greeted by the chief rabbi of the Jewish community, who presented him with a parchment scroll with the Ten Commandments in Hebrew. After graciously accepting the document while informing the rabbi that he rejected the Jewish interpretation, the delegation retired and the cavalcade continued on its way. Moore, who was very captious about Catholic practices, could not resist mentioning that the modern *possesso* was no fit successor to the past triumphs of the ancient Romans. He also criticized the illuminations (the display of tapestries from windows and the draping of columns in red damask hangings) of the Capitoline palaces, stating that it disgraced Michelangelo's architecture.[81] But the cavalcade occasioned much rejoicing among the Romans, and the pomp and display of the day were concluded by public fireworks and entertainments in the traditional fashion.

Although the Chinea and the Lateran *possesso* festivals were Rome's most anticipated popular entertainments, there were numerous political events abroad that led to spectacular public festivals of a celebratory nature in Rome, usually centered on the foreign embassies. Royal marriages and births were often commemorated with appropriate festivities that usually included food and wine for the crowds and always ended with fireworks. The ambitious fête held in the Piazza Farnese in 1745 to celebrate the marriage of the French dauphin (son of Louis XV and Marie Leczinska and father of the future Louis XVI) is a characteristic example of numerous similar events. The centerpiece of the festival was a grand fireworks display, probably designed by Giuseppe

Panini, the son of the famous painter Giovanni Paolo; the elder Panini's large view painting of the event is an important document for the celebration.[82] Rising from a tall base decorated with plaster statues, the central pavilion contains mythological figures that symbolize the wedding of the heir to the French throne to a Spanish princess. This pavilion is crowned by a small cupola from which a tall obelisk springs. Panini's close connections to the French Academy and to the French embassy doubtless account for his and his son's involvement. Given Rome's status as an international city and the capital of the Catholic Church, foreign ambassadors competed with one another to put on increasingly spectacular public festivals, and the beneficiaries were the city's poor, who were both fed and entertained.

Finally, the festivals and ceremonies associated with the elevation of cardinals and the elections of popes (it was customary for the people to sack the residence of a cardinal upon receiving news of his election to the papacy, so *papabili* judiciously removed valuables from their palaces before entering the conclave) were often great public occasions, and marriages and births among the Roman aristocracy were also publicly celebrated. On a reduced scale, even bourgeois births and marriages were occasions for widespread rejoicing. On a more somber note, it should be remembered that funerals of political and ecclesiastical figures, both local and foreign, were public events and were frequently commemorated by the erection of grand catafalques placed in the churches where the obsequies took place. Often designed by leading architects, these structures were usually engraved and helped spread Roman architectural ideas throughout Europe. The catafalque of Pope Innocent XII erected in St. Peter's for the pope's funeral in 1700, designed by the renowned architect Giovanni Battista Contini, gives an indication of the ambition of the ceremony and the inventiveness of the architect in making a design that he knew would be widely circulated. Arranged as a grand altar reached by a tall staircase, and bearing a medallion profile portrait of the deceased pope, the ensemble is crowned with the papal tiara.[83] Metaphorically, Contini made a direct equation of the pope and the Church, and the portrait hovers above the altar almost like a suspended Host. The central element of the composition is flanked by paired, elongated obelisks bristling with tapers. When lit, the catafalque must have been a sublime sight in the interior of the cavernous Vatican basilica.

Celebratory festivals were not unique to Rome in the eighteenth century, but their frequency, given the need to commemorate religious holidays and jubilees, and to dignify the

competing social and political ambitions of foreign personages and the local aristocracy, among many other causes, created an expectation of urban spectacle unimagined elsewhere, with the possible exception of Venice. The festivals were not only ways of appeasing (and pleasing) the poor, but were also important tourist attractions in their own right. Any serious consideration of the Grand Tour needs to take these ephemeral events into account and, arguably, important Grand Tourists became a type of public spectacle in their own right. The arrivals of foreign grandees, often traveling incognito in order to avoid court protocol but always dispensing largesse to the people, were frequently marked in Rome by impromptu street dancing, private balls, fireworks, and the distribution of food. Such august visitations increased dramatically in the last third of the century and gave a brilliant luster to the twilight of the *ancien régime*.

## ROME AND THE GRAND TOUR

Heads of state rarely visited foreign capitals in the eighteenth century, with the exception of Rome, and even high-ranking aristocrats seldom ventured beyond their own borders, except to go to Italy. The list of politically and socially important Europeans who came to Rome during the Settecento is truly remarkable, as even an abbreviated survey shows. The visit of King Gustav III of Sweden has already been mentioned, but the diplomatic difficulties the visit occasioned, while unusual, indicate the types of problems these incognito "state" visits could generate. Hearing of the Swedish monarch's arrival on Christmas Day, 1783, Pius sent his secretary, Vincenzo Catenacci, to greet him. However, when Catenacci presented himself at the Porto del Popolo, he unexpectedly encountered Emperor Joseph II of Austria, who was traveling as the Count of Falkenstein and who wished to take the pope by surprise. Joseph II and Gustav III loathed one another, so the pope was left in a rather precarious diplomatic position. Fortunately for Pius, the emperor stayed less than a week, continuing on to Naples on December 29 to visit his sister Queen Caroline.[84] He returned for a few weeks in the new year, after the departure of the king of Sweden.

During the reign of Pius VI, the French ambassador in Rome was Cardinal François-Joaquin de Bernis, whose embassy near the Piazza di Spagna became a grand reception center for Rome's illustrious visitors of all nationalities. The correspondence between the directors of the French Academy and the Surintendants des Bâtiments du Roi are important documents for the list of visitors and the staggeringly expensive entertainments

provided by the French cardinal.[85] Bernis's dinners were legendary, and the amount of food distributed to the city's residents on such occasions made Louis XVI's ambassador very popular. Much of Bernis's hospitality was prompted by his desire to show France as the premier Catholic power, despite the fact that the lavishness of his hospitality almost bankrupted him. Few high-ranking visitors to Rome did not pass through his salon, a fact well known to artists, *ciceroni* (well-informed cultural docents willing to guide visitors through the city's museums, churches, and monuments), and art dealers, who made their services known to the élite visitors through the cardinal's generosity. Bernis's crucial influence on patterns of art patronage in the last two decades of the eighteenth century needs further study.

Although many aristocrats had come to Rome before the election of Pius VI, it was only after 1775 that the stream of visitors became a flood. In the summer of 1775 the Archduke Maximilian of Austria, the brother of Joseph II, came to Rome as the Count of Burgau. In addition to the obligatory dinner with Cardinal de Bernis, the archduke was fêted by Prince Sigismondo Chigi and entertained by a fireworks display in the Piazza Colonna. Anton von Maron, Mengs's brother-in-law and an important painter in his own right, served Maximilian as *cicerone*, his native command of German being much in his favor in such a capacity. Pius VI even illuminated the dome of St. Peter's in the archduke's honor, a rare distinction even for visitors of the highest rank. Other members of the Habsburg clan also visited, including the Archduchess Maria Christina (sister of Queen Caroline of Naples and Queen Marie-Antoinette of France) and her husband, Duke Albert of Saxe-Teschen, whose famed collection of Old Master drawings became the Albertina in Vienna and who was also the patron of Canova's justly celebrated *Monument to the Archduchess Maria Christina of Austria*. Although the couple came to Rome in strict incognito, Pius still honored the archduchess with the order of the Golden Rose, the highest papal distinction for women.

In addition to the Habsburgs, many German rulers and members of their families ventured south to the Eternal City. In the fall of 1775 Prince Leopold of Brunswick arrived, accompanied by the amateur and art theorist Gotthold Ephraim Lessing, who served him as *cicerone*. A few weeks later, the heir to the Duchy of Brunswick, the Margrave of Ansbach-Bayreuth, joined his compatriots. In 1777 Landgrave Friedrich of Hesse-Kassell and Prince August of Saxe-Gotha were received by the pope. The pace of princely visitations accelerated in 1780 with the Duke and Duchess of Courland spending six months in

Rome, while the Austrian Archduke Ferdinand, governor-general of Milan, came for a brief visit in the same year. In 1783 the Elector Palatine stayed in Rome as the guest of his diplomatic agent, Marchese Antici. The arrival of the intelligent and culturally enlightened Dowager Duchess Amalie von Weimar in 1788 was a boon to the German artistic community; her itinerary had been planned by no less a personage than Goethe, who left Italy shortly before Amalie's arrival. She visited Rome again in 1789 on her way home from Naples.

Among the many eastern European notables to visit the papal city were the Russian Grand Duke Paul and his German wife, Sophia Dorothea of Brunswick, who employed the incognito titles of the Conti del Nord. They were lavishly entertained by Bernis, Pius VI, his nephew Luigi, and many Roman patricians. Their engagement with the city's monuments and art was exceptional, and the grand duke commissioned a *Holy Family* from Batoni, now in the Hermitage in St. Petersburg, among other works of art. Pius presented them with mosaics, tapestries, and a suite of Piranesi prints as a remembrance of their visit.[86] The Polish Princess Lubomirski arrived in 1785; she commissioned a full-length marble portrait of her son, *Prince Henry Lubomirski as Cupid*, from the young Canova, a work that is still in the family's possession.

While the number of titled Britons who came to Rome throughout the century is too great to list in detail, the unprecedented visits of members of the Protestant royal family should be noted.[87] The first of these royal tours was that of Edward Augustus, Duke of York, who came in 1763 at the end of the Seven Years' War and sat for a portrait by Pompeo Batoni.[88] The Duke of Gloucester, son of King George III, came to the papal capital for the third time in 1786, accompanied by his wife and a large retinue. Four years later, another royal couple, the Duke and Duchess of Sussex, the brother and sister-in-law of George III, also came to Rome. The removal to Florence of the remnant of the Stuart Pretender court greatly facilitated visits by members of the Hanoverian dynasty and also encouraged other loyalist aristocrats who no longer had to worry about accidental meetings with the Pretender or his entourage that could be misinterpreted back in Britain.

The aristocratic visitations by the French never matched the enthusiasm of the British in terms of numbers, but several members of the Bourbon royal family visited Rome, especially after 1780. The expenses incurred on these occasions by Cardinal de Bernis led him to complain bitterly about the mania for travel. The cousin of Louis XV, Louis-Philippe, Duc d'Orléans, and his duchess (who had already

visited Rome in 1776) stayed for several weeks in 1780 as the Comte and Comtesse de Joinville. Both were granted a rare private audience by the pope. The abbé de Bourbon, a natural son of Louis XV, toured the city for several months in 1785–86, and in 1790, after the outbreak of the French Revolution, Rome began to fill with émigré aristocrats, chief among them Louis XVI's aunts the Princesses Victoire and Adelaide, popularly known as the Mesdames de France.[89] All were received according to their rank by the pope, and one only wonders how Pius VI had any time to carry on the business of government. Little did anyone suspect that in just a few years, Rome as an oasis of peace and the cultural entrepôt for Enlightenment Europe would disappear forever with the arrival of the revolution in Italy.

Among the numerous social and cultural factors that encouraged the growth of the Grand Tour and Rome's pride of place on it was the city's mystique and its privileged place in the imagination of Europe.[90] As a cultural phenomenon of remarkable complexity and profound significance for western traditions, the Grand Tour flourished in the twilight of the *ancien régime* and provides the most eloquent testimony to the cosmopolitan character of the eighteenth century. The Grand Tour has received much attention from scholars in the last decade and has been the subject of a major recent exhibition,[91] but there has not been a sustained attempt to describe and document visually both the Roman and the international repercussions of this unprecedented degree of cultural and artistic cross-fertilization, one of the chief goals of the present exhibition.

Rome had long attracted the gaze of Europe as a city of art, tradition, and even salvation, but only in the Settecento did it achieve cult status. Roman cultural institutions, especially the Accademia di S. Luca, the Accademia dell'Arcadia, and the Virtuosi al Pantheon, did a great deal to foster the international republic of letters that was the chief *desideratum* of the European intelligentsia.[92] Even a summary perusal of the membership rosters of these academies proves the point. Although London, Paris, and arguably Naples were more important intellectual centers, Rome was the intellectual entrepôt, the cultural clearing house, and the academy of Europe.[93] As has been mentioned, the foreign presence in Rome, however that may be defined, substantially shaped the cultural and artistic life of the city, and its impact on antiquities and archaeology, on the art market and modern professional practice, and on patterns of European art collecting cannot be overestimated.

Any attempt to reconstruct late eighteenth-century Europe's idealized vision of Rome

Fig. 15  Henry Fuseli, *The Artist Moved by the Grandeur of Ancient Ruins*, 1778–79, red chalk and sepia wash on paper; Kunsthaus Zurich

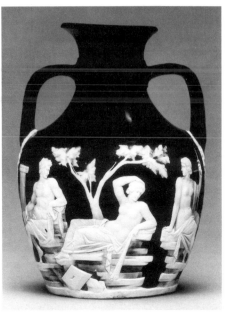

Fig. 16  *The Portland Vase*, Roman, first century BC, glass, sardonyx and cameo; British Museum, London

ate member of the Royal Society of Antiquaries in London. Its most celebrated visualization, however, is Henry Fuseli's drawing *The Artist Moved by the Grandeur of Ancient Ruins* of 1778–79 (fig. 15). Indeed, Fuseli's artistic circle in Rome was the most important locus of Piranesi's almost metaphysical vision of Roman antiquity.[96] Piranesi's fantasy became a type of reality for many Grand Tourists, and on no national group did his visualization have a greater impact than on the British, who were the main purchasers of his engravings.

Our single most valuable source for documenting Europe's obsession with Settecento Rome is travel literature. An extraordinary number of travel accounts were penned by tourists of both genders and almost all nationalities from a remarkable variety of social, spiritual, intellectual, and political perspectives. Published accounts appeared in the form of collected letters to family and friends or as personal diaries, but most authors wrote with a wider public in mind, particularly fashioning their narratives to reveal taste and erudition. Many, of course, were intended as guides for those who would follow them to Rome.[97] By far the most common feature of these books is their attention to the description of canonical works of art and conspicuous monuments, although these rarely rise above the level of cliché. Some tourists, such as Charles-Nicolas Cochin, made numerous comments on works of art elsewhere in Italy but gave up on Rome as being beyond description, both in number

must begin with the prints of Giovanni Battista Piranesi. In such publications as *Le vedute di Roma*, *Le antichità romane* (1756), *Delle magnificenze* (1761), and *Campo Marzio* (1762), among others, Piranesi's matchless engravings gave Europe a thrilling visual image of the ancient and the modern city as a sublime place of monumentality, decay, urban splendor, and romantic fascination.[94] In fact, many visitors to the city had been so swept away by the Venetian architect's vision of Rome that they were disappointed in the actual scale of the ancient monuments when they saw them, not quite understanding Piranesi's artistic license as chief apologist for Roman grandeur as opposed to Greek simplicity (the greatest aesthetic debate of the late Settecento). Two examples may serve as cases in point. In *View of the Foundations of Hadrian's Mausoleum* (the Castel S. Angelo) from *Le antichità romane*,

Piranesi deliberately selected a *di sotto in sù* (worm's-eye) perspective and literally fabricated an enormous pile of cut stones to give an impression of overwhelming grandeur and monumentality (cat. 438). In part reflecting the artist's sublime sensibilities, the print also serves to make the polemical point about the peerless magnificence of scale and design that Piranesi championed in ancient Roman art as a superior conception to the more diminutive scale and restrained expression of Greek art promoted by Winckelmann, Mengs, and Cardinal Albani.[95]

Sublimity reaches megalomania in the frontispiece to *Il Campo Marzio dell'antica Roma*, a visionary "reconstruction" of the area of the ancient city between the Pantheon and the mausoleum of Augustus. The audience for such a vision is hinted at in the inscription, in which Piranesi identifies himself as an associ-

of noteworthy monuments and in their high quality.[98] The reaction of the English visitor Thomas Gray in a letter of April 2, 1740, to his mother exemplifies the awestruck reaction of so many tourists: "As high as my expectation was raised, I confess, the magnificence of this city infinitely surpasses it. You cannot pass along a street but you have views of some palace, or church, or square, or fountain, the most picturesque and noble one can imagine."[99]

Many observers, however, were willing both to praise and to blame, and many of their commentaries, flush with juicy anecdotes, have done much to form the modern conception of Settecento Rome. Dr. John Moore, whose account of Pius VI's Lateran *possesso* cavalcade has already been discussed, is an especially informative source. As a physician and cultural adviser to the Duke of Hamilton, Moore belonged to the intellectually élite bourgeoisie that had such a crucial impact on the Roman cultural milieu. In addition to remarking on the better-known monuments and repeating local gossip, Moore described events that give great insight into life in the eighteenth-century city. His story of a Scottish Presbyterian's abuse of the pope during a ceremony in St. Peter's (the disturbed fanatic had gone to Rome especially for the purpose of converting Pius VI to the Scottish Kirk) is entertaining evidence for the relative freedom of speech enjoyed in the papal capital.[100] Moore also praised the skills of the Vatican mosaicists in preserving astonishingly faithful copies of the oil on canvas masterpieces in St. Peter's that were being transferred to more salubrious locations.[101] Even in his descriptions of celebrated antiquities, Moore often reveals something a bit out of the ordinary. Describing the Farnese *Hercules*, he singles it out as a model of masculine strength (typical enough), but adds that many women did not like it, finding in it "something unsatisfactory, and even odious." He relates the reaction of an unnamed lady with whom he visited the Palazzo Farnese who turned from the statue in disgust, saying it reminded her more of a crude giant and a ravisher of women than "the gallant Hercules, the lover of Omphale."[102] Such language underlines the importance of gender to cultural response.

Most eighteenth-century visitors to Rome came to see the sights, enjoy church ceremonies, witness popular festivals, meet compatriots of social and political influence, and purchase souvenirs of various types, including small mosaics (usually framed), cameos, coins, medals, prints (usually views of the city and its environs), and, occasionally, a picture or a small statue. On the Roman itinerary were the studios of the most important established Roman artists, above all Batoni and Canova; the major

churches; the ancient monuments; aristocratic and other private collections; and, after 1736, the Museo Capitolino and, later, the Museo Pio-Clementino. Only in the eighteenth century did the distinction between museums and private collections take on its modern meaning, the museum becoming increasingly associated with the notion of public accessibility. Before 1750 such "public" museums were primarily an Italian phenomenon (examples existed at Turin, Verona, Naples, Cortona, and even Volterra, in addition to those at Rome). These collections privileged ancient sculpture, and the rise of the museum as the essential strategy of display of institutionalized culture is closely linked to the secularization of European élites, even in papal Rome.[103] It is no surprise to learn that the Grand Tour put great demands on the Roman cultural establishment for edifying entertainment, and the establishment and proliferation of museums were predictable consequences.

The urge to acquire works of both high and decorative art was strong among most visitors to Settecento Rome, but only the richest and most culturally ambitious could purchase major works of art, and then often with considerable difficulty. A number of agents active in Rome could help those with enough money to buy second-rank, often heavily restored, ancient statues. Bartolomeo Cavaceppi's Lansdowne *Diskobolos*, an antique fragment restored in 1772–76, is an above average example of the types of ancient statues tourists were actually able to export from Rome (cat. 121). Many collectors were frustrated by the inalienability of the most important works, regardless of whether they were a part of the "public" patrimony or in Roman private collections, since papal anti-exportation edicts were surprisingly effective, despite the modern notion that rich British tourists picked the city clean during the heyday of the Grand Tour. In fact, papal edicts set the tone for similar legislation elsewhere in Europe during the nineteenth and twentieth centuries and are a good indicator of how effective the government could be when dealing with such a vital issue.[104] New excavations were the best resource for foreign collectors, but even then the pope had first refusal of the finest works unearthed, and rarely did a first-rate antiquity elude the papal net.

Among the many agents who assisted tourists in augmenting their art collections, the Britons Thomas Jenkins and James Byres enjoyed the greatest success. Jenkins, who like Byres also doubled as a *cicerone*, kept Cavaceppi, Bracci, and other sculptors occupied with antiquities restorations. Jenkins condoned such dubious practices as staining new marble with tobacco juice to give the

restored works the patina of age, and he operated a cameo factory that produced objects that were sold as genuine antiquities to unsuspecting tourists.[105] Charles Townley, who amassed one of the largest collections of antique sculpture in eighteenth-century Britain, often used Jenkins as his agent. The dearth of high-quality ancient sculpture in the Townley collection, celebrated in the famous painting by John Zoffany, is excellent evidence of the vigilance of the Roman government.

Byres seems to have concerned himself with the picture trade more than with the sale of restored antiquities, and he had some singular successes. In 1764 he arranged the sale of Nicolas Poussin's *Assumption of the Virgin*, now in the National Gallery in Washington, from the collection of Count Soderini to Brownlow Cecil, 9th Earl of Exeter. He was probably the earl's *cicerone* in Rome, a role he had also played for Edward Gibbon, among many other cultural celebrities. Byres's most famous acquisition was the *Portland Vase* (fig. 16), a cameo and glass object from the first century BC purchased from Donna Cornelia Barberini-Colonna, who needed cash to pay gambling debts. In 1783 Byres was able to sell it to Sir William Hamilton, and the vase eventually entered the collection of the British Museum. In his apartment near the Piazza di Spagna Byres displayed numerous works by contemporary artists, and since he was frequently found at home by his clients, he had the opportunity to connect patrons to practicing artists. He owned Gavin Hamilton's *Cupid and Psyche, View of the Ponte Molle* by Jacob More, *The Origin of Painting* by David Allan, and Giuseppe Cades's *The Origin of Music*, along with paintings, pastels, and portraits by Nathaniel Dance, Hugh Douglas Hamilton, Batoni, Maron, and Henry Raeburn, and graphic works by Fuseli and Piranesi, among many others.[106]

The nefarious extraction of Poussin's celebrated *Seven Sacraments* from the Bonapaduli collection and their private sale to the Duke of Rutland for £2,000 was Byres's most spectacular professional achievement as an art dealer. This shocking fraud led Joshua Reynolds to expose it to Rutland, saying that it would likely be repeated, given the difficulty of exporting important works of art from Rome. The Bonapaduli had tried to sell the seven pictures many times but had never been able to secure an export license. Byres saw to it that each of the paintings was copied in great secrecy and that the copies slowly replaced the originals, which were hidden. By November 1785 Byres possessed all the originals and by the following summer they were in England, probably legally exported as copies. While it is likely that key officials were bribed, Byres was

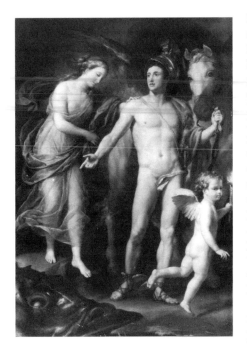

Fig. 17 Anton Raphael Mengs, *Perseus and Andromeda*, 1777, oil on canvas; The State Hermitage Museum, St. Petersburg

nonetheless able to take clients to see the "Poussins" in Palazzo Bonapaduli without blushing.[107] It should be noted, however, that the export of Old Master paintings by such artists as Salvator Rosa, Claude, Poussin, Dughet, and others, especially if they were landscapes or genre paintings, was much less difficult than works by Raphael (which were coveted above all others, leading to a cottage industry in fakes) and the Bolognese, which were vigilantly watched as a vital part of the Roman patrimony.

In addition to the numerous portrait commissions from visiting foreigners given to such Roman artists as Maratti, Chiari, Trevisani, Masucci, Batoni, and Mengs, and to resident foreigners such as Subleyras, Hewetson, Hugh Douglas Hamilton, and many others, commissions from élite Grand Tourists for works in other genres were also vital to the Roman artistic community. Three examples may stand for numerous others. Sir Watkin Williams-Wynn, an extremely wealthy Welsh baronet, commissioned *Bacchus and Ariadne* from Batoni and Mengs's *Perseus and Andromeda* (fig. 17) , arguably the Saxon painter's masterpiece. Now in the Hermitage, Williams-Wynn unfortunately never saw Mengs's picture, since the ship on which it was being transported to Britain was seized by a French privateer.[108] Frederick Hervey, Earl of Bristol and Bishop of Derry, was also an active art patron with an immense fortune, although few artists had fully satisfactory dealings with

him because of his mercurial personality. In addition to the *Fury of Athamas* (fig. 100), which he commissioned from John Flaxman, probably at Canova's instigation, he was also a major patron of Jacob More, and ordered more than a dozen landscapes for his new mansion, Ickworth, in Suffolk.[109] Finally, Gavin Hamilton's *Death of Lucretia* (cat. 231) was commissioned by Lord Charles Hope: its depiction of a scene from ancient Roman history encouraged many other artists to pursue commissions for paintings of historical themes in addition to the ubiquitous portraits and view paintings that were so much in demand. Angelika Kauffmann's conspicuous interest in painting scenes from ancient history and literature was arguably encouraged by the success of such artists as Hamilton in attracting foreign patronage for such subjects.[110]

Major commissions from Grand Tourists for sculptures, history paintings, and altarpieces from Rome's large colony of artists helped to create a flourishing cultural entrepôt that highly valued history painting and sculptures on historical themes. This phenomenon stands in stark contrast to complaints from French and British artists back home about the dearth of commissions for subjects that ranked in the highest category in the academic hierarchy of the genres.[111] History painting and monumental sculpture were alive and well in eighteenth-century Rome. Indeed, it was to Rome that Jacques-Louis David returned in 1784 to execute *The Oath of the Horatii* (fig. 18), a picture that became a manifesto of a formally innovative, politicized Neoclassicism that absorbed and transmogrified Roman traditions, ironically helping to create a new type of painting that would be substantially independent of the classicizing traditions represented by Rome. It was the beginning of the end of Roman supremacy in the arts in the European imagination.

## CONCLUSION

In order for its significance to be fully understood, and its goals evaluated, the present exhibition needs to be placed in the historical sequence of exhibitions devoted to Settecento Italy and to Rome. The first comprehensive exhibition of Settecento Roman visual culture occurred in 1959, under the auspices of the Associazione Amici dei Musei di Roma.[112] This pioneering show included objects in many different media and was especially important for its attempt to integrate the so-called minor arts (prints, metalwork, vestments, furniture, and so on, objects now referred to more accurately as material culture) into a visual narrative that historically had privileged painting, sculpture, and architectural design. One major problem

of this exhibition, however, was its emphasis on historical documentation that often overlooked questions of artistic exchange and quality. The result was a major contribution to Roman antiquarianism that had little impact on the broader field of Italian art history and did little to assimilate eighteenth-century Rome into the sequence of period "styles." Moreover, *Il Settecento a Roma* failed to have a significant impact on the public's consciousness, and the art of the era remained an art-historical footnote.

Subsequent exhibitions have also been problematic, if in different ways. *Painting in Italy in the Eighteenth Century: Rococo to Romanticism*, the title of a 1970 exhibition seen in Toledo, Chicago, and Minneapolis, was an attempt to overview Settecento Italian art by dividing it into "local" schools.[113] Despite this exhibition's emphasis on works of high quality, it had many conceptual problems. First of all, Rococo and Romanticism are highly problematic terms for characterizing eighteenth-century Roman art, and the limitation to painting, while understandable, did little to stake out a broader context for the arts in general. As a result of the exhibition catalogue's being divided into regional sections, such artists as Sebastiano Conca and Corrado Giaquinto, to name only two of the most obvious, were discussed only in the Neapolitan school, although they were also obviously of great significance to Rome. And no non-Italian artists were included at all, a fact that greatly limited the exhibition's ability to present a convincing picture of the international character of the Roman eighteenth century.

Finally, *The Academy of Europe: Rome in the 18th Century*, an exhibition organized by the University of Connecticut in 1973, attempted a broader, multi-media overview of Settecento Rome while paying special attention to the cosmopolitan character of cultural production. This exhibition showcased graphic art, both drawings and engravings, as pedagogical tools and tokens of memory. The catalogue entries are still useful in reconstructing the historical context in which the exhibited objects were created. A small budget and a peripheral venue, however, precluded foreign loans and the inclusion of large-scale works, impediments that greatly diminished the exhibition's public profile. It also helped perpetuate the antiquarian approach manifested on a more ambitious scale in the 1959 Rome exhibition. And while subsequent exhibitions devoted to individual artists, particular types of art, and broader cultural currents have done much to increase our knowledge of eighteenth-century art, until now there has been no opportunity to view Settecento Roman art in a synthetic and comprehensive manner.

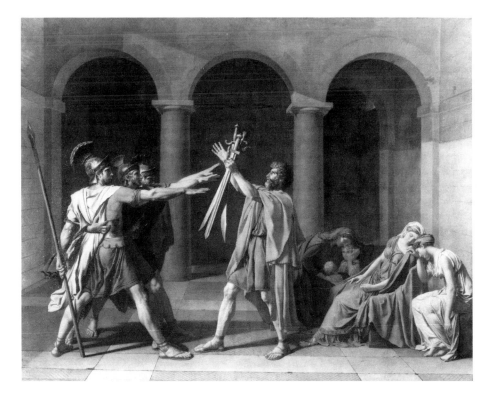

Fig. 18 Jacques-Louis David, *The Oath of the Horatii*, 1784–85, oil on canvas; Musée du Louvre, Paris

Only the remarkable growth in scholarship devoted to the Settecento Romano in the last two decades has made such an ambitious exhibition as the present one possible, a *sine qua non* predicted by such pioneers as Ellis Waterhouse and Anthony Morris Clark, among others.[114] In specialized studies too numerous to mention scholars have initiated a systematic historical and cultural reconstruction of Settecento Rome that has done much to establish the century as an independent "field" of art-historical inquiry. Quite fittingly, this has been an international effort. And although there is still much to be done, the emergence of a new cadre of younger scholars who have decided to make the Roman Settecento their home is encouraging. What has been lacking until now, however, is a synthetic vision, the type of definitive statement that will take the level of intellectual discourse in this emerging field to a new level. *Art in Rome in the Eighteenth Century* approaches that definitive statement, in the sense that it embodies the current state of thinking on the topic and charts a course for future research. This "definitive" character is, hopefully, only of the moment. The overriding purpose is to provoke reaction and reexamination and, above all, to present a vital and intensely influential century of Rome's cultural and artistic history to an audience now equipped to evaluate it on its own terms.

Notes

*Sources listed in the notes are meant to be helpful references to additional information on the topics under discussion and should be complemented by the more complete bibliographic references accompanying the catalogue entries and the other essays. I would like to thank Edgar Peters Bowron, Fred Licht, Mary D. Sheriff, Jeffrey L. Collins, Richard B. Wright, Maurie D. McInnis, Elizabeth J. Moodey, Karin Wolfe, Paul Barolsky, Tommaso Manfredi, and Jon Seydl for assistance and encouragement. All translations are my own unless otherwise indicated.*

1   Sir Joshua Reynolds, "Discourse XIV," in *Discourses on Art*, 2nd ed., edited by Robert R. Wark (New Haven and London: Yale University Press, 1975), pp. 248–49. The text reads "I will venture to prophecy, that two of the last distinguished Painters of that country [Italy], I mean Pompeio Battoni, and Raffaelle Mengs, however great their names may at present sound in our ears, will very soon fall into the rank of Imperiale, Sebastian Concha, Placido Constanza, Massuccio, and the rest of their immediate predecessors; whose names, though equally renowned in their lifetime, are now fallen into what is little short of total oblivion." Discourse XIV was delivered to the Royal Academy on December 10, 1788, and is an attack on the work of the recently deceased Thomas Gainsborough, although in the guise of a eulogy.

2   Two books deserve mention here: Bindman and Baker 1995, and Minor 1997. Robert Enggass did much to promote the study of Settecento Roman sculpture, but the book's limited chronological span and emphasis on stylistic description, based on Baroque descriptive categories (Berninesque, *barocchetto*, and so on),

have perpetuated the shadow of the Baroque over the eighteenth century (Enggass 1976).

3   No exhibition of eighteenth-century Roman art to date can compare to such ambitious efforts as the Metropolitan Museum of Art's 1989 exhibition of the works of Canaletto (see Baetjer and Links 1989). The vast bibliography included in this splendid exhibition catalogue (only the most sumptuous of many such publications devoted to the Venetian view painter) gives a fair indication of modern interest in the artist. It is arguable that more has been written on Canaletto in English than on all the major artists of Settecento Rome combined. I am not arguing that Canaletto is unworthy of the attention, but only that his intense popularity among scholars and the public has created a distortion of his historical importance. On a smaller scale, the same could be said of Canaletto's compatriot Pietro Longhi.

4   For Mengs's popularity among the British visitors to Rome, both as a historical painter and as a portraitist, see Roettgen 1993, with additional bibliography.

5   The best source for Hervey is still Ford 1974, "The Earl-Bishop," pp. 426–34. See also the detailed entry in Ingamells's magisterial study (Ingamells 1997, pp. 126–30), with considerable notations of primary source materials both published and unpublished.

6   Some eighteenth-century survey courses have adopted the rather breezy overview by Levey 1966, which has been reprinted by Oxford University Press. Levey's purpose was not to produce a comprehensive survey, but his neglect of Rome has been detrimental to the desire for a more balanced evaluation of Settecento Italian art and to the inclusion of Roman material in eighteenth-century survey classes.

7   Wittkower 1982.

8   Held and Posner 1971. Another characteristic feature of this text is the inclusion of Pierre Subleyras in the chapter on eighteenth-century France, even though Subleyras spent his entire career in Rome. A recent text (Craske 1997) refreshingly foregrounds Rome as the center of European culture and academic ideology, but largely ignores contemporary Roman artists and architects, with the predictable exception of Batoni. The same could be said of Boime 1987.

9   The chief apologist in English for *barocchetto* is Robert Enggass (see Enggass 1972, pp. 81–86). Enggass does not limit the term's application to Tiepolo and Venice. See my critique of *barocchetto* in Johns 1993, pp. 206–7, and passim. Ornament and decoration were of profound importance to eighteenth-century art, and they were viewed positively (see Bauer 1962). For a provocative study of the organic relationship between art and decoration in a French context, see Scott K. 1995, although this study does not deeply concern itself with gender issues.

10  Charles Poerson, director of the French Academy at Rome, actually became Principe (President) of the Accademia di S. Luca after the death of Carlo Maratti in 1714. See Johns 1988, pp. 1–23.

11  In an attempt to encourage *pensionnaires* to return home after their studies in Rome, the French Academy frowned upon students accepting local commissions without permission. Pierre Legros's major work for the chapel of S. Ignazio in Il Gesù in the 1690s irritated his

academic superiors. For the chapel see Levy 1993. For Legros's activities in Rome, see Bissell 1997. The prominence of French sculptors in the series of statues for the nave of St. John Lateran is discussed in Johns 1989, pp. 279–85.

12 For Fragonard's activities in and around Rome, see Rosenberg 1988, pp. 61–70, which includes a useful chronology. For Saint-Non and the *Voyage pittoresque*, see the excellent study by Petra Lamers (Lamers 1995).

13 Haskell 1971, especially pp. 38–62. Haskell's brief and highly negative view of Roman painting in the early Settecento is related to his identification of a "decline" of Roman patronage in the wake of anti-nepotism. In a more positive light, I would emphasize the different nature of patronage before and after the bull suppressing nepotism, while declining to privilege one or the other in relation to my own aesthetic preferences.

14 An excellent case study of the importance of nepotism to Seicento papal families is found in Scott J. 1991. I thank Professor Scott for many illuminating discussions about this and related issues.

15 For the *zelanti*, Cardinal Albani, and the bull of suppression of papal nepotism, see Johns 1993, pp. 15–19. Ironically, Albani had been made cardinal by Alexander VIII Ottoboni, whose spectacular nepotism did much to provoke Innocent XII's reaction.

16 Johns 1993, especially chapter 2.

17 The positive evaluation of intellectual life at Rome is a frequent theme of Goethe's Italian journey of 1786 to 1788 (Goethe [1788] 1982). While not diminishing the importance of his evaluation of Rome, Goethe's intense francophobia should be kept in mind when assessing his statements about France. Both Rome and France in theory had strict censorship of published and spoken words, but in both places it was only sporadically effective.

18 Quoted in Pastor 1938–53, vol. 35, pp. 182–83. For additional sources on Benedict XIV and the arts, see especially Biagi Maino 1998.

19 Johns 1993, pp. 26–28, with additional bibliography.

20 Pastor 1938–53, vol. 35, pp. 223–25. Ottoboni's library included the former papal libraries of Pope Marcellus II and Alexander VII, that of Cardinal Ascanio Colonna, Duke Giovanni Angelo Altemps, and the enormously important collection of Queen Christina of Sweden, whose antiquities had unfortunately already left the city to enter the royal collection in Madrid. In total, there were more than 3,300 manuscripts in Greek, Latin, and Hebrew in addition to hundreds of printed books. Benedict's interest in the Vatican Library was also manifested in his decision to begin the colossal inventory of the collections, something for which all scholars must be thankful.

21 For the Capponi monument, see Levey 1993, pp. 113–15, with additional bibliography.

22 Gross 1990. See my review of this problematic book in Johns 1991, pp. 204–5.

23 Baroque Antwerp and Settecento Venice are only two examples of flourishing cultural and intellectual centers in dramatic economic and political decline. It is perhaps significant that many of the leading artists and intellectuals of these two cities had to seek patronage abroad. Venetian patronage in particular was severely limited in the eighteenth century, and even Canaletto spent a number of years in England,

hoping to find new patrons. Tiepolo's extended sojourns in Würzburg and Spain are similar cases in point. Rome, on the other hand, was flourishing in the same era. Few major Roman artists expatriated themselves for economic reasons during the eighteenth century, while many outsiders came to Rome with the expectation of patronage. Indeed, Pompeo Batoni refused an invitation to become Frederick the Great's court painter in Potsdam, and a number of important Neapolitan artists worked also in Rome, Francesco Solimena and especially Corrado Giaquinto being prominent among them. How the old stereotypes about the decline of art patronage in Settecento Rome can continue to be repeated in the face of overwhelming contrary evidence is still a mystery.

24 For an eyewitness account of the deposition of Pius VI and the sack of the city in 1798–99, see Duppa 1799. The spoliation was both systematic, as in the selective looting of the Vatican Museum and the Museo Capitolino and the summary confiscation of the property of the Braschi and Albani families, and spontaneous, as in the looting of the Vatican Library. Chilling stories of illuminated manuscript pages scattered through the Borgo where looters had cast them aside, interested only in the gold lettering on the vellum bindings, are characteristic of this rather sensationalized account. Church furnishings and vestments, medals, and any portable object of value were among the chief losses. Smelters mounted on the backs of wagons made their way from church to church, melting down patens, chalices, gospel book covers, croziers, processional crosses, and other objects fashioned in precious metals. The loss to the Roman artistic patrimony is incalculable.

25 The best study of the political vicissitudes of the Settecento papacy is Chadwick 1981. Volumes 30–40 of Pastor's monumental *History of the Popes* are still fundamental, although the papalist agenda is everywhere evident (Pastor 1938–53).

26 Chadwick (1981, p. 274) observed that "more calamities happened to the Papacy during this pontificate [that of Clement XI] than under any Pope since the Reformation." For a discussion of Albani and the daunting political problems he faced, see Johns 1993, pp. 1–6, with additional bibliography.

27 The subject of the first class in architecture for the Concorso Clementino of 1716 was a project for a church to be erected in gratitude for a victory, a theme also closely related to the Holy League activities of the pope. In fact, Clement XI and subsequent pontiffs often used the Accademia di S. Luca student competitions as "laboratories," in Hellmut Hager's phrase, for projects under consideration. For the architectural Concorso of 1716, see Hager 1981, pp. 86–95. For Marchetti's entry in the context of Albani's plans for the Capitoline Hill, see Johns 1993, pp. 190–94. Related projects of Clement XI include the installation of a papal portrait gallery in the Palazzo del Quirinale of marble busts of pontiffs who had been active in anti-Ottoman activities and the erection of Alessandro Specchi's triumphal portico in the courtyard of the Palazzo dei Conservatori on the Capitoline Hill. For Fontana's designs for the papal bust gallery, see Braham and Hager 1977, pp. 156–58, and Johns 1993, pp. 8–10. For Specchi's arch, see especially De Felice 1982, with additional bibliography.

28 For the Paleochristian revival generally and the restoration of the basilica of S. Clemente in particular, see Johns 1993, pp. 39–54, and 94–117.

29 The decoration of the nave of St. John Lateran was an extremely expensive undertaking, 5,000 *scudi* being required for each of the Apostle statues and 800 *scudi* for each of the Prophet paintings. Clement XI very resourcefully secured money from many Italian and foreign prelates and dignitaries by appealing to their Catholic sentiments while holding out the possibility of future political consideration. For this innovative way of financing cultural initiatives, see Johns 1993, pp. 82–83. In this way, Clement XI was able to save the money left by Cardinal Pamphili for the erection of a much-needed façade, an undertaking completed by Alessandro Galilei for Clement XII in 1736. Elisabeth Kieven's long-awaited study of Galilei should shed new light on the financing of the façade.

30 For an overview of Roman urbanism during the Albani pontificate, see Johns 1993, especially chapter 8. For the Trevi Fountain, see Pinto 1986, and for the Spanish Steps, see the still fundamental Lotz 1969, pp. 39–94. For the Porto di Ripetta, see Marder 1975.

31 Alberoni, who was a close advisor to King Philip V and Queen Elisabetta Farnese of Spain, encouraged them to attack Sicily and Sardinia, possessions of the Habsburg monarchy, while the imperial armies were fighting the Ottomans in the Balkans. The surprise invasion forced the Austrians to settle with the Turks so that their armies could turn to Italy to meet the Spanish threat. This perfidy (the Spanish were in alliance with the empire) ended Clement XI's Holy League and the papacy was accused by Austria of being in collusion with the Spanish invasion. Alberoni's trial was partly an appeasement of Austria and partly an attempt to punish a cardinal who had so damaged papal diplomatic credibility.

32 For the St. Peter mosaics, see DiFederico 1983, pp. 59–72, with additional bibliography.

33 The entry for August 16, 1723, in the *Diario Ordinario di Roma*, popularly called *Chracas*, records Innocent's intentions vis-à-vis the Lateran façade and the Spanish Steps: "Our Lord [the Pope] . . . has ordered that the façade of the Sacrosanct Lateran Basilica be erected . . . and similarly the staircase of the Minims at Monte Pincio, and many other things" (entry no. 967). Among these "other things" was a gift of 3,000 *scudi* for a restoration of the church of S. Eustachio; De' Conti had been born in this parish. The high altar painting of the restored church (not completed until the 1730s) is *The Martyrdom of Saint Eustace*, the masterpiece of Francesco Fernandi, *called* Imperiali. This neglected painter is better known as Batoni's teacher. See Associazione Culturale Alma Roma 1997, vol. 1, p. 21.

34 For Ghezzi, the son of the Accademia di S. Luca life secretary Giuseppe Ghezzi and godson to Carlo Maratti, see Martinelli 1990 and, more recently, Lo Bianco 1999.

35 The most notable saints canonized by Benedict XIII were Margaret of Cortona and Toribio of Lima, a New World saint who joined his compatriot Rose of Lima, who had been canonized by Pope Clement X Altieri (1670–76). Orsini also authorized the inclusion of the office of Pope Gregory VII into the Roman breviary, an act that infuriated the Catholic monarchs, who viewed it as a reassertion of papal authority

over secular rulers, recalling the papal excommunication of Henry IV. Such was the power of history in the eighteenth-century imagination.

36 For Raguzzini, see especially Rotili 1982. See also the useful study of Settecento Roman architecture through the pontificate of Benedict XIV by Nina A. Mallory (Mallory 1977). The use of the term Rococo for Settecento architecture is problematic.

37 For the complex territorial exchanges made at the end of the War of the Polish Succession, see Sutton J. 1980, with additional bibliography.

38 Vincent de Paul, who died in 1660, was a particularly appealing candidate for sainthood in Settecento Rome. A charismatic overachiever who moved easily among the wealthy and powerful (he was a close advisor to Anne of Austria, the widow of Louis XIII), he also had spectacular success in his ministry to the poor and sick, especially in areas ravaged by war. As the founder of the Lazarists he set an example for disinterested Christian service (Lazarists were not allowed to accept ecclesiastical preferments), and he also established the Sisters of Charity, the first order of uncloistered women dedicated to nursing and teaching. The Lazarists and Sisters of Charity were objects of admiration even for the *philosophes*, because of their social utility. Such a canonization was also a notable political gesture toward Louis XV.

39 Many controversies surround the Jansenist sect. It was named for the seventeenth-century Dutch bishop Jansen, who promoted a severe form of Augustinian theology that was widely interpreted as anti-authoritarian in both the ecclesiastical and political sense. Jansenism also favored a quasi-Protestant form of predestination that directly challenged traditional Catholic dogma. Endemic in France and the Low Countries but influential almost everywhere, by the early eighteenth century the ideology was considered a threat to the sacred and secular authorities, and Clement XI condemned it, at Louis XIV's insistence, in the bull *Unigenitus* of 1713, easily the most controversial papal document of the century. Many progressives embraced Jansenism as a means of subversion of the absolutist system and of Jesuit influence. While the French government and various popes were ultimately successful in eradicating Jansenism as a viable movement, it was absorbed into the Enlightenment critique of both institutions and was arguably an important precedent for much revolutionary thought. The bibliography on Jansenism is vast. See especially Chadwick 1981, pp. 273–78, which may serve as a useful introduction.

40 For the design process for the Lateran façade and especially for Fuga's ideas, see Kieven 1988, p. 41.

41 For Fuga's designs for the Palazzo della Consulta, see Kieven 1988, pp. 43–46, with additional bibliography.

42 Fuga's work at the Palazzo Corsini is described in Kieven 1988, pp. 51–54, with additional bibliography. See also Manfredi 1995, pp. 399–411.

43 For Fuga and the Corsini Chapel, see the appropriate sections in Matthiae 1952, and Pane 1956. For Della Valle's *Temperance*, see Minor 1997, pp 130–35, with additional bibliography.

44 The marriage of the Old Pretender to a Polish princess, Clementina Sobieski, was arranged by Clement XI, who provided a subsidy for the maintenance of the Stuart court in Rome's Palazzo Muti in Piazza Ss. Apostoli. This court,

supported by subsequent pontiffs, became a center of espionage and intrigue, in particular before the Jacobite risings in Scotland in 1715 and 1745–46. The unhappy marriage produced two sons, Charles James Edward, known as the Young Pretender or Bonnie Prince Charlie, and Henry, Duke of York, who became a cardinal and styled himself Henry IX after the death of his childless elder brother. Cardinal York was the last of the Stuart line. While continuing to pay lip service to Stuart legitimacy, Benedict XIV came to an amicable agreement with the Hanoverians, paving the way for semi-official visits by members of the royal family to Rome and allowing British tourists to come to the city without fear of accusations of Jacobite sympathies. Before mid-century the activities of British visitors to Rome were carefully monitored, and reports of contact with the Stuart court were sent by such agents as Philipp von Stosch to the British resident in Florence, Horace Mann, since there were no official diplomatic ties between London and Rome. For the Stuart court as a center of political and cultural espionage, manifested above all in the person of the collector, antiquarian, and spy Stosch, see Lewis 1961, with additional bibliography.

45 For Batoni's painting, see Clark and Bowron 1985, p. 269.

46 For Fuga's activities at S. Maria Maggiore, see Matthiae 1952, pp. 29–30, and 33–38. See also Pane 1956, pp. 73–94.

47 For Gregorini and Passalacqua and the renovation of S. Croce in Gerusalemme, see especially Mallory 1977, pp. 145–70, with additional bibliography. Mallory presents a convincing case for Gregorini as the primary architect, and appositely notes the combination of earlier Rococo elements into the new monumentality in Roman architecture establbished under Clement XII by Galilei and Fuga.

48 Benedict XIV was able to extend his patronage through the encouragement of others. The Marchese Girolamo Teodoli's reconstruction of the small church of Ss. Pietro e Marcellino, with its small but exquisite high altar painting of the martyrdom of the titular saints by Gaetano Lapis, is a case in point. Like many previous pontiffs, Benedict urged cardinals titular to pay attention to the state of repair of the churches entrusted to their care and to see to their embellishment. The renovation of the church of S. Michele in Borgo was achieved in this manner. One other project should be mentioned in this context—the reorientation and embellishment of the basilica of S. Maria degli Angeli in the Baths of Diocletian. At Lambertini's orders, the architect Luigi Vanvitelli reoriented the church built by Michelangelo and created an enlarged transept out of what had been the nave. In addition, he presented a number of important altarpieces from St. Peter's to adorn the new transept, including Subleyras's grand *Mass of Saint Basil* and Batoni's controversial *Fall of Simon Magus*. The Subleyras altarpiece had been replaced by a mosaic copy in the Vatican basilica, which was notorious for its dampness. Many of Benedict's ecclesiastical projects were geared towards improving the city's churches in anticipation of the jubilee year of 1750.

49 Pastor 1938–53, vol. 35, pp. 219–22. As a scholar, Benedict was aware of the usefulness of an inventory for such a collection, and he commissioned one from Vettori that is still in use. He

also wished to stress the continuity of papal rule through a chronological sequence of pontifical coins, medals, and medallions from Adrian I (772–95) to those of his own reign.

50 Quoted in Pastor 1938–53, vol. 35, pp. 327–28.

51 Pastor 1938–53, vol. 35, pp. 172–73. Benedict extended the discipline of the Stations of the Cross to the Universal Church, and Leonardo da Porto Maurizio set up over 500 stational sites. He was canonized in the nineteenth century by Pope Pius IX.

52 Pastor 1938–53, vol. 35, pp. 312–14. The other three saints canonized by Lambertini were the Capuchins Fidelis of Sigmarigen and Giuseppe da Leonessa, and the Franciscan Pedro Regalato. Benedict had beatified Camillo de Lellis on April 7, 1742.

53 For the Camillian painting, see Michel and Rosenberg 1987, pp. 307–13. The red cross worn on the habits of the Camillian brothers is still associated with hospitals and healing.

54 Michel and Rosenberg 1987, pp. 317–18.

55 For the importance of the Sacred Heart to Jesuit devotions and for Batoni's painting, see Johns 1998, "That Amiable Object," pp. 19–28, with additional bibliography.

56 For Batoni's portrait of Clement XIII, see Clark and Bowron 1985, p. 279.

57 Translated in Pastor 1938–53, vol. 36, p. 183; taken from Justi 1923, vol. 2, p. 15.

58 For Piranesi's activities for Giovanni Battista Rezzonico and the church of S. Maria del Priorato, see Jatta 1998. I thank John Wilton-Ely for allowing me to accompany him on a tour of the Aventine exhibition *Piranesi sull' Avetino* in September 1998 and for so graciously answering my many questions.

59 For Mengs and for the Vatican *Allegory of History* fresco, see especially Roettgen 1980, pp. 189–246, with additional bibliography.

60 For the Palazzo Braschi and the dealings of Pius VI with his nephew, see Collins 1995, especially chapter 4. Professor Collins is currently preparing for publication a book on the art patronage of Pius VI.

61 For the ecclesiastical disputes between Joseph II and Pius VI and the issue of Josephinism, see especially Chadwick 1981, pp. 411–18, with additional bibliography.

62 See Chadwick 1981, pp. 418–31, with additional bibliography.

63 For the Treaty of Tolentino and the cultural spoliation of Rome, see Johns 1998, pp. 172–75, with additional bibliography.

64 For Pius's sacristy, see especially Collins 1995, chapter 5, with additional bibliography. The best discussion of Marchionni is still Gaus 1967. Clement XI's competition for designs for a new sacristy, held in 1715, was an important source for Marchionni, and a number of the models survive (see Hager 1970). Nicola Michetti's design is included in the present exhibition.

65 For the Braschi obelisks, see Collins 1997, with additional bibliography.

66 For an enlightening discussion of collaborative excavations in Rome, see Wilton and Bignamini 1996, pp. 203–5, with additional bibliography. Unfortunately, in two major instances the pope was not able to prevent the export of celebrated antiquities. In 1775 the Grand Duke of Tuscany decided to transfer the major works from the Villa Medici in Rome (grand ducal property) to Florence. Twelve years later, in 1787, most of the antique marbles in the Palazzo Farnese were removed to Naples, including the famed

Farnese *Hercules*. Although Pius VI pleaded with their owners to allow the works to remain in Rome, the rulers of Tuscany and Naples were also promoting agendas that called for cultural accumulation in the respective capitals. For this transfer of works of art from Rome, see Pastor 1938–53, vol. 39, pp. 85–86.

67  Braschi's fundamental role in the establishment of the Museo Pio-Clementino is conveniently summarized in Collins 1999. For a detailed discussion of the architectural development of the museum, see especially Consoli 1996, with additional bibliography. I am grateful to Professor Consoli for discussing the topic with me.

68  The supposedly casual encounter between the pope and the Swedish monarch took place in the museum on New Year's Day, 1784, a happy "accident" that allowed a Protestant sovereign to meet the head of the Roman Catholic Church without the limitations traditional protocol would have dictated. Both rulers were impressed with one another, and presents were eventually exchanged. Gustav III agreed to allow the public celebration of Mass in Sweden for the first time since the Reformation and eased legal restrictions on the Swedish Catholic minority. Art had often been used as diplomatic "camouflage" in the past, and this is an important modern example of the practice. For Gagneraux's painting, see Laveissière et al. 1983, pp. 98–100. The major figures in this large historical painting, including many contemporary artists, are identified on p. 99. This catalogue is a major contribution to our understanding of artistic life at the French Academy in the last years of the *ancien régime*.

69  For a detailed analysis of the population of both Rome and the Papal States during the eighteenth century, see Gross 1990, pp. 55–87, with additional bibliography.

70  Valesio [1770] 1977–79, vol. 5, pp. 126–27, 165. For purposes of comparison, it should be noted that in less than one season's gambling, Albani lost half the money necessary to fund one of the colossal marble statues for St. John Lateran, thought to be exceptionally costly at 5,000 *scudi* each. A full-length portrait by Batoni cost about 600 *scudi*.

71  Quoted in Giuntella 1960, pp. 304–5.

72  Valesio [1770] 1977–79, vol. 5, pp. 44–45, Monday, April 4, 1729.

73  Fiorani 1970, p. 226.

74  Fiorani 1970, p. 241.

75  For the Albani project for the Piazza della Bocca della Verità, also called the Piazza di S. Maria in Cosmedin, see Johns 1993, pp. 175–79. Clement XI also commissioned a major fountain in the Piazza della Rotonda, in front of the Pantheon, the chief ornament of which was a red granite Egyptian obelisk.

76  For crime and punishment in Settecento Rome, see especially Andrieux 1968, pp. 90–104, with additional bibliography.

77  These instances of interconnectedness and many others are described in an excellent essay by Olivier Michel (Michel 1996, *Vivre et peindre*, pp. 75–84, with additional bibliography).

78  The Carnival season officially began after the feast of the Epiphany (January 6) and continued through Shrove Tuesday, the day before Ash Wednesday, but the final week was the culmination of the popular festivities. The center of the public spectacle was via del Corso, where crowded carriages paraded in confused processions. People of all classes mingled (prostitutes alone were forbidden the festivities), often in transvestite costume, engaging in confetti barrages and throwing sugared almonds at one another. The main event was the race of the Barbary horses, a competition of riderless horses spurred on by barbs attached to their flanks by pieces of rope; the horses ran from the Piazza del Popolo toward the Palazzo di Venezia, often causing injury and mayhem in their wake. Sometimes the fireworks used to encourage the horses started fires, and the race was the subject of extensive wagering and frequent brawls. On the evening of Shrove Tuesday revelers holding candles (*moccoli*) went about contriving to keep their taper lit while blowing out those of others, a game that intrigued and delighted visitors. Private evening balls often punctuated the week's activities, but all came to an abrupt end before the beginning of Lent, and Tuesday's bacchanalians became Wednesday's penitents in a remarkable transformation. For vivid anecdotes about the eighteenth-century Carnival, see especially Andrieux 1968, pp. 141–47. For a general view of Roman society in the Settecento, see especially Silvagni 1883–85.

79  For the Chinea, see Moore J. 1995, pp. 584–608. The passage in the text is quoted on p. 589.

80  For the Lateran *possesso* cavalcades and the accompanying engravings of the ephemeral arches, see Cancellieri 1802.

81  Moore 1792, vol. 2, pp. 42–46.

82  For the festival in the Piazza Farnese and Panini's painting, see especially Fagiolo 1997, vol. 1, p. 240, with additional bibliography. For Panini's activities as a recorder of Roman festivals generally, see Arisi 1986.

83  Fagiolo 1997, vol. 2, pp. 38–39, with additional bibliography.

84  Pastor 1938–53, vol. 39, pp. 104–8. Gustav III returned to Rome on March 10, 1784, after visiting Naples, and remained until April 19. During his second visit Pius VI decorated him with the order of the Golden Spur, a singular distinction for a Protestant, even a monarch. Gustav's younger brother the Duke of Ost Gothland had come to Rome in 1776 and was afforded royal honors by the papal court, a favor that must have predisposed King Gustav in Pius's favor. The last Swedish sovereign to visit Rome had been Queen Christina in the late seventeenth century, but she came only after her conversion to Catholicism and subsequent abdication. The Lutheran Christian IV of Denmark had planned a trip to Rome during the pontificate of Clement XI, but only got as far as Venice. The visit of a Protestant king to papal Rome opened a new era of relations between the Church and many non-Catholic nations. Had it not been for the allure of art and culture, this thaw might have taken a very different historical trajectory.

85  Several references in the letters from Rome to Paris are informative in this regard. See Montaiglon 1887–1912, vol. 14, pp. 275, 279, 284, 297, and passim.

86  Pastor 1938–53, vol. 39, pp. 102–3.

87  The exhibition catalogue *Pompeo Batoni and His British Patrons*, published in conjunction with the exhibition held by the Iveagh Bequest, Kenwood, London (Bowron 1982), provides an impressive list of visitors, a virtual who's who of upper-class Grand Tourists to Rome. Although not everyone of social importance who came was painted by Batoni, a surprisingly large number were.

88  For Batoni's portrait of the Duke of York, see Clark and Bowron 1985, pp. 294–95, with additional bibliography.

89  Pastor 1938–53, vol. 39, pp. 108–9.

90  Rome's almost magnetic attraction to Europe's imagination is the subject of a series of essays entitled *Rome dans la mémoire et l'imagination de l'Europe* (Fumaroli 1997), although the texts are not limited to the eighteenth century.

91  The handsome catalogue of the Grand Tour exhibition held at the Tate Gallery in London has been the most ambitious study to date, and contains many valuable insights, but is little concerned with the interaction of visiting tourists and artists with the Roman cultural and artistic establishment. Kirby 1952 is still a useful introduction. For the historical context of the development of the Grand Tour among the British, see Chaney 1998, especially chapter 8, pp. 203–14. Chloe Chard's forthcoming book on the Grand Tour, which deals with such largely neglected issues as spectacle and spectatorship, class, and gender, will be a major contribution to our understanding of the phenomenon.

92  For the Virtuosi al Pantheon, see an excellent recent study, Bonaccorso and Manfredi 1998, with additional bibliography.

93  I borrow the apt phrase "academy of Europe" from an exhibition catalogue, Broeder 1973. To my knowledge, this is the first scholarly exhibition held in the United States devoted exclusively to the art of eighteenth-century Rome.

94  For the perception of Rome filtered through the prints of Piranesi that was widespread in eighteenth-century Europe, see especially Wilton-Ely 1983, pp. 317–37. Wilton-Ely's numerous authoritative publications on Piranesi and eighteenth-century Rome are fundamental to modern understanding of the artist. Piranesi's publications, especially the *Vasi, candelabri, cippi* … of 1778, were also extremely influential on European design during the Neoclassical era.

95  For an excellent brief summary of the Greeks versus Romans debate, see Honour 1968, pp. 50–62.

96  For the Swiss painter's Roman sojourn and the impact of Rome on his art, see especially Pressly 1979. Most of Fuseli's artistic contacts in Rome were with British travelers and visiting artists, and despite his nationality he was a founding member of the British Royal Academy and one of the most influential history painters working in eighteenth-century London.

97  Typical examples of the travel accounts under discussion are Beckford 1805; Knight 1905; and Miller 1777. For a highly useful study of travel literature focusing on the French *parlementaire* De Brosses, see Harder 1981, with additional bibliography.

98  In Cochin's words: "Je n'ai pu faire aucune note sur les belles choses qu'on voit à Rome, à cause de leur quantité, qui est en quelque façon innombrable … je crus devoir employer le séjour que je pourrois faire dans cette ville, à dessiner. Au reste, les curiosités qu'on voit à Rome, sont plus universellement connues que celles qui sont dans le reste de l'Italie; & d'ailleurs il y a toujours tant d'artistes de toute nations dans cette ville, qu'il est facile à tout amateur de se faire accompagner de quelqu'un d'eux." See Michel 1991, *Vivre et peindre*, p. 129. Cochin was in the suite of the Marquis de Vandières, who had been sent to Italy by his sister Madame Pompadour and Louis XV as

preparation for assuming the office of Surintendant des Bâtiments du Roi. The architect Germaine Soufflot, future builder of the Pantheon in Paris, was also in the marquis's party.

99 Quoted in Kirby 1952, p. 76, no. 3.

100 Moore 1792, vol. 1, p. 273. The physician's paraphrase of the denunciation is worth reading: "O thou beast of nature, with seven heads and ten horns! Thou mother of harlots, arrayed in purple and scarlet, and decked with gold and precious stones and pearls! Throw away the golden cup of abominations, and the filthiness of thy fornication!" The unfortunate zealot was briefly imprisoned but the pontiff intervened, thanking him for his good but misguided intentions and paying for his return passage to Scotland. See Kirby 1952, p. 83.

101 Moore 1792, vol. 2, pp. 38–39. Part of this passage is worth quoting: "The finest of all the ornaments [in St. Peter's] have a probability of being longer preserved than would once have been imagined, by the astonishing improvements that have of late been made in the art of copying pictures in mosaic … By this means, the works of Raphael, and other great painters, will be transmitted to a later posterity than they themselves expected; and although the beauty of the originals cannot be retained in the copy, it would be gross affectation to deny that a great part of it is. How happy would it make the real lovers of the art in this age, to have such specimens of the genius of Zeuxis, Apelles, and other ancient painters!"

102 Moore 1792, vol. 2, pp. 34–35. A sustained study of gendered response to antiquities, above all to male and female nude statues, would be a fundamentally important contribution to our understanding of the eighteenth century.

103 For the cultural transformation of the private collection to the public museum, and Italy's primacy in the process, see especially Pomian 1993, pp. 9–27, with a useful bibliography.

104 Francis Haskell has pointed out that very few important antiquities were actually alienated from Rome before the calamitous sack of 1798–99. See Wilton and Bignamini 1996, pp. 11–12.

105 For Jenkins, see especially Ford 1974, "Jenkins," pp. 416–25, with additional bibliography. The sculptor Joseph Nollekens is the source for Jenkins's cameo factory, and no less a personage than Goethe called him a scoundrel. The dealer was also loathed by the Jacobite court, who accused him of being a Hanoverian spy.

106 For Byres, see especially Ford 1974, pp. 446–61, with additional bibliography.

107 The sad story of the Poussin Seven Sacraments, now on loan to the National Gallery of Scotland in Edinburgh, is recounted in Ford 1974, pp. 458–59.

108 For Williams-Wynn, see especially Ford 1974, "Williams-Wynn," pp. 435–39, with additional bibliography. The Perseus and Andromeda is discussed on p. 436.

109 For the Hervey's activities in Rome, see Ford 1974, "The Earl-Bishop," pp. 426–34, with additional bibliography. The Englishman's addiction to travel is documented in the presence of hotels named Bristol in many Italian cities.

110 For Kauffmann and history painting in the Roman context, see Roworth 1998, with additional bibliography.

111 The hierarchy of the genres, the academic sine qua non since the late seventeenth century, ranked the various types of painting (and sometimes also sculpture, as in the case of grand funerary monuments) according to the amount of imagination necessary to visualize a given topic or subject. The representation of a text, for example, requires abstract reasoning and the felicitous combination of many figures in configurations that more or less correspond to the narrative. At the other end, still-life painting required mere "copying" of nature, and thus was little esteemed intellectually. History painting, including allegory, mythology, scenes from the lives of the saints and the Bible (with Apocrypha), antique and, by the late eighteenth century, medieval history, and, increasingly, representation of contemporary events of historical importance, had pride of place in all European academies. After history was portraiture, with portraits having mythological or historical referents outranking simple likenesses, and depictions of important people being more esteemed than others. Generally speaking, full-lengths were more prized than half-lengths or busts. Portraits were followed by the broad category of genre painting (scenes of everyday life), with landscape and still life a distant fourth and fifth. This hierarchy, like the hierarchy of society, was eroded and largely deconstructed by the end of the eighteenth century.

112 Settecento 1959. Unfortunately, this catalogue is quite rare.

113 Maxon and Rishel 1970. The section "Rome and the Papal States" (pp. 163–216) was edited by Anthony Morris Clark.

114 Two articles from the 1970s by scholars interested in the Roman eighteenth century when it was very much out of fashion served as a metaphorical call to arms. See Waterhouse 1971, pp. 19–21, and Clark 1975, pp. 102–7. These short articles rejected modern views of the derivative and "second-rate" (the phrase is Francis Haskell's) quality of Roman art and pointed out how little essential archival, analytical, and synthetic work had been done on this important era. The two essays were fundamental to my decision to investigate the eighteenth century in Rome as a graduate student, and I am grateful to Ellis Waterhouse for his encouragement and generosity.

# Arcadian Rome, Universal Capital of the Arts

## LILIANA BARROERO AND STEFANO SUSINNO

In the eighteenth century, at least until its star was temporarily eclipsed by the Napoleonic occupation, Rome continued to play a dual role, as mother city of universal Catholicism and as a center for the transmission of the culture of classical antiquity to modern times. As well as meeting the challenges posed by new ideas and changing political alliances in Europe, the popes were responsible for the government of the Papal States, though there was not necessarily a conflict between the various spheres of secular activity and their religious basis. Against this background, the arts continued to communicate and express the ideological identity of both Church and city in ever new forms. The artists resident in Rome, whatever their nationality, formed a distinct class, with complex subdivisions, around which much of Rome's cultural life turned, to an extent unmatched in other Italian and European centers. Through the various artistic institutions in which they were active, they played a leading role in the life of the city, and reports of their activities occupied an ever-growing place in contemporary accounts of public affairs. The Accademia di S. Luca and the French Academy were the official centers of artistic activity, but other organizations—public and private, local and foreign-based—also contributed to give the city a coherent, albeit highly diversified, artistic identity.

This unity in diversity, over so wide a field and so long a period, was ensured by an institution which had influenced the entire cultural scene since its foundation in 1690: the Accademia dell'Arcadia, which was still energetically promoting reform along classical lines at the end of the following century and beyond.[1] In the final decade of the seventeenth century, the concept of *ut pictura poesis* put forward by the ancient Roman poet Horace , whereby painting and poetry were seen as sister arts,[2] was realized in the privileged setting of this academy, which was essentially a literary institution founded to promote a reform in taste in accordance with classical precepts. The "Ragunanza degli Arcadi" was

officially instituted on October 6, 1690, in the garden of the convent of S. Pietro in Montorio. Among the fourteen founder members, prominent roles were taken by Giovan Mario Crescimbeni, who was appointed *custode generale* (custodian, a position he held until his death), and Gian Vincenzo Gravina, who in 1696 drafted the regulations. In governing the academy, the *custode* was assisted by a *savio collegio* of eminent Arcadians.[3]

Arcadian rationalism was based on a few key concepts: balance between nature and reason in the name of "good taste," between imagination and intellect, and between poetic invention and verisimilitude, in the name of "good sense." Finally, to Baroque "extravagance" and "wantonness" it opposed the authority of "national" literary tradition and the Church. The academy adopted the Infant Jesus as its protector, and the late Queen Christina of Sweden, to whose intellectual circle the founder members belonged, was proclaimed its *basilissa* (a title used in the Byzantine court to refer to the queen). The name Arcadia was a reference to the region of ancient Greece associated with the mythical Golden Age. It had been celebrated as such in the fifteenth century by Jacopo Sannazaro (in his poem *Arcadia*) and in the sixteenth century by Torquato Tasso (in his *Aminta*). The members of the academy, known as *pastori* (shepherds) and *pastorelle* (shepherdesses), each assumed a name borrowed from Greek, Latin, or Italian bucolic literature and took up symbolical residence in a district of the province.[4] The cornerstone and driving force of Arcadian reform was the doctrine of the "Idea" formulated by Giovan Pietro Bellori, a friend and confidant first of Poussin then of Carlo Maratti. Bellori provided the fullest definition of the aesthetic theory that the academy existed to promote:[5] the concept of the "Idea," however variously discussed and interpreted, was to inform all artistic activity, expressed most importantly in drawing as the common foundation of all the arts. Similarly, the term *pensiero* (thought), deriving from this same concept, was chosen by Felice Giani for his Accademia de' Pensieri in the 1780s,[6] and Luigi Sabatelli published images which he referred to as *pensieri* in 1795.[7] Moreover, the academy's literary repertory was consistently reflected in artists' and patrons' choice of subject

matter throughout the century, keeping alive the fortunes of Ovid and Horace, Apuleius and Virgil, and giving a classical veneer to the burgeoning sentiment of pre-Romantic Europe.

The vital contribution made by the Accademia dell'Arcadia to the definition of eighteenth-century Roman culture (and to that of other parts of Italy and Europe) has been underlined by recent studies.[8] It is not just that many artists belonged to the academy;[9] the Arcadia also played an important part in unifying the literary and artistic spheres, which had never before been so complementary and interactive.[10] Any attempt to characterize Roman art in the early eighteenth century must take this fact into account. "Arcadian classicism" is certainly a more appropriate label than the now obsolete and unsatisfactory, albeit widely accepted, "barocchetto romano" or the more awkward "proto-Neoclassicism." It certainly defines the aspirations of the artists, scholars, patrons, and sponsors in the small but universal city, a fact confirmed retrospectively by the appearance in 1819, during the Restoration period, of the prestigious *Giornale Arcadico di Lettere ed Arti*. The periodical was self-consciously opposed to Romantic culture, which was felt to be remote and foreign to the cultural identity that Rome still sought to defend.[11]

Some types of subject matter, though rooted in the history of the Church, were given renewed emphasis and ritual significance in Arcadian circles, from the key image of the Good Shepherd (*Pasce oves meas*) to the cult of the Infant Jesus. This tendency was supported by the Arcadian Cardinal Piermarcellino Corradini, who around 1735 commissioned the decoration of the reconstructed church of the Bambino Gesù in via Urbana and was also behind the building of a church promoting the same cult in his home town of Sezze. More than a hundred years later, the most intellectual of the Roman artists of his time, Tommaso Minardi, expounded the theories of *purismo*— a desire to recapture the simplicity of fifteenth-century art—in a speech he delivered to the academy entitled "Painting the Nativity," renewing one of the most characteristic themes of the Arcadian sensibility.

(OPPOSITE) detail of Antonio Canevari, *Perspective View of the Garden of the Accademia dell'Arcadia (the Bosco Parrasio) on the Janiculum*, c. 1725 (cat. 5)

## THE ARCADIAN IDEOLOGY

The academy functioned throughout the eighteenth century as a meeting place for artists, or rather those artists most interested in theoretical concerns, and for representatives of the world of letters, science, and antiquarian and religious scholarship. An understanding of Arcadian thought will therefore lead to a better understanding of the development of Roman art from the pontificate of Clement XI Albani to that of Pius VI Braschi. "Auch ich in Arcadien!" ("Et in Arcadia ego") were the words adopted by Johann Wolfgang von Goethe as the epigraph to his *Italienische Reise*.[12] Guercino and Poussin's famous motif recurs in Roman landscape paintings and drawings in the latter decades of the eighteenth century, when contemporaries were very aware of the role of the papal city as a cosmopolitan melting-pot.

The artists and intellectuals of Rome constituted an important social and cultural pressure group closely linked with the civil and ecclesiastical authorities. Throughout the century, they managed to maintain and strengthen their position in the city as the idea of "Rome, capital of the arts" took hold—a concept that lasted well into the nineteenth century. The influence of the artist class can be appreciated by examining their social and family ties and by exploring the biographical and economic evidence. But it is also borne out by that masterpiece of eighteenth-century cartography, Giovambattista Nolli's plan of Rome (1748; cat. 18).[13] The evidence in the plan of the close relationship between artists' dwellings and studios and the various residential, commercial, and industrial districts of the city provides plenty of material for a new approach to the subject. Also of great value are surviving inventories giving detailed accounts of the homes and possessions of many major and minor artists. The various documents reveal a fabric of family ties, marriage alliances, and relationships of a "sacramental" nature (determined by cultural traditions which were not threatened until modern times). Godfathers and witnesses at weddings were sometimes princes or prelates who were also patrons or collaborators involved in decorative schemes, festive displays, and even major monumental projects. Thus they were protectors and associates concerned as much as the artists themselves with matters of iconography and style. Important examples of this kind of patronage were Niccolò Maria Pallavicini,[14] cardinals Pietro Ottoboni,[15] Alessandro Albani, and Silvio Valenti Gonzaga,[16] and princes Abbondio Rezzonico,[17] Marcantonio Borghese, Sigismondo Chigi, and Paluzzo Altieri. And these figures provided a model for most of the enlightened and cultured members of the European aristocracy.

The legacy of classicism—such a distinctive element in the artistic idiom of Rome[18]—became increasingly influential throughout Europe. It reached the height of its authority around 1770, in a confrontation that took place far from Rome itself, in the Palacio Real in Madrid, where the Arcadian classical vision of Mengs was preferred to the late Baroque illusionism of Tiepolo.[19] Equally indisputable is the status of Rome, from the Counter-Reformation until well into the nineteenth century, as the source of a series of major works of art—from the entire sculptural and decorative panoply of cathedrals to simple altarpieces, from history paintings to portraits—which found their way to almost all the capitals of the Catholic world and beyond. It is possible to study the distribution of such commissions in the provinces of the Papal States, in other Italian and European states, in Russia, and in the Americas in terms of a system of patronage based, in the case of the most specifically "Roman" religious art, on relations between the Curia and the Catholic world.

However, it has only recently become possible to demonstrate the links between the cultural power of Rome and the rise of Neoclassicism, in order to prove the central role played by the papal capital in the diffusion of the new style. Its role was greater than that envisaged by even relatively recent studies (with the exception of the groundbreaking work of Anthony Morris Clark). Individual instances of the dissemination of Roman works of art are certainly well known, but they have generally been studied in relation to a specific area, rather than interpreted in terms of their overall significance. Before trying to assess the influence of Rome throughout Europe, and before making any ultimate aesthetic judgments, however, it is important to examine the motivation and the material conditions behind artistic activity in Rome itself during the eighteenth century.[20]

One of the prime aims of Italian Romanticism was to destroy the Accademia dell'Arcadia by making it appear ridiculous. The writers, particularly from Lombardy, who laid the foundations of a literature open to modern European influences by fostering the ideals of liberty and the secular state that were to underpin the Risorgimento saw the academy as one of the structures most supportive of the *ancien régime* that they sought to undermine. Their judgments therefore seem to be unanswerable condemnations of a sclerotic and politically reactionary classicism. In 1819, for example, Ugo Foscolo published his *Vita di Pio VI*.[21] Foscolo was a poet whose original classical inspiration had become tinged with Romanticism as a result of foreign contacts. For him, the fact that Pius VI had tolerated and

protected the Arcadians was that pope's greatest weakness. The Accademia dell'Arcadia, wrote Foscolo, had been founded for:

> a not unworthy purpose; but for many years it had been a disgrace and a nuisance, filling Italy with its shepherds and affiliated colonies, to which any blockhead capable of producing a sonnet and a sequin gained ready admittance, was granted the title of poet, a pastoral name and a plot of land in some romantic region of ancient Arcadia.

Only a need to affirm the criteria of literary modernity could have caused so forthright an attack on the institutions of the past. Mocked for its classical literary and artistic roots, Arcadianism was also prone to criticism from other directions in the nineteenth century. Ludovico di Breme, who in 1818 had jeered at "Arcadian childishness,"[22] the following year published a well-received satire in *Il Conciliatore*, the official organ of the Milanese Romantic movement, in which an Arcadian was represented holding a censer and carrying a beggar's haversack.[23] The censer symbolized the predominance of the clerical class, to which—it has to be said—much of the enlightened element of eighteenth-century Italy's governing class belonged. The beggar's haversack stood for the way in which all intellectual, literary, and artistic activity was strictly conditioned by patronage and authority.

Under the *ancien régime* this situation was indeed widespread, and not only in the Papal States. However, these old arguments should not be allowed to prejudice our view of eighteenth-century Roman art. The reality is that it was the Accademia dell'Arcadia which first provoked the reaction against the late Baroque, and later against the occasionally insipid prettiness exhibited in its own circles. The grandiose aspirations of the academy penetrated all aspects of culture and were inherited and strongly emphasized by the promoters of Neoclassical taste.[24]

In 1776 Voltaire wrote to the sculptor François-Marie Poncet, addressing him as "dear brother in Arcadia,"[25] and this moniker is by no means the only sign of the esteem in which the Roman institution was held by even the most progressive elements in French culture (the French naturalist Buffon was also a member). Olivier Michel has analyzed this relationship,[26] identifying a number of factors that serve as a corrective, at least in part, to the persistent conviction that the French were little interested in the Italian "republic of letters."[27] If there was a lack of interest, it was more evident in the last three decades of the century, when the tendency for artists to stay for shorter periods in Italy prevented

them from putting down roots there, and when the Enlightenment was instrumental in bringing about a renaissance in French literature. Even so, as late as 1804 Madame de Staël, who in *Corinne ou l'Italie* provided Europeans with the key to a sympathetic if somewhat stereotyped understanding of Italian culture, spoke of the academy with greater respect and consideration than many of Italy's own Enlightenment figures had done.

An analysis of the nine thousand or so names on the academy's eighteenth-century membership lists[28] yields a small but by no means negligible number of artists, accounting for approximately 3% of the total. However, 40% of the artists of real merit resident in Rome were academicians, and this percentage rises to 90% if only artists of the top rank are taken into account. Many of the artist members were foreigners, the French forming the most substantial group. What then were the criteria for admittance to the Bosco Parrasio, the venue for meetings of the Arcadians?[29] The first and most obvious qualification was the office of director of the French Academy, housed in the Palazzo Mancini. (Poerson and Ménageot were Arcadians, as were Natoire, Vien, and de Troy. The only exception was Lagrenée, though his wife and youngest daughter were admitted as *pastorelle*.) But the overriding criterion for full acceptance as one among equals was familiarity with the craft of writing.[30] Among the French artists are such major names as Jean Barbault, Hubert Robert, Pierre Subleyras,[31] René-Michel Slodtz, and Claude-Joseph Vernet. The architect Soufflot, for example, had translated some of the works of Pietro Metastasio, while the sculptor Jacques Saly had written two short pamphlets in 1771 describing his monument to Frederick V in Copenhagen.[32] The personal libraries of these artists, where they have been examined, reveal a substantial number of Latin and Greek classics, historical works, plays, novels, and biographies. Being an Arcadian was a mark of distinction and offered an *entrée* into society. Membership tended to be combined with other honorary distinctions: if the king of France awarded a French artist the cross of St. Michael, Rome tended to respond with the titles of *accademico di S. Luca* and *pastore d'arcadia* ("shepherd of Arcadia"). In a letter to the Duc d'Antin, Poerson congratulated himself on the privileged social relations to which his membership had opened the way:

> Here, sire, there is an academy famous for the fine minds of those who belong to it, among whom are twelve or thirteen cardinals, several princes, and other learned persons. As I have the honor to be known to a good number of these gentlemen, they have done me the kindness, without my asking it, of offering me a vacant seat, increasing their number in my favor, as is expressed in the letters patent they have granted me. This academy is called Arcadia; I have been given the name Timant, because each academician must take the name of a shepherd.[33]

Admittance to the academy, then, helped artists make a name for themselves and, at a time when academic careers were becoming more institutionalized, was often an important step on the ladder of success. Even if they lacked exceptional talent, artists could take advantage of their literary leanings and social contacts to obtain positions, if not in Rome then in the provincial academies of Florence, Bologna, Bordeaux, Lyon, Marseille, and elsewhere. Fifty years later, according to the report of one keen French observer, the Accademia dell'Arcadia—and with it Roman art and culture generally—had suffered a loss of international prestige. In 1767 Charles Duclos wrote that Rome "is greatly in need of regeneration. Literature, the sciences and arts, with the exception of music, are languishing … The Arcadian Academy, with its deluge of sonnets, is a mere parody of true learned societies."[34]

Later, however, the desire to acquire prestige within their own class overrode all reserve on the part of foreign artists admitted to the academy in the last decades of the century. In those years, under the leadership of Gioacchino Pizzi (until 1790) and Luigi Godard, the institution underwent something of a revival, admitting to its circles representatives of empiricism and early northern Romanticism. It is amusing to note the astuteness of a butcher's son from Carlisle, Guy Head, who had received honorary membership in local academies at every stage of his journey to Rome (Accademia Clementina, Bologna, February 1787; Accademia delle Belle Arti, Parma, July 1787; Accademia di Belle Arti, Florence, September 1787). On arrival in Rome in 1788, he consorted with the vast and often turbulent crowd of artists from his native land. As he remarked to the 4th Earl of Bristol: "All the English artists in Roam [sic] were most infamously debauched with respect to women."[35] Having become a close friend of the sculptor Vincenzo Pacetti, in whose house he lived in the strada Felice, the English painter became an Arcadian (*alias* Clistene Epireo) and, at the cost of being considered a snob, limited his social contacts to Flaxman and Canova. By virtue of this careful image management, he was soon admitted to the Accademia di S. Luca. Similarly, Frederick Rehberg enhanced his reputation as an elegant painter in the Greek style by posturing as a privileged friend in the international salon of Angelika Kauffmann.

A vivid picture of the close relationship between the literary Accademia dell'Arcadia and the most highly regarded master of Roman painting at the turn of the eighteenth century, Carlo Maratti, is contained in a description of an imaginary visit by a number of young women to the artist's studio. Following the conventions of the academy, the young women, all of noble birth, are represented as woodland nymphs. As a friendly gesture, they have also included in their group Faustina, the artist's daughter, a distinguished poet in her own right. The painter himself is depicted as an elderly shepherd, surprised in his rustic hut. This is of course his studio, in which are displayed some of his most celebrated works. The text is effectively a critical interpretation of Maratti's work as a painter during that period. It was written by the current custodian of the Accademia, Giovan Mario Crescimbeni,[36] and describes some of the artist's most significant paintings, selected for their adherence to the aesthetic and ideological canons of the academy. Of the various themes of Maratti's work—mythology and fable, history, love, beauty, immortality achieved through art and poetry—one appears to pervade eighteenth-century Roman culture perhaps more than all the others put together: religious sentiment. When the shepherdesses arrive, the elderly artist, now reaching the end of his long career, is busy painting an altarpiece of the *Assumption*, a quintessentially Roman and Catholic subject. This had been commissioned in 1703 by Pope Clement XI, an early member of the academy and now its most ardent supporter, for his family chapel in Urbino Cathedral.

Crescimbeni's choice of paintings provides a useful introduction to a series of subjects and images that recur in different forms throughout the eighteenth century. These images are of course not exclusive to the Roman school, but their wide distribution in Italy and the rest of Europe nevertheless reflects the school's figurative heritage, and represents the continuing importance of the Horatian principle of *ut pictura poesis*. As Stella Rudolph has observed,[37] taken together, Maratti's paintings offer a vision so in keeping with the taste and poetic principles of the early Arcadians that it is worth reviewing them in detail, beginning with the mythological subjects borrowed from Ovid's *Metamorphoses*. In *Venus and the Rose*, Venus, pricked by a thorn, is depicted coloring the barely opened flower with a drop of her blood, while being consoled by Cupid. It is significant that the picture, only recently rediscovered, was described by Giovan Pietro Bellori as a "poesia."[38] Crescimbeni lays emphasis on the presence in the background of "a beautiful Adonis," who is torn between his hunting (his dogs are straining at the leash) and his love of

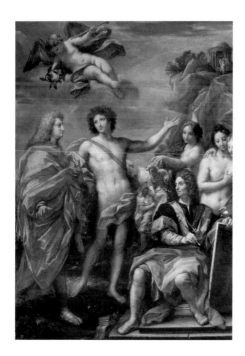

Fig. 19 Carlo Maratti, *Allegorical Portrait of The Marchese Niccolò Maria Pallavicini and Carlo Maratti*, 1692–95, oil on canvas; Stourhead, Wiltshire

Venus (Cupid points to the wounded goddess). The scene is set in a primitive natural landscape exemplifying "the symbiosis of woodland and pastoral genres which constituted—at least for the Roman adherents—the quintessential habitat of the mythical Arcadian race."[39]

Another of Maratti's paintings described by Crescimbeni, also of a mythological subject, is *The Judgment of Paris* (1708). Here the theme of Beauty victorious and triumphant could well be an allusion to the privileged role of the arts. Love, poetry, and nature are also treated in *Apollo and Daphne* (1681; see fig. 104), while *The Seasons* concerns the theme of passing time. A natural development of this sequence would have been history, the importance of which as a source of ethical models was stressed by the breakaway Arcadia Nova (which became the Accademia Quirina), which emphasized the virtues and memorable deeds of the ancient Romans. In Maratti's *Cleopatra*, however, it is sentiment that prevails in the figure of the unhappy queen, while the virtue of other famous women, such as Lucretia or the vestal Tuccia (also depicted by Maratti in a celebrated series of figures in natural settings), is the theme of the sonnets of Faustina (*alias* Aglauro Cidonia), the painter's daughter.[40] Maratti, as "primo dipintor d'Arcadia," to quote Crescimbeni, fulfills the function of transmitting to later generations of artists compositional models rooted in the tradition of the "grand manner," from Annibale Carracci to Francesco Albani and Domenichino.

Lastly, Crescimbeni describes a painting that sums up so much of the Arcadian poetic. It is an allegory, a genre that some years later Gian Vincenzo Gravina claimed to be the most complete form of poetic expression, and it features the painter and his patron and fellow-member the Marchese Niccolò Maria Pallavicini, here depicted ascending in true Arcadian style to the summits of civic virtue (fig. 19). To represent such complex conceits, Maratti composed a vast apparatus, in which contemporary reality consorts on equal terms with classical mythology. Niccolò Pallavicini enters stage left, sumptuously dressed in classical garb. He is addressed by Apollo, wearing the poets' laurel crown, who points to the "temple of Glory" in the distance, rising on the high, rocky slopes of Mount Helicon. There the marchese is awaited by a personification of Virtue, depicted as a winged angel. In the background Minerva, goddess of wisdom, dictates Pallavicini's name to History, who inscribes it on a bronze shield to perpetuate his memory. The other half of the composition is occupied by a self-portrait of Maratti, seated "in the splendid finery he used to wear when not working," sporting the insignia of *cavaliere* and depicted in the act of drawing—in other words performing the function central to the recovery of good taste governed by honesty and truth that was identified with academic art. He is shown representing the same scene, of which he is a privileged witness, while the Graces, mediators of beauty, stand around him in a circle, two of them contemplating his work, the third encouraging the marchese to overcome difficulty and win the promised crown of glory. Fame, in the form of a *genietto*, holds out the crown and trumpet ready to celebrate the merits of both protagonists. An amalgam of the centrally planned republican Temple of Vesta in the Foro Boario, the temple of the Sybil on its rock at Tivoli, and the Pantheon of Agrippa, the "temple of Glory" in Maratti's painting found a modern counterpart in the gallery of famous men begun at the end of the sixteenth century around the tomb of Raphael in S. Maria ad Martyres (once the Pantheon) and enlarged in the eighteenth century, where many artists were elevated to heroic status. Elsewhere, the same model was used to celebrate national figures (a concept alien to the cosmopolitan spirit of Rome), as in the *tempietto* commissioned by Lord Burlington for his park at Chiswick, near London (1724),[41] or the neo-Grecian Walhalla at Regensburg (1830–42).

Maratti's paintings illustrate with extreme clarity the artistic and cultural climate in which the Arcadian ideology gained ascendancy, partly as a result of his own contribution. The role he played was confirmed during a solemn prizegiving ceremony for young artists held on April 24, 1704, on the Capitoline Hill, where poets were traditionally crowned. On this occasion the pope decorated Maratti with the insignia of knight of the Order of Christ, as if to emphasize that this charismatic figure was the focal point of the papal program of reform in the arts.

## EARLY EIGHTEENTH–CENTURY ARCADIANISM

Even the fraught problem of finding a suitable place for the academy's poetic meetings, and of what the Bosco Parrasio should look like provides important clues to the dynamics and development of contemporary Roman art. It also involved individuals such as cardinals Pietro Ottoboni and Benedetto Pamphili, who, as patrons or organizers of large-scale public projects, exerted great influence on Roman artistic life. Crescimbeni, who published the first volume of his *Vite degli Arcadi illustri* in 1708,[42] subsequently devoted a great part of his literary efforts to illustrating the history and restoration of sacred buildings with roots in Early Christian churches. His writings can be read as a parallel to Arcadian pleas for the need to recover the heritage of Rome's golden centuries, and as a response to the initiatives of Pope Clement XI, who, despite the political and financial difficulties facing the Papal States, did not give up promoting often extremely costly building works when the Catholic powers were prepared to support his endeavors. Having concerned himself with S. Giovanni a Porta Latina (1716), S. Salvatore in Lauro (1716), S. Maria in Cosmedin (1719), and S. Anastasia (1722), in 1723 Crescimbeni wrote about the greatest project of church decoration undertaken in the early decades of the eighteenth century: the renovation of the interior of St. John Lateran,[43] cathedral church of Rome and the whole Catholic world. All of Catholic Europe, from the Elector of Mainz to King John V of Portugal, contributed financially, making common cause in the decoration of the majestic nave.

The project had begun with the monumental statues of the Apostles in Borromini's niches, for which the architect Carlo Fontana had left precise instructions. Bernini's virtuosity was ruled out; the guiding principle was to be "the model established by the great men of antiquity," and it must be possible to discern "the outlines of the nude" beneath the draperies.[44] Unity was to be achieved on the basis of drawings prepared by Maratti, though not all the artists accepted the subordinate role implied in this arrangement. In the decorative scheme of St. John Lateran, it is Maratti who forms a bridge between mature seventeenth-century

classicism and the Arcadian classicism of the new century. It was he who set the noble tone for the figures of the Apostles *Matthew* and *James the Great*, sculpted by Camillo Rusconi in 1715 and 1718 respectively,[45] and his influence is clearly apparent in the Prophet *Obadiah*, painted by Giuseppe Chiari between 1716 and 1718. The archpriest of the basilica was Benedetto Pamphili (*alias* Fenicio Larisseo), who in those years was writing libretti for Handel and who tackled a didactic allegorical subject in his oratorio *The Triumph of Time over Repentant Beauty*. The cardinal chaired the committees appointed by the pope which were supposed to decide on the content of the work in St. John Lateran and supervise its execution.[46] Other Arcadians engaged on this project were the French sculptors who had chosen Rome as their main field of activity: Pietro Stefano Monnot (who in 1695 had portrayed Don Livio Odescalchi, protector of Gravina, on a medal *all'antica*),[47] creator of *Saint Peter* (1706) and *Saint Paul* (1708), and his younger colleague Pierre Legros II, who was responsible for *Saint Thomas* (1711) and *Saint Bartholomew* (1712).[48]

The paintings are even more interesting as a cross-section of the different tendencies in Roman art brought together by this great project. These were the years in which the Accademia di S. Luca, in drawing up new statutes under the aegis of Pope Clement XI (1715), sought to establish its hegemony over the management of public commissions and, more generally, over all institutional policy relating to the arts. In the mind of the reformers, this action may have been seen as a necessary attempt to promote professionalism and accountability in the true interests of art. But it was immediately resisted by those who tended to defend ancient privileges and freedoms now threatened by the desire of the papal authorities and the two major academies (the French Academy and the Accademia di S. Luca) to regulate the arts. The intention of the reformers was to entrust such management to a qualified, self-renewing body, pursuing excellence and achieving legitimacy as the only true representative of the Roman school. As in the case of the Accademia dell'Arcadia, where the superior prestige of the pope served to overcome contradictions and crises, sometimes by forced mediation, some of the seats on the Lateran committee were allocated to representatives of the protest movement, who in any case could rely on the protection of powerful cardinals. Consequently, the great Prophets cycle brought together works by painters who were openly antagonistic to one another, and not only because of rivalry over quality.

The painters were asked to provide canvases to fill the oval openings, which were edged with sculpted garlands of "palm and laurel branches and flowers," in the words of the superintendent of the seventeenth-century restoration, Monsignor Virgilio Spada. In Borromini's plan they had been intended to frame, "like a jewel in a ring," sections of the brick walls of the original Constantinian basilica.[49] Giuseppe Chiari (responsible for *Obadiah*), Andrea Procaccini (*Daniel*), and Giovan Paolo Melchiorri (*Ezekiel*) had all been pupils of Maratti (who had recently died) and still shared in his reflected glory. But another protégé of the academy was the virtual beginner Pier Leone Ghezzi (the creator of *Micah*), son of Giuseppe Ghezzi, another painter and Arcadian, who had defined the institution's ideology in speeches, delivered on the Capitoline and subsequently printed, at official prize-givings.[50] Whereas Francesco Trevisani (*Baruch*) was an Arcadian shepherd in his own right (*alias* Sanzio Echeiano),[51] Benedetto Luti (*Hosea*) and Sebastiano Conca (*Jeremiah*)— "created" respectively by Don Livio Odescalchi and Cardinal Ottoboni—also moved in Arcadian circles and shared the academy's ideals. The "ecumenical" character of the Lateran restoration committee, however, also resulted in the inclusion of the most authoritative opponent of the academic monopoly, Marco Benefial, a protégé of Cardinal Pamphili, who was to spend the rest of his career paying for the stubborn position he had adopted in the anti-academic revolt. Giovanni Odazzi (*Hosea*) represented a late but modified Baroque style, inherited from his teacher Gaulli, while Luigi Garzi (*Joel*) could claim a classical pedigree deriving from Andrea Sacchi. The others were the Sienese Giuseppe Nicola Nasini (*Amos*), who also contributed to the *salone* of the Palazzo della Cancelleria,[52] and the Bolognese Domenico Maria Muratori (*Nahum*), "virtuoso"[53] of Cardinal Giuseppe Renato Imperiali. Spurred on by their rivalry, Chiari and Procaccini, Luti and Trevisani, Garzi and Muratori, Conca and Benefial prepared sketches and *bozzetti* to perfect the "movement" of their models, with an eye to rhetorical elegance of gesture, the fall of the draperies, striking light effects, and combinations of colors. The monumental subjects were intended to recall illustrious precedents, from Michelangelo to Domenichino, and to focus the attention of the public and of connoisseurs on figures poised between history and myth, balanced on clouds yet each powerfully occupying its own space.[54] Papal munificence was particularly evident on June 25, 1718, in the public ceremonies organized to celebrate the nativity of Saint John the Baptist, when the artists were presented with medals coined for the occasion.[55]

Somewhat different was the experience of those artists who a few years earlier had decorated the central nave of S. Clemente.[56] In this project, undertaken by the same pope in honor of his patron saint immediately after his election but not carried out until around 1714, the painters worked side by side on the scaffolding, transferring their subjects from preparatory cartoons.[57] In such circumstances, sharing and comparing ideas was inevitable. The painters therefore formed a more homogeneous group, brought together under the aegis of the Accademia di S. Luca. The dominant figure in this case was Giuseppe Bartolomeo Chiari, assisted by his less gifted brother Tommaso, while the most memorable single contribution was Pier Leone Ghezzi's *Martyrdom of Saint Ignatius of Antioch*. The dramatic scene in which the saint is thrown to the wild beasts was well suited to the artist's realism: here "Arcadian" took on the sense ascribed to it by Gravina, with the emphasis on naturalism and verisimilitude, even to the detriment of outward decorum.[58]

As for secular decorative schemes in private buildings, the ceilings of the *appartamento nobile* of the palazzo built by Livio de Carolis present an anthology of the art of these years. The merchant turned marchese[59] chose for his palazzo the kind of allegorical subjects fashionable in the major aristocratic residences, commissioning a series of canvases that were painted in the artists' studios and then mounted on site. Apart from Ludovico Mazzanti, all the artists concerned were already engaged on the Lateran project. It would appear that the "ecumenical" attitude of the new marchese was modeled on that of the pope and Benedetto Pamphili, with the result that again different schools and tendencies here rubbed shoulders. It was in any case common, throughout the eighteenth century and during the early decades of the nineteenth, for artists regarded as rivals to be deliberately contrasted in this way, and the interest and curiosity that such real or supposed rivalry arouses seems to have been a deliberate feature of the decorative display. This strategy is further proof that the Roman school saw its identity as consisting in a well-ordered diversity of voices and accents, as well as in respect for the classical heritage. Mutual emulation, together with the perennial and always problematic conflict between ancients and moderns, were the structural characteristics of an inherently composite artistic reality. The same aspiration to a reconciliation of conflicts and programmatic differences seems to have been behind the policies of the orthodox branch of the Accademia dell'Arcadia, and was reflected in those of the the Accademia di S. Luca and the French Academy at Rome. It also explains their temporary merging from 1704 to 1718 under the leadership of so committed and conformist an Arcadian as Charles Poerson.

In the decoration of the Palazzo de Carolis, the achievement of noble status by the exercise of *virtù* is depicted allegorically, and mythological figures give a timeless dimension to the themes of agriculture and labor, the flow of the hours and seasons, and the importance of the arts and literature in human affairs. No doubt the subject matter was also chosen to suit the functions of the various rooms. For instance, Andrea Procaccini's *Dawn* (which dates at least part of the cycle as being pre-1720, the year of his final departure for Spain) was particularly fitting for the bedroom, as was Benedetto Luti's *Diana*. Ludovico Mazzanti's *Zephyrs Driving Away Winter* and *Spring* allude to the changing seasons, while Giuseppe Bartolomeo Chiari's *Bacchus, Venus, and Ceres* and Luigi Garzi's *Chariot of the Sun* symbolize summer and autumn, and serve as a reminder of the marchese's previous activities.[60] More intriguing is Francesco Trevisani's "moral fable' of *Minerva Saving Adolescence from the Blandishments of Venus*,[61] a subject previously painted by Pietro da Cortona for the Palazzo Pitti in Florence. It is one of a series of contemporary exhortations to virtue in which Hercules or Minerva is called to counter the wiles of Venus, no doubt as a warning to the eldest son of the household. The whole decorative scheme is epitomized by Sebastiano Conca's *Allegory* (described by Lione Pascoli as *The Triumph of Virtue*), in which Virtue is depicted seated among the Arts (Painting, Sculpture, Architecture), while Liberality (represented as a *genietto*) pours out the cornucopia of Abundance and, on the other side of the picture, History, backed by Fame and Poetry, triumphs over Time. Among these varied styles and expressive trends, the clearest contrast is that between the dignity and decorum of Chiari, who produced a *quadro riportato*, based on a canonical scheme of three main figures, and Luti's airy nocturnal scene, viewed from below, in which delightful girls—one a sleeping nude, another clothed in contemporary style—form a circle around the virgin huntress and embody two contrasting concepts: one nobly rhetorical, the other sweetly intimate.

The decoration of the ground-floor apartment of the Palazzo Ruspoli (1715) differs from the schemes typical of the residences of the great Roman families.[62] The paintings, executed in more delicate gouache, were intended to provide a link with the adjacent garden, exhibiting a lightness and escapism more suited to a suburban villa. This setting was appropriate for the so-called "minor" genres, in particular landscape and *bambocciate* (little pictures of genre scenes), exactly the type of art that, in the hierarchy of genres advocated by the Accademia di S. Luca, was not in the

front rank and was practiced mainly by specialists—precisely the people who felt threatened by the rigid regulations set out in the statutes of 1715. Prince Francesco Maria Ruspoli, a protector of the Arcadia, personally supervised the work of the various artists, who were set a program linking the ground-floor rooms of his palazzo with the natural world in all its aspects. The decision to apply this kind of treatment to an apartment that, with its formal throne room and gallery of statues, still served as the reception area of a princely urban residence, may have been influenced by the new perception of the garden as a setting for poetry. This concept was very real to the prince, who had shown his munificence by renting the Ginnasi Garden on the Aventine for Arcadian assemblies. The Palazzo Ruspoli rooms therefore featured marine and hunting scenes, *bambocciate*, and views of the family feuds. Where figure painting was included, it was limited to Michelangelo Cerruti's Sala delle Ninfe. In 1715 the *Mercurio Errante* described seeing here "various classical fables, such as Diana bathing, Mount Parnassus and others of that sort"—a strictly woodland and pastoral mythology in a setting enhanced by the playing of a fountain.[63]

## ARCADIAN ICONOGRAPHY

A great opportunity for the Roman Arcadians to give concrete form to what until then had been no more than a figment of their poetic imaginations arose as a result of the generosity of John V of Portugal. Elected to the academy in 1721 (*alias* Arete Melleo), to the seat formerly occupied by Pope Clement XI, the Portuguese king donated 4,000 *scudi* to buy a plot of land on the slopes of the Janiculum and to transform it into an area suitably laid out for the academy's assemblies. Its character as a recreation of the mythical Bosco Parrasio in which the "shepherds" could meet regularly was to be neither that of a suburban villa, nor that of a garden, nor that of rustic countryside, but rather a combination of all these elements.[64] The totally new combination of architecture and landscape they envisaged was planned by Antonio Canevari (cat. 5), who designed the surrounding buildings and sculptural decoration and selected and arranged the various species of trees. The entrance from the city was flanked by two service buildings. From here, stairways and fountains hidden among thickets and hedges of laurel (the sacred plant of Apollo) led to the summit of the hill, where there was an open-air amphitheater to accommodate the Arcadians and their guests (only cardinals were allocated individual seats). The sculptures along the way were obvious in their significance: first, the river gods of the Tiber

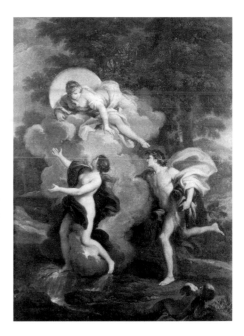

Fig. 20  Stefano Pozzi, *Alpheus and Arethusa*, c. 1745, oil on copper; private collection, Rome

and the Arno symbolizing Latin and Italian poetry, then, on the first level area, a seated statue of Apollo holding out a laurel crown and, with his other hand, pointing to a commemorative inscription recording the "munificence of the benefactor and the gratitude of the beneficiaries." The symbolic layout, of which Vittorio Giovardi has left a detailed description (1727), continued with a statue of Alpheus (founder of Greek lyric poetry), installed in a grotto dripping with water, while Syrinx was represented by her instrument, the panpipes, repeated on the capitals of the pilasters. Finally, crowning the summit was a statue of Pegasus, the winged horse of Parnassus, striking the rock with his hoof to produce a spring of water, the constant flow of which was a reminder of the easy flow of verses and ideas expected in Arcadian assemblies.

No trace of these sculptures has survived, and there is no definite proof that they were ever actually carved. However, the description by Giovardi of this complex is the most elaborate surviving testimony to the way the poetic myths were represented, in the manner reestablished by Maratti and continued just as expressively by his eighteenth-century disciples. The themes of the Bosco Parrasio, at the very center of the Roman figurative tradition, can be traced back to one of Maratti's masterpieces, the *Apollo and Daphne* in Brussels (fig. 104).[65] They were developed in Giuseppe Bartolomeo Chiari's interpretations of Ovid for the Galleria Spada (four episodes from the *Metamorphoses*), Filippo Lauri's tempera wall paintings in the Palazzo Borghese, and, toward

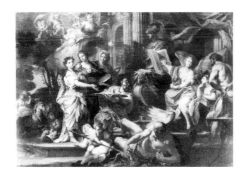

Fig. 21 Sebastiano Conca, *The Allegory of the Arts*,
1724, oil on canvas; private collection

the mid-century, in Stefano Pozzi's coppers
of *Pan and Syrinx* and *Alpheus and Arethusa*
(fig. 20)[66]—possibly the most perfect depic-
tion of Arcadian grace until Mengs's interpre-
tations of the theme (which retained its vitality
until well into the nineteenth century).[67]

Is there such a thing, then, as a specifically
Arcadian iconography? One way of answering
this question might be to take Gravina's text
*Delle antiche favole* (1696) and see how the fables
in question were treated in the figurative arts,
particularly in the cultural circles presided
over by the central figure of Cardinal Pietro
Ottoboni. This will help to place the many
paintings featuring Diana and Endymion or
Mercury and Argus, the fable of Leto or the
drama of Pyramus and Thisbe, the constant
proliferation of which cannot be adequately
explained by their general suitability for deco-
rative purposes. Even Winckelmann said he
regarded Gianvincenzo Gravina's *Ragion poetica*
as superior to any other treatise on aesthetics
and, in a letter dated June 9, 1762, recommended
to Friedrich Reinhold von Berg that he read it
and commit its contents to memory.

Bearing in mind how Gravina explicitly
identified allegory as the Arcadian form *par
excellence*, it may be useful to examine the cele-
bration of the arts as another theme closely
related to the Arcadian ideal. An example
from the early years of the century is Sebastiano
Conca's ceiling for one of the rooms in the
Palazzo de Carolis (c. 1720), part of a decora-
tive scheme intended to legitimize the newly
acquired social prestige of a corn merchant
who had rightly identified the celebration of
the arts as an appropriate strategy to this end.
Then, some fifty years later, there is the deco-
ration of the main reception room (Salone
d'Onore) of the Palazzo Borghese, in which a
patron of the caliber of Prince Marcantonio IV
chose the arts, symbolized by noble female
figures, to frame the heraldic emblems of his
illustrious house.[68] Between these two works,
many key examples can be found of a similar
celebratory nature, which in Rome had a par-

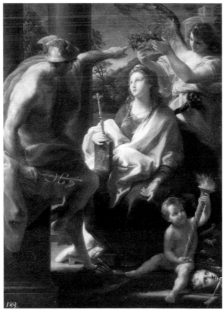

Fig. 22 Pompeo Batoni, *Mercury Crowning Philosophy
Mother of the Arts*, 1747, oil on canvas;
The State Hermitage Museum, St. Petersburg

ticular social and economic resonance. These
include another work by Conca, *The Allegory of
the Arts* (1724; fig. 21), painted for the Elector of
Mainz, Philipp Franz von Schönborn;[69]
*Mercury Crowning Philosophy, Mother of the Arts*
(1747; fig. 22) by Batoni;[70] *The Arts Led by
Mercury to the Temple of Glory* (1750) by Placido
Costanzi[71] (in both canvases, the presence of
Mercury is a reminder of the importance of
the art trade for the papal capital); and many
allegories of Painting as representative of art
in general. (Not until the end of the century,
in the reign of Pius VI, did Henry Fuseli first
detect a reversal of roles in favor of Sculpture,
bearing witness to what was then no more
than a vague inkling in his disturbing allegori-
cal drawing of a sculptor armed with a chisel,
driven by a wind issuing from the Braschi
coat-of-arms, overthrowing a painter lost in
meditation (fig. 23).[72] Meanwhile, Felice Giani
was still celebrating Painting as the art favored
by the gods (1784),[73] and Michael Köch was
depicting *Time, History, the Genius of Painting and
of Architecture around the Herm of Raphael*.)[74] A list
of works celebrating the primacy of painting
reads like a roll-call of the great masters of the
profession, in a line going back through
Maratti[75] to the origins of eighteenth-century
Roman classicism in the Carracci brothers. It
includes the allegories already referred to by
Sebastiano Conca (who incidentally delivered
an important discourse on artistic principles
to the Accademia di S. Luca),[76] and allegories
of Painting by Batoni (1740),[77] Francesco
Mancini (c. 1745),[78] Corrado Giaquinto (c. 1750),[79]

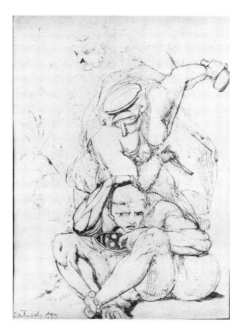

Fig. 23 Henry Fuseli, *The Second Allegory of Painting*,
1777, pen and ink over pencil; private collection

and Domenico Corvi (1764).[80] An interesting
variant on the theme is Francesco Caccianiga's
*Painting Scorned by Ignorance* (1736),[81] in which a
distinguished antiquarian, Giovanni Battista
Furietti,[82] is ridiculed in the guise of Harlequin.[83]
The frequency with which Batoni painted
these subjects is explained by his closeness to
Arcadian circles. His first biographer (1757)
was in fact the Arcadian Francesco Benaglio,
of whom Batoni had painted a portrait (Clark
and Bowron 1985, p. 269, n. 201). Batoni was
also responsible for one of the most signifi-
cant images of a *pastorella*, in the portrait of
Giacinta Orsini Boncompagni Ludovisi (*alias*
Euridice Aiacense), 1757–58 (Clark and
Bowron 1985, pp. 271–72, n. 206). Batoni's own
daughter Rufina, a musician and poet, was an
Arcadian with the name of Corintea. Having
died young, as recorded in the *Diario Ordinario*
(no. 982 of May 29, 1784), she was commemo-
rated by the academy on March 20, 1784 (Clark
and Bowron 1985, p. 59, n. 14). Another illustri-
ous *pastorella* was the Marchesa Margherita
Sparapani Gentili Boccapaduli, whose portrait
was painted in 1777 by Pécheux (fig. 24).

It is against this background that the
allegories of Mengs should be interpreted,
although they were on a very different intellec-
tual level. In the ceiling Mengs painted for
Cardinal Albani in 1761, he depicted Apollo
surrounded by the Muses (cat. 378), and he
produced the *Allegory of History* for the Stanza
dei Papiri of the Museo Sacro Vaticano in 1772.
This complex of literary and antiquarian allu-
sions was most fully developed by Tommaso

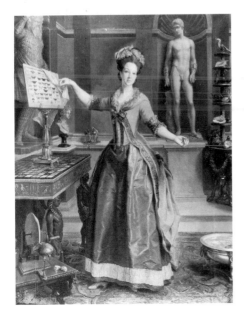

Fig. 24 Laurent Pécheux, *Marchesa Margherita Sparapani Gentili Boccapaduli (Semira Epicense)*, 1777, oil on panel; private collection

Fig. 25 Tommaso Maria Conca, *The Triumph of Apollo over Marsyas*, 1782-87, fresco; Museo Pio Clementino, Rome, Ceiling of the Sala delle Muse

Fig. 26 Pompeo Batoni, *The Choice of Hercules*, c. 1750, oil on canvas; Galleria Sabauda, Turin

Maria Conca in the ceiling of the large Sala delle Muse of the Museo Pio-Clementino (1782–87), where, around the victorious figure of Apollo, the literary themes of classical antiquity are interwoven with parallel evocations of art and archaeology (fig. 25). The scenes that exalt poetry as the inspiration of the arts are *The Triumph of Apollo over Marsyas*, in the central panel, *Mercury among the Sages of Ancient Greece*, and *The Inspiration of Homer and the Greek Poets*.[84] In this setting, where Pius VI brought together some of the Vatican collections' key works, there is again a hint of the growing importance of sculpture, which painting and poetry are called to celebrate.[85]

Parallel to these glorifications of the god of poetry, which centered around the cult of the *Apollo* Belvedere in the Belvedere Court, was another very Roman development: the casting of Hercules as the prototype of a modern hero, making virtuous decisions to reach the heights of a moral or social Olympus. Again, classical statuary, such as the Farnese *Hercules* or the Capitoline *Hercules*, provided the formal models, while there was a well-known precedent for the figure of the thoughtful hero torn between vice and virtue in Annibale Carracci's *Hercules at the Crossroads*, in the *camerino* of the Palazzo Farnese[86]—a model that was frequently copied.[87] In 1744, for example, Marco Benefial painted an *Apotheosis of Hercules*, now lost, for a room in the Palazzo di Spagna,[88] commissioned by a fellow Arcadian,[89] Cardinal Troiano Acquaviva. In 1748 a new room was inaugurated in the Museo Capitolino, designed by Ferdinando Fuga to house the paintings

acquired by Benedict XIV from the Sacchetti family. This room later became the setting for the large bronze *Hercules* which since the early years of the sixteenth century had been on show in the Palazzo dei Conservatori, a gift from the popes to the people of Rome. Some twenty years later, the same statue provided Giuseppe Bottani with the model of a young, beardless Hercules for his vast canvas of *Hercules on His Way to the Temple of Virtue*. The painting was intended for the ceiling of one of the state rooms of the Palazzo Pamphili, decorated in 1768 to mark the marriage of Andrea IV Doria Pamphili and Leopoldina di Savoia Carignano.[90] Meanwhile, the image of the mature Hercules derived from the Farnese *Hercules* (which was sent from Rome to Naples in 1787 together with the Farnese antiquities inherited by the Bourbons) never went out of fashion. After a series of faithful reproductions as academic exercises (Sergel) or scaled-down versions for the art market (Righetti, Zoffoli), it was given a new lease of life and new gestures in Cristoforo Unterperger's ceiling for the Villa Borghese (1784), and found its final expression in Canova's colossal marble *Hercules and Lychas*,[91] undertaken for Onorato Caetani in 1795.

These are examples of Hercules' appearance in prestigious, large-scale works that were undoubtedly the subject of contemporary artistic debate. The crowning example must be Mengs's reworking and enlargement of his teacher Benefial's composition for the Conversation Room in the Palacio Real, Madrid (1776).[92] But Hercules also featured in many paintings, drawings, and sculptures showing scenes from his life, from the *Labors* to the *Rape of Deianeira* (Bianchi, Pécheux). In these, as in the other cases cited, it is not simply the iconography that shows how deeply Hercules was a part of contemporary culture, but the fact that such themes lasted so long and were so common.[93] The iconography became so

familiar that variants with a completely different meaning were created, and yet were recognized as being based on earlier models. A good example is the self-confident and worldly painting *Garrick between Tragedy and Comedy*, which, on his return from Rome, Sir Joshua Reynolds dedicated to the actor David Garrick.[94] Here Garrick is poised like Hercules choosing between the muse of tragedy and that of comedy, and the most cultured of the English painters shows him smiling and yielding to the more seductive prospect.[95]

It was during this period that the new custodian of the Accademia dell'Arcadia, Gioacchino Pizzi, published his *Ragionamento sulla tragica e comica poesia* (1772), in which he encouraged a new openness to the literature of other countries, which was to be a feature of his tenure and which led to a general reawakening of interest in the institution. In any case, in Rome, the theme of the dilemma of choice between two options represented by allegorical female figures soon reappeared in a picture by Angelika Kauffmann (a bridge figure between Roman and London art circles),[96] in which this artist, loved by men of letters,[97] shows herself torn between Music and Painting (cat. 234).[98] The subject of virtuous choice was also treated by Kauffmann in a modern story very familiar to a northern European public, *Henry of Navarre, Head of the Huguenots, Persuaded by His General Philippe de Mornay to Abandon His Lover Gabrielle d'Estrée to Pursue Glory*.[99] Returning to the iconography of Hercules, the Palazzo Farnese *Choice of Hercules* was the model used by the romanized Neapolitan Paolo de Matteis in interpreting the instructions he received from Lord Shaftesbury[100] and by Batoni for a picture he painted around 1750 for the Piedmontese Count Girolamo Malabayla (fig. 26).[101] Here the hero's pose is borrowed directly from Annibale's prototype. When, in 1785, Domenico Corvi was asked to paint a

self-portrait for the Uffizi collection, he depicted himself painting a Hercules lost in thought—not so much a perfect example of an academic nude as an example of the artist–philosopher heroically championing his own professional activity (cat. 204). Here the figure of Hercules is also a reminder of the artist's Arcadian pseudonym, Panfilo Eracleate (the second name indicates that Hercules was Corvi's role model and also alludes to his native town of Viterbo, said to have been founded by Hercules).

In the literary sphere, Giacomo Casanova (whose brother Giovanni, a pupil of Mengs, went by the Arcadian name of Saurio Procense) chose Hercules for the subject of a sonnet recited at the prizegiving ceremony for pupils of the Accademia di S. Luca in 1771.[102] The ceremony was held on the Capitoline Hill, the most appropriate meeting place, apart from the Bosco Parrasio, of the Arcadian and art worlds. Such prizegivings, solemnized by public speeches composed and declaimed by the Arcadian shepherds, were held there throughout the eighteenth century, in a setting dominated by the bronze *Hercules* of heroic dimensions mentioned earlier and the allegorical portrait of the emperor Commodus in the same guise. In the early years the ceremonies included simple orations, pronounced on several occasions by Giuseppe Ghezzi (elected to the academy in 1705, *alias* Afidenio Badio);[103] by the last three decades of the century they had become ever more institutionalized high-profile, public celebrations of the arts. The proceedings were reported in official pamphlets published by the Arcangelo Casaletti printing house, the favored publisher of Arcadian texts, and in the *Giornale delle Belle Arti*.[104] Indicative of this close relationship between the literary and art worlds was the funeral oration in praise of Mengs pronounced on May 11, 1780, by Giovanni Cristoforo Amaduzzi (*alias* Biante Didimeo), scholar, antiquarian, and professor of Greek at the Archiginnasio della Sapienza (*Discorso funebre in lode del cavaliere Antonio Raffaele Mengs recitato nella generale Adunanza tenuta nella sala del serbatoio d'Arcadia il dì 11 maggio 1780*), in which Amaduzzi defined the arts as "favorite daughters of genius and reason and fortunate pupils of freedom."[105] This is a good example of a literary exposition stressing some of the main points in the eighteenth-century critical debate on the function of the arts and their role in promoting freedom of mind. As such, it is a contribution, with its own particular emphasis, to the wider European debate.

## ARCADIA AND THE CHURCH

As part of the general development of intellectual life in eighteenth-century Rome, a number of bodies were founded to study church matters: the Accademia dei Concili, the Accademia dei Dogmi, and the Accademia di Teologia. Frequented by aristocratic churchmen, they were intended to train the governing class of the Papal States, and had a profound impact on both literature and the arts. In particular, large-scale ecclesiastical commissions for the decoration of churches were linked to a renewed cult of the early Church,[106] the development of Christian archaeology, and the need to use art to reemphasize the centrality of the universal Church in opposition to the Jansenist and Ultramontane influences that were sapping its foundations. The College of Cardinals, which reflected the opposing political tendencies of the different European courts, used its vast network of ecclesiastical appointments, nunciatures, legations, protectorates of monastic orders and national churches, recommendations, and benefices of all kinds to influence even the autocratic will of the pope. The power they wielded was manifest in the urban fabric of Rome and in sacred buildings and monuments in which evidence of papal patronage was intermingled with that of the munificence of cardinals and princes.

The fact that even an ascetic with little interest in literature and the arts such as Pope Benedict XIII was able to become an Arcadian does not necessarily mean that membership of the academy was automatic or simply a matter of form. It almost always implied a real belief in the founding principles of the institution, the constitution of a unitary and supranational "republic of letters" consisting of free and equal men associating on the basis of talent but dominated by the Roman ecclesiastical class. It is therefore easy to understand why the princes of the Church, and the pope himself, accepted the literary fiction of a symbolic pastoral region as the setting in which government policy could be transmitted to the learned classes of civil society. They were not merely members of the Accademia dell'Arcadia. They were also teachers at La Sapienza (the University of Rome), directors of church colleges, artists, and men of science. Firmly based in their own institutions, they regarded the Bosco Parrasio as a meeting ground where, in the name of poetry, they could form rewarding relationships, the purpose of which was not solely utilitarian. Moreover, although the Arcadia could not elevate its members to noble rank, it did away with class differences by assigning them poetic names and granting each a rural estate in the land of myth. Here for instance, is Lione

Pascoli's account of the reception by the academy of an artist so profoundly anti-classical in style as Giuseppe Ghezzi, on the occasion of the first centenary of the Accademia di S. Luca (1695):

He delivered a learned and elegant oration which won the universal applause of the audience, and many of the prelates and cardinals present wanted to congratulate him, especially Cardinal Albani, who then took him under his protection and continued to protect him after he had ascended the papal throne.[107]

Ghezzi's status as papal protégé is clear, no doubt encouraged by the fact that the artist and his principal admirer were both from the Marches. But Pascoli insisted on his well-rounded character as painter and man of letters:[108]

He introduced his speech [on the arts] in good order, and subsequently enlarged on his theme in the same orderly fashion … and contributed greatly to the celebration of the arts. He adorned and sprinkled the grand hall of the Campidoglio with learned and witty words. … Recognizing his talent and spirit, the Arcadians admitted him to the academy.[109]

A hundred years later, the orator for the second centenary was the secretary of the Accademia di S. Luca, the architect Francesco Navone (*alias* Edrasto), who spoke on *I pregi delle belle arti*, both on the Capitol and at the Accademia di S. Luca, then presided over by "il signor cavaliere Tommaso Maria Conca" (*alias* Demofilo Imerio). His words inevitably echoed those of Prince Baldassarre Odescalchi, who four years earlier, on the occasion of the first centenary in 1791 of the Accademia dell'Arcadia itself, had praised the Arcadians for having restored "the pure style of the Ancients," with the result that "poems sometimes worthy of the century of Augustus" were heard in the Rome of Pius VI.[110] Among the good deeds of Giuseppe Ghezzi, Pascoli stressed his having begun the collection of portraits of members of the Accademia di S. Luca,[111] memorializing those who attended the oratorical performances of Navone or Odescalchi. A distinct group of canvases by Anton von Maron depicts them in noble costume and attitude, without the usual paraphernalia of their trade such as paint brushes, chisels, or compasses. They include the sculptor Vincenzo Pacetti (*alias* Telefane Foceo), the doyen of the Spanish artists in Rome, Francisco Preciado de la Vega (*alias* Parrasio Tebano), with his wife, Caterina Cherubini (miniaturist and *pastorella* Ersilia Ateneia),

Navone himself, and finally Maron (*alias* Melanto Sicionio*), one of whose self-portraits[112] was described by the Abbé Giuseppe Carletti (*alias* Eumenide Ilioneo) in the *Giornale delle Belle Arti* in terms that convey more effectively than any sociological analysis the self-ennobling strategies of the eighteenth-century artist: "The great painter is depicted seated in a pearl-colored satin housecoat, his feet warmed by the finest Muscovy fox furs ..."[113]

Like Clement XI, Benedict XIV (Prospero Lambertini) was an Arcadian before his elevation to the papal throne. Bestriding the middle years of the century, he has often been seen by modern historians as an Enlightenment pope, in friendly dialogue with contemporary philosophers and scholars on the strength of their common participation in the "republic of letters." In fact, the former archbishop of Bologna built on the foundations laid by his predecessors in strengthening an image of the Church that relied on the practice of the Christian virtues as the best defense against the secularization of the contemporary world.[114] While, to quote a recent and very illuminating definition, charity was adopted as a method of government,[115] it was piety toward the visible signs of Early Christian Rome that guided the pope's policy in the arts. In this he continued and confirmed a tradition dating back to the Counter-Reformation; the chronicles of his pontificate describe him visiting building sites, consecrating new projects, and distributing the relics of Early Christian martyrs to altars and chapels, parishes and basilicas, in and outside Rome. On September 14, 1744, for example, he went to say Mass at the basilica of S. Croce in Gerusalemme (from which he derived his title as cardinal). Coming out of the church, where he had taken the opportunity to admire the new ceiling by the Cavaliere Corrado,[116] the pope engaged in conversation with the architect Domenico Gregorini (*alias* Silvasio Gnidio) and, before returning to his carriage, turned to survey the new façade. Designed "with a new architectural concept no less natural than exact,"[117] the façade, with its adjacent portico, presented its luminous, gently convex surface to the setting sun, crowned with a triumphal array of statues which blazed in the evening light: Constantine and Saint Helena, the four Evangelists at their sides, all turned toward the towering cross at the center of the group, it too made of blond Roman travertine, with two angels kneeling in admiration at its foot.[118] The composition, so in harmony with the almost domestic forms of the façade, seemed to recreate in stone the ephemeral decorations created for the Easter ceremonies. In its celestial iconography, it is similar to the statues on the attic story of St. John Lateran, put in place a few

Fig. 27  Giuseppe Lironi, *Virgin and Child, 1742*; S. Maria Maggiore, Rome, façade statue

years earlier, which represent the Savior between Saint John the Baptist and Saint John the Evangelist, and the Doctors of the Greek and Latin Church.[119]

To emphasize the connection between the two basilicas, the pope opened up the wide avenue running from the Lateran to S. Croce, and presented the Milanese Gioacchino Besozzi, the titular cardinal of the basilica, with 650 trees to create one of the first shaded walks on the fringe of the city. Though to the inattentive modern visitor these groups of statues may appear essentially decorative, to the Catholic faithful making pilgrimage to Rome they were a visual materialization of the doctrinal foundations of the faith. Of similar significance are the lofty statues surmounting the façade of S. Maria Maggiore, also erected during the pontificate of Prospero Lambertini (again the architect was an Arcadian: Ferdinando Fuga, *alias* Dedalo Ipodromiaco). These represent the Virgin with the popes who founded the basilica (fig. 27)—a powerful and highly visible symbol of the renewed cult of Mary, a distinctive feature of the Roman Church setting itself against all ancient and modern heresies.[120] And while the Roman skyline was being redefined by this heavenly host of new and striking statues, which complemented the seventeenth-century array of Christ, Peter, Paul, and the rest of the apostles and saints crowning the façade and colonnade of St. Peter's, inside that building also the religious orders continued their work of combined

artistic and religious piety, financing and erecting monumental statues of their founders. It was an undertaking that breached the time constraints of any normal commission: the redecoration of St. Peter's, planned at the time of the Counter-Reformation (though actually begun under Clement XI), continued, unchanged in motivation and stylistic variants, into the twentieth century.[121]

Clearly maintaining the policy of earlier popes, Benedict XIV emphasized "a constant and intense reminder of the authority of the Vicar of Christ"[122] and was energetic in promoting academic institutions, especially those devoted to the study of canon law and Church history. These were indeed places of scholarly historical research, but not, as is often unwisely asserted, in the modern sense of adapting to Enlightenment criteria of interpretation; rather, they "combined the sophisticated culture of the Roman Curia with a clearly defined political and religious objective."[123] Recent historical studies stress the "specific character of the Roman social and cultural structure, setting aside the constrictive conceptual paradigm dominated by a uni-directional idea of modernization." Instead, they emphasize "faithfulness to tradition as the first priority, whilst always revealing a high degree of elasticity, a capacity … for innovation in continuity, mostly concerned with using the former to confirm and strengthen the latter."[124] A similar assumption lies behind the hieratic fixity of the timeless image of the pontiff, designed by Giacomo Zoboli and translated into the perennial medium of the mosaic, which Pietro Paolo Cristofari (1744) created for the pope's native city.[125]

In his arts policy, Benedict XIV could rely on the competence and well-informed taste of his secretary of state, Cardinal Silvio Valenti Gonzaga. It was undoubtedly Gonzaga who was responsible for improvements to the Musei Capitolini (which became, like the Museo Pio-Clementino, a model for all similar European institutions) and for the inauguration there of a "Scuola del Nudo." At least one building, however, was specifically created by Pope Benedict: the Coffee House, or Caffehaus,[126] in the Quirinal Gardens. Commissioned by the pope shortly after his election and built between 1741 and 1743,[127] it was intended to serve as a venue for informal receptions not governed by court protocol, which inevitably emphasized the holiness of the pope's person. This should not be seen as an attempt on the part of the pope to avoid the ceremony sanctioned by a thousand-year-old tradition, but as indicating that in order to preserve the sacred aura of the presence of the Vicar of Christ in his official residences and the great basilicas, a special place needed to

be set aside for private audiences. The iconography of the decoration of the Coffee House had therefore to indicate clearly to the visitor the basis of papal authority, and the enduring principles of the pope's political and administrative functions. The paintings in the two side rooms off the central portico allude to the mission of the Church and the powers of the pontiff. On one part of the ceiling of the Coffee House is Pompeo Batoni's *The Delivery of the Keys to Peter*. Here Batoni returned to the old-fashioned symmetrical arrangement used by Perugino in his fresco of the same subject in the Sistine Chapel, yet softened by a naturalism inspired by Raphael. On another part is Agostino Masucci's *Christ Entrusting His Flock to Saint Peter*. The frescoes are surrounded by ovals containing respectively the four evangelists and the four major prophets: Isaiah, Jeremiah, Ezekiel, and Daniel. On the walls, among allegories of Fortitude, Justice, Mercy, and Kindness, are Jan Frans van Bloemen's vast landscapes, where the figures painted by Placido Costanzi, of the Good Samaritan and Christ and the Canaanite Woman, allude to the virtues of Charity as the basis of the temporal government of the Church. Opposite these, Giovanni Paolo Panini celebrated the more recent magnificence of papal Rome with views of the Piazza del Quirinale and the new façade of S. Maria Maggiore. This venue Benedict XIV chose, on November 3, 1744, to receive Charles III of Bourbon, as if to emphasize through painting the ancient feudal rights of the Holy See over the kingdom of Naples. The event is recorded in lively style in other paintings by Panini, now in the Museo di Capodimonte, depicting two episodes in the king's visit to the pontiff (cats. 271–72).[128]

These paintings can be compared with another pictorial account of a memorable visit to Rome: that of Gustav III of Sweden, who with the gentlemen of his court met Pius VI in the Museo Pio-Clementino in 1784. The Lutheran king had no real political or diplomatic reason to meet the pontiff. He was in Rome thinly disguised as the "Count of Haaga," effectively making the Grand Tour. Interestingly, there was a strong polemical vein in the northern protestantism of Swedish circles at this time, which found expression in the satirical—even blasphemous—anti-Catholic drawings of Johan Tobias Sergel. These factors may have influenced Bénigne Gagneraux's large painting of the event, which also contains a portrait of Sergel.[129] Pope and king are depicted together without distinction of rank, while the Swedish gentlemen and Roman prelates engage in informal conversation. The setting, however, with its collections of antiquities, suggests that the two central figures have something in common: a shared enthusiasm for classical statuary.[130]

Almost as a natural corollary to this interest in the culture of antiquity, the Accademia dell'Arcadia recognized Gustav III as a brother. Warmly welcomed on April 12, 1784, under the name of Anasandro Cheroneo, the king kept up his relationship with the Arcadia, even sending it a copy of his state portrait four years later.[131] The Arcadians took delivery of the painting, presented by Fredenheim, at one of their assemblies in the Bosco Parrasio. The event was recorded in a watercolor by Jonas Åkerstrom (fig. 52),[132] which is one of the most valuable eyewitness accounts of the life of the academy during the custodianship of Gioacchino Pizzi, a time when even the king's sister Sophia Albertina visited Rome.

## THE ARCADIAN LANDSCAPE AND PRIVATE DECORATION

Antiquity and landscape, and the way they were interwoven in classical literary culture, were the most obvious components of the Arcadian outlook in the latter decades of the century. The connections between the cultural climate of northern pre-Romanticism and that of late eighteenth-century Arcadian Rome are revealed by Riccardo Merolla's synthesis of the literary "history and geography" of the Papal States produced in 1988.[133] Among the figures he mentions are, first and foremost, the abbé from Rimini, Aurelio de' Giorgi Bertola, who served as an intermediary between modern German culture and Roman Arcadian circles, not just on account of his well-known translation of Gessner's *Idyllen* but also by virtue of his historical essays, notably *L'idea della poesia alemanna* (1779), *L'idea della bella letteratura alemanna* (1784), and his *Elogio di Gessner* (1789). These texts were of course widely disseminated in Rome, where a sensual Arcadian aesthetic ideal had grown up, the central tenets of which were *grazia, naturalezza, eleganza,* and *melodia*. These same concepts dominated the critical ideology of Giovanni Gherardo de Rossi, according to Merolla "almost the only figure of any importance in the dense ranks of minor personalities of the late Roman Arcadia." In his writings, De Rossi (*alias* Perinto Sceo) sought to redirect the elegance of the style along more strictly "Neoclassical" lines, even attempting a "philosophical" systemization of concepts based on "common sense" and rational moderation. He took up and passed on the original "esprit de géometrie" of the Accademia dell'Arcadia, applying it to his interpretation of paintings and sculptures on which he commented in the *Memorie per le Belle Arti*, published monthly between 1785 and 1788.[134]

The other outstanding intellectual of the late nineteenth century, renowned for his

vast classical erudition, was Ennio Quirino Visconti, whose observations on the *Stato attuale della romana letteratura*, presented in 1785 to Prince Sigismondo Chigi,[135] raise points of central importance to art history. These include his condemnation of the uncritical adoption of "ultramontane models," to which should be preferred "the study of the great Greek and Latin originals, together with a reading of the modern classics of the cultivated European languages." In terms of landscape painting, this position seems to support that of De' Rossi, who in the *Memorie* continued to regard the canonical seventeenth-century exemplars—from Claude to Dughet, Poussin to Salvator Rosa—as a vital touchstone, although he was also open to the modern interpretations of Jacob More, Jakob Philipp Hackert, Nicolas-Didier Boguet, or Abraham Ducros. And the so-called "antiquarian" culture—which Visconti still defined as the "faculty which presides over belles lettres, guides the arts, and is the torch of history"[136]—provided a stimulus to the discovery of antique sites to bring to the attention of the public and to celebrate in sometimes unusual views. This notion is confirmed by the way in which landscape painters tended to be inspired by the discoveries of scholars. Good examples are the expedition to the valley of the Licenza in search of Horace's villa, or the search for the home of Maecenas at Tivoli, or Bonstetten's account (1806) of his quest for the places mentioned in the last six books of the *Aeneid*, an undertaking repeated on a grander scale by the Duchess of Devonshire in 1819.[137] In the first case, Hackert's famous expedition with his brother and their advisor, Reiffenstein—an excursion also mentioned by Goethe—which took them to the places later immortalized in the ten tempera paintings housed in the Goethemuseum in Düsseldorf, was inspired by the publication in Rome, in 1767, of Bertrand Capmartin de Chaudy's volume *La découverte de la maison de campagne d'Horace*. The tempera paintings and engravings that resulted consisted of a series of views of the valley of the Licenza and its neighboring towns, sites admired for their wild beauty, never previously drawn or painted, now observed, explored, and reproduced through the eyes of a traveler. As has been noted with regard to the places associated with Tibullus and the landscapes of Nicolas Didier Boguet, "there appeared, in the latter decades of the century, a new interest in Latin poets—in particular Virgil, Horace, and Tibullus—who had celebrated the Arcadian, idyllic values of the countryside, of a simple, natural lifestyle (echoing Rousseau), in contrast with the worldly, artificially comfortable and wealthy ways of the big city."[138] An example of this was the expedition of Sir

Richard Colt Hoare (in Italy between 1785 and 1791), who followed the route from Rome to Brindisi described by Horace (*Satires*, I. v). He was accompanied by Carlo Labruzzi, who painted more than four hundred watercolors en route, even though the journey had to be cut short at Capua.[139]

Returning to eighteenth-century sources, it is evident that the paintings they refer to as cornerstones of contemporary taste were soon to lose their significance and interest in the eyes of critics; and that the condemnations and hasty judgment of the many observers who, in the name of the Romantic myth of nature and natural truth, decreed the demise of Arcadian and ideal landscape, were equally misguided. A good example is the artist praised by Joshua Reynolds as the greatest of modern landscape painters, the Scotsman Jacob More, who spent the last twenty years of his life in Rome (1773–93). Strangely, the whereabouts of some of his major works remain unknown to this day—works that made him so famous as to permit the far from modest self-portrait he painted for the Uffizi, in which he appears *al naturale*, seated with the Tivoli grottoes in the background.[140] In this same collection of portraits, Raphael had been content to depict himself in a more discreet *mezzobusto*, but in those years the proud Scot was so highly regarded as to fear no adverse comparison, not even in presenting himself in heroic mode and almost life size. Of More's many paintings that have disappeared from view, one of the saddest losses is his vast *Landscape with Apollo and Daphne*, painted for Prince Marcantonio Borghese, who had also entrusted More with the task of transforming much of the park of the Villa Borghese into an English garden. The picture, which occupied one wall of the room that displayed Bernini's *Apollo and Daphne*, forming a background to this masterpiece,[141] was removed in 1891. Together with many of the paintings and furnishings that had made the Villa Borghese the epitome of Roman Neoclassical taste, it was included in a notorious sale held to save the Roman princely family from the consequences of a financial crash. The painting had been discussed in the *Memorie per le Belle Arti* of September 1785. The editor, Giovanni Gherardo de' Rossi, gives an impressive analytical description of More's work and sets out his criteria for judging landscape painting, which he shared with the connoisseurs of the time. He analyzes the general composition of the painting, which is primarily an exposition of the fable of Daphne's transformation into a laurel bush, and considers the faithful study required of an artist before he can arrive at a free reinterpretation of the endless variety of natural phenomena in creating an ideal image

of his subject. Classical critics often returned to this concept of ideal beauty ("bello ideale") in landscape, which was seen as complementing the ideal beauty of the figure. More is again praised by the *Memorie* for his correct "choice of site" in a commentary on two large landscapes painted for Lord Breadalbane. The periodical stressed times of day or season as criteria of verisimilitude, while asserting that the artist must not be a slave to "accidents."

In the same year, the *Memorie* reported on an instance of moral content, or *exemplum virtutis*, being injected into landscape painting to lend it historical dignity. The occasion was the exhibition in Rome of Jacques-Louis David's *Oath of the Horatii* in August 1785, on which the *Memorie* commented extensively. The idea of moral exemplariness was approved by Pierre-Henri de Valenciennes, who in his treatise of 1800 took it as the theoretical basis for reassessing the place of the historical landscape in the academic hierarchy. With reference to a painting (also now lost) by Abraham-Louis-Rodolphe Ducros depicting *Cicero before the Tomb of Archimedes, Having Had it Cleared of Brambles*,[142] De Rossi explicitly praised the choice of a historical subject, maintaining that "landscape painters should always choose subjects of this kind to make their works more important and more useful." At the same time, he deplored the repetition of purely decorative subjects, which implied that "Arcadian" might simply mean light and frivolous. The adoption of this position by the most authoritative Roman art periodical is important, because such reservations regarding the generally perceived banality of the Arcadian world already indicate the essential reasons for its inevitable decline in the face of the pressing demands of pure natural truth, on the one hand, and Romantic subjectivism reflected in nature, on the other.

The return of landscape painters to Poussin's theme of *Et in Arcadia ego* is a confirmation that the late-eighteenth-century Arcadian spirit was anything but mawkish and affected. Many of these artists were northern Europeans and regarded modern Italy as the ancient land of myth, where not only the landscape but even the people's costumes and bodies had been less corrupted by civilization.[143] The themes of the transience of life, and of death the leveler, together with the myths of Apollo and Orpheus, lent themselves to a melancholy approach that blended easily with nascent Romantic sensibilities. Artists such as Cristoph Heinrich Kniep and Johann Christian Reinhart, who journeyed to Italy in their youth to make a career in landscape painting, came to share Goethe's vision at the end of the 1780s and gave it substance in a series of works, particularly drawings and

Fig. 28 Johann Christian Reinhart, *Et in Arcadia ego*, 1786–87, gray and blue-gray watercolor; Hessisches Landesmuseum, Darmstadt

watercolors, in which a poet's tomb attracts the thoughtful gaze of a small following of nymphs and shepherds (fig. 28). Translated into modern dress and set in the evocative grounds of the Protestant cemetery near the Pyramid of Gaius Cestius, the same subject recurs in one of the most famous of Jacques Sablet's pictures, *Roman Elegy* (1791; fig. 29),[144] in which two travelers are depicted in quiet meditation beside a memorial stone decorated with a laurel crown.

An unusual personality at the center of an international network of scholars, poets, and artists with a common interest in antiquity and open to Christian and oriental influences was the eminent Danish archaeologist and philosopher Georg Zoega, a disciple of Winckelmann. His features are familiar from a symbolic portrait by Carlo Labruzzi (*alias* Antifilo Naucrazio),[145] in which Zoega is depicted dressed in classical style with the Roman forum in the background, leaning against a sarcophagus decorated with the figure of Minerva breathing life into Prometheus's man of clay. The poet Friederike Brun, who spent time with him during her visits to Rome, regarded Zoega as a reincarnation of Diogenes, while Cardinal Stefano Borgia (*alias* Erennio Melpeo), an early collector of the Italian primitives, drew on Zoega's knowledge in cataloguing his collection of Egyptian coins. His natural environment was via Felice, between the studio/salon of Angelika Kauffmann and the rustic Villa Malta, a stronghold of German pre-Romanticism. Here another Dane, Asmus Jakob Carstens, pursued his personal revolt against the Berlin academy in his imaginative drawings, which recreate a mythical golden age (see cat. 332). This act links him with an Arcadian tradition that was continued in the following century by Joseph Anton Koch. Although Koch, with his painting of *Apollo's Music Civilizing the Rough Shepherds of Thessaly* (1792),[146] had first given

Fig. 29 Jacques Sablet, *Roman Elegy*, 1791, oil on canvas; Musée des Beaux-Arts, Brest

Fig. 30 Pietro Ferrari, *Frugoni in Arcadia*, 1760, oil on canvas; Galleria Nazionale, Parma

symbolic expression to the educational function of art and poetry, there had nevertheless been a significant precedent in a painting that the first minister of Parma, Du Tillot, had ordered from Pietro Melchiorre Ferrari in 1760. A manifesto of the Arcadian outlook, it depicts Carlo Innocenzo Frugoni, Metastasio's successor in eighteenth-century lyric poetry, clad in skins, standing by the River Alpheus in the shadow of a herm of Pan and reciting poetry to a happy gathering of nymphs and shepherds (fig. 30).[147] This important painting, commissioned by the reforming minister of the little Bourbon court of Parma, gives a clear indication of the extension of Arcadian influence, through the academy's colonies, to the whole of Italy,[148] and therefore of the unifying function of the "republic of letters" centered in Rome.

The cultural complexity of the three main commissions for large-scale decorative projects during the papacy of Pius VI can be ascribed largely to the sponsors' Arcadian connections. The restructuring and redecoration of Marcantonio Borghese's villa on the Pincio was directed by the architect Antonio Asprucci (*alias* Agatereo Rodio), but many of the more significant artists called to execute the vast complex of history paintings, landscapes, genre scenes, ornamental sculptures, and bas-reliefs that gave renewed splendor to the villa's interior were Arcadians and at the same time prominent members of the Accademia di S. Luca. It is not known exactly who drew up so elaborate an iconographical program, which required both an allusion to the many classical sculptures in the collection, and a celebration of more modern renderings of ancient myths (for instance, Bernini's *Apollo and Daphne* and *Aeneas and Anchises*),[149] but it is reasonable to suggest that, in addition to the prince and the cultured artists of his entourage, his brother Cardinal Scipione Borghese (*alias* Melissono Elatense) played

an important part. Moreover, the eighteenth-century decoration of the Villa Borghese can be seen as the culmination of a vast program of patronage on the part of the Borghese family, who in the immediately preceding years had devoted their efforts to their palazzo on the Ripetta and the church of S. Caterina da Siena in via Giulia. The renovation of the church had begun in 1766 to plans drawn up by the architect Paolo Posi (*alias* Minete Calidonio), under the aegis of Cardinal Scipione Borghese as representative of the most prominent Sienese family resident in Rome.[150]

On the ground floor of the Villa Borghese on the Pincio, Tommaso Maria Conca (*alias* Demofilo Imerio) was responsible for the decoration of two rooms which posed special problems of classical scholarship. Particularly successful was his treatment of the Egyptian Room, which develops aspects of Piranesi's Caffè degli Inglesi, created in the 1760s, or of the same artist's *Diverse maniere di adornare i cammini*. His motifs from ancient Egyptian art take up the subjects and antiquarian interpretations of the Borghese collection of Egyptian statues to which the room was dedicated. Conca must have been helped in his task by long familiarity with scholarly problems, a familiarity mentioned in the oration at his funeral, probably composed by Melchiorre Missirini in 1823 and preserved at the Accademia di S. Luca.[151] The author of this text points out that the work on the Villa Borghese must have been the most satisfying time of Conca's life, when, aged about forty, he enjoyed the esteem and companionship not only of colleagues and men of letters such as Nicola Spedalieri, Ennio Quirino Visconti, Vito Maria Giovinazzi, and Giovanni Gaetano Bottari (all Arcadians), but also of cultured churchmen such as cardinals Domenico Maria Orsini (*alias* Stagildo), Giuseppe Rinuccini (*alias* Dallo Geliastense), and Scipione Borghese himself, who on account of their common member-

ship of the "republic of letters" treated him as an equal, paying visits to his house as well as inviting him to theirs. On the upper floor of the villa, the Virgilian story of Dido and Aeneas was entrusted to another Arcadian, Anton von Maron (*alias* Melanto Sicionio), while Domenico Corvi (*alias* Panfilo Eracleate) painted the vaporous figure of *Dawn* for a small bedroom and also proved his excellent knowledge of anatomy in restoring Giovanni Lanfranco's ceiling of the loggia, to which he added a series of splendid nudes of his own invention for the lunettes.[152] One of the major sculptors, alongside Tommaso Righi and Agostino Penna, was Vincenzo Pacetti (*alias* Telefane Foceo), who carved the bas-reliefs of Homeric gods accompanying Gavin Hamilton's cycle of paintings in the Helen and Paris Room.[153] The other artists who worked on the Villa Borghese ceilings—Mariano Rossi, Laurent Pécheux, Giuseppe Cades, Francesco Caccianiga, Felice Giani, Pietro Antonio Novelli, Domenico de Angelis, Pietro Angeletti, Gavin Hamilton, Cristoforo Unterperger, Bénigne Gagneraux, Filippo Buonvicini, the animal painter Wenceslas Peter, and the trompe l'œil specialist Giovambattista Marchetti[154]— were not actually *pastori*, although many were members of the Accademia di S. Luca and so had close connections with Arcadian circles.

The relationship between Marcantonio Borghese and the group of Anglo-Roman intellectuals and artists was built on the complex affinities between Britons such as Gavin Hamilton and the Venetian cultural environment represented by Piranesi, Volpato, and Canova. A key figure in this respect was Don Abbondio Rezzonico, the favorite nephew of Clement XIII, whom the pope made a Roman senator, the highest civic dignity under the *ancien régime*. In 1766, aged twenty-five, Rezzonico had a formal portrait of himself painted by Batoni,[155] in which he appears majestic in his purple robes, with the symbols of Rome and of legislative authority. The venue for these Anglo-Venetian contacts—apart from the Palazzo di Venezia and the adjacent church of S. Marco, the traditional centers of the Serenissima in Rome—may well have been the apartment in the Palazzo Senatorio on the Capitol where Abbondio (*alias* Crisandro Prieneo) had assembled choice elements from the family art collection, in particular some sixteenth- and seventeenth-century Venetian paintings. In an architectural setting created by Quarenghi and Piranesi and decorated by Giuseppe Cades hung state portraits of the pope, a masterpiece by Mengs in a sumptuous silver-gilt frame (cat. 255), and of his brother Cardinal Giovanni Battista (by Angelika Kauffmann), as well as the portrait of Rezzonico painted by Batoni.

A far more unusual figure was Prince Sigismondo Chigi (*alias* Astridio Dafnitico), a man of letters and a student of economics with an interest in classical antiquity and modern painting.[156] Ludwig Guttenbrunn depicted him in a dressing-gown embracing a statuette of Lycian Apollo,[157] while Gaspare Landi painted him on horseback on his farm at Castel Fusano.[158] But it was on his ancestral estates in the Ariccia area that the prince found an outlet for his interest in art and nature, celebrating the literary glories of ancient Greece and modern Italy in the pictorial decoration of the seventeenth-century villa, and transforming the park into an unspoiled pastoral site. While nature was left to its own devices to recreate the setting of a fabulous Golden Age, art was used to elevate poetry as the loftiest dimension of human existence (the prince normally enjoyed the company of literary figures such as Vittorio Alfieri and Vincenzo Monti), celebrating both the poetry of antiquity and Ariosto's fables. The artist chosen for the interior projects at Ariccia was Giuseppe Cades,[159] who had also produced a decorative scheme with figures of the Muses (1784; destroyed)[160] for the prince's city residence. In 1763, to mark the marriage of Sigismondo Chigi and Maria Flaminia Odescalchi, this palazzo had acquired one of the most sumptuous of all Roman interiors. The Salone d'Oro, designed by Giovanni Stern under the supervision of the bridegroom's uncle, Prince Emilio Altieri, was decorated with stuccowork by Tommaso Righi, paintings by Niccolò Lapiccola, and other late eighteenth-century works skillfully attuned to the new setting, such as necromantic landscapes by the Fleming Jan de Momper and Gaulli's sensual *Endymion*.[161] The memorial that Chigi erected in the church of S. Maria del Popolo for his wife, who died in childbirth when aged little over twenty in 1771, is both an epitome of his own taste and a display of Roman princely dignity. In its structure, it is based on the heraldic arms of the Chigi and Odescalchi families, both of which had produced popes (fig. 31). As well as Sigismondo and Flaminia herself (a competent poet, *alias* Eurinome Elidea), the architect Paolo Posi was also an Arcadian and undoubtedly consulted with the prince in planning the monument. The result was a polychrome composition combining the specialist skills of the figure sculptor Agostino Penna (the putti, portrait, and drapery), the animal sculptor Francesco Antonio Franzoni (the eagle, lion, and rocks), and the silversmith and bronzeworker Bartolomeo Burone (the oak tree and other metal features).[162] Admired by Canova in his youth, the monument shows some continuity with the Baroque style, soon to be superseded by the return to classical antiquity. Created

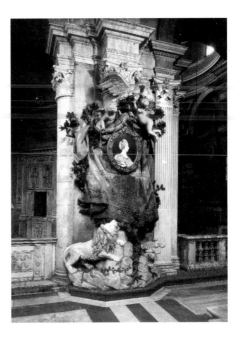

Fig. 31 Paolo Posi, *Monument to Maria Flaminia Chigi Odescalchi*, c. 1772, marble and bronze; S. Maria del Popolo, Rome

over a period of thirty years, the Salone d'Oro of Palazzo Chigi, the Sala degli Imperatori on the ground floor of the Villa Borghese (fig. 32), and the Gabinetto Nobile of the Palazzo Altieri form a trio of decorative masterpieces combining the aura of antiquity with modern grace—a result that could only have been achieved by virtue of the Roman Arcadian poetic.

A wedding was again the occasion for the redecoration of the apartment in the Palazzo Altieri: Paluzzo, son of Prince Emilio, was marrying Marianna of Saxony (*alias* Nicori Amantutea) and called on the former Jesuit scholar Vito Maria Giovinazzi to draw up plans for the decoration. Giovinazzi referred back to an early sixteenth-century manuscript, *Li nuptiali*, composed by another member of the Altieri family, Marco Antonio,[163] in search of marriage allegories based on ancient history and, in particular, the alliance of Romans and Sabines. The model of the Palazzo Pamphili, in which biblical allegories predominated,[164] was therefore superseded by one based on Roman history and mythology. This was inspired not so much by an interest in examples of virtue, an interest developed by the French *pensionnaires* at the Palazzo Mancini, but by a scholarly enthusiasm for local tradition. To the familiar names of von Maron, Cades, Gagneraux, Unterperger, Tommaso Maria Conca, and Giani (all employed by Marcantonio Borghese on his villa or city residence), must now be added those of Marcello Leopardi (fig. 33),

Fig. 32 Villa Borghese, Rome, Sala degli Imperatori, 1780

Antonio Concioli, Stefano Tofanelli, and Antonio Cavallucci,[165] younger artists who all reinterpreted the style of Batoni or Mengs with an emphasis on their roots in seventeenth-century art. At almost the same time (1787), not far from the Palazzo Altieri, Antonio Canova was unveiling his monument to Clement XIV in the church of Ss. Apostoli, a commission obtained through the good offices of Gavin Hamilton and Giovanni Volpato. While the Abbé Giovinazzi, on the other side of via del Corso, was inveighing against Canova's work "in a great assembly of princes"[166] (as Altieri's architect, Giuseppe Barberi, records in one of his caricatures), in the pages of the *Memorie per le Belle Arti* Giovanni Gherardo de Rossi was greeting the event as one likely to initiate "some fortunate revolution in the Arts."[167] Here again, the main protagonists in the debate were two celebrated representatives of the "republic of letters." Another precept of Gian Vincenzo Gravina's *Ragion poetica* proved very much to the point in one of the best critical interpretations of Canova's *Venus and Adonis*, sculpted in the years 1789 to 1794 for the marchese Berio of Naples, which was described in painstaking detail by Carlo Castone della Torre di Rezzonico (*alias* Dorillo Dafneio),[168] who grasped the overall significance of the work. As for Gravina the Farnese *Hercules* was enhanced by "the distinct expression of muscles, veins and nerves,"[169] so Rezzonico grasped in Canova's sculpture the meaning of action, its effects, and the story it recounts.

About a year after Baldassarre Odescalchi had celebrated the restoration of the Bosco Parrasio, marking the academy's first centenary, Giuseppe Valadier had the idea of laying out another great gathering space on a hill, at the other end of Rome. Valadier's initial plans for the Piazza del Popolo date from 1792–94, signaling the conclusion of eighteenth-century developments in the arts and the beginning of

Fig. 33 Marcello Leopardi, *Hecuba Giving the Infant Paris to One of Her Servants*, 1791, oil on canvas; Palazzo Altieri, Rome

Fig. 34 View of the Piazza del Popolo, Rome

a new century, when the square was eventually laid out in a different form during the French occupation. Harking back to the precedent of the Arcadian site on the Janiculum, the new square's sculptural decoration, combined with architecture and landscape gardening, takes up the themes of mythology, the changing seasons, and the evocation of Roman power, and embodies them in the vast natural amphitheater offered by the wooded slopes of the Pincio (fig. 34). The square, which welcomes the traveler from the north, is in perfect keeping with the epigraph celebrating the happy and auspicious arrival of Christina of Sweden, the cultured queen who was appointed *basilissa* of the Accademia dell'Arcadia.

## A COMMUNITY OF ARTISTS

In history it is common to focus on what appears new, innovative, and different from the past, and thereby to stress changes, new trends, or outright revolutions in taste and style. However, in examining the artistic life of a city such as Rome, where painters, sculptors, architects, and their dependants were a constant presence and formed an identifiable and quantifiable class, what immediately strikes the observer is the continuity, the recurrence of structures, mechanisms, and traditional career patterns. An investigation of the eighteenth century and the careers of individual artists working in Rome provides concrete examples that explain the condition of the artist and his position in a network of relationships that encompasses the entire economic, social, and cultural fabric—in short, the history—of the time. This kind of research is based on data such as the geographical origin of the artist (local or foreign), his status at birth (reflected in the profession of father and family), and the terms of his apprenticeship. It is then necessary to examine the early stages of his career, the structure of his relations with patrons, and

the period of his maturity, when the artist has carved out his niche in the market, often reinforced by the ties contracted through marriage or the choice of godparents for his children.[170] Then there were family systems associated with the topography of Rome and places of residence, with patronage linked to common national origins, and with the passing on of artistic specialities from one generation to the next. Other relationships depended on methods of production, in particular the monumental projects which brought together groups of artists from similar backgrounds to form the teams that carried out vast and complex schemes for churches and residences in Rome and elsewhere in Italy, as well as throughout Europe. Professional success was reflected in financial success, and the acquisition of possessions that can be verified by wills and inventories; it was reflected also in a degree of upward social mobility. An artist might first be admitted to a mutual-aid organization such as the Congregazione dei Virtuosi al Pantheon,[171] and later to the more selective Accademia di S. Luca, and his growing prestige be acknowledged by the granting of the rank of Cavaliere or, in rare cases, a higher title of nobility. The artist's tomb can also be a significant clue, ranging from a simple memorial plaque (better than burial in a common grave, as was the general practice) to a monument or even a family chapel, as in the case of Maratti at Camerano.[172]

The sources used for reconstructing the careers of individual artists are singularly consistent in providing this kind of information. Nicola Pio[173] and Lione Pascoli,[174] for example, who wrote their collections of biographies in the early decades of the eighteenth century, always describe the circumstances of the birth, the family's social position and, when possible, the network of family members, friends, and neighbors which, together with financial information, provides the clearest picture of each artist's start in life.

Beginning with the generation of artists born in the seventeenth century and active in Rome in the early years of the eighteenth, the truth is that very few of them can accurately be defined as native Romans. Of these, only the following can be described as major figures: Giuseppe Bartolomeo Chiari (though his father was a Florentine), Giuseppe Passeri, Giovanni Odazzi (who had a Milanese father), Andrea Procaccini (also undoubtedly of Milanese extraction), and Marco Benefial (son of a French father and Roman mother). The others came either from the Papal States (Maratti and Giuseppe Ghezzi), or from other Italian states, such as the dukedom of Milan (Camillo Rusconi, Pietro de' Pietri, Carlo Fontana) or the Spanish-ruled Kingdom of the Two Sicilies (such as Giacinto Calandrucci from Palermo and Sebastiano Conca from Gaeta). Benedetto Luti, Luigi Garzi, the sculptor Giuseppe Mazzuoli, and the architect Giovan Battista Contini were subjects of the Grand Duke of Tuscany, while the sculptors Pietro Stefano Monnot and Pierre Legros were French. Even this short list serves to show that artistic activity in Rome was anything but homegrown, and this continued to be the case in the following decades. But it also reveals a general similarity of status, with all these artists belonging to a fairly homogeneous class, neither aristocratic, nor working-class in the true sense, nor even what was then described as *civile*, which presupposed a certain standard of living and the ownership of property. Of those already mentioned, the most favored by birth would seem to have been Maratti, whose Dalmatian parents had invested their capital in property in the district of Ancona, Andrea Procaccini, born "of comfortably off parents," so that "his parents instructed and educated him in accordance with their civil status and wealth," and, even more than the other two, Giuseppe Ghezzi, son of the painter and architect Sebastiano Ghezzi, with whose work the King of Portugal had been "so satisfied that … he granted him a rich cross, making him and his descendants cavalieri to the third generation. Having grown up with that noble title, he had his son educated in the aristocratic manner and, while sending him to school to learn grammar and rhetoric, instructed him in drawing." This elevated social status seems always to have been an important factor in Giuseppe Ghezzi's complex social relationships, and subsequently in those of his son Pier Leone, who was also a Cavaliere in his own right,[175] and played an important part in his acceptance within the academic environment. Lower down the social scale, most practitioners were sons or heirs of artists who expected to make a career in their fathers' workshops (Passeri, Rusconi, Legros, Monnot,

Fig. 35 Giuseppe Bartolomeo Chiari, *Self-portrait with the Artist's Family*, 1716, oil on canvas; Museo di Roma, Rome

Fontana, Contini), or were of humble condition and hoped to make their way in the art world. For example, Chiari was the son of an innkeeper; Benefial's father was a weaver; De' Pietri was the cousin of a wine merchant; and, according to Pascoli, Sebastiano Conca was of humble birth and studied with the support of an uncle who was a priest.[176] Finally, Giovanni Battista Gaulli is recorded as having been "without support, without substance and without hope of gaining any," being of a wealthy family that had fallen on hard times and been decimated by the plague. However, one common thread emerges from all these biographies: discipline in the exercise of the artist's craft, which was lived as a form of worship. In the case of Pietro de' Pietri, Pascoli sums it up in a few eloquent words: "He greatly venerated his profession, and always feared God."[177]

A self-portrait of Giuseppe Bartolomeo Chiari (1716; fig. 35)[178] shows him with his wife, children, and brother Tommaso, another painter. As well as explaining the identity of all the members of the family—his wife: Lucrezia Damiani, and children Stefano (the eldest), Carlo, and Teresa—Pascoli recounts their social success, no doubt owing to their father's status. Stefano became a canon of S. Maria in Cosmedin, Carlo followed in the footsteps of his father and uncle as a painter, while Teresa married a "rich jeweler."[179] Even higher social status, in this case with sophisticated intellectual connotations, is revealed in a group portrait (1766) of the family of the famous silversmith Luigi Valadier. Giuseppe Bottani

depicted Valadier's wife, Caterina della Valle, as Latona and gave their two children, Giuseppe and Clementina, the attributes of Apollo and Diana (cat. 190),[180] in a *travestimento classico* normally reserved for members of the aristocracy. Evidently this was not regarded as excessive for an artist who, thanks to his privileged relations with the Chigi and Borghese families, had attained the highest social position.

Both paintings also serve as a reminder that artistic traditions were handed down within families. Carlo Chiari became a painter (albeit not a particularly famous one);[181] Giuseppe Valadier went on to become the architect and town planner of Neoclassical Rome. Incidentally, Caterina della Valle was the daughter of the sculptor Filippo della Valle (her sister Ottavia married Cristoforo Unterperger and another sister, Petronilla, married the French painter Gabriel Duran).[182] As well as the Chiari and Valadier "firms," there were the Bracci (Pietro, a sculptor, and his son Filippo, a painter); Ignazio, Ludovico, and Vincenzo Stern; the brothers Stefano and Giuseppe Pozzi; Vincenzo, Camillo, and Michelangelo Pacetti, who maintained a family tradition as sculptors, restorers, and art dealers; Pompeo Batoni and his children Domenico, Romualdo, and Benedetta Maria, a celebrated miniaturist; Giovanni Battista and Francesco Piranesi, the well-known engravers; Giuseppe and Mariano Vasi, also engravers; the mosaic specialists Fabio and Pietro Paolo Cristofari; the gemstone engravers Antonio, Giovanni, and Luigi Pichler; the Fidanza family landscape painters … and so on throughout the century. Workshops and techniques, equipment and customers were handed down from generation to generation, both in the "major" arts, and in the crafts.

Kinship ties within the artistic community could also be a strategic consideration in increasing clientele or strengthening a dominant position (Anton von Maron, for instance, married the miniaturist Terese Mengs, sister of the charismatic Anton Raphael Mengs). Sometimes, the strategy adopted was less direct but nonetheless effective. To take one significant and subtle example, the wife of Placido Costanzi, Anna Maria Barazzi, was the sister of Francesco Barazzi, who is known to have had close links (as a renter of rooms, guide, and consultant on antiquities) with English tourists and with the clientele of Batoni;[183] and it is reasonable to assume that this may have given rise to an exchange, if not of commissions, at least of information and contacts between the two celebrated painters.[184] Also fairly common among artists in Rome were marriages between Italians and members of other national communities. In addition to the Roman-born daughters of Filippo della

Fig. 36 Johan Tobias Sergel, *Self-portrait with the Artist's Wife, Anna Rella, and Her Son Gustav*, pen and brown ink; Nationalmuseum, Stockholm

Valle, who married artists of French or Austrian origin, Maria Felice Tibaldi (cat. 283) married the French artist Subleyras; Blanchet the daughter of the engraver Dies; Sergel a Roman woman, Anna Rella (fig. 36); and Giuseppe Ceracchi a young Austrian woman, Teresa Schliesahan of Vienna.[185] The case of Mengs was also repeated on numerous occasions: to marry his model, Margherita Guazzi, "a most beautiful, modest, but poor young girl,"[186] the Protestant painter from Saxony had to overcome the opposition of her family by converting to Catholicism (as his sisters did also). The marriage, which proved to be a happy one, was celebrated in the summer of 1749. Twenty years earlier, Batoni, too, had married a woman from an inferior social class. Caterina Setti was the daughter of the caretaker of the Farnesina, with whose family (of Tuscan origin) the young painter was lodging. His patrons back in Lucca stopped his living allowance on account of this decision and Batoni, in later life, confided to his pupil Johann Gottlieb Puhlman that he now saw his first marriage as a youthful error.[187] In contrast to this mingling of nationalities and social classes, many artists still preferred to take wives from their own region and community. For example, the Sicilian painter Gioacchino Martorana married the daughter of the engraver Giuseppe Vasi, also of Sicilian origin.

In other cases kinship was of a sacramental nature, with ties formed on such occasions as

baptisms or confirmations. The godfather, whose role was—should the need arise—to act on behalf of the child in place of the natural parents, might be an aristocrat with whom the artist dealt on an equal footing. Such was the case of Maratti and Niccolò Maria Pallavicini: the Marchese Pallavicini acted as godfather to the first child of Faustina, the beloved only daughter of the most celebrated painter of his day.[188] But when an artist undertook to take care of the child of another artist–Lambert Krahe was sponsor at the confirmation of Luigi Subleyras; on his deathbed Filippo della Valle entrusted the care of his underage children to Luigi Valadier–the mechanisms involved were similar to those still current today: affinities of class, wealth, and culture led to the formation of pacts and reinforced cooperation.

The best way to determine the status achieved by an artist, after he had gone through all the stages of his training, made contacts with patrons (almost always through the master in whose workshop he had served his apprenticeship), and exercised his profession for a longer or shorter time, is by reference to such tangible and unforgiving documents as wills and post-mortem inventories of property left to heirs. Lists of customary household artifacts, descriptions of garments and their condition, the presence or absence of valuables and works of art, details of *luoghi di monte*,[189] debts and sums owed, and descriptions of studios and libraries all provide an extraordinarily rich mine of information, which often confirms the assessments given by the early biographers. Pascoli and Pio often provide accurate information as to the importance of the estate, or record those rare instances in which the artist was not interested in accumulating wealth. The apartment of Giuseppe Passeri, according to Pascoli, was "worth seeing on account of its rarity, taste and cleanliness"; on the other hand, he reports that Pietro de' Pietri cared little for comfort and wealth, "lived like a philosopher," and left "little capital" to his brother.

Quite different was the lavish establishment suggested by the inventories of Carlo Maratti (who died in 1713) and his spouse, Francesca Gommi.[190] This situation may seem natural given the painter's status, his perception of himself, and his glorification during his lifetime as a master to whom popes and sovereigns paid homage. But it is not so obvious, given the financial situation of another major artist, Pompeo Batoni, who on his death in 1786 did not even leave enough to keep his family in a degree of comfort.[191] Being recognized as a great artist did not therefore always result in becoming part of the élite who could live off unearned income. There were cases of famous artists who, unable to continue the

exercise of their profession owing to illness, spent their last years in poverty, in some cases supported by a compassionate patron. A signal, if not tragic, example is Benefial, blind and without means of support, who relied on the generosity of his benefactor Niccolò Soderini.[192] Benefial showed little skill in managing his affairs, whereas Corrado Giaquinto and Placido Costanzi showed great skill in administering theirs.[193] In addition to luxury items such as silverware and jewelry, paintings and sculptures, and signs of rank such as swords, guns, and wigs *alla cavaliera*, the inventory of Costanzi's assets[194] lists *luoghi di monte* and real estate that gave the painter a solid financial foundation. He even owned a vineyard with a house on via Nomentana (at Pratalata, now Pietralata), bordering the properties of aristocrats such as the conti Bolognetti and the marchesi Nuñez. The estate of Giovanni Pichler[195] reflected the activity of a self-sufficient family firm, which ran a private academy (evidenced by the stool and lamps provided for the models) and produced—in addition to the incised gemstones for which Pichler was famous—history and figure paintings. For this purpose, they owned many prints, pattern books, manuals, and academic life drawings compiled by Corvi and Batoni as well as Pichler himself.

In addition to paintings by masters as diverse as Rubens and Maratti, Lanfranco and Corvi, Pichler's house also contained fifty or so landscapes, marines, and cloud studies ("nebbie") by Fidanza (the inventory does not say whether Francesco, Giuseppe, or Giacomo). This collection highlights another activity frequently engaged in by artists who, by virtue of their profession, came into direct contact with an often foreign clientele: that of art dealer. For some, this activity became an alternative profession, and in this respect the British artists held a privileged position on account of their contacts with their wealthy fellow-countrymen making the Grand Tour. Gavin Hamilton, for example, frequently acted as an intermediary for the sale of archaeological artifacts and classical and modern works of art, and there is an inventory dated 1790 describing the rooms occupied by James Byres near Piazza di Spagna which is more indicative of commercial activity than an interest in collecting. As well as carved and gilded furniture and marble-topped tables, there were so many antique busts, copies of classical masters, and works by contemporary English artists that much of the contents can only have been intended for sale.[196]

A unique case is the studio of Bartolomeo Cavaceppi in via del Babuino, of which there are engravings as well as very detailed inventories.[197] From the extensive apparatus of materi-

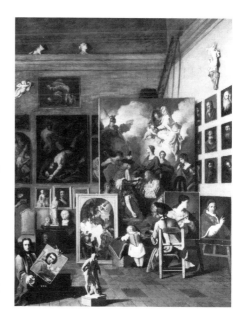

Fig. 37 Pierre Subleyras, *The Painter's Studio*, 1748, oil on canvas; Gemäldegalerie der Akademie der Bildenden Künste, Vienna

als, tools, and instruments, this studio would seem to have been the best-equipped center for the restoration, production, and export of sculpture in eighteenth-century Rome. Cavaceppi intended that it should become a public school run by the Accademia di S. Luca but, owing to a combination of unfortunate circumstances, the whole corpus of drawings, sculptures, and plaster casts became dispersed throughout Europe within a very short space of time.

Because of their unusual specifications, studios were often handed on from one artist to another. In Costanzi's former studio, between Piazza del Popolo and Piazza di Spagna, David painted and subsequently exhibited his *Oath of the Horatii*. Pierre Subleyras's studio in the Casa Stefanoni in via Felice (now via Sistina)—known from the celebrated painting now in Vienna (fig. 37)—was successively occupied by Domenico Corvi (1751–52), Anton Raphael Mengs (1753–57), and Gavin Hamilton (1758–62).[198] Study of documents such as *stati delle anime* (Easter censuses of each dwelling made by parish priests) shows that artists tended to be concentrated in certain districts of the city, which led to the sharing and handing on of studios and workshops. From the seventeenth century, and even earlier, painters seem to have favored the area between via Felice and via Paolina (now via del Babuino), where the workshops of antiquarians and inns for travelers were also situated. Sculptors were also present in the Campo Marzio area,[199] while storerooms (one owned by Piranesi) and the workshops of stonecut-

ters and marbleworkers tended to be found at Macel de' Corvi, where Michelangelo had lived in the sixteenth century and where it was relatively easy to obtain materials, because of the proximity of the Roman forums.

The inventory of the possessions of Placido Costanzi, referred to earlier, provides an insight into two other aspects of an artist's career: attendance at a private academy, and strategies for acceding to noble rank. From the highly detailed description of all the rooms in the house, which was subsequently left to the Accademia di S. Luca (except for the rooms occupied by his widow, which passed to the academy only after her death), it emerges that Costanzi used part of the house as his studio.[200] It was subdivided into a "studio grande," a "studio superiore," and a "studio dei giovani," in which the art expert Filippo Evangelisti (better known for his long partnership with Benefial than as a painter in his own right) recorded the presence of finished paintings and preparatory studies by Costanzi himself, cartoons by Trevisani and Domenichino, portfolios of life drawings, a lamp for illuminating the model, adjustable wooden dummies, whole plaster casts and fragments (heads, arms, busts …), "collections of prints by various authors," as well as the usual panoply of paints, easels, palettes, brushes, cloths for covering paintings, and even the maulstick on which the artist supported his arm while painting. Not even the Maratti inventory (though it lists plaster casts, cartoons, and pattern books), nor that of the Ghezzis, gives so complete a picture of the teaching process. The lamp for lighting the models indicates the practice of drawing from the nude,[201] the plaster casts the study of the antique, the Domenichino and Trevisani cartoons the importance of "classical" and modern models, the pattern books and prints the study of the "bella e esatta maniera," while the many unfinished canvases—specifically mentioned as being by Costanzi's own hand—suggest that the "giovani" were also employed on the master's works. Other artists' houses—those of Pietro Stefano Monnot in via delle Carrozze,[202] of Pietro Paolo and Fabio Cristofari in the Borgo,[203] of Piranesi in the Palazzo Tomati,[204] and of Giovanni Pichler in via dei Pontefici[205] (belonging respectively to a sculptor, two celebrated mosaicists, the century's most famous engraver, and the most successful carver of gemstones)—include workshop areas (Monnot in particular needed premises suited to the production of large-scale sculptures), but in none of them are there rooms so obviously devoted to the functions of schooling younger artists.[206]

Despite the wigs alla cavaliera scrupulously listed together with cups and china, it would appear that Placido Costanzi—unlike his brother Carlo, Arcadian and gem engraver, known as "Hunchback Costanzi"[207]—was never granted the title of Cavaliere. This distinction was very much sought after by artists, and those who had been so ennobled tended to depict the insignia in their self-portraits and refer to the title in their signatures and on every other possible occasion. In the seventeenth century the fact that Gaspare Celio was awarded the distinction rather than Orazio Borgianni seems to have led to Borgianni's premature death. According to Casanova, "when someone wrote to Mengs [in Madrid] without mentioning the title of cavaliere in the address … he was mortally offended."[208]

It therefore seems strange that an artist at the center of social and intellectual life, such as Francesco Trevisani, several times declined the distinction from both popes and sovereigns,[209] eventually accepting it from Pope Benedict XIII. The cross of the Order of Christ was only bestowed for special services. Not even Maratti was granted it until late in his life, in 1704, from the hand of Clement XI. Many of the painters and sculptors responsible for the images of Prophets and Apostles in St. John Lateran (including Odazzi and Rusconi, among others) were dubbed cavalieri in recognition of their work The youngest of them was Benefial. Others had already been granted noble rank by foreign sovereigns: Benedetto Luti by the Habsburg Emperor Charles VI, "who placed a crown in his coat-of-arms to give him the distinction of ancient nobility"; and Giuseppe Nicola Nasini by Joseph I. Sebastiano Conca was made "cavaliere di Cristo" in 1729 at a sumptuous ceremony in S. Martino ai Monti by Cardinal Pietro Ottoboni, who wanted to bestow a personal honor upon him.[210] To this distinction was added the title of nobility conferred on Conca by the Bourbon King Charles III in 1757, with the right to hand it on to his descendants until the third generation. Batoni and Mengs were also made cavalieri of the Order of Christ and received noble titles from a foreign sovereign, in their case Maria Theresa of Austria. Francesco Mancini, on the other hand, had to intrigue for several years to be granted any sort of distinction.[211] Even more interesting is the case of Corrado Giaquinto, who accumulated enormous assets partly with the aim of acquiring a feudal estate worth 80,000 ducats. His ambition was still not realized at the time of his death, but in the meantime, as if in anticipation of the event, the painter and his sons, in Spain and in Naples, had already adopted the lifestyle of wealthy aristocrats.[212]

Insisting on the nobility of the profession and its liberal character was the only way under the ancien régime to free art from its "mechanical" condition, still based on the perception that it was a manual activity. Knightly status and membership of the Accademia, involvement in society salons and Arcadian assemblies, the practice and teaching of drawing were the factors that enabled Domenico Corvi, virtually on the eve of the French Revolution, to depict himself in his self-portraits with the confident, haughty air of a nobleman. Corvi's self-portraits are perhaps the most explicit indication of the striving of a whole profession to achieve parity of esteem with the upper echelons of society in the name of the arts and sciences (cat. 204). Toward the end of the century, when established society was being overtaken by political events, Pius VI nevertheless decided to raise Vincenzo Pacetti to the rank of "count palatine."[213] Even though the advent of bourgeois ideology might seem to have frustrated the age-old struggle of artists to achieve higher status, when the social parameters of the ancien régime were to some extent restored in Rome during the Restoration period, the title of marchese—never previously bestowed on an artist—was granted to Canova, prince of his profession.

The poverty or worldly success of an artist tended to determine whether he was buried in obscurity or in solemn state. The latter was the case for the Sicilian painter Agostino Scilla, whose funeral was celebrated in Rome in 1700 with the participation of the academicians of S. Luca, the Virtuosi al Pantheon, and many artists.[214] Similar treatment was accorded to Angelika Kauffmann, who lay in state surrounded by her pictures and was attended by a host of aristocrats, cardinals, and ordinary people such had not been seen for many years.[215] An artist might be buried in his own parish without any special mark of distinction (Giovanni Battista Gaulli, Pierre Subleyras, Pompeo Batoni) or with a simple memorial stone in a church (Giuseppe Bartolomeo Chiari at S. Susanna, Giuseppe and Pier Leone Ghezzi at S. Salvatore in Lauro, Antonio Cavallucci at S. Martino ai Monti), with a monument erected by his children (Agostino Masucci at S. Salvatore ai Monti), prearranged by the artist himself (Carlo Maratti at S. Maria degli Angeli , Filippo della Valle at S. Susanna, Giovanni Battista Piranesi at S. Maria del Priorato),[216] or paid for by a patron (Mengs in S. Michele in Borgo),[217] but this funerary hierarchy did not always correspond to the degree of success achieved by artists during their lifetime. In any case, it was nullified by the series of portraits in the Accademia di S. Luca, which placed all artists on an equal footing, only the profession of their art conferring any special dignity. The ultimate accolade was a bust in the Pantheon, the "temple of glory"—the

Fig. 38 Vincenzo Pacetti, *Marco Benefial*, 1784, marble; Protomoteca Capitolina, Rome

Fig. 39 Façade of the Scolopite College, L'viv, Ukraine, c. 1764

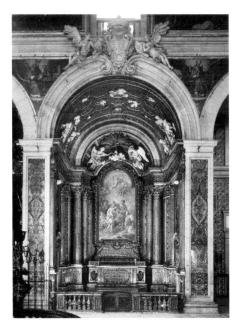

Fig.40 Luigi Vanvitelli, *Chapel of St. John the Baptist*, 1742–47; Museo di São Roque, Lisbon

posthumous distinction accorded to Camillo Rusconi, Pietro Bracci, Benefial (fig. 38), Mengs, Angelika Kauffmann, Pichler, and Piranesi.[218]

## ARCADIA OUTSIDE ROME

When his patrons insisted that the architect Nikolaus von Pacassi design the Gardekirche in Vienna "in the Roman manner," they were merely reiterating, in a far more prestigious situation, the request made at the end of the sixteenth century by the Vecchiarelli, the most prominent family of Rieti, a small town in the Papal States, who had asked Carlo Maderno to build their new palazzo "alla romana e alla grande," specifically mentioning the residences he had designed for Cardinal Salviati and the Marchese Crescenzi.[219] Similar tastes were behind the building of a church in Potsdam in the mid-eighteenth century, the façade of which is a direct copy of the façade of S. Maria Maggiore, or the elevation of the Scolopite College at L'viv, Ukraine, which is modeled on St. John Lateran (fig. 39).[220] Specifically Arcadian influence is evident in two large-scale projects outside Rome: the complex commissioned by John V of Portugal at Mafra in the 1730s and 1740s,[221] and the pictorial decoration of Pisa Cathedral. The first is instructive in that it employed the full range of techniques, from architecture to the decorative arts, the second in its continuity, covering the whole of the eighteenth century and carrying over into the next. The two projects are also very different in terms of the commitment required by the

artists involved. At Mafra the Portuguese monarch's intention was to create his own idealized Rome, and he relied mainly on the architect who had planned the Bosco Parrasio, Antonio Canevari. But despite his efforts and the enormous capital investment, the results were patchy: not all the artists grasped the importance of the commission, and some responded with a less than wholehearted commitment, leaving much of the work to assistants. This is certainly true of Giaquinto, though Pietro Bianchi gave one of his best performances.[222] Nor were the artists all of the same high standard. As well as the masters already mentioned, to whom can be added Francesco Mancini, Sebastiano Conca, and Etienne Parrocel (and the sculptors Giovanni Battista Maini, Carlo Monaldi, and Filippo della Valle), they included hacks such as Emanuele Alfani. This disparity undoubtedly also reflects a different system of supervision. At Pisa a painted model of the planned work was automatically required and put on display in a public museum,[223] and when the final version arrived it was also exhibited before its final installation, giving the opportunity for public comment, comparison, and, if appropriate, criticism. However, when supervision was exercised directly by the architect in charge, as was the case with the chapel of St. John the Baptist in the church of Sã Roque in Lisbon, designed by Luigi Vanvitelli (fig. 40),[224] the quality of the workmanship, from the paintings by Agostino Masucci to the tiny mosaics and silverwork, tended to come up to the expectations of the patron.

The great pictorial project intended to complete the decoration of the ancient cathedral of Pisa was promoted by the local Arcadian colony.[225] The existing decorative scheme included episodes from the life of the Virgin, to whom the church was dedicated, and the city's patron saints. This program was reorganized and extended with large-scale canvases commissioned from the major artists of the Tuscan, Bolognese, and Roman schools, but it

was undoubtedly the Romans who ensured the unity of the whole and transformed the cathedral into the most impressive gallery of eighteenth-century Italian painting. The cycle begins in the chapel of S. Ranieri with a striking masterpiece by Benedetto Luti, a Florentine who had trained in Rome under the influence of the prince Livio Odescalchi and was therefore more attuned to the doctrinal outlook of Gravina's academy. In 1712 Luti delivered *The Investiture of Saint Ranieri* (fig. 41), which contains in germ many of the compositional motifs evident in the canvases that follow, right through to Antonio Cavallucci's *Investiture of Saint Bona* (cat. 197), delivered eighty years later and painted with the advice of the Arcadian poet and philosopher Appiano Buonafede.[226] It has the same melodic composition, the same delicate flesh tones, the same solemnity of presentation and extraordinary perspective effects in the depiction of vestments and costume that had characterized Luti's opening work. The series had continued in 1719 with a Carracci-style painting by the Romanized Bolognese artist Domenico Maria Muratori, *Saint Ranieri Freeing a Demoniac*, then—after a fruitless request to the most famous of the painters then working in Rome, Francesco Trevisani, who refused on the grounds of his advanced age—in 1730 with *Saint Ranieri Resurrecting a Young Girl*, by Felice Torelli, another Bolognese. These were followed in 1746 by Francesco Mancini's *The Blessed Gambacorti Instituting His Order*, again modeled on the Carracci but softened by the influence of Correggio, and in 1748 by one of

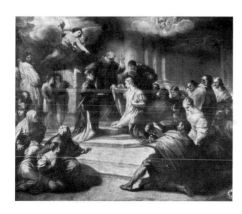

Fig. 41 Benedetto Luti, *modello* for *The Investiture of Saint Ranieri*, 1712, oil on canvas; Museo di San Matteo, Pisa

Conca's mature and most nobly "academic" compositions: *Urban VI Approving the Rule of the Blessed Gambacorti*. After a Tuscan intermezzo in the form of Gian Domenico Ferretti's *Transfer of the Relics of the Blessed Guido della Gherardesca* (1752), Rome is again dominant in Giaquinto's *Birth of the Virgin* (1753) and in the final work of Placido Costanzi's glittering career, *The Martyrdom of Saint Torpè*, not delivered to the cathedral until after the master's death in 1759. (The commission had originally been assigned to Batoni, who refused because he was too heavily engaged elsewhere.)

As the project in Pisa continued, and regardless of the intentions of individuals, it emerged ever more clearly as an anthology of the excellence of the various schools of Italian painting, represented by their own acknowledged masters and especially by those who had cultivated the precept of the primacy of drawing. The Veneto was not represented by Ricci or Tiepolo, but rather by Giambettino Cignaroli from Verona (*The Discovery of the Head of San Torpè*, 1766), and Bologna by Gaetano Gandolfi (*The Blessed Domenico Vernagalli Founding the Orphan Hospital*, 1788). But the immense cycle of canvases concluded on a Roman note. Laurent Pécheux may be regarded as Roman, even though his painting of *The Baptism of the Son of the King of the Balearic Islands* was delivered from Turin in 1784, while Domenico Corvi's *Santa Ubaldesca among the Sick*[227] is effectively a paradigm (albeit soon forgotten) of a manner of painting reformed not along doctrinaire and antiquarian Neoclassical lines, but by way of a return to a tradition of naturalism based on the sciences of perspective and anatomy, with dramatic light effects that hint at melodrama. The painter from Viterbo was singled out by the Pisan Abbé Ranieri Tempesti, a member of the Colonia Alfea, on account of the "correctness, precision, and elegance of his drawing, truly, as they say, *di Scuola*."[228] Other

virtues praised by the cultured abbé were Corvi's personal qualities and his adherence to the criteria of Arcadian taste in those years: "a pictorial imagination … full of spirit and enthusiasm but also disciplined and selective, as a result of which his compositions are animated by an expression all his own. His coloring is extremely soft, mellow, fresh, beautiful, unique to himself, and in a style somewhere between Mengs and Maratti."[229]

While Corvi's style was immediately adopted by the Pisan Giovambattista Tempesti in his canvas of *Pope Eugenius III Celebrating Mass*,[230] his lesson of ideological rigor was taken up by one of his most brilliant pupils, Pietro Benvenuti, who ensured that Corvi's professional legacy was carried over into the next century. Between 1802 and 1804 Benvenuti painted a *Martyrdom of the Blessed Signoretto Alliata*, to replace an unrealized work by Giuseppe Cades.[231] The Arcadian influence in the modern decoration of the "Greco-Barbarian" cathedral at Pisa is reflected in the comment of the Roman *Giornale delle Belle Arti*: "Of the many ornaments of this building, the vast paintings hung on the walls are certainly unusual and unique, all executed by the best and most famous practitioners that Italy has produced."[232]

From a reexamination of the biographical and documentary sources of eighteenth- and nineteenth-century scholarship,[233] it is possible to assess not only the very important economic aspect of the export of works of art from Rome, but also the importance and wide influence of the Roman school in those parts of the western world that maintained an uninterrupted dialogue with Rome. Before attempting to identify the deep-seated historical and cultural reasons for this phenomenon, it is perhaps worth mentioning a few, albeit disparate, examples. They range from the twelve statues and eight bas-reliefs produced by Pietro Stefano Monnot in the second decade of the century for the Marmorbad at Kassel in Germany (see cats. 139–40)[234] to the great marble altarpiece sent by Camillo Rusconi to Philip V of Spain for the Madrid monastery of Las Descalzas Reales between 1723 and 1727.[235] In the second half of the century many works of sculpture were sent to England, whither Rusconi had already dispatched a copy of the Farnese *Hercules*. In 1756 Bartolomeo Cavaceppi exported works of his own and some by Carlo Monaldi (including a *Diana Hunting*[236] and a *Venus on a Dolphin*), and their example was followed by Filippo della Valle, whose relations with patrons in Britain appear to have been longlasting and lucrative. The agent in these transactions was often the Marchese Girolamo Belloni,[237] who in 1752 dispatched a copy of the Capitoline *Flora* and a

bust of *Augustus*, and in 1757 modern busts of *Epicurus*, *Pythagoras*, and "Czar Peter of Moscow"[238] (possibly also by Della Valle). But Della Valle's most important work for an English client was undoubtedly his noble interpretation of the sculpture of *Livia* in the Vatican, ordered by Horace Walpole for the tomb of his mother, Lady Catherine (1743), in Westminster Abbey.[239] The major commissions included both copies and originals, virtually without distinction.

As if wanting to recreate around him the spirit of ancient Rome, Stanislas II Augustus of Poland ordered copies of the classical statues he most admired from the principal sculptors then active in the city (all Italians, except for his "pensioner" André Le Brun). Tommaso Righi made him a marble copy of the Vatican *Cleopatra*; Lorenzo Cardelli of the Medici *Vase* (1786);[240] Vincenzo Pacetti of the *Wounded Amazon* (1789); Giuseppe Angelini of *Calliope* (1792) and the Farnese *Hercules* (1793), to which he added a *Euterpe* of his own invention (1792); Carlo Albacini of the Farnese *Flora* (1793) and a head of the Vatican *Athena* (1795); Antonio d'Este of the *Apollo* Belvedere; and Agostino Penna of *Silenus with Bacchus as a Child* from the Borghese collection. Sculptors of lesser reputation were constantly employed in making the Polish king Bacchuses, Venuses, and Apollos.[241] In 1786 he asked Canova for a group of *Venus and Adonis* (never completed) and the small-scale plaster casts of *Henrick Lubomirski*, *Theseus*, and a number of heads, while from Giovanni Volpato he commissioned a series of his celebrated biscuit figurines.[242] Some time earlier, on the initiative of Lord Malton, Wentworth Woodhouse in south Yorkshire had been filled with copies of antique statuary carved by sculptors of various nationalities, especially Giovanni Battista Maini, Filippo della Valle, and Bartolomeo Cavaceppi.[243]

In subsequent years, export licenses and contemporary chronicles provide evidence of the growing number of foreign artists resident in Rome. They ranged from Sergel, who in 1778 dispatched portraits and classical groups (*Mars and Venus*, *Cupid and Psyche*),[244] to François-Marie Poncet, who in 1784 packed a *Venus* for shipment to France and an *Adonis* for England,[245] together with sensitive copies of two famous Capitoline groups, *Cupid and Psyche* and *Bacchus and Ariadne*, after a recurrent decorative scheme adopted by, among others, Carlo Albacini, for a chimneypiece for the Earl of Bristol.[246] Of the more convincing recreations of antique statuary, sticking faithfully to classical canons, the *Memorie per le Belle Arti* mentions, between 1786 and 1788, the four Arcadian *Seasons* in the form of gods sculpted by the young Württemberg "pensioners" Johann Heinrich Danneker and Philipp Jakob

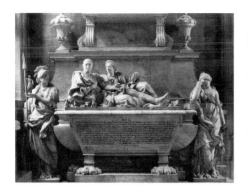

Fig. 42 Pietro Stefano Monnot, *Monument to the 5th Earl of Exeter*, 1704, marble; St. Martin's Cathedral, Stamford, Lincolnshire, U.K.

Scheffauerd, which were immediately sent to Stuttgart to adorn the library of Schloss Hohenheim.[247]

But the true productive capacity of the Roman art industry is best measured by commissions for large-sale funerary memorials combining classical monumentality with traditional excellence in the difficult themes of allegory. The 5th Earl of Exeter ordered his own tomb from Monnot, which was shipped from Rome in 1704 and installed in the church of St. Martin (Stamford, Lincolnshire; fig. 42).[248] End-of-century exports include: the Baldwin monument made by Christopher Hewetson for Trinity College, Dublin;[249] Giuseppe Angelini's cenotaph for Archbishop Carl F. Mennander in Uppsala Cathedral (fig. 43);[250] the complex of marbles, bronzes, and mosaics designed by Vincenzo Pacetti in 1766 for the grand master of Fonseca in the cathedral in Malta;[251] the monument to Prince Gabriele Lancellotti di Torremuzza for the Palermo Pantheon of S. Domenico, created by Canova's disciple Leonardo Pennino;[252] and Giuseppe Ceracchi's aborted Van de Capellen monument for Antwerp, fragments of which now adorn the avenues of the Giardino del Lago at the Villa Borghese. Gottfried Schadow's tomb for Count von der Mark, in Berlin (1790),[253] carved shortly after the return of the artist from Italy, can also be described as "Roman," with its echoes of Michelangelo's ceiling for the Sistine Chapel.

The influence and presence of Roman art across the rest of Italy and Europe, then, depended not only on Batoni's portraits and Panini's *vedute*. Roman art was distributed through two main channels. First, owing to the prestige of the Roman school and its artists, it was collected by celebrities making the Grand Tour or exploited by rulers who wished to conduct their cultural policy along the lines of classical magnificence. Secondly, there was the traditional channel of ecclesiastical

patronage, with artists supplying large altar paintings (and also sculptures and furnishings). Good examples of the first category were the canvases Conca, Masucci (cat. 250), Francesco Fernandi (*called* Imperiali), and Giaquinto created for the Palazzo Reale in Turin, where the large-scale decorative schemes were also entrusted to artists trained in Rome, such as Beaumont and Pécheux or the sculptors Ignazio and Filippo Collino; or the full-scale reproduction of Raphael's Vatican Logge for the Winter Palace of Catherine II in St. Petersburg, together with copies of the most famous statues from the Museo Pio-Clementino.

This second category included commissions for the Papal States,[254] which naturally looked to the capital in artistic matters (though Bologna could boast a no less prestigious tradition), and for other states in the Italian peninsula where there were close relations between the Roman Curia and local courts and peripheral ecclesiastical structures, which in any case all had their own representatives in Rome. The unifying cultural function of the Accademia dell'Arcadia and its offshoots played a part in spreading Roman influence in the form of art, as did the system of "pensioners" sent by the academies in other European cities to perfect their craft in Rome, who thereby acquired a prior claim to fulfill major artistic commissions from their places of origin. A few examples will amply illustrate the magnitude of a phenomenon which, seen as a whole, is bound to bring about a profound change in modern perceptions of Italian art history, shifting the center of gravity of cultural predominance in the eighteenth century very definitely in favor of Rome.

The export of the "correct" style to Lombardy dates from the time when the *gerolamini* of Milan decided to commission the paintings for their church of Ss. Cosma e Damiano from the most renowned of the Roman classicists. The renovation began in 1738, and Subleyras was the first contributor with a depiction of *Saint Jerome*, "a magnificent anatomical study … painted with all the skill acquired by the artist during the years spent at Palazzo Mancini."[255] Again in response to orders from the abbot, Paolo Alessandro Serponti, the driving force behind the eighteenth-century redecoration of the church, Subleyras subsequently sent from Rome a severe *Crucifixion*, dated 1744. Writing in his *Nuova guida di Milano*, printed in 1787, Carlo Bianconi refers to the painter as "more Roman than French, on account of his studies and long stay in the city." Also from the "universal capital of the arts" came the other paintings that complete this decorative scheme, an important testimony to "Roman" art in pre-

Fig. 43 Giuseppe Angelini, *Monument to Archbishop Carl F. Mennander*, 1790, marble; Uppsala Cathedral, Sweden

Neoclassical Lombardy: *The Holy Family with Saints Elizabeth, Zacharias, and the Infant John the Baptist*, painted by Batoni between 1738 and 1740,[256] and *The Departure of Saint Paula for the Holy Land*, painted by Giuseppe Bottani in 1745.[257] When the church was converted into a theater in 1796, this anthology of "philosophical and reformed" painting from the early years of the pontificate of Benedict XIV was transferred, as a stylistic model, to the Accademia di Brera.[258]

In any case, from the late 1730s to the 1780s many "exemplary" paintings found their way from Rome to Milan and the rest of Lombardy,[259] for instance Batoni's altarpieces for S. Maria della Pace in Brescia, the first dating from 1735–36, the second some ten years later,[260] and his *Blessed Bernardo Tolomei* for S. Vittore al Corpo in Milan, painted in 1745.[261] Also deserving of mention is Domenico Corvi's *Hero and Leander*, which, according to the *Giornale delle Belle Arti* of November 19, 1785, "is soon to be sent to Milan to adorn one of the most important residences."

Two shipments of altarpieces to Lombardy in the final decade of the century exemplify the workings of a phenomenon that involved both acknowledged masters and relative beginners. Angelika Kauffmann, who enjoyed enormous international acclaim, was asked to paint a *Holy Family with the Infant Saint John* for the Colleoni Chapel in Bergamo, while the young Giovanni Battista dell'Era, her devoted disciple, a native of Treviglio, near Bergamo, who was paid a modest allowance to study in Rome by his local community, was awarded

his first major commission in the shape of an altarpiece of *Esther before Ahasuerus* for the parish church of Alzano Lombardo.[262]

Where the Kingdom of Naples is concerned, distinctions need to be made between the capital city, the mainland regions, and the island of Sicily. In Naples itself and at the royal palace in Caserta, Roman paintings were often a feature of major building projects, such as the choir of the cathedral, renovated by Paolo Posi in 1744 on the orders of Archbishop Cardinal Giuseppe Spinelli. Here Stefano Pozzi was called to fresco the ceiling with a *Choir of Angels* and paint one of the large canvases for the side walls depicting *Saint Gennaro Liberating the City from the Saracens*,[263] while the canvas opposite, representing *The Transfer of the Relics of Saints Acuzio and Eutichietes*, by Giaquinto, was sent down from Rome.[264] Together with Filippo Juvarra, Giaquinto and Conca were the outstanding artists from southern Italy who had won fame and fortune in Rome, and institutional patrons were therefore more likely to turn to them. Giaquinto, for instance, painted many works for his native Puglia region,[265] while Conca painted the altarpiece for the royal palace in Caserta, as the architect Luigi Vanvitelli considered there was no one in Naples "who could do so good a job."[266] Having both been made cavalieri, Giaquinto and Conca could count on a large following of pupils, often of southern origin, to whom they naturally tended to pass on Roman styles, subject matter, and production techniques. Giaquinto, by virtue of his relations with the Bourbon court, was chosen to fresco the Palacio Real in Madrid, and there consolidated his already conspicuous fame. Conca was also able to send works to the Spanish court (*Alexander the Great in the Temple at Jerusalem*) by the same channels. In relations between the courts of Naples and Madrid, the Roman art world tended to be an essential point of reference, not only for history painting and large-scale decorative projects, but also for such genres as portraiture and landscape painting. Mengs and Angelika Kauffmann were called on to paint the official portraits of the Neapolitan royal family, and Gaspare Vanvitelli's legacy of *vedute* (view paintings) was later taken up by the Roman Giovanni Battista Lusieri, who migrated to Naples, where natural curiosities and archaeological discoveries were attracting a large international clientele.[267]

Though Sicily had less obvious links, Roman painting was represented in the island as early as 1695 by Maratti's masterpiece *The Virgin of the Rosary* for S. Zita in Palermo. The city also received *The Holy Family* (1716) by Giovanni Odazzi, for the church of S. Teresa alla Kalsa and, around 1720, Conca's very fine

*Virgin Enthroned with Saints*.[268] Messina also began to receive major Roman works at an early stage, including a painting by Trevisani, while Benefial worked for the church of the Crocefisso at Monreale (1724–27), and in 1763 Filippo della Valle sent a large bas-relief of *The Last Supper* to Syracuse Cathedral. The close relationship between the Sicilian and Roman art worlds was clearly identified by the monk and painter Fedele da San Biagio (also an Arcadian, author of a large number of paintings for San Lorenzo Nuovo, the town created near Viterbo by Pius VI), who in his *Dialoghi* (1788) defined the Sicilian school of painting as the "daughter" of the Roman.

There were many distinguished Sicilian practitioners active in Rome who sent works to their native region, from Salvatore Monosilio to Gaspare Serenario, from Vito d'Anna to Gioacchino Martorana, from Mariano Rossi to the Manno brothers. But the tendency to choose Rome-based artists for the most ambitious commissions is best exemplified at Catania. The decoration of the Benedictine church of S. Niccolò all'Arena, a monastic complex second in size only to that at Mafra in Portugal, was begun in the late 1780s and was not finished until the 1830s with the arrival of a neo-Cinquecento-style canvas by the most famous Roman painter of the day, Vincenzo Camuccini. The church embraces an anthology of styles expressing the wide range of tendencies to be found in Rome during the pontificate of Pius VI. The first work to arrive was a painting by the Calabrian artist Niccolò Lapiccola, who, like the Sicilian Mariano Rossi, author of three later contributions, had worked successfully on projects for the Borghese family. Subsequent contributors were Antonio Cavallucci, Bernardino Nocchi, and Stefano Tofanelli. With the addition of the names of Marcello Leopardi (who during the same period also painted a cycle of canvases for the Minorite church in Catania)[269] and Tommaso Maria Conca, who in 1804 sent *The Miracle of Saint Clare* for the church of the same name, this represents the main stylistic trends in Roman painting of the period: from the "severe style" of Lapiccola to Rossi's monumentality, which looks back to Pietro da Cortona.[270] The influence of Angelika Kauffmann and her circle is represented by Cavallucci, while the legacy of Mengs is reflected in the work of Nocchi, who was from Lucca. The style of Tofanelli, also from Lucca, shows the rigorous German influence of Philipp Hetsch, Johann Heinrich Tischbein, and Heinrich Füger, while the figurative taste of Leopardi can be traced back to Batoni and is akin to that of the younger members of the Accademia de' Pensieri such as Giani, Landi, and Dell'Era.

The Kingdom of Sardinia also owes a debt to eighteenth-century Roman art. In addition

to the examples already mentioned for the Palazzo Reale in Turin, Roman imports include an impressive series of works for ecclesiastical projects planned by Juvarra. The career of this architect from Messina was determined on the one hand by political events, and on the other by his Roman connections. In his native city he had come into contact with the Savoy family during the brief period in which the northern dynasty ruled the Kingdom of Sicily (1714), trained in Rome, then worked in Turin and Spain, between times reestablishing his links with the papal capital by way of commissions he had promoted, always with a concern for excellence. In the Turin church of S. Filippo (which already housed Maratti's *Virgin and Child with Saints* and which Juvarra reconstructed in 1715 after its collapse) and in the adjacent oratory, the outstanding Roman contributions are Francesco Trevisani's *Martyrdom of Saint Lawrence* and Sebastiano Conca's *The Immaculate Virgin with Saint Philip Neri*. Conca is also represented in other churches in the city and, with Trevisani again, in the chapel of the royal hunting lodge (1724). In the sacristy of S. Filippo is a painting by a Palermo painter of the school of Maratti, Giacinto Calandrucci, but the most surprising result of Sicilian–Roman collaboration in the Piedmontese capital is a powerful work which Juvarra was allowed to commission "for his personal devotion"[271] for an altar in the same church. He asked Conca, in Rome, to paint an image of Saint John Nepomuk, to which was later added the figure of the "Madonna della Lettera" (protector of the city of Messina), painted in 1733 by Corrado Giaquinto. Giaquinto was then working in Turin on the decoration of the royal residences, for which his series of episodes from the *Aeneid* is one of his highest achievements.[272]

Rome's most important export in the years immediately following was intended for a provincial town. "This vast painting raised his reputation to new heights," commented the *Memorie per le Belle Arti*, some fifty years later,[273] recalling the excitement aroused by the exhibition in the Roman church of S. Maria dell'Anima of an immense canvas painted in 1737 by Pierre Subleyras on behalf of the regular canons of the Lateran for the refectory of their convent of S. Maria Nuova at Asti. In his *Banquet in the House of Simon*, which measured a good 23 feet (7 m) across, the Rome-based French artist featured twenty-six figures (and a dog), harmoniously arranged to lead the eye toward the heart of the composition: the figure of the Magdalen drying Christ's feet with her hair. To display the painting before it was dispatched to Asti, the canons, though resident in S. Maria della Pace, preferred the vast open spaces of the adjacent S. Maria dell'Anima. It was

common for connoisseurs—artists, men of letters, members of the aristocracy—to gather in Roman churches, which were used for exhibitions as well as for worship, to view important paintings and engage in passionate discussion of their strengths and defects before the works were finally sent on their way.

A high point of Roman artistic influence in Piedmont was a project undertaken by Cardinal Carlo Vittorio Amedeo delle Lanze, commendatory of the Abbazia di Fruttuaria at San Benigno Canavese, not far from Turin. This prelate, an Arcadian (*alias* Parmenide Sireo) and honorary member of the Accademia di S. Luca, influenced in his education by Cardinal Alessandro Albani and also a friend and correspondent of Giovanni Gaetano Bottari, had founded the new abbey church and procured from Rome the relics of Early Christian martyrs for its various altars. He took St. Peter's as his model and used painting to express his Jansenist, anti-Jesuit inclinations,[274] in a symbolism centered on the cult of the saints of the old monastic and preaching orders of Augustinians, Benedictines, and Dominicans. The cardinal, who had consolidated his links with Rome during the conclaves of 1769 and 1774, engaged artists of varying merit and prestige, some of them young or little known, possibly because he wanted to keep the costs down. They included important names such as Mariano Rossi (active at the royal tapestry works in Turin since 1771), who painted a canvas of *The Annunciation*, and the young Cades, who was responsible for the surprisingly Rubensian *Martyrdom of San Benigno*, but also the young Sardinian "pensioner" Angelo Giacinto Banchero and a number of minor figures. Despite the particular doctrinal leanings of Cardinal delle Lanze, the export of religious paintings from Rome was normally a guarantee of Catholic figurative orthodoxy—which Rome was obviously in a position to impose by exploiting the organic relationship between the ecclesiastical authorities and cultural institutions (the Accademia dell'Arcadia perfectly exemplifies the continuity of this connection)—and of a certain style. This trend became more evident as the century progressed, especially as the Church promoted new subjects of veneration and raised altars (adorned with images as the Roman authorities devised)[275] to the new saints of the Catholic world. Solemn canonizations in St. Peter's were followed by the dispatch of large-scale images to the new saints' places of origin (and elsewhere). These were intended to speak to the hearts and minds of the people of Russia and Portugal, Chile and Poland, Asti, and Messina. And, as well as the religious and historical message, they would draw from them an epic poetry expressed in the most noble figurative language. In 1726, for

example, the authorities established and disseminated the official iconography of Saint Turibio, bishop of Lima,[276] the Spaniard Saint John of the Cross, and the young Polish Jesuit Stanislas Kostka. These were followed in 1734 by the French Jesuit Jean-François de Régis, and Vincent de Paul, spiritual director of Jeanne-Françoise Frémot de Chantal (canonized in 1767, together with the Pole Jana Kantego). Meanwhile, in 1746, it was the turn of the German Fidelis of Sigmaringen, and another Spaniard, Pedro Regalato, both Franciscans. From preliminary research,[277] it would seem that a complex hierarchy of artists was involved, from the often famous authors of paintings done for the pope himself to the more modest disseminators of religious prints.

This situation also needs to be taken into account when considering the financial issues involved. Anthony Morris Clark and Olivier Michel have already done useful research on this aspect of the work of artists such as Batoni and Giaquinto,[278] but it still remains to conduct an overall survey of the effect of the export of contemporary works of art on the economy of eighteenth-century Rome and the Papal States, and make comparisons with other art-exporting centers such as Venice or Paris. Such a survey would also provide a better understanding of the temporal and geographical relationship between works painted in the earlier and later parts of the eighteenth century (though the phenomenon, rooted in the Counter-Reformation, was still significant well into the nineteenth century) and sent to so many parts of Europe (and later the Americas).

In the first half of the eighteenth century, many important works found their way beyond the borders of Italy, and some by Maratti even journeyed as far as Siam.[279] Paintings by Francesco Trevisani were sent to the French cathedrals of Avignon, Besançon, and Carpentras,[280] to Prague Cathedral and other Bohemian churches, such as Oppocno and Zamberk[281]; Pietro de' Pietri also sent works to Besançon[282] and to Cîteaux (another painting with obvious doctrinal content, *The End of the Schism of Anacletus*, done for the Cistercians); Giovanni Odazzi to Segovia; Benedetto Luti to Malta;[283] Placido Costanzi to Beaume-les-Dames[284] and as far as Lima in Peru;[285] Stefano Parrocel to Marseille;[286] and Sebastiano Conca to various destinations in Germany. To give an idea of an artist's reputation, Pascoli often refers in summary fashion to works executed for a wide range of European countries, from Spain to Poland, as in the cases of Odazzi, Ghezzi, Luti, and Chiari. During the second half of the century the examples are so numerous that listing them would be irritatingly repetitive. Some, however, cannot be passed over: Francesco Caccianiga's four canvases

sent in 1769 to the chapel of the University of Salamanca to represent the dogmas of Catholicism in the place appointed for the training of Spain's ruling class; Batoni's seven altar paintings for the basilica of the Sacred Heart, at the Estrela in Lisbon, painted between 1781 and 1786; the *Deposition* that Giuseppe Cades painted, through the mediation of the Jesuit priest John Thorp, for the private chapel of the 8th Lord Arundel at Wardour Castle in Wiltshire in 1787;[287] and Tommaso Sciacca's *Holy Family*, sent to Poland in 1792 for the parish church at Petrykozy. Meanwhile, for the cathedral of Solothurn in Switzerland, on the frontier between the Catholic world and the strongholds of Calvinist iconoclasm, from 1773 to 1778 Domenico Corvi painted the most provocatively explicit and symbolically perspicuous representations of the doctrinal foundations of the Roman Church: *The Institution of the Eucharist*,[288] *Pentecost*, *The Incredulity of Saint Thomas*, and *The Coronation of the Virgin*. One could also mention Roman projects in Spoleto[289] and Ravenna,[290] Gubbio[291] and Pisa,[292] Cagliari[293] and Pontremoli,[294] or point out isolated but no less significant works of art in capital cities and remote abbeys, cathedrals, and oratories from Dublin to Warsaw, Croatia to Franche-Comté, and farther afield. But the important thing is to establish the unity of this impressive phenomenon of the presence of "Roman" art far beyond the confines of the city or the tiny state of which it was the temporal capital. Its predominance extended through time and space, spanning long periods of history—periods that modern developments seem set to contract and negate.

The return to classicism in the figurative arts of Enlightenment Europe and the increase in the number of art academies, which were important disseminators of the influence of the Roman school, also led to the temporary or permanent emigration of many of its leading exponents to European courts and reformed academies. They were well aware of their superiority, proclaimed, according to a late but reliable source, by Mengs, who is supposed to have said that "the lowliest practitioners in Rome were the foremost in other parts of the world."[295] And there is no need to cite a long series of names and circumstances, beginning with Johannes Widewelt's dissemination of Winckelmann's gospel and spanning the whole century, to confirm "the continual example of sovereigns who in this emporium sought court painters and heads of academy," as Lanzi expressed it in the conclusion to his chapters on the Roman school.[296] It is interesting that Sebastiano Conca, Pompeo Batoni, and Gaspare Landi declined so honorable a conclusion to their careers, not wanting to

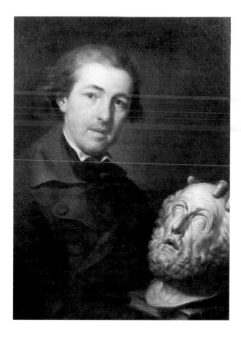

Fig. 44 Anton Raphael Mengs, *Giuseppe Franchi*, c. 1772–73, oil on canvas; private collection

Fig. 45 Johann Heinrich Wilhelm Tischbein, *Konradin of Swabia in Prison Being Told of His Condemnation*, 1784, oil on canvas; Schlossmuseum, Gotha

abandon the strong position they had achieved in Rome, while others refused the opportunity "from religious zeal,"[297] such as Pietro de' Pietri, who turned down an invitation to transfer to the English court, where he had been offered the tempting "salary of two hundred *scudi* a month." In the field of sculpture, which was about to achieve primacy on the eve of the nineteenth century, at least in Italy there was continuity in the fact that Giuseppe Franchi was appointed to the chair of the Accademia di Brera in 1775 on the strength of his Roman experience. In the portrait of the sculptor painted in Rome by Mengs, there is an explicit reference to his preference for a severe style in the head of Homer resting on a copy of his poem (fig. 44). This was the period when Arcadian literary figures such as Melchiorre Cesarotti and Vincenzo Monti were attempting to translate Homer's epics. Franchi was succeeded, at the end of the century, by Camillo Pacetti, nephew of Vincenzo, who took with him to Milan from Rome an allegory of the origins of statuary: his noble version of *Minerva*, shown breathing a soul into the statuette of Prometheus she has just formed.[298]

Teaching methods and equipment—the collections, drawings, and plaster casts of the Real Academia de S. Fernando in Madrid, the Düsseldorf academy, or the Accademia Braidense in Milan—also confirmed the prestige of the Roman school in setting standards for the return to antiquity on which progressive eighteenth-century aesthetics were based.[299] But to call it a school is perhaps to understate the truth. According to Luigi Lanzi,

"those who do not approve of the word school prefer university, or some other term for a place where painting is taught and practised."[300] This was no less true of sculpture, as is clearly evidenced by the cases of Nollekens (in Rome from 1760 to 1770), Poncet, Hewetson, and particularly Flaxman, who found there, between 1790 and 1794, fertile soil for the creation of two great masterpieces: the groups of *Cephalus and Aurora* and *The Fury of Athamas* (see fig. 100). To these young northern artists seeking to establish their reputations, Rome also offered the language and setting in which they could develop a new Romantic iconography to express the myths, history, and literary themes of their countries of origin. This was certainly the case for Johann Heinrich Wilhelm Tischbein, who in 1784 drew on elements from antique statuary to produce his dramatic depiction of *Konradin of Swabia in Prison* (fig. 45). The young prince has the looks of the *Apollo Belvedere*, while the features of the judge, Roberto da Bari, are modeled on a head of Vitellius. Similarly, in 1788, Jean-Pierre Saint-Ours set his idyllic reconstruction of *German Nuptial Rites*[301] in a kind of pastoral Greek landscape. Even earlier, the Irish painter James Barry had produced his first masterpiece, *The Temptation of Adam*,[302] while working in Rome between 1767 and 1770. The rendering of the nudes is in a truly classical style, and the artist was evidently more strongly influenced by Milton's *Paradise Lost* than by the biblical text. According to Lanzi, it was because of the continual circulation of artists and such fundamental works as these great test pieces (with

which "pensioners" generally concluded their period of study) that so many had become "men of worth" as a result of visiting Rome, or rather could not "appear such to the world unless they had Rome's approval."

From the time of Maratti at the beginning of the century to that of Canova at its end, artistic developments in Rome expressed ideas and feelings that only partially outlived the great leap into the modern world. The Holy City, adorned and embellished by artists, stood on a faultline between two eras that were gradually but irreversibly drawing apart. Art is undoubtedly the key to a rediscovery of the treasures of this lost Atlantis. In the eighteenth century the wonderful remains of classical art were an education to contemporary artists, and "the nations flocked to the common mother of the fine arts, bringing a variety of notions and tastes that were clarified by this meeting, making the public of this city one of the most enlightened in Europe" (Ennio Quirino Visconti, 1785).[303] For the modern viewer, as well as recovering a sense of Rome's predominance, it is important to understand her message, a task that requires the simplicity and openness with which a young nobleman from Ferrara, Leopoldo Cicognara, arriving in the city one year after Goethe with the intention of becoming an artist,[304] wrote to his father: faced with Rome, "you must forget all that is small, base, vile, and plebeian. Everything radiates greatness, a bewitching greatness."[305]

## Notes

1 For a short history of the institution, see Graziosi and Tellini Santoni 1991, pp. 181–92, which contains a useful list of documents and printed sources.

2 On this subject, see Rensselaer W. Lee, *Ut Pictura Poesis: The Humanistic Theory of Painting* (New York: W. W. Norton, 1967).

3 The disagreements that soon arose between Crescimbeni and Gravina led to a split in 1711. Gravina subsequently founded the Accademia Quirina (1714), but this body was virtually dissolved four years later, on the death of its founder, even though its membership included some very prestigious Arcadians, such as Pietro Metastasio.

4 Merolla 1988, pp. 1060–65.

5 Giovan Pietro Bellori's discourse '*L'idea del pittore, dello scultore e dell' architetto scelta dalle bellezze naturali superiore alla natura*' was delivered at the Accademia di S. Luca in May 1664 and printed as an introduction to his *Vite de' pittori, scultori e architetti moderni* (Bellori [1672] 1976).

6 On this subject, see Rudolph 1977.

7 Paolozzi Strozzi 1978, "Il Sabatelli."

8 The most serious and carefully researched of these studies are the essays of Stella Rudolph. Interest in this subject is also evident in many recent articles, Griseri 1982, and in the papers presented to the Convegno di Studi (*Arcadia: Atti del Convegno di Studi per il III centenario, Roma 15–18, maggio 1991*) marking the third centenary of the academy.

9 See the names listed in Giorgetti Vichi 1977.

10 Significantly, the pamphlets printed by the Accademia di S. Luca in 1706 to mark the competition of that year are entitled *Le belle arti in lega con la poesia*.

11 Further evidence of this continuity is provided by the large paintings that some Neapolitan artists painted while in Rome and sent home to their patrons as trial pieces. These include *Shepherds of Arcadia* by Filippo Marsigli, exhibited in 1830 at the Real Museo Borbonico, and the *Pastor Fido*, a scene from Giovambattista Guarini's poem of the same title, painted by Camillo Guerra in 1835 (Museo Archeologico Nazionale, Naples).

12 Goethe 1816.

13 An excellent edition of Nolli's plan was published in Bevilacqua 1998.

14 The character of this extraordinary collector was brilliantly brought to light in Rudolph 1995.

15 See Edward J. Olszewski's preliminary studies of the Ottoboni collections. In anticipation of his completed work on this subject, it is worth consulting Matitti 1994, "Santa Genuinda," and Matitti 1995. For an in-depth study of the rise of the Ottoboni family in Roman society, see Menniti Ippolito 1996.

16 Cormio 1986; Prosperi Valenti Rodinò 1996.

17 Noè 1980; Pavanello 1998, with additional bibliographical references.

18 The first research on the continuity of the classical style in eighteenth-century Rome was conducted by Italo Faldi (Faldi 1977).

19 Rudolph 1984, in particular the conclusions on p. 320.

20 Essential sources for a knowledge of artistic activity are the *Diario Ordinario di Roma*, first published by the Chracas printing house in 1718, and that of the abate Francesco Valesio (edited by Gaetana Scano, 1977). For the final years of the century, see the as yet unpublished diary of Vincenzo Pacetti (*Giornali di Vincenzo Pacetti riguardanti li principali affari, e negozi del suo studio di scultura, ed altri suoi interessi particolari, incominciato dall'anno 1773 fino all'anno 1803*, Biblioteca Universitaria Alessandrina, Rome, MS 321), generous extracts of which have been published on various occasions, and periodicals such as *Antologia romana*, *Memorie per le Belle Arti* and *Il Giornale delle Belle Arti*, which are referred to below. A useful list of printed sources (chronicles, diaries, "notices"), covering the first forty years of the century, is to be found in Matitti 1995, pp. 170–73.

21 Foscolo 1978, pp. 23–24; Izzi 1994.

22 Izzi 1994, p. 441.

23 Izzi 1994, pp. 441–42.

24 Merolla 1988, p. 1084.

25 "Mon cher confrère de Lyon et d'Arcadie" (letter dated February 6, 1776; see Theodore Besterman, ed., *Voltaire's Correspondence* [Geneva: Institut et Musée Voltaire, 1965], vol. 93, p. 86).

26 Michel 1996, *Vivre et peindre*, pp. 96–107.

27 Bonora 1994, p. 8.

28 Giorgetti Vichi 1977.

29 Initially accommodated in the Farnese Gardens on the Palatine and then in the Ginnasi Garden on the Aventine, the academy eventually found a permanent site on the Janiculum, thanks to the generosity of John V of Portugal (Ferraris 1995).

30 The same is true to some extent in the English Society of Dilettanti, whose members, according to Elizabeth Einberg (in Wilton and Bignamini 1996, p. 292), came from all political parties. Here gentlemen of relatively modest means could mix on equal terms with some of the most wealthy men in England, united by a common enthusiasm for the arts and the classical world.

31 For more information about Subleyras and his relations with cultured Roman circles, see Michel and Rosenberg 1987, pp. 96–97.

32 Produced between 1761 and 1764. For further information about Saly, his stay in Rome, and his work in Denmark, see Majo, Jørnaes, and Susinno 1989, pp. 35–37.

33 Montaiglon 1887–1912, vol. 4, p. 139.

34 Hersant 1988, p. 496.

35 Ingamells 1997, pp. 479–80.

36 Giovan Mario Crescimbeni's text (1708) has been analyzed and commented on by Stella Rudolph (1994). As in many of her earlier writings, she examines Maratti's role in Clement XI's program of reform for the arts.

37 Rudolph 1994, pp. 393–94.

38 Bellori [1672] 1976, p. 645.

39 Rudolph 1994, pp. 395, 406, fig. 4. A picture corresponding to Crescimbeni's description is listed in the inventory of Maratti's effects (Bershad 1985, p. 78).

40 Romano Cervone 1994.

41 For the idea of the English garden as an Arcadian setting, see Calvano 1996, p. 53.

42 The biographies, printed by Antonio de' Rossi, continued to be published until 1751.

43 Baldeschi and Crescimbeni 1723.

44 Conforti 1980, p. 254.

45 Rusconi also sculpted the statues of *Saint Andrew* (1709) and *Saint John the Evangelist* (1712). The close relationship between Rusconi and Maratti, attested to by Pascoli, is best illustrated in the chapel that Maratti had built for himself in the church of S. Faustina at Camerano, his hometown. His funeral monument and that of his wife, Francesca Gommi, are both decorated with low-relief portraits by Rusconi (Rudolph 1979).

46 Two separate committees were responsible for the project at St. John Lateran: for the sculptures, Benedetto Pamphili, Carlo Fontana, Orazio Albani, and Curzio Origo (Broeder 1967; Conforti 1980); for the Prophets, Benedetto Pamphili, Carlo Stefano Fontana, the Lateran canons Monsignor della Molara and Monsignor Vico, and Father Diodato Nuzzi, vicar-general of the Augustinian order, see Negro 1993.

47 On this portrait, now in the Musée du Louvre, see Loire 1998, p. 228. Livio Odescalchi, heir by way of Cardinal Azzolini to the collections of Christina of Sweden, commissioned from Pietro Stefano Monnot a monument to his uncle Pope Innocent XI, based on a drawing by Maratti (the drawing was discovered in 1701 and the monument completed soon afterwards). For Odescalchi, Monnot had also made various low reliefs on mythological subjects (the terracotta models are kept in the Louvre). The medal portrait of Livio (Bershad 1984) is in an austere "republican" style, eschewing modern dress, based on antique coins or a gem. The oval was mounted in a frame of *verde antico* with a stand of yellow marble.

48 The authors of the other sculptures were Lorenzo Ottoni (*Saint Thaddeus*, 1712), Angelo de' Rossi (*Saint James the Less*, 1715), Giuseppe Mazzuoli (*Saint Philip*, 1715), and Francesco Moratti (*Saint Simon*, 1718). The enormous cost of the sculptures was borne by Peter II of Portugal, his son John V, Cardinal Lorenzo Corsini (the future Clement XII), Cardinal Benedetto Pamphili, Cardinal Portocarrero, Elector Max Emanuel of Bavaria, the prince-bishop of Würtzburg, and the grand master of the Teutonic Knights, Leopold of Lorraine (Broeder 1967).

49 The diaries of Monsignor Virgilio (Oratorian and brother of Cardinal Bernardino) have been published by Heimbürger Ravalli 1977, and Güthlein 1979.

50 For this aspect of Ghezzi's activity and the role he played, see Rudolph 1988–89, particularly pp. 239–40, n. 59; De Marchi 1999, "Ghezzi," pp. 64–75.

51 Pascoli (1981) makes a point of Trevisani's qualities as a poet. But see also Griseri 1962.

52 Regarding the significance of the decoration of the "gran sala" of the Palazzo della Cancelleria, in which Ludovico Sergardi set out to celebrate the pontificate of Clement XI, see Rudolph 1978.

53 That is, official painter.

54 Each stage of the creative process is well documented in the case of Benefial's *Jonah*, with drawings (now in Berlin) of the nude, the draped figure, and the final composition, and the *bozzetto* (McCrindle collection; see Clark and Bowron 1981, p. 72).

55 *Diario Ordinario di Roma*, June 11, 1718 (no. 166). An example of the medal coined for the restoration of St. John Lateran, formerly in the Anthony Morris Clark collection, is kept at the Philadelphia Museum of Art (Hiesinger and Percy 1980, p. 135, no. 123).

56 On the S. Clemente frescoes, see Gilmartin 1974, and *Seicento e Settecento* 1998, pp. 47–63.

57 The cartoon was the final full-scale drawing, used for transposing the composition to the canvas or the newly plastered wall. In his biography of Giuseppe Chiari, Nicola Pio mentions the cartoons produced by the artists who painted the Prophets in St. John Lateran.

Ponfredi (in Bottari and Ticozzi 1822–25, vol. 5, pp. 5–39) mentions Benefial's cartoons for S. Gallicano and his *Episodes from the Life of Saint Lawrence* at Viterbo in the collection of Count Soderini.

58 The name of Pier Leone Ghezzi does not appear in academy membership lists. However, the painter himself declared in the margin of a drawing depicting the Bosco Parrasio (after 1726), "sono anch'io Arcade" (Lo Bianco 1985, p. 23). Also attributed to Pier Leone Ghezzi is a *Portrait of Gravina* (Lo Bianco 1999, p. 120, cat. no. 24), which would tend to confirm a relationship between the two men. His caricatures include sketches of Crescimbeni and Gravina.

59 Livio de Carolis was the fourth son of a corn merchant from Pofi, one of the Colonna estates in the Ciociaria region. In 1726, he acquired the title of marchese from the Altieri family, together with the Prossedi estate, but in 1714 began building his own residence in Rome based on a plan by Alessandro Specchi (Giuggioli 1980). He also immediately acquired a country house, described in the *Mercurio Errante* of 1732. In aspiring to noble rank, he contracted enormous debts, and in 1750 his heirs were obliged to sell the residence.

60 The subject of Chiari's fresco seems to refer to the De Carolis coat-of-arms: two eight-pointed stars and two doves pecking two ears of corn.

61 Trevisani painted a second canvas for the Palazzo de Carolis, *Venus in Vulcan's Forge*, dated 1725 (IRIARTE 1989, pp. 91–110).

62 Michel 1996, *Vivre et peindre*, pp. 587–97.

63 The paintings for the Palazzo Ruspoli apartment have not survived. Their style can be surmised from the decoration of the Palazzo Rospigliosi at Maccarese. See Negro 1996.

64 On the transfer of the Bosco Parrasio from the Palatine to the Aventine and then to the Janiculum, see Predieri 1990, pp. 39.

65 Musées Royaux, Brussels.

66 Private collection, Rome (see Pacia and Susinno 1996, p. 157, n. 47).

67 Until the time of Leopoldo Cicognara, who devoted a chapter of his essay *Del bello* to the subject of "grace" (Pisa 1808, now in Barocchi 1998, pp. 33–99).

68 This commission was entrusted to Ermengildo Costantini, who drew inspiration from Pietro da Cortona's ceiling for the Palazzo Barberini in depicting the Borghese coat-of-arms upheld by a winged figure in the presence of the Figurative Arts, Music, and Poetry. Above them flies the figure of Liberality and, in the bottom part of the composition, is depicted the defeat of Ignorance. The central part of the fresco was painted in 1767–68, but Constantini did not complete the figures of the Liberal Arts and Virtues until 1773–74. See Fumagalli 1994, p. 141.

69 Schönborn collection, Pommersfelden; this work is the pendant to a *Triumph of Love (Atalanta and Hippomenes)* painted in 1723. See Maue and Brink 1989, pp. 408–9, no. 314. Conca often painted this subject, on canvas (the two small-scale *Allegories of the Arts and Music* in the Galleria Spada, Rome) and in fresco (*Allegory of the Sciences*, Palazzo Corsini, Rome).

70 Hermitage, St. Petersburg (Clark and Bowron 1985, p. 240, no. 110).

71 Location unknown. See Sestieri 1994, vol. 2, fig. 369. Another interesting work by the same artist is the *bozzetto* for *The Arts Triumphing over Time* (Leicester collection, Holkham House, Norfolk; see Sestieri 1994, vol. 2, fig. 362).

72 Private collection (Schiff 1973, fig. 493).

73 See Ottani Cavina et al. 1979, pp. 11–12, no. 8.

74 Ottani Cavina 1998, p. 499, fig. 10.

75 Carlo Maratti, *Allegory of Painting* (Palazzo Corsini, Rome).

76 *Conca* 1981, pp. 396–99.

77 Pinacoteca, Dresden; Clark and Bowron 1985, p. 219, no. 39. For other examples of the same subject, see nos. 40–48 on pp. 219–22.

78. Lemme collection, Rome; Loire 1998, p. 202, no. 77.

79 Szèpmuvészeti Muzeum, Budapest.

80 Walters Art Gallery, Baltimore. The picture was painted in 1764 for Palazzo Reale, Turin. Tscherny 1977–78.

81 Formerly in the Schneider collection, Cleveland, Ohio; Rudolph 1998, p. 119, fig. 5. On this painting, later given by the artist to Marcantonio IV Borghese, and the episode that led to its composition (a dispute over payment for a canvas for the church of Ss. Celso e Giuliano), see *Memorie per le Belle Arti* (Rome) July 1786.

82 He was famous for having found the two *Centaurs* (Musei Capitolini, Rome) at Hadrian's Villa.

83 An allusion to the fact that Furetti came from Bergamo, with which the character of Harlequin was associated. A similar idea (merit not duly esteemed) may be behind the portrait of Paolo de Matteis (formerly owned by Anthony Morris Clark), in which Pier Leone Ghezzi depicts him painting an allegory of Fortune crowning an ass while not noticing the noble horse in front of her.

84 According to the *Memorie per le Belle Arti*, the idea for this program came from Giovambattista Visconti. This is confirmed by a Vatican document discovered by Gian Paolo Consoli (1996, pp. 37–38).

85 On the Museo Pio-Clementino, see Consoli 1996; for the "new" artists engaged on the pictorial decoration (from Lapiccola to Nocchi), see Rudolph 1985.

86 Museo di Capodimonte, Naples. The canvas, mounted in the ceiling of the *camerino* and depicting episodes from the life of the hero, interestingly described by Bellori ([1672] 1976, p. 47) as "Images of Virtue," was removed in 1662 and transferred to the Farnese residences in Parma. It subsequently went to Naples with the rest of the painting and sculpture collections. However, it was very well known from a multitude of engravings.

87 Two episodes from the life of Hercules were painted in fresco by Federico Zuccari in a room in his palazzo in via Gregoriana. A plaster cast of the Farnese *Hercules* features several times in paintings of the artist's studio, where it has a dual significance as formal model and philosophical point of reference (Lecoq 1983, pp. 7–8).

88 Hercules was regarded as the founder of the Spanish Bourbon monarchy (Roettgen 1993, p. 130).

89 Benefial was elected to the academy with the name of Distanio Etneo in 1743. A preparatory drawing for the decoration has survived (Hiesinger and Percy 1980, p. 41, no. 28).

90 Susinno 1978. In the same palazzo, the *galleria* overlooking via del Corso, built by Gabriele Valvassori in the 1730s, was frescoed with *Episodes from the Life of Hercules* by Aureliano Milani.

91 Galleria Nazionale d'Arte Moderna, Rome; according to Alessandro Verri (1796), the work was intended for the King of Naples (Colucci 1998, p. 70, n. 33).

92 There is a preparatory drawing at the National Gallery of Scotland, Edinburgh (Roettgen 1993, pp. 130–31).

93 Another example is Sebastiano Conca's painting of *Hercules Crowned by Fame before the Temple of Glory* (Sestieri 1994, vol. 2, fig. 299).

94 Some years later, the Roman sculptor Giuseppe Ceracchi, on his return to Rome from England, painted a portrait of Reynolds, which is mentioned in the *Giornale delle Belle Arti* (see Ceracchi 1989, p. 49, cat. no. 1).

95 Wind 1986, fig. 32.

96 In 1791 Angelika Kauffmann painted the portraits of two leading figures in Roman literary and social circles in the allegorical guises of Tragedy and Comedy (Nationalmuseum, Warsaw). Her subjects were Domenica, daughter of Giovanni Volpato and wife of Raffaello Morghen, both renowned engravers, and Maddalena, daughter-in-law of the former.

97 For the English poet George Keate, in May 1790 Angelika Kauffmann painted "an Arcadian scene inspired by an Arcadian poet written by the said poet." It featured the cult of tombs and the rather more cheerful subject of a pastoral wedding (Kauffmann 1998, p. 52).

98 Pushkin Museum, Moscow.

99 Voralberger Landesmuseum, Bregenz.

100 Ashmolean Museum, Oxford (Wind 1986, p. 66, fig. 22). The relationship between philosopher and painter dates from the period when Shaftesbury was writing *A Notion of the Historical Draught or Tablature of the Judgement of Hercules* (first published in 1712, in French, in the *Journal des Sçavants*).

101 Galleria Sabauda, Turin; see Clark and Bowron 1985, p. 257, no. 173.

102 Giacomo Casanova, *Storia della mia vita*, edited by Piero Chiari and Federico Roncoroni (Milan: Arnoldo Mondadori, 1989), vol. 3, pp. 787–88, 1115–16.

103 On Giuseppe Ghezzi and the academy, see De Marchi 1999, "Ghezzi," pp. 79–90.

104 The academy's custodian Gioacchino Pizzi was a frequent speaker: *In lode delle belle arti*, 1758, published by Marco Pagliarini (another important printing house: see Barroero 1996, pp. 678–79, n. 8), *I pregi dell'architettura nel solenne concorso delle belle arti celebrato in Campidoglio dall'insigne Accademia del Disegno di San Luca*, Rome, Angelo Casaletti, 1768, and *La fortuna: canto di Gioacchino Pizzi recitato in Campidoglio in lode delle belle arti per il concorso dell'anno MDCCLXXI*, Rome, Arcangelo Casaletti, 1771. His speeches for the prizegivings of the years 1773, 1775, 1777, 1779, 1781, and 1783 are extracts from his poem *Il tempio del Buon Gusto*.

105 Donato 1996, pp. 71, 241. For Amaduzzi's role in the academy "between Christianity and Enlightenment," see Rosa 1999, pp. 142–44, 290–93, and passim.

106 This was a continuation of the process initiated by the Oratorian Cardinal Cesare Baronio in the time of Clement VIII (1592–1605) and pursued throughout the seventeenth century, with greater intensity in jubilee years.

107 Pascoli 1992, p. 652.

108 The contemporary biographer Nicola Pio (c. 1724) also describes Giuseppe Ghezzi as "painter and orator."

109 Pascoli 1992, p. 652.

110 Paratore 1994, p. 17.

111 Incisa della Rocchetta 1979.

112 Kunsthistorisches Museum, Vienna.

113 *Giornale delle Belle Arti*, June 23, 1787.

114 On this subject, see the observations of Elisabeth and Jörg Garms (Garms and Garms 1998). For Benedict XIV and the new theories of the wider Catholic Enlightenment, see Rosa 1999, pp. 149–84.

115 This is the title of Piccialuti Caprioli 1994.

116 The "cavaliere" in question was of course Corrado Giaquinto. For the precise dating of his work, see Vasco Rocca 1985.

117 The report in Chracas (no. 4236) seems to show some reservation, which was also shared by the pope, if it is really true that he referred to the new façade as a "porcaria moderna" ("modern rubbish").

118 The sculptors concerned were Agostino Corsini, Bernardino Ludovisi, Carlo Marchionni, Pieter Verschaffelt, Pierre Lestache, Tommaso Brandini, and Giovanni Battista Grossi. On the projects of this kind promoted by Pope Benedict XIV, see Michel 1998.

119 Work on these sculptures was in hand by 1735. The authors included Paolo Benaglia, Bartolomeo Pincellotti, Agostino Corsini, Bernardino Ludovisi, Giovan Battista de' Rossi, Pierre Lestache, Pascal Latour, and a number of lesser names. Benedict's XIV's policy of continuity was also evident in his choice of sculptors.

120 As with the Lateran portico, the bas-reliefs are part of the same doctrinal program (Michel 1998). The sculptors were again Carlo Marchionni, Carlo Monaldi, Agostino Corsini, Bernardino Ludovisi, Pieter Verschaffelt, and others including Pietro Bracci, Filippo della Valle, Giovanni Battista Maini, and Michel-Ange Slodtz.

121 Noè V. 1996.

122 Garms and Garms 1998, p. 398.

123 Garms and Garms 1998, p. 396.

124 Caffiero 1992, p. 369.

125 Vasco Rocca and Borghini 1995, pp. 522–23.

126 The name was normally spelled Caffehaus in the eighteenth century, particularly in documents relating to the *casino* (lodge) on the Quirinale.

127 Pantanella 1993; Stoschek 1998.

128 *Charles III Visiting the Basilica of St. Peter's, Rome* (1745); *King Charles III Visiting Pope Benedict XIV at the Coffee House, Palazze del Quirinale, Rome Quirinal Gardens* (1746).

129 Nationalmuseum, Stockholm, 1785. The king asked Gagneraux to paint a second version (1786), which was given to Pius VI (now in the National Gallery, Prague). Regarding the first version, see Laveissière et al 1983, pp. 98–99, no. 26; for the second, Wilton and Bignamini 1996, pp. 81–82, no. 38.

130 The previous year, using the good offices of Carl Fredrik Fredenheim, the king had appointed Francesco Piranesi as his agent in order to acquire classical marbles in Rome. Fredenheim, incidentally, was the chief patron of Giuseppe Angelini (Caira Lumetti 1990, p. 38).

131 Kept at the Museo di Roma, Rome. The king also donated a series of medals commemorating his reign. They are still kept at the Accademia di S. Luca, together with a profile portrait sculpted by Pacetti after Sergel.

132 Institut Tessin, Paris.

133 Merolla 1988, particularly pp. 1056–91.

134 For details of this periodical, probably funded "clandestinely" by Prince Abbondio Rezzonico,

and its rival, the *Giornale delle Belle Arti e della Incisione Antiquaria, Musica e Poesia*, see Barroero 1999.

135 Visconti 1841.

136 Visconti 1841, pp. 43–44.

137 Nappi 1997.

138 Fusconi 1984, p. 8.

139 Another such original explorer was Marianna Candidi Dionigi, who in 1809 published her own short treatise on antiquarian topography entitled *Viaggio in alcune città del Lazio che diconsi fondate da re Saturno* ("Travels to towns in the Lazio region said to have been founded by King Saturn"), which contained extraordinary descriptions of unspoiled places still belonging to the realm of myth, seen through romantic eyes.

140 Wilton and Bignamini 1996, p. 70, no. 26.

141 The pendant to it was a similar landscape by Carlo Labruzzi. The appearance of the room is known from a watercolor by Charles Percier (Institut de France, Paris). González-Palacios 1997.

142 Painted for the Earl-Bishop of Bristol (*Memorie per le Belle Arti*, March 1785, p. 55). Not long afterwards, Pierre-Henri de Valenciennes painted the same subject in a picture now in the Musée des Augustins, Toulouse.

143 Charles-Nicolas Cochin, 1774, in Michel C. 1993, p. 411.

144 Musée Municipal, Brest. It is worth noting that Sablet had been elected to the Accademia dell'Arcadia.

145 The portrait of Zoega (for details of which, see Majo, Jørnaes, and Susinno 1989, p. 144, no. 10) is kept at the Museo di Roma.

146 Watercolor, Berlin.

147 Galleria Nazionale, Parma (Ceschi Lavagetto 1990, p. 246, fig. 10).

148 There were eighty-six Arcadian colonies in the eighteenth century (see list in Giorgetti Vichi 1977, pp. 406–8).

149 From the first full description of the villa after the interventions of Marcantonio IV (Visconti 1796), it would seem that the thinking behind the program was due to Asprucci himself, with instructions from the prince. As regards the decoration of the Salone d'Onore with its exaltation of the Borghese family in the person of Furius Camillus, Carole Paul (1992) convincingly argues that the source was a speech—*L'amor della patria*—delivered by Francisco Preciado, Arcadian and chief of the Accademia di S. Luca, to mark the Capitoline prizegiving of May 19, 1777.

150 Borghini 1984.

151 Michel 1996, *Vivre et peindre*, pp. 292–94.

152 Ferrara 1974–75.

153 Ferrara 1954, and Ferrara Grassi 1987. Massimiliano Laboureur, Lorenzo Cardelli, and Luigi Valadier also contributed to the sculptural decoration.

154 For the decoration as a whole, see Petereit Guicciardi 1983. For the relationship with antiquity, see Herrmann Fiore 1998.

155 Pavanello 1998.

156 For further information, see Caracciolo 1997.

157 Private collection; reproduced by Rudolph 1983, fig. 331.

158 The painting dates from 1785. There is another version by Teodoro Matteini, signed and dated 1792.

159 Caracciolo 1992, p. 104. Also active on this project was Nicola Lapiccola, who in 1781 and 1782 painted a picture of *Apollo and the Muses*

and seventeen episodes from Ariosto's *Orlando furioso*. These scenes were replaced (1788) by Cades's tempera paintings on the same subject (for further details and an exhaustive profile of Sigismondo Chigi, see Di Macco 1973–74).

160 Caracciolo 1992, p. 53.

161 Lefevre 1973, p. 182; Guerrieri Borsoi 1993, p. 145. For Tommaso Righi's stuccos, see Zeri 1985.

162 González-Palacios 1998.

163 Speroni 1990. A recent edition of the poem (Altieri [1873] 1995) was edited by Massimo Miglio.

164 On the decoration of the apartment, see Susinno 1978 and Cappelletti 1996.

165 Others involved were the painters Saint-Ours, Francesco de Capo, and Giuseppe Campovecchio, and the sculptor Raffaello Secini.

166 Debenedetti 1997,"Giuseppe Barberi," pp. 205–6, n. 17.

167 March 1787.

168 He was the author of the important *Discorso sul disegno* (1772) and *Elogio dell'abate Carlo Innocenzo Frugoni* (1770). His comment on Canova's work can be read in his *Lettera a Diodoro Delfico* (Saverio Bettinelli; see Barocchi 1998, pp. 51–56). On the relationship between Frugoni, Della Torre Rezzonico, and Godard, and the academy's openness to "European" influences under the custodianships of Gioacchino Pizzi and Luigi Godard, see Dionisotti 1998.

169 Gravina 1973, p. 309.

170 For these types of "sacramental" relationships, characteristic of Catholicism, see Signorini 1981.

171 On the role of the Congregazione dei Virtuosi (for the years 1700–1758), see Bonaccorso and Manfredi 1998, pp. 17–52.

172 Rudolph 1979.

173 The manuscript of Nicola Pio, "dilettante romano" (Rome 1673–1736), was published in 1977 by Catherine and Robert Enggass (Pio [1724] 1977). On the portraits and self-portraits of artists and his collection of drawings, see Bjurström 1995.

174 Lione Pascoli (Perugia 1674–Rome 1744) published his *Vite de' pittori, scultori ed architetti moderni* in two volumes, in 1730 and 1736 respectively. The work (republished with a commentary, in 1992) was dedicated to Victor Amadeus II of Savoy. Pascoli had intended to complete the work with a section of biographies of the greatest living artists, but this remained in manuscript and was not published until 1981. Whereas, in the case of the older artists, he drew freely, and sometimes uncritically, on earlier sources, from Bellori to Baldinucci and Nicola Pio (which is why Bottari had reservations about his work), for his contemporaries he could often count on direct or indirect testimonies from the artists themselves (diaries, information from family members, etc.). He tended to show greater appreciation for the more modern artists as promoters of "progress in the arts." He was also innovative in his ability to recognize the value of still-life and landscape painting.

175 According to Nicola Pio, Pier Leone "was deservedly dubbed cavaliere by the Duke of Parma on his own merits" (1710).

176 Moücke 1752–62, vol. 4, pp. 247–57.

177 Pascoli 1992, p. 312.

178 Museo di Roma, Rome; Susinno 1974, pp. 232–35, n. 25.

179 Pascoli 1992, p. 290.

180 Museo di Roma, Rome (Susinno 1976).

181 Pascoli 1992, pp. 299–300, n. 50.

182 Minor 1989.

183 Information about these kinship ties was supplied by Maria Grazia Lavalle, who is doing research for her degree thesis on the social status of Placido Costanzi. On Francesco Barazzi, see Zinzi 1994.

184 The close ties between Batoni and Costanzi are confirmed in various circumstances: their work as figurists for the Orizzonte landscapes and their collaboration on important commissions (the Quirinale Coffee House) and public projects (Costanzi took over from Batoni on one of the paintings for Pisa Cathedral).

185 Scheurmann and Bongaerts-Schomer 1997, vol. 1, p. 209.

186 Bianconi 1998, p. 253.

187 Clark and Bowron 1985, p. 16.

188 For details of the relationship between Maratti and Niccolò Maria Pallavicini, see Rudolph 1995.

189 Bonds that paid an annual sum of interest.

190 Bershad 1985.

191 Clark and Bowron 1985, pp. 20–22.

192 This is attested to by his pupil Giovanni Battista Ponfredi, 1764 (in Bottari and Ticozzi 1822–25, vol. 5, p. 24).

193 Regarding the social and financial success of Giaquinto, see Michel 1996, *Vivre et peindre*, pp. 297–318.

194 The inventory, mentioned by Cordaro (1987) is due to be published soon by Cinzia Maria Sicca.

195 The inventory of Pichler's effects was drawn up with the expert help of Giuseppe Lovera for the paintings, Carlo Albacini for the sculptures and Alessandro Cades for the gems [casts], tools, and equipment.

196 Ingamells 1997, p. 171. Byres was responsible for the fraudulent sale (1786) of Poussin's *The Seven Sacraments* from the collections of Cassiano del Pozzo and then owned by Boccapaduli.

197 Cavaceppi 1768–72; Gasparri and Ghiandoni 1993 (Inventory 1802), pp. 14–48, 257–95.

198 Michel and Rosenberg 1987, p. 96.

199 Bonfait 1996; Scheurmann and Bongaerts-Schomer 1997, vol. 2, pp. 209–11. Antonio Canova's own workshop was in via delle Colonnette.

200 So did Giuseppe and Pier Leone Ghezzi (Corradini 1990).

201 On academic drawing and studies from the nude, see Bowron 1993; Susinno 1998, Susinno 1999 and the biography contained therein.

202 1733; see Fusco 1988.

203 Guerrieri Borsoi 1991.

204 Rome, Archivio di Stato, *Michelangelo Clementi*, vol. 32, pp. 611–99, 1778.

205 Giovanni Pichler's inventory is mentioned by Palazzolo 1996.

206 Workshop equipment was often dispersed when a family "firm" went out of business. For example, on the closure of Agostino and Lorenzo Masucci's studio, the *Diario Ordinario di Roma* (no. 1106) of August 6, 1785, announced a sale of "paintings, prints, plaster casts, and drawings by famous authors." Cristoforo Unterperger's equipment was sold by his son Giuseppe.

207 Pirzio Biroli Stefanelli 1984.

208 Casanova 1997, vol. 2, p. 51.

209 Pascoli 1981, p. 34.

210 Pascoli 1981, p. 159.

211 In 1737, for example, Mancini asked the community of Sant'Angelo in Vado, his native town, to have him entered in the ranks of the local nobility, but was refused because at that time he had not distinguished himself by any special acts of merit. He was eventually made Cavaliere by Benedict XIV (information kindly provided by Luciano Arcangeli, who is writing a monograph on this painter).

212 What amounts to a projection of Giaquinto's determination to achieve noble status is evident in his portrait of the singer Farinelli, who also belonged to a particularly mobile social category. Giaquinto's strategies also included lending large sums to such eminent personalities as the empress Maria Theresa to meet her expenses in the Seven Years' War.

213 In reporting the news, the *Diario Ordinario di Roma* (no. 2194) of January 9, 1796, pointed out that no artist had previously been honored with this title.

214 Susinno 1974, pp. 243–44.

215 De Rossi [1811] 1970, pp. 104–5.

216 The robed figure sculpted by Giuseppe Angelini (1780) replaced the candelabrum that Piranesi himself had wanted for his tomb. Inspired, according to Leopoldo Cicognara, by a statue of Zeno, it is reminiscent of models with which Angelini may have become familiar during his stay in London (1770–77), in particular Giovanni Battista Guelfi's monument to James Craggs (1727) in Westminster Abbey. (Guelfi was a pupil of Rusconi who had been taken to England by Lord Burlington.) About ten years later, echoes of the statue of Piranesi are evident in John Bacon's monument to Samuel Johnson in St. Paul's Cathedral. For sculpture in England, see Whinney 1988, pp. 160, 308.

217 The tomb was carved by Vincenzo Pacetti at the expense of Cardinal Gianmaria Riminaldi.

218 In 1786 a bust of Poussin by André Ségla was also included. Around 1820 there were about sixty of them, mostly of artists. They were removed by order of Pius VII and are now kept in the Protomoteca Capitolina.

219 See Fenici 1990, p. 118.

220 This was the subject of a lecture (soon to be published) by Richard Bösel at the Istituto Storico Austriaco in Rome.

221 Vasco Rocca and Borghini 1995; *Joanni V Magnifico* 1994.

222 Now in the Escola Pratica de Infantaria (*Joanni V Magnifico* 1994).

223 Sicca 1990, pp. 273, 282, n. 113; Sicca 1994.

224 For details of this project, see Garms 1995.

225 The project was promoted by Prior Orazio Felice Della Seta, who had been elected to the academy in 1691 (alias Algido Tricolorio), and was one of the founders of the "Colonia Alfea" (Sicca 1990, which also contains details of work by other Roman artists in Pisan churches).

226 Roettgen 1979.

227 Commissioned in 1786, delivered in 1787.

228 Letter to the cathedral deputies; Curzi 1998, pp. 45–46.

229 The concept of "enthusiasm" as the driving force of intellectual activity (Lord Shaftesbury) was developed in Italy by Melchiorre Cesarotti, particularly in the *Ragionamenti* with which he prefaced his translation of Voltaire's tragedies (1762).

230 Tempesti had been a pupil of Placido Costanzi in Rome and had certainly also studied with Corvi (whose Scuola del Nudo he attended). In *The Death of San Ranieri* (installed in 1747), the Pisans Francesco and Giuseppe Melani made every effort to adapt their pictorial idiom to that of the "Roman" paintings already in situ.

231 *Bozzetti* at Pisa and Baltimore; other artists involved were Gaspare Landi (who refused the commission) and, in the following century, Giuseppe Collignon and Giuseppe Bezzuoli.

232 *Giornale delle Belle Arti*, July 1787, pp. 199–200.

233 In addition to the *Diario Ordinario*, the *Memorie per le Belle Arti*, the *Giornale delle Belle Arti*, and Vincenzo Pacetti's *Giornale*, the writings of Antonio Bertolotti (1875, 1878, 1879, 1880) are a mine of useful information.

234 Loire 1998, p. 228.

235 Pascoli 1992, p. 369. The large bas-relief, still in its original location, depicts *The Glory of the Blessed Jean-François de Régis*.

236 Bertolotti 1880, p. 83. An example of this type of sculpture is Vincenzo Pacetti's *Diana*, formerly owned by the Borghese family and now in the Ruffo collection. At Syon House, decorated by Robert Adam for the Duke of Northumberland, there is still a *Ceres* signed by Bartolomeo Cavaceppi.

237 Belloni was also a powerful banker, and as such looked after the interests of Mengs's son (Michel 1996, *Vivre et peindre*, p. 418, note 65).

238 Bertolotti 1880, p. 83.

239 Other works produced by the sculptor for an English clientele are mentioned by Minor 1989 (at Syon House and Wentworth Woodhouse).

240 As well as some marble chimneypieces (Mankowski 1948, p. 80).

241 Mankowski 1948, pp. 9–21.

242 Mankowski 1948, pp. 21, 80–81.

243 Whinney 1988, pp. 259–60.

244 Bertolotti 1878, p. 301.

245 For details of these and other sculptures, see Michel 1996, *Vivre et peindre*, pp. 255–65.

246 Copies of these were made by Laboureur, Carradori, Albacini, and others.

247 Now at Schloss Ludwigsburg. Scheffauerd sculpted *Spring* and *Winter*, Danneker *Summer* and *Autumn*. See Holst 1987, pp. 125–32, cat. nos. 14–15.

248 Whinney 1988, p. 146.

249 1771–83. See Nicola Figgins in Ingamells 1997; the monument is also referred to in the *Giornale delle Belle Arti*.

250 The bishop was the father of the sculptor's principal patron. For details of this tomb, see Francesco Leone (forthcoming).

251 Michel 1996, *Vivre et peindre*, pp. 236–37.

252 The *Diario Ordinario di Roma* (no. 2126) of May 16, 1795, announced that the monument to the prince, a well-known writer and scholar, was on display in the sculptor's studio at Trinità dei Monti (previously occupied by Subleyras, Hamilton, and Corvi).

253 Dorotheenstädtische Kirche; reproduced in it original form by H.W. Janson. See H.W. Janson, *Nineteenth-century Sculpture* (London: Thames & Hudson, 1986), fig. 58.

254 For examples of the "good government" of Pius VI and the promotion of architectural works in particular, see Collins 1995.

255 Michel and Rosenberg 1987, pp. 244–45, no. 66.

256 Clark and Bowron 1985, p. 217, note 29.

257 Perina 1961.

258 Scotti 1979. In 1809 the painting was transferred to the Pinacoteca, where it can still be seen.

259 Regarding the fortunes of the Roman school in Milan, see Morandotti 1996, p. 87. To reconstruct the pattern of these relationships, it is also vital to read Verri for information about the Lombard cardinals Archinto, Carrara, Riminaldi, and Stoppani.

260 Clark and Bowron 1985, pp. 211, 238, notes 5, 106.

261 Bona Castellotti 1980.

262 Rodeschini Galati 1996, p. 476, no. 1.

263 Pacia 1996, pp. 128–29, n. 12–13.

264 Pozzi and Giaquinto were occupied, with Batoni and some Neapolitan painters, in producing cartoons for the tapestries for the royal palace at Caserta.

265 Paintings for Molfetta, Bari, Terlizzi, etc.

266 Michel 1996, *Vivre et peindre*, p. 274.

267 However, for the role of Naples in the first half of the century, see Norci Cagiano de Azevedo 1997.

268 Conca painted many other altarpieces for churches in Palermo (See *Conca* 1981).

269 Siracusano 1983–84. The canvases, three in number, were sent between 1793 and 1795, the year of Leopardi's death. They represent *The Death of Saint Joseph*, *Saint Agatha Interceding for an End to the Plague* and *Saint Francesco Caracciolo*. The preliminary sketches are kept at the Museo di Castell'Ursino in Catania.

270 For details of this painter, see Michel 1989. One of the preliminary sketches for S. Niccolò all'Arena is in the Lemme collection in Rome (*Martyrdom of Saint Agatha*; see Loire 1998, p. 274, pl. 117).

271 *Conca* 1981, p. 210, cat. no. 63.

272 Now in the Quirinale, Rome.

273 February 1786, pp. 28, 34.

274 On the cardinal and the significance of his project, see Castelnuovo and Rosci 1980, pp. 159–69.

275 Casale 1990; Casale 1997; Casale 1997, "Addobbi"; Casale 1998.

276 The most celebrated image of this saint was painted by Sebastiano Conca (*Miracle of San Turibio*, Pinacoteca Vaticana, Rome), from which several copies were made.

277 Casale 1990.

278 Of special interest in this respect is the *Memoria delle piture* [sic] in which Angelika Kauffmann recorded details of works, patrons, and prices (see Kauffmann 1998).

279 According to Pascoli (1992, p. 206), the paintings in question were two Virgins.

280 Trevisani painted a *Holy Family* for Avignon, a *Crucifixion* for Besançon, and *Saint Lawrence and Saint Siffrein before the Virgin* for Carpentras.

281 Pascoli (1981, p. 45) mentions a Magdalen "in a church of the Fathers of Saint Pantaleon in Germany."

282 Brejon de Lavergnée 1987.

283 *Mary Magdalene*, 1721, in S. Caterina degli Italiani.

284 After the destruction of the abbey during the French Revolution, the two paintings, dating from 1758, were transferred to the church of S. Francesco Saverio in Besançon (Brejon de Lavergnée 1987).

285 According to Nicola Pio (c. 1724), this was a "large painting" for the Dominicans depicting *The Virgin of the Rosary and All the Saints of the Dominican Order*.

286 1739, *Saint Jean-François de Régis Praying for an End to the Plague*, for the Jesuit church.

287 Caracciolo 1992, p. 207, n. 36.

288 For the significance of the cult of the Eucharist and the Sacred Heart in the strategy of the eighteenth-century Church, see Rosa 1999, pp. 17–109.

289 In the 1780s and 1790s, Spoleto Cathedral was decorated with altar paintings by Unterperger, Nocchi, Cavallucci, Corvi, and Pietro Labruzzi, in an architectural setting renovated by Valadier. For the spread of Roman works and models in Umbria, see Casale et al. 1976; Barroero et al. 1980; Casale 1990, "La pittura."

290 Church of the Maddalena: canvases by Tommaso Sciacca, Mariano Rossi, Domenico Corvi, and Marcello Leopardi.

291 Church of S. Benedetto, "carried out … under the supervision and to the design of Count Berardi, a cavaliere well known in aristocratic circles, and in the literary republic of science and letters" (Pascoli 1981, p. 162), with canvases by Gaetano Lapis, Pietro Bianchi, and Sebastiano Conca (1730s and 1740s).

292 Conca, Zoboli, Benefial, and Trevisani in S. Matteo.

293 Canvases by Pietro Angeletti for the cathedral.

294 Giuseppe Bottani in the cathedral of S. Francesco.

295 *Diario Ordinario di Roma* (no. 2194) of January 9, 1796.

296 Lanzi 1809, vol. 1, pp. 431–32. As well as the signal examples of Mengs and Giaquinto, it is worth mentioning Giuseppe Bottani, called to Mantua by Maria Theresa of Austria in 1770 to direct the first reformed academy in the Lombardo-Venetian kingdom; Laurent Pécheux, who worked in Turin; Marcello Bacciarelli in Poland; and Germans such as Füger and Tischbein, who were qualified by their Roman experience to reform the academies of Vienna and Naples.

297 Pascoli 1992, p. 312. Similarly, Pichler's wife opposed her husband's wish to move to England, because she did not want to live in a non-Catholic country (De Rossi 1792, pp. 22–23).

298 1804; Accademia di Brera, Milan (Musiari 1995, p. 11). A similar intention to celebrate sculpture is evident in the placing of Niccolò Stefano Traverso's *Genius of Sculpture* beside a classical bust of Vitellius in the Galleria delle Statue (now Galleria degli Specchi) of the Palazzo Reale, Genoa. Traverso was sent to Rome as a "pensioner" in 1775. The work, according to Dr. Simone Frangioni of the Soprintendenza ai Beni Ambientali e Architettonici in Genoa, was definitely in place by 1798.

299 Many of the Madrid drawings came, via Andrea Procaccini, from the estate of Carlo Maratti. The Düsseldorf drawings were collected in Italy by Lambert Krahe in the mid-eighteenth century.

300 Lanzi 1809, vol. 1, p. 259.

301 Both works are discussed in the *Memorie per le Belle Arti* (April 1788 and January 1785 respectively).

302 The National Gallery of Ireland, Dublin. See William L. Pressly, *James Barry: The Artist as Hero* (London: Tate Gallery Publications, 1983), pp. 51–52, no. 1.

303 Visconti 1841, p. 28.

304 In his memoirs, published by Vincenzo Malamani (*Memorie del Conte Leopoldo Cicognara tratte dai documenti originali*, [Venice, 1888], vol. 1, p. 32), Cicognara recalls his apprenticeship with Vincenzo Camuccini, Luigi Sabatelli, and Pietro Benvenuti—great artists who in the early nineteenth century determined the course of Italian Neoclassical art in Rome, Milan, and Florence—at the private academy of Domenico Corvi (Curzi 1998, p. 36; Susinno 1998, pp. 173, 189, n. 63).

305 Now in Barocchi 1998, p. 113.

# Key Figures in Eighteenth-Century Rome

## ORNELLA FRANCISCI OSTI

**Acquaviva d'Aragona**, Francesco, Cardinal (Naples 1665–1725 Rome). Papal nuncio to Spain until 1706. Intensely loyal to Philip V; sold silverware to help the king during the War of Spanish Succession, and secured the safety of Philip's first wife, Luisa Maria Gabriella of Savoy. Appointed minister and protector of Spain at the papal court by Philip V; in 1714 used his influence to achieve the Spanish monarch's second marriage, to Elisabetta Farnese. Cardinal bishop of the church of S. Cecilia, Rome, and responsible for restoration work there, completed by his nephew Troiano.

**Acquaviva d'Aragona**, Troiano, Cardinal (Atri 1694–1747 Rome). Nephew of Cardinal Francesco. In 1732 titular cardinal of S. Cecilia, Rome, where he is buried. From 1732 acted as representative of the Infante Charles, son of Philip V of Spain, at the Holy See. Appointed Spanish legate in 1735, and took up residence at the palace in the Piazza di Spagna; as protector of the Kingdom of Naples in the Sacro Collegio advocated the marriage of the thirteen-year-old Maria Amalia of Saxony to the Infante Charles (King of Naples as Charles VII from 1734; King of Spain as Charles III from 1759); also in 1735 arranged sumptuous festivities for the annual festival of the Chinea. Granted rich ecclesiastical livings and appointed to the lucrative archbishopric of Monreale by Philip. Handsome and intelligent, a *grand seigneur* according to De Brosses, Troiano held well-attended twice-weekly receptions in Rome, at which there would occasionally be gaming, sometimes music, but at which "quantities of chocolate besides … delicious cinnamon-flavoured sorbets" would invariably be consumed (De Brosses 1977, vol. 2, p. 196). Extremely influential, he helped to secure the election of Pope Benedict XIV and in 1746 was responsible for ousting the prime minister of Naples, Montealegre. Vico dedicated the definitive edition of *Scienza nuova* (1744) to him.

**Albani**. Family of Albanian origin established in Urbino in the mid-fifteenth century. Orazio (1576–1653), ambassador of Duke Francesco Maria II della Rovere to Rome, concluded the treaty incorporating the duchy of Urbino into the Holy See, thus attracting the favor of Pope Urban VIII Barberini, who appointed him to the senate (1633). The Albani family now enjoyed the protection of the Barberini family, and Carlo became its majordomo. Carlo's sons were Giovan Francesco (the future Pope Clement XI), Orazio (whose own sons were the cardinals Annibale and Alessandro), and Carlo; the latter married Teresa Borromei and was father of Cardinal Giovan Francesco and Giulia Augusta, who married Agostino Chigi in 1735. In 1719 Carlo bought the Palazzo alle Quattro Fontane from the S. Maria della Pietà asylum for the poor and mentally sick which, after considerable alteration, became the family residence (now known as the Palazzo del Drago, currently the seat of the British Council). Princes of the Holy Roman Empire after 1710, this branch of the family became extinct in 1852 on the death of Prince Filippo, whose possessions were divided between Maria Antonietta Albani Litta and Agostino Chigi Albani (son of Sigismondo Chigi), who became the founder of the Chigi Albani line.

**Albani**, Alessandro, Cardinal (Urbino 1692–1779 Rome). Son of Orazio, younger brother of Cardinal Annibale, nephew of Clement XI, and uncle of Cardinal Giovan Francesco. Followed a military career (in 1708 led the papal cavalry, defeated by the imperial troops at Comacchio), but by 1718 had already begun his dazzling ecclesiastical career. Made cardinal by Innocent XIII in 1721, was extremely active in politics and diplomacy. Involved in various concordats with the kingdom of Sardinia (1727, 1741) and the Austrian Habsburgs (1741, 1743, 1745); anti-French and anti-Jacobite, was de facto—if not officially—the British government's diplomatic representative after Philipp von Stosch had left Rome. Ambitious and unscrupulous, and a passionate antiquarian and patron of the arts. His villa, completed in 1763, was designed to house the collections of antiquities assembled for the most part with the help of Stosch and

Winckelmann. By 1728 sold the King of Poland thirty of the most valuable statues in his collection, and in 1734 Clement XII bought an important series of busts, later donated to the newly founded Museo Capitolino. A large number of bronzes, most from Hadrian's Villa, were sold to Ludwig of Bavaria, after being looted by Napoleon's invading forces. Arcadian *alias* Chrisalgus Acidanteus. A collection of epigraphs, coins (catalogued by Ridolfino Venuti), and medals was seized by the French, but no record of these has survived. Built up an important library by acquiring libraries such as that of Cardinal Federico Cesi and employed Winckelmann as his librarian. De Brosses described him in his *Lettre LIV* thus: "He loves gaming, women, entertainments, literature and the fine arts, of which he is a great connoisseur" (De Brosses 1977, vol. 2, p. 345). Countess Francesca Gherardi Cheruffini, his lover from about 1740, held a salon with concerts and music. Alessandro had two daughters by Countess Gherardi Cheruffini, to whom he was godfather. One of the daughters, Vittoria, married G. Lepti and is said to have been immortalized by Mengs in his *Parnassus*. A portrait by an anonymous artist hangs in the Vatican Library.

**Albani**, Annibale, Cardinal (Urbino 1682–1751 Rome). Elder brother of Alessandro. In accordance with the wishes of his uncle Clement XI studied at the Jesuit Collegio Romano and began his ecclesiastical career in 1703. Appointed apostolic nuncio to Vienna (1709), became a cardinal under Innocent XIII in 1712, and sought to mediate in the great conflicts between the Holy See and France after Clement XI issued the *Unigenitus* bull (September 1713) condemning the Jansenists, but did not succeed in preventing their excommunication (1718). Did his utmost to ensure that the Church recognized Frederick Augustus of Saxony, King of Poland (Augustus III), who had already publicly abjured Lutheranism in 1712. Described by De Brosses as "very highly regarded for his abilities, hated and feared to excess; without faith and principles, an implacable enemy even when he appeared to be reconciled; a great genius in business … " (De Brosses 1977, vol. 2,

p. 344). Probably in the pay of the French, through their minister Guillaume Dubois. He became chamberlain in 1719 and his word carried great weight in the various conclaves. Was a discerning patron, to the benefit of Urbino: appointed Pietro, the son of Alessandro Scarlatti, Maestro di Capella in the cathedral; erected monuments; encouraged glass and printing industries; financed a chair of the Greek language at the university. In 1733 included modern works for the first time in the legislation governing works of art. Henry Stuart, Cardinal of York, inherited a considerable number of his positions and livings.

**Albani**, Giovan Francesco: see **Clement XI**.

**Albani**, Giovan Francesco, Cardinal (Rome 1720–1803 Rome). Augustus III of Poland persuaded Benedict XIV to make Giovan Francesco a cardinal in 1747, although his uncles Alessandro and Annibale were already cardinals. Succeeded Annibale as protector of Poland in 1751, supported the election of Clement XIII, and was a member of the congregation responsible for deciding the fate of the Jesuits. Initially favored the suppression of the order; changed his mind in the conclave of 1769 and became a zealot, opposing the election of Clement XIV and refusing to collaborate with the Holy See. Supported the election of Pius VI. When the French Revolution broke out, called for the armed defence of the Papal States. Held responsible for the death of Basseville after the killing of Duphot; fled Rome for Naples in early 1798; the French later devastated his villa and confiscated his assets. As cardinal dean, chose Venice as the seat of the conclave, and was appointed by Pius VII as his legate to precede him to Rome and govern the Papal States.

**Albany**. Ancient place name for some areas of Scotland. For the Countess of Albany, see **Stolberg-Gedern**, Louise; for the Duchess of Albany, see **Stuart**, Charlotte.

**Aldobrandini**. Noble Florentine family, which took up residence in Rome in the seventeenth century; family members held very high offices in the Curia, particularly Ippolito (1536–1605), who became Pope Clement VIII in 1592. Cardinal Ippolito (1592–1638), the last of his line, left his assets to the second-born son of his niece Olimpia (1623–1682), Princess of Rossano, who married (1638) Paolo Borghese (see **Borghese** family) and later

(1647) Camillo Pamphili. When the Pamphili line became extinct (1760), the Aldobrandini fortune passed to the Borghese family.

**Alfieri**, Vittorio (Asti 1749–1803 Florence). Author and poet. A. was the greatest and most imaginative playwright of the last quarter of the eighteenth century, and is best remembered for his life and work in Rome between 1781 and 1783, though he first visited Rome in 1766. He had a passionate love affair with the Duchess of Albany (Louisa Stolberg-Gedern), the wife of Charles Stuart; she became his lifelong companion and A. dedicated most of his *Rime* (Poems) to her. The premiere of his *Antigone* (1776) was performed in Rome in 1782 in the private theater of the Spanish ambassador and A. read *Virginia* (1777–83) in the salon of Maria Cuccovilla Pizzelli. He also took part in the commemoration in Arcadia for the death of P. Metastasio, which Sigismondo Chigi also attended. His tragedies were banned in Rome on June 18, 1790.

**Altieri**, Livia: see **Antici**, Tommaso.

**Altieri**, Vincenzo Maria, Cardinal (Rome 1724–1800 Rome). Youngest son of a noble family, appointed cardinal in 1780. At the proclamation of the Roman republic in 1798, renounced the cardinalate, but retracted a few days before his death. Buried in the Altieri Chapel in S. Maria sopra Minerva.

**Amaduzzi**, Giovanni Cristofano (Savignano di Romagna 1740–1792 Rome). Scholar. Settled in Rome in 1762 and dedicated himself to the study of oriental languages and law. In contact with many writers, artists, and scholars, also the Italian Jansenists and nonconformists such as G. G. Bottari, P. F. Foggini, M. Compagnoni Marefoschi and, in particular, S. de' Ricci. In the last years of his life was persecuted for sympathizing with the Jansenists. The brief suppressing the Jesuits is attributed to him; supported the religious policy of Clement XIV, whose confidence he enjoyed. Became professor of Greek at La Sapienza (1769) and at the Collegio Urbano di Propaganda Fide (1780). Was appointed superintendent of the Propaganda Fide printing house in 1770, and published numerous ancient alphabets. Wrote many scholarly works, and collaborated on the Florentine *Novelle letterarie* and *Annali ecclesiastici*; the *Effemeridi letterarie di Roma* and *Antologia romana*; and the Palermo *Notizie de' letterati*; his letters

are preserved in various Italian libraries. Left his library, including interesting collections of journals, to Savignano. Among the surviving autograph works are an unfinished history of the Villa Giulia, and diaries of his travels in central and northern Italy, with descriptions of monuments, libraries, and archives.

**Anfossi**, Filippo (Taggio, Imperia 1748–1825 Rome). Dominician. Taught for many years in the order's colleges in Liguria and Piedmont, and preached and wrote against rationalism, the Enlightenment, and Jansenism. Called to Rome in 1803, he became the official defender of the papal bull of 1794, in which Pope Pius VI condemned the Synod of Pistoia. Was an intransigent supporter of the Curia's conservative political, doctrinal, and philosophical attitudes.

**Angelucci**, Angelo. Brother of Liborio Angelucci.

**Angelucci**, Liborio (Rome 1746–1811 Rome). Surgeon and obstetrician to the French colony in Rome. As friend of V. Monti, in 1791 published a monumental version of the *Divine Comedy*, edited by Fra Baldassarre Lombardi and dedicated to Cardinal D. C. Carafa. Friend of Basseville and disseminator of revolutionary ideas, was accused of having plotted to assassinate Pope Pius VI, but after Cardinal Carafa's intervention was released from the Castel S. Angelo. In 1797 arrested again, and forced into exile. On returning to Rome, then under French occupation, became prefect of the victualing board, then consul of the Roman republic. Once in power, he overturned these expectations, maintaining the good will of the French and strengthening his family's financial position. Fell from public favor, resigned the consulship, and became a senator. After the fall of the Roman republic in 1799, followed the French to Paris, then Milan, where he was a surgeon. Returned to Rome in 1809, when the city was again occupied by the French, but never regained public office.

**Antici**, Tommaso (Recanati 1731–1812 Recanati). Prelate. A born intriguer, he was agent of Stanislas Augustus of Poland, of the electors of the Palatinate and Bavaria, and protected by Livia Altieri and various cardinals. Initially an anti-Jesuit, after their suppression (1773), but later changed sides. Appointed cardinal in 1776. In 1797 encour-

aged surrender to the French. When the French occupied Rome, renounced his office. Retired to Recanati, where he died.

**Antonelli**, Bernardino (1725–1809). Keeper of the fortress of Senigallia. Brother of Leonardo Antonelli. In his youth he attended the private academy of Domenico Corvi, of whom Leonardo was a patron.

**Antonelli**, Leonardo, Cardinal (Senigallia 1730–1811 Senigallia). His progress in the Church was the reward for intelligence and reliability, although his uncle Cardinal Nicola Maria helped him gain entrance to Roman circles. Appointed cardinal in 1775 and prefect of the Propaganda Fide in 1780, was responsible for relations with Russia, Ireland, and France. Voted against the Treaty of Tolentino, but remained in Rome when Pius VI fled. Was arrested and exiled. Later took part in the election of Pius VII at the conclave held in Venice and, on the pope's return to Rome, was one of the most strenuous opponents of the French concordat. Attended the coronation of Napoleon, who is nevertheless said to have ordered his arrest (1808). Died in exile in his home town.

**Antonelli**, Nicola Maria, Cardinal (Pergola, Urbino, 1698–1767 Rome). Studied civil and canon law in Rome. Became privy chamberlain to Clement XII. Noted for intelligence and culture, in 1730 was appointed librarian at the Collegio Urbano and three years later became prefect at the archives of Castel S. Angelo. In 1741 Benedict XIV appointed him to the commission whose task it was to reform the Breviary; later secretary of Propaganda Fide. Became cardinal in 1759, but continued to produce scholarly work, including the *Sermones S. Patris Iacobi* of 1756. Prefect of the Congregation of the Indulgences in 1760, he succeeded Cardinal Passionei as secretary of papal briefs. Left his vast library (some of which had belonged to Queen Christina of Sweden, and afterwards Cardinal Ottoboni) to his nephew Leonardo, who later donated them to the library of Senigallia. Domenico Corvi was his protégé, and painted two portraits of him (Galleria dell'Accademia di Belle Arti, Naples; Biblioteca Antonelliana, Senigallia).

**Appiani**, Giuseppe (Milan 1712–1742 Bologna), *alias* Appianino. Counter-tenor. His first success was in Rome in 1729 in the *Contesa dei Numi*, libretto by Metastasio and music by

L. Vinci in the performance at the Palazzo Altemps given by Cardinal de Polignac in honour of the birth of the dauphin. Recorded in Rome again in 1731 at the Teatro Alibert, subsequently in Venice, Genoa, and Milan (where he sang Glück's *Artaxerxes*), in Vienna, and in *Eumene* by Jommelli, performed in Bologna in 1742. Member of the Accademia dell'Arcadia.

**Assemani**. Family of orientalist scholars of Lebanese origin. Giuseppe-Simonio (?1687–1768 Rome) was brought to Rome as a child and studied there at the Maronite college. Was soon able to write school books in Arabic on Syrian grammar and collaborated on a historical treatise on the Fathers of the Eastern Church. Ordained in 1710, he entered the Vatican Library as a scribe for Syrian and Arabic. In 1715 commissioned by Clement XI to bring oriental and Greek manuscripts back from Egypt. Traveled throughout the eastern Mediterranean, collecting Coptic, Ethiopian, Arabic, Persian, Turkish, and above all Syrian manuscripts. On return to Rome devoted himself to cataloguing this material and published the four folio volumes of the *Bibliotheca orientalis* (1719, 1721, 1725, 1728). First non-Western to be custodian of the Vatican Library (1739). On the orders of Clement XII presided over the national synod of the Maronite Church in the Lebanon (1736–38), accompanied by his nephew Stefano Evodio, but was unable to settle all the liturgical and legal controversies. According to De Brosses he refused an offer to come to Paris to organize the oriental section of the Royal Library. In 1766 was ordained bishop of Tyre. Giuseppe Luigi (Tripoli, Syria, 1710–1782 Rome), nephew of Giuseppe-Simonio, in 1737 taught Syrian at La Sapienza university in Rome, and oriental liturgies from 1749. Stefano Evodio (Tripoli, Syria, 1711–1782 Rome), nephew of Giuseppe-Simonio, attended the Maronite college in Rome (1720–30). Became titular archbishop of Apamea (1738). Sent to Florence (1741) by Clement XII to promote the beatification of Joseph Calasanz. Wrote and published the catalogue of oriental manuscripts of the Biblioteca Medicea-Laurenziana, edited by the Florentine scholar A. F. Gori, and worked on the catalogue of the codices of the Biblioteca Ricciardiana. In 1782 was appointed chief custodian of the Vatican Library.

**Azara**, José Nicolás de (Barbuñales, Aragon 1730–1804). Spanish diplomat and man of letters. Sent to Rome in 1765 as general agent for Clement XIII, where he stayed until 1797 (from

1784 as plenipotentiary minister). Was particularly skillful at dealing with the expulsion of the Jesuits from Spain; was also a famous scholar in contact with authors such as A. Verri and artists including A. R. Mengs (on whom he published a work in two volumes in 1780) and A. Canova. After 1800 Giuliana Falconieri Santacroce was his mistress and followed him around Italy and to Paris.

**Balsamo**, Giuseppe, *alias* Alessandro Cagliostro (Palermo 1743–1795 San Leo). Adventurer. Born into a family of modest means, educated at the seminary of S. Rocco in Palermo. In 1756 became a novice at the monastery of the Fatebenefratelli at Caltagirone, where he probably learned the basic elements of chemistry and medicine. This knowledge, together with his great power of suggestion and his hypnotic character as a healer and magician, secured his fame. In 1768 married the beautiful Lorenza Feligiani, daughter of a foundryman, and with her began his life as an adventurer and confidence man, marked by great successes, swindles, sudden flights, and arrests. In London in 1776 established a new masonic lodge—the mystic Egyptian Rite—which, shrouded in mystery, was enthusiastically embraced across Europe by noble and intellectual circles. In Paris was implicated with his protector, Cardinal Louis de Rohan, in a 1785 scandal involving the queen: imprisoned in the Bastille; later found innocent but expelled from France. Returned to England, where his arguments with Théveneau de Morande led the Frenchman to reveal B.'s true identity, an event that began his undoing. Tried in 1789 to introduce an Egyptian Rite lodge at the Villa Malta on the Pincio in Rome but, denounced by his wife, was arrested and convicted in a symbolic attack against masonry by the Church (his books and masonic implements were burned in the Piazza della Minerva). His sentence of death was reduced to life imprisonment; he died under strict watch and harsh treatment, just before the French troops arrived.

**Basseville**, Nicolas-Jean-Hugon (Hugou) de (Abbeville 1753–1793 Rome). Diplomat. Destined for the Church, but become tutor to the Morris family of Philadelphia. Dedicated a history of the French Revolution to Lafayette, and was later secretary at the embassy of Louis XVI in Naples. In 1793 lived in Rome at the house of Stefano Mout (commercial agent, fanatic, and intriguer), where he met men of letters and artists such as V. Monti and G. Ceracchi. Secured the release of French artists from prison. Was attacked by the

crowd on January 13, 1793, during riots in front of Palazzo Mancini on the Corso, where the French Academy wanted to raise the republican flag. Died the next day. Satires and sonnets were published praising the murderer, among them Monti's *La Bassvilliana*, which he retracted in 1797.

**Bassi Veratti**, Laura (1711–1778). Scientist from Bologna. Taught philosophy and physics at the University of Bologna; also wrote poetry. Gained international acclaim and advised the Prince Archbishop of Augusta to take Giovanni Ludovico Bianconi as his physician.

**Batoni**, Rufina (d. 1794). Daughter of the painter Pompeo Batoni. Despite her premature death, was well known for her interest in mathematics, singing, and poetry. Member of the Accademia dell'Arcadia, with the *alias* Corintea, and the dedicatee of many poems under that *alias*. Took part in musical academies held by Cardinal de Bernis.

**Belli**, Giuseppe Gioacchino (Rome 1771–1863 Rome). Poet and secretary to Stanislas Poniatowski.

**Belloni**. Family of merchants and bankers from Codogno in Lomellina. First established in Bologna, they prospered in trade, obtaining state contracts for processing and selling tobacco. Giovanni Angelo came to Rome in 1710–11, obtaining the contract for tobacco and aqua vitae. Having summoned his nephew Girolamo (died Rome, 1760), opened a bank in the Piazza Fiammetta. Girolamo traded on the principal foreign markets, often acting as agent for the Stuart family. In 1730 became director of the general custom office and strongly influenced the economic policies of the Vatican, a position consolidated under Pope Benedict XIV. Shortly after 1740 bought a large palazzo in via del Governo Vecchio (also the castle of Prossedi, with title of marchese, from Michele de Carolis), later sold to purchase Villa Verospi from the Altieri family (since destroyed), and the estates of Oliveto and Posta at Sabina from the Santa Croce. In 1750 printed the highly successful *Del commercio* with the Pagliarini brothers in Rome, dedicating it to the pope, who had made him a marchese. The family also had manufacturies (wool at Ronciglione). They supported the publication of the map of Rome by G. B. Nolli, were interested in archaeological excavations, collected paintings, and were active in contemporary society. Francesco

(died Rome, 1806), son of Girolamo, was one of the lovers of Margherita Sparapani Gentili Boccapaduli. Without male heirs, he left the bank (in 1793) to Ferdinando Acquaroni, leaving the Torlonia family to dominate the economic scene in Rome. A few years later the Bologna line of the family also became extinct.

**Benaglio**, Francesco (Treviso 1708–1759 Padua). Polymath. Initially a follower of Jesuit teachings, attended courses by D. Lazzarini at university in Padua and in 1725 embraced Lazzarini's rationalism, love of Greek and Latin classics, and Aristotelian ideas about poetry and theater; subsequently spent all his life trying to collect and publish Lazzarini's work. In Venice met Marco Foscarini, who took him to Rome (1736–40) as his secretary, a position subsequently held with Francesco Venier (1740–43). Here he came into contact with men of letters and admired the natural attractions and works of art in the city. Became a member of the Accademia dell'Arcadia with the *alias* Timbreo Tinariano. Traveled with Venier to the Middle East (1745–49). Returned to Rome as librarian to Prospero Colonna. In contact with artists and men of letters he wrote and translated *Abbozzo di vita non finita*, dedicating it to Batoni in exchange for a portrait. Also engaged in correspondence with Bettinelli; though he did not believe Bettinelli to be the author of the *Lettere Virgiliane*, he stayed with him in Naples at the house of the Duchess of Ligneville.

**Benedict XIII**, Pope (Gravina 1650–1730 Rome). Born Pierfrancesco Orsini. Despite the disapproval of his family and his uncle Cardinal Virginio Orsini, in 1668 became a Dominican friar in Venice, taking the name Vincenzo Maria. Renounced his feudal inheritance in favor of his brother Domenico, and took his vows in the monastery of S. Sabina in Rome. Ordained in 1671 and in the same year was appointed reader of philosophy in Brescia. On becoming a cardinal in 1672 obtained several offices and livings as bishop of Siponto (1675), and reformed the way of life of the clergy by imposing the duty of residence, overseeing the customs of priests, and reorganizing the assets of the diocese. In 1678 set up an experimental system of agrarian credit but provoked great controversy, resulting in his transfer to the diocese of Cesena in 1680; also behaved in the same manner at the archdiocese of Benevento in 1686. Was elected pope on May 29, 1724, with the support of cardinals who had connections with the Bourbons and the Habsburgs. Considered to be politically inexperienced. "He did not

understand what it meant to be Pope; he was not interested in the affairs of State, only religious ceremonies, rites, baptisms, consecrating churches and altars, blessing church bells, ensuring that clothes were clean and fresh …" (P. Giannone, *Vita*, edited by F. Nicolini [Naples, 1905], p. 127; quoted in DBI, vol. 8, p. 387). Modern historians concur with this judgment and explain his behavior as induced by his immediate circle (including Cardinal Coscia), the members of which, except for Cardinal Fabrizio Paolucci di Calboli, his secretary of state, were self-seekers. His policies were unsuccessful, because of the economic decadence of the Papal States and the political situation in Europe. The Church proved unable to maintain the balance between the Habsburgs and Bourbons, and to curb the long-running conflict between the governments of Sicily and Turin. Remembered for commissioning F. Raguzzini from Benevento to build the hospital of S. Gallicano in Rome. Canonized many saints during his papacy, including Margaret of Cortona, Luigi Gonzaga, Stanislas Koska, John of Nepomuk, and John of the Cross.

**Benedict XIV**, Pope (Bologna 1675–1758 Rome). Born Prospero Lambertini. Studied in Bologna with the Somaschi Fathers and from 1688 in Rome, obtaining a doctorate in theology and law in 1694 at the Collegio Clementino. Worked in various congregations and undertook to simplify the complex post-Tridentine legislation; successful in concluding difficult negotiations with various European states. Became a cardinal in 1728 and archbishop of Bologna in 1731. His main interests were the growth of parochial activities, the duty of residence of the clergy, the sound administration of convents, and the usefulness of missions (supported Leonardo di Porto Maurizio and Paolo della Croce). At the conclave of 1740 was elected Pope only after six months of conflict between the cardinals appointed by Benedict XIII and their adversaries led by Cardinal Annibale Albani and foreign powers. Strongly opposed to nepotism, forbade his family to come to Rome unless he summoned them (which he never did). Although his papacy was much criticized, he was tolerant and ecumenical, and opposed the Curia's Counter-Reformist leanings. Proclaimed his opposition to the new veneration of the Sacred Heart of Jesus and recommended "disciplined veneration" of images of saints and the presence of the crucifix in churches. In 1740 banned burials in churches and public floggings. Interested in the eastern churches, and persisted in prohibiting vernacular languages and reading the

Bible. Surrounded himself with outstanding advisors, such as Cardinal Valenti Gonzaga, the banker Belloni, Cardinal Guérin de Tencin, S. Maffei, L. A. Muratori, R. Boscovich, B. de Fontenelle, and F. Algarotti, among others. Ordered a revision of the Index of Prohibited Books in 1753, advocating that the accused be allowed to defend themselves, but did not prevent *L'Esprit des lois* by Montesquieu (a work defended by Cardinal Passioniei, among others) from being included. Passionate about exotic objects and Chinese porcelain, in an attempt to persuade the ambassador of Portugal, E. Pereira de Sampaio, to present him with two pieces B. had them "stolen." Under his papacy culture flourished in Rome. Founded many academies, including the Accademia del Nudo at the Capitoline Hill (1754) and one for history and antiquities; built up the collections of the Capitoline palaces and founded the Museo di Antichità Cristiane (1755). During his papacy writings by R. Venuti, G. Vasi's *Le magnificenze di Roma*, and G. B. Piranesi's *Antichità romane* were published, and the collections of the Vatican Library grew considerably. Between 1749 and 1752 he commissioned excavations of Roman catacombs, and set in train the reform of the universities of Rome and Bologna (a museum of anatomy was founded and the Institute of Sciences received his personal library, opened to the public in 1756). Among the buildings restored in Rome, often with the financial assistance of King John V of Portugal, were the Colosseum, S. Maria Maggiore, S. Maria degli Angeli, and the Pantheon; the Trevi Fountain was also completed. In 1748 beatified Joseph Calasanz (1558–1648). There are numerous portraits by Subleyras.

**Benti**, Maria Anna, *alias* La Romanina (Rome 1684/86–1734 Rome). Opera singer.
In Genoa, Venice, and Naples she sang operas by contemporary composers, but is famous because she was the first of three women named Maria Anna to have a relationship with Metastasio, whom she discovered in 1721. Made her debut in 1724 in Naples, singing in his *Didone abbandonata*, to music by D. Sarro. In 1727 moved to Rome with her husband, Domenico Bulgarelli. Unable to perform because of the anti-women regulations of the Holy See, she coached actors and kept a very lively salon, frequented by singers, men of letters, and aristocrats; this salon was particularly important for Metastasio, who moved into her house on the Corso with his parents and siblings. When Metastasio left, she continued to promote his interests and he was nominated as the sole beneficiary of her will, though he renounced his inheritance in favor of her husband. Metastasio asked P. L. Ghezzi to paint a portrait of her, but only a drawing in ink and a sketch remain. However, Ghezzi was not allowed to make an engraving of her for a work to be published in England on musicians and singers.

**Benvenuto**, Tito: see Appiano **Buonafede**.

**Bernis**, François-Joaquin de, Cardinal (St. Marcel d'Ardeche 1715–1794 Rome). Educated, cheerful, witty, and amusing; his poetry (elegant but not outstanding) ensured him the protection of Mme. de Pompadour until 1752, when he was sent to Venice as ambassador. Became a minister of state, then foreign secretary in 1757, but found this post tedious and asked to be replaced; thanks to Mme. du Barry's influence became cardinal in 1758. At the conclave of 1769 informed Cardinal Ganganelli of his election as pope (Clement XIV) at the behest of Austria and Spain, and as a reward was appointed ambassador to Rome (1769–91). Set up house in the Palazzo de Carolis on the Corso, near the Palazzo Doria and the French Academy in the Palazzo Mancini. Known as "the French pope," he looked favorably on freemasons, including G. Balsano, and lived a luxurious life; his receptions were renowned and his banquets lavish (his guests included A. Kauffmann and E. Vigée-Lebrun). Enjoyed academies for singing, with poetry, refreshments, and entertainments, though dancing was forbidden in a cardinal's residence. The beautiful Giuliana Falconieri, wife of Santacroce and sister of Costanza Falconieri, acted as his hostess. Later devoted himself to assisting the French clergy. Died in his palace and was buried in S. Luigi dei Francesi. There is a portrait in the cathedral of Albano; and a portrait of Giuliana Falconieri Santacroce by Angelika Kauffmann, in the Museum Narodowe, Warsaw.

**Berthier**, Louis-Alexandre, General (Versailles 1753–1815 Bamberg). After the French ambassador, Joseph Bonaparte, had left Rome and General Duphot had fallen at the Porta Settimiania, was sent to Rome to avenge Duphot's death and establish the Roman republic. On February 9, 1798, his troops occupied Monte Mario, and on February 10 Castel S. Angelo surrendered and the French invaded the city with the compliance of the people of Rome, as requested by secretary of state G. Doria Pamphili Landi. The republic was proclaimed on February 15 and the tree of liberty erected on the Capitoline Hill in front of the statue of Marcus Aurelius. French troops were billeted in the Vatican, at the monasteries of Minerva, S. Agostino, and the Ss. Apostoli, at the houses of the Jesuits in the Piazza del Gesù, in the courtyard of La Sapienza, in the palace of St. John Lateran, the Piazza di Spagna, the Piazza S. Maria Maggiore, and at the Palazzo Doria (seat of the chief of staff), while republican flags (black, white, and red) were raised above the Capitoline Hill and the Quirinale. After staying at the Villa Mellini, he moved to the Villa Poniatowski (spiteful rumors suggested this was closer to a quicker exit from Rome). On February 20 Pius VI left for Siena and on February 23 a former Scolopian father, Faustino Gagliuffi, commemorated the death of Duphot in St. Peter's Square. On February 24 the people's representatives requested the protection of the French republic. Berthier then made his entrance through the Porta del Popolo on horseback, with a large following of the populace and soldiers, and took possession of the city, following a route past the Capitoline Hill, St. Peter's, the Forum, and back to the Piazza del Popolo (Pope Pius VII entered Rome in triumph by the same gate on July 3, 1800). Was responsible for establishing the new structure of the republican state, based on the French model, and initiated the secularization of the administration, in Rome and in the Papal States.

**Bettinelli**, Saverio (Mantua 1718–1808 Mantua). Jesuit polymath. Taught in various northern Italian cities and visited Paris and Switzerland, where he met Rousseau and Voltaire. In Germany was tutor to the Hohenlohe princes (1755). When the Jesuits were suppressed in 1773, settled in Mantua. Author of poems, tragedies, free verse, and rhyme, he became famous on publication of the *Lettere Virgiliane* in 1757, and anthology with prefaces by various authors (Algarotti, Frugoni, and himself). In this work Virgil is imagined as a judge of Italian literature. In fact, Bettinelli was very critical of Dante (significantly, publication of the *Divine Comedy* was banned in Rome), and this resulted in a strong public reaction. His *Dodici lettere inglesi, sopra vari argomenti e sopra la letteratura italiana* of 1766 is an interesting work in which he wrote as a foreigner who likes Italy and is unimpressed by the great English writers and Newton; his writing seeks to glorify minor writers, simultaneously belittling the great ones, always on a light level. His contributions to worldly and courtly literature include *Lettere XX di una dama … sulle belle arti* (1793) and *Dialoghi sull'amore* (1796). Clever and ambitious, though somewhat lacking in originali-

ty, he was neither philosopher nor historian. His reappraisal of the Middle Ages (*Del Risorgimento d'Italia … dopo il Mille*, 1775) is interesting, although he cannot be considered the creator of neo-Guelph historiography. A Jesuit by choice, a man of the world by nature, his letters are the most coherent and effective expression of the Jesuit exploitation of literature in the eighteenth century. Contributed to a reawakening of Italian culture, fought against pedantry, and had a good understanding of art. Admired S. Valenti Gonzaga, whose biography he wrote, and shared his enthusiasm for astronomy and the optical sciences in particular.

**Bianchini**, Francesco (Verona 1662–1729 Rome). Scientist. Studied in Bologna with the Jesuits and with Giuseppe Ferroni, a follower of Galileo. In 1680 wrote the *Dialogo fisico-astronomico contro il sistema copernicano*, so he was able to speak authoritatively about Galileo's theory, which was prohibited, and the same year he went to Padua to study theology; there met Geminiano Montanari and other scientists, and became interested in scientific historiography studying archaeology, and numismatics. In 1684 gained protection of Cardinal Ottoboni in Rome, became his librarian, and catalogued manuscripts in the cardinal's library and in the Palazzo della Cancelleria, living there until 1707. Made a sundial for Cardinal Ottoboni. Attended the Accademia Fisica-Matematica at S. Agnese in Agone, and worked also on the application of the principles of mechanics to medicine (in Verona at the Accademia degli Aletofoli). Began drafting a *Storia universale*, to restore the authority of the Scriptures on the evidence of scientific data, thereby anticipating Vico's *Scienza nuova*. Traveled frequently to the north of Italy and Naples, and was in contact with the more progressive members of scientific circles. Appointed privy chamberlain to Clement XI; lived in the Vatican palaces. In 1700 founded the Academy of Alexandrine Antiquarians, as a tribute to Alessandro Albani, nephew of his protector. Was secretary of the congregation for the reform of the calendar (1701), though not able to complete it as accused of sympathizing with "heretics." In 1702 built the sundial at S. Maria degli Angeli, which was admired (by Leibnitz among others) but also criticized. Deciphered the tables and the Easter cycle of 112 years on the statue of Saint Hippolytus (now at the entrance to the Vatican Library); by combining astronomy and archaeology managed to reconstruct the Julian calendar, and communicated his astronomical observations regularly to the Académie des Sciences, and from 1706 was

one of its eight foreign associate members. From 1730 was president of antiquities in Rome, and decreed that no finds from excavations could be removed without his written consent. Also established the custom of publishing the results of the excavations annually. Solved the problem of erecting the Antonine Column (1705), which was hailed by the playing of whistles and drums and salvoes from cannons. Traveled in France (1712) and England (1713), where he met Swift, Halley, and Newton, who gave him a copy of his *Opticks* (now in the Vatican Library). He loved England so much that he learned English in 1720 from Maria Clementina Sobieska and was an assiduous visitor at the Stuart court. Increasingly interested in geography and astronomy, his work was disseminated by E. Manfredi and used by many, including R. Boscovich. Simultaneously published important historical and philological works (the first three volumes of the *Liber pontificalis* was completed by his nephew Giuseppe), and works about mathematics and astronomy. Also devised the *Carte da gioco nelle quali vien a comprendersi l'istoria universale*, published in Rome in 1765. On his death was found to be wearing sackcloth.

**Bianchini**, Giuseppe (Verona 1704–1764 Rome). Scholar. Nephew of Francesco, most of whose unfinished work he completed, including the *Liber pontificalis* and *Historia ecclesiastica*. Expert in ancient manuscripts and particularly interested in Christian antiquities, studying the manuscripts whose catalogue had been published by S. Maffei. Owing to difficult relations with Maffei and the local clergy left Verona and moved to Rome, where in 1732 was admitted to the congregation of the oratory of S. Filippo Neri. Compiled the catalogues of the Biblioteca Vallicelliana, and a collection of manuscripts referring to Roman monuments. Studied other Roman libraries and established an international network of scholars with whom he collaborated to continue the work started by his uncle. In 1738 the oratory asked him to continue *Annales ecclesiastici* of C. Baronio, but did not complete this task. His research gave new impetus to Bible studies: collected all the Latin versions prior to Saint Jerome and eventually published the famous *Evangeliarum quadruplex*. For the holy year of 1750 planned to publish *Delle magnificenze di Roma antica e moderna* in ten volumes illustrated by G. Vasi, but it was not completed until 1761. From 1740 was granted a monthly salary of ten *scudi* for a copyist. In 1755 persuaded Benedict XIV to found the Museo di Antichità Cristiane at the Vatican. Interested in physics and mechanics

and, at the end of his life, also in European economics and trade. When he died, was about to publish a new edition of the polyglot Bible and was working on the Greek version of the Book of Daniel, which he wished to dedicate to the King of Naples.

**Bianconi**, Carlo (1732–1802). Painter, sculptor, architect, and writer. Brother of Giovanno. Winckelmann stayed at his house in Bologna on his first visit to Italy. Carlo was a printer in Rome from 1777 to 1778 at his brother's house and in 1778 director of the Accademia di Brera.

**Bianconi**, Giovanni Ludovico (Bologna 1717–1781 Perugia). Physician and writer. His uncle Giovanni Battista, a theologian and scholar, taught him humanities but he was more interested in medicine and in 1741 obtained a degree in philosophy and medicine. Became a famous physician and on the recommendation of Benedict XIV and the Bolognese scientist Laura Velati Bassi was employed as personal physician to the Prince-bishop of Augusta in 1744. In Leipzig published the *Journal des Savants d'Italie* (1748–49) to inform German readers of scientific and literary achievements in Italy. Was an affiliate of the Academy of Sciences of Berlin from 1750 and in the same year at the court of Dresden became physician, chief advisor, and librarian to the elector of Saxony, the King of Poland, Augustus III, and it is due to B. that Raphael's *Sistine Madonna* is in Dresden. During the Seven Years' War left Dresden and stayed in Bavaria. In 1736 his *Letters* to Marchese Filippo Hercolani were published in Lucca, and recorded with the "peculiarities" of Bavaria and other German states. From 1764 was minister for Saxony in Rome and encouraged interest not only in medicine but also in literature and archaeology. In 1772 promoted the *Effemeridi letterarie*, which gave news of new literary works, followed by the *Nuovo Giornale dei Letterati Italiani*; also collaborated on the *Anecdota litteraria* and the *Antologia romana* from 1775 to 1785, whch reported scientific advances. Among his last works were the *Elogio storico del cav. Giambattista Piranesi* of 1779 and the important *Elogio storico di A. R. Mengs* in 1780. His *Descrizione dei circhi e dei giochi in essi celebrati* was published posthumously in Rome in 1789 by Carlo Fea.

**Bichi**, Vincenzo, Cardinal (Siena 1668–1750 Rome). Studied in Rome, became nuncio in Switzerland (1703–9), then in Portugal. John V

ordered him not to leave Portugal unless raised to the purple by the pope. After much hesitation (also because B. had caused a scandal with the sale of indulgences) Clement XII finally made him a cardinal (1731) following intervention by **Fonseca de Evora**; B. entered Rome in great pomp, paid for by John V.

**Boccapaduli**, Giuseppe: see **Sparapani Gentili Boccapaduli**, Margherita.

**Boncompagni**, Pier Gregorio: see **Ottoboni**, Pietro.

**Boncompagni Ludovisi**, Antonio: see **Orsini**, Giacinta.

**Borghese**. Family originally from Siena. Giovanni Battista (1558–1609) was brother of Camillo (Pope Paul V, 1552–1621), governor of Castel S. Angelo and father (by Virginia Lante) of Marcantonio II (1601–1658), whose only son (by Camilla Orsini) was Paolo (1624–1646). Paolo married Olimpia Aldobrandini, only daughter and heir of the princes of Rossano, and niece of Clement VIII: their son Giovanni Battista (1639–1717) thus inherited from his mother the Aldobrandini principality of Rossano. Olimpia's second marriage was to Camillo Pamphili and when the Pamphili line became extinct in 1760 the Aldrobrandini fortune was inherited by the Borghese. Giovanni Battista married (1658) Eleonora Boncompagni, niece of Gregory XIII. Maria Virginia (1642–1718), sister of Giovanni Battista, married Agostino Chigi, who was also Prince Farnese and nephew of Alexander VII. Giovanni Battista's sons were Marcantonio III and Scipione. Marcantonio III married Flaminia Spinola and their children were Camillo and Francesco Scipione (Rome 1697–1759 Rome), cardinal of S. Pietro in Montorio from 1729, and protector of Germanic lands. Marcantonio IV, son of Camillo and Agnese Colonna, married Marianna, the last heir of the Salviati family; thus the assets and titles of the Salviati were added to those of the Borghese. Of their children, Camillo (Rome 1775–1832 Florence) married Pauline Bonaparte in 1803, but died without heirs. In 1818 Camillo purchased the *Virgin* by Sassoferrato (now in the Galleria Borghese) and Correggio's *Danae*, bought in Paris in 1827, but was forced to sell the Louvre 344 objects. Camillo enlarged the park of his villa as far as the Porta del Popolo and placed

majestic propylaea at the entrance. The second son of Marcantonio IV, Francesco (1776–1839), Prince Aldobrandini, inherited the title of Prince Borghese on the death of his brother Camillo. Francesco reorganized the museum and assets of the family and in 1833, after compiling catalogues of works that could not be sold, a new trust was set up. Francesco and his wife, Adelaïde de Rochefoucauld (1793–1877), had several sons, with Marcantonio V (1814–1886) inheriting the title of Prince Borghese, Camillo (1816–1902) that of Prince Aldobrandini for himself and his heirs, while Scipione (1823–1902) became Duke Salviati.

**Borghese**, Camillo (Rome 1693–1763 Rome). Eldest son of Marcantonio III and Flaminia Spinola. Decorated the Villa Taverna in Frascati magnificently. His wife, Agnese Colonna (1702–80), an educated and intelligent woman, was responsible for cataloguing the Borghese family's assets, which had been looted by French merchants. This task took her almost twenty years, and the Borghese archive can now be consulted at the Vatican archives. Her children included Scipione and Marcantonio IV.

**Borghese**, Marcantonio III (Rome 1660–1729 Rome). Son of Giovanni Battista and Eleonora Boncompagni. Married Flaminia Spinola (1691). Famous for lavish receptions, such as the one given in 1698 for which an ephemeral castle was built in the country near Carocceto in honour of Innocent XII, who was en route to survey the work at the port of Anzio. On his father's death Marcantonio inherited titles and high offices, and his lifestyle became even more worldly and lavish at the Villa Pinciana (now the museum at the Villa Borghese). In 1721 was appointed caretaker viceroy of Naples, much to the delight of the Neapolitans. In the fourteen months of his office one of his tasks was to protect the kingdom from the plague, which had broken out in Marseille in 1720. Left Naples in 1722, and withdrew to his villa in Rome. Among his sons were Camillo and Francesco Scipione.

**Borghese**, Marcantonio IV (Rome 1730–1800 Rome). Son of Camillo and Agnese Colonna. Was chiefly responsible for the present-day appearance of the Villa Borghese and the modernization of the park. Commissioned the architect A. Asprucci to redesign the interior in a Neoclassical style, in harmony with the previous late Baroque decor. Was also responsible (1785) for placing Bernini's *Apollo*

*and Daphne* at the center of the room with the base remodeled by V. Pacetti, using pieces of the original. Renovated the ground floor gallery in the palace in Campo Marzio, the Borghese Chapel in S. Maria Maggiore, and the casino in Pratica di Mare. After the Treaty of Tolentino (1797) was forced to send his most precious paintings and classical sculptures to Paris. During the French occupation carried out important excavations on the Pantano estate and put the finds in the Gabinio museum, which was sold to the French. Married Marianna Salviati, the last heir of her family, whose assets and titles passed to the Borghese.

**Borghese**, Maria Virginia (1642–1718). Noblewoman. Daughter of Paolo and Olimpia Aldobrandini, sister of Giovanni Battista (see **Borghese** family). Married Agostino Chigi, who used her dowry to improve the standing of the Chigi family in Roman society.

**Borghese**, Scipione, Cardinal (Rome 1734–1782 Rome). Third son of Camillo and Agnese Colonna. Began his ecclesiastical career under the protection of his maternal uncle, Cardinal Girolamo Colonna. Chamberlain to Clement XIII and supported him in his defense of the Jesuits. Clement XIV appointed him cardinal in 1770 and entrusted him with the legation of Ferrara, which he administered meticulously. Responsible for restructuring the university and initiating public works. Also expropriated, sold, and seized the assets of the Jesuits (Jesuits expelled from Portugal, South American colonies, and Bourbon states had sought refuge in the area). In the 1775 conclave, opposed the election of Pius VI. Although Pius supported the restoration of the Jesuits, he allowed Scipione to continue to administer the legation of Ferrara. In 1778 returned to Rome.

**Borgia**, Stefano, Cardinal (Velletri 1731–1804 Lyon). Prelate, writer, and collector. Member of the Accademia Etrusca of Cortona, the Colombaria of Florence, and the academy of Fermo. Was in Rome from 1756, and when rector at Benevento (1759–64) published three volumes of *Memorie storiche … di Benevento* from 1763 to 1769. From 1764 in Rome was secretary of the Congregation of Indulgences and was ordained in 1765. In 1770 became secretary of the Propaganda Fide and was thus able to collect exotic objects for his museum at Velletri, as well as medals (taken by Murat to the Museo Nazionale in Naples) and manuscripts (from 1902 in the Vatican Library),

including the famous Mexican illuminated manuscript, the Codex Borgianus. Employed Protestant scholars in his printing press at the Propaganda Fide for detailed studies on the collections; and G. Zoega was one of his assistants. Driven by great religious zeal, and carried out his missions intelligently, entertaining good relations with sympathizers of the Roman Jansenists, including G. C. Amaduzzi, despite his strenuous defense of the temporal interests of the Church. Appointed cardinal in 1789 and governor of the city of Rome, became a member of the Congregation of State, which was responsible for the foreign policy of the Holy See, and supported resistance against the French to the bitter end. Was imprisoned and exiled in 1798. Took part in the Conclave of Venice, and accompanied Pius VII to France for the coronation of Napoleon, but died in Lyon. Left numerous writings on many subjects, including the history of art.

**Boscovich** (Bošković), Ruggero Giuseppe (Ragusa [now Dubrovnik] 1711–1787 Milan). Jesuit scientist and scholar. Son of a Serb merchant, his mother came from Bergamo. Studied with the Jesuits and in 1725 was a novice at S. Andrea delle Fratte in Rome. Became a teacher, published writings on mathematics, astronomy, geodetics, and mechanics, reworking the ideas of Newton and his English and French followers. On taking his vows in 1744 and joining the Accademia dell'Arcadia under the name of Numerius Anigreus, was already well known in Europe. In Rome was supported by cardinals Passionei, Albani, and Valenti Gonzaga. His plan for reinforcing the dome of St. Peter's with metal bands, executed by Luigi Vanvitelli, brought him worldwide fame. Professor of mathematics at the Collegio Romano, he also wrote on archaeology and (in verse) scientific subjects, such as eclipses, the refraction of light, infinitesimal analysis, and even Arcadian mythology. An affiliate of the French Academy (1748), he refused the invitation of John V of Portugal to go to Brazil and map the country, preferring to compile a map of the states of the Church (1750–52), which enabled him to measure the arc of the meridian between Rome and Rimini. In Vienna (1758) published *Philosophiae naturalis theoria* but despite his friendship with Newton was not completely faithful to the spirit of the Englishman's theories in his attempt to give global synthesis to a unique formula. In 1759 went to Paris, probably on a diplomatic mission for Clement XIII and Father L. Ricci. His letters record numerous contacts there, from Mme. de Pompadour to the queen, the Jesuits at court and the

scholars. In 1760 visited Greenwich, Oxford, and London, where he published the poem *De solis ac luna defectibus*, and was admitted to the Royal Society, which entrusted him with the task of observing the transit of Venus from Constantinople; arrived there too late but stayed on for six months. Went next to St. Petersburg in 1762 with the English ambassador J. Porter, and from Poland returned to Rome (1763). His *Giornale di un viaggio da Costantinopoli in Polonia* was reprinted in 1966. Published *Sul prosciugamento delle paludi pontine e di vari problemi d'ingegneria idraulica* in 1764. Taught at the University of Rome (1764–68) and built the Brera Observatory in Milan. Due to the intrigues of his *confrères*, was forced to resign (1773) and the dissolution of the Jesuits prompted him to accept an offer from Paris, where from 1773 to 1781 he was involved in developing the achromatic telescope for the navy. Returned to Italy and settled in Bassano with the Remondini family of printers until 1785. Became insane before his death in Milan.

**Bottari**, Giovanni Gaetano (Florence 1689–1775 Rome). Man of letters and privy chamberlain to Clement XII, Benedict XIV, and Clement XIII. Versatile and genial, he made important contributions in the fields of civil engineering, hydraulics, and port design, as well as in the practice of astronomy and optics. His wideranging interests (including Tuscan literature, medieval and modern art, and Christian archaeology), his thirst for knowledge, the anti-Jesuit feelings he harbored (which intensified over the years), and his collaborations with other scholars were significant in the context of eighteenth-century Italy, while still contained within his own strict interests. Studied in Florence, where in the 1710s he directed the printing house of the grand duke and frequented anti-Jesuit circles. The date of his ordination is unknown but was certainly while in the service of the Corsini family; his fame as a linguist was so great that the Accademia della Crusca asked him to edit the new edition of the dictionary (1729–37). In 1725 went to Rome (and Naples) for the first time and became involved in theological and Jansenist matters. Lived in the Palazzo Corsini in Rome. His handsome face, keen glance, and great stature helped him to establish a very animated group of intellectuals (the Burchiello club) in the Palazzo, which was less seditious than the Archetto circle, founded in 1749. In 1730 obtained a canonry at the Collegiata di S. Anastasia from Clement XII, also the chair of ecclesiastical history at the University of Rome. A palatine prelate, in 1732 he carried out a survey of the Tiber with E. Manfredi from below Perugia as far as the

confluence with the Nera (1746). In 1735 Clement XII ordered him to establish the rich Corsini library (one of the very few in Rome still in its original state) and appointed him as his privy chamberlain. In 1736 Clement XII ordered a new edition of *Roma sotterranea* by A. Bosio from him. On appointment as deputy custodian of the Vatican Library (1739), gave up teaching at La Sapienza University. Benedict XIV helped him to become a member of numerous Roman academies and bestowed on him the canonry of S. Maria in Trastevere (where he is buried). After 1740 became more reformist and sympathized with the Jansenists; nonetheless, he accepted the pope's condemnation of Jansen and disapproved of the disobedience of the Church of Utrecht. Had French books sent from Paris and supported the Roman printer N. Pagliarini in the translation and dissemination of Jansenist literature, but was careful not to promote secularization. Opposed the 1750 banning of Montesquieu's *L'esprit des lois*, but insisted on some abridgement. During the expulsion of the Jesuits from Portugal Neri Corsini was protector of the country, but the ambassador of Portugal and Minister Pombal were in contact with Bottari. The Italian translation, which he suppported, of the catechism of François-Philippe Mésenguy, published in Naples and Venice (1758–60; 1761) provoked further condemnation (1761). He never dared openly to defy the Holy See, and in 1761 was promoted to chief custodian of the Vatican Library. His numerous writings on history of art reveal an interest in conservation and restoration methods, sources, illustrated records, and theoretical works. Published Vasari's *Vite* with an introduction and commentary (1759–1760) and the *Raccolta di lettere sulla pittura … scritte da' più celebri personaggi … dal sec. XV al XVII* (7 vols., Rome 1757–73)—written with the assistance of Count G. Carrara—is still considered a seminal work. Edited the last revised edition (1763) of the *Studio della pittura, scoltura et architettura nella chiese di Roma* by F. Titi. In the *Dialoghi sopra le tre arti del disegno* (Lucca, 1754) his narrators were Maratti and Bellori: a pleasant essay that gently mocks "modern" artists.

**Braschi**, Giovan Angelo: see **Pius VI**.

**Braschi Onesti**, Luigi (Cesena 1745–1816 Rome). Duke of Nemi, son of Girolamo Onesti and Giulia Braschi, sister of Pius VI. In 1780 came to Rome to be betrothed to Costanza Falconieri, whom he married in 1781 in the Sistine Chapel. In the same year he and his brother Romualdo were adopted by Pius VI, who appointed him Duke of Nemi,

having purchased the title from the Frangipane family. Within a few years he became extremely wealthy, by buying assets cheaply from the Jesuits, receiving presents of reclaimed land in the Pontine marshland, and engaging in unscrupulous commercial speculation. The duke and duchess were immortalized by V. Monti (their secretary and possibly father of the daughter Giulia) in *La bellezza dell'universo*, and also in numerous lampoons; according to G. G. Belli in *Quattro miracoli* of 1835 the last miracle of Saint Peter was the lavish Palazzo Braschi. Appointed prince of the Holy Roman Empire on accompanying Pius VI to Vienna (1782). Charles IV made him a Spanish grandee, the king of Sardinia bestowed on him the order of Ss. Maurizio e Lazzaro, and Louis XVI the order of Saint Esprit. In 1797, on behalf of the pope, negotiated with the French at Tolentino. In 1798, when the French entered Rome, the Palazzo Braschi was besieged, but he managed to flee and preceded the pope to Siena. Forced by the French to leave Tuscany, sought shelter in Venice, only returning to Rome in the retinue of Pius VII; accompanied him to Paris in 1804 for Napoleon's coronation. In 1809 became mayor of Rome under the French, and was excommunicated by the pope. An obedient collaborator, though not particularly intelligent or well educated, on the occasion of the birth of the king of Rome B. led the Roman delegations, and in 1814 welcomed Murat at the Capitol. Eventually received a pardon from Pius VII. Buried in S. Maria sopra Minerva.

**Braschi Onesti**, Romualdo, Cardinal (Cesena 1753–1817 Rome). Son of Girolamo Onesti and Giulia Braschi. In Rome from 1778, embarked on an ecclesiastical career at the wish of his uncle Pius VI, who adopted him and his brother Luigi in 1781. As apostolic legate at the French court, obtained the abbey of Choage in the diocese of Meaux from Louis XVI (at 5,000 *scudi* a year). Prefect of the holy palaces, grand prior of the order of Malta in Rome (1784), and cardinal in 1786. Kind and gentle, scholarly and tolerant, he remained in Naples in 1797, on the occasion of a visit to request aid against the French, but later sought refuge in Venice, where he was instrumental in electing Pius VII from Cesena as pope in 1800. After returning to Rome, he did not receive the highest offices, but rather was a strenuous opponent of Cardinal Consalvi. Was in the pope's retinue for the coronation of Napoleon in Paris, but the French forced him into confinement in Cesena in 1809. After the restoration, returned to Rome, tak-

ing care of the education of Pio, son of his brother Luigi. Left 10,000 *scudi* for the monument by Canova of Pius VI in St. Peter's.

**Broschi**, Carlo, *alias* Farinelli (1705–1782). Singer. See **Metastasio**, Pietro, and **Vinci**, Leonardo.

**Brosses**, Charles de (Dijon 1709–1777 Paris). Author, advisor, and from 1741 president of parliament of Burgundy. Studied history, archaeology, and languages. His most important work is *Histoire de la république Romaine dans le cours du VIIe siècle* of 1777, intended as a critical reconstruction of Sallust's *Historiae*. Stayed in Italy at the houses of aristocrats and high-ranking prelates; his letters, published posthumously (1799) as the *Lettres historiques et critiques sur l'Italie*, reveal an erudite, witty, and unprejudiced view of contemporary Italian life, particularly in Rome.

**Bulgarelli**, Domenico: see **Benti**, Anna Maria.

**Buonafede**, Appiano (formerly Tito Benvenuto) (Comacchio 1716–1793 Rome). Scholar and cleric. Notorious for the most aggressive and scandalous literary dispute of the eighteenth century, in which he virtually forced G. Baretti, the Italian scholar and author of the *Frusta letteraria* into exile. He entered the congregation of Celestine Benedictines, who—though followers of Pope Celestine V—were known for their sociability and worldly philosophy; and visited several monasteries in Italy, making friends among scholars. In 1771, as procurator-general of the congregation, moved to Rome under the protection of Clement XIV. In 1754 was admitted to the Accademia dell'Arcadia under the *alias* Agatopisto Cremaziano. Appointed 1777 prefect-general of his order and was obliged to live in Morrone near Sulmona, but returned in 1782 to Rome, where he lived in the monastery "as much a man of the world as he appears ascetic in his work" (G. B. Salinari, "Buonafede, Appiano," in DBI, vol. 15, p. 103). Appreciated the splendors of Rome, enjoyed sketching, took part in the performance at the Istituto di Bologna of an *Orazione per le tre arti*, and dedicated sonnets to various artists (Mengs, Batoni, Cavallucci), who consulted him about subjects for their works. According to B. Croce, he possessed "the intellect of a jobbing preacher … with a task to carry out … an enemy to defeat … never distracted either by the search for the truth or admiration

for what is beautiful" (Croce 1949, p. 229). But according to other scholars, he was exceptionally well versed in doctrine, and far superior in intellect to Baretti (Giulio Natali, *Storia letteraria d'Italia: Il Settecento* [Milan: Dottor Francesco Vallardi, 1936], vol. 2, p. 1147).

**Byres**, James Townley (Aberdeen 1734–1817). Antiquarian. A Catholic Jacobite Scot recorded in Rome from 1758 to 1790, he wished to study painting with Mengs but was more successful in his architectural studies, winning third prize for architectural draftsmanship in 1762 at the Accademia di S. Luca, where he was elected honorary academician in 1768; a portrait of him hangs there, attributed to von Maron. Was the perfect antiquarian and guide. He varied his rates if he personally accompanied the tourist or instructed the student and ranked his tours based on the satus of persons involved. In 1766 was one of the first to visit the underground tombs of Tarquinia. Remembered by contemporaries as pleasant and communicative, but also pedantic and litigious. Though not as famous as Thomas Jenkins, he also illegally sold works of art for noble families, providing them with copies (also traded in fakes). Among the most famous works that he removed from Rome were Poussin's *Assumption* (National Gallery, Washington) and the Portland Vase (British Museum, London) and the Boccapaduli series of Poussin's *Seven Sacraments* for the Duke of Rutland. Owned a valuable collection of precious stones and paintings by contemporary British artists. Often depicted in contemporary conversation pieces.

**Caetani**, Francesco (1738–1810). Duke of Sermoneta. Brother of Onorato Caetani; his wife, Teresa Corsini, was niece of Cardinal Neri Corsini.

**Caetani**, Onorato (Rome 1742–1797 Rome). Prelate. A keen scholar of classics, science, and modern languages at the Collegio Nazareno with the Scolopian Fathers, thus able to read Voltaire, Wolff, and Pope in the original. Graduated in law from La Sapienza. Between 1760 and 1770 attended meetings of the Archetto circle, where celebrities such as Foggini and Bottari fostered his anti-curialism, which particularly emerged at this time, partly because he never received honorific posts from the Curia. Disagreed with elder brother Francesco on financial matters, but was commissioned by him to build a library in his palazzo on via delle Botteghe Oscure, which became notable for its collection of

texts annotated by famous people. This complex task brought him into contact with eminent librarians and cultural figures (including P. B. de Felice), whom he also met on his journeys round Italy (in 1774 published his observations on Sicily). His interests were amateurish, but he formed a famous collection (now lost) of coins with images on reverse sides, and was noted for his interest in scientific research, including the study of electricity and collaboration on the construction of an observatory on his palazzo.

**Cagliostro,** Alessandro: see **Balsamo,** Giuseppe.

**Capece** (Capeci), Carlo Sigismondo (Rome 1652–1728 Polistena, Calabria). Man of letters and a celebrity in the opulent environment of Roman theater between the late seventeenth century and early eighteenth (Ariella Lanfranchi, "Capece [capeci], Carlo Sigiamondo, in DBI, vol. 18, pp. 408–11), Was secretary of Italian and Latin letters to the Queen of Poland Maria Casimira.

**Capponi,** Alessandro Gregorio (Rome 1683–1746 Rome). Antiquarian, bibliophile, and collector. Last of the Roman branch of a noble Florentine family, buried in the church of S. Giovanni dei Fiorentini. Initially collected paintings and engravings (Dürer, Lucas van Leyden, also Maratti, Panini); later, encouraged by F. Ficoroni, became interested in archaeological finds (commissioned Vasi to engrave a Roman fresco, discovered in a columbarium on via Appia, copied by P. L. Ghezzi). Also collected precious stones, coins, and inscriptions for their decorative effects rather than for philological study. His friendship with Clement XII brought him official positions. Was responsible (with architect G. Teodoli) for the restoration of the Arch of Constantine by F. Barigioni and P. Bracci. In 1733 purchased the sculpture collection of Cardinal Alessandro Albani on behalf of the pope and mounted the display in the Museo Capitolino, of which he became president for life. Was also in charge of restoration of the Arch of Augustus at Rimini (1733–34) and numerous excavations in Rome, leaving the finds to Father C. Contucci so they could be assembled in the Museo Kircheriano, now the Museo Nazionale Romano. Left his sister Maria Anna, who was married to Antonio Cardelli, the palazzo on via Ripetta with statues, inscriptions, and paintings. Bequeathed his fine collection of manuscripts and Italian literature (mainly language and poetry) to the Vatican Library, where twenty-one volumes of his letters are kept. The catalogue published in 1747 bears a motto by Seneca, found on Etruscan vases and inscribed in his library: *non refert quam multos sed quam bonos habeas.*

**Capponi Cardelli**, Anna Maria: see **Capponi,** Alessandro.

**Carafa**, D. C., Cardinal. Fra Baldassarre Lombardi dedicated his great *Divine Comedy* to him in 1791, published by Liborio Angelucci.

**Carandini**, Filippo, Cardinal (Pesaro 1729–1810 Modena). Accused Sigismondo Chigi of trying to poison him.

**Carestini**, Giovanni, *alias* Il Cusanino (Monte Filottrano, Ancona 1705–1760 Monte Filottrano). Singer. At age twelve moved to Milan and enjoyed the protection of the Cusani family (hence the *alias*). Soon became one of the most famous *castrati* and made his debut at the ducal theater in Milan in 1719. Recorded in Rome in 1721 at the Teatro Capranica in *Griselda* by A. Scarlatti, also in 1727 at the Alibert in *Catone in Utica* by L. Vinci. A *soprano castrato* at the Hofkapelle in Vienna (1723–25) he performed in the most important theaters in Europe. Engaged by Handel in 1733 at the Haymarket Theatre in London and sang in many works; also performed in Dresden, Berlin, and St. Petersburg. Sang with the greatest contemporary *maestri*. Hasse declared that those who had not heard his singing would never know perfect style. According to contemporaries, the strong vibrant soprano of his early years became one of the richest, deepest, and most beautiful of counter-tenor timbres. Tall and handsome, he was also a great actor.

**Casanova**, Giovanni Giacomo (Venice 1725–1798 Dux, Bohemia). Adventurer who wrote about his life in Rome in his *Memoirs.*

**Casanova**, Paolo Girolamo: see **Leonardo da Porto Maurizio.**

**Cesarini**, Angelo (d. 1810). Canon: see **Stuart,** Henry Benedict Maria Clement.

**Cheruffini**, Francesca: see **Gherardi Cheruffini**, Francesca.

**Chigi**. Family originally from Siena, whose most illustrious member was Agostino the Magnificent (Siena 1465–1520 Rome), an immensely wealthy banker and generous patron of the arts; in Rome he left the villa alla Lungara (later villa Farnesina) and the chapel at S. Maria del Popolo. The fortunes of the Chigi family rose again under Fabio (Siena 1599–1667 Rome), who in 1655 became Pope Alexander VII. His nephew Agostino, from whom the Roman branch of the family descends, received the titles of Prince Farnese (1658), Prince of the Empire (1659), Prince of Campagnano (1661), and Duke of Ariccia (1662). Agostino married Maria Virginia Borghese, daughter of Paolo and Olimpia Aldobrandini, who in 1658 sold her son-in-law, for 41,314 *scudi*, the palace in the piazza Colonna that still bears the name Chigi today, while the Borghese dowry was used purchase the duchy of Ariccia from the Savelli family. Their son Augusto (1662–1744) became marshal of the church in 1712 and permanent custodian of the conclave (an office inherited by all the first-born sons of the family). The son of Augusto, Agostino (1710–1769) married Giulia Augusta Albani and they had a son, Sigismondo Chigi. Sigismondo's son Agostino (1771–1855, see **Albani** family) took the family name and arms of the Albani and became founder of the Chigi Albani line when the Albani line died out in 1852.

**Chigi**, Sigismondo (Rome 1736–1793 Padua). Prince Farnese, Marshal of the Holy Roman Church, man of letters and patron of the arts. Son of Prince Agostino and Giulia Augusta Albani. C. studied in Siena, showing talent for literature. Returned to Rome, becoming a member of numerous academies; his *alias* in the Accademia dell'Arcadia was Astridio Dafnitico. As marshal of the Holy Roman Church and custodian of the conclave, in 1774 was obliged to return to Rome from Lucca to fill this position. Meanwhile, wrote on several subjects. His violent satire *Del conclave dell'anno MDCCLXXIV* (1774) ran to at least ten editions, and forgeries and anonymous translations of it were made. In the holy year 1775 welcomed Maximilian of Austria and commissioned P. Camporesi to create a spectacular "fire machine" representing the forge of Vulcan. In 1767 married Flaminia Odescalchi, who died in 1771 giving birth to their son Agostino. His second marriage (1776) was to Maria Giovanna Medici d'Ottaviano from Naples and for their wedding the Salone

d'Ore was decorated at the Palazzo Chigi. Between 1777 and 1780 C. devoted himself successfully to archaeology, horses, and art (planned to have all the paintings of the Siena school engraved); he was also interested in science and economics (in 1781 published a poem entitled *L'economia naturale e politica* anonymously in Paris and dedicated it to the Grand Duke of Tuscany, Pietro Leopoldo). Corresponded with Metastasio, frequented literary salons in Rome (including that of Maria Cuccovilla Pizzelli), where he met V. Alfieri and V. Monti. F. Milizia dedicated *I principi di architettura* (1783) to him. Commissioned E.Q. Visconti and C. Fea to organize his library. As his wife produced no heirs, C. sent her to Naples. In 1790, when Cardinal Carandini accused C. of intending to poison him, it was thought that C. wanted revenge because his wife was Carandini's mistress. She was never allowed to return to Rome. C. was exiled, but the intention was possibly to punish him for sympathizing with freemasons and *illuminati*, and for satires against the economic policies of the government. Not wishing to undergo the trial (September 1, 1790) he left Rome, after having emancipated his son Agostino (Rome 1771–1855 Rome), son of his first marriage, who had served in the republican and papal administrations and had twelve children by Amalia Carlotta Barberini.

**Clement XI**, Pope (Urbino 1649–1721 Rome). Born Giovan Francesco Albani. Son of Carlo Albani. Studied in Rome at the Jesuit Collegio Romano. Created cardinal and deacon in 1690, on October 6, 1700, celebrated his first mass, and on November 23 was elected pope, supported by the *zelanti* and public consensus. Jovial and tolerant, he lacked international experience and had to face a difficult period, marked by famines and the complex War of Spanish Succession (1700–1714), resulting in serious misappropriations of lands belonging to the government or under papal protection in Ferrara, Bologna, and Naples. His pontificate was full of contradictions and complexities. Supported James Stuart; was sympathetic to the French and had excellent relations with well-known characters such as F. Fénelon and O. Pianciatici, but his bull *Unigenitus* (1713) was decidedly anti-Jansenist and evoked intense opposition. Opposed nepotism, yet supported two nephews who were cardinals (Alessandro Albani and Annibale Albani). Horrified by the ignorance of the populace, promoted education and sponsored missions. The fragmentation of estates, facilities for agrarian credit, education, price control, and roads were all issues considered, but never solved. Restored the S. Michele complex in Rome as a rehabilitation center for juveniles, who were trained as craftsmen (the school of tapestry was noteworthy). Founded the oriental section of the Vatican Library, financed excavations, and attempted to safeguard archaeological finds; restored the Raphael *Stanze* and Pantheon. The erection of the Antonine Column was made possible after a calculation by his protégé F. Bianchini; the obelisk in Piazza del Pantheon was erected; early Christian basilicas were restored and refurbished with the help of funds supplied by John V of Portugal, and La Sapienza was renovated. C. typified the inexperience of the Curia at that time and the inability to keep pace with profound changes in society, states, and the Church. Of Counter-Reformation inclinations, his vision was of a triumphant Catholicism, based on the distinction (already obsolete) between *Ecclesia romana* and *Ecclesia universalis*. In 1712, with extraordinary pomp, canonized Pius V Ghislieri, the Theatine Andrea Avellino, the Capuchin Felice da Cantalice, and Catherine of Bologna.

**Clement XII**, Pope (Florence 1652–1740 Rome). Born Lorenzo Corsini. From a noble and ancient mercantile family, from 1667 studied in Rome at the Collegio Romano with the Jesuits. Protected by his uncle Cardinal Neri Corsini, who refused (1670) to become archbishop of Florence in order to influence and foster his nephew's ecclesiastical career. When Neri Corsini was obliged to accept the cardinalate (1672) Lorenzo went to Pisa, graduated, and on returning to Florence attended to his family's affairs. On the death of his father, Bartolomeo (1678), decided to return to Rome and pursue an ecclesiastical career, like his brother Ottavio. Was victualing officer (his brother was head of the Annona, the granary of Rome), and in 1690 Alexander VIII granted dispensation (as C. was not yet ordained) and appointed him archbishop of Nicomedia and papal dignitary. Received major orders in 1690, became bishop and in 1695 treasurer and general collector of the apostolic chamber, also governor of Castel S. Angelo. Implemented profound economic, agrarian, and monetary reforms (promoted liberalization of corn trade but also restricted imports). Created cardinal in 1706, refused the appointment as legate to Ferrara (1709), and in 1710 became chamberlain and member of various congregations of cardinals. In the conclaves of 1721 and 1724 was a candidate for pope and in the conclave of 1730 was eventually elected unanimously. The earliest years of his papacy were marred by the unwise appointment of Cardinal Coscia. Established the lottery (1731) and the free port of Ancona to replenish state funds; in 1731 appointed V. Bichi as cardinal, thereby restoring diplomatic relations with Portugal. In Rome, he gave princely honors to Maria Amalia of Saxony, who came to marry Charles Bourbon (see **Acquaviva d'Aragona**, Troiani, and **Vaini**, Girolamo), but abolished feudal rights of the Church (for example, in Parma and Piacenza). The King of Sardinia earned the favor of the papacy by tricking P. Giannone into coming to Savoy, where he was arrested and left to die in prison. In 1733 set up a congregation to control crime: the *In supremo iustitiae solio* (1735) renewed the ban on carrying arms of any kind, limited the capacity to grant mercy, and abolished ecclesiastical sanctuary. In 1738 condemned the freemasons (*In eminenti* bull); in 1733 limited inclusion of local rites into Catholicism overseas, which the Jesuits favored. The cultural mark of C. on Rome was considerable. In the palace at Piazza Fiannetta systematically arranged his uncle's library, making it available to scholars; the Corsini family moved to the Palazzo Pamphili on Piazza Navona in 1713, where the Accademia dei Quirini reconvened; the library grew by absorbing other collections; the cardinal-nephew transferred it to the palace, where it is found today (formerly Riario alla Lunghara). Commissioned F. Fuga to enlarge the Palazzo Quirinale, constructed the Palazzo della Consulta, the façade of St. John Lateran, and the Corsini Chapel in the basilica. The Vatican Library made important accessions, and A. Capponi enlarged the collections of the Museo Capitolino (assisted by legacies from the Albani family), which was opened to the public. De Brosses, while declaring him *"le plus magnifique seigneur"* of Rome and the Holy College (De Brosses 1977, vol. 2, pp. 128–46), could not resist recording (De Brosses 1977, vol. 2, pp. 69–90) that the pontiff, attempting to lift as much as 14–15 pounds in bed, gave himself a large hernia.

**Clement XIII**, Pope (Venice 1693–1769 Rome). Born Carlo Rezzonico. His family was from Como, entered in the Golden Book of Venetian nobility in 1687 on payment of 100,000 ducats. Studied in Bologna with the Jesuits and at the University of Padua, and entered the Curia in Rome in 1716. The Spanish ambassador wrote that Cardinal Neri Corsini received 30,000 *scudi* from Rezzonico to persuade Clement XII to make him a cardinal in 1737. Became bishop of Padua in 1743, and Benedict XIV, while considering him politically naïve, later described him as "the most worthy prelate that we have

in Italy. He lives off his assets and spends his income only on the poor and the Church …" (L. Cajani and A. Foa, "Clement XIII," in DBI, vol. 26, p. 329). The conclave of 1758 elected him pope after pressure by Austria as well as by those who criticized Benedict XIV for allowing the jurisdiction of state to impinge on ecclesiastical matters, and those opposed to the pecuniary interests of religious orders, in particular the Jesuits. His papacy was undoubtedly the most disheartening of the eighteenth century. He refused to contemplate any internal criticism or reform of the Church; at the time of his death the suppression of the Jesuits was imminent, and would lead to their exile from many European states (Portugal, France, Naples, Malta, Parma). His papacy was also marred by a financial crisis so serious as to deplete half of the 3 million *scudi* that Sixtus V had deposited in Castel S. Angelo by 1762 in order to address the drought and subsequent famine of that year. Clement made the cult of the Sacred Heart of Jesus official, urged on by the Jesuits though opposed by the Jansenists. His painful death from apoplexy prompted the rumor that he had been poisoned by the Jesuits. On this, the letter from the ambassador of Spain, Azara is revealing: "the Pope was praying to all the blessed, begging for prayers to be said for him by nuns and friars, handing out vast quantities of alms, so that God would illuminate him, (…) but the God that would speak through 'all these blessed activities' was the ex-Jesuit Father L. Ricci" (cited in Cajani and Foa, in DBI, vol. 26, p. 336). In the arts, he is remembered only for having completed the Trevi Fountain, covering the nakedness of the Vatican statues, and because his funerary monument in St. Peter's by Canova was paid for by his nephew the cardinal C. Rezzonico. In the nineteenth century Catholic historians compared him to the greatest popes of Christianity, but this has been called into question by recent research. There are portraits by Mengs (Pinacoteca Nazionale, Bologna (cat. 255); Batoni, Palazzo Barberini, Rome; and Pinacoteca Ambrosiana, Milan), and a good sketch likeness at Stratfield Saye, U. K. Duke of Wellington Collection. He canonized, among others, the piarist Joseph Calasanz.

**Clement XIV**, Pope (S. Arcangelo di Romagna 1705–1774 Rome). Born Giovan Vincenzo Antonio Ganganelli. Studied with the Jesuits in Rimini and in 1723 entered the Franciscan monastery at Mondaino (Forlì), taking the name of Lorenzo. His career was provincial and limited to scholastic duties and internal affairs of the order. In Rome (1728–31) studied at the Collegio di S. Bonaventura,

becoming its director in 1740. Created a cardinal in 1759, he dressed as a friar with red hat and stockings. His views on the Enlightenment are not known, though a report written by him, and read before the pope in January 1760, condemned the anti-semitic demonstrations in Poland and made accusations of ritual murders. Elected pope in 1769 after a stormy conclave (February 15 to May 19); on pressure by the Spanish cardinals who expected C. to suppress the Jesuits—which did happen after much hesitation in 1773. Took *possesso* of the Lateran basilica on November 26, the last pope to ride there on horseback (he fell off at the Arch of Septimius Severus and continued on a litter) through the Capitol with all the windows decked out, and the Forum decorated with magnificent ephemeral arches (the one facing the Farnese Gardens was given by King Ferdinand IV of the Two Sicilies and made by Panini). Political intervention during his difficult papacy was often negative. Important events were the first partition of Poland in 1772, conflict with the Spanish court about the Jesuits, and inconclusive negotiations for the restitution of Avignon to the Holy See; however, essentially he wanted to curb the spreading of the ideas of the Enlightenment, as can be shown by the number of books placed on the Index. The conflict between the Jesuits and their opponents was the origin of the "prophesies" that began to circulate in 1773, suggesting that he would die before the jubilee of 1775; there were also tales of the miracles he performed, followed by the rumor that he had been poisoned. Some of the less depressing episodes in his papacy included the award of the order of the Golden Spur to Mozart (in the Sistine Chapel; during the holy week of 1770 Mozart heard G. B. Allegri's *Miserere*, which he quickly transcribed). Also ordered the reform of the University of Rome, carried out by his friend G. C. Amaduzzi; and encouraged publishing and relations with the eastern churches. The Vatican Library's collections were enlarged and the Sala dei Papiri was frescoed by Mengs. E. Q. Visconti persuaded him to introduce laws to limit the export of works of art from the Papal States. He reorganized the museum that came to be called the Museo Pio-Clementino. He liked the English: in 1772 received the Duke of Gloucester and two years later the Duke of Cumberland and the Duchess of Kent, but was reluctant to recognize the Young Pretender (Charles Stuart). Loved Castel Gandolfo and studying natural history, especially botany. His monument in Ss. Apostoli, by Canova, was paid for by Carlo Giorgi, a merchant from the country. The extensive literature on him is still divided:

some consider him a weak character influenced by stronger men, while others see him as a philosopher, willing to embrace important changes. During his papacy he supported the canonization causes of Odorico di Pordenone, Angela da Foligno, Antonio Lucci, Clemente A. Sandreani, and J. Palafox y Mendoza.

**Coccia**, Maria Rosa (born Rome 1759). Musician. First woman to request admission to the Accademia di S. Cecilia and be accepted (1774), though the examiners declared she was accepted "out of kindness, because she was a woman" (B. M. Antolini, "Coccia, Maria Rosa," in DBI, vol. 26, p. 509). Was also admitted to other prestigious academies: the Filarmonica of Bologna (1784) and one of the Forti in Rome. Her compositions include six sonatas for harpsichord, dedicated to Charles II (1772); the oratorio for four voices, *Daniello*, performed at the oratory of S. Filippo; and the *Isola disabitata* with libretto by Metastasio (never performed). In 1832 requested a subsidy from S. Cecilia, on account of having composed, taught, and kept her parents and sisters all her life (see *Donna e … : l'universo femminile nelle raccolte casanatensi* [Milan: Aisthesis, 1998], pp. 218, 224).

**Colonna**, Agnese (1702–1780). Noblewoman. Daughter of Fabrizio, Prince of Paliano, who married Camillo Borghese in 1723.

**Colonna**, Girolamo, Cardinal: see **Borghese**, Scipione.

**Colonna**, Prospero, Cardinal (Rome 1707–1765 Rome). Son of Francesco and Vittoria Salviati, he embarked on an ecclesiastical career. As prefect of the victualing office (1739), promoted the liberalization of the corn trade. Cardinal deacon of S. Giorgio al Velabro (1743) and prefect of the Propaganda Fide, he used influence to procure the return of Spanish Franciscans to Cochin China, from where they had been expelled and replaced by French lay priests and Jesuits. As protector of France played an important part in the 1758 conclave that elected Clement XIII. His decision not to publish in France the pope's speech suppressing the right of national parliaments to expel Jesuits, and his decision not to reveal in Rome the decree suppressing the Jesuits by Louis XV, now seem highly debatable.

**Compagnoni Marefoschi**, Mario, Cardinal (Macerata 1714–1780 Rome). Son of Francesco Compagnoni and Maria Giulia Marefoschi. His uncle Cardinal Prospero Marefoschi procured his admittance to the Collegio Nazareno of the Somaschi Fathers and nominated him as sole beneficiary of his will in 1732, on condition Mario renounced his father's surname. It is not known precisely when he entered the Church, but from 1740 he was a prelate, and as protégé of Benedict XIV quickly made a career, although his fervent anti-Jesuit stand caused difficulties. The Jesuits declared that as secretary of the Propaganda Fide Congregation in 1750, he used his position to encourage anti-Jesuit elements. Affiliated to the Archetto circle (which included Bottari, Foggini, and Passionei), had close links with the Jansenist church of Utrecht. Made a cardinal in 1770 and titular cardinal of S. Agostino (where he is buried), in 1771 became prefect of the Holy Congregation of Rites. In addition to the Archetto, frequented the Oratorians, and was the object of ferocious criticism and lies. Neither pure Jansenist nor enlightened Catholic, he was a strict Augustinian and within the Catholic hierarchy played an important role mediating between the supporters and opponents of austerity.

**Concina**, Daniele (Cauzetto, Udine, 1787–1756 Venice). Dominican and theologian. Tenacious adversary of the Jesuits who also wrote tracts on the immorality of the theater, supported by P. F. Foggini.

**Consalvi**, Ercole, Cardinal (1757–1824). Close friend of Cardinal H. B. Stuart, heir and executor of his will.

**Conti del Nord**. Name used by Paul I, Czar of Russia, nominal son of Catherine II (his natural father was Count Soltykov) and his wife from 1773, Wilhelmina of Hesse-Darmstadt, on their journey round Europe in 1781–82. In Italy they visited Venice, Naples, Rome, Florence, and Turin, and returned to Rome, staying at the Locanda di Londra in the Piazza di Spagna in 1782. Pius VI gave them a warm welcome, and had a portrait of Paul painted by Batoni; they were accompanied by Prince Nikolai Yussupov. Paul was crowned in 1796 and murdered, with the consent of his son and heir, Alexander, in 1801.

**Contucci**, Contuccio (Montepulciano 1688–1768 Rome). Jesuit. Prefect of the Museo Kircheriano in Rome, and compiler of its catalogue (1763–65). He was admired by such intellectuals as L. Muratori, S. Maffei, and Winckelmann, and was appreciated because he was not preoccupied with publishing, and was happy to offer advice.

**Corelli**, Arcangelo (Fusignano 1652–1713 Rome). Musician. Most of his career as violinist and composer was spent in Rome but studied in Bologna before 1675. Was one of the four violinists engaged for the patron saint's celebration at S. Luigi dei Francesi in Rome in 1675. His solo performances were much appreciated (described by G. Muffat as the "Orpheus of Italy" for the violin), but was also an excellent conductor of compositions that required extremely complex orchestral arrangements. G. M. Crescimbeni recalled that he was "the first in Rome to introduce symphonies, and in such great numbers and with so many instruments that it was almost impossible to believe that they could be conducted without great difficulty, particularly because of the accord of wind and string instruments, which often exceeded one hundred" (*Notizie storiche degli arcadi morti* [Rome, 1720]). Queen Christina of Sweden and Cardinal P. Ottoboni were his patrons, and he was in the service of Ottoboni from 1689, after being music master at the Palazzo Pamphili. Dedicated the twelve sonatas, Opus 2, to Cardinal B. Pamphili. His *Sonate à tre* for two violins, bass, and harpsichord, and his church music (organ as basso continuo) were the highest expression of this kind of music; the first four series (Op. 1–4) were published between 1681 and 1694, followed c. 1700 by a fifth series of sonatas (Op. 5), which includes the famous *Folly*. Was admitted to the Accademia dell'Arcadia in 1706, with A. Scarlatti and B. Pasquini. Shy and retiring, he abandoned all public performances after 1708 and spent his final years reworking and perfecting the only orchestral music he composed, the twelve *concerti grossi* (Op. 6), published posthumously in 1714 by his favorite pupil, Matteo Fornari, to whom he bequeathed his manuscripts and violins. An admirer of painting, he collected works by G. Dughet, F. Trevisani, and C. Maratti, as recorded in the inventory of his house at the Tritone. Buried in the Pantheon.

**Corilla**, Olimpica: see **Morelli**, Maria Maddalena.

**Corsini**, Andrea, Cardinal (Rome 1735–1795 Rome). Son of Filippo di Bartolomeo (1706–1767). His education was the responsibility of G. G. Bottari, who appreciated the young man's determination and impartiality, then of his great-uncle Neri Corsini and P. F. Foggini; under their influence he became a perfect Jansenist and a leading light of the Archetto circle at the Lungara. Was in close contact with the Portuguese minister F. de Almada, and the Roman printer N. Pagliarini; supported the appointment (1780) of S. de Ricci as bishop of Prato and Pistoia. On the orders of Benedict XIV traveled throughout Europe, then returned to Rome. Made apostolic protonotary in 1758 and cardinal in 1759 (by Clement XIII, who had to compensate the family for the support of Neri Corsini in his election). Ordained in 1769, protector of England in 1773, he was given a considerable pension by the Portuguese, who desired his intervention with the pope in favor of the suppression of the Jesuits. Became a member of the special congregation that published the brief confining L. Ricci to Castel S. Angelo, and apportioning the assets of the Jesuits, thus becoming the target of threats. It is not known what his actual responsibility was toward Father L. Ricci, although he did everything he could to leave the implementation of the decisions to the secretary of state, Cardinal F. S. Zelada. As bishop of Sabina (1776) and cardinal of York, he devoted himself to pastoral work with great zeal. A strenuous defender of the power of jurisdiction of the pope over the whole of the Church, after the murder of Basseville, the Grand Duke of Tuscany asked him to request Pope Pius VI to reestablish diplomatic relations, but Pius remained opposed to this. On December 10, 1793, was appointed vicar-general for the diocese of Rome. Buried in the Corsini Chapel at St. John Lateran.

**Corsini**, Lorenzo: see **Clement XII**.

**Corsini**, Neri, Cardinal (Florence 1685–1770 Rome). Son of Filippo (1647–1705), brother of Clement XII. Assisted by his elder brother Bartolomeo, viceroy of Sicily, between 1709 and 1713, he traveled with the aim of making contacts in European diplomatic circles but also occupied himself with his family's commercial interests, continually writing letters to his cardinal uncle with news of the War of Spanish Succession and political and religious matters in France. Hoped to be entrusted with a diplomatic mission by the grand duke but only represented him (1716) on the accession of Louis XV to the throne. Before

1718 he wrote several papers on the right of the grand duke to choose the succession to the throne of Florence, and the liberty and independence of the grand duchy. Fought against Spanish interests by supporting the English. Returned to Italy in 1725, realizing that Gian Gastone de' Medici did not appreciate his work, and went to Rome as the secretary of his uncle, who in 1730 was elected pope as Clement XII, partly as a result of Neri's use of bribery and corruption. Made cardinal in 1730, protector of Ireland in 1737, of Portugal in 1739, and secretary of the Holy Office. Helped to appoint (1733) Cardinal Giuseppe Firrao as secretary of state, while retaining control of all government activity. Often ineffective, despite his political experience, De Brosses described him as "a man whose capacities were less than mediocre" (De Brosses 1977, vol. 2, p. 71). Was overwhelmed by the conflict between the religious interests of the state and the interests of his family, the War of Polish Succession, and by the breakdown in relations between Madrid and Naples (his brother Bartolomeo was a viceroy of Sicily). In the 1740 conclave was instrumental (with P. Guérin de Tencin and the French) in the election of Benedict XIV, whom he soon opposed. Carefully followed the problems of the Jansenists through his French contacts, and protégés and friends, such as G. G. Bottari, P. F. Foggini, and the entire Archetto circle in the Palazzo alla Lungara, purchased in 1736 from the Riario family and restored by F. Fuga; no expense was spared on the vast library inherited from his uncle in 1733, which, after enlargement, was opened to the public in 1754. Studied history and wrote poetry. His relations with Clement XIII were very poor, as he was considered protector of the Jansenists, though controlled by the Jesuit supporter Cardinal L. M. Torrigiani. Despite his fame, as secretary of state of the Holy Office, condemned *De l'esprit* by Helvétius, even the Lucca edition of the *Encyclopedia*. Buried in the magnificent Corsini Chapel, which he and his uncle Clement XII built in St. John Lateran.

**Corsini**, Ottavio: see **Clement XII**.

**Coscia**, Niccolò, Cardinal (Pietradefusi, Avellino 1681–1755 Naples). From a family of modest means, he was introduced to ecclesiastical life by the archbishop of Benevento, the future Benedict XIII. A papal dignitary in 1725, was made cardinal in the same year. Led the Beneventan clique, described by Montesquieu as nobodies who brought their influence to bear on a weak pope. Despite

protests, was a favorite of the pope, who spoke to him in Beneventan dialect and gave him money that C. had notoriously stolen. Certainly sold positions and livings, but was not alone in this, and with others was responsible for the indebtedness of the state and for negotiating with the Sicilian monarchy and the house of Savoy. When the pope fell ill in the summer of 1729, Coscia began to send "objects and pictures" to Benevento, and after February 1730, when chamberlain Annibale Albani forced the "Beneventans" out of the sacred palaces, fled from the furious crowds, seeking refuge in Cisterna with the Duke of Sermoneta. M. Caetani accompanied him to Rome, to take part in the conclave, but an anonymous pamphlet circulated, accusing Coscia of crimes ranging from murder, rape, and sodomy to usury. The newly elected Clement XII started legal proceedings against him, so he sought shelter in the kingdom of Naples, placing himself under the protection of the emperor. His movables and library, kept at Castel S. Angelo, were sold and he forfeited his livings. On returning to Rome in 1733 was condemned to ten years imprisonment in Castel S. Angelo, to excommunication, restitution of everything he had misappropriated, a fine of 100,000 ducats, and suspension from the conclaves. After so many humiliations, in 1734 the pope annulled his excommunication and restored his right to take part in conclaves. Participated in the conclave of 1740, which elected Benedict XIV, who restored all of his positions, except the diocese of Benevento. Retired to Naples, where he died, leaving houses and land to his brother, and furnishings in his chapel to various churches.

**Costanzi**, Giovanni Battista, *alias* Giovannino da Roma or Giovannino del Violoncello (Rome 1704–1778 Rome). Musician in the service of Cardinal Pietro Ottoboni. From 1755 was master of the Capella Giulia at the Vatican.

**Crescimbeni**, Giovan Mario (Macerata 1663–1728 Rome). Man of letters. Studied law at university; in 1679 moved to Rome. Attended the popular academies of the time (the Umoristi, Intracciati, and Infecondi). In 1690 was one of the fourteen founders of the Accademia dell'Arcadia, becoming the first custodian (1711) and taking the *alias* Alfesibeo Cario; his leadership of the Accademia was marred by ferocious arguments with G. V. Gravina, eventually won by Crescimbeni. Made canon in 1705 and dean of the basilica of S. Maria in Cosmedin in 1719; toward the end of his life entered the Society of Jesus. Conducted serious research into the history

of the Church, and was the author of pioneering works on Italian literary history, writing in a style that was sophisticated and worldly. Undoubtedly the savior of the Accademia dell'Arcadia.

**Cuccagni**, Luigi (Città di Castello 1740–1798 Rome). Prelate. Studied in Rome and, by virtue of his acquaintances with P. F. Foggini and M. Compagnoni Marefoschi, was appointed rector of the Collegio Irlandese in 1772, control of which had been removed from the Jesuits. In 1773 called Pietro Tamburini (Brescia 1737–1827 Pavia) to the college; Tamburini was an ardent Jansenist, but the two men soon fell out and Tamburni left Rome to teach in Pavia from 1778 to 1792. In the *Vita di S. Pietro principe degli apostoli* (1777, 1781) Cuccagni attempted to prove he was not pro-Jansenist, and published numerous documents in defense of the primacy of the pope over the universal Church. His religious "diplomacy" was based on compromise and dissimulation, and he even accepted the wordly ideals of Cardinal de Bernis. With the support of F. T. M. Mamachi, directed the weekly *Giornale Ecclesiastico di Roma*, which opposed the more radical periodicals of Florence and Pistoia. Assisted by the Holy See, the *Giornale* achieved a wide circulation, and regional editions were published in French (1787) and German (1788). His prudent stance was greatly undermined by the *Supplemento* to the *Giornale*, whose twice-monthly pamphlets were written by the Abbé Marchetti, and showed a marked preference for the Jesuits and violent opposition to the bishop of Pistoia, S. de' Ricci. The general political situation and the triumph of the French Revolution caused Cuccagni to be less tolerant of the independence of local churches; however, he did openly declare that the pope should concern himself less with territorial interests and concentrate on religion. (To rally popular support in defense of the Church, the *Giornale* even reported miracles.) Wrote that the Catholic Church was ready to support monarchies, as this religion was the most suitable for all forms of government. In 1798 the Collegio Irlandese was suppressed and on June 30 of the same year the last edition of the *Giornale Ecclesiastico* was published.

**Cuccovilla Pizzelli**, Maria (Rome 1735–1807 Rome). Patron of culture. Beautiful, erudite, with an interest in science, she held her literary salon in the Palazzo Bolognetti (later destroyed), frequented by scholars and poets such as R. Boscovich, A. Verri, and V. Alfieri.

**Cusanino, Il**: see **Carestini**, Giovanni.

**Doria Pamphili Landi**, Giuseppe, Cardinal (Genoa 1751–1816 Rome). Son of Prince Giovanni Andrea Doria and Eleonora Carafa d'Andria. In 1761 moved to Rome with his family, first studying with the Jesuits. As the Doria were Spanish grandees, when the Jesuits were expelled he completed his studies with the Somaschi Fathers, then at La Sapienza. Graduated in 1771, taking his vows in the same year. Traveled to Madrid as special nuncio to deliver the holy bands to the newborn infanta. Became bishop of Madrid in 1773 and went to Paris as nuncio. His diplomacy was tested during the conflict between France and Rome over Avignon, and the new French administration. In 1783 presented the holy bands sent by Pius VI to the son of Louis XVI, who bestowed on him the abbey of Gource in Lorraine (in Rome received the abbey of the Tre Fontane). Made cardinal in 1785 and returned to Rome. As legate to Urbino, he was instrumental in improving the state's economy and administration. On his return to Rome in 1794, he took a conciliatory attitude to France, but the counter-revolutionaries mocked him, calling him "le bref du Pape" on account of his small stature, and saying he was "smaller in intellect than in stature." (M. Formica, "Doria Pamphili Landi, Giuseppe," in DBI, vol. 20, p. 478). As secretary of state (1797–99), after the assassination of Duphot, he was forced to give Joseph Bonaparte permission to leave Rome, offending B. by his lack of support; under Berthier he celebrated a solemn *Te Deum* of thanksgiving with thirteen other cardinals for the French restoration of the freedom of the Roman people. Shortly afterward, however, he was arrested and exiled. He joined Pius VI in Siena, and went to Venice for the conclave. In 1800 accompanied Pius VII to Rome and thereafter actively sought to establish good relations with Napoleon and France. Buried in S. Cecilia a Trastevere.

**Dubois**, Guillaume (Brive-la-Gaillarde 1656–1723 Versailles). French minister and cardinal. Chamberlain for foreign affairs to the regent Philippe of Orléans, later foreign secretary from 1718 and prime minister in 1722. Intelligent and unscrupulous, in religion opposed Jansenism and supported the Roman Catholic Church. Made cardinal in 1721 by Innocent XIII; see also Annibale **Albani** and Pierre **Guérin de Tencin**.

**Duphot**, Léonard (Lyon 1769–1797 Rome). Soldier. Made a general after notable heroic service in Spain, he followed Napoleon to Italy in 1796, and in 1797 arrived in Rome, where Joseph Bonaparte was installed as ambassador of the French republic in the Palazzo Corsini alla Lungara. Eugenia Clary, the ambassador's sister-in-law, was his fiancée. When Bonaparte refused to give the Roman "patriots" protection, Duphot tried to calm the angry crowds but was killed by them before Porta Settimiana in Trastevere. On February 23, 1798, the former Scolopian Father F. Gagliuffi held a memorial service in St. Peter's Square. Eugenia Clary married General Bernadotte in 1798, becoming queen of Sweden.

**Falconieri**, Costanza (born Rome 1766). Aristocrat. Daughter of Mario and Giulia Mellini. Her marriage (1781) to L. Braschi Onesti, Duke of Nemi, was celebrated in the Sistine Chapel by Pius VI, the bridegroom's uncle. Though not particularly beautiful, she was elegant and ably represented in Roman society the family of this pope, who personally established the ceremonial for receptions at the Braschi residence. On the anniversary of the pope's election, Roman and foreign aristocrats and the ambassadors and members of the Sacro Collegio were obliged to pay homage to her; all the grandees and authorities who came to Rome had to pay her compliments. She also had the duty of providing gifts for births (such as the holy bands) and marriages of European royalty. The bands for the dauphin were displayed for eight days in the *floreria* in the apostolic palace so that people could admire the embroidery, decoration of pearls, and miniatures painted by Clémentine Subleyras. F. was recompensed with two bracelets bearing portraits of the king and queen, and a clock with the portrait of the dauphin surrounded by diamonds. Her *alias* in the Accademia dell'Arcadia, Egeria, symbolized beauty, while her husband was known as Aldemonte Cleoneo, symbolizing strength. As the family's poet-in-residence, V. Monti composed *La bellezza dell'universo* for her wedding and attended her salon (one of the most exclusive in Rome). Monti was believed to be her lover, and was possibly the father of some of her children. She continued to be a leading society hostess during the papacy of Pius VII.

**Falconieri Santacroce**, Giuliana (born Rome 1761) Sister of Costanza Falconieri: see **Bernis**, François-Joaquin de. A portrait of her by A. Kauffmann is in the Muzeum Narodowe, Warsaw. See also **Azara**, José Nicolás de.

**Fantuzzi**, Gaetano, Cardinal (Gualdo 1708–1778 Rome). From a patrician family from Ravenna, he received an erudite education in humanities, studying at Pisa and graduating in law at Ravenna (1730). On taking minor orders, moved to Rome and joined several academies, gaining an excellent reputation as a jurist. Appointed as a judge of the Rota for the city of Ferrara in 1743 and ordained in 1745, he became a cardinal in 1759 and in 1768 became titular cardinal of S. Pietro in Vincoli, where he is buried. Noteworthy because of his passion for studying and his spartan lifestyle, rare among Roman cardinals. An academy of law and theology was organized at his house. Although anti-Jesuit, he believed that the suppression of the Jesuits was the root cause of the misfortunes of the Church. A member of many congregations (Good Government, Bishops and Regulars, the Correction of Books of the Eastern Church, etc.). The first protector of the noble Collegio dei Drogheri della Città di Roma, and obtained the approval of its byelaws (1760) from Clement XIII. Took part in the 1769 and 1774–75 conclaves, and had good chances of election. The appointment of Cardinal Braschi as Pius VI upset him so much that he retired to his villa in Albano. A passionate scholar, was interested in science, numismatics, and musical instruments; grew herbs, and on recommendation of the canon from Pesaro G. A. Lazzarini, collected pictures from all periods. After his death, everything was moved from the villa at Albano to Gualdo (now the Villa Ginanni Fantuzzi), which, though destroyed during World War II with most of its contents (including the library and archives) has since been rebuilt.

**Fantuzzi**, Marco (Rome 1740–1806 Pesaro). Scholar. Educated in Ravenna, then Rome, and from 1754 lived at the house of his uncle Gaetano, where he met scholars and men of letters. Studied the history of Ravenna, and was especially interested in agriculture and hydraulics. On his return to Ravenna (1765) was given positions of responsibility, and hoped that Clement XIII would order a reorganization of the state. The election of Pius VI led to a further distancing from Rome: the pope ordered him to write the history of the Braschi family (*De Gente Honestia*, 1786) and appointed him superintendent-gen-

eral of finances and customs in Romagna, an honorary post that he held for ten years, and which enabled him to reestablish contacts with Rome and the Curia. In 1796, as general commissioner of the army of Romagna, he was in favor of negotiations with the French, aware of the army's total disorganization. Was ignored and after the defeat, though still governor of the province, took the exchequer and documents to Ancona, then Rome, and went into voluntary exile in Venice at the time of the Roman republic. Spent his final years writing *Memorie economiche e politiche* (1799–1800) and works on a variety of subjects (some of the manuscripts are at the villa in Gualdo).

**Farinelli**, nickname of the singer Carlo Broschi. See **Metastasio**, Pietro, and **Vinci**, Leonardo.

**Fea**, Carlo (Pigna, Nice, 1753–1836 Rome). Scholar. Came to Rome to study, first at the Collegio Romano, then at La Sapienza, and graduated in 1776. Ordained in 1781; also studied law. In 1783 Sigismondo Chigi appointed him assistant librarian to E. Q. Visconti; in the same year wrote *Progetto per una nuova edizione dell'architettura di Vitruvio*, followed by other projects, none of which was published. Soon became famous for his edition (praised by Goethe) of Winckelmann's *Storia delle arti del disegno presso gli antichi* (1783–84). Was the first to claim that the "barbarians" were not responsible for the destruction of ancient monuments in Rome, but that these should be attributed to natural disasters and neglect (following the transfer of the capital to Constantinople) and to the Renaissance. Before the Treaty of Tolentino (1797) wrote anti-French pamphlets, exhorted the Italians to prevent their works of art from being looted, and insisted that foreign powers should return everything they had removed. *Lo sperone d'oro al pattriotismo romano*, attributed to him, exhorts the Roman aristocracy to make financial restitution to the Papal States for the great benefices received. After the assassination of Duphot, and the arrival of Berthier, was obliged to seek shelter in Florence; on his return, was arrested several times: by the Neapolitan, French, and papal forces. During the restoration, became commissioner of antiquities (1801), a post he held until his death. Also succeeded Visconti (who had taken refuge in Paris) as president of the Museo Capitolino and prefect of the Chigi library. In 1802 a hand-written papal document banned the export of all archaeological finds from the Papal States (F. was the first to set export duties for old masters and sculptures). A founder member of the Accademia di Archeologia, he was responsible for many excavations and restorations, published his own and others' discoveries. Was the first to declare the *Diskobulos*, now at the Museo Nazionale Romano at the Palazzo Massimo, a Roman copy of the original by Myron.

**Felice**, Placido Bartolomeo de, *name in religion* Fortunato Bartolomeo (Rome 1723–1789 Yverdon). Scholar. Studied at the Collegio Romano with the Jesuits, then in Brescia with the reformed Friars Minor. Ordained in Rome (1746), was called to Naples by Celestino Galiani on a special mission to teach ancient and modern geography. Despite his great skill as a teacher, he was forced to leave Naples, having abducted Agnese Arquato, wife of Count Panzuti. On settling in Bern (1757), became a Protestant and was excommunicated. In Yverdon set up a printing house, publishing and disseminating the latest Italian and Swiss works to an international readership; in 1770–80 published a new edition of Diderot and d'Alembert's *Encyclopédie*, in which he rewrote the religious entries from the Protestant viewpoint. Corresponded frequently with Onorato **Caetani**.

**Ficoroni**, Francesco de' (Lugnano [now Labico] 1664–1747 Rome). Antiquarian and scholar. Expert in numismatics and author of many controversial works on archaeology, including *Osservazioni di F. de' Ficoroni sopra l'antichità di Roma pubblicato dal Padre d. Bernardo de Montfaucon* (1709), *Le memorie più singolari di Roma e le sue vicinanze* (1730), and *I piombi antichi* (1740). A great friend of Cardinal Alessandro Albani, he gave his collection of lead seals to the Museo di Antichità Cristiane. The Ficoroni cista, discovered at Lugnano in 1738 and donated by him to the Museo Kircheriano, is in the Museo Nazionale of Villa Giulia, and another part of his collection is kept at the Museo Nazionale in Naples. Described by English literature as a "guide" and "pope" of the antiquarians, always read to sell something to the English and sometimes falling foul of the law, he acted as agent for the Earl of Leicester and Lord Carlisle.

**Firrao**, Giuseppe, Cardinal (Castello di Luzzi Sila 1667–1744 Rome). Described by de Brosses as a skillful diplomat. Was made cardinal due to intervention by Cardinal Neri Corsini, secretary of state of Clement XII.

**Foggini**, Pier Francesco (Florence 1713–1783 Rome). Theologian and scholar. Son of sculptor Giovanni Battista Foggini. Graduated in Pisa and Florence, and began to write on theology and Tuscan antiquities. *De primis florentinorum apostolis* (1740) provoked immediate outrage, as it contested the popular tradition according to which Florentine saints were disciples of Saint Peter. His defense was to publish the early sources. In 1741 was invited by G. G. Bottari to visit him in Rome at the Palazzo Corsini and join the circle of Tuscans led by Cardinal Neri Corsini, who formed the lively Jansenist community of the Archetto. Opposed the beatification of R. Bellarmine (who only became a saint in 1930). Promoted the translation and publication of religious French literature, and as theologian to Cardinal Neri Corsini and his nephew Andrea, secretaries of the Holy Office, prepared the speeches for their congregation. Increasingly rigorist, he supported D. Concina in his writings (mostly anonymous) against the theater. As deputy custodian of the Vatican Library (1768), promoted the Italian translation of F. P. Mésenguy's catechism (Naples 1758–61), which was placed on the Index. However, his religious views on culture and life condemned both the French *parlement* (which wanted to expel the Jesuits) and the Lucca edition of the *Encyclopaedia*. After the expulsion of the Jesuits, became responsible for Father L. Ricci and the administration of the Collegio Irlandese, previously run by the Jesuits. Assisted Cardinal Andrea Corsini during a visit to his diocese of Sabina, which has remained exemplary in the annals of the Church. On becoming chief custodian of the Vatican Library in 1782, he retired. Supported Jansenist bishop of Prato and Pistoia, S. de Ricci, and urged him to moderation. Buried in S. Giovanni de' Fiorentini.

**Fonseca de Evora**, José Maria de (Evora 1690–1752 Oporto) Friar Minor. Came to Rome in 1712 with the Marques de Fontes. Energetic and cultivated, he took it upon himself to improve relations between the Church and Portugal, broken off after the refusal of Clement XI to make nuncio Vincenzo Bichi a cardinal, though this was done by Clement XII. Became ambassador in 1735 and stayed in Rome until 1741, the year of his appointment as bishop of Oporto. A dignitary of the Accademia Etrusca of Cortona, probably responsible for commissioning Italian artists (including A. Masucci, F. Trevisani) for work at Mafra and Portuguese artists for work in Rome, in particular the ephemeral decorations at the church of S. Maria in Aracoeli, of which he

was titular, and in which he restored the Savelli Chapel (with an altarpiece by Trevisani), later consecrated by Benedict XIII, and commissioned splendid decorations for the canonization of Saint Margaret of Cortona. Responsible for Franciscan churches, in particular the church and monastery of Palazzola, where he laid out the magnificent gardens round the Lake Albano (subsequently destroyed by English religious in favor of the Gothic Revival). A great friend of the Corsini family (he appears in a conversation piece with Neri Corsini, Clement XII, M. Passeri, and Cardinal A. F. Gentili by A. Masucci; Biblioteca Nazionale, Rome); built a magnificent library at Aracoeli, destroyed when the monument to Victor Emanuel II was erected. There is a portrait bust by C. Monaldi at the Collegio Romano and others at the Portuguese Istituto di S. Antonio.

**Fontes**, Rodrigo Anes de Sá e Meneses (Lisbon 1676–1733 Lisbon), Marques (later Marques de Abrantes). Portuguese ambassador, political and artistic advisor to John V, special ambassador in Rome in the entourage of J. M. de Fonseca de Evora.

**Fornari**, Matteo. Musician: see **Corelli**, Arcangelo.

**Foscarini**, Marco. Venetian ambassador in Rome. F. Benaglio was his protégé.

**Furnese**, Robert (1687–1733). Antiquarian. In Rome in 1706 purchased paintings from F. Ficoroni for 2,000 *scudi*. Also acquired engravings and three statues by Soldani in Florence. In 1758 a Furnese sale of old masters included works by Guido Reni and Carlo Maratti.

**Gabrielli**, Caterina (Rome 1730–1796 Rome). Singer. The daughter of a cook, hence her nickname, *La Cochetta*; she was the most famous singer of the second half of the eighteenth century. Made her debut in Lucca in 1747, and performed in all the European courts; was much admired by Parini and invited by Metastasio to Vienna, becoming chief singer at court. Protégé of Agnese Colonna, wife of Camillo Borghese, with whom she had a rich correspondence.

**Gagliuffi**, Marco Faustino (Ragusa 1765–1834 Novi Ligure). Scolopian brother. In 1784 was admitted to Arcadia as Chelinto Epirotico; on February 23, 1798, commemmorated the death of L. Duphot in St. Peter's Square; during the Roman republic participated in the National Institute and Tribunate. From 1801 was in Paris, then returned to Genoa. Main activity was printing. See also **Berthier**, L. A.

**Ganganelli**, Giovan Vincenzo Antonio: see **Clement XIV**.

**Gentili**, Antonio Saverio, Cardinal (Rome 1680–1753 Rome). Great-uncle of Margherita Sparapani Gentili Boccapaduli**,** who appears in a conversation piece with Fonseca de Evora, Neri Corsini, Clement XII, and M. Passeri.

**Gherardi Cheruffini**, Francesca (1709–1778). Countess. In 1733 married Count Ranuccio Cheruffini (died 1757); mistress of Alessandro Albani, held a literary salon popular with the English providing concerts and musical entertainment (also mentioned by G. Casanova) at the palazzo Rondanini on the Corso, in the piazza della Pilotta, and in the former Palazzo Orsini at Monte Giordano.

**Giannone**, Pietro (Ischitella, Foggia 1676–1748 Turin). Historian. Studied in Naples and became known for works such as *Istoria civile del regno di Napoli* (1723) and *Triregno* (published posthumously in 1895). Fought courageously for independence of the lay state and against abuse by ecclesiastical authorities. Was persecuted for his ideas and forced to leave Naples, and later Vienna, where he had taken refuge. Arrested by Piedmontese authorities in 1736, died in jail (during imprisonment wrote *Vita scritta da lui medesimo*); see **Benedict XIII** and **Clement XII**.

**Gigli**, Girolamo (Siena 1660–1722 Rome). Author and playwright. Published criticism and satire about the Florentine Accademia della Crusca; on losing his post as reader of "Florentine language" in Siena, settled in Rome, working as tutor to the Ruspoli family. His best-known works are: *Vocabolario caterini-ano* (1707), *Don Pilone* (1711), and *La sorellina di Don Pilone* (1719). Also wrote libretti for operas; see **Scarlatti**, Domenico.

**Gonzaga**, Luigi (1745–1819). Prince: see **Morelli**, Maria Maddalena.

**Grant**, Peter (Moray 1708–1784 Rome). Scottish Jesuit and antiquarian. From the 1730s, with Jenkins and Byres, acted as guide to English visitors; showed them works of art, introduced them to important people, and sold them works of art, sometimes illegally. Was considered a traitor to his own country, as he was in the service of the Stuarts; was obliging and useful, in the absence of an English ambassador to Rome, acting as a spy and in other dubious capacities.

**Gravina**, Gian Vincenzo (Roggiano, Cosenza 1664–1718 Rome). Man of letters. Settled in Rome in 1689, and acted as agent for Cardinal Francesco Pignatelli; the following year was one of the founders of the Accademia dell'Arcadia. Taught canon and civil law at La Sapienza and published several books on these subjects. A great scholar of Dante, he also wrote poetry and many tragedies. Opposed Jesuit morals and casuistry; defended Cartesianism and asserted that the rules for poetry should be "reasonable," not imposed by tradition, a stance that made him many enemies among scholars and the clergy. On the appointment of Crescimbeni in 1711 as chief custodian of the Accademia dell'Arcadia, accused him of reducing the academy to "delighting in fatuous and affected pastoral poetry," (quoted in N. Merola, "Crescimbeni, Giovan Mario," in DBI, vol. 30, p. 675), which resulted in a serious division in the academy. Lost his battle with Crescimbeni, as the Curia did not intend to adopt a more austere policy, and looked favorably on refined entertainment. His *Ragion poetica* (1708), a bible of Neoclassicism, was translated into all the European languages. Also wrote *Regolamento degli studi di nobile e valorosa donna* and was interested in a wide range of subjects, with the exception of natural sciences. Pietro Metastasio was his protégé and heir.

**Guattani**, Giuseppe Antonio (Rome 1748–1830 Rome). Archaeologist and scholar. Son of Carlo (1709–1773), famous surgeon of the Ospedale di Spirito Santo in Rome. Was prefect and secretary of the Pontificia Accademia di Archeologia, also of the Accademia di S. Luca, superintendent of archaeology and antiquarian to Augustus III of Poland. A prolific writer, his publications include the seven volumes of *Monumenti antichi e inediti* (1784–89), complementing

work by Winckelmann, and the eighth and last volume of the *Museo Pio-Clementino descritto* (1808).

**Guérin de Tencin**, Pierre, Cardinal (Grenoble 1679–1758 Lyon). Thanks to his sister Mme. de Tencin, mistress of the minister G. Dubois, he quickly made his fortune. In 1721 was the conclavist of Cardinal de Bissy and *chargé d'affaires* of France; until 1724 archbishop of Embrun; from 1724 to 1726 French ambassador in Rome. A cardinal in 1739, in Lyon in 1740, and a minister of state in 1742, he left the court in 1751. Was a favorite of Benedict XIV, who wrote to him, without realizing that his letters were being sent immediately to Paris; their correspondence is fundamental for an understanding of the eighteenth century. According to De Brosses, he was very hospitable, in fact, he and P. H. de Saint-Aignan, French ambassador to Rome (1732–40), were "the only great lords of Rome" (De Brosses 1977, vol. 2, p. 73, which also describes his clothes, and the excellent French wines at his table). In *Letter LIV* De Brosses reported that he "carried the Holy Spirit in his pocket" (De Brosses 1977, vol. 2, p. 55). Was very influential in the conclave, and on the death of Clement XII, had already decided who the next pope would be. There is a caricature by P. L. Ghezzi.

**Guglielmi**, Pietro Alessandro (Massa 1728–1804 Rome). Composer, son of the Maestro di Capella of A. Cybo, Duke of Massa. Studied in Naples, where he performed his first known work, *Don Chichibio*, in 1737. Had already performed his works in Rome, at the Teatro Capranica in 1759 and the Tor di Nona in 1762, when he was commissioned to compose *Tito Manlio* in 1763 for the Teatro Argentina. Also visited Venice, Turin, Milan, and London (1772); in Naples from 1776 to 1793. A dispute with G. Paisiello and D. Cimarosa was so violent that the king had to intervene. From 1793 was Maestro di Capella at St. Peter's and S. Lorenzo in Lucina. Member of numerous institutes and academies, he wrote a dozen comic operas which gained international success and were part of the repertoires for several decades, also two oratorios, *Morte di Oloferne*, and *Debora e Sisara*, the performance of which in 1798 at the Teatro Argentina was halted because it was feared it could be considered anti-French.

**Innocent XIII**, Pope (Poli 1655–1724 Rome). Born Michelangelo Conti. Nuncio first in Switzerland (1695–98), then Lisbon (1698–1710), where he arranged the marriage of King John V of Portugal and Maria Anna of Austria in 1708. His reports on the court of King Peter II of Portugal and the coronation of John V are most revealing. Created cardinal in 1706, was protector of Portugal (1709–12). Succeeded Clement XI in 1721. Attempted to appease Spain, and in 1723 absolved Cardinal Alberoni, which Clement XI had refused to do, and invested Charles VI with Naples and Sicily, gaining the approbation of the Chinea but not a concordat. Also appeased the French court by appointing G. Dubois cardinal in 1721 and condemning the pro-Jansenist cardinals. However, afforded no special protection to the Jesuits (though appreciating the Chinese rites). Totally honest and energetic, he was also "serious and majestic, magnificent, with great respect for the dignity of his office; he was also extremely fat, which resulted in awkwardness" (Moroni, 1840–61, vol. 97, p. 193). Moroni described the "summer holidays" of this pope in the Villa Catena of the Conti family in Poli (Moroni 1840–61, vol. 97, p. 194). During his papacy the administration of the Papal States was particularly enlightened.

**Jenkins**, Thomas (Devon 1721–1798 Yarmouth). Painter and antiquarian. Went to Italy in 1751 with Richard Wilson to study painting; visited Venice, Bologna, Florence, and Rome, where he settled before 1763 (in 1761 became a member of the Accademia di S. Luca). His commercial activities are better documented than his painting; was such a good businessman that, according to contemporaries, he was the richest and most influential person among the British in Rome in the second half of the eighteenth century. His lifestyle on the Corso was lavish, and equally magnificent was his villa at Mondragone a Castel Gandolfo from 1775, where he was visited by Goethe. Offered hospitality not only to English painters staying in Rome (who often accused him of wanting to ruin them) but also to aristocrats, whom he introduced into Roman society (was also considered a government spy against the Jacobites); poached clients from Peter Grant and James Byres. Wrote to London, providing detailed descriptions of archaeological finds, and promoting his interests with visitors. Suggested that Winckelmann be admitted to the Society of Antiquaries; the latter in turn proposed J. as an agent for the sale of the collection of precious stones belonging to Philipp von Stosch in 1763. Considered a favorite of Clement XIV, whom he described as a patron of archaeological excavations; handled the sale of important collections (Villa Mattei, Villa d'Este, Villa Montalto-Negroni). Employed restorers such as Carlo Albacini, pupil of Cavaceppi, and Lorenzo Cardelli, both of whom helped to "discover" archaeological finds: the so-called Jenkins Vase (National Museum of Wales, Cardiff) was probably a wellhead from the Carafa collection in Naples. Also a great friend of Batoni and Mengs. Even founded a bank. His clients included Angelika Kauffmann, who painted a portrait of him with his niece Anne Marie (National Portrait Gallery, London) and bought a carriage from him. The *Raccolta di disegni di vari autori incisi da artisti diversi* was dedicated to him in 1764, and in 1775 *La véritable guide des voyageurs en Italie* was published. The political situation forced him to leave Rome in 1798, and he died shortly after returning to Britain. Portraits by von Maron (1791), and by Richard Wilson (Pierpont Morgan Library, New York).

**John V**, King of Portugal (Lisbon 1689–1750 Lisbon). Son of Peter II. Never visited Rome, but his desire for the court of Lisbon to equal, if not outdo the court of Rome, led him to spend vast amounts of money. Believing that America had been discovered by the grace of God, thought it fitting to send gold from Brazil to Rome. On his death, entire rooms at the palace of Terreiro do Paço were found to be full of models of Roman churches and palaces, maps, drawings, engravings of façades, obelisks, and triumphal arches. An absolute monarch, he invited many Italian artists to Portugal, and collected Italian works of art. Also financed refurbishing of Roman buildings; his piety was matched by his love of the spectacular (such as the statues for St. John Lateran, the renovation of S. Antonio dei Portoghesi, and elaborate ephemera made by the most famous artists of the day). A connoisseur of refined taste, he greatly appreciated music (Niccolò Jommelli, dedicated an opera and a mass to him; Domenico Scarlatti was his court musician). Also collected Roman antiquities and rare objects. The close contacts between his family and the Jesuits are reflected in the floors of the church of the Gesù in Rome (2,000 *scudi*) and the improvements to S. Roque in Lisbon. The plans for the chapel of St. John the Baptist, drawn up by the leading Roman artists of the time (Luigi Vanvitelli, N. Salvi, A. Masucci), were kept at the house of Alessandro Gregorio Capponi so the pope could bless them. His protégés among the Roman artists included Carlo Fontana, whom Peter II had made knight commander of the order of Christ. The splendor and expense of the convent and church of Mafra (the plan is a copy of

S. Ignazio in Rome) were famous throughout Europe. Spent 4,000 *scudi* on the Bosco Parrasio in Rome and the plan by G. Canevari for the new seat of the Accademia dell'Arcadia, which was opened in 1726 (Ghezzi immortalized him as patron of the Accademia, of which he was *pastore* from 1721, inheriting the *alias* Arete Melleo from Clement XI). His agents and ambassadors spared no expense to glorify him, and after 1748 he received the title of Rei Fidelissimo. F. Vieira made drawings of the arrival of the ambassador De Fontes in 1716, accompanied by Carlos Gimac; Gimac was scene painter, designer of carriages, architect, poet, and scholar, who described religious and civic buildings of Rome in his diary. De Fontes, later Marques de Abrantes, lived in such splendor in Rome that even the court in Lisbon complained. In 1731, when the former nuncio V. Bichi was made cardinal by Clement XII, the king offered him 25,000 *cruzados* for a majestic entry into Rome.

**Jommelli**, Niccolò (Aversa 1714–1774 Naples). Composer. Began his career in Naples as Maestro di Capella for the Duke of Avalos. His operas were performed all over Europe and in Rome his *Ricimero re de' Goti* (1740) and *Astianatte* (1741) were successful; also composed music for Cardinal de la Rochefoucauld in honor of the marriage of the dauphin to Maria Josepha of Saxony (1747). Between 1750 and 1753 was assistant at the Capella Pontificia and a member of the Accademica di S. Cecilia. Settled at the court of Stuttgart as Kapellmeister for Karl Eugen of Württemberg, and composed his best works here. Returned to Italy in 1769, but found his music unappreciated, so concentrated on religious music, composing his famous *Miserere* for two voices and orchestra. Gave great importance to dramatic and theatrical expression, and was one the best interpreters of poetry by Metastasio, whom he had met in Vienna in 1749. His music was innovative and an important contribution to the development of serious Neapolitan opera, combining the harmony of J. A. Hasse with grace and elegance. A painting by G. P. Panini at the Louvre shows the interior of the Argentina during a performance on July 15, 1747, of a cantata by J. with libretto by F. Scarselli and sets by G. Panini.

**Labre**, Benoît-Joseph, Saint (Amettes, Pas-de-Calais, 1748–1783 Rome). Anchorite. Eldest of fifteen children of poor country peddlers, was taught Latin by his uncle, a clergyman. At sixteen decided to become a Trappist, but was refused by various monasteries, on the grounds of mental instability. In 1770 left for Italy, believing that on his journey he would find the solitude denied him by the monasteries. A holy vagabond, he deliberately cultivated his lack of cleanliness, and lived in the open, wearing a ragged tunic, a novice's scapular, and carrying a sack that contained the *Imitation of Christ*, the New Testament, and the Breviary. Visited Loreto, Assisi, Naples, and Bari several times, also Einsiedeln and Santiago di Compostela. From 1777 lived in Rome on charity, and devoted himself to the most popular religious rites (the Via Crucis, the forty hours' devotion, the Sacred Heart). This earned him the disapproval of Giovanni Cristofano Amaduzzi, who called him "a devout lice-infested sluggard," while the French Jansenists considered him the antithesis of worldly pomp and ceremony. The house he died in is now the Centro Pro Sanctitate, with a sanctuary and reliquaries, next to the Madonna dei Monti, where he is buried. His fame grew after his death and prophesies were attributed to him, though these occurred after the events in question. Canonized in 1881. Portrait by A. Cavallucci (Museum of Fine Arts, Boston).

**Lambertini**, Prospero: see **Benedict XIV**.

**Leonardo da Porto Maurizio**, Saint (Porto Maurizio [now Imperia] 1676–1751 Rome). Born Paolo Girolamo Casanova. Attended the Collegio Romano from the age of twelve, then the oratories of the Caravita and Filippini in the city. Became a friar minor in 1697 at Ponticelli (Rieti) and took the name of Fra' Leonardo, soon entering the retreat of Beato Bonaventure on the Palatine. Ordained in 1702 and responsible for teaching philosophy and preaching missions in Italy; renovated and founded many retreats, and preached complete seclusion. The missions he taught (339 are recorded) were in the Papal States, the grand duchy of Tuscany, the republic of Genoa, and the kingdom of Naples; all were preceded by elaborate preparation, lasting fifteen to eighteen days, followed by a week in which he devoted himself to confessions. Promoted the placement of the monogram of Christ on house doors, and was so devoted to the Via Crucis that permission was given for them to be set up in non-Franciscan churches: that erected at the Colosseum in 1750 (subsequently destroyed) was paid for by Benedict XIV, who also approved of the Confraternità di Gesù e Maria, for which Leonardo was responsible. Writings reveal his knowledge of doctrine, as well as his great piety and fervor; believed in the exercise of the three theological virtues, to inform the mind, the memory, and the will, and opposed sentiment. Benedict XIV approved highly of him, as did the Duc de Saint-Aignan, the French ambassador in Rome, who had a copy made by his jeweler of the crucifix this Franciscan wore round his neck, and asked Subleyras to paint a portrait of the reclusive friar (Saint-Aignan returned to France with three portraits). Beatified in 1796 and canonized in 1867.

**Lepri**, Amanzio. Nobleman. His inheritance was shared by his grand-daughter Marianna with Luigi Braschi Onesti.

**Lepri**, Giuseppe: see **Albani**, Alessandro.

**Luci Benloch**, Cassandra: see **Poniatowski**, Stanislas.

**Mamachi**, Tommaso Maria. Erudite Dominican. Also librarian and theologian at the Biblioteca Casanatense, secretary of the Index, Master of the Sacred Palace. Supported the appointment of L. Cuccagni as editor of the *Giornale Ecclesiastico* of Rome.

**Manfredi**, Eustachio (Bologna 1674–1739 Bologna). Scientist. Also poet (member of the Bolognese branch of Arcadia); see also **Bianchini**, F., **Bottari**, G. G., and **Maratti**, F.

**Maratti**, Faustina (Rome c. 1680–1745 Rome). Poet. Daughter of Carlo Maratti. A noted beauty, she married the poet G. F. Zappi (Imola 1667–1719 Rome), who dedicated many poems to her. A member of the Accademia dell'Arcadi, her *alias* was Aglauro Cidonia. From 1704 she celebrated the heroines of ancient Rome in her verse, trying to raise the profile of women from "precious" to "heroic." In Volume 3 of the *Prose degli Arcadi* (1718) she ended a dispute between Petronilla Paolini Massimi and Prudenza Gabrielli Capizzucchi, by asserting the superiority of platonic love. The salon she held at her house was attended by famous Arcadians, and also by many devoted admirers, such as scholar P. J. Martello, scientist E. Manfredi, and composer A. Corelli. Much of her poetry alludes to an attempt by Giangiorgio Sforza Cesarini to abduct her. Portrait by Carlo Maratti (Galleria Nazionale d'Arte Antica, Rome).

**Marefoschi**, Prospero, Cardinal:
see **Compagnoni Marefoschi**, Mario.

**Maria Casimira**, Queen of Poland
(c. 1641–1716 Blois). Daughter of Henri de la
Grange d'Arquien, she went to Poland in the
entourage of Maria Luisa Gonzaga, wife of
Ladislaw IV. In 1658 married Jan Zamojski;
after his death married John III Sobieski, King
of Poland (1674), and after his death (1696) left
Poland. An account of her journey to Rome,
where she arrived in March 1699, was written
by A. Bassani and dedicated to Carlo Barberini,
protector of Poland. In Rome on the occasion
of the 1700 jubilee, she was accompanied by
her father, who, despite his age, had been cre-
ated cardinal in 1695. Was joined by her sons
Giacomo (later father of Maria Clementina
Sobieska), Costantino, and Alessandro.
Alessandro died in Rome in 1714 and was
buried in the Capuchin church of S. Maria
della Concezione e Morte in via Veneto. There
is a monument to him by C. Rusconi in the
church, also a portrait of him dressed as a
Capuchin (the sumptuous ornaments and
vestments in the church on the occasion of
his funeral were paid for by Clement XI, and
appear in an engraving by Alessandro
Specchi). Roman chronicles of the time
record the presence of mother and sons at
religious ceremonies, and of her sons in bois-
terous society gatherings. In December 1700
the young men received the Cordon Bleu of
the order of the Saint-Esprit from Louis XV in
the church of S. Luigi dei Francesi, followed
by a reception in the Palazzo di Spagna.
Initially they lived in the Palazzo Odescalchi
in the Piazza Ss. Apostoli, then at the Palazzo
Zuccari (now the Bibliotheca Hertziana); this
building still bears the family's arms on the
*tempietto–loggia*, attributed to Juvarra, built
around 1711 (in 1702 it had a wooden bridge
built to link the Palazzo Zuccari with the
Villa Torres on via Felice-Sistina, where M.'s
father lived). "I was born a simple hen of a
cockerel/I lived among the chickens and then
as queen/I came to Rome a Christian, not
Christina" (Valesio [1770] 1977–79, vol. 4,
p. 428). This pasquinade reveals the disap-
pointment of the Romans with this queen,
who they believed could not compare to
Christina of Sweden. Nevertheless, she was a
*pastora* in the Accademia dell'Arcadia, taking
the *alias* Amerisca Talea in 1710. Her secretary
was C. S. Capeci whose *alias* was Metisto
Olbiano. She also had a theater built at the
Palazzo Zuccari, where her son Alessandro
(an Arcadian from 1709) worked with Juvarra
on the sets for the melodramas by Capeci, set
to music by Domenico Scarlatti (many
designs and twenty sketches are kept at the

Biblioteca Nazionale, Turin). Also put on
plays at the Teatro Capranica. Was awarded
the Golden Rose by Innocent XII, and was
very charitable. Her Christian devotion can
be seen in her relations with Poland; she
brought nuns of the Adoration of the
Sacrament to Rome, donated the body of
Saint Justine to the Capuchins of Monceau,
and in 1705 went to Naples for the miracle of
Saint Januarius. In 1714, settled in France
brought there in a papal galley. The church of
SS. Nome di Maria, built in 1738, was to be the
seat of the archconfraternity, and was used to
celebrate the victory over the Turks and the
liberation of Vienna by John Sobieski. This
church was also used for the funerals of those
who had died in these wars and to celebrate
the victory of the Battle of Lepanto.

**Martello**, Pier Jacopo (Bologna 1665–1727
Bologna). Man of letters. In Rome between
1708 and 1718. Arcadian and author of the
*Canzoniere* (1710), tragedies, comedies, and
various critical works. In Rome frequented
literary salons, including the one held by
F. Maratti.

**Medici d'Ottaviano**, Maria Giovanna:
see **Chigi**, Sigismondo.

**Mello e Castro,** André. Portuguese
ambassador of John V. In Rome between
1707 and 1728.

**Metastasio**, Pietro (Rome 1698–1782 Vienna).
Poet. Son of Felice Trapassi, a soldier in the
papal army. Godson of Cardinal Ottoboni.
From 1710 was the protégé of Gian Vincenzo
Gravina, who gave him his Greek surname,
was responsible for his literary and philo-
sophical education, adopted him, and left him
(1718) his Roman estate, including an impor-
tant library. In 1717, after taking minor orders,
he published his first poetry. His début was
almost certainly in the serenade *Angelica e
Medoro* to music by N. Porpora, sung by the
young Farinelli; a lasting friendship devel-
oped between the two, and the many letters
they wrote to each other over a lifetime allude
to themselves as "twins," with similar des-
tinies. Joined Accademia dell'Arcadia as
Martino Corsario in 1718. He settled in Naples
after Gravina's death in 1718. In Naples aban-
doned the scholarly circles he had been intro-
duced to by Gravina, in favor of the company
of poets, singers, and actors. Wrote the words
to the *Orti alle Esperidi*, a cantata to music by
Porpora which, it is reported, was sung by

M. A. Benti in 1721, for the birthday celebra-
tions of Elisabetta Farnese, wife of Philip V,
organized by the viceroy of Naples,
Marcantonio III Borghese. From then on,
an intense artistic collaboration and a close
friendship developed between him and Benti.
In 1730 settled in Vienna, and became court
poet; was the protégé of Marianna Pignatelli
(widow of Conte d'Althan and lady-in-waiting
to the empress), who died in 1755; an uncon-
firmed rumor suggested that they were secretly
married. Died at the house of Giuseppe and
Marianna Martinez, who had been a pupil of
Benti's and, according to Stendhal, "knew full
well how the human voice could win hearts"
(Stendhal, *Vies de Haydn, de Mozart, et de
Métastase*, [1814 Paris: Le Divan, 1928]). Is con-
sidered the father of Italian melodrama. His
*canzonette* are perfect examples of eighteenth-
century Italian literature, and his works
were—according to *Letter LI* of De Brosses—
"pleines d'esprit," rich in interesting features
and situations, and *coups-de-scène* (De Brosses
1977, vol. 2, p. 302). According to Stendhal, his
verse, accompanied by music written by the
greatest contemporary composers (such as
Hasse, Mozart, Cimarosa, and Pergolesi) were
perfect in clarity and purity of thought and,
although totally naturalistic, kept the sad real-
ities of life at bay. The simple language,
respect for poetry, balance of music and verse,
combination of heroic and lyrical style, and
the elegance and decorum of the dialogues
pleased both Leopardi and Rossini. The cere-
mony in Arcadia mourning his death includ-
ed such diverse and international figures as
A. Kauffmann, G. B. Piranesi, G. Hamilton,
J. H. W. Tischbein, J. Zoega, and V. Altieri.

**Morelli**, Maria Maddalena (Pistoia 1727–1800
Florence). Poet. Her Accademia dell'Arcadia
*alias* was Corilla Olimpica. Was court poet
(1765–75) to the Grand Duke of Tuscany and
crowned at the Capitol in 1776, after sunset
so as not to cause scorn and anger among
the people, though this did occur, as she was
considered an enemy of the Jesuits and the
opposing faction wished to bring its influence
to bear on Pius VI. At this time, her lover and
patron was the young prince Luigi Gonzaga,
who persuaded the senate to raise her to the
Roman nobility. The *Atti della incoronozaione di
Corilla Olimpica* and all the poetry written for
the occasion (except for the pasquinades)
were published by the printer G. B. Bodoni.
Was the mistress of princes and clergymen,
visited several courts, and was expelled from
a number of cities but her improvised recita-
tions, with her hair flowing loose, her eyes

raised to the heavens, and her pleasant voice, attracted the public. There is a portrait bust by Christopher Hewetson.

**Morison**, Colin (1732–1810 Rome). Scottish painter and antiquarian. Came to Rome in 1754 to study drawing at the school of Mengs, turned to sculpture, and in 1778 declared he wished to become an antiquarian. Competed with James Byres, Thomas Jenkins, and Peter Grant for the title of *cicerone* of Rome. His contemporaries considered him "learned, accurate and ingenious," with "such a prodigious quantity of body that it would require at least two souls to animate it" (Ingamells 1997, pp. 679–80). Among the many celebrities he conducted on guided tours of Rome was James Boswell, who followed the course with such intensity that he "began to speak Latin" without noticing (Ingamells 1997, p. 680). There are many records of requests for him to give his professional opinion on paintings and classical sculptures, which he often restored.

**Odescalchi**, Flaminia: see **Chigi**, Sigismondo.

**Orsini**, Giacinta (Naples 1741–1759 Rome). Poet. Daughter of Domenico, Duke of Gravina, and Paola Erba Odescalchi. In 1757 married Antonio Boncompagni Ludovisi (Rome 1735–1805 Rome) and her dowry was so great that Benedict XIV had to make an exception to the bull of Sixtus V, which prohibited excessively large dowries. A member of the Accademia dell'Arcadia, with the *alias* Euridice Aiacense, was sorely missed by her fellow Arcadians after her early death in childbirth. Beautiful and intelligent; Goldoni, who was her guest, dedicated his *Vedova spiritosa* to her. When Mme. du Boccage, a poet known to the Arcadians by her *alias* Doriclea, addressed her as the goddess of Rome, she replied "The Romans have always taken their gods from foreigners." Her poetry is collected in the *Rime degli Arcadi*.

**Orsini**, Domenico. Duke of Tolfa. See **Benedict XIII**.

**Orsini**, Pier Francesco: see **Benedict XIII**.

**Ottoboni**, Pietro, Cardinal (Venice 1667–1740 Rome). Son of the scholar Antonio di Agostino and great-nephew of Pope Alexander VIII, who appointed him cardinal in 1689. In 1710 made protector of France by Louis XIV, which caused relations between Venice and France to be broken off until 1720. Not ordained until 1724; in 1738 was appointed bishop of Ostia. Died during the conclave that elected Benedict XIV. A magnificent patron of the arts and literature, his great library (of which Francesco Bianchini was librarian) was acquired by the Vatican Library. His grandiosity is demonstrated by the works commissioned by him, which include the sepulcher of his great-uncle in St. Peter's (1706–15), designed by C. A. di San Martino, and the refurbishing of S. Lorenzo in Damaso and the Palazzo della Cancelleria, where he lived with his erudite court. Virginio Spada was his majordomo and *maestro di camera*. Godfather to Metastasio, friend of Corelli, and protector of the Congregazione di S. Cecilia. Often held musical and theatrical evenings (in 1709–10 Juvarra built a theater on the second floor of his residence). For the birth of the dauphin in 1729, in competition with Cardinal de Polignac, ordered a performance of *Carlo Magno*, a drama that he had written to music by G. B. Costanzi, a composer and cellist in his service from 1725. Despite reputedly fathering over sixty illegitimate children (according to Montesquieu), he was the last of his line. The daughter of his brother Marco, Maria Francesca, was his sole heir; she married Pier Gregorio Boncompagni, the first Ottoboni duke of Fiano.

**Pagliarini**. Family of Roman printers, the most notable members being Nicola and Pietro; see **Belloni**; **Bottari**, G. G., and **Corsini**, A.

**Pamphili**, Benedetto, Cardinal (1653–1730). Patron of the arts; see **Corelli**, A.

**Paolini Massimi**, Petronilla (Tagliacozzo 1663–1726 Rome). Poet. Became wife of the Marchese Francesco Massimi at age ten. Deserted her old and brutal husband to enter a convent and pursue her studies. Called "the poetess of Rome," she composed sacred oratories and drama set to music; was praised by G. Crescembeni, L. A. Muratori, and F. Maratti.

**Paul of the Cross**, Saint (Ovada 1694–1775 Rome). Born Paolo Francesco Danei. Of noble origin, from childhood he exhibited a passion for Jesus on the cross, and renounced his inheritance to devote himself to this vocation, inspired by mystic visions. Founded the Congregazione dei Passionisti, officially approved by Benedict XIV in 1746. Excellent preacher; considered one of the greatest miracle workers of his time. Clement XIV was very fond of him. At the time of his death, in the retreat of Ss. Giovanni e Paolo in Rome, the congregation (which, from 1770 also accepted communities of nuns) had twelve monasteries in Italy and quickly spread worldwide. Canonized in 1867.

**Parker**, Mark (Florence 1698–1775 Paris). Antiquarian. Son of an English *intendente* in Florence and a German Catholic mother, he served in the papal navy; his daughter Virginia Cecilia (born Rome 1728) married the French artist J. Vernet in Rome (1745). Was known as an antiquarian and had fine collections in his houses in Florence and Rome, such as the one at the Villa Cybo. Considered a spy for the British government, in 1749 the Inquisition forced him to leave Rome. From 1754 lived in France with his daughter and son-in-law. There is a portrait in the Akademie der Bildenden Künste, Vienna.

**Passionei**, Domenico, Cardinal (Fossombrone 1682–1761 Rome). Studied in Rome from 1694 at the Collegio Clementino and chose a diplomatic career in Paris (1706), where he was in contact with men of letters and scientists, and frequented Jansenist circles. A representative of the pope at Utrecht (1712–13), nuncio in Switzerland (1721) and Vienna (1730), in 1738 was appointed secretary of briefs and cardinal. From 1741 was protolibrarian and prefect of the Vatican Library. Rustic appearance and brusque manner belied his intelligence and culture. As well as his official residence at the Palazzo della Consulta, had a splendid mansion at S. Bernardo alle Terme. According to Winckelmann, his library was one of the greatest in Rome; in 1763 it was purchased by the Augustinians with the help of Clement XIII and is now part of the Biblioteca Angelica. His collection of engravings is now in the Albertina in Vienna, and his medals at the Museo Pio-Clementino; part of his collection of classical sculpture was sold to antiquarians, but some pieces found their way into museums (Vatican Museums, British Museum and Sir John Soane's Museum, London). From 1736 began to visit the hermitage of the Camaldoli (Frascati) which, at the time of Paul V, was already a favorite retreat for privileged persons; gathered an "army" of artists and craftsmen to carry out the decorations (F. Fuga, P. L. Ghezzi, I. Heldmann) and collected valuable sculptures and literary works, in addition to

laying out magnificent gardens. Supported the Italian Jansenists; died of a bout of apoplexy, caused by his fury at being forced by Clement XIII to condemn the catechism of F. P. Mésenguy, which was translated by Bottari. Acquainted with Montesquieu and corresponded with Voltaire and Rousseau.

**Pereira de Sampajo**, Emmanuel (Lagos, Algarve 1692–1750 Civitavecchia). Portuguese ambassador in Rome (1739–50); buried at S. Antonio dei Portoghesi. See **Benedict XIV**.

**Piccolomini**, Enea Silvio, Cardinal (Siena 1709–1768 Rome). Descendant of the great humanistic pope. In 1730 refused a prebend in order to pursue his ecclesiastical career in Rome. Honorary chamberlain to Clement XII and in 1736, as canon and secretary of Latin letters, read the funeral oration for the pope. Appointed prefect at the state ecclesiastical archive by Benedict XIV. Made governor of Rome, cardinal deacon (though never officially ordained), and apostolic legate (1766) to Ravenna by Clement XIII. Often in the company of titled women, Italian and foreign; they are said to have beseeched him to throw off his cardinal's robes for a military career. The most famous was the Florentine singer Vittoria Tesi. Vittoria only came to Rome to see P., and she particularly loved the atmosphere of Trinità dei Monti. In her letters, written between 1736 and 1742, she requested gloves, bonnets, and beads, though she did not wish to receive them as gifts.

**Pius VI**, Pope (Cesena 1717–1799 Valence). Born Giovan Angelo Braschi. Handsome and vain (proud of his white hair and his feet in old age), he was a superficial and ostentatious patron who championed the reclamation of the Pontine marshes (once drained the land became the property of his family). From 1766 treasurer to Clement XIII, residing in the Palazzo of Montecitorio. As cardinal was supported by A. Albani, and despite opposition from the anti-Jesuit camp, was unanimously elected pope in 1775 (the sixth pope crowned by Albani). His interest in outward appearances also resulted in blatant nepotism, as he wanted his family to be considered equal to royalty. Brought his sister's sons to Rome, creating Romualdo cardinal and Luigi Duke of Nemi. Built the last of the great Roman palaces (Palazzo Braschi, now the Museo di Roma) for his nephew. Tried to usurp the inheritance of the Lepri family and give it to his nephews, but the resulting scandal forced him to compromise. Commissioned the

vestry of St. Peter's from Carlo Marchionni, completed the museum (planned by Clement XIII and continued by Clement XIV) later known as the Museo Pio-Clementino. Among those who worked on this project were Winckelmann and Ennio Quirino Visconti, who illustrated and published the project. Also set up the obelisks in the Piazza del Quirinale (1787) and the Piazza Montecitorio (1792), and the one at Trinità dei Monti, all erected by the architect G. Antinori. His papacy was an economic disaster; heavy debts were incurred by the draining of the Pontine marshes and natural calamities (earthquake and floods in 1785), which were exacerbated by famine, and revolt connected with the French Revolution. Despite the first issue of paper money (1787), in 1788 he removed 36,000 pounds of silver from the S. Casa di Loreto. Dared to indict Nicola Bischi for embezzlement. Bischi was a speculator, general administrator of corn supplies, and husband of one of Clement XIV's nieces. However, the papacy was a period of peace, during which important visitors traveled to Rome; received by Costanza Falconieri Braschi, these visitors included Joseph II, the Conti del Nord, Gustav Adolfus of Sweden, and the Elector Palatine. Forced to abandon Rome and the Papal State on February 20, 1798 (on February 15 the Roman republic had been proclaimed). Taken by the French to Siena, then went to the charterhouse in Florence and finally to Valence, France, where he died. In 1801 his body was taken to Rome and in 1822 Canova's statue of him in prayer was placed in St. Peter's, thanks to his nephew Romualdo.

**Pizzelli**, Maria: see **Cuccovilla Pizzelli**, Maria.

**Polignac**, Melchior de, Cardinal (Puy-en-Velay 1661–1741 Paris). Patron of the arts and scholar. A conclavist in Rome in 1689, and again in 1692, was ambassador to Poland (1695), but unable to achieve election of Prince François-Louis de Conti as king; exiled to Bon Port and there wrote the *Anti-Lucretius, sive de deo et natura* (published posthumously in 1745). Was auditor of the Rota in Rome (1706), then plenipotentiary at the Congress of Utrecht (1712). Created cardinal in 1713, he came to Rome for the conclave of 1721 and remained, as French *chargé d'affaires*, until 1732, distinguishing himself as a compromising though firm negotiator. Lived in the Palazzo Altemps (now part of the Museo Nazionale Romano), where his receptions were renowned, depicted in engravings and paintings. For the birth

of the dauphin (1729), turned his palace into a theater, for a performance of *La contesa dei Numi*, with libretto by Metastasio and music by Leonardo Vinci; decorated the Piazza Navona in the style of ancient Rome after a design by P. L. Ghezzi, for a grand firework display. The *Te Deum* was sung in S. Luigi dei Francesi in the presence of the Sacro Collegio, while Berber horseraces along the Corso were provided for the populace. Intelligent and eloquent, in 1704 succeeded J. B. Bossuet at the French Academy. Montesquieu, during his visit to Rome, was keen to report his opinions of P. His collection of marbles was purchased by Frederick of Prussia, and his name appears on the most important inscription on the flight of steps leading up to Trinità dei Monti, together with that of Louis XV.

**Poniatowski**, Michael (1736–1794). Cleric. Brother of Stanislas Augustus, King of Poland. Educated by the Theatines of Warsaw and intended for an ecclesiastical career. His first visit to Rome was in 1754. Ordained in 1761; in 1773 became bishop of Plock and primate of Poland in 1784. Known for his reform of the University of Krakow. A freemason and an avaricious and suspicious character. Was the guest of Tommaso Antici in Italy; Pius VI gave him a silver-gilt chalice decorated with lapis lazuli and enamel, made by Luigi Valadier (cat. 79). Like his brother, loved to be surrounded by Italian artists, and his villa at Jablonna was restored by Domenico Merlini and Antonio Bianchi. A portrait by Marcello Bacciarelli is at the Accademia di S. Luca.

**Poniatowski**, Stanislas (Warsaw 1754–1833 Florence). Polish aristocrat. Son of Casimir, the elder brother of Stanislas Augustus and Michael. A spendthrift (Frascati, his villa near Warsaw, was famous for its beautiful park), and a charming liar, handsome and wealthy. Educated in Europe, in 1776 visited Rome for the first time. Interested in natural sciences, mineralogy, English fashions, and social reform. In 1785, returned to Italy, visited Calabria and Sicily; met Angelika Kauffmann, who painted his portrait; attended a meeting of Polish freemasons in Rome. In 1786 went to Florence and from there returned to Poland. Political situation in Poland forced him to leave in 1791, and, after staying in Vienna, settled in Rome (1792). Described Pius VI, who had received the Young Pretender before him, as "discourteous, lacking in etiquette and subject to rages like those of a sixteenth-century friar" (Andrea Busiri Vici, *I Poniatowski e Roma* [Florence: Edam, 1971], p. 159). In 1794 attended receptions in Arcadia

and in 1795 traveled to Vienna. Returned to Rome in 1801, and with the help of Luigi Valadier bought a building in via della Croce. Cassandra Luci Benloch became his mistress and they married in 1830, after the birth of five children. Commissioned architectural works from Valadier, was an eclectic collector (intaglio gems, ethnographic collections, paintings and prints, *gesso* works), and was advised by Augustus Moszynski (his collections were sold by Christie's in London in 1839). Was a member of the Accademia di S. Luca and an Arcadian; acquainted with archaeologists and freemasons who were connoisseurs and collectors; Piranesi dedicated his plan of Hadrian's Villa to him and Seroux d'Agincourt left him his library in 1814. Buried at S. Marco, Florence.

**Renazzi**, Filippo Maria (Rome 1742–1808 Rome). Jurist and professor at La Sapienza. Published four volumes of *Elementa juris criminalis* (1773–81), and, following C. Beccaria, tried to reduce the subject of crime and punishment to a scientific system. This work procured him invitations from Catherine the Great (to reorganize criminal law procedures in Russia), and from the universities of Pavia and Bologna, but he preferred to stay in Rome.

**Rezzonico**, Carlo; see **Clement XIII**.

**Rezzonico**, Carlo, Cardinal (Venice 1724–1790 Rome). Nephew of Clement XIII. Bishop of Porto and S. Rufina, published for his diocese the *Regole et istruzzioni delle scuole pie delle zitelle*.

**Rezzonico**, Giambattista (1740–1783). Venetian nobleman. Nephew of Clement XIII, steward of the Curia, cardinal (1770), grand master of the order of Malta, and protector of D. Corvi and Piranesi.

**Ricci**, Lorenzo (Florence 1703–1775 Rome). General of the Jesuits. Entered the Society of Jesus in 1718 and taught in Siena and Rome, where he was spiritual father in the Collegio Romano. Became secretary-general of the Jesuits in 1755, and was appointed provost-general in 1758. The favor shown him by Clement XIII, a strenuous defender of the Jesuits—to such an extent that he did not want to accept even minimal changes to their rule—provoked the wrath of his enemies. On receiving the brief *Dominus ac Redemptor* in 1733, during the reign of Clement XIV, stating that the Company was to be suppressed, R. was taken to Castel S. Angelo and accused of having concealed Jesuit assets. Though acquitted of this offence, R. was never freed, not even under Pius VI, who looked favorably upon him. His brother Corso was a canon whose ideas were the exact opposite of R.'s, and who left his library to Scipione de' Ricci.

**Ricci**, Scipione de' (Florence 1641–1810 Florence). Cleric. Despite opposition from his mother, Luisa Ricasoli, after studying in Pisa he took holy orders and became an auditor at the nunciature in Florence. Through his studies and friends, he entered Jansenist circles. In 1780 was appointed bishop of Pistoia and Prato and became the focal point for opposition to the Jesuits. Employed by Leopold Habsburg, Archduke of Tuscany, as a mouthpiece for his ecclesiastical reforms. Suppressed the cult of the Sacred Heart, destroyed altars, removed reliquaries, and introduced a new Jansenist catechism. His ideas were forcefully expressed at the Synod of Pistoia in 1786, convened to "purge the Church of filth," and Pietro Tamburini drew up the decrees of this synod. Public reaction forced him to abandon his see and seek shelter in Florence (1791). The proposals of the Synod of Pistoia had already been disowned by the Tuscan bishops, and were condemned outright by Pius VI in his bull *Auctorem fidei* (1794). In 1799 he was arrested as a French sympathizer. While support of Jansenism faded in Italy, abandoned to the fortunes of war, his last years were very unhappy.

**Russel**, James (c. 1720–1763 San Casciano dei Bagni). English artist and antiquarian. In Rome from 1740, studied painting at the school of Francesco Fernandi (*called* Imperiali) and later acted as a guide for English visitors to Rome and elsewhere in Italy. His first years in the city are recorded in letters home (James Russel, *Letters from a Young Painter Abroad to His Friends in England*, 2 vols. [London: W. Russel 1748]), in which he described the excavations at Herculaneum. Known for trading in antiquities and paintings, some by contemporary artists. His pictures sold at auction by Christie's in 1769 included works by Raphael, Titian, Poussin, and Guercino.

**Saint-Aignan**, Paul Hippolyte de Beauvillier, Duc de (1684–1776). Diplomat. French ambassador in Rome (1732–40). Collector and patron of the arts, worked to provide the Burgundian and Breton commu-nities in Rome with churches and hospitals: see **Leonardo da Porto Marizio**; and **Vaini**, Girolamo.

**Salviati**, Marianna: see **Borghese**, Marcantonio IV.

**Santacroce**, Giuliana: see **Falconieri Santacroce**, Giuliana.

**Scarlatti**, Alessandro (Palermo 1660–1725 Naples). Composer. Came to Rome aged twelve, and probably studied with Francesco Foggia or Bernardo Pasquini. Soon revealed his exceptional talent, and became Maestro (1678) at S. Girolamo della Carità. In 1679 his first opera, *Gli equivoci nel sembiante*, was performed at the Teatro Capranica, and was very well received. Was in the service of Queen Christina of Sweden (godmother to one of his daughters); his music was much appreciated by the Spanish ambassador at the Vatican, Gaspar de Haro y Guzmán, who took him to Naples when he was made viceroy of the city. From 1684 was chief musician at the Cappella Reale and Teatro Reale in Naples, where his melodramas were performed (over thirty before 1702). Failed to enter the service of the Grand Duke of Tuscany, Ferdinand III de' Medici, so returned to Rome and became deputy *maestro di cappella* at S. Maria Maggiore. During this second Roman period, before returning to Naples (at the end of 1708 became music master at the court), mainly composed cantatas, liturgical music, and oratorios; was a close friend of Cardinal Ottoboni, who wrote a Latin epigraph on his tomb in the Neapolitan church of Montesanto. Also in the service of Queen Maria Casimira. Dedicated the *Missa Clementina II* (1706) to Clement XI, which gained him the award of the Golden Spur; was admitted to the Accademia dell'Arcadia with Corelli. Visited Rome once more (1717–21), and composed new melodramas for the Teatro Capranica. A prolific composer who left his mark on the melodrama, particularly the aria, the most elaborate expressive element of this medium. His many children became musicians and singers; his eldest son, Pietro (1679–1750), was music master at Urbino Cathedral, under the patronage of Cardinal Annibale Albani.

**Scarlatti**, Domenico (Naples 1685–1757 Madrid). Composer. Sixth child of Alessandro, who wanted him to pursue a musical career. In a letter to the Grand Duke

of Tuscany in 1705, his father wrote "This son of mine is an eagle whose wings have grown. He cannot remain idle in the nest and I cannot stop his flight" (Kirkpatrick, 1953, p. 21). *maestro di capella* for Maria Casimira and her children in Rome, and produced several melodramas (1709–14) in the theater of the Palazzo Zuccari. In 1715 composed the music to *Hamlet* (to a libretto by C. S. Capeci) for the Teatro Capranica, and the satire–intermezzo *La Dirindina* by the playwright Girolamo Gigli. From 1714 to 1719 was *maestro* at the Cappella Giulia in St. Peter's, but the circle of Cardinal Ottoboni provided the most stimulating environment for his developing career; through the cardinal he met Corelli and Handel, who was in Rome between 1707 and 1710, and with whom he formed a lasting friendship. Overwhelmed by his father's strong personality, he began to make a career for himself only when he left Italy in 1720. After a visit to London, in 1721 Domenico was invited to the court of John V in Lisbon. *Maestro* to the Infanta Maria Barbara of Braganza, Domenico traveled to Seville and Madrid when she married Ferdinand, future King of Spain. In Portugal and Spain composed religious music and sonatas for harpsichord, which show to best effect the ingenuity and brilliance of his work, a perfect balance between geometry and passion.

**Sobieska**, Maria Clementina (Macerata 1702–1735 Rome). Wife of James Stuart, the Old Pretender. Daughter of Giacomo Sobieski and Edvige Pfalz-Neuburg, born in Macerata in the palace of Cardinal Marefoschi (uncle of Cardinal Compagnoni Marefoschi). One of the richest princesses in Europe, her father negotiated her marriage. The wedding took place by proxy at Bologna in 1719 (depicted in a miniature by Angelo Tosi in the Archivio di Stato, Bologna). She came to Rome as Mme. de Saint George, wife of the "king of England," and entered the city at the Piazza del Popolo, escorted by cardinals F. A. Gualtieri and F. R. Acquaviva. When the Old Pretender's attempt to return to England failed, he asked her to join him at Montefiascone, and on September 10 the bishop officiated at their church wedding in the cathedral. Her marriage was not a happy one, and the couple disagreed over the education of their children, whom James wanted to frequent Protestant circles. In 1727 she sought shelter in the convent of S. Cecilia in Trastevere for a short time. Abbé Volpini da Piperno criticized her and the pope in a pamphlet, and was beheaded for this in 1720 at Campo Vaccino. In contrast to her unhappy life, died in a saintly manner at the Palazzo

Muti, and after her funeral at the Ss. Apostoli, was carried across the city to the Vatican in state; her cortège, which was composed of confraternities and regular clerics, was led by a cavalcade directed by the captain of the Swiss Guards. There were commemorations all over Italy; poems in eighteen different languages were read and printed in magnificent publications by the Propaganda Fide. In Rome alone two monuments were raised to her: one at the Ss. Apostoli by F. della Valle (1737), where her heart is buried, and the other in St. Peter's to a design by F. Barigioni, with her portrait in mosaic after a design by L. Stern, made by F. Cristofori. A portrait by P. L. Ghezzi is in the Muzeum Narodowe, Warsaw.

**Sobieski**, Alessandro (1677–1714): see **Casimira**, Maria.

**Sobieski**, Costantino (1680–1726): see **Casimira**, Maria.

**Sobieski**, Giacomo (1667–1737): see **Casimira**, Maria.

**Sparapani Gentili Boccapaduli**, Margherita (died Rome 1820). Daughter of Antonio Maria Sparapani, nobleman of Camerino, and Costanza Giori, niece of Cardinal A. S. Gentili and his brother the Marchese Filippo, from whom she inherited the family title and estate (the Villa Gentili, now Villa Dominici, by the Aurelian walls between the Porta Tiburtina and via di Porta S. Lorenzo). In 1754 married Giuseppe Boccapaduli, their uncles and magistrates guaranteeing the nobility of their blood and the authenticity of their family's relics. The Boccapaduli were titulars of the chapel in S. Maria in Aracoeli dedicated to Margaret of Cortona, canonized by Benedict XIII, which contains two paintings, by M. Benefial and F. Evangelisti. In 1747 Boccapaduli had been made a knight of the papal guards. The couple were childless and their adopted daughter married Urbano del Drago in 1814, and inherited the Gentili estate. Their palazzo, restored between 1726 and 1729, with entrances on via dei Falegnami and the Piazza Costaguti, was the location for one of the many Roman literary salons, and Margherita was responsible for the prolonged visit to Rome of Alessandro Verri, with whom she attended physics lessons at La Sapienza. Francesco Belloni was her lover.

**Spinola**, Flaminia: see **Borghese**, Marcantonio III.

**Stolberg-Gedern**, Louise (Mons 1752–1824 Florence). Countess of Albany. Wife of the Young Pretender, Charles Stuart. From 1777 mistress of V. Alfieri, and after his death, of the artist F. X. Fabre, who left assets from the Stuart and Alfieri families to the Fabre Museum in Montpellier.

**Stosch**, Philipp, Baron von (Küstrin, Brandenburg, 1691–1757 Florence). Collector, antiquarian, and diplomat. Studied theology in Frankfurt-an-der-Oder. Began a career as numismatist in London, probably accompanying Prince Eugene of Savoy. Came to Rome in 1715, granted a pension by Clement XI, and became a friend of Alessandro Albani, working on his collections with Winckelmann. From 1719 was royal antiquarian in Dresden for the elector of Saxony, but in 1722 settled in Rome, in the service of the British government, receiving payment for information about the Stuart court and the political ideas of many British travelers. Despite his pseudonym (John Walton), the Jacobites forced him to leave Rome ten years later. From 1731 lived a life of luxury in Florence in a house full of treasures. His collection of over 3,000 precious stones with intaglio decoration was catalogued by Winckelmann (*Description of the Intaglio Gems Belonging to the Late Baron von Stosch*, 1760). Also employed young artists to copy erotic paintings to sell to tourists. Unfortunately, his rich correspondence was lost at sea in 1863 on its way to the Prussian archives. His books, maps, drawings, and engravings were sold in Vienna; and the Vatican Library recovered manuscripts and books previously belonging to the library. There is a caricature by P. L. Ghezzi; a medal by G. B. Pozzo (1727; Palazzo Venezia, Rome), and a portrait bust by Bouchardon (Berlin).

**Stuart**, Charles Edward Louis Philip Casimir, the Young Pretender (Rome 1720–1788 Rome). Eldest son of James Stuart and Maria Clementina Sobieska. Received an education that reflected the insecurity of his parents: first from the Jesuits, then the Protestants, and later the Jacobite militia. At fourteen fought at the siege of Gaeta (1734), then took part in several unsuccessful Jacobite campaigns: the last of which ended in defeat at Culloden in 1745. While dissolute by nature, he had a vivacious personality and a particular talent for music. His performance (with his brother) at Christmas 1740 of a concerto

by A. Corelli was specifically noted by De Brosses. Traveled around Europe. With Clementina Walkenshaw he had a daughter, Charlotte. On his father's death, returned to Rome but the pope refused to recognize his right to the throne, removed the royal coat of arms from the door of the Palazzo Muti, and insisted on calling him "Count of Albany." On Good Friday, 1772, married Louise Stolberg Gedern at Macerata, in the palace of Cardinal Marefoschi, and entered Rome in grand style: a medal was struck for this occasion. In 1774 moved to Florence and bought the Palazzo Guadagni in 1777 (the year when his wife began her friendship with V. Alfieri. She described her husband as "the most insupportable man that ever existed, a man who combined the defects and failings of all classes as well as the vice common to lackeys, that of drink" (Ingamells 1997, p. 199). In 1780 Louise Stolberg returned alone to Rome, and lived in the Cancelleria with her brother-in-law Henry Stuart. The marriage was dissolved in 1784. After she moved to Florence to live first with Alfieri and, on his death in 1803, with the artist F. X. Fabre, the prince returned to Rome in 1785, and also lived with Henry Stuart at the Palazzo Muti. In 1787 he was described as "drunken Silenus more asleep than awake." (Ingamells 1997, p. 200). On his death the British government contributed towards Canova's monument to the last of the Stuarts in St. Peter's. Portraits by A. David, R. Carriera, J. E. Liotard.

**Stuart**, Charlotte (Liège 1753–1788 Bologna). Duchess of Albany. Daughter of Clementina Walkenshaw and the Young Pretender, Charles Stuart, whom she assisted in his later years. In Florence she had great success in society and may well be the beloved Carlotta of V. Monti in Florence.

**Stuart**, Henry Benedict Maria Clement, Cardinal, Duke of York (Rome 1725–1807 Frascati). Second son of James Stuart and Maria Clementina Sobieska. In 1747, after the Stuarts had failed in several attempts to regain the English throne, he was created cardinal and made titular cardinal of S. Maria in Campitelli, engaging B. Galuppi (1750) as chorus master there. From 1749 relations with his father became difficult, because of his exaggerated intimacy with his chamberlain, Father Lercari, who was persuaded to move to Genoa in 1752. Bishop of Corinth in 1758, his appointment was celebrated in magnificent style in Ss. Apostoli by Clement XIII. Bishop of Tuscolo in 1761 and deputy chancellor from 1763, he maintained a court of 150 courtiers at

the Cancelleria. Resided in the Villa Muti and the Palazzo della Rocca at Frascati, restored by the Polish architect T. Kuntz after 1775. Rebuilt and maintained the seminary, which included a printing house. His vast library, consisting of books, manuscripts, and scores, eventually became part of the Vatican Library. A vivacious character, sensitive to any opposition to his wishes. When the Young Pretender died (1788), he wished to be called "His Royal Highness, Most Eminent and Most Serene," and had medals struck depicting himself as King Henry IX of England, France, and Ireland. At the time of the Treaty of Tolentino, sold his jewelry to help the pope. One of the most radical and vigorous opposers of the Roman republic, he prohibited the clergy who had supported the republic from officiating. In 1803 became chamberlain at the Sacro Collegio. Very attached to the future cardinal E. Consalvi, and appointed him executor of his will and beneficiary of 6,000 *scudi*. Another beneficiary was canon Angelo Cesarini, who lived in the villa at Frascati. His funeral was held at S. Andrea della Valle and he was buried in the Vatican grottoes.

**Stuart**, James Francis Edward, the Old Pretender (London 1688–1766 Rome). Son of James II and Maria Beatrice d'Este. His father had to abandon the throne at his birth and sought shelter in France, where Louis XIV supported his cause and helped him in various attempts (all unsuccessful) to regain the throne. In 1717 accepted the invitation of Clement XI, who recognized him as the rightful sovereign (James III) and offered him the Palazzo Muti in the Piazza Ss. Apostoli, in addition to the Palazzo Savelli at Albano and a large annual pension. Married Maria Clementina Sobieska in 1719 at Montefiascone. The birth of their son Charles Edward in 1720 was celebrated with salvoes from the cannon at Castel S. Angelo and public celebrations in Arcadia. The little Stuart court celebrated his birthday—on the first day of the year—along with a mass on St. George's Day (April 23) in Ss. Apostoli and with a formal visit to the pope before his departure for the country in May. In 1725 a second son, Henry Benedict, was born. Royal privileges accorded to James Stuart included being allowed to take communion without fasting, to appoint a cardinal and the bishops of Ireland, and to have a privileged position at entertainments. On Clementina's death (1735), the Old Pretender led an increasingly solitary life in his villa at Albano. When he died, Cardinal G. F. Albani, protector of Scotland, officiated at the requiem mass and memorial

services were sung in all the churches and basilicas of the city. Even though it was Carnival, the theater was suspended and all the lights dimmed, as had been done on the death of his wife. In 1718 Antonio David was appointed court artist and the Old Pretender was painted by many artists, including Trevisani (1720) and Liotard (1737); a contemporary commented that he had "the look of an idiot, particularly when he laughs or prays; the first he does not often, the last continually" (Ingamells 1997, p. 549). Buried in the grottoes of St. Peter's; in the left nave of the basilica is the monument (1817–19) by Canova to the last of the Stuarts, commissioned by Pius VII and paid for by the British government: a stele with busts of James and his two children; P. Bracci designed a monument (pen-and-ink drawings, Art Institute of Chicago and Canadian Centre for Architecture), which was never built.

**Tencin**, Pierre: see **Guérin de Tencin**, Pierre.

**Tesi**, Vittoria (1700–1775). Singer. Born in Florence, daughter of a servant to the musician De Castris, favorite of Ferdinando de'Medici. Not beautiful, but with a marvelous contralto voice, T. was a superb actress with excellent speaking voice and a very good teacher; was also appreciated by Metastasio, sang all over Italy, in Poland, Madrid, and Vienna, where aged fifty took up residence with Prince Saxe Hildeburghausen; T. was also the mistress of Cardinal Enea Silvio Piccolomini.

**Torrigiani**, Ludovico Maria, Cardinal (Florence 1697–1777 Rome). Pro-Jesuit, made cardinal in 1753 by Benedict XIV and secretary of state to Clement XIII.

**Trapassi**, Pietro: see **Metastasio**, Pietro.

**Vaini**, Girolamo, Prince of Cantalupo (Rome 1674–1744 Rome). Nobleman. His father, Guido, was obsessed with princely ostentation, and had reputedly bought his title from the pope. Appears very frequently in Roman chronicles of the times, partly due to his eccentricity. Tormented Cardinal de Polignac in order to receive the Cordon Bleu of the order of Saint-Esprit, which was accompanied by a considerable living, but finally received his award at S. Luigi dei Francesi in 1737 from the French ambassador in Rome, Paul Hyppolite de Beauvillier, Duc de Saint-

Aignan, "with extraordinary pomp" (De Brosses 1977, vol. 2, p. 93); the ceremony was painted by Subleyras. In 1738, with Saint-Aignan, received Maria Amalia, daughter of Augustus III of Saxony, King of Poland, at Monterotondo, in order to take her to Gaeta, where she was to meet Charles, King of Naples, whom she had married by proxy in 1737. Maria Amalia was accompanied by her brother Friedrich Christian, the prince elector (a portrait by Subleyras of him in Rome in 1739 hangs in the Staatliche Kunstsammlungen, Dresden).

**Valenti Gonzaga**, Silvio, Cardinal (Mantua 1690–1756 Viterbo). After studying, traveled in Italy, Sicily, and abroad. In 1730 was made cardinal and legate at Bologna, then nuncio in Madrid. Returned to Rome for the conclave that elected Benedict XIV. Appointed secretary of state, prefect of the Propaganda Fide (1745), and bishop of Sabina (1754). An erudite man with an inquiring mind; advisor to Eugene of Savoy on his collections, studied the monuments of Rome, introduced stricter laws governing the trade of works of art (even contemporary ones) in 1750, and established a public archive. An honorary member of the Accademia di S. Luca (1742), Arcadian with the *alias* of Fidalbo Tomeio. Supported the *Giornale dei Letterati* (1745–56); had F. Titi's *Guida di Roma* reprinted; on his recommendation Ruggero Boscovich was asked to strengthen the dome of St. Peter's. Encouraged the pope to promote conservation and restoration of basilicas and early Christian churches, to reopen the Scuola del Nudo (1749), and complete the Trevi Fountain. His villa, between the Porta Pia and the Porta Salaria, comprised a sixteenth-century mansion and a new one, which was incomplete on his death, probably the work of Panini, J. P. Maréchal, and P. Posi. With the help of Saverio Bettinelli and Abbot Wood, set up a scientific museum in the basement. Was extremely proud of the "magic table," used to lift food and drink from the kitchens to the first floor, and the machinery to set the fountains in motion, which was concealed among his exotic plants (he was the first to grow pineapples in Rome). A connoisseur of exotic objects, the walls of his many rooms were decorated with Chinese paper, and his shelves were full of porcelain. On his death, the villa was bought by Cardinal Prospero Colonna of Sciarra. The residence, now the Villa Paolina (where Pauline Bonaparte lived), is now the French embassy at the Holy See. Most of his precious library, collected during his travels, was absorbed into the Biblioteca Nazionale Centrale, while his magnificent collection of prints was acquired by the marchese Francesco Saverio Leonori of Pesaro.

**Venier**, Francesco. Venetian nobleman. Ambassador to Rome (1740–43) and protector of F. Benaglio.

**Venuti**. Family of scholars from Cortona. Ridolfino, archaeologist and printer (Cortona 1705–1763 Rome), preceded Winckelmann as prefect of Roman antiquities under Benedict XIV, and left essays on different subjects, ranging from geography to ethnography, topography and art, such as *Antiqua numismata* (1739–44), *Accurata e succinta descrizione topografica delle antichità di Roma* (1763), and *Accurata e succinta descrizione topografica e istorica di Roma moderna* (1766). Postulated that what is beautiful should not be reserved solely for the rich and powerful in his catalogue (1750) of the museum of antiquities at the Palazzo dei Conservatori. His brother Filippo (Cortona 1709–1769 Cortona) was a priest and lived in France for eleven years. A member of the Académie des Inscriptions et Belles-Lettres in Paris, he translated many works from the French, and was esteemed by Voltaire and Montesquieu; also one of the founders (1726) of the Accademia Etrusca of Cortona. Another brother, Niccolò Marcello (Cortona 1700–1755 Cortona), was interested in the antiquities of Cortona and Tuscany, carried out excavations and published (1748) news of the first discoveries at Herculaneum; his son Marcello (1745–1817) was director of the porcelain factory at Capodimonte.

**Veratti Bassi**, Laura:
see **Bassi Veratti**, Laura.

**Verri**, Alessandro (Milan 1741–1816 Rome). Author. Studied with the Barnabites, joined the recently established Accademia dei Pugni, and was actively involved in the monthly literary journal *Caffè* (1761–66). He supported a more modern concept of literature, in opposition to the purists. Also advocated reform of the judicial system; during these years wrote an essay on the history of Italy (unpublished). After visiting Paris and London, in 1767 settled in Rome and fell in love with Margherita Sparapani Gentili Boccapaduli. Gradually abandoned his enlightened views and adopted a more gloomy and fatalistic attitude to human destiny, reflected in his descriptions of archaeological landscapes and a return to classical style, sometimes quite extreme.

Was one of the first to translate Shakespeare into Italian (*Hamlet*, 1768; *Othello*, 1777); translated the *Iliad* (1789) in summary form and in prose, and wrote novels: *Le avventure di Saffo, poetessa di Mitilene* (1782) and *Notti romane al sepolcro degli Scipioni* (1792, 1804, 1967), which brought him fame.

**Vinci,** Leonardo (Strongoli, Calabria, 1696–1730 Naples). Composer and musician. Considered the greatest composer of serious opera in the new melodic style, which differed from that of Alessandro Scarlatti, by giving importance to poetry, melody, and vocal skills, thus making a significant contribution to the Neapolitan school. De Brosses remembered him as one of the most important composers working in Rome, and contributed to spreading his reputation as a gambler and libertine, who may have been poisoned because of his many love affairs. Made his debut with musical comedies in Neapolitan dialect, but after 1722 composed many *opere serie*, performed by the most famous singers of the day, such as Farinelli and Carestini. Succeeded Scarlatti as deputy *maestro di cappella* at the Cappella Reale, Naples; in 1728 became Maestro di Capela at the conservatory and taught Pergolesi, among others. His operas performed in Rome include *Didone abbandonata* (Teatro Alibert, 1726), the *Contesa dei Numi* (Palazzo Altemps, 1729) for Cardinal de Polignac, and *Artaserse* (Teatro Alibert, 1730), all based on poetry by Metastasio, who appreciated the elegance, expression, and fluency of his music.

**Visconti**, Ennio Quirino (Rome 1751–1818 Paris), Archaeologist. Son of the archaeologist Giovanni Battista (Venice 1722–1784 Rome). At fifteen had translated Euripides' *Hecuba*. Was librarian at the Vatican, while continuing archaeological studies (according to Leopardi, he was unequaled in this subject), also philology and literature. In fact, his poetry was often an inspiration for V. Monti, whose Italian translation of the *Iliad* was edited by him. Commissioned by Pius VI to publish the *Museo Pio-Clementino descritto* (vol. 1, 1782). Although published as the work of his father, this was mostly the work of Ennio, as were the following six volumes. A conservator at the Museo Capitolino from 1784, he examined and described the newly discovered monuments. With his father persuaded Clement XIV to impose strict laws on the export of works of art from the Papal States. In 1798 became head of the ministry of internal affairs, and championed the Roman republic. Sought refuge in France, and when Rome was invaded by Napoleon, was appointed curator

at the Louvre. As a member of the Institut de France, he published many important works in French. In 1815 was asked to examine the Elgin Marbles in London, which he deemed to be of great value.

**Walkenshaw**, Clementina. Mistress of the Young Pretender, Charles Stuart, and mother of Charlotte Stuart.

**Walton**, John: see **Stosch**, Philipp von.

**Winckelmann**, Johann Joachim (Stendal 1717–1768 Trieste). Archaeologist. In Rome from 1756, as librarian for Cardinal Alessandro Albani, helping him to build up an important collection, which was displayed in his villa on via Salaria. As prefect of Roman antiquities and librarian at the Vatican, was the first to write a history of ancient art (*Geschichte der Kunst des Alterthums*, 1764), later translated into Italian by C. Amoretti (1779) and annotated by A. Fumagalli and C. Fea (1783–84).

**York**, Duke of: see **Stuart**, Henry Benedict Maria Clement, Cardinal.

**Yussupov, Nikolai**. Russian prince. Ambassador (1783–89) in Turin, Venice, and Naples. A man of great taste, Y. was patron of A. Canova and J. L. David, also artistic advisor to Catherine the Great. Possessed one of the most important collections in Russia of eighteenth-century Italian and French works of art. Accompanied the Conti del Nord to Rome.

**Zelada**, Francesco Saverio, Cardinal (Rome 1717–1801 Rome). Secretary of state to Pius VI from 1789 to 1796 (see Andrea Corsini). As a keen archaeologist, Z. reviewed and added to the Kircher collection; published at his own expense descriptions of the most important antiquities, including copies of inscriptions, hieroglyphics and the Ficoroni and Capponi collections. Portrait of by Mengs in the Art Institute of Chicago.

**Zoega**, Jürgen (Dahler 1755–1809 Rome). Archaeologist. From a poor Danish family, studied in Göttingen. His reading of Homer and Winckelmann encouraged him to come to Rome in 1766. Earned his living as a tutor, but in 1782 was asked to catalogue the royal medal collection. Visited Rome again in 1783, and converted to Catholicism; the protégé of Stefano Borgia, whose collection of ancient Egyptian imperial coins he catalogued. An exceptional scholar, he was one of the greatest archaeologists of the post-Winckelmann generation. From 1790 studied Egyptian obelisks (*De usu et origine obeliscorum*, 1797). With E. Visconti, was employed in the Servizio di Storia e Antichità (1798). His incomplete work *Li bassirilievi antichi di Roma* (1808) is considered of great importance, although limited to the Albani collection. Many of his manuscripts are now in the Kongelige Bibliotek, Copenhagen.

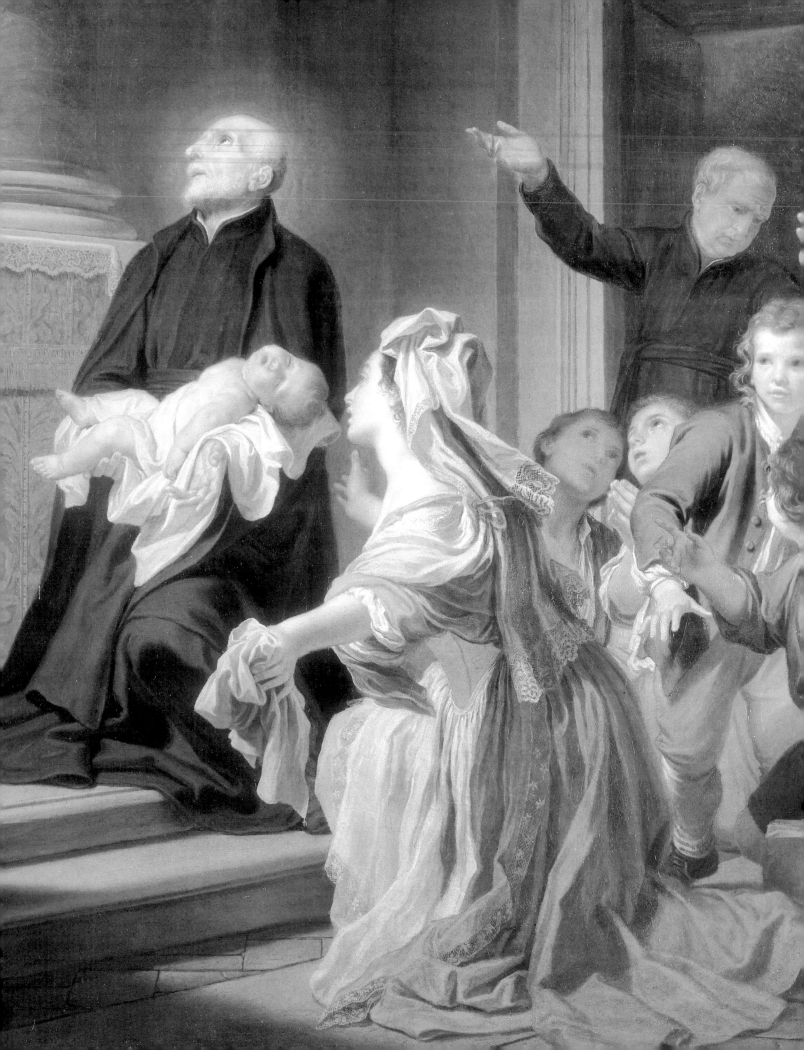

# Chronology

## JON L. SEYDL

Fig. 46 Pier Leone Ghezzi, *Pope Clement XI (Giovan Francesco Albani)*, oil on canvas; Walpole Gallery, London

Fig. 47 Robert Auden-Aert, *The Barberini Faun*, 1704, engraving; from *Raccolta di statue antiche e moderne*, by Domenico de Rossi and Paolo Alessandro Maffei

(OPPOSITE) detail of Domenico Corvi, *The Miracle of Saint Joseph Calasanz Resuscitataing a Child in a Church at Frascati*, 1767 (cat. 203)

### CLEMENT XI

(Giovan Francesco Albani)
1700–1721
born: July 22, 1649
elected: November 23, 1700
*possesso*: October 10, 1701
died: March 19, 1721

1700   Jubilee year.

Giovan Mario Crescimbeni publishes *La bellezza della volgar poesia*, a text articulating the principles of the Arcadian movement.

1701   The War of the Spanish Succession begins, with Bourbon France fighting Habsburg Austria (joined by England, Prussia, the Netherlands, Portugal, and Savoy) over the succession to the throne of Spain. In the first major war between Catholic kingdoms since the Reformation, Clement XI leans toward France.

Clement XI issues an edict prohibiting the exportation of statues, bronzes, gems, and paintings from the Papal States, one of many actions to protect the artistic patrimony of Rome (followed by another in 1704 to protect stuccos, mosaics, documents, and inscriptions).

Clement XI initiates the Founders series, a project aiming to line the nave of St. Peter's with large statues depicting the founders of each religious order.

1702   Francesco Branchini installs the Linea Clementina, the meridian line used to ensure accurate charting of the calendar, on the floor of S. Maria degli Angeli: it exemplifies Clement's support for empirical, scientific research.

The first Concorso Clementino is held at the Accademia di S. Luca.

1703   Earthquakes destroy three arches of the Colosseum and damage the Quirinal, St. Peter's, and S. Lorenzo.

A prison for young men is established at S. Michele, the first of many public facilities to fill the social welfare complex along the Tiber.

Clement XI acquires Carlo Maratti's extensive collection of Renaissance and Baroque drawings, which remains in Albani hands until 1762, when bought by George III of England.

1704   Clement XI condemns Jesuit missionary practice in China, in which the Jesuits incorporate Chinese ancestor cults into Christian rites.

Developments along the Tiber follow three disastrous floods since 1700: a floodgate is constructed on the river, and Alessandro Specchi and Carlo Fontana design the Porto di Ripetta.

Domenico de Rossi and Paolo Alessandro Maffei publish *Raccolta di statue antiche e moderne*.

1705   The first performance of the oratorio of *Santa Maria Maddalena de' Pazzi* at the Collegio Clementino in Rome, with music by Alessandro Scarlatti, setting a text by Cardinal Benedetto Pamphili, reaffirms Rome's role as a key European center for sacred music.

The public granaries at Termini in the Baths of Diocletian are expanded, to designs by Domenico Fontana, an example of the pope's interest in fostering economic reform.

1706   Clement XI creates twenty new cardinals, including the future popes Innocent XIII and Clement XII.

A severe drought in central Italy leads to serious food shortages.

Clement XI initiates the Lateran Apostles series, involving the leading sculptors in Rome, with the last works installed in 1718.

1707   Austria conquers Naples during the War of Spanish Succession.

Georg Friedrich Handel debuts his oratorio *Il trionfo del tempo e del disinganno*, with a libretto by Cardinal Benedetto Pamphili, in the Palazzo della Cancelleria in Rome.

Giovanni Battista Gaulli frescoes *The Apotheosis of the Franciscan Order* on the ceiling of Ss. Apostoli, his last major work.

1708   Clement XI declares war on Austria; papal defeat at Comacchio.

1709   Clement XI surrenders to Austrian demands for free passage through papal territory, recognizes Habsburg claims in Spain, and accepts disarmament, marking the end of the pope's military role in Europe.

The Bourbon King Philip V of Spain breaks ties with the Papacy.

An influenza epidemic strikes Rome during a brutal winter.

The first mosaic replacements for painted altarpieces damaged by the humidity in St. Peter's are commissioned.

1711   Schism in the Accademia dell' Arcadia led by Gian Vincenzo Gravina, who founds a rival institution, the Accademia dei Quiriti.

Repeated earthquakes strike Rome.

1712   Canonization of Andrea Avellino, Catherine of Bologna, Felice da Cantalice, and Pius V Ghislieri.

1713   Clement XI issues the bull *Unigenitus*, condemning Jansenists as heretics.

Plague strikes Rome.

The treaty of Utrecht ends the War of the Spanish Succession with Habsburg victory; the Duchy of Milan, the Kingdom of Naples, and Savoy all pass to Habsburg Austria; England assumes Canadian territories from France and Gibraltar from Spain; the Bourbon Philip V becomes king of Spain.

1714   After the death of Queen Anne, the elector of Hanover ascends the throne of England as George I; the Stuarts assert their claim to the throne in exile, leading to an uprising the following year.

Giovanni Giardini publishes his influential patternbook for metalwork *Disegni diversi* …

Arcangelo Corelli's last collection of works, *Opera sesta*, is published posthumously, with dedications to Cardinal Pietro Ottoboni and Johann Wilhelm, the Elector Palatine.

**1715** Louis XIV of France dies; Philippe d'Orléans assumes power as regent until the fifteen-year-old Louis Bourbon turns twenty-one.

Giuseppe Maria Lancisi founds a school of medicine, surgery, and anatomy in the Hospital of S. Spirito, having established a medical library there the previous year. Lancisi also publishes the medical texts *Dissertatio de recta medicorum studiorum rationae instituenda* and *Dissertatio historica de bovilla peste*, exemplifying the social welfare projects and scientific learning promoted by Clement XI.

The Accademia di S. Luca modifies its statutes, intending to establish itself as the dominant artistic force in Rome: all public works must have the Accademia's approval, and private academies are banned unsuccessfully.

**1716** The Papal States repel Turkish attacks on the Adriatic coast, in concert with Venice, Austria, Spain, and Portugal. Eugene of Savoy secures a Habsburg victory over the Turks at Peterwardein.

Clement XI extends the feast of the Rosary to the Universal Church in honor of the victory over the Ottoman empire.

**1717** The renovation of the Piazza della Bocca della Verità begins, an example of the pope's interest in linking urban beautification projects to the restoration of Early Christian monuments, economic improvements (a major new marketplace, the Foro Boario), and public health schemes (a new fountain designed by Carlo Bizzachieri).

Giuseppe-Simonio Assemani brings an extensive cache of ancient manuscripts back from Egypt, Cyprus, Syria, and Libya for the Vatican Library.

The Teatro Capranica produces the tragicomedy *Pirro*, with music by Francesco Gasparini and text by Apostolo Zeno.

A concordat with Bourbon Spain restores diplomatic relations broken by the War of the Spanish Succession.

**1718** A crop failure in the Papal States leads to serious food shortages and brings 8,000 refugees to Rome.

**1719** The restoration of S. Clemente concludes, the climax of the pope's many projects celebrating the early Church.

Clement XI marries Maria Clementina Sobieska of Poland to James Stuart, the "Old Pretender" to the British throne.

In Paris, Bernard de Montfaucon publishes the first volumes of *L'Antiquité expliquée*, a work meant to illustrate every known antique sculpture; the text becomes the standard sourcebook for ancient art well into the nineteenth century.

**1720** Sebastiano Giannini publishes the works of the architect Francesco Borromini, evidence of the continued Settecento interest in Baroque art and architecture and the dominating influence of Borromini.

The Giustiniani collection of ancient marbles is sold to Thomas Herbert, Earl of Pembroke, in the first of the eighteenth-century sales of major Renaissance and Baroque family collections; later sales include the Odescalchi (1724), Chigi (1728), and Mattei (1770) collections.

## INNOCENT XIII
(Michelangelo Conti)
1721–1724
born: May 13, 1665
elected: May 8, 1721
*possesso*: November 18, 1721
died: March 7, 1724

**1722** Louis XV Bourbon is crowned King of France.

The Chinea, the annual symbolic celebration in Rome of papal sovereignty over Naples, resumes.

In London, Jonathan Richardson publishes *An Account of Some of the Statues, Bas-Reliefs, Drawings and Pictures in Italy*, one of the influential texts promoting the Grand Tour.

**1723** In Naples, Pietro Giannone publishes *Istoria civile*, an influential anti-curial text calling for the extrication of the Papacy from Italian political affairs; the book is placed on the Index the following year.

## BENEDICT XIII
(Pierfrancesco Orsini)
1724–1730
born: February 2, 1649
elected: May 29, 1724
*possesso*: September 24, 1724
died: February 21, 1730

**1724** Cardinal Melchior de Polignac is named French ambassador to Rome and moves to the Palazzo Altemps.

Excavations at Hadrian's Villa begin in earnest, under the aegis of Giuseppe Fede, Liborio Michilli, and Francesco Antonio Lolli (they last until 1742).

Nicola Pio completes the manuscript *Le vite di pittori, scultori et architetti*, a crucial compilation of biographies of seventeenth- and eighteenth-century artists; Pio fails, however, to find a publisher and sells the portrait drawings commissioned as illustrations in 1714–15; Gregorio Capponi later buys the manuscript.

In Amsterdam Phillip von Stosch publishes *Gemmae antiquae caelate*.

**1725** Jubilee year.

Key construction projects include the Spanish Steps (by Francesco de Sanctis), the restoration of S. Cecilia in Trastevere and S. Gregorio al Celio, the portico of S. Paolo fuori le Mura (by Giacomo Antonio Canevari), the Hospital of S. Gallicano (by Filippo Raguzzini), and the equestrian statue of *Charlemagne* (by Agostino Cornacchini) for the portico of St. Peter's.

Peter I Romanov of Russia dies; the supreme privy council subsequently emerges.

Benedict XIII convenes the Lateran Council, marking the pope's commitment to ecclesiastical reform.

The French Academy moves from the Palazzo Capranica to the Palazzo Mancini on via del Corso.

The *Trattato teologico dell'autorità ed infallibilità de' papi* is published, the first Italian translation of the 1724 French tract by Mathieu Petit-Didier, a major treatise arguing for papal infallibility and attacked by Jansenists.

Fig. 48 San Michele Manufactory, *Pope Innocent XIII (Michelangelo Conti)*, tapestry designed by Pietro Ferloni, after Agostino Masucci; Musei Lateranesi, Rome

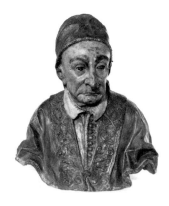

Fig. 49 Pietro Bracci, *Pope Benedict XIII (Pietrofrancesco Orsini)*, 1724, terracotta; Museo del Palazzo di Venezia, Rome

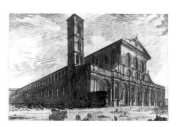

Fig. 50 Jean Barbault, *View of the Basilica of San Paolo fuori le Mura*, engraving, from *Les Plus Beaux Monuments de Rome ancienne…*, 1761, by Jean Barbault

Fig. 51 Agostino Masucci, *Saint John of the Cross Saved by the Virgin*, 1726, oil on canvas; Pinacoteca Vaticana, Vatican City

Fig. 52 Jonas Åkerstrom, *Meeting in the Bosco Parrasio*, 1788, watercolor on paper; Institut Tessin, Paris

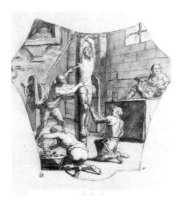

Fig. 53 Marco Benefial, *The Torture of Saint John of Nepomucene*, c. 1729, black chalk on paper; Staatliche Museen zu Berlin Preussischer Kulturbesitz, Kupferstichkabinett

Fig. 54 Filippo della Valle, *Pope Clement XII (Lorenzo Corsini)*, marble; Biblioteca Corsiniana, Rome

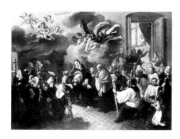

Fig. 55 Pier Leone Ghezzi, *The Death of Saint Giuliana Falconieri*, 1737, oil on canvas; Galleria Nazionale d'Arte Antica, Rome, Palazzo Corsini

1726 Canonization of Agnese di Montepulciano, Giacomo della Marca, Luigi Gonzaga, John of the Cross, Pellegrino Laziosi, Stanislas Kostka, Francisco Solanus, and Toribio Alfonso de Mogrovejo of Lima.

*Didone abbandonata*, with music by Leonardo Vinci and text by Pietro Metastasio, debuts in the Teatro delle Dame.

The members of the Accademia dell' Arcadia hold their first meeting in the Bosco Parrasio on the Janiculum Hill, designed by Antonio Canevari and funded with a 1722 gift from John V of Portugal.

1727 Filippo Raguzzini begins restructuring the Piazza S. Ignazio, a key monument in the development of Roman urban design, completed in 1736.

1728 John V of Portugal demands that Benedict XIII automatically nominate all Portuguese nuncios to the College of Cardinals; Benedict XIII refuses to halt further encroachments on papal power, leading to a break in relations until his successor, Clement XII, relents in 1731.

Canonization of Margaret of Cortona.

Benedict XIII extends the feast of Saint Gregory VII (a papal saint who represented pontifical power triumphing over secular kings) to the Universal Church; the papacy ignores the strenuous objections of the Austrian, French, and Venetian governments.

1729 Canonization of John of Nepomucene.

The birth of the dauphin to Louis XV of France and his queen, Maria Leczinska, is celebrated widely in Rome with events organized by Cardinal de Polignac.

## CLEMENT XII
(Lorenzo Corsini)
1730–1740
born: April 7, 1652
elected: July 12, 1730
*possesso*: November 19, 1730
died: February 6, 1740

1730 Lione Pascoli publishes the first volume of *Vite de' pittori, scultori, ed architetti moderni*, a key collection of biographies of seventeenth- and eighteenth-century artists.

John V of Portugal initiates a massive sculptural commission for his new palace and basilica in Mafra, involving Rome's leading sculptors, including Monaldi, Lironi, Giuseppe Rusconi, Maini, Della Valle, Bracci, and Ludovisi, as well as artists from other Italian cities.

1731 The state lottery, banned under Benedict XIII, is reinstated in an attempt to control the mounting deficit.

1732 The Teatro Argentina, designed by Girolamo Teodoli, is inaugurated during Carnival with a production of *Berenice* by Domenico Sarri.

Nine models and twelve drawings for the façade of St. John Lateran are displayed at the Palazzo del Quirinale, marking the start of the major architectural projects fostered by Clement XII.

1733 Lione Pascoli publishes *Testamento politico*, marking a shift in Roman economics from traditional mercantilism to an advocacy of free trade, currency reform, and a reduction of state monopolies.

The War of the Polish Succession begins on the death of Augustus II; Stanislas I Leszczynski is elected King of Poland, with the support of France, Savoy, and Spain; Austria, Prussia, and Russia support Augustus III of Saxony.

Cardinal Niccolò Coscia is condemned to ten years in prison in Castel S. Angelo for alleged financial abuses during the pontificate of Benedict XIII; Clement XIV annuls the sentence in 1742.

1734 The Museo Capitolino is founded under the direction of Alessandro Gregorio Capponi, with 408 antique marbles acquired the previous year from the Albani collection; Cardinal Alessandro Albani begins his second collection of antiquities.

*An Essay Concerning Human Understanding*, by the English philosopher John Locke, appears on the Index.

The Bourbons reconquer Naples from the Habsburgs and, after installing Charles VII (the future Charles III of Spain) on the throne of Naples, demand recognition of the new king from Clement XII.

1735 Work begins on Alessandro Galilei's façade of St. John Lateran, Ferdinando Fuga's Palazzo della Consulta, and Giuseppe Sardi's church of the Maddalena.

1736 The Trevi Fountain is inaugurated.

A financial crisis and currency shortage hits Rome.

Work begins on major church decoration projects, illustrating the common eighteenth-century practice of working in teams: the sculptural decoration of Galilei's Corsini Chapel in St. John Lateran by Adam, Rusconi, Cornacchini, Della Valle, Maini, Monaldi, Lironi, and Montauti; and the renovation of Ss. Celso e Giuliano, including paintings by Batoni, Caccianiga, Lapis, Triga, and Valeriani.

After Rome breaks with Bourbon Spain, Spanish agents coerce Roman citizens into Spanish military service and maraud the city, leading to riots to liberate Romans sequestered in the Palazzo Farnese. Clement XII does not act to stop the disturbance, enraging Philip V of Spain.

1737 The annual Salon exhibition revived in Paris.

Gian Gastone de' Medici, the last Medici grand duke, dies; Francis II Habsburg assumes the seat of Tuscany.

Canonization of Catherine Fieschi Adorno of Genoa, Juliana Falconieri, Vincent de Paul, and Jean-François de Régis.

Giovanni Gaetano Bottari publishes the first volume of *Sculture e pitture sagre estratte dai cimiterj di Roma*. The text reveals continued interest in Early Christian art and architecture, extolled by Corsini intellectual circles for their purity and honest expression.

1738 The Peace of Vienna marks the end of the War of the Polish Succession; Augustus III, Elector of Saxony, is recognized as king of Poland; Austria loses Naples and Sicily and gains Parma and Piacenza.

Clement XII issues the anti-masonic bull *In eminenti*.

Excavations at Herculaneum begin in earnest.

1739 The crucial Renaissance architectural treatise by Jacopo Barozzi da Vignola *Regola delli cinque ordini di dett'architettura* appears in a new edition.

The important medical treatise *Delucidazioni fisico mediche tendenti a richiamare la medicina pratica alla preziosa purità in cui la lasciò il grande Ippocrate*, by Dionigi Andrea Sancassani, is published posthumously.

1740 Frederick II (the Great) ascends the throne of Prussia.

Charles VI Habsburg of Austria dies; Maria Theresa succeeds him, provoking the War of the Austrian Succession, which will last until 1748. Although it begins as a conflict between Austria and Prussia over Silesia, the war expands as England and the Netherlands join Austria, while Spain, France, and Bavaria join Prussia.

## BENEDICT XIV

(Prospero Lambertini)
1740–1758
born: March 31, 1675
elected: August 17, 1740
*possesso*: April 30, 1741
died: May 3, 1758

1740 Benedict XIV announces a special jubilee in honor of his papacy.

1741 Benedict XIV reaches a concordat with Savoy, initiating his policy of conciliation with secular rulers.

Construction begins on Ferdinando Fuga's façade of S. Maria Maggiore.

Giovanni Gaetano Bottari with Piero Francesco Foggini publishes the first volume of ancient sculptures in the Museo Capitolino, with engravings based on drawings by Giovanni Domenico Campiglia.

1742 Economic reform: the pope reaffirms the peasants' right to glean fields.

1743 The Coffee House in the Quirinal Gardens opens, designed by Ferdinando Fuga, with interior paintings by a team that includes Batoni, Panini, Pier Leone Ghezzi, Costanzi, Van Bloemen, and Masucci.

Benedict XIV creates twenty-six new cardinals, including the future Pope Pius VI.

Benedict XIV initiates tax reform to reduce a serious deficit.

Major restoration of the Colosseum begins.

1744 Charles VII Bourbon of Naples enters Rome to meet with the pope after six months of war in the Papal States between Habsburg Austria and Bourbon Spain and Naples.

The author and adventurer Giovanni Giacomo Casanova arrives in Rome.

Benedict XIV fixes the limits of Rome's *rioni* (districts), and Bernardino Bernardini publishes the results in *Descrizione del nuovo ripartimento de' rioni di Roma*.

1745 Jacobite rebellion in Britain, instigated in large part through the Stuarts in Rome.

Church reform stipulates that boys ordained before the age of sixteen must now decide for themselves whether to take a vow of celibacy at seventeen. This practice prevents parents from placing unwilling sons in the priesthood.

Benedict XIV weakens the ban on usury.

1746 The Jacobites are defeated at Culloden in Scotland.

Canonization of Fidelis of Sigmaringen, Giuseppe da Leonessa, Camillo de Lellis, Pedro Regalato, and Caterina de' Ricci.

Secular reform restricts use of the title of *nobilis romanos* to 187 families.

1747 The chapel of St. John the Baptist, designed by Luigi Vanvitelli for S. Roque in Lisbon (with paintings and decorative arts by a team of Rome's leading practitioners), is unveiled and temporarily mounted inside the Palazzo Capponi-Cardelli for the approval of the Portuguese ambassador before shipment *in toto* to Lisbon.

Baptism no longer required of Jewish children in Rome, an indication of increased tolerance of Roman Jews.

Giuseppe Vasi publishes the first volume of *Delle magnificenze di Roma antica e moderna*.

1748 The War of the Austrian Succession ends with the Treaty of Aix-la-Chapelle and Prussian victory, establishing Prussia as the leading European power; Maria Theresa confirmed as empress of Austria.

Pompeii is discovered.

Giambattista Nolli publishes his map of Rome, *Nuova pianta di Roma data in luce*.

Giovanni Battista Piranesi publishes *Vedute di Roma*, which would be reissued with numerous editions, substitutions, and changes throughout the artist's career.

The Vatican purchases the Ottoboni library, the most important Roman collection of books and manuscripts in private hands, part of the pope's commitment to expanding the papal collections.

The controversial restoration of the dome of St. Peter's by Luigi Vanvitelli and Giovanni Poleni concludes.

1749 Ruggero Giuseppe Boscovich publishes *De determinanda orbita planetae ope catopricae*, illustrating the leading role of Jesuit scientists in the Collegio Romano in the study of Newtonian physics and astronomy.

The Pinacoteca Capitolina, a public museum of Vatican paintings, opens with a core of 187 pictures purchased from the Sachetti collection.

1750 Jubilee year.

Leonardo da Porto Maurizio establishes the Stations of the Cross in the Colosseum, a centerpiece of the jubilee that firmly establishes the cult.

John V of Portugal dies and Peter II assumes the throne. Sebastião José de Carvalho, first Marquês de Pombal, ascends in Portugal as prime minister.

Girolamo Belloni writes *Del comercio*, an influential treatise on economic reform.

1751 Stefano Zucchino Stefani publishes *Lo specchio del disinganno per conoscere la deformità del moderno costume*, an example of the strict moral reform that accompanied the spiritual revival of the jubilee.

1752 The ancient Greek erotic novel *De' racconti amorosi di Cherea e Calliroe*, by Chariton, appears in a new translation by Michele Angelo Giacomelli.

Benedict XIV issues a special brief condemning the *philosophes*; Charles-Louis Montesquieu's *Esprit des lois* and Diderot's *Encyclopédie* appear on the Index.

1753 Annibale Carracci's frescoes in the Palazzo Farnese are published in *Aedium Farnesiarum tabulae ab An. Caracci depictae, a C. Caesio aeri insculptae atque a L. Philarchaeo explicationibus illustratae*.

1754 Etienne-François, Duc de Choiseul, is named French ambassador to Rome.

Another earthquake strikes Rome.

The Accademia del Nudo opens on the Capitoline Hill, with Stefano Pozzi as first director.

1755 An earthquake levels Lisbon.

The Teatro Tordinona presents *Il vecchio bizzaro*, by the Venetian playwright Carlo Goldoni, the dominant voice of eighteenth-century Italian theater.

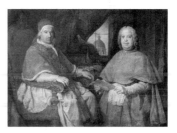

Fig. 56 Giovanni Paolo Panini, *Pope Benedict XIV (Prospero Lambertini) and Cardinal Silvio Valenti Gonzaga*, oil on canvas; Museo di Roma, Rome

Fig. 57 Ferdinando Fuga, exterior of the Coffee House del Quirinale, Rome

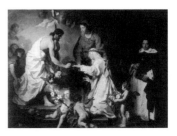

Fig. 58 Pierre Subleyras, *The Mystical Marriage of Saint Caterina de' Ricci*, c. 1746, oil on canvas; private collection, Rome

Fig. 59 Ottone Hamerani, *Pope Clement XIII (Carlo Rezzonico)*, 1762, bronze; Philadelphia Museum of Art, Bequest of Anthony Morris Clark

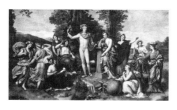

Fig. 60 Anton Raphael Mengs, *Parnassus*, 1761, fresco; Villa Albani, Rome

Fig. 61 Giuseppe Cades, *The Ecstacy of Saint Joseph of Copertino*, 1779, oil on canvas; church of Ss. Apostoli, Rome

1756 France and Austria agree to the first Treaty of Versailles, paving the way for the Seven Years' War, which pits England, Prussia, and Denmark against France, Austria, Russia, Saxony, Spain, and Sweden (the first Bourbon–Habsburg alliance in three centuries).

*L'Antigono*, composed in Rome by Christoph Willibald Gluck, setting a text by Pietro Metastasio, receives its first performance in the Teatro Argentina.

Piranesi publishes *Le antichità romane*.

1757 Giovanni Gaetano Bottari publishes the first volume of *Raccolta di lettere sulla pittura, scultura e architettura*, an influential compilation of correspondence on art from the Renaissance forward.

## CLEMENT XIII

(Carlo Rezzonico)
1758–1769
born: March 7, 1693
elected: July 6, 1758
*possesso*: December 12, 1758
died: February 2, 1769

1758 *Esposizione del simbolo della fede cattolica*, the Italian translation of François-Philippe Mésenguy's Jansenist catechism, is published, marking the escalation of collaboration between religious reformers and secular Italian rulers; the work is placed on the Index in 1761.

1759 With the urging of prime minister Pombal, Peter II of Portugal expels the Jesuits, beginning the suppression of the order.

Marco Pagliarini publishes a new version of *The Lives of the Artists*, by Giorgio Vasari, with illustrations and corrections by Bottari.

1760 George II of England dies and is succeeded by his son George III.

The publisher Niccolò Pagliarini is arrested for printing anti-Jesuit literature anonymously.

1761 Anton Raphael Mengs reveals his fresco *Parnassus* in the Villa Albani, hailed as a pivotal statement of the new classicism.

Jean Barbault publishes *Les plus beaux monuments de Rome ancienne*.

Piranesi publishes *Della magnificenza ed architettura dei romani*, promoting the notion of the originality and artistic autonomy of Roman art from that of ancient Greece.

1762 The Trevi Fountain is finally completed: waters rush in from the Aqua Vergine, a major source of Rome's water since antiquity.

Elizabeth I Romanov of Russia dies and is succeeded by Catherine II (the Great).

Francesco Algarotti publishes *Saggio sopra l'opera in musica* and *Saggio sopra la pittura*, tracts that condemn Rococo and Mannerist excesses in art, music, and theater and urge adherence to High Renaissance academic principles.

Mengs publishes *Gedanken über die Schönheit und über den Geschmack in der Malerey*, reaffirming Giovanni Pietro Bellori's seventeenth-century notion of ideal beauty and valorizing Raphael, Titian, and Correggio as the prime exemplars of *buon gusto*.

1763 The Treaty of Paris and the Treaty of Hubertusberg end the Seven Years' War with the victory of England and Prussia; Prussia emerges as one of Europe's key powers and British primacy in North America and India is assured.

Excavations begin along the Tiber to improve navigation.

Pagliarini publishes the annotated fifth edition of Filippo Titi's *Nuovo studio di pittura, scultura ed architettura nelle chiese di Roma*, the primary guidebook of eighteenth-century Rome.

1764 Louis XV expels the Jesuits from France.

Cesare Beccaria anonymously publishes *Dei delitti e delle pene*, a hugely influential proposal for criminal justice reform based on rational principles and rejecting the death penalty; the book is placed on the Index in 1766.

Johann Joachim Winckelmann publishes *Geschichte der Kunst des Altertums*.

The drought of 1763–64 leads to massive grain shortages and hunger in Italy. Clement XIII establishes shelters and food distribution centers, but the cost of importing grain provokes an economic crisis.

1765 Clement XIII approves the Feast and Mass of the Sacred Heart, the first broad official papal recognition of the popular cult.

Clement XIII issues the bull *Apostolicum pascendi mumus* in support of the Jesuits, resisting strong pressure from Bourbon Spain and France.

1766 James Stuart, the "Old Pretender," dies in Rome.

Gotthold Ephraim Lessing publishes *Laokoön, oder, Über die Grenzen der Malerei und Poesie*, an influential theoretical treatise on the distinction of the visual arts from literature.

Piranesi completes the remodeling of S. Maria del Priorato, the church of the Knights of Malta on the Aventine Hill.

1767 Charles III Bourbon expels the Jesuits from Spain and Naples.

Canonization of Joseph Calasanz, Jeanne-Françoise Frémot de Chantal, Joseph of Copertino, Jana Kantego, Girolamo Maini, and Serafino da Montegranaro.

The Salone d'Oro at the Palazzo Chigi is completed for the wedding of Don Sigismondo Chigi and Donna Maria Flaminia Odescalchi; this influential interior design project by Giovanni Stern, Tommaso Righi, and Luigi Valadier marks a departure from the prevailing Rococo style in favor of the new classicism.

1768 The Accademia di S. Luca initiates the Concorso Balestra.

Bartolomeo Cavaceppi publishes the first volume of *Raccolta d'antiche statue … restaurate da Bartolomeo Cavaceppi, romano*.

Clement XIII condemns and annuls the anti-ecclesiastical actions of the duke of Parma in the bull *Monitorum*, arguing that the papacy has supreme authority in all Church-related matters; European monarchs universally ignore the bull.

## CLEMENT XIV

(Giovan Vincenzo Antonio
Ganganelli)
1769–1774
born: October 31, 1705
elected: May 19, 1769
*possesso*: November 26, 1769
died: September 22, 1774

**1769** Clement XIV announces a special
jubilee for the Papal States.

Gavin Hamilton and Piranesi initiate
new excavations at Hadrian's Villa,
uncovering some of the most sensa-
tional antiquities of the eighteenth
century, including the Warwick
Vase; many objects are exported
out of the country, to the alarm of
the pope.

Leopold Habsburg, Grand Duke of
Tuscany, begins to move the Medici
collection of antiquities from Rome
to Florence.

Factions opposed to the Jesuits
promote the canonization of the
Mexican anti-Jesuit hero Juan de
Palafox y Mendoza with a new
Italian translation of his seven-
teenth-century treatise *Il pastore
della notte*.

**1770** Clement XIV honors the fourteen-
year-old Wolfgang Amadeus Mozart
as a knight of the Golden Spur.

The Museo Clementino opens to
stem the tide of ancient art exported
from Rome; major restructuring of
the Vatican antiquities collection
begins.

In England James Hargreaves
receives a patent for the spinning
jenny, marking the onset of the
Industrial Revolution.

**1771** Clement XIV announces another
special jubilee.

Giovanni Cristoforo Amaduzzi,
head of the Congregazione di
Propaganda Fide press, begins
publication of an important series
of ancient and eastern alphabets
(*Alphabetum veterum Etruscorum,
Hebraicum, Graecum*, and
*Brammhanicum seu Indostanum*).

**1772** Giovanni Ludovico Bianconi begins
the *Effemeridi letterarie*, the first of the
prominent intellectual journals to
emerge in late eighteenth-century
Rome.

The first partition of Poland is
carried out by Austria, Russia,
and Prussia.

**1773** Clement XIV abolishes the Jesuit
order in his brief *Dominus ac
redemptor*.

Filippo Maria Renazzi publishes the
first volume of *Elementa juris criminalis*,
a notable work of the Roman
Enlightenment, proposing to
systematize Roman criminal law
according to rational principles.

Cardinal François Joachim de Pierre
de Bernis is named French
ambassador to Rome.

**1774** Louis XV Bourbon of France dies;
Louis XVI ascends.

Mariano Rossi is commissioned
to fresco *Marcus Curius Camillus
Expelling the Gauls* in the entrance
hall of the Villa Borghese, the
capstone of the influential interior
decoration scheme of the villa.

## PIUS VI

(Giovan Angelo Braschi)
1775–1799
born: December 27, 1717
elected: February 15, 1775
*possesso*: November 30, 1775
died: August 29, 1799

**1775** Jubilee year and apogee of the Grand
Tour: Archduke Maximilian of
Austria; William Henry, Earl of
Gloucester and brother of George III
of England; Leopold of Ansprach-
Bayreuth; the princes of Brunswick;
and Charles Theodor, the Elector
Palatine, all come to Rome.

*L'arte della pittura*, a new Italian
translation of the treatise on art
by Charles-Alphonse du Fresnoy,
appears, dedicated to Cardinal Carlo
Rezzonico.

**1776** The festival of the Chinea ends
because Pius VI refuses to name
Serafino Filangieri, the new,
anticurial archbishop of Naples,
a cardinal.

The Declaration of Independence
is signed in Philadelphia.

Major architectural projects begin
at the Vatican, signals of the new
pope's vigorous revival of papal
cultural power; they include the
new sacristy of St. Peter's (by Carlo
Marchionni) and two branches of
the Museo Pio-Clementino.

The installation in the Pantheon
of honorific sculptural portraits
honoring Italian artists begins
with the bust of Pietro Bracci by
Vincenzo Bracci; the series
continues until its relocation in
the Capitol in 1820.

**1777** Construction work begins on the
Linea Pia, a hydraulic drainage canal
running along via Appia designed
by Gaetano Rappini; this project
leads to the successful reclamation
of the Pontine Marshes southeast of
Rome for agriculture, the most
notable Roman engineering
accomplishment of the latter half
of the century.

Pius VI initiates a wide swath of
economic reforms (for taxation,
currency, agriculture, industry,
and commerce) that results in
mixed success.

Severe flooding of the Tiber in
December continues into 1778.

**1778** Maria I of Portugal and the papacy
reach a concordat, restoring the
religious authority of the pope in
Portugal and marking the decisive
end of the rift that began with
minister Pombal.

Mengs exhibits his last major work,
*Perseus and Andromeda*, in the artist's
studio at the top of the Spanish
Steps; the work's sensational
reception announces the full
triumph of the new classicism.

**1779** Luigi Valadier mounts the Vatican
cameo collection.

**1780** During Carnival, Domenico
Cimarosa performs his first *opera
seria*, *Caio Mario*, with a libretto by
Gaetano Roccaforte, at the
Teatro della Dame.

Maria Theresa Habsburg of Austria
dies, succeeded by Joseph II.

**1781** Girolamo Adelasio publishes
*De eletricitate*, an example of the
important scientific studies coming
out of Rome under Pius VI,
promoted especially by Cardinal
Francesco Saverio de Zelada.

Francesco Milizia publishes *Dell'arte
di vedere nelle belle arti del disegno
secondo i principi di Sultzer e di Mengs*.

German philosopher Immanuel
Kant publishes *The Critique of Pure
Reason*.

**1782** Pius VI visits Joseph II of Austria
in Vienna, attempting to forestall
Habsburg ecclesiastical reforms;
state visit of the pope to Venice.

The play *Antigone*, by Vittorio Alfieri,
is performed as a private reading in
the Roman salon of Maria
Cuccovilla Pizzelli, marking the
birth of Italian tragedy, a form that
would grow to dominate Italian
theater in subsequent decades.

Giovanni Battista and Ennio
Quirino Visconti publish the first
volume of *Il Museo Pio Clementino
descritto*.

**1783** Gustav III of Sweden and Joseph II
of Austria make celebrated visits to
Rome.

Carlo Fea publishes the first volume
of an edited Italian edition of
Winckelmann's *Geschichte der Kunst
des Altertums*, hotly contested among
Italian scholars of antiquity.

An impressive engineering feat by
Giovanni Antinori moves the
enormous *Dioscuri* on the Piazza del
Quirinale to their present position;
in 1786 the obelisk—discovered in
pieces near the Mausoleum of
Augustus in 1781—will be moved
to its present position between the
statues.

The Treaty of Paris marks the
formal end of the American War
for Independence.

**1784** To popular and critical acclaim,
Jacques-Louis David exhibits
*The Oath of the Horatii* in his Roman
studio near the Spanish Steps
before he ships the work to Paris.

Giavambattista Occhiolini publishes
*Memoria sopra il meraviglioso frutto
americano chiamato volgarmente patata
ossia pomodi terra*, a treatise on the
potato, an example of the scientific
studies linked to commercial enter-
prises encouraged under Pius VI.

*Giornale delle Belle Arti*, one of the
chief art periodicals of the eigh-
teenth century, begins publication;
it continues to 1787.

**1785** Earthquakes strike the Papal States
and Rome endures particularly
severe flooding of the Tiber.

Pius VI creates fourteen new
cardinals.

Thomas Jenkins makes his
celebrated purchase of the Villa
Montalto-Negroni collection.

The first issue of *Giornale Ecclesiastico
di Roma* appears; the pro-papacy,
anti-Jansenist publication, led by
Luigi Cuccagni, continues to 1798.

Fig. 62  Giuseppe Ceracchi, *Pope Pius VI (Giovan Angelo Braschi)*, marble; Galleria di Palazzo Rosso, Genoa

Fig. 63  Francesco Manno, *Study for "Carlo Marchionni Offering his Project for the New Sacristy of St. Peter's to Pope Pius VI,"* 1788, oil on canvas; Fabrizio Lemme, Rome

Fig. 64  Alessandro Mochetti, *The Departure of Pius VI Pope Braschi from Rome in 1798*, 1801, engraving from a design of G. Beys; Museo di Roma, Rome

Fig. 65  Felice Giani, *The Roman Republic (Study for the Letterhead of the Consulate of the Roman Republic)*, pen and wash on paper; Museo Napoleonico, Rome

1786    Giovanni Volpato, Raphael Morghen, and Costanzo Angelini publish *Principj del disegno tratti dalle più ecellenti statue antiche*.

Pius VI makes his nephew Romualdo Braschi Onesti a cardinal, announcing the full-scale revival of nepotism.

Johann Wolfgang von Goethe visits Rome for the first time.

Giovanni Volpato opens the papal porcelain works.

Scipione de' Ricci organizes the synod of Pistoia, an expression of the continued support for Jansenist theology; Joseph II of Tuscany supports the movement, leading toward schism.

1787    Charles VII removes antiquities from the Farnese collections to Naples.

Antonio Canova unveils his monument to Clement XIV in Ss. Apostoli, an influential classicizing departure from Baroque sculpture formulae.

Carlo Fea revises and publishes *Opere*, by Mengs, one of the most significant texts of art theory and criticism of the eighteenth century.

*Aristodemo*, a tragedy by Vincenzo Monti, dominates the theatrical season at the Teatro Valle.

The American constitution is approved.

1789    The French Revolution erupts.

Severe flooding of the Tiber.

1790    After the death of Joseph II of Austria his brother Leopold leaves Tuscany to take the throne.

Pius VI announces a special jubilee of eight days for the city of Rome on May 8.

Sigismondo Chigi is accused of attempting to poison Cardinal Filippo Carandini. Nothing is proven but Chigi is exiled, an event perceived as a blatant attempt of the Braschi family to seize Chigi property.

1791    Pius VI condemns the actions of the National Assembly in Paris, putting the papacy in official opposition to the progress of the French Revolution.

Construction begins of the Palazzo Braschi, designed by Cosimo Morelli, the last palace constructed by any pope.

Pius VI announces (on November 24) another special jubilee of eight days for the city of Rome.

1792    Gustav III of Sweden is assassinated in Stockholm by a disgruntled nobleman.

Austria, Spain, Portugal, and Prussia unite against France, which defeats the coalition decisively five years later.

1793    A Roman mob kills the French Jacobin diplomat Nicolas Jean Hugou de Basseville after the revolutionary flag is raised at the Palazzo Mancini; a riot leads to general attacks against the French and Jews in Rome. Prussia declares war on Austria; coalitions form across Europe.

Prussia and Russia agree to the second partition of Poland.

Tommaso Piroli publishes engravings after drawings by John Flaxman for a new edition of Homer's *Iliad*, a crucial vehicle for the severe, classicizing, contour line drawing style.

Jacobin terror in France.

1794    Economic reforms under Pius VI change course, concentrating now on agricultural improvements instead of the earlier focus on industrial development.

Giacomo Panacci publishes the *Esercizio della Via Crucis*, leading to the beatification of Leonardo da Porto Maurizio in 1796.

Pius VI issues the bull *Auctorem fidei*, condemning thirty-five of the propositions of the 1786 synod of Pistoia.

1795    Asmus Jakob Carstens holds an influential exhibition of drawings in his via Bocca di Leone studio.

Poland disappears from the map, following the third partition by Austria, Russia, and Prussia.

Luigi Lanzi publishes the first volume of *Storia pittorica della Italia*.

1796    Napoleon's invasion of Italy begins with victories in northern Italy against the armies of Austria and Savoy; the French invasion of the papal territories of Bologna and Ferrara follow. After the Armistice of Bologna, talks between Pius VI and France fail.

Ennio Quirinio Visconti publishes *Sculture del Palazzo della Villa Borghese*.

1797    French troops invade the Papal States; Joseph Bonaparte becomes ambassador of Rome; churches induced to sell property to pay French reparations from the Armistice of Bologna.

In the Treaty of Tolentino Pius VI renounces Avignon, Bologna, and Ferrara; the Papal States must pay a vast cash indemnity and release 500 important manuscripts and 100 major antiquities and other works of art to France.

General Mathieu Etienne Duphot is killed attempting to quell a riot in front of the French ambassador's house.

1798    On January 11 General Louis-Alexandre Berthier occupies Rome and secures the city within a month. The pope is exiled. On February 15 "L'Atto del popolo sovrano" is read in the Forum, proclaiming the Roman republic and officially ending the existence of the Papal States.

1799    The Directory in France ends; Napoleon declares himself first consul; the Roman republic collapses. Austria, Prussia, England, Portugal, Naples, and the Ottoman empire form a second coalition against France, which will last until 1802.

Pius VI dies in Valence; Pius VII restores papal rule in Rome the following year.

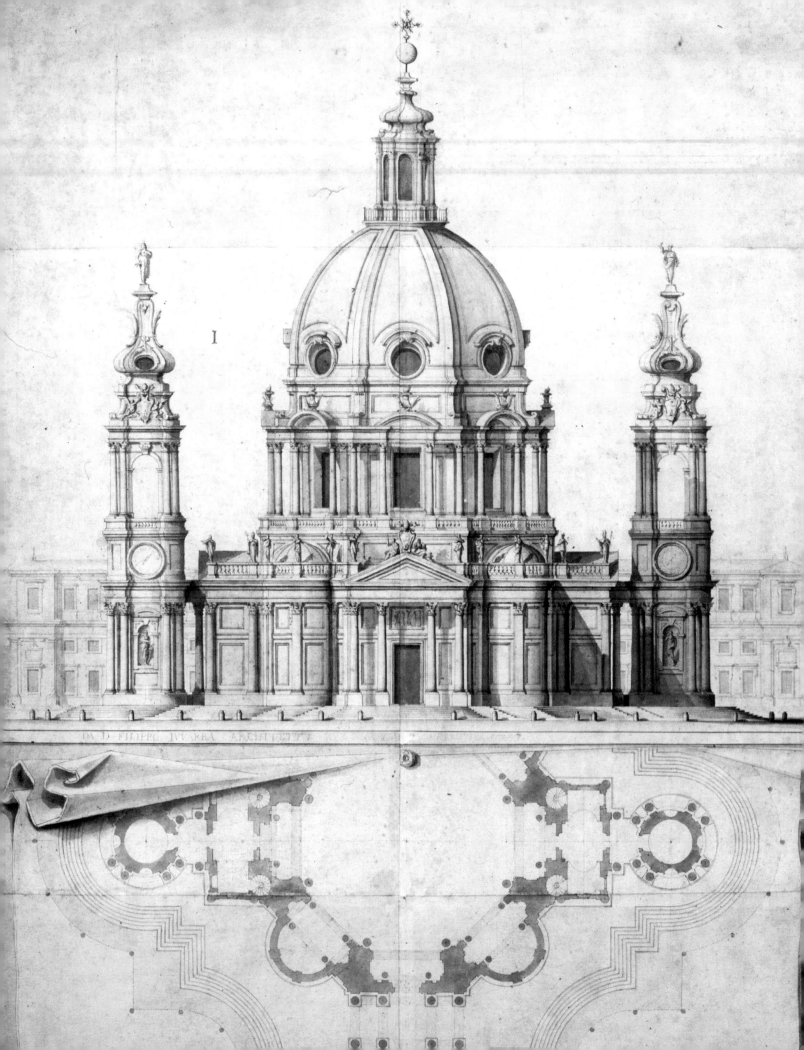

I

DA D. FILIPPO IVVRRA ARCHITETTO

# Architecture and Urbanism

## JOHN PINTO

The eighteenth century was a period in which patrons, artists, and architects furnished Rome with many of its most admired monuments and shaped the city's cumulative urban countenance. It is evident not only from single images, such as Giambattista Nolli's plan of 1748 and Giuseppe Vasi's panoramic view of 1765, but also from compilations of prints, such as Piranesi's *Vedute di Roma* and Vasi's *Magnificenze*, that it was during the eighteenth century that papal Rome received its definitive form, which endured until the city's transformation into the capital of unified Italy in 1870.

At the same time, it was a period when, through the countless prints as well as the experiences of several generations of aristocrats on the Grand Tour, an awareness of Roman monuments, ancient and modern, spread throughout Europe. The impressive series of prints by Falda, Vasi, and Piranesi collectively illustrate the city's highly textured and densely layered urban structure. When Vasi published his panoramic view, he could count on an international audience for whom the identification of monuments such as St. Peter's, the Capitoline Hill, Castel S. Angelo, and the Pantheon was unnecessary, and who would also recognize a contemporary building such as the Palazzo Corsini, which occupies a prominent place in the foreground. Vasi's panorama of Rome viewed from the Janiculum Hill captures in a single image the majestic setting of the city framed by the Sabine and Alban Hills, what Garibaldi, the defender of the Janiculum heights, would later call "the greatest theatre in the world."[1]

Goethe's enthusiastic remarks upon his arrival in Rome in 1786 illustrate the extent to which the city had become the cultural property of all Europe: "Now, at last, I have arrived in the First City of the world! … All the dreams of my youth have come to life …"[2] Diderot's entry on Rome in the *Encyclopédie*, written around the middle of the century, presents a more critical assessment: "It is true that from the days of Julius II and Leo X until the middle of the last century Rome was the center of the fine arts, but it has rapidly been equaled by some of them and surpassed in

others."[3] By comparison with the developing nation-states of northern Europe, the power and authority of the papacy had drastically declined. In spite of the efforts of eighteenth-century popes—notably Clement XI and Clement XII—to foster trade, the economy of the Papal States languished.[4] Diderot's assertion that Rome's dominant position in the arts was no longer absolute is certainly accurate, but it failed to acknowledge the central role she continued to play as the school of Europe and the contributions her most outstanding architects were making at the very time he was writing.

Diderot's Enlightenment attitudes, consciously stressing secular notions of progress and unconsciously expressing the cultural values of France, exerted a powerful influence on the scholarly reception of Italian art and architecture of the eighteenth century for two hundred years. Until relatively recently, art historians tended to accept a destiny-fulfilling view of the eighteenth century that considers French art more advanced and qualitatively superior. Historians of Italian art have focused on the sixteenth and seventeenth centuries, to the relative neglect of the eighteenth century, when the arts were thought to be in decline compared with their glorious past. The criticism of Francesco Milizia and other rationalists, who condemned what they considered to be the excesses of Baroque designers,[5] also contributed to the neglect of Roman eighteenth-century architecture.

With relatively few exceptions, intensive scrutiny of eighteenth-century Roman art and architecture began only in the last generation. Rudolf Wittkower's *Art and Architecture in Italy, 1600–1750* appeared in 1957. Wittkower's book, together with the 1959 exhibition *Il Settecento a Roma*, demonstrated the richness and variety of Roman art in the eighteenth century and provided an invaluable point of reference for scholars. Wittkower's call for monographic studies of major artists, architects, and monuments did not go unheeded, and in the last several decades the publication of a number of specialized works has expanded and deepened our understanding of the period.[6] The work of synthesizing the scholarship of the last forty years has yet to occur, but for architecture an important step was taken in the exhibition catalogue *In urbe architectus* (1991), devoted to the architectural profession in Rome between

1680 and 1750. The second half of this volume consists of richly documented entries on 464 architects active in Rome during this period.[7] These are the figures, who, although often in bitter competition with one another, gave final shape to papal Rome.

Architects practicing in eighteenth-century Rome were heirs not only to the accomplishments of their seventeenth-century predecessors, but to the traditions and artifacts of what Paolo Portoghesi aptly termed an "architectural civilization" extending back through the Renaissance to the monuments of classical antiquity.[8] The case of Filippo Juvarra provides an instructive illustration. When Juvarra entered Carlo Fontana's studio in 1704 he was set to drawing buildings by Michelangelo; his sketchbooks also contain numerous drawings after the masters of the Roman Baroque—Bernini, Borromini, Pietro da Cortona, and Carlo Rainaldi—as well as sketches of ancient Roman monuments.[9]

## URBANISM

In general, the scale of urban interventions in Rome became more modest during the eighteenth century, resembling rather more the model of Pietro da Cortona's piazza in front of S. Maria della Pace than Bernini's enormous St. Peter's Square. Taken together, however, the efforts of eighteenth-century architects and planners may be said effectively to have transformed the outward appearance of the city.

The first major eighteenth-century adjustment to the urban fabric was the Porto di Ripetta, the city's upper river port near the Mausoleum of Augustus (fig. 66).[10] Designed in 1703 by Alessandro Specchi, the Porto di

Fig. 66 Alessandro Specchi, Porto di Ripetta, 1703

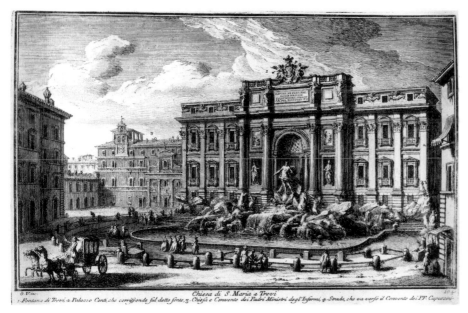

Fig. 67  Nicola Salvi, Trevi Fountain, 1732–62

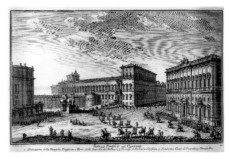

Fig. 68  Ferdinando Fuga, Palazzo della Consulta, 1733–37

Fig. 69  Filippo Raguzzini, Piazza S. Ignazio, 1727–35

Ripetta introduced a theme—the imaginative use of curving stairs to express movement from one level to another—that would be further developed in the Spanish Steps and in such painted compositions as Hubert Robert's *Capriccio* of 1761. Specchi's print representing his own design captures the bustling activity focused on the sinuous steps ascending to the preexisting church of S. Girolamo degli Schiavoni. The improvement of the port facilities and the construction of a custom house was one of the initiatives taken by Clement XI to encourage commerce in Rome and the Papal States. Specchi's scenographic arrangement, displaced by the Tiber embankments in 1890, counts among the most serious losses to the city's inventory of eighteenth-century buildings.

The Spanish Steps, constructed between 1723 and 1728, provided a visual link between the seventeenth-century Barcaccia Fountain at the base of the Pincian Hill and the sixteenth-century church of the Trinità dei Monti above.[11] Since the seventeenth century the embassy of the Spanish crown has fronted on the piazza at the bottom of the hill, giving it the name of Piazza di Spagna. The church of the Trinità dei Monti at the top of the hill belonged to a French religious order, the Minims, and had been associated with the French crown since the early sixteenth century. During the seventeenth and eighteenth centuries, as these two Catholic powers vied with one another for dominance in Europe, the hillside became a hotly contested space.

The English name given to the staircase is misleading, for in spite of its vicinity to the Piazza di Spagna and the Spanish embassy, it was initially conceived as a monument to the glory of the French monarchy and was paid for out of the bequest of a French diplomat. Politically and visually, the steps relate to the French church of the Trinità dei Monti above, rather than to the Spanish embassy below. In the 1660s the French went so far as to solicit a design for a permanent staircase on the hillside where so many ephemeral displays had been built. This staircase would have had as its centerpiece an equestrian monument of Louis XIV. The erection of such a monument in the heart of papal Rome would have constituted a visual affront to the pope and a thumbing of the Gallic nose at the embassy of their arch-rivals, the Spanish. As such, it was not sanctioned.

After a hiatus of several decades, Pope Clement XI revived the project, favoring a design by Alessandro Specchi. The French Minims preferred to employ their own architect, Francesco de Sanctis, and since the French controlled the purse strings they eventually prevailed. Significantly, De Sanctis's executed design betrays the clear influence of the proposals of Bernini and Specchi. Through the sinuous play of reentrant curves de Sanctis effected a fluid civic armature that facilitates movement but also encourages passers-by to pause and admire the spectacle of the city or engage in conversation. In this respect, the Spanish Steps are overtly scenographic in nature, providing a dignified urban stage on which the drama of daily life continues to be played out.

Following closely on the construction of the Spanish Steps, Filippo Raguzzini designed the exquisite Piazza S. Ignazio (1727–35; fig. 69).[12] Working within the existing street pattern, Raguzzini constructed five apartment blocks that defined a square in front of the great Jesuit church dedicated to St. Ignatius. The buildings are related to one another by means of three tangent circles which generate their curving ground plans and façade elevations. The delicate, cursive forms of Raguzzini's structures are in conscious contrast to the monumentality of Orazio Grassi's colossal Baroque façade, to which they do not relate in scale, materials, or pretensions.

The traditional relationship between a major architectural monument and its urban setting has been reversed. Raguzzini's square does not exist primarily to set off the church, which cannot in any case be viewed comfortably from within its confines; rather, it is from the ample stairs of the church that the observer is invited to view the domestic structures defining the piazza. The audience has been invited on stage, as it were, to enjoy the spectacle of city life, which takes place in the stalls and boxes that Raguzzini, with consummate skill, carved out of the surrounding urban fabric. It is precisely Raguzzini's inversion of the accepted relationships in Baroque planning that gives the Piazza S. Ignazio its charm and compelling interest.[13]

In the course of the eighteenth century the surroundings of the papal summer palace on the Quirinal were developed into a monumen-

tal complex providing for the needs of the papal household and government offices. In 1721–24 Alessandro Specchi began to define the Piazza Monte Cavallo with the construction of the papal stables. Ferdinando Fuga added the magnificent Palazzo della Consulta (1733–37; fig. 68) and extended the Palazzo del Quirinale along strada Pia with the addition of the Manica Lunga and the Palazzina delle Cifre (1731–33). In 1766 Paolo Posi further expanded the Quirinal complex with the construction of the palace for the papal *famiglia* and the First Datary.[14]

Three other squares were embellished in the eighteenth century. In 1711 Clement XI had the Piazza della Rotonda in front of the Pantheon cleared, and commissioned Filippo Barigioni to erect a small obelisk over the pre-existing fountain designed by Giacomo della Porta.[15] In the mid-1730s the approaches to Palazzo Montecitorio were embellished with new buildings, and the Piazza di Trevi was transformed by the construction of Nicola Salvi's great fountain.

The Trevi Fountain is perhaps the most overtly scenographic of all examples of Baroque city planning (fig. 67). Not only does its architecture function as a grand urban *scaenae frons* (scenic frontispiece), but the stairs leading down to the fountain serve to accommodate an audience. The sculptural figures appear to enter upon the rustic stage comprised of the *scogli*, or imitation marine reefs. The marble figures enact an event—the *adventus* of Oceanus—that has close parallels in contemporary dramatic compositions.

Salvi conceived and executed the design for the Trevi Fountain in consciously theatrical terms. Pietro Bracci's mythological figures move out aggressively from the plane of the façade toward the audience gathered to observe the continuing spectacle. The water over which Oceanus rides in his shell chariot is sonorous and constantly moving, which attracts spectators, thus engaging them as active participants in the scene. Salvi's exquisite choreography blurs the traditional barriers separating illusion and reality by uniting sculpture and architecture, which climax in the central cascade.

The success of Salvi's grand theater is in large part the result of the total environment he created. While the architectural backdrop, sculpture, and water naturally dominate, the observer's attention is further focused by the enveloping *scogli* and the embracing concavity of the stairs facing the main prospect. It is an important distinction that the Trevi is set off—but not cut off—from the piazza and the neighboring streets. The bollards and elegant railings provide a sense of security to observers below but present no visual barrier to passers by, who then succumb to the fountain's seductive atmosphere of calm and refreshment.

The enormous scale of the Trevi in relation to its urban environment constitutes another characteristically Baroque feature of its design. Like the façades of so many seventeenth-century churches, the sheer mass of the Trevi dominates the square, an effect compounded by the way in which the fountain proper moves out from the façade to occupy most of the area comprising the piazza. Moreover, the disparity in scale between the Trevi and the surrounding buildings is increased by their proximity to one another. The immediate visual impact of the fountain is in large part a function of its particular urban setting, which Salvi accepted, adapting his design to exploit the peculiarities of the site so that, in his own words, "this irregularity may serve in some way as an adornment of the whole work."[16]

## CHURCH RENOVATIONS

In the course of the eighteenth century the fabric of the city was greatly enriched by the erection of numerous new church façades that provided visual accents to preexisting streets and squares:[17] via Giulia, for example, was enlivened by three new façades: Fuga's S. Maria dell'Orazione e Morte, Posi's S. Caterina da Siena, and Alessandro Galilei's S. Giovanni dei Fiorentini.

After the virtual completion of the exterior of St. Peter's by the end of the seventeenth century, successive popes turned their attention to the embellishment of the other major basilicas. In 1725 Alessandro Specchi added a portico to the façade of S. Paolo fuori le Mura, but this was only a modest intervention compared to the construction of a magnificent new façade for St. John Lateran undertaken during the first years of the pontificate of Clement XII. A great many architects competed for this commission, including Nicola Salvi and Luigi Vanvitelli, but the project was eventually entrusted to Alessandro Galilei. Galilei's façade, employing a colossal order of pilasters and engaged columns (fig. 70), consciously incorporates features of Maderno's design for the façade of St. Peter's. In its rigorous interlocking structure of vertical and horizontal elements, the façade also reflects Galilei's close study of Renaissance architecture (notably the work of Michelangelo) and a general interest in Vitruvian classicism.[18] Galilei was also responsible for the Corsini Chapel in the Lateran (begun in 1734), which provided the architectural framework for many of the most talented sculptors practicing in Rome at this time.[19]

Clement XII's successor, Benedict XIV, commissioned Ferdinando Fuga to erect a new façade for the basilica of S. Maria Maggiore (1741–43), perhaps the architect's most spirited

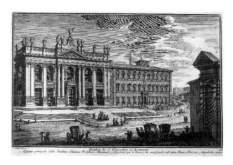

Fig. 70 Alessandro Galilei, St. John Lateran, 1732–35

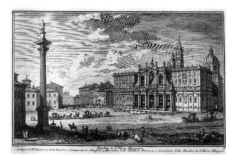

Fig. 71 Ferdinando Fuga, S. Maria Maggiore, façade, 1741–43

and overtly Baroque design (fig. 71).[20] Fuga was constrained by the need to preserve and maintain visible the medieval mosaics on the preexisting façade. His solution, a two-story façade with a portico below and a benediction loggia above, in its open transparency allows the mosaics to be admired from below. More successfully than in any other of his buildings, Fuga established a rhythmic play of chiaroscuro effects and contrasting relationships of mass and void. On both levels the pediments carried by his two superimposed systems of orders project upward into attic levels, thus introducing vertical accents that culminate in Giuseppe Lironi's statue of the Virgin and Child (see fig. 27). The tension between vertical and horizontal elements, and between curving and prismatic forms, as well as the superb rhythmic scansion of Fuga's façade for S. Maria Maggiore clearly distinguish it from the restraint of Galilei's more severe and monumental work on the Lateran. Fuga also renovated the interior of the basilica for the holy year of 1750, collaborating with Pietro Bracci on the elegant high altar canopy.

The restoration of the fourth major basilica, S. Croce in Gerusalemme, was also commissioned by Benedict XIV. Domenico Gregorini's sinuous façade and oval atrium of 1741–44 (fig. 72) recall the work of his master, Filippo Juvarra, as well as several unexecuted projects for the Lateran façade.[21] The atrium is one of

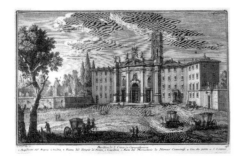

Fig. 72 Domenico Gregorini and Pietro Passalacqua, S. Croce in Gerusalemme, 1741–44

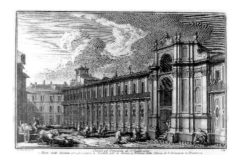

Fig. 75 Filippo Raguzzini, Hospital of S. Gallicano, 1724–26

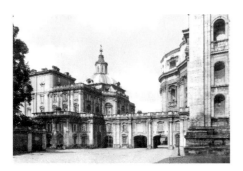

Fig. 73 Carlo Marchionni, St. Peter's, Sacristy, 1776–84

Fig. 74 Francesco Fontana, S. Maria ad Nives, 1706–8

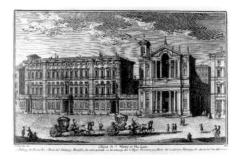

Fig. 76 Gabriele Valvassori, Palazzo Doria Pamphili, 1731

the most dynamic interior spaces of eighteenth-century Rome.

Many other churches were restored and transformed internally, notably S. Clemente, Ss. Giovanni e Paolo, and S. Marco. No less significant was the construction of monasteries, convents, and oratories. Notable among these are the imposing Jesuit college centered on Fuga's S. Apollinare and Vanvitelli's monastery associated with S. Agostino.

The major eighteenth-century contribution to the fabric of St. Peter's was the construction of the sacristy between 1776 and 1784 (fig. 73). The need to provide an adequate sacristy and suitable lodgings for the canons of the basilica had long been recognized, and earlier in the century had prompted competitions that resulted in numerous designs and models, such as those of Filippo Juvarra and Nicola Michetti.[22] Apart from the expense of the enterprise, the need to adapt the sacristy to the vast scale of the basilica posed daunting problems. Pius VI Braschi, who had been a canon of St. Peter's before becoming pope, entrusted the Roman architect Carlo Marchionni with the task of building the sacristy.[23]

Marchionni drew inspiration from the earlier sacristy projects in designing a free-standing block crowned by a dome. Following the lead of Juvarra and Michetti, he used corridors to connect the sacristy and canons'

palace to the basilica. The relatively low profiles of Marchionni's twin corridors only minimally interrupt the view of Michelangelo's imposing cliff face of masonry. Much as he had done earlier in designing the casino of the Villa Albani, Marchionni adapted Michelangelo's formal vocabulary, effectively integrating his own design with that of its distinguished Renaissance predecessor. Within the octagonal core of the sacristy, Marchionni continued his synthetic approach, drawing on motifs from the work of Borromini and Pietro da Cortona, which are integrated into a spare and planar geometric matrix characteristic of the later eighteenth century.

## RELIGIOUS ESTABLISHMENTS AND CHARITABLE INSTITUTIONS

The prints in the seventh and eighth books of Vasi's *Magnificenze* illustrate numerous minor religious establishments that were erected in the course of the eighteenth century. Modest though many of these were, they offered important opportunities for patronage. New oratories were also constructed to serve many of these religious communities. Among the most outstanding are Francesco Fontana's S. Maria ad Nives (fig. 74), the oratory of the SS. Sacramento in Piazza Poli, and the oratory of the SS. Annunziata associated with the church of S. Spirito in Sassia.

During the eighteenth century there was also a marked increase in the quantity and quality of the city's charitable institutions. In the course of the century the hospice of S. Michele along the Tiber was expanded—notably by Carlo Fontana under Clement XI and by Ferdinando Fuga under Clement XII—to form an enormous centralized complex of buildings serving the needs of Rome's poor. In another quarter of Trastevere, Benedict XIII commissioned Filippo Raguzzini to erect the Hospital of S. Gallicano (fig. 75). Raguzzini's plan incorporated the most advanced views regarding hospital design, particularly where ventilation was concerned. In 1742 Benedict XIV commissioned Ferdinando Fuga to expand the hospital of S. Spirito; significantly, both hospitals continue to function today.

## PALACES

The construction of private palaces, many on a grand scale, continued throughout the century. To cite only three notable examples, via del Corso was aggrandized through the construction of Alessandro Specchi's Palazzo de Carolis (1714–24) and Gabriele Valvassori's Palazzo Doria Pamphili (1731; fig. 76), while along via della Lungara Ferdinando Fuga erected the Palazzo Corsini (1736–54). In marked contrast to the almost unrelieved flatness of the long street façade, the rear elevation of the

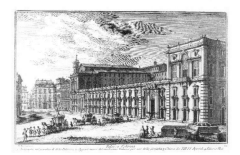

Fig. 77  Nicola Michetti, Palazzo Colonna, 1732–33

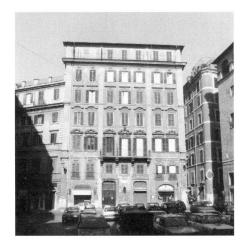

Fig. 78  Alessandro Dori, Casa Giannini on Piazza Capranica, 1744–46

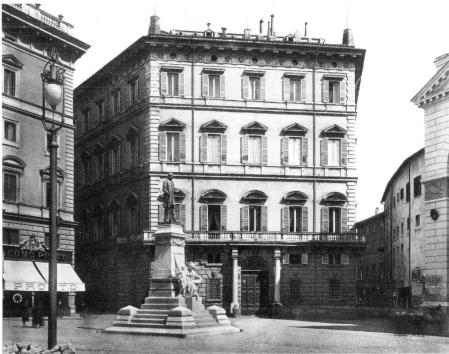

Fig. 79  Cosimo Morelli, Palazzo Braschi, 1791–93

Palazzo Corsini (visible in the center foreground of Vasi's 1765 panorama) projects boldly toward the extensive gardens that extend to the summit of the Janiculum Hill, embracing the landscape and drawing light into its interior in a way few Roman palaces can rival. The library of the Palazzo Corsini, its contents intact and arranged according to a rich pictorial program, remains one of Rome's most perfect eighteenth-century interiors.

In 1732–33 Nicola Michetti added a new façade to the Palazzo Colonna facing Piazza Ss. Apostoli, which provided a scenographic frame for the ephemeral structures erected by the Contestabile Colonna to celebrate the festival of the Chinea (fig. 77). The interior of the southern façade pavilion is perhaps the lightest and most delicate eighteenth-century space in Rome. Unlike contemporary Rococo interiors in France and Germany, however, Michetti's pavilion displays an emphatically tectonic approach to architecture. Not only do exquisitely molded *scagliola* columns project boldly from the wall surface, but every detail of the ornamentation serves to heighten an awareness of the continuing tension of load and support, both real and perceived.

Large family palaces continued to be constructed until the end of the century, and the imposing Palazzo Braschi (fig. 79), built for the family of Pius VI, is perhaps the most outstanding late example. The palace, begun in 1791 to the designs of Cosimo Morelli, was structurally complete by 1793; however, work was interrupted by the French occupation of Rome, and was only completed between 1802 and 1811. The trapezoidal plan adapts creatively to the complex site at the confluence of via Papale and the Piazza Navona. Within, the grand staircase recalls Michelangelo Simonetti's work in the Museo Pio-Clementino of the Vatican.

As well as the palaces of princely and papal families, a new domestic building type began to appear. The palace block consisted of a series of private apartments appropriate to the social status and financial means of middle-class functionaries serving in the growing papal bureaucracy.[24] These blocks eventually became so numerous that they changed the external aspect of the city. Important early examples are the Casa Giannini in Piazza Capranica (fig. 78) and the neighboring Palazzo del Cinque, to which may be added later examples, such as the wing of the Palazzo Doria facing the Piazza Venezia and a palace in via dei Prefetti designed by Giovanni Stern.

## VILLAS AND GARDENS

Nolli's plan, Vasi's panorama, and Diderot's description all record the remarkable extent to which the densely built-up quarters of Rome, concentrated in the bend of the Tiber, were surrounded by open countryside. A close examination of the two prints reveals that, contrary to Diderot's critical remarks, much of this peripheral area consisted of a garland of villas and their associated gardens. Many of these had been laid out in the seventeenth century, but in the course of the next hundred years significant additions were made to Rome's green belt of villas, notably the Villa Corsini and the Villa Albani. While the Villa Corsini was swept away during Garibaldi's defense of the Janiculum heights, the Villa Albani survives substantially intact.[25]

In 1756 Cardinal Alessandro Albani commissioned Carlo Marchionni to build a casino on the suburban property he had acquired a short distance outside the Aurelian walls along via Salaria.[26] The main pavilion was designed to display the cardinal's remarkable collection of ancient sculpture, and Marchionni's drawings reveal that he devoted considerable attention to their placement. Cardinal Albani was the leading antiquarian scholar and collector in Rome, and with his librarian Johann Joachim Winckelmann, paved the way for Neoclassicism; Anton Raphael Mengs's *Parnassus*, painted on the vault of the main *salone* in 1761, provides a pictorial distillation of the new style.

In contrast to the rich and inventive interiors, the exterior of the main pavilion appears to be relatively muted and retrospective, playing variations on sixteenth- and seventeenth-century models, notably Michelangelo's Palazzo dei Conservatori and the loggia of the Villa Mondragone at Frascati. By far the most striking architectural features of the Villa Albani are the pavilions in the form of temple-fronts that project from the lateral wings of the main pavilion. Here the new taste for Greek art championed by Winckelmann in his publications is evident, although in a hybrid form more reminiscent of Piranesi's nearly contemporary *Parere su l'architettura*.

Much as the Villa Albani provided the setting for antiquarian debate, the exquisite garden of the Accademia dell'Arcadia on the slopes of the Janiculum Hill furnished an appropriate background for recitation of pastoral verse. Laid out by Antonio Canevari, a member of the Arcadians, the so-called Bosco Parrasio resembles nothing so much as a rustic version of the Spanish Steps, which were nearing completion in 1725 when ground was broken on the Janiculum site. The curving ramps leading up to the oval ampitheater where the Academicians met to recite their poetry express the metrics and imagery of the Arcadians admirably: graceful, free from ponderous rhetoric and oppressive structure, and fully integrated with nature.

Most of the great Roman gardens of the sixteenth and seventeenth centuries received new pavilions and landscape features in the course of the eighteenth. Valvassori's additions to the Villa Doria Pamphili, Fuga's Coffee House in the Quirinal Gardens, and the transformation of part of the Villa Borghese into a landscape garden *all'inglese* at the hands of Mario Asprucci, Cristoforo Unterperger, and others are three notable examples. Unterperger's sham ruin in the form of a Temple of Antoninus and Faustina (1792) and Asprucci's Temple of Diana (1789), together with the Giardino del Lago and its Temple of Asclepius, illustrate the influence of Sir William Chambers's restructuring of Kew Gardens.

## MUSEUMS

The collections of ancient sculpture assembled during the Renaissance in the Belvedere Court of the Vatican and on the Capitoline Hill in the Palazzo dei Conservatori may be said to have constituted the foundation of the modern museum, and these collections were emulated by princely families such as the Albani, Borghese, Colonna, Giustiniani, and Ludovisi, who gradually built up extensive holdings. The display of works of art, and especially antiquities, in Roman collections would have impor-

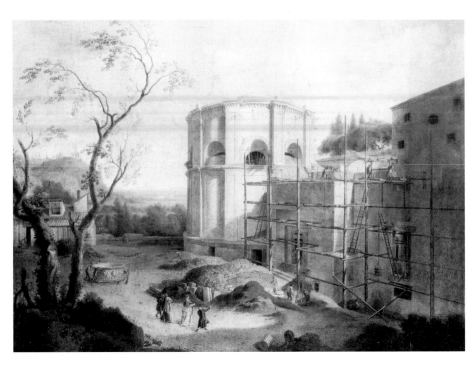

Fig. 80 Michael Wutky, *The Sala a Croce Greca and Sala Rotonda of the Vatican Museo Pio-Clementino under Construction*, c. 1782–83; Philadelphia Museum of Art, Bloomfield Moore Collection

tant consequences for the development of museums abroad, from Stockholm and St. Petersburg to Paris and London. The reorganization and display of antiquities in the Museo Capitolino under Clement XII and Benedict XIV, and the creation of the Museo Pio-Clementino in the Vatican along new, more rational, and systematic lines must count as one of the signal contributions of eighteenth-century Rome to Western culture.

The buildings in which such collections were housed were intended to be an integral part of the display. In the Vatican the architecture, together with its accompanying pictorial program executed by Tommaso Maria Conca and others, provided a coherent structure and well-illuminated environment ideally suited to the study of art. The sequence of halls newly constructed for the purpose, including Michelangelo Simonetti's Sala delle Muse, Sala Rotonda, and Sala a Croce Greca, are among the most magnificent museum interiors ever created. Simonetti placed fragments of ancient architectural ornament and sculpture and mosaic into his design to provide a rich setting consistent with the objects on display; for example, egyptianizing telamones from Tivoli were used to frame the portal leading from the Sala a Croce Greca to the Sala Rotonda.

A remarkable painting by the Austrian artist Michael Wutky illustrates the Sala a Croce Greca and the Sala Rotonda while they were under construction (fig. 80).[27] At center, the Sala Rotonda is structurally complete;

through one of its windows the wooden beams used to provide temporary support for its vault are visible. To the right, masons on the scaffolding are engaged in raising the walls of the Sala a Croce Greca, which suggests a date of 1782–83.[28] The painting, for which there is a preparatory drawing in the Albertina, Vienna, provides revealing insights into an eighteenth-century construction site, similar to those offered earlier in the century by Michetti's drawing of the interior of S. Apostoli under construction (cat. 15).[29] At the right materials are being winched to the top of the scaffold, while in the middle ground are piles of *pozzolana* (volcanic dust) and sand (some of which is being passed through a screen) and a large quantity of bricks fresh from the nearby brickyards of via delle Fornaci.[30] The group at bottom center includes the architect Simonetti kneeling before Pope Pius VI, who is depicted visiting the site. The verdant slopes of Monte Mario are visible in the distance.[31]

## THE ARCHITECTURAL PROFESSION:
## ACADEMY AND STUDIO

Like so many Roman artists and architects of the eighteenth century, Pietro and Virginio Bracci were profoundly influenced by the Accademia di S. Luca. Some of Pietro Bracci's early architectural drawings may be related to printed sources and to monuments that figured prominently in courses of instruction at the Accademia. His studies after Borromini and Pietro da Cortona, informed by such architectural publications as Domenico de Rossi's *Studio*, conform to the curriculum of the Accademia.[32] In the case of Bracci's son Virginio, his prize-winning entry in the 1758 competition exists, as does a later revision of the same project. Virginio's unexecuted design for a central-plan church recalls earlier Accademia projects, notably Juvarra's of 1707 and Vittone's of 1733, which would have been known to him from the Accademia archive (cats.11, 39, and 40).

The architectural curriculum of the Accademia di S. Luca was strongly influenced by Carlo Fontana, through whose studio passed many of the most outstanding architects of the next generation. From the capitals of northern Europe came architects such as Gibbs, Tessin, Hildebrandt, and Fischer von Erlach, who all played an important part in transforming the architectural appearance of their native lands.[33] Within Italy, a younger generation of Fontana pupils, among whom were Juvarra and Giovanni Battista Vaccarini, was instrumental in spreading the Roman Baroque style the length and breadth of the peninsula. Others, such as Antonio Canevari and Nicola Michetti, carried the idiom of the Roman High Baroque, as synthesized by Fontana, to even more distant and alien lands. Within Rome itself, a host of Fontana-trained pupils, among whom Alessandro Specchi was perhaps the most outstanding, continued to work at renovating the face of the city well into the eighteenth century. Indeed, Fontana's influence on the formation of subsequent generations of architects continued long after his death; two sketchbooks by Bernardo Antonio Vittone in the Musée des Arts Décoratifs in Paris contain many copies of Fontana drawings, probably done in Rome in 1732.[34]

It is difficult to describe Fontana's studio practice and its organization, and how these may have influenced his pupils.[35] There are of course a few anecdotes that cast some light on Fontana's methods, and these suggest that he was not particularly innovative as a teacher. The immensely talented and already fully trained Filippo Juvarra was told, upon entering Fontana's studio, to draw after Roman monuments, particularly those by Michelangelo, to

purge his style of its native Sicilian decorative tendencies.[36] There must have been some formal instruction too, probably based on the program of the Accademia di S. Luca, of which Fontana was elected Principe in 1686. What seems to be clear from comparing Fontana's drawings with those of his pupils is that instruction and learning must have taken place in the course of the design and construction of commissioned buildings. From the 1680s on, Fontana always had in hand a number of vast projects which necessitated a large but well-organized and disciplined studio, all working within a common style, using proven working procedures and standardized graphic conventions. Prevailing conventions, including the placement of scales of measurement, the preparation of plans, elevations, and sections to the same scale, the presentation of various design alternatives by means of flaps, and the use of three-dimensional models may be traced back to Fontana's studio practices and to instruction at the Accademia di S. Luca.

## PATRONAGE AND STYLE

In spite of its near monopoly on formal artistic instruction and theoretical discourse, the Accademia di S. Luca was powerless to affect the crisis in architectural patronage that occurred under Benedict XIII. During Benedict's reign members of the Roman architectural establishment were systematically excluded from the salaried positions and commissions that many of them had either long relied upon or looked forward to as a means of support and a potential springboard to success. To the outrage of native Romans, Benedict XIII saw to it that for the duration of his pontificate the most important papal commissions were awarded to his kinsman from Benevento, Filippo Raguzzini. Moreover, Raguzzini occupied not one but two of the most desirable salaried architectural positions in eighteenth-century Rome, through which a steady volume of work was channeled: Architetto del Popolo Romano and Architetto della Reverenda Camera Apostolica. So long as Benedict lived, then, most architects experienced hard times and eagerly waited for the day when the hated *beneventani* would be swept out of office.

It is indicative of Raguzzini's command of the major sources of patronage at this time that Nicola Michetti, a respected architect who had recently returned to Rome from St. Petersburg, where he had designed projects of enormous scale for Czar Peter the Great, was reduced to working as Raguzzini's assistant on one of his major architectural commissions, the Hospital of S. Gallicano in Trastevere. From the building accounts it is clear that in 1726–27 Michetti functioned in a relatively minor

capacity as a *stimatore* supervising work on the site and evaluating the work of masons and contractors alike.[37] Michetti's association with Raguzzini in the mid-1720s is also significant for what it reveals about the diversity of architectural styles coexisting in Rome at this time. Raguzzini and Michetti were both influenced by Borromini, whose work, through publications and the renewed study of his buildings by Bracci and others, was enjoying a revival of sorts.[38] Yet how different was the approach of such architects as Bracci and Michetti to Borromini's legacy from that of Raguzzini. Bracci and Michetti employed a rational process of selection acquired in the Accademia di S. Luca and Fontana's studio, while Raguzzini responded more spontaneously, with the open eye of a provincial architect trained outside the Roman tradition and attuned to the potential for introducing movement to the spare style of Benevento.

It is important to emphasize the role of Rome as a meeting place where different styles and traditions of architecture were discussed, assimilated, and frequently combined, not as a battleground over which revolutionaries and reactionaries were locked in a bitter ideological struggle. The fact that both classical and Rococo elements can be detected in most buildings designed in Rome during the 1720s and 1730s makes it difficult to agree with the view that an extremely complex situation can be explained in terms of a simplistic polarization of conflicting artistic ideologies.[39] Indeed, the rhetoric of this imagined conflict seems to have been manufactured *post facto* and can scarcely be detected in the theoretical literature of the time.[40] What comes closer to the truth is the fact that in eighteenth-century Rome, as had also been true in the Renaissance, the peculiar nature of papal patronage meant that each new pontiff favored different artists and architects. Such was certainly the case with Clement XII Corsini, a Florentine who favored his countrymen Galilei and Fuga but also saw merit in the work of such Romans as Salvi, Vanvitelli, and Michetti.

As Florentines, members of the Corsini entourage were naturally looked upon by the Romans as outsiders. The first architectural competition initiated under the new pope, which was won by the Florentine Alessandro Galilei, confirmed the worst suspicions of the Roman architects. Galilei's design for the façade of St. John Lateran, particularly in its original conception, projected an austere monumentality that breaks with the more exuberant Roman Baroque (fig. 70). Its planarity, its emphasis on trabeated forms, and above all its insistence on a horizontal crown for the façade all reflect Galilei's close study of Vitruvius and Michelangelo. In contrast, Salvi's

design for the Lateran façade appears more sculptural and stands directly in the tradition of the Roman Baroque (cat. 31).

It is natural, therefore, that Salvi, and to a lesser degree Vanvitelli, should have been championed by the Roman camp in this debate over taste. It is probable that Salvi won the competition for the Trevi not merely because of his superior design but because the award to a Roman was intended as a belated act of artistic diplomacy on the part of the Corsini. Salvi's architecture constituted an acceptable compromise between the reforming style of Galilei favored by the Corsini and the tradition of late Baroque classicism espoused by the Roman architectural profession. Not that Salvi consciously set about formulating a personal style that would appeal equally to the divergent tastes of his patrons and the Roman public, but his training and theoretical principles naturally led him to design in a way that would be appreciated by both groups.

An important component of Salvi's training was his close study of Vitruvius and Michelangelo. As a member of the Accademia dell'Arcadia he was naturally predisposed to temper the excesses of Baroque imagery and metaphor and to value the example of Renaissance models. At the same time, however, Salvi's association with the Arcadia led him also to explore and master a range of irregular, picturesque forms analogous to pastoral imagery that are so expressively embodied in the *scogli* of the Trevi. Moreover, Salvi highly esteemed the great Roman architects of the seventeenth century, from whom he learned how to use the classical orders to achieve bold sculptural effects.

That the patronage of the Corsini pope and his family represented a return to many of the values of classicism has long been noted. Giovanni Bottari, the secretary of the pope's influential cardinal-nephew, made this very clear in his treatise on the fine arts, which was written during the early 1730s.[41] It would be a mistake to read too much into this critical attitude, however. The Corsini were unusual not so much in fostering the classical strain of Baroque art by their patronage, as in articulating, through Bottari, their own definition of classical art with such clarity. Classicism, after all, is an important component of Baroque art and particularly in Rome was always present, even in the most exuberant Baroque compositions.[42] It is simplistic to argue that architects such as Salvi and Vanvitelli were anti-Baroque.[43] To be sure, classical principles of clarity and utility (as defined by Bottari) are prominent in their work, but the increased prominence of the classical component in their art only tempers, and does not deny, their essentially Baroque character.

Salvi's synthesis of classical and Baroque forms was no doubt one of the factors contributing to the close study devoted to his work by architects practicing throughout Europe. Salvi counted a Moravian architect, Franz Anton Grimm, among his students. The many drawings Grimm executed under Salvi's direction, including academic exercises in addition to measured drawings after such Roman monuments as the Trevi, suggest that Salvi's studio may have become the successor of Carlo Fontana's as a training ground for architects. In addition to Grimm, we know that other foreign architects, including Carl Harleman, Simon-Louis du Ry, Jacques-Germain Soufflot, James Gibbs, William Chambers, and Robert Adam, paid close attention to Salvi's architecture.

Giovanni Battista Piranesi, too, greatly admired the Trevi, which he represented repeatedly throughout his career as a print-maker. When Piranesi first visited Rome in 1740 Salvi's master mason and contractor, Nicola Giobbe, served as his guide. Giobbe's learning was unusual in his profession; his will reveals that he owned a library of twelve thousand titles, including all the standard architectural treatises, as well as a collection of some three hundred paintings and prints.[44] Piranesi's heartfelt dedication of the *Prima parte di architettura e prospettive* expresses his debt to Giobbe, who introduced him to the most outstanding Roman architects, including Salvi and Vanvitelli.

Piranesi was certainly impressed by the many building projects underway in Rome at the time of his first visit, most of them initiated by the Corsini pope. Under Clement XII's successor Benedict XIV, however, the scope of architectural patronage was to decline dramatically. This was partly the result of the new pope's lack of interest in expensive architectural projects. A letter written in 1743 captures Benedict's attitude; in it, he refers to the large sums expended on building by his predecessor as "two million [*scudi*] won from the lottery and employed in stones."[45] Benedict's own interests tended more towards historical and literary studies. The pope's austere architectural program also reflected the harsh realities of the papal economy in the aftermath of the War of the Polish Succession, and during Benedict's reign architectural projects were undertaken only when absolutely necessary.[46]

In 1750 Ferdinando Fuga and Luigi Vanvitelli left Rome for Naples, attracted by opportunities to build on a scale no longer possible in Rome, and the death of Nicola Salvi in the following year further impoverished the Roman architectural scene. Among the more notable architects practicing in Rome after 1750 were Paolo Posi, best known for his ephemeral designs, and Carlo Marchionni, whose designs for the

Villa Albani and the sacristy of St. Peter's, have already been discussed. The failure of Clement XIII Rezzonico to execute Piranesi's remarkable projects of 1764 for the tribune of the Lateran is revealing (cats. 22, 23). Equally significant is the modest scale of the one design Piranesi succeeded in building, the renovation of S. Maria del Priorato on the Aventine (cat. 24). While some buildings of quality were built in Rome during the second half of the eighteenth century—for example Simonetti's work in the Vatican Museums—Roman architecture had lost its role as a model.[47] During the last decades of the century, the city came to be admired less for the relatively few additions to its urban fabric and more for its value as an open-air museum documenting the history of architecture.

## ROME AS AN INTERNATIONAL CENTER OF ARCHITECTURAL DISCOURSE AND EXCHANGE

Throughout the eighteenth century Rome functioned as a magnet attracting architects from every major European center. While some spent only a short time there, others passed years becoming familiar with the monuments of classical antiquity and the more recent past. Foreign institutions such as the French Academy brought a distinguished series of architects to Rome, many of whom interacted with their Italian counterparts, for example Piranesi's influence on the *pensionnaires* of the academy in the mid-1750s, the same period in which he also exerted a formative influence on Robert Adam.[48] Gilles-Marie Oppenord spent seven years in Rome (1692–99) measuring ancient buildings and drawing works by the masters of the Roman Baroque, especially Bernini and Borromini. A generation later, Jacques-Germain Soufflot traveled to Rome, where he spent several years before becoming a *pensionnaire* of the Academy (1734–38). While there, Soufflot devoted intense study to the Roman Baroque, especially Bernini. His drawings and observations made in Rome formed the basis for theoretical discussions in the academy of Lyon after his return to France. In 1751 Soufflot made a second trip to Italy; significantly, on this visit he appears to have been more attentive to antiquities, for he traveled to Herculaneum and Paestum, as well as Hadrian's Villa, where he left his signature in the crypto-portico of the Peristyle Pool Building. In 1765 Hubert Robert also visited Hadrian's Villa, where he inscribed his name on a niche set into the north flank of the Circular Hall. While there he devoted careful study to the axial extension of the Scenic Triclinium, which influenced his project for enlarging the Grande Galerie of the Louvre (1796) and his painting of the same gallery in ruins.[49]

In addition to contributing to the formation of Italian architects, the Accademia di S. Luca provided more-or-less formal instruction in architecture to a wide range of foreign-born architects, who competed with their Italian counterparts.[50] Among the competitors for the Concorsi Clementini were many foreigners from France, Spain, Poland, and South Germany—including Cosmas Damien Asam, who won first prize in painting in 1713. These students were attracted by distinguished teachers, among whom were Domenico Martinelli, Filippo Juvarra, Antoine Deriset, and Giovanni Paolo Panini.

Some foreign architects, such as Johann Conrad Schlaun, acquired their familiarity with Bernini, Borromini, and other Baroque architects while on study trips. When Clemens August of Bavaria became prince-bishop of Paderborn and Münster in 1719 he appointed Schlaun to the position of land surveyor of Münster and provided him with the means to travel in order to broaden his horizons beyond Westphalia. A significant part of Schlaun's three-year *Studienreise* (1720–23) were the months he spent in Rome in 1722, where he drew not only after the acknowledged masters of the Roman High Baroque, but also buildings by his contemporaries, including Giovanni Battista Contini and Antonio Canevari.[51] As already seen, other architects were drawn to the studios of such established Roman architects as Carlo Fontana and Nicola Salvi.

## PAPER ARCHITECTURE

Architecture in its two-dimensional, graphic form travels easily, and one measure of the importance of eighteenth-century Rome as a cultural entrepôt is its role as a center for architectural publications. The various editions of Domenico de Rossi's *Studio d'architettura civile*, providing architects with measured drawings of the latest Roman monuments, circulated widely in northern Europe.[52] Andrea Pozzo's treatise *Prospettiva de'pittori e architetti* (1693–1700) was immediately translated into German, French, and Latin.[53] An English edition came out in 1707, to which Hawksmoor, Vanbrugh, and Wren, among others, subscribed; by 1737 there was even a Chinese edition. Sebastiano Giannini's publication of the work of Borromini (1720 and 1725) contributed to the revival of interest in this seventeenth-century architect's work both in Rome and abroad.[54] Although best known for his antiquarian publications, Piranesi's polemical works, especially the *Parere su l'architettura* (1765), contested the rigorous functionalism of Frémin, Cordemoy, and Laugier, with their emphasis on purist rigor and slavish imitation of the Greeks. Piranesi, who exalted instead artistic freedom and stylistic pluralism ("diverse maniere"), contributed to a spirited international debate.[55]

Notes

1  "Sul teatro delle maggiori grandezze del mondo, nell'Urbe"; quoted in Trevelyan 1908, p. 2.
2  Goethe [1788] 1982, pp. 115–16.
3  Denis Diderot, *Encyclopédie ou Dictionnaire raisonné des sciences, des arts et des métiers* (Stuttgart-Bad Cannstatt: Frommann, 1966), vol. 14, p. 348.
4  See Gross 1990, pp. 88–151.
5  Milizia 1781. Milizia's *Memorie*, first published in 1768, is an important statement of rationalist attitudes toward Baroque architecture, most of which he condemned for excess of ornament and unwarranted license in the use of the Orders.
6  For a comprehensive bibliography of studies dealing with eighteenth-century Roman architecture, see Contardi and Curcio 1991, pp. 477–501.
7  Contardi and Curcio 1991, pp. 313–459.
8  "Storia di una civiltà architettonica": the subtitle of Portoghesi 1966.
9  Millon 1984, p. xvii.
10  See Marder 1980, pp. 28–56; Spagnesi 1997, pp. 19–26.
11  Lotz 1969, pp. 39–94.
12  See Metzger Habel 1981, pp. 31–65.
13  For an alternative interpretation of the Piazza S. Ignazio, which does not view it in scenographic terms, see Connors 1989, pp. 292–93.
14  Kelly 1992, pp. 816–57.
15  Marder 1974, pp. 310–20.
16  "La surnominata irregolarità servisse in alcuna maniera per adornamento di tutta l'Opera," Vatican Library, Cod. Lat. 8235, 23. A revealing example of Salvi's sensitivity to the urban context of the Trevi is the way the axis of via della Stamperia, paralleled by the retaining wall, determines the right edge of the fountain's space and hence that of the basin itself.
17  These include S. Brigida, S. Francesco delle Stimmate, S. Maria in Cosmedin, S. Clemente, S. Paolo alla Regola, S. Bartolomeo dei Bergamaschi, S. Claudio dei Borgognoni, Ss. Celso e Giuliano, S. Maria della Quercia, S. Maria del Priorato, the SS. Nome di Maria, the Maddalena, S. Trinità degli Spagnoli, S. Quaranta, and Ss. Bonificio ed Alessio.
18  Kieven 1987, pp. 255–75; Kieven 1991, "Il ruolo," pp. 78–123.
19  Kieven 1989, pp. 69–95.
20  Pane 1956; Pietrangeli 1988, pp. 247–52.
21  Varagnoli 1995.
22  Hager 1970.
23  Gaus 1967, pp. 67–110; Benedetti 1989, pp. 247–57; Kieven 1992, pp. 910–17.
24  See the essays in Debenedetti 1994, and Debenedetti 1995.
25  Eleuteri 1996, pp. 109–24.
26  Gaus 1967, pp. 19–66; Cassanelli 1985, pp. 167–210; Roettgen 1987, pp. 17–83.
27  Formerly attributed to Claude-Joseph Vernet. Wutky was in Rome from 1771 to 1801.
28  Pietrangeli 1985, p. 68.
29  Garms 1972, no. 513.
30  Giustini 1997.
31  For Simonetti, see Mancini 1983, pp. 10–16.
32  Millon 1984.
33  Bernini's studio had attracted many foreign sculptors, among them the German brothers Schor, and the Frenchmen Claude Poussin, Niccolò Sale, and Michel Maille. None of these artists, however, returned to his native country to practice on the scale of Fontana's pupils.
34  Wittkower 1967, pp. 165–72.
35  The principal body of evidence documenting Fontana's atelier, his design process, and the part played by his students in it is Fontana's corpus of more than one thousand drawings. See Braham and Hager 1977, especially pp. 19–23.
36  See the biographies of Juvarra by Scipione Maffei and another, anonymous, author, both published in Rovere, Viale, and Brinckmann 1937, pp. 19, 23.
37  Rome, Archivio di Stato di Roma, Ospedale di S. Gallicano, Busta 91 (*Giustificazioni Diverse, 1724–1728*, nos. 61 (11/17/26), 72 (12/23/1726), and 116 (12/1/1727).
38  Connors 1991, pp. 204–13.
39  Portoghesi 1966, part 2.
40  The best survey of the literature remains the chronological list of architectural publications from 1700 to 1800 in Meeks 1966, appendix A.
41  Bottari 1772.
42  Blunt 1980, pp. 61–80.
43  Benedetti 1972, pp. 337–91.
44  Brunel 1978, "Recherches," pp. 77–146.
45  "Un pajo di milini vinti al lotto, ed impiegati in sassi." Morelli 1955–84, vol. 1, p. 101.
46  Kieven 1993, "Roman Architecture," p. xv.
47  Kieven 1993, "Roman Architecture," p. xx.
48  Harris 1967, pp. 189–96.
49  MacDonald and Pinto 1995, p. 235.
50  Millon 1984.
51  Kieven 1995, pp. 135–71.
52  Ciofetta 1991, pp. 214–28.
53  Carta and Menichella 1996, pp. 230–33; Oechslin 1996, pp. 189–206; Salviucci Insolera 1996, pp. 207–14.
54  Connors 1991, pp. 204–13.
55  Wittkower 1938–39, pp. 147–58; Wilton-Ely 1972.

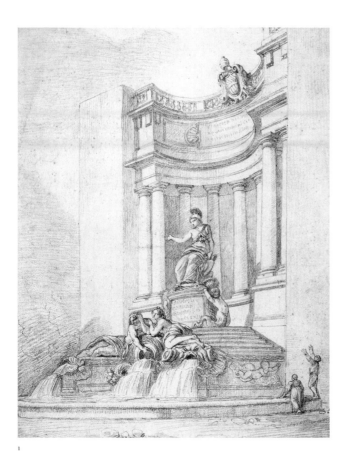

1

## EDME BOUCHARDON

CHAUMONT-EN-BASSIGNY
1698–1762 PARIS
*For biography see Sculpture section*

### 1

## Edme Bouchardon
*Unexecuted Project for the Trevi Fountain*

1730
Red chalk on paper
16½″ × 12⅝″ (425 × 325 mm)
PROVENANCE P. J. Mariette; Louis Corot;
Georges Bougarel (1922)
BIBLIOGRAPHY Roserot 1908, pp. 17–37;
De Brosses 1931, vol. 2, p. 58; Pinto 1986,
pp. 109–13
Musée Antoine-Vivènel, Compiègne,
France

Among the many architects who
entered the competition for the design
of the Trevi Fountain sponsored by
Pope Clement XII in 1730 were two
*pensionnaires* of the French Academy
at Rome, Lambert-Sigisbert Adam
and Edme Bouchardon. Both sculptors
prepared elaborate models, which,
along with some thirty others, were
displayed in the Palazzo del Quirinale.
While Bouchardon's model (like all the
others) has been lost, two chalk draw-
ings appear to record his design: this
one from Compiègne and another at
Waddesdon. Bouchardon's fountain,

sculpture, and architectural backdrop
are concentrated at the center of the
new Palazzo Conti façade and are
framed by its two projecting wings.
The clarity and restraint of
Bouchardon's design as well as its high
quality distinguish it from many of the
other projects for which drawings
survive, and lend support to the artist's
contention that his model was the most
beautiful of those submitted to the
pope. Bouchardon's use of a spare
Tuscan colonnade erected on a concave
plan to provide a setting for the foun-
tain and to accentuate the recessed
center of the palace façade is particu-
larly successful. The centerpiece of
Bouchardon's fountain is a statue per-
sonifying Rome, below which recline
two river gods; silhouetted against the
sky is the escutcheon of Clement XII.
Bouchardon described his model in
a letter of 1731, written from Rome to
his father:

I constructed my model in two
different ways. The first: I con-
formed to the site and related the
architecture and ornament to the
palace, which has already been
built according to a very
mediocre design. The second: I
followed my genius; I may say
that it would be one of the most
beautiful things of this type in
Rome, but since half of the palace
would have to be demolished to
build it, the Prince would never

consent. This is what leads me to
believe that he who makes the
worst model and has the most
powerful supporters will prevail
over all others; this is what one
sees all the time in Rome judging
from the poor works that are built
in these days (cited on Roserot
1908, pp. 30–32).

In certain respects Bouchardon's
design anticipates the fountain on rue
de Grenelle in Paris, which he began in
1739, after his return from Rome.
Common to both are an embracing
concavity and the governing role
played by architecture in determining
the placement and composition of the
statuary. Specific details of
Bouchardon's early design for the
Trevi, such as the bas-reliefs set above
the waterline and the reclining river
gods with vases, have close counter-
parts in the later fountain.
Bouchardon's approach to fountain
design was more restrained than that
of his Italian counterparts. His distinc-
tively French classicism was appreci-
ated by Charles de Brosses, who saw
Bouchardon's model a decade later and
considered it to be superior to Salvi's
design. Marcus Tuscher, an architect
from Nuremberg who was in Rome in
1728–30, appears to have responded
to Bouchardon's design for the Trevi;
among Tuscher's drawings in
Copenhagen is one for a public build-
ing employing an order of his own
invention (the Norico) that is partially
inspired by Bouchardon's model. [JP]

## PIETRO BRACCI
ROME 1700–1773

Pietro Bracci received his first artistic
instruction from his father, Bartolomeo
Cesare, who was a woodcarver. Later
he studied drawing with Giuseppe
Chiari and sculpture with Camillo
Rusconi. Bracci's drawings reveal that
between 1718 and 1722 he also studied
architecture. He appears to have con-
tinued his apprenticeship with Rusconi
until 1724, when he opened his own
studio on the Piazza della Trinità dei
Monti. This is confirmed by Bracci's
own list of works, the earliest of which
dates to 1725. At this time Bracci won
two distinctions marking the end of
his academic study and the beginning
of his intellectual and artistic maturity:
in 1724 he was admitted to the
Accademia dell'Arcadia, and in 1725
he won first prize for sculpture in the
Concorso Clementino of the
Accademia di S. Luca.
From 1725 until his death Bracci's
activity as a sculptor is documented
by an impressive list of securely dated
works. According to the list of sculp-
ture compiled by the artist himself, his
first independent works were two

busts representing Pope Innocent XII
and Cardinal Fabrizio Paolucci, which
he carved for Ss. Giovanni e Paolo in
1725. Following Paolucci's death only
one year later, his nephew commis-
sioned a monument from Bracci for
the family chapel in S. Marcello. The
Paolucci monument was Bracci's first
exercise in the design and execution of
a wall tomb for a family chapel, a
theme on which he would continue to
produce variations throughout the
rest of his career. The principal com-
ponents of the monument are a winged
personification of Fame holding up an
oval portrait of the deceased, set off
against the background of a pyramidal
cenotaph.
In 1730 King John V of Portugal
commissioned the most outstanding
Roman sculptors to provide statues
for the ambitious sculptural program
of the basilica of Mafra. The followers
of Camillo Rusconi, including Bracci,
Giovanni Battista Maini, and Filippo
della Valle, are especially prominent
among this group. Bracci's two monu-
mental statues representing Saint
Peter Nolasco and Saint Felix of Valois
display animated drapery that recalls
his master's Apostles in the Lateran
nave, but their complicated silhou-
ettes and delicacy of surface modeling
illustrate his growing independence.
In 1732 Bracci contributed a relief to
the decoration of the Corsini Chapel
in the Lateran. In the same year he was
also engaged in the restoration of
sculpture on the Arch of Constantine.
In later years he restored important
antiquities for Cardinal Alessandro
Albani. In 1733 he began work on a
monumental seated statue of Clement
XII in marble, which was sent to
Ravenna. Three years later another
seated statue of the Corsini pope was
commissioned from Bracci, this time
by the representatives of the Roman
municipal government. In 1740
Bracci's bronze statue was placed in
the Palazzo dei Conservatori on the
Capitoline hill, where it stood until its
destruction in 1798. At the same time
Bracci was engaged in producing the
two statues of Clement XII, he was
also carving a statue of Clement's pre-
decessor, Benedict XIII Orsini, for his
tomb in S. Maria sopra Minerva. Work
began in 1734 and the finished monu-
ment was unveiled one year later.
In 1739 Bracci secured the presti-
gious commission to carve the monu-
ment of Maria Clementina Sobieska
for St. Peter's. Maria Clementina had
married James Stuart, the exiled Old
Pretender on whom English Catholics
vainly pinned their hopes. Bracci also
projected a monument for the Old
Pretender, intended for the pier oppo-
site his wife's tomb, but his design was
never executed. Also in 1739 the arch-
bishop of Naples commissioned Bracci
to adorn the high altar of the cathedral

with a marble statue of the Assumption surrounded by a host of adoring angels and putti in stucco. Bracci remarks in his diary that the composition was inspired by Bernini's *gloria* above the altar of the Cathedra in St. Peter's. The finished monument, which was completed by early 1743, demonstrates the artist's ability to orchestrate sculpture on a grand scale, as well as his command of dramatic light effects.

No doubt reflecting the critical success of his major works of the late 1730s, Bracci was admitted to the Accademia di S. Luca as an *accademico di merito* in 1740. Over the next two years he executed sculpture for the façade and narthex of S. Maria Maggiore. In 1741 he began work on the monument of Cardinal Giuseppe Renato Imperiali in S. Agostino. This is one of Bracci's most successful compositions, employing a rich range of colorful materials and brilliant silhouetting. In 1748 he received the commission for the monument of Cardinal Leopoldo Calcagnini in S. Andrea delle Fratte, the last of his distinguished series of cardinals' tombs. As part of the ongoing efforts to renovate S. Maria Maggiore for the holy year of 1750, Bracci executed the crowning features of the canopy over Fuga's high altar, including four marble angels clad in bronze drapery, the whole perfectly scaled to the restricted vertical dimensions within which he had to work. In 1753 Bracci received another distinction, election to the Virtuosi al Pantheon. Three years later he was elected Principe of the Accademia di S. Luca, an indication of his respected position within the Roman artistic establishment.

In 1759 Bracci began work on the main sculptural component of the Trevi Fountain, which was completed three years later. In this project he was obliged to follow the full-scale stucco models installed by his predecessor, Giovanni Battista Maini, but he introduced a number of important modifications. A colossal figure of Oceanus is represented skimming over the water in a rocaille shell chariot pulled by a pair of winged sea horses accompanied by tritons. Together with the action of the water that rushes out between them, these superb figures animate the vast composition of the Trevi with movement and vitality.

If Bracci's monumental sculpture for the Trevi Fountain constitutes his most outstanding secular commission, the directive to erect a monument to Benedict XIV in St. Peter's, which he received in 1763, was the capstone of his long career as a sculptor in the service of the Church. Bracci's executed design for the monument departed from tradition by introducing a standing figure of the pope, cast into full relief by the deep

shadows of the niche behind. Bracci's surviving wooden model and numerous preparatory drawings for the monument shed light on the evolution of his design. He probably presented the model to the Accademia Clementina of Bologna in 1763, when he became a member.

In the history of Italian sculpture, Bracci occupies a prominent position between Bernini and Canova. Unlike these two commanding figures, Bracci did not effect a fundamental transformation of the medium in terms of style and iconography. Working within traditional genres, however, he executed exquisite variations on familiar themes such as the portrait bust, the narrative bas-relief, the private memorial, and the papal monument, consistently realizing works of the very highest quality. [JP]

BIBLIOGRAPHY Domarus 1915; Gradara Pesci 1920; Zamboni 1964; Pinto 1986; Novara 1992; Kieven and Pinto 2000

## 2

## Pietro Bracci
*Preparatory Study for the Monument of Benedict XIV in St. Peter's*

1763
Signed in lower left corner: *Petr. Bracci Inven.*
Inscribed: *Palmi Romani*; scale = 30 *palmi*
Pen and black ink, brown wash and gouache highlights over graphite on laid paper
16¼″ × 10½″ (414 × 268 mm)
PROVENANCE Bracci family archive; Duke Arturo Pini di San Miniato
BIBLIOGRAPHY Gradara Pesci 1920, pp. 72–75; Kieven and Pinto 2000, cat. no. 51
Collection Centre Canadien d'Architecture/Canadian Centre for Architecture, Montreal

Unlike his predecessors, Benedict XIV did not make provisions for his own sepulchral monument. His unpretentious character and ironic self-deprecation endeared him even to such critics of the Church as Voltaire. As Benedict had not bestowed great favors on his family, his heirs had no wish to commission an expensive memorial. Thus, it was left to the cardinals created during Benedict's reign to provide for the erection of a monument. In 1758 the pope's remains were provisionally stored in a niche in the south aisle of the basilica. Not until May 1764 was the commission definitely decided upon and given to Pietro Bracci. In 1765 work was underway and the finished monument was unveiled in the north aisle of the basilica in June 1769. This is how Bracci recorded the commission in his diary:

Tomb of Pope Lambertini erected in St. Peter's at the

expense of the cardinals he created. Having announced a competition, they chose my design and appointed me as sculptor and architect of this endeavor. I fashioned a wooden model of my design, painted and gilded; I carved the pope as standing giving a benediction with one hand while the other rests on the arm of the chair; I also carved one of the lateral statues representing sacred Wisdom; the other statue representing Unselfishness, I had carved by the sculptor Sibilla. (Gradara Pesci 1920, p. 108)

The crucial step in Bracci's conceptual process was his introduction of a standing figure of the pontiff, which represented a break with tradition. In addition to the unusual posture depicted, the design introduced a new allegorical message. The traditional tomb allegories of Faith and Ecclesia are replaced by representations of Divine Wisdom and Unselfishness. They allude far more directly to the

personal qualities of the pope, whose intellectual interests were in canon law and the history of the Church and whose neglect of worldly concerns was apparent.

No fewer than eleven drawings by Bracci record the evolution of his project for a papal monument, but only five are directly related to the Benedict XIV tomb. This drawing is very close to the executed version of the monument, departing from earlier studies in the spareness of the portal surround and the decidedly non-illusionistic treatment of the niche. As the position and attitude of the two allegories correspond to the executed monument, this drawing is obviously intended as an alternative study for the treatment of the pedestal. This design also records the change in the pope's attitude, and must, therefore, have been made after the model. The "modelletto" that Bracci mentioned in his diary was given by him to the Accademia Clementina in Bologna upon his being elected honorary member in 1763 and is preserved in the academy collection. [JP/EK]

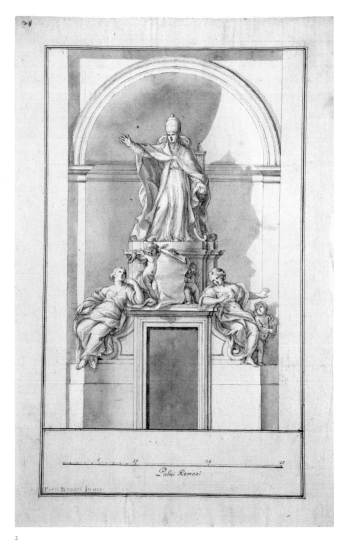

2

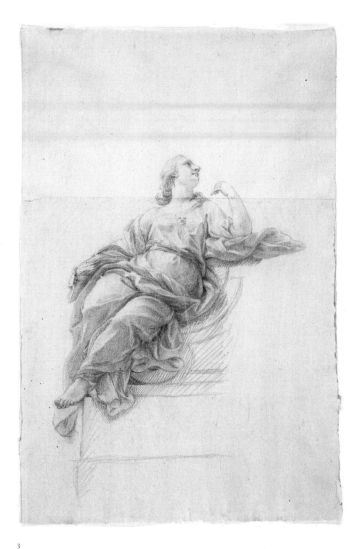

3

## 3
## Pietro Bracci
### Study for the Figure of Divine Wisdom on the Monument of Benedict XIV in St. Peter's

c. 1765
Black chalk on two sheets of bluish paper
14½″ × 9½″ (368 × 242 mm)
PROVENANCE  Bracci family archive; Duke Arturo Pini di San Miniato
BIBLIOGRAPHY  Kieven and Pinto 2000, cat. no. 134
The Montreal Museum of Fine Arts, Gift of the Duke and Duchess Pini di San Miniato

This detailed study for the statue of Divine Wisdom for the Benedict XIV monument, which was executed according to this design, is perhaps the most beautiful of all Bracci's figural drawings. In an exceptional way this sheet demonstrates the best of Bracci's draftsmanship: the subtle, controlled but infinitely graceful movement of the figure, which reclines relaxed but with poise, turning her head aloft and resplendent with divine radiance. The modeling, composed of delicate strokes of black chalk, brilliantly casts the figure into relief. The drawing is composed of two sheets of paper, joined along the line of the figure's neck and wrist. In its original form the figure was probably more frontal, with her head facing the observer. Bracci most likely inserted a new head and hand in an effort to relate Wisdom more closely to the statue of the pope.

The foreshortened view, especially evident in the treatment of the head, effectively captures the impression of an observer looking up at the actual monument. The angle of the light also indicates that Bracci was seeking to capture the effects of light falling from the dome above the monument. This rare finished drawing illustrates the care and discipline Bracci devoted to refining his designs for sculpture. It forms the end of the long process of designing, shaping, and reworking a work of sculpture until the message it is to convey finds coherent formal expression and it is effectively linked to the other figures composing the monument. [JP/EK]

## 4
## Pietro Bracci
### Elevation and Ground Plan of a Monument for James III, the Old Pretender, in St. Peter's

c. 1766
Signed in brown ink on the lower left side
*Petrus Bracci Rom.F.*
Inscriptions: *Jacobus III* in brown ink on the base of the statue; at the bottom: *Scala di 30 Palmi Romani*
Pen and brown ink with gray and brown wash highlighted with white gouache over graphite on paper
16¼″ × 9⅞″ (412 × 251 mm); flap on lower part
PROVENANCE  Bracci family archive; Duke Arturo Pini di San Miniato
EXHIBITION  Montreal 1993, cat. no. 8
BIBLIOGRAPHY  Denison, Rosenfeld, and Wiles 1993, pp. 12–14; Kieven and Pinto 2000, cat. no. 53
Collection Centre Canadien d'Architecture/Canadian Centre for Architecture, Montreal

In St. Peter's, monuments were originally reserved for saints and popes. It was Pope Urban VIII who extended to Catholic sovereigns the privilege of interment in St. Peter's; in 1633 he had the body of Countess Matilda of Tuscany transferred from Mantua and commissioned Bernini to design her tomb. Queen Christina of Sweden, who had converted to the Catholic faith and died in Rome in 1689, was the next to be so honored. The continuous loss of political power and influence that the papacy suffered during the eighteenth century is visibly expressed in the Stuart monuments, the last royal tombs to be erected in St. Peter's.

The royal tombs occupy the narrow bays of the side aisles in St. Peter's, thus differing in width from the wider aedicules of the papal tombs. The narrowness of these bays stands in marked contrast to their height, which was predetermined by the colossal engaged columns that flanked the bays and formed the given framework for every design. The tomb for James Stuart was intended to be erected in the south aisle across from that of his wife, Maria Clementina Sobieska, which Pietro Bracci had executed in 1739 after the design of Filippo Barigioni. The death of the Pretender in 1766 probably prompted proposals for an appropriate monument to his memory.

The drawing on display belongs to a set of four presentation sheets, formerly in the Bracci archive in Rome, all drawn to scale and obviously intended as an array of different solutions. This drawing and another one are now in the collection of the Canadian Centre for Architecture; a third is in the Montreal Museum of Fine Arts and the fourth is in the Art Institute of Chicago.

When Bracci chose to represent the king as a life-size standing figure, he adhered to a new type of Roman tomb sculpture that had only two predecessors: the statue of Cardinal Neri Corsini, executed in 1734 by Giuseppe Maini in the Corsini Chapel in the Lateran basilica, and his own statue for the tomb of Pope Benedict XIV, still underway in 1766 (cat. 2). For the royal monument Bracci used the scheme of "honorary statues," such as the one representing Henry IV of France in the Lateran and that of Philip IV of Spain in S. Maria Maggiore, which depict kings in the guise of Roman emperors. This had also served as a model for the funeral exequies of Augustus II of Poland in 1733. By introducing this different typology, Bracci found a way to distinguish the royal monument from those of popes, princes, and cardinals, clearly marking the difference in hierarchy but in keeping with the style and appearance of the other monuments in St. Peter's.

Allegories of Strength and Religion flanking a sarcophagus provide a stable base for the standing figure of the king in the niche above. In a preliminary version, preserved under the flap, the sarcophagus was omitted and instead an allegorical figure, a putto, and a lion appear as part of the sculptural ensemble. Above, standing on an inscribed pedestal, the king appears in armor, assuming the attitude of a victorious warrior. In his right hand he holds a scepter, which projects boldly from the niche. The king's elegant figure emerges from the dark background into the light that falls from one of the smaller domes of the side aisle. The washes and the strong highlighting with white gouache are characteristic of Bracci's drawing technique and demonstrate his intention to convey graphically the three-dimensionality of executed sculpture. The contrast of strong shadows and bright light enhances the dynamic impression of a truly Baroque movement.

It is not known whether Bracci's designs were commissioned by Cardinal Henry Duke of York, the king's second son and archpriest of St. Peter's, or whether Bracci presented his drawings on his own initiative. In any event, Bracci's proposal was never executed. Although Pope Clement XIII supported the idea that James III should be interred in St. Peter's, he was not favorable to the political ambitions of his sons. A triumphal monument to James Stuart would have caused diplomatic repercussions with the British government. The execution of a memorial to the Stuarts in St. Peter's fell to another sculptor, Antonio Canova, whose Neoclassical monument was not unveiled until 1819. [JP/EK]

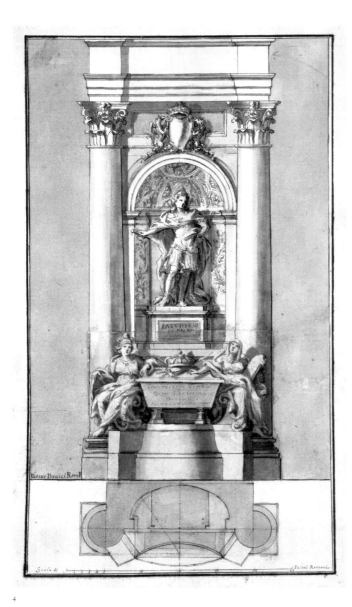

4

## ANTONIO CANEVARI
### ROME 1681–1764 NAPLES

Antonio Canevari's career admirably illustrates the extent to which, by the eighteenth century, many Roman architects sought employment beyond the boundaries of the Papal States. Canevari studied with the architect Antonio Valeri and with Pierfrancesco Garolli, who taught perspective at the Accademia di S. Luca. In 1703 his design for a papal palace won first prize at the Accademia. Along with his master Valeri, Canevari was one of the entrants in the 1715 competition for the sacristy of St. Peter's; his model survives.

Like many of his contemporaries, Canevari participated in the renovation of Early Christian basilicas encouraged by Clement XI. Canevari was engaged in the renovation of Ss. Giovanni e Paolo (1714–18) and later restored the portico of S. Paolo fuori le Mura in 1725. Around 1717 he took over the construction of a new church, S. Francesco delle Stimmate, from Giovanni Battista Contini, executing the façade and spirited bell tower to his own designs; the church was consecrated in 1719.

In 1713 Canevari became a member of the Congregazione dei Virtuosi al Pantheon. Three years later, he was admitted to the Accademia dell' Arcadia. Election to the Accademia di S. Luca followed in 1724. Under Innocent XIII, Canevari prepared a design for the façade of the Lateran basilica, which incorporated Borromini's intentions (1724–25); he subsequently entered the competition of 1732 sponsored by Clement XII.

By 1722–23 Canevari had entered the service of King John V of Portugal, to whom he sent measured drawings of the Vatican complex, the basis for a large-scale model. In 1723 he became architect of the Accademia dell' Arcadia, and in this capacity he designed the exquisite garden on the slopes of the Janiculum Hill that served as their permanent meeting place. This is Canevari's masterpiece, in which the curving ramps and oval ampitheater are perfectly set within the contours of the site. The sponsor for the garden was the Portugese king, and Canevari's successful completion of the Bosco Parrasio in 1725–26 led to his being called to Lisbon, where he lived between 1727 and 1732. Little of his work there, including the clock tower of the royal palace, survived the disastrous earthquake of 1755. Canevari's departure after five years was motivated by the failure of his design for the aqueduct of Aguas Livres, intended to supply Lisbon.

During Canevari's absence from Rome, his pupil Nicola Salvi carried forward the commissions that were already underway, notably a ciborium for the abbey of Montecassino. Six years after his return and failure in the competition for the Lateran façade of 1732, Canevari left Rome permanently for Naples, where he served as architect to the King of the Two Sicilies. There he worked on the hunting lodge of Capodimonte, the royal palace of Portici (1738–59), and other commissions until his death. [JP]

BIBLIOGRAPHY Pio [1724] 1977; Milizia 1785; Golzio 1938, pp. 464–66; Pane 1959, pp. 193–235; Hager 1970, pp. 38–42; Venditti 1973, pp. 358–65; Ferraris 1995, "Canevari," pp. 57–66

## 5

### Antonio Canevari
### *Perspective View of the Garden of the Accademia dell'Arcadia (the Bosco Parrasio) on the Janiculum*

c. 1725
Pencil, pen, and brown ink with gray wash on paper
44½″ × 29⅛″ (1130 × 740 mm)
BIBLIOGRAPHY Crescimbeni 1712; Rinaldi 1990, pp. 485–504; Ferraris 1995, pp. 137–48
Accademia Nazionale di San Luca, Rome

The Accademia dell'Arcadia, a prestigious literary society, was established in 1690 as an offshoot of Queen Christina's academy, which had met in the Palazzo Riario gardens below the Janiculum Hill. In reaction to the artificial and complex literary compositions of the Baroque, the Arcadians self-consciously sought to return poetry and drama to simpler themes of a pastoral nature. As they sought to temper the excesses of Baroque imagery and metaphor, the Arcadians also reasserted the example of Renaissance models. Pietro Metastasio, unquestionably the greatest Italian literary genius of the century, belonged, but so did artists and architects, including Giovanni Battista Piranesi, Giuseppe Vasi, Nicola Salvi, and Luigi Vanvitelli. Piranesi's *Grotteschi* have been related to the poetry of the Arcadians, and Salvi's association with them probably led him to explore and master a range of irregular, picturesque forms analogous to pastoral imagery that are so expressively embodied in the *scogli* of the Trevi Fountain. The Arcadians' interests in the reform of poetry intersected with the visual arts in other ways, notably in their literary celebrations of the fine arts recited at the award ceremonies on the Capitoline Hill for the Concorsi Clementini of the Accademia di S. Luca.

In keeping with their name, the Arcadians convened out of doors in garden settings, and for the first three and half decades of its life the Accademia had no fixed meeting place; for a while they met in the Farnese Gardens on the Palatine. In 1721, after the death of Pope Clement XI, the Arcadians had the inspired idea of naming King John V of Portugal to fill the vacancy left by the pope. In accepting a place among the Arcadians the king effectively became the protector of the academy, and two years later he provided funds for the purchase of land to provide a permanent meeting place; on October 9, 1725, the first stone was laid on the slopes of the Janiculum. The Arcadians naturally chose one of their own members to survey the site, design the garden, and supervise construction: Antonio Canevari, who had joined their ranks in 1716.

Canevari's design for the Bosco Parrasio, recorded in this perspective drawing and in an accompanying ground plan, was for the most part followed quite closely in execution. The garden fits beautifully into a difficult triangular site defined by via di Porta S. Pancrazio and the wall of the Palazzo Corsini gardens. The central axis connects the entrance at the bottom with the most important ceremonial space (an oval ampitheater where the Arcadians met to recite their poetry) at the top by means of gracefully curving ramps set into the contours of the hillside. In a number of ways the Bosco Parrasio appears to be a rustic version of its more polished urban cousin the Spanish Steps, which were still under construction at the time Canevari developed his design.

Certain features in the drawing were never executed, notably the twin gate pavilions (within which the Arcadians could shelter in case of rain) and the profusion of sculpture. The sculptural program was, predicably, very carefully thought out. Two pairs of statues above the portal represent the Arcadians (*Pan* and *Syrinx*) and

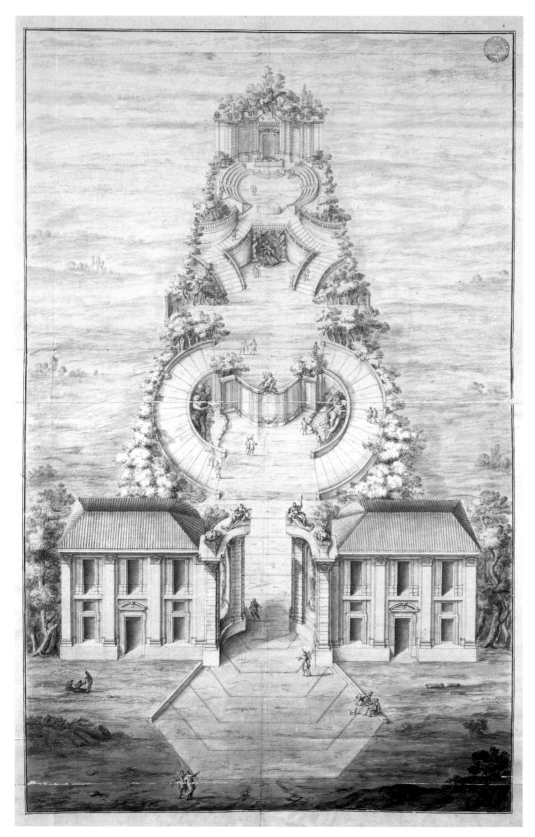

literati (*Athena* and *Mercury*). Occupying the lowest level of the garden are colossal personifications of the Tiber and the Arno, the sources of Latin and Tuscan literature. Above, and on axis, is Apollo holding a laurel crown. Set into a fountain grotto at the rear of the middle terrace is a statue of the River Alpheus, representing Greek poetry. Crowning the entire garden is the figure of Pegasus, whose presence was intended to identify the site with Mount Helicon, the abode of the muses. Even without its sculptural compliment, the Arcadian garden remains an enchanting site, overgrown and shaded by towering umbrella pines. Within its confines the spirit of Settecento Rome lives on. [JP]

## CARLO FONTANA

RONCATO, COMO 1638–1714 ROME

One of numerous architects, engineers, and masons from the Ticino who gravitated to Rome, Carlo Fontana was a distant relation of Domenico Fontana, the celebrated engineer of Pope Sixtus V. By the early 1650s Fontana was established in Rome, where he worked with Pietro da Cortona and Gianlorenzo Bernini. Fontana assisted Bernini in the capacity of Misuratore e Stimatore della Camera Apostolica from 1664 on, and in 1666 he was named Misuratore della R. Fabbrica di S. Pietro; in 1697 he became architect of the basilica.

Fontana had a distinguished academic career. In 1667 he joined the Accademia di S. Luca as *accademico di merito*, and he served for many years as Principe. After the reorganization of the Accademia instigated by Clement XI in 1702, Fontana was replaced as Principe by Carlo Maratti, but retained authority over architectural matters.

Among Fontana's earliest independent works were the façades of Ss. Faustina e Giovita (c. 1664) and S. Biagio in Campitelli (c. 1665). In 1669–71 he built the Teatro Tor di Nona, for which he also provided set designs. This was followed by the commission for the Ginetti Chapel in S. Andrea della Valle (1671–84) and his spirited baldachin for the high altar of S. Maria in Traspontina (1674), above which angels support a crown in the shape of a cupola.

Several of Fontana's most significant designs date from the decade of the 1680s. Foremost among these is the façade of S. Marcello al Corso (1682–84), a distillation of late Baroque classicism. Fontana also constructed the Cybo Chapel in S. Maria del Popolo (1682–84), with its rich polychromy and fusion of architecture, painting, and sculpture. In this period he also designed the imposing central-plan sanctuary of St. Ignatius at Loyola

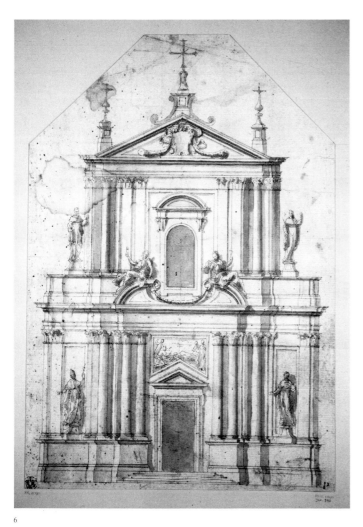

6

---

in Spain (1681), the first example of Fontana's architecture for export.

In the 1690s Fontana's studio continued to dominate the architectural profession in Rome, providing designs for the Casanatense Library (1690–92) and the adaptation of the Palazzo Ludovisi into the Curia Innocenziana (Palazzo di Montecitorio, 1691–1700). Under Clement XI, Fontana was involved in many projects, of which the Albani Chapel in S. Sebastiano (1706–12) and the reformatory (1703–4) embedded in the hospice of S. Michele are particularly worthy of mention. After Fontana's death in 1714, his pupil Nicola Michetti supervised the completion of the three large-scale buildings his master had underway at that time: the reconstruction of Ss. Apostoli, the completion of the Palazzo di Montecitorio, and the hospice of S. Michele.

Carlo Fontana was extremely effective as a publicist of his own work, but his numerous publications are significant also in the degree of historical engagement they bring to such buildings as St. Peter's and the Colosseum, as well as such topographical sites as the Montecitorio. His monumental

volume on the history of St. Peter's, the *Templum Vaticanum* of 1694, set new standards for the publication of architectural monographs. His role as a teacher also deserves particular note. His studio attracted architects from within Italy (notably Juvarra and Michetti) as well as from abroad (James Gibbs and Fischer von Erlach, for example). Through the work of these and other Fontana students, late Baroque classicism became a truly international style that flourished for much of the eighteenth century in major European centers from the shores of the Baltic to the island of Malta, from London to Dresden. [JP]

BIBLIOGRAPHY Fontana 1694; Coudenhove-Erthal 1930; Hager 1967–68, pp. 189–306; Hager 1968, pp. 299–314; Hager 1973, pp. 58–74; Hager 1973, "Carlo Fontana," pp. 319–37; Hager 1974, pp. 47–61; Hager 1975, pp. 344–59; Braham and Hager 1977; Eguillor, Hager, and Hornedo 1991; Hager 1991, pp. 155–203; Hager 1993, pp. 123–55; Hager 1995–97, pp. 337–60

---

## 6
## Carlo Fontana
### *Study for the Façade of S. Marcello al Corso*

1682
Graphite, pen, and brown ink with brown wash on paper
13⅛″ × 9″ (340 × 230 mm)
EXHIBITION Stuttgart 1993, cat. no. 62
BIBLIOGRAPHY Hager 1973, pp. 58–74; Wittkower 1973, pp. 373–75; Jacob 1975, pp. 85–86; Kieven 1993, pp. 178–79
Staatliche Museen zu Berlin, Kunstbibliothek

The façade of S. Marcello al Corso (1682–84) provides an excellent example of Carlo Fontana's synthesis of the essentials of the Roman Baroque style. The façade follows a concave plan, but unlike Borromini's S. Carlo alle Quattro Fontane and S. Maria dei Sette Dolori, its curving surface does not interact dynamically with the space before it, nor is its organization so densely active and full of tension. In the tradition of the Roman aedicular façade, there is at S. Marcello an increase in activity, depth, and chiaroscuro effects towards the center, which is the result of a measured concentration of basic architectural elements, and not an aggressive expression of architectural energies. The important role played by sculpture in this façade also ties it to the Roman tradition of façade design from Maderno's S. Susanna onwards, but, like their architectural framework, the statues seem contained and content to play their parts within the limits defined by framing columns and supporting pediment. It is precisely the clarity and controlled subordination of elements in the façade that caused Wittkower to remark of it that "Here everything is unequivocal, proper, easily readable" (Wittkower 1973, p. 373); and it is this same clarity that made Fontana's style so communicable and easily assimilated.

This drawing represents an early preparatory study by Fontana, which was subsequently developed in another drawing for a print issued in 1683. For this reason, the façade differs in a number of important respects from Fontana's preparatory study. This is most evident in the sculptural component, and the treatment of the window at the center of the upper story. The statues of Pope Marcellus and Saint Philip Benizi to the left and right of the portal are placed within niches on the façade itself. The statues on the upper story representing Faith and Hope (on the pediment) and two saints of the Servite order: Gioacchino da Siena and Francesco Patrizi, were installed only in 1703.

Although designed late in the seventeenth century, the S. Marcello

façade was a critical monument for the younger generation of architects who trained in Fontana's studio and came into their own during the first two decades of the new century, and traces of its influence may be observed throughout Europe. This is particularly evident in the work of Filippo Juvarra, notably in the early design for the façade of S. Brigida in Naples and the executed façade of S. Cristina in Turin. [JP]

---

## 7
## Carlo Fontana
### *Study for an Ephemeral Triumphal Arch for Pope Clement XI*

1701
Signed at bottom in Fontana's hand: *Io cav.e Carlo fra.co fontana ho fatto di ppa mano*
Pen and brown ink with gray wash on paper
17⅞″ × 11½″ (456 × 290 mm)
PROVENANCE Pacetti Collection
BIBLIOGRAPHY Erffa 1963, pp. 335–70; Jacob 1975, p. 86; Kieven 1993, pp. 182–83; Fagiolo 1997, vol. 2, pp. 20–22
Staatliche Museen zu Berlin, Kunstbibliothek

The design of ephemeral structures provided valued opportunities for many architects in eighteenth-century Rome. Among the most prestigious of such commissions were those for the festive arches honoring newly elected popes on the occasion of their procession to take possession of the Lateran basilica, the so-called *possesso*. Foremost among these were the arches erected by the Farnese dukes of Parma opposite Vignola's gateway to their gardens on the Palatine. From the Vatican the procession wended its way along via Papale to the Capitoline Hill, from which it passed through the Campo Vaccino, the site of the ancient Roman forum. Following the path of ancient triumphal processions, but in reverse, the pope and his retinue passed under the festive arch of the Farnese before going through the Arch of Titus on their way to the Lateran.

Throughout his long career Carlo Fontana was active in providing designs for ephemeral structures appropriate to a variety of different functions. In 1692 he had designed a similar arch for the Farnese celebrating the *possesso* of Innocent XII. The arch he designed for the procession of Innocent's successor, Clement XI, resembles his earlier effort in several important respects, notably in the use of standing allegorical figures of virtues set at the level of the column bases. Fontana's spirited sketch, which was preparatory to a print by his pupil Alessandro Specchi, provides sufficient detail to allow the

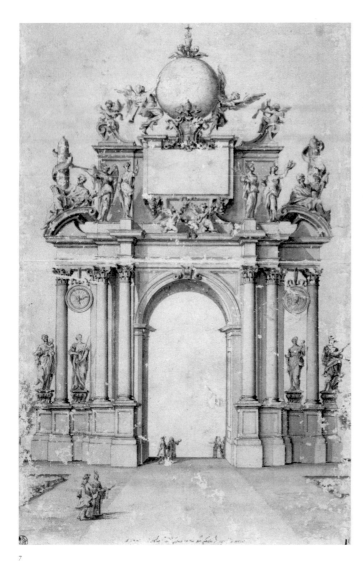

7

virtues to be identified: Charity, Religion, Justice, and Prudence. In the attic, reclining figures of Saint Peter and Saint Paul are accompanied by other allegorical figures and trumpeting fames. Crowning the arch is an orb surmounted by the cross, host, and chalice, symbolizing the triumph of Religion over the world.

Although Fontana's effective use of shading contributes to an impression of solidity and permanence, documents reveal that such arches were constructed of painted canvas and stucco laid over wooden armatures, and were dismantled soon after the conclusion of the festivity. More enduring were the prints that were issued to provide a record for distinguished participants in the procession, onlookers, and those who were unable to attend. Collectively, these prints constitute an impressive series, which was consulted by later architects when called upon to provide new designs. Twenty years later, for example, when Pietro Bracci drew proposals for the *possesso* arch of Innocent XIII (which was eventually

designed by another artist), he was profoundly influenced by Fontana's design. [JP]

## FERDINANDO FUGA
FLORENCE 1699–1782 ROME

Ferdinando Fuga studied with the sculptor and architect Giovanni Battista Foggini in Florence before departing for Rome in 1718. Henceforward, his long and productive professional career was divided between Rome and Naples, which, with Turin, constituted the principal centers of architectural patronage in eighteenth-century Italy. Fuga's first Roman sojourn, between 1718 and 1726, was a period of intense study and assimilation of the city's architectural heritage. Three unexecuted designs survive from this period: a project for the façade of St. John Lateran (1722), a proposal for the Trevi Fountain (1723), and another for the façade of S. Maria sopra Minerva (1725). The Trevi design shows the young architect's awareness of

Francesco de Sanctis's design for the Spanish Steps, which were then under construction.

In 1726 Fuga was called to Naples by Cardinal Nicola del Giudice, thus initiating the first of his two extended periods of activity in southern Italy. While there, he executed his first independent design, a chapel (1726–27) undertaken along with other additions to the Palazzo Cellamare in Naples. By 1729 Fuga was evidently in the service of the King of Naples, because in that year he was sent to Sicily to design a bridge over the River Milicia. The election of the Florentine Lorenzo Corsini to the papacy as Clement XII brought Fuga back to Rome.

Fuga's appointment as architect of the papal palaces in 1730 marks the beginning of his artistic maturity. Under the pontificates of Clement XII and his successor Benedict XIV, Fuga was awarded numerous commissions which, both in scale and importance, were remarkable in Rome during this period. It is likely that Fuga's Florentine origins played a part in securing him his papal appointment, for Clement XII openly favored Florentines. In the early years of Clement's pontificate, Fuga was concerned almost exclusively with enlarging the papal palace on the Quirinal (1732–37) and with the construction of new buildings in its vicinity. Between 1730 and 1732 he extended the Manica Lunga further along strada Pia and added the Palazzina del Segretario delle Cifre as its terminus. Of far greater interest is the Palazzo della Consulta (1732–37), diagonally opposite the main entrance to the Palazzo del Quirinale, which provided accommodation for the secretaries of the Consulta and the Brevi, as well as lodgings for two small corps of papal guards.

Between 1733 and 1737, at the same time as Fuga was occupied with the Palazzo della Consulta, he also was building the church of S. Maria dell'Orazione e Morte (1733–37) on via Giulia. In its longitudinal oval plan Fuga brilliantly integrated the sinuous continuity of mural structure in Francesco Borromini's S. Carlo alle Quattro Fontane with the muted axis of Gianlorenzo Bernini's S. Andrea al Quirinale. The rich relief of the façade and the paired columns set into recessed compartments recall the highly sculptural designs of earlier Tuscan architects, notably Michelangelo, Bartolomeo Ammannati, and Pietro da Cortona.

In 1736 Fuga was elected to membership in the Roman Accademia di S. Luca, over which he would preside as Principe from 1752 to 1754. The last major building Fuga undertook during the pontificate of Clement XII was the family palace on via della Lungara. In building the Palazzo

Corsini (1736–54) Fuga was obliged to incorporate an earlier structure, the Palazzo Riario, into his design. In marked contrast to the almost unrelieved flatness of the long street façade, the rear elevation reaches out to embrace the extensive gardens which extend to the heights of the Janiculum.

Benedict XIV commissioned Fuga to erect a new façade for the basilica of S. Maria Maggiore (1741–43), perhaps the architect's most spirited and overtly Baroque design. Also in 1741, Fuga designed the Coffee House in the gardens of the papal palace on the Quirinal. The Coffee House has been interpreted as an anticipation of Neoclassical architecture, but such a viewpoint misconstrues Fuga's historical position. There is no evidence to suggest that he was theoretically disposed to emulate the architectural principles of ancient Greece, any more than he was familiar with specific Greek monuments. Rather, Fuga stands as a transitional figure, whose synthesis of earlier Baroque architecture led him, especially in secular buildings, to designs of increasing austerity and reductive simplicity.

The third major building project in which Fuga was engaged under Benedict XIV was the church of S. Apollinare, which was begun in 1742 and dedicated in 1748, just three years before his departure for Naples. This substantial edifice was built to serve the German and Hungarian College, in which it is incorporated. Throughout S. Apollinare, but especially in the sanctuary, Fuga utilized the full repertoire of Baroque ornament, but subordinated it to clear and distinct structural divisions, a mark of his growing classical restraint in the years following the façade of S. Maria Maggiore.

In 1750 Ferdinando Sanfelice and Domenico Antonio Vaccaro, the two most distinguished Neapolitan architects of the first half of the eighteenth century, both died. In the following year Charles III, King of Naples, prevailed upon Fuga and Luigi Vanvitelli to leave Rome and enter his service. While Vanvitelli was given the commission to build the royal palace at Caserta, Fuga was called upon to design the Albergo dei Poveri (1751–81), an enormous poorhouse intended to provide for some eight thousand needy persons. Thus began the final period of Fuga's professional career. This vast undertaking occupied him for the last thirty years of his life, and although work continued long after his death, only a fraction of the building was completed. Even in its incomplete state, however, the Albergo dei Poveri must be counted among the most ambitious architectural projects of the eighteenth

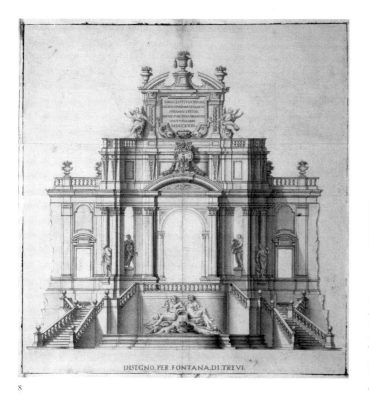

8

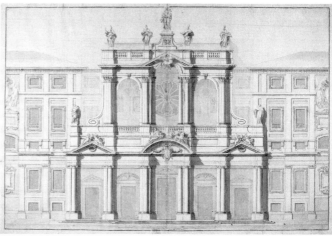

9

century, rivaling even the utopian fantasies of Etienne-Louis Boullée. Fuga was responsible for other important buildings in and around Naples, among which were the Villa Favorita at Resina (c. 1768) and the great public granary (1779) undertaken in his last years.

Together with Vanvitelli, Fuga contributed to the formulation of an imported, classicizing court style in Naples, reflecting contemporary developments not only in Rome, but also in France. Parallels between Fuga's work and French architecture around 1750 suggest that there may have been a reciprocal exchange of ideas in this period. At the end of his career, stimulated at once by the utilitarian nature of his major commissions and the taste prevailing at court, Fuga's style became increasingly simple and classical, a process that had already begun before his departure from Rome. Nonetheless, as is evident in the oval atrium of the Villa Favorita in Resina, Fuga's work continued to embody Baroque features. Ferdinando Fuga may be characterized historically as a transitional figure, whose early work represents a creative synthesis of late Baroque forms which, after mid-century, give way to an ever more rigorous and academic classicism. [JP]

BIBLIOGRAPHY  Milizia 1785, vol. 2, pp. 287–91; Matthiae 1952; Bianchi L. 1955; Pane 1956; Hager 1964; Blunt 1975, pp. 169–72; Pinto and Kieven 1983, pp. 746–49; Kieven 1987, pp. 255–75; Kieven 1988

## 8

### Ferdinando Fuga
### *Unexecuted Project for the Trevi Fountain in Rome, Elevation*

Signed and dated 1723
Pencil, pen, and black ink with gray wash on paper
25″ × 22⅞″ (635 × 580 mm)
PROVENANCE  Stanza del Borgo, Milan
BIBLIOGRAPHY  Bareggi and Pino 1972, p. 34; Pinto and Kieven 1983, pp. 746–49; Pinto 1986, pp. 90–93; Kieven 1988, p. 42
Staatliche Museen zu Berlin, Kunstbibliothek

The abandonment of Bernini's ill-fated project of the 1640s for the Trevi Fountain prompted numerous proposals for the fountain's embellishment. This remarkable series of drawings, which constitutes a highly instructive compendium of Baroque fountain designs, comprises many projects from the first three decades of the eighteenth century, before the final construction of the fountain in 1732. Among these, Ferdinando Fuga's proposal of 1723 offers one of the most striking solutions. This elevation corresponds in every detail to a ground plan in the Gabinetto Nazionale delle Stampe in Rome, which has long been recognized as one of his early designs.

The relatively low level of the Acqua Vergine, which feeds the Trevi, made it difficult to produce a spectacular display of water, so naturally in Fuga's design for the fountain the monumental character of the architecture dominates the sculpture and

play of water. Fuga's project shows a modest basin of irregular outline, above which recline two statues representing personifications of local rivers, the Tiber and the Erculaneo. The water of the Acqua Vergine flows from a vase set between these two figures and, after washing over the ornamental rockwork, falls into the basin below.

The upper portion of Fuga's design functions independently of the fountain at its base. Fuga's great *mostra*, or architectural display, of the Trevi is overtly scenographic in character, recalling contemporary festival designs. The high basement, angled staircases, and festive façade resemble designs for fireworks displays, such as those celebrating the Chinea ceremony, as well as other ephemeral designs made by Fuga himself later in his career. The central archway and projecting attic carrying an inscription also recall the temporary triumphal arches erected in the Campo Vaccino on the occasion of the papal *possessi*, two of which Fuga designed later in the century. The staircase, with its sharp, angled turns reveals Fuga's awareness of the Spanish Steps (1723–26), which were under construction at the time his project for the Trevi was drafted.

Four statues personifying the seasons flank the central arch. Above, and placed between two allegorical statues of Fames, an inscription plaque records the date and patron of the commission: Pope Innocent XIII Conti. Between the inscription and the split pediment of the arch rests the papal escutcheon. In 1723 the secular branch of the pope's family acquired property behind the fountain, and Fuga's project is the first of a series of unexecuted designs for the Trevi conditioned at least in part by the Conti family's desire to incorporate the fountain into a new palace façade. The Conti succeeded in erecting a new palace façade in 1728, but to their great

frustration it was covered over only five years later by the present fountain, and crowned not by their family arms, but by those of the reigning pontiff, Clement XII Corsini. [JP]

## 9

### Ferdinando Fuga
### *Portico and Benediction Loggia of S. Maria Maggiore, Sections*

1741
Pen and brown ink with gray, blue-gray, and pink washes on paper
23″ × 35¼″ (585 × 895 mm)
EXHIBITION  Stuttgart 1993, cat. no. 99
BIBLIOGRAPHY  Bianchi L. 1955, p. 67; Pane 1956, pp. 84–92; Kieven 1988, pp. 61–63; Kieven 1993, pp. 264–65
Ministero per i Beni e le Attività Culturali, Istituto Nazionale per la Grafica, Rome

S. Maria Maggiore, one of the seven basilicas of Rome, was a fourth-century foundation. In the twelfth century its façade was enriched by a portico with mosaics above. The portico had been restored for the jubilee year of 1575 and to the east Pope Paul V had added a structure for the canons. By 1735 the old portico was threatening collapse and Ferdinando Fuga was called in to design a replacement, but with the depletion of the papal treasury on other projects and the distractions of the War of the Polish Succession, it was not constructed. Five years later, under Benedict XIV, Fuga was asked to furnish designs for a more ambitious project, a new façade that would unify the disparate structures composing the south front of the basilica. Two other requirements were part of the program: it was necessary to maintain the visibility of the twelfth-century mosaics while providing a benediction loggia on the second story. Fuga was thus severely constrained in preparing his design for the new façade. The old portico was

demolished in January 1741, and the foundation stone of the new façade was laid in March of the same year. By 1743 construction was complete; as architect of the chapter of S. Maria Maggiore, Fuga continued to work inside the basilica until the jubilee of 1750.

Fuga's solution to the problems presented by the façade was to design a two-story *scaenae frons* (or scenic frontispiece) with a portico at the ground level and an open benediction loggia above, through which the old façade mosaics would be visible. The drawing, presenting both a longitudinal and a transverse section of the portico, reveals this arrangement with admirable clarity. Particularly interesting is Fuga's proposal to wash the medieval mosaics with light dropped from oval windows hidden behind the façade. In spite of the fact that they have faded somewhat, Fuga's masterful use of colored washes is clearly evident. [JP]

## FILIPPO JUVARRA
MESSINA 1678–1736 MADRID

Filippo Juvarra was the most accomplished architect of the first half of the eighteenth century. Born into a family of silversmiths, he studied for the priesthood and was ordained in 1703. The next year he traveled to Rome, where he studied with Carlo Fontana. Juvarra's gifts as a draftsman were immediately evident, and as early as 1705 he won first prize in the Concorso Clementino. Two years later he was elected to membership in the Accademia di S. Luca. In this period he produced hundreds of drawings, both original designs and studies after Roman architectural monuments spanning the period from classical antiquity through the High Renaissance

and the masters of the Roman Baroque, especially Bernini, Borromini, and Pietro da Cortona.

The one significant design Juvarra succeeded in building in Rome is the Antamoro Chapel in S. Girolamo della Carità (1708–10), on which he collaborated with the sculptor Pierre Legros. The chapel reveals Juvarra's mature command of lighting and silhouette, as well as his familiarity with the altar designs of Bernini and Pozzo. In 1709 Juvarra's antiquarian interests were directed towards a large presentation drawing intended for the visiting King of Denmark; this reconstructed the Capitoline Hill in antiquity, depicted its eighteenth-century condition, and projected its transformation into a grand Baroque space. Between 1708 and 1714 Juvarra furnished set designs for Cardinal Pietro Ottoboni's theater in the Cancelleria and other Roman theaters. These demonstrated his mastery of scenography and explored themes in his ephemeral set designs that would later emerge in his built architecture. Toward the end of his Roman sojourn Juvarra taught architecture at the Accademia di S. Luca.

In 1714 Victor Amadeus II of Savoy, also King of Sicily, called Juvarra to Messina to provide designs for completing the royal palace there. Later in the same year Juvarra arrived in Turin, which, in the course of the next twenty years, he transformed with numerous buildings of his own design. Among the many projects of his first years in Turin, three stand out as being of special significance and illustrating the fruits of his period of study in Rome. In the façade of S. Cristina on Piazza S. Carlo (1715) Juvarra played an exquisite variation on the theme of the aedicular façade,

with particular reference to S. Marcello al Corso, by his Roman master Carlo Fontana. The votive church of the Superga (1716–31) recalls his 1707 presentation drawing for the Accademia di S. Luca. His model for the Castello di Rivoli (1718) incorporates a system of ramps that were clearly inspired by his reconstruction of the ancient Capitoline Hill. Although Juvarra's design for the façade of the Palazzo Madama (1718) draws on French precedent, particularly the model of Versailles, the grand staircase within reflects his original fusion of decorative elements from Cortona and Borromini. Among the major undertakings of his later years in Piedmont are S. Andrea in Chieri (c. 1728), the Palazzina di Stupinigi outside Turin (1729–35), and the church of the Carmine in Turin (1732–36). The oval salon of the royal hunting lodge at Stupinigi is the realization in concrete form of Juvarra's earlier set designs.

During his two decades in Piedmont, Juvarra traveled extensively. Shortly after his arrival in Turin he returned to Rome to participate in the competition for the Vatican sacristy; his model of 1715 survives, but his design was not executed. A later visit in 1732 also failed to yield a major commission. In 1718–20 Juvarra was away from Turin for extended trips to Paris, Portugal, and London. For King John V of Portugal he made designs for the port and a royal palace with adjacent church, none of which was executed.

In 1735 Philip V of Spain requested his relative Charles Emmanuel III of Savoy to grant Juvarra permission to travel to Madrid in order to design a new royal palace. Juvarra arrived later that year and immediately set to work on the garden façade of the palace of

La Granja at San Ildefonso. This design was executed after Juvarra's death in 1736 by his assistant Giovanni Battista Sacchetti, who also succeeded in building a reduced version of his master's royal palace design.

Rome was crucial to the formation of Juvarra's style. Although he never succeeded in winning a major commission there, he effected a highly original synthesis of Roman architectural design that infused his work elsewhere in Italy and abroad. In his great Piedmontese monuments especially, the tradition of Michelangelo, Bernini, Borromini, and Cortona was instilled with new vigor and projected into the eighteenth century. [JP]

BIBLIOGRAPHY Rovere, Viale, and Brinckmann 1937; Accascina 1957, pp. 50–62; Accascina 1957, "Juvara III," pp. 150–62; Viale 1966; Pommer 1967; Hager 1970; Viale Ferrero 1970; Boscarino 1973; Carboneri 1979; Pinto 1980, "Juvarra," pp. 598–616; Millon 1984; Millon 1984, "Filippo Juvarra," pp. 13–24; Gritella 1992; Barghini 1994; Comoli Mandracci and Griseri 1995; Bonet Correa, Blasco Esquivias, and Cantone 1998

## 10
## Filippo Juvarra
### *Project for a Royal Palace For Three Important Persons*

1705
Pen, brown ink, and gray wash on brown paper
18½" × 43" (471 × 1084 mm)
PROVENANCE Pacetti Collection
BIBLIOGRAPHY Rovere, Viale, and Brinckmann 1937, pp. 119, 160; Jacob 1975, p. 145; Hager 1981, pp. 32, 34; Millon 1984, pp. 313–14; Millon 1984, "Filippo Juvarra," pp. 13–24; Kieven 1993, pp. 200–1
Staatliche Museen zu Berlin, Kunstbibliothek

10

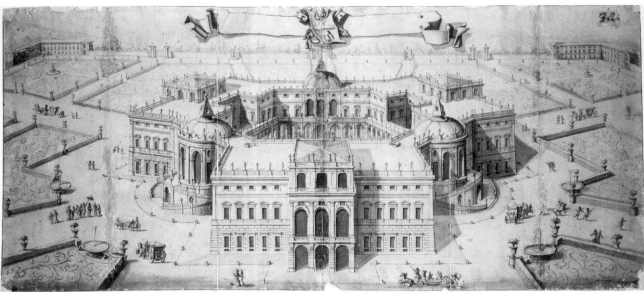

Juvarra's perspective is closely related to his three drawings in the Accademia di S. Luca that won first prize in the Concorso Clementino of 1705. The program for the competition was to design "a royal palace as a villa for the pleasure of three important personages, [to be] equally divided" (Millon 1984, p. 313). Juvarra's anonymous biographer relates that in addition to presenting the required plans, elevations, and sections, the architect also prepared a supplementary perspective rendering, which corresponds to this drawing.

The plan of the palace is generated by an equilateral triangle, which in 1705 the Accademia adopted as an emblem symbolizing the unity of the three visual arts. Three identical rectangular blocks connected by round vestibules or salons are grouped around a central hexagonal courtyard. The motif of the triangle is extended to the pyramidal lanterns of the salon cupolas and to the angled parterres of the surrounding formal garden. Above the palace, at the center of a blank banderole, are the arms of Clement XI.

Juvarra's perspective rendering is an illusionistic tour de force, a demonstration within the Accademia of his superior talents. The anonymous biographer reported that on seeing Juvarra's drawings the Accademia's Principe, Carlo Maratti, attempted to exclude them from the competition, remarking that the Concorso was intended for beginners, not for masters. The matter was resolved when Francesco Fontana, a professor of architecture at the Accademia, testified that Juvarra had been studying in Rome for only six months. Within two years of the competition, Juvarra was elected a full member of the Accademia, effectively joining the ranks of the teaching faculty. He taught there from 1707 to 1709, and from 1711 to 1712; significantly, during the second period his instruction focused on perspective.

The academic nature of the competition is amply reflected in Juvarra's drawing. The program—a royal palace for three—bears little relationship to the realities of the architectural profession, especially in Rome. The eclecticism of Juvarra's design is also consistent with the prevailing culture of the Accademia. Allusions to earlier architecture abound, including references to the work of Juvarra's Roman master, Carlo Fontana, and a number of foreign architects such as Fischer von Erlach, Le Vau, and Le Pautre. At the same time, Juvarra's originality shines through in the monumentality, coherence, and clarity of his conception. [JP]

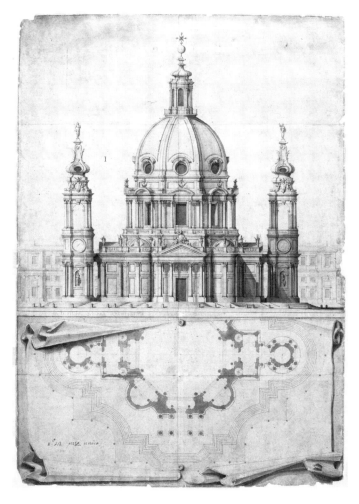

11

## Filippo Juvarra
### *Central-plan Church Project*

1707
Pen, gray ink, and gray wash on paper
39⅛″ × 27⅞″ (1000 × 710 mm)
PROVENANCE Pacetti Collection; Accademia di San Luca, Rome
BIBLIOGRAPHY Rovere, Viale, and Brinckmann 1937, p. 119; Jacob 1975, p. 146; Hager 1981, pp. 141–45; Millon 1984, pp. 311–12; Kieven 1993, pp. 204–5
Accademia Nazionale di San Luca, Rome

Artists who entered the Accademia di S. Luca through a recommendation from a member to the Principe and subsequent nomination and election in a meeting were known as *accademici di merito*. In recognition of the honor, they were expected to donate an example of their work to the Accademia, and this church project is Juvarra's presentation of 1707. There are a number of autograph variants of his design, and this elevation has a counterpart in the Berlin Kunstbibliothek, which may be a slightly later elaboration.

During the Renaissance the centralized church with dominating dome emerged as a major theme and was addressed by successive generations of practicing architects and theoreticians. Juvarra's design, like his Concorso Clementino palace design of two years earlier, represents a masterful synthesis of historic precedents while displaying his own originality. The use of flanking bell towers to frame a domed rotunda, for example, recalls Bernini's efforts at St. Peter's and Rainaldi's at S. Agnese in Agone. The bell towers themselves betray the influence of Borromini's campanile for S. Andrea delle Fratte. By dispensing with pendentives Juvarra produced a vertically unified interior, expressed on the exterior by the steep profile of the dome and the tall lantern. In these respects this 1707 project may be seen as leading to Juvarra's executed design for the Superga in Turin a decade later. The design is overtly scenographic in the way its component elements are arranged like a screen animated by rich and varied silhouetting. Within, the openness of the plan is evident, inviting vistas along the cross axes and into the diagonal chapels.

In a virtuoso display of draftsmanship, Juvarra illusionistically repre-sents the ground plan as if it were drawn on a separate sheet of paper superimposed on the elevation and partially rolled up, a convention repeated by other architects, for instance Piranesi. At the center appears a medallion with the Albani arms resting on crossed palm frond. Albani escutcheons with the papal tiara and keys appear on the two bell towers. Juvarra's project continued to exert a powerful influence on architecture well into the century, as is evident in Bernardo Antonio Vittone's Accademia project of 1732. [JP]

## 12

## Filippo Juvarra
### *"Deliziosa": Design for Act II, Scene XI, of "Tito e Berenice"*

1713
Pen and brown ink with gray wash and black chalk over graphite on laid paper
7⅞″ × 7½″ (200 × 192 mm)
PROVENANCE Collection of Count Enrico Cibrario, Turin
EXHIBITION Montreal 1993, cat. no. 1
BIBLIOGRAPHY Viale Ferrero 1968, pp. 11–20; Viale Ferrero 1970, pp. 272, 372; Denison, Rosenfeld, and Wiles 1993, pp. 3–6
Collection Centre Canadien d'Architecture/Canadian Centre for Architecture, Montreal

During the second half of his Roman sojourn (1709–14), Filippo Juvarra was active as a set designer. In this capacity he worked mainly for Cardinal Pietro Ottoboni's theater in the Cancelleria, but he also provided designs for performances in other Roman theaters. One of these was the Teatro Capranica, located just northeast of the Pantheon within the fifteenth-century palace of the same name. It opened in 1678 and continued to function until 1698, when the edict of Innocent XII closed Roman theaters. After a hiatus of more than a decade, it reopened in 1711. Two years later Juvarra is recorded as having made improvements to its stage, and during the carnival season of 1714 he provided the set designs for a performance of *Tito e Berenice*, a historical drama based loosely on Roman history. The libretto for this performance survives (it was edited by Cardinal Ottoboni), and the last scene of the second act is described as a *deliziosa*, or palace of delights. This is the scene that is probably recorded in this drawing. Of the ten scenes mentioned in the libretto, Juvarra's drawings for six have been identified.

For Juvarra, as for many of his contemporary architects, the theater was both a laboratory in which new ideas could be tested and an opportunity to project fantastic structures that no

12

patron's resources would ever be sufficient to build. Juvarra's *deliziosa*, while figuring in a historical drama set in ancient Rome, could not be more exuberantly eighteenth-century in its formal vocabulary, particularly the play of convex and concave forms composing its multi-tiered entrance. Juvarra gave free rein to his fantasy, and was less constrained by the desire to produce appropriately classical settings for the action than he was in earlier plays set in ancient Rome for which he provided the scenery. The grand edifice, so full of movement, is exquisitely framed by the arching boughs of trees in a surrounding park and adorned by symmetrically disposed fountains surmounted by statues, which are represented silhouetted in the middle ground. Some of the same conventions appear in the garden scenes Juvarra designed for the 1711 performances of *Giunio Bruto* and *Teodosio il Giovane*.

Juvarra presented the *deliziosa* as a *scena per angolo*, which allowed him to exploit two vanishing points and the scenic effects of diagonal recession. As a result, the pleasure pavilion's façades converge on the corner and appear to pass behind its projecting convexity to reemerge as the splayed towers framing the entrance. The resulting X-shaped intersection, with the diagonal arms emerging from a convex core, calls to mind Juvarra's later designs for the central pavilion of the palace at Stupinigi, outside Turin. [JP]

## LOUIS-JOSEPH LE LORRAIN
PARIS 1715–1759 ST. PETERSBURG

Le Lorrain practiced extensively as a painter, architect, furniture designer, and engraver. After studying painting with Jacques Dumont, he won the *prix de Rome* from the Académie Royale de Peinture in 1739. With the support of the architect Anges-Jacques Gabriel he was granted permission to travel to Rome and take up residence at the French Academy in 1740. Le Lorrain remained in Rome as a *pensionnaire* for

eight years. While there he profited from the company of Joseph-Marie Vien and produced designs for the annual Chinea festival in 1745, 1746, and 1747, which illustrate the powerful influence of Giovanni Battista Piranesi. Le Lorrain collaborated with Piranesi, etching vignettes for the title pages of Piranesi's *Opere varie* (1750) and *Le magnificenze di Roma* (1751). Together with Piranesi, Le Geay, Challe, and other artists working in Rome, Le Lorrain made early and fundamental contributions to the formation of international Neoclassicism.

On his return from Rome, Le Lorrain was *agréé* ("accepted") as a historical painter at the Académie Royale in 1752 and admitted to full membership in that institution four years later. Among his influential patrons was the Comte de Caylus, who recommended the artist to Count Carl Gustav Tessin of Sweden, whose country house at Åkerö Le Lorrain decorated with illusionistic Doric columns in 1754. To Caylus, Le Lorrain also owed the commission for the illustrations in Julien-

David Le Roy's *Les Ruines des plus beaux monuments de la Grèce*, a crucial text of international Neoclassicism published in 1758. To judge from a drawing by Le Lorrain depicting monumental buildings along the Seine (Canadian Centre for Architecture, Montreal), the artist appears to have remained in close touch with Gabriel, whose project for the Place de la Concorde it resembles.

Le Lorrain was also active as a designer of furniture in the Neoclassical style, producing designs that are decidedly architectural in character. One piece from a suite of ebony furniture designed in 1756–58 for Ange-Laurant de La Live de Jully survives in the Musée Condé in Chantilly. Le Lorrain's furniture for La Live made an important contribution to the formation of the *goût grec*, the new style that replaced Rococo in France during the 1750s.

In 1758 Le Lorrain moved to St. Petersburg, where Empress Elisabeth appointed him to be the first director of the newly founded academy of arts, although his hopes of pursuing a career as a furniture designer in Russia were dashed when a shipment of furniture was captured in transit by English pirates. [JP]

BIBLIOGRAPHY Eriksen 1961, pp. 340–47; Eriksen 1963, pp. 94–120; Harris 1967, pp. 193–94; Erouart 1976, pp. 201–15; Denison, Rosenfeld, and Wiles 1993, pp. 152–54; Sassoli 1994, pp. 114–15

## 13
## Louis-Joseph Le Lorrain
*The Temple of Minerva: The Second Chinea Macchina of 1746*

1746
Etching
15¾" × 18¾" (401 × 476 mm)
BIBLIOGRAPHY Harris 1967, pp. 193–94; *Inventaire du fonds français: graveurs du dix-huitième siècle*. Paris: Bibliothèque Nationale, 1977, vol. 14, no. 9; Denison, Rosenfeld, and Wiles 1993, pp. 152–54; Sassoli 1994, pp. 114–15
Ministero per i Beni e le Attività Culturali, Istituto Nazionale per la Grafica, Rome

The series of prints documenting the ephemeral structures erected as part of the celebration of the Chinea constitute a remarkable record of cross-currents in the history of eighteenth-century Roman architecture. Nicola Michetti's designs for the 1733 festival (see cat. 17) were the last ones made for five years, because of the change of government in Naples following the War of the Polish Succession, as a result of which Austrian rule was replaced by that of the Bourbons. When the series of Chinea designs resumed in 1738,

13

14

Michetti was no longer responsible and for the next six years figures predominated in compositions that are pictorial rather than architectural. Only in 1745 did the character of the festival structures revert to the architectural.

The *macchine* of the following year maintain the emphasis on architecture, but with a marked shift in style away from the late Baroque classicism of Michetti and towards Neoclassicism. A crucial agent in this transformation appears to have been the French painter Louis-Joseph Le Lorrain, whose *Temple of Minerva* of 1746 introduces features that would subsequently be taken up by artists and architects practicing in the Neoclassical style in the decades of the 1750s and 1760s. Le Lorrain arrived in Rome in 1740, and like other *pensionnaires* at the French Academy, seems to have fallen under the influence of Giovanni Battista Piranesi, himself a recent arrival in Rome. Le Lorrain's temple appears to be a stripped down version of the rotunda in Piranesi's *Campidoglio antico*, one of the plates that appeared in the *Prima parte* of 1743.

The basic geometrical forms of Le Lorrain's temple—its cubic core, the cylindrical portico, and the hemispherical dome—are emphasized both by the dramatic play of light and shadow and by the sparing use of ornament, particularly evident in the lower levels of the edifice. Le Lorrain introduced a frieze of sacrificial figures forming a band around the base of the dome, an inspired invention without Roman precedent. From an altar at the center of the frieze a plume of smoke rises, blurring the bulbous profile of the dome and forming a cloud-like pedestal for the statue of Minerva that crowns the edifice.

The dramatic shift in Le Lorrain's style can be seen by comparing the *Temple of Minerva* with a festival structure for the Piazza Farnese designed in the previous year by Giovanni Paolo Panini to celebrate the wedding of the dauphin and Maria Teresa of Spain. Le Lorrain etched the plate recording Panini's spirited Baroque design, so he certainly knew it. In place of the weighty solidity and sparing use of ornament in Le Lorrain's *Temple of Minerva*, Panini's two-story circular building (crowned somewhat implausibly by an obelisk) is embellished by a profusion of sculpture calculated to yield a light and airy silhouette. Le Lorrain seems consciously to have set out to correct Panini's Baroque exuberance by providing an alternative grounded in a more rigorous and elemental approach to classicism. [JP]

## GIOVANNI BATTISTA MAINI

CASSANO MAGNAGO 1690–1752
ROME
*For biography see Sculpture section*

## 14

### Giovanni Battista Maini
*Study for the Central Sculptural Group of the Trevi Fountain*

C. 1735
Red chalk on coarse paper
30⅜″ × 16½″ (772 × 420 mm)
BIBLIOGRAPHY Voss 1910; Pinto 1986, pp. 205–11
Staatliche Museen zu Berlin, Kunstbibliothek

The sculptural program of the Trevi Fountain was devised by its architect, Nicola Salvi, whose detailed memorandum explaining the iconography survives. In keeping with late seventeenth- and early eighteenth-century practice in Rome, Salvi also provided a governing design that the sculptors responsible for executing the statuary were expected to follow. As early as 1734 Salvi began to engage sculptors, and in August of that year Giovanni Battista Maini received his first payment for a wax model of the Oceanus group. It seems likely this Berlin drawing represents one of Maini's small *bozzetti* set against Salvi's large wooden model. The composition is emphatically volumetric and sculptural; figures spill out into the foreground plane, while others lead the eye back in depth across a considerable distance. Here, indeed, are manifested all of the characteristic elements of Baroque sculptural compositions, softened only by the use of lighter and more gently curving forms, and the warm tonalities of the red chalk.

Maini's composition differs markedly from Salvi's more architectural view of the Trevi sculpture, which is known from other drawings. In Salvi's scheme the overall effect is rather flat and relief-like, lacking a strong volumetric dimension; the figures, rather than projecting from the façade, seem spread out along it, occupying a shallow foreground plane of their own. The architecture of the fountain, like a classical scenic frontispiece, determines the choreography of the sculptural figures. These differing visions of the correct relationship between architecture and sculpture inevitably led to conflict later on. What is striking is the role played by

models, architectural and sculptural, throughout the design process.

In April 1739 the large wooden model of the fountain was taken to Maini's studio, no doubt to assist him in designing the full-scale stucco models of the figures composing the central group of sculpture, which were installed by the summer of 1740. The appearance of Maini's models evidently displeased Salvi, and by September of the same year it was public knowledge that a controversy had broken out between sculptor and architect. In a letter of that month, Cardinal Felice Passerini, who as Presidente delle Acque was responsible for the work on the Trevi, wrote that "because of the disagreement that has arisen between Salvi and the sculptor Maini over the central group, its execution in marble still has not begun. Maini is obliged to make a new model in reduced scale quite different from the large one, since Salvi says that Maini made many mistakes in its composition" (Rome, Biblioteca Corsiniana, Cod. Cors. 1160, fol. 67).

At some point late in 1740 or early in 1741, the disagreement between Salvi and Maini over the design of the large models was resolved through outside arbitration. Maini, writing on April 1, 1741, about his work on the "Fontana Eterna" as he bitterly called it, noted that he was currently engaged in altering the models on the site and would be finished by the end of the month (cited by Colombo 1966, pp. 37–38). A memorandum drawn up in the summer of 1741 by the painter Agostino Masucci explains how he was appointed by Cardinal Neri Corsini to effect a compromise between architect and sculptor, and that he had recommended certain changes intended to satisfy all parties concerned.

As a result of Masucci's diplomacy, work on the sculpture resumed, but at a slow pace. During the summer of 1742 workmen were still engaged at the fountain in dismantling Maini's first set of stucco models, and throughout the following year Maini labored to perfect their replacements. These full-scale models are the statues that were unveiled on July 4, 1744, when the Trevi was inaugurated by Pope Benedict XIV, an event recorded in a painting by Giovanni Paolo Panini. Maini died without installing permanent marble statues on the Trevi; these were carved by his successor, Pietro Bracci, and unveiled in 1762. In general, Bracci followed the compromise design agreed upon by Salvi and Maini, while introducing a number of minor changes. [JP]

## NICOLA MICHETTI
ROME 1672/81–1758 ROME

Nicola Michetti's architectural practice, which extended over a period of more than fifty years, can be conveniently divided into five periods. In the first of these, roughly between 1704 and 1713, he was involved in projects that were outgrowths of his training in the studio of Carlo Fontana. Michetti's earliest known design is an unexecuted project for the Trevi Fountain (1704), which shows clearly the influence of his master. The most significant early commissions he received were chapels for two Roman patrons, the Rospigliosi family (1710–19) and Cardinal Giuseppe Sacripante (1712), in which architecture, painting, and sculpture are orchestrated to create illusionistic compositions that have their source in the work of Gianlorenzo Bernini. Also during this time Michetti furnished designs and supervised work on festival decorations for Cardinal Ottoboni.

In a second period, between 1713 and his departure for Russia in 1718, Michetti was engaged in two large-scale projects: an oval-plan church erected in Zagarolo (1717–23) and the preparation of a model of his St. Peter's sacristy design (1715), which was not executed. Both of these designs bear comparison with the work of Michetti's great contemporary Filippo Juvarra, who was one of Michetti's competitors in the Vatican sacristy competition. Between 1718 and 1723 Michetti was in Russia, where he worked for Peter the Great, primarily in the new imperial capital of St. Petersburg. In the service of the czar, Michetti erected two imposing summer palaces, at Tallin in Estonia (1718–20) and Strelna near St. Petersburg (1720–23), and laid out extensive gardens in the French style at Peterhof (1719–23). Other unexecuted projects are known from his drawings in the Hermitage Museum, one of which was for a monumental lighthouse over five hundred feet tall.

The ten years following Michetti's return from Russia, especially those between 1729 and 1733, were his most productive. In recognition of his stature as architect of the czar, Michetti was elected to the Accademia di S. Luca in 1725. Between 1731 and 1732 he built an imposing new façade for the Palazzo Colonna, perhaps his most successful design. The freestanding corner pavilion of the palace contains one of the finest secular spaces of eighteenth-century Rome. Its airy lightness, scenographic effects of mural transparency, and exquisite stuccos bear comparison with contemporary designs by Juvarra in Piedmont. At the same time Michetti was also producing ephemeral designs for festivals and the theater,

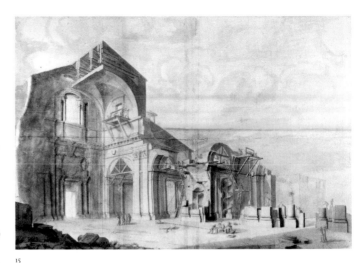

15

which were recorded in prints. In 1729 he designed the elaborate sets for a play entitled *Carlo Magno*, which was performed in Cardinal Ottoboni's theater in the Cancelleria, and between 1730 and 1733, as architect of the Colonna family, he was responsible for six large-scale fireworks displays for the Chinea festival.

After 1733 and until his death Michetti held two salaried positions as architect of both the Camera Apostolica and the Theatine order, which demanded most of his attention. The spare and utilitarian Polveriera, or gunpowder magazine, he built just inside Porta S. Paolo in 1752 characterizes his work for the papal administration, while the apartment building adjacent to the monastery of S. Andrea della Valle (1755–57) is representative of his activity in service of the Theatines.

Michetti's respect for the classical orders and his predilection for scenographic compositions remained constant through his career, and constituted the essence of his style. At the same time, he showed himself to be unusually receptive to a variety of influences, both native and foreign, and capable of incorporating them into an imaginative synthesis that reveals the richness and complexity of late Baroque design. Such a synthesis is evident in an early work such as the Rospigliosi Chapel, which betrays his study of Bernini and Andrea Pozzo, as well as in a mature design, such as the monumental plan for the gardens at Peterhof, so profoundly influenced by André Le Nôtre and Jean-Baptiste-Alexandre Le Blond. Michetti also actively contributed to the dissemination of the grand Roman tradition of architecture; along with Fischer von Erlach, James Gibbs, Lucas von Hildebrandt, and other pupils of Carlo Fontana, he played a major role in exporting what might be called an international style of late Baroque design to northern Europe. [JP]

BIBLIOGRAPHY Costanzi [1729] 1987; Grabar 1909; Lo Gatto 1935, vol. 2, pp. 50–52; Lavagnino 1942, pp. 139–47; Pansecchi 1962, pp. 21–31; Voronikhina 1972, nos. 21, 24–26, 44–54, 60–62; Pinto 1976; Pinto 1977, pp. 853–57; Pinto 1979, pp. 375–81; Pinto 1980, pp. 289–322; Voronikhina 1981, pp. 62–86; Tancioni 1988; Curcio 1989, pp. 65–80; Curcio 1991, pp. 401–3; Kelly 1991, pp. 57–67; Pinto 1991, pp. 50–57; Pinto 1991, "Sagrestia," pp. 58–69; Pinto 1992, vol. 2, pp. 526–65; Morganti 1995, pp. 303–12; Millon 1999, pp. 533–34, 562–63; Pinto 1999, "Architettura"; Pinto 1999, "Michetti"

## 15
## Nicola Michetti
### *Interior of Ss. Apostoli under Construction*

c. 1706

Signed on plaque in left foreground: *Nicola Michetti*

Pen and ink, chalk, and gray wash on paper 19⅝" × 28½" (498 × 725 mm); two sheets joined vertically

PROVENANCE Pope Clement XI; Cardinal Alessandro Albani; George III (1762)

BIBLIOGRAPHY Zocca 1959, pp. 59–65; Pinto 1976, vol. 1, pp. 20–24; Braham and Hager 1977, p. 178

The Royal Collection, Her Majesty Queen Elizabeth II

The Early Christian basilica of Ss. Apostoli had long shown signs of structural decay. On September 22, 1701, a committee of architects headed by Francesco Fontana reported that, in spite of earlier repairs, the roof and its supporting walls were leaning towards the piazza and the entire church was in need of rebuilding. Francesco Fontana, Carlo's son, had inherited the post of architect of the convent from Carlo Rainaldi, who had died in 1691. After the state of the early church had been documented, demolition work began under the younger Fontana's direction in the area of the

nave, and the foundation stone was set in place by Pope Clement XI on February 27, 1702. Work proceeded rapidly on the nave and side aisles, which were vaulted by the summer of 1705. In 1706 the task of decorating the nave and the chapels of the side aisles, following the model that Fontana had prepared, was begun. In the following year Giovanni Battista Gaulli agreed to fresco the vault "according to the design already made" (Rome, Archivio del Convento dei Ss. XII Apostoli, *Libro dei consigli del conto de Ss. Apostoli* [1697–1727], fols. 61–74). Throughout this first phase of the construction the tribune of the Constantinian church had been left standing, and it was not until the spring of 1708 that it was demolished to make way for the new chancel and apse. Work had just begun on the tribune when, on July 3, 1708, Francesco Fontana died.

One week later the aging Carlo Fontana was elected to complete his son's design. However, work progressed slowly, and the tribune was still unfinished at the death of the elder Fontana in 1712. In a meeting on September 12, 1712, the congregation resolved to entrust the completion of the church to Nicola Michetti, remarking on "the great services Michetti has rendered to the congregation, for when the Cavaliere Francesco Fontana was still living he daily supervised work on the nave and aisles of the new church without ever receiving any payment" (*Libro dei consigli del conto de Ss. Apostoli* [1697–1727], fol. 104). The minutes of this meeting go on to make it quite clear that Michetti had continued to direct the construction of the church under Carlo Fontana, "who because of his age had been unable to visit the site for many months" (*Libro dei consigli del conto de Ss. Apostoli* [1697–1727], fol. 104). For the most part, Michetti appears to have been content to execute Francesco Fontana's designs, which are known from the plan and elevations published by De Rossi in 1721. Only in the area of the tribune vault did Michetti feel the need to depart from Francesco Fontana's model, there making relatively insignificant structural alterations. The most important aspect of Michetti's activity in the construction of Ss. Apostoli is not his positive influence on the design, but rather the experience he must have gained in directing work on a large-scale project.

This signed pen and wash drawing by Michetti shows the interior of Ss. Apostoli under construction. It provides a rare glimpse of the appearance of a building site in early eighteenth-century Rome and gives a good idea of the kind of practical experience Michetti acquired while in Fontana's studio. It seems unlikely that the drawing represents a survey of the actual state of the building at any given time; rather, Michetti seems to have illustrated various operations in the construction process. To this end he subordinated the appearance of the edifice, omitting the southern aisle altogether and slicing through the nave vault to show its structure. More than twenty-five workmen are engaged in various operations at different levels of the church, working on scaffolding, climbing ladders, and operating machinery. The centering of the arches supporting the north aisle is still in place and two windlasses are being used to hoist mortar to the upper levels, presumably to lay the vaults. At the center a group of men operating another windlass is lowering a block of cut stone into place to form one of the pilasters facing the nave. In the foreground other architectural elements, including a column base, lie waiting to be set in place.

To the left of center in the drawing is a group of four standing men, one of whom (the architect?) points towards the workmen engaged in arming the aisle vaults. As the drawing illustrates work in progress in the area of the nave and aisles, and not the tribune, it is reasonable to assume that the architect depicted is Francesco Fontana. And, since it is known that he assisted daily on the site from the very beginning, it is likely that Michetti, too, is shown among this group, which may also include Carlo Muggiani, the master mason who contracted with Francesco Fontana in 1702 to provide the labor and materials for the new church.

This drawing illustrates how much there was for a young architect to learn on a site such as Ss. Apostoli, and how much there was for him to do. Not only were there drawings to be made and piecework to be organized and supervised; there was also the laborious task of inspecting and evaluating work. Bills submitted by contractors and masons had to be scrupulously itemized, checked, and corrected. This work constituted one of the most time-consuming tasks of eighteenth-century architects, and was one that was to occupy Michetti throughout his career. Finally, it was among the contractors and masons with whom a young architect such as Michetti worked in his early years that he made the contacts that served him well in numerous other building enterprises. [JP]

## 16
## Nicola Michetti
## *Model for the Pallavicini Rospigliosi Chapel in S. Francesco a Ripa*

c. 1715

Wood and plaster with wax and papier mâché; painted in imitation of marble revetment

66⅞" × 44⅛" × 37¾" (1700 × 1120 × 960 mm)

PROVENANCE Pallavicini Rospigliosi Collection

EXHIBITION Rome 1959, cat. no. 1000

BIBLIOGRAPHY *Settecento* 1959, p. 237; Pansecchi 1962, pp. 21–31; Negro 1987, pp. 157–78; Pinto 1991, pp. 50–57; Millon 1999, pp. 562–63

Museo di Roma, Rome

The Pallavicini Rospigliosi Chapel in the church of S. Francesco a Ripa was the first important commission executed by Nicola Michetti. Among the most significant evidence bearing on the history of the chapel is this remarkably well-preserved model, which is complemented by another smaller model belonging to the Pallavicini family, and numerous drawings (four of them signed by Michetti) in the Vatican Library.

The chapel opens off the right transept of S. Francesco. The first impression is of the altar wall, where two columns of *verde antico* crowned by gilt bronze capitals frame Giuseppe Chiari's altarpiece representing Peter of Alcántara and Pasquale Baylon, the two Franciscan saints to whom the chapel is dedicated. Only upon entering the chapel are the rich sculptural decorations on the lateral walls and the gilded stuccos and painted ovals in the vault completely visible. On the right wall is the monument of Maria Camilla Pallavicini, in which the sculptor Giuseppe Mazzuoli represented Prudence and Charity, flanking the central casket. Facing this is the memorial of Stefano and Lazzaro Pallavicini, also by Mazzuoli. At the lower level, flanking the central casket as in the other monument, Mazzuoli placed allegorical figures of Fortitude and Justice, while above are oval bas-relief portraits of the two prelates.

The first reference to work on the chapel occurs in 1710, when the structure of the enclosing walls was begun. Work on the framework of the chapel continued until the summer of 1713, presumably supervised by Michetti, who at this time was the salaried architect of the Rospigliosi family. The earliest mention of architectural models relating to the chapel dates from this period. Six documents of 1711–12 record payments in connection with more than one model representing the chapel, and in 1712 Giovanni Battista Vanelli, an *intagliatore*, was paid for work on a model that corresponds in every particular to the Museo di Roma model. The models of the Rospigliosi Chapel were intended to aid architect, sculptor, and patron to assess proposals for its decoration. This larger model, complete by 1713, represents the masonry structure of the chapel substantially as it was built, and was fashioned so as to permit smaller models (such as one in the Pallavicini collection) to be inserted within its framework, thereby presenting a number of different design options.

Around 1716, or shortly thereafter, the composite model with its variant laterals must have been submitted for approval to the client, who, after considering it in all its particulars, arrived at a decision to incorporate or delete specific elements. In the altarpiece in the model, the Virgin and Child appear in a miraculous vision to the two Franciscan saints, while in the vault fresco God the Father is represented in the midst of a heavenly choir of angels. In the chapel as executed, the decorative program has been significantly reduced and simplified: God the Father has descended, as it were, to take the place of the Virgin and Child in the altarpiece and gilded ornamental stuccos have replaced the fresco above. Moreover, the oval bas-reliefs in the pendentives of the model have been replaced by painted allegories by Tommaso Chiari, and the two statues of angels seated on the cornice flanking the baldachin have been eliminated altogether. The four twisted columns of *verde antico* boldly projecting into the chapel interior in the model have been replaced in execution by two fluted Corinthian columns recessed into the altar wall.

This dramatic reduction of the role of sculpture above the cornice heightens the importance of the sepulchral monuments on the lateral walls. The primary function of the chapel was to be a memorial to members of the Rospigliosi family, so the reductive character of these alterations is both logical and justified.

In preparing his design for the Rospigliosi Chapel, Michetti appears to have studied Bernini's Alaleona Chapel of 1649 in Ss. Domenico e Sisto. The architectural enframement of the altar walls in both chapels is almost identical and the relationship of the sculptural group of Christ and the Magdalen to the angels hovering above is similar to that uniting the altarpiece and stuccos in the Rospigliosi Chapel. Michetti's use of an arch of gilded rosettes set within panels forming the upper frame of the altar wall also derives from the earlier chapel.

In 1710 the reputation of Andrea Pozzo as a designer of monumental

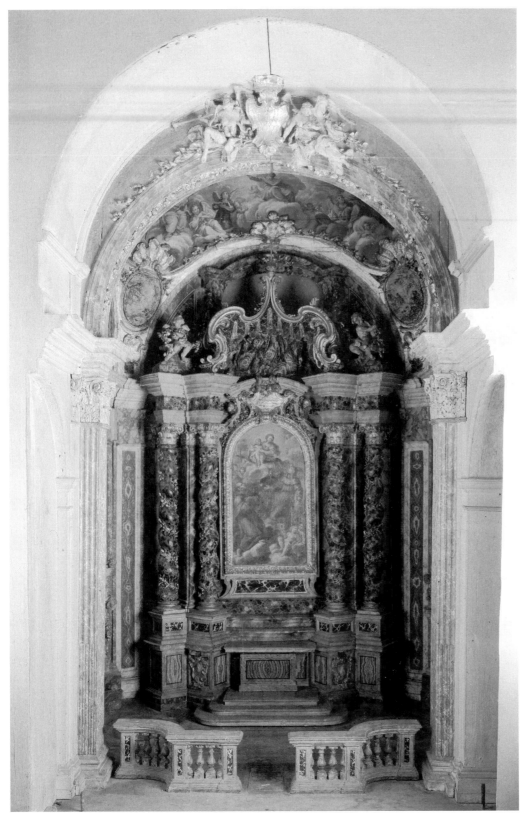

16

## Nicola Michetti
### *Design for the Second Chinea Macchina of 1733*

1733
Pen and brown ink with brown and gray washes on paper
15⅝″ × 14⅞″ (398 × 378 mm)
PROVENANCE Acquired from Trinity Fine Art Ltd., London
BIBLIOGRAPHY Rome, Archivio Colonna, I. A. 218, nos. 254, 324; Pinto 1980, pp. 308–13; Sassoli 1994, pp. 54, 101; Moore J. 1995, pp. 584–608; Fagiolo 1997, vol. 2, pp. 42–55
The Pierpont Morgan Library, New York

By far the greatest number of firework displays in eighteenth-century Rome were organized by the Contestabile Colonna, the representative of the King of Naples. Each year on the feast of Saint Peter and Saint Paul the King of Naples made the symbolic gesture of giving the pope a white horse (called *chinea* in Neapolitan dialect) to acknowledge his obeisance to the papal authority. This was the origin of the Chinea ceremony, the festival aspect of which was expanded in 1722 by the presentation of fireworks on the evenings before and after the horse was escorted to the Vatican. For the next sixty years, with few exceptions, two large fireworks *macchine* were presented annually, constituting a series of designs of considerable importance to the study of eighteenth-century Roman architecture and ephemeral design. As permanent records of these ephemeral spectacles, the Colonna family commissioned prints that were distributed to foreign dignitaries, as well as prominent figures in Rome. Michetti's drawing for the second of the two fireworks *macchine* presented in 1733 provided the design for the print etched by Domenico Mariano.

In 1731 Michetti succeeded Gabriele Valvassori as architect to the Colonna, for which he received a monthly stipend as a member of the household. Later in the same year he signed a contract to design and supervise the construction of the west façade of the family palace toward the Piazza Ss. Apostoli, the public space in which the Chinea fireworks *macchine* were displayed in the 1720s and 1730s. Another of his responsibilities was to provide designs for the Chinea festival structures, and documents in the Colonna archive confirm that he was responsible for the six *macchine* presented in three successive years: 1731–1733. These same documents record payments for the 1733 *macchine* (all approved by Michetti) to others engaged in executing his designs, including the painter Giovanni

altar surrounds must have rivaled, if not actually surpassed, that of Bernini. Not only was it firmly based on his two great Roman altars in the transepts of the Gesù and S. Ignazio, but the designs of these and other altars were published in his treatise, *Perspectivae*

*pictorum atque architectorum* (1702). In the architectural frame for the altar in his model, Michetti used twisted columns and sculpture in a way that clearly recalls Pozzo's great altar surrounds in the Gesù and S. Ignazio. In spite of the noticeable reduction in

scale, complexity, and richness necessitated by the private nature of the commission, the Rospigliosi Chapel may be interpreted as an act of homage paid by the young architect to the great Jesuit designer. [JP]

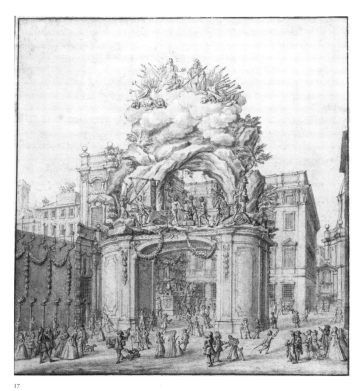

17

Angelo Soccorsi and the contractors Antonio and Nicola Giobbe. At this time the elder Giobbe, together with his son Nicola, were serving as general contractors for the new wing of the Palazzo Colonna as well as for the neighboring Trevi Fountain; it was Nicola Giobbe who befriended Piranesi when the Venetian first arrived in Rome and to whom the *Prima parte di architetture e prospettive* (1743) is dedicated.

Both of the 1733 *macchine* employ mythological themes to extol the reign of Charles VI, the Habsburg emperor whose authority extended to Naples. The second *macchina* depicts Jove and Minerva enthroned in the midst of martial standards as they consult with one another concerning how best to maintain the peace. In a cave opening into the side of the mountain on which they sit is the forge of Vulcan, where a number of figures are engaged in the manufacture of arms. This theme accurately represents the contemporary political situation in Europe, where England, France, Spain, and Austria were arming in preparation for the War of the Polish Succession, which would begin before the year was over. Michetti's *macchine* for the Chinea of 1733 were the last ones made for five years.

It is important to remember that although the surviving prints and drawings naturally emphasize the appearance of the Chinea *macchine* as large-scale environmental sculpture, they were designed to be blown up in a thunderous pyrotechnic blaze of color. Documents reveal that above a

relatively solid base that provided the support for both *macchine*, the super-structures were made of stiff canvas supported by a wooden armature that was covered by a gesso coating and then painted. Both the 1733 *macchine* are raised up on a high arched base-ment standing isolated at the center of the square and are not attached to the Palazzo Colonna, as was usually the case, because the center of Michetti's new palace wing was still under construction. The recently completed southern corner pavilion projects behind and to the left of the fireworks apparatus. The arch of the *macchina* frames a temporary wine-dispensing fountain that provided refreshment to the crowds that gathered. The seven-teenth-century Palazzo Bonelli is set back further behind the festival struc-ture. At the extreme right is visible the profile of the church of the SS. Nome di Maria, which had recently been demolished and was under construc-tion in 1733.

Even studied at one remove through the medium of graphic reproductions, designs for eighteenth-century ephemeral architecture delight and charm the observer. The scale and volume of the work produced, much of it by first-rate artists, are remarkable, and the designs display an imagination and daring that could never have been incorporated in structures built of more lasting materials. Through prints these designs circulated widely and once reduced to a two-dimensional format became, for all practical pur-poses, indistinguishable from graphic representations of permanent archi-

tecture. The degree to which festival structures transformed familiar urban spaces on a regular basis should also be noted; over time they came to be closely bound up with the identity and function of major Roman squares, including the Piazza di Spagna, the Piazza Farnese, the Piazza Navona, and the Piazza Ss. Apostoli. [JP]

## GIAMBATTISTA NOLLI

MONTRONIO, COMO 1701–1756
ROME

Little is known of Nolli's background except his birthplace and the fact that he apparently trained as a surveyor. He is known to have been engaged in that trade in Milan in 1722 and in the Kingdom of Piedmont and Sardinia in 1729, and his work seems to have been of high quality. His decision to go to Rome may have been influenced by his future patron Cardinal Alessandro Albani, who was the papal representa-tive in Piedmont when Nolli was working there. A letter dated August 1736 grants him papal permission to enter "all the basilicas, churches … and convents, even those of Cloistered Nuns, in order to make necessary measurements" (Faccioli 1966, pp. 421–22). This was the beginning of the twelve-year task of accurate measurement, drawing, engraving, and printing that resulted in the publi-cation of the *Nuova pianta di Roma* in 1748 (known as the *Pianta grande*).

In 1742 Nolli was also commis-sioned, with the architect Ferdinando Fuga, to mount the surviving frag-ments of the *Forma urbis Romae* in the Museo del Campidoglio. This was the early third-century marble plan of Rome acquired by Pope Benedict XIV Lambertini in 1741. Only ten percent of the *Forma urbis* survived, so Nolli made no effort to arrange the pieces in one overall topographical map. Instead they were organized arbitrarily in twenty rectangular panels disposed on the walls of the museum's main stairway.

This project was later criticized by Piranesi, who reproduced the frag-ments in his 1756 *Le antichità romane*, in which he said that some of the smaller fragments had not been recognized as parts of larger ones (Giovanni Battista Piranesi, *Le antichità romane* (Rome: Stamperia di Angelo Roti, 1756), vol. 1, fol. 7). Indeed, Nolli does not seem to have used the topographical informa-tion provided by the *Forma urbis* frag-ments for reconstructing antiquities on his own *Pianta grande*. A fragment bearing a semicircular plan marked *(TH)EATR(VM) MARC(ELLI)* should have prevented him from making the mistake of reconstructing the theater of Marcellus in elliptical form. However, for his *Pianta grande* Nolli did

borrow from the *Forma urbis* the graphic device of distinguishing public monu-ments from the rest of the buildings.

Even before its publication Nolli's plan was used to support other projects. In 1744 Count Bernardino Bernardini published a book describing the redrawing of the boundaries of Rome's fourteen *rioni* (administrative regions), for which he was responsible as Priore dei Caporioni of the city. In it he acknowledged his debt to "the new plan of Rome, drafted exactly by Signor Giovambatista Nolli, from Como, well-known Surveyor, and Architect …" (Bernardini [1774] 1978, pp. 13–14). Near the end of the book a foldout map with the new *rione* boundaries is signed *Car[lo] Nolli*, Giambattista's son and collaborator on the main map project. These *rione* boundaries are later faith-fully recorded as dotted lines on the *Pianta grande*. In 1747 Giuseppe Vasi published the first of his ten-volume *Delle magnificenze*, in which he depicted the gates and the walls of the city, and at the end of this volume he included a list giving "The Measure of the dis-tances from one City-gate to the next … provided to the Author by the Architect, and Surveyor Sig. Gio. Battista Nolli from Como" (Vasi 1747–61, vol. 1, p. 73). This link between the two printmakers suggests that Vasi also used Nolli's map as a principal source for the numerous views of the city in the other volumes of the *Magnificenze*.

Nolli's collaboration with Piranesi must have occurred shortly before the publication of the *Pianta grande*. Included with the large map were two smaller ones. One was a reduction of the 1551 plan-map of Rome by Leonardo Bufalini, which Nolli acknowledged as the direct predeces-sor to his own. The other was a reduc-tion of the *Pianta grande* itself on to a single sheet. This is inscribed *Piranesi e Nolli incisero*. Clearly Nolli supplied the map while Piranesi drew the capriccio of the Baroque city below it. This col-laboration did not prevent Piranesi from taking Nolli to task later for mis-taking the orientation of the Theater of Pompey on his large map, and in his *Il Campo Marzio* of 1762 Piranesi men-tioned Nolli by name below a repro-duced map section showing the area of the theater, describing and correct-ing the error (Piranesi, *Il Campo Marzio dell' antica Roma* [1762], pl. XVI).

Nolli dedicated the completed map to Benedict XIV, and presented the first two copies to him in April 1748. Despite the pope's approval and that of important scholars, the map was not a financial success: by 1750 only three hundred of the 1874 copies printed had been sold. Nonetheless the *Pianta grande* remained the model for most of the plan-maps of the city for the next two centuries.

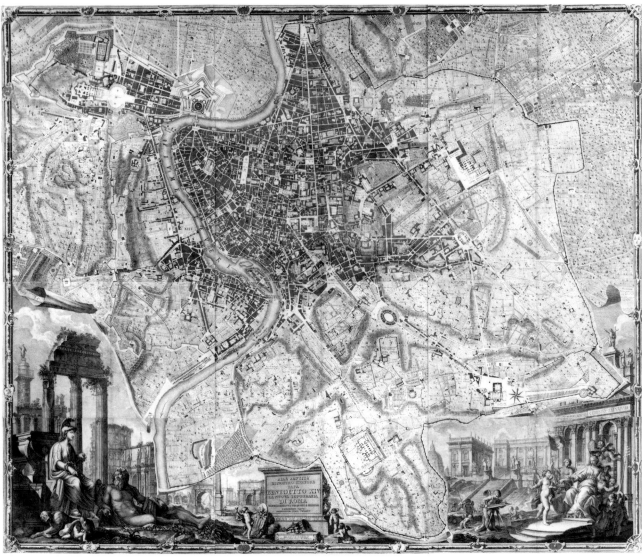

18

On his large map the artist signs himself *Giambattista Nolli Geometra e Architetto*, and as an architect he designed the layout of the gardens for the villa of Cardinal Alessandro Albani, and the church of S. Dorotea in Trastevere (1751), in which he was buried in 1756. [AC]

BIBLIOGRAPHY Bernardini [1774] 1978; Faccioli 1966, pp. 415–42; Zänker 1973, pp. 309–42; Rykwert 1977; Ceen 1984; Ceen 1990, pp. 17–22; Bevilacqua 1998

## 18
## Giambattista Nolli
### *Plan of Rome*
### (*Nuova pianta di Roma*)

1748

Signed and dated, to right of dedicatory inscription: *Misurata delin. ed a proprie Spese data in luce da Giambatt.a Nolli Geom.a ed Arch.o l'Anno 1748*

Dedicatory inscription: ALLA SANTITA / DI NOSTRO SIGNORE / PAPA / BENEDETTO XIV / LA NUOVA TOPOGRAFIA / DI ROMA / OSSEQUIOSA-MENTE OFFERISCE E DEDICA / L'UMILISSIMO SERVO / GIAMBATTISTA NOLLI COMASCO

Etching

70″ × 108″ (1778 × 2743 mm), 12 sheets combined

BIBLIOGRAPHY Ehrle 1932; Frutaz 1962; Zänker 1973, pp. 309–42; Pinto 1976, "Origins," pp. 35–50; Ceen 1984; Ingersoll 1986, pp. 21–23; Borsi 1993; Bevilacqua 1998

Pace Master Prints, New York

The fame of Giambattista Nolli rests solely on the great plan-map of Rome (*Pianta grande*). Of the many maps of the city, his stands out as the most innovative, informative, and influential. Historic maps of Rome can be divided into two groups: the view-maps, which present a bird's-eye view of the city, and the plan-maps which are ichnographic (orthogonal) plans of the city. Up to Nolli's time, the view-maps had predominated because they were easier for most visitors to the city to grasp. Of over fifty maps of the contemporary city between 1400 and 1748, only five are plan-maps. The earliest of these was the 1551 plan by Leonardo Bufalini, which is also the first known plan-map of Rome since the early third century *Forma urbis*. Despite its large and uneven distortions, Nolli recognized Bufalini's map as the most important antecedent to his own, and acknowledged his debt by republishing this pioneering plan together with his own large and small plans of the city.

Bufalini in turn relied in part on the Renaissance ichnographic plan tradition best exemplified by Leonardo da Vinci's plan of Imola, which itself drew upon Leon Battista Alberti's technique of city measurement through the use of polar coordinates. Interestingly, it was in Rome that Alberti developed this system by taking angular measurements between sightings of major landmarks of the city from the highpoint of the tower on the Capitoline Hill's Palazzo Senatorio, and plotting these against distances measured from the tower to the same landmarks. Only Alberti's measurements survive; his map, if ever drawn, does not. Nolli complemented this technique with numerous triangulations in the field. This is illustrated at the bottom right of the *Pianta grande* by the two putti measuring distances with a surveyor's folding "chain" and by the putto recording the results on a plane-table (swiveling board on tripod); upon this rests an alidade for taking sightings, which were traced directly on to a sheet of paper affixed to the table.

This technique was integrated with alignments taken with a magnetic compass. The importance of the compass or *bussola* to Nolli's plan is evidenced by its appearance on the date block with two putti gesturing to it and to the map above. This linkage was Nolli's way of indicating the unusual orientation of his map: north instead of the traditional east. He was also the first Roman mapmaker to note the distinction between true and magnetic north. This is recorded in

the only change between the first and
second state of Nolli's print, which is
the compass rose added to the space
in front of the Lateran basilica, and an
accompanying "Avvertimento" on the
right edge of the map, which explains
this distinction.

Like Bufalini, Nolli includes recon-
structions of ancient buildings, but
distinguishes between existing (black)
and missing (white) parts. He also
shows the interiors of churches and
major buildings in plan, though in far
more detail than Bufalini's purely
schematic interiors. In this he appears
to have been drawing on the graphic
convention of the *Forma urbis* of con-
trasting public and private spaces. In
doing so Nolli has produced what
architects call a "figure-ground" plan
of the city. All public space (streets,
squares) and semi-public space
(courtyards, covered passageways,
church and theater interiors) is shown
in white. Hatching is used to fill in the
rest of the city's structures. The result
is a clear depiction of the spatial con-
tinuum that constitutes the public city.
Passage through the city on this map is
aided by a 1320-item index correspond-
ing to the numbers inscribed on it.

What makes Nolli's work stand out
from that of his predecessors is the
sheer quantity of precise detail he
was able to depict. Every church
and palazzo, every twist and turn of
Rome's complex urban fabric, is accu-
rately drawn. Lesser elements, such as
columns, stairs, fountains, arches,
even sewer openings are included.
Nolli even included two tiny dots
on Gianlorenzo Bernini's St. Peter's
Square, which are the centers of the
two circles used to generate its oval
form. The map is a perfect tool for
studying Rome's rich urban relation-
ships. Bernini's use of the axis of
Borgo Nuovo as a major determinant
in defining the right arm of the colon-
nade of St. Peter's Square as well as the
Scala Regia and the corridor leading
up to it, is easily readable on the map.

The larger figures in the bottom
margins allegorically depict a vibrant
personification of the Church on the
right, couched among resplendent
contemporary monuments (St. Peter's,
the Capitoline Hill, and St. John
Lateran) triumphing over a sad personi-
fication of the pagan past on the left,
seated among the crumbling but still
noble ruins of the city. This relation-
ship can be thought of as symbolizing
Nolli's greater interest in the contem-
porary city than in the ancient one.
[AC]

## GIOVANNI PAOLO PANINI

PIACENZA 1691–1765 ROME
*For biography see Paintings section*

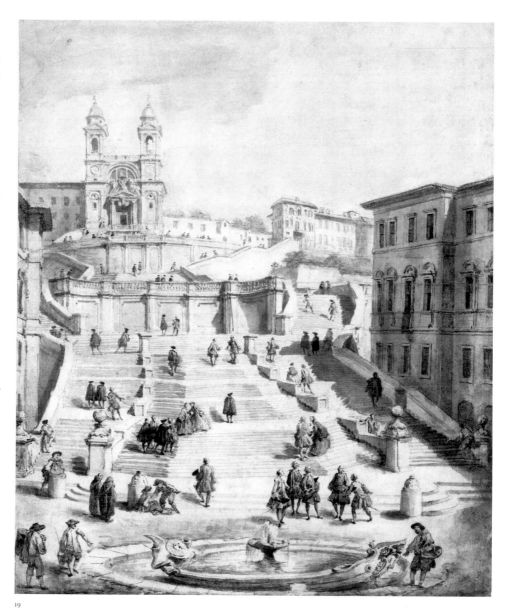

19

## 19
### Giovanni Paolo Panini
*The Spanish Steps*

C. 1757
Inscribed in pen and brown ink on verso:
*g. p. panini*, and *N.o 110*
Watercolor, over black chalk on paper
13¼″ × 11½″ (348 × 293 mm)
PROVENANCE  Jacques-Laure Le Tonnelier
de Breteuil (1786); Jean-Baptiste-Pierre
Lebrun (1791); Marquis de Lagoy; Maldwin
Drummond (1970)
BIBLIOGRAPHY  Lotz 1969, pp. 39–94;
Gillies 1972; Arisi 1986, p. 465; Bean and
Griswold 1990, no. 151
The Metropolitan Museum of Art, New
York, Rogers Fund

The Spanish Steps, constructed
between 1723 and 1728 following the
designs of Francesco de Sanctis, consti-
tute the most important eighteenth-
century addition to the urban armature
of Rome. They effect a graceful transi-
tion between the early sixteenth-
century streets occupying the flood
plain of the Tiber below, and the radi-
ating system of streets Pope Sixtus V
laid out at the end of the century on the
hills above. The church of the Trinità
dei Monti and the adjacent monastery
of the French Minims had stood in a
commanding position on the Pincian
Hill since the early sixteenth century;
its twin-towered façade was com-
pleted in 1570. At the foot of the steps
water issues from the Barcaccia
Fountain, executed in 1627–29 by
Pietro Bernini, who was probably
assisted by his son Gianlorenzo.

In the 1660s Bernini provided
designs for a monumental ramp
leading up to the Trinità dei Monti,
which would have celebrated the
French presence in the papal capital,
most notably through the inclusion of
an equestrian monument to Louis XIV
as its centerpiece. For political reasons
Bernini's design was never realized,
but his basic scheme was adapted by
De Sanctis in his executed design. It is
significant that Sanctis had served as
architect of the Minims, the French
order that controlled the funds used
to build the steps, since 1715. This posi-
tion gave him an advantage over the
other entrants in the competitions of
1717 and 1723, both of which he won,
even though Pope Clement XI pre-
ferred the designs of his own architect,
Alessandro Specchi. Unlike Bernini,
De Sanctis wisely separated pedestrian
traffic from horse-drawn carriages.
The latter were accommodated by the
ramp ascending the Salita di
S. Sebastianello, which is not visible
in Panini's sketch. This crucial deci-
sion ensured that the Spanish Steps
would function as a theatrical setting
for those who wished to be seen and
to participate in the passing spectacle
of urban life, as well as facilitating
movement from one part of the city
to another.

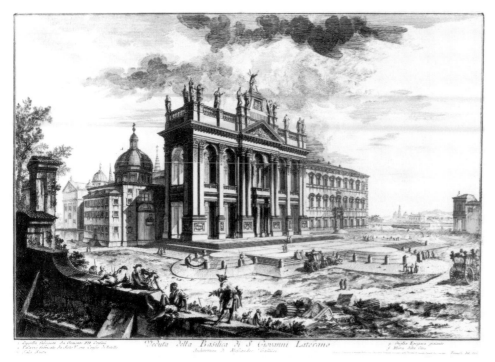

20

- Cappella fabricata da Clemente XII Corsini
- Palazzo fabricato da Sisto V ora Conser. di Zitelle
- Scala Santa
- Guglia Egiziaca giacente
- Mura della Citta Presso l'Autore a Strada Felice nel Palazzo Tomati vicino alla Trinità de' Monti

Veduta della Basilica di S. Giovanni Laterano
Architettura di Alessandro Gallilei

In most important respects, Panini's *veduta*, which can be dated to around 1757, corresponds closely to the appearance of the steps today. The escutcheon of the king of France above the church portal has been removed, and the obelisk that Pope Pius VI erected in front of Trinità dei Monti in 1786 does not appear. The low range of buildings to the right of the church façade has been replaced by a multi-story modern building, but the Palazzo Zuccari continues to anchor the skyline at the top of the steps. At the base of the steps the two leading bollards have been removed to facilitate the flow of traffic. The spare eighteenth-century *casamento* to the right of the staircase served as John Keats's residence before his death there in 1821.

There is no known painting by Panini that isolates the Spanish Steps, but the sketch corresponds closely to one of the painted *vedute* of the Scalinata that appear in two versions of Panini's *Vedute di Roma moderna*, both of which can be dated to 1757. The painted version is more vertical in format and eliminates both the *casamento* and the right-hand base of the steps. In spite of these minor differences, it seems clear that Panini made the sketch as part of his preparation for executing the paintings depicting a gallery of Roman views. The drawing's earliest recorded owner, Jacques-Laure Le Tonnelier de Breteuil, ambassador of the Sovereign Order of Malta to the Holy See from 1758 to 1777, probably acquired it in Rome. [JP]

## GIOVANNI BATTISTA PIRANESI

MOGLIANO DI MESTRE 1720–1778
ROME
*For biography see Prints section*

### 20

# Giovanni Battista Piranesi
*View of the Basilica of St. John Lateran*

1746?–48?
Etching
From *Vedute di Roma* (Rome, before 1778)
Signed below image, lower right
Inscription below image (center): *Veduta della basilica di S. Giovanni Laterano/Architettura di Alessandro Gallilei*
Inscription below image (left and right): *1. Cappella fabricata da Clemente XII. Corsini/2. Palazzo fabricato da Sisto V. ora Conser. di Zitelle/3. Scale Santa/4. Guglia Egiziaca giacente/5. Mura della Citta/Presso l'Autore a Strada Felice nel Palazzo Tomati vicino alla Trinità de' Monti. A paoli due e mezzo*
15⅜″ × 21½″ (390 × 545 mm)
BIBLIOGRAPHY Focillon 1918, no. 790; Hind 1922, "The Views of Rome," no. 8 iii/vi; Kieven 1987; Kieven 1989; Campbell 1990, *Piranesi*, no. 4; Kieven 1991; Wilton-Ely 1994, vol. 1, no. 139
Philadelphia Museum of Art, Gift of Lessing J. Rosenwald

This view of the Lateran was one of the earliest of the *Vedute di Roma* to be issued by Piranesi, an indication of the importance of the site. The Lateran is the cathedral of Rome, presided over by the pope in his role as bishop. As such, it is the goal of the *solenne possesso*, the ritual procession in which each newly elected pope travels from the Vatican to take possession of the Lateran. In the eighteenth century the Lateran was also the goal of many pilgrims, who were also attracted by the presence of the Scala Santa, housed in the building at the extreme right in the print. The staircase was believed to have been brought from Pilate's palace in Jerusalem by the Emperor Constantine's mother, Saint Helena.

Dominating the composition is the façade of the Lateran, which had only recently been completed following the design of Alessandro Galilei. In 1732 Pope Clement XII Corsini had organized a competition for the commission, in which numerous architects had entered. The selection of an outsider, the Florentine Galilei, by a Tuscan pope was viewed critically by the Roman architectural establishment. Galilei's design, executed between 1733 and 1735, is a brilliant exercise in monumental classicism. It builds upon the precedents of Michelangelo and Maderno at St. Peter's while introducing a more austere and measured rigor evident in the treatment of the Orders and the emphasis on interlocking right-angled relationships. In this respect, it also expresses a revival of interest in Renaissance models, such as Michelangelo's unexecuted design for the façade of S. Lorenzo in Florence, as well as an expression of a new, more Vitruvian classicism.

Piranesi's choice of an oblique viewpoint casts the façade, which encloses a narthex and a second-story benediction loggia, into bold relief. It also serves to emphasize the Corsini Chapel, the dome of which appears prominently just behind the façade. The chapel was also designed by Galilei, and was under construction at the same time as the façade. Within, the subordination of the sculptural component to Galilei's governing architecture offered a new and more sober approach to the integration of the arts. Piranesi's caption gives full credit to Galilei for providing the venerable basilica with a monumental façade. His print may thus be seen as representing an engagement with the architecture of his own day that complements the emphasis on antiquities, which figure in so many of the prints in the *Vedute* series. In this regard it is worth noting that the façade figures in one of the vignettes of Giambattista Nolli's contemporary plan of Rome as a symbol of both *Roma sacra* and *Roma moderna*, in contrast to the other vignette of ruins representing *Roma profana* and *Roma antica*. Granted the date of issue, it is likely that Piranesi, who always had an eye on the market, was looking forward to the Holy Year of 1750, which would attract pilgrims particularly interested in representations of the patriarchical basilica. [JP]

### 21

# Giovanni Battista Piranesi
*Study for the Reorganization of the Pantheon Attic*

1756
Black and red chalk, pen and brown ink, sepia wash
13⅜″ × 10″ (340 × 256 mm)
BIBLIOGRAPHY De Fine Licht 1968, p. 125; Marder 1989, pp. 628–45; Kieven 1993, pp. 332–33; Pasquali S. 1996, pp. 68–119
Biblioteca Apostolica Vaticana, Vatican City

Above all other Roman monuments, the Pantheon was the most universally admired for its structural daring and proportional harmony. This is not to say that it was above criticism, however. From the Renaissance through the eighteenth century, architects had raised questions about the attic zone of the interior, in which they perceived disjuncture between the classical Orders below and the coffering of the dome above. As can clearly be seen in Panini's depiction of the interior (cat. 266), the pilasters of the attic interrupted the vertical alignment of lower columns and the ribs defined by the coffering of the dome.

After the holy year of 1750 Pope Benedict XIV sponsored the restoration of the attic and vault of the Pantheon. In the course of 1756–57, the architect Paolo Posi removed the ancient marble revetment and replaced it with the system of alternating square plaques and rectangular openings crowned by triangular pediments that

21

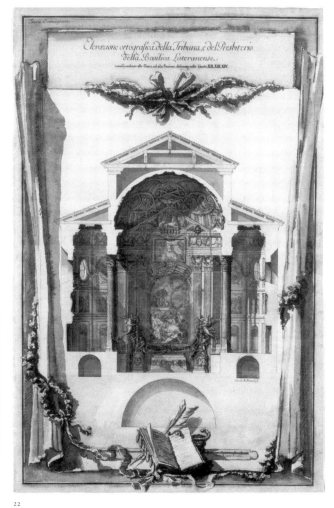

22

exists today. Posi's solution satisfied those who, inclining towards Neoclassicism, objected to the license of the attic pilasters. At the same time, it offended another group who believed that such a hallowed monument should be respected, some because they cast themselves in the traditional role of custodians of antiquity, others because the compositional liberty represented by the ancient attic licensed freedom for their own creativity. The foremost spokesman for the value of complexity and contradiction in Roman architecture and its legacy in the architecture of his own day was Giovanni Battista Piranesi.

Piranesi's drawing is perhaps best understood not as a concrete project competing with Posi's, but rather as a critique drawn after the fact. Significantly, Piranesi depicted the lower zone of the Pantheon and the upper one of the dome using broad brushstrokes of wash, reserving pen and ink for the detailed rendering of the attic. Like its ancient predecessor, Posi's attic is essentially two-dimensional; in contrast, Piranesi's attic design is a richly layered three-dimensional composition. Piranesi's archaeological publications document his interest in Roman architectural ornament that departed from the norms of Vitruvian classicism, and his theoreti-

cal works, especially the *Parere*, argue passionately for the creation of new, non-traditional forms. Piranesi had few opportunities to put this attitude into practice, but the ornament he designed for the church of the priory of the Knights of Malta on the Aventine is stunning in its novelty.

Piranesi's design takes its point of departure from the pilasters of the ancient attic, but casts them into bold sculptural relief, arranging them in triadic clusters. The rectangular niches of the attic are used to frame statues, and a continuous ornamental frieze works its way around the niches and behind the most boldly projecting pilasters, effectively knitting the layered composition together. Other motifs, including a strigilated frieze and fan-shaped reliefs, animate the attic, illustrating Piranesi's ability to employ familiar forms in striking new ways. Piranesi viewed the diversity and inventive power of the ancients as an inspiration for creative design in his own day; paraphrasing Sallust, he dismissed his critics by proclaiming, "They despise my novelty, I their timidity" (Piranesi, *Parere su l'architettura* [Rome, 1765], pl. 6). Piranesi's graphic meditation on the Pantheon attic reveals the brilliance of his novel approach to architectural ornament. [JP]

## 22

### Giovanni Battista Piranesi
*Presentation Drawing Relating to the Sanctuary of St. John Lateran: Transverse Section through the Choir*

1764

Inscriptions: *Cav. G.B. Piranesi f.* (at lower right);
*Elevazione ortografica della Tribuna, e del Prespiterio della Basilica Lateranense corrispondente alla Pianta, ed alla Sezione, delineate nelle Tavole XII.XIII.XIV* (at top);
*Scala di palmi Romani* (at bottom, just to right of center)
Pen and brown ink, with gray and brown washes
35¼" × 22½" (897 × 572 mm)
PROVENANCE Arthur M. Sackler
Arthur M. Sackler Collection, Avery Architectural and Fine Arts Library, Columbia University in the City of New York

## 23

### Giovanni Battista Piranesi
*Presentation Drawing Relating to the Sanctuary of St. John Lateran: Longitudinal Section Showing the South Wall, with Transept and Beginning of Nave*

1764

Inscriptions: *Cav.r G.B. Piranesi fece* (at lower right);
*Sezione ortografica di fianco della Tribuna del Presbiterio, e dell'Esedra della Basilica Lateranense immaginati con architettura corrispondente a quella gran Nave, e de' lati.* (at top);
*Palmi Romani* (under scale at top);
1. *Uno de'Coretti da mostrar le Sacre Reliquie.*
2. *Coro de'Musici della Cappella* (at bottom center)
Pen, gray and brown ink, with gray and brown washes
21⅞" × 35⅛" (556 × 893 mm)
PROVENANCE Arthur M. Sackler
Columbia University, Avery Library
BIBLIOGRAPHY Nyberg 1972, pp. 46–49; Piranesi 1975, pp. 48–53; Wilton-Ely 1992, pp. 57–58, pls. 21–22; Wilton-Ely 1993, pp. 63–85
Arthur M. Sackler Collection, Avery Architectural and Fine Arts Library, Columbia University in the City of New York

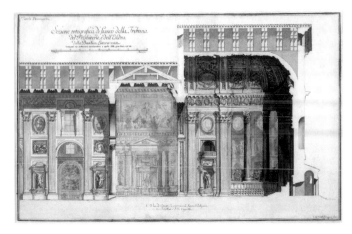

23

These two sheets belong to a set of twenty-three drawings presenting proposals for the sanctuary of St. John Lateran that Piranesi, with assistance from members of his studio, prepared in 1764. The drawings were probably prompted by the commission he received in 1763 from his countryman the Venetian Pope Clement XIII for a new high altar for the basilica. The commission seems to have stimulated Piranesi to propose much more ambitious schemes involving the transformation of the entire apse and choir zone of the Lateran. These grandiose designs were never executed, and once Piranesi realized the commission had been abandoned he adapted them for presentation to Cardinal Giambattista Rezzonico in 1767. Piranesi elaborated five schemes for the tribune, each distinct but also related to the others, one of which is illustrated by the two drawings on display. While the two sections are closely related to one another, they do not correspond precisely and each contains unique features not present in the other.

Piranesi's longitudinal section clearly reveals the three major phases of renovation within the Lateran basilica: Borromini's 1650 transformation of the nave appears at the left, the renovated transept dating from 1600 at center, and Piranesi's 1764 proposal for the apse on the right. In order to provide a visual link between the nave and the apse, Piranesi proposed to continue Borromini's system of colossal pilasters. He also carried over other elements from Borromini's nave: the pilasters frame aedicules at floor level while above are paintings set within oval frames. The frieze carried by the pilasters echoes that of Borromini's nave, but in the tribune area its ornament, including the tower and cross of the Rezzonico arms, allude to Piranesi's patron. Piranesi even repeated the distinctive capitals with inverted volutes inspired by Hadrianic originals, revealing his

affinity with Borromini's esteem for the variety and novelty of ancient architecture. In distinction to the nave, the tribune is vaulted and covered with a profusion of ornament that recalls Piranesi's contemporary stucco work in S. Maria del Priorato on the Aventine. Piranesi's hand is most evident in the area of the sanctuary; he also appears to have heightened details of the nave elevation with brown ink.

The transverse section offers a frontal view of the high altar set within the apse. This is the finest drawing of the series, with dazzling virtuoso tonal effects achieved through Piranesi's mastery of layered washes. As so often occurs in Piranesi's prints, light slants in dramatically, here illuminating the papal altar framed by colossal candelabra. Above the altarpiece and projecting into the frieze Piranesi sets a panel with the iconic image of the Savior, watched over by the Lamb of God, which reclines on the Bible. Piranesi has embellished the original presentation sheet with other decorative flourishes. The paper on which the section is drawn appears to curl over on either side while ribbons and garlands enrich the borders. At the bottom appears a brilliant vignette composed of an open book, quill pen, and the serpent of eternity superimposed on an architect's scale, which may express Piranesi's recognition that his creative designs would survive through his publications rather than his buildings.

Had they been executed, Piranesi's designs for the Lateran tribune would have provided both a powerful visual climax to the interior and a compelling synthesis of the venerable basilica's architectural history. There seems little doubt that Piranesi's tribune would also rank as one of the outstanding architectural achievements of the eighteenth century. [JP]

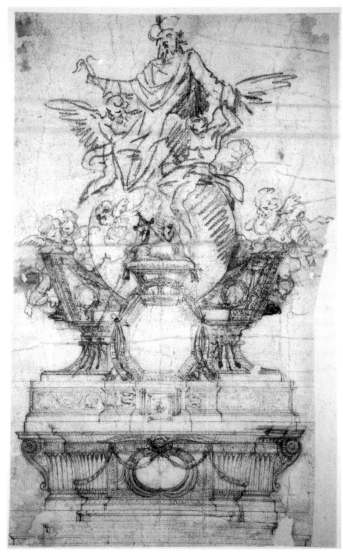

24

## 24
## Giovanni Battista Piranesi
### *Study for the High Altar of S. Maria del Priorato*

1764–65
Black chalk with pen and brown ink on paper
13⅜″ × 7⅜″ (340 × 187 mm)
BIBLIOGRAPHY  Jacob 1975, p. 169; Wilton-Ely 1976, pp. 214–27; Wilton-Ely 1978, p. 108; Kieven 1993, pp. 336–37; Wilton-Ely 1993, pp. 106–7; Jatta 1998
Staatliche Museen zu Berlin, Kunstbibliothek

Piranesi's renovation of the small church of S. Maria del Priorato on the Aventine Hill constitutes one of his rare executed architectural designs. His Venetian origins normally put Piranesi at a disadvantage in competing with Roman architects, but the election of his countryman Carlo Rezzonico as Pope Clement XIII in 1758 undoubtedly gave him an edge in

obtaining this commission. As prior of the Knights of Malta, the pope's nephew Cardinal Giambattista Rezzonico saw to it that the project was awarded to Piranesi. The account book detailing expenditures on the church preserved in the Avery Library, Columbia University, shows that work was carried out between 1764 and 1766.

Several preparatory drawings for the high altar survive, which shed light on Piranesi's conceptual process. The Morgan Library possesses a more summary preliminary sketch and a second, more finished drawing that focuses on the architectural portions of the altar. The Berlin drawing illustrates the crucial step Piranesi took in introducing the great orb providing the base for the sculptural group representing the apotheosis of Saint Basil of Cappadocia. The original priory church in the Forum of Augustus had a painted altarpiece representing Saint Basil, and Piranesi translated the subject into the three-dimensional medium of sculpture. Using black chalk, Piranesi

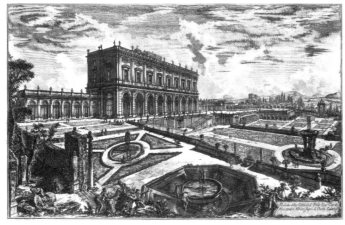

25

brilliantly captured the saint's fluttering drapery and picturesque silhouette. Pen and ink are employed to study the richly detailed surfaces of three superimposed forms reminiscent of ancient Roman sarcophagi, as well as the octagonal tabernacle surmounted by the paschal lamb.

Piranesi's altar design plays variations on themes and motifs that were already introduced in other parts of the scheme, effectively linking it decoratively (as well as scenographically) into the cumulative experience of the site. The oculus cut into the altar table, the scroll-corbels at its sides, and the flame-like striations all repeat motifs introduced on the façade of the church. Within the oculus is faintly sketched the chi-rho monogram, a symbol that appears within a roundel on the vault. The pointed features projecting from the base of the uppermost sarcophagus form are rostra (the bronze beaks of ancient warships, intended to allude to the Sovereign Order's victories in naval battles), a motif that is introduced in Piranesi's portal to the priory.

As executed by Tommaso Righi, a specialist in stucco sculpture, the altar departs only marginally from Piranesi's design. The octagonal tabernacle relief, which is blank in the drawing, represents the Virgin with Christ and Saint John, the patron saint of the order. John Wilton-Ely correctly observed that the highly original combination of geometric forms composing the altar was anticipated in Piranesi's frontispieces for the *Antichità romane* (published some ten years earlier) and also bears comparison with the use of basic geometrical forms by such Neoclassical designers as Claude-Nicolas Ledoux in the following decade. A number of decorative motifs evident in the drawing for the priory church also appear in Piranesi's nearly contemporary drawings for the Lateran tribune. [JP]

## 25
## Giovanni Battista Piranesi
## *View of the Villa of His Eminence Cardinal Alessandro Albani, outside Porto Salaria*

1769

Etching
From *Vedute di Roma* (Rome, before 1778)
Signed below image, lower left
INSCRIPTION *Veduta della Villa dell'Emo. Sig.r Card/Alesandro Albani fuori di Porta Salaria*
17½″ × 27½″ (443 × 698 mm)
BIBLIOGRAPHY Focillon 1918, no. 853; Hind 1922, "The Views of Rome," no. 89 i/iii; Gasparri 1985; Roettgen 1987; Campbell 1990, *Piranesi*, no. 90; Bevilacqua 1993; Wilton-Ely 1994, vol. 1, no. 222; Gasparri 1996
National Gallery of Art, Washington, D.C., Mark J. Millard Architectural Collection, acquired with assistance from The Morris and Gwendolyn Cafritz Foundation

Piranesi's inclusion of the Villa Albani in the series of the *Vedute di Roma* was motivated by a number of considerations—pragmatic, polemical, and personal. By the time he issued this print in 1769, the Villa Albani had become a major center of antiquarian studies. This was in large measure the result of the display there of the extensive collections of classical art amassed by its owner, Cardinal Alessandro Albani, together with the influential publications of his librarian, Johann Joachim Winckelmann, who had died only one year earlier, in 1768. By 1766, the date of Ridolfino Venuti's influential guidebook, a visit to the Villa Albani had become obligatory for antiquarian and Grand Tourist alike, both groups Piranesi targeted in expanding the audience for his prints. Venuti's remark that he remained undecided for a long time about whether to include the Villa Albani in his volume on ancient Rome or in the one devoted to modern Rome reveals the extent to which the villa appealed to modern as well as to antiquarian sensibilities.

Piranesi's polemical engagement with the Villa Albani had to do with his advocacy for the primacy of Roman art over that of the Greeks, for whom Winckelmann had become the most eloquent exponent. Piranesi repeatedly used works from the villa's collections as evidence against Winckelmann and his fellow Philhellenes; no fewer than thirty-four examples appear in Piranesi's graphic work to illustrate the variety and creativity of Roman artists. Recent research has revealed that Piranesi contributed also to the villa's ornament, designing a frieze for the Hall of Parnassus and a fountain for the gardens. Thus, in depicting the Villa Albani, Piranesi was also representing his own work.

Situated a short distance outside the Aurelian walls along via Salaria, Cardinal Albani's magnificent suburban estate was the last in a distinguished line of great Roman villas extending back to the sixteenth century. Laid out between 1756 and 1762 by Carlo Marchionni, the main casino of the Villa Albani stands opposite a pavilion, the semicircular form and name (Canopus) of which were intended to evoke one of the pavilions of Hadrian's Villa at Tivoli. The close integration of architecture and sculpture at the Villa Albani also recalls Hadrian's Villa, the source of many of the finest works in the cardinal's collection. Nowhere is this so evident as in the Hall of Antinous, where the celebrated relief bust of Hadrian's favorite unearthed at the Villa Adriana in 1735 is given pride of place over the mantelpiece and Paolo Anesi's frescoes depict fanciful reconstructions of the imperial villa.

Marchionni's architecture owes more to Renaissance than to ancient architectural precedent, however, and appears relatively conservative and static. Piranesi's oblique point of view, stressing diagonals, together with his expressive use of contrasting light and shade, serve to introduce a measure of drama into Marchionni's decidedly planar casino. Far more innovative are the projecting frontispieces incorporating ancient fragments into unprecedented new combinations that resemble compositions in Piranesi's contemporary polemical publications. A short distance from the main building Marchionni constructed a ruined temple composed of disparate fragments, which underscores the enduring relation between ruins and landscape. Piranesi's *veduta* admirably captures the vistas extending in all directions out over the Roman Campagna, which could be enjoyed from the villa until the modern city grew up around it. [JP]

## 26
## Giovanni Battista Piranesi and Francesco Piranesi
## *Plate II of the Plan of the Surviving Buildings of Hadrian's Villa*

1781

Etching
One of six plates, each 27¾″ × 20½″ (705 × 519 mm)
BIBLIOGRAPHY Pinto 1993, pp. 63–84; Wilton-Ely 1994, vol. 2, no. 1009; MacDonald and Pinto 1995, pp. 246–65
Robison Collection

During the last decade of his life Piranesi devoted himself to documenting the extensive remains of Hadrian's Villa near Tivoli, one of the richest archaeological sites in the environs of Rome. Piranesi's printed views of the villa are well known, but the culmination of his study was a large plan based on a detailed survey of the entire site. The plan was only issued in 1781, three years after Piranesi's death, by his son Francesco. A large drawing in Naples is a preparatory study, drawn to the same scale as the published plan. It was well advanced by the time of Giovanni Battista's death in 1778 (the second sheet is dated 1777) and substantial passages are by his hand.

Piranesi's plan, entitled *Pianta delle fabbriche esistenti nella Villa Adriana*, is printed on six folio sheets, and these, when mounted together, extend over nine feet in length. The large scale of the plan (1:1,000), together with Piranesi's unparalleled etching technique, permitted him to delineate every component of the villa in detail. Sophisticated conventions—solid lines for existing structures, lighter ones for missing features—allow distinctions to be made between verifiable remains and conjectural reconstructions. Piranesi also employed dotted lines to distinguish between the elaborate system of subterranean roads, corridors, and chambers and the ground-level structures.

The entire plan appears to be inscribed on a long marble slab, its worn and irregular borders secured to a wall by metal cramps. This is an obvious reference to the great marble plan of ancient Rome, the *Forma urbis Romae*, fragments of which inspired Piranesi's site descriptions after 1756. The apparently thick edges of the slab play against the regular borders of the plates comprising the *Pianta*, enhancing the illusion that the plan is incised on marble rather than printed on paper. Piranesi further emphasizes this effect by the superimposition of other fragments, such as the dedicatory inscription and brickstamps (at

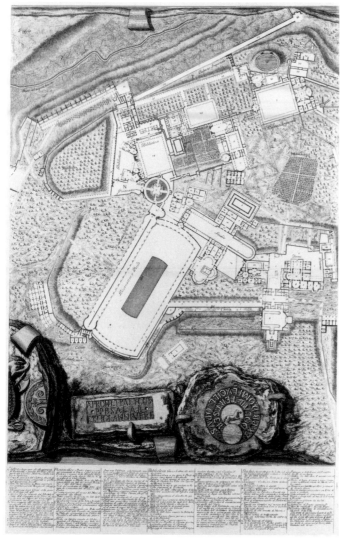

26

## Giovanni Battista Piranesi
### *View of the Large Trevi Fountain, Formerly Called the Acqua Vergine*

1746?–48?
Etching
From *Vedute di Roma* (Rome, before 1778)
Signed below image, lower right
INSCRIPTION *Veduta della vasta Fontana di Trevi anticamente detta l'Acqua Vergine./Architecttura di Nicola Salvi/Presso l'Autore a Strada Felice nel Palazzo Tomati vicino alla Trinità de' Monti. A paoli due e mezzo*
19¼″ × 21¼″ (401 × 552 mm)
National Gallery of Art, Washington, D.C., Mark J. Millard Architectural Collection, acquired with assistance from The Morris and Gwendolyn Cafritz Foundation
1985.61.19

28

## Giovanni Battista Piranesi
### *Frontal View of the Trevi Fountain*

1773
Etching
From *Vedute di Roma* (Rome, before 1778)
Signed below image, lower left
INSCRIPTION *Veduta in prospettiva della gran Fontana dell'Acqua Vergine detta di Trevi, Architettura di Nicola Salvi*
18⅝″ × 28″ (474 × 711 mm)
BIBLIOGRAPHY Focillon 1918, no. 734; Hind 1922, "The Views of Rome," no. 104 i/iii; Pinto 1986, pp. 162–63; 211–14; Campbell 1990, *Piranesi*, pp. 51, 112–13; Wilton Ely 1994, vol. 1, no. 237
National Gallery of Art, Washington, D.C., Mark J. Millard Architectural Collection, acquired with assistance from The Morris and Gwendolyn Cafritz Foundation

the bottom of plates I and II) and the Doric column drum and base inscribed with the compass points (at the bottom right of plate IV), on top of the main slab.

The wealth of graphic information on Piranesi's plan is greatly complemented by an extensive commentary of 434 entries, which provide identification and analysis of almost every villa feature. The commentary also records the find-spots of works of art such as Cardinal Furietti's celebrated dove mosaic and basalt centaurs, later acquired by Pope Benedict XIV for the Museo Capitolino. Piranesi's commentary far surpasses the earlier descriptions of Ligorio and Contini, and constitutes the most complete analysis of the villa written before the twentieth century.

Piranesi's *Pianta* constitutes an important document in the history of archaeological site description, significant as much for how it interprets the evidence as for what it records. With far greater rigor and authority than in any of his earlier antiquarian studies,

Piranesi applied principles he first began to formulate in the mid-1750s. He applied his archaeological method developed in the course of compiling the *Antichità romane* to his survey of the villa. No longer was he content to represent the exteriors of individual buildings, as in the *Vedute*; he fleshed out ruined or vanished structures by means of conjectural plans and whenever possible employed ancient literary sources, as in the commentary. Most important, he brought all of these means to bear on his ultimate end, a complete reconstruction. [JP]

Piranesi's two views of the Trevi Fountain, issued more than twenty years apart, provide valuable insights into the history of its sculptural program. The oblique view depicts the fountain as it appeared in 1751, with Giovanni Battista Maini's revised stucco models of the main sculptural component in place. The large format of the *veduta* allowed Piranesi to include a wealth of detail; moreover, the oblique viewpoint helps to clarify the three-dimensional relationship of the different figures in the central group of sculpture. The two triton groups are placed in the same plane parallel to the façade, and Maini's commanding figure of Oceanus appears very clearly at the center. The lateral niches appear to be occupied by statues of two figures associated with the early history of the Trevi: Agrippa and Trivia. Above these statues appear to be bas-reliefs, which depict events in which they figure: Agrippa supervising the construction

of the Acqua Virgine (the aqueduct that supplies the Trevi) and Trivia showing Agrippa's scouts the source of the water. In actual fact, what appear to be statues and reliefs are the provisional chiaroscuro paintings by Antonio Bicchierari that decorated the fountain for sixteen years, from 1744 to 1760.

The central figure of Oceanus holds both of his arms relatively close to his body and maintains a well-balanced stance, his feet firmly planted on the edge of the seashell. A voluminous mass of drapery, the shaded folds of which serve to set off the powerful limbs of the deity, reinforces this impression of strength and solidity. From his elevated position on top of the *scogli* Oceanus gazes upward, ignoring the action below him and leading the viewer's eye outward and away from the composition. The deaths of Salvi and Maini in 1751 and 1752 respectively made it inevitable that, in providing the Trevi with permanent marble statues, changes would be introduced to the sculptural program.

Piranesi's frontal view of the Trevi, issued in 1773, depicts the permanent sculpture by Pietro Bracci, Filippo della Valle, and others that had been placed on the fountain in 1758–62. Comparing Maini's Oceanus to Bracci's statue a number of small but nonetheless significant changes become apparent. The most obvious change introduced by Bracci is the right arm of Oceanus, which now projects boldly from the central niche. Bracci's Oceanus looks down and to the right, his gaze directing attention to the sculpture below him and effectively closing the composition. Bracci also makes a more limited use of drapery, which appears far less substantial, and his Oceanus stands further back on his heels in a more transitory pose. Furthermore, his legs are not spread so far apart and occupy different planes, with the result that the triangular stability of Maini's Oceanus gives way to a more elegant *figura serpentinata*.

Also visible in the frontal *veduta* are the lateral statues of Abundance and Health by Della Valle, which replaced the painted representations of Agrippa and Trivia called for by Salvi's iconographic program. Above, real bas-reliefs narrating the fountain's history have replaced Bicchierari's provisional chiaroscuro paintings, both set in place in 1762. The one on the left representing Agrippa was carved by Andrea Bergondi, while its counterpart on the right, depicting Trivia, is by Giovanni Grossi.

Piranesi's two *vedute* of the Trevi also capture its overtly scenographic character. The oblique view stresses the dialogue between the fountain

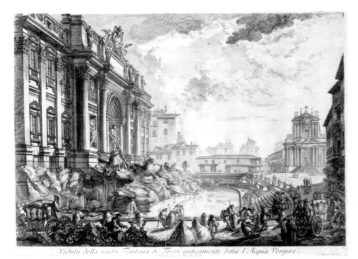

Veduta della vasta Fontana di Trevi anticamente detta l'Acqua Vergine.

27

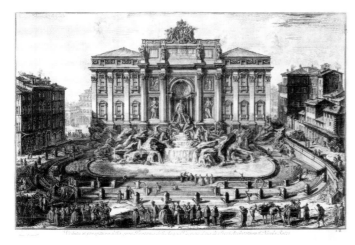

28

façade and that of the seventeenth-century church of Ss. Vincenzo e Anastasia diagonally opposite it. The two monuments appear to call and to answer one another, creating a visual counterpoint across the resonant space of the piazza that is metaphorically echoed by the pairs of trumpeting Fames perched above the two façades. Both prints reveal the sunken basin and the gently curving stairs protected by bollards and handsome wrought-iron railings that lead down to it. The steps not only effect the transition between street level and the basin but double as seating for passing spectators who choose to pause a while and enjoy the aquatic spectacle. [JP]

## ANDREA POZZO
### TRENTO 1642–1709 VIENNA

Andrea Pozzo was perhaps the most imaginative Italian painter, architect, and theoretician practicing in the last decade of the seventeenth century and the first of the eighteenth century. He studied painting in Trento, and in 1665 he joined the Society of Jesus in Milan,

as a lay brother, a vocation that he followed throughout his life. After a three-year novitiate in Genoa, Pozzo transferred to Milan, where, from 1668 to 1681, he lived in the Casa Professa of S. Fedele. The Jesuits recognized Pozzo's skill as a painter early on, and at S. Fedele he produced a series of highly acclaimed ephemeral decorations. While based in Milan, he executed important works in other north Italian centers, notably the church of S. Francesco Saverio at Mondovi and the Jesuit church in Turin (1678).

In 1681, on the advice of Carlo Maratti, Padre Giovanni Paolo Oliva, the general of the order, called Pozzo to Rome. Among Pozzo's first works after his arrival were the frescoes in the corridor outside the rooms occupied by Saint Ignatius in the Casa Professa of the Gesù (1681–86) and the fictive dome and baldachin in the Jesuit church at Frascati (1681–84). In 1682 he designed the first of several ephemeral structures that transformed the interior of the Gesù on the occasion of the fortieth anniversary devotions. In these designs for sacred theatrical performances Pozzo exper-

imented with sophisticated illusionistic effects that fused painting, stagecraft, and architecture.

Pozzo's undisputed Roman masterpieces are in the two great Jesuit churches of S. Ignazio and the Gesù. For S. Ignazio he painted the fictive dome (1684–85), nave vault (1688–94), and choir (1685–88; 1697–1701), as well as designing the altar of S. Luigi Gonzaga (1697–99). For the Gesù he designed the altar of St. Ignatius Loyola (1695–99) fusing architecture, sculpture, and painting: a set piece of Baroque religious art, the influence of which extended well into the eighteenth century. In the 1690s, perhaps encouraged by the success of his two great altars, Pozzo began to engage directly with real three-dimensional architectural projects. These included several proposals for the façade of St. John Lateran that acknowledge his debt to Francesco Borromini. In 1699–1700 Pozzo furnished designs for the Jesuit church in Dubrovnik and the cathedral of Ljubljana. In 1700–02 he sent designs to Trento for the church of S. Francesco Saverio, and in 1701–2 designed the Jesuit church in Montepulciano.

In 1703 Pozzo left Rome for Vienna. There, until his death in 1709, he was engaged in a number of important projects, including the Universitätskirche (1703–9), the frescoes of the Marmorsaal of the Liechtenstein garden palace (1704–9), and the ciborium of the Franziskanerkirche (1706). While in Vienna, Pozzo trained a number of followers who extended his work geographically into central Europe and chronologically well into the eighteenth century.

Pozzo's treatise *Perspectiva pictorum et architectorum*, published in two volumes (1693 and 1700), greatly enhanced his influence. It was rapidly translated into the major European languages and became a sourcebook for many eighteenth-century architects and designers. Not only did it provide practical instruction and a rich repertory of forms, but it also codified an essentially scenographic approach to architecture that would flourish in Rome for the next century. For Pozzo, the practice of architecture involved the pictorial—and graphic—representation of illusionistic space as much as it did the shaping of three-dimensional space. Pozzo claimed an independent reality for architectural drawings; in his treatise they function as distinct entities, in no way subordinate to built structures. Architecture, for him, was ultimately a system of representations, an intellectual and optical abstraction rather than an arrangement of concrete forms. [JP]

BIBLIOGRAPHY Pozzo 1693–1700; Kerber 1971; De Feo 1988; Pascoli 1992, pp. 691–715; *Andrea Pozzo* 1996; De Feo and Martinelli 1996

## 29
## Andrea Pozzo
### *Study for the Altar of S. Luigi Gonzaga in S. Ignazio, Rome*

c. 1696–97
Red chalk on cream laid paper
10¾″ × 8½″ (273 × 218 mm)
PROVENANCE Andrew Ciechanowiecki (1973); Anthony Morris Clark
EXHIBITIONS New York 1976, not catalogued; Philadelphia 1980, cat. no. 2
BIBLIOGRAPHY Pozzo 1693–1700, vol. 2, pp. 64–65; Hiesinger and Percy 1980, pp. 11–12; Contardi 1991, pp. 23–39; Contardi 1996, pp. 97–120; Millon 1999, pp. 558–61
Philadelphia Museum of Art, Bequest of Anthony Morris Clark

This drawing is of special interest because it appears to be a preparatory study for the altar of S. Luigi Gonzaga in S. Ignazio. While it bears certain similarities to Pozzo's altar of S. Ignazio in the Gesù, the colossal order of Corinthian pilasters framing the aedicule proves that the setting for the design is actually the transept of S. Ignazio. On the basis of documentary evidence, the drawing is unlikely to have been executed before the fall of 1696. It bears a close resemblance to the model for the S. Luigi Gonzaga Altar in the collection of the Museo Nazionale di Castel S. Angelo.

In preparing this design for the Gonzaga altar, Pozzo clearly used the earlier S. Ignazio altar as a point of departure. The sketch repeats the central motif of a freestanding statue of the saint set within a niche flanked by two columns with straight shafts. Pozzo may have borrowed the statues of Virtues flanking the columns from another project for the S. Ignazio altar: Sebastiano Cipriani's design of 1696. The drawing is also related to the designs for the Gonzaga altar that appear in Pozzo's treatise. In plate 64 of the second volume, which the artist described as his "prima idea," there are statues of Virtues and spiral columns, but no central niche. Much closer is the design illustrated in plate 65, which contains the Virtues as well as a freestanding statue of S. Luigi Gonzaga kneeling on his reliquary casket, an arrangement that resembles the sculptural group at the center of the drawing. As executed, the design of the altar is further removed from this sketch: the Virtues are eliminated, the number of columns doubled, and the magnificent bas-relief by Pierre Legros II replaces the freestanding sculptural group.

The drawing appears to have been executed in several stages. Using draftsmen's instruments, Pozzo drew in the outlines of the existing architecture and the dimensions of the niche to serve as a guide. Working freehand,

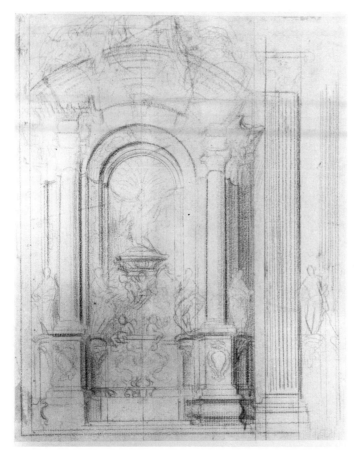

29

he then rendered the architectural members of the aedicule in perspective, introducing strong passages of shadows that cast the projecting elements of the altar into relief. Finally, he shifted his concern to the design and placement of the sculpture. The study represents an interim stage in the conceptual process, especially striking in its spontaneity and rich in its power of suggestion. Because of its strength and the light it casts on the planning stages of the Gonzaga altar, it constitutes a significant addition to the corpus of drawings by or attributed to Pozzo. [JP]

## NICOLA SALVI
### ROME 1697–1751 ROME

Salvi showed an early interest in philosophy and mathematics, studied medicine and anatomy, and also wrote verse. In 1717 he was admitted to Rome's most prestigious literary society, the Accademia dell'Arcadia. Under the influence of the Arcadians, he came to value Renaissance models and to explore irregular, picturesque compositions in his designs; he also esteemed seventeenth-century Roman architecture, from which he learned how to use the classical orders to achieve bold sculptural effects. Salvi's biographer Niccolò Gabburri

recorded that he spent nine years deciding on which career to pursue. In this period he attended classes at the Accademia di S. Luca given by the painter Nicolò Ricciolini, who directed his interest toward architecture and introduced him to Antonio Canevari.

While training in Canevari's studio, Salvi studied Vitruvius particularly closely and is said to have committed the latter's treatise to memory. He also drew after ancient monuments as well as the acknowledged masterpieces of Renaissance and Baroque architecture. In 1727, after Canevari's departure to Portugal, Salvi took charge of his master's Roman studio, and his first identifiable designs date from this time. The most interesting of these was the large temporary structure of 1728 in the Piazza di Spagna that celebrated a royal marriage between the houses of Spain and Portugal. Other projects from this period include the baptistry of S. Paolo fuori le Mura (destroyed in 1823), the ciborium of the abbey church at Montecassino, and the choir of S. Eustachio.

In 1732 Salvi participated in both of the great architectural competitions organized by Pope Clement XII. His projects for the façade of St. John Lateran were unsuccessful, but he won the commission for the Trevi Fountain. Its construction was extremely protracted, but as early as 1735 the archi-

tectural framework was complete, and by Salvi's death in 1751 the ornamental rock formations and full-scale models of most of the sculpture were in place. During the course of his work on the fountain Salvi's health failed, perhaps because of the long hours he spent supervising work in the subterranean aqueducts that feed the fountain.

Salvi's poor health severely limited his architectural activity after 1744, and he executed no other designs approaching the scale of the Trevi. However, several smaller buildings attest to the range and quality of his work. Among the most important of these is his remodelling of the interior of S. Maria dei Gradi in Viterbo, which was much admired by William Chambers. In 1742 King John V of Portugal commissioned Salvi and Luigi Vanvitelli to design the chapel of St. John the Baptist in the church of S. Roque, Lisbon. The chapel was executed in Rome and then shipped to Portugal. Salvi was also responsible for the expansion of Bernini's Palazzo Chigi-Odescalchi in Rome in 1745, to which he added additional bays repeating Bernini's façade treatment.

Although he was less productive than his better-known contemporaries Vanvitelli and Fuga, Salvi's command of architectural theory, his abilities as a teacher, and the outstanding quality of his design for the Trevi Fountain made him a figure of considerable stature. Among those attracted to Salvi's studio was the Moravian architect Franz Anton Grimm, who studied with Salvi between 1739 and 1740, copying many of his master's drawings. Salvi's accomplishments received official recognition in 1733, when he was elected a member of the Accademia di S. Luca, and again in 1745, when he was admitted to the Congregazione dei Virtuosi al Pantheon. Salvi's biographers claim also that his dedication to the Trevi Fountain led him to decline several positions, including offers from the courts of Turin and Naples and from the governing body of Milan Cathedral.

Like his great contemporary and friend Vanvitelli, Salvi's historical significance rests largely in his ability to express the scenographic potential of architecture and in his more tempered, classicizing interpretation of traditional Baroque forms. Perhaps, as Francesco Milizia wrote, the Trevi Fountain is the finest eighteenth-century building in Rome; it is certainly Salvi's masterpiece. [JP]

BIBLIOGRAPHY Florence, Biblioteca Nazionale Centrale, Niccolò Gabburri, *Vite*, p. 1975 Ms. cod. Pal. E.B.9.5, iv, ; Vatican City, Biblioteca Apostolica Vaticana, cod. Lat. 8235, 10-14v; Milizia 1827, pp. 376–80; Schiavo 1956, pp. 13–24; Pinto 1986, pp. 121–27; Kieven 1987, pp. 255–75; Kieven 1991, pp. 65–87; Pinto 1999, pp. 22–24

## 30
### Nicola Salvi
#### *Fireworks Apparatus*

1728
Etching by P. Pannini (draftsman) and Filippo Vasconi (etcher)
18½″ × 24⅜″ (470 × 620 mm)
BIBLIOGRAPHY Moschini 1929, pp. 345–47; Schiavo 1956, pp. 33–36; Pinto 1986, pp. 122–23
Biblioteca Casanatense, Rome

Nicola Salvi's first independent architectural commission was ephemeral in nature, a large firework apparatus celebrating a double wedding between the royal houses of Spain and Portugal, which was erected in the Piazza di Spagna in 1728. In all likelihood, the commission came to Salvi through Antonio Canevari, in whose studio he trained. Canevari had left Rome the year before to become court architect of King John V of Portugal, and it is probable that he recommended his pupil to his new master.

Salvi's grandiose firework apparatus is depicted by two prints, one of which records its placement in the Piazza di Spagna. The enormous scale of the structure is immediately evident, for it stood more than 150 feet tall, rising considerably higher than the recently completed Spanish Steps, the lower portions of which are just visible beneath the clouds to the right of the apparatus. Such large-scale, temporary architectural structures, made of wood, plaster, and painted canvas and designed to be blown up, were frequently employed to celebrate special occasions in eighteenth-century Rome.

The caption identifies the imposing edifice rising illusionistically from a cushion of clouds as the palace of Hymen, who appears enthroned within the central arch. The sources of this design provide a revealing indication of the comprehensive study Salvi devoted to historical monuments while in Canevari's studio. The first story is a free variation on Borromini's façade of S. Agnese in Agone and Pietro da Cortona's reconstruction of the sanctuary of Fortuna Primigenia at Palestrina. The first story also anticipates certain aspects of Bernardo Antonio Vittone's design for a central-plan church submitted to the Accademia di S. Luca in 1733 (cat. 40); the second story was probably inspired by one of Fischer von Erlach's published designs for a garden pavilion. The overall composition also betrays the influence of similar ephemeral designs published by Andrea Pozzo in his influential treatise. Salvi's design owes much to its seventeenth-century precursors, but it is nonetheless a creative synthesis of the sources, not a pastiche.

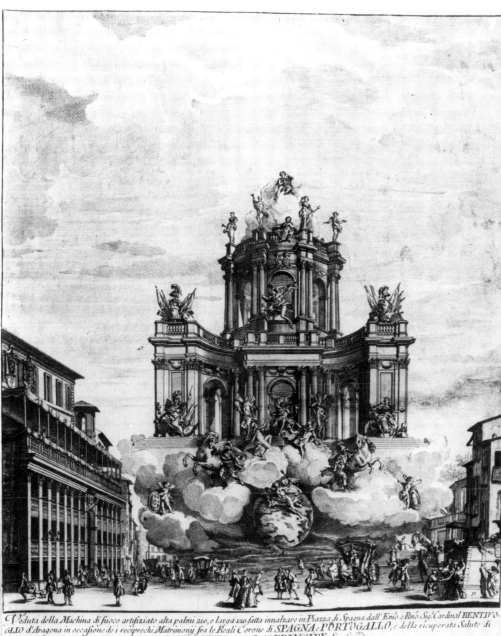

*Veduta della Machina di fuoco artifiziato alta palmi 210, e larga 120 fatta innalzare in Piazza di Spagna dall'Emo e Rmo Sigr Cardinal BENTIVO-GLIO d'Aragona in occasione de i reciprochi Matrimonij fra le Reali Corone di SPAGNA, e PORTOGALLO, e della ricuperata Salute di S. M CATTca e del Sermo PRINCIPE Spoſo*

30

The relationship between architecture and sculpture in Salvi's fireworks *macchina* appears to have provided the point of departure for his design of the Trevi Fountain four years later. The central statue of Hymen set within a niche is paralleled by that of Oceanus at the Trevi. The figures of Castor and Pollux with their rearing horses set diagonally below the center prefigure the tritons accompanied by sea horses at the Trevi. The four statues crowning the attic of the *macchina* and the trumpeting Fame set within the central arch of the lantern also have their counterparts on the fountain. Even the clouds that appear to support the palace of Hymen resemble the rustic *scogli*, or marine reefs, at the base of the Trevi. In both of Salvi's designs sculpture is subordinated to architecture, its role and placement clearly defined by the system of classical Orders. [JP]

## 31
## Nicola Salvi
### *Unexecuted Project for the Facade of St. John Lateran*

1732
Pen and brown ink with gray and black washes on paper
26⅜″ × 33⅞″ (670 × 860 mm)

BIBLIOGRAPHY Matthiae 1954, pp. 161–70; Schiavo 1956, pp. 37–61; Jacob 1972, pp. 100–17; Marconi, Cipriani, and Valeriani 1974, vol. 2, no. 2172; Lorenz 1981, pp. 183–87; Pinto 1986, pp. 122–23; Kieven 1987, pp. 255–75; Kieven 1991, "Il ruolo," pp. 78–123

Accademia Nazionale di San Luca, Rome

Nicola Salvi was one of many architects who participated in the 1732 competition for the façade of the Lateran basilica. He entered three projects, two of which are known from copies, and one from this handsome autograph drawing he presented to the Accademia di S. Luca upon his election in 1733. All of Salvi's projects for the Lateran exhibit a restrained classicism; in this drawing his manipulation of the Orders is at once confident, bold, and sculptural. His composition builds to a powerful climax at the center of the benediction loggia, where pairs of freestanding columns frame a niche with a coffered vault recalling the central feature of the Trevi Fountain, which he designed a few months later.

Unlike Alessandro Galilei in his winning design for the Lateran, Salvi did not propose to employ a colossal order to unify the two stories of the façade. Instead, he designed a double-tiered façade based on a creative reevaluation of fifteenth-century examples, especially Michelangelo's model for the façade of S. Lorenzo in Florence. Salvi's rhythmic grouping of bay units and his extensive use of bas-reliefs attest to his close study of Michelangelo's design. So too does the way in which his central aedicular motif supported by paired Corinthian columns is framed by lateral bays. Another feature of Salvi's project is modeled on Michelangelo's design for the Capitoline Hill; the Ionic columns carrying flat lintels that frame the entrances to the narthex of the Lateran basilica are juxtaposed with larger composite columns carrying the main entablature in a way that deliberately recalls the portico of the Palazzo dei Conservatori. Nonetheless, he used his Renaissance models creatively to generate original solutions specific to the problems posed by the Lateran commission, notably the monumental scale and four aisles of the basilica, which were different from those Michelangelo had to overcome in the more modest façade of S. Lorenzo. In the clear definition of its component parts and the classical rigor governing its composition, Salvi's façade is tempered by Renaissance precedent; at the same time, however, it possesses a unity and a dynamic tension that are characteristically Baroque.

The jury charged with evaluating the numerous designs submitted by the architects vying for the Lateran commission initially favored the projects of Nicola Salvi and Luigi Vanvitelli. In the end, however, Alessandro Galilei was proclaimed winner of the competition in the summer of 1732. The subsequent work of Salvi, Galilei, and Vanvitelli—and to a lesser degree that of Ferdinando

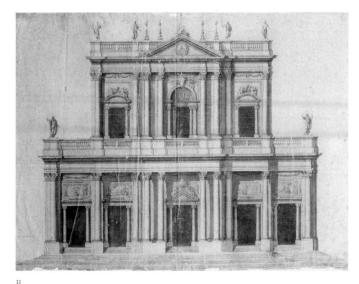

31

Fuga—ensured that late Baroque classicism would prevail as an architectural style until well past the middle of the century. [JP]

## 32
## Nicola Salvi
## *Elevation of the Trevi Fountain*

1733
Pen, gray and brown inks, gray and brown washes, with pencil under drawing on heavy cream-colored paper
15⅞″ × 21⅞″ (397 × 557 mm)
Inscribed: *Scala di Palmi Romani* along the bottom border; scale = 240 palmi
PROVENANCE Bequest of Contessa Anna Laetitia Pecci-Blunt, 1971
EXHIBITIONS Rome 1959, cat. no. 1140; Rome 1976, cat. no. 37
BIBLIOGRAPHY *Settecento* 1959, p. 265; Incisa della Rocchetta 1976, p. 19; Pinto 1986, pp. 60–63; Kieven 1991, pp. 68–70
Gabinetto Comunale delle Stampe di Roma, Rome

Since the 1640s the Trevi Fountain had languished in a pitiful condition, with water issuing from the unfinished foundations laid by Gianlorenzo Bernini. Despite many proposals, the Trevi still awaited completion in 1730, when Pope Clement XII sponsored a competition aimed at its embellishment. The competition was protracted, and not until 1732 was the project awarded to Salvi. Salvi's winning design appears to have embodied all the essential characteristics of the fountain as executed. If not the actual presentation sheet, this autograph drawing by Salvi is certainly the earliest and closest reflection of his design, which, just as the executed fountain, fuses the architectural forms with sculpture and water into a monomorphic unity. By simplifying the architecture of the centerpiece into the form of a triumphal

arch replete with a projecting attic level, Salvi assures the dominance of the fountain. At the same time, by continuing the colossal order across the two wings Salvi effectively binds palace and fountain. The component parts of Salvi's executed design interpenetrate to an extent that makes it a difficult exercise to distinguish one from the other.

With the exception of the pilaster base at the right corner, which is not shown to be crumbling, Salvi's rendering of the architectural component of the fountain corresponds in every detail to the Trevi as it appears today. The basin and the artificial marine reefs, or *scogli*, however, differ substan-

tially from the fountain as executed. Salvi's depiction of the statuary, too, contrasts with what is seen today. The basin is smaller than at present, meeting the façade at the midpoints of the lateral pavilions, while as built it embraces all but the outermost bay of each wing. Since Salvi's rendering is an orthogonal projection, it is difficult to judge accurately the three-dimensional development of the *scogli* without a plan corresponding to his elevation. Although Salvi repeatedly altered his design as work progressed, at least one feature of the *scogli* must have been planned from the outset: the drawing shows several plants, the flora eventually carved by Giuseppe Poddi and Francesco Pincellotti, sketched on the surface of the *scogli* and against the rusticated basement of the fountain. The most prominent feature of the *scogli* as they appear in Salvi's drawing is the central cascade, the surface of which is covered with scalelike facets, dropping directly into the basin from beneath the shell chariot of Oceanus. [JP]

## ALESSANDRO SPECCHI
ROME 1668–1729 ROME

Specchi belonged to the generation of artists and architects that came of age in the decade following the death of Bernini. A gifted architectural draftsman and engraver, he contributed large numbers of plates to a series of publications that provided views and measured drawings of important

Roman buildings erected in the seventeenth and early eighteenth century, notably Domenico de' Rossi's *Studio d'architettura civile* (1702–21). Early in his career he furnished plates for Carlo Fontana's monograph on St. Peter's (1694), and it was in Fontana's studio that Specchi received his architectural training, working on such projects as the renovation of the Teatro di Tor di Nona (1700). Later in his career, Specchi and Filippo Barrigioni (another Fontana student) assisted their master in executing the Albani Chapel in S. Sebastiano fuori le Mura (1706–12).

Specchi's masterpiece, the Porto di Ripetta, no longer survives, but is well known from prints and early photographs. Undertaken in 1703 as part of Pope Clement XI's program of works directed at revitalizing the economy of the Papal States, the docking area along the banks of the Tiber was one of the most important civic spaces of eighteenth-century Rome. Specchi's design, employing sinuous, wave-like ramps, effected a dynamic relationship between river and shore. In expressing movement through the use of dynamic curving forms Specchi drew upon his knowledge of the work of Francesco Borromini, and he employed similar design principles in his unsuccessful competition entries (1717 and 1723) for the staircase of the Trinità dei Monti, the so-called Spanish Steps. Francesco de Sanctis's executed design for the staircase is clearly indebted to Specchi's proposal.

32

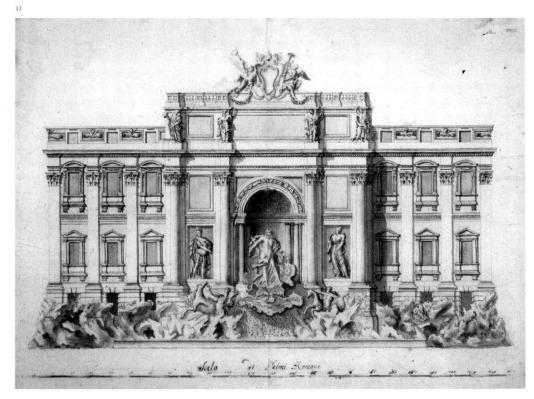

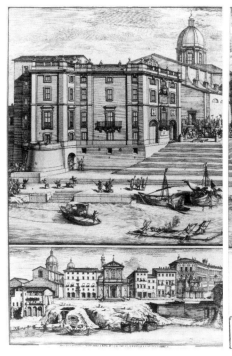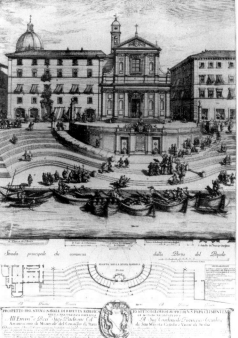

33

Specchi enjoyed considerable success in the field of palace design, including the rebuilding of the Palazzo Pichini on Piazza Farnese (1705–8) and the Palazzo de Carolis (1713–28) on the Corso. Late in his career he designed the stables facing the Palazzo del Quirinale (1722) and projected the extension of the papal summer palace known as the Manica Lunga (1721–24). In 1715 Specchi designed the high altar of the Pantheon, which was not completed until 1727. As architect of the Colonna family, he provided designs for the Chinea festivals in the period 1722–27.

Throughout his career Specchi held a number of appointed positions in which he supervised and initiated architectural activity: Architect of the Tribunale delle Strade (1702–28), Architect of the Popolo Romano (1713–29), and Architect of the Fabric of St. Peter's (1708–29). He was also elected to membership in the Congregazione dei Virtuosi al Pantheon (1702) and the Accademia di S. Luca (1711). In 1728 Specchi was taken seriously ill and ceded several of his salaried positions to Filippo Raguzzini before his death in November of the following year. Specchi contributed greatly to the definition and diffusion of the image of eighteenth-century Rome through his graphic representations of the city's architectural monuments and his own buildings. His masterpiece, the Porto di Ripetta, exerted a powerful influence on subsequent design both within Rome and abroad, as far afield as Czar Peter the Great's summer gardens on the shores of the Baltic. [JP]

BIBLIOGRAPHY Ashby and Welsh 1927, pp. 237–48; Marder 1978, pp. 62–70; Marder 1980, pp. 28–56; Marder 1980, "Specchi," pp. 30–40; Manfredi 1991, pp. 445–48; Spagnesi 1997

## 33
## Alessandro Specchi
*View of the Porto di Ripetta*

1704
Etching in bound volume
26⅛″ × 17″ (665 × 430 mm) (left);
26⅛″ × 18⅛″ (665 × 467 mm) (center);
26⅛″ × 16⅛″ (663 × 428 mm) (right)
BIBLIOGRAPHY Ashby and Welsh 1927, pp. 237–48; Marder 1978, pp. 62–70; Marder 1980, pp. 28–56; Spagnesi 1997, pp. 19–26
Vincent J. Buonanno, Chicago

The demolition of the Porto di Ripetta in 1889 removed one of the most important eighteenth-century contributions to the urban development of Rome. As a result of this loss, the appearance of Rome's northern river port can only be studied through view-paintings and early photographs, and prints by Piranesi and Vasi. Alessandro Specchi, the architect who designed the port in 1703, was also a master printmaker, and he clearly extended himself in documenting his most significant executed work. Three separate plates preserved in the Calcografia were etched to produce a composite image, including a perspective view of the port from the river, a plan of the ramp system, and two smaller views, one providing a view of the site as it appeared before 1703 and

the other a view over the new port structures toward the Prati di Castello and St. Peter's. Specchi also recorded the visit of Pope Clement XI to the site in 1704; the Albani pope appears just to the right of center admiring the inscription set into the curving terrace wall, which carries his name.

Comparison with the view of the pre-1703 condition of the port shows how Specchi's ramp system, by replacing a muddy slope, greatly facilitated the unloading of river boats. Specchi centered the ramp on the pre-existing church of S. Girolamo degli Schiavoni, much as the Spanish Steps would later be aligned with the Trinità dei Monti. To anchor the upstream end of the port Specchi built a custom house, which in the print partially blocks the unfinished façade of S. Rocco. This *dogana* is a reminder that the port project was part of an ambitious program devised by Clement XI, aimed at stimulating commerce in the Papal States. Visible on the curving terrace extending in front of S. Girolamo is a fountain with rustic blocks in the shape of *monti* crowned by a star, the escutcheon of the Albani pope. The fountain survives and has been moved to a new position in front of the river loggia of the Palazzo Borghese, which dominates the right-hand portion of Specchi's large perspective view. Standing opposite the custom house and anchoring the southern end of the upper terrace is what appears to be a chapel, its portal crowned with the Albani arms. In fact, this was a modest house decorated to look like a church, but which never functioned as one.

Specchi's port structure opened the city up to the river and the fields of the Prati beyond, as is evident in the detailed view at the lower right. It provides an opening halfway along one of Rome's major urban axes, via di Ripetta and its continuation via della Scrofa. Not only could passers-by pause to view the activity of the busy port, beautifully captured in one of Piranesi's *Vedute di Roma*, but they could also watch the progress of the ferry that crossed over to the Prati, visible in the small view in Specchi's print and also on Nolli's plan. Later, Specchi's Porto di Ripetta scheme was adapted by Nicola Michetti for an ornamental lake in Peter the Great's summer palace at Peterhof, and of course it profoundly influenced the design of the Spanish Steps. The picturesque qualities of the Porto di Ripetta were naturally appreciated by painters, and it inspired one of Hubert Robert's most spirited architectural capriccios, painted in Rome in 1761. In Robert's painting the Pantheon replaces S. Girolamo degli Schiavoni as the crowning feature of a monumental staircase that wraps around a convex terrace wall as it descends to a quay, an arrangement clearly suggested by Specchi's ramps. [JP]

## GIUSEPPE VALADIER
ROME 1762–1839 ROME

Giuseppe Valadier was born into a family of distinguished goldsmiths. His grandfather Andrea had emigrated from Provence to settle in Rome in 1714, and his father, Luigi, took charge

of the workshop in 1759; he directed it until his death in 1785. Giuseppe demonstrated an early interest in architecture and at the age of thirteen was awarded a prize in the Concorso Clementino of 1775. By 1781 he was appointed Architetto dei Sacri Palazzi, in which capacity he assisted Carlo Marchionni on the construction of the Vatican sacristy. In 1786, following the death of Marchionni, he was named Architetto Camerale, in which capacity Valadier was responsible for extensive restoration work in the Papal States following a disastrous earthquake in 1786, including the rebuilding of the Urbino Cathedral. In Rome, Valadier prepared designs for the Palazzo Braschi (1790), the last of the great papal family palaces, and his plans for the reorganization of Piazza del Popolo (1793) influenced his later proposals for Rome's grand urban frontispiece.

Valadier adapted readily to the French occupation in 1798, and actively served his new imperial masters as well as Pius VII, especially after the coronation of Napoleon by the Chiaramonti pope in 1804. Among his important works from this period two stand out: the superstructure of the Ponte Milvio (1805) and the façade of S. Pantaleo (1806). In 1810–11 he prepared drawings for a number of unexecuted urban projects, including the clearing of the Piazza di Trevi, the Piazza della Rotonda, and the demolition of the so-called *spina* of the Borgo, which would have provided a monumental avenue leading to St. Peter's.

The grandest of the French schemes envisioned the reshaping of the eastern and western sides of Piazza del Popolo and its integration with extensive public gardens laid out on the Pincian Hill. This project occupied Valadier from 1811 through 1824, with results that may still be admired. The execution of Valadier's vast design for Piazza del Popolo dramatically reshaped the city and is rightly considered his masterpiece.

Following the restoration in 1714, Valadier continued to serve Pius VII in Rome and throughout the Papal States. Within the capital he was actively involved in the restoration of ancient monuments, including the Colosseum (1820), the Arch of Titus (1819–21), and the Temple of Fortuna Virilis (1832), as well as such churches as S. Maria ai Monti (1828–29), and S. Andrea in via Flaminia (1829–35). Valadier participated in the debates surrounding the restoration of S. Paolo fuori le Mura after its destruction by fire in 1823, but his recommendations were not followed. His last major work was the façade of S. Rocco (1834), completed shortly before his death.

Valadier was the most distinguished exponent of French Revolutionary Neoclassicism practicing in Rome at

the end of the eighteenth century. His designs show strong affinities with those of Claude-Nicolas Ledoux and Etienne Boullée, particularly in their emphasis on pure geometric forms. There is also a strong element of another international movement in his work: neo-Palladianism. A late work such as the S. Rocco façade owes a profound debt to Palladio and is related as well to the Renaissance master's eighteenth-century followers, such as Tommaso Temanza in Venice, Giacomo Quarenghi in Russia, and Sir William Chambers in England. Valadier's sensitivity to northern European theory and practice, remarkable as it was in Rome during this period, did not isolate him from the historical development of Roman architecture. Indeed, in his works the classical strain evident in the designs of Carlo Fontana, Luigi Vanvitelli, and Giovanni Battista Piranesi was continued well into the nineteenth century. Valadier published many books, including a collection of his lectures at the Accademia di S. Luca (1828) and two volumes that were devoted to his own work: *Progetti architettonici* (1807) and *Opere di architettura* (1833). [JP]

BIBLIOGRAPHY Valadier 1807; Valadier 1828–39; Valadier 1833; Schulze-Battmann 1939; Marconi 1964; Hoffmann 1967; Debenedetti 1979; *Three Generations* 1991; Kieven 1992

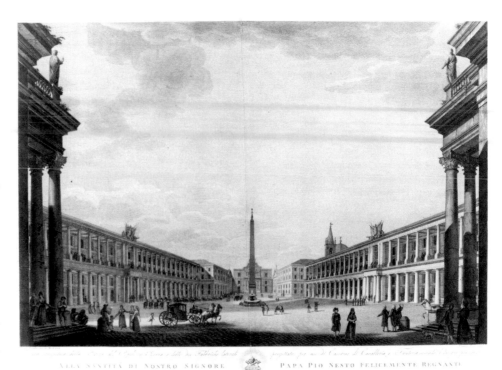

34

VLLA SANTITÀ DI NOSTRO SIGNORE    PAPA PIO SESTO FELICEMENTE REGNANTE

## 34
## Giuseppe Valadier
### *Project for the Piazza del Popolo*

c. 1794
Etching by Vincenzo Feoli
21¾″ × 30⅜″ (552 × 773 mm)
BIBLIOGRAPHY Marconi 1964, pp. 87–92; Ciucci 1974, pp. 87–119; Marconi, Cipriani, and Valeriani 1974, vol. 2, pp. 2700–725; Kieven 1991, p. 141
Gabinetto Comunale delle Stampe di Roma, Rome

Since the mid-seventeenth century, when Carlo Rainaldi embellished its southern end with two nearly identical churches, the Piazza del Popolo had functioned as the grand scenic frontispiece to the city. At its center stood the Egyptian obelisk erected in the sixteenth century by Domenico Fontana, and to the north the gateway and the adjacent church of S. Maria del Popolo. To the east and west, however, the piazza lacked definition, and was closed by low, undistinguished buildings that formed the long arms of a narrow trapezoid, clearly visible on the Nolli plan.

The earliest recorded proposal to define the east–west axis of the piazza with symmetrically placed buildings appeared among Lione Pascoli's recommendations for improving commerce in the Papal States, published in 1733. Four decades later, the Accademia di S. Luca set the adornment of the Piazza del Popolo as the theme of the Concorso Balestra. The academic projects produced on this

occasion provide essential background to Giuseppe Valadier's proposal of 1793, recorded in this print. Valadier's project was prompted by the desire of Pius VI to erect permanent barracks for papal troops in the Piazza del Popolo. The caption stresses the project's function— barracks for infantry and cavalry— and papal patronage. A drawing by Valadier in the collection of the Museo di Roma is preparatory to Feoli's print. Other drawings in the Accademia di S. Luca, including plans and elevations, flesh out Valadier's project.

The porticos of Carlo Rainaldi's twin churches dramatically frame Valadier's perspective, which looks north to the Porta del Popolo. To the east and west, Valadier's Neoclassical porticos, composed of two superimposed Doric colonnades, provide a severe contrast with Rainaldi's Baroque churches. To the right of the portal, Valadier replaced the fifteenth-century façade of S. Maria del Popolo with a Neoclassical temple front, balanced by a symmetrical counterpart on the other side of the gate. Valadier's porticos give powerful architectural definition to a funnel-shaped shaft of space that opens out from the angled intersections of the streets converging on the southern end of the piazza, via del Babuino and via della Ripetta. While establishing a transverse axis (marked by the projecting elements at the centers of the two porticos, and the martial arms silhouetted against the sky), the barracks effectively enclose the piazza, giving it a decidedly urban aspect.

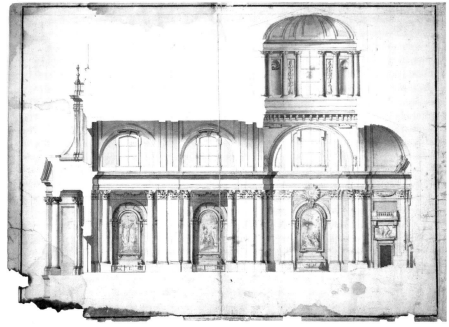

35                               36

After the French occupation of Rome in 1798, Valadier's early proposal for the Piazza del Popolo was set aside as he drafted new, more ambitious plans aimed at linking the piazza both visually and physically to the gardens of the Pincian Hill. Valadier's executed design, begun in 1811 during the French occupation and completed in 1824 following the restoration of papal authority, effectively gave the piazza the shape it has today, including the grand system of ramps that climb the Pincio. [JP]

## LUIGI VANVITELLI
### NAPLES 1700–1773 CASERTA

Luigi Vanvitelli was the son of the Dutch view-painter Gaspare van Wittel and a Roman mother. Soon after his birth the family moved to Rome, where Luigi was trained as a painter and an architect, studying with Antonio Valeri. Cardinal Annibale Albani employed him in the decoration of the family palace and chapel in Urbino (c. 1729). Around 1730 he designed the Vermicino aqueduct and fountain near Albano.

Vanvitelli participated in both of the great architectural competitions sponsored by Pope Clement XII, for the façade of St. John Lateran and the Trevi Fountain, neither of which he won. His surviving designs for these competitions reveal a monumental classicism closely resembling the style of his friend and fellow competitor Nicola Salvi. In 1733, no doubt on the basis of his strong showing in these two competitions, he was admitted to the Accademia di S. Luca as *accademico di merito*. The Corsini pope had a third

major commission to bestow: the port structures relating to the harbor of Ancona, and this was given to Vanvitelli, who designed the pentagonal lazaretto and the Arco Clementino at the head of the mole (1733–38). While directing the work in Ancona, Vanvitelli also designed the Jesuit church (1739–43). In his capicity as architect of the Camera Apostolica, Vanvitelli supervised work on many buildings in Umbria and the Marches, notably the monastery of Montmorcino in Perugia (1739–62).

During the 1740s Vanvitelli was more actively engaged in Rome itself. Between 1742 and 1747, as architect of St. Peter's, he collaborated with the mathematician Giovanni Poleni on the consolidation of Michelangelo's dome. In this period he also collaborated with his colleague Salvi on the expansion of the Palazzo Chigi-Odescalchi (c. 1745) and on the design of the chapel of St. John for the church of S. Roque in Lisbon which was prefabricated in Rome between 1743 and 1745 before being shipped to the Portugese capital. For the Augustinians Vanvitelli designed the sacristy and monastery of S. Agostino (1746–56), as well as churches in Siena and Ancona. For the Carthusians he remodeled the church of S. Maria degli Angeli, which Michelangelo had set within the Baths of Diocletian, reorienting its entrance and enriching its interior with *scagliola* columns.

In 1750 Vanvitelli was finally given the opportunity to build on the grandest possible scale when the king of the Two Sicilies, Charles III Bourbon, called him to Naples. Within one year he completed the planning of the royal palace at Caserta, the construc-

tion of which occupied him for over a decade. This vast complex includes a scenographic staircase and extensive waterworks, the latter supplied by an impressive aqueduct of Vanvitelli's devising. Within Naples, Vanvitelli undertook many projects as court architect, among which his designs for the Foro Carolino (now Piazza Dante) of 1758–63 and the church of SS. Annunziata (1761–82) are particularly noteworthy.

At the time of his death Vanvitelli was recognized as one of the dominant architectural figures in Europe. His fame and his style were spread by his followers, notably his son Carlo in Naples, Carlo Murena in Rome and St. Petersburg, Giuseppe Piermarini in Lombardy, and Francesco Sabbatini in Spain. Vanvitelli's Neapolitan buildings reflect the new Neoclassicism while retaining his deft command of massing, expressive use of concave surfaces, powerful displays of columns, and rich decorative vocabulary, much of it derived from Borromini. [JP]

BIBLIOGRAPHY Vanvitelli 1756; Fichera 1937; De Fusco 1973; Garms 1973; Garms 1974, pp. 107–90; *Convegno Vanvitelliano* 1975; Vanvitelli 1975; Strazzullo 1976–77; Carreras 1977; De Seta 1978, pp. 40–46; *Luigi Vanvitelli* 1979; Pasquali 1980; Hersey 1983; Garms 1993, "Annunziata," pp. 396–429; Marinelli 1993

## 35
## Luigi Vanvitelli
*Unexecuted Project for the Church of the Gesù in Ancona, Longitudinal Section*

c. 1739
Pen and brown ink with gray and brown washes over traces of graphite on laid paper
19⅛″ × 27¼″ (493 × 691 mm); borders damaged
PROVENANCE Bracci family archive
Collection Centre Canadien d' Architecture/Canadian Centre for Architecture, Montreal

## 36
## Luigi Vanvitelli
*Unexecuted Project for the Church of the Gesù in Ancona, Transverse Section*

c. 1739
Pen and brown ink with gray wash over traces of graphite on laid paper
18½″ × 14″ (469 × 356 mm); borders damaged
PROVENANCE Bracci family archive
BIBLIOGRAPHY Carreras 1977, pp. 101–13; Bösel 1985, pp. 19–29
Collection Centre Canadien d' Architecture/Canadian Centre for Architecture, Montreal

These drawings are the only known records of Vanvitelli's preliminary design for the Jesuit church in Ancona. In the 1730s the Adriatic port of Ancona was being developed as part of a systematic program aimed at stimulating trade in the Papal

States. Vanvitelli designed important structures related to the harbor, including an arch at the end of the mole and a lazaretto for the quarantine of plague victims. Vanvitelli's activity outside of Rome was by no means unusual; in the eighteenth century many architects based in Rome actively sought commissions outside of the capital. It can be assumed that Virginio Bracci came into possession of these drawings when he worked as an apprentice in the studio of Vanvitelli and Carlo Murena.

In 1733 the Jesuit college in Ancona was partly destroyed by fire. Luigi Vanvitelli received the commission for the rebuilding of the college in the same year. In 1738 plans to rebuild the adjacent church were discussed. The construction of the church began in 1739, but was interrupted in 1740 because of financial problems; however, by 1743 the fabric was finished. The church was executed according to the present plans with the exception of the cupola. The financial difficulties of 1740 obviously forced the Jesuits to execute a reduced version without a drum.

Vanvitelli had to respect the site and structure of the old church. The building was placed on the slope of a mountain and overlooked the harbor of Ancona. He created a concave façade with a portico that accords with the building's prominent position. The small site did not permit the construction of aisles, and for this reason the transverse nave has the same depth as the two side chapels, which line the main nave on both sides. Vanvitelli's use of trabeated columns and pilasters to unify the interior also places a strong emphasis on the crossing, where the columns are doubled and the drum enlarges the structure. The elegance of the restrained architectural vocabulary is apparent and corresponds to the excellence of draftsmanship in the drawing.

The careful orchestration of repeated elements is visible in the design of the altar, where the concave movement of the wall is reminiscent of that of the façade. The altarpiece and the altar are not singled out but united with the general architectural setting and incorporated into the architectural order. The ornament is fully integrated into the tectonic structure. The design also illustrates Vanvitelli's superb sense of balance and scenographic effects. [JP/EK]

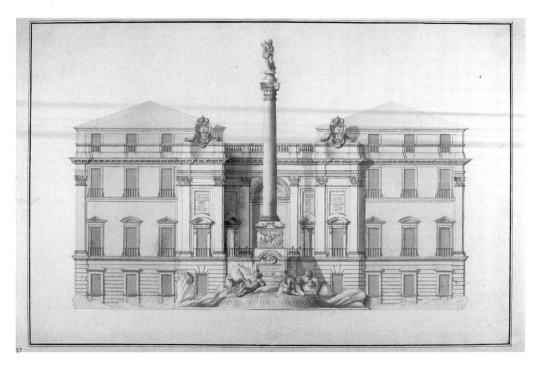

37

## Luigi Vanvitelli
### *Unexecuted Project for the Trevi Fountain, Elevation*

c. 1760
Drawing by Virginio Bracci
Pen and gray-black ink; pencil under-drawing, gray and blue washes on paper
20″ × 29″ (510 × 735 mm)
PROVENANCE Bracci family archive
BIBLIOGRAPHY Gradara Pesci 1920, pp. 76–80; Pinto 1986, pp. 114–15; Kieven 1988, p. 109; Garms 1993, pp. 65–77
Ministero per i Beni e le Attività Culturali, Istituto Nazionale per la Grafica, Rome

This elevation and a corresponding plan of Luigi Vanvitelli's project for the Trevi, also in the collection of the Gabinetto Nazionale delle Stampe in Rome, once belonged to the Bracci archive. The inscriptions on the façade elevation carry the date 1730, but the draftsmanship of both sheets appears unlike Vanvitelli's hand. Rather than autograph originals, they are accurate copies of Vanvitelli's design by his pupil Virginio Bracci. Another set of drawings after Vanvitelli's project has recently been identified on the art market in Milan.

Relative to other entries in the 1730 competition for the Trevi, Vanvitelli would have aggrandized the fountain at the expense of the Palazzo Poli façade. Comparison with projects from the first phase of the competition shows how the central *mostra*, from being confined within the two projecting bays of the palace, has now expanded laterally to overlap the first bay of each wing. However, Vanvitelli

respected the fenestration and skyline of the existing façade, which resulted in several awkward compromises, the most obvious of which is the break in the entablature to the left and right of center so as not to interrupt the second-story windows.

Vanvitelli proposed using engaged pilasters to articulate the architectural backdrop of the fountain, which curves gently at the center, taking advantage of the recessed space between the two wings to provide a shallow segmental concavity against which to set off the Antonine Column. The column itself would have been set at the center of the basin and well in front of the façade. The intervening space, in the form of an oval, would have provided an elevated viewing platform out over the fountain accessible from the interior of the palace. This terrace would also have allowed the close inspection of the celebrated reliefs on the sides of the pedestal of the Antonine Column.

The column itself was to have been crowned by a statue representing the Virgin and Child, an iconographical theme going back to Bernini's seventeenth-century proposal for the Trevi. One of the inscriptions on the façade records the dedication of the column to the Virgin, while the other commemorates its excavation under Pope Clement XI. The remaining sculpture is ranged around the base of the column, raised on rustic rocks. Two reclining river gods, probably representing the Tiber and the Nile, are accompanied by their respective attributes, the wolf suckling Romulus and Remus, and a lion. Both sculpture and water play relatively modest parts

in Vanvitelli's design, which is primarily architectural in character. [JP/EK]

## GIUSEPPE VASI
CORLEONE, SICILY 1710–1782 ROME

Giuseppe Vasi is first recorded in 1736 as a printmaker in Palermo, where he contributed ten views to *La reggia in trionfo*, a book celebrating the crowning of Charles III Bourbon as King of the Two Sicilies. That same year Vasi moved to Rome, where he established his own workshop; the move must have been agreed to by the king because Vasi never lost the patronage of the royal family.

Among the earliest of his works produced in Rome are three prints of Filippo Juvarra's designs for a mausoleum for the king of France, and one of the fresco of the *Virgin and Child with Saints* by Sebastiano Conca from the chapel of S. Nicola in the church of S. Lorenzo in Damaso. Although Vasi could not have had direct contact with Juvarra, who died in Portugal the year that Vasi reached Rome, it is clear that he did make contact with Conca, who was living and working in the city, and who contributed the drawing for the frontispiece of Vasi's masterwork *Delle magnificenze di Roma antica e moderna*.

Early ties with contemporary architects came in 1738, when Vasi made etchings from Luigi Vanvitelli's drawings of the port and lazaretto of Ancona, and in 1740, when he etched Ferdinando Fuga's design for the catafalque for Pope Clement XII Corsini in S. Giovanni dei Fiorentini. Later, he was to make prints of works by Alessandro Galilei, Paolo Posi, and

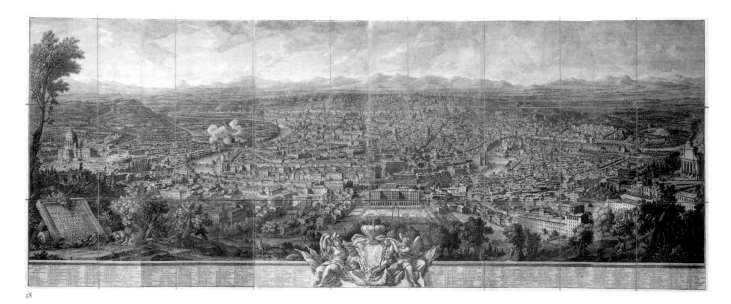

38

Giuseppe Palazzi. An early patron in Rome was the nephew of Clement XII, Cardinal Neri Corsini, whose library in Palazzo Corsini contained an extensive collection of books of prints. This collection, which included many views of Rome, including works by Falda and Specchi, provided Vasi with models for his own Roman views in the *Vedute sul Tevere*, published about 1743, and in the later *Magnificenze*.

Vasi's connection with Piranesi, who worked in the Vasi studio during his early days in Rome, ended in acrimony for reasons not recorded. Henry Millon found a convincing relationship between some of the views in Vasi's 1739 *Vedute sul Tevere* and Piranesi's 1748 *Antichità romane* and suggested that some of the plates for the latter were carried off by Piranesi from Vasi's studio on his departure (Millon 1978, p. 350). More amicable was Vasi's connection with Giambattista Nolli, who, even before publishing his own *Nuova pianta di Roma* (cat. 18), used it to supply Vasi with measurements between gates in the Aurelian city walls for the first volume of the *Magnificenze* (Vasi 1747–61, vol. 1, index page).

The most ambitious of Vasi's efforts was the ten-volume series of the *Magnificenze*, with 220 prints and extensive explanatory text, published irregularly between 1747 and 1761. This work provides the most comprehensive and faithful visual record of the eighteenth-century city available. Unlike the more dramatic plates of Piranesi's *Vedute di Roma* (published contemporaneously), which concentrate on the ancient and monumental, Vasi's prints give a capillary view of the city, penetrating into its every corner. Thus his ten volumes successively portray city walls and gates, piazzas, basilicas and "ancient" churches, palazzi and streets, river and bridges,

parish churches, monasteries, convents for women, colleges and hospitals, villas and gardens. These contextual perspective views provide the perfect third dimension to Nolli's two-dimensional *Nuova pianta di Roma*.

In 1747 Vasi dedicated the first volume of the *Magnificenze* to Charles III, and went to Naples to participate in celebrations for the birth of the king's heir. There he prepared nine plates for the publication commemorating this event, perhaps as a result of which, in 1748 he was awarded apartments in the Bourbon-owned Palazzo Farnese, to which he also transferred his printshop. Vasi was invariably picked to prepare etchings of the elaborate temporary *apparati* set up in Roman piazzas by Charles III on occasion of the annual presentation to the pope of the Chinea. The same applied to numerous other ephemeral *apparati* commissioned by Charles, such as the triumphal arch in the forum designed by Fuga for the *possesso* of Pope Clement XIII Rezzonico in 1758.

Vasi also dedicated the largest image he was to produce (1765) to Charles III. This was the *Prospetto dell'alma città di Roma*, a comprehensive panorama of the city viewed from the Janiculum Hill (cat. 38). It is not only an all-embracing summation of Vasi's *Magnificenze*, but also a visual paean to his adopted city. He had promised to produce this view in the preface of the last volume of the *Magnificenze* (Vasi 1747–61, vol. 10, p. 4). Four large prints (39⅛″ × 27⅛″) designed to accompany the *Prospetto*, two published the same year and two in 1771, can be thought of as illustrations of parts of the city that did not stand out on the large panorama. The unifying theme of these four impressive views is that of the four patriarchal basilicas, but in two cases (the Lateran and S. Paolo fuori le Mura) the churches play a marginal role in the image. They

are really views of the Forum from the Capitoline Hill (Lateran), the Aventine from the port of Ripa Grande (S. Paolo), the river and Borgo (St. Peter's) and via Felice from Quattro Fontane (S. Maria Maggiore).

At the bottom of the *Prospetto* is a numbered index with 390 items corresponding to numbers on the view itself. This list is labeled "Index of notable items divided into eight days." The eight days refers to the divisions in a guidebook Vasi had published in 1763, entitled *Itinerario istruttivo diviso in otto giornate per ritrovare con facilità tutte le antiche e moderne magnificenze*. Of the long series of guidebooks on Rome, this is one of the most successful. In the introduction Vasi explained "I arranged it in the form of an itinerary divided into eight days and in each section I have placed numbers corresponding to the plates of the ten volumes [of the *Magnificenze*]." He republished the *Itinerario* the same year as the *Prospetto*, changing the title to *Indice istorico del gran prospetto di Roma*, thus interlinking his three major works—probably in an effort to provide a comprehensive description of Rome, and possibly with an eye to sales.

While half of the ten volumes of the *Magnificenze* are dedicated to the Bourbon circle, the remaining five and many of Vasi's single prints bear dedications to other princes and to powerful cardinals. This, coupled with his titles of Conte Palatino and Cavaliere dell'Aula Lateranense, gives the impression of Vasi as a well-established and successful artist at both royal and papal courts. His epitaph in S. Caterina della Rota, near his home in Palazzo Farnese, bears this out. [AC]

BIBLIOGRAPHY Petrucci 1940, pp. 8–15; Petrucci 1941, pp. 11–22; Petrucci 1946; Millon 1978, pp. 345–62; Scalabroni 1981; Coen 1996

## 38
## Giuseppe Vasi
### *View of the City of Rome (Prospetto dell' alma città di Roma)*

1765
Signed and dated in the dedicatory inscription, lower left: *Giuseppe Vasi … MDCCLXV*
Dedicatory inscription: PROSPETTO D[ELL'] ALMA / CITTÀ DI ROMA / VISTO DAL MONTE GIANICOLO / E SOTTO GLI AVSPICI / DELLA SAC. MAESTÀ CATTOL. / DI CARLO III / RE DELLE SPAGNE / PROMOTORE ECCELSO / DELLE SCIENZE E BELLE ARTI / DISEGNATO E INCISO E DEDICATO / ALLA MAESTÀ SVA / DA GIUSEPPE VASI CONTE PAL. / CAV. DEL-L'AVLA LATERAN. / NELL'ANNO MDCCLXV
Etching
40¼″ × 10⅛″ (1025 × 264 mm), 18 sheets combined

BIBLIOGRAPHY Vasi 1747–61, vol. 10, pp. 4, 41–42; Casamorata 1925, pp. 173–78; Petrucci 1941, pp. 11–22; Petrucci 1946, p. 93; Frutaz 1962; Scalabroni 1981, pp. 30–32; Coen 1996, p. 22
Getty Research Institute, Los Angeles

At the time that he published his great *Prospetto*, Vasi was well established in Rome and renowned for his numerous detailed prints of the city's individual monuments. With this new and ambitious work he moved into the field of view-maps. In this he followed in the footsteps of Giovanni Battista Falda, who, a century before, had published in both fields and produced one of the major view-maps of seventeenth-century Rome, entitled *Nuova pianta et alzata della città di Roma* (1676). However, although Vasi produced a map of the city directly derived from the Falda in 1781 (*Nuova pianta di Roma in prospettiva*), the *Prospetto* is of a different type. It has a closer kinship with the vertically compressed view of Rome by Antonio Tempesta (1593). Vertical compression

in a view-map simulates the perspective effect of reality. As in Tempesta, the vertical compression is less in the lower half than in the upper half of the *Prospetto*, with the result that more can be seen of the built-up part of the city in foreground, while the emptier section (still within the Aurelian walls) is played down. Vasi also followed Tempesta in rotating the whole of Borgo clockwise so that more of St. Peter's can be seen.

The vantage point of the *Prospetto* has been identified correctly by Paolo Coen as the Casino Corsini on the Janiculum Hill in the gardens of Palazzo Corsini. In the 1748 plan of Rome by Giambattista Nolli (cat. 18) the casino appears just inside the Baroque walls as a hatched square in line with the main avenue of the gardens of Palazzo Corsini. The back of this palazzo, home of Vasi's early patron Cardinal Neri Corsini, appears clearly on the *Prospetto* above the coat of arms of Charles III. In the last volume of his *Magnificenze* Vasi referred to "that high point from which all Rome and its Campagna can be seen admirably, and from which I plan to make the promised view of the city so as to complete this work." The view from where the casino once stood, now Piazzale Garibaldi, is indeed comprehensive, and except for intervening trees, today yields much the same panorama as the *Prospetto*.

Inevitably Vasi made some adjustments and distortions so as to highlight select monuments and sites. The two framing elements of the panorama, St. Peter's on the left and the Acqua Paola on the right, are somewhat turned on the print so as to be more clearly visible. The entrance gate to the Bosco Parrasio of the Accademia dell'Arcadia (no. 1193 on the Nolli map), to which Vasi belonged, stands out on the lower right even though it could not be seen from that viewpoint. Nonetheless, a visit to the spot where the *nobile casino* once stood discloses the fidelity of the *Prospetto* to the view. Sightings from that vantage point reveal the radial alignments of domes and palazzi on the print to be remarkably accurate in most cases. Exceptions are the dome and façade of the Chiesa Nuova, which on the *Prospetto* are shown vertically aligned, while in actuality the dome appears to the left of the façade.

As already noted, Vasi compresses the vertical distances less in the lower half of the print so as to diminish the masking effect of the buildings in the Campo Marzio and adjacent areas. Thanks to this technique, moving from left to right from St. Peter's the whole of Castel S. Angelo can be discerned (with cannon smoke billowing from it), the horizontal space of Piazza Navona (accented by the dome of S. Agnese), the dome of the Pantheon, S. Andrea della Valle (directly above Palazzo Corsini and Palazzo Farnese), the island on the Tiber, the Aventine Hill, and finally the Aurelian walls with the pyramid of Caius Cestius. Vasi accentuates the whole sweep of the river, which is not readily seen from this viewing point. He also emphasizes the rectilinear sequence of via Flaminia and the Corso from Ponte Milvio almost to the Capitol, whose stair and *cordonata* form a V to the right of center. Moving up from the island, an oddly diminished Colosseum can be seen contrasting with the enlarged towers of the transept façade of St. John Lateran.

The *Prospetto* was reprinted in 1829 (in twelve rather than eighteen sheets) and imitated by later printmakers, but was never equalled in either size or completeness of the urban panorama. [AC]

## BERNARDO ANTONIO VITTONE

### TURIN 1702–1770 TURIN

Bernardo Antonio Vittone, a native of Turin, extended the tradition of the Piedmontese Baroque established by his predecessors Guarino Guarini and Filippo Juvarra into the later eighteenth century. He may have studied architecture with his uncle Gian Giacomo Plantery and appears to have designed a number of relatively modest churches in and around Turin before leaving for Rome in 1731. In Rome he entered the Accademia di S. Luca, where he won first prize in the Concorso Clementino of 1732. The following year he was elected to membership in the Accademia, offering a design for a central-plan church as his presentation piece (cat. 40). Vittone's drawings of his Roman period reveal that he effected a synthesis of early eighteenth-century architecture, especially the work of Carlo Fontana and Filippo Juvarra, and that he became intimately acquainted with ancient architecture and ornament, through both direct study of its substantive remains and familiarity with publications such as Fischer von Erlach's *Entwurf einer historischen Architektur* (1721). Vittone frequented the library of Cardinal Alessandro Albani, who subsequently recommended him to the House of Savoy.

In 1733 Vittone returned to Turin, where he may have assisted Juvarra until the latter's death in 1736. In the period 1735–37 Vittone prepared the text of Guarini's architectural treatise, the *Architettura civile* for publication, and this experience undoubtedly heightened his awareness of the creative potential inherent in Guarini's open structures.

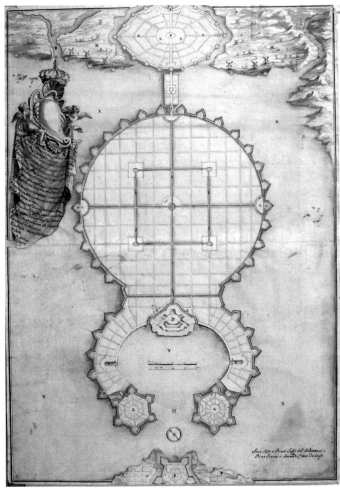

39

This potential is evident in a series of highly original church designs executed in the five-year period between 1737 and 1742, which include the chapel of the Visitazione at Valinotto (1738), S. Bernardino in Chieri (1740), and S. Chiara in Bra (1741). These buildings introduce themes that Vittone pursued throughout the rest of his career, notably the exploitation of concentric structures nested within one another, the scenographic effects of screening elements through which other portions of an interior may be glimpsed, pierced shell-like vaults, and the manipulation of light from hidden sources. These themes are still evident in the hexagonal church at Borgo d'Ale, under construction at his death. Although Vittone was also active in the realm of civil architecture, his designs for public buildings are considerably less original and striking.

Vittone published two architectural treatises, the *Istruzioni elementari* of 1760 and the *Istruzioni diverse* of 1766. These offer insights into his theory of architecture (much indebted to Guarini), his sources (including Vignola, Borromini, and Bernini), and his own works. In advocating a system of musical proportions he stood in a long tradition extending back to the Renaissance. Vittone's theory was rejected by his younger contemporaries, who also turned their backs on his brilliant spatial illusionism in their zeal for Neoclassical rigor. Viewed in a historical context, however, Vittone's executed designs represent at once a highly personal interpretation of space-molding architecture and a synthesis of strains—Roman late Baroque classicism, Piedmontese open structures, and central European planning—that effectively summarize and conclude a grand tradition. [JP]

BIBLIOGRAPHY Vittone 1760–66; Vittone 1766; Portoghesi 1966, *Bernardo Vittone*; Carboneri and Viale 1967; Oechslin 1967, pp. 167–73; Pommer 1967; Oechslin 1972; *Vittone Convegno* 1972

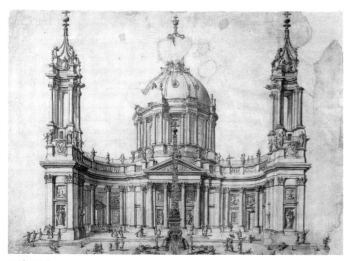

40 (elevation)

40 (plan)

## 39

### Bernardo Antonio Vittone
*Design for a City Surrounded by the Sea*

c. 1732
Pen and colored washes on paper
29⅛″ × 21⅝″ (740 × 550 mm)
BIBLIOGRAPHY  Oechslin 1972, pp. 15–32;
Hager 1981, pp. 108–15
Accademia Nazionale di San Luca,
Rome

Vittone arrived in Rome in the fall of 1731, after practicing independently as an architect in Turin. He enrolled in the Accademia di S. Luca, and in 1732 this design for a city surrounded by the sea won first prize in the Concorso Clementino. This general plan is one of five drawings he submitted; the others represent details of the scheme: a plan of the central piazza, an elevation and section of one of the four churches fronting on the piazza, and an elevation of the piazza's centerpiece, a fountain crowned by an equestrian monument.

The detailed program set for the contestants left little room for creative invention, stipulating a lengthy list of details, including a harbor defended by two fortresses at its entrance, a central avenue, a majestic piazza surrounded by eight buildings with identical façades, a magnificent fountain, and much more. The overriding symmetry and crystalline geometry of Vittone's ideal scheme harkens back to the Renaissance and the visionary utopias of Filarete, Fra Giocondo, and Cattaneo. It was frequently the case that the themes set for the Concorsi Clementini, for all their apparent detachment from reality, were informed by an awareness of concrete enterprises under consideration in Rome and the Papal States. Such was the case in 1732; within a few years, at the Adriatic port of Ancona, Luigi Vanvitelli built a triumphal arch at the head of a new mole and a pentagonal lazaretto offshore. [JP]

## 40

### Bernardo Antonio Vittone
*Design for a "Temple of Moses"*

1733
Pen and wash on paper
21⅝″ × 31″ (550 × 790 mm) (elevation);
21⅝″ × 31″ (550 × 790 mm) (plan)
BIBLIOGRAPHY  Oechslin 1967, pp. 167–73;
Oechslin 1972, pp. 147–57; Wittkower 1973,
p. 424; Hager 1981, pp. 162–65
Accademia Nazionale di San Luca, Rome

Just as Filippo Juvarra had done a quarter century earlier, in 1733 Bernardo Antonio Vittone presented a set of drawings to the Accademia di S. Luca upon being accepted as a member. Vittone's elevation closely resembles an engraving in one of the two architectural treatises he later published: the *Istruzioni elementari* of 1766. The published text explains that the church is dedicated to Moses, and functions as a scenic frontispiece to a college, portions of which extend behind the left flank in the ground plan. The plan appears to be drawn on a sheet of paper that has been illusionistically rolled back to reveal the architect's drawing instruments.

Appropriately for its intended academic audience, Vittone's church design draws on a wide range of historical sources extending back to such seventeenth-century examples as S. Agnese in Agone and the Collegiata dell'Assunta in Valmontone, as well as Juvarra's 1707 *accademico di merito* drawings. Vittone's project also reflects his knowledge of more recently executed designs, such as Juvarra's for the church of the Superga outside Turin and Fischer von Erlach's for the Karlskirche in Vienna. The obelisk fountain in the center foreground may also reveal the influence of Fischer's treatise, the *Entwurf einer historischen Architektur* of 1721, in which similar antiquarian motifs abound. Vittone's design no doubt also alludes to the fountain in front of the Pantheon, which Filippo Barigione had embellished with an obelisk in 1711.

Vittone's 1733 design introduces the theme that courses through his later work: the central-plan church. As Wittkower noted, Vittone's mature work united both the "bizarre" and the "sober" traditions in Italian architecture, linking him to Borromini and Guarini on the one hand and Palladio, Bernini, and Carlo Fontana on the other (Wittkower 1973, p. 431). To these Vittone added a profound awareness of contemporary developments throughout Europe, notably in Germany and Austria, but also in France and England. The scenographic quality of his design also connects him to Palladio by way of Juvarra. [JP]

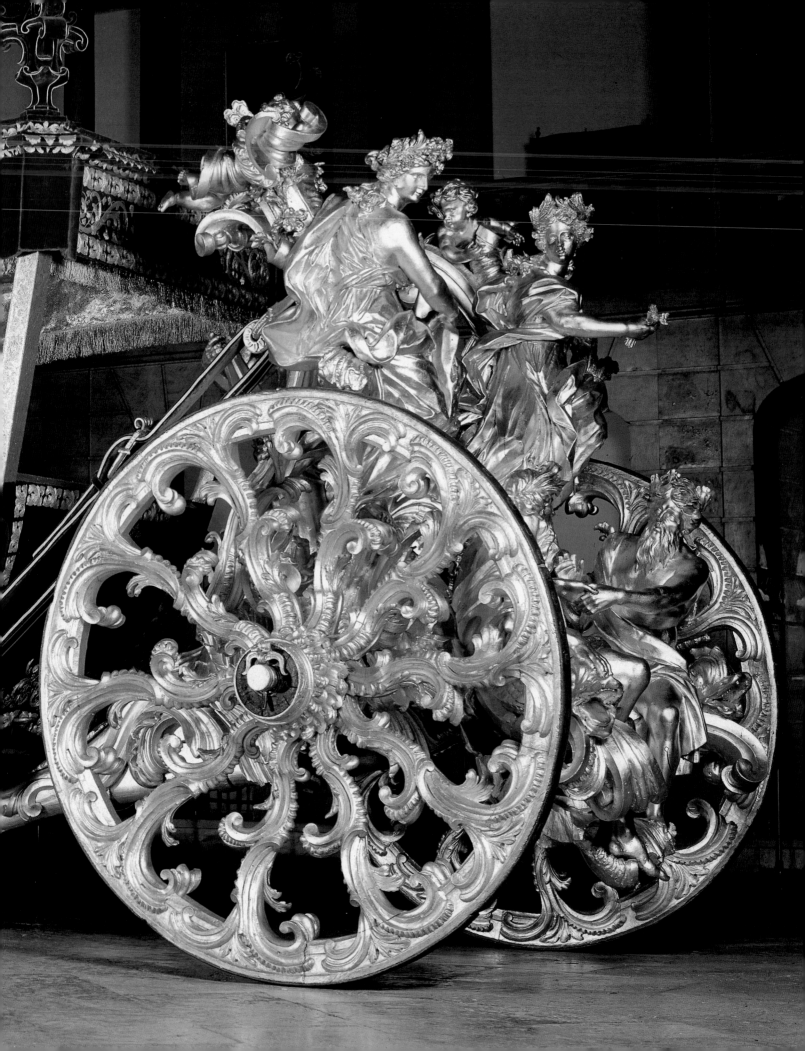

# Open Queries: Short Notes about the Decorative Arts in Rome

## ALVAR GONZÁLEZ-PALACIOS

These short notes are conceived as an incentive for further study and not as a complete overview of the subject. It is my intention to draw attention to several little-known aspects of recent research in the field, to new areas of investigation, and to some rather singular facts about the period. My primary source is Chracas's *Diario Ordinario di Roma*, which, although the best-known publication of the period, is actually referred less than is often thought. In fact, much of the information presented here has never before been published.

### FURNITURE

After thirty years of study of the history of furniture in Rome, I can honestly say that a lot more remains to be discovered about the subject sometimes—sometimes, indeed, the unknown is more considerable than what is more or less known—and this is true even of a period such as the Settecento, which is relatively well investigated. I would therefore like to bring attention to a few interesting points that might help open up new avenues of research. The first is that in the Settecento quite a number of furniture makers came from abroad. Recently I identified several works of the Breton Yves Livinec, about whom only the barest facts were familiar to a handful of scholars, such as Olivier Michel and Luciana Ferrara. Livenec is known above all for his collaboration with the century's greatest silversmith, Luigi Valadier, with whom he made two pairs of commodes for Prince Borghese, one for the palace in the city and the other for the villa on the Pincio.[1]

The name of Giovanni Ermans, possibly a relative of the German furniture maker Jacopo Herman, active during the pontificate of Alexander VII (1655–67), has been known for some time. Ermans had a workshop on the Piazza Rondanini. A document of February 25, 1764, which calls him a Roman, states that he executed a "noble altar," designed by the architect Melchiorre Passalacqua, "completely veneered with burr walnut" ("un nobile altare tutto impelliciato di radica di noce"). Many years ago I found payments to Ermans for work done for Cardinal Flavio II Chigi, who owned an exquisite small piece exhibited here (cat. 52).

We know that Giuseppe Maggiolini, Lombardy's greatest furniture maker, sent pieces to Naples, because the name of the Queen of Naples, Maria Carolina, appears in drawings concerning furniture made for her. But his name has never been connected with anything in Rome, even though he may well have made furniture for that city. However, Francesco Abbiati, a furniture maker who can be considered close to the style and technique of Maggiolini, sold several pieces in Rome. Although, unfortunately, it is not known where they are today, two of the most important publications of the period speak of them in glowing terms. Both the *Giornale delle Belle Arti* (May 5, 1787) and the *Memorie per le Belle Arti* (1788) mention a mechanical table, operated by ingenious devices, that the Queen of Naples bought in 1783. Some time later, Abbiati exhibited in his workshop in Campo Marzio, near the Palazzo di Firenze, two important commodes, which were inlaid with such skill that the marquetry resembled relief decoration. However, Abbiati's basically Lombard manner does not seem to have found complete favor in Rome, as in 1791 he is recorded in Madrid as a favorite at the court of Charles IV and his queen, Maria Luisa of Parma. Several of his signed pieces and others that can be attributed to him date to this period.[2]

Besides Francesco Abbiati, the above-mentioned *Memorie per le Belle Arti* of 1788 records another furniture maker, the German Gaspare Seiz, of whom even less is known. However, I came across a payment in the account books of the Vatican dating to April 1774, stating, "[paid] to Gaspare Saix for a commode consisting of two drawers and shaped like an urn, with a plaque in the center above, of a reddish violet color, with incised, carved, and stamped embellishments, in a purple color, and a table top in the same manner" ("A Gaspare Saix per un commò a due tiratori fatto ad urna, con suo specchio in mezzo di color violetto rosso, con suo frescio di color paonazzo, interziato, contornato, bolinato e suo coperchio lavorato nella stessa maniera").[3]

One of the greatest masterpieces of furniture in Rome, which, because it was not widely accessible even in its own time, had no influence on local styles, is a magnificent altar frontal, donated by Carlo Vittorio delle Lanze,

Fig. 81 Pietro Piffetti, *Altar Frontal Given to Pope Benedict XIV by Cardinal delle Lanze* (detail), 1747–48, mother-of-pearl, tortoiseshell, precious woods, ivory, and gold; Vatican City

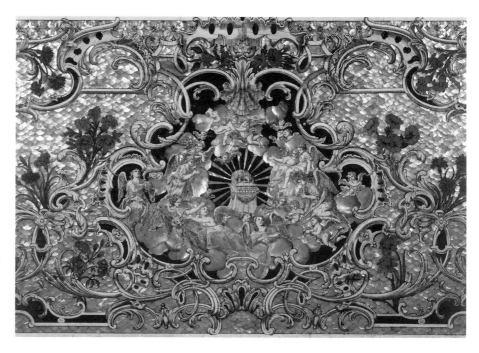

(OPPOSITE) detail of *The Oceans' Coach*, 1716 (cat. 62)

from Turin, to Benedict XIV, the pope who had nominated him a cardinal in 1747 (fig. 81). Inlaid with extremely precious mother-of-pearl, ivory, tortoiseshell, and gold, this piece is among the most important works of Pietro Piffetti, who learned many aspects of his craft in Rome, and who returned specially from Turin to install this altar in the Palazzo del Quirinale. In 1990 I was extremely lucky to track it down in the storerooms of the Sistine Chapel.[4]

One area that merits much more attention is the relationship between architecture and furniture, and architects' role in designing furniture. Documents can help resolve this issue, as can also the *Diario Ordinario*. On April 9, 1735, for example, this publication records the role of the architect Filippo Barigioni in the construction of the new choir stalls of the church of S. Marco in Rome, although, unfortunately it does not mention the name of the cabinetmaker. Eight years later, on December 7, 1743, the *Diario* relates how Friar Vincenzo Rossi da Fermo, "expert in doing fine work in walnut," was preparing, on the commission of the Lambertini pope, Benedict XIV, similar choir stalls for the cathedral of Ancona. The *Diario* explains how the pope, when he was archbishop of Bologna, had commissioned the friar to make choir stalls for the collegiate church of nearby Cento. But if in 1735 the name of the cabinetmaker is not mentioned, in these later cases it is the name of the designer that is left out.[5] Could it have been the friar himself?

It is not well known that in the Settecento antique furniture was also collected. Cardinal Acquaviva bought pieces from the estate of Cardinal Pico, whose audience hall contained much-admired brocade hangings, and a baldachin and seat covers in the same material.[6]

One would need almost unlimited time to organize and publish all the documents on furniture making in the Roman archives. One would also like to find some of this documented furniture. I have frankly never been able to discover anything that fits the description of a large cabinet made in 1697 for the Barberini by the carver Giovanni Sebastiano Giorgetti, which is said to have included in its rich sculptural decoration carved eagles, cupids, and, most obviously, the family's heraldic bees.

The embellishments on Roman furniture consisted of the most various materials: marbles and stone, glass, and even textiles. And it was necessary to call upon many different specialists for a single piece of furniture—cabinetmakers, woodcarvers, carpenters, painters, gilders, and even silversmiths. In this regard I would like to note one further document, which records how in 1731 a well-known goldsmith named Giovanni Paolo Zappati made a series of six silver capitals to ornament

a cabinet of the Barberini family, obviously constructed from rare woods.[7]

## LACQUER

European interest in the Orient has several, distant beginnings, but in the Settecento two artistic forms—porcelain and lacquer (fig. 82)—seem to compete for attention. As early as 1616 a traveling English painter, William Smith, wrote to Lord Arundel about how in the previous two years he had been employed in Rome by both princes and ecclesiastics, "in works after the China fashion w[ch] is much affected here." It is thought that these works, which imitated oriental models, involved lacquer painting. In any case, Roman interest in China is not to be doubted, and one of the greatest stylists of the Italian language and a curious man, the Jesuit Daniello Bartoli, published a book on the subject, *Della Cina*, in 1663. Four years later another Jesuit, Father Attanasio Kircher, issued a book on the same theme, in which it is explained that in Europe lacquer was known and highly valued thanks to the numerous lacquer boxes and furnishings arriving from the Orient. In the same text Kircher affirmed that many artisans sought to imitate this technique, but that decent results were obtained only after the arrival in Rome of the Augustinian Father Jamart, who had a reliable recipe, which Kircher described point by point.[8]

In any case, there are many examples of donations, shipments, and purchases of lacquer works arriving in Rome in the eighteenth century. In 1720 Clement XI (Albani) received from China a "piombo" (a screen, derived from the Spanish word *biombo*) "of *scialò* wood … completely painted in the Chinese style with such intense and beautiful colors that art could not do more. The foreground depicts different rocks, mountains, and plains with ships, boats, flowers, trees, Chinese-style houses, with around it a graceful arabesque" ("di legno Sscialò … tutto dipinto alla cinese con colori così vivi e belli che l'arte non può fare di più. La parte anteriore rappresenta diversi marassi, monti e piani con navi, barche, fiori, alberi, case alla maniera cinese, con intorno un vago arabesco").[9]

Another curious piece of information concerns a gift given by Prince Ruspoli to the family of the pope on December 22, 1725: "a painted Indian tray with a porcelain set for chocolate and coffee" ("uno schifo indiano di vernice con suoi servizi di porcellana per cioccolata e caffè").[10] A few years later two priests returning from China brought Pope Benedict XIII Orsini gifts from the emperor, among which were "several writing desks, tables, tabletops, cases, and plates of Japanese lacquer as well as plates and small vases in leather"

("varj scrigni, tavole, mense, casse e piatti di vernice del Giappone, piatti e urnette di cuoio").[11] In 1743 a certain Monsignor Barzia gave to Pope Benedict XIV Lambertini "a Chinese desk and case made of enameled tombac [an alloy of copper and zinc] and a tray in the Chinese style" ("una scrivania di tombaca smaltata con custodia della Cina e uno schifo alla cinese").[12]

Filippo Bonanni, author of a small treatise on paints and varnishes, asserted that in 1720 in Rome there lived on via dei Coronari a master capable of decorating tables and boxes with what seems to have been this type of painting.[13] Little survives, but there exists a microscope with the Barberini arms decorated in this manner and signed by the Jesuit Paolo Maria Petrini.[14]

The inventory drawn up on the death in 1750 of the Portuguese minister in Rome, Pereira de Sampajo, lists numerous lacquered pieces of furniture, such as a sofa painted in the Chinese style and even a wood chimneypiece with Chinese-style flowers. Even Pope Benedict XIV's secretary of state, Cardinal Valenti Gonzaga, who died six years later, collected porcelain, chinoiseries, and lacquered goods.

Until a few years ago a trace of this taste survived in the papal villa of Castel Gandolfo, where there are now only a few lacquered pieces. In 1747, however, in the *Diario Ordinario*

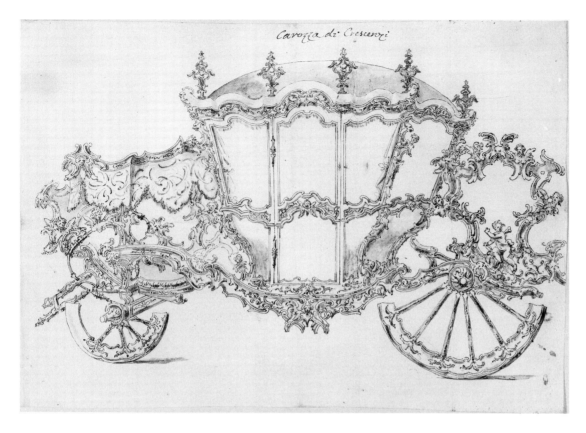

Fig. 83 *Project for a Carriage for a Member of the Crescenzi Family*, c. 1720; Staatliche Kunstsammlungen Dresden, Kupferstichkabinett

Chracas reports Benedict XIV's pleasure in visiting the main gallery and the adjoining large room, which were specially decorated for him in the Chinese manner.[15] In the small Chinese rooms, which still exist in the Palazzo Sciarra, there seems never to have been furniture with chinoiseries, to complement the wall decorations in that style—that is, if one believes the inventory of the palace drawn up at the death in 1765 of its owner, Cardinal Prospero Colonna di Sciarra.[16]

Many records survive concerning works of this type, even if the terminology is not always the same. Several documents from the Chigi family dating to around 1769, for example, speak of decorations by the artisan Pietro Rotati "ad uso di porcellana," a phrase that probably indicates, as in France, lacquer.[17] "A white poplar bureau made in the English style and decorated with small prints and varnished in the Chinese manner" ("un burrò di albuccio fatto all'inglese guarnito con cartine e verniciato sopra alla cinese") refers to still another technique, a rather inexpensive process, sometimes known as *arte povera*, in which the piece is decorated with cut-out prints, glued on to the wood surface, and then lacquered. This object was the property of Cardinal Giovanni Battista Rezzonico in 1783.

## CARRIAGES

Carriages, one of the great feats of the figurative arts in the Roman Settecento and a grand example of the fantasy of the period, are still in need of new research. In this field Rome was unsurpassed by any other European capital: the manufacture of carriages, together with that of silver and mosaics, represents one of the city's greatest moments of artistic accomplishment.

Because of various involved circumstances, today we possess, on the one hand, a few superb carriages that cannot be documented and, on the other, an endless series of documents that speak of vehicles that no longer survive. The present author published some of these papers in which several new names of Roman artisans working for Portugal before 1720 were discovered.[18] From these one can better understand how the work was divided up. The ornamental parts of the vehicles were given over to a carver, who, however, divided his work with a sculptor. Unfortunately, I was not able to ascertain on exactly which carriage a certain Francesco Tibaldi, the woodcarver, and one Tommaso Corsini, the sculptor, worked.

Several years ago a penetrating article by the late Max Terrier was published in my periodical *Antologia di Belle Arti*,[19] which gave rise to much discussion. I do not agree with all of Terrier's conclusions, particularly with his

attribution to Juvarra of a group of drawings in Dresden for a carriage design (fig. 83), but the problem is fascinating, even if not yet completely solved. From my point of view, the drawings are Roman and curiously close to those by Giuseppe Bettati, that flamboyant collaborator of Luigi Valadier's. The carriage in the Dresden drawing shows many decidedly Roman characteristics, such as winged masks, female heads placed on architectural fragments in a whimsical manner (the *espagnolettes*, as the French and Terrier call them), and intricate profiles that are intentionally irregular. What particularly concerns me is the stylistic similarity of this sheet not only with several of the works in the Museu Nacional dos Coches in Lisbon (I am thinking in particular of the so-called carriage of John V, which is not always thought to be Roman) but also with furniture that is undoubtedly Roman.

I can only cite a few examples here. The first is the large organ in the church of S. Maria Maddalena in the Campo Marzio, for which, unfortunately, no artist has been identified.[20] In this one finds several points of comparison: the small heads poised on the ostentatious moldings of the frame and the extensive openwork ornamentation. The second example, which is in the present exhibition (cat. 50), is a console from the Palazzo Accoramboni. In the catalogue entry I discuss how this piece

Fig. 84 *Console Table*, second quarter of the 18th century; Grimsthorpe and Drummond Castle Trust, U.K.

Fig. 85 *Carriage of John V* (detail); Museu Nacional dos Coches, Lisbon

resembles other tables in Grimsthorpe Castle (fig. 84), the Getty Museum, and the Palazzo Corsini in Rome. The three-dimensional heads that decorate it are close to both the drawing in Dresden and the carriage of John V (fig. 85). This is certainly not chance relationship. The association between the major arts and carriages (and also furniture) is much closer than is generally believed. For example, on April 20, 1748, the *Diario Ordinario* of Chracas mentions the young Cardinal of York's new gilt carriage decorated with paintings by a well-known artist, Ignazio Stern.[21]

## MOSAICS

In the Settecento, Rome became famous worldwide for its mosaics, at first for those large-scale mosaics that, already in the Seicento, had been produced to counter the humidity of the holy sites in the Vatican, where paintings were often damaged. This factory, located at St. Peter's, was called the Studio del Mosaico. Its most famous director (*soprintendente*) was also a great artist, the Cavaliere Pietro Paolo Cristofari (after his death in 1743, the painter Pier Leone Ghezzi took his place). In addition to these monu-

mental works, however, there arose a process of production, based in many private artists' studios, devoted to creating luxury objects in mosaic, frequently intended as souvenirs, depicting views, ornamental compositions, small animals, and genre scenes, that were incorporated in little boxes, *tabatières*, and even jewelry. This fashion—derided with little sense of humor by Goethe—began in the late eighteenth century and continued through the whole period of the papal dominion of Rome. Mosaics were used for the popes' diplomatic gifts, of which the most sumptuous is the magnificent double portrait of the Emperor Joseph II and Grand Duke Leopold I of Tuscany, his brother, painted by Batoni (cat. 172) and done in small tesserae by Bernardino Regoli. Now in the Kunsthistorisches Museum of Vienna, it was sent in a luxurious frame, as a gift from Clement XIV to the Empress Maria Theresa, mother of the two sitters.

The King of Portugal had three large altar-pieces made by the mosaicist Mattia Moretti in Rome for the decoration of an extremely rich chapel for his capital on the Tagus.[22] It became a custom for the popes to give important visitors to Rome mosaics that were neither too large nor too small—not altarpieces, but then

again hardly just snuff boxes. It was usual to put these works in gilded copper and bronze frames, which were often the work of select goldsmiths such as Giuseppe Spagna.[23] However, when Queen Maria Amalia of Naples passed through Rome from her native Saxony to meet her bridegroom, Don Carlo of Borbone, the pope sent her a pair of Cristofari's mosaics depicting Christ and the Virgin, now at Aranjuez, sumptuously framed by Francesco Giardoni, a famous silversmith and caster.[24]

On the other hand, nothing is known about the "mosaic image of great value depicting the most Blessed Virgin" ("un quadro di mosaico di gran valore rappresentante la Beatissima Vergine"), that Benedict XIII sent to the Grand Princess of Tuscany in 1725. I have not been able to track down this piece in Florence, but since it was made for Violante of Bavaria, it is possible that she, the widow of the Grand Prince Ferdinando, bequeathed it to one of her German relatives.[25]

I was already aware of a pair of mosaic images, practically identical to the one belonging to Maria Amalia of Saxony, which belonged to John V of Portugal, because I was able to identify them in Portugal many years ago.[26] However, I did not then know that John V also

owned other Roman mosaics. Chracas relates that a certain Marchese de' Cavalieri, brother of the papal nunzio in Portugal, sent the king "two most graceful mosaic life-size portraits by the virtuous Sig. Cavalier Cristoforo [sic], one depicting his royal personage, and the other that of the queen, decorated with two very beautiful arabesque gilt frames, the work of the virtuous Signor Francesco Giardoni, and of Sig. Bianchini" ("due vaghissimi ritratti di mosaico al naturale, in due quadri lavorati egregiamente dal virtuoso Sig. Cavalier Cristoforo [sic] l'uno rappresentante la sua Real persona e l'altro quello della Regina, ornati con due bellissime cornici arabescate, e fogliate di metallo dorato, opera del virtuoso Signor Francesco Giardoni e del Sig. Bianchini").[27] It is, unfortunately, probable that these extraordinary objects were lost in the terrible 1755 Lisbon earthquake in which, we know for sure, many Settecento Roman masterpieces were destroyed.

## METAL

Roman silver now enjoys universal fame largely because of the high quality of its manufacture and because its design, the expression of a great figural and ornamental culture, can be counted among the most elegant manifestations of the genre anywhere in Europe (fig. 86). Unfortunately, the Napoleonic Wars had disastrous consequences for the history of precious materials in Rome and elsewhere; in fact, after the Treaty of Tolentino of 1797, thousands of irreplaceable works were destroyed. But the French troops did not reach Sicily, where there is an important altar frontal by Angelo Spinazzi in Syracuse Cathedral and another by Luigi Valadier in Monreale Cathedral. Nor did they go to Lisbon, where, despite the 1755 earthquake, the entire chapel of St. John the Baptist, commissioned by John V, survives intact with all its silver ornaments, among the most exquisite works of this kind.

The fame of Roman silverwork is in large part due to the monumental study of Costantino Bulgari (*Argentieri, gemmari e orafi d'Italia*, 1958) that gave rise to modern investigation of Italian decorative arts. More recently, I sought to examine the versatile talents of the Settecento's most accomplished goldsmith, Luigi Valadier, on the occasion of a monographic exhibition (*L'oro di Valadier: un genio nella Roma del Settecento*, Rome, 1997). This artist was not only a gold- and silversmith, but also a designer and maker of both bronze and stone objects. Moreover, among his other achievements, Valadier was one of the first to perfect small-scale reproductions in bronze of classical masterpieces, which in his hands became precious objects, embellished by decoration

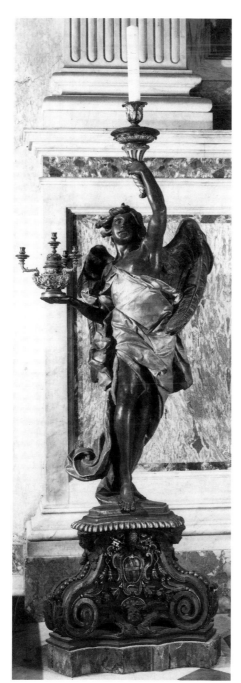

Fig. 86 Agostino Cornacchini and Angelo Spinazzi, *Angel with Torchère*, 1735, bronze, partly gilded; St. John Lateran, Rome, Corsini Chapel

and settings made of ancient colored marbles. Valadier also knew how to create table centerpieces (*deser*). These complex objects, in which archaeology and fashion interacted, soon found their way on to the tables of royalty and of the greatest families of Europe.

The reduction of ancient sculptural prototypes into small bronze statuettes has its origins in the Renaissance, but in Settecento Rome this art reached its greatest height, thanks to Giuseppe Boschi (cat. 83), the Zoffoli

(cat. 160), and the Righetti (cat. 147) families. The high quality of their productions overcomes the customary negative associations with works of reproduction. Francesco Righetti and his son Luigi also knew how to produce full-scale casts, as did Luigi Valadier, as can be seen in the cast of Canova's *Napoleon* in the courtyard of the Brera in Milan and the colossal equestrian statues of Charles III and Ferdinand IV in front of the Palazzo Reale in Naples. Long before such late works, however, Francesco had already proved to European collectors, starting with the Czarina Catherine II, the perfection of his products.

Another artist of the period, Francesco Giardoni, was among the leading bronzeworkers in European, and many documents also attest to his activity as a silversmith. We know from Chracas of an important lost work: on September 4, 1745, the writer reported that Giardoni had executed a group of candlesticks, ten *palmi* high, and a silver-gilt cross for export to Portugal.[28] Giardoni must have been skilled in many different fields, as he created a firework display for the pope in August 1751.[29] As a metal caster he obtained sublime results, as can be seen in the table in the Musei Capitolini, for which his authorship has been established here (see cat. 42).

## TAPESTRIES

Roman tapestries have not in general been much admired, even though some of them are worthy of attention. In Rome itself tapestries have always been collected, and, indeed, the history of the city's princely houses could not be understood without taking tapestries into account. In several palaces and, in particular, in the Quirinale, which throughout the entire period served as the papal residence, tapestries were necessary in rooms that would otherwise have had little adornment. Obviously, these tapestries were not always of local manufacture; there were examples from all over Europe in the city, and several princely families could boast highly desirable series. Many, however, have been dispersed during in the last two centuries and are now in foreign museums and collections.

In the Settecento popes often donated tapestries, particularly those made at S. Michele, to important personages: On October 25, 1755, Benedict XIV gave to an otherwise unknown Count of Werth two tapestry depictions of Saint Peter and Saint Paul in beautiful frames. Three years later, on August 19, 1758, the French ambassador, the bishop of Laon, received a framed tapestry of Saint Peter; and on 26 August the Imperial ambassador, Monsignor Antonio Clerici, received a tapestry depicting Saint Paul.[30]

Fig. 87 Giuseppe Folli, *Saint Pius V Ghilsieri*, 1780, tapestry with carved frame by Pasquale Marini bearing the arms of Pope Pius VI; Kunsthistorisches Museum, Vienna

Fig. 88 Giuseppe Folli, *Cleopatra*, c. 1775, tapestry with frame bearing the arms of Pope Pius VI; present location unknown

Fig. 89 Francesco Righetti, *Frame with a Profile Portrait of Saint Pius V Ghilsieri and a Smaller Portrait of Pope Pius VI* (by Giovanni Pichler), jasper ground with gilt-bronze and silver frame; Sotheby's (formerly Château de Groussay)

In the account books of the papal palaces there are many payments for both tapestries and their frames. On September 6, 1784, Giuseppe Folli was paid for tapestries of Saint Cecilia, the Persian Sibyl, and Cleopatra.[31] Two years previously the same artist consigned to the Floreria Vaticana (the papal wardrobe) two framed tapestries of Lucretia and a Sybil "to be used when necessary" ("da valersene all' occurrenza"), implying that they would be kept until a decision was made as to how to use them as papal gifts.[32]

I take this opportunity to illustrate two examples of this type of tapestry: the first, in the Kunsthistorisches Museum of Vienna, represents Saint Pius V Ghilsieri (fig. 87), with a richly carved frame containing the arms of Pius VI; the second (fig. 88), whose present location is unknown, shows Cleopatra, based on a picture by Carlo Maratti, in a very rich frame crowned, in a rather unorthodox manner, by the arms of Pius VI, as he used them at the beginning of his reign, in 1775.

Documents in the Vatican dating to the 1780s often mention works of this sort. They were usually framed by Pasquale Marini, who seems to have been the papal court's most able carver, and gilded by Alessandro Ricchebach. Three payments to Marini concern frames for small tapestries depicting Saint Pius V in 1784 and 1786 as well as an earlier one of 1780,[33] which must be for the frame illustrated here. It appears that Pasquale Marini was a very able artisan, and, although this is not the place to

enumerate his works, I would like to mention that, working under the direction of the architect Pietro Camporese, he made the decorations for the entrance to the Museo Pio-Clementino and some table bases for the apartments of Pius VI, of which several were adorned with the head of Hercules.

## MISCELLANEOUS MATERIALS

Porcelain manufacture did not exist in Rome, except for the rather modest products of Filippo Coccumos, and, toward the end of the century, the small-scale biscuit copies of classical statuary made for Giuseppe Volpato. The most important families at the papal court treasured Saxon porcelain, which was actively collected and prized as gifts. In December 1741, for example, the pope sent a chalice in this material along with a gold paten as a gift to the charterhouse of Bologna.[34] A few years later Cardinal Albani brought the pope the King of Poland's gift of three Meissen porcelain services, for tea, coffee, and chocolate, adorned with gold fittings and the papal arms.[35] Cardinal Orsini presented another service to the Marchesa Nari on the occasion of a family baptism,[36] and Cardinal Albani gave the pope a porcelain bust of Saint Francis de Sales, and an entire porcelain desk set and two snuff

boxes with gold fittings, all from Saxony.[37] On July 19, 1755, a German princess, the Margravine of Bayreuth, sent a Roman gentleman a clock with a Meissen porcelain encasement, also with gold fittings, painted with landscapes and figures in green.[38] In the Vatican account books for November 1776 there is mention of several dozen porcelain coffee cups from the Ginori factory at Doccia, near Florence, with round-shaped handles and a decorative pattern of roosters in gold and red.[39]

Rome was not a city where *pietre dure*, semi-precious stones, were often employed in the decoration of furniture and objects (fig. 89), whereas in Florence there was a manufactory sponsored by the Medici and afterwards by the family of Lorraine, their heirs. However, *pietre dure* were used for important architectural schemes. To cite a single example, Chracas notes how in November 1735 the architect Dalmazzoni adorned the main chapel of S. Gregorio al Celio with precious marbles, lapis lazuli, and gilded bronze.[40] Gifts of *pietre dure* are also known: the Marchese Gambuccini gave to Cardinal Passionei a small *pietre dure* box, which had been presented to him by the Grand Duke of Tuscany, "of the most perfect manufacture and of great value".[41] Years later another grand duke, François de Lorraine, husband of Maria Theresa, sent the pope a

Fig. 90 Carlo Sartori, *Project for a Miter*, c. 1780; Artemis Group, London. The stones came from the Vatican Treasury, and the drawing is part of a series from the workshop of Luigi and Giuseppe Valadier.

*pietra dura* mosaic picture of which all that is known is that it depicted figures.[42] In her will the last of the Medici, the Palatine Electress Anna Maria Luisa, bequeathed to the pope an Ecce Homo in an ebony and lapis lazuli frame, which the pope later donated to the church of the Monache Barberine.[43]

Gifts to the pope could also be unusual, bizarre, and magnificent. In 1741 Cardinal Giudice gave Benedict XIV an amethyst set into a gilded metal sphinx, as well as a cup made of narwhal tusk decorated with diamonds.[44] While work on the commissions of the King of Portugal was underway, Benedict XIV was rewarded with several exceptional objects, including a gold chalice by Francesco Giardoni, immediately donated to St. Peter's, which bore bas-reliefs in rock crystal, and the papal and regal arms.[45] Gifts from exotic places also entered the papal collections. In 1742 the bishop of Cartagena sent a gilt-bronze bas-relief of the Virgin against a blue ground, with a black frame, and a "porcelain" cup made in the West Indies, which had a silver-gilt base. In October that year there arrived a portrait of the pope in copper and two vases, each one *mezzacanna* in height and made of *boccaro*, a type of red clay used by the Indians of the Spanish colonies, which was often decorated in *pietre dure* with myths of those peoples.[46]

From what can be deduced from the archives, Rome does not seem to have produced much scagliola, a paste made in imitation of marble. However, we know that in 1771 Clement XIV was given a picture in scagliola made by the Vallombrosan monk Enrico Hugford. A rather curious speciality was the small-scale reproduction in cork of antique monuments. The best-known artisans specializing in this technique were Augusto Rosa (a descendant of the painter Salvator Rosa), Giovanni Altieri (whose beautiful reduction of the Temple of Vesta is in the Soane Museum in London), and above all Antonio Chichi, whose work is well represented in the museum in Darmstadt.[47]

The Vatican Computisteria (account book) contains a record dated December 18, 1781, of a considerable sum paid to Carlo Sartori for his work in decorating "a very rich miter made of pearls and stones taken from miters and other objects in the Papal Sacristy". The list of gems and their sources is mind-boggling. They came from papal tiaras, one of which had belonged to Paul III, miters of Urban VIII, Cardinal Buglione, and Cardinal Roma, nine crosses of varying quality, brooches, ferrules, valuable purses, and a notable series of silver candlesticks and bells, as well as saucers, plates, and paxes.[48] Directly related to this miter are three drawings, now the property of the Artemis Group in London, from the workshop of Valadier (fig. 90).

Notes

1   González-Palacios 1993, pp. 224–25, 338.
2   González-Palacios 1993, pp. 350–59.
3   Archivio Segreto Vaticano, Sacri Palazzi Apostolici, Computisteria, f. 908.
4   González-Palacios 1991, cat. no. 101. See the entry in this catalogue for Pierre Daneau, referring to his possible contacts with Piffetti (cat. 41).
5   Chracas, *Diario Ordinario di Roma*, 2759, April 9, 1735, no. 2759, p. 2; December 7, 1743, p. 7.
6   *Diario Ordinario*, December 7, 1743, no. 4113, p. 16.
7   Biblioteca Apostolica Vaticana, Archivio Barberini, Computerista, f. 420, c. 8.
8   Ronald Lightbown, "Oriental Art and the Orient," *The Journal of the Warburg and Courtauld Institutes*, vol. 32 (1969), p. 262 and passim.
9   *Diario Ordinario*, June 28, 1720, no. 462.
10  *Diario Ordinario*, December 22, 1725, no. 1308, p. 17.
11  *Diario Ordinario*, October 4, 1727, no. 1585, p. 7.
12  *Diario Ordinario*, August 3, 1743, no. 4059, p. 2.
13  Huth 1967, p. 336. In 1683 a certain Giovanni de Pedibus, "painter in the Indian style on the Coronari" ("pittore all'indiana ai Coronari"), furnished the Colonna with a set of chairs painted in the Indian manner and decorated with gold. This may, in fact, be the painter mentioned by Bonanni. See Eduard Safarik, *Palazzo Colonna*, [Rome: De Luca, 1997], p. 256.
14  Among other things there is a small lacquered chest with silver decorations that has the stamp of the Roman silversmith Filippo Tofani, who obtained his license in 1735. An even earlier piece is the portable shrine, depicting a procession during the pontificate of Clement XI, most recently seen in the exhibition *Fasto romano*.
15  *Diario Ordinario*, June 10, 1747, no. 4662, p. 11.
16  Carlo Pietrangeli, *Palazzo Sciarra* [Rome: Istituto Nazionale di Studi Romani, 1987].
17  I know of a set of two commodes, two sofas, and other seats, lacquered with chinoiseries in gold on dark green, that have a Borghese provenance. They are signed by Lorenzo Molinari, an artisan about whom very little is known. Besides these lacquered pieces, there are also painted ones, for example one by Sebastiano Conca, which I published (González-Palacios 1984, fig. 192).
18  González-Palacios 1993, pp. 111–14.
19  Max Terrier, "La mode des Espagnolettes, Oppenord et Juvarra," *Antologia di Belle Arti*, no. 27–28, 1985, pp. 123–46.
20  Giovanni Battistelli, et al., *Organi e cantorie nelle chiese di Roma* [Rome: Istituto Poligrafico e Zecca dello Stato, Libreria dello Stato, 1994], p. 104. The musical works of 1735–56 are by the Tirolese Johann Konrad Werle. The name of Giovanni Domenico Barbiani has been suggested as the carver, whereas I think that the gilding of the choirs was executed in 1758 by Alessandro Ricchebach, who is mentioned later in this introduction.
21  *Diario Ordinario*, April 20, 1748, no.4797, p. 9.
22  González-Palacios 1984, figs. 365–67.
23  Alvar González-Palacios, "Cornici di Pio VI," in *Studi di storia dell'arte in onore di Mina Gregori* [Milan: Cariplo, 1994], pp. 348–59.
24  González-Palacios 1993, p. 175.
25  *Diario Ordinario*, June 16, no. 1725, 1227, p. 2.
26  González-Palacios 1993, p. 177.
27  *Diario Ordinario*, January 16, 1740, no. 3503, pp. 4–5.
28  *Diario Ordinario*, September 4, 1745, no. 4386, p. 8.
29  *Diario Ordinario*, August 28, 1751, no. 5322, p. 4.
30  *Diario Ordinario*, no. 5973, p. 8; no. 6414, p. 6; no. 6417, p. 13.
31  Archivio Segreto Vaticano, Sacri Palazzi Apostolici, Computisteria, f. 389, c. 199.
32  Archivio Segreto Vaticano, Sacri Palazzi Apostolici, Computisteria, f. 378, c. 156.
33  Archivio Segreto Vaticano, Sacri Palazzi Apostolici, Computisteria, f. 366, c. 14.
34  *Diario Ordinario*, December 9, no. 1473, 3801, p. 5.
35  *Diario Ordinario*, May 18, 1743, no. 4026, p. 4.
36  *Diario Ordinario*, August 8, 1744, no. 4218, p. 6.
37  *Diario Ordinario*, May 8, 1745, no. 4335, p. 5.
38  *Diario Ordinario*, July 19, 1755, no. 5931, p. 18.
39  Vatican City, Archivio Segreto Vaticano, Sacri Palazzi Apostolici, Computerista, f. 912.
40  *Diario Ordinario*, November 15, 1735, no. 2852, p. 5.
41  *Diario Ordinario*, August 16, 1738, no. 3283, p. 5.
42  *Diario Ordinario*, December 29, 1753, no. 5688, p. 2.
43  *Diario Ordinario*, June 1, 1743, no. 4032, p. 3.
44  *Diario Ordinario*, July 1, 1741, no. 3732, p. 17.
45  *Diario Ordinario*, July 7, 1742, no. 3891, p. 5.
46  *Diario Ordinario*, July 21, 1742, no. 3897, p. 11; October 6, 1742, no. 3930, p. 6.
47  On Hugford, Rosa, and Chichi, see Vernon Hyde Minor, "References to Artists and Works of Art in Chracas, *Diario Ordinario* 1760–1785," *Storia dell'Arte*, vol. 46 [1982], pp. 217–77 (especially pp. 240, 246, 255). Chracas discusses certain work done by the architect Chichi for Catherine II, namely miniatures of the Vatican Logge, executed by Cristoforo Unterperger. See also Anita Büttner, *Korkmodelle von Antonio Chichi* [Tübingen, Germany: Kunsthalle Tübingen, 1975].
48  Archivio Segreto Vaticano, Sacri Palazzi Apostolici, Computisteria, f. 376, c. 67.

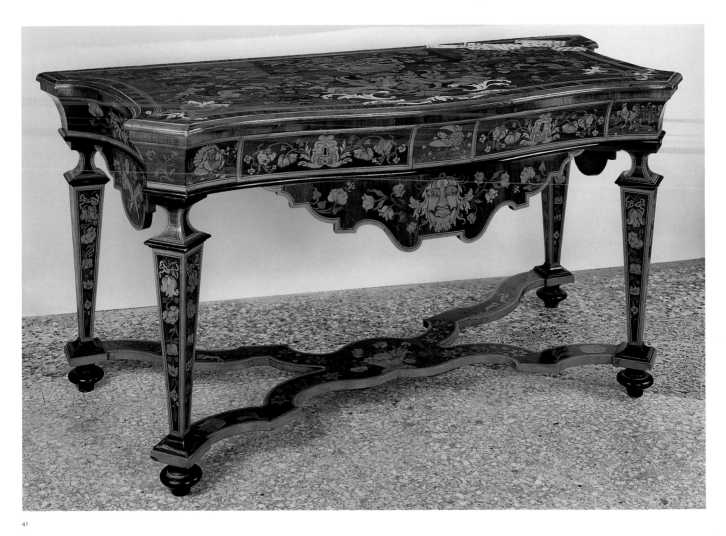

41

## 41

## Pierre Daneau
*Console Table*

1731
Veneered and inlaid with various woods
and ivory
36″ × 73″ × 32″ (91.5 × 187 × 82 cm)
PROVENANCE Barberini princes
EXHIBITION Rome 1991, *Fasto romano*,
cat. no. 92
Private collection

The table's bun feet rest on reversed
obelisk legs joined by a curvilinear
stretcher. A scalloped apron hangs
from the frieze, which has a concave
profile tapering towards the bottom,
containing two large drawers. The top
has concave sides, and the front is
convex in the middle. It is covered
with a rich decoration of floral and
foliar marquetry, with a mask on the
apron and some domestic animals at
the sides of the drawers. The top pre-
sents various decorative motifs in a
tracery of spirals, flowers, and leaves,
two-handled vases, scrolls, shells, and
fantastic animals; on the right can be
seen some playing cards, one of which
bears some illegible writing.

The table has a pendant, now in
another private collection: the motifs
inlaid on the frieze are alternated, a
practice usual in pairs of furniture,
while the pictorial marquetry on the
working surface includes a scroll with
the Barberini arms, which plausibly
demonstrates that both the pieces
were made for a member of that family.

The marquetry that decorates this
piece is unusual in Rome, where
simple floral motifs or spirals are
much more common. However, the
structure of both tables, especially the
shape of the legs, has much in
common with other known Roman
models. Both pieces appear to be
signed, although the signature of the
cabinetmaker is not easy to decipher:
these inscriptions are written on
labels stuck on the back, below the
working surfaces. On the one with the
Barberini arms the label is clearer,
being protected by a sliding panel: *Fait
Par Moy Pierre/ Da… Parisien a Rome/
Lan De Grase 1731* ("Made by me Pierre/
Da… Parisian in Rome/ the year of
grace 1731"). On the table exhibited
here the label is not protected and so
is hard to read, the only words still
comprehensible being part of the cab-
inetmaker's surname and his national-

ity: "… *aneau Parisien*". The maker can
thus be identified as Pierre Daneau, a
Parisian cabinetmaker working in
Rome in 1731.

Pierre Daneau was the son of a cab-
inetmaker also called Pierre Daneau
(or Dasneau), who was working in
Paris at the beginning of the eighteenth
century. In 1702 the latter had as an
apprentice the famous cabinetmaker
Gilles Joubert and in 1705 was
described as "fleuriste en marqueterie
de pièces de rapport" ( Daniel Alcouffe,
communication with author, May
1991). In an act of July 3, 1751, it appears
that the man who was certainly the
younger Pierre Daneau had been
absent from Paris for twenty-six years,
having left France in 1725, when he was
about age sixteen (communication
with author, November 1991). In 1751 it
was not known where he was living.

The type of marquetry used here
still contains echoes of work done in
France in the reign of Louis XIV by
such cabinetmakers as Pierre Gole
and André-Charles Boulle. It should
not be forgotten that in Italy—in
Florence—marquetry-decorated fur-
niture was being created that rivaled
the best work being done in France. In
this case too the makers were mainly

foreigners, for example the Flemish
Leonardo van der Vinne (died 1713)
and a Frenchman whose work still
remains little known, Richard Lebrun
( died after 1730; called Riccardo Bruni
in Florence). This was the situation in
the early eighteenth century, and it
clearly had a bearing on the career of
the younger Daneau.

The quality of the marquetry exhib-
ited here reveals the presence of an
experienced artisan, not so much in
the form of the piece itself as in the
superb execution of its decoration.
It is not known whom the commis-
sioner of this piece (and its pendant)
could have turned to for the design
of such an extraordinary decorative
program, but whoever the artist was,
he must have been aware of the
models then in vogue in Florence and
Paris, notably the tables by Van der
Vinne and those not documented (but
probably by Van der Vinne) now in
the Villa della Petraia and in a private
collection (Enrico Colle, ed., *I mobili di
Palazzo Pitti: il periodo dei Medici,
1537–1737* [Florence: Centro Di, 1997],
pp. 31–43). It is also evident that the
craftsman in question must have
made other pieces comparable to the
table shown here, and they should be

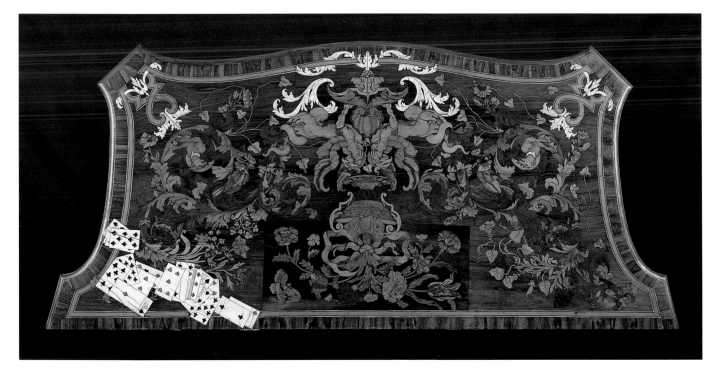

41 (top)

sought among those of the same taste and style that still remain unattributed (see Maddalena Trionfi Honorati, "Ipotesi per il Piffetti," *Antichità Viva*, vol. 35, no. 1 (1997), figs. 14–17, 21).

An intriguing aspect of the question of attribution is the fact that Italy's most famous cabinetmaker of the eighteenth century, Pietro Piffetti, must have been associated with the same general context from which this console table comes. In November 1730, when he had been in Rome for some time, he was summoned to Turin as furnituremaker to the King of Sardinia. Piffetti asked for a period of delay in which to complete some pieces he was in the process of making, including some tables. By June 1731 Piffetti was in Piedmont, and it was precisely in that same year, 1731, that Pierre Daneau signed the table exhibited here and its companion. Could Piffetti have worked in this Parisian cabinetmaker's Rome workshop or have had some sort of contact with him? The circumstance is plausible, since four tables certainly by Piffetti are known, one of which is an exact derivation from that exhibited here (Palazzo Madama, Turin; illustrated in Giancarlo Ferraris and Alvar González-Palacios, with the collaboration of Roberto Valeriani, *Pietro Piffetti e gli ebanisti a Torino, 1670–1838* [Turin, Italy: Allemandi, 1992], pp. 32–33, 50–51, 110–11). [AGP]

## 42
## Francesco Giardoni
### *Console Table*

1742
Bronze and ancient mosaic
40⅛" × 74" × 40½" (102 × 188 × 103 cm)
BIBLIOGRAPHY *Settecento* 1959, nos. 2653–54; Pietrangeli 1964
Pinacoteca Capitolina, Rome

One of a pair, this table has four supports in the form of winged monopod lions that terminate in fluted plinths. The lions' chests are encircled with garlands, and the plinths are linked by a slightly arched X-frame stretcher decorated with leaves and grotesque masks, and bearing in the middle the arms of Benedict XIV surmounted by the papal keys and tiara. The frieze surrounding the table top is decorated with inverse corbels and a female head in a shell, from which flow festoons of oakleaves. The rim comprises an egg-and-dart molding female heads at the corners. The table tops are covered in antique mosaics.

In *De musivis* (Rome, 1752, pp. 53–54), Cardinal Giuseppe Alessandro Furietti mentions mosaics he recovered from a floor during excavations at the Villa Adriana, which he gave to Pope Benedict XIV (elected in August 1740). That the mosaics on these tables are indeed the ones from the Villa Adriana is proved by the illustrations in *De musivis* (see plate no. IV). The tables are also mentioned in a list of the statues and monuments of the Museo Capitolino, dated May 2, 1742: "in the middle of the *Gran Sala* are two

tables of antique floor mosaics from the Villa Adriana now measuring eight *palmi* by four, with richly decorated metallic supports displaying the arms of the reigning pope by whom they were donated."

Until now nothing was known about the manufacture of these two extraordinary pieces, which provide a felicitous conjuncture of classical (the monopod lions) and Baroque forms, anticipating the taste of Giovanni Battista Piranesi. It is obvious that they must have been designed by an architect, while the bronze elements must have been the work of one of the bronze casters active in Rome at that time. And indeed this was the case. A brief entry (overlooked until now) in the *Diario Ordinario* of Chracas (March 31, 1742, no. 3849, p. 10) states that the pope had had the two mosaic table tops in question "enriched with

42

the most magnificent metal feet, which he had had made by the celebrated Francesco Giardoni, *Fonditore Pontificio e Camerale*" before sending them to the Capitol. This was the very year in which Giardoni completed the restoration of the Mithridates Vase given by Benedict XIV to the Capitoline Museums (as pointed out by Bulgari 1958–74, vol. 1, p. 533; Barberini 1996).

The unusual design of these pieces was bound to influence the Roman furniture of the time (see cat. 43) and was copied in a pair of consoles for the Palazzo del Quirinale in Rome (Alvar González-Palacios, with the collaboration of Roberto Valeriani, *I mobili italiani* [Milan: BNL, 1996], pp. 170–73). [AGP]

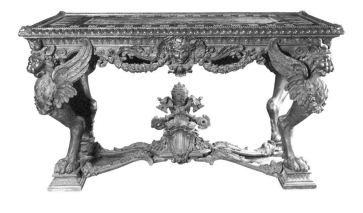

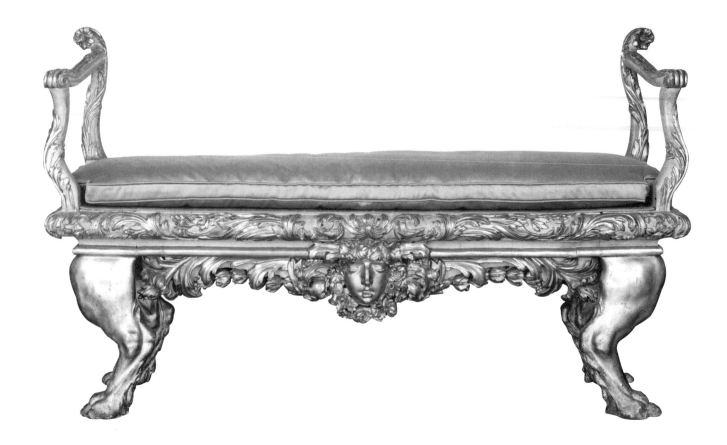

43

## 43
### *Bench*

Mid-eighteenth century
Carved, painted, and gilded wood
33½″ × 58¼″ × 16⅛″ (85 × 148 × 41 cm)
EXHIBITIONS Rome 1991, *Fasto romano*,
cat. no. 100; Rome, Palazzo Braschi. *Mostra
nazionale dell'antiquariato*. 1996, pl. 181
Private collection

The bench stands on four lion's-claw
feet naturalistically carved and joined
along the front by an elaborate swag
of leaves and flowers with a female
head in the middle; vegetal motifs
also appear on the seat rails and on
the armrests and their supports.

This design of backless seat with
arms was not uncommon in Rome
throughout the eighteenth century,
and the upper part of the piece is
typical of many examples (Lizzani
1970, pp. 96–97). This particular work
shows a surprising richness of imagi-
nation in the support, which exhibits
proto-Neoclassical ideas unknown
before this time, and was probably
designed by an architect. The inspira-
tion is comparable to that of the
bronze table in the Musei Capitolini
bearing the arms of Benedict XIV
(cat. 42) made in 1742.

The idea of standing a piece of fur-
niture on animal feet goes back to
antiquity. Small tables with such feet
can be seen even in the frescoes of the
Raphael Logge in the Vatican, and the
idea was taken up later by painters
such as Poussin, becoming immensely
popular in the late eighteenth century.
The bench seen here was once part of
a set of four, two of which were smaller.
[AGP]

## 44
### *Cabinet with "The Miracle
of Savona"*

Second quarter of the eighteenth century
Painted pearwood with carved and gilded
ornament; painted terracotta ornamenta-
tion; internal back panel, oil on wood
39¼″ × 39″ × 22½″ (99.7 × 99 × 57 cm)
Dr. Alfonso Costa, Pittsburgh

The cabinet is supported on scroll-
shaped feet holding the heads of
cherubs. It has three glazed doors sep-
arated at the corners by pilasters. These
bear secondary pilasters tapering
downward, with female heads, cascades
of foliage and capitals at the top. Carved
vegetal motifs with stylized *cartelle* on
the bases counterbalance the arches
on the façade. A pedimental feature of
double volutes is further embellished
by angels and foliage. The interior is

painted with a representation of the
Virgin Mary appearing to a peasant
against a landscape background.

The scene depicted upon this
domestic shrine alludes to the so-
called Virgin of Savona, and refers
specifically to the miraculous appari-
tion that occurred in the city on
March 18, 1536, and was twice
repeated before the end of the six-

44

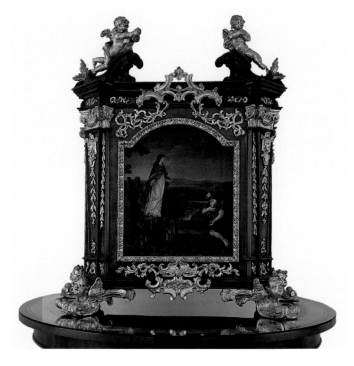

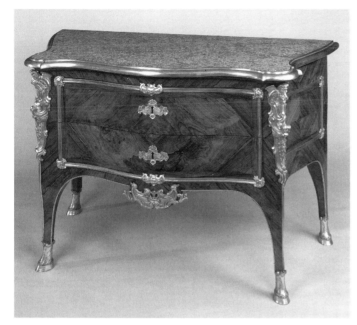

45

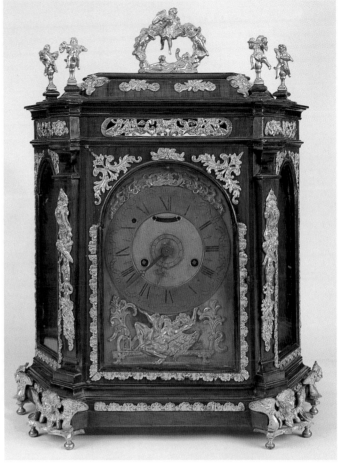

46

teenth century. The place where the miracle occurred was regarded as holy, and the incident led to the founding of a famous sanctuary that was soon embellished by significant works of art such as Gianlorenzo Bernini's bas-relief of *The Visitation of the Virgin to Saint Anne*. The cult of the Virgin of Savona also gave rise to numerous paintings similar to this one that could be found the length and breadth of Italy.

The cabinet that contains the painting, which is attributed to Paolo Anesi, displays features of construction (such as the tapered pilasters not unlike the lacquered prie-dieu, cat. 56) and carving that suggests connections not only with other pieces of Roman furniture but also with the work of goldsmiths, from which it imitates the delicately and intricately tooled quality of the applied elements. One is also reminded of the late-seventeenth century inventions of Filippo Passarini (cat. 90), particularly in the volutes that crown the whole piece. The outsize capitals surmounting the pilasters closely echo those flanking the marble bas-relief in the crypt of the sanctuary itself.

The success enjoyed in Rome by images associated with a Ligurian cult may well have owed something to the presence in the capital of Genoese families such as the Spinola and Giustiniani. [RV]

## 45
## *Commode*

Mid-eighteenth century
Rosewood veneer with gilt-bronze mounts, marble top
35″ × 64⅞″ × 25⅛″ (89 × 165 × 64 cm)
Private collection

Sheathed in bronze and shaped like goat hooves, the feet of this commode flow into the body and continue upwards as bronze mounts on the outer edges. The front has two drawers contained within a single bronze molding with ornamental scrolls and molded escutcheons (or keyhole covers) on the upper and lower drawers. A larger plaque in half-shield shape forms the centre of the apron. The side panels, to which the veneer was applied in mirror-image quarters, are edged with bronze moldings. Cartouches with complex patterns of volutes and foliage decorate the front corners. The marble top is enclosed within a bronze border.

Three further examples of this design are known, all evidently from the workshop of a single cabinet-maker and all of the highest quality. The first belonged to Prince Urbano Barberini (Lizzani 1970, fig. 208), the second is in a private collection, and the third appeared, with some refurbishment, at a Christie's auction (Sale catalogue, Christie's, Rome, October 20, 1981, lot 193; considered then to be north Italian). The dimensions of these pieces and of the one exhibited here are all similar. The veneering technique and the wood are the same, as is the magnificent bronzework. (The design of the apron below the drawers is different on the Barberini commode and the one in private

hands, while the Barberini piece has no moldings on the sides.) The commode that turned up at the Christie's auction has had handles added at a later date and the bronze moldings around the drawers are certainly not original. Contrary to usual Roman practice, the marble is set within a bronze border in all examples apart from the one in private hands. The overall shape of the commode and the arrangement of the bronze mounts are both unusual, while the quality of the veneering and the workmanship generally suggests the work of a northern European cabinetmaker active in Rome around the middle of the eighteenth century. The quality of the bronzework, too, which is similar in all the recorded pieces, reveals that the cabinetmaker used the same supplier throughout, and that he must have been a metalworker of unusual talent. [AGP]

## 46
## Tommaso Umani
## *Clock*

Mid-eighteenth century
Inscribed on the face: *Tomasso Umani F. Roma*
Kingwood, copper, and gilt-bronze
24¼″ × 19⅜″ × 9″ (63 × 50 × 23 cm)
Private collection

The clock rests on four feet modeled in the shape of plumed harpy heads. The upright members on the front take the form of pilasters that narrow towards the base, on which gilt-copper festoons with various attributes are applied. The niched sides are arranged diagonally in relation to the front, with a centered glass door and other ornaments with stylized foliate motifs. The sloping top has four putti on the corners representing the Seasons and a handle with figures. The face, which bears both roman and arabic numerals, is supported by an ornament representing Time.

This clock is of a design not infrequently found in Rome around the mid-eighteenth century. Various examples are known, signed by Francesco Portii, Domenico Crudeli, Agostino Ajmunier, Giovanni Battista

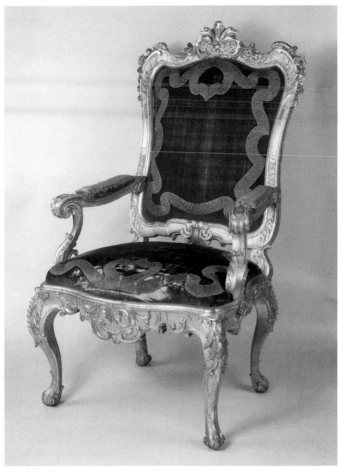

47

48

Vespasiani, and Giovanni Battista Alberici. Unfortunately these mechanisms have not been firmly dated, and suggested datings are based on the stylistic appearance of the cases containing them and on the extremely rare dated examples. The latter include a clock with a mechanism signed by Agostino Ajmunier, dated 1734, and an architectural case similar to the clock shown here but simpler and possibly older (Enrico Morpurgo, *Dizionario degli orologiai italiani* [Milan, 1974], p. 251). Other works by Tommaso Umani, the clockmaker whose signature appears on this example, are known. One is almost identical to the clock displayed here, both in size and in its metal embellishments (González-Palacios 1984, fig. 194). At least one of these ornaments, that of the Time/Atlas that supports the face, is of French derivation, in the style of André-Charles Boulle. An almost identical figure in gilt-bronze is to be found on a clock by Martinott Balthazar, now in the Ecole d'Horlogerie at Dreux (Tardy 1967, vol. 1, p. 119). [AGP]

## 47
### Armchair

Mid-eighteenth century
Carved and gilded wood
55⅞″ × 30⅝″ × 24⅛″ (142 × 78 × 62 cm)
Obra Pia, on deposit at the Spanish Embassy to the Holy See, Rome

The chair's feet are cabriole-shaped, the seat rails curved; the armrests are set back on S-shaped supports; the back, linked to the seat by foliate volutes, is waisted in the middle and swells outwards at the upper corners. The carving, of foliate design, is symmetrical and includes *rocaille* decoration and corollas on the shoulders of the back. Two cartouches filled originally with latticework decoration are placed on the apron and the toprail respectively. The red velvet upholstery is decorated with gold galloon.

One of a notable set now numbering twenty-one, this armchair is a Roman version of the formal French prototype known as *à la Reine*, intended to be ranged around the walls of drawing rooms. It echoes famous examples of early eighteenth-century Parisian chairs, here overlaid with restrained but reasonably substantial carved decoration not far removed, especially as regards the

lower parts, from the heavier seventeenth-century style of decoration, all perfectly symmetrical. Similar examples can be found in many European palaces, but those with original upholstery, such as this one, are rare. In Rome there is a set in the Casa Massimo (see González-Palacios 1991, cat. 99) and in Naples a pair of armchairs in the Palazzo Reale, the latter certainly made by a local craftsman and signed Gennaro Arata (see *Civiltà del '700* 1979–80, vol. 2, no. 436). In both cases the armchairs are similar to the one exhibited here, and a third Roman example is to be found in the Palazzo Patrizi, though the upholstery in this instance is not original (see Lizzani 1970, fig. 175).

This type of chair continued to enjoy a degree of favor throughout the nineteenth century. In the Palazzo del Quirinale, for example, where there are several dating from the eighteenth century, there are also copies or variants of designs first made a hundred years earlier (Alvar González-Palacios, with the collaboration of Roberto Valeriani, *I mobili italiani* [Milan: BNL, 1996], nos. 106–8, 136, 138, and 139). [AGP]

## 48
### Prie-dieu

Third quarter of the eighteenth century
Veneered in rosewood with banding in rosewood and *giallo angiolino* (maple)
34¼″ × 27⅛″ × 23¼″ (87 × 69 × 59 cm)
Private collection

The plinth and prie-dieu rest on short incurved legs and have a decorative edge molding. That around the prie-dieu is convex, while the plinth has a concave molding. Attached to the plinth is a table-like element standing on cabriole legs with goat's-hoof feet. A drawer is set into the frieze. The surfaces are bordered by rosewood banding.

The Roman prie-dieu was usually made in the form of a small commode attached to a prie-dieu, such as that by Giovanni Ermans (cat. 52), or was sometimes simpler, such as the lacquered example below also exhibited here (cat. 56). More elaborate versions were made, however, such as the prie-dieu from Palazzo Doria Pamphili (photograph in the Gabinetto Fotografico Nazionale E 45493 and illustrated in González-Palacios 1984, fig. 144). Like the one on show, all these pieces follow the style of the period for commodes. The present example has

49

50

the basic shape of a small, graceful table whose cabriole legs are ingeniously supported on bases not dissimilar to those of decorative statuettes. Since no analogous piece is known, this prie-dieu is believed to be unique. [AGP]

## 49
### Chair

Third quarter of the eighteenth century
Carved and gilded wood
40″ × 22″ × 19¼″ (113 × 56 × 49 cm)
Private collection

This chair has cabriole legs and scroll feet. It is decorated with carved foliate motifs, with scrolls in the upper part that flow directly into the seat rail. This is decorated with a mixture of straight lines and curves with a scallop shell in the centre. The back, supported by double volutes, has a smooth frame, trimmed with moldings, that narrows in the middle and rises for the cresting. Concise stylized foliate embellishments decorate the horizontal framing ele-

ments. The upholstery is in crimson velvet (antique but not original), attached to a drop-in seat and back.

The outline of this piece is very similar to that of chairs made for the villa of Cardinal Flavio II Chigi in via Salaria, around 1768–69, by such artisans as the woodcarver Nicola Carletti. Those are the only known and documented chairs of this date (this problem is discussed in González-Palacios 1991, no. 121, and Alvar González-Palacios, with the collaboration of Roberto Valeriani, *I mobili italiani* [Milan: BNL, 1996], no. 109).

The example exhibited here, however, displays more sober sculptural decoration, in a taste that conforms to the then prevalent symmetrical decoration in Rome, for which an obvious comparison is provided by the armchairs preserved in the Palazzo Patrizi (Lizzani 1970, fig. 175). This example, part of a larger suite that also included armchairs and sofas, probably comes from the Palazzo Barberini and was dispersed before the Second World War. [AGP]

## 50
### Console Table

Second quarter of the eighteenth century
Carved and gilded wood; top veneered with *africano* marble
36″ (37¼″ with marble top) × 79⅛″ × 35″ (91.5 [96] × 216 × 89 cm)
Private collection

The console stands on four supports. These are composed of curves that meet to form an external projection on which rests a female head, and have richly decorated inner branches. The stretcher, which undulates in a similar manner, is ornamented with scrolls, lambrequins and, in the center, another winged female head. The whole is composed of sinuous motifs, broken volutes, and stylized botanical ornaments, including the frieze, which has a mask in the middle.

Eighteenth-century furniture seldom displays the exuberance of Baroque equivalents because after the death of Gianlorenzo Bernini forms tended to become lighter in response to the more refined taste developing in northern Europe (particularly in France and Germany) that would become known as Rococo. This console table exhibits some of these new tendencies while retaining total symmetry of ornamentation; there are still allusions to the more florid shapes of the late seventeenth century. Stately in its dimensions and style, this piece is certainly the product of a particularly skilled workshop of carvers, and the design is irrefutably the work of an architect. The execution would have required a carpenter to provide the basic construction, a carver for the decoration, and a sculptor to provide the more expressive figurative details (the five female heads carved in the round). Once they had finished, the gilding was applied by a master capable of exploiting all the different gradations and shades of gold, while a marbleworker dealt with the magnificent slab of *africano* marble.

The same workshop was also responsible for three similar pieces, two of which were probably conceived as a pair: a table in the Getty Museum that was purchased in Paris several years ago (Clarissa Bremer-David et al 1993, no. 322); another in Grimsthorpe Castle (see Gervase Jackson-Stops, "Grimsthorpe Castle," *Country Life* (December 3, 1987, fig. 6); and a third in the Palazzo Corsini that is almost identical to the other two (published when it was wrongly removed to the Palazzo Barberini, in Alvar González-Palacios, *Il mobile nei secoli* [Milan: Fabbri, 1969], vol. 3, fig. 27). As already mentioned, this piece is very similar to the other three, even in its dimensions, but there are differences. The position of the heads on the front uprights, which in this instance are facing outward, is different, while the stretcher connecting the feet replaces a double scroll crowned with small heads with a larger, imposing winged head; in the three examples mentioned, the middle of the apron is occupied by a female head, while in the one we have here it is decorated by a large grinning mask.

This console first belonged, according to unconfirmed tradition, to the Roman branch (there was also an Umbrian one) of the Accoramboni family, which died out at the beginning of the nineteenth century and of which Virginia Pepoli, widow of the last marchese, Filippo Maria, was the partial heir (she subsequently married a member of the Poggiolini family; see Baldassare Capogrossi Guarna, *Ricordi storici della famiglia Accoramboni* [Rome, 1896], passim).

As the introduction explains, the furniture in this group shows such close similarities to the decoration of two royal carriages (now in the Museo dos Coches, Lisbon) that it seems likely all these splendid pieces came from the same Roman workshop. The console is still accompanied by two carved and gilded curtain hooks that form part of the same set. [AGP]

51

## 51
### *Writing Desk*

c. 1765
Veneered and inlaid with rosewood and
*giallo angiolino* (maple) with gilt-bronze
mounts
31½″ × 69¼″ × 34⅝″ (80 × 176 × 88 cm)
Private collection

The legs are slightly cabriole with
inlays using botanical motifs, feet
with curly *sabots* in gilt-bronze, and an
angular chamfer towards the top. The
body, with rectilinear sides, holds
three drawers and supports a writing
surface with protruding wavy edges.
Small inlays decorate the corners of
the central writing area, which is sur-
mounted by two side drawers.

This piece exemplifies well the
development of eighteenth-century
Roman cabinetmaking. In the first
half of the century it was perhaps
Dutch influence that brought about
the use of inlaid decorations contrast-
ing a pale wood (*bois clair*), here the so-
called *giallo angiolino*, with a dark
ground. In the piece exhibited here
this type of decoration is maintained
(in reverse, with dark inlays on a pale
ground) only on the legs, while the
other surfaces are veneered with
exotic woods such as kingwood and
rosewood, adapting to a more
modern style. The shape of the legs
seems to conform to French models,
abandoning the reversed obelisk or
volute supports employed earlier. The
use of gilt-bronze *sabots* also derives
from French models.

There exist a few dated or datable
pieces that make it possible to deter-
mine when this desk was made:
namely a table signed by the cabinet-
maker Nicola Bargilli in 1751 and a
bedside table or small commode by
Giovanni Battista Barnabei, from
Centocelle, of 1758 (González-Palacios

1984, figs. 195, 197). The second piece
is completely decorated with inlays in
*giallo angiolino*, while Bargilli's, which
does not include this type of decora-
tion, is more bombastic in shape and
not adorned with any metalwork. The
piece exhibited here, therefore, appears
to provide a conceptual demarcation
between early eighteenth-century
taste and the new French models arriv-
ing from Paris after the middle of the
century. In Rome the writing desk was
to become lighter, with curved legs;
inlays in light wood were abandoned,
and greater use was made of metal
mounts, as in a desk from the Chigi
family attributable to the cabinetmaker
Andrea Mimmi and datable to around
1765–70 (González-Palacios 1984,
figs. 147–48). Very similar to the piece
exhibited is a small table auctioned in
Rome in the 1980s (Sale catalogue,
Finarte, Rome, October 3, 1989, no. 54).

Unusually, the writing desk shown
here still has the small drawers situated
above the working surface. According
to recent investigations, the writing
desk attributed above to Mimmi simi-
larly had two drawers on the working
surface. [AGP]

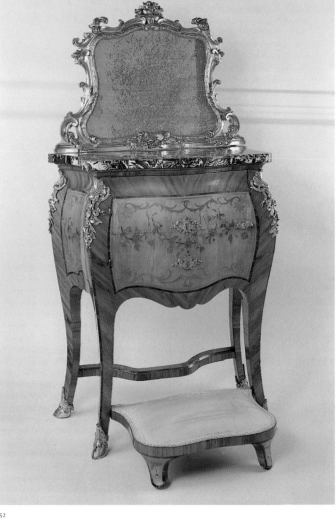

52

## 52
### Giovanni Ermans
### *Prie-dieu*

1765–66
Veneered and inlaid with various woods;
ornaments in gilded wood and gilt-bronze;
marble top
54″ × 26⅛″ × 13¾″ (137 × 67 × 35 cm)
PROVENANCE villa of Cardinal Flavio II
Chigi on via Salaria
EXHIBITION Rome 1991, *Fasto romano*,
cat. no. 123
BIBLIOGRAPHY González-Palacios 1984,
fig. 149
Private collection

This small commode has tall cabriole
legs with goat's feet in gilt-bronze. On
the sides and the slightly convex front
there are satinwood panels inlaid with
spirals and festoons; on the corners
gilt-bronze cascades pour out of
shells. On the lower part a foldaway
section serves as a prie-dieu. Resting
on the piece is a panel in a gilded
frame enriched with carved volutes,
leaves, and flowers.

In the Chigi Archive in the Vatican
Library, among Cardinal Flavio II

Chigi's accounts for the works in his
villa on via Salaria, is a long bill from
the cabinetmaker Giovanni Ermans for
a series of works carried out between
December 15, 1765, and October 20,
1766. Mentioned among these are this
exquisite piece and its pair:

N. 2 comodini con suoi sportelli
e crociata sotto che fa inginoc-
chiatore tutti impillicciati di
legno di Portogallo con suoi
fondi violetto pavonazzo con
interziature di legni di vari colori
lavorati puliti ricercati e rinettati
affenimento ed allustrati che
considerata la gran fattura si
valuta scudi 35. Per averci fatto
alli sudetti comodini le due
testierine sopra tutte contornate
sopra intagli di foglie rabescate;
con fiori e pelle di legname di
tiglio con sue tavolette dentro il
battente ove viene messo il
parato assumiglianza della
stanza il tutto rinettato e ricer-
cato a fenimento con pulizia che
considerato la sua fattura si
valuta scudi 6. ("Two bedside
tables with their doors and

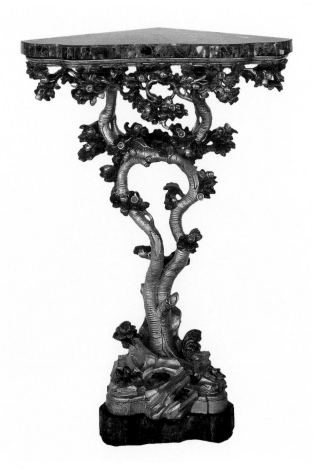

53 (one of a pair)

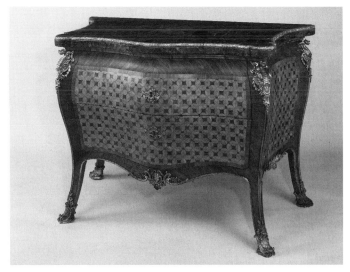

54

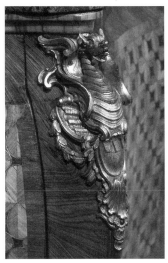

54 (detail)

crosspiece below, which makes a prie-dieu all veneered in Portuguese wood with its peacock violet ground with inlays of woods of various colors worked cleanly, examined, and corrected to perfection and polished; which considering the good workmanship is valued at 35 *scudi*. For having made for the aforesaid bedside tables the two headboards above all surrounded above carvings of leaves decorated with arabesques; with flowers and skins of limewood with its stretcher behind the frame, where is placed the fabric in likeness to one used in the, room the whole recleaned and reexamined to perfection; which considering its workmanship is valued at 6 *scudi*.")

Giovanni Ermans seems to have been not only a cabinetmaker but also a carver, seeing that it was he himself who supplied the frames around the back panels. Other works of carving by him are mentioned in the same account. The cabinetmaker's bill also makes it possible to understand the way in which the little panels on top of this type of furniture were finished.

They always contained a piece of fabric the same as that used on the walls of the room; usually some sacred image was mounted on this panel. These pieces of furniture remained in the Villa Chigi until about 1960. [AGP]

## 53
# Nicola Carletti, Angelo and Alessandro Clementi, and Pietro Rotati
*Pair of Corner Tables*

1768–69
Carved, painted, and gilded wood, with marble tops
Each 37¾″ × 27½″ × 9½″ (96 × 70 × 24 cm)
PROVENANCE Villa Chigi, via Salaria, Rome
BIBLIOGRAPHY González-Palacios, Alvar. "Tre tavoli importanti." In *Scritti in onore di Giuliano Briganti*. Milan: Longanesi, 1990, p. 257
Private collection, courtesy Massimo Martino Fine Arts and Projects, Mendrisio, Switzerland

The tables both rest on a socle painted to resemble marble; the base is shaped into the form of a rock, with flowers and leaves; from this rises the trunk of an oak that forks into a maze of leafy

branches. The interwoven vegetation expands into the apron below the mixtilinear top. The oak was one of the heraldic emblems of the papal Chigi family. The tables come from the villa of Cardinal Flavio II Chigi on via Salaria, which was completely furnished between 1765 and 1769. They may be recorded in that cardinal's *Filza dei conti diversi* (Chigi Archive in the Vatican Library). Among the requests for payment addressed to the cardinal are those from the woodcarver Nicola Carletti, already known as the maker of other pieces of furniture (González-Palacios 1984, p. 67), who in 1768 was preparing a set of small tables for one of the rooms in the villa. These pieces were part of this group. The request reads: "For preparing five small scalloped tables with frames, carved, three of them with oak branches and acorns and *pelle* and leaves, with their crossed stretchers scalloped and an oak branch in the middle and likewise at the foot and at the top."

When the carving was finished, the tables, like most of the valuable furnishings of the villa, were passed into the hands of the gilders Angelo and Alessandro Clementi and those of the painter Pietro Rotati, many of whose accounts from the year 1769 are still preserved. The idea behind these pieces of furniture, in Rococo style, dates back to an earlier era, the Baroque: they can be compared with a group of drawings from the circle of Bernini and the Austrian Giovanni Paolo Schor (González-Palacios 1984, fig. 181). One of these drawings actually shows the trunk of an oak tree with acorns, the heraldic motif, as mentioned earlier, of the Chigi family. [AGP]

## 54
# Commode

Mid-eighteenth century
Veneered and inlaid with various kinds of wood; gilt-bronze mounts; top veneered in marble with bronze borders
35⅛″ × 50¼″ × 26″ (90 × 129 × 66 cm)
EXHIBITION Rome 1991, *Fasto romano*, cat. no. 116
Private collection

The outline of the piece is defined by the splayed feet that continue upwards in a sinuous curve to create an elegant *bombé* appearance and narrow slightly into a throat just beneath the top. The front, divided by two drawers, is slightly bowed while the sides are concave. Front and sides are both decorated with inlaid panels in geometric designs surrounded, as are the legs, by banding of kingwood. The whole piece is trimmed with bronze mounts, and the same material has been used on the keyhole escutcheons, the feet, the centre of the apron, and the tops of the sides. The marble top and its rim

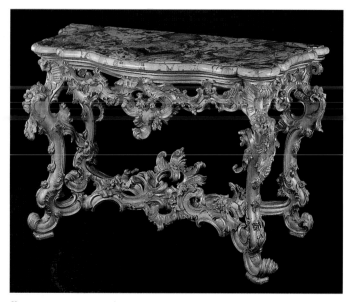

55

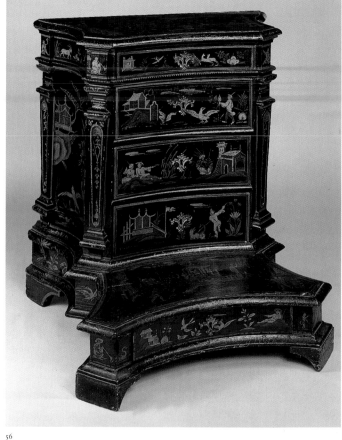

56

of chased gilt-bronze are not original but are nevertheless of the same period.

The imposing shape of this commode can be compared to that of other Roman furniture of the period, such as the pair of commodes in the Palazzo del Quirinale (Alvar González-Palacios, with the collaboration of Roberto Valeriani, *I mobili italiani* [Milan: BNL, 1996], pp. 74–75) and the one inlaid with floral motifs in the possession of Prince Odescalchi (Lizzani 1970, fig. 202). The piece exhibited here is particularly interesting for its unusual inlay and marquetry and the wonderful quality of the gilt-bronze mounts. The embellishments, of unique design and handsomely crafted, include a golden dragon and three truncated gold bands, representing the heraldic devices of the princes of Boncompagni Ludovisi, descendants of popes Gregory XIII and Gregory XV. [AGP]

## 55
### Console Table

Third quarter of the eighteenth century
Carved and gilded wood; top veneered with *fior di pesco* edged by marble
35½″ × 58⅛″ × 27⅛″ (90 × 148 × 69 cm)
PROVENANCE Colonna family
Private collection

The supports have a triple curve developing from feet scrolling outwards and are joined by a crosspiece with rocailles in the center. Similar elements, joined to corollas and scrolling motifs, form the apron below the table top and fill the entire structure. Although it retains a solid, still Baroque, layout, this rare example of a console table draws on the Rococo repertory, as is demonstrated by the whimsical profusion of flowers on the uprights, the irregular course

of the shell elements on the aprons, and particularly the asymmetrical cartouches in the center of the latter and the stretcher that joins the supports.

This is therefore a work that, although it dates from the second half of the century and exhibits the new ornamental taste derived from the French, still retains an older shape typical of the Roman taste, which has little inclination towards lightness. Two pieces of furniture that, despite being more elaborate than this example, have many of the same characteristics are worth mentioning here: a table formerly in the possession of Count Magnelli (Lizzani 1970, fig. 128) and another in the Palazzo del Quirinale (Alvar González-Palacios, with the collaboration of Roberto Valeriani, *I mobili italiani* [Milan: BNL, 1996], cat. no. 53). However, these two works and other similar ones have two features typical of the Rococo Roman console table that are noticeably absent here. Their feet scroll inwards, and the space between the apron and the lower stretcher leaves a gap that is not entirely successful. Here, by contrast, the solution is clearer and this piece is more convincing and less weak as a result, despite being poised uncertainly between two antithetical styles. [AGP]

## 56
### Commode with Prie-dieu

Mid-eighteenth century
Carved, painted, lacquered, and partially gilded wood
33½″ × 33″ × 27½″ (85 × 84 × 70 cm)
EXHIBITION Rome 1991, *Fasto romano*, cat. no. 104
Private collection

This piece has concave sides, marked at the corners by pilasters and inverted obelisks. At the bottom, a section with concave sides serves as a prie-dieu. The main body contains four drawers and is decorated with gilded chinoiseries on a dark green ground.

In its structure the piece resembles a typical early eighteenth-century Roman chest of drawers with the addition of a projecting part. Even constructed in this way, however, this type of furniture is not wholly unusual. The lacquer decoration is fairly rare; although less popular than in Venice and Turin, it was used in Rome more often than is generally believed. By the early seventeenth century it appears that lacquered objects were already in fashion in Rome (see pp. 158–59 above), while inventories from the second half of the century (Pamphili) listed furniture termed *all'indiana* ("Indian fashion"), which probably indicates a type of lacquer. In any case,

Filippo Bonanni, author of a small book on varnishes, states that in 1720 there lived in via dei Coronari in Rome a master skilled in decorating lacquered tables and caskets (Huth 1967, p. 336). At least two incontestably Roman works decorated in lacquer are known: a microscope with the Barberini crest, signed by the Jesuit Paolo Maria Petrini (1707–1773; Huth 1967, p. 336), and a casket with stamped silver fittings by Filippo Tofani (who received a silversmith's license in Rome in 1735). A curious lacquered object dating from the pontificate of Clement XI (1700–1721; see González-Palacios 1991, no. 180) is also known.

Finally it must be said that furniture definitely lacquered like this piece is listed in eighteenth-century inventories: namely those of the Portuguese minister in Rome, Pereira de Sampajo, and of Benedict XIV's Secretary of State, Cardinal Silvio Valenti Gonzaga, who died in 1750 and 1756 respectively. A few pieces of furniture (as yet unpublished) have decoration very similar to the piece exhibited here. It appears they are signed by a certain Lorenzo Molinari, who was working for the Borghese family toward the middle of the eighteenth century. [AGP]

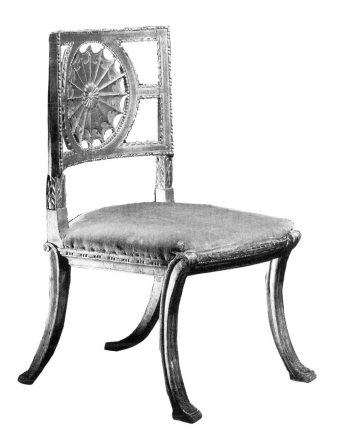

57

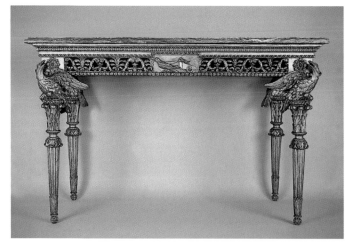

58

## 57
## Lucia Landucci
### *Chair*

1784
Carved and gilded wood
39⅜″ × 10¼″ (100 × 26.9 cm)
BIBLIOGRAPHY González-Palacios 1993,
pp. 241–42, fig. 475
Galleria Borghese, Rome

The chair's legs are composed of sabre-shaped reeded bands, which engage with the smooth seat rail. The deeply concave back is supported by leafy clusters and is formed by a rectangular compartment centered by a ring in which sits a star-shaped patera with sixteen points. All the rails and uprights are decorated with a bead-and-reel molding.

Being considered a typical expression of Neoclassicism in Rome, this chair has been much publicized and appears to be perfectly documented in the Borghese Archive in the Vatican. It was made in 1784 together with another nine pieces by a craftswoman whose name was until recently entirely unknown, Lucia Landucci. She was probably the widow (or daughter) of Antonio Landucci, who was for many years the head woodcarver in the service of Marcantonio Borghese. In 1782 the name of Antonio Landucci

disappears from the Borghese accounts, but immediately afterwards, from 1783, that of Lucia Landucci begins to appear frequently. In fact on February 27, 1784, she was paid for this chair and its companions, destined for the *stanza di Monsù Cristofano* (as the painter of this room, Cristoforo Unterperger, was then called) in the Villa Borghese. Lucia Landucci's original account specifies that the chairs were "alla crusca ossia Gothica … con la stella ad uso di scuola di Raffaello" ("*Crusca* style, in other words Gothic … with the star as used in the school of Raphael"). The chairs would then have been passed on to a gilder, who at that time was often Pietro Francini. It is possible that the well thought-out and elegant design of this magnificent piece of furniture was the brainchild of the architect of the Villa Borghese itself, Antonio Asprucci. This chair design evidently enjoyed a certain popularity, as the Museo di Roma contains exhibits that appear to be versions of the one on show here (Lizzani 1970, fig. 174). [AGP]

## 58
### *Console Table*

Last quarter of the eighteenth century
Carved and gilded wood, with alabaster top
39⅜″ × 63″ × 26¾″ (100 × 160 × 68 cm)
Private collection

The tapering fluted legs of this console table, standing on foliated feet, have acanthus ornamentation at the top that spreads to support a circular plinth carrying eagles carved in the round. The frieze is pierced and carved with a variety of alternating botanical and stylized floral motifs; it terminates in a dado at each corner. A central panel at the front bears a relief carving of a carriage drawn by a bird and driven by a locust. Beneath the alabaster slab are two moldings, one spiral and one foliate.

This table is a fine example of Roman Neoclassical workmanship. It can be dated to the middle years of the pontificate of Pius VI (1775–1799) not only by the ornamental motifs but also by the shape of the legs, which shows a marked resemblance to furniture commissioned by Prince Marcantonio Borghese.

The piece is architectonically conceived, but scope has been allowed for sculptural finishing touches. The top rests on a deep frieze, which is lightened by pierced panels and has in the center an exact copy of an ancient picture from Campania (the buried ancient cities near Naples) reproduced in *Le antichità di Ercolano*.

An eagle and a dragon together form the armorial bearings of the Borghese family. But although both these heraldic beasts are seen in the sumptuous pair of tables made for Marcantonio Borghese in 1773 by Antonio Landucci and now in the Palazzo del Quirinale (Alvar González-Palacios, with the collaboration of Roberto Valeriani, *I mobili italiani* [Milan: BNL, 1996], pp. 184–85), they sometimes occur singly, even in

important works. An example is the bronze table with caryatids made by Alessandro Algardi and substantially modified by Luigi Valadier in 1773–74: the caryatids support the Borghese arms but only the eagle is present (González-Palacios 1993, pp. 44–45).

There are other examples of the eagle appearing alone on furniture made for Prince Borghese. In 1780, for example, the gilder Carlo Palombi sent him an invoice for four pier-glasses decorated with only an eagle and vegetal festoons (González-Palacios 1993, p. 256). The catalogue of objects from the Palazzo Borghese and Villa Borghese auctioned in 1892 lists, in addition to the four pier-glasses already mentioned, a fifth pier-glass and a console table embellished with eagles alone, and another table with only the heraldic dragon (Borghese 1892, lots 327–30, 388, 601, 646).

A console table very similar to the one on show was auctioned some years ago (Sale catalogue, Salga, Rome, November 21, 1975, lot 66). The only differences lay in the shape of the lower part of the legs and the design on the frieze, which was carved instead of being pierced. [AGP]

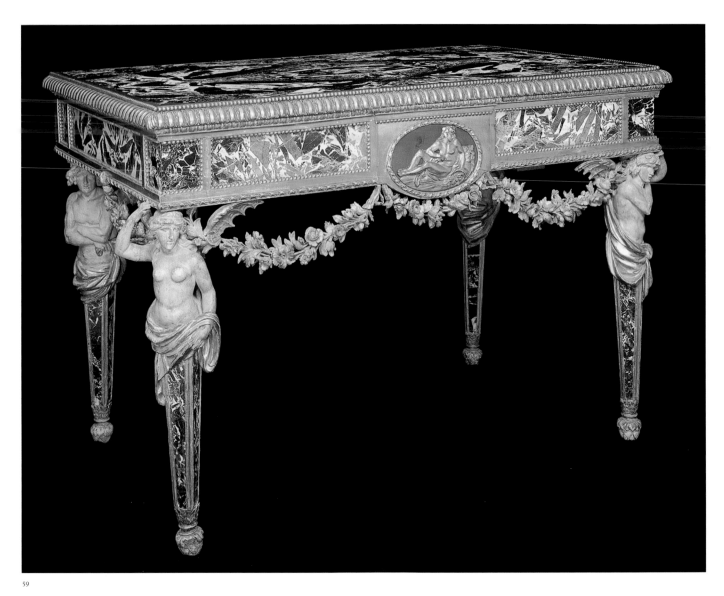

59

## VINCENZO PACETTI

ROME C. 1746–1820 ROME
*For biography see Sculpture section*

### 59
### Vincenzo Pacetti, Casimiro Ponziani, Carlo Palombi, Antonio De Rossi, and Paolo Tozzi
*Console Table*

1780
Carved, painted, and gilded wood;
marble top; mosaic
35″ × 57″ × 32 ¼″ (89 × 145 × 82 cm)
PROVENANCE Villa Borghese
EXHIBITION Rome 1991, *Fasto romano*,
cat. no. 133
BIBLIOGRAPHY González-Palacios 1993,
pp. 217–18
Private collection

The table's four legs, rising from foli-
ated feet, are conceived as inverted

obelisks, with marble sides out of
which rise the torsos of draped and
winged caryatids and atlantes. Three-
dimensional festoons of flowers hang
below the deep apron, which is inset
with marble and framed by beading.
The oval medallion in the center of the
apron shows an allegorical figure
(possibly Summer) in gilt-bronze on
a mosaic ground of blue tesserae. The
marble top is framed by an edge
molding with several registers of gilt-
bronze leaves, ovules and pearls.

This console table—and its three
companions, only one of which has
been identified, in a private collection
in Rome—was well documented by
the the present writer (some other
documents were also found by
Luciana Ferrara Grassi; see Ferrara
Grassi 1987, p. 247, n. 39–40). The ear-
liest mention of the pieces was by the
sculptor Vincenzo Pacetti in his as yet
unpublished journal (Rome, Biblioteca
Alessandrina, MS. 321), where there is
an entry for February 12, 1780, stating
that the architect Antonio Asprucci

had commissioned him to produce a
full-size model for a table intended for
the gallery of the Villa Borghese. Dated
soon afterwards, in the household
accounts of Prince Marcantonio
Borghese, occur entries referring to
Casimiro Ponziani, the marbleworker
who usually dealt with all the prince's
requirements where marble was con-
cerned, which mention that the marble
required (*bianco e nero di Aquitania*) for
one of the tables was purchased on
March 8, 1780. Another entry, for
November 22, 1780, records a payment
to Pacetti "for the wax models of eight
caryatids and assistance to the wood-
carver … for the wax models of four
medallions … and to Paolo Tozzi,
mosaic-worker, for the marble tables
for the ground-floor gallery." It is pos-
sible that the wood-carver (or sculp-
tor) assisted by Vincenzo Pacetti was
Antonio Landucci, who at that time,
and until his death, was constantly
working for the prince.

At the end of December 1780 the
gilder Carlo Palombi was paid for the

finishings in gesso, glue, and fine gold,
"to simulate metal on two tables in
*nero antico* marble with very elaborate
carving … with four figures requiring
much labor … for the ground-floor
gallery of Villa Pinciana" (a name fre-
quently used in the eighteenth
century for the Villa Borghese).
Shortly afterwards an invoice was
received from Carlo Palombi for the
two companion tables.

The magnificent bronze decora-
tions on the tables are also well docu-
mented. Wax models for the four
medallions representing the Seasons
were supplied, as already mentioned,
by Pacetti, but the casting was
entrusted not to Luigi Valadier, the
famous bronze founder and gold-
smith to whom the Borghese family
usually turned, but to a hitherto
obscure brazier, Antonio De Rossi,
who was paid for all the bronze deco-
ration and the medallions of the
Seasons. The ground-floor gallery
(now called Sala degli Imperatori, "Hall
of the Emperors") was left intact—

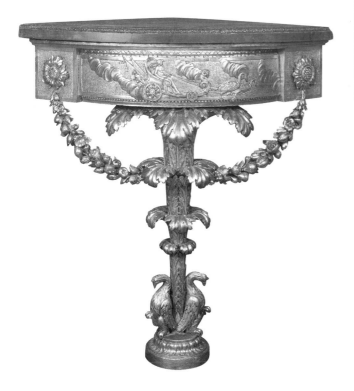

60 (one of a pair)

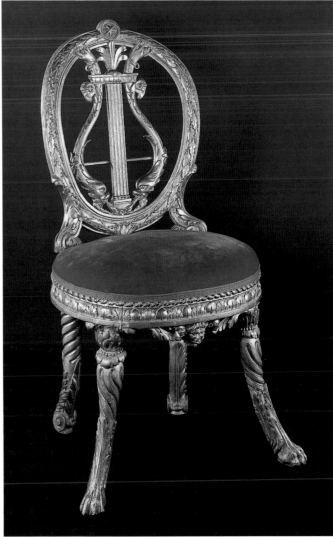

61

apart from the classical statues which were sold, together with the antiquities of the Villa Borghese, to the French by Camillo Borghese in 1808—until around 1892, when the Italian state acquired the villa and all its collections except the furniture, which was deemed at the time to be of no artistic interest. [AGP]

## 60
### Pair of Corner Tables

1790–93
Carved and gilded wood, tops veneered in alabaster and marble with rims in gilt-bronze
38″ × 37″ × 26¼″ (96.5 × 94 × 68 cm), including tops
BIBLIOGRAPHY González-Palacios 1991, p. 186
A.B.I.–Associazione Bancaria Italiana, Rome

The tables rest on a central support composed of three tiers of acanthus sprays rising from a leafy circular foot on which stand two storks. Two festoons of flowers and fruit connect the stem with corollas placed at each end of the deep apron, occupied almost entirely by a bas-relief frieze depicting a god and a goddess on a chariot drawn by storks. The tables form part of a set of four designed *en suite* with a large console table supported by telamons (and with a top unlike those on

the corner tables exhibited here, being inlaid with marbles with a star in the center). Also the frieze of this large table is decorated with a carving depicting various gods on chariots drawn by animals.

It is probable that the designer of the whole set was Giuseppe Barberi, who directed the works on the apartment prepared for the nuptials of Palazzo Altieri (see cat. 61). These two tables (as well as the largest one in the set) suggest some connection with the ideas of Piranesi, who restored a candelabrum that later entered the collection of Sir Roger Newdigate and is now in the Ashmolean Museum in Oxford (Wilton-Ely 1994, vol. 2, pp. 988, 989), and which also has supports in the form of storks. One of Piranesi's contemporaries, the Frenchman J. G. Legrand, wrote that the great artist was a friend of Giuseppe Barberi, who worked as his assistant on at least one occasion, and who provided useful advice (Brunel 1978, p. 286). [AGP]

## 61
### Chair

1790–93
Carved and gilded wood
34⅜″ × 17⅝″ × 14⅞″ (88 × 45 × 38 cm)
EXHIBITION Rome 1991, *Fasto romano*, cat. no. 135
A.B.I.–Associazione Bancaria Italiana, Rome

The circular seat rail is adorned with leaves and a ribbon pattern. The curved legs are of different design front and back, the front ones with claw feet, the back ones with scroll feet. The apron shows a head surrounded by leaves. The concave back has an oval frame of laurel leaves attached to the seat by carved acanthus leaves; the lyre-shaped splat is formed by two facing dolphins, their tails ending in rams' heads and further extended by dragons' heads. Above them is a star on an engraved ground.

This chair, one of a set of ten, is probably the most beautiful of all those made in Rome towards the end

of the *ancien régime*. Although the decoration is complex, the design is clear-cut and extremely elegant, a happy combination of classical and more whimsical motifs. The dragons' heads and the star are probably heraldic allusions to the Altieri family and the house of Saxony. The quality of the carving and the gilding, which shows gradations of depth and engraved grounds, is impeccable.

This chair was part of the new furnishings ordered for a suite of rooms in the palace, where it has remained ever since. The apartment was being refurbished for the use of Don Paluzzo Altieri, Duke of Monterano, heir to Prince Altieri, and his intended bride, Marianna Lepri, whom he was due to marry in 1788. The elaborate refurbishment was well advanced before the wedding was canceled. Five years later, in 1793, Don Paluzzo married Princess Marianna of Saxony.

The overseeing of the works was in the hands of a bizarre architect and decorator, Giuseppe Barberi, who designed the whole project and super-

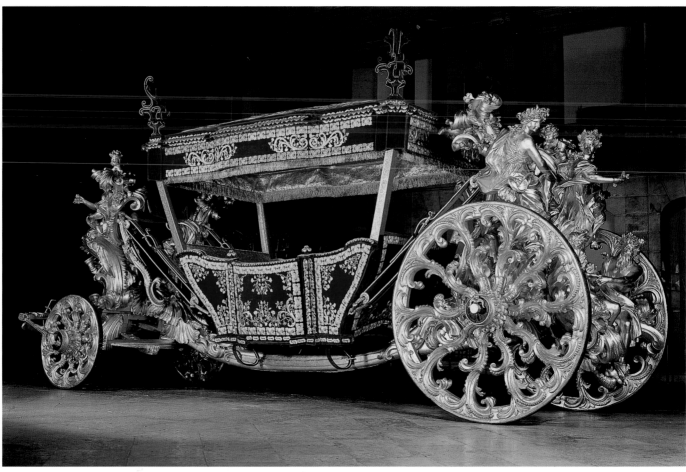

62

vised a large team of craftsmen that included well-known artists such as the sculptor Vincenzo Pacetti and the painters Felice Giani and Giuseppe Cades (Schiavo 1960, p. 34, and passim). Unfortunately permission was not granted us to study eighteenth-century documents in the family archives, where, presumably, the names of those responsible for designing and making this piece and the rest of the furniture in the apartment are recorded. A comparison with other designs known to be by Barberi, however, indicates that he was in all probability the artist concerned.
[AGP]

## 62
### *The Oceans' Coach*

1716
Carved and gilded wood; silk; and iron
11′ 9″ × 8′ × 22′ 2″ (358 × 245 × 677 cm)
PROVENANCE  Museu Nacional dos Coches, Lisbon
BIBLIOGRAPHY  Chracas 1716; Simões, Augusto Filippe. *A exposição retrospectiva de arte ornamental portugueza e hespanhola em Lisboa.* Lisbon: Typographia Universel de T. Quintino Antunes, 1882; *Carros nobres: arreios de tiro e cavallaria aprestos des torneio.* 2d ed. Lisbon: Repartição, 1905; Botto 1909; Freire 1923; Ayres de Carvalho

1960–62; Pereira 1987; Quieto 1990; Vasco Rocca, Borghini, and Ferraris 1990; Bessone 1993; Vasco Rocca and Borghini 1995; Calvet de Magalhães, Garret Pinho, and Bessone 1996
Museu Nacional dos Coches, Instituto Português de Museus, Lisbon

*The Oceans' Coach* is one of only three extant examples of eighteenth-century ceremonial vehicles constructed in Rome to take part in the opulent processions that regularly enlivened the pontifical city. They followed the strict etiquette imposed for the public entry of the ambassadors and representatives of European monarchs into the courts of His Holiness the Pope. It was built by order of King John V of Portugal to be part of the entourage of his extraordinary ambassador to the Holy See, Rodrigo Anes de Sá Almeida e Meneses, the Marquês de Fontes, for the audience granted by Pope Clement XI on July 8, 1716. This ceremonial vehicle, as well as the two other examples that were part of this embassy (also belonging to the Museu Nacional dos Coches collection), comprise an outstanding grouping of Italian Baroque magnificence, which is displayed not only in the architecture of the boxes, but principally in the sculptural groups,

still in the tradition of Bernini, that make up the front and rear panels of each of the vehicles.

The importance that this embassy took on capped a long process of diplomatic relations intended to obtain the title of Church and Patriarchal Basilica for the royal chapel in Lisbon and the conciliation of the relationships with the Holy See concerning the so-called "Chinese rites" tolerated by the Portuguese missionaries in the Orient. Special attention was therefore given to the preparations so as to present a commanding demonstration of the grandeur of Portugal and the effectiveness of its royal power in the expansion and defense of the values of the Catholic faith. This was likewise demonstrated in the naval assistance supplied by the Portuguese in the fleet sent against the Turks in the defense of Corfu in the same year of 1716.

The ambassadorial procession thus proclaimed the glorious deeds of the Portuguese nation in the decorative program of the three coaches. The first was dedicated to "navigation and conquest," and the second to the "coronation of Lisbon, capital of the empire." The third coach, which completed the group, was described by Luca Antonio Chracas in the *Distinto*

*raguaglio,* printed in Rome in 1716. It refers to *The Oceans' Coach*

that with the two previous formed a single grouping. Because this was only possible thanks to the Portuguese discovery of the connection between the two Oceans, this deed as necessary as memorable was portrayed allegorically on the rear panel of the vehicle where there were two dolphins set on enlarged volutes that formed the supports of the tailpiece. Each of them carried on its back a half-naked old man with long hair and beard and crowned with aquatic plants; the one who offers his right hand with confidence as a sign of a new friendship and association represented the Atlantic Ocean, the other being the Indian Ocean, astonished not only by the grandeur of the first, but also by the fact of it being crossed by completely unknown ships. Between them protruded a rock beaten by the waves as a symbol of the Cape of Good Hope that separated them, formed by the base of the tailpiece upon which rested the terrestrial globe with two winged

Spirits, symbols of the two poles. (Luca Antonio Chracas quoted in Calvet de Magalhães, Garret Pinho, and Bessone 1996, p. 104)

Although the overall design of the processional coaches remains an area of some controversy and uncertainty, its iconographical scheme could only have been planned by Portuguese artists, or by foreigners who had lived for some time in Portugal and thus were responsive to the intention of the message and of portraying it symbolically. The Marquês de Fontes himself, about whom all the chronicles are unanimous in stating that he had highly developed artistic gifts and a thorough knowledge of painting, sculpture, and principally architecture, could have been the creator, if not of the plan, at least of the decorative scheme. Chracas supports this hypothesis when he refers to the role of the Marquês in the presentation of the procession "as well as the perfect exhibition of the ideas and allegories designed and idealized by the great mind of His Excellency" (Chracas, quoted in Calvet de Magalhães, Garret Pinho, and Bessone 1996, p. 67). The presence in the entourage of the Marquês de Fontes in Rome of the painter Vieira Lusitano and of the Maltese architect Carlos Gimac, who had for years lived in Lisbon and worked on triumphal arches constructed for the marriage in 1708 of King John V to Maria Ana of Austria, suggests that they too were connected with the plan for these vehicles.

The *Oceans' Coach* has an open box with a trapezoidal profile with a reverse curved indentation on the side panels, each of which has a square door that opens only inward by means of a strap. Posts extend up at the corners of the box upon which rests the rectangular roof—a simple valance of velvet, finished on top with four knobs resembling flames. The outside of the box, the top, and the knobs are covered with crimson silk velvet embroidered with ornate plant-shaped designs in gilt silver thread. The inside is covered with silk brocade embroidered in semi-fine gold.

This cloth covering, on both the inside and outside, was in a very poor state of preservation. During a recent restoration project it was taken out and replaced by a replica of the original cloth produced in France by the company Tassinari & Chatel on eighteenth-century looms according to the traditional techniques and copying the patterns documented from the original fragments. The cloth that was removed was retained as part of the museum's collection.

As for the structure of the coach, the box rests on a longitudinal beam that connects the rear and front wheels and is partially decorated with alettes, various foliage, and shell-shaped motifs. From these last motifs emerge the braces for the coach box on the front panel dominated by two life-size, female figures representing Winter and Autumn, on the left and the right, respectively, of the coach. The first of these figures has a brazier and a full cape, which covers her head. The second is crowned with fruit and has more fruit in her lap. A small cherub hovers above and to the rear of each of these figures. In the center on a higher level is the coachman's seat with a brown leather cushion covered with velvet. The original cover was lost; it has been replaced by a replica of extant examples from other contemporary vehicles. On the front panel are two elegant and imposing volutes that function as the support board for the coachman.

On the front wheel are repetitive decorative plant motifs. The spokes of the wheels are made of double volutes oriented in opposite directions forming two concentric circles. Encircling the outer rim of the wheel is an iron band with regular breaks and with hemispheres of the same metal designed to give better traction.

On the rear panel of the coach, which would have been the most obvious portion when it was in a procession, are five outstanding, life-size sculptured figures arranged on two levels. In the center of the upper level is the semi-nude figure of Apollo shown with his lyre. With his right arm raised, pointing upward, he seems to emerge from the terrestrial globe that occupies the lower half of this panel, on which sit two winged spirits. On each side of the sun god are Summer and Spring which, like the other two seasons of the year, are represented by female figures. Summer is shown with a sheaf of wheat and a plant crown. Spring holds a cornucopia of flowers and wears a floral crown. These two figures are likewise accompanied by two cherubim.

On the lower level, two figures of venerable old men shake hands in a powerful image representing the joining of the Atlantic and Indian Oceans, discovered by the Portuguese, and comprising the main theme of the allegorical presentation of this coach.

The rear axle is similar to a column with capitals of acanthus and a shaft decorated with low-relief plant motifs. The slightly concave wheels are identical to those of the front, but larger.

*The Oceans' Coach* is thus an excellent example of the magnificence with which the king invested his reign, and of how he made the image of Portugal renowned throughout Europe—and beyond—in the eighteenth century. [SB]

## FILIPPO COCCHI
ROME C. 1740/1750–1818 ROME

A member of a well-known family of mosaicists (he was the son of Alessandro Cocchi and brother of Vincenzo), Filippo Cocchi appears to have worked in the Vatican mosaic workshops from 1762. He was responsible for restoration and worked with his brother on the triangular sections of the dome in the Gregorian Chapel in St. Peter's, depicting the *Doctors of the Church* after cartoons by Nicola Lapiccola. For the Loreto Congregation he made *The Archangel Michael*, after Guido Reni, *Saint Francis* after Domenichino, *The Last Supper*, after Simon Vouet, and *Saints Charles and Emidius* after Anton von Maron. In 1806 he obtained a contract for a fourth part of the mosaic version of Caravaggio's *Deposition* after a cartoon by Vincenzo Camuccini (completed in 1814 and now in the Vatican vestry). His later works include two altar frontals for St. Peter's. [RV]

BIBLIOGRAPHY Branchetti 1982, p. 447; Alfieri, Branchetti, and Cornini 1986, p. 168

## GIUSEPPE SPAGNA
ROME 1765–1839 ROME

Giuseppe Spagna was the son of the silversmith Paolo Spagna (1736–1788; master's certificate awarded 1771), who had a studio in via del Pellegrino and worked for the papal court, executing important commissions such as the Golden Rose, a special gift from the pope to queens or cities (1781 and 1784), frames for mosaics, and household silver. After his father's death, Guiseppe obtained his license in 1791 and shortly thereafter moved the studio from via del Pellegrino, a street where most of the goldsmiths' workshops had been located since the sixteenth century. He opened another on via del Corso, where he remained until at least 1811. He continued his father's work for Pius VI, executing a few bronze frames for mosaics (cat. 63) and numerous pieces of silver for the papal table. In 1792 he completed the commission for a Golden Rose.

In 1812 Spagna moved to the building belonging to his brother-in-law Giuseppe Valadier in via del Babuino and managed the studio with his son Pietro Paolo. In 1806 he cast two new bells for the Capitoline Hill, commissioned by Pius VII. In 1828 he executed the bronze decorations for the baptismal font in S. Maria Maggiore, based on the designs of Adamo Tadolini. He produced these in collaboration with Giuseppe Valadier, from whom he finally bought the studio in 1827. [RV]

BIBLIOGRAPHY Bulgari 1958–74, vol. 2, p. 426; González-Palacios 1997, *Valadier*, pp. 246–48

## 63
## Filippo Cocchi and Giuseppe Spagna
*Poetry*

1785, 1790

Inscription on recto: *Philippus Cocchi Romanus hanc tabulam musivam fecit anno 1785*
Mosaic; bronze and copper, chased and gilded
43 ⅛″ × 35 ⅞″ (110 × 91 cm)
EXHIBITION Rome 1997, *Valadier*, cat. no. 101
BIBLIOGRAPHY Zahlen 1966; González-Palacios, Alvar. *Mosaici e pietre dure: mosaici a piccole tessere, pietre dure a Parigi e a Napoli.* Milan: Fabbri 1981, vol. 1; Bertelli, Carlo, ed. *Il mosaico.* Milan: Mondadori, 1988, p. 272; González-Palacios 1994
Det danske Kunstindustrimuseum, Copenhagen

This mosaic, signed and dated by the famous mosaic maker Filippo Cocchi in 1785, is mounted in a frame of gilt-bronze and copper composed of a deep molding with a laurel wreath and a beveled fascia. It is trimmed with various motifs and crowned with two putti and two figures of Fame flanking the arms of Pope Pius VI. The object was given by the pope to Princess Sofia Albertina of Sweden in 1793 (see Zahlen 1966), though it was made slightly earlier than this date.

Newly discovered documents show that this mosaic by Cocchi was purchased on March 10, 1788, three years after it had been made (Archivio Segreto Vaticano, Sacri Palazzi Apostolici, Computisteria, fol. 406, c. 69). However, the payment to Giuseppe Spagna, silversmith to the Apostolic Palaces, for the frame itself dates only to February 18, 1790 (Archivio Segreto Vaticano, Sacri Palazzi Apostolici, Computisteria, fol. 418, c. 67). This detailed document mentions that the lower right-hand putto at the top of the frame originally held a laurel wreath. On completion the work appears to have been put into store in the Floreria Apostolica, but the mosaic may have been damaged, because a payment entry made on April 23, 1791, states that another mosaicist, Lorenzo Roccheggiani, had made some unspecified corrections to the work by Cocchi (Archivio Segreto Vaticano, Sacri Palazzi Apostolici, Computisteria, fol. 425, c. 103). González-Palacios found the design by Giuseppe Spagna for the frame of this work among drawings from Valadier's workshop (belonging to the Artemis Group in London).

Cocchi found his inspiration for the subject of this mosaic—*Poetry*—in a painting by Francesco Fernandi (*called* Imperiali) in the collection of the Duke of Hamilton at Lennoxlove (as pointed out by Timothy Clifford). [AGP]

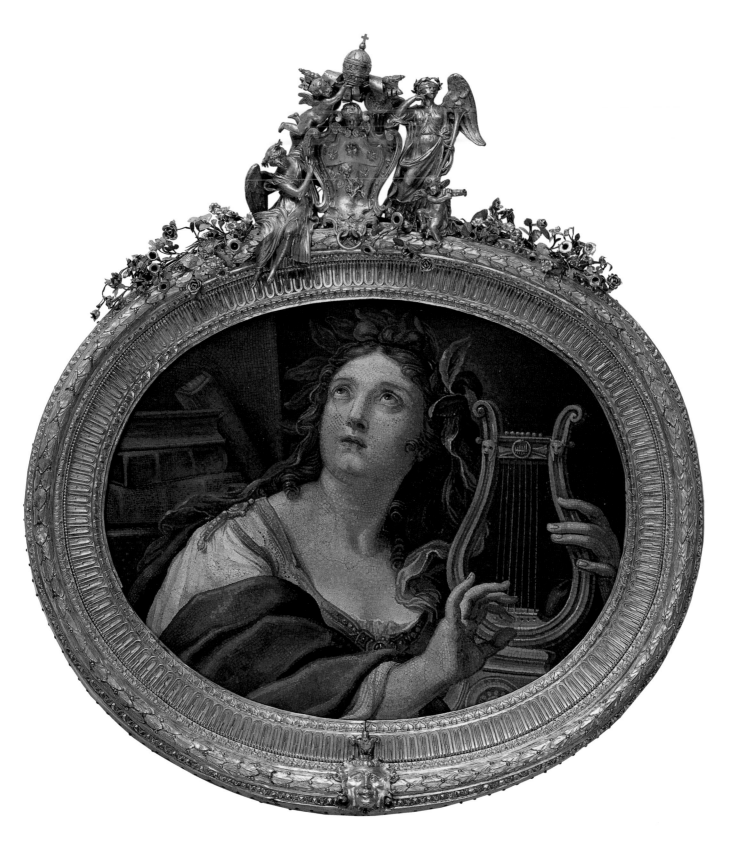

63

## 64

### Pompeo Savini
### *Tripod Table*

1788
Carved and gilded wood; mosaic top
35½″ × 35″ × 28¼″ (90 × 89 × 72 cm)
BIBLIOGRAPHY *Memorie per le Belle Arti*,
vol. 4 (1788), p. ccxxiv; Ferrara 1968
The Royal Łazienski Museum, Warsaw

This table has three cabriole legs, resting on cloven hoof feet, terminating at the top in rams' heads on acanthus leaves with garlands hanging from their sides. A stretcher with leaf carvings is centered by a vase with a fluted body. The frieze has beaded borders that enclose scrolled foliage interrupted by medallions with antique heads in profile. The top in mosaic, with bronze rim, bears in the center a bull enclosed in a Greek key frame and surrounded by a band of scrolling foliage and a ribbon frame.

The *Memorie per le Belle Arti* (the most noted periodical about Rome's artistic activity of the epoch) asserts that in 1788 the mosaicist Pompeo Savini had completed the mosaic top of this occasional table, which was sent to the Polish king, Stanislas Augustus Poniatowski, through Marcello Bacciarelli, a Roman painter in the king's service. The work is described thus:

> This is a small round table 3 *palmi romani*, 1 *once* in diameter (about 27½″ or 70 cm), in the middle of which, in a circle surrounded by a meander, is seen a very fine bull [the king's arms] with some birds above in a very graceful manner and round about it a circle of very elegant foliage, all from the painting by the famous Wenceslas Peter, excellently carried out in extremely minute little prisms, identical in size top and bottom.

So the mosaic was designed by Wenceslas Peter, a Bohemian painter active in Rome, who specialized in the portrayal of animals and whose designs were often used by the Roman mosaicists of the period. The top's middle frieze is based on a spiral decoration of classical origin, not dissimilar to those chosen for various altar frontals in St. Peter's made about the same time at the request of Pope Pius VI.

The wooden part of the piece derives from models by Giovanni Battista Piranesi, as is the case with much Roman decorative art in the last quarter of the eighteenth century. In fact, the legs of this occasional table recall those of the ones made for

64

64 (top)

Clement XIII's nephew Giovanni Battista Rezzonico, now divided between museums in Amsterdam and Minneapolis, while the rail, composed of a frieze of spirals interrupted by shields with profiles, can be compared with plate XI in Piranesi's *Diverse* *maniere d'adornare i cammini* (1769). The table now in the Łazienki Palace is very similar to the one exhibited in González-Palacios 1991, no. 130. [AGP]

## GIACOMO RAFFAELLI
### ROME 1753–1836 ROME

Giacomo Raffaelli belonged to a family of glassworkers who since the second half of the seventeenth century had provided vitreous materials for the mosaics for St. Peter's, firing their work in the kiln in via Cappellari. The kiln was still in use in the nineteenth century. Giacomo was probably the most celebrated of the craftsmen who worked as suppliers to the Studio Vaticano del Mosaico, the Vatican's own mosaic workshop, and sources reveal that he was the first to make small mosaics with extraordinarily subtle spun enamels. In 1787 his fame brought him to the notice of King Stanislas II Augustus of Poland, who conferred the title of "Polish Nobleman" on him and appointed him artistic adviser. His workshop was in Piazza di Spagna, but in the early 1800s his studio was in via del Babuino, in a building designed by Giuseppe Valadier that was also partially residential. Around 1804 he produced a magnificent *deser* (now in the Villa Carlotta, Como) for a nobleman, Francesco Melzi, viceroy of Milan, and shortly afterwards moved to the capital at the invitation of the new viceroy, Eugène de Beauharnais. While in Milan he produced the great mosaic version of Leonardo's *Last Supper* that was sent to the Minoritenkirche in Vienna. Also in 1804 he made a pendulum clock and a chimneypiece, both in mosaic, as gifts from Pius VII to Napoleon. (The latter, stripped of its mosaics and stones, is now at Malmaison.)

When Raffaelli returned to Rome after the Restoration he set about producing a great variety of articles. The inventory made after his death included pictures, plaques, boxes, jewelry, domestic artifacts and table tops all decorated with mosaic, as well as other items in bronze, marble, or *pietra dura*, such as vases, parts of table centerpieces, and chimneypieces, some encrusted with mosaics. Several of these works were later acquired by the Russian royal family and are now in the Hermitage. Among them is a pair of tables sculpted in marble with *pietre dure* inlay and small mosaic panels. After the fire in St. Peter's in 1823 Raffaelli was commissioned for the replacement of the mosaic surface completely covering the arch at the top of the nave, known as Placidia's arch. To do this, he experimented with a new and laborious technique of detaching the mosaic from the wall. Giacomo's son Vincenzo, also a mosaicist, was invited to Russia several times by the czar, who asked him to found a factory in Moscow. [RV]

BIBLIOGRAPHY González-Palacios 1984, pp. 143–45; Alfieri, Branchetti, and Cornini 1986, with previous bibliography; Valeriani 1993

65

## 65

### Giacomo Raffaelli
*Circular Plaque*

1800
Signed on the back: *Giacomo Raffaelli*
*feci in Roma 1800*
Mosaic; gilt copper
Diameter 2⅞″ (7.3 cm)
BIBLIOGRAPHY Rome 1991, *Fasto romano*,
cat. no. 203
Private collection

A dove with a red ribbon, resting on a shrub, stands out against a dark blue background. It is surrounded by a border decorated with butterflies. The metal rim is engraved with tiny undulating motifs.

Giacomo Raffaelli's studio appears to have specialized primarily in the adaptation of mosaics to small plaques that could be mounted on various types of boxes, as in this example. This sort of marketing of a certain type of manufactured article, specifically mosaics, which were usually large and costly, popularized the Roman market. This brought about a proliferation of studios belonging both to private individuals and to mosaicists from the Vatican Studio, who at the same time were involved in much larger-scale works. The contents of Raffaelli's factory, demolished after his death (Valeriani 1993), included a large number of plaques of this type, both individual plaques and examples mounted on stone boxes or in enamel. Those known today are always of a very high quality, often exemplified, as in the work shown, by edges executed with tesserae. These were individually composed of more colors, adopting the ancient technique of *murrine* (a bar of glass, composed of smaller bars; its sections showed the different colors of the components). In addition, the subject matter, which illustrates various favorite themes of Neoclassical ornamentation, excels in variety and composition, often showing an unusual originality of design. [RV]

66

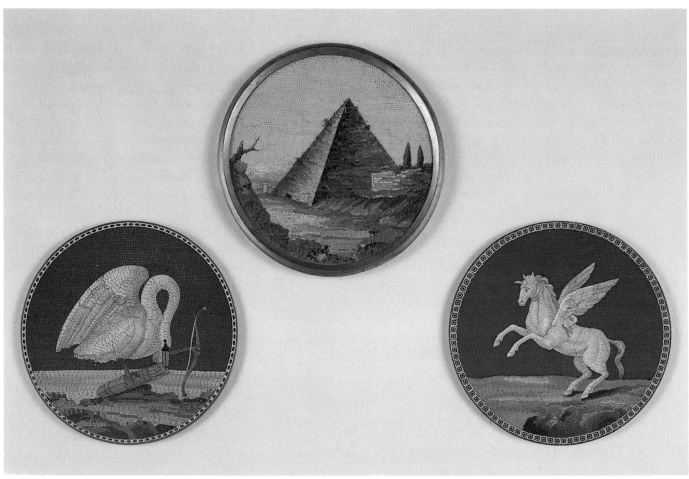

## 66

### Unknown artist
### *Three Plaques*

Late eighteenth century
Micromosaic on copper
Diameter of each 2¾″ (7 cm)
EXHIBITION  Rome 1991, *Fasto romano*,
cat. no. 211
Private collection

These three micromosaics depict the
Pyramid of Cestius, a swan with a
quiver, and Pegasus. They are all the
same size and are mounted on metal
plaques, the borders of which form
narrow frames. These are typical of
work produced in the micromosaic
workshops that flourished in late
eighteenth-century Rome. The plaque
was usually mounted on a box made
of marble, *pâte de verre*, and occasion-
ally tortoiseshell. Similar work signed
by the mosaic worker Giacomo
Raffaelli was mounted on boxes
whose frames bore the stamps of
foreign jewelers. It is not known
whether these mounts were commis-
sioned by the purchaser or whether
the Roman mosaic workers used com-
ponents acquired in France.

Plaques such as these usually depict
scenes of ancient Roman buildings (as
here the Pyramid of Cestius) copied
from popular late eighteenth-century
engravings such as those by Pronti, or
may show vignettes inspired by antiq-
uities with a combination of elements
from Roman paintings and sixteenth-
century grotesques and imaginary
scenes in the prevailing "Etruscan"
style. Other subjects include antique
statues and, more unusually, species
of animals reminiscent of the taste for
the paintings of Bohemian artist
Wenceslas Peter, who is known to have
been involved, in at least one celebrated
case, in mosaic design (see cat. 64). [RV]

## 67

### Nicola de Vecchis
### *Pair of Vases with Lids*

Late eighteenth century
Statuary marble, micromosaic
Height 22 ⅞″ (58 cm)
EXHIBITIONS  Vatican City. *Mosaici minuti
romani del '700 e dell'800*. 1986, fig. 32;
Rome 1991, *Fasto romano*, cat. no. 206
BIBLIOGRAPHY  González-Palacios, Alvar.
*Mosaici e pietre dure: mosaici a piccole tessere,
pietre dure a Parigi e a Napoli*. Milan: Fabbri,
1982, vol. 1, p. 19
Private collection

Each vase stands on a porphyry plinth
that supports a circular foot consist-
ing of a wreath of laurel leaves and
decorative pods (*baccelli*). The fluted
body of the vase, covered with over-
lapping leaves, is interrupted by a

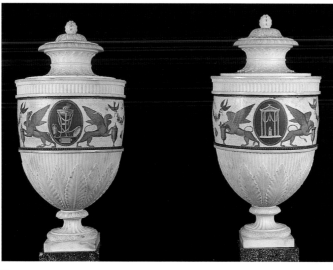

67

band of mosaic decoration featuring
pairs of drinking griffins. The beasts
are separated by ovals containing
miniature temples and surrounded by
festoons, skulls, birds and butterflies.
The narrow neck and the cover of the
vase are decorated with bands of leaves.

These two unusual pieces are the
combined work of a marble carver
and a mosaicist. The latter may have
been the same Nicola de Vecchis who,
according to a document in the
Vatican Mosaic Studio archive, in 1795
made two vases with mosaic decora-
tion "in the Etruscan style" to his own
design. The document in question was
unearthed by González-Palacios and
associated with two vases similar to
the ones on display here, except that
they had handles and antique marble
inlays: *Selections from the Gilbert
Collection* [Alvar González-Palacios,
*The Art of Mosaics: Selections from the
Gilbert Collection* [Los Angeles: Los
Angeles County Museum of Art, 1977]
The same scholar noted on this occa-
sion that two vases of a similar type
featured in the inventory of the
Empress Josephine at Malmaison.
The imperial residence also boasted a
chimneypiece and a clock, decorated
using the same technique, which can
be attributed with certainty to the cel-
ebrated mosaicist Giacomo Raffaelli.

As well as the vases on display here
and those illustrated in the Los
Angeles exhibition catalogue, it is also
worth mentioning a pair, not previ-
ously studied, at the Residenz in
Bayreuth. These are also made of
white marble carved with foliage
motifs, and are decorated with oval
mosaic plaques featuring birds. [RV]

### GIOVANNI GIARDINI
#### FORLÌ 1646–1721 ROME

A goldsmith and bronze founder,
Giardini served his apprenticeship in
Rome in the workshop of the silver-
smith Marco Gamberucci from 1665
to 1668 and obtained his master's cer-
tificate in 1675. The following year he
took over his teacher's workshop in
partnership with Marco Ciucci.
Although the partnership was dis-
solved in 1680, Giardini stayed in the
workshop, conceded to him by the
former owner, and took on his brother
Alessandro to help him. Throughout
his career he held important offices in
the Roman silversmiths' guild. In 1698
he was appointed official bronze
founder to the Reverenda Camera
Apostolica (the papal administra-
tion), and in this capacity produced a
great variety of works, ranging from
the bronze decoration for the bap-
tismal font in St. Peter's to the casting
of armaments for Castel S. Angelo.

In 1700 Giardini was responsible
for the plaque and other gilt-bronze
decoration for the tomb of Queen
Christina of Sweden in St. Peter's. In
1702 he produced a holy water stoup
in silver, gilded copper, and lapis lazuli
presented by Pope Clement XI to
Giovanni Battista Borghese, ambas-
sador extraordinary to Philip V of
Spain (Metropolitan Museum of Art,
New York). Another holy water stoup,
decorated with the figures of Justice
and Charity, was produced in 1709 and
sent by the pope the following year to
the Emperor (Residenz, Munich).

Silver-mounted articles commis-
sioned from Giardini by the administra-
tion of the pontifical palaces
include caskets containing swaddling
bands blessed by the pope and sent by
him to the crowned heads of Europe
for their children (for example, the
heirs of the French and Spanish mon-
archs) and also decorative objects for

the papal residence, such as inkstands
and chalices. In 1703 he executed the
metalworks for the church of S.
Giovanni in La Valletta, and in 1707
the bronze decoration surrounding
the image of the *Madonna del Fuoco* in
Forlì Cathedral. A porphyry and gilt-
bronze reliquary (Schatzkammer,
Vienna) containing a reliquary cross
made by the Roman goldsmith Pietro
Paolo Gelpi was made in 1711. In 1684
Giardini executed a rapier sent to the
King of Poland by Alexander VIII, and
in 1716 made a second rapier for
Clement IX to send to Eugenio of Savoy.

In 1712 Giardini entered into a con-
tract with a Bohemian printer,
Massimiliano Giuseppe Limpach, to
publish a book of engravings, *Disegni
diversi*, in 1714. The volume was
reprinted in 1750 under the title
*Promptuarium artis argentariae*. In 1720
he cast the bell for the clock tower of
the Palazzo del Quirinale, the official
papal residence outside the Vatican
Palaces. [RV]

BIBLIOGRAPHY  Bulgari 1958–74, vol. 1,
p. 529; Grigioni 1963; Honour 1971,
*Goldsmiths*, pp. 114–21; Lipinsky 1971;
González-Palacios 1995; Rudolph 1995,
p. 111, and passim; Montagu 1996, pp. 117–32

## 68

### Giovanni Giardini
### *Disegni diversi inventati e
### delineati da Giovanni Giardini
### da Forli …*

Engraved by Maximilian Joseph Limbach
1714
Bound volume 15¼″ × 21″ (38.7 × 53 cm)
EXHIBITION  Rome 1999, cat. no. 165a
BIBLIOGRAPHY  Bulgari 1958–74, vol. 1,
p. 259; Grigioni 1963, passim; Honour
*Goldsmiths* 1971, pp. 115–21; González-
Palacios 1984, passim; Montagu 1996,
p. 117; Rudolph 1995, p. 111 and passim
The Getty Research Institute for the History
of Art, Research Library, Los Angeles

In this magnificent set of plates
Giovanni Giardini, Rome's most
famous silversmith of the late seven-
teenth century and early eighteenth,
assembled the Baroque era's vastest
repertory of church and secular silver-
ware. The volume won such renown
that it earned a second edition many
years after the death of its author, who
was considered one of the greatest
Roman masters of his art, and in 1750
the *Promptuarium artis argentariae*,
which reproduced unaltered the
engravings of Giardini and Limpach,
was published.

As has been pointed out by Jennifer
Montagu, Giardini sometimes had to
call on the help of other artists for the
execution of the more conspicuous
naturalistic details that appear on many
of the items in the volume, such as the

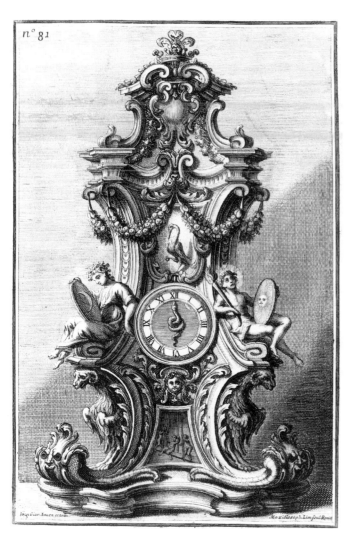

n° 81

68

recurrent figures of putti or angels; this aid can be deduced from the series of original drawings in Berlin on which the engravings are based, and in some of which the hand of the painter Benedetto Luti is believed to be recognizable, above all in the figurative details. The collection of engraved models in the volume can also be seen as one of the most extraordinary testimonies of the formal development of Baroque silversmithing between the seventeenth and eighteenth centuries. It includes an extremely diverse array of church ornaments (such as lamps, reliquaries, chalices, and monstrances), as well as secular objects that provide substantial information not only on stylistic matters but also on the uses and the diffusion of certain standard forms. It contains, for instance, many examples of the great incense burners that, according to a practice common from at least the sixteenth century, were used during gala banquets (see the seventeenth-century drawing by the Swedish artist P. P. Sevin, depicting a banquet offered to Queen Christina

of Sweden; Fagiolo 1997, vol. 2, p. 121). There are also numerous ornamental table stands of every sort, intended to be exhibited on their own or as supports for other furnishings: these include some notable pyramidal constructions, used to display chocolate pots and teacups, or to show off the elaborate vases that sometimes accompanied large console tables in the Baroque style. Equally noteworthy are the designs for table fountains, decorated with allegorical figures, and the design for metal finials to be set on the top of ceremonial chairs. The collection concludes with designs for door handles and bell pulls.

The objects depicted often bear the arms of the papal families, including the Albani, Rospigliosi, and Chigi. There is, in fact, no certain evidence that any of the silverware marked in this way was ever really made for these houses. However, it is known that the Marchese Niccolò Maria Pallavicini, whose arms appear on various engravings, was one of the silversmith's main clients (Rudolph 1995). [RV]

69

The *Pietà* stands on a kind of altar, the surface of which opens into large and small beanpod motifs. The altar is enclosed on either side by scrolls with cherubim and surmounted by architectonic features. The heart-shaped pediment has a shell in the centre flanked by two festoons of bay. The goldsmith's mark (a basket of flowers) and the town mark of Rome, perhaps the one in use in 1720, are found both on the base and on the plinth (Anna Bulgari Calissoni, *Maestri argentieri gemmari e orafi di Roma* [Rome: Palombi, 1987], no. 81).

Giovanni Giardini was certainly the most famous silversmith in Rome at the end of the seventeenth century and the beginning of the eighteenth. Many of his works are now lost, but the two volumes containing roughly a hundred of his designs, both for ecclesiastical and lay use, give some idea of the breadth of his creative imagination (Giovanni Giardini, *Disegni diversi, inventati e delineati*, 2 vols. [Rome, 1714]; see cat. 68). Decorative features seen here on the *Pax* occur also in many of the plates in these volumes (see for

example nos. 23, 52, 60). Among the designs for sacred objects is one for a tabernacle showing a *Pietà* (no. 17), though different from the one shown here. A model for the latter, or for the *Pax* exhibited here, was listed in the inventory of Giardini's possessions after his death on February 10, 1722: "A large ornament in wood that served as a model for a metal cast; within it an unfinished bas-relief in copper representing the *Pietà*" (Grigioni 1963, p. 91). [AGP]

## 69
## Giovanni Giardini
*Pax with the Pietà*

1721
Cast, embossed, and gilded silver
8″ × 6⅝″ (20.4 × 17 cm)
EXHIBITION London 1995, cat. no. 105
Trinity Fine Art, Ltd., London

## 70
## Unknown artist
### *Pair of Candelabra*

c. 1723
Gilt-bronze
Height 27½" (70 cm)
BIBLIOGRAPHY *Tesori d'arte* 1975,
cat. no. 314
Famiglia Odescalchi

The triangular stem consists of a series of volutes that, starting from the double volute that forms the base, alternate with architectural motifs to form a central decorative feature and culminate in a baluster-shaped sconce with nozzle. The decoration consists of small vegetal and beanpod motifs and garlands with different types of gilding. The front of the base bears the joint arms of the Odescalchi and Borghese families, while the other sides bear in relief the censer that forms part of the Odescalchi arms.

These two candelabra belong to a set of six that graces the chapel of St. Anthony of Padua in the basilica of Ss. Apostoli. This *sacellum* was acquired by Prince Livio Odescalchi as a family chapel, but by his death in 1713 it appears that little work of any importance had been carried out. Prince Livio's will stipulated that his nephew and heir Baldassarre Erba Odescalchi should build the chapel, and Baldassarre later commissioned the work from Ludovico Rusconi Sassi. In a doctoral thesis by Cathie Cook Kelly (Kelly 1980, pp. 80–103) the author lists the payment orders made to the craftsmen responsible for each feature of this splendid chapel, filled with marble (carved by Francesco Maria Perini) and sparkling with gilt metal. The payments include one made on July 10, 1723, to "Ferdinando Reiffi, sculptor of metals, for work completed." Details of the work done by Reiff (who came from a German family) have been traced (Rome, Archivio di Stato, Archivio Odescalchi, XIV, B 1, n. 81), which describe each single fixture in copper (capitals, ciborium, frames), though the movable decorative objects are not mentioned. However, it is possible that the candelabra were commissioned from the same bronze founder some time after completion of the decorative work, on the evidence of receipts discovered made out to "Ferdinando Reiffi" (and "Francesco, his uncle") as late as 1724.

Ferdinand Reiff is a relatively unknown sculptor and architect. He was a member of a German family that included Peter Paul Reiff (his father), who was active around 1700 on the altar of St. Ignatius in the church of the Gesù (see Enggass 1976, pp. 107–8), and the latter's brother Francis, who appears to have been a goldsmith (see

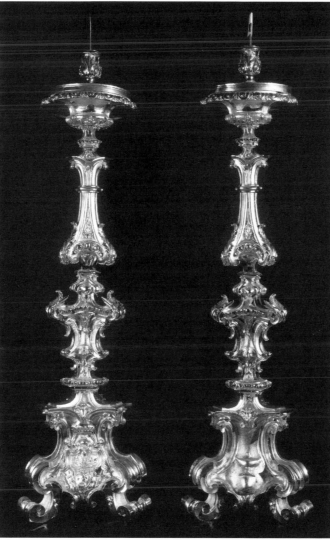

70

Friedrich Noach, *Das Deutschtum in Rom seit dem Ausgang des Mittelalters* [Aalen, Germany: Scientia, 1974], vol. 2, pp. 475–76). Ferdinand Reiff (died 1750) is known to have taken part in various Concorso Clementino architectural competitions in the early eighteenth century and to have designed ephemeral constructions. It is also known that he produced a set of designs in 1733 for the Nunciatura building in Madrid.

The design for these candelabra, with their distinctive decoration of broken volutes, is strongly reminiscent of the ornamental taste propagated by the engravings of Giovanni Giardini (*Promptuarium artiis argentariae*, published in Rome in 1714); in fact, a similar treatment to the one shown here can be seen, for example, in plate 30 of Giardini's book. The name of one Domenico Antonio Giovannelli recurs in the Odescalchi accounts during the years the chapel was being built. This craftsman described himself as a woodcarver and is known to have worked in 1725

on wooden details of the altar in the basilica of S. Maria in Cosmedin under Filippo Raguzzini. In 1724 Giovannelli—who also made decorative objects and carriages—made some sets of wooden candlesticks for the Odescalchi family to decorate the church of the Palo. He also supplied a "model in carved wood … to be cast in iron and placed inside fireplaces." This is presumably a reference to the plaques with the family coat of arms that were used to protect the base of chimneys.

The arms on the foot of the candelabra are those of the client, Baldassarre Erba Odescalchi, and the family of his two wives: Flaminia Borghese, whom he married in 1717, and her sister Maria Maddalena Borghese, who became his wife on her sister's death. [RV]

## ANGELO SPINAZZI
PIACENZA C. 1700–BEFORE 1789
ROME

Spinazzi received his master's certificate in Rome in 1721 and set up his workshop in via del Corso. He held various offices in the Congregazione degli Orefici (the goldsmiths' guild) but relinquished them in 1755, when Pope Benedict XIV sent him to Bologna. By 1758 he was back in Rome. He is reported to have been absent in 1767, but according to sources he had returned by 1785. In 1789 he is reported to have died (that year or earlier).

Spinazzi's long and prolific service to the papal palaces seems to have begun in 1732 with a series of silver ware for the dining table and dressing table as recorded in accounts of the papal court. The Golden Rose was commissioned in 1740. Earlier, in 1732–34, he executed an altar frontal based on models by Camillo Rusconi for the church of the Ascension in Siena. Ledger entries beginning at this time indicate a series of works in silver and bronze for the Corsini Chapel in St. John Lateran, including two torchbearers in the form of angels, based on models by Agostino Cornacchini, the choir screen, a pyx, and various articles of altar furniture. In 1736 he cast a lion in bronze for the monument to Cardinal Innico Caracciolo in the church at Aversa. An altar set for a church in Fiorenzuola d'Adda, which is said to be based on a design by Giovanni Paolo Panini.

For the church of S. Roque in Lisbon he designed a set of large candlesticks and a cross, only two items of which he made himself, the rest being entrusted to Tommaso Politi and Giovanni Felice Sanini. In 1752 he executed a great altar front for Syracuse Cathedral. [RV]

BIBLIOGRAPHY Bulgari 1958–74, vol. 2, p. 433; Rodrigues 1988, pp. 127, 248; González-Palacios 1993, p. 103; Montagu 1996, passim

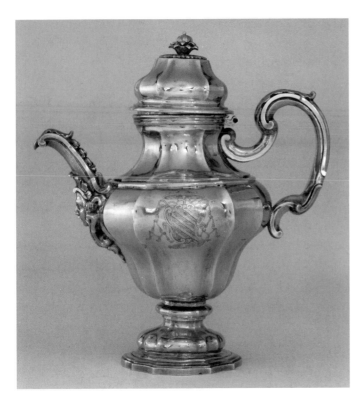

71

## 71
## Angelo Spinazzi
*Teapot*

After 1728
Silver-gilt
9⅛″ × 8⁹⁄₁₆″ × 4¼″ (23.8 × 21.7 × 12 cm)
BIBLIOGRAPHY González-Palacios 1993,
pp. 103–4, fig. 158
Staatliche Museen zu Berlin,
Kunstgewerbemuseum

Angelo Spinazzi, from Piacenza, was one of the finest silversmiths and casters working in Rome during the second and third quarters of the eighteenth century. This piece, which bears his mark, has some elements that are slighly antiquated in style. It can be compared to the incense burner supported by torch-bearing angels, based on models by the Tuscan sculptor Agostino Cornacchini, which Spinazzi cast in patinated and gilt-bronze in 1735 for the Corsini Chapel in St. John Lateran. The style of those incense burners is entirely consonant with that of the Berlin teapot, whose spout rises from a very similar female head. Two trays stamped by Spinazzi have been identified that were undoubtedly part of the same silver-gilt service as the teapot. Like this, they are engraved with a cardinal's crest, that of the papal family of Carafa. It is very likely that the crest is that of Cardinal Pierluigi Carafa, created cardinal in 1728. He was an important figure who was later highly influential at the conclave of Benedict XIV in

1740. These pieces are outstanding for the excellence of their execution, the elegant restraint of their ornament, and the sturdy compactness of their shape. [AGP]

## LEANDRO GAGLIARDI
ROME 1729–1798 ROME

Gagliardi was a member of a family of bronze founders and silversmiths, of which his father, Giuseppe, was the most distinguished. He learned his craft with Filippo Tofani, with whom, according to documents, he was working as an apprentice in 1748. The following year he was awarded his master's certificate.

Together with his father he executed work for the Portuguese royal family commissioned by Commendator Sampajo. In 1749 he made replicas of the censer and incense-boat originally made by Antonio Gigli for Lisbon but presented, at the monarch's request, to the pope (now in Bologna, Tesoro di S. Pietro). He also made four reliquaries, now lost, for Lisbon. [RV]

BIBLIOGRAPHY Bulgari 1958–74, vol. 1, p. 483; Rodrigues 1988, passim; González-Palacios 1993, passim; Montagu 1996, passim

## 72
## Leandro Gagliardi
*Altar Set*

1776
Cast, engraved, and gilded bronze and copper
Candlesticks 20⅛″ (51.2 cm); Crucifix 36⅞″ (93.7 cm); Saint Peter 19⅛″ (48.7 cm); *Saint Paul* 19¾″ (50 cm); *Saint Andrew* 20½″ (52.5 cm); *Saint John* 19⅛″ (48.7 cm) Mass cards 17¼″ × 19⅛″ (43.7 × 48.7 cm) and 12½″ × 9″ (31.8 × 23 cm)
PROVENANCE Cardinal Flavio II Chigi
BIBLIOGRAPHY González-Palacios 1993, pp. 185–87, with previous bibliography
The Art Institute of Chicago, David Adler and European Decorative Arts Funds, Mary Waller Langhorn Endowment, and Gift of the Antiquarian Society

The altar set comprises four figures of saints based on the Apostles series in St. John Lateran. The famous marble originals date from the reign of Pope Clement XI (1700–1721) and constitute one of the most typical images of eighteenth-century Rome. The figures of *Saint Peter* and *Saint Paul* are based on statues by Pietro Stefano Monnot. In the case of *Saint Paul*, the posture is copied faithfully enough with only the drapery modified, whereas *Saint Peter* has been changed more visibly by bringing the left hand with the book and keys closer to the body and lowering the right. Monnot's *Saint Peter*, half a century older than Gagliardi's, had proved popular and was used on other occasions as well, for example by Luigi Valadier for his considerably larger silver figure on the altar of Monreale Cathedral, dated around 1770 (Winter 1991–92, p. 92). This *Saint John* takes as its model Camillo Rusconi's original. The general lines of the composition, including the lift of the head and the position of the right hand, have been retained, though the eagle has been repositioned. The *Saint Andrew*, surprisingly, echoes Rusconi only in the lower half of the body: the head and torso, although reversed, are modeled on a famous, much older figure by François Duquesnoy in St. Peter's (for the Lateran Apostles, see Enggass 1976, vol. 1, passim, and vol. 2, pls. 30–32, 35–39, 57–59; also Broeder 1967).

Slightly taller than the figures, the four candlesticks (like the foot of the crucifix) are in the Roman Baroque tradition, given a lighter feel by the addition of flowers, shells, and pierced work, symmetrically arranged. (There is a group of gilt-bronze candlesticks very similar to these in the basilica of S. Marco in Rome, donated by Clement XIII [1758–69] towards the end of his pontificate for the Cappella del Beato Gregorio Barbarigo, built in 1765.) The Mass cards are in a freer

style, with undulating borders decorated with scrolls, flourishes, and delicate applications of flowers, leaves, and cherubs.

All the works exhibited here were exhaustively documented in Cardinal Flavio II Cardinal Chigi's *Filza di conti diversi* (Vatican Library, Chigi private archive, folder 911, c. 113). On May 30, 1776, a very specific invoice listing all the articles comprising the altar set was settled in favour of the founder and silversmith Leandro Gagliardi. The document specifies that the articles in question were "gilt copper very finely worked and engraved," while the statuettes were "individually cast in a single piece with their bases with the arms of His Eminence." Detailed descriptions are then given of the making of the cardinal's crest, he being a member of one of the most distinguished papal families, which boasted Alexander VII among its ancestors. At this time Cardinal Chigi was furnishing his house on via Salaria, which contained some of the finest pieces of Roman furniture of the period. In 1961 pieces that had been identified by the eminent scholar Giovanni Incisa della Rocchetta as the models in carved and gilded wood for this altar set were placed in the chapel of the via Salaria villa. There is no specific documentation to prove that the gilt-bronze set was designed for the villa; while such a hypothesis is possible, it is also possible that the cardinal intended them for his apartment in the city. [AGP]

## VINCENZO BELLI
TURIN 1710–1787 ROME

The first references to Vincenzo Belli in Rome date from around 1740, when he was registered as an apprentice. At that time he was living with his father-in-law, Bartolomeo Balbi, who was also a silversmith. In 1741 Belli obtained his master's certificate (*patente*), at which occasion several silversmiths from Turin vouched for his honesty, affirming that he had worked in their studios in his native city from an early age. Between 1742 and 1749 he had his workshop and home near the church of S. Luigi dei Francesi, while from 1757 he seems to have moved to near the Teatro Valle. His seems to have been one of the busiest and best-known workshops, judging from the quantity of works that survive, the fact that at the master's death the workshop counted around twenty workers, and that fact that the dynasty of craftsmen founded by him continued to be active until the late nineteenth century.

Besides the works executed for the King of Portugal exhibited here, another ewer with a basin (Museo di

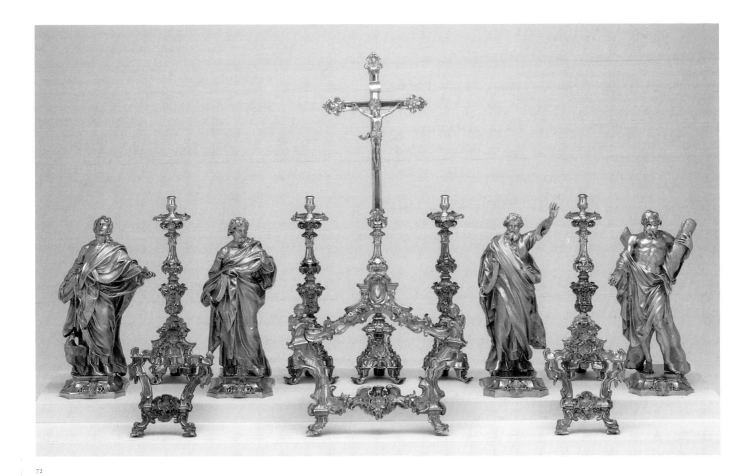

72

Palazzo Venezia, Rome), bearing the coat of arms of Cardinal Francesco Antamoro, is particularly worthy of mention. [RV]

BIBLIOGRAPHY Bulgari 1958–74, vol. 1, p. 126; *Settecento* 1959, nos. 2095–96; *Palazzo Braschi*, Rome. *Argenti romani di tre secoli nelle raccolte private*. Rome: De Luca, 1970, p. 19; Honour 1971, *Goldsmiths*, pp. 199–201; *Tesori d'arte* 1975, p. 143; Faranda, Franco. *Argentieri e argenteria sacra in Romagna: dal medioevo al XVIII secolo*. Rimini, Italy: Luisè, 1990, p. 219

## 73
## Vincenzo Belli
### *Ablution Set: Ewer and Basin*

c. 1745
Engraved silver-gilt
Ewer 8″ × 12″ × 5½″ (30 × 20 × 14 cm); Basin 17″ × 21¼″ (43 × 54 cm)
PROVENANCE Museu de São Roque, Santa Casa da Misericórdia, Lisbon, St. John the Baptist Chapel Collection
EXHIBITION Lisbon, Pavilhão da Santa Sé da Expo '98. *Fons vitae*, 1998
BIBLIOGRAPHY Rodrigues 1988, p. 152; Viterbo and D'Almeida 1997, p. 31
Santa Casa da Misericórdia, de Lisboa, Museu de São Roque, Lisbon

The works in metal belonging to the St. John the Baptist Chapel Collection in the church of S. Roque, Lisbon, mark the end of the Baroque tradition in silver and bronzework that first developed in Rome in the seventeenth century. These are works of unprecedented artistic quality, never surpassed in Italy. Although on the one hand these objects faithfully reflect a transitional period when the first hints of a Neoclassical visual language were starting to emerge, on the other hand they clearly embrace an inspiration drawn from the great genius of the Baroque—Gianlorenzo Bernini (Montagu 1996, p. 180).

Even though the St. John the Baptist Chapel treasury comprises a magnificent collection, it is no longer as opulent as when it was first assembled. Various pieces are missing, including some of great importance not only for their artistic value but also for the value of their raw material. The main reason for these gaps in the collection can be found in the French army's intervention in Portugal and the decree of February 1, 1808, ordering the Portuguese churches and religious bodies to hand over their silver to the Mint. The records of the Mint reveal that on February 15, 1808, there was, "a note of the silver [pieces] delivered there that came from the chapel of St. John the Baptist, but shortly afterwards there was a notice dated March 26 ordering them to be preserved and later, on October 4, another notice concerning the

response to a request from the chapel administrator. Now the last two documents do not coincide with the first, because they specify a larger number of pieces" (Viterbo and D'Alameida, p. 27). Some of these silver items were returned, but it is not known what became of others, such as, for example, two cruets in silver-gilt also made by the goldsmith Vincenzo Belli.

The design of this particular ewer is classical in appearance, with the royal arms of King John V on the lower part

73

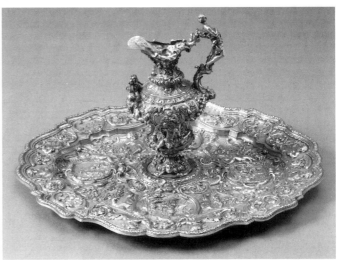

of the bulge supported by two angels and three medallions representing Christian symbols: specifically, the Passion and Purity; Christ and the Virgin; and Faith and Justice. On the handle are stylized floral elements entwined with a graceful female figure. The basin is oval in form, with a polylobate rim around which representations of angels alternate with the figures of the four Evangelists. The central area has a decorative border composed of volutes, garlands of

flowers, festoons of laurel and acanthus, vine leaves, bunches of grapes, and ears of corn. This frames two oval medallions and two cartouches representing the Miracle of the Loaves and Fishes, the Risen Christ Appearing to Mary Magdalene, Saint John Preaching in the Desert, and Saint Peter Receiving the Keys of Heaven.

The finest silversmiths of the day were contracted to fill the large and sumptuous order placed for the St. John the Baptist Chapel Collection in the church of S. Roque, namely Giuseppe Gagliardi, Antonio Gigli, and Vincenzo Belli. Belli, who is considered one of the most exceptional Italian goldsmiths of the eighteenth century, founded a dynasty of silversmiths that remained celebrated until the middle of the following century (Nuna Silva, *Fons vitae* [Lisbon, 1998], p. 110).

The goldsmith received 976 *escudos* and 27 *bajocos* for this set, of which 128 *escudos* were for the silver, plus an additional 8 *escudos* and 27 *bajocos*, with 180 *escudos* for the gilding and 660 for his workmanship. The case to accompany the silverware cost 10 *escudos*. Belli also made two cruets with a dish in silver-gilt, which unfortunately have not survived to the present day (Viterbo and D'Almeida, p. 32). [TM]

## ANTONIO VENDETTI
COTTANELLO, ITALY 1699–1796
ROME

Between 1713 and 1717 Vendetti was employed in the workshop of Giovanni Francesco Arrighi (a member of one of the most renowned families of Roman silversmiths in the seventeenth and eighteenth centuries). He obtained his master's certificate (*patente*) in 1737 and set up in via del Pellegrino, a street in which by tradition the majority of silversmiths' workshops were concentrated. In the 1740s Vendetti held important positions within the Congregation of Goldsmiths and later moved his workshop to the prosperous Banco di S. Spirito district, near Castel S. Angelo. In 1756 two of his colleagues confirmed, in connection with his provision of liturgical vessels for John V of Portugal, that he was not able to design or model the works himself, but had access to other craftsmen in case of necessity. Three years later Vendetti gave up his workshop to a silversmith from Perugia, but he seems, despite his advanced age, to have resumed work suddenly, with his son Angelo, in 1781, moving to via Giulia, where he died at the age of nearly one hundred.

Apart from his two sets of mass cards (*cartaglorie*) from Lisbon, which remain his most important works, only a few objects can still be definitely

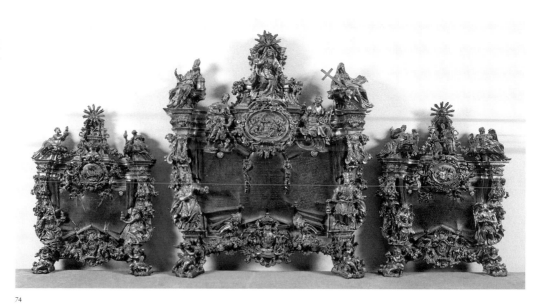

74

attributed to Vendetti. They include a chalice in the church of S. Spirito in Sassia, in Rome. The *Diario Ordinario* by Chracas recorded on May 17 1749, a new censer made by Vendetti in the shape of a temple for the bishop of Braga in Portugal. [RV]

BIBLIOGRAPHY Bulgari 1958–74, vol. 2, p. 253; *Tesori d'arte* 1975, p. 133; Montagu 1996, pp. 166–68

## 74
## Antonio Vendetti
### *Set of Mass Cards*

Central Mass Card 25″ × 21″ × 4″ (64 × 54.5 × 10 cm); Gospel Mass Card 17¾″ × 14″ × 2¾″ (45 × 35.5 × 7 cm); Epistle Mass Card 18″ × 14″ × 2¾″ (45.5 × 35.5 × 7 cm)

c. 1745

Chased, cast, and engraved silver-gilt

PROVENANCE Museu de São Roque, Santa Casa da Misericórdia, Lisbon, St. John the Baptist Chapel collection

EXHIBITIONS Rome 1990, *Lusitana*, cat. no. 86; Brussels 1991, cat. no. 1168; Lisbon 1993, cat. no. 1168

BIBLIOGRAPHY Bulgari, 1958–74, vol. 2, p. 523; Rodrigues 1988, pp. 111–19; Montagu 1996, pp. 166–67; Viterbo and D'Almeida 1997, p. 34

Santa Casa da Misericórdia, de Lisboa Museu de São Roque, Lisbon

This set of three Mass cards forms part of the majestic collection of liturgical objects commissioned in Rome in the third quarter of the eighteenth century to adorn the celebrated St. John the Baptist Chapel in the church of S. Roque in Lisbon.

The St. John the Baptist Chapel is a valuable example of religious architecture that bears witness to the great economic prosperity Portugal experienced during the reign of King John V, "the Magnanimous." Thanks to an abundance of gold and precious stones

taken from Brazil, Portugal enjoyed a period of great ostentation and magnificence in every sphere of life, including religious worship. Imbued with this spirit, King John V was a particularly ostentatious monarch, open to the influence of other European courts, especially the French court of Louis XIV, with which he was fascinated.

The Italian St. John the Baptist Chapel was brought to Portugal accompanied by a fabulous treasure of liturgical objects comprising items worked in gold and sets of vestments in a variety of colors as well as lace and books. The king's decision to proceed with this commission was partly due to his great admiration for the Society of Jesus, an order whose house he visited frequently. The Italian priest Father Carbone, who exercised great influence at court in both religious and worldly matters, was entrusted with the task of overseeing the project and immediately began to correspond with Portugal's chargé d'affaires in Rome, the Comendador Manuel Pereira de Sampaio, to whom he gave the main instructions with regard to how the scheme was to be carried out. The aim of this minutely detailed correspondence, begun on October 26, 1742, was to lay down guidelines for the Roman artists to follow in their work. All the preliminary sketches and designs were submitted for the approval of the Portuguese court, at which stage they were sometimes amended. The opinion of the architect João Frederico Ludovique also had a strong influence on the project's general outline.

This priceless heritage, which has survived to the present day accompanied by a valuable collection of works of art, withstood the 1755 earthquake that destroyed a number of monuments of King John V's reign. It now

provides evidence of the king's vigorous interest in all kinds of artistic and intellectual expression.

The set of artifacts exhibited here, the designs of which were approved in 1745, is made up of three Mass cards that were commissioned in Rome in about 1742 and arrived in Lisbon on September 1, 1747. The central Mass card, traditionally known as the Great Mass Card, has an elegant rectangular frame and a medallion in low relief on the architrave that depicts the institution of the Eucharist with the symbolic figures of Aaron and Melchizedek, flanked in turn by the theological virtues Charity and Hope. There is an allegorical depiction of Faith seated on a throne on the upper part, flanked in turn by allegories depicting the pontificate and the Church. This ensemble is decorated with eucharistic symbols composed of grapes and wheat. The bottom of the text, which is engraved on a silver plaque, is adorned with the Portuguese royal arms surrounded by angels, volutes, and cherubim.

The Gospel Mass card is also surrounded by a rectangular frame with the text engraved on a white silver plaque. The central medallion, which crowns the text, represents Saint John the Evangelist flanked by putti with the Paschal Lamb above him, and the symbol of God at the top. At the extremities of the upper register there are figures of prophets proffering mystical vessels. The pelican appears in the lower medallion, which is also flanked by angels. The remaining decorations are dominated by cherubim, shells, and garlands in the Rococo style.

The Epistle Mass card is identical in shape and depicts the Lord of the Green Branch (or Aaron's rod) flanked by putti and crowned by the New Testament scene of Pilate Washing His Hands, which is depicted in the

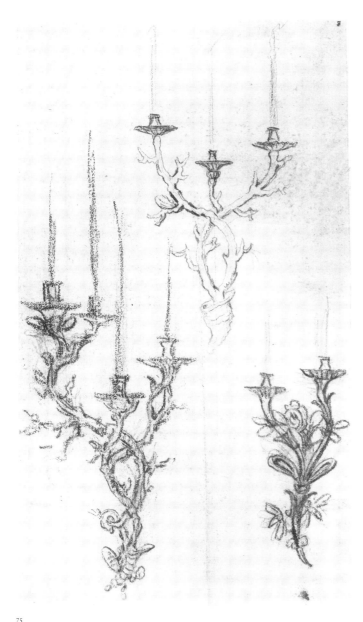

75

## GIOVANNI BATTISTA PIRANESI

MOGLIANO DI MESTRE 1720–1778
ROME
*For biography see Prints section*

### 75
### Giovanni Battista Piranesi
*Design for Sconces*

c. 1769
Red chalk over black chalk on paper
9⅛″ × 5¼″ (23.3 × 13.2 cm)
BIBLIOGRAPHY  González-Palacios 1984,
fig. 263; Wilton-Ely 1993, fig. 120
The Pierpont Morgan Library, New York

On the bottom left of the page is a sconce with two arms arranged to resemble three stems tied with a ribbon, the middle of which is the stem of an open rose. The other two sketches show sconces with three and four almost identical arms shaped like twiggy branches rising out of horns of plenty. As Wilton-Ely noted, the drawing at the bottom right is a preparatory sketch for the sconce pictured top left in a plate of the famous *Diverse maniere d'adornare i cammini*, which Piranesi published in 1769 and which also shows a console table supported by fantastic beasts. Two examples of this table are still in existence, one at the Minneapolis Institute of Arts and another in the Rijksmuseum in Amsterdam. At the base of this engraving is the following note: "This table and other decorative works to be found scattered throughout this volume are to be seen in the apartments of His Excellency Monsig.ʳ. D. Gio. Batt.ᵃ Rezzonico, nephew and steward to His Holiness Pope Clement XIII." It may therefore be presumed that the piece was made with the intention that it would be used in the furnishing of apartments for the nephew of Pope Clement XIII in his capacity of steward to the pontiff. As the pope's steward, Monsignor Rezzonico had to live in one of the papal palaces, but he later moved to the Palazzo Senatorio on the Capitoline Hill, where his brother Abbondio, a senator, lived (Clark 1965).

There is nothing elsewhere in Piranesi's graphic work that resembles these sketches for wall lights, naturalistically designed to look like almost leafless branches; however, as pointed out by González-Palacios, there is a similarity here with designs by Luigi Valadier for certain works for the Salone d'Oro in the Palazzo Chigi, where the silversmiths and founder prepared naturalistic decoration for the mirrors (see González-Palacios 1997, *Valadier*, p. 22). [RV]

## LUIGI VALADIER

ROME 1726–1785 ROME

Luigi Valadier was the son of Andrea Valadier, a Frenchman who had settled in Rome in 1714; there he learned the silversmith's art. In 1732 Andrea owned a workshop in the Piazza S. Luigi dei Francesi, and in 1744 made some bronze railings for the patriarchal church in Lisbon. Some of the payments relating to this commission were signed by the young Luigi, evidently already involved in his father's business. Together they made a set of gilt-bronze candlesticks for the church of S. Apollinare in 1748 and, two years later, some of the bronze fittings for the papal altar of S. Maria Maggiore. In the same year Luigi was awarded a prize in the Concorso Clementino for an architectural drawing. In 1754 he seems to have been in Paris to perfect his skills as a goldsmith, but must have returned to Rome in 1756, when he married the daughter of the sculptor Filippo della Valle.

After his father's death in 1759, Valadier managed the workshop with his brother Giovanni. In the early 1760s he began to work for the Borghese princes, who subsequently gave him regular commissions. He made the bronze decorations for the altar of the Borghese Chapel in S. Maria Maggiore, including the set of Mass cards that can still be seen there. In 1764 he obtained his silversmith's patent. He separated from his brother and moved to via del Babuino. Between 1760 and 1764 he was commissioned for three large chandeliers for the sanctuary of Santiago de Compostela. In 1766 and 1767 he made the gilt metal fittings for a new apartment in the Palazzo Chigi, recently redecorated by Giovanni Stern: embellishments to the mirrors in the Salone d'Oro—garlands of flowers spilling over on to the plinth—the decoration of two fireplaces, firedogs, wall lights, door furniture, fittings for marble tabletops, and other decorative features. For the Chigi he also made other items in silver, now dispersed, including a dressing-table set and one for a writing desk. In 1768 he was responsible for the (still surviving) silver ornaments for the altar of Monreale Cathedral, including low reliefs and large statues. His reputation with foreign clients in these years is confirmed by a commission for a church in Mexico (1767): a silver ostensory with twelve thousand white topazes, followed a year later by candlesticks and chalices decorated in similar style. Meanwhile, he was casting replicas of antique statues for the Duke of Northumberland (1765, now at Syon House), and in 1772 he supplied the bronze fittings for a Carlo Albacini

central medallion above the text. At the top there are representations of the Sun and Moon and figures of archangels appear at the extremities of the upper register. The phoenix appears in the lower medallion, which is also flanked by angels. The remaining decorations follow the same outline as in the previous pieces. The ensemble is dominated by a distinctly architectural structure in which the language of the Baroque, now showing clear signs of exhaustion, combines harmoniously with the first symptoms of Neoclassical influence.

The goldsmiths made a set of silvergilt Mass cards for the St. John the Baptist Chapel for 3,515 *escudos* and 17 *bajocos* (the cases for which, now lost, apparently cost 18 *escudos*), and another set in gilt-bronze for 1,208 *escudos* and 20 *bajocos*. On August 15, 1898, they were exhibited in the sacristy of the church of S. Roque when

the St. John the Baptist Chapel collection was put on display to the public for the first time; they are now in the Museu S. Roque. The set of silver-gilt mass cards was intended for use during Mass on high days and holidays, while the gilt-bronze set was for low Masses.

Although there is no doubt that this work was executed by Vendetti, evidence of other goldsmiths shows that Vendetti never executed any works of great importance or magnificence but confined himself to minor pieces. In fact, owing to his inability to draw and model, he resorted whenever necessary to designs and models executed by specialists, such as Luigi Landinetti and Lorenzo Morelli (Bulgari 1958–74, vol. 2, p. 523). There are also references to the fact that this work received a number of alterations, and that the goldsmith replaced over twenty-three pieces (Montagu 1996, pp. 168, 245). [TM]

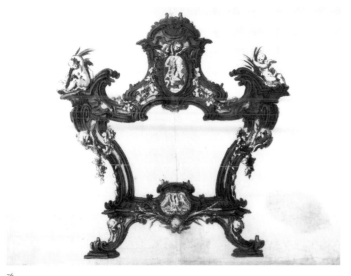

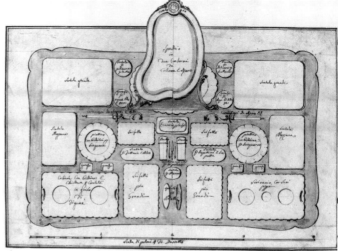

76

77

fireplace for Penrice Castle, the residence of Thomas Mansel Talbot. In the same year he cast the statue of *Saint John the Baptist* for the baptistry of St. John Lateran. The following year he cast scaled-down bronze versions of the *Apollo Belvedere* and the *Callipigian Venus*, for Madame du Barry in Paris (see cat. 80).

In the early 1770s he received even more orders from the Borghese family. Although the many items of gold- and silverware have been lost, the castings he made for the remodeled Palazzo Borghese have survived: the head of Bacchus for a marble herm, and bronze adornments for tables of precious marble. He also restored and modified a celebrated table supported by bronze figures designed by Alessandro Algardi.

Valadier's production during this decade was prolific and very varied, evidencing the Europe-wide reputation of a workshop employing large numbers of artisans skilled in different techniques, including marble and *pietra dura* work. In 1777 he completed the bronze and silver lamps for Lord Arundel that can still be seen at Wardour Castle, and in 1778 composed a centerpiece for a table that attracted a great deal of attention: it included scale models of ancient buildings and obelisks made of rare marbles, cups and sparkling embellishments in gilt-bronze. This piece was acquired by the Knight-Commander de Breteuil and, on his death, sold in Paris to the King of Spain (it is still in the Palacio Real in Madrid). Honored in 1779 with the title of Cavaliere by the Pope, who also appointed him superintendent of cameos in the papal museums (some of this collection is now in the Louvre), in that year he exhibited a scale replica of Trajan's Column (Schatzkammer, Munich) and four casts of ancient statues for the Comte d'Orsay. In 1781

he was working on two of the four cabinets for the Vatican Museo Profano, intended to display archaeological finds. In 1783 he completed a centerpiece (now in the Louvre) for the pope's nephew Duke Braschi, and was working on a grandiose silver dinner service for Prince Borghese, the appearance of which can be reconstructed from the many surviving workshop drawings. He committed suicide in 1785, which possibly suggests that, despite its extraordinary activity and prestigious commissions, his business had run into difficulties. The workshop nevertheless continued in production under his son Giuseppe. [RV]

BIBLIOGRAPHY González-Palacios 1997, *Valadier*, with previous bibliography

## 76
## Workshop of Luigi Valadier
### *Design for a Mass Card*

C. 1760
Pencil, pen, and brown ink with light blue wash on paper
19⅛″ × 25⅞″ (50 × 65.7 cm)
PROVENANCE Artemis Group, London
Philadelphia Museum of Art, Purchased with the J. Stogdell Stokes Fund

The Mass card rests on scroll feet with cherubs, supporting a frame with curved sides that widens out towards the top, and is surmounted by a broken pediment. Festooned cherubs uphold the swelling sides of the frame, while freestanding putti with palm leaves are seated on the reversed corbels on the top of the side pieces of the pediment, which rises in the middle to form an aedicule with the risen Christ in an oval at the center. At the base is another plaque depicting a pelican, a symbol of Christ.

There are various drawings from the workshop of Luigi Valadier and his son Giuseppe (mostly belonging to the Museo Municipale in Faenza and the Artemis Group in London) featuring designs for Mass cards, but until now only one of these has been identified with an actual surviving work—part of the liturgical equipment for the Borghese Chapel, which Prince Borghese ordered from Luigi Valadier in 1762 (González-Palacios 1997, *Valadier*, nos. 33–34).

This drawing is more akin to another sheet from the same collection, attributed to Giovanni Bettati (c. 1700–1777), featuring two designs for a Mass card, which has many similarities with the one displayed here (Winter 1991, fig. 4). Giovanni Bettati was a silversmith and ornament maker who must have had connections with Luigi Valadier (among the Valadiers' papers are some sixty sheets of drawings done by Bettati). He is also known to have acted as a consultant in various controversies surrounding the liturgical items made by the Roman silversmith Antonio Vendetti for the chapel of St. John the Baptist in the church of S. Roque in Lisbon, commissioned by John V. It is therefore interesting to compare this design with Bettati's drawings and the Mass cards made by Vendetti for the Lisbon chapel, which seem to have been composed to a similar architectural design, featuring a pediment, aedicule, and putti crowning a similar, albeit more rigid, flared structure (cat. 74). [RV]

## 77
## Luigi Valadier
### *Design for a Dressing Table Service*

1765–70
INSCRIPTION *Scala di palmi 4 di Passetto* (with various other inscriptions to indicate the objects)
Pen, brown ink, gray and light blue washes on paper
11⅞″ × 16⅛″ (30.3 × 40.9 cm)
EXHIBITIONS Florence and London 1991, cat. no. 81; Rome 1997, *Valadier*, cat. no. 73
BIBLIOGRAPHY González-Palacios 1993, fig. 418
Private collection

The scale at the bottom indicates that the longer sides of the dressing table, which is shown with rounded corners, are roughly three feet in length. The inscriptions are as follows: *Spechio in due contorni da calare e alzare* ("a mirror with two shapes of frame to be raised and lowered"—that is to say, the frame is effectively shown in two different forms and comes to be shaped on a piece of stuck-down paper, so it can be lifted); immediately to left and right are two *scatole p polvere p le mani* ("boxes for powder for the hands") and two *garafe p aque di odore* ("ewers for perfumed water") flanked by two *scatole grandi* ("large boxes"). Below these items are two *cornucopi da alzare e calare* ("chandeliers, which may be raised or lowered") and between them a *scatola e cuscino p le spille* ("pinbox and cushion"). On either side of the pinbox are two *scifetto* ("trays"), *scatole p fettucce e altro* ("boxes for ribbons and other items"), and a *scatola p scopettini e scopetta* ("box for brushes"), separated by two *stuccio* ("cases") and a *coltellino con altri p la polvere* ("small knife, with others, for powder"). In the bottom row, in the center, are two *scifetti più grandi* ("larger trays"), with between them a *scatola p*

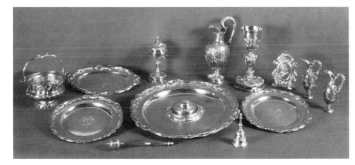

78

*mosconi* ("box for beauty spots") and two *spolette p nodetti* ("spools"). On either side is the circular shape of a *piattino con bicchiere p sciaquare* ("small plate with rinsing glass") and the rectangular shape of a *scatola mezzana* ("medium-sized box"). Below these are spaces for *garafe* ("ewers"). In the bottom left is a *scrivania con suoi pezzi* ("small desk and inkstand") and, in the bottom right, a *cabaré con bichiere e chicara per cocolata in guisa di digiuné* ("tray with glass and cup for chocolate").

The collection of drawings from the Valadier workshop also includes individual illustrations of the various types of object grouped together here. It is evident that, in the mid-eighteenth century, a sumptuous dressing table service of this kind comprised a wide range of items, more in number and variety than are found in comparable services from the Baroque period (see the description of the silver dressing table service owned by Maria Mancini, niece of Cardinal Mazarin, who in 1661 married Prince Colonna, in Eduard A. Safarik, *The Colonna Collection of Paintings: Inventories, 1611–1795* [Munich: K.G. Saur, 1996], p. 380). There is documentary evidence of a large service of this kind made by Luigi Valadier for Princess Chigi in 1767, costing the vast sum of more than 700 *scudi* (González-Palacios 1997, *Valadier*, p. 24). [RV]

## 78
## Luigi Valadier
### *Pontifical Service*

c. 1779

All items bear both stamps of Valadier
Silver-gilt

Two plates, diameter 10½" (26.5 cm); ewer, height 11⅞" (30 cm); salver, diameter 16½" (42 cm); salver, diameter 12¼" (32.5 cm); paten, diameter 3½" (9 cm); chalice, height 11¼" (28.5 cm); bell, height 4½" (11.5 cm); cruets, height 2⅜" (6 cm); stoup, height 4⅜" (11 cm); holy-water sprinkler, height 8⅞" (22.5 cm); pyx, height 8½" (21.5 cm); pax, height 6⅞" (17.5 cm)

BIBLIOGRAPHY Bulgari 1950–74 nos. 1055–56; Ruotolo, R. *Argenti in Basilicata.* Rome: Salerno, 1994, pp. 58–61; González-Palacios 1997, *Valadier*, cat. no. 33

Cattedrale di Muro Lucano, Tursi (Matera), Italy

This service is kept in a brass-studded black leather case with brass fittings, lined with blue velvet. Only recently identified by Renato Ruotolo, it is clearly one of the finest works by Luigi Valadier. The gilding is of excellent quality and is in perfect condition; each detail of the decoration is particularly fine, with motifs ranging from themes typical of Louis XVI, such as ribbons and garlands, to Rococo elements.

Drawings by Luigi Valadier in London and Faenza include several designs that are connected with this pontifical service. The drawings are not exactly preparatory studies for the pieces on display, but there are certain similarities. First and foremost, a sheet in Faenza, signed and dated Rome, 1779, shows a basin, ewer, spoon, and bell with religious motifs. The bowl and spoon bear little relation to the service from Muro Lucano, but the ewer—and the bell in particular—are almost identical. This discovery is important not only because it throws light on the techniques used by Valadier, but also because it helps to date these wonderful pieces. The drawing is detailed and complete, and though it was probably a design for another service, it must also have been used for the Muro Lucano pieces. Other drawings at the Pinacoteca Civica in Faenza show an oval and a circular salver for one set. The latter even has the same armorials, which appear on several of the other pieces in the service: the reed and leaf decorations of the border in exquisite Neoclassical style are the same in the beautifully executed works on a partially engraved ground. Even if these sheets at Faenza correspond exactly to the silver service, in other drawings in London and in a private collection the model appears less well defined. One of these is a preliminary study for the cruets, and in part, for the ewer.

Another sheet is a preliminary study for the stoup, and is perhaps even more beautiful than the end product; the decoration of reeds in the central panel is more detailed and the shape of the handle more naturalistic. It appears highly likely that several studies were made for the final version, and may still exist today, in some

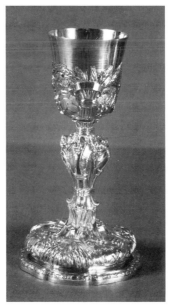

78 (chalice)

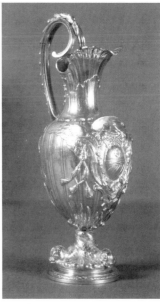

78 (ewer)

unknown location (for example, there are two sheets at Wardour containing models that are very reminiscent of the Muro Lucano ewer and basin).

There is some doubt whether all the components of the service can be dated to the same year. As the craftsmanship is of outstanding quality and precision, it is somewhat surprising that there should be a lack of consistency in some of the less important motifs, which should be identical throughout. For example, while the bases of the pyx and chalice are identical (in various sections with garlands of vegetation in the centre of each section), the bases of the pax and stoup are different; moreover, the cruets have yet another decorative motif of pointed leaves, a theme that also appears on the central section of the bell. This may suggest that the items were made at different times, for reasons that have not yet been established. The chalice, pax, and pyx seem to be slightly earlier than the bell and ewer. However, these factors are not necessarily indicative, as chronology and style are not always consistent in Luigi Valadier's work.

Ruotolo has established that this princely set belonged to Cardinal Domenico Orsini, who (as Moroni reveals in his biography [Moroni 1840–61, vol. 49, pp. 171–72]) was the grand-nephew of Pope Benedict XIII and was born in Naples in 1719 into the family of the Dukes of Gravina. Cardinal Orsini was awarded the order of San Gennaro, created by Charles of Bourbon; after the death of his wife (a member of the Odescalchi family), Orsini was made a cardinal deacon by Benedict XIV in 1743, as a tribute to Benedict XIII, who had been his protector and made him a cardinal. Cardinal Orsini embarked on a daz-

zling career, receiving all kinds of honors. He was always a favorite of his sovereign, who became in 1759 Charles III of Spain, and of the minister Tanucci and of the new king of Naples, the very young Ferdinand IV, for whom he acted as ambassador in Rome. His role was instrumental in several conclaves, particularly in 1769, when Clement XIV was made pope. Orsini died in the conclave of 1789. As cardinal deacon, he was not allowed to celebrate Mass, and it is not known when he was ordained: this date would certainly be of assistance in determining exactly when the Muro Lucano service was made. Also significant for the dating is the fact that the Orsini arms in these pieces are surmounted by the canopy and keys of Saint Peter, symbols of the *sede vacante* or interregnum, with the cross of the order of San Gennaro below. [AGP]

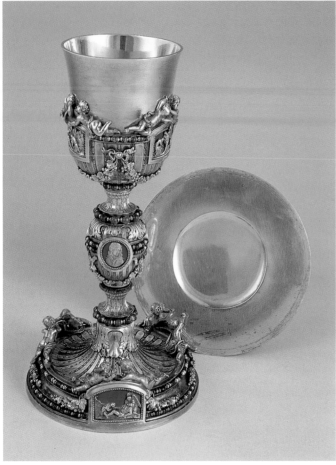

79

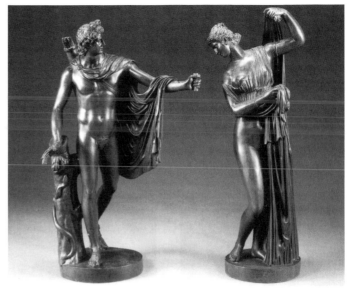

80

## GIUSEPPE VALADIER

ROME 1762–1839 ROME
*For biography see Architecture section*

### 79
## Luigi Valadier and/or Giuseppe Valadier
*Chalice and Paten*

c. 1785–90
Silver-gilt, lapis lazuli, and enamel
Chalice: height 9¾″ (25 cm); paten:
diameter 5⅞″ (14.8 cm)
PROVENANCE Michael Poniatowski (?),
Countess Tyskiewicz, Prince Talleyrand
EXHIBITIONS Paris 1994, cat. no. 12; Rome
1997, *Valadier*, cat. no. 38
BIBLIOGRAPHY Bottineau, Yves. *Musée de
Louvre et Musée de Cluny: Catalogue de
l'orfèvrerie du XVIIe, du XVIIIe, et du XIX siècle.*
Paris: Editions des Musées Nationaux, 1958,
no. 347; Busiri Vici 1972, *Poniatowski*, pl. 39;
González-Palacios 1984, fig. 236
Musée du Louvre, Paris, Département des
Objets d'art

The chalice stands on a circular base,
the sides of which are formed of a
concave molding between two rows
of lapis lazuli beads separated by
gilded elements. Around the base are
three small plaques with shallow
archer and translucent dark blue

enamel backgrounds, against which
are placed bas-reliefs—the Sermon in
the Garden, the Meeting with Veronica,
and the Lament over the Dead Christ—
surmounted by pairs of putti. The
stem is composed of an oval knop
between two narrowing bottlenecks.
The different sections are separated by
further rows of beading. On the knop,
plaques depicting Christ, the Virgin,
and Saint John on enamel backgrounds
are accompanied by vine leaves. The
cup is similarly decorated with fes-
toons. The upper part is smooth, while
the lower part is adorned with plaques
similar to those of the base, sur-
mounted by fluttering putti. The reliefs
depict Christ Washing the Disciples'
Feet, the Sacrifice of Isaac, and the
Supper at Emmaus. The piece bears
Luigi Valadier's stamp.

The only clue to the history of this
sacred artifact, traditionally known as
the Poniatowski Chalice, is a card that
accompanied it when it was donated
to the Louvre in 1930. The card states
that the piece was presented to Prince
Joseph Poniatowski, archbishop of
Kraków and primate of Poland, by
Pius VI, and subsequently passed to
Stanislas Poniatowski, King of Poland.
This statement contains an error, in
that the primate of Poland was
Michael Poniatowski, not Joseph (it is

worth adding that Michael was arch-
bishop of Gniezno, not Kraków,
though he was responsible for the
affairs of the Kraków diocese during
the illness of the incumbent).

Michael Poniatowski (1736–1794),
younger brother of the King of Poland,
visited Rome in 1754, became primate
of Poland in 1784, and was appointed
archbishop of Gniezno in February
1785. In 1789 he made another journey
to Italy, arriving in Rome in December
and staying there for a time before
moving on to Naples. Chracas's *Diario
Ordinario* for February 20, 1790 (n. 1580,
p. 15), reports his arrival in the city and
records some of his doings, including
visits to the Vatican Library and the
Museo Pio-Clementino. He stayed
until the following May.

Assuming that the chalice did in fact
belong to Michael Poniatowski, it is
impossible to say at present whether it
was given to him in Warsaw, when he
was appointed primate in 1784, when
he was made archbishop in 1785, or
whether he received it during his visit
to Rome in February–May 1790. In the
latter case, the chalice would have
been made by Giuseppe Valadier, who
had been running his father's work-
shop for the previous five years and
continued to use his father's silver-
smith's stamp.

The chalice should be compared
with a drawing from the Valadier
workshop papers (the part of the col-
lection kept at the Museo Civico in
Faenza), which exhibits similar design
features, in particular the bas-relief
medallions. Another drawing from the
collection, now in London, depicts a
ciborium with base and cover adorned
with circular bas-relief plaques
flanked by pairs of putti. [RV]

### 80
## Luigi Valadier and/or Giuseppe Valadier
*Apollo Belvedere, Callipigian Venus*

Late eighteenth century
Patinated bronze
Height *Apollo*: 40¼″ (103.5 cm);
*Venus*: 39¾″ (101 cm)
Private collection

These scaled-down replicas of famous
classical sculptures (the *Apollo* stands
in the Belvedere Courtyard in the
Vatican, hence its name, while the
Callipigian *Venus* was originally in the
Farnese collection in Rome and is now
in the Museo Nazionale in Naples)
were cast in Luigi Valadier's workshop
in Rome. Valadier made a number of
copies of both works. For example, a
version of the *Venus*, smaller in size
than this and gilded, fashioned in 1773
and now in the Metropolitan Museum
in New York, adorns a candelabrum
from the Palazzo Borghese (González-
Palacios 1997, *Valadier*, no. 27), while a
full-size version of the *Apollo* (there-
fore much larger than the one exhib-
ited here) was made in 1780 for the
Comte d'Orsay (now in the Musée du
Louvre, Paris).

After Luigi Valadier's death, the
workshop was run by his son Giuseppe,
who in 1810 drew up a *registro* of his
entire stock. The *Apollo* and the *Venus*
are both mentioned several times in
this long document, as he owned
models and finished versions of several
sizes, made of various materials.

The pieces exhibited here are almost
identical to a pair in the Louvre, which
were made by Luigi Valadier in 1773.
The Louvre bronzes (González-
Palacios 1997, *Valadier*, no. 48) were

81

acquired by Louis XV's favorite, Madame du Barry, through the architect Charles de Wailly in Rome. The pieces on display here may be slightly later in date, toward the end of the eighteenth century, but the magnificent patinas and the excellence of the castings are indicators that they also came from the Valadier workshop. Note the correction on the left side of the *Apollo*, intended to enhance the surface of the bronze, which dates from the period when the statuette was made. [AGP]

## 81
### Pietro Scirman
### *Chalice with Leather Case*

1772–80?
Chased, embossed, and gilded silver; leather case with gold tooling
Height 10⅞″ (27.5 cm); 12⅝″ (32 cm) with case
PROVENANCE  Cardinal Pietro Pamphili; Schwarzenberg princes
Private collection

The base, the outline of which is formed of complex curves, has a stepped profile broken by cherubs shown in relief. Other cherubs shown in full relief rest between scrolls that stand out against an engraved background and contain symbols of the Passion alternating with bands of vine tendrils. The stem is divided into sec-tions, with three sides defined by architectural elements and additional cherubs, shells, and other symbols alluding to Christ. The upper part of the chalice is plain and supported by a cup ornamented like the base. On the underside of the support is an engrav-ing of the Pamphili family coat of arms with a cardinal's hat. The leather case is tooled in gold; the inside is lined in light blue velvet with narrow golden braid. It bears a heavy S-shaped mark and the stamp of the city of Rome.

The craftsman's mark affixed on the chalice appears to identify it as work of Pietro Scirman, a silversmith active in Rome who became licensed to practice as goldsmith in 1772 (Bulgari 1958–74, vol. 2, p. 390). At that time the only cardinal who could wear the Pamphili arms was Pietro Colonna, son of the prince of the same name, but who received the Pamphili prelature that had been established in his family since the preceding century (Moroni 1840–61, vol. 14, p. 309). Born in 1723, he became cardinal under Clement XIII in 1766 and died in 1780. This exceptional work of craftsman-ship was thus probably executed between 1772 and the date of the car-dinal's death. It still displays all the stylistic characteristics of taste typical of the height of the eighteenth century and is made with a delicate, refined engraving indicative of great skill. Works of this type often continued to illustrate—in the early years of the development of Neoclassical motifs—

a certain disposition towards lavish, profuse forms. Two examples that can be dated to the 1770s include a chalice by Bartolomeo Boroni in the basilica of S. Paolo fuori le Mura (*Tesori d'arte* 1975, no. 223), and one in Forlì Cathedral, made in Rome by Antonio Vendetti around 1765 (Franco Faranda, *Argentieri e argenteria sacra in Romagna: dal medioevo al XVIII secolo* [Rimini, Italy: Luisè, 1990], no. 132). The latter example displays the same formal arrangement as the Cardinal Pamphili chalice. [RV]

## VINCENZO COACI
### MONTALBODDO 1756–1794 ROME

A native of a village near Senigallia in the Marches, Vincenzo Coaci is docu-mented in Rome in 1782. Several con-temporary sources record that he was also active in Luigi Valadier's work-shop. Disputes with the Roman gold-smiths' guild, which judged his silversmithing activities to be unlawful, were resolved in 1783 with the granting of a master's certificate or *patente*. Little is known about his work, except for the few pieces of information reported by Bulgari regarding disputes with the Università degli Argentieri and one of his projects to reform the system of refining gold and silver. It seems that Coaci's son Achille carried on the business, after Vincenzo's rather pre-mature death, in a workshop near the Palazzo Ercolani; the Ercolani family had protected and supported Vincenzo in his youth.

Among Vincenzo Coaci's known works is a chalice in the treasury of the basilica of S. Maria Maggiore, with putti executed in the round on the base and a stem in the shape of a cir-cular small temple. This is fairly similar to one kept in the treasury of St. Peter's that is said to have been the gift of the Marchese Ercolani to Pope Pius VII, as well as to another in Ravenna Cathedral. [RV]

BIBLIOGRAPHY  Bulgari 1958–74, vol. 1, p. 299; Palazzo Bracshi, Rome. *Argenti romani di tre secoli nelle raccolte private.* Rome: De Luca, 1970, pp. 23, 24; *Tesori d'arte* 1975, p. 90; Faranda, Franco. *Argentieri e argenteria sacra in Romagna: dal medioevo al XVIII secolo.* Rimini, Italy: Luisè, 1990, p. 234

## 82
### Vincenzo Coaci
### *Inkstand in the Form of the Quirinal Monument, with Leather Case*

1792
INSCRIPTIONS  *Vincentis Coacius fecit Roma 1792* and *Vincenco Coaci Argentiere*
Silver, silver-gilt, lapis lazuli, and marble; leather case with gold tooling
26⅛″ × 20½″ ×  14¾″ (67.9 × 52.1 × 37.5 cm)
EXHIBITION  London 1972, cat. no. 1753
BIBLIOGRAPHY  Parsons 1969 (with previous bibliography)
The Minneapolis Institute of Arts, Gift of The Morse Foundation

This group of the Quirinal Monument on a base supported by sphinxes stands on a plinth supported with foliar feet, garlands of pearls, and a panoply at the front. One of the hidden drawers contains trompe l'oeil engravings of Coaci's visiting card, an archer from a print by Salvator Rosa, a musical score, and a scene showing a *Rosone Antico nel Foro di Nerva*. The tooled leather case is in the form of a building with ramparts and crenel-lated domes, with a column in the center.

This extraordinary object is a reduced-scale version in precious materials of the obelisk erected in front of the Palazzo del Quirinale by the architect Giovanni Antinori between the two colossal statues of the Dioscuri, which had been stand-ing on the hill for centuries. The obelisk came from the Mausoleum of Augustus, near the Tiber, and was taken to the papal palace on the orders of Pius VI. Antinori made some preliminary designs in 1782, while the stonecutter Giuseppe Giovannelli completed the necessary restoration work. In 1786, after the giant statues had been placed in a more suitable position on either side of the ancient Egyptian obelisk, the work was almost complete, though the large basin in oriental granite from the Campo Vaccino (which figured in Antinori's design) was not moved there until 1818 by the architect Raffaele Stern (D'Onofrio 1965, pp. 256–67, with pre-vious bibliography).

A dispatch sent on December 8, 1787, by the minister of Lucca at the Holy See, Lorenzo Prospero Bottini, contains a description of a work which may be the one exhibited here:

The silversmith Vincenzo Coaci … has completed by order from the Marchese Ercolani a superb inkstand, presented to His Holiness without the name of the donor being known. This silver object represents the new obelisk and its giant statues,

horses, fountain and other details at the Quirinal, on the same large scale as the plaster model … inside the base are … drawers for writing materials, and simply by touching a lion's head the two horses return to their original position. The whole work is executed with great precision and skill and its value is enhanced by the gilding and base in lapis lazuli and the decoration. (Giovanni Sforza, "Episodi della storia di Roma nel secolo XVIII," *Archivio Storico Italiano*, 4th ser., vol. 20, no. 60 [1887], p. 426)

However, contrary to what has been written by modern scholarship, the inkstand was given to Pope Pius VI not by the Marchese Ercolani but by an anonymous donor not mentioned in Bottini's dispatch. Ercolani was a protector and patron of Vincenzo Coaci, who mentioned him in his will and inventory. Bottini's letter seems to imply that Ercolani was not the donor, merely the agent for another party.

On April 14, 1792, in his *Diario Ordinario*, Chracas reports that Vincenzo Coaci had finished a work with (another) reduction of the Montecavallo obelisk "made entirely of silver, many parts gilded, in different colors, with a base of lapis lazuli, the whole work being an exact scale replica of the original." In this version it was also possible to move the horses by pressing a lion's head, and the base concealed different sections to contain writing implements. On one of the two pull-out shelves were seen decorative papers engraved in the silver. Chracas added that there were "four sphinxes on the base … each with a vase of flowers on its head and when the vase is removed the sphinxes can be used as candlesticks." Another mechanism was set in motion by a spring causing two flies to move round the inkwell.

On publishing news of this object when it was acquired by the Museum of Minneapolis, Merribel Parsons mentioned a chronological discrepancy between the two descriptions of 1787 and 1792, but thought they referred to the same object. However, the 1787 description does not mention the sphinx "candlesticks" nor the fine engravings that decorate the drawer, only stating that the inkstand was given to Pius VI, which seems to correspond to the date when the obelisk was completed in 1786. An earlier dispatch from Bottini (Sforza, p. 415 see above) points out that on December 31, 1785, Antinori had presented to a group of cardinals and ambassadors "a model in scagliola of the obelisk to be erected in the Piazza del Quirinale between two horses placed at an angle

82 (case)

with adjacent fountains, still to be built. A similar model, already approved by His Holiness, could previously be seen in his antechamber." It is hardly surprising that some rich man would want to replace the stucco or scagliola model in the pope's apartments with a similar but far more precious version.

The report by Chracas of 1792 does not mention whether the inkstand, which is described in minute detail and the date of which is identical to the one exhibited here, was ever given to the pope. Thus, it seems likely that two inkstands were made that were very similar but probably not identical. This new theory appears credible because neither the Minneapolis masterpiece nor its magnificent case bears

any reference to Pius VI (as would be usual for such an important gift) or the papal arms (only at the top of the obelisk is the pope's heraldic device visible; it corresponds, however, to that represented on the actual ancient obelisk). [AGP]

## GIUSEPPE BOSCHI
### ROME C. 1760–AFTER 1821 ROME

A founder and bronzeworker, Boschi is first recorded in 1783, when he won a prize at the Accademia di S. Luca for a relief of *Abraham with Three Angels*. Roman sources record his work in 1786 in the parish of S. Andrea delle Fratte, in which he is described as a sculptor aged twenty-six. This period

is presumably when he was making his first copies of ancient statues, which was the practice in the most famous studios of sculptors in bronze, such as those of Valadier, Righetti, and the Zoffoli. In a letter from Charles H. Tatham to Henry Holland (architect to the Prince of Wales) dated Rome July 1795, the writer states that Boschi was being paid less for his figures and candelabra (cat. 83) than Righetti and Valadier, though in support of the quality of Boschi's work he quotes testimonials by Angelika Kauffmann, Antonio Canova, Ennio Quirino Visconti, and other influential figures in the art world. Also mentioned is a pendulum clock for Lady Spencer, which has only recently been identified (Althorp, Earl Spencer Collection).

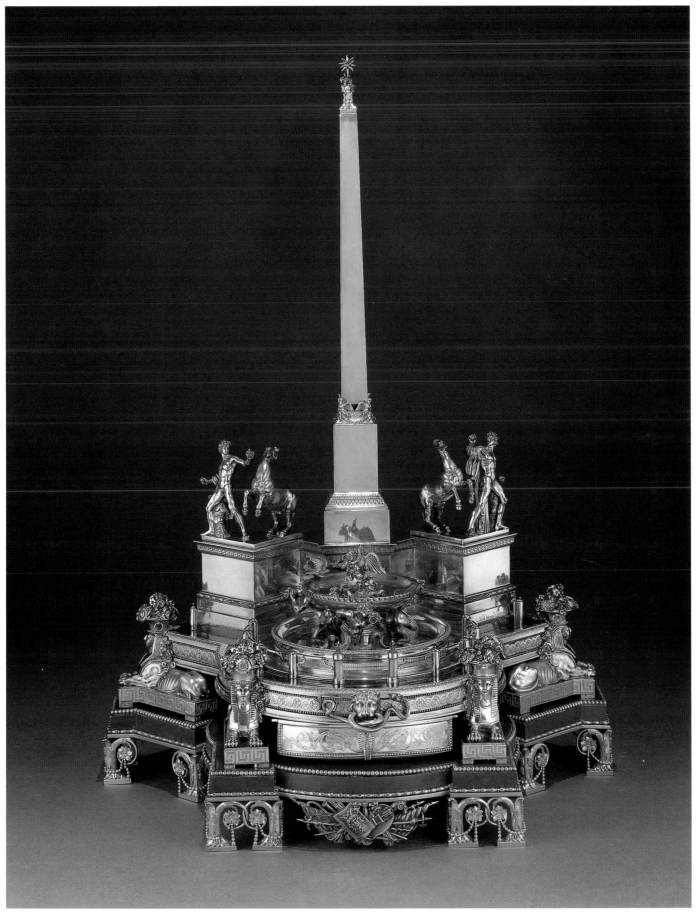

82 (inkstand)

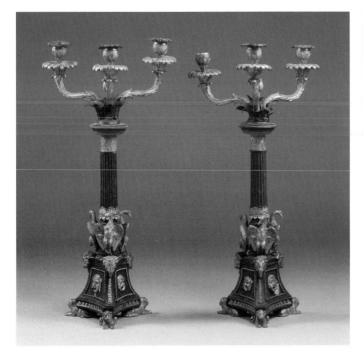

83

At the same time Boschi was working as a goldsmith, though he did not have a license until 1806. In 1805 he cast the bronzes for a table centerpiece commissioned by the Spanish ambassador in Rome after models by the Catalan sculptor Damià Campeny (Galleria Nazionale, Parma). Boschi married a sister of Vincenzo Pacetti, who enabled him in 1805 to become a member of the Congregazione dei Virtuosi al Pantheon, and mentioned him often in his unpublished journal. In 1808 he made a large-scale copy in bronze of Antonio Canova's *Hebe*. [RV]

BIBLIOGRAPHY Honour, Hugh. "Boschi, Giuseppe." In DBI, vol. 13, p. 167 (with previous bibliography); González-Palacios 1993, pp. 318–19; Goodison, Nicholas. "Minerva and Pupils." *Furniture History*, vol. 29 (1993), pp. 144–46

## 83
## Giuseppe Boschi
### *Pair of Candelabra*

Late eighteenth century
Marble, patinated bronze, and partly gilded bronze
Height 20¼" (51.5 cm)
EXHIBITION Naples, Museo di Capodimonte a Palazzo Reale. *Civiltà dell'Ottocento*. 1997, cat. no. 6.115 (wrongly attributed to Pietro Mertz)
BIBLIOGRAPHY González-Palacios 1984, p. 141, fig. 283 (for the identical pair in the Palazzo Pitti, Florence)
Museo di Capodimonte, Naples

Each candelabrum has a three-sided base supported by lions with theatrical masks in the central panels, the base culminating in rams' heads. From it

rises the fluted stone stem flanked at the base by three storks. From it emerge three arms with foliar motifs and a sconce in the form of a large bud.

These two candelabra (from a set of four and almost identical to another pair at the Palazzo Pitti supported by sphinxes) are by the Roman bronzeworker and goldsmith Giuseppe Boschi. They match one of his designs (and even more so the corrected version of this design by Charles Heathcote Tatham, agent to the Prince of Wales in Rome). Boschi's imaginative and free design was skillfully adapted by Tatham, who commissioned four such pieces on behalf of the prince, a fact revealed in a letter he wrote on July 10, 1795, to Henry Holland, architect to the future George IV (this letter and the two designs are in the Victoria and Albert Museum collections, under D 1498–1500–1898). Referring to the designs in his letter, Tatham mentions that "the candelabra were obtained from Giuseppe Boschi, an obscure Artist here, whose designs as well as prices, both for merit and reasonable demand induced me to procure them." Tatham points out that the estimates he requested from the more famous bronzeworkers, Righetti and Valadier, were significantly higher than Boschi's figure:

the extraordinary difference in the estimates and the only manner in which I can account for it, is that the latter is himself the Artist, and not a principal, which inables him to afford them as specified, that is as much cheaper. You must not

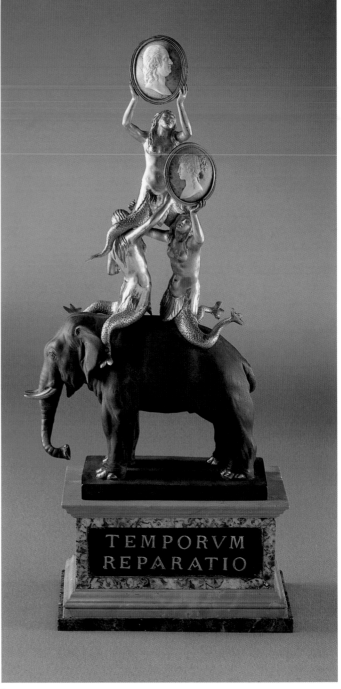

84

thereby conceive that the work of G. Boschi will be proportionably defective, for, from the Authority of Madame Angelica [Kauffmann], Zucchi her husband, Canova, Visconti & Bonomi, I have every reason to assure you is not the case.

Tatham provided assurances that the candelabra ("the gilding with the best *sicane* … in the manner of the french, the bronze … in the best colour") would be ready by March 15, 1796, and adds: "The Drawings and models have been studied with great

care and attention, the Candelabra in particular closely copied in every part from the antique." The architect is referring here to a marble candelabrum, a composite work completed by Giovanni Battista Piranesi, who sold it to Sir Roger Newdigate (now in the Ashmolean Museum in Oxford; engraved in *Vasi, candelabri, cippi, sarcofagi* [Rome, 1778]).

Nothing is known of the fate of the candelabra mentioned by Tatham. However, it is curious that the Museo di Capodimonte actually has four of them, though their provenance remains a mystery. [AGP]

## CARLO ALBACINI
1735–1813?
*For biography see Sculpture section*

## 84
## Workshop of Carlo Albacini
*Elephant*

c. 1805
Patinated and gilded bronze,
colored marbles
Height 22⅞″ (58 cm)
EXHIBITION  Naples, 1980, cat. no. 543
BIBLIOGRAPHY  González-Palacios 1993,
pp. 324–31
Kunsthistorisches Museum, Vienna,
Kunstkammer

An elephant bearing a group of three
sirens, which are holding oval cameos
depicting members of the Neapolitan
royal family, stands on a high plinth of
*alabastro fiorito orientale a occhio* with
borders of *verde antico* and *giallo antico*
bearing inscriptions on the sides. This
curious object is part of a *deser* (or
table centerpiece) made about 1805
at the workshop of Carlo Albacini in
Rome for Maria Carolina of Austria,
Queen of Naples and wife of
Ferdinand IV of Bourbon. The com-
plete work comprises many different
pieces of colored marble from excava-
tions, bronze, and other materials. It
stands on a mosaic plinth (19 ½″ ×
33 ⅜″; 49.7 × 85.5 cm) and has an exact
replica in miniature of the three Greek
temples at Paestum at the center. The
work was conducted under the watch-
ful eye of Cavaliere Domenico Venuti,
at a time when the erudite Tuscan
archaeologist had been exiled from
the court in Naples, where he had
directed the royal porcelain factory
for many years. Venuti also edited the
slim volume *I tempj di Pesto deser ese-
guito d'ordine di Sua Maestà la Regina delle
Due Sicilie dal Cav. Domenico Venuti* for
the publisher Pagliarini in Rome in
1805. It is the only surviving source
of information about this magnificent
work of art, except for a long article by
Giuseppe Guattani published in 1806
in the famous Roman art yearbook of
the time, the *Memorie Enciclopediche
Romane*. Guattani gives a detailed
description of the elephants.

> The most important part of the
> decoration, the most poetic and
> allusive, is a bizarre notion of
> trophies … two elephants (an
> animal often seen on medallions
> of Paestum) … each bears a
> group of three Neapolitan sirens,
> seated and intertwined, holding
> up cameos with portraits of the
> Neapolitan royal family. The
> panels on the base bear the fol-
> lowing inscription in gold on
> silver: TEMPORUM REPARATIO /

85 (ducal hat)

> PROVIDENTIA AUGUSTA / SALUS
> PVBLICA / HILARITAS VNIVERSA.
> The models of the trophies are
> the accomplished work of Mr
> Filippo Albacini, a young and
> talented sculptor.

Filippo Albacini was Carlo's son.
Domenico Venuti's son Ludovico, an
artist of no particular talent, also con-
tributed some designs of urns for the
centerpiece. González-Palacios has
identified a sketch for the whole piece
in the Gabinetto dei Disegni e Stampe
at the Museo Nazionale di
Capodimonte in Naples. It is possible
that the drawing in color is the work
of the younger Venuti, who was devel-
oping the ideas of his father and of
Queen Maria Carolina. The original
idea for the work is attributed to the
queen, possibly in courtly deference.

The beautiful cameo portraits of
members of the royal family of Naples
borne by sirens are not documented.
However, they may be the work of the
renowned stone engraver Filippo
Rega, who worked for many years in
Naples in the royal *pietre dure* work-
shop, or of Teresa Talani, who has left
several signed works of this type.
Early in 1806 the Bourbons were
forced to leave Naples and take refuge
in Sicily when the city was invaded by
the French. There is no record of the
date when the centerpiece (which was
granted an export license from Rome
by Antonio Canova as papal inspector
of fine arts on January 19, 1805)
reached the south of Italy, if indeed it
ever did, since by 1808 it is documented
in Vienna as a gift from the court of
Naples. [AGP]

## 85
## Francesco de Martinis, Flavio Sirletti, Francesco Banchieri, Sebastiano Porena, Francesco Ambra, Giovanni Battista Moranti, and others
*Ducal Hat, Belt, Scabbard, and Case*

1725
Hat: leather, silk, applied pearls and gar-
nets; belt: silk embroidered gilt and silver-
gilt thread, silk appliqué, buckle in silver-
gilt; scabbard: wood, silk with silver
thread, enameled gold; case: leather with
gold tooling
Hat: 11¾″ (30 cm); belt: 70⅞″ × 2¾″
(180 × 7 cm); scabbard: 42 ¼″ (107.5 cm)
BIBLIOGRAPHY  Haenel, E. *Kostbare Waffen
aus der Dresdener Rüstkammer*. Leipzig,
Germany: Hiersemann, 1923, pl. 66;
Thurman 1975, no. 112; Bäumel 1986,
pp. 133–39; Bäumel 1990; *Pod jedna korona:
Kultura i sztuka w czasach unii polsko-saskiej*.
Warsaw: Zamek Królewski w Warszawie,
1997, cat. no. 27
Staatliche Kunstsammlungen Dresden,
Rüstkammer

During the mid-nineteenth century
the scholar Gaetano Moroni composed
an impressive series of volumes on the
history, personalities, and every other
aspect of the Catholic Church. In this
work he describes in great detail the
meaning and history of the papal
sword, or *stocco*, a weapon consecrated
by the pope in a solemn ceremony cel-
ebrated on the night or morning of
the Nativity. It was then sent to princes
as a gesture of thanks or to exhort them
to defend the Church (*Dizionario di*

*erudizione storico-ecclesiastico* [Venice,
1854], vol. 70, pp. 39–61). Together with
the Golden Rose, which was usually
sent to queens or cities, the sword was
the greatest expression of papal
benevolence. It was an especially valu-
able and highly regarded article that
involved the work of numerous crafts-
men because of the complexity and
richness of its composition. The sword,
which was furnished with a sheath
and belt and enclosed in a bag, was
accompanied by a hat with tails. This
was referred to as the *berrettone ducale*,
sometimes also known as a *pileus* or
*morione* and bearing an embroidered
dove alluding to the Holy Spirit. The
coat of arms of the pope presenting
the sword was represented in many
places on the weapon itself and its fin-
ishings. With the Dresden scabbard,
the gold and silver thread embroidery,
silver finishings of the belt, and the
leather case containing the hat all bear
the coat of arms of Benedict XIII
Orsini. The inscription *Benedictus XIII
Pont: Max:* was engraved on the blade,
with the inscription *An: MDCCXXV.
Pontif. Sui anno II* on the back. As
described at length by Jutta Bäumel,
this rare ensemble was sent to Warsaw
in August 1726 by Benedict XIII to the
heir apparent of Saxony and Poland,
Frederick Augustus (reigned
1733–1763), delivered by the legate
Vincenzo Santini. A report from the
same year mentions the event, and
even Moroni, in the previously cited
work, recalls how the same pope had
earlier presented a sword to the Grand
Master of Malta, and in 1726 he also
presented a sword to the Prince of
Saxony, who in 1717 had made public
his own conversion to Catholicism
five years before.

85 (detail of scabbard)

85 (detail of belt)

In order to understand the construction stages of this unique ensemble today, it is essential to bear in mind that the sword and Golden Rose were usually made each year, but not necessarily sent after being completed. Frequently, these items were sent after having been made several years earlier. Among the many documents found by the author is a bill from the *spadaro* (sword maker) Lorenzo Boccalari, who on February 18, 1725, removed from a blade the coat of arms of the pope who had died two years previously (Innocent XIII Conti, whose coat of arms bears an eagle). The bill specifies that the craftsman "removed two eagles from a broad blade and removed the name of Innocent and made there the name of His Holiness" (Rome, Archivio di Stato, Camerale 1, Giustificazioni di Tesoreria, b. 500/3).

A few months later, on December 20, 1725, the silversmith Francesco de Martinis (1661–1740) presented the bill for "the sword lining, guard and buckle, and ferrule" (later specifying that the design was included). On February 11, 1726 (ivi), the work was assessed by another well-known silversmith, Stefano Bartalesi. The number of craftsmen involved in the manufacture of this type of object means that the records branch off in many directions, as well as being incomplete, but De Martinis's involvement in the Dresden sword is borne out by the fact that it was inspected only in February 1726. Another invoice from the hat maker Sebastiano Porena was even more explicit. Among the orders sent in 1725 is the following:

You will make a hat of Spanish wool, called the Pileus, which you will cover in rose-colored velvet to be delivered to you by Biagio Chelucci, Merchant, fabric weaver of the above-mentioned Holy Palace, with flaps, a small belt, and embroidered

tails, which you will line inside with a crimson light silk fabric, which will be delivered to you … by the above-mentioned Merchant … you will trim … in narrow gold braid which will be delivered to you by the Lacemaker of the Palace … for the sword that Holiness wants to present to the Grand Master of Malta … December 20, 1725.

However, on the back of the form, a note dated April 2, 1726, indicates this work's intended fate: "I … Wardrobe Keeper of His Holiness hereby bear witness that the above-mentioned was made … and consecrated by His Holiness, was placed in the wardrobe in place of that given last year by His Holiness to the Grand Master of Malta" (ivi, b. 507/17, followed by the detailed bill of manufacture). Therefore, an old sword, perhaps that on which the papal coat of arms was changed, had been sent to Malta (the expenses for that journey date back to February 1725), and the one finished recently was in the storage rooms of the papal palace in time to be sent later to Warsaw.

Other bills partially make up the long list of names of those involved in the undertaking. The lacemaker (*trinarolo*) alluded to by Porena was

Francesco Antonio Fedele (or Fedeli), who on February 26, 1725, provided the crimson silk ribbon and two bows "to tie together the sword bag and hat" (ivi, b. 509/18), and subsequently pale crimson velvet and light silk fabric "for the cover of the scabbard" (November 26). On December 14, still to Porena, he delivers "narrow braid … gold fringe … to attach it to the tails" for the hat (ivi, b. 502/8). Fedele's bills also show the names of the upholsterers and tailors (*banderari*) who made sacred vestments, accoutrements for worship and anything else possibly requiring the use of textiles. On October 27, 1725, he provided Filippo Ambra and Giovanni Battista Moranti (or Morandi) with crimson light silk fabric for the lining of the bag and scabbard, along with velvet and taffeta for other related pieces (ivi, b. 503/3). Finally, on November 29, 1725, he provided "gold fringe … to decorate the sword belt" (ivi, b. 502/8). On November 26, Morandi and Ambra both presented their bill for the bag ("a bag for the sword, of crimson light silk fabric lined with red lace … the sword sheath lined with crimson light silk fabric … the belt lined with embroidered satin for the above-mentioned sword … decorated here and there with Venetian gold lace trimming," ivi, b.509/18).

The costly finishings of the ensemble even include enamels on gold set on the hilt of the blade and pearls embroidered in the shape of a dove. Flavio Sirletti (1683–1737), a renowned goldsmith and gemstone engraver, contributed to these details. His itemized bill specifies:

On December 20, 1725, for the manufacture of four large coats of arms, the two largest placed on the pommel of the sword, enameled in gold of various colors, with the depiction of the office of N.S. … for the introduction of gold in the largest coat of arms of the sword pommel … for the introduction of gold in the coat of arms for the hat … for the purchase of forty-four pearls, and delivery to the embroiderer for the sword hat.

In addition, on the back it is specified that in this instance, sword and hat were transferred to the wardrobe in March 1726 (ivi, b. 502/3).

The embroiderers' names to which the goldsmith alludes are indicated in a bill from the previously mentioned silk weaver, Chelucci. On November 26 he provided the embroiderers with "pale crimson rose-colored velvet" to make the flaps and tails of the hat. The craftsman signing the delivery receipt is Francesco Banchieri, although from other bills it is known that these artisans formed part of a group of palace embroiderers (referred to elsewhere as the suppliers). This group was composed of Stefano Gui, Marcantonio de Romanis, Giovan Battista Salandra, and Giuliano Saturni, the last two well known for taking part in the manufacture of furnishings intended for Lisbon.

Immediately afterwards, Chelucci provided the box maker Carlo Antonio Taddini with the taffeta to line the box containing the entire ensemble (ivi, b. 503/3). Although it is evident that not all those involved were mentioned, it is likely that the same embroiderers and upholsterers took part in the set seen here. Finally, among the suppliers to Benedict XIII, mention should be made of the wood-carver Giovanni Tommaso Corsini. In 1724 he worked jointly with the silversmith De Martinis, providing him with designs for a frame and folding stool in silver.

Immediately after finishing this work, all the craftsmen mentioned here became involved in the creation of a new sword, the fate of which remains unknown. In addition to the swords made in 1726 and 1727, Francesco de Martinis added the finishing touches to a case sent by the pope to the empress "with the root of Jansen," and in 1728 made the Golden Rose for Urbino Cathedral. [RV]

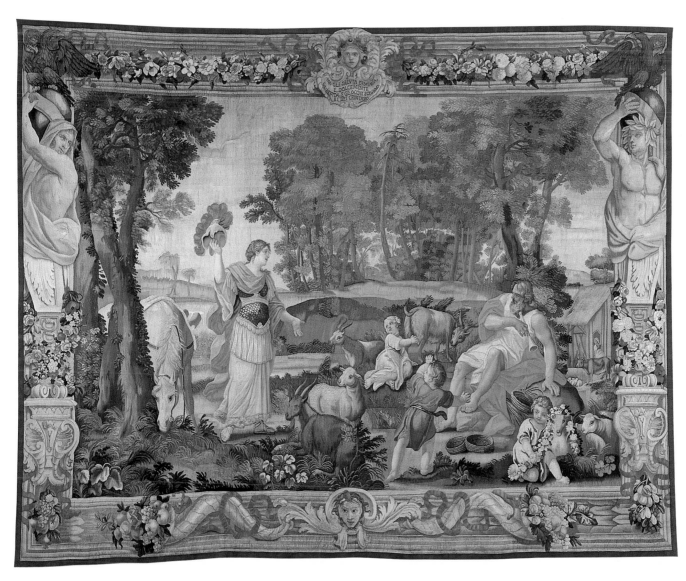

86

## 86

## San Michele Manufactory
### *Erminia and the Shepherd*

1733

Designed by Domenico Paradisi between 1689 and 1693; one from the original set of fifteen depicting scenes from *Gerusalemme Liberata*

Wool and silk

11′ 11″ × 15′ (362.8 × 456.7 cm)

PROVENANCE  Possibly acquired in Italy by the 10th Duke of Hamilton; though not included in the 1825 inventory of Hamilton Palace, possibly among the "Pieces of fine large Tapestry Work" listed in additions made between 1835 and 1840; seen by Dr. Waagen at Hamilton Palace, 1850; sold by the 12th Duke of Hamilton at Hamilton Palace by Christie's, June 17–20, 1882; Elizabeth U. Coles; bequeathed to The Metropolitan Museum of Art, 1892

BIBLIOGRAPHY  Waagen, G. F. *Treasures of Art in Great Britain*. London, 1854, vol. 3, p. 305; Olszewski 1982; De Strobel 1989, pp. 51–78; Petrucci F. 1995

The Metropolitan Museum of Art, New York, Bequest of Elizabeth U. Coles, in memory of her son William F. Coles

The closing of the great tapestry manufactory under the private patronage of the Barberini family in the 1680s left Rome without a tapestry workshop until the founding in 1710 by Pope Clement XI of the tapestry workshop of the Ospizio Apostolico de' Poveri Fanciulli di S. Michele a Ripa under the sponsorship of the Vatican. This hospice, which housed an orphanage, churches, and workshops for the poor, trained orphan boys in painting, carving, *pietra dura* work, and tapestry weaving. The staff of the tapestry workshop included its director, the Parisian weaver Jean Simonet, a painter of tapestry cartoons, Andrea Procaccini, and three weavers. Simonet was succeeded in 1717 by Pietro Ferloni and upon his death in 1770 by Giuseppi Folli. From 1790 to 1796 it was directed by Filippo and Girolamo Cettomai, and from 1796 to 1798, the period of Napoleon's occupation of Rome, by Filippo Percioli. San Michele remained the official tapestry works of the Vatican until the unification of Italy in 1870, when it became a state-run school, before finally closing in 1928. The manufactory's production was primarily papal commissions, ranging from small-scale works, such as portraits of the popes and images of the Virgin, to larger-scale church baldachins and sets of tapestries, usually with a religious subject matter and frequently copied from works by great masters such as Guido Reni, Guercino, and Maratta. Lady Pomfret, an Englishwoman visiting the workshop in 1741, commented on the high quality of both the weaving and tapestry designs, noting particularly the exceptional likeness between the cartoons and the finished works.

Included in the tapestry collection of Pietro Ottoboni, the last of the cardinal-nephews, and patron of the arts, were some forty-six tapestries inherited from his great-uncle Pope Alexander VII, others woven in Brussels during the mid-seventeenth century that Ottoboni purchased from various sources, and a set that he commissioned from the San Michele tapestry workshop. Ottoboni's redecoration of the Palazzo della Cancelleria, his official residence after being nominated cardinal and vice-chancellor of the Church in 1689, included the embellishment of the walls of his palace apartment with imitation tapestries painted on canvas (*arazzi finti*). These illustrated the histories of Tasso and were painted between 1689 and 1693 by Domenico Paradisi, possibly assisted by Michaelangelo Ricciolini, a figure painter, and François Simonot (also known as Francesco Borgognone), a landscape painter. The *arazzi finti* not only served as decorative wall coverings in the palace but also appear to have been used in the same manner as the woven tapestries, for street and

church decoration on special occasions such as feast days. One of these sets of painted cloths included scenes taken from Tasso's heroic poem *Gerusalemme Liberata*. This poem, particularly the story of Rinaldo and Armida, was frequently used as a source for themes by painters during the seventeenth century in both France and Italy. In the 1730s and 1740s the poem enjoyed a revival of interest, the most notable examples being the Tasso cycles painted in Venice by Giambattista Tiepolo (c. 1742) and Gianantonio Guardi (c. 1745–50).

Between 1732 and 1739 Ottoboni commissioned the San Michele workshop to reproduce fifteen of Paradisi's *arazzi finti* from Tasso as woven tapestries, using the original painted versions as the cartoons for their weaving on a high warp loom. The *arazzi finti* themselves were later sent to decorate one of Ottoboni's villas. The subjects of these tapestries were taken from the poem's first seven cantos: the tapestry seen here is from Canto 7 and shows Erminia and the Shepherd. It was one of the first from this series to be woven. According to the 1740 Ottoboni inventory, the name P. Ferloni and date 1733 were originally woven into the tapestry's outer guard borders, which are now missing. The pagan princess Erminia, daughter of the King of Antioch, hearing the sound of a shepherd's pipe, comes upon an old man with his three young sons seated among his flock of sheep and goats, and the baskets he is weaving. Erminia, wrapped in a cloak and wearing armor she has borrowed from Clorinda, a warrior maiden, has removed her helmet, which she holds in her right hand, revealing to the frightened boys that she is indeed a woman. The upper border of the tapestry shows a central female mask and the inscription MA GLI SALVTA ERMINA/E DOLCEMENTE/GL AFFIDA, E GL OCCHI SOPRE/E I BEI CRIN D'ORO ("But Erminia saluted them and sweetly trusted them and uncovered her eyes and her beautiful golden hair"; Canto 7, stanza 7). Each of the side borders contains a herm on a carved support, each of which is unique in its design. The lower borders include central male masks and beribboned cornucopias overflowing with fruit, flowers, and leaves. The masks in both the upper and lower borders are identical to those found in another set, with scenes from Genesis after ceiling paintings in the Vatican Logge, woven at San Michele between 1733 and 1734, the same years as the first tapestries in the Tasso suite. [DEB]

87

## Fillippo Gabrielle
### *Passion Curtain for the Central Painting*

C. 1744
Silk grosgrain embroidered with silver-gilt
12′8″ × 7′2″ (386 × 218 cm)
PROVENANCE Museu de S. Roque, Santa
Casa da Misericórdia, Lisbon, St. John the
Baptist Chapel Collection
BIBLIOGRAPHY Rodrigues 1988, pp. 168,
207; Viterbo and D'Almeida 1997, pp. 51, 94
Santa Casa da Misericórdia de Lisboa,
Museu de São Roque, Lisbon

In addition to its celebrated treasure comprising examples of the goldsmith's art, the St. John the Baptist Chapel Collection is further enriched by a magnificent set of hangings and vestments made by the greatest Italian craftsmen of the day. Sousa Viterbo has every reason to say that the workshops where these rich silks were woven and the ecclesiastical vestments embroidered are no less worthy of mention than the goldsmiths' workshops. There are records to show that tapestry-makers, silk-weavers, vestment-makers, and embroiderers were employed to execute the various textile items in this collection (Viterbo and D'Almeida 1997, p. 51). These textiles alone shows how intent King John V was on demonstrating his great reverence for liturgical ceremony, and he expressed his obsession with worship by placing numerous orders with Italian artists.

The vestments in the collection are divided into sets for High Mass in two liturgical colors (red and white) with a cloth of silver ground completely embroidered with gold; sets for Low Mass on high days and holidays in five liturgical colours (red, white, purple, green, and pink) with a cloth of silver ground embroidered with gold, sets made of linen embroidered with gold and silver, sets made of silk grosgrain embroidered with silver-gilt, and sets of vestments for everyday use in five liturgical colours (red, white, purple, green, and black) with silk or silk grosgrain grounds embroidered with twisted silk (Rodrigues 1988, p. 168).

This curtain stands out from the rest, not only for the materials used for the ground but also for its format. It is rectangular in shape with a semi-oval extension in the upper edge, designed to cover the central panel in the Chapel of St. John the Baptist during Holy Week. The mosaic on this panel represents the *Baptism of Christ by Saint John the Baptist*, which is why the symbols of Christ's Passion are depicted in the central area. The set also includes two side curtains, which are rectangular in shape and would

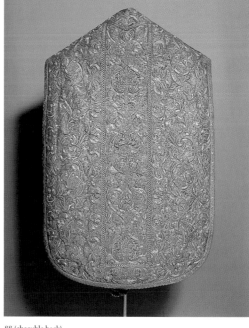

88 (chasuble front)                    88 (chasuble back)

have covered the two side panels on the same occasion. These depict Pentecost and the Annunciation, the latter embroidered by Giuliani Saturni. In all three cases the central image is surrounded by evocative motifs drawing their inspiration from plant forms and forming part of a predominantly Baroque visual language.

In addition to this curtain, which cost 1,323 *escudos*, Fillippo Gabrielle also executed the gold embroidery of a hanging in green silk lamé, half of a tabernacle curtain in the same color. He embroidered in gold on violet *anvers* and also executed the embroidery in silk on the vestment of violet *anvers* and on another green vestment (Viterbo and D'Almeida 1997, p. 94).

The curtain was exhibited in the sacristy of the church of S. Roque on August 15, 1898, when the St. John the Baptist Chapel collection was put on public display for the first time. It is currently in the Museu de S. Roque reserve collection. [TM]

## 88
## Cosimo Patrenostro
### *Ceremonial Vestments*

C. 1744
Chasuble for the violet vestment
48″ × 29½″ (122 × 75 cm);
Chalice cover for the violet vestment
30″ × 29½″ (76 × 75 cm);
Missal cushion for the violet vestment
20½″ × 24″ (52 × 60 cm);
Burse for the violet vestment 14½″ × 15¼″
(37 × 40 cm);
Stole for the violet vestment
12″ × 98″ (30 × 249 cm);
Maniple for the violet vestment
12″ × 39½″ (30 × 100 cm)
Cloth of silver embroidered with gold

88 (chalice cover)

PROVENANCE Museu de S. Roque, Santa
Casa da Misericórdia, Lisbon, St. John the
Baptist Chapel Collection
BIBLIOGRAPHY Rodrigues 1988, pp. 202,
206–7; Madeira Rodrigues, Maria João.
"Colecção de S. João Baptista." In *Dicionário
de arte barroca em Portugal*. Lisbon: Presença,
1989; Viterbo and D'Almeida 1997,
pp. 58, 94
Santa Casa da Misericórdia, de Lisboa,
Museu de São Roque, Lisbon

This group represents part of the magnificent set of ceremonial vestments embroidered with gold in high relief on violet lamé for the St. John the Baptist Chapel in the church of

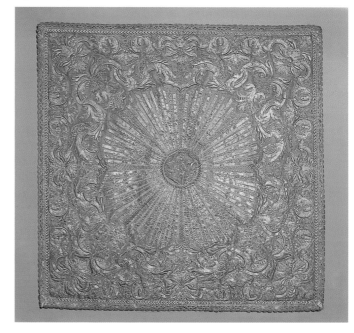

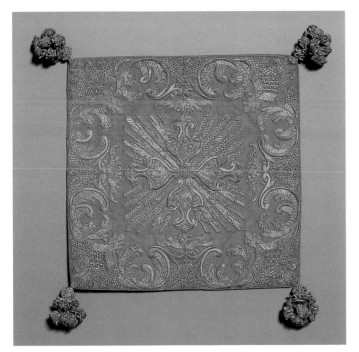

88 (burse)

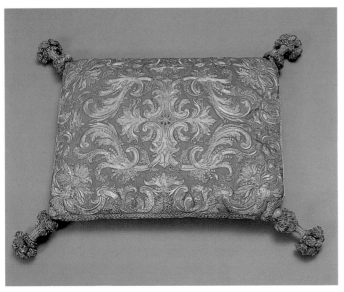

88 (missal cushion)

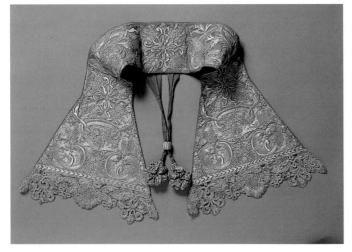

88 (maniple)

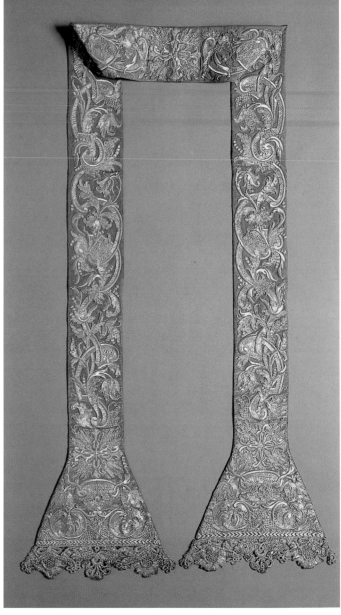

88 (stole)

S. Roque in Lisbon. This sumptuous ensemble executed by the embroiderer Cosimo Patrenostro, every item of which is completely covered with evocative embroidery, shows all the splendor of religious ceremonies during high days and holidays. At the same time, it offers evidence of what Italian workshops were producing in the mid-eighteenth century in response to the increase in orders from Portugal for vestments and liturgical accoutrements, known for the most part from correspondence with King John V's representatives in Rome.

The decorative motifs are basically the same in all the various pieces in this group, although they are arranged differently in response to the shapes of the individual objects. Motifs with a plant theme predominate, governed by scrolling forms and small sections patterned with rosettes revealing the persistence of a certain Mannerism in a predominantly Baroque visual language. It should be remembered that when King John V commissioned this collection, Roman art was beginning to lose the originality it had acquired in the previous century and that during this period it was trying to achieve a synthesis of Baroque cultural tradition with the new, recently imported Rococo forms (Rodrigues 1988, p. 427).

According to references in the documentation of the St. John the Baptist Chapel Collection assembled by Sousa Viterbo and Vicente d'Almeida, it was Cosimo Patrenostro who embroidered the rich violet vestment and one of the violet curtains of the chapel's two lateral paintings (Viterbo and D'Almeida, p. 94).

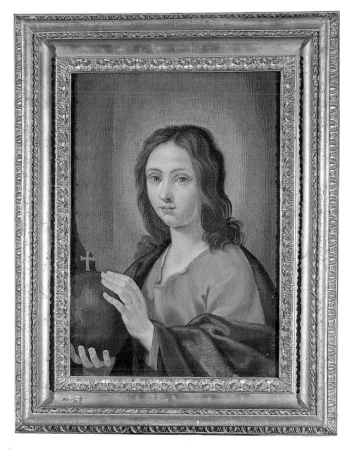

89

90

The only items anywhere in Portugal that rival the vestments in the St. John the Baptist Chapel Collection are those of the basilica of Mafra, which date from the same period and were also commissioned on behalf of King John V. With good reason, the consecration ceremony of the basilica of Mafra was considered the most magnificent in the kingdom.

In spite of the unparalleled opulence that distinguishes all the vestments in the St. John the Baptist Chapel collection, this set was nonetheless designed for an essentially utilitarian purpose, namely for use during an act of worship in a Catholic church. Yet the ascendancy of pomp and luxury that marked the reign of King John V and the European courts of the eighteenth century was such that it ultimately outweighed the practical purposes for which most of these objects were originally intended. Even so, Madeira Rodrigues emphasizes that, in order to grasp the full significance of the St. John the Baptist Chapel Collection, it is necessary to bear its practical liturgical uses in mind (Rodrigues 1988, p. 426). [TM]

## 89
## San Michele Manufactory
### Salvator Mundi

c. 1750

Tapestry; silk warp; silk and wool weft; framed in carved and gilded wood
23″ × 16″ (58.5 × 41.5 cm)
BIBLIOGRAPHY  Rome 1991, *Fasto romano*, cat. no. 173
Private collection

This tapestry shows the young Christ with the globe in his hands. It is mounted in its original carved and gilded frame, which bears a wax seal on the back with the interlaced letters CM. As was stated at the time of its first publication (De Strobel 1989), this delicate devotional image for domestic use was woven in the San Michele tapestry workshop set up in Rome in 1710. On the basis of a stylistic examination of the original frame, the writer identified its period of execution as mid-eighteenth century and pointed to a lost painting done by Guido Reni for Cardinal Gozzadini as the probable model on which this tapestry was based.

The San Michele workshop (De Strobel 1989, pp. 51–74), which was managed by Pietro Ferloni from 1717 to 1770, while it also produced weavings on a larger scale, favored from the outset the production of small tapestries such as the one exhibited here, which were often intended as gifts from the pope to important persons. The subjects were often taken from paintings by the most celebrated artists of the seventeenth century; in such cases a contemporary painter would undertake to prepare a cartoon of the required size for the weaver; in the case of the work exhibited here, the painter may have been Stefano Pozzi. Anna Maria de Strobel reports the existence of a tapestry similar to the work shown here but reversed, which is at present in the collection of the Principi Colonna. [RV]

## 90
## Filippo Passarini
### Nuove inventioni d'ornamenti d'architettura e d'intagli diversi utili ad argentieri intagliatori ricamatori et altri professori delle buone arti del disegno inventati ed intagliati da Filippo Passarini

1698

Bound volume
14″ × 35″ (36 × 89 cm)
EXHIBITION  Rome 1999, cat. no. 164
BIBLIOGRAPHY  González-Palacios 1984, figs. 28, 124, 128, passim
The Getty Research Institute for the History of Art, Research Library, Los Angeles

The book contains thirty-two plates. The first four are designs for altars complete down to the last liturgical detail and crowned with monstrances. These are followed by a kind of theatrical scene (plate 5), in which a chariot with Faith is chasing Heresy off stage, and then by a group of tabernacles and cases, monstrances, a baptismal font, stands for crucifixes, candlesticks, reliquaries, a catafalque, an organ, and some pulpits. After these comes a series of domestic furnishings, notably console tables with frames primarily composed of vigorous scrolls and corollas. There are various designs for table legs, from balusters through wide cartouches with swags to naturalistic figures of crouching Turks and war trophies. There is also a wide variety of clocks, ranging from the architectonic (plate 15) to the fantastic and bizarre, with sculptural motifs based on the themes of Time, Death, and Fate topping cases decorated with swags in a complex, open, richly detailed style that foreshadows the Rococo. Plates 18 to 25 show carriages and other vehicles either with details of embroideries and buckles or as a whole, with great sculptural features ornamenting the front and back. The final plates show beds, cradles, and prie-dieux followed by a fountain topped by a statue of Neptune.

Nothing is known about the author of this extraordinary catalogue (who may have died the year it was published, 1698) accounted one of the most comprehensive graphic anthologies of Italian furniture and decoration of the period. Up to now only one design of all those shown is known to have been realized, a pair of torch bearers with breastplates and palms in the church of S. Maria della Vittoria (Maria Grazia Bernardini, ed., *Gian Lorenzo Bernini: regista del barocco* [Milan: Skira, 1999], no. 132).

This latter type of decoration, relating to the events of war (in this case the victory over the Turks cemented by the capture of Belgrade in 1688), was obviously of particular inspiration to the author, as seen, for example, in plate 28, which shows a bed covered by a military-style awning or pavilion

91 (single sheet)

held up by captured slaves that even form part of the accompanying prie-dieu. The finished pieces that most closely resemble these designs are the consoles in the gallery of the Palazzo Colonna, which were made at the beginning of the eighteenth century (González-Palacios 1984, fig. 125; Eduard A. Safarik, *Palazzo Colonna:* [Rome: De Luca, 1997], fig. 4).

The fortune of the catalogue, whose designs for furniture found an echo in Roman furniture of the early eighteenth century, must have been longlasting, thanks to the variety of its decorative ideas, which, as noted with regard to the tables, included a range of motifs that followed the Berninian taste for vigorous naturalism as well as more innovative, and more abstract, ideas that found favor with goldsmiths and carvers in the first years of the new century. [RV]

## 91
### *The Strozzi Stone Collection*
Late seventeenth century to
early eighteenth
*Pietre dure,* rare marbles, vellum, leather, gilt copper
13¼″ × 10⅛″ (33.5 × 27 cm)
BIBLIOGRAPHY Montfaucon 1702, p. 284; Ficoroni 1744, pp. 190–90; Marangoni 1744, p. 342; Venuti, Ridolfino. *Roma moderna.* Rome, 1767, vol. 1, p. 661; De Brosses 1858, vol. 2, p. 83; Montesquieu, Charles Secondat de. *Voyage d'Italie.* Bordeaux, 1894–96; Gnoli 1971, p. 78; González-Palacios, Alvar. *Mosaici e pietre dure: mosaici a piccole tessere, pietre dure a Parigi e a Napoli.* Milan: Fabbri, 1982, vol. 2, p. 20; González-Palacios 1993, pp. 414–19
Philip Hewat-Jaboor, London

Each of the two albums has a leather binding with mounts of green porphyry on the covers, the mounts held in place by fine gilt metal laurel wreaths and crescents. Inside, irregular laminae of marble and *pietre dure* are mounted and numbered on eight sheets of vellum, each specimen accompanied by its name in Italian. On the inner cover of one album is a large cartouche in pen and ink containing the arms of the Strozzi family; in the other album the corresponding sheet is painted brown and forms the background for an ornate frame decorated with drapery suspended from a lion's jaw with a quotation from Ariosto in the center: "Ne mirabil vi son le pietre sole / ma la materia e l'artificio adorno / contendon" ("And priceless worth not in the gems alone/Resides, but an observer scarce can say/ Which of these two his judgment more enthrals:/ The craftsmanship or substance [of these walls]").

The presence of the three crescents from the Strozzi coat of arms (gold with a red band bearing three silver

crescents) on the binding of this album (and its companion, not exhibited here) enabled the provenance of the work to be identified. It was very famous in the eighteenth century and was described by a number of travelers and scholars. The portable collection, which is virtually unique, belonged to a member of the famous Strozzi family from Florence, who also lived in Rome in a palace near the church of the Ss. Stimmate (rebuilt in the nineteenth century; now the seat of the Besso Foundation in the Piazza della Torre Argentina).

Monsignor Leone Strozzi (1652–1722) was a prelate, collector, and erudite scholar who held a number of high offices in the academic world and the Church. A close friend of many of the *savants* of the times (including the diarist Francesco Valesio, the antiquarian Francesco Ficoroni, and the painter Pier Leone Ghezzi), Strozzi was particularly well versed in the history of colored marbles and *pietre dure,* on which he wrote several works, though none was published. The few passages made known by R. Gnoli make it all the more regrettable that it is not possible to read the whole manuscript. Strozzi was particularly well known for his splendid collection of cameos and intaglios, many of which were illustrated by the notorious Baron Philipp von Stosch in a magnificent volume published in Amsterdam in 1724, *Pierres antiques gravées sur lesquelles les graveurs ont mis leurs noms,* illustrated with beautiful prints by Bernard Picart. Eleven plates show the gems of the Strozzi collection. These include, of course, only the signed pieces, such as the *Medusa* of Solon and the sardonyx with *Germanicus* of Epitincanus, while none of the anonymous masterpieces mentioned by many connoisseurs of the period is shown.

The album on display here (and the companion volume) fascinated many famous scholars, such as Montfaucon (who mentions it in his *Diarium italicum* in 1702), Montesquieu, Ficoroni, Charles de Brosses ("you could not find another collection of stones more beautiful and easy to handle"), Marangoni, and Ridolfino Venuti. Unfortunately, in 1746 most of the Strozzi collection in Rome, which at the time was the property of Princess di Forano Strozzi, was stolen. After that all trace was lost of these very rare incunabula until González-Palacios identified them in 1993 in London, the provenance being an auction in Stockholm. [AGP]

92

## 92
### Unknown artist
### *Bookbinding for Pope Innocent XIII*

Innocent XIII. *Epistolae ad principes viros et alios*
c. 1722
Tooled red morocco binding
16⅛″ × 11″ (41.1 × 28.1 cm)
BIBLIOGRAPHY Michelini Tocci 1977, no. 253
Biblioteca Apostolica Vaticana, Vatican City

This volume is a manuscript of 180 pages that bears the arms and illuminated portrait of Pope Innocent XIII Conti (elected 1721, died 1724). The covers in red morocco are decorated with a filleted double border surrounding a central panel containing the arms of the pope. There are urns in the inner corners exuding elaborate scrolling foliage and stars and small urns at the outer corners, while the inner edges of the board and spine are decorated with leaves.

The art of fine bookbinding made great progress in Rome from the early sixteenth century on. By the seventeenth century some of the most

important bindings of this type had already been produced. Despite the influence of the prevailing French fashion in bookbinding, which was extremely ornate and magnificent (these bindings were called *à la fanfare*), Italian bindings were generally perfectly proportioned and tended toward an imposing, monumental approach.

This work was usually carried out by expert binders but was also undertaken by suppliers of books and graphic materials, often employing workers whose names were not recorded unless they were celebrated masters. At the end of the seventeenth century Nicolas Lhullié and his son were working in Rome, and one of the decorative motifs typical of their bindings appears to have been a small vase of flowers, similar to the ones shown here.

Bookbinding also required the skills of other craftsmen, namely a specialized metalworker who would provide clasps and rivets at a later stage; the binder also used tools, wheels, and panels provided by a seal engraver. Shortly before the end of the reign of Pope Innocent XIII the name of Agostino Fasolo appears in the

93

94

accounts of the Vatican: in 1724 he was paid for "gilding two books … making the embellishment, corner decorations, and arms of His Holiness" (Rome, Archivio di Stato, Giustificazioni di Tesoreria, b.501/1).

At the same time Filippo Farinelli, a paper merchant, was making more modest bindings in parchment or pigskin (this work was in the so-called "Paduan style," whereas the more elaborate bindings were "in the French style"). Other craftsmen who specialized in leather work for different purposes also occasionally made bindings. At the time it was the custom to cover many types of furniture with tooled leather, and the style of the ornament on the books was the same as that used for tablecloths, cushions, and carriage upholstery. [RV]

## 93
## Unknown artist
### Bookbinding for Pope Benedict XIV

Roberto Sala. *Index librorum impressorum Bibliothecae Alexandrino-Vaticanae …*
c. 1755
Brown morocco binding
16⅝″ × 10⅞″ (423 × 277 cm)
BIBLIOGRAPHY   Michelini Tocci 1977, no. 258
Biblioteca Apostolica Vaticana, Vatican City

The manuscript dates from 1723 and contains 222 sheets with marbled edges. The gold tooling on the cover contains a double outer border, with motifs backed by fillets. An inner border is composed of an outer band analogous to the previous ones, with an inner band of dentillation. Double-handled urns and acanthus leaves are placed at an angle in the corners. The front cover bears the arms of Pope Benedict XIV Lambertini, and the back cover the arms of Cardinal Domenico Passionei, which enable the binding to be dated to between 1755 (the year Passionei was appointed director of the Vatican Library) and

1761 (the year of his death). Passionei was one of the most erudite men of the period, in contact with *savants* from all over Europe, and a collector of antiquities.

The style of this binding, though elaborate, shows that even in the heyday of Roman Rococo there was a tendency to use decoration that was elegant without being overelaborate. The decoration of the binding bears a noticeable similarity to motifs employed in contemporary embroidery. From the seventeenth century on, one of the major sources of inspiration for tool- and blockmakers was the pattern books used by embroiderers, widely available throughout Italy, which gave rise to the term *à dentelles*, frequently used with reference to bookbinding. [RV]

## 94
## Unknown artist
### Bookbinding for Pope Pius VI

Jean Baptiste Faure. *Miscellanea di scritti dedicato a Pio VI*
Late eighteenth century
Light calf binding
11⅜″ × 8″ (28.8 × 20.2 cm)
BIBLIOGRAPHY   Michelini Tocci 1977, no. 266
Biblioteca Apostolica Vaticana, Vatican City

This manuscript on paper consists of 186 pages. The covers have a raised border with rounded inner corners containing four circular flowered bosses flanked by two cornucopias; these extend in spirals of vegetation separated by masks in the center on each side. The central panel contains the arms of Pope Pius VI Braschi (elected 1775; died 1799). The spine and edges of the board feature tooled foliar decoration.

The elegant design of this decoration shows a clear adherence to the Neoclassical style. However, other bindings with the arms of Pius VI are known with flower motifs that are more Rococo in style; this work may

95

96

therefore date from the late 1780s, especially since an identical binding is known (at the Casanatense Library) that bears the arms of Cardinal Romualdo Braschi Onesti in the center. The cardinal was the pope's nephew, who was raised to the purple in 1786 (Piccarda Quilici, *Legature antiche e di pregio* [Rome: Biblioteca Casanatense, 1995], no. 1173).

In works such as this a notable feature is the use of impressions made almost exclusively with large panels, limting the use of small tools to only a few elements. [RV]

## 95
## Johann Friedrich Reiffenstein
### *Endymion*

1764–c. 1768

Inscription on the reverse: *Endimion from an ancient Bas Relief in the Villa Albani near Rome. This oval was made in imitation of the Antient Roman Pastes by Mr Reiffensten Counsellor of the Langrav of Hesse Cassel; Hebe feeding Jupiter …*
*Pâte de verre* in carved and gilded wooden frame
6¾″ × 4½″ (17 × 11.4 cm) without frame; 12¼″ × 9⅞″ (31.5 × 25 cm) with frame
BIBLIOGRAPHY  Valeriani, Roberto. "Reiffenstein, Piranesi e i fornatori romani del Conte di Exeter." *Antologia di Belle Arti*, no. 55–58 (1998), pp. 145–54
The Burghley House Collection, Stamford, Lincolnshire, U.K.

## 96
## Johann Friedrich Reiffenstein
### *Ganymede*

1764–c. 1768

*Pâte de verre* in carved and gilded wooden frame
6¾″ × 4½″ (17 × 11.4 cm) without frame; 12¼″ × 9⅞″ (31.5 × 25 cm) with frame
BIBLIOGRAPHY  Valeriani, Roberto. "Reiffenstein, Piranesi e i fornatori romani del Conte di Exeter." *Antologia di Belle Arti*, nos. 55–58 (1998), pp. 145–54

The Burghley House Collection, Stamford, Lincolnshire, U.K.

The notes attached to the reverse, which indicate the subjects of the two reliefs and their maker, seem to be in the handwriting of Brownlow Cecil, 9th Earl of Exeter (1725–1793), who visited Italy twice, stopping in Rome on both occasions, first in 1763–64, and later in 1768–69 (Ingamells 1997, pp. 343–44). It was possibly on his first visit that he made the acquaintance of Reiffenstein, the famous guide and agent to various European courts, who was living in the city from 1762 (Friedrich Noack, *Das Deutschtum in Rom* [Aalen, Germany: Scientia, 1974], vol. 2, pp. 476–77). His interest in ancient techniques made him famous, particularly for what he knew about encaustic painting. Both Winckelmann and Goethe, to whom Reiffenstein was very close, recorded his attempts to recreate ancient cameo glass, of which there existed in Rome at that time some of the most famous examples, such as the Barberini Vase (now better known as the Portland Vase, British Museum, London) and a bacchanalian scene from the Carpegna collections, which at that time was in the Vatican collections (now in the Louvre, Paris; see González-Palacios 1997, *Valadier*, no. 7). According to Winckelmann's own written record, these experiments by Consigliere Reiffenstein began around 1764 and

he wrote a brief but informative account of them in the form of letters to Winckelmann himself. Goethe, a few years later, recorded that "the wide vault of an old kitchen of Reiffenstein's lent itself admirably to the purpose" and described the procedure of melting and molding used, according to him, to produce small decorative objects.

In this case there were indeed two demanding processes, which resulted according to the writings (which were not wholly accurate, inasmuch as Ganymede is mistaken for Hebe) in reproductions of two of the most famous antique bas-reliefs of the period: the *Sleeping Endymion* now in the Musei Capitolini (but previously in the Albani collections; see Stuart Jones 1912, p. 219) and the *Ganymede Feeding Jove in the Form of an Eagle*, still in the Villa Albani. [RV]

97

98

## 97
## Unknown artist
### *Pedestal*

c. 1765
Marble
34⅜″ × 18⅛″ × 18⅛″ (88 × 46 × 46 cm)
BIBLIOGRAPHY Wilton-Ely 1994, vol. 2, p. 1009; Valeriani, Roberto. "Reiffenstein, Piranesi e i fornatori romani del Conte di Exeter." *Antologia di Belle Arti*, no. 55–58 (1998), pp. 145–54
The Burghley House Collection, Stamford, Lincolnshire, U.K.

On four animal paws rests a step partially concave and fluted; higher up is a band decorated with scrolls with four sphinxes at the corners supporting an upper section, its faces decorated with festoons of oak knotted in the middle, from which hang snakes. On the front is written D.M. QUINTIAE SATURNINAE / C. VALERIUS TERMINALE GONIUG SUAE CARISSIMAE. Above a molding with dentils surmounted by palmettes is a fluted coping with

a frontal tympanum terminating in rosettes with two birds in the middle.

This marble is depicted in plate 46 of the volume *Vasi, candelabri, cippi… disegnati e incisi dal Cav. Gio. Batt. Piranesi* (Rome, 1778) accompanied by the caption *Piedestallo che si vede in Inghilterra presso sua Eccellenza Milord Exeter* ("pedestal on view in England at the home of His Excellency Lord Exeter"). The pedestal, made in Piranesi's workshop, belongs at present to the art collection in Burghley House, the home of the Earls (later Marquesses) of Exeter, and its inclusion in that collection came about through two visits to Italy by Brownlow Cecil, 9th Earl of Exeter, who was in Italy between 1763 and 1764, then again in 1768 to 1769. On one of these occasions Exeter acquired the fireplace—also from Piranesi's workshop, in statuary marble and *rosso antico*—that is still in the stately home (illustrated in plate 1 of *Diverse maniere d'adornare i cammini*, published by Piranesi in 1769).

Piranesi's fame as an archaeologist and engraver was equaled by his repu-

tation as a dealer in archaeological finds, which were restored in his shop in via Sistina, visited by all the great personalities passing through Rome, and were often assembled in imaginative compositions that represented the height of the fashion for a return to the classicism of antiquity. This pedestal, like other famous works, seems to be the result of a process of combination of disparate elements, incorporating a funerary urn (the central body with the inscription) a cornice and a cover, both almost entirely reconstructed, and a base with sphinxes and scrolls, a fairly similar version of which is found again on another pedestal illustrated in the volume of *Vasi* dedicated to the Consigliere Reiffenstein and now in Kassel (Oleg Neverov, "Giovanni Battista Piranesi, der Antikensammler," *Xenia*, vol. 3 [1982], pp. 71–90, fig. 21).

The relationship between Piranesi and the count was probably mediated by James Byres and Thomas Jenkins, who, according to the correspondence still preserved at Burghley, suggested modern paintings and excavation works to the count even after his visits to Rome. [RV]

## GUILLAUME-ANTOINE GRANDJACQUET
### REUGNEY 1731–1801 ROME

## 98
## Guillaume-Antoine Grandjacquet
### *Amphora with Lid and Stand*

1785–87
*Granito verde minuto borghesiano*; red porphyry
Height 30¾″ (78 cm); diameter 15¾″ (40 cm)
BIBLIOGRAPHY Faldi, Italo. *Galleria Borghese: le sculture dal secolo XVI al XIX*. Rome: Istituto Poligrafico dello Stato, 1954, no. 52; González-Palacios 1993, fig. 462
Galleria Borghese, Rome

This has a fluted foot with the lower rim sinuously curved and the upper beaded. The ovoidal body has flat decorative pods (*baccelli*) at the top and bottom and is encircled by a wide band of stylized leaves and flowers. Two short handles connect to the neck with a scroll, which has a small Egyptian head in the centre. The handle of the fluted lid is decorated with masks. The vase is on its original stand, octagonal in section, with the same rare stone and red Egyptian porphyry.

This vase is evidence of an obsession, dating from the days of the ancient Roman empire, with stones that were both rare and extremely hard to work. In Rome during the late Renaissance such materials were most eagerly sought by collectors, who then

entrusted them to artisans of proven expertise to produce inlaid table tops or vases of various kinds. The stone used in this piece is so rare that it takes its name from the vase itself, *granito verde minuto borghesiano*. It probably came from Gebel Dukhan in Egypt's western desert (Gnoli 1971, p. 134).

The large amphora was carved from a single block of stone by Grandjacquet, a specialist in this very arduous kind of work who produced very fine articles much admired by his contemporaries such as Ennio Quirino Visconti. Italo Faldi has noted that the payments to Grandjacquet mentioning a vase made of so-called *granito basaltino* are dated 1785, the year in which work was carried out at the Helen and Paris Room in the Villa Borghese, for which it was intended and where it remained for many years. The amphora was apparently only placed in that room in 1787.

It should be noted that Grandjacquet's fame in his day was originally specifically technical. While dismounting ths vase for this exhibition, it was possible to study the inside of the piece, which has been reduced to a thickness of only about half an inch, an almost prodigious achievement with such a hard granite as the one employed here. The support of the amphora, also made by Grandjacquet, has had a double plinth (veneered with other types of marble) added to it, probably in the nineteenth century; this will now be removed. [AGP]

## AGOSTINO PENNA

C. 1703–1800 ROME

Agostino Penna was one of the most famous and esteemed sculptors and antiques restorers in Rome during the second half of the eighteenth century, but few of his biographical details are known today. He received considerable official recognition: in 1768 he became a member of the Accademia di S. Luca and in 1787 he was elected its Principe. In 1796 he was appointed regent of the Congregazione dei Virtuosi al Pantheon. Among his sculptural works that can be dated with certainty is his involvement in 1771 in the collegiate church of S. Eustachio, to designs by the architect Melchiorre Passalacqua. His contribution to the tomb of Flaminia Odescalchi Chigi, to designs by Paolo Posi, in S. Maria del Popolo in Rome also dates from that year.

In 1776 Penna executed a chimneypiece in *rosso antico* for Prince Sigismondo Chigi and around that date he started a series of works for the Villa Borghese, including restorations of marble antiquities as well as new creations. In the gallery of the Villa Borghese, for example, between 1778 and 1779 he prepared four of the putti on the doors, some of the bas-reliefs on a mosaic ground set on the pilasters, and two stucco bas-reliefs. His numerous restorations include the famous relief in the entrance hall of the villa, showing Marcus Curtius throwing himself into the chasm. In 1782, for the upper rooms of the villa, Penna produced one of his chimneypieces in *rosso antico* and in the same year the bas-reliefs for the pedestal of the Gladiator (cat. 99) and the statues of Paris and Helen completed in 1784 (in the Ruffo della Scaletta collection). Among his last works for the Borghese family was the nymph set at the side of the Temple of Esculapius in the garden of the Villa Borghese. The bust of Cardinal Henry Stuart, Duke of York, now at Frascati, is not dated. [RV]

BIBLIOGRAPHY Ferrara 1954; Hubert 1964, *Sculpture*, pp. 56–57, figs. 8–11; Ferrara Grassi 1987; González-Palacios 1993, p. 251, no. 27, passim; Paardekooper, Ludwin. "The Monument to Maria Flaminia Chigi Odescalchi, 1771–72." *Labyrinthos*, no. 29–32, [1996–97], pp. 261–315

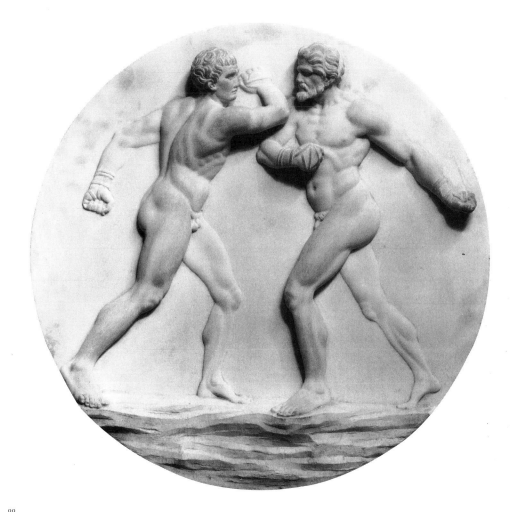

99

## 99
## Agostino Penna
### *Two Boxers*

1782
Marble
PROVENANCE Villa Borghese, Rome
BIBLIOGRAPHY Hubert 1964, *Sculpture*, p. 57; Ferrara Grassi 1987, p. 265; González-Palacios 1993, p. 251; González-Palacios, Alvar. "La stanza del Gladiatore." *Antologia di Belle Arti*, no. 43–47 (1994)
Musée du Louvre, Paris, Département des Sculptures

In Ennio Quirino Visconti's description of the Hall of the Gladiator in the Villa Borghese, (*Sculture del Palazzo della Villa Borghese*, Rome, 1796), when it was newly decorated in the program of modernization and reorganization of the villa ordered by Marcantonio IV Borghese, he expressly mentions this marble panel and the other three that accompanied it on the base of the antique statue of the Gladiator. This was placed in the centre of the room (the history of which is reconstructed in González-Palacios 1994), and its subject determined the choice of some of the other statues collected there as well as the new pictorial deco-

ration. Visconti records the large pedestal, square and isolated, completely clad in noble alabasters and other precious mixtures, with a richly carved molding in white marble. The four sides were further adorned with four marble bas-reliefs, in which figure the exercises of ball play, wrestling, the contest of boxing, and that of the gladiators, the compositions and work of Agostino Penna. The carved decoration on the pedestal, according to a further contemporary source, was the work of another decorative sculptor, Lorenzo Cardelli, who also contributed to other details in the hall.

Together with the other marbles belonging to the Borghese family, the Gladiator was among the sales carried out by Prince Camillo to Napoleon in 1807. Thus it went to the Louvre, where, possibly early in the twentieth century, its base was removed and dismantled. The four bas-reliefs by Penna, two circular and two oval, were rarely exhibited after that and have sometimes been erroneously attributed to Vincenzo Pacetti. [RV]

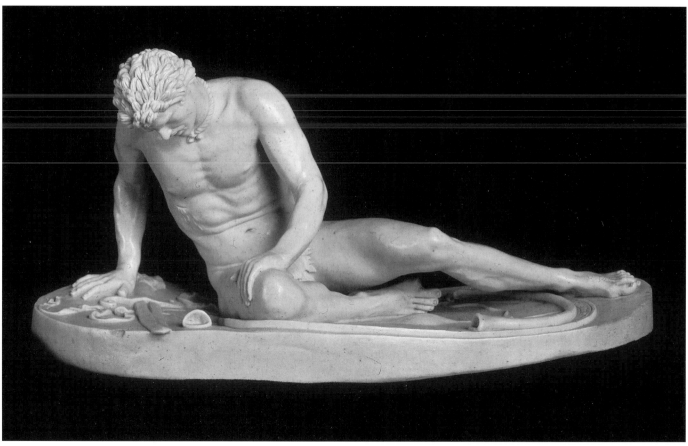

100

## GIOVANNI VOLPATO

### ANGARANO C. 1735–1803 ROME

The uncertainty of Volpato's date of birth is compounded by the curious fact that he adopted the surname of his maternal grandmother. As a young man, he completed his training at the famous printworks of Giovambattista Remondini in Bassano. In 1762 he moved to Venice to work in the studio of Francesco Bartolozzi, where he executed several works after paintings by Jacopo Amigoni. He then began to collaborate with the painter Francesco Maggiotto and worked extensively in the printworks of Joseph Wagner. Alongside this activity, he also managed to work as an agent for the Remondini family in Venice, where he came into contact with painters, collectors, and scholars living or passing through the city. By the end of the 1760s Volpato's fame as a printer was confirmed by his collaboration with Bodoni in Parma and his appointment as an honorary member of the academies of Verona and Parma.

By 1771 he was in Rome, where he began his celebrated series of engravings of Raphael's frescoes in the Vatican Logge. These were collected in three volumes produced between 1772 and 1777. While actively working as an engraver, he also spent time researching antiquities. In 1779 he started

several excavations in different areas of Rome, commissioned by the pope and private individuals. During this same year he welcomed the young Antonio Canova, who had just arrived in the city. He continued to produce other publications, including many prestigious commissions, which culminated in the visit of King Gustav III of Sweden to his studio in 1784. An influential figure in the circle of Roman artists, scholars, antiquarians, and merchants, he knew and associated with Goethe, Gavin Hamilton, and Angelika Kauffmann.

In 1785 Volpato opened a porcelain factory near the church of S. Pudenziana. The following year Pius VI granted him a *privativa*, a license that effectively allowed him a city monopoly for the production of such material. The output included adaptations of classical prototypes executed in biscuit porcelain. The pieces were small and generally bore the mark *G. Volpato. Rome*. A printed list of these in French was sent by Charles H. Tatham to Henry Holland, architect to the Prince of Wales. This list provides information on the variety of figures and shapes that, as it expressly points out, could be combined to decorate tables and fireplaces. Only a single example is known to date: a table centerpiece originally from the Chigi family and today belonging to

Princess Pallavicini. By 1801 he had also established an English-style earthenware factory in Civita Castellana. His death in 1803 was shortly followed by that of his son. The factory, which had been turned over to Francesco Tinucci, already head sculptor, continued Volpato's enterprise until 1831, with the death of the founder's grandson. [RV]

BIBLIOGRAPHY Morazzoni 1960, pp. 192–94; Honour 1967; Biavati 1977; Tittoni Monti 1983; Marini 1988; González-Palacios 1993, pp. 321–25; Di Castro 1996

## 100

## Giovanni Volpato
### *Dying Gaul*

Late eighteenth century
Bisque
Height 5⅛″ (13 cm)

EXHIBITIONS Rome 1959, cat. no. 2051; Bassano del Grappa, Italy, Museo Bibliotheca Archivio; Rome, Istituto Nazionale per la Grafica. *Giovanni Volpato*. 1998

BIBLIOGRAPHY Mottola Molfino, Alessandra. *L'arte della porcellana in Italia*. Busto Arstizios, Italy: Bramante, 1977, vol. 2, fig. 95; Tittoni Monti 1983, fig. 12
Pinacoteca Capitolina, Rome

Although not bearing the mark that usually identifies Volpato's biscuit-

ware, the quality of the porcelain demonstrates that this statuette undoubtedly came from the kiln of that manufacturer. In the catalogue printed in French (Victoria and Albert Museum, London) that lists the pieces on sale from Volpato, there appears a "Gladiateur mourant étendu du Museum Capitolin" costing six gold *zecchini*. This refers to a reduced version of a famous ancient sculpture first recorded in 1623, when it appeared in the collection of the Princes Ludovisi and had perhaps been found some years earlier when the Ludovisi Villa was being built on the remains of the Sallustio gardens (Haskell, and Penny, 1981, no. 44). Its fame made it the subject of numerous reproductions in various materials and sizes. [RV]

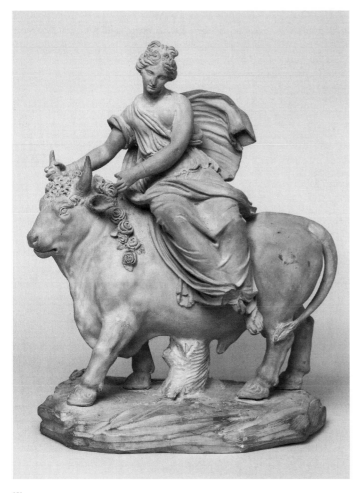

101

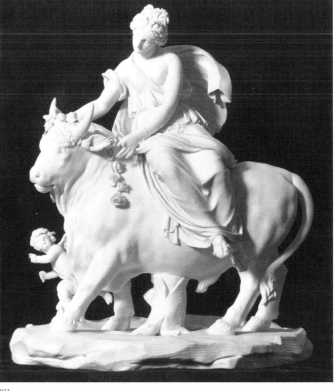

102

## 101

### Unknown artist
### *Model for "The Rape of Europa"*

End of the eighteenth century
Terracotta
Height 11⅜" (29 cm)
BIBLIOGRAPHY  González-Palacios 1993,
fig. 556
Private collection

This terracotta depicts the famous episode from classical mythology in which Jupiter disguises himself as a bull to carry off the young Europa. It was certainly used as the model for a biscuit group produced at the Roman factory of Giovanni Volpato, two examples of which are known to us: one at the Minneapolis Institute of Arts (cat. 102), the other in the Cini Collection of the Musei Capitolini in Rome (Morazzoni 1960, vol. 2, pl. 277; Tittoni Monti 1983, fig. 14). Not only does it correspond almost exactly to the porcelain pieces, but it is slightly larger, proving that it was the original model, rather than a copy (porcelain figures are always smaller than the terracottas on which they are modeled).

Nothing is known of the sculptors who supplied Volpato (an engraver

and an entrepreneur who himself never sculpted) with the models for the many biscuit pieces his factory began to turn out in 1785. All we know is that the workshop's chief model maker, Francesco Tinucci (or Finucci), married the widow of Giuseppe Volpato— Giovanni's son and successor—who died in 1805, two years after his father. However, it is impossible to say whether this Tinucci (or Finucci), who managed the factory until his own death in 1818, made the models himself.

It is certain that Vincenzo Pacetti sold at least one terracotta model to Senator Ginori, owner of the celebrated Doccia porcelain factory near Florence, and this model must certainly have been used by the Florentine factory. Pacetti was closely acquainted with Giovanni Volpato, as is evident from several entries in the sculptor's (as yet unpublished) journal, though his dealings with Volpato were mainly concerned with classical marbles. But we also know that Pacetti made some wax figurines to be used for a or table centerpiece (*deser*). It is at least possible that Vincenzo Pacetti made models that could have been used by a porcelain factory. This is not to say that the terracotta on display here is definitely

Pacetti's work, but he is perhaps the most likely author of this small piece. [AGP]

## 102

### Giovanni Volpato
### *The Rape of Europa*

End of the eighteenth century
INSCRIPTION  G. Volpato Roma.
Bisque
Height 10¼" (26.2 cm)
BIBLIOGRAPHY  Mottola Molfino,
Alessandra. L'arte della porcellana in Italia.
Busto Arstizio: Bramante, 1977, vol. 2,
fig. 97; González-Palacios 1993, fig. 555
The Minneapolis Institute of Arts, The
Ethel Van Derlip Fund

The French catalogue of Giovanni Volpato's factory (a copy of which is kept in the Print Room of the Victoria and Albert Museum, among the Tatham papers, n.D.1479/17–98) mentions, together with groups of varying sizes, "une Europe sur le Taureau," which could be bought for nine *zecchini*, not a modest sum. There are few differences between this biscuit group and the preceding terracotta (cat. 101). The only obvious one is the cupid running along beside the bull, of which there is no trace on the original model, nor on its base. It is therefore probable that this little putto was added at the time of manufacture, using (as was often the case) a preexisting figure. It may be a slightly altered version of a little cupid that can be seen in the

Musei Capitolini (Marini 1988, p. 39). It is simplicity itself to combine diverse items in a single porcelain group. There is another example of this piece in the Cini Collection in the Musei Capitolini in Rome. [AGP ]

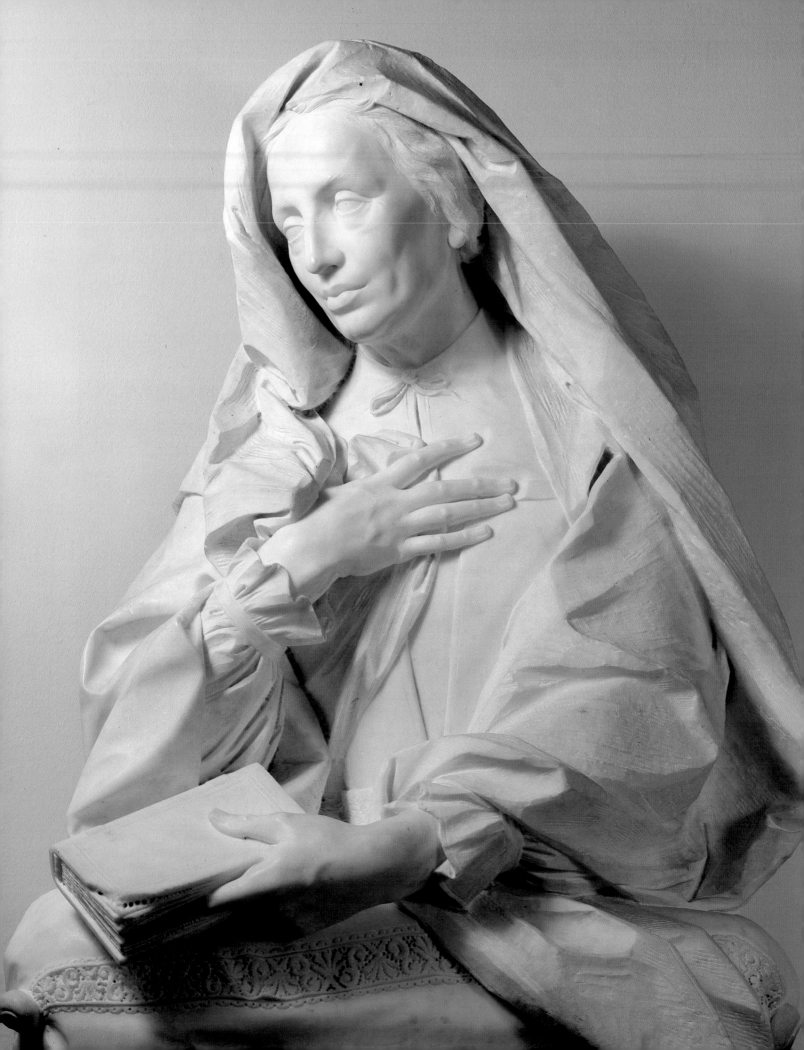

# An Introduction to Sculpture in Rome in the Eighteenth Century

## DEAN WALKER

### 1700–1760

In 1772, in a book intended for circulation throughout Europe, the sculptor Bartolomeo Cavaceppi proclaimed Rome to be the "regina città del mondo."[1] His confidence may surprise many today, particularly regarding sculpture. The primacy of Counter-Reformation Rome in European sculpture of the 1600s has been accepted for decades. But the importance of the city as a center for sculpture in the following century has had few champions.[2] The number of such scholars has been growing, however, as demonstrated by the catalogue commentaries that follow. It does not require much reflection to understand why there is as yet no satisfactory overview of this Roman sculpture: it is because the subject itself is so vast. To understand the first half of the century requires appreciation of the late phases of Baroque art. After 1750 the main themes involve the intertwined emergence of Neoclassicism and Romanticism. Related to both halves of the century, and especially important for Neoclassicism, is the subject of antiquities and the rise of an international taste and avid market. Finally, to understand the role of the city fully, it is necessary to include the activities of foreign artists and patrons, more numerous than at any previous time. Each of these topics remains challenging, even for specialists.

It is also true that few of the sculptors are well known today. In this exhibition Antonio Canova is probably the only famous Italian name. The other figures likely to be familiar to museum visitors are the French or English artists Jean-Antoine Houdon, Clodion, and John Flaxman, who spent only portions of their lives in Italy. Because so much about eighteenth-century sculpture in Rome is currently obscure, it is practical to begin with an introduction of the artists arranged by generation. This will establish a basic outline of the succession of sculptors for the course of the century.

In 1700 the most prominent sculptor in Rome was Domenico Guidi, a prolific, influential but uneven artist who died the following year. At work in Rome in the first decade of

the century were sculptors belonging to three age groups. Jean-Baptiste Théodon, a resident Frenchman, and Giuseppe Mazzuoli, from Siena, were both born in the 1640s. The latter, an assistant of Gianlorenzo Bernini in the 1670s, continued to be active and evolve artistically until his death in 1725. The important sculptors Pietro Stefano Monnot and Camillo Rusconi were born in the late 1650s; Pierre Legros II and Bernardino Cametti in the late 1660s; and Angelo de' Rossi in 1671. All of these artists were in the flower of their careers around 1700 and were the dominant figures during the first third of the eighteenth century. A younger group—Agostino Cornacchini, Giovanni Battista Maini, Bernardino Ludovisi, and Antonio Montauti, born in the 1680s to early 1690s—would all be active by the 1720s, although Montauti did not come to Rome until 1733.

Around the turn of the new century so many sculptors were born that it is possible to speak of the generation of 1700. This group includes Filippo della Valle, Pietro Bracci, and Carlo Marchionni, and the French artists Edme Bouchardon, Lambert-Sigisbert Adam, and Michel-Ange Slodtz. The Frenchmen would spend only part of their careers in the city, the former two from 1723 to the early 1730s, while Slodtz remained longer, from 1728 to 1746. Della Valle and Bracci emerged with early successes in 1725. Along with the older Maini, they became the most influential Roman sculptors into the 1760s. Cavaceppi, Innocenzo Spinazzi, Jacques Saly (contemporaries of Piranesi and Winckelmann), born between 1716 and 1720, and Tommaso Righi, born in 1727, would begin to work toward mid-century.

After the first third of the century, there is an increase in the number of future sculptors born. Each decade produced artists, whose Roman careers would necessarily coincide in the decades after 1760. Italian sculptor Carlo Albacini was born in 1735; Giuseppe Angelini, Giovanni Volpato, Francesco Righetti, and Vincenzo Pacetti in the 1740s. Their foreign contemporaries belong to the stream of visitors to Rome in the last third of the century. Three British sculptors—Thomas Banks, Christopher Hewetson, and Joseph Nollekens—were all born in the mid-1730s. The latter became a member of Cavaceppi's studio in the 1760s. Hewetson settled in Rome

for life in 1765. Banks arrived in the 1770s. Among the French artists, Clodion and François Poncet, born in the 1730s, were in Rome in the 1760s, and Poncet remained until 1775. Born in the 1740s, Johan Tobias Sergel and Houdon were also in Rome in the 1760s, and Sergel left only when obliged to, in 1778.

Artists born in the 1750s include Giuseppe Ceracchi, Camillo Pacetti, and Canova (in 1757). Their foreign contemporaries, whose Roman years overlapped, include Friedrich Wilhelm Eugen Doell, Flaxman, Joseph Chinard, and John Deare, who arrived in 1785 and remained until his death. The most important events for sculpture in Rome in the last decades of the century were Canova's settling there in December 1780, and Flaxman's stay from 1787 to 1794.

From this brief overview it is clear that the two halves of the century involve different groups of artists with a period of transition occurring in the central decades. Until mid-century many artists enjoyed long careers, and younger artists obtained commissions at a reasonable rate. Then, until the emergence of Canova, it is hard to follow the Italian artists in Rome. More distinct, these days, are the revolving groups of foreign sculptors sojourning there. The introductory essays by Professors Sussino and Barroero and Professor Johns reveal Rome to have been an active place, but one whose fortunes fluctuated considerably during the eight pontificates that span the century. Even the preceding simple presentation of sculptors' dates reflects the changing needs and opportunities of the eighteenth-century city. A consideration of some notable sculptures and major projects confirms this impression.

The year 1700 saw the election of Pope Clement XI, who initiated two of the most conspicuous sculptural projects of the century. In 1706 Pierre Legros completed the figure of Saint Dominic, the first of the statues intended for the empty niches inside the basilica of St. Peter's. These prominent spaces were reserved for saints associated with the origins of the holy orders, known as the Founders.[3] Nineteen sculptures in the series were finished by 1767. This project was superseded immediately by another commission to fill the empty niches designed by Francesco Borromini in the 1640s for the nave of St. John Lateran, a

(OPPOSITE) Camillo Rusconi, *Giulia Albani degli Abati Olivieri*, c. 1719 (cat. 152)

church second in importance only to St. Peter's. Under the direction of the architect Carlo Fontana and the painter Carlo Maratti, sculptors were asked to submit models, most of them based on Maratti's designs. The statues were intended to demonstrate the noble dignity of the academic late Baroque style, a reaction to what was seen then as the exaggerated manner of Bernini. To achieve the colossal statues, seven artists explored various traditions from ancient sculpture and the works of Michelangelo to contemporary paintings. The Apostles, carried out between 1703 and 1718, confirmed the stature of Monnot, Legros, and especially Rusconi.

Two statuettes in this exhibition, each probably made for a foreign donor who paid for a colossal statue, demonstrate the stylistic extremes of the Lateran project. Rusconi's *Saint Andrew* (cat. 150) is a variation on François Duquesnoy's famous statue at the crossing of St. Peter's. (The nature of the solution for each figure was determined in response to its architectural setting.) Rusconi's figure is less heroic in physique, its drapery is more restrained, and above all, Andrew's mood, instead of being directed outward, is an intense inward meditation on the cross, the instrument of his martyrdom. The saint's rapt gaze is clearer from the proper left side, which presents an especially beautiful view. By contrast, Mazzuoli's *Saint Philip* (cat. 135) is the only one of the Apostles in a Baroque style indebted to Bernini. Saint Philip, who vanquished a great serpent through the power of the cross, is depicted as an active victor. Mazzuoli employed a dynamic composition in which the figure strides and leans forward implicating the space in the nave, and the saint confronts the viewer dramatically. Thereby, Mazzuoli manages to overcome the lateral restrictions of the niche and the imposing, but distracting, *verde antico* columns and pilasters with their elaborate capitals. Although not influential in Rome and often neglected by historians, the statue is successful in its own terms.

Until his death in 1728, Rusconi headed the most important sculpture studio in Rome, which attracted many of the leading artists of the future, including Della Valle, Bracci, and Maini. Rusconi's achievements would remain influential into the middle of the century. His tomb sculptures with their superior effigies are especially memorable. One of these masterpieces is the half-length figure of Giulia Albani degli Abati Olivieri (cat. 152). The type itself, more frequent in late seventeenth-century tombs, was employed into the 1720s. The orientation of her gaze, folded book, and hand on her breast, as seen here, are established elements of the type. Characteristic for Rusconi are the clear composition of the figure, calm

facial expression, and avoidance of details. His carving technique for rendering the striated veil is especially assured. The whole figure is unified by an exceptional understanding of the play of light over white marble. The result is a monumental work without heaviness and a portrait that is at once serious and refined. These qualities, expressed on a larger scale, also distinguish another masterpiece by Rusconi, the tomb of Gregory XIII in St. Peter's.

Rusconi's example as a portraitist was important for Bracci, who won notice with his bust of Cardinal Paolucci in 1725 and, in time, became the leading papal portraitist into the early 1760s. Nevertheless, in his best works one senses a different personality than Rusconi's, one in which a greater attention to the details of appearance convey suggestions about character or temperament, as with the unusually fully realized bust of Benedict XIV (cat. 109).

This was not the only current in portraiture. Cametti, in his bust of Giovanni Andrea Muti (cat. 110), demonstrates a brilliant technique that revels in the crisp rendition of details of physiognomy and costume. In striking contrast is Bouchardon's bust of Lord Hervey—represented here by the preparatory terracotta model (cat. 107). This is one of several portraits from the 1720s that were unmistakably intended to recall antiquity. The style became standard decades later for portraits of antiquarians, scholars, and artists. In yet another style is Slodtz's bust of Nicolas Vleughels (cat. 157), a subtle study, naturalistic and quietly perceptive. Generally, portrait busts, aside from papal likenesses, appear to have been rather rare in Rome, and the memorable ones were often not carved by Italian artists. Among the superior busts produced in Rome from the 1720s and 1730s, work by the French sculptors Bouchardon and Slodtz have long been prominent. When portrait busts emerged in greater number after 1765, the best-known Roman specialist was the Irishman Hewetson (see cat. 130), who settled there. Although a prominent figure in the artistic life of the city, he drew most of his sitters from among the foreign visitors. Does this mean that sculpted portraiture was unfashionable with the Romans themselves, or are there many busts in private collections currently unknown?

These few objects introduce the range of styles, sometimes contemporaneous, from a period of considerable demand for sculpture. In the current exhibition the best demonstration of this point is found in relief sculpture. It is fitting that this sculptural type was so prominent: the period was dominated by a pictorial aesthetic and was critical of Bernini, relief sculpture being a type to which he made no substantial contribution. The acknowledged

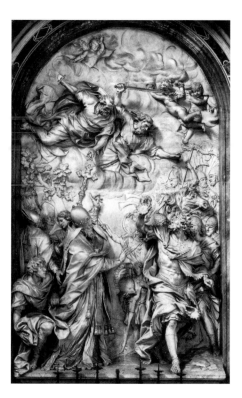

Fig. 91 Alessandro Algardi, *Saint Leo the Great and Attila*, 1653, marble; St. Peter's, Vatican City

masterpiece of the genre was, rather, the *Saint Leo the Great and Attila* relief in St. Peter's by Bernini's rival Alessandro Algardi (fig. 91). This impressive composition provided the prototype for the large marble altarpiece, a format that enjoyed a vogue in Rome in the late 1600s, primarily through works by Domenico Guidi, and into the early eighteenth century.

Many forms of relief, mostly on religious subjects, were required during the first half of the century. These works could be ordered in series for exterior and interior projects, or function as elements within more decorative schemes. A relief sculpture appears at the center of four eighteenth-century papal tombs (cat. 134). Not surprisingly then, the requirements of reliefs varied according to the nature of particular commissions. For some projects, such as the reliefs for St. John Lateran around 1735, sculptors were encouraged to create their own individual compositions. Hence the variety in their solutions. This approach was followed at S. Maria Maggiore and in works by Roman sculptors for the Chigi Chapel in Siena in 1748. Elsewhere a unified look was desired, as in the stucco decorations at Ss. Luca e Martina, S. Marco, and the vault of SS. Nome di Maria. For some of these projects, only information from documents allows us to identify the contributions of individual artists.

Reliefs tested a sculptor's intellectual ability to interpret subjects and his practical

Fig. 92 Pierre Legros II, *Youth Holding a Bas-relief,* detail from *The Arts Paying Homage to Clement XI,* 1702, terracotta; Accademia di S. Luca, Rome

skill in controlling the balance of figures and spatial recession. These challenges were judged as appropriate for the important competitions for student sculptors at the Accademia di S. Luca (cat. 144), Rome's most prestigious art academy. Hence, a relief appears in the hands of the youthful sculptor in Legros's depiction of the arts rendering homage to Clement XI for establishing the Concorso Clementino (fig. 92). Also, sculptors newly admitted to the academy usually presented one of their terracotta relief models as their required gift to the organization.[4]

One of these donations was Maini's *The Archangel Michael Presenting the Shield Inscribed "Charitas" to Saint Francis of Paola* (cat. 133), a relief more freely executed than most and appealing for its demonstration of the artist's easy control of malleable clay. The development of such an assured skill in modeling was a basic requirement for sculptors. Generally, however, sketchier preparatory works were not preserved, finished models being valued as more instructive. Nevertheless, the kind of fluid dexterity seen here had an important

place, especially in the execution of the many decorative works in stucco that are so important to Roman interiors.

Three objects in this exhibition give an indication of the variety to be seen in relief sculpture in the years around 1700. One is related to a masterpiece of Italian relief sculpture, Legros's *Saint Luigi Gonzaga in Glory,* the centerpiece of a huge altar in the crossing of S. Ignazio, completed in 1699. The relief draws on earlier Baroque devices by artists including Bernini and Melchiorre Cafà, but the resulting vision of elegant sentiment is Legros's own distinctive creation. The intimate mood seen here is to be found in much early eighteenth-century religious art in Rome, although it is rarely depicted so memorably as in this marble. Legros establishes an atmospheric background from which project the central figure and groups of angels above and below him. The saint's expression is introspective, but through the positioning of his head, it is possible for a viewer far below to experience a moving connection with the saint. A terracotta preparatory model shows the composition in an advanced stage (cat. 132). Later in the preparation process, full-scale plaster models were commonly used by sculptors before they set to work on marble (cats. 134, 155). Although such works were usually destroyed, Legros's plaster for this relief was saved and installed in another chapel in S. Ignazio.

Legros's carving skill was exceptional, but in general the technical dexterity of the sculptors active after 1700 was markedly superior to that of their elders, a point not made often enough. The new standard can be appreciated in De' Rossi's marble *Christ in the Garden of Olives* (cat. 149). Sculptures of this scale and format are sometimes found in pairs flanking larger religious images in altar decorations. Interestingly, De' Rossi's style appealed to artisans, and was adapted successfully by silversmiths to their objects.[5] Another type of relief was the traditional one of the representation of the Virgin and Child, which became something of a specialty of Monnot. In one such composition (cat. 138), a finished preparatory model, the tender grouping of the Holy Family is situated in a contemporary interior. Finished marbles on this scale could be the focus of private worship or be placed in galleries alongside paintings that they closely resemble.

The objects presented here indicate some of the richness of relief sculpture from the years around 1700. They have some qualities in common. All are accomplished in the ways in which they solve the problems of rendering numerous figures, spatial recession, and incidental details; and all depict intimate moods comparable to paintings of the same time. However, the artistic personalities of their

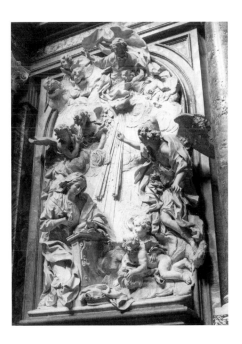

Fig. 93 Bernardino Cametti, *The Annunication,* 1729, marble; La Superga, Turin

makers are not to be confused. It is also important to realize that these same artists successfully undertook very different kinds of sculptures, including the Lateran Apostles only slightly later in date.

The mid-1710s and the 1720s were years rich in new talent as younger sculptors emerged. In the 1720s, when the Founders series was taken up again, Maini and Cornacchini each contributed a grand and vibrant statue, very different from the aesthetic of the Lateran Apostles. (Rusconi's design, based on his small model, was carried out by his assistant Giuseppe Rusconi, not a relative.) Cornacchini's ability was soon appreciated. It is demonstrated in this exhibition in the Deposition group, usually dated around 1714–16 (cat. 128). Here Cornacchini expands the confines of the relief form by creating a work that must be viewed from 180° for all its composition and details to be understood. In this active composition, intertwined figures project into space in a way unlike the reliefs just discussed, or earlier pieces such as Legros's and Théodon's marble figural groups on the Saint Ignatius altar in the Gesù, or the reliefs by these artists in the chapel of the Monte di Pietà. An extremely pictorial aesthetic is involved here. Jennifer Montagu compares the Deposition to fully three-dimensional compositions found in Florentine and French bronze groups. Cornacchini's figures can be related to the restless poses of the statues of *Hope* and *Charity* by Cornacchini and Cametti, in the Monte di Pietà, which extend outward from their niches. In the late 1720s these sculptors

went on to carve their astonishing reliefs at the Superga in Turin (fig. 93). Exuberant figures defy the limitations of their necessary background plane in these densely populated Baroque altarpieces, carved with bravura.

Scholars have long observed that the papacy of Pope Clement XII Corsini (1730–40) saw the rise of a distinctive style in art, expressed in ambitious projects carried out all over Rome. This was also the period of the commission of King John V of Portugal, in which Roman artists created a virtual Roman interior for Mafra in Portugal.[6] Some Roman commissions produced unexpectedly novel effects in sculpture, such as the allegorical figures and trophies that enliven the monumental façade of the Palazzo della Consulta. These sculptures possess a freedom generally associated with stucco sculpture or ephemeral decorations. Under this pope, the landmark Trevi Fountain was commissioned with public competitions for both the architecture and its sculptural decoration, an indication of the importance of the project and, perhaps, that the choice of the artists to carry it out was not foreordained. In 1730 a group of artists submitted thirty models for the project. According to tradition, the sculptural component was awarded to the French artist Lambert-Sigisbert Adam. However, both he in this project and Bouchardon in the design for a Corsini tomb in St. John Lateran were to be replaced by Italian sculptors. These events raise interesting questions about the opposition of established Roman sculptors to outsiders for important commissions and, also, about the reluctance of French officials to permit their young sculptors to stay in the city for a long time.

In many of the Corsini projects, artists from the family's native Florence had an important share, and there is a general refinement and lightness and a more sedate movement that differ from the styles of the preceding decades. One statue that has served as a touchstone for this style is *Temperance*, in the Corsini Chapel in St. John Lateran, by Della Valle, who is usually officially referred to as Florentine, although his career was Roman. A terracotta model of the figure is included here (cat. 158). Her demure appearance, graceful movement, and gentle folds of her garments express this subject beautifully. The viewer does not question the efficacy of her action of pouring water to dilute the wine, although her attention is elsewhere.[7] Her facial expression and pose appropriately reduce any erotic appeal from the detail of her bared breast. Indeed, the figure as a whole is subtly metaphorical. That sculptures of this period can contain such meaning has generally not been admitted. And it is true that Della Valle could produce allegories of the greatest refine-

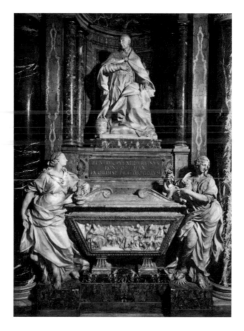

Fig. 94  Carlo Marchionni and Pietro Bracci, tomb monument of Pope Benedict XIII, 1734–39, marble; S. Maria sopra Minerva, Rome

ment with less content, such as the figures of Religion and Fidelity on the tomb of Sir Thomas Dereham.

Bracci, Della Valle's contemporary, whose art is the more vigorous of the two, responded to this style around 1741 in his figure of Strength for the tomb of Renato Imperiali, designed by Paolo Posi (cat. 108). Her seated pose and attributes are traditional. This tranquil, unaccented figure possesses a seamless beauty which may appear to us today as wholly independent of the figure or its symbols. To people more accustomed to the high Baroque of the seventeenth century, such a figure may appear bland to the point of meaninglessness. However, in the context of the tomb, her shadowed face and lassitude express strength in abeyance, in contrast to the activity of a pendant figure of Charity, who gestures as she turns to witness a winged figure of fame displaying the portrait of Imperiali. Thus a distinction is established between the two virtues.

Similar observations can be made about aspects of the stucco relief of Benedict XIII by Marchionni, a work especially admired when it was temporarily installed in 1737 (cat. 134). Romans must have appreciated the way the composition, depicting the meeting of the Lateran Council called by this pope, showed mastery of Algardi's prototype from the tomb of Pope Leo XI and included even more figures carved in a lower relief. They would have remarked, as modern spectators do, that here the blessing pope, though enthroned, is shown sitting at nearly the same level as the

host of cardinals surrounding him, rather than being set off above supplicant figures like the pontiffs in several earlier reliefs. This image of condescension and community appears between statues representing Purity and Humility, unusual choices for papal allegories, above which an effigy by Bracci is posed in a strikingly original way (fig. 94). Turned away from the viewer, Benedict XIII falls to one knee and addresses the altar in unmistakable adoration of the painting of the Virgin appearing to Saint Dominic.

In this world, different styles coexisted as they had before, although their differences were rarely jarring. Such a situation challenges contemporary art historians both to identify styles and to chart their changing courses, which are seldom abrupt. Even in an ensemble as unified as the sumptuous Corsini Chapel some variations in styles are discernible. In Maini's celebrated full-length portrait of Neri Corsini senior and the adjacent standing weeping angel on the cardinal's tomb, for example, there is a marked degree of clarity and naturalism that recall the classicizing Baroque of the seventeenth century. These concerns were not unique to Maini, since they can be seen in works by other artists from the mid-1730s and into the next decade.

For the statues added to the Founders series, sculptors did not abandon refinement, but Maini, Monaldi, and Montauti each created an image of a famous religious leader with a new look. Their approach is at work, as well, in some figures on the façade of S. Maria Maggiore, one of the major schemes of Pope Benedict XIV, from 1742. This is especially clear if these statues are compared with the looming saints on the Lateran portico. One such example, the figure of Della Valle's *Blessed Niccola Albergati*, seen out of context and in miniature form in the statuette exhibited here, may not register as especially remarkable (cat. 159). However, the full-scale statue, situated prominently on the portico, possesses a striking pose and a portrait-like head. The result is a convincing individual likeness of a person famous for his humility. The sculptor was, no doubt, responding to the pope's special interest in this figure, as Vernon Hyde Minor writes. Nevertheless, the statue is not unique in the project: four of the exterior figures here have far more distinctive appearances than usual.

In his well-known book on Italian Baroque art and architecture, Rudolf Wittkower wrote about the disintegration of allegory, noting the new emphasis on genre-like aspects in sculpture near mid-century.[8] This current can be detected in many objects in which the artists aim to make the meaning more narrative and direct. Saly's pensive head of a little girl (cat. 154), less a portrait than a description

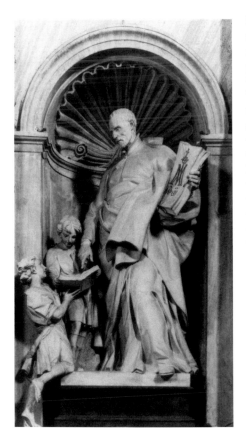

Fig. 95 Innocenzo Spinazzi, *Saint Joseph Calasanz*, 1755, marble; St. Peter's, Vatican

of a mood, can be related to this movement. So can works by Della Valle, even though his style does not dramatically alter in the course of his career. In the 1740s, nevertheless, he takes pains to create more naturalistic infants for the figure of Charity in his tomb of Innocent XII. A deeper exploration of a new sensibility occurs in his *Saint John of God*, one of the Founders series, said to have been based on a model by Bianchi, finished in 1745. The saint displays and supports a dying man, whose pose beautifully echoes a *Pietà*, with a cloth soon to be his shroud. Slodtz's more famous *Saint Bruno Refusing the Miter*, from 1744, is a more immediately striking composition. The gesture of his left hand seems more one of surprise than refusal, a feature that detracts from the essential meaning of the saint's renunciation of the bishop's miter and his embrace of a skull—indicative of a hermit's life. The most severe of the Founder saints and also the simplest in composition is Innocenzo Spinazzi's statue of *Saint Joseph Calasanz*, after a model by Maini, completed in 1755 (fig. 95). This statue stands midway between the naturalism of Algardi and the realism of the nineteenth century.

In some mid-century sculpture, the coexistence of various styles is uneasy or unsatisfy-ing. This situation is evident in the sculptural decoration of the Trevi Fountain, conceived in 1730 and completed in 1762. Part of the problem has to do with the scale of the figures within the monumental architecture. Della Valle's two female allegories are inflated to fit their niches and their gracefulness is impaired as a result. The Oceanus is the largest figure in the design, but he appears small in relation to the opening of the large arch behind him. With limbs pulled in various directions to look active from any view, his pose is a distorted stance that feigns movement. He is not enlivened by the drapery that billows around him. Below, the tritons and sea horses move freely, as do the figures of Fame flanking the Corsini shield on top of the cornice. The decorative standing allegories are charming enough in their sub-sidiary role, although rather small in propor-tion to the rest of the sculpture. These criticisms notwithstanding, it is necessary to admit that there is an ideal viewpoint for the monument. If a spectator stands in the center at the lowest level near the water facing Oceanus, all the sculpture falls into the correct scale within the façade, and the whole takes on an impressive life that curiously dissipates when viewed from other directions. How a viewer reacts to this fountain may be determined by preferences and expectancies about the rela-tionship of sculpture to architecture or sculpture within architecture.

The issue of the architectural setting for sculpture here is a reminder of how often this matter was important in eighteenth-century Roman art. The Saint Ignatius altar after 1695, the niches of St. John Lateran, the niches of the nave of St. Peter's, and the locations for papal tombs all involved settings in which sculptors faced challenging tasks that, no matter what their talents, were difficult to surmount and in which their creations were bound to function as elements of a larger whole. A number of these spaces also required colossal figures, a particularly demanding sculptural type. These were the projects that gave sculptors their greatest opportunities. But the results can be curious, as with Legros's marble tableau of the dying Stanislas Kostka, and Cornacchini's equestrian statue of Charlemagne, a sculpture whose merits are overwhelmed by its setting and its cruel placement opposite Bernini's *Constantine*.[9]

Otherwise, certain kinds of sculpture diminished in importance in the first half of the century. Tombs, generally, became smaller. Independent portrait busts were not nearly as prevalent as in the seventeenth century, and three-dimensional effigies on tombs were gradually replaced by portraits, either in relief or painted. (It is paradoxical then that one of the new sculptural types should have been the standing portrait or effigy, a tradition that begins with Legros's splendid statue of Girolamo Casanate, which presides over his library.) Important marble sculpture by the best artists was rarely required for fountains, and there are few large-scale independent marble figures or groups. The exceptions include Cametti's *Diana* of 1716–24, at the Staatliche Museen in Berlin, installed as a fountain decoration for an interior; Guidi's *Andromeda* of 1700, at the Metropolitan Museum of Art; and Mazzuoli's freestanding *Adonis* of 1709, at the Hermitage. It is hard to know for what sort of placement Monnot intended his statues of mythological figures (cats. 139, 140), conceived over a twenty-year period. They were eventually installed as an ensemble in a garden pavilion, the Marmorbad in Kassel. Montauti's *Pietà* group of 1733–40 was commissioned for the crypt of the Corsini Chapel.

The status of sculptors in the Roman art world after 1700 is in need of study. Before 1760 the leading sculptors—Rusconi, Maini, Della Valle, and Bracci—were honored by their colleagues by being elected Principe of the Accademia di S. Luca. From 1730 to 1736, Lione Pascoli wrote biographies of sculptors, then recently deceased, for Guidi, Rusconi, Legros, De' Rossi, Mazzuoli, and Monnot. The contrast of their careers with that of Bernini, described in the life published by his son in 1713, must have made some sculptors wonder about the changing fortunes of their art. The frequency of projects in which sculptors fol-lowed painters', or architects' designs—a tra-ditional practice—needs more attention, as do the prices paid for their work. Although it was not customary for sculptors to sign or date their objects, it is interesting that Monnot signed several reliefs in 1699 and inscribed his name twice on his tomb of Innocent XI. Rusconi's inscription on the tomb of Pope Gregory XIII refers to his status as a knight and claims the role of inventor and sculptor of the monument. Monaldi in 1738 and Slodtz in 1744 signed their statues of Founders in St. Peter's, as did Francesco Vergara, Pietro Pacilli, and Spinazzi in the 1750s. At present it is diffi-cult to know what significance, if any, these actions may have had.

Nevertheless, Roman sculptors in the first half of the century attracted some international clients. In addition to sculptures ordered by foreigners for placement in Rome, a number of works were acquired by collectors in England and, of course, Portugal.[10] Rusconi had a Spanish commission and was also invited to provide a model for an equestrian monument in Russia. Monnot's statues, mentioned above, created a complete Roman ensemble for Kassel. Sculptors in Rome also provided

objects for other Italian locations, and, following tradition, for their native towns or districts as well.

## THE REVIVAL OF ANTIQUITY

In the second half of the eighteenth century the production of sculpture changed substantially for various reasons. The most striking shift of emphasis was the rise, steadily through the century but sharply from mid-century, of the taste for ancient sculpture, which reached a level of prominence it had not hitherto attained in the European consciousness. In recent years aspects of this revival have been studied by a number of scholars. A comprehensive presentation of the subject can be found in *Taste and the Antique*, by Francis Haskell and Nicholas Penny.[11] Classical culture in the form of ancient Roman history was the common property of every educated European. Ancient sculpture was of interest to many for its relation to the history and literature of the Roman empire and to the early Catholic Church. Montfaucon's ambitious *L'Antiquité expliquée* of 1719 made a large repertory of images available in print form. Only later did the subject take on the concerns of nascent art history, most famously with Winckelmann's *Geschichte der Kunst des Alterthums*, published in Dresden in 1764, and in an Italian edition in 1783–84, which sparked intense debate over the merits of Greek versus Roman art.

Since the Renaissance, antiquities had been the most prestigious of sculptures to collect, and the most important holdings were papal, royal, or princely. This pattern continued in the eighteenth century with the dispersal of famous Roman collections. The Giustiniani collection was acquired by the Earl of Pembroke in 1720. The Odescalchi collection was bought by the King of Spain in 1724. The Chigi collection was purchased by Augustus the Strong of Poland in 1728. The collection of antiquities formed by Cardinal Polignac in Rome in the 1720s was acquired by Frederick of Prussia in 1742. Later, in the 1770s, the sale of the Mattei collection brought a large number of pieces on to the market. This decade marked the high watermark of international interest in collecting antiquities. Finally, in 1785 Thomas Jenkins, the English dealer established in Rome, bought the entire Villa Montalto-Negroni collection.

In addition to collections that changed hands, new pieces were discovered through excavations, which continued to be undertaken. Projects at Hadrian's Villa at Tivoli, carried out from 1724 to 1742 and again in 1769, produced many works for sale. There were enough pieces to support an international demand so that opportunities to collect existed for rich aristocrats and gentlemen, as well as heads of state. Many of the works that went through the market were not of high quality, and few of the most important antiquities left Rome by sale. However, it was a serious matter when, in 1769, the Medici began to send to Florence the family's antiquities previously kept in Rome, or when Charles VII removed the Farnese collection to Naples in 1787. Thereby a group of the antiquities most admired since the sixteenth century left Rome forever.

The popes tried to counter the exodus of antiquities in several ways. In 1701 Clement XI passed legislation to prevent the export of statues, bronzes, and gems from the Papal States. They also added to collections themselves. In 1734 Clement XII acquired over 400 statues from Cardinal Albani. These became the basis for the Museo Capitolino, which, with the attached Pinacoteca, constituted Rome's only collections open to the public. Benedict XIV bought a number of antiquities in the 1740s and conceived the Museo Cristiano at the Vatican, completed in 1756. Clement XIV, encouraged by the future Pius VI, acquired important pieces from the Mattei collection, after which the new Museo Clementino was founded. Until Clement XIV the collections at the Vatican included the old Antiquario in the Belvedere, unchanged since the sixteenth century, and the Vatican Museum, the library of which comprised sacred and profane sections. In 1776 plans were drawn up for two branches of the future Museo Pio-Clementino. The new museum was opened in the 1780s. A catalogue of its collection was published in seven volumes from 1782 to 1807.

The study of famous antiquities, either from drawn or modeled copies, was a fundamental part of the education of artists. The opportunity to learn from them was, indeed, the principal reason for young artists to attempt a sojourn in Rome. The international growth of interest in academies and art schools reinforced the primacy of study after the antique across Europe. In Rome, however, it could be difficult for artists to obtain permission to study pieces in private collections. Hence the importance of the Capitoline, which was readily accessible, and the Vatican collections. For much of the century plaster casts were a rarity. It required influence to persuade owners to allow molds to be taken from original works, and the casts themselves were expensive to make. For these very reasons, one of the most important places for young artists in Rome was the French Academy, housed in the Palazzo Mancini after 1725. Installed there, for the primary benefit of French students, was the only collection that assembled plaster casts after all the most admired antiquities. Artists of other nationalities were allowed to draw there, too. This collection was much admired and, eventually, imitated. In the late 1740s the rich Abbot Farsetti of Venice—aided by his influential uncle the future Pope Clement XIII—set about creating a similar collection for his native city and for the academy in Bologna.

The restoration of antiquities was a traditional part of a Roman sculptor's activities. By long custom, fragmentary or damaged pieces were repaired and restored to look complete. It was not unusual for a young sculptor to make copies or restore sculptures as part of his training. French *pensionnaires*, for example, were usually required to copy an ancient work for eventual placement in royal buildings in France. Lambert-Sigisbert Adam's experience of studying the *Laocoön* is clearly reflected in his head of *Dolore*, presented to the Accademia di S. Luca (cat. 103). Lesser artists might continue to specialize in routine copies and restorations. However, to be entrusted with a famous work, such as Bracci's restoration of a statue of Antinous belonging to Cardinal Albani, was an honor as it had been in the sixteenth century, when artists were consulted over works such as the *Laocoön*, and in the seventeenth century, when Bernini, Algardi, and Duquesnoy all restored important statues. Among the most important Roman sculptors, Rusconi, Maini, and Della Valle made copies of antiquities for English patrons. At the end of his life Rusconi, then the leading sculptor in Rome, took great care over the carving of the statuette of a Faun (cat. 153), after an antiquity, as a present for an unknown friend.

In the 1740s, when a number of antiquities acquired by the pope were in need of restoration, the main sculptor employed was Bartolomeo Cavaceppi. He gradually transformed the previously mostly anonymous activity into a lucrative international business. In time, he acquired a palace to house his workshops and vast collections, which came to be an attraction for foreign amateurs. Cavaceppi's ambitions to open his own academy did not come to fruition, but his studio served as the training ground for sculptors, some of whom, such as Nollekens and Albacini, became important artists. In the 1760s, when general economic problems may have prompted him to prepare to dispose of some of his already numerous works of art, Cavaceppi published three volumes of his illustrated *Raccolta*. The first volume contained pieces he had already sold: mostly to England, although some had been sold to Germany and Russia as well; the second volume consisted entirely of pieces identified as for sale.[12]

This exhibition contains a selection of works by Cavaceppi. Included are two terracotta models, retained in his studio, which were made in relation to restoring antiquities

(cats. 117, 122). Presumably, they were shown to prospective clients as well. Much of his studio's activity was devoted to the production of portrait busts of ancient Romans. The marble busts of *Faustina the Younger* and *The Emperor Caracalla*, shown here, are rarities, being signed and exceptionally well-carved copies (cats. 119, 120). Versions of favorite models were turned out by Cavaceppi's assistants in varying quality and in considerable numbers. Heads of the Faustina, for example, can be found in eighteenth-century collections from Liverpool to St. Petersburg. Agents, architects, or collectors often ordered such copies in quantity for decorative purposes. However, purchasers must have been frequently misled about the authenticity or the amount of restoration involved in their acquisitions.

One of Cavaceppi's most interesting restorations is the *Myron's Diskobolos Restored as Diomedes with the Palladion* in this exhibition (cat. 121). Most museum visitors will immediately recognize the pose of the figure as that of the *Discus Thrower*. However, the correct, complete composition was not understood until later in the eighteenth century. As Seymour Howard has written, it was the painter Gavin Hamilton who found this fragment in 1772, and who probably provided Cavaceppi with the idea for restoration of the torso as the figure who stole the idol of the gods from the temple of Troy. In his letter to a knowledgeable client, Lord Lansdowne, Hamilton offered the statue as a potential pendant to another marble figure already in Lansdowne's collection, by proposing that they would form a pair—a Greek hero to join a Roman one, Cincinnatus. The need to identify the subject of just such a fragment must have been a source of constant interest in learned circles in Rome, and it was essential, of course, before restoration could be undertaken. Hamilton's reference to Greece in this instance—correct in style, if not in subject— would have been especially meaningful given the direction of informed taste of the day.

Cavaceppi sold other kinds of pieces as well. From his studio issued the *Boy on a Dolphin* (cat. 141), an eccentric composition that was surprisingly popular in the 1760s. Versions were produced in several sizes for English, Irish, French, and Russian clients. In his *Raccolta*, Cavaceppi claimed that the design was by Raphael and executed by Lorenzetto, the sixteenth-century sculptor known to have carried out some of the painter's compositions for sculpture. (Sculptures by Michelangelo and Mannerist artists such as Giambologna were of increasing interest to foreign artists and visitors after 1760.) Seymour Howard's research shows that Nollekens was known to be the executant of the example shown here as well as other versions, so some of the purchasers

must have known that theirs was neither an old nor a unique object. These transactions illustrate the potential value of the making of copies and versions, for which there was a potentially wide market. Far less expensive were the bronze reductions of famous antiquities that began to be cast—some after models by sculptors such as Vincenzo Pacetti—in the 1760s, first by Giacomo and Giovanni Zoffoli and then by Righetti (cats. 147, 160). These pieces were usually purchased in groups to be displayed together, as on a chimneypiece. After 1785 statuettes of similar dimensions were produced in porcelain by the Volpato factory (cats. 100, 102). These high-quality items, intended for tourists, found ready buyers to the end of the century.

It is one of the concepts most alien to the modern mind, which prizes originality in a work of art, that copies were so esteemed and sought after. Sculptors of two generations gained considerable fame as well as fortune from these works. Eventually, Cavaceppi was succeeded as a restorer by his former assistant Carlo Albacini. His *Flora* (cat. 104), after one of the most admired female statues from antiquity, demonstrates the finesse of his carving, through which the original models are subtly transformed into particularly elegant variants. The positive attitude towards copying changed only toward the end of the century. Canova was in a minority, in 1779, in his disapproval of copying antiquities. Nevertheless, he grew to admire the craftsmanship displayed in copies by Cavaceppi and Angelini. Moreover, it was the strength of this established taste that led to the interest in similar kinds of works by contemporary artists and provided the models against which their sculptures were judged.

## 1760–1800

In the two decades following the completion of the sculpture of the Trevi Fountain there were few notable commissions of public sculptural monuments in Rome. Nevertheless, a small number of conspicuous works point to creativity of different kinds and the emergence of a new stylistic direction. Bracci demonstrated interesting innovations in his tomb of Benedict XIV, from 1769 (fig. 96). The progressive features include the handsome, spare architectural setting, the notable allegorical subjects, Wisdom and Disinterestedness, and the pope's stance, which has struck most writers as unstable. Nevertheless, Bracci brought his skills as a portraitist to his rendering of the pope's features, and the standing pose is a fresh interpretation of the traditional blessing gesture of the pontiff. It is not a solemn or noble figure; rather, it has a degree of convincing liveliness—following the fashion then

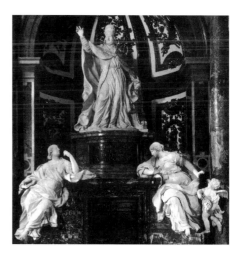

Fig. 96 Pietro Bracci, tomb monument of Pope Benedict XIV, 1769, marble; St. Peter's, Vatican

current, seen in the representation of saints— that makes it memorable among the papal monuments in St. Peter's.

Within the traditional type of the single statue of a saint, Houdon's *Saint Bruno*, of 1766–67, is unlike anything else in Rome. Even if the sculptor learned from the monumentality of Spinazzi's *Saint Joseph Calasanz*, Houdon's figure possesses a striking and unique self-containment. This quality is even visible in the plaster statuette that probably preserves Houdon's original model (cat. 131). The naturalism of the quiet colossus is not a matter of superficial appearance but of concept and structure. Houdon has meditated about the form most appropriate for the founder of the Carthusians, an order that requires a vow of silence. Also, Houdon applied lessons learned from his radical study of anatomy, which led to his famous *écorché* of 1766–67, in creating the head of the saint.[13] The final statue is expressive in a concentrated way that is almost symbolic.

Two other monuments demonstrate different approaches to another kind of artistic problem, designs of an overtly theatrical nature. Giovanni Battista Piranesi's composition from the 1760s for the altar with the glory of Saint Basil (cat. 24) demonstrates his eclectic and synthetic approach to the art of the past, which here transforms the altar form. The design combines ancient sarcophagi, a tender image of the Virgin and Child and Saint John, and putti worthy of Della Valle in a dynamic depiction of the saint, realized in a combination of stucco and marble. Another theatrical creation is Agostino Penna's monument to Maria Flaminia Chigi Odescalchi, from around 1771 in S. Maria del Popolo, a project designed by Paolo Posi, which presents, uniquely, the aesthetic of a temporary decorative "machine,"

Fig. 97 Giuseppe Angelini, tomb monument of Giovanni Battista Piranesi, 1780, marble; S. Maria del Priorato, Rome

but one executed in the costly, noble materials of marble and bronze. The two monuments have remarkably different effects. The Piranesi altar looks part monochrome apparition, part large, provisional model, enhanced by its location in the architect's unusual, all-white interior of S. Maria del Priorato. The Odelscalchi monument has a different unexpected impact as a secular-looking decorative composition carried out lavishly and on a large scale, with great attention to detail, and unquestionably intended for permanence.

The marked individuality of these works sets them apart from the approach visible in pieces by three artists, then emerging, in this exhibition. In the model of *Achilles and Penthesilea*, from 1773, Vincenzo Pacetti clearly adapted the famous ancient Pasquino group for his basic pose (cat. 145).[14] The contrasting treatment of the sexes and their expressions reflect contemporary interests to be found in works by other sculptors, such as Sergel. Nevertheless, it is interesting how Pacetti gives weight to different elements, essentially maintaining the legacy of Baroque art while admitting innovative features. The relief of *Judith Showing the People the Head of Holofernes*, by Camillo Pacetti, from 1775 (cat. 144), is an ambitious exercise in the Baroque style, aspects of which go back to reliefs of the 1730s, only there is here an increased attention to a genre-like description of reactions among the witnesses to Judith's shocking triumph.

Perhaps because these were works created to submit to the Accademia di S. Luca for competitions, they reflect a conservative side of Roman art. It is interesting, as well, to see that another Roman style attracted the attention of a newly arrived French sculptor Poncet. An artist who had already executed precocious, Neoclassical work in France, Poncet created in 1773 a relief of a Holy Family (cat. 146) that must have been intended to demonstrate his understanding of the style of Della Valle, who had died in 1768, as seen most prominently in his large marble relief of the Annunciation from 1750. These works, by artists little known outside Italy, are instructive about the range of Roman sculpture and the potential for continuity or renewal of Roman styles that existed in abundance at the beginning of the last quarter of the century.

These sculptures also make the impact of Angelini's statue for the tomb monument of Piranesi of 1780 more appreciable (fig. 97). Here the naturalistic head of Piranesi, based on the portrait in this exhibition (cat. 142), in a style comparable to ancient Roman portraits, is joined to a classicizing togated body. The result may not seem remarkable today. However, when unveiled, this statue resonated in the city's artistic circles as the first demonstration of a correct Neoclassicism. Angelini's then much-admired style is apparent, as well, in the allegorical group of *Spem alit Prudentia* given by the sculptor to the Accademia di S. Luca in 1789 (cat. 105).

While the complexities of the Roman sculptural scene after mid-century are only now beginning to be appreciated, the work of visiting young foreign artists has received more attention. The chronological tables in the *Dictionary of British and Irish Travellers to Italy* contain statistics revealing why the phenomenon of visiting artists needs to be reckoned with after mid-century.[15] In the 1740s twenty-four British artists visited Italy, whereas in the 1750s and 1760s the number doubled. From 1770 to 1780 the number of visiting artists rose to seventy-five. In the 1780s fifty-two visited, and even in the turbulent 1790s forty-four are recorded. Of course, other British and Irish travellers came to Italy as well. The phenomenon of the Grand Tour transformed the nature of the traditional Italian sojourn for artists. Then, they could meet potential clients, earlier in their careers and often more easily than in England. For sculptors, sometimes, works that might never have left the model stage were chosen to be carried out in marble, or were purchased from the sculptor's studio by English visitors fired by the possibility of exercising their taste and means. Artists who settled in Rome were often engaged in the sale or commission of objects for their countrymen.

Describing the attractive status possible for an English artist residing in the city, John Deare wrote home "I live like a gentleman."

Rome could also serve to launch careers from afar. Nollekens conceived his bust of Laurence Sterne (cat. 143), modeled while the famous writer visited Rome, as a piece to be sent to London for exhibition. It made Nollekens's reputation, as John Kenworthy-Browne observes. French artists had traditionally used the Roman sojourn to prepare works to show at the academy's Salon upon their return, a crucial event for an artist. Officials in Paris and Rome involved in administering the French Academy at Rome normally monitored the progress and promise of the pensioners in Italy with thoughts to future employment on royal projects. However, during the third quarter of the century, French, Swedish, and Russian connoisseurs kept an eye on the promising young French sculptors while they were in Rome or met them there, so that there was more potential for commissions for the students and for early recognition. Gérard Hubert's concise survey details how international the foreign population of artists was during these decades.[16]

Two of the most appealing of the foreign sculptors, Clodion and Sergel, were friends. Clodion, who arrived in Rome in 1762, enjoyed an early success with his small models, said to have been purchased "even before they were finished" by important collectors, Italian, German, and Russian, as well as French. In the reclining figure of the River Rhine of 1765 (cat. 124), the sketchy surface suggests a preparatory model. Nevertheless, no full-scale project for the figure is known, and Clodion made several versions of the sculpture during his Roman years. Soon the sculptor developed a degree of finish not far from Cavaceppi's models, but with a degree of delicacy and subtlety that transformed the terracotta into sculpture meant to be appreciated as a finished object. This intention is reinforced by the presence of Clodion's signature and a date on some objects, not normally found on traditional preparatory terracottas. Today, the number of marble works created by Clodion in Rome is unknown. The only such statuette certainly commissioned in Rome was ordered in 1768 for Catherine the Great by the Russian envoy Shuvalov, most likely after he saw the small model shown here (cat. 127). The marble was one object in a commission to four young French sculptors at the French Academy at Rome. It is a tribute to Clodion's inventiveness and craft that, even when such compositions have classical prototypes, they are not immediately thought of as copies or reductions. The marvelous small vase in Chicago (cat. 126) is also related to a terracotta model.

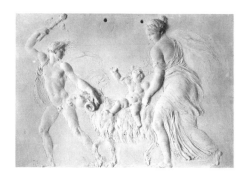

Fig. 98 Johan Tobias Sergel, *Infant Bacchus Riding a Goat*, 1770s, terracotta; Nationalmuseum, Stockholm

Sergel—who had studied previously in Paris and attracted notice there—began working in Rome in the mid-1760s by concentrating on drawings, and, in the 1770s, went on to create a number of terracotta models of single figures and groups, choosing dramatic subjects from the *Iliad* and *Odyssey* (cat. 156). Around 1770 he became famous for his *Reclining Faun*, much admired for its vibrant naturalism. Versions of the small statue were ordered by the Bailli de Bréteuil (who owned an example of Nollekens's *Boy on a Dolphin*) and the King of Sweden. The full-scale plaster of *Mars and Venus* (cat. 155) is a more ambitious composition, worked up from a small model in Rome, but the carving was not completed until after Sergel's return to Stockholm. (Initially Sergel had planned to execute this group on a colossal scale.) The intensity of the group is enhanced by the compression of the figures, which anticipates the form of the marble block, so different from the traditional, hellenistically derived composition of Pacetti. Sergel's plaster also carries to the final dimensions the impetuous sketchiness of his small model, a feature that was effaced in the final marble.

Both Sergel and Clodion also created distinctive terracottas in relief. Sometimes Clodion combined various techniques in the same work. In the relief *Three Maenads Dancing* (cat. 125), freely based on the *Borghese Dancers*, as Anne Poulet has shown, assured graphic passages are joined to modeled areas of a high finish, skillfully manipulated throughout to appear spontaneous. The relief, which once had a pendant, is signed and dated. Sergel must have known just such pieces by Clodion. In his own reliefs he employed the same means, but the resulting works possess a characteristic vigor and rough freshness, equivalents in clay of his sketchy drawings (fig. 98).

Terracottas by these two artists belong to an interesting phenomenon, the increased importance of this material for artists and collectors. Although most of Sergel's known ter-

racottas remained in his studio, Clodion intended his to be sold, as has been mentioned. In Rome terracottas must have been common, if mostly in sculptors' studios. At the Accademia di S. Luca there was the collection of models by students submitted for competitions and the gifts from members (cats. 105, 133, 144, 145).[17] By mid-century Bartolomeo Cavaceppi had a collection of 100 terracottas in his possession. Around 1750, in Rome, Abbot Farsetti assembled a group of 200 terracottas, now mostly at the Hermitage, for his museum in Venice, which functioned partially as an academy. One Della Valle model in this exhibition (cat. 158) was purchased from Rome for an English collector in the 1740s, and other Englishmen were especially interested in sixteenth-century material after the 1760s. Several interrelated issues are involved here. There is the collectors' interest in acquiring exquisite reductions of notable sculptures or preparatory models, some by acknowledged Old Masters. The taste for new sculptures in the material of preparatory models is another matter. Artists, meanwhile, explored the preparatory process—more or less conventionally, according to their temperament—and some, such as Clodion, created pieces in terracotta that were intended as the finished works of art. These clay objects might possess the customary finish of pieces for presentation, or retain the sketchiness of working models.

The 1770s saw a remarkable transformation of the ambitions of relief sculpture. The style of Doell's *Minerva Handing Pegasus over to Bellerophon* is astonishingly advanced for its date of 1774–75 (cat. 129). An artist in the circle of antiquarian connoisseurs Winckelmann and Johann Friedrich Reiffenstein, Doell created here an image of striking Neoclassical purity. The nude male figure of Bellerophon is an adaptation to a relief format of the famous bronze statuette the *Idolino* in Florence.[18] The incorporation of three-dimensional figures to the demands of relief explains the awkwardness in the positioning of Pegasus and the weakness of the central gesture. Nevertheless, this male nude did not have a clear successor until Canova's first Roman statue, *Apollo Crowning Himself*, of 1781, at the J. Paul Getty Museum. The other important marble reliefs from the mid-1770s were executed by Thomas Banks, who had carved reliefs, now lost, earlier in England. In Rome he created four compositions recognized, then as now, as the first epic Neoclassical reliefs by an English sculptor. The relief in this exhibition (cat. 106) demonstrates several sides of Banks's artistic personality, the study of ancient sarcophagi for the nude figure of the grieving Achilles and the interests of a like-minded group of friends including Sergel,

Nicolai Abraham Abildgaard, and Henry Fuseli, whose influence is especially clear in the passage of the entwined figures of Thetis and her nymphs. The lyrical aspect of the composition—not to be found on ancient reliefs—is certainly pictorial, but it may be indebted, as well, to compositions on ancient engraved gems, as Malcolm Baker suggests. These are brave creations, treating demanding literary subjects, chosen by the artist and worked up to the scale of the finished model without the assurance of a secure commission. Banks found patrons to order three of the compositions in marble, but he was badly treated about payment, notably by the Earl of Bristol and Bishop of Derry, who ordered and then canceled this project. By the early 1780s Sergel, Clodion, Doell, and Banks had left Rome, and few of their works are known to have remained in the city. Although there is still much to be learned about the artistic genesis of their objects, the cross-influences among these acquaintances are intriguing, as Nancy Pressly's study of the Fuseli circle has demonstrated.[19] No one can overlook that these creations were inspired by the challenges and possibilities that arose from the artists' synergetic Roman experiences.

In 1779 Antonio Canova visited Rome from Venice, and by the spring of 1781 he had settled there. With the completion of *Theseus and the Minotaur* in 1783, Canova became the most interesting sculptor in Italy, and his tomb of Clement XIV, finished in 1787, established his reputation as the finest sculptor of his time. This great artist is still in the process of being rediscovered, and this deserved attention makes it all the harder to a reconstruct a comprehensive view of sculpture in the city he chose to live in.[20] Like other artists from outside Rome, Canova was considered a foreigner. This situation could have some advantages, as it did for Canova, since the Venetians in Rome included his generous and sympathetic protectors, Ambassador Girolamo Zulian and Prince Abbondio Rezzonico. Certainly, Canova encountered more hostility because he was such a successful outsider: the fact that he was not elected a member of the Accademia di S. Luca until 1800 reveals the degree of Roman rivalry he inspired. This was after he had completed two papal tombs, an honor not achieved by a sculptor since Bernini, and was acknowledged throughout Europe as the preeminent sculptor. His international clientele exceeded Bernini's own considerably. Canova even received a commission for a tomb monument in Philadelphia in 1794, a project that unfortunately did not proceed beyond the stage of a small model (fig. 99).

Excellent treatments of Canova's life and career can be found in short and longer forms

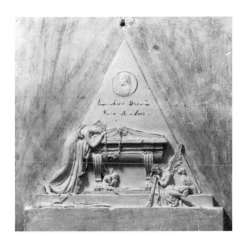

Fig. 99 Antonio Canova, model for a tomb monument to an unknown friend of Frank Newton, 1794, plaster; Museo Civico, Bassano del Grappa

in various sources. This essay will consider only some general issues and a few works of art. To begin with, it is essential to acknowledge the number and ambition of the artistic problems he undertook. In the 1780s Canova created a range of sculptures, including the single male nude figure, a group with two male figures, two designs for papal tombs, a pair of compositions of seated lovers, and a series of narrative reliefs. In the 1790s he produced three compositions of lovers (standing and reclining in motion), numerous tomb designs, including several in the form of a stele, various Christian subjects, and a standing figure of *Perseus*. He explored the theme of standing figures in motion in the graceful single figure of *Hebe* and the violent group of *Hercules and Lichas*.

From the beginning of Canova's career in Rome, his work was admired as rivaling or surpassing antiquity. As Seymour Howard notes, Canova intended to create new classics. For all his consultation of earlier objects, he was considered, as he intended to be, a modern artist. This can be seen in the Giustiniani Stele (cat. 114), an ancient type revived by Canova, designed according to his proportions, and whose seated personification of Padua does not copy an ancient model. The stele is full of distinctive elements, including the rendering of drapery, the angel mostly hidden by the inscription, and the owl represented in flight. The artist's letters and other sources testify to the range of art he studied. In this he was not unusual. However, the unpredictability, richness, and originality of his art are notable. The degree of refinement in the lines and forms of his sculpture, the rendering of the smallest elements, and the astonishing surfaces, which rival aspects of paintings or any earlier sculpture, must have been intended for the kind

passionate examination and attention to detail that are found in Winckelmann's writings on antiquities.

The breadth of Canova's artistic personality can be seen in his attraction to many media, including his idiosyncratic drawings and paintings. The searching side of his creative process is apparent in his three-dimensional models. Three of them are included here to give some indication of their variety. The *Cupid and Psyche* (cat. 112) is a sketchy compositional study in which the combined poses of the figures are largely worked out and the opposing nature of their facial expressions is suggested. The unsystematic scoring of the surface is interesting, since some of the strokes that help establish the three-dimensional forms, after which clay was added or smoothed in some areas, also enliven the surface. The resulting degree of graphic animation is expressive of both the speed of execution and the violence of the subject. (A beautiful, disciplined use of overall scoring appears on the plaster group of *Adonis Crowned by Venus* at Possagno.) *Antigone Mourning the Dead Eteocles and Polynices* (cat. 115), from just before 1800, is a study with a greater range of surface treatments. There are schematic, efficiently executed abstract forms in the outstretched arm on the ground, but also well worked-out interlocking figures, suggestions of grieving expressions, and an attention to details such as hair and a helmet—in all, a number of competing elements pursued at the same time and kept in balance. A third kind of model, is the statuette of *Piety* or *Meekness* (cat. 111), an idea for a figure for the tomb of Clement XIV. This is a figure in which the earlier stages have been refined, approaching their final form. Although the face is simplified, the figure's stance, hands, and drapery are impressively realized. Normally Canova would carry out a finished full-scale plaster model before carving was begun. That Canova fired his clay models and retained so many—parting with them usually only to friends or acquaintances he admired—point to the importance he attached to objects produced during the process of creation.[21]

Several aspects of Canova's art stand out as particularly significant in an overview of eighteenth-century Roman sculpture. One of his finest qualities was his ability, when required, to deal with the existing spaces for which his works were destined. Not since Bernini had a Roman sculptor been so sensitive to the settings of his works. However, whereas Bernini managed through his grasp of proportion to involve the space around his figures or compositions, Canova created discrete works that exist in, but are not compromised by, their surroundings. By their perfection they can even dominate their locations, as in the tombs

of Clement XIII and Clement XIV. Canova achieved this while often treating intimate or internalized emotion. The seated Clement XIV has a weighty symbolic presence with his arm outstretched, while the kneeling Clement XIII is a compelling figure even though he is absorbed in prayer, with his head lowered. When not facing a specific intended location, Canova generally fixes the viewer's attention through subtle, often stylized, but original, poses for his figures. These often enhance the meaning or narrative of the subjects and are formally rich, creating many interesting viewpoints, even though a figure or group may have a pronounced frontal orientation.

From an early stage Canova chose original subjects or interesting ways of approaching familiar themes. This is especially evident in the reliefs from the late 1780s and early 1790s, which were never carried out in marble. They include the classical frieze of *The Departure of Briseis*, the stately procession of *The Trojan Women*, the violent *Death of Priam*, a gentle *Homecoming of Telemachus*, the joyful *Dance of the Sons of Alcinous*—remarkable for their extremely varied approaches to composition and their explorations of many poses, emotions, and details. The lack of stylistic unity and variations in format made the reliefs an unconventional series by normal decorative standards. Nevertheless, as Giuseppe Pavanello has shown, sets made up of varying numbers of reliefs were acquired by important Venetian families.[22] In 1796 Canova demonstrated a very different approach in the reliefs of *Teaching the Ignorant* and *Feeding the Hungry* (cat. 113) by reducing the number of figures and concentrating on the symbolic nature of the subjects.

That Canova attracted an international patronage by the late 1780s is a tribute to his genius. However, this is only explicable because he came to attention in Rome, the center of the market for ancient marbles, and because his sculptures appealed to that already well-established taste. Eventually, to satisfy the demands for his sculptures, he faced practical problems rather like Cavaceppi's, and he certainly employed numerous well-trained assistants. However, unlike the restorers of antiquities, he was scrupulous about attending to the finishing touches of his works himself, even when it was a matter of a repetition.

A good example is *Cupid and Psyche* (cat. 116). The group takes up aspects of two previous works. Psyche is derived from a single figure which Canova created in 1789. The theme of standing, embracing lovers he had explored beginning in the same year, with *Venus and Adonis*, who gaze into each others' eyes. In 1796 he conceived the idea of making a standing group of Cupid and Psyche to symbolize innocence, as a pendant to the group of Cupid

embracing a reclining Psyche, which symbolizes lust. The central gesture of the standing group consists of Venus placing a butterfly, symbol of the soul, into the palm of her lover's hand, and it is the butterfly they both contemplate. Innocence is conveyed by the adolescent body types and the direction of their gazes, but sentimental and erotic implications are present nevertheless, if very subtly expressed, in the poses and the sensuously worked surface of the marble. This Cupid and Psyche group exists in two marble versions, of which the one shown here is the second, acquired by Empress Josephine. (It and the earlier example at the Louvre are based on a full-scale plaster model that Canova kept in his studio.) In executing his repetition, Canova slightly refashioned the heads and faces of his lovers, and made a number of changes and refinements in the figure of Psyche and her garment, enhancing the delicate expression of the group overall. This is just the process described by Quatremère de Quincy, which he said justified calling the later versions "original copies." Seeing the first version some years after it was finished, Canova recut some passages to improve it, as well.

All of these aspects of Canova's art point to the caliber of his creativity and his high standards as a craftsman, through which modern sculpture affirmed its independence from a subsidiary role. The recognition of the new value of sculpture was not only aesthetic but monetary. Hugh Honour has commented that sculptors were able to ask higher prices in the 1790s than in the decade before, because of Canova's example.[23] However, Canova was not alone in the 1790s in extending claims for sculpture. Especially in the eyes of English connoisseurs, a rival existed in Flaxman. Luckily, Flaxman enjoyed the protection of rich patrons, so he was able to execute various projects concurrently around 1790. For Thomas Hope he created a model for the restoration of the Belvedere Torso as a Hercules, to which he added a diminutive figure of Hebe. His two-figure group of *Cephalus and Aurora* bears comparison with Canova in that the male nude looks back somewhat to the *Apollo Crowning Himself* and the Aurora precedes the figures of *Hebe* and *Victory*, but the sculpture is truly innovative as a group of two figures in motion. Although it is easy to criticize as derivative today, *The Fury of Athamas* was yet more ambitious (fig. 100). In this survey of eighteenth-century sculpture the group has a significant place as the first freestanding colossal marble of four figures depicting violent movement that directly sets out to rival the most famous Hellenistic sculptures, such as the *Niobids* and the so-called *Paetus and Arria*.[24] Canova was considering this problem in 1795 in his astonishing and powerful group of *Hercules and Lichas*,

for which the full-scale model was completed by April 1796. Flaxman's greatest fame, however, was not derived from these works but came about from his drawings (cat. 345), intended as ideas for relief sculpture, that illustrate subjects from the *Iliad* and the *Odyssey*. The designs, consisting of simple outlines derived from vase paintings to suit the Homeric subjects, were hailed universally as authentically antique when engraved in 1793. They would be put to a seemingly endless variety of decorative purposes. In a short span of years, between them, Canova and Flaxman made the greatest sculptural contributions to the end of one century and beginning of the next.

For the years around 1780, the decoration of the Villa Borghese is the project that reveals the situation of sculpture by Roman artists most clearly.[25] The conditions governing the commissions were traditional with sculptors sometimes working in teams, sometimes providing their own models, but sometimes being given models or drawings to follow. This explains the wide range of styles to a degree, although diversity was certainly an overall aim. The predominant role of the architect Antonio Asprucci was emphasized in E. Q. Visconti's contemporary guidebook to sculpture.[26] From 1776 to 1778 come the *Dance of the Corybantes* in the Room of the Gladiator and reliefs for the Room of the Vase, by Vincenzo Pacetti, who based his designs on antiquities, although the effects are different, one resembling a Wedgwood plaque and the other a heavy composition by Gavin Hamilton.[27] The team of sculptors that decorated the large Room of the Emperors around 1780 created narrative stuccos in a surprisingly Baroque style, although the smaller lozenges on the pilasters below are more classical. It is hard to know what stylistic name to apply to the four translucent vases by Laboureur of 1785. The form of the vases is essentially classical. Running around the vases are friezes of children, representing the activities of the seasons, like those on ancient gems, but the backgrounds are filled out with landscape details. The most clearly Neoclassical sculptures in the villa are the four reliefs in yellow marble of seated deities, from 1782 to 1784, in the Room of Paris and Helen, again by Pacetti. These are probably based on designs by Gavin Hamilton, who executed the ceiling painting. Originally the room contained two marbles by Agostino Penna, of *Paris* and *Helen*, probably also designed by Hamilton.[28] The statues, although based on ancient models, have elongated proportions and swaying stances of an almost Mannerist elegance. They look closer to figures in paintings by Hamilton or Mengs than to sculptures. They, with the Pacetti reliefs in the same room, provide the best compar-

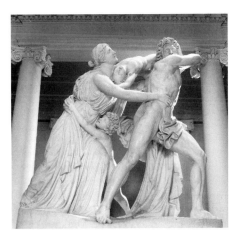

Fig. 100 John Flaxman, *The Fury of Athamas*, 1790–94, marble; Ickworth House, Suffolk

isons to set off the originality of Canova's *Theseus and the Minotaur*. Sculptors were also put to other tasks at the villa, restoring antiquities, devising sculpture for fountains, carving precious materials for fireplaces, and executing models for furniture elements. A good example of the unexpected affinities to be found in Roman work around 1780 are the figures Vincenzo Pacetti provided for the console table (cat. 59) for the villa, which demonstrates a continuity of sixteenth- or seventeenth-century classicism rather than a Neoclassical approach. Now that the restoration of the villa is complete, the brilliant, imperial elegance of the interior can be appreciated anew. However, although the activity of eighteenth-century sculptors was apparent and was described in Visconti's book, only in the Room of Paris and Helen, on the second floor, did works by Pacetti and Penna provide the entire sculptural decoration, and were the only contemporary pieces illustrated by Visconti, in comparison with the many antiquities and Bernini's creations installed throughout the main galleries.

Two later projects by Pacetti point to the almost bewildering diversity that existed in decorative sculpture then. For the Palazzo Altieri's Gabinetto Nobile, in 1789–91, he executed the charming marble frieze with children depicted in ancient games, under the direction of the architect Giuseppe Barberi, and perhaps after drawings by Felice Giani.[29] And for S. Salvatore in Lauro, under the architect Asprucci, Pacetti produced the glory of stucco angels with marble heads of cherubs. As one of the last exercises in a frankly Baroque style, it is not an original work. It is, however, a beautifully executed, satisfying decoration. And it serves as a final reminder of the suitability of the Baroque for certain kinds of sculpture for which Neoclassicism would have no comparably successful solutions.

In this period that witnessed grand artistic ambitions, not all projects were successful. Ceracchi, who returned from a sojourn in England, searched in vain for support in his schemes for monuments to famous political figures. He lost four years from 1785 to 1789 to the project for a monument to the Dutch republican sympathizer Baron van der Capellen, the designs for which are like Neoclassical reformulations of papal tombs. Four of the large figures—the effigy, two allegories and the Batavian lion—are to be seen in the gardens of the Villa Borghese, with outsized, vigorous poses, executed with perhaps too much confidence. Ceracchi's political ideals and ambitions would lead him all over Europe and to the emergent United States. In Philadelphia, he portrayed a number of the Founding Fathers, including George Washington (cat. 123). Although Ceracchi's hopes for a colossal monument to Liberty were not to be realized, his portraits have real artistic merit as well as historic interest. Over the years he would vary his approach to the features of Washington, some versions looking distinctly idealized. The bust shown here is the most careful likeness, more accurate than Houdon's, especially in the rendering of Washington's mouth. The excellent likeness, when joined with the heroic ancient style bust and Roman hair, however, did not please American eyes, which preferred the more natural bust form of Houdon.

The impact of the French Revolution had devastating effects on Rome, beginning in 1793. Among artists, the French *pensionnaires* were naturally affected first. Chinard, who sympathized with republican ideals, was denounced and imprisoned briefly in 1792. His designs for candlesticks substantiated the claims. One model depicted Reason in the form of Apollo trampling a figure labeled Superstition, with the chalice and cross, symbols associated with Religion, a standard papal allegory (fig. 101). The rendering is as exquisite as a Clodion. However, the attenuated proportions are highly personal and represent a marked change from the sculptor's earlier mythological groups, probably encouraged by the candlestick form.

Some artists stayed in Rome throughout the decade, while others remained until events forced them away. Flaxman had trouble evading French troops and encountered delays on his return to Britain. Canova left Rome for Possagno and Venice in 1792. In 1797 he briefly considered going to America; and in 1798 he traveled to Vienna and other central European cities. By November 1799 he was back in the city and welcomed Pacetti, then Principe of the Accademia di S. Luca, to his studio, an event that led to an invitation to Canova to join the academy. The arrival of young, foreign

sculptors continued around the political turmoil. Richard Westmacott won a first prize at the academy in 1795, aided by Pacetti. Bertel Thorvaldsen arrived in 1797. In 1800 he received the commission for a statue of Jason that allowed him to stay, an event that set the stage for a rivalry with Canova that dominated Roman sculpture for the first two decades of the nineteenth century.

Despite this artistic activity, Rome was shaken by historical events in a way it had not seen since the sack of 1527. The Papal States were dissolved in 1798, and the pope was exiled in the same year. The ultramontane reverence of Italian antiquities and works of art produced its most brutal tribute of admiration in the confiscation by French authorities of masterpieces from 1796 to 1798. Around 1798 Moitte carefully copied two famous reliefs from the Arch of Titus (cats. 136, 137). A much-admired draftsman, Moitte had already designed decorations for the festivals of the republic, and he would continue to do so under Napoleon. It is an indication of a bizarre, new relevance of ancient masterpieces that he studied these objects when he did. *The Despoiling of the Temple* is a most apposite choice in relation to Moitte's actual administrative responsibilities while in Rome. He was there to supervise the selection and shipments of famous antiquities to send to France as a result of the Treaty of Tolentino of 1797. He returned to Paris, presumably with the reliefs shown here, for the official festival in which famous works from Rome were presented in a parade in the ancient style.

Pride of place was given to the antiquities (still in their packing cases), which included works beginning, by then, to be out of favor with connoisseurs.[30] Nevertheless, the Neoclassical style nurtured by their study had been adopted by then throughout Europe. Projects for George Washington, Pitt the Elder, Clement XIII, Catherine the Great of Russia, and soon for Napoleon indicate the wide application of the style.[31] The most famous artist in Europe was a sculptor, Canova. Neoclassical marble statues were the most desirable modern objects. The universal acceptance of this taste made it impossible to appreciate much earlier eighteenth-century Roman art, especially outside the city, a situation that still prevails to some extent. A subsequent revolution, of course, submerged the universal fame of Canova, in its turn.

The continuous sculptural activity sketched here involves objects produced for many reasons. But overarching changes transpired. The waning of the papacy as the leading patron of important sculpture is one of the principal currents of the century. It is matched in significance by the rise of a pan-European audience for antiquities and the art

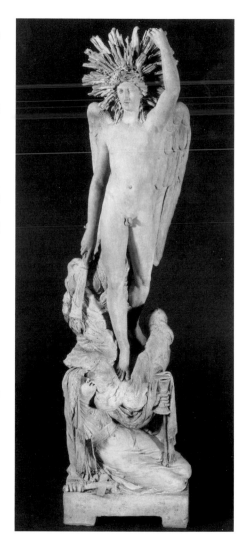

Fig. 101 Joseph Chinard, model for a *Candlestick with Figures of Apollo Crushing Superstition*, 1791, terracotta; Musée Carnavalet, Paris

they inspired. Although the Baroque style, after many still little-known permutations, was replaced by the antique taste, a moment's reflection reemphasizes the degree to which that revolution was nurtured by a host of past styles. The High Renaissance, Mannerism, the ideal styles of the Seicento, even art before Raphael, and the ever-present model provided by nature—these styles existed in monuments throughout Rome which were there to be seen afresh by new eyes. The subsidiary role of sculpture within architectural projects largely came to an end through the reestablishment of sculpture as an independent work of art, and in the diminution of a unified interior aesthetic in which new sculpture was a large component of the decoration. The local Roman school gradually embraced Neoclassicism by the end of the century, and finally adopted Canova. The presence of foreign sculptors continued.

The eighteenth century is a period of great richness, achievement, and change for European sculpture. Of course, not everything of artistic importance or historic significance in European sculpture occurred in Rome. However, as the preceding pages show, the sculpture made in the city is remarkably varied, beautiful, and interesting. This is not generally admitted, and the importance of the Roman scene in relation to activities in other countries is not often appreciated. No other city, however, contained or produced such a range of sculpture or equaled the prestige of Rome. For sculpture, the city fulfilled a role not to be matched elsewhere. Modern art historians still look at this central place with many biases, usually without confronting it directly. The information presented in the catalogue entries contains many of the new thoughts of the leading figures in the field. To everyone else, most of the sculptures selected for inclusion here will be unfamiliar. Nevertheless, we trust that new admirers will emerge in response to their many attractions and merits.

Notes

1  Cavaceppi 1768–72, vol. 3.
2  There is no detailed survey of eighteenth-century Roman sculpture in English. The most important contribution to the subject is the monograph by Robert Enggass, *Early 18th-century Sculpture in Rome* (University Park and London, 1976). Enggass concentrates on the sculpture of the first third of the century, providing illuminating general introductory chapters, artists' biographies, catalogue entries, and very good photographs. (The lack of good photographs of sculptures remains a large stumbling block for the advance of the subject.) In this essay that period is abbreviated because interested readers can consult Enggass's book (see Enggass 1976). Rudolph Wittkower's *Art and Architecture in Italy, 1600–1750* (Harmondsworth, 1973) is the classic survey of this large subject (see Wittkower 1973). A new edition has just been published with new notes and bibliography. The few pages on the late Baroque and Rococo are written from the point of view of the High Baroque and Bernini's art in particular. Wittkower's observations are often interesting and provocative, but the book does not provide the basis for an unbiased approach to eighteenth-century Roman sculpture. Readers will find references to writings by Hugh Honour in this essay and elsewhere in the catalogue. Everything he has written about eighteenth-century Italian art is solid, perceptive, and helpful. A recent general treatment, Bruce Boucher's *Italian Baroque Sculpture* (London, 1998), contains a chapter on the transition from the late Baroque to Neoclassicism (see Boucher 1998). Antonia Nava Cellini's *La scultura del settecento* (Turin, 1982) begins with two chapters on sculpture in Rome (see Nava Cellini 1982). She does not include many foreign sculptors or proceed much beyond the mid-1780s, but the book is full of learned and sensitive observations and is highly recommended. Although not richly illustrated, the book has well-selected and useful photographs. Andrea Bacchi's *Scultura del '600 a Roma* (Milan, 1996) deals with the seventeenth century (see Bacchi 1996). However, he includes a number of artists who continued working after 1700, for whom the biographies are very informative. The photographs are superb, although eighteenth-century sculptures are not included. A recent book in which sculpture figures in a contextual study of the art of early eighteenth-century Rome is Christopher M. S. Johns's *Papal Art and Cultural Politics, Rome in the Age of Clement XI*, Cambridge, 1993 (see Johns 1993).
3  For the Founders series, see Rocchi Coopmans de Yoldi 1996, pp. 305–437.
4  For terracottas associated with the academy, see Golzio 1933. For the names of student sculptors and the subjects of their submissions for the academy's Concorsi, see Cipriani and Valeriani 1988–91, vols. 2–3.
5  Montagu 1996, pp. 129, 148, 151–54.
6  Vasco Rocca and Borghini 1995.
7  In addition to his entry in this catalogue, see Minor 1997, pp. 29–43. This recent study is one of the few monographs in any language on an important eighteenth-century Roman sculptor.
8  Wittkower 1973, pp. 293–95.
9  Other potentially interesting subjects, beyond the scope of this essay, are tomb sculpture, sculpture designed to ornament gardens, and small sculptures made for interior decoration. The wide range of names given by scholars in this century to various artistic styles in Rome is too complicated and debatable a subject to try to present concisely here.
10  Honour 1958.
11  Much of the following information is derived from their book. Haskell and Penny 1981.
12  Cavaceppi's first two volumes were published in 1768 and 1769 respectively. The third volume, cited in, note 1, published in 1772, also includes architectural fragments and ornaments and bas-reliefs, a number of which are identified as in Cavaceppi's possession.
13  Houdon's *écorché* became a standard feature in art schools in Europe and America; see Arts Council 1972, pp. 251–52, no. 389, and Arnason 1975, pp. 13–14.
14  The subject is now often identified as Menelaos and Patroclus; see Haskell and Penny 1981, pp. 291–96.
15  Ingamells 1997.
16  Hubert 1964, *Sculpture*, pp. 38–53.
17  On traditions of collecting terracottas, see Walker 1998, pp. 14–29.
18  For the *Idolino*, see Haskell and Penny 1981, pp. 240–41.
19  Pressly 1979.
20  The catalogue for the great Canova exhibition of 1992 (Pavanello and Romanelli 1992) had editions in Italian and English. With its essays by a number of scholars, fine photographs, and bibliography, it is the most useful single publication on the artist. *L'opera completa del Canova* (Milan, 1976), by Mario Praz and Giuseppe Pavanello (Pavanello and Praz 1976) remains an essential reference, as are all of Hugh Honour's studies. For Canova's two papal tombs, see Johns 1998, "Canova." A recent monograph carries studies of Canova's patronage into the nineteenth century: Johns 1998.
21  The best concise discussion of Canova's technique is Honour 1992. Also perceptive about Canova's preparatory models is the chapter on that subject in Licht 1983, pp. 224–41.
22  Pavanello 1984.
23  Honour 1960, "Pacetti."
24  For these likely sources, see Haskell and Penny 1981, pp. 274–78, 282–84.
25  The most useful photographs of sculpture at the Villa Borghese are to be found in Pergola 1962.
26  Visconti 1796.
27  For Vincenzo Pacetti, the best sources are Honour 1960, "Pacetti," and Honour 1963, "Pacetti."
28  For illustration of Penna's statues and on this room generally, see Ferrara 1954.
29  For this room, see Schiavo 1960.
30  See Haskell and Penny 1981, pp. 108–24.
31  The best introduction to Neoclassicism in many of its forms is still *The Age of Neo-Classicism* exhibition catalogue of 1972 (see Arts Council 1972).

## LAMBERT-SIGISBERT ADAM
### NANCY 1700–1759 PARIS

Lambert-Sigisbert Adam (called Adam *l'aîné*) was born on October 10, 1700, the son of Jacob-Sigisbert, a sculptor. After training with his father and a sojourn in Metz in 1718, Adam moved the next year to Paris, where he worked in several ateliers, including that of François Dumont. In 1723 he won the first prize for sculpture at the Académie Royale and traveled to Rome. There he was not always fortunate in his commissions. He produced models for a series of statues of French rulers intended to decorate the Spanish Steps, a project canceled in 1725. An important contact for Adam in Rome was Cardinal Melchior de Polignac, appointed ambassador to the Holy See in 1724. Polignac purchased Adam's marble busts of *Neptune* and *Amphitrite* (now in Potsdam; terracotta models in the Los Angeles County Museum of Art and the Art Institute of Chicago), which were specifically said by his early biographer Dom Calmet to have been made by Adam *en étude*, that is, without being commissioned. Polignac employed Adam and his brother Nicolas-Sebastien, who came to Rome in 1726, in the restoration of antiquities. The cardinal also obtained permission for Adam to copy the Ludovisi *Mars* in July 1726. Adam's personal collection eventually contained drawings and ancient sculptures formerly belonging to Polignac, pieces probably received by the sculptor in payment for his own work. Additional aspects of Adam's Roman activity can be gathered from the inventory after the sculptor's death, in which certain objects are identified as having been made by Adam in the city. In 1730 he won one of the most prestigious commissions of the century, for the sculpture of the Trevi Fountain, the result of a competition ordered by Pope Clement XII Corsini. Although the model he submitted is lost, a verbal description and a drawing survive (Pinto 1986). However, the project was delayed, and the sculpture was eventually executed by Roman artists. Adam was included, along with most of the finest sculptors in Rome, in the decoration of the Corsini Chapel at St. John Lateran, for which he carved, after May 1732, a marble relief of *The Virgin Appearing to Saint Andrew Corsini*. In November 1732 Adam was elected to the Accademia di S. Luca, for which he carved the marble head of *Dolore*. According to his death certificate, the sculptor was also a member of the Accademia Clementina in Bologna. The experience of almost ten years in Rome was essential for the formation of Adam's character as an artist, one that is especially marked by his great

affinity for the sculpture of Gianlorenzo Bernini.

Upon his return to France, Adam obtained a number of commissions from the crown, princely patrons, and the Church. This may explain why his *morceau de reception* for the Académie Royale, *Neptune Calming the Waters*, a variation of Bernini's *Neptune*, although modeled in 1734, was not presented until 1737. For royal gardens, his figures for the cascade at St.-Cloud (1733–34) were followed by the *Triumph of Neptune and Amphitrite*, in lead, for the Bassin de Neptune at Versailles (1736–40), the most Baroque fountain in the park and the most successful of French eighteenth-century monuments in the Baroque style. Private patrons were also soon interested in his work. For the sumptuous interiors of the Hôtel de Soubise, Adam provided four stucco reliefs for the *salon oval* on the ground floor. For the royal chapel at Versailles, Adam executed a bronze relief of *Saint Adelaide* in 1742. Figural groups representing *Hunting* and *Fishing*, created for La Muette, were sent by Louis XV to Frederick the Great in 1752. Despite his many commissions, Adam's most ambitious bids for the king's favor did not succeed. He was asked to take back an allegorical portrait bust of the king with the attributes of Apollo, and his model for a complicated allegory of France and Louis XV was not chosen to be executed on a large scale. In 1750–52, for Mme. de Pompadour, Adam carved a figure of *Lyric Poetry*, and a statue of *Abundance* for her was incomplete at the time of the artist's death. For private collectors he also completed groups on a smaller scale, such as the *Boy Bitten by a Lobster* (c. 1750). A series of sculptures for the high altar of Reims Cathedral was unfinished when Adam died of an apoplectic attack on May 13, 1759. Adam possessed a significant collection of drawings (identifiable by the artist's prominent signature), prints, and sculptures—both his own models going back to the beginning of his career and terracottas by Bernini and Duquesnoy, and a group of antiquities. In 1754 he published seventy-three prints of his statues, busts, and reliefs, mostly antique sculpture but including a few of his own works as well.

Posterity has long had a skewed view of the gifted, aggressive sculptor and his place in French art. This is undoubtedly due to the change in taste toward classicism, already apparent during Adam's life in the partisan support of the influential triumvirate the Comte de Caylus, P.-J. Mariette, and C.-N. Cochin for Edme Bouchardon, Adam's near contemporary, a shift that became increasingly dominant after mid-century. Adam's art was influential for his younger

brother, whose mature style is nevertheless distinct, and for his nephew Claude Michel, called Clodion, whose works demonstrate an understanding of Baroque style despite their exquisite Rococo classicism. [DW]

BIBLIOGRAPHY Calmet [1751] 1971, cols. 7–16; Lami 1910, vol. 1, pp. 2–9; Lugts, Frits. *Les Marques de collections de dessins & d'estampes: marques estampillées et écrites de collections particulières et publiques*. Amsterdam: Vereenigde Drukkerijen, 1921, vol. 1, pp. 1–2; Souchal 1973; Fusco 1975; Souchal 1996

## 103
## Lambert-Sigisbert Adam
### *Dolore*

1733
Inscribed, on the front: DOLORE; on the vertical edge, proper left side of the bust: *LEM.t SIGISBERT ADAM/LOTARINGIE F.t* [?] 1733
Marble
27⅞″ × 14⅛″ × 13⅜″ (71 × 36 × 34 cm)
PROVENANCE presented by the artist to the Accademia di S. Luca, Rome, January 1733
EXHIBITION Rome 1959, cat. no. 3
BIBLIOGRAPHY Fusco 1978
Accademia Nazionale di San Luca, Rome

In the summer of 1732 the Duc d'Antin, superintendent of royal buildings in France, forbade Lambert-Sigisbert Adam to undertake new work in Rome, where the sculptor had been living since 1723. Nevertheless, Adam carved this bust for the Accademia di S. Luca in the short interval between November 16, 1732, when his name was proposed and accepted for membership in Rome's most prestigious artists' academy, and late January 1733, when he left the city. This unusual reception piece has been the subject of a study by Peter Fusco, from which most of the following information derives.

Normally, after joining the academy, sculptors presented terracotta models, and bas-reliefs were preferred. Usually, the sculptures were pieces that sculptors already had on hand. Adam could easily have submitted such a work since he had completed a relief of the *Virgin Appearing to Saint Andrea Corsini* for the Corsini Chapel in St. John Lateran in 1732, for which his terracotta model survives at the Musée des Beaux-Arts, Nancy. He chose, however, another sculptural type with which he was familiar, an allegorical bust. Previously during his Roman sojourn, Adam had created busts of *Neptune* and *Amphitrite*, *Achilles* and *Ulysses*, and the elements, in the form of two pairs of male and female figures from mythology.

The head of *Dolore* was calculated to stand out from the other gifts to the academy, and Adam surely intended it to be appreciated on several levels.

The representation of *Dolore* as an old man bitten by a serpent follows the traditional iconography as depicted in Cesare Ripa's *Iconologia*. Adam identified the subject by carving the title on the plaque below the bust. In style, the bust reflects directly Adam's two principal sources of inspiration: ancient sculpture, in the form of the head of Laocoön, the central protagonist in the famous sculptural group at the Belvedere, and the art of Bernini, specifically, the marble head of the *Damned Soul*, then at the museum in the Palazzo dei Conservatori.

The expression of *Dolore* is the most extreme of any of Adam's surviving early works. For Fusco, this may reflect the reception pieces of sculptors for the Académie Royale, which Adam would have known from his years in Paris. Adam's generalized treatment of the chest area of the bust sets off the ferocious biting snake's head. The tousled hair and beard actively frame both the man's contorted forehead, carefully described eyes, and open mouth, and the polished form of the serpent coiled around the man's neck. Adam did not choose to imitate the smooth eyeballs of Laocoön, and every aspect of the bust is more detailed than the worn surface of the classical head. *Dolore* is, also, a more complex creation than Bernini's famous rendition of an instantaneous expression. Because of Adam's rendering of the eyes, in particular, his head may impress most viewers more as an image of physical pain and suffering, perhaps even terror, than the emotions of grief, sorrow, and regret—all possible English translations of "dolore". The exact nature of Laocoön's pain and the appropriate ways to depict it in art were themselves central issues of debate for eighteenth-century artists and aestheticians.

In producing such a forceful bust in a short time, Adam certainly demonstrated his sculptural prowess, which included, as Fusco has noted, carving the bust, base, and socle from a single piece of marble. Adam's biographer Niccolo Gaburri, with whom the sculptor stopped in Florence on his return trip to France, wrote that Adam wished *Dolore* to demonstrate his extreme sorrow in having to leave the city in which he had so delighted. Chief among his regrets must have been the loss of the major commission for the sculpture of the Trevi Fountain. Although the history of the project after the fall of 1730 to 1732 is far from complete, scholars usually say that the decision to shift attention away from the Trevi Fountain to the Lateran façade was the result of intrigue among Adam's Roman colleagues, who did not wish to see the project awarded to a foreigner. In the sculptor's œuvre, this head demonstrates

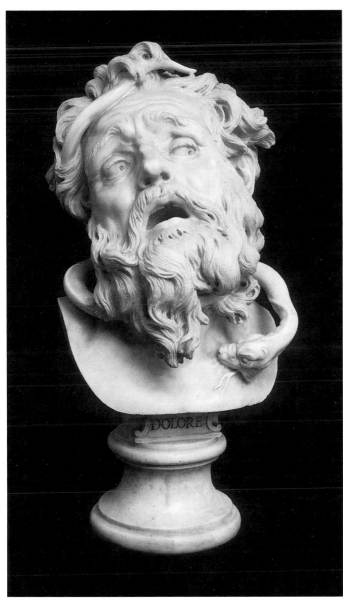

103

Adam's preparedness for future works such as *Neptune Calming the Waves*, his reception piece for the Académie Royale, and the exuberant fountain decoration of *Neptune and Amphitrite* at Versailles; its power inevitably invites speculation, too, about what he might have created for the Roman landmark.

Adam exhibited a terracotta version of *Dolore*, probably his finished model, in the Paris Salon of 1740. This work is most likely to be identified, also, with the head of *Douleur* listed (no. 75) in the inventory of the sculptor's belongings made after his death, for which the medium is not recorded. [DW]

## CARLO ALBACINI
1735–1813?

As a noted and sought-after restorer and copyist of antiquities among the many contemporary practitioners of that trade, Carlo Albacini was second only to his master, Bartolomeo Cavaceppi. From 1756, at age twenty-two, until 1759 Albacini lived in Cavaceppi's household in the artists' quarter of Rome. He apparently remained in the immediate circle of his master during Cavaceppi's heyday through the 1760s until the early 1770s, by which time Albacini was independently making restorations for English clients and dealers in Rome who were also dealing with Cavaceppi: Charles Townley, William Blundell, the Earl of Lansdowne, Thomas Mansel-Talbot, James Smith Barry, and others. This commerce continued intermittently until the

Napoleonic occupation of Italy. Albacini worked with both the noted Scottish painter, excavator, and antiquities agent Gavin Hamilton and, especially, the powerful English painter, banker, and papal confidant Thomas Jenkins. (Albacini restored Bernini's *Neptune and Triton*, sold by Jenkins to Joshua Reynolds.) Jenkins together with Townley, whose collection helped to found the British Museum, favorably reviewed and promoted much of Albacini's work, as is known from their correspondence and personal accounts.

During the 1760s Albacini worked in the mature style of Cavaceppi, which he and such other assistants as Cavaceppi's younger brother Paolo probably helped to develop. He shared with his master a consummate facility in matching, cutting, polishing, and finishing, but moved further from Cavaceppi's Baroque residuum of plump and ductile coloristic form to a harder bisque surface and taller proportions with a long refined sweep and delicate rigidity of line, illustrating a full assimilation of Winckel-mann's ideals of whiteness, purity, grace, and beauty—and effecting a porcelain-like charm and delicacy that characterized the evolution of Neoclassical style.

After 1770 Albacini began to work for the new Vatican museum, the Pio-Clementino, established partly with the aid of works from Cavaceppi's studio. During the last quarter of the century Albacini also restored and copied works for collectors in Germany, Russia, and Spain: for example, Frederick II of Kassel, Catherine the Great, and Anton Raphael Mengs's protector Cardinal Nicolàs de Azara (Prado, Aranjuez). Before 1781 he sold various copies to Count (and General) Johann Ludwig Walmoden of Hanover, son of George II of England.

In the 1780s, through the agency of the dealer and scholar Johann Friedrich Reiffenstein, Albacini sold antiquities and copies to Catherine the Great and obtained commissions from her for original works—monuments dedicated to Mengs and Giovanni Battista Piranesi (St. Petersburg). In the same decade Vincenzo Pacetti, directing extensive renovations for the Villa Borghese, enlisted Albacini for restorations. In 1783 Albacini was elected to the Accademia di S. Luca. In the 1790s he supplied mantle reliefs in Berlin to Frederick Wilhelm von Erdmannsdorff, architect–decorator for the Duke of Anhalt-Dessau; both were partly trained by Winckelmann and Cavaceppi in the 1760s.

Albacini's most notable commission, 1786–1800, was the restoration of the many Farnese antiquities in Rome before their removal to the collections of Ferdinand IV in Naples. These works were refurbished in his

large studio below the Porta del Popolo, the tourists' north gate to Rome. This workshop, with its many antiquities, copies, and casts, became a place of great attraction and was visited by Pius VI, Goethe, and Antonio Canova, among many other artists and notables, native or on the Grand Tour.

Although Canova in general despised the profession of restorer and copyist, he much admired the work and facility of his friend Albacini, who restored many of the most important antiquities renovated during the last quarter of the eighteenth century. Canova's audacious originals, acclaimed as "new classics," initially and in essence stemmed from the improvisatory, classicizing, eclectic, and pastiche methods of restorers informed by recently excavated antiquities (especially from Hadrianic and Pompeian sites) and by fashionable scholarly archaizing in the arts. Their works directly influenced the vision and production of Canova and his admirers.

Albacini was a well-connected leader among the scores of sculptors in his profession, in a time when antiquities still far outsold "original" productions. His copy of the famous Capitoline *Flora* is a fine example of work from his studio, with its subtle trend toward a Neoclassicism informed by antiquity and changing contemporary taste at the end of the Enlightenment. In 1838 Albacini's son and assistant Filippo sold his father's large collection of 225 casts of ancient portrait busts—based on his own work, that of Cavaceppi, and other sources—to the trustees of the academy, Edinburgh; 154 now survive. [SH]

BIBLIOGRAPHY Townley, C., Townley Papers. London, British Museum. Department of Classical Antiquities, manuscript; Chracas, *Diario Ordinario di Roma*, 1783, no. 922; Goethe [1788] 1982, pp. 405–10; Goethe 1805, p. 357; Riccoboni 1942, pp. 315, 327, 373, 384–86; De Franciscis 1946; Bianco, Antonio. *Museo del Prado: Catálogo de la escultura*, I. Madrid, 1957, passim; Pietrangeli 1958, pp. 96, 137, passim; Bassi 1959, pp. 32–33, 103, 138–39; Honour 1959, "Canova," esp. p. 244; Honour 1960; *Walker Art Gallery: Foreign Catalogue*. Liverpool: Merseyside County Council, 1977, nos. 6537, 6538, 6900, 9106; Howard 1982, pp. 14, 23, 29, 84, 97, 112, 153–54, 192, 198, 223; Hertel 1983; Pinelli 1983; Howard 1990, pp. 68, 76, 86, 106, 128, 151, 253, 255, 258, 274–75, 277, no. 30; Davies 1991, Howard 1991; Smailes 1991; Vaughan 1991; Howard 1997, pp. 218, 225–26, 323, 341, 351

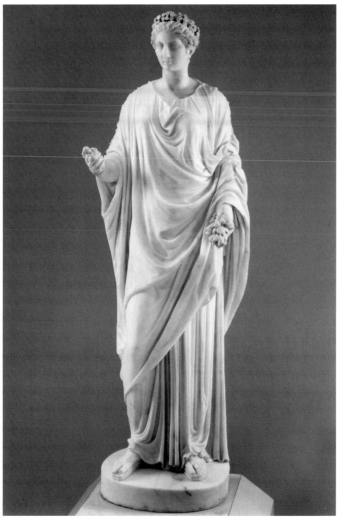

104

## 104
## Carlo Albacini
### *Flora*

After 1770
Signed: *CARLO ALBACINI FECIT*
Marble (probably from Carrara)
40½″ × 13½″ × 10″
(102 cm × 34.3 cm × 25.4 cm)
PROVENANCE art market, England; Heim Gallery, London, 1972; Indianapolis Art Museum
EXHIBITIONS Bregenz and Vienna 1968, cat. no. 104; London 1972, *Paintings*, cat. no. 32
BIBLIOGRAPHY Lucatelli 1750, pp. 46–47; Ficoroni 1757, p. 136; Stuart Jones 1912, p. 353, no. 14, pl. 87; Helbig 1966, pp. 239–40; Vorarlberger Landesmuseum 1968, no. 104, fig. 358; Heim Gallery 1972, p. 20, no. 32; Archäologisches Institut 1979, pp. 15, 20, nos. 7–10, 12–19, 25, 31, pp. 96–98, nos. 53–54; Haskell and Penny 1981, p. 215, nos. 40–41, fig. 112; Howard 1982, pp. 32, 44, 153, 426, appendix 5 nos. 202, 1063, M49, M121, M154, M164, C67, C261; Barberini and Gasparri 1994, pp. 22, 71–76, esp. p. 74, 85–114, nos. 7, 10, 25
Indianapolis Museum of Art, The Orville A. and Elma D. Wilkinson Fund

among the earliest such arrivals in Germany during what, in England, Adolf Michaelis happily termed "The Golden Age of Classical Dilettantism," a time when the Indianapolis *Flora* was apparently also made for another of Albacini's English clients.

Soon after its supposed discovery at Hadrian's Villa and acquisition for the Museo Capitolino (1743–44), the Capitoline *Flora* became the rival of the famous Farnese *Flora* (later restored by Albacini, c. 1800). It was frequently reproduced in copies and casts, as well as in bronze statuettes of ancient favorites by Giovanni Zoffoli and by Francesco Righetti (Giovanni Zoffoli, *Serie di figure fatte, e da farsi in bronzo dell' altizza di un palmo e mezzo bono romano*, and Francesco Righetti, *Aux amateurs de l'antiquité et des beaux arts*, 1764 [Victoria and Albert Museum Print Room, D.1479–1898, p. 7]; see Haskell and Penny 1981, pp. 342–43, nos. 13, 38). It was among the works of art transferred to the Louvre by Napoleon between 1797 and 1815.

Restored by Carlo Monaldi, a student of Camillo Rusconi, the Capitoline *Flora* was so extensively and inventively cut, or recut, with fantastic outer drapery, in a then-fashionable *barocchetto* manner, that its antiquity has been rightly questioned, as has the restored subject. It has been variously identified by Winckelmann, E. Q. Visconti, and others as Primavera, Juno, Polyhymnia, Sabina, or simply a young woman with flowers. (The flowers recall restorations on the famous Albani Antinous Relief, found at Hadrian's Villa in 1735.)

Cavaceppi, who was Monaldi's colleague at the Capitoline during the 1740s and exported a fine restoration by him to Holkham Hall, Norfolk, at the time of his death (1799), owned several copies of and improvisations on the Capitoline *Flora*—in marble, plaster, and terracotta. With a sketch of the Cesi *Juno*, three of these terracotta copies of *Flora* are now in the Palazzo di Venezia. One was once whitewashed, apparently to simulate porcelain or marble. Another is a half-sized quietened version of the Capitoline *Flora*, marked with *puntelli* for reproduction. Its head is based on the Capitoline *Younger Faustina* bust, which Cavaceppi restored and which was several times copied in his studio. These works were surely known to Albacini; he perhaps even contributed to their manufacture.

In Albacini's copies of the Capitoline *Flora*, as in Cavaceppi's terracotta one of the same size, the jowly *barocco* original is flattened and made more svelte and linear, creating a restrained Neoclassical ensemble illustrating the ethos, aesthetics, and décor of the generation of Robert Adam. Albacini's copies are even more

thin, elegant, and formally abstract, approaching a refined porcelain bisque purity and fragility associable with the growing Neoclassical style.

Canova, who later employed Albacini's son Filippo, reported with admiration that one of Albacini's many assistants told him it took nineteen months to complete a copy (perhaps now in Liverpool) of the Borghese large portrait bust of Lucius Verus. As décor, such perfected marble copies of famous antiquities were often preferred to the much-mutilated and much-restored second-rate antiquities then available for sale. [SH]

## GIUSEPPE ANGELINI
### ROME 1742–1811 ROME

Very little is known about the training of this Roman sculptor. Tradition has it that he studied drawing with Niccolò Ricciolini and sculpture with Bartolomeo Cavaceppi, but there is no record of him in the Accademia del Nudo in those years, nor in the competitions periodically announced by the Accademia di S. Luca, a central reference for artistic training in Rome. Certainly important for the young Angelini was his attendance at the studio of Giovanni Battista Piranesi (Wilton-Ely 1976, "Nollekens"), because of its cosmopolitan environment and for the opportunity it gave him to meet artists and collectors. Above all he was introduced there to British artists such as the painters Thomas Jenkins and Gavin Hamilton, and the sculptor Joseph Nollekens (whose stay in Rome was crowned by winning first prize in the Concorso Balestra of 1768, run by the Roman academy). It was probably not coincidental that Angelini moved to England in 1770, the year Nollekens returned home. In 1772 Giuseppe Angelini was enrolled in the Royal Academy. In the years immediately following he worked for Nollekens and then for Josiah Wedgwood, with whom he stayed in touch even after his London visit, during the 1780s, doing work on commission but also helping young sculptors such as Henry Webber and others, whom he invited to Rome to complete their artistic education. In 1777 in London he had found himself in difficulty and obtained a grant from the Royal Academy, but his English experience was by then drawing to a close. In this period and in the following decade he traveled to Paris and Naples, but by the end of 1778 he was definitely in Rome, where, between 1779 and 1780, at the request of Francesco Piranesi, he found himself replacing Vincenzo Pacetti in charge of the funeral monument for Piranesi.

The funeral statue of Piranesi that Angelini consequently made for the church of S. Maria del Priorato in

In 1968 this signed, half-sized copy of the Capitoline *Flora* was displayed in an exhibition on Angelika Kauffmann and listed as owned by the Heim Gallery, London. In 1972 it was advertised for sale by Heim as acquired in England and as possibly a copy from the Walmoden collection, partially dispersed in England. In 1979 in a catalogue of the Walmoden collection in Hanover, a slightly more severe virtual twin copy appeared, identically autographed but on a rectangular, not oval, base. It and an unsigned copy of the Capitoline's Cesi *Juno*, which was restored by Cavaceppi's master Carlo Antonio Napolioni, were there published and illustrated as a pair by Albacini; both had been listed in a 1781 inventory of sculptures in the Hanover collection, with three other copies by Albacini, and nine by Cavaceppi. Count Johann Ludwig Walmoden, son of George II of England and the Countess of Yarmouth, began his collection of antiquities in Rome, between 1756 and 1757, buying restored works and copies mainly from Cavaceppi, but also from other sculptors. Sent to Hanover, these were

Rome is a full-length figure of the architect, in classical dress, holding his architectural instruments and a plan of the Temple of Neptune at Paestum, in a pensive attitude, resting his right elbow on a herm of the double-headed Janus. This was an important work at the time because of the fame of its subject, and for the implications of the son's choice, cultural and artistic. It is recorded that after January 1779 Giuseppe Angelini invited Vincenzo Pacetti to his studio to show him the progress of the Piranesi statue, asking for his opinion, but probably primarily anxious to overcome any ill-feeling harbored by the colleague originally given the work. At this time it was a common habit among artists to visit each other's studios for frank discussion of work in progress. In November of that year the young Antonio Canova recorded that he had visited Angelini's studio and seen the newly made model for the statue. By 1780 the work was finished and the comments of his contemporaries were quite favorable.

The following year, at the request of Don Abbondio Rezzonico, a public comparison was arranged between Angelini and Canova, one sculpting a *Minerva*, the other an *Apollo Crowning Himself*. This episode was the basis for the tradition of viewing the two as champions of two different ways of conceiving and executing sculpture, a tradition maintained today by those who see Angelini as "Canova's main rival" (Gross 1990, p. 423).

It is obvious now that the young Canova and the established Angelini, well-known as the sculptor to St. Peter's, and superintendent of the Vatican and Capitoline museums, had two different concepts of antiquity. In the last two decades of the century, for example, King Gustav of Sweden, through his emissary Fredenheim, approached Angelini to value some collections of antique pieces that came from Francesco Piranesi and Vincenzo Pacetti, and consulted him as critic and connoisseur in the important purchase of the *Minerva Pacifera* for the museum of the Royal Palace, and also as an original sculptor of specially devised statues.

In 1789 Angelini executed another work for Fredenheim, the funeral monument to his father, Archbishop Menander, in Uppsala Cathedral, noteworthy for its modern pyramidal structure and the intrinsic equilibrium of the figures. In the following years he added numerous busts—family portraits or copies from antiquity—for the same patron. The Swedish acceptance of Neoclassicism was thus part of an acceptance of Roman "academic" culture at the end of the century, rather than resulting from an appreciation of Neoclassical ideas, in

themselves, which matured in the open artistic atmosphere of Rome, and which were expressed artistically in David's *Oath of the Horatii* and Canova's monument to Clement XIV.

From the mid-1790s Angelini increasingly devoted himself to his public responsibilities, rejecting offers of work from Swedish patrons so firmly as to suggest that he developed religious scruples about having made the funeral monument of a Protestant prelate. A more credible hypothesis, however, is that he sensed that his works, however advanced in comparison with the late Baroque context, had lost touch with the current artistic debate, and in the last years of his life he gave more attention to his own public role, concentrating mainly on the restoration of ancient treasures for the museums of Rome, a job to which he devoted himself with rare knowledge and true passion. [ANC]

BIBLIOGRAPHY  *Settecento* 1959; Pepe 1961; Hubert 1964, *Sculpture*, pp. 55–56, 65, 67–68; Pyke, E. J. *A Biographical Dictionary of Wax Modellers*. Oxford: Clarendon Press, 1973, p. 7; Wilton-Ely 1976, "Nollekens"; Caira Lumetti 1990; Gross 1990; González-Palacios 1991, p. 112; Wilton-Ely 1993

## 105
## Giuseppe Angelini
### *Spem alit Prudentia*

1789

Inscribed on front of base: SPEM ALIT PRUDENTIA; signed on right of base: *Ph:joseph:angelini aut.or 1789*

Terracotta

27½″ × 12½″ × 10½″ (70 × 32 × 27 cm)

PROVENANCE  gift of the artist to the Accademia di S. Luca

EXHIBITION  Rome 1991, *Fasto Romano*, cat. no. 15

BIBLIOGRAPHY  Nava Cellini 1988, pp. 59–67; González-Palacios 1991, pp. 113–14, no. 15

Accademia Nazionale di San Luca, Rome

Giuseppe Angelini submitted this terracotta group to Rome's Accademia di S. Luca on November 15, 1789, in support of the proposal put forward by their principal, the sculptor Agostino Penna, to elect him a member of the academy. The minutes of this meeting record: "After the usual prayers we proceeded to pass round the ballot box for Signor Giuseppe Angelini, sculptor of the Rev. Fabbrica di S. Pietro, who in the last assembly had been proposed as *accademico di merito* and in the current one exhibited to the judgment of the assembled Professors a group modeled by him, upon which Signor Angelini was received as *accademico di merito* with full marks" (Rome, Archivio S. Luca, vol. 54, fols. 103–103v).

The two female figures forming the group are shown advancing with slow

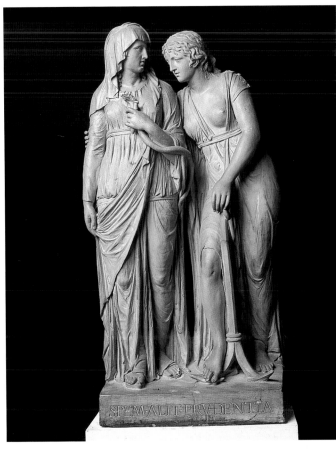

105

but decisive tread. The veiled figure represents Prudence, her head turned to encourage Hope, who leans on her. Prudence holds a serpent and what is probably the handle of a mirror, according to the iconography of this Virtue, who from Cesare Ripa onwards has usually been represented as a woman looking at herself in a mirror and holding a snake twisted round her arm. The act of looking at herself symbolizes self-recognition, the need to know one's own defects in order to regulate one's actions. The serpent, which when it is attacked coils itself around its own head, exemplifies the need to use all available resources against the blows of Fate. The other female figure is identified as Hope by the anchor she leans on, which helps in Fate's moments of greatest danger.

The personifications of the two Virtues, joined in dialogue, translate into sculptural terms the theme inscribed on the base. It is Prudence who sustains and feeds Hope who, without her, could become vain, in danger of tripping over the anchor that should support her.

Angelini's choice of this theme for the group with which he faced the judgment of the academicians reveals a good deal about his artistic personality. Apart from being a work of sculpture, the group is a philosophical

statement that perfectly describes Angelini himself, essentially prudent in his decisions, attentive to the critical evaluation of his own qualities and to the moral honesty of his own choices. Formally the two figures are perfectly balanced in space. The barely suggested movement of the step forward and the soft spontaneity of the gestures prevent any "heroic" or "declamatory" reading of the composition. The dialogue between the two protagonists, further emphasized by the slight curvature of the body of the right-hand figure, is calmly stated. Without being forced, classical models are adapted here to express contemporary meaning. The arms and heads naturally guide the spectator's gaze to a reading of the group with slowed rhythms. The perfection of the anatomy, the skill rendering the various textures of the draperies, and the absence of any form of emphasis or dramatic accentuation transform this group into incontrovertible proof of a clear, conscious interpretation of Neoclassicism, entirely independent of what Canova was expressing in the same period, but no less significant for all that.

This group is one of the most convincing examples of Angelini's work, and also one of the last in terracotta, an academic custom that was shortly to disappear. In 1808 it was decided to "notify to Bertel Thorvaldsen, also to

the Illustrious Signor Antonio Canova and to Signor [Joseph Charles] Marin, that in past times the Gentlemen Academicians admitted gave one of their works not in plaster but rather in terracotta so that they will please not deviate from the custom" (Rome, Archivio S. Luca, vol. 56, fols. 77v–78). Elected in 1801 and 1806 respectively, the two artists had submitted works in plaster, which the academy had reluctantly accepted. Whereas in the "new" sculpture, classical forms and materials were used with different meanings, Angelini upheld history, using classicism as an ideal instrument for the objective interpretation of modernity. He was thus assuming a clear position in the contemporary debate, one that was sustained by a deep knowledge of his profession but was difficult to interpret and little adapted for the wider public appeal that the new century demanded. [ANC]

## THOMAS BANKS

LONDON 1735–1805 LONDON

Banks was the son of the steward to the 4th Duke of Beaufort at Badminton, Gloucestershire. After attending school in Ross-on-Wye, Herefordshire, he was apprenticed to the London mason William Barlow. Having already spent some time in the studio of Peter Scheemakers, where he had become acquainted with Joseph Nollekens, he attended life classes at the St. Martin's Academy and in 1763 won the first of four premiums awarded by the Society of Arts. During the 1760s he was also exhibiting at the Free Society of Artists and by 1769 was apparently to be found employed in the studio of the sculptor Richard Hayward, whose lists compiled between 1753 and 1775 form an important source about visitors to Rome. Banks was admitted to the Royal Academy schools in 1769 and in 1770, having shown two models of *Aeneas and Anchises*, was awarded the Royal Academy's gold medal for his relief of the *Rape of Proserpine*. None of these early works survives. Although he failed to be elected as an associate then, in 1772 he won the academy's three-year traveling stipend and, as the first sculptor to receive this, set off with his wife for Rome, where he was to spend seven years in all.

In Rome, Banks became acquainted with many British artists then in the city, among them James Northcote, Prince Hoare, James Jeffreys, Maria Hadfield (who later married Richard Cosway), and, especially, Ozias Humphrey. But even more important for his sculpture were his close connections with various foreign artists, most notably the Swiss Henry Fuseli, the Dane Nikolai Abildgaard, and the Swede Johan Tobias Sergel. Banks's

ability in marble carving—"in which," as he remarked in a letter of 1774 to Nathaniel Smith, "the Italians beat us hollow"—certainly seems to have benefited from some training with Giovanni Battista Capisoldi, who had earlier worked in London with Joseph Wilton. On the other hand, the compositions of the figures and reliefs carved by Banks during his seven years in Rome grew out of a continuing dialogue with these particular foreign artists, all of whom were working with similar subjects, especially those drawn from Homer.

Although the chronology of Banks's work in Rome is not entirely clear, his first major undertaking was a relief of *The Death of Germanicus*, probably commissioned by Thomas William Coke, later 1st Earl of Leicester (of the second creation), while visiting Rome between April 1772 and April 1774. Although possibly conceived as a pendant to the Mannerist relief that it pairs in the hall at Holkham Hall, Norfolk, the composition seems to have been based on a combination of Poussin's painting of the same subject (Minneapolis Institute of Art) and Gavin Hamilton's *Andromache Mourning the Death of Hector* (1761; Hunterian Museum, Glasgow). Another ambitious marble relief of *Caractacus before Claudius* (Stowe, Buckinghamshire) was commissioned between 1774 and 1777 by George Grenville, later 2nd Earl Temple, who later placed it opposite Christophe Veyrier's *Darius before Alexander* in the hall at Stowe. But in this case Banks encountered what was to be a familiar problem for artists in Rome, when Grenville paid him only half the requested sum of £200. The relief of *Alcyone and Ceyx* (Lotherton Hall, Leeds, Yorkshire) was also probably commissioned by a patron who failed to pay, prompting Banks first to exhibit it at the Royal Academy in 1775 and then in 1779 to have it offered as a prize in a raffle.

The patron who caused Banks (and many other artists) most disappointment, however, was the bishop of Derry, who had commissioned from the sculptor a figure of *Cupid with Psyche Alighting on His Wing*, two heads, and a relief that may be identified as cat. 106. When the heads were "quite finish'd" and the others "almost compleated," all these were then "return'd on his hands," the figure "with the frivolous excuse of its being Improper for a Bishop to have a Naked figure in his house" and the others without any stated reason (Bell 1938, p. 34). The *Cupid* (formerly Pavlovsk Palace, Russia) was singled out by Flaxman as "highly interesting to the mind by its philosophical allusion to the power of love, divine or natural, on the soul," its "outline . . . finely varied in the different views" and "the softness of the

form . . . classically beautiful" (Flaxman 1838, p. 291). In the absence of the *Cupid*, the surviving reliefs constitute the most substantial evidence of Banks's activity in Rome, although his daughter recorded that he also modeled many terracotta figures, perhaps including those in Sir John Soane's Museum, London, and the *Achilles Arming* (terracotta; Victoria and Albert Museum, London). As well as showing how the sculptor had interacted with Fuseli and Sergel to develop a relief style distinguished by its clear contours and muscular, elongated male nudes and high finish, these works above all prompted Reynolds to describe Banks as "the first British sculptor who has produced works of classic grace."

In 1779, beset by financial difficulties, Banks and his wife spent a month in Naples with Maria Hadfield and others and then departed for England. After two years he went St. Petersburg, where he sold the *Cupid* to Catherine the Great and hoped to succeed Etienne-Maurice Falconet at her court, but returned in 1782. Thereafter his fortunes in England changed with his election as an associate of the Royal Academy in 1784 and a series of commissions for busts and monuments. Yet, although in his last twenty years he carved a dramatic *Falling Titan* (Royal Academy, London) when made a full academician in 1786, exhibited an eight foot plaster model of *Achilles Mourning* in 1784, and six years later executed a marble of *Thetis Dipping Achilles in the Styx* (Victoria and Albert Museum, London), his reputation as "one whose mind was ever dwelling on the ancient Greeks" (Cunningham 1829–33, vol. 3, p. 86) rested primarily on those ideal works executed in Rome between 1772 and 1779. [MB]

BIBLIOGRAPHY Cunningham 1829–33, vol. 3, pp. 82–121; Flaxman 1838, pp. 271–94; Bell 1938; Irwin 1966, pp. 55–57; Hassall and Penny 1977; Pressly 1979, pp. 48–53; Bryant 1983; Whinney 1988, pp. 321–36; Bryant 1996; Ingamells 1997, pp. 47–48

## 106

## Thomas Banks
### *Thetis and Her Nymphs Rising from the Sea to Console Achilles for the Loss of Patroclus*

Begun 1777–78; finished 1805–6
Marble
36″ × 46¾″ (91.4 × 118.7 cm)
PROVENANCE given by the sculptor's daughter Lavinia Forster to the National Gallery, London, 1845; transferred to the Tate Gallery shortly after 1900; lent to the Victoria and Albert Museum, 1936; formally transferred to the Victoria and Albert Museum, 1984
EXHIBITIONS London, British Institution, 1806, cat. no. 46; London, *International Exhibition*, 1862 (plaster cast exhibited in class 29); London 1951, cat. no. 671; London 1959, cat. no. 466; London, Tate Gallery, *New Hang*, no catalogue, 1990
BIBLIOGRAPHY *The Director*, vol. 1 (February 7, 1807), p. 78; Cunningham 1829–33, vol. 3, pp. 100–1; Flaxman 1838, p. 292; *Illustrated London News*, February 21, 1846, p. 132; Cunningham, P. 1863, p. 5; Bolton 1919, p. 3; Bell 1938, pp. 35, 40–41; Irwin 1966, p. 56; Keutner 1969, p. 333, pl. 232; Whinney 1971, p. 128; Stainton 1974, "Banks," pp. 327–29; Pressly 1979, pp. 51–52; Bryant 1985, pp. 62–63; Whinney 1988, p. 324
Victoria and Albert Museum, London

This relief represents the passage in Book XVIII of Homer's *Iliad* in which the Greek warrior Achilles, grief-stricken at the death of his friend Patroclus, is comforted by the nymphs summoned from the deep by his mother, the goddess Thetis, who (in Alexander Pope's translation) "Heard his loud cries, and answered groan for groan." As Banks's daughter Lavinia Forster recorded when she gave the work to the National Gallery in 1845, the model "was made by my Father during his residence in Rome, where it was ordered to be executed in Marble by the Right Rev.d Earl of Bristol and Bishop of Derry—but being subsequently countermanded, Mr Banks brought it with him to England in 1779, the marble being only roughly 'got out', and it was finished at a later period" (London, National Gallery Archives, MS NG5/60). Along with the figure of *Cupid* and two heads, this relief must have been commissioned by the bishop (later the 4th Earl of Bristol) after he arrived in Rome in November 1777 and canceled before November 1778, when Banks was murmuring in his fever about his ill usage by George Grenville, adding, "Oh, the Bishop, thou also has a hand in it" (Bell, p. 36). Having been brought to England on Banks's return, the marble (according to a report in *The Director* in 1807) "remained till after his death, when it was finished from the original model."

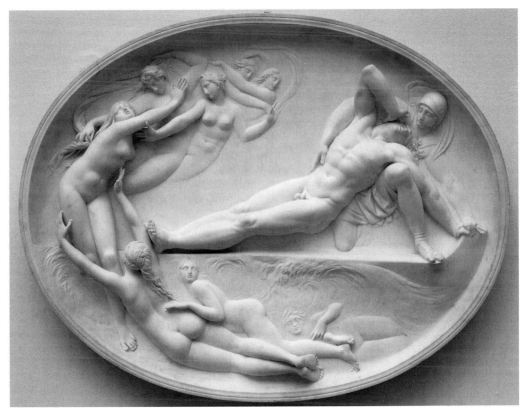

106

This plaster (not terracotta) model, which had appeared in the posthumous sale of May 22, 1805 (lot 76), was acquired by Sir John Soane and remains in Sir John Soane's Museum, London.

Banks's choice of a Homeric subject is but one example of the attraction that the *Iliad* had for artists in Rome from the 1760s onwards, beginning with Gavin Hamilton's large history paintings and continuing in the 1790s with Flaxman's illustrations of Homer. But the sculptor's interpretation of these texts was not so much an individual enterprise as a collaborative exchange, which also involved Johan Tobias Sergel, Nikolai Abildgaard, and Henry Fuseli, all of whom were engaged at the same time with common subjects. As Pressly has shown, Sergel had by June 1777 already executed a sketch that was perhaps based on an earlier version of Banks's relief, while Achilles' pose closely resembles that of Saul in Fuseli's *Saul and the Witch of Endor* (Victoria and Albert Museum, London), dated September 1777. The exaggerated angularity of Achilles' pose and the emotional intensity this carries strongly recall other works by Fuseli, but some of the latter's drawings in their turn suggest his response to Banks's reliefs, especially this example.

Like the marble relief of *Alcyone and Ceyx* (Lotherton Hall, Leeds, Yorkshire), the *Thetis* relief differs from the rectangular *Death of Germanicus* (Holkham Hall, Norfolk) or the *Caractacus before Claudius* (Stowe, Buckinghamshire) in

being carved as a concave oval. Although the carving of the figures of the nymphs varies from very low relief to high relief, the latter demanding the retention of supports linking individual limbs with the background, the way in which much of the carving lies below the raised edge of the oval gives it something of the quality of an engraved gem, hugely enlarged. Despite the undercutting, the relief's form and composition ensure that the substantial, almost monumental forms are contained within a linear pattern. Perhaps it was this quality, as much as the treatment of the subject, that appealed to Flaxman, who commented that this "is of the epic class, … the sentiment and character is beautiful and pathetic, the composition is so unlike any work ancient or modern, that the combination may be considered the artist's own" (Flaxman 1838, p. 292). [MB]

## EDME BOUCHARDON

CHAUMONT-EN-BASSIGNY
1698–1762 PARIS

Bouchardon received his initial training as a sculptor under his father, Jean-Baptiste, with whom in 1719 he executed the relief of *The Martyrdom of Saint Stephen* for St.-Etienne, Dijon. As a result he seems already to have had a well-established familiarity with sculptural techniques before undertaking any formal training as an artist in the French academic system. In 1721 he came to Paris, where, having begun to study with Guillaume Coustou, he won in 1722 the *prix de Rome* for his *Gideon Choosing His Soldiers*. In the following year he traveled to Rome, along with his fellow sculptor Lambert-Sigisbert Adam, who had won the *prix de Rome* for 1723. Under the direction of François Poerson and then, after 1725, Nicolas Vleughels, Bouchardon devoted himself to drawing antique sculpture with a quite exceptional commitment and energy. As well as being significant for the classicizing features of his later sculpture, these drawings played an important role in establishing and maintaining his reputation as an artist. Highly esteemed by collectors such as Mariette, his drawings prompted M.-F. Dandre-Bardon to comment that if Bouchardon's sculptures equaled the achievements of the ancients, his drawings surpassed them. Already in the 1720s Bouchardon seems to have been aware of their

potential by collaborating with the German engraver Georg Martin Preissler, who in 1732 published prints after them.

To meet the requirements made of sculptor *pensionnaires*, Bouchardon was expected to execute a copy in marble of an antique sculpture; in his case this was the Barberini *Faun* (Glyptothek, Munich). Because of the original's condition, the sculptor was not permitted to take a plaster cast from which he could work but instead produced in 1726 a terracotta model, making the marble on which he worked until 1730 (Louvre, Paris) a free interpretation rather than a close copy. For the Comte d'Angivillier forty-eight years later this marble was the proof that it was possible to make a copy more beautiful than the original. The unusually long time taken over this copy after the antique was in part the result of Bouchardon's involvement in a number of other projects. In 1728 he produced a model for the tomb of Clement XI, with the encouragement of Cardinal Albani. But despite this support, the commission was in 1730 given to an Italian sculptor, just as an Italian was eventually to be chosen instead of him or Adam for the other major public project, the Trevi Fountain, for which Bouchardon submitted a proposal in 1731. While both Bouchardon and Adam were being seriously considered for such schemes, Vleughels's attempts to secure prestigious public commissions for French sculptors seem to have been less successful than those of his predecessors a generation earlier. While Bouchardon may have failed to emulate the earlier success enjoyed by Pierre Legros or Pietro Stefano Monnot with major ecclesiastical or urban works, his period was nonetheless extremely productive as far as other types of sculptural patronage were concerned. Between 1727 and his return to Paris in 1733 he executed not only various portraits of ecclesiastical sitters that attracted much attention but also a series of busts that through the adoption of a severely classical mode gave this familiar genre a new seriousness.

The first of these busts was the marble he executed in 1727 of *Baron Stosch* (Staatliche Museen, Berlin), which was engraved, like Bouchardon's drawings, by Preissler. As well as acting as Cardinal Albani's librarian, Stosch had close links with the Pretender's court and Jacobite visitors to Rome, on which he secretly reported to the British government, and Bouchardon's portrait of him probably prompted commissions for busts in a similar antique manner from John Gordon in 1728 (on deposit at Inverness Museum, Scotland) and Lord Hervey in 1729 (cat. 107). In 1730

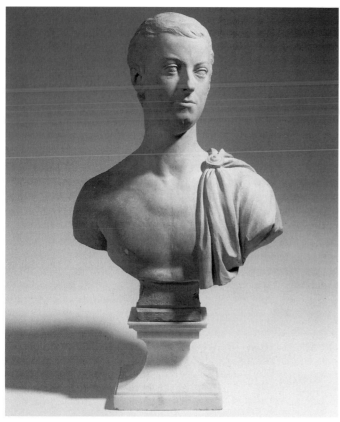

107

he carved a portrait of Lady Lechmere, pairing Filippo della Valle's bust of her husband, Sir Thomas Robinson (Westminster Abbey, London), and produced drawings for a classicizing statue of the prince de Waldeck, never executed because of the prince's death. In the following year Bouchardon produced portraits of Cardinal Polignac (Musée Bossuet, Meaux), Cardinal Rohan (private collection, Strasbourg)—both in Rome for the election of the successor to Pope Benedict XIII—and a bust of the newly elected Pope Clement XII (terracotta, De Young Memorial Museum, San Francisco; marble, Palazzo Corsini, Florence). As the sculptor recorded in a letter to his father, this last work created much excitement, prompting a commission for a portrait from the Duchess of Buckingham (private collection, England), the illegitimate daughter of James II, who had "never ceased labouring to restore the house of Stuart" (Horace Walpole, *Reminiscences*, edited by Paget Toynbee [Oxford, 1924], p. 92).

In the portraits of Clement XII and the two cardinals Bouchardon was drawing on a tradition of ecclesiastical portraits established by Bernini and Algardi, although he heightened still further the subtlety of the surface carving, as he did on the Buckingham marble, a bust of comparable scale and ambition. For the other busts, on the other hand, the sculptor drew on

antique models to formulate a new severe convention that was already being used on a smaller scale in Giovanni Pozzo's ivory reliefs of several of the same sitters who commissioned busts from Bouchardon.

Such commissions were not viewed very sympathetically by the Duc d'Antin, Surintendant des Bâtiments du Roi, who commented that "it is not to enrich foreign countries that the King spends so much on his Academy" (Roserot 1908, p. 36), and perhaps in response to such comments Bouchardon returned to Paris in 1733, having carved in the previous year a bust of Madame Vleughels (Louvre, Paris). There he collaborated on the sculpture on the Bassin de Neptune at Versailles (1735–40) and from 1736 until his death produced designs for medals struck by the royal mint. However, his most important commissions in France consisted of the fountain made for the city in the rue de Grenelle (1739–45), the statue of *Cupid Cutting a Bow from Hercules' Club* carved for the Salon d'Hercule at Versailles (completed 1750), and the bronze equestrian figure of Louis XV, cast after the sculptor's death and finished by Jean-Baptiste Pigalle in 1763. While these major French commissions show most clearly Bouchardon's achievement in combining antique models with a bold anatomical naturalism, the nine years spent in Rome can be seen as the period in which his distinctive qualities as

both draftsman and sculptor were formed. [MB]

BIBLIOGRAPHY  Caylus 1762; Roserot 1908; Roserot 1910; Metz and Rave 1957; *Bouchardon* 1962; Vetter 1962; Weber 1969; Harrison 1996; Sherf 1999; Baker and Harrison 2000

## 107
## Edme Bouchardon
### *John, Lord Hervey*

1729
Terracotta
Height without base 24¼" (62 cm)
PROVENANCE  presumably commissioned by Lord Hervey in 1729 and sent to Ickworth; by descent to his sons, the 2nd, 3rd and 4th Earls of Bristol, and thereafter to successive marquesses of Bristol; surrendered with Ickworth in lieu of death duty in 1957 and passed to the National Trust
BIBLIOGRAPHY  Halsband 1973, p. 82 (as a "plaster replica"); Kerslake 1977, p. 141; Jackson-Stops 1985, p. 312, no. 237; Baker 2000; Baker and Harrison 2000
Ickworth, The Bristol Collection (The National Trust)

Lord Hervey, eldest surviving son of the 1st Earl of Bristol, sat to Bouchardon when he was in Rome between April and June 1729 and his portrait bust belongs to a series of male portraits—predominantly of British sitters—that initiated a new mode of portrait sculpture in a severe classical mode. This terracotta was recently found at the Bristol family's seat at Ickworth by Alastair Laing, who convincingly identified it as the model for the marble, signed and dated 1729, formerly at Melbury House (collection of Lady Teresa Agnew). The terracotta was presumably used as the basis for the later marble copy, which had earlier been considered Bouchardon's original. The Melbury marble was seen in 1762 by Horace Walpole at Redlynch, the house of Stephen Fox (later Lord Ilchester), who had accompanied Hervey to Italy and nursed him through his illness there. The bust seems to have been commissioned by Hervey as a token of friendship for Fox, who was probably his homosexual lover and had shown him, in his own words, "an affection and friendship I am as incapable of forgetting, as any nature but his is incapable of feeling" (Lord John Hervey, *Some Materials towards Memoirs of the Reign of George II*, edited by Romney Sedgwick [London, 1931], p. 974). The terracotta was presumably retained by Hervey himself when the marble was given to Fox. It is conceivable, however, that the second marble version at Ickworth was carved in London by Michael Rysbrack as a verse published in the *Grub Street Journal* for September 20, 1736 (cited by Matthew Craske, "The London Sculpture Trade and the Development

of the Imagery of the Family in Funerary Monuments of the Period 1720–1760," Westfield College, London, Ph.D. diss., 1992, p. 161) refers to Fox coming across a noble bust of Hervey in the sculptor's workshop. Implicit in this satire may be a contrast between the rigorous mode of classicizing bust being developed by Rysbrack and the more refined manner employed by Bouchardon.

Portrait busts showing sitters in classical dress based on ancient Roman models seem to have become popular with British sitters by the 1720s, but Bouchardon's version of this convention was innovative and distinctive. While Pietro Stefano Monnot had already in 1701 represented the 5th Earl of Exeter in Roman armour and drapery resembling a toga (Burleigh House Collection, Stamford, Lincolnshire), the bust still has a Baroque fullness. By contrast, Bouchardon's busts in the antique manner, beginning with that of Baron Stosch (1727; Staatliche Museen, Berlin) and continuing with those of John Gordon (1728; on deposit at Inverness Museum, Scotland) and Hervey, draw more directly on a first-century AD type, with bare chest and one draped shoulder, so creating an effect that was at once more authentically antique as well as more modern. One starting point for Bouchardon's formulation of this type may have been the ivory and wax medallions being produced by Giovanni Pozzo, which show sitters in profile and wearing antique dress; these include portraits of both Stosch (1717; Staatliche Museen, Berlin) and John Gordon (1728; Victoria and Albert Museum, London) pre-dating or contemporary with Bouchardon's marbles of the same subjects. No Pozzo medallion of Hervey is recorded but an agate relief by Johann Lorenz Natter (private collection, England), working in the same circle as Pozzo, shows him in similar antique mode. Although Bouchardon's portrait of Hervey employs the same format as that used for Stosch, the drapery is now drawn tightly around the truncation of the sitter's left arm, so playing with the inherent artificiality of the bust form as well as alerting the viewer to the way the antique convention is being inflected. The mode of this particular image may have carried some homoerotic significance for Hervey and Fox, but its classical connotations were more overt and evidently continued to have meaning as the bust was reproduced (albeit in an abbreviated form) as the frontispiece for the 1778 edition of *Letters between Lord Hervey and Dr Middleton concerning the Roman Senate*. The antiquarian Conyers Middleton himself had his medallion portrait carved by Pozzo in an antique manner while in Rome in 1724. [MB]

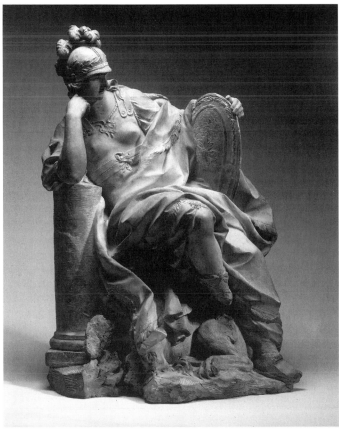

108

## PIETRO BRACCI
ROME 1700–1773 ROME
*For biography see Architecture section*

## 108
### Pietro Bracci
### *Allegory of Strength*

c. 1741
Terracotta
The foot of the right leg and head of the lion are missing; the foot of the left leg is badly damaged; the figure shows signs of previous restoration
21¼″ × 13⅛″ × 10¼″ (54 × 34 × 26 cm)
EXHIBITIONS St. Petersburg 1989, cat. no. 31; Rome and Venice 1991, cat. no. 30
BIBLIOGRAPHY *Museo della casa* 1788, p. 24; Petrov, P. N. *Sbornik materialov diva istorii imperatorskoy S.-Peterburgskoy Akademii Khudozhest v.* St. Petersburg, 1864, p. 600; Treu, G. *Ukazatel' skul' pturnago muzeya Imperatorskoy Akademii Khudozhest v: Skul' ptura XIV–XVIII stoletii.* St. Petersburg, 1871, p. 51, no. 723; Androsov 1991, p. 79, no. 30; Honour 1994, pp. 63, 91
The State Hermitage Museum, St. Petersburg

In the Farsetti collection catalogue, this figurine was entered under the name *Fortezza sedente col Leone, e scudo, del suddetto [Bracci]*. G. Treu mentions it as a copy of Bracci's original. In the Hermitage inventory it was entered as *Minerva or Allegory of Strength by Pietro Bracci*; the figurine was not displayed until the 1989 exhibition at the Hermitage. The terracotta figurine of the Farsetti collection is a preliminary study for a similar figure made as a monument for the tomb of Cardinal Giuseppe Renato Imperiali, which Bracci carried out for a project by the architect Paolo Posi in the church of S. Agostino in Rome. According to Bracci's own diary, he began this work in 1741 (Gradara Pesci 1920, pp. 50, 52). The cardinal's remains were interred at the tomb on August 21, 1745, before work on it was fully completed (Mallory 1974, p. 170). It therefore follows that the terracotta figurine at the Hermitage probably dates from around the year 1741.

Judging from its relatively large size and details in the work, the Farsetti collection figurine is one of the final variants of the model. This kind of *modellino* was, it seems, quite often presented to the client for approval. Even so, the terracotta figurine retains the freshness and naturalness of the original. Despite, therefore, the difficulty of making comparisons with similar works by Bracci, the authorship of the sculpture is beyond doubt. This is borne out by the shared features of the terracotta figurine and the final statue executed in marble. The posture of the marble figure is almost exactly the same as the Hermitage model although their spacial positioning differs. *Strength* in the Farsetti collection sits on a pedestal representing the ground, and leans with her right hand on the column; beneath her feet is a recumbent lion. The marble figure has no pedestal nor either of the allegorical attributes of *Strength*; she is seated, leaning on the sarcophagus with her legs hanging down. These differences are probably not accidental and may well have been made at the last moment at the client's wishes, to alter the allegorical meaning of the female figure. This supposition is supported by the fact that in Bracci's diary the figure has a double name: *Constancy of Spirit or Strength (la Costanza d'Animo o sia Fortezza)* (Gradara Pesci 1920, p. 103).

Pietro Bracci should be considered not only the most influential, but also the most interesting, of all the sculptors in Rome in the middle of the eighteenth century. It was entirely logical for him and him alone to be entrusted with such important commissions as the figure of Oceanus in the Trevi Fountain and the tombs of popes Benedict XIII (church of S. Maria sopra Minerva) and Benedict XIV (St. Peter's). Bracci's works make their great impression primarily through internal tension and hidden power, their ultimate expressiveness being achieved by quite simple means, as the *Allegory of Strength* also shows. This is one reason why Bracci should be considered the sculptor who anticipated and, to a certain extent, paved the way for Neoclassicism towards the end of the eighteenth century.

The interest in Cardinal Imperiali's tomb shown by the young Antonio Canova soon after he arrived in Rome may not be coincidental. In spite of the fact that the name of the church is missing from Canova's notes for November 23, 1779, Hugh Honour's suggestion that he was writing about the tomb of Cardinal Imperiali seems very convincing: "Entrassimo poi nella chiesa de. … vi era un deposito che sta anco in casa Farsetti quello che tiene il ritratto in pittura" ("We went into the church of … where there was a monument to the same man of whom there is a painted portrait in the Casa Farsetti"; Honour 1994, pp. 63, 91). One might add that, besides *Strength*, there is another work in the Farsetti collection related to the same monument. It is mentioned there as "Il Deposito del Cardinale Imperiali a S. Agostino in Roma" (*Museo della casa* 1788, p. 19). Although this terracotta figurine was classified as a part of the "Modelli di Bassirilievi", it may well be a model for the entire composition, which has not survived. It was obviously this model, or the figure of *Strength* described here, that Canova was referring to when he mentioned the tomb at Farsetti's house. [SA]

## 109
### Pietro Bracci
### *Pope Benedict XIV*

c. 1750–53
Carrara marble
Height without base 16½″ (42 cm)
PROVENANCE purchased in Florence for the Königliche Museen, Berlin, 1873
EXHIBITIONS Rome 1979, cat. no. 129; Wörlitz and Stendal 1998, cat. no. I.15
BIBLIOGRAPHY Bode, Wilhelm, and Hugo von Tschudi. *Königliche Museen zu Berlin: Beschreibung der Bildwerke der christlichen Epoche.* Berlin: E. A. Spemann, 1888, p. 79, no. 272, pl. XVI; Breck 1913, p. 276; Schottmüller 1913, p. 193, no. 440; Domarus 1915, p. 41, no. 36; Gradara Pesci 1920, pp. 66–67, 86–87; *Italienische Skulpturen im Kaiser Friedrich Museum.* Berlin: Staatliche Museen zu Berlin, 1933, no. 91; Schottmüller 1933, pp. 228–29, no. 345; Taylor 1952, p. 232, pls. 5–6; Honour 1971, p. 622; Nava Cellini 1982, pp. 51, 55, pl. 2; Schlegel 1988, p. 30; Penny, Nicholas. *Catalogue of European Sculpture in the Ashmolean Museum: 1540 to the Present Day.* Vol. 1. Oxford: Clarendon Press, 1992, p. 27, nos. 22–25; Achilles-Syndram 1998
Staatliche Museen zu Berlin, Skulpturensammlung

With the election of the Bolognese Prospero Lambertini as Pope Benedict XIV in 1740 a cultured yet very cheerful personality gained the Holy See. During his eighteen-year rule he astonished his contemporaries with popular appearances and a quick-witted humor. The contemptous character sketch made of the pope by the German archaeologist Johann Joachim Winckelmann does not do justice to the pope's farsighted diplomacy, his enlightened and sharp way of thinking, and his cultural achievements. His writings on the history of law set new standards; his promotion of the natural sciences was exemplary. As an admirer of the antique he protected the Colosseum from further demolition, arranged excavations, and enlarged the Capitoline collections through generous donations. But his interests were not limited to Greek and Roman antiquities: he also founded a museum for Egyptian art and a picture gallery on the Capitol. Furthermore, for the opening of the Museo Sacro in the Vatican he started an extensive program in which numerous Early Christian sarcophagi were restored. His greatest love, however, was for the contemporary arts, and Benedict XIV improved the education of young artists by installing a class on the Capitol that was devoted exclusively to the depiction of the nude. Pietro Bracci himself was a teacher at this institution.

The life-size marble portrait shows Benedict XIV in frontal view. His full face is enclosed by the *camauro*, by his hair at the sides, and by the smooth collar under his chin. The shoulders are cut in a narrow way so that the

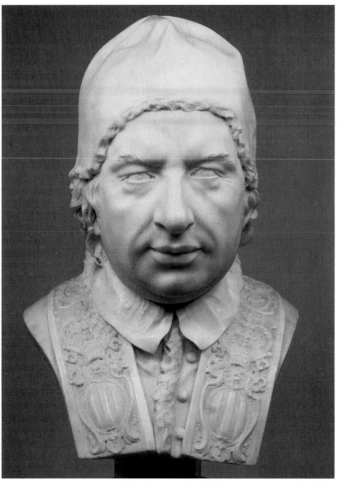

109

mozzetta is completely covered by the stole. The decoration of the latter is dominated by the papal coat of arms, which stands in contrast to the rough background. Because of the small size of his chest, the different elements of the arms, such as the striped cartouche and the tiara over the papal keys, are striking and impressive. The spectator's eyes are attracted immediately to the carefully modulated physiognomy, with its rich and colorful play of shades. The virtuoso relief carving gives the eyes a vivid and sparkling expression. The soft but sharp-edged lips are slightly opened and suggest the movement of breathing around the chin, while the nose reveals its character primarily in the profile view. The artist has captured with psychological sensitivity and some humor the spirit of this complex personality—a personality who urges the sculptor or painter to represent him in a solemn, idealized attitude.

This portrait bust, purchased in 1873, was one of the first and most remarkable acquisitions of Wilhelm von Bode, who was appointed in 1872 as an assistant director of the Königliche Museen in Berlin, and who later was director-general. Bode travelled through Italy for the first time in

1872–73, exploring the local art market. As the grandezza of Roman Baroque art was not generally to Bode's taste, the simple, intimate aura of the portrait must have appealed to him. It was published in 1888 as an anonymous work around 1750, but it was Frida Schottmüller who connected it in 1913 with the name of Pietro Bracci. Kurt von Domarus confirmed this attribution, although the piece was not mentioned in the sculptor's journal, started in 1725. In the scanty literature on the Berlin bust Bracci's authorship has been mostly accepted. Gerald Taylor's attempt to attribute it to the South German sculptor Joseph Claus is not convincing, as the comparison with his signed marble portrait of Benedict XIV in the Ashmolean Museum in Oxford demonstrates.

Pietro Bracci, kept in good favor by several popes, was considered an expert in papal portraits. In the jubilee year of 1750 he received from the Confraternità dei Pellegrini in Rome the commission to carry out a small marble monument for Pope Benedict XIV, which was completed in 1753. During this time, between 1750 and 1753, Bracci may have also executed the Berlin bust, which seems to

have provided Joseph Claus with a model for the above-mentioned bust in Oxford, which is dated 1754. Unfortunately, the portrait journal kept by Bracci is incomplete, and several papal busts have been included in the catalogue of his works without convincing stylistic arguments. Serious work on this issue is still to be done. Of the busts of Benedict XIV attributed to Bracci and listed by Domarus and Schottmüller, the one in the Castello Sforzesco in Milan is the closest to the Berlin marble portrait, especially in the physiognomy and in the ornamentation. The attribution to Joseph Claus for the Milan bust, proposed by Nicholas Penny, is therefore difficult to understand. On the other hand, the pope's bust in the museum of Grenoble differs in the flat and undifferentiated ornamentation of the stole. While the character of this portrait is still similar to the Berlin bust, the marble portraits of Benedict XIV in Assisi and New York show no artistic relationship to it.

Bracci's funeral monument for Benedict XIV in St. Peter's in Rome (completed 1769) has been criticized often as an old-fashioned work, still attached to the Roman Baroque tradition. The Berlin bust of Benedict XIV, by contrast, shows that Pietro Bracci, a brilliant portrait sculptor, was capable of combining true expression full of directness and vitality with a calm and classicizing form, and of adjusting his personal style to the taste of the new era. [KAS]

## BERNARDINO CAMETTI
### ROME 1669–1736 ROME

Bernardino Cametti received his first training under Lorenzo Ottoni, in whose atelier he remained for a full fifteen years (Enggass 1976, vol. 1, pp. 149–50). It is likely that the younger sculptor worked independently or on advanced projects towards the end of this period, since he soon outshone his master. Various sources (Enggass 1976, vol. 1, p. 150) mention that Cametti assiduously studied the standard models for young artists, the sculpture of Antiquity and the paintings of Raphael, and—more significantly—that he worked in the studios of the French Academy at Rome. The French influence on Roman painting and sculpture, which reached its apex in the 1680s and 1690s, is evident throughout Cametti's œuvre, more so than any stylistic mannerisms he might have adapted from his teacher Ottoni. Nonetheless, Cametti developed a distinct style that synthesizes his own Roman background with French influences.

Cametti first came to public notice with the marble relief of The

Canonization of Saint Ignatius on the right side of the St. Ignatius Chapel in the Gesù in Rome, completed between 1695 and 1698. He, together with many of his talented contemporaries, participated in this most important collaboration of sculptors at the end of the century. The basic composition for the Canonization, which had been predetermined by the supervising painter–architect, the Jesuit Andrea Pozzo, shows Pope Gregory XV enthroned handing a scroll to two kneeling Jesuits among onlookers and putti hovering above. But it was Cametti who imbued the relief with vigor and drama through deep undercutting, strong outlines, and by adjusting figures slightly to streamline the design. The carefully considered combination of decorative detail and strong plasticity gives the work its verve while preserving its clarity, even in its high location. As noted by Schlegel (1963, p. 49), Cametti retained this basic approach in all of his future reliefs.

During the first two decades of the eighteenth century a steady stream of commissions came Cametti's way, chiefly for tombs with portraits and attendant figures, as well as various reliefs of religious or historical subjects. Cametti was knighted by Pope Clement XI Albani between 1704 and 1706 and was accepted into the Accademia di S. Luca in 1719, yet all the major works of this period, the relief of the Navicella (1703) in Frascati, the tombs of Taddeo and Antonio Barberini (1704) in Palestrina, the Glory of Angels (1714–18) in Orvieto, and the large marble statues of the evangelists Saint Luke and Saint Mark in Bologna (1716), were destined for places outside of Rome. Therefore, although the artist apparently never left the city for long periods, carving his sculptures there before shipping them abroad, he contributed significantly to the dissemination and influence of Roman late Baroque sculpture in northern Italy.

Among his works in Rome, the tomb of Gabriele Filipucci in St. John Lateran (after 1706) is a variation of the type derived from Bernini and ultimately Raphael (Chigi Chapel, S. Maria del Popolo), which Cametti had already employed in his highly successful Barberini monuments of about two years earlier. In all three, the composition is anchored by a tall, flattened pyramid, symbol of eternity. At the foot of the pyramid a winged, heavily draped personification of Fame draws attention to the portrait of the deceased. While the Barberini tombs show Taddeo and Antonio as imposing, lively busts projecting out of oval niches, Filipucci appears more remote, a portrait medallion in high relief. The mourning attendant figure holding it is now the central focus of

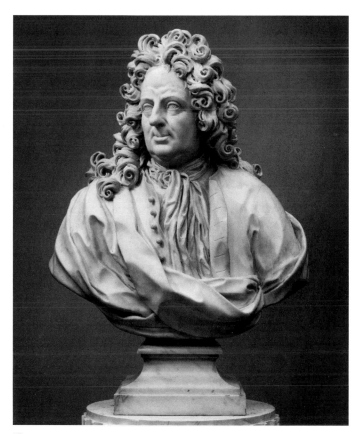

110

the composition. The efficacy and popularity of Cametti's compositional formula are demonstrated by a number of later tombs by Filippo della Valle (*Emanuele Pereira de Sanpaio*, 1759; S. Antonio dei Portoghesi; *Girolamo Samminiati*, 1733; S. Giovanni dei Fiorentini) and Pietro Bracci (*Cardinal Fabrizio Paolucci*, 1729; S. Marcello; *Cardinal Renato Imperiali*, 1741–45; S. Agostino; *Carlo Leopoldo Calcagnini*, 1749; S. Andrea delle Fratte). Cametti's work as a portraitist reached its highpoint with the mature monuments for *Giovanni Andrea Muti* and *Maria Colomba Vicentini* in S. Marcello al Corso (1725). There the pyramid was abandoned in favor of staging the couple (who were related but not married) in arched balconies, emerging above prayer benches and gesturing or leaning towards the altar in "eternal adoration" (Bruhns 1940, pp. 408–9). The extremely lifelike half-figures in luminous white marble are set off against the surroundings of colored stones and carved with utmost attention to the texturing of different facial features, hair, laces, and draperies. From his early terracotta bust of *Taddeo Barberini* in the Museo di Roma (1704) to the marble bust of *Giovanni Andrea Muti* (1725) in the Metropolitan Museum of Art, New York (cat. 110), the rich palette of light and shadow in Cametti's portraits demonstrate his mastery as a carver.

Cametti was not invited to contribute to the series of monumental

Apostle statues in the Lateran but his *Saint Rasius* in the Pantheon (1717 or 1723–24), the *Charity* in the chapel of the Monte di Pietà (1721–24), and the *Saint James* and *Saint Simon* (1722) in Orvieto clearly prove that he was capable of creating figures on a comparable scale and of equal complexity. Certain aspects of the poses and complicated rippling and wrapping of the draperies in each of these statues combine influences from successful French sculptors, particularly Jean-Baptiste Théodon and Pierre Legros the Younger, who both also contributed to the chapel of the Monte di Pietà. The *Saint James* and *Saint Simon* were clearly inspired by the Lateran figures of the French-born Pietro Stefano Monnot and the Roman Camillo Rusconi. The composition of Cametti's *Saint James* recalls Monnot's *Saint Peter* and the *Saint Simon* his *Saint Paul*; Cametti strove for but did not quite match the grand rhetoric of Rusconi's *Saint John*, *Saint Matthew*, and *Saint James*.

A notable exception from Cametti's usual fare of portraits, tombs, and religious works was his dazzling *Diana as a Huntress* (1716–22; Staatliche Museen, Berlin), a lifesize figure of the fleet-footed goddess accompanied by a leaping hound. While close to classical models, Cametti's *Diana* is full of Baroque dynamism, deep undercutting, fluttering draperies, and narrative details in an attempt to emulate

Bernini's masterwork *Apollo and Daphne* (1622–24; Galleria Borghese). The original commission for Cametti's mythological statue is unknown, but it was admired by Nicola Pio between 1716 and 1724 while still in the sculptor's studio and stood in the Palazzo Orsini at Monte Savelli until 1896 as part of a fountain arrangement (Schlegel 1963, "Cametti," pp. 151–63; Schlegel 1978, pp. 101–10). Like Cametti's Apostle figures mentioned earlier, the *Diana* is also related to a contemporary series of similar mythological statues by Monnot carved in Rome for the Marble Bath in Kassel (Walker S. 1995, p. 288).

Cametti's final commission was also his most prestigious: two large marble reliefs of *The Annunciation* (1729) and *The Blessed Amadeo of Savoy Asking the Virgin's Intercession* (1733), which decorate the church of the Superga in Turin. They were ordered by King Victor Amadeus II of Savoy, who was so pleased with Cametti's work that he issued a royal patent in 1729 declaring him his court sculptor (Schlegel 1963, "Cametti," pp. 173–83). In their execution the two monumental reliefs show a love of detail and surface sensibility that bespeak French influence, as well as the brilliant drillwork, vigorous movement, and decisive modeling that are Cametti's own.

Cametti creatively adapted compositions and artistic approaches of Roman sculptors, such as Ercole Ferrata and Domenico Guidi, from the post-Bernini generation, as well as Monnot, Legros, and Théodon. As Schlegel noted (1963), impulses for Cametti's distinctive figure types and the painterly effects in his reliefs were frequently derived from Carlo Maratti, the most influential painter of late seventeenth-century Rome. Numerous works by later sculptors, such as Della Valle and Bracci, testify to Cametti's own contribution, which was less that of an innovator than a successful synthesizer of various sources of inspiration. Cametti's sculptures still resonate with the pathos and rhetoric of the late Baroque; they are more energetic and less focused on an overall elegance than other contemporary works. Rich compositions, dramatic contrasts of light and shadow, and proudly displayed technique make Cametti's œuvre memorable and celebrate the virtuosity of his chisel. [SW]

BIBLIOGRAPHY Bruhns 1940, pp. 408–9, 414, figs. 330–32; Pericoli 1963; Schlegel 1963; Schlegel 1963, "Cametti"; Enggass 1976, vol. 1, pp. 148–58, and vol. 2, figs. 147–56; Nava Cellini 1982, pp. 20–23; Barroero 1996, "Interventi," pp. 293–96

## 110

## Bernardino Cametti
### *Giovanni Andrea Muti*

c. 1725
Marble
Height without base 30⅞" (78.5 cm); with base 38½" (97.8 cm) (base is separate piece of marble)
PROVENANCE Edouard Kann, Paris, before 1942
BIBLIOGRAPHY sale catalogue, Hôtel Drouot, Paris, May 7, 1942, lot 56, pl. XIV (as French, anonymous, seventeenth-century); Schlegel 1978, p. 100; Raggio 1991, pp. 241–42, fig. 19; Souchal 1993, vol. 1, pp. 222–23, no. 116 (as *Coysevox, Duc de Montausier*, private collection)
The Metropolitan Museum of Art, Purchase, The Josephine Bay Paul and C. Michael Paul Foundation, Inc., and the Charles Ulrick and Josephine Bay Foundation, Inc.

The decisive turn of the sitter's head and shoulders out of a frontal position toward his right animates all the parts of the bust and makes the portrait come alive. The mantle wrapping the right shoulder and lower rim of the bust, the wavy edges of the open coat, and even the twist of the necktie respond to the figure's motion. The writhing, deeply cut curls of the man's generous wig seem to take on a life of their own, as they frame his face and cascade on to his back and forward on to his right shoulder. His features and steadfast gaze into the distance convey both formality and a certain benevolence through the brows furrowed over a large but noble nose and the narrow, slightly smiling mouth with its distinctive, drawn upper lip.

Although the bust is neither signed nor dated, the identity of the sitter, the artist, and the probable occasion for this forceful portrait have been determined. The work represents the nobleman Giovanni Andrea Muti the Younger (1663–1722) and is undoubtedly a mature masterpiece by the late Baroque sculptor Bernardino Cametti (Schlegel 1978, p. 100). The attribution results from a comparison with a marble half-figure bearing the same striking physical features in the Muti Bussi Chapel at S. Marcello al Corso in Rome. Documents and inscriptions prove that the tomb in S. Marcello was completed by Cametti in 1725 at the behest of Giovanni Andrea's heir, Innocenzo Muti Bussi (Enggass 1976, vol. 1, pp. 156–57). The posthumous portrait shown here was probably made at the same time and may well have stood in the family palace of the Muti Bussi, which still exists in via Aracoeli (Raggio 1991, p. 242). While the half-figure in S. Marcello has long been recognized as a major work by Cametti, this portrait is less well known but of equally fine quality. Although the bust lacks the tomb

figure's overtly theatrical elements, such as the gesturing arms and bending upper body, it retains its lively presence through Muti's expressive face, noble carriage, and flowing wig.

The portrait bears all the hallmarks of Cametti's vigorous and technically accomplished manner. In its formality and the conventions of the sitter's dress the piece evinces the influence of French sculpture, in particular the marble busts of Louis XIV and other royal family members by Antoine Coysevox from the later seventeenth century. Coysevox's formula for this portrait series was widely copied and adapted, for example the windswept curls, the head turned to one side, and the carefully arranged cravat. This work was even once thought to be by Coysevox, but it differs from his style in the distinctly Italian brio of its carving and differentiation of surface textures. The folds turn crisply, the drilling is deeper, the undercutting more decisive, and the modeling of the face more pronounced. The composition and inherent vitality of Cametti's rendition bear a close comparison to the portrait of Carlo Maratti (1704–8; S. Maria degli Angeli, Rome) by Francesco Maratti (Enggass 1976, vol. 2, p. 116, fig. 82). Stylistically, the masterfully executed bust of Giovanni Andrea Muti by Cametti represents a transitional moment at the close of the late Baroque before the onset of a more severe Neoclassicism in Roman portrait sculpture. [SW]

## ANTONIO CANOVA
### POSSAGNO 1757–1822 VENICE

Born a subject of the Serene Republic of Venice in a hill town near Treviso, Antonio Canova rose to heights of cultural fame undreamed of in Venice since the Renaissance. His paternal grandfather, Pasino Canova, a provincial stonecarver, taught his grandson the rudiments of his future profession. Canova fortunately attracted the attention of a patrician, Giovanni Falier, who enabled the young sculptor to come to Venice to study with the leading local sculptor, Giuseppe Bernardi. After the successful exhibition of *Orpheus, Eurydice,* and *Daedalus and Icarus,* juvenilia remarkable for their Rococo naturalism, Canova journeyed to Rome in 1779 to study collections of modern sculpture and antiquities. He remained there for several months and through the intervention of the Venetian ambassador to the Papacy, Girolamo Zulian, was awarded a pension from the Venetian senate, an unprecedented gesture of confidence and esteem. He returned to Rome in 1781 and remained there, with only infrequent absences of short duration, until his death.

Canova's meteoric rise to international celebrity began with the unveiling of his first major Roman sculpture, *Theseus with the Dead Minotaur,* which was thought to rival the antique in its ideal beauty and quiet dignity. The success of his début led immediately to the commission for the tomb of Pope Clement XIV Ganganelli, completed in 1787. This controversial monument to the pontiff who had suppressed the Society of Jesus utterly transformed the Baroque traditions of papal tombs best represented by Bernini in St. Peter's. To the indignation of the established sculptors of the Accademia di S. Luca, Canova also landed the commission for a second pontifical monument, the tomb of Pope Clement XIII Rezzonico, this time for St. Peter's; it was unveiled to wide acclaim in 1792. The enmity of the cultural establishment towards the "modern Phidias" was manifested by his exclusion from membership in the Accademia until 1800.

While papal tombs brought Canova considerable fame and professional enmity, his reputation as Europe's greatest artist was established largely by his graceful mythological figures in marble, of which the recumbent *Cupid and Psyche* now in the Louvre is the most famous example. By the 1790s demand for Canova's mythological figures far exceeded the supply, and patrons had often to wait several years to receive their commissioned works. The sculptor's professional dealings, above all with the British, were severely hampered by the wars with France that lasted from 1792 until the fall of Napoleon in 1815. Nonetheless, a steady stream of gleaming, nacreous marble gods, goddesses, and heroes flowed from Canova's chisel during this parlous time, including *Perseus with the Head of Medusa,* purchased by Pope Pius VII, *Paris* and *The Three Graces,* executed for the Empress Josephine, and *Psyche,* acquired by the Venetian count Giuseppe Mangilli.

Canova's celebrity as the sculptor of feminine grace *par excellence* led him to accept in 1795 a challenging Neapolitan commission for *Hercules and Lichas,* a horrific subject executed on a colossal scale. Completed almost two decades after its original conception, the group sculpture was purchased by the Roman banker Giovanni Torlonia. Throughout his career Canova was eager to execute works in a variety of modes in rivalry with the masterpieces of antiquity. This competitive mentality was only increased by the removal of the major masterpieces of ancient sculpture from the papal, civic, and patrician collections of Rome by the French in 1798–99 and again in 1808–14, a cultural spoliation the artist resented bitterly.

Finding renown and fortune with the popularity of his marble mytholo-

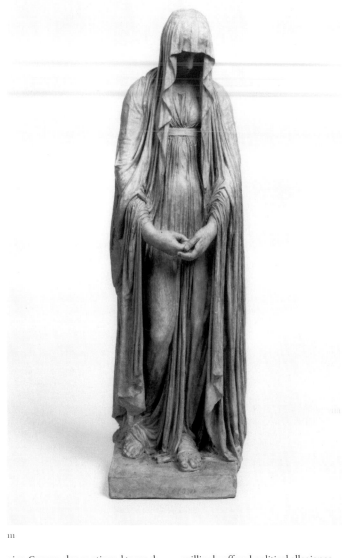

111

gies, Canova also continued to work in the epic mode of the funerary monument, and from 1798 to 1805 created his masterpiece in the genre, the deeply moving tomb of the Archduchess Maria Christina of Austria. Erected in the Habsburg Augustinerkirche in Vienna and paid for by the archduchess's widower, Duke Albert of Saxe-Teschen (founder of the Albertina), the pyramidal tomb approached by a procession of figures to be identified as a reified humanity is a vital monument to the syncretic notions of the Neoclassicists relating to death, the monument, and immortality. The sculptor also produced more modest funerary memorials for bourgeois consumers, including the monument to Giovanni Volpato in the narthex of the Ss. Apostoli in Rome, a forerunner of the modern tombstone.

Often associated with Napoleonic patronage, Canova was, however, never a court artist of the regime (unlike his rival in painting, Jacques-Louis David). He refused all court positions and

willingly offered political allegiance only to the republic of Venice (overthrown by Napoleon in 1797) and to the Papacy. He was conservative, Catholic, and anti-French, although the politics of the Napoleonic period often compelled him to suppress his true feelings. After the Battle of Waterloo, Canova went to Paris to oversee the return to Rome of works of art seized by the French, for which vital service he was made Marchese d'Ischia by a grateful Pius VII. While in Paris in the fall of 1815, he made a short trip to London, where he was favoured by the prince regent (later George IV) and fêted by the Royal Academy. During his visit Canova examined the Elgin Marbles and testified to a parliamentary committee on their worthiness for purchase for the nation. He also accepted a number of lucrative commissions, including *Mars and Venus* for the prince regent and a second version of *The Three Graces* ordered by the Duke of Bedford. Later, he also agreed to sculpt the cenotaph

of the last Stuarts for St. Peter's, a work that commemorated the end of Stuart pretensions to the British throne.

Disillusioned by the ultra-conservative reaction prevalent in Rome after the restoration of Pius VII, a phenomenon that was hostile to the classicizing culture of late eighteenth-century Neoclassicism to which Canova was so deeply committed, the artist focused his attention on his many British commissions and on the construction and decoration of a grand church, the Tempio, on a mountain top in his native Possagno. An architectural melding of the Pantheon and the Parthenon with a traditional Christian apse, the Tempio stands as Canova's greatest religious monument and a vivid affirmation of his traditional Catholic sentiments and local patriotism. During its construction Canova's health began to fail and he died, rather suddenly, during a visit to his beloved Venice. Probably no artist had risen to such a level of celebrity and popularity in their own lifetime, and few fell into near oblivion so quickly. Only with the demise of modernist criticism of classical, academic art and highly finished marble sculpture in recent years has Canova reemerged and taken his place as the most important artist of European Neoclassicism. [CMSJ]

BIBLIOGRAPHY Missirini 1823; Quatremère de Quincy M. 1834; D'Este 1864; Malamani 1911; Pavanello and Praz 1976; Licht 1983; Pavanello and Romanelli 1992; Honour 1994; Johns 1998

## 111

## Antonio Canova
## *Piety*

1783
Terracotta
Height 15¼" (39 cm)
PROVENANCE gift of the artist to Henry Blundell of Ince Blundell Hall, c. 1791; private collection
EXHIBITIONS London 1972, cat. no. 306; London 1998, cat. no. 67
BIBLIOGRAPHY Pavanello and Praz 1976, p. 93, no. 26; Ingamells 1997, pp. 101–2
Private collection, England

*Piety* is a model for Canova's first idea for the allegorical figure on the left side of the tomb of Pope Clement XIV Ganganelli in the Roman basilica of the Ss. Apostoli. The figure was eventually changed to a personification of Temperance. On a commission from Carlo Giorgi, a confidant of the deceased pontiff, Canova was chosen for the project by the celebrated Roman engraver Giovanni Volpato, who had been asked by Giorgi to select a suitable sculptor. The small, heavily draped and veiled erect female figure is highly expressive in its forms and embodies Canova's working

dictum of "model with fire, sculpt with phlegm." In addition to providing valuable insight into the artist's working procedure, *Piety* is an excellent example of Canova changing his mind. Not only is the identity of the allegory altered for the final tomb, but the conception of the marble figure is radically different. Temperance, whose languid, mournful, leaning pose is the perfect embodiment of Neoclassical mourning (she leans gently upon the top of the papal sarcophagus and holds a metallic bridle, her traditional attribute, in her right hand), inhabits a different world from the almost mystical, deeply moving *Piety*. The sense of the artist's touch on the surface of the clay and the sense of creative immediacy, typical of most of Canova's terracotta *modelli*, is what made them much more popular to the twentieth-century modernists than his "finished" marble sculptures, which were all too frequently characterized as "erotic frigidaires."

The Ganganelli tomb, begun in 1783 and unveiled to an enraptured public in 1787, along with the *Theseus and the Dead Minotaur* of 1781–83, confirmed Canova's reputation in Rome as the most promising Neoclassical sculptor. The tomb was highly controversial, both for its radical departure from Baroque stylistic precedents and also because Ganganelli had suppressed the Society of Jesus in 1773 with the brief *Domine ac Redemptor*. The monument's success helped Canova receive the commission for the tomb of Clement XIII in St. Peter's from the Rezzonico family; the *modello* for the figure of Religion in that monument has similar formal affinities to *Piety*, but none of its intense pathos.

Henry Blundell, a wealthy Roman Catholic squire from Lancashire, purchased the *modello* directly from Canova, probably in about 1789, when he commissioned the marble *Psyche*, which is still in the family collection at Ince Blundell Hall and for which he paid the considerable sum of £300. It was probably also at this time that Canova gave Blundell the *modello* for *Theseus and the Dead Minotaur*, the marble statue having been sold to the Viennese Count Josef von Fries and removed to the Austrian capital. The fact that the artist gave the terracotta model for the work that firmly established his reputation (and which subsequently changed the course of the history of modern sculpture) to Blundell must indicate a high level of personal esteem. Roman Catholics were barred from both political and military service in Great Britain, so art collecting and cultural patronage became avenues into the public sphere for such rich gentlemen as Blundell and his friend Charles Townley, who formed one of the most

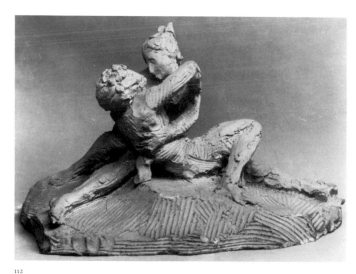

112

important collections of ancient sculpture outside Italy. It is possible also that the religious intensity of *Piety* appealed to Blundell's Catholic sensibilities. [CMSJ]

## 112

## Antonio Canova
## *Cupid and Psyche*

c. 1787
Terracotta
9½" × 16½" × 11" (24 × 42 × 28 cm)
PROVENANCE given to G. Zardo Fantolin by Giovanni Battista Sartori-Canova around 1823; Domenico Zoppetti Collection from 1847; bequeathed to the Museo Correr in 1849
EXHIBITIONS Rome 1959; London 1972, cat. no. 308; Venice 1978, cat. no. 112; Venice and Possagno 1992, cat. no. 79
BIBLIOGRAPHY Pavanello and Praz 1976, p. 98
Musei Civici Veneziani, Museo Correr, Venice

As Giuseppe Pavanello has convincingly demonstrated, this *bozzetto* is a preliminary sketch for the celebrated recumbent *Cupid and Psyche* now in the Louvre. Begun in 1787, the year the sculptor began work on the tomb of Pope Clement XIII Rezzonico in St. Peter's, the marble sculpture was initially a commission from a Scottish patron, Colonel John Campbell (later Baron Cawdor). In all likelihood, the Correr *bozzetto* was made in the year the commission was given—1787. Financial problems and the outbreak of war between the French republic and Great Britain (which made shipment between Rome and the British Isles risky) caused Campbell to relinquish the statue, and it was eventually acquired by Napoleon's brother-in-law General Joachim Murat (later king of Naples), but not directly from Canova. Another sketch for the Louvre *Cupid and Psyche*, now in the

Gipsoteca Canoviana at Possagno, is closely related to the Correr *bozzetto*.

Such traditional mythological themes as Cupid and Psyche, Venus and Adonis, Hebe, Venus and Cupid, Cephalus and Procris and many others were highly attractive to the young Canova, who had recently established his studio in Rome. His connections to the British community of artists and Grand Tourists, facilitated by the Venetian ambassador to the Holy See, Girolamo Zulian, did much to create Canova's international reputation. The suave, languid, and engagingly erotic mythological subjects favored by the sculptor were enormously appealing to his contemporaries, and the closest parallels to such works are the small terracotta table-top sculptures by such French artists as Clodion and the small-scale, intimate erotic genre paintings of Jean-Honoré Fragonard.

In the studies for *Cupid and Psyche*, Canova explored various compositional placements for the protagonists. In the Correr *bozzetto*, Cupid seems to be attempting to break away from Psyche's yearning embrace. In the definitive solution in the Louvre marble sculpture, Canova achieved a perfect synthesis of erotic engagement and emotional longing in the thrillingly interlocking forms while giving Cupid the physically dominant position, unlike his initial exploration of the languid Cupid and aggressive Psyche. The rapidity of execution is clearly evident in the textural markings in the clay, and a comparison of the *bozzetto* and the finished work provides an excellent illustration of the dictum: "Sketch with fire and execute with phlegm." [CMSJ]

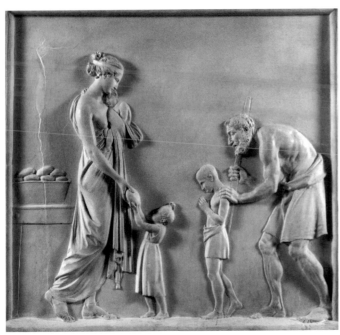

113

## 113
## Antonio Canova
### *Feeding the Hungry*

1795–96
Plaster
45 ¼″ × 50″ (115 × 127 cm)
PROVENANCE  Antonio Cappello, Venice; Teodoro Correr, Venice, before 1830; Palazzo Correr, Venice, 1830–1922; Museo Civico Correr, Venice, from 1922
EXHIBITIONS  Venice 1978, cat. no. 92; Venice and Possagno 1992, cat. no. 113; London 1994, cat. no. 288
BIBLIOGRAPHY  Arts Council 1972, pp. 213-24, no. 330; Pavanello and Praz 1976, p. 101, no. 93, fig. 93; Bassi 1978, pp. 67, 73; Pavanello and Romanelli 1992, p. 207, nos. 112-13; Martineau and Robison 1994, p. 415, no. 288, fig. 288
Musei Civici Veneziani, Museo Correr, Venice

This relief is a pair with *Teaching the Ignorant*, also at the Museo Correr. In 1804 these subjects were described as representing two acts of mercy. The date for the completion of the reliefs is provided in *Teaching the Ignorant*, in which the tablet held by the little boy is inscribed *A.C./Pos./1796*. The reliefs are said by Pavanello (Pavanello and Praz 1976) to have been commissioned by the Roman senator Prince Abbondio Rezzonico on the basis of C. L. Fernow's comment, published in 1806, that plaster reliefs of these subjects were placed in a free school in the environs of Bassano near which Rezzonico had a large villa. Prince Rezzonico had earlier commissioned Canova's *Apollo Crowning Himself* of 1781–82 and the tomb of Pope Clement XIII (Rezzonico) of 1787-92. The reliefs survive in several sets. They

are markedly different from the range of styles Canova had explored earlier in the nine reliefs of 1787–92 depicting themes taken from ancient literature. In 1824 Leopoldo Cicognara approved the severity of the later relief style "by virtue of its superb simplicity." This style is echoed in the small vignette of the mythical founding of Padua that appears on the Giustiniani stele of 1796–97 (cat. 114).

The simplicity of *Feeding the Hungry* and its pendant is deceptive, and of the two compositions the relief included here is the more richly suggestive. The statuesque woman at left has aspects of the traditional figure of Charity: one of her breasts is bared, and she holds a sleeping child. Charity is often attended by two children, so the girl receiving the bread could be a creative adaptation of the familiar theme. Another demonstration of charity appears in the boy who guides the blind old man. Together they represent two ages of man and the cycle of care by one and dependence of the other, like the young woman and the baby. These are but several of the allusions worth considering in this composition, which is more complex than its short frieze-like format would initially suggest. As most writers have noted, Canova used the figure of the old man again in his tomb monument for Maria Christina of Austria (1798–1805) in the Augustinerkirche in Vienna.

Canova never carved marble versions of the reliefs of the two acts of mercy. However, in addition to the reliefs at the Museo Correr, other pairs in plaster are to be found at the Gipsoteca at Possagno, at the Musée des Beaux-Arts in Dijon (first recorded

in 1843), and at the Istituto Finlandese di Cultura in Rome. A pair formerly in the Palazzo Sambonifacio in Padua is recorded in the possession of Antonio Piazza in the early nineteenth century. In 1972 Honour commented that the reliefs in Dijon and Possagno appeared to be cast from the same molds, to which Pavanello (Pavanello and Praz 1976) added those in Venice and Padua. In 1978 Pavanello discussed the popularity of Canova's plaster reliefs with the patrician families of Venice. [DW]

## 114
## Antonio Canova
### *Giustiniani Stele*

1796–97
Inscribed on the tablet: NICOL. ANT. IUSTINIANO / PONTIFICI / NOSOCOMII AUCTORI / ME / GRATES MEDITANTEM UNUS / SCULPAT CANOV
Marble
73¼″ × 50″ × 4¼″ (186 × 127 × 12 cm)
PROVENANCE  commissioned by the city of Padua and delivered in 1801; set up in Palazzo Congregazione di Carità, 1806; transferred to Ospedale Civile, 1821; moved to the Museo Civico, 1896
EXHIBITIONS  London 1972, cat. no. 135; Venice and Possagno 1992, cat. no. 114
BIBLIOGRAPHY  Bratti 1917, pp. 325–30; Pavanello and Praz 1976, pp. 101–2, no. 96
Assessorato alla Cultura del Comune di Padova–Musei Civici, Padua

Commissioned from Canova by the city fathers of Padua in 1795, the Giustiniani Stele, like many other monuments created during the tumultuous 1790s, has a complex history. Padua, a provincial capital in the Venetian Terra Ferma, originally approached Canova for a portrait bust or herm portrait of Girolamo Giustiniani, a Venetian patrician who had served as captain and vice-podestà of Padua earlier in the century. Disliking portraits per se, the sculptor declined, but offered instead to execute a work in relief and, after rather tiresome negotiations, he began work, completing two models (one with the seated female figure at right, the other with her at left) by May 14, 1796. Knowing where the commissioners wished to place the work, Canova rejected the right-facing *modello* (this was later used for the monument to Giuseppe Nicola de Azara and is still preserved at the Gipsoteca Canoviano at Possagno) because of the lighting conditions at the site. In the original version, the sculptor included a profile relief portrait of Giustiniani within the inscription on the tablet prominently displayed by the female personification of Padua, but this was later effaced. After the occupation of the entire Veneto by the French in 1797, the new Jacobin government asked

Canova to replace Girolamo Giustiniani's portrait with that of Napoleon Bonaparte, but he refused, agreeing only to leave the tablet blank for whatever inscription the Paduans preferred. Nothing happened until the Austrian annexation the following year, when the decision was made to change the stele into a monument for Girolamo's uncle Nicolò Antonio Giustiniani, who had been bishop of Padua from 1772 until his death in 1796. The bishop was the founder of the Ospedale Civile, where the monument was erected in a special *tempietto* in 1821 under Canova's supervision.

The Giustiniani Stele is the prototype of many of Canova's relief stele funerary monuments, including the more famous Volpato Monument, and was also a formative influence on later freestanding sculptures of seated women, especially *Letizia Ramolino Bonaparte* and *Marie-Louise of Parma as Concord*. The stele's iconography is the most complex ever attempted by Canova in relief format. Seated on a curule chair, the female personification of Padua is completing the last letter of Canova's name on a tablet that rests on a caduceus that has been placed on her thigh. She is aided in this endeavor by a winged putto. Padua's elegant, severe, classicizing profile and the gentle folds of her draperies clearly identify the antique sources of the artist's inspiration. The coiffure is styled *all'antica*, and is held in place by a fillet and crowned by a crenellated tower, a reference to Padua's august medieval past. This venerable motif appears later in the celebrated monument to Vittorio Alfieri in Florence as an allusion to Italy. The rather curious medallion hanging from Padua's left elbow is the seal of the city, and her footstool is adorned with a relief showing the founding of Padua by the Trojan hero Antenor, a bit of civic pride appropriate for the Paduans, who rejoiced that their city was much older than Venice. An owl, attribute of Minerva and associated with Antenor, flies in from the upper right. The owl as a traditional symbol of wisdom, however, might also be a reference to the University of Padua, one of the oldest and most distinguished in Europe.

It is generally acknowledged that the stele format, replete with a pediment adorned with a garland and a banderole and crowned by palmette acroteria, is a direct imitation of a classical Greek funerary form. This particular type of ancient sculpture was rare in Rome, where the sculptor lived and worked, but much more prevalent in his native Venice, which had for centuries ruled large areas of the Greek mainland, the Peloponnese, and, until the late seventeenth century, Athens itself, where so many grave

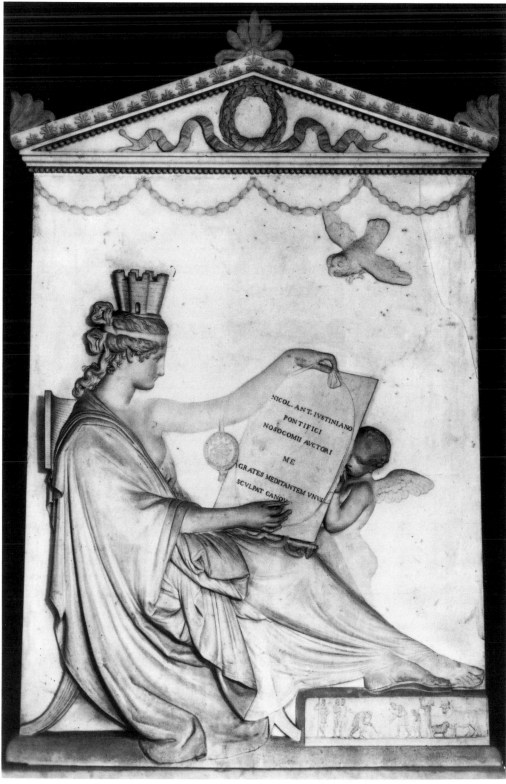

114

**115**

**Antonio Canova**
*Antigone Mourning the Dead
Eteocles and Polynices*

c. 1798–99

Terracotta

6¾″ × 15¼″ × 9⅞″ (17 × 40 × 25 cm)

PROVENANCE  gift of Giovanni Battista
Sartori-Canova to G. Zardo Fantolin,
c. 1823; Domenico Zoppetti Collection,
1847; bequeathed to the Museo Correr in
1849

EXHIBITIONS  Venice 1978, cat. no. 119;
Venice and Possagno 1992, cat. no. 83

BIBLIOGRAPHY  Pavanello and Praz 1976,
p. 103

Musei Civici Veneziani, Museo Correr,
Venice

Although the date of this *bozzetto*
is uncertain, it bears close stylistic
affinities to such sketches as *Hercules
Killing His Children*, probably executed
about 1798–99 (Museo Correr, Venice).
Further evidence for the 1798–99
dating lies in Canova's choice of
subject. Themes of mad passion, death,
and mourning dominated the sculp-
tor's creative imagination during this
parlous period in his professional life,
and he is known to have made a series
of clay and wax *bozzetti* at this time. It
was also at this time that he made
numerous drawings and models for
the monumental *Hercules and Lichas*,
Canova's best-known essay on the
theme of heroic insanity. The most
important painting by the artist in this
genre is the large *Mourning the Dead
Christ* executed for the high altar of the
parish church in Possagno in 1799.
This impressive picture was retouched
around 1820 and relocated to the high
altar of the Tempietto, Canova's superb
architectural tribute to his home town
of Possagno. Both Canova and his half-
brother Giovanni Battista Sartori-
Canova (who inherited *Antigone
Mourning the Dead Eteocles and Polynices*
after the artist's death in 1822), are
buried in the church, which was built
entirely at the sculptor's expense.

Canova's preoccupation with
funerary themes in a mythological or
literary context in the last four years
of the eighteenth century was occa-
sioned by the cataclysmic events of
the French invasion of Italy. Beginning
in 1796, the Army of Italy, led by the
brilliant young Napoleon Bonaparte,
swept down into the peninsula, over-
throwing the existing governments
and sacking the churches, museums,
and many private collections in Milan,
Parma, Modena, Bologna, Urbino,
Perugia, Rome, and Venice, among
other Italian cities. With the deposition
of Pope Pius VI Braschi in 1798 and the
establishment of the short-lived
Roman republic, Canova fled from
Rome to his native Possagno, then

stelae originated. At the time he exe-
cuted the Giustiniani Stele, Canova
was also involved in the reinstallation
of Venice's public collection of antiq-
uities in the Biblioteca Marciana in the
Piazza S. Marco. It is probably no acci-
dent that a number of Canova's funer-
ary stelae were executed for, or in
honor of, Venetians, including the

Giustiniani Stele, the Volpato Stele, the
monument to Giovanni Falier, and
the monument to Angelo Emo. [CMSJ]

115

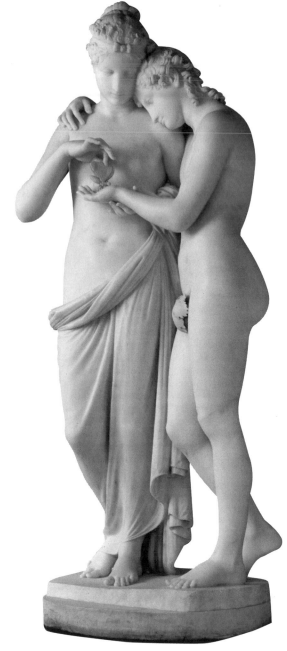

under Austrian control. While in the Veneto, he worried constantly about his Roman studio and the future of his professional practice. In addition, he lamented the spoliation of so much of Italy's cultural heritage and was depressed by the constant political riots, battles, and the disruption of artistic activity all over the peninsula. This caused him considerable anxiety and led to a highly depressive and pessimistic state of mind. It was during this exile from Rome that he went to Vienna and accepted the commission for the monument to the Archduchess Maria Christina from Albert of Saxe-Teschen, which he completed and installed in the Augustinerkirche in 1805.

The story of Eteocles and Polynices is taken from Aeschylus' tragedy *Seven Against Thebes*. This canonical literary source had earlier inspired Vittorio Alfieri's play *Polynices*, which was completed in Rome in 1781, shortly after Canova moved from Venice to the papal capital. Canova later executed the tomb of the great poet in the church of S. Croce in Florence. Placed on an oval base, the sculptor displays the bodies of the two brothers, who have killed one another in combat, while their sister Antigone mourns over their bodies, accompanied by their faithful tutor. Antigone's pose recalls that of the figure of Temperance who leans over the sarcophagus of the deceased pontiff in Canova's tomb of Pope Clement XIV Ganganelli (1783–87; Ss. Apostoli, Rome). The expressive modeling and the rapidly executed, highly generalized forms are typical of Canova's style for small *bozzetti* of this type. [CMSJ]

## 116
## Antonio Canova
*Cupid and Psyche*

c. 1800–1802
Marble
Height 58¼″ (148 cm)
PROVENANCE commissioned by Col. John Campbell, later 1st Baron Cawdor, and ceded in 1803 to Josephine Bonaparte; purchased from Josephine's heir, Eugène de Beauharnais, by Czar Alexander I in 1814; property of the Russian state from 1918
EXHIBITION Rome 1991, *Canova*
BIBLIOGRAPHY Kosareva 1961; Pavanello and Praz 1976, p. 102; Hubert 1977
The State Hermitage Museum, St. Petersburg

The mythological theme of the love of Cupid and Psyche was one of the most popular ancient fables during the Neoclassical period, its literary source ultimately deriving from Apuleius's *The Golden Ass*. It was essayed by Canova on at least three occasions—the celebrated recumbent version in the Musée du Louvre, a standing version also in the Louvre, and the Hermitage version, which was acquired from the Château de Malmaison by Alexander I shortly after the death of the Empress Josephine in 1814. *Cupid and Psyche* was commissioned by Canova's impecunious but indefatigable Scottish admirer John Campbell, who had a history of ceding commissions to other patrons who could afford to pay for them. Josephine's statue was the second version of Canova's creation; the first had been completed on commission from Campbell in 1797 but had also gone to a French collection—that of Joachim Murat, Napoleon's brother-in-law. In 1802, at a fête honoring the first consul at Murat's Château de Villiers, both the recumbent and standing versions of *Cupid and Psyche* were on display (Murat acquired neither sculpture directly from Canova, but purchased them from their original owners). Napoleon and Josephine admired the

116

statues and wished to commission something from their creator. In about 1803 Campbell agreed to let Josephine have his second version, perhaps because of the difficulty in delivering works of art to English patrons during the Napoleonic Wars.

Canova often created variants of marble statues based on an original plaster model, but he always added fresh touches and usually executed the more detailed work himself. In fact, potential patrons visiting his Roman studio were confronted by numerous plaster models from which they could select a work that could then be transferred into marble. This à la carte menu gave a significant amount of professional independence

to Canova and allowed him to receive patrons in his own establishment, rather than the traditional (and rather humiliating) practice of "waiting upon" them in their palaces and offices. In addition, the task of making replicas of a single model allowed Canova to train and employ numerous stone-carvers and professional sculptors, and this helped his studio to flourish.

The love of Cupid and Psyche had traditionally been interpreted in a Christianized context as a metaphor of Christ's love for the Church. The Neoclassicists, however, were much more interested in such notions as sensual innocence and platonic love. Indeed, many artists and patrons were obsessed with adolescent sexuality,

and the smooth, rounded muscles of Cupid in the Hermitage sculpture suggest a state of physical development somewhere between childhood and maturity. François Gérard's *Cupid and Psyche* of 1798, a celebrated painting that owes a debt to Canova's essays on the theme, is a particularly important example of the phenomenon, although the erotic potential in Gérard's painting is decidedly more pronounced. In Canova's statue Psyche, who innocently proffers a butterfly (her traditional attribute, and a symbol of the Christian soul) to her platonic lover, is semi-draped and even the view of her budding breasts is partly obscured by her right hand. The softened forms, the compositional compactness, and the placement of Cupid's head and right hand on Psyche's shoulders suggest fraternal attachment much more than carnal desire; the passion and kinetic energy of the recumbent *Cupid and Psyche* in the Louvre is altogether a different conception. This sculpture was exhibited, with Josephine's permission, at the Salon of 1808, where it generated favorable comment. [CMSJ]

## BARTOLOMEO CAVACEPPI

ROME 1716–1799 ROME

Cavaceppi's apprenticeship is uncertain; according to his own account, he was apprenticed to the French sculptor Pietro Stefano Monnot from 1729. Surviving documents mention a number of other names, certainly less celebrated, of sculptors involved in the busy and growing trade in excavation and restoration of antiquities. It was to these artists and to their technical skills that Cavaceppi owed his initial training, which took place in a very dynamic cultural milieu that fostered collecting, dealing in antiquities, and lucrative commissions.

In 1732, at the age of fifteen, Cavaceppi was working at the Accademia di S. Luca, although it is uncertain who introduced him to the Concorso Clementino. In 1738 he won second prize in the sculpture class on the subject Joseph and Potiphar's Wife. During these years he frequented the studio of Carlo Antonio Napolioni near the church of Gesù e Maria on the Corso. Napolioni's particular skill was in working different types of stone, including rare materials, which won him such prestigious commissions as the restoration (1737) of the two Furietti centaurs made of *bigio morato* marble, found at Hadrian's Villa.

Napolioni died in 1742, and left his studio to his nephew Clemente Bianchi, a young man the same age as Cavaceppi, who also received a modest legacy, proof of the bond between him and his mentor. Soon after, Cavaceppi began working with Bianchi on an equal footing. In 1743 the two sculptors obtained a commission for the restoration of a herm, as a trial piece (Rome, Archivio Capitolino Roma, Fondo Cardelli).

In 1744 the prestigious patronage of the Marchese Capponi, the first curator and director of the Museo Capitolino, won for the two young sculptors a commission to restore the *Faun in "Rosso Antico"*, a work from the Hadrianic period and a copy of a Greek bronze. The record of payment shows how the work was divided between the two: Bianchi was a good worker of marble, while Cavaceppi was responsible for all the preparatory models, casts, and the final cleaning (Vatican City, Biblioteca Apostolica Vaticana, Codice Capponi 293, Pitture e anticaglie, MS. 92, 190, 200, 1717–46).

In 1746 Capponi died and was succeeded as director of the Museo Capitolino by Giovan Pietro Lucatelli. Lucatelli continued to add sculptures to the collection, and in 1748 the bust of a *Faustina* was restored, probably by Cavaceppi; in 1749–53 Bianchi and Cavaceppi restored fifteen statues from the Villa d'Este at Tivoli (Vatican City, Archivio Segreto Vaticano, SPA, Computisterio, vol. 259, 1750); and in 1750 Bianchi requested payment for the restoration of four statues at the Capitoline.

Cavaceppi also worked for Cardinal Alessandro Albani, who was again enlarging his collection, and had started on the construction of his villa on via Salaria. At this time also Cavaceppi met the German archaeologist Johann Joachim Winckelmann, and their discussions about the museum of statues gave rise to the idea that "as far as possible it would be advisable to adapt these ancient marble statues to the site and to the use for which it appeared they had been made" (quoted in Salvatore Settis, ed., *Memoria dell'antico nell'arte italiana* [Turin, Italy: Giulio Einaudi, 1986], pp. 232–36), a concept that Cavaceppi fully endorsed.

His friendship with Winckelmann introduced Cavaceppi to the circles of General Wallmoden-Gimborn (illegitimate son of George II) and Margrave of Bayreuth, which gave him access to the royal house of Prussia, for whom he restored marble statues in the royal collection at Potsdam and Sanssouci.

In the 1750s Cavaceppi requested permission to export antique statues to England, dealing directly with Lord Anson and Lyde Brown, and made friends with Gavin Hamilton, a pupil of Agostino Masucci who conducted a flourishing trade in paintings and antiquities as well as being a history painter. He also became acquainted with Thomas Jenkins, another busy dealer in antiquities.

Throughout the 1750s and 1760s Cavaceppi worked on restorations for a number of Roman collections, but in 1761 Cardinal Albani commissioned an original work, the first known. This was the statue of *Saint Norbert*, to be placed in a niche facing the entrance to the basilica of St. Peter's. However, the work was rejected by the chapter of the order and replaced in 1762 with a sculpture by Pietro Bracci, a protégé of Pope Clement XIII. In the same decade Cavaceppi produced a group of original works, including a series of *bozzetti* for a *Flora*, a *Diana*, and a *Venus*, and three portrait busts, including *Frederick II* (Rome, Archivio Stato Roma, Nicolaus Ferreus, Testamenta, fol. 801 r, 1799).

In 1768 Cavaceppi traveled to Berlin with Winckelmann, a journey that he recorded in the *Collection of Ancient Statues, Busts, Bas-Reliefs and Other Sculptures Restored by Bartolomeo Cavaceppi, Roman Sculptor*, an unofficial catalogue of sales written and published by Cavaceppi. The marble statues he restored eventually became part of the collections of Catherine II of Russia, at St. Petersburg, and Gustav III of Sweden.

Cavaceppi became a member of the Accademia di S. Luca in 1782, and toward the end of his career was engaged on important commissions for the Chigi and Borghese families, and the sale of ancient sculptures and tombstones on behalf of the Museo Pio-Clementino. After his death he left his studio and collections to the Accademia—over one thousand ancient marble statues, clay models, modern sculptures, casts, and an enormous collection of drawings (about 8,000), sold in 1843 to the Museum of Berlin. However, the will was contested by Cavaceppi's wife and heirs, and eventually the collection was purchased by the Marchese Giovanni Torlonia for 10,000 *scudi*. The marble sculptures and some of the small bronzes remain in the Torlonia family collection, while the collection of clay models was dispersed in the early twentieth century. [MGB]

BIBLIOGRAPHY Lucatelli 1750; Cavaceppi 1768–72;. Stuart Jones 1912; Giuntella 1958; *Settecento* 1959, pp. 434–46; Pietrangeli 1963, n. 12; Haskell and Penny 1981; Picón 1983; Gasparri 1985, pp. 211–19, no. 17; Howard 1988; Palma 1992; Barberini 1993, pp. 24–32; Franceschini 1993, pp. 73–80; Barberini 1994; Barberini and Gasparri 1994; . Petrucci F. 1998; Weiss 1999

117

## 117

## Bartolomeo Cavaceppi
*Three-bodied Hecate*

c. 1750
Height 17" (43 cm)
Terracotta

PROVENANCE studio of Cavaceppi, after 1750; Torlonia collection, 1802; collection of Evan Gorga, 1900; Museo di Palazzo Venezia, 1948

EXHIBITION Rome 1994, *Cavaceppi*, cat. no. 9

BIBLIOGRAPHY Rome, Biblioteca Istituto Archeologia e Storia Arte. Libro delle sculture della collezione Cavaceppi che sono in società delli signori Marchese Torlonia, Vincenzo Pacetti, e Giuseppe Valadier, 42 Tripod con tre dee *scudi* 10, 1802; Stuart Jones 1912, vol. 1, p. 228; Rome, Palazzo Venezia. Catalogo collezione Gorga, 112 Ecateo gruppo in terracotta: copia dall'antico, 1948; Gasparri and Ghiandoni 1993, p. 280; Barberini and Gasparri 1994, p. 94 Museo del Palazzo di Venezia, Rome

The sculptural model for this small statue was probably the *Three-Bodied Hecate* of the late Antonine period (Palazzo dei Conservatori, Rome). This terracotta study, made with a good clean impasto, is a light tan color. After being modeled on a lathe, it was sculpted with a wide serrated spatula, then smoothed over with a cloth to soften the hard edges. The result is a sculpture of great formal elegance, both balanced and flowing, which recalls the work of Clodion. The heads were deliberately omitted, as evidenced by the clearly visible cuts made by the wire, and the same is true of the hands, which in the marble version hold the torch, Hecate's symbol, as she lights the way for

Persephone on her exit from Hades. The distinctive shape of the base suggests that the work was made to order and was intended for decoration. Curiously, in Pacetti's book the *Hecate* is combined with the *Tripod*, as if the two sculptures were superimposed in some whimsical invention. [MGB]

## 118

## Bartolomeo Cavaceppi
### *Tripod*

c. 1750
Terracotta
On the breast of one of three griffins: 42
Height 18⅞" (48 cm)
PROVENANCE studio of Cavaceppi, c. 1750; Torlonia collection, 1802; collection of Evan Gorga, 1900; Museo di Palazzo Venezia, 1948
EXHIBITION Rome 1994, *Cavaceppi*, cat. no. 8
BIBLIOGRAPHY Rome, Archivio Stato Roma. Nicolaus Ferreus, Testamenta, fol. 728 v, 1799; Rome, Biblioteca Istituto Archeologia e Storia Arte. Libro delle sculture della collezione Cavaceppi che sono in società delli Signori Marchese Torlonia, Vincenzo Pacetti, e Giuseppe Valadier, 42 Tripode con tre dee *scudi* 10, 1802; Stuart Jones 1912, vol. 1, p. 349, and vol. 2, p. 87; Rome, Palazzo Venezia. Catalogo collezione Gorga, 249 Tripode con tre grifi alati in terracotta, secolo XIX, 1948; Barberini and Gasparri 1994, p. 93
Museo del Palazzo di Venezia, Rome

This terracotta is a reduced-scale version of the sculpture in marble from Luini (near Carrara) in the Museo Capitolino (Sala del Galata), restored by Cavaceppi in 1754, as shown in a receipt (Vatican City, Archivio Segreto Vaticano, SPA, vol. 273, c. 192). The document gives a detailed description of the restoration carried out on the bowl of the vase and the rim, the heads of the griffins and their wings. In the terracotta version, it is evident from the incisions in the unfired clay at the joins that the heads and the feet were modeled and fired separately. There are two possible explanations for this: it was either done for a technical reason connected with the drying of the clay and its consequent shrinkage, or because the heads and feet were ideal reconstructions.

It can be assumed that this is a studio model executed before the life-size version, from which the plaster cast would be made. In the 1750s Cavaceppi and Bianchi had a system of sharing and organizing work. Bianchi was chiefly expert at preparing and assembling marble statues, which was indispensable if the work was to be successful and to guarantee the perfect integration of the restoration. Cavaceppi was the sculptor, making models and plaster casts and carrying out the final cleaning. His

inventive qualities enabled him to obtain commissions for work where creative restoration was required for pieces that were missing.

All the models that follow, catalogued by Camillo Pacetti on Cavaceppi's death, passed into the Torlonia collection. However, they were sold in the early nineteenth century and part of the collection was acquired by a famous opera singer, Evangelista Gorga, the first Rodolfo in Puccini's *La Bohème* (Turin, 1896). His collection was wide-ranging and included ancient weapons, fossils, toys, and works of art. Gorga ran into debt because of his mania for collecting and eventually left his entire collection to the state; part of it was then placed in the Museo di Palazzo Venezia. [MGB]

## 119
## Bartolomeo Cavaceppi
### *The Emperor Caracalla*

c. 1750–70
Signed on the front, proper right side, at the bottom edge of the cuirass: BAR-TOLOMEVS/CAVACEPPI/FECIT
Marble
28″ × 21½″ × 13″ (71.1 × 54.6 × 33 cm)
PROVENANCE Private collection, New York (sold, Sotheby's, New York, June 6, 1994, lot 112); Daniel Katz, Ltd., London
BIBLIOGRAPHY Sale catalogue, Sotheby's, New York, June 6, 1994, lot 112; Sale catalogue, Sotheby's, London, December 7, 1995, lot 96; The J. Paul Getty Museum. "Acquisitions – 1994." *The J. Paul Getty Museum Journal*, vol. 23 (1995), p. 121, no. 100; Bassett and Fogelman 1997, p. 25; Fusco 1997, p. 15
The J. Paul Getty Museum, Los Angeles

The bust of *The Emperor Caracalla*, signed by Cavaceppi, is a copy of an ancient portrait of Marcus Aurelius Antoninus (AD 188–217), nicknamed Caracalla, who ruled the Roman empire from AD 211 until his assassination. Busts of Caracalla were popular in the eighteenth century, and the Getty marble is one of many contemporaneous copies after the antique— for example, those executed for Woburn Abbey (see Avery 1988, fig. 4), Ince Blundell Hall (see Walker Art Gallery, *Supplementary Foreign Catalogue: Paintings, Drawings, Watercolours, Sculpture, Prints, Photographs* [Liverpool: Merseyside County Council, 1984], p. 37, no. 10336; Fejfer 1991, p. 246, pl. 10), and Finchcocks, Kent—which derive from the same or similar prototypes. Characteristic of these portraits, in which Caracalla dons the cuirass and toga of a Roman soldier, are the simple, compact volumes, strong turn of the head, furrowed brow, tense facial features, and almost scowling expression. The fascination with this

bust type no doubt derived from its forceful evocation of ancient history as well as its obvious aesthetic appeal, which Johann Joachim Winkelmann ranked as being worthy of Lysippus (Winckelmann 1783–84, vol. 2, p. 131). Furthermore, Caracalla was elected emperor at York, creating a circumstantial connection with England that may have influenced eighteenth-century British patrons (see Fleming and Honour, 1968, p. 511).

Cavaceppi seldom signed his copies after the antique. Among his other rare, signed copies are the bust of *Faustina the Younger* in the Philadelphia Museum of Art (cat. 120) and the bust of the *Blind Homer* in the Wallmoden collection (Boehringer 1979, pp. 94–96, no. 52). The prominence of the artist's signature on the front of the Getty bust may indicate his pride in the quality of its carving, which is exceptional within Cavaceppi's œuvre. Other versions of Caracalla's portrait by Cavaceppi include: a marble bust of Caracalla, possibly identifiable as the Getty bust, in the sculptor's possession when he died ("Libro delle sculture della collezione Cavaceppi che sono in società delli Signori Marchese Torlonia, Vincenzo Pacetti e Giuseppe Valadier," no. 982, published in Gasparri and Ghiandoni 1993, p. 277; the possible connection between the Getty bust and this inventory item was first made by Maria Giulia Barberini [correspondence, November 8, 1994, Getty Museum files]); a reduced model after the antique, identified by Carlo Gasparri as one of the "Dodici Cesari in bustini" listed in Cavaceppi's studio and now in a private collection (Gasparri 1993, p. 39, fig. 39; Gasparri and Ghiandoni 1993, p. 282); and a restored antique bust of Caracalla made for Charles Townley, now in the British Museum, London (*Townley Gallery* 1836, vol. 2, p. 51; attributed to Cavaceppi by Howard 1982, p. 226). In this last example the head, purportedly excavated in Rome in 1776, is much more frontal than in the Getty example and the modern chest differs in its drapery and truncation.

The dating of the Getty bust remains problematic. According to the stylistic chronology suggested by Seymour Howard, as Cavaceppi matured his restorations and copies became more constrained in their volumes, shallower in their modeling, homogeneous in the finish of their surfaces, and suppressed in their colorism (Howard 1982, p. 226). On the other hand, Cavaceppi's earlier works exhibit deeper modeling and a contrast between polished and matt surfaces. Stylistically the Getty bust of *Emperor Caracalla*, with its deep drillwork and carving of the hair and beard creating dramatic contrasts with the smooth

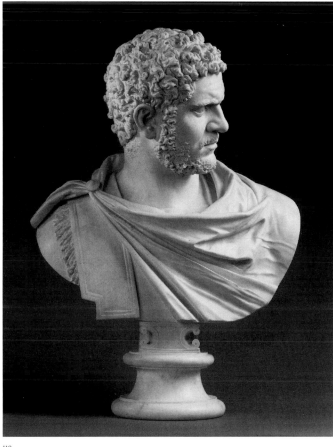

119

surfaces of the face and neck, would seem to belong to Cavaceppi's early years, before the end of the 1760s. However, this conclusion has no documentary basis, and a more specific and accurate date may not be possible without further information on the commission and provenance.

The prototype for Cavaceppi's marble and similar copies has traditionally been identified as Cardinal Alessandro Farnese's bust of Caracalla, which stood in the family's Roman palace in the mid-sixteenth century and is now in the Museo Archeologico Nazionale, Naples (Inventory no. 6033; Bernoulli [1882–94] 1969, vol. 2, p. 50; Hekler 1912, p. xlv, fig. 290; Wiggers 1971, p. 70; Haskell and Penny 1981, p. 172; for the Farnese provenance see Ministero della Pubblica Istruzione 1878, vol. 1, p. 73; Riebesell 1989, p. 58, no. 10). The Farnese *Caracalla* gained a reputation, lasting centuries, as the primary, most beautiful ancient example of this portrait type. Although many scholars now doubt its ancient origins, eighteenth-century antiquarians upheld the Farnese *Caracalla* as the archetypal antique representation of that Roman emperor; Jonathan Richardson, for instance, took for granted its unchallenged authenticity (Richardson J. 1722, pp. 50, 150, 282). Bertrand Jestaz recently asserted that Cardinal Alessandro Farnese's marble

had left the Roman palace by around 1570, making it unavailable to later artists, and had been replaced by a second marble bust of Caracalla in which the costume and orientation were reversed (Jestaz 1993, pp. 37–41). Nonetheless, other ancient portraits of Caracalla that accurately followed Cardinal Alessandro's marble could be seen by Cavaceppi in Rome. For instance, a very good marble bust of Caracalla was in the Vatican collection and, considering Cavaceppi's position as primary restorer of antiquities for Cardinal Albani and the pope, would have been easily accessible (see Wiggers 1971, p. 70). Cavaceppi had a plaster cast of a Caracalla bust in his studio when he died, and it can reasonably be assumed it was the same portrait type as that represented by the Vatican bust and copied in the Getty marble (see Howard 1991, p. 210, no. 219). [PF]

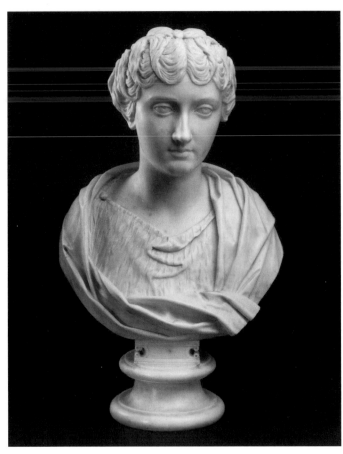

120

## 120

### Bartolomeo Cavaceppi
*Faustina the Younger*

Probably 1761–62

Inscribed, on the back, on the edge of the
marble below the shoulders of the bust, at
center: *BARTOLOMEVS CAVACEPPI FECIT ROM.*
Marble
24¼″ × 14¾″ × 10¼″ (61.4 × 37.5 × 26.2 cm)
PROVENANCE probably ordered by James
Adam in Rome, before July 1762; Hugh
Smithson, Earl (later Duke) of
Northumberland, Syon House, Middlesex,
England; by descent to the 10th Duke;
Sotheby's, London, December 15, 1967,
lot 37; Heim Gallery, London; Anthony
Morris Clark, April 18, 1968; Bequest to the
Philadelphia Museum of Art, 1978
EXHIBITIONS New York 1978, *Crosscurrents*,
not in catalogue (shown only in New
York); Los Angeles, Philadelphia, and
Minneapolis 1993, not in catalogue (shown
only in Philadelphia)
BIBLIOGRAPHY Hussey, Christopher.
*English Country Houses: Mid-Georgian,
1760–1800.* London: Country Life Limited,
1956; Fleming 1962; Howard 1970, pp.
128–32, n. 10–12, fig. 8; Howard 1982; Picón
1983, pp. 66–67; Fejfer and Southworth
1991, p. 46, n. 2; Gasparri and Ghiandoni
1993; Barberini and Gasparri 1994, p. 111,
no. 25; Ingamells 1997; Leander Touati
1998, p. 39
Philadelphia Museum of Art, Bequest of
Anthony Morris Clark

This portrait bust is a copy of an
ancient one traditionally identified as
Faustina the Younger (c. AD 125/30–175)
in the Musei Capitolini, Rome (Stanza
degli Imperatori 32, inv. 449). The
subject was the daughter of Roman
emperor Antoninus Pius and Faustina
the Elder and became the wife of
Emperor Marcus Aurelius. The bust in
Rome was presented to the Museo
Capitolino in 1748 by Pope Benedict
XIV. Bartolomeo Cavaceppi has been
credited with restoring the ancient
bust in the 1740s. The form of the
modern supports—produced by
Cavaceppi—with a narrow plaque
above a round socle is the same on
both busts.

The Philadelphia bust probably
figured among the sculpture that
architect James Adam acquired in
Rome in 1761–62. These purchases
were packed for shipment to England
by July 1762. Among the then clients
of his more famous architect brother
and partner Robert, was the Earl of
Northumberland, the owner of Syon
House, which Robert Adam was
remodeling. Photographs taken around
1930 show the bust in place in the ante-
room at Syon, one of Robert Adam's
grandest Neoclassical interiors.

This bust is one of the rare works
bearing Cavaceppi's name. In this
version, the locks of the complicated
coiffure are notably well defined, and

the mouth is rendered with unusual
delicacy. The superior quality of the
carving and the presence of the carved
inscription are evidence that
Cavaceppi attached exceptional
importance to the commission.
Howard mentioned four other busts
at Syon as copies by Cavaceppi after
antiquities, and his statue of Ceres in
the Great Dining Room is also signed
in full by the sculptor.

Published references to the collec-
tion history of the Philadelphia bust
after it left Syon have been incomplete
or mistaken on one point or another.
The bust was sold at auction at
Sotheby's to the Heim Gallery in 1967.
Anthony Morris Clark bought it in
1968 for his own collection, not, as
often reported, for the Minneapolis
Institute of Arts, where he was then
director. The bust was given to the
Philadelphia Museum of Art by the
estate of Mr. Clark along with a
notable collection of eighteenth-
century Roman drawings and medals.

Cavaceppi and his assistants pro-
duced a number of copies of the
ancient bust of Faustina the Younger.
The best-known are those acquired by
English collectors, the sculptor's most
enthusiastic clients. The Philadelphia
bust is currently the earliest version
known to have been purchased for
England. The bust at Broadlands was
probably acquired by Viscount
Palmerston in 1764. A version for-
merly at Ince Blundell Hall, and now
at the Walker Art Gallery, Liverpool
(Ince no. 201), could have been bought
by Henry Blundell in 1777 at the earli-
est. The 1802 inventory after
Cavaceppi's death, published by
Gasparri and Ghiandoni, includes two
marble *Faustinas* (nos. 310 and 624)
and one plaster cast (no. 109). A
detailed list of existing versions was
published by Howard in 1972. Other
copies of the bust are to be seen in
Gustav III's museum of antiquities
in the royal palace, Stockholm, the
Yusupov Palace, St. Petersburg, and at
Pavlovsk. In 1778 Johan Tobias Sergel
bought in Rome a bronze copy of the
bust for Gustav III. This work is prob-
ably to be identified, according to
Anne-Marie Leander Touati, with a
sculpture at the Nationalmuseum,
Stockholm (NM Sk 294). Additional
examples are likely to be recognized
as studies of eighteenth-century col-
lections of antiquities progress.

For mid-eighteenth-century collec-
tors, the identification of the subject
of the bust as a member of the Roman
imperial family certainly contributed
to its desirability, although Faustina
was not herself an interesting histori-
cal figure. Henry Blundell described
her as "the wife of Marcus Aurelius,
but a woman of indifferent character"
(quoted in Howard 1970, p. 132, n. 12).
However, aside from Faustina the

Younger's historical identity, the
style of the bust appealed to nascent
Neoclassical taste. The oval shape of
the face, its bland expression, bisque
texture, and linearity (characteristics
defined by Howard) were aspects of
Hadrianic sculpture admired by such
leading tastemakers as Cardinal
Albani and Winckelmann. Howard
detected the influence of the subject's
facial type elsewhere in works by
Cavaceppi, and M. G. Barberini recog-
nized that this bust was Cavaceppi's
source for the head on a terracotta
version of the Capitoline *Flora* in the
Museo del Palazzo di Venezia. [DW]

## 121

### Bartolomeo Cavaceppi (?)
### and Gavin Hamilton
*Myron's Diskobolos Restored as
Diomedes with the Palladion*

c. 1772–76
Marble
Modern: both arms and attributes, both
legs from below the knee, trunk support
and plinth, neck; patches on the ancient
torso, thighs, head, and left shin
Height 65″ × 39″ × 40″ (165 × 99 × 102 cm)
EXHIBITIONS London 1930, cat. no. 61;
London 1983, not catalogued
BIBLIOGRAPHY Dallaway 1800, p. 337;
Michaelis 1882, pp. 467–68, no. 89; Smith
1889, pp. 43–44, 77–78, no. 89; Christie,
Manson and Woods 1930, pp. 94–95;
Howard 1962; Picón 1983, no. 1; Vaughan
1992, pp. 44–45, figs. 7, 11; Howard 1993,
p. 245
Trustees of the Bowood Collection, Calne,
Wiltshire

More than most, this restoration illus-
trates the creative fancy of Neoclassical
sense and sensibility. Its ancient torso
fragment is one of over twenty extant
ancient copies of Myron's celebrated
*Diskobolos.* Two marble torsos of this
type were known and restored before
this one, which was found by Gavin
Hamilton in his excavations at Ostia
in 1772. One was restored in a cen-
trifugal composition as a *Fallen
Warrior* by the Franco-Roman sculptor
Pietro Stefano Monnot shortly before
it was acquired for the Museo
Capitolino in 1734; there it served as a
tacit companion to the *Dying Gaul.*
The second was restored as the hunter
*Endymion* supported by his dog and
hiding from Selene; it was re-restored
after mid-century as a *Fleeing Niobid
Boy* for the large Niobid group in the
Villa Medici, before the sculptures
were transferred to the Uffizi.

Clearly the subject was still a puzzle
to Hamilton, who was painting scenes
from the *Iliad,* wherein the theft of the
Palladion by Diomedes precipitates
the fall of Troy. Reference to the
Diskobolos type later reappeared in

his *Death of Achilles* (1784). On March 25, 1776, Hamilton expressed his enthusiasm and rationale for the completed restoration in a revealing letter to the Earl of Shelburne, who bought the statue for Lansdowne House in London:

> I have never mentioned to your Lordship one of the finest things I have ever had in my possession, as I was not sure of getting a license to send it out of Rome. Now that I have got it safe on board the Felucca for Leghorn, I have ventured to recommend it to your Lordship as something singular and uncommon. It is a Diomede carrying off the Palladium. Your Lordship when in Rome mentioned to me particularly subjects of this sort as interesting to you, but besides the subject, give me leave to add that the sculpture is first-rate, and exactly in the style and size of the Cincinnatus [a Lysippic Jason] to which I mean it as a companion, being a Greek Hero to match the Roman. The legs and arms are modern, but restored in perfect harmony with the rest. He holds the Palladium in one hand, while he defends himself with the right holding a dagger. Your Lordship will ask me why I suppose this statue to be a Diomede. I answer because it would be to the last degree absurd to suppose it anything else, as I believe your Lordship will easily grant when you see it. Every view of it is fine and I could wish it to be placed so as to be seen all round. With regard to the price, I have put it at £200, but as I have made so many draughts of late, I shall suspend every view of interest till it arrives and meets your Lordship's approbation. All I beg is that it may be placed near the Cincinnatus. The contrast will add beauty to each. Your Lordship will excuse the liberty I have taken, as my principal motive is to increase your collection with something entirely new and uncommon. (Smith 1889, pp. 43–44, 77–78, no. 89; Christie, Manson, and Woods 1930, pp. 94–95)

Hamilton apparently acted as an iconographer for his restorer, most likely Cavaceppi, with whom he had dealt since 1760, after taking over the agency in Rome of the architect Matthew Brettingham the Younger.

The restoration methods and much of the minutiae in this finished composition point to Cavaceppi's work and the restorative dentistry performed

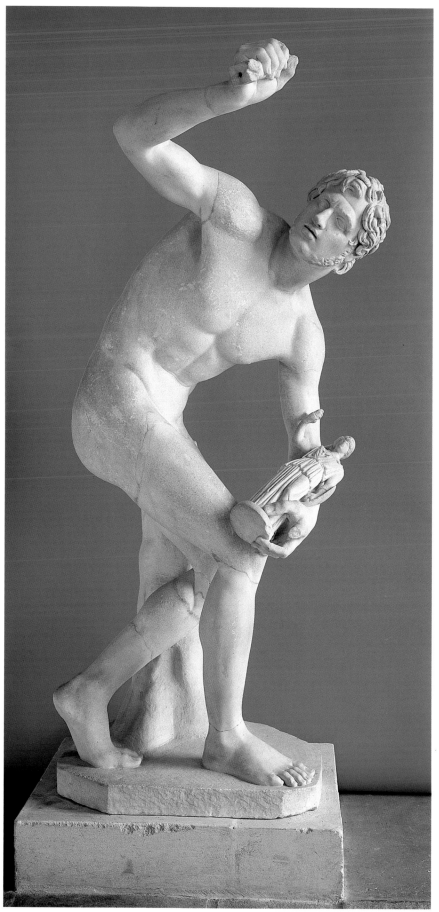

121

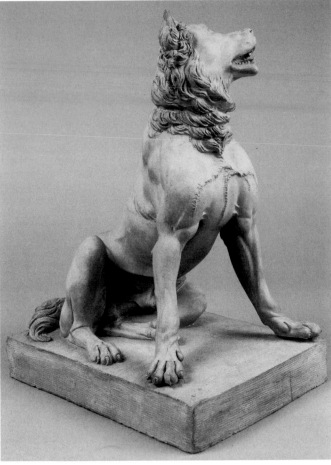

122

by his studio and circle after the 1750s: additions attached at strong recut curving joins, a bisque-like reworked surface, use of a cowl to join the antique but anachronistic Pergamene baroque head of a Gaul(?) also resembling Hellenistic fragments from Sperlonga, and the more archaeologically circumspect imitation of fifth-century peplos figures for the Athena statuette. The relief-like silhouette of the Neoclassical composition is clearly far more compatible with the original Greco-Roman fragment and Myron's classic design of about 460 BC than with the passé Baroque restoration made by Cavaceppi's master Monnot. But for its historicizing theatricality, legitimized by antiquarian references, the "Diomedes" restoration well illustrates the compatibility between modern Neoclassical form and that of the ancient Greco-Roman neo-classical copy of Myron's bronze of the Classical period.

The torso's original subject was not known until a complete copy was found buried at the Villa Massimi with its head attached, looking backward to the discus as the figure leans into the throw.

Interestingly enough, two fairly well preserved copies of the figure without their heads were later found

at Hadrian's Villa in 1791. Despite the evidence of the Massimi (now Lancelotti) example—identified in 1783 by the archaeologist Carlo Fea as by Myron, on the basis of descriptions by Lucian and Quintillian—both were restored with heads looking forward, heightening the relief-like character of the composition. In 1794 the noted collector Charles Townley, who already knew of the *Diomedes and the Palladion* through Hamilton and eventually owned drawings of all the statues, bought the better-preserved of these fragmented copies (now in the British Museum) from the notorious antiquities dealer, banker, and one-time painter Thomas Jenkins. After a misleading correspondence with Townley, Jenkins directed its restoration by Carlo Albacini, Cavaceppi's student, who attached an ancient but alien head with the aid of a modern neck insert, creating two Adam's apples. The other figure, in the Vatican Museum, was restored by Albacini for the learned curator Ennio Quirino Visconti, with a modern "Myron" signature and a new head and other missing parts, based on the Townley example and its pose. Twentieth-century "restorations" now reconstruct the figure with plaster casts taken from selected ancient frag-

ments held up without external supports and painted bronze, the better to simulate current views about Myron's original composition. [SH]

122

## Bartolomeo Cavaceppi
### *Molossus*

1750?
Terracotta
Height 13⅜" (37 cm)
PROVENANCE studio of Cavaceppi, after 1750; Torlonia collection, 1802; collection of Evan Gorga, 1900; Museo di Palazzo Venezia
EXHIBITION Rome 1994, *Cavaceppi*, cat. no. 15
BIBLIOGRAPHY Cavaceppi 1768–72, vol. 1, pp. 6–9; Rome; Archivio Stato Roma. Nicolaus Ferreus, Testamenta, fol. 801 r., 1799; Rome, Biblioteca Istituto Archeologia e Storia Arte. Libro delle sculture della collezione Cavaceppi che sono in società delli Signori Marchese Torlonia, Vincenzo Pacetti, e Giuseppe Valadier, 17 Cane *scudi* 1.50, 1802; Rome, Palazzo Venezia. Catalogo collezione Gorga, 119 Cane seduto in terracotta: copia dall'antico, 1948; Howard 1982, p. 55, fig. 117; Picón 1983, pp. 81–82; Gasparri and Ghiandoni 1993, p. 180; Barberini and Gasparri 1994, p. 100; Petrucci F. 1998
Museo del Palazzo di Venezia, Rome

This is a reduced-scale model of Molossus in marble, a Roman copy of a lost Greek original, possibly in bronze. The marble statue was restored by Cavaceppi between 1748 and 1756 and was purchased by Henry Jennings from the sculptor's studio. In April 1778 the statue became the property of Charles Duncombe of Duncombe Park in Yorkshire. The Jennings *Molossus* was famous throughout the eighteenth century and was praised by Winckelmann and Nollekens, who declared he had also seen versions of it in wax and in plaster. The *Molossus* appears in Cavaceppi's *Collection*, with an attribution to Phidias, and inspired his restoration of the *Dionysus* now at Petworth House.

The Ferri inventory of 1799 mentions that there was a plaster model in Cavaceppi's studio, probably used for restorations of other ancient copies. The receipt for this work reads: "Today I have received from His Excellency Prince Ghigi [*sic*] sixty-five *scudi* in payment of the restoration of a hound carried out by myself and I declare that I am satisfied, signed July 7 1783/65 *scudi* – Cav. Bartolomeo Cavaceppi" (Vatican City, Biblioteca Vaticana Apostolica, Archivio Chigi, no. 2485). This copy, which became state property after the sale of the Palazzo Chigi, was placed in the collections of the Galleria Nazionale d'Arte Antica and is currently on loan

to the Farnesina, the Italian Ministry of Foreign Affairs. [MGB]

## GIUSEPPE CERACCHI
ROME 1751–1801 PARIS

Although raised in Rome, Ceracchi led a markedly peripatetic life, spending much of his career traveling from capital to capital in pursuit of what he perceived to be his best opportunities. The son and grandson of goldsmiths, he studied with the sculptor Tommaso Righi, and was active in the Roman Accademia di S. Luca. In 1773 he moved to London, where he exhibited at the Royal Academy, met with particular success as a portraitist, and refined his Neoclassical style.

Though he met with particular success as a portraitist, Ceracchi's ambition was to sculpt major monumental groups. In pursuit of this goal he designed a monument to William Pitt the Elder, which, although he exhibited a model for it in 1779, failed to attract a sponsor. In the wake of this and other disappointments, the sculptor traveled to the Netherlands and Prussia, eventually settling in Vienna for several years. In 1785 he married Therese Schliesshan and took her with him to Rome, reestablishing his studio there. During that same year Ceracchi traveled to Amsterdam, accepting a major commission for a monument to Baron Derk van der Capellen, a Dutch proponent of liberalism and democracy. Ceracchi spent four years working on this monument in his Roman studio, only to be disappointed when the political position of his Dutch patrons dissolved with the return of William V to The Hague in 1787. In 1789, inspired by the French Revolution, Ceracchi began to commit himself increasingly to politics.

In early 1791, continuing his quest for a project that would assure the immortality of his reputation, the artist traveled to Philadelphia to seek the commission for a monument to American liberty. Politically sympathetic to the young republic and its leaders, Ceracchi threw himself at the opportunity, presenting an extraordinarily ambitious concept for a hundred-foot monument capped by an equestrian figure of George Washington (later replaced by an allegorical figure of Liberty) and populated by a rich supporting cast of allegorical figures. In the pithy formulation of James Madison, Ceracchi was "an enthusiastic worshipper of liberty and fame and his whole soul was bent on securing the latter by rearing a monument to the former" (quoted in Gardner 1948, p. 190). In an attempt to win over key members of the government, the sculptor modeled portraits

of them, in many cases offering these as gifts to the sitters. During this period Ceracchi portrayed a number of the American founding fathers, including Benjamin Franklin, Alexander Hamilton, John Jay, George Washington, John Adams, Thomas Jefferson, and James Madison.

After returning to Europe by way of Amsterdam, Ceracchi traveled to Munich, where Elector Karl Theodor von Wittelsbach commissioned him to design a monument to the unification of Bavaria and the Palatinate. This project was doomed, however, as the elector's attention and funds were soon diverted to the Napoleonic Wars. Back in Rome by the end of 1792, Ceracchi set to work translating his American portraits from terracotta into marble, and connected with the radical republican and Jacobin elements in the city. His studio became a gathering place for them, and the sculptor the object of suspicion to the papal government. Eventually, in the wake of the assassination of the French minister de Bassville, Ceracchi was expelled from Rome. His work interrupted, he left for Florence, only to find himself unwelcome in the grand duchy as well. By way of Munich, Vienna, and Amsterdam the sculptor made his way again to Philadelphia, arriving in the fall of 1794 to renew his efforts to secure the commission for the monument to American liberty. When it became clear that Congress was in no position to apportion the considerable sum of money necessary for Ceracchi's project, his supporters (including George Washington himself) instituted a campaign to raise the money by private subscription. This effort was not successful, however, and Ceracchi became increasingly disillusioned with his American experience. Before departing Philadelphia for the last time he dispatched several angry letters to the president and other members of the government and attempted to collect payment for various sculptures he had presented as "gifts." This brash move attests to Ceracchi's cupidity, a recurring theme in his biography, and his embitterment over the failure of a project so close to his heart.

Unable to return to Rome, Ceracchi sailed for France, and reached Paris by July 1795. There, he swiftly gained entry into the highest Jacobin circles, befriending the painter Jacques-Louis David. Still eager to create a career-defining statue group, Ceracchi made a model for a monument to the French Revolution, reusing ideas from his failed American project. His ambitions in this period were not only in the field of sculpture: he also sought to enter into political circles and offered the government his services as an expert on Italian matters. His trea-

tise on the potential invasion of Italy was helpful to Napoleon in the planning of his Italian campaign, and won the sculptor his friendship and admiration. Bonaparte sat for two portraits by Ceracchi, and invited him to be the "first sculptor" to the French state, an offer that the sculptor declined.

Ceracchi's friendship with Napoleon soured as the first consul moved away from republican principles in favor of increasingly imperial ambitions. Eventually, the sculptor entered into a conspiracy with several others, plotting the assassination of Bonaparte. When the first plan (in which Ceracchi was to kill Napoleon during a portrait sitting) failed, the conspirators resolved to assassinate him at the opera. Arrested prowling the loge with a loaded pistol in each pocket, Ceracchi was tried and sentenced to death along with his compatriots. Napoleon, who clearly valued Ceracchi's artistic talents, offered clemency on the condition that the sculptor renounce his anti-Bonapartist stance. Ceracchi, perhaps insane and certainly committed to his principles, refused and was guillotined on January 31, 1801. Reports that he rode to the scaffold in a chariot, dressed as a Roman emperor, are probably not true: nevertheless, it is easy to imagine Ceracchi, who inserted such strong Roman rhetoric into his art, thinking of Roman exemplars in the last moments before his own "virtuous death" (see Smith J. 1828, vol. 2, pp. 116–18 and Johnston 1882, pp. 170–71); yet Jean Duplessis-Bertaux's sketch of the conspirators at the scaffold (illustrated in *Ceracchi* 1989, p. 84) shows the conspirators garbed in contemporary dress. [JH]

BIBLIOGRAPHY Demerville 1801; Desportes 1963; Desportes 1964; Vasco Rocca and Caffiero 1979; *Ceracchi* 1989

## 123
## Giuseppe Ceracchi
### *George Washington*

1794–95
Signed and dated on reverse: *Ceracchi faciebat Philadelphia 1795*
Marble
28⅞″ × 23¼″ × 12″ (73.3 × 58.9 × 30.5 cm)
PROVENANCE purchased from the artist by Josef de Jaudenes y Nebot, Cádiz (Spain), c. 1795–1812; Richard W. Meade, Philadelphia, c. 1812–28; Mrs. Richard W. Meade, 1828–52; Governor Kemble, Cold Spring, New York, 1852–75; Kemble Estate, 1875–1904; John L. Cadwalader 1904–14; bequeathed to The Metropolitan Museum of Art, New York, 1914
EXHIBITIONS New York 1831; New York 1853, cat. no. 55; New York 1889, cat. no. 94; New York 1932; New York 1942; Philadelphia 1976, cat. no. 39; Athens and New York 1979, cat. no. 6; Northampton 1980, cat. no. 6; Rome 1989, cat. no. 2;

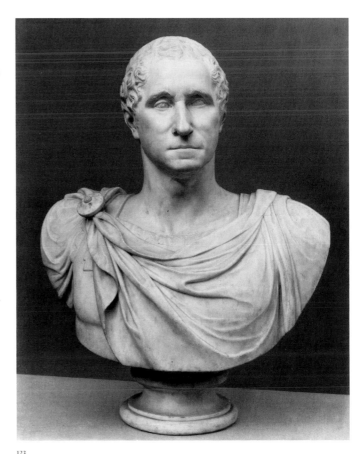

123

Washington, D.C., National Portrait Gallery. *George and Martha Washington: Portraits from the Presidential Years.* 1999
BIBLIOGRAPHY Montanari 1841, p. 19; Johnston 1882, pp. 170–71; Gardner 1948; Desportes 1963; Desportes 1964; Hubert 1964, pp. 24–37
The Metropolitan Museum of Art, New York, Bequest of John L. Cadwalader

In this marble bust Giuseppe Ceracchi created a stern, intense vision of the first president of the United States. Possessing strong revolutionary sentiments himself, Ceracchi had a sympathetic admiration for the protagonists of the American Revolution. Formed in the artistic ambient of Settecento Rome, he naturally called upon the examples of Roman antiquity to glorify these modern heroes, anachronistically garbing his sitters in ancient costume. Ceracchi certainly idealized aspects of Washington, who wears his exaggerated curls bound with a fillet in the manner of an ancient emperor or god. On the other hand, the artist interpreted the features of the sitter's face with an accuracy and psychological penetration that led such discerning critics as Thomas Jefferson to praise this portrait for its faithfulness.

Ceracchi was drawn to America by the prospect of winning the commission for a commemorative monument to the American Revolution. When he arrived in Philadelphia in 1791 he

already enjoyed a reputation as one of Europe's great portraitists, having sculpted busts of Pope Pius VI, Cardinal Albani, Frederick the Great of Prussia, the Holy Roman Emperor Joseph II, Prince Elector Karl Theodor of Bavaria, and Sir Joshua Reynolds. Eager, however, to try his hand at the creation of a major public monument, Ceracchi went to Philadelphia and presented an ambitious project featuring an equestrian figure of Washington surrounded by complex allegorical groups. While Congress weighed his proposal, the artist set to work modeling Washington's features in clay. At the same time he went about energetically seeking to win over anybody in a position to influence the government's decision, employing his skill as a portraitist to curry favor.

Ceracchi took his clay likeness of Washington back to Europe and in 1794 began to carve this marble version. On returning to America later in that year, he altered it on the basis of several more sittings with the president. Upon completion (the bust is signed and dated *Philadelphia 1795*) the artist attempted to present it to the president and his wife as a gift. When the Washingtons refused the offer on ethical grounds, the insistent artist asked them to "store" the bust temporarily. Thus the portrait was displayed in the presidential residence for several months.

By May 1795 support for Ceracchi's staggeringly expensive monument, in which a chariot-riding figure of Liberty had replaced the equestrian Washington, had evaporated. Clearly embittered by the experience, the artist prepared to depart again for Europe. Surprisingly, he wrote to the various influential Americans to whom he had presented "gift" portraits, requesting payment. Washington, although irritated by the audacity of Ceracchi's request and the exorbitant asking price, responded with genuine sympathy, offering to purchase the bust at a price determined by an outside expert. In the end, though, the artist sold the Washington bust to the Spanish ambassador.

This is not the only portrait bust of Washington by Ceracchi; rather, it is one of several versions that he sculpted on the basis of his original clay likeness, now lost. One, a more abstracted colossal head (Musée des Beaux-Arts, Nantes) is probably a full-scale model for the head of Ceracchi's projected equestrian statue. Life-size copies, apparently based on this variant, survive in Charleston (Gibbes Art Gallery), Baltimore (Washington Monument) and Washington (the White House). The Metropolitan Museum bust, however, is Ceracchi's most faithful and direct portrait of Washington and the only one to reflect the second set of sittings.

The bust is of particular importance for the iconography of Washington, as Ceracchi was one of only two sculptors to have modeled the first president's features from life. Many of those who knew Washington preferred Ceracchi's likeness to that of the other, by Jean-Antoine Houdon: the sources seem to agree that Ceracchi more realistically captured the set of Washington's mouth. Houdon's portrait, however, received greater circulation and became the most authoritative and iconic sculpted image of the first president. The viewer should, however, mind the words of the early American painter John Trumbull, who cautioned that anyone who says that Ceracchi's bust does not resemble Washington means really to say that it does not resemble Houdon's Washington.

In the context of the Roman Settecento, the bust fits in a continuum with the classicizing works of Hewetson and Cavaceppi. Through his American portraits, and even through his failed monument to American liberty, Ceracchi was a key figure in the introduction of Neoclassicism to America. With its classical grandeur and faithfulness to life, the portrait not only records Washington's features, but also documents the taste of his time and the transfer of Settecento style to the New World. [JH]

## CLODION (CLAUDE MICHEL)
### NANCY 1738–1814 PARIS

Claude Michel, *called* Clodion, was one of the most inventive and versatile French sculptors of the second half of the eighteenth century. Born into a family of artists in Lorraine, he was the tenth child of Thomas Michel and Anne Adam. His maternal uncles were the famous sculptors Lambert-Sigisbert, Nicolas-Sébastien, and François-Gaspard Adam, and it was to Lambert-Sigisbert's studio in Paris that Clodion went for his initial training before the spring of 1756. His uncle had spent nine years in Rome, where he was deeply influenced by antique sculpture as well as by Roman Baroque art, particularly that of Bernini. He also owned an important collection of antique marbles that had belonged to Cardinal Polignac, a catalogue of which he published in 1755. Clodion was to absorb these influences, which would mark the rest of his career.

Following the death of Lambert-Sigisbert in May 1759 Clodion was briefly the student of Pigalle until the fall of that year, when he won the *prix de Rome*. In December he entered the Ecole des Elèves Protégés, where the painter Carle van Loo was director and Michel-François Dandré-Bardon was professor of history. In preparation for his stay at the French Academy at Rome he studied Greek and Roman history and mythology, as well as drawing and modeling after life and plaster casts. He left for Rome in the fall of 1762, arriving at the French Academy on Christmas day.

Clodion was to spend nine years in Italy (from December 1762 until March 1771), and while there he studied the major collections of antique sculpture, many individual items of which were to have a profound influence on his work for the rest of his career. Charles-Joseph Natoire, the director of the French Academy, encouraged students studying sculpture to make copies after the antique in clay rather than drawing them (Montaiglon 1887–1912, vol. 11, p. 97, no. 5113), which may partially explain why there are no known drawings attributable to Clodion. Following the example of his uncles, Clodion also familiarized himself with Italian Baroque sculpture, particularly that of Bernini. By 1765 he had perfected a type of highly finished small terracotta sculpture that was in demand from an international clientele, including Catherine II of Russia and the Duc de La Rochefoucauld, as well as famous amateurs such as La Live de Jully, Jean de Julienne, and Jacques-Onésyme Bergeret. Natoire himself had several works by Clodion in his collection, as did François

Boucher. Clodion's decision to prolong his stay in Italy six years beyond the three years funded by the academy may have been the result of his success in Rome. His biographer wrote: "His charming productions, some inspired by the antique, and others by this taste for the pleasant and graceful genre that was natural to him, were much sought after. They were bought even before they were finished" (Dingé 1814, pp. 1–2).

Clodion returned to Paris in the spring of 1771. He was accepted as a candidate for membership in the Académie Royale in May 1773, and he exhibited at the Salon for the first time in August of that year, presenting a figure of Jupiter as the model for his *morceau de réception* as well as a number of his Roman works such as *Le Fleuve du Rhin séparant ses eaux* (cat. 124). Anxious to prove himself a master not only of small decorative terracotta and marble sculptures, but also of monumental works, Clodion received commissions for two funerary monuments in 1772, only one of which, that for the Comtesse d'Orsay, was completed (Poulet and Scherf 1992, pp. 150–56). In 1773 he was chosen to execute several sculptures for Rouen Cathedral (Poulet and Scherf 1992, pp. 164–79). Between December 1773 and July 1774 Clodion returned to Italy to choose the marble at Carrara for the Rouen commission as well as for four large allegorical sculptures ordered by Abbé Terray, superintendent of buildings to the king, for his new Paris *hôtel*. While in Rome, Clodion seems to have made a careful study of Baroque monuments, as is reflected in his statue of *Saint Cecilia* for Rouen Cathedral, which recalls Duquesnoy's *Santa Susanna* in S. Maria di Loreto, as well as in the relief of *The Death of Saint Cecilia*, which echoes the composition of Domenichino's fresco of the same subject.

Between 1776 and the French Revolution Clodion enjoyed a highly successful collaboration with the architect Alexandre-Théodore Brogniart, who designed a number of luxurious new houses and interiors in Paris for which Clodion created decorative reliefs, vases, and sculptures. Among the most famous of these collaborative projects is the Salle de Bains (Musée du Louvre, Paris) of the Hôtel de Besenval at 142 rue de Grenelle, built for the Baron de Besenval, and completed in 1782 (Poulet and Scherf 1992, pp. 228–51). Clodion carved for the bathroom two large reliefs executed in limestone, *Venus and Cupid and Leda and the Swan* and *Pan Pursuing Syrinx while Cupid Watches*, two pairs of vases, and a large female figure of *The Fountain*.

Despite his academic training, Clodion never became a member of the Académie Royale and only

received one major royal commission during his long career. In 1778 the Comte d'Angiviller, superintendent of buildings to the king, chose Clodion to do the seated figure of *Montesquieu* (Musée du Louvre, Paris), one of the series of *Famous Men* intended to decorate the Grande Galerie of the Louvre. The plaster model (lost) exhibited at the Salon of 1779 was severely criticized for its vaguely antique costume and partial nudity. In the final marble version of 1783, Clodion showed the philosopher in a historical costume with his books and pen in hand, and it met with a far more enthusiastic reception.

There was a constant demand among famous collectors, financiers, ministers, and aristocrats for Clodion's small terracotta and marble figures, vases, and reliefs from the 1760s until the revolution, and they were the mainstay of his career. From about 1795 he created a series of ambitious terracotta Neoclassical groups of extremely high quality, which were collected by the returning émigrés and newly rich in Paris.

Under the consulate and the empire the demand for Clodion's sculpture diminished. Nevertheless, he produced a number of important and innovative works. In an effort to prove to Napoleon and to the artistic establishment that he was able to create monumental sculpture in the taste of the time, he exhibited at the Salon of 1801 a life-size plaster group entitled *Scene of the Flood*. Despite its critical success, it did not lead to the commission of a marble, as Clodion had hoped (Poulet 1991, pp. 51–76). In 1804 he did, however, receive the commission for a statue of *Cato of Utica* for the new Salle des Séances designed by the architect Chalgrin for the senate in the Palais de Luxembourg, as well as for several busts in plaster and marble. In 1802 Alexandre Brogniart, director of the porcelain factory at Sèvres and son of the architect who had collaborated with Clodion before the revolution, hired the sculptor to design a column for the *Olympic Service*. Clodion was also involved in creating other decorative models for ceramics. By his death in 1814 his sculpture had fallen from favor. [ALP]

BIBLIOGRAPHY Dingé 1814; Thirion 1885; Guiffrey 1892; Guiffrey 1893; Guiffrey 1893, "Clodion"; Lami 1911, pp. 142–59; Guiffrey 1912, pp. 210–44; Poulet 1984; Poulet 1991; Scherf 1991; Poulet and Scherf 1992

## 124

## Clodion (Claude Michel)
### *The River Rhine Separating the Waters*

1765

Inscribed in clay before firing in center of rockwork on back: *Clodion./1765*

Terracotta

10¾″ × 18⅛″ × 12¼″ (27.2 × 46 × 31 cm); length of base 13¼″ (33.8 cm)

PROVENANCE The provenance of this terracotta is unclear. It may be identical with the sculpture exhibited by Clodion at the Salon of 1773, no. 245, "The River Rhine Separating the Waters, terracotta sketch, 16 inches wide" (*Collection des Livrets des Anciennes Expositions depuis 1673 jusqu'au 1800: Exposition de 1773* [Paris, 1870], p. 44), or it may have stayed in Clodion's studio until his death and be the sculpture listed in his inventory after death as, "a terracotta sketch representing a river, priced 1 Franc" (Jules-Joseph Guiffrey, "Inventaire après décès de Clodion [30 avril 1814],, *Archives de l'Art Français*, n.s., vol. 6 [Paris, 1912], p. 234). The sculpture was purchased on the London art market by the Kimbell Art Museum in 1984

EXHIBITIONS possibly exhibited at the Paris Salon of 1773, no. 245; possibly exhibited at Paris, *Exposition Universelle*, 1900, no. 4719; New York 1984, *Clodion*, cat. no. 1

BIBLIOGRAPHY "Livret du Salon de 1773." In *Collections des Livrets des Anciennes Expositions depuis 1673 jusqu'au 1800*. Paris, 1870, p. 44, no. 245; Paris, Bibliothèque Nationale. Collection Deloynes, vol. 10, p. 83, no. 147; Paris, Bibliothèque Nationale. Collection Deloynes, vol. 10, p. 77, no. 148; Paris, Bibliothèque Nationale. Collection Deloynes, vol. 10, p. 468, no. 156; Dingé 1814, p. 3; Augin 1875, p. 304; Bellier de la Chavignerie and Auvray 1885, vol. 2, p. 86; Thirion 1885, pp. 263–64, 266, 269; Guiffrey 1893, p. 415; Obser 1908, p. 36; Lami 1911, p. 145; Varenne 1913, p. 39; Brinckmann 1923–25, vol. 3, pp. 126–27, 169; Kalnein and Levey 1972, p. 159; Poulet 1984, pp. 7–8; Kimbell Art Museum, Fort Worth, Texas. *In Pursuit of Quality: The Kimbell Art Museum*, Fort Worth, Kimbell Art Museum, 1987, p. 250; Poulet and Scherf 1992, pp. 22, 53, 125–28, fig. 71

Kimbell Art Museum, Fort Worth, Texas

This terracotta figure of a river god, executed three years after Clodion's arrival at the French Academy in Rome, is among the sculptor's earliest dated works. It reflects his studies in Paris with his uncles Lambert-Sigisbert Adam and Nicolas Sébastian Adam, both of whom had worked in Italy and passed on to their nephew their knowledge of Roman antique and Baroque sculpture. When Clodion first came to Paris from his native Nancy, he worked in the studio of Lambert-Sigisbert, who had executed monumental figures of the *Seine* and *Marne* rivers for the cascade at Saint-Cloud in 1734 as well as the Fountain of Neptune for Versailles in 1740, a work strongly influenced by Bernini. Clodion would also have known well a small marble figure of the river god

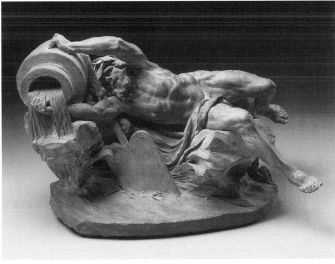

124

*Acheloüs* (Lambert-Sigisbert Adam, *Collection de sculptures antiques grecques, et romaines, trouvées a Rome dans les ruines des Palais de Neron, et de Marius* [Paris: Chez Joullain, 1755], pl. 22) from the collection of Cardinal Polignac, for which his uncle Lambert-Sigisbert was "curator" and "restorer", and later owner. Clodion often found inspiration in this collection. In this case, the diminutive size of the antique marble (31″ long, or 78.1 cm), the attributes of a bearded figure with a crown of reeds in his hair, the use of rockwork with water gushing over it on to the base, and the drapery loosely placed under the nude male figure and wrapped around one leg, all appear in Clodion's sculpture.

The dynamic pose of Clodion's river god, however, with his arms stretched over his head grasping an overturned urn, his splayed legs, and the impression of cascading and swirling water over rockwork surely owes its greatest debt to Bernini's famous *Fountain of the Four Rivers* in the Piazza Navona in Rome, particularly the figure of the Ganges (Rudolf Wittkower, *Gian Lorenzo Bernini*, 2d ed. [London: Phaidon, 1966], pp. 219–22, no. 50, pl. 78). That Bernini's fountain was held in high esteem at the French Academy in the 1760s is indicated by the fact that the director, Charles-Joseph Natoire, owned a terracotta described in the sale after his death as, "a preliminary idea for the fountain in Piazza Navona at Rome, by Bernini" (Natoire sale, Paris, December 14, 1778, p. 17, no. 68). It is interesting to note that Natoire also owned three terracotta figures by Clodion (Natoire sale, p. 18, nos. 75–76). While the general composition of the terracotta reflects the influence of Bernini, the modeling of the torso reveals Clodion's careful study of the *Laocoön*, a plaster cast of which was recorded in his inventory after his death (Guiffrey 1912, p. 234).

After his return to Paris in 1771 Clodion exhibited a number of his Roman works at the Salon of 1773. Among them was a terracotta sketch of the same subject (see Provenance above). The river god in the present terracotta, who reaches with his right hand to separate into two distinct streams the flow of water from the overturned urn above his head, corresponds to the Salon description in material, subject matter, and size. Furthermore, the sculpture is covered with tool marks and has a very freely modeled surface, which makes its description as a sketch appropriate. There are two other versions of this sculpture of similar size, finish, and quality, one in the Fine Arts Museums of San Francisco (signed and dated 1765) and the other in the Victoria and Albert Museum in London (signed but not dated). The latter differs from the others in that the streams of water fall from the lip of the vase to the base, and the oar has a one-lobed rather than a double-lobed blade. The three versions are so similar, however, that it is impossible to identify which was shown at the Salon of 1773.

Even though the present terracotta appears to be a preliminary sketch, there is no record of Clodion having executed a larger-scale or more finished version of a river god, or ever having been commissioned to do so. It would seem, rather, that he was experimenting with the genre of the Baroque sketch, and that the work was sufficiently pleasing that he was asked to do it more than once.

The subject of the River Rhine Separating the Waters is rare. Taken from *Germania* by the Roman historian Tacitus (rev. ed. [Cambridge: Harvard University Press, 1970], p. 129), written in AD 98, it represents the Rhine River separating the territory of the Gauls on the west bank from that of the Germans on the east bank. This

subject was one of particular significance in mid-eighteenth-century France since the duchy of Lorraine on the west side of the Rhine had returned to French control when the dethroned King of Poland Stanislaus Leszczynski, who was also the brother-in-law of King Louis XV of France, became Duke of Lorraine in 1738. He held a brilliant court in Lorraine until his death in 1766. Clodion, who was a native of Nancy, one of the most important cities of Lorraine, would have been especially aware of the contemporary relevance of this subject. [ALP]

## 125

## Clodion (Claude Michel)
### *Three Maenads Dancing and Holding Hands*

1765

Signed and dated at lower right corner: *Clodion/ 1765*

Terracotta

11⅛″ × 7⅞″ (28.9 × 20 cm)

PROVENANCE This relief is probably one of a pair sold at the Vente du Cabinet de M. M[orelle et autre], Paris, April 19, 1786 (postponed to May 3, 1786), lot 436, as "M. CLAUDION. Two bas-reliefs, in terracotta, each comprising three women dancing: both pieces are finely and pleasantly executed. Height 11 inches, width 8 inches"; it may, however, be identical with a relief sold at the Hôtel Drouot, Paris, May 23–24, 1872, lot 406, under "Terracottas", "Clodion. Fine bas-relief representing nymphs dancing"; sale of the collection of M. E. Secrétan, Galerie Sedelmeyer, Paris, vol. July 4, 1889, lot 219, "Terracotta: bas-relief vertical format, by Clodion (signed and dated 1765). It depicts three nymphs dancing and holding hands. Height 29 cent, width 11 cent"; sale of the Elizabeth Parke Firestone Collection, Christie's, New York, March 22, 1991, lot 849; acquired at the sale by Daniel Katz, Ltd., London; purchased from Daniel Katz, Ltd., by Malcolm Wiener in October 1993

BIBLIOGRAPHY Thirion 1885, pp. 398–99; Lami 1911, p. 157; Laverack, Peter, ed. *Daniel Katz Ltd., 1968–1993: A Catalogue Celebrating Twenty-Five Years of Dealing in European Sculpture and Works of Art*. London: Daniel Katz Ltd., 1992, pp. 121–23; Poulet and Scherf 1992, pp. 337, 443

Malcolm Wiener Collection

This terracotta relief of three dancing female figures is among the sculptor's earliest dated works. Clodion had won the *prix de Rome* in 1759, and after the requisite three years at the Ecole des Elèves Protégés, he arrived at the French Academy at Rome on Christmas Day, 1762.

There are no known drawings by Clodion, and the present relief is a fine example of his ability to sketch or draw in clay. The raised arm of the figure in the left background is literally drawn into the surface of the clay with

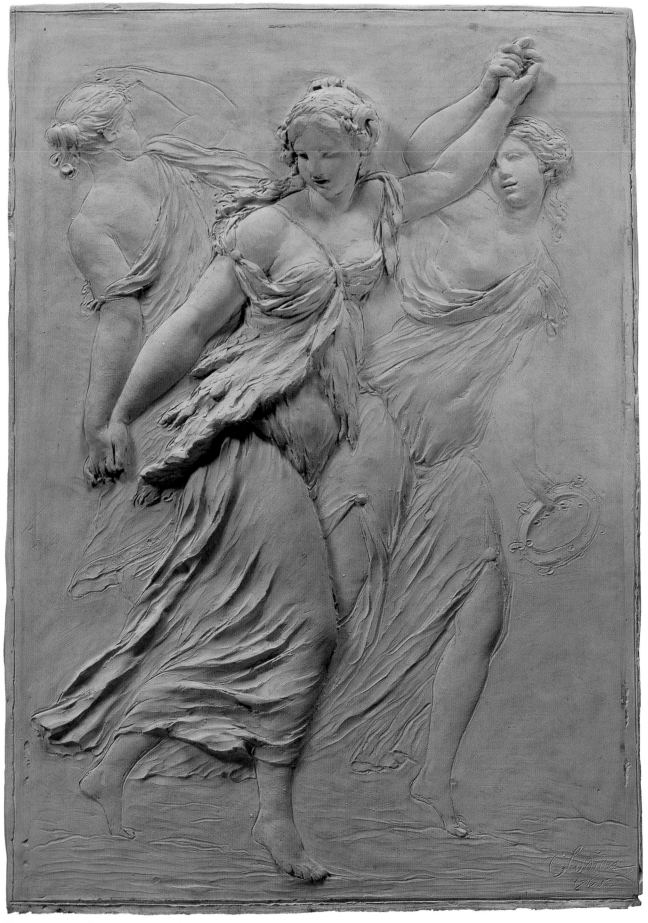

125

a stylus, as are the lowered arm and tambourine of the dancer on the right. The twenty-four-year-old sculptor deftly handles the transitions between low and high relief, creating an impression of depth and movement with great subtlety.

Like most of Clodion's Roman terracottas, this relief was conceived as a finished work rather than a preparatory model and was probably destined for the sculptor's growing clientele of collectors. His biographer Dingé wrote: "His charming productions were sought after, both those inspired by the antique, and those inspired by his natural feeling for this pleasing and graceful art form. They were bought even before they were finished. French, Italian, German, and Russian amateurs sought to employ him" (Dingé 1814, pp. 1–2).

The terracotta sculptures that date from Clodion's nine-year stay in Italy reflect his study of a wide range of antique prototypes. In this case it is clear that his inspiration was taken primarily from the first-century Roman neo-Attic marble relief of dancing female figures then in the Borghese collection (now in the Musée du Louvre; see Haskell and Penny 1981, pp. 195–96, no. 29). In the eighteenth century the Borghese *Dancers* were among the most admired of Roman antiquities. The poses and drapery of the dancers in the center and left of Clodion's relief are quite close to those of two of the Borghese figures; however, the sculptor interprets his model quite freely. He has transformed the staid, quiet rhythm of the Borghese women, whose joined hands are lowered, to a more animated, even frenzied dance in which the figures overlap and their joined hands are lowered on the left and raised on the right. Clodion has given his figures the attributes of maenads, women who were in the entourage of Bacchus and whose wild dancing—wearing animal skins, with clinging drapery, loosened hair, and holding tambourines—was often depicted on Roman sarcophagi, altars, and candelabra (see Phyllis Bober and Ruth Rubinstein, *Renaissance Artists and Antique Sculpture: A Handbook of Sources* [New York: Oxford University Press, 1986], pp. 120–22, nos. 86–89a).

It was often Clodion's practice to return to themes and compositions first treated in Italy for his later sculptures. The central female figure of the present relief is repeated with only slight changes in the treatment of the hair and the addition of a thyrsus in a terracotta relief of *The Triumph of Ariadne* dating from the late 1770s (Petit Palais, Paris; see Poulet and Scherf 1992, pp. 200–203, no. 37). Another relief representing a frieze of *Six Dancing Maenads and a Putto*, also

probably dating from the late 1770s, takes up the theme of the Borghese *Dancers*, and repeats the central and right dancers from the present relief, with only minor changes (see Poulet and Scherf 1992, p. 341, fig. 180). In 1803 Clodion was given a commission to create a column for the *Surtout Olympique*, an elaborate table decoration designed by his friend Alexandre-Théodore Brongniart for the Sèvres porcelain factory. Once again, he found inspiration in the Borghese *Dancers*, modeling a series of six graceful female dancers in high relief, their joined hands alternately raised and lowered, around the base of a column (Poulet and Scherf 1992, pp. 337–42, no. 71).

This relief corresponds in dimensions and subject matter to two terracottas sold from the collection of "M. M[orelle]" on May 3, 1786 (see above). If identical with one of these reliefs, then it had a pendant, also representing three female dancers. They may have been acquired directly from Clodion in Rome by Monsieur Morelle. Unfortunately, nothing is yet known about this collector. [ALP]

## 126

### Clodion (Claude Michel)
### *Vase Decorated with a Relief of Five Women Sacrificing*

1766

Signed and dated on the edge of the lip of the vase: CLODION-MICH *inventit et fe. in Roma* 1766.

White marble

14¼″ × 7¾″ (diameter 7¾″) (36.4 × 19.8 cm; diameter 18.3 cm)

PROVENANCE The provenance of this vase is not known before 1930, when it was catalogued in the collection of George and Florence Blumenthal (Stella Rubinstein-Bloch, *Catalogue of the Collection of George and Florence Blumenthal*, vol. 5: *Paintings, Drawings, Sculptures, XVIIIth Century* [Paris, 1930], pl. LVIII). It was purchased on the London art market in 1987 by The Art Institute of Chicago

EXHIBITIONS New York 1935 cat. no. 99; Paris 1992, cat. no. 7

BIBLIOGRAPHY Rubinstein-Bloch 1930, pl. LVIII; Poulet 1989; Scherf 1991, pp. 51, 58, n. 53; Poulet and Scherf 1992, pp. 94–105, cat. no. 7

The Art Institute of Chicago, The George F. Harding Collection by exchange, The Harold Stuart Fund

In the course of his career Clodion produced a relatively small number of works in marble. This vase, signed and dated 1766, is the earlier of two dated marble sculptures known from the artist's Roman period. The second is a figure of a *Vestal* of 1770 in the National Gallery of Art, Washington, D.C. (Ulrich Middeldorf, *Sculptures from the Samuel H. Kress Collection:*

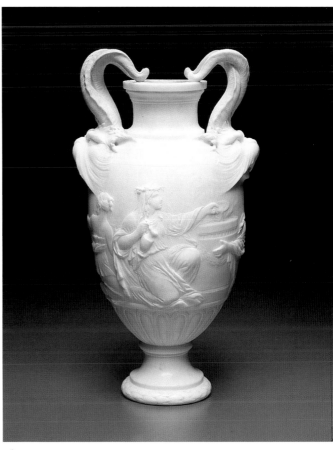

126

*European Schools XIV–XIX Century* [London: Phaidon, 1976], pp. 106–8, no. K1672, fig. 182). Several other marbles that probably date from his years in Italy are mentioned in eighteenth-century sale catalogues, but their present location is unknown (Poulet and Scherf 1992, pp. 102–5). These early marbles are small in scale, often copied after or derived from antique prototypes, and of extremely high quality. Carved with great delicacy and subtlety, they attest to the young Clodion's skill with a chisel. Prized by major collectors, such as M. le Bailli de Breteuil, they brought comparatively high prices at auction in the eighteenth century.

There are two terracotta versions of this vase, both of which are signed and dated 1766, one in the collection of the Louvre and the other in the Detroit Institute of Arts. They are slightly larger than the marble and are decorated with the same frieze of sacrificing female figures; however, the Louvre vase, like the marble, has five figures, while the Detroit vase has a sixth figure added. The quality of these terracotta vases is very high, and there is no indication that one has been cast from the other; they appear to be finished works rather than preliminary models. During his years in Rome Clodion sometimes repeated a composition, such as the river god (cat. 124).

Since he had a steady stream of international amateurs and collectors buying his sculptures, it may be that, having admired a sculpture in Clodion's studio, a collector would commission a copy for himself. In the case of this marble vase, because of the cost of the material, it is likely that it was commissioned after the terracotta.

In the mid-eighteenth century the creation of vases, whether drawn, painted, or sculpted, became a preoccupation of a number of French artists and a primary means of expression of the Neoclassical style (Svend Eriksen, *Early Neoclassicism in France* [London: Faber, 1974], pp. 33–44, 171–84, 195–255). The present vase reflects Clodion's awareness of both antique and contemporary prototypes. Its classical shape and subject of vestals sacrificing recall vase designs and paintings by Joseph-Marie Vien, a leading exponent of the Neoclassical style in France (Thomas W. Gaehtgens and Jacques Lugand, *Joseph-Marie Vien: Peintre du roi (1716–1809)* [Paris: Arthena, 1988], cat. no. 80, pp. 175–92), whose work had a marked influence on the young Clodion. The poses and distribution of the five female figures seem to be based, in part, on those in the foreground of Boucher's composition of *Psyche Refusing Divine Honours*, which Clodion could have known in Rome from Phillippe-Louis Parizeau's engraving after it.

127

The scene of women pouring libations on an altar depicted on the vase can be associated with the cult of Vesta, the Roman goddess of the hearth and home. Young girls, sworn to chastity, had the responsibility of keeping the altar flame burning. Here Clodion has shown two veiled young women, one pouring oil from a *patera* on to an altar and the other kneeling in supplication with her arms reaching around its sides. The other three women hold sacrificial animals, a ram and two birds. Scenes of vestals sacrificing were popular with artists and patrons in the eighteenth century, as were allegorical portraits of women as vestals, since they allowed artists to depict attractive young women in chaste poses and fashionable Neoclassical garb. It is a theme to which Clodion would turn more than once during his years in Rome (cat. 127). [ALP]

## 127
## Clodion (Claude Michel)
### *A Vestal Sacrificing*

1768

Signed and dated on drapery in back:
*Mi. CLODION. In Roma 1768*

Terracotta

Height 18¾″ × 7¼″ × 6⅜″
(47.6 × 18.4 × 16.2 cm)

PROVENANCE  probably identical with the terracotta sold with the collection of M. [Lenglier], Paris, April 24, 1786, lot 150, under "Terres cuites. Claudion": "Une vestale en terre cuite, petit modèle de la figure que cet artiste a exécutée en marbre, pour l'Impératrice de Russie. Hauteur 18 pouces" (sold to Lebrun for 245 livres); it then appeared in the Vente du cabinet de M. Lebrun, Paris, April 11, 1791, lot 361, under "Terre cuite. Clodion": "Une Vestale voilée et couronnée de fleurs, tenant de la main droite une patère, et de la gauche un vase. Près d'elle est placé un trépied de forme antique. Cette belle terre cuite fut exécutée avec étude recherchée par cet artiste, dont les productions de ce genre sont toujours précieuses aux amateurs de l'art: Hauteur 18 pouces; largeur, 7 pouces" (sold for 456 livres à Nadet); it may be identical with the sculpture sold in the "Vente après décès de la comtesse de Montesquiou-Fézensac," Paris, January 29–31, 1872, lot 121: "Terre cuite—par Clodion—signée. Belle statuette de Vestale, debout près d'un autel à trépied" (sold for 4,100 florins); the sculpture was in the sale

of the collection of Thelma Chrysler Foy, Parke-Bernet Galleries, New York, May 22–23, 1959, p. 94 (as one of a pair); it was then in the sale of the inventory of French & Co., Parke-Bernet Galleries, New York, November 14, 1968, lot 135 (as one of a pair); acquired by The Carnegie Museum of Art, Pittsburgh in 1968 with funds given by the Women's Committee of the Museum of Art, inv. no. 68.33.1

BIBLIOGRAPHY  Thirion 1885, pp. 398, 401; Lami 1911, p. 150; Comstock 1940; Middeldorf, Ulrich. *Sculptures from the Samuel H. Kress Collection*. London: Phaidon, 1976, pp. 107–8; Poulet 1984, pp. 9–11, no. 4; Poulet and Scherf 1992, pp. 25–27, 446–47, fig. 6

Carnegie Museum of Art, Pittsburgh, Museum Purchase, Gift of the Women's Committee

One of the recurring subjects treated by Clodion during his years in Rome is that of the vestal. Vestals were attendants of Vesta, the Roman goddess of fire and the domestic hearth, whose cult was widespread in antiquity. In Rome girls between the ages of six and ten were elected to serve as vestals for a period of thirty years. Sworn to chastity, a vestal learned her duties of maintaining the sacred fire and the temple during her first decade of service; during the second she performed them, and during the third she instructed others. Clodion's interest in this theme seems to have been stimulated by antique Roman sculptures and sarcophagus reliefs as well as by paintings and prints by French contemporary artists, especially the works of Joseph-Marie Vien.

This terracotta represents a standing vestal wearing a tunic of fine cloth with a peplum over her torso and a long, heavy outer garment that also covers her head. She holds in her left hand a vase decorated with laurel leaves, while she holds in her right hand a patera from which she pours oil onto an altar fire. Clodion has taken his inspiration for this figure from an antique marble in the Galleria degli Uffizi, Florence, which was engraved and published as a *Vestale* in 1734 (A. F. Gori, *Museum Fiorentinum*, vol. 3 [Florence, 1734] and F. A. David, *Le Museum de Florence, ou Collection des Pierres gravées, statues, médailles et peintures* [Paris, 1798]). Clodion may have seen the sculpture on his way to Rome from Genoa in December 1762, but it is likely that he worked from the engraving when he created this terracotta in 1768. While he used the same pose as that of his antique model as well as a similar placement of drapery, he has softened the movement of the drapery and added ornamental details such as the crown of roses, the vase, and the altar in the form of a tripod decorated with swags and rams' heads. These embellishments recall those found in the Neoclassical paintings of charming young priestesses and

vestals by Vien of the 1750s and early 1760s, which were admired by influential critics such as Diderot and collected by distinguished amateurs such as Mme. Geoffrin. In Vien's painting of *A Priestess Burning Incense on a Tripod*, executed for Mme. Geoffrin in 1762, there is a tripod altar decorated with rams' heads and feet, on which a young priestess pours a libation that closely resembles Clodion's tripod. The painting enjoyed considerable success at the Salon of 1763. Diderot wrote, "How redolent all of that is of the antique style!" (Thomas W. Gaehtgens and Jacques Lugand, *Joseph-Marie Vien: Peintre du Roi (1716-1809)* [Paris: Arthena, 1988], pp. 171–72, figs. 184–85). The painting was engraved by J. J. Flipart in 1765 and exhibited at the Salon of the same year. Since Natoire and the students at the French Academy at Rome followed the events at the Salon closely, it is quite possible that Clodion knew of the success of this picture and saw an engraving of it in Rome.

Two earlier terracottas of vestals by Clodion, which must have been quite similar in composition, are recorded in sale catalogues. They indicate his early interest in the subject and the popularity of vestals with collectors. One was owned by the famous amateur Jean de Julienne and described as "a crowned priestess pours libation on the altar," sold in 1767 (sale after the death of Jean de Julienne, Paris, March 30, 1767, lot 1304). Another, in the collection of M. Fortier, is described as "a vestal garlanded with flowers, holding a vase in one hand, leaning over a tripod, and in the other hand holding a patera … made by Clodion in Rome, in 1766" (sale after the death of M. Fortier, Paris, April 2, 1770, no. 84). The combination of the chaste and moral attendant of Vesta with the charming young female figure proved particularly appealing to patrons.

In 1768 General Shuvalov commissioned Clodion to execute a marble figure of *A Vestal Sacrificing* for the collection of Catherine the Great of Russia. In a letter of April 20, 1768, Natoire states that Clodion, Boizot, Boucher, and Bauvais have each been asked to do a figure in marble about four feet high for the Empress of Russia. It seems virtually certain that this marble is identical with the *Vestal Sacrificing* signed and dated 1770 that is now in the National Gallery of Art, Washington, D.C., since it corresponds in size and date to the commission and has a Russian provenance. Furthermore, this is the only known large marble figure by Clodion that dates from his Roman years. Its superb quality and subtle modeling indicate, however, that the young artist was as gifted as a carver

of marble as he was a modeler of clay. It is equally probable that the Pittsburgh terracotta of *A Vestal Sacrificing* is a highly finished model for the marble. Not only is the composition of the figure the same as that of the Washington *Vestal*, but it is also described in a sale catalogue of 1786 as "a vestal in terracotta, a small model of the figure that this artist executed in marble for the Empress of Russia. Height 18 inches" (Vente du Cabinet de M. [Lenglier], Paris, April 24, 1786, no. 150). The height corresponds exactly to that of the Pittsburgh figure. Its identity is confirmed by the more detailed description in the Lebrun sale "a veiled and garlanded vestal, holding in her right hand a patera and in the left a vessel. Near her is an antique tripod altar" (sale of the cabinet of M. Lebrun, Paris, April 11, 1791, lot 361).

During his years in Rome, Clodion enjoyed a great success among an international group of patrons with these figures inspired by antique prototypes. Like Vien's paintings, they satisfied the Neoclassical taste of collectors while also appealing to their eighteenth-century sensibilities. His biographer wrote, "He had an original talent, which he augmented and perfected without perverting it. He preferred some failings, redeemed by a native talent and grace, to those cold and silent beauties that are as close to the antique manner as death is to life" (Dingé 1814, p. 1). [ALP]

## AGOSTINO CORNACCHINI

PESCIA 1686–1754 ROME?

Agostino Cornacchini was eleven when his father Ludovico moved from Pescia to Florence, and in the same year he entered the studio of Giovanni Battista Foggini, the leading sculptor in Florence, and Architetto Primario of Cosimo III de' Medici. Cornacchini's earliest known independent work was a mask of "the King of France" (Louis XIV?), for which in 1709 he attempted to secure the payment. This was presumably related to a carnival or theatrical performance; indeed, like most Florentine artists, Cornacchini was much involved in such enterprises: in 1712 he made the drawing for an engraving by C. Mogalli of the opening scene of an opera staged at the Teatro della Pergola, and in the same year produced one of the figures, *Zeal of Religion*, for the celebration of the canonization of Pius V. In 1609 he was employed to make drawings after sculptures for John Talman, which, to the Englishman's annoyance, he was very slow to produce. The statue of Clement XI in Urbino, frequently ascribed to Cornacchini and incorrectly dated 1710, is a documented work of Francesco Moratti (Negroni 1986).

While still in Foggini's studio, Cornacchini had come to the attention of the patron and collector Francesco Maria Niccolò Gabburri, who commissioned the sculptor to make stucco decorations for his palace, and also, in 1711, for the chapel of S. Giovanni Gualberto in S. Trinità; both these Florentine decorations were destroyed in the nineteenth century—although, as for the ephemeral works of this Florentine period, some drawings remain (Cannon-Brookes 1976). In 1712 Gabburri took him to Rome. On his departure in 1714 Gabburri left the sculptor in the care of his uncle Cardinal Carlo Agostino Fabroni, a powerful member of the Church hierarchy, who took him into his palace, where he remained from 1714 to 1720; after Fabroni's death in 1727 Cornacchini was commissioned to carve his tomb-slab in S. Agostino in Rome (lost, if it was ever made). It was for Fabroni that he executed the marble group exhibited here, but the only other known works of this period are a terracotta copy of the Uffizi seated boar, signed and dated 1716, and a bronze *Sleeping Endymion*, made by 1717, of which the terracotta model is in Boston, another bronze cast in Moscow, and a version in marble in Cleveland.

By 1720 Cornacchini must have acquired some reputation, for with the help of Lodovico Sergardi he obtained the commission for the marble equestrian *Charlemagne*, finished in 1725, a counterpart to Bernini's *Constantine* at the opposite end of the portico of St. Peter's. Cornacchini lavished much care on the preparation, borrowing books of engravings of equine anatomy, and obtaining casts of horses by Giambologna and the legs of the horse of the antique statue of Marcus Aurelius, and engravings of horses by Tempesta, as well as studying living horses, and making nude studies for the figure. Yet the result was a thoroughly theatrical piece of Rococo sculpture, much criticized ever since its unveiling. For the interior of the basilica he modeled the holy-water stoups and carved one of the supporting putti (1724–25), and the strongly Michelangelesque *Saint Elijah* (1725–27), the putative founder of the Carmelites, for the series of the Founders of Religious Orders. Further proof of Cornacchini's interest in the past is a small encaustic painting of a sleeping Christ Child (Victoria and Albert Museum, London), dated 1727 and proudly signed as a "new invention," but clearly intended as a revival of a classical technique.

Between 1721 and 1724 Cornacchini carved the figure of *Hope* for the chapel of the Monte di Pietà, and in 1722 made a bronze group of *Judith and Holofernes* (now in Birmingham) for

the electress palatine in Florence (here too Sergardi was involved). Both works display an almost spiky liveliness in contrast to the more fluid grace sought by his contemporaries, a highly individual approach that anticipates the Rococo. Between 1725 and 1727 Cornacchini remade the arms for the *Laocoön*, which is unikely to have been his only restoration of an antique statue. Most likely toward the end of the decade he carved the busts of Cardinals Ferdinando d'Adda and Luigi Omodei for S. Carlo al Corso (Rome), and probably during that decade he made a now destroyed recumbent *Blessed Jean-François de Régis* for Madrid. In 1622 he received the commission for an *Archangel Michael*, and a *Guardian Angel* for the cathedral of Orvieto, finished in 1727 and 1729 respectively.

By 1730 Cornacchini had completed a relief of the *Nativity of the Virgin* for the Superga in Turin, and was immediately commissioned to carve another, of the *Pietà*, accompanied by the two marble putti now in Raleigh (North Carolina). In 1731 his statue of *Saint John of Nepomuk* was set up on the Milvian Bridge in Rome and in 1733 he signed a contract for marble sculptures for the chapel the Florentine Pope Clement XII was building in the St. John Lateran: these were a relief of *The Battle of Anghiari*, and a statue of *Prudence* accompanied by two putti, one of four personifications of Virtues in the chapel; he also provided the models for the two elegant candle-bearing bronze angels. Cornacchini was further commissioned to carve a seated statue, *Clement XII*, for the portico of the basilica, but almost immediately the pope gave it to Ancona, where it survives, much mutilated and restored.

After this active and successful career (in 1724 he was elected to the Accademia Clementina in Bologna, in 1733 to the Accademia del Disegno in Florence; his marriage in 1727 to Maria Angelica Papi brought him considerable wealth, so that in 1750 he was able to provide his daughter with the handsome dowry of 2,000 *scudi*, without harming the interests of his two sons), no further sculptures are known, until in February 1754 Cornacchini received the relatively minor commission for a travertine statue of *Saint Ursula* for the colonnade of St. Peter's to replace one destroyed by a thunderbolt. By the end of the year he was dead. [JM]

BIBLIOGRAPHY Keutner 1957–58; Keutner 1958; Lankheit 1962, pp. 188–89, 225 (doc. 13); Faccioli 1968; Cannon-Brookes 1976; Corbo 1976; Enggass 1976, vol. 1, pp. 193–206; Nava Cellini 1982, pp. 23–33; Enggass 1983; Pratesi 1993, vol. 1, p. 41, and vol. 2, pp. 74–75, figs. 105–18; Rocchi Coopmans de Yoldi 1996, pp. 347–53

## 128

### Agostino Cornacchini
### *The Descent from the Cross*

1714–16?
Marble
41⅛" × 28½" × 16⅞" (104.5 × 72.5 × 43 cm)
PROVENANCE Cardinal Carlo Agostino Fabroni
EXHIBITION Detroit and Florence 1974, cat. no. 5

BIBLIOGRAPHY Florence, Biblioteca Nazionale. Raccolta Rossi Cassigoli, ms. cas. XII.V.2; Tolomei 1821, pp. 89–90; Keutner 1958, pp. 36, 38, pl. 2; Lankheit 1962, pp. 189, 225 (doc. 13); Faccioli 1968, pp. 434–35; Enggass 1976, vol. 1, pp. 194–95; Nava Cellini 1982, pp. 23–25; Pratesi 1993, vol. 1, pp. 42, 75, and vol. 2, pl. 117; Rocchi Coopmans de Yoldi 1996, p. 349
Biblioteca Capitolare Fabroniana, Pistoia

*The Descent from the Cross* and its companion piece, *The Nativity* (more accurately *The Adoration of the Shepherds*), representing the death and birth of Christ, were carved for Cardinal Fabroni and adorned the *apartamento nobile* of his palace in Rome, so it is reasonable to suppose that they were carved while Cornacchini was living there. Keutner assumed that they were made between 1714 and 1716 (Keutner 1958, p. 38, no. 6), and although he gives no reason, this has been generally accepted. However, there are notable differences between the two groups, the *Descent from the Cross* tending more markedly toward the rather stylized physiognomies and taffeta-like folds that characterize the sculptor's mature works. What both pieces share is a highly unusual approach to the sculptural group, which is not to be found in any other Roman sculpture of this time. This could be regarded as a development from the high relief, or as a transference into marble of the compositions that can be found among the Florentine small bronzes—although such groups were a rather later development.

Like reliefs, these marbles involve complex compositions of several figures engaged in narrative scenes, in the case of the *Nativity* including an architectural setting, and both were designed to be set against a wall. But all the figures are carved in the round, and they involve none of the complicated mixture of real and illusory space typical of the high-relief form. Moreover, although they were clearly intended for viewing from the front, they make logical, if not aesthetic sense when viewed from other angles—indeed, in the *Descent from the Cross* it is only from the right side that the man (Nicodemus or Joseph of Arimathea) whose head is behind Christ's left elbow, but whose hands are visible from the front, can be seen, and it is only from this side that Saint

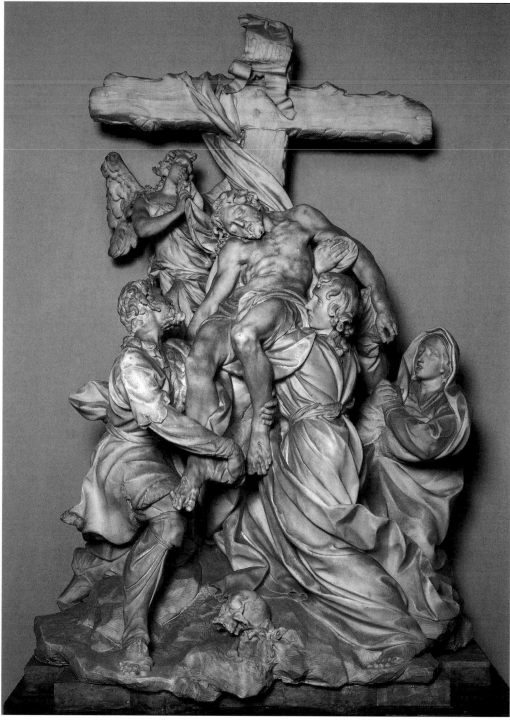

128

which successfully rivals contemporary painting both in its composition and in its highly charged emotional drama, accurately described by Gabburri as "executed with great animation, intelligence, diligence, and love" (Keutner 1958, p. 38).

On May 26, 1726, Cardinal Fabroni drew up a deed of donation, giving his extensive library to his native city of Pistoia and stating that the books were to be accompanied by these two marbles. After his death on September 19, 1727, the books were sent from Rome, although nothing is said of transporting the sculptures; however, they have remained together ever since in the library that bears his name. [JM]

## FRIEDRICH WILHELM EUGEN DOELL

VEILSDORF, THURINGIA 1750–1816
GOTHA

After a five-year apprenticeship with the modeling master Wenzel Neu in Fulda, Friedrich Wilhelm Eugen Doell worked at the Veilsdorf porcelain factory as a modeler. Through the agency of Friedrich Melchior von Grimm, the representative of the dukes of Gotha in Paris, in 1770 he entered the service of the crown prince (later Duke Ernst II of Sachsen-Gotha-Altenburg). It was at this time that he produced his first portrait busts, still essentially Baroque in style.

When Jean-Antoine Houdon visited Gotha in 1771, in connection with a design for the tomb of Duchess Luise Dorothee, the crown prince sent Doell back to Paris with him to continue his training. Little is known about Doell's activity there, although during the fourteen months he spent with Houdon he also attended lectures by the anatomist Tetier. Then the crown prince sent him to Rome, where he was able to continue his artistic education from 1773 to 1782 under the supervision of Johann Friedrich Reiffenstein, who had been appointed a councilor to the court of Gotha in 1772. (Gotha, Germany, Thüringisches Staatsarchiv Gotha, Geheimes Archiv, E XIII/A/7, Reiffenstein's letters to Duke Ernst II of Sachsen-Gotha-Altenburg from 3.3.1773 to 27.4.1782; Reiffenstein kept the duke informed in great detail regarding Doell's training.) Until 1776 Doell worked under the protection of the sculptor Giuseppe Franchi, mainly copying antique models. He made copies in terracotta and marble, such as the heads of *Sappho* and the Medici *Venus*, the Farnese *Flora*, the relief of the Borghese *Warrior*, and works of his own based on classical antiquity, such as the group of *Theseus Dedicating a Picture of Venus to Apollo* (1774) and the bas-relief of *Minerva Handing Pegasus Over to Bellerophon* (1774–75).

John's action is wholly intelligible. In this respect also it might be considered more advanced than the *Nativity*.

Although both Giovanni Battista Foggini and Massimiliano Soldani had created bronze groups that were more complex and spatially expansive than those of their Florentine predecessors (with the exception of Giovanni Francesco Susini), it was only with the series of bronzes made for the electress palatine in the early 1720s that they really broke new ground in what is traditionally regarded as sculpture,

although similarly adventurous groups had been produced in France. As an example of an attempt to create three-dimensional groups that rival paintings in the depiction of figures in their landscape or architectural setting there is the set of four small silver and hardstone reliquaries Soldani made for S. Lorenzo about 1690, although the very elaborate groups made in sugar (*trionfi* in Italian) to decorate banqueting tables should not be forgotten.

All such works may have been in Cornacchini's mind when he produced this highly pictorial sculpture: the cross is carefully carved to imitate wood (the bark visible at the sides), and the skull that gave its name to Golgotha (it may also allude to the grave of Adam) lies on the rocky ground. The swirling draperies suggest that the angel at the left is rising upward in twisting flight, and—most strikingly "pictorial"—the almost ungainly body of Christ is seen in sharp foreshortening, while, of course, his head is clearly presented to the viewer. It is a tour de force of intricate carving,

After the return of Anton Raphael Mengs to Rome from Spain in 1777, Doell continued his training under Mengs's aegis. To Reiffenstein's delight he constantly improved his ability to work in the spirit of the Greeks, overcoming the "modern French style" (Letter from Duke Ernst II of Altenburg, June 25, 1774). Apart from the copy of a *Genius* in the Museo Pio-Clementino in Rome for a Russian count and a *Bust of Corinna* (both 1779), he made busts of *Bacchus, Ariadne*, and *Faustina* (all 1781). The artist created the allegorical marble group *Gratitude* for the Russian Count Shuvalov, along with his portrait medallion (1779–80) and the life-size statue of *Catherine II as Minerva* (1780–81) for Count Tshernyshev. On his own account he made the outstanding portraits of *Anton Raphael Mengs* and *Johann Joachim Winckelmann* (both 1779–80), now in the Schloss Gotha.

Having failed to persuade Bartolomeo Cavaceppi to undertake a bust of Winckelmann, Reiffenstein asked his protégé to produce several variants of the portrait of the great archaeologist. (Reiffenstein had taken over the role of his friend Winckelmann, who had been murdered in 1768, as an art *cicerone* in Rome.) In 1781 Doell's new, colossal bust of Winckelmann, commissioned by Reiffenstein, was installed in the Pantheon (now in the Albergo dell'Orso). A development not only of the Gotha marble portrait, but also of a drawing by Giovanni Battista Casanova (produced under Mengs's supervision and executed in bronze by Louis Valadier [Müller W. 1940; Zeller and Steinmann 1956]), this bust became the definitive image of Winckelmann. Along with Doell's previous portraits of Winckelmann, it brought the young sculptor to the attention of the Roman art world and established his reputation as a portraitist.

During his time in Italy Doell received only a few commissions from his patron, the duke. After Houdon's project for a mausoleum of the late Duke and Duchess of Gotha came to nothing in 1774 because of Reiffenstein's criticisms, the intention was that Doell should be entrusted with the task. But apart from the relief of *Minerva and Bellerophon*, he made only a *Mercury* (1777) for the temple in Gotha Park and an urn (1780) for the tomb of the crown prince for his employer while in Rome.

Before returning to the Thuringian capital, Doell visited in 1781 the cities of Naples, Bologna, Venice, Vienna, Prague, and Dresden. After his return Duke Ernst II appointed him professor of fine arts in 1782. Four years later Doell opened a drawing school in the palace at Gotha and at the same time

became the curator of the Friedenstein collection of casts established in 1779. In 1792 he was also appointed to the office of keeper of the Kunstkammer. The first casts of antique sculptures from Italy had reached Gotha in the 1770s as a result of Reiffenstein's activities. Doell himself had made some casts for the collection while in Rome, such as a *Dancing Faun*, and the head and statue of the *Apollo* Belvedere.

To judge by written sources, Doell's œuvre was very extensive. However, only a relatively small proportion of his many portraits, statues, funerary monuments, and decorative works made for the courts in Gotha, Weimar, Meiningen, and Anhalt-Dessau, and for various institutions in German cities, has survived.

From Ernst II's successor, Duke August of Sachsen-Gotha-Altenburg, Doell received only a few meager commissions. On the other hand, he did receive commissions from other members of the court at Gotha and from the Gotha middle classes. He created several noteworthy portraits of members of the ducal family, the court at Gotha, and other eminent figures in the Greek manner (particularly noteworthy are: *Ernst II* and *August of Sachsen-Gotha-Altenburg, Hans Wilhelm* and *Moritz August von Thümmel, Johann Benjamin Koppe*, the mathematician *Kästner*, and *Juliane Franziska von Buchwald*, after Houdon's bust of the vestal virgin), as well as busts of prominent persons in modern dress. (Examples include: *Prince Emile August* and *Prince Friedrich of Sachsen-Gotha-Altenburg* and *Christian Friedrich Samuel Hahnemann*; Schuttwolf 1995, pp. 159–67, 196–201).

Doell also produced some imposing reliefs for the interiors and exteriors of buildings, such as the sculpted decorations in the rooms occupied by the ducal family at Schloss Friedenstein and Schloss Belvedere in Weimar. He also made the bas-relief *Castor with Pegasus* for Meiningen c. 1782 and supplied the court at Dessau with two busts of the reigning Princess Luise von Anhalt-Dessau (1789), a sandstone bas-relief with Gustavus Adolphus on horseback (1785), and twenty-two designs for stucco reliefs depicting the history of the art of riding (1790–95) for the prince's riding school in Dessau. Around 1797 he designed the gable relief *Minerva Settling the Quarrel between the Muses and the Sirens* for the portico of the Pantheon at Wörlitz and created all the Egyptian-inspired sculptures for its cellar. In 1801 he made the relief for the tympanum at the Temple to Flora in Wörlitz (Bechtoldt and Weiss 1996, pp. 201–4, 242, 244, 404, 411).

Before 1796 Doell executed the marble group *Faith, Love, Hope* for the Johanneskirche at Lüneburg, a statue

of Leibniz for Hanover, and one of Lessing for the library in Wolfenbüttel ("Doell" 1913). A monument by him with a marble bust of the astronomer Johannes Kepler (1808) was erected in Regensburg. Various casts of Doell's works were sold by the Leipzig art dealers Rost; these include a *Vestal Virgin* carrying the sacred flame, which was made after the statuette of a vestal virgin by Houdon dating from c. 1768, which used to be in Gotha. He also ran a factory in Altenburg which produced some of his works (Schneider 1987, vol. 1, p. 113).

In his day Doell was regarded in Thuringia as a sculptor of distinction. He received public recognition through his nomination as an honorary member of the Berlin Academy in 1788. [AS]

BIBLIOGRAPHY Beck 1854, pp. 241–61; "Doell" 1913; Müller W. 1940; Zeller and Steinmann 1956; Bechtoldt and Weiss 1996, pp. 201–4, 242, 244, 404, 411

## 129
## Friedrich Wilhelm Eugen Doell
### *Minerva Handing Pegasus Over to Bellerophon*

1774–75
Inscription with signature and date on the pedestal of the block of stone: *Doell. inv. Roma. 1774*
Carrara marble
41″ × 45¼″ × 5½″ (104 × 115 × 14 cm)
PROVENANCE Rome, 1775; Schloss Friedenstein, Gotha, 1780 (Schlossmuseum Gotha, *Verzeichniss der antiquen Abgüsse*, director's copy [1845], fol. 24, no. 31, wrongly described as a gift from Leopold Doell)
EXHIBITION Duisburg and Gotha 1987, cat. no. 95
BIBLIOGRAPHY Beck 1854, p. 243; Wolfgang, Eduard. *Verzeichniss der Sammlung der Abgüsse im Herzoglichen Museum zu Gotha*. Gotha, 1854, vol. 4, no. 55; Zeller and Steinmann 1956, p. 33; Hebecker, Michel, and Wolfgang Steguweit. *Von der Kunst Kammer zum Museum: Plastik aus dem Schlossmuseum Gotha/DDR*. Duisburg, Germany: Wilhelm-Lehmbruck-Museum, 1987, cat. no. 95; Schuttwolf 1995, cat. no. 66
Schlossmuseum Gotha

A female form in a peaceful, upright attitude sits majestically above a narrow strip of ground on a ribbed block of stone. She is wearing a peplos tied with a belt and a cloak that lies over her right shoulder and cascades down her back to the ground, enfolding her legs. Her right foot is resting on a footstool. With her outstretched left hand she holds the bridle of a powerful and fiery winged horse, which stands out from the ground of the relief with its left forefoot raised. The Corinthian helmet and the snake-

edged breastplate with the gorgon identify the woman as Minerva. The snake crawling up the helmet must be regarded as Doell's invention. Turned toward the goddess on the right stands a naked youth in classical contrapposto. His softly modeled body with slightly elongated limbs is well-formed, and almost immaculate. He is framed by a short cloak, the chlamys, which billows across his left shoulder, falls down over his back in folds, and is draped over his lower right arm. His head is turned to the right and his gaze directed towards Minerva's left hand.

The scene depicted comes from the myth of Bellerophon, who was the son of Glaucus and Eurymede and the grandson of Sisyphus. He rejected the love of the wife of Proetus of Tiryns, who avenged herself by accusing him falsely. Proetus then sent him to his father-in-law, King Iobates, in Lycia with instructions that he should be killed. Like Proetus, the king could not carry out the deed and instead sent Bellerophon to fight in the most dangerous places. Out of pity the gods sent him Pegasus—with Minerva herself putting on the bridle. In this composition Minerva is handing Pegasus's bridle to the young hero, who can tame the war horse and avail himself of its miraculous strength so as to triumph over the challenges he encounters (Hiller 1970, pp. 9–13; Hederich [1770] 1996, cols. 533–38).

The construction of the nearly square-format relief is characterized by great clarity, in line with Winckelmann's principles. The figures appear in three-quarter profile, the heads in full profile. The two forms in the foreground, worked almost half in the round, and the flatter form of Pegasus in the middle ground convey the impression of spatial depth through the layering of the relief. The surface is carefully handled. Bellerophon's finely modeled flesh and the sensitively worked wings and body parts of the horse proclaim Doell's skill as a craftsman. Although Minerva's richly structured cloak, with its sharp-edged folds, produces a somewhat agitated effect, the sculpture as a whole reveals a great affinity to antiquity. The figure of Minerva suggests the influence of seated figures on Greek tomb stelae or dedicatory reliefs. It has not been possible to ascertain whether, in devising the work, Doell adapted the scene from a now-unknown antique relief or adapted single figures to create a set piece. A model for the form of Bellerophon was the figure known as Idolino in the Museo Archeologico in Florence (Beck, Bol, and Bückling 1990, p. 361), which itself is probably derived from the famous statue of Doryphoros by Polyclitus. Doell

129

adopted both the body pattern and the standing pose as well as the head of hair from this sculpture of Idolino. The object in his left hand may be the result of a misunderstanding. Doell could have referred to a 1680 set of engravings by F. Bartoli publicizing the tomb of the Nasoni discovered at that time. Among the wall paintings reproduced there is a composition showing Bellerophon between two women. Here too the youth holds a similar attribute in his hand that in the original was no doubt a sword (see Hiller 1970, p. 41).

At the beginning of his study period in Rome Doell created his own subjects, based on antique mythology, as bas-reliefs in clay under the guidance of Giuseppe Franchi and Anton von Maron in order to acquire confidence in handling anatomy and perspective (Gotha, Germany, Thüringisches Staatsarchiv Gotha, Geheimes Archiv EXIII/A/7, Reiffenstein's letters to Duke Ernst II of Sachsen-Gotha-Altenburg, January 25, 1774). A letter written by Johann Friedrich Reiffenstein to Doell's patron, Ernst II of Sachsen-Gotha-Altenburg, reveals that the young artist himself selected the subject of Minerva and Bellerophon for conversion into stone: "A beautifully clothed figure, a youthfully naked heroic figure, and the winged horse here give him the

opportunity to make a thorough study of three different types of nature; he is now executing the most successful combination he made in clay in exactly the same size as he intends to sculpt it in marble, in order to be able humbly to lay such a piece at the feet of your Ducal Excellency next year, as proof of his progress." Reiffenstein also reports that initially the sculptor thought of making the relief in the form of an upright oval the size of an imposing chimneypiece (Letter from Reiffenstein to Duke Ernst II of Sachsen-Gotha-Altenburg, August 30, 1774), and "after many necessary changes in the composition as well as in the forms themselves" (Letter from Reiffenstein to Duke Ernst II of Sachsen-Gotha-Altenburg, November 2, 1774) arrived at the existing format. Because of its clearly classical formal vocabulary and the perfection of the craftsmanship, the work was well thought of among the artists in Reiffenstein's circle. After Duke Ernst had approved the purchase of a block of marble, Doell was able to make a start on converting it into stone in June 1775. He completed the work in December 1775, but another five years went by before it was sent to Gotha. Twenty years later, in the course of alterations to the interior of the Schloss at Gotha, Doell created a stucco relief showing

Bellerophon taming Pegasus at the moment when a spring wells up where the ground has been struck by the horse's hoof. [AS]

## CHRISTOPHER HEWETSON

THOMASTOWN, CO. KILKENNY
C. 1736–1798 ROME

Hewetson was born into a Protestant family in County Kilkenny, the son of a lieutenant in a troop of horse. After an education at Kilkenny College, he went to Dublin and probably trained with the leading sculptor then active in the city, John van Nost the Younger, for whom he worked in the late 1750s on statues for the rotunda gardens. In 1765 he is recorded in Rome, along with the painter Henry Bainbridge, from Philadelphia. There, with the support of the influential agent and dealer Thomas Jenkins, he soon established himself as an admired sculptor of portrait busts and became patronized by prestigious and wealthy visitors from all over Europe.

Hewetson's earliest busts include those of three sitters who were important patrons of artists working in Rome in the 1760s and 1770s: the antiquary Charles Townley (1769; private collection); the Welsh collector Sir Watkin Williams Wynn (1769;

National Gallery of Ireland, Dublin), and Frederick Hervey, bishop of Derry (c. 1770; National Portrait Gallery, London). Commissions for busts of other collector clients of Jenkins followed. Among these were Thomas Mansel Talbot (1773; Victoria and Albert Museum, London), who in the same year purchased a version of Hewetson's celebrated portrait of Clement XIV, commissioned in 1771 (cat. 130), and John Campbell, 1st Baron Cawdor (c. 1784; National Gallery of Scotland, Edinburgh), who was shortly afterwards to commission the *Cupid and Psyche* group from Antonio Canova. During the 1770s and early 1780s Hewetson continued to carve portraits of British sitters visiting Rome, some of whom also sat to Pompeo Batoni; these included the Duke of Gloucester (1772; Royal Collection, Windsor Castle, Berkshire), Sir Thomas Gascoigne, Henry and Mary Swinburne (all c. 1778; bronze versions by Luigi Valadier; Lotherton Hall, Yorkshire), and the author of the *Geneological History of the House of the Stewarts*, Andrew Stuart (c. 1789; Signet Library, Edinburgh). But his reputation extended far beyond the circle of British Grand Tourists, attracting patrons as varied as the Spanish ambassador, José Nicolas de Azara (1778; Bibliothéeque Mazarine, Paris), the Polish magnate Franciszek Salezy Potocki (c. 1782; Lancut Castle, Poland), and Grand Duchess Maria Fyodorovna of Russia (1783; location unknown). Though primarily occupied with portrait busts, he was in 1773 commissioned to produce the monument to Provost Baldwin that was exhibited in Rome in 1783, before being shipped to Dublin and set up in Trinity College. Hewetson's description of the monument, with its comments on both the materials and the imagery, is one of the few known such accounts by a sculptor about his own work. In 1783 Hewetson was commissioned to execute the monument to Cardinal Giambattista Rezzonico (S. Nicola in Carcere, Rome), nephew to Clement XIII, but by this date his reputation was beginning to wane, following the arrival of Canova in Rome in 1779. Despite the earlier success of Hewetson's bust of Clement XIV, it was Canova who was to gain the commissions for the monuments to both him and Clement XIII. Yet, though unsuccessful in the competition for these projects, Hewetson responded generously by giving a dinner in honour of Canova, who long afterwards referred to the Irish sculptor's work with respect.

Hewetson's busts make use of a range of conventions and formats. Some, such as the portrait of the Duke of Gloucester, are cut quite high across the chest and shoulders, with

the sitter represented in a combination of classical and contemporary dress. Increasingly, however, Hewetson drew on different antique bust types, including the severe herm type used for his portrait of the painter Gavin Hamilton (1784; Hunterian Museum, Glasgow). Common to all his busts is the careful carving of the hair and facial features, and these qualities no doubt attracted his many patrons, directed to his studio by an influential circle of supporters. But his responsiveness to the potential offered by the forms of antique busts, already exploited by Edme Bouchardon (cat. 107) in the late 1720s and Joseph Wilton working in Florence in the mid-1750s, also allowed him to offer a distinctive and relatively novel type of Neoclassical portrait bust to sitters who had for some time admired the classicizing elements in Batoni's painting and were to appreciate the innovations of Canova. Although Hewetson's work has usually been discussed within the context of British or Irish sculpture, both his career and the range of his portrait busts are best understood in terms of his significant position in the Roman art world during the 1770s and 1780s. For a decade at least he was the leading portrait sculptor working in the city, though, as Berry remarked on a visit to his studio in April 1784, "Rome is not the place to admire modern busts" (Mary Berry, *Extracts of the Journals and Correspondence of Miss Berry, from the Year 1783 to 1852*, edited by Lady Theresa Lewis [London: Longmans, Green, & Co., 1865], vol. 1, p. 104). His close association with Thomas Jenkins, reflected in the latter's bequest to the sculptor of money for a ring to commemorate their friendship, led John Deare to refer to them as "those thieves the antiquarians and monopolizing artists" (London, British Library. MS Add. 36.496, fol. 307 [1794]). But the commissions for busts also came about through Hewetson's connections with many other figures, including Hamilton and Anton Raphael Mengs. Similarly, their production sometimes involved collaboration with the bronze founders Luigi Valadier and Righetti. Although on occasion signing himself *Christophorus Hewetson Hibernicus*, he never returned to Ireland and, apart from two visits to Naples, remained in Rome until his death. [MB]

BIBLIOGRAPHY Esdaile 1947; Hodgkinson 1954; Honour 1959, "Canova"; De Breffny 1985; Barnes 1996; Ingamells 1997

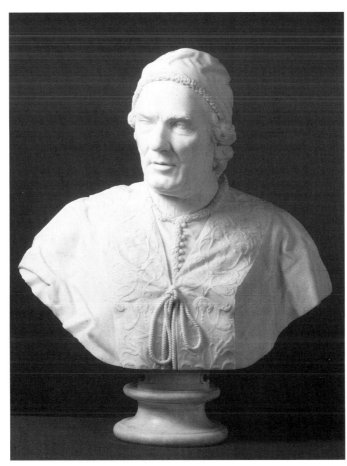

130

## 130
## Christopher Hewetson
### *Pope Clement XIV*

1772

Signed and dated: *Christophorus Hewetson Fec.t 1772*

Marble

Height 24¼″ (63 cm) (with socle)

PROVENANCE said to have been bought by the 4th Baron Hylton in Paris beween 1815 and 1835; by descent to John Twyford Joliffe, Ammerdown Park, Somerset; sale, Christie's, December 11, 1990, lot 48, when purchased by the National Gallery of Scotland

BIBLIOGRAPHY Hodgkinson 1954; De Breffny 1985, p. 55, no. 2c; Jackson-Stops 1985, p. 270; Honour and Westin-Lewis 1995, p. 11

National Galleries of Scotland, Edinburgh

The bust of Clement XIV, of which this is one of four signed and dated versions, played an important role in establishing Hewetson as the leading sculptor of portrait busts active in Rome during the 1770s. From his arrival in Rome in 1765 the Irish sculptor had succeeded in obtaining commissions for portraits from various influential British sitters as well as the support of Thomas Jenkins and Gavin Hamilton. But it was probably through this more ambitious image that Hewetson made his name known to a far wider circle of international patrons. As well as being larger in format than his earlier busts, this impressive example of a papal bust—a class of sculptural portrait with a distinguished history—provided Hewetson with the opportunity to demonstrate his ability as a virtuoso carver of marble, seen here in both the vividly executed face and such details as the embroidery on the stole and the knotted cord.

The pope probably came to agree to sit to Hewetson through the influence of Thomas Jenkins, who had sold him much antique sculpture for his planned extension of the Vatican galleries (now the Museo Pio-Clementino), although Father Thorpe commented that this had come about "by means of the all-powerful Abbe Grant" (Ingamells 1997, p. 495). It is uncertain whether the image was commissioned or undertaken by Hewetson as a speculative venture. Of the four signed versions, one was bought directly from Hewetson and another given as a gift by the pope himself. The earliest of these, dated 1771 (Beningborough Hall, Yorkshire), was probably acquired by Giles and Margaret Earle, who visited Rome between November 1770 and September 1771 and stayed in Cardinal Albani's villa at Castel Gandolfo, recording that the pope "has shown us both marks of the most condescending distinction" (Ingamells 1997, p 327). Another version (Gorhambury, Hertfordshire), dated 1772 (like the one exhibited here), was given to Edward Walter by the pope, who also gave an Elsheimer to Walter's daughter Harriet. The fourth, dated 1773 (Victoria and Albert Museum, London), was purchased from Hewetson by Thomas Mansel Talbot—a valued client of both Thomas Jenkins and Gavin Hamilton—for £140, some £72 more than the sum paid to the same sculptor for his own bust. A further unsigned marble (Yale Center for British Art, New Haven) differs in the details on the stole and is probably a workshop replica.

The close connections between the sitter and English dealers and visitors may account for the fact that three of the four known versions were acquired by British collectors. There is no evidence, on the other hand, that the present example was originally bought by (or given to) a British visitor, and its French provenance may suggest otherwise. Nonetheless, despite the way in which the British seemed keen to include a bust of the pope among their own collections of antique and modern marbles, the form of this sculpture sets it apart from Hewetson's other images of contemporary sitters. While the meticulous carving of the lines around the eyes and the pouches of skin on the cheeks recalls the subtle effects of marble carving already found in Joseph Wilton's busts in the 1750s, the image is perhaps best understood in terms of its relationship to recent papal images, most notably Pietro Bracci's marble of *Benedict XIII* (Thyssen-Bornemisza Collection, Madrid), probably carved posthumously between 1762 and 1773, or Bernandino Ludovisi's *Benedict XIV*, a version of which had been paired with the present bust when in Lord Hylton's collection (Christie's sale, London, December 13, 1990, lot 47). Such comparisons allow Hewetson to be seen as a Roman sculptor.

In its characterization of the sitter, as well as in its qualities of carving, this portrait must rank as one of Hewetson's outstanding achievements. Its status was implicitly acknowledged by Canova, when he employed a plaster version (Museo Civico, Bassano) as the basis for his own image of the pope on the monument in St. Peter's, the commission that he gained in competition with Hewetson. [MB]

## JEAN-ANTOINE HOUDON
VERSAILLES 1741–1828 PARIS

Unlike many French sculptors of the eighteenth century, Houdon did not come from a dynasty of artists. His father held the modest position of concierge at the hôtel of the Comte de Lamotte in Versailles. When he was eight, Houdon's family moved to Paris, where his father became concierge at the Ecole des Elèves Protégés, a school created to prepare artists who had won the *prix de Rome* for their studies in Italy. In a memoir of 1794 Houdon wrote: "Born on the doorstep of the academy, so to speak, I have produced sculpture from the age of nine" (Réau 1964, vol. 1, p. 99). In 1758 he registered as a student at the academy, with the sculptor Michel-Ange Slodtz listed as his teacher. Three years later he won the *prix de Rome* with a relief of *The Queen of Sheba Bearing Gifts to Solomon* (now lost). Houdon then was enrolled at the Ecole des Elèves Protégés from 1761 to 1764 under the director, Carle van Loo; there his very limited education was expanded to include history, mythology, and religion, as well as technical training in the carving of marble.

After arriving at the French Academy in Rome on via del Corso in November 1764, Houdon became a diligent student whose intense study of Renaissance, Roman Baroque, and classical sculpture, combined with that of anatomy, were to be the foundation of all his later work. Under the directorship of Charles-Joseph Natoire, he became adept at sketching and modeling in clay as well as in carving marble. Natoire did not believe that sculptors needed to draw, and there are no known drawings that can be convincingly attributed to Houdon's hand. As a result of his Roman studies of anatomy with the surgeon Séguier, he created his famous *Ecorché*, plaster casts of which were acquired by art academies throughout Europe. His sculpture of *Saint John the Baptist*, commissioned along with a sculpture of *Saint Bruno* (cat. 131) by the Carthusians for the vestibule of S. Maria degli Angeli, was based on the figure of the *Ecorché*. These two colossal figures were highly accomplished works and established Houdon's reputation as a master of monumental religious sculpture. Also dating from his Roman years is *The Priest of the Lupercalia*, a running Bacchic figure that reveals his study of Bernini's *Apollo and Daphne* group, and a figure of a *Vestal* inspired by an antique statue of *Pandora* in the Museo Capitolino.

Following his return to Paris, a selection of Houdon's Roman works was shown at the Salon of 1769, where they received modest critical praise. It was at the Salon of 1771, however, that

Houdon's reputation as a portrait sculptor was established with a bust of the Enlightenment philosopher and *encyclopédiste* Denis Diderot. The bust was admired for its striking likeness to the sitter and for its intelligent, lively expression. Its sober antique Roman style, depicting the sitter nude and without a wig, was seen as the perfect expression of Diderot's thought and personality. Despite this success, major commissions did not materialize, and Houdon turned to patrons outside of France, traveling in 1771 and again in 1773, to work at the court of Saxe-Gotha, where he executed portraits of Duke Frederick III, Duke Ernest-Louis, and Marie-Charlotte de Saxe-Meiningen, as well as other family members. During the 1770s he also received commissions from Russia for two funerary monuments for the Galitzin princes and a large marble bust of Catherine the Great, executed for Count Strogonov. Houdon was very proud of the fact that after he returned to Paris he mastered the technique of bronze casting and set up his own foundry.

Houdon became a member of the Académie Royale de Peinture et de Sculpture in 1777 with his marble of *Morpheus*, submitted as his reception piece. Although trained to work for the French crown, he received only a few commissions from the king, the most important of which was the marble statue of the Maréchal de Tourville, one in the series of *Great Men*, ordered in 1789. His most famous works—the large marble *Diana*, dated 1780, first intended as a garden sculpture for the court of Saxe-Gotha, but later acquired by Catherine the Great, and the marble *Seated Voltaire*, shown at the Salon of 1781 and commissioned by Voltaire's niece, who gave it to the Comédie Française—were not done for the crown. While he did execute some garden sculptures, reliefs, and religious sculptures, the focus of Houdon's work after 1771 was on portraiture, and his sitters were the great figures of the Enlightenment such as Voltaire, Rousseau, Buffon, and d'Alembert, as well as aristocrats, magistrates, military figures, writers, actors, actresses, and children. His American sitters included Jefferson, Franklin, Governor Morris, Robert Fulton, and George Washington. Jefferson wrote to Washington in December 1784, "I find that a Monsieur Houdon, of this place, possesses the reputation of being the first statuary of the world" (Réau 1964, vol. 1, p. 57), and recommended that Houdon do the portrait of Washington for the state of Virginia. Houdon then traveled to the United States with Benjamin Franklin in September 1785, and stayed three weeks in order to

measure and model a bust of Washington. The full-length marble statue was not delivered until 1796. As in the case of Washington, Houdon's works often established the accepted image of his sitters.

In the years immediately following the French Revolution, Houdon had few commissions and turned to modeling busts of members of his family and friends, in which he achieved a freshness, intimacy, and informality that were to influence the work of sculptors such as David d'Angers and Carpeaux. Under the directory and the empire he executed a number of portraits of prominent figures such as Lavoisier, the Marquis de Pastoret, and Marie-Joseph Chénier, as well as those of Napoleon and Josephine, adapting his style to the fashions of the time while maintaining a very high level of quality in the depictions of his sitters. He exhibited for the last time at the Salon of 1814, and fell into mental illness at the end of his life. [ALP]

BIBLIOGRAPHY Lami 1910, pp. 408–36; Giacometti 1929; Mansfeld 1955; Réau 1964; Arnason 1975

## 131
### Jean-Antoine Houdon
*Saint Bruno*

Probably 1766–67
Plaster
33¼″ × 12¾″ (84.4 × 32.5 cm)

PROVENANCE Brinckmann states that this and other plasters by Houdon came from the estate of the court sculptor in Gotha, F.W.E. Doell (Brinckmann 1923–25, p. 133), and Réau states that this *Saint Bruno* is the "original plaster model presented by the artist to the duc de Saxe-Gotha" (Réau 1964, vol. 2, p. 16), but there is no documentary evidence to substantiate either claim. The earliest mention of the sculpture in the surviving inventories of the court of Saxe-Gotha is in the Schlossmuseum Archive, "Catalog der Sammlung der Gips-Abgüsse" [manuscript], 1845, under "Kleinere Statuen," no. 54. "*Saint Bruno* (von Goùdon [*sic*] )"; it is listed in subsequent inventories: Schlossmuseum Archive, as "Verzeichniss der antiquen Abgüsse" [manuscript], written before 1851, no. 54; Schlossmuseum Archive, "Verzeichniss der Abgüsse antiker und moderner Bildhauerarbeiten im Herzogl: Antiken-Cabinet zu Gotha" [manuscript], 1857, no. 61; Schlossmuseum Archive, "Journal für die Sammlung der Abgüsse antiquer Bildwerke" [manuscript], 1858, no. P2H; and Edouard Wolfgang, "Verzeichniss der Sammlung der Abgüsse im Herzoglichen Museum zu Gotha" (Gotha, 1869), p. 23, no. 37

EXHIBITIONS Paris 1769, *Salon de 1769*, not catalogued; Berlin 1955, no number; Duisberg and Gotha 1987, cat. no. 85

BIBLIOGRAPHY *Lettre sur l'exposition des ouvrages de peinture et de sculpture au Salon du Louvre*. Paris, Bibliothèque Nationale, Collection Deloynes, 1769; *L'année littéraire*. Paris, Bibliothèque Nationale, Collection Deloynes, 1769; *L'avant-coureur*. Paris,

Bibliothèque Nationale, Collection Deloynes, 1769; *Sentiments sur les tableaux exposés au Salon*. Paris, Bibliothèque Nationale, Collection Deloynes, 1769; *Lettre adressée aux auteurs du Journal encyclopédique au sujet des ouvrages exposés au Salon du Louvre en 1769*. Paris, Bibliothèque Nationale, Collection Deloynes; Dierks 1887, pp. 25, 116; Aldenhoven 1911, p. 142; Réau 1923, pp. 43–46, 49–50, 52; Brinckmann 1923–25, vol. 3, pp. 132–33; Giacometti 1929, vol. 2, 26, vol. 3, pp. 218–19; Schwark 1930, p. 49, pl. 40.1; Lindeman 1942, pp. 228–35; Réau 1945, pp. 96–98; Mansfeld 1955, pp. 28–32, no. 2; Bogyay 1964, p. 113; Réau 1964, vol. 2, p. 16, no. 18; Arnason 1975, p. 12, pl. 7; Schuttwolf 1995, pp. 132, 173, no. 46
Schlossmuseum Gotha

This plaster sculpture of Saint Bruno is a small-scale version of, and perhaps a cast of the original model for, Houdon's over life-size marble statue of Saint Bruno in the church of S. Maria degli Angeli in Rome. The *Saint Bruno*, along with a statue of Saint John the Baptist, was commissioned by Dom André Le Masson, the French procurator-general of the Carthusian order of friars in 1766 from the twenty-five-year-old Houdon, who had arrived as a *prix de Rome* winner at the French Academy in Rome in late 1764. Representing the patron saint and the founder of the order, the statues were to occupy two niches flanking the vestibule of the church, which was the seat of the Carthusian order in Rome. Natoire, director of the French Academy, wrote to Marigny on July 16, 1766: "One of our sculptors, named Oudon [*sic*], has undertaken to produce two statues for the Carthusian church in Rome. The French procurator-general of the house, who knows the young artist, told me about his project and of his intention to avail himself of Mr. Oudon. I very much approved of his idea and assured him of the merit of his choice, with the result that the young sculptor has set to work and made a very good model, which he is now executing full-size. I believe this opportunity could be the making of him." ( Montaiglon 1887–1912, vol. 12, p. 119). The colossal marble statue of *Saint Bruno* was completed and installed in its niche in 1767.

Houdon's *Saint Bruno* is a remarkable achievement for a young sculptor. It was certainly conceived as a stylistic alternative to the dramatic neo-Baroque marble figure of the same saint executed by Houdon's teacher Michel-Ange Slodtz in 1744 for St. Peter's in Rome. In contrast to the twisting figure of Slodtz's *Saint Bruno*, who gestures with his left hand to refuse a bishop's miter and staff offered by a putto while pointing to a skull with his right hand, Houdon's robed figure stands motionless and introspective, without attributes, his

arms folded across his chest, and his eyes lowered. Contemporary critics praised the figure for embodying the humility, faith, and vow of silence associated with the Carthusian order. Avoiding all narrative detail, Houdon has distilled these qualities in his monumental figure of the saint.

From the memoirs of a fellow student at the French Academy, Johann Christian von Mannlich, it is known that in 1766 Houdon was studying anatomy by dissecting corpses under the tutelage of a French professor of surgery named Séguier at S. Luigi dei Francesi in Rome (see Johann Christian von Mannlich, *Histoire de ma vie* [Trier: Spee, 1989], vol. 1, pp. 260, 269). From these studies he composed his famous *Ecorché*, which served as a model for the statue of Saint John the Baptist and the head of which also served as a model for the head of Saint Bruno. One senses the body of the saint under his heavy robes, and the ideal proportions of the figure, as well as his pose recall those of famous classical statues familiar to Houdon, such as the *Antinous* in the Museo Capitolino. The style of the *Saint Bruno*, which was the result of the sculptor's close study of anatomy combined with an equally careful study of classical prototypes, was to characterize all of Houdon's later work.

Two small terracotta statuettes in Hamburg (see Christian Theuerkauff and Lise Lotte Möller, eds., *Die Bildwerke des 18. Jahrhunderts* [Braunschweig, Germany: Klinkhardt & Biermann, 1977], pp. 280–83, nos. 164–65) have been attributed convincingly to Houdon and seem to be preliminary studies for the figure of Saint Bruno. In one the saint is depicted holding an open book, and in the other his hands are clasped in front of him in a slightly more active pose as he looks down to his right. The plaster here, which is virtually identical to the marble, is simpler and more columnar in composition, and the saint, who has his eyelids lowered in contemplation, is conceived to fit quietly into the space of a niche.

It is possible that the reduced plaster version of the *Saint Bruno* that Houdon exhibited at the Salon of 1769, following his return to Paris, is identical with this version. Other examples of his work from the Roman years were shown at that Salon (Réau 1964, vol. 1, p. 26), and of them four are in the collection of the court of Saxe-Gotha. Perhaps when Houdon made his second trip to Gotha in 1773 he took the plasters of the four sculptures with him. Eighteen plaster casts of sculptures by him appear in the court inventory of 1845, but their dates of acquisition are not mentioned, and earlier inventories have not survived. [ALP]

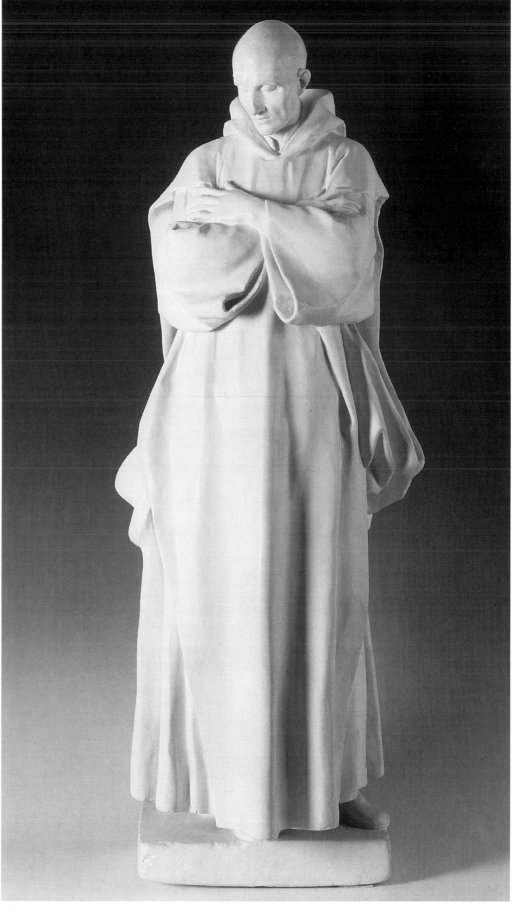

131

## PIERRE LEGROS II

### PARIS 1666–1719 ROME

Pierre Legros must be considered the most important French sculptor working in Rome during the last years of the seventeenth and first two decades of the eighteenth century. Much like his compatriot Nicolas Poussin two generations earlier, Legros came to Rome to study but ended up settling there for good. He became, for all intents and purposes, a Roman sculptor, although his works reveal his French roots. Legros arrived in Rome in 1690, after having received his first training in France from his father, Pierre Legros I, a capable, though not outstanding member of the team of sculptors decorating Versailles. The younger Legros attended the Académie Royale in Paris and was sent as a *pensionnaire* to Rome to complete his education. His extraordinary talent was soon recognized, and he garnered notable commissions, for example in 1695 the large marble group *Religion Overthrowing Heresy* for the Chapel of S. Ignazio in the Gesù, the mother-church of the Jesuits in Rome. Perhaps Legros's best-known work, it conveys the dramatic narrative of a painting or relief, although it lacks a background. The figures, arranged on a sharp diagonal, are not just statues on a pedestal: the huge personifications of Hatred and Heresy tumble over architectural elements rather than being supported by them, while the putto ripping leaves from a heretical book braces it against a conveniently located volute. In 1697 Legros won the competition for the life-size silver statue of *Saint Ignatius* above the altar of the same chapel with a model chosen among twelve rival entries. The artist's brilliant career continued with an uninterrupted succession of substantial and innovative works that covered all categories of sculpture.

Among his large single figures, the *Saint Dominic*, 1701–6, in St. Peter's and, even more so, the *Saint Francis Xavier*, 1702, in S. Apollinare show an approach to composition that was fundamentally different from that of preceding or contemporary Italians. Legros conceived his figures less anatomically—from the inside out, so to speak—but rather in the reverse direction. Keeping the poses simple and natural, he invested most of his creative energy in the surface, the sculptural "skin," which he chiseled into extremely subtle patterns, ranging from small, flickering patches to large, deep zones of light and dark. While this surface sensibility and love of detail are essentially French, Legros also absorbed Bernini's models of theatrical presentation and use of colored marbles, for example, in his *Saint Stanislas Kostka*, 1702–3, in the novi-

tiate of S. Andrea al Quirinale. The luminous, almost sickly white of the dying young saint's skin is paired with deep black for his habit and striped ocher for the bedcover. The highly polished marbles strike the visitor, who approaches the recumbent figure without any barriers, simultaneously as shockingly realistic and strangely removed.

Legros's statue of *Cardinal Girolamo Casanate* (1706–8; Biblioteca Casanatense, Rome) ushered in a new type of sculptural full-length portrait whose grand, elongated figure has been compared to paintings by Philippe de Champaigne (Nava Cellini 1982, p. 10), but whose relaxed authority and self-confidence bespeaks the greater informality of the eighteenth century and inspired Giovanni Battista Maini's *Cardinal Neri Corsini* (1733–34; Corsini Chapel, St. John Lateran). Legros was one of only three sculptors invited to create more than one statue for the great Apostles series in St. John Lateran. Unlike most of the others involved, neither Legros's *Saint Thomas*, (1705–11), nor his *Saint Bartholomew*, (1705–12), derive from drawings by the supervising painter Carlo Maratti, underscoring the sculptor's reputation and independence. For large, official works, such as the Lateran Apostles, Legros employed a rhetorical grandeur and overt pathos related to Bernini and other Baroque masters, but most of his statues exude a more restrained, intimate, even introverted attitude with sweet faces and large, heavy-lidded eyes that belong to the spirit of the new century.

Beginning with his early *Pius V on His Deathbed* (1697–98; S. Maria Maggiore) and *Saint Luigi Gonzaga in Glory* (1698–1700; S. Ignazio), Legros's reliefs must have astonished contemporaries. The *Pius* is a very shallow relief in glittering gilt bronze with a largely linear, yet extraordinarily powerful depiction of the deceased, while the *Saint Luigi* pushed pictorial effects in sculpture to new limits. In the *Tobit Lending Money to Gabael* (1702–5; chapel of the Monte di Pietà) and the late *Saint Francis of Paola Interceding for the Sick* (1716–19; S. Giacomo degli Incurabili) the narrative remains effective despite the complex compositions with numerous figures. In the *Tobit* relief the actions of the protagonists in the foreground remain clear amid rich draperies, detailed furnishings, and other decorative elements. The detailed and minutely modeled physiognomies of the figures in the *Saint Francis* relief are particularly expressive and moving, as is the soft flesh of an ailing child, which is contrasted with the more sharply drawn muscles of the adult sufferers. Stylistically, Legros's reliefs owe more to Bernini and especially Alessandro

Algardi, but completely bypass his immediate predecessors, Antonio Raggi and Domenico Guidi, and only occasionally take up compositional motifs from Ercole Ferrata or Melchiorre Cafà.

With Jean-Baptiste Théodon and Pietro Stefano Monnot, Legros was one of the prominent and influential members of the French school of sculptors that held sway in Rome until the definite reestablishment of Roman hegemony under Camillo Rusconi and his students. The fact that Legros was never patronized by Clement XI Albani, who favored Rusconi, is indicative of the pope's deliberate support of a native artist over a foreign-born one, in spite of the latter's proven abilities and success. Legros's rarified surface aesthetic had no lasting following in Rome but was promulgated in France, for example by his student Guillaume Coustou. Modifying the Roman Baroque, Legros's unusual and brilliant works constitute an interlude in early eighteenth-century Rome that heralds the sensibilities of the Rococo. [sw]

BIBLIOGRAPHY Enggass 1976, vol. 1, pp. 124–48, and vol. 2, figs. 93–146; Nava Cellini 1982, pp. 9–12; Souchal 1993, vol. 2, pp. 273–99, and vol. 4, pp. 145–50; Bissell 1997

## 132

## Pierre Legros II
### *Saint Luigi Gonzaga in Glory*

c. 1699
Terracotta
34″ × 16″ (86.4 × 40.6 cm)

PROVENANCE Bartolomeo Cavaceppi, Rome, before 1791; Villa Torlonia, Rome, by 1802; Kurt Glaser, Berlin; Schaeffer Galleries, Inc., New York

EXHIBITION Detroit 1965, cat. no. 61

BIBLIOGRAPHY Richardson 1942; Cummings, Frederick J., and Charles H. Elam, eds. *The Detroit Institute of Arts Illustrated Handbook*. Detroit: Wayne State University Press, 1971, p. 113; Kerber 1971, p. 184; Enggass 1976, vol. 1, p. 135; Contardi 1991, p. 39; Souchal 1993, vol. 2, p. 282, no. 10b; Barberini and Gasparri 1994, pp. 130–31, fig. 118; Contardi 1996, pp. 96–114; Bissell 1997, p. 45, n. 3, cat. no. 10A

The Detroit Institute of Arts, Founders Society Purchase, General Membership Fund

This terracotta represents a preparatory model for one of Legros's most innovative early works, the *Saint Luigi Gonzaga in Glory*. The large marble relief forms the centerpiece of the Lancellotti Chapel in the right transept of the Jesuit church of S. Ignazio. The painter–architect Andrea Pozzo, himself a Jesuit, oversaw the design and construction between 1697 and 1699, collaborating with Legros, as he had on the altar of S. Ignazio in the

Gesù just a few years earlier. From an engraving after an early design, it is known that Pozzo provided the first idea for the composition, but Legros felt free to alter it substantially. Taking inspiration from the *Saint Catherine of Magnapoli* relief by Melchiorre Cafà from 1667, Legros united Pozzo's separated elements—the statue of the saint, the upper and the lower groups of angels—into a single, monumental marble picture. In the terracotta, as in the marble, the young saint, rising up tall and slender, dominates the scene, although his head is modestly bowed. His quiet, introverted meditation, emphasized by his hands pressed to his heart, stands in marked contrast to the swirling clouds and busily engaged angels and putti. The lower group, which provides a kind of base for the saint to kneel on, has as its main protagonist a prominent larger angel in the lower left, holding a lily (his arm is missing in the terracotta). His glance and gesture are reciprocated by his counterpart in the upper group, who holds a wreath of flowers (also broken in the terracotta). The two angels form part of a long diagonal that visually connects the ends of the tall relief and leads the viewer's eye to concentrate on the saint in the center. Indicated in the terracotta but even more apparent in the marble are the different surface textures that Legros employed with great mastery. The entire figure of Saint Luigi, in his simple, unadorned habit, was given such a gleaming polish that he stands out in startling white against the more roughly stippled clouds and less shiny angels. This makes the viewer experience the heavenly radiance that illuminates the saint's body as a symbol of his inner purity. In his statue-cum-pictorial relief Legros effectively combined features of both sculpture and painting (Bissell 1997, p. 45), an achievement that his contemporaries greatly admired, as is proven by numerous copies on paper and in sculpture (references compiled in the curatorial files of the Detroit Institute of Arts).

The Detroit terracotta documents a particular stage in the typical process of creating a large marble relief. Expensive and complex, such a work required careful deliberations, especially when more than one artist was involved. As mentioned above, Pozzo prescribed the basic parameters of the work, which Legros would have refined in a series of sketches. A drawing in the Musée du Louvre (Inv. 30495) is disputed among scholars as to its attribution to Legros (Kerber 1971, p. 184; Contardi 1991, p. 26; Bissell 1997, p. 45, n. 1). An architectural model by Pozzo of the entire chapel with a painted rendition of the central relief is preserved in Castel S. Angelo, Rome. In

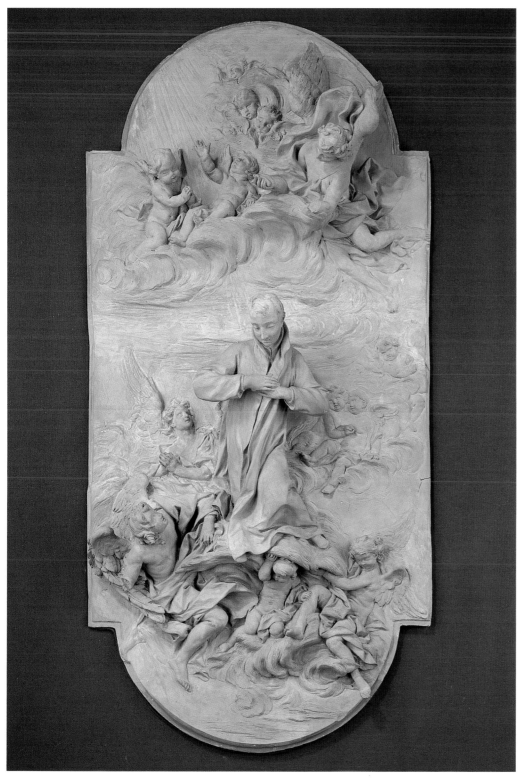

132

lection of Baroque models is known to have owned this piece in the late eighteenth century. That this master of Neoclassicism thought so highly of Legros's work is testimony to the lasting fascination with his innovative, proto-Rococo art. [SW]

## GIOVANNI BATTISTA MAINI

### CASSANO MAGNAGO 1690–1752 ROME

Born in a small town in Lombardy, Maini probably received his first training in Milan, before entering the studio of Camillo Rusconi; he lived with his teacher (together with Giuseppe Rusconi) from 1709, and the contract of 1721 for Camillo's altar of St. Jean-François de Régis in Madrid specified that, in the event of his death, it should be completed by either Maini or Giuseppe Rusconi. On his marriage in 1725 to Margarita Scaramucci, Maini moved to his own house (where Filippo della Valle lived with him until he too married). Rusconi's influence was profound, and Maini adopted many of Rusconi's mannerisms, such as his liking for broad planes and drapery stretched over outreaching arms, and followed his modified Baroque style, which owed more to Algardi than to Bernini.

Maini's first known work, the angels, putti, and glory over the high altar of S. Agnese in Rome (contract 1724), was designed by the architect Domenico Calcagni, and F. S. Baldinucci stated that Camillo Rusconi designed Maini's tomb of Innocent X in the same church, completed in 1729, though this is improbable. By 1730, when the authorities in Foligno commissioned Maini to provide the model for the gilt-bronze and silver statue of their patron Saint Feliciano for the cathedral, they called him "the foremost sculptor in Rome" (M. Faloci Pulignani, *I priori della Cattedrale di Foligno* [Perugia, Italy, 1914], p. 332).

Camillo Rusconi was to have made stucco emblems of the Evangelists in the pendentives of the Accademia di S. Luca's church of Ss. Luca e Martino; after his death in 1728 Giuseppe Rusconi followed his model for the *Saint Matthew*, and this, or Camillo's drawings, provided the basis for Maini's *Saint John* and *Saint Luke*, and Della Valle's *Saint Mark*. Pietro Bianchi provided designs for several sculptors, and is said to have made that for Maini's *Saint Francis of Paola* among the statues of the Founders of Religious Orders along the nave of St. Peter's, completed in 1732. But normally Maini designed his own work, and his inventive capacity can be judged from his many fine drawings, mainly in private collections.

consultation with the painter–designer, Legros would have prepared a number of wax or terracotta *bozzetti*, smaller, quick, three-dimensional sketches, none of which appears to survive. These would have culminated in a *modello* that represented the agreed-upon, more or less final composition. That this piece is in fact such a *modello* is proven by its finished surface, the

only minor deviations from the final work, and the unusual scalloped shape of the terracotta which corresponds to that of the executed relief. The *modello in grande*, a large-scale proof in plaster or stucco, was the last step before carving the marble. For the *Saint Luigi* relief it still exists in the Cereria of S. Ignazio and was used to test lighting effects and correct perspectival distortions.

Smaller sculptural works, such as this terracotta were avidly sought by fellow artists, who kept them in their ateliers as models by admired masters and tools for study and inspiration. Only in the eighteenth and nineteenth centuries did they begin to be seen as works of art and became connoisseurs' collectibles. The sculptor Bartolomeo Cavaceppi, who amassed a huge col-

Four statues for the church of Mafra, *Saint Gabriel* (1731) and *Saint Michael* (1732), *Saint Clare* and *Saint Elizabeth of Hungary*, established Maini's reputation in Portugal. By the early 1730s he had completed his stuccos for the altar of Saint Francis of Paola in S. Andrea delle Fratte in Rome. In 1733 he signed the contract for his best-known work, the tomb of Cardinal Neri Corsini in St. John Lateran; the figure of the cardinal is indebted to paintings such as Philippe de Champaigne's *Cardinal Richelieu*, and the figure of Religion beside him owes much to Camillo Rusconi's tomb of Leo XIII. Maini also made the model for the bronze figure of Clement XII on his tomb in the same Corsini Chapel, and, in the portico of the basilica, a relief of *Saint John Preaching*. From 1734 to 1737 he produced his second statue for the nave of St. Peter's, *Saint Philip Neri*, this time certainly from his own design.

From 1734 dates Maini's involvement with the Trevi Fountain. Disputes with the architect Niccolò Salvi, the deaths of popes, and shortage of funds dragged the work on until after Maini's death, when his work was abandoned, to be replaced by remarkably similar statues of *Oceanus* and a pair of *Tritons* with their seahorses by Pietro Bracci.

By 1741–43 Maini was one of many sculptors employed on the façade of S. Maria Maggiore in Rome (*Virginity* and *Saint Gelasius I Burning the Heretical Books*), and in 1742 he made the stucco decoration for the altar in the left transept of the cathedral in Città Castellana, surmounted by almost slinky personifications of Faith and Charity. In 1744 he began his extensive work for Lisbon: the models for a bronze relief of the *Virgin and Child* and a silver *Virgin of the Immaculate Conception* for the destroyed Patriarcate, and models for some of the silver altar furniture for the church of S. Roque.

For Rome, he made the *Angels* over the altar in the right transept of S. Maria della Scala (before 1745) and probably in 1745–46 the stucco altar and allegorical reliefs in the Ristretto degli Angeli of the oratory of the Caravita. He modelled the stucco *Annunciation* in the dome of the SS. Nome di Maria (1746) and the stuccos of the altar of Saint Anne in S. Andrea delle Fratte (begun 1749). In 1749 he contracted to make the tomb of Scipione Santacroce in S. Maria in Publicolis, which was finished in the following year. From 1750 dates the seated statue of *Pope Benedict XIV* in the convent of S. Agostino, and the stucco decoration in the vault and transepts of St. Peter's, by the windows of the nave, and on the inner façade; two gilt stucco reliefs in the grotto below the high altar were probably also made for the holy year. In 1748 he sent a marble statue of *Charles III* to Montecassino

133

(largely destroyed) and in the same year signed the contract for the marble relief of the *Death of the Virgin* for the decoration of the Chigi Chapel in the cathedral of Siena (terracotta in Berlin).

Other works, some destroyed, some at least projected, are attested to by his drawings, and, like all sculptors of the time, Maini made copies of ancient marbles for British Grand Tourists, such as the Callipigian *Venus* at Wentworth Woodhouse (England) of 1749–50.

Also typical of the time was Maini's involvement in collaborative enter-

prises, but his contributions stand out for their originality, sometimes showing little interest in spatial norms, and reducing the setting to a few symbolic elements (as in the *Death of the Virgin* in Siena). The simplified planes of his draperies are broken by sharply angular folds, or are set billowing out against the laws of nature (as in the *Annunciation* in SS. Nome di Maria or *Gelasius I* in S. Maria Maggiore). Maini was possibly less successful, and certainly less well known than his younger rival Pietro

Bracci, but his manner was carried on by pupils such as Pietro Pacilli and, in his earlier works, Innocenzo Spinazzi. [JM]

BIBLIOGRAPHY Golzio 1933; Riccoboni 1942; Colombo 1966; Colombo 1967; Fleming and Honour 1967; Colombo 1968; Lavalle 1981, pp. 276–304; Nava Cellini 1982, pp. 34–36; Montagu 1985, pp. 387–88; Montagu 1993; Enggass 1995, pp. 423–38; Montagu 1995, pp. 386–90; Montagu 1996; Montagu 1996, "Statue"; Rocchi Coopmans de Yoldi 1996, pp. 359–64; Marchionne Gunter 1997

## 133
### Giovanni Battista Maini
*The Archangel Michael Presenting the Shield Inscribed "Charitas" to Saint Francis of Paola*

After 1728
Terracotta
The extensive and serious cracks have been restored for the exhibition.
22⅜″ × 17″ (57 × 43 cm)
BIBLIOGRAPHY Golzio 1933, pp. 33, 51; Riccoboni 1942, p. 287; Fleming and Honour 1967, pp. 255, 258; Rocchi Coopmans de Yoldi 1996, p. 359
Accademia Nazionale di San Luca, Rome

On August 8, 1728, Maini was elected to the Accademia di S. Luca, together with Giuseppe Rusconi and Giacomo Cioli. On September 5 all three took the customary oath, and Rusconi and Cioli presented a terracotta and an architectural drawing as their respective reception pieces; Maini, however, "not having any model," was allowed six months to provide one (Rome, Archivio dell'Accademia Nazionale di S. Luca, Congregazioni, vol. 49, fol. 37v). There appears to be no record of his doing so, but this terracotta has always been assumed to be the reception piece that, presumably, he did present, since he remained in good standing in the academy, and even became its Principe in 1746.

The wording of the entry, "Il S.r Gio. Batta Maini, non avendo alcun modello … ," suggests that, rather than make something special for the academy, newly elected members would give a previous work (Congregazioni, vol. 49, fol. 37v). In this case, the terracotta is closely related to the stucco half-lunette over the chapel of St. Francis of Paola in S. Andrea delle Fratte in Rome; indeed, apart from the angels at the upper left and the tree just below them, filling the area added to the composition to turn it into a rectangle (in the stucco the rays from the shield overlap the frame), it would seem to correspond almost exactly. The only other noticeable differences from the stucco are the smaller proportions of Saint Michael, and the position of the three infant angels on the ground, who are slightly further to the right in the stucco. Most probably this is a copy derived from the models Maini must have made for the relief.

This represents the miraculous appearance of Saint Michael (to whom Saint Francis of Paola was particularly devoted), bearing a radiant shield inscribed with the word *Charitas* ("Charity"), which the saint was instructed to take as his own emblem, and that of the order he founded, the

Minims. The stucco is to the left of the window in the arch over the altar; on the right is Pietro Bracci's stucco relief of the three crowns that were seen over the head of the kneeling saint during mass. The archivault above is covered with heavy decorative stuccowork, incorporating cherubim that may well have been modeled by Maini. Over the altar-frame is a group of five cherubim supporting the Cross: the clouds, three stucco cherubim, and one cherub head are Maini's own figures, but for the two holding the Cross he incorporated, and presumably completed, two unfinished marble putti by Bernini that had remained in the family after the sculptor's death, and which were still there in 1731 (see Marchionne Gunter 1997). The frame of the altarpiece (a standing figure of the titular saint) is supported by two gilt stucco angels, also by Maini.

The chapel of Saint Francis of Paola, in the right transept of the church, was built between 1726 and 1736, to the designs of Filippo Barigioni, with the active support of the undersacristan, Fra Giulio Casali. In 1749 Casali was to initiate the altar of Saint Anne in the opposite transept, where Maini was responsible for all the stucco in the arch above, which follows the same general design.

No documentation recording the history of the construction of the altar of Saint Francis of Paola has been published; nor did Bracci include his companion stucco relief in the diary of his sculptures, which lists only those in marble and bronze. While it is normal to begin the decoration of an altar from the top, in this case it may have been prudent to postpone the stucco modelling over the altar until the basic building work had been completed. If so, this might explain why the model was available only after August 1728.

Stylistically, it is clearly an early work, with none of the eccentricities that mark Maini's fully developed manner, and which are so evident in the stuccos of the opposite transept. The composition has been compared to Camillo Rusconi's relief of *Saint Jean-François de Régis* in Madrid, and the easy flow of the composition and the broad planes of the drapery are derived from Rusconi, but the curling end of the angel's robe at the right is a more personal touch. It is modeled throughout with great sureness, and the high degree of finish in many of the details does not lessen its lively spontaneity. [JM]

### CARLO MARCHIONNI
ROME 1702–1786 ROME

Carlo Marchionni was an unusual eighteenth-century Roman artist because he did everything. In a tradi-

tion of omnicompetence that was more widespread in the Renaissance and Baroque periods, he eschewed specialization: he was painter, sculptor, architect, scenographer, designer, and a draftsman of the highest order. His six hundred or more surviving drawings run the gamut from architectural ground plans, elevations, designs for sculpture, plans for festive events, to landscape sketches, caricatures, even calling cards. He studied under the architect Filippo Barigione (who also provided designs to sculptors) and won the first prize for architecture in the Concorso Clementino at the Accademia di S. Luca in 1728. His prize-winning drawing shows an arcaded belvedere arranged as a hemicycle or exedra that anchors a portside piazza. This may have captured the attention of Cardinal Annibale Albani, who used Marchionni as the architect of a seaside villa at Anzio.

Marchionni's sculptural activity was mostly restricted to the years 1730–48. He was not of the caliber of Della Valle, Bracci, or Maini; nor did he compete with them. Although the corpus of his sculptural production is fairly slight, his relief of the Lateran Council of 1725 (cat. 134) demonstrates both a remarkable facility in the arrangement of a complex relief narrative and significant skills in cutting marble. In addition to collaboration on the tomb of Benedict XIII, he designed the architecture for the tomb of Cardinal Gian Giacomo Millo (1760; sculpture by Pietro Pacilli) for the church of S. Crisogono, statuary for the façade of S. Maria Maggiore, a half-figure of Benedict XIV for S. Croce in Gerusalemme, a figure of Saint Ignatius for S. Apollinare, and busts of Founders (c. 1745) in the Collegio di Propaganda Fide (all in Rome). He also sent outside of Rome reliefs showing the life of the Virgin (1747) for the chapel of S. Roque in Lisbon and a statue for the chapel of the Madonna del Voto (1748) in Siena.

Marchionni was perhaps more at ease in his smaller constructions than in the larger ones. The half-figure of Benedict XIII (S. Croce in Gerusalemme), who seems to be emerging from his own pedestal, at first seems an ungainly and unlikely presentation of a blessing pope. His over life-size figure of Saint Ignatius (S. Apollinare) is more successful and is reminiscent of figures by such French sculptors active in Rome in the early eighteenth century as Pierre Legros and Michel-Ange Slodtz. Marchionni's sculptural style is somewhere between the refinement and elegance of the *francese* and the weightier late Baroque style of Camillo Rusconi.

Marchionni labored in the shadow of more successful architects until

about 1750. By then Alessandro Galilei was dead, and Luigi Vanvitelli and Ferdinando Fuga had left for Naples. Having worked for years for the Albani family, he was a natural choice as architect of the new villa built for Cardinal Annibale Albani. The designing of the Pallazina was begun in 1755, and the interior decorations were completed by 1762. It has often been pointed out that Marchionni may have been in some ways the least appropriate architect for Cardinal Albani, whose love and knowledge of antiquity are nowhere reflected in the actual design of the villa. However, there are numerous decorative touches on the interior that are inspired by ancient Roman, Greek, and Egyptian sources, and if Marchionni had any role in the designing of the two Greek temples (one of which was built as a ruin), then he was satisfying the taste for the antique.

In the 1770s Marchionni held several positions with the Fabric of St. Peter's. First he was Architetto Revisore (an architectural "auditor" or reviewer of projects), and chief architect in 1773. There he undertook the daunting task of building a sacristy. Because of the great scale of the adjacent basilica, Marchionni had to make a monumental statement in a building that does not normally require much size or grandeur. The main part of the building is a large, domed octagon, with subsidiary spaces clustered about the center.

Since the papacy of Clement XII, there had been considerable work carried out on the harbor at Ancona. Clement felt that he could improve the papal economy by making Ancona a free port. He largely succeeded in creating the port and renewing the urban fabric nearby, but as an economic strategy it was a disaster. Natural resources departed by the port, and wool, leather, and silk—goods that directly competed with Italian production—entered, free of tax. Nonetheless, once the harbor at Ancona became busy, it needed attention. Marchionni worked on the wharf and other architectural projects in Ancona off and on throughout the later years of his career, including the church of S. Domenico (1763–86), and after his death, his son Filippo carried on the projects into the next century.

Although he was connected to the grand tradition of the Baroque through his apprenticeship with Barigioni (who was a student of Carlo Fontana and Mattia de Rossi, both disciples of Bernini), Marchionni spent most of his artistic career in the century of good taste and, eventually, Neoclassicism. In both his architecture and his sculpture he compromised among the various modes open to him, creating a not unpleasant mélange of styles. Like many other half-forgotten artists, his

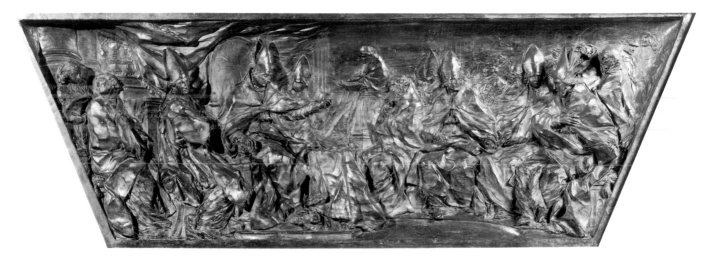

134

134

talents outstripped his accomplishments, yet he left behind an interesting body of works that deserves further study within the circumstances of a complex period of shifting values and power structures. [VHM]

BIBLIOGRAPHY Berliner 1958–59; Gaus 1967; Polichetti 1975; Gambardella 1979; Cousins 1981; Hager 1981; Roettgen 1982; Arcangeli 1985; Debenedetti 1988; Garms 1992; Kieven 1996

## 134
## Carlo Marchionni
### The Lateran Provincial Council of 1725

1737
Signed: *C Mar Arch s Roma fe Anno 1737*
Patinated stucco
Height 18⅞″ (48 cm); top measurement 51¼″ (138 cm); bottom measurement 39″ (99 cm)
PROVENANCE exhibited with the completed monument in the chapel of S. Domenico, S. Maria sopra Minerva from 1737 until 1739; Palazzo Orsini; Orsini sale, Galleria S. Giorgio, Rome, 1896, no. 429
BIBLIOGRAPHY Chracas, *Diario Ordinario di Roma*, August 11, 1736, no. 2969; Chracas, *Diario Ordinario di Roma*, August 10, 1737, no. 3124; Chracas, *Diario Ordinario di Roma*, February 28, 1739, no. 3365; Domarus 1915, pp. 19–21; Gradara Pesci 1920, pp. 35–37, 99–100; Gaus 1967, pp. 132–35; Nava Cellini 1982, pp. 52–54
Private collection

Pietro Francesco Vincenzo Maria Orsini was pope from 1724 to 1730 with the name Benedict XIII. He died on February 21, and for a while word of his demise was kept from Rome's carnival revelers. When finally in the evening of the same day his death was announced, the theaters emptied and everyone returned home, honoring the man perhaps more than his papacy. Although a prelate of great humility and piety, his ignorance of

human deceit was nearly absolute. He left the management of papal affairs to Cardinal Niccolò Coscia, infamous for his perfidiousness and cunning (he was excommunicated and imprisoned by Benedict's successor Clement XII [De Caro 1966]).

Nonetheless, Benedict recognized human vanity when he saw it, and railed against the worldliness of the clergy. With much resistance from the elegant cardinals, he forbade them wigs (their perukes, he objected, hid the tonsure). In 1725, once again against the wishes of the cardinals, he called the provincial council, depicted here, seeking to clarify and reassert the duties of bishops and parish priests.

Benedict was known for his stubbornness, which is evident in the details of the relief. The conference report reveals that the opening discourse lasted up to three quarters of an hour (*Diario del Concilio romano celebrato 1725* [Rome, 1728]). Marchionni's relief represents both the opening speech, and in proleptic form, all subsequent addresses and sermons. The sculptor stressed the pope's demureness by showing his head lowered, but with Benedict's rising hand there can be little doubt that the bishops and cardinals received his message. Marchionni introduced a remarkable degree of detail into the relief so that the observer can read gestures and expressions and conjecture the reactions to Benedict's commands. The sculptor also demonstrated his skill at *rilievo schiacciato*, "crushing" the surfaces so as to create a sense of impressionistic background detail and significant depth, one far greater than the actual pitch of the relief.

There were a number of good results from the council (see Pastor 1938–53, vol. 34, pp. 162–64). New guidelines were developed that pertained to the instruction of young boys, on how sermons should be adapted to the interests and the intel-

lectual level of the listeners, and on the necessity of annual visits by bishops to their dioceses. Benedict is also shown discoursing on the choice and quality of *vicari generali*—the deputies of bishops—and on the just distribution of benefices and housing for priests, the keeping of inventories, the proper life of an ecclesiastic, the sanctification of festivals, and the need for provincial and pastoral councils every three years. The participants (although there were thirty-three cardinals present, and eighty other ecclesiastical dignitaries, Marchionni shows mostly bishops) were certainly thoroughly lectured during the two and a half months of the council; they also received, as recompense for their dutiful attendance, a personal indulgence from the pope and the right of a funeral in the cathedral of Rome, St. John Lateran.

Although there is little likelihood that Marchionni attended the council, we know in fact there was an artist present, Pier Leone Ghezzi (Thieme and Becker, vol. 13, p. 540). Like Marchionni, Ghezzi was an inveterate sketcher, one who made some of the most entertaining and revealing caricatures and portraits of the eighteenth-century Roman cast of characters. He completed a painting (now lost) of the Provincial Lateran Council of 1725 (probably for Cardinal Lercari, Benedict's Secretary of State; Pascoli 1730–36, vol. 2, p. 206), and it seems highly likely that Marchionni consulted it for his relief (Lercari was one of those present at the dedication of the funeral monument in 1739). Marchionni captures that sense of the anecdotal that was also a hallmark of Ghezzi's history paintings.

For a somewhat restricted and shallow space in the chapel of S. Domenico in the church of S. Maria sopra Minerva, Marchionni (perhaps with the assistance of the painter Pietro Bianchi) designed the basic

arrangement and architectural setting for the tomb of Benedict XIII. Pietro Bracci sculpted the marble portrait of Benedict and the allegorical figure of Religion (on the left). Bartolomeo Pincellotti made the figure of Humility who turns modestly away from the pope, while trampling a crown and embracing a lamb. Although Marchionni's relief received more attention in the eighteenth-century Roman press, today Bracci's figure tends to attract more attention. It is an exceptionally unflattering yet deeply moving image of a pope who is half kneeling but fully enraptured by his devotions. His right hand pushing into his heart intensifies the pope's trance-like emotional state. In a spiritual sense, he is far removed from the immediate spaces surrounding him.

Cardinal Alessandro Albani (in whose household Marchionni was employed) and Duke Domenico of Gravina, the pope's nephew, absorbed the expenses and oversaw the designs and construction of the funerary monument. The preparatory model for the tomb was in place by 1733 (Chracas, *Diario Ordinario di Roma*, August 11, 1736, no. 2969); by 1737 the work was completed, except that Marchionni inserted this stucco relief in the space intended for the marble version (Chracas, *Diario Ordinario di Roma*, August 10, 1737, no. 3124). Nearly two years went by before Marchionni completed the slightly larger redaction of the relief, now in marble. Thus the stage was set for the ceremonies attending the placing of Benedict's body in its final resting place. Chracas's *Diario Ordinario* records the service in some detail (Chracas, *Diario Ordinario di Roma*, February 28, 1739, no. 3365). The journalist explains that on that same day—February 28—and the same day of the week—a Sunday—six years earlier the body of Benedict had been brought from the Vatican and placed in a temporary tomb in the

chapel of the Magdalen. Now, with the completion of Marchionni's relief (which all of Rome "applauded"), the body could be put into its own tomb. The earthly remains of Pope Benedict XIII await his salvation in a memorial far more lavish than anything he would have wished. The stucco *modello* was then presented to the Orsini family, who kept it in their Roman palazzo until selling it at the end of the nineteenth century. [VHM]

## GIUSEPPE MAZZUOLI

### VOLTERRA 1644–1725 ROME

Giuseppe Mazzuoli stemmed from a distinguished Tuscan family of architects, sculptors, and artisans who settled in Siena, and of which he was the one to achieve the greatest fame. He probably was initially trained in Siena by his elder brother Giovanni Antonio (*fl.* before 1644–after 1706) and participated in the busy workshop manned by a number of his relatives. Some time after the election in 1655 of Pope Alexander VII, who also came from Siena as a descendant of the powerful banking family of the Chigi, Mazzuoli decided to make the move to Rome. He hoped—correctly, as it turned out—to gain the protection of his papal compatriot and was patronized above all by Alexander's nephew Cardinal Flavio Chigi. Mazzuoli was certainly active in Rome before 1667, as he is mentioned as having studied under the leadership of the short-lived but influential Melchiorre Cafà in the large workshop of Ercole Ferrata (Schlegel 1978, p. 70). Executing the personification of *Charity* for the tomb of Alexander VII in St. Peter's (c. 1673–75) provided Mazzuoli with the opportunity to work directly for Gianlorenzo Bernini, whose art and style he had already imbibed in Ferrata's studio.

Although he resided mostly in Rome, Mazzuoli continued to deliver sculpture to his home town. In the late 1660s and early 1670s he worked on the decoration of the chapel of the Cross in S. Vigilio and three altars in S. Martino, Siena, at the behest of the De' Vecchi family, whose ancestors Pietro de'Vecchi and his wife, Giulia Verdelli (d 1633), he portrayed in posthumous busts (Angelini 1995). During the decade between 1679 and 1689 he completed a series of large marble Apostle figures for the nave of Siena Cathedral, which were removed in 1890 and are now installed at Brompton Oratory, London. This group is remarkable for its date, which precedes the better-known series in the Lateran by roughly twenty years, and given the fact that all the statues can be attributed to one artist, but Mazzuoli must have relied heavily on his family for assistance, providing the initial terracotta models and retaining overall supervision of the execution (Butzek 1988; Butzek 1991).

The sculptor kept equally busy in Rome, although he usually contributed to larger projects as a subcontractor, rather than as the main responsible artist. In this manner he created, for example, the large marble figure of *Clemency*, in about 1684, for the tomb of Clement X in St. Peter's, designed by Mattia de' Rossi, and, between 1678 and 1690, provided the *Saint John the Baptist* and *Saint John the Evangelist* flanking the high altar of Gesù e Maria, Rome, designed by Carlo Rainaldi. Very briefly, after the death of Ferrata in 1686, Mazzuoli was given the honorable task of instructing the students at the Accademia Fiorentina in Rome, before it was closed in the same year. Around the turn of the eighteenth century the sculptor created a number of smaller works, including two pairs of portrait busts of Pope Alexander VII and Cardinal Sigismondo Chigi, now in the Palazzo Chigi of Ariccia and the Vatican Library (c. 1680; see Angelini 1995), a pair of *Kneeling Angels* for the main altar of S. Donato in Siena (1695; see Draper 1994), as well as two terracotta reliefs with *Scenes from the Life of Saint Galganus*, made for Cardinal Flavio Chigi (1701; see Butzek 1993).

The major documented works of Mazzuoli's late phase fall into the last two decades of his life. In 1705, or shortly thereafter, he was commissioned with his most prestigious independent work, the *Saint Philip* in the nave of St. John Lateran, which was completed by 1715 (cat. 135). In S. Maria in Campitelli, Rome, he contributed the fine, restrained portrait busts of Prince Angelo Altieri and his wife, Laura Carpegna, and four mourning putti for the family chapel in about 1709. For the grandiose and colorful Rospigliosi-Pallavicini Chapel in S. Francesco a Ripa, Rome, designed by Nicola Michetti, Mazzuoli created four stately seated personifications—Prudence and Charity, Strength, and Justice—flanking the two huge family funerary monuments and dated between either 1710 or 1715 and 1719. Two busts of Pope Clement XI and Pope Innocent XII in S. Cecilia in Trastevere, Rome, are attributed to him and dated 1723–25, but Mazzuoli's final masterpiece is his large and complex figure of *Charity* in the chapel of the Monte di Pietà, Rome (1721–23), which he signed a year before his death, giving his age as seventy-nine (Salerno 1974, *Cappella*).

A comprehensive, analytical monograph on the artist is still outstanding, but most scholars consider Mazzuoli a last holdover of the Bernini school in the early eighteenth century. His art was shaped decisively by the emotional, deeply religious style of the ageing master, as exemplified by Mazzuoli's *Dead Christ and Kneeling Angels*, in S. Maria della Scala, Siena, made in Rome about 1673, a late Baroque model frequently copied well into the eighteenth century (Schlegel 1978, p. 73). In spite of their often complicated stance, heavy proportions, and voluminous garb, the broad and sweetly smiling faces of Mazzuoli's female figures have crisply carved edges and draperies that are deeply excavated and break in sharp folds. Some see in his fine, if anachronistic, late work a certain reflection of current trends, such as a concern for decorative, rather than expressive, considerations in the design of the drapery (Nava Cellini 1982, p. 8) and the use of increasingly hard, sharp curves (Schlegel 1978, p. 73). The issue of defining Mazzuoli's style is confused by the fact that he taught his Roman manner to his prolific family in Siena, so that the many smaller, unsigned works in marble, plaster, and terracotta that survive in Siena and collections worldwide often pose intractable attribution problems. The pieces from the large family workshop may range widely in quality, but they document the validity of Mazzuoli's late Baroque, which was so influential in Siena and typical of the generalized, tempered Bernini style that was the norm in most of Europe for roughly the first half of the eighteenth century. [SW]

BIBLIOGRAPHY Suboff 1928; Pansecchi 1959; Schlegel 1967; Schlegel 1972; Salerno 1974, *Cappella*; Westin and Westin 1974; Schlegel 1978, pp. 70–77; Nava Cellini 1982, pp. 7–9; Butzek 1988; Genitlini and Sisi, 1989, passim; Butzek 1991; Butzek 1993; Draper 1994; Angelini 1995; Fagiolo dell'Arco and Petrucci 1998, pp. 80–84, cat. nos. 16A, 16B

## 135

## Giuseppe Mazzuoli
### *Saint Philip*

c. 1715
Marble
Height 30⅝" (78 cm)

PROVENANCE Prince-Bishop Johann Philipp von Greiffenclau, Würzburg, about 1715; Pickert Collection, Nuremberg, before 1912

BIBLIOGRAPHY Pascoli [1730–36] 1965, vol. 2, p. 482; Brinckmann 1923–25, vol. 4, p. 6, fig. 2; Schlegel 1967, fig. 3; Bott 1989

Germanisches Nationalmuseum, Nürnberg

Although he rests his weight on his right leg, Mazzuoli's *Saint Philip* gives the impression of impending dramatic action. With his bent body and right arm stretching forward, he seems intent to step not only on but over the vanquished dragon whose head he tramples underfoot. Yet in a counterpoint to this directional thrust, the long cross cradled in his left arm leans away from him to the right and is firmly placed on the dead beast. Though cross and dragon are attributes specific to this saint, they would also have been read as a general symbol of religious victory, Faith triumphing over Heresy, a common theme of the time. Saint Philip's gaze down toward the lifeless monster and the open gesture of his right hand convey wonder at his deliverance and invite the viewer to contemplate the evidence and implications of this miracle. The rich and varied drapery adds further dynamic impulses to the already complex composition of the pose. One broad swath creates a diagonal over the saint's left knee, designed to produce a greater, if somewhat unmotivated, sense of movement. Another band flows over the left shoulder and curls around the stem of the cross in an adaptation of the independently furling drapery of Bernini's *Saint Longinus* in the Crossing of St. Peter's, which was certainly an important point of reference for Mazzuoli (Enggass 1976, vol. 1, p. 40). Heavy folds ripple over the right arm and propped knee, while the high forehead, deep set eyes, and wavy hair and beard complete the impression of agitated pathos.

This sculpture faithfully copies the much larger statue Mazzuoli carved between 1705 and 1715 as part of the grand series of Apostle figures decorating the niches of the nave of St. John Lateran. Like most of the other sculptors involved in this project, Mazzuoli was supplied with a drawing by the painter Carlo Maratti, who, together with the architect Carlo Fontana, served as an artistic adviser to the committee of clerics overseeing the commission. However, as also can be shown for many of his colleagues, Mazzuoli was by then a senior, well-

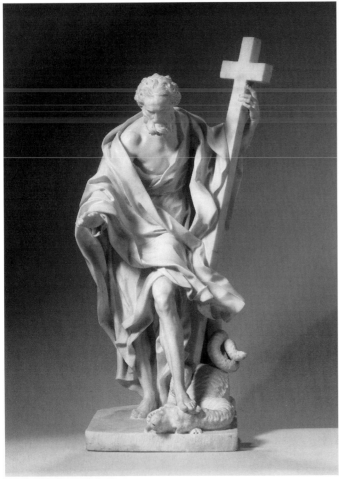

135

established artist and appears to have taken broad liberties with Maratti's now lost design. The resulting statue is quite different from all of the rest of the series and has much more in common with other works by the sculptor than with any by the painter. As has been noted by other scholars, Mazzuoli's composition—not wholly successful in every respect—is an affirmation of late Baroque traditions rooted in the works of Bernini, to which Mazzuoli remained faithful throughout his career. In comparison, his *Saint Philip* seems oddly out of step with the more progressive Apostle statues of the younger Camillo Rusconi, Pierre Legros, and Pietro Stefano Monnot. Through its reduction in size and softer surface texturing, however, the statuette tones down the larger figure's somewhat lumbering grandeur and pathos.

Recent study has confirmed Lione Pascoli's report that Mazzuoli himself created the present copy for the prince-bishop of Würzburg around 1715 (Bott 1989). Johann Philipp von Greiffenclau supplied the funds for the carving of the Lateran statue—the Apostle is his namesake, it should be noted—and probably received the smaller version as a memento or

token of gratitude from the supervising committee or the sculptor himself. There are two parallel cases known of fine, small copies that may have been intended as presents to sponsors of the large figures and are attributable to the originating artists. One is the bronze *Saint Andrew* by Rusconi (cat. 150), formerly in the collection of the bishops of Salzburg and now in the Kunsthistorisches Museum, Vienna (Johann Kronbichler, ed., *Meisterwerke europäischer Kunst: 1200 Jahre Erzbistum Salzburg* [Salzburg, Austria: Dommuseum zu Salzburg, 1998], p. 184). The other is a marble version of *Saint Bartholomew*, of comparable size to the *Saint Philip*, in the Metropolitan Museum of Art, New York, which, in the light of the other two figures, may now be given with greater confidence to Legros. A number of copies and adaptations of Mazzuoli's *Saint Philip* in terracotta and porcelain suggest the broader impact and later influence of this figure, and specifically this statuette, on German artists such as Johann Joachim Kändler and Johann Peter Wagner (Bott 1989). [sw]

## JEAN-GUILLAUME MOITTE
### PARIS 1746–1810 PARIS

Moitte ranks among the leading monumental sculptors in France during the period 1780–1810. He obtained patronage from each successive regime from Louis XVI to Napoleon I. Unfortunately, his public sculpture reflected the political agendas of the *ancien régime*, the republic, and Napoleon's empire. Works produced for Louis XVI were destroyed in the revolution of 1789. His masterpiece, the blatantly republican bas-relief *The Fatherland Crowning Virtue and Genius* for the Paris Pantheon, was covered over during the empire and demolished under the Bourbon restoration. His bas-relief *The Fatherland Summoning its Children to its Defense*, destined for Palais du Luxembourg during the directory, never proceeded beyond the plaster model. Moitte did fare extremely well during the empire in terms of regular and extant commissions, ranging from the tomb of General Desaix in the hospice of Grand Saint-Bernard to the bas-relief *History Inscribing the Name of Napoleon* for the Cour Carrée of the Louvre. With the bicentennial of the French Revolution in 1989, Moitte and his generation—so long forgotten—came to be reassessed and newly appreciated in the wake of new scholarship. In 1993 Gisela Gramaccini published her definitive and comprehensive catalogue raisonné (Gramaccini 1993).

The artist was the son of the professional engraver and Royal Academician Pierre-Etienne Moitte and his wife, Marie Vitray. In 1761 he entered the studio of Jean-Baptiste Pigalle. In 1768 he was awarded the *prix de Rome* for his bas-relief *David Bearing the Head of Goliath in Triumph*, and subsequently attended the Ecole des Elèves Protégés, under the tutelage of the sculptor Jean-Baptiste Lemoyne. In October of 1771 Moitte arrived at Rome, where he executed numerous drawings after such ancient monuments as the Arch of Titus, as well as statuary and artifacts but succumbed to a severe fever, brought on from the adverse effects of the warm Italian climate. This eventually led to a nervous breakdown, and Moitte was constrained to abandon his beloved Rome and to return to Paris at royal expense. There is no documentation for sculptural works during this first Roman sojourn. Moitte was back in Paris by July 1773, where he gradually recovered his health. At this time, he worked mainly in terracotta and produced a significant number of drawings that reflect the most progressive, classicizing aspect of the Louis XVI style. In 1776 he became a member of the Paris Académie de St. Luc.

In about 1782 Moitte was commissioned by the architect Pierre Rousseau to execute statuary, bas-reliefs, and ornaments for the Hôtel de Salm-Kyrbourg (now the Palais de la Légion d'Honneur) in Paris. The following year, he was received as an *agrée* (provisional member) of the Académie Royale in Paris; however, he never submitted his marble reception piece, *A Sacrifice*, and never became an academician. In 1783 Moitte made his début at the Paris Salon with a plaster figure *Orestes*, a portrait bust of *Madame Rousseau: Wife of the Architect*, a terracotta bas-relief *The Festival in Honor of Palès*, and the drawings *Bacchic Fête* and *The Four Seasons*. The critics observed that his bas-reliefs and drawings proved the extent of his genius.

The 1780s proved to be a highly productive decade for Moitte. His commissions included stucco sculptures of the *Virgin and Child* and *Saint Rieul* and ornaments for the choir of the cathedral at Senlis (1784); a marble monument to Bossuet and Fénélon for the Palais Peyrou at Montpellier (model completed 1785; never executed); statues and bas-reliefs for the notorious *Barrières* (1784–87) of Paris under the direction of the architect Claude-Nicolas Ledoux; and a marble statue of the astronomer Dominic Cassini for a prestigious royal commission for the Great Men of France series (1788), intended to be installed in the Louvre.

Apart from his sculptural œuvre, Moitte was a brilliant and prolific draftsman. He provided revolutionary and much admired designs for furniture, vessels, and ornaments for the goldsmith Henry Auguste, and executed designs for prints of allegorical, mythical, and historical subjects. He also produced book illustrations for Fénélon's *Les Aventures de Télémaque* (1785) and Racine's *Thébaïde* (1801) published by Didot. During the revolution he designed ephemeral works for the various ceremonies, including reliefs for an arch raised for the festival of the Federation in 1790, which depict the destruction of the Bastille, and the triumph of law. In 1794 the sculptor executed a drawing for a colossal statue in honor of the French people, to be erected on the Pont-Neuf. Like so many projects during this period, the statue was never produced. Similarly, in 1794 Moitte rendered a terracotta model for a statue of Jean-Jacques Rousseau intended for the Champs-Elysées; which never proceeded beyond Moitte's plaster model, now lost.

During the consulate and empire, Moitte received many commissions, including a marble bust of *Leonardo da Vinci*, a marble statue of *General Custine*, and a bas-relief for the tomb of General Leclerc. Between 1796 and

1798 Moitte returned to Rome in the capacity of an arts commissioner authorized to confiscate artistic masterpieces for display at the Louvre.

In an obituary for Moitte, Antoine-Chrystôme Quatremère de Quincy, the theorist, patron, and friend of the artist observed: "At the very outset of his career, Moitte distinguished himself with a plethora of drawings which simultaneously display his own taste and also exude the air of antiquity, of which he revealed himself a disciple" (Quatremère de Quincy 1810, pp. 495–96). [RJC]

BIBLIOGRAPHY Hubert 1964, *Sculpture*; Herding 1973; Campbell R. 1982; Kleiner 1992; Gramaccini 1993

## 136
## Jean-Guillaume Moitte
*The Triumph of Titus*

c. 1798

Terracotta

13¾" × 24" (35 × 61 cm)

PROVENANCE Heim Gallery, London; Gallery Carrol, Munich; purchased by the Los Angeles County Museum of Art, 1986

BIBLIOGRAPHY Herding 1973, p. 29; Pröschel 1977, no. 37; Campbell R. 1982, p. 249, n. 69; Gramaccini 1993, vol. 2, pp. 91–92, n. 217.1, 217.2

The Los Angeles County Museum of Art; Gift of Camilla Chandler Frost

## 137
## Jean-Guillaume Moitte
*The Spoils from the Temple of Jerusalem*

c. 1798

Terracotta

13¾" × 24" (35 × 61 cm)

PROVENANCE Heim Gallery, London; Galerie Carrol, Munich; purchased by the Los Angeles County Museum of Art, 1979

EXHIBITION Munich 1977, cat. no. 37

The Los Angeles County Museum of Art, Purchased with funds provided by Camilla Chandler Frost

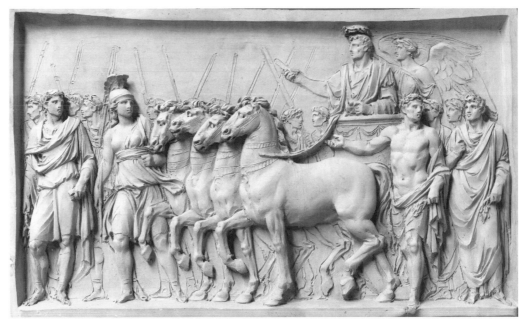

136

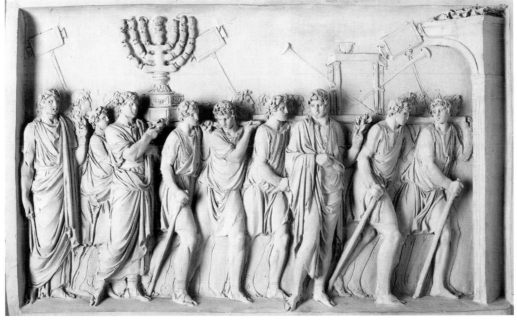

137

Moitte's terracottas are copies of the bas-reliefs the *Triumph of Titus* and the *Spoils from the Temple of Jerusalem* that adorn the central bay of the Arch of Titus, situated on the Velia, the hill in the Roman Forum (see Pfanner 1983; Kleiner 1992, pp. 183–91). This triumphal arch commemorates the conquest of Judaea by the Emperor Vespasian and his son Titus and the capture of Jerusalem in AD 70 by the latter. It was erected in AD 81 during the reign of the Emperor Domitian. The arch is located on the Via Sacra and the reliefs are oriented toward the Temple of Jupiter on the Capitoline Hill—the destination of Roman conquerors.

The first relief depicts the triumphal procession of the Emperor Titus in AD 71. Titus, bearing Jupiter's scepter and a palm branch, stands in a chariot drawn by four horses. He is flanked by an allegory of Victory who crowns him with a laurel wreath. The bare-chested Genius Populi Romani and the toga-clad Genius Senatus accompany the emperor on foot. (The inscription on the attic of the arch indicates that the monument was erected by the people of Rome and the Senate in honor of the divine Titus, son of the divine Vespasian). The quadriga is led by the goddess Roma. In the background, twelve lictors bearing fasces escort the emperor. The second relief represents Roman soldiers carrying the sacred utensils, seized from the Temple of Jerusalem, through a triumphal arch en route to Vespasian's Temple of Peace, where they were to be displayed. The temple spoils include a golden, seven-branched lamp, an incense burner and an acacia-wood table overlaid with gold for the Sabbath shewbread and the long trumpets that summoned the faithful to prayer or battle. In the background two soldiers bear on poles tablets inscribed with the names of the conquered cities of Judaea. These bas-reliefs of the Arch of Titus are deemed masterpieces of Flavian epoch sculpture.

Herding described the reliefs as exercises in sculpture comparable to such "theses in painting" as David's *Oath of the Horatii* (1785) and Regnault's *Freedom or Death* (1795). The reliefs, then attributed to Moitte, were in a private collection in London. The attribution was confirmed in 1982, based on stylistic similarities with a terracotta relief executed by Moitte in 1783, *Festival in Honor of Palès*, exhibited at the Paris Salon of the same year (Grammacini 1993, vol. 2, p. 195, fig. 103). The genre of the bas-relief was Moitte's forte; he was also a gifted draftsman. The *Pales* terracotta is multiplanar, rhythmically linear, and fundamentally pictorial in conception. Significantly such "pictorial illusionism" has been traditionally associated with Flavian-era reliefs. Also, the rendering of the physiognomies with the right-angle noses, the squarish feet

and toes, and the crisp fastidious modeling of the drapery folds are consistent with Moitte's documented terracottas. Gramaccini compared the rendering of the bare-chested Genius Populi Romani in the *Triumph of Titus* relief to figural drawings executed by Moitte during the 1790s, especially in the modeling of the thorax.

Moitte first came to Rome in 1771 as a *pensionnaire* of the French Academy, and diligently applied himself to drawing after the antique. A pen, ink, and wash drawing after the relief on the Ara Pacis Augustae in the collection of the Ecole des Beaux-Arts, Paris, and a series dating 1772–73 of sanguine studies of figures on Trajan's Column, conserved at the Musée Tavet, document this phase of his activity (Grammacini 1993, vol. 2, pp. 168–69, 172–73, figs. 37, 40, 48–52). As noted above, the effects of the climate debilitated Moitte's health and hindered his execution of sculpture.

Between 1796 and 1797 Moitte returned to Italy as an arts commissioner in the service of the French Ministry of the Interior. In the aftermath of Napoleon's victory at Arcola in 1796 and the subsequent treaty of Tolentino in 1797, arts commissioners followed in the wake of the French army to confiscate works of art in Italy to be transported back to Paris. By November 1796 Moitte had arrived in Italy; he traveled to Turin, Milan, and Modena and reached Rome by April 1797. Works were seized from the Capitoline and Vatican museums. Moitte also supervised the seizure and packing of the *Apollo* Belvedere (Tutey 1910). It is known that Moitte made models of antiquities during this period (Campbell R. 1982). Moitte was aided in this enterprise by the Italian marble cutter Mariano Giosi, a foreman at the Museo Pio-Clementino, who accompanied the commissioners back to Paris (Hubert 1964, *Sculpture,* p. 147).

On July 28, 1798, Moitte and his fellow commissioners assembled on the Champ-de-Mars to present to the members of the directory the spoils taken from Italy. Such masterpieces as the Medici *Venus,* the horses from St. Mark's Basilica, the *Laocoön* and the *Apollo* Belvedere were paraded in a public fête inspired by depictions of Roman triumphal processions such as the reliefs on the Arch of Titus. [RJC]

## PIETRO STEFANO MONNOT
### BESANÇON 1657–1733 ROME

Of the three preeminent sculptors in Rome at the beginning of the eighteenth century—Pietro Stefano Monnot, Pierre Legros II, and Camillo Rusconi—Monnot is in many ways the most interesting. Several factors of his life and development as an artist did not fit the usual mold: unlike his contemporaries Jean-Baptiste Théodon or Legros, Monnot was not educated in the royal academies in Paris and Rome, but arrived in the city in 1687, thirty years old and already a fully trained sculptor. He had been taught first by his father, a successful woodcarver from Besançon, and continued his studies with Jean Dubois, the leading Baroque sculptor in Dijon, before leaving for Rome. It is unclear for or with whom Monnot may have worked initially, before he rose to public prominence in 1695, although archive references and a few earlier, signed and dated works prove that he was patronized by Livio Odescalchi, the nephew of Pope Innocent XI, and was already fairly well-off financially before this date.

Without following in the footsteps of any single older sculptor, Monnot adapted artistic principles and motifs from several different artists and combined them with his own preferences to create a highly effective stylistic synthesis according to the nature of the commission at hand. His exuberant *Angels Holding the IHS Monogram,* 1695–97, over the central niche of the altar of St. Ignatius in the Gesù, Rome, follow a design by Andrea Pozzo, but improve the prescribed basic pose with the sculptor's own gentle, beatific faces and buoyant draperies. For his most prestigious commission, the tomb of Pope Innocent XI, 1697–1701, in St. Peter's, Monnot was asked to execute a rather conventional design by Carlo Maratti, although the sculptor had proposed another, much more innovative composition, which is preserved in a terracotta sketch in the Museo Nazionale del Bargello, Florence (Walker S. 1995, pp. 124–28). Like Maratti himself, Monnot adopted two distinctly different stylistic modes: a grander, more formal one for more public or official, large works, such as the papal tomb, and a gentler, more intimate one for more private, religious, and generally smaller works. This "private" manner is evident, among others, in the *Adoration of the Shepherds* and *Flight Into Egypt,* 1695–99, in the Capocaccia Chapel of S. Maria della Vittoria, Rome, and the *Virgin and Child with the Young Saint John the Baptist* (1709; Wardour Castle Chapel, Wiltshire) and is one of the sculptor's most remarkable contributions (see cat. 138).

Representing his monumental *Saint Paul* (1704–8; St. John Lateran), as a preaching orator, Monnot experimented with gestures from ancient statues and drapery motifs from Renaissance and Baroque masters to arrive at his own complex and highly idiosyncratic solution. A sign of his high reputation, Monnot was called to complete and execute the statue of *Saint Peter,* 1708–11, which had been left unfinished in the modeling stage by Théodon. Once more, Monnot was required to consult with the ageing Maratti, although the true extent of their collaboration is unclear. Nonetheless, the sculptor produced one of the most commanding images of the "Prince of Apostles": combining Baroque pathos and classical simplicity, the grand upward sweep of the saint's right arm, his powerful gaze, and the rich repetition of deep parallel curves in his robe and mantle became exemplary for later, more classicizing figures.

Monnot was also an excellent portraitist; however, his best works in this genre were sent or made abroad at the behest of his two most important foreign patrons. For John Cecil, 5th Earl of Exeter, he created the first entirely romanizing bust in 1701, with a short, Caesarean haircut and cuirass which, displayed at Burghley House (Lincolnshire), found wide imitation in England. Equally innovative was the matching portrait of Exeter's wife, Countess Anne, which shows her coiffed with long, curling tresses and a bun over a thin, belted chemise. In both cases, Monnot balanced these classical motifs with very sensitive and surprisingly unidealized renditions of the faces. In 1714 the sculptor portrayed the Landgrave Karl of Hesse-Kassel and his wife, Maria Amalia of Kurland, in two magnificent marble busts (Hessisches Landesmuseum, Kassel) based on the late Baroque idiom of French ruler portraits—a large wig and contemporary armor for the man; jeweled curls and an ermine mantle over lacy flounces for the woman. Here Monnot succeeded in combining the elegance and formality of French effigies with the Italianate sensation of a living, breathing bodily presence.

The same patrons also gave Monnot the opportunity, unfettered by the current Roman conditions of collaborative projects and committee decisions, to create two of his most influential and authentic works. The tomb of John, 5th Earl of Exeter, and the Countess Anne (1699–1704; church of St. Martin, Stamford, Lincolnshire) was Monnot's most elaborate work for Exeter, in addition to a small religious relief, two mythological fountains, and a large *Andromeda and the Sea Monster* (Metropolitan Museum of Art, New York) which Monnot may

have completed for the recently deceased Domenico Guidi. The huge, marble funerary monument again shows the earl and his wife in Roman dress. They lie on a sarcophagus, but are propped up on pillows and alert, as if in animated conversation. Lacking any overt religious motifs, the memorial is constructed in front of a soaring pyramid and flanked by allegorical figures of Minerva as Wisdom or Nobility and the Arts mourning the loss of her patron. The compositional formula of Monnot's Exeter tomb as well as numerous individual motifs and poses had an enormously invigorating impact on eighteenth-century English funerary sculpture and inspired such artists as James Gibbs, Peter Scheemakers, Michael Rysbrack, and Henry Cheere (Walker S. 1995, pp. 141–57).

Monnot's career culminated in the completion of a lifelong project close to his heart, which involved a singular series of large mythological statues after Ovid's *Metamorphoses* and other classical sources. The earliest works, *Leda and the Swan* and *Bacchus,* date from 1692, but it took Monnot until 1714 finally to find a sponsor in Landgrave Karl of Hesse-Kassel, who was willing to purchase and even expand the entire ensemble. Known as the *Marmorbad,* or Marble Bath, a simple garden pavilion was transformed by Monnot into a dazzling proto-Rococo pantheon, creating a unique memorial for the Landgrave as well as for himself. Working in Kassel for almost fourteen years, Monnot decorated the interior of the small building at Schloss Orangerie with pastel-colored marble incrustations around a large octagonal (non-functional) marble basin, twelve statue groups, eight mythological reliefs, as well as medallion portraits of the princely couple over chimneypieces and allegorical reliefs on the ceiling. The freestanding statues in particular are among Monnot's very finest works. Spanning his entire career, they display the evolution of his creative classicism, a refined play of references on classical as well as Baroque models, which thrilled later Neoclassicists, such as Bartolomeo Cavaceppi, who even referred to Monnot as "mio Maestro" (Walker S. 1995, pp. 288–89). Although installed outside of Italy, the *Marmorbad* decorations constitute the most remarkable ensemble of secular sculpture from early eighteenth-century Rome and, with their elongated proportions, small heads, and wavy, tapering fingers, herald the figural aesthetic of the coming decades. [SW]

BIBLIOGRAPHY Enggass 1976, vol. 1, pp. 77–88, and vol. 2, figs. 20–39; Schlegel 1978, pp. 87–93; Fusco 1988; Bacchi 1994; Walker S. 1995; Burk 1998

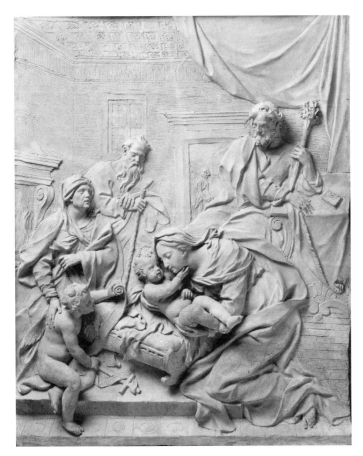

138

## 138
### Pietro Stefano Monnot
*The Holy Family with the Young Saint John the Baptist and His Parents*

Between 1700 and 1710
Terracotta
28⅛″ × 22⅜″ (71.4 × 56.8 cm)
PROVENANCE  Antonio Valeriani, Rome, 1733; Heim Gallery, London, 1983
BIBLIOGRAPHY  Schlegel 1974; Heim Gallery. *Portraits and Figures in Painting and Sculpture, 1570–1870*. London: Heim Gallery, no. 29; Fusco 1988, pp. 75–76, n. 71, fig. 6; Walker S. 1995, pp. 161–65
The Museum of Fine Arts, Boston, Gift of Randolph J. Fuller

The setting for this image of the Holy Family is charmingly anachronistic: while the protagonists wear the familiar, timeless, vaguely classical robes, the group is assembled in a modern interior with a coffered ceiling, glazed window, curving mantle over the fireplace, and tiled floor. Even the carved table and central cradle, albeit simplified and perhaps idealized, recall contemporary furniture. Together the surroundings help to create an intimate, cozy atmosphere suitable to this interpretation of the religious topic. The relief intentionally stresses genre-like domesticity, while divine aspects, such as the

sketchy angel entering through the door in the background, are muted. As informal as the rendition may seem, its composition is thoughtfully calibrated and focuses on the Christ child and his mother at the center. Their mirrored faces and paired gestures—he reaches under her chin as she cradles him in her arms—emphasize their close and special bond. The Virgin's humbly bowed and loving pose shields her son and separates them both from the other onlookers. Contemplating them quietly are Joseph at the right, holding his attribute of the miraculously flowering staff, and, on the left the elderly Zachary and Elizabeth, the parents of the young Saint John the Baptist, who offers a roll of swaddling. Carefully executed details, such as Joseph and Zachary's benign heads, Elizabeth's soulful glance upward, and the childish eagerness of Saint John give the relief added conviction and profundity despite its small size.

The terracotta appears to be a preparatory model for a marble version with square proportions, now in the collection of the Staatliche Museen in Berlin (Schlegel 1978, pp. 89–92). Yet the Boston relief was clearly considered an artwork in its own right, since it is mentioned in Monnot's will as a bequest to one of his executors, Antonio Valeriani, and was valued, together with another similar piece, at

the considerable sum of 12 silver *scudi* by the sculptor Bernardino Ludovisi in the inventory taken after Monnot's death in 1733 (Fusco 1988, p. 75, n. 71; Walker S. 1995, pp. 383–84). Another marble relief of the Virgin and Child group, excerpted from the larger composition, now in an English private collection, is also mentioned in the inventory (Fusco 1988, p. 74, no. 62), but should be considered a good workshop copy, while both the Boston and Berlin reliefs are authentic.

Within Monnot's œuvre, his small-scale religious reliefs form a distinct group that bears a special relationship with contemporary painting. The fairly sizable number of surviving examples in marble and terracotta are the main exponents of the artist's "private" manner, an equivalent in sculpture to the works produced by such leading early eighteenth-century masters as Francesco Trevisani and Benedetto Luti. Like them, Monnot picked up on the sweet, almost sentimental type of Virgin and Child images originally propagated by Carlo Maratti in the 1680s. The *Maratteschi*, such as Ludovico Gimignani and Trevisani, chose idyllic domestic and landscape settings for their religious paintings, preferring contemplative, peaceful family scenes, and in this sense Monnot can be included among them as the earliest sculptor. He first experimented with this mode in the larger Capocaccia reliefs of the *Adoration of the Shepherds* and *Flight Into Egypt* (1695–99; S. Maria della Vittoria), but was more successful on a smaller scale with his *Virgin and the Sleeping Christ Child* (1700; Burghley House, Lincolnshire), a documented, but lost *Rest on the Flight into Egypt*, from 1706, and the *Virgin and Christ Child with the Young Saint John the Baptist* (1709; Wardour Castle Chapel, Wiltshire), among others. These works give the timeframe for the dating of the present piece, which somewhat surprisingly lacks any signature or date by the artist. Trevisani's *Holy Family* in the Cleveland Museum of Art provides a striking parallel to Monnot's in style, atmosphere, and even certain motifs, suggesting strongly that the two artists knew each other's works well.

By 1702 Monnot was known to English travelers as "a man who makes fine tables" (Walker S. 1995, p. 355), and one of his reliefs was included among the paintings Pier Leone Ghezzi exhibited at S. Salvatore in Lauro as early as 1693 (Walker S. 1995, p. 171). The pictorial quality of his sculptures was taken literally and highly prized for its uniqueness. Indeed, the intimacy of his superb Virgin and Child from this *Holy Family* is comparable in a late Baroque idiom to the peaceful serenity of Renaissance Virgins by Raphael or Rossellino. [sw]

## 139
### Pietro Stefano Monnot
*Venus and Cupid*

c. 1708
Terracotta
Height 26″ (68 cm)
Private collection

## 140
### Pietro Stefano Monnot
*Narcissus and Echo*

c. 1708
Terracotta
Height 28″ (72 cm)
Private collection

These two terracottas, which still retain their original patina and gilding, are the small preparatory models for two monumental marble groups sculpted by the artist. One is the *Venus and Cupid* signed and dated 1708 and the other the *Narcissus and Echo* signed and dated 1712, both sculptures housed in the *Marmorbad* pavilion in Kassel. The terracottas present a remarkable degree of finish, intended to convey not only the characteristics of the compositions but also the differing qualities of the surfaces, rendered with admirably skillful subtlety. This suggests that they are models intended to be shown to a client, to whom they would have been able to suggest a fairly precise notion of the works to be realized in marble. Nor is there any reason to doubt that they are effectively preparatory studies, and therefore precede execution of the statues. In addition to the highly sensitive quality of the modeling, this is confirmed by the numerous important differences evident in comparison with the marbles, particularly the *Narcissus*. In fact, in the Kassel work the sculptor has introduced a drapery that covers the background tree and part of the young man, who is there accompanied by a cupid, while in the terracotta there is a young woman who can be identified as Echo, the unfortunate girl who fell in love with Narcissus. So originally Monnot had evidently thought of adhering more closely to Ovid's text, placing beside Narcissus the figure of Echo helplessly watching the tragic end of the young man as he admires his own image reflected in the water (*Metamorphoses*, vol. 3, pp. 491–510). Later, possibly because the actual structure of the block of marble imposed a different structuring of the composition, he introduced the cupid, who attempts to distract Narcissus from his vain contemplation.

It is possible that the two very similar models were executed contemporaneously and that they

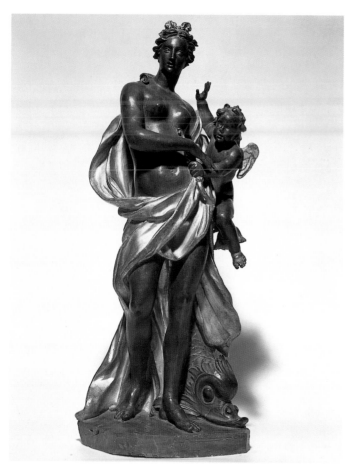

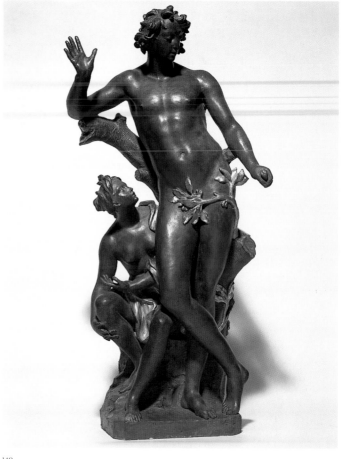

139

140

can therefore be dated no later than 1708, the year in which the first marble group of for the *Marmorbad* was created. It is also entirely probable that the two models should be identified as two terracottas that were in the sculptor's Roman workshop in 1733. The inventory of these objects, drawn up the day after his death, includes a considerable nucleus of maquettes that appear to be connected with the *Marmorbad* figures, none of which was known until now (see Fusco 1988, p. 73). Among them is a "Venus with a cupid by the arm 3p" and "a nude figure grouped with another 3 *palme*" (three Roman *palme* correspond to 26", or 67 cm). The indications of the subjects and the dimensions suggest that these models can be recognized as the terracottas exhibited here. If Peter Fusco had thought that the description of the Venus in the inventory alluded to a small model for the Kassel marble, the second quote would have remained more enigmatic, since it did not correspond to either of the marbles; today's rediscovery of the terracotta where the figure of Echo appears beside Narcissus makes sense of that description.

Many questions still remain regarding the date and methods by which Monnot completed the monumental undertaking of the *Marmorbad*, of which

he was the architect. The pavilion holds twelve mythological figures, eight large reliefs of scenes from the *Metamorphoses*, and two reliefs above the fireplaces featuring the Landgrave Karl of Hesse and his consort, Maria Amalia of Kurland, accompanied by a series of allegories and the decoration of the cupola with the Seasons and the Four Elements. What helps to give unity to this complex is the extraordinary display of the different materials. The walls are lined entirely with marbles of different colors toned round a few dominant ones—*giallo antico* (antique yellow), *brocatello* (yellow and purple or reddish with a little white), *verde antico* (green and gray), *pavonazzetto* (white with purple markings) and black. In the cupola the various figures (Seasons and Elements) are constructed by the application of thin layers of Carrara marble on to the *giallo antico* marble background. The oldest evidence of Monnot's association with the landgrave remains the marble portraits of him and the landgravine (Staatliche Museen, Kassel) signed and dated by the sculptor in 1714. As for the circumstances that brought about the *Marmorbad* commission, there is no evidence that Monnot and the landgrave had met before 1701, when the latter visited Italy. It seems a reasonable guess that

it was the Roman architect Giovan Francesco Guarnieri (see Contardi and Curcio 1991, pp. 387–88), who was in Kassel from 1701 to 1713, actually in the service of the landgrave, who introduced Monnot to Karl of Hesse.

A long letter only recently discovered, which was written by Monnot to the landgrave on January 2, 1715, reveals how at this time a very detailed project had already been designed for a sumptuous bathing apartment (Burk 1998, pp. 123–24). Monnot was already in Kassel and the decoration involved the execution of five large reliefs for the walls (in the event ten were made, eight with scenes from the *Metamorphoses* and two devoted to the landgrave and his consort) and eight reliefs for the cupola. Another fact clearly emerging from the letter is that the sculptor also offered the landgrave "ten marble figures made by me being at present in my studio in Rome" (Burk 1998, p. 123, doc. 1). He meant the figures of *Bacchus, Leda, Paris, Venus, Narcissus, Latona, Apollo and Mars, Mercury,* a *Faun,* and a *Bacchante.* Together with the *Minerva* and the *Aurora,* which the sculptor made much later, towards the end of his life, all these statues were to be sited in the *Marmorbad.* They were made over a very long period of time, the *Bacchus* and the *Leda* being dated 1692, the

*Mercury* and the *Apollo and Mars* 1698, the *Venus* 1708, the *Latona* and the *Narcissus* 1712, the *Faun* and the *Bacchante* 1716, and the *Paris* 1720. It is also obvious that the dates of the last-mentioned works must be reconsidered since all ten statues are mentioned in 1715 as being "done, studied and finished front and back with the ultimate lightness and delicacy that the style of sculpture can permit him."

What has still to be explained is the genesis of all these statues, which Monnot had mostly sculpted before he had any contact with the landgrave. In fact, the reason why Monnot had over the years made so many marble statues apparently without destination remains unknown.

Not even what Lione Pascoli had to say on the subject is convincing, although he knew Monnot directly. He in fact wrote that Monnot had been all set to do this great work since the 1690s, working on it "for no pay, or when he was not busy on other pressing things or when he was bored with these and wanted a change" (Pascoli 1992, p. 946). In reality no sculptor of this period would have undertaken such a task without a precise commission. Probably Monnot himself said nothing to Pascoli about the circumstances, but it is very prob-

able that the marbles, all of whose subjects were drawn from the *Metamorphoses*, were initially intended for Livio Odescalchi, who was the greatest contemporary patron of the sculptor and who had died in 1713, just one year before Monnot came into contact with the Saxon court.

The hypothesis that the marbles were devised and carried out for Livio is a more convincing one than Pascoli's suggestion. It is not difficult to imagine these figures in the context of the extraordinary collection of ancient marbles assembled by Odescalchi, and it is relatively easy to comprehend the many sophisticated references to classical statuary, which make them in some sort a Roman response to the classicism of the sculptures at Versailles. [AB]

## JOSEPH NOLLEKENS
### LONDON 1737–1823 LONDON

Nollekens, the son of Joseph Francis Nollekens, a painter of genre, was born in Soho, London, and at the age of eleven was apprenticed to the sculptor Peter Scheemakers; he learned drawing at Shipley's school in the Strand, and studied at the Duke of Richmond's gallery of casts in Whitehall. Between 1759 and 1762 he won six prizes at the Society of Arts for modeling, drawing, and carving, totaling some £134, and in the words of the judges he had "eminently distinguished himself." His prize-winning objects were shown in the Society's great room, with the exhibition of the Free Society of Artists in 1761 and 1762. With enough money to travel to Rome, he left London after May 21, 1762 (the day he received his last prize), and passing through Paris, Lyon, Turin, and other Italian cities, reached Rome on August 11. Scheemakers and his supporter James "Athenian" Stuart no doubt gave him advice from their own experience.

At Rome Nollekens joined the studio of Bartolommeo Cavaceppi, who worked for Cardinal Albani, and he became acquainted with the circle of the Villa Albani, which included Gavin Hamilton and Thomas Jenkins. In 1764 Hamilton found Nollekens commissions to reproduce a curious group, *Boy on a Dolphin* (Hermitage Museum, St. Petersburg), which then belonged to Cavaceppi. The magnificent full-size copy that Nollekens made for Lord Exeter demonstrates his skill in carving (Burghley House, Lincolnshire), and small versions were made for Lord Palmerston (Broadlands, Hampshire, cat. 141) and Lord Spencer (Althorp, Northamptonshire).

Besides restoration work for Cavaceppi, and for Piranesi, Nollekens worked for other dealers and on his own account. His work was bought by William Weddell (Newby Hall, Yorkshire) through the none-too-honest Thomas Jenkins, and by Thomas Anson (Shugborough, Staffordshire) through James Stuart. For Thomas Anson he carved a fine copy of the 'Ildefonso' *Castor and Pollux* (1765–67, Victoria and Albert Museum, London).

Nollekens's earliest portrait bust was commissioned early in 1764 by David Garrick; the payment, 12 guineas, suggests that it was in terracotta, but a marble version came to Lord Spencer by 1768 (Althorp, Northamptonshire). On July 4, 1764, James Martin "saw busts done by Mr Nollekins. Those of the Duke of York, Mr Wodehouse & Mr Richards are very like …" (MS. journal, private collection). The only other busts that can confidently be given to Nollekens's Rome years are of the young Earl of Carlisle (1768; Castle Howard, Yorkshire) and those of Sterne (cat. 143) and Piranesi (cat. 142). They are intimate, lively portraits, different from the grander style that the artist developed after 1770. Certain works, including portraits and the *Castor and Pollux* marble, were sent to London, where James Stuart arranged to show them with the Free Society of Artists.

From 1764 Nollekens shared lodgings with the Irish painter James Forrester in via del Babuino, near Cavaceppi's studio. In 1768 he entered the Concorso Balestra with a terracotta group, *Jupiter, Juno, and Io*, and won the gold medal. In June 1770 he was made a member of the Accademia di S. Luca at Florence. In October 1770 Nollekens started his journey home, and reached Dover on December 24. He was already well known in London, not only for his exhibited sculpture but also in the City, having made investments totalling some £20,000.

In 1771 Nollekens still had forty-six working years ahead. At his first Royal Academy exhibition, May 1771, he showed two models, probably made at Rome, and a marble bust of Lord Holland. He was elected an associate of the academy in 1771 and a full member the next year, and he exhibited regularly until 1816. His facility in modeling heads and his fine carving of the marble revived a fashion for busts that had slumped in the 1760s. His portrait busts number more than 150, and he was busiest in the years after 1800. His more popular busts were repeated many times, particularly two he made of Charles James Fox (1791; Hermitage Museum; and 1800; Woburn Abbey, Bedfordshire), and one of William Pitt (1806; Dalmeny House, Scotland). Busts of women are less numerous than men, but they seem of a more consistently high standard. That of Frances Knight (1793; Philadelphia Museum of Art) demonstrates his particular weakness: the eyes are not really convincing. Cunningham summed up Nollekens's portrait style: "unaffected and elegant; the best are simple without weakness, and serene without austerity … there is little dignity, but much truth … the chief defect is want of dignity and sentiment" (Cunningham 1831, vol. 3, p. 170). In funeral monuments, the figures and bas-reliefs often represent allegories that are classical and traditional, but the sentiments conveyed are very simple. Some monuments are large works with portrait statues. That to Mrs Howard (1800; Wetherall, Cumberland), with Religion comforting the mother dying in childbirth, was thought by Benjamin West superior to works by Canova.

Mythological figures by English sculptors were hard to sell, but Nollekens made four early statues of goddesses for Lord Rockingham (J. Paul Getty Museum, Malibu, and Victoria and Albert Museum, London), and two statues for Lord Yarborough (Usher Art Gallery, Lincoln). These ideal statues lack vigor and sentiment; according to John Flaxman, Nollekens "wanted mind." Nonetheless, he made a fortune and died worth £200,000. John Thomas Smith, a one-time pupil and lifelong friend, was disappointed of his promised legacy, and in retaliation spent five years writing his famous biography, which ridiculed Nollekens's appearance, his general ignorance, imbecility, and the squalid, miserly habits in which he was excelled by his wife, Mary Welch. As a result of Smith's book the sculptor has become a figure of fun. From other sources, however, particularly from Joseph Farington's *Diary*, it seems that Nollekens was a conscientious academician, and that his opinions on the antique were respected by connoisseurs. He was also highly professional; no complaints are known for bad work, excessive prices, or late delivery. [JKB]

BIBLIOGRAPHY  Smith [1828] 1920; Cunningham 1831, vol. 3, pp. 122–99; Whitley 1930, pp. 40–41; Howard 1964; Howard 1973; Garlick, Macintyre, and Cave 1978–84; Kenworthy-Browne 1979; Kenworthy-Browne 1979, "Nollekens"; Whinney 1988; Ingamells 1997, pp. 709–11; Kenworthy-Browne 1998

## 141
## Joseph Nollekens, after Bartolomeo Cavaceppi (?)
### *Boy on a Dolphin*

1764–66
Marble
14″ × 23⅝″ × 12¼″ (35.5 × 60 × 31 cm); base and tablet 5½″ (14 cm)
BIBLIOGRAPHY  Cavaceppi 1768–72, vol. 1, pl. 44; Howard 1964; Howard 1967, p. 224, pl. 61, fig. 5; Ridgeway 1970, p. 95; Kenworthy-Browne 1979, figs. 2–3; Roettgen 1981, pp. 139–41, n. 45, 49, 59; Neverov 1984, p. 40, n. 85–86, pl. 7, fig. 15; Ost 1984, pp. 112–15, figs. 44–46; Montagu 1985, pp. 3, 11, n. 16, p. 238, n. 15, figs. 2, 8; Söldner 1986, vol. 2, p. 382, n. 11; Grassinger 1994, pp. 111–12, 116–18, pls. 6–7, no. 40, figs. 3, 6, 217–19
Lord Romsey

The history of this statuette admirably illustrates, in capsule, mysteries and machinations in mid-eighteenth-century Neoclassical taste and dealing. On August 2, 1764, Gavin Hamilton wrote to Henry Temple, 2nd Viscount Palmerston:

"Mr Nolekins is making a new model of his Boy & Dolphin, much better than his former, & hope he will do himself honour with regard to the finishing of every individual piece … your Lordship may depend upon my watchfullness that nothing be slighted …" (Broadlands MSS, Hamilton to Palmerston correspondence, cited in Howard 1964, p. 177). He subsequently states (February 10 and April 12, 1776) that the group is finished with "honour," and on its way to England. Hamilton, a favored part-time antiquities agent, was also planning an original history painting for Broadlands, and the putto figure is reflected in his work at the time.

The roughly finished "former" model to which Hamilton referred was apparently a terracotta sketch of the composition (untraced) made in Rome in 1763–64 for the actor David Garrick, who had already promoted the work of Nollekens in London. Nollekens then also made a copy of the group in marble for Lord Spencer (Althorp, Northamptonshire). These amateurs and their entourage made an attractive Grand Tour society lionized in Rome and Naples, as noted by Winckelmann and Cardinal Albani. Nollekens rendered still another copy (larger) for their fellow-member of the Society of Dilettanti, Brownlow Cecil, Earl of Exeter (Burghley House, Lincolnshire), and yet another, through Hamilton in 1766, for Frederick Harvey, bishop of Derry and Earl of Bristol, for "Ireland's Blenheim," Downhill (now at Ickworth, Suffolk). A replica is also recorded in the Chinese Palace Oranienbaum, St. Petersburg. Nollekens probably made others

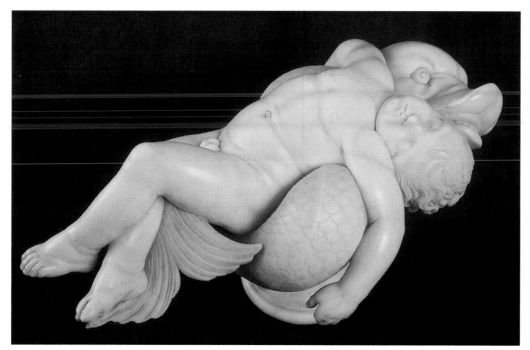

141

which significantly affected and reflected historicizing contemporary taste in form and sentiment, combining Neoclassical antiquarianism with vestigial Rococo and early Romantic interests. [SH]

142

Joseph Nollekens
*Giovanni Battista Piranesi*
Probably c. 1765–70
Inscribed on the name plaque: CAVALIERE
G.B.PIRANESI / ARCHITETTO (partly
obscured by modern brass)
Marble
23¾" × 11⅞" × 9⅛" (60 × 30 × 23 cm)
PROVENANCE commissioned by the
Accademia di S. Luca, Rome; recorded at
the Accademia in 1779 (Bianconi 1779)
EXHIBITIONS London 1978, cat. no. 283;
London and Rome 1996, cat. no. 153
BIBLIOGRAPHY Bianconi 1779, p. 284;
Smith [1828] 1920, vol. 2, p. 74; Wilton-Ely
1976, "Nollekens"; Kenworthy-Browne
1979, p. 1848, fig. 8; Wilton and Bignamini
1996, p. 206, no. 153
Accademia Nazionale di San Luca, Rome

during his stay in Rome (1760–70) and afterward.

The group reproduces a composition illustrated in Bartolomeo Cavaceppi's *Raccolta* as the work of Raphael, executed by Lorenzetto, his sculptor-aide, who rendered life-size Raphael's design for the vaguely similar *Jonah and the Whale* in the Chigi Chapel, where Cavaceppi had earlier studied while preparing for competitions at the Accademia di S. Luca. The *Raccolta* group was owned by the Maltese ambassador to the papal court, Baron Breteuil, who had other ostensible Raphaels in his collection. In 1779 it was published by Lyde Browne of Wimbledon, director of the Bank of England, in a list of antiquities sold to Catherine the Great, along with many other sculptures once in Cavaceppi's studio and now in the Hermitage Museum.

The group's narrative is a sentimental melodrama by the second-century AD anthologist and moralist Aelian the Sophist elaborating on earlier accounts. A dolphin loved a beautiful youth from the nearby gymnasium and eventually coaxed the boy to mount, ride, and frolic with him in the sea, until one day the exhausted child fell on to his erect spinal fin and was mortally wounded. The blood-soaked dolphin, overcome by remorse, bore the boy to shore, where both died— an example of masculine (and thinly veiled homoerotic) love and devotion teasingly applauded by the author (*De natura animalium* VI.15).

What aspiring fledgling collector-enthusiast "who saw with his ears" (Cavaceppi's phrase [Cavaceppi 1768–72, vol. 2, n.p.]) could resist this

thrilling story, provenance, and subtly insinuating form and sentiment? Designed to be viewed from all sides, the piece swivels on a dowel, inducing mild vertigo. In this context, it is important to observe that through Hamilton, and together with other sources from Cavaceppi and Pompeii, it directly influenced the love–death masculine attachments in Canova's first fully fledged Neoclassical composition, *Theseus and the Minotaur* (1781; Victoria and Albert Museum, London).

The composition in fact alludes to various ancient visual and literary sources that influenced works by Renaissance, Baroque, and Neoclassical artists. In a sizable literature, scholars have attributed its creation to each age—even antiquity. The initial and long-sustained attribution to Raphael followed upon the then recent discovery of a letter briefly mentioning a putto (but no dolphin) sketch by him, as well as the group's vague similarities to work from Raphael's studio, such as the *Jonah* and Farnesina *Galatea*. An untraced marble *Boy and Dolphin* once in the Ludovisi collection, made between 1625 and 1631 by Giulio Cesare Conventi, teacher of the Baroque classicist Alessandro Algardi, whose *Sonno* (1635–36) resembles this child, seems a more likely candidate for the original. In the nineteenth century the *Boy and Dolphin* was already viewed as an eighteenth-century invention and was reproduced as a sentimental motif in various decorative arts.

Cavaceppi advertised a wide gamut of works in his *Raccolta*: massively and modestly restored antiquities as well as unrestored fragments; his own

antico copies, fakes, and inventions; and sculptures with grandly inflated attributions—such as a Pierino da Vinci relief ascribed to Michelangelo. It seems unlikely that he would feature an invention by his underling and imitator Nollekens as a work of Raphael, although reference to the famous sculptor–restorer Lorenzetto, who rendered Raphael's designs in marble, may make a droll allusion to himself. Carlo Albacini, assessor of Cavaceppi's estate (1799), called his cast of the *Boy and Dolphin* "modern," like nearby works by his master. Records of plaster casts of the work in the collection of Anton Rapheal Mengs and in the estate of Nollekens (1823) do not mention Raphael either. For all their interest in such work, Cavaceppi's close colleagues Mengs and Hamilton did not connect it with Raphael, and Winckelmann did not even mention it, which probably indicates that it is an eclectic fusion of sources, like other pastiche inventions of Cavaceppi.

For many reasons the group may be ascribed to Cavaceppi: the finish and characteristic handling of such minutiae as the eye, fins, and base; characteristic confoundings as in the fish-scaled but mammalian dolphin with human-looking teeth; and its similarity to work once in his studio, such as the Hermitage *Boy Riding a Dolphin* and a semi-reclining *Boy on a Hippocamp* formerly in the collection of the Marquess of Rockingham at Wentworth Woodhouse. Cavaceppi's authorship is, however, hardly certain. Even if not by his hand, the *Boy and Dolphin* can be viewed as his "ready-made," selection and promotion of

In 1761 Piranesi was elected a member of the Rome Accademia di S. Luca, which asked for his portrait. The sculptor of this bust was unknown for many years, and it has been attributed to Giuseppe Angelini, merely because of its general resemblance to the 1779 statue in S. Maria in Priorato, Rome, the church designed by Piranesi. Angelini, like Nollekens, worked for Cavaceppi and Piranesi; in about 1770 he came to London and remained there for some eight years, working partly as assistant to Nollekens.

In his biography of Nollekens, J. T. Smith listed a portrait bust of "Peranesi, J. B." Some twenty-five years ago Professor Wilton-Ely found that Nollekens's lost bust was none other than that at the Rome Accademia. The reference to it is in the biography of Piranesi by J. G. Legrand, compiled from the reminiscences of the artist's children; the manuscript is preserved in the Bibliothèque Nationale, Paris: "J.-B. Piranesi was actually associate of several academies: that of St. Luke at Rome was eager to have him as a member and asked for his portrait which the English sculptor Nolickings [sic] made, a very good likeness and well characterized" (Erouart and Mosser 1978, p. 236). The only other suriving portrait made of Piranesi in his lifetime is the 1750 etching by Felice Polanzani, which appeared as frontispiece to Piranesi's *Opere varie*, and was reissued in 1756 for *Le antichita romane*. Polanzani's inscription reads: GIO. BAT. PIRANESI / VENET. ARCHITECTUS. Like that on the bust, it recorded his architectural and not his graphic

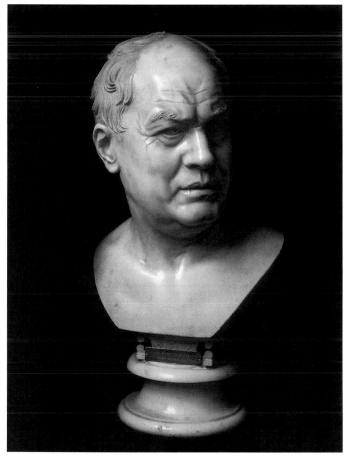

142

143

achievement, even though Piranesi's only executed works in architecture were not then built: the church S. Maria in Priorato, and the Piazza de' Cavalieri di Malta, which leads to it (1764–66).

The bust was probably made towards the end of Nollekens's time at Rome, between 1765 and 1770, and is more or less contemporary with Piranesi's works at S. Maria in Priorato, and his publication *Diverse maniere d'adornare i cammini* (1769). It is in the manner known as *à l'antique*, which imitates an ancient Roman format, with close-cropped hair and bare neck and chest. The hair, stylized like classical Greek sculpture, may be compared with the more natural hair on Nollekens's bust of Laurence Sterne (cat. 143). Piranesi was described in 1779 by his first biographer, G. L. Bianconi, as "rather large in person, of dark complexion, with very lively eyes that never closed." He went on with a curious remark, that "if our successors think they can see his image in a bust that is at the Academy … they will be wrong because it does not resemble him at all" (Bianconi 1779, p. 284). Other evidence, however, contradicts Bianconi. Angelini's statue, and an oil painting by Pietro Labruzzi (Palazzo Braschi, Rome), both of them commemorative

portraits begun in 1779, are clearly based on the Nollekens bust rather than the etching by Polanzani (see Wilton-Ely 1976, "Nollekens").

Nollekens had great ability in modeling heads; and yet this one is not like the rest. None of his other works is so animated, so perceptive, so incisive. The evidence for his having modeled Piranesi's portrait in clay can hardly be doubted, but, conceivably, the carving could be from another hand. In fact the treatment of the back and the rough "combed" surface left by the claw-chisel are not like any other of his busts. [JKB]

## 143
## Joseph Nollekens
### *Laurence Sterne*

Modeled 1766; the marble probably 1767–70
Inscribed on the back: *STERNE*
Marble
19¼" (including 4"socle) × 12" × 7" (50.2 [including 10.2 cm socle] × 30.5 × 19 cm)
PROVENANCE sculptor's collection; Nollekens's sale, Christie's, July 4, 1823, bought by Mrs. Russell Palmer for 58 guineas; Mrs. Palmer sale, Christie's, March 27, 1847, lot 266, bought Graves, 37 guineas; Broderip sale, February 7, 1872 (266), bought Heugh; Amor, St. James's Street, London; bought by Lt.-Col. G. B.

Croft-Lyons, who presented it to the National Portrait Gallery, London, 1920
EXHIBITIONS London 1951, cat. no. 25; London 1991, *Portrait*, cat. no. 30
BIBLIOGRAPHY Kerslake 1977, vol. 1, pp. 265–67, and vol. 2, pl. 770; Pressly W. 1978; Cash 1985–86, vol. 1, pp. 311–13, and vol. 2, pp. 239–40, 535–54
National Portrait Gallery, London

Laurence Sterne was the son of an impoverished infantry ensign. After education at Cambridge, paid for by a cousin, he took orders and became vicar of Sutton, prebendary of York, and in 1760 perpetual curate at Coxwold, Yorkshire. Always a popular preacher, he suddenly became famous in 1759 with his whimsical and rather bawdy novel *The Life and Opinions of Tristram Shandy*, the success of which was such that by 1765 Sterne had expanded it from two to eight volumes.

The comic character in *Tristram Shandy* is Parson Yorick, whose name derives from Shakespeare's jester: "a fellow of infinite jest, of most excellent fancy" (*Hamlet*, act V, scene 1). In later books, his sermons, and the *Sentimental Journey* (1768), Yorick was the pseudonym of Sterne himself. Joshua Reynolds's remarkable portrait of Laurence Sterne conveys all his wit and impishness (1760; National Portrait Gallery, London). Kerslake

pointed out that the picture was not, probably, a commission, but painted as a speculation (Kerslake 1977, vol 1., p. 261). Reynolds had it engraved in mezzotint by Edward Fisher; at the Free Society of Artists in 1761 both painting and engraving were exhibited, and prints were sold for five shillings. Nollekens, who exhibited at the same show, would certainly remember this.

Sterne suffered from tuberculosis and went abroad from 1762 to 1764 for his health. In 1765–66 he made a tour of France and Italy, which included visiting Rome and Naples between December 25, 1765, and April 17, 1766. In Rome he had an introduction from Sir Horace Mann to Cardinal Albani, which suggests one way he might have met Nollekens. Sterne was not well-off and is unlikely to have commissioned the bust. Nollekens, it seems, wanted his portrait bust to repeat the success of Reynolds's canvas, and that is more or less what happened.

In 1767 Nollekens sent the bust to London to be shown at the Free Society of Artists; number 309 in show was a "Busto of the Rev. Dr. Stern." The material was not stated; he may have shown the terracotta model (see below), but Kerslake thought a plaster cast more likely. One surviving

copy of the printed catalogue does not include the bust, which suggests that it arrived late. A reason for delayed arrival could be that the sculptor completed a marble version. This was the first of Nollekens's portrait busts to be exhibited in England, and it made his reputation. As J. T. Smith wrote, "With this performance, Nollekens continued to be pleased even to his second childhood, and often mentioned a picture which [Nathaniel] Dance had made of him leaning upon Sterne's head" (Smith [1828], 1920, vol. 1, p. 7). The portrait survives (Forbes Magazine Collection); William Pressly convincingly attributed it to John Francis Rigaud, about 1772.

Seven weeks after the sculptor's return to England, on February 12, 1771, plaster casts were advertised by Sterne's publisher friend Thomas Beckett at one guinea each, and six shillings extra if marbled or bronzed. No plaster versions are known today, but in addition to the present marble bust, Kerslake listed four others (one is at the Henry E. Huntington Library, San Marino, Calif.), and another is now at Sterne's house, Shandy Hall, Coxwold, Yorkshire. Most versions are copies made by Nollekens in London, but the present bust looks like an early work, carved in Rome. The chest is unusually low; the light tooling of the back and slightly tapered central shaft are not typical of his London works. (The socle seems to be later, and the inscription looks mid-nineteenth century.) This bust was kept by the sculptor and was sold with his property in 1823. Also at the sale, lot 22 on July 5, was "A terracotta bust of Sterne … done at Rome.—This Bust first brought Mr. Nollekins into repute, as a Sculptor." It was bought by Agar Ellis (lst Baron Dover) for 44 guineas, but is now lost.

The bust is in an "antique" format, with short matted hair and naked neck and chest, the raised right shoulder suggesting movement. Though serious, it is animated and conveys something of Sterne's convivial good nature and wit; it has his sharp nose and comical look. A bust with so much detail was surely more recognizable than Reynolds's generalized portrait. "When Sterne's remains were exhumed in London in 1969 for reburial in Coxwold, the skull was identified in part by location, in part by an anatomist's demonstration that it perfectly matched the Nollekens bust" (Cash 1985–86, vol. 2, p. 239, no. 44). [JKB]

## CAMILLO PACETTI
### ROME 1758–1826 MILAN

A Roman sculptor and restorer, son of Andrea, an engraver of precious stones, and younger brother of the sculptor Vincenzo, Pacetti grew up in the environment of Rome's academic culture. He worked in Rome until the age of forty-seven, when he was invited to teach sculpture at the Accademia di Belle Arti di Brera in Milan, a post he held for nearly twenty years, promoting the formation and spread of a more modern view of sculpture in the contemporary debate. The earliest information about Pacetti's training goes back to September 1771, when he won third prize for sculpture in the Accademia Capitolina del Nudo, directed in that session by the sculptor Andrea Bergondi. He took part in the same competition the following March, again carrying off third prize, and yet again in March 1773, when he came first, while that September, he entered the drawing competition and won first prize in the first class. Two years later Pacetti was the only contender in the first class when he presented himself at the Concorso Clementino announced by the Accademia di S. Luca; his bas-relief of *Judith Showing Her People the Head of Holofernes* (cat. 144) was awarded second prize.

There has been little study of Pacetti's early career on which to base any authoritative evaluation of his attitude to antiquity in the latter part of the eighteenth century. He probably worked a good deal with his brother Vincenzo, however, who by then enjoyed considerable fame in Rome as a sculptor, but even more as a connoisseur and restorer of antique sculpture. And Vincenzo's manuscript diary does provide indirect information about Camillo's activity. It was in fact the elder brother who sent Camillo to work with the sculptor and restorer Francesco Antonio Franzoni, who provided advice and instruction during his first independent professional jobs, from the stuccos for S. Lorenzo in 1783 to the "glory of stucco outside Rome" in 1784, the "putti di Altieri" in 1788 (Rome, Biblioteca Universitaria Alessandrina, "Il Giornale di Vincenzo Pacetti," ms. 321), and the stuccos in S. Nicolò da Tolentino, which Vincenzo turned down in favor of his brother because he himself had too much work, as well as the restoration of the *Melpomene* in 1789 and the *Hermaphrodite* in 1794.

The terracotta group that Pacetti made in 1786 for the Concorso Balestra of that year won him second place behind the victor, Joseph Chinard, but ahead of J. G. Schadow, amid much argument over his delay in submitting the work because of damage sustained during firing. Still conserved among the models left by the family to the Accademia di Belle Arti in Milan is a little terracotta of *Perseus and Andromeda*, probably the *bozzetto* for the lost model from the competition in question. The sculpture was to illustrate faithfully the story Ovid tells in his fourth book: "Perseus having slain the sea monster and delivered the virgin Andromeda from the rock, carries her away as was already promised at his victory, to make her his bride. Equal in them both is content, honesty, and the desire to celebrate the wedding," and it is easy to imagine how Pacetti's training may have guided him—as the judges clearly also thought—towards formal and poetic choices exactly halfway between the refined grace of the early eighteenth century and the austere classicism of the later part. This same balance, characteristic of the artistic climate in Rome in the late eighteenth century, is reflected in other works by Pacetti of this period, in which there is a gradual acceptance of Neoclassicism, based mainly on the fashion for direct study of antiquity, fed by new archaeological finds, and even more by the need to restore those finds. Linked to these finds was the enormous demand from illustrious foreign patrons for restored antique pieces, or else plaster casts or copies for their gesso museums. Pacetti accordingly worked almost exclusively as a restorer, yet in his application to the Accademia di S. Luca in 1793, to be accepted as an academician, he presented himself as a sculptor who held open studio in Rome and had exhibited some of his works for public assessment in various Roman churches.

The harmony that the young Canova brilliantly achieved between the classical world and eighteenth-century grace did not come easily to Pacetti, who, at the turn of the century, seems to have had little work: in 1801 his brother records: "I have sent a statue to Camillo for restoration to help him as he is without work" (Rome, Biblioteca Universitaria Alessandrina, "Il Giornale di Vincenzo Pacetti" [July 14, 1801], ms. 321). However, eventually his restoration work and the friendship and advice of Canova himself enabled him to free himself from his youthful, slightly Baroque style and from the influence of his brother, and to move towards Neoclassicism. Through the interest of Canova, who clearly appreciated Pacetti's professional ability, he was appointed in January 1805 to the chair of sculpture at the Accademia di Belle Arti di Brera. In the spring of that year he accordingly moved both his family and his studio to Milan. The radical change of political climate and the particularly lively cultural atmosphere in which he consequently became involved finally spurred him on to establish his own artistic personality, one drawn ever more closely to an explicit Neoclassicism, but never lacking harmony or grace. In Milan Pacetti created a flourishing school, thanks also to the important monumental commissions of the Napoleonic period. When he left Rome he took with him many gesso models he then had in his studio, including the group of *Minerva Instills Life into the Automaton of Prometheus*, an interesting work in terms of both its subject and its formal qualities; in 1807 this underwent a political transformation to become *Napoleon Animates Italy with the Sacred Flame and the Call to Greater Destinies*. In 1810 Pacetti undertook to direct the façade of Milan Cathedral and, in 1812, the Arco del Sempione, working personally on certain statues for the cathedral and some bas-reliefs for the arch. Also dating from this second decade of the nineteenth century are his portraits of Giuseppe Bossi and the painter Andrea Appiani in the Accademia di Brera. Among his last works was the *Ganymede* of 1819, an essentially Neoclassical work that is nevertheless tinged with naturalism, a blend that had by then become his hallmark.

In 1822 Pacetti was struck with paralysis and four years later he died. During his time in Milan, a time of political upheaval, he had made an important contribution to the diffusion of the modern Neoclassical artistic language, not only within the traditionalist circles of the Fabbrica del Duomo, but throughout Lombardy. [ANC]

BIBLIOGRAPHY  *In lode delle Belle Arti* 1775, pp. x, xvi; *In lode delle Belle Arti* 1786, pp. 6–7; *Discorsi letti in occasione della pubblica distribuzione de' premi fatta da S. E. il sig. Ministro dell'Interno il giorno XXIV di giugno an. MCCMV nell' Accademia Nazionale di Milano.* Milan, 1805; Golzio 1933; Golzio 1939; Honour 1960, "Pacetti"; Hubert 1964, *Sculpture*, p. 59; Caramel, Luciano, and Carlo Pirovano, eds. *Galleria d'arte moderna: opere dell'Ottocento.* Milan: Electa, 1975, pp. 653–54; *Mostra dei maestri di Brera, 1776–1859.* Milan: Centro Grafico Linate, 1975, pp. 80–84; Nava Cellini 1988; Germanò Siracusa 1996

144

## 144
## Camillo Pacetti
### *Judith Showing Her People the Head of Holofernes*

1775
Terracotta
22½″ × 31½″ (57 × 80 cm)
PROVENANCE  Concorso Clementino, 1775;
Accademia di S. Luca, Rome
EXHIBITION  Rome 1959, cat. no. 403
BIBLIOGRAPHY  *In lode delle Belle Arti* 1775,
p. 16; Golzio 1933, pp. 25–26, 44–45, 64;
*Settecento* 1959, p. 158, no. 403
Accademia Nazionale di San Luca, Rome

The announcement of the Concorso Clementino, proclaimed in the holy year of 1775, asked the competitors in the first class of sculpture for a terracotta bas-relief representing "Judith in the piazza of Bethulia in a prominent place or on the steps of some public building surrounded by torches, showing the severed head of Holofernes to the people and the nobles of the city, among whom their prince Ozìa must be distinguished. Some of the bystanders shall be in the act of thanking God, and some in acts of exultation and applause for Judith, at whose feet shall be seen the sack in which she had concealed the head of the dead Holofernes" (*In lode delle Belle Arti* 1775, p. 10). The choice of theme is suggestively Baroque, as was the subject proposed for copying in the third class, "a model of the statue of *Saint Bibiana* by Bernino [sic]" (*In lode delle Belle Arti* 1775, p. 10). The lure of a

classicist treatment is obvious, but a more modern approach might suggest a less intimate and introspective rendering of the figure of Judith than in the seventeenth century. Here the heroine, no longer accompanied by the single maidservant, is to be represented together with the people who will benefit by that death. To express the idea that her action may be the execution of a higher will, it is suggested that half the people be shown "in the act of thanking God" (*In lode delle Belle Arti* 1775, p. 10). The proposed text emphasizes the realism of the narrative, recommending the placing of lights around the heroine so that the onlookers, even at a distance, can recognize the head of Holofernes that is being shown to them, and reminding the sculptor of the need to draw attention to the now empty sack that had contained it.

The scene to be represented is therefore of necessity crowded with figures. The young sculptor, just turned seventeen, tackled the work by dividing the scene into two, creating a depth, by making the figures in the centre less prominent, that enabled him to give the necessary emphasis to the figure of Judith on the right and, at the same time, to make the head of Holofernes clearly recognizable. The suggestion of the steps, at the top of which Judith's gesture can be seen by all the people, is achieved by giving them a curved layout, curiously incongruous in relation to the space defined by the rectilinear bases of porticoes with which

they were connected, but useful for introducing a sense of movement. The treatment of the group on the left, although showing inventiveness and skillful control of the various levels of relief, seems to be based on a knowledge of the balanced dynamism of the previous century. The figures on the right, from the half-kneeling woman with the child, to the maidservant leaning over the shoulder of the protagonist, are precise reiterations of many similar seventeenth-century models, reproduced with a complacent and overt sensibility that is entirely eighteenth-century. The diagonals in each of the two parts, suggested by lances and torches, which neatly frame Prince Ozìa on the left and Judith on the right, relate to an even more rigidly academic scheme. The urban landscape, explicitly required, is summarily indicated in the less raised part of the background, more drawn than modeled.

The judges' laconic appraisal, "seeing that there is only one competitor in the first class, and he does not deserve the first prize either for the bas-relief or for the overall effect, we award him the second" (Rome, Archivio S. Luca, vol. 53, fol. 64v), is justified by the uncertainties, hesitations, and incoherences—both formal and poetic—that are apparent in the work. There is clear evidence of the rich experience Pacetti gained during his early working years, in his explicit quotations of classical, antique, and contemporary prototypes. However, the display of technical ability often

appears an end in itself—as in the barely engraved relief on the architectural background, or in the crowd of bystanders—while the prostrate figure with clasped hands in the centre of the scene lacks the importance needed to function as the pivot and meeting point of the entire scene. The articulation of the story imposed by the complex iconography patently fails to find a unifying rhythm, either stylistic or narrative. The male figures on the left, rigidly restrained and almost squashed by their vertical arrangement, fail to interact with the female figures arranged on the right in a brief arch that emphasizes the horrific apparition of the severed head of Holofernes.

Apart from Camillo Pacetti, however, no other young sculptor who was in Rome in that year was inclined to take on the proposed theme, calling as it did for difficult narrative constraints to be translated into convincing formal solutions. It was quite a different story in the second and third classes of the competition, however, where much simpler themes were stipulated, resulting in the announcement of three prize winners in the second class and four in the third. [ANC]

## VINCENZO PACETTI
### ROME C. 1746–1820 ROME

A sculptor, restorer, and collector, Vincenzo was the son of the gem engraver Andrea, and the elder brother of Camillo, another sculptor. He received his training in the Rome environment, probably between his father's workshop and the Accademia del Nudo on the Capitoline Hill, where he studied from 1762 to 1770 under the direction of Tommaso Righi, Andrea Bergondi, Paolo Pacilli, and Francisco Preziado, winning various prizes and distinguishing himself as one of its most brilliant pupils. In 1766, 1768, and 1773 he entered the competitions held by the Accademia di S. Luca, winning prizes of considerable value to a young man needing to attract the attention of potential patrons. In the Concorso Clementino of 1766 he was awarded third prize in the first class; the competition required a bas-relief illustrating a passage from Genesis: *Pharoah Seated on His Throne Receiving Jacob Led by His Son Joseph*. Two years later he took part in the first Concorso Balestra with a group in terracotta that was to represent the episode from the first book of Ovid: *Juno, Jove, and a Cow Teased by a Cloud*. His work was awarded second prize, behind that of Joseph Nollekens but ahead of the Frenchman Stefano d'Antonio and the Swiss Vincenzo Mazzetti. In the same

competition in 1773, he was at last awarded the first prize, together with Giuseppe Martini from Lucca. The theme of this competition required entrants to depict *The Meeting of Achilles and Penthesilea, Queen of the Amazons, Whom He Has Mortally Wounded* (cat. 145).

In these years Pacetti worked as a restorer of ancient marbles under the guidance of Pacilli and Cavaceppi. In 1775 he applied unsuccessfully to become an academician of S. Luca, but won unanimous election only four years later, in 1779. Gradually, though, his sculpture, which combined a thorough technical knowledge with an instinctive ability to reconcile the prevailing late Baroque style with the renewed interest in classicism, found ever wider approval in the form of numerous requests for his work, official recognition from Rome's major artistic institutions, and the friendship of artists, writers, and other intellectuals. The brief handwritten notes that comprise his diary offer an intimate picture of Vincenzo Pacetti's progress in the Roman environment, the center of European culture. He was several times regent of the Congregazione dei Virtuosi al Pantheon, and served several terms as Principe of the Accademia di S. Luca in the difficult years between 1796 and 1801, when he demonstrated his ability as a mediator as well as his concern for Rome's greatest artistic institution. He was also appointed director of the Accademia del Nudo on several occasions, and enjoyed the opportunities this offered both for teaching and contact with young people.

Pacetti's artistic career began formally in 1774, directly after his victory in the Concorso Balestra, with the commission for the funeral monument of the Grand Master Emanuele Pinto de Fonseca in Valletta Cathedral in Malta. In 1776 he began his collaboration with the architect Mario Asprucci on the complex work of decorating first the Casino Borghese and then the little Temple of Esculapius in the same villa, which took them over ten years. He showed his skill as a decorator in the reliefs for the Romulus Room in the new apartment of the Palazzo Altieri (1789–91), and in reliefs for numerous churches both in Rome and elsewhere. But he was also an efficient portraitist, as demonstrated by the bust of Mengs in the monument in Ss. Michele e Magno, and those of Pietro Bracci, Benefial, Pope Pius VI, and many other leading figures in the Roman society of his time. Above all, he was an intelligent restorer of classical remains, many of them only recently excavated, intuitively selecting the most interesting pieces. Working often in collaboration with the sculptor Francesco Antonio Franzoni, he

assembled numerous works in his studio for sale to Roman prelates and princes, and to foreigners. His archaeological philosophy was largely derived from Winckelmann, whose ideas were propounded mainly by Cavaceppi. This philosophy sanctioned the combination of antique pieces that were unrelated as long as they were compatible, and seems to have been shared by Canova himself, though later he developed a different approach (Nava Cellini 1988, p. 61). Many foreign artists and collectors visited Pacetti's studio, including Hamilton, Kauffmann, Jenkins, Head, and many others, but through the mediation of Francesco Piranesi a special rapport was established between Pacetti and the Swedish court, for whose new museum the "Pacetti collection" was acquired in 1794, supported by the expertise of Giuseppe Angelini and Ennio Quirino Visconti.

A sculptor of classicism still imbued with eighteenth-century grace, closer to the style of Mengs than of Canova, in his later years Pacetti witnessed the end of the culture to which he had made such a major contribution. One emblem of the new cultural climate was the certificate that he asked the Accademia di S. Luca to sign in May 1809, confirming the decorum with which he exercised his "profession of distinguished head sculptor of both school and the studio that was named after him, not subcontracting to other professors to execute works not his own" (Rome, Archivio S. Luca, vol. 56, fol 84v). Some years later, in December 1815, when the Roman academy decided to mark the return of the works of art by the French with marble busts of the pope, Cardinal Camerlengo, the cardinal secretary of state, and the Marchese Antonio Canova, other sculptors were commissioned to execute them, but not the elderly *cavaliere* Vincenzo Pacetti, although he was still alive and active. [ANC]

BIBLIOGRAPHY *Orazione e componimenti poetici in lode delle Belle Arti. Relazione del solenne concorso e della distribuzione de' premi celebrata sul Campidoglio dall'Insigne Accademia del Disegno in S. Luca il 24 novembre 1766, essendo Principe di essa il Sig. D. Francesco Preziado alla Santità di Nostro Signore Clemente XIII.* Rome, 1766; *In lode delle Belle Arti. Orazione e componimenti poetici. Relazione del concorso e de' premj distribuiti in Campidoglio dall' Insigne Accademia del Disegno in S. Luca. Il dì 24 novembre 1768 per nuova istituzione del nobil uomo Carlo Pio Balestra essendo principe il signor Andrea Bergondi scultore.* Rome, 1768; *In lode delle Belle Arti. Orazione e componimenti poetici. Relazione del concorso e de' premj distribuiti in Campidoglio dall' Insigne Accademia del Disegno in S. Luca. Il dì 27 aprile 1773 secondo l'istituzione del nobil uomo Carlo Pio Balestra essendo Principe dell' Accademia il Signor Andrea Bergondi scultore.* Rome, 1773; Brinckmann 1923–25, vol. 2, pp. 122–23; Golzio 1933;

145

Golzio 1939; *Settecento* 1959, no. 405; Honour 1960, "Pacetti"; Honour 1963, "Pacetti," pp. 368–73; Hubert 1964, *Sculpture,* p. 59; *Mostra dei maestri di Brera, 1776–1859.* Milan: Centro Grafico Linate, 1975; Nava Cellini 1988; Caira Lumetti 1990; González-Palacios 1991, pp. 110–11; Germanò Siracusa 1996

## 145
## Vincenzo Pacetti
### *Achilles and Penthesilea*

1773
Terracotta
26¼" × 18½" × 16½" (68 × 47 × 42 cm)
PROVENANCE Concorso Balestra, 1773; Accademia di S. Luca
EXHIBITIONS Rome 1959, cat. no. 403; Rome 1991, *Fasto romano,* cat. no. 13
BIBLIOGRAPHY *In lode delle Belle Arti. Orazione e componimenti poetici. Relazione del concorso de' premj distribuiti in Campidoglio dall' Insigne Accademia del Disegno in S. Luca il dì 27 Aprile 1773 secondo l'istituzione del Nobil Uomo Carlo Pio Balestra, essendo principe dell'Accademia il Signor Andrea Bergondi scultore.* Rome: Casaletti, 1773; Brinckmann 1923–25, vol. 2, pp. 122–23; Golzio 1933, pp. 24–25, 50; Golzio 1939; *Settecento* 1959, no. 403; Honour 1960, "Pacetti," pp. 174–81; Nava Cellini 1988; González-Palacios 1991, no. 13
Accademia Nazionale di San Luca, Rome

In the second Concorso Balestra, announced by the Accademia di S. Luca in 1773, the theme assigned to the young sculptors was: "The

Amazons having come to the aid of the Trojans, the young Achilles encounters their queen, Penthesilea, in battle and mortally wounds her; he takes off her visor, is stunned by her beauty and falls in love with her, then is tormented with pain as he watches her expire in his arms" (*In lode delle Belle Arti,* p. 7, see above). The sources quoted are particularly scholarly: Quintus Smyrnaeus's sequel to the *Iliad* and the fifth book of Pausanius. The entirely Baroque theme of the link between love and death is treated here in a manner already imbued with a pre-Romantic temperament. Unfortunately the only known sculptural interpretation is Vincenzo Pacetti's terracotta, as the entry submitted by the other prize-winning sculptor, Giuseppe Martini from Lucca, has been lost. The group here stands on a low base of rocks suggested schematically by masses articulated by parallel strokes. The helmet and breastplate lying on the ground before the two characters are somewhat sketchy in form, more graphic than plastic, to indicate that they belong to a woman, in contrast to the weapons of Achilles, depicted in detail with a strong, impressive head of Medusa, which are on the ground behind them. The figures entwine in an embrace structured along two strong diagonals: the one extending down Achilles' right arm, which supports Penthesilea's limp body and

continues along her inert left arm, is balanced by one running from the slanting drapery on the left side of the hero's chest, through the clothes softly slipping over the queen's lifeless body. The visor of the warrior's valuable helmet, and the curls that frame his face, create an unusual effect of light that emphasizes his pained and questioning expression, a light spread over his broad chest, while a more modulated half-light softens as it conveys the flimsiness of the tunic over her breast, which is the true focus of the group. A stability both physical and visual is conveyed by the rendering of the half-bent leg against which the dying woman leans as in the most celebrated ancient models. The key to the interpretation of the given theme that Pacetti seems to be offering lies in this counterpoise between the softness of the limp body and the vigor of the heroic nude. The first is treated in almost sentimental terms, dwelling on the careful rendering of the drapery, the ribbons, and the ruffled folds disrupting the connection between breast, neck, and shoulders, and reducing the head to a triangular shape to accentuate the angle of vertex of the right shoulder. The ample drapery that clothes the hero's left shoulder and right side, still Baroque in its expressionistic swelling, recalls earlier, more classical approaches. The face is classical, arranged in a way very similar to that of the *Laocoön*, as are the positions of his arms: the left, now missing its hand, is reminiscent of analogous poses of antique statues of Apollo filtered through Bernini's reinterpretations, while the right, supporting the body of the dying queen, quotes antiquity with an ease possible only for one with long experience of copying. Less elegant, but very important to the group's physical and visual stability, is the left leg, extended to support the abandoned body, which very effectively echoes the manner of Michelangelo.

Brinckmann read this work as the announcement of victory over the Baroque. According to him, it was Pacetti who, with this work, introduced classicism into Italian sculpture, not Canova, who was then only sixteen. Golzio had already rejected this hypothesis, stressing that the Baroque is undeniably present in this terracotta, from the flexible and sinuous outline of the base to the composite, contorted architecture and the fluttering draperies. Santangelo, in the historic 1959 exhibition, *Roman Art in the Eighteenth Century*, emphasizing the extremely fine execution, pointed to the artist's classicizing approach, evident despite the technically relaxed and expressive but still Baroque workmanship. Considering, however, that

this is a competition entry, the most convincing hypothesis is that Pacetti wanted to demonstrate the full range of his expressive ability, combining in a single group the heroic and the dramatic styles, the desire for the ideal simplicity of the classic, and the taste for the involved and emphatic narrative, the revival of the antique and the modern tradition. The resulting composition is original in its introduction of "classical" elements drawn from the antique, but still too Baroque in style and implication to mark a decisive step towards classicism. [ANC]

## FRANÇOIS-MARIE PONCET
LYON 1736–1797 MARSEILLE

Poncet is often regarded as being from Lyon, and occasionally as being from Marseille; in fact he had a foot in both cities, since his family were from Chazelle-sur-Lyon, where his grandfather Pierre was a court clerk and schoolmaster. Pierre died young, and Benoît, his son, went to seek his fortune in Marseille, where he became a domestic servant. In 1736 he was employed in the service of the ambassador to the king of Naples, Charles VII of Bourbon, on a visit to Paris. Thus François-Marie Poncet, born in Lyon on September 9, was by chance reunited with his origins. He acquired his artistic training at the Académie des Beaux-Arts in Marseille, founded in 1752, and was awarded a prize in 1754; his masters must have been the obscure Bertrand and Jean-Michel Verdiguier. He then went to Paris, where he joined the studio of Etienne Falconet and was twice given the "term" prize (awarded four times a year): second prize in 1757 and first prize in 1759. He was turned down, however, for the *prix de Rome*. In 1759 this was won by Clodion, and in 1760 by Martin-Claude Monnot. When the young Houdon entered for it in 1761, Poncet withdrew and set off for Rome at his own expense. There he applied to the French Academy for lodgings, but was refused. He appears to have distanced himself from the academy from this point on, mixing rather with artists associated with Mengs and Winckelmann, who were arguing strongly for a return to antiquity. These included Laurent Pécheux from Lyon and François-Joseph Lonsing from Belgium, both painters, and the sculptor Etienne Dantoine, another former pupil, like Poncet, of the academy of Marseille.

The earliest surviving works by Poncet are two bas-reliefs in terracotta, the *Artemisia Fainting* (Musée Historique, Lyon) and the *Holy Family* of 1773 (cat. 146). During his first stay in Rome, which lasted until 1775, he made a copy of the Callipigian *Venus*,

a *Drowned Girl*, and a statue of *Artemisia Weeping over the Urn Containing the Ashes of Her Husband, Mausolus*. These three sculptures have been lost, but the last is known from an engraving by Angelo Campanella. After nearly fifteen years in Rome, Poncet decided to try his luck in France. In an ambitious move he went to Ferney to make a bust of Voltaire. In Lyon at the end of 1775, he was elected a member of the academy, making a show of his origins and his title of *pastor of the Accademia dell'Arcadia*, awarded in Rome in 1771. He spent several weeks at Ferney in 1776, and presented a plaster model of the portrait to the academy in Lyon, where it remains. There are six known marble copies (three signed replicas in the former collection of Tony Dreyfus, Museums of Dijon and Dunkirk, three unsigned, in private collections, including that of Theodore Besterman). He went to Paris and applied to sculpt a bust of D'Alembert, who refused, but was accepted by Turgot and by Charlotte, Duchess of Albany, then at school in France. According to the Lyon poet Chassaignon, Poncet also went to Versailles to make busts of the king's two brothers and of Marie-Antoinette. Except for the bust of Voltaire, none of these works is known today. It is curious to note that Houdon was sculpting the same subjects during the same period (competition between the two men tilted in Houdon's favour with the Voltaire bust of 1778).

However, the Voltaire bust did serve as a springboard for Poncet, and he is still known for this work. Replicas were no doubt sold, and by the time he returned in 1777 to Italy, where he was elected a member of the Accademia Clementina in Bologna, he seems to have gained financial security; he moved into a huge studio, later visited by Gustav III in the company of Sergel. During this second period in Rome, from 1777 to 1784, he enjoyed great success and worked for French, English, and Russian collectors. Although these collectors have not been identified, it is known that he worked for Nicolas de Montribloud and Imbert-Colomès, both from Lyon, and that he made a *Lucretia* and a *Virginia* for the Duc de Montmorency (now lost). There is a *Venus* in the Musée Cognacq-Jay in Paris (signed and dated 1778), executed for an unknown patron, and an *Adonis* (1784) in the National Gallery, Dublin, commissioned by Lady Saint-George Usher. During this period he employed young artists from Lyon and the Danish sculptor Nicolas Dajon in his studio. He spent the years 1784 to 1786 in Paris, installing a large funerary monument for Louis de Boullenois de Blasy in the Eglise des Carmes, Place Maubert, a work begun

in 1780. It provoked great debate, being considered too "Italian" for French taste, with its great pyramid, sepulchral urn in antique style, and the statue of *Justice* inspired by the Medici *Niobe*. The tomb was pulled apart during the French Revolution. Two engravings of it have survived, together with the eagle, sculpted in blue stone, by Francesco Franzoni, now in the Ecole des Beaux-Arts in Paris. Poncet then traveled to London to sculpt statues of George III and Queen Charlotte, before returning to Rome for a final period from 1786 to 1789. The only surviving work from this last sojourn is a bust of a young girl dated 1788 (Daniel Katz Gallery, London, 1996). Poncet was forced to leave Rome for good in 1789, at the time of the Cagliostro affair. He was probably a freemason, and may have found himself politically compromised. He fled to Florence, where he was admitted to the Accademia del Disegno in 1792 and copied the head of *The Death of Alexander* in the Uffizi. He finally resurfaced in Marseille, in 1796, where he signed a petition for the "confiscation" of further works of art from Italian collections.

Poncet died in Marseille on August 24, 1797. In 1800 a number of his works were sold in Paris, probably those recovered from his studio in Rome by the beneficiaries to his will; they provide a useful résumé of his career, which was principally centered around the copying and imitation of antique works of art, including the *Antinous*, *Bacchus*, *Ceres*, *Flora*, the *Hermaphrodite*, the *Venus Pudica*, and the Callipigian *Venus*. [OM]

BIBLIOGRAPHY Michel 1984; Michel 1996, *Vivre et peindre*

## 146
## François-Marie Poncet
*Holy Family Worshiped by Angels*

1773
Signed on the reverse: *F. Poncet in. fecit Rome 1773*
Terracotta
Diameter 22¼″ (56.5 cm)
PROVENANCE Parisian collection; London, Gallery "Romulus" (Mr Jan J. Millner)
BIBLIOGRAPHY Michel 1984; Michel 1996, *Vivre et peindre*
Galleria Nazionale d'Arte Antica, Rome, Palazzo Barberini

The origin of this work is unknown; when it appeared on the London art market it was unattributed, the signature on the reverse having been concealed. Dated 1773, it was made toward the end of Poncet's first stay in Rome, about which relatively little is known. He arrived in 1761 to discover

146

antique sculpture and study the classical works of the seventeenth and early eighteenth century, such as those by Pierre Legros, as well as by his own contemporaries, in particular Filippo della Valle, whose influence can be detected here in the typically Florentine elegance of the figures. The classical feeling of his work is also reminiscent of Mengs and Batoni. He signed his first, fairly conventional work in 1769, a bas-relief in terracotta showing *Artemisia Fainting* (Musée Historique, Lyon), and his progress over four years can be judged from the fine treatment of the faces and the delicacy of the modeling, as well as from the technique of sculpting drapery which became significantly richer and more supple.

The Virgin is seated on a rock at the center of a circular composition, with the infant Jesus asleep on her lap. To her left stands Joseph, behind the central rock, holding a rod in his right hand, facing toward the central group, with his left hand placed on his chest, as though in a gesture of prayer. On the right side of the relief two kneeling angels contemplate the child; the first angel holds the edge of the cloth on which the child lies. Above the scene the heads of four cherubs are seen, lightly sketched in the middle of clouds. This may be a simple adoration scene or a *Rest on the Flight Into Egypt*, but since such traditional elements of the latter as date trees laden with fruit are absent, the simple descriptive title of *Holy Family Worshiped by Angels* has been preferred.

This is the only surviving religious work by Poncet. From his baptismal certificate and the parish register it is known that he was a Catholic, and a practising one, and that he observed the requirement to take communion every year at Easter. Curiously, criticism by Parisian jounalists of the mausoleum for Boullenois in 1786 at the Eglise des Carmes in the Place Maubert, focused on his lack of religious feeling, and his undue attachment to pagan antiquity. It is true that his entire work was based on the copying and imitation of antique models, but does this necessarily imply that he personally was lacking in spiritual depth? It is true, too, that he was a *bon vivant*, and that Chassaignon, the writer from Lyon, spoke critically of his excesses, but does this necessarily have any bearing on his work as a sculptor? The artist adapts to the work in hand as an actor does to his role.

In fact, Poncet was far from ignorant of religious sculpture, which he first encountered in his early days in Paris. The bas-reliefs he created for the *prix de Rome* competition in 1759 have not survived, but they are known to have depicted *Absalom Has His Brother Amon Killed at a Banquet* (1759) and *The Sacrifice of the Israelites on the Recovery of the Ark from Philistine* (1760). Furthermore, he would have been working in Falconet's atelier while the latter, aided by Pajou and Huez, was creating a series of sculptures for the church of St.-Roch, from 1753. These included a *Virgin Annunciate* (1755), *Christ in the Garden of Olives* (1757; the only surviving piece ), the *Angel of the Annunciation* of 1758, and a *Calvary* group (1760), known today from the painting by Nicolas-Bernard Lépicié (Musée

Carnavalet, Paris), on some of which Poncet himself probably worked.

The graphic character of this bas-relief is particularly noteworthy. Although none of this sculptor's drawings have survived, two of his contemporaries, Gabriel Bouquier and Chassaignon, reported that he was an exceptional draftsman. [OM]

## FRANCESCO RIGHETTI
ROME 1749–1819 ROME

As a sculptor, silversmith, and bronze founder, Francesco Righetti worked on large-scale projects for popes and monarchs: he is best remembered, however, for his small bronze statuettes after famous antiquities. Righetti trained in the workshop of the leading Roman sculptor–silversmith of the day, Luigi Valadier, and emerged from his training as a versatile artist–craftsman in his own right. Righetti's first major independent commission came in 1781, from the English banker Henry Hope. Hope requested twelve full-sized lead replicas of famous sculptures, which were to be painted white to simulate marble. The group, intended to decorate a country home, included not only copies of antiquities but also of works by Giambologna and Duquesnoy. Righetti's refined metalwork soon attracted the highest level of patronage. For the famous Grand Tourist Frederick Hervey, Bishop of Derry and Earl of Bristol, Righetti fashioned two bronze candlesticks, the design of which incorporated antique figures. In 1786 Catherine the Great of Russia commissioned Righetti to create a marble model of Mount Parnassus, which he populated with bronze statuettes of Apollo, the Muses, and the winged horse Pegasus. With the exception of Pegasus, the figures were all reduced-scale versions of a celebrated statuary group in the Vatican's Museo Pio-Clementino. To such connoisseurs as the empress and her agents, the imitative nature of such art enhanced rather than detracted from the value of the bronzes: the admiration of such specifically identifiable antiquities as the Vatican *Muses* was a signal of taste and cultivation. The rearrangement of the miniatures, whether on a specially commissioned marble Parnassus or on the chimney-piece of an aristocratic studio, was a further exercise in cultivation.

During the 1780s Righetti established himself as a producer of bronze miniatures after famous antique prototypes, a genre of sculpture that developed in the second half of the eighteenth century in response to the burgeoning art market. While such bronzes had enjoyed popularity among Italian collectors and connois-

seurs for two centuries, they held particular appeal to the Grand Tour market. The vogue for such objects can be attributed in part to the spiraling prices of real antiquities in the eighteenth century. This, combined with tightening papal control over the excavation and export of archaeological material, placed the acquisition of choice artifacts beyond all but the very wealthiest collectors. Artists such as Righetti and his competitors Giovanni and Giacomo Zoffoli obliged and fed demand for the bronze miniatures, while other artists did similar work in terracotta or biscuit porcelain.

Like any metal-casting project, Righetti's enterprise was collaborative. Aside from maintaining a workshop staff that included his son Luigi, Righetti is known to have employed other artists to sculpt for him. Documentary sources indicate, for instance, that the sculptor Camillo Pacetti copied antiquities for Righetti in 1785.

In 1794 Righetti published a catalogue-style price list of the miniature statues available in his workshop, a document that attests both to the scope of his production and to his promotional talent. The offerings included seventy-eight single figures, twenty-five figure groups, forty-six busts, and various vases, trophies, and animal sculptures. Although most of the advertised bronzes were after noted antiquities, the catalogue also lists copies of modern works, including four statuettes after Bernini and five after Giambologna. In the same document the sculptor expressed his willingness to do custom work, offering to copy statues of the buyer's choice either in miniature or in full scale. Significantly, the 1794 price list is written in French, suggesting that Righetti conceived the miniatures for a foreign clientele.

In 1801 the newly elected Pope Pius VII paid Righetti the unusual honor of visiting the artist in his workshop. Admiring his work, the pope commissioned a gilt bronze set of altar furnishings as a gift for the church of S. Giorgio Maggiore in Venice. Two years later Righetti created a pair of miniature obelisks commemorating the marriage of Prince Camillo Borghese to Paolina Bonaparte, the sister of Pius VII's nemesis, Napoleon. That same year, almost certainly at the commission of the king of Naples, Righetti and his son produced a set of *Apollo and the Muses* (Capodimonte, Naples) that recalls the *Parnassus* group carried out seventeen years before for Catherine the Great. Again the models were the Vatican statues, although instead of the marble mountain, four classicizing architectonic bases provide the ambient for the

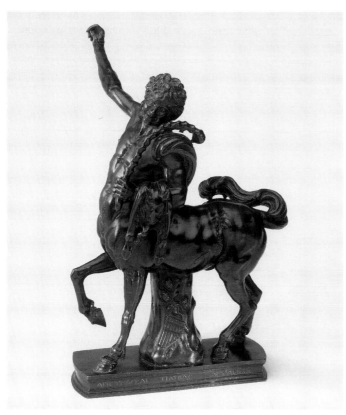

147

bronze figures. The king later commissioned Righetti to make a set of altar furnishings for his great votive church in Naples, S. Francesco di Paola.

While Righetti's copies of antique statuary reflect the artist's desire for faithful reproduction, his decorative work shows another side of his personality. In vases, candelabra, tripods, and other projects Righetti drew from the influence of his teacher Valadier and from the capricious eclecticism of Giovanni Battista Piranesi. In his more flamboyant works Righetti mingled exoticizing Egyptian sources, classical motifs, and vegetal forms, treating all with an imaginative sense of *grotesquerie*.

Righetti also worked on the casting of large-scale bronzes, and in 1805 Pope Pius VII appointed the artist to succeed Giuseppe Valadier as director of the Vatican foundry. In 1809, in his capacity as a bronze founder, Righetti collaborated with Antonio Canova to produce the giant bronze figure of Napoleon (Brera, Milan) for Prince Eugène de Beauharnais, the French viceroy of Italy. In 1819 Righetti and his son Luigi cast Canova's monumental equestrian *Charles III*, which still stands before the royal palace in Naples. After Righetti's death later that year, the family enterprises in Naples and Rome continued under the direction of his son Luigi Righetti and grandson Francesco Righetti the Younger. The works of the family, highly prized and for the most part easily portable, are distributed in

some of the most important European and American collections. [JH]

BIBLIOGRAPHY Righetti 1940; Righetti 1941; Bulgari 1958–74, vol. 2, p. 340; Honour 1963; González-Palacios 1976; Hiesinger and Percy 1980; Haskell and Penny 1981; Luchs 1996; González-Palacios 1997, *Valadier*

## 147
## Francesco Righetti
### *Young Centaur*

1787
Signed and dated: *F.RIGHETTI.F.ROMAE.1787.*
Inscribed on base: ΑΡΙϹΤΕΑϹΡΑΙ ΠΑΠΙΑϹ ΑΦΡΟΑΕΙϹϹΙϹ [sic]
Bronze
15⅝″ × 9½″ × 4⅞″ (39.7 × 24.2 × 12.4 cm)
PROVENANCE The Drawing Shop, New York; purchased by Anthony Morris Clark in 1969; by bequest to the Philadelphia Museum of Art in 1978
EXHIBITION Philadelphia 1980, cat. no. 112
BIBLIOGRAPHY Hiesinger and Percy 1980, p. 126
Philadelphia Museum of Art, Bequest of Anthony Morris Clark

The centaur, a stock creature of Greco-Roman mythology, combines the attributes of man and horse. Dwelling in the wilderness, centaurs represent the wilder side of the human psyche, and are often associated with Bacchus, the god of wine. The dancing movement of this lively specimen, his arm thrown up in abandon, conveys an appropriately bacchic sense of

revelry; meanwhile, the knobby club in his left hand indicates the centaur's potential for violence, a potential frequently realized in the ancient legends.

Righetti's bronze is a small-scale copy of one of the Furietti *Centaurs*, a pair of statues excavated in 1736 by Monsignor (later Cardinal) Alessandro Furietti on the site of Hadrian's Villa at Tivoli. The life-size centaurs, carved in an exotic red basalt, are generally regarded as second-century copies after Hellenistic bronze originals. With their imperial provenance and dramatic composition, the centaurs were a sensation at the time of their discovery, and entered immediately into the canon of the most celebrated Roman antiquities.

The fame of the statues, reflected by Righetti's selection of them as models for his bronze miniatures, grew over the course of the century. Monsignor Furietti contributed to this himself by commissioning Nicolo Onofri and Pompeo Batoni to design engravings of his centaurs. Pope Benedict XIV himself coveted the statues but was unable to persuade Furietti to part with them; Clement XIII finally acquired them in 1765 for the staggering price of 13,000 *scudi*. He immediately presented them to the Museo Capitolino, Rome's oldest public art museum, and regarded the transaction as such an accomplishment that he had a medal struck to celebrate it.

Francesco Righetti produced multiple statuettes of both Furietti *Centaurs*, which collectors could purchase singly or as a pair; a pair exists, for instance, in the collection of the Victoria and Albert Museum in London. The *Centaurs* were part of the line of bronze miniatures that the Righetti workshop marketed to connoisseurs and northern European Grand Tourists, and they appear in Righetti's 1794 printed list of available statues and ornaments. Nor was Righetti the only artist to offer miniature versions of the Furietti *Centaurs*: his rivals Giacomo and Giovanni Zoffoli produced similar versions in their slightly less expensive line of statuettes, and models in plaster and biscuit porcelain are also known. Displayed on chimneypieces, dining tables, and side tables of a stately home, such objects would serve—much as the Canalettos on the wall—as mementoes of the owner's voyage to Italy and symbols of his status and cultivation.

Although Righetti was typically very faithful in his reproduction of antiquities, the inscription that appears on the base of the exhibited bronze is incorrectly copied from that of the original. The inscription on the Museo Capitolino marble in fact reads ΑΡΙϹΤΕΑϹ ΚΑΙ ΠΑΠΙΑϹ ΑΦΡΟΔΕΙϹΕΙϹ, indicating that the original statue was produced by Aristeas and Papias,

sculptors from the city of Aphrodisias (Haskell and Penny 1981, p. 178; the original inscription uses the ϲ shown here instead of the more conventional Greek sigma). Aside from Righetti's imperfect command of Greek, there are other aspects of the sculpture that are typically Settecento. Righetti's very selection of the Furietti *Centaurs* depends on their attractiveness to a period eye. Moreover, the original marble centaurs were extensively restored shortly after their discovery, and thus inevitably reflect the taste of the restorer. Finally, very subtle hints of Settecento style may be identified in Righetti's interpretation of his model, most notably a slight sweetening of the centaur's facial expression.

The method of production of such bronze miniatures as Righetti's *Centaur* began with a sculptor studying the original and fashioning a reduced version in terracotta or wax. Righetti sometimes collaborated with other artists in the sculpting of these models: a 1785 entry in the diary of Camillo Pacetti's brother mentions that Camillo was making "alcune copie per Righetti il Metallaro" (Honour 1963, p. 199). From the model, a reusable mould would be formed from which multiple bronze casts could be produced. When the bronze had cooled, the artist would chase the surface, working to sharpen details and give a uniform polish. The statuettes were occasionally gilded. Righetti's training as a silversmith was important to the success of his production, and connoisseurs delighted in the fineness of the work. [JH]

## ANGELO DE' ROSSI
### GENOA 1671–1715 ROME

Angelo de' Rossi, with his remarkably original style, was a central figure in Rome's art world in the early eighteenth century. He received a distinctly Baroque training, which he referred to in a letter written on February 8, 1702, to Antonio Pellegrino Orlandi. It appears that around 1680, while still a child, he joined the workshop of the great Genoese sculptor Filippo Parodi and stayed with him for about eight years, a period that largely coincides with Parodi's years in Veneto; it seems that during the 1680s he was employed in Venice, mainly as official sculptor to the Morosini family, as well as in Padua, where his work included the thorough renovation of the Cappella delle Reliquie in the Santo.

De' Rossi is first documented in 1692, when he was already in Rome and won first prize in the first class of sculpture at the Accademia di S. Luca with his relief *The Three Young Men Thrown into the Furnace by*

*Nebuchadnezzar*, beating among others Giovanni Baratta, Francesco Maratti, and Bernardino Cametti. It is thought, however, that another group may date from even earlier, the marble *Little Satyr Holding a Bunch of Grapes*, recorded by Carlo Giuseppe Ratti (Ratti 1797, p. 239) as being in the Palazzo Durazzo (now the Palazzo Reale) in Genoa. There was a signed version in bronze of this composition, belonging to Anton Loews of Troppau (Bohemia) in the early twentieth century (Franz-Duhme 1986, p. 181).

De' Rossi's first public work, however, was his bronze relief—cast by Adolf Gaap—depicting *Saint Ignatius Healing a Man Possessed by a Devil*, made for the base of the altar of St. Ignatius in the Gesù in Rome. On February 14, 1696, he was paid for the model, which was inspired by a painting by Andrea Pozzo. It seems that in 1697 he was commissioned to do two putti for the same project which, cast in bronze by Carlo Spagna, were to be placed on the altar rail. In the meantime, by September 1695 De' Rossi had signed a contract to make a great marble relief of *Paul III Approving the Jesuit Constitution*, for the same chapel, intended to be placed to the left of the altar as a pendant to a similar relief entrusted to Bernadino Cametti. It took De' Rossi almost four years to do this work, and the relief was installed on May 6, 1699 (Enggass 1976, vol. 1, p. 160). In June of the same year De' Rossi went to Macerata, according to a note written on the back of a signed and dated terracotta, *Saint John the Baptist* (private collection; see Bacchi 1996).

The works for the Gesù, although done by a sculptor who was still aged under thirty, did not go unnoticed and were decisive in ensuring De' Rossi's fame as an unchallenged master in the field of reliefs. It is therefore not surprising that in 1698, before he had even finished the *Paul III*, he was taken into the circle of Cardinal Pietro Ottoboni, who paid him a salary and provided him with accommodation in the Palazzo della Cancelleria, where, as vice-chancellor, he lived. But most importantly Ottoboni entrusted to De' Rossi the execution of the sculptures for the monument to his great-uncle, Pope Alexander VIII, planned for St. Peter's. The design for the monument had already been worked out by Carlo Enrico, Count of San Martino, the cardinal's right-hand man, commander of the papal troops in Romagna, poet, engraver, and also amateur architect (the most complete biographical reference is in *Schede vesme: l'arte in Piemonte dal XVI al XVIII secolo* [Turin: Società Piemontese di Archeologia e Belle Arti, 1968], vol. 3, pp. 960–61). Three years earlier, in 1695, Ottoboni had entrusted the creation of the sculptures to Francesco

Papaleo from Palermo, who, according to the documents, had already made the full-size models when he was replaced by De' Rossi (Franz-Duhme 1986, pp. 61–62, 152, 204).

The undertaking of the papal tomb should have sealed Angelo de' Rossi's fame, but in fact he managed only to complete the marble relief on the pedestal (*Alexander VIII Canonizing Five Saints*), which was done by 1703. Praised by Ratti as "the most excellent bas-relief," it is now in St. Peter's (Ratti 1797, p. 238). It became remarkably famous, even among French sculptors; there is a plaster cast of it in the French Academy at Rome, another is recorded in the Paris workshop of the Slodtz family, and Mariette declared it "a masterpiece which serves as a model for all sculptors to study for this part of their art" (Mariette 1851–60, vol. 5, p. 16). As regards the other parts of the tomb, it is recorded that by 1706, when the pope's body was transferred to its new resting place, De' Rossi appears to have completed, apart from the relief, only the full-size models in stucco for the statue of the pope (for which there also exists the terracotta *bozzetto*; cat. 148) and for the two allegorical figures *Religion* and *Prudence*. The tomb was not completed until 1725, ten years after De' Rossi's death; the figure of the pope was cast, according to Ratti, by a Giuseppe Bertosi, while it remains the subject of discussion (see Franz-Duhme 1986) how much part De' Rossi actually took in the execution of his two marble allegories. Ratti attributed them to one Gagliardi, otherwise unknown. Records have shown that the relative blocks of marble were already in De' Rossi's workshop in 1707, but the rather disappointing quality of these figures, which not only fit awkwardly into the group but are unconvincing even when looked at individually, suggests that his role in this part of the monument was limited.

In the early years of the eighteenth century De' Rossi was asked to make a monumental statue of the new pope, Clement XI Albani, perhaps commissioned from him by Cardinal Ottoboni, as it was intended for the chancellery. Ignored by authoritative sources, the statue is mentioned in a poetic composition by Giovanni Battista Brancadoro (Enggass 1976, vol. 1, p. 160). The marble statue sculpted is now lost, but it is believed that a terracotta in the Berlin museum is its preparatory *bozzetto* (Schlegel 1978, pp. 94–100). It appears that Angelo de' Rossi also made a second statue of the Albani pope, this time in bronze, at the request of Niccolò del Giudice, household steward and prefect of the Palazzi Apostolici. This too has been lost and is known today only through a print by B. Farjat and a small bronze

generally believed to be a reduction and now in the Hermitage (Enggass 1976, vol. 1, p. 160; Bacchi 1996, vol. 1, pp. 839–40).

De' Rossi's most impressive achievement in the field of statuary remains his *Saint James the Lesser* for St. John Lateran, commissioned in 1705 but executed between 1710 and 1711 (Franz-Duhme 1986, pp. 217–20) and placed, together with the other Apostles by Rusconi, Legros, Monnot, Mazzuoli, Ottoni, and Maratti, in the nave of the basilica. The most highly debated problem relating to this cycle concerns the role played by Carlo Maratti, the artist whom the pope placed in charge of the project and who produced a series of drawings that were then passed to the sculptors. In the case of De' Rossi both the documents and the style of the finished work leave no doubt as to his intelligent adherence to the drawings supplied by Maratti, designs that the sculptor nevertheless had to rethink for himself in a series of sheets now in Düsseldorf (inv. nos. 2970, 3278 r. and v., 3279) and in a terracotta *bozzetto* in the Hermitage.

In the program of radical renovation of the Pantheon interior promoted by Clement XI, De' Rossi was entrusted with the new high altar. He planned a monumental relief in bronze showing the Assumption of the Virgin. He first made a terracotta *bozzetto* that, according to Ratti, "much pleased His Holiness; and it is still kept in the ground-floor rooms inside the Vatican palace" (Ratti 1797, p. 239). He then produced the life-size model in stucco that was placed above the altar in the Pantheon, but which, according to Ratti, aroused jealousies, so that its translation to bronze was postponed, and after the artist died even the stucco model was removed.

Other works include the youthful bronze relief of the *Pietà*, recorded by Ratti as being with Giorgio Doria in Genoa and rediscovered by Franz-Duhme (Franz-Duhme 1984) in a private collection. There is also a terracotta of the same subject in a private collection (Helga Nora Franz-Duhme, "Zum Reliefstil von Angelo de Rossi (1671–1715)." *Jahrbuch der Berliner Museen*, n.s., vol. 29–30 (1987–88), pp. 218–21) and a gilded bronze (Rau Collection, Marseille), which Jennifer Montagu identified as the work quoted in early eighteenth-century inventories as executed by Giovanni Giardini after a model by De' Rossi (Montagu 1996, pp. 129–31).

An equally famous composition was *The Adoration of the Shepherds*, the terracotta original of which was donated in 1711 to the Accademia di S. Luca, on the occasion of De' Rossi's admission as *accademico di merito*. Of the original relief only fragments remain (Museo di Palazzo Venezia,

Rome). Thirteen preparatory drawings are known, however, as well as several variants in different materials taken from a plaster cast that Giovanni Battista Maini took from the original (Franz-Duhme 1986; Montagu 1996, p. 242, no. 120): Museo di Palazzo Venezia, Rome (stucco); Museo Lia, La Spezia (terracotta); Bologna Cathedral (silver). Finally, there is the initialled relief exhibited here with *Christ in the Garden of Olives* (cat. 149). Although the effigies of many contemporary figures appear, above all in the Vatican relief, nothing is known of any documented work by De' Rossi in this field. Nevertheless, the bust of Arcangelo Corelli (Protomoteca Capitolina, Rome), although not documented, is unanimously recognized as his. [AB]

BIBLIOGRAPHY Ratti 1797, pp. 235–40; Enggass 1976, vol. 1, pp. 159–67; Franz-Duhme 1986; Pascoli 1992, pp. 377–78; Bacchi 1996, pp. 839–40

## 148
## Angelo de' Rossi
### *Pope Alexander VIII*

c. 1700
Terracotta
18″ × 11″ (46 × 28 cm)
PROVENANCE J. Pierpont Morgan, New York; French and Company Inc., New York, acquired by the museum, 1937
BIBLIOGRAPHY Martinelli 1959; Franz-Duhme 1986, pp. 213–14; Bacchi 1996, p. 839
The Fine Arts Museum of San Francisco, Museum Purchase by exchange, M. H. de Young Endowment Fund

The story of the creation and construction of the tomb of Pope Alexander VIII, which stands in St. Peter's, is complicated (the authoritative text, including numerous unpublished documents, is that of Franz-Duhme 1986, pp. 204–13). Commissioned by the pope's *nipote* Cardinal Pietro Ottoboni, the monument was planned by an amateur architect, Count Carlo Enrico di San Martino, who had close ties with Ottoboni. Early on, in 1695, a Sicilian, Pietro Papaleo, was commissioned to carry out the sculptural part, and within about three years (the final payment is dated July 31, 1698) he had made the full-size models of the various figures, including that of the pope. A payment dated February 13, 1699, to a carpenter, Gregorio Bonarelli, for works carried out in connection with the "models of the figures made on the orders of Monsieur Theodone and Signor Pietro Beletti," suggests that in 1699 the Frenchman Jean-Baptiste Théodon was involved in the enterprise. At this point Angelo de' Rossi had also been involved in the project for almost a year, for on April 18, 1698, he ordered "five pounds of

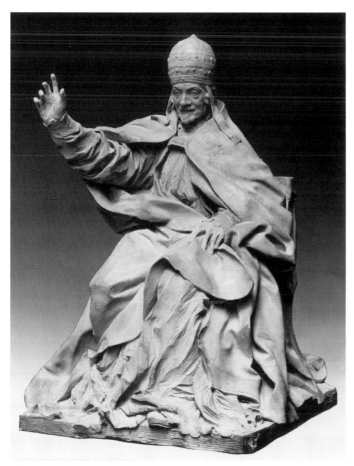

148

iron wire needed for the statue for the Tomb" (cited in Franz-Duhme 1986, p. 143). It was probably at this time also that the relationship began between De' Rossi and Ottoboni, who arranged for the sculptor to live in his household at the Palazzo della Cancelleria and paid him a salary.

"Concerning the tomb of Pope Alexander VIII the idea of the architecture is Count S. Martino's, the order of His Eminence is that I must make the figures all accordingly"; these are the words, not lacking in pride, that the young sculptor, then thirty-one, wrote on February 8, 1702, to Pellegrino Antonio Orlandi, who was collecting information about contemporary artists. In the records of the basilica his name appears on an undated document in which a master builder, Nicolò Zaballi, is paid for having "specially made the bridge for the use of Signor Angelo, sculptor, for the other statue of the Pope in the said tomb in place of the one that has fallen to pieces." On May 31, 1704, the new model in stucco for the statue was moved into St. Peter's, and the documents reveal that De' Rossi's colleague was the sculptor Simone Giorgini. The model was 114⅛" (2.9 m) high and after the tomb was completed it was moved "into the salon of the Palazzo Fani, near to the church of S. Lorenzo in Lucina"

(Ratti 1797, p. 238). Less than two years later, on February 18, 1706, Francesco Valesio wrote in his diary, "the body of Pope Alexander VIII was solemnly transported from the place where he lay by way of a tomb … to the new tomb … The new tomb remained from that day unveiled, and has turned out magnificent with the statues of the pope and the two Virtues in stucco, which will later be made, the first in bronze and the other in marble" (above quotations cited in Matitti 1995, p. 209). It appears therefore that De' Rossi had already executed the models for *Religion* and *Prudence* and completed the relief of *Alexander VIII Canonizing Five Saints*. But he did not survive to see the tomb finished. He died in 1715, and it was not until ten years later, in 1725, that the two completed marble allegories were placed in St. Peter's, according to Ratti, by "a certain Gagliardi." Jennifer Montagu has mentioned the presence in Rome at that time of the goldsmith Giuseppe Gagliardi, of whom it is written in the records of a lawsuit that he "practised the study of sculpture" (Montagu 1996, pp. 172, 246, no. 100). It is also on the basis of Ratti's testimony that the casting of the pope's statue was also attributed to an otherwise unknown artist, Giuseppe Bertosi (Ratti 1797, p. 237), unless Ratti's Giuseppe Bertosi can be identified

with Francesco Bertos, a famous specialist in bronze sculpture working during the same period mainly, though not exclusively, in the Veneto.

The small terracotta model exhibited here was first connected (by Valentino Martinelli) with the statue in St. Peter's (Martinelli 1959). Nevertheless, the documents published in 1986 by Franz-Duhme concerning an original model made between 1695 and 1698 by the Sicilian sculptor Papaleo, do not, in theory, exclude the possibility that this terracotta model, which is certainly not identical to the bronze in St. Peter's, might be by him. It is also true that, compared with the terracotta, the bronze appears animated by a tension more explicitly Baroque, as indicated by the wider gesture of benediction and the more lively flow of the drapery. Nevertheless, the attribution of this sculpture to De' Rossi remains the most convincing. The small model, although more restrained and less emphatic, corresponds too closely to the bronze in St. Peter's. Furthermore, it seems hard to imagine that Papaleo's models, rejected by Ottoboni, could have been so close to the definitive solution later conceived by De' Rossi. Its interest lies in the powerful originality of De' Rossi's rethinking of the great prototypes of seventeenth-century papal statuary, particularly Bernini's *Urban VIII* (St. Peter's, Rome) and Alessandro Algardi's *Innocent X* (Palazzo dei Conservatori, Rome). It retains their monumentality, but in place of their heroic quality there is a different feeling into which a detail—for example the imperfectly centered papal tiara—impinges an entirely eighteenth-century note of subtle irony. [AB]

## 149
## Angelo de' Rossi
### *Christ in the Garden of Olives*

c. 1700–1705
Signed: *A.R.F*
Marble
29" × 25" (75 × 65 cm)
PROVENANCE donated by the Theodor Klopfer Museum, Munich, 1900
BIBLIOGRAPHY Ratti 1797, p. 239; Pascoli 1992, p. 377; Bacchi 1996, p. 840
Bayerisches Nationalmuseum, Munich

In his *Life* of Angelo de' Rossi, published in 1730, Lione Pascoli, after having listed the sculptor's most important public works, wrote "He made many private works for various people … and especially for Arcangelo Corelli a bas-relief representing Jesus Christ in the Garden, which he then gave to Cardinal Ottoboni; because the price did not suit him" (Pascoli 1992, p. 377). The relief was later recorded by Ratti without mentioning Corelli, simply as having been presented by the sculptor to Ottoboni (Ratti 1797, p. 239). Subsequently all trace of the work was lost and, as Franz-Duhme has pointed out, no mention of it appears in any known Ottoboni inventories (Franz-Duhme 1986, p. 228).

The hypothesis that it can now be identified as this marble is confirmed both by the signature *A.R.F.* incised above the angel's foot, and, most importantly, by the work's style and technique. The narrative and compositional focus of the scene is the chalice brought to Christ by the angel who, with one foot already on the ground and the other about to touch it, bursts sorrowfully onto the scene with draperies still agitated by the flight. With one hand he offers the chalice, with the other he points upward to where three cherubs are playing with the cross among the clouds. The clouds around him allude to his celestial origin, and behind him a young angel, stupefied and disconcerted, presses close to him, clasped hands against his cheek, the lower part of his body entirely covered by the clouds. Christ, kneeling, turns towards the angel, pointing to the chalice. The strongest expressive element of this figure is the cloak that covers him. The border, stiff and decorated in an almost abstract way, is articulated down a long diagonal, which seems to oppose the movement of the angel. In the background, behind two palm trees with elegantly waving fronds, are the armed men who have come to capture Christ. The artist's ability to articulate the different planes of the scene results in a surprising depth of field and is combined with a singular virtuosity in modulating the surface of the marble, to evoke the

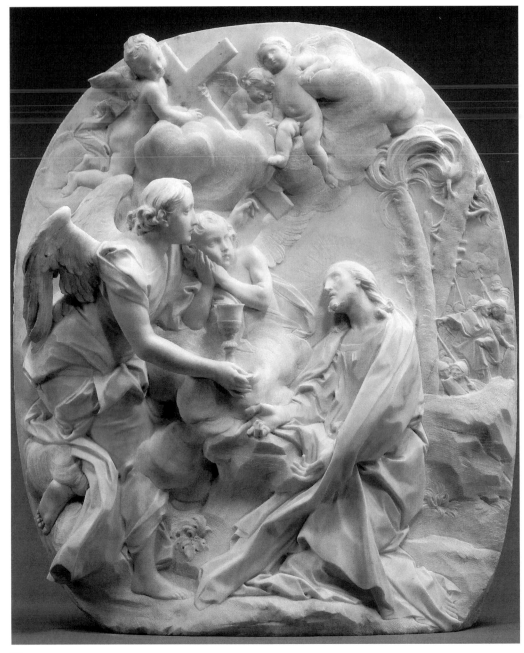

149

various textures of clouds, tree trunks, angels' wings, and the tenderness of the flesh.

These were the stylistic and technical elements that must have impressed the Romans in *Paul III Approves the Jesuit Order* (1695–99), the work by this sculptor which is closest to this relief. The most likely dating is the early years of the century.

In Baroque Rome, if there was one field in which Bernini could not boast of complete supremacy, it was the field of reliefs. First Algardi and then Melchiorre Cafà had produced absolute masterpieces of relief sculpture. It was by them, above all, that Pierre Legros, the great eighteenth-century practitioner of the genre, was inspired. But Angelo de' Rossi took up

a different position. He did not connect directly to this tradition but his own training with Filippo Parodi made him a follower of Bernini. He thus attempted to give life to Baroque reliefs, as exemplified by this work. The angels, for example, in their palpitating presence, recall examples by Caffà and Legros, while the sharp outline of Christ's mantle is close to models deriving from Bernini, such as those by Antonio Raggi.

The composition, although intended for a private collector, became an immediate success. A version in marble of very similar dimensions to those of the original is housed in S. Nicolò at Carpi. Undoubtedly eighteenth-century, it repeats the composition with remarkable fidelity, although

with a simplified background, with no soldiers advancing on Christ, and above only the faces of the angels can be seen. (Garuti 1992, pp. 86–145, particularly pp. 120–21). Jennifer Montagu (Montagu 1996, p. 129) pointed out that in the inventory of the belongings of the goldsmith Giovanni Giardini, drawn up on February 10, 1711, are mentioned "two bas-reliefs in gilded metal measuring about two spans, one representing Our Lord taken down from the Cross with a gloria of putti, and the Eternal Father, and the other Christ in the garden with a background of lapis lazuli … made by the hand of Angelo de' Rossi and finished by Monsù Germano" (Montagu 1996, p. 238, no. 61). In 1744 the two reliefs were acquired by Benedict XIV,

who then gave them to Charles III of Spain. Jennifer Montagu has suggested identifying *The Dead Christ Mourned by the Angels* with a relief in the Rau Collection in Marseille, a replica of which is in the Museo degli Argenti in the Palazzo Pitti in Florence, and which can be related to a terracotta relief in a private collection in Rome, attributable to Angelo de' Rossi. The document is of great importance both because it testifies to this composition's great fame, and because it supplies a useful chronological deadline for the dating of this marble. [AB]

## CAMILLO RUSCONI
### MILAN 1658–1728 ROME

At the age of fifteen Camillo began his training as a sculptor in the workshop of Giuseppe Rusnati, who not long before had come back to Milan after several months in the Roman workshop of Ercole Ferrata, one of the most gifted peers of Gianlorenzo Bernini. Thus the young Rusconi was exposed to the most modern developments in Roman Baroque sculpture. Rusnati recognized his pupil's talent and recommended him to Ercole Ferrata.

In 1684 Rusconi is for the first time documented in the Roman workshop of Ferrata, who seems to have called on this new assistant to collaborate in various running projects, such as the group of *Saint Elizabeth* for the chapel of the same name in the cathedral of Wroclaw (Breslau), Poland, and a few other small-scale figures, such as the *Infant Hercules* that recently appeared on the art market, and a terracotta group representing wrestling boys that could be the one now in the Hermitage in St. Petersburg. Ferrata's death in 1686 prompted Rusconi to open his own workshop in Rome, and his first years of artistic independence were spent mainly on minor commissions, usually for works in stucco. His services were enlisted for the four Virtues in the Ludovisi chapel of S. Ignazio. His collaboration is, moreover, documented in the stucco decoration of the Roman churches of S. Silvestro in Capite, S. Salvatore in Lauro, Ss. Vito e Modesto, S. Maria dell' Orto, SS. Trinità dei Pellegrini, and S. Maria in Vallicella, the so-called Chiesa Nuova. One of his first independent works is to be found outside Rome, in Montefalco, where he executed the altar of St. Onofrius for the church of S. Chiara. The first official commission that gave Rusconi the chance to work with marble was for the two angels above the door on the wall to the right of the altar of St. Ignatius in the Gesù in Rome, which date from the last years of the seventeenth century.

Rusconi's marble works of this early Roman period were otherwise the result of private commissions. On these occasions, Rusconi executed tombs for Giuseppe Paravicini in S. Francesco a Ripa and for Raffaele Fabretti in S. Maria sopra Minerva. He also produced a relief portrait of Francesca Gommi, the wife of Carlo Maratti, in S. Faustina, Camerano, and another of Giuseppe Eusanio, which is part of Eusanio's tomb in S. Agostino, Rome. To establish his reputation Rusconi also executed various small-scale sculptures during these years. The bust of the Virgin in Houghton Hall, Norfolk, may date from this period, as may the silver statuette of *Saint Sebastian in Fumone*, for which Rusconi probably provided the model. Also among these smaller sculptures were copies after such famous antique works as the Farnese *Hercules*, the *Apollo* Belvedere, and the Belvedere *Torso*, which he reproduced in terracotta as well as in marble. These small-scale sculptures seem to have allowed him to establish contacts with important patrons, among whom Niccolò Maria Pallavicini became the most important. Rusconi made for him the four marble putti representing the seasons, today in the Royal Collection at Windsor Castle.

Rusconi seems to have been introduced to Pallavicini by Carlo Maratti, who had become his artistic mentor in Rome. It was Maratti too who provided the design for the statues of the twelve Apostles in the nave of the Lateran basilica, which marked the turning point in Rusconi's career. Initially entrusted with the statue of Saint Andrew, on which he began working in 1705, Rusconi was promptly given the commission for the statue of Saint John, and was then commissioned to do the statues of Saint Matthew (1712–15) and Saint James the Great. When he finished in 1718, he was the only sculptor to have realized more than two of the colossal statues. By then, he had almost reached the peak of his career. The pope had honored him by visiting his workshop twice and conferred on him the title Cavaliere di Cristo, one of the most prestigious titles for artists at the time.

In the years following his work on the Lateran Apostles Rusconi accepted only the most renowned commissions. He was entrusted with the tomb of Gregory XIII in St. Peter's, and with that of Giulia Albani, the pope's aunt, of which only the portrait bust has survived (Kunsthistorisches Museum, Vienna). A monumental relief representing the apotheosis of Saint Jean-François de Régis was commissioned by King Philip V of Spain for the Iglesia del Noviciado in Madrid (today in the church of Las Descalzas Reales). Another royal commission was for

the tomb of the Polish crown prince Alexander Sobieski, which Rusconi executed for the church of S. Maria della Concezione in Rome. The completion of other works was halted by Rusconi's death on December 9, 1728. At that time, a marble statuette of *A Faun* (Skulpturengalerie, Berlin), a colossal statue of *Saint Ignatius* (St. Peter's), and a relief for one of the pendentives in the church of Ss. Luca e Martina were unfinished and had to be completed by his longtime pupil and collaborator Giuseppe Rusconi. Since 1727 Rusconi had been Principe of the Accademia di S. Luca, whose members were present when he was buried with great pomp in S. Maria della Concezione in Rome. Among his pupils were the most prominent sculptors of Roman sculpture of the second and third quarter of the eighteenth century, including Pietro Bracci, Filippo della Valle, and Giovanni Battista Maini. [FM]

BIBLIOGRAPHY Bottari and Ticozzi [1822–25] 1976, vol. 2, pp. 310–23, and vol. 6, pp. 178–83, nos. 41–42; Elkan 1924; Wittkower 1926–27; Ladendorf 1935; Baumgarten 1936–37; Webb 1956; Lavin 1957; Honour 1958, pp. 223–24; Schlegel 1963, pp. 74–75; Schlegel 1969; Enggass 1974; Baldinucci 1975, pp. 88–99; Montagu 1975; Bershad 1976; Enggass 1976, vol. 1, pp. 89–106; Conforti 1977, pp. 274, 278–80, 382–90, 409–30; Nessi 1978; Rudolph 1979; Dunn 1982, pp. 613–14; Schlegel 1988, pp. 16–21; Tamborra 1988; Androssov 1991, cat. nos. 58–59, 66–68; Androssov 1991, "Maderno"; Olsen 1992; Pascoli 1992, pp. 359–70; Androssov and Enggass 1994; Rudolph 1995, pp. 82–85, 143, 159, 212, 224; Bacchi 1996, pp. 841–43; Martin 1996; Noè 1996, pp. 349–60; Rocchi Coopmans de Yoldi 1996, pp. 365–70; Minor 1997, "Rusconi"; Martin 1998; Wardropper 1998, cat. nos. 32–33

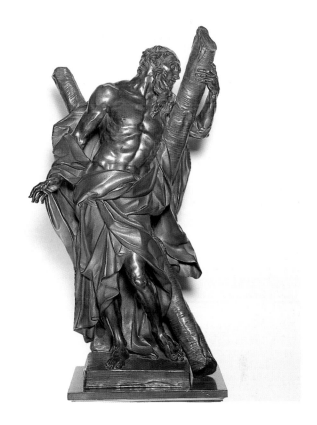

150

## 150
## Camillo Rusconi
### *The Apostle Andrew*

c. 1705

Highly finished bronze with a different surface for the statuette's garments, brownish patina

Height 28⅜" (72 cm)

PROVENANCE Kunsthistorisches Museum, Vienna, 1891; probably from Salzburg

EXHIBITION Salzburg 1998, cat. no. 102

BIBLIOGRAPHY Schlosser 1910, pl. 45; Brinckmann 1923–25, vol. 2, p. 110; Planiscig 1924, p. 183, no. 298; Wittkower 1926–27, pp. 9–12; *Settecento* 1959, p. 204; Conforti 1977, pp. 230–31, no. 13

Kunsthistorisches Museum, Vienna, Kunstkammer

The statuette was first published by Julius von Schlosser, who rightly noted its dependence upon Rusconi's colossal marble statue in the nave of St. John Lateran. The correspondences in attitude and drapery are in fact striking, with differences in style almost entirely ascribable to differences in size and material. The change in the portion of the Apostle's garment at the right hip, however, may attest to the bronze having derived from a small-scale model executed during the statue's genesis. An unpublished terracotta in the Musée des Beaux-Arts in Nîmes has sometimes been connected with the Viennese bronze statuette. This would allow a date for the bronze of around 1705, the year Rusconi received the

first payment for the *modello in grande*, which small-scale terracottas must have preceded. The terracottas, on the other hand, are unlikely to date before 1703, when the first references to the Apostle series appear.

The hypothesis that the Viennese bronze statuette was executed during Rusconi's work on the colossal statue is also plausible in the light of the Lateran statue commission. The series of Apostles for the basilica's nave were part of Francesco Borromini's plan to reshape the space, undertaken during the pontificate of Innocent X. The nave was reopened to the public for the holy year of 1650, but its niches remained empty until the early eighteenth century, when the project was completed under Clement XI. Clement met the most pressing problem, financing, by recruiting patrons among the kings and princes of the Church throughout Europe. The expenses for the statue of the Apostle Philip, for example, were assumed by Prince-Bishop Johann Philipp von Greiffenclau, who, in order to understand what he was paying for, got a small-scale marble copy of the colossal statue (Germanisches Nationalmuseum, Nuremberg; cat. 135). A similar situation may have obtained in the case of Camillo Rusconi's Saint Andrew, as its sponsor, Johann Ernst Thun, Prince-bishop of Salzburg, may also have wanted an author's copy for his Salzburg residence. In fact, a bronze statuette representing the Apostle Andrew is listed in the 1776

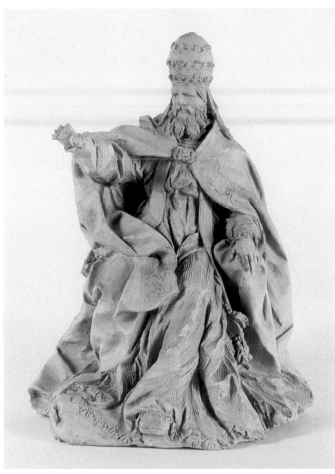

151

inventory of the collection of the prince-bishops of Salzburg and again in the 1805–6 inventory of the gallery of their residence in Salzburg. Thus, it may be assumed that the bronze statuette of Saint Andrew once belonged to the collection of Johann Ernst Thun, and that it was ordered from the creator of the colossal statue by its sponsor.

Rusconi's *Saint Andrew* may have derived from a drawing by Carlo Maratti, who was engaged to provide designs for the series of the Lateran statues. It is documented that Rusconi owned a Maratti drawing representing Saint Andrew, but as nothing is known about this drawing, it is difficult to examine the painter's influence on the statue. Nonetheless, the Lateran *Saint Andrew* follows the classicizing style of Maratti's paintings. The statue's drapery, for example, suggests the body underneath, rather than expressing the figure's emotions as would have been the case in Bernini's sculptures. In effect, the statue exemplifies late Baroque classicism, which pervaded Roman sculpture in the decades after Bernini's death.

Rudolf Wittkower provided the most sensitive characterization of Rusconi's *Saint Andrew*. He noted how Rusconi's work refers to the other colossal Roman statue of the Apostle,

François Duquesnoy's *Saint Andrew* in the crossing of St. Peter's (1629–1640). Duquesnoy's saint is designed to be seen from the front, however, and Borromini's projecting convex niches in the Lateran required Rusconi to create a statue to be seen from three sides. With this particular situation in mind, Rusconi bent his Apostle's torso to the left, changing not only the emotional state of the figure, who now seems to accept his imminent death by embracing almost tenderly the instrument of his martyrdom, but also the statue's alignment, which now offers different aspects depending on the viewing point. Rusconi conceived his *Saint Andrew*, in other words, as a freestanding sculpture that can best be seen when walking around the small-scale bronze statuette. [FM]

## 151

### Camillo Rusconi
### *Pope Gregory XIII*

1715–18

Inscribed in ink in a later hand on the figure's back: *Camillo Rusconi fec: Gregorio XIII a St Pietro*
Terracotta
11⅝″ × 8½″ × 6⅘″ (30 × 21 × 17 cm)
EXHIBITION Rome 1959, cat. no. 567
BIBLIOGRAPHY Riccoboni 1942, p. 268; Martinelli 1953, pp. 238–39; Montini 1957, p. 338; Schlegel 1963, p. 75; Enggass 1976, vol. 1, p. 103, fig. 71; Di Gioia 1990, pp. 18–20; Olsen 1992, p. 256, no. 25; Bacchi 1996, p. 842; Martin 1998, p. 86, fig. 7
Museo di Roma, Rome

The statuette depicts the enthroned Pope Gregory XIII invested with amice, chasuble, and tiara and with his elevated right arm blessing. It corresponds in almost every detail to the colossal marble figure of Gregory XIII that Camillo Rusconi executed between 1715 and 1723 for the pope's tomb in St. Peter's. There, Gregory sits above a sarcophagus flanked by allegorical figures representing Religion, on his right, and Magnificence, on his left. The establishment of the Gregorian calendar is represented in the relief on the front of the sarcophagus, from beneath which a dragon crawls, in allusion to the pope's coat of arms.

The statuette seems to have been created during the tomb's genesis. Supporting this hypothesis is the terracotta's rough surface, the result of the artist's quick handling of the material. Concentrating on his composition, the sculptor attended mainly to the figure's attitude and certain details, rather than defining the fabric of the pope's amice. Moreover, he neglected the parts that would not be seen in the marble monument, such as the undergarment to the left of the pope's left foot, which was to be hidden behind the drapery raised by Magnificence in order to reveal the relief on the front of the sarcophagus. There are stylistic differences between the terracotta and the marble statue, for example in the chasuble to the right of the pope's right leg, which has been smoothed in the marble version, and in the outstretched arm, which is more elevated in the tomb figure. These observations argue for the statuette as a model for the marble figure, rather than as a copy of it. In addition, the throne's back does not appear in the statuette, further identifying it as a *modello*. There can be little doubt, therefore, that the statuette is by Camillo Rusconi.

Given this, the terracotta's role in the tomb's genesis merits further attention, as another terracotta representing the whole of the tomb's composition (Hermitage, St. Petersburg),

a drawing of an early design stage of the tomb (collection of the heirs of Vincenzo Bonello, Valletta, Malta), and a description of it in the July 1715 contract have also survived. The drawing shows the earliest design stage, indicated by its different program and also by certain details, such as the absence of the liturgical pallium that hangs around the pope's neck in both terracottas and in the marble figure. Thus, the terracottas seem to represent later but different stages in the tomb's genesis. Whereas in the St. Petersburg model the chasuble is held under the pope's left hand, forming a voluminous bowl, in the Roman *modello* it hangs in the manner shown in the marble statue. The Roman terracotta is therefore the most similar to the marble statue and thus might have been executed not long before Rusconi began work on the *modello in grande*. As the St. Petersburg model differs from the contract description, it must be dated after July 1715. The same should be true for this terracotta, as it represents a version nearer to the marble figure. Yet both must have been finished before 1718, when Rusconi set to work on the Carrara marble.

Nothing is known of the terracotta figure's whereabouts before 1936, when it was purchased for the Museo di Roma from a private Roman collection. It may once have belonged to Filippo Farsetti, one of the most prestigious collectors of sculpture in eighteenth-century Italy. In the oldest inventory of the Farsetti collection, dating from around 1788, two works are noted that relate to the tomb of Gregory XIII. One is a model of the whole monument ("deposito di Gregorio XIII. del Rusconi"), the second a model of the pope's figure ("Papa Gregorio XIII. del Rusconi"). The first is almost certainly the terracotta in St. Petersburg, where the majority of the Farsetti collection was sold. There is, however, no trace of the second model in St. Petersburg. The heirs of Filippo Farsetti may have sold it elsewhere, and it may thus be the model that reappeared in 1936 and was purchased by the Museo di Roma. [FM]

## 152
## Camillo Rusconi
### *Giulia Albani degli Abati Olivieri*

C. 1719
Marble
Height 37¼" (96 cm)
PROVENANCE S. Domenico, Pesaro; Almerici family, Pesaro; by descent to Carandini family, Pesaro; sold by Mr. Eppstein to the Kaiserlich-Königlich Österreichisches Museum für Kunst und Industrie (later Österreichisches Museum für Angewandte Kunst), Vienna; transferred in exchange to the Kunsthistorisches Museum, 1940
BIBLIOGRAPHY Pascoli 1730–36, vol. 1, pp. 263–64; Bologna, Italy, Biblioteca Comunale. Marcello Oretti, "Pitture nella città di Senigaglia ed alcune nella città di Pesaro," 1777. Ms. B165, part 2, fol.229; Becci 1783, p. 68; Pesaro, Biblioteca Oliveriana. Domenico Benamini, "Uomini illustri di Pesaro." ms. 1063; Gradarini 1821, p. 45; Bottari and Ticcozzi 1822–25, vol. 2, p. 319; Österreichisches Museum 1929, p. 13; Montagu 1975; Brancati 1978; Santi 1980–81, vol. 2, p. 109; Nava Cellini 1982, pp. 4, 14–15
Kunsthistorisches Museum, Vienna, Kunstkammer

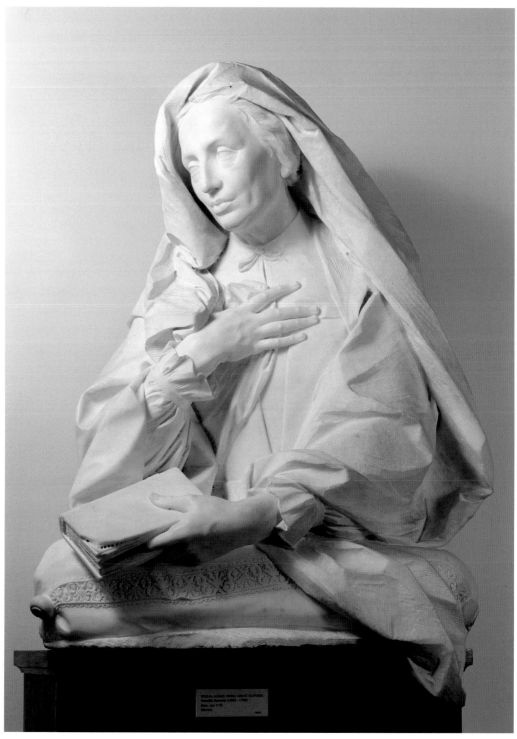

152

According to the early biographies of Rusconi, it was while he was working on the tomb of Gregory XIII that the reigning pope, Clement XI Albani, came in 1719 to see the model. The pope was delighted with it, and commissioned the tomb of his aunt, who had died on March 28, 1718. Despite the recorded inscription on Giulia Albani's tomb, which says it was set up by her son Cardinal Fabio Olivieri, the pope is the more likely patron, for his own mother had died when he was one year old, and he had been brought up by his aunt, and the deep and lasting affection between them is well attested.

Giulia Albani was born in 1630 into a noble family of Pesaro, married Giovanni Andrea degli Abati Olivieri, and passed all her life in the city, before being buried in the church of S. Domenico there, with a ceremony and subsequently published oration held in the church of S. Ubaldo on the day after her death. She was renowned for her piety and the excellence of her writing: her letters display "such force and solidity in their reasoning, such elegance in their style, delicacy in their thoughts, nobility in their sentiments, wisdom and piety in their maxims, that one could scarcely find anything more perfect" (Lafitau 1752, pp. 4–5). To this was added a "superiority of courage, which raised her above her sex" (Reboulet 1752, pp. 5–6). It was she who persuaded Clement XI to erect an altar to the local *beata*, Michelina of Pesaro, in the church of S. Francesco, and to her that Anton Maria Bonucci dedicated his *Vita della B. Michelina da Pesaro* in 1708.

This is the book that she holds in an engraved portrait by Benoit Farjat, in which she is clearly younger than in Rusconi's bust; obviously the same woman, although much older, is depicted in an anonymous painting in the Castelbarco Albani collection at Villa Imperiale (incorrectly identified as Clement XI's mother, who died young in childbirth), but what may well have been Rusconi's model is a painting sold at Sotheby's New York on October 13, 1989 (lot 202A), implausi-

bly attributed to Ceruti. In this painting the face closely resembles that of the bust, the age is right, and, although all three images show similar clothing, here it comes closest to the bust; she even holds a closed book in her left hand. Of all the painted portraits, this is the only one to approach Rusconi's achievement in conveying the aristocratic dignity, piety, wisdom, and gentleness of Giulia Albani.

It is not only the skill in conveying the character (of someone he had

never seen) that proclaims Rusconi's authorship. Typical of his style is the use of space, twisting the traditional bust "in eternal adoration" (of the altar) to a three-quarter angle, projecting into the viewer's space. Typical also is the treatment of the surface, ranging from the high polish of her face and hands to the daring raw-cut marble of her veil. Similar diagonal poses can be seen in his *Apostles* in the Lateran, particularly the *Saint James the Great*, and in the tomb of Gregory XIII

in St. Peter's, where the marks of the claw chisel give a variety of textures to the statues.

According to Baldinucci, the bust was set up on a pilaster, but it was more probably on the side-wall of a chapel. In 1778–79 when the existing church of S. Domenico was destroyed, the bust passed to the descendants of the Olivieri family, the Almerici. From them it passed by marriage to the Carandini family, who presumably sold it to Eppstein; Brancati made the convincing suggestion that Eppstein confused "Carrandini" with the better-known "Contarini", for it was as a member of the Contarini family that it entered the Vienna Museum für Angewandte Kunst, or applied arts museum, in 1864. Art historians would not look there for sculpture, and most ignored the bust; but artists recognized its aesthetic merits: Franz Xavier Pawlik reproduced it in a plaquette, and in 1900 Gustav Schrägle painted an artist in his studio, with what must have been a cast of this bust behind him. Only in 1970 was it put on exhibition in its new home, and subjected to serious study. [JM]

## 153
## Camillo Rusconi
### *Faun*

1728
Signed under the figure's left foot:
EQV.[ES]/CAMILL.[VS]/RVSCONI
Marble
Wrist of the left hand broken and repaired; slight chip to forefinger
Height 30¼" (77 cm)
PROVENANCE purchased from the art market in 1986
BIBLIOGRAPHY Elkan 1924, p. 49; Donati 1942, p. 536; Sale catalogue, Sotheby's, New York, June 10–11, 1983, lot 115; Schlegel 1988, pp. 17–21, cat. no. 4; Tamborra 1988, p. 30; Schlegel 1989, p. 27; Olsen 1992, p. 257; Pascoli 1992, p. 362; Bacchi 1996, p. 842; Martin 1996
Staatliche Museen zu Berlin, Skulpturensammlung

Before 1983, when the statuette first appeared on the art market, its location was unknown. The only source testifying to its existence was Lione Pascoli's life of Rusconi, which described the figure's genesis thus: "Among other things he had begun a Faun three spans high, which he wanted to give to a dear friend of his; and he had already practically finished it, because he only had to give it a few more touches, when he began a little wax model of *Saint Ignatius*, and another for the stuccos in the angle of the cupola of the very beautiful temple of S. Martina" (Pascoli 1992, p. 362). The statue of *Saint Ignatius* at St. Peter's and one of the pendentives

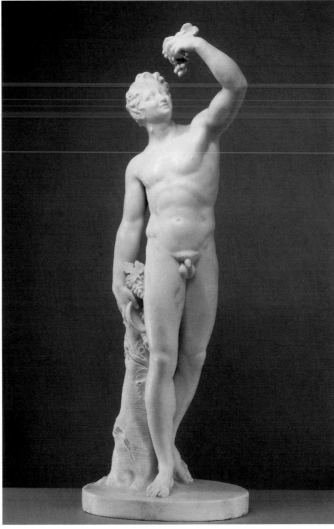

153

in Ss. Luca e Martina were unfinished when Rusconi died; in the case of the *Faun* the few touches that, according to Pascoli, remained to be made in order to get the sculpture finished were attended to by Giuseppe Rusconi, Camillo's longtime pupil and collaborator, who Pascoli says completed the work. Thus, Pascoli's *Vita* is important for dating the statuette, as it suggests the *Faun* was completed around 1728, the year Rusconi died. This hypothesis is supported by the inscription; the term *eques* indicates Rusconi began the figure after September 1718, when he became a Cavaliere di Cristo. Once before, on the tomb of Gregory XIII in 1723, Rusconi had used the title, signing in nearly the same manner: EQU[ES].CAMIL[LUS].RUSCONI. MEDIOLANEN[SIS].INVEN[IT].ET. SCULP[SIT].

Although primarily human in form, a faun, silenus, or satyr often has a bestial aspect. In the case of Rusconi's figure, it is apparent in the goat-tail, the dewlap on the throat, and the horselike ears. They underscore a relationship to the god Pan,

whose sons mythologists consider fauns to be. Fauns are associated with a love of music and revelry, as well as with unbridled lust. Like Rusconi's figure, they are often depicted with flat noses, pointed ears, and disheveled hair, which may combine with laughing mouths to achieve uncontrolled facial expressions. Unlike Rusconi's *Faun*, they are usually shown balancing on tiptoe in order to express their unstable, unrestrained character.

An antique statue in the Villa Albani, Rome, sheds further light on the genesis of Rusconi's *Faun*: not only is the antique statue shown as if walking instead of balancing on tiptoe, but also its right hand holds a bowl and its raised left hand once held, according to late eighteenth-century description, a bunch of grapes, instead of the rabbit it now holds. Thus, the two statues resemble each other in almost every detail and there can be little doubt that Rusconi's *Faun* is a copy after the antique. Yet the Albani *Faun* was much less famous than the other antique statues the artist copied, and the first mention of it, in 1785, is in

one of the rooms of Villa Albani, where it was less accessible. Therefore, the question arises where Rusconi could have seen the antique *Faun*, and why he might have made a copy of it. It has been suggested that Rusconi may himself have been the restorer of the Albani *Faun*, of which, in fact, only the torso is antique. Adding legs, arms, and head to the figure could have been the occasion for Rusconi to make a marble copy. Such a copy would have demonstrated his ability to deal with the antique, equally, a copy of an exquisite little-known antique statuette would certainly have been a sophisticated gift for the mysterious "dear friend" to whom Pascoli alluded. [FM]

## JEAN-JACQUES-JOSEPH SALY
VALENCIENNES 1717–1776 PARIS

Jacques Saly was born in Valenciennes, where his first teachers were Antoine Gilles and Antoine Pater. At fifteen he moved to Paris and became the student of Guillaume Coustou. After winning a second prize in 1737 and a first prize in 1738 at the Académie Royale, he was sent in 1740 to Rome, where he remained until 1748. His earliest surviving work is a vigorously modeled terracotta portrait of Pater, dated 1738 (Valenciennes).

In Rome, Saly worked assiduously and was appreciated by the director, Jean-François de Troy. Although marble was then scarce for French students, and the practice of carving copies of famous antiquities was beginning to be considered unnecessary because of the number of such copies that existed already, Saly finished an *Antinous* begun by Lemarchand and copied Bernini's *Saint Susanna*. In 1746 Saly engraved a set of his own designs of vases, which he dedicated to de Troy, prints significant for the history of early Neoclassicism. The set was reissued later in Paris. This project has been related to the interests of young architects, the first group to be sent to the French Academy in Rome. The designs for the prints could be connected, as well, to an idea of Philibert Orry, superintendent of royal buildings in Paris. In 1741 he wrote to de Troy that if the students made good drawings of vases perhaps they could be executed in marble. On a visit to Naples, Saly modeled an elephant from life. More importantly, in Rome Saly created the models for the sculptures that made his reputation on his return to Paris and for which he is best known today—the *Faun with a Kid* and the bust of a *Young Girl*. He exhibited the plaster model of the former and a marble version of the bust along with other pieces, including a portrait and three terracotta sketches of tombs, in

the Paris Salon of 1750. These compositions have been associated with three projects, respectively, for the Comte de la Marche (formerly in Saint-Roch, Paris), M. de Valory (in Quesnoy), and one ordered by Pineau de Luce (in Tours). *The Faun with a Kid* was selected to be carved in marble as Saly's reception piece for the Académie Royale. Presented in May, 1751, it was given by the academy to Christian VII of Denmark in 1768. Traditionally, this statue has been identified with the version in the Musée Cognacq-Jay in Paris; however, distinctly finer is the one (ex-Emile Galichon and the baron du Teil) acquired by the J. Paul Getty Museum.

Warmly recommended by De Troy, Saly was soon employed in projects related to the crown. A standing statue of the king was erected in Valenciennes in 1752 (destroyed 1792; fragments in Valenciennes). Much discussed at the time and recorded by Pierre Patte in *Les monuments érigés en France à la gloire de Louis XV*, this statue was judged harshly by P.-J. Mariette. Also in 1752, Saly was at work on busts of Louis XV and Mme. de Pompadour. For her, he carved statues of *Hebe* and a *Cupid*.

In 1753, on the recommendation of Edme Bouchardon, who declined the commission, Saly—still in his mid-thirties—was invited to Copenhagen to execute the bronze equestrian statue of Frederick V. Saly remained there for twenty years. In 1754 he was named director of the Kongelige Danske Akademi for de Sjønne Kunster. The model of the statue was completed by 1764, and the bronze was installed in 1768. In that year, at the request of Christian VII of Denmark, Louis XV awarded Saly the order of Saint-Michel and raised him to the nobility. In 1769 a group of Saly's works was exhibited at the Salon of the Copenhagen academy. Related to the project for the equestrian statue are two publications by Saly, *Description de la statue équestre que la Compagnie des Indes orientales de Dannemarc a consacrée à la gloire de Frédéric V, avec l'explication des motifs qui ont déterminé sur le choix des différens partis qu'on a suivis dans la composition du monument* (Copenhagen, 1771) and *Suite de la Description du monument consacré à Frédéric V par la Compagnie des Indes de Dannemarc pour être jointe a l'explication des motifs qui ont déterminé sur le choix des differens partis qu'on a suivi dans la composition de ce monument, et dans laquelle l'on rend compte des différentes études et observations faites d'après des chevaux, ainsi que des moyens dont on s'est servi pour exécuter le monument* (Copenhagen, 1773). While in Copenhagen, Saly made portraits of Frederick V, Senator Wasserschlebe, and two of Count Adam Gottlieb de Moltke.

After returning to Paris, Saly was awarded an atelier in the Louvre in 1775. A member of the academies of Florence, Bologna, Marseille, and St. Petersburg, he died unmarried a year later. [DW]

BIBLIOGRAPHY Lami 1911, pp. 321–26; Thorlacius-Ussing 1942, pp. 281–310; Kalnein and Levey 1972, pp. 80–83

## 154
## Jean-Jacques-Joseph Saly
### *Young Girl*

c. 1744–48
Marble
18½″ × 20⅛″ (47 × 51 cm) with base
PROVENANCE Jean-François de Troy (1679–1752), Rome, by 1748; acquired in Rome by Thiroux d'Epersenne, in his possession in Paris by 1753, until 1767; by bequest to his sister-in-law Mme. Thiroux d'Arconville, in 1767, to before 1789; David-Weill collection, Neuilly-sur-Seine, by 1945; private collection, Paris
EXHIBITION Paris, August 1750. Académie Royale de Peinture et de Sculpture, no. 147 (probably this sculpture)
BIBLIOGRAPHY Mariette 1851–60, vol. 5, p. 168, notes after August 1753; Benisovich 1945, p. 35, fig. 5; Beaulieu 1955; Babelon 1964; Levey 1965, p. 91; Freytag 1976; Black 1994; Gaborit, Jean René, et al. *Sculpture française: II, Renaissance et temps modernes*. Paris: Réunion des Musées Nationaux, 1998, vol. 2, p. 585; Trusted, Marjorie, Deputy Curator of Sculpture. Notes. Victoria and Albert Museum, Department of Sculpture, London
Private collection

154

Among the submissions in his 1750 début in the Paris Salon, Jacques Saly exhibited a single work in marble, the head of a *Young Girl*. In 1753 Pierre-Jean Mariette wrote about it in his *Abécédario*: "he [Saly] was in Rome when he made there for M. de Troy a pretty head of a girl, in marble, which M. Thiroux d'Espercennes [sic] … brought back from Italy and which he keeps in his study. It is one of the most pleasing pieces that Saly will ever make" (Mariette 1851–60, vol. 5, p. 168). Mariette's words have proven to be true. This bust has become one of the most famous sculptures of a child, reproduced innumerable times. This example, the finest known, is probably Saly's original. Another marble, always dated to the eighteenth-century, is at the Victoria and Albert Museum. Both are unsigned. The early history of the bust cannot be reconstructed completely. That Saly's careful autograph list of works carried out between 1748 and 1752 does not include the bust is important evidence that the sculpture was finished earlier, in Rome, as Mariette says. D'Epersenne certainly already owned the sculpture by 1753.

The subject of the sculpture is never named in the eighteenth century. It is impossible to identify the girl as Alexandrine d'Etiolles, the daughter of Mme. de Pompadour, an idea dating to the 1870s and repeated every so often, without any factual basis. Michael Levey has proposed a plausible candidate for the model in the daughter of Jean-François de Troy, described by the painter in 1745 as "fort jeune." Her mother died in 1741, and the girl herself predeceased her father. Mariette's words suggest that the bust could have been a commission from the director of the academy. A precedent for such private work can be found in the marble busts of Vleughels and his wife ordered by the painter himself when he was director of the French Academy in Rome.

Later generations have dubbed the girl *La Boudeuse* ("The Pouting or Sullen Girl"), but these descriptions are questionable. The girl is posed frontally, her head tilts downward at an extreme angle, and her eyes are almost closed, making her expression difficult both to see and to interpret. The bust blurs distinctions between genres: it appears to represent an individual, but the singular pose and description of a mood override the conventions of portraiture. This sculpture is essentially a study after a model, but one that is unusually convincing in suggesting an interior life. In doing so, it goes beyond such traditional precedents as the much admired infants of François Duquesnoy, although it bears comparison with his head of the *Putto with a Bow* in Berlin, of which some examples exist in bust form (see Freytag). In its truthful observation, the girl's head can be related to the principal project of Saly's Roman period, the figure of the *Faun*, whose lithe body in the Getty marble demonstrates study from a model rather than a classical prototype. The beautiful surface of this small-scale work also reveals Saly's high standards of execution early in his career, when he had relatively little experience in carving marble. The naturalism of the bust is set off by the classicizing plaque and base of the socle. Here caution is necessary since bases can be easily changed. This one is close to the design that Bartolomeo Cavaceppi used for ancient heads in the 1740s, and it appears earlier on busts with an antique savor.

Saly's bust cannot, however, be considered solely by itself. Recently, Bernard Black has related this head to a bust of a boy wearing a turban that has an identical base (The Huntington Library, San Marino). This sculpture was carved by Louis-Claude Vassé, a fellow *pensionnaire* of Saly's, in Rome from 1740 to 1745. Could the Vassé bust be the portrait of de Troy's son mentioned by Edme Bouchardon in a letter of 1742? If so, does this strengthen the identification of the little girl as the daughter of de Troy and, perhaps, encourage a slightly earlier dating of the bust? In Thiroux d'Epersenne's collection, these pieces were paired, according to documents published by Babelon. Compositionally, they are not obvious mates so the commissions may have been successive, like the Vleughels busts, or the two busts could have been acquired and paired by d'Epersenne, who liked small sculptures. Clearly, more evidence is needed before these questions can be resolved. Nevertheless, the busts do make meaningful pendants. The little boy's face is open, animated, and engaged in observation; the little girl's is withdrawn, almost expressionless, and avoids interaction. Levey has observed that if she is de Troy's daughter she may well have been his only living child at the time.

The comparison is telling, as well, about the relative talents of the two sculptors. Although possessing real charm, the Vassé bust is not memorable as Saly's is: it contributed to his early success in Paris and was soon appropriated by other artists (see Beaulieu's list), notably François Boucher. In 1756 this painter represented the bust in the center of an allegory of sculpture, an overdoor for Christian VII of Denmark, as a tribute to Saly, who had recently arrived in Copenhagen to take up the prestigious commission for the equestrian monument of Frederick V. [DW]

## JOHAN TOBIAS SERGEL
STOCKHOLM 1740–1814
STOCKHOLM

The work of Johan Tobias Sergel marks the beginning of a truly Swedish sculpture. Until the mid-eighteenth century the eminent sculptors in Sweden had all been foreign immigrants, and sculpture as a whole was sparsely represented. Stockholm was almost entirely lacking in public sculptural monuments; there was effectively only one site with any significant sculptural embellishment: the newly built royal palace, completed in 1754. It was here that Sergel took his first steps in sculpture.

Sergel's artistic apprenticeship spanned the transition from Rococo to early Neoclassicism. He was influenced by contemporary French art both through the work of Jean Eric Rehn and his own principal teacher, Pierre-Hubert L'Archevêque, a French sculptor summoned to the Swedish court. The young Sergel was at times so close to L'Archevêque in style and subject matter that scholars have found difficulty in distinguishing the work of the pupil from that of his master. It was not only a feeling for the tasteful composition or graceful ornamentation of French style that Sergel adopted; he was also profoundly inspired by his teacher's incisive realism, which found expression not least in L'Archevêque's portraiture.

Enormous hopes were raised for the young Sergel in the highest quarters. When he received a scholarship to study abroad from the royal palace building committee, his patrons had in mind primarily the completion of the sculptural adornment of the palace itself. Few could have foreseen that during his studies in Rome (1767–78) Sergel would break away entirely from the French style of architectural, decorative Rococo classicism. His encounter not only with the classical sculpture of antiquity but also with les grands maîtres was such an overwhelming experience that he completely distanced himself from the artistic ideals of his former teacher. His reaction was so vehement that he even employed such hyperbolic phrases as "that abominable French affectation" (Stockholm, Stockholm Royal Library, Sergel's autobiography [manuscript], 1785) to express this repudiation. The French Academy in Rome, where Sergel was to study both plaster-cast and living models, was equally influential. Paradoxically, it was the literary picture collection of a Frenchman, the Tableaux tirés d'Homère et de Virgile of the Comte de Caylus, with its themes from the Iliad, that was to inspire his choice of subjects during his time in Rome. Some years of intensive study led to a fusion of the ideal classical form and the more true-to-life in his work. With a sequence of monumental pieces such as The Faun (1770–74), commissioned in marble by the French ambassador to Naples, the Baron de Breteuil, and Diomedes (1771–74), executed in marble for the Englishman Thomas Mansel-Talbot, Sergel became one of the pioneers of early Neoclassical sculpture, without degenerating into a rigid purism. Other masterpieces from his years of study abroad are Mars and Venus (1771–1775/1804), Amor and Psyche (1774–1778/1786) and Otryades (1778–79). Many of these sculptures share the common compositional device of a contrast in movement, skilfully capturing the transition from perfect repose to active motion.

Sergel's significance for European sculpture of the period is a difficult question. He moved primarily among a group of artists of many different nationalities and was admired by foreign connoisseurs, not least the British. Many of these were very positive about him, as is evidenced by Sir William Hamilton's eulogy to the deputy head of the Académie Royale, the Comte d'Angiviller (see below). Later research has also revealed Sergel's direct influence on the development of European Neoclassicism, and not only in the case of the English sculptor Thomas Banks. Elvy O'Brien is probably right to state that Sergel's Diomedes was even of significance for the restoration of antique works. A fragment of a diskobolos, for instance, was turned into a Diomedes with the Palladion by Gavin Hamilton and Bartolomeo Cavaceppi (cat. 121) and made its way into the ownership of Lord Shelburne, an admirer of Sergel.

Sergel's increasing renown aroused fear in Sweden that he would not return to his homeland. This, together with an inflammatory chauvinistic campaign against his teacher L'Archevêque, finally led to his recall by King Gustav III in 1778. The remarkable feature of these events was the king's protracted passivity, which forced his brother Duke Fredrik Adolf and his traveling companion Baron Evert Taube, the royal chamberlain, to act in the king's name during their visit to Rome to prevent important works by Sergel being sold to other prospective buyers. As Sergel was leaving Rome in the spring of 1778 the Swedish ambassador to the French court, Count Gustaf Philip Creutz, wrote to Gustav III that it would be best if Sergel were to stay in Italy, where his contact with the great works of classical art would mean that he could continue to execute masterpieces for the king. In particular, Creutz cited the opinion of the great connoisseur and collector Sir William Hamilton in Naples:

Chevalier Hamilton said recently, in my presence, to Monsieur d'Angiviller that Sergel was not only the foremost sculptor now working in the whole world, but that he was also the greatest since the days of Michelangelo. In its beauty of expression and purity of form he ranks Amor and Psyche among the most significant sculptural groups to have been produced in modern times. He went on to say that for the sculptor to devote himself to the sublime in art and not to lose his refinement of taste he should be allowed to continue to work in Rome for the rest of his life in order to be able to execute there the works that Your Majesty would desire, and have constantly before him the beautiful sculptures of Classical antiquity. (Olausson 1990, pp. 83)

On his return to Sweden in the summer of 1779 Sergel's artistic development took a totally different course from that which Creutz had envisaged. Gustav III certainly had a very high opinion of Sergel as an authority on art and kept company with him in an unconventional way that shocked many contemporary observers, but the works which he commissioned were not to be based on the great Homeric themes. Gustav's first assignment for Sergel was characteristically a bust of himself. Then followed commissions either related to great patriotic and historical subjects or of a decorative architectural nature. The royal as well as private commissions amounted to a total of forty busts and almost two hundred portrait medallions, which together constituted a disappointing end to the sculptor's career. And if the king was partly responsible for Sergel's artistic decline in Sweden, the purchase of the sculptor's remaining work by the Swedish state in 1815, after his death, led to an unfortunate concentration of his sculptures in Sweden and Stockholm, a factor further contributing to the relatively insignificant place accorded to Sergel in most international surveys of Neoclassicism, despite the inherent quality of his work and his demonstrable significance for his contemporaries in Rome. [MO]

BIBLIOGRAPHY Neergaard 1804; Molbech 1814–17, vol. 2; Göthe 1898; Brising 1914; Göthe 1921; Moselius 1934; Antonsson 1936; Antonsson 1942; Josephson 1956; Bjurström 1976; O'Brien 1982; Cederlöf and Olausson 1990; Olausson 1990

## 155
## Johan Tobias Sergel
### Mars and Venus

1771–72
Plaster
Height 36⅝" (93 cm)
PROVENANCE artist's estate 1814; purchased by the Swedish government from his heirs in 1815
BIBLIOGRAPHY Neergaard 1804, p. 189; Molbech 1814–17, vol. 2, p. 214; Göthe 1898; Brising 1914, pp. 154–57; Göthe 1921, p. 43; Antonsson 1936, pp. 83–86; Antonsson 1942, p. 214; Josephson 1956, vol. 1, pp. 184–92
Nationalmuseum, Stockholm

There are few sculptural works from Sergel's Rome period that produced such prolific preliminary studies, whether in the form of drawings or of sculptural models, as the Mars and Venus group. It can be assumed that he was engaged on this new subject directly before, or possibly in parallel with, the creation of another major piece, Diomedes, from the autumn of 1771 to the spring of 1772. The two works are closely related in concept. The primary task of the two male protagonists is to protect a goddess, Venus and Athena respectively, and they are both prepared for a surprise attack. The sculptor has based his work on the same anatomical model, but despite obvious similarities of detail and gesture he has given the figures different characters and ages. Diomedes is the bold and vigorous youth, Mars the irascible god of war, the mature man.

Sergel's inspiration was Homer's description of Diomedes wounding Venus's wrist with his lance in battle. The goddess of love is borne away from the tumult by Iris, the messenger of the gods, and then tended by Mars. In his first sketch, clearly visualized as a sculptural group, Sergel merged the separate events into one, with Mars appearing in the role of Iris. The lack of fidelity to the original text was due partly to the fact that Sergel encountered the stories of the Iliad in the form of the Comte de Caylus's versions, and partly to his excessive attachment to his sculptural prototypes, the Apollo Belvedere and one of the Dioscuri on Monte Cavallo, an ideal of manliness so venerated by the Neoclassicists. The enormous girth of the torso and the pronounced compartmentalization of the physique, as well as the vigorous bulging of the muscles of the arms and legs, provided paradigms for Sergel's Mars. Yet it would be wrong to think that he composed this and other classically based sculptural groups in a purely mechanical manner. In a humorous and anecdotal contemporary drawing Sergel portrayed his Danish friend the artist Peter Brünniche as having fallen half-naked

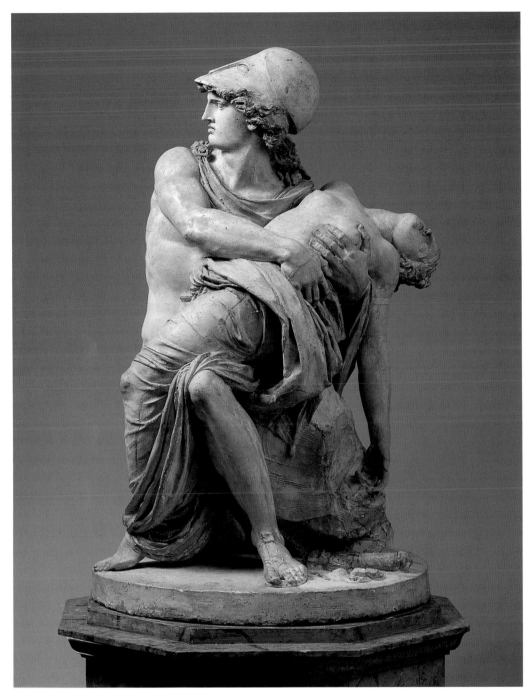

In the main, Sergel's sculptures were intended to be seen from a single viewpoint, but *Mars and Venus* is manifestly meant to be seen in the round, as can be noted in the representation of the war god's cloak, where the folds are so thoroughly and subtly executed and where no single element has a simply decorative function but all form an integral part of the dynamic of the group. In fact the multifacial quality of *Mars and Venus* is inherent in the richly contrasting sense of movement that is its fundamental compositional idea. [MO]

## 156
## Johan Tobias Sergel
### *Achilles at the Shore*

1775–76
Terracotta
12⅝″ × 17¼″ (32 × 44 cm)
PROVENANCE artist's estate 1814; purchased by the Swedish government from his heirs in 1815
EXHIBITION Stockholm 1990, cat. no. 200
BIBLIOGRAPHY Göthe 1898, pp. 98, 103; Göthe 1921, p. 48; Antonsson 1936, p. 89; Antonsson 1942, pp. 191–93; Josephson 1956, vol. I, pp. 224–34
Nationalmuseum, Stockholm

In the mid-1770s Sergel's desire to experiment seemed to grow stronger. His striving for new forms of expression manifested itself both in his sculpture and in his drawing. The lines became sketchy and summary, scribbled on the paper at impatient, almost breakneck speed. Even his wash-drawing technique gradually took on dramatic qualities, with great contrasts between light and shade. Gone too was the perfection of form that had previously characterized his sculpture. There was a clear correspondence in his works between this artistic boldness and a new and pronounced emotional content, full of sorrow and desperation. Some influence on Sergel's change of direction has been ascribed to his Danish artist friend Nikolai Abraham Abildgaard and later to the Swiss painter and writer Henry Fuseli. It was thus not entirely unexpected that during his *Sturm und Drang* period in Rome Sergel should come closer to painting, an observation summarized by his countryman Louis Masreliez: "It seems to me that our modern sculptors are far too keen to be painters" (Moselius 1934, p. 24). Even though Masreliez's criticism was intended as extremely negative, he was correct in his judgment on Sergel's new artistic direction, not least as applied to his sculpture.

Throughout 1775 and into the following year Sergel evidently tried to render in plastic form some of the subjects that Abildgaard was simulta-

out of bed with an equally naked woman; it is not intended as an erotic scene: the two figures must have been models for *Mars and Venus* who lost their balance and fell off the podium.

Looking at Sergel's first sketches, it is easy to see that he was not satisfied with his positioning of the figures. In terms of composition and expressiveness it is not entirely successful. Instead he moved events forward to try new possibilities, accentuating the goddess's lamentation and surrender to pain. He chose the moment when the seated Mars receives Venus as she falls to her knees in a daze and beseeches him for help. Sergel's intention was not to

sculpt a man who was merely heroic, but rather to create one who also displayed tenderness toward the woman he was protecting: in other words, two gods showing fuller and more complex emotions. Having come to a decision through a series of different sketches as to how he would finally solve the problem of form, Sergel again chose his model from classical antiquity, the *Dying Gaul*. It is even possible that he was inspired by representations of a classical love story about the passionate feelings that arise between Achilles and Penthesilea, queen of the Amazons, when the hero's sword pierces her breast.

In his first terracotta (now in the Konstmuseum, Gothenburg) Sergel has let Mars hold the distressed Venus in his arms as she falls helpless across his knee. In his second terracotta model and in his scale model (both Nationalmuseum, Stockholm) he has increased the dramatic charge of the group by giving greater emphasis to Venus's falling movement. The overt play on the antithesis between their physical union and their contrasting emotions contributes in no small measure to the expressive power of the group. Mars represents a concentration of strength, while Venus looks all the more defenseless.

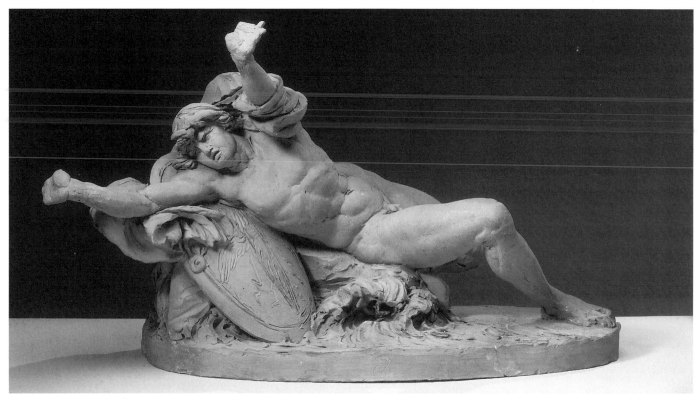

156

neously working on, including *Philoctetes* and *Achilles*. But only *Achilles Appealing to His Mother, Thetis, after the Loss of Briseis*, usually called *Achilles at the Shore*, seems to have been completed. The hero lies half in the sea, hair streaming, wild-eyed and open-mouthed, arms outstretched and fingers splayed. Sergel is depicting here a howling, raging grief of uninhibited emotion. The well-composed torso bears witness to Sergel's study of the Belvedere *Torso* and of course to works by Michelangelo, an influence he had in common with Abildgaard. The summary treatment of the sea and of the shield and drapery reinforces the fundamental painterly quality of the sculpture, as does the depiction of the manneristically extended limbs. Achilles' hands are somewhat mutilated in this terracotta model, but it may be assumed that they originally resembled the condition of the feet. The tendency towards elongated extremities was increasingly to characterize Sergel's sculpture and to culminate in the final production of his years abroad, *Otryades*. It contributed also of course to the expressive power and lack of formal perfection in his work.

Sergel produced other variations on the Achilles theme: the group composition *Achilles' Grief on the News of Patroclus' Death* and *Achilles Consoled by a Maiden*. The latter in particular shows the same violence of emotion as the lone *Achilles at the Shore*, with a boldness of line and form that almost threatens to dissolve the image. The

former two compositions are both drawings, though in one version Sergel has added a plinth, which points to the possibility that at least one was realized in terracotta. *Achilles Consoled by a Maiden* may have been one of the terracottas that he inadvertently left behind in Paris at the end of his stay there in 1778–79, and which he was never to see again. So *Achilles at the Shore* is one of the few extant examples of Sergel's new expressive form from his later years in Rome. [MO]

## RENE-MICHEL (called MICHEL-ANGE) SLODTZ
PARIS 1705–1764 PARIS

René-Michel Slodtz was the youngest of three sculptor brothers, sons of Sebastien Slodtz, a sculptor active at Versailles and the Dôme des Invalides and involved also in the production of ephemeral decorations for the Menus Plaisirs du Roi. Although he won only two second-place awards in Rome prize competitions, the young sculptor was sent to the city in 1728 and attracted the attention of the director, Nicolas Vleughels. In Rome, Slodtz began to be called Michel-Ange, a name he used for the rest of his life. Slodtz remained at the French Academy longer than usual. While there, he carved several copies of antiquities, including *The Knucklebone Player* (1733–39) and a copy of Michelangelo's *Christ* in S. Maria sopra Minerva (1731–36; Dôme des Invalides, Paris). Vleughels remarked

on Slodtz's need for time to improve himself; he had had little experience carving marble before Rome. Slodtz's slow execution and high standards of finish would prove to be serious liabilities in his career. Probably about the time he left the academy, Slodtz carved his first portrait bust, that of Vleughels (cat. 157).

In 1736 Slodtz set up an independent studio in Rome, taking on students, including the sculptor Jean Tassaert. His activities for the next ten years form one of the most interesting chapters in eighteenth-century Roman sculpture. He carved portraits of Frenchmen or people with relation to France. Perhaps following Lambert-Sigisbert Adam's example, he produced the paired heads of a Greek priest and Roman priestess, *Chryses* and *Iphigenia* (1737; Lyon) and a striking group of *Diana and Endymion* (1735–40; private collection, Geneva). The busts and the marble group were acquired from Slodtz's studio by two collectors from Lyon. Around 1740 Slodtz participated on teams executing decorative projects for S. Maria della Scala (1738), SS. Nome di Maria (1740), and S. Maria Maggiore (1741–42), in which his work is very close to that of his Italian colleagues. In 1741, upon his election to the Accademia di S. Luca, Slodtz contributed his terracotta *modello* for the relief of *The Ecstasy of Saint Theresa*, part of the altar decoration in S. Maria della Scala.

Also in the 1740s Slodtz undertook the three monuments on which his fame principally rests. For St. Peter's

he carved *Saint Bruno*, the most striking of the Founders series. For the cathedral of Vienne he produced the monument to Cardinal de la Tour d'Auvergne and Archbishop Montmorin, a splendid tableau that is indebted, in part, to Pierre Legros's statue and tomb of Cardinal Girolamo Casanate. Finally, he executed the tomb of Marchese Capponi in S. Giovanni dei Fiorentini. (On the issue of Slodtz as the designer of this monument and his relationship to the architect Fuga, see Souchal 1967). In its combination of colored marbles, beautifully carved figures, and control of scale in relation to the site, it is one of the most distinctive and successful of eighteenth-century Roman tomb monuments.

After returning to France in 1746, Slodtz did not achieve a success equal to his Roman one. Opinion was divided about his monument to Languet de Gergy (1757) in Saint-Sulpice. This Baroque tomb is strikingly reminiscent of late seventeenth-century works, as if Slodtz had meditated on elements from various monuments by Domenico Guidi but achieved a more successful composition. Slodtz abandoned his projected reception piece and so never joined the Académie Royale. Nor did he finish commissions for Mme. de Pompadour or for Frederick the Great. He was much involved with his brothers in projects for the Menus Plaisirs. He also undertook the modernization of the interior of Bourges Cathedral, provided reliefs for the exterior of

Saint-Sulpice, and two reliefs for Ange-Jacques Gabriel's buildings for the Place de la Concorde (after 1758). Although his Parisian years were rather disappointing, Slodtz was estimated among the finest sculptors by the crown, and in 1760 he declined an invitation to go to Germany to work for Frederick. Among his many pupils were the important sculptors Jean-Antoine Houdon and Louis-Simon Boizot and the painter Hubert Robert. Three of Slodtz's terracotta models were in the collection formed by the discerning La Live de Jully. Without a doubt, the range of styles in which Slodtz demonstrated his mastery is a testament to the depth of his talent and to the complexity of art in both Rome and Paris in the decades of the artist's maturity. [DW]

BIBLIOGRAPHY Lami 1911, pp. 338–43; Souchal 1967; Acanfora 1996; Souchal 1996, "Slodtz"

## 157
## René-Michel (called Michel-Ange) Slodtz
### Nicolas Vleughels

1736
Marble
23⅜" × 22⅞" (60 × 58 cm)

PROVENANCE Nicolas Vleughels, until 1737; his widow, née Marie-Thérèse Gosset, Palazzo Mancini, Rome (died 1756); probably inherited by their son Bernardin; purchased by Mme André, in Italy, in the early 20th century; Musée Jacquemart-André, Paris

BIBLIOGRAPHY Souchal 1967, pp. 208–9, 660–61, no. 149, pl. 18b; Hercenberg 1976, p. 54, cat. no. 2, pl. 2, fig. 2; Scherf 1999

Institut de France, Musée Jacquemart-André, Paris

The painter Nicolas Vleughels was the successful co-director (1724) and later director (1727–37) of the French Academy in Rome and improved the academy's program for young prizewinning French artists remarkably. In teaching, he emphasized drawing by establishing classes using the nude model, encouraged the study of landscape as well as Old Masters of various schools, and supported students in their original work. He was an adroit diplomat, working harmoniously with his superior the Duc d'Antin (then superintendent of royal buildings in France) and establishing relations with important Romans. It was Vleughels who found the Palazzo Mancini on the Corso to house the academy and made it a prominent showplace for visitors.

Although he also promoted the sculptors Edme Bouchardon and Lambert-Sigisbert Adam, Vleughels was especially sympathetic to Slodtz. Whether or not their common Flemish

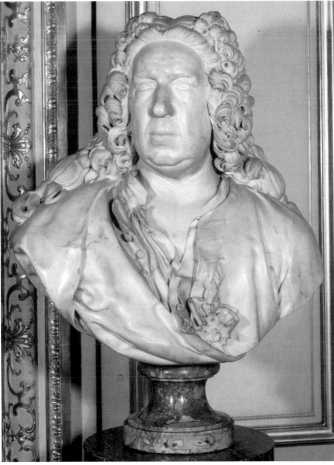

157

ancestry played a role in Vleughels's interest, as is often repeated, the painter's comments in correspondence with the Duc d'Antin show him to have been attentive to and admiring of Slodtz's talent. The sculptor, who arrived at the academy in 1728, was permitted by Vleughels to stay until 1736, well beyond the three or four years normally allowed for sculptors.

While this bust bears no inscription, it is usually dated 1736, around the time Slodtz left the academy to set up his own premises in Rome. Pierre-Jean Mariette notes that the bust of Vleughels was commissioned as a pendant to one of Mme. Vleughels carved by Edme Bouchardon in 1732, a bust acquired recently by the Louvre. From research into the collections of the academy in Rome, there is no evidence that the busts of Vleughels and his wife ever belonged to that institution. Therefore, the busts would have been private property. This idea is supported by the unofficial nature of the portraits. Bouchardon shows Mme. Vleughels with short hair, wearing a chemise with a hint of a mantle, a beautifully rendered naturalistic image. In Slodtz's portrait Vleughels's wig is not completely dressed, his shirt is open at the throat (although he wears an unbuttoned

jacket, from which is attached the order of Saint-Michel—the award of which caused much jealousy among Vleughels's artist contemporaries) and an outer mantel covers one shoulder. This image is unlike the formal relief medallion that Slodtz carved later for Vleughels's tomb, after the latter's unexpected death in 1737. Although it is not an extremely informal image, the bust belongs generally to the well-established French portrait type of the artist represented en négligé. This form, known in French sculpture since the seventeenth century, but rarer in Italy, is treated by Slodtz with a directness unlike the animation or inflated scale of slightly earlier works by sculptors such as the Le Moynes.

This bust—the earliest sculpted portrait by Slodtz—does not show obvious debts to French or Italian artists. In its strong grasp of form and likeness it is rather similar to the artist's portrait drawing of his contemporary Trémollière. The features of Vleughels—a man far from handsome—are described as accurately as Pier Leone Ghezzi's caricature of the sitter. However, Slodtz's broad rendering of the contours of Vleughels's face sets off the individuality of the features and makes the whole face more youthful (a combination Houdon

would imitate). Slodtz surely composed his bust to be a subtle mate to Mme. Vleughels's portrait, even imitating the form and smooth finish at the back of Bouchardon's bust. The gaze of Mme. Vleughels is directed to her left, and that of her husband meets it as his head turns to his right. The steady glance and furrowed brow give Vleughels a slightly solicitous expression that unites the paired busts in a happy and affecting variation on the traditional subject of unequal lovers. (Vleughels was sixty-three and his wife was twenty-eight at the time of their marriage.)

In general, Vleughels emphasized the study of nature in many forms and defended the usefulness of portraiture. Did he infer from Slodtz's drawings that the young sculptor might have talent in that direction? The Vleughels bust must have been appreciated since the maréchal d'Harcourt commissioned a portrait from Slodtz during a visit to Rome in the winter of 1736, as did Cardinal Neri Corsini, nephew of Pope Clement XII and a friend of Vleughels, in 1737. The similarities of the Vleughels bust to the posthumous bust of Marco Benefial by Vincenzo Pacetti (1783–84; Protomoteca Capitolina) suggests, at least, a possible distant significance of Slodtz's marble bust as a prototype for another artist. [DW]

## FILIPPO DELLA VALLE
### FLORENCE 1698–1768 ROME

As an artist, Filippo della Valle was fortunate in his birth. His mother was the sister of Giovanni Battista Foggini, the most prosperous sculptor and the leader of the largest sculptural studio in Florence (he also had been appointed by the court as First Sculptor and First Architect) during the reigns of the last Medici, Cosimo III and Gian Gastone. Florence at the turn of the eighteenth century enjoyed the stability that came with Cosimo III's regime, which was also accompanied by the continuation of a fairly rich artistic culture. But Florence was no longer an intellectual or artistic "center," as it once had been. The Florentine seventeenth and eighteenth centuries are, in Eric Cochrane's terms, the "forgotten" centuries (Eric Cochrane, *Florence in the Forgotten Centuries, 1527–1800: A History of Florence and the Florentines in the Age of the Grand Dukes* [Chicago and London: The University of Chicago Press, 1973]).

Della Valle, like his uncle before him (who had studied with Ciro Ferri and Ercole Ferrata), followed the path to Rome. There, in Hugh Honour's apt phrase, he was soon to discover a St. Martin's summer of papal patronage with the election of Clement XII, Lorenzo Corsini (Honour 1959).

Despite his early training and undoubted competence, Della Valle had still to seek the support and authorization of the Accademia di S. Luca, for this was the institution that acted as gatekeeper for ecclesiastical commissions. Although not yet a member in 1725—his first year in Rome—he entered the competition sponsored by the Accademia for young artists, and shared first prize with Pietro Bracci for his terracotta relief of *Josiah, King of Judah, Giving Money for the Temple* (*Il trionfo delle Tre Nobili e Belle Arti … Mostrate nel Campidoglio … l'Anno Giubileo, MDCCXXV* [Rome, 1727]; for Della Valle's life and a catalogue raisonné of his works see Minor 1997).

Soon after proving his mettle in the Accademia's *concorso*, Della Valle moved to the studio of Camillo Rusconi, then Rome's *éminence grise* of sculptors and old friend of Foggini. After Rusconi's death in 1728, the Englishman John Breval wrote that "I cannot leave Rome, without taking some Notice of so eminent a Man in his Way as the late excellent Sculptor Camillo Rusconi. I saw him at his Chisel, with several young Elèves about him, who express'd a generous Emulation" (Enggass 1976, vol. 1, p. 91). The young Filippo, certainly among Rusconi's pupils, had by this time completed his extended apprenticeship, and became a full member of the Accademia in June 1730. He subsequently became one of the two or three most sought-after sculptors in Rome. In addition to his numerous commissions for funeral monuments and portrait busts, he was called upon to contribute to nearly every important sculptural campaign from then until the end of his career in the early 1760s.

A listing of these undertakings provides a catalogue of the major public works carried out during the papacies of Clement XII, Benedict XIV, and Clement XIII. Life was especially good for a Florentine artist during the papacy of Clement XII, from the noble Corsini family of Florence. The pope so favored his fellow Tuscans that Filippo Juvarra, an architect from Messina, was moved to protest that in Rome "Tuscany exalts and laughs!" (Rovere, Viale, and Brinckmann 1937, p. 96). The first of the undertakings that were to benefit the Tuscan artists was the Corsini Chapel in the patriarchal basilica of St. John Lateran (see cat. 158). Clement also supported the refurbishing of the church of S. Giovanni dei Fiorentini in the mid-1730s, with Della Valle providing a relief for the façade (and allegorical figures over the main door; although these were added toward the end of the 1740s), and a funeral monument with a bust of the pope inside the church. At about the same time, the

old palazzo on the Monte Cavallo that had been restored by Paul V, was torn down and replaced by Ferdinando Fuga's Palazzo della Consulta. Della Valle ordered more than fifty carts of marble from Carrara, sculpted and built sets of military trophies that surmount the lateral doors, and provided allegorical representations of Justice and Religion over the main door.

During the early years of the pontificate of Benedict XIV, Della Valle was hired to assist in the renovation of S. Maria Maggiore. In addition to the statue of the Blessed Nicola Albergati (see cat. 159), he was called upon to carve the Holy Spirit on the Loggia della Benedizione and several heads of putti, placed above entranceways. It was during the 1740s also that Della Valle contributed two statues to the Founders series in St. Peter's, *Saint John of God* (1745) and *Saint Teresa* (1754). And working from a wooden model provided by his old colleague the architect Ferdinando Fuga, he erected the exquisite tomb of Innocent XII in 1746.

In 1750 Della Valle's monumental relief of the *Annunciation* in the church of S. Ignazio was completed. The dedication of this piece was described in singular detail by the Roman weekly journal, *Diario Ordinario di Chracas*, which wrote that "one observed the Holy Father's great satisfaction, not only for the sumptuous decoration, which was complemented by a portrait of his Beneficence … but also for the new and most noble Chapel of the Holy Annunciation, which had been unveiled with great effect, having just been brought to fine completion, within which was to be commended, among other things, the relief which forms the altarpiece, by the sculptor Sig. Filippo Valle" (Chracas, *Diario Ordinario di Roma*, February 28, 1750, no. 5088). Rome remained a city that reveled in ceremony and display, a city in which daily life and the witnessing of works of art could hardly be separated from ancient practices of ritual.

Della Valle continued his vigorous activity through the later 1750s and into the early 1760s, although at some point—probably around 1765/6—he suffered a stroke and worked no more. The last great public project for the Florentine sculptor was the preparation and erection of two colossal statues of Health and Fertility in the final phase of the long and tortuous campaign for the completion of the Trevi Fountain. For the figure of Fertility, he revisited his earlier statue of Temperance for the Corsini Chapel. Although he inflated the figure considerably and exaggerated the tension of its dramatic twists and turns, Della Valle paid homage to his earliest work in Rome and put to rest any assumption that a major artist must show growth and development in his style.

Once Filippo della Valle found his style, he stuck with it, producing elegant, temperate, and tranquil monuments for an age dominated by kindly, gentle, and good-humored popes: Maurice Andrieux's remark that "in Rome everyone gives orders and nobody obeys them, and really things work well enough" (Andrieux 1968, p. 30).

Although Della Valle was fortunate in his birth, his large family (eleven children survived into adulthood) and the generally impecunious ways of ecclesiastical and noble patrons meant that he did not luxuriate in riches. In 1750 Lord Malton advised his father the 1st Marquess of Rockingham that he had ordered copies of antique statues (at least two of which were by Della Valle), which were to be sent to Wentworth Woodhouse in Yorkshire. He commented that "I have been obliged to take up £200 to advance the others money which is scarce here, the People so poor that so large a work as these that if one did not advance money, the Greatest Sculptor here would starve before it was finished" (Honour 1958, p. 224). Nonetheless, Della Valle did make a career of sculpture and was very much part of the artistic establishment in eighteenth-century Rome. For a total of four years (1752–53, and 1760–61) he was Principe of the Accademia di S. Luca. He also served as Reggente of the Congregazione dei Virtuosi al Pantheon in 1747, 1757, and 1762 (he joined in 1744). And at least from the 1740s he was inscribed in the Accademia dell'Arcadia as Prassino Ateniense. In a book published the year Della Valle died, the anglophile (and former Arcadian) Joseph Baretti wrote that Della Valle was considered the leading sculptor of Rome and that he was looked upon as "tolerably ingenious," did not "betray servile imitation," and demonstrated "some power of invention" (Baretti 1768, vol. 1, pp. 275–76). In 1766 Filippo della Valle's *avvocato*, displaying none of Baretti's adopted British understatement, wrote at the top of the sculptor's last will and testament: *celebris in hac alma urbe sculptor*. [VHM]

BIBLIOGRAPHY Moschini 1925; Honour 1959; Minor 1997

## 158
## Filippo della Valle
## *Allegorical Figure of Temperance*

1732–34
Terracotta
Height 25¼" (60.4 cm)

PROVENANCE purchased in Rome by agents of Henry Howard, 4th Earl of Carlisle, probably in the 1740s; Castle Howard, Yorkshire (sale, November 11, 1991, part of lot 47: "an Anglo-Flemish terracotta Allegorical Figure of a Woman, late 17th century, standing heavily draped next to a vase decorated with swags") Correspondence in Castle Howard Archives suggests that the earl generally bought from Michele Lopez Rosa, Belisario Amidei, and Francesco de Ficorini
EXHIBITION New York 1995, cat. no. 111
BIBLIOGRAPHY Yorkshire, Castle Howard Archives F1/1, Probate Inventory of Henry, 4th Earl of Carlisle, "Furniture from London continued, Antiques etc., continued: A Small Female Figure in Plaister the Arm lost."; Yorkshire, Castle Howard Archives, II 2/2/3, Catalogue of Statuary, Bronzes etc., at Castle Howard, compiled by John Duthie, 1881, "Long Gallery, 101, small statue of a Female, terracotta 23 inches high, repaired."; Yorkshire, Castle Howard Archives, II 2/2/5, 1917 Inventory, "101, Small terracotta statue of a Woman, 23 inches high, £20."; Honour 1959, p. 175; Souchal 1967, pp. 226–27; Caraffa 1974, pp. 301, 307–8; Kieven 1989, pp. 79, 80, 82, 86–88, 94; Minor 1997, pp. 130–35
Trinity Fine Art, London

Already old and infirm when he was elected pope in 1730, Clement XII turned over much of his artistic program to his nephew Cardinal Neri Corsini. In his capacity as majordomo, Neri supervised two substantial campaigns at the patriarchal basilica of St. John Lateran in the 1730s. Alessandro Galilei erected the Corsini Chapel and rebuilt the façade of the old basilica. According to a contemporary lampoon, Clement commented when he was elected to the papacy that "the higher I rise the lower I get. As a priest I was rich. I became a bishop and was comfortably off. I became a cardinal and was poor. Now I am Pope I am ruined" (Chadwick 1981, p. 313; see also Fagiolo M. 1957, p. 197). He was, in other words, a notorious spendthrift, and no monument gives greater credence to that charge than his family's funeral chapel, kept private by the Corsini family to this day.

Above each of the four doors set into the base of the chapel is a sarcophagus for a member of the Corsini family. In the niches above the tombs stand statues of the four cardinal (or platonic) virtues. In addition to Della Valle's *Temperance*, there are Giuseppe Rusconi's *Fortitude*, Giuseppe Lironi's *Justice*, and Agostino Cornacchini's *Prudence*. There also is a bronze figure of *Clement XII*, modeled by Giovanni

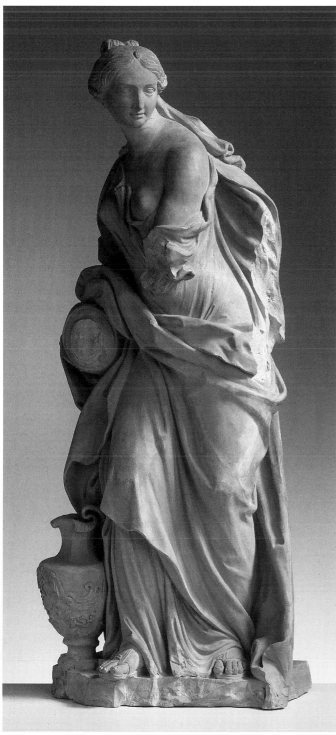

158

Battista Maini, who also sculpted the figure of Neri Corsini.

This figure of *Temperance* pours water into wine, so as to demonstrate (as Saint Thomas Aquinas had maintained) that temperance is not abstinence but "just measure." Plato had written in the *Laws* that "the temperate life is in all things gentle, having gentle pains and gentle pleasures" (Plato, *The Dialogues of Plato*, 3d ed., trans. Benjamin Jowett [Oxford: Clarendon Press, 1892], vol. 5, p. 116). With the

calm twists and torsions of her body, and the shallow, slightly crinkled folds in her garment, *Temperance* embodies the virtue of moderation.

Because this terracotta follows in most of its detail the original statue and—except for damage to the arm and vase—bears a very close resemblance to Count Seilern's terracotta (now in the Princess Gate Collection, Courtauld Gallery, London; each figure stands approximately 25"; 63.5 cm), it is likely not to have been

a preparatory figure but a "presentation" piece. A figure done as a *modello* would anticipate the final statue but would not have all the details worked out. As a copy made afterward, it would be an effective gift, probably given out during the dedication of the chapel in 1735, perhaps to a member of the Corsini family as a gift from Filippo della Valle, or to some other honored guest. According to the information in the Castle Howard inventories, this terracotta was purchased sometime in the 1740s. [VHM]

## 159
## Filippo della Valle
### *Niccola Albergati*

1740s
Terracotta
Height 25" (63.5 cm)
PROVENANCE Heim Gallery, London; purchased by the Museum, 1981
BIBLIOGRAPHY Jones 1986, vol. 1, p. 273; Minor 1997, pp. 187–94
The Los Angeles County Museum of Art, Purchased with Funds Provided by the Mary Pickford Foundation and Museum Purchase Funds

Niccola Albergati (there are variations on the spelling of his first name), cardinal and bishop of Bologna, was born in Bologna in 1357 and died in Siena in 1443. He had become a Carthusian monk in 1394 and was zealous in his reform of the clergy and religious orders. He also was a great friend of learned men. As legate of Pope Eugenius IV, he began discussions with the Greeks in anticipation of the great meeting on the union of the Orthodox and Western Churches that was to be held in Ferrara and Florence. Because Albergati was known for his humility and austerity, Eugenius named him Grand Penitentiary just before his death. Ludwig von Pastor wrote that "When created a cardinal, in his humility he assumed no armorial bearings, but simply a cross, an example which was followed by his old companion Parentucelli, on his elevation to the Papacy" (Pastor 1938–53, vol. 1, p. 268). Upon his election to the throne of St. Peter, Parentucelli honored his old mentor by adopting the name Nicholas V.

When Albergati was an archpriest at S. Maria Maggiore in the first half of the fifteenth century, some parts of the basilica were already a thousand years old. The southeast portico had been most recently rebuilt under Pope Eugene III in the twelfth century. In 1736 the canons of S. Maria Maggiore lobbied Clement XII to repair the basilica, but to no avail. Within days of Benedict's elevation to the papacy late in 1740, the canons urged him to repair the façade, which they feared

was about to collapse upon itself, to fix the roof, which allowed water to pour through the ceiling when it rained, and to rebuild the stairs immediately behind the portico. Ferdinando Fuga, named Architetto del Capitolo di S. Maria Maggiore during the reign of Clement XII, had been making plans for nearly five years. As soon as the great friend of the papacy and liberal patron of the arts John V of Portugal offered 20,000 *scudi* in seed money, Fuga was ready to proceed.

Benedict, especially devoted to the Blessed Virgin Mary (he promoted the Feast of the Immaculate Conception, which was made dogma in the following century by Pius IX), vigorously supported the rebuilding and refurbishing of the church, and before he was done had spent enormous sums preparing the venerable basilica—and indeed much of Rome—for the holy year of 1750. The travertine statue of *Niccola Albergati* was a small but important part of Benedict's plans. The pope took the unusual position of specifying that Albergati be included as part of the iconographic program, even though he was neither saint, apostolic father, nor pope. Although he had been an archpriest at the church, what was of more immediate importance to Benedict XIV, was that Albergati had been a fellow countryman—a Bolognese—and it was Benedict's intention to canonize him. In fact, in his brief on the "Causa canonizationis B. Nicolai Albergati" Benedict specified that he wanted a statue of Albergati on the façade of the church (Anselmi 1990). Moreover, he wanted it directly on the Loggia della Benedizione, the place from which the pope blesses the city and the world. Only two other churches in Rome have such a loggia—St. Peter's and St. John Lateran.

The question remains as to the exact function of this terracotta. This kind of figure (that is, a terracotta copy in miniature of a monumental statue) has long been regarded as a *bozzetto* or preparatory model, one employed by an artist to work out proportions and general features of the final work. Because this has been finished to such a high degree and also because it does not differ significantly from the final piece, it is unlikely to have been something used by Della Valle to represent his first thoughts on the statue of Albergati. It seems more likely that this piece, and many others like it, was made as Signe Jones has argued either as a presentation piece (as discussed in the entry on cat. 158) or directly for what appears to have been a fairly brisk art market. Such small terracottas would have been most desirable purchases for local and foreign collectors, and as an added interest, there must have been considerable curiosity and

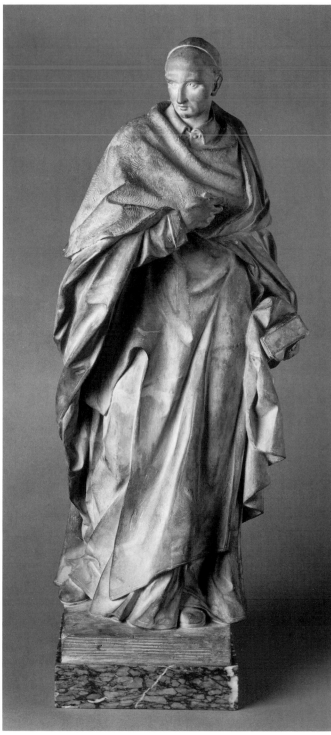

159

enthusiasm among the holy year pilgrims concerning the newest statues to grace such an important Roman building. [VHM]

## GIACOMO ZOFFOLI (c. 1731–1785) and GIOVANNI ZOFFOLI (c. 1745–1805)

Relatively little is known about the lives of Giacomo and Giovanni Zoffoli, two Roman sculptors and metalsmiths who were among the leading producers of bronze statuettes during the second half of the eighteenth century. Giacomo, the elder of the two, was probably the uncle of Giovanni, although he may have been his brother. As the two worked so closely together, and because the younger doubtless received his training from the elder, it is not surprising that their styles are almost indistinguishable. The difficulty of specific stylistic attribution is compounded by their regular use of the abbreviated signature *G. Zoffoli*.

Giacomo trained not as a sculptor but as a worker in precious metals. He was active in the Roman goldsmiths' professional guild, the Università dei Lavoranti, and served as the deputy of that organization from 1758 to 1760. By this time, though, he was gaining a reputation as a sculptor of bronze miniatures after famous antique statues. His talent in this area won the admiration of Pope Clement XIII, who in 1763 commissioned him to produce a small bronze after the Capitoline *Marcus Aurelius*, the most famous equestrian statue to have survived from antiquity. Presented by the pope to the Elector of Saxony, the piece survives in Dresden.

Giacomo Zoffoli built a thriving business marketing small copies of famous statues to Italian connoisseurs and especially to wealthy foreigners who visited Rome on the Grand Tour. At the same time he continued to produce silver plate and vessels for ecclesiastic and domestic use, and received in 1775 the prestigious title of Master Silversmith. Zoffoli also participated in the modeling and casting of larger-scale sculpture, and is documented as having collaborated with Tommaso Righi on a bust of Pope Pius VI for the city of Montecchio (now Treia).

In or before 1766 Giacomo Zoffoli married Gertrude Tofani, and in 1784 the couple was recorded as living in the parish of S. Andrea delle Fratte with their four daughters and infant son. The following year Giacomo died and Giovanni Zoffoli succeeded to the direction of the Zoffoli sculpture workshop; he eventually moved into the studio floor of Giacomo's house and remained there until his own death in 1804. Giacomo continued to add to the stock of available bronze miniatures, and promoted the business by circulating printed lists of his offerings. A list that survives from around 1795 gives an indication of the scope of Zoffoli's production; it catalogues miniature versions of many of the most famous antiquities in Italian collections. From Rome, selections include the *Apollo* Belvedere, the Vatican *Antinous*, Vatican *Cleopatra* (now known as *Ariadne*), the *Laocoön*, the Furietti *Centaurs*, Capitoline *Dying Gaul*, and Capitoline *Spinario*. From outside of the papal city, the list includes the Medici *Venus*, the Uffizi *Faun with Cymbals*, the Farnese *Callipygian Venus*, Farnese *Hercules*, and Farnese *Flora*, among other works (the list is published in full in Honour 1961, p. 205). The promotional list also offered copies after the sixteenth-century work of Giambologna, and busts of the Italian literary figures Petrarch, Dante, Tasso, and Ariosto.

Bronze is an inherently collaborative medium, and it is not clear to what extent the figures that the Zoffoli signed were created by Giovanni and Giacomo themselves. Certainly they maintained a workshop of craftsmen to assist production. There is also documentary evidence that on at least two occasions Giovanni Zoffoli commissioned the sculptor Vincenzo Pacetti to model the terracotta scale replicas from which the molds for the bronzes were taken (Honour 1961, p. 199). However, once the bronze was cast, the metalworking talents of Giovanni or Giacomo came into play: each sculpture was chased, carefully worked to bring its surface to refined polish and high resolution of detail. The finished objects were prized by connoisseurs, and entered some of the most distinguished princely collections of Europe.

Charles Heathcote Tatham, acting as an agent for the Prince of Wales in gathering furnishings for the redecoration of Carlton House during the 1790s, purchased ten statuettes from Zoffoli's list. Writing back to England, Tatham expounded on the superiority of the Italian bronzes to contemporary French production. Recommending the former, he informed his correspondent that "the bronze used by the Italians is of the best metal, with what they call a patina, meaning the outward color, of good nature … above all their execution is superlatively good, having artists employed who study the antique with attention and model with great ingenuity and taste" (quoted in Honour 1961, p. 201). The Zoffoli often sold their bronzes in groups, some of which are still intact: a set of ten acquired by the Duke of Northumberland survives at Syon House; a group of five, now at Saltram House, Devon, was probably purchased by Lord Boringdon to decorate a chimneypiece at this country seat; another group of five, now in Stockholm, were probably acquired by King Gustav III himself, who made his rounds in Rome in the company of the Neoclassical sculptor Johan Tobias Sergel. [JH]

BIBLIOGRAPHY Bulgari 1958–74, vol. 2, p. 558; Honour 1961; Hiesinger and Percy 1980; Sutton 1982, p. 31; Wilton and Bignamini 1996, pp. 280–81

## 160

### Giacomo or Giovanni Zoffoli

*Seated Roman Matron ("Agrippina")*

c. 1780–90
Signed: *G.ZOFFOLI.F*
Bronze
11⅛″ × 11⅝″ × 4″ (28.9 × 29.5 × 10.2 cm)
PROVENANCE The Eighteenth Century Shop, New York; purchased by Anthony Morris Clark in 1956–57; by bequest to the Philadelphia Museum of Art in 1978
EXHIBITION Philadelphia 1980, cat. no. 113
BIBLIOGRAPHY Honour 1961; Hiesinger and Percy 1980, pp. 127–28
Philadelphia Museum of Art, Bequest of Anthony Morris Clark

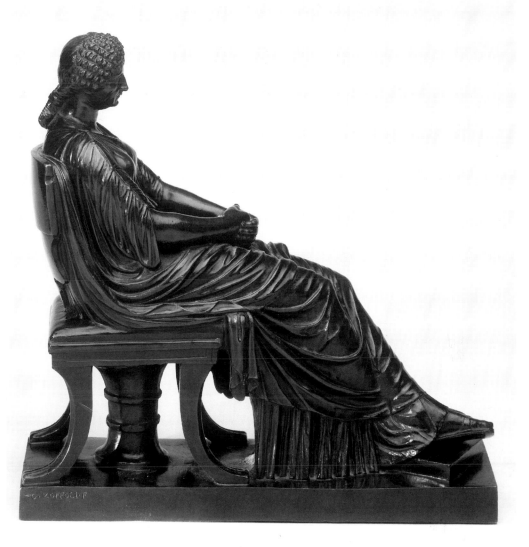

160

This bronze is a miniature of a life-size Roman marble from the celebrated Farnese collection. During the first half of the eighteenth century the original, thought to represent Nero's mother, Agrippina, decorated the semi-public Farnese Gardens on the Palatine Hill. Later it was removed from Rome to Naples by King Charles III, the heir of the Farnese family. A second, very similar, version, also an original Roman antiquity, remained in Rome, in the Museo Capitolino. The fame of the so-called "*Agrippina*" led Zoffoli to copy it in reduced scale and include it in the line of bronze miniatures that he offered to Italian connoisseurs and to the cultivated foreign amateurs who visited Rome on the Grand Tour.

In its scale, its exquisitely worked finish, and its classical subject the "*Agrippina*" is a typical example of the miniature production of the Zoffoli. It is difficult, however, to attribute this undated piece more precisely, as the signature reads simply *G. Zoffoli F.* While the *F* is an abbreviation for *fecit* (Latin for "made it"), the *G* could indicate either Giacomo or Giovanni. Since these two kinsmen collaborated closely and since in many cases they finished sculptures cast from the same set of molds it seems imprudent to attempt a more specific attribution.

In 1795 Giovanni Zoffoli issued a printed catalogue list of the fifty-nine miniature bronze sculptures available from his workshop. The "Agrippina, Madre di Nerone" is the fifth entry on the list, where it is offered for a price of 15 Roman zecchini. The exhibited bronze is a multiple rather than a unique object: another Zoffoli "*Agrippina*" survives as part of a five-piece *garniture de cheminée* at Saltram House, Devon. There it is paired with a seated figure of Menander, a juxtaposition that has more to do with symmetry and decorative balance than with meaning.

Yet meaning was often important to the buyer, and part of the desirability of the bronze miniature "*Agrippina*" derives from the notoriety of the subject's story. According to the ancient historian Suetonius, the empress Agrippina murdered her husband Claudius with a poisoned dish of his favorite mushrooms. The same historian, whose passion for the scurrilous made his *Twelve Caesars* such popular reading (translations in various languages were published throughout the eighteenth century), reported Nero's "lecherous passion" for his mother. Eventually the capricious emperor turned against his mother and resolved to have her killed. Attempting at first to have her drowned in a staged boating accident, Nero dispatched his assassins to her villa, where they clubbed and hacked her to death.

While modern scholars agree that the marble (and hence the exhibited bronze) does not represent Agrippina, Settecento viewers did not question the identification. The travel writer Mariana Starke felt that the statue captured the mood of the doomed woman, back in her villa after the first attempt on her life and knowingly awaiting the second. Looking at the quietly reflective pose of Zoffoli's figure, with its bowed head, one may join Mrs. Starke in imagining the "mild, pathetic, deep despair" that filled the imperial lady's final hours (quoted in Haskell and Penny 1981, p. 134).

The quiet, restrained compositional style of the "*Agrippina*" attracted admiration during the last quarter of the eighteenth century, a period in which a stern Neoclassicism was coming into fashion. Antonio Canova paid the sculpture the highest compliment when he followed it closely in his life-size marble portrait of Napoleon's mother; "Madame Mère" must have been flattered enough by the comparison to an ancient Roman empress to overlook the more negative aspects of Agrippina's reputation. For the Grand Tourist the display of such pieces was meant as a sign of the owner's worldly cultivation. For many connoisseurs, an object such as the "*Agrippina*" was appreciated as a possessable simulacrum of one of the world's most famous sculptures. Above all, however, the miniatures were regarded as artworks in their own right, admired for their beauty and technical virtuosity. [JH]

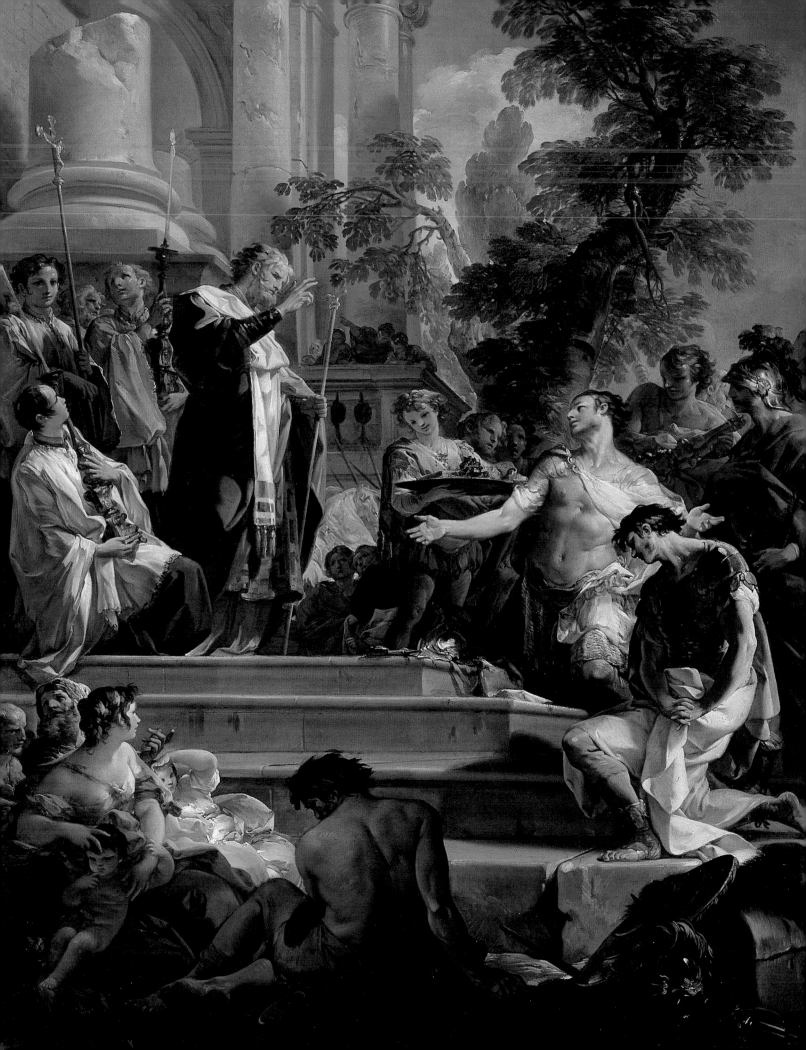

# Painters and Painting in Settecento Rome

### EDGAR PETERS BOWRON

Fig. 102 Carlo Maratti, *Triumph of Clemency*, 1674, fresco; Palazzo Alteri, Rome

"The seminal center of artistic ideas in Italy in the eighteenth century,"[1] Rome throughout the Settecento was a melting pot for hundreds of painters from all over Europe. A wonderful variety of pictorial styles was to be found there: "Late Baroque classicism," "*barocchetto,*" "High Baroque Classicism," "proto-" or "early-Rococo," "Rococo," "proto-Neoclassicism," "Neoclassicism", "neo-Cinquecentismo," "neo-Mannerism," "proto-Romanticism," "Romanticism," are a few of the terms art historians have employed to describe the stylistic diversity of painting in the city. But Rome was also where artists, patrons, and collectors gathered to admire the art of the ancients, of Raphael and of the Bolognese painters Annibale Carracci, Domenichino, Guido Reni, and their numerous students and followers. No other European city possessed this classical heritage, and Rome's classical grandeur, the archaeological enthusiasm of the era, and its vibrant

(OPPOSITE) detail of Corrado Giaquinto, *Saint Nicholas of Bari Blessing the Soldiers,* 1746 (cat. 226)

tradition of classical painting affected every painter who visited the city.

In 1700 the most influential artist in Rome—indeed, it might be argued, in all of Europe—was Carlo Maratti. Appointed first painter to the King of France and to seven popes, and having received the title of Cavalier of the Order of Christ in 1704 from Pope Clement XI, Maratti's successes were prominent. He enjoyed extensive local and foreign patronage and was besieged for portraits as well as religious and mythological paintings. In Rome alone, Maratti supplied major altars for S. Andrea al Quirinale, S. Carlo al Corso, S. Croce in Gerusalemme, the Gesù, S. Giovanni in Fonte, S. Giuseppe dei Falegnami, S. Isidoro, S. Marco, S. Maria sopra Minerva, S. Maria in Montesanto, S. Maria della Pace, S. Maria del Popolo, S. Maria dei Sette Dolori, S. Maria in Vallicella, and St. Peter's. His frescoed ceiling in the salone of the Palazzo Altieri illustrating *The Triumph of Clemency* (1674; fig. 102), based on a program devised by the art theorist and antiquarian Giovanni Pietro Bellori, introduced the "Grand Style" to Rome, the style that, in Ellis Waterhouse's phrase, "was to become for a century the idiom of cultured court art in Europe."[2]

Well before the first years of the new century, Maratti had created an effective style that synthesized the classical and the Baroque trends of Roman Seicento painting into a manner that commanded the attention and respect of nearly every young painter in Rome. Maratti's great achievement as a painter was to incorporate the kinetic, spatial, and naturalistic achievements of the High Baroque into a classical framework, resulting in a brilliant fusion of the predominant modes of Roman Baroque painting. The strongly formalized, classicizing works of Maratti's maturity—*Saint John the Evangelist Expounding the Doctrine of the Immaculate Conceptiopn to Saints Gregory, Augustine, and John Chrysostom* (c. 1686, fig. 103), *The Virgin and Child with Saint Francis and Saint James the Great* (1686–89; S. Maria in Montesanto, Rome), *The Death of the Virgin* (c. 1686; Villa Albani-Torlonia, Rome), and *The Baptism of Christ* (1699, S. Maria degli Angeli, Rome)—provided inspiration to scores of painters. The ennobled, idealized figures in these dignified compositions, which Maratti himself had developed from the works of Raphael, Andrea Sacchi,

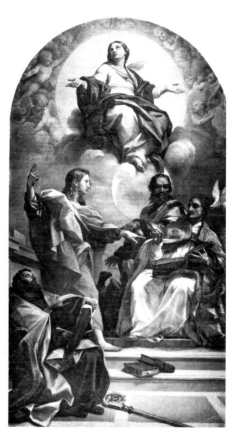

Fig. 103 Carlo Maratti, *Saint John the Evangelist Expounding the Doctrine of the Immaculate Conception to Saints Gregory, Augustine, and John Chrysostom,* c. 1686, oil on canvas; Cybo Chapel, S. Maria del Popolo, Rome

Guido Reni, Giovanni Lanfranco, and Pietro da Cortona, led to a new grandeur and nobility in Roman painting that reverberated through the century.[3]

It is difficult today to appreciate adequately the authority that Maratti, this modern "Apelles of Rome," exercised on the European artistic imagination in the early decades of the eighteenth century. No monograph of his œuvre exists; he has never been the subject of an exhibition; and major paintings from his hand are almost non-existent in public collections outside Italy.[4] But for several generations of painters from the 1670s to the end of the eighteenth century, Maratti was the embodiment of the ideal classical artist and the chief exemplar of the tradition of Roman painting

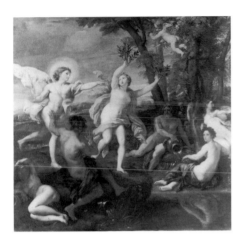

Fig. 104 Carlo Maratti, *Apollo and Daphne*, 1681, oil on canvas; Musées Royaux, Brussels

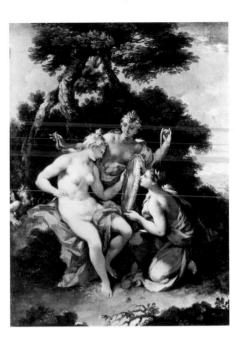

Fig. 105 Michele Rocca, *Toilet of Venus*, c. 1710, oil on canvas; Museum of Art, Rhode Island School of Design, Providence

that began with Raphael. Nearly every painter who encountered Maratti's works was affected profoundly, and subtly reoriented his art thereafter toward new ideals of formal dignity, nobility, purity of contour and silhouette, and compositional clarity. The Neapolitan artist Francesco Solimena, who experienced a radical change in the direction of classicism after he entered the orbit of Maratti during a one-month trip to Rome in 1700, is a case in point.[5] Even decades after Maratti's death, reflections of his grandiose and decorative style are visible in Anton Raphael Mengs's fresco ceiling of 1757–58 in S. Eusebio, Rome, and in his *Parnassus* (1760–61; Villa Albani-Torlonia, Rome; see cat. 387).

Maratti's dominion in the Roman art world was maintained by a very large and flourishing studio with a great number of painters (the so-called *Maratteschi*) who carried his artistic idiom into the new century. They inherited his privileged position with successive popes, and succeeded to his leadership role in the Accademia di S. Luca. Elected to membership in 1662, Maratti served as the academy's Principe in 1664–65 and again from 1700 to 1713. In 1701 he received the unprecedented honor of being named Principe for life. Maratti wielded his power and influence within the academy to establish the authority of his stylistic creation, which many art historians have designated "late Baroque classicism," and most of its members seem to have accepted both the terms of his pedagogy and the implications of his art.

The Accademia di S. Luca neither engendered a specific style, nor attempted to set forth a clear, systematic statement of artistic intent. Under the influence of Maratti, however, the institution advocated a respect for the Roman classical tradition, the codification of approved models, a reliance on reason, and a well-defined sense of decorum. From the

beginning of the Settecento, judging from the evidence of the works of its members, the academy encouraged a simplification of expression, a reasonable and serious use of imagery, and an avoidance of fantastic Baroque elaboration. Periodically, rebellious painters in the city attempted to subvert the academy's authority, but the institution maintained its influence over the vast majority of its members and enforced the academic notion that classically "correct" history painting—a broad term that embraced sacred themes, scenes from legend and literature of a morally edifying kind, and actual historical events— was the painter's proper pursuit. It should be noted, however, that although landscape and topographical view painters, and even still-life painters and *bambocciate*, flourished in Settecento Rome, they generally received short shrift from the Accademia di S. Luca.

Another Roman academic institution, the Accademia dell'Arcadia, fostered a similar reaction to the Baroque style that proved influential in many avenues of contemporary culture. Although the Arcadia was concerned principally with the reform of poetry—which it sought to make more rational and less artificial—the notions of natural expression, simplicity, and the elimination of bombast that gained favor in Roman intellectual circles were paralleled by changes in the visual arts in the early Settecento. The Arcadian style, a mode of painting that flourished in small, intimate cabinet pictures, both sacred and profane, allowed painters a greater degree of freedom than in large-scale, public works of art. They could experiment with a personal artistic manner, explore a wider range of pictorial effects, and look to non-Roman sources such as the paintings of Correggio and the Venetians as models of inspiration. In the emerging aesthetic of Arcadianism, Maratti here, too, played a crucial role. His *Apollo and Daphne* (1681; fig. 104), executed for Louis XIV, was one of the most celebrated works of the time, praised by Bellori for its expression of the *affetti* and of ideal beauty in the secular realm. Maratti's small-scale cabinet pictures of devotional subjects—which earned him the nickname "Carluccio delle Madonna" and express in their tenderness, innocence, and grace an entirely new sensibility—held great significance for the history of Settecento Roman religious painting.

The new treatment of traditional religious subjects such as the Virgin and Child (see, for example, cat. 293), the Holy Family, and the Rest on the Flight into Egypt (cat. 199) show how profoundly Arcadianism influenced Roman painting in the early decades of the Settecento. Paintings of non-narrative religious themes found great favor with a refined

and culturally sophisticated élite in Rome and abroad. Intended for domestic rather than ecclesiastical settings, cabinet-sized devotional images and Old and New Testament scenes (see, for example, cats. 198, 242) were deliberately created for connoisseurs and collectors, and practically burst with painterly artifice and exquisite pictorial effects. Often painted on copper supports to enhance their preciosity, pastoral Arcadian scenes such as Sebastiano Conca's *Rest on the Flight into Egypt* announced simultaneously a new aesthetic and a mode of religious sensibility characteristic of the Roman Settecento.

The emergence of Arcadianism around 1700 also stimulated a new interest in secular paintings for the collector's cabinet and enabled artists of the first rank—Giuseppe Bartolomeo Chiari, Benedetto Luti, Sebastiano Conca, and Francesco Trevisani—to conduct a thriving and lucrative trade in small-scale cabinet pictures to local patrons and foreign clients alike.[6] That Roman painters shared the general eighteenth-century ideals of grace, elegance, and suavity is confirmed by Chiari's famous set of four Ovidian themes painted in 1708 for Cardinal Fabrizio Spada (Galleria Spada, Rome). Mythological cabinet pictures were ideal for a painter with a light touch and a predilection for the coyly erotic, such as Michele Rocca (fig. 105). Such pictures, as has been pointed out, are not simply reductions of designs for large historical compositions—their daintiness, elegance, and mannered movements, acceptable on a small scale, would have looked silly if

translated into the scale of life.[7] They represent a new development in painting in Rome, one that became so powerful that Trevisani's international reputation, it can be argued, depended more on his Arcadian mythologies and "his porcelainy children, who frequent his compositions in and out of season,"[8] than on such magnificent and moving public commissions as *The Ecstasy of Saint Francis* (fig. 106), which are among the greatest paintings produced in Europe during the eighteenth century.

The artistic and stylistic independence encouraged by the Arcadian movement notwithstanding, a respect for traditional "Roman" painting was strongly impressed upon painters in the Eternal City from the earliest moments of their professional training. When a young artist in eighteenth-century Rome became the protégé of a master, he (and, rarely, she) learned the technical procedures for preparing and mixing colors and priming canvases, as well as other rudiments of the painter's art. But, above all, the student received hours, months, even years of instruction in drawing, for only by constant practice could a young painter gain the ability to draw in the accepted Roman style, grasp the fundamentals of *disegno*, and acquire the *giustezza d'occhio* possessed by every great painter. And only by drawing continuously could the apprentice gain mastery of such technical problems as proportional accuracy, foreshortening, detail–mass relationships, and the creation of convincing volumetric and spatial form.

Most painters in eighteenth-century Rome followed a path of instruction similar to that of Antonio Cavallucci, a painter from Sermoneta who spent most of his life in the papal capital. One of the artist's contemporary biographers described how the artist arrived in Rome at the age of fourteen and advanced under the direction of Stefano Pozzi—copying profiles, heads, hands, feet, and other details of the body from drawings and engravings; studying the entire figure *per se* through outline drawings; and representing three-dimensional objects, usually plaster casts of classical sculptures (both Costanzi's and Mengs's studios were renowned for their collections of casts), before undertaking the live model. The goal was to develop *accuratezza*, *diligenza*, and *naturalezza* in drawing, and the attainment of these technical skills was considered so indispensable to artistic success that those not trained in history painting—landscape painters, for example—remedied their shortcomings with a period of instruction from a recognized figure painter. Andrea Locatelli, who drew the human figure under the direction of Biagio Puccini, for example, and Panini, who spent several years drawing with Benedetto Luti, are two of many examples of this phenomenon.

*Disegno* was more highly prized in Rome than elsewhere in Europe, and young artists from all corners of the Continent flocked to the city for the opportunity to draw with an experienced master. By the middle of the century it had long become an established European tradition for artists to travel to Rome to complete their education. The city remained unrivaled as a training ground for young painters, a place where they could imbibe the "true" sources of the Roman school: nature, antiquity, and Raphael. In Rome they could improve their ability to draw, and the city became the "Academy of Europe" in great measure because of the opportunities it offered in life drawing. Artists could study from the model at the two "official" academies, the French Academy and the Accademia di S. Luca; they could draw at the Accademia del Nudo, established by Pope Benedict XIV in a large room below the Pinacoteca Capitolina in the Palazzo dei Conservatori; they could enroll in one of the local evening drawing academies held by Rome's leading masters; and they could—and often did—organize their own independent life-drawing classes.[9]

For many eighteenth-century Roman painters, life drawing was such an indispensable element of their training that they continued to draw from the nude well into maturity, both to maintain and sharpen their skills as draftsmen and to show off their abilities in this field. The academy drawings of Domenico Corvi, for example (cat. 340), one of the chief exponents of the Roman classical tradition in the second half of the eighteenth century, were avidly sought by his contemporaries and, according to the contemporary historian Luigi Lanzi, were valued even more highly than his paintings. Lanzi praised Corvi's incomparable command of anatomy, perspective, and design, but in fact almost all the painters represented in the present exhibition achieved in their best works a similar exactitude, precision of contour, and finish and shading. Put more bluntly, painters trained in Rome became better draftsmen than artists elsewhere, at least until the end of the century, when the methods and training conducted there became available through the establishment of academies throughout the major cities of Europe.

Novice painters in Rome were also ordered to study the grand models of *disegno* in order to learn articulation of musculature, modulation of light and shade, and construction of drapery. This meant endless sketching before Raphael's frescoes in the Vatican Stanze and the Villa Farnesina, Annibale Carracci's frescoes in the Farnese Gallery, Domenichino's *Scenes from the Life of Saint Cecilia* in S. Luigi dei Francesi, his *Death of Saint Jerome* in S. Girolamo della Carità, his pendentives of the *Four Evangelists* in

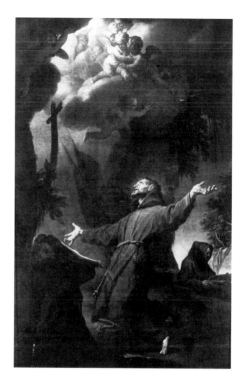

Fig. 106  Francesco Trevisani, The *Ecstacy of Saint Francis*, c. 1722, oil on canvas; Ss. Stimmate di S. Francesco, Rome

S. Andrea della Valle, and his *Scourging of Saint Andrew*, and Guido Reni's *Saint Andrew Led to Martyrdom* in the Oratorio di S. Andrea, S. Gregorio Magno. Works by the other acclaimed masters of classicism of the early Seicento were also studied assiduously and sketched. Utter familiarity with these masterpieces of Roman painting impressed upon young artists the importance of Roman *disegno* in the conventions of invention, expression, composition, and anatomy.

The influence of Maratti, the authority of the Accademia di S. Luca, emphasis upon drawing, and absorption of the earlier Roman classical painters left a deep imprint on young artists in Rome and hastened their transformation into truly "Roman" painters. This explains why, in Clark's words, the Roman Settecento "is generally considered one of the hardest moments in any European school to distinguish individuals, and it is true that the basic artistic agreement was exceptional strict."[10] In the case of artists from outside Rome, their experiences in the city quickly resulted in a conversion of their *pregiudizzi* and a waning of their biases in favor of regional styles and local heroes of painting "back home." This was never more true than in the case of David, who consciously abandoned the "bad" Rococo French manner of his training. But in shedding their earlier artistic predispositions, most Roman Settecento painters gained a new

mastery in their ability to express gestures, attitudes, and expressions and a deeper understanding of ideal beauty, decorum, and the other principles of the Grand Manner, which had, after all, provided the theoretical underpinning for much European art since the time of Raphael.

But because the ablest painters from elsewhere in Italy and beyond—Luti and Bottani from Florence, Batoni from Lucca, Conca and Giaquinto from Naples, Subleyras from Paris, Mengs from Dresden, Maron from Vienna—arrived daily in Rome, both the spirit and content of Rome's classicism evolved continuously decade after decade. "Romanization" was not a conservative process but a highly creative action, one that would be reiterated again and again by many significant eighteenth-century artists, native and foreign, who worked in Rome. Even a cursory glance at the works in the exhibition reveals the transformation of Settecento Rome's classical inheritance into a fresh and original pictorial manner that at once honors the traditional while simultaneously offering something unmistakably new. Marco Benefial, to cite one example, was a master of a variety of styles and could produce devotional works in the manner of Guercino, or mythological pictures such as the *Pyramus and Thisbe* (cat. 177) in a classicizing version of the style of Giovani Battista Gaulli.[11] Half a century later, Giuseppe Cades turned heads with his seemingly effortless ability to paint and draw in every style from Neo-Mannerist to Baroque to Romantic (cats. 193–95, 324–28), revealing along the way his inspiration from Raphael and the Roman High Renaissance, Giulio Romano and Mannerism, Veronese and the Venetians, Rubens and Van Dyck, and Guercino.

With the arrival and establishment of the innovative young northern artists who gathered in Rome around Henry Fuseli and Johan Tobias Sergel in the 1770s, the sources invigorating Roman painting widened even further. Strongly opposed to Mengs and the fashionable artistic circles in Rome, Fuseli sought inspiration from Hellenistic sculpture, Michelangelo, and Mannerism. "It was no longer recourse to recognized models but experimentation with the possibilities of their own pictorial imaginations and an ironic questioning of reality and tradition which determined the new approach," as Steffi Roettgen has put it.[12]

The works shown here reveal several unifying pictorial qualities common to Roman painting from the beginning to the end of the eighteenth century: polished drawing, precise handling, luminous color, idealization of nature, and, often, an acuity of perception and observation that approaches naturalism. Judged strictly by their ability to manipulate

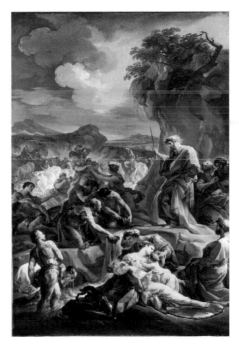

Fig. 107 Corrado Giaquinto, *Moses Striking the Rock*, c. 1724, oil on canvas; National Gallery, London

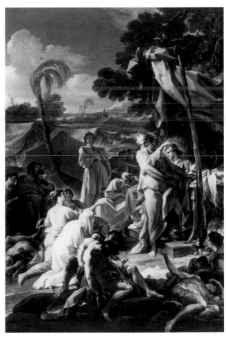

Fig. 108 Corrado Giaquinto, *Moses and the Brazen Serpent*, c. 1724, oil on canvas; National Gallery, London

oil paint, artists in Rome had few rivals, in Italy or elsewhere, in leaving an appealing freshness and sparkle of touch. Virtuoso handling and the ability to impart in oils effects of richness and sensuousness seem to have been prized in the ateliers of Rome and were not unnoticed by contemporary critics. The manipulation of paint ranges from the "florid, nervous vivacity" of Conca's *Rest on the Flight into Egypt*[13] to the smooth surfaces, minute finish, and polished detail of Luti's *Saint Charles Borromeo Administering Extreme Unction to the Victims of the Plague* (cat. 241) and Batoni's *Benedict XIV Presenting the Encyclical "Ex Omnibus" to the Count de Choiseul* (cat. 168), to the spontaneous brushwork and liquid handling of Giaquinto's brilliant *modelli* for S. Croce in Gerusalemme (cats. 224, 225), to Cades's virtuoso brushwork in the altarpiece for the cathedral in Ascoli Piceno (cat. 194).

The ease with which such painters as Pierre Subleyras (cats. 283–87) or Antonio Cavallucci (cat. 197) could wield a brush and leave impasto highlights, sensuous surfaces, and softly brushed forms on their canvases is an inevitable by-product of their training and skills as draftsmen. Batoni, for example, who was arguably the finest draftsman among all eighteenth-century portrait painters, employed a precise and controlled method of working in oils—varied, but certain, direct, and confident—that his contemporaries admired.[14] His polish and high finish were "qualities which have always appealed to the richest level of art

patrons of the less intellectual sort," in Ellis Waterhouse's observation, "and it was from such that Roman artists were increasingly to earn their living."[15]

Given the fluency with which Roman artists could manipulate oil paint, it is not surprising that oil sketches, *bozzetti*, and *modelli* played a significant role in their working methods. Although oil sketches in the eighteenth century are often associated primarily with Venice and Giovanni Battista Tiepolo, in the context of contemporary Roman practice, painters from Luti (cat. 243), to Giaquinto (cats. 224, 225), to Antonio Cavallucci (cat. 197), to Cades (cat. 195) relied equally on preparatory sketches in oils for a variety of purposes. For most of these painters, the physical act of painting was effortless, and they were content to rework and alter their designs on canvas until satisfied. For some, such as Marco Benefial, it is apparent that by relying upon a series of rapidly painted oil sketches blocking out and highlighting the forms, accenting the lights and shadows, it was possible to preserve the spontaneity of their original inspiration.[16]

Of course, highly finished models in oils served the traditional function of providing a patron an indication of the finished appearance of a design or composition. Giaquinto's large-scale oil sketches for the choir walls of S. Croce in Gerusalemme in the National Gallery, London (figs. 107, 108)—which were not lent to the present exhibition because of their pristine preservation on original, unlined

canvases—show how finely wrought and brilliant such paintings could be. And given the alterations to the original appearance of Giaquinto's frescoes in Rome from the effects of humidity and unsuccessful restorations in the nineteenth century, the brilliance of his achievement in S. Croce can be appreciated more satisfactorily today in these exquisitely finished preparatory sketches than in the actual finished works *in situ*.

Most will find surprising the luminosity and color of so many Roman Settecento paintings. One of the most sophisticated colorists of the early century was Benedetto Luti, who translated to oils the rich chromatic effects of his justly famous pastels. Luti managed to infuse the great traditions of Roman classicism with the luminosity and color of the paintings of Federico Barocci and the Florentine Baroque, and works such as his great canvas of 1712 depicting the *Investiture of San Ranieri* (Pisa Cathedral; see fig. 41) revealed a color scheme so vibrant that it changed the course of Roman painting. Luti employed a lighter palette than many of his contemporaries, and his abrupt juxtapositions of high-keyed hues and irridescent pastel tints resulted in stunning visual effects. He was a virtuoso in the painting of silk and satin, and his preference for sherbet pastels of green, white, orange–yellow, and violet, all tinted in a much higher key with white (derived in part from Guido Reni's paintings of the late 1620s and 1630s), left its mark on his Roman contemporaries.

Luti's *Allegory of the Enthronement of Pope Martin V* in Palazzo Colonna, c. 1718–22, modulates and juxtaposes hues, tints, and shades with a virtuosity equal to any French painter of the Rococo. The vibrant luminosity and high-keyed hues and irridescent pastel tints of lilac, lemon, lavender, pink, and gray–green that mark Pompeo Batoni's magnificent *Sacrifice of Iphigenia* (cat. 163) underscore the influence of both Reni's later works and Luti's, which Batoni would have studied as he prepared his own decorations for the same ceiling.[17] Giaquinto's vivid and luminous canvases (cats. 223–26) also reveal a luxuriant palette of transparent greens, blues, violets, reds, pinks and grays that raises the inevitable comparison to the art of François Boucher, one of the most important French Rococo painters to study in Rome.[18]

Many Roman painters in the eighteenth century possessed the ability to create striking, memorable images; for example, Batoni and Mengs in their portraits. Batoni's portraits command attention by the freshness of their coloring, precision of drawing, and polish of handling. Very few contemporary portrait painters could match his ability to produce an accurate likeness. Batoni "values himself

Fig. 109 Anton Raphael Mengs. *Cardinal Francesco Saverio de Zelada*, 1773–74, oil on panel; Art Institute of Chicago

for making a striking likeness of everyone he paints," wrote Father John Thorpe, the Jesuit priest and antiquarian,[19] and his sitters were almost always pleased with this aspect of their portraits. Accurate likenesses were highly valued by Batoni's clients, but his portraits were more than accurate; they were also vivid and powerfully compelling: Stephen Beckingham's portrait was so memorable that a stranger, upon being introduced to the sitter at a dinner party in London, recalled seeing the picture several years earlier in an Italian custom house, where it had turned up after being nearly lost at sea.[20]

Mengs, too, could create expressive and highly individualized likenesses of great vividness and immediacy (cats. 253–55, 259). The liveliness of expression and intensity and the spontaneity of his work in oils and pastel are epitomized by the memorable portrait of *Cardinal Francesco Saverio de Zelada*, 1773–74 (fig. 109). The cardinal, who played a significant role in the dissolution of the Society of Jesus during the reign of Pope Clement XIV and, as Secretary of State, served as an intermediary between the papal state and revolutionary France, sat to Mengs in 1773. The portrait was hailed in the *Diario di Roma* of April 22, 1780, as "one of the most beautiful ever done by the immortal Cavalier Mengs;"[21] its subtle modeling of flesh tones, intense illusionism, and vivid coloring result in a tour de force of portraiture. Mengs, like Batoni, could endow any of his portraits with an extraordinary degree of naturalness, although the

demands of the genre often required him to dilute his initial free and spontaneous observation with the details of costume, accessories, and setting.

Naturalness, immediacy, and directness were not, however, restricted to portrait painting. There is a rich vein of dramatic naturalism that runs through Settecento Roman painting and explains why, for instance, in the realm of sacred painting, scenes from the life of little-known saints of the period appear so remarkably convincing to a modern audience. Beginning with Benedetto Luti, Roman painters devoted considerable skill and effort toward making the drama of the fictive scene before the observer a real and present event. Three paintings in the exhibition especially—Luti's *Saint Charles Borromeo Administering Extreme Unction to the Victims of the Plague* (cat. 241), Pier Leone Ghezzi's *Miraculous Intercession of Saint Philip Neri on Behalf of Cardinal Orsini, the Future Benedict XIII* (cats. 220–21), and Benefial's *Vision of Saint Catherine Fieschi Adorno of Genoa* (cat. 178)—convey the special style of Roman eighteenth-century religious painting. Each in a slightly different way encourages the emotional involvement of the observer by means of a rational presentation of sacred drama in a convincing narrative manner. Depiction of sacred scenes with such vivid degrees of concreteness, suggesting to the beholder the illusion that the scene is being enacted before his eyes, is one of the achievements of the Roman Settecento.

This humanization of the emotion of religious experience gathered steam at the end of the previous century in Maratti's late altarpieces, such as the *Virgin and Child with Saint James and Saint Francis* (1689; S. Maria di Montesanto, Rome), continuing a trend in Italian painting that began during the Catholic Counter-Reformation a century and a half earlier. Intimacy between spectator and painting is the norm in Roman Settecento religious painting, above all in themes related to ecclesiastical and papal history and in the growing genre of scenes from contemporary religious life: ceremonies, rites, the promulgation of important bulls (cat. 168), royal and aristocratic marriages (Agostino Masucci, *The Marriage of Prince James Francis Edward Stuart and Princess Maria Clementina Sobieska* [Scottish National Portrait Gallery, Edinburgh]) and baptisms (Pier Leone Ghezzi, *The Baptism of Prince Charles Edward Stuart* [Scottish National Portrait Gallery, Edinburgh]), *Te Deum* masses for military victories and advantageous peace treaties, and papal elevations. As Christopher Johns has pointed out, "Even in more traditional types of sacred art the presence of swarms of angels, hosts of airborne saints, and dramatic shafts of golden light is often underplayed in

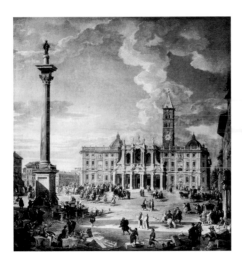

Fig. 110 Giovanni Paolo Panini, *Piazza Santa Maria Maggiore*, 1742, oil on canvas; Coffee House, Palazzo del Quirinale, Rome

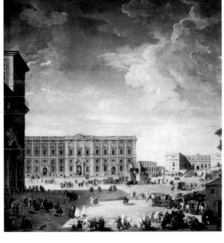

Fig. 111 Giovanni Paolo Panini, *Piazza del Quirinale*, 1742, oil on canvas; Coffee House, Palazzo del Quirinale, Rome

favor of more matter-of-fact representations with relatively limited casts of characters."[22]

This new informality, characterized by a naturalistic description of setting and figures, and by a lively interest in anecdote, also pervaded secular painting in eighteenth-century Rome. The tendency is exemplified by the work of Pier Leone Ghezzi, appearing first in his six small scenes from the life of Pope Clement XI (1712–15; Palazzo Ducale, Urbino), painted for the salone of the papal palace at Castelgandolfo.[23] However, it is Ghezzi's recorative fresco cycles painted for Cardinal Alessandro Falconieri in the castle of Torrimpietra (1712–32), and in the Villa Falconieri at Frascati (1724–34) that present most successfully his brand of precise, descriptive, witty realism. The figures are fashionably dressed, and for the most part drawn from life, providing a vivid picture of the society of the time, at once Roman and cosmopolitan, papal and libertarian.[24]

The didactic piety of paintings such as Luti's and Trevisani's small-scale devotional pictures on copper (cats. 242, 290, 295) is one link in a chain that stretches from Guido Reni's Virgins through Batoni's Sacred Heart of Jesus (Il Gesù, Rome), one of the most revered images in the Roman Church,[25] to the nineteenth-century religious oleograph. Nonetheless, it must be emphasized that this type of religious painting was not intended for the delectation of the simple-minded. One measure of the reception accorded such pictures in the early Settecento is the enthusiasm of such sophisticated collectors as Augustus III, Elector of Saxony and King of Poland, whose agent acquired a *Mater Dolorosa* (Gemäldegalerie Alte Meister, Dresden) with a pendant *Blessing Christ* (destroyed 1945) in 1742, at the same time

as he purchased works by Veronese, Tintoretto, Domenico Fetti, and Anthony van Dyck.

The notion that Rome declined as an artistic center from about 1700 is, as Waterhouse observed thirty years ago, almost wholly an invention of the twentieth century.[26] Rome was a destination for the most ambitious young artists in Europe, not only for its educational opportunities but also for its extraordinary promise of patronage. No other European city offered such unparalleled support for its painters. This breadth and diversity of patronage in Rome is one of the reasons few successful painters ever left the city (as opposed to the situation in Venice, for example, whose painters criss-crossed the Continent seeking employment), although even Giaquinto (in 1753) and Mengs (in 1761) could not resist the call of the wealthy Spanish court.

The Church and the curial world of papal patronage were the most prestigious sources of pictorial commissions and made Rome the center of religious painting in Europe. The order for an altarpiece for St. Peter's, or one of the patriarchal basilicas, was among the highest honors an artist could obtain in eighteenth-century Rome and a sign that he had entered the circle of papal favor. The plan of Pope Clement XI to decorate the clerestory level of the nave of St. John Lateran with large, oval paintings of twelve prophets (cat. 243), for example, was the most important single papal commission of the early Settecento.[27] But papal patronage also extended significantly to the secular realm, as in the decoration of the Coffee House in the Quirinal Gardens, built for Benedict XIV by Ferdinando Fuga in 1743. Masucci and Batoni were given the major roles, but the commission to Panini for a pair of splendid historicizing views (figs. 110, 111)

was perhaps the first occasion on which topographical paintings were treated as serious works at such an exalted level.[28] Individual popes of course had their artistic favorites: Clement XI consistently honored Chiari with important commissions; the esteem Benedict XIV held for Francesco Mancini resulted in the commission of the high altarpiece in the newly renovated S. Maria Maggiore for the jubilee year of 1750; Pius VI called Antonio Cavallucci "il Raffaello dei nostri tempi."[29]

The decoration of altars and chapels in churches throughout the city and its environs was enormously remunerative for painters in Rome. From S. Silvestro in Capite, which in the late Seicento provided significant employment to several painters who would attain great prominence early in the new century (Chiari, Giuseppe Ghezzi, Luigi Garzi, and Trevisani), to S. Andrea in Subiaco, which was erected by Pope Pius VI and decorated by Cavallucci, Pietro Labruzzi, Marcello Leopardi, Laurent Pécheux, Pietro Tedeschi, and Cristoforo Unterperger at the end of the century, churches in Rome and the Papal States provided exceptional opportunities for the city's painters. In fact, the continuous refurbishment of the interior of Rome's churches constitutes at least as great an urbanistic achievement as the more visible official projects that make the city visually memorable today, such as the Spanish Steps and Trevi Fountain. The interiors of existing churches continued to be remodeled, the vaults covered over, and elaborate decorative schemes devised to proclaim the authority of the Church. The interiors of nearly all of the city's churches were altered in some way during the eighteenth century, but many—including Ss. Apostoli, S. Cecilia, Ss. Claudio e Andrea de' Borgognoni, S. Clemente, S. Gregorio al Celio, and S. Maria in via Lata owe their predominant decorative character to the efforts of the architects, painters, sculptors, and craftsmen in this exhibition.

Individual members of the Roman ecclesiastical hierarchy, acting outside their capacity as officials of the Church (a distinction not always easy to recognize), emerged among the most active patrons in eighteenth-century Rome. Cardinal Pietro Ottoboni, great-nephew of Pope Alexander VIII, made the Palazzo Cancelleria the center of the most influential patronage in the city early in the century and the repository of inestimable treasures of silver, tapestries, pictures, antiquities, books, and manuscripts. He was the chief protector of Trevisani, who painted his portrait (cat. 291) and produced for him one of the greatest Roman Settecento landscapes, *The Rest on the Flight into Egypt*, (c. 1715; Gemäldegalerie Alte Meister, Dresden; fig. 112). The breadth of

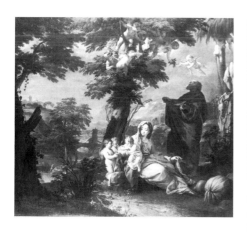

Fig. 112 Francesco Trevisani, *The Rest on the Flight into Egypt*, c. 1715, oil on canvas; Gemäldegalerie Alte Meister, Dresden

Fig. 113 Jan Frans van Bloemen, *called* Orizzonte, *Roman Landscape*, oil on canvas; Palazzo Rospigliosi-Pallavicini, Rome

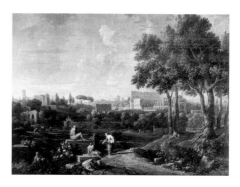

Fig. 114 Jan Frans van Bloemen, *called* Orizzonte, *View of Rome with the Colosseum and the Arch of Constantine*, oil on canvas; Palazzo Rospigliosi-Pallavicini, Rome

Ottoboni's taste is demonstrated by the fact that he not only patronized Roman painters such as Gaulli, Chiari, Conca, Luti, and Trevisani, but also brought Sebastiano Ricci to Rome from Venice and around 1712 commissioned Giuseppe Maria Crespi to paint his great series of the Seven Sacraments, also today in Dresden.

Arguably the most famous instance of cardinalate patronage to an eighteenth-century Roman painter was Mengs's famous fresco of *Parnassus* on the main ceiling of the villa–museum built for Cardinal Alessandro Albani, the most celebrated Roman collector of antiquities in the eighteenth century (see cat. 378). But Albani's influence reached much further in the local art world; he was a close friend and correspondent of Sir Horace Mann, British representative at Florence for nearly fifty years, and thus a valuable contact both for British artists in Rome and for British patrons in search of works of art in Italy. He was, moreover, chargé d'affaires and imperial minister-plenipotentiary in Rome for Maria Theresa of Austria, who was Britain's ally, and as such he "protected" British interests in the city. He knew in advance of the arrival of most British visitors to Rome, many of whom sought his advice and protection, and he often directed them to the studios of Batoni and Mengs, among other artists, antiquarians, and dealers.

A complete record of contemporary Roman churchmen who provided significant patronage to the city's painters would be extensive. Figuring large on this list would be the influential Cardinal Giuseppe Renato Imperiali, the patron of Imperiali (cat. 215), Cardinal Antonio Felice Zondadari (cats. 180, 206), Cardinal Domenico Orsini (cat. 168), and Cardinal Silvio Valenti Gonzaga, secretary of state to Benedict XIV. Valenti Gonzaga emerged as one of the city's great ecclesiastical patrons, eventually acquiring some eight hundred paintings by Italian and northern painters that included not only subject pictures by Trevisani, but *bambocciate*, still lifes, topographical views, and landscapes, including a splendid pair by Claude-Joseph Vernet (cats. 300, 301). But many lesser-known clerics also proved a fruitful source of patronage, such as the abbot Domenico Martelli, the scion of an old and distinguished Florentine family, who lived in Rome almost uninterruptedly from 1698 until his death in 1753. His collection, vestiges of which remain in the family palace, consisted essentially of religious paintings and landscapes of small format by the most representative painters of the Roman school: Paolo Anesi, Benefial (cat. 176), Pietro Bianchi, Jan Frans van Bloemen, Conca, Costanzi, Giaquinto, Masucci, and Gaspar van Wittel.[30]

The Roman nobility numbered many connoisseurs and collectors who provided a fruitful source of support to the city's painters. One of Rome's leading patrons was Marchese Nicolò Maria Pallavicini, one of Carlo Maratti's closest friends and greatest supporters, who commissioned nearly twenty pictures from him, including a large allegorical self-portrait celebrating the relationship between painter and patron (c. 1705; Stourhead, Wiltshire, National Trust; see fig. 19). Pallavicini shared with other collectors from Rome's privileged families a great enthusiasm for still lifes and landscapes, which he commissioned from artists such as Van Bloemen, Christian Berentz, and Trevisani.

The Casa Colonna proved a potent source fof patronage in the eighteenth century: Don Fabrizio Colonna, succeeding his father in 1714 as constable of the Kingdom of Naples, continued the family tradition of artistic patronage centered on the family palace in Rome, where commissions to Chiari, Luti, Pietro Bianchi, Batoni, and Mancini furthered the ambitious architectural and decorative schemes begun by his father and grandfather. Cardinal Girolamo II Colonna, *majordomo* to Benedict XIV, made major additions to the palace, which involved Stefano and Giuseppe Pozzi. The 1763 inventory of his collection contained numerous works by many of the major protagonists of contemporary Roman painting—Conca, Trevisani, Costanzi, Agostino Masucci, Giaquinto, and Batoni—and reveals that he too shared his family's traditional enthusiasm for landscapes and *vedute*, with fifty-seven pictures by Vanvitelli, twenty-five so-called *boscarecce* of Van Bloemen, fifty-eight *paesaggi* by Andrea Locatelli, who in 1741 had executed a series of decorations in "sughi d'erba" in the palace.[31] A pair of Van Bloemen's greatest and most classicizing landscapes à la Poussin—*Ideal Landscape with the Vatican Belvedere* and *View of Rome with the Colosseum and the Arch of Constantine* (figs. 113–14) were commissioned by the Colonna family.

The most important secular commission involving Roman painters early in the century, the ceiling decorations in Palazzo de Carolis, was provided by Don Livio de Carolis. The leading painters in Rome were invited to paint the allegorical and mythological scenes, including Chiari, Conca, Garzi, Luti, Domenico Maria Muratori, and Giovanni Odazzi. A lucrative stream of projects throughout the eighteenth century resulted in some of the most sumptuous interiors of the era, such as, notably, Gabriele Valvassori's Galleria degli Specchi in the Palazzo Doria Pamphili with its mythological ceiling frescoes by Aureliano Milani, 1732–33. Domenico Corvi also decorated the Palazzo Doria Pamphili in celebration of Andrea Doria's marriage to Leopolda of Savoy-Carignan, with a huge fresco of *David and Abigail* and a ceiling painting of the *Apotheosis of Andrea Doria*, that survives only as an oil sketch in the Minneapolis Institute of Arts. At the Palazzo, almost all rooms of the ground floor were redecorated with subjects from classical mythology by Gioacchino Agricola, Francesco Caccianiga, Gaetano

Lapis, Laurent Pécheux, and Mariano Rossi. In the vaulted ceilings in the rooms in the upper floor of the Casino Borghese, now the Borghese Gallery, in the Villa Borghese, several painters supplied mythological compositions between 1784, when the *modelli* were described by the *Giornale delle Belle Arti*, and 1786, when the finished ceilings were commented upon by the *Memorie per le Belle Arti*. A measure of the importance of such works is given by Cristoforo Unterperger's *Apotheosis of Hercules* (fig. 115), cited as one of the most significant achievements of Roman classicism toward the end of the eighteenth century,[32] which appropriately derives its general arrangement from some of the vaults in Raphael's Loggie and even influenced Canova's colossal marble *Hercules and Lichas* (Galleria Nazionale d'Arte Moderna, Rome), begun in 1795.

Rome's wealthy older families also played a sustained role in the restoration and refurbishing of Rome's parish churches, a source of patronage for altarpieces and other pictorial decorations. In the restoration of the decayed medieval parish church of S. Maria in Monticelli in 1715, for example, Pope Clement XI relieved the pontifical treasury of expense by soliciting individuals to underwrite the costs of decorating various side chapels and permitting them to place familial crests in them in acknowledgment of their contributions. The Roman aristocracy played a major role in the project, and members of the Albani, Ottone, Mandosi, and Massimi families commissioned chapel altarpieces by the painters Jean-Baptiste van Loo, Stefano Parrocel, Giovanni Battista Puccetti, and Odoardo Vicinelli.[33] This was a common practice, and dozens of examples could be cited to underscore the abundance of patronage to Rome's painters, such as Giovanni Battista Rospigliosi's endowment of a family memorial chapel dedicated to the Rospigliosi and Pallavicini families in S. Francesca a Ripa, built between c. 1710 and 1725 by Niccolò Michetti, with sculptural decorations by Giuseppe Mazzuoli and paintings by Giuseppe Bartolomeo Chiari, one of the finest church interiors of the early Settecento (cat. 15).

By mid-century Rome had become the main focus of the Grand Tour, which brought to the city an enormous gathering of influential patrons and collectors, notably the *milordi inglesi*. British patronage of painters in eighteenth-century Rome has been so widely and thoroughly examined over the past half century in articles, monographs, and exhibitions it scarcely requires discussion here. It is worth reiterating, however, the reverence by the British for the art of Raphael, Annibale Carracci, and Guido Reni and the other earlier exemplars of the classical ideal. This is epitomized by a famous commission from Hugh

Fig. 115 Cristoforo Unterperger, *Apotheosis of Hercules*, after 1786, oil on canvas; Villa Borghese, Rome

Percy, later 1st Earl of Northumberland, in 1752 for full-size copies of their most celebrated 34.[29] The commissions to several of the best-known history painters in Rome of the time, Batoni, Costanzi, Masucci, and Mengs, through the mediation of Cardinal Albani (who played a decisive part in the selection of the works to be copied), underscores both the tenacity of belief in the study of proven classical models and the influence of British purchasers and patrons in the second half of the Settecento. The British preference for an academic, classically moderated style, adorned with rhetorical effects, as Roettgen observed, "encouraged the emergence of an ideal of taste which was in many respects identical with what is now called Neo-Classicism."[35]

But the British were hardly the only game in the field of Italian artistic patronage, which had changed dramatically at the end of the seventeenth century, as Francis Haskell demonstrated years ago.[36] The traditional sources of support widened with an influx of collectors and their agents from Berlin, Düsseldorf, Madrid, Munich, Paris, St. Petersburg, Stockholm, and Vienna. The German ecclesiastical and secular princes of the Holy Roman Empire, in particular, provided an important new source of artistic benefaction. Having recovered from the effects of the Thirty Years' War, which had devastated their cities, impoverished their treasuries, and driven away native artists and architects, the German rulers turned to Italy as a source of artistic endeavor. From the 1690s the Wittelsbachs, Schönborns (see cat. 244), Liechtensteins, the Margraves of Brandenburg (cat. 167), and others employed not only Italian painters, sculptors, and architects, but also Italian musicians, singers, and dancers. Numerous German principalities were wealthy enough to attract the attention of the leading Italian painters, a number of Romans among them. (Of course, their inducements to leave Rome were usually ignored by the more successful and established Roman painters, such as Batoni, who refused

the invitation of Frederick II, King of Prussia, to Potsdam in 1763.)

Among these energetic new art patrons were men such as the Palatine Elector Johann Wilhelm, the aristocratic and elegant prince of the Holy Roman Empire, who created a collection of pictures that eclipsed all other eighteenth-century collections. The 384 paintings listed in the late eighteenth-century inventory of the prince–elector's famous gallery in Düsseldorf, the majority of which have passed into the Bavarian state collections, contained masterpieces by Rembrandt, Rubens, and Van Dyck. But Johann Wilhelm also had a taste for Italian painting, stimulated by Giorgio Maria Rapparini, a Bolognese painter and writer who had studied under Maratti, and so —in addition to paintings by Raphael, Titian, Barocci, and Domenichino—he acquired works by contemporary painters, including Luti's *Saint Charles Borromeo Administering Extreme Unction to the Victims of the Plague* (cat. 241) and the *Education of the Virgin* (Alte Pinakothek, Munich).

To list the European monarchs, royal families, and aristocrats who either visited Rome or employed agents to keep them abreast of current artistic developments in the city is pointless, except as a reminder of the prestige Roman painters commanded throughout Europe in the eighteenth century. They included: Leopold I, Grand Duke of Tuscany; Joseph II, Holy Roman Emperor (cat. 172); Frederick II (cat. 167); Philippe II, Duc d' Orleans; Catherine II, Empress of Russia; Maria Theresa, Archduchess of Austria and Queen of Hungary; Augustus III, Elector of Saxony and King of Poland; Prince Karl Wilhelm Ferdinand, Duke of Brunswick and Lüneburg, Prince Nicholas Yussupov, Grand Duke Paul I (cat. 175), and Grand Duchess Maria Feodorovna of Russia, each of whom either bought or commissioned works from painters in this exhibition.

Given the breadth of pictorial freedom and the abundance of available patronage, Rome in the eighteenth century was by any measure an enviable milieu for a painter of talent. The papal city was cosmopolitan, open-minded, and culturally innovative. Painters in the Settecento enjoyed a wealth of opportunity and a creative freedom unparalleled in the city's history. Their professional status rose dramatically, too, during the century, in part a legacy of Carlo Maratti's exalted position in the artistic and social life of Rome. His social standing is indicated by his ownership of a Roman palazzo and a country house at Genzano and a large art collection. Moreover, his professional activities were not centered exclusively upon painting: Pope Innocent XI appointed him keeper of Raphael's Vatican

Stanze; he was active as a restorer, commissioned to restore the Raphael frescoes in the Villa Farnesina and in the Vatican and those by Annibale Carracci in the Palazzo Farnese; in 1702 he was appointed Director of Antiquities in Rome; he was active as a designer of sculptural decorations, notably the series of life-size marble *Apostles* for St. John Lateran; and he was consulted by Italian and foreign collectors as a connoisseur of ancient art.[37] Although the honors and prestige enjoyed by Maratti were unmatched by any other Roman eighteenth-century painter, many prospered in Rome's open cultural climate and also mingled daily with popes and cardinals, aristocrats and patricians, juggling a variety of artistic and social activities in addition to their purely professional pursuits. Giuseppe Ghezzi, for example, coordinated the prestigious annual exhibition of paintings at S. Salvatore in Lauro and the Pantheon, counseled popes and ambassadors, advised Rome's most prominent art collectors, and restored Old Master paintings. Benedetto Luti also moved easily among the amateurs and collectors whose taste characterized the early eighteenth century—Cosimo III de Medici, Grand Duke of Tuscany (in whose Roman palace he lived), Grand Prince Ferdinando de Medici, Pierre-Jean Mariette, Pierre Crozat, and Thomas Coke, 1st Lord Leicester. Pier Leone Ghezzi was a noted man about town, a witty and amusing conversationalist, and an accomplished musician, dancer, fencer, and equestrian. In 1708 Clement XI appointed him painter of the Camera Apostolica, which involved oversight of the Vatican collections and supervision of decorations for ceremonial occasions and the manufacture of papal tapestries and mosaics. All of this, of course, in addition to his principal "professional" activities as painter, draftsman, engraver, scenographer, and archaeologist. Later in the century Stefano Pozzi was appointed Custode delle Pitture di Raffaele in the the Vatican Palace, and Nicola Lapiccola Custode ed Antiquario del Campidoglio.

Foreigners in search of works in Rome inevitably ended up in the studios of local painters, many of whom shrewdly sensed the need for appraisers and intermediaries in the sale of works of art and adjudicators in matters of connoisseurship and expertise. Moreover, many of the painters in the exhibition assembled important collections of their own.[38] With a reputation as the "best connoisseur in Rome,"[39] Benedetto Luti was one of the principal dealers on the Roman art market (he was involved in the sale and dispatch of Queen Christina's famous collection of paintings to Philippe II, Duc d'Orlèans, in Paris) and not coincidentally amassed a private collection of drawings estimated by one contemporary to number around 15,000 items. The long list of Roman painters who dealt in art included Maratti, Pier Leone Ghezzi, and Jan Frans van Bloemen. Giuseppe Ghezzi owned an important collection of drawings and his son a distinguished *quadreria* that included paintings by Veronese, Scipione Pulzone, the Carracci, Guercino, Nicolas Poussin, and Guido Reni.[40] The Scottish painter Gavin Hamilton augmented his income by dealing in antique sculptures, sixteenth- and seventeenth-century paintings and copies. From the early 1760s he acquired and sold paintings, visiting many parts of Italy himself, accompanied by an artist to make copies of the altarpieces that he hoped to buy. His most important purchases of Renaissance paintings included Raphael's *Ansidei Madonna* in 1764 and Leonardo's *Virgin of the Rocks* in 1785 (both now National Gallery, London). In 1773 he published *Schola italica picturae*, a volume of engravings of sixteenth- and seventeenth-century Italian paintings, designed to stimulate interest among the young noblemen and dilettanti on the Grand Tour of Italy. Hamilton also undertook archaeological excavations with great profit, the most important and lucrative of which was that of Hadrian's Villa at Tivoli in 1769–41.[41]

These brief biographical notes provide merely a hint of the richness of Settecento Roman artistic life. An entire book could be written on the artistic milieu of eighteenth-century Rome, but until such a volume appears those interested in the subject will be quite stimulated by an essay by Oliver Michel, "La vie quotidienne des peintres à Rome au dix-huitième siècle,"[42] which distills a lifetime of thinking and writing about painters and painting in the Eternal City during one of its happiest moments.

## Notes

1 Waterhouse 1971, p. 8.
2 Waterhouse 1937, p. 35.
3 Johns 1993, p. 201, has pointed out that "Any convincing history of Settecento Roman painting must begin with a careful reevaluation of the contribution to the arts of Carlo Maratti."
4 The best brief overview of Maratti's life and work is Mena 1996, with further bibliography.
5 Ferdinando Bologna, *Francesco Solimena, L'arte tipografica* (Naples, 1958), p. 94, described this change as the "accademizzazione del barocco."
6 Lo Bianco 1997, p. 65: "The gradual rise of a middle and upper-middle class gradually altered the city's urban configuration. The residences of these emergent classes were the new palazzi of five or six floors, typical examples of a dignified modern type of building still standing between the Corso, Piazza di Spagna, and via del Babuino. The constraints of living space created a demand for pictures of relatively small dimensions that were less "ambitious" in subject portraits, landscapes, topographical views, *bambocciate*, and small Arcadian scenes, sacred and profane."
7 Waterhouse 1971, p. 10.
8 Waterhouse 1971, p. 14.
9 See Bowron 1993.
10 Clark and Bowron 1981, p. 92.
11 Waterhouse 1971, p. 15.
12 Roettgen 1993, p. 36.
13 Clark and Bowron 1981, p. 3.
14 Clark and Bowron 1985, pp. 23, 40. The Italian critic Comte Leopoldo Cicognara called Batoni's polished finish his "laboriosa finitezza olandese."
15 Waterhouse 1971, p. 18.
16 See Clark 1966.
17 Clark and Bowron 1985, pp. 216–17.
18 Wittkower 1982, p. 465.
19 Clark and Bowron 1985, p. 30.
20 Clark and Bowron 1985, p. 31.
21 Roettgen 1970, p. 65.
22 Johns 1993, p. 202.
23 Raffaella Bentivoglio Ravasio, "Pier Leone Ghezzi," in DA, vol. 12, p. 553.
24 Lo Bianco 1997, p. 65.
25 See Johns 1998, "That Amiable Object."
26 Waterhouse 1971, p. 7.
27 See Johns 1993, pp. 87–91, for the most recent discussion.
28 Waterhouse 1971, p. 18.
29 Chracas, *Diario Ordinario di Roma*, September 19, 1789, no. 1536.
30 Civai 1990.
31 Eduard A. Safarik, with the assistance of Cinzia Pujia, *Italian Inventories 2: The Colonna Collection of Paintings, Inventories, 1611–1795* (Munich: K. G. Saur, 1996), pp. 612–28.
32 Federico Zeri, *Italian Paintings in the Walters Art Gallery* (Baltimore: Walters Art Gallery, 1976), vol. 2, p. 538; Felicetti 1998, pp. 206–8.
33 Johns 1993, pp. 124–31.
34 Clark and Bowron 1985, pp. 262–63; Roettgen 1999, pp. 189–96.
35 Roettgen 1993, p. 9.
36 Haskell 1971, pp. 199–202.
37 Mena 1996, p. 374.
38 See Fagiolo dell'Arco and Pantanella 1996, for Gaulli's collection of paintings and sculpture.
39 Richardson J. 1722, p. 182.
40 Martinelli 1990 and De Marchi 1999, "Ghezzi."
41 Irwin 1962, pp. 87–92, 98–102.
42 Michel 1996, *Vivre et peindre*, pp. 41–64.

## NICOLAI ABRAHAM ABILDGAARD

COPENHAGEN 1743–1809
SORGENFRI

Nicolai Abildgaard's father was an employee at the royal archives in Copenhagen who from the 1750s to the 1770s traveled Scandinavia drawing ancient monuments. His son inherited a gift for drawing and an enduring interest in bookish pursuits. When studying in the 1760s at the Kongelige Danske Kunstakademi he met kindred ideals. His teachers, including the sculptor Johannes Wiedewelt, admired the so-called patriarchs of Neoclassicism, the Comte de Caylus, Anton Raphael Mengs, and Johann Joachim Winckelmann. In young Abildgaard they discerned a gift for philosophical allegory and history painting. A royal grant enabled Nicolai to study in Rome from 1772 to 1777. Here he copied what was expected, and much else besides: Raphael (for whom his admiration was profound), Giulio Romano, and the Carracci brothers, but also ancient sculpture, Titian, and Michelangelo; the latter's influence was to endure. His lifelong friendship with Johan Tobias Sergel gave him numerous British and German contacts, among them Henry Fuseli, in whom he found a kindred impatience with the Neoclassicism advocated by Winckelmann; now, his fascination with the "sublime" in drama and poetry came to the fore. From then, Shakespeare, Homer, and Ossian became lifelong influences. His illustrations of Ossian (whom he seems to have been the first continental artist to illustrate), of the Norse Edda, and the medieval historian Saxo Grammaticus anticipated his future work on national history.

Abildgaard's *Philoctetes* (cat. 161) gives him a position in the pre-Romantic avant-garde, but Michelangelo's pathos would never obliterate his profound admiration for Raphael's *disegno*. Dreams, ghosts, and sublime terror are prominent themes in his imagery, but as a dedicated supporter of the Enlightenment he was at the same time a firm believer in the ideals of art's philosophical mission and regarded history painting as the most eminent genre of all. The "realism" of portraits and landscapes was beneath his dignity (here as elsewhere there are clear parallels with Fuseli and William Blake). His line and color are sometimes highly mannered, even after 1790, when his ideals became more uniformly classical.

On his return from Rome in 1777 Abildgaard was appointed royal history painter, and from 1778 to 1790 he decorated the Great Hall at the royal palace of Christiansborg with a series depicting the history of Denmark and

its monarchs. Beginning with its "modern," final section, which celebrated the tricentenary of the ruling dynasty, Abildgaard finished the first ten canvases and fifteen *soprapporte* by 1791, but the works were then brought to a halt, never to be resumed; all but three panels (still at Christiansborg) were destroyed in a fire that gutted the palace in 1794. What survives reveals a remarkable control of the grand form. While allegories in the antechamber represented *The History of Europe* as a *histoire philosophique* reaching from dark age superstition to modern enlightenment, the panels of the Great Hall represented the history and geographical extension of Denmark. The styles range from traditional allegory at either end of the series to the modern realism of its central panels, which reminded contemporaries of a Benjamin West.

In the public sphere Abildgaard soon became a well-known, controversial figure. His enlightened outlook and skeptical attitude toward established religion left a clear impact on his work. Through the prints by his friend Johan Frederik Clemens, his *Adam and Eve, Socrates and his Demon, Ossian,* and *Niels Klim* became widely known. A series of anonymous political satires from 1787 spoke emphatically in favour of enlightened reform. The French Revolution gave his outlook a radical turn. In 1790, when suggesting an iconography of freedom for the final panel in the Great Hall, the painter fell out with his royal employer, and was eventually fired. But his appeal for a Column of Liberty (1792–97) in Copenhagen to celebrate the recent Danish emancipation of the peasants met with strong public support; his medal to celebrate the Danish ban on the slave trade (1792) illustrates the impact of the events in France, and so does his michelangelesque tricolor allegory of *Jupiter Weighing the Fates of Mankind* (from 1793; Kunstmuseum, Ribe). Outside France, Abildgaard seems to have been the most prominent pro-revolutionary among European painters.

With the fall of Robespierre (July 1794) came political disillusion; while remaining faithful to his political creed—as evidenced by a satirical *Triptycon* from 1800 (Statens Museum for Kunst, Copenhagen)— Abildgaard's political stance gave rise to friction with court officials; in 1802 he complained that political censorship made his work impossible. Other factors contributed further to his move away from serious painting. The fire of Christiansborg destroyed his paintings, but also gave him new tasks. From 1794 to 1798 his royal patrons demanded a redecoration (complete with paintings and Neoclassical furniture) of their new

residence, the Amalienborg Palace in Copenhagen.

With the withdrawal of royal patronage, Abildgaard turned to new, bourgeois customers, for one of whom he built a city residence (Nytorv 5, Copenhagen) in Palladian style: the piano nobile is decorated with illustrations (1798–1803; *in situ*) of one of Voltaire's "Roman" tragedies, *Le Triumvirat.* The tragic theme prepared the way for a series with four scenes from *The Girl from Andros* (1801–4; Statens Museum for Kunst, Copenhagen) by the ancient Roman playwright Terence. With its illusionistic setting in an idealized classical context (Athens, Rome, and Neoclassical Copenhagen provided the architecture) and its striking adaption of mask figures from Roman manuscripts as well as from the paintings of Pompeii, the series is a complex statement of artistic principle. By depicting himself with his wife and new-born child among the comedy's *dramatis personae*, the whole seems a new departure. Like most of Abildgaard's late work, it was painted for his private lodgings, now celebrating his private happiness. The work of this late period is characterized by a joyful immersion in a world dominated by the erotic. Motifs from Apuleius's *The Golden Ass*, from Homer's *Odyssey*, from the Greek love lyrics of Sappho (embracing one of her beloved girls), and from Anacreon (admiring his lover Bathyllos), all executed between 1808 and 1809 (Statens Museum for Kunst, Copenhagen), seem to celebrate the transforming power of love.

The influence of the Danish *pictor philosophus* on his German pupils Philipp Otto Runge and Caspar David Friedrich has yet to be determined; on Asmus Jakob Carstens it is well documented, but often forgotten, and on Bertel Thorvaldsen it was profound: Abildgaard, according to Thorvaldsen, "never said much, but his verdicts on art I have treasured as were they from the Holy Bible itself" (quoted by Thorvaldsen's friend Christian Fædder Høyer in "Nicolai Abildgaard," in *Raketten* [Copenhagen, 1833], vol. 1, p. 83). [PK]

BIBLIOGRAPHY Riis 1974; Fischer 1976; Statens Museum for Kunst, Copenhagen. *N. A. Abildgaard: Tegninger.* Copenhagen: Statens Museum for Kunst, 1978; Pressly 1979; Kragelund 1983; Kragelund 1987; Honour, Hugh. *The Image of the Black in Western Art.* Cambridge and London: Harvard University Press, 1989, pp. 77–78; Kragelund 1989; Kragelund 1991; Fischer 1992

## 161

## Nicolai Abraham Abildgaard
*Philoctetes*

1775
Signed, lower right, in Greek: *Nicolai, the son of Søren, from Copenhagen, painted this*
Oil on canvas
48⅜″ × 68⅜″ (123 × 173.5 cm)
PROVENANCE painter's estate; acquired for the Royal Collection of Paintings, 1849
EXHIBITIONS Copenhagen 1778, cat. no. 173; Copenhagen 1809, cat. no. 28; Copenhagen 1990, cat. no. 1; Los Angeles and New York 1993, cat. no. 1
BIBLIOGRAPHY Rosenblum 1967, pp. 12–13; Fischer 1976; Argan, Giulio Carlo. *Da Hogarth a Picasso: l'arte moderna in Europa.* Milan: Feltrinelli, 1983, p. 148; Kragelund 1999, vol. 1, pp. 210–24
Statens Museum for Kunst, Copenhagen

During his stay in Rome (1772–77) Abildgaard's teachers and supervisors at the Kongelige Danske Kunstakademi would from time to time ask for reports about his progress and for samples of his work. In 1774 the time had come for a full-size painting. Although initially planning to paint a copy of a Titian (when studying, his teachers had copied Mengs and Poussin), Abildgaard at some point abandoned this project in favour of a far more daring venture: an original composition depicting the wounded Philoctetes.

Given the admiration with which his teachers regarded Johann Joachim Winckelmann, this motif was almost by definition controversial. In the *Laocoön* (the painter owned a copy of the first edition from 1766) Gotthold Ephraim Lessing had contrasted the violent pathos of this hero with Winckelmann's ideal of "noble simplicity." As Lessing (whom Abildgaard revered) had objected, the Greek heroes of Homer and Sophocles were violently extrovert; and in the so-called "Fuseli circle" to which Abildgaard belonged, others must have expressed their impatience with Winckelmann's subdued vision of Greek pathos. To be sure, Winckelmann's pupil Stefano Raffei had recently published a treatise on a *Filottete addolorato* ("Wounded Philoctetes") in the Villa Albani. This was another of the authorities that Abildgaard consulted, but to him it mattered little that Raffei had repeated Winckelmann's injunctions: that in the visual arts the pathos permissible in literature should be avoided, and that the painter instead should strive to emulate the Greeks by displaying classical restraint in suffering.

Abildgaard's hero utterly "flouts … the idea of Greek nobility in suffering" (Rosenblum 1967, p. 13). As opposed to Winckelmann's Laocoön, who suffers in silence, uttering no more than an

161

inaudible sigh, this hero is "on the verge of crying out loud" (Fischer 1976, p. 87) and his tormented figure seems on the verge of bursting out of the narrow picture frame. The parallels with the *ignudi* of the Carracci (in whose Galleria Farnese Abildgaard had copied) seem to highlight the contrasts. The impression is one of unbearable tension—between frame and body, as well as between aesthetic doctrine and artistic truth. By signing his work in Greek on the surface of the rock behind Philoctetes, the young painter is, as it were, insisting that he has depicted an example of true Greek heroism.

It speaks well of his professors' tolerance that, when receiving this provocative canvas, they recommended that Abildgaard be appointed royal history painter. At the Copenhagen Salon in 1778 it must have caused a stir; and for more than a generation it remained his most widely appreciated painting. Then a reaction set in, and it was only with the advent of a new interest in the painters of the "sublime" that this astonishing debut regained its original status, in and outside Denmark.

*Philoctetes* is Abildgaard's first great achievement, but in a number of minor essays datable to his years in Rome, or soon after, he would again and again return to the subject of the desperate and outcast hero. His *Hamlet Seeing the Ghost of His Father* (1778; Statens Museum for Kunst, Copenhagen) is strongly influenced by Fuseli. It was described by a contemporary Romantic poet as a sublime masterpiece. The prince is, unusually, depicted with his tense back turned against the spectator. Thereby he involves the spectator in his dilemma, as he hovers uneasily between his father's demands and his mother's insistence that what he sees is but a "coinage of your brain" (*Hamlet*, Act 3, Scene 4).

*Adrastos Killing Himself at Atys's Grave* (c. 1775; Kunstmuseum, Aarhus) is also datable to his years in Rome. The motif (which illustrates the range of Abildgaard's learning) is from Herodotus' history of Adrastos, whose misfortune it was to kill his benefactor, King Croisus' son, by accident. Since this was what Fate had ordained, Croisus refused to punish Adrastos—but the hero could not live with his guilt and "slaughtered himself" at his friend's grave. The heroic suicide owes much to ancient sculpture (such as the *Gaul Killing Himself* in the Ludovisi Collection and *Laocoön* in the Belvedere Court in the Vatican), and the tense, almost vibrant diagonal of his body contrasts strikingly with the cubic solidity of Atys' tombstone. Once again, the contrast to Winckelmann's idea of Greek nobiblity seems deliberate; instead, Adrastos gives in to feelings of guilt that he cannot endure.

One parallel seems illuminating: the suicide of Goethe's *Werther* (1774) caused a stir throughout Europe. In Denmark the Church demanded that the novel be banned, since suicide defies God's will. That autumn Fuseli received in Rome a copy of *Werther*. And at roughly the same time Abildgaard chose to depict one of the least edifying of classic suicides. [PK]

## POMPEO BATONI

LUCCA 1708–1787 ROME

Pompeo Girolamo Batoni was born in Lucca on January 25, 1708, the son of a distinguished local goldsmith named Paolino, and his wife, Chiara Sesti. He achieved a local reputation for deco-rating and engraving precious metals in his father's workshop, but in 1727 left his native city to study painting in Rome. In the years 1727–30 he engaged in the usual activities of newly arrived artists, drawing the antique sculptures in the Vatican collections, copying Raphael's Stanze frescoes and *Transfiguration*, Annibale Carracci's Palazzo Farnese ceiling, and other acknowledged masterpieces of modern painting, and drawing from live models in the private academies of local artists. His drawings after the antique came to the attention of British antiquaries and collectors in Rome and provided him with both a source of income and the beginnings of an artistic reputation. The most important of these clients was Richard Topham, who owned fifty-three drawings by Batoni (Eton College Library, Windsor). These drawings, nine of which are signed, are among the most beautiful surviving reproductions of antique sculpture in Roman collections of the time (see cats. 310–13).

Beginning in the 1730s, Batoni painted altarpieces for Roman churches in a strongly classicizing style that proved immediately popular

and anticipated the Neoclassicism of the later eighteenth century. By 1740 the artist's reputation was firmly established as a history painter, for both private patrons and the Church (cat. 168). His colossal altarpiece for St. Peter's, *The Fall of Simon Magus* (1746–55; S. Maria degli Angeli, Rome), represents the climax of his development in this regard. Enormous and complex, rich in varied attitudes, gestures, and expressions, the painting was exhibited in St. Peter's in 1755, but within a year the project to translate it into mosaic was abandoned, and in 1757 the rejected canvas was transferred to S. Maria degli Angeli.

Batoni did not give up history painting thereafter, but he never again produced a major altarpiece for a Roman church, nor did he pursue private commissions for subject pictures with anything like his previous vigor. The result was that his history paintings became extremely expensive and were commissioned almost exclusively by the Church, European sovereigns (cat. 167), and visiting nobility, or the occasional British Grand Tourist (cats. 163, 174). Nonetheless, certain of Batoni's history paintings, notably *Saint Mary Magdalene* and *Saint John the Baptist* (both c. 1742–43; Gemäldegalerie Alte Meister, Dresden, destroyed 1945) were among the most famous in Europe in his day.

It was during the 1740s, when Batoni was at his most productive as a history painter, that he forged his connections with British (primarily Irish) visitors to Rome with dramatic consequences for his career as a portrait painter. He began slowly with the emerging British clientele, producing only half a dozen portraits during the decade, notably *Joseph Leeson, 1st Earl of Milltown* (1744; National Gallery of Ireland, Dublin). Between 1750 and 1760 he produced nearly sixty portraits of British sitters alone, including such sensitive and beguiling images as *John, Lord Brudenell, Later Marquess of Monthermer* (1758; The Duke of Buccleuch and Queensberry, Boughton House, Northamptonshire). During this decade Batoni painted only about twenty subject paintings, and he maintained a similar ratio over the following two decades, continuing to concentrate on portraits.

Batoni's fame as a portrait painter was quickly established as firmly on the Continent as in Britain, and a great number of royal and sovereign sitters visited his studio (cat. 172). His major output, however, remained his portraits of British gentlemen on the Grand Tour. He did not invent the Grand Tour portrait: nearly all the features associated with his portraiture had been anticipated in the preceding decades by the Italian painters Francesco Trevisani, Andrea Casali,

Marco Benefial, Antonio David, and Agostino Masucci. Nevertheless, Batoni surpassed them in the freshness of his coloring, the precision of his draftsmanship, and the polish of his handling. No contemporary painter in Rome, or elsewhere in Europe, could draw more incisively than Batoni, and very few could match his ability to produce an accurate likeness. Batoni "values himself for making a striking likeness of everyone he paints," wrote an English visitor to Rome, and his sitters were almost always pleased with this aspect of their portraits.

A striking feature of Batoni's portraits was the emblematic use of antiquities and views of Rome to establish both the sitter's presence in the city and his status as a learned, cultivated, yet leisured aristocrat (cat. 169). Batoni popularized the portrait type of a casually posed sitter in an open-air setting, surrounded by classical statuary and antique fragments, and often set against the backdrop of a classical building. Among the objects that Batoni employed most often as accessories in these portraits were the most famous and admired antique marbles in eighteenth-century Rome (cat. 171), although a host of lesser-known antiquities also appear, included presumably at the sitter's request. The backgrounds of his portraits present glimpses of such famous antique monuments as the Colosseum and the Temple of the Sibyl at Tivoli.

Batoni's reputation among the international travelers who visited Rome in the second half of the eighteenth century was highest among the British, and for nearly half a century they offered him a sustained and intensely fruitful source of patronage. His virtuosity in depicting British gentlemen on the Grand Tour was highly admired: James Bruce's acclamation that he was "the best painter in Italy," and Lady Anna Riggs Miller's declaration that he was "esteemed the best portrait painter in the world" (quoted in Clark and Bowron 1985, p. 42) are typical of contemporary estimations of his talent.

Batoni, one of eighteenth-century Rome's most notable citizens, was well known to residents and visitors alike. He was created a Cavaliere by Pope Benedict XIV and ennobled by the Archduchess Maria Theresa, and had received in his studio popes Benedict XIII, Clement XIV, and Pius VI; the Holy Roman Emperor (cat. 172), the Grand Duke of Russia; and many other distinguished visitors. He was, however, largely indifferent to Rome's artistic officialdom and to the Accademia di S. Luca, of which he was the oldest and most famous member at his death. Batoni was elected to the academy on December 19, 1741, and, although he held various offices within

the institution, he was never elected Principe. His major participation in the affairs of the academy involved the "Accademia capitolina del nudo," established by Benedict XIV in 1754 to permit instruction in life drawing under the supervision of such painters as Batoni (cats. 317–18).

In spite of Batoni's considerable contemporary fame, after his death on February 4, 1787, his reputation diminished. By 1800 the descendants of his famous British patrons ignored his art, which was virtually unknown to the general public. His portraits, on which such a substantial part of his fame had depended, had been shipped on completion straight to England, Scotland, and Ireland to hang in the home either of the sitter or of a relative, where most of them have remained ever since, unseen except by the occasional privileged visitor. Only one painting seems to have been shown publicly in London in the artist's lifetime, and none in Great Britain in the late eighteenth century or the nineteenth.

Batoni's critical fortunes began to revive in the twentieth century with the increasing general and scholarly interest in Italian painting of the seventeenth and eighteenth centuries. The exhibition *Il Settecento a Roma* (1959) brought the work of Batoni to the attention of a generation of younger scholars. A monographic exhibition devoted to the artist was held in Lucca in 1967; a second, focusing on his patronage by the British, was held in London in 1982; and the monograph and catalogue raisonné of his art by Anthony Morris Clark, who brought the painter's brilliance to the attention of museum curators, collectors, and art historians in Europe and North America, was published in 1985. [EPB]

BIBLIOGRAPHY Boni 1787; Benaglio 1894; Emmerling 1932; Belli Barsali 1967; Puhlmann 1979; Pascoli 1981, pp. 178–89; Bowron 1982; Clark and Bowron 1985; Barroero 1990, "Batoni"

## 162
## Pompeo Batoni
### *Allegory of the Arts*

1740
Signed and dated at lower right: *Pompejus Battonius Lucensis pinxit.| An. D.* MDCCXL
Oil on canvas
68⅛″ × 54⅛″ (174.8 × 138 cm)

PROVENANCE commissioned in 1740 by Marchese Vincenzo Riccardi, Florence; Medici-Riccardi collection, Florence, until 1806; purchased by Johann Friedrich Städel in 1818 from Francesco de Bandinelli for 2,500 florins

EXHIBITION Florence, SS. Annunziata. *Opere de' più accreditati Artefici nella Architettura, Pittura, e Statuaria.* 1767, no. 4

BIBLIOGRAPHY *Verzeichniss der öffentlich ausgestellten Kunst-Gegenstände des Städel'schen Kunst-Instituts.* Frankfurt, 1883, p. 87, no. 56; Weizsäcker, Heinrich. *Catalog der Gemälde-Gallerie des Städelschen Kunstinstituts in Frankfurt am Main.* Frankfurt, 1900, pp. 27–28, no. 56; Voss 1924, p. 650; Emmerling 1932, p. 128, no. 169; Belli Barsali 1964, p. 74, fig. 1; *Verzeichnis der Gemälde aus dem Besitz des Städelschen Kunstinstituts und der Stadt Frankfurt.* Frankfurt, 1966, p. 14; Borroni Salvadori 1974, p. 36 (citing the 1767 exhibition in Florence); De Juliis 1981, pp. 61, 66 (as described in an inventory of 1752, no. 20, "rappresenta le Arti liberali"); Clark and Bowron 1985, p. 220, pl. 45, no. 41

Städelsches Kunstinstitut, Frankfurt am Main

The personification of various Arts as beautiful young women in half- or full-length formats was a popular theme in Batoni's œuvre to which he returned several times during his career. He was especially enamoured early in his career with comely depictions of the musical, literary, and visual arts, which he represented in various guises in accordance with the descriptions and attributes provided by Cesare Ripa's *Iconologia*, the standard iconographical source book for European artists since the Counter-Reformation. Around 1740 he produced a number of allegorical compositions featuring the arts that appear to have been initiated by his early Lucchese noble patrons, such as Francesco Conti; one of the earliest and most original is *Painting, Sculpture, and Architecture* (c. 1740; Gemäldegalerie Alte Meister, Dresden; Clark and Bowron 1985, pp. 219–22). Batoni was at his best in pictures such as these, which call for a display of grace and charm, as Hermann Voss observed seventy-five years ago (Voss 1924, p. 646), and few of his Roman contemporaries could compete with him in combining the light and refined character of the French Rococo with traditional Roman restraint and decorum.

Seated in the center of the Frankfurt composition is a personification of Painting as a beautiful young woman holding a palette, brushes, and mahlstick in her left hand. She points with the brush held in her upraised right hand to a canvas on an easel on which there is an unfinished painting of Mercury, god of eloquence and reason, in flight. She appears to converse with a personification of Poetry, who is beautifully dressed in a rich white mantle and crowned with laurel. Poetry holds a lyre, the symbol of Apollo, the god of lyric poetry. Sculpture is seated at the left on the dais, her figure bared to the waist, her right hand resting on the knee of Painting; their fingers are intertwined. She holds a mallet in her right hand; beside her on the floor is a bust of Hadrian, chisel, and drill. On the floor opposite are two books,

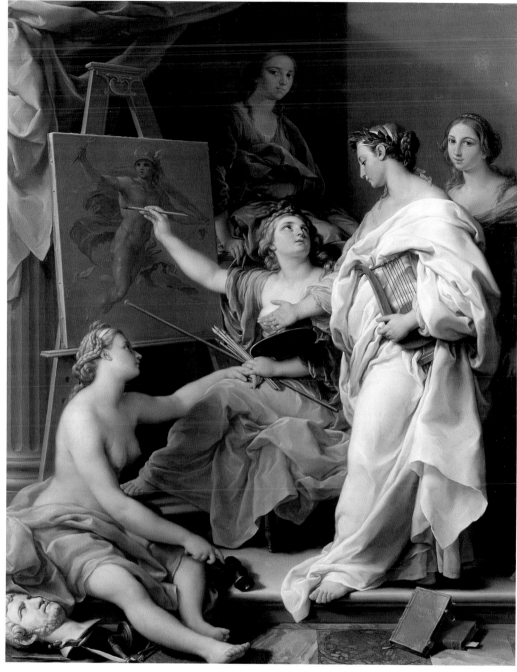

162

## Pompeo Batoni
### *The Sacrifice of Iphigenia*

1740–42

Oil on canvas

60¼″ × 75″ (153 × 190.6 cm)

PROVENANCE commissioned by John Blackwood for Thomas, 2nd Lord Mansell; purchased by David Wemyss, Lord Elcho; in the possession of the Wemyss family by 1771; thence by descent at Amisfield and Gosford House; on loan to the National Gallery of Scotland from 1978

EXHIBITION London 1982, cat. no. 44

BIBLIOGRAPHY Holloway 1980, fig. 35; Russell 1985; Clark and Bowron 1985, pp. 224–26, no. 59, pl. 55 (erroneously captioned), col. pl. III; Russell 1988, p. 854

The Earl of Wemyss and March

*The Sacrifice of Iphigenia* is one of Batoni's most arresting history paintings and the masterpiece of his early career. His paintings of the early 1740s are remarkable for their coloring, clear, firm draftsmanship, and emotional expression, and they reveal how successfully Batoni could treat scenes from legend and literature in a grand and noble manner. His works from this period are marked by a new sensibility that derives from his absorption of the rhetoric, energy, and realism of the early Seicento into his own idiom. One of the artists Batoni studied with close attention in these years was Guido Reni, and his paintings were praised in the eighteenth century for their Guido-like qualities. The proportions, gestures, and expressions of the female figures in the *Sacrifice of Iphigenia* emulate Guido's grace and ideal of beauty, and the blond coloring of Guido's later paintings is an important source for Batoni's own luminous palette, with its high-keyed hues and iridescent pastel tints of lilac, mauve, pale green, and pink.

In a letter to one of his patrons in 1740, Batoni described the visual rendering of the *affetti*, the emotions of the human soul, as the true purpose of painting. He had neither the theoretical inclinations of Anton Raphael Mengs nor the programmatic aid of an intellectual such as the historian and antiquarian Johann Joachim Winckelmann, but he was nonetheless deeply committed to the fundamental tenets of classical art theory. The gestures, attitudes, and expressions of the figures in the *Sacrifice of Iphigenia* reveal the depth of his commitment to the notions of ideal beauty, decorum, and other tenets of the Grand Manner, which, since the days of Annibale Carracci, had been an important preoccupation of painters in Rome. A comparison with Batoni's works of the previous decade discloses the effort he has made to signify and individualize each figure in this composition,

inscribed OMHPOS (Homer) and VIRGI/LIVS (Virgil). A personification of Architecture is enthroned behind, holding a pair of dividers in her right hand, a T-square in her left. At the right of the composition stands a personification of Music, holding a double flute as an allusion to Pan.

The Frankfurt *Allegory of the Arts* is first mentioned in a letter of July 29, 1740, from Batoni to one of his Lucchese patrons, Lodovico Sardini, in which he expresses the hope that the painting for Marchese Vincenzo Riccardi will be finished within a month. In a subsequent letter of October 22, Batoni writes that he has finished the canvas, "which has

turned out well," but in a letter of December 17 he apologized to Sardini for not attending to his commissions for him because he still needed to "perfect" the painting for Marchese Riccardi (Clark and Bowron 1985, p. 220). The 1752 inventory published by Giuseppe de Juliis listed two additional works by Batoni in the Riccardi collection that cannot be traced: a *Santa Conversazione* and a *Virgin and Child with Saint John of Nepomuk*.

Batoni produced a *modello* in oils that establishes the basic composition of the finished painting, with its harmonious and rational placement of figures, although he left to a later stage the final disposition of the architectural

setting and several minor details, such as Sculpture's tools in the lower left corner (Clark and Bowron 1985, pp. 219–20, pl. 48, no. 40). This sketch, which vividly reveals the artist's grace of handling, was owned by one of Batoni's most enthusiastic patrons at the time, Count Cesare Merenda of Forlì (see cat. 165), suggesting that early in his career the young painter maintained quite close relations with his patrons outside of Rome. A preparatory study for the head of Poetry in red chalk is in the collections of the Statens Museum for Kunst, Copenhagen (Clark and Bowron 1985, p. 380, D56). [EPB]

163

and to express its purpose by means of studied gestures. Of course, Batoni has transformed this heritage into his own highly individual manner, and the minute finish and polished detail; the freshness and spontaneity of handling; and the luminosity of tone and atmosphere that imbue the *Sacrifice of Iphigenia* are inimitable.

The references to the *Sacrifice of Iphigenia* among the papers of Dr. John Clephane published by Francis Russell make it one of the most fully documented of all Grand Tour commissions. The picture was commissioned for Thomas, 2nd Lord Mansell, by his stepfather, John Blackwood, the Scottish-born picture dealer and collector. The third party in the commission was Clephane, who served as the intermediary between a number of English patrons and the Roman art world. In 1739 Clephane accompanied Lord Mansell as a tutor on his Grand Tour, and in early February 1740 the pair reached Rome, where they took

an apartment near strada della Croce. Mansell commissioned the *Sacrifice of Iphigenia* from Batoni before his departure for Venice, where the party attended the Ascension Day celebrations (Ingamells 1997, p. 215).

The painting, Batoni's first major English commission, was evidently only "little advanced" at the time Mansell and Clephane left Rome. A letter from Blackwood to Clephane of June 10, 1741, suggests that Batoni had not made much progress in the interim: "Pray what is Pompeya doing, if you find my picture as little advanced as when you left it, let it drop for I think the money may be laid out to more advantage—at least with more certainty … ." (Russell 1988, p. 854). On March 23, 1742, Clephane "paid thirty crowns to P. Battoni on the picture of Iphigenia," (Russell 1988, p. 854) and left the matter of obtaining the finished picture with a Frenchman, Pierre Berton, whom he and Blackwood employed as agent.

A letter of October 23, 1741, from Clephane at Rome to Lord Mansell suggests the difficulties Batoni's patrons experienced in getting him to finish his commissions and offers evidence of his compositional practice: "Pompeo is a sad dog & ought not to be employed; I really believe we shall at last be obliged to have recourse to the Governour for order to recover the money he has already received; a month ago I came to an agreement with him; he was to begin working afresh & for every figure finisht, I was to order him 4 Sequers; since the day of agreement I have seen nothing more of him … I shall be … if Pompeo do not finish his, because it will be [the] Devil & all to recover the money already paid, yt is p … & I really like the picture; the Story seems well told, & tho' the Colouring will always be dryish, yet the light & attitudes seems to be well understood, from his taking all from Clay-models as you remember his way" (Russell 1988, p. 854).

No other reference to Batoni's employment of clay models is recorded, although there were precedents for their use in the Renaissance and Baroque periods (notably by Nicolas Poussin) and by Batoni's contemporary Pietro Bianchi . Batoni often worked from life in adjusting the pose of various figures in his compositions, but, as Francis Russell has observed, it is surprising that only one drawing for so elaborate a composition survives. Batoni produced an oil sketch for the *Sacrifice of Iphigenia* (Clark and Bowron 1985, p. 224, no. 58, pl. 54), which he himself retouched in 1742, with the result that it serves as much as an autograph reduction of the larger composition as an actual *bozzetto*. Other versions of the subject sold in the eighteenth century suggest, however, that Batoni produced additional compositional sketches in oil.

The sacrifice of Iphigenia is one of the most famous episodes of the

Trojan War and derives from Ovid's Metamorphoses (XII. 25–28). Iphigenia, daughter of Agamemnon, King of Mycenae, was sacrificed to appease the goddess Diana, whom her father, the leader of the Greek forces against Troy, had offended by killing a stag sacred to the goddess. When Diana prevented the Greek expedition from sailing by sending unfavorable winds, he consulted a seer, who told him that he must sacrifice his daughter as an act of propitiation. Iphigenia, ashen and shaken in the center of the composition and surrounded by weeping attendants, swoons before an altar attended by a bearded priest, robed and cowled, at the left. The gesture and expression of the grief-stricken Agamemnon, fearfully gazing upwards at the statue of Diana, is worthy of the theme, which aroused powerful emotions in ancient writers such as Cicero, Quintilian, Pliny the Elder, and Valerius Maximus. [EPB]

## 164
## Pompeo Batoni
### Saint Luigi Gonzaga

c. 1744

Inscribed on a nineteenth-century English exhibition label on the back of the canvas: *C. A. Turner/ S. Aloysus/ Raphael Mengs.* Inscribed on another label: *The Property of Sir C. Turner,* and on another: *acheté a Bruxelles par le Marquis de Sagenzac en 1925.*

Oil on canvas

31⅛″ × 26⅛″ (81 × 67 cm)

PROVENANCE  possibly Sir Charles Turner, Kirkleatham, Yorkshire; Marquis de Sagenzac, Brussels, 1925; M. & C. Sestieri and Alberto di Castro, Rome, 1968; from whom purchased by the owner in 1968

EXHIBITION  New York 1982, cat. no. 6

BIBLIOGRAPHY  Clark and Bowron 1985, p. 234, no. 89, pl. 89

Private collection, New York

Batoni obviously possessed an innate gift for producing compelling visual images, and it is known that his contemporaries noticed and admired this talent. The religious easel pictures produced by Batoni in the first half of the 1740s are especially remarkable for their quality and visual intensity. The bold composition, precise draftsmanship, and vivid palette of *Saint Luigi Gonzaga* exemplify Batoni's small devotional paintings. Works such as this satisfied a powerful undercurrent of taste for sentimental and emotional religiosity that remained undiminished in Rome from the Counter-Reformation throughout most of the eighteenth century.

By the early 1740s Batoni was an artist fully matured and fully conscious of his own beautiful drawing, superlative handling, masterly sense of tone, and very pretty poetry. A

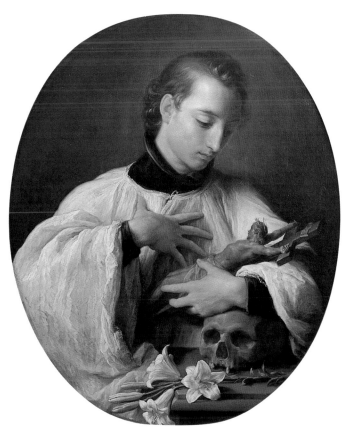

164

general mood of gentleness and innocence prevails throughout Batoni's sacred paintings of this decade; in this representation of the patron saint of Roman Catholic youth, it is particularly appropriate. The painting marks one of Batoni's earliest uses of the half-length oval format, which he was to employ with such phenomenal success twenty years later in *The Sacred Heart of Jesus* (Il Gesù, Rome; see fig. 9 above). In the artist's day, it was one of his best-known religious paintings and perhaps the most venerated sacred image produced in the eighteenth century.

Once his cult was approved by the Catholic Church in 1621, the immensely popular saint Luigi Gonzaga (1568–1591) was a mainstay of Jesuit iconography around the world. The eldest son of the Marquess of Castiglione and his wife, who was lady-in-waiting to the Queen of Spain, Gonzaga renounced a military vocation and entered the Jesuit novitiate of S. Andrea al Quirinale in Rome in 1585, against his father's will. He made his vows in 1587 and nursed the sick in the Jesuit hospital of S. Maria della Consolazione e Morte, opened during an epidemic of the plague in Rome in 1691, where he contracted a fever from which he never recovered. During his sickness he was ministered to by Saint Robert Bellarmine, the celebrated cardinal, theologian, and Doctor of the

Church, who afterwards testified to his holiness. Beatified by Paul V in 1605, canonized by Benedict XIII in 1726, and declared patron of youth in 1729, the saint was interred in a magnificent urn of lapis lazuli wreathed with festoons of silver in the right transept of the church of S. Ignazio, Rome. The enormous marble relief above the altar by Pierre Legros, 1698–99, depicting the glorification of the saint, is one of the masterpieces of late Baroque sculpture in Rome (Enggass 1976, vol. 1, pp. 49–50, and vol. 2, figs. 99–105). The celebration there of the saint's feast day, June 21, is now an occasion of supplication for and remembrance of AIDS victims.

*Saint Luigi Gonzaga,* the finest of the known versions by Batoni of the subject, can be dated to 1744 on the basis of a painting produced for Francesco Buonvisi of Lucca and now untraced (Marcucci 1942, p. 16, no. 9, citing the artist's letter of July 4, 1744, to Bartolomeo Talenti in the Archivio di Stato in Lucca, Italy). Batoni has depicted the young saint according to traditional iconography, dressed in the white surplice of the Jesuit novitiate and adoring a crucifix in the presence of a skull, symbols of his ascetic life; the lily, a symbol of purity, is a usual attribute of virgin saints.

The "C. A. Turner" identified as an owner of the painting in an inscription on a nineteenth-century label on

the back of the canvas may indicate a provenance from Charles Turner, of Yorkshire, who visited Rome in 1751 and was painted there by Sir Joshua Reynolds in several caricature groups that included Joseph Leeson and John Woodyeare, both of whom sat to Batoni (Clark and Bowron 1985, nos. 87, 139; Ingamells 1997, p. 956). [EPB]

## 165
## Pompeo Batoni
### The Virgin and Child in Glory

1747

Oil on canvas

40″ × 24″ (118 × 61 cm)

PROVENANCE  Merenda family, Forlì (house lists, nos. 116, 176), and thence by descent until about 1958; P. & D. Colnaghi & Co., London; purchased by the Toledo Museum in 1963

BIBLIOGRAPHY  Calzini 1896, p. 130; Casadei 1928, pp. 381–82; Marcucci 1944, pp. 95, 98, no. 5 (c. 1743); The Toledo Museum of Art, Ohio. *European Paintings.* Toledo: The Toledo Museum of Art, 1976, p. 20, pl. 31; Bowron 1982, p. 10, fig. 5; Clark and Bowron 1985, p. 240, no. 112, pl. 108; Quieto 1988, pp. 101–2

The Toledo Museum of Art. Purchased with funds from the Libbey Endowment, Gift of Edward Drummond Libbey

One of the artist's most beautiful devotional paintings, *The Virgin and Child in Glory* exemplifies the outstanding level of quality Batoni attained in the 1740s, the period of his greatest production of history paintings. The provenance of the Toledo oil sketch prompts mention of the man who acquired it from the artist, Count Cesare Merenda (1700–1754), one of the most active contemporary collectors of Roman Settecento paintings. Merenda and his brother Don Giuseppe (1687–1760), scions of one of the oldest patrician families in Forlì, owned numerous paintings by contemporary Roman artists, including Paolo Anesi, Giuseppe Chiari, Sebastiano Conca, Corrado Giaquinto, Andrea Locatelli, Agostino and Lorenzo Masucci, Paolo Monaldi, and Pierre Subleyras. What really distinguished the Merenda collection, however, were the more than thirty canvases by Pompeo Batoni and a similar number by Hendrik Frans van Lint (Bowron 1987).

Merenda's enthusiasm for the work of Batoni led him to become one of the artist's most important Italian patrons, and he eventually acquired some three dozen of his works in the late 1730s and early 1740s. These included one of the paintings most responsible for Batoni's fame outside Italy in the eighteenth century, the Dresden *Saint Mary Magdalene,* and its companion *Saint John the Baptist,* and

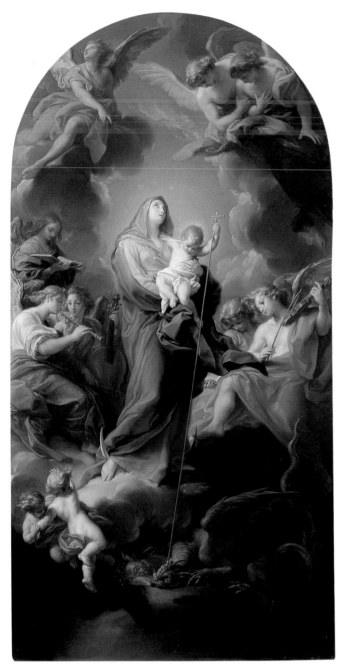

165

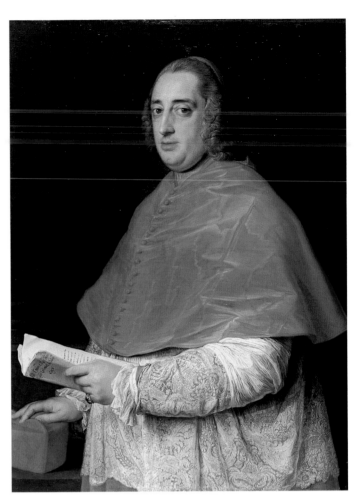

166

the well-known series of Apostles that are now scattered throughout the United States, England, and Italy (Clark and Bowron 1985, nos. 60–61, 76–85, passim). The Toledo *Virgin and Child in Glory* defines Merenda's taste, and it is clear that he preferred paintings marked by minute finish and polished detail, freshness and spontaneity of handling, and luminosity of tone and color. Like many eighteenth-century Italian collectors, he preferred smaller and more intimate pictures, and a clue to his sensibility is provided by the number of devotional works in his collection. He appears to have been collecting with the picture gallery in

Forlì firmly in mind, because not only are the majority of works of roughly equivalent scale and dimensions, they are also consistently framed. Nearly all of the frames on the canvases by Batoni, for example, are uniformly carved and gilded in the style of what are commonly referred to as "Salvator Rosa" or "Carlo Maratti" frames, which had originally appeared in the seventeenth century.

The *Virgin and Child in Glory* was conceived either as a devotional picture or as a *modello* for a larger, unexecuted altarpiece. Batoni has transposed the Virgin and Child, with variations, into the traditional imagery of the

Immaculate Conception (Revelations 12: 1–5, 11). In contemporary inventories of the Merenda collection, the Toledo *Virgin and Child* was described as "uno la concezzione [sic] in Gloria." A second *La concezione* listed in the Merenda inventories and house-lists is identifiable with a small oil sketch in The Art Museum, Princeton University (Clark and Bowron 1985, p. 240, no. 111). The Princeton sketch, identical except for discrete changes in the attitudes of the music-making angels and putti surrounding the Virgin and for the looser and softer handling of paint, bears a dated authentication in Batoni's hand on the back of the canvas (orig [ina] le de Pompeo Batoni/ 1747).

The existence of six sheets of red chalk drawings on yellow prepared paper related to the Toledo painting attests to the care and precision with which Batoni continued to develop his final composition after the elaboration of an initial painted sketch. Clark identified a red chalk drawing in the National Gallery of Scotland as a study for the angel playing the recorder at the left (Clark and Bowron 1985, no. D58); he himself owned, and bequeathed to the Toledo Museum of Art, studies of the pointing angel at the upper left (D218). A sheet of studies

of details in the composition—the head of the Child and two of the angels at the Virgin's right—is in the Witt Collection, Courtauld Institute Galleries, London (D101). Other drawings recording from life the figure of the Virgin, and studies of her hand and drapery (D111), studies for the drapery of the angel with a violin at the right (D160), and studies of the hands of the music-making angels (D104), remain untraced. [EPB]

## 166
## Pompeo Batoni
### *Cardinal Prospero Colonna di Sciarra*

C. 1750
Inscribed on the front of the letter held by the sitter: *All' Emin^mo e Rev^mo Prine/ il Card Colonna de Sciar^ra*
Oil on canvas
39¼″ × 29⅝″ (100.7 × 75.4 cm)
PROVENANCE Colonna di Sciarra family (?), Rome; Don Marcello Massarenti, Rome; Henry Walters, Baltimore, acquired with the Massarenti collection in 1902; bequeathed by Walters with his collection to the city of Baltimore in 1931
EXHIBITIONS New York, Wildenstein. *Treasures of the Walters Art Gallery.* 1967,

cat. no. 2; Chicago, Minneapolis, and Toledo 1970, cat. no. 68.

BIBLIOGRAPHY Clark 1964–65, pp. 50–54; Zeri, Federico. *Italian Paintings in the Walters Art Gallery.* Baltimore: The Walters Art Gallery, 1976, vol. 2, pp. 526–27, pl. 272, no. 415; Clark and Bowron 1985, pp. 248–49, pl. 131, no. 140

The Walters Art Gallery, Baltimore

Although the numerous likenesses of British Grand Tourists loitering among Roman antiquities are Batoni's best-known works, the clerical portraits are among the finest and most serious of his productions. The traditional conventions of official ecclesiastical portraiture in Rome certainly limited Batoni's pictorial inventiveness, but at the same time the genre provided an exceptional opportunity for the display of his extraordinary technical skills, with the result that the portraits of Cardinal Prospero Colonna di Sciarra and other clerics are among the most memorable images he created. The Walters portrait may be more modest in format and less ambitious in conception than some of Batoni's other cardinalate representations—*Cardinal Jean-François Joseph de Rochechouart* (1762; The Saint Louis Art Museum; Clark and Bowron 1985, no. 251), for example—but it is equally beautifully controlled and exquisitely executed.

Prospero Colonna di Sciarra (1707–1765), the son of Francesco Colonna and Vittoria Salviati, belonged to a secondary branch of the famous Roman Colonna family and held the title of Prince of Carbognano. He studied at Rome, Parma, and Padua, and began his rise in the papal court in 1730, when Pope Clement XII appointed him among the protonotaries of the Holy See; in 1733 he was named Consultant of the Rites. After having been appointed Chierico di Camera in 1739 and president of the Tribunal of the Grascia, Colonna was made Pope Benedict XIV's Maestro di Camera in 1740. He was created cardinal on September 9, 1743, and later received many important appointments, including the prefect of the Segnatura and of the Propaganda Fide. In 1758 Louis XV appointed him Protector of the French Crown in Rome.

Batoni fully understood the conventions of the Roman tradition of state portraiture, based on official portraits from the time of Raphael, established in the early seventeenth century by such painters as Domenichino, and refined more recently by Carlo Maratti, Giovanni Battista Gaulli, and Jacob Ferdinand Voet. Austerity, sophistication, and strong likenesses characterized this tradition, and portraits of popes and cardinals were necessarily more conservative and severe in style than those of rich Protestants on holiday. Batoni

has invested Cardinal Colonna di Sciarra (identified by the letter held in the figure's left hand) with the dignity and restraint appropriate to his position within the Church hierarchy. To concentrate attention on the subject, Batoni often showed no background, and here he has eliminated the standard Roman ecclesiastical portrait accessories—curtain, table, inkstand, bell, and book. The cardinal's pose and gesture offer the impression that he has been momentarily interrupted while reading, his attention fixed outside the painting upon the spectator.

Like all successful portrait painters, Batoni subtly underplayed the physical imperfections of his sitters while commemorating them with a distinguished and, in the case of his ecclesiastical sitters, almost direct likeness. Batoni's works are full of elegance and beauty of form, and the richness of his palette and polish of his handling are evident in the Walters portrait. By placing the cardinal before a neutral background he dazzles the viewer with the brilliance of the scarlet and white costume, highlights his mastery of the details of ecclesiastical dress, and reminds the onlooker that such portraits are supreme exercises in craft. The cardinal's attire inspired a bravura display of brushwork in the description of the cardinal's shimmering, scarlet watered-silk *mozzetta* and cassock, and the exquisitely painted lace rochet. Clark observed that Masucci, as Batoni's immediate predecessor as the leading Roman portraitist, "would have designed his portraits as carefully, severely, and powerfully" as the Walters portrait, "but not as delicately nor with such a fine visual sense of color and texture" (Clark 1970, p. 168).

A version of this portrait of the cardinal was engraved by Johann Georg Wille in 1754 (Clark 1964–65, fig. 3) and is extremely close to the Walters portrait, although the letter is not inscribed. The needs of an important cardinal would have included a number of replicas of his portrait, the prime version being kept by the cardinal's family and other versions or copies going his religious establishments in or beyond Rome. Batoni himself prepared superb replicas and supplied less expensive studio replicas, specified as such, of considerable quality, and yet apparent as studio work. Wille made his print in Paris, presumably from a version of the portrait sent by the cardinal to the French king that has not been identified. Marcello Massarenti could have acquired the present portrait, which is either the prime version or a very good autograph replica, during the dispersal of the Sciarra collection in the late nineteenth century. [EPB]

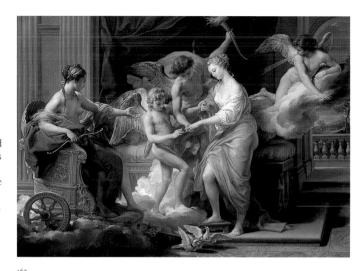

167

## 167
## Pompeo Batoni
### *The Marriage of Cupid and Psyche*

1756
Signed on the base of the bed: *PonPeo. Batoni Pire A. o. 1756. Roma.*
Oil on canvas
33½" × 46⅞" (85 × 119 cm)
PROVENANCE commissioned for Frederick II, King of Prussia, in 1756; Picture Gallery, Potsdam-Sanssouci, 1763–1830; Kaiser Friedrich Museum, Berlin, 1830–1945; Bodemuseum, Staatliche Museen, Berlin, 1945–90s; Gemäldegalerie, Berlin, 1998
EXHIBITIONS Bregenz and Vienna 1968; Munich 1992, cat. no. 32
BIBLIOGRAPHY Clark and Bowron 1985, pp. 268–69, no. 198, pl. 182; *Gemäldegalerie Berlin: 200 Masterpieces.* Berlin: Staatliche Museen zu Berlin Preussischer Kulturbesitz, 1998, p. 414

Staatliche Museen zu Berlin, Preussischer Kulturbesitz, Gemäldegalerie

By the 1750s Batoni's paintings of classical and religious subjects had become too expensive for the average wealthy visitor to Rome, and such pictures as *The Marriage of Cupid and Psyche* were commissioned almost exclusively by the Church, European sovereigns and visiting nobility, and the exceptionally wealthy British Grand Tourist. Frederick the Great probably learned of Batoni from Count Francesco Algarotti, who in 1751 attempted to arrange a commission for him. The king heard more of Batoni's reputation from his sister, Wilhelmine, Margravin of Bayreuth, who in 1755 had traveled to Italy with her husband and visited Rome and Naples. On May 23, 1755, she wrote to her brother: "Batoni, too, is a great painter and not at all expensive; he is by far superior to [Antoine] Pesne" (Erich Schleier in *Gemäldegalerie*, p. 414, see above). The commission for the *Marriage of Cupid and Psyche* was arranged through George Keith,

9th Earl Marischal, in Rome in March 1756, together with a companion piece by Placido Costanzi, *Apollo and Daphne* 1757; (reproduced in *Gemäldegalerie*, p. 414, see above), and a pair of mythological paintings by Mengs.

The commission coincided with the onset of the Seven Years' War, and Batoni sent his finished painting in 1756 to Frederick in his Dresden winter quarters during the Prussian occupation of Saxony. The king is reported to have taken the picture with him on his travels throughout the duration of the war. Frederick authorized the inspector of his new picture gallery, Matthias Oesterreich, to pay Batoni 400 ducats for the painting in 1763 when peace was declared. It was hung in the finished gallery as the only example of a living painter's work; Costanzi's pendant was found unsatisfactory and relegated to the Neues Palais; the war prevented Mengs from completing and dispatching his order. Frederick unsuccessfully invited Batoni to Potsdam in 1763 to become his court painter, and at the same time ordered from him three large paintings with subjects from Greek and Roman history and mythology. Only one of these commissions, *Alexander and the Family of Darius* (1775; (Neues Palais, Potsdam-Sanssouci; Clark and Bowron 1985, no. 382), was ever completed, although the king managed to acquire an earlier biblical work (*The Finding of Moses* 1746; Clark and Bowron 1985, no. 99) from the artist through one of his agents in Rome.

Johann Gottlieb Puhlmann, a young Prussian painter who was Batoni's pupil and assistant from 1774 until 1783, described Batoni's painting in an 1805 inventory of the picture gallery at Sanssouci as follows: "Venus gives her consent to the union of Cupid and Psyche, whom Hymen joins in marriage while Zephyr wafts a cooling breeze" (Erich Schleier in *Gemäldegalerie*,

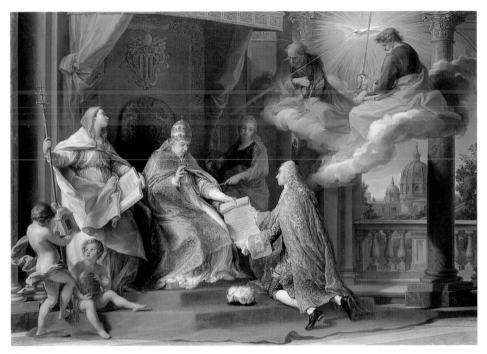

168

p. 414, see above). On the left Venus, seated in a chariot drawn by a pair of doves, motions to her son Cupid to place the ring on Psyche's finger. Hymen, the god of marriage, holds Psyche's hand with its outstretched ring finger. Venus and the two gods float on clouds, whereas Psyche, a mortal, stands on the base of the nuptial bed. According to Puhlmann, Psyche was modeled on Batoni's wife, Lucia, reputedly one of the most beautiful women in Rome in her youth.

The *Marriage of Cupid and Psyche* is one of Batoni's masterpieces and confirms the importance and quality of both his subject pictures and portraits during the 1750s. In its incisive drawing, rich, well-balanced composition, brilliant colors, and subtle chiaroscuro modeling, it is typical of his finest paintings during this decade. The elegant and gracious figures summarize the Roman classical tradition from Raphael to Annibale Carracci to Carlo Maratti, and anticipate the Neoclassicism of Anton Raphael Mengs, whose Parnassus ceiling in the Villa Albani was painted only four years after Batoni's work. The charming, idealized setting of the *Cupid and Psyche*, its deliberate prettiness, and refinement of ornament and draftsmanship have led more than one critic to characterize Batoni's work as an exemplar of the Roman Rococo rather than a precursor of the Neoclassical style; for example, Michael Levey (Levey 1966, p. 176) described the picture as "a perfectly charming, perfumed vision." It is precisely the polish and finish of such paintings as the Berlin mythology, however, combined with exquisite drawing and rav-

ishingly pretty coloring, that made Batoni's works so appealing to wealthy visitors to Rome during the third quarter of the century. [EPB]

## 168
## Pompeo Batoni
### *Pope Benedict XIV Presenting the Encyclical "Ex Omnibus" to the Comte de Choiseul*

1757
Signed with initials and dated on the column base at right: *P. B. 1757*
Oil on canvas
50¼″ × 70⅝″ (128.9 × 179.5 cm)
PROVENANCE painted for Cardinal Domenico Orsini as a gift to Pope Benedict XIV; Dr. Gustave Fall, Vienna, 1931; by descent to Dr. Greta H. Van Fenema and Dr. Frederick Fall, Washington, D.C., until 1961; from whom acquired by the Minneapolis Institute of Arts in 1961
EXHIBITIONS Dallas Museum of Fine Arts. *Four Centuries of European Painting.* 1951, no. 57; Chicago, Minneapolis, and Toledo 1970, cat. no. 69; New York 1982, cat. no. 14
BIBLIOGRAPHY Schaffran 1931; Minneapolis Institute of Arts. *European Paintings in the Minneapolis Institute of Arts.* Minneapolis: Minneapolis Institute of Arts, 1970, pp. 440–41, no. 235; Waterhouse 1971, p. 9, 19; Brigstocke 1983, p. 214; Clark and Bowron 1985, p. 269, no. 200, pl. 185
The Minneapolis Institute of Arts, The William Hood Dunwoody Fund

Etienne-François Stainville, Comte and later Duc de Choiseul, was sent as an ambassador to Rome by Louis XV at the end of 1754 to gain a papal decision that would alleviate the religious

troubles in France between the Gallican Church, the schismatic Jesuits, and the popular parliament. These problems were of great importance, and the activities of the parliament against the Church and weak royal opposition were in a real sense the first act of the French Revolution. An encyclical, or letter, addressed to the French bishops was the result of Choiseul's embassy on October 16, 1756; the document is shown in the painting inscribed with its preliminary lines. The count, whose hat is shown on the floor in the Minneapolis painting because he has just kissed the pope's toe, wears the *cordon bleu* of the Order of the Holy Spirit which he received from his king on January 1, 1756. His is not a true portrait, even though his gold and blue court dress is shown accurately. No commission from Choiseul to Batoni is known and the French ambassador's only known patronage of a Roman artist was of Panini in 1756 and 1757 (cats. 265, 275).

The enthroned pope, Benedict XIV Lambertini, is flanked by graceful female personifications of Religion and Divine Wisdom; two putti at the left hold symbols of the papacy. Before a view of St. Peter's, the patrons of the Holy Church of Rome, Saints Peter and Paul, appear on a cloud below the Holy Ghost, which is shown inspiring the pope. The canopy is embroidered with the papal arms and the date of Benedict's reign (XVII; that is, 1757). The garden casino in which the scene takes place would be in the Vatican gardens and is imaginary; it may be based on the so-called Coffee House of the Palazzo del Quirinale, where the encyclical was actually pre-

sented. The portrait of the ageing Benedict XIV is intended as an accurate likeness and sensitively represents a man who had been a great patron of the artist. In 1742 the pope had commissioned from Batoni decorations for the ceiling of the Coffee House in the garden of his residence, *Christ Delivering the Keys to Saint Peter* and *The Four Evangelists*; in 1743 he asked Batoni to paint one of a series of oval paintings, the *Annunication*, as part of his campaign to refurbish the interior of the ancient basilica of S. Maria Maggiore; and in 1746 he commissioned for the Capella Clementina in St. Peter's one of the largest and most important subject paintings produced by the artist, *The Fall of Simon Magus* (Clark and Bowron 1985, nos. 62–66, 86, 184).

The painting was almost certainly commissioned by Cardinal Domenico Orsini d'Aragona as a pendant to an allegorical painting by Placido Costanzi (Clark and Bowron 1981, p. 64, fig. 71), which represents Benedict XIV settling a dispute between Austria and the Republic of Venice. Cardinal Orsini had presented the picture to Benedict XIV in 1752, and it and the Minneapolis painting show the two main diplomatic efforts of the pope and of Cardinal Orsini, one of the principal diplomats of his reign. The *Diario Ordinario* records a number of visits by Cardinal Orsini to the pope in 1757, the year in which Batoni painted the cardinal's daughter, Princess Giacinta Orsini Buoncampagni Ludovisi (Clark and Bowron 1985, no. 206), either upon her marriage in April or upon her death in November. At the time of the daughter's marriage, unspecified presents were exchanged between the Orsini family and the pope, and it is probable that the Minneapolis picture was a gift to Benedict XIV before the pope's death in 1758.

Ellis Waterhouse observed the "meticulous naturalism" (Waterhouse 1971, p. 19) of the figures in the Minneapolis painting, which is the result of Batoni's obsessive devotion to drawing from the life model—a trait conspicuous in the works of the later 1750s. This is confirmed by the existence of several sheets of studies for various details of the composition in the Musée des Beaux-Arts at Besançon, the Minneapolis Institute of Arts, and elsewhere (Clark and Bowron 1985, nos. D40, D53, D132, D316, D318).

Batoni painted an oil sketch for the composition that appeared as lot 500 in the Orsini sale, Rome, March 12–23, 1896. [EPB]

## 169
## Pompeo Batoni
### *Sir Wyndham Knatchbull-Wyndham, Baronet*

1758–59

Oil on canvas

91¼″ × 63½″ (233 × 161.3 cm)

PROVENANCE  by descent in the family of the sitter at Mersham Hatch, Kent; purchased in 1994 through Simon Dickinson, Ltd., London

EXHIBITION  London 1982, cat. no. 14

BIBLIOGRAPHY  Bolton, A. T. "Mersham Hatch, Kent," *Country Life* (March 26, 1921), p. 373; Russell 1973, p. 1610, fig. 8; Clark and Bowron 1981, pp. 114–15, fig. 150; Clark and Bowron 1985, pp. 275–76, no. 218, pl. 199; Tutsch 1995, p. 141, n. 663; Redford, Bruce. *Venice and the Grand Tour.* New Haven and London: Yale University Press, 1996, pp. 86, 89, pl. 33

Los Angeles County Museum of Art, Gift of the Ahmanson Foundation

This splendid full-length is the portrait with which, as Francis Russell remarked, Batoni attained his majority as *the* painter of the Grand Tourist, and it remains one of his masterpieces. The painting epitomizes the artist's ability to transmute the Baroque portraits of Sir Anthony van Dyck into a sophisticated and subtle hybrid that lies between the Rococo and Neoclassicism. The sitter (1737–1763) was the only son of Sir Wyndham Knatchbull-Wyndham, 5th Baronet, whom he succeeded in 1749, and his wife, Catherine Harris. Educated at Oxford, Sir Wyndham, like many of Batoni's portrait sitters, made his Grand Tour upon leaving university, in 1757–60. He arrived in Florence in August 1758 and in Rome in December. In March 1760, while still in Italy, Sir Wyndham was suggested by the Kent Whigs as a possible candidate for a seat in the House of Commons. He came back to England for the election on June 18, 1760, and was returned unopposed. He held the seat until his sudden death on September 26, 1763.

From our knowledge of Sir Wyndham's travels, it is clear that the Los Angeles portrait was begun between October 1758 and April 1759, when the sitter had arrived in Venice. That the painting had not been finished by the time Sir Wyndham left Rome is known from a message that Winckelmann, the German archaeologist and art historian, sent him in 1759, saying that, as he had not seen the work completed, he should know that his portrait by Batoni could be considered as one of the best in the world and that one could hardly imagine anything more beautiful (Winckelmann 1952–57, vol. 2, p. 53, letter of November 28, 1759, to Philip von Stosch).

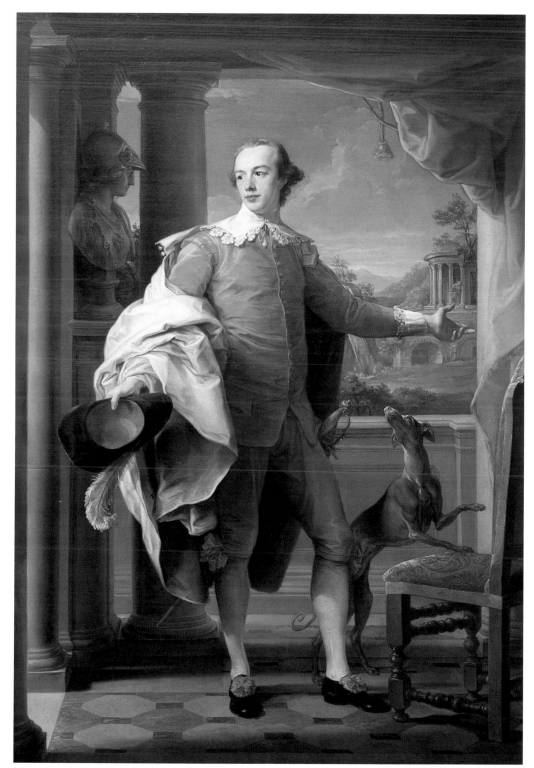

169

In surrounding the fresh-complexioned, twenty-two-year-old English aristocrat with the columns and curtains that were the deliberate trappings of the grand manner, Batoni has captured the Baroque spirit also expressed by the flamboyant pose (intended to evoke the *Apollo* Belvedere), and by the Sir Wyndham's Van Dyck costume. His debonair stance was later repeated by Batoni for a full-length of *Frederick*

*Augustus, 5th Earl of Berkeley* (1765; Clark and Bowron 1985, no. 287) and employed with subtle variations in many other compositions. In showing Sir Wyndham attended by his greyhound, Batoni was also following a convention of Van Dyck portraiture, although many British Grand Tourists brought their dogs with them to Italy.

The wearing of a "Van Dyck" costume as a masquerade dress by

fashionable men and women was quite common in the 1740s and was popularized in English portraiture by Thomas Hudson. Its appearance in Batoni's paintings may have derived from his connection with Thomas Jenkins, the *cicerone*, or guide, to Roman visitors, who was a Hudson pupil. The vogue for Van Dyck dress was to last for over forty years, but it is perhaps hardly surprising that relatively few

sitters chose to wear it for portraits painted in Rome, probably considering it inappropriate for their role as Grand Tourists. Sir Wyndham's plain silk suit, with the lace collar fastened at the neck with a button and tassels, is similar in style to that worn by other Batoni sitters (Clark and Bowron 1985, nos. 177, 197, 357, 438), and one wonders whether the artist might have kept such a costume for those who wished to be portrayed in it, altering the details slightly for each sitter.

The so-called Temple of the Sibyl, or Temple of Vesta, at Tivoli in the background was one of Batoni's favorite motifs, and was first employed in this full-length of Sir Wyndham. The depiction of the temple is quite accurate, both by comparison with other eighteenth-century representations and with the ruin as it still exists. Tivoli was a powerful image to the contemporary Englishman, both because of its classical associations and because it was familiar as the sketching ground of the seventeenth-century landscape painters he most admired, Claude Lorrain and Gaspard Dughet, as Anne French has remarked (Anne French, *Gaspard Dughet, Called Gaspar Poussin, 1615–75: A French Landscape Painter in Seventeenth-Century Rome and His Influence on British Art* [London: Greater London Council, 1980], p. 17, n. 74). Batoni incorporated the Temple of the Sibyl into nearly a dozen of his portrait compositions of Grand Tourists in the 1760s and 1770s (Clark and Bowron 1985, nos. 295, 305, 336, 338, passim).

The bust at the left is another of Batoni's most common portrait accessories, derived from the full-length marble *Minerva* Giustiniani, a Roman adaptation of a bronze original of the fourth century BC, today in the Vatican Museums. Batoni first depicted the statue in a subject painting of 1737, *The Triumph of Venice* (The North Carolina Museum of Art, Raleigh; Clark and Bowron 1985, no. 13), but it was as a table-top bust rather than as a full-length statue that the *Minerva* Giustiniani appears in more than a dozen of his portraits of visitors to Rome during the next three decades (Clark and Bowron 1985, no. 177, passim). Haskell and Penny (1981, pp. 269–71, fig. 140) document the particular enthusiasm of the English for the *Minerva* Giustiniani, recording an anecdote of Goethe's, who was told by the custodian of the Giustiniani collection that the English worshiped the statue and kissed one of its hands so frequently that it was whiter than the rest of the marble.

Batoni's brilliant handling of paint in his portraits is vividly evident following the cleaning of the Los Angeles painting by Joseph Fronek in 1994. The removal of several layers of extremely discolored varnish has revealed a surprisingly subtle and silvery color scheme that contrasts with the bolder, high-keyed palette that Batoni usually employed for his Grand Tour portraits. Now the play of light around and through the composition, the way in which it enters the picture in subtle layers and degrees, defining highlights and shadows, can be appreciated as Batoni intended. Fronek has made a number of observations about Batoni's technique that contribute to an understanding of his method of working. He painted on a canvas primed with a thick red ground—left exposed and visible in many areas of the canvas—that helps to mute and unify the colors. Batoni's deft brushwork is now highly visible, and his direct application of paint onto the canvas and the resulting surface texture can be admired with the unaided eye. The variation in Batoni's handling can be seen, for example, in the contrast between the sketchy manner in which he created the shadows on the floor and the thicker application of paint in long, sinuous strokes to define the white drapery over Sir Wyndham's arm. (Batoni has employed glazes only minimally; the purplish shadows of this white drapery are not created by glazes but by directly applied paint.)

Batoni appears to have begun the painting with Sir Wyndham's face, the foundation of which is a layer of green paint. The blue sky is painted around the face; the white collar is painted after the flesh and sky, but the white clouds were executed after the collar. The architecture appears to have been laid in before the sky, and the curtains after the architecture and the sky. Batoni was very deliberate in the assembly of his compositions, although changes of intention, or *pentimenti*, are occasionally visible. Here several slight adjustments are visible to the naked eye, including the hind legs of the dog, the outline of Sir Wyndham's head, and the front leg of the chair (information from Joseph Fronek, letter of January 7, 1999). [EPB]

## 170
## Pompeo Batoni
### *Louisa Grenville, Later Countess Stanhope*

1761
Inscribed on reverse of original canvas (relined in 1934 during cleaning): *Louisa Grenville/ Pompio Battone/ pinxit/ Roma.*
Oil on canvas
41″ × 26½″ (104.2 × 67.3 cm)
PROVENANCE painted for, or for presentation to, Richard Grenville, 2nd Earl Temple, the sitter's uncle; presumably returned to the sitter, and by descent through the issue of her husband, Charles, 3rd Earl Stanhope, by his first marriage, to the 7th Earl Stanhope, by whom Chevening was bequeathed to a private charitable trust (the house is now an official residence of the Foreign Secretary)
EXHIBITIONS London 1963, cat. no. 40; London 1982, cat. no. 15; Washington, D.C. 1985, cat. no. 199
BIBLIOGRAPHY *Portraits and Busts in the Principal Rooms at Chevening.* London, 1859, p. 10; Tipping, H. A. "Chevening—III: Kent, Seat of Earl Stanhope." *Country Life* (May 1, 1920), p. 590, fig. 7; Clark and Bowron 1981, p. 115, fig. 144; Clark and Bowron 1985, p. 282, no. 238, pl. 221, col pl. VII
The Board of Trustees of the Chevening Estate

Louisa Grenville (1758–1829) was the only child of the Hon. Henry Grenville, MP, a former governor of Barbados, and Margaret Eleanor, daughter of Joseph Bankes, of Revesby Abbey, Lincolnshire. In 1781 Lousia Grenville married Charles Stanhope, Viscount Mahon, later 3rd Earl Stanhope, who was painted in turn by Allan Ramsay, Liotard, Prud'hon, and Gainsborough. In 1786 he inherited Chevening and initiated signifcant alterations to the house, which had been acquired by the 1st Earl in 1715.

Louisa's father was appointed ambassador to the Porte of Constantinople in 1761 and immediately left England with his wife and daughter for Turkey, visiting Italy on the way. They arrived in Turin on October 16, and were presented at court the next day. Shortly thereafter the family must have departed for Rome, because the portrait can be dated on the basis of a letter of November 27, 1761, from the *cicerone* Thomas Jenkins to Sir Henry Mainwaring, for whom he had acted in Rome: "Pompeo Batoni has made a pretty Picture of Miss Grenville, its intended for Lord Temple" (Dunham Massey MSS; information from Francis Russell). The Grenvilles were in Naples from November 17, 1761, to January 24, 1762, when they embarked for the Levant (Ingamells 1997, p. 429).

The outstanding feature of this sympathetic portrait—one of Batoni's rare portraits of children—is, as Anthony Clark pointed out, its beautiful and simple presentation: "as if a plain statement by Hogarth had been perfected by Fragonard" (Clark and Bowron 1985, p. 282). The closely orchestrated color and tonal scheme, with the child's silhouette set off against the gray-green background by the precise manipulation of contrasting hues and tones, anticipates two of Batoni's most successful portraits of Englishwomen, *Georgiana, Countess of Spencer* (1764; The Earl Spencer, Althorp, Northamptonshire; Clark and Bowron 1985, no. 269) and *Lady Mary Fox* (1767–68; cat. 173).

Louisa Grenville, who looks considerably older than her actual age of three years, is shown in a dress of apricot silk. As girls of this period left off their infant frocks at about this age, this is probably her first semi-adult dress; the scarlet, flat-heeled child's shoes contrast with its delicacy and lightness. The puppy she holds was presumably brought with the family from England and appears to be either a Maltese or Havanese terrier or possibly a Löwchen (information from Barbara Kolk, The American Kennel Club Library, letter of April 27, 1999).

The elaborately carved giltwood Rococo frame, shaped to the canvas and composed of a wreath of feathers, was supplied after the painting had reached England. There are apparently no feathers in the arms of either the Grenville or the Stanhope families, none of the other picture frames at Chevening is at all similar, and there are no feathers on other furnishings or objects in the house. The symbolic or emblematic significance, if any, of the feathers is unclear. However, as Paul Mitchell and Lynn Roberts have suggested, if the necklet of pearls at the top of the frame is seen as innocence (see the medieval English poem *Pearle*), then the feathers might be symbolic of spring (from the association of birds and spring), like the florets spaced at intervals around the frame, and thus indicative of the sitter's youth. The dove and the phoenix can also represent chastity.

Contemporary Rococo picture and looking-glass frames are frequently shaped in a similar way, and are also—both in drawings and in the objects themselves—created of sinuously arranged natural forms, but these are almost exclusively vegetal forms: palms, rushes, or attentuated acanthus leaves. The single example using feathers appears to be a much later Hepplewhite chairback, dating from 1788, and in that instance the feathers are not elegant quills, as here, but curled Prince of Wales feathers. The Chevening day book and inventories have not been published, or even apparently much studied; they may hold the answer in the form of an order or invoice for the frame. A possible answer to the source of this unique design may be that the little girl herself was known as "Feather" to her family, or that she always wore feathers on her cap or her dress (letter from Paul Mitchell to Lynn Roberts, May 5, 1999).

By 1859 this portrait already hung in its present place in the recess of the drawing room. [EPB]

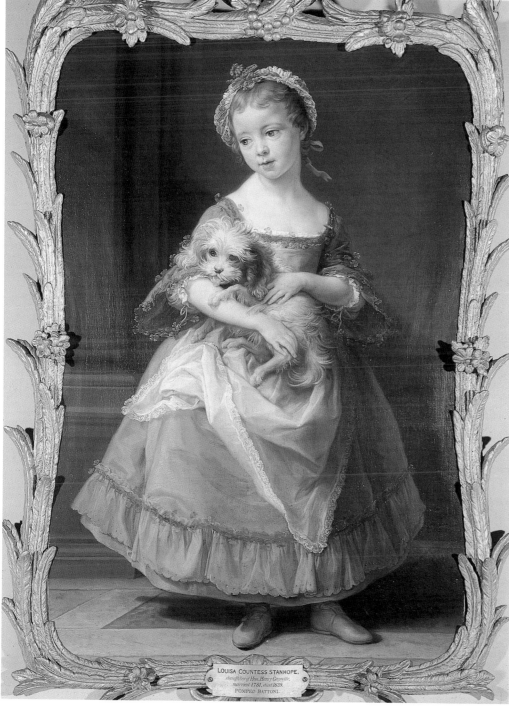

170

LOUISA COUNTESS STANHOPE,
*A daughter of Hon. Henry Grenville,
married 1781, died 1829.*
POMPEO BATTONI.

## Pompeo Batoni
### *Count Kirill Grigoriewitsch Razumovsky*

1766

Signed and dated on the sculpture base at
the left of the sitter's feet: *POMPEIUS BATONI
PINXIT/ ROMAE./ ANNO 1766*

Oil on canvas

9½″ × 77⅛″ (298 × 196 cm)

PROVENANCE by descent to the sitter's son,
Andrey Kirillovitsch Razumovsky (trans-
ferred to Vienna in 1791); in 1836 to his sec-
ond wife, Countess Constantina-Domenica
von Thürheim, Thürheim Castle,
Schwertberg; Count Camillo Razumovsky,
Schloss Schönstein, near Troppau, Opava,
c. 1890–1946; thence by descent to the pre-
sent owner

EXHIBITIONS Rome 1959, cat. no. 44;
The National Trust, Waddesdon Manor,
Buckinghamshire, 1997–99; Frankfurt
1999, *Mehr Licht*, cat. no. 11

BIBLIOGRAPHY Vasil'cikov. *The Razumovsky
Family*. St. Petersburg, 1887, vol. 4, p. 401;
Mikhailovitch, Grand Duke Nicholas
Romanoff. *Portraits russes des XVIIIe et XIXe
siècles*. St. Petersburg, 1906, vol. 2, no. 13,
pl. 13; Antonov 1977, pp. 351, 353, n. 6;
Rudolph 1983, pl. 57; Bowron 1985, p. 29,
fig. 4; Clark and Bowron 1985, pp. 303–4,
no. 299, pl. 274; Pinto S. 1991, pp. 350–51, 356

Private collection

One of the most memorable features
of Batoni's portraits is the emblematic
use of antiquities and views of Rome
to establish his sitters' presence in the
Eternal City and to depict them as
learned, cultivated, yet leisured aristo-
crats. Batoni employed a whole
anthology of motifs alluding to Rome
and Roman civilization, but what is
surprising in his œuvre is the rela-
tively infrequent appearance of the
half-dozen ancient marbles most
highly esteemed in the eighteenth
century, notably the *Apollo* Belvedere,
Belvedere *Antinous, Laocoön*, and
Vatican *Ariadne*. This portrait of Count
Kirill Razumovsky, unrivaled in its
grandeur of conception and matched
in size among Batoni's portraits only
by two other whole-lengths, features
all of these antique sculptures.

Count Kirill Razumovsky
(1728–1803) was the younger brother
of Empress Elizabeth's morganatic
husband, Alexey Razumovsky. He
was sent abroad at the age of fifteen
to study at Königsberg with the Swiss
mathematician Leonhard Euler, and
also at Strasbourg, and returned to
Russia completely europeanized.
Elevated to the nobility by the empress
in 1744, he was appointed a royal
chamberlain the following year. A
large landholder, Razumovsky served
as Grand Hetman of the Cossacks
from 1750 to 1764, during which time
he carried out a series of economic
and administrative policies on behalf
of the Ukrainian nobility, including

restrictions of the free movement of peasants and the institution of a population census. For his role in planning the palace revolution of 1762, which brought Catherine II to the throne, he was made a senator and adjutant general. In 1764, when the hetman rule was abolished in the Ukraine, Razumovsky was appointed a field marshal general; he later served as a member of the council of state, 1768–71. A man of considerable learning, he was president of the St. Petersburg Academy of Sciences from 1746 until 1765. He brought to Russia the Italian architect Antonio Rinaldi, and initiated the construction of the cathedral of St. Andrew in Kiev (1747–67) by the Moscow architect I. F. Michurin on the designs of Bartolommeo Francesco Rastrelli.

Razumovsky traveled abroad in the years 1765–67 and in the spring of 1766 visited Rome. In addition to commissioning his portrait, he acquired from Batoni a *Choice of Hercules* (1763–65; The Hermitage, St. Petersburg; Clark and Bowron 1985, no. 288) and a *Holy Family* that remains untraced. In the portrait Razumovsky is shown wearing on his coat the star, sash, and badge of the order of Saint Andrew, which he received from Catherine II in 1745; as the "house-order" of the Romanov family, this was the highest civil decoration in czarist Russia. On his breast he wears the Polish order of the White Eagle. He is shown elegantly, if casually, leaning against a chair (itself a studio prop that Batoni actually owned) in a cross-legged pose that was standard in eighteenth-century portraiture and that Batoni repeated with variations throughout his career. In this instance, however, the combination of the pose and background results in a tour de force that ranks as one of the greatest of all Batoni's portraits.

The collection of marbles assembled in the background gives the picture its greatest distinction: only in the portrait of *Thomas Dundas, Later 1st Baron Dundas* (1764; The Marquess of Zetland, Aske Hall, West Yorkshire; Clark and Bowron 1985, no. 278) did Batoni present such a panoply of "the most beautiful statues," the ancient marbles that so hypnotized the great princes and sovereigns of Europe and that made a visit to Italy such an important part of the education of the cultured eighteenth-century gentleman. (For this subject, see above all Haskell and Penny 1981). Razumovsky directs the viewer's attention to the Vatican *Ariadne* just behind him. In an aedicule at the rear, the fictitiously arranged sculptures include, from left to right as in the Dundas portrait, the *Apollo* Belvedere, the *Laocoön*, and the so-called Belvedere *Antinous*. These sculptures were among the most famous of all antiquity, and there can

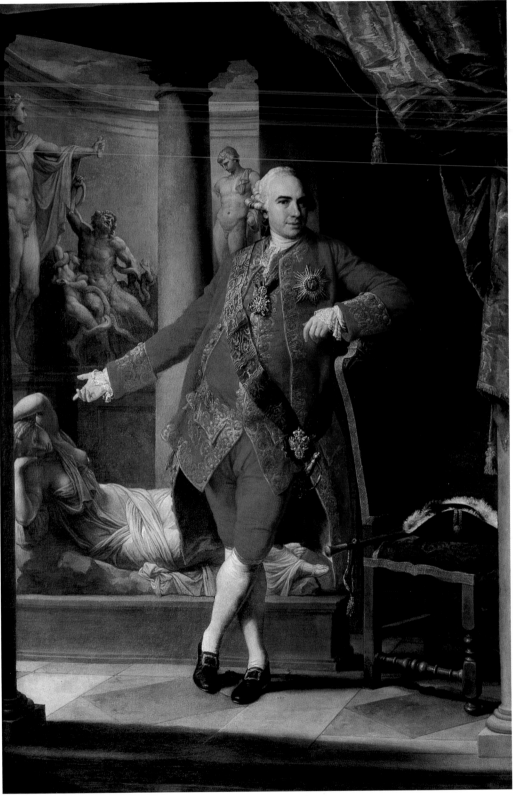

171

be no doubt that they were included at the request of Razumovsky, who presumably was not content with the more general allusions to the taste for the antique which appear in most of Batoni's Grand Tour portraits.

The fame of these antique sculptures among contemporary writers, artists, and connoisseurs was immense. The Vatican *Ariadne* (Museo Pio-Clementino, Rome) is a case in point. The statue was acquired early in the sixteenth century by Pope Julius II and installed as a fountain on an antique marble sarcophagus in the Belvedere courtyard. Later the

"Cleopatra" (as the sculpture was known until the late eighteenth century) was taken to a room adjoining the courtyard and again set up as a fountain in a niche, where it remained until the creation of the Museo Pio-Clementino (Haskell and Penny 1981, pp. 184–87, fig. 96). Batoni capitalized

on the current enthusiasm for the sculpture and employed it in several portraits, notably in that of *Thomas William Coke* (1774; Viscount Coke, Holkham Hall, Norfolk; Clark and Bowron 1985, no. 377), in which the statue's features were associated at the time to those of Louise Stolberg-Gedern, Countess of Albany, wife of the Young Pretender , with whom Coke was said to have had an affair.

Razumovsky's second son, Count Andrey Cyrillovich, was a celebrated Russian statesman, art collector, musician, and patron of music. He served as Russian ambassador to Vienna and, athough retired, as Russia's main representative at the Congress of Vienna in 1814. Friend and maecenas of Beethoven, it is this Razumovsky whose name is associated primarily with the string quartets Opus 59, in which the composer introduced Russian folk themes in his patron's honor. [EPB]

## 172

## Pompeo Batoni

### *The Holy Roman Emperor Joseph II and His Brother Leopold I, Grand Duke of Tuscany*

1769

Signed and dated on table at lower right:
POMP.BATONI.LVCENSIS/ ROMAE. AN. 1769./ DVM PRAESENTES ESSENT. PING.

Oil on canvas

68⅛″ × 48″ (173 × 122 cm)

PROVENANCE commissioned by Maria Theresa, Archduchess of Austria and Queen of Hungary and Bohemia; in the Kunsthistorisches Museum collections from 1824

EXHIBITIONS Vienna 1930, cat. no. 93; Stockholm, Nationalmuseum. *Konstkatter från Wien.* 1948, cat. no. 76; Rome 1959, cat. no. 46; Stockholm 1948, no. 76; Rome 1959, cat. no. 46

BIBLIOGRAPHY Clark and Bowron 1981, pp. 105, 116, fig. 145; Clark and Bowron 1985, pp. 315–17, no. 332, pl. 302 (with documentary references); Ferino-Pagden, Silvia, Wolfgang Prohaska, and Karl Schütz. *Die Gemäldegalerie des Kunsthistorischen Museums in Wien: Verzeichnis der Gemälde.* Vienna: Christian Brandstätter, 1991, p. 29, pl. 186

Kunsthistorisches Museum, Vienna, Gemäldegalerie

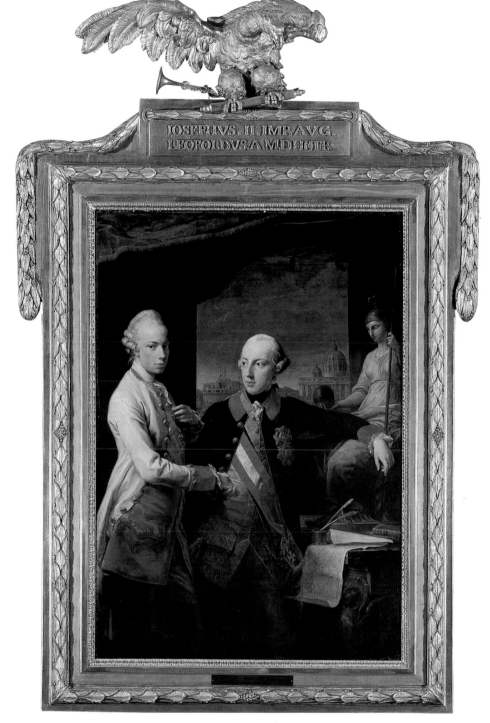

172

One of Batoni's most important portraits of a European sovereign is this image of Emperor Joseph II (1741–1790) and his brother Leopold I, Grand Duke of Tuscany (1747–1792). Joseph was the eldest son of Maria Theresa of Austria and Francis Stephen, Duke of Lorraine, the future Emperor Francis I. After the death of his father in 1765, Joseph became Holy Roman Emperor and was made co-regent by his mother in the Austrian dominions but had little authority. Following his mother's death in 1880, Joseph initiated far-reaching reforms toward the abolition of hereditary and ecclesiastic privileges, and the creation of a centralized and unified state administered by a civil service based on merit and loyalty rather than birth. He initiated a series of fiscal, penal, civil, and social laws intended to establish some measure of social equality and secularity for the masses. In this respect, he was typical of the "enlightened despots" of the eighteenth century, but he differed from other contemporary rulers in the fanatical intensity of his belief in the power of the state when directed by reason.

Joseph II arrived in Rome during the conclave to elect a successor to Clement XIII on March 15, 1769, and resided with his brother at Villa Medici until March 30, when he departed for Naples, returning briefly on April 10 on his way to Vienna. The brothers spent almost all their time visiting the sights of Rome and attended a number of public and private entertainments held in their honor. In spite of their active schedule, Joseph and his brother sat to Batoni in his studio on six consecutive mornings for the portrait. On April 10, following Joseph's return from Naples, he and his brother visited the studio for an hour to examine the por-

trait, and on that occasion presented Batoni with a gold snuff box, a necklace, and a gold medal. The sittings, presents, and "great marks of favour" shown by Emperor Joseph II to Batoni were widely noted, and Father John Thorpe compared the emperor's patronage to Charles V's patronage of Titian (letter to Lord Arundell of April 15, 1769; quoted in Clark and Bowron 1985, p. 317).

The portrait was executed with exceptional speed, and Father Thorpe reported in a letter of June 6 that Batoni's studio was "crowded every day, like a theatre, by persons of all ranks coming to see the picture." The Lucchese envoy in Rome, Filippo Maria Buonamici, reported on June 10, 1769, that the canvas was to be shipped that evening to Florence on its way to Vienna. The following morning, however, the portrait was shown to Clement XIV at the Palazzo del Quirinale. The enthusiastic reception of the portrait by the pontiff and by the visitors to Batoni's studio anticipated the dowager empress's response in Vienna. In September, her envoy in Rome, Baron Saint Odile, presented Batoni with a letter dated July 26, 1769, expressing her pleasure with the portrait, together with a diamond ring and twenty-six gold medals worth 3,000 *scudi*. On April 7, 1770, Saint Odile presented Batoni with a patent of nobility from the empress signed by Chancellor Wenzel Anton von Kaunitz.

Joseph and his brother held a true affection for each other, which Batoni conveyed by means of their clasped hands. The emperor, dressed in a black coat and gold waistcoat, wears the jewel of the order of the Golden Fleece, the sash and star of the order of Maria Theresa, and the star of the order of Saint Stephen. He is shown leaning his left arm on a reduced version of a statue of *Roma*, at the base of which are several books, including Montesquieu's *L'esprit des lois*, writing implements, and a map inscribed *Plan de Rome*. In the distance is a fictitious view of the Castel S. Angelo and St. Peter's. The grand duke, whose likeness is exceptionally finely drawn and sensitive, is shown in a white coat and scarlet waistcoat; he also wears the jewel of the order of the Golden Fleece and the sash of the order of Maria Theresa.

On June 18, 1769, Clement XIV commissioned Batoni to paint a replica of the painting to commemorate the visit to Rome of the two sovereigns. In September he ordered a full-length replica; the fate of these commissions remains unknown, but Batoni presumably produced a replica of sorts, which was used as the model for the mosaic copy today in the Sammlung für Plastik und

Kunstgewerbe, Kunsthistorisches Museum, Vienna, executed in 1772 by Bernardino Regoli on the order of the pope as a gift to Maria Theresa (Clark and Bowron 1985, p. 317, pl. 303). The fame of Batoni's original portrait is confirmed by the nearly two dozen copies of it that exist today in various formats. (For a three-quarter length replica painted by Batoni for Maria Theresa in 1769–70, see Clark and Bowron 1985, pp. 318–19, no. 337; reproduced in Rudolph 1983, pl. 58.)

The Vienna portrait of the Holy Roman Emperor and his brother underscores why, after the 1760s, Batoni emerged as incontestably the most distinguished portraitist in Rome. "Just as Alexander the Great would allow himself to be painted by no artist other than Apelles, so, too, Batoni may take pride in the fact that almost all of the princes and crowned heads who visited Rome in his time were pleased to be portrayed by him," was the opinion expressed by Batoni's contemporary and biographer, Onofrio Boni, in the *Elegio* he dedicated to the artist in 1787 (Boni 1787, p. 47). [EPB]

## 173
## Pompeo Batoni
### *Lady Mary Fox, Later Baroness Holland*

1767–68

Inscribed on the back of the canvas: *P. B. Rome*, and *1767*. Inscribed lower right in a later hand: *Mary/Baroness Holland*.

Oil on canvas

48″ × 36″ (121.9 × 91.4 cm)

PROVENANCE by descent in the family of the sitter at Holland House, London, and at Melbury House, Dorset

EXHIBITION London 1982, cat. no. 25

BIBLIOGRAPHY Steegman 1946, p. 60, no. 45; Ribeiro 1985, p. 107, pl. 64; Clark and Bowron 1985, p. 313, no. 323, pl. 294, col. pl. IX

Private collection, England

The subject of one of Batoni's most attractive portraits of a woman, Lady Mary Fox (1746–1778) sat to the artist on her wedding tour in Italy. She was the eldest daughter of John Fitzpatrick, 1st Earl of Upper Ossory, and Lady Evelyn Leveson-Gower, eldest daughter of John, 1st Earl Gower. In 1766 Lady Mary married the Hon. Stephen Fox, MP, and from 1774 2nd Baron Holland, but she died of consumption in 1778 at the age of thirty-two, leaving two children. Called "the most amiable person that ever lived" and praised for her elegance, she was highly admired by Horace Walpole (Walpole 1937–74, vol. 33, p. 22).

In the fall of 1766 Lady Mary and her new husband traveled overland

173

from Marseille to Naples with his mother, his younger brother Henry, and his cousin Clotworthy Upton. In Naples they joined his father, Lord Holland, his younger brother Charles, and his cousin Lord Offaly. According to his mother, Stephen suffered from deafness and shyness and his size was "enormous," but Lady Mary, on whom Stephen doted, grew "more amiable every day" (Ingamells 1997, pp. 378–79). At the end of February 1767 Lady Mary and Stephen left the rest of the party in Naples, intending to see Venice, Genoa, and Livorno (Ingamells 1997, pp. 378–79). The couple arrived in Rome early in March 1767 and stayed there long enough for Lady Mary to sit for her portrait to Batoni and to make the acquaintance of Piranesi, who later dedicated to her a plate in the *Vasi, candelabri, cipri, sarcophagi* (1778).

Batoni's reputation for dilatoriness is a dominant and recurring theme in accounts of his work. "He never keeps his promise," lamented Sir Horace Mann to Horace Walpole (Walpole 1937–74, vol. 22, p. 255), and certainly the time Batoni required to complete a painting varied widely. Batoni's sitters frequently had to leave Rome without their portrait in hand and to prod the artist to finish it. In spite of the

inscribed date of 1767 on the reverse of the canvas, the portrait apparently remained unfinished after the sitter had returned home from Italy. In an an undated letter, written from Rome before January 7, 1769, Gavin Hamilton mentioned the painting to Lady Mary's father: "Agreeable to your Lordship's desire I have desired Sigr Barazzi [Francesco Barazzi, the Roman banker] to speak to Pompeo to induce him to finish immediately Lady Mary Fox's portrait, we have accordingly his solemn promise to deliver it finished in a few days and hope he will be as good as his word." Batoni kept his word, and Gavin Hamilton was able to write again on January 7, 1769, referring to the dispatch of Batoni's portrait of Lady Mary (information from Sir Brinsley Ford; Clark and Bowron 1985, p. 313).

Lady Mary is shown before a russet curtain holding a spaniel, of the sort that appears to be an early ancestor of what is known in England as the King Charles spaniel. She wears a gray traveling costume called a German habit or Brunswick. This was adapted from male riding clothes and consisted of a jacket, here fitted to her body, and a skirt, usually of a matching fabric, in this case a gray silk. With its wrist-length sleeves and hood, this is a prac-

tical and yet feminine costume. It has pink and white striped ribbons at the elbow, and ruched decoration, pinned into the lace jabot at the neck, and trimming the lace headdress. By the middle of the century such costumes had replaced for English women travelers the earlier, more masculine riding dress. This type of attire is, however, unique in Batoni's work, and is only rarely portrayed by other artists, the exception being Francis Cotes in a number of portraits of the 1760s.

In his portraits of British women, Batoni generally discarded the usual Grand Tour trappings, and the presentation here is simple and direct. The portrait is very English in feeling, perhaps coming closest in its reticence and delicacy, both of coloring and of mood, to the female portraits of Allan Ramsay (who had spent time in Batoni's studio as a young painter). Indeed, English prototypes were clearly in Batoni's mind at this period, for his portrait of *Georgiana, Countess Spencer* (1764; The Earl Spencer, Althorp, Northamptonshire; Clark and Bowron 1985, no. 269) is closely modeled on a composition by Thomas Hudson. [EPB]

## 174
## Pompeo Batoni
### The Appearance of the Angel to Hagar in the Desert

1774–76

Signed and dated on rock at lower right:
POMPEO DE BATONI/ P. ROMAE. 1776

Oil on canvas

39⅛" × 59⅛" (100 × 151 cm)

PROVENANCE commissioned by Father John Thorpe for Henry, 8th Lord Arundell; thence by family descent at Wardour Castle, Wiltshire; sale, Christie's, May 20, 1953, lot 142; purchased in London by the Galleria Nazionale d'Arte Antica in 1953

EXHIBITIONS Rome 1959, cat. no. 52; Paris 1960, cat. 61; Lucca 1967, cat. no. 55; Leningrad, The State Hermitage Museum. *Pittura italiana del Settecento*. 1974, cat. no. 1; London 1982, cat. no. 53

BIBLIOGRAPHY Clark and Bowron 1981, p. 106, fig. 131; Rudolph 1983, pl. 62; Clark and Bowron 1985, pp. 341–42, no. 396, pl. 357, col. pl. XIV

Galleria Nazionale d'Arte Antica, Palazzo Barberini, Rome

Henry, 8th Baron Arundell (1740–1808), was, according to Horace Walpole, "a devout Catholic Lord" (Walpole 1937–74, vol. 21, p. 309), and this must account for the unique collection of religious compositions and portraits by or after Batoni that he assembled over the years. He visited Rome in 1759, and subsequently acquired for Wardour Castle, in addition to the present painting, an oil sketch for the high altar of the

174

Oratorian church of S. Maria della Pace, Brescia (Clark and Bowron 1985, no. 4); a copy by Vincenzo Robigliard after the full-length portrait of *Senator Abbondio Rezzonico* (Clark and Bowron 1985, no. 297); and other works that he believed to have been painted by Batoni. Lord Arundell's agent in Rome was Father John Thorpe, whose correspondence is an important source of information concerning Batoni's artistic activity from 1769 until 1787 (Ingamells 1997, pp. 939–42). Father Thorpe's negotiations with the artist on behalf of his patron were frequently difficult, and the fate of certain commissions, for example a pair of ancestral portraits that Lord Arundell wanted copied, remains unknown.

*The Appearance of the Angel to Hagar in the Desert* is one of Batoni's rare subject pictures to have entered a British collection during the artist's lifetime— although British collectors readily purchased religious pictures by Old Master painters, only a Catholic patron would have commissioned such a large-scale religious work from a contemporary artist. The other history paintings commissioned by British patrons from Batoni, for example, mostly represent subjects from classical history and mythology— *The Sacrifice of Iphigenia* (cat. 163), *Hector's Farewell to Andromache, Diana and Cupid,* and *Bacchus and Ariadne* (Clark and Bowron 1985, nos. 222, 235, 353).

Batoni appears to have turned his attention fully to the commission in 1774, when Father Thorpe reported in a letter of March 21 that, following the artist's recovery from a brief illness, a

sketch had been begun. He had previously advanced Batoni some money on account, and, according to the contract, he expected the painting to be finished within eight months: "His agreement is to paint a picture representing Agar her son & Angel in a country scene of 6 palms long and 4 high which is 4½ feet by 3 do Eng. measure for the sum of two hundred sequins about a hundred pounds." Father Thorpe informed Batoni that, if the painting were delivered within the allotted period, Lord Arundell would order a companion picture. Thorpe requested Batoni to suggest a subject and then proceeded himself to recommend "Jacob's bargain with old Laban for his fair daughter Rachel" (information from Brinsley Ford Archive; Clark and Bowron 1985, p. 341).

The painting was evidently in progress by May 1774, but delays continued, and Lord Arundell was informed by his agent on March 18 of the following year: "Your Agar … unfinished, and if Batoni goes to the Vatican to paint the Pope [Pius VI], she may prolong her weeping, for he will then have an excuse for neglecting her, which admits of no reply" (Clark and Bowron 1985, p. 342). The painting was still unfinished a year later when Thorpe wrote on May 11, 1776, that he had considered a request "to have something changed in Agar, which however as it may not displease other eyes I shall not attempt to disturb" (Clark and Bowron 1985, p. 342). On July 13 he informed Lord Arundell: "Pompeo once again has not kept his promise of finishing Agar before the end of June; however, there

is strong assurance of his doing it before August and be at an end; because now he is to paint some part of it every week, on condition of receiving 30 or 40 crowns each week that he does so. He hitherto keeps his word & & the picture begins to come on admirably" (Clark and Bowron 1985, p. 342). The elaborately finished canvas was completed before September 1776 and proved to be one of the most elegant and refined of Batoni's late subject paintings.

Batoni had proposed *The Sacrifice of Abraham* "as a proper companion to the Agar," (Clark and Bowron 1985, p. 342) but in the end the negotiations for a pendant fell through. Father Thorpe had suggested the Old Testament subject of the Return of the Prodigal Son, but Batoni objected, "because the son must be an emaciated figure, & meanly clad. The drapery of the old father must also be [illegible]. The whole scene affords him no place for brilliancy of coloring; he proposes the Sacrifice of Abraham, or Pharoah's daughter finding Moses. Your Lordship has a fine piece of the first subject by Poussin, & it is not a history that becomes agreeable by being too often repeated" (Father Thorpe to Lord Arundell, November 20, 1776; quoted in Clark and Bowron 1985, p. 342).

The following year Father Thorpe observed Batoni's reuse of the model for Hagar in a similar pose in *The Preaching of Saint John the Baptist* (1777; S. Antonio Abate, Parma; Clark and Bowron 1985, no. 397) and informed Lord Arundell, "Your Lordship's Agar—but without her tears—is

introduced in the Altarpiece going to Parma, & is the most engaging figure in it" (letter of December 10, 1777; quoted in Clark and Bowron 1985, p. 342).

Batoni painted another picture for Lord Arundell that remained untraced until its acquisition in 1998 by The Art Institute of Chicago, *An Allegory of Peace and War*. The painting was described by Father John Thorpe in the postscript to a letter of September 24, 1776, to Lord Arundell: "[Pompeo] has finished his picture of two figures representing Peace & War: it is surely a masterpiece, & shows powers perhaps superior to any master who ever painted at his time of life: it has all the perfection & brilliancy of his best & favourite performances" (Clark and Bowron 1985, p. 369). [EPB]

## 175

### Pompeo Batoni

*The Holy Family with Saint Elizabeth and the Infant Saint John the Baptist*

1777

Signed and dated on the hem of Saint Elizabeth's dress: POMPEO DE BATONI PINXIT ROMAE 1777

Oil on canvas

89″ × 58⅞″ (226 × 149.5 cm)

PROVENANCE bought from the artist in 1782 by Grand Duke Paul I of Russia for 1500 zechini; presumably given by him to Catherine II, probably in 1783; transferred to the Hermitage in 1789

BIBLIOGRAPHY Boni 1787, p. 49; Waagen, G. F. *Die Gemäldesammlung in der Kaiserlichen Ermitage zu St. Petersburg*. Munich: F. Bruckmann, 1864, p. 98, n. 326; Somof, A. *Ermitage Impérial: Catalogue de la Galerie des Tableaux*. St. Petersburg: La Companie d'Imprimerie artistique, 1899, vol. 1, p. 20, no. 326; Voss 1924, pp. 413, 648; Emmerling 1932, pp. 114–15, no. 88; Fomicieva, Tamara. "Paintings by Pompeo Batoni in the Hermitage [text in Russian]." *Trdy Gosudarstvennogo Ermitazha*, vol. 1 (1956), p. 90–91, fig. 9; Tischbein, Johann Heinrich. *Aus meinem Leben*. Edited by Kuno Mittelstädt. Berlin: Henschelverlag, 1956, p. 0246; Antonov 1977; Clark and Bowron 1985, pp. 342–43, no. 398, pl. 360

The State Hermitage Museum, St. Petersburg

By the middle of the eighteenth century Batoni's paintings of biblical, allegorical, and mythological subject matter had become too expensive for the average wealthy visitor to Rome, and such pictures were acquired almost exclusively by the Church, European sovereigns, and visiting nobility, as well as the occasional British Grand Tourist. The Hermitage *Holy Family* is among these late paintings acquired by patrons of exceptional means and one of the loveliest works of the artist's maturity. Having established a basic style in his subject pictures of the 1740s, Batoni only

175

gradually modified his art as he grew older. During the next three decades he slowly progressed toward the pictorial qualities of his late style, a development that is readily evident in a comparison between the *Wedding of Cupid and Psyche* (cat. 167) and the St. Petersburg *Holy Family*. The charming, idealized setting of the earlier mythology, its deliberate prettiness, and refinement of ornament and draftmanship, have been transformed in the later work by a powerful undertone of restraint and gravity. Not only has the composition become simpler and narrower in depth, dominated by verticality, and the forms more faintly colored, but the opulence and sumptuousness are restrained, the handling is softer, and the incidental pictorial effects subdued. The increasing elongation of Batoni's figures, the "intense, almost tottering spiritualization" that Anthony Clark observed (Clark and Bowron 1981, p. 111), marks the flowering of a quite new personal style and imparts to the *Holy Family* a monumentality that was unique in Rome at the time. Like Batoni's other great

works from about the same period, such as *Alexander and the Family of Darius*, commissioned by Frederick II in 1763 (1775; Bildergalerie, Sanssouci; Clark and Bowron 1985, no. 382), the *Holy Family* is especially noteworthy for the treatment of expression and movement in the individual figures.

The painting was described by the Jesuit priest and antiquarian Father John Thorpe in a letter of December 10, 1777, from Rome to his patrol, Henry 8th Baron Arundell:

[Pompeo's] Holy Family is his own & every one's favorite piece. It is indeed a fine picture, & at his age to be done with so much freedom of pencilling and brilliancy of colour, is a surprising performance. All the figures are as large as life & composed with more dignity than is observed in most paintings of this subject by the greatest masters. This picture is, as he says, made for his own keeping, like the other of Peace & War [1776; The Art Institute of Chicago]. Thus whoever will

purchase them must pay more than a high price. (Clark and Bowron 1985, p. 343)

Batoni's contemporary and biographer Onofrio Boni described the Hermitage painting as a pendant to *The Marriage of Saint Catherine with Saint Jerome and Saint Lucy* (1779; Palazzo del Quirinale, Rome; Clark and Bowron 1985, no. 421), which remained unsold and in the possession of the artist's heirs until at least 1802. Cracas reported the purchase of the *Holy Family* for the enormous sum of 1500 *zecchini* by Grand Duke Paul, later Emperor Paul I, at the time he sat to Batoni for his own portrait in March 1782 (Clark and Bowron 1985, no. 431), remarking that all of the "connoisseurs" who had seen the canvas found it to be the most beautiful painting the artist had made to date (Chracas, *Diario Ordinario di Roma*, March 23, 1782, no. 754, pp. 3–5; see also Clark and Bowron 1985, p. 343). The commission for the portraits of the grand duke and his wife, Maria Feodorovna, was arranged through the collector and connoisseur Prince Nikolay Yussupov, who had acted as agent for Catherine II in Italy and bought or commissioned for Russia many paintings from contemporary artists. He was surely responsible for advising the grand duke to acquire the *Holy Family* from Batoni, but the failure to acquire the pendant *Marriage of Saint Catherine*, which was also in the artist's studio at the time, is unexplained.

A black chalk study for Saint Elizabeth reaching upward to take the Christ Child in her arms is in the Staatliche Graphische Sammlung, Munich (Clark and Bowron 1985, p. 384, no. D140, pl. 359). The painting was engraved by James Walker in 1788 with a dedication to Empress Catherine II. [EPB]

## MARCO BENEFIAL
### ROME 1684–1764 ROME

Benefial was born in Rome into a family of French origin. His mother, Maria Mattei, was Roman and his Gascon father, Francesco, was a *velettaro* or weaver of lightweight fabrics (Petraroia 1980, p. 372, n. 7–8). Giovanni Battista Ponfredi, first Benefial's pupil and subsequently his biographer, wrote that from around 1698 to 1703 the young Marco studied painting under Ventura Lamberti da Carpi, a former pupil of the Bolognese painter Carlo Cignani, with whom he collaborated in the creation of decorative work for the cupola of the Cappella del Sacramento in St. Peter's (Bottari and Ticozzi 1822–25, vol. 5, pp. 5–39; Petraroia 1980). None of the works mentioned by sources regarding his early Roman activity has survived. Only the design for a competition at the Accademia di S. Luca (1702) documents this early stage of his career. From 1711 he collaborated with the painter Filippo Germisoni, a partnership in which according to Ponfredi, almost all the paintings were by Benefial (including *The Vision of Saint Nicholas*, formerly in S. Nicola ai Cesarini, and, after the demolition of the church, in the Carmelite convent of S. Alberto).

Benefial is chiefly notable for his innovative power and rigor, and he stands outside the stylistic trends and schools of the time. Similarly, the earliest of his remaining works, executed during the second and third decades of the century, and in which Benefial's Bolognese cultural origins are dominant, are never the dull reworkings of Maratti's vision that were so common during the first twenty years of the century. These works include *The Martyrdom of Saint Saturninus* for the church of Ss. Giovanni e Paolo (1716); *Jonah* for St. John Lateran (1718), which won him the title of Cavaliere; *The Virgin Offering the Child to Saint Anthony of Padua* (1718), formerly in S. Giovanni a Porta Latina and now in the modern monastery of the Turchine; and the *Mater Dolorosa with Angels Bearing the Symbols of the Passion* (1721) in the monastery of S. Maria dei Sette Dolori. From the knowledge gained from Lamberti and the legacy of Carlo Maratti, Benefial returned instead to the origins of the great classical and Baroque traditions, from the Carracci to Lanfranco and from Guercino to Andrea Sacchi. This is exemplified in the two lunettes of S. Maria delle Fornaci (*The Preaching of Saint John the Baptist* and *The Beheading of Saint John the Baptist*), where the ideas expressed by Sacchi in his cycle in the baptistry of St. John Lateran are reinterpreted with passion and vigour, and characterized by an interaction of authentic-

ity and tradition. This has led Benefial's work to be described—not always opportunely or consistently—as a precursor of Neoclassicism, or even nineteenth-century Realism. In reality, as shown by recent critical works, including those of Anthony Morris Clark (Clark 1966) and Giorgio Falcidia (see the bibliography), he was neither a forerunner of Neoclassicism or other revolutionary stylistic trends nor a simple receiver of academic formulae (another characterization). Rather, he was a tireless experimenter, continuously seeking a direct relationship between the great legacy of the pictorial tradition and the truth of objects and events represented. This unflagging commitment to experiment and artistic inquiry is evident in looking at Benefial's artistic development chronologically, from the four canvases on the subject of Christ in Monreale (church of the Crocefisso, commissioned in 1722 by Archbishop Francesco Giudice, then residing in Rome, and *in situ* from 1724 to 1727) to the three paintings for the church of the Ospedale di S. Gallicano in Rome (1725–26), to the *Scenes from the Life of Saint Lawrence* for the cathedral of Viterbo (c. 1720–27; partially lost but also documented by the related sketches in the premises of the Cassa di Risparmio). Other particularly notable examples include the chapel dedicated to Saint Margaret of Cortona in S. Maria in Aracoeli in Rome (*Margaret of Cortona Finding the Body of Her Lover* and *The Death of Saint Margaret of Cortona*, 1729–32).

After his early collaboration with Germisoni, it is not clear why, at the end of 1718, Benefial formed a second artistic partnership, this time with the painter Filippo Evangelisti, a protégé of Cardinal Piermarcellino Corradini. This partnership, puzzling since Benefial himself was valued and protected by the Pamphili family, lasted until 1754 and because of the agreement to an 'equal partnership' many of Benefial's Roman works were for a long time credited to his less gifted companion. This is clearly not the case for the paintings executed for or in other cities, such as *The Ecstasy of Saint Francis* (1723) for the Capuchin church of Bagnoregio, the *Sibyls* frescoes in the Palazzo Chigi-Zondadari in Siena (1733), *The Miracle of Saint Fiorenzo* in the collegiata of Fiorenzuola d'Arda (1741), the frescoes of the Palazzo Massimo in Arsoli (1749), or those, distinguished by a singular, intense, crude naturalism, in the cathedral of Città di Castello (1747–49). *The Virgin of the Carmine Giving the Scapular to Saint Simon Stock*, sent from Rome to Savignano (Forlì), which shows a luminous, refined range of colors, is from 1740. Two other works are perhaps contemporary with this:

the monumental, exalted *Assumption with Saint Terence and Saint Mustiola* from the Pesaro Cathedral and the outstanding *Saint Matthew Baptizing the Queen of Ethiopia* in S. Matteo in Pisa. Other important religious works include *The Death of the Blessed Giacinta Marescotti* (1736; see cat. 320), *The Vision of Saint Catherine Fieschi Adorno of Genoa* (1737; cat. 178), *The Martyrdom of Saint Agnes* (1750; S. Trinità degli Spagnoli, Rome), and *The Vision of Saint Anthony of Padua* (1755; S. Filippo, Macerata), all of them distinctive, dramatic works. A similar vitality can be seen in Benefial's historical, mythological, and biblical subjects, such as *The Massacre of the Innocents* (1730; Gallerie, Florence), *The Expulsion of Athaliah* (Galleria Nazionale d'Arte Antica, Rome), *Hercules and Omphale*, *Pyramus and Thisbe* (cat. 177), *Adam and Eve before God* (cat. 179), and *Adam and Eve Cast out of Paradise* (all Galleria Nazionale d'Arte Antica, Rome), as well as in his prolific and varied series of portraits. In addition to the two self-portraits in the Uffizi and Faldi collections (which clearly inspire the bust sculpted in 1784 by Vincenzo Pacetti for the Pantheon, today in the Capitoline Protomoteca), these include *The Orsini Family* (1746; Museum of Rome), *The Princess Giacinta Ruspoli Marescotti Orsini* (Fondazione Cini, Venice), and the disconcerting and long misunderstood *Missionary's Family* (Galleria Nazionale d'Arte Antica, Rome).

The 1740s were probably Benefial's most productive years. In 1743 he was admitted to the Accademia dell'Arcadia with the name of Distanio Etneo, and this association may have served to strengthen his relations with the great families of the Roman aristocracy—the Orsini, Ruspoli, and Massimo. He also was commissioned to create frescoes (*The Apotheosis of Hercules*, 1744) for the Sala Regia in the Palazzo di Spagna (lost but known by one study now in Philadelphia [Hiesinger and Percy 1980, p. 41, no. 28]). Benefial's relations with the Roman academic environment, however, were less friendly and, despite his prestige and fame, it was not until 1741 that he was admitted to the Accademia di S. Luca. Moreover, in 1755 he was expelled from this group because of his contemptuous attitude towards his colleagues.

In the last decade of his life, blindness made it impossible for Benefial to paint, and he was supported by a sole patron and main collector, Count Niccolò Soderini, who had an entire room in his own palace dedicated to Benefial's works, around the "magnificent self-portrait by the artist himself" (Chracas, *Diario Ordinario di Roma*, November 16, 1782, no. 822). He had his own school, also frequented by the young Mengs. His students included

Giuseppe Duprà, John Parker, Giovanni Battista Ponfredi, Ermenegildo Costantini, and Pietro Labruzzi. [LB]

BIBLIOGRAPHY Soderini, Niccolò. *Lettera di un amico ad un Accademico di S. Luca, sopra alcuni decreti di quell'Accademia contro al sig. cav. Marco Benefiale Romano*. Livorno, Italy 1757; Bottari and Ticozzi 1822–25; Paponi 1958; Falcidia 1963; Falcidia 1964; Paolini 1965; Borea 1966; Clark 1966; Calbi 1978; Falcidia 1978; Petraroia 1980; Falcidia 1983–84; Barroero 1990, "Benefial"; Calbi 1994; Sestieri 1994; Rangoni 1998

## 176
## Marco Benefial
### *The Vision of Saint Philip Neri*

1721
Signed on the arched lintel of the doorway at the right: MARCI/BENEFIAL. F
Oil on canvas
39⅜" × 25⅝" (100 × 65.1 cm)
PROVENANCE purchased in 1721 in Rome by the Abate Domenico Martelli; inherited by Paola Martelli in 1950; sold (after 1963) on the antiques market
BIBLIOGRAPHY Clark 1966, pp. 23, 26; Clark and Bowron 1981, pp. 72–73, 76; Fagiolo, Marcello, and Maria Luisa Madonna, eds. *Roma 1300–1875: l'arte degli anni santi*. Milan: Arnoldo Mondadori 1984; Civai 1990, pp. 74, 99, n. 13; Calbi 1994, p.33
Private collection, England

It is due to Anthony Clark that this painting has been brought to the attention of the public as an example of the "manners and methods" used by Benefial for his oils on canvas examined. It can be considered a masterpiece of the early eighteenth-century Roman school, with its "graceful and good color … , poetry… delicate and very strong" (Clark and Bowron 1981, p. 73). The Abate Domenico Martelli (1672–1753: son of the senator Nicolò Martelli and Teresa Gerini) bought the painting from the artist, and it is first recorded in his picture gallery as "The Ecstasy of Saint Philip Neri with many figures four *palmi* high" on December 30, 1721 (Civai 1990, pp. 74, 99, n. 13). It was the first of Benefial's works to be acquired by this high-ranking prelate, who came from an ancient and renowned Florentine family, and lived in Rome almost uninterruptedly from 1698 to his death. (Martelli also acted as artistic advisor to Violante of Bavaria and Gian Gastone de' Medici; information on him and his collections can be found in Civai 1990, pp. 73–81, and Rudolph 1995, p. 146.) Other paintings by Benefial acquired by Martelli and meticulously recorded in his documents include the *Saint Joseph with the Infant Jesus* (1721), *Flora* (also 1721; possibly alluding to the Arcadian *alias* Floralgo), and *Pallas* and *Venus* (these works "of three spans" were acquired

176

in 1724). Also commissioned on behalf of his brother Bishop Giuseppe Maria was a large *Death of Saint Joseph* (1722), which is still in the family's palace in Florence, with a *Noli me tangere* (1741), inscribed with the artist's name. Besides the works by Benefial (which Martelli clearly held in high esteem), the collection contained paintings of landscape and figures by the most important artists of the Roman school, including Chiari, Luti, Van Bloemen, Conca, Costanzi, Bianchi, Locatelli, Paolo Anesi, Luigi Garzi, Giaquinto, Masucci, Van Wittel, Van Lint, and Michele Rocca. This collection of contemporary works began with two large architectural views by Viviano Codazzi, which he inherited from his cardinal uncle (1717) and was probably well known in Rome before it was moved to the residence in Florence in 1753; the *Saint Philip Neri* remained in the family collection until 1950. Despite the evidence of the signature of Benefial, it was subsequently attributed to Pietro da Cortona and was inherited by Paola Martelli, a cloistered nun in the Benedictine convent of Civitella San Paolo, near Rome. On her death (1963) the painting was sold on the antiques market (Civai 1990, p. 99, n. 13) and was believed to have been lost, but in the meantime it had been acquired by the current owner, who, as Anthony Clark remarks, attributed it to Benefial even before cleaning revealed the artist's signature (Clark and Bowron, 1981, p. 78, n. 12). The help of Edgar Peters Bowron is gratefully acknowledged here for having discovered that this painting was part of the Martelli collection, and this information has been crucial for the reconstruction of its history.

Biographies of Saint Philip Neri go into lavish detail about the numerous apparitions of the Virgin Mary to him during the celebration of mass, while praying in his room, and when he was ill. Benefial's painting seems to want to evoke all these apparitions and for this reason it is quite different to the numerous other versions of this subject. The event shown in the foreground took place in the Roman church of S. Girolamo della Carità, where Saint Philip lived before S. Maria in Vallicella was built. According to the detailed account that can be read in the *Acta sanctorum*, while celebrating Mass, Philip levitated several feet into the air and a little girl immediately turned to her mother and exclaimed that the man was possessed by the devil ("Arreptitium hominem istum opinor!"). Her mother told her to be quiet: this was a saint in ecstasy ("Vir sanctus est, atque extasim patitur"; see "Vita II S. Philippi Nerii," *Acta Sanctorum XIX, Maii VI* [Paris and Rome: Victorem Palme, 1866], p. 584, paragraph 359). Benefial includes characters who are alleged to have witnessed his visions, such as Cardinal Cesare Baronio (the prelate praying, behind whom some Oratorians appear) and gentlemen who are devout followers of the saint (the biographies record Fabrizio Massimo and Francesco della Molara, among others). A lady dressed in dark clothes, possibly Anna Borromeo, is almost a full portrait, while the servant bears a clear resemblance to Francesco Maria Tarugi, the founder of the Congregation of the Oratory with Philip Neri. Unlike the depictions of ecstasy in famous paintings by Guido Reni, Guercino, and Pietro da Cortona (all in S. Maria in Vallicella) in which the saint is alone in the presence of the divine apparition—in the fresco by Pietro da Cortona the only other figures are Oratorians, peering through a door standing ajar—and which Benefial certainly knew, this painting is treated as a public and choral event. The lively "orchestra" of angels is a clear allusion to the *oratorio* (sacred musical drama) and to the many occasions in which Philip Neri "listened to angelic music," as described in the description of a painting by Cristoforo Roncalli in the church of the Vallicella. To these supernatural manifestations the portrait-like features provide a vivid historical account that has nothing in common with the more stereotyped "vision" as painted by Conca or Tiepolo. This vein of realism certainly influenced the work of artists in Rome who were overt realists, such as Pier Leone Ghezzi, but even the more traditional artists of classical leanings, such as Placido Costanzi, in his *Miracle of Saint Joseph of Copertino* (Galleria Nazionale d'Arte Antica, Rome), for example, shows awareness of Benefial's *Saint Philip Neri*, which is probably due to the fact that his paintings were also part of the collection at that time (Pio [1724] 1977, p. 195, specifically mentions that Costanzi was active "for Cardinal Martelli's nephew").

A comparison with the "account'" of another vision, the *Saint Catherine Fieschi Adorno of Genoa* (cat. 178), painted sixteen years later, shows great mastery of expressiveness even at this early date of 1721 by the twenty-seven year old "cavaliere," who—despite the respect in which he was held—was obliged to share work with Filippo Evangelisti. This painting shows affinities with Luti, Trevisani, Conca, and Mancini (masters whose works were also displayed in the collection of the Abate Martelli), though Benefial's work is just as good if not superior to theirs, as Anthony Clark remarks (Clark and Bowron 1981, p. 73). Clark also praises the technical skill and use of color: luminous blues and warm tones of red and gold, which convey the splendour of the vision and the spontaneous evocation of the celebration of mass. [LB]

## 177
## Marco Benefial
### *Pyramus and Thisbe*

1730–40
Oil on canvas
85¼" × 53⅛" (218 × 135 cm)
PROVENANCE collection of Count Nicolò Soderini; Torlonia donation, 1892
EXHIBITION Chicago, Minneapolis, and Toledo 1970, cat. no. 72
BIBLIOGRAPHY Bottari and Ticozzi 1822–25, vol. 15, p. 15; *Piccola guida artistica del Palazzo di Montecitorio*, 1930; Falcidia 1966; *Palazzo Montecitorio* 1967, pp. 3, 397; Maxon and Rishel 1970, p. 176, no. 72; Mochi Onori 1988, p. 47; Sestieri 1994, vol. 1, p. 26; Vodret 1994, p. 396
Galleria Nazionale d'Arte Antica, Palazzo Barberini, Rome

The painting, with its companion piece *Hercules and Omphale* (Galleria Nazionale d'Arte Antica, Rome) belonged to Count Niccolò Soderini, whose collection is described by Ponfredi in 1764 (Bottari and Ticozzi 1822–25, vol. 5, p. 26). It is not clear whether Benefial executed the painting for him directly or whether the count acquired it later. Soderini was the maternal uncle of the Marchese Camillo Massimo, and commissioned Benefial to paint the vault of the salon of the Palazzo Massimo at Arsoli (a sketch for this vault is listed in the Soderini inventory). He defended the artist when he was expelled from the Accademia di S. Luca, and was probably the anonymous author of a *Lettera apologetica*, probably published in 1756, contesting the decision (Petraroia 1980, p. 37, n. 3–4). Soderini owned several of Benefial's paintings: about thirty, according to his inventory (1779). The *Diario Ordinario di Roma* records that "in the Palazzo Astalli under the Aracoeli we observed the open aristocratic apartment of Monsignor Soderini … whose large chamber is decorated with pictures by the celebrated painter Cavaliere Benefial; in the middle of the room is the artist's

177

magnificent self-portrait" (Chracas, *Diario Ordinario di Roma*, November 16, 1782, no. 822). Nearly all of these works became the property of the Torlonia family and are mentioned in their inventory from 1814 (Vodret 1994). They subsequently entered the collection of the Galleria Nazionale d'Arte Antica in 1892. Both *Hercules and Omphale* and *Pyramus and Thisbe* were given on consignment to the Camera dei Deputati in the Palazzo di Montecitorio. Only after 1980 were they returned to the Palazzo Barberini.

The stories of Pyramus and Thisbe and Hercules and Omphale are both treated as allegories of love: the former shows death as a result of love, while the latter depicts the triumph of love over force. The tragic tale of Pyramus and Thisbe—recounted in Ovid's *Metamorphosis*—was often depicted in paintings in which the story of the young lovers takes on a color of languid eroticism. Examples include works by Gregorio Pagani

(Uffizi, Florence) and Jacopo Vignali (Rospigliosi collection, Pistoia) in the early seventeenth century and by Pietro Bianchi in the eighteenth (Sestieri 1994, vol. 2, fig. 109). The story, a kind of *ante litteram* Romeo and Juliet, tells of two young Babylonians who belong to warring families and are thus forced to meet secretly outside the walls of the city. Thisbe, arriving at the meeting place first, is attacked by a lioness and flees, dropping her cloak. Pyramus, finding only her bloodstained cloak and thinking her dead, kills himself with his own sword. Like all the other painters who treated the subject, Benefial portrays its conclusion, when Thisbe, returning to the original trysting place, pulls out the sword from the breast of her dying lover and lets herself fall on it, plunging it into her heart. The blood of the two unfortunate lovers turns the berries of the mulberry tree a dark red. Two cupids provide a commentary on the event,

one overturning the torch—the classical symbol of death—the other lifting up the bloodstained cloak, the discovery of which has caused the tragedy.

Benefial was apparently aware of Pagani's treatment of the story. This is shown by the setting, with the cypress trees in the background, as well as by the relationship between the figures, which have obviously lost any late Mannerist contrivances, to give life to a more 'classical' representation (Clark correctly mentioned Guido Reni here). No preliminary drawings have so far been located for *Pyramus and Thisbe*, although two are known for the *Hercules and Omphale* (Cleveland Museum of Art, TR 11136/63; see Maxon and Rishel 1970, p. 176, no. 72; for the finished study for the figure of Hercules, now in the Cabinet des Dessins in the Louvre, see Falcidia 1966, p. 68; Legrand and d'Ormesson-Peugeot 1990, p. 115, no. 117). A very beautiful reclining nude today in Berlin may be seen as a first idea for the figure of Pyramus, although it may have been intended for the lover of Saint Margaret of Cortona in the Boccapaduli Chapel (Van Dooren 1989, no. 203). This also seems to confirm the dating suggested by Clark for this canvas (1730–40), as does the similarity—allowing for differences in technique—between the figure of Thisbe and the frescoed *Sibyls* of 1733 in the Palazzo Chigi-Zondadari in Siena. [LB]

## 178
## Marco Benefial
## *Vision of Saint Catherine*
## *Fieschi Adorno of Genoa*

1737
Signed on the bottom right, on the footstool: EQ.ES MARCVS BENEFIAL
Oil on canvas
78¾" × 115¾" (200 × 294 cm)
PROVENANCE collection of Cardinal Neri Maria Corsini; acquired for the Italian State in 1883
EXHIBITION Rome 1997, cat. no. A54
BIBLIOGRAPHY Voss 1924, p. 641; Falcidia 1964, p. 20; Falcidia 1978, p. 38; Magnanimi 1980, p. 105; Rudolph 1983, fig. 71; Barroero 1990, "Benefial," p. 621; Casale 1990, pp. 553, 564, 575, fig. 818; Sestieri 1994, vol. 1, p. 26; Borsellino 1996, p. 47, fig. 24; Casale 1997, p. 140, fig. 24; Fagiolo 1997, p. 248, no. A54
Galleria Corsini, Rome

Caterina Fieschi was born and lived in Genoa, where she died in 1510. She belonged to one of the most important families of the city (her father, Giacomo, was viceroy of Naples under Robert d'Anjou). Married to the nobleman Giuliano Adorno, she was celebrated for her beauty, intelligence,

and culture, gifts that made her a prominent figure in Genoese high society. On March 20, 1473, at the age of twenty-six, following a visit to her sister, a nun at the church of S. Maria delle Grazie, she had a vision of Christ carrying the cross. In her own autobiography, she wrote that it appeared as if the entire house was flooded with the blood that poured from his wounds. Her life changed radically after this event. She dedicated herself to works of compassion, especially to helping the sick, and wrote several important spiritual treatises. She was canonized by Pope Clement XII on June 16, 1737, along with saints Vincent de Paul, Jean-François de Régis, and Giuliana Falconieri.

Benefial's painting, which depicts the moment when Christ appears to the noblewoman, was executed for the supporter of the canonization, Cardinal Neri Maria Corsini, nephew of the pope. The work is now displayed in the Galleria Nazionale d'Arte Antica along with the collection given to the Italian government by Prince Tommaso Corsini in 1883 (Alloisi 1984; Borsellino 1996). It is mentioned for the first time in an inventory of the Palazzo Corsini in 1750 (Magnanimi 1980, p. 106, no. 221). At that time the cardinal had other pictures by Benefial: a *Saint Andrew Corsini* (bequeathed to him by the will of the Sienese Cardinal Pier Maria Pieri, and a *Virgin with the Christ Child and Saint Catherine* by Carlo Maratti, described in a note by Bottari as "the last of his work finished by Marco Benefial" (quoted in Magnanimi 1980, p. 105). Mentioned in the 1808 inventory of Prince Tommaso Corsini, in addition to the preceding pictures, are *Saint Giuseppe da Leonessa Presenting a Renegade to the Pope*, "an original by Benefial" and *Saint Catherine of Verona* [sic] "by Benefial" (Magnanimi 1980, "Inventari," pp. 103, 109). It is concluded from this that Benefial was also involved in the canonization of Giuseppe da Leonessa, celebrated in 1746 under Benedict XIV.

As explained by Vittorio Casale in his works on beatifications and canonizations celebrated in the Seicento and Settecento (Casale 1990; Casale 1997; Casale 1998), these ceremonies, in which 'heroes' of the Christian faith were honored, were opportunities for important commissions involving artists in every medium. These included the architects who created the ephemeral decorations in St. Peter's, where the main ceremony took place, and in the churches of the religious orders, as well as the painters who provided standards with the lives of the saints, from the preliminary design to the final completed work. Also involved in the ceremonies were engravers, embroiderers, goldsmiths,

178

and sculptors, and churches, chapels, and altars dedicated to the new saints were also erected. The most renowned painters executed paintings intended for the pope and cardinals. It was therefore a sign of great distinction that Benefial was requested to paint a picture for the cardinal, which was displayed together with others of the same type in an antechamber of the Palazzo Corsini at Lungara, and henceforth known as the "antechamber of the canonizations" (quoted in Magnamini 1980, pp. 106–7). The Palazzo Corsini at Lungara, the cardinal's residence, had been rebuilt for the Corsini by Ferdinando Fuga, having previously been the Palazzo Riario, the residence of Christina of Sweden.

The picture was painted by Benefial during the period of his collaboration with Filippo Evangelisti, between the *Adoration of the Shepherds* in the church of the Bambino Gesù (1733–36) and the *Baptism of Christ* in S. Maria della Quercia (1738). Precisely because of the artist's "equal partnership," these two works were for a long time attributed to Evangelisti. In the case of *The Vision of Saint Catherine*, however, the signature, affixed in full and bearing the title of "cavaliere," proudly

reclaims the authorship of this masterpiece for its true creator. Benefial also executed the drawing for an engraving (perhaps corresponding to a lost painting) portraying the saint in the act of writing her mystical treatises, where the explicit indication *Marcus Benefial invenit* appears. The engraving was created for Giovan Carlo Allet; a copy is in the Istituto Nazionale per la Grafica, Rome. Probably attributed to this engraving is the drawing for the figure of Saint Margaret now in Berlin (Kdz 15893; Clark 1966, n. 6; Van Dooren 1989, p. 107, cat. no. 155). In Düsseldorf there is a preliminary drawing for the figure of the saint, already perfectly characterized in posture, bearing, and style of dress, and executed with that simultaneously concise and complex technique so characteristic of his graphic art during this period.

The painting is an exemplary illustration of the painter's lyrical quality and style. The harmony between the story and its visual depiction is absolute, with no additional ornamentation. The figure of Christ, seen from behind, descends from the clouds, bent under the weight of the cross. Walking on his own blood, he makes his way towards the young

woman, who wrings her hands expressively. The angels turn both toward the protagonists of the scene and outward, as if entreating the observer to participate. A maid moves away the curtain, behind which another maid can be seen absorbed in her work, a return to the calm activities of daily life. Christ is a luminous and perfect male nude figure. Catherine and the women of the house are dressed fashionably. The cushion and the elegant seat not only allude to the central character's social standing but also serve to illuminate the darkness of the surroundings with shades of rose and red, in which the celestial light cuts a path that follows the progression of the Savior. The painting is both an accurate portrayal of the religious narrative and an expression of the artist's other "religion"—a genuine and direct relationship with the fundamentals of painting. [LB]

## 179

## Marco Benefial
*Adam and Eve Before God*

1750–60?
Oil on canvas
55⅞″ × 52⅛″ (142 × 133 cm)
PROVENANCE collection of Count Nicolò Soderini, Torlonia donation, 1892
EXHIBITION Chicago, Minneapolis, and Toledo 1970, cat. no. 73
BIBLIOGRAPHY Maxon and Rishel 1970, p. 178, no. 73; Faldi 1971, p. 568; Falcidia 1978, pp. 35, 48; Sestieri 1994, vol. 1, p.26; Vodret 1994, pp. 394–95
Galleria Nazionale d'Arte Antica, Palazzo Barberini, Rome

This picture, together with its companion piece portraying *Adam and Eve Cast Out of Earthly Paradise*, comes from the Torlonia collection. Both paintings formed part of the collection of Niccolò Soderini; they are not expressly mentioned by Ponfredi, who limits himself to listing only six of Benefial's works "among the many that [Soderini] has of this worthy man" (Bottari and Ticozzi 1822–25, vol. 5, pp. 24–26; see also the entry for *Pyramus and Thisbe*, cat. 177). However they are described in the Soderini inventory (1779) and then in the exten-

179

sive Torlonia inventory, according to Gaspare Landi's report of 1814 (Vodret 1994, pp. 394–95, nos. 469, 474; assessed at 50 *scudi* each).

The painting depicts the moment immediately following the sinful act: only after tasting the forbidden fruit do Adam and Eve realize their own nudity. Covering themselves with fig leaves, they hear God's condemnation. From a stylistic point of view, the painting has marked differences from *The Expulsion of Adam and Eve*, which is unquestionably handled in a more concise, vigorous, and dramatic manner, as is the preliminary study (Van Dooren 1989, no. 129). Indeed, the composition of this picture more closely resembles Benefial's works from the 1740s and 1750s (such as the Arsoli frescoes). The *Expulsion* may in fact have been commissioned at a later date to accompany the first painting. In the soaring depiction of Eternity supported by a group of angels, the references to Raphael and Michelangelo are immediate, although they are transformed into the sharp and luminous idiom of the painter's last works. The dynamic modeling of the two nude figures that immediately calls to mind the painter's constantly declared passion for the study of anatomy. [LB]

## PIETRO BIANCHI
### ROME 1694–1740 ROME

Pietro Bianchi was born on September 5, 1694, the son of a cooper, Giovanni Bianchi, of Ligurian origin. He was orphaned at the age of two and was taken in by one of his older sisters, whose husband, Arrigo Giorgi, was in the service of the Marchese Marcello Sacchetti. Bianchi was apprenticed to the painter Giacomo Triga at an early age and then placed in the studio of Giovanni Battista Gaulli, *called* Il Baciccia. There he acquired his nickname, "il Creatura di Baciccia," on account of his youth and small stature. On the death of Gaulli in 1709, Bianchi moved briefly to the studio of Giuseppe Ghezzi, but was dissatisfied with his master's endless pontifications and around 1710 began to study with Benedetto Luti. He prospered under Luti's tutelage and remained with him until the painter's death in 1724. Bianchi won prizes in the Accademia di S. Luca *concorsi*, or student competitions, in 1707, 1711, and 1713; in the last he was placed second in the first class with a magnificent drawing of a *Miracle of Saint Pius V Ghilsieri* (Galleria di Accademia Nazionale di S. Luca, Rome; Cipriani 1990, no. 46). He was elected to membership of the academy in March 1735, five years before his death.

Bianchi's first commissions date from around 1715, but he did not acquire a serious and public reputation until about ten years later. Although his paintings are singularly beautiful, too few are known to estab-lish a chronology. In 1724 Bianchi completed a painting left unfinished by Luti representing *The Archangel Gabriel with Saints Sebastian, Roch and Eusebius* (untraced), which Filippo Juvarra had commissioned for the chapel at the Venaria Reale, near Turin, but which Bianchi sold to King John V of Portugal, for the church of S. Vicente de Fora in Lisbon. Bianchi (cat. 181), along with Sebastiano Conca, Giovanni Odazzi, and Placido Costanzi (cat. 206), contributed to the series of paintings depicting scenes from the lives of Pope Alexander VII and his great-nephew Cardinal Antonio Felice Zondadari.

Bianchi was offered a knighthood by Clement XII but refused it, accepting instead a commission for St. Peter's "che pu chiamarsi il Toson d'oro per un Pittore" as one of Mengs's biographers put it (Clark 1964, "Bianchi," p. 46). In 1730 Cardinal Annibale Albani, prefect of the Fabbrica di S. Pietro, placed the commission for a monumental canvas, *The Immaculate Conception Worshiped by Saints John Crysostom, Francis of Assisi, and Anthony of Padua* (S. Maria degli Angeli, Rome), to be executed in mosaic for the basilica. A lost *bozzetto* was made in 1730; the altarpiece was begun and a payment received in 1734 but put aside in 1735–36 because of differences between Bianchi and the bursar of the Fabbrica, Monsignor Altoviti. In 1738 Bianchi received another payment on the condition that he finish the painting within one year, but apparently it was only barely finished at the time of his death in 1740. The canvas received its final touches (the adoring angels, *angelini*, heavenly glory, and the Virgin's face) by his leading pupil, Gaetano Sardi, and the composition was executed in mosaic for St. Peter's from 1744 to 1747 (DiFederico 1983, p. 79, no. 27, pl. 148).

Toward 1737 Bianchi was commissioned by Don Fabrizio Colonna to paint a ceiling insert, *Fame Crowning Merit*, the first of a set of six allegorical decorations that were to surround an earlier canvas by Luti in the Palazzo Colonna. The cycle was completed by Pompeo Batoni about 1737–39, and it is probable that the two artists were originally given equal shares of the work and that Bianchi's two smaller scenes were not ready on his death. Bianchi's oil painting of *The Blessed Giovanni Angelo Porro Worshiping the Crucifix* (S. Maria in Via, Rome) probably dates from about this period. In 1738 he began work on his last major painting, a *Rest on the Flight into Egypt* (S. Maria delle Grazie alle Fornaci, Rome), which was completed after his death by Sardi.

Bianchi's refined style, which Clark called "lithe, grand and poetic," (Clark 1970, p. 180) and his personal transfor-mation of Maratti's and Luti's *bel disegno* brought him commissions from the Roman ecclesiastical community and aristocracy, but he was never satisfied with his work and corrected and recorrected it to excess. He was known to have destroyed entire pieces in order to rework them, so that like his master Luti, his output is sparse. In the eighteenth century it was already observed that his paintings were singularly beautiful but difficult to find.

Although Jacques Lacombe wrote in his *Dictionnaire portatif des beaux-arts* (1759) that Bianchi "painted with equal success subjects from history, landscapes, portraits, seascapes, and animals," only his subject pictures and landscapes are known today. He is said to have had a passion for the open air (and to have died from working too hard in his garden), so it is not surprising that his history paintings are often set in naturalistic landscapes (cat. 180) and that he produced small gouache landscapes for the Roman tourist trade (The National Trust, Felbrigg Hall, Norfolk; Clark 1981, figs. 54–55).

Bianchi studied sculpture in the workshop of Pierre Legros at an early age and, like Carlo Maratti before him, he supplied designs and advice to Filippo delle Valle (*Saint John of God*, St. Peter's, Rome), Giovanni Battista Maini (*Saint Francis of Paola*, 1732; St. Peter's, 1732), Pietro Bracci (Paolucci tomb, 1726; S. Marcello al Corso; Benedict XIII tomb, 1734–37; S. Maria sopra Minerva; statue of Clement XII, 1734; formerly Capitoline Hill), and Carlo Marchionni. Bianchi's professional interest in sculpture derived in part from his own practice of arranging small clay and wax figures and carefully lighting them in the course of preparing his paintings.

Bianchi devoted much time to his pupils, who in addition to Gaetano Sardi included Francesco Mattei, Raimondo Paticchi, and the Portuguese sculptor João Grossi. Olivier Michel has pointed out (1995), the confusion on the part of modern biographers between Bianchi and his exact namesake, a painter from Como (c. 1657–1732), who was a protégé of Cardinal Francesco Acquaviva. Pietro Bianchi died on March 12, 1740. [EPB]

BIBLIOGRAPHY Dezallier d'Argenville 1752, pp. 76–80; Soprani and Ratti 1768–69, vol. 2, pp. 292–305; Clark 1964, "Bianchi"; Rangoni 1990, "Bianchi"; Pampalone 1995; Sestieri 1995; Casale 1996; Michel 1996, "Bianchi"

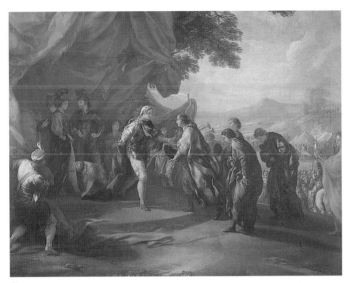

180

## 180
## Pietro Bianchi
### *The Meeting of Cardinal Zondadari and Philip V, King of Spain*

c. 1727

Inscribed on the back of the original canvas: *INCONTRO DEL CARDINAL ZONDADARI CON FILIPPO V NEI PADIGLIONI DA CAMPO.*
Oil on canvas
48½" × 57⅞" (113 × 147 cm)
PROVENANCE Palazzo Chigi Zondadari in Quirico d'Orcia; Bellini collection in Florence; Florentine art market; purchased by the Galleria Nazionale d'Arte Antica
EXHIBITION Rome 1972, *Acquisti*, cat. no. 24
BIBLIOGRAPHY Pascoli [1730–36] 1933, vol. 2, p. 394; Soprani and Ratti 1768–69, passim; Moroni 1840–61, passim; Pastor 1938–53, vol. 34, passim; Clark 1964, "Bianchi"; Ragghianti 1967; Boschetto 1968; Clark 1968, "Costanzi"; Minneapolis Institute of Arts. *European Paintings from the Minneapolis Institute of Arts*. New York: Praeger, 1971, p. 447, cat. no. 238; Faldi 1972; Johns 1993, p. 24
Galleria Nazionale d'Arte Antica, Palazzo Barberini, Rome

Cardinal Antonio Felice Zondadari (born September 13, 1665), depicted in Pietro Bianchi's picture as quite boyish-looking despite his thirty-six years, was a member of a prominent Sienese family. In 1645 his father, Ansano Zondadari, married Agnese Chigi, the sister of Cardinal Flavio Chigi and the niece of Pope Alexander VII. Ansano took the Chigi name, as did his eldest son, Bonaventura. The other three sons—Marcantonio, Antonio Felice, and Alessandro—all kept the Zondadari name.

Not long after the death of King Charles of Spain on November 1, 1700, the War of the Spanish Succession broke out, even though the king had named Philip of Anjou, the son of the dauphin and the nephew of King Louis XIV, as heir to his throne in his will. In an attempt to negotiate a peace, on November 21, 1701, Pope Clement XI named three nuncios extraordinary to be sent to the courts of Vienna, Paris, and Madrid. Antonio Felice Zondadari, a bishop at the time, was sent to Spain in this capacity. From 1706 he served in the regular office of papal nuncio to Spain. After inflicting a crushing defeat on the papal forces in Bologna, Emperor Joseph I then marched on Rome and forced Pope Clement XI to recognize his younger brother the Archduke Charles as Charles III of Spain. As a result, the nunciature in Madrid was closed and Zondadari was expelled from Spain. He then spent three years in Avignon before being made a cardinal on May 8, 1712. Zondadari was a candidate for the pontificate in the conclave of 1724 and again in 1730. He died in the family palace in Siena on November 23, 1737.

Sometime before 1728 (and probably after the conclave of 1724) Zondadari commissioned various artists to paint a series of pictures depicting important events in his family's history, nine of which are known. Eight, including this work by Pietro Bianchi, are now in the Galleria Nazionale d'Arte Antica in Rome, and a ninth, signed by Placido Costanzi (cat. 206) is in the Minneapolis Institute of Arts. Lione Pascoli referred to this series in his biography of Giovanni Odazzi and mentioned that the artist had painted one of the pictures. The inventory of Cardinal Antonio Felice Zondadari's property that was drawn up in Rome (presumably for those items in his living quarters in Rome) confirms Pascoli's statement. According to the inventory, the picture painted by Odazzi represented the abdication of Queen Christina of Sweden in the Consistory during the reign of Alexander VII.

Interestingly, the inventory lists only nine, rather than ten, paintings in the series: Pietro Bianchi's picture, which, according to the inscription on the back, depicts the meeting of Cardinal Zondadari, probably as nuncio extraordinary, with King Philip V of Spain in the pavilions during military exercises, is not included in the inventory. There can be no doubt, however, that it was indeed part of the original series, given that it, along with the seven other paintings now in Rome, had at one time been in the Palazzo Chigi-Zondadari in the small town of Quirico d'Orcia (not far from Siena). Furthermore, Carlo Ratti referred at length to Cardinal Zondadari's commissioning of Pietro Bianchi to paint this scene from the beginning of the cardinal's embassy in Spain. This painting evidently had already been taken to another location well before the cardinal's death.

The inventory indicates that Cardinal Zondadari commissioned six different artists to paint this series of ten pictures. Odazzi and Sebastiano Conca are mentioned by Pascoli and Bianchi by Ratti; Costanzi's work bears his signature. Of the three paintings in Rome that have hitherto remained anonymous, the canvas inscribed *Monsignor Zondadari sbarca ad Alicante* is by Pietro Bianchi; Luigi Garzi painted the scene of Cardinal Flavio Chigi in front of S. Maria del Popolo in Rome during the plague of 1656; and the Sienese painter Giuseppe Nasini was responsible for the depiction of the cardinal's younger brother Alessandro being enthroned as archbishop of Siena. [MLB]

## 181
## Pietro Bianchi
### *Mercury and Argus with Io*

1730–35
Oil on canvas
72¼" × 50⅜" (183.7 × 128.1 cm)
PROVENANCE painted for Pietro Mancini, Rome; with the artist's heirs, Rome; Paul Ganz, New York; from whom acquired in 1965
EXHIBITIONS Minneapolis Institute of Art, 1962; Cleveland 1964, cat. no. 9; New York, The Metropolitan Museum of Art, 1965; Chicago, Minneapolis, and Toledo 1970, cat. no. 74
BIBLIOGRAPHY Dézallier d'Argenville 1752, p. 80; Soprani and Ratti 1768–69, vol. 2, p. 298; Clark 1964, "Bianchi," p. 44, pl. 58; Held, Julius S., Rene Taylor, and James N. Carder. *Museo de Arte de Ponce, Fundación Luis A. Ferré: Paintings and Sculpture of the European and American Schools.* 2nd ed. Ponce, Puerto Rico: Museo de Arte de Ponce, 1984, pp. 18–19
Museo de Arte de Ponce, Puerto Rico

Antoine Joseph Dézallier d'Argenville mentioned a painting of Mercury and Argus belonging to Bianchi's heirs, and Giuseppe Ratti described the large and handsome painting in Ponce as "un quadro di sette palmi, entrovi Mercurio, che sta in atto di recidere il capo ad Argo addormentato" (Dézallier d'Argenville 1752, vol. 2, p. 80). Little is known of Bianchi's patron, Pietro Mancini, except that he also owned a pair of hermit saints in a landscape by the artist, *Saint Onuphrius* and *Saint Mary of Egypt*, described by Ratti and discovered by Anthony Clark in the collection of the descendants of Gianlorenzo Bernini in Rome (Casale 1996, p. 108, figs. 1, 2).

The Ponce painting shows Mercury preparing to slay the giant Argus, depicted here as a brawny shepherd sleeping under a tree. The tale is told by Ovid (*Metamorphoses* 1: 668–721) in his account of Jupiter's infatuation with Io, the daughter of Inachus, first King of Argos. Jupiter changed himself into a cloud to conceal his infidelity from his wife, Juno, and seduced the princess. Juno was not deceived, however, and so Jupiter "transformed poor Io into a sleek white heifer (lovely still although a cow)" (*Metamorphoses* 1: 639–63). Juno then asked her husband for the heifer as a gift, which she knew he could not refuse, and entrusted her to the hundred-eyed giant Argus, whom Bianchi, like most eighteenth-century painters, has depicted as a noble shepherd.

Jupiter then sent his messenger Mercury to lull the giant to sleep with his reed pipes and to cut off his head. Bianchi has depicted the climax of the drama, the moment when Mercury, arrayed in ankle-wings and magic cap, has finally induced Argus to sleep on a rock by playing his pan pipes for hours. Following the murder of Argus, Io was freed and returned to human form. She was made a goddess and bore Jupiter a son, Epaphus. Anthony Clark observed that "The shepherd Argus's hut, shown behind the cow Io, is of an architecture still to be found in the haystacks of the Campagna, and extended back to Roman prehistory. Local and ancient meanings of the hut and cow would have been known to Bianchi and are above and beyond the Greek fable he is telling" (Maxon and Rishel 1970, p. 180).

The subject was popular in eighteenth-century Italian painting, in part for the opportunity it provided painters to demonstrate their skill in drawing and modeling the male nude. Ubaldo Gandolfi, for example, painted a series of six large canvases of mythological subjects to adorn the walls of the palace of the Marescalchi family in Bologna that included depictions of the episodes immediately pre-

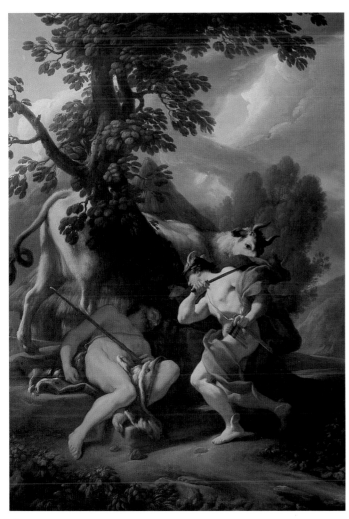

181

ceding the slaying of Argus, *Mercury Lulling Argus to Sleep* and *Mercury about to Behead Argus* (c. 1770–75; The North Carolina Museum of Art, Raleigh). In spite of their obvious differences in color, composition, and handling, Bianchi's and Gandolfi's paintings are startlingly similar in one respect —the confident understanding of human anatomy that these artists gained from drawing from the live model and that was such an important part of the Roman and Bolognese traditions of *disegno*.

Clark admired Bianchi's "impressive use of landscape, the ability to construct the picture with, and keep a strong impression of, weather and the natural scene, [that] are far beyond the powers of Locatelli, with whom Bianchi was obviously familiar" (Clark 1964, "Bianchi," p. 44). Although appreciated by modern critics principally as a history painter, Bianchi was in fact one of the most accomplished landscape painters of the first half of the Roman Settecento. He inherited Benedetto Luti's gift for creating transparent and delicate landscape backgrounds, and in the presence of the Ponce painting one

can believe Giuseppe Ratti's anecdote that, upon seeing Bianchi's landscapes, Jan Frans van Bloemen (*called* Orizzonte) "remained stupefied." His landscapes were widely appreciated in his own time, and a measure of their contemporary esteem is provided by the example of Cardinal Annibale Albani's gift of *Venus Mourning the Dead Adonis* to Count Heinrich Brühl, the powerful minister of Augustus III, King of Poland and Elector of Saxony (Soprani and Ratti 1768–69, vol. 2, p. 298).

*Mercury and Argus with Io* is one of Pietro Bianchi's finest paintings, a masterpiece of landscape painting in the Arcadian mode. The device of the leafy tree extending vertically through the composition was a favorite of the artist's, familiar in such works as *Pyramus and Thisbe* and *The Death of Adonis* (private collection; Sestieri 1994, vol. 2, figs. 109–10, the latter a copy of a lost original). Bianchi's soft brushwork, pastel-like handling, and velvety texturing of line underscore his debt to Benedetto Luti, even toward the end of his relatively short life. He remained for years in his master's workshop, to the extent that

his career got underway only after Luti's death in 1724, thanks to several prestigious commissions from Spain and Portugal. According to his biographers, Bianchi was an enthusiastic fisherman and hunter, to which activities he always took along his paper and pencil. [EPB]

## LOUIS-GABRIEL BLANCHET
### VERSAILLES 1701–1772 ROME

Louis-Gabriel Blanchet was born on November 29, 1701, the son of Gabriel Blanchet, valet de chambre of one Monsieur Blouin, himself the principal valet of King Louis XIV. Nothing is known of Blanchet's youthful artistic activity until April 30, 1727, when he competed at the Académie Royale de Peinture et de Sculpture for the *prix de Rome* in painting, and was placed second to Pierre Subleyras. He was nominated on March 12, 1728, for a *pension* at the French Academy at Rome and resided at the Palazzo Mancini from November 1728 to 1733. Nicolas Vleughels, director of the French Academy, seems to have had little esteem for Blanchet's abilities as a painter, but the young artist managed to retain his lodgings at the academy under one pretext or another. With the arrival in Rome in 1732 of the Duc de Saint-Aignan, French ambassador to the Holy See, Blanchet found a significant patron. While in Rome, Saint-Aignan began to form a collection of paintings and other works by French artists, most of whom were resident at the French Academy. Among Blanchet's earliest works for this patron is a series of four overdoors with allegorical subjects; *Painting Paying Homage to Pope Clement XII* (*Settecento* 1959, fig. 38), signed and dated 1732, in particular reveals his strong classicizing orientation, and a style based on the paintings of Francesco Imperiali and Subleyras. Like Subleyras, with whom he shared a lodging in 1737, Blanchet remained in Rome for the rest of his life and can be said to have been truly a Roman painter.

Blanchet's modern reputation rests primarily on his portraits of visitors to Rome, mostly French and British, notably the exiled Stuarts in Rome. Among his seven paintings acquired by the Duc de Saint-Aignan was the double portrait of *The Reverend Fathers François Jacquier and Thomas Leseur* (1752; Musée des Beaux Arts, Nantes), mathematicians who contributed to the scientific reputation of the Minim convent of S. Trinità and are depicted amidst telescopes, an armillary sphere, and celestial globe. Blanchet's portraits of two rich Lyonese, the brothers Claude Tolozan D'Amaranthe and Louis Tolozan de Montfort (1756; Musée des Beaux-

Arts, Lyon; The Walters Art Gallery, Baltimore), represent his elegant, luminous, and colorful style of painting. He employed a naturalistic and truthful approach to portrait painting, and he loved to render the beauty of costume and the play of colors and materials. Blanchet was a refined colorist, and his paintings, like those of Subleyras, are distinguished by the luminosity of his whites and the richness of his handling of oil paint.

One of Blanchet's earliest portraits of a British Grand Tourist was of the architect William Chambers (1753; untraced) whom he depicted beside volumes of Vitruvius and Palladio. The following year Blanchet depicted *Henry Willoughby, Later 5th Baron Middleton* (1754; Lord Middleton, Birdsall, North Yorkshire) in a familiar mode, wearing a richly embroidered coat, seated beside a classical bust. A portrait inscribed *Lord Arundel* presumably represents Henry, 8th Baron Arundell of Wardour (sale catalogue, Sotheby's, Monte Carlo, June 17, 1988, lot 887), who was in Rome in 1760. Blanchet enjoyed favorable relations with artists of various nationalities and produced portraits of the Danish painter *Johan Mandelberg* (1756; Royal Academy of Fine Arts, Copenhagen) and the British sculptor and painter James Barry (c. 1767; Royal Society of Arts, London).

In 1737–38 Blanchet was commissioned by James Francis Edward Stuart, the Old Pretender, to paint full-length portraits of the Stuart princes, Charles Edward and Henry Benedict (cats. 183–84), as a gift for the Duchess of Parma. He also painted portraits of the Old Pretender and his wife, Clementina Sobieska, and in effect served as a portraitist to the exiled Stuart court in Rome. His portraits of Roman visitors were not restricted to the British and French; he painted the young Wolfgang Amadeus Mozart (private collection, Glyndebourne, Sussex) at the time of the young composer's trip to Italy in 1769–71 (Clark and Bowron 1985, p. 373).

In 1752 Blanchet finished *The Vision of Constantine* (Musée du Louvre, Paris), a copy of Giulio Romano's fresco in the Sala di Costantino in the Vatican, which, together with a *Victory of Constantine over Maxentius* (1746; Musée des Beaux-Arts, Lille), he had begun more than a decade earlier as part of project initiated in 1737 to supply the Gobelins tapestry manufactory with copies after the Vatican frescoes. This turned out to be a traumatic affair involving the artist and the authorities of the French Academy. In the last two decades of his life Blanchet produced a number of history paintings, beginning in the 1750s with a series of allegories depicting putti as personifications of Painting, Sculpture, and the

Arts, and in other guises. Three were shown in the exhibition held on March 19, 1750, in the portico of Pantheon under the auspices of the Congregazione dei Virtuosi al Pantheon. One example of the genre involves a strange scene in which two women attend four little children, one of whom is chained, within a prison (1751; private collection). Other works in this vein include a set of *Seasons*, each with four putti, once owned by the Bailli de Breteuil, ambassador to Rome of the order of Malta from 1758 to 1777; *Summer* can be identified with a painting attributed to Boucher in the Museum Narodowe in Warsaw.

In the late 1750s Blanchet turned to religious themes; notably a *Saint Paul* (1757; Musée Calvet, Avignon); an *Adoration of the Magi* (1757; Musée de la Bénédictine, Fécamp); and a *Virgin and Child with the Infant Saint John the Baptist* (Chaucer Fine Arts, London). In his maturity Blanchet returned to the subjects from the 1750s, such as an *Allegory of Painting and Sculpture* (1762; untraced) and a series of allegorical themes depicting female personifications of *Summer* and *Autumn* (1769 and 1772; untraced). In 1765 he painted eight chiaroscuro copies of antique sculptures for Saltram House, perhaps an indication of an association with Robert Adam. (Among Blanchet's effects following his death were found a number of drawings "di statue grandi" and "di statue le più celebri di Roma misurate e segnate con tutte le regole di disegno"; Michel 1996, "Blanchet," p. 485).

Blanchet was an accomplished draftsman and produced a number of views of Rome and the Roman countryside. These are distinguished by a common technique of black and white chalks on gray or buff paper, and closely similar dimensions (for example, Hiesinger and Percy 1980, no. 24). Some are inscribed with numbers, written out in Italian, suggesting that they may have been grouped in albums. They do not appear to have been preparations for engravings, as no example is known. The attribution of these sheets rests on tradition; only one of them is signed, and since none is dated it is difficult to establish a chronology. These drawings may be compared to similar works by Richard Wilson and Charles-Michel-Ange Challe, both of whom Blanchet appears to have influenced.

Blanchet cannot have been financially successful—or he may have been a spendthrift, for he was imprisoned on October 11, 1752, for debt. He appears to have recovered thereafter, and his financial woes were certainly eased on September 27, 1755, when he married Annunziata Dies, the daughter of a Venetian goldsmith living in the Piazza di Spagna, and received 500 *scudi* as a dowry. He died on September 17, 1772. [EPB]

BIBLIOGRAPHY Montaiglon 1887–1912, passim; Le Moël and Rosenberg 1969; Hiesinger and Percy 1980, pp. 36–37; Michel 1995; Michel 1996, "Blanchet"

## 182
## Louis-Gabriel Blanchet
### *Giovanni Paolo Panini*

1736

Indistinctly signed and dated on the cover of the sketchbook: *L G Blanchet [fec] it/ 1736*; inscribed on the back of the original canvas: *J. Paolo Panini. Peintre d'Architecture/ Orig.[le] Peint par L G Blanchet a Rome*
Oil on canvas
38" × 30" (96.5 × 76 cm)
PROVENANCE Arthur Tooth & Sons, London; London, Sotheby's, March 28, 1979, lot 69 (as by Carle van Loo); purchased by the British Rail Pension Fund Collection; sale, London, Sotheby's, July 5, 1995, lot 54; purchased by the present owner
EXHIBITION Marble Hill House, Twickenham, on loan 1985–95
BIBLIOGRAPHY Arisi 1986, p. 1 (as by Carle van Loo); Kiene 1992, fig. 21 (as by Van Loo); Konrad O. Bernheimer Kunsthandel, Munich. *Gemälde 1996–1997*. Munich, 1996, no. 11

Konrad O. Bernheimer, Fine Old Masters

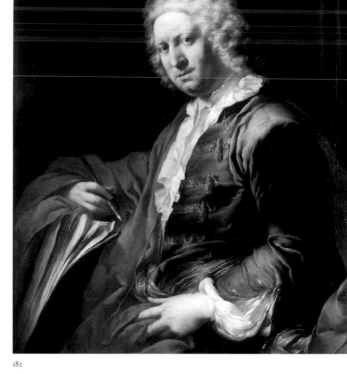

182

Blanchet has shown Panini before his easel, leaning on a portfolio, brush in hand. The white cuffs and open collar of his chemise and richly embroidered gold and blue jacket contrast vividly with the brilliant red cloak that flows around the sitter like an antique toga. Blanchet's usual confident command of light, color, and texture is supremely evident in this portrait of Panini, whom he conveys as a relaxed and elegant gentleman–painter amidst the tools of his profession. In this picture Blanchet has managed to transcend the often static genre of the portrait of the artist at his easel and has introduced a surprising vivacity through Panini's sober expression and critical gaze, the arrangement of his limbs and tilt of his head, and the play of light across his features and dress.

The portrait is the only known painted likeness of the celebrated view painter, apart from the self-portraits that appear in several of Panini's own paintings. He depicted himself, for example, in *Preparations to Celebrate the Birth of the Dauphin of France in 1729 in Piazza Navona, Rome*, 1731 (cat. 264); *Interior of the Picture Gallery of Cardinal Silvio Valenti Gonzaga*, 1749 (Wadsworth Atheneum, Hartford, CT; Arisi 1986, p. 430), and in several versions of his interiors of an imaginary picture gallery (cat. 275). The painting was traditionally attributed to Carle Vanloo and recorded as such in much of the recent literature on Panini; however, in 1979, during relining of the picture, the inscription on the reverse of the original canvas was discovered.

During the restoration undertaken by Viola Pemberton-Pigott in 1982, the cover of the sketchbook on which the artist rests his right hand was found to have been entirely repainted at an early stage in the painting's history. During removal of this repaint, traces of a signature and date were visible, confirming that an earlier restorer had effaced most of Blanchet's signature and repainted the passages with a false signature emulating that of Vanloo. Removal of the old and discolored varnish also revealed the brilliance of Blanchet's palette, notably in the crimson robe and blue coat worn by Panini. There are several significant *pentimenti* discernible in the working of the striped sash, and the red cloak seems to cover a golden yellow cloth; the hands and fingers have also been reworked.

That Panini would have been formally portrayed by one of the leading French painters in eighteenth-century Rome is not surprising—he was associated with the French community in the city from the outset of his career. In 1718, for example, he chose Reynaud Levieux, an *orefèvre* from Languedoc, as the godfather of his eldest son, Rinaldo Giuseppe; in 1724 he married as his second wife, Catherine Gosset, daughter of a French banker in Rome and the sister-in-law of Nicolas Vleughels, director of the French Academy at Rome from 1724 until his death in 1737. Panini was intimately involved in the affairs of the academy and for many years taught perspective there (Olivier Michel, "Panini et l'Académie de France" in Michel 1996, *Vivre et peindre*, pp. 85–93). In 1732 he was received as a member of the Académie Royale de Peinture et de Sculpture in Paris, an honor accorded few Roman artists. Patronized by Cardinal Melchior de Polignac, Louis XV's ambassador in Rome from 1724 to 1732 (cat. 264), the Duc de Choiseul, French ambassador to Benedict XIV (cats. 275, 276), and the Abbé de Canillac, chargé d'affaires of the embassy of France to the Holy See in 1724–25 and 1748–49, Panini inevitably made the acquaintance of every important French artist who traveled to Rome, and he greatly influenced younger French painters such as Jean-Nicolas Servandoni, Charles-Louis Clérisseau, Claude-Joseph Vernet, Fragonard, and Hubert Robert, who had traveled to Italy to complete their artistic education (see Loire 1993).

These important French contacts notwithstanding, the nature of Panini's relations, personal and professional, with Blanchet are still not explained; nor are the circumstances of the commissioning of the present portrait, which is presumably a portrait of honor or an official commission from a French source. [EPB]

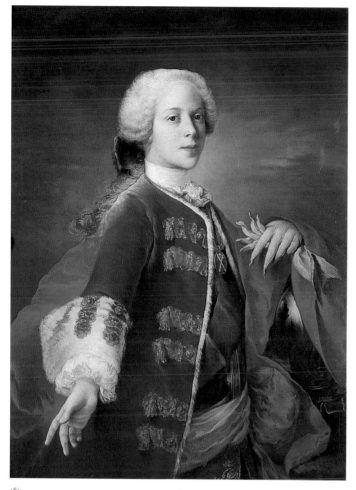

183

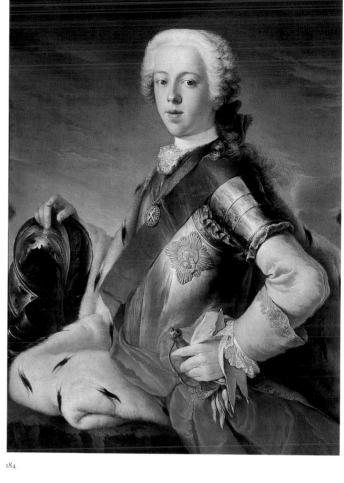

184

## 183
### Louis-Gabriel Blanchet
*Prince Henry Benedict Stuart,*
*Later Cardinal York*

1739
Oil on canvas
38¼″ × 28¼″ (97.8 × 73 cm)

PROVENANCE  acquired in Rome by
William Hay, Edington, Scotland; by
descent to Lt.-Col. G. H. Hay, DSO, Duns
Castle, Berwickshire; his sale, London,
Christie's, March 25, 1966, lot 83; acquired
by the late Lord Woolton and ceded by him
to Her Majesty Queen Elizabeth II for the
Holyrood Amenity Trust

EXHIBITIONS  Edinburgh, Board of
Manufactures. *Loan Exhibition of Works of
Old Masters & Scottish National Portraits.* 1883;
no. 4; London, The New Gallery. *Exhibition
of the Royal House of Stuart.* 1889, no. 176;
Edinburgh, Seven Charlotte Square. *An
Exhibition of Rare Scottish Antiquities.* 1950,
no. 149d; London 1982, *Kings,* cat. no. 43

BIBLIOGRAPHY  Kerslake 1977, vol. 1, p. 43,
and vol. 2, pl. 930

Her Majesty Queen Elizabeth II

## 184
### Louis-Gabriel Blanchet
*Prince Charles Edward Stuart*

1739
Signed and dated: *L G Blanchet/ fecit 1739*
Oil on canvas
38¼″ × 29¼″ (98.4 × 75.6 cm)

PROVENANCE  acquired in Rome by
William Hay, Edington, Scotland; by
descent to Lt.-Col. G. H. Hay, Duns Castle,
Berwickshire; his sale, London, Christie's,
March 25, 1966, lot 83, acquired by Her
Majesty Queen Elizabeth II in conjunction
with the Holyrood Amenity Trust

EXHIBITIONS  Edinburgh 1883, cat. no. 3;
London 1889, cat. no. 160; Edinburgh,
Scottish National Portrait Gallery, 1949–50;
Edinburgh 1950, cat. no. 149c; London 1982,
*Kings,* cat. no. 43

BIBLIOGRAPHY  Nicholas, Donald. *The
Portraits of Bonnie Prince Charlie.* Maidstone,
England: Clout & Baker Ltd., 1973,
pp. 16–17; Kerslake 1977, vol. 1, p. 43, and
vol. 2, pl. 112

Her Majesty Queen Elizabeth II

The Jacobite court in exile in Rome
employed a variety of artists to supply
portraits of its members, both for pro-
paganda purposes and as gifts for sup-
porters of the Stuart cause at home
and abroad. Their number included
the painters Pompeo Batoni,

Domenico Corvi, Ozias Humphry,
Laurent Pécheux, Girolamo Pesci,
Francesco Trevisani, and the medalists
Thomas Pingo and Ottone and
Gioacchino Hamerani, although the
artists most closely identified with the
Stuart court were Antonio David,
Domenico Dupra, and Louis-Gabriel
Blanchet. Prince James Francis
Edward Stuart, the Old Pretender, the
only son of King James II, was secretly
conveyed to France with his mother,
Mary of Modena during the revolu-
tion of 1688. After his father's death in
1701, he was recognized as James III, *de
jure* king of England, by Louis XIV and
by his Jacobite supporters.

After failing in his attempts to
regain the throne, Prince James took
final refuge in Italy at the invitation of
Pope Clement XI. On his arrival in
Rome in the early summer of 1717, the
exiled prince was fêted and received
with royal honors. By the time he
approached thirty, his followers were
desperate for him to marry and con-
tinue the Jacobite line, so in 1719 he
married a seventeen-year-old Polish
princess, Maria Clementina Sobieska,
granddaughter of the King of Poland.
The birth of his two sons, Charles and
Henry, encouraged his supporters, but
he himself had long since given up

hope of leading a successful invasion
of Britain and remained in seclusion
in the Palazzo Muti in Piazza dei Ss.
Apostoli, which the pope had placed
at his disposal. James and Clementina
were married first by proxy, then by
the bishop of Montefiascone (espe-
cially appointed for the marriage by
Clement XI) on the night of
September 1, 1719, in a temporary
chapel erected in one of the apartments
in the prince's residence. A record of
the marriage ceremony was commis-
sioned from Agostino Masucci and is
today in the Scottish National Portrait
Gallery, Edinburgh (Rudolph 1983,
pl. 459).

Prince Charles Edward Stuart
(1720–1788) was born on the evening
of December 31, 1720, and immedi-
ately entrusted to his governess, Lady
Misset; within hours he was baptized
by the bishop of Montefiascone in his
mother's chapel in the Palazzo Muti.
A painting of this event by Masucci
and Pier Leone Ghezzi (Scottish
National Portrait Gallery, Edinburgh;
Kerslake 1977, vol. 1, p. 159, and vol. 2,
pl. 436) was painted for the Old
Pretender a number of years after the
event, using portrait engravings for
likenesses of the English, Scottish, and
Irish nobility present at the ceremony.

Prince Charles ("Bonnie Prince Charlie," the Young Pretender), considered to be prince of Wales by the Jacobites, was born and brought up in Rome and trained for a military career. He made several efforts to regain the throne for his father, but in April 1746 his army was routed at Culloden by the government forces under the Duke of Cumberland. After a period of hiding in the western Highlands, Charles escaped to France and remained in exile for the rest of his life. In 1748 he was banished from France and, after, various travels, settled again in Rome in 1766. In 1772 Charles married Princess Louise Stolberg-Gedern, by whom he had no children. His later life was marked by depression and alcoholism, and although he styled himself Charles III, all hope of the restoration of the house of Stuart was gone. By his mistress Clementina Walkinshaw, he had in 1753 an illegitimate daughter, Charlotte, whom he created Duchess of Albany.

Prince Henry Benedict Stuart (1725–1807) was the younger son of Prince James and Maria Clementina Sobieska. At an early age he took orders in the Roman Catholic Church and pursued a successful ecclesiastical career, becoming bishop of Ostia, Velletro and Frascati in 1745, archbishop of Corinth in 1759, and bishop of Tusculum in 1761. He was created cardinal in 1747 by Pope Benedict XIV. His adherence to Catholicism lessened still further the chance to produce a male Stuart heir and alienated many of his English and Scottish supporters. In his youth he had been called "duke of York" by the Jacobites, and from this title he became known as Cardinal York. After the death of his brother Charles in 1788, Prince Henry was considered by the Jacobites to be the next claimant to the throne. He styled himself Henry IX, but made no claim to the throne, except to strike a few medallions that bore this title. He amassed a large fortune but was financially ruined during the Napoleonic occupation of Italy in 1799; King George III took pity on him and awarded him an annual pension of £4,000. When he died in 1807, the male line of the house of Stuart became extinct.

Many portraits of the Young Pretender and his brother Henry were painted throughout their lifetimes. Not all were painted from life; many were either copies, based on engravings, or imaginary portraits recognizable only from the princes' dress, having no physical likeness. The practice of making copies was widespread and stemmed from the Stuarts themselves. If a commissioned portrait was to their liking, they would often have replicas and miniatures made as gifts for loyal supporters. The Holyroodhouse portraits are genuine likenesses and

among the most beautiful and engaging images of the brothers ever painted. In the portrait of *Prince Charles*, for example, one writer has seen "an early indication of the elegant, confident young man who was to charm his way beyond history into legend" (Alan Bold, *Bonnie Prince Charlie* [London: Pitkin Pictorials Ltd., 1973], p. 1, reproduced on the cover).

In November 1737 Blanchet had received from Prince James the commission for a pair of portraits of the princes for their great aunt the Duchess of Parma, who was delighted with them. These full-lengths were completed in 1738 and are today in the National Portrait Gallery (Kerslake 1977, vol. 1, pp. 43, 326). The following year Blanchet painted the present pair at the Palace of Holyroodhouse to complement portraits of their father and mother (National Portrait Gallery, London; Kerslake 1977, vol. 2, pls. 442, 511) dressed in red ermine-lined cloaks. The portraits of the prince and his brother were painted for Captain William Hay, a Scot in the employ of the Jacobite court in Rome and the Pretender's groom of the bedchamber. There is a note from James Edgar, James Francis Edward Stuart's secretary, to Hay, who on June 25, 1740, was sent from Rome to Scotland, stating that the portrait of the Pretender was not quite ready. It was, however, sent off in April 1741, and Blanchet received 15 *zecchini* in payment (Kerslake 1977, vol. 1, p. 179, citing extracts from the Stuart papers, Royal Archives, Windsor). Of the various references to Blanchet in the Stuart papers at Windsor, none appears to pertain to either of these portraits.

Prince Charles is shown half-length, in breastplate and paulron, an ermine cape around him, standing with his right hand resting on a helmet and his left on the hilt of his sword, wearing the orders of the Garter and the Thistle. His brother is shown three-quarter length, in a plum-colored coat with gold embroidery and red cloak, standing with his left arm resting on a helmet, and holding gloves in his left hand, wearing the ribbon and star of the Garter and the badge of the Thistle. The young princes must have given fresh sittings, for apart from differences of pose and appearance (they appear both slightly older and more mature), the princes do not wear the orders of the Garter and the Thistle in the earlier full-lengths.

Nearly a decade later Blanchet painted a grand full-length of Cardinal York in his robes, signed and dated 1748 (The Darnaway Castle Collection; Kerslake 1977, vol. 1, p. 327, and vol. 2, pl. 938). [EPB]

## JAN FRANS VAN BLOEMEN, *called* ORIZZONTE

### ANTWERP 1662–1749 ROME

Born into a Catholic family of painters and draftsmen in Antwerp, Jan Frans van Bloemen was baptized on May 12, 1662, in the cathedral of Notre Dame. His first teacher was his brother Pieter van Bloemen, called "Lo Stendardo," a prolific painter of animals, landscapes, and views of ruins who became a master in the Antwerp Guild of St. Luke in 1673 and traveled the following year to Rome. Jan Frans next studied between 1681 and 1684 with another Antwerp painter, Anton Goubau, a painter of market scenes and *bambocciati* situated in Roman or Mediterranean settings, who had himself lived in Rome from c. 1644 until 1650.

Van Bloemen traveled to Paris in 1684–85 and then to Lyon, where he rejoined his brother Pieter, and the pair traveled to Italy, stopping briefly in Turin and then going on in 1686–87 to Rome. Both brothers were members of the Schildersbent, the clique of Dutch and Flemish artists active in Rome; Jan Frans was given the *bent* name, or nickname, Orizzonte (Italian for "horizon"), in recognition of his facility for producing panoramic landscapes. The Van Bloemen brothers lived in via Margutta, in the area habituated by artists from the north of Europe and occupied the studio that had previously belonged to Claude Lorrain. Jan Frans married Matthia Rosa Barosini, a native of Zagarolo, in Rome in 1693, and the Dutch artist Gaspar van Wittel (Gaspare Vanvittelli) was godfather to the couple's first child, baptized in 1694. Apart from an eight-month journey to Naples, Sicily, and Malta, he lived in Rome for the remainder of his life and died there on June 13, 1749.

Van Bloemen loved the beauty of the countryside of Rome, and idealized evocations of the Roman Campagna became the principal subject of his paintings. He made numerous *passeggiate* to draw the landscape around the Alban Hills and incorporated into his works evocative motifs from the towns and small villages there, dating from the Middle Ages and often in ruins. Van Bloemen was also deeply inspired by the classicizing landscapes of the French painter Gaspard Dughet; for Lione Pascoli, one of Van Bloemen's contemporary biographers, the combination of nature and Dughet's landscapes was sufficient to explain his art. Gaspard's transcriptions of the Roman Campagna continued to enjoy tremendous popularity in the eighteenth century, and it is clear that Van Bloemen's contemporaries considered him the principal successor to Dughet and the landscapists of the previous century. In Pascoli's words, "Per lo cui saporito, morbido e armonioso pennello l'età nostra non invidia alla passata i Gellé, i Grimaldi, i Dughet, e i Rosa" (quoted in Busiri Vici 1974, p. 230).

Although Van Bloemen's works from his earliest years in Rome are dominated by the influence of Dughet, he nonetheless gradually assumed his own distinctive personality. Already by the end of the seventeenth century his paintings began to anticipate the *vedute* of the Settecento. By the second decade of the eighteenth century he was regarded as the foremost landscapist in Italy, and his consciously idealized landscapes were avidly sought by both the local aristocracy and visiting Grand Tourists. In the 1730s Van Bloemen began to adapt his delicate and sensitive manner decisively toward a more overtly noble and idealized vision of landscape painting, echoing the classical serenity of Poussin's compositions and even borrowing elements directly from the French painter, as in *Landscape with the Belvedere of the Vatican* (Galleria Pallavicini-Rospigliosi, Rome) and *Landscape with a Temple* (Villa d'Este, Tivoli). Van Bloemen's efforts to idealize the actual buildings and sites of his landscapes and to ennoble them with heroic figures have been linked by modern critics to the high artistic goals implied by Bellori's *Idea*, in which the artist aspires not merely to emulate nature, but to surpass it.

Van Bloemen has been called "the Canaletto of the *idea* of the Roman campagna," (Clark 1970, p. 70) and his lush and expansive landscapes came to represent the ideal of nature in Rome in the eighteenth century. He enjoyed patronage from the leading Roman aristocratic families—the 1783 catalogue of the Galleria Colonna lists no fewer than eighty of his works—but he also found favor with the more sophisticated ecclesiastical collectors such as Cardinals Colonna, Ottoboni, and Imperiali, and his smaller canvases were greatly admired by connoisseurs and *amatori*, such as Piero Ranieri, Fabio Rosa, and Giambattista Costantini. By the middle of the 1730s his works had entered collections throughout Italy and abroad, and he had become a favorite with visiting Grand Tourists, particularly the wealthy British aristocracy.

Although Van Bloemen was elected to membership in the Congregazione dei Virtuosi al Pantheon in 1714, his artistic career was marred by a prolonged confrontation with the Accademia di S. Luca. Pascoli wrote that because of his reputation and success as a painter, he incurred the envy of the members of the

185

186

Accademia, who considered landscape an inferior genre of painting. They evidently defeated attempts to admit the Flemish painter during Carlo Maratti's tenure as Principe of the Accademia between 1701 and 1713; on September 30, 1725, under Giuseppe Chiari's presidency, Van Bloemen was officially approved as *accademico di merito*, but inexplicably his name does not appear subsequently in the academy's records. The precise reasons for this omission are not known, and it was not until May 6, 1742, that Van Bloemen appears to have become a member of the Accademia di S. Luca. [EPB]

BIBLIOGRAPHY Pio [1724] 1977, pp. 93, 279, 337–38, 352; Clark, 1961, "Figures"; Busiri Vici 1968; Zwollo 1973, pp. 27–38; Busiri Vici 1974; Coekelberghs 1976, pp. 19–74; Salerno, Luigi, ed. *Dittori di paesaggio a Roma, 1600–1760.* Rome: Ugo Bozzi, 1978, vol. 3, pp. 848–55; Whitfield 1978, cat. nos. 8–11; Rangoni 1990, "Bloemen"

## 185

Jan Frans van Bloemen, *called* Orizzonte

*Landscape with an Abbey and a Ruined Doric Temple*

c. 1715–20
Oil on canvas
33¼″ × 52″ (85.7 × 132.1 cm)
PROVENANCE England, private collection
EXHIBITION Atlanta, Oglethorpe University Museum. *The Grand Tour: Landscape and Veduta Paintings, Venice and Rome in the 18th century.* 1997, cat. no. 29
Walpole Gallery, London

The mature paintings of Jan Frans van Bloemen represent such a very grand and heroic type of pastoral landscape, a world of ruins, waterfalls, pine trees, and distant towers so satisfying in conception and articulation, that it is easy to overlook his efforts of nearly fifty years to perfect this formula. Van Bloemen's artistic formation can be grouped into four distinct periods, beginning with his training in his native Antwerp under Anton Goubau, a painter of Italianate landscapes who strove to evoke the atmosphere of Rome rather than render exact topographical views. In his early years Van Bloemen was also attentive to the tradition of pseudo-Italianate landscape painting expressed, for example, in the work of Cornelis Huysmans and Adriaan van der Cabel.

The second period in Van Bloemen's development began with his arrival in Rome in the late 1680s and his close attention to the works of Crescenzio Onofri, Jacob de Heusch, and, above all, Gaspard Dughet, who had died there a little more than a decade before, in 1675. Van Bloemen inherited Gaspard's enthusiasm for the landscape of the Roman Campagna, and he returned time and again to the sites around Tivoli, the Alban hills, and the environs of Rome that had been made popular by the French painter (and by Claude Lorrain before him). In Rome, Van Bloemen was immediately exposed to the variety of Dughet's landscapes and enjoyed ample opportunity to study his work at first hand. He made faithful copies after Dughet in his early years in Rome, and his integration of the style of these works into his own manner was so thorough that many of his paintings passed under Dughet's name, and vice versa. (In the 1783 catalogue of the Galleria Colonna two large tempera paintings by Dughet are even cited as "ritoccati da Orizzonte"; see Coekelberghs 1976, p. 46).

In the third phase of his career, roughly 1710–30, according to Denis Coekelberghs, Van Bloemen began to develop his own pictorial idiom and to requite his debt to Dughet; his landscapes now are very much his own creation. The appearance of *vedute* made on the spot give some idea of the expansion of his repertory during these years. The landscapes of Dughet never lay much below the surface of Van Bloemen's artistic consciousness, however, and served as the link to the other two great seventeenth-century French *paysagistes*, Claude Lorrain and Nicholas Poussin. It is from the idealized landscapes of Poussin's later years, such as the *Funeral of Phocion* (Earl of Plymouth, Oakly Park, Ludlow) that Van Bloemen developed his final, grand style of landscape painting, a *maniera magnifica* that resulted in his most memorable works, the grand classical landscapes of the second half of the 1730s and 1740s in the Galleria Pallavicini-Rospigliosi and other Roman collections, many of which are signed and dated. (For an excellent discussion of Van Bloemen's development as a landscape painter, see Coekelberghs 1976, pp. 34–67.)

*Landscape with an Abbey and a Ruined Doric Temple* reveals Van Bloemen's inspiration from Dughet in its selection of motifs taken from the scenery around Rome (the abbey has not been identified, but was presumably was drawn from life), the overall construction of the landscape by means of a series of intersecting diagonals, the device of the three trees extending almost to the height of the composition at the left, and the seated figure in antique dress observed three-quarters from the rear, which make an appearance in Orizzonte's compositions before the end of the seventeenth century and thereafter. The French master's approach to landscape painting, however, has been modified here by Van Bloemen—his striking naturalism muted in favor of a more carefully and artificially constructed landscape, his shifting play of light and shade replaced with more even nuances of tone and atmosphere, his palette lightened and his chromatic range widened, and his broad touch replaced by a sparkling pointillism. Within Van Bloemen's own development this landscape anticipates works of the 1720s and 1730s in its calmer rhythms, increased luminosity (the delicate tinted light in the background is particularly beautiful), and lucid and rational structure which anticipates the grand, classical landscapes of the late 1730s and 1740s in the style of Poussin. The increasing suppleness and naturalism of the figures suggest Van Bloemen's progress toward mastering the requirements of academic figure painting.

The complexity of this canvas, its size (*tela d'Imperatore*), provenance, and richly gilded English frame with classicizing ornament indicate that it was one of the many landscapes by Orizzonte bought by the *cavalieri inglesi* in Settecento Rome. [EPB]

## 186

Jan Frans van Bloemen, *called* Orizzonte

*A Panoramic View of Rome Observed from Monte Mario*

c. 1730–35
Oil on canvas
67¼″ × 97¼″ (172 × 247 cm)
PROVENANCE acquired on the London art market in the 1940s by the present owner's father
Mrs. Juliet M. E. Hambro

In his life of Van Bloemen, Nicola Pio described the painter's landscapes in terms that describe the great portion of his œuvre: "Beautiful pictures done in such beautiful sites, with verdant foliage, limpid silver water, and with an agreeableness of color; accompanied by small figures of the utmost gracefulness, with rural dwellings and urns: all so well assembled, that his

pictures were welcomed into all the galleries of Italy" (Pio [1724] 1977, p. 93). Interestingly, Orizzonte's gradual development from a careful imitator of Gaspard Dughet to the creator of some of the grandest and most idealized depictions of the Campagna ever painted did not include many topographical views recorded on the spot. Although he continuously made pen and ink drawings of the environs of Rome in the open air as part of his working method, most of the views he painted were imaginary and created in the studio.

A Panoramic View of Rome Observed from Monte Mario, one of the most admired prospects of Rome in the eighteenth century, is thus distinguished as one of Van Bloemen's rare vedute reali. This view of the city lining the banks of the Tiber with the Alban Hills in the distance was familiar to many contemporary visitors as they followed via Trionfale on to the eastern slopes of Monte Mario, the ancient clivus Cinnoe. Sketched boldly with Van Bloemen's loose, impressionistic brushwork are a number of ancient and modern monuments, from the Ponte Milvio, on the left, to S. Giovanni dei Fiorentini and the Castel S. Angelo on the right. On the right-hand side of Van Bloemen's composition is the Villa Madama, the suburban villa designed by Raphael for Cardinal Giuliano de' Medici (Pope Clement VII).

The painting is a variant of a canvas formerly in the collection of Delegazione Montedison, Rome (Busiri Vici 1974, no. 211, figs. 10, 33, 34, 190). The differences between the two versions of the view occur largely in the foreground figures and the herd of sheep at the lower right. Busiri Vici dated the Montedison painting to around 1735; Coekelberghs (1976, p. 48) preferred a broader date in the 1730s. One of Van Bloemen's versions must have been known to Richard Wilson, who painted a similar view for William Legge, 2nd Earl of Dartmouth, in 1753, now in the Yale Center for British Art, New Haven. Aside from following Van Bloemen's arrangement of framing trees, Wilson has even repeated such small details as the gesturing figure at the left of the foreground in the Montedison painting and the triangular highlight on the villa (London, Tate Gallery, Richard Wilson [Tate Gallery, London, 1982], p. 162). [EPB]

## 187

### Jan Frans van Bloemen, called Orizzonte, and Placido Costanzi
### The Flight into Egypt

c. 1735–40
Oil on canvas
39″ × 53½″ (99 × 135.9 cm)

PROVENANCE acquired in Rome by Henry Blundell, for Ince Blundell Hall, Lancashire, England; thence by descent to Col. Sir Joseph Weld, who sold Ince in 1960, but kept the art collections, transferring the paintings to Lulworth Castle, Dorset

EXHIBITIONS Liverpool 1960, cat. no. 42; Bournemouth, England, Russell-Cotes Art Gallery and Museum. Paintings from the Lulworth Castle Gallery. 1967, cat. no. 42

BIBLIOGRAPHY Blundell 1803, p. 231, no. LXVI; Neale, John Preston. Views of the Seats of Noblemen and Gentlemen in England, Wales, Scotland, and Ireland. London, 1823, vol. 6, n. p., q.v. "Ince, Lancashire; The Seat of Charles Blundell, Esq.," Gronau, H. "Ince Blundell Hall Catalogue." Ince Blundell Hall (typescript handlist), 1948; Busiri Vici 1974, p. 212 (as "Mr. Blindell Weld's")

Private collection, England

## 188

### Jan Frans van Bloemen, called Orizzonte, and Placido Costanzi
### The Rest on the Flight into Egypt

c. 1735–40
Oil on canvas
39″ × 53½″ (99 × 135.9 cm)

PROVENANCE as above

EXHIBITIONS Liverpool 1960, cat. no. 43; Bournemouth, England, Russell-Cotes Art Gallery and Museum. Paintings from the Lulworth Castle Gallery. 1967, cat. no. 44

BIBLIOGRAPHY Blundell 1803, p. 231, no. LXVII; Neale, John Preston. Views of the Seats of Noblemen and Gentlemen in England, Wales, Scotland, and Ireland. London, 1823, vol. 6, n. p., q.v. "Ince, Lancashire; The Seat of Charles Blundell, Esq"; Gronau, H. "Ince Blundell Hall Catalogue." Ince Blundell Hall (typescript handlist), 1948; Busiri Vici 1974, p. 212 (as "Mr. Blindell Weld's")

Private collection, England

Lione Pascoli noted in his biography of Van Bloemen that Carlo Maratti "did the figures" in a pair of important landscapes for Marchese Niccolò Maria Pallavicini, and that Giuseppe Bartolomeo Chiari, Benedetto Luti, and Luigi Garzi also supplied figures for other important commissions. In spite of the popular conception that Van Bloemen commonly relied upon local history painters for the figures in his landscapes, only the paintings of his last decades, his most classicizing and ambitious, luxurious and prestigious productions, reveal the evidence of such professori ben noti as Sebastiano

Conca and Pompeo Batoni. The collaborators normally supplied only the largest, most prominent characters in the foreground of his compositions (often with allusions to Raphael, Domenichino, and Guido Reni); Van Bloemen himself painted the less important staffage in the second and third planes. Even in the late 1730s and 1740s Van Bloemen's collaboration with other painters is not nearly so extensive as is commonly believed. He was himself an accomplished figure painter, described in contemporary documents as "Monsù Orizonte celebre di paesi e figurine," and he quickly learned to imitate the styles of his collaborators, with the result that many of his landscapes on the art market bearing attributions to the more prestigious contemporary history painters are entirely by his own hand.

The artist Van Bloemen collaborated with most frequently and successfully was the delicate, intelligent, and noble painter Placido Costanzi. The two appear to have begun working together as early as 1725–30, although the earliest signed and dated painting with indisputable contributions to the staffage by Costanzi appears to be from 1737, followed by others from 1741, 1742, and 1744 (Busiri Vici 1974, pp. 134–48, nos. 315, 327, 348). The working relationship of the two painters was well known in contemporary Rome, and Pier Leone Ghezzi acknowledged their collaboration in a pen-and-ink caricature of Costanzi dated February 29, 1740, in which he is shown standing before an easel, brushes and palette in hand, contemplating a wooded landscape without figures (Busiri Vici 1974, fig. 161). And at the end of the century, Luigi Lanzi noted that "Placido Costanzi is often mentioned with approbation in the collections of Rome, for the elegant figures he inserted in the landscapes of Orizzonte" (Lanzi [1809] 1847, vol. 1, p. 499).

The most important collaborative commission shared by the two painters, Landscape with Christ and the Woman of Cana and Landscape with the Good Samaritan, was installed in the right-hand saletta of the Coffee House, created for Pope Benedict XIV in 1742 in the gardens of the Palazzo del Quirinale (Busiri Vici 1974, nos. 345–46, figs. 166–67). The Palazzo del Quirinale was the preferred residence of the pope, and from the beginning of his pontificate he embellished the palace and made it more comfortable. Among other improvements, he commissioned Ferdinando Fuga to construct a palazzino di ritiro in the gardens to serve as a place both of repose and reception. The interior pictorial decoration involving Batoni, Masucci, Panini, Costanzi, and Van Bloemen was executed in 1742–43, and the pay-

ments to the respective artists confirm the fact that, although contemporary landscapists were steadily successful economically, the set and standard prices for landscapes were inevitably lower than those for religious and other subject pictures. Only large landscape machines with elegant figurine, for which there was only a limited market, rose toward the grand prices. The documents of payment show that Batoni and Masucci were each paid 400 scudi, Panini 300 scudi, and Van Bloemen and Costanzi (whose canvases set into the walls are the smallest in the entire program) 80 scudi each for their respective paintings (Clark and Bowron 1985, pp. 53, 228).

The expansive, panoramic landscapes at Lulworth Castle with their large, carefully drawn figures represent one of the most successful collaborations between the two artists in the 1730s. (In the Ince Blundell catalogue by H. Gronau cited above, the following anecdote is recorded: "Orizzonti, on seeing the figures, was so much pleased with them, that he begged to have the pictures to retouch, and always declared these to be two of the best he ever painted.") Van Bloemen's landscapes are carefully constructed to circumscribe and accent the foreground figures, and the towering mountains and limpid vistas closing the horizons of each suggest why the artist was known to his contemporaries as "Orizzonte." The colors are strong and rich, the light radiant, and the brushwork sparkling. The arrangements between Van Bloemen and Placido were probably informal, and there is no evidence that Placido even supplied drawings in advance of his execution of the figures. If he did, Van Bloemen may have kept them for use in painting replicas with figures entirely by his own hand (Busiri Vici 1974, no. 246, with figures by Van Bloemen). The Lulworth paintings are not signed but, as Coekelberghs (1976, p. 34) observed, the presence of flowers in the landscapes of Van Bloemen (whose name means "flowers" in Flemish) may be interpreted as a kind of floral signature.

Pascoli noted the enthusiasm for Van Bloemen's landscapes on the part of the cavalieri inglesi in Rome, and indeed the present pair was acquired by one of the great English collectors of the late eighteenth century, Henry Blundell. The scion of a distinguished Roman Catholic Lancashire family, Blundell was thirty-six when his father, Robert (whom he succeeded in 1773), made over to him the family seat, Ince Blundell Hall, near Liverpool. English penal law against Roman Catholics in force at the time prevented Blundell from holding public office, and the honorary posts

187

188

obtained by gentlemen of similar station were unavailable to him, so after the death of his wife in 1767 he devoted his energies and his considerable fortune to collecting.

Blundell began to collect paintings in England sometime between 1763 and 1767, and even before his visit to Italy commissioned four large landscapes of the Roman Campagna from Richard Wilson for a room at Ince. The inspiration to collect on a grander scale seems to have come from Charles Townley, a Lancashire neighbor and fellow Roman Catholic, who in 1772 returned from seven years' residence in Rome with an important group of classical sculptures and antiquities that was to become one of the founding collections of the British Museum. Blundell made his Grand Tour in 1777 and visited Rome in March and April, when he was accompanied by Townley and taken in hand by one of the leading *ciceroni* to the visiting Grand Tourists, Thomas Jenkins.

Largely under Jenkins's guidance, Blundell bought antiquities from the Villa Mattei and the Villa d'Este as well as from the collections of other Roman families. He made subsequent trips to Rome in 1782–83, 1786, and 1790, and during all of these visits he bought sculptures and paintings from the English dealers—Jenkins, Gavin Hamilton, James Byres, and Father John Thorpe—and from Italian dealers, antiquarians, and sculptors such as Albacini, Volpato, and Antonio d'Este. Henry Blundell took to collecting with an enthusiasm bordering on obsession, and at the time of his death in 1810 there were over 500 pieces of ancient sculpture at Ince. The collection was one of the two largest private collections of ancient marbles ever formed in Great Britain—Townley's was the other—and was comparable in importance and quality to those created in the 1770s by other British collectors of the

classical sculpture and antiquities such as William Weddell of Newby.

Blundell's enthusiasm for pictures matched his passion for antique sculpture, and the 1803 catalogue of his collection, *An Account of the Statues, Busts, Bass-Relieves, Cinerary Urns, and other Ancient Marbles, and Paintings, at Ince. Collected by H. B.*, lists 197 paintings and drawings. The collection he assembled at Ince reflected the prevailing taste of the period for the Italian Baroque and for Dutch seventeenth-century landscapes and genre scenes. In Italy he patronized Antonio Canova and acquired numerous works by contemporary painters including Pompeo Batoni, Giuseppe Cades, Antonio Cavallucci, Corrado Giaquinto, Gavin Hamilton, Anton Raphael Mengs, and Pietro di Pietri. Like many of his English compatriots, he had a great passion for landscape painting, and his collection contained dozens of landscape and topographical paintings by Dutch, English, French, and Italian artists. And like many Grand Tourists, he avidly sought topographical views of the sights he had visited on his Italian sojourns, in particular Rome, Venice, Naples, and their environs. In addition to the present pair, he purchased in Rome five landscapes by Carlo Labruzzi. (For a résumé of Blundell's Grand Tour and collecting activities, see Bowron 1991, pp. 7–8, 12; Ingamells 1997, pp. 101–2, each with further references.) [EPB]

## GIUSEPPE BOTTANI
### CREMONA 1717–1784 MANTUA

When Giuseppe Bottani went to Rome in 1735 he had already had some training in Florence with Antonio Puglieschi and at the studio of Vincenzo Meucci, who was in turn the pupil of one of Guido Reni's students, Gian Gioseffo del Sole from

Bologna. Meucci cultivated Bottani's taste for correct drawing by directing him to study Andrea del Sarto's frescoes in the cloister of the SS. Annunziata. So it was natural that the young artist, born in Cremona on December 27, 1717, into a family who may have come from Pontremoli, should have headed in the direction of Agostino Masucci's studio, which at that time enjoyed a good reputation for continuing the tradition of the Carracci and Maratti (Marrini 1765-66, vol. 2, p. 3).

Bottani's career progressed through the usual stages: works for Roman churches and the Papal States as well as for the rest of Italy and Europe, commissions from princely families, and finally, in 1758, membership in the Accademia di S. Luca, whose Principe, or head, was then the painter Placido Costanzi. Bottani's reception piece was the *modello* for an altarpiece of *Saint Joachim and Saint Anne with the Virgin Mary as a Child*, installed that same year in S. Andrea delle Fratte in Rome (Faldi 1977, p. 507). In April 1764 Bottani was made director pro tempore of the Capitoline Scuola del Nudo. At the conclusion of this canonic career course, which made him one of the most accredited artists in Rome in the 1760s, he won appointment as director of the recently reformed academy of Mantua. In the Empress Maria Theresa's decree, dated Vienna May 29, 1769, confirming his nomination, he was called "Direttore e Professore Primario," and given a salary of 1200 florins (Perina 1961, p. 58, n. 13).

In the earliest of Bottani's known paintings, *The Rest on the Flight to Egypt* (1743) for the church of the Missione a Montecitorio in Rome (Susinno 1971, pp. 10–15), Bottani put to good use his studies of the antique, Raphael, and the Carracci Farnese Gallery, adhering to a clearly anti-Rococo style of composition, solidly anchored in the traditions of the sixteenth century and

sustained from the very first by faultless handling of the nude and of drapery (Perina 1961). A good example of this practice is a surviving sketchbook of academic studies (Rome, Palazzo Venezia, ms. 4; Perina Tellini 1971, p. 406).

There followed numerous altarpieces for various centers in the Papal States, where there was a movement to diffuse the cult of the early martyrs through the dissemination of relics and the renovation of altars and other manifestations of their cult. The best example is the tightly conceived altarpiece of Orte, made sometime before 1752, in which the statuesque figures of eight idealized early Christian saints appear below a noble *Assumption of the Virgin* that recalls Maratti (Susinno 1969–70, pp. 63–72). Maratti was also the source for another painting of the same subject with Saints Gregory and Silvia, dating around 1744, in S. Gregorio di Sassola, near Tivoli (Susinno 1969–70, pp. 72–74).

Bottani's workshop production of altarpieces was one of the most conspicuous and financially rewarding aspects of his work. In these years many were executed for locales in west Tuscany, Pontremoli, Livorno, and Pescia. Because of his own family's origins in Pontremoli he maintained contact with the local aristocracy as we know from a letter of July 2, 1757, in the archives of the Dosi-Delfini family, in which the painter asks the Marchese Antonio Dosi not to hire outside artists for a painting of *The Death of Saint Francis* in the local church of S. Nicolò. The painter particularly appeals to the marchese's ability to distinguish "the Roman manner from other incorrect and untrue ones" (Bertocchi and Dosi-Delfini 1970, pp. 15–16). Other works include an altarpiece for the cathedral as well as other paintings in which Bottani was assisted by his brother Giovanni (Rybko 1990, "Bottani";

Susinno 1969–70, pp. 75–104; Hiesinger and Percy 1980, p. 63, no. 50). For Livorno, Giuseppe Bottani painted at least four altarpieces (Chracas, *Diario Ordinario di Roma*, March 5, 1757, no. 6186; Tellini Perina 1973, fig. 2; Susinno 1969–70, pp. 96–98) including an *Immaculate Conception* for the cathedral which literally copies a painting in the Palazzo S. Bernardino in Tivoli (Bernardini M. 1997, pp. 70–73, no. 12). In 1769 he sent to Pescia a *Birth of the Virgin* for the Forti Chapel in the cathedral, which had been completely renovated in the Roman manner with architecture by Ferdinando Fuga and sculpture by Filippo della Valle (Ansaldi 1816, p. 12).

Orazio Marrini, Bottani's first biographer, also records works destined for Roman Catholic churches in Ireland and Poland. Long before he settled for good in Lombardy, Bottani's style, so purely based on that of Domenichino, had been admired in Milan, where his *Saint Paula Setting Out for the Holy Land* significantly took its place alongside canvases by Batoni and Subleyras in the church of Ss. Cosma e Damiano (1745: now in the Pinacoteca di Brera, Milan) and this did not change substantially after his move to Mantua, when his solemnly rhetorical altarpieces were distributed around northern Italy, helping promote a recovery of the Roman-Bolognese classicism of the seventeenth century (Marrini 1765-66, vol. 2, p. 32, nos. 1–3; Tellini Perina 1973; *Mantova nel Settecento* 1983, pp. 165–72; Bianchi 1997). Academic recognition in addition to membership of S. Luca, the Accademia Clementina of Bologna, and the Accademia del Disegno, Florence (in 1767) was lavishly bestowed on this "distinguished painter and man skilled in geometric and astronomical sciences," who "with bold step" trod "the simplest and loveliest paths of nature and of truth" (Marrini 1765–66, vol. 2, p. 31), and he was able to treat any subject matter successfully. His compositions included great historical works, such as *The Death of Cleopatra* and *The Torment of Mezio Fufezio*, painted for the Venturini Pontremoli family or the grandiose *Death of Dido* (Susinno 1969–70, pp. 152–54; Tellini Perina 1973, p. 16, figs. 10–11; Perina 1961, p. 59, fig. 9), which Anton von Maron appears to have studied for his canvas on the same theme (and both painters were in turn influenced by the Guercino in the Galleria Spada) on the ceiling of the Casino Borghese (1786). But he also produced some highly successful landscapes with biblical or mythological scenes, such as those bought by Richard Dalton for King George III of England, including *The Flight into Egypt* and *The Return to Nazareth* (Michael Levey, *The Later Italian Pictures in the Collection of Her*

*Majesty the Queen* [London: Phaidon, 1964], nos. 362–63, figs. 112–13) and two subjects taken from the Odyssey (*Athena Pointing Out Ithaca to Ulysses* and *Athena Transforming Ulysses into a Beggar*; *Mantova nel Settecento* 1983, pp. 168–69, nos. 184–85). Lastly, the lively representation of the great country fair organized by Prince Camillo Rospigliosi on his estate at Maccarese (1755; Museo di Roma), shows Bottani as a skillful animal painter (Susinno 1976). The painting also contains anatomically perfect and fashionably dressed figures.

While keeping his own work distinct, Giuseppe Bottani could count on the collaboration of his brother Giovanni, with whom he shared his accommodation on the selciata di S. Sebastianello during his last years in Rome, together with their sister Teresa. In 1767, to celebrate the marriage of Prince Giovanni Andrea IV Doria Pamphili to Leopoldini di Savoia Carignano, Bottani redecorated the ceiling of the apartment on the piano nobile of the Palazzo Doria Pamphili with a large painting of *Hercules Ascending to the Temple of Glory*, a subject chosen over his other suggestion, the *Birth of Venus* (Susinno 1978). The new décor was to be the setting for a great feast offered by the prince to Joseph II, co-Emperor of Austria-Hungary, and his brother Grand Duke Leopold of Tuscany, on the occasion of their visit to Rome in 1769. The work was in line with the hoped-for reforms in art training by the minister Carlo di Firmian (see Scotti 1984, pp. 283–309), and probably as a result Bottani was invited to take on the post of director of the painting and sculpture classes in the academy of Mantua, where in 1769 he was invited to replace the aged Giuseppe Bazzani, champion of a lingering Rococo. Drawing on his suggested alternative to the *Hercules* in the Palazzo Doria Pamphili, Bottani painted for Firmian a new *Venus Rising from the Sea* with a cortège of cupids, naiads, and tritons (1770), earning praises from his patrons "for the nude of such various ages" (see *Mantova nel Settecento* 1983, p. 165; Bianchi 1997, p. 67), while his *Minerva Raising Painting* (1770; private collection, Milan) and *Saints Theresa and Joseph* (1780; Galleria Nazionale d'Arte Antica, Rome), are allegories on the themes of good government and the fine arts, respectively.

After Bottani's death on September 17, 1784, his brother Giovanni inherited his office in Mantua and the contents of his studio, with gessos brought from Rome, numerous preparatory drawings, life studies, and unfinished works. Just as Pécheux was to do in Turin a year later, he attempted to sell everything as a job lot to the Austrian government in 1802 as a stock of

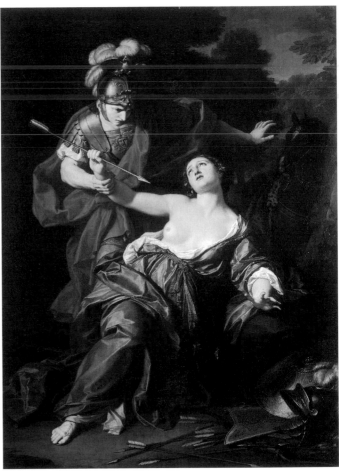

189

teaching material for the academy of Mantua, but without success. The inventory he drew up is now a valuable source, providing evidence of how "Roman" artistic methods were disseminated outside the confines of the papal capital. [SS]

BIBLIOGRAPHY Marrini 1765–66, vol. 2, pp. 31–32; Perina 1961; Susinno 1969–70; Perina Tellini 1971; Tellini Perina 1973; Susinno 1976; Susinno 1978; Hiesinger and Percy 1980, pp. 59–63; Magni 1984; Rykbo 1990, "Bottani"; Sestieri 1994, vol. 1, pp. 32–35; Zatti, Susanna. "Bottani, Giuseppe." In AKL, vol. 13, p. 254; Bianchi 1997; Loire 1998, pp. 83–88

## 189

## Giuseppe Bottani
### *Armida about to Wound Herself, Restrained by Rinaldo*

1766
Signed and dated lower left: *Joseph Bottani fecit Romae 1766*
Oil on canvas
80″ × 58″ (205 × 147 cm)

BIBLIOGRAPHY Marrini 1765–66, vol. 2, part 2, pp. xxxi–ii; *Il trionfo* 1767, p. xx; Zaist, Giovanni Battista. "Notizie istoriche de' pittori scultori ed architetti cremonesi." Cremona, Italy: P. Ricchini, 1774, vol. 2, pp. 173–74; Borea, Evelina. "L'armida che tenta di uccidersi di Giuseppe Bottani e

una biografia aggiornata al 1769." In *Pier Maria Cionini Visani: Scritti di amici*. Turin, Italy, 1977, pp. 133–35; Susinno 1978, p. 309 Galleria degli Uffizi, Florence

This work sent by Bottani to the exhibition mounted in July 1767 by the Accademia del Disegno in the cloister of SS. Annunziata in Florence, to which "all ranks of persons ere allowed access, not excluding women, but excepting lowly people" (*Gazzetta Toscana* [1767], no. 28, p. 117; quoted in Borroni Salvadori 1974, p. 48), appeared at exhibitions with the title used here, and with an indication that it belonged to Bottani himself (Borroni Salvadori 1974, p. 69). The exhibition was opened by the Grand Duke Leopold, and contained 830 works by 257 artists, lent by 65 art lovers and collectors and a handful of the artists themselves. For the most part they were classic works, from the previous century, owned by the great Florentine families who generously lent their canvases by Carlo Dolci and Salvator Rosa, Guido Reni and Luca Giordano, and marbles and bronzes by Giambologna and Massimiliano Soldani Benzi (Borroni Salvadori 1974, p. 47). There were few Roman painters, but those few showed a swing in Florentine taste from which

Bottani could benefit: the Marchese Giuseppe Riccardi lent *The Holy Family with the Sleeping Virgin*, now in Pommersfelden and the "large picture" showing *The Allegory of the Arts* by Pompeo Batoni (cat. 162) in Frankfurt (Clark and Bowron 1985, p. 220, no. 41, and p. 240, no. 113) (it should be noted that an engraving designed by Bottani was dedicated to the marchese's relative Francis Maria Riccardi, see *Mantova nel Settecento* 1983, p. 182). The Marchese Carlo Gerini also lent paintings by Batoni: *Hercules at the Crossroads* (now in the Galleria d'Arte Moderna, Florence) and *Dido Restraining Aeneas* (Ford Collection, London; see Clark and Bowron 1985, pp. 228-29, no. 67, and p. 241, no. 115). Gerini already possessed an important painting by Bottani of *The Incredulity of Thomas* (see *Mantova nel Settecento* 1983, p. 176). He also lent Placido Costanzi's *Mercury with the Liberal Arts* (now in a private collection; see Sestieri 1994, vol. 2, fig. 369). The senator Martelli sent a *Noli me tangere* by Marco Benefial (see Civai 1990, p. 139, fig. 34). Bottani's painting was soon to pass into the collection of the grand duke, where it was recorded by Zaist (1774), and where it remained unknown until found and published by Evelina Borea in 1977.

The modern literary theme is taken from a passage in the twentieth canto of Tasso's *Gerusalemme liberata* (octaves 122-130), which Bottani illustrated with extreme fidelity. After the final defeat of the Muslim army, Armida flees on horseback to a secluded, protected spot with the intention of killing herself. She puts aside her weapons, which the painter depicts in the foreground, and turns to them almost as though reproving them for not being bathed in enemy blood and inviting them to wound her soft breast, which she has now exposed: "If every other bosom to you seems made of diamond/You will dare to wound a feminine breast/In this of mine, which stands naked before you/ May your merits and your victories lie/ vulnerable to blows is this of mine; know well/ Love, that you will never strike in vain." Having chosen an arrow "the most piercing and strong," she is just about to stab herself when Rinaldo, who has followed her, prevents her desperate move: "From behind he approaches her and takes her arm/ Which already aims the savage point at her breast." Armida sees him and faints. "She falls, like a flower half cut, / Bending her limp neck: he holds her up."

The theme had enjoyed a certain popularity in serial illustrations of the poem, such as those by Guercino and Simon Vouet, but rarely had such a theatrical and dramatic scene been represented as an independent subject (see Andrea Buzzoni, ed., *Torquato Tasso: tra letteratura, musica, teatro e arti*

figurative [Bologna, Nuova Alfa, 1985], pp. 314–16]. Bottani creates his Armida partly by referring to classic precedents such as Guido Reni's *Suicide of Lucretia* (Neues Palais, Potsdam), and partly by idealizing nature itself in the beautiful feminine form of the sorceress, as can also be seen in the documented drawing by the artist, delicately executed in black pencil (see Susinno 1978, p. 309, fig. 2). It is difficult to establish whether or not Giuseppe Bottani, who was not married, had any opportunity to portray from life the ivory (or rather marble) female nudes of his Venuses and his majestic heroines (for instance these illustrated in Susinno 1978, fig. 7; *Mantova nel Settecento* 1983, no. 182; Bianchi 1997, pp. 67–68). Certainly in some cases Virgin figures or allegorical ones such as Faith appear to have been achieved by adding drapery to studies of clearly male nudes (see Susinno 1978, p. 309, figs. 3, 5), as Federico Barocci had already done (Andrea Emiliani, *Mostra di Federico Barocci* [Bologna: Alfa, 1975], nos. 25, 141). Bottani's female figures here and elsewhere always turn out like statues, even though they are based on a deep knowledge of anatomy. It is more worthwhile to emphasize the extreme richness and elegance of the draperies, echoing the art of Reni, and the virtuoso display of illusionism in rendering the surface and texture of various materials, from the red woolen cape thrown over Rinaldo's armor to the soft white gleam of the linen and the sumptuousness of Armida's silken garments "which the looms of Lyon never could make as shiny and bright" (as said in 1800 by Matteo Borsa while discussing the 1745 Brera altarpiece *The Departure of Saint Paola*, mentioned in Perina 1961, p. 52).

In the Florentine grand duke's collections, this picture from Tasso would soon be joined by Bottani's *Self-portrait* of 1765, from the collection of the abbot Antonio Pazzi (*Gli Uffizi: catalogo generale*, 2nd ed. [Florence: Centro Di, 1980], p. 818, inset A 140). Therefore, the grand duke would have known both the artist's name and face when he met him in Rome during the journey he made in 1769 with his brother the emperor designate Joseph II. Both of them must have admired his merits, since the Grand Duke Leopold sat for a portrait for which there remains a finished drawing (Susinno 1978, p. 309, fig. 4), and Joseph, supporting his minister Firmian's desire to introduce Roman-inspired reforms in the arts, instituted the academy in Mantua. [ss]

190

## 190
## Giuseppe Bottani
### *Caterina della Valle Valadier with Her Children Giuseppe and Maria Clementina*

c. 1766

Oil on canvas

28¼" × 23½" (72 × 60 cm)

PROVENANCE bought by the government of Rome in 1934 from Signora Seni ved. Fedi and passed on to the Museo di Roma in 1935

BIBLIOGRAPHY Susinno 1976, pp. 41–44, fig. 8; Barroero 1990, p. 433, fig. 619; Rybko 1990, "Bottani"; Sestieri 1994, vol. 1, p. 33, and vol. 2, fig. 144; Zatti, Susanna. "Bottani, Giuseppe." In AKL, vol. 13, p. 254
Museo di Roma, Rome

The painting was bought in 1934 from a private source in Rome, descendants of the son-in-law of Giuseppe Valadier, Giuseppe Seni, husband of Marianna Valadier. It was then attributed to Anton Raphael Mengs, but was restored to Giuseppe Bottani in 1976, on the basis not only of the clearly characteristic style, but also of a detailed study of the hands of a female figure recognized among the artist's drawings (see Susinno 1976, p. 44, fig. 9).

The group portrait, distinguished by a restrained elegance that captures the social ambitions of a rising class, is one of the most intensely evocative portrayals of Rome and its artistic life in the 1760s. In 1756 Caterina della Valle, daughter of the famous sculptor Filippo, originally from Florence, became the wife of Luigi Valadier, and in 1760 their first son, Andrea, was born, taking the name of his paternal grandfather, who had died the year before. The young wife is portrayed with the little Giuseppe, born on April 14, 1762 (and baptized the following day in the church of S. Luigi dei Francesi by his paternal aunt and uncle Margherita and Giovanni Valadier), and with Maria Clementina —who like Andrea has until now escaped the scholarly reconstruction of the family genealogy—baptized on June 14, 1764, in the parish church of S. Lorenzo in Lucina, following the family's move to strada Paolina (via del Babuino) in the heart of the artistic quarter around the Piazza di Spagna; like her brother, Maria Clementina's godfather was her maternal uncle Pietro della Valle and her godmother Margherita Valadier.

A significant link between the births is the midwife Anna Spagna, from the parish of S. Lorenzo in Damaso, a member of the family that would take over the running of the Valadier silverware shop after Giuseppe had reached the peak of his career as an architect and had married his second wife, Margherita Spagna (in 1817).

Caterina Valadier is placed at the center of a significant network of family relationships within Rome's artistic class open to the contributions of widely diverse nationalities: of her sisters, Ottavia was to marry the Tyrolese painter Cristoforo Unterperger in 1775, and Petronilla the Frenchman Nicolas Duran. A third, Camilla, who died in 1779 at the age of twenty-nine, was a distinguished miniaturist in her own right; for herself and her father she erected an elegant sepulchral memorial in archaeological style in the parish church of S. Susanna, on which she had her own portrait in profile placed in a gilt-bronze medallion; it is logical to suppose this had been made by her brother-in-law Luigi, or at least in his flourishing workshop (on Camilla, see Minor 1978, p. 247, n. 54). Such biographical details underline the state of relative autonomy of this family group of French and Tuscan origins compared with traditional aristocratic patronage, and explain the tendency of its members to seek artistic recognition primarily from within their own circle. The closeness of the group was partly topographical—Caterina had only to cross the Piazza di Spagna with her children to reach Bottani's studio in the Salita di S. Sebastianello. He was about ten years older than Luigi Valadier, and already an established artist, as well as being a sought-after portraitist of provincial ecclesiastics and nobility (see Hiesinger and Percy 1980, p. 62, no. 49; Sestieri 1994, vol. 1, p. 33, and vol. 2, fig. 143), and had become a member of the Accademia di S. Luca in 1766, at a time when silversmiths and bronze workers could not go beyond enrolment in the more modest Compagnia dei Virtuosi al Pantheon. It is probable that there was a pendant to this painting, a portrait of Luigi, either alone or with his elder brother Andrea, who may have died in infancy since he is not mentioned in a census of spring 1769, which records two other children, the two-year-old Filippo and the eight-month-old Maria Anna (Archivio del Vicariato, S. Lorenzo in Lucina, census 1769). These facts, and the apparent ages of the children in the painting, suggest a date of around 1766.

Bottani's group is compared in a noble, classical style that looks back to Domenichino, articulating the figures through deep knowledge of perspective and anatomy, but rendering the gestures and expressions of the children with a completely natural and anti-rhetorical grace. Caterina, dressed up all'antica as Juno or Cleopatra, is adorned with a rich diadem quite different in design from the Roman jewelry of the eighteenth century (see Stefano Aluffi Pentini, "Roman Jewelry of the Seventeenth to the Early Nineteenth Century," *Jewelry Studies*, vol. 4, [1990], pp. 37–45) but similar to that with which Batoni adorns his queens. It is a jewel that falls halfway between the evocation of classical prototypes (for example, a similar band of gold, but after the classical model, without inset stones and pearls, crowns the colossal head of Juno in the Barberini Sciarra Colonna collection, now housed in the Ny Carlsberg Glyptothek in Copenhagen, and is an ideal model for the head of Caterina) and the sort of prop used by both painters and actors, the production of which constituted a significant local industry. Signora Valadier has assumed the allegorical costume of Latona, daughter of the Titan Ceo, and loved by Jupiter, by whom she conceived the divine twins Apollo and Diana. Here Bottani shows Giuseppe (whose features were to remain unaltered right up to the official portrait that Wicar did of him for the series of the Accademia di S. Luca in 1827; see Incisa della Rochetta 1979, pp. 66, 199, cat. no. 247) displaying a lyre, the attribute proper to Apollo, the god of music, and Maria Clementina as the infant Diana, recognizable by the silvery crescent moon in her hair. In the Rome of the 1760s, the family of the silversmith described by Father John Thorpe as "the first workman of these things in Europe" (see *Three Generations* 1991, p. 132), might be embellished, without fear of incurring the censure of snobs and aristocrats, with the same ornaments and the same symbolic evocations that Marco Benefial had used twenty years earlier to represent Princess Paola Erba Odescalchi Orsini d'Aragona with her children Paolo and Giacinta, when he depicted them similarly as Latona with her children Apollo and Diana (Museo di Roma; see Falcidia 1964).

The Valadiers' social strategy, here precociously entrusted to the persuasive discourse of the pictorial image, would prove victorious several years later when, in 1779, Luigi obtained the knighthood of the Golden Spur, which brought with it the prestigious titles of Conte Palatino and Nobile Romano (see Marconi 1963, p. 79). These proved useful, if nothing else (together with the presumably good offices of the ecclesiastical entourage of Pius VI Braschi, into whose graces he had entered) in helping him avoid the ignominy of an anonymous grave in the "Camp Scellerato" behind the Muro Torto, to which he would otherwise have been condemned by his mysterious suicide in 1785. And so it was in the family tomb in S. Luigi dei Francesi that Giuseppe would ask to "rest my ashes beside those of my greatly beloved parents" (see Debenedetti 1987, p. 429). It was left to his son Antonio to carve on his tombstone his string of academic, knightly, and above all noble titles (such as that of his first wife, Laura Campana, Marchesa di Cavello) intended to ensure for his descendants a place among the ranks of the Roman aristocracy. [SS]

## GIOVANNI BATTISTA BUSIRI

ROME 1698–1757 ROME

Giovanni Battista Busiri was among the earliest eighteenth-century Roman painters to cater to the taste of British tourists for pictorial records and attractive souvenirs of their stay in the Eternal City. He was born in Rome, the youngest of three sons of a French architect, Simon Beausire, and a Roman-born mother, Angela Francesca di Barlandino Manzoni. His activity as an amateur painter of landscapes and *vedute* began around 1720 and is documented by four paintings in tempera representing Rome and its environs (Busiri Vici 1966, pp. 26–27). In 1735 Busiri was documented as residing in the parish of S. Lorenzo in Lucina, Rome, at strada Paolina (via del Babuino), 51, together with the painter Ignazio Stern. In the years 1750 and 1751 he lived in the parish of S. Andrea delle Fratte, at via della Purificazione, 121, in a house in which the sculptor Giovanni Maini, principe of the Accademia di S. Luca, also resided.

Busiri's oil paintings reveal the powerful influence of Gaspard Dughet upon his development as a landscape painter (Hawcroft 1959, p. 297, figs. 1–2). However, he preferred to work in gouache (bodycolor) rather than oil, and seems to have deliberately cultivated the matt finish and dry surface achievable through this medium. Busiri's views of the ancient sites of Rome, the Campagna, and the Alban Hills enjoyed considerable success with British Grand Tourists in the 1730s, 1740s, and early 1750s. Charming, portable, and exquisitely painted and framed in their precious, Roman-made "Salvator Rosa" frames, these little *vedute* provided ideal souvenirs of a Roman holiday. Busiri confined his subject matter to a relatively restricted repertory of views that he repeated frequently, pairing one site with another, including the Capitoline Hill and Campo Vaccino, Basilica of Maxentius; Colosseum; Pyramid of Cestius; Castel S. Angelo; Pantheon; Temple of Minerva Medica, and the Tomb of Cecilia Metella.

Busiri supplied suites of views to a number of English and Irish patrons, such as Ralph Howard, 1st Viscount Wicklow, one of the most discriminating Irish connoisseurs of the eighteenth century, who acquired eight views by Busiri during his visit to Rome in 1751–52, presumably through his agent, James Russel. Among these views one pair, a View of the Ponte della Coira near Tivoli and a View of Civita Castellana, representing a bridge and aqueduct respectively, explain Busiri's rationale in matching one view with another. Busiri's patrons constitute a Who's Who of British visitors to Rome in the eighteenth century and include a number of discerning collectors: William Legge, 2nd Earl of Dartmouth; Joseph Leeson; Henry Clinton, 9th Earl of Lincoln; and Sir Robert Hildyard, 3rd Baronet.

The most famous group of Busiri views was acquired by William Windham, who formed a collection of twenty-six gouache paintings, eleven dating from 1739 and ten from 1740, as well as a series of six large oils by Busiri, while he was in Rome in 1739–40. The "cabinet" at Felbrigg Hall was designed especially to house the majority of pictures acquired by Windham abroad and survives intact as a distinguished example of an Englishman's taste shaped by the Grand Tour. The gouaches in situ by Busiri are a notable feature of this ensemble. "In their beautiful gilt frames, probably by the carver René Dufour, and hanging on crimson damask, they impart a character to a room which has few rivals in its evocation of the taste of Grand Tour collector in the mid-eighteenth century" (Sutton 1982, p. 22).

Robert Price (father of Uvedale Price, writer on the Picturesque) also had great enthusiasm for Busiri's views and is known to have taken drawing lessons from the artist in Rome. Writing to Lord Haddington at Geneva on December 19, 1741, Price described how he had smuggled his Busiris into England (presumably to avoid import tax) by concealing them in his fiddle case. In the same letter he declares, "I would not give the worst of my Busiris water-colours, for four of the best pictures I ever saw of him" (a reference to John Wooten, to whom his father had recently introduced Price). His tutor, the botanist and dilettante Benjamin Stillingfleet, described Busiri "as one of the first masters of drawing landscapes with the pen" (Hawcroft 1959, pp. 296–97).

Busiri's works are documented in the collections of the Doria, Colonna, and Sanseverino families; Carlo Marchionni, architect of the Villa Albani and the Vatican Sacristy, is also recorded as owning a cache of paintings and drawings by the artist. Busiri was an excellent draftsman and an album of his drawings, primarily rapid studies in pen and brown ink, belongs to the Fitzwilliam Museum, Cambridge (including sketches of Pisa, Siena, Viterbo, Naples, and Marino); a series of fifty-seven others

are at the British Museum, London, where they were traditionally attributed to Jan Frans van Bloemen.

Few of Busiri's views of Rome and its environs are signed, and those that are often provide variations of his given name, Giovanni Battista. (He was known by a variety of names—"Tista," "Titta," "Tittarella," "Titarelli"—that appear to derive from both the diminutive form of Battista and his short stature; and a number of his views are thus inscribed in contemporary writing.) Many of Busiri's works have been attributed to other painters, notably Marco Ricci, Jean-Baptiste Lallemand, and Charles-Louis Clérisseau. It was not until 1958, with Francis Hawcroft's presentation of the documented landscapes at Felbrigg Hall at the Norwich Castle Museum in *Eighteenth Century Italy and the Grand Tour*, and the following year in Rome at *Il Settecento a Roma*, that Busiri's distinctive individual manner achieved widespread recognition. A number of his paintings were engraved by other artists, including four views of Rome and its environs that were reproduced by the engravers Thomas Smith and Francis Vivares and published in London in 1746. [EPB]

BIBLIOGRAPHY  Hawcroft 1958; Hawcroft 1959; Busiri Vici 1966; Busiri Vici 1972; Moore A. 1985, pp. 123–32; Martin S. 1997

191

## 191

### Giovanni Battista Busiri
*View of the Colosseum, Rome*

c. 1740–45
Gouache on paper
8⅝" × 13⅛" (22 × 33.5 cm)
PROVENANCE  Tulloch collection, Ireland; C. Marshall Spink, London, 1961 (as by Marco Ricci); London, Sotheby's July 3, 1989, lot 233; where acquired by the present collection
BIBLIOGRAPHY  Busiri Vici 1966, pp. 36–37, 67, n. 36; Wynne, Michael. "A Cache of Busiris." In Maria Teresa Caracciolo, ed., *Hommage au dessin: mélange offert à Roseline Bacou,* Rimini, Italy: Galleria, 1996, p. 461
Private collection

192

## 192

### Giovanni Battista Busiri
*The Piazza di Bocca della Verità, Looking toward the Tiber, Rome*

c. 1740–45
Gouache on paper
8⅜" × 13⅛" (22 × 33.5 cm)
PROVENANCE  Tulloch collection, Ireland; C. Marshall Spink, London, 1961 (as by Marco Ricci); London, Sotheby's July 3, 1989, lot 233; where acquired by the present collection
BIBLIOGRAPHY  Busiri Vici 1966, pp. 36–37, 67, n. 36; Wynne, Michael. "A Cache of Busiris." In Maria Teresa Caracciolo, ed., *Hommage au dessin: mélange offert à Roseline Bacou.* Rimini, Italy: Galleria, 1996, p. 461
Private collection

Busiri's depiction of the vast, half-ruined structure of the Flavian amphitheater, the most famous monument of ancient Rome and the emblem of the city's eternity, requires little comment. His other view represents the "classic" view, popular from Gaspar van Wittel (Gaspare Vanvitelli) to nineteenth-century photographers of Rome, of the part of the ancient Forum Boarium (in classical times, the main cattle market) known as the Piazza di Bocca della Verità. The site was leveled during the papacy of Clement XI and a fountain installed in 1717–18, executed after a design by Carlo Francesco Bizzaccheri and Francesco Moratti (for the pope's interest in the fountain and rationale for intervention at the site, see Johns 1993, pp. 175–79, fig. 103). The support for the great bowl is in the form of two tritons, acting like Atlantes, their fish-like bodies entwined. The round temple in the background on the right of the square is popularly known as the Temple of Vesta (simply because of its circular shape), although the actual deity to which it was dedicated is unknown. One of the best-preserved temples in Rome and the first to be built of marble (c. 100 BC), the building owes its survival to its conversion into a church early in the Middle Ages; the alterations depicted in Busiri's painting were removed in 1809–10, when the circular temple was restored by Luigi Valadier to its original appearance. The temple was important among the precedents for

the plans of the centralized churches of the Renaissance.

Busiri developed his own, highly individual, picturesque style, framing his views between feathery trees and placing rapidly sketched figures at rest or in conversation in and around the monuments depicted. He typically placed an architectural feature as the central point of the composition and constructed an imaginary landscape around it. His *vedute* are immediately recognizable by their pale blue skies and the radiant sunshine that floods the buildings, figures, and vegetation and the aesthetic effects of the gouache medium. Whereas Gaspar van Wittel presented the principal sights of Rome panoramically, to paraphrase Andrea Busiri Vici (Busiri Vici 1966, p. 29), Busiri chose to capture the city in a series of snapshots, constructing a composite of the preeminent monuments of antiquity view by view, in isolation: the temples of Saturn, Vespasian, and Vesta; Minerva Medica; the tombs of Cecilia Metella, Cestius, the Horatii and Curiatii; the ponte Lucano, Milvio, Nomentano, Rotto, and Salario; the Colosseum, and so forth.

The genesis of Busiri's topographical views is to be found in his pen-and-ink sketches made out-of-doors, on the spot, and elaborated and refined in the studio. This was vividly demonstrated by Busiri Vici in his monograph, in which he compared, for example, drawing no. 54 in the album at the Fitzwilliam Museum, depicting the Arch of Constantine, with a small gouache of the same view (Busiri Vici 1966, p. 38, pl. ix), and a pen drawing of the Temple of Saturn from the same source with a painted gouache of the site (Busiri Vici 1966, p. 42, pl. x).

Busiri's view of the Colosseum exhibited here should be compared to a similar view that belongs to a set of eight small gouaches acquired in Rome by Joseph Leeson, 1st Earl of Milltown (National Gallery of Ireland, Dublin; Wynne, p. 461, fig. 2, see above). The Dublin view of the Colosseum is the only one of the eight to be signed and bears the signature *Giõ B:sta*. Michael Wynne has observed Busiri's characteristic method of establishing a prominent architectural feature as the central point of a composition that could be repeated endlessly in the studio with only minor changes of staffage. In the case of Busiri, the "staffage" comprises not only the figures but also architectural fragments, bits of columns, cornices, architraves, and the insertion of other non-existent ruins. The compositions of the Dublin and London views are nearly exactly alike in their treatment of the Colosseum and surrounding buildings; the differences

are confined to the fountains and the figures lolling beside them in the foreground, and the distribution of antiquities—for example, the antique marble vase near the center of the composition that is derived from or intended to suggest the Borghese Vase (Musée du Louvre, Paris). A third variant of the composition is in a private collection in Rome; a fourth was engraved in London in 1746 (Busiri Vici 1966, pl. xiii, fig. 36). A similar if slightly later gouache view of the Piazza di Bocca della Verità by Busiri was sold at Sotheby's, London, on December 1, 1983 (lot 95), and demonstrates further his penchant for modifying his basic compositions, in this instance by disposing differently the figures in the foreground.

The dating of Busiri's views is almost entirely dependent upon knowledge of their original patron or owner's Grand Tour visit to Rome—the exception being a number of the *vedute* acquired by William Windham for the cabinet at Felbrigg, which are dated 1739 and 1740. But even when the travels of an owner are known, ambiguity regarding the dating of a work is not necessarily resolved, as in the case of the eight Dublin gouaches collected by Joseph Leeson. Leeson made two visits to Rome, 1744–45 and 1750–51, and the Busiris have been dated to each of these periods (Wynne, p. 460, as 1744–45, see above; Sergio Benedetti, *The Milltowns: A Family Reunion* [Dublin: National Gallery of Ireland, 1997], p. 84, as bought by Leeson during his second Grand Tour). The earlier date may be preferred for the Dublin gouaches and a date of around 1740–45 for the exhibited views of the Colosseum and the Piazza di Bocca della Verità, on account of their extraordinary quality and richness, which is comparable to examples at both Felbrigg and Dublin.

The present pair of "deliziose tempere," like the best of Busiri's temperas, remain fresh, vivacious, and colorful, their appearance hardly dimmed by the passage of two hundred and fifty years. The medium of gouache proved exceptionally longlasting, and Busiri's views in the medium are remarkably well preserved; when they have been kept framed and glazed and out of the light, they are marked only by a slight discoloration. The *figurette* that inhabit Busiri's landscapes are sketched with a lively and nimble brush and are in perfect keeping with their setting.
[EPB]

## GIUSEPPE CADES
### ROME 1750–1799 ROME

Cades was born to a French father (Jean Cades, naturalized in Rome as Cadeotti, a tailor and amateur painter from the Languedoc village of Saint-Orens) and an Italian mother. He was a precocious artist, his first dated drawings produced as early as 1762. In 1766 he won the first prize in the Concorso Clementino at the Accademia di S. Luca for the second category of painting with a drawing depicting the Healing of Tobit, which has remained in the academy's collection ever since. That same year he fell out with his master, Domenico Corvi, who disapproved of his pupil's excessive independence, and gave up his academic training. He then associated with the more marginal circles of foreigners in Rome, in particular with the circle of northern artists centered around Fuseli and Sergel and with the Frenchmen who were most independent of their academy. Cades won his first official commission in 1774: an altarpiece depicting the martyrdom of Saint Benignus intended for the church of the abbey of S. Benigno di Fruttuaria at San Benigno Canavese in Piedmont. His first patron was Cardinal Vittorio Amedeo delle Lanze. But the output of the artist's early years consists mainly of drawings—usually large-format, very finished, and doubtless intended for sale. Of these, *Achilles Withdrawing to His Tent with Patroclus, Surprised by Ulysses* (Musée du Louvre, Paris; cat. 324) is the only one of which a painted version is known (Musée du Louvre, Paris); this was formerly in the Puymaurin collection. These drawings demonstrate the new way in which the artist looked at ancient history, conveying it with theatrical pathos tinged with irony. Breaking with the most traditional trends of Roman painting and its arduously achieved balance between classical and Baroque, Cades reverted to the grand manner of the sixteenth century. He thus succeeded in formulating an original "neo-Mannerist" style in which the crisis of the transition between the ageing Baroque and the nascent Romantic aesthetic is expressed.

The altarpiece at the Roman basilica of Ss. Apostoli, *The Ecstasy of Saint Joseph of Copertino* (1777; in situ) marks a renewed interest in Venetian art in Cades's painting, no doubt influenced by his contact with the Venetian circle in Rome, centered around the papal nephews of Pope Clement XIII Rezzonico. Using distemper, he painted the decoration of a music room designed by the architect Giacomo Quarenghi for the residence of one of those nephews, Don

Abbondio Rezzonico. It was at this point that Cades met the young Canova and also made contact with Piranesi; a portrait of the latter by Cades was engraved by the sitter's son Francesco.

In the period 1780–90 Cades was involved in many schemes for the decoration and embellishment of Roman palaces: Ruspoli (1782), Chigi (1784; 1788–90), Altieri (1787; 1791), and Borghese (1787). His most important works in this field are based on literary and poetic themes: for Prince Borghese's Casino at Porta Pinciana he painted the story of Gualtieri d'Angversa, inspired by a short story in Boccaccio's *Decameron* (cat. 195), and for the Palazzo Chigi at Ariccia he did tempera and fresco paintings of poetic subjects taken from Ariosto's *Orlando furioso*. The refined literary and artistic tastes of his client, Prince Sigismondo Chigi, certainly had an influence on the selection and iconography of those subjects. At the same time Cades sent works to the provinces of the Papal States (Ascoli Piceno; 1781, *Saint Peter Appearing to Saint Agatha in the Presence of Saint Lucy*; cat. 194) and to other Italian states (Genoa, 1785). It was probably in the early 1780s that he traveled to northern Italy for study purposes. He stayed for a while in Venice, a visit documented by notes in his own handwriting and drawings contained in a notebook now held at the Thorvaldsen Museum in Copenhagen. In 1786 he was elected a member of the Accademia di S. Luca. From that year he is registered with his wife, Anna Teresa Leonetti, in the Trinità dei Monti district: he lived in a house in the scesa S. Giuseppe (near the parish of S. Andrea delle Fratte). His first child, a daughter named Vittoria, was born in 1787, followed by Raffaello, Michelangelo, Chiara, Marianna, and Angela.

Cades's great technical virtuosity and his curiosity about the past prompted him to experiment with a variety of techniques, some of which had fallen into disuse: in the early 1790s he used encaustic—in accordance with theories rediscovered and published in 1784 by Vicente Requeno—to paint two compositions inspired by the life of Alexander the Great. These had been commissioned by Czarina Catherine II, who intended them for her son Alexander Pavlovitch (Hermitage, St. Petersburg). Two original etchings are known at present: a *Death of Leonardo da Vinci in the Arms of Francis I* and an episode from the Gospels, *Suffer the Little Children to Come unto Me* (copper plates at the Calcografia in Rome). From the 1790s a classicist tendency, sometimes pushed to the point of purism, became established in Cades's painting. It is openly expressed for the first

time in the four canvases sent to the monastery of the Friars Minor Conventual in Fabriano, in the Marches, in 1790. That trend, which favored sober colors and a spare layout, did not prevent the reemergence of Mannerist forms in some late works: this constant in Cades's manner as a painter, and especially as a graphic artist, was no doubt derived from his constant interest in Michelangelo.

Cades died prematurely at the age of only forty-nine. He left several works unfinished—in particular *The Fall of the Rebel Angels*, for a Russian client, and a *Martyrdom of the Blessed Signoretto Alliata*, for Pisa Cathedral; the sketches for these are held in Chicago (Art Institute) and Baltimore (Walters Art Gallery) respectively. [MTC]

BIBLIOGRAPHY Orsini [1790] 1977; Lanzi 1809; Müller, L. *Description des tableaux et dessins du Musée Thorvaldsen.* Copenhagen, 1847–50; Luzi 1894; Noack 1911; Stein 1913; *Galleria Ascoli Piceno* 1919; Cardarelli and Ercolani 1954; Schiavo 1960; Clark 1964; Clark 1968; Maxon and Rishel 1970, p. 184; Vitzthum 1971; Caracciolo 1973; Clark 1973; Roettgen 1973; *L'Accademia* 1974; Caracciolo 1977; Bernini, Dante, and Alfio Ortenzi. *La pinacoteca civica di Ascoli Piceno.* Rome: Autostrade, 1978; Caracciolo 1978; Caracciolo 1978, "Cades"; Incisa della Rocchetta 1979; Rudolph 1983; Caracciolo 1984; Cera 1987; Mellini 1987; Caracciolo 1988; Caracciolo 1988, "Cades"; Barroero 1990; Caracciolo 1991–92; Caracciolo 1992; Petrioli Tofani, Prosperi Valenti Rodinò, and Sciolla 1993–94; Caracciolo 1994; Caracciolo 1996; Caracciolo 1996, "Cades"; Wintermute 1996; Caracciolo 1997; Pavanello 1998

## 193
## Giuseppe Cades
### Self-portrait

Second half of the 1770s
Inscription: *Giuseppe Cades Pitt.re Rom.o 1786*
Oil on canvas
25⅝″ × 19¼″ (65 × 50 cm)
PROVENANCE gift from the artist's widow in 1800 (Archives of the Accademia di S. Luca, *Decreti … ,* 55, 1793–1803, folio 92 verso)
EXHIBITIONS Florence 1922, cat. no. 155; Chicago, Minneapolis, and Toledo 1970, cat. no. 76; Rome 1970, cat. no. 42; Leningrad, Moscow, and Warsaw. *Ital'ianskaja zivopis XVIII veka iz muzeer Italii.* 1973, cat. no. 76; Rome 1998, cat. no. 103
BIBLIOGRAPHY Caracciolo 1973, p. 8: Clark 1973, p. 74; Susinno 1974, p. 264; Incisa della Rocchetta 1979, no. 193, pl. XXXI; Caracciolo 1992, no. 32. pl. 1
Accademia Nazionale di San Luca, Rome

The date noted at the bottom right corner of this picture seems to be a later addition, like the whole inscription; it refers to the artist's election as a member of the Accademia di S. Luca, which took place in two stages on January 8 and August 6, 1786. Cades is

GIVSEPPE CADES Pitt.e Rom.

193

here between twenty-five and thirty-years old and the painting can be dated approximately to the second half of the 1770s. The artist depicts himself wearing an unusual neo-Renaissance costume, with his hair straggling over his shoulders. His right arm, hidden by the puffed sleeve, straddles the edge of the foreground, creating a skillfully foreshortened effect: in the resulting space that is both restricted and deep the fine head is turned in a three-quarter view, as the sitter abandons his reading and turns his serious gaze to meet the eyes of the viewer.

The layout of the picture is reminiscent of Titian's *Portrait of a Man* (National Gallery, London), then believed to be a portrait of Ariosto, a famous work in Cades's day. The game of disguise and changed identity, so typical of the eighteenth century, here takes the form of a specific reference to a period, a school of painting, and an individual; Cades's work here embodies one aspect of Romantic art, already taking shape in Cades's day, which involved looking to the art of the past for sources of inspiration and infusing them with a new life; this in turn laid the foundations for the revivalist spirit of the nineteenth century. The extremely free touch in this self-portrait, which seems to have

remained almost in the state of a sketch and the *en camaïeu* effect of the background bring to mind effects in portraits by David dating from the period of the French Revolution, and are surprising in the way they foreshadow some works produced by Romantic painters in the following century.

Among the members of Fuseli's circle in Rome, the English painter James Jefferys (in Rome from 1775 to 1781) produced a self-portrait similar to this one by Cades, in which he depicted himself in seventeenth-century costume with his curly hair loose on his shoulders and his serious, dreamy eyes raised from reading and drawing to look at the viewer (Pressly 1979, p. 83, fig. 82). [MTC]

## 194
## Giuseppe Cades
### Saint Peter Appearing to Saint Agatha in the Presence of Saint Lucy

1781
Signed and dated lower left: *G. Cades 1781*
Inscription *Petrus Paolus Leonardi/Epus et Pnps [Episcopus et Princeps] Ascolanus/Tabulam pictam et aram/in elegantiorem formam/aere suo redegit*

Oil on canvas
98⅛″ × 57⅞″ (250 × 147cm)
PROVENANCE commissioned by Pietro Paolo Leonardi, bishop of Ascoli Piceno, for the city's cathedral, where the picture remained until 1918; deposited at that date in the Pinacoteca
BIBLIOGRAPHY Orsini [1790] 1977, p. 4; Luzi 1894, p. 130; *Galleria Ascoli Piceno* 1919, p. 40; Voss 1924, p. 666; Cardarelli and Ercolani 1954, p. 75; Roettgen 1973, p. 60; Bernini, Dante, and Alfio Ortenzi. *La pinacoteca civica di Ascoli Piceno.* Rome: Autostrade, 1978, pl. LI; Rudolph 1983, no. 113; Cera 1987, no. 187; Caracciolo 1992, p. 261, no. 70A, pl. 10
Pinacoteca Civica di Ascoli Piceno

This altarpiece, commissioned by Bishop Pietro Paolo Leonardi, as the inscription at the bottom of the column attests, was intended for the first altar on the right of the nave of Ascoli Piceno Cathedral. It is the first work Cades sent to the Marche, a province of the Papal States that between 1787 and 1790 would provide him with the prestigious commission for five large altarpieces for the Franciscan monastery of the Friars Minor Conventual in Fabriano. For one of the five later pictures, *The Holy Spirit Appearing to Saint Lucy and Saint Apollonia*, the artist reverted to the composition of this picture, with variations. In this composition Cades associates the two Sicilian saints, Agatha of Catania and Lucy of Syracuse, following the tradition according to which Agatha appeared to Lucy, who had made a pilgrimage to her tomb, to tell the latter of her imminent death. It illustrates a moment in the martyrdom of Agatha in AD 251: during the night following her torture, during which the executioner had chopped off her breasts, Saint Peter appears to the saint in her prison and heals her mutilated body. Beside her, Lucy proffers her two eyes, the symbol of her own martyrdom, on an engraved tray.

In this picture Cades adopts a new, simple, pared-down layout: he avoids concentrating his figures, releasing them from their tension and easing the compression of events in the drama. Only the volume of the three figures, planted powerfully against the mists of the background, indicates the depth of the space. Made to stand out by deliberate isolation—reminiscent of some of Goya's characters—the figure of Saint Lucy—with her ravishing face imprinted with a haughty, almost disdainful expression—authoritatively dominates the whole composition.

The picture's charm lies above all in the richness of the coloring and its superb range, in which deep pinks predominate, skillfully harmonized with bronze and mother-of-pearl tones and more delicate yellows and blues. The martyrdom of the two

saints, which had been depicted since the previous century (albeit often quite differently) by Bolognese and Roman classical masters, takes on a new note with the refined colors and the silky effects of the fabrics, and the discreet sparkle of the jewelry adds a sophisticated fashionable touch to the subject. It evokes the "conversation pieces" or group portraits made by the artist around this time (in particular the superb portrait in pastels of Princess Anna Maria Salviati Borghese as Cornelia, with her two children Camillo and Francesco, dated 1779; now in a private collection). In this field Cades was following the most up-to-date trends in portrait painting, brilliantly represented in Rome by Batoni, but he was also very open to English influence through intermediary figures such as Angelika Kauffmann and Antonio Zucchi. Antonio Cavallucci seems to have been inspired by the figure of Saint Lucy for the central character in his picture depicting *The Investiture of Saint Bona*, intended for Pisa Cathedral (see cat. 197).

At present two drawings relating to this painting are known. The first, held in the Suida Manning collection in New York, is definitely a preparatory study for the painting. The second, which formed part of Bertel Thorvaldsen's collection, now in the Thorvaldsen Museum in Copenhagen, is probably subsequent to the painting; it may have been made by the artist later, in connection with an etching by Giovanni Battista Romero which reproduces Cades's painting in reverse and is dated 1800. [MTC]

## 195
## Giuseppe Cades
*Study for "The Recognition of Gualtieri d'Angversa, or Count Gualtieri d'Angversa Recognized by His Grandchildren"*

1787
Oil on canvas
14½″ × 27½″ (37 × 70 cm)
PROVENANCE Galerie Marcus, Paris, 1959; Wildenstein Gallery, New York, 1962; acquired at that date by the museum
EXHIBITIONS Rome 1959, cat. no. 113; Cleveland 1964, cat. no. 98; New York 1967, fig. 19a; Storrs 1973, cat. no. 123
BIBLIOGRAPHY The Art Institute of Chicago. *Quarterly*, vol. 57 (1963–64), no. 4; Caracciolo 1988, "Cades," p. 71; Barroero 1990, p. 455; Caracciolo 1992, pp. 294–95
The Art Institute of Chicago, Charles H. Worcester Sketch Collection

At the end of 1787 Cades was finishing a canvas intended for the ceiling of

195

one of the *camerini* (rooms intended for displaying paintings) on the second floor of the villa of Prince Marcantonio IV Borghese at Porta Pinciana (now the Galleria Borghese). The ceiling (*in situ*; restored in the second half of the 1990s) depicts the story of the miraculous recognition of Gualtieri d'Angversa, after the eighth tale recounted on the second day of Boccaccio's *Decameron*. The canvas, set into the ceiling, depicts the crucial moment in the long, sad story of Count Angversa.

The count's fiefdom cannot be identified with the Flemish town of Antwerp (as some translators have it). Even though Boccaccio specifies that the person in question is a French gentleman (perhaps a Comte d'Angers), it is preferable to stick to the Italian formulation of the name and regard him as a purely imaginary figure. According to the story, the attractive Count Angversa owes all his misfortunes to the selfish passion felt for him by the wife of his lord, the French dauphin. Having loyally spurned the forbidden love she offers him, Gualtieri is then accused by her of attempted rape, banished from France, and stripped of all his possessions. Separated from his two children, he leads a miserable vagrant life on the roads of England and Ireland until the day when he is received in the grand house where his daughter, who has made a rich and happy marriage, lives with her husband and children. Feeling pity for the old man, the couple give him food, and their children develop an affection for him, so that Gualtieri ends up staying with the family. A few years later, on the point of death, the French princess now confesses her guilt and reveals the innocence and loyalty of Gualtieri; officially rehabilitated, his honor restored, he can recover his titles and

possessions. In his picture Cades illustrates the point in the story where Gualtieri's daughter and grandchildren "recognize" the beggar, that is, receive, feed, and shelter him as they would do for their own grandfather. It is a moment that highlights the deeper meaning of the story, namely the primacy of the "voice of the heart" and the impulses of the spirit over the dispassionate approach of reason.

The subject had seldom been depicted, but had recently resurfaced from the past in English- and German-speaking literary circles following the republication in 1765 of the Scottish ballad *The Beggar's Daughter of Bednall Green*, which may have been one of Boccaccio's sources, even though this hypothesis has never, apparently, been put forward. The ballad was republished in the collection *Reliques of Ancient English Poetry* (edited by the Revd Thomas Percy): a collection of traditional English poems the origins of which were lost in the mists of time; it had a considerable influence on the genesis of German Romantic poetry and is similar in spirit to the publication (or rather invention) in 1760 of the poems of the legendary warrior Ossian, by Macpherson. In any case the old Scottish poem was certainly one inspiration for the *Ballade vom vertriebenen und zurückkehrenden Grafen* by Goethe, composed between 1813 and 1817, the musicality and mystery of which endow the theme with a special charm. It may be remembered that in 1973 Anthony Morris Clark put forward the hypothesis that the picture by Cades could have been influenced "by a ballad by Goethe" (Clark 1973, p. 75); today the relationship must be reversed, and it may be assumed that Goethe, who was in Rome between 1786 and 1788 and was very interested in the decorations at

the Villa Borghese, could have noticed this rare and unusual pictorial interpretation of the Scottish ballad and the tale from the *Decameron* and remembered it later on when composing his own poem. Cades departs from Boccaccio's text in locating the episode not in England but in Venice; some of that city's buildings are portrayed with historical accuracy in what is one of his most deliberately neo-Venetian works—neo-Veronesean, even—and is also scattered with genre quotations after Rubens and Van Dyck. It remains an isolated work in the context of the Roman art of the 1780s and foreshadows the costumed history painting of the following century with amazing prescience.

The *modello* exhibited here—although it lacks the Doges' Palace, included in the final painting—constitutes one of the most finished preparatory painted versions of the ceiling and is certainly later than the little sketch in the Ford collection and the one held in the Pinacoteca Ambrosiana in Milan. The supple, free execution of the painting, with the luminous, deftly inserted highlights, is very typical of Cades's manner in the 1780s. [MTC]

## VINCENZO CAMUCCINI
ROME 1771–1844 ROME

As the champion of the most severe mode of Neoclassicism, Vincenzo Camuccini dominated early nineteenth-century Italian art, rivaled only by Antonio Canova. Showered with prestigious commissions and eminent governmental and academic posts, he was self-consciously the culmination of a long tradition of Roman painting leading back through Maratti and

Poussin to Raphael. Yet Camuccini first emerged in the late Settecento as a rebellious outsider, nurtured as a young hero of the avant-garde and styling himself as an artistic, moral, and political reformer.

Camuccini initially trained in the studio of Domenico Corvi, the leading Italian painter working at that time in Rome. He broke from this distinguished apprenticeship for an extended, independent campaign in the late 1780s, drawing the works of Raphael and Michelangelo in the Vatican as well as corpses in the hospital of S. Spirito. These works (Camuccini Collection, Cantalupo) established his lifelong commitment to High Renaissance models and the careful study of the human body, always retaining the precise, controlled draftsmanship instilled by Corvi. His brother Piero, a fast-rising dealer in Rome, also found lucrative work for the young artist copying Renaissance and Baroque masterpieces for the tourist market, indicating that economics fueled Camuccini's split from Corvi. Nonetheless, in its parallel to the careers of Giuseppe Cades and Asmus Jakob Carstens, the fracture also exemplified the splintering of the studio and academy system at the end of the century.

Camuccini developed instead under the close watch of Rome's avant-garde, who saw the youth as a burgeoning model of the modern, reforming artist. Through his brother's connections he associated with Angelika Kauffmann's circles and from the age of thirteen he drew at the Villa Borghese, where he witnessed the collaboration of Rome's most advanced artists and antiquarians on the villa's decoration. Gavin Hamilton's spare, sentimentalizing classicism proved especially influential for Camuccini's first public commission, *Paris Entrusted to the Shepherds on Mount Ida* (cat. 196). The antiquarian Ennio Quirio Visconti cast an even longer shadow, commissioning drawings of antiquities for his 1796 catalogue of the Borghese collection. Visconti urged Camuccini to study ancient visual and textual sources intensely, marshaling antiquity to convey stoic, heroic virtues to modern audiences. From 1790 to 1796 Camuccini also participated in the Accademia de' Pensieri, an alternative academy run by Felice Giani, where the young artist forged ties with the new wave of Italian artists—including Luigi Sabatelli, Giovanni Battista dell'Era, and Gaspare Landi. The Pensieri sketched their initial ideas quickly and spontaneously, a novel procedure that Camuccini subsequently adapted to his own working method (cats. 330, 331), building up slowly from brilliant, turbulent sketches through increas-

ingly clarified drawings and *bozzetti* to sleek, carefully worked paintings.

By the early 1790s Camuccini's supporters encouraged the vanguard artist to make a splashy début on Rome's art scene. *The Death of Caesar* and *The Death of Virginia* (Museo di Capodimonte, Naples) stand as Camuccini's most significant achievements and established the direction of Italian painting for the next four decades. Begun in 1793 and completed over the next fourteen years, these colossal works developed under intense public scrutiny (Camuccini destroyed the initial version of *Caesar* in a dramatic, self-sacrificing response to criticism). Completely rejecting his initial foray into sentimental Neoclassicism, Camuccini now adopted a pure, hard-edged language and a drier palette to present these stoic, moralizing tales of the Roman republic austerely, in a mode linked both to earlier work by Hamilton and Anton Raphael Mengs as well as the work of progressive French artists he knew in Rome, particularly Jacques-Louis David and Jean-Germain Drouais.

Despite the claim of Camuccini's early biographers that he eschewed politics, both *Caesar* and *Virginia* address burgeoning nationalist ideas in turn-of-the-century Rome. Based directly on tragedies of political oppression by Vittorio Alfieri, Camuccini's paintings express the contemporary playwright's militant tone and anti-tyrannical fervor, borne out by the enthusiastic pro-Roman rhetoric that characterized the pictures' reception. Although Joachim Murat ultimately purchased the paintings for Naples, Frederick Hervey, the 4th Earl of Bristol, was the initial patron. The Alfierian subject matter and aggressively modern style relate intimately to Hervey's politicized collecting goals, which connected to his interest in Irish Catholic liberation.

By the century's end Camuccini was Rome's preeminent painter. His earlier anti-establishment stance now shifted, and the artist joined the Accademia di S. Luca in 1802 and became Principe in 1805. During the Napoleonic occupation, European royalty and Italian nobility filled the vacuum when the international community of tourists and artists who formed his initial clientele dispersed. His history paintings, following *Caesar* and *Virginia*, now focused almost exclusively on moralizing subjects, usually drawn from the history of the Roman republic (*The Continence of Scipio*, Palazzo Taverna, Rome) but he also spearheaded the use of later Italian history (*Study for The Entry of Malatesta Bagliani into Perugia*, Camuccini Collection, Cantalupo). The artist traveled to Paris in 1810 as a

196

Roman representative to Napoleon's court, and he renewed his ties with French colleagues, including David and Anne-Louis Girodet. Camuccini's political engagement still needs clarification, but his resistance to direct commissions from Napoleon, insistence on local subject matter, and invention of the archetypal image of Pope Pius VII Chiaramonti (a touchstone for Italian nationalism and resistance), indicate that he did not abandon his early role as reformer.

Camuccini curated the Vatican painting collection from 1809 and became the chief arts administrator in the Papal States from 1814. His increasing connection to the papacy paralleled his growth as a religious painter. Such celebrated altarpieces as *The Conversion of Saint Paul* (1832–35; S. Paolo fuori le Mura, Rome), and *The Miracle of San Francesco di Paola* (1824–30; S. Francesco di Paola, Naples) reveal the artist's debt to Renaissance and Baroque precedent most clearly.

Camuccini's authority held sway until his death, affecting several generations of Roman artists and scholars as a teacher, policy maker, conservator, and curator as well as a painter. Camuccini represented the end of the Roman classical tradition, already perceived as moribund in his last years by younger Nazarene and *Purismo* artists. Nonetheless, his aggressive insistence on upholding the eighteenth-century Roman authority of draftsmanship, the unswerving commitment to the High Renaissance, and the notion of the artist as an engaged public servant

remain Camuccini's lasting contributions. [JLS]

BIBLIOGRAPHY Missirini 1823; Falconieri, Carlo. *Vita di Vincenzo Camuccini, e pochi studi dulla pittura contemporeana*. Rome, 1875; Pfister 1928, pp. 21–30; Lupi Manicota, B. "Il pittore Vincenzo Camuccini." *Latina Gens*, vol. 13, nos. 6–7 (1935), pp. 148–62; Bovero, Anna. "Vincenzo Camuccini." In DBI, vol. 17, pp. 627–30; Hiesinger 1978; Piantoni de Angelis 1978; Hiesinger and Percy 1980; Olson, Roberta J. M. "Representations of Pope Pius VII: The First Risorgimento Hero." *The Art Bulletin*, vol. 68 (1986), pp. 77–93; "Sovrani e principi europei nella vita e nell'arte di Vincenzo Camuccini." *Strenna dei Romanisti* (1988), pp. 91–106; Ceccopieri, Isabella, ed. *L'archivio Camuccini inventario*. Vol. 32. Rome: La Società alla Biblioteca Valicelliana, 1990; Penny, Nicholas. "Raphael's 'Madonna dei Garofani' Rediscovered." *The Burlington Magazine*, vol. 134 (1992), pp. 67–81

## 196

## Vincenzo Camuccini

### *Paris Entrusted to the Shepherds on Mount Ida*

1796–1800
Oil on canvas
17 ¾" × 26" (45 × 66 cm)
PROVENANCE Christie's (as anonymous); Sir Anthony Blunt by 1964; Heim Gallery, London; purchased by the present owner in 1964
EXHIBITIONS Cleveland 1964, cat. no. 161; Bregenz and Vienna 1968, cat. no. 134; London 1972, cat. no. 40
BIBLIOGRAPHY Visconti 1796; Ferrara 1954; Vorarlberger Landesmuseum 1968; Hiesinger 1978; Piantoni de Angelis 1978
Private collection, Chicago

The narrative of Paris and Helen derives from an amalgam of ancient sources, including Homer and Ovid, but the story retold by Camuccini in this painting comes specifically from the *Library* of Apollodorus (Book III.xii.5). While pregnant with Paris, Hecuba dreamt that she gave birth to a firebrand. King Priam, the baby's father, perceived this dream as a bad omen for the country, and handed the infant over at birth to be left for dead in the wild. Agelaus, the servant responsible for the task, discovered after five days that Paris had been miraculously nursed by a bear and thus survived. Camuccini painted the happy conclusion to this story, when Agelaus brings the infant home to his family, where Paris will be raised.

This canvas is probably a *ricordo* of Vincenzo Camuccini's first major public enterprise—a ceiling panel for the Room of Helen and Paris at the Villa Borghese. Prince Marcantonio Borghese IV originally commissioned the decoration of the room in 1782 from the Scottish painter Gavin Hamilton, who assigned the sculptural and decorative works to artists such as Antonio Asprucci, Guillaume-Antoine Grandjacquet, Luigi Valadier, and Agostino Penna. Reserving the paintings for himself, Hamilton executed the original version of *Paris Entrusted to the Shepherds* as well as three large canvases for the walls (now in the Museo di Roma) and five canvases set into the ceiling.

According to documents in family archives, Camuccini completed his interpretation of this myth in 1796. In that year Ennio Quirio Visconti (a key

player in the promotion of Camuccini's early career) attributed the whole suite of paintings to Hamilton in his description of the Villa Borghese, so Camuccini's work could not have been mounted in the ceiling to replace Hamilton's original before that point (Piantoni de Angelis 1978, p. 20). Why Hamilton's canvas was removed remains a mystery, as does the relation between Camuccini's canvas and the original. (Hamilton's composition is now lost, although a *bozzetto* exists in a Minnesota private collection [*L'Accademia* 1974, p. 150]). Critics never singled out the lost canvas for criticism, and the 1784 reviews in the *Giornale delle Belle Arti* (January 3, February 7, and December 4) discussed the entire series of paintings with great enthusiasm. If the image needed repainting in 1796, the youthful Camuccini would have been an obvious choice for the work, since he was already well known by the artists working at the Villa Borghese. A student of Antonio Asprucci, the primary architect at the villa, Camuccini had sketched the Borghese antiquities for years. Moreover, Camuccini knew Gavin Hamilton through his brother, Pietro Camuccini, who often collaborated with Hamilton as a fellow dealer in paintings and antiquities.

Extant preparatory studies expose Camuccini's typically careful development of a composition. Preliminary drawings (Piantoni de Angelis 1978, p. 21) reveal progress toward a simpler, more balanced image. Camuccini reduced the number of figures and spread them along a frieze to make the narrative clearer from the ground. By centralizing Agelaus and his wife and pulling the figures to the front of the picture plane, the artist emphasizes the sensitive exchange of the helpless infant Paris to his adoptive father. The rounded forms arching toward the center also lend a unity and compactness to the grouping that recall antique cameos. At least two smaller painted versions exist, the one exhibited here and the work given to the Accademia Nazionale di S. Luca by the artist as his reception piece in 1803. Both renderings use rectangular canvases rather than the attenuated octagons of the Borghese ceiling, and thereby include landscape elements eventually dropped in the final version.

This work, as well as the panel on the Borghese ceiling, reveals Camuccini adapting to the sentimental classicizing style that characterizes the eighteenth-century decorative painting at the Villa Borghese. The creamy colors, reductive simplicity, gentle design, and graceful handling align with the other paintings in Hamilton's ceiling and show the early influence of the older artist on Camuccini. Scenes of tender familial intimacy were common currency among artists in Rome during the last two decades of the Settecento, fueled especially by the success of Angelika Kauffmann's brand of history painting. Camuccini's work shows the impact not only of Kauffmann, but more specifically that of the tender interpretations of *The Meeting of Hector and Andromache* by Gaspare Landi (cat. 235) and Antonio Cavallucci. Despite the assurance with which he embraced this style, Camuccini quickly abandoned this mode for the severity, nobility, and virtuous, politicized messages of his highly successful first major history paintings. [JLS]

## ANTONIO CAVALLUCCI
### SERMONETA 1752–1795 ROME

Among the principal exponents of the Roman Settecento, Antonio Cavallucci is perhaps the one who was the slowest to enjoy recognition subsequently, despite the consistent acclaim with which his works were received during his lifetime. Cavallucci was one of the favorite painters of Pius VI, who described him as "the Raphael of our times" (Chracas, *Diario Ordinario di Roma*, September 19, 1789, no. 1536), and was even more highly thought of by Giovanni Gherardo de Rossi, the influential protagonist of artistic and literary Neoclassicism. De Rossi frequently wrote about the artist in the *Memorie per le Belle Arti*, the most authoritative periodical of the time, and in 1796 offered a complete and generally reliable, if occasionally inaccurate, biography of the artist.

Francesco Caetani, the Duke of Sermoneta, for whom the painter's father, Bartolomeo, served as a locksmith, recognized the artist's talents and introduced him to the studio of Stefano Pozzi, then one of the eminent figures of the Roman pictorial panorama. Upon his death in 1768, Cavallucci studied with Gaetano Lapis, thereby effecting an almost natural progression from a classicism that was still substantially derived from Maratti to a truer Neoclassicism. In the Concorso Clementino of 1771 he won first prize with his drawing of the *Three Angels Appearing to Abraham*. In the Concorso Balestra of 1773 he won second prize with a painting portraying the *Hector's Farewell to Andromache* (Accademia di S. Luca, Rome). With these successes behind him, he obtained numerous important commissions, including works for the Caetani family. Of these early works for his patrons the only one to have survived is *Abigail before David* (Fondazione Caetani, Rome). Particularly notable for its artistic commitment and formal inventiveness is Cavallucci's decoration of the piano nobile of the Palazzo Caetani, which the family itself acquired in via delle Botteghe Oscure. This project, begun in 1776 with *Scenes of Atalanta and Hippomenes* and *Scenes of Diana and Apollo*, along with other subjects celebrating the glory of the family, was completed in 1780. In 1786 Cavallucci added to this series one of his masterpieces, *The Origin of Music*, for the music room of the duchess. Monsignor Francesco degli Albizzi, a relative of Caetani, also commissioned Cavallucci to create four overdoors for St. Peter's, two for the sacristy of the Beneficiati (*The Calling of Peter and Andrew* and *Domine quo vadis?*) and two for the sacristy of the canons (*The Liberation of Saint Peter* and *Paul* and *Barnabas before Peter*). However, it was a journey in north Italy in 1787 that directed Cavallucci towards his unmistakable interpretation of Neoclassical aesthetics, where the original influences from Maratti are blended with very clear signs of a deeper interest in sixteenth-century artists such as Andrea del Sarto, Fra Bartolomeo, and, above all, Correggio. Upon his return to Rome in 1788, and as part of the same commission for Albizzi, he executed the grand altarpiece for the parochial church of Palidoro near Rome, *Saint Philip and Saint James*, which distinctly reveals his new sources. A sketch of this work is in the Lemme collection in Rome. In 1790 he also executed a lunette depicting *Saint Joseph Calasanz* for the chapel of the Ospedale di S. Spirito (today in the Palazzo del Commendatore in Borgo).

His membership in the Accademia dell'Arcadia, where he was registered in 1788 under the name of Ippomiero Sermoneo, enabled Cavallucci to profit from the suggestions of the poet and philosopher Appiano Buonafede, who advised him on the composition of his more complex paintings. Notable among these is the large painting depicting *The Investiture of Saint Bona* (c. 1792) for Pisa Cathedral. It is likely that membership of the academy also served as the background to his involvement in the cycle of scenes from Roman history for the Palazzo Altieri—the plan of which was drawn up by the Jesuit scholar and antiquarian the abbot Vito Maria Giovinazzi (himself a member of the Accademia dell'Arcadia) at the occasion of the marriage of Paluzzo Altieri and Marianna of Saxony. This took place around 1791, and apart from Cavallucci (who executed *Tarpeia Showing Titus Tatius the Entrance to the Capitol*), it involved Anton von Maron, Giuseppe Cades, Marcello Leopardi, and Francesco Manno. The support of Pius VI also resulted in important commissions for Cavallucci, including *The Presentation of the Virgin in the Temple* for Spoleto Cathedral and *The Dream of Joseph* for the new church of S. Andrea in Subiaco. Paintings for this church were also provided by Laurent Pécheux, Cristoforo Unterperger, Marcello Leopardi, Pietro Labruzzi, and Pietro Tedeschi. Cavallucci sent major works to Catania (*Saint Maurus and Saint Placidus Presenting Themselves to Saint Benedict*; cat. 333), Sansepolcro (*Virgin of the Rosary* in the Cathedral), Urbino (*Saint John the Evangelist* for one of the pendentives of the dome of the cathedral), and Carpentras (*Crucifix*, for the cathedral). One of his most fervent admirers, Cardinal Francesco Saverio de Zelada, commissioned numerous canvases from Cavallucci for, S. Martino ai Monti in Rome, including *Elijah on Mount Carmel*, as well as the decoration of the apse, which was finished after his death by Giovanni Micocca.

Cavallucci's production consisted of almost entirely religious works, with the exception of the Caetani cycle, the *Tarpeia* of the Palazzo Altieri and a small number of portraits (*Francesco Caetani, Teresa Corsini*, Fondazione Caetani, Rome; *Girolamo Silvestri*, Accademia dei Concordi, Rovigo; *Romualdo Braschi*, private collection). During a trip to Naples he executed a portrait of the prince of Belvedere (Capodimonte, Naples). Subsequently, he also painted a portrait of Pius VI (private collection). However, according to a contemporary source, the pope was not satisfied with this work, and commissioned a replacement by Gaspare Landi.

Cavallucci was a member of the Accademia di S. Luca (1786) and of the Congregazione dei Virtuosi al Pantheon (1788). In 1790, probably because of his friendship with Giovanni Gherardo de Rossi, he was appointed professor in the Accademia del Portogallo in Rome. One of Cavallucci's unmistakable characteristics is the refined perfection of his draftsmanship, accompanied by delicate color and an extreme, attentive consideration for composition and design. His constant interest in Maratti—the unfailing and unsurpassed model for all religious painting of the age—and his roots in seventeenth-century art, especially Guido Reni and Cigoli, and, naturally, his obvious debt to Raphael, remain clear. But Cavallucci stands out from his contemporaries by his luminosity of color ("brilliant light that radiates everywhere," according to De Rossi 1796, p. 69), which renounces the "excessively dark" chiaroscuro effects, while defining space and form perfectly. [LB]

BIBLIOGRAPHY Vinci 1795; De Rossi 1796; Roettgen 1976; Roettgen 1979; Hiesinger and Percy 1980, pp. 90–91, no. 79; Casale 1990; Rangoni 1990; Sestieri 1994, vol. 1, pp. 45–47; Kunze 1997; Loire 1998, pp. 106–13; *Seicento e Settecento* 1998, pp. 103–9; Sestieri 1998

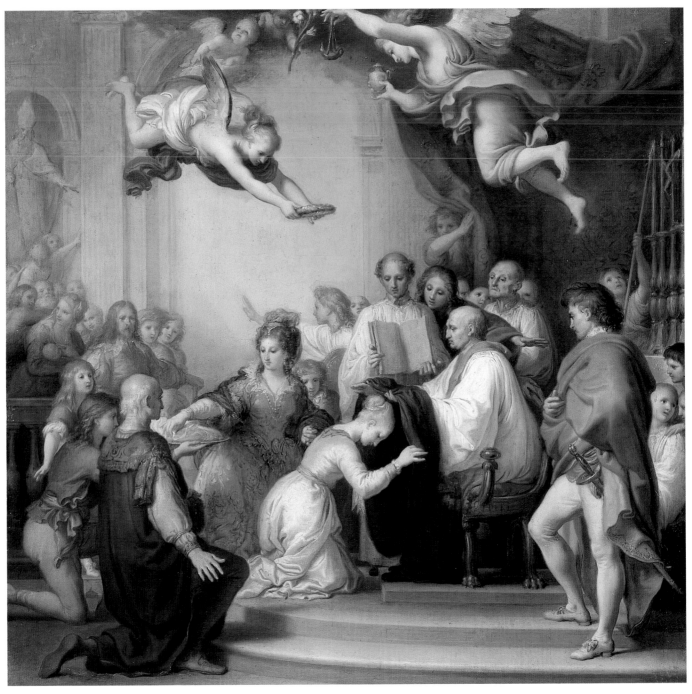

197

## 197

### Antonio Cavallucci

*The Investiture of Saint Bona with the Habit of the Oblate of Saint Augustine*

C. 1792
Oil on canvas
29⅛″ × 29⅛″ (74 × 74 cm)
PROVENANCE Christie's, Rome, November 21, 1995; to present owner
EXHIBITIONS Paris 1998, cat. no. 26; Paris, Milan, and Rome 1998, cat. no. 26
BIBLIOGRAPHY De Rossi 1796, p. 46; Sale catalogue, Christie's, Rome, November 21, 1995, p. 71, lot. 243; Loire 1998, pp. 106–8;

*Seicento e Settecento* 1998, pp. 103–5, no. 26
Lemme Collection, Rome

This refined work was recognized by Roberto Longhi (letter of August 9, 1959; Sale catalogue, Christie's, Rome, November 21, 1995, p. 71) as a model for the large picture (17′ 8½″ × 18′ ½″) of the same subject intended for the Pisa Cathedral (see Sicca 1990, p. 273, 282, n. 113; Sicca 1994; Adriano Peroni, ed., *Il Duomo di Pisa* [Modena, Italy: F. C. Panini, 1995], vol. 1, p. 487).

In this painting the patron saint of the Tuscan city is portrayed, still as a young girl, receiving the habit of the

Oblate from the regular canons of S. Agostino. The picture was dedicated by the Marchesa Ricciarda Catanti Tanucci with a letter dated April 8, 1788 (Ciardi 1991, pp. 124–25, 141), in which she allowed the representatives of the cathedral complete freedom of choice as far as subject matter and artist. On March 1, 1790, Cavallucci contracted to send the *bozzetto* within two years (Enzo Carli, ed., *Il duomo di Pisa: il battistero, il campanile* [Florence: Nardini, 1989], p. 110). Both the sketch and the picture were delivered in 1792 (see Adriano Peroni, p. 487, above), although in the previous year the sculptor Vincenzo Pacetti

had already praised the large painting in his journals (Honour 1963, p. 376). The final *modello* is in the Museo di S. Matteo in Pisa (Ciardi 1991, pp. 124–25, 141). It is larger than (38″ × 45¼″), and of slightly different proportions from, the Lemme collection picture, but virtually identical in composition and formal solutions. A drawing in the Gabinetto dei Disegni e Stampe degli Uffizi (inv. 99135, 13¾″ × 12¼″; Ciardi 1991, pp. 128, 145, 147), already well defined in spite of the variations, charts an earlier stage in the composition. In addition, studies have been identified for the heads of the kneeling man in the foreground and the young

man in profile in the center (National Gallery of Scotland, Edinburgh, D516; Sicca 1990, p. 267, 275).

It is not certain whether the painting displayed here is a *modello* preceding the picture in Pisa Cathedral, in spite of the slight variations noticeable in that work. It is more likely to be one of the small-scale replicas that, according to the assertions of his biographer Giovanni Gherardo de Rossi (De Rossi 1796, p. 46), Cavallucci used to make his greater works, often with the help of his collaborators Tommaso Sciacca and Giovanni Micocca. One of these replicas, carried out with the limited participation of an assistant but finished and perfected by Cavallucci himself, was actually the *Investiture of Saint Bona*, which De Rossi owned together with other works by the painter. Another contemporary writer and biographer, Giovambattista Vinci, wrote that a *bozzetto* for the Saint Bona picture was in the Caetani house (Vinci 1795, p. 37, n. 1); one of these two could be the painting displayed here. The other known *modello*—an equally accomplished work located in the Pisa museum—was delivered on January 3, 1793, to the clients in Pisa (see Enzo Carli, p. 110, above). This indicates that it is neither the 1795 model reported "in the cabinet of the Prince of Teano"—the Caetani—nor the *modello* still owned by De Rossi in 1796.

The large painting in Pisa Cathedral is part of a cycle by Cavallucci that probably represents, along with the decoration of the church of S. Matteo in Soarte (carried out entirely in Rome by Francesco Trevisani, Sebastiano Conca, Giacomo Zoboli, and Marco Benefial between 1730 and 1740) the high point of the Pisan Settecento (Garms 1984). The cycle was executed under the direction of the local Arcadian "colony" (see especially Sicca 1990, and Sicca 1994) and encompassed practically all the artistic developments of the century as well as the most illustrious painters active at the time. Predominantly "Roman" in nature—the contributions introduced by the Bolognese and Tuscan painters appear more limited—it generated such interest that the paintings were shown in churches in the city before being displayed in their final location. In addition, the handing over and conservation of the *bozzetti* and *modelli*, as was reported by Cinzia Maria Sicca, were strictly controlled in order to prevent abuse and misappropriation. In 1742 a town council decree ruled that the *modelli* should be kept in a room in the city hall, thereby assuring that the Pisan cycle would remain well documented.

The *Investiture of Saint Bona* was already considered by contemporaries as Cavallucci's masterpiece (Vinci 1795, p. 37; De Rossi 1796, pp. 33–34;

Lanzi 1809, vol. 1, p. 421; Chracas, *Diario Ordinario di Roma*, November 28, 1795). The subtle color gradations, precise draftsmanship, and clear arrangement of space revealed Cavallucci's profound agreement with his most important sources, identified by the artist's friend and adviser De Rossi: Anton Raphael Mengs, Pompeo Batoni, and Angelika Kauffmann, whom, according to Giovambattista Vinci, Cavallucci knew and respected (Vinci 1795, p. 44). [LB]

# GIUSEPPE BARTOLOMEO CHIARI
### ROME 1654–1727 ROME

Although the early artists' biographer Nicola Pio claims that Chiari was born in Lucca in 1654, both Pascoli and manuscript sources at the Accademia di S. Luca state that he was born in the Eternal City. Late in life he claimed to be Florentine, but there is no other evidence for this and he doubtless spent almost his entire life in Rome. The son of Tuscan parents resident in Rome, Stefano Chiari and Maria Francesca di Sante Mariani, Chiari entered the studio of Carlo Maratti in 1666, initiating an intimate teacher–student relationship that lasted until the latter's death in 1713. Both contemporary critics and modern historians have recognized the aesthetic sympathy exhibited in Chiari's art for the work of his teacher, and certainly the younger artist was the most faithful follower of the doyen of the Roman school of classicizing artists whose influence reached into the middle decades of the Settecento. Chiari differs from his master in a heightened sense of elegance and an emphasis on intimacy and grace, seen to great advantage in his numerous religious and mythological cabinet pictures executed for a wide variety of patrons, both Italian and foreign. Chiari was the leading conduit of the Marattesque idiom from the last decades of the Seicento to the dawn of Neoclassicism, primarily through his decisive influence on Agostino Masucci, Maratti's last important student, and on Anton Raphael Mengs.

Chiari was no prodigy. His almost twenty-year apprenticeship with Maratti partly explains the profound respect for the teacher everywhere evident in his art. Around 1683–84 he executed his first important independent works—two lateral altarpieces for the Marcaccioni Chapel in the church of S. Maria del Suffragio. The great success achieved by these paintings firmly established Chiari as a leading exponent of the Marattesque style, and a series of spectacular private commissions soon followed. In 1693 Prince Urbano Barberini commissioned

an ambitious ceiling fresco in the Palazzo Barberini, *Apollo and the Four Seasons with Chronos*, a complex allegorical/mythological painting programmed by the learned classicizing theorist Giovanni Pietro Bellori, one of Chiari's closest friends. The biographer Lione Pascoli states that such was Barberini's admiration for Chiari that he allowed the painter to select as the site for his work any salon in the palazzo not already frescoed. The patron must have been satisfied, since he soon ordered another ceiling fresco, *The Birth of Pindar*. The artist's most important commission for a secular ceiling fresco, however, came in 1700, when he executed *The Apotheosis of Marcantonio Colonna* for Prince Colonna's palace in the Piazza dei Ss. Apostoli. This grand, airy painting occupies the entire ceiling of the gallery of the piano nobile (the main, or second, story) and shows the arrival of the august Colonna ancestor, the hero of the naval battle of Lepanto against the Turks in the sixteenth century, on Mount Olympus. In this mythic empyrean Marcantonio is introduced to the other deities by the demigod Hercules. Although Chiari continued from triumph to triumph until his death in 1727, he never again worked on such an imposing scale.

After egregious success working for noble patrons in domestic settings, Chiari entered the official world of papal patronage during the long reign of Clement XI Albani. This art-loving pontiff consistently honored him with important commissions. Among the earliest was the painter's employment as a restorer for several fragments of the fresco by Melozzo da Forlì that had been destroyed during the rebuilding of the basilica of Ss. Apostoli. These included the large *Christ in Majesty* still seen in the Palazzo del Quirinale and the justly celebrated heads of angels from the same Renaissance fresco. Albani also commissioned a tapestry cartoon, *Pentecost*, as a model for the weavers at the newly established tapestry works in S. Michele a Ripa, one of many attempts by him to stimulate the luxury trades locally and to reduce imports from France and Flanders. Chiari also painted *The Allegory of the Church*, an iconographically complex painting showing Saint Peter and a blindfolded Ecclesia steadying the ship of the Church in troubled seas. Executed around 1712, the picture was intended as a present from the pope to James Stuart, the Old Pretender, as a mark of esteem. In addition, Chiari was chosen to complete the grand cartoons for mosaic decorations for the Presentation Chapel in St. Peter's, a papal project inherited from Maratti.

The most important papal commissions, however, were for the ceiling

painting of the newly restored basilica of S. Clemente, *Saint Clement in Glory*, and for one of the Lateran Prophets, *Obadiah*. The ceiling fresco in S. Clemente pays homage to Maratti's *Triumph of Clemency* of 1676 in the Palazzo Altieri and had a demonstrable impact on Mengs's ceiling fresco in S. Eusebio, *Saint Eusebius in Glory*. For *Obadiah*, Chiari executed a small *modello* that he gave to his papal benefactor and also made a scale version that was displayed in the Palazzo Montecitorio. The works for S. Clemente and St. John Lateran established Chiari as one of the premier painters in Rome and helped promote his studio as one of the city's most popular and influential.

In such public commissions as *Saint Clement in Glory*, Chiari paid careful respect to the classical tradition of Maratti, but in more intimate cabinet paintings his quiet, suave elegance is seen to greater advantage. In 1708 he painted for Cardinal Fabrizio Spada four mythological subjects taken from Ovid, works that fully accord with the gentler and more refined sensibilities of the early Settecento. This graceful style is also seen in smaller religious paintings such as *Christ and the Woman of Samaria*, painted around 1710–12 for Christian Schaumberg-Lippe, one of Chiari's most important foreign patrons. Similar to Urbano Barberini's gesture of respect in the Barberini ceiling project, Cardinal Spada allowed Chiari to select the subjects, stipulating only the dimensions for the pictures, a compliment to the painter's eminence in his profession. In 1714 Chiari painted *The Adoration of the Magi* (now in Dresden), probably for Cardinal Pietro Ottoboni; even though on a large scale, it retains the augmented grace and delicacy seen in the Spada mythologies and the Schaumberg-Lippe *Samaritana*. Commissions for similar pictures poured in from Britain, Germany (the Elector of Saxony was an especially avid patron), and even France, in addition to other parts of the Italian peninsula. In his seventies Chiari was still capable of executing grand altarpieces in a more personalized variant of the Marattesque idiom, chief among them *Saints Peter of Alcántara and Paschal Baylon Adoring the Trinity*, executed for the Rospigliosi-Pallavicini Chapel in S. Francesco a Ripa (see cat. 16), and the charmingly lyrical *Angelic Consolation of Saint Francis* for the Colonna family in their chapel in Ss. Apostoli.

Chiari's professional career reached its apex in 1722, when he was elected Principe of the Accademia di S. Luca, a position of enormous power and prestige that he retained until 1725. He had been a member since 1697. It was during his administration that the academy began to require members

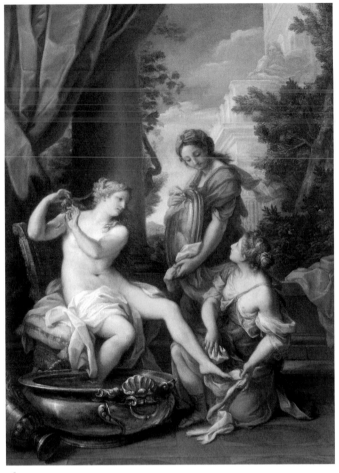

198

to donate one of their works to the institution's diploma gallery, an innovation that has turned the Accademia di S. Luca into a major venue for eighteenth-century Roman art. With Andrea Procaccini and Giuseppe Passeri, both of whom he long outlived, Chiari was the chief continuator of the Roman grand tradition whose roots ultimately lay in the art of Raphael. As Nicola Pio stated, the fame of Chiari's Marattesque style resounded throughout Europe and provides an essential link from the Roman High Renaissance to European Neoclassicism.[CMSJ]

BIBLIOGRAPHY Pio [1724] 1977, pp. 108–9; Pascoli [1730–36] 1933, vol. 1, pp. 209–17; Voss 1924, pp. 604–6; Kerber 1968; Dreyer 1971; Schleier 1971–73; Waterhouse 1976, pp. 65–66; Scavizzi 1982; Guerrieri Borsoi 1989

## 198
## Giuseppe Bartolomeo Chiari
### *Bathsheba at Her Bath*

c. 1700

Oil on canvas

53½″ × 38½″ (135.9 × 97.8 cm)

PROVENANCE Moratilla Collection, Paris, until 1952–53; Mario Modestini Collection, New York, until 1993

EXHIBITIONS Princeton 1980, cat. no. 14; Frankfurt, Bologna, Los Angeles, and Fort Worth 1988, cat. no. D30

BIBLIOGRAPHY Kerber 1968, p. 80; Maxon and Rishel 1970, p. 190

The Metropolitan Museum of Art, New York, Gift of Mario Modestini

This superbly delicate painting by Chiari, long unrecognized as his work, is a reversed variation of a painting of the same subject by Carlo Maratti executed for the Liechtenstein family. Chiari's interpretation, however, is remarkably different from the Maratti prototype, and is probably based on an engraving. Chiari's Bathsheba is a Veronesque blonde rather than a Reniesque brunette, more slender in proportion and much more at ease in her state of nudity than the self-conscious woman of the

Maratti. Bathsheba's standing maid is also more demure, and the attendant who washes her feet stares unabashedly into her mistress's face.

Many other details of the two pictures are also at variance. Chiari includes a large basin full of water ornamented by an elegant *rocaille* handle, adding a grand column with drapery behind the nude figure to emphasize her aristocratic status and to place her in a palatial setting necessary to the textual source. Significantly, Chiari reveals little of Bathsheba's reflection to the beholder; like the admiring maid, the spectator is intended to focus on the original rather than the facsimile. Maratti, on the other hand, shows the reflected face full-on, and the major conceit of the picture is the theme of vanity that leads to tragedy. In both paintings King David observes the object of desire from a balcony, but with Maratti's interpretation Bathsheba's self-absorption seems to suggest her susceptibility to the king's blandishments. Chiari's Bathsheba, on the other hand, reduces the king and the spectator to the role of passive admirers, emphasizing female beauty with little hint of dire moral consequences. This is an excellent example of the change in aesthetic and narrational sensibilities from the Baroque to the eighteenth century, a phenomenon seen in such related religious subjects as Christ and the Woman of Samaria, Rebecca and Eliezer at the Well, Christ and the Woman Taken in Adultery, and many others.

King David's espying of the bathing Bathsheba from the roof of his palace, his summons to her and their subsequent adultery, the betrayal of her husband Uriah the Hittite and his death in battle ordered by David, her conception and the death of their son are recounted in 2 Samuel 11: 2–24. The moral seriousness of the biblical theme, underscored by the mirrored image of vanity in Maratti's painting, is greatly relieved by the grace and decorative delicacy exhibited in Chiari's painting. Its pale, cool colors suffuse the palace garden setting with a sense of languid twilight and erotic possibilities. The frank admiration of all the figures for the seated nude Bathsheba aligns the painting to cabinet pictures executed for private galleries that were intended to be closely scrutinized for content and painterly technique. In addition, coy grace, sensual nudity, and the attractive attendants could rather easily allow the painting to be read as a Diana with her Nymphs, with David interpreted as Actaeon, a fact that emphasizes the decreased authority of canonical texts with eighteenth-century artists. Indeed, such paintings in Rome must have been influential in

the development of the *genre galant* in France, whose chief exponents were François Lemoyne, François Boucher, and Charles Natoire, in the early and middle decades of the century.

While displaying an open admiration for the eroticized female form that surpasses his Maratti model, Chiari nonetheless exhibits a profound admiration for his master and for the classical tradition he inherited. In addition to the powerful influence of Maratti, there is also a suggestion of close study of late works by Pietro da Cortona, Giovanni Battista Gaulli, Guido Reni, Francesco Albani, and, ultimately, Annibale Carracci. John T. Spike has convincingly attributed a drawing in the National Gallery of Scotland in Edinburgh to Chiari, pointing out its close affinities to the torso and arms of Bathsheba in the Metropolitan painting. That the drawing had long been misidentified as a Maratti is eloquent testimony to the younger painter's thorough training in this international classicizing idiom. Although nothing is known about the history of the painting before the twentieth century, it has been dated on stylistic grounds to the last years of the Seicento, with 1693, the date of the Maratti picture in Vaduz, serving as a *terminus ante quem*. There is no reason, however, to assume the painting was executed shortly after the completion of Maratti's painting. The narrow face and ovoid features of the standing attendant, the pale colors, and especially the refined, soft brushstroke and changeant palette, along with the delicate languor of the female nude are also frequently encountered in paintings by Chiari after about 1700, and any attempt to date it more precisely must be ultimately problematic. [CMSJ]

## 199
## Giuseppe Bartolomeo Chiari
### *The Rest on the Flight into Egypt*

c. 1707–15

Oil on canvas

19½″ × 26⅛″ (49.5 × 66.4 cm)

PROVENANCE Baron de Breteuil by the mid-eighteenth century; Julius Weitzner, New York, 1955

EXHIBITIONS Detroit 1965, cat. no. 120; Storrs 1973, cat. no. 10; Tulsa 1994, cat. no. 35

BIBLIOGRAPHY Kerber 1968, p. 82; Johns 1988, pp. 11–13; Johns 1993, pp. 199–200

Bob Jones University Collection, Greenville, South Carolina

Despite its lack of an eighteenth-century provenance and the fact that it has only been correctly attributed to

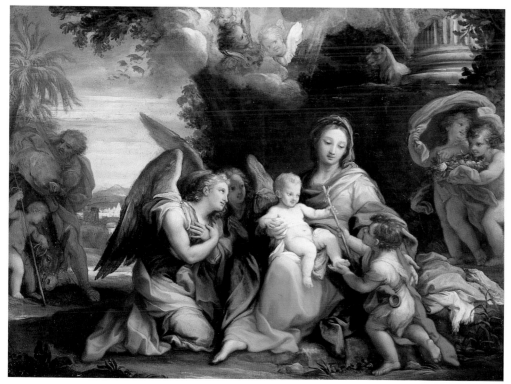

199

record of it. In the absence of documentary evidence, the traditional title, *The Rest on the Flight into Egypt*, is the appropriate one. [CMSJ]

## 200
## Giuseppe Bartolomeo Chiari
### *The Adoration of the Magi*

c. 1715
Signed, lower left: *IOSEPH CHIARI*
Oil on canvas
70″ × 50″ (178 × 127 cm)
PROVENANCE  Earl of Dunraven Collection, by 1773; Kaiser-Friedrich-Museums–Verein; acquired by the Staatliche Museen Preussischer Kulturbesitz, 1972
BIBLIOGRAPHY  Schleier 1971–73; *Preussischer Kulturbesitz* 1978, p. 102
Staatliche Museen zu Berlin, Preussischer Kulturbesitz, Gemäldegalerie, Property of the Kaiser-Friedrich-Museums–Verein

Chiari by Federico Zeri as recently as 1955 (it was formerly thought to be by Maratti), the *Rest on the Flight into Egypt* has become one of the most familiar early Settecento Roman images. Suffused with a sophisticated, languid elegance and notable for its alluring profusion of color, this painting is precisely the type of image favored by private collectors for small cabinet collections of precious objects intended for close scrutiny by connoisseurs. Similar images abounded in such Roman private collections as that of cardinals Ottoboni, Spada, and Corsini, among others, and were highly sought after by foreign collectors, above all the British and Germans. What particularly delighted collectors and connoisseurs alike were distinctive brushwork, diffuse compositions, and inventive narratives that took significant departures from canonical texts, all features seen in Chiari's painting. Spread across a lyrical, expressive, "exotic" landscape prominently marked by such egyptianizing elements as a sphinx, a palm tree, a truncated column (according to apocryphal texts, pagan idols crumbled as the Holy Family passed them on their way into Egypt), and a distant cityscape with a pyramid, Chiari has imbued the painting with a sense of sweet elegance and purposeful, naïve wonder.

It is tempting to associate the painting with the new spirit of reform espoused by the Accademia dell'Arcadia. The Arcadians, led by Giovan Mario Crescimbeni and Gian

Vincenzo Gravina, advocated a reform of Italian poetry and culture by emphasizing simplicity, naïveté, and direct metaphor, holding Baroque complexity, bombast, and euphuism in abhorrence. They often gathered *al fresco* for poetic recitations, and many artists and leaders of the clerical and cultural hierarchy, including Maratti, his daughter Faustina Maratti Zappi, Pope Clement XI, Cardinal Pietro Ottoboni, and Chiari himself were numbered among the *pastori* (shepherds), as the members of the academy were called. The patron of the Arcadians was the Baby Jesus, a symbol of regeneration, reform, and innocence. While harking back stylistically to Bolognese seventeenth-century artists such as Albani and Reni, the *Rest on the Flight into Egypt* nonetheless embraces a new spirit, a lighter sensibility, a more delicate palette, softer brushwork, and a greater inventive freedom from notions of *ut pictura poesis* that were regnant in the Baroque era.

Some scholars have supported a new, curious identification for the iconography of the painting, suggesting that the subject is actually the extremely rare *Return from the Flight into Egypt*, for which *The Return from Egypt* (Townsend 1994, p. 184) is presumably intended. This reading is based largely on the presence of John the Baptist in the scene, an admittedly unusual (but not unprecedented) inclusion for the iconography of the Flight into Egypt. While the idea that the "subject" of a painting is a per-

sonal artistic invention rather than a visualization of a textual narrative is cogent for Arcadian paintings, the omnipresence of things Egyptian suggests that if the Holy Family are indeed en route from Egypt, they have not gotten very far. Moreover, after a seven-year residence in Egypt, according to the pseudo-Bonaventure's popular *Meditationes vitae Christi*, the principal source for the story in the eighteenth century, the Christ Child still seems to be an infant. In addition, pseudo-Bonaventure explicitly states that the Holy Family met the youthful Baptist *after* they had traversed the desert and just before they crossed the Jordan River. Furthermore, the apocryphal text makes the point that the journey home was more arduous than the passage to Egypt seven years before, because Mary could no longer carry her son. Thus, the presence of John the Baptist in the Greenville painting cannot be explained logically by reference to the Return from Egypt.

Artistic inventiveness, not a different iconography, is suggested by the presence of the flower-bearing cherubs at right, the youthful John the Baptist and adoring angels around Mary and the Christ Child, and Saint Joseph unburdening the donkey with the assistance of another cherub at left. The fact that there are several paintings closely related to this one also militates against such an arcane iconography. If such a rare subject had been often repeated for the market by so prominent an artist as Chiari, it seems unlikely that there would be no

The Berlin *Adoration of the Magi* is a reduced version of a painting of the same subject, also by Chiari, in the Gemäldegalerie, Dresden, a work probably painted for Cardinal Pietro Ottoboni that is signed and dated 1714. Unlike the Dresden prototype, it is vertical in format, and the figures are reduced in scale. Signed but not dated, the *Adoration of the Magi* was painted sometime between 1714, the documented date of the Dresden painting, and the artist's death in 1727, but probably much closer to the earlier date. The circumstances surrounding the creation of the Berlin painting are unknown. It could have been commissioned from the artist for a private collection or possibly was made for a church, its dimensions being congruent with those of paintings executed for flanking chapel altarpieces or lateral paintings for one of the side walls. This supposition, however, is mere speculation, based solely on the vertical format and dimensions of the picture. The first record of the existence of the *Adoration of the Magi* is from the second half of the eighteenth century, when it appeared in the collection of the 1st Earl of Dunraven. The Irish nobleman probably acquired the picture during his visit to Rome in 1773, when Pompeo Batoni painted his portrait. Without documentary evidence, however, the picture's origins must remain obscure.

The compositional source for both the Dresden painting and the Berlin *Adoration of the Magi* is a representation of the same theme that Chiari executed as a lateral altarpiece c. 1685 for the Marcaccioni Chapel in S. Maria del Suffragio, an early work that did much to establish him as one of the premier Roman painters of the rising

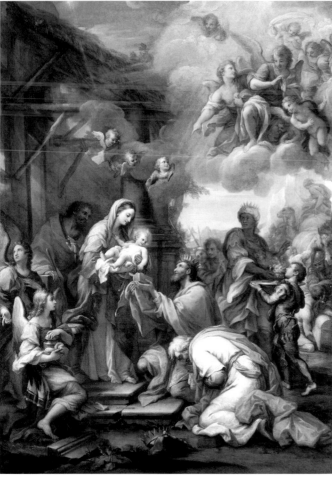

200

generation of *Maratteschi*. As might be expected, in all three of Chiari's interpretations of the subject there are direct references to his teacher Carlo Maratti, especially the figure of the angel kneeling at left in the Berlin picture. The Virgin proffering the Christ Child to the kneeling Magus in the Berlin *Adoration* is also an adaptation of the figure of the Virgin in an altarpiece by Maratti in S. Maria di Montesanto. The intersecting compositional diagonals are seen in numerous late Seicento altarpieces, and one senses a profoundly eclectic conservatism throughout the painting. These visual references, fully understood by contemporaries, were a means of visualizing Chiari's aesthetic allegiances and claiming Maratti's legacy; they are not indications of an "exhausted" tradition, dearth of artistic imagination, or other negative characteristics traditionally projected on to such academic paintings by modernist historians and critics who only value "originality." There is a delicacy of color and a suavity of gesture, however, that are Chiari's own contribution. Coupled with the painter's deep reverence for the grand traditions of Roman religious painting seen to advantage in the *Adoration of*

the *Magi* are a subtle scheme of lighting and an elegant informality. These visual qualities, much less developed in Maratti, Gaulli, Guglielmo Cortese, and other late Baroque painters, herald the mature styles of Sebastiano Conca and Agostino Masucci. [CMSJ]

## SEBASTIANO CONCA
GAETA 1680–1764 NAPLES
*For biography see Drawings section*

## 201
Sebastiano Conca
*Christ and the Woman Taken in Adultery*

1741
Signed and dated in the lower left corner:
*Eques Sebastianus Conca f. 1741*
Oil on canvas
46″ × 63″ (114 × 158 cm)
PROVENANCE sale, Christie's, London, June 28, 1974, lot 123; where acquired by Ira Spanierman Inc., New York, 1976; British Rail Pension Fund, London; sale, Sotheby's, New York, January 30, 1997, lot 111; where acquired by the present owners
EXHIBITIONS Barnard Castle, co. Durham, The Bowes Museum, on loan 1977–84; Gaeta 1981, no. 96; Austin, Texas, Archer

M. Huntingdon Art Gallery, University of Texas, on loan 1985–96
BIBLIOGRAPHY Sestieri 1994, vol. 1, p. 58
Private collection, Washington, D.C.

This impressive, grandiloquent painting, signed and dated 1741, was first published by Giancarlo Sestieri in 1981. Like the theme of Christ and the Woman of Samaria, this subject allowed artists to juxtapose pretty penitence to Christian moral philosophy. To this end, Conca represents a kneeling Christ tracing words in the dust on the pavement of a public square, while the adulteress looks on in gracious dismay. The narrative comes from the Gospel of John (8: 3–11), and describes how, while he was teaching in the temple, a group of scribes and Pharisees brought before Jesus a woman caught in the act of adultery. Hoping to trick him into blasphemy, they pointed out that the law of Moses demanded that such a sinner be put to death. Jesus did not answer, but knelt and wrote in the sand, the only Gospel reference to the fact that he was literate. Christ's detractors continued to demand a judgment, and he uttered the celebrated statement: "He that is without sin among you, let him cast a stone at her," and continued writing on the ground. Soon all had departed, and Christ told the woman to go in peace and sin no more.

Conca's depiction shows the point in the narrative when Jesus is actively writing as the scribes and Pharisees continue their accusations; the two who stand nearest the woman try to discern what Jesus is actually writing, which neither the text nor the painter reveals. The crowd of accusers, almost all of whom are male, are represented in active postures. One actually holds a stone, in anticipation of the traditional punishment for the sin of adultery, although the unfortunate woman's partner in crime is nowhere to be seen. Significantly, the two women at the lower right of the composition and the female figure on the far left react in fear and horror, revealing gendered differences in response. The scene is set in an elaborate square framed on three sides by classicizing architecture, the large arch with short ionic columns in the middle distance possibly standing in for the temple in Jerusalem, where John sets the story. The arcade crowned by a balustrade in the far distance recalls similar structures from the paintings of the Venetian Renaissance artist Veronese. Christ, the adulteress, and the crowd of scribes, Pharisees, and women are arranged in a frieze-like fashion across the front plane of the composition, clearly indicating Conca's connections to the classical traditions of Roman painting, above all Poussin,

Pietro da Cortona, and Carlo Maratti. The mannered grace of the poses and the delicacy of the colors, however, are hallmarks of the highly personal style that Conca had been practicing in Rome for over thirty years.

Although no patron for *Christ and the Woman Taken in Adultery* is known, it is likely that the painting was executed for a private collection, since its relatively modest dimensions would have precluded use as a lateral altarpiece in a chapel or some other public, ecclesiastical function. Such works were popular with the clerical hierarchy in Rome, who would have seen no impropriety in hanging such a picture next to a mythological painting or a scene from ancient history. The religious sensibilities of such patrons and such pictures, however, should not be underestimated. Deeply familiar with the gospels, collectors valued narratives that also provided subtle maxims based on thorough knowledge of the texts; in this instance, verse 12, immediately following the narrative of the woman taken in adultery, quotes Christ: "I am the light of the world." Such textual interrelationships between narratives and maxims appealed to the sophisticated spiritual and literary tastes of patrons just as visual issues of artistic discernment and connoisseurship stimulated their aesthetic proclivities. [CMSJ]

## DOMENICO CORVI
VITERBO 1721–1803 ROME

Just as Carlo Maratti had been a dominant figure in the Roman school throughout the second half of the seventeenth century, so Domenico Corvi became one of the most influential masters there during the second half of the eighteenth. Having entered the studio of Francesco Mancini in 1736, at the age of fifteen, he won a first prize (*ex aequo* with Jean-François Vignal) for a drawing submitted to the 1750 Concorso of the Accademia di S. Luca. He was admitted to the academy on November 9, 1756, and a year later was elected director of the Accademia del Nudo for the first of several times (see Curzi and Lo Bianco 1998; Italo Faldi, *Pittori viterbesi di cinque secoli* [Viterbo, Italy: Cassa di Risparmio della provincia di Viterbo, 1970], pp. 351–75; Rudolph 1982). Yet the conspicuous group of paintings, in which he formulated his distinctive, pithy style and imagery derived from the Baroque tradition of Rubens and such followers of Caravaggio as Honthorst, was not to be found in Rome. In fact, between 1754 and 1756 Corvi had sent three altarpieces to churches in Senigallia, thanks to the recommendation of Monsignor Nicola Antonelli; in 1756–57 he frescoed a lunette (*The*

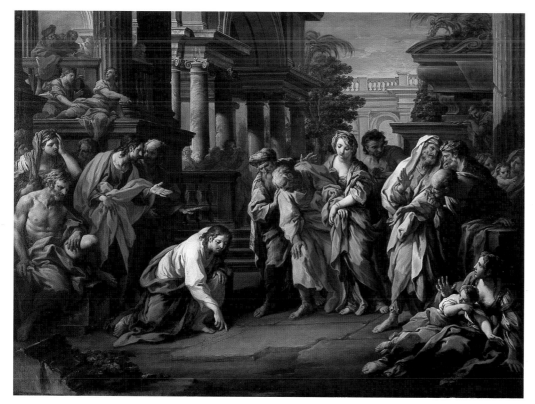

201

the force of the revolution, even though something of his manner can be seen in the Roman Neoclassicism of Vincenzo Camuccini. [SMCR]

BIBLIOGRAPHY  Faldi, Italo. *Pittori viterbesi di cinque secoli*. Viterbo, Italy: Cassa di Risparmio della provincia di Viterbo, 1970; Rudolph 1982; Curzi and Lo Bianco 1998

## 202
## Domenico Corvi
### The *Virgin and Child Worshipped by Saints Nicholas of Bari, Mary Magdalene, Paolino, Emidio, Vincenzo Ferrer, and Nicholas of Tolentino*

1753–54

Oil on canvas

9′ 7″ × 6′ 2¾″ (292 × 190 cm)

PROVENANCE  church of the Madonna di Loreto (the "Cappella di Palazzo" incorporated in the Palazzo Comunale), Senigallia, until 1930, when demolished; Palazzo Comunale, Senigallia, 1930–97

EXHIBITIONS  Senigallia, Italy, Palazzo Baviera. *Restauro tra pubblico e privato: per una casa comune dei beni culturali.* 1997, cat. no. 20; Viterbo 1998, cat. no. 9

BIBLIOGRAPHY  Margutti 1886; Cucchi, P. *Il passato e l'avvenire di Senigallia.* Senigallia, Italy, 1931, p. 31; Cucchi, P. *Il Palazzo Comunale di Senigallia.* Senigallia, Italy, 1934, p. 27; Serra, Luigi, Bruno Molajoli, and Pasquale Rotondi. *Inventario degli oggetti d'arte d'Italia: VII, provincia di Ancona e Ascole Piceno.* Rome, 1936, p. 117; Zazzarini 1937, p. 15; Curzi 1990, pp. 113, 117, pl. x, fig. 1; Giovannelli 1992–93; Sestieri 1994, vol. 1, p. 63; Faldi, Italo. "Domenico Corvi a Viterbo." *Bollettino d'Arte*, 6th ser., vol. 80, no. 95 (1996), pp. 121–26; Palazzo Baviera, Senigallia, Italy. *Restauro tra pubblico e privato: per una casa comune dei beni culturali.* Senigallia, 1997, pp. 36–37, 85–97; Curzi and Lo Bianco 1998, pp. 36–37, 86–89 Comune di Senigallia (Ancona), from the Chiesa di S. Rocco

*Beheading of Saint John the Baptist*) and figures of two apostles on the vault in the church of the Gonfalone in Viterbo; and in 1758 he completed the cycle of four canvases commissioned by Cardinal Domenico Orsini for the church of S. Chiara in Palestrina (Italo Faldi, pp. 78–80, see above).

It is still unclear why Corvi, despite the support of his master Mancini and full academic recognition, was finding it so difficult to make headway in Rome, to the extent that by 1759 he was eking out a living as drawing master to the young brother of Prince Marcantonio IV Borghese. The situation righted itself only when, after having reached the age of forty, his lateral canvases were unveiled in a chapel in S. Marcello al Corso in 1762: the formidable execution and imaginative combination of classical models (the *Niobe* statues in the *Finding of Moses*) and Giaquinto's painterly flamboyance (in the *Sacrifice of Isaac*), within verdant Locatellian landscape settings, introduced Corvi to the Roman public as a talent to be reckoned with (Loire 1998, pp. 132–34). Thereafter he was sought out by the foremost patrons, the nature of whose commissions stimulated him to produce ever more novel solutions for church and palace decorations over the next ten years. Examples are the tapestry ensemble woven between 1764 and 1766 to his designs for the Sala del Trono in the Capitoline Palazzo dei Conservatori, the *Clement XIII Rezzonico Approving the Beatification*

of *Gregory Barbarigo* fresco (1765) in the nave of S. Marco, the compellingly dramatic altarpiece of *Pope Gregory VII Extinguishing the Fire Started by the Troops of Henry IV in the Vatican* (1769) in the Borghese church of S. Caterina da Siena, as well as the contemporary frescoes on ceilings of the Palazzo Doria-Pamphili (*The Apotheosis of Andrea Doria*, now lost, documented by the *modello* in the Minneapolis Museum of Art; and the extant *Abigail Pacifying David*; see Curzi and Lo Bianco 1998).

Corvi's versatility in coping with unusual subjects is evidenced in the canvases executed in 1765 for a room in the mezzanine apartment of Principessa Costanza Barberini Colonna di Sciarra in the Palazzo Barberini, which include two colorful scenes from the lives of earlier members of the Colonna family resplendent in historical costumes and also one representing the spectral, neo-Gothic figure of *Saint Margaret Colonna Expelling Demons in a Landscape*. In 1770 he proceeded to decorate the Stanza di Chiaroscuro in the same apartment with illusionistic statues, and this shift from a predominant Rococo taste to the classicizing modes then being defined by Mengs and Hamilton, Batoni and Lapiccola, can be perceived in the contrast between his still vaporous *Triumph of Apollo*, frescoed in 1771 on a vault of the Palazzo Borghese, and that of the *Sacrifice of Iphigenia*, completed a year later in the same palace. The latter—a

nocturne of almost surreal elegance in its silvery tones and sculptural figures plotted against a Piranesi-like perspective of columns and cypresses—remains his masterpiece. By now the master's fame had spread (as indicated by the canvases he sent in 1774–78 to the abbey of Solothurn); he was given the pastoral *alias* Panfilo Eracleate in 1777 at the Accademia dell'Arcadia and, while consolidating his preeminence as a "Pictor Doctus" through teaching anatomy (see cat. 340), he branched out into other areas such as the 1779–80 restoration of Lanfranco's frescoed loggia in the Villa Borghese.

The apogee of Corvi's career, represented in his 1785 self-portraits (see cat. 204), coincided, however, with the beginning of his inexorable marginalization, despite the beautiful *Aurora* triptych which he painted in 1782 for a ceiling in the Villa Borghese: subsequently he was forced again to accept commissions for altarpieces in churches far from Rome. The increasingly harsh realism and schematic simplification of these compositions (sent to such towns as Cascina, Canino, and Rocca di Cave), together with his exclusion from the team of the major painters employed for the decoration of the Palazzo Altieri in the 1790s, indicate the isolation felt by a former leading light. Unlike Maratti, whose interminable school influenced Roman art right up to the death of his last pupil, Masucci, in 1759, Corvi was almost abruptly cast into obscurity by

The seventeenth-century altarpiece in the "Cappella di Palazzo" had been so severely damaged by an earthquake in 1741 that, during a pastoral visit some years later, the bishop deemed it unfit for cult purposes. Consequently, on June 9, 1753, the municipal council resolved to commission a new canvas for the high altar and request Monsignor Nicola Antonelli to "find in Rome an expert painter" to undertake the task (see Curzi 1990, pp. 113, 117, nn. 5–8). Since Nicola's nephew Count Bernardino Antonelli also resided in Rome at that time and frequented Corvi's private "Accademia" as a dilettante, it is not surprising that Corvi was chosen for the job (see Curzi and Lo Bianco 1998, p. 35). He soon produced a preparatory oil sketch, probably submitted to the council for approval, and consigned

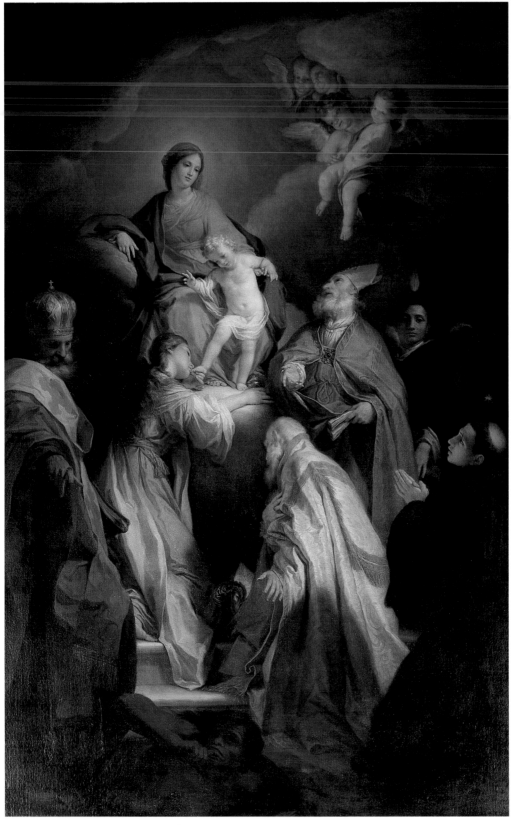

The specific requirements of the commission obliged Corvi to create a modern icon, for the canvas was destined to a sanctuary full of *ex-voto* objects honoring the Virgin and the patron saints of the city, whose number had been doubled after the 1741 earthquake by the addition of Emidio, Vincenzo Ferrer, and Nicholas of Tolentino. Therefore the artist had to accommodate all six saints and opportunely gave prominence to the original trio, situated in the center and left part, relegating the "newcomers" to the right margin in a composition that perfectly clarifies even in a chronological sense their hierarchy. The finely calculated pyramidal arrangement of so many figures in a criss-crossing of diagonals, culminating in the apparition of the Virgin and Child on a cloud platform against the suffused rosy light of the empyrean, contains numerous references to the sources of Corvi's art, from Correggio, Domenichino, and Rubens to Mancini, Conca, Subleyras, and even Gaetano Lapis. By 1754 he had forged these eclectic gleanings into a style of his own, particularly distinguishable in the sculptural folds and delicate hues of the Magdalen's costume and the expressive head of Saint Nicholas.

These connotations of form, together with the tensity pervading the hushed devotion of the saints, place Corvi at the very forefront of the artists who were then distancing themselves from the current Rococo idiom in an attempt to invigorate Roman painting with a more trenchant interpretation of past and present models. [SMCR]

## 203
## Domenico Corvi
### *The Miracle of Saint Joseph Calasanz Resuscitating a Child in a Church at Frascati*

1767
Oil on canvas
87¾″ × 69¼″ (223 × 176 cm)
PROVENANCE probably Pope Clement XIII Rezzonico, Rome, 1767; anonymous private collection; Heim Gallery, London, 1980; whence purchased in 1981 by the Wadsworth Atheneum
EXHIBITION London, Heim Gallery. *From Tintoretto to Tiepolo.* 1980, cat. no. 20
BIBLIOGRAPHY Heim Gallery, London. *From Tintoretto to Tiepolo.* London: Heim Gallery 1980, no. 20; Rudolph 1982, pp. 35–36; Pansecchi 1989–90, pp. 343–45; Cadogan 1991, pp. 120–21
Wadsworth Atheneum, Hartford, Connecticut, The Ella Gallup Sumner and Mary Catlin Sumner Collection

the picture shortly before May 15 of the following year, receiving the final installment of payment, amounting to 130 Roman *scudi*, on August 31 (the *bozzetto* appeared on the London art market some years ago and is cited by Curzi in *Restauro tra pubblico e privato,* p. 90, see above). Thus it came about that the thirty-three-year-old Domenico Corvi made his somewhat tardy public début as an artist in Senigallia rather than Rome, with an ambitious and meticulously executed altarpiece that remains the prime document of his earliest manner as well as an indication of the fundamental role played by the local Antonelli family in promoting his career.

This important picture was presented in a 1980 Heim Gallery exhibition with a correct attribution ("immedi-

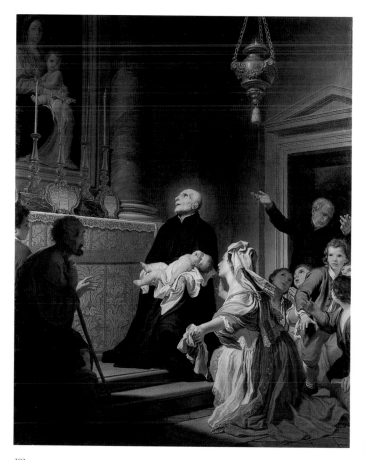

203

204

ately recognizable as a Corvi") and a mistaken identification of the saint as "evidently" Philip Neri (1515–1595), who still figures in the title by which it is catalogued in the Wadsworth Athaeneum (Heim Gallery, *From Tintoretto to Tiepolo*, no. 20, see above; Cadogan 1991, pp. 120–21). However, ten years ago Fiorella Pansecchi pointed out that the saint is Joseph Calasanz (1558–1648), who—like Philip Neri, Ignatius Loyola, and Charles Borromeo—was one of the major personalities who emerged in the wake of the Counter-Reformation to renew the Catholic Church (Pansecchi, 1989–90, p. 344; the identification is confirmed by the features of his death-mask conserved in the Congregazione Generalizia dei Padri Scolopi in Rome). The great achievement for which he is revered was the creation, following his move in 1592 from Spain to Rome, of the Scuole Pie, providing a highly qualified *cursus studiorum* free of cost to children of the impoverished classes. Founded in 1597 adjacent to the Trastevere church of S. Dorotea, thence transferred in 1612 to that of S. Pantaleo near Piazza Navona (still the headquarters of his "Scolopi" order recognized five years later by Paul V as a congregation), this prototype of a modern public school rapidly spread throughout Italy and northern Europe in a network of pres-

tigious Scolopian institutions that even today maintain the educational standards set by Calasanz.

The saint's iconography, established in various pictures after the 1748 beatification, lays emphasis on his pedagogical merits and devotion to the Virgin Mary, a case in point being the 1765 altarpiece by Gaetano Lapis in the Scolopian convent at Frascati, near Rome, which represents him indicating to a group of young students the apparition of the Virgin on clouds above an altar (both the altarpiece and the *modello* are illustrated by Angela Negro in Rome 1993, no. 23, pp. 45–47). Calasanz was one of the several saints canonized by pope Clement XIII Rezzonico on July 16, 1767, in St. Peter's, on which occasion the upper register of the interior was decorated by Carlo Marchionni with eighteen simulated statues of female virtues painted in monochrome on the designs of Corvi; furthermore, the Scolopian Fathers commissioned a picture from Corvi recorded as the *Miracle of Joseph Calasanz Resuscitating a Child at Frascati*, which they gave to the pope in commemoration of the event, and Pansecchi has convincingly suggested that it is the present canvas of the same subject (Pansecchi 1989–90).

Corvi visualized the miracle as a contemporary *tableau vivant* of historical exactitude in the costumes and

extraordinary precision of details such as the hanging lamp and veritable "still life" of the altar with candles, crucifix, and Mass cards, lace and brocade trappings, veined marble column and gilt-framed icon of the *Virgin and Child*. The emotive import of the scene is enhanced by an oblique illumination, casting into shadow the pilgrim kneeling at the foot of the altar and into relief the lovely profile and colorful local dress of the suppliant mother, while the entry of a gesticulating Scolopian Father with a clutch of youthful pupils from a door to the right adds a note of animation that offsets the utter stillness of Saint Joseph Calasanz rapt in prayer. In the studied blending of realism and spirituality Corvi recycled motifs from his earlier figural repertory (the mother in his 1766 votive canvas for S. Domenico in Turin), yet with a fresh inventiveness and superlative execution that explain the numerous other commissions he received from the Rezzonico family around that time. [SMCR]

## 204
## Domenico Corvi
## *Self-portrait of the Artist in His Studio*

1785
Signed on the top sheet of the papers on the table to the right: *D. Corvi*
Oil on canvas
37½″ × 20½″ (95.3 × 52.1 cm)
PROVENANCE Eckilstuna (Sweden); Richard Hellgren Collection; London, Daniel Katz Ltd., 1998; whence purchased by the present owner
EXHIBITION Viterbo 1998, cat. no. 32
BIBLIOGRAPHY Bowron 1993, p. 76, fig. 36; Curzi and Lo Bianco 1998, pp. 150–51, no. 32
Private collection

Domenico Corvi's splendid self-portrait, commissioned by the Grand Duke of Tuscany, Leopold, for the Galleria degli Uffizi collection of artists' self-portraits, was exhibited in Rome in November 1785 and delivered to the Florentine museum on March 20 of the following year (see Galleria degli Uffizi, Florence, *Gli Uffizi: catalogo generale* [Florence: Centro Di, 1979], p. 847, no. A 255; Curzi and Lo Bianco 1998, pp. 140–51, nos. 31–32). That full-

length effigy remains an eloquent visual statement of both the master's pride of status at the height of his career and the essential ingredients and accoutrements of his chosen profession, condensed in a scene that shows him in action rather than as the customary face staring from the wall. In full artisan-professional regalia (from turban headdress and scarlet mantle to beribboned breeches and slippers), seated on an elaborately upholstered chair with palette and brushes in hand, Corvi has captured himself for posterity in a moment of concentration while painting a nude figure of Hercules, on the canvas mounted on an easel illuminated by a studio lamp, as he turns to scrutinize the (live?) model out of view to the left. Behind him to the right a plaster cast of the Medici *Venus* (the original is in the Uffizi), plus a stack of volumes on anatomy and perspective clamping down several physiognomical drawings (autograph studies, as evinced by his signature) piled on a table, indicate the canonical sources of the art he is practicing.

If this, then, was Corvi's public testimony of his rank as a leading painter (and merited a gold medal in recognition from the grand duke), the smaller three-quarter-length figure replica exhibited here refers a more intimate rendition of the scene with several interesting variants. The artist (without turban) is now seated on an ancient marble "stool," whose figures carved in relief represent the Judgment of Paris, an allusion to the timelessly classical aesthetic of Beauty (Venus *Victrix*). Moreover, he is making a preliminary drawing of the same Hercules on the canvas with a porte-crayon and the mahlstick supporting his right hand, the background reduced to just two books and the sheaf of drawings on a cupboard and, above in a nitch, a plaster cast of a youth posed like the Farnese *Hercules*. Above all, it is the subtle pastel tonality that distinguishes this version of the composition, not to mention the winsome insertion of Corvi's pet dog thrusting its tousled little head up against his leg in the lower left corner.

On the one hand, the declensions of Corvi's two self-portraits shed light on his character and calling in 1785, at the age of fifty-four. On the other, they resume the currently held premise regarding the premier role of the Roman school, from antiquity to Raphael and thence to Maratti—who had portrayed himself in a like fashion a century earlier and explicated the foundation of this credo in a drawing of *The Accademia di Disegno* engraved by Dorigny—up to the present (see Hiesinger and Percy 1980, pp. 114–16, no. 101a, for Maratti's drawing for the

Dorigny engraving, with further bibliography; Rudolph 1988–89, pp. 242–43). As it turned out, Corvi was the last major exponent in an eminent line of Roman masters. It may be felt, consequently, that the eighteenth-century prolongation of the saga ends here, with Corvi's majestic attestation in the two varying self-portraits to what it still signified at that time to be an innovative heir to a thoroughly grounded, perennial tradition. [SMCR]

## PLACIDO COSTANZI

### NAPLES 1702–1759 ROME

Placido Costanzi, the son of a goldsmith and gem-engraver, Giovanni Costanzi, enjoyed early success. Nicola Pio's biography of Placido lists an impressive group of patrons and paintings for a young artist just embarking on his career after having completed five years of apprenticeship with Francesco Trevisani and another five years with Benedetto Luti; in addition to works that Placido painted for cardinals Alberoni, Zondadari, Martelli, Acquaviva, and Tolomei to decorate buildings in Rome and elsewhere in Italy, there were also those that were sent to France, Flanders, Spain, and even as far away as Lima, Peru. Placido followed up with three major commissions: the ceiling fresco of *The Trinity with Saints Romuald and Gregory* (1726) in S. Gregorio al Celio in Rome (cat. 205); the ceiling fresco of *Saint Peter Defeating Paganism* (1732) in S. Pietro in the village of Castel S. Pietro Romano; and *Saint Peter Resurrecting Tabitha* (1736–40 and 1757), the design for a mosaic in St. Peter's that was eventually executed in 1758–60. Placido was also among those artists commissioned to decorate the throne room of the Spanish king's new palace at La Granja (1735–38), the nave of S. Maria Maggiore in Rome (1740), the Coffee House of the Palazzo Quirinale in Rome (1741–43), and a gallery in the London house of the Earl of Northumberland (1752–53). Along with other commissions, Placido left the extremely large canvas of *The Martyrdom of Saint Torpè* for the cathedral of Pisa unfinished at his death on October 3, 1759.

What makes Placido rather unusual is the richness of the documentary record that survives and the light it sheds on his character and personality. His skill notwithstanding, it is only necessary to look at the hand of Tabitha in the center of Placido's design for the mosaic in St. Peter's and the hands of the female allegorical figures in the *modello* for the ceiling fresco of *Peace and Justice Crowning Innocence Who Overthrows Calumny* in

the no longer extant Roman palace of Cardinal Alberoni to see that Placido lacked the raw talent and inspiration of his slightly younger contemporary, Pompeo Batoni. Close examination of the oval pendants *Christ in Benediction* (cat. 208) and *The Immaculate Conception* (cat. 209) also reveals his frequent reuse of the same facial types and poses, even in the same paintings.

No story of an early demonstration of Placido's artistic talent has survived, unlike that regarding the recognition of Pompeo Batoni's talent in his drawings on his father's engraving plates; however, the return of Placido and his family from Naples in 1711 or 1712 seems to coincide with the start of Placido's apprenticeship with Trevisani. According to Pio's biography, Placido supplemented the training he received in the studios of Trevisani and Luti with the drawing of the works of Raphael in the Vatican and Annibale Carracci's frescoes in Palazzo Farnese. From the contents of Placido's studio at the time of his death, which included many loose drawings and prints as well as twenty-six bound volumes of engravings of works by "celebri autori," it seems likely that Placido never ceased his careful study of the works of the Old Masters and those of his teachers' generation. The numerous plaster casts and uncounted figures in potter's clay further emphasize a very deliberate and studious mode of working.

Placido's diligence paid off. Three deeds of sale (for the house and stable in Rome and two adjoining properties on the outskirts of Rome that Placido purchased) each stated that he paid for the property with funds from his substantial savings from his earnings as a painter. His success also allowed him to marry into the upper reaches of the bourgeoisie in Rome; Anna Maria Barazzi's father, Filippo, and her brother Francesco were both merchants who engaged in a wide variety of commercial transactions.

When Placido's design for the mosaic was displayed in St. Peter's it stirred up great controversy, according to Pier Leone Ghezzi; Ghezzi stated that the composition was terribly botched and it was wrong to have art students sketch it and the populace go see it under the mistaken impression that Placido's painting was excellent. Even more vicious was a caricature the truculent painter Marco Benefial drew of Placido sitting in the dead of night straining to defecate. Despite these scathing characterizations of Placido's artistic output, he persevered. Although no action was taken regarding the making of the mosaic for well over a decade, in 1756 Placido finally requested and received space where he could "make the nec-

essary corrections." In contrast, the mosaic that was to be made for St. Peter's from Pompeo Batoni's design was never executed.

From the records of both the Accademia di S. Luca, to which he was elected a member in 1741, and the Virtuosi al Pantheon, it is clear that Placido conscientiously carried out his duties in the various offices he held, including president of each. As president of the Virtuosi (in 1750) he paid for remodeling expenses, for a new door, out of his own pocket. He also gave some silver to both groups, even though he himself had had to pawn several items and had not paid the annual rent on the properties he owned for several years. His greatest act of generosity was to leave his estate jointly to these two organizations, which maintained ownership of the house in Rome until 1923.

Even though in his own lifetime Placido Costanzi was not necessarily considered an artist of the first rank, he nevertheless produced some very attractive and charming works. The pastel heads of a young woman and a page in the Palazzo Corsini in Rome and the figures he painted in the landscapes in the Coffee House are among his most appealing works. The pastels exhibit a freshness and a dreamy quality; the figures in the Coffee House, unlike some of Placido's more classicizing works, do not appear stiff or labored. [MLB]

BIBLIOGRAPHY Pio [1724] 1977, pp. 194–95; Clark 1968, "Costanzi"; Bowron 1980; Rudolph 1983; Cordaro 1984; Schiavo 1985; Cordaro 1987; Bryan 1994

## 205

## Placido Costanzi

*Study for "The Trinity with Saints Romuald and Gregory and the Triumph over Heresy"*

1726

Oil on canvas

62″ × 30″ (157.5 × 76.2 cm)

PROVENANCE Paolo Rosa, Rome; P. & D. Colnaghi, London; from whom purchased in 1975 by the Toledo Museum

BIBLIOGRAPHY Gibelli 1888, p. 38; Clark 1968, "Costanzi"; Mallory 1976; The Toledo Museum of Art, Ohio. *European Paintings*. Toledo, Ohio: The Toledo Museum of Art, 1976, pp. 41–42; Rudolph 1983; Sestieri 1991; Bryan 1994

The Toledo Museum of Art, Purchased with funds from the Libbey Endowment, Gift of Edward Drummond Libbey

This picture is Placido Costanzi's *modello* for his ceiling fresco of *The Trinity with Saints Romuald and Gregory the Great and the Triumph Over Heresy* in the church of the Camaldolese Order in Rome, S. Gregorio al Celio. In the

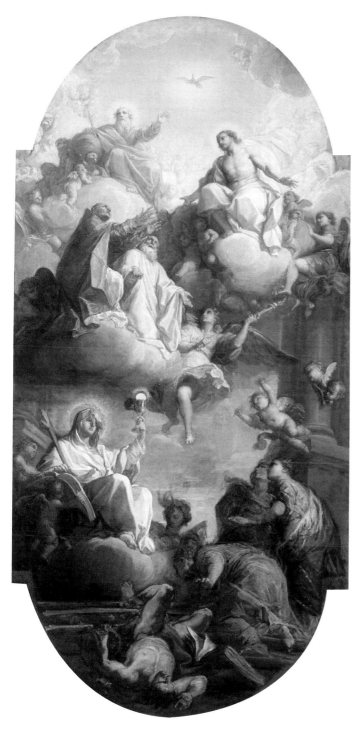

205

the grand master of the Knights of Malta, and Giovanni Odazzi's picture of the abdication of Queen Christina of Sweden.

Cardinal Zondadari was the protector of the Camaldolese order; he paid for the cost of Placido's fresco, which came to 300 *scudi*, out of his own personal funds. The cardinal's personal papers have not come to light in either the Vatican or Siena, but from those records conserved in the order's archive in Camaldoli it is known that the commission spanned an almost two-year period from January 14, 1726, when Placido was awarded the commission, to its public unveiling on October 14, 1727. Placido submitted one half of the cartoons on December 23, 1726, and the remainder on February 24, 1727; the cartoons, which had been mounted on the ceiling of the nave, were then examined by cardinals Zondadari and Imperiali along with the sculptor Camillo Rusconi and the Flemish landscape painter Jan Frans van Bloemen on March 5, 1727. Placido began the actual painting of the fresco on April 2, 1727. Assuming that Placido painted the *modello* and received Zondadari's approval before making full-scale cartoons, the *modello* must date from the second half of 1726. The author of the entry in the Toledo Museum of Art's catalogue *European Paintings* speculated that this sketch may have remained in the possession of the order after the fresco was completed. It was, in fact, hanging on the wall of the gallery on the piano nobile of Placido's house for some time after his death in 1759; his property inventory refers to a "bozzetto della volta di S. Gregorio" that measures 7 *palmi* by 3½ *palmi* or approximately 61⅝ by 30¾ inches (156.4 × 78.2 cm), which is very close to the measurement given in the Toledo catalogue entry.

There are only relatively minor differences between the *modello* and the finished fresco. For instance, in the *modello* the gaze and the head of God the Father are directed off toward the right, whereas in the fresco his head faces the same general direction as his outstretched right arm. The column base behind the allegorical figure of Faith in the *modello* is absent in the fresco. Perhaps the most striking (and puzzling) change is in the head of Saint Gregory. In the fresco he has become much younger looking and bears a striking resemblance to Carlo Maratti's depiction of Saint Charles Bartolomeo in the 1690 altarpiece for the high altar in S. Carlo al Corso. In addition, Placido's figure of Christ in both the *modello* and the fresco distinctly echoes the Christ in Maratti's altarpiece, despite the differences in the positioning of Christ's legs and the tilt of his head and torso.

According to an unidentified source, Placido "was praised by everyone for having had such spirit and courage to create a work so worthy, being only 26 years old, and for this [work] to be the first by this painter in fresco. Poems were written and printed for him" (Gibelli 1888, p. 38). Even though the unnamed author of this report appears prone to exaggeration—Placido had already painted at least one known ceiling fresco (in Palazzo Alberoni)—this passage makes it clear that the unveiling was a moment of public triumph for the artist. [MLB]

## 206
## Placido Costanzi
### *The Departure of Cardinal Zondadari from Madrid*

1728

Initialed and dated on a rock in center foreground: P.C.F.A. 1728.

Inscribed on the back of the original canvas: DI CASA ZONDADARI/RAPPRESENTA MONSIG[NO]R ZONDADARI QUANDO PARTE DALLE SPAGNE, E DA LA/BENEDIZIONE AL POPOLO

Oil on canvas

45½″ × 58″ (115.6 × 147.3 cm)

PROVENANCE acquired in 1969 by the museum

BIBLIOGRAPHY Pio [1724] 1977, pp. 194–95; Pascoli [1730–36] 1933, vol. 2, p. 394; Pastor 1938–53, vol. 34, passim; Clark 1968, "Costanzi"; Minneapolis Institute of Arts. *Bulletin*, vol. 58 (1969), pp. 93, 100; Minneapolis Institute of Arts. *European Paintings from the Minneapolis Institute of Arts.* New York: Praeger, 1971, p. 447, cat. no. 238; Faldi 1972; Faldi 1977; Cordaro 1984; Krautheimer, Richard. *The Rome of Alexander VII, 1655–1667.* Princeton, N.J.: Princeton University Press, 1985, p. 12; Cordaro 1987; Olivier Michel. Conversation with author, March 5, 1993

The Minneapolis Institute of Arts, Gift of Dennis Charles Bergquist in honor of his family and friends

This picture bears the date 1728, which Anthony Clark initially misread as 1723 (Clark 1968, "Costanzi"). Despite including the correct date for this picture in the catalogue *European Paintings from the Minneapolis Institute of Arts* (1971), Clark in his entry still spoke of "the 1723 Zondadari series." Presumably he continued using the 1723 date on the basis of Nicola Pio's statement (1723–24) that Placido had painted some pictures for Cardinal Antonio Felice Zondadari, and the fact that the ceiling frescoes in the family palace in Siena (see cat. 207) date after 1724, as does the ceiling fresco in S. Gregorio al Celio in Rome (cat. 205). The inventory of the cardinal's property that was drawn up in Rome, however, includes two other paintings by Placido, a *Saint Lawrence*

upper part of the picture, the older, bearded man on the left is Saint Romuald, the Camaldolese order's founder, and on the right is Saint Gregory, whose patrician family home was believed to be beneath the church. In the lower half the allegorical figure of Faith, seated on a cloud, is surrounded by female allegorical figures who represent (moving clockwise from the male figure of Heresy in the midst of tumbling over backwards and falling out of the painting) England, France, Spain, and Africa.

These allude to the heresies that Pope Gregory the Great stamped out in each place: idolatry in England, neophytes and simony in France, Arianism in Spain, and Donatism and Manichaeism in Africa. This subject relates to the Counter-Reformation theme of the Church Triumphant, two late examples of which appear in the series of paintings commissioned by Cardinal Zondadari–Sebastiano Conca's depiction of the standards from a captured Turkish ship being presented to Marcantonio Zondadari,

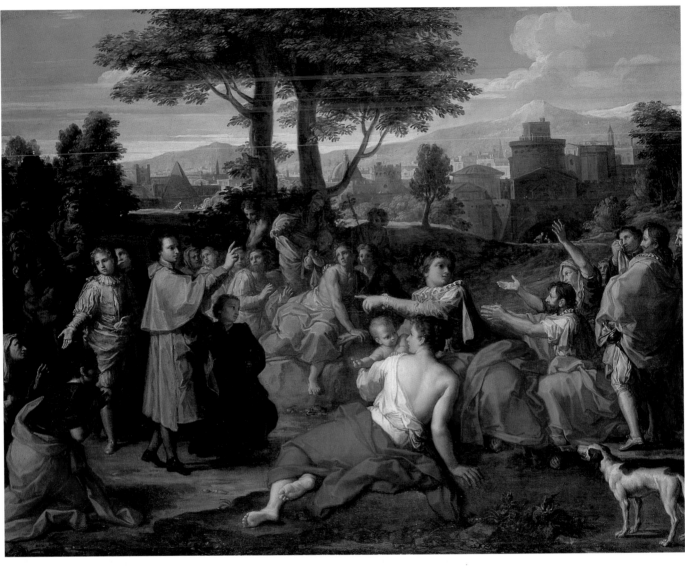

206

and a *Saint Stephen*, which may have been the works Pio had in mind.

Clark identified this scene as "the young nuncio leaving for Spain (1706)" and commented on "the convincing but highly fanciful view of Rome with the Alban Hills and Monte Cavo behind" (Anthony Morris Clark in *European Paintings* [see above]) Both the inscription on the back of the picture and the description of it in the inventory ("la partenza di Madrid di S.E. defonto"), however, strongly suggest that the scene actually depicts Zondadari's departure from Madrid either at the end of his service as nuncio extraordinary or in 1709 after having been expelled as papal nuncio. Rather than intending the cityscape in the background to be a literal depiction of Rome, it appears that Placido used a pastiche of Roman scenes to create what could pass for a view of Madrid.

Along with this picture Placido painted two others: *Antonio Felice Zondadari Taking Leave of His Spanish Escort in the Pyrenees* (initialed and dated 1727) and another whose subject is not entirely clear. It depicts Alexander VII when he was still a cardinal arriving to attend a meeting. According to Olivier Michel, the inscription on the back of the canvas, which has been recorded as *Vir-Ech*, probably was meant to be *Utrecht*. The inventory gives the location as Brussels. Michele Cordaro (1984) was probably correct in identifying the intended location as Münster, where the signing of the Treaty of Westphalia that ended the Thirty Years' War took place in 1648.

Lione Pascoli in his biography of Sebastiano Conca mentioned that the artist had painted two pictures and two replicas for the Zondadari series. These depicted Antonio Felice's older brother Marcantonio, the grand master of the Knights of Malta, receiving the standards from a Turkish ship that was captured on May 23, 1721, and Antonio Felice's first meeting as papal nuncio with King Philip V in 1706. The inventory reveals that the replicas were not exact duplicates, but huge, almost 9 by 12 foot, copies of only five of the ten original paintings. These five copies, which included, in addition to the two events painted by Conca, Giovanni Odazzi's depiction of the abdication of Queen Christina in 1655, Luigi Garzi's of Cardinal Flavio Chigi during the Roman plague of 1656, and Giuseppe Nasini's of Alessandro becoming archbishop of Siena in 1714, were all hung together in the hall or salon of the "primo apartamento nobile." No mention was made in the inventory of the authorship of these enormous copies, only that they were valued at 35 *scudi* apiece, as opposed to the 50 *scudi* for each of the originals. Evidently Cardinal Zondadari intended this pictorial survey of his family's history to make an immediate and overwhelming impression on his visitors. The fate of these copies is unknown. Unfortunately for Cardinal Zondadari, all his efforts to enhance his standing—the work on Palazzo Chigi-Zondadari in Siena, the renovation of S. Gregorio al Celio in Rome, and this series—failed to procure the papal tiara for him. The very thing he stressed in this series of ten paintings as well as in the conclave of 1730, his service as nuncio in Spain, resulted in the defeat of his candidacy at the hands of the Spanish and French.

[MLB]

207

## 207
## Placido Costanzi
*Study for "Charity"*

c. 1727/28–1731
Oil on canvas
16⅛″ × 13⅞″ (41.5 × 35.2 cm)
PROVENANCE  London, Christie's, July 4,
1997, lot 365A; Walpole Gallery, London
BIBLIOGRAPHY  Pio [1724] 1977,
pp. 194–95; Romagnoli 1840, p. 29;
Spagnoli 1987–88; Legrand and
d'Ormesson-Peugeot 1990; Roettgen 1994;
Loisel-Legrand 1995
Private collection

Work on the expansion and remodel-
ing of Palazzo Chigi-Zondadari in
Siena took place from 1724 to 1726.
Although documents indicate that
this was at the behest of the primo-
genitor of the family, Giuseppe Flavio
Chigi Zondadari, given his youth (ten
years), Steffi Roettgen argued that it
was probably Cardinal Antonio Felice
Zondadari who was responsible for
commissioning the new construction
and decoration of the palace. The date
Marco Benefial included in the
inscription he painted below the
Libyan Sybil indicates that frescoes
were still being painted as late as 1733.
According to Ettore Romagnoli, in
addition to Benefial, Placido Costanzi
and Vincenzo Meucci were also
involved in the decoration of the
palace. Romagnoli gave no indication
of the subjects of Placido's paintings

and only stated that they were located
"nella sala e nei prossimi salotti."
     Antonella Spagnoli identified three
ceiling frescoes in rooms on the piano
nobile as being the work of Placido: the
fresco in the grand salon that she called
*Conscience Reigning Over Beauty, Peace,
and Justice* (others have referred to it as
*Allegory of Virtues*), *Intelligence* (in an
adjacent room), and *Charity* (located in
another adjacent room, now used as a
chapel). The locations of these pictures
notwithstanding, Spagnoli's observa-
tion about the striking similarity of
the face of Intelligence to that of
Conscience (the woman seated on the
throne) and the face of Charity to that
of the woman in the upper left side of
the ceiling fresco in the grand salon
makes these attributions all the more
convincing. Furthermore, the painting
technique of these three frescoes is very
different from that employed in the six
Sibyls and the allegorical figure of Hope
attributed to Benefial: in the former
the colors were already blended on the
palette before application to the plaster,
whereas in the latter the majority of
the modulation of the colors was
achieved by applying darker colors in
a dabbing motion, almost like stippling,
over broad swaths of lighter colors,
much like the technique Pietro da
Cortona used in the Palazzo Barberini
ceiling fresco and the crosshatching
technique Giambattista Tiepolo and
his son Domenico used in their
various frescoes.

Catherine Legrand, likewise, recog-
nized the hand of Placido in the alle-
gorical figure of Intelligence and the
fresco in the grand salon (see Legrand
and d'Ormesson-Peugeot 1990, and
Loisel-Legrand 1995). Steffi Roettgen
agreed with the attribution of the
fresco in the grand salon to Placido,
but despite the stylistic similarities
between this work and the Charity
and Intelligence frescoes, she pro-
posed instead that they were entirely
the work of Giovanni Odazzi or that
Odazzi died before these two frescoes
were completed and Placido merely
retouched them. It does not seem
likely that an artist would work on
two different frescoes in different
rooms simultaneously. The existence
of Placido's *modello* for *Charity* and his
drawing of a Sibyl in Frankfurt, which
appears to be an early formulation of
the design used for *Intelligence*,
strongly militate against such a sce-
nario as Roettgen's, especially consid-
ering that the fresco remained largely
unchanged from Placido's *modello* for
*Charity*, aside from the addition of
another putto in the lower left and the
sweetening up of Charity's face. In
addition, the dark spots in the sky
around the head of Intelligence are
very much like those in the book and
Saint Peter's drapery in Placido's
fresco *Saint Peter Defeating Paganism*
(1732) in the church of S. Pietro (in the
town of Castel S. Pietro Romano)
which entailed making round depres-
sions in wet plaster.
     The question remains as to why
what seems to be the preliminary
sketch for the allegorical figure of
Intelligence is actually a drawing of a
Sibyl. Even more puzzling is the fact
that this drawing is one of a series of
five drawings of Sibyls (all attributed
to Placido), and yet Placido did not
paint one Sibyl in Palazzo Chigi-
Zondadari. Loisel-Legrand in trying
to make sense of the existence of
Placido's drawings of Sibyls in light of
Benefial's authorship of the Sibyl fres-
coes, referred to Placido's and
Benefial's "rapporto reciprico" and
speculated that "one finished the
project left incomplete by the other"
(Loisel-Legrand 1995, p. 92). There
does not appear to be any relationship
whatsoever between the drawings of
Placido and the frescoes of Benefial. In
fact, none of Benefial's designs bears
any resemblance to any another,
whereas Placido's are all quite similar
to each other. Perhaps Cardinal
Zondadari had initially intended to
award the commission for the Sibyls
to Placido, but, because of the draw-
ings' lack of *invenzione*, he gave it
instead to Benefial. [MLB]

## 208
## Placido Costanzi
*Christ in Benediction*

Before 1753
Oil on canvas
51⅛″ × 39⅛″ (130 × 100 cm)
PROVENANCE  collection of Fabio Rosa;
bequeathed to the Accademia di S. Luca in
his will of 1753
BIBLIOGRAPHY  Clark 1968, "Costanzi";
Pietrangeli 1969; L'Accademia 1974; Faldi
1977; Cordaro 1984; Rybko 1990; Sestieri
1991; Cipriani and De Marchi 1992; Bryan
1994; Sestieri 1994, vol. 1, pp. 65–67
Accademia Nazionale di San Luca, Rome

This picture of Christ, shown seated
on a cloud with his arms raised and
palms up with the stigmata clearly
visible, and its pendant, *The Immaculate
Conception* (cat. 209), did not constitute
Placido Costanzi's reception piece,
which each artist was supposed to
submit to the Accademia di S. Luca
after becoming a member. Despite
the unlikelihood that an artist would
donate two pictures when one was
that was required, Anthony Clark
(1968) was the first to speculate that
Placido that did indeed submit these
two works; Italo Faldi (1977), Michele
Cordaro (1984), Ana Maria Rybko
(1990), and Giancarlo Sestieri (1991
and 1994) all repeated Clark's specula-
tion. These two works were, in fact,
part of the collection of Fabio Rosa, a
papal accountant, who expanded the
collection of pictures he had inherited
from his father, Francesco, a painter.
Fabio Rosa, in turn, bequeathed his
collection to the Accademia.
     Not only was Placido the author of
these two paintings; he was also the
appraiser responsible for the record-
ing and valuing of the artworks in the
inventory of Fabio Rosa's property
after his death in 1753. According to
the inventory, and hence the artist
who painted these pictures, their
precise subjects were the Redeemer
("il Santissimo Salvatore") and the
Immaculate Conception ("la Santissima
Concezzione"). The fact that the
wounds are clearly visible on Christ's
palms is in keeping with the iconogra-
phy of Christ as the Redeemer.
     Faldi called attention to the classi-
cizing features of this painting,
namely the "impeccably frontal" (Faldi
1977, p. 504) pose of Christ, whose
figure is located on the central vertical
axis and is surrounded by a circular
grouping of angels. According to
Faldi, although this picture follows
the academic tradition of Maratti
and Chiari, it already is "beckoning"
to Winckelmann's canons, which
informed the late eighteenth-
and early nineteenth-century
Neoclassicism style. One must be cau-
tious, however, not to equate Placido's
exercises in classicism with proto-

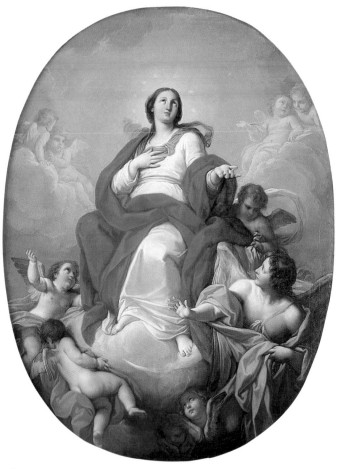

208

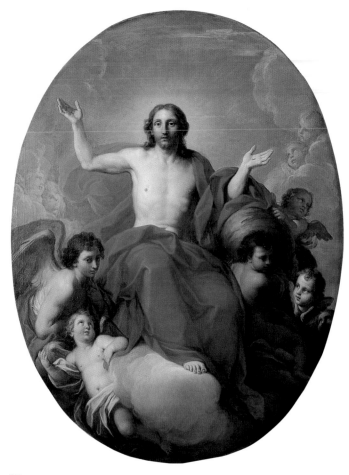

209

Neoclassicism. Placido, as is confirmed by what is known of his working method from his surviving drawings and paintings as well as other documentary evidence, was a careful student of the past, not an innovator. Furthermore, the striking contrast between Placido's depiction of Christ the Redeemer and a much earlier painting called *Il Redentore*, which entered the collection of the Pinacoteca Vaticana only in 1832, points to how Placido's painting is very much a product of its time rather than looking forward to Neoclassicism.

The authorship of the painting in the Vatican (Musei Vaticani Archivio Fotografico XXVI-13-2) is uncertain; according to the curatorial notes in the Pinacoteca Vaticana, it has been believed to be the work of Correggio or perhaps a copy by Annibale Carracci after a lost original by Correggio. Regardless of who painted the Vatican *Redentore*, the rigid frontality of Christ is striking; the head, torso, and legs are in perfect symmetrical alignment with the central vertical axis that runs through Christ's figure. Even the arms are almost perfectly symmetrical, extending out from his sides at a slight angle from his shoulders with a bend at the wrists so the palms are tilted slightly upward. Placido's Christ is

very different in character. His head is tilted slightly to his right; his right arm juts almost straight out from the shoulder, and the forearm is raised such that his right hand is just above his head; his left elbow, however, is drawn in close to his side, and his left hand is about level with his jaw. His lower body is twisted to his left so that even his right foot is to the right of the central vertical axis. This, albeit subtle, spiral arrangement of his body is typical of Settecento style.

Despite the wonderfully rendered inward gaze of the angel in the lower left of the picture, in this painting Placido's lack of *invenzione* is particularly conspicuous. The hair and face of the angel on the left are echoed in the small wingless boy to the right of Christ. In addition, the facial features of the putto in the lower left, the putto in the shadows to the right of Christ, and the cherub below are all very similar, if not absolutely identical. Furthermore, the putto in the lower left is not all that different from either the putto to the left of the Virgin (cat. 209) with its right hand raised or the left-hand putto above and to the right of the Virgin. [MLB]

## 209

## Placido Costanzi
### *The Immaculate Conception*

Before 1753
Oil on canvas
51¼″ × 39⅛″ (130 × 100 cm)

PROVENANCE collection of Fabio Rosa; bequeathed to the Accademia di S. Luca in his will of 1753

BIBLIOGRAPHY Golzio 1964; Clark 1968, "Costanzi"; Pietrangeli 1969; *L'Accademia* 1974; Bowron 1980; Rudolph 1983; Cordaro 1984; Rybko 1990; Sestieri 1991; Cipriani and De Marchi 1992; Bryan 1994; Sestieri 1994, vol. 1, pp. 65–67; Loisel-Legrand 1995 Accademia Nazionale di San Luca, Rome

According to the property inventory of Fabio Rosa, the original owner of the *Immaculate Conception* and of *Christ in Benediction* (cat. 208), these two paintings were hung together on the same wall in a room in Fabio Rosa's home in Rome on via Paolina. Even without this documentary evidence, it would be impossible not to recognize these two oval canvases as pendants. In each the main figure is located on the central vertical axis and is seated on a cloud surrounded by an angel, putti, and a single cherub. The poses of Christ and the Virgin are loose mirror images of one another: the

Virgin's right elbow is drawn in close to her body, and her left leg is further forward than her right leg, the opposite of the positioning of Christ's limbs. In addition, in each picture the single angel is located in the lower part of the composition, on the same side as the forward projecting leg of the main figure, thus acting almost as visual brackets.

Taking into account the standard practice of reading from left to right, it seems very likely that Placido intended for the picture of Christ to be hung to the left of the *Virgin Mary*. The rather large right arm of the angel to the left of Christ and the drapery that rises over Christ's right thigh form a curved line that pulls the viewer's eye to the head and shoulders of the small wingless boy to the right of Christ. Nothing prevents the viewer's eye from moving down the boy's legs and out of the picture, whereas in the *Immaculate Conception* the extended right arm of the angel to the right of the Virgin serves to bring the viewer's eye back into the lower center of the painting, after having already followed a diagonal up from the putti in the lower left and the blue cloak on the Virgin's right side and then down another diagonal from her head to the angel on the right of the picture.

In addition to the title given in the inventory, the crescent moon and the crown of stars indicate that the subject of this painting is the Immaculate Conception. Another picture by Placido depicting the Virgin, the *Assumption of the Virgin*, in the collection of the Accademia di S. Luca, may have been his reception piece. Just as the figures of Christ and Gregory the Great in the ceiling fresco in S. Gregorio al Celio represent a borrowing from Carlo Maratti, almost the entire pose of the Virgin in the *Assumption*, except for the feet, derives directly from Domenichino's treatment of the same subject in the ceiling medallion in S. Maria in Trastevere.

Costanzi may well have borrowed the pose of the Virgin in this rendering of the Immaculate Conception, but he definitely borrowed from his own work for at least one of the other figures. The head of the angel in this work is almost identical to that of the kneeling page in Placido's depiction of *Antonio Felice Zondadari Taking Leave of His Spanish Escort in the Pyrenees*, one of the ten paintings from the Zondadari series (see cats. 180, 206); even the angles of the heads and the shoulders of these two figures are essentially the same. Given the striking similarity of these two figures along with that of the dark-haired angel to the wingless boy in *Christ in Benediction* (cat. 208), it might appear that Placido used the same model, just as Catherine Legrand postulated on the basis of the similarity between the face of Saint John in *Pace oves meas* in S. Giorgio in Siena and that of *Narcissus*. It seems more likely, however, that Placido repeatedly used the same prototype, as opposed to the same live model. Both the head of the angel in the *Virgin Mary* and that of the kneeling page in the picture from the Zondadari series are clearly related to, and quite possibly were derived from, the pastel head of a young man in the Galleria Nazionale d'Arte Antica in Palazzo Corsini that had formerly been attributed to Benedetto Luti, which Anthony Clark reattributed to Placido. [MLB]

## JACQUES-LOUIS DAVID
PARIS 1748–1825 BRUSSELS

With Canova, Jacques-Louis David is the towering pan-European artistic figure of the late eighteenth century. Both men irrefutably changed the views by which art should be made during the 1770s and 1780s, and both were able, through their influence and tremendously charged productions, to carry this revolution well into the 19th century. Both came to the essential principles of their new views in the city of Rome, and shaped these

fundamental shifts in artistic values through their mutually foreign response to the artistic culture, past and present, of that place.

David was the son of a haberdasher. His artistic promise was not evident in his youth but, through a distant family connection to Boucher, he gradually entered the strict Parisian system of artistic advancement and, in 1775, won the *prix de Rome* after several unsuccessful attempts. He had the good fortune to travel to Italy from Paris with the newly appointed head of the French Academy at Rome, Joseph-Marie Vien. As he would himself later report, David was not particularly enthusiastic about this very necessary step in his progression, as he remembered that few artistic reputations were made in France by those who did not follow the regime of a Roman tutelage.

In Rome, David shared lodgings with his fellow pensioner Peyron, and absorbed himself in the regular instruction in drawing from the nude at the Palazzo Mancini (the headquarters of the French Academy on the Corso since 1725). He also developed a deep passion for drawing after the antique, either in reality or from casts. One telling anecdote relays his pleasure that Giovanni Paolo Panini (an instructor at the French Academy and an important bridge between the students and the broader artistic community of the city) had a new casting made of the entire frieze of Hadrian's Column to replace an earlier cast that had been allowed to disintegrate. Surviving sketchbooks from these years (and they are numerous) abound in these drawings.

David was rigorous in his exploration of the masterpieces of the High Renaissance and the Baroque: Raphael received his greatest praise, although there is remarkably little graphic evidence of his visits to the Vatican, major painting galleries, or churches to underscore this passion, which emerges more clearly through the paintings done during his five years in Rome. Unfortunately, what must have been an important step in his evolution at that point—a full-size copy after Valentin's *Feast at Cana* in the Barberini gallery—has been lost. Among David's first Roman works, *The Funeral of Patroclus* (1779; National Gallery of Ireland, Dublin), for all its energy and complexity, is still done in the spirit of Boucher and the manner he left behind in Paris. However, his first large-scale academy figures of the same date, his *Hector* (cat. 210)—one of the required samples of progress to be sent back to his sponsors at the academy in Paris—show the first clear signs of his now limited (and much darker) palette, a new pleasure in shadows (a radical departure from his pastel and sunny early work), and,

above all, a sobriety of focus and simplification, which would be the foundation of his radical "return to order" principles, and which would govern his work for the next thirty years, up and through his service to Napoleon.

It is often said that the greatest lesson learned by David in Rome was to look at nature straight on, to rid himself of any Rococo interest in decoration and embellishment. The freshness and unadorned quality of his numerous landscape drawings (often of dramatically light, cuboid structures), or contemporary genre subjects (an ox, or a peasant at rest, for example), certainly support this. It is this quite literal cleansing of his eyes, along with his passion for antique sculpture and paintings of the Roman past, that ironically placed him as one of the great anti-academics of all time: on becoming essentially the art czar of France in 1793, one of his first acts was to close the academy.

But can these three elements—his nurturing encounter with nature head-on, the antique, and art from Raphael through the Carracci—fully explain the remarkable sea-change that David underwent during his five years in Rome? This critical moment in the formation of a great genius has, more often than not, been observed from a French national viewpoint that would both focus exclusively on his activity within the French artistic community of Rome, and then later emphasize his position as the seminal figure for much that would happen in the next (and indeed "French") century.

The purpose here in representing this young artist by perhaps a disproportionate number of works in the present exhibition—nearly equal to those representing Mengs, and more than, for example, Benefial (a figure as radical in intention, if not effect, as the young David)—is to provoke the little-examined issue of David's exact relationship to the actual Rome of his time as a living artistic environment, and one that was the most vital in the world.

David often did not rest easy in Rome—or Italy, for that matter. In his memoirs there are flashes of dark prejudice about the Romans themselves and mysterious fits of melancholy, brought on in part (as the painter himself acknowledged) by his frustration at his own limitations before the wonders that he beheld, but also by other pulls that are still hard to explain.

And many before now have faltered in an attempt to place David in some relationship to his immediate contemporaries (in or out of the Palazzo Mancini), even those convinced of the essential oneness of cosmopolitan Roman artistic culture. But there are few facts to draw on. Steffi Roettgen points to an annotation on drawings

after antique sculptures "nella museo da Mengs" as a hint at some interest in, along with Pompeo Batoni, the most celebrated artist in Rome at that time; indeed Mengs displayed his collection of casts after famous antique statues in the arcades of St. Peter's Square, or the loggia of the Palazzo Barberini, where earnest students went to make drawings after them. Schnapper concludes that David must have known Mengs personally; Mengs would have returned from his nearly twelve years in Spain in 1777, and died in 1779, the year before David returned for the first time to Paris. And certainly general comparisons can be made between Mengs's *Perseus and Andromeda* of 1777 (State Hermitage Museum, St. Petersburg; fig. 17)—displayed in such triumph and with such an enthusiastic reception—and David's "pure" celebration of the male nude (albeit via the *Apollo* Belvedere) up and through his equally elevated *Leonidas at Thermopylae* (completed 1814; Musée du Louvre, Paris), painted when memories of Rome had seasoned considerably.

Pompeo Batoni, Mengs's rival as preeminent artist in Rome at this point, visited David's studio once, if not twice. On the first occasion (and there the documentation seems to come first-hand) it was to see the altar of Saint Roch, commissioned by the city of Marseille and displayed at the French Academy with great success in 1779 before being sent to France (cat. 212). It was at this point Batoni is said to have beseeched the young artist to remain and continue his career in Rome, where he would, undoubtedly, have become the director of the academy (*chef d'école*). A very similar story (so similar, and originating from a somewhat later date in the vast documentation surrounding David) reports a visit by the aged Batoni to see the completed *Oath of the Horatii* in 1784, when he made a second plea for David to stay. On one of these occasions Batoni is said to have presented the Frenchman with one of his own palettes as a sign of his esteem.

But what visual evidence is there for Rome's influence on David? In ways far from easy to explain, several compositional features and narrative details of David's *Antiochus and Stratonice*, done in 1774, the year before he left Paris for Rome, reflect to a remarkable degree elements in Batoni's own famous treatment of the same theme. Batoni's painting never left Rome during the eighteenth century, but may have been known in Paris through an (as yet untraced) engraving. There is more justification for comparing Batoni's beautiful *Death of Meleager* (Conte Minutoli Tegrimi Collection, Lucca) with David's treatment of the female

figures on the right side of his *Andromeda*, done after his first return to Paris in 1780, where strong memory of both the pose, but more tellingly, the whole emotional tenure of the Batoni figure, is maintained.

Beyond these comparisons, hard evidence is difficult to find beyond the broad view that David's evolution into the maker of tableaux of great restraint and dignity, played out in a precise and rhetorical manner within a shallow, schematically defined interior, is part of a larger, general process. The work of the grand manner so central to the history of painting in Rome from the young David to Batoni (see, for example, the *Alexander at the Tent of Darius* in Potsdam) to Gavin Hamilton to Placido Constanzi (in whose studio, ironically, David painted the *Horatii*), to Poussin, straight back to Raphael and antique relief sculpture demonstrates this process. A similar transformation can be seen in David's drawings in Rome, where, quite early on, he entered his "second manner," which emphasized outline, rather than a Rococo hatching of defined edges, above all else, the most characteristic quality of Roman drawing (carried to the extreme by Flaxman; see cat. 345). This development was noted by Goethe's friend and guide Tischbein, who lived just across the street from David in 1784–85.

In 1780 David returned with great enthusiasm to Paris, where he was forced, despite the high praise received by the *Saint Roch* when it was shown at the Salon the year before, to create a new work to mark his entry into the academy. He chose the poignant story of *The Discovery of Belisarius* (first version, Musée des Beaux-Arts, Lille; second version, Musée du Louvre, Paris), which assured his reputation and placed him firmly as the new center of painting in Paris. He secured and heightened his fame with a series of masterpieces over the next four years. To encourage the man whom he would, perhaps rightly, see as the greatest evidence of the success of his program of artistic reforms in Paris and in Rome, in 1784 d'Angiviller raised the level of state encouragement of the arts by declaring the king's own direct sponsorship in a series of commissions to decorate royal residences. David's assignment was the charged and deeply patriotic subject of *The Oath of the Horatii*—perhaps his most famous creation (he chose the image of one arm grasping a sword as his own emblem)—and, as it would turn out, one of the images most deeply symbolic of the history of France over the next two decades.

David chose to return to Rome to undertake this huge (the final canvas measures 10′ 9⅞″ × 13′ 11⅛″;

3.30 × 4.25 m) and ambitious task, even at the cost of expanding his expenses beyond the state subsidy (he had to borrow money from his in-laws). This decision was made with great difficulty. His second son had just been born, he was established with a large atelier with students in Paris, his mixed feelings about Italy and the Italians gave no evidence of resolving themselves, and yet there seems to have been no hesitation in his mind that the commission should be carried out in Rome. On the negative side, it has been pointed out that he was escaping Pierre, the head of the Parisian academy, whose rigidity and small-mindedness he detested. Meanwhile, Vien noted from Rome that David's return may also have been prompted by greed and ambition. However, perhaps the most telling reason was simply the artist's desire to return to the capital of art to make his masterpiece.

David, now with his expanded household of family and students, rented the large studio formerly belonging to Placido Costanzi just off the Piazza del Popolo at via Babuino and via Margutta. His landlords were the Accademia di S. Luca, to whom Costanzi had willed the property. There, over the next year and a half, with Drouais as his most trusted assistant, he executed the huge painting that he unveiled to the Roman public for only a few days in the summer of 1785 before it was crated and shipped, with considerable difficulty, to Paris, where it arrived late at the Salon. This, of course, had the advantage of attracting still more attention.

The Roman response was broad and positive. As David himself reported to d'Angiviller, the *Diario de Roma* described the work with remarkable accuracy, and praising eloquence. Tischbein confirmed the response, although noting its quality was considerable for a "French" picture.

On its return to Paris, quickly followed by David and his family, the painting came to be seen, remarkably rapidly, as the milestone in the history of art it has been considered ever since. It is, of course, naïve to claim that this picture (along with earlier Italian works from his five-year stay in 1775–80) is entirely Roman in its stylistic and expressive make-up, just as it would be foolish to think that it could have been painted anywhere else at that moment. The *Horatii* profoundly absorbs and represents a vast history of painting and sculpture and, as evidenced by the next years of painting and sculpture in France (through David d'Angers and Delacroix), renews and transforms works made in the grand tradition. What is its legacy in Rome itself? Through figures such as Vincenzo Camuccini, it plays out

210

well into the new century and, if a new elevation and sobriety of color and composition, as practiced by Unterperger, Maron, or Nocchi, seem in many ways related, as does an interest in elevated subjects, Mengs (and for that matter, Batoni) is a more direct explanation of this evolution of style. [JR]

BIBLIOGRAPHY *David 1989*

## 210

## Jacques-Louis David
### *Academy Male, Called "Hector"*

1778
Oil on canvas
47⅛″ × 67⅞″ (123 × 172 cm)
PROVENANCE kept by David in his Paris studio in the Louvre and, perhaps, in Cluny thereafter; in Baron Gros's studio by 1820; acquired in 1835 by the Marquis de Moncal-Gozon; purchased by the Musée Fabre in 1851
EXHIBITIONS Rome, Palazzo Mancini. September 1778; Paris 1781, *Salon de 1781*, no number; Paris 1989, cat. no. 30
BIBLIOGRAPHY *David 1989*, p. 92, no. 30
Musée Fabre, Montpellier

Among the many reforms brought about by the new director in charge of the visual arts under the crown, the in 1775 of the royal drawing school in Paris. For him its very existence challenged one of the essential reasons why a talented young figure (working through the procedure of competitive exercises) would be sent, at the state's expense, to Rome, where closely supervised drawing of posed male nudes had been an essential (*the* essential, arguably) element of instruction since the founding of this academy in the seventeenth century.

Students in Rome were required periodically to send back to Paris examples of their progress in this fundamental element of their education,

not simply as draftsmen but to display their mastery of drawing, chiaroscuro, and elemental uses of color. This figure, an unidealized young model posed in one of the set positions, was David's *envoi* (literally "sent item") for the year 1778. It is a key document of the pervasive practice of life studies in all young artists' education, as well as a remarkable example of the powers already within the grasp of this still growing young artist working within very tight strictures. It is unclear when the perfectly apt heroic title *Hector* (a reference to the fallen Trojan hero who was then dragged by his heels from Achilles' chariot around the city walls) was first applied. A second *envoi* called *Patroclus* (Musée Thomas Henry, Cherbourg)—with a more dramatic and alert figure seen from behind—seems to have fulfilled the requirement two years later with equal merit (although equally without clear attributes).

All the lightness of touch, the pleasure in animating an entire surface, and the evenness of light that marked David's earlier work, and reflect his first master Boucher, are entirely purged from this picture, whose power and dignity are well beyond its essential purpose as an academic exercise. The figure is brilliantly lit while the background is brought down to deep shadow. No elements, other than those directly observable in the simplest of studio arrangements, are added to embellish or entertain. A stark, monumental presence, justifying the heroic title, is established here for the first time on this scale in David's painting, which will prove fundamental to all his later creations. [JR]

## 211

## Jacques-Louis David
### *Saint Jerome*

1780

Signed and dated, lower right: *J. L. David.*
*f/roma 1780*

Oil on canvas

68½″ × 48⅞″ (174 × 124 cm)

PROVENANCE  J. G. Moitte in his death sale,
1810; Cardinal Fesch, sold in Rome in 1845;
Gustav Maitland 1880 and given by his
descendants to the basilica of Quebec in
1922; put on deposit to the seminary;
museum in 1884; on extended loan to the
National Gallery of Canada, Ottawa, since
1995

EXHIBITIONS  Rome, Palazzo Mancini,
1779[*sic*]; Paris 1781, *Salon de 1781*, no num-
ber; Paris 1989, cat. no. 36

BIBLIOGRAPHY  *David* 1989, p. 100, no. 36
Notre-Dame de Québec, from the collec-
tion of the council of churchwardens, on
deposit at the Musée de la civilisation,
Quebec, on loan to the National Gallery of
Canada

How exactly this simple depiction of
the aging hermit saint, looking up from
his seclusion in a hut in the wilderness
to receive sustenance from above,
relates to the officially required works
(the *envois*) that were sent from Rome
back to Paris to display a student's
progress, is unclear. It is possible that
the painting can be identified among
those "half nude" figures critiqued
favorably in Paris in 1780 (Michel R.
1981, p. 101). Aside from this connec-
tion, this is David's first ambitious
encounter with a religious subject.

As David noted in his reaction to
earlier Italian painting upon his arrival
in Rome, Guercino played a major
role in his early evolution. And while
the exact location, during David's stay
in Rome from 1775 to 1780, of the
Baroque master's very similar version
of the same subject (now in the
Mahon collection at the National
Gallery, London) is unknown, the
Guercino makes a tempting compari-
son to David's *Saint Jerome*.

All the interest in rugged detail,
plainly witnessed and rendered in
an almost colorless exercise of earth
tones, looks back at early seventeenth-
century Roman painting in the tradi-
tion of Caravaggio (to whom David
never refers). So does the description
of the aged man's flesh and the unide-
alized poignancy of his expression.
This is as close to historicization as
David will ever bring himself. The
highly effective (in terms of emotional
impact) pose of the figure in folded
and twisted stature, very atypical for
David, reflects his close attention to
his models, if not to those elements
that he will retain in his later work.
The *Saint Jerome* is a work that antici-
pates his more ambitious (and com-
missioned, which this work certainly
was not, even given its subsequent

211

illustrious history as a perused object
of piety and desirability) *Saint Roch*,
the work that first established his rep-
utation in Rome and would, upon its
arrival in Paris, begin the process that
would end with the artist's position as
first painter to the Emperor Napoleon
Bonaparte in 1804. [JR]

## 212

## Jacques-Louis David
### *Saint Roch Interceding for the Victims of the Plague*

1780

Signed and dated lower left: *L. David faciebat/Rmae. 1780*

Oil on canvas

8′ 6⅛″ × 77⅛″ (260 × 196 cm)

PROVENANCE David's studio in Rome and Paris, 1780–82; Department of Health, Marseille, by February 1782; hung in their public offices until its transfer to the museum in 1944

EXHIBITION Paris 1989, cat. no. 40

BIBLIOGRAPHY *David* 1989, pp. 105–7, no. 40

Musée des Beaux-Arts, Marseille

212

On May 10, 1780, David exhibited at the Palazzo Mancini his altarpiece showing Saint Roch imploring the Virgin's favor for the plague victims of Marseilles. Joseph-Marie Vien, his friend and the director of the French Academy at Rome, would report to the director-general of fine arts, the Comte d'Angiviller, on the success of the this work, noting that this was no longer the production of a talented student but rather the creation of a great master. From this success, Angiviller offered David another year's pension to continue his studies in Rome, at the same moment when Pompeo Batoni (the leading dean of Roman painting) encouraged him to remain in the city and bring it glory. However, David, mindful of the direction of his career in a fashion that is particularly revealing in the context of this exhibition, refused and returned to Paris the following summer, where the *Saint Roch* was shown to acclaim at the Salon that August.

The department of health of the city of Marseille wanted a work for its chapel to commemorate the plague of 1720, the horrors of which made were still vivid to the people of that city sixty years later. Alert to the economy such an arrangement would allow, they asked Vien in Rome to give the commission to a talented *pensionnaire*. After several acrimonious interactions David, whose emergence as a major figure pivoted around this work, both in Rome and Paris, pressed them for more money until the final delivery in 1782.

The subject is conventional and perfectly apt to the commission. Saint Roch, a victim himself (the wound on this left thigh would be licked clean by his faithful dog), had been since the fourteenth century the patron saint of plague victims. In a preparatory oil sketch attributed to David (Musée Magnin, Dijon) it is clear that his original intention was to limit the narrative to three figures: the Virgin, Saint Roch, and the lamenting, Lazarus-like figure in the foreground. However, as he expanded the composition he heightened its theatricality with the additions of a beseeching woman, a horrified adolescent, and a whole procession of victims (their corpses borne by others) streaming in from the background against a city view and a bleak, overcast sky.

Much has been written about the sources for this work, which obviously draws heavily on Roman and Bolognese Baroque paintings, most specifically Guercino and Guido Reni but also the plague scenes by Poussin (most specifically his *Plague of Assdod*; Musée du Louvre, Paris), while the recumbent figure in the foreground may reflect his early thinking about the works of Charles Le Brun, even while in Rome (see Robert Rosenblum, "Moses and the Brazen Serpent: A Painting from David's Roman Period," *The Burlington Magazine*, vol. 105 (1963), pp. 557–58). However, as intelligently as the painting may refer to this heritage, its essential grandeur and the immediacy of the narrative are very modern and completely the work of David. The more revealing comparisons are to his own, Roman, contemporaries. The mother and child in complete profile, silhouetted against the radiant (and hope-giving) sun as it bursts through the clouds, will have great resonance in the works of Cades, for example. The urgency of the shouting youth (reflective in turn of Caravaggio and Valentin) has its parallel, on the other hand, in the contemporary emotional

intrusions in Corvi's altarpieces, which create dramatic subplots in a way quite unique to Roman painting at this moment. And, perhaps most important, this rather obvious, and extremely effective, formal division of the spaces into three—with the principal figure set in a very shallow space—has little to do with the Baroque in either France or Spain, and much more in common with the grand history and religious paintings of Batoni and most especially Mengs (see Roettgen 1993, "Mengs," pp. 70–71). [JR]

## 213
## Jacques-Louis David
### *The Oath of the Horatii*

1786

Signed and dated lower left: *J. L. DAVID FACIEBAT/PARISIIS, ANNO MDCCLXXXVI*

Oil on canvas

51¼" × 65⅜" (130.2 × 166.2 cm)

PROVENANCE  painted for the Comte de Vaudreuil, 1786?; Firmin-Didot family, by 1794; Hyacinthe Didot, 1880; Louis Delamarre, Paris, by 1913; Baronne Eugène d'Huart; (Paul Roux et al. sale, Paris, December 14, 1936, lot 116); Wildenstein, Paris and New York, 1937

EXHIBITIONS  Paris, Galerie Lebrun. *Explication des ouvrages de peinture exposées au profits des Grecs.* 1826, cat. no. 40 (as by David, entirely retouched by him five years after 1786; Paris 1913, cat. no. 25 (as by Girodet, retouched by David); Rome Palazzo delle Esposizioni. *Mostra di capolavori della pittura francese dell'ottocento.* 1955, cat. no. 27 (as by David); Cleveland 1964, cat. no. 114, (as by David); London 1968, cat. no. 179, fig. 338 (as by David); Berlin, Nationalgalerie, *Bilder von Menschen.* 1980, cat. no. 29; Stockholm 1982, cat. no. 10, pp. 32–34

BIBLIOGRAPHY  Thiery, L. *Guide des amateurs et des étrangers voyageurs à Paris.* 1787, p. 548 (as a reduction by David of the Louvre painting); Landon, C. "Exposition publique des tableaux du cabinet de M. Didot." *Journal de Paris* (March 26, 1814), p. 4 (as "excellent copy by Girodet"); Rosenblum 1965; Wittmann, O. "Letters: Jacques-Louis David at Toledo." *The Burlington Magazine,* vol. 107 (1965), pp. 323–24; Wittmann, O. "Letters: The Toledo Horatii." *The Burlington Magazine,* vol. 108 (1966), pp. 90, 93; Wildenstein and Wildenstein 1973, pp. 23 (no. 176), 209 (in no. 1810), 226, 227 (23, in no. 1938); The Toledo Museum of Art, Ohio. *The Toledo Museum of Art, European Paintings.* Toledo: The Toledo Museum of Art, 1976, pp. 51–52, pl. 211; Stackelberg 1980, p. 11; Canaday, John. *Mainstreams of Modern Art.* 2d. ed. New York: Holt, Rinehart, and Winston, 1981, pp. 10–18, 21, 24, 25, 29, 31, 47, 55, 61, 63, 64, 72, 134, 149, 152, 173, 195, 247, 252, 260; Crow 1985, pp. 7, 163, 209, 212–17, 219–20, 223, 230, 232–33, 235–41, 242, 244, 249–55; Michel R. 1988, pp. 34–42, 40–41; Crow 1989, pp. 47, 49; Carr 1993, pp. 307, 308, 315, fig. 3; Johnson 1993, pp. 4, 11, 14, 38–39, 58–66, 69, 80, 82, 162, fig. 2, pl. 1; Crow, Thomas. *Emulation: Making Artists for Revolutionary France.* New Haven and London: Yale University Press, 1995, pp. 90, 91 (as by Girodet), 92, 102, 315,

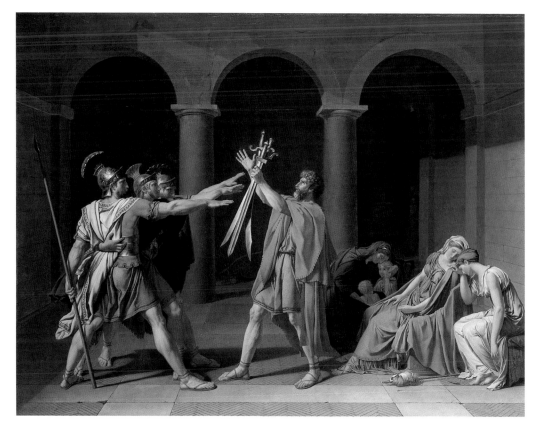

213

nn. 23, 24, pl. 69; The Toledo Museum of Art, Ohio. *Toledo Treasures.* Toledo: The Toledo Museum of Art 1995, p. 113
The Toledo Museum of Art, Purchased with funds from the Libbey Endowment, Gift of Edward Drummond Libbey

This painting is a reduced version of the large (10′ 9½" × 13′ 11¼"; 330 × 425 cm) canvas David made in Rome during his second trip in 1784–85. It is the work that, from its first showing in Rome that summer to its inclusion in September in the Paris Salon, established once and for all David's preeminent position in the history of French (and Roman) art, and serves as a point of departure for the entirely irreversible direction painting would take. The painting's inclusion in this exhibition is dictated both by its considerable refinement and beauty as an independent work of art, as well as (obviously, but unapologetically) its being a substitute for the larger work, the size of which forbids its removal from the Louvre. This is despite, or, indeed because of, the complex debates that surround the actual authorship of the present canvas.

The source of the subject—which was to take on vast implications as the French Revolution advanced and notions of patriotism, and the individual's proper relationship to the state, evolved—are drawings from several ancient and contemporary sources, most accessible to David through the

play by Corneille. The royal commission, as arranged by the Comte d'Angiviller, required themes that would rekindle patriotic feelings and virtue. Challenged by the traitorous Curatii brothers of Alba, the three sons of Horatius vowed loyalty to Rome and their father, slew the Curatii, and returned victorious to Rome, only to find their sister Camilla, who was married to one of the traitors, collapsed in grief. She in turn was killed for her disloyalty by her brother, who was pardoned for his crime by popular demand. David's initial choice seems to have been the later, climactic episode of the story (as shown in the drawing in the Louvre, RF 1917); however, he soon shifted to the dramatic moment (which does not occur in Corneille's play) of the departing youths vowing their lives to their father and country.

The *Horatii*'s artistic progenitors are many, but most certainly include Poussin's *Death of Germanicus,* which David would have known well from his visits to the Barberini collections. His attention to archaeological details was nearly as applauded by his contemporaries in Rome and Paris as the splendid and restrained gravity of the effect. In Rome itself—despite the alert and very enthusiastic reception the picture was given when shown there before being shipped to Paris— the lesson of this new, radical departure found less fertile ground, perhaps

just because of the profound, ungiving severity of the work. That balance between grandeur and grace is perhaps too weighted to the former for a completely Roman acceptance, as, possibly, is the unmitigated moral force of the image.

The attribution of the picture, purchased as a David by the Toledo Museum of Art in 1950, was heatedly debated in the pages of *Burlington Magazine* during 1966 and 1967 between Robert Rosenblum and the museum's then director, Otto Wittmann. Rosenblum established that there was a long chain of documentary evidence, back to 1840, crediting David's pupil Anne-Louis Girodet, who—depending on the source cited—executed almost the entire painting, or at least a good part of it, with the master coming in only to finish up at the end. David may then have considerably reworked the surface five years after its dated completion to accommodate the second owner of the painting, the famous, and rich, Parisian painter Firmin-Didot. Wittman countered with the claim that all these statements had been made after David's death, and that the overall merit of the picture justified an unqualified attribution to David himself. Perhaps the most substantial and lasting outcome of this exchange—and the majority of scholars since that time have favored the attribution to Girodet while accepting

David's own hand by degrees—is the realization that contemporary scholars' rather modernist biases are ill-equipped to deal with the complex activities of a large artistic studio such as David's, in which young, extremely talented artists were asked to make replicas of major works by the principal *chef d'atelier*. Created under the master's supervision and with his direct involvement, particularly at the moment of completion, these—to judge by the prices they fetched—were held in very high esteem. Such activity is well established in David's studio, particularly through the Louvre repetition of the *Belisarius*, or the studio involvement in the numerous (four or more) variants after the famous *Napoleon Crossing the Alps*, in which the "original" version is still in question. David himself proudly points to Drouais's work on the large version of the *Horatii* (the arm of the third brother, as well as the large passage of yellow drapery) adding a further, muting element to any debate that would see attribution in too categorical a light. And, as Wittmann initially noted, it is nearly impossible to distinguish different "hands" or, for that matter, variants of quality between any given passage and another, in this masterful reduction of the vast painting. [JR]

## JEAN-GERMAIN DROUAIS
### PARIS 1763–1788 ROME

In marked contrast to his master Jacques-Louis David, Jean-Germain Drouais was early recognized for his talent: his successful entry in the competition for the *prix de Rome* in 1784 was held up in comparison to Le Sueur or Poussin, remarkable praise for so young an artist. From the third generation of an artistic dynasty, he studied first with his father, the successful and excellent portrait painter François-Hubert Drouais. From his father, he moved in his early training to Nicolas-Guy Brenet, but by 1781 he had allied himself to David, who would form a profound affection for him and, in turn, hold his talent in great respect. David had just returned from his five-year training period in Rome. It is telling, particularly in the context of this exhibition, the purpose of which is to examine the hold that Rome had over the making of art in the eighteenth century, that David took Drouais, his most treasured student and assistant, back with him to Rome when he left Paris in 1784 to take up the colossal work of *The Oath of the Horatii* (cat. 213). Drouais is supposed to have actually executed the arm of the third brother and the yellow dress of Sabina. Thomas Crow even argues that it was David's affec-

214

tion for Drouais, who was destined for Italy in any case after his success in the 1784 *prix de Rome*, which prompted the elder artist to move back to that city (Thomas Crow, *Emulation: Making Art for Revolutionary France* [New Haven and London: Yale University Press, 1995], p. 20).

Drouais stayed on in Rome after the completion of the *Horatii* and David's second return to Paris in 1785. Freed from the supportive but dominating influence of his master, he executed three remarkably innovative and independent paintings in the next two years: a *Wounded Athlete* (Louvre,

Paris), which like David's *Hector* (cat. 210), goes well beyond the conventional academy figures; the huge *Marius at Minturnae* (also Louvre), which received the praise of no less a figure than Thomas Jefferson, who knew it upon its return to Paris; and the *Philoctetes* (cat. 214). These three ambitious works all show, in their strong direct lighting, shallow space, and severe exploration of the virtue of dignity and restraint in the face of high passion, pain, and grief, a direct and very profound understanding of the work of David (with whom Drouais continued on close terms

through letters). However, they also mark a decisive step—a heightened level of theatricality and slipping of restraint—quite different from David's work. This development of a new style and sentiment was cut short by Drouais's early death in Rome, of smallpox, on February 13, 1788.

The loss of so great a talent was immediately felt in Rome, as well as in Paris. Goethe, who visited Drouais's studio to see the *Philoctetes* on February 22, notes in his *Italienische Reise* the profound grief that afflicted the artistic world of Rome. An ambitious tomb relief honoring Drouais,

designed by Charles Percier and executed by Charles Michollon, was placed in S. Maria in via Lata, near the French Academy headquarters in the Palazzo Mancini. It was paid for by his fellow academicians. David is said to have closed himself in his room after receiving the news, and eventually had a memorial cenotaph to the dead youth built in his own garden, the center of which was a lead vase containing Drouais's letters. His sense of Drouais's promise, as well as the magnitude of his talent, is reflected in his famous statement: "I have lost my emulation. He alone could trouble my sleep." (Wildenstein and Wildenstein 1973, *David*, p. 401). [JR]

BIBLIOGRAPHY Ramade and Fournier 1985

## 214
## Jean-Germain Drouais
### *Philoctetes*

1787–88
Oil on canvas
88⅜" × 68½" (225 × 174 cm)
PROVENANCE returned to the artist's mother in 1788; it was offered to the state by various owners until its final acquisition in 1883 by the museum in Chartres
EXHIBITION Rennes, France, Musée des Beaux-Arts de Rennes. *Jean-Germain Drouais, 1763–1788.* 1985
BIBLIOGRAPHY Ramade and Fournier 1985
Musée des Beaux-Arts de Chartres

Although it was begun in 1787 as a demonstration of the young academician's mastery of a subject requiring a male nude (not unlike David's *Saint Jerome*), correspondence between Drouais and David reveals that the ambitious work was not finished in time for a Paris showing, nor for the annual exhibition at the Palazzo Mancini in August. Drouais, as exemplified by his work as an assistant on David's *Horatii* (which already defied the rules of the academy), stood well outside its regulations. It was not, sadly and ironically, until the following August, on the suggestion of the director-general of the fine arts in Paris, the Comte d'Angiviller, that the painting was shown in Rome, then as a tribute to the dead artist, and received a mixed reception, in part because of its unfinished state.

The subject enjoyed a considerable vogue in the last quarter of the eighteenth century. James Barry depicted it in 1780 (Pinacoteca Nazionale, Bologna), and Abildgaard also produced a version (cat. 161). Drouais's friend and fellow academician Louis Gauffier showed a *Philoctetes Mourning the Death of Hercules*, presumably in a landscape (untraced), while back in Paris it was used by Taillasson and Jollain in Salon submissions and by the sculptor Delaistre.

The story of Philoctetes has many versions, coming down from antiquity through Homer and Aeschylus (but only in fragments), Euripides, and most extensively through the tragedy by Sophocles, which seems to be the primary source used by Drouais. The hero (sometime king and lover to Helen) joined the Greek fleet in its war against the Trojans. Bitten by a sacred snake, his agony was so great (as was the stench from the wound) that he was put ashore and abandoned on the island of Lemnos, in some versions at the command of Ulysses himself. In continuous pain, he managed to survive through his skills as an archer; here in the foreground a dead bird can be seen, left uneaten; from its wing he has improvised a fan, with which he attempts to cool his unhealing wound. The bow and arrows were a gift to Philoctetes from his friend Hercules, two of whose labors are shown on the quiver (quoted from an antique relief in the Villa Albani, for which a Percier drawing survives). The arrows had the magic power never to miss their mark. The treacherous retrieval of the arrows by Ulysses, and the use of this miraculous weapon in the slaying of Paris and the final destruction of Troy, place Philoctetes as a critical character at both the beginning and end of the epic.

It is tempting to see Drouais consciously attempting to take up the current debate in Rome about propriety in art, and its limitations, in contrast to literature, in depicting pathetic subjects advocated by Lessing in his *Laocoön* and in direct confrontation with the views of Winckelmann. However, there is no evidence in his correspondence that Drouais was engaged at such a theoretical level. And, if anything, his depiction of the victim of fate and the gods—the punishment of Philoctetes is variously attributed to his disloyal revelation of a secret told him by Hercules, and to Venus's desire to prevent his participation in war against her favored Trojans—would seem to defy those arguments about how best to depict pathos with due restraint and dignity. For example, the upturned gaze of Philoctetes could be either the beginning of a swoon or an entreaty for escape. Arguably a simple carryover from an antique bust of the blind Homer, which serves as a model for the head, this troubling introduction of a sentiment very close to individual expression tests the boundaries of Lessing's dictum and challenges David himself, in whose works heroes neither swoon nor implore. Even at this young age, Drouais had stepped beyond his master and taken up a direction of artistic exploration that would have its play in Rome during the next ten years, just as it was trans-

ported back to France through other French students active there, such as Anne-Louis Girodet. [JR]

## FRANCESCO FERNANDI, *called* IMPERIALI
### MILAN 1679–1740 ROME

A painter important in the transformation of the late Baroque into the Neoclassical, Imperiali arrived in Rome around 1705, following a brief period of training with a minor Milanese painter, Carlo Vimercati, and subsequent travels throughout Italy. He appears to have had a significant residence in Palermo, where, according to Pio, he painted "molte tavole and quadri per quei principi e signori" (Pio [1724] 1977, p. 40). He was patronized in Rome by Cardinal Giuseppe Renato Imperiali, whose name he adopted. In his early years he produced a number of minor works, including "tutte sorte di animali e pesci" (examples now at Penicuik House, Midlothian, and Hopetoun House, West Lothian, and Holkham Hall, Norfolk, a pair bought in 1714). Their naturalism and dark painterly handling derive from a northern Italian tradition and recall the art of Sinibaldo Scorza. Also among his early works were small studies of conversation pieces (Penicuik House) that suggest Imperiali's awareness of painting in Venice and Bologna. In handling and tone they are similar to certain works of Giuseppe Maria Crespi.

Imperiali gradually developed a more elevated style under the influence of such older Roman painters as Carlo Maratti, Giuseppe Ghezzi, and Luigi Garzi, from whom his broadly sculptured drapery and physical types derive, refined by the infusion of the graceful classicism of Raphael. In 1720–22 the Irish impresario Owen McSwiny commissioned him to paint *The Allegorical Tomb of George I* (private collection), one of a series of paintings commemorating British historical figures commissioned from Italian artists. Several overdoors—*Tobias before His Father, Abraham and the Angels, The Sacrifice of Tuccia, The Continence of Scipio*—were painted for the Palazzo Reale in Turin in 1721–22 and reveal what Clark described as the painter's "slightly glum, earthy and unpretentious poetry" (Clark and Bowron 1981, p. 82). The paintings of Nicolas Poussin attracted Imperiali, and their influence is vividly apparent in his *The Sacrifice of Noah* and *Rebecca Hides Her Household Gods from Laban* (early 1720s; The National Trust, Stourhead, Wiltshire). Imperiali's monumental altarpiece depicting *The Martyrdom of Saint Eustace* (early 1720s; S. Eustachio, Rome) even quotes Poussin directly, adopting the figures of the priest and

naked saint from the French painter's *The Martyrdom of Saint Eustace* (Pinacoteca Vaticana, Rome). Poussin also inspired *The Martyrdom of Saints Valentine and Hilary* and *The Beheading of Saints Valentine and Hilary* (before 1724; chapel of Sts. Valentine and Hilary, Viterbo Cathedral).

Imperiali's work "in tutti li generi delle cose naturali" presumably prevented him from admittance to the Accademia di S. Luca; on September 12, 1723, he was unsuccessfully proposed for membership along with his friend Agostino Masucci, who was successfully elected two years later (Clark 1964, "Imperiali," p. 229, n. 6). In 1723 he asserted his independence by joining an attempt of artists not in the academy, led by Michelangelo Cerruti, to challenge the institution's control over artistic production in Rome. In a letter of 1726, however, Imperiali is cited as one of the leading history painters in Rome, along with the other "pittori istorici eroici", Giuseppe Chiari, Francesco Trevisani, Sebastiano Conca, and Giovanni Odazzi (Waterhouse 1958, p. 101, citing a letter of the Abate Giuseppe Gentile to Lothar Franz von Schönborn, the elector-bishop of Mainz, of July 20, 1726). By the 1720s Imperiali had fully transformed his earlier dark, realistic manner into a vigorous classical style that revealed all the proprieties of drapery and setting, and his works from this date onward are often described as "proto-Neoclassical."

Other important works by the artist include *The Virgin of the Rosary with Saints Jerome, Dominic, and Francis* (cat. 215); four scenes commissioned by Elector Clemens August to record his meeting with Benedict XIII at Viterbo in 1727; and an altarpiece in S. Francesco, Gubbio, painted around 1730. His altarpiece for S. Gregorio al Celio, Rome, *The Death of Saint Romuald*, painted in 1733–34, is marked by a directness and vigor of handling that Clark thought the inspiration for the "unornamented naturalism" of Marco Benefial (Clark and Bowron 1981, p. 85). Throughout his career Imperiali produced mythological and biblical paintings for private clients, particularly British visitors to Rome who, according to Pio, admired "la sua bella e vagha e gustosa maniera" (Pio [1724] 1977, p. 41). Imperiali's reputation in England is confirmed by the high prices fetched by his paintings in the London salerooms. He was among the contemporary Italian painters whose works fetched more than £40 at auction in the first half of the eighteenth century (Iain Pears, *The Discovery of Painting: The Growth of Interest in the Arts in England, 1680–1768.* New Haven and London: Yale University Press, 1988, p. 218).

Imperiali's last official commission was for a painting to decorate the throne room of King Philip V of Spain at La Granja. The program was devised in 1735 by Filippo Juvarra to illustrate royal virtues through scenes from the life of Alexander the Great, and eight large pictures were commissioned from Francesco Solimena, François Lemoyne, Francesco Trevisani, Placido Costanzi, Agostino Masucci, Pittoni, Donato Creti, and Domenico Prodi. Lemoyne was replaced upon his death (in 1737) by Carle van Loo; Parodi's terms were exorbitant, and by 1736 he was replaced by Imperiali. The series are ready in 1737 and the paintings are now in a battered state at the Real Collegio di Alfonso XIII at the Escorial. Imperiali's oil sketch for *Liberality*, or *Alexander Rewarding His Soldiers* (private collection, London; Clark 1964, "Imperiali," fig. 60) richly quotes from several famous compositions by Poussin.

The classical rigor of Imperiali's figures began to soften in his late works, and this shift can also be seen in his choice of literary subjects set in pastoral, Arcadian landscapes, such as *Erminia Carving Her True Love's Name* (ex Yvonne FFrench collection; Clark 1964, "Imperiali," fig. 58). Clark saw in such paintings "Imperiali's special contribution to Roman Arcadian taste" (Clark 1964, "Imperiali," p. 233).

Imperiali was evidently a natural, prolific draftsman, whose surviving drawings represent a fraction of the compositional sketches and studies for individual groups and single figures he made in the preparation of oil paintings. (The largest surviving group of autograph drawings belongs to Sir John Clerk, Bt., Penicuik House, Midlothian; see Clifford 1993, passim, who does not discuss the large number of drawings after Imperiali's drawings at Penicuik.) Imperiali attracted English and Scottish patrons and also acted as an agent and entrepreneur on behalf of British collectors seeking drawings of classical antiquities in Rome.

Beginning in the 1730s, he took on a number of pupils, notably Pompeo Batoni and Camillo Paderni, and his drawing classes were attended by Alexander Clerk, William Hoare, William Mosman, Allan Ramsay, James Russel, and other young British artists in Rome. According to Ramsay, "Imperiali was a person of great humanity and honour. Often after Mass on Sundays and on Holy Days he would conduct … a number of pupils around some of the churches and palaces and … instruct them in observing and often his remarks upon all the best pieces of painting, statuary and architecture in and about the city of Rome, from Raphael, Michel

Angelo and Bernini downwards to that time" (Clifford 1993, p. 45, quoting an unpublished travel diary). In light of Imperiali's connections with Scottish visitors to Rome, as both a painter and a *cicerone*, and his relations with Cardinal Imperiali, protector of the Scottish nation and a close confidant of the Stuart court in exile, it has been suggested that the artist may have doubled as a Jacobite agent (Clifford 1993, pp. 45–46). Imperiali died on November 4, 1740. [EPB]

BIBLIOGRAPHY Pio [1724] 1977, pp. 40–41; Waterhouse 1958; Clark 1964, "Imperiali"; Prosperi Valenti Rodinò 1987, pp. 19, 37, 45–46, figs. 3, 24–26; Rangoni 1990, "Imperiali"; Clifford 1993; Prosperi Valenti Rodinò 1996, "Imperiali"

## 215

## Francesco Fernandi, *called* Imperiali

*Virgin of the Rosary with Saints Jerome, Dominic, and Francis*

1723–24
Oil on canvas
9′ 5¼″ × 6′ 2¾″ (289 × 210 cm)
PROVENANCE painted for Vetralla Cathedral, 1723–24
EXHIBITION Rome 1959, cat. no. 377 (as by Ludovico Mazzanti)
BIBLIOGRAPHY Griseri 1962, p. 36 (as by Giovanni Antonio Grecolini); Clark 1964, "Imperiali," p. 233, fig. 56 (as attributed to Imperiali and assistants); Raho 1996–97, pp. 123–25, pl. 6; Raho, F. "Precisazioni documentarie sul duomo di Vetralla." *In Informazioni: periodico del centro di catalogazione dei beni culturali, amministrazione provinciale di Viterbo, nn. 90–98. Forthcoming

Chiesa di Sant'Andrea, Vetralla

Vetralla, a medieval town forty miles north of Rome in the province of Viterbo, was transformed at the beginning of the eighteenth century with the erection of a new cathedral on the site of a church dedicated to S. Andrew. Thanks to the research of Dottoressa Francesca Raho (based on documents located in the Archivio Storico del Comune di Vetralla), it is known that the construction of the new cathedral to the designs of Giovanni Battista Contini proceeded in tandem with the demolition of the "vecchio duomo" from the end of 1710. The cornerstone of the new church was laid in 1711 and the building consecrated in 1720, although it was not finally finished and decorated until several years later.

For the apse of the church and the several lateral nave chapels, altarpieces were comissioned from several painters in Rome. Cardinal Imperiali, Prefetto della Congregazione del Buon Governo and patron of Francesco

Fernandi, played an important intermediary role between the artists and the priori di Vetralla, the local citizens charged with representing the interests of the community. The painters commissioned to supply altarpieces included Imperiali (*Virgin of the Rosary with Saints Jerome, Dominic, and Francis*), Marco Benefial (*The Transfiguration*), Domenico Maria Muratori (*The Martyrdom of Saint Andrew* for the high altar, *Vision of the Immaculate Conception Appearing to Saint Hippolytus*, and *Assumption with Saint Clement and Saint Eustace*), and Giacomo Triga (*Saints John the Baptist, Lucy, Gregory the Great, and Mary Magdalene*). Muratori's altarpiece devoted to the titular saint was in place for the consecration of the church on May 7, 1720, but the other paintings were not commissioned or produced until a few years later.

Imperiali's painting was the last to be commissioned—Raho's publication of the documents confirms both the date and authorship of the painting. Until Clark's article of 1964, the work had been attributed previously to Ludovico Mazzanti and to Giovanni Antonio Grecolini. Raho also published an exchange of letters during May 1722 between Cardinal Imperiali and the priori di Vetralla, in which the choice of Imperiali and the subject and site for his picture were mentioned. The first payment to the artist for the picture is dated September 27, 1723 (50 *scudi* in advance of a total payment of 220 *scudi* "including also the price of the canvas, as ordered by Cardinal Imperiali"); the second on October 13, 1724 ("payment to Ferrante of 170 *scudi*, the last and final payment for the picture of the Virgin of the Rosary with other saints, to be placed on the altar of this cathedral" [quoted in Raho 1996–97, p. 124]).

Initially, the priori di Vetralla seem to have wanted a painter to retouch or restore a venerated image of the rosary that depicted the respective "mysteries of the Virgin" in a series of small, rectangular images along the lines of a traditional example surviving in the sacristy of S. Maria della Pace, Ronciglione. Cardinal Imperiali informed the priori that no distinguished painter from Rome would undertake such a menial task and convinced them that their interests would be better served by allowing his protégé, Imperiali, to paint a new altarpiece for the chapel devoted to the "Ss. Misteri del Rosario." The theme is represented in the Vetralla altarpiece according to the traditional Counter-Reformation dictates, the Virgin and Child each holding a rosary and enthroned before Saint Dominic. (The invention of the rosary by Dominic was claimed by early historians of his order, who related that the Virgin appeared to him in a vision

215

and presented him with a chaplet of beads that he called "Our Lady's crown of roses.")

Anthony Clark wrote of the *Virgin of the Rosary with Saints Jerome, Dominic, and Francis*:

This is surely an Imperiali creation of the early 1730s which has taken the flying *putto* and the enthroned Virgin and Child directly from Maratti's painting of the same subject in Palermo [1695, oratory of S. Citha]. I would offer that the execution of this painting is not wholly Imperiali's, excepting the Virgin and Child, the flying *putto* and the Saint Francis. A drawing which carefully and beautifully reproduces the Audenaerd engraving of the Maratti exists and bears a convincing old attribution to Batoni. The Maratti, the Gubbio Imperiali, and the present painting are the clear sources of Batoni's earliest altarpiece [1732–33, S. Gregorio al Celio, Rome], and Batoni repeats the figure of the Saint Jerome several times in his career. The entire figure of Saint Jerome is the most Batonian feature of any Imperiali and the rendering of the habit of Saint Dominic, although within Imperiali's stylistic laws, is done with the impersonal precision often characteristic of Batoni.(Clark 1964, "Imperiali," p. 233)

Any possible participation by Batoni in the execution of the Vetralla altarpiece is impossible in light of its documented date of 1723–24: the younger painter did not arrive in Rome from his native Lucca until 1727. Nonetheless, the *Virgin of the Rosary*

216

*with Saints Jerome, Dominic, and Francis* remains a significant source of inspiration in his artistic formation, and it is entirely credible that Batoni would have made the short journey to Vetralla to see this *capolavoro* from the hand of his mentor, Imperiali. The older painter had helped Batoni prepare a cartoon for his first public work in Rome, an altarpiece for S. Gregorio al Celio, and was working on his own altarpiece, a *Death of Saint Romulus*, for the church at about the same time. [EPB]

## 216
## Francesco Fernandi, *called* Imperiali
### *Rebecca and Eliezer at the Well*

c. 1725
Signed at lower left: *Franus Feranus d. Imperiali*
Oil on canvas
48½" × 62¼" (123.2 × 158.1 cm)
PROVENANCE Henry Pelham, Archibald Douglas Pelham-Clinton, 7th Duke of Newcastle, Clumber House, Nottinghamshire; by inheritance to the Earl of Lincoln; sale, Christie's, London, March 31, 1939, lot 24; bought by Spink, London; sale, Christie's, London, October 24, 1986, lot 118
EXHIBITION Nottingham Castle Museum, on loan until about 1939
BIBLIOGRAPHY Waterhouse 1958, pp. 105–6, fig. 3; Clark 1964, "Imperiali," p. 229; Clifford 1993, p. 42
Private collection

Francesco Imperiali often depicted Old Testament subjects, in particular Rebecca and Eliezer at the Well (Genesis 24: 10–27) and Jacob and Rachel at the Well (Genesis 29: 1–14). It is often unclear which scene is actually being represented in his paintings of these biblical themes, although the present painting appears to represent Rebecca being addressed by Eliezer, the servant of Abraham. For Imperiali, the distinction between the two scenes seems to lie in the presence of the camels described in the first event and the sheep in the second. In the biblical account the patriarch Abraham, wishing to find a wife for his son Isaac, sent his servant to look for a bride among his kinsfolk in Mesopotamia rather than from the people of Canaan, where he lived. When Eliezer reached the town of Nahor in Chaldea, he waited at the spring for the young women to come from the town in the evening to draw water. He prayed that whoever gave him and his camels water would be the one God had chosen for Isaac. Eliezer had barely finished when Rebecca, a beautiful virgin, appeared at the spring and filled her pitcher. She invited him to drink and drew water for his camels. Fortuitously, she belonged to the family of Abraham through his brother Nahor, and Eliezer took her back to Canaan to become the bride of of Isaac.

*Rebecca and Eliezer at the Well* exemplifies Imperiali's pleasing and dignified manner and his cultivated feeling for design and color. For Clark the painting was "one of the finest among the group of paintings by Imperiali of Old Testament scenes, in all of which the artist only chose those subjects which could be shown in rural splendor, with an animal or two." The painting represented for him a "combination of academic nobility and what might be called rustic virtue" (Clark 1964, "Imperiali," p. 229) common to a number of followers of Carlo Maratti; it was Imperiali's distinction to avoid the Rococo distillation of Maratti's work by drawing carefully upon a range of classicizing models from Poussin to that same

Maratti, including works by Giuseppe Ghezzi and Placido Costanzi. Yet, whatever their academic indebtedness, Imperiali's paintings, in Clark's words, are "simply felt and strongly conceived." *Rebecca and Eliezer at the Well* is significant, too, as an example of Imperiali's use of Arcadian settings for his subjects and "Imperiali's special contribution to the Roman Arcadian taste" (Clark 1964, "Imperiali," p. 233).

The genesis of the composition of *Rebecca and Eliezer at the Well* can be traced to a red-chalk drawing by Imperiali in Philadelphia, signed and dated 1722, that appears to represent Jacob's first sight of Rachel by the well where she had come to water her father's flocks (Hiesinger and Percy 1980, no. 15). The drawing was either preceded or immediately followed by an oil sketch now in the collection of Fabrizio Lemme, Rome, that represents the three principal figures of Rachel, Jacob, and one of the townswomen (*Seicento e Settecento* 1998, no. 51). More importantly, the Lemme sketch delineates the motifs of the sheep drinking from the well and the cow in profile behind, in addition to the basic elements of the foliage and long sloping hill in the background of the London painting. A red-chalk preparatory drawing for the head of one of the sheep at the well is in the collection of Sir John Clerk, Bt., Penicuik House, Midlothian (Clifford 1993, p. 53, no. 22, fig. 43).

Unfortunately, not enough is known of Imperiali's working procedures to reach a satisfactory conclusion regarding the relationships among these sketches and the London painting. Nor is it possible to date *Rebecca and Eliezer at the Well* precisely beyond the common-sense assumption that the full composition must follow rather than precede the use of common motifs in the two smaller, sketchy depictions of Jacob and Rachel. In spite of the evidence of a number of documented works ranging over two decades of artistic activity, Imperiali's independent easel paintings remain difficult to date and defy the construction of a convincing chronology. He treated the subject of Rebecca and Eliezer at the Well in 1721–22 in an overdoor at the Palazzo Reale, Turin (Rudolph 1983, fig. 256), and again in a richly painted version with many figures at Penicuik House, which appears to date from the 1730s (Clifford 1993, pp. 49–50, fig. 45, as representing Jacob and Rebecca at the Well). [EPB]

## BENIGNE GAGNERAUX
### DIJON 1756–1795 FLORENCE

The son of a barrel maker from Burgundy, Gagneraux entered the school of drawing in Dijon, his native town, in 1767 or 1768. François Devosge, the director and founder of this provincial academy, had as his most celebrated pupils the painter Pierre-Paul Prud'hon and somewhat later the sculptor François Rude. Gagneraux was convinced of his vocation: in 1774 he arrived secretly in Rome, but found it impossible to earn a living there. Two years later, inspired by his example, the Burgundian States established a *prix de Rome*, one for a painter, one for a sculptor. Gagneraux was awarded the sculpture prize in the first year (Prud'hon would win it in 1784). With this he was able to live in the Eternal City, albeit under difficult circumstances, from 1776 to 1780, during which time he worked on. amongst other pieces, a copy of Raphael's *School of Athens*. His grant expired after four years, but he decided to stay on in Rome. Although he was completely independent of the French Academy in Rome, its successive directors Joseph-Marie Vien and Louis Lagrenée, in 1781 and 1782 encouraged him to apply for the *prix de Rome* offered by the Académie Royale in Paris; however, he was prevented by illness from doing so and earned his living drawing antiquities for Francesco Piranesi's engravings.

Good fortune came his way in 1784, when Gustav III, King of Sweden (whose agent for antiquities in Rome was Piranesi), visited Gagneraux's studio while staying in Rome on his Grand Tour. He bought a painting Gagneraux had been working on since 1780, *Blind Oedipus Commending His Family to the Gods* (Nationalmuseum, Stockholm). The king also commissioned a painting of *The Meeting of Gustav III and Pope Pius VI at the Museo Pio-Clementino, Vatican* (1785; Nationalmuseum, Stockholm). Pius VI also commissioned a copy of this work (1786; National Museum, Prague). Gagneraux's position was strengthened by this double patronage, and he was soon flooded with commissions from clients in Rome and abroad: he painted a ceiling for Prince Borghese in his villa on the Pincio and an overdoor for Prince Altieri's palazzo by the Gesù; French, Portugese, Swedish, Swiss, and Dutch amateurs also commissioned easel paintings from him.

Although Gagneraux had never visited Paris, he was now the most fashionable French painter in Rome: a very different position from that of the pupils of the French Academy at Rome, housed in the Palazzo Mancini, which was directed by Joseph-Marie

Vien (1775), Louis Lagrenée (1781), and François Guillaume Menageot (1787–93). Winners of the *prix de Rome* at the Académie Royale included Jean-Baptiste Regnault (1776), Jean-Germain Drouais and Louis Gauffier (1784), and Anne-Louis Girodet (1789), all preparing for careers in Paris, although some of these artists chose to remain in Italy during the French Revolution. Gagneraux's artistic milieu was more international than French, including people as diverse as Angelika Kauffmann, Giuseppe Cades, Tobias Sergel, and John Flaxman. His work has much in common with that of these figures, particularly of his two friends Sergel and Flaxman. The line engravings published by Gagneraux in 1792 only slightly pre-date the *Odyssey* and the *Iliad*, both engraved by Piroli after Flaxman.

In 1788 and 1789 Gagneraux produced two large paintings of battle scenes for the Palais des Etats de Bourgogne at Dijon, showing the exploits of the Prince de Condé in the seventeenth century (Musée des Beaux-Arts, Dijon), but his success was largely due to his "graceful" subjects, mythological scenes similar to those of Francesco Albani, or love allegories inspired by Anacreon. *Love Triumphs over Force* (1793; Musée des Beaux-Arts, Dijon) adopts a hellenistic style, but is inspired also by Titian and Poussin's cherubs and other putti. His aim is simply to create a kind of "pictorial love poem," similar to the short pieces of Anacreon and those found in the *Greek Anthology*. Even so, he never abandoned the "grand genre," the history painter's tradtional route to more lasting success. His masterpiece in this field is *Soranus and Servilia* (1793; Musée des Beaux-Arts, Dijon), a heroic Roman subject, shown after his death in the Paris Salon of Year VII.

Gagneraux died young. In 1793 he risked his life in the anti-French riots in Rome and left for Sweden to take up the position of history painter to the court. He stopped off en route in Florence, a francophile city, which had also welcomed Francois-Xavier Fabre and Louis Gauffier. The Grand Duke of Tuscany commissioned him to paint a *Lion Hunt* (now lost), but above all he enjoyed the patronage of Jean de Sellon, a Swiss art lover, in whose household he remained for over a year, as drawing master to his two daughters. Gagneraux died in Florence on August 18, 1795, after falling from a window: an apparent suicide, possibly prompted by an unhappy love affair and the psychological shock of his dangerous flight from Rome.

Gagneraux's paintings can be seen in the Galleria Borghese and the Palazzo Altieri, Rome, in the

Nationalmuseum, Stockholm, and Löfstadt Castle in Sweden, and above all at the Musée des Beaux-Arts in Dijon. Largely neglected after Henri Baudot's study of 1847 (republished in 1889), Gagneraux enjoyed a revival with the renewed interest in Neoclassicism, when his works were shown at exhibitions in 1972 (London 1972) and in 1974–75 (Paris, Detroit, and New York 1974). A thesis by Birgitta Sandström (1981) and the monograph exhibition *Bénigne Gagneraux*, shown in Rome and Dijon (see Laveissière et al. 1983) helped to restore his reputation. Gagneraux is a perfect example of the constrasting aspects of international Neoclassicism between 1780 and 1790: the persistence of the severe "grand manner," which began with Poussin, was developed by Jean-François Pierre Peyron and revitalized by Jacques-Louis David; purist studies inspired by the Greek vases, anticipating Ingres; but also *terribilità* and eroticism—for which, in Rome, Gagneraux found numerous models in the works of the Renaissance and its mannerist legacy.
[SL]

BIBLIOGRAPHY  Baudot 1889; Sandström 1981; Laveissière et al. 1983

## 217
### Bénigne Gagneraux
### *The Genius of the Arts*

1789
Signed and dated lower left, top of bas-relief: *B. Gagneraux. 1789*
Oil on canvas
43″ × 33⅛″ (109 × 84 cm)
PROVENANCE  Galerie Marcus, Paris, around 1970; Hôtel des Ventes de Dijon, June 5, 1994, lot 111 (Emmanuel de Vrégille and Christian Bizouard; Eric Turquin, Paris); W. Apolloni Gallery, Rome, 1996
BIBLIOGRAPHY  Baudot 1889, p. 41, nos. 10–11; Sandström 1981, pp. 48, 137–38, mentioned in no. 11, fig. 41, Laveissière et al. 1983, pp. 122–23, no. 44; *Gazette de l'Hôtel Drouot* (Paris), no. 24, June 10, 1994, p. 211
Private collection

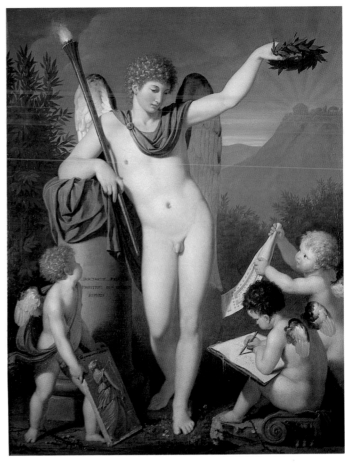
217

Two surviving versions of this composition are known, both painted in Rome, identical in size, and signed and dated 1789. One was bought in 1956 from a dealer in Aix-en-Provence, by the Musée des Beaux-Arts in Dijon and was shown at Dijon during the Gagneraux exhibition of 1983. The other—which came on to the Parisian art market around 1970, was recognized from a photograph, and reappeared in 1994—is the one shown here. The minor differences between the two versions lie in the position of the signature (bottom right, beneath the Ionic capital, in the Dijon painting), the motif drawn by the little seated genius (Apollo's head in the Dijon version; an old man's

head in the other), and the rays streaming from the temple of glory, which are absent in the Dijon version. The latter is delicately painted, but has been worn away by excessive cleaning, which has revealed several changes of mind on the painter's part. The other canvas (from Rome) is more finished, better-preserved, and appears to be the later of the two.

Gagneraux himself drew up a handwritten catalogue of his work, according to which he painted two versions of this subject: "no. 10, painted in 1788, depicts the *Genius of the Arts, Surrounded by Three Small Genii*, is 4 feet high, 3 feet wide, and belongs to M. Renoir, a Dutch banker; no. 11, also painted in 1788, is a second version of the preceding painting, same size, for M. Rémond de Lavelenet, Marseille" (Baudot 1889). The date "1788" and the larger dimensions are not necessarily surprising: the information in this document is frequently approximate and the two surviving paintings, signed and dated 1789, must be the two described. Furthermore, the painter's brother Jean-Baptiste-Claude Bénigne Gagneraux describes the subject Bénigne has just finished painting in a letter written from Rome, dated May 30, 1789, to the teacher of both brothers, François Devosge (Laveissière et al. 1983, p. 122),

and goes on to say: "It is intended for Paris, and has been shown in the residence of Cardinal Bernis, and was much admiired. A similar one has been commissioned for London."

That Bénigne Gagneraux only mentioned two versions in his catalogue, suggests that the first painting, "for Paris," shown at the residence of Cardinal Bernis, is that of the Dutch banker Renoir, and that the second version, "for London," is that of Rémond de Lavelenet (even though he is referred to as "from Marseille"). But which reference corresponds to which of the two surviving paintings? The painting in the Dijon museum is designated in the *Catalogue des Peintures Françaises* published in 1968, as that painted for Rémond de Lavelenet, but none of the records in the museum archive confirms this assertion (probably a hasty deduction based on the fact that it came from Aix-en-Provence, a town close to Marseille). The alterations made to the painting mentioned above suggest rather that this is in fact the first of the two paintings, belonging to the Dutchman Renoir, who would therefore have been resident in Paris.

One of the paintings is mentioned in two Parisian sales, the first held on December 14, 1813, of Gabriel-Auguste Godefroy, former "contrôleur général"

of the fleet, lot no. 52, set at 110 francs, the second of M. Sarrazin held on January 8, 1816, lot no. 82. The dimensions (reversed in 1816) are the same, 40 inches by 30 inches, identical with the two existing paintings. The sketch made of this composition has recently been discovered (Paris 1995, no. 2).

On the altar is written: DOCTARUM … PRAEMIUM// FRONTIUM DIIS MISCENT// SUPERIS ("Reward for great minds, they join the gods on high"). The temple of Glory, which glows brightly on the righthand side of the picture, is the goal held out to young artists, represented here by the three small genii of Sculpture, Drawing, and Architecture, while the ground is strewn with brambles, symbolizing the hardships of the artist. The Genius of the Arts, bearing the flame of knowledge, holds a laurel crown above the head of the child representing Drawing (the primacy of drawing must be acknowledged!), who remains seated, absorbed in his work, while his two companions are already standing, one presenting a bas-relief, the other an architectural plan.

During this same period Gagneraux was painting furious battle scenes for Dijon (Musée des Beaux-Arts, Dijon) while his *Tancred Baptizing Clorinda* (Louvre, Paris) refers back to Mannerism. This picture, however, displays the calm purity of line, the sweetness and color demanded by its subject: amid the pinks, slate blues and grays, rare colors are employed – the blondness of the hair, the green of the laurel, and the red drapery. In this sculpted vision, beauty can only be immobile. The desired ideal, according to the theories of Johann Joachim Winckelmann, is grace, hence the supple Praxitelean lines of the Genius, reminiscent of the Farnese *Genius* (Museo Archeologico, Naples) and the *Marble Faun* (Museo Capitolino, Rome). This work is closely related to that of Pierre-Paul Prud'hon, a fellow pupil at the school of drawing in Dijon. The two artists were also in close contact during the three-year Roman period of 1785 to 1788. It was in Rome that Prud'hon worked on the composition of *Union of Love and Friendship* (Minneapolis Institute of Arts), his first major painting, which he showed at the Salon of 1793. Although it was based principally on the study of Leonardo da Vinci and of Antonio Canova, it may owe something to the purism of Gagneraux, who was in turn influenced by the grace already apparent in Prud'hon's drawings. [SL]

# GIUSEPPE GHEZZI
COMUNANZA, NEAR ASCOLI PICENO 1634–1721 ROME

Ghezzi was born on November 6, 1634, the son of Sebastiano Ghezzi, a painter, sculptor in wood, architect, and engineer (see Semenza 1999). In a letter to Father Pellegrino Orlandi (1701), Ghezzi recalled with resentment his father's ruinous experiments in alchemy, which "left his heirs in poverty" (De Marchi 1999, p. 24). The young Ghezzi consequently went to study law and philosophy in Fermo, where he also applied himself to painting. In 1651 he moved to Rome and for several years worked in the legal profession, finally becoming an independent notary in 1671 (see De Marchi 1999). When he was thirty-seven and the father of one son (the future abbot and papal official Placido Eustachio), Ghezzi abandoned his legal career, through which he had undoubtedly expanded his circle of acquaintances and contacts in Rome. He dedicated himself to painting, which he had always practiced as an inquisitive amateur, modernizing his style by assimilating the artistic influences of Rome and sending works to his native region. In 1672 his public exhibition in Rome of the *Madonna del Suffragio* for the church of the same name was followed immediately by a *Virgin of the Rosary* for the adjacent oratory (Pansecchi 1984, p. 724). Both works were painted in a skillful and erudite manner, modeled on the Baroque masters and characterized by a natural "flavor" and passionate sentiment that marked all his best works. The year 1674 marked the birth of his son Pier Leone as well as the beginning of Ghezzi's success as a leading figure in the Roman artistic milieu. He was accepted as a member of the Accademia di S. Luca and also elected as its permanent secretary on the basis of his past experience as a notary. He held this task until 1718 (Missirini 1823, p. 143). His design for the Accademia, even though it attracted controversy and criticism, was used until 1716, when it was modified by Domenico Campiglia (Turner 1976).

At the same time, other institutions requested Ghezzi's numerous skills: the first of these was the archconfraternity of the Marchigian community for which he was *festarolo* from 1676. Until 1718 he organized picture exhibitions in S. Salvatore in Lauro, of which he left many valuable reports (see De Marchi 1987). Subsequently, he was employed by the Congregazione dei Virtuosi al Pantheon for thirty-five years as secretary and/or regent involved in drawing up the new constitution in 1698. He also wrote prayers for ceremonies and commemorative texts in honor of Cardinal

Protector Pietro Ottoboni (1692) and produced a history of the Compagnia in 1706 (De Marchi 1999, pp. 74–79). In addition, in 1705 the Accademia dell'Arcadia admitted him as a *pastor* with the *alias* of Afidenio Badio, and in 1708 he became a member of the academy's "council of wise men." The Accademia not only acknowledged his personal talents as a man of letters, but also responded warmly to his plan—in accordance with the prevailing Horatian spirit of fraternity —officially to provide space for the "confederate" group of Arcadian poets during the awards ceremonies for young artists on the Capitoline Hill. These events were often solemn occasions, with musical accompaniment. Ghezzi later published the poets' compositions, which frequently related to past and contemporary works of art, including his own (see De Marchi 1999, "Ghezzi," pp. 79–90).

Obviously, Ghezzi's key position within the Roman academies allowed him to associate not only with artists but also with the nobility, diplomats, and high-ranking prelates involved with the arts in various ways (an admiring Pascoli provides a detailed list of this). Hence his close involvement in the production of expert reports, estate appraisals, and acquisitions, and his ability as a result to collect works on his own account, primarily drawings (see Prosperi Valenti Rodinò 1999). But he also continued to paint, and to carry out restoration works on a fairly regular basis for Roman churches: the Annunziata delle Monache Turchine, S. Cecilia (1676), S. Margherita, S. Maria in Aracoeli, S. Maria della Scala, S. Maria in via Lata (all 1680s), and S. Giuseppe dei Falegnami (1692). He finally succeeding in obtaining commissions for important decorative groups such as those for the chapel of the Pietà in his national church of the Marches region, S. Salvatore in Lauro (1694–97) and S. Silvestro in Capite (c. 1696). In the paintings in Glasgow and the chapel of S. Silvestro, and in the cycle in S. Maria in Vallicella, Ghezzi displayed inventive originality and structural clarity combined with a passionate adherence to late Baroque composition based on contrasts of light and vigorous paint impasto, and in his oration for the centenary of the Accademia di S. Luca—the most serious and revealing documentation of the artist's theories—he recalled with admiration the work of Bernini, Lanfranco, Baciccio, and Pietro da Cortona (Ghezzi 1696). For the holy year of 1700 Ghezzi succeeded in obtaining the commission for as many as four paintings for the decoration of the nave of S. Maria in Vallicella (only Daniele Seiter exceeded this with five;

one was allowed to Domenico Parodi, one to Giuseppe Passeri, and two to Lazzaro Baldi). In describing the two paintings for the transept, Anthony Clark, the first modern connoisseur of Ghezzi's work, speaks of the "original imagination and memorable force, despite the characteristically unimpressive execution" (Clark 1963, p. 11).

The beginning of the eighteenth century in Rome saw the rise of a thriving group of veritable lobbyists from the Marches region (Clark notes that Ascoli, among others, provided many "bold and efficient bureaucrats" [Clark 1971–73, p. 62]). Ghezzi, had already been able to avail himself of Maratti's friendship (the artist was godfather at the confirmation of Ghezzi's son Pier Leone) and the favor and esteem of cardinals Decio Azzolini and Giovan Francesco Albani. When the latter became Pope Clement XI, Ghezzi had the satisfaction of commending him publicly each time in the accounts of competitions he organized on his commission from 1702. The 1705 report mentions the papal interventions for the beautification of Rome and exalts him for continuing the work of Sixtus V, the other pontiff from the Marches region (see Ghezzi 1705, p. 13). For the pope he painted in 1706 the holy protector of Urbino, Saint Crescentinus, in the Roman church of S. Teodoro. Over the next few years—embittered by the controversies that arose within the Accademia di S. Luca because of modifications to the constitution (see De Marchi 1999, "Ghezzi," pp. 71–74)—he published reports for Pope Clement's Concorsi Clementini until 1716, painted a large painting (lost) for the Roman church of the Napoletani in 1710 at the age of seventy-six, and even a lunette for the church of the Maddalena in Rome (c. 1718; see Pansecchi 1984, p. 729, n. 27; Fondazione Lungarotti 1988, p. 58, n. 23).

"The solidity of old age is like winter's calm": one of the maxims copied by Ghezzi's son Pier Leone while on holiday in May of 1730 in the villa "Benedicta Literaria" seems to suit Ghezzi perfectly. Proof of the older Ghezzi's mental and physical well-being is provided by Nicola Pio in a biography identified by Jacob Hess and overlooked by scholars, dedicated to the "painter and orator" and written before Giuseppe's death: "He lives happily at an advanced age with the decorum and splendor of the Professio." (British Library, London, Harley MS 6032, fol. 93 r). Giuseppe Ghezzi died on November 10, 1721. [FP]

BIBLIOGRAPHY Pio [1724] 1977; Clark 1963; Clark 1971–73; Pansecchi 1984; Lo Bianco 1985; De Marchi 1987; Martinelli 1990; Pascoli 1992; De Marchi 1999; Lo Bianco 1999; Costanzi, Massa, and Montevecchi 1999

218

## 218
## Giuseppe Ghezzi
### *Venus Giving Arms to Aeneas*

Before 1721
Oil on canvas
38" × 53" (96.5 cm × 135.5 cm)
EXHIBITION  Ascoli Piceno 1999, cat. no. 32
BIBLIOGRAPHY  Buchanan 1970, p. 20;
Maxon and Rishel 1970, p. 194; Lo Bianco
1985, p. 120; Sestieri 1994, vol. 2, fig. 467; Lo
Bianco 1999, cat. no. 32
Glasgow Museums, Art Gallery and
Museum, Kelvingrove

The figures in the painting are taken
from Book VIII of Virgil's *Aeneid*, but
the scene is organized in a completely
original and amusing way and with
unusual details. It is clear that the
weapons are already on the ground
near an oak tree (verse 616) and the
cupids are playing with the plumed
helmet; Venus, gracefully robed and
in a maternal attitude, leans over the
gilded chariot pulled by doves and
driven by cupids, and gestures theatri-
cally toward the unexpected spectacle:
the robust and ruddy Tiber, who has
emerged from the water rather than
being the customary semirecumbent
old man. He wears a crown of reed
foliage (verse 34) and a short skirt of
the same material, and appears with a
gesture of agreement to support
Aeneas, who has just emerged from
bathing in the fatal waters of the river;
a cupid is beside him, ready with the
perfumed ointments. Venus looks
toward Aeneas, who leans on the
lance that he has just been given and
contemplates the site in the Latium
where he will found Rome. Giuseppe
Ghezzi found the story of Rome par-
ticularly exciting and he used it also
in the Concorsi Clementini (see his
accounts of the years 1708, 1709, and
1711), but carried out with a quite
typical eighteenth-century grace.

This painting is attributed to Pier
Leone in the Glasgow Museum cata-
logue, and Anna Lo Bianco, who
dated it to around 1725, could not help
pointing out the many stylistic and
typological similarities with the work
of his father, Giuseppe (Lo Bianco
1985, p. 120). As early as 1970 Anthony
Clark insisted that "we will not under-
stand Pierleone until the paintings of
Giuseppe are known and under-
stood," and considered the Glasgow
painting to be "perhaps [Pier Leone]
Ghezzi's most magnificent painting"
(Clark 1970, p. 194); indeed, so magnif-
icent is it that it is actually by
Giuseppe. That this is the work of the
more cultured and reflective Ghezzi
senior is amply supported by detailed
comparison with various other works
of his, starting with the theatrical and
sensual *Pygmalion* in Budapest, of
similar format and dated about 1695.
But in paintings of quite another type
—for example those in S. Silvestro in
Capite in Rome (c. 1696–97)—the
artist has set the figures against stormy
skies lit by golden clouds, contrasted
ruddy and pallid nudes, and set cleanly
edged against sky-blue waters. The
figures' clothes are light and flowing
and the colors sharp and vibrant. More
specifically, the features of the cupid
valet in the foreground are close to
those in the Louvre's beautiful prepara-
tory drawing for the lunette in the
Roman Chiesa della Maddalena
(Legrand 1991, p. 45).

In the hope that the work of
Giuseppe Ghezzi is at long last being
recognized, after years of being over-
looked in favor of his son Pier Leone, a
few points are worth mentioning. The
painting *Jesus among the Doctors* men-
tioned by Pier Leone as by his father,
"which seemed done by Rubens," is
undoubtedly the one listed among the
works of Giuseppe de Sestieri (Sestieri
1994, vol. 1, p. 81) exhibited in
Matthiessen's London exhibition
(London 1987, p. 89, no. 24). The *Rest
on the Flight into Egypt with Saint John* (Lo
Bianco 1999, p. 1209, no. 26), attrib-
uted by Stella Rudolph to Pier Leone,
may be attributable to his father—not
least for its marked affinity with
Maratti, similar to that of the two ver-
sions of the Holy Family painted by
Giuseppe for Rome and Ascoli and
possibly identifiable with the Virgin
of Egypt which Ghezzi exhibited as
his own work in the exhibition at
S. Salvatore in Lauro (De Marchi 1987,
p. xxi, n. 53). It is not impossible that
Giuseppe's name could also be
assigned to to catalogue no. 25 on
p. 220 of the Ascoli catalogue (1999),
since he frequently visited the Fathers
of the Oratory, and his hand has also
been recognized by Anna Lo Bianco
in her examination of the painting,
which she attributes to Pier Leone. [FP]

## PIER LEONE GHEZZI
### ROME 1674–1755 ROME

Pier Leone Ghezzi was born to
Giuseppe Ghezzi and Lucia Laraschi
on June 28, 1674. His father, Giuseppe,
originally from the Marche, was also a
painter and gave his son his first lessons
in preparation for an academic, schol-
arly lifestyle, particularly in drawing,
according to the precise biographies
by Moücke and Pascoli (see Pascoli
1992, pp. 651–63). To reinforce his son's
chances of a brilliant career, Giuseppe
chose an exceptional baptismal godfa-
ther for him, Carlo Maratti, then at the
height of his fame (see De Marchi 1999,
pp. 190–92). His first known work is
the *Landscape with Saint Francis*, signed
and dated on the back 1698, now in the
Pinacoteca Civica in Montefortino,
near Ascoli Piceno. In 1702 he painted
the first of his four self-portraits, (all
except the last, from 1747, now in the
Galleria degli Uffizi, Florence). This
graceful, playful little work is furnished
with a long inscription in verse, in the
artist's hand, on the back of the canvas,
perfectly indicative of the witty, per-
ceptive spirit which is the constant
characteristic of Ghezzi's personality:

> Pier Leone am I/ Of the house of
> Ghezzi who, on the day 28 June/
> When to one thousand six
> hundred/ Years seventy four
> more/ were added I was born
> and added/ To these is my age of
> twenty eight years/ Now that in
> seventeen hundred and two/
> Time shows himself to me, with
> his measures/ now while he flies
> and never stops/ I laugh in his
> face and redeem myself/ by giving
> perpetual life to my portrait.

In 1705, a little over the age of thirty,
Ghezzi was admitted to the Accademia
di S. Luca. As his reception piece he
did a painting featuring the *Allegory
of Gratitude*, still in the Accademia and
inspired by his father's style, which
was indebted to Maratti. On the heels
of this came other important official
recognitions: his appointment as
Pittore della Camera Apostolica in
1708, with the right to succeed
Giuseppe Passeri, who died in 1713;
the title of knight inherited from his
father and his grandfather Sebastiano,
also an artist, on whom it had been
conferred by the King of Portugal; and
the cross of knighthood conferred on
him by the Duke of Parma in 1710. In
1743, with the death of Pietro Paolo
Cristofari, these honours were followed
by his appointment as superintendent
of the mosaic factory attached to
St. Peter's (Cipriani M. 1999,
pp. 190–92). Soon after 1710, and now
well established in the academic world
of figurative art, the artist took part in
the great public commissions ordered
by Pope Clement XI Albani, who had
a real affection for Ghezzi. In 1712 he
was commissioned to paint *The
Election of Saint Fabian* for the Albani
Chapel in the church of S. Sebastiano
fuori le Mura, designed by Carlo
Fontana for Clement. The artist's lan-
guage still appears late Baroque,
perhaps to adapt to the other great
altarpiece in the chapel, painted by
Giuseppe Passeri, depicting *The
Communion of Emperor Philip the Arab*.

In 1715 Ghezzi took part in one of
the most important commissions of
all the Albani pope's reign, the fresco-
ing of the nave of the ancient basilica
of S. Clemente, in which all the most
famous artists of the time participated:
Giuseppe and Tommaso Chiari,
Giovanni Odazzi, Giacomo Triga,
Antonio Grecolini, Pietro de'Pietri,
Giovanni Domenico Piastrini,
Sebastiano Conca, and Pietro Rasina,
representatives of each of the various
figurative styles current in Rome.
Ghezzi produced a famous work, *The
Martyrdom of Saint Ignatius of Antioch*,
for which there exists a preparatory
sketch on canvas, formerly in the
Lemme collection, but donated by
Lemme himself in 1997 to the Galleria
Nazionale di Arte Antica in the Palazzo
Barberini. Soon afterward, in 1718, the
artist was once more active in a great
papal enterprise, the decoration of the
nave of St. John Lateran, for which he
painted *The Prophet Micah*, one of
twelve ovals entrusted to the leading
Roman artists. Also commissioned by
Albani was one of the most significant
paintings of this period, *The Miracle of
Saint Andrea Avellino* (private collec-
tion, Rome), solemn in its composi-
tion and narrative and rich in detail.

The artist also devoted himself to
portraiture around this time, with a
series of examples striking in their
unusual and immediate rendering of
the sitters. The most important of
these are the portrait of Clement XI

(Museo di Roma, Rome), the portrait of Carlo Albani (Staatsgalerie, Stuttgart), the portrait of Annibale Albani (private collection, Milan), the portrait of Gabriele Filippucci (Pinacoteca Comunale, Macerata), and the portrait of Benedetto Falconcini (Worcester Art Museum). The unusually informal and realistic tone of these paintings derives from the practice of caricature to which Ghezzi had been devoted from childhood. His works in the latter genre form a vast body of work amounting to thousands of examples, held in collections all over the world. The most numerous and famous collection however, is that of the Vatican Library, to which the artist himself gave the title *Mondo nuovo*; it comprises eight volumes of the Codici Ottoboniani Latini, from 3112 to 3119, each containing between a hundred and thirty and two hundred caricatures arranged and bound by Ghezzi himself. The artist may be regarded as the real founder of this genre, now practiced professionally and bought by admirers all over Europe.

After the deaths of both his father and the pope in 1721, the artist seems to have distanced himself progressively from academic principles in favour of a freer style of painting, descriptive but illusionistic, in which the celebratory intention combines with the narrative style. The most obvious example is the great *Lateran Council*, painted for the 1725 jubilee (North Carolina Museum of Art, Raleigh; see fig. 4), which clearly suggests the influence of Panini, as can be seen by a comparison with the *Views from the Castle of Rivoli* (Castello di Racconigi and Museo Civico di Arte Antica, Turin). Further examples of his style in these years are the two famous scenes of *The Miraculous Intercession of Saint Philip Neri for Vincenzo Maria Orsini, the future Pope Benedict XIII*, one in the Stanze of S. Filippo in S. Maria in Vallicella, the other at Matelica in the Marches, in the church of S. Filippo. From the same period date Ghezzi's frescoes for Alessandro Falconieri in his summer residences at Torrimpietra and Frascati, near Rome. In the first case the paintings cover the entire reception room of the castle and continue in several adjacent rooms. They celebrate Falconieri's appointment as a cardinal in 1724 with scenes on the theme of *The Visit of Pope Benedict XIII and His Retinue to the Estate* in a series of unusual group portraits immortalizing the pope and the prelates of his court, shown against a landscape background that suggests the surrounding countryside. Soon afterwards, in 1727, the artist produced his famous *Conversation Scenes* in the villa at Frascati, in which appear the members of the patron's family in

fashionable dress, full-length and life-size, along with Ghezzi himself in a self-portrait, signed and dated, shown facing the spectator, to celebrate himself and his work. This sort of *plein air* portraiture *ante litteram*, is strongly reminiscent of the illusionistic style of Panini, with whom Ghezzi worked subsequently on the celebrations organized in 1729 by Melchior de Polignac in honour of the birth of the French dauphin, for which Ghezzi devised the firework display (see cat. 264). He was at that time also busy on various other projects, as his biographers have pointed out: "Not to painting alone is his expertise restricted; for he turns wood, and engraves on copper, and in semi-precious stones. He has studied medicine, anatomy … Understands also architecture and has fully proved himself in various operations and singularly in that of the superb firework display" (Pascoli 1730–36, vol. 2, p. 206). Again for Melchior de Polignac, he did the drawings after the antique of one of the most important recently discovered monuments, *The Burial Chambers of Liberti and Liberte di Livia Augusta*, published in one volume in 1731. This is also the date of the great paintings for the church of S. Salvatore in Lauro, which belonged to the Marchigian community in Rome: *Saints Joachim, Anna, and Joseph* and *Saint Emidio and Other Marchigian Saints* (the latter now moved to the sacristy), both recorded in the *Memorie del Cavalier Ghezzi scritte da se medesimo da gennaro 1731 a luglio 1734*.

From 1730–35 on Ghezzi was less active and allowed himself to concentrate on his many side interests. His final painting for a Roman church, *The Investiture of Saint Giuliana Falconieri*, is signed and dated 1737, and was done for the church of S. Maria dell'Orazione e Morte on a commission from the Falconieri family (cat. 222); the last known painting on a religious subject, *The Holy Family* (Musée des Beaux-Arts, Nantes), is signed and dated 1741, and shows new artistic interests. The work reveals the powerful influence of the art of Pierre Subleyras, from which his *Saint Joseph and the Child Jesus* (1741; Musée des Augustins, Toulouse) is clearly derived. He continued to produce portraits, but less prolifically than in his youth. Dating from 1732 are his portrait of the sculptor Edme Bouchardon (Uffizi, Florence) and the portrait of Paolo de Matteis (private collection, Rome), almost a caricature in paint. Slightly later are his *Portrait of a Woman* (Musée des Beaux-Arts, Nantes), the *Portrait of a Man* (private collection, Milan), and his self-portrait of 1747, produced for the Accademia di S. Luca, where it remains. Also in 1747 Ghezzi decorated the gallery in the papal palace at Castel Gandolfo with rural landscapes, com-

219

missioned by the steward of Pope Benedict XIV, as the documents record (Vatican City, Archivio Segreto Vaticano, S.P.A., Computisteria, vol. 269, cited in Lo Bianco 1985, pp. 85–88). This was the last big undertaking completed by the artist, who died at the height of his fame on March 6, 1755, and was buried in the family tomb in S. Salvatore in Lauro. His wife, Caterina Peroni, whom he had married at a late age, in 1736, followed him in 1762. The inventory of the Ghezzi family possessions revealed a rich collection of paintings, drawings, and books (Corradini 1990). [ALB]

BIBLIOGRAPHY  Lo Bianco 1999

## 219
## Pier Leone Ghezzi
### *Carlo Albani*

c. 1705–10
Oil on canvas
39″ × 29½″ (99 × 7.5 cm)

PROVENANCE  collection of Palazzo Chigi-Albani—Papacqua di Soriano del Gimino (Viterbo); collection of Anthony Morris Clark; sale, Christie's, London, 1978, lot 36; sale, Chaucer Fine Arts, Inc., London, December 1978, lot 7; to the current owner

EXHIBITIONS  Paris 1982, cat. no. 80; Ascoli Piceno 1999, cat. no. 15

BIBLIOGRAPHY  Clark 1963, p. 11;

Winckelmann 1975–76, p. 57; Sale catalogue, Christie's, London, July 6, 1978, lot 36; Sale catalogue, Chaucer Fine Arts Inc., London, November 28–December 21, 1978, lot 7; "Ghezzi" 1980; *Portrait en Italie* 1982, p. 144; Lo Bianco 1985, p. 104; Sestieri 1988, p. 43; Lo Bianco 1997, p. 73; Lo Bianco 1999, p. 105

Staatsgalerie Stuttgart

Carlo Albani, son of Orazio, brother of Clement XI, who was born in Urbino in 1687, and died in 1724 at the age of only twenty-seven, had been named "knight commander of the equestrian order of Saint Stephen with the authority given him by the Grand Duke of Tuscany, the grand master of the order" (Valesio [1770] 1977–79, p. 430, August 16, 1705). Carlo had two brothers, Annibale and Alessandro, both more famous than he and both acquainted with Pier Leone Ghezzi. There exists a very fine portrait of Annibale, signed by the artist and held in a private collection in Milan, showing him when he had just been made a cardinal in 1712. The second brother, Alessandro, noted for his passion for classical antiquity, is immortalized in many caricatures drawn by Ghezzi (Pampalone 1990, p. 86). The painting indicates the close bonds between the painter and the Albani family, which produced Pope

220

anchored in the seventeenth century, compared with Pier Leone's disregard of the rules. According to Francesco Valesio, in 1705 Albani had just been invested with the title of knight of Saint Stephen and so the painting should be dated to immediately after then, in the period just preceding his portrait of Annibale Albani of 1712. [ALB]

## 220

## Pier Leone Ghezzi

### The Miraculous Intercession of Saint Philip Neri on Behalf of Cardinal Orsini, the Future Pope Benedict XIII

1724–26
Oil on canvas
39″ × 29″ (99.5 × 74.5 cm)
EXHIBITIONS Rome, Palazzo Venezia.
*In corso d'opera situazioni e progetti.* 1988, no
number; Ascoli Piceno 1999, cat. no. 15
BIBLIOGRAPHY Moücke 1752–62, vol. 4,
p. 223; Clark 1963, p. 18; Escobar 1964,
p. 158; Dania, L. "La chiesa di S. Filippo a
Matelica," *L'Azione* (December 5, 1970), p. 3;
Lo Bianco 1985, p. 126; Rome, Palazzo
Venezia. *In corso d'opera situazioni e progetti.*
Rome: Palombi, 1988, p. 32; Sestieri 1994,
vol. 1, p. 82; Negro 1995, p. 288; *Regola e la
fama* 1995, p. 556; Lo Bianco 1997, p. 82; Lo
Bianco 1999, p. 138
Congregazione dell'Oratorio di S. Filippo
Neri, Rome

This painting is mentioned for the first time in 1726, in an inventory of the movables of the Chiesa Nuova as "A picture of 4 *palmi* showing the miracle reported by His Holiness Pope Benedict XIII under the ruins of the earthquake in Benevento by the intercession of Saint Philip Neri, with a gilded frame" (Negro 1995, p. 294). The original rich scroll attached to the frame bearing the words *Petri Card. Ottoboni Vicecancellarius munus* explains the work's presence in the church. It was in fact a gift offered to the Oratorians by Cardinal Pietro Ottoboni, who was closely bound to the community, with whom he had spent a period of spiritual meditation not long before, in 1724, and to whom he had left numerous gifts, as again recorded by Angela Negro.

However, the painting had not been done for the cardinal, but for Pope Benedict XIII himself, as recorded in the painter's biography written by Francesco Moücke, who likewise reports its whereabouts "with the Oratorian Fathers in the Chiesa Nuova." It is therefore highly probable, as Negro suggests, that the pope offered the small canvas to Cardinal Ottoboni to cement the close link that was forming between them, and therefore gave this gift to the Chiesa Nuova.

Clement XI. It was to his close ties with the pope that Ghezzi owed his involvement in the most important public commissions of the period.

When Clark published the painting in 1963, he emphasized the traditional format, derived from Carlo Maratti and Giuseppe Passeri, but suggested that there already appeared a desire for more intense and intimate characterization, which Ghezzi obtained through elegant and free brushwork. Although the influence of Maratti is clear—it suggests his very fine *Portrait of an Unknown Man* in the Galleria

Corsini—the characteristics of a more informal and naturalistic style are already apparent, and became more marked in later works, from c. 1720 to 1730. The monumentality of the poses is emphasized by his full-bodied chromatic color and flowing drapery, which reveal the influences of his academic training. The official nature of the portrait gives the painter an opportunity for minute description of the rich robes of office: the ample cape of iridescent black velvet bordered with gold braid and matching lace, and the gleaming white lace

cravat from which hangs the knight's cross in silver and enamel. A particularly sophisticated detail is the gloved hand in the foreground, admirably blending academic drawing with fashionable refinement, and creating a powerful center of attention. A painting by his father, the beautiful *Saint Liborio* in the church of S. Caterina at Comunanza, near Ascoli Piceno, may be considered as a precedent: here the detail of the red-gloved hand recurs, with the same eyecatching effect. The general tone of the painting is profoundly different, for it is still firmly

Vincenzo Maria Orsini, the future Benedict XIII, intended this picture to commemorate a miraculous event that happened to him in 1688 when, as archbishop at Benevento, he survived a disastrous collapse of the episcopal palace caused by an earthquake. Many sources report the episode; among them, Giovanni Marciano published a letter by Orsini himself testifying to the miracle, meticulously describing the sequence of events. This written account makes particularly interesting reading as it corresponds closely to the detailed layout of the area depicted by Ghezzi, who evidently knew its contents and must have discussed them with the pope himself. Thus the fortunate combination of circumstances through which the protagonist remained unharmed are known: as he himself wrote, his head happened to be protected by

> some thin canes, which formed a small roof above me, enough to shield my head and allow me to breathe comfortably. In the room where I fell there was a cupboard of walnut, full of Scriptures, inside which I kept all the effigies wrapped in paper, which express historically some of the most celebrated facts about the life of my glorious Guardian Saint Philip Neri … This cupboard came to rest on that fragile little roof of canes, which protected my head as I said, and it opened, although it had been locked, and out came the illustrations of the life of the Saint, which scattered around me, and under my head landed the one in which is depicted the occasion when the Saint, as he was praying, saw the Blessed Virgin supporting with her most holy hand the beam of the old Chiesa della Vallicella, which had come out of place … (Giovanni Marciano, *Memorie historiche della Congregazione dell'Oratorio* [Naples: De Bonis Stampatore Arcivescovale, 1693–1702], vol. 1, p. 208)

In fact everything coincides, even the subject of the drawing shown on Orsini's head as he emerges from the rubble, depicting the famous scene of the miracle of the beam, painted by Pietro da Cortona on the vault of the nave of the Chiesa Nuova. The saint's role then further confirmed by the sculptured bust that Ghezzi depicts, whole and still on its pedestal, in the center of his composition, a detail omitted in the version at Matelica. To these elements is added a large group of characters, depicted in attitudes of stunned agitation or frantic activity, which offered Ghezzi the starting

point for a delightfully entertaining gallery of portraits, bordering on caricatures, with his usual attention to the particulars of clothes and headgear, symptomatic of his interest in fashion. With a few variations the painting was copied in an engraving designed to illustrate the life of Saint Philip Neri of Florence: the drawing was executed by Pier Leone Ghezzi and the engraving by Gerolamo Frezza.

Its mention in the 1726 inventory establishes a latest possible date for the painting, which must be before then but after 1724, which was when Orsini was elected to the papacy. Very shortly afterwards the artist replicated the painting for the church of S. Filippo in Matelica, near Macerata in the Marche. Its commissioning can be connected to a precise individual, Filippo Piersanti, who was actually born in Matelica. This version, later than that in the Chiesa Nuova, cannot be later than 1730, the end of the pontificate of Benedict XIII, who must have been behind its commission. [ALB]

221

## 221

# Pier Leone Ghezzi

## The Miraculous Intercession of Saint Philip Neri on Behalf of Cardinal Orsini, the Future Pope Benedict XIII

1725–30?
Oil on canvas
68″ × 68″ (173 × 173 cm)

EXHIBITIONS Urbino, Italy, Palazzo Ducale. *Restauri nelle Marche: testimonianze acquisti e recuperi*. 1973, cat. no. 132; Rome 1995, *Regola*, cat. no. 115; Ascoli Piceno 1999, cat. no. 35

BIBLIOGRAPHY Bigiaretti, S. "Matelica e dintorni." *Picenum*, vol. 9 (1912), p. 74; Dania, L. "La chiesa di S. Filippo a Matelica." *L'Azione* (December 5, 1970), p. 3; Palazzo Ducale, Urbino, Italy. *Restauri nelle Marche: testimonianze acquisti e recuperi*. Urbino: Arti Grafiche, 1973, p. 508; "Ghezzi" 1974, p. 364; Rudolph 1983, no. 291; Lo Bianco 1985, p. 126; Sestieri 1988, p. 42; Valazzi 1990, p. 344; Zampetti 1991, p. 76; *Regola e la fama* 1995, p. 556; Mariano, Fabio. *Le chiese filippine nelle Marche: arte e architettura*. Florence: Nardini, 1996, p. 112; Lo Bianco 1999, p. 138

Chiesa di S. Filippo Neri, Matelica (Macerata)

As has already been suggested (Lo Bianco 1995), this painting should not be considered the preliminary version of the small work in the Chiesa Nuova, but is actually a larger replica based upon it. In fact the original is the Roman canvas mentioned in Francesco Moücke's biography, which records it as being a commission from the pope himself to commemorate the miraculous event of which he was the protagonist in the course of the earthquake at Benevento in 1688 (see cat. 220).

The large painting in Matelica proves more than anything the Rome picture's success in papal circles, which led to the wish to repeat it, in an enlarged version, as a mark of respect to Benedict XIII. The patron of this work, intended for a church also dedicated to Saint Philip, can be identified with an individual closely linked to the pope. This was Filippo Piersanti, born in Matelica itself, who held important posts under the pope, which were later renewed under successive papacies. From 1724 he was master of ceremonies and papal chaplain. It was from the Orsini pope that he learned his true veneration of San Filippo—whose name he also happened to bear, a veneration shown fully on the occasion of this important commission, dedicated to the saint, and for the church with his name, in his native city. It was enhanced in this way by the work of a great artist, based on an original that was exceptional in that it had been executed for the pope himself. Given also that Piersanti was born in 1688, the year of the miracle depicted, the reasons behind the commission are clear. Taking all these details into consideration, it is also possible to date the picture to the years immediately after 1724–26, when the smaller version was painted, but certainly not later than 1730, the end of the papacy of Benedict XIII, who was undoubtedly responsible for the commission.

The difference between the two versions consists, first, in this work's great emphasis on a composition seen close-up, and square rather than rectangular shape, which thereby reduces the view of the background and the

number of persons depicted. Their facial expressions are, however, identical, equally excited and astonished, and there is the same entertaining collection of portraits, verging on caricatures, with the same concern for fashion details. And, as in the Rome painting, the portrait of Orsini, then archbishop of Benevento, stands out above everything in his undignified and to some extent ridiculous position as he emerges from the rubble, with more than a hint of caricature. [ALB]

## 222

# Pier Leone Ghezzi

## The Investiture of Saint Giuliana Falconieri between Saint Philip Benizi and Saint Alessio Falconieri

1737
Signed and dated on the altar: *1737*
Oil on canvas
114″ × 70″ (290 × 178 cm)

EXHIBITION Ascoli Piceno 1999, cat. no. 42

BIBLIOGRAPHY Moücke 1752–62, vol. 4, p. 222; Titi 1763, p. 463; Nibby 1839–41, vol. 1, p. 446; Pistolesi 1841, p. 548; "Ghezzi" 1920, p. 539; Voss 1924, p. 365; Loret 1935, p. 303; Hager 1964, p. 84; Graf and Schaar 1969, p. 50; Vasi M. 1970, p. 389; Salerno, Luigi, Luigi Spezzaferro, and Manfredo Tafuri. *Via Giulia: una utopia urbanistica del 500*. Rome: Stabilimento Aristide Staderini, 1973, p. 469; "Ghezzi" 1974, p. 364; Lo Bianco 1985, p. 132; Corradini 1990, "Testimonianze," p. 52; Sestieri 1994, vol. 1, p. 83; Lo Bianco 1997, p. 84; Lo Bianco 1999, p. 148

Chiesa di S. Maria dell' Orazione e Morte, Rome

222

This painting, restored in 1999 by the Centro di Conservazione Barbabianca, is signed and dated 1737. Commissioned by the Falconieri family, who had given the site for the building of the church designed by Ferdinando Fuga, the canvas is one of the numerous variants of scenes from the life of the saint done by this painter: these include the large canvas of *The Death of Saint Giuliana Falconieri* from his early years (Galleria Corsini, Rome) and the altarpiece of *Saint Giuliana and Saint Alessio Presented to the Virgin Saint Philip Benizi*, created for the church of S. Marcello in the jubilee year 1725. The reference to the two saints of the Falconieri family is emphasized by the presence in the picture's background of *The Annunciata* in Florence, in SS. Annunziata in Florence, the mother church of the Servite order, which Saint Alessio founded.

Surrounding the main character, who is in the act of receiving the reli-gious habit from Saint Philip Benizi, are the clerics and family members shown in contemporary dress; the figure to the right in the background, looking out at the viewer, can be iden-tified as a self-portrait of Ghezzi himself, swathed in a red cloak—repeating a favorite motif. The recent restoration has brought out some sophisticated and moving details, such as the saint's short, dishevelled hair, just cut for her ordination as a nun.

This beautiful painting, its render-ing of the figures couched in extremely naturalistic terms, constitutes one of the happiest examples of Ghezzi's reli-gious work, but his last for a public destination. The rendering of the refined drapery of the white surplices is equalled by that of the lace trim-mings on the clothes, the jewels of the old lady with clasped hands, the silky material of the saint's garment, all per-fectly consistent with the interest in fashion manifested by the artist at that period. The depiction of the carpet, with the shadow of the step crossing the colored stripes, also displays great skill.

The novelty of the layout is matched by an equally unusual choice of colors, offering lighter and lighter shades to imitate the fine fabric of the veils and lightweight materials. The only dark patch is the rich red of the painter's cloak in his self-portrait. The intense psychological characteriza-tion of the faces and air of something taking place imprinted on the painted scene suggest a response to Benefial's objective and documentary style of portraiture.

The painting is dated 1737, the year in which the work in the church, undertaken by Clement XII, was com-pleted; it was also the year in which Saint Giuliana was canonized, on June 16 (Pastor 1938–53, vol. 34, p. 410). The church was consecrated on October 20, 1738 (Mariano Armellini, *Le chiese di Roma: dal secolo IV al XIX*, rev. ed. [Rome: R.O.R.E., 1942], vol. 1, p. 518).

The preparatory drawing is in the Kunstmuseum, Düsseldorf (inv. FP 3207). It is characterized by the inked strokes and the swift brush-work typical of Ghezzi's graphic output. [ALB]

## CORRADO GIAQUINTO

MOLFETTA 1703—1766 NAPLES

Although today the work of Corrado Giaquinto is generally unknown outside a small group of scholars and astute connoisseurs, in his own life-time—and especially from the 1740s onwards—he was considered Rome's supreme decorative painter and fres-coist and in some quarters was her-alded as one of Europe's most important artists. His prominence was confirmed in 1753, when he was called to Madrid by Ferdinand VI, one of the richest kings in Europe, to serve as his First Painter. Giaquinto had already been working for the power-ful Spanish Bourbons during his two decades in Rome. This patronage , along with that of the Savoys in Turin in the 1730s and of Pope Benedict XIV in Rome during the 1740s, meant that unlike many artists, such as Pompeo Batoni, Giaquinto never needed to depend on the mass of Grand Tour clients flooding Italy in order to promote his career. Paradoxically, this fact was largely responsible for his lack of recognition from both con-noisseurs and the art historical com-munity over the following two centuries. While the works of Carlo Maratti, Sebastiano Conca, and Pompeo Batoni are well represented in important English collections and international museums, Giaquinto's extant works, which are mainly to be found in Italian churches, Spanish palaces, and other royal collections, have been relatively inaccessible to the general public. Although the tradition of luxurious and propagandistic deco-rative commissions promoted by autocratic courts lasted both in Spain and in the Kingdom of the Two Sicilies until well into the early nine-teenth century, it had generally come to an end in other parts of Europe by the time of Giaquinto's death in 1766. With its demise, Giaquinto's name and the significance of his contribu-tion to eighteenth-century European painting quickly faded from memory.

Born in the provincial town of Molfetta, in Apulia, southern Italy, Giaquinto began his artistic training there in the studio of Saverio Porto, where he worked until 1721, when he left for Naples. Except for a brief return to his native city (1723–24), Giaquinto remained in Naples for the next six years. Corrado's earliest biog-rapher, De Dominici (1742–44) stated that in Naples the painter entered the studio of Nicola Maria Rossi, but undoubtedly his most significant influence in the Neapolitan capital was Francesco Solimena. Giaquinto's close study of the master's work is evident in his *Visitation* (Pucci Collection, Naples), inspired by Solimena's famous altarpiece of the same subject in the church of S. Maria Donnalbina. Equally important to the development of Giaquinto's mature style were the luminous fresco deco-rations painted by Luca Giordano for the Certosa di S. Martino, Naples, in 1704.

Giaquinto left Naples for Rome in 1727. Over the next thirteen years he worked as an independent artist, modifying his robust Neapolitan style to reflect the more refined Rococo taste exemplified by the works of Sebastiano Conca and other first-gen-eration followers of Carlo Maratti. Giaquinto's reputation was firmly established by 1733, when he com-pleted the extensive fresco cycle in the nave and cupola in the French church of S. Nicola dei Lorenesi, Rome. The critical success of this commission prompted two invitations to the Savoy court in Turin (1733 and c. 1735). There, he produced mythological frescoes for the Villa della Regina (c. 1733), the painted and frescoed cycle of the life of Saint Joseph for the church of S. Teresa (c. 1735), and six oil paintings based on the story of Aeneas (now in the Palazzo del Quirinale, Rome), all of which attest to the perfection of his elegant Rococo forms and pastel palette. Besides working for the Savoys, Giaquinto also received employment from the Spanish Bourbons, who, in 1735, asked him to provide two paint-ings for an Aeneas series commis-sioned for Philip V 's retirement palace

at La Granja. Other important commission of the 1720s and 1730s include the small *Virtues* ceiling fresco (c. 1727–30) in the Palazzo Borghese and the large altarpiece of the *Assumption of the Virgin* (1739), commissioned by the powerful Roman cardinal Pietro Ottoboni, for the church of S. Maria Assunta, in Rocca di Papa (cat. 223).

The years between 1740 and 1753 were the most productive and distinguished of Giaquinto's time in Rome. In 1740 the painter was admitted to the Accademia di S. Luca. Around the same time he established a studio and was put in charge of training all of the Spanish students sent to Rome to perfect their craft (among them, Antonio González Velázquez, Preciado de la Vega, and José del Castillo). Large decorative commissions completed during this decade include the Saint John of God cycle in S. Giovanni Calabita, the large canvas of the *Translation of the Relics of Saint Acutius and Saint Eutyches* (c. 1744; see cat. 360) for Naples Cathedral, and, most notably, the vast fresco and painted cycle commissioned by Benedict XIV for S. Croce in Gerusalemme. This important commission, completed c. 1744 (cats. 224, 225) established Giaquinto's international reputation as a leading member of the Roman Rococo school. During this time Giaquinto's style progressed from the delicate Rococo forms of the 1730s toward a more solid classicism that pays homage to the tradition exemplified by Carlo Maratti, the last great master of the Roman Baroque. The prevailing classicizing taste (which was especially strong during the 1740s when Pompeo Batoni and the Frenchman Pierre Subleyras established reputations in Rome) is brilliantly expressed in Giaquinto's *Baptism of Christ* for S. Maria dell'Orto. This altarpiece, completed for the holy year festivities of 1750 (cat. 227), epitomizes the languid elegance and sophistication of Giaquinto's mature Roman style at mid-century.

Despite his triumphs in Rome, which culminate in the exquisite decorative cycle comprising paintings, frescoes, and decorative stuccos commissioned by the Spanish Bourbons for S. Trinità degli Spagnoli (c. 1748), Giaquinto's greatest and most influential years were spent in Madrid, where he worked from 1753 to 1762 decorating the new royal palace (now known as the Palacio de Oriente). During these years Giaquinto acted as director-in-chief of artistic affairs at the Spanish court and established himself as Europe's foremost painter–decorator after Giovanni Battista Tiepolo, who succeeded him in Madrid. Within the royal palace Giaquinto completed three vast fresco cycles

above the royal staircase (*Spain Rendering Homage to Religion and the Church*), the Capilla Real, and one in the Hall of Columns (*The Birth of the Sun and the Triumph of Bacchus*). In terms of patronage, a comparison of Giaquinto's frescoed and painted decorations in the Capilla Real with the cycle he provided for Rome's S. Croce offers a telling contrast between the financial, political, and artistic realities of the impoverished Rome of Benedict XIV and the fabulous wealth at the court of Ferdinand VI in Madrid.

In 1762, suffering from ill health after years of grueling responsibilities in Madrid, Giaquinto returned to Naples, where he remained until his death in 1766. During his final years he retained his position, his salary, and all his honors as First Painter to the King of Spain (now Charles III) and completed the *Allegory of Fortitude and Vigilance* (1763; Palazzo Reale, Caserta) and a Marian series of six large oils for the royal church of S. Luigi di Palazzo (1764–65), where he worked with his good friend the royal architect Luigi Vanvitelli.

Giaquinto's artistic influence lived on long after his death. His sumptuous brushwork can be discerned in the early Roman paintings of Jacques-Louis David, who worked in Rome in the 1770s. In Spain, Giaquinto's stylish coloration and compositional flair were emulated by the youthful Goya and many others in the succeeding generation of court artists, such as Antonio González Velázquez, Francisco Bayeu, Mariano Salvador Maella, and José del Castillo, who were charged with decorating the new Bourbon palace and other important royal sites. Countless other earnest but uninspired imitations of the master's hand are detected in the works of artists working in Naples, Palermo, and throughout the Kingdom of the Two Sicilies , where the official Bourbon court style created by Giaquinto in the 1750s was practiced well into the new century. [IC]

BIBLIOGRAPHY De Dominici 1742–44, vol. 3, pp. 722–23; Moschini 1924; D'Orsi 1958; Videtta 1962; Videtta 1965; Videtta 1966; Videtta 1967; Laskin 1968; *Studi su Corrado Giaquinto* 1971; Amato 1976; Fernandez 1977, pp. 116–50; *L'Art européen* 1979, pp. 179–82; *Golden Age* 1981, vol. 1, pp. 107–16; Amato 1985; Siracusano 1986; *Taste for Angels* 1987, pp. 303–13; Cioffi 1992; Cioffi 1993; *Giaquinto* 1993; Cioffi 1996; Michel 1996, *Vivre et peindre*, pp. 297–318; Rowlands 1996, pp. 396–404; Cioffi 1997; Mann 1997, pp. 30–35, 59

223

## 223
## Corrado Giaquinto
### *Study for "The Assumption of the Virgin"*

1739
Oil on canvas
38¾″ × 25¼″ (98.4 × 64.1 cm)
BIBLIOGRAPHY unpublished; for finished altarpiece and related works see: D'Orsi 1958, p. 48, fig. 43; *Settecento* 1959, p. 116, no. 258, fig. 9.
Private collection, U.S.A.

Among Giaquinto's Roman works is this previously unpublished *bozzetto* in oil for his large-scale altarpiece for the church of S. Maria Assunta in Rocca di Papa, a small town in the Frascati hills just outside Rome. The commission was given by Cardinal Pietro Ottoboni, one of Rome's most important artistic patrons, who lived in the center of town in the splendid Palazzo della Cancelleria. Working within Ottoboni's prestigious circle conferred high status on an artist, and Giaquinto's entry into it denoted his

success. In later years Giaquinto and others favored by Ottoboni, such as the architect Filippo Juvarra and the composer Domenico Scarlatti, were to enjoy the lavish patronage of the Spanish kings Philip V and Ferdinand VI in Madrid.

Several other versions of this oil sketch are known to exist (D'Orsi 1958, p. 49), and it is around this time, in the late 1730s, that questions of attribution, which are particulary problematic in Giaquinto's case, become more evident. By this date the artist had already completed several important Roman commissions and had distinguished himself as an important decorative artist at the Savoy court in Turin, where he worked for two lengthy periods during the 1730s. Little is known about the Giaquinto studio per se, but it is clear that many copies of his works were being made by his students and other close followers. It was standard studio practice at the time for younger artists to copy a master's work, and Giaquinto had done so himself when he was training in the studio of

Francesco Solimena in Naples. While many of these contemporary copies are artistically competent and aesthetically pleasing, they all lack the precision of brushwork, subtlety of coloration, and elegant figural types always evident in Giaquinto's autograph work. These characteristics are amply present in this oil sketch, which displays all the freshness and verve associated with his paintings.

Compositionally, the painting is constructed along the lines of a stable isosceles triangle, which is formed at the lower left and right by figures kneeling in the foreground plane, and culminates at the top with the head of the Virgin Mary. At the center of the canvas is the pivotal miraculous event—the dramatic discovery of the Virgin's empty tomb by incredulous onlookers . With the stone cover askew, the white cloth and blush-pink roses that had shrouded the Virgin's dead body tumble out in disarray. At the left, a bearded man in a blue mantle points upward to Mary, who is carried aloft to the heavens by accompanying angels and a cupid bearing a golden plate with a white flower, indicating the Virgin's purity. Although this image does not explicitly denote the Immaculate Conception, the painting's subject does suggest it in a general way. During the first half of the eighteenth century the issue of the Immaculate Conception was very controversial. The most important advocates of the Immaculist point of view were the Spanish kings, who were then pressing the Italian popes to define the popular doctrine as official Church dogma (Cioffi 1992, vol. 1, pp. 194–225). Simply stated, the doctrine argues that the Virgin, like her son Jesus, was divinely (rather than humanly) conceived within the womb of her mother, Saint Anne, and was thus spared the taint of Original Sin. Sharing this purified character, otherwise unique to Jesus, Mary, like her son, was bodily assumed into Heaven to sit at the right hand of God the Father. The Virgin's corporeal Assumption, one of the specific proofs of her divinity, is depicted here.

The coloration of this sketch exhibits the slightly darker and more saturated hues characteristic of Giaquinto's paintings. The facial types of the two male figures in the background at the lower right of the sketch are slightly more rustic than those found in later works, and stand in contrast to the loveliness of the Virgin. Giaquinto's dazzling use of delicate pastel hues are found in the rose, blues, and golden-yellows of the Virgin and angel group, the coral and turquoise of the background landscape, and the combination of delicate pink and green garments on the kneeling figure at the lower left. The

main elements of the preliminary sketch are carried through in the final large oil, with the exception of the figure with unshod feet bowing in front of the Virgin's coffin at the left. In the Rocca di Papa altarpiece this figure has been enlarged and accentuated and is shown kneeling in a more courtly and upright position, kissing the Virgin's white shroud. [IC]

## 224
### Corrado Giaquinto
*Study for "The Adoration of the True Cross on the Day of the Last Judgment"*

1740–42
Oil on canvas
32¼″ × 53¼″ (81.7 × 135.4 cm)
The Nelson-Atkins Museum of Art, Kansas City, Missouri, Purchase Nelson Trust

## 225
### Corrado Giaquinto
*Study for "Saint Helena and the Emperor Constantine Presented to the Holy Trinity by the Virgin Mary"*

C. 1744
Oil on canvas
137″ × 56¼″ (348 × 143 cm)
BIBLIOGRAPHY Laskin 1968; Plummer 1983; Vasco Rocca 1985, pp. 97–111; *Taste for Angels* 1987, pp. 303–13; Rowlands 1996, pp. 396–404; Mann 1997, pp. 30–35, 59
The Saint Louis Art Museum, Purchase, Gift of Frederick H. Ludlow

Of all Giaquinto's Roman commissions, by far the most prestigious—and most taxing—was that of producing a series of paintings for the renovation of the ancient church of S. Croce in Gerusalemme. Both the large scale and the exquisite finish of these two magnificent examples of Giaquinto's mature Roman style attest to the supreme importance of the S. Croce in Gerusalemme commission, both in the artist's œuvre and in the context of eighteenth-century Roman painting. The paintings shown here are *modelli* of two of these paintings: preliminary, smaller-scale versions which would have been shown to the patron for approval before the final versions were undertaken. In this case Giaquinto's patron was Pope Benedict XIV, known throughout Europe for his great intellect and sophisticated taste.

As originally conceived, Giaquinto's paintings were to form part of a comprehensive iconographic scheme glorifying the ancient foundation of the church, which dated back

224

to the first Christian emperor, Constantine, and his mother, Saint Helena. Tradition has it that Helena traveled to the Holy Land and brought back relics of Christ's Passion, among them fragments of the True Cross, a nail used for the Crucifixion, the superscription deriding Jesus's claim to supreme kingship, and remnants of the crown of thorns. Upon her return to Rome, these relics were housed in the private chapel of her villa, the site upon which S. Croce later arose

Within the church of S. Croce, the subject of the Saint Louis painting was greatly enlarged to form a monumental canvas set into a decorated wooden ceiling covering the long nave. A monumental version of the Nelson-Atkins *modello* was also painted on a large canvas that was was set just beyond, at the nave crossing. Below, on the lower choir walls flanking the high altar Giaquinto painted two subjects from the life of Moses in *fresco secco*, rather than the more durable *buon fresco*. As a result of time and neglect, Giaquinto's S. Croce frescos are now damaged beyond repair, and his two ceiling paintings have darkened with age. Hence the entire S. Croce commission can best be appreciated in the four extant *modelli*, which are all in excellent condition and illustrate the freshness of color and vibrancy of brushwork for which Giaquinto was famous.

Although there is some conjecture as to the identity of some of the secondary figures in the Saint Louis painting, its meaning is still wholly ascertainable. Following Vasco Rocca's iconographical analysis of the painting (Vasco Rocca 1985), which is the most comprehensive disussion of the S. Croce iconographical program thus far, at the bottom of the canvas is the figure of Saint Michael. Dagger in hand, he stands elegantly and supremely poised over Lucifer, who has toppled from his throne, and the flailing bodies of the other rebel angels, who fall into the hot and smoky pit of Hell at the lower left.

Pointing upward, Saint Michael guides the viewer to the next group of figures, which include Saint Augustine, shown wearing his bishop's miter. To his left, holding the distinctive papal cross, is Saint Sylvester, who baptized Constantine into the Christian faith. Beside him, hand piously held to his chest, is Saint Peter, who appeared to Constantine in a vision. Directly to the left are the main protagonists, Constantine in battle armor and Saint Helena, who recommends her son to the Virgin Mary, whom she holds in a steadfast gaze. To the right of Helena is Saint Louis (King Louis IX of France), who brought the crown of thorns (two thorns of which are also held in S. Croce) to the Sainte Chapelle, Paris. Next to the French king is Joseph and just above his shoulder, held aloft by a cherub, is a flowering branch, which evokes both the Tree of Knowledge, from which the True Cross was supposedly made, and the staff of Saint Joseph, which bloomed to indicate his future role as the Virgin's husband. Next on the right, resting on a cloud and swathed in a mantle of deep heavenly blue, is the Virgin herself, shown in the fullness of her beauty and youth. Next to the Virgin is her mother, Saint Anne, who is presented by a cherub with a nail of the Crucifixion. Anne's inclusion here attests to her daughter's identification as the Virgin Immaculate, a theological point that was especially controversial during Benedict XIV's papacy (Cioffi 1992).

Moving upward, the religious drama culminates with Jesus, who holds a banner of victory and kneels in supplication before God the Father . He in turn points to the crown of thorns, the superscription, and the Cross. Anchoring the composition at the very top of the painting is the white dove of the Holy Spirit.

The adoration of the True Cross is picked up and emphasized in Giaquinto's other large oil the Nelson-Atkins painting. Here the principal Apostles, featuring (from the left)

James with a sword, Peter with his keys, and John the Evangelist, behold the heavenly vision of the Holy Cross held aloft by angels. Overwhelmed by awe and amazement, they convey all the terror and glory of Judgment Day. The miraculous apparition of the True Cross to the Apostles also alludes to Constantine's vision of the Cross in a dream that preceded his victory over Maxentian's troops at the Milvian Bridge in AD 312.

Frescoed slightly later in the decade, on the lower choir walls, Giaquinto's *Moses Striking Water from the Rock* (Exodus 17:1–16) and *The Serpent of Bronze* (Numbers 21:1–9) complete the iconographical program (see figs. 107–8). These subjects introduce pre-Christian episodes that foreshadow Christ's passion: the institution of the New Covenant through his sacrifice on the Cross, and the redemption of sin through the sacrament of Baptism.

Stylistically, the S. Croce *modelli* offer ample testimony to the sophistication and technical bravura of Giaquinto's mature style. The Saint Louis canvas attests to his ability to create complex and dynamic compositions of groups of figures without compromising iconographical legibility. Added to this are the refinement and delicacy of the coloring. The ability to present strict theological subject matter in so pleasing a guise, to inform beauty with meaning, was Giaquinto's particular talent.

Giaquinto's substantial gifts as a painter–decorator were recognized in his own time, most especially after this demanding commission, for which he gained international renown. However, despite the importance of the commission and the quality of the artist's work, the entire S. Croce commission was a deep disappointment to Benedict XIV, who, when it was finished in 1744, lamented the whole enterprise as "una porcaria [sic] moderna" ("a modern mess" [Plummer 1983, vol. 1, p. 70, n. 28]). The pope's frustration was understandable, for the initial grand renovation project for his former titular church—which included an extensive renovation and realignment of its principal façade along the path of a new *stradone* or boulevard planned for the holy year celebrations of 1750— had to be abandoned halfway through due to lack of money. The funding for the entire enterprise had come from the coffers of the Dataria, a tribunal of the papal Curia. In the 1740s the Dataria functioned as a semi-secret discretionary fund entirely controlled by the pope without reference to the Curia. During this decade Benedict XIV used these funds (which were officially allocated to charitable purposes such as alms, aid to religious orders in financial straits, and pensions to

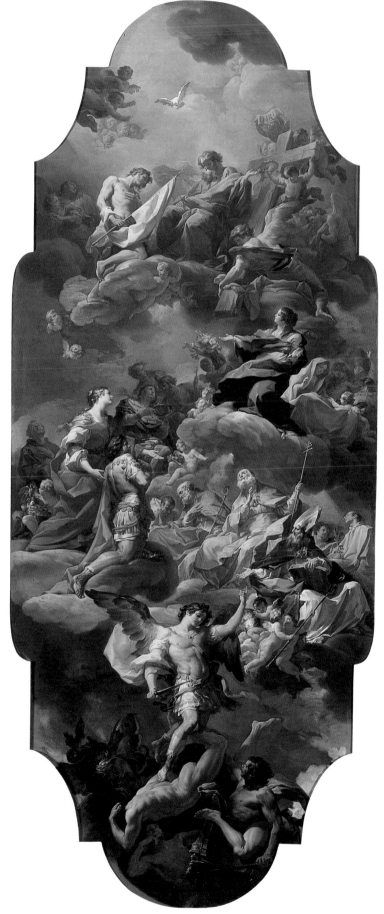

225

preletes) to fund the renovation of S. Croce. Because the project cost far more than originally anticipated, the situation became grave when funding for the Dataria, which came mostly from duties paid to the papacy by Spain, was drastically reduced owing to the new concordat then being negotiated between King Ferdinand VI and the pope. In terms of Giaquinto's œuvre, the financial misfortune that halted the S. Croce project largely destroyed the anticipated aesthetic effect and consequent appreciation of his greatest Roman commission. The poverty of the papacy at mid-century stood in stark contrast to the wealth of the Spanish Bourbons in Madrid, for whom Giaquinto worked from 1753 until 1762. Anticipated but never realized in S. Croce, the rich splendor of Giaquinto's decorative ensembles, in which luminous frescoes are set into vast expanses of gleaming white and gold stucco, are best appreciated on the vaults of the Capilla Real in Madrid, which the artist finished painting just before the death of his patron, Ferdinand VI, in 1759. [IC]

## 226
## Corrado Giaquinto
### Study for "Saint Nicholas of Bari Blessing the Soldiers"

1746
Oil on canvas
53⅛" × 38¼" (135 × 97 cm)
PROVENANCE collection Pio Santamaria, Rome 1972, Staatsgalerie Stuttgart
EXHIBITIONS Florence 1922, cat. no. 474; Bari 1993, cat. no. 22
BIBLIOGRAPHY *Mostra in Palazzo Pitti* 1922, cat. no. 474; D'Orsi 1958, pp. 68, 142, figs. 70–71; Cioffi 1993; *Giaquinto* 1993, cat. no. 22
Staatsgalerie Stuttgart

This strikingly beautiful oil *modello* is a study for a larger oil painting commissioned in 1746 for S. Nicola dei Lorenesi, which was the most important French church in Rome after S. Luigi dei Francesi. Located just behind the Piazza Navona on via dell'Anima, this small church was built in 1635–36 by the Lorraine-born François du Jardin, known in Italy as Francesco Giardini. During his two decades in Rome, Giaquinto completed two important decorative projects for the church. The first work for S. Nicola dates to c. 1731–33, when he frescoed its nave, choir vaults, and cupola. The intimate scale and delicate coloration of these frescoes are typical of the Roman Rococo style practiced by Giaquinto (Palazzo Borghese, Rome, vault fresco, 1727–30) and other international

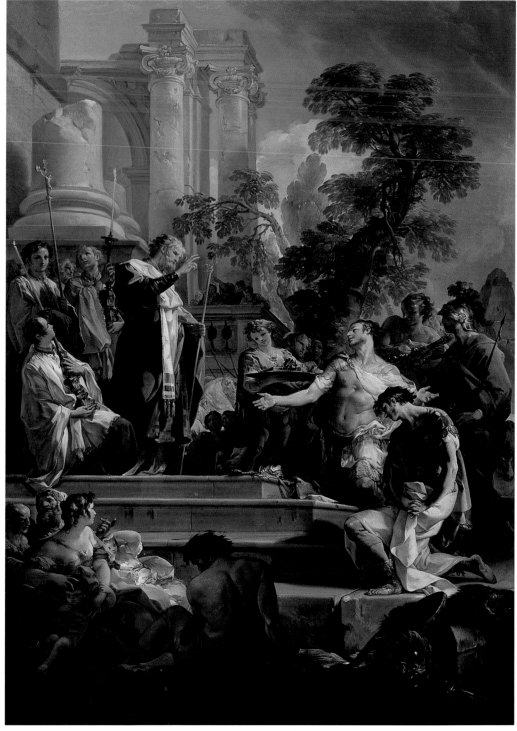

226

artists of his generation working for important patrons such as cardinals Ottoboni, Acquaviva, and Polignac.

The Stuttgart painting shown here relates to Giaquinto's second decorative commission of 1746, and its style reflects the more monumental and classicizing character of his paintings of the 1740s. Giaquinto's patron in both cases was the church's chaplain, Domenico Fabri, who in 1746 also commissioned the luxurious marbling of Sicilian jasper that heightens

the decorative effect of the church's interior and of Giaquinto's two large oils. These were set just below the cupola on the walls flanking the high altar in the presbytery. The twin to the Stuttgart picture, *Saint Nicholas of Bari Saving the Victims of a Shipwreck*, was destroyed in the nineteenth century and replaced by a copy made by Ghilardi in 1827. Fortunately Giaquinto's exquisite *modello* for the lost painting (also from the Pio Santamaria Collection, Rome) has

survived in a superb state and is in the Pinacoteca Provinciale in Bari.

The subject of the commission of 1746 was Saint Nicholas of Bari, the fourth-century bishop of Myra in southwest Turkey. According to tradition, Saint Nicholas's relics were translated to Bari when his shrine in Myra was overrun by the Muslims in 1087. He was also the patron saint of Giaquinto's home town of Molfetta, which, like other southern Italian coastal towns, venerated him because

of his aid to victims at sea. While the Bari *modello* pays homage to this tradition, the Stuttgart painting shows three generals of the Emperor Constantine's army who had been wrongly accused of crimes and sentenced to death by decapitation. Through Saint Nicholas's intervention they were exonerated. Here they are shown kneeling before him in profound gratitude and homage while receiving his blessing.

Compositionally, Giaquinto's painting draws inspiration from Roman Baroque sources, most notably Pier Franco Mola's fresco of 1657, *Joseph Making Himself Known to His Brethren*, in the gallery of the Palazzo del Quirinale. The broken column, which suggests the eighteenth-century interest in classical antiquity and is reminiscent of Piranesi, adds a contemporary touch to the mainly traditional treatment. From the 1740s onward some of Giaquinto's large-scale works clearly show signs of assistance by members of his studio, and this seems to be the case in the finished oil for S. Nicola. The extant painting in the church shows some changes in the background architecture, which is extended and enlarged giving the composition a monumental but somewhat ponderous quality. In addition, the kneeling altar boy grasping an elaborate golden candleholder at the left of the *modello* is eliminated in the final version, and the luxuriant background of trees has been simplified.

Whereas the final painting (which is also marred by age and modern restoration) does not demonstrate the freshness of color and exquisite detail of Giaquinto's best work, these traits are amply evident in this *modello*. There is much to appreciate in the painting, but the most refined feature is the delicacy of Giaquinto's distinctive palette of acid-yellow, olive-green, coral, pink, rose and turquoise-blue. Known throughout his lifetime as an exceptionally humble and religious man, Giaquinto was able to infuse his many sacred subjects with a unique sense of piety and quiet reverence. An autograph oil sketch that precedes the execution of the Stuttgart picture is in the Museo di Capodimonte, Naples (D'Orsi 1958, fig. 70). [IC]

## 227

## Corrado Giaquinto
### *The Baptism of Christ*

1750
Oil on canvas
86⅞" × 72⅞" (220 × 185 cm)
EXHIBITION  Rome 1984, *Roma*, fig. XI.23
BIBLIOGRAPHY  D'Orsi 1958, p. 79, figs. 84, 87; Olsen 1971, fig. 1; Broeder 1973, p. 79, fig. 20; Barroero 1975, fig. 4
Chiesa di S. Maria dell'Orto, Rome

Giaquinto created this magnificent *Baptism of Christ* for the chapel of St. John the Baptist in S. Maria dell'Orto, located in Trastevere, Rome. The church, which was originally attached to a hospital, was founded in 1492 by the association of fruit growers, hence the name (*orto* being Italian for "garden"). In 1750, in time for the holy year celebrations, Gabriele Valvassori restored the St. John the Baptist Chapel and Giaquinto's painting was placed above the altar. Like many of Giaquinto's altarpieces, this painting has a landscape setting, but in this case it has been significantly reduced to focus the viewer's attention on the two main protagonists of the sacred act, who are shown in a pose of almost balletic grace. In the foreground, kneeling on a rock with his right foot immersed in water, is Jesus. He holds his hand to his chest in an attitude of piety, humbly accepting the sacrament meant to cleanse the human soul of Original Sin. Conforming to tradition, the ritual purification is administered through the agency of water by Saint John the Baptist, who acts as an active counterpoint to the still and contemplative Son of God kneeling before him. The miraculous nature of the event is conveyed by the golden halo that emanates from Jesus's head and by the dove of the Holy Spirit, from whose breast a glowing beam descends. Two angels at the right look on in wonder and awe.

The dignity of the figures, the restrained emotion, the simplicity of composition, the cool coloring and soft lighting epitomize the refined style that Giaquinto practiced at mid-century. Its clear antecedents include works of the seventeenth-century Bolognese school, such as *The Baptism of Christ* by Francesco Albani (Pinacoteca Nazionale, Bologna) and the later *Baptism* altarpiece created for St. Peter's in Rome, by Carlo Maratti, the last great master of the Roman Baroque. These reflections of the past do not, as has often been implied, denote a lack of creative imagination on the artist's part (D'Orsi 1958, p. 80). It is important to remember that Giaquinto borrowed freely from his artistic antecedents in the process of

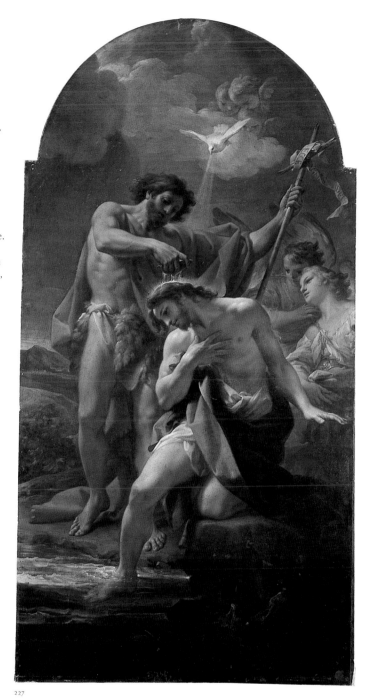

227

creating his own highly decorative style. Hence, not only are the exuberant Neapolitan models of Francesco Solimena and Luca Giordano found in his work, but also those of Pier Francesco Mola, Pietro da Cortona, Giovanni Lanfranco, and Annibale Carracci, whose Roman decorative cycles Giaquinto studied very closely.

Stylistically, the S. Maria dell'Orto altarpiece has much in common with two smaller oils, both entitled *Christ at the Column* (collection of the late Joseph F. McCrindle; Broeder 1973, p. 79, fig. 20; and private collection, location unknown), which can be dated to the same period. Preliminary works for the large altarpiece in S.

Maria dell'Orto include a poignant study for the head of Christ in the Villafaletto Collection, Rome (D'Orsi 1958, p. 81, fig. 67), and an enchantingly fresh oil sketch on copper (Olsen 1971, fig. 1) that closely anticipates the final version. [IC]

## ANNE LOUIS GIRODET DE ROUSSY-TRIOSON

MONTARGIS 1767–1824 PARIS

Anne Louis Girodet de Roussy-Trioson was born in January 1767 in a small town in the province of Loiret, not far from Paris. His father, Antoine Girodet, was director and controller of the *apanage* (crown estate) of Orléans, that of Philippe Egalité, who was beheaded in 1793. The *apanage* of Orléans was made up of the Orléanais, the county of Blois, and the estates of the Gatinais, which included Girodet's native town. Socially, therefore, Antoine Girodet was not far from noble rank. He died in 1784, when his son was only seventeen. The boy's upbringing was taken in hand by Docteur Trioson, a family friend, also originally from Montargis, now living in Paris, where Girodet had been educated from a tender age. Madame Girodet died in 1786, leaving the artist an orphan at only nineteen. Two years earlier Girodet had started studying with David, the greatest painter of his day, whose work and personality would leave a significant mark not only on the art of painting but also on the system by which the arts were organized in France. Benoît François Trioson was equerry, councillor, and physician in ordinary to the king and his armies, and military physician to the Comte d'Artois and the Duc d'Orléans. In 1809 he formally adopted Girodet and settled his inheritance on him, and Girodet duly added Trioson's name to his own.

Girodet won the *grand prix de Rome* in 1789, but his stay in the city was troubled by anti-French riots and the burning, in January 1793, of the French Academy. He fled to Naples, but remained in Italy until 1795. Girodet's letters to Trioson and to François Gérard, a friend from his days in the atelier, are the most important surviving documents concerning the anti-revolutionary upheavals in which Hugou de Basseville, representative of the French republic in Rome, was killed. After Girodet's death in 1824 a grand funeral was held, which several artists and critics referred to as the funeral of classicism—at a time when a new generation, represented by Géricault, Horace Vernet, and Delacroix, was introducing a new style, already termed "Romantic."

In assessing Girodet's place in the history of French painting, attention should be focused on his five major works. Of these, *The Sleep of Endymion*, in the Louvre, was painted while he was in Rome, between 1790 and 1792 (the painting exhibited here is a later version, from the Musée Girodet). *Ossian and the French Generals* (also known as *Apotheosis of French Heroes Who Died for the Country during the War for Liberty*), in the Musée Malmaison, combines a homage to republican generals killed in battle during the revolutionary wars with a treatment of the subject of *Ossian*, a poem by Scotsman James MacPherson. (Ossianic literature was all the rage in Europe at the beginning of the nineteenth century. Bonaparte kept a copy by his bed. Madame de Staël, Goethe, and Chateaubriand all swore by Ossian, the new Bible, the "Homer of the North." This book turned out to be one of the most extraordinary archaeological fakes in the history of literature, but it left a huge pictorial legacy and was the subject of several exhibitions.) The painting of Ossian was commissioned by Charles Percier, as decoration for the Château de Malmaison, where Napoleon lived when he was still only First Consul. David said of this painting that "Girodet was mad, and had painted figures of crystal." *The Deluge*, also in the Louvre, was painted in 1806 and, in the face of such competition as David's *Intervention of the Sabines*, won the *prix Décennal* for best history painting, organized in 1806 by the imperial government. *The Burial of Atala*, shown in the Salon of 1808 (now in the Louvre), was based on Chateaubriand's novella *Atala, or, The Love Story of Two Savages in the Desert*, a work published in 1801, which would radically transform the shape of poetry and literature in France through the introduction of the Romantic sensibility. And finally, *Revolt at Cairo* was a large-scale history painting, whose violent subject was treated in vivid color; it subsequently adorned the walls of the Tuilleries Palace, and was presented at the Salon of 1810.

Recent art historians have been prepared to grant an increasingly significant role to Girodet in the evolution of the Davidian school and in the beginnings of French Romanticism. Although his fame rests on his highly accomplished history painting, recent discoveries have concentrated more on his portraiture. Girodet painted at least fifty portraits, of which around twenty remain untraced. The portrait known as *Romainville-Triason* shown at the Salon of 1800 (Musée du Louvre, Paris), the portrait of *Mademoiselle Lange in Denmark*, shown at the Salon of 1799 (Minneapolis Institute of Arts), that of *François René de Chateaubriand*, and the portrait of *Jean-François Belley, Black Parliamentary Representative from Martinique*, shown at the Salon of 1798 (Musée National des Châteaux de Versailles) are some of his most significant works. The least-known aspect of Girodet's work is his landscape painting, to which he attached particular importance—he believed that it was a genre that encompassed all the others. The main reason for this neglect is that many of his landscape paintings have been lost, or misattributed to other Neoclassical landscape painters.

Girodet was a complex, cultivated, and sophisticated artist, one of the most educated of David's pupils. He read and translated Greek and Latin texts, including works by Virgil, Musaeus, Sappho, and Anacreon. He also devoted much time and effort to producing an illustrated edition of the *Aeneid*, and to writing a didactic autobiography in descriptive verse, a genre made famous at the end of the eighteenth century by the now little favored poet Dellile. David vouchsafed to Etienne Décluze—his pupil and future art critic, as well as the author of some of the most important diaries for the understanding of his age—that "Girodet was too erudite" (Etienne Jean Décluze. *Louis David: son école et son temps* [Paris: Didier, 1855], p. 264). Baudelaire too said of him that "his paintbrush was always dipped in the most literary of sources" (Charles Baudelaire, "Le musée classique du Bazar Bonne-Nouvelle," in *Critique d'art: suivi de critique musical* [Paris: Gallimard, 1992], p. 71). To understand Girodet fully, it is essential to bear his literary sophistication in mind. He was always considered a bizarre personality and his comment "I prefer the bizarre to the flat," has been much repeated. [SB]

BIBLIOGRAPHY: Coupin 1829; Gérard H. 1886; Benoit, Francois. *L'Art français sous la révolution et l'empire; les doctrines, les idées, les genres.* Paris: L. H. May, 1897; Bordes 1974; Bernier 1975; Levitine 1978; Rubin 1978; Bellenger 1993; Crow, Thomas. *Emulation: Making Artists for Revolutionary France.* New Haven and London: Yale University Press, 1995; Grigsby 1995; Solomon-Godeau, Abigail. *Male Trouble: A Crisis in Representation.* New York: Thames & Hudson, 1997; Clark, Alvin, ed. *Mastery and Elegance: Two Centuries of French Drawings from the Collection of Jeffrey E. Horvitz.* Cambridge: Harvard University Art Museums, 1998, nos. 109–10

## 228

## Anne-Louis Girodet
### *The Sleep of Endymion*

1810?

Oil on canvas

35¼" × 46" (89.5 × 117 cm)

PROVENANCE  at the museum before 1900, gift of Madame de Clarival, the heir of René-Ange Dumeis

EXHIBITIONS  Bregenz and Vienna 1968, cat. no. 248 A; Tokyo, Tokyo Fuji Bijutsukan Gakugeika. *Furangu. Kakumei to Roman Shugi Ten.* Traveling exhibition, 1987–88, cat. no. 101; Avignon, France, Musée Calvet. *La mort de Bara.* 1989, cat. no. 41; Copenhagen, Statens Musuem for Kunst. *Mellem guder og helte: historiemalet i Rom, Paris og København, 1770–1820.* 1990, cat. no. 39; Tours, France, Musée des Beaux-Arts de Tours. *Balzac et la peinture.* 1999, cat. no 32

BIBLIOGRAPHY  Coupin 1829; Gérard H. 1886; Benoit, Francois. *L'Art français sous la révolution et l'empire; les doctrines, les idées, les genres.* Paris: L. H. May, 1897; Bordes 1974; Bernier 1975; Levitine 1978; Rubin 1978; Bellenger 1993; Crow, Thomas. *Emulation: Making Artists for Revolutionary France.* New Haven and London: Yale University Press, 1995; Grigsby 1995; Solomon-Godeau, Abigail. *Male Trouble: A Crisis in Representation.* New York: Thames &Hudson, 1997; Clark, Alvin, ed. *Mastery and Elegance: Two Centuries of French Drawings from the Collection of Jeffrey E. Horvitz.* Cambridge: Harvard University Art Museums, 1998, nos. 109–10

Musée Girodet, Montargis

*The Sleep of Endymion* is a key work in the history of French painting. Girodet painted it in Rome while he was still a pupil of David, albeit one of the most brilliant. It represents a conscious departure from David's Neoclassicism, which dominated French and European art for over a quarter of a century, from the revolution right through to the end of the empire. Girodet won the *grand prix de Rome* in 1789 and arrived in Rome in July 1790. He set about this composition a few months after enrolling at the French Academy at the Palazzo Mancini, and worked on it until October 1791. In an attempt to achieve greater freshness of color, Girodet was inspired to mix his paints with olive oil. As a result, he had to start his main figure over again from scratch when the paint failed to dry. It was exhibited in Rome that same year, along with other compulsory works by the royal *pensionnaires*, and thereafter at the Paris Salon of 1793, under the title *Endymion, by Moonlight*.

This painting immediately made Girodet's reputation. He showed it again at the Elysée exhibition in 1797, and once more, twenty-three years later, at the 1814 Salon. The *Sleep of Endymion* started life as one of the life study exercises required of the *pensionnaires* as part of the Académie syllabus. Quatremère de Quincy, in his historic eulogy, records that "it was in fact one of the compulsory studies assigned to the pupils, in which they were expected to demonstrate their skill in rendering, and their knowledge of, the nude figure, while still giving some room for personal expression and poetic interpretation." On the basis of these criteria, the assessment of the jury of the Académie Royale de Peinture et de Sculpture (1793) was that painting needed more "fluidity of movement, greater fidelity to nature in the details. Less curvaceousness, less ghostly whiteness in the flesh tones, even given that the light source is the moon, less conventionality in the rendering of forms …

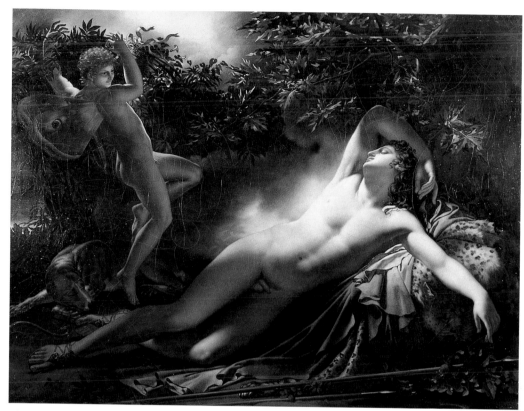

228

but these comments should not obscure our overall esteem for this truly poetic piece of work, evidently the product of a talent we are pleased to acknowledge."

Girodet succeeded in transforming an academic exercise into a major, historic painting. His subtle interpretation of the mythological subject was the inspiration for the unique and original lighting effects, which became Girodet's personal trade mark, evident in all his work, from *Ossian* to the *Burial of Atala*. This discovery allowed him to depart from Davidian realism and to develop an entirely new, dreamlike style, the roots of which can be traced back neither to late eighteenth-century Rome, nor, even, to the school of northern European artists whose work he might have come across in Rome. The approach is more obviously related to literary sources, to those poetic sensations which Girodet sought, throughout his life, to transpose into the visual medium—so much so that from 1812–14 on he himself became more interested in poetry and versification than in painting.

The theme of Endymion was widely popular with painters and poets. In 1801 Francois Noël, an editor, lithographer, scholar, and member of numerous erudite societies, published his *Dictionary of Fable*, an important two-volume mythological dictionary. Noël and Girodet had become friends in Venice in 1795, when Noël, in his role as republican consul, offered the

painter his protection against anti-Jacobean militia. In his preface to the expanded edition of 1803, he pays tribute to Girodet, thanking him for "generously sharing much of his own valuable research." The entries for *Ossian* and *Endymion* benefited considerably from Girodet's erudition, and offer some insight into his understanding of the Endymion legend. Endymion appears sometimes as a shepherd from Asia Minor, at others as the twelfth King of Eulide, who, when banished from his throne, devoted himself to the study of the heavens, where he encountered Diana. The grandson of Jupiter, he is generally associated with the moon. He is said to have been granted his wish—to be plunged into everlasting sleep, in order to escape the ravages of old age and death. Diana fell in love with him on account of his great beauty and came to visit him every night in a cave on Mount Latmos. By Endymion she had fifty daughters and one son, Etolus. Another, less common legend, interesting for its evocation of the morbid and homoerotic aspects of the myth, tells how Endymion was beloved of the god of sleep, who in order that he might have the perpetual pleasure of Endymion's lovely eyes, made him sleep with them wide open.

Girodet, who was extremely widely read, would have been familiar with these variants. George Lévitine, and after him Thomas Crow, traced a

Greek source, not mentioned by Noël, but which corresponds in exact detail to Girodet's scene: the *Dialogues of the Gods*, by the Greek philosopher Lucian, in which Aphrodite raged at Diana for having dared watch Endymion as he slept out under the heavens, and gone to visit him where he lay. The other-worldly light that seems to emanate from the young man's body as he sleeps, and the presence/absence of the goddess, represented here by her attribute, the moon—or rather, by moonlight, the symbol of the nocturnal world she inhabits—are both indicative of the depth and originality of Girodet's reading of the myth. Endymion as anti-Narcissus, asleep for all eternity, absent even from himself, exposed to the gaze of the "other," is both Eros and Tanatos at once. Love, disguised as a zephyr, parts the branches, allowing Diana's shining rays to pass, and to play upon the sleeping Endymion's lips. In several letters to Dr. Trioson, Girodet remarks proudly on how radically his treatment sets him apart from David. Some time later, in a letter written either to Bernadin de Saint-Pierre or to the Marquis de Pastoret, he attempted, paradoxically, to play down the creative aspects of his Endymion, insisting rather on the imitative aspect of his masterpiece. He drew attention to the importance of his illustrations for *Virgil*, done in Rome (1791–2), and for *Racine* (1801). This may be taken as evidence of his

increasing love of literature, or as a first sign of panic as he discerns the faint beginnings of a change of direction of the part of the French school. Too late. Endymion had introduced a hitherto unknown, interiorized world, a Caravaggio-like softness, a new sensibility, that chimed with the times and would eventually find its full expression in romantic feeling.

The painting has been in the Louvre ever since it was acquired by Louis XVIII. The Montargis version is smaller, and passed into the collection of the Musée Montargis some time before 1900, bequeathed by the Viscountess of Clairvil, heir of René Ange Dumeis (1808–1864), a pupil and apprentice of Girodet. The painting is of superb quality, and the catalogue to the Montargis exhibition held in 1967, the first of its kind, drew attention to the important differences existing between this and the Louvre painting, concluding that the Montargis picture was a sketch, and not a studio copy. Several lithographs have been made of the painting, one by Auby Leconte in 1822, another by Francois Noël in 1827, both versions of the Louvre painting. A third, earlier version, dated 1810, by Henri Guillaume de Chatillon, is quite clearly made from the Montargis picture, and makes apparent the various compositional differences between the two paintings. Chatillon, a friend and pupil, worked with Girodet to produce the lithographs of Anacreontis, a series that would not be published until after Girodet's death. One hypothesis is that the Montargis painting was executed at the same time as the lithograph. The dedication reads: "To Docteur Trioson, doctor of medicine, former field doctor to the French army, by his adopted son Anne Louis Girodet Trioson, member of the Légion d'honneur." The fact that the lithographer has signed and dated the lithograph, taken together with the considerable warmth of the dedication, would seem to suggest that Chatillon, as would have been common practice in a studio at that time, was also involved with the execution of the painting itself. [SB]

## JAKOB PHILIPP HACKERT
PRESZLAU, GERMANY 1737–1807
SAN PIETRO DI CARPEGGI, ITALY

By the time of his arrival in Rome in 1768, the Prussian landscape painter Jakob Philipp Hackert already enjoyed a pan-European reputation. He has since then justly come to be understood as a pivotal figure in the history of eighteenth-century landscape painting, the man who both reformed and isolated the *veduta* tradition through his ability to subsume carefully observed, recognizable places

229

230

into a generic, idealized style that looks back to Claude Lorrain. This style would have a very strong effect on landscape painting and printmaking, particularly as traced by other northern artists, well into the nineteenth century.

Hackert's paintings have a remarkable sameness, despite his wide diversity of geographic sites and range of scale, from small gouaches (often done in series) to large-scale decorative cycles, for example at Schloss Bodwiz on the island of Rügen in Stralsund, Pomerania.

With their encaustic-like surfaces and completely even lighting, they also have an arcadian magic that, particularly after Hackert settled into Italy permanently, created through its magical spell of goatherds and radiant ruins taken up by Walpole—and through shifts in Italian taste for "English" garden design and informality—a new definition of values about nature and man's place in it.

Born in northeast Brandenburg, Hackert was a member of an artistic dynasty. He was one of five sons, all of whom became artists, and he studied in Berlin with his father (also called Philipp), a portrait and animal painter. A student of Blaise Nicolas Le Sueur at the Berlin academy from 1755, Hackert was introduced early to works by Claude Lorrain and to Dutch landscape painting. He then worked throughout northern Germany, settling for a time in Stockholm (where he received royal commissions) before moving to Hamburg and then Paris. In Rome, where he lived until 1786 (with sketching tours to Switzerland as well as Sicily and Naples), he was allied with the cosmopolitan world already established by his German-speaking colleagues Anton Raphael Mengs and Johann Joachim Winckelmann. His patronage extended as far as Russia, where the Empress Catherine II obligingly had one of her battleships blown

up off Livorno so that Hackert could observe the nocturnal light effects (the huge painting is still at Petershof). In 1786 Hackert was asked by Ferdinand IV, King of Naples (whom he first met in 1782), to move south, where he lived for the next thirteen years. While there, his international fame was consolidated and he established, seemingly forever, modern perceptions of the Neapolitan islands and the Campagna. Forced to leave Naples after the temporary fall of the Bourbons in 1799, he retreated to Tuscany, where he died. In 1787, in Naples, he had met Goethe, who befriended him and who, in 1811, using material left him by Hackert, edited and published the painter's memoirs, giving him a place of privilege in German letters and art history. [JR]

BIBLIOGRAPHY: Hackert 1994; Krönig and Wegner 1994; Weidner 1998

## 229
### Jakob Philipp Hackert
### *View of the Villa Albani*

1779
Oil on canvas
25¼″ × 35″ (65.5 × 89 cm)
BIBLIOGRAPHY Hackert 1994, pp. 242–43, no. 81
Anhaltische Gemäldegalerie Dessau

The Villa Albani, on via Salaria beyond the Aurelian Walls of Rome, must have held a particular attraction for Hackert, as it was the seat of the antiquarian and theoretician Johann Joachim Winckelmann, who served as secretary to Cardinal Albani and helped form the large group of antiquities there (see cat. 25). The villa was, therefore, central to a German-speaking intellectual community that Hackert would enter only after the tragic assassination of Winckelmann. It was also the site of the fresco of

*Parnassus* (see cat. 378), the great triumph of his friend and colleague Anton Raphael Mengs. Yet as accurate as Hackert's view of the villa is, with its two-story pavilion connecting to the peristyle ellipse across a formal garden, the artist completely underplays its importance as a treasure house of hotly discussed (and newly excavated) sculpture or as a center of modern painting. Rather, he produces an idyllic evocation of the Campagna populated by villas as perfect and abstracted as those invented by Claude, harking back to Horace and a pastoral arcadia.

An engraving done in Naples in 1785 and dedicated to Prince Yussupov records another, more closely seen but nearly identical view of the villa and the surrounding buildings. This print follows a painting done for Catherine of Russia, which is still at Tsarskoe Selo and dated 1784. [JR]

## 230
### Jakob Philipp Hackert
### *The Beach at Practica di Mare with the Palazzina Borghese*

1780
Signed and dated lower left: 1780
Oil on canvas
25¼″ × 38⅝″ (64 × 98 cm)
BIBLIOGRAPHY González-Palacios 1991, p. 142, no. 61; Vasale 1992; Hackert 1994, p. 159 no. 21, p. 159
Staatliche Museen zu Berlin, Nationalgalerie

The subject is as idyllic as the day. Fisherman and aristocrats mix happily along a beach in front of a pretty pink villa. Dogs romp, children laugh, ships gaily skim across the Tyrrhenian Sea. As the inscription carefully explains, the scene is the villa of Prince Borghese at Practica, a property on the sea not far from Rome

owned by Marcantonio IV Borghese, whose family crest can dimly be made out on the façade of the house.

The painting is a smaller version (although not necessarily a reduced replica) of a painting (49″ × 68″; 125 × 175 cm) owned by the Borghese family, also dated 1780. It is part of a series of works by Hackert commissioned by Marcantonio as part of his extensive redecoration of the interior spaces of the Villa Borghese on the Pincio. Hackert mentioned his work on the project, one of the last great artistic undertakings of the century in Rome, in a letter to his friend John Meerman in July 1779. Five large paintings plus four smaller seascape overdoors are described by Goethe in his memoir of Hackert as being in place by 1782. These paintings appear in guidebooks until the late nineteenth century as in the central space, formerly an open loggia, on the "back" of the villa under Lanfranco's ceiling. Goethe said that the inspiration for this ambitious decorative scheme comes from Marcantonio IV's uncle Prince Aldobrandini, in his house in Frascati, where a cabinet room was decorated with paintings in "gouache" by Hackert. The antique notion of completely transforming a room with large landscape views was a particularly Roman taste, most vividly played out in the murals by Pier Leone Ghezzi at Torrinpietro, outside Rome. The immediate reproduction by Hackert of one of these specific scenes for consumption outside Italy simply underscores the great charm and probable charm of the idea. [JR]

## GAVIN HAMILTON
MURDIERSTON HOUSE, SCOTLAND
1723–1798 ROME

Although not well known to modern audiences, Gavin Hamilton maintained a reputation of the highest order during

his lifetime, and his peers thought him a crucial pioneer of the vigorous and noble classicizing mode forged in mid-eighteenth-century Rome. He arrived in Rome in 1748, and chose to enter the studio of Agostino Masucci, the principal champion of the long-standing classical tradition in Roman art, leading back through Carlo Maratti to Raphael. The young artist initially painted portraits for British Grand Tourists, but the economic support of his affluent family allowed him to concentrate on history painting, the most noble but least lucrative genre of painting. While in Rome, Hamilton fell under the sway of the antique, fostered in the 1750s by influential visits to Herculaneum and personal contact with Robert Adam and Johann Joachim Winckelmann. His university education (in Glasgow), unusual among eighteenth-century artists, enhanced his ability to pursue history painting through a thorough knowledge of classical literature, and his 1761 acceptance into the Accademia di S. Luca attests to his importance among the international community of artists in Rome.

The Scottish painter first drew attention for a series of works after the *Iliad*, initiated in 1760 with *Achilles Lamenting the Death of Patroclus* (Countess of Seafield, Cullen House). Advanced at the same time that Anton Raphael Mengs worked on the *Parnassus* fresco at the Villa Albani, *Achilles* placed Hamilton at once in the vanguard of the new style. The series dominated his production for the next fourteen years and included *Andromache Lamenting the Death of Hector* (1761; lost); *Achilles Dragging the Body of Hector around Troy* (1766; lost); *The Anger of Achilles* (1769; Broadlands); *Priam Redeeming the Body of Hector* (date unknown; lost); and *Hector Taking Leave of Andromache* (1775; Hunterian Gallery, University of Glasgow). The restrained palette, stoic expression, and frieze-like compositions announced a new epic dimension in painting, rooted in careful study not only of ancient sculpture but also of Poussin and Charles LeBrun, whose works Hamilton knew largely through engravings. The stern Homeric subjects moreover placed the artist at the forefront of the movement to return to the most archaic classical sources, perceived as more pure and heroic.

Despite the ultimate destination for all six paintings in inaccessible British country houses, the Homeric series attracted significant notice in Rome. Their high visibility derived in part from their display in the artist's studio, which doubled as a popular gallery. Owing to Hamilton's slow working method, building up from initial oil sketches, each work

remained on the easel for years. Even more significantly, from 1764, Hamilton shrewdly engaged Rome's leading printmakers (particularly Domenico Cunego) to engrave his paintings. As a result, his compositions were widely disseminated in an elegant, unified set, and artists as diverse as Jacques-Louis David and John Trumbull were able to draw repeatedly on his ideas; the engravings also provide a valuable record for modern art historians of Hamilton's work.

Hamilton also served as one of Rome's best-known and most successful dealers. Involved in many celebrated archaeological excavations in the Papal States during the latter half of the century, he led particularly lucrative digs at Hadrian's Villa in 1769–71, as well as at Ostia and Gabii. Englishmen in Rome on the Grand Tour formed Hamilton's principal clientele, but he sold important works to Clement XIV Ganganelli and Pius VI Braschi for the Vatican Museums and counted Catherine the Great among his customers. His finds include some of the most renowned discoveries of the period, including the *Wounded Amazon* from Monte Cagnolo (Metropolitan Museum of Art, New York), the Lansdowne *Discobolus*, the Warwick Vase from Tivoli (Burrell Collection, Glasgow), the Townley *Venus* from Ostia (British Museum, London), and the Shelburne *Hermes* from Tor Columbo (Santa Barbara Museum of Art). Hamilton also dealt in Old Master paintings, with the *Ansidei Madonna* by Raphael and *The Virgin of the Rocks* by Leonardo (both National Gallery, London) among his most sensational coups.

Hamilton remained true to the Hellenic subject matter that established his reputation, but he experimented with other material during the most active phase of his career. The best-known of these images portray episodes from the Roman republic, including the *Death of Lucretia*. The painter also explored subjects treating Scottish heroes, including *Mary Queen of Scots Resigning Her Crown* (1765) and *The Discovery of Palmyra by Wood and Dawkins* (1758; both Hunterian Art Gallery, University of Glasgow). The latter work moreover provided a crucial precedent for the contemporary history painting of Benjamin West by presenting an eighteenth-century event in a classical guise. Hamilton also executed some of the earliest works of art based on Milton with the *Penseroso* and *Allegro* of 1765 (both lost). He executed portraits throughout his career, with *The 8th Duke of Hamilton with Dr. John Moore and Ensign Moore* of 1777 (Duke of Hamilton, Lennoxlove) standing as his most substantial achievement in this arena.

231

Although Hamilton's production slowed during the last decades of the century, his style responded to new currents in painting. Prince Marcantonio Borghese IV provided his most significant late commission, the design of the Room of Helen and Paris at the Villa Borghese, crowning the series of classicizing interiors planned by Hamilton for his British clients. For this space, dismantled in 1891, the artist engaged Rome's leading sculptors and craftsmen to create one of the most harmonious environments at the villa. Hamilton reserved the painted decoration for himself, narrating the lives of Paris and Helen with five works set into the ceiling (four still *in situ*) and three large canvases for the walls (Museo di Roma). The lighter coloring and fluid handling in these paintings, coupled with the pliant bodies and dynamic use of space, reveal a crucial shift from the rugged toughness of the earlier canvases and demonstrate the impact of Angelika Kauffmann, Pompeo Batoni, and the other artists working at the villa.

Hamilton never outlined his theoretical position in print, but in 1773 he published *Schola italica picturae*, forty engravings of High Renaissance and early Baroque paintings arranged in an ideal gallery. This volume, coupled with extant letters and conversations reported by Quatremère de Quincy, reveals a stance squarely rooted in the tradition of Pietro Bellori and tied to the ideas of Mengs and Winckelmann: artists, fueled by the creators' good taste and intelligence, selected the best aspects from nature, antiquity, and sixteenth- and seventeenth-century Italian art, and recombined them into an ideal form. Hamilton did not have a studio per se, but he heavily influenced the careers of several generations of Anglo-American and

international artists alike, particularly Antonio Canova, Benjamin West, David Allan, Alexander Runciman, and Vincenzo Camuccini. [JLS]

BIBLIOGRAPHY Hamilton 1879; Waterhouse 1953; Ferrara 1954; Waterhouse 1954; Irwin 1962; Stainton 1974; Irwin and Irwin 1975; Macmillan 1986; Rangoni 1990, "Hamilton"; Macmillan 1994; Williams 1994; Rodgers 1996

## 231
## Gavin Hamilton
### *The Death of Lucretia*

1767
Oil on canvas
84″ × 104″ (213.3 × 264 cm)

PROVENANCE Hopetoun House, 1768; Dowell's, Edinburgh; Alexander, Glasgow; Christie's, London, March 22, 1968, lot 28 (as *The Sacrifice of Iphigenia*); Colnaghi, London; Paul Mellon; gift to the museum, 1981

BIBLIOGRAPHY Waterhouse 1954; Rosenblum 1961; Skinner 1961; Tomory 1978; Macmillan 1994

Yale Center for British Art, New Haven, Paul Mellon Collection

Gavin Hamilton presents the pivotal, brutal event leading to the foundation of the Roman republic. Sextus Tarquinius, the son of the last Etruscan king, came to Lucretia's home while her husband was away at battle. Intending to rape Lucretia, Sextus threatened to murder her and to lay a slave beside her corpse to imply that she had been killed in the act of adultery. Rather than suffer this dishonor, Lucretia ceded to Sextus. She reported the attack the next day to her spouse, father, and two other men, including Lucius Junius Brutus. Although they declared her innocence, Lucretia stabbed herself before their eyes and demanded revenge. The

pledge she secured from the men ushered in a popular uprising against the Tarquins led by Brutus, which ended tyrannical Etruscan rule and established the republic.

Closely following Livy (Book I), Hamilton portrays the exact instant after Lucretia withdraws the dagger and the men swear to avenge her. To convey a narrative at once suffused with sentimental pathos and forceful resolve, the artist divides the canvas in two parts. On the left, Lucretia slumps into a chair, supported by her grief-stricken husband. Sobbing uncontrollably into his mantle, he holds her dying body with a gentle gesture that empathetically echoes that of his expiring wife. By contrast, the other men leap into action, stepping toward the viewer and focusing their eyes on the bloody dagger. Their taut muscles and angular gestures balance one another, forming a single, locked unit. Brutus stands in the physical center of the canvas, but Lucretia's body acts as the hinge for the two narratives. Although she falls backwards into her husband's arms, Lucretia looks not toward her spouse but up at the dagger, actively connecting her to the pledge. Despite her lifeless right arm, the expiring woman summons her remaining energy to clutch Brutus's garment with her opposite hand. Lucretia's arm thereby forms a striking horizontal line that echoes the arm with which Brutus holds the dagger, a dramatic visual strategy that links their actions and renders her last moment participatory instead of passive.

To create the startling vigor of the scene, Hamilton pulls the enormous figures to the front of the picture plane. A severe colonnade directly behind the protagonists eliminates any recession into the background and thus any distraction from the theme's gravity. The precision of Hamilton's handling as well as the aggressive contrasts of light and dark further accentuate this seriousness, and the highly saturated, muted colors form an equally stern palette. Although Hamilton painted Lucretia during the ascent of the new classicizing style, his canvas owes little to the refined and elegant mode promoted by Anton Raphael Mengs but forges a distinct mode of "heroic primitivism" (Macmillan 1994, p. 81).

Despite the popularity of Lucretia's story from the Renaissance onward, artists usually selected other parts of the narrative, particularly the rape (often eroticized) or the pathos of her suicide (for example, The Death of Lucretia by Ludovico Mazzanti, cat. 251). One important exception combined the oath with Lucretia's suicide—The Death of Lucretia by Luca Giordano (Staatsgemäldesammlungen,

Munich), a work that evidently inspired the Scottish painter (Tomory 1978, pp. 59–60). However, little residue of Giordano's exuberant Baroque machine remains in Hamilton's blunt and severe picture. By shifting to the oath, Hamilton accentuated the nobility of Lucretia's action and revealed an explicitly political dimension to the story, an effect wholly distinct from the ebullient Neapolitan design.

Hamilton only painted three Roman subjects across his long career—Lucretia, Agrippina Landing at Brundisium (Earl of Spencer, Althorp), and Volumnia's Appeal to Germanicus (lost)—and each notably features a female protagonist. Duncan Macmillan has recently argued that these three pictures jointly champion moral sentiment as the fundamental virtue driving political action. In each case, feeling governs Hamilton's heroines, and their sentiment therefore tempers and guides masculine action. Only Lucretia's loyalty to her husband can provoke and direct her male avengers to act against tyranny; Lucretia therefore stands as the moral conscience that fuels human freedom (Macmillan 1994, pp. 84–89).

Hamilton's canvas heavily influenced subsequent developments in late eighteenth-century art, encouraged by its long tenure in the painter's Roman studio and especially its wide dissemination in a 1768 print by Domenico Cunego. Lucretia catalyzed the theme of the heroic pledge so crucial to painting in this period—recast in such varied works as Henry Fuseli's Oath of the Rutili of 1778–81 (Rathaus, Zürich) and Jacques-Louis David's Oath of the Horatii (Louvre, Paris) of 1784 (Rosenblum 1961, pp. 14–16)—although none of these offers such a daring role for a female character.

Charles, Lord Hope, commissioned the canvas in 1763 while on his Grand Tour, presumably from a modello already on view in the painter's studio. Documents record the painting's development over the next six years, until its 1768 shipment to Hopetoun. Hamilton also painted at least two other versions, one on view in Hamilton's studio in 1779 and commented on there by Antonio Canova in 1780 (evidently the version in the Theatre Royal, Drury Lane, London). An early sketch is in the National Gallery of Scotland (Rosenblum 1961, pp. 11–12; Skinner 1961). [JLS]

## ANGELIKA KAUFFMANN
CHUR, SWITZERLAND 1741–1807
ROME

Angelika Kauffmann has long been appreciated as one of the few female artists of the eighteenth century to achieve international fame during her lifetime. Nonetheless, the early literature—largely biographical—cast the painter as a society portraitist and decorator in England. The explosion of monographic studies of Kauffmann over the past twenty-five years, rooted in feminist theory and committed to reexamining primary sources, has dramatically altered this earlier view. Kauffmann now stands as one of the most influential artist–intellectuals of the eighteenth century and fundamentally rooted within the international community of Settecento Rome.

Kauffman's father, a peripatetic Swiss painter of modest accomplishment, pegged his daughter as a child prodigy in both music and painting. The young artist received her early training at home—a typical pattern for female artists—and by age twelve she had established her bent for portraiture by painting The Bishop of Como (lost). The following year she executed the first of the many self-portraits (Tiroler Landesmuseum, Innsbruck) that punctuated her career. In 1754 Kauffmann accompanied her father to Milan, where she painted likenesses of prestigious local figures and copied works of art. After a brief return to Switzerland upon the death of her mother, when she assisted her father with frescoes in the Schwarzenwald parish church, the Kauffmanns returned to Italy in 1759. During this period she boldly abandoned music to concentrate on art, making the unparalleled decision to pursue history painting (cat. 234). Such ambitious goals could only be achieved through further travel, with Rome as the ultimate goal. En route, she copied canonical works in Modena, Parma (Correggio), and Bologna (Reni and the Carracci), compiling extensive sketchbooks; she later translated the drawings into widely distributed etchings.

Florence marked Kauffmann's decisive shift toward classicism. Through friendships with Benjamin West and Johann Friedrich Reiffenstein she joined the city's vanguard community of Anglo-German artist–intellectuals. Upon her subsequent 1763 arrival in Rome, the young painter gravitated to figures at the core of the new style, including Gavin Hamilton, Johann Joachim Winckelmann, Giovanni Battista Piranesi, and Pompeo Batoni. Portraits—both traditional Grand Tour commissions and more intimate images of her colleagues—dominated her output (cat. 232). She showed astonishing growth as an artist in this

period and joined the Accademia di S. Luca in 1765 (adding to membership in the Florentine and Bolognese academies), submitting as her reception piece an allegory of Hope. Her first history paintings emerged in 1764: Bacchus Discovering Ariadne (Bregenz) and Penelope at Her Loom (Hove Museum and Art Gallery, Sussex). The understanding of ancient literature and sculpture brought to these canvases demonstrates Kauffmann's aggressive pursuit of knowledge, with their balance and restraint deriving from the theories of Winckelmann and Mengs. The pictures' common theme, the experience of women, became Kauffmann's hallmark.

Primarily working for a British tourist clientele, the young artist left Italy in 1766 for London, the most financially rewarding market for portraiture. Kauffmann at once cultivated a salon–studio, bringing together a powerful network of female patrons while simultaneously retaining strong ties with British artists, especially Joshua Reynolds. Two years later she helped found the Royal Academy, where she henceforth exhibited regularly. Portraits such as Augusta, Duchess of Brunswick (1767; Royal Collection, UK), and John, Lord Althorp, with His Sisters (1774; Althorp, Northamptonshire) not only reveal the heady prestige of her London clientele but also her quick development toward larger, more complex compositions. These pictures, often full-lengths with multiple figures, presented sitters in learned allegorical guises, invested simultaneously with classical gravity and lyrical charm. Her audiences identified this grace with sentiment, a mode of expression emerging in eighteenth-century England and tied inextricably to femininity. Kauffmann extended this female sensibility into history painting, a genre normally considered male. While providing the moral instruction demanded by the genre, female characters and domestic subject matter transmitted her ideas (Cleopatra Adorning the Tomb of Marc Antony, 1770; Burghley House, Lincolnshire), and she pioneered British, Ossianic, and Germanic sources for subject pictures (Eleanora Sucking Poison from the Wound of Edward I, 1776; private collection).

Kauffmann returned to Rome in 1782 after marrying Antonio Zucchi, who yielded his own career as a decorative painter to manage his spouse's finances. Economics partly motivated their move, since Mengs's recent death and Batoni's slowing career positioned Kauffmann as Rome's dominant portraitist, decisively secured by the 1783 commission to paint the Neapolitan royal family (1784; Capodimonte, Naples). Moreover, the

explosion of the Grand Tour among the nobility of northern and eastern Europe opened vast new markets for the multilingual painter, exemplified by the Bariatinskaya family portrait (1791; Pushkin Museum, Moscow). Moreover, Rome proved a more hospitable market for history paintings than London. Her account book reveals extensive sales of subject pictures, escalating in scale and authority, but retaining her distinctive gentle style (cat. 233).

By assuming the grand quarters formerly occupied by Mengs atop the Spanish Steps, Kauffmann cast herself as the prime heir to the classicizing tradition of Roman painting. Operating with unusual independence, she rarely participated in the group commissions so important in late eighteenth-century Rome. Her studio not only housed an important collection of antiquities and modern paintings, but also her well-known *conversazioni*. These public events brought together the cosmopolitan literary and artistic figures converging in late Settecento Rome, explaining the expanding erudition of Kauffmann's late work. Above all, she fostered the cults of friendship and genius, seen in her allegorized self-portraits (cat. 234; see also *Self-portrait as Painting Embraced by Poetry*, 1782; Iveagh Bequest, UK) as well as the small images of her friends—Goethe chief among them (1787; Goethe-Nationalmuseum, Weimar)—that form crucial instruments in this atmosphere of intellectual exchange. Kauffmann enthusiastically promoted new talent, particularly accomplishments of women, recorded in such allegorized portraits of central figures as the poet *Fortuna Sulgher Fantastici* (1791; Galleria Palatina, Florence). Though famously devout, Kauffmann painted significant religious pictures only later in her career. The 1789 *Holy Family* for Bergamo led to several notable projects, secured by her close rapport with Rome's most prominent cardinals. Her contribution to the Santa Casa in Loreto, *The Virgin with Saint Anne and Saint Joachim* of 1791, commissioned by Pope Pius VI, culminated this aspect of her career and occasioned a papal visit to her studio.

Kauffmann never outlined a theoretical position in print. However, the artist's biographer and colleague Giovanni Gherardo de Rossi, described the artist as "la Pittrice delle Grazia." In eighteenth-century terms, grace embodied the reason, erudition, judgment, and balance of her painting, aspects thought reinforced by her rational, learned, and virtuous personality. Though she withheld from drawing the male nude, the cornerstone of Roman eighteenth-century practice, Kauffmann's hard work and

natural talent overcame any potential defect with rigorous application to drawing, color, and above all elegant harmony of composition.

Kauffmann's classicism—sophisticated, learned, and suffused with sentiment—established the chief alternative to the revolutionary, aggressive mode of David and Camuccini. As such, her work held sway over multiple generations of artists in the late Settecento, including Canova, Girodet, and Ingres, and established the anacreontic style that would last well into the nineteenth century. [JLS]

BIBLIOGRAPHY  De Rossi [1811] 1970; Gerard 1892; Manners and Williamson 1924; Vorarlberger Landesmuseum 1968; Walch 1968; *Angelika Kauffmann* 1979; Clark and Bowron 1981, pp. 125–38; Roworth 1984; Roworth 1988; Baumgärtel 1990; Rosenthal 1992; Roworth 1992; Roworth 1994; Rosenthal 1996; Baumgärtel 1998; Sandner 1998; *Mehr Licht* 1999

## 232
## Angelika Kauffmann
### *Samuel Powel*

1764–65
Oil on canvas
49½″ × 39¼″ (125.4 × 99.7 cm)
PROVENANCE  Samuel Powel, Philadelphia; thence by descent
EXHIBITION  Philadelphia, Philadelphia Museum of Art, 1931, inaugural installation
BIBLIOGRAPHY  Moon, Robert C. *The Morris Family of Philadelphia.* Vol. 2. Philadelphia. 1898–1909; Powel, Samuel "Short Notes on a Course of Antiquities at Rome in Company with Messrs: Apthorp, Morgan & Palmer." In *The Journal of Dr. John Morgan of Philadelphia From the City of Rome to the City of London, 1764.* Philadelphia: Lippincott, 1904; Philadelphia Museum of Art. *Bulletin,* 1931; Tatum 1976; Marks, Arthur. "Angelika Kauffmann and Some Americans on The Grand Tour." *The American Art Journal,* vol. 2, no. 2 (1980), pp. 4–25; Prown 1997
Private collection, U.S.A.

232

Samuel Powel's brocaded topcoat and proud, erect posture combine with the plain background to present the twenty-six-year-old American as a serious, cultured gentleman. He looks out from the canvas with a measured gaze, unrolling a floorplan for a classicizing villa, and architectural tools strewn before him indicate that the design is the sitter's own. Kauffmann therefore casts Powel not as a leisured visitor but as an architect, actively absorbing the lessons of Roman culture and reinterpreting them for the New World. Such a presentation not only places the sitter squarely in the context of the learned circles converging on Kauffmann's studio in the mid-1760s, but also argues powerfully for the intellectual merits of the Grand Tour, an important theme for the

artist in her own first years in Rome.

Born into a prestigious Philadelphia Quaker family, Samuel Powel (1738–1793) inherited the family fortune upon his father's 1759 death. Shortly thereafter, he graduated from Philadelphia College and embarked on a trip to England, where he connected with John Morgan, a fellow Philadelphian studying medicine in Edinburgh. In 1763 the young men began a Grand Tour of France and Italy that was considered "the most celebrated taken by any American abroad in the eighteenth century" (Whitfield J. Bell, "Samuel Powell," in *Patroit-Improvers: Biographical Sketches of Members of the American Philosophical Society* [Philadelphia: American Philosophical Society, 1997]). Americans traveled to Italy far less frequently than their British counterparts because of the prohibitive distance and cost. Those who did so largely went as merchants or for professional training, as was the case with Benjamin West, John Singleton Copley, and John Morgan. For its purely cultural emphasis, Powel's journey was therefore doubly unusual.

Through their London contacts (particularly West), Powel and Morgan quickly integrated themselves into Roman expatriate society. They trav-

eled through Italy with the Duke of York and contracted the two leading Scottish *ciceroni,* James Byres and Abbé Peter Grant. Byres led the young men through a rigorous nineteen-day course of the chief ancient and modern sights of Rome, recorded in notes by both men (Prown 1997, pp. 92–95). Grant furthermore secured them a private audience with Pope Clement XIII Rezzonico and membership in the Accademia dell'Arcadia, acts that suggest the breadth and seriousness of their intellectual interests.

The two-month visit of Powel and Morgan to Rome coincided with Angelika Kauffmann's second stay there from April 1764 to June 1765. The painter had already established herself there as a portraitist, primarily among the British and German intellectual communities, and her close rapport with West, Byres, and Grant may have drawn the young men into her studio.

The works Kauffmann executed in the two years preceding her 1765 departure for London reveal a remarkably diverse range of expression and rapid-fire growth as a painter, including her first history paintings. Her portraits range from the lively informality of *Johann Joachim Winckelmann*

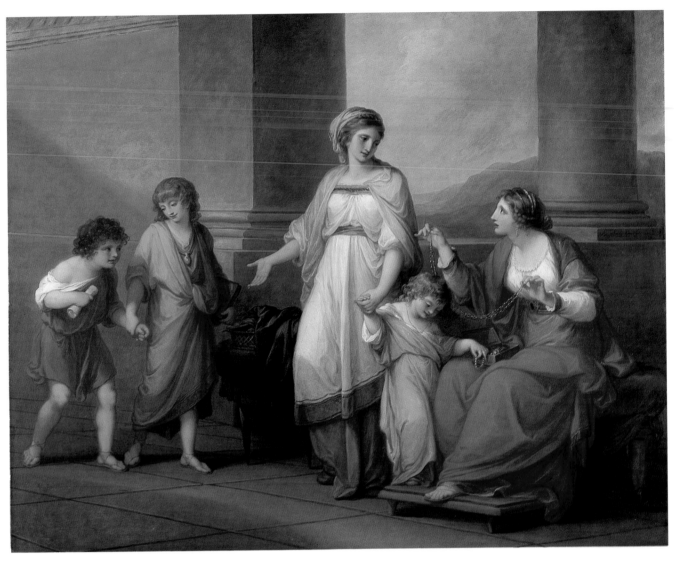

233

of 1764 (Kunsthaus, Zürich) and *David Garrick* (Burghley House, UK) to the grandeur and easy authority of *John Byng* (Wrotham Park, UK) and *John Morgan* (National Portrait Gallery, Washington, D.C.), works directly influenced by Pompeo Batoni's dominant style. Powel's image, like many portrait drawings in Kauffmann's Italian sketchbook (Victoria and Albert Museum, London), adopts a third, more traditional mode. Inspired by English colleagues in Rome, such as Nathaniel Dance, these less animated works eliminate elaborate settings and focus tightly on the sitters' staid expressions.

Despite these distinctions, Kauffmann's portraits in this period share a modest scale and a light and liquid handling of paint. Above all, they present the sitters as engaged artists and intellectuals. Her work thus looked away from the more commercially successful style of Batoni and Louis-Gabriel Blanchet, which emphasized luxury and consumption, and paved the way for the cerebral

countermode of portraiture later refined by Anton Raphael Mengs. The Americans' choice of Kauffmann as their portraitist indicates that they considered themselves part of the accomplished milieu surrounding the young painter, confirmed by the learned and carefully selected attributes she assigned to the sitters.

The precise identity of the drawing Powel holds remains unclear, for while Powel's journal describes drawing ancient monuments in Rome, the plan portrays contemporary classicizing architecture. The sheet may represent initial ideas for Powelton, the now destroyed West Philadelphia country house designed by the sitter following his return to America, or it may show a Roman building of special interest. No documents have emerged regarding the commission, but scholars have ascribed the work to Kauffmann through family tradition and stylistic evidence, an attribution recently reaffirmed by Wendy Wassyng Roworth (personal communication, 1998). The

Americans evidently left Rome before Kauffmann finished their canvases, and she shipped the work to Powel in London the following year (Marks, pp. 12, 16; see above). [JLS]

## 233
## Angelika Kauffmann
*Cornelia, Mother of the Gracchi*

1785

Signed on plinth at right: *Angelica Kauffmann pinxt.*

Oil on canvas

40″ × 50″ (101.6 × 127 cm)

PROVENANCE George Bowles; Rebecca Rushout Bowles, 1818; Ann Rushout, Wanstead Grove, by 1826; Harriet R. Cockerell, 1851; Charles Rushout, 2nd Baronet, 1869; Charles Fitzgerald, 3rd Baronet, 1879; Phillips and Neale, London, November 9, 1879; Government of the Province of Alberta, Canada; Christie's, London, November 22, 1974; Herner Wengraf, London, 1925; Virginia Museum of Fine Arts

EXHIBITIONS London, Royal Academy, 1786; Los Angeles, Austin, Pittsburgh, and Brooklyn 1976, cat. no. 50; Chicago 1978, cat. no. 13; Vaduz and Milan 1992, cat. no. 46; Düsseldorf, Munich, and Chur 1998, cat. no. 26

BIBLIOGRAPHY *Giornale per le Belle Arti* April 1785, pp. liii-liv; Hirt 1785; De Rossi [1811] 1970; Manners and Williamson 1924; Walch 1968; Baumgärtel 1987; Roworth 1988; Baumgärtel 1990; Roworth 1992; Roworth 1994; Schulze 1996; Baumgärtel 1998; Kauffmann 1998; Sandner 1998

Virginia Museum of Fine Arts, Richmond, The Adolph D. and Wilkins C. Williams Fund

The artist's memorandum of paintings from October 20, 1785, describes the present canvas in this way: "Cornelia, mother of the Gracchi, is visited by a noblewoman friend who has them see all her beautiful jewels and asks to see Cornelia's. Cornelia then chooses the moment when her sons Tiberius and Caius, together with her little daughter Sempronia, return home from public school, and she presents them to the woman, saying: 'These are my most precious jewels.'" (Kauffmann 1998, p. 31, author's translation).

This subject had few visual precedents and was derived from *Factorum ac dictorum memorabilium*, by Valerius Maximus (Book IV.1, introduction), later retold in Charles Rollin's *Histoire romaine*. The widowed daughter of Scipio Africanus, Cornelia devoted her life to the moral upbringing of her children, most notably her two sons, who later became great reformers of the Roman republic, acclaimed for their intelligence and uprightness. Cornelia thus represented the model mother and exemplified feminine virtue.

The artist significantly altered her initial idea (seen in a preliminary sketch in the Kupferstichkabinett, Berlin, reproduced in Baumgärtel 1998, no. 227) in order to heighten the work's monumentality and dynamism. Initially conceived as a seated figure of Charity, Cornelia now stands in the center of the canvas, dominating the pyramidal composition: her regal pose contrasts dramatically with that of her seated and humbled neighbor. The severe vertical folds of the heroine's modest garment align with the stark Doric architecture in the background, further accentuating her integrity and moral strength. By placing the figures on a diagonal, with the boys entering from the left, Kauffmann energizes the composition and transforms Cornelia's virtuous motherhood into noble activity rather than a passive state. Even Sempronia has a meaningful role, toying with the noblewoman's jewels to emphasize their childish insignificance.

As Bettina Baumgärtel has stressed, the image affirms a contemporary ideal of the good mother, fostered in the eighteenth century most famously by Jean-Jacques Rousseau. Cornelia fulfils her essential nature as a woman, modest and self-abnegating, uniting motherly love, domestic happiness, and benevolent virtue (Baumgärtel 1998, pp. 381; Baumgärtel 1990, pp. 30–31). By locating these fundamental values in an example of the Roman republic and presenting them in the format of a history painting, Kauffmann elevated these domestic, feminine virtues to the highest possible rhetorical level, and identified them as equal to the public, masculine qualities customarily affirmed by Settecento history painting.

The painting employs Kauffmann's trademark repertory of gracefully drawn figures, tender gestures, and gentle, harmonious coloring, which she considered the appropriate language for such a sentimental, moralizing subject. Despite the delicate handling and the sweet figures, the painting demonstrates a severity and majesty unprecedented in Kauffmann's œuvre. Anthony Clark connected this shift to the impact of

Jacques-Louis David's *The Oath of the Horatii* (Louvre, Paris), which Kauffmann would have seen the previous year in the Frenchman's nearby Roman studio (Clark and Bowron 1981, p. 137). While she adopts the spare, pure language of Rome's most radical painters to accentuate Cornelia's virtue, Kauffmann simultaneously embeds a critique of David's painting in her own composition. Instead of opposing the passive, emotional response of David's women to the heroism of the warriors, Kauffmann explicitly valorizes the feminine, domestic sentiment and takes that as the primary subject of the painting.

George Bowles, one of Kauffmann's steadiest patrons, commissioned *Cornelia* as part of a triad of history paintings for his home in Wanstead Grove, England, which also included *Pliny the Younger and His Mother at Miseneum* (Princeton University Art Gallery) and *Virgil Writing His Own Epitaph at Brundisium* (private collection, Bowdoin, Me.). The connection among the three paintings has not yet received adequate explanation, although the pairing of *Pliny* and *Cornelia* clearly ennobles the bonds between mother and child (Roworth 1992, p. 92).

*Cornelia* became Kauffmann's most significant history painting. According to the April 1785 issue of the *Memorie per le Belle Arti*, she exhibited the canvas that year in Rome to great public acclaim, and Giovanni de Rossi extolled the work for its erudition, inventiveness, and grace. The artist furthermore reprised the composition twice for important patrons, in each case forging alternate interpretations of *Cornelia* by combining the picture with different pendants. For Queen Maria Carolina of Naples in 1785, Kauffmann joined the picture with *Julia, the Wife of Pompey, Swooning* (both Kunstsammlungen zu Weimar) to address the honor of family loyalty. Three years later Prince Poniatowski of Poland commissioned a third version, which Kauffmann paired with *Brutus Condemns His Sons to Death* (lost), startling pendants that contrast feminine allegiance to family to masculine devotion to state (Roworth 1994, pp. 53–56). Kauffmann's image also enjoyed wide distribution in a 1788 engraving by Francesco Bartolozzi, and through this means the composition influenced subsequent versions of the subject by such diverse artists as Benjamin West, Pierre Peyron, Louis Gauffier, and Vincenzo Camuccini. [JLS]

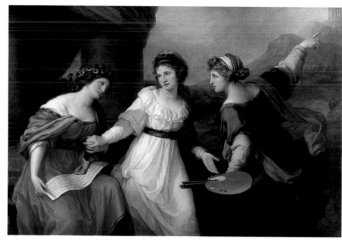

234

## 234

### Angelika Kauffmann
### *Self-portrait between the Arts of Music and Painting*

c. 1796

Signed on belt: *Angelica Kauffmann Se Ip:s Pinx Roma 179 ...* [date illegible]

Oil on canvas

57⅞" × 85⅞" (147 × 218 cm)

PROVENANCE James Forbes, Stanmore Hill, Middlesex; Christie's, London, June 25, 1839, lot 163; Mrs. Strickland, Cokethorpe; thence by descent; Knight, Frank, and Rutley's, November 12, 1908, lot 158; Lord St. Oswald, Nostell Priory, Wakefield

EXHIBITIONS London 1955, cat. no. 14; Nottingham 1987, cat. no. 15

BIBLIOGRAPHY De Rossi [1811] 1970; Gerard 1892; Brockwell 1915; Manners and Williamson 1924; The Iveagh Bequest 1955; Walch 1968; Clark and Bowron 1981, pp. 125–38; Parker, Rozsika, and Griselda Pollock. *Old Mistresses: Women, Art and Ideology*. London: Routledge & Kegan Paul, 1981, pp. 21–22; Shawe-Taylor 1987, no. 15; Roworth 1988; Baumgärtel 1990; Rosenthal 1992; Roworth 1992; Rosenthal 1996; Baumgärtel 1998

National Trust, Nostell Priory, St. Oswold Collection, London

Choosing to abandon Music to pursue Art, Angelika Kauffmann stands in the center of the canvas, flanked by these allegorical figures. Painting points insistently to their goal, the sublime temple of immortality emerging in the rocky background, and her animated sash, severe profile, and insistent lean emphasize her urgent entreaty. Kauffmann turns to leave but glances back tenderly at the sentimental figure of Music, who sorrowfully holds Kauffmann's hand to her chest in a final parting gesture.

Writers have continually interpreted this image biographically. According to a narrative established by De Rossi, Kauffmann's first biographer, the artist left behind her early study of music to focus on painting

(De Rossi [1811] 1970, pp. 16–17). She had shown prodigious talent in both arenas, but deliberation with her local priest convinced the teenager to elect painting, the more challenging and less immediately rewarding pursuit. Moreover, she intended to pursue history painting, the most prestigious genre, and the one most inaccessible to women.

By placing the protagonist between two allegorical figures in a moment of difficult decision, Kauffmann invokes the Choice of Hercules. This theme enjoyed wide popularity in the eighteenth century, fueled by the Earl of Shaftesbury's 1713 text *A Notion of the Judgement of Hercules*. Shaftesbury allegorized the hero's decision between Vice and Virtue to encourage history painting, which he saw as the most demanding but morally rewarding genre. Kauffmann surely encountered the book in England, and she knew many artists' interpretations, including those by Annibale Carracci, Benjamin West, Pompeo Batoni, and Joshua Reynolds, as well as an ancient relief at the Villa Albani. Kauffmann's most direct inspiration, however, likely came from one of her chief British patrons, the Hoare family. Visiting their country seat at Stourhead (whose garden design played out the Choice of Hercules), the painter would have seen their celebrated version of the story by Nicolas Poussin.

The image not only presents Kauffmann's decision in moralizing terms, but also explicitly identifies her as a Roman artist–intellectual. Settecento Roman artists adopted Hercules as the archetype of the modern hero (see p. 54 above) and the use of this image in a self-portrait asserts that only Rome opened such an elevated choice for the painter. By melding the genres of allegory and history painting with portraiture, the painter amplifies the intellectual status of the artist and inserts her own work in the ongoing dialogue of

Roman self-portraits addressing this theme throughout the century (see, p. 62; see also cats. 193, 204, 248). Another crucial antecedent for Kauffmann's picture hung at Stourhead, Carlo Maratti's *Self-portrait with Niccolò Pallavicini*, a work that similarly fuses traditional categories to elevate the intellectual position of the artist. By embedding the distant temple from Maratti's canvas into her own work, Kauffmann unmistakably places her self-portrait in this distinctly Roman tradition.

Recent studies have also interpreted the Hercules trope in light of Kauffmann's exceptional position as a woman pursuing history painting. Earlier artists customarily presented Vice as an eroticized and often nude female figure, an approach Kauffmann rejected by painting both figures in modest classical dress. The juxtaposition of Music and Painting does not therefore strictly contrast Vice to Virtue, but addresses the more complicated choices between an emotional or rational pursuit, and a domestic or public career (Baumgärtel 1990, p. 175). The decision thus revolves around purely intellectual concerns specific to a woman challenging the dominant paradigm of the artist. By recasting the Choice of Hercules with a female protagonist, Kauffmann justifies her rejection of a more predictable and socially acceptable career for an eighteenth-century woman and honors her adoption of one customarily coded as male.

The three female figures balance one another in harmonious poses that counteract the tension of the narrative and present the triad as the Three Graces. Layering an iconography customarily associated with women over that of Hercules, Kauffmann masks her bold insertion into the male sphere of history painting, and thus makes her statement more acceptable to an eighteenth-century audience (Rosenthal 1992, pp. 47–48; Rosenthal 1996, pp. 347–48). In addition, the Three Graces represent ideal friendship in Cesare Ripa's *Iconologia*, thus emphasizing that Kauffmann retained Music as a warm memory rather than a discarded vice. The motif furthermore embodies the central theoretical values held by the artist: grace, harmony, and balance.

Countess Catherine Bariatinskaya (the Princess Holstein-Beck) of Russia purchased the initial version of this painting in 1792 (Pushkin Museum, Moscow). This canvas is one of two reprisals (De Rossi [1811] 1970, p. 17) and may date to 1796, when John Forbes, the first recorded owner and a major Kauffmann patron, commissioned another large allegorical picture from the artist in Rome (London 1955, pp. 13–14).

The painting stands as one of Kauffmann's most complex productions. It fuses the genres of allegory, history painting, and portraiture while giving common iconographies unexpected, new meanings. Kauffmann thereby simultaneously identifies herself as an heir to the heritage of Roman history painting and comments on her complicated and unique relationship to that tradition demanded by her gender. To convey these ideas, Kauffmann created a work memorable not only for its learned iconography and penetrating psychology but also for the composition itself: its bold, jewel tones; subtle layers of thin glazes; and the powerful, inventive design of the figures. [JLS]

## GASPARE LANDI
### PIACENZA 1756–1830 PIACENZA

Despite their connection to the patrician house of Landi from Mezzanone Oltrepò, Gaspare Landi's parents, Ercole and Francesca Rizzi, were poor. This brought him a troubled youth and family misfortune, with separation from his mother and from his sisters, who were both sent early to a convent. He did not receive a regular artistic training but was educated at first by the Jesuits. Later, an uncle indulged his artistic vocation by placing him in the studio of Gaspare Bandini, a figure painter from Parma. Still later, with a painter on glass, Antonio Porcelli, he studied Oliviero Gatti's manual of engravings after Guercino (Oliviero Gatti, *Principi del Guercino, ovvero primi elementi per introdurre le giovani al disegno* [Mantua, 1619]; Arisi, di Grapello, Mischi 1981, p. 175). He then progressed to copying Old Masters (Pordenone, Camillo Procaccini, Ludovico Carracci, and Guercino), becoming associated with the perspective specialist and decorative artist Mariano Nicolini. Landi's first attempts in the field of religious painting (*Santa Rosa of Viterbo, Santa Chiara, Santa Catarina of Bologna*, in S. Maria di Campagna, Piacenza) and portraiture (*Portrait of Count Alfonso Scotti di Fombio*; lost) earned him the protection of the Marchese Giambattista Landi delle Caselle, a distant relative, who generously paid for him to complete his artistic apprenticeship in Rome, where he went in 1781.

Despite strong ties with his native town and its aristocracy, who were always lavish with commissions, Landi decided to settle in Rome. He left it only for temporary returns home (1790–92 and 1797–1800, fleeing from political upheavals) and for a stay in Milan in 1791, when, as the guest of Prince Alberico di Belgioioso,

he met Giuseppe Bossi, Andrea Appiani, and Pietro Verri, and executed a portrait of Giuseppe Parini. However, he was never tempted to leave Rome permanently, even when Bossi and Leopoldo Cicognara offered him the chairs of painting in the Milan and Venice academies in 1804 and 1808.

Received in Rome as by the powerful Della Somaglia family (*Portrait of Cardinal Giulio della Somaglia*, 1787; Galleria Nazionale d'Arte Moderna, Rome), Landi attended the private school of Pompeo Batoni, then that of Domenico Corvi, which he left within a short time to study independently the masterpieces of antiquity and the Renaissance. From the former he learned soft brushwork, and from the latter he adopted the technique of drapery and dramatic light effects seen in the painting that won him the 1783 Parma academy competition, *The Theft of the Palladium* (Galleria Nazionale, Parma). But only by studying the pictorial and theoretical work of the recently deceased Anton Raphael Mengs did Landi attain artistic maturity, under the banner of a quest for ideal beauty and the grand manner. A *Self-portrait* (c. 1801; private collection), inspired by that of Mengs and preserved in the D'Alba Collection in Madrid, can be seen as a homage to the master (Mellini 1983, p. 39). His friendship with Canova (*Portrait of Antonio Canova*, 1806; Galleria Borghese, Rome) was also decisive. Besides appealing to Landi through its natural affinity with the *goût grec* as defined by Angelika Kauffmann and the later Gavin Hamilton—far from the heroic moralizing commitment of David or of the *pensionnaires* of the French Academy—Canova's graceful work proved for him a source of continual stimulus in both subject matter and form (*Hebe as Cup-bearer to Jupiter*, 1790; Galleria d'Arte Moderna, Brescia). His aim was to render in paint the softness of living flesh, as in the sculptor's marbles, and, by studying nature, to ward off the danger of a stony, bloodless style (the *statuino*) associated with copying the works of antiquity. He often borrowed Canova's iconography, such as that of the pose of *Meekness*, quoted by Landi in *Antiochus and Stratonice* (c. 1790; private collection; Mellini 1983, p. 36); conversely, Canova sometimes included in his own sculptures details derived from solutions worked out by Landi. This type of dialogue legitimizes the reading of many of Landi's paintings as pictorial transpositions of the sculptor's work.

Canova also introduced the young man from Piacenza into his regular circle. In Rome, Landi came to know Arcadians such as Vincenzo Monti, Giovanni Gherardo de Rossi, and Prince Sigismondo Chigi, whom he

portrayed in 1785 on horseback, together with Giovanni Stern amid Roman antiquities (Casa Chigi Albani, Rome), and illustrious exponents of the antique such as Ennio Quirino Visconti, from whom he asked advice in 1795 as to a philologically correct representation of *Asclepius* (lost; letter of October 14, 1795, cited in Fiori 1977, p. 43).

Landi's extraordinary talent as a portrait painter soon brought him into rivalry with Kauffmann in the favor of contemporaries. A large part of his success in the nineteenth century is due to the naturalness and psychological penetration that he brought to his portraits. These qualities can be seen in such masterpieces as the *Portrait of Count Giacomo Rota* (1798; Museo Civico, Piacenza), the *Self-portrait with the Family of the Marchese Landi* (1797; D'Albertas Collection, Turin), and the portrait of his pupil *Tommaso Minardi* (1810; Accademia di S. Luca, Rome). Although considered inferior in the academic hierarchy, portraiture was remunerative and so enabled Landi to finance his more demanding figurative compositions. From his first attempts in Rome, he emerged as a great interpreter of subjects from mythology (*Prometheus on the Rock*, 1782; lost), literature (*Francesca da Rimini*, 1786, painted for the Marquis de Créqui; *Oedipus at Colonna*, 1805; lost), history (*Veturia at the Feet of Coriolanus*, 1817; Galleria d'Arte Moderna, Florence; *Mary Stuart Leaving France*, 1817–27; for the Duke of Berwick and D'Alba) and from scripture (*Hagar*, 1787; Colleoni Chapel, Bergamo). A shrewd promotion, resting on the interpretation of De Rossi's *Lettere pittoriche* and the systematic exhibition of the works in his studio in vicolo S. Giacomo degli Incurabili, at the Pantheon, or in the Palazzo di Spagna, before they were sent to their final destination, won him an international clientele. His more prestigious commissions included *Hector Welcomed on Olympus* (1813) for the Palazzo Torlonia and the two paintings for the Quirinale—a commission obtained thanks to Canova, who praised him to Napoleon as one of the greatest contemporary painters. Based on subjects dictated by Denon—*Aaron Racheld in his Tent with the Wise Men from the East Who Follow Him in the Army* and *Pericles Surrounded by Athenian Artists and Philosophers Visits the Works of the Parthenon* (1811–13, Museo del Sannio, Benevento)—these paintings for the Quirinale's Sala dello Zodiaco were intended to record historical examples of good government and cultural advancement, with which the Napoleonic regime identified itself.

Other works for this room were provided by Landi's rival Cammuccini.

Comparison between the two artists became a *topos* (Stefano Susinno, "La pittura a Roma nella prima metà dell'Ottocento," in Enrico Castelnuovo, ed., *La pittura in Italia: L'Ottocento* [Milan: Electa, 1991], vol. 1, pp. 406–7), in which Landi came to be seen as the champion of color, capable of fusing "the mellowness and beauty of Venetian *colore* with the softness of Lombard chiaroscuro" (Betti 1830, p. 7), and Camuccini as that of Tuscan-Roman tradition of *disegno*. *The Road to Calvary* (1806–8; S. Giovanni in Canale, Piacenza), which is considered Landi's sacred masterpiece (along with two paintings placed in the cathedral to replace two works by Ludovico Carracci, which were sent to France [*The Deposition of the Virgin* and *The Three Marys at the Sepulcher*, 1797–1803]), was described by the secretary of the Bologna academy, Pietro Giordani. He compared it to its pendant, Camuccini's *Presentation in the Temple*, and admired above all its dramatic power and variety of the expressions. Landi's power of expression was rooted in the art of Leonardo and Raphael, but he had previously been inspired by the "simplicity of composition" of the Primitives, "adding thereto all that by which Painting was improved in later centuries," as wrote the scholar Onofrio Boni in 1815 concerning *The Three Marys at the Sepulcher* (1810–12; Galleria d'Arte Moderna, Florence, quoted in Pinto S. 1972, p. 38; for a deeper account of the relationship between Landi and the Primitives see Agostini 1985). Landi was professor of painting at the Accademia di S. Luca from 1812 to 1827, becoming its permanent president in 1817. On his death, on February 28, 1830, he left unfinished *The Immaculate Conception* (S. Francesco di Paola, Naples) painted for the Bourbon King Ferdinand I. [SG]


BIBLIOGRAPHY Pindemonte 1795; De Rossi 1804; De Rossi 1804, *Lettera*; De Rossi, Giovanni Gherardo. "Lettera sopra un quadro dipinto dal signor cavalier Gaspare Landi pittore piacentino al chiarissimo abate d. Luigi Lanzi." Manuscript, 1808; Betti 1830; Masini 1841; Scarabelli 1843; Giordani 1859; Ambiveri 1879, pp. 166–92; Fermi 1906; Ozzola 1907; Ozzola 1907, "Proposito"; *Mostra landiana* 1922; Arisi 1960, pp. 267–76, 338–39; Pinto S. 1972, pp. 37–39; Fiori 1977; *Piacenza del Settecento* 1979, pp. 21–22; *Settecento emiliano* 1979, pp. 207, 209, 214; Ceschi Lavagetto 1983; Mellini 1983; Agostini 1984; Agostini 1985; Cera 1987, pls 475–99; Mellini 1987, "Landi"; Natoli and Scarpati 1989, vol. 1, pp. 354–57; Barilli, Renato, ed. *Il primo '800 italiano: la pittura tre passato e futuro*. Milan: Mazzotta, 1992, pp. 129–31, 204–5, 270–71; Mellini 1992


## 235
## Gaspare Landi
### *The Meeting of Hector and Andromache with Their Son Astyanax at the Gates of Troy*

1793–94
Oil on canvas
59″ × 80¼″ (150 × 205 cm)
PROVENANCE Ranuzio Anguissola, Piacenza; given to the Istituto Gazzola in 1884 by Fanny Visconti di Modrone Anguissola
EXHIBITIONS Piacenza 1922, cat. no. 337; Piacenza 1979, cat. no. 48; Milan 1992
BIBLIOGRAPHY De Rossi 1804, *Lettera*; Masini 1841, p. 11; Scarabelli 1843, p. 69; Ambiveri 1879, p. 173; Fermi 1906, pp. 199–202; Arisi 1960, pp. 273–74; Arisi, Di Grapello, and Mischi 1981, p. 141; Mellini 1983, pp. 31–32
Istituto Gazzola di Piacenza

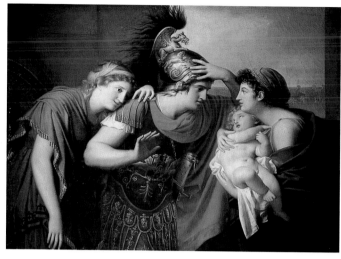

235

When Landi returned to Rome from Piacenza in the autumn of 1792, he brought with him, among the other commissions he had received in his home town, one for "one or more pictures on any subject at a set price of two hundred *zecchini*" (Fiori 1977, p. 80) ordered by the Marchese Ranunzio Anguissola of Grazzano. During that stay in his native town, started two years earlier but interrupted by a long sojourn in Milan, the artist had probably painted the pair of extraordinary portraits of *The Marchese Ranunzio Anguissola with His Son* and his wife, *The Marchesa Bianca Stanga di Soncino* (Museo Civico, Piacenza). His client's complete satisfaction had evidently generated the production of more works, the prelude to a further order in 1795 for two more paintings "with two or three half-length figures" (Fiori 1977, p. 44), which Landi appears to have produced in the following year and which can probably be identified as a *Savior* and a *Virgin* mentioned in a letter to the Marchese Giambattista Landi dated October 20, 1797 (Fiori 1977, p. 51). These two different commissions suggest the freedom granted to the painter, a freedom of style that can be evinced in works produced for the local aristocratic patrons—intended to support their compatriot's high professional achievement, through commissions, and so enhance civic prestige, but also to indulge his autonomous artistic choices. But they also testified to the artist's social and cultural prestige as he continued to establish himself as a master of history painting thanks to a thorough literary grounding which, for his patrons, guaranteed success.

To fulfill the 1792 commission Landi planned two paintings conceived as pendants, with recurrent subjects from Book VI of Homer's *Iliad*, which he probably read in the prose translation by Melchiorre Cesarotti. The artist's freedom in his interpretation of *The Meeting of Hector with Andromache* and of *Hector Reproving Paris*, gives the two canvases particular significance. Here Landi demonstrated his preference for literary subjects and at the same time concentrated on the exploration of ideal beauty and the expression of emotion—ideas that absorbed him in the last decade of the century. The precise definition of the figures in the foreground looks back to the seventeenth century, and in particular to Guercino, whom Landi had studied in Antonio Porcelli's studio in his youth. In a letter of February 23, 1795, to the Piacenza scholar Gian Paolo Maggi, Landi explained that he had chosen the "half-length figures" to give himself the chance to work on a large scale, over life-size, despite the limited width of the canvases available to him (Fermi 1906, p. 201). In the two paintings the artist explored the idea of contrast, between an irascible Hector and a radiant Hector, and variety. In *Hector Reproving Paris* the *exemplum virtutis* became the pretext for an exercise on the theme of the ideal beauty. The contrasting types of beauty were derived from antiquity and corresponded to the character of the exemplary figures drawn from Homer, as pointed out by the playwright and art expert Giovanni Gherardo de Rossi, director of Portugal's Real Accademia de Belas-Artes, in his 1795 ekphrastic description of the painting (De Rossi 1804, *Lettera*, p. 9). They ranged from the model of virile, heroic beauty exemplified by Hector to Paris's gentle beauty and the perfection of Helen's feminine beauty. Their diversity was emphasized by the variable gradations of their flesh coloring.

The pendant, *The Meeting of Hector and Andromache*, dealt, on the other hand, with the moving domestic emotions of Homer's tale. The different psychological attitudes of the event's protagonists offered Landi the opportunity for a variation on the theme of "expression," a motif that Leonardo had treated exemplarily in his *Last Supper* (De Rossi 1805, p. 7). The refined play of facial expression within an ideal of beauty close to the antique, but also to Canova, was again decodified by De Rossi. Hector displays "fatherly tenderness in his face" as he lifts the imposing helmet which had frightened his son Astyanax. The boy, turning to his nurse, "presses himself timidly against her breast, while she, supporting him in her arms, would fain approach the great Hero, on whom she fixes her eyes in wonder and reverence." Finally, Andromache, in tears as she expects her husband's imminent end, but already smiling at the reaction of their son, is caught in an extraordinary "mixture of pain and happiness" (De Rossi 1804, *Lettera*, p. 13). De Rossi drew attention to Paris's soft flesh tones and the emotion of Andromache, and these were also mentioned by Landi in writing to Maggi (letter of February 23, 1795, cited in Fermi 1906, p. 201). The Horatian principle of *ut pictura poesis*, followed by the painter in his adherence to Homer's text, was also celebrated by Ippolito Pindemonte, who translated *The Odyssey*, and in a sonnet dedicated to the painter's work wrote: "Your brush is worth as much as Homer's lute" (Pindemonte 1795, n. p.). Andromache's pose recalls not only that of Correggio's Mary Magdalene in *The Virgin of Saint Jerome* (Parma, Galleria Nazionale; De Rossi 1804, *Lettera*, p. 13), but also that of Canova's *Temperance*, mourning over the sepulcher in the *Monument to Clement XIV* (Rome, Ss. Apostoli); of all Canova's works this was the one Landi most admired. But perhaps Canova himself later remembered the languidly drooping arm of the figure painted by

Landi—a visual translation of the recurrent epithet of Andromache, "of the pale arms"—for his statue of *Italy Weeping* on the tomb of Alfieri (S. Croce, Florence). Hector's helmet was derived from the Borghese *Mars* (Louvre, Paris), with the variants of the griffin and the sphinx replaced by the lion and the winged dragon respectively—the latter probably in homage to the arms of the Anguissola family, which in fact bear a winged dragon on the crest (Crollalanza [1886–90] 1965, vol. 1, p. 47). In the painting Landi displayed his talent as a colorist. The chromatic contrasts, through a continuous, soft transition between points of light and shade in the pyramidal composition, became harmonies. The technique of glazing, recommended to the pupils instead of a virtuosity of touch (Scarabelli 1843, p. 100), ensured that the hues would have mellowness and finish, together with the transparency necessary to preserve the local color even in the shadows, in a *sfumato* technique inherited from Leonardo. [SG]

## HENDRIK FRANS VAN LINT, *called* MONSU STUDIO

### ANTWERP 1684–ROME 1763

Hendrik Frans van Lint was one of the finest *petits-maîtres* of landscape working in Rome in the eighteenth century. He was born in Antwerp on January 28, 1684, the son of the Flemish painter and draftsman Pieter van Lint and his wife, Anna Morren. He trained briefly under the Antwerp painter Pieter van Bredael in 1696–97, but shortly after 1700 traveled to Rome; he remained there for the rest of his life except for a brief return to Antwerp in 1710 following the death of his mother. In his early years in Rome, Van Lint was deeply influenced by the works of the great *vedutista*, Gaspar van Wittel, whose topographical views dominated the youthful activity of Van Lint and left a powerful imprint upon his methods and manner of working.

Van Lint's *bent-name* (given him by colleagues in the Schildersbent, the fraternity of Dutch and Flemish artists in Rome), with which he often signed his paintings, was "Studio," a pseudonym indicative both of his meticulous approach to his work and possibly a reference to his assiduous attention to the paintings of Claude Lorrain. Van Lint was patronized to a great extent by visitors to Rome on the Grand Tour, who acquired his paintings as souvenirs of their travels through the Campagna to Rome, but he also came to be enthusiastically collected by the patrician families of Rome, Altoviti, Capponi, Pamphili, Sacchetti, and Soderini. Don Lorenzo Colonna in

particular admired Van Lint's landscapes, and more than seventy of his works are listed in the 1783 catalogue of the Galleria Colonna. Inevitably a strong component in his contemporary popularity were the echoes of the ideal landcapes of Claude Lorrain, whose favorite motifs he often set within even more picturesque combinations. Van Lint always maintained a veneration for the art of Claude, whose compositions he often literally copied, occasionally signing them with his own name. He possessed an exceptional ability to enter into the spirit of Claude's pastoral landscapes, which he would have known at first hand in a number of Roman collections. His own delicate and picturesque treatments of the landscape in and around Rome evoke a similar sense of the pastoral serenity of a Golden Age.

Van Lint's earliest topographical views (*vedute dal vero*) of Rome include sweeping panoramic views of the city from a variety of approaches and locations that suggest the breadth and reach of his aspirations as a *vedutista*. His repertory of views eventually encompassed practically everything worth seeing in the Eternal City, and he returned again and again to such classical sites as the Colosseum, Arch of Constantine, Pyramid of Cestius, and the Baths of Diocletian and Caracalla. Van Lint held an obvious affection for Rome's rivers with their picturesque bridges, which he endowed with a curious mixture of naturalism and poetry. His ability to imbue these scenes with an almost magical luminosity and capture the particulars of a scene with extraordinarily acute powers of observation is without parallel in the Settecento. His views constitute a catalogue of the sites along the Tiber such as the Porto di Ripetta, Castel S. Angelo, S. Giovanni dei Fiorentini, and the Isola Tiberina and the Sant' Angelo, Sisto, and Rotto bridges.

Van Lint also held deep feelings for the beauty of the countryside around Rome, gathering from the Campagna material for his painted compositions in the form of pencil, pen, and wash drawings made on the spot. The starting point for his paintings was often a drawing made out-of-doors to which he frequently added ruins, buildings, hillsides, and foliage as imaginary elements to the actual landscape. He paid scrupulous attention to the memorable remains of antiquity in the Campagna and often such archaeological monuments as the tomb of Caecilia Metella, Tor de' Schiavi, the so-called tomb of the Horatiae and Curiatii, the Temple of the Sibyl at Tivoli, and the tomb of Nero on via Cassia appear in various formats in his landscapes of Latium.

Like his cohort, the Roman landscapist and view painter Andrea Locatelli, Van Lint was powerfully drawn to scenes with water; not only views of the Tiber and Aniene rivers, but also the cascades at Tivoli and the falls at Terni, which in the eighteenth century were among the principal natural spectacles in Italy. He was deeply impressed by the beauty of the coastline near Rome, which practically from his arrival Italy figured in both his realistic and imaginary views, reflecting the inspiration of a variety of sources ranging from Jan Brueghel to Claude Lorrain. There are a number of views of Naples and Venice signed by Van Lint, but there is no documentary evidence that he actually traveled to these cities, and he appears to have developed these scenes on the basis of compositions by Van Wittel.

Van Lint often endowed his compositions with decisively classical figures copied from famous works by Guido Reni and other Seicento painters (cat. 237) and, according to Busiri Vici, supplied by Pompeo Batoni, Giuseppe Chiari, Sebastiano Conca, Corrado Giaquinto, Adriaen Manglard, Anton Raphael Mengs, and Pierre Subleyras. Van Lint in turn emulated the style of these *figurine* by his collaborators, occasionally copying them exactly himself at a later date.

Van Lint was a prominent member of artistic society in Rome, accepted as a member of the Congregazione Artistica dei Virtuosi al Pantheon in 1744 (although not of the more prestigious Accademia di S. Luca), a corporation of artists who organized an annual exhibition of their own paintings in the portico of the Pantheon. He was elected Reggente, or rector, of this body in 1752. He married Ludovica Margareta Tassel di Giacomo in 1719, and among their ten children Giacomo became a distinguished landscapist in his own right. There is contemporary evidence that Hendrik Frans van Lint also acted as a picture restorer on occasion. He died in Rome on September 24, 1763, in his house on via del Babuino. [EPB]

BIBLIOGRAPHY Zwollo 1973, pp. 90–119; Coekelberghs 1976, pp. 75–129; Roethlisberger 1983, pp. 190–94; Busiri Vici 1987, pp. 21–269

## 236

## Hendrik Frans van Lint, *called* Monsù Studio

### *A View of Borghetto, near Rome*

1713
Signed and dated at lower left: *HF* [monogram] *van lint Fi./ 1713*
Oil on canvas
21¼″ × 42½″ (55 × 108 cm)

PROVENANCE acquired in Rome in the early eighteenth century by a member of the Hearne family of Hearnesbrooke House, Killimor, co. Galway, Ireland; purchased with Hearnesbrooke House by Judge Aeneas MacKay; Hearnesbrooke House sale, December 6, 1912, lot 188; sale, Christie's, London, December 13, 1996, lot 87, where purchased by the present owner
BIBLIOGRAPHY Briganti 1996, p. 174 (described as dated 1711)
Private collection

Van Lint's best-known works are his relatively straightforward views in and around Rome, the topographical objectivity of which derives from the methods and manner of Gaspar van Wittel, with whom he was associated in his early years in Rome, between 1700 and 1710. Their relationship must have been close, although no documentation links the two painters beyond their fellow-membership in the Schildersbent, the fraternal association of northern artists in Rome. Denis Coekelberghs (Coekelberghs 1976, p. 85) noted that Van Lint arrived in Rome at a time when the older artist found it difficult to keep up with the pace of his commissions, and Van Lint's knowledge of Van Wittel's compositions strongly suggests that he worked in the older artist's studio before emerging as an independent artist in 1711. *A View of Borghetto, near Rome* was sold in 1996 with a striking pendant view by Gaspar van Wittel of *St. Peter's, the Vatican and Rome from the Vigna di Santo Spirito* (Briganti 1996, p. 174, no. 116; cat. 308). Other instances of the two painters sharing the execution of a pair of paintings have been suggested (London 1978, nos. 7 and 24, as the work of Van Wittel and Van Lint, respectively), and at Holkham Hall a signed view by Van Lint of Castel S. Angelo (Busiri Vici 1987, p. 79) hangs en suite with seven views by Van Wittel acquired in Rome in 1716 by Thomas Coke (Jackson-Stops 1985, p. 264).

Van Lint was a close observer of his surroundings, in Rome and in the Campagna, and the Dutch writer Arnold Houbraken relates how he had "the habit, at certain times of the year, of spending a few weeks outside Rome drawing ruined palaces, rocks, mountains, and attractive landscapes, in order to ease his mind"

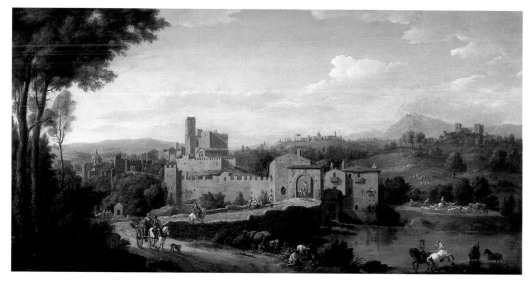

236



(Coekelberghs 1976, p. 80). These trips to Amelia, Ariccia, Capranica, Caprarola, Castelgandolfo, Civita Castellana, Nemi, Sutri, and Valmontone provided the raw material in the form of sketches and drawings for picturesque views he composed and painted in his studio. The landscapists of the Seicento went out into the Campagna, and returned with drawings from nature; Van Lint is distinguished, as Clovis Whitfield has observed, for being among the first eighteenth-century painters to realize the picturesque possibilities of these views, after ignoring their topographical exactness in favor of aestheticism (London 1978, *Grand Tour*, biographical note).

Borghetto, or Castello Savelli, is a ruined thirteenth-century castle built on Roman foundations along the ancient via Latina between Grottaferrata and Frascati. It passed from the counts of Tusculum to the Savelli, and later to Julius II, who converted it into an outwork of the abbey of Grottaferrata. The site was obviously pleasing to Van Lint, for seven other views of Borghetto are known, all different (Busiri Vici 1987, pp. 108–12, nos. 106, 109–14). The present painting is much the largest and finest and in the opinion of Giuliano Briganti it "may be numbered among the finest works of Van Lint" (letter described in Christie's sale catalogue, London, December 13, 1996, p. 153). A pen-and-ink drawing in Berlin (Busiri Vici 1987, p. 108, no. 108) was clearly used for this depiction of the village and its medieval castle, which still survive. [EPB]

## 237

### Hendrik Frans van Lint, *called* Monsù Studio
### Ideal Landscape with Bacchus and Ariadne on the Island of Naxos

1741
Signed and dated at the lower left: *Enrico Franco van Lint d. studio. Fe. Rome 1741*
Oil on canvas
59⅜″ × 76¼″ (151 × 195 cm)
PROVENANCE Chevalier Raoul Tolentino, Rome; sale, American Art Association, New York, May 1–2, 1919, lot 297; sale, American Art Association, New York, April 22–26, 1924, lot 334; Appleby Brothers, London; sale, Christie's, London, November 26, 1976, lot 81; Richard L. Feigen & Co., New York; from whom purchased by the present owner
EXHIBITIONS Milan, Arte Antica srl. *Dipinti dal XV al XVIII secolo*. 1978; Munich 1983, cat. no. 126; Frankfurt, Bologna, Los Angeles, and Fort Worth 1988, cat. no. D32
BIBLIOGRAPHY Clark 1961, "Figures," p. 55 (assigning the figures to Pompeo Batoni); Clark and Bowron 1985, p. 373 (rejecting the earlier attribution to Batoni); Busiri Vici 1987, pp. 232–33, no. 277; Jaffé 1993, p. 84, fig. 97 (erroneously reattributing the figures to Pompeo Batoni)
Sandra H. Payson Collection

One of Hendrik Frans van Lint's rare large-format canvases and clearly a major commission from a patron who has not been identified, *Ideal Landscape with Bacchus and Ariadne on the Island of Naxos* is loosely derived from a famous landscape painted in Rome by Claude Lorrain a hundred years earlier (1648; Galleria Doria-Pamphili, Rome). Van Lint has reversed and made a number of modifications to Claude's composition, analysed by Roethlisberger (Roethlisberger 1983, p. 194) in his discussion of the two paintings. The most significant differ-

ence is neither Van Lint's simplification of the earlier composition nor his alteration or suppression of various natural and figural elements in Claude's landscape (although his substitution of a herd of elephants for a waterfall in reference to Bacchus' sojourn in India is highly amusing), but rather his creation of a radiant, crystal-clear morning light that suffuses the landscape. Van Lint's palette is also blonder and his colors higher in key than Claude's, and the result is a landscape that anticipates the paintings of Jakob Philipp Hackert (in the second half of the eighteenth century) more than it reflects its ultimate heritage, the ideal landscapes of Annibale Carracci a century and a half earlier.

The subject is Bacchus' rescue of Ariadne following her desertion by Theseus on the island of Naxos (Ovid, *Metamorphoses* 8: 176–82). Bacchus is seen arriving with his retinue, among which are music-making satyrs and maenads and putti carrying his

thyrsus. The drunken Silenus emerges from the path on the right, accompanied by revelers. The main group of figures is derived from the composition of Guido Reni that Cardinal Francesco Barberini had commissioned in 1637–40 for Queen Henrietta Maria of England, which was later destroyed but was widely known in the eighteenth century through a number of contemporary copies and engravings (D. Stephen Pepper, *Guido Reni: A Complete Catalogue of His Works with an Introductory Text* [Oxford: Phaidon, 1984], pp. 278–79, pl. 202). Van Lint reused the central group in his landscapes on several other occasions.

The motif of the sleeping nymph in the lower right corner is common in van Lint's work, deriving from ideal landscapes of the Seicento such as Claude's *Landscape with Narcissus and Echo* (1644; National Gallery, London), although it can be traced back through Giorgione's *Sleeping Venus* (Gemäldegalerie Alte Meister, Dresden) to its original prototype in ancient sculpture. Steffi Roettgen (Frankfurt, Bologna, Los Angeles, and Fort Worth 1988, p. 612) has suggested that this nymph may be associated with Ariadne, exhausted after her painful abandonment by Theseus and now awakened to gaze upon her new and happy destiny with Bacchus.

Beginning in the 1730s, Van Lint employed Pompeo Batoni to supply the "numerose figurette" in his pastoral landscapes (Clark and Bowron 1985, nos. 7–12; Busiri Vici 1987, nos. 246, 249, 251, 256, 260). Batoni's earliest biographers emphasized his admiration for Reni, Domenichino, and, of course, Annibale Carracci. He continued in the late 1730s and early 1740s to study Reni, and it was recognized that he was one of the few painters of this period who could produce a successful modern equivalent of Reni's work.

237



Father John Thorpe reported in a letter of April 2, 1774, to Lord Arundell that he had been offered six "views" in private hands at a grand price "because all of the figures which are many in each were put by Pompeo when young, and are chiefly copied from original pictures" (Clark and Bowron 1985, pp. 53–54).

The joint masterpiece of Van Lint and Batoni, a collaboration of the late 1730s now in the Staatsgalerie Stuttgart, was inspired by a Claude of 1644 now in Grenoble (Clark and Bowron 1985, no. 12). Comparison between the *figurine* in that painting and in this reveals substantial differences, and underscores the fact that Van Lint, like Jan Frans van Bloemen, was quite capable of adopting the figural styles of the history painters with whom he collaborated and executing the figures in his landscapes entirely by himself. The figures in the present work are unquestionably by Van Lint, probably after drawings made earlier for him by Batoni. An important record of Batoni's repertory of figural motifs for this purpose is the pocket album of sketches at Philadelphia, which contains, for example, quite a number of ideas for *figurine* in works that can be dated to the second half of the 1730s, including a drawing for the standing figure of a woman carrying a child in her arms in a landscape collaboration between the two artists (Clark and Bowron 1985, pp. 54, 63, n. 148). [EPB]

## ANDREA LOCATELLI
### ROME 1695–1741 ROME

Born on December 19, 1695, Locatelli was one of the foremost eighteenth-century interpreters of the landscape of the Roman Campagna. He received his initial artistic training from his father, Giovanni Francesco, a little-known Florentine painter who settled in the district of Trastevere in Rome around 1700. Nicola Pio recounts that at the age of twelve he became a pupil of "Monsù Alto," a little-known painter of coastal views in the style of Adrian Manglard and Jacob de Heusch, few of whose works exist. After Alto's death around 1712, Locatelli entered the studio of another marine painter, Bernardino Fergioni, and then went on to Biagio Puccini to draw from life and the human figure. This pattern of study appears quite common in the careers of eighteenth-century Roman *vedute* painters.

Locatelli's art developed from a close reliance upon seventeenth-century sources to an increasingly imaginative idealization of the Roman countryside. His earliest works consist of landscape capriccios incorporating Roman ruins such as the Arch of Titus and Pyramid of Cestius that reveal a profound debt to Giovanni Ghisolfi and Salvator Rosa and anticipate the early works of Panini, with which they have been confused. In 1715 he oversaw the painting of a room on the ground floor of the Palazzo Ruspoli in Rome, whose walls were covered with marine scenes in gouache. It appears that Locatelli painted only the figures and was already being paid at the rate customary for a master painter. He also decorated Prince Antonio Ottoboni's apartments in the Palazzo della Cancelleria, Rome, with landscapes (untraced) that were highly praised by Pio.

Locatelli's principal contemporary reputation derived from his landscapes and *vedute* on canvas, and before 1723 he was an independent master, in demand from both foreign and local patrons such as Cardinal Alessandro Albani and Cardinal Pietro Ottoboni. His most distinguished early decorative commissions were from Filippo Juvarra on behalf of Vittorio Amadeo II of Savoy for two views of the unfinished Castello di Rivoli in Turin, in which Locatelli interpreted Juvarra's plans and designs (1723–25; Castello di Racconigi, Turin). In 1735, again through Juvarra, he received a commission from King Philip V of Spain for two over-doors in the "Chinese Room" designed by Juvarra in the Palace of S. Ildefonso in Segovia, which show *Christ in the Desert* and *Christ and the Woman of Samaria.* In 1738 Locatelli decorated two doors in the Palazzo Corsini, Rome, each with four decorative panels of landscapes. The Colonna family bought many of his paintings and a 1783 inventory of Palazzo Colonna lists more than eighty of his works; the Barberini once owned more than twenty of his landscapes.

Locatelli first specialized in river and coastal scenes strongly influenced by the marine paintings of Salvator Rosa. His early works also include a group of paintings that show landscapes with ancient ruins, although his interest in the genre was brief. His later, idyllic views of the Roman Campagna show his absorption of the Arcadian landscapes of Gaspard Dughet, which he made lighter, airier, and more idealized under the influence of Jan Frans van Bloemen. (In Anthony Clark's words, "Locatelli can best be compared with the older van Bloemen, than whom he is more realistic, introspective, clear in his use of light, and rounded in his sense of form" [Clark 1970, p. 198]). In 1728 Pier Leone Ghezzi inscribed a caricature of him, *A. Lucatelli famoso pittore di paesi* (Vatican Library, Cod. Ottob. Lat. 3116, fol. 87), and mythological scenes in Arcadian landscapes became a feature of his career in the 1730s and 1740s.

Locatelli painted a few realistic *vedute* of Roman sites on copper, notably a *View of the Piazza Navona with a Market* and *View of the Roman Forum* (1733; Gemäldegalerie der Akademie der Bildenden Künste, Vienna); these remain an exception from his usual, more fanciful interpretations of the city and its environs. He also painted *bambocciate* in his later years that take advantage of his competence as a figure painter and seem to reveal the inspiration of the art of Filippo Lauri. On the other hand, Locatelli occasionally made use of the talents of history painters such as Giuseppe Tommasi, Pierre Subleyras, and Pompeo Batoni to supply the figures in his landscape compositions.

Locatelli suffered considerable financial difficulties during his lifetime, in part because he worked slowly and was burdened with a large family and poor health. He died on February 19, 1741, according to Olivier Michel, "after a dissolute life, in poverty and unlamented, his widow renouncing all claim to an estate that was crippled with debts" (Michel 1996, "Locatelli," p. 525). [EPB]

BIBLIOGRAPHY Pio [1724] 1977, pp. 185–86, 310–11; Mosco 1970; Maxon and Rishel 1970, p. 198; Busiri Vici 1976; Fernandez 1977, pp. 274–77, 477–78, pl. 78; Michel and Michel 1977; Rangoni 1990, "Locatelli"; Michel 1996, "Locatelli"

## 238
## Andrea Locatelli
### *Landscape in Latium with Fisherman at a River*

c. 1730–35
Oil on canvas
51⅞″ × 37⅜″ (132 × 95 cm)
Private collection

## 239
## Andrea Locatelli
### *Landscape with Herdsmen and Animals*

c. 1730–35
Oil on canvas
51⅞″ × 37⅜″ (132 × 95 cm)
PROVENANCE Geri collection; sold Milan, March 16–19, 1937, lots 167, 168; with Colnaghi, London, c. 1962; Michael Jaffé, Cambridge; Thomas Agnew & Sons, Ltd., London, 1976; private collection, U.S.A.
BIBLIOGRAPHY Busiri Vici 1976, pp. 102, 264, nos. 165–66, figs. 122, 122a
Private collection

It is difficult to establish a chronology for Andrea Locatelli's œuvre, since his style remained fairly homogeneous throughout his career and he rarely signed and dated his paintings. His early style has its roots in the work of Giovanni Ghisolfi and Salvator Rosa, but these influences gave way in his mature paintings to a more poetic and idealized interpretation of the Roman landscape. He developed an individual type of "idyllic" Arcadian landscape that accounts for most of his production, aside from some *bambocciate* and a few topographical views. By the mid-1720s Locatelli's landscapes were in considerable demand from both Roman and foreign patrons, and his reputation in his lifetime rivaled that of his elder contemporary Jan Frans van Bloemen. The compositional assurance and decorative impact evinced in this exceptional pair of landscapes make it easy to understand why Locatelli was so successful.

Another powerful source lies behind Locatelli's development, whose allure few eighteenth-century Roman *paesisti* could resist—Gaspard Dughet's landscapes, which were held in great repute and were abundant in the collections of local aristocratic families such as the Colonna, who had been the painter's greatest patrons. The compositions seen here employ a number of features adopted from Gaspard's Campagna landscapes and reveal Locatelli's admiration for the French master's works—for example, the highly classical arrangement of the landscape with fisherman, expressed in the recession of planes parallel to the picture surface leading to a vista in the distance; the long sloping diagonal leading into the middle ground in the companion painting; and the classical framing and containing use of trees, extending from the bottom to the top of each canvas. There is no confusing Locatelli's delicate handling with Gaspard's, however, and his high-keyed palette and luminous atmosphere are distinctly his own.

Anthony Clark's witty and intelligent insights into the work of Locatelli are relevant when looked at in comparison with these large and memorable landscapes:

Locatelli's style begins in Salvator Rosa and tends to remain rough, autumnal and dry (doubtless from the Attic salt Lanzi noticed). He is a wistful and sympathetically candid artist, and the extremely delicate but rather fatuous poetry of Filippo Lauri was another influence, transformed by Locatelli into something more rough, brawny, and male …. Unlike van Bloemen he almost always does his own figures, using a woebegone type, which is usually sympathetic and sometimes exquisite. He specialized in rustic genre scenes as well as less populated landscapes and in these scenes he was imitated by his pupil Paolo Monaldi, who

238

239

had none of Locatelli's sense of tension and interplay between landscape and human figure (which van Bloemen, mechanically modernizing Gaspard Poussin, also missed) ... In all his best pictures Locatelli's humans are battered but real participants in nature. They do not loiter in an easy park as in Van Bloemen. Even though they may be pensioners of a certain defeat they are inhabitants with accurate tasks. In most of the best pictures there is a concern with water, even though water is the rarest presence in Locatelli's pictures. (Clark 1970, p. 198) [EPB]

## 240
## Andrea Locatelli
*View of the Roman Forum*

c. 1733
Oil on copper
28¾″ × 36⅝″ (73 × 93 cm)
PROVENANCE possibly Liechtenstein family collections, Vienna; Hazlitt, Gooden & Fox, London, 1997–98; from whom acquired by the present owner

BIBLIOGRAPHY Busiri Vici 1976
Private collection, courtesy of Hazlitt, Gooden & Fox Ltd., London

Among Locatelli's several hundred surviving paintings, only a handful depict topographically accurate views. The earliest of these are a pair of large perspective views of the projected Castello di Rivoli, based on Filippo Juvarra's designs, and painted in 1723–25 for Vittorio Amedeo II of Savoy (Castello di Racconigi, Turin). His other *vedute reali* encompass a view of the Tiber with the Ponte Rotto (Städtisches Museum-Gemäldegalerie, Wiesbaden), a view of the Tiber with the Castel S. Angelo (private collection, Rome), and a view of the Piazza Navona, signed and dated 1733 (Gemäldegalerie der Akademie der Bildenden Künste, Vienna; Busiri Vici 1976, nos. 213–17).

This present view of the Roman forum is almost certainly the pendant to the Vienna picture, with which it shares the same dimensions and copper support, which Locatelli rarely employed. Both paintings are distinguished by their pictorial quality, faithful depiction of Roman sites, and elision of the genres of *bambocciate* and topographical view painting. The Piazza Navona, with its famous foun-

tain by Bernini and memorable façade of S. Agnese by Borromini, was one of the major squares in Rome and an obligatory destination on every seventeenth- and eighteenth-century tourist's itinerary. Gaspar van Wittel recorded the Piazza Navona in a series of paintings on parchment, copper, and canvas from 1688 to 1721 (Briganti 1996, nos. 36–44), and it is his angled view observed from the piano nobile of the Palazzo Massimo Lancelotti that Locatelli has used in the Vienna picture. Given the contemporary interest in views of the Piazza Navona—recorded by Panini, Canaletto, Bellotto, and Vasi among many others—it is not at all unusual that Locatelli would have fulfilled a request for a *veduta esatta* of the Piazza Navona as a vast open-air market, although the pairing of the square with the forum is unusual. (Van Wittel, for example, most often linked his views of the Piazza Navona with a pendant showing the square of St. Peter's.)

In the view of the Roman forum, as in that of the Piazza Navona, Locatelli reveals his *horror vacui*, filling every inch of his composition with representatives from the lower ranks of Roman society, horses, sheep, dogs,

oxen, and, above all, cows. The forum was, after all, a cow pasture in the seventeenth and eighteenth centuries (when it was called the Campo Vaccino) and its rural character is deliberately emphasized by Locatelli. He has chosen the usual viewpoint, with his back to the Capitoline Hill, looking from west to east, but in comparison to the two views in the exhibition by Panini (cats. 267, 274), he has taken spectacular liberties with the topography of the site. For example, this view appears to begin roughly halfway down the forum, about where the fountain and water trough erected there in the sixteenth century and removed to the Piazza del Quirinale on Monte Cavallo in 1816 was located. This perspective affords a clear view of S. Maria Liberatrice (now destroyed) and the Farnese Gardens on the right. However, the Arch of Titus, marking the eastern boundary of the forum, seems nearly as distant as in Panini's view (now in Detroit), and the three columns and a fragment of entablature of the Temple of Castor look oddly out of place (and forlorn) at the extreme right edge of the composition.

Locatelli's interest in the depiction of low-life figures and animals vies

240

with his concern for topography, however, and this almost surreal scene of the forum as cow pasture shows why he was so successful in the tradition of Pieter van Laer and Netherlandish painters in Rome. His scenes of simple country life (games, dances, festivals, eating and drinking at rural *osterie*) in Arcadian settings that are often characterized by ruined, thatched buildings were evidently popular in the 1730s, and his *bambocciate* were owned by such sophisticated collectors as Cardinal Silvio Valenti Gonzaga (Busiri Vici 1976, nos. 218–53). His principal follower in this genre was Paolo Monaldi, whose work in this vein for Prince Camillo Rospigliosi and decorations in the 1770s of the second-floor apartments in the Palazzo Barberini give an indication of the sustained popularity of genre painting in Settecento Rome.

The gift of the companion view of the Piazza Navona to the Akademie der Bildenden Künste, Vienna, by the estate of Prince Johann of Liechtenstein in 1881 (Robert Eigenberger, *Die*

*Gemäldegalerie der Akademie der Bildenden Künste in Wien* [Leipzig, Germany, 1927], p. 234), suggests a similar provenance for this work. [EPB]

## BENEDETTO LUTI
### FLORENCE 1666–1724 ROME

Benedetto Luti was one of the most significant and influential artists active in Rome in the first quarter of the Settecento. The son of a Florentine artisan, he was born on November 17, 1666, and trained in his native city under the direction of Anton Domenico Gabbiani, from whom he thoroughly absorbed the style of Pietro da Cortona and his late Baroque successors. In 1690 he left Florence for Rome, where in 1692 he made his artistic début in the annual Saint Bartholomew's Day exhibition with a monumental painting of *God Cursing Cain after the Murder of Abel* (The National Trust, Kedleston Hall, Derbyshire) and in the same year won first prize in the first class of painting

in the Concorso Clementino at the Accademia di S. Luca. He quickly rose to prominence and in 1694 was elected to the academy as *accademico di merito*. He produced a variety of works for the leading Roman families—the Torri, Colonna, Pallavicini, Barberini, and Odescalchi—and enjoyed the patronage of Pope Clement XI, Cardinal Pietro Ottoboni, Cardinal Carlo Agosto Fabbroni, and Padre Antonin Cloche, master-general of the Dominican order. His public works in Rome included altarpieces for S. Caterina da Siena a Magnanapoli and Ss. Apostoli; he also painted for the churches of S. Maria degli Angeli, Pistoia; Ss. Jacopo e Filippo, Pontedera; and S. Caterina d'Italia, Valetta.

Luti was invited to participate in the most important papal commission to painters in Rome in the first quarter of the century, the series of Old Testament Prophets above the nave arcade in St. John Lateran (cat. 243). He was also involved in the major secular commission of the time in

Rome, a group of ceilings in the Palazzo de Carolis (now the Banca di Roma), contributing an *Allegory of Diana* (c. 1720; *in situ*). In Florence he enjoyed the support of Grand Duke Cosimo III de' Medici, and it was through his connection with the Tuscan court that his artistic reputation spread to France, England, and Germany.

Like many young artists in Rome around 1700, Luti consciously adopted his native style of painting to conform to the Roman classical tradition and devoted years to the study of Raphael, Annibale Carracci, Domenichino, Guido Reni and Carlo Maratti, the grand exemplars of Roman *disegno*. His long years of study were rewarded in 1712, when he produced *The Investiture of Saint Ranieri* (Pisa Cathedral), his first major work to reveal on a grand scale his mastery of the traditional Roman conventions of invention, expression, composition, and anatomy. This brilliant rephrasing of Roman classicism according to the lighting, color, and

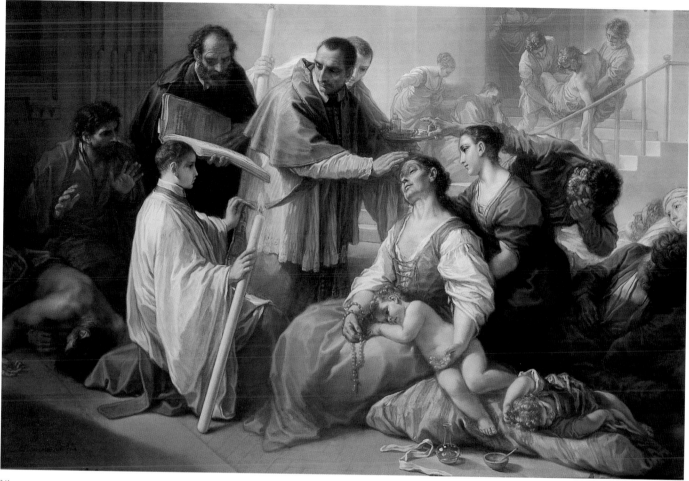

241

handling of Florentine Baroque painting resulted in a style that was distinguished, within the context of contemporary painting in Rome, by its effects of luminosity, color, painterly richness, and naturalism.

The grand, rhetorical manner of the Pisa painting, which formed the basis of all Luti's subsequent works, was taken a stage further in 1713 in one of his greatest pictures, *Saint Charles Borromeo Administering Extreme Unction to the Plague Victims* (cat. 241). In that year Luti also dispatched the first of several paintings commissioned by the electoral archbishop of Mainz, Lothar Franz von Schönborn, for Schloss Weissenstein in Pommersfelden (cat. 244). Following the death of Maratti in 1713, Luti's reputation in Rome was greater than that of any other painter in the city, and during his lifetime it was seriously rivaled only by that of Trevisani and Chiari.

Luti was one of the great colorists of eighteenth-century Rome, and his influence on later artists, such as Pompeo Batoni, was considerable. He was not, however, a prolific painter (only about seventy-five autograph paintings survive), and he is probably better-known today for his pastel and colored chalk drawings (cats. 366–68). These studies of heads and busts of apostles, saints, angels, and children are remarkably fresh and brilliant. They were deliberately imitative of the art of Correggio, which enjoyed enormous vogue in the eighteenth century, and share with the paintings of the sixteenth-century Emilian master similar qualities of sweetness, charm, suavity, and, above all, grace of color and drawing.

One explanation for Luti's restricted artistic production is his activity in the Roman art world as a connoisseur, collector, and academician. As a result of the patronage of Grand Duke Cosimo III, Luti received countless opportunities to meet foreign visitors and their agents in Rome. With a reputation as the "best connoisseur in Rome" (Richardson J. 1722, p. 182), he was one of the principal dealers on the Roman art market. He maintained close relationships with foreign collectors, in particular with Pierre Crozat and Pierre-Jean Mariette, and he was involved in the sale and dispatch of the famous collection of paintings of Queen Christina of Sweden to Philippe II, Duc d'Orléans, in Paris. As a collector, Luti achieved an even greater reputation, among Romans and foreigners alike, and one contemporary estimated his collection of drawings to number around fifteen thousand.

Benedetto Luti was also active as a teacher and academician. He held private drawing classes and maintained a large studio on a more formal basis, especially between 1710 and 1720. Among his more notable pupils were Pietro Bianchi, Placido Costanzi, William Kent, Jean-Baptiste van Loo, Carle van Loo, Giovanni Paolo Panini, and Giovanni Domenico Piastrini. He exercised an important teaching and administrative role in the Accademia di S. Luca: from 1704 or earlier he was elected annually as one of the judges for the academy's competitions; he frequently taught the life drawing classes; he played a prominent role in 1715 in the deliberations leading to the major changes in the institution's statutes intended to consolidate its authority in the Roman art world; and in 1720 he was elected the academy's Principe. Luti died on June 17, 1724. [EPB]

BIBLIOGRAPHY Pio [1724] 1977, pp. 24–25; Bottari and Ticozzi 1822–25, vol. 2, pp. 70–84, vol. 5, pp. 304–5, and vol. 6, pp. 165–70 (a selection of the artist's letters); Moschini 1923; Heinzl 1966; Sestieri 1973; Bowron 1979; Bowron 1980; Coccia 1990, "Luti"; Pascoli 1992, pp. 317–23; Bowron 1996

## 241

### Benedetto Luti
*Saint Charles Borromeo Administering Extreme Unction to the Victims of the Plague*

1713
Signed and dated at lower left: *Roma 1713/ Benedetto Luti fece*
Oil on canvas
41½″ × 61⅜″ (108 × 159 cm)

PROVENANCE acquired by the Palatine Elector Johann Wilhelm, Düsseldorf; evacuated to Munich in the winter of 1805–6 during the Napoleonic wars and incorporated into the collection of the electorate of Bavaria; Bavarian State collections

BIBLIOGRAPHY Pigage 1778, vol. 1, p. 25, no. 134; Parthey, Gustav. *Deutscher Bildersaal: Verzeichniss der in Deutschland vorhandenen Oelbilder verstorbener Maler aller Schulen.* Berlin: Nicolais, 1863–64, vol. 2, p. 63, no. 11; Moschini 1923, p. 111, no. 30, fig. 8; Voss 1924, pp. 365, 609–10; Sestieri 1973, p. 253, no. 71; Bowron 1979, pp. 164–71, 282, no. 68, fig. 95; Bowron 1996

Bayerische Staatsgemäldesammlungen, Munich, Staatsgalerie Schleissheim

The conditions of artistic patronage in Italy changed dramatically at the end of the seventeenth century, and the traditional sources of patronage expanded with an influx of collectors and their agents from London, Paris, Düsseldorf, Vienna, Munich, Stockholm, and Madrid. One of the most energetic of these new patrons was the Palatine Elector Johann Wilhelm (1658–1716), the aristocratic and elegant prince of the Holy Roman Empire. In 1678, after becoming ruler of the duchies of Jülich and Berg, he rapidly expanded his art collections and established the foundation for a picture gallery that eclipsed all other eighteenth-century German collections. He acquired masterpieces by Rembrandt, Rubens, Van Dyck, Titian, Raphael, and Veronese, the majority of which have passed into the Bavarian state collections, but he was also keen to acquire paintings by contemporary masters and filled his galleries with Italian late Baroque paintings.

The two paintings by Luti owned by Johann Wilhelm—the present canvas, finished September 30, 1713, and an *Education of the Virgin* (1715; Alte Pinakothek, Munich)—were probably acquired as part of the continuing exchange of gifts between the courts of Florence and Düsseldorf. On May 17, 1691, the elector had taken a second wife, Anna Maria Luisa de' Medici, daughter of Cosimo III, and the occasion prompted a dispatch of presents from the grand duke to his son-in-law, including paintings and sculptures executed by his favorite artists in both Florence and Rome, including Luti, Anton Domenico Gabbiani, Massimiliano Soldani Benzi, and Giovanni Battista Foggini.

The earlier of the paintings by Luti acquired by the elector for his Düsseldorf gallery depicts an event in the life of Charles Borromeo (1534–1584), one of the most exalted figures in Counter-Reformation art. Popular devotion to the saint, viewed by his contemporaries as an exemplar of Christian charity, continued undiminished into the eighteenth century, especially in Italy. Saint Charles was, moreover, revered personally by Johann Wilhelm—himself a devout Catholic, educated by Jesuits—who once paid a visit to the relics of Saint Charles in the church of S. Ambrogio in Milan. The most notable event in the saint's life occurred on August 2, 1576, during the plague that devastated Milan. In the extensive hagiographical literature that flourished at the time of his canonization in 1610, his heroism in caring for the dead and dying and administering the sacraments to them was extolled and popularized as a theme in the visual arts. In the Schleissheim painting, Saint

Charles, wearing a violet mozzetta, is shown in the streets of the city amid a crowd of dying citizens. He is flanked by a deacon holding a missal and a server bearing a plate with the chrism. Although the literary sources report that the saint administered the sacraments of Confirmation, Penance, and Extreme Unction to the plague-stricken, here there is little doubt that the woman in the foreground receives the Last Rites.

The principal source for Luti's design is Pierre Mignard's 1657 altar for S. Carlo ai Catinari, Rome, *Saint Charles Borromeo Administering Eucharist to the Dying*. Although replaced ten years later by Pietro da Cortona's painting of a related episode in the life of the saint, Mignard's composition continued to inspire eighteenth-century painters through Jean Audran's engraving. Besides the general compositional arrangement of the principal figures, Luti has adopted from Mignard's painting such specific thematic motifs as the young acolyte bearing a candle, the stricken woman holding a rosary, the dying infant sliding from her lap, and the ribbon, flask, and bowl in the lower right foreground.

Luti has also borrowed from such other obvious sources as Marcantonio's engravings after Raphael, Nicolas Poussin's *Plague of Ashdod* (a copy was in the Palazzo Colonna by 1715), and Domenichino's *Saint Cecilia Distributing Alms* (S. Luigi dei Francesi, Rome). The influence of these classical models is evident in the lucid organization of the figures, the solidity and definition of the individual forms, and in the sharp, precise drawing. Luti has used these classicizing sources to moderate the Florentine Baroque style he brought to Rome in order to create an entirely original and personal pictorial solution to the difficult demands of history painting. The Schleissheim painting represents a major success for Luti in his effort to achieve a pictorial clarity and grandeur of effect worthy of Raphael and Maratti. One explanation of Luti's contemporary success is his ability to engage his audience sympathetically and make the drama of the scene he depicts a real and present event to the observer. Another is found in the painter's own aesthetic sensibility, his preference for quiet poses and diminished movement, for subtle color harmonies and tonal nuances, and for refined emotional content. [EPB]

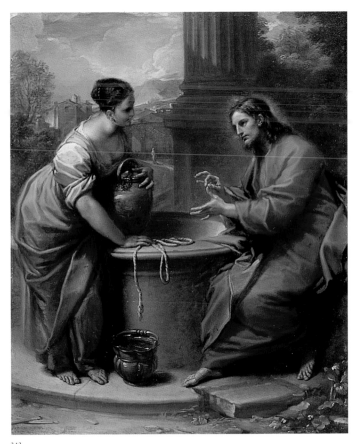

242

## 242
## Benedetto Luti
### *Christ and the Woman of Samaria*

c. 1715–20

Inscribed in ink on the reverse of the support: *Mr. West*, and an illegible catalogue number or price: W^c 18

Oil on copper

14½″ × 11¾″ (37 × 30 cm)

PROVENANCE said to be from Benjamin West's collection; Arthur Appleby, London, 1960; from whom purchased by Anthony Morris Clark, Minneapolis and New York, 1960–76; private collection

EXHIBITION Chicago, Minneapolis, and Toledo 1970, cat. no. 84

BIBLIOGRAPHY Sestieri 1973, p. 252, no. 33; Bowron 1979, pp. 179–80, 268, no. 32, fig. 109

Private collection, Houston

Although paintings in oil on copper are generally associated with northern European painting of the late sixteenth and seventeenth centuries, a number of Roman Settecento painters employed the support for small cabinet paintings. Copper had of course been used as a support for small devotional paintings by Annibale Carracci, Guido Reni, and Domenichino in the early seventeenth century, but Carlo Maratti's small *Holy Family* (Gemäldegalerie, Kunsthistorisches Museum, Vienna),

painted in 1704 for one of the most important patrons of the day, Cardinal Pietro Ottoboni, sparked renewed interest in the technique in Rome in the first half of the eighteenth century. Placido Costanzi, Sebastiano Conca, and Francesco Trevisani notably painted small, exquisite paintings, sacred and profane, on copper but one can find examples of the technique in the œuvres of Batoni, Giaquinto, and many other contemporary Roman artists.

These painters utilized copper with the deliberate intention of fashioning something that would be out of the ordinary and remarkable, and the small cabinet-sized pictures with their jewel-like surfaces and delicate handling found an enthusiastic response in both cultivated lay and ecclesiastical circles of patronage in Rome. Benedetto Luti's *Christ and the Woman of Samaria*, once a treasured work in the collection of Anthony Morris Clark, shows the *soavità* of handling that he could achieve in painting on the smooth, hard surface of a metal support. Luti was both the most sensitive painter and the most individual colorist of the early eighteenth century in Rome, and the exquisite color of the garments worn by Christ and the Samaritan woman are particularly memorable.

The painting is typical of Luti's mature devotional works, which are

usually harmoniously composed scenes with a few, often just one or two, noble and robust figures. The composition has a simplicity and stability worthy of its ultimate compositional prototype in Annibale Carracci's *Christ and the Woman of Samaria* in the Pinacoteca di Brera. Luti's treatment of the interval of space between the figures, which allows the wellhead and fluted column to exercise important roles in the rhythm of the design and permits a glimpse of the Alban Hills in the distance, is particularly skillful. On the evidence of the weight and clarity of form, and the accomplished and balanced composition, the work may be dated to the years 1715–20.

The differences between late Baroque and early eighteenth-century painting in Rome are vividly revealed when *Christ and the Woman of Samaria* is compared with a painting nearly identical in subject, size, and format by Ciro Ferri formerly in the Liechtenstein collection (London, Christie's, November 29, 1974, lot 57, reproduction). Ciro's declamatory late Baroque manner has been transformed by Luti, in Rudolph Wittkower's phrase, into an "elegant and sweet eighteenth-century style" (Wittkower 1973, p. 467). He has accomplished this by unifying his tonal range within a narrow register by the liberal use of gray; creating an impression of greater luminosity with a higher scale of values; and employing a brighter and warmer palette than his predecessor. Typically, Luti's forms are relaxed and less complex in attitude than those of his late Baroque predecessors, their volume is increased by ample drapery, and their physical movement diminished.

The evident sincerity and contemplative piety of the painting are quite in keeping with Settecento religious feeling. Few writers have commented upon Luti's refined spiritual temper, but certainly the mode of feeling expressed in his private religious works is as distinctive as their precious and subtle effects of color and tone, and their gentle and delicate figures. The sentimentality of his devotional images, like those of the best of his contemporaries such as Sebastiano Conca, is saved from lachrymosity by a deep-rooted gravity and seriousness, which is the legacy of Seicento religious attitudes.

A painting by Luti's pupil Placido Costanzi of the same subject and composition, together with a pendant *Noli me tangere* (Busiri Vici 1974, pp. 140, 144, figs. 169–70), suggests the existence of a lost companion for the present painting. [EPB]

## 243
## Benedetto Luti
### *Study for "The Prophet Isaiah"*

c. 1716–17
Oil on canvas
29½″ × 21⅞″ (75 × 55.5 cm)
PROVENANCE Palazzo Albani alle Quattro Fontane, Rome, at least until 1819; Bryan collection, England; acquired by the present owner at Bonham's, London, in the 1970s
EXHIBITION London 1995, cat. no. 26
BIBLIOGRAPHY Conca 1981, p. 127; Pascoli 1992, p. 321

Walpole Gallery, London

Benedetto Luti was one of the artists selected to participate in the most important papal commission to painters in early eighteenth-century Rome, the decoration of the interior of St. John Lateran. When Cardinal Benedetto Pamphili became archpriest of the basilica in 1699, he found the cathedral church of Rome much as it had been left after its partial refurbishment by Borromini earlier in the century. At the architect's death in 1667, the twelve large niche tabernacles that line the nave were left empty along with twelve empty oval stucco frames of Borromini's design on the clerestory level of the nave walls. Under the direction of a *congregazione* deputized by Pamphili, twelve colossal marble statues of Apostles were commissioned for the niches from Camillo Rusconi, Pierre Legros, Pietro Stefano Monnot, and other sculptors. Exactly when the decision was reached to fill the oval surrounds above with canvas paintings of the Prophets is uncertain, but according to a contemporary account it must have been made before 1714, the date of the death of the papal architect Carlo Fontana (for the particulars of the Lateran project and its significance for the art patronage of Clement XI, see Johns 1993, pp. 75–92).

The rationale for decorating the clerestory level of the basilica with Prophets was based on Saint Paul's dictum, "Super fundamentum Apostolorum et Prophetarum" (Ephesians 2: 20): "The Church has the Apostles and the Prophets for its foundation and Christ Jesus for its cornerstone." The principal contributor was Lothar Franz von Schönborn, the elector of Mainz (see cat. 244), who had not previously participated in the Lateran decorations. The remote location of the Prophets high above the nave of the Lateran has caused their critical neglect but, as Pascoli noted, the twelve painters responsible were "twelve of the most celebrated painters in Rome" (Pascoli 1992, p. 321). Beginning with the first prophet on the left of the nave, closest to the major altar, the painters and

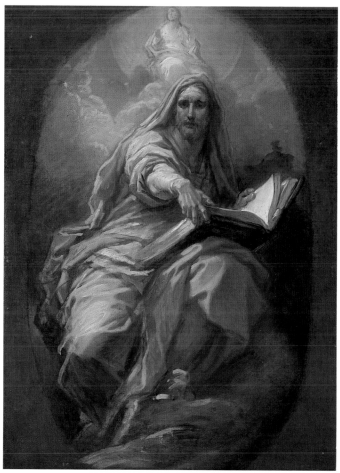

243

their subjects are as follows: Benedetto Luti, *Isaiah*; Francesco Trevisani, *Baruch*; Andrea Procaccini, *Daniel*; Luigi Garzi, *Joel*; Giuseppe Bartolomeo Chiari, *Obadiah*; Pier Leone Ghezzi, *Micah*; Sebastiano Conca, *Jeremiah*; Giovanni Paolo Melchiori, *Ezekiel*; Giovanni Odazzi, *Hosea*; Giuseppe Nasini, *Amos*; Marco Benefial, *Jonah*; and Domenico Maria Muratori, *Nahum*.

Luti's *Isaiah* (reproduced in Johns 1993, fig. 43) is depicted in the act of reading his prophetic codex; above him is the monogram of the Virgin, and under his foot on the right is a tablet inscribed with the words of the text that the Evangelists accepted as a prohecy of the virginal conception of Jesus: "A young woman is with child and she will bear a son" (Isaiah 7: 14). The Lateran committee overseeing the commission seems to have exercised close supervision throughout all stages of the work. Each painter was required to submit a small *modello* for official approval, and in some cases changes were ordered. An unusual stipulation was that, after approval of the first design in oils, the artists had to submit a full-scale version for reevaluation. These models were transferred to the Palazzo del Quirinale to be displayed as a group,

and as late as 1819 the paintings of Luti, Nasini, Muratori, and Benefial were still in the palace (cited in London 1995, cat. no. 26), although the others had been dispersed or transferred to the Vatican gallery.

There is a significant variation between the London oil sketch and the final painted version: the Virgin, who in the sketch appears in a celestial vision, was replaced, doubtless upon the advice of the *congregazione*, by the abstract monogram of the Virgin. However, between this oil *bozzetto* and the final design there must have been other preparatory studies, such as the beautiful red, black, and white chalk drawing at Yale that depicts Isaiah in a pose and attitude quite close to his final disposition in the finished canvas (Bowron 1979, p. 208, n. 98, fig. 146). This drawing represents Luti's idea of the figure at a moment immediately after it had been developed from the life model, but preceding the execution of at least one other design in oils.

The Lateran Prophets were installed in their stucco surrounds in time for the feast of the birth of John the Baptist on June 24, 1718, an especially important holy day for the Lateran basilica. Luti was probably engaged in the Lateran project from about 1716 to

1718, and as late as January 17 of that year he wrote to the Elector of Mainz apologizing for not being able to deliver a painting owing to his work for the basilica (Bowron 1979, p. 206, n. 94). In the light of the compositional differences between the Walpole Gallery *bozzetto* and the final design (there is no indication of the inscribed tablet, for example) and Luti's loose, improvisatory handling, the sketch would appear to belong to a fairly early stage in the evolution of the compositional scheme. With its extraordinary pinks, vermilions, and yellows, this sketch is a splendid example of what Lione Pascoli admired as Luti's "tender and delicate manner, softly and gently colored with perfect drawing and harmonious composition modulated with his exquisite taste" (Pascoli 1992, p. 317). [EPB]

## 244
## Benedetto Luti
### *The Education of Cupid*

1717

Signed and dated at lower left: SACRI ROMANI IMPERII/ EQVES BENEDICTVS LVTI/ ROMAE PINGEBAT/ ANNO MDCCXVII

Oil on canvas

106½″ × 78″ (271 × 198 cm)

PROVENANCE  commissioned by Lothar Franz von Schönborn, Elector of Mainz, in 1713 and installed in the audience hall in Schloss Weissenstein, Pommersfelden

EXHIBITION  Rome 1959, cat. no. 354

BIBLIOGRAPHY  Moschini 1923, p. 111, no. 15; Voss 1924, pp. 362, 610; Sestieri 1973, p. 252, no. 44; Bowron 1979, pp. 198–203, 273–74, no. 47, fig. 138; Carlsen and Mejer 1982, pp. 33, 39–40, n. 40. fig. 4

Graf von Schönborn, Kunstsammlungen, Pommersfelden

Mythological subjects, particularly those calling for the depiction of the female nude, enjoyed a resurgence in late Baroque Italian painting. Among those who most persistently requested such subjects were the German princes of the Holy Roman Empire. Having recovered from the effects of the Thirty Years' War, which had devastated their cities, impoverished their treasuries, and driven away native artists and architects, the German rulers turned to Italy as a source of artistic endeavor. From the 1690s, the Wittelsbachs, Schönborns, Liechtensteins, Margraves of Brandenburg, and others employed not only Italian painters, sculptors, and architects but also musicians, singers, and dancers. This new source of patronage proved fruitful for a number of Roman painters in the early eighteenth century, encouraging them to modify their production to conform to the tastes of these princes (Bowron 1979, p. 190, n. 60).

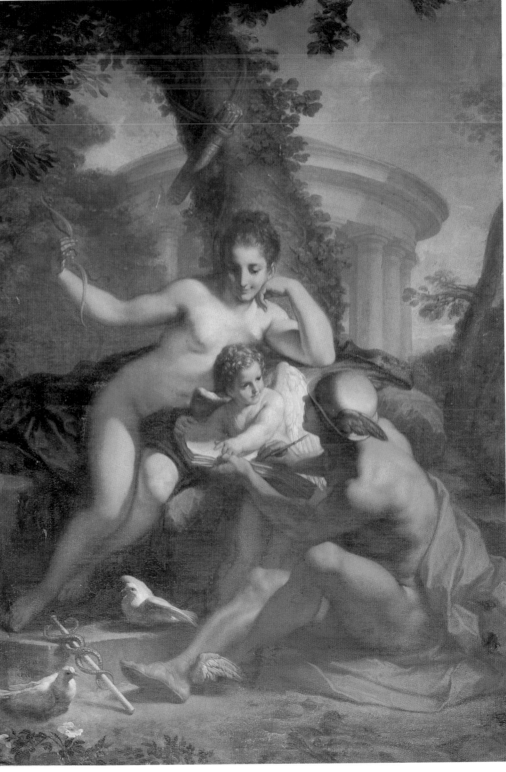

244

One of the leaders of the German cultural resurgence, together with the palatine elector (see cat. 241), was Lothar Franz von Schönborn (1655–1729), arch-chancellor of the Holy Roman Empire, Elector–archbishop of Mainz, Prince–bishop of Bamberg, and canon of Würzburg. Typical among the German autocratic rulers, Lothar Franz was passionately devoted to painting, sculpture, and architecture. In 1711 he began the construction of a summer residence at Pommersfelden in Franconia, Schloss Weissenstein, which also served as the main repository for his collection of pictures. By 1715 construction of the gallery in the palace was sufficiently advanced for 250 paintings to be hung; by 1719 the elector's collection had increased to 500 pictures, necessitating the transfer of some to his other residence, Schloss Gaibach.

As early as 1708 Lothar Franz, acting through his agents in Rome, the Hofrat Bauer von Heppenstein and the Abate Giovanni Melchiori, began commissioning works from Roman painters, including Francesco Trevisani and Sebastiano Conca. He

favored small cabinet pictures of mythological subjects and larger canvases intended for decorative purposes such as overdoor paintings. The shared feature of such works was their ability to delight through both content and form. Lothar Franz delighted particularly in erotic themes and demanded female nudes above all else, even in Old and New Testament themes. The earliest appearance of Benedetto Luti's name in connection with Lothar Franz occurs in 1712, and the following year the artist supplied the elector with a pair of mythologies representing *Diana and Endymion* and *Venus and Adonis* (1713; Schloss Weissenstein, Pommersfelden; Bowron 1979, pp. 272–73, figs. 131–32).

Even before the mythologies of 1713 arrived in Pommersfelden, the elector commissioned two more paintings from Luti, notably the monumental *Education of Cupid*. The artist informed Hofrat Bauer in 1716 that the painting was completed—adding his opinion that it was his finest work to date—but he insisted upon the necessity of reworking certain passages "per dare alcune grazie maggiori." The work is, indeed, Luti's most impressive mythological painting and, after its completion in 1717, became the source of countless repetitions of paintings, prints, and drawings. The elector's impatience is understandable when it is understood that this painting was intended to fulfill a much more significant role in the decorative program of Schloss Weissenstein than most previous writers have suggested. It was not placed in the Schlossgalerie but in the great Marmorsaal, or saloon, the culminating achievement of the palace, which Lothar Franz intended as a great audience hall (Walter Jürgen Hofmann, *Schloss Pommersfelden: Geschichte seiner Entstehung* [Nuremburg: H. Carl, 1968], pp. 137–41).

The *Education of Cupid*, which was once considerably larger than its present dimensions, in order to correspond to the accompanying thematic pictures in the decorative scheme, occupied the center of the main entrance wall. The education of gods and heroes was a popular theme since the Renaissance, reflecting interest in the revival of learning. The subject of Mercury, the god considered since antiquity to be the inventor of the alphabet and of the arts in general, teaching Cupid and Venus the Liberal Arts is of especial importance in this context, both iconographically and for its obvious reference to a famous version of the subject by Correggio, *Venus with Mercury and Cupid* (c. 1525; National Gallery, London), in the Settecento an exemplar of grace and elegance. Much of the allure of the Pommersfelden *Education of Cupid* lies

in the breadth and idyllic quality of its pastoral mood; the large and tranquil figures in their landscape setting are undoubtedly intended to recall something of Correggio's original effect.

Another underlying influence upon the *Education of Cupid* is Pietro da Cortona's frescoes in the Sala della Stufa, Palazzo Pitti, Florence. Luti was, after all, a Florentine-trained painter, and his admiration for his great countryman is evident here. The figures especially recall the animation of gesture and pose, the specific turn of head and glancing eyes developed by Cortona in the 1630s and 1640s. The pose of Cupid quotes directly a putto in Cortona's *Age of Gold*, but even the general features of Venus, her high brow, slender nose, and tapering chin, as well as her breadth of form, reveal the predominant influence of Cortona's models. [EPB]

# FRANCESCO MANCINI
### SANT'ANGELO IN VADO 1679–1758 ROME

Mancini was born in a small town in the Marche, near Urbino. He was trained under the most important Emilian master of that time, Carlo Cignani, alongside the slightly older Marcantonio Franceschini. It is not known precisely when the young painter from the Marches began work; this was not in his home town, however, but in the neighboring region of Romagna. At this time (the first decade of the eighteenth century) he did some paintings for Cesena, *San Pellegrino Leziosi Heals a Blind Man* (church of S. Domenico) and *San Mauro, Abbot* (abbey of Madonna del Monte), in which the influence of Cignani is very evident. Mancini's destiny was sealed by his meeting with the cultured and authoritative head of the Camaldolese order of monks, Father Pietro Canneti, who entrusted to him the decoration of Ravenna's renovated Biblioteca Classense; there, between 1713 and 1714, Mancini frescoed the ceiling with *The Triumph of Divine Wisdom* and also painted the large canvases of *The Union of the Latin and Greek Churches* and *Gregory X and Graziano Compile the Sacred Canons*. Father Canneti's protection helped Mancini to obtain increasingly important commissions, particularly in Umbria. In 1719 he was commissioned to fresco Foligno Cathedral—a project that kept him busy for several years; in the second half of the 1720s he was asked to paint the cupola of the Oratorian church in Perugia. Previously, also for the Oratorians, he had carried out an altarpiece in Città di Castello, *The Meeting of Christ and Saint Peter* ("*Domine quo vadis?*") (Pinacoteca, Città di Castello).

From 1720 Mancini was often to be found in Rome, which was to become his home and the main center of his work, and in 1725 he was made an academician of S. Luca. But he also strengthened his ties with the region of his birth, particularly the town of Fano. Outstanding among the works that he did for the town is the great altarpiece for the church of S. Cristina, *The Virgin and Child with Saints Christina, Francis of Assisi, and Felix of Cantalice* (cat. 245). It is one of the masterpieces of eighteenth-century painting from the Marches and is a good example of the tender style, with effects suggestive of pastel, which characterizes the artist's whole production. In 1724 he had taken on the young painter Sebastiano Ceccarini, from Fano, as a pupil. Ceccarini's rapid progress in public commissions was one of the reasons why, in 1726, the people of Fano proclaimed his teacher, Mancini, an honorary citizen. It is highly likely that the success of the young Ceccarini's paintings was due to the direct intervention of his master: one proof is *The Virgin Appearing to San Rocco*, signed by Ceccarini (Pinacoteca Civica, Fano), which repeats in reverse a composition by Mancini and contains several touches typical of Mancini himself.

In 1730 began Mancini's period of greatest achievement and recognition. His activity expanded not only in Italy but also in Portugal, where he sent works for the royal monastery of Mafra, the pictorial decoration of which had been entrusted by King John V to painters of the Roman school. Mancini also took part in another ambitious decorative program of the time, that of Pisa Cathedral, dedicated to the stories of Pisa's saints and *beati*; his contribution was the great canvas *The Blessed Gambacorti Founding His Order*. In 1736 he moved to Macerata, on the invitation of one of the principal representatives of the town's aristocracy, Guarniero Marefoschi; there he stayed, almost without a break, until the end of the decade. For Marefoschi Mancini carried out the main part of the pictorial decoration (frescoes and canvases) of one of the most refined eighteenth-century religious complexes in the Marche, the little basilica of the Madonna della Misericordia, built by Luigi Vanvitelli, while two other canvases in the church were entrusted to Sebastiano Conca. Among the works that Mancini did in Macerata should be mentioned the altarpiece *San Giuliano*, depicting the town's protector, for the cathedral, and the two paintings *The Crucifixion* and *The Virgin Appearing to Saint Philip Neri* for the Oratorian church. He is also represented in his native town, Sant'Angelo in Vado, with a group of

altarpieces in the church of S. Maria dei Servi, among which *San Pellegrino Laziosi Healed by the Crucifix* stands out for its intensity.

Examples of secular decoration by Mancini are scarce. After his youthful *Sun Chariot*, painted in the Palazzo Albacini in Forlì (where his master, Cignani, had also done paintings), his most important secular work is the decoration of the Coffee House in the Palazzo Colonna in Rome with *The Fable of Psyche*, done in the 1730s or early 1740s. Toward the end of the 1730s there was an episode that prejudiced Mancini's relations with his native town. In December 1737, wanting some social recognition, the artist asked to be included in the group of local nobility. Refusing this request, the authorities even denied him citizenship. From that moment his dealings with Sant'Angelo became rarer, and he went ever more frequently to Rome. With the election of Pope Benedict XIV Lambertini, Mancini's position was strengthened. He was in fact one of the pope's favorites, and in 1740 Benedict conferred a knighthood on Mancini. The same pope entrusted him with the altarpiece for the high altar in the basilica of S. Maria Maggiore, which was being renovated for the jubilee year of 1750, and also the design for one of the enormous altarpieces for St. Peter's, *Saint Peter Healing the Lame Man*, which was subsequently reproduced in mosaic.

By now a group of new pupils was gathering around Mancini, including the painter and theorist Giovanni Andrea Lazzarini, Nicola Lapiccola, and the gifted Domenico Corvi. Although Mancini's repertory of images was limited, his highly refined draftsmanship and muted colors stand as a link between the moderate Emilian classicism of the early eighteenth century and the more extreme stance, anticipating the Neoclassicism adopted by some of his own pupils (and supporters, such as Mariano Rossi) toward the end of the century in Rome.

In 1750 Mancini was appointed principal of the Accademia di S. Luca, a role that he filled until 1751. Among his last works in Rome are two altarpieces for the church of S. Gregorio al Celio. His final work was once more for his home town, *The Triumph of Saint Michael Archangel*, donated to the cathedral of Sant'Angelo in Vado in 1754. [LA]

BIBLIOGRAPHY *Catalogo delle pitture* 1740; Tomani Amiani, Stefano. *Guida storico artistica di Fano* (Manuscript 1853). Edited by Franco Battistelli. Pesaro, Italy: Banca Popolare Pesarese, 1981; D'Aciardi 1914; Pietrangeli 1951; Sestieri 1977, "Mancini"; Battistelli and Diotallevi 1982; Pietrangeli 1982, pp. 143–46; Schiavo 1985, "Virtuosi"; Fucili Bartolucci 1986, pp. 449–54; Cleri 1992; Ambrosini Massari, Anna Maria,

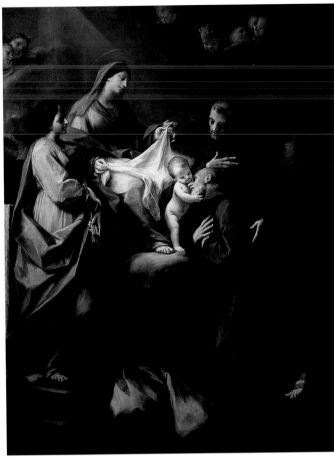

245

Rodolfo Battistini, and Raffaela Morselli, eds. *La Pinacoteca Civica di Fano, catalogo generale: collezione Cassa di Risparmio di Fano*. Milan: CARIFANO, 1993; Sestieri 1994, vol. 1, pp. 111–13

## 245
### Francesco Mancini
### *Virgin and Child with Saints Christina, Francis of Assisi, and Felix of Cantalice*

1715–20
Oil on canvas
115" × 92½" (292 × 235 cm)
PROVENANCE  S. Cristina, Fano; Collezioni comunali 1866; Pinacoteca Civica, Fano
BIBLIOGRAPHY  *Catalogo delle pitture* 1740; Tomani Amiani, Stefano. *Guida storico artistica di Fano* (Manuscript 1853). Edited by Franco Battistelli. Pesaro, Italy: Banco Popolare Pesarese, 1981, pp. 78–80; Sestieri 1977, "Mancini," p. 78; Battistelli and Diotallevi 1982, p. 105; Fucili Bartolucci 1986, p. 453; Cleri 1992, p. 187; Ambrosini Massari, Anna Maria, Rodolfo Battistini, Raffaela Morselli, eds. *La Pinacoteca Civica di Fano, catalogo generale: collezione Cassa di Risparmio di Fano*. Milan: CARIFANO, 1993, p. 149
Pinacoteca Civica di Fano

Mancini's work for the Marche, his native region, is concentrated mainly in three towns: Fano, Macerata, and the town where he was born,

Sant'Angelo in Vado. In the first two he lived and worked for a time; to Sant'Angelo he sent work from Rome. Of the works created for Fano this altarpiece is definitely the most ambitious, and it represents one of the highest peaks of the artist's early work. It is held to be the oldest of those that Mancini is known to have done for Fano. Although a firmly documented date is not available, various details indicate that it is early, before the fresco decoration of Foligno Cathedral, for which Mancini was engaged in 1719 and where he worked from about 1721 or 1722 until 1725.

First of all, the church and the adjoining monastery (now demolished), belonged to the order of Capuchin Friars (an offshoot of the Franciscans), and had been built extremely slowly in the course of the seventeenth century; not until 1723 was it possible to consecrate the church, according to Fano's most important historian, Stefano Tomani Amiani, who quotes the commemorative inscription in his guide. It is logical to assume that by that time the painting, which stood on the high altar, was already in place. Furthermore, a document has been recently discovered (Cleri 1992, p. 187) in the Fano archives concerning payment by the Capuchin Friars for

the painting on the high altar; and although it indicates neither subject nor artist, it must certainly refer to the altarpiece by Mancini. Thus, even if Mancini had not yet started the painting, he must already have been in negotiation with the friars. A dating between 1715 and 1720 is also confirmed by stylistic reasoning, in that the Fano altarpiece is extremely close, in its elongated figures and angular draperies, to the altarpiece for the Oratorians of Città di Castello (now in the Pinacoteca there) entitled *The Meeting of Christ and Saint Peter ("Domine, quo vadis?")* painted in 1718–19, before he moved to Foligno.

The altarpiece for the Fano Capuchins would therefore represent an important moment of passage between the painter's early independent activity, carried out mainly in Emilia-Romagna under the influence of Cignani, and his mature activity, when his center of gravity shifted to Rome, with consequently new artistic sources (the school of Maratti and Benedetto Luti in particular, but also the legacy of Pietro da Cortona). Even if the ties with Cignani and Emilian painting are evident, Mancini here reveals his own strong identity: the extraordinary mother-of-pearl translucence of the figures, who appear weightless, and the pastel-like delicacy of the handling outstrip any other Emilian painter of the period, and seem to originate from a personal rethinking of the late Guido Reni. The tenderness of gestures and feelings that informs the entire composition is characteristic of the art of the Marche, and is linked to the gentle, poetic quality of the *affetti* which found in Barocci a model to be imitated for centuries. Another point to stress is the unusual presence of the Early Christian martyr Saint Christina, characterized by arrows, the instruments of her torture, in this otherwise thoroughly Franciscan picture. The saint is linked to the oldest church occupied by the Capuchins of Fano, which stood in the countryside and had been dedicated to her even before their arrival. When the Capuchins moved into the town at the end of the sixteenth century and began to build their new church, they wished that it should remain forever dedicated to Saint Christina, and therefore her image could not be missing from the altarpiece on the main altar. [LA]

## ANTON VON MARON
### VIENNA 1731–1808 ROME

Although Maron produced some history paintings, it was for his portraits that he was most highly esteemed in his lifetime. It was in his birthplace, Vienna, that Maron received his first artistic training. In his obituary—so far the only source for this information—Carlo Nighem (probably Karl Aigen, a member of the Vienna academy) and Daniel Gran are named as his teachers. From 1755 he continued his studies in Rome, where he lived, from 1756, in the house of Anton Raphael Mengs; until 1761 he was Mengs's pupil and studio assistant. Two joint commissions for frescoes in Rome are known from this period: the ceiling of the church of S. Eusebio (1757) and the *Parnassus* at the Villa Albani (1760–61). Mengs, who had no previous experience in the field of fresco painting, made use of Maron's existing practical knowledge of the fresco technique. This collaboration brought about a fundamental change of style in Maron's work: he turned away from the Viennese late Baroque style and adopted a new formal vocabulary influenced by Roman tastes and Mengs's reforming ideas. Of all Mengs's pupils Maron was regarded in the Roman art world as the one whose artistic development had been most deeply influenced by the German's precepts, which Maron continued to represent even after his teacher's death in 1779. Over the years a lifelong friendship developed out of the teacher–pupil relationship. This was further manifested through Maron's marriage in 1765 to Therese Concordia, Mengs's elder sister and a successful miniature painter.

Mengs's summons to Madrid in 1761 entailed a fundamental change in Maron's position as an artist in Rome. He now ran Mengs's studio, together with the Würzburg court painter Christoph Fesel, and was the agent for Mengs's affairs in Rome. In this way Maron came to enjoy a reputation previously enjoyed by Mengs, as Batoni's only rival in Rome. He received portrait commissions that would otherwise have gone to Mengs, and became one of the most successful portrait painters in the city. His portraits tended toward the type in which Batoni specialized, depicting travelers interested in art, who often stopped in Rome on their Grand Tour, shown amid famous antiquities and Roman landscapes. Maron's acquaintance with Winckelmann, who had many varied contacts in Rome, helped to bring him commissions, probably including the portrait of Prince Anhalt-Dessau (1766). At the end of the 1760s Winckelmann himself was the subject of a widely discussed por-

trait by Maron, completed only after the scholar had been murdered, which spread the painter's reputation beyond the confines of Rome into Germany.

In the 1770s, in addition to painting portraits of visitors to Rome, Maron turned also to official portraits for the house of Habsburg, as well as occasional multi-figure compositions in the field of history painting. Probably in 1770, in connection with a portrait of the two-year-old Archduke Francis, subsequently Emperor of Austria, Maron formed contacts at the Habsburg grand-ducal court in Florence. Through them, his name became known in Vienna, and subsequently he was selected as their resident court painter in Rome. For instance, the 1771 portrait of the grand duchess with her three children, as well as the portraits of Emperor Francis I and his wife, Empress Maria Theresa, in widow's weeds, made in later years, are evidence of this. For his services to the Austrian imperial court Maron was ennobled in 1772. His artistic reputation, which reached its peak in the mid-1780s, was also reflected in various offices such as his election as Principe of the Accademia di S. Luca in Rome between 1784 and 1786.

Maron's achievements in the field of multi-figure mythological and religious compositions have had a mixed critical reception, particularly with respect to his compositional technique. The picture cycle based on the story of Aeneas that the artist executed in 1784–85 for the Casino in the Villa Borghese is generally regarded as his masterpiece in history painting. The mythological picture *The Return of Orestes* (1786) also dates from the same period. Numerically, history paintings have only a minor place in Maron's output; however, the great importance that he himself attached to these paintings is evident in his inclusion of scenes from the Villa Borghese cycle in the background of both his 1787 self-portraits.

Two groups of works represent the final high points in Maron's artistic output. Between 1779 and 1786, following Mengs's death, Maron continued the work his teacher had begun on a collection of engravings, published by Camillo Buti, based on the antique frescoes discovered in the Villa Negroni. A few years later, while staying in Genoa in 1791–92, he completed a series of portraits of the Genoese aristocracy—including the Doge Michelangelo Cambiaso, Marchese Berio, and Maria Pieri Brignole Sale. These portraits depart from his earlier style, showing the influence of Van Dyck. They were intended not only to impress his noble Genoese clients but also to give a new impetus to Maron's career as a portrait painter, which had been clearly in

decline in Rome since the 1780s. Art critics attribute this to the arrival in Rome of Angelika Kauffmann, whose portrait style, based on English painting, was more in tune with the taste of the time. By the turn of the century Maron had virtually ceased to receive any commissions. He died in Rome on March 3, 1808. [IS]

BIBLIOGRAPHY  Roettgen 1972; Tutsch 1995, pp. 29–35

## 246
## Anton von Maron
### *Elizabeth Hervey, 4th Marchioness of Bristol*

1778
Oil on canvas
29⅞" × 23⅜" (76 × 59.5 cm)

PROVENANCE  acquired in 1980 by the Kunsthistorisches Museum, Vienna, from the Austrian art market; now in the Gemäldegalerie, Vienna

EXHIBITIONS  Nara, Japan, Prefectural Museum of Art; Shibuya, Japan, Bunkamura Museum. *Treasures of the Habsburgs: Masterpieces of the Kunsthistorisches Museum, Vienna.* 1996, cat. no. 47

BIBLIOGRAPHY  Childe-Pemberton, William Shakespear. *The Earl Bishop: The Life of Frederick Hervey.* New York: E. P. Dutton, 1924, vol. 1, p. 213; Ford 1974, "The Earl Bishop"; Fothergill 1974; Eckardt 1985; Bunkamura Museum, Shibuya, Japan. *Treasures of the Habsburgs: Masterpieces of the Kunsthistorisches Museum, Vienna.* Nara, Japan, 1995, p. 184

Kunsthistorisches Museum, Vienna, Gemäldegalerie

This is probably the earlier of two paintings by Maron of Elizabeth Hervey. The later, official 1779 portrait of the Marchioness of Bristol remained in the possession of the family for many years after the death of the subject, and only came to auction in 1964, at Christie's, London (lot 11); in May 1991 it emerged from the American art market and was auctioned at Sotheby's, New York (lot 55).

The subject of the portrait was originally descended from an Antwerp family, and was the daughter of Sir Jeremyn Davers, Baronet, of Rushbrooke Park, and his wife, Margaretta, daughter of the Reverend Edward Green. In 1752 she married Frederick Augustus, 4th Earl of Bristol, the celebrated bishop of Derry, with whom she had two sons and three daughters. Although her husband was an Anglican bishop of one of the wealthiest Irish dioceses, he was also an Irish nationalist and a passionate supporter of suppressed Catholics, and committed himself wholeheartedly to their cause. This unusual combination of status and stance brought him into disrepute with the English king. Not only his artistic interests, but also his brief to

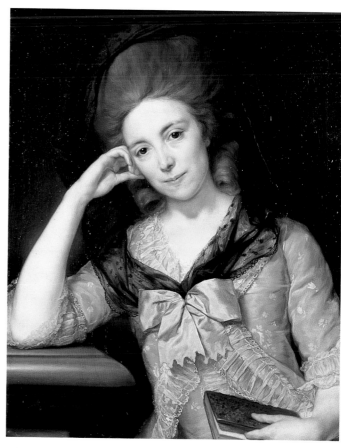

246

acquire works of art for the bishopric took him to Italy. In total he visited Italy eight times. The first occasion was in 1765, when he was accompanied by his wife. In the international society of Rome he had a reputation as one of the eminent and, at the same time, most open-minded of patrons of the arts. His tastes were also known to be highly unorthodox, and he was somewhat feared in artistic circles for his eccentric behaviour.

Between 1777 and 1779 the earlbishop settled in Rome with his family. Soon after he arrived, he commissioned Pompeo Batoni to paint his likeness. It was characteristic of Frederick Hervey that he should simultaneously commission a portrait of his wife from Anton von Maron, a painter of lesser renown than Batoni. Unlike the later 1799 portrait of Elizabeth Hervey, the Vienna picture is undated and unsigned. It can be assumed, however, on the basis of the Italian travel journals of Prince Augustus of Saxe-Coburg—in which, in an entry for May 7, 1778, the prince mentions having seen the portrait of Mrs. Hervey in Anton von Maron's studio—that it dates from the first half of 1778. The journals also refute the possibility that the subject of the painting might (from her apparent youthfulness) be one of the older daughters of Mrs. Hervey

The Vienna portrait of Mrs. Hervey could be a study for the later, official version. Mrs. Hervey sits squarely facing the viewer, against a dark, monochrome background. She is wearing a tearose-colored dress. Over her hair is a black veil, which fastens at the cleavage with a taffeta bow. This is a fashion much influenced by the popular "Van Dyck" dress of the time. Her right arm rests on a pedestal and her right hand is laid against her cheek, while her left hand rests in her lap, holding a book. The pose is traditionally one suggestive of contemplation, and was particularly popular in the representation of intellectuals and society ladies in English portraiture at the time. It implied a mixture of dignity and elegance, and was used as a means of ennobling the subject. In addition, Elizabeth Hervey's pose is reminiscent of the melancholia motif, turned in upon her own thoughts. Maron has given the sitter an expression rather of disappointment and melancholy: her mouth is tightly closed, her damp-looking eyes focus severely on the onlooker. The facial features have been defined by the life she has lived. At the time this portrait was painted, the Herveys' marriage had long since foundered, and only a year later the couple separated. The earl-bishop is reported to have referred to his wife as a "majestic ruin"

(Ford 1974, "The Earl Bishop," p. 427). Her sadness and embitterment at her unhappy private life are well documented in Mrs. Hervey's letters to her daughter. In the summer of 1778 she wrote that she felt like "almost such a skeleton as Voltaire," reduced to the point where she was "thinner than ever and wizened like a winter apple" (Childe-Pemberton, p. 213, see above). She might have rapidly gained weight had the frequent foul moods and general behavior of her husband not played havoc with her nerves.

These declarations may well be the product of vanity; nevertheless, this picture of an attractive but unhappy wife is a highly expressive example of Maron's gift as a portrait painter. Under the protective veil of social convention, he manages to convey the distress of Mrs. Hervey without exaggeration or heavy-handedness. [IS]

## 247
## Anton von Maron
### *The Return of Orestes*

1786

Signed and dated on bottom left edge of picture: *Ant. De Maron pingebat/ Roma 1786*
89⅛" × 59½" (227 × 151 cm)
PROVENANCE  possibly Sir John Williams (1761–1830), 1st Baronet, Bodelwyddan Castle, Rhyl, co. Clwyd, Wales, and thence by family descent until 1985; Clwyd County Council, which purchased the estate and contents of Bodelwyddan Castle; sale; Sotheby's, London, April 3, 1985, lot 193; acquired by P. & D. Colnagi, London; from whom purchased by the museum
BIBLIOGRAPHY  *Giornale delle Belle Arti*, October 14, 1786, pp. 221–22, no. 14; *Memorie per le Belle Arti*, November 1786, pp. ccli–ccliii; Roettgen 1972, pp. 11, 15, n. 31; Colnaghi, London. *Italian Paintings and Sculpture*. London: Herbst, 1986, pp. 54–57
The Museum of Fine Arts, Houston, Museum Purchase with funds provided by Nina and Michael Zilkha

*The Return of Orestes* is a superb example of late eighteenth-century Roman history painting and, along with the cycle of paintings from the *Aeneid* for the Villa Borghese, it is Maron's outstanding mythological picture. Painted in 1786, it was executed in a period of creativity during which Maron devoted himself only briefly to this genre, alongside portrait painting. As the *Giornale delle Belle Arti* of October 14, 1786, reports, the commission for the picture came from an Englishman, possibly Sir John Williams of Bodelwyddan, the descendant and heir of Sir Watkin Williams Wynn II, a great patron of the arts, of contemporary Roman painting in particular, and of Anton von Maron, who had painted a copy after Raphael for him in 1768.

Maron's contacts with well-to-do, cultivated travelers who arranged to

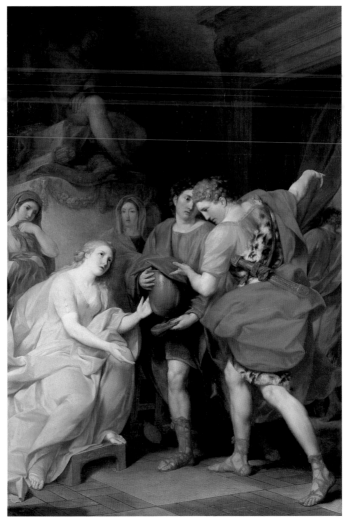

247

have their portraits painted on their Grand Tour, as well as his close friendship with Winckelmann, could have provided the impetus for this unusual subject. Scenes from the story of Electra, as dramatized by Sophocles, were only occasionally painted by Italian and non-Italian artists. For example, in 1614 the Dutch painter Pieter Lastmann illustrated the quarrel regarding the sacrifice of Orestes and Pylades in a picture richly animated with figures; and other episodes were depicted in the works of Maron's contemporaries Benjamin West, Henry Fuseli, and Angelika Kauffmann.

There is a signed drawing relating to Maron's *Return of Orestes* in the Kupferstichkabinett in Berlin. Here all the details of the composition, gestures, attitudes, and setting are already established; it shows only slight variations from the painting. The drawing was originally in the collection of the Roman sculptor Vincenzo Pacetti, one of Maron's close friends. The scene takes place in front of the royal palace in Mycenae. Orestes—the son of Agamemnon, the former King of Mycenae who has

been murdered by his wife, Clytemnestra, and her lover Aegisthus—returns home from Phocis with his cousin Pylades. He has been commanded by Apollo to avenge his father with the blood of his mother and her lover. A statue of Lycian Apollo, the wolf-killer, stands on a plinth in the background of the picture, on the left, looking down on the scene. Maron's comprehensive knowledge of the original drama is clearly evident, as is his intention to adhere as faithfully as possible to the text. This Apollo, seated on the Python of Delphi, which he has killed, a lyre in his right hand and the arrows of his bow lying at his feet, is indebted iconographically to the Hermes of Naples, which had been discovered in Herculaneum in 1768.

At the foot of the plinth sits Orestes' sister Electra, surrounded by female servants. According to the description in the *Memorie per le Belle Arti* of November 1786, Maron has depicted the moment when Orestes, unrecognized by Electra because of his outlandish attire, goes up to her and explains that he is looking for

Aegisthus to give him news of Orestes' death and bring him the urn containing his ashes. Pylades steps between the brother and sister and draws his cloak aside to reveal the urn, which the sorrowing Electra tries to seize. Orestes illustrates his intentions with gestures: with his left arm he indicates the urn, while his outstretched right arm points toward the palace doors, where an old man is keeping watch.

The three main protagonists stand out by virtue of the carefully chosen gestures, the soft flowing lines and their richly colored robes of purpled-red, azure blue, and golden yellow. The clothing of Orestes is particularly striking: with the tiger skin wound around his body under his cloak, he conveys the impression of being a "barbarian," as the *Giornale delle Belle Arti* puts it. Influenced stylistically by Angelika Kauffmann, the leading history painter of the time, Maron here successfully creates a harmonious picture in which the rich coloring of the Roman Baroque is fused with a classical use of form. [IS]

## 248
## Anton von Maron
### *Self-portrait*

1787

Oil on canvas
41" × 31¼" (104 × 79.5 cm)
EXHIBITIONS  Rome 1959, cat. no. 374; Bregenz and Vienna 1968, cat. no. 334
BIBLIOGRAPHY  Grohn 1960; Prinz, Wolfram. *Geschichte der Sammlung*. Vol. 1 of *Die Sammlung der Selbstbildnisse in den Uffizien*. Berlin: Mann, 1971, pp. 217–18; Roettgen 1972, p. 167; Galleria degli Uffizi, Florence. *Gli Uffizi: catalogo generale*. Florence: Centro Di, 1979, p. 929; Bock, Henning, ed. *Gemäldegalerie Berlin*. Berlin: Staatliche Museen zu Berlin, 1996, p. 75, cat. no. 2202
Galleria degli Uffizi, Florence

According to current research, four self-portraits by Anton von Maron have been preserved, dating from the years between 1787 and 1794. This example was painted in 1787, shortly after Maron had completed a similar self-portrait for Cardinal Doria, now hanging in the Kunsthistorisches Museum in Vienna. It was commissioned for the famous Galleria degli Autoritratti by Giuseppe Pelli, then director of the Uffizi. The documents published by Wolfram Prinz (see above) regarding the genesis of this gallery of self-portraits include a draft letter from Pelli to Maron dated November 10, 1787, in which he writes in excited anticipation that he awaits "with impatience your portrait, for which I am sure I can obtain one of the highest prices ever paid for a

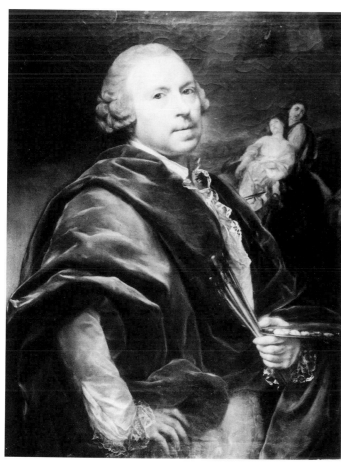

248

modern work in this field. Your name and your talent are too well known for there to be any doubt of it." In November 1787 Maron delivered the portrait, for which he was awarded a gold medal.

Maron presents himself half-length, standing in front of his easel, with his head half-turned toward the viewer. His proud stance, with the right hand resting on the hip, and the serious, slightly downward-looking gaze are deeply indebted to court portraiture. The official character of the portrait is further enhanced by the periwig and the lustrous red cloak artfully draped over his lace shirt, all of which give the subject a refined, dignified appearance.

In his left hand Maron holds his brushes and palette. Beside him to the right in the background, *The Death of Dido*, a scene from the five-part cycle of paintings for the Villa Borghese (Pinciana), can be seen. With reference to this, Maron wrote in a letter to Pelli dated December 8, 1787: "With regard, then, to the painting that I am putting into my portrait, it is a small fragment taken from a sketch, one of four or five that I made for a room in the Villa Pinciana … and it shows the death of Dido. I wanted to show in this portrait some evidence of another side of my work in Rome, undertaken in the service of Cardinal Antonio

Doria, who himself wanted me to introduce here one of the five paintings executed for his villa, to demonstrate that I am not just a portrait painter" (quoted in *Geschichte der Sammlung*, p. 218, see above). In the self-portrait for Cardinal Doria mentioned above, Maron chose the *Rescue of Anchises by His Son Aeneas* from the same cycle of paintings to put into the background (on the left side). The passage quoted makes it clear that in his choice of background Maron wanted to emphasize his importance as a history painter. This can be explained by the fact that history painting was then far more highly regarded than portrait painting in the hierarchy of genres.

The Uffizi's Galleria degli Autoritratti was the most important collection of its kind at that time. Consequently Maron adopted a more imposing attitude in this portrait than in the one for Cardinal Doria, presenting himself in all the splendor and self-confidence of a highly regarded painter and dignitary, who not only exercised prestigious offices in Rome but was also a member of the academy in Florence. The importance Maron attached to this portrait is expressed yet again in another letter to Pelli written on October 27, 1787, in which he asks him to ensure that it is

hung to set it off to the best possible advantage.

A comparison with Maron's last self-portrait, painted in 1794 and now in the Gemäldegalerie der Staatlichen Museen zu Berlin, shows a virtually identical portrayal of the head, with a periwig, firmly closed lips, and a right-turned gaze. But the expression of pride and self-confidence has given way to worried wrinkles on his forehead. His simple appearance and the restrained gestures indicate that in Rome, too, the egalitarian spirit had taken hold.

There is an anonymous hand-colored engraving of the Uffizi self-portrait in the Österreichische Nationalbibliothek in Vienna. An inscription below the picture carries the following words: *Antonio Maron Pittore nato in Vienna dell'Austria nel 1731. Vive in Roma.* The use of the present tense indicates that the engraving must have been made in or before 1808. [IS]

## AGOSTINO MASUCCI
### ROME 1691–1768 ROME

Agostino Masucci was apprenticed for two years to Andrea Procaccini, who introduced him to the *gran cavalier* of Roman painting, Carlo Maratti. A particular favorite of the ageing artist, Masucci rose quickly to a privileged position within Maratti's studio, imitating the great master "with assurance and feeling." Like most young artists in Rome at the time, he participated in the Concorso Clementino at the Accademia di S. Luca, competing in 1706 (when he won second prize in the second class of painting), 1707 (first in the first class of painting), and 1708 (first prize in sculpture). After Maratti's death in 1713, the Princess Pamphili sponsored Masucci for a time, and his thorough study of Raphael's Stanze in the Vatican enabled him, in Pio's words, to become a "bravo disegnatore." Pio was especially pleased with Masucci's twenty-two portrait drawings for his *Vite* (cats. 373, 374), praising them for their originality and beauty of handling.

In 1717 Masucci received his first public commission from the Marchesa Girolama Bichi Ruspoli for a pair of canvases depicting scenes from the life of Saint Venantius for the main chapel of the Roman church of Ss. Venanzio ed Ansuino Camerinesi (now in Ss. Fabiano e Venanzio, Rome). Praised by contemporaries for their "bel disegno" and pretty and harmonious coloring, these paintings show Masucci working in a disciplined Marattesque idiom but equally aware of the more atmospheric, coloristic effects pursued by the older master Luigi Garzi in the high altarpiece there. By the 1720s Masucci was

recognized among Rome's more important young painters, and he was elected in 1724 to the Accademia di S. Luca. Among his prestigious clients was Monsignor Niccolò del Giudice, the papal majordomo and Prefect of the Sacred Palaces. His oval canvases depicting the Life of the Virgin in the nave of S. Maria in via Lata (1721–25) are among the loveliest and most tender religious paintings made in Rome in the first half of the Settecento. Their classical balance and serenity, impeccable draftsmanship, and subtleties of handling anticipate his fully matured style in *The Virgin Mary Appearing to the Seven Founders of the Servite Order* (1728; S. Marcello al Corso). This altarpiece brought Masucci into direct competition with Aureliano Milani and Pier Leone Ghezzi, each of whom had recently completed paintings for the church. In contrast to his rivals' tougher and more outwardly emotive works, Masucci's lucid composition, smooth handling, correct drawing, and delicate spiritual temper reveal why, after the death of Giuseppe Chiari in 1727, he emerged as the undisputed heir to the official, Marattesque tradition.

Masucci emerged as the leading portrait painter in Rome during the 1720s and 1730s, working principally for the Rospigliosi and Corsini families, as well as a growing number of Grand Tour sitters. His portraits are distinguished by their severity, directness, and gravity, and likenesses such as *Cardinal Banchieri* (Palazzo Rospigliosi-Pallavicini, Rome), *Clement XII Corsini* (Camuccini Collection, Cantalupo), and *Padre Devora and Cardinals Neri, Corsini, and Passeri* (Biblioteca Nazionale, Rome) set the direction of eighteenth-century portraiture. His portrait of *James Ogilvy, Lord Deskford* (1740; Cullen House, Banff, Scotland) leads squarely to the Grand Tourist portraits of Pompeo Batoni and Anton Raphael Mengs. Unfortunately, the fame Masucci developed as a portraitist declined after the cool reception of his portrait of *Pope Benedict XIV* (1743; Galleria Accademia Nazionale di S. Luca, Rome), painted for a competition won by Pierre Subleyras.

Masucci gained leadership in the Roman art world in the 1730s, after he was elected regent of the Congregazione dei Virtuosi al Pantheon in 1735 and Principe of the Accademia di S. Luca in 1737. He spread the Roman classical tradition beyond Rome with a series of important international commissions, beginning with the 1729 altarpiece in Prague Cathedral, *Saint John of Nepomuk in Glory*, commissioned in honor of the newly canonized Bohemian saint. Other important commissions for secular and religious paintings came

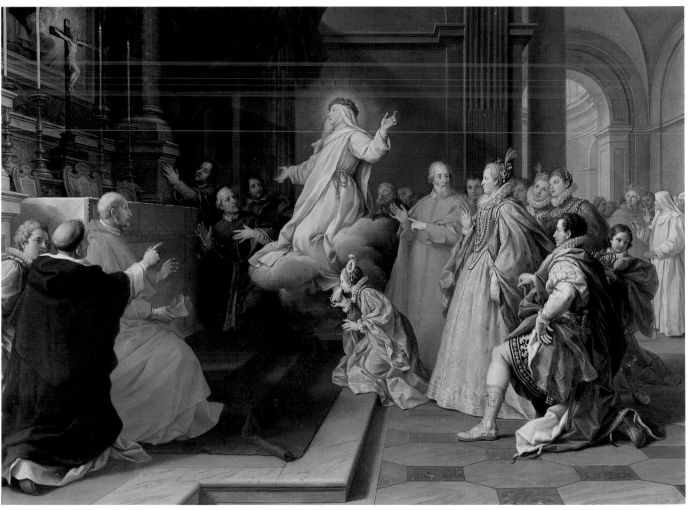

249

from the courts of Savoy, Spain, and Portugal, culminating with Masucci's designs for the mosaic altarpieces for the chapel of St. John the Baptist in S. Roque Cathedral in Lisbon. Masucci placed compositional lucidity above all other stylistic qualities, achieving a cool simplicity by his continual clarification of the high Baroque vocabulary inherited from Maratti with a classicism derived from Guido Reni and ultimately from Raphael. Masucci also had great impact as a teacher, operating one of Rome's most important studios and offering life drawing and other instruction to several of the more advanced painters of the next generation, including Pompeo Batoni, Gavin Hamilton, Stefano Pozzi, and Giuseppe Bottani.

Masucci's patronage from Benedict XIV Lambertini was mixed. Together with Panini and Batoni, he decorated the ceiling of the Coffee House in the grounds of the Palazzo del Quirinale with canvases of the *Four Prophets* and *Christ Entrusting his Flock to Saint Peter* (1742–43), and he painted a *Holy Family* in the same years as part of the restoration of S. Maria Maggiore, but he never received a commission for an

altarpiece in St. Peter's. If, by the 1740s, Batoni and other painters had begun to eclipse Masucci, the general judgment was that given by Charles Cochin in 1750, when he listed the artist along with Mancini, Giaquinto, and Batoni as one of the best painters in Rome. Masucci's later works, including the 1757 altarpiece *The Education of the Virgin* (SS. Nome di Maria, Rome), are excellent devotional pictures, but they often repeat compositional formulae developed a quarter of a century earlier and must have seemed *retardataire* within the context of Roman art in the second half of the century.

Anthony Clark summarized Masucci as Maratti prettified, rationalized, and neated up, but he emphasized his fundamental contribution to the classical inheritance in Roman painting in the first half of the Settecento. Masucci stands more comfortably at the end of one tradition rather than at the beginning of something new, but he resolved the formal development of painting away from the Baroque and set the stage for the more radical intellectual and stylistic shifts forged by younger artists at

mid-century. Masucci died on October 19, 1768. His son Lorenzo Masucci (died July 3, 1785), was a minor painter who continued his basic style. [EPB/JLS]

BIBLIOGRAPHY Pio [1724] 1977, pp. 145–46, 254–55, 313–15; Clark 1967, "Masucci"; Dreyer 1971, pp. 202–7; Casale 1984; Czére, Andrea. "Zeichenkunst von Agostino Masucci." *Jahrbuch der Berliner Museen*, vol. 27 (1985), pp. 77–100; Negro 1989; Cipriani and Valeriani 1988–91, vol. 2, pp. 71, 84, 92, 104; Rangoni 1990, "Masucci"; Rybko 1996

## 249
## Agostino Masucci
### *The Ecstasy of the Blessed Caterina de' Ricci*

Probably 1732
Oil on canvas
78¾″ × 9′2¼″ (200 × 280 cm)

PROVENANCE Cardinal Neri Maria Corsini by 1750; thence by family descent; acquired by the Italian State from Principe Tommaso Corsini in 1883

EXHIBITION Bologna, Palazzi del Podestà e di Re Enzo. *L'arte del '700 emiliano:* Traveling exhibition, 1979–80, cat. no. 361

BIBLIOGRAPHY Faldi 1977, p. 499 (as Zoboli), fig. 5; Magnanimi, 1980, p. 107, no. 222, p. 126, n. 25, fig. 9; Alloisi 1984, p. 65, no. 2; Sestieri 1988, p. 53; Barroero 1990, p. 403 (as 1737), fig. 579; Casale 1990, pp. 572–74, n. 1; Sestieri 1994, vol. 1, pp. 123 (as 1747), 124, and vol. 3, fig. 720; Borsellino 1996, p. 49, fig. 27; Casale 1997, p. 138
Galleria Corsini, Rome

Born to a patrician Florentine family, Caterina de' Ricci (1522–1590) entered at the age of thirteen the Dominican convent of S. Vicenzo at nearby Prato, founded under Savonarola's influence. Here she meditated constantly on the

Passion of Christ, but also blessed with a talent for administration, became in turn novice-mistress, sub-prioress, and, in 1552, prioress of the convent. Caterina's reputation for holiness and wisdom brought her visits from many lay people and clergy. She is famous above all for the extraordinary series of ecstasies in which she beheld and enacted chronologically the scenes that preceded Christ's crucifixion. Beginning in 1542, each Thursday and Friday, she vividly experienced the Passion of Christ; her bodily movements conforming exactly to those of Christ's, her visions accompanied by the impression of the stigmata on her hands, feet, and side. These mystical raptures continued for twelve years and became public spectacles, especially popular among the Florentine nobility.

Through her extensive and beautifully written letters, Caterina de' Ricci communicated with such significant Catholic Reformation figures as Saints Philip Neri, Charles Borromeo, and Maria Maddalena de' Pazzi, as well as the members of the Medici family, actively encouraging a depoliticized Savonarolan spirituality and a simple devotional life grounded in Christ's Passion. Her gentle-minded reforms enjoyed great popularity in the eighteenth century, leading to her beatification in 1732 by the Florentine pope, Clement XII Corsini. The canonization cause, in which the future Pope Benedict XIV played devil's advocate before the Congregation of Rites, critically examined all relevant claims including Caterina's psycho-physical phenomena. Ultimately, in the words of a recent writer, "canonization was granted in 1746 not for extraordinary phenomena but for heroic virtue and complete union with Christ" (David Hugh Farmer, *The Oxford Dictionary of Saints*, 4th ed. [Oxford]: Oxford University Press, 1997, p. 427). Masucci represents Caterina de' Ricci in an ecstatic state, rising on a cloud before an altar bearing a crucifix. Her open arms emulate the crucified Christ upon whom she gazes, and her hands reveal the stigmata. Onlookers crowd the chapel to witness her mystical rapture, including Dominican clerics, cardinals, and various patrician spectators richly dressed in what is presumed to be sixteenth-century Florentine costume. Whether the painting is intended to depict a specific episode in Caterina's life is not clear, although the presence of the cardinals may relate the picture to the celebrated 1544 visit to Florence of Cardinal Roberto Pucci, envoy of Paul III Farnese, which marked the official confirmation of Caterina's visions.

Masucci's careful drawing, controlled light and atmosphere, pretty and harmonious coloring, and measured composition reveal his allegiance to the legacy of Raphael and his heir, the *gran cavalier* of modern Roman painting, Carlo Maratti. The sentimental treatment of the subject, epitomized by the motif of the little girl reverently kissing Caterina's foot, the air of intimacy and quietude, and the gentle and graceful gestures of the spectators, are typical of the depiction of sacred subjects in Roman Settecento painting. The figures are presented to the beholder with an immediacy and directness that concentrate the attention on the miraculous event of Caterina's mystical levitation as if it were taking place in the present instead of two centuries earlier. The painting vividly demonstrates the active concerns of contemporary Roman painters to encourage the emotional involvement of the worshipper by means of a rational presentation of sacred drama in a sensible, convincing narrative scene.

*The Ecstasy of the Blessed Caterina de' Ricci* is first recorded in an inventory of the Palazzo Corsini in 1750, when it hung alongside four similar canvases commissioned by Cardinal Neri Corsini to celebrate the four saints canonized by Clement XII Corsini in 1737, *Catherine Fieschi Adorno of Genoa, Vincent de Paul, Giuliana Falconieri*, and *Jean-François de Régis*. Masucci's canvas has been dated variously, although on the grounds of provenance it would seem to have been painted in 1732, in conjunction with Caterina de' Ricci's beatification ceremonies held under the auspices of the Corsini pope, rather than in 1746, the year of her canonization.

The pictorial character of the painting is less helpful in determining whether it should be dated to 1732 or a decade later. Masucci's "clear, cool, and cultivated style" (Voss 1924, p. 611) was more or less formulated by the 1720s, and his relatively few dated and documented works thereafter do not provide decisive visual evidence with which to create a convincing chronology. The drawing, coloring, and morphology of the individual figures in the *Ecstasy of the Blessed Caterina de' Ricci*, however, appear to have more in common with Masucci's altarpiece of 1728 for S. Marcello al Corso, *The Virgin Mary Appearing to the Seven Founders of the Servite Order*, than with the overdoor painted for the Palazzo Reale, Turin (cat. 250) a decade later. An elaborately finished compositional drawing in mixed media exists in the Szépművészeti Múzeum, Budapest (inv. no. 3137). [EPB/JLS]

250

## 250

## Agostino Masucci
### *The Judgment of Solomon*

1738

Signed and dated on the base of the throne: *Aug.s Massucci. Rom.faciebat. /1738*

Oil on canvas

74⅞″ × 82¾″ (190 × 210 cm)

PROVENANCE commissioned by Charles Emmanuel III, King of Sardinia-Piedmont, for the Palazzo Reale, Turin; Palazzo Carignano, Turin; Museo Civico d'Arte Antica, Turin, by 1865 (where recognized as by Masucci by Conte A. Baudi di Vesme, director, after having been misattributed)

EXHIBITIONS Rome 1959, cat. no. 376; Turin, Italy, Palazzo Madama, Palazzo Reale, and Palazzina di Caccia di Stupinigi. *Mostra del barocco piemontese*. 1996, vol. 2, cat. no. 201; Turin 1996, cat. no. 306

BIBLIOGRAPHY Nipote, I. *Il pregiudizio smascherato*. Venice: Deregni D., 1770, p. 40 ("Le sopraporte notano/ Quando le donne portansi/ A Salomon che giudichi/ Chi debba aver il figlio./ E'd'un Romano l'opera/ Masucci, che discepolo/ Del Gran Maratti vantasi/ Valente, ma non cognito"); Voss 1924, p. 611; Malle, L. *Museo Civico di Torino: I dipinti del Museo d'Arte Antica*. Turin, Italy: Museo Civico di Torino, 1963, pp. 127–28, pl. 182; Clark 1967, "Masucci," p. 262, fig. 12; *Conca* 1981, pp. 222–25; Rudolph 1983, pl. 465; Mossetti 1987, pp. 13, 44

Musei Civici di Torino, Turin

The painting was commissioned by Charles Emmanuel III, King of Sardinia-Piedmont, through the agency of the architect Francesco Juvarra, as one of a set of four overdoors for the Sala dei Solimena (so-called for the presence of four biblical paintings by the Neapolitan master) in the king's winter apartments in the Palazzo Reale in Turin. The accompanying paintings also represented Old Testament themes and included Sebastiano Conca's *David Dancing before the Ark of the Covenant* (Palazzo Reale, Turin), Francesco Monti's *Triumph of Mordecai* (Palazzo Reale, Genoa), and Giovanni Battista Pittoni's *Sacrifice of the Daughter of Jephthah* (Palazzo Reale, Genoa; each discussed and illustrated in *Conca* 1981, pp. 222–25). Masucci received a payment of Lire 242:10 on March 30, 1733, "in deposit and on account of the cost of a painting which he is making for His Majesty." That the painting was completed in 1738 is confirmed by a letter of September 13, 1738, from Cardinal Alessandro Albani to the Marchese d'Ormea, ambassador to the king: "This morning I went to see the painting that Masucci has done for His Majesty, and which he will send by courier this evening. I found it beautiful enough; I hope it will be to the satisfaction of His Majesty, and that he will be happy with the work of the artist, who has delayed so long in finishing the work, for which he humbly begs pardon." A final payment of *Lire* 700:8 to Masucci in Rome is recorded in the royal archives in Turin on October 16, 1738, "in payment for a painting representing the Judgment of Solomon, which reached here this year for the king, and including the costs of packaging" (quoted in Alessandro Baudi di Vesme, *L'arte in Piemonte dal XVI al XVIII secolo* [Turin, Italy: Società Piemontese di Archeologia e Belle Arti, 1966], vol. 2, p. 663).

*The Judgment of Solomon* is an excellent example of Masucci's mature work, which Anthony Clark considered a keystone in the painter's stylistic development:

The lighting, the style, the gestures, the surface handling are subordinated to the extraordinary logical clarity of narrative, composition, space, and individual forms. The spectators on the far balcony seem to comment that the world of Panini can be as impeccable as Poussin (and, not incidentally, as ancient Rome), and as authoritative as Raphael. In the claustrophobia of conventional correctness, with the deliberately studied elements, there is a foretaste of the hieratic preciousness and odd ornamentalism of the true Neoclassical and of the Empire style. The next and final step before the Neoclassical might be represented by Mengs' 1760 *Augustus and Cleopatra* [National Trust, Stourhead], in which Rococo graciousness is exhausted and the lingering Baroque pictorial devices, quietly present in the Masucci, may be said to disappear. (Clark 1967, "Masucci," p. 262)

Masucci's Turin *sopraporta* depicts an episode in the Old Testament (I Kings 3: 16–28) in which the Israelite king was called upon to judge between the claims of two prostitutes who dwelt in one house, each of whom had given birth to a child at the same time. One infant had died, and each woman claimed that the living child belonged to her. To settle the dispute over the possession of the child, Solomon ordered a sword to be brought, saying, "Cut the living child in two, and give half to one, half to the other." At this, the mother of the living child, shown by Masucci struggling with the executioner and imploring Solomon, renounced her claim in order that its life be spared; the other mother is depicted with her back to the viewer. The painting illustrates the moment of Solomon's decision ("which all Israel came to hear") to restore the child to its rightful mother, earning him the awe of his subjects, who recognized his divine wisdom for dispensing justice.

In this composition Masucci demonstrates all that he had learned from his master, Carlo Maratti, and from the earlier exemplars of Roman classicism, Raphael, Annibale Carracci, and Domenichino. Tackling a heroic subject intended to be read in an edifying manner, Masucci has paid especial attention to the language of gesture and expressions, and the depiction of emotion throughout the painting. A complex pen-and-wash compositional drawing in the Szépmüvészeti Múzeum, Budapest (Andrea Czére, "Zeichenkunst von

Agostino Masucci," *Jahrbuch der Berliner Museen*, vol. 27 [1985], p. 97, fig. 25, inv. no. 2900) records the basic layout of the composition and suggests the care with which Masucci worked out the disposition of Solomon, the principal characters, and the onlookers to the biblical drama, even down to such details as the dog sniffing the dead child in the left foreground. The magnificent barrel-vaulted architectural setting in the finished design, which imposes such classical rigor upon the composition, is only vaguely indicated in red and black chalks in the drawing, suggesting that Masucci produced other preliminary drawings for the layout of the painting as well as studies of individual figures. [EPB]

## LUDOVICO MAZZANTI
ROME 1686–1775 ORVIETO

Ludovico Mazzanti exemplifies the tendency of early eighteenth-century Roman painters to draw upon a variety of sources in the course of fashioning an independent, workable manner. For this reason he is often a difficult artist to grasp stylistically, and his works elude efforts to establish a convincing profile of his activity. Mazzanti was born on December 5, 1686, and trained in the studio of Giovanni Battista Gaulli from 1700 onwards. He appears to have been attracted to the Baroque style of painting of Giovanni Lanfranco and Giovanni Battista Beinaschi, although at the same time he was clearly aware of the overwhelming importance of Carlo Maratti and the increasing dominance of Maratti's form of classicism. Like most young artists in Rome at the time, he participated in the Concorso Clementino at the Accademia di S. Luca, competing in 1703, 1704 (cat. 375), 1705, and 1708, placing first in the first class in painting in the last competition.

Mazzanti's parents originated from Orvieto, and among his earliest known works was a design for the upper mosaic on the façade of the city's cathedral (1713–14; recorded by a print). He produced around this time several paintings for Florentine patrons, including Cosimo III, Grand Duke of Tuscany. In Rome, together with Sebastiano Conca, Giuseppe Bartolomeo Chiari, Benedetto Luti, Francesco Trevisani, and others among the greatest artists of Rome, he participated in the decoration of the Palazzo de Carolis (now Banca di Roma), the most prestigious secular commission to Roman painters in the first quarter of the century (1720–22; *Zephyr Chasing Away Winter* and *Zephyr and Flora*, large, charming canvases set into the ceiling of the piano nobile). Around this time, he also began to receive major commissions from the Church; notably

from the Jesuits, whose order and saints he glorified throughout his career. In 1720 he painted the frescoes for the chapel of the Annunciation in S. Ignazio, Rome, *Assumption of the Virgin*, *Adoration of the Shepherds*, *Presentation in the Temple*, and *David and Jeremiah* (all in situ with rich overtones of Gaulli and Giovanni Odazzi); and between 1721 and 1725, an altarpiece, *Virgin and Child with Saints Ignatius of Loyola, Francis Borgia, and Luigi Gonzaga*, and two lateral canvases depicting scenes from the life of Saint Stanislas Kostka in the chapel of S. Ignazio in S. Andrea al Quirinale, Rome, in which the influence of Maratti, Gaulli, and the Bavarian painter in Rome, Ignazio Stern, have been observed. His enormous altarpiece representing *The Assumption of the Virgin* for the church of S. Giovanni, Macerata, probably dates from the second half of the 1720s.

Between 1731 and 1732 Mazzanti painted *The Apparition of the Virgin to Saint Lucy* for the cathedral in Viterbo. He also worked in Naples, where he settled in 1733, and his paintings naturally enough reveal an orientation to the work of such Neapolitan painters as Francesco Solimena and Paolo de Matteis, and a renewal of his interest in the work of Lanfranco. Between 1733 and 1736 Mazzanti painted *The Four Evangelists* in the pendentives beneath the dome and several Old Testament overdoor frescoes for the church of the Gerolamini, and seven paintings featuring scenes from the life of the Virgin for the abbey of Montevergine (these were considerably overpainted during the restoration carried out at the end of the nineteenth century). The climax of his Neapolitan period was a series of seven paintings of the life of the Virgin and two large canvases depicting Saint Stanislas Kostka for the church of the Jesuit novitiate in Pizzofalcone (1736–39; better known as the church of the Nunziatella). At the same time he painted canvases for the Collegiata of S. Maria delle Grazie at Marigliano and *The Martyrdom of Saint Stanislas Kostka* (private collection, Naples).

Between 1740 and 1744 Mazzanti was again active in Orvieto; between 1744 and 1746 he returned to Rome, where he painted a *Vision of Saint Luigi Gonzaga* for the church of S. Apollinare, which was rebuilt by Ferdinando Fuga under the patronage of Benedict XIV. Continually peripatetic, he painted in Viterbo, Perugia, Fabriano, and Ancona during the remainder of the decade. At Città di Castello he executed paintings for the monastery of S. Chiara, and for the cathedral he painted in 1751 the Four Evangelists in the pendentives beneath the dome, variations on the compositions made earlier for the church of

the Gerolamini in Naples. After settling definitively in Rome in 1752–53, Mazzanti executed frescoes of mythological scenes and marines (of which no trace survives) for the palace of Monsignor Raimondo Bonaccorsi in Macerata as well as easel paintings and overdoors. A contract dated 1757 between Mazzanti and Paolo Borghese documents the execution of paintings and decorative panels for overdoors. For the sanctuary of S. Giuseppe da Copertino at Osimo (Ancona), Mazzanti painted in 1767 a large canvas depicting *Saint Joseph of Copertino in Ecstasy at the Sight of the Sanctuary of Loreto*.

Ludovico Mazzanti was sufficiently celebrated in Rome by the second quarter of the eighteenth century to receive commissions from a variety of northern European patrons; for example his *Death of Saint Francis Xavier* (Stadtmuseum Düsseldorf; *bozzetto* in the Philadelphia Museum of Art) was sent to Poland. He was less successful as a portrait painter than as a painter of religious and mythological subjects, but a few works survive to suggest modest activity in this genre. Admitted as *accademico di merito* to the Accademia di S. Luca, Rome, on September 6, 1744, and to the Accademia Clementina in Bologna on December 16, 1748, Mazzanti died on August 29, 1775. [EPB]

BIBLIOGRAPHY Santucci 1981; IRIARTE 1989, pp. 108–10; Casale 1990, "La pittura," pp. 354–55, 365, 368–69, figs. 511, 513, 519; Rybko 1990, "Mazzanti"; Rybko 1996, "Mazzanti"

## 251
## Ludovico Mazzanti
### *The Death of Lucretia*

1735–37
Oil on canvas
71" × 56" (180.3 × 142.2 cm)
PROVENANCE possibly Prince of Aragon, Naples; Walter P. Chrysler, Jr., New York; private collection; Rejace collection, New York; Christophe Janet, New York; from whom acquired in 1982

BIBLIOGRAPHY Santucci 1981, pp. 119, 170; Schaefer, Scott, and Peter Fusco. *European Painting and Sculpture in the Los Angeles County Museum of Art*. Los Angeles: Los Angeles County Museum of Art, 1987, p. 68; Spinosa 1993, p. 145, no. 235, fig. 321
The Los Angeles County Museum of Art, Gift of the Ahmanson Foundation

The powerful sculptural forms, subtle coloring, and dramatic action of *The Death of Lucretia* epitomize Mazzanti's style toward the end of his sojourn in Naples in the late 1730s, when he produced many of his most dramatic paintings. The painting was unknown in the scholarly literature before its appearance on the art market in the

251

early 1980s and subsequent acquisition by The Los Angeles County Museum of Art. Mazzanti recorded in a notebook annotation of 1770, cited by Paola Santucci, a picture showing Lucretia taking her own life as having been painted for the Prince of Aragon in Naples (Santucci 1981, p. 119, no. 60). He listed several other paintings as being in the same collection, including a "*Sacrifice of Hercules*," which Richard Rand suggested may have been a pendant to the Lucretia.

Mazzanti's notebook also records a second painting of the subject of Lucretia's suicide, also "painted in Naples," belonging to the Sciviman family in Venice. These annotations have been taken to refer to the Los Angeles painting and another of the same subject now in the Crocker Art Museum in Sacramento (Philip Conisbee, Mary L. Levkoff, and Richard Rand, *The Ahmanson Gifts: European Masterpieces in the Collection of the Los Angeles County Museum of Art* [Los Angeles: Los Angeles County Museum of Art, 1991], pp. 101–2, n. 1, fig. 25a). The two versions are quite close in detail, although the Los Angeles painting is considerably larger and the head of Lucretia is more sharply turned to the left than in the Sacramento painting. The latter also

differs by the inclusion of a statue of a draped figure in a niche in the left background. The exact relationship between the two variants is not clear, and it is not certain which one Mazzanti painted first. The Los Angeles painting is more finished in execution and seems more successfully resolved in composition, which suggests that it followed the version in Sacramento. However, as Richard Rand has observed, that painting (39⅛″ × 29¼″; 99.4 × 74.3 cm;) seems too large to have served as a *modello*.

The *Death of Lucretia* can be related to several works painted during Mazzanti's second visit to Naples, notably his paintings in the church of the Gerolamini of 1736. The powerfully modeled draperies, the heroine's jutting elbow, and the angle of her head are comparable to several figures in *The Expulsion of Heliodorus*, for example. The disposition of Lucretia and the nature of the setting and its furnishings compare closely to Mazzanti's *Joseph and Potiphar's Wife* (private collection, Rome), which must have been painted around the same time, although Santucci dates the painting to 1738–40 (Santucci 1981, p. 113, fig. 50).

In the legendary history of early Rome (Ovid, *Festivals* 2: 725–852; Livy,

*History of Rome* 1: 57–59), Lucretia, a virtuous woman, the wife of a nobleman, was raped at knifepoint by Sextus Tarquinius, the son of the tyrannical King Tarquinius Superbus, who ruled Rome. The following morning Lucretia summoned her father and husband and, after demanding that they avenge her honor, took her own life. The episode led to a rebellion and the exile of the Tarquins, laying the foundations for the Roman empire. The suicide of Lucretia was an enormously popular subject in the Renaissance and its aftermath as a moral exemplum, and Lucretia herself became a popular heroine embodying virtue and courage.

Richard Rand has commented on the epic quality of Mazzanti's treatment of the legend, dominated by the monumental figure of Lucretia, posed in dramatic *contrapposto*:

The heroine twists in agony, turning her head to the heavens as she plunges the dagger into her breast. The viewer's sense of her agitaiton is increased by the electric folds of the draperies, which crackle about her form as if driven by a swirling wind. Yet in Mazzanti's rendition of the story almost all of Lucretia's moral righteousness and heroic self sacrifice is hidden beneath a veneer of sexual allure. The artist eroticizes the story by painting an attractive Lucretia, *en déshabille*, in a provocative and inviting setting. The bed on which she was assaulted is covered with billowing robes and plump pillows; the furniture boasts a sculpted harpy and a leering satyr head. Rather than emphasizing the social and political ramifications of Lucretia's action, the painting concentrates on the seductive charms of the woman's great beauty. Lucretia is cloistered alone in her bedroom, where her suicide is enacted in a personal rather than public context. (See *The Ahmanson Gifts*, pp. 102–2, above)

Mazzanti's devoted orientation to Neapolitan painting at this moment in his career is evident most vividly in the comparison between the *Death of Lucretia* and the figure of Delilah in *Samson and Delilah* (c. 1690; Herzog Anton Ulrich Museum, Braunschweig; reproduced in Spinosa 1993, fig. 8). [EPB]

## ANTON RAPHAEL MENGS
AUSSIG, BOHEMIA 1728–1779 ROME

From early childhood Anton Raphael received a good grounding in the arts from his father, Ismael, a painter at the Saxon court in Dresden, who modeled his son's education on the syllabus of the Académie des Beaux-Arts in Paris. In 1740, when Anton was twelve, his father took him to Rome with his sisters Therese Concordia and Julie Charlotte, both of whom were to become competent miniaturists. He studied the nude under Marco Benefial and set himself to copy the works of Raphael and Michelangelo in the Vatican. Returning to Dresden in 1744, he was appointed *peintre du cabinet* by Friedrich August II, Elector of Saxony and King of Poland. His earliest works were a series of striking pastel portraits (Gemäldegalerie Alte Meister, Dresden). The Saxon court financed a second visit to Rome from 1746 to 1749, allowing him to study the art of history painting. Back in Dresden, he was appointed *premier peintre* to the Dresden court in 1751, succeeding Louis de Silvestre, who had held the post from 1716 until 1748. The young painter's first official commission was for three altarpieces for the Katholische Hofkirche, conceived as a symbolic representation of the resurgence of Catholicism in Saxony and dedicated in June 1751. For the *Ascension*, destined for the high altar, Mengs chose as his model Titian's *Assumption* (S. Maria de' Frari, Venice). This entailed a lengthy stay in Venice from 1751 to 1752.

On his third visit to Rome, from 1752 to 1761—longer than predicted due to the outbreak of the Seven Years' War—Mengs found himself accepted as a full member of the academic circle in Rome on account of the commissions he received from influential church dignitaries and also from foreign visitors, the English in particular, who valued his abilities as a portrait painter. These same abilities won him a commission to paint a portrait of the new pope, Clement XIII (cat. 255). Although his popularity never rivaled that of Batoni, he had his own clientele primarily among the English intellectuals rather than the aristocrats. In the field of mural painting, too, he had a great success in 1760 with the ceiling of the church of S. Eusebio (cat. 377). Friendship with the archaeologist Johann Joachim Winckelmann (cat. 259) resulted in Mengs acquiring a considerable knowledge of the art of the ancient world, and this began to influence his own style as can be seen in the works he produced after 1756 (see cat. 261). Painted after a stay in Naples in 1760 and 1761, his famous fresco *Parnassus* for the ceiling of the gallery at the

252

Villa Albani in Rome (cat. 378) was greeted by his contemporaries as the manifesto of a new style of painting, later known as Neoclassicism. The most unusual features of this painting are that—in contrast with the conventions of the Baroque—Mengs uses perspective in the same way as would be expected in an easel painting, and he has adopted antique statues as models.

Invited to the Spanish court in Madrid by Charles III in 1761, Mengs worked on the decoration of the ceilings in the Palacio Real, employing as his assistants only Spanish painters, among whom were Francisco Bayeu (Goya's teacher) and Mariano Maella. Mengs's work as court painter and superintendent of pictorial work for the Spanish crown was overlapped by the activity of Giambattista Tiepolo, who arrived in Madrid a year later (1762). In 1767 Mengs was officially appointed Primer Pintor de Camera, a position he had already held temporarily during the absence from Madrid of Corrado Giaquinto. Mengs, as the king's favourite painter, executed a number of paintings for him on religious themes besides many portraits of members of the royal family. On his return to Italy in 1770 for health reasons, he was fêted throughout the country. After short stays in Monaco and Geneva, he went to Florence, where he remained for nearly a year working on the restoration of Masaccio's paintings in the Brancacci Chapel in the church of S. Maria del Carmine, which had been damaged by fire. In March 1771 he was elected Principe of the Accademia di S. Luca, a position he held until November 1772. Over the same period he executed the ceiling of the Stanza dei Papiri in the Vatican.

After further periods in Naples (1772–73) and Florence (1773–74) Mengs returned to Madrid in the summer of 1774. That same year he used his good offices to obtain employment for Francisco Goya y Lucientes as a designer of tapestries in the royal tapestry workshop, which signaled the start of Goya's career as an official court painter to the Spanish court. Before the end of 1776 Mengs completed the two ceilings in the Palacio Real he had begun some time previously (Apotheosis of Hercules and Apotheosis of Trajan). He also began work on the ceiling of the private theater in the Palacio Real at Aranjuez in Spain, on which, among other things, he painted The Theft of Pleasure by Time.

With special permission from King Charles III, Mengs returned to Rome in 1777, but by now he had only two years to live. A condition that was never diagnosed but that was probably the result of his practice of preparing his own pigments had undermined his health to the extent that he was no longer able to fufill his commissions, and this at a time when his fame was at its height. His last finished work was the large painting Perseus and Andromeda (fig. 17), exhibited to the Roman public in 1778. He began an altarpiece for St. Peter's but never got beyond the preparatory stage. Other commissions, such as an altarpiece for Salzburg Cathedral, were also left unfinished. He died on June 29, 1779, leaving a considerable legacy of unfinished works as well as drawings. The inventory of his heritage also lists a large number of books as well as engravings of all the most important pictures since the Renaissance besides paintings and drawings by other artists. Most famous of all was his collection of plasters of classical sculpture, all of the highest quality. Some of these plasters were sold in 1785 to Dresden, others went in the collection of the Academia de San Fernando in Madrid.

Mengs enjoyed considerable success as an author, too, his theoretical treatises on the models and principles of art being highly regarded until well into the nineteenth century. During his life and for some while afterwards, he was hailed as the greatest painter of his age, but as the Romantic movement gained ground his reputation began to decline. [SR]

BIBLIOGRAPHY  Roettgen 1993; Roettgen 1999; Roettgen 2000

252
## Anton Raphael Mengs
### Semiramis Receives the News of the Babylonian Resistance

1755
Oil on canvas
Cut, left-hand side; restored 1993
43⅛″ × 54″ (105.5 × 137 cm)

PROVENANCE  Marchioness Wilhemine von Ansbach-Bayreuth to 1758; Crown Prince Friedrich Christian von Ansbach-Bayreuth; Count von Limburg-Styrum, from 1763; art dealer M. Joly, rue St.-Honoré, Paris, 1793; auctioneer La Raynière, Paris, 1793, purchaser Boucher; Cardinal Fesch, Rome to 1841; auctioneer George, Rome, 1843; sale, Paris, 1846; private collection, Denmark, to 1946; English and American private owner; Montgomery Galleries, San Francisco, to 1991

EXHIBITION  Bayreuth, Germany, Staatlichen Schlösser, Garten und Seen. Paradies des Rokoko. 1998

BIBLIOGRAPHY  Mengs, Anton Raphael. Œuvres de M. Mengs: premier peintre du roi d'Espagne & du roi de Pologne, professeur de l'Académie Capitoline à Rome. Translated by Doray de Longrais. Paris, 1782; Catalogue des tableaux composant la galerie de feu son eminence le Cardinal Fesch. Rome, 1841, p. 29, no. 593; Hojer, Gerhard. Anton Raphael Mengs, Königin Semiramis erhalt die Nachricht vom Aufstand in Babyon. Berlin: Kulturstiftung der Länder, 1995; Krückmann, Peter O., ed. Paradies des Rokoko. Munich: Prestel, 1998, vol. 1, pp. 132–33; Roettgen 1999, pp. 174–76, no. 113
Bayreuth, Neues Schloss, Bayerische Verwaltung der Staatlichen Schlösser, Gärten und Seen, Bayreuth

Doray de Longrais, Prange, and Azara-Fea all provide detailed accounts of the origin and history of this painting. It was commissioned from Mengs by Wilhelmine, Margravine of Ansbach-Bayreuth, who visited Rome with her husband in 1755 (see Roettgen 2000). According to Doray de Longrais, the commission was negotiated by Nicholas Guibal. Mengs charged a sum of 50 ducats per figure; this came to a total of 250 ducats for the five figures, that is, around 500 Roman scudi. It was common practice to base the price for the painting on the number of figures in it.

The painting hung over a doorway in the castle in Bayreuth, and was one of a pair with a painting by Batoni of Augustus and Cleopatra. After the death of the marchioness, Crown Prince Friedrich Christian swapped the picture with the Count of Limberg-Styrum for an eight-horse carriage. The new owner—one Count von Wilmersdorf—soon wanted rid of the painting, and sent it to the Duke of Württemberg. From Stuttgart the picture is thought to have found its way to Paris, and to have been sold for 6,000 scudi—while Mengs himself was still living. According to Jansen, the painting passed into the hands of the Parisian art dealer Joly in 1781. A year later, however, Doray de Langrais was already unable to account for its whereabouts. In 1793 it came to light at a sale at the art dealer and auctioneer La Raynière, and was acquired by someone called Boucher for 2002 francs. The date of Fesch's purchase of the picture is not known. In 1841 it is listed in his collection catalogue, with a very detailed description: "Raphael Mengs has made use in this beautiful composition of the full range of brilliant and harmonious tones provided by his palette. The draftsmanship is remarkable for its purity, and the execution is masterful. This is one of the painter's most acclaimed works" (see Roettgen 1999, p. 174).

Despite an even more glowing and detailed description in the sale catalogue of 1843, the picture was not sold. In 1845 and 1846 it underwent restoration (the second time in Paris) and was represented at auction, but achieved only the low price of 141 francs. The picture did not resurface until 1991. There could be no doubt about its identity, given the two copies in Copenhagen and the drawing in Gotha. The drawing, which corresponds to the Mosman copy in London, differs from the final execution in respect of two details: the wall in the background is shown as a viaduct, and the letter is larger. The painting was later cut down by 2–3 inches on the lefthand border, as can be seen by comparing the two painted copies, which still have the same dimensions as the original.

The connection with the Bolognese school of the seventeenth century can be clearly seen in the composition and the opulent rendering of the drapery. This is particularly true for the principal figure, whose rich drapery is ornamental almost to the point of being freestanding, reminiscent, in this, of the heavily pleated robes found in the paintings of Reni's middle period, or Guercino's early work of 1620–24. The face of Semiramis also shows the influence of heads by Reni or Domenichino. The messenger, on the other hand, belongs to a type of masculine figure that can be traced back to a style used, following Pietro da Cortona, for the depiction of Romans (for example, The Rape of the Sabine

*Women*, Museo Capitolino, Rome). Significantly, the Marchioness Wilhelmine drew comparisons between Mengs and Reni in her journal and in letters home (see Roettgen 2000). This type of characterization should therefore be considered in the context of contemporary taste. The small bottle of lotion and the three-legged table, on the other hand, are, according to Heger, accurate archaeological representations, and indicate that the painter was already interested in antiquity. For the general design of the composition Mengs followed the existing example of Guercino's painting of the same subject, one version of which could be seen in the Gemäldegalerie, Dresden, until 1945; a copper engraving of it was made by J. Falck in 1677. However, the handling of the action does indicate important differences with Bolognese classicism.

The choice of the subject can probably be traced back to the marchioness herself (see Lorenz Seelig, *Friedrich und Wilhelmine von Bayreuth: Die Kunst am Bayreuther* [Munich: Schnell & Steiner, 1982]). Semiramis is seen at the moment at which she receives news of the danger threatening the states over which she rules. The moral substance of the picture lies in the fact that the female ruler turns from "womanly tasks" in order to assume control of her state-related duties. The theme of Semiramis enjoyed a significant revival around the middle of the eighteenth century, probably as a result of political-dynastic relationships of the day. The Assyrian queen embodied the contemporary ideal of the wise, circumspect, and virtuous female ruler, concerned less with fripperies than with state business. Gluck's opera of the same name, first performed in Vienna in 1748, was written in honour of Maria Theresa. The marchioness herself evidently recognized her ideal in Semiramis. She commanded a production of an opera entitled *Semiramis* in 1753, in Bayreuth, the libretto of which she wrote herself, based on the work by Voltaire. [SR]

## 253
## Anton Raphael Mengs
*John Viscount Garlies (1736–1806), Later 7th Earl of Galloway, as Master of Garlies*

1758

Signed lower right: *Antonio Raphael Mengs/ fecit/ Roma 1758*

Oil on canvas

39⅛" × 28⅜" (99.5 × 72 cm)

PROVENANCE  the Earl of Galloway, Cumloden, Kirkcudbrightshire, Scotland; sale, Christie's, London, December 16, 1998, lot 73

EXHIBITION  Edinburgh 1966, no catalogue

253

BIBLIOGRAPHY  Russell 1979, pp. 13, 17; Skinner 1990; Roettgen 1993, p. 22; Ingamells 1997, p. 391; Sale catalogue, Christies, London, December 16, 1998, lot 73, p. 114; Roettgen 1999, p. 282, no. 213 Colnaghi, London

The subject was the eldest son of the 6th Earl of Galloway. After completing his studies in Glasgow he had set out on the Grand Tour, accompanied by his tutor, a Mr. Smith; this was probably in 1757, although the exact dates are not known. Points of reference for Garlies's activities during his stay in Italy are given in a letter written by John Parker, a painter and agent living in Rome, which James Russell made known on the basis of excerpts in the Brinsley Ford archives. According to the letter, Garlies was already in Rome on April 5, 1758. On April 26, 1758, he began lessons in the fundamentals of architecture from the Scottish architect Robert Mylne, who lived in Rome. Garlies ordered a copy after Titian's painting *Venus and Adonis*, which was in the Galleria Colonna, from the Scottish painter James Nevay, a pupil of Mengs's who had been living in Rome since 1755. Garlies appears also to have owned a painting by Mengs of John the Baptist preaching; at least a painting of that subject is mentioned

in the auction of the Galloway collection (Christie's sale, London, February 12, 1825, lot 80).

On his journey home in August 1758, Garlies made a stop in Turin. From the "Letter Book" of Andrew Lumisden (National Library of Scotland, Edinburgh) it emerges that while there he unpacked the portrait by Mengs to show it to friends or traveling companions. When it was being repacked, a piece of paper stuck to the canvas, which was obviously not yet completely dry, as the engraver Robert Strange, who was a friend of Lumisden's later discovered (see Ingamells 1997, p. 391). These circumstances confirm that it was at least sometimes the custom to paint portraits of those doing the Grand Tour expeditiously and briskly, so that the sitters could take the paintings with them in their luggage. This in turn implies a manageable size: in the case of bigger—that is mainly full-length portraits, such as both Mengs and Batoni painted—it would hardly have been practicable, however, for the pictures to accompany the Tourists home.

Garlies is standing in front of a neutral background, the left side of which is lit up, while the narrower area to the right is in darkness. The line separating these two parts of the back-

ground appears almost three-dimensional: this reinforces the volume of the sitter, who is presented in a self-confident pose with a luxuriously draped cloak. The face is fully illuminated and stands out convincingly against the background. The sitter is wearing an outfit in the seventeenth-century style which was described in Italy as a "Van Dyck" costume, beloved around the mid-eighteenth century by the English and the Scots alike. A white collar edged with lace lies over the buttoned doublet, and the satin cloak, brightened and animated by highlights, is thrown over his arm, which is resting on his hip. The cuffs of the sleeves are also trimmed with lace.

Mengs chose this costume for several of his British portraits, probably guided by his clients' wishes. But the portrait of Viscount Garlies imitates Van Dyck not only in the clothing but also in its composition. The direct model for the pose is Van Dyck's portrait of Petrus Stevens in what was known as the *Iconography*, a series of one hundred engravings after portraits by Van Dyck that became one of the most widely used and correspondingly frequently reprinted repertoires of portrait poses during the seventeenth and eighteenth centuries. In the present case the pose is copied almost exactly. On the other hand, this picture is much broader than the Van Dyck portrait, and the axis of the sitter's body divides the picture surface into two equal parts. The voluminous cloak, the gesture, and the vibrant lighting give this portrait an almost Baroque character. The consciously traditional note, which is also revealed in the adoption of a Van Dyck pose, may also have had something to do with the fact that Garlies was a Jacobite. It may therefore be possible to interpret the reference to the English portrait tradition here as a hidden allusion to the political circumstances of the seventeenth century.

Politics aside, it was quite common for British visitors to Rome to opt for this discreet yet elegant garb, which also alluded to their northern origins. It is noticeable that portraits of this kind are more common in the work of Mengs than in that of Batoni, whose clients generally preferred more lavish and colorful clothing. Winckelmann commented on this fashion in his *Geschichte der Kunst des Alterthums*, which may be due to the fact that he had repeatedly seen portraits of this kind in Mengs's studio. In connection with a camera that was done in the neo-Attic style, he remarks: "Here, for example, it is possible to do portraits with the sitter dressed in the manner of Van Dyck, a form of attire that has not caught on yet with the English but which is better from the artist's point of view—and the subjects—than the restrained clothes of today" (Johann

254

255

Joachim Winckelmann, *Geschichte der Kunst des Alterthums* [Dresden, 1764], p. 124). [SR]

## 254
## Anton Raphael Mengs
### *Thomas Conolly of Castletown*

1758
Signed on the base of the column at the right: *Ant. Raf. M(…) Sassone*
Oil on canvas
53⅛″ × 38⅜″ (135 × 98cm)
PROVENANCE  Lady Anne Conolly, London, Grosvenor Place; Conolly family, Castletown; acquired by the National Gallery of Ireland from the Hon. Desmond Guiness in 1966
BIBLIOGRAPHY  Le Harivel, Adrian, and Michael Wynne. *National Gallery of Ireland Acquisitions, 1982–83*. Dublin: National Gallery of Ireland, 1984, pp. 30–32; Wynne, Michael. *Later Italian Paintings in the National Gallery of Ireland: The Seventeenth, Eighteenth, and Nineteenth Centuries*. Dublin: National Gallery of Ireland, 1986; Roettgen 1999, p. 273, no. 201
National Gallery of Ireland, Dublin

This picture was painted in 1758 in Rome, the last stop on Conolly's Grand Tour before he returned that same year to Britain, where he would later marry Louise Lennox, the sister of the Duke of Richmond (for details of the character and biography of the subject refer to Le Harivel and Wynne, p. 30, see above). One of the two identical, officially signed versions of the portrait is mentioned by Horace Walpole as being in the possession of the subject's mother, Lady Anne Conolly, in Grosvenor Place, London. It is impossible to say which of the two portraits this might have been. It is unusual for there to be two versions of a portrait commission. The reason for this suggested by Le Harivel and Wynne is that one of the portraits was intended as present for the subject's mother.

Conolly is shown in three-quarter figure, in front of a columnar architectural structure. On the right, in the background, can be glimpsed a patch of southern-looking landscape with a bay tree. The two impressive columns stand on a stone parapet, the visible side of which shows a relief of the Muses, formerly in the Museo Capitolino (now in the Musée du Louvre, Paris).

A few years later Mengs borrowed several motifs from this famous antique relief for his *Parnassus* frescoes in the Villa Albani. The section shown here depicts, from left to right, Cleo, Urania, and Melpomene. It may be that his choice of this Roman reliquary, and of this precise section of it, was inspired by particular references that now remain opaque for lack of documentation. The helpless and apparently incoherent gesture with which Conolly points towards the frieze could—although it is a common theme in representational portraits by Mengs—be read as a clue to a reference of this kind. Both the pose and the composition owe a debt to works by Batoni, though this portrait fails to achieve the latter's air of assured worldliness. In this respect it may be compared with the portrait of Lord Brudenell of roughly the same period. [SR]

## 255
## Anton Raphael Mengs
### *Pope Clement XIII Rezzonico*

1758?
Oil on canvas
60¼″ × 43⅜″ (153 × 111 cm)
PROVENANCE  Edoardo and Maria de Pecis, 1827
BIBLIOGRAPHY  Prange 1786, vol. 1, p. 177; Goethe [1788] 1974, p. 523; Winckelmann 1952–57, vol. 1, p. 258; Bassi 1959; Artemieva et al. 1998, p. 9; Roettgen 1999, pp. 227–29, nos. 156, 158
Pinacoteca Nazionale, Bologna

Mengs portrayed Clement XIII Rezzonico, who was elected pope on July 6, 1758, in two different poses. Whereas the portrait in Bologna (Pinacoteca Ambrosiana) is in the Roman tradition of papal portraiture going back to Raphael's portrait of Pope Julius II, the one in Milan is based on the tradition of sculptural papal portraits in which the gesture of benediction is relatively common. Also unusual is the frontal view, which gives the portrait a severe, hieratic character, to some extent at odds with the mild, good-humored expression on the pope's face.

In fact Clement XIII was apparently not very satisfied with the first of the two portraits painted by Mengs. This is implied in an anecdote recounted in Prange's biography of Mengs (Prange 1786, vol. 1, p. 177), which also describes the more detailed circumstances of the portrait sitting, which took place in the papal residence in the presence of a monsignor. Mengs had heard that Subleyras had knelt to

paint the portrait of Benedict XIV (though this is not correct; see Michel and Rosenberg 1987, pp. 92–93), but he refused to do the same as his colleague. He justified this on the grounds that he could not paint in that position. Furthermore, during the sitting with the pope he would occasionally start to whistle tunes, which he was forbidden to do.

Even if some parts of Prange's account are the usual stuff of artistic legend, it does reveal something about the procedures customary for these portraits: for example, that it was customary to paint the first official portrait of a new pope from start to finish in the papal palace; that there was an articulated dummy (*manichino*) specially for the preparation of portraits which was used for the representation of the pontificals, and finally that no payment was made for the first copy of the official portrait.

The two different versions of the portrait of the pope were intended for his nephews. One of the two went first to the Rezzonico family palace in Venice, where it was provided with a lavish silver frame specially made for it in Padua (Roettgen 1999, no. 156). According to Canova, however, the same portrait was later in Rome, in the possession of D. Abbondio Rezzonico, senator of Rome, who lived in the Palazzo Senatorio, on the Capitoline Hill. It was admired there in February 1788 by Goethe ([1788] 1974, p. 523). In this connection Goethe quotes an extract from the diary of his friend and later collaborator Heinrich Meyer, who had explained that in this portrait Mengs had imitated the coloring and modeling of Venetian painters. In the same connection Meyer also mentions that the Pope's head showed up well against a "curtain of gold material." This detail, which is missing in the versions known so far, is found in a painting in Venice acquired in 1997 from a private Venetian owner (Museo del Settecento Veneziano, Ca' Rezzonico) that otherwise objectively corresponds with the Milan portrait. There are therefore strong grounds for believing that this portrait, hitherto regarded as the work of an unknown artist, is the painting that once hung in the Palazzo Senatorio in Rome. The portrait in Milan, the provenance of which cannot be traced back beyond 1827, would consequently have to be regarded as the best of the replicas and copies of the portrait known up to now.

A letter from Winckelmann dated December 1, 1758, discloses that Mengs had by then completed the portrait of the pope, though which of the two portraits this comment refers to remains an open question (Winckelmann, 1952–57, vol. 1,

pp. 439–40). As this was the first official portrait of the pope, it may be assumed that the two portraits were painted within a very short interval. The fact that the commission for the first official papal portrait went to a foreigner who was a Catholic convert makes it clear how high Mengs's standing in Rome was at that time. Around the same time he painted portraits of several important representatives of the Curia in Rome, including Cardinal Archinto, secretary of state to Benedict XIV, Cardinal York, and the pope's nephew Carlo Rezzonico. Then in 1760 Batoni was also commissioned to paint an official portrait of Clement XIII; this falls into the less usual category of a standing three-quarter-length portrait (Curzi and Lo Bianco 1998, p. 81). [SR]

## 256
## Anton Raphael Mengs
### *Sibyl*

1761?
Oil on canvas
46⅜" × 36⅝" (118.5 × 93 cm)
EXHIBITIONS s'Hertogenbosch, Heino, and Haarlem 1984, cat. no. 105; Rome 1988, *Artisti*, cat. no. 56; Frankfurt, Bologna, Los Angeles, and Fort Worth 1988, cat. no. D40; London 1993, cat. no. 23
BIBLIOGRAPHY Mengs 1787; *Conca* 1981; Roettgen 1993; Busch 1998; Roettgen 1999, no. 114
Chaucer Fine Arts Ltd., London

After returning from a fairly long stay in Naples, in the spring and summer of 1761 Mengs painted "three half-length figures" for an unknown English client. Both *The Penitent Magdalen* (cat. 257) and the *Sibyl* seem to have been among them. Azara said that *Sibyl* was in England; but it must have been in Rome until May 1762, as it was copied at that time by Benjamin West (Roettgen 1993, pp. 110–11), as the copyist reported in a letter dated May 11, 1762. Mengs's picture was later engraved by Nikolaus Mosmann (Roettgen 1999, p. 177).

The theme and subject of Mengs's work are both derived from Guercino's *Persian Sibyl* (Pinacoteca Capitolina, Rome). Formally—particularly in the character of the head and the treatment of the drapery—it owes more to Domenichino; in its coloring, to Reni. This strong influence from seventeenth-century Bolognese classicism is also characteristic of other works that Mengs painted in these years (such as *Saint Cecilia*, private collection, Rome; Roettgen 1999, no. 78). Here Mengs successfully combines these sources with contemporary eighteenth-century taste, which valued idealized contemplation more highly than dramatic or pathetic expressive-

256

ness. This becomes clear if his *Sibyl* is compared with works in this genre by Batoni (*Cleopatra*, 1744–46; Galleria Pallavicini, Rome; see Clark and Bowron 1985, fig. 94) or Sebastiano Conca (1726; Museum of Fine Arts, Boston; *Conca* 1981, no. 34). The picture's qualities of timelessness and spiritual intensity, as opposed to dramatic action, bespeak the painter's modern interpretation of the theme and place the work in a category dubbed by Werner Busch the "one-figure history picture" (Busch 1998, title of essay). This is clearly demonstrated in the iconography of the picture, which departs from the Christian iconography traditionally associated with this subject. Although the turban, book, and contemplative expression symbolically identify the figure as a sibyl, the conventionally essential distinguishing feature—the banderole with appropriate prophecies—is absent. Consequently it is not a specific sibyl who is portrayed, but an idealized woman posing in a sibylline attitude. The shaft of a Doric column overrunning the left-hand edge of the picture and the block of stone on which she is resting her arm are inserted for atmosphere, as is the deeply shaded background in which a hilly landscape in lush green with a high horizon line can be distinguished. The soft lighting makes the face

appear as if moonlight is falling on it. A dark shadow is cast on the column.

The exquisite coloring of the clothing, which is based on secondary colors (purple, ochre-yellow, lemon-yellow, light reseda green), strongly influenced Angelika Kauffmann's palette: she also found inspiration in the form and theme of this picture. Her personification of hope (*La Speranza*), submitted to the Accademia di S. Luca in 1763 as her admission piece, adopts some motifs (the pose of the hands) almost directly from Mengs's *Sibyl* (Baumgärtel 1998, pp. 146–47). The drapery of the silk material on the sibyl's sleeve here, conveyed with fine bar strokes and breaks, also anticipates Angelika Kauffmann's silk materials, though they do not appear in Kauffmann's work until the 1770s and 1780s.

At the same time as the *Sibyl* was painted, Mengs was finishing the ceiling painting of the *Parnassus* in the Villa Albani (cat. 378). This may explain why the *Sibyl* could pass for a sister of the muses. She is particularly closely related to the muses' mother, Mnemosyne (included in the actual painting), and to Calliope, whose arms are in the same pose as the sibyl's. [SR]

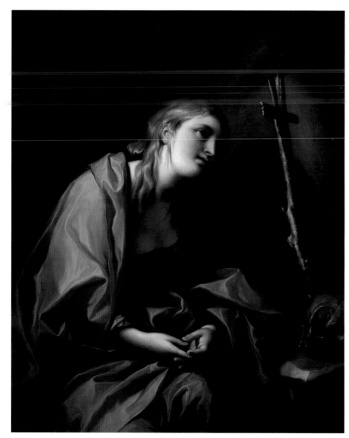

257

## 257

### Anton Raphael Mengs
### *The Penitent Magdalen*

1761?
Oil on canvas
43¾″ × 35″ (111 × 89 cm)
PROVENANCE  Col. Joseph Weld, Lulworth
Castle until 1967
EXHIBITIONS  Bournemouth, England,
Round-Cotes Art Gallery and Museum.
*Paintings from Lulworth Castle*. 1967,
cat. no. 81; London 1981, *Collecting*,
cat. no. 12; London 1993, cat. no. 21
BIBLIOGRAPHY  Roettgen 1993, pp. 90–91,
cat. no. 21; Roettgen 1999, p. 139, cat. no. 91
Chaucer Fine Arts Ltd., London

This half-length figure of Mary
Magdalene is one of the paintings
that brought Mengs particular acclaim
from his clients. Its popularity is
evident in the fact that he personally
painted at least four versions of the
subject that are virtually identical.
Presumably the present painting is
one of three pictures with single half-
length figures mentioned by Azara
that Mengs painted in Rome for an
English client shortly before being
summoned to Spain in 1761 (see
cat. 256). The fact that three of the ver-
sions in his own hand have turned up
in Great Britain in the twentieth
century suggests that they had been in
that country for a long time, especially
as examples of *The Penitent Magdalen*

by Mengs are featured in several auc-
tions in Britain in the eighteenth
century and early nineteenth.
Furthermore, the only currently
known engraving after this composi-
tion is by the British engraver Thomas
Chambers. Mengs later repeated the
subject in Spain as a commission for
the queen mother, Isabella Farnese,
but because of different coloring and
modeling the character of the portrayal
has greatly altered (Roettgen 1999, no.
94). A cartoon or "master picture"
kept in Mengs's studio in Rome served
as the basis for all these versions. A
version that turned up on the English
art market in 1987 (Roettgen 1993, no.
22) was probably the model for the
graphic copy that Nikolaus Mosmann,
one of Mengs's pupils, made in Rome
for the Earl of Exeter (London, British
Museum, inv. No. T.5–7, vol. VI,
no. 212). However, the large tear on
the nose in the version shown here is
missing from that drawing.

Most eighteenth-century portrayals
of Mary Magdalene are either full-
length or landscape format; their point
of departure for form and iconography
was Correggio's then much-admired
small-format picture in Dresden,
which hung in the royal bedchamber
(see the description by Mengs in
"Memorie sopra il Correggio" in
Mengs 1787, p. 182). Apart from
Correggio, it was mainly seventeenth-
century Bolognese painting that pro-

vided the prototypes for eighteenth-
century portrayals of Mary Magdalene.
Mengs also followed that tradition.
There is a close connection between
his Magdalen and a famous picture by
Giovanni Gioseffo dal Sole (Palazzo
Bianco, Genoa) frequently copied in
the eighteenth century, and then
believed to be by Guido Reni.

Besides this relatively heavily veiled
half-length Magdalen, Mengs painted
several pictures of her reclining,
showing more of her body. The
typical image of Mary Magdalene
reclining in a grotto had become espe-
cially popular and famous through
Batoni's *Mary Magdalene*, painted in
1742 (formerly Gemäldegalerie Alte
Meister, Dresden), which was widely
imitated. Even in the eighteenth
century it was still necessary to have a
valid thematic pretext for depicting
the female body naked or semi-naked.
The image of the repentant Magdalen
lying outstretched derived its attrac-
tion from the official pretense that
while the viewer was feasting his eyes
he was also piously reflecting on the
moral lesson of the sinner's repen-
tance. It was also charming that Mary
Magdalene, engrossed in repentance
and remorse, cared neither that she
was naked nor that she was being
observed. The viewer thus became an
appreciative voyeur who was in the
advantageous position of not being
open to reproach in view of the
Christian subject matter.

The facial type of the Magdalen
and the pose of the head indicate the
closeness in date to the Cleopatra
Mengs painted for the British banker
Henry Hoare for Stourhead House
(Roettgen 1999, no. 105). In painterly
terms this picture is outstanding for
the virtuoso rendering of the silk
materials, with their multitude of
tonal gradations, conveyed in the
broken colors typical of Mengs—the
subdued red lake of the luxuriantly
draped robe and the yellowish-green
of the low-cut gown stand out effec-
tively from the dark, shaded sur-
roundings. Here, as with the *Sibyl*
(cat. 256), the figure is set against a
cave-like space only faintly lit by
moonlight, which nevertheless gener-
ates a powerful cast shadow. The ren-
dering of the raguly cross and the
skull has the quality of a still life. [SR]

## 258

### Anton Raphael Mengs
### *The Adoration of the Shepherds*

1764–65
Oil on canvas
104″ × 60″ (264.2 × 152.4 cm)
PROVENANCE  Palacio Real Madrid until
1813; Joseph Bonaparte, 1813–44; William
Wilson Corcoran, through a bequest of
May 10, 1869, to its present location
BIBLIOGRAPHY  Mengs 1787, pp. 183–84;
Curzi and Lo Bianco 1998, p. 94; Roettgen
1999, pp. 55–58, no. 23
The Corcoran Gallery of Art, Washington,
D.C., Gift of William Wilson Corcoran

The theme of the Adoration occupies
an important position in Mengs's cre-
ative output. Starting with his early
alternative design for the high altar of
Dresden Hofkirche in 1750 (Roettgen
1999, pp. 52–54, cat. no. 21), he turned
to this theme again and again, and in
the course of his life came up with
various compositional solutions for
it. His first period working in Madrid
(1761–69) was marked by a particularly
intense and frequent preoccupation
with the subject. The point of depar-
ture for this was the picture, now in
Washington, that Mengs painted in
1764–65 for the altar in the private
chapel of Charles III at the Palacio Real
in Madrid. Because of the unfavorable
reflections of light in the chapel, it had
to be removed shortly afterward and
was hung elsewhere in the palace. It
was replaced in the chapel by a fresco,
which was destroyed during alter-
ations to that part of the palace in
1880 (Roettgen 1999, p. 490, QU 12).
As nothing is currently known
regarding the appearance of that
fresco, apart from the fact that it
treated the same subject, it is not clear
whether the composition was altered
in relation to the oil painting. There
are in existence five drawings by
Mengs that resemble the Corcoran
painting to varying degrees (Roettgen
1999, pp. 57–58), and it may be that
one or more of these relates partly to
the lost wall painting.

More markedly than in any other
version of the theme—the best-
known of which is the wooden panel
for Charles III completed in Rome in
1772 (Museo del Prado, Madrid)—the
composition here is based on an altar-
piece by Correggio, who, along with
Raphael and Titian, was Mengs's most
important artistic influence.
Correggio's *Adoration of the Shepherds*
("La Notte"), which was purchased in
1747 for the Gemäldegalerie Alte
Meister in Dresden, was regarded as
an incomparable masterpiece of
*chiaroscuro* painting. Mengs had seen
the picture himself and wrote an
excellent description of it, which

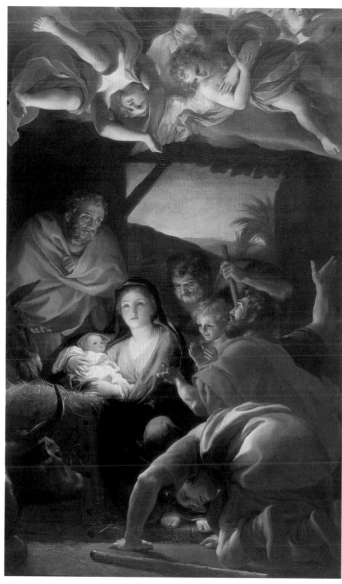

258

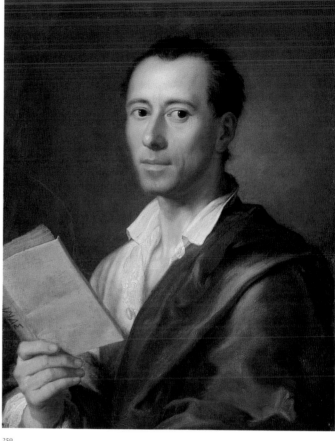

259

reveals something about his own working methods. He goes into particular detail about the direction of light, including the effect light has on the poses of those present at the event. He explains the poses and movements of Mary and the Child based on the control of light and shade, and puts forward the view that the figural composition is based on the absolute priority Correggio put on the direction of light. He reserves particular praise for the angels, emphasizing their beauty, grace, and perfection (Mengs 1787, pp. 183–84), qualities of great importance to Mengs in his own work.

The background of his description of Correggio's *Adoration* provides a better understanding of the picture painted by Mengs. For him, too, the Child in the crib is the most important source of light and all contrasts and reflections of light can be traced back to it. The face of Mary, gazing directly out of the picture, is illumi-

nated especially powerfully by that light, which is reflected somewhat more weakly on the faces of Joseph, standing in the background on the left, and of the shepherds, in the right-hand half of the picture, and on the swirling robes of the angels hovering above the scene. A second, hidden source of light illuminates the background, as it does in the Correggio, revealing a landscape with a low horizon. In view of these similarities, the differences between the two paintings are all the more striking. Whereas in Correggio's painting the strong movement of the shepherds and angels gives the left side of the picture a strong ascendancy that contrasts with the mysterious peace of the darker right side, the light reflections in Mengs's picture are distributed meticulously over the figures, which are arranged more or less in the same place. Mary, with the Child, is somewhat farther forward, and although

she is the main focal point she is not the only one. Thus, in spite of all the movement, the picture is less dramatic and mysterious than the Correggio. This can be attributed to the carefully balanced division of the picture surface and the equilibrium of the figures.

The tradition of night-time pictures of the Adoration, starting with Correggio, extends in academy-influenced Roman painting from Lanfranco and Guido Reni by way of Maratti and Passeri on to Benefial and Corvi. Nonetheless, among eighteenth-century painters in Rome Mengs tends to stand alone in his close dependence on Correggio. Only Corvi, with his *bozzetto* at the Accademia di S. Luca, painted before 1756, can be compared with him in this respect (see Curzi and Lo Bianco 1998, p. 95). This may be due to the close relationship between the two painters in those years. However, compared with Corvi's picture, the painting by Mengs shown here is considerably more academic and classical in its effect. [SR]

## 259
## Anton Raphael Mengs
### *Johann Joachim Winckelmann*

1768?
Oil on canvas
25″ × 19⅛″ (63.5 × 49.2 cm)

PROVENANCE  José Nicolás de Azara, c. 1787–1804; Isabella Princess Lubomirski, 1810–16; family of the princes Lubomirski, until 1947

EXHIBITIONS  Florence 1911, cat. no. 67; Hartford, Conn., Wadsworth Atheneum. *Homage to Mozart.* 1956, cat. no. 40; Bregenz and Vienna 1968, cat. no. 342; London 1972, cat. no. 192; Storrs 1973, cat. no. 98; Washington, D.C., National Gallery of Art. *The Age of Thomas Jefferson.* 1976, cat. no. 155; Hamburg 1989, cat. no. 59

BIBLIOGRAPHY  Winckelmann, 1952–57, vol. 3, p. 510, and vol. 4, p. 117; Schulz 1953, p. 6, 54–55; Zeller and Steinmann 1956; Roettgen 1982, pp. 61–184; Baumgärtel 1998, pp. 129–33; Roettgen 1999, pp. 306–7, no. 237

The Metropolitan Museum of Art, New York, Harris Brisbane Dick Fund

Johann Joachim Winckelmann arrived in Rome at the beginning of November 1755 to keep the Dresden court supplied with up-to-date reports regarding finds of antiquities, in particular the discoveries at Herculaneum. Thanks to his versatile scholarly interests, he was soon in touch with the Roman world of clerics

and scholars, gained access to libraries and Roman salons, and made friendly contact with foreign artists and high-ranking travelers. Right from the start Mengs was helpful to him in this respect, and as a frequent guest in Mengs's home Winckelmann enjoyed good company and a relaxed, hospitable atmosphere. The close friendship between the two men was mutually stimulating, encouraging the painter to pursue art theory and the scholar to examine works of art in greater, more concrete detail. This is confirmed by a letter Mengs wrote to the engraver Johann Georg Wille in Paris on September 1, 1756, which includes the following remarks: "I have the happiness of enjoying his friendship, and we spend many peaceful hours together. He nourishes me with his knowledge; and when he is tired I begin theorizing about art, about beauty, about lofty thoughts and the deep knowledge of the ancient masters, who have given us both so much happiness" (Winckelmann 1952–57, vol. 4, p. 117). When Winckelmann became secretary to Cardinal Alessandro Albani in 1758, he was concerned above all with the scholarly processing of the cardinal's extensive and constantly expanding collections of antiquities, and he took many foreign visitors to see them at the Villa Albani, which became one of the city's star attractions. Through his letters and his reports on the villa, Winckelmann created an important, reliable body of documentation regarding the history of its genesis, which also provides eloquent evidence of its days of glory.

The close and mutually beneficial friendship between Winckelmann and Mengs continued for several years after Mengs's departure from Rome in the summer of 1761. In 1765, however, it suffered a deep rupture that could not be repaired because of several adverse circumstances. For a long time it was therefore assumed that Mengs's portrait of Winckelmann must have been painted between 1755 and 1761. But it is not mentioned in documents or letters in the lifetime of either Winckelmann or Mengs. The earliest evidence of its existence dates from 1804 (Roettgen 1999, p. 306). The paucity of sources explains why at times it even ceased to be ascribed to Mengs (Schulz, Rehm).

However, the failure of the usual biographical sources to mention the portrait may be explained by the possibility that the picture dates from the final years of Mengs's life. Some circumstances even suggest that it may be a posthumous portrait in which Mengs wanted belatedly to record his admiration for his friend, who had been murdered in 1768. In 1777 the German sculptor Friedrich Wilhelm

Eugen Doell was in Rome, engaged on the execution of a bust of Winckelmann intended for the Pantheon (Pinacoteca Capitolina, Rome). Initially Doell used a preparatory drawing by Anton von Maron which had been made in connection with his 1767 portrait of Winckelmann (Staatliche Kunstsammlungen, Weimar [Baumgärtel 1998, pp. 129–33]). If a portrait of Winckelmann by Mengs had already been in existence, there would have been no need to rely on Maron's portrait. However, Councilor Reiffenstein, who had given Doell the commission, was not satisfied with the result, and he therefore turned to Mengs, asking him to advise the artist regarding the modeling of the head. Mengs immediately recommended Doell to take as his model an antique head in the Uffizi, believed to be a portrait of Cicero, of which he himself owned a plaster cast. This was because Mengs saw fundamental similarities between the shape of Winckelmann's head and physiognomy and the Roman head, which would enable the sculptor to get a better concept of his appearance in the round than he could from painted portraits. Reiffenstein reports that Mengs was of great help to the young artist in conceiving the head "because the said master drew on his memory and so gave him a quite different idea both in respect of attitude and likeness" (Zeller and Steinmann 1956, p. 46). In fact, not only the bust made by Doell under Mengs's guidance but also Mengs's own portrait show a dependence on the head said to be Cicero's. This is particularly apparent in the modeling of the eye area and the nose, as well as in the mouth and ears.

With regard to style, ascribing a later date to the portrait, putting it in the last years of Mengs's life, is illuminating. Like other portraits from this last creative period, the painting is remarkable for its simplicity, allied to a certain monumentality. Compared with Angelika Kauffmann's portrait (Kunsthaus, Zurich), painted in Rome in 1764 and circulated as an etching, Mengs's portrait appears remote and impersonal. This results from the subject's turning away from the viewer. Winckelmann holds an open book in his hand and presents an earnest, composed face, but without looking at the viewer directly. The way that the cloak lies over his left shoulder and the hand holds the book in such a way that the viewer sees only the binding have a distancing effect. On the spine of the book the Greek letters ΙΛΙΑΣ can be clearly seen. Winckelmann used to turn to the *Iliad* with the same frequency as others read the Bible. According to the list of personal property found in his pos-

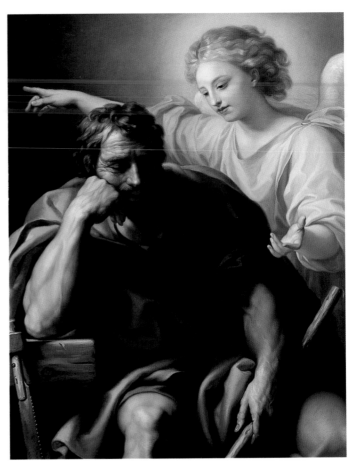

260

session on his death, he also had the book with him on his fateful journey to Germany, which he interrupted ahead of schedule to return to Rome via Vienna and Trieste, where he was killed. The book also refers to Winckelmann's mission—since the late seventeenth century the *Iliad* had been the preeminent symbol for the imitation of antiquity which Winckelmann had advocated and for which he had recommended a new way, summarized in the formula "noble simplicity and calm grandeur" (Johann Joachim Winckelmann, *Kleine Schriften, Vorreden, Entwürfe*, edited by Walter Rehm [Berlin: Walter de Gruyter, 1968], p. 43). [SR]

## 260
### Anton Raphael Mengs
*The Dream of Saint Joseph*

1770s?
Oil on walnut
43¾″ × 34″ (111 × 86.4 cm)
BIBLIOGRAPHY Hiesinger and Percy 1980, no. 57; Roettgen 1999, pp. 59–62, cat. no. 27, Collection of The John and Mable Ringling Museum of Art, the State Art Museum of Florida, Sarasota, Bequest of John Ringling

The painting is an identical second version of a picture now in Vienna

(Kunsthistorisches Museum) that Mengs painted in the winter of 1773–74 for Leopold of Habsburg-Lorraine, then Grand Duke of Tuscany as well as being the son-in-law of King Charles III of Spain, in whose service Mengs was then employed. In the *Gazzetta Toscana* of March 12, 1774, it is mentioned that the grand duke had thanked the painter by presenting him with a gold enamel box containing 100 *florins* (a gold coin with the same value as a Roman *zecchine*; Roettgen 1999, p. 61). The 3rd Earl of Cowper, who lived in Florence and already owned several works by Mengs, must have ordered the second version while Mengs was still in Florence, where he remained until April 15, 1774. However it is not known when this version was painted. It is mentioned for the first time in the 1779 inventory of the Cowper collection. In 1786 Cowper then gave the painting to the Duke of Dorset (John Frederick Sackville), who took it to England. After several changes of owner it arrived in Sarasota before the middle of the twentieth century.

The equal quality of the two versions makes it hard to assign with any precision the copies and engravings that have been preserved (Roettgen 1999). But it can be assumed that the English engravings and the copies of

English provenance are based on the version formerly owned by Cowper. A third version in Helsinki, painted on canvas (Sinebrychoff Art Museum), which is in a very poor state of preservation, varies slightly in detail and does not achieve the quality of the two other versions painted on wooden panels, although this is also due to the fact that it is obviously unfinished (Roettgen 1999, p. 59, no. 25).

The pose of Joseph, who is shown close up and treated in a very sculptural, monumental style, has been borrowed from Michelangelo's prophet Jeremiah on the ceiling of the Sistine Chapel. The intensive study of Michelangelo that is also discernible in other works by Mengs from these years was possibly triggered by the commission for the ceiling of the Stanza dei Papiri in the Vatican Palace, which the artist carried out in 1771–72. The sleeping Joseph, depicted with the attributes of his trade as a carpenter, is wearing a gray-white robe and a honey-yellow wrap. The brightly clothed angel emerges softly from the background, a relatively insubstantial being compared with this powerful, robust figure. Perhaps the strong contrast between the two figures can be explained by the artist's wish to express their differing reality. The representation of Joseph's dream refers to Matthew 2:13, which describes how an angel appears to Saint Joseph in a dream and exhorts him—as can be seen from the angel's pointing gesture—to leave Bethlehem with Mary and the Child and travel to Egypt. This portrayal should not be confused with the first dreaming face of Saint Joseph described in Matthew 1:20–23, where it is a question of dissuading Joseph from abandoning Mary because she is pregnant. Mengs depicted this latter subject in 1750 on an altarpiece in the choir of the Dresden Hofkirche (Roettgen 1999, pp. 40–42, no. 11), and it differs markedly from the treatment here.

The fact that Saint Joseph was one of the patron saints of the house of Habsburg was a decisive factor in the choice of theme. The grand duke of Tuscany is supposed to have had the painting hanging above his bed. Through this reference to the Habsburgs the religious theme gains a programmatic and symbolic meaning, certainly intentional, which can be translated as surrender to the will of God. Just as Joseph is pointed in the right path by the angel, the prince, too, hopes for divine guidance imparted in a dream. The extent to which the grand duke regarded the painting as his personal property is made clear by the fact that when he was elected Holy Roman Emperor as Leopold II (on September 30, 1790), he took it with him to Vienna.

Against the background of this close thematic reference to the owner of the first version of the picture, one is prompted to wonder what led Cowper to order a second version. Perhaps he thought it would add to his prestige if he enriched his collection of works by the court painter of Spain with another picture by Mengs identical to one that hung above the grand duke's bed.

Mengs also worked on converting the idea of the picture into a tondo, as can be seen from a sketch in Philadelphia (Hiesinger and Percy 1980, no. 57). In this drawing Joseph and the angel are sketched in a pose that is almost identical, but the cut-out area is smaller. [SR]

## 261
## Anton Raphael Mengs
### *Saint John the Baptist in the Wilderness*

1771–73

Inscribed on the scroll: *ECCE AGNUS DEI*
Oil on canvas
84½″ × 58¼″ (215 × 148 cm)

PROVENANCE given by the Rev. Father Joseph to St. Gabriel's Retreat, Blythe Hall, Omskirk, Lincolnshire; sale, Sotheby's, London, February 20, 1974, lot 28; P. & D. Colnaghi, London; from whom purchased in 1974

EXHIBITIONS Charleston, South Carolina, Gibbes Art Gallery. *Masterpieces of Italian Art*. 1982, cat. no. 16; Frankfurt, Bologna, Los Angeles, and Fort Worth 1988, cat. no. D 41

BIBLIOGRAPHY Pignatti, T. *Five Centuries of Italian Painting, 1300–1800*. Houston: The Sarah Campbell Blaffer Foundation, 1985, pp. 220–21; Roettgen 1999, pp. 127–28, no. 79

The Sarah Campbell Blaffer Foundation

261

Although the early history of this impressive painting, which conveys vividly Mengs's accomplishment as a painter of religious scenes, remains untraced, its size and format suggest that it was intended as an altarpiece in a church dedicated to John the Baptist. Mengs treated the theme of the Baptist in the wilderness on several occasions (see Roettgen 1999, pp. 128–32); his most compelling, theatrical, and emotional representation is probably the large canvas showing the saint preaching, acquired from his estate by Catherine II of Russia in 1781 and now in the Hermitage. Mengs' anticipated the St. Petersburg composition here, in the presentation of John the Baptist seated upright in a rocky landscape (many eighteenth-century painters, including Pompeo Batoni and Mengs himself, on occasion, preferred to depict the saint reclining on the ground).

Although contemporary antiquarians might well have recognized the general similarity between the saint's pose and one of the antique sculptures most widely admired in Rome in the second half of the eighteenth century, the Barberini *Faun* (Palazzo Barberini, Rome, until 1799; now Glyptothek, Munich), Mengs probably had in mind more recent pictorial examples when he conceived *Saint John the Baptist in the Wilderness*. The composition derives ultimately from Leonardo (c. 1515, Musée du Louvre, Paris), but whatever inspiration Mengs derived from Renaissance models was almost certainly drawn from a painting whose invention is Raphael's, although it is almost unanimously attributed to his workshop (c. 1518–20; Accademia, Florence). Mengs's direct prototypes for the present work, as Steffi Roettgen has noted, are two full-length seated representations of the saint by one of the exemplars of sixteenth-century classicism, Guido Reni. The earlier version, *Saint John the Baptist Preaching* (1624–25; Vitetti Collection, Rome), anticipates the gesture of the saint's raised right arm in the Houston painting; the later *Saint John the Baptist in the Wilderness* (1636–37; Dulwich Picture Gallery; see D. Stephen Pepper, *Guido Reni* [Oxford: Phaidon, 1984], pls. 117, 190),

in the famous Balbi collection in Genoa in the eighteenth century, could well be the specific source for the saint's diagonal posture with his left leg extended and his right akimbo, and for the motif of the Baptist's bent arm nestled against the drapery-covered rock, his fingers gently cradling the long slender reed cross against his body.

Two black-chalk compositional studies by Mengs in the Philadelphia Museum of Art may represent the genesis of the present composition, as Roettgen observed many years ago (Hiesinger and Percy 1980, p. 71, no. 57, and p. 154, no. 113; Roettgen 1999, p. 455, nos. Z 94, 95). The inspiration for each was Raphael's painting of the subject, located in the eighteenth century in the Tribuna of the Uffizi, which Mengs could have seen during his stay in Florence in 1770. Although these quick compositional sketches suggest only the germ of the Houston *Saint John the Baptist in the Wilderness*, the confirmed dating of the sheets to the early 1770s corresponds to the presumed date of the painting during Mengs's break in his service to the Spanish court in Madrid and sojourn in Rome from 1771 to 1773.

The conception and composition of *Saint John the Baptist in the Wilderness* reveal unquestionably the stamp of Mengs's pictorial imagination. However, whether the execution is entirely his remains open to question, as Roettgen wrote in the Philadelphia catalogue cited above. Although the overall drawing, layout of the figure, and brushwork of the drapery reveal convincingly Mengs's hand, the handling of certain passages strongly suggests the participation of his brother-in-law Anton von Maron, especially the treatment of the saint's head and facial features and of the flesh tones. Mengs may well have been overwhelmed by commissions during his return from Spain—in 1771 he was commissioned to decorate the Stanza dei Papiri in the Vatican Library—and called upon his former pupil and assistant for assistance in finishing various commissions. [EPB]

## AURELIANO MILANI

BOLOGNA 1675–1749 BOLOGNA

The Bolognese painter, draftsman, and engraver Aureliano Milani enjoyed significant artistic success in Rome, where he was one of the more active painters in the second quarter of the Settecento. His art is marked by a deep commitment to the artistic culture of his native Bologna and of the Carracci family, to whom he was distantly related. As a young artist he trained briefly with his uncle Giulio Cesare Milani and the Bolognese painters Lorenzo Pasinelli and Cesare Gennari. His true "academy," however, was the celebrated fresco cycles by the Carracci in the Palazzo Magnani and the Palazzo Fava in Bologna. He was given free access to the Palazzo Fava as well as financial assistance by Count Alessandro Fava, and his exacting study of the Carracci served as the basis for the creation of his own personal style. Almost all writers on the artist have observed the degree to which he attempted to emulate the naturalism of his illustrious predecessors, particularly in his drawing and in the treatment of anatomy, which reflect "a profound assimilation of the Carracciesque studies of the live model" (Czére 1988, p. 133).

Milani's earliest works, fresco decorations for several private houses in Bologna and a fresco of *The Annunciation* for the former convent of the Servite order in Bologna, exemplify his efforts to intiate a neo-Carracciesque revival. His reputation was established in Bologna with altarpieces for local churches such as *The Martyrdom of Saint Stephen* and another depicting various saints in S. Maria della Purificazione (c. 1715; destroyed), and *Saint Jerome and the Blessed*

*Buonaparte Ghisilieri* in S. Maria della Vita (c. 1718). His *Resurrection* in the Palazzo Arcivescovile (one of a series of six oval canvases from the demolished Oratorio di S. Maria della Purità) is a vigorous paraphrase of Annibale Carracci's painting of the theme in the Musée du Louvre. It is admired by modern writers as being rivaled among Milani's Bolognese contemporaries only by Giuseppe Maria Crespi. Milani also painted a series of history paintings for Francesco Farnese, Duke of Parma, and enjoyed the patronage of other influential persons. However, the lack of commissions in his native city and the responsibility for a large family led him to seek a more profitable arena for the expression of his talents, despite the fact that in 1709 a painting of his representing *Saint Luke* was exhibited in Rome along with works by other Bolognese painters at an exhibition in S. Salvatore in Lauro to little enthusiasm, to little effect whatever.

General Luigi Ferdinando Marsigli, a vigorous promoter of the newly formed Accademia Clementina, attempted to ensure a favorable reception for Milani in Rome, advising him to send a large drawing, *The Fall of Simon Magus* (untraced), as a gift to the Bolognese pope, Clement XI, and he equipped him with a letter of introduction to a friend in Rome, Cardinal Fabrizio Paolucci de' Calboli. Milani settled in Rome in 1719 and the following year received his first commission, a fresco of *The Martydom of Saint Pancras* for the major altar of the cathedral at Albano and other works, from Paolucci. In 1722 the cardinal gave him a commission for six altarpieces for his titular church of Ss. Giovanni e Paolo; *The Martyrs from Scilium* is the most dramatic and vivid demonstration of Milani's continuing allegiance to his Carracciesque heritage. For the Paolucci Chapel in S. Marcello al Corso, Milani painted in 1725 the main altar, *Christ Appearing to Saint Pellegrino Laziosi*, and two lateral canvases, *Saint Pellegrino Laziosi Healing a Blind Youth*, and a *Miracle of the Madonna del Fuoco* (cat. 262). Commissions for other Roman churches included a *Holy Family* for the fathers of the Mission (lost) and another altarpiece for the same patrons, *Saint Vincent de Paoli* (1729; SS. Trinità dei Missionari); a *Beheading of Saint John the Baptist* (1732; S. Bartolomeo dei Bergamaschi); frescoes of *Christ Preaching to the Multitude* for the apse and triumphal arch of S. Maria Maddalena (1732); and a fresco depicting *The Birth of the Virgin* (1742; S. Maria Maggiore).

Milani's most memorable Roman work is the *quadratura* fresco cycle depicting *The Labors of Hercules*, *The Fall of the Giants*, and *The Four Parts of the World* in the vault of the Galleria degli Specchi in the Palazzo Doria Pamphili

painted in 1732–33 for Principe Pamphili. With this extraordinary series of scenes, Milani found the proper venue for a demonstration of his power as a figure painter and his ability to reinterpret well-known subjects in an innovative way. Milani's biographer Zanotti described his works as "full of beautiful fantasies" (Zanotti 1739, vol. 2, p. 165), and these frescoes suggest how versatile he could be in both subject matter and manner. The result, in the words of one scholar, is "a kind of eighteenth-century reincarnation of Annibale Carracci, his style tastefully modified, however, by a certain decorative brio which gives the decoration an indisputably eighteenth-century flavor" (Miller D. 1974, p. 331). Milani possessed a gift for depicting the male nude in striking athletic poses, and many of his paintings prominently feature such figures, especially four scenes from the life of Samson (Banca Popolare, Modena); *Cain Founding the City of Enoch* and *Noah Building the Ark* (Szépművészeti Muzeum, Budapest); and *Moses and the Brazen Serpent* (private collection, Rome).

Like the Carracci before him, Milani was fascinated by genre painting and often conceived his biblical and other religious works as genre pieces. For Paolo Magnani, Bolognese ambassador to the Holy See, he painted *The Mission* (Molinari Pradelli Collection, Marano di Castenaso) and its pendant, *Market Scene in a Roman Square* (Museo Civico, Pesaro), "subjects for which our Milani had a particular genius," in Luigi Crespi's words (Crespi 1769, p. 150): "In these works he unexpectedly revealed an intriguing fancy for the picturesque character of contemporary Italian life and a surprisingly fine ability in landscape painting" (Miller D. 1996, p. 539).

Milani was an active draftsman—his contemporary biographers Zanotti and Crespi both remarked that he had a higher reputation as a draftsman than as a painter—and his engraving in three large sheets of *Christ Carrying the Cross* (1725; British Museum, London) is among the most ambitious and imposing prints of the century. [EPB]

BIBLIOGRAPHY Zanotta 1739, vol. 2, pp. 159–67; Crespi 1769, pp. 146–50; Roli 1964; Miller D. 1974; Roli, Renato. *Pittura bolognese, 1650–1800: dal Cignani ai Gandolfi*. Bologna: Alfa, 1977, pp. 57–58, 115–16, 177–78, 188–89, 277, figs. 48, 205–9; Czére 1988; Rybko 1990, "Milani"; Cera 1994, figs. 1–24; Miller D. 1996

## 262

## Aureliano Milani
### Study for "The Miracle of the Madonna del Fuoco"

1724–25
Inscribed on a plaque in the foreground: *Asbcdefgh/ lmnopqrs*, at the left, a cross, and below, *ano*[illegible]; traces of a signature on the small sheet of paper held in place by a pebble: A[ureliano]/ Mil[ani]
Oil on canvas
45" × 39½" (114.3 × 100.3 cm)
PROVENANCE Schweitzer Gallery, New York, acquired in 1971
BIBLIOGRAPHY Roli 1964, pp. 344–45, figs. 107b, 109a; Clark 1971–73, pp. 65, 67, n. 7, fig. 4
The Minneapolis Institute of Arts, The John R. Van Derlip Fund

In the early 1720s Aureliano Milani was extremely busy with commissions for several Roman churches that were obtained largely through the influence and patronage of a powerful prelate, Cardinal Fabrizio Paolucci de' Calboli. Paolucci, cardinal secretary of state to Clement XI, was responsible for the renovation and refurbishment of three churches where he secured employment for Milani, the cathedral in Albano and the churches of Ss. Giovanni e Paolo and S. Marcello al Corso in Rome. The church of S. Marcello is particularly interesting for its rich and diverse miscellany of Settecento painting, notably the canvases by Pier Leone Ghezzi, *Saints Philip Benizi, Alessio Falconieri, and Giuliana Falconieri* (1725), Agostino Masucci's *The Virgin with the Seven Founders of the Servite Order* (1727), Giacomo Triga's *Saint Mary Magdalene with Angels* (1728), Domenico Corvi's *The Finding of Moses* and *The Sacrifice of Isaac* (1762), and Milani's altarpiece and lateral canvases for the chapel of S. Pellegrino Laziosi.

The chapel, fifth to the right of the nave of S. Marcello, was originally dedicated in the sixteenth century to Saint Anthony of Padua. In 1716 patronage of the chapel was obtained by Cardinal Paolucci, who, belonging to an illustrious family from Forlì, dedicated it to the medieval *forlivese* Servite friar and priest, the Blessed Pellegrino Laziosi (1265–1345). The chapel was refurbished between 1720 and 1725 under the direction of the Roman architect Ludovico Rusconi Sassi, and unveiled during the Holy Year of 1725. On the right wall is the funeral monument of Cardinal Paolucci, designed by Pietro Bracci in 1726; on the left is the monument of his nephew Cardinal Camillo Paolucci, completed by Tommaso Righi in 1776 (Lauri Gigli, *San Marcello al Corso* [Rome: Palombi, 1996], pp. 101–7).

The iconographic program of the chapel is devoted to episodes from the

life of Saint Pellegrino Laziosi and to a significant legendary event in the history of Forlì. Milani's altarpiece, *Saint Pellegrino Laziosi Healed by the Redeemer*, depicts a miracle of which the saint himself was the beneficiary. For many years he had suffered from severe varicose veins in one leg, and doctors eventually decided to amputate. He prayed most of the night and in the morning awoke to find that his leg had completely healed. The lateral canvas on the left, *Saint Pellegrino Laziosi Healing a Blind Youth*, depicts one of the many miracles attributed to him. Both paintings were inevitably intended to have played a role in the promotion to sainthood of the Blessed Pellegrino Laziosi, whose immemorial cult had been approved by the Holy See in 1609 and who was eventually canonized on December 26, 1726.

*The Miracle of the Madonna del Fuoco* to the right of the altar depicts the legendary event for which the chapel of Pellegrino Laziosi was to become a center of devotion in Rome. The "Madonna del Fuoco" refers to an early fifteenth-century woodcut of the Virgin and Child that miraculously survived a house fire in Forlì on February 4, 1428. The sheet was immediately brought to the city's cathedral and venerated, and can still be seen there. The venerated image is considered the "patron" and protectress of Forlì and is kept in a special chapel of the cathedral that was rebuilt starting in 1619. The actual altar in the cathedral was refurbished in 1718 on the commission of Cardinal Paolucci; the tribune was designed by Giovanni Giardini and has two marble angels supplied by Camillo Rusconi, so that Milani's painting in S. Marcello can be seen as yet another expression of his patron's devotion to the cult of the Madonna del Fuoco. (see Casadei 1928, pp. 60–65).

Like most eighteenth-century Roman painters, Aureliano Milani relied extensively on the use of oil sketches during the preparation of large-scale compositional designs for his subject paintings, and two *bozzetti* survive to document the evolution of the commission for S. Marcello, a *modello* in oils for *Saint Pellegrino Laziosi Healed by the Redeemer* (Convento dei Serviti, Bologna) and the Minneapolis canvas, which differs from the final composition *in situ* in only a few minor details, such as the objects in the foreground and the position of the head of the central male figure, who stares in awe at the woodcut floating in air. In his depiction of the miraculous event, Milani may be compared to Pier Leone Ghezzi in his antirhetorical stance, naturalism, and choice of humble and ordinary characters to populate what Anthony Clark called a "Christian street scene"

262

(Clark 1971–73, p. 65). Milani was the worthy heir of the Bolognese tradition of everyday life paintings from the Carracci to Giuseppe Maria Crespi; the humbly dressed figures, the still-life elements in the foreground, and the sense of unvarnished reality inevitably raise comparison back in time to the *bamboccianti* and forward to the genre paintings of Giacomo Ceruti. The painting is another example of Milani's *gusto carracesco* and his lifelong adherence to the traditions of Bolognese and Emilian painting in which he was trained, the ideals of which he revered throughout his life.
[EPB]

## BERNARDINO NOCCHI
### LUCCA 1741–1812 ROME

Like his more illustrious fellow townsman Pompeo Batoni, Bernardino Nocchi continued to be identified with Lucca, even though the entirety of his career was made in Rome and the Marche. First trained by Guiseppe Antonio Luchi, Nocchi left Lucca for Rome in 1769 with his close friend and follower Stefano Tofanelli. The two men's attempt to join the studio of Batoni failed, for reasons that are unclear, and they studied instead under the Calabrian painter Niccolò Lapiccola, whose instruction in fresco techniques set Nocchi's future course. Early in the pontificate of Pope Pius VI Braschi, Nocchi gained favor and in 1780 he was appointed Pittore dei Segretario dei Brevi. His most important works of this period are frescoes

in the Palazzo di Consulta and in the Vatican Museums. With the weakening of papal patronage at the end of the century, he painted several altarpieces in the Marches and in Lucca. After the French invasion and the decline in religious commissions, his considerable talents as a draftsman were used by the engraver Giovanni Volpato and by Antonio Canova (after 1804). As noted by Olivier Michel: "Political circumstances, combined with his weak temperament, prevented him from realizing his full potential" (Michel 1996, "Nocchi").

Anthony Clark summarizes Nocchi's talent and position in the history of Roman painting as one of the most important new artists to appear on the scene during the last decade of the century, placing him alongside such painters as Cades, Cavallucci, Tommaso Maria Conca,

and Tofanelli (see Clark and Bowron 1981, p. 130). His work stands as a gentle evolution from the elevated lyricism of Batoni to the neo-Mannerist (for some, "romantic") newness of Cades, astutely avoiding, through his reverence of Roman classical painting of the seventeenth century, any Davidian rhetoric or quality of "Neoclassicism." At his best, Nocchi seems the logical (if conservative) heir to Batoni (who would have had David, of course) but also to Mengs, whose position at the Madrid academy Nocchi was offered in 1779. In 1785 the Portuguese court attempted to lure him to Lisbon; however in both cases he refused, steadfastly remaining in Rome for his entire life. [JR]

BIBLIOGRAPHY Giovannelli 1985; Rudolph 1985, pp. 200–231; *Recensir col tratto* 1989

## 263
### Bernardino Nocchi
*Ulysses Abandoning Calypso*

1794
Signed and dated lower left: BERN. NOCCHI. PINX. / ROMAE A.D. MDCCXCIV
Oil on canvas
78″ × 60⅝″ (198 × 154 cm)
PROVENANCE as recorded by Nocchi's grandson: Nocchi's studio; bought by Charles IV, King of Spain, while resident in Rome; by inheritance to the Queen of Naples, who left it to the Archduchess of Naples in 1850; Maria Luisa, Queen of Etruria, and to her son Lodovico
EXHIBITION Rome 1959, cat. no. 399
BIBLIOGRAPHY Giovannelli 1985, pp. 136–37
Museo Nazionale di Palazzo Mansi, Lucca

Perhaps Nocchi's most famous easel painting, this work was commissioned by Carlo Conti, a major art figure in Lucca who shot himself in the head in August 1794, shortly after this final act of patronage. He may also have asked Nocchi for a pendant (untraced) showing Ulysses secretly returning to Ithaca by night. The sketches for both works, once attributed to Batoni, are in the Galleria Campori, Modena. A beautiful, very finished drawing for the figure of Mercury is also in the collection of the Palazzo Mancini, Lucca, which is inscribed as being for the painting *Dea Calipso* (the "Goddess Calypso"). At various times the work has been called "The Tears of Ulysses" or "Mercury Sent by Jove to the Grotto of Calypso to Order Her to Release Ulysses."

The narrative follows closely the fourth book of the Odyssey, where Homer relates the sad end of Ulysses' seven-year stay on the island of Ogygia. Thrown naked on the shore, he is grandly received and entertained by the sea nymph Calypso. Her love for him is so great that she tempts him

263

with eternal life should he stay with her; however, he desires to return to his wife and his native Ithaca: "These thoughts kept him pensive and melancholy in the midst of pleasure. His heart was on the seas …" (*Odyssey*, book 5, verses 118–39). When Minerva saw her favorite, pining on the shore—"indignant that so wise and brave a man as Ulysses should be held in effeminate bondage"—she demanded that Jupiter send his messenger Mercury to the island to claim his release.

His message struck a horror, checked by love, through all the faculties of Calypso. She replied to it incensed,

You gods are insatiate, past all that live, in all things which you affect; which makes you so envious and grudging. It afflicts you to the heart, when any goddess seeks the love of a mortal man in marriage, though you yourselves without scruple link yourselves to women of the earth. And now you envy me the possession of a wretched man, whom tempests have cast upon my shores, making him lawfully mine; whose ship Jove rent in pieces with his hot thunderbolts, killing all his friends. Him I have preserved, loved, nourished, made him mine by protect, by every tie of gratitude mine; have

vowed to make him deathless like myself, him you will take from me. But I know your power, and that it is vain for me to resist. Tell your king that I obey his mandates. (*Odyssey*, book 5, verses 118–39)

Nocchi's one departure from the classic version of the narrative is the introduction of the cup-bearing youth (Ganymede accompanying Mercury on Jove's mission?) who reaches for a piece of cloth directly from the loom beyond—probably the glorious fabric of Calypso, which saves Ulysses (and all who use it after) from the sea on his next adventure. [JR]

## GIOVANNI PAOLO PANINI
PIACENZA 1691–1765 ROME

The most celebrated and popular view painter in eighteenth-century Rome, Giovanni (Gian) Paolo Panini, was born on June 17, 1691, in Piacenza, which was then part of the Duchy of Parma. Although as a youth he had prepared for a career in the Church, he studied architectural painting in his native city, and probably also stage design, since the Farnese court at Piacenza was a major center for scene painting. He may have trained with such specialists in this field as Ferdinando Galli Bibiena and

Giovanni Battista Galluzzi. His interest in architecture and perspective problems is documented as early as 1708, when he wrote a summary of a manuscript on perspective by Giulio Troili da Spinlamberto, published in 1683, and supplied illustrations of his own (Piacenza, Biblioteca Comunale, Ms Pallastrelli 256).

Panini had also received some training as an architect by the time of his departure for Rome in November 1711. By then recognized as an independent painter of landscapes and architectural and perspective views, he attended the drawing academy of the figure painter Benedetto Luti until about 1717–18. Luti's luminous colorism also played a role in lightening Panini's palette, as did the paintings of Sebastiano Conca. The formative influences upon his landscape style were the classical ruin paintings of Alberto Carlieri, the landscapes of Jan Frans van Bloemen and Andrea Locatelli, and the topographical views of Gaspar van Wittel (Gaspare Vanvittelli).

In his early years Panini established himself principally as a fresco decorator of the villas and palaces of the Roman aristocracy and ecclesiastical intelligentsia. These decorations included work at Villa Patrizi outside the Porta Pia (1718–25; destroyed 1849), where he frescoed the vaults, overdoors, and windows with ornaments, putti, and festoons. In 1720 he was commissioned to decorate the Palazzo de Carolis (now the Banca di Roma) on via del Corso, and between 1721 and 1722 he was involved with the decoration of the Seminario Romano (now destroyed) for Cardinal Spinola. In 1722 he received a commission from Pope Innocent XIII to decorate the mezzanine apartment of the Palazzo del Quirinale, a few fragments of which survive. He also painted a perspective view in the courtyard of the Palazzo Patrizi near S. Luigi dei Francesi (1722); the decoration of the library of the monastery at S. Croce in Gerusalemme (1724); and frescoes at the Palazzo Alberoni (1725–26), a surviving section of which was transferred to Palazzo Madama. The decoration of the Villa Montalto Grazioli in Frascati in the 1720s and 1730s is Panini's most complete surviving fresco cycle.

On October 9, 1718, Panini was elected to the Congregazione dei Virtuosi al Pantheon, and some time between then and early 1719 to the Accademia di S. Luca in Rome. *Alexander Visiting the Tomb of Achilles* (1719; Galleria Accademia Nazionale di S. Luca, Rome; Arisi 1986, no. 114), painted to mark Panini's reception into the academy, is his first documented easel painting. In 1754 and 1755 he served as Principe of the academy.

264

In 1743 he was admitted to the Accademia dell'Arcadia with the name of Ludio Frigiense. Panini's associations with the French in Rome advanced his career significantly, especially after 1724, when he married Caterina Gosset, the sister-in-law of Nicolas Vleughels, director of the French Academy at Rome. (His first wife, Anna Teresa Faya, died in 1722, aged thirty-two.) Panini taught perspective there and in 1732 was received as a member of the Académie Royale de Peinture et de Sculpture in Paris, an honor accorded few Roman artists. Patronized by Cardinal Melchior de Polignac, Louis XV's chargé d'affaires in Rome from 1724 to 1732, and by the Duc de Choiseul, French ambassador to Benedict XIV, he greatly influenced younger French painters such as Jean-Nicolas Servandoni, Charles-Louis Clérisseau, Claude-Joseph Vernet, Jean-Honoré Fragonard, and Hubert Robert, who had traveled to Rome to complete their artistic education. Robert, a protégé of the Duc de Choiseul, may actually have been a pupil of Panini, and his early works have been confused with the older painter's.

Panini's professional interests extended beyond painting. He also worked as an architect, designing in 1728 Cardinal Valenti Gonzaga's villa and, in 1734, the chapel of S. Teresa (inaugurated 1745) in S. Maria della Scala in Rome. He produced displays of fireworks, designed festival apparatuses and other ephemeral architectural decorations (and painted magnificent records of them), provided drawings for carvings and ecclesiastical furnishings, designed stage sets, served as an art "expert," and in 1732 sat among the judges for the competition to design the façade of

St. John Lateran. It was the views of Rome that Panini painted in the last thirty years of his life, however, that secured his lasting reputation, and in his own day he was certainly regarded as being as important as Canaletto or Piranesi. His views were of two main types, *vedute reale* (carefully and accurately rendered views drawn from life) and *vedute ideate* (imaginary views and combinations of particular buildings and monuments). Panini's masterpieces are a pair of large canvases depicting the Piazza S. Maria Maggiore and the Piazza del Quirinale that he painted in 1742 for Benedict XIV for the Coffee House in the gardens of the Palazzo del Quirinale (Arisi 1986, nos. 322–23).

Panini's views of ancient and modern Rome encompassed practically everything worth noting in the eighteenth-century guidebooks to the papal city. His paintings were not idealized or symbolic representations of Rome's past and present grandeur, but accurate and objective portrayals of the most famous, picturesque, or memorable sights of the city. In the 1740s and 1750s Panini produced numerous views of ancient and contemporary Rome to meet the growing demand created by foreign visitors to the city on the Grand Tour. The popularity of his work among the British, in particular, is confirmed by the large number of paintings (and many replicas and copies) with a British provenance (cats. , 265, 267–70).

In addition to the view paintings for which he is best known, Panini produced religious and historical scenes (notably four scenes from the life of Christ for King Philip V of Spain's palace at La Granja, 1735–36; Arisi 1986, nos. 243–44, 246, 248);

records of contemporary historical events such as the visit to Rome of the Bourbon monarch, *Charles III Visiting Pope Benedict XIV at the Coffee House, the Palazzo del Quirinale, Rome* (cat. 272); real and imaginary architectural pieces; and fantasy views, or capriccios, of Roman ruins. Panini also painted huge imaginary interiors stacked with views of the most famous sites of Rome (cats. 275, 276), ancient and modern, which he adopted from a seventeenth-century Flemish tradition. The earliest of his imaginary picture galleries was painted for Cardinal Valenti Gonzaga in 1749 and depicted the cardinal's collection of paintings (Wadsworth Atheneum, Hartford; Arisi 1986, no. 400).

The finest of Panini's paintings show him to have been a skillful and facile painter of figures, whose supple brush could give individuality, vitality, and movement to his scenes. The tremendous size of Panini's œuvre, the number of extant versions of certain compositions, and the mechanized and routine handling characterizing many of these canvases confirm that he relied upon an extensive workshop to produce reproductions of his more popular compositions. One of Panini's sons, Francesco, served as his principal studio assistant, while another, Giuseppe, made drawings for engravings after his father's canvases. Panini died on October 21, 1765. [EPB]

BIBLIOGRAPHY Arisi 1986; Kiene 1990; Rybko 1990, "Panini"; Kiene 1990–91; Kiene 1992; Arisi 1993; Marshall 1997

## 264

### Giovanni Paolo Panini
*Preparations to Celebrate the Birth of the Dauphin of France in 1729 in Piazza Navona, Rome*

1731
Signed and dated: *I. P. PANINI 1731*
Oil on canvas
43″ × 96⅛″ (109 × 246 cm)
PROVENANCE Cardinal Melchior de Polignac, by whom commissioned; by descent in the De Polignac family, from whom acquired by the 3rd Lord Ashburton; 4th Lord Ashburton sale, Christie, Manson & Woods, London, June 3, 1871, lot 31; where purchased by the National Gallery of Ireland for 610 guineas
EXHIBITIONS London, Burlington House. *Old Master Exhibition*. 1882, no. 209; Rome, Castel Sant'Angelo. *Royal Commission International Exhibition, British Historical Section: La vita degli stranieri a Roma*. 1911; London 1954, cat. no. 368; Rome 1997, vol. 1, cat. no. A23, pl. 18
BIBLIOGRAPHY Arisi 1961, p. 143, no. 85; Arisi 1986, p. 336, no. 211, fig. 211; Wynne, Michael. *Later Italian Paintings in the National Gallery of Ireland: The Seventeenth, Eighteenth and Nineteenth Centuries*. Dublin: National Gallery of Ireland, 1986, pp. 81–82, no. 95, fig. 112; Kiene 1992, p. 107, fig. 34; Arisi 1993, p. 82
The National Gallery of Ireland, Dublin

Panini emerged as Rome's pictorial chronicler par excellence of the festivals, ceremonies, and state visits of prominent figures that played such an important role in the civic life of the city. He painted these *quadri di ceremonia* throughout his career, and among the notable examples of the genre are *View with Firework Machine to Celebrate the Birth of the Infanta of Spain* (1727;

Victoria and Albert Museum, London); *The Piazza Farnese Decorated for a Celebration in Honor of the Marriage of the Dauphin* (1745; The Chrysler Museum, Norfolk, Va.); *Festival at the Teatro Argentina in Rome for the Dauphin's Second Marriage* (1747; Musée du Louvre, Paris); and *Charles III Visiting the Basilica of St. Peter's, Rome* (1745; cat. 271) and *Charles III Visiting Pope Benedict XIV at the Coffee House, the Palazzo del Quirinale, Rome* (1746; cat. 272).

The Dublin painting is one of two works by Panini recording the festivities marking the birth, on September 4, 1729, of a son (and heir, known as a dauphin) to Louis XV of France and his consort, Maria Leczinska. In Rome the king's ambassador to the Holy See, Cardinal Melchior de Polignac, arranged ten days of celebrations, religious and secular, culminating in a fireworks display in Piazza Navona on November 30, 1729. The cardinal commissioned from Panini a record of the event, *Preparations to Celebrate the Birth of the Dauphin of France in Piazza Navona* (1729; Musée du Louvre, Paris; Kiene 1992, pp. 51–59, 106–7, no. 6; Arisi 1993, p. 82, no. 3), which he gave to the king in 1731. Before parting with it he probably asked the artist to produce the present replica, which is nearly identical to the original in dimensions, format, and composition, but presents numerous variations in the figures.

For the festivities in the Piazza Navona Cardinal de Polignac commissioned Pier Leone Ghezzi to decorate the square with wood and papier mâché arches, trophies, and columns evoking the site when it was the stadium, or circus, of Domitian. Panini (who himself achieved a reputation in Rome as a designer of festival decorations and fireworks displays) chose to represent the moment in which the preparations for the festivities were still underway, the piazza crowded with figures milling before the imposing façade of the church of S. Agnese in Agone, as workers put the finishing touches to the decorations. Cardinal de Polignac, dressed in black with a tricorn hat and wearing the French order of the Holy Spirit, is shown prominently among a group of gentleman in the foreground. Somewhat behind and to the right of this group are the exiled Stuarts—James, the "Old Pretender," and his sons Princes Charles Edward and Henry Benedict Stuart (cats. 183, 184). Other personalities have been identified, notably a pair of men to the left of the Stuart group, representing Panini himself and, most probably, Ghezzi.

A precise description of the festival decorations and the fireworks machines is provided by a drawing, probably contemporary to the event,

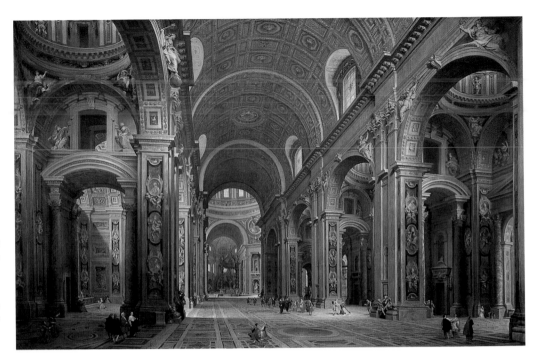

265

in which Salvatore Colonelli Sciarra provided the architecture and Gaetano Piccini the figures (Sassoli 1994, pp. 183–84, nos. 134–35). Thus, Bernini's Fountain of the Four Rivers at the center of the piazza is shown decorated with torches, *lumini*, and dolphins, flanked by two triumphal arches of wood and cartapesta representing on the left and right, respectively, a Temple of Peace and Justice and a Temple of Piety and Fortitude. On the outside of each of these constructions are the arms of the king and his consort supported by trophies, dolphins, and statues representing Fame; next are two similar devices displaying the arms of the Dauphin above trophies surmounting statues that represent various guardian spirits of France. Enclosing these decorations on either side are two colossal *colonne istoriate* celebrating the deeds of Saint Louis of Toulouse and Louis XIV, respectively, surmounted with statues of the two figures in simulated bronze. At the extremities of the piazza the *fontane di vino* were erected to erupt with red and white wine during the celebrations and serve as the apparatuses for the detonation of fireworks. The palaces lining the Piazza Navona, adorned with tapestries, torches, and lanterns, include, from the left: a glimpse of the building on the present site of the Palazzo Braschi; Palazzo Orsini with the tower of Sangallo; Palazzo Pamphili adorned with the papal arms, on the left of Santa Agnese; and on the right, Palazzo de Cupis-Ornani, leased to Cardinal Pietro Ottoboni (from 1709 protector of the French crown) and for the occa-

sion lent to Cardinal de Polignac for the reception on the evening of the *festa* to entertain the Sacro Collegio and the prelature. At the extreme right of the composition Panini has included the Palazzo Altemps, the actual residence of Cardinal de Polignac, which would not be visible from the selected viewpoint in the center of the square.

The Dublin canvas shows Panini to have been a skillful and facile painter of figures, whose supple brush could give individuality, vitality, and movement to the characters. Because in this canvas they are comparatively large in scale, the figures are finished to a degree rare in many of his straightforward views, where the emphasis is primarily upon landscape and setting. For this reason, too, the figures in Panini's *quadri di cerimonia* are often more freely painted than those in the tighter, harder, and more mechanized commercial topographical views.
[EPB]

## 265
## Giovanni Paolo Panini
### *Interior of St. Peter's, Rome*

1731
Signed and dated above the first doorway on the left aisle: *I. Paul Panini Romae 1731*
Oil on canvas
57⅛" × 89⅛" (145.3 × 227.6 cm)
PROVENANCE Lord Gwydir, Grimsthorpe Castle, Lincolnshire; sale, Christie's, London, May 9, 1829, lot 185; L. W. Neeld, Grittleton House, Wiltshire; sale, Christie's, London, July 13, 1945, lot 21; Cosmos Art, Inc., New York, from whom purchased in 1946

BIBLIOGRAPHY Waagen, Gustave. *Treasures of Art in Great Britain.* London, 1854, vol. 2, p. 245 (as in the Neeld collection); Levey 1957, pp. 53–54, 56; Arisi 1961, p. 143, no. 186, fig. 138; Arisi 1986, p. 336, no. 212, fig. 212; Mann 1997, pp. 10–13, 56
The Saint Louis Art Museum, Purchase

## 266
## Giovanni Paolo Panini
### *Interior of the Pantheon, Rome*

c. 1734
Oil on canvas
50⅜" × 39" (128 × 99 cm)
PROVENANCE the Dowager Countess of Norfolk; her sale, Christie, Manson & Woods, London, November 20, 1925, lot 69; bought by William Sabin, London; sold presumably by him to Count Alessandro Contini-Bonacossi, Rome; purchased by Samuel H. Kress, New York, 1927; given by him to the National Gallery in 1939
EXHIBITIONS Venice 1929, cat. no. 12; Cambridge, Mass., Fogg Art Museum, on loan 1931–32; Memphis, Tenn., Brooks Memorial Art Gallery. *An Exhibition of Italian Paintings Lent by Mr. Samuel H. Kress of New York to Museums, Colleges and Art Galleries.* Traveling exhibition, 1932–35, cat. no. 27 or cat. no. 31, depending on catalogue and venue; New York, World's Fair, 1940, no. 37

BIBLIOGRAPHY Arisi 1961, pp. 161–62, no. 136, figs. 186–87; Shapley, Fern Rusk. *Paintings from the Samuel H. Kress Collection: Italian Schools XVI–XVIII Century.* London: Phaidon, 1973, p. 122, fig. 242; Shapley, Fern Rusk. *Catalogue of the Italian Paintings.* Washington, D.C.: National Gallery of Art, 1979, vol. 1, pp. 349–51, and vol. 2, pl. 254, no. 283, pl. 129 (detail); Arisi 1993, pp. 40–41, De Grazia and Garberson 1996, pp. 189–93
National Gallery of Art, Washington, D.C., Samuel H. Kress Collection

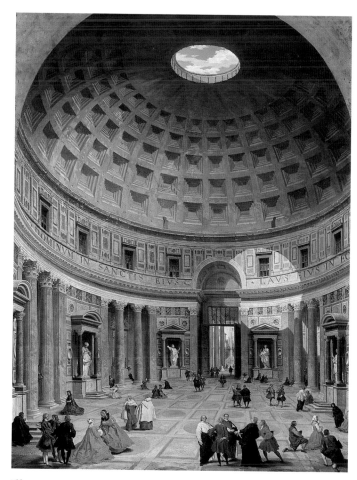

266

Nearly all of Panini's views of the interior of the Pantheon were painted between 1730 and 1735, the period when the artist seized the commercial possibilities of small, topographically interesting paintings highlighting the sights of Rome for visiting tourists. The existence of several autograph versions of this particular subject indicates the interest that the Pantheon, one of the most impressive and admired antique monuments in eighteenth-century Rome, held for both the artist and his patrons. Originally part of the Baths of Agrippa, the rotunda was rebuilt early in the second century AD by Hadrian and dedicated to the seven major gods worshiped by the Romans. In 609 the building was consecrated by Pope Boniface IV as a Christian church and mausoleum, S. Maria ad Martyres, and thereafter was periodically altered and renovated, especially during the seventeenth and eighteenth centuries.

Panini painted his views of the interior of the Pantheon from one of two hypothetical vantage points: one from a position near the center of the apse at the south end, behind two fluted Corinthian columns; the other, adopted in the National Gallery's painting, from a position in front of and slightly to the east of one of the

columns. The viewpoint of each is from the main altar to the right of the central axis, looking north toward the entrance, through which can be seen the columns of the porch, and, beyond, the fountain and obelisk in the Piazza della Rotunda. Panini has skillfully adjusted the optical perspective and altered the actual proportions of the vast interior of the building, proclaimed by Pope Urban VIII "the most celebrated edifice in the whole world." Yet he has captured the immensity of the rotunda in a single convincing view and emphasized its most memorable architectural features—the floor paved in colored granite, marble and porphyry; the great niches symmetrically arranged around the interior walls, each screened by a pair of colored marble columns and flanked by temple fronts or aediculae containing marble statues; the marble and porphyry veneer decorating the storey below the coffers of the dome; the geometry of the dome itself; and the oculus.

In order to create a more harmonious and interesting composition, Panini took considerable liberties with the pictorial and sculptural decoration of the interior of the Pantheon. He rearranged the sculptures in the tabernacles around the interior, for

example, and eliminated the paintings that were located there in the early 1730s. Lorenzo Ottoni's statue of *Saint Anne and the Virgin*, made about 1713–15 for the niche just visible at the extreme left of the painting, is shown in the adjacent aedicula immediately to the right; likewise, Bernardino Cametti's statue of *Saint Anastasius* and Francesco Moderati's of *Saint Rasius*, produced in 1725–27 for the right and left flanks of Alessandro Specchi's high altar at the south end of the building (and thus out of sight in the present view), are shown in the pier niches at the left and right of the entrance. In fact, only Vincenzo Felici's statue of *Saint Agatha* in the tabernacle at the extreme right of the composition is shown in the painting in its eighteenth-century location. In most of his early versions of the interior of the Pantheon, Panini also eliminated the portrait busts installed in the small oval niches flanking each of the altars.

The prototype for the National Gallery's version of the subject is a painting signed and dated 1734 in the collection of Asbjorn R. Lunde, New York (Arisi 1986, no. 221). The brushwork, coloring, and handling of the figures are comparable in each, and there can be little doubt that the two works were painted at approximately the same time. The greatest differences among Panini's various views of the Pantheon are the disposition of the figures—clerics, ladies of fashion, beggars, British *milordi*—which animate the interior of each. The variety of figures Panini painted into his compositions relieves what would otherwise have been boring architectural records. For the staffage the artist depended upon a large repertory of human types and figures that he created around 1730 and that he and his workshop assistants continued to exploit over the next thirty years. The principal sources for these models are a sketchbook in the British Museum and a group of figure drawings formerly in the collection of the Roman sculptor Vincenzo Pacetti and now in the Kupferstichkabinett, Staatliche Museen Preussischer Kulturbesitz, Berlin. Arisi identified among the latter drawings preparatory studies for the man in the central foreground, wearing a dark mantle over a white tunic; the woman in black at the right edge of the painting carrying a rosary; and the gentleman kneeling with a book in his hand, his tricorn hat held under his arm, in the middle distance at the left. Each was employed first in a painting of 1730, now in the Musée du Louvre, Paris, commemorating the visit of Cardinal Melchior de Polignac to St. Peter's (Arisi 1986, no. 200). [EPB]

## 267
## Giovanni Paolo Panini
*View of the Roman Forum from below the Capitoline to the Arch of Titus, Rome*

1735
Signed and dated on stone fragment at lower right: *I. P. PANINI/ ROMA 1735*
Oil on canvas
28⅛″ × 53″ (73.4 × 134.7 cm)
PROVENANCE  Duke of Norfolk, Beech-Hill, Yorkshire; Arturo Grassi, New York; purchased by the museum in 1947
EXHIBITIONS  Worcester, Mass., Worcester Art Museum. *Special Exhibition of Paintings Notable for the State of Preservation–Condition Excellent.* 1951, cat. no. 19; Philadelphia 1960, cat. no. 66; Chicago, Minneapolis, and Toledo 1970, cat. no. 87b
BIBLIOGRAPHY  Richardson 1948; Richardson, Edgar P. *Catalogue of Paintings and Sculpture Given by Edgar B. Whitcomb and Anna Scripps Whitcomb to the Detroit Institute of Arts.* Detroit, 1954, p. 96–97; Wunder 1954, pp. 13, n. 9, 16, fig. 5; Arisi 1961, p. 147, no. 98, fig. 149; Arisi 1986, pp. 119–20, 346. no. 229
The Detroit Institute of Arts, Founders Society Purchase with Funds from Mr. and Mrs. Edgar B. Whitcomb

## 268
## Giovanni Paolo Panini
*View of the Palatine, Arch of Constantine, and the Colosseum, Rome*

1735
Signed and dated on stone fragment at lower right: *I. P. PANINI/ ROMA 1735*
Oil on canvas
29⅛″ × 53″ (74 × 134.7 cm)
PROVENANCE  Duke of Norfolk, Beech-Hill, Yorkshire; Arturo Grassi, New York; purchased by the museum in 1947
EXHIBITIONS  Philadelphia 1960, cat. no. 60; Chicago, Minneapolis, and Toledo 1970, cat. no. 87a
BIBLIOGRAPHY  Richardson 1948; Richardson, Edgar P. *Catalogue of Paintings and Sculpture Given by Edgar B. Whitcomb and Anna Scripps Whitcomb to the Detroit Institute of Arts.* Detroit, 1954, pp. 96–97; Wunder 1954, pp. 13, 16, n. 9, fig. 5; Arisi 1961, p. 148, no. 99, fig. 150; Arisi 1986, p. 346, no. 230
The Detroit Institute of Arts, Founders Society Purchase with Funds from Mr. and Mrs. Edgar B. Whitcomb

Panini's great distinction among contemporary Roman landscape painters was the ease with which he could record Rome's classical heritage in carefully and accurately rendered views that appear as if they were taken on the spot (*vedute presa dal luogo*) or that subtly adjust and rearrange the actual topographical elements of the scene at hand into convincing imaginary compositions (*vedute ideate*). Many of Panini's views of the city are of course outright fantasies, or *capric-*

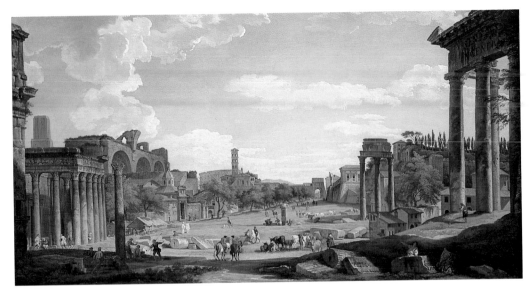

267

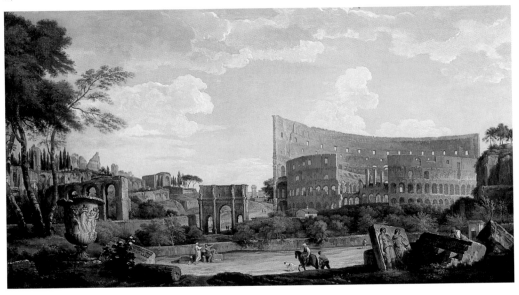

268

allowed himself discrete license with elements of the topography in order to create a memorable view. So as not to obstruct the vista down the center, he has eliminated some buildings that actually stood within his view—specifically, the so-called Dogana del Mercato (market customs office) on the left, and some two-story houses on the right. Just to the right of the Arch of Septimius Severus on the left he has introduced the top of the Torre delle Milizie, which cannot be seen from the viewpoint chosen for the painting. In the eighteenth century this was called the Tower of Nero, and it was widely believed that the emperor had watched the burning of Rome from its top, so Panini probably included the ruin for its romantic appeal and association with the popular conception of early Rome laid in ruins.

In the companion view Panini has altered to a greater degree the actual details of the topography in the interest of producing a harmonious composition. He appears to have combined two points of view, one from the Piazza di S. Gregorio, depicting the slopes of the Palatine, the other from the slopes of the Caelian Hill, embracing the Arch of Constantine and the Colosseum. The hill with ruins and cypress trees rising on the left represents the eastern slope of the Palatine facing the Caelian Hill. The arcade in the left foreground is the branch aqueduct of the Acqua Claudia, which brought water from the Caelian to the imperial palaces on the Palatine. The Arch of Constantine, dedicated in AD 315 to commemorate the Emperor Constantine's victory at the Milvian Bridge over his co-regent Maxentius, is at the center; and at the right is Rome's most famous antique monument, the celebrated Flavian amphitheater, built in AD 80 and universally known as the Colosseum. In the left foreground Panini has placed a frequent accessory in his paintings, the so-called Borghese Vase, a famous marble of Greco-Roman workmanship that is now in the Musée du Louvre and that during the eighteenth century was among the most celebrated works of ancient art in the Eternal City. A fragment of a Roman relief, possibly suggested by a sarcophagus frieze or by one of the reliefs of either the Arch of Titus or the Arch of Constantine, has been introduced near the lower right corner.

Given the rich visual and historical significance of the Roman Forum and the Colosseum, and Panini's magical transcriptions of each, it is not surprising that the artist made numerous versions of each composition between roughly 1725 and 1750. Two views of the Forum in particular (Arisi 1986, no. 155; cat. no. 7262), painted mostly from the same viewpoint as the Detroit canvas,

cios, in which ruins and monuments from all over Rome have been combined into imaginative and decorative assemblages. Nevertheless, the beautiful complementary landscapes in Detroit reveal how subtly and magically Panini could transcribe the localities of Rome to the delight of visitors from all over Europe, who acquired his paintings as souvenirs of their sojourn in the Eternal City.

The view of the Forum, taken from near the base of the Capitoline Hill, looking from west to east, is a faithful representation of the site as it appeared during the eighteenth century before the extensive excavations of the nineteenth. For centuries the Forum remained a cow pasture (when it was called the Campo Vaccino), and its rural character is deliberately contrasted with the more urban air of the companion canvas. Panini's composition encompasses the principal monuments and ruins that would have

appealed to and interested the contemporary visitor to the site. From the left, these include a corner of the triumphal Arch of Septimius Severus; the portico of the Temple of Antoninus and Faustina (transformed into the church of S. Lorenzo in Miranda); and, behind, the colossal vaults of the Basilica of Constantine, considered for a millennium one of the "marvels of Rome." Also visible on the left are the churches of Ss. Cosmas and Damian (encompassing the ancient circular temple of Romulus and the area of the Forum Pacis) and, at the far end of the view, S. Maria Nova (S. Francesca Romana), with its Romanesque bell tower, beyond which can be seen the upper part of the Colosseum and the Monti Praenestini, near Tivoli, on the horizon. Just to the right of center, marking the eastern boundary of the Forum, is the Arch of Titus (set up in AD 81–82), as it looked before the nineteenth-century restorations, sup-

porting the remains of a medieval fortress. Along the right side is the retaining wall of the Farnese Gardens, built during the sixteenth century by Giacomo Vignola, its entrance gate (demolished in 1882) seen in profile; the Casino Farnese is on top of the Palatine Hill, and the gardens are marked by a cypress grove. In the middle ground on the right are the three columns and a fragment of entablature of the Temple of Castor, through which may be seen the Baroque church of S. Maria Liberatrice, now destroyed. In the right foreground are the Ionic columns of the Temple of Saturn, through which is visible the circular church of S. Teodoro, which Panini has shifted slightly from its actual location in order to include it in the view.

Although the *View of the Roman Forum from below the Capitoline to the Arch of Titus* (cat. 274) is recorded with great accuracy, Panini inevitably

demonstrate Panini's ability to modify his basic compositions, imaginatively adjusting them by expanding or cropping, adding or deleting minor elements to convince his clients that each had acquired a unique work of art, in spite of its general similarity in composition and point of view to other depictions of the same subject. The Detroit paintings, for example, were echoed in 1747 by a very similar pair of complementary views, now in the Walters Art Gallery, probably commissioned by William Drake of Shardeloes, Buckinghamshire, who made his Grand Tour in 1743–45 but continued to acquire works from Rome after his return to England (Wunder 1954, pp. 16–17, figs. 2, 4).

Panini's great skill in animating his compositions is seen in the view of the Campo Vaccino, which is filled with a variety of figures. Several loll beneath the fluted Corinthian column dedicated in the early seventh century to the Byzantine Emperor Phocas in the left foreground (Byron's "nameless column with the buried base," one of the last "antique" monuments erected in the Forum); two gentlemen on horseback discuss the scene before them; a cattle drover tends his herd in the center of the foreground. In the middle distance two Camaldolese monks stroll, and in the center of the composition several figures and animals gather around the fountain and water trough erected there in the sixteenth century and removed to the Piazza del Quirinale on Monte Cavallo in 1816. What ties together all of these disparate elements—buildings, ruins, humans, animals—is of course Panini's gifts as a landscape painter. As Richard Wunder, a perceptive scholar of Panini's work, wrote nearly a half century ago of paintings such as the Detroit *vedute*,

in them the artist goes beyond merely setting down the scene at hand, for in such works as these we have a feeling of sunshine and atmosphere, a pleinairistic quality which was to become such a concern with the nineteenth-century landscape painters of France, but which was also evident, to a somewhat less degree, in the works of the Venetian topographical painters of Panini's own day. In Piranesi's engravings, too, we feel the warmth of a Roman summer's day, but Piranesi was apt to be sullen and foreboding, moods never encountered in Panini's works. (Wunder 1954, p. 9) [EPB]

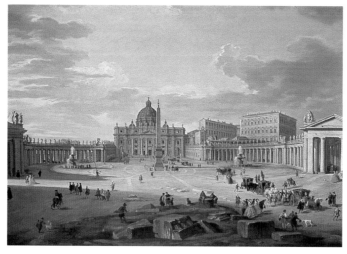

269

## 269
### Giovanni Paolo Panini
*View of St. Peter's Square, Rome*

1741
Signed and dated at lower right: *I. PAVL. PANINI/ ROMAE 1741*
Oil on canvas
38¾″ × 53½″ (98.4 × 135.9 cm)
PROVENANCE  Sir Thomas Lucas, 1st Baronet, Ashstead Park, Surrey, and Kensington Palace Gardens, London; his posthumous sale, Christie, Manson, & Woods, London, June 9, 1902, lot 280; bought by John Lewis Rutley (of The Reynolds Galleries, London), acting as agent for Maj. Arthur Cecil Tempest, Broughton Hall, Skipton, Yorkshire; by descent to his grandson Captain Stephen Tempest; his sale, Sotheby's, London, November 25, 1970, lot 13; bought by Edward Speelman, London, from whom purchased by the museum
BIBLIOGRAPHY  The Toledo Museum of Art, Ohio. *The Toledo Museum of Art, European Paintings*. Toledo: The Toledo Museum of Art, 1976, 123, pl. 27; Bowron 1981, pp. 44–45, fig. 2; Arisi 1986, pp. 134, 385, no. 308; Arisi 1991, pp. 132, 134, fig. 24; Arisi 1993, pp. 42, 43; Rowlands 1996, p. 409, fig. 49a

The Toledo Museum of Art, Purchased with funds from the Libbey Endowment, Gift of Edward Drummond Libbey

## 270
### Giovanni Paolo Panini
*View of the Piazza del Popolo, Rome*

1741
Signed and dated on rock at lower right: *I. PAVL. PANINI/ ROMAE 1741*
Oil on canvas
38″ × 52¾″ (96.5 × 134 cm)
PROVENANCE  as cat. 269 until Sotheby's, London, November 25, 1970, lot 13; bought by David M. Koetser Gallery, Zurich; private collection, Switzerland; Colnaghi, London, 1978; from whom purchased, 1979
EXHIBITIONS  London 1978, *Grand Tour*, cat. no. 26; Kansas City, Mo., The Nelson-Atkins Museum of Art. *City Views*. 1983, cat. no. 21; London, Colnaghi. *Art, Commerce, Scholarship: A Window on to the Art World—Colnaghi 1760 to 1984*. 1984, cat. no. 29; Kansas City, Mo., The Nelson-Atkins Museum of Art. *A Bountiful Decade: Selected Acquisitions, 1977–1987*. 1987, cat. no. 46
BIBLIOGRAPHY  Bowron 1981, pp. 37–55, figs. 1, 3, 11; Arisi 1986, pp. 134, 300, 385, no. 307; Arisi 1991, pp. 132, 134, fig. 23; Arisi 1993, pp. 42, 43; Rowlands 1996, pp. 406-12, no. 49

The Nelson-Atkins Museum, Kansas City, Purchase, acquired through the generosity of an anonymous donor

Panini's views of ancient and modern Rome encompassed practically everything worth noting in the eighteenth-century guidebooks to the papal city. As Giuliano Briganti has observed, such paintings did not assume that the purchaser possessed a humanistic education or a literary or sentimental awareness of past greatness. Rather than idealized and symbolic representations, what was demanded were accurate and objective portrayals of the most famous, most picturesque, or most memorable sights of the city (Briganti 1970, pp. 15–16). Views such as *St. Peter's Square* were obviously painted to comply with such requirements and typify the marketable

scenes Panini furnished to meet the growing demand for such works created by foreign visitors to Rome, Venice, Naples, and other places admired in the age of the Grand Tour.

The exciting and dramatic atmosphere of Rome's streets and squares was invariably noted by foreign visitors in the eighteenth century, and as a result Panini was frequently called upon by the wealthier tourists to produce views of the city's most stirring vistas, especially St. Peter's Square, Piazza del Quirinale, Piazza S. Maria Maggiore, Piazza Navona, and Piazza del Popolo. He frequently matched one view with another to create complementary pairs of uniform size and scale, the specific choice of subjects probably having been left to his clients.

The subject of the Toledo painting is the classic representation of St. Peter's Square, dominated by the Egyptian obelisk at its center, flanked by Bernini's semicircular colonnades, and terminated by the basilica itself, the monumental Vatican Palace at the right. (The ruins in the foreground are fanciful, added by the painter to enhance the interest of the scene.) The effect of spacious welcome experienced by the pedestrian upon entering the wide and festive square, symbol of the all-embracing power of the Church, was profound. Contemporary visitors such as the British novelist Tobias Smollett were often elated at the sight: "The piazza of St. Peter's Church is altogether sublime. The double colonnade on each side extending in a semi-circular sweep, the stupendous Egyptian obelisk, the two fountains, the portico, and the admirable façade of the church, form such an assemblage of magnificent objects, as cannot fail to impress the mind with awe and admiration" (Smollett 1766, p. 236).

That this canvas was paired with a pendant view of the Piazza del Popolo is natural, for both represent superlative examples of the monumental public spaces that contribute to the unique character of Rome. The two piazzas were among the city's most famous. What is more, together they represented the two fundamental sides of Rome: the Piazza del Popolo was the "secular" entry for tourists from the north; St. Peter's Square marked the final destination of Christian pilgrims from all over the world. And, in Panini's day, there was ample precedent for pairing these particular two views. This had been done by the founder of topographical painting in Rome, Gaspar van Wittel, and Panini's viewpoint is nearly identical to and certainly derived from the Dutch-born painter's eight views of St. Peter's Square executed between 1684 and 1721 (Briganti 1996,

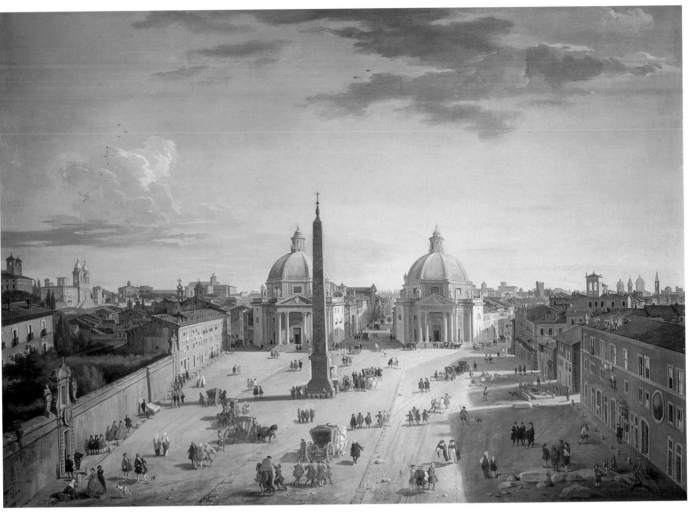

270

pp. 168–72, nos. 100–113). Panini himself had paired the two views in 1738–39 (Bowron 1981, figs. 7–8), and in his imaginary picture galleries filled with views of "modern" Rome (see cat. 276), the two squares are displayed opposite one another, suggesting their compatibility as pendants.

The *View of the Piazza del Popolo, Rome* is an equally outstanding example of Panini's famous views of "modern" Rome. It represents the principal entry into the Eternal City from the north, a sight that astounded many eighteenth-century visitors. William Beckford's response was typical: "Shall I ever forget the sensations I experienced upon slowly descending the hills, and crossing the bridge over the Tiber; when I entered an avenue, between terraces and ornamented gates of villas, which leads to the Porta del Popolo, and beheld the square, the domes, the obelisk, the long perspective of streets and palaces opening beyond, all glowing with the vivid red of sunset? You can imagine how I enjoyed my beloved tint, my favourite hour, surrounded by such objects" (October 29, 1780, cited in *Italy, with Sketches of Spain and Portugal*, [Paris, 1834], p. 110). Many

contemporary travelers, Goethe among them, received their first impressions of the papal city from the Piazza del Popolo, and from the sight of the broad squares filled with coaches and pedestrians from all walks of life that were such an essential part of Rome at the time.

Panini's view, looking south from an elevated point on or near the top of the Porta del Popolo itself, faithfully records all the architectural features of the piazza and its surroundings. In the left foreground is the entrance to the garden of the Augustinian friars based at S. Maria del Popolo (the church is just out of sight at lower left). The street leading off to the left from the Piazza del Popolo is via del Babuino. At the center are the twin churches of S. Maria in Montesanto (completed in 1675) and S. Maria dei Miracoli (completed 1675–79), built by Carlo Rainaldi and then Carlo Fontana, working under Bernini's direction. The noble façades of these churches form a monumental backdrop to the piazza, the crowning feature of the compound that the English composer and musical historian Charles Burney hailed as a "grand and noble spectacle"

(Burney [1771] 1974, p. 129). Between the two churches runs one of Rome's major thoroughfares, via del Corso; the other major artery leading from the square is via di Ripetta, at the right.

In the center of the piazza is the red granite Egyptian obelisk brought by the Emperor Augustus from Heliopolis to Rome and rediscovered in the Circus Maximus in 1587. It was erected on its present site in 1589 by Domenico Fontana, as part of the urban planning initiatives of Pope Sixtus V. Just behind this obelisk (and barely visible in the painting) is Giacomo della Porta's fountain, installed in 1573, but removed in the nineteenth century to the Janiculum Hill near S. Pietro in Montorio, and now stands in Piazza Nicosia. The large washing trough placed on the west side of the piazza by Sixtus V was also removed to permit the construction of houses on the site.

A close examination of the horizon confirms Panini's accuracy as a topographer: he has carefully recorded, from left to right, the Villa Medici (since 1804, the seat of the French Academy); the double bell towers of the church and convent of SS. Trinità dei Monti; the distant mass of the

Palazzo del Quirinale behind Borromini's campanile of S. Andrea delle Fratte and the twin towers of S. Atanasio dei Greci; the dome of the Gesù; the dome of the Pantheon; the arcaded tower of the Palazzo Palma; and the cupolas of S. Carlo ai Catinari, S. Andrea della Valle, and S. Agostino. The Nelson-Atkins painting contains one minor but unusual inaccuracy, however, the result of Panini's dependence on Gaspar van Wittel's views of the piazza produced between 1680 and 1721 (Briganti 1996, pp. 131–36, nos. 1–15). Panini occasionally made errors of this kind when basing his topographical views on an earlier source, and in this instance he appears to have overlooked a major change in the topography—the construction of the Spanish Steps (cat. 18), constructed between 1723 and 1726 after designs by Francesco de Sanctis. They should descend from SS. Trinità dei Monti, the double bell-towered church in the distance at left.

Panini made a small copy in oils of one of Vanvittelli's compositions in about 1738 that may have functioned as a *modello* for the Nelson-Atkins painting as well as for other versions

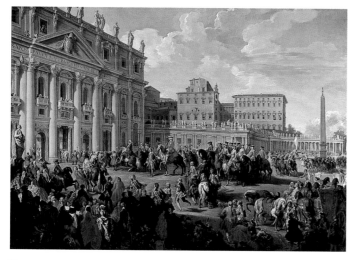

271

272

(Rowlands 1996, pp. 409–10, fig. 49c, and for a discussion of Panini's other views of the piazza). He adopted so closely the essentials of Van Wittel's view (in particular, a small gouache of 1638; Briganti 1996, p. 132, no. 3), in terms of composition, vantage point, time of day, and disposition of the figures and coaches, for his own views of the Piazza del Popolo that the oil sketch could for all practical purposes be considered a copy. This explains why he could paint the Kansas City picture in an essentially *alla prima* manner with no underdrawing (Rowlands 1996, pp. 406, 408).

Although neither the circumstances of the original commission nor the original owner of the Toledo and Kansas City paintings is known, the pair of views was almost certainly produced with the Grand Tour traveler in mind. Before Panini, visitors to Rome had contented themselves with more modest images, such as the prints of Israël Silvestre, Lieven Cruyl, and Giovanni Battista Faldi, or the small gouache and oil paintings by Van Wittel. By the breadth of his compositions and the sheer volume of his work, Panini soon dominated this market. In a manner equaled only by the engravings of Piranesi, his paintings have colored people's perceptions of Rome ever since. [EPB]

## 271
# Giovanni Paolo Panini
*King Charles III Visiting the Basilica of St. Peter's, Rome*

1745
Signed and dated on a chest at center bottom: *I. PAU. PANII 1745*
Oil on canvas
47⅝″ × 67⅛″ (121 × 171 cm)
PROVENANCE commissioned by Charles III, King of Naples; Bourbon collections; Palazzo Reale di Capodimonte, Naples
EXHIBITIONS Venice 1929, cat. no. 7/1; Paris, Petit Palais. *Exposition de l'art italien de Cimabue à Tiepolo*. 1935, cat. no. 334; Rome 1959, cat. no. 419; Paris 1960, cat. no. 71; Piacenza 1993, no. 42
BIBLIOGRAPHY Rome, Biblioteca dell'Ambasciata di Spagna presso la S. Sede, MS. 394; "Relazione della Venuta in Roma della Maestà di D. Carlo Re delle due Sicilie li 2 November 1744." In *Cavalcate, Battesimi et altre cose notabili* (1738–45), p. 213; Cochin, Charles-Nicolas. *Voyage d'Italie*. Paris, 1773, p. 132; Voss 1924, pp. 392, 631; Arisi 1961, pp. 178–79, no. 176, figs. 228–29; Arisi 1986, p. 414, no. 367, pls. 157–58, 160; Arisi 1991, pp. 108–10, no. 35
Museo di Capodimonte, Naples

## 272
# Giovanni Paolo Panini
*King Charles III Visiting Pope Benedict XIV at the Coffee House, Palazzo del Quirinale, Rome*

1746
Signed and dated on the trunk of the tree at left: *I. P. PANII/ ROMA/ 1746*
Oil on canvas
48⅝″ × 68⅛″ (123.5 × 173.5 cm)
PROVENANCE as for cat. 271
EXHIBITIONS Florence 1922, cat. no. 725; Venice 1929, cat. no. 7; London, Royal Academy of Arts. *Italian Art*. 1930, cat. no. 141; Paris, Petit Palais. *Exposition de l'art italien de Cimabue à Tiepolo*. 1935, cat. no. 335; Rome 1959, cat. no. 420; Paris

1960, cat. no. 72; Piacenza 1993, no. 43.
BIBLIOGRAPHY Rome, Biblioteca dell'Ambasciata di Spagna presso la S. Sede, MS. 394; "Relazione della Venuta in Roma della Maestà di D. Carlo Re delle due Sicilie li 2 November 1744." In *Cavalcate, Battesimi et altre cose notabili* (1738–45), p. 213; Cochin, Charles-Nicolas. *Voyage d'Italie*. Paris, 1773, p. 132; Voss 1924, pp. 392, 631; Arisi 1961, pp. 179–80, no. 177, figs. 230–32; Rudolph 1983, pl. 542; Arisi 1986, p. 414, no. 368, pls. 155–56, 159; Arisi 1991, pp. 104–6, no. 34
Museo di Capodimonte, Naples

Among Panini's most celebrated and best-known works, the Capodimonte paintings were commissioned by Charles III, the Bourbon King of Naples and the Two Sicilies, to commemorate his state visit to Rome on November 3, 1744, and reception by Pope Benedict XIV. The occasion was the celebration of his victory over the Austrians at Velletri a few months before, on August 12, an important episode in the War of the Austrian Succession. The meeting between the king and the pope was described in the principal Roman chronicle of the day, Chracas's *Diario Ordinario* (November 7, 1744, no. 4257) and other contemporary documents cited by the Panini scholar Ferdinando Arisi in his various writings on the paintings over the years. The king visited the pope first at the Coffee House in the garden of the pope's preferred residence, the Palazzo del Quirinale, then with his entourage visited St. Peter's and St. John Lateran.

The Naples paintings are Panini's most extraordinary *quadri di ceremonie*, or records of contemporary events and festive celebrations, and reveal what an acute and gifted observer of the contemporary Roman scene he was. Both works vividly reveal his mastery as a painter of architecture and architectural views, of atmospheric effects, and of the human figure. Panini recorded the formal homage the Bourbon king paid to the center of the Catholic world in *Charles III Visiting*

*the Basilica of St. Peter's*, which shows Charles III, followed by his personal guard and members of his household, approaching the steps of the basilica where senior papal representatives, escorted by Swiss Guards, await to greet him before dozens of eager spectators. In this painting Panini demonstrates why he had few rivals among contemporary *vedutisti* in depicting the human figure with respect to gesture, movment, and costume; none was able to arrange figures with such certainty and freedom within a spatial setting. The multitude of spectators—porters, grooms, footmen, soldiers, clerics, cardinals, and aristocrats—lining St. Peter's Square in a great ellipse to catch a glimpse of the king on horseback at the center of the square has drawn the admiration of numerous observer's of Panini's art over the course of this century. Hermann Voss, in his pioneering study of Roman eighteenth-century painting written seventy-five years ago, summarized as well as anyone Panini's gifts when he noted that the artist's success as a view painter depended upon his ability to define his entire compositions down to the tiniest details with clarity, with a quality of realistic truth, and with a dramatic conviction based on precise observation and draftsmanship (Voss 1924, p. 629).

Panini's depiction of the meeting between Charles III and Benedict XIV in the companion painting shows to great effect the charming *palazzino* built for Benedict XIV by Ferdinando Fuga in 1741–43 in the Quirinal gardens to serve as a place of both repose and reception. The restrained classical exterior of the U-shaped pavilion dominates the scene; the king is shown on the right of veranda, welcomed by an unidentified cardinal; Benedict XIV himself is visible inside the building, seated in the interior of the Saletta del Mezzanino at the left, where Panini's large canvases depicting perspectival

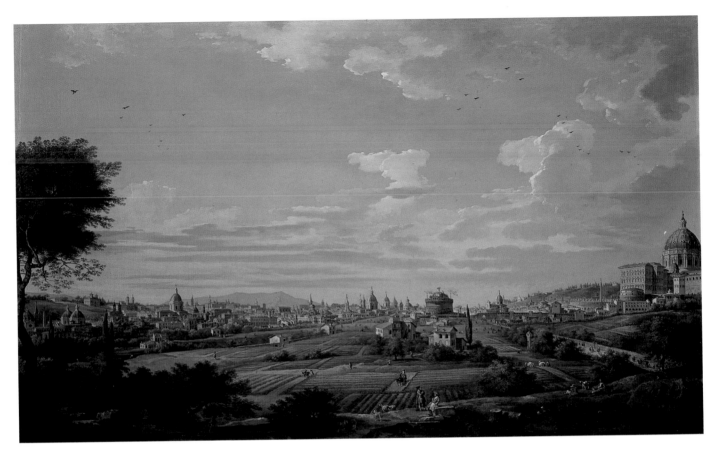

273

views of the Piazza S. Maria Maggiore and Piazza del Quirinale were let into the walls (see figs. 110, 111 above). Panini's early training as a scenographer is evident in his skillful organization of the composition, framed on the left and right by tree trunks and branches, and balanced by the three enormous arched portals of Fuga's façade. Within this theatrical compositional setting, Panini animates the scene with a panoply of onlookers drawn from various quarters of Roman life, from the dogs in the immediate foreground, to the three gentlemen in the middle ground, posing as gracefully as dancing masters, to the the spectators clambering in the trees and on the façade of the Coffee House itself for a better look at the proceedings. As was often his practice, Panini has made subtle alterations and adjustments to the actual architectural details of Fuga's building to create a more harmonious and scenographic composition; for example, he has doubled the number of windows on the left wing and inserted paired pilasters between them, paired the pilasters on the principal façade and doubled the number of busts on the roof balustrade above, and added the fountain at the right.

The surviving pencil sketches of figures for both works in the British Museum and in the Kupferstich-kabinett, Staatliche Museen Preussischer Kulturbesitz, Berlin, suggest that Panini was himself a witness to these historical events. The precise documentary details of the royal patronage await discovery, but Panini was presumably advised in advance of the king's visit and of the proposed commission. In addition to drawings, he probably made numerous painted preparatory sketches for the compositions, one of which, an oil sketch depicting various onlookers at the right of the composition (Hall and Knight, New York and London, 1999), survives to demonstrate the artist's skill as a draftsman and figure painter and, incidentally, the influence upon his style of the French painter Pierre Subleyras, then working in Rome. Panini's relations with the French artistic community have often been noted, but in few other works did he so closely approach such painters of gallant social gatherings as Watteau and his French followers as in these depictions of festive activity. [EPB]

### 273
### Giovanni Paolo Panini
### *View of Rome Looking Southeast from below Monte Mario*

1749
Signed and dated on a stone in the center foreground: *I. P. PANINI ROMAE 1749*
Oil on canvas
40″ × 66⅛″ (101.5 × 168 cm)

PROVENANCE presumably commissioned by Frederick II, King of Prussia, and hung in the Royal Palace of Sanssouci, Potsdam, from 1773; after 1945 transferred to the Gemäldegalerie, Berlin-Dahlem; returned recently to the Royal Palace to hang in the room dedicated to *vedute*

EXHIBITION London and Rome 1996, cat. no. 6

BIBLIOGRAPHY Oesterreich, Matthias. *Beschreibung aller Gemählde, Antiquitäten, und anderer Kostbarer und merkwürdiger Sachen, so in denen beyden Schlössern von Sans-Souci.* Berlin: Decker, 1773, p. 92, no. 348; Arisi 1961, pp. 192–93, no. 206, fig. 257; *Catalogue of Paintings: 13th–18th Centuries.* 2nd ed., rev. Translated by Linda B. Parshall. Berlin: Mann, 1978, pp. 316–17; Arisi 1986, pp. 156–57, 428, no. 395, pl. 195; Bock, Henning, et al. *The Complete Catalogue of the Gemäldegalerie, Berlin.* New York: Abrams, 1986, fig. 1427; Arisi 1993, pp. 48–49 Stiftung Preussischer Schlösser und Gärten, Berlin–Brandenburg

### 274
### Giovanni Paolo Panini
### *View of the Roman Forum from below the Capitoline to the Arch of Titus, Rome*

1749
Signed and dated on block of a marble at the right: *I. P. PANINI/ ROMAE./ 1749*
Oil on canvas
39¼″ × 66⅛″ (101 × 168 cm)

PROVENANCE as for cat. 273

BIBLIOGRAPHY Oesterreich, Matthias. *Beschreibung aller Gemählde, Antiquitäten und anderer kostbarer und merkwürdiger Sachen, so in denen beyden Schlössern von Sans-Souci.* Berlin: Decker, 1773, p. 92, no. 349; Arisi 1961, pp. 193, no. 207, fig. 258; *Catalogue of Paintings. 13th–18th centuries.* 2d ed. Translated by Linda B. Parshall. Berlin: Mann, 1978, pp. 317–18; Arisi 1986, pp. 156–57, 428, no. 395, pl. 195; Bock, Henning, et al. *The Complete Catalogue of the Gemäldegalerie, Berlin.* New York: Abrams, 1986, fig. 1428; Arisi 1993, pp. 48–49 Stiftung Preussischer Schlösser und Gärten, Berlin–Brandenburg

The paintings were probably commissioned by Frederick the Great for the royal palace of Sanssouci. The panorama of Rome is unique in Panini's repertory of views and shows the city from the unusual viewpoint of the slope of Monte Mario, as it appeared to pilgrims and travelers approaching the city from the north.

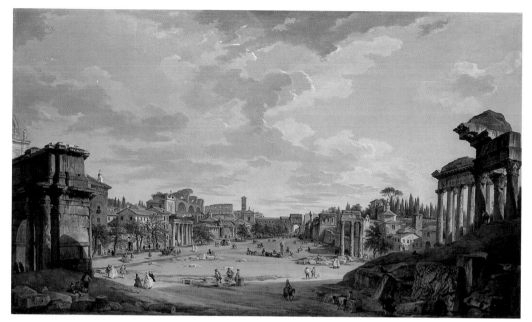

274

The spacious, wide-angle view encompasses a profile of the city from the hill of the Pincio on the left, with the Villa Medici and SS. Trinità dei Monti, to the Vatican Palace and St. Peter's with Bernini's colonnades embracing St. Peter's Square at the extreme right of the canvas. A highly realistic view within the context of Panini's œuvre, the horizon of the composition bristles with the domes and spires of Rome's churches, from the three surrounding the Piazza del Popolo at the left, S. Maria di Montesanto, S. Maria dei Miracoli, and S. Maria del Popolo, to S. Giovanni dei Fiorentini at the right.

Panini has placed the Castel S. Angelo almost in the center of the picture and in the vanishing point of the central perspective. To judge from Panini's enormous contemporary success, visitors to Rome greatly admired the artist's carefully con-structed compositions and in this instance would have found great satis-faction in the accurate topographical description of the city's buildings jutting above the horizon in marked contrast to the expanse of fields, or *prati*, outside the Vatican in the fore-ground of the painting. The accuracy with which Panini recorded Rome in this painting has been explained as a result of his awareness of Canaletto's Venetian views and of Bellotto's extra-ordinary transcriptions of Rome's squares made during his sojourn to the city in 1742 (Wilton and Bignamini 1996, p. 46). For subsequent genera-tions of visitors to Rome this particu-lar view became familiar through a large panoramic print made by Giovanni Volpato in 1779 on the basis of a drawing by Panini's son Francesco, which was used at the end

of the eighteenth century to illustrate souvenirs and guidebooks (Wilton and Bignamini 1996, no. 67).

The companion view of the Forum from the Capitoline Hill provides an interesting comparison to Panini's transcription of the site fifteen years earlier in a painting in Detroit (cat. 268). The point of view is taken from closer to the base of the Capitol, with the result that much more of the Arch of Septimius Severus is visible at the left as well as a small portion of the façade and dome of Pietro da Cortona's church of Ss. Luca e Martina, and beyond the arch, further to the right, S. Adriano (the ancient Roman Curia). By comparison with the earlier composition, the Forum has become a place where elegantly dressed people stroll and coaches promenade, and the Via Sacra has regained the function of an actual thoroughfare. The animals pastured in the Detroit painting have been removed, and the function of the Forum as cow pasture restricted to an area in the right background, where the animals are seen emerging from their stables within the walls of the Farnese Gardens. The entire char-acter of the Forum has, in short, been transformed into a tourist attraction, epitomized by the two gentlemen in the right foreground admiring a frag-ment of a bas-relief before the remains of the Temple of Vespasian. [EPB]

## 275
## Giovanni Paolo Panini
### Interior of an Imaginary Picture Gallery with Views of Ancient Rome

1756–57
Oil on canvas
73¼" × 89⅜" (186 × 227 cm)

PROVENANCE Etienne-François de Choiseul-Stainville, later Duc de Choiseul, Château de Chanteloup, near Amboise, or Paris; purchased by Jacques-Donatien Le Ray de Chaumont, Paris, in 1772; by descent to his son-in-law Pierre-Armand-Jean-Vincent Hippolyte, Marquis de Gouvallos, Paris, in 1803; bought by William J. Davis, Boston, 1834; purchased from him in that year by the Boston Athenaeum; John W. Brett, 1837, who acquired the painting together with *View of St. Peter's Square, Rome*, by an exchange with the Boston Athenaeum; from whom acquired in 1838 by Lord Francis Egerton, later 1st Earl of Ellesmere; and thence by descent through the collections of the Earls of Ellesmere (Duke of Sutherland); sold by order of the Trustees of the Ellesmere 1939 Settlement, Christie, Manson & Woods, London, July 2, 1976, lot 94; bought by Leger Gallery, London, 1977; from whom purchased, 1978

EXHIBITIONS Boston, Athenaeum Gallery, 1834, no. 1; London, British Institution, 1841, no. 217; Edinburgh, National Gallery of Scotland, on loan 1953–61; Manchester, Heaton Hall, on loan 1961–76; London, The Leger Galleries, Ltd. *Exhibition of Old Master Paintings.* 1977, no. 1; Dortmund 1994, cat. no. 6; London and Rome 1996, cat. no. 233

BIBLIOGRAPHY *Descriptive Catalogue* 1834, pp. 2–3; Jameson, Anna Brownell. *Companion to the Most Celebrated Private Galleries of Art in London.* London: Saunders and Otley, 1844, p. 111; *Catalogue of the Bridgewater Collection of Pictures, Belonging to the Earl of Ellesmere at Bridgewater House.* London: J. M. Smith, 1851, p. 4, no. 5; Ellesmere, Francis C. G. E. *Catalogue of the*

*Bridgewater and Ellesmere Collections of Pictures and Statuary at Bridgewater House.* London, 1907, no. 5; *Catalogue of the Collection of Pictures and Statuary of Right Honourable John Francis Granville Scrope, Earl of Ellesmere.* London, 1926, no. 5; Swan 1940, pp. 124–25; Arisi 1961, pp. 214–15, no. 247, fig. 308; Haskell and Penny 1981, p. 84, fig. 5; Arisi 1986, p. 464, no. 470; Millon 1999, pp. 426–27
Staatsgalerie Stuttgart

## 276
## Giovanni Paolo Panini
### Interior of an Imaginary Picture Gallery with Views of Modern Rome

1757
Signed on the stone block at lower left: *I. PAVL PANINI ROMAE*, and dated on edge of stone: *1757*
Oil on canvas
67" × 96" (170 × 244 cm)

PROVENANCE as above until 1834, when acquired by the Boston Athenaeum; from which purchased in 1975

EXHIBITIONS Boston, Athenaeum Gallery, 1834, no. 4; Albany, New York, Gallery of the Fine Arts. *Catalogue of the Fourth Exhibition.* 1849, no. 92; Museum of Fine Arts, Boston, loan 1876–1975; Hartford, Conn., Wadsworth Atheneum. *Pictures with-in Pictures.* 1949, no. 35; Rome 1959, cat. no. 426; Philadelphia 1960, cat. no. 69; Storrs 1973, cat. no. 49; Boston, Museum of Fine Arts. *The Great Boston Collectors: Paintings from the Museum of Fine Arts.* 1985, cat. no. 17

BIBLIOGRAPHY *Descriptive Catalogue* 1834, pp. 7–8; Maclagan, E. "Bernini's 'Neptune and Glaucus.'" *The Burlington Magazine,* vol. 58 (1931), p. 157, pl. A; Swan 1940, pp. 124–25; Arisi 1961, pp. 213–14, no. 246, figs. 306–7; Bowron 1981, p. 44, fig. 6; Arisi 1986, no. 465, no. 471; Millon 1999, pp. 426–27
Museum of Fine Arts, Boston, Charles Potter Kling Fund

This pair of magnificent imaginary interiors hung with paintings of the monuments of "ancient" and "modern" Rome and its companion canvases, *Interior of St. Peter's* (cats. 272, 277), and *View of St. Peter's Square with the Departure of the Duc de Choiseul* (Duke of Sutherland, Mertoun, Melrose, Scotland; Arisi 1986, no. 472), were commissioned in 1756 by the new French ambassador to Rome, Etienne-François de Choiseul-Stainville, the future Duc de Choiseul, who arrived in Rome in 1754. The four canvases were brought to Boston in 1834 and exhibited to the public at the Athenaeum Gallery, where they were extravagantly praised for their "most masterly manner": "For *spirit and truth of touch* it is doubtful whether there are here or in Europe, works of any master that can successfully compete with them" (*Descriptive Catalogue* 1834, p. 2). The Athenaeum was urged to buy the pictures, in part through letters of support to members of

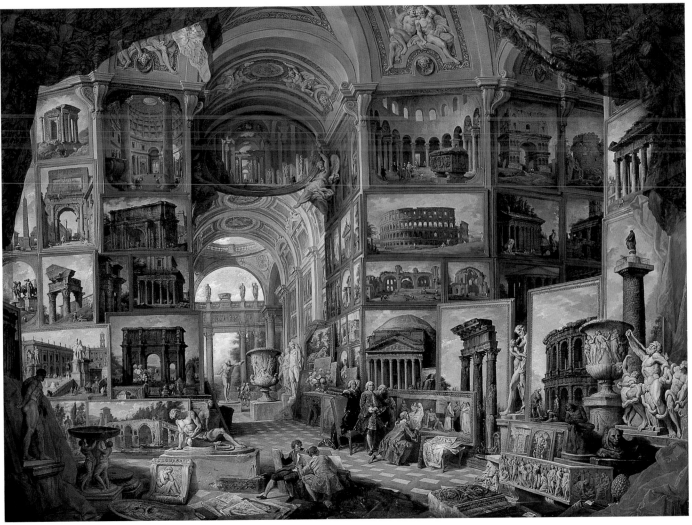

275

the board of trustees from such prominent artists as Chester Harding, Samuel F. B. Morse, and George L. Brown. Two of the paintings were purchased for $4,000, and the remaining two were acquired immediately thereafter for $2,000 raised by public subscription. Within three years, however, the *View of St. Peter's Square* and *Interior of an Imaginary Picture Gallery with Views of Ancient Rome* were exchanged for other paintings, and in 1975 the *Interior of an Imaginary Picture Gallery with Views of Modern Rome*, which had hung in the Museum of Fine Arts, Boston, since its doors opened at the Copley Square site, was sold to the museum. (The often-repeated assertion that the four Paninis were among the first important Italian paintings to come to America, supposedly having been brought here by Jacques-Donatien Le Ray de Chaumont, the French patron of Benjamin Franklin, in 1780, can be disproved by a letter dated January 17, 1835, in the archives of the Boston Athenaeum, ascertaining the titles of the pictures and confirming their recent importation from France.)

The earliest paintings depicting the interior of private galleries, or *Kunstkammern*, were produced in Antwerp in the early seventeenth century. Several variations on this genre developed, notably "portraits" of collections that can be identified along with their owners, the most prestigious of which are probably the dozen or so works that David Teniers II painted in Brussels after 1651, as court painter and keeper of the collections of Archduke Leopold William, showing the collector among his treasures. Panini's first undertaking on the theme of "pictures within a picture" was painted in 1749 for Cardinal Silvio Valenti Gonzaga, secretary of state to Pope Benedict XIV and an important collector of books, scientific instruments, drawings, sculptures, and, above all, paintings. About 1749 the cardinal's collections were installed in a villa near Porta Pia in Rome that had been built for the purpose by Panini, Paolo Posi, and Jacques-Philippe Maréchal. A portion of the contents of the cardinal's collection—he owned 892 paintings—is depicted in an invented setting in a painting now in

the Wadsworth Atheneum, Hartford (Arisi 1986, no. 400). Panini's work is immediately distinguished from his northern seventeenth-century predecessors both by the size of his canvases ($77'' \times 89''$) and by the scale and complexity of his compositions.

In the pair of canvases in Stuttgart and Boston, Panini catalogued the obvious sights of ancient and modern Rome, respectively, in the form of individual, framed canvases displayed as if within an actual picture gallery, views within a view. What distinguishes these compositions from all others of their type is Panini's grandiose architecture, dazzling use of perspective, and combination of descriptive exactitude and trompe l'œil bravura. In each, the nominal pretext is a visit by the Duc de Choiseul to the imaginary gallery, which is filled to dizzying heights with Panini's views of ancient and modern Rome (although he painted as independent compositions relatively few of the views shown), and antique and modern sculptures, which are to be understood as real. Both interiors are animated by young

students in the act of copying the great works of antiquity, and of the Renaissance and Baroque periods.

The individual canvases in *Interior of an Imaginary Picture Gallery with Views of Ancient Rome* encompass most of the ancient monuments in and around Rome familiar to the eighteenth-century tourist: the interior and exterior of the Pantheon; the Colosseum; the temples of Vespasian, Antoninus and Faustina, Fortuna Virilis, Minerva Medica, and the Sibyl at Tivoli; the arches of Titus, Constantine, and Septimius Severus; the basilica of Constantine and Maxentius; the tomb of Cecilia Metella; and the obelisk in the Piazza del Popolo. Equally interesting is the selection of antique marbles arranged throughout the composition, several of which were among the most famous and admired works of art in the middle of the eighteenth century (and all of which ornament variously Panini's capriccios of Roman ruins): the Farnese *Hercules*, *Weeping Dacia*, *Dying Gladiator*, Borghese *Gladiator*, Medici Vase, *Silenus with the Infant Bacchus*, and *Laocoön*.

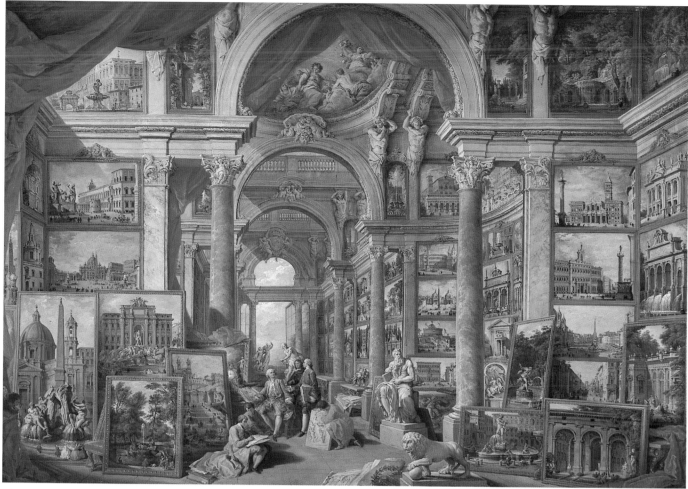

276

The views of modern Rome mainly depict the achievements of post-Renaissance Rome, with special emphasis on the architectural monuments created between about 1725 and 1745, including Francesco de Sanctis's Spanish Steps, Nicola Salvi's Trevi Fountain, Alessandro Galilei's façade of St. John Lateran, Ferdinando Fuga's façade of S. Maria Maggiore, and Carlo Marchionni's Villa Albani. Below, Panini has introduced a group of sculptures which, although smaller than that in the companion painting, signifies the most brilliant accomplishments of the sculptor's art after antiquity: Michelangelo's *Moses*; Bernini's Fountain of the Four Rivers, *David*, and *Apollo and Daphne*; and Flaminio Vacca's *Lion* after the antique marble acquired by Grand Duke Ferdinand for the Villa Medici in Rome.

In the Boston painting the Duc de Choiseul is shown seated at a table gesturing to a folio volume opened to a plate illustrating Bernini's baldachin in St. Peter's. He is engaged in conversation with a gentleman who holds a sheaf of drawings under his arm, and before him several young art students are engaged in a drawing exercise. The principal figure in the Stuttgart paint-

ing appears to be Panini himself, standing well-dressed, brush and palette in hand, and wearing the cross of the Cavaliere dello Speron d'Oro, for which he had been sponsored by Cardinal Valenti Gonzaga and was awarded in October 1749. He is shown standing before the Aldobrandini *Wedding*, an antique painting discovered in 1606 (and claimed by some to have been painted by Apelles), in the presence of several unidentified amateurs. In the nineteenth century the suggestion was advanced that Panini had depicted himself as if he were putting the finishing touches to his copy of the ancient painting, but this interpretation has recently been doubted. If the Aldobrandini *Wedding* has any special significance in relation to Panini, its presence is probably intended to imply that he has equaled or surpassed the finest painters of antiquity (Millon 1999, pp. 426–27).

The exact function of these canvases remains a mystery. Choiseul, an important collector of contemporary and Old Master paintings, shared in the popular enthusiasm for Roman archaeology stimulated by the excavations at Herculaneum (1738) and Pompeii (1748). His choice to be

painted with his friends by Panini, whose works he admired and collected, in these large imaginary interiors decorated from floor to ceiling with framed views of "ancient" and "modern" Rome therefore seems inevitable. That they were intended, together with the companion views depicting the interior of St. Peter's and St. Peter's Square with the departure of Choiseul following his audience with Pope Benedict XIV, to record and glorify Choiseul's diplomatic activities in Rome is certain. There is always an aspect of self-advertisement in any depiction of a collector amongst works of art, and the fact that Choiseul is depicted not among his own possessions but in the presence of some of the greatest works of art and architecture of both antiquity and the modern age emphasizes the allegorical function of the paintings to enhance his reputation as a connoisseur and collector. Choiseul's importance as a patron—among the contemporary artists he supported was Panini's pupil Hubert Robert, who had come to Rome with the duke—is underscored by the presence of the young students engaged in drawing and painting. The Stuttgart

canvas in particular also serves the function of celebrating Panini's ability as a *vedutista*.

In 1757 Panini painted for Choiseul a second set of views of *Roma antica* and *Roma moderna* that is today in the Metropolitan Museum of Art (Arisi 1986, nos. 474–75; Millon 1999, pp. 426–27). A third, larger, pair now in the Musée du Louvre (Arisi 1986, nos. 499, 500), dated 1758 (*Roma antica*) and 1759 (*Roma moderna*), was commissioned by François-Claude de Montboissier, abbot of Canillac, chargé d'affaires of the embassy of France to the Holy See, and a friend and patron of the painter. [EPB]

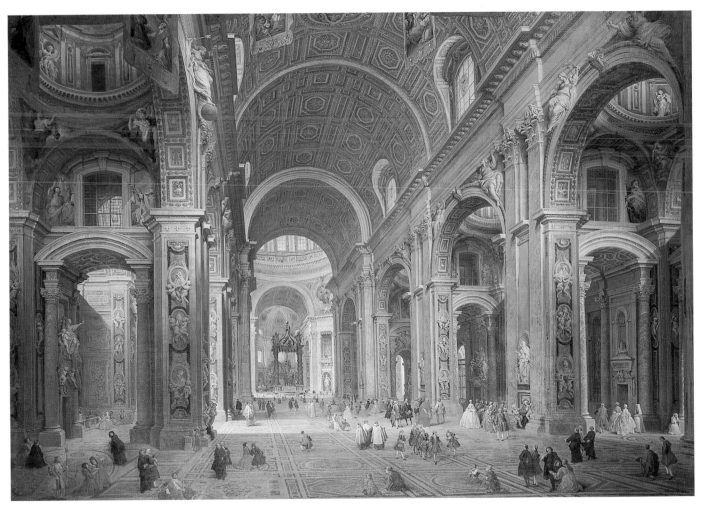

277

## 277
### Giovanni Paolo Panini
*Interior of St. Peter's, Rome*

1756–57
Oil on canvas
64⅝" × 92¾" (164.3 × 235.5 cm)
PROVENANCE Etienne-François de Choiseul-Stainville, later Duc de Choiseul, Château de Chanteloup, near Amboise, or Paris; purchased by Jacques-Donatien Le Ray de Chaumont, Paris, in 1772; by descent to his son-in-law Pierre-Armand-Jean-Vincent Hippolyte, Marquis de Gouvellos, Paris, in 1803; bought by William J. Davis, Boston, 1834; purchased from him in that year by the Boston Athenaeum
EXHIBITIONS Boston, Atheneum Gallery, 1834, no. 2; Albany, New York, Gallery of the Fine Arts. *Catalogue of the Fourth Exhibition.* 1849, cat. no. 12; Boston, Boston Atheneum. *A Climate for Art.* 1980, cat. no. 21, fig. 15; Museum of Fine Arts, Houston, on loan 2000–01
BIBLIOGRAPHY *Descriptive Catalogue* 1834, pp. 3–5; Quincy, Josiah. *The History of the Boston Athenaeum.* Cambridge, Mass.: Metcalf, 1851, pp. 135, 137; Swan 1940, pp. 124–25; Arisi 1961, pp. 211–15, no. 248, fig. 309; Harding, Jonathan P. *The Boston Athenaeum Collection: Pre-Twentieth Century American and European Painting and Sculpture.* Boston: Boston Athenaeum,

1984, p. 86, pl. 17; Arisi 1986, p. 466, no. 473
The Boston Athenaeum

Panini's earliest view of the interior of St. Peter's, now in the Musée du Louvre, signed and dated 1730 (Kiene 1992, pp. 138–39, no. 37; Arisi 1993, p. 84, no. 6), shows Cardinal Melchior de Polignac visiting the basilica. One of several paintings commissioned in 1729 by the cardinal, French ambassador to the Holy See from 1724 to 1732, on the occasion of the birth of the dauphin, son of Louis XV (see cat. 264), the work immediately became one of the painter's most popular compositions: Président Charles de Brosses judged it "particularly pretty in its detail, accuracy, and distribution of light" (quoted in Arisi 1993, p. 84). Over the next thirty years Panini produced at least six indisputably autograph versions in various sizes, often paired with complementary or related views; many more repetitions of the composition were produced in his studio. In the painting now in Paris, Panini established the conventional view of the interior of the basilica, looking west toward the tribune and high altar from an ele-

vated position above the nave near the entrance, encompassing the right and left aisles. Gian Lorenzo Bernini's colossal bronze baldachin over the grave of Saint Peter is visible in the crossing, and through it may be seen, as the climax to the progression from the nave to the altar in the apse of the church, the Cathedra Petri, also designed by Bernini.

Panini recorded with unusual precision the architectural modifications to the interior of St. Peter's, particularly those made following the election of Pope Benedict XIV in 1740, and careful comparison of the numerous versions permits their arrangement into several chronological periods (Levey 1957, pp. 53–54; De Grazia and Garberson 1996, pp. 194, 198, n. 10, 12). The earliest group includes the views painted between 1730 and 1742, when Pietro Bracci's tomb of Clementina Sobieski, wife of James Stuart, the "Old Pretender," was unveiled above the first doorway in the left-hand aisle in December of that year. A second group includes the paintings dating between 1746, when a statue of *Innocent XII* and allegorical figures of *Charity* and *Justice* by Filippo della Valle were placed upon the pope's tomb

above the second doorway in the right-hand aisle, and 1750, when gonfalons (banners) were hung from the ceiling of the basilica, evidently on the occasion of the holy year of that date. A further group of paintings includes the views painted between 1750 and 1754, the date of the installation in the niches of the main nave of the statues of *Saint Theresa* and *Saint Vincent de Paul* by Della Valle and Bracci, respectively, on the order of Benedict XIV. The final composition in the sequence, which shows the statues in their niches, was initiated by a painting signed and dated 1755, now in the Niedersächsisches Landesgalerie, Hanover.

Although Panini's attentiveness to the changing appearance of St. Peter's permits a reasonably precise dating of the various versions of the view, he inevitably made slight changes in each of his depictions of the basilica, exaggerating certain elements and eliminating others in the interest of enlivening his compositions. For example, in the Saint Louis version the location of the medallion bearing the arms of Pope Paul V Borghese on the vaulted ceiling of the basilica has been moved further toward the altar,

perhaps, as suggested by Judith Mann (1997, pp. 12–3, n. 12), in order to increase the grandeur and awe-inspiring expanse of the vast interior. In comparison to the Louvre version, Panini also heightened his palette and diminished the contrasts of light and shade in the Saint Louis painting (and in all subsequent versions), which had the effect of making the composition more decorative and immediately appealing.

The *Interior of St. Peter's* in Boston belongs to a series of four paintings commissioned in Rome around 1756 by Etienne-François de Choiseul-Stainville, later Duc de Choiseul, that included a more or less direct pendant, *View of St. Peter's Square with the Departure of the Duc de Choiseul* (Duke of Sutherland, Mertoun House, Scotland), and a pair of imaginary interiors, *Interior of an Imaginary Picture Gallery with Views of Ancient Rome* and *Interior of an Imaginary Picture Gallery with Views of Modern Rome* (cats. 275, 276). In comparison with the Saint Louis composition painted nearly three decades earlier, the Boston interior immediately reveals several prominent installations of sculptures that had occurred during the interim: Bracci's tomb of Clementina Sobieska, unveiled above the first doorway in the left-hand aisle of the church in December 1742; Della Valle's statue of *Innocent XII* and accompanying allegorical figures placed above the pope's tomb in the right aisle; and Bracci's statues of *Saint Theresa* and *Saint Vincent de Paul* installed in the niches of the main nave in 1754.

A notable feature of the Boston view is the presence of the gonfalons hung from the ceiling of the basilica. These banners, usually painted on silk rather than woven, were created expressly for specific occasions such as canonizations and holy year celebrations. They occur in an interior view of St. Peter's by Panini in the Detroit Institute of Arts, signed and dated 1750 (Arisi 1986, no. 407), and thereafter, which suggests either that the banners remained hanging in St. Peter's after the conclusion of the ceremonies that they celebrated or that Panini continued to include them in his compositions for the interest and decorative effects they contributed. Unfortunately, little is known about these banners, which bear images of the Virgin and Child, Philip Neri, Theresa of Avila, and other saints and holy figures.

In the Louvre *Interior of St. Peter's* and a few of the early repetitions, Cardinal de Polignac's features, dress, and decorations are recognizable, but, as Levey has observed (1957, p. 53), no particular significance appears to attach to the scene. With the success of this composition, Panini's subsequent

versions usually included a cardinal, but certainly after the death of Polignac in 1742, the figure is generalized as a type, not a specific portrait. A cardinal appears prominently in both the Saint Louis and Boston interiors, but he does not appear to be recognizable in either painting.

One significant difference between the two views, however, is the vast increase in the number of figures in the later painting, by comparison with which the interior of the basilica in Saint Louis appears relatively deserted. The variety of figures Panini painted into his compositions relieves what otherwise would have been unenlivened architectural records. For the clerics, ladies of fashion, beggars, and British *milordi* that animate these works, Panini depended upon a large repertory of human types and figures that he created around 1730 and which he and his workshop assistants continued to exploit over the next thirty years. The principal sources for these models are a sketchbook in the British Museum and a group of figure drawings formerly in the collection of the Roman sculptor Vincenzo Pacetti and now in the Kupferstichkabinett, Staatliche Museen Preussischer Kulturbesitz, Berlin. The origin of a number of figures that appear in both the Saint Louis and Boston interiors can be traced to the Louvre painting commemorating the visit of Cardinal de Polignac to St. Peter's. Presumably at this time Panini made the drawings that served as sources for figures in numerous subsequent repetitions and variations of the composition. [EPB]

## JEAN-FRANÇOIS PIERRE PEYRON

AIX-EN PROVENCE 1744–1814 PARIS

Peyron was a cultured painter: at the wish of his family he studied law in Aix-en-Provence, but he had, as the expression goes, a vocation. With the support of his fellow countryman Michel-François Dandré-Bardon, Peyron entered the Ecole de Dessin in his home town in 1765. By 1767 he had moved to Paris, where he trained at the Académie Royale de Peinture et de Sculpture. In 1773 he was awarded the *prix de Rome* for his *Death of Seneca* (untraced). The following year he worked on the decoration of the Hôtel Grimod de la Reynière, one of the earliest examples of a Neoclassical interior in Paris.

In 1775 Peyron set off for Rome, as a *pensionnaire* at the French Academy, which at that time was housed in the Palazzo Mancini on the Corso, under the brilliant directorship of Joseph-Marie Vien. That same year, David— winner of the Grand Prix in 1774,

runner-up to Peyron in the previous year—also left Paris for Rome. Peyron would spend the next seven years in Italy, during which time he painted some of his most important works, including his *Belisarius* (1775) and his *Cornelia, Mother of the Gracchi* (1780), both now in the Musée des Augustins in Toulouse. The Comte d'Angiviller, Surintendant des Bâtiments du Roi, preferred Peyron to David, and commissioned him to paint both *The Funeral of Miltiades* (cat. 278), and *Socrates and Alcibiades*, a painting long thought to have been lost. These works mark a turning point in the history of French painting. They focus on narrative, which seeks to be moving and sober, with a high moral content. Following Poussin's example, Peyron places great stress on execution, a highly refined use of color, and the rendering of minute detail in the drapery and in the portrayal of the figures. There is also, and above all, discipline and rigor in layout and composition.

On Peyron's return to Paris, the rivalry between him and David became more marked and intense. However beautiful, Peyron's *Death of Alcestis* (Musée du Louvre, Paris), in the Salon of 1785, could not begin to compete with David's *Oath of the Horatii*, also in the same Salon. From that point on, the outcome was quite clear. But even so, Peyron did not give up painting. He tried a second time to make his mark, with his *Death of Socrates*, now in the Assemblée Nationale in Paris (sketch in the Statens Museum, Copenhagen), which unfortunately, but unequivocally, suffers by comparison with David's treatment of the same subject, in the Metropolitan Museum, New York. He subsequently repeated, with some success, some of the compositions of his earlier years, producing for the famous publisher Didot, as editor, illustrations for works by Montesquieu and Racine, and produced important works under the Empire (*Death of General Valhubert*, 1808; Musée du Château, Versailles).

Peyron was unlucky: he had David as his rival. Although more delicate, refined, and without doubt more intellectual, he lacked David's persuasive power and clarity of composition, his strength and audacity, his sense of history, and his capacity to produce continually fresh work—such an important part of artistic genius. However, the finest homage to Peyron came from David himself, who, speaking at his funeral, said that Peyron had "opened my eyes." [PR]

BIBLIOGRAPHY Rosenberg and Van de Sandt 1983

## Jean-François Pierre Peyron
*Cimon Removes the Body of His Father, Miltiades, from Prison, and Has Himself Locked Up Instead (also known as The Funeral of Miltiades)*

1782
Signed and dated lower left: *P. Peyron. f. Ro. 1782*
Oil on canvas
38½″ × 53½″ (98 × 136 cm)

PROVENANCE commissioned in February, 1780, by the Comte d'Angiviller, Surintendant des Bâtiments du Roi, through Joseph-Marie Vien, then director of the French Academy at Rome; seized during the Revolution (1794) from d'Angiviller's house; since then in the national collections, and permanently at the Louvre since the beginning of the nineteenth century
EXHIBITIONS 1782, Rome, French Academy, no catalogue; Paris, *Salon de 1783*, not catalogued; London 1972, cat. no. 209; Antwerp 1972, cat. no. 29; Rome 1981, cat. no. 54; Stockholm 1982, cat. no. 51; Hamburg 1989, cat. no. 226; Paris 1989, cat. no. 413; Copenhagen 1990, cat. no. 8; Kōbe and Yokohama 1993, cat. no. 25
BIBLIOGRAPHY Rosenberg and Van de Sandt 1983, pp. 98–99, no. 60, with a previous bibliography and a list of autograph replicas and preparatory drawings; Rudolph 1983, fig. 569; Crow 1985, pp. 202, 206, fig. 97; Barroero 1990, fig. 649; Cantarel-Besson 1992; Berchtold 1995, pp. 27–47; Gramaccini 1996, pp. 562, 564, 571, nn. 43–44, fig. 6; Rosenberg 1999, pp. 163, 165,
Musée du Louvre, Paris, Département des Peintures

In 1780, the Comte d'Angiviller, Surintendant des Bâtiments du Roi, commissioned two paintings from Peyron, in whom he placed great faith, through Vien, then the director of the French Academy at Rome. Both works were to be based on the life of Socrates. The commission was kept secret because at the time the *pensionnaires* at the academy were not supposed to work for anyone but the king himself. After some hesitation, Peyron chose to paint *The Funeral of Miltiades* and *Socrates and Alcibiades* (the latter painting was long thought to have been lost; in fact it is in a private collection in Aix-en-Provence).

Painted in Rome while Peyron was still a pupil at the French Academy, *The Funeral of Miltiades* was not completed until just before he returned to Paris. It was shown during the final days of the 1783 Salon (which explains why it is not mentioned in the catalogue). Since the publication of Robert Rosenblum's book (*Transformations in Late Eighteenth-century Art*), now over thirty years

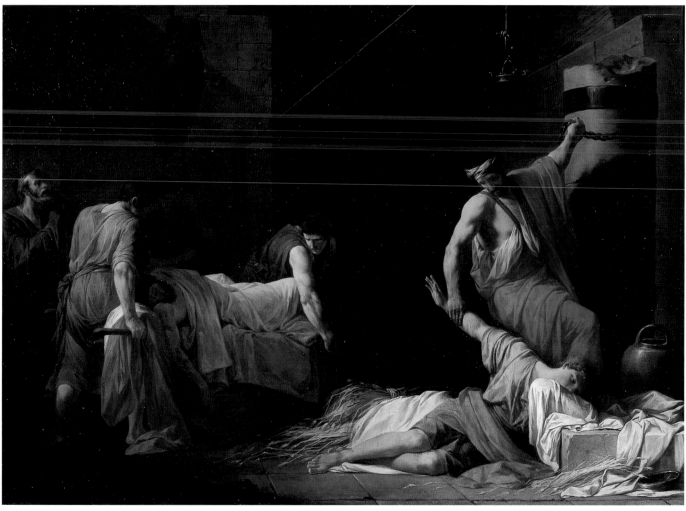

278

ago—the first, it would appear, to
reproduce a photograph of the paint-
ing—and the memorable exhibition in
London in 1972, the painting has been
reproduced many times both in black
and white and in color, as well as being
exhibited on numerous occasions.

Peyron chose a relatively rare subject,
taken from Valerius Maximus (V, 3: 3,
and V, 4: 2), and, more particularly,
from Justin's second-century BC
*Philippic History of Trogus Pompeius*
(Book II, Chapter 15). The Athenian
general Miltiades, conqueror of the
Persians at Marathon (490 BC), was
unjustly accused of treason after a
later, unsuccessful, military campaign.
Although condemned to death, his
punishment was commuted to a heavy
fine. Unable to pay, he was thrown into
prison, where he died of an old wound.
His son then volunteered to take his
father's place in prison. On the left of
the painting the body of Miltiades can
be seen laid out on a bier, carried by
two bearers, while a loyal attendant
holds up the standard of the victori-
ous Battle of Marathon. On the right,
Cimon allows himself to be chained
up by his jailers, refusing to turn and
look at the funeral procession.

Peyron's aim was to paint two
examples of virtue: he evokes both the
tragic fate of Miltiades, the hapless
hero, victim of betrayal by his own
men, and the heroic gesture of his son,
who prefers incarceration to dis-
honor—examples of injustice, of
human ingratitude, and of filial piety.
The conjunction to the two scenes in
one painting makes the reading some-
what difficult, but Peyron succeeds
magnificently in depicting the glau-
cous light and shade of the prison, the
solemnity of the moment, and its high
moral import.

Like Poussin before him, Peyron
sought both to touch the spectator
and to make him think. It is probable
that he showed this painting in 1782 at
the Palazzo Mancini, home to the
French Academy. The Romans must
have been stupefied—artists and
public alike—as they had never seen
anything like it. It was a new way of
painting: precise, of porcelain deli-
cacy, with a dark, cold palette, a subtle
and delicate use of color and, above
all, an entirely new approach to paint-
ing itself, which aimed to provoke
reflection on the fallen hero's fate: it
was clear that the future of painting

was no longer to be decided in Rome.
David's *Oath of the Horatii* (1785) would
give further, even stronger proof of
this. [PR]

## STEFANO POZZI
ROME 1699–1768 ROME

Only recently, thanks to Geneviève
Michel's research (Michel G. 1996;
Michel G. 1996, "Stefano Pozzi"), has
a complete biography emerged of
Stefano Pozzi. He was born in Rome
to Giovanni, an ivory carver from
Bergamo, who had worked for Cardinal
Albani and who had been the subject
of one of Pier Leone Ghezzi's carica-
tures (Michel G. 1996, p. 5). Stefano, a
prolific and conscientious painter, was
the stable point of reference for a large
family of four generations of artists,
which included his brothers Rocco,
Giuseppe (Stefano's close collaborator),
and Andrea, his sons Francesco and
Giovanni, and his nephew Andrea. The
family's social and cultural identity
cannot be separated from their involve-
ment in the arts, and Pozzi's own career
must be seen in light of his family's ties
within Rome's artistic community

and of his own friendships with archi-
tects and cardinals who patronized
him. In addition, he held many impor-
tant offices in artistic associations.

Many of Pozzi's works have been
identified in the years since the first
published list appeared in 1933 in
Thieme–Becker. From what we can
now understand of this stylistically
cohesive body of paintings is that the
artist represents the last recognizable
gasp of the school of Maratti, which,
thanks in part to Pozzi and his faithful
student Pietro Angeletti, who died in
1798, almost survived into the nine-
teenth century. Among Pozzi's other
students were Domenico de Angelis,
Antonio Cavallucci, Marcello Leopardi,
and the less well-known Eugenio
Porretta (or Porretti da Arpino, the
painter, on the master's design, of *Saint
Gregory Barbarigo Invoking Saint Charles
Borromeo* in S. Lucia del Gonfalone,
Rome), the decorator Pietro Paolo
Panci, and the Pole Andrea Stroinski,
these last two, winners of the second
and third painting prizes of the 1762
Concorso Clementino of the
Accademia di San Luca.

In 1716 the seventeen-year-old Pozzi
had himself won the first prize of the

Concorso Clementino, besting his contemporary Luigi Vanvitelli. Like the young Batoni or Campiglia, who made a living drawing after the antique for British tourists, Pozzi worked for Richard Topham (Connor 1998, pp. 52–54). Pascoli (1736) talks of Pozzi's training as a painter with Andrea Procaccini and then with his near contemporary Agostino Masucci. Without ever abandoning his roots, Pozzi managed to absorb other influences, such as the free and brightly colored Roman works of Sebastiano Ricci, whose 1701 fresco was in the sacristy of Pozzi's own parish church of Ss. Apostoli, or the Rococo manner of some of Gaulli's followers, such as Giovanni Odazzi or Ludovico Mazzanti. But his preferred artists remained Sebastiano Conca and, later, Batoni. Poised halfway between the graces of Giaquinto and the classic monumentality of Subleyras, a position close to that of his contemporary Placido Costanzi, Pozzi found his calling in a grand decorative style, in the expression of a devout, but humanly warm, religious faith, and in the arcadian elegance of the mythological fables which he depicted for connoisseurs and collectors in paintings on copper (Pacia and Susinno 1996, pp. 174–75) and in finished drawings, many of which are now in the Kupferstichkabinett of Düsseldorf.

Early in his career Pozzi's work found its way into several Roman churches: S. Norberto al Quirinale (before 1727), S. Francesco di Paola (early 1730s) and S. Silvestro al Quirinale (c. 1736), where he executed the ovals between the windows. In 1736, his *Saints Joachim, Anne, and the Young Virgin* for the Jesuits of S. Ignazio, one of Rome's most renowned modern churches, at Campo Marzio, in the center of the city, brought him even more in the public view. During the papacy of Benedict XIV he did three of his most important compositions for churches in Rome: in 1748, in S. Apollinaire, rebuilt at that time by Fuga, he frescoed the vault with the *Glory of Saint Apollinaris,* in an attempt to rival the earlier vaults by Conca in S. Cecilia (1725) and by Costanzi in S. Gregorio al Celio (1726), and anticipating that of Natoire in S. Luigi dei Francesi (1758). *The Miracle of the Blessed Niccolò Albergati,* commissioned by Cardinal Girolamo Colonna for the forthcoming jubilee of 1750 for S. Maria Maggiore, is surrounded by important works by Batoni and Masucci. Pozzi's most successful and mature altarpiece *The Death of Saint Joseph* in the church of SS. Nome di Maria, dates 1755, and indicates an awareness of the work of Trevisani, but also of a certain realism of Benefial, of which he may have known a painting of the same subject made for the archbishop of Florence,

Giuseppe Maria Martelli (Civai 1990, fig. 33). He returned to the Masucciesque manner in painting in 1763 for S. Ignazio *The Virgin and Child with Saints Stanislas Kotska and Jean-François de Régis* for S. Ignazio in 1763. Although Pozzi had paintings in many of the churches of Rome, he was never commissioned to produce an altarpiece for St. Peter's, as were Mancini, Costanzi, and Batoni. His only work in the Vatican basilica was of an ephemeral nature; for example, he prepared designs for standards for the canonizations of 1746, but even these were probably executed by other artists (Hiesinger and Percy 1980, no. 45 and Barroero 1998, "Pozzi"). Outside the capital he was active in Magliano Sabina, Roccantica, Fabriano, and Urbino, and produced significant work for the Olivetan monks of Perugia, in which he emulated the delicate color combinations used by Subleyras in his paintings for the same order (Michel G. 1996, "Stefano Pozzi"). And in 1767 he also sent to Poland a painting of *The Vision of Saint Jana Kantego*. His friendship with Paolo Posi, and his connection with Cardinal Giuseppe Spinelli brought Pozzi further important commissions, such as that for the tribune of the cathedral of Naples, where he went in 1744—the only time that the artist traveled beyond Rome—to decorate *in situ* the vault of the presbytery with a choir of angelic musicians. As was often the case with members of the Accademia di S. Luca (Michel G. 1996, "Stefano Pozzi," p. 28), his relationship with Spinelli may have been the result of an invitation to one of the Accademia's award ceremonies. His *Saints Januarius and Agrippino Liberating Naples from the Saracens,* for one of the great laterals, suffers in comparison with Giaquinto's *Translation of the Relics of Saint Acutius and Saint Eutyches* (cat. 360), one of his most brilliant and animated works, placed immediately opposite. Charles-Nicholas Cochin severely criticized Pozzi's painting as a "very little and mediocre thing" (Michel C. 1991, vol. 1, p. 140)." Through Vanvitelli and Fuga, Pozzi was commissioned by the Neapolitan court to produce the *Pax e iustia osculate sunt* (c. 1762–65), a canvas intended also as a tapestry design.

With the cooperation of his brother Giuseppe, Pozzi executed a number of secular frescoes, the first of which was a cycle, now lost, of Roman stories for the casino of the master builder Nicola Giobbe (before 1748), who was the godfather of Pozzi's first child (Michel G. 1996, "Stefano Pozzi," p. 26; Brunel 1978 "Recherches"; Barroero 1998, "Pozzi"). Between about 1751 and 1758 he worked for Cardinal Girolamo Colonna in the Palazzo Colonna, one of Rome's most extraordinary eighteenth-century decorative com-

plexes, overseen by the architect Posi. In the main salon on the piano nobile he produced a delightful turquerie recalling the family's involvement in the Battle of Lepanto, while in the Gabinetto degli Specchi his decorative verve reached its peak with a masterly evocation of sixteenth-century grotesques and traditional cameos with cupids and Olympian gods. In the antechamber of the Sala dell'Aurora lively sketches allude to the various parts of the world: Europe is represented by a gentleman in contemporary dress, which is a portrait of Posi with the Sienese coat of arms, the "blazana," beside a pair of calipers and the inscription *S.P.Q.S.* at his feet. Pozzi also worked in the Palazzo Sciarra, for which he executed chinoiseries in the Parisian style, and in the Palazzo Borghese (allegories of *Night* and *Dawn,* 1746–49). His decorative masterpiece was also his last work: the Gabinetto dei Toeletta (1767) on the theme of Venus for the Palazzo Doria Pamphili on the Corso.

In 1736, the year he married Lucia Frezza, daughter of the engraver Girolamo, Pozzi became a member of the Accademia di S. Luca, and he later became director of the Scuola del Nudo. He entered the Congregazione dei Virtuosi al Pantheon in 1748, and ten years later succeeded Masucci in the post of Custodian of the Paintings of Raphael. This position required him to make a mosaic copy of Raphael's *Transfiguration,* then in S. Pietro in Montorio, as well as cover up some of the nudity in Michelangelo's *Last Judgment,* which had already in the Cinquecento been "censured" by Daniele da Volterra. During this period he produced various works for the Vatican museums (in 1757 for the Museo Sacro *Faith and Religion,* and in 1767, *Minerva Taking from the Temple the Artistic Souvenirs of the Past*), and for the Fabbrica di S. Pietro, and the Scuola del Mosaico. At the Palazzo del Quirinale he executed *The Triumph of Divine Wisdom with the Cardinal Virtues and Our Lady of the Assumption,* a subject that he also painted for the chapel of the Congregazione della Conferenza in S. Maria Donnaregina, Naples (Michel G. 1996, "Stefano Pozzi," p. 32), as well as decorations for the chapel of the Uditori di Rota (1767). [SS]

## 279
## Stefano Pozzi
### *Antiochus and Stratonice*

c. 1746–59
Oil on canvas, in original carved and gilded frames
46⅞" × 19⅛" (119 × 48.5 cm)
Unpublished
Private collection, Rome

## 280
## Stefano Pozzi
### *Marius among the Ruins of Carthage*

c. 1746–59
Oil on canvas, in original carved and gilded frames
46⅞" × 19¼" (119 × 49 cm)
Unpublished
Private collection, Rome

Antiochus fell in love with Stratonice, the young wife of his father, Seleucus, the founder of the dynasty that governed Asia after the death of Alexander the Great, and became mortally sick in trying to hide this feeling which he believed to be sinful. The court doctor, Erasistratus, hurrying to his bedside at the king's request, recognized the secret nature of the complaint when the prince's pulse suddenly quickened at the sight of his stepmother. When Seleucus was told, he gave up both the throne and his young wife in favor of his son. The story, taken from Plutarch (*Life of Demetrius,* 38) interested a number of writers and artists (N. Stechow, "The Love of Antiochus with Fair Stratonice in Art," *The Art Bulletin,* vol. 26 (1945), pp. 221–37) and could be used as an *exemplum virtutis* illustrating the triumph of a just and "natural" love in the context of noble feelings pushed to their limit. Pozzi had dealt with the same theme in a larger painting formerly in the collection of Anthony Morris Clark (present location unknown, Pacia and Susinno 1996, p. 160, no. 5), in which there is a different relationship between the group of figures and the background, conditioned here by the panel's vertical form, but the principal variation is the style of the state bed on which Antiochus is lying: in the larger painting it is decorated with a laurel wreath alluding to the youth's valor, and surmounted with a helmet supported by cupids, while in this version it is transformed by decorative partitions in an imaginatively Gothic style, which divide the headboard into three. Both the compositions relate in turn to one on the same subject, signed and dated by Pompeo Batoni in 1746, and now in the Museo de Arte de Ponce, Puerto Rico (Clark and Bowron 1985, fig. 97)

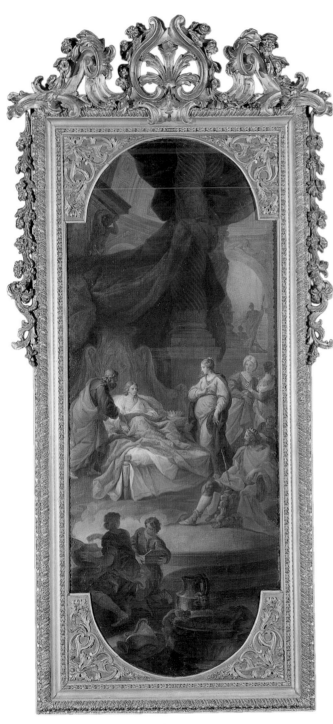

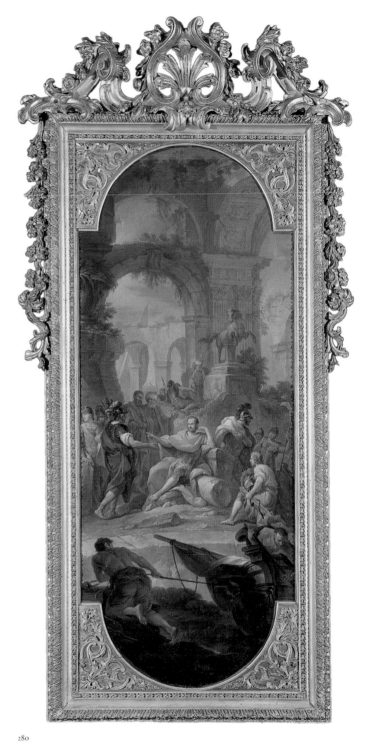

Apart from the differences in style, all the paintings show the figures arranged from left to right, with an old doctor in profile, leaning towards his young patient who is resigned and languishing in Batoni, more alert in Pozzi, while Stratonice makes a gesture of innocent surprise and Seleucus already ponders what will be for him the painful conclusion of the episode. The similarities and the precise correspondences between the compositions of the two different painters point to the inevitable conclusion that one of the two had a thor-

ough familiarity with the work of the other. And while it is hard to imagine that Batoni would have wanted to quote the older man with such obvious accuracy, it is of some significance that, as Clark asserted, Batoni's painting, the original location of which is not known, was easily seen as long as it remained in Rome. Later artists such as James Barry, in a lost painting of which there is a copy in the Worcester Museum of Art, and Jacques-Louis David, in a painting in the Ecole des Beaux-Arts, Paris, quoted from it. It seems probable therefore that Pozzi

too must have seen the Batoni, although in the present version he gave equal importance to the historical scene and its extraordinary setting in a sort of enchanted palace worthy of Ariosto's fantasies.

The second painting depicts an episode in the history of republican Rome in an original way. Marius, a general and politician born near Arpino in Lazio in 156 BC and victor over the Cimbri in the Battle of Vercelli during his consulate between 104 and 101 BC, had fled from Rome following his clashes with Silla and,

failing to reach Africa as he had hoped, took refuge in the marshes around Minturno, a small town in Campania. He was captured and condemned to death by a vote of the senate, but the execution of the sentence was entrusted to a Cimbrian slave, who, terrified by the implacability of the Roman general who had defeated his people, fled screaming. After this event, Marius was allowed to embark for Africa. Pozzi depicted the moment of his arrival. As soon as Marius landed, the governor of the region sent a messenger to him with

an order to leave. Marius, downcast, remained silent then finally said to the messenger, "Go and tell your master that you have seen Caius Marius, wandering and exiled, seated on the ruins of Carthage." This event, also narrated by Plutarch in his *Life of Marius* (XXII, 40), could be seen as a reflection on the fickleness of fortune.

Unlike other versions of the story, which show Marius as an isolated figure musing over the ruins of Carthage, Pozzi chose to depict a literal account of the conversation between the disgraced Roman general and the governor's messenger. Onlookers, background events, surrounding landscapes, and buildings fill the vertical extension of the space, and the center is reserved for the main figure, to whom the messenger is speaking. In the foreground appear the prows of the vessels that have brought Marius to his fate. These recall compositions of Pozzi's occasional collaborator Manglard. (Barroero 1998, "Pozzi"). The background consists of ruined classical buildings, meant to be the remains of an imaginary Carthage, where a lively bronze horse still rises on its pedestal. These last point decidedly towards Panini—a similar horse, based on that of Marcus Aurelius in the Capitoline Hill, appears in Panini's *Alexander the Great at the Tomb of Achilles* (see Arisi 1986, p. 243, n. 53–54)—even though Pozzi had for years been able to count on the collaboration of a professional *quadraturista* such as Angeloni, (Pacia and Susinno 1996, pp. 160, 174) without such airy and delicately colored results.

The existence in the same collection of a third painting of the same dimensions and characteristics, also in its splendid original frame, helps to establish the date of these unpublished canvases of Pozzi's, of which the provenance is unknown. This is a *Bathsheba* for which Jan Frans van Bloemen executed the landscape and Placido Costanzi the figures, prominent among which is the lovely female nude of the beautiful bather. Costanzi's death in 1759 establishes an *ante quem* date for the three paintings, which were probably part of a more extensive decorative group, of which it is difficult to figure out the general theme (Plutarchian themes joined by a not particularly virtuous biblical episode) without the evidently missing works. A corresponding *post quem* date may be indicated by Batoni's *Antiochus and Stratonice* of 1746. In the late 1740s Pozzi began to work for the entrepreneur Nicola Giobbe and by 1748 the artist had executed a fresco for this cultured patron of non-aristocratic origins in a salon of his now destroyed pleasure house on stradone di S. Giovanni. This place was said to have included

some unspecified subjects from Roman history, and Caius Marius may perhaps have been one of these.

The two paintings with their fusion of figurative elements, fantastic architectural settings, and knowing play of light and color in different areas of the picture are unusual even in this artist's varied output, and certainly bear comparisons with the Galleria dei Paesi in Palazzo Colonna (c. 1751–58), executed by Stefano Pozzi possibly in, collaboration with his brother Giuseppe, which also recalls Panini's complex arrangements of figures and scenic backgrounds. [SS]

## 281
## Stefano Pozzi
### *The Immaculate Conception*

c. 1762

Oil on canvas

46″ ×34½″ (117 × 88 cm)

PROVENANCE Cardinal Flavio II Chigi; art market, c. 1964

BIBLIOGRAPHY Hiesinger and Percy 1980, p. 59, no. 1; Michel G. 1996, "Stefano Pozzi," pp. 41–42; Pacia and Susinno 1996, p. 159, no. 52; Susinno 1999, no. 52, p. 159

Private collection, Rome

Between 1761 and 1765 Stefano Pozzi received a series of payments from Cardinal Flavio II Chigi, among which was one for eight paintings carried out "for the service of the …[private] chapel" of the cardinal on the second floor of the family palace between Piazza Colonna and the Corso (Michel, G. 1996, "Stefano Pozzi," pp. 41–42, 52). Two of these, a *Crucifixion* and the *Divine Compassion*, appear to be missing since the cardinal left them in his will to the Boncompagni princes of Piombino, whose palace, now destroyed, stood on the other side of the Corso, while the others were dispersed around 1960 to various public and private collections (Hiesinger and Percy 1980, p. 59, n. 1). An old photograph of the Chigi archive shows some of them as part of a series on the theme of the Virgin's divine maternity—*The Annunciation*, *The Visitation*, *The Presentation in the Temple*—and others relating to the cult of the Guardian Angel—*The Archangel Raphael Pointing out the Fish to Tobias* and *The Archangel Raphael Appearing to Tobit and Tobias* (see Michel G. 1996, "Stefano Pozzi," p. 42). The doctrinal significance of the works, more than being about Marian themes, needs, as has been suggested, to be considered in a Jesuit context and most specifically with regard to the chapels dedicated to the Guardian Angel and the Virgin in the Roman church of the Gésu. The devotion of the Chigi family to the Guardian Angel is borne out by a

281

painting by Pompeo Batoni executed around the time of Pozzi's works for the chapel of the cardinal, perhaps for Prince Sigismondo Chigi (Clark and Bowron 1985, p. 281).

As was common, the Chigi palace was subdivided into individual apartments for the head of the family and the younger brothers who entered the church. As can be seen in a survey taken in 1763 for the parish of S. Maria in Via (Renato Lefevre, *Palazzo Chigi* [Rome: Editalia, 1987], p. 178, n. 15), one was occupied by Prince Agostino with his wife, Giulia Albani, and the heir Sigismondo (at least until the latter's 1767 marriage to Maria Flaminia Odescalchi); the second was reserved for Flavio; whom Pope Benedict XIV made a cardinal in 1753; and the third was occupied by Sigismondo's youngest brother, Francesco, already embarked on a brilliant ecclesiastical career that was ended by his early death in 1772. Flavio II, even though his career in the church had been predetermined by his order of birth, was known for his devotion and piety, to the extent that he was a viable candidate for the papacy in 1769. But beyond his personal virtues, the outcome of the conclave that elected Pope Clement XIV Ganganelli reflected the temporary

victory of the hard-liners within the Church. It is not impossible that Cardinal Chigi had to pay for his family's support of the Jesuits. Agostino Chigi had commissioned the redecoration of the first chapel on the right in the Jesuit church of S. Ignazio, where, in 1763, Pozzi's great altarpiece *Saint Stanislas Kostka Receiving the Child from the Virgin in the Presence of Saint Jean-François de Régis* was installed on the altar designed by Filippo della Valle. (Hiesinger and Percy 1980, p. 63).

The image of Mary in the *Immaculate Conception* reflects the ideals of restraint, grace, and exquisite elegance that the painter could readily share with Chigi, a member of the Accademia dell'Arcadia, with the *alias* Aufilo Sireo, a person of extensive and varied culture. Chigi had added four thousand books to the family library, run at his behest by the scholar Stefano Evodio Assemani, who in 1764 published the monumental catalogue of the collection. The painting's iconography and its dimensions, like those of the others in the same series, reveal its character as a private devotional work. In contrast to the grandiose 1750 altarpiece of the same subject by Corrado Giaquinto in Ss. Apostoli,

Pozzi's painting looks back to Roman precedents from within a Jesuit and Counter-Reformation devotional tradition in which the Virgin sits on a throne of clouds. The work's most important forerunners are *The Assumption*, by Scipione Pulzone (1584–88) in the chapel of the Madonna della Strada in the Gesù, from which Pozzi copied the position and the almost childlike appearance of the Virgin, as well as the great altarpiece by Maratti (c. 1686) which stood in the Cybo Chapel directly across from the Chigi Chapel in S. Maria del Popolo (see cat. no. 369). The cult of the Immaculate Conception, promoted by the most traditional elements of the Church (despite Ludovico Antonio Muratori's call for moderation in the 1740 *De superstitione vitanda*, published under the pseudonym Antonio Lampridio), united the iconography of the Woman of Genesis (3:15) with the Woman of the Apocalypse (Revelations 12:2). Pozzi faithfully reflected this tradition, inserting the apocalyptic dragon in place of the biblical serpent and the crescent moon at the feet of a very young Mary, crowned with twelve stars as in Saint John's text (a tradition that would be officially approved by Pope Pius IX in 1856). Pozzi is original in his sentimental treatment of the theme and his adherence to the extreme youth of the Virgin (her gentle and solemn expression is that of a proper convent schoolgirl), and the suffused pearly glow of his colors make this a work of intimate, personal religious feeling, one that reflects the "religion of the heart" by which the Church of Rome sought in that time to resolve its conflict with Jansenist rigor (Rosa 1999). [SS]

## HUBERT ROBERT

### PARIS 1733–1808 PARIS

Apart from eleven years in Rome as a student, Robert spent most of his life in Paris, where he enjoyed a long and successful career. His father was attached to the household of the Marquis de Stainville, whose son, the Comte de Stainville, later became the powerful Duc de Choiseul, and who played an important role in the artist's career. Little is known about Robert's early education, except that he was well versed in classical literature and knew Latin. Pierre-Jean Mariette's statement that the student learned drawing as a pupil of the sculptor René-Michel Slodtz must be taken seriously, since Mariette knew Robert and was a major collector of his drawings. Robert arrived in Rome at the end of November, 1754. There he lived and studied at the French Academy. Normally admission to the academy

282

was limited to pupils who had already studied in Paris at the Académie Royale de Peinture et de Sculpture and had then won the prestigious *prix de Rome*. But when the Comte de Stainville was appointed French ambassador to the Holy See, he also arranged that Robert accompany him to Rome, where his protégé would be housed at the French Academy, in order that the young artist be exposed to classical antiquity and the Italian masters of the Renaissance and the Baroque, which were then considered an essential part of an artist's education. Robert's admission to the academy was thus highly irregular, and the institution's director, the artist Charles-Joseph Natoire, insisted that Robert follow their program of study. Robert made such impressive progress that in 1759, when a position as a *pensionnaire* became available, it was awarded to him; until then, the student's expenses were underwritten by the Comte de Stainville.

The French Academy was then located in the Palazzo Mancini, on the Corso. Across the street was the workshop of Piranesi. Given Robert's interest in the classical past, it was inevitable that the two artists should meet, and a friendship developed between them. Undoubtedly, though, the artist who most influenced Robert's years in Italy was Giovanni Paolo Panini, who had close ties to the French Academy (in 1731 his sister-in-law married Nicolas Vleughels, then the academy's director). The next year Panini was elected a member of the Académie Royale de Peinture et de

Sculpture in Paris, where he had major patrons. Panini's reputation rests largely on his capriccios, imaginary compositions of celebrated antique Roman monuments intermingled with references to modern buildings. There is reason to suppose that on occasion Panini and Robert worked together, probably on some of the Italian artist's more ambitious commissions. Panini's lasting influence on Robert's art is found most clearly in Robert's watercolors, with their firmly drawn contours, transparent washes of color, and skillful control of the liquid medium to suggest the dappled play of light across luxuriant vegetation and the dilapidated surfaces of Roman ruins. By the end of October 1762 Robert had finished his course of study at the French Academy, but other means (perhaps commissions and the generosity of friends) enabled him to remain in Rome until late in the summer of 1765, when he returned to Paris.

During his eleven years in Italy Robert was among the most lauded students at the French Academy. Natoire held his pupil's abilities in the highest esteem, and in Paris Robert's works were already in the prestigious collections of such personalities as Pierre-Jean Mariette, Claude-Henri Watelet, and the Marquis de Marigny, Abel-François Poisson (the younger brother of Mme. de Pompadour), who was the official in Paris to whom Natoire reported. Thus when Robert reappeared in Paris his work was already familiar to several powerful individuals who were in a position to

advance his career. At the July 26, 1766, meeting of the Académie Royale de Peinture et de Sculpture, Robert was both accepted for membership and given full voting rights (a rare occurrence) on the strength of his painting *The Port of Ripetta*, a larger version of the 1761 canvas he had painted as a commission for the Comte de Stainville. Between 1767 and 1798 Robert's works were shown regularly at the Paris Salons, where they attracted generally favorable comment. The artist had a large clientele, many of whom were aristocrats, and the social skills of Robert and his wife enabled them to move easily in this milieu. The landscapes that preponderate in Robert's work include many references to his lifelong love of Italy, but they also reflect changing taste in contemporary garden design which now favored a more informal, "picturesque" arrangement of nature. (The artist was given the opportunity to create actual garden landscapes with his appointment in 1778 as landscape designer to the king). Robert's diplomatic skills gave him an important role in planning what was to become the Musée du Louvre, a project initiated in the reign of Louis XVI. During the French Revolution the painter was imprisoned briefly in 1793–94, but was released. He continued to work well into old age, favoring landscapes that often look back to the experience of his student years in Italy. Robert died suddenly at his easel one evening, shortly before he and his wife were to go out to dinner. [VC]

BIBLIOGRAPHY Montaiglon 1887–1912; Gabillot 1895; Nolhac 1910; Beau 1968; Carlson 1978; Cayeux 1985; Cayeux 1989; Boulet, Cuzin, and Rosenberg 1990

## 282
## Hubert Robert
### *Garden of an Italian Villa*

1764
Oil on canvas
36¾″ × 52⅜″ (93.5 × 133 cm)
National Gallery of Canada, Ottawa

Robert painted this view of an Italian garden in 1764, about a year before he left Italy to return to Paris. A flight of steps leads upward to a terrace, framed on either side by arching trees which form a bosky path opening on to a sunny vista. Six figures move around the garden to establish a sense of scale as well as to add a note of anecdotal interest. At the right is the corner of a villa, which it has not been possible to identify with certainty. In a general way the blocky, two-story villa resembles the garden façade of the Villa Farnesina in Rome, designed by Baldassare Peruzzi c. 1505–6 for Agostino Chigi, although it is impossible to locate this view of a staircase and terraces on a ground plan of the garden (Belli Barsali 1983, pp. 128–41). It would not be surprising if the composition were Robert's invention rather than a view of a specific site. In any event, the actual subject of Robert's painting is the Italian landscape and the play of brilliant light over the garden's luxuriant vegetation, from the dense arch of foliage covering the stairs to delicate branches silhouetted against an expanse of sky. Robert painted only a few Italian landscapes of this type, in which his fundamental subject matter is his delight in the forces of nature: air, light, and the growth of vegetation. Another work painted in Italy shows a garden after a storm, with trees felled by the wind strewn across the foreground. The canvas is undated but must have been executed about the same time as Robert drew a red chalk study of fallen branches in Valence that for stylistic reasons should be dated c. 1762–63, a year or so before he executed the Ottawa canvas. (This related painting, *In the Park after the Storm*,was formerly in the collection of Paul Delaroff; its present location is unknown. It is illustrated, together with the Valence drawing, in Cayeux 1985, pp. 160–62, cat. no. 33, fig. 46).

During 1762–63 Robert drew a number of highly finished red chalk studies of trees in abandoned or neglected gardens. These studies are remarkable evidence of Robert's ability to evoke the natural forms and textures he encountered in these locations, whether the brittle fragility of a dead branch or a sturdy tree trunk thickly entwined with vines. These views of nature *en beau désordre* also demonstrate the artist's ability to situate forms convincingly in space through his control of tonal values (for discussions of these drawings see Carlson 1978, cat. nos. 14 a and b, p. 55; Cayeux 1985, cat. nos. 39–42, pp. 174–81; Boulet, Cuzin, and Rosenberg 1990, cat. nos. 111, 118, 136, pp. 168–69, 175–76, 191–92). At this time Robert immersed himself in the study of nature to an extent entirely unprecedented in his work in Italy, and these works prepared him to execute this ravishing view of an Italian garden, which is exceptional in its fresh, assured touch and its lyrical vision of the elements of nature. [VC]

## PIERRE SUBLEYRAS
### SAINT-GILLES-DU-GARD 1699–1749 ROME

France occupies a unique position in the artistic life of eighteenth-century Rome. Subleyras was an important factor in this. Born in the same year as Chardin, he too was a painter of silence, frozen gestures, and controlled emotion. His preference was for large-scale compositions on religious themes. The son of an unexceptional painter from Uzès, Subleyras trained in the studio of Antoine Rivalz in Toulouse. Judging by the few paintings from this period that have survived—essentially, the five inset medallions in the vault of the church of the Pénitents Blancs (now in the Musée des Augustins, Toulouse), and two sketches now in a private collection in Malta—it seems clear that he was very much influenced by the tradition of the school of Toulouse, at that time still one of the most distinguished outside the capital. His earliest portraits also date from this period: *Madame Poulhariez and Her Daughter* (Musée des Beaux-Arts, Carcassone) and *The Sculptor Pierre Lucas* (Musée des Augustins, Toulouse).

In 1726, almost certainly with the aid of a grant from the city of Toulouse, Subleyras went to Paris. The following year he applied for the *prix de Rome*, which he won with *Moses and the Brazen Serpent* (Musée des Beaux-Arts, Nîmes), thus gaining admission to the French Academy at Rome. In 1728 he left Paris for good, arriving in the Eternal City at the age of thirty—like Poussin, to whom he may also be compared in several other respects. Already he was a master of his profession. At this time the director of the French Academy (housed in the Palazzo Mancini) was Nicolas Vleughels. Several letters written by Vleughels to the Surintendant des Bâtiments du Roi, the Duc d'Antin, give details of the young painter's development, particularly rapid in the area of portraiture. The letters also reveal that Subleyras had no desire to return to France. Two factors secured his continuing presence in Rome, and his residence at the Palazzo Mancini, where he remained until 1735: the first was the representations made on his behalf by the Princess Pamphili to the Duchesse d' Uzès, who in turn brought her influence to bear on the Duc d'Antin; the second was his paintings illustrating the *Contes* of La Fontaine (Museum of Fine Arts, Boston, and Musée du Louvre, Paris) executed for the Duc de Saint-Aignan, at that time French ambassador in Rome.

Subleyras's first major secular commission was *The Bestowing of the Order of the Holy Spirit on Prince Vaini by the Duc de Saint-Aignan* (two large-scale versions in Paris, one in the Musée de la Légion d'honneur, the other in a private collection; studies for particular details are held in private collections and at the Musée Carnavalet, Paris). Equally important is the *Feast at the House of Simon the Pharisee*, painted in the same year (1737), commissioned by the order of St. John Lateran, for the convent at Asti, in Piedmont (Musée du Louvre, Paris; sketch also in the Musée du Louvre, as well as many autograph replicas). From 1737 until his death twelve years later, Subleyras received, through various different religious orders, some of the most important church commissions of the time in Italy—a *Saint Jerome* for Ss. Cosma e Damiano in Milan, for example, in 1739, and a *Christ on the Cross, with Mary Magdalene, Saint Philip Neri and Saint Euphebus* (1744; both Pinacoteca di Brera, Milan)—and even in France (examples in Toulouse and Grasse). In 1739 he married Maria Felice Tibaldi, the miniaturist and daughter of the musician Giovanni Battista Tibaldi, whose sister had been the wife of the painter Charles Trémolières since 1734. Maria Felice would collaborate with her husband frequently: the famous painting in the Akademie der Bildenden Künste in Vienna *The Painter's Atelier* (fig. 37) depicts the entire Subleyras family at work, with the walls covered with paintings by the artist.

In 1740 Cardinal Valenti Gonzaga recommended Subleyras to Pope Benedict XIV, whose official portrait he painted shortly afterward (cat. 284). The protection of the pope brought him the commission to paint *Saint Basil Celebrating Greek Mass before the Emperor Valens*, for St. Peter's (now in S. Maria degli Angeli, Rome; several sketches, notably in the Louvre, Paris, and Hermitage, St. Petersburg). Subleyras was only the fourth French painter, after Vouet, Poussin, and Valentin, to receive a commission for St. Peter's.

But before completing this huge canvas in 1748, he painted some of his finest works: the *Miracle of Saint Benedict* ( for the Olivetans of Perugia, now at the church of S. Francesca Romana; cat. 286), *Saint Ambrose Giving Absolution to Theodosius* (for the same order, now in the Galleria Nazionale dell' Umbria, Perugia), *Saint Camillo de Lellis Adoring the Cross* (church of Rieti), *The Mystic Marriage of Saint Catherine* (private collection, Rome; sketch in Smith College, Northampton), and perhaps his masterpiece, *Saint Camillo de Lellis Saving the Sick* (cat. 287), one of the finest of all eighteenth-century paintings. On January 16, 1748, Subleyras's *Saint Basil* was exhibited at St. Peter's, and was received with unprecedented acclaim. From then on, his position was assured. But his health was poor. Despite a period of convalescence in Naples in 1747, he died in Rome, aged fifty. Into his shoes stepped Pompeo Batoni, who was a whole generation younger and who himself had no other serious rival. Although Subleyras was first and foremost a history painter, an ambition shared by all artists of the day, he was also a painter of still life (an example is in the in Musée des Augustins, Toulouse), genre scenes such as the illustrations of La Fontaine's *Contes* (two in the Hermitage, St. Petersburg, in addition to those mentioned above), portraits (*Don Cesare Benvenuti*, Musée du Louvre, Paris; the *Blessed Juan de Avila*, Birmingham City Art Gallery; sketch in the Musée du Louvre), mythological subjects (*Charon*, Musée du Louvre, Paris), and the nude (such as the exceptional *Female Nude*, Galleria Nazionale, Rome). Whatever the genre, his compositions demonstrate a rigor, strength, calm, and simplicity that are already Neoclassical. His touch is delicate, detailed, quite unlike that of any other artist. But above all it is his use of colour that sets him apart from other painters; Subleyras had three favorite shades, which he used with extreme subtlety; black, white (two studies of a deacon in the *Mass of Saint Basil*, Musée des Beaux-Arts, Orléans), and above all a delicate pink.

Subleyras was a sophisticated, often poetic painter, whose fame remained undiminished throughout the late eighteenth century. However, he is still not accorded the recognition he really merits, although the exhibition in 1987 at the Musée du Luxembourg, Paris, then at the Villa Medici in Rome, home of the French Academy, did go some way toward restoring the reputation he richly deserves. [PR]

BIBLIOGRAPHY Arnaud, Odette. "Subleyras, 1669 à 1749." In Louis Dimier, ed., *Les Peintres français du XVIII e siècle*. Paris, 1930, p. 62, no. 132; Michel and Rosenberg 1987

283

284

## 283

### Pierre Subleyras
*Madame Subleyras, née Maria Felice Tibaldi*

c. 1739?
Oil on canvas
39" × 29¼" (99 × 74.5 cm)

PROVENANCE bought from Müller, in Amsterdam, by Helen Bigelow Merriman, who bequeathed it to the Worcester Art Museum in 1901

EXHIBITIONS Boston, Copley Society. *Portraits and Pictures of Fair Women.* 1902, cat no. 25; London 1968, cat. no. 647; Paris and Rome 1987, cat. no. 63, pl. IX

BIBLIOGRAPHY Arnaud, Odette. "Subleyras, 1699 à 1749." In Louis Dimier, ed. *Les Peintres français du XVIIIe siècle.* Paris, 1930, p.13; Michel and Rosenberg 1987, pp. 77–81, 238–39, with previous bibliography

Worcester Art Museum, Massachusetts, Gift of Helen Bigelow Merriman

When and where Subleyras first met Maria Felice Tibaldi has not been definitely established, but it is clear that by the time they married on March 23, 1739, at the church of S. Maria in via Lata, they had already known one another for several years. The painter postponed marriage until he was financially secure enough to support his wife. Maria Felice Tibaldi, who is undoubtedly the subject of this portrait and was herself a very talented miniaturist, was the eldest of the eight daughters of a famous violinist, Giovanni Battista Tibaldi. In 1734 one of her sisters, Isabella, married the painter Charles Trémolières, a close friend of Subleyras in Rome. This portrait may have been painted for the occasion of their marriage in 1739, but it is impossible to say for sure. Of the three works Subleyras chose to include in the painting, only one has been successfully identified. The miniature in Maria Felice's hand—most certainly one of her own works—and the *Woman Reading* on the little table in the background, left, are unknown. However, the large framed miniature—again, without doubt, one of her own works—is a copy of *Cupid and Pan* by Francesco Mancini (see Sestieri 1977, "Mancini," pp. 67–74, fig. 23; Rudolph 1983, pl. 421). Subleyras was a first-rate portrait painter, at ease with men and women alike. Here he paints every detail of his sitter's clothing, the trimmings, the precious stones, the sleeves gathered at the mid-point with charming red ribbons. At her bosom, a somewhat intimidated-looking Madame Subleyras wears a large pink carnation, Subleyras's own favourite color. Through his use of pose and gesture the painter endows his sitters with an air of serenity and nobility, emphasized still further by his delicate use of color. Even when painting his own wife, albeit with great distinction, Subleyras maintains his instinctive reserve, a quality almost always present in his work. The discrete nature of his analysis sets him apart from all other eighteenth-century portrait painters, French and Roman alike. [PR]

## 284

### Pierre Subleyras
*Pope Benedict XIV Lambertini*

1740 or early 1741
Oil on canvas
46⅛" × 37¼" (118 × 96 cm)

PROVENANCE presented on May 31, 1766, by Charles-Nicolas Cochin, secretary of the Académie Royale de Peinture et de Sculpture, to the Académie (Anatole de Montaiglon, *Procès verbaux de l'Académie Royale de Peinture et de Sculpture, 1648–1793* [Paris, 1886], vol. 7, p. 330); seized along with the Académie collections during the French Revolution; exhibited at Versailles from 1802

EXHIBITION Paris and Rome 1987, cat. no. 69, pl. XIII

BIBLIOGRAPHY Arnaud, Odette. "Subleyras, 1669 à 1749." In Louis Dimier, ed., *Les Peintres français du XVIIIe siècle.* Paris, 1930, p. 62, no. 132; Ergmann 1987, p. 42; Michel and Rosenberg 1987, pp. 13, 92–94, 119, 248–52 (with previous bibliography and a list of autograph and studio replicas and copies of the compositions); Scott 1987, pp. 370–71, fig. 2; Michel 1996, *Vivre et peindre*, p. 154; Casale 1998, pp. 22–23 Musée national des Châteaux de Versailles

Prospero Lambertini was elected pope on April 17, 1740. If he chose Subleyras, whose art he already admired, to paint his official portrait, it was not just because he was a francophile but also because of the artist's skills, which nobody contested and which he preferred to those of Agostino Masucci.

The "original" version—and the word "original", which appears frequently in contemporary writings, is used advisedly here—is without question the version housed today in the Musée Condé at Chantilly (Nicole Garnier-Pelle, *Chantilly, Musée Condé: peintures du XVIIIe siècle* [Paris: Réunion des Musés Nationaux, 1995], no. 99). It was presented to the Sorbonne by the pope in 1757, seized during the revolution, and subsequently passed into the collections of Alexandre Lenoir and the Duke of Sutherland, to be acquired in 1876 by the Duc d'Aumale. But the Versailles version shown here, given by Cochin to the Académie Royale de Peinture et de Sculpture in Paris, is incontestably autograph.

(How and where it came into Cochin's possession is not known: possibly in Rome in 1750?) It differs from the Chantilly version in a number of details. Countless replicas, copies, and variants of the original exist, some better than others. The appeal of a composition that was wrangled over by Catholic courts and princes is not difficult to appreciate.

The personality of Benedict XIV is well documented. His love of the arts continues to be much discussed, and was the theme of a symposium held in 1994, the proceedings of which were published recently under the editorship of Donatella Biagi Maino. The words of Président de Brosses (1709–1777) written shortly before Benedict was elected pope are particularly worth quoting (*Lettres familières sur l'Italie*, 3 vols. [Paris 1739]; ed. 1931, vol. 2, p. 492): "Bolognese by origin, bishop of Bologna, a *bonhomme*, plain-living, easy of temperament, devoid of arrogance, a rare quality among his kind; teasing and licentious in his speech; exemplary and virtuous in his actions; more charm of person than brilliance of mind; well versed above all in canon law; thought to have Jansenist leanings; highly esteemed and beloved by his peers, despite his lack of arrogance, which is most remarkable" (De Brosses 1931, vol. 2, p. 492).

Subleyras's portrait of Benedict is not particularly innovative. But in stripping his subject of that worldly air which had guaranteed his popularity, and in idealizing somewhat the image of the newly elected pope, he was responding to an image that the Church cherished, and indeed cultivated, in its papal sovereigns. Through the combination of commonplace and grandiose elements, Subleyras succeeds in the difficult task of harmoniously blending the human and the divine. [PR]

## 285
## Pierre Subleyras
### *A Youth in Costume*

1740–45
Oil on canvas
47⅛" × 35½" (119.5 × 90 cm)

PROVENANCE Swiss private collection; sold, Sotheby's, London, April 9, 1990 (lot 45); Colnaghi, London, 1990; French investment fund; Christie's, New York, January 29, 1999, to present owners
EXHIBITION New York, Colnaghi. *Colnaghi in America: A Survey to Commemorate the First Decade of Colnaghi*. 1992, no number
BIBLIOGRAPHY Sestieri 1994, vol. 1, fig. 1052; Rosenberg 1996, fig. 40; Wintermute, Alan. *The French Portrait: 1550–1850*. New York: Colnaghi, 1996, pp. 44–46, fig. 31

The Ivor Foundation, New York

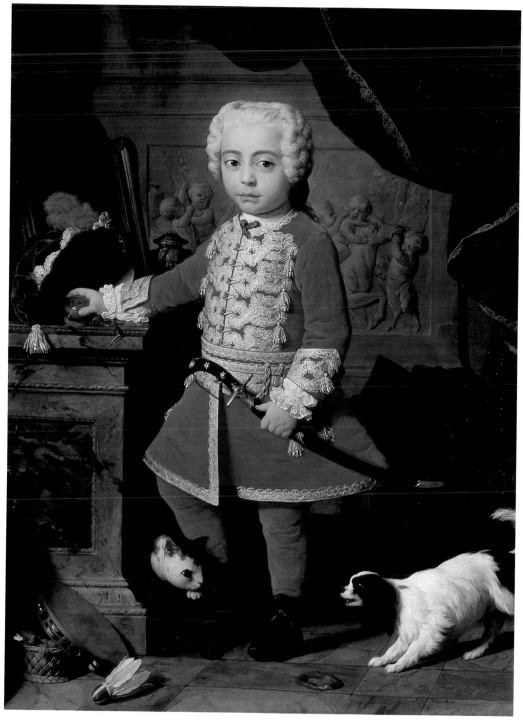

285

Very few new works by Subleyras have come to light since the exhibition of 1987 (see Rosenberg 1996). The most important is without question this portrait of a youth in highly decorative costume. The painting was identified by Everett Fahy and its attribution confirmed by Alastair Laing (see the entry in sale catalogue, Sotheby's, London, April 9, 1990, lot 45). It does, however, raise certain problems. The first of these is the date: the chronology of Subleyras's portraits is not easy to establish: the date of c. 1740 (sug-gested in Rosenberg 1996) would seem acceptable, although it is now tempting to move it forward slightly, to somewhere between 1740 and 1745.

Much has been written about the possible identity of the model. A clue was thought to lie in the "Hungarian" or "Hussar" costume. In 1990 Laing suggested it might be Prince Paul Anton II Esterházy, but there are no real grounds for supposing that the prince was living in Italy at this time. Again, Bianca Riccio has suggested the portrait might represent a member of the Odescalchi family, who had close links with Hungary and commissioned a number of works from Subleyras (sale catalogue, Christie's, New York, January 29, 1999, lot 44). As yet, there is no definitive solution to the problem.

The model wears an ornate costume, with a wig on his head, and a saber in his hand. At his feet are a drum, a pretzel, a work basket, and a kite (Chardin's *Young Girl with a Kite* dates from 1737). A long-haired King Charles Spaniel and a brown and white cat

exchange mistrustful stares. The young man, who is holding a pocket watch in his hand, has laid down his feathered hat on a stone ledge in front of a mirror. In the background a curtain trimmed with gold has been drawn back to reveal a Duquesnoy relief, a trompe l'œil painting after the popular fashion of the time in France well represented by Desportes, Oudry, and Chardin (see Roland Michel 1992). Marion Boudon, who is working on a monograph on Duquesnoy, has confirmed that the relief is inspired by the *Bacchanal of Putti* in the Galleria Doria Pamphili, Rome.

It is the richness of the costume that is so striking in this painting: the subtle patterning of the cherry red fabric and the silver details, the white lace at the wrists and neck, where it is topped with a pretty blue bow. The young man stares out with large, dark eyes, expressing curiosity and some disquiet. The bloom in his cheeks, the slight pout, introduce a note of intimacy into this otherwise official image, a note accentuated by the presence of the watch in the boy's hand, as though to remind us that the sitting has been going on now quite long enough. [PR]

## 286
## Pierre Subleyras
### The Miracle of Saint Benedict

1744
Signed and dated lower center, on a step: *Petrus Subleyras Pinxit Romae/1744*
Oil on canvas
10′ 8″ × 7′ ⅝″ (325 × 215 cm)

PROVENANCE painted for the church of the Olivetan convent in Perugia; convent suppressed in 1810 and picture moved to the church of S. Francesca Romana, Rome, in 1822

EXHIBITION Paris and Rome 1987, cat. no. 91

BIBLIOGRAPHY Arnaud, Odette. "Subleyras, 1669 à 1749." In Louis Dimier, ed., *Les Peintres français du XVIII e siècle*. Paris, 1930, pp. 66–68, pl. 12, no. 51; Frank 1987, p. 37, fig. 3; Michel and Rosenberg 1987, pp. 13, 100–1, 286–95, with previous bibliography; Scott 1987, p. 371, fig. 3; Michel 1996, *Vivre et peindre*, pp. 83, 156
Chiesa di S. Francesca Romana (S. Maria Nova), Rome

In 1737 the Olivetans of Perugia, a branch of the Benedictine order, decided to build a new monastery under the direction of the architect Luigi Vanvitelli. Of the four large paintings destined for the interior decoration, two were commissioned from Stefano Pozzi and two from Subleyras—this painting and *The Absolution of the Emperor Theodosius* (1745; Galleria Nazionale dell' Umbria, Perugia; see Paris and Rome 1987, no. 96). The *Saint Benedict* was moved

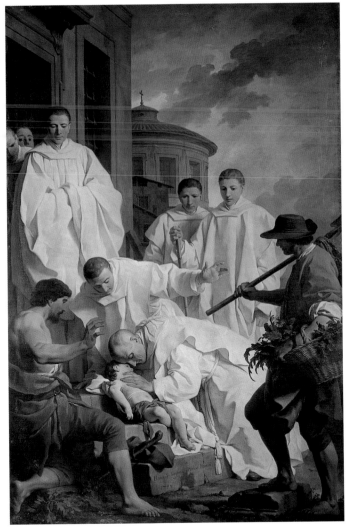

286

to Rome after the Napoleonic secular reforms of 1810. Apart from the vast *Saint Basil* now in S. Maria degli Angeli (see Michel and Rosenberg 1987, p. 334, fig. 2), it is the only other large-scale religious composition by Subleyras on view in Rome, the city so dear to the painter's heart. Several preliminary drawings for the work exist (in New York, the Louvre, and the Musée Atger in Montpellier) and several sketches with variants (Louvre, Munich, Perugia), as well as numerous studio replicas and copies made at different times, all proof both of the care Subleyras put into the execution of the painting and of the widespread popularity that the work rapidly acquired.

Subleyras took his subject from the *Dialogues* of Saint Gregory the Great (II. 32). Olivier Michel gives the following subtle account: "The painter seeks to grasp the very moment in which the supernatural becomes tangible; Saint Benedict, dressed, like the Olivetans, all in white, leans over the dead body of a small child, which has been left on the monastery steps by its father, a poor peasant. The miracle of

resurrection is effected through this tender human movement, observed by a curious onlooker, a humble gardener, who is painted in a lively colorful manner; but the solemnity of the moment is expressed in the group of monks, transfixed in expectation, their white robes forming a luminous cluster, whose light is focused on the saint" (Michel 1996, *Vivre et peindre*, p. 156).

This painting has always been greatly admired, both for the fine quality of its areas of white light and for the rigor with which the artist has dealt with its composition and execution. It is indisputably one of Subleyras's greatest achievements, exemplifying his ability to draw the eye to the exact place and moment at which the miracle occurs. There is nothing declamatory in the work, nor does it seek to create an overpowering impact. Subleyras is not trying to move us: his subject is serenity, contemplation, peace of mind. He seeks to convey the feelings of the Olivetans. [PR]

## 287
## Pierre Subleyras
### Saint Camillo de Lellis Saving the Sick of the Hospital of Spirito Santo from the Floodwaters of the Tiber

1746
Signed and dated lower right, on the stretcher: *P. Subleyras Pinx 1746*
Oil on canvas
67¾″ × 97 ⅝″ (172 × 248 cm)

PROVENANCE commissioned by the Camillans on the occasion of the canonization of their founder, June 29, 1746, and presented to Pope Benedict XIV; given or bequeathed by the pope to Cardinal Girolamo Colonna (Eduard A. Safarik, *The Colonna collection of paintings. Inventories 1611–1795* [Munich: KG. Saur], 1996, p. 613; see also p. 662); passed down to the Barberini family; acquired by the Museo di Roma in 1960

EXHIBITIONS Rome, Palazzo Braschi. *I francesi a Roma dal Rinascimento agli inizi del romantismo*. 1961, cat. no. 568; Rome, Palazzo Braschi. *L'Accademia di Francia a Roma*. 1966–67, cat. no. 67; London 1968, cat. no. 650; Toledo, Ohio, The Toledo Museum of Art; Chicago, The Art Institute of Chicago; Ottawa, The National Gallery of Canada. *The Age of Louis XV: French Painting, 1710–1774*. 1976, cat. no. 97; Paris and Rome 1987, cat. no. 101, pl. xv

BIBLIOGRAPHY Arnaud, Odette. "Subleyras, 1669 à 1749." In Louis Dimier, ed., *Les Peintres français du XVIII e siècle*. Paris, 1930, pp. 53–54, 67–68, no. 55; Frank 1987, p. 38, fig. 2; Michel and Rosenberg 1987, pp. 13, 104–6, 307–16, with previous bibliography; Sestieri 1994, vol. 3, fig. 1056; Michel 1996, *Vivre et peindre*, pp. 83, 158; Casale 1998, p. 23
Museo di Roma, Rome

On the night of December 23, 1598, the River Tiber flooded the Hospital of Spirito Santo in Rome. Camillo de Lellis rushed from his convent of S. Maria Maddalena to go and help. But the staff at the hospital, convinced that the river water would not rise above a certain level, tried to resist Camillo's efforts to evacuate the sick. Throughout the night, aided by his companions, he moved the invalids up to the topmost floor of the hospital. Scarcely was the evacuation complete when the river water flooded into the rooms where the patients had lain.

In 1591 Camillo de Lellis founded his congregation, the Camillans, with their distinctive red felt crosses stitched on to black habits. He was canonized by Benedict XIV on June 26, 1746, for which occasion the Camillans commissioned two paintings from Subleyras, both (including this one) intended for presentation to the pope. Subleyras paid great attention to the composition, for which two sketches survive, one in the Pushkin Museum in Moscow (copy in the Weimar Museum), and another in a private

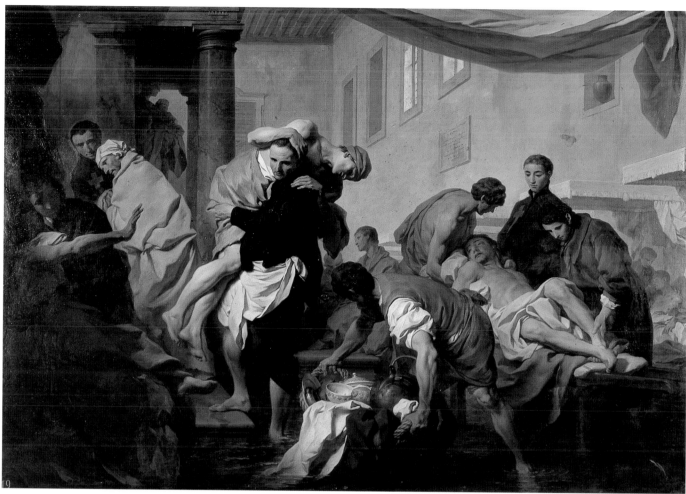

287

collection in Paris; also two preparatory drawings (one of which is unpublished) in private collections in Paris.

Subleyras was the greatest exponent of classicism in Rome during the first half of the eighteenth century. This work, with its rejection of lyrical effusion and of facile brushwork, is a perfect example of the movement. But Subleyras thought of himself equally as a realist painter. The careful depiction of the hospital, its serried lines of box beds, the remarkable basket in the foreground with its blue and white drapery, kettle, large lemon, and porcelain bowl—one of the finest still lifes of the century—the saint's feet, and his habit hitched up to his knees, all contribute to the creation of an image of reality. The beauty of the painting resides as much in the quietly controlled movements of the figures as in the way the painter has interiorized their expressions and emotions.

Subleyras skillfully combined the familiar with the supernatural. *Camillo de Lellis* is a noble and dignified work, both solemn and serene, the balance of sick and able bodies subtly achieved, perfectly modulated throughout. It ranks without doubt among the very finest of Subleyras's works. [PR]

## MARIA FELICE TIBALDI SUBLEYRAS

### ROME 1707–1770 ROME

Maria Felice Tibaldi was the eldest daughter of a musician from Modena, the violinist Giovanni Battista Tibaldi. Tibaldi had eight daughters by his second marriage, to Maria Maddelena Mandelli, a number of whom, including Teresa—also a miniaturist— devoted themselves to the arts.

Maria Felice was considered a precocious talent. She was taught miniature painting by the abbot Giovanni Felice Ramelli, and she achieved fame at an early age. When her father found himself in difficulty, Maria took charge of her younger siblings and supported the family financially. This must explain, in part, the relatively late age at which she married Pierre Subleyras. She is known to have met him as early as 1735, but they could not marry until March 23, 1739, by which time Subleyras had achieved a secure reputation as a painter. They were married at the church of S. Maria in via Lata, opposite the Palazzo Mancini, home of the French Academy at Rome, which Subleyras attended from 1728 to 1735.

Their marriage was a happy one. They had four children: two daughters, Carlotta and Clementina—also a well-known miniaturist—and two sons, Luigi, a poet and writer, and Giuseppe, the architect. Maria Felice was a devout woman. After her husband's death in 1749, she concentrated with great dignity on the tasks of educating her children and making miniatures, although the number of works which can be attributed to her is relatively small.

Several works depicting Maria Felice's own face have survived: a portrait by her husband (cat. 283; note the three miniatures in the picture), a rather unflattering caricature by Pier Leone Ghezzi, dated March 18, 1739, a few days before her wedding (Vatican Library, Rome) and the drawing, most likely a self-portrait, kept in the Gabinetto dei Disegni at the Uffizi in Florence. A second portrait by her husband has been lost, but is known from a drawing by Gabriel de Saint-Aubin (1724–1780) made in the margin of a sale catalogue of 1776 (reproductions of all these works can be found in Michel and Rosenberg 1987, pp. 134–35). It is possible that the figure shown from behind, painting,

in Subleyras's masterpiece *The Atelier*, in the Akademie der Bildenden Künste, Vienna, is also Maria Felice.

A fair number of miniatures by Maria Felice Tibaldi have survived, many of which are illustrated in the catalogue to the 1987 exhibition of the works of Subleyras: the portrait of Abbot Giovanni Felice Ramelli (Palazzo Reale, Turin; p. 84); the portrait of Karl Theodor, Palatine Elector, and of his wife, Elisabeth Maria (Bayerisches Nationalmuseum, Munich; p. 110), both after the portraits by Johann Georg Ziesenis; *Poetry* (p. 111); the *Madonna della Sedia* after Raphael (p. 112); and the portrait of Joseph Vernet, after a painting by her husband now in the Musée des Beaux-Arts, Amiens (private collection, Paris; p. 235). Mariette is known to have owned a miniature by Maria Felice, the *Rape of the Sabine Women* after Ciro Ferri (sale beginning November 15, 1775, no. 1366, sketched by Saint-Aubin in the margin of his copy of the catalogue; now in the Museum of Fine Arts, Boston), though the current whereabouts of this work are unknown (records have survived of five sales held during the eighteenth century, which mention nine of Maria Felice

Tibaldi's miniatures). Others include the portrait of Cardinal Colonna di Sciarra after Pompeo Batoni, now in the Château de Bussy-Rabutin, signed and dated 1758, and finally the design for a fan, showing the Triumph of Harlequin, now in the Musée des Augustins in Toulouse, first shown in Toulouse in 1773 (Roland Michel 1960, pp. ii–iii).

Maria Felice was the second woman ever to be admitted to the Accademia di S. Luca, after Rosalba Carriera. She enjoyed a brief moment of glory, but her reputation today rests entirely on the present work, with which visitors to the Museo Capitolino will be familiar. A detailed study of the miniatures of Maria Felice Tibaldi is long overdue. [PR]

BIBLIOGRAPHY  Michel and Rosenberg 1987

## 288
## Maria Felice Tibaldi Subleyras
### *Feast in the House of Simon the Pharisee*

1748
Inscribed lower left: *M.F. Tibaldi Subleyras Accediorum Sancti Luca Arcadiaque vocantur socia pinxit. Roma anno 1748*
Watercolor on vellum
10⅝″ × 25⅛″ (27.2 × 63.8 cm)
PROVENANCE  acquired directly from the artist in 1752, for 1,000 *scudi*, by Pope Benedict XIV
EXHIBITION  Rome 1750. The "Congregation of San Giuseppe di Terra Santa dei Virtuosi al Pantheon" under the "Portico of S. Maria ad Martyres" as "another miniature, representing Mary Magdalene in the House of the Pharisee, by M. Felice Tibaldi" (see Waga 1968, p. 10)
BIBLIOGRAPHY  Waga 1968, p. 10; Bruno, Raffaele, ed. *Roma, Pinacoteca Capitolina.* Bologna: Calderini, 1978, pp. 84–85; Michel and Rosenberg 1987, pp. 109, 199, fig. 1; Villata 1996, p. 160
Pinacoteca Capitolina, Rome

Maria Felice was one of the most celebrated miniaturists of her day. It is not surprising that she should have chosen to reproduce one of her husband's most famous paintings, the vast *Feast in the House of Simon the Pharisee* (canvas, 7′ ⅞″ by 25′ 5½″; Musée du Louvre, Paris), painted, in 1737, for the refectory

288

of the convent of S. Maria Nuova in Asti, near Turin. Maria Felice did not copy the definitive version of the work since in 1748, the date of her miniature, she would not have had access to it. For this version she must have painted from one of the many sketches of the composition, most likely that kept by Subleyras for himself (now also in the Louvre), which later came into the possession of Charles Natoire, before being bought in 1786 by the Comte d'Angiviller on behalf of the king. In this sketch, as in the miniature in the Museo Capitolino, the servant, in the center of the work, is turned towards the viewer, whereas in the final painting he is looking at the Magdalen figure as she wipes the feet of Christ with her hair, on the left of the composition.

In the long inscription of the miniature, Maria Felice Tibaldi mentions that she is a member of the Accademia di S. Luca (elected April 8, 1742; her husband had been elected two years before that) and also of the Accademia dell'Arcadia (which had accepted herself and Pierre Subleyras in 1743; her *alias* was Asteria Aretusa). In 1750, in her role as member of the Accademia di S. Luca, she lent the work for the exhibition of "Virtuosi" held beneath the entrance to the Pantheon, but it should be remembered that between the date of execution of the miniature (1748) and that of the exhibition, Maria Felice Tibaldi had lost her husband, on May 28, 1749. When Subleyras, whose health had always been delicate, fell seriously ill, Father Léonard de Port-Maurice, whose portrait Subleyras had painted some years previously (location unknown), attended him several times to perform the last rites. On his third visit, Benedict XIV asked Father Léonard to give Subleyras his blessing in *articulo mortis*, along with his promise that he would take care of the couple's children. This he did by buying the *Feast at the House of Simon the Pharisee* for a thousand sovereigns, a considerable sum, far higher than what Maria Felice would normally have charged for her miniatures.

Although in her day she was widely admired for the faithfulness of her reproductions, for their brightness and harmoniousness, Maria Felice Tibaldi is largely forgotten today, a victim of the fate usually due to the miniaturist.

But this work serves to remind us of her talent, and of one of the great Roman paintings of the eighteenth century. [PR]

## STEFANO TOFANELLI
NAVE, NEAR LUCCA 1752–1812
LUCCA

Tofanelli's artistic production spans two distinct periods in the evolution of Neoclassicism: his most interesting work dates from the last thirty years of the eighteenth century and is followed by a wholly Empire epilogue after his return from Rome to Lucca when Principessa Elisa Bonaparte Baciocchi reigned there (see Tommaso Trenta, *Memorie e documenti per servire alla storia di Lucca*, vol. 8 [Lucca, 1822]; Giovanelli 1992–93). At the age of ten he entered the studio of a local painter, Giuseppe Antonio Lucchi, where he formed a lasting friendship with another pupil, Bernardino Nocchi, eleven years his senior. Nocchi had in effect become, four years later, his master, and in 1768 the two set off together for Rome to complete their training, subsidized by a group of Lucchese gentlemen who soon began to commission pictures from them (see Rudolph 1985, pp. 201–2).

Although the most celebrated painter in Rome at the time was their compatriot Pompeo Batoni, the two fledgling artists found no welcome in that quarter but instead were taken up as assistants by Nicola Lapiccola, with whom they collaborated on the execution of the frescoed decorations of rooms in the Villa Giulia, the Palazzo Pontificio at Castel Gandolfo and the Palazzo Chigi at Ariccia. In hindsight it would seem that the association with this rather independant Calabrian master prompted Nocchi and Tofanelli to experiment with those innovative currents in Roman painting of which each had become a protagonist by the end of the 1770s. Tofanelli participated in the 1771 Concorso held by the Accademia di S. Luca with a prize-winning drawing (*Abraham and the Three Angels*); a decade later he was running a school of his own and in 1787 took over that of his friend Gavin Hamilton in via dei Greci, by which time he had started to produce with regularity the drawn copies of famous pictures engraved by Domenico Cunego, Giovanni Folo, Raffaello Morghen, Giovanni Volpato, and others, whose plates are conserved in the Calcografia Romana.

Tofanelli's reputation as a portraitist was launched by the 1783 *Self-portrait Flanked by the Artist's Father, Andrea, His Young Brother Agostino, and an Oval Portrait of His Master, Bernardino Nocchi* (cat. 289), the 1784 *Portrait of the Sculptor Christopher Hewetson at Work on a Marble Bust of Gavin Hamilton* (c. 1784;

Wallraf-Richartz Museum, Cologne), the *Portrait of the Sculptor Carlo Albacini at Work on a Model of a Female Figure* (Galleria dell'Accademia Nazionale di S. Luca, Rome), and the lost *Self-portrait with the Abate Giovenozzi, the Engraver Mogalli, Father Casini, and Monsignor Gualtieri*, painted for the latter and surely an enticing visual reference to the master's circle of acquaintances in Rome (Clark and Bowron 1985, pp. 139–41, figs. 178, 181). If the grave realism of such effigies, in their tonal restraint and sharp definition of form, was at odds with the florid, courtly taste still purveyed by Batoni, his magisterial cycle of frescoes and canvases with *Stories of Apollo*, carried out in various stages between 1784 and 1791 in the *salone* of Luigi Mansi's villa at Segromigno (Lucca), reveals that Tofanelli had assimilated the neohellenistic modes recently coined by Hamilton and Maron, fortifying also Lapiccola's ornamental repertory with borrowings from the Raphael tradition (in the monochrome "cameo" vignettes; see Lazzareschi 1930).

The 1787–94 redecoration of the Appartamento Nobile in the Palazzo Altieri, commissioned by Prince Emilio and supervised by the architect Giuseppe Barbieri (yet another collegue portrayed by Tofanelli; Galleria dell'Accademia Nazionale di S. Luca, Rome), brought together two generations of the leading painters in Rome (with the notable exceptions of Nocchi and Corvi), thus documenting the state of the arts there before the 1798 republican upheaval in the city. With his sedate, Raphaelesque *Apotheosis of Romulus* canvas, surrounded by deities frescoed in a classical frieze on the vault of the *salone*, Tofanelli managed to hold his own with the likes of Maron, Cavallucci, Cades, and the emergent talents Giani, Leopardi, and Camuccini, despite the by now somewhat conventional imagery and a touch of flaccidness in the execution. The same is also true of his altarpieces for S. Nicolò all'Arena in Catania, begun in 1790, and for two churches at Gubbio, of the 1794 altarpiece sent to S. Antonio in Tivoli, and of another sent in 1795 to the Pieve di Vorno (Lucca).

The intrepid Nocchi remained in Rome after the destitution and death of his patron Pius VI Braschi (1799); Tofanelli, on the other hand, withdrew to Lucca and captured all the honors available when Napoleon's sister Elisa Baciocchi, from 1805 on, held the ex-republic as a principality and rendered it a microcosm of imperial patronage. He was nominated Maestro di Disegno e di Pittura nell'Università, Socio Ordinario dell'Accademia Napoleone, court painter, and even senator (1805); and

he produced portraits of his sovereign and her husband, Felice, frescoed decorations in their residences (for example, at Villa Marlia), and in the Cappella del Sacramento in the cathedral, and painted canvases for the Buonvisi Chapel in San Frediano (Tosi 1986). However, the master's creative vein had dried up through the repetition, aided by assistants, of his best inventions in the provincial context of Elisa's court. As Anthony Morris Clark, observed this last phase of his career indeed "foundered in the disasters of the Napoleonic period" (Clark and Bowron 1985, p. 123). [SMCR]

BIBLIOGRAPHY Trento, Tommaso. *Memorie e documenti per servire alla storia di Lucca*. Vol. 3. Lucca, 1822; Clark and Bowron 1985, pp. 139–41; Giovannelli 1992–93

## 289
## Stefano Tofanelli
*Self-portrait Flanked by the Artist's Father, Andrea, His Young Brother Agostino, and an Oval Portrait of His Master, Bernardino Nocchi, on an Easel*

1783
Oil on canvas
43⅝″ × 34″ (111 × 86.5 cm)

PROVENANCE Paolo Santini, Lucca, from 1783, thence his heirs; Ottolini Collection, Lucca; art market, Rome, whence purchased in 1954 by the Museo di Roma

BIBLIOGRAPHY Lazzareschi 1930, p. 207; Pietrangeli 1959, "Tofanelli"; Clark 1963, "Neo-Classicism," pp. 358–59; *L'Accademia* 1974, pp. 263–64; Rudolph 1983, fig. 667; Rudolph 1985, pp. 203–4, fig. 1; Giovannelli 1992–93, pp. 424–25, 428–29

Museo di Roma, Rome

The picture was first published in 1959 by Carlo Pietrangeli, but without reference to an essential footnote in a 1930 article by Emilio Lazzareschi, citing a letter sent from Rome on April 24, 1783, by the artist to Girolamo Orsucci in Lucca, in which he mentions that he was at work there on this canvas for his patron Paolo Santini there (Lazzareschi, p. 207, n. 1; see also Rudolph 1985, p. 203). In yet another missive, written to Santini on July 23, Tofanelli described at length the portrait just finished, stating that he had only recently added the figures of his father and brother "per mio piacere […] e per mio capriccio" on occasion of their visit to Rome. The following excerpts explain the artist's intentions: "My portrait shows me in the act of painting Nocchi, who is turned as if to hear the opinion of those who view him"; all four figures "are painted in their real dimensions; and you will not only be able to see our appearance, but also our height, and I believe that

289

you will be surprised to see Stefano who left Lucca as a boy now taller than Nocchi. The costumes are *alla pittoresca* in the manner of our ancient Masters so as to avoid the fashions that habitually render paintings odious when they are too obvious" (cited in Giovannelli 1992–93, pp. 428–29, n. 16).

Already conceived as a self-portrait of the painter at work on an oval portrait of his master, Bernardino Nocchi, the picture had thus become during the months of execution an even more poignant homage to his friend and mentor Nocchi, as well as an autobiographical document of Tofanelli's own growth into manhood and artistic competence. In fact the placement, on an easel to the right, of the canvas representing Nocchi holding his portfolio of drawings, while Tofanelli in the center is seated behind a table with brush in hand, finds its counterpart on the left in the heads of the elderly Andrea and the adolescent Agostino, who look across to that effigy in oils with expressions of deep affection: for, as Nocchi had been a surrogate father to his pupil Stefano after their move to Rome, so now Andrea Tofanelli was about to hand over to him also his younger son for training as an artist.

The 1783 portrait, much acclaimed when it reached Lucca, belongs to the most creative period in Tofanelli's career, when he enunciated the inci-

sive stylistic and expressive sobriety that constituted then an avant-garde trend in Roman painting. In that context Anthony Morris Clark judged it to be "if anything even vaguely comparable with David" and admirably summed up its novelty and quality in the following terms:

The Hellenistic statuary which inspired the Carracci and Bernini and which was not entirely cast out by Winckelmann had no place in Tofanelli's Doric style; the Baroque is finally and entirely dead and the scrupulous plainess which we have seen in Masucci has been brought to its final conclusion. Instead of Baroque grandeur or Rococo grace there is the profound and lucid regard upon the artist's face, the tender and vigorous realism of the father and younger brother, and the clear and measured forms. These forms, carefully calculated in outline and proportion, must (and we know do) proceed from a canonic study of reality - reminiscent of that of Polykleitos. This is a Neoclassical portrait in the purest and highest sense. (Clark 1963, "Neo-Classicism," pp. 358–59) [SMCR]

## FRANCESCO TREVISANI
CAPODISTRIA 1656–1746 ROME

One of the premier artistic figures of the first half of the eighteenth century in Rome, Francesco Trevisani was born in the Venetian town of Capodistria (now Koper, Slovenia). Initially a pupil of the Venetian historical painter Antonio Zanchi, whose influence on his early Roman work was profound, Trevisani also studied under the pioneer *vedutista* Joseph Heintz the Younger, who helped develop the young Istrian artist's talent for genre painting. Unfortunately, none of the student works executed in Venice is now known, and by 1678 Trevisani had moved permanently to Rome, where he came under the protection of Cardinal Flavio Chigi. From c. 1680 until the cardinal's death in 1693, Trevisani executed a series of genre paintings for the family's various residences and also produced at least three altarpieces for Flavio, including two for the Chigi Chapel in Siena Cathedral, which reveal the strong contemporary influence of Carlo Maratti.

Two events in the mid-1690s ensured Trevisani's professional success in the Eternal City. The first was his introduction to Cardinal Pietro Ottoboni, perhaps the greatest art patron of his era, and the second was the commission for a series of oil on canvas altarpieces and fresco decorations for the Crucifixion Chapel in S. Silvestro in Capite. This choice commission, awarded by the nuns of S. Chiara possibly on Ottoboni's advice, put Trevisani in direct competition with other leading Roman painters, including Giuseppe Chiari and Lodovico Gimignani. These spectacularly successful paintings, which combine the classicizing grace of the *Maratteschi* with the somber grandeur of the Bolognese and seventeenth-century Venetian traditions, were executed between 1695 and 1696. The chapel's *cupoletta* and pendentives, painted in fresco, represent the Holy Cross in Glory and symbols of the Passion and are Trevisani's only known works in this medium, which was widely practiced by almost all other major artists of the period. The S. Silvestro decorations confirmed Ottoboni's high opinion of the artist and helped cement an especially close artist–patron relationship that lasted forty years.

Ottoboni's avid promotion of Trevisani and the presence of the painter in the cardinal's Roman residence, the Palazzo della Cancelleria, helped secure numerous Roman and foreign commissions for altarpieces and decorative cabinet pictures, often of mythological subjects. Among Trevisani's prestigious foreign patrons was Prince–Bishop Lothar Franz von

Schönborn, who ordered several pictures to decorate his palace at Pommersfelden. In 1708 the prince–bishop purchased Trevisani's *Penitent Magdalen*, a work that depicts the saint in sensuous half-length meditating upon a book, a skull, and a cross. In this devotional painting Trevisani shows himself a master of the traditions of the Venetian Cinquecento. Shortly afterwards, Lothar Franz ordered three mythological cabinet pictures from Trevisani—*Apollo and Daphne, The Rape of Persephone,* and *Luna and Endymion*—all done in a highly sophisticated, international style. This cosmopolitan aesthetic idiom has close affinities to contemporary French art and arguably influenced the generation of François Boucher and Charles Natoire, who further developed this *genre galant*. In addition to Schönborn, Trevisani also used his Ottoboni connections to obtain commissions from Turin (*The Immaculate Conception with Saint Louis and the Blessed Amadeus of Savoy*), from King John V of Portugal (*The Virgin and Child with Saint Anthony of Padua*) and from King Philip V of Spain (*The Family of Darius before Alexander the Great*). In many cases, Trevisani's friendship with the peripatetic architect Filippo Juvarra, whom he knew intimately at the Cancelleria when they were both under Ottoboni's protection, led to these lucrative undertakings. The painter also received numerous commissions for travel portraits and cabinet pictures from prominent British visitors to Rome and from the exiled court of the Stuart Pretender.

After the death of Giovanni Battista Gaulli in 1709, the papal commission for cartoons for mosaic decorations for the Baptismal Chapel in St. Peter's, which Gaulli had barely begun, was awarded to Trevisani, although little serious work on the project was undertaken until the 1730s. These impressive cartoons have a reductive quality and a deep pathos appropriate to the august setting and clearly reveal Trevisani's wide range of expression. Another papal commission for one of twelve paintings of Old Testament prophets for the upper walls of the nave arcade in St. John Lateran, *Baruch* of c 1718–19, has similar qualities of grandeur and imposing dignity. A decided tendency towards simplified, severe compositions and a reduction in the number of figures are very apparent in Trevisani's later altarpieces (for example, *The Vision of Saint Anthony of Padua*, c. 1722–23; Ss. Stimmate di S. Francesco, Rome) and is seen initially to great advantage in the paintings he executed for the chapel of St. Lucy of Narni in Narni Cathedral in 1715.

In his public altarpieces Trevisani demonstrated a profound respect for the great Roman classical tradition of

Raphael, the Carracci, and their followers Andrea Sacchi and Carlo Maratti. This careful classicism, however, is deftly balanced by his own Venetian heritage and his absorption of certain Neapolitan tenebrist trends, especially from the work of Francesco Solimena. But in his more intimate cabinet pictures of both religious and mythological themes, Trevisani reveals a lyrical, idyllic, cosmopolitan sensibility at the progressive forefront of contemporary Roman painting. This style was decisively influenced by a broader cultural trend, Arcadianism, that promoted an anti-Baroque agenda calling for reform of both literature and the visual arts and ultimately aimed at a profound reform of modern society. Among the leading *pastori*, or members, of the Accademia dell'Arcadia, the institutional organ of this reforming impetus, were such cultural, intellectual, and political luminaries as Pope Clement XI Albani, Carlo Maratti, Faustina Maratti Zappi (an important poet and daughter of Carlo), Cardinal Pietro Ottoboni, the famed composer Arcangelo Corelli, and Giovan Mario Crescimbeni (the academy's chief literary apologist and most important early historian).

Trevisani was active among the Arcadians by about 1704 and was doubtless introduced to the academy by Cardinal Ottoboni, one of its leading lights. He was elected to membership in 1712, taking the *alias* Sanzio Echeiano. One of the chief features of much Arcadian painting is a sensitivity to the civilized beauties of landscape, and the Arcadian impulse is seen to advantage in such works by Trevisani as *The Rest on the Flight into Egypt*, probably painted for Ottoboni and now in Dresden, and *Joseph Being Sold into Slavery* (cat. 294), executed for Marchese Niccolò Pallavicini and now in Melbourne, Australia. In both works, as in Giuseppe Chiari's *The Rest on the Flight into Egypt* (cat. 199), which was probably also done for Ottoboni, there is a delicate balance between figures and landscape and a sylvan sensibility that accords well with the Arcadia's desire for a more "natural," a less bombastic, euphuistic, and artificial art. Trevisani's small religious genre subjects such as *The Dream of Saint Joseph* and *The Virgin Sewing* (both 1690s; both Uffizi, Florence) also champion a domesticated classicism and emphasis on the simple, diurnal quality of religious experience that found its greatest Settecento exponents in Giuseppe Maria Crespi and Marco Benefial. [CMSJ]

BIBLIOGRAPHY Moücke 1752–62, vol. 4, pp. 99–103; Griseri 1962; DiFederico 1977, pp. 85–86; Sestieri 1977, "Trevisani"; Pascoli 1981, pp. 25–57; DiFederico 1983, pp. 71–72; Ruggeri 1996

290

## 290
### Francesco Trevisani
### *Sophronia and Olindo Rescued by Clorinda*

Early 1690s
Inscribed in black ink on the reverse:
*Card. de Polignac/ 95*
Oil on copper
10⅛″ × 13¼″ (26.4 × 33.7 cm)
PROVENANCE Cardinal Melchior de Polignac, Rome; probably Cardinal Carlo Colonna, Palazzo Colonna, Rome, 1783; sale, Sotheby's, New York, May 20, 1993, lot 111; bought by Colnaghi, London; from whom acquired by the present owner
BIBLIOGRAPHY *Catalogo … Casa Colonna in Roma*. Rome, 1783, no. 578; Guiffrey, Jules. "Inventaire du mobilier et des collections antiques et modernes du Cardinal de Polignac (1738)." *Nouvelles Archives de l'Art Français*, vol. 15 (1899), p. 267, no. 97, "Olinde et Sophrenie, de Trevillani, sur cuivre 9 ¼ pouces × 1 pied"; DiFederico 1977, p. 81 (as location unknown); Sestieri 1994, vol. 1, p. 175
Private collection, Courtesy Colnaghi, London

Oil paintings on copper were highly popular in Rome in the first quarter of the Settecento, especially for private devotional paintings, and the depiction of mythologies and scenes from classical history and literature. Trevisani frequently utilized copper supports for small-scale sacred subjects, and this painting from an early phase in his career suggests that along with artists such as Filippo Lauri, he played a significant role in establishing the vogue in the new century for such precious, cabinet-sized pictures.

One of the most popular sources for artistic themes in seventeenth- and eighteenth-century Italy and France was the romantic epic *Gerusalemme liberata* by the Italian poet Torquato Tasso (1544–1595). Appearing in pirated editions against the author's

wishes in 1575–76, the poem is an idealized account of the First Crusade against the Saracens, which ended with the capture of the holy city in 1099 by Godfrey of Bouillon and the establishment of a Christian kingdom. Tasso modeled his poem on the two great epics of antiquity, the *Iliad* and the *Aeneid*. Like those classics, the appeal of *Gerusalemme liberata* owes much to its rich human and romantic content, particularly its many amorous adventures between Christian and pagan men and women. Tasso's epic created excitement among artists, writers, musicians, and playwrights almost immediately upon its publication in 1581 and continued to inspire them for the next 200 years.

Trevisani has illustrated here the tale of the young lovers Sophronia and Olindo. A Christian girl, Sophronia was condemned to death at the stake by the Saracen king for her supposed part in a plot concerning a holy image. Olindo chose to die with her, but as the executioners were lighting the pyre, Clorinda, a female warrior from the East, who has been described as "a kind of pagan Joan of Arc" (James Hall, *Dictionary of Subjects & Symbols in Art* [New York, 1979], p. 228), appeared in full armor on a white horse and took pity on the couple. She promised the king to help in the struggle against the Crusaders if he would release Sophronia and Olindo, and her wish was granted.

In keeping with the heroic sweep of Tasso's poem, Trevisani has imparted an appropriate sense of movement and urgency to the scene. The painting was probably executed in the early 1690s, when the artist was employed by Cardinal Flavio I Chigi on such small-scale works on copper as the clock face with the *Flight into Egypt* in Palazzo Senatorio, Rome, and the *Martyrdom of Saint Stephen* in the Galleria Nazionale d'Arte Antica, Palazzo Corsini, Rome

(DiFederico 1977, pp. 39–40, pls. 2, 3). In handling, lighting and color, composition, and figural types, *Sophronia and Olindo Rescued by Clorinda* also bears comparison to the *Martyrdom of Saint Lucy* of about 1688 in the Palazzo Corsini, Rome, which Frank DiFederico defined as typical of Trevisani's manner at this period. Commenting on the artist's "spotlighting technique," which emphasizes the principal narrative event of the scene over the secondary forms and figures, he noted further the fully drawn and vigorously modeled figures, the strong chiaroscuro, the wet, fluid brushwork, and the predominantly brown palette (DiFederico 1977, p. 9, pl. 6).

The arrangement of Sophronia and Olindo tied to the stake at the center of the composition is related to the saints in *The Martyrdom of the Four Crowned Saints*, commissioned in 1688 by Cardinal Chigi for Siena Cathedral, for which at least two preparatory drawings for the bound saints are to be found in the Uffizi (DiFederico 1977, pp. 40–41, pl. 5, figs. 32–33). DiFederico tentatively associated an additional drawing in the Uffizi of a half-figure on horseback with the mounted warrior on the extreme right in *The Martyrdom of Saint Andrew* of the early 1690s in S. Andrea delle Fratte, Rome (DiFederico 1977, pp. 45–46, pl. 28, fig. 35). In the painting the figure and horse are reversed from the drawing, and the extended arm of the man holds a baton. The drawing is in fact much nearer to the pointing figure of Clorinda in the present composition, which was not known to DiFederico. It may be that Trevisani used the Uffizi drawing for both compositions, respectively.

Cardinal Melchior de Polignac did not commission this little copper directly from Trevisani, but almost certainly acquired the painting in Rome, where he represented France at the papal conclave of 1724 and remained as ambassador until 1732. He contributed much to the magnificent animation of Rome during the reign of Benedict XIII Orsini and is remembered in particular for his commissions to Giovanni Paolo Panini (cat. 264). [EPB/DGA]

## 291
## Francesco Trevisani
### *Cardinal Pietro Ottoboni*

c. 1700–1710
Oil on canvas
52⅞" × 38¼" (134.3 × 98.5 cm)
PROVENANCE collection of Cardinal Pietro Ottoboni; possibly collection of Arcangelo Corelli; purchased by John Bowes in Bologna in 1874

EXHIBITION Rome 1959, cat. no. 624
BIBLIOGRAPHY Waterhouse 1953; Maxon

and Rishel 1970, p. 212; Young, Eric. *Catalogue of Spanish and Italian Paintings.* Durham, England: County Council of Durham, 1970, pp. 126–27; Ostrow and Johns 1990; Johns 1993, pp. 32–35 Bowes Museum, Barnard Castle, Durham, U.K.

Although the precise date and circumstances of Ottoboni's commission for his portrait from Trevisani are not known, the Bowes painting is still the best-known representation of the cardinal and is arguably Trevisani's finest portrait. Shown three-quarter length, Ottoboni stands next to a table on which is a letter inscribed *All Emmo e Revmo Sigre/ Il Sigre Cardle Ottoboni/ Vicecanre/ Per/ Francesco Trevisani* ("To the most excellent and reverend Signore/ Signore Cardinal Ottoboni/ Vice-Chancellor [of the Holy Roman Church]/ by/ Francesco Trevisani"). He is depicted in a scarlet robe with lace surplice and wears a biretta on his head—the official "uniform" of members of the Sacred College of Cardinals. On the adjacent table are a bell, writing paper, and a silver inkstand. A sculpted double-headed eagle placed on an orb, the heraldic emblem of the Ottoboni family, ornaments the chair in the right background. This portrait, one of many of the painter's major patron mentioned in contemporary sources, has an especially high degree of linear precision and crisp handling of paint, stylistic features seen especially in the gilt bell, the surplice, and the highly focused features of Ottoboni's face. In these particulars, it bears close affinities to a number of portraits of Church dignitaries by Giovanni Battista Gaulli.

Trevisani had a close artist–patron relationship with Cardinal Ottoboni from the mid-1690s until the latter's death in 1740. As vice-chancellor of the Holy Roman Church, a highly lucrative ecclesiastical sinecure, Ottoboni's official residence was the Palazzo della Cancelleria, where Trevisani had his lodgings and studio for most of his professional career. The palace was celebrated all over Europe as a center of music, drama, scholarship, and the arts. Despite an enormous income and the huge legacy of his papal uncle Alexander VIII, the lavish scale of Ottoboni's cultural patronage and hospitality severely strained his resources, and the collection was broken up at his death (which made the family extinct) to satisfy a legion of creditors. A close friend of Clement XI, Cardinal Ottoboni shared the Albani pontiff's interests in the restoration of ancient and Paleochristian monuments and in the collecting of rare manuscripts in Latin, Greek, and Hebrew. His vast array of books and manuscripts was acquired for the Vatican Library by

291

Benedict XIV. Ottoboni also had the good sense to employ the celebrated polymath Francesco Bianchini as his secretary/librarian. Working in the Palazzo della Cancelleria, Bianchini earned a European reputation for his astronomical research (which led to the meridian line constructed in S. Maria degli Angeli in 1702), for publications on ecclesiastical history, rites, and sacred relics as well as pioneering works in archaeology and modern history. In addition, Bianchini was probably the first Italian successfully to perform Isaac Newton's experiment with prismatic light.

As Ottoboni's principal painter, Trevisani received numerous commissions from the cardinal's friends and from many who wished to curry favor with the powerful prelate. Ottoboni also was a leading member of the Accademia dell'Arcadia and doubtless did much to promote the group's agenda through commissions to Trevisani, who is still identified as the painter with the most pronounced Arcadian sensibility. It should be noted, however, that Ottoboni also employed numerous other artists and architects for important commissions, among them Nicola Michetti, Agostino Cornacchini, Carlo Fontana, Giuseppe Bartolomeo Chiari, and

Sebastiano Conca. All things considered, Pietro Ottoboni ranks as the single most important private art patron of the first half of the century.

In addition to his cultural interests, Pietro Ottoboni was also a major figure in Curial politics during the first four decades of the eighteenth century. In 1709 he became cardinal protector of the French crown in Rome, a type of unofficial representative of the Bourbons in the papal capital who received a generous stipend in return for representing the dynasty's interests, above all in the conclaves that elected new popes. In this capacity he served French interests in three conclaves (Innocent XIII, Benedict XIII, and Clement XII) and actually died during the conclave that elected Benedict XIV, a learned cardinal with whom he shared many cultural and intellectual interests. As archpriest of S. Maria Maggiore, a bastion of Spanish influence in Rome, Ottoboni was even more closely tied to Bourbon interests. As an official representative of Louis XV, he earned the enmity of the Austrian Habsburgs, an impediment that possibly cost him the papacy in 1724 and again in 1730. Next to the various Albani cardinals, Ottoboni was the most important politician in early Settecento Rome. [CMSJ]

292

## 292

### Francesco Trevisani
#### Dead Christ with Angels

c. 1705–10
Oil on canvas
54¼″ × 48⅛″ (139 × 124 cm)
PROVENANCE  probably painted for Pope
Clement XI; Albani collection, Rome;
acquired by the Imperial collection in
Vienna, 1802
EXHIBITION  Rome 1959, cat. no. 15
BIBLIOGRAPHY  Waterhouse 1937, p. 97;
DiFederico 1977, p. 54; Ferino-Pagden,
Silvia, et al. *Die Gemäldegalerie des
Kunsthistorischen Museums in Wien: Verzeichnis
der Gemälde*. Vienna: Christian Brandstätter,
1991, p. 125
Kunsthistorisches Museum, Vienna,
Gemäldegalerie

The *Dead Christ with Angels* is in all
probability to be identified with the
reference in Lione Pascoli's biography
of Trevisani: "For Clement XI a picture
with Jesus carried by angels, in half
length, life scale." Among the many
versions of this composition executed
by Trevisani or produced by his studio,
the Vienna painting is the only one
that conforms completely to Pascoli's
description; others are either small-
scale (such as the work on copper in
the Galleria Pallavicini-Rospigliosi in
Rome) or of slightly reduced dimen-
sions (such as the version in the City
Art Gallery in Bristol, England). A
smaller variant also exists in the
Metropolitan Museum of Art in
New York.

Trevisani was one of the most
favored painters in Rome during
the pontificate of Clement XI Albani
(1700–21). He probably came to the
future pope's attention through
Cardinal Pietro Ottoboni during the
pontificate of Innocent XII Pignatelli
(1692–1700), a period in which Albani
and Ottoboni were especially close.
Both the pontiff and the painter were
intimately associated with the
Accademia dell'Arcadia, and Clement
chose Trevisani in 1718 for one of the
paintings of the Prophets (*Baruch*) for
St. John Lateran. The pope's most
important notice of the artist was the
commission in 1709 for cartoons for
mosaics to be executed for the bap-
tismal chapel in St. Peter's. At first
glance, it seems remarkable that
Trevisani was passed over for the series
of important paintings commissioned
by Clement XI for the nave of
S. Clemente, one of the most impor-
tant restorations of the entire century,
but all these works were in fresco, a
medium in which Trevisani had almost
no experience. Indeed, the artist's
absence from the S. Clemente series
may be an important indication of a
personal dislike of fresco painting.

Although on the scale of life, *Dead
Christ with Angels* still falls into the cat-
egory of devotional painting, and may
have been intended for a private chapel
rather than a picture cabinet, although
the latter is certainly a possibility. The
languid figure of Christ is painted in a
highly naturalistic style, and the star-
tlingly large wing of one of the sup-
porting angels dramatically links Jesus'
body with the heavenly aperture at
the upper left. The dolorous, excep-
tionally full-figured angels are less self-
consciously charming than in many
contemporary religious paintings and
have a closer affinity to Guercino and
Lanfranco than to Maratti or Trevisani's
colleagues. The unusually strong
chiaroscuro also increases the histri-
onic intensity of the painting, making
it one of the most stylistically conser-
vative works of Trevisani's entire
career. It is possible that the rigorous
decorum governing this type of
sacred depiction dictated a more cir-
cumspect treatment, in vivid contrast
to his more stylistically progressive and
humanized arcadian cabinet pictures.
[CMSJ]

## 293

### Francesco Trevisani
#### The Virgin and Child with the Young John the Baptist

1708
Signed and dated
Oil on canvas
39⅛″ × 29⅛″ (99.5 × 74 cm)
PROVENANCE  purchased by the Elector
of Saxony from Le Leu and Le Brun, Paris,
in 1734
BIBLIOGRAPHY  Voss 1924, p. 617;
DiFederico 1977, p. 48; Walther, Angelo,
ed. *Gemäldegalerie Dresden, Alte Meister:
Katalog der Ausgestellten Werke*. Dresden:
Staatliche Kunstsammlungen Dresden;
Leipzig, Germany: E. A. Seemann, 1992,
p. 387
Gemäldegalerie Alte Meister, Staatliche
Kunstsammlungen, Dresden

The production of small-scale cabinet
pictures, often of devotional themes
such as the Virgin and Child and the
Holy Family, was a salient feature of
Roman painting in the early decades
of the Settecento. Under the influence
of Arcadian ideas, artists focused on
non-narrative religious themes exe-
cuted with a genre-like sensibility.
These paintings were widely popular
both in Rome and abroad, and fea-
tured prominently in the most impor-
tant private collections of the period.
It should be noted that despite the
sacred subjects, such paintings rarely
were commissioned for ecclesiastical
settings. Playing to Arcadian notions
of self-conscious naïveté, suave sweet-
ness, and painterly elegance, this type
of religious painting is deliberately
untheatrical. Baroque bombast and
fustian grandiloquence are replaced

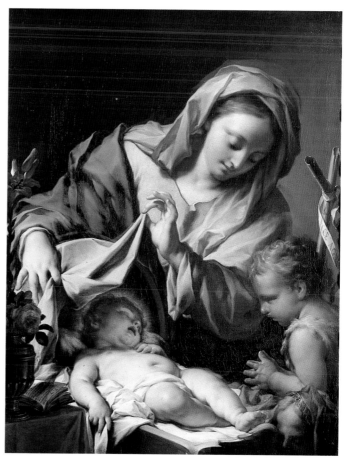

293

by a sense of restraint, delicacy, and
understatement. While drawing upon
the rich traditions of Bolognese
Seicento art, this refreshed, progres-
sive style of painting was introduced
to the eighteenth century by Carlo
Maratti and was promulgated by his
numerous students, followers, and
imitators. Its progeny includes such
pervasive and influential images as
Pompeo Batoni's *Sacred Heart of Jesus*
of c. 1765 (see fig. 9 above).

Trevisani's painting depicts a highly
Marattesque Virgin lifting a pale
mauve cloth from over the Christ
Child asleep in his cradle so that the
young John the Baptist may adore his
infant cousin. All three figures are
placed very close to the picture plane
and the background is plain, focusing
attention entirely on the figures. The
only concessions to setting are the
cradle and the table at the extreme left
margin of the painting. This table
bears an open book and a gilded vase
that contains pink peonies and a lily,
similar to the type seen in the Uffizi
*Virgin Sewing*. The material objects are
very carefully described and under-
score the importance of still life to
Trevisani's art.

Typical of Trevisani's style in the
early decades of the century is the
expressive use of light and shadow
to create a mood of domestic warmth
and well-being. Unlike his Baroque
predecessors, the artist's palette tends
to pastels; a great deal of white has
been added to Mary's pink tunic and
blue cloak in order to give a greater
sense of decorative lightness. The
pastel pink tonality of the tunic is
picked up in the peony and is reflect-
ed in the gentle face of the Virgin and,
more intensely, in the ruddy cheeks
of John the Baptist, whose hair is
composed of a few bravura flourishes
of the brush. In its sweet domesticity
the work reveals Trevisani's careful
study of his immediate predecessors,
but the overarching influence is that
of Correggio. In an era that valued
decorative grace and human values
highly, Correggio's reputation rose to
rival that of Raphael in the aesthetic
and academic hierarchies that had
such an important impact on artistic
production. [CMSJ]

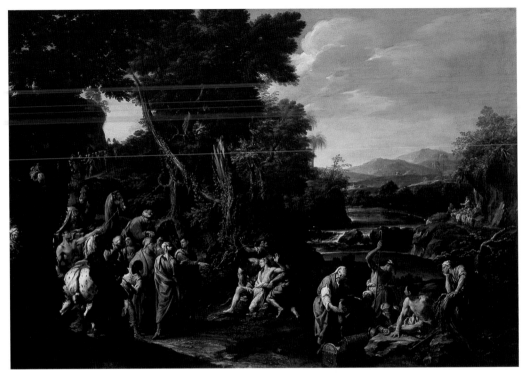

294

given augmented importance, and he also purchased more conventional pastoral landscapes by such artists as Jan Frans van Bloemen. The painting's cool, lucid colors and sophisticated composition must also have appealed strongly to Pallavicini, who admired similar qualities in the works of Carlo Maratti, of whom he was a major patron. Trevisani's close professional contacts with Pallavicini and Cardinal Pietro Ottoboni, coupled with considerable knowledge of their impressive collections, may have been partly responsible for the change in his style from the tenebrism of his northern training to the overtly classical style of the *Maratteschi*. [CMSJ]

## 294
## Francesco Trevisani
### *Landscape with Joseph Being Sold into Slavery*

c. 1710
Oil on canvas
44⅛″ × 61⅝″ (112 × 156.7 cm)
PROVENANCE collection of Marchese Niccolò Maria Pallavicini until 1714; collection of the Duke of Westminster, Grosvenor House, London by 1821; purchased on the London art market by the museum
BIBLIOGRAPHY Griseri 1962, p. 30; Hoff 1973, p. 155; DiFederico 1977, p. 58; Pascoli 1981, p. 33; Rudolph 1995, p. 204
National Gallery of Victoria, Melbourne, Australia, Felton Bequest

Although the subject of this painting has traditionally been identified as Joseph Being Sold by His Brothers, according to the text (Genesis 37), Joseph was actually enslaved by a group of Midianite merchants who discovered him in the waterless pit where his brothers had placed him while deciding his fate. The traditional theme that the sale was made by Joseph's own brothers comes from an alternative textual tradition based on an ambiguous verb in the Vulgate. After initially planning to kill him and then claim he had been devoured by a wild beast, the brothers decided to sell him after seeing a fortuitous Ishmaelite caravan appear in the distance. Joseph had excited their envy and hatred because their father, Jacob, preferred him to the others and because Joseph's dreams foretold

that they would later become his supplicants. But when they returned to the pit they discovered to their dismay that Joseph was gone and then learned that he had been sold to the caravan. They took his celebrated cloak of many colors, dipped it in a goat's blood, and presented it to Jacob (Israel) as evidence that Joseph was dead. They would later encounter their younger brother in Egypt.

Trevisani's artistic emphasis in the painting is primarily on the landscape. Joseph was sold in Dothan, which the painter has rendered as a lush, verdant, hilly, and well-watered land rather than the arid, pastoral terrain described in Genesis. In the foreground an anguished young Joseph is being bound by three slavers, while at the right the money is paid out on the flat surface of a stone, the silver having been retrieved from the chest seen at the feet of the standing trader. The right third of the painting is taken up by the Ishmaelites, their goods and camels, who form a procession that winds into the middle distance in the manner of the train of the Magi in traditional Adoration scenes. The right middle distance is occupied by a river with a gentle cascade; hazy blue mountains appear in the far distance. On the painting's right margin is a flock of sheep. This may be a reference to Joseph's brothers, who were shepherds and who are soon to discover him missing from the pit. If the brothers are included among the crowd of figures in the foreground—and, given the traditional preference for the interpretation that it was his brothers who

sold him into slavery, this is likely—they are not identified by any attribute. Thus, the less explicit title *Landscape with Joseph Sold into Slavery* covers both textual readings.

The numerous figures are rather small in relation to the panoramic setting, a fact that underscores the admiration for landscape not only as a backdrop for significant human activity but as an object worthy of considerable visual interest in its own right. This painting is similar in its emphasis on landscape to the artist's *Landscape with the Rest on the Flight into Egypt* in Dresden and to the painting of the same subject by Giuseppe Chiari in the Bob Jones Collection, although the landscape element is not quite so emphasized in the latter painting. Indeed, the idyllic, lyrical mood of all three works connects them to Arcadian tendencies prevalent in early eighteenth-century Roman painting.

*Landscape with Joseph Being Sold into Slavery* was commissioned by the Marchese Niccolò Maria Pallavicini, one of the most influential and progressive art patrons of the era. Pascoli mentions that the picture was purchased from Trevisani along with a larger *Susanna at the Bath*, now lost, among several other paintings ordered by the nobleman from the artist. Although the relationship of *Susanna* to *Landscape with Joseph Being Sold into Slavery* is unclear, it is not difficult to imagine that they were paired because of a common emphasis on landscape. Pallavicini had a decided inclination for biblical and mythological subjects in which the outdoor setting was

## 295
## Francesco Trevisani
### *Abate Felice Ramelli*

c. 1715–20
Oil on copper
11¾″ × 7⅞″ (30 × 20 cm)
PROVENANCE Angelo Reycend, Turin
EXHIBITION Florence 1911, cat. no. 42
BIBLIOGRAPHY Bodmer 1939, p. 390; Gasparini 1950, p. 106; DiFederico 1977, p. 80 (as location unknown)
Derek Johns, London

Giovanni Felice Ramelli (1666–1741) was a successful copyist and painter of historical subjects and portraits in miniature at Rome, where he resided for the greater part of his life. Born of noble parentage at Asti, he took holy orders and in 1682 became an Augustinian canon (Canons Regular of the Lateran) at S. Andrea at Vercelli. In 1707 and 1708 he served as abbot of the monastery of S. Maria Nuova at Asti (for the refectory of which he commissioned in 1737 Pierre Subleyras's immense *Feast in the House of Simon the Pharisee*; Musée du Louvre, Paris; Michel and Rosenberg 1987, no. 33), and in 1709 of S. Pietro at Gattinara. Ramelli is said to have learned his craft from another member of his order, Danese Rho, a portraitist and copyist in miniature. He traveled to various north Italian cities, including Venice (c. 1700) and Bologna (1701–1703), where he produced copies after Guido Reni, Lorenzo Pasinelli, and Giovanni Giuseppe dal Sole and was later invited to membership in the Accademia Clementina. About 1710 Ramelli traveled to Rome, and from 1717 until his death he served as Custode dei Codici (keeper of manuscripts) at the Vatican Library, and in 1718 he was appointed *abate privilegiato perpetuo*.

Abate Ramelli worked for Popes Clement XI and Innocent XIII, and for Victor Amadeus II (1666–1732), King of Sicily and of Sardinia-Piedmont. In 1737 he gave to Charles Emmanuel III

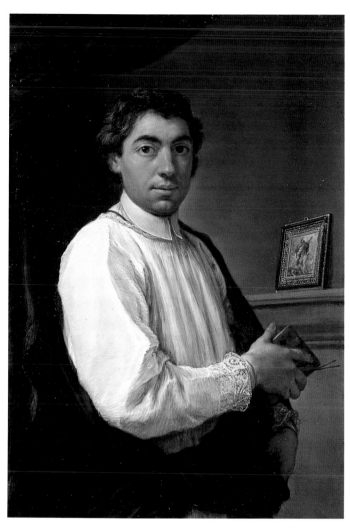

295

of Savoy some seventy miniature copies of famous paintings, mostly celebrated canvases in the Florentine picture galleries, which the king installed in the so-called Gabinetto delle Miniature in the Palazzo Reale at Turin (Mossetti 1987, pp. 52–53). His work is today scattered across Europe; for example, at Dresden (a center of miniature painting in the eighteenth century), Padua, and Amsterdam, where his miniature on ivory (7⅞″ × 6″) of *Joseph and Potiphar's Wife*, after an original by Carlo Cignani (1628–1719), is inscribed on the verso, *Opera Singularissima del famoso Padre Abate Ramelli fatto nel l'anno 1725* (*All the Paintings of the Rijksmuseum in Amsterdam: A Completely Illustrated Catalogue* [Amsterdam: Rijksmuseum, 1976], p. 765). Among his pupils was Subleyras's wife, Maria Felice Tibaldi. (For biographical information regarding Ramelli, see Alessandro Baudi di Vesme, *L'arte in Piemonte dal XVI al XVIII secolo* [Turin, Italy: Società Piemontese di Archeologia e Belle Arti, 1963–68], vol. 3, pp. 885–93; Michel and Rosenberg 1987, pp. 81, 84–85, 123, passim.)

Although Trevisani's most famous portrait is his great likeness of *Cardinal Pietro Ottoboni* in the Bowes Museum (cat. 291), his historical importance in the field lies in his portrayals of British visitors in Rome in the 1720s. Nearly all the features now associated with the Grand Tour portrait as perfected by Pompeo Batoni and Anton Raphael Mengs in the 1750s were anticipated by the leading portrait painters of the previous generation such as Trevisani, whose portrait of *Sir Edward Gascoigne* (1725; City Art Gallery, Leeds), for example, depicts the subject seated at a table with a copy of Horace and pointing to a landscape with the Colosseum in the background. He was much sought after by British visitors to the court of James Stuart in Rome, and his portraits of the Old Pretender himself (DiFederico 1977, pl. 104) and of the Scots in his retinue established a model of Grand Tour portraiture that was to be fully exploited by subsequent painters in the 1730s and 1740s.

Trevisani painted relatively few Italian subjects and his few portraits of artists—self-portraits and a portrait of Jan Miel (1599–1663)—were painted as gifts (see DiFederico 1977, pls. 96–97, 101). In the absence of any information about the date or circumstances of the commissioning of the portrait of Abate Ramelli, it may be assumed that personal considerations also played a role in its creation as a keepsake. The small-scale, intimate presentation of the sitter, looking out directly at the spectator and holding the palette and tiny brushes of a miniaturist, and the delicate, exquisite handling suggest that someone involved in the commission—patron or recipient—knew and admired Ramelli and his work. Trevisani's unusual choice of a small copper plate further implies that he intended this to be both a precious and unusual portrait and a demonstration of his own considerable skills in the miniaturist's art. The treatment in particular of Ramelli's ecclesiastical dress (the Canons Regular of the Lateran were conspicuous for their white linen rochets and known as *rocchettini*) confirms Nicola Pio's observation that no one could equal Trevisani's "ability for embellishing portraits with dress and accessories, all painted in the most realistic and lively manner possible" (Pio [1724] 1977, p. 38).

Liliana Barroero has observed that the miniature representing *Joshua Stilling the Sun over Gibeon* in an exquisite gilt and ebony Roman "Salvator Rosa" frame beside the sitter records a lost work by Carlo Maratti executed for Marchese Niccolò Maria Pallavicini (Rudolph 1995, pp. 45–47, fig. 26; for a likeness of Felice Ramelli at a considerably older age, probably after an original by Subleyras in Palazzo Reale, Turin, see Michel and Rosenberg 1987, p. 84). [EPB]

## JEAN-FRANÇOIS DE TROY
### PARIS 1679–1752 PARIS

Of all French painters of the eighteenth century, Jean-François de Troy had one of the longest and most profound relationships with Italy. First apprenticed to his father, the famous portrait painter François de Troy, Jean-François was sent to Italy in 1698. At first he attended the French Academy at Rome, but only for a brief time, before moving on to Venice and Pisa. This sojourn lasted seven years and must have been highly formative, although there is little evidence of it in the works Troy executed shortly after his return to France. His early association with Italy won him, in 1709, his first public commission (not executed) for the Genoese senate. Back in Paris, he set out to achieve a typical and successful academic career. In 1706, he was *agréé* at the academy with his *Niobe and Her Children* (Musée Fabre, Montpellier) and was made associate and full member of the academy on the same day. He developed into one of the most important Parisian artists of his generation, achieving enormous success with carefully finished and highly detailed genre scenes, the fame of which eclipsed until recently his accomplishments as a history painter. He received his first royal commission in 1724. His entry to the *concours* of 1727 was awarded the first prize (which he had to share with his rival François Lemoyne). His ambition to work for the crown was thwarted by Lemoyne's success in securing the decoration of the Salon d'Hercule at Versailles. Troy was, however, much in demand by some of the greatest Parisian collectors and art patrons. Furthermore, his aptitude to create large decorations was rewarded by his association with the Gobelins tapestry manufactory (*History of Esther*). In 1738 he was offered the directorship of the French Academy at Rome. His second stay in Italy left a more profound impact on his work. His later paintings show a sense of accomplishment, and a vigorous strength that set them apart from his earlier—often mannered—production. The complexity of the Roman milieu, dominated by followers of Maratti, but also by strong individual painters (not only Roman), from Giaquinto to Subleyras, helped Troy redefine his style. His active participation in the culture of the city is attested by such important commissions as his *Resurrection* (1739) for the church of S. Claudio dei Borgognoni, *Gerolamo Emiliani Presenting Poor Orphans to the Virgin* (1749; S. Nicola de' Cesarini), or his masterful reception piece for the Accademia di S. Luca, *Romulus and Remus Found by Faustolus* (1739), or again by the ultimate homage of a caricature by Pier Leone Ghezzi, accompanied by an inscription (Vatican City, Vatican Library, Codex Ottoboniano Latino 3117, fol. 178). Troy's success in Rome led to open polemics between Marco Benefial and Gregorio Guglielmi on one hand and Troy and Subleyras on the other regarding Church commissions. Troy, who enjoyed the patronage of Benedict XVI, was made Principe of the Accademia di S. Luca—the highest privilege an artist could obtain. The position allowed him to shore up his position among the Roman painters and, for instance, in 1744 to defend Batoni against the rivalries of fellow painters. Troy's prominent position in Rome increased the fame and visibility of the French Academy at Rome. Under his direction the *pensionnaires* created two famous masquerades, in 1748 and 1751, in which Joseph-Marie Vien and Jean Barbault took an active part.

In his later years Troy, who had been renowned for paintings that epit-

omized the spirit of Paris in the 1720s, became an increasing presence on the Roman art scene. His hope to be made Premier Peintre du Roi upon his retirement—a title that would have then been purely honorific—was never fulfilled, and his replacement by Charles-Joseph Natoire at the head of the French Academy at Rome, a nomination that precipitated Troy's return to France, was painfully felt by the artist. He returned to Paris, where he died in 1752. [JPM]

BIBLIOGRAPHY Brière 1930

## 296
## Jean-François de Troy
### The Judgment of Solomon

1742
Signed and dated lower left: *DeTroy Rome 1742*
Oil on canvas
75⅛″ × 56¼″ (191 × 143 cm)
PROVENANCE Cardinal de Tencin, Rome (and later, Lyon); private collection, Lyon; Ange Peretti, Lyon
EXHIBITION Rome 1959, cat. no. 629
BIBLIOGRAPHY Brière 1930, p. 26; Rocher-Jauneau 1953; Busiri Vici 1970; Ternois 1978; Salmon 1993
Musée des Beaux-Arts, Lyon

This imposing composition belongs to a group of six paintings commissioned from Troy by the Bailli de Tencin, a resident of Rome between 1739 and 1742, where he occupied the function of ambassador of the order of Malta, and was made cardinal by Benedict XIV in 1742. The six paintings later adorned the archiepiscopal palace in Lyon, where Tencin lived after his return from Rome until his death in 1758. Following the cardinal's death, the group remained *in situ* in the palace. Three, including the present picture, apparently disappeared during the revolution; the three remaining pictures were removed in the 1820s on the occasion of renovations of the palace, and have subsequently vanished. Only the painting presented here can be identified as part of this important Roman commission.

The year 1742 was a particularly tragic one in the life of the artist. After the death of three of his four sons, his wife also died. Troy, shortly after this misfortune, sojourned in Naples. The influence of Neapolitan painting—from Giordano to Giaquinto—can perhaps be felt in the majestic breadth of this work. Yet the audacious and effective composition, defined by the strong diagonal formed by the supplicant mother and the executioner, is highly original, and can only be attributed to Troy's particular deft expression of pathos and drama, which he had perfected in his large decorative

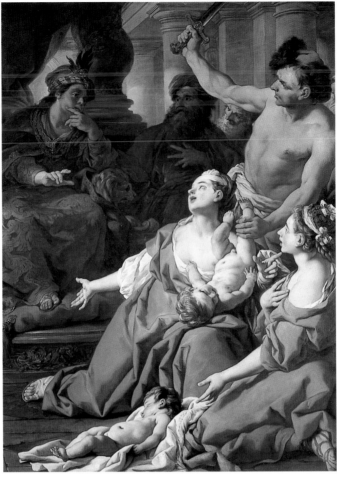

296

compositions for tapestry work. Xavier Salmon has noted the similarities between this Judgment and a composition of the same subject shown by Hyacinthe Collin de Vermont at the Salon of 1757—the last Salon Troy could have seen before his departure for Rome (a drawing by Collin de Vermont for this composition is in the Ashmolean Museum, Oxford [inv. 1964.16.4], and is reproduced in Salmon 1993). As noted by Salmon, some of these similarities can be attributed to the recommendations established by the academy to represent specific subjects. More importantly, perhaps, the originality of the composition demonstrates Troy's full understanding of some of the most advanced painting done in Rome at the time, from Benedetto Luti to Marco Benefial, and above all Pierre Subleyras. [JPM]

## CRISTOFORO UNTERPERGER

CAVALESE, ALTO ADIGE 1732–1798 ROME

After studying with one paternal uncle, Franz Sebald Unterperger, Cristoforo went to Vienna in 1748 to study with another, Michelangelo Unterperger. He won his first academic award in 1751–52 with a painting (now lost) depicting the Adoration of the Magi. In 1753 he was awarded the academy's first prize for his painting (now lost) *Tobias Restoring His Father's Sight*. During 1756–57 he visited Verona, Venice, and his native Val di Fiemme. From 1759 the painter was living in Rome, in a house called Casa Lana in via Sistina, with a group of transalpine artists that included the Tyrolean Martin Knoller. During these first years in Rome most of Unterperger's work was in response to commissions from religious establishments in his own region including Cavalese (1761), Bressanone (1767 and 1773), and the abbey at Novacella (1769). In 1772 he was elected *accademico di merito* by the Accademia di S. Luca, then under the direction of Anton Raphael Mengs, who has frequently—though baselessly—been

cited as Unterperger's teacher in Rome. The two did, however, collaborate on the exquisite and elaborate decoration for the vault of the Stanza dei Papiri in the Vatican, completed in 1775.

From 1771 until his death Unterperger lived in via Condotti. For several years (1769–76) he was assisted by his younger brother Ignazio (1742–1797), who was fascinated by the study of antiquity. In 1775 he married Ottavia, daughter of the sculptor Filippo della Valle. He received several commissions for decorations to the newly founded Museo Pio-Clementino in the Vatican (Galleria dei Busti, Atrio del Torso, Galleria delle Statue; see cats. 297, 298) and for the papal residences (Quirinale, Castel Gandolfo, Sala del Bigliardo). Unterperger also restored the paintings in the Raphael's Logge and the Sala di Costantino in the Vatican. It was probably because of this restoration work that he received an extremely prestigious commission in 1778 from Catherine I of Russia, who asked him to make a complete, life-size copy of the Logge using the "magical" encaustic technique. The first part of the Russian commission, which occupied him until 1788, was transferred to the Quirinale in 1780 to be shown to Pope Pius VI, one of the most fervent admirers of Unterperger's decorative talents. Unterperger was one of the first Roman artists to study the decorative painting of the Renaissance, which was known to most people primarily through copies and engravings. This was a time when Rome was being swept by a wave of popularity for the new taste in decoration which primarily involved the decoration of interiors, as can be seen in the splendid rooms of the Villa Borghese. One of the artists who collaborated with Unterperger on the Russian commission after 1780 was Felice Giani. Although it is difficult to be precise about the extent of Unterperger's influence on the man who was labeled the "future rebel" of Roman art, Giani's style obviously acquired some of its freedom, and he some of his academic training, during this phase of his career.

Unterperger was also employed to paint altarpieces for the Papal States (Spoleto, Jesi, Subiaco, Gallese, Loreto, and Urbino). His religious works concentrate on a few key figures displaying significant gestures and actions, and the rich movement demonstrating an expressive force that does not conceal its roots in the Baroque. Although this is in the tradition of Roman art, it follows work in the style of Mengs. After the death of Mengs in 1779, Unterperger became one of the favorite artists of the papal court. Among his most important commissions for the Roman aristocracy was that from Marcantonio IV Borghese

for his splendid villa on the Pincio where, in 1784–86, Unterperger painted five imposing works for the ceiling of the Stanza d'Ercole representing the Labors of Hercules. Together with Antonio Asprucci, Unterperger now devoted himself to architecture, supplying designs for monuments and fountains in the gardens of the Villa Borghese. One of his last works in Rome was the canvas *Achilles and Chiron* for the Gabinetto nobile of the Palazzo Altieri (1790–93). After a brief final visit to Cavalese (1796–97), where he executed numerous works for the local church, Unterperger returned to Rome, where he died in January 1798. [SR]

BIBLIOGRAPHY Felicetti 1998

## 297
### Cristoforo Unterperger
### *Study for "Composition with Ignudi and Grotesques and an Allegory of Painting"*

Oil on canvas
43¼″ × 12″ (109.7 × 30.5 cm)

## 298
### Cristoforo Unterperger
### *Study for "Composition with Ignudi and Grotesques and an Allegory of Sculpture"*

Oil on canvas
43¼″ × 12″ (109.7 × 30.5 cm)

PROVENANCE Sir John Leslie, 1st Baronet of Glaslough; purchased by him in Italy in the 1840s

BIBLIOGRAPHY Clark 1961; Michel 1972; Roettgen 1980; De Angelis 1998; Felicetti 1998; Guerrieri Borsoi 1998; Herrmann Fiore 1998

Worcester Art Museum, Massachussetts, Eliza S. Paine Fund in memory of William R. and Frances T. C. Paine

The two *modelli* were identified as works by Unterperger by Anthony Morris Clark in 1961, and connected with the decoration of a room in the Museo Pio-Clementino in the Vatican. This is the room today known as the Vestibolo Quadrato, in the middle of which Pius VI exhibited the *Torso del Belvedere*, which remained there until 1973. The room, which was furnished during the papacy of Julius III (1550–55), has a ceiling with a stucco and painted decoration by Daniele da Volterra with scenes from the Old and New Testaments (De Angelis 1998, p. 38). On May 8, 1776, Unterperger received the sum of 1,100 *scudi*, paid to him through Pietro Camporese, the architect of the Sagri Palazzi Apostolici (Michel 1972, pp. 189–90; Felicetti 1998, pp. 264–65, document

297

298

45), for the restoration of these paintings and for works carried out to his own design. Unterperger also restored the painting of the eight wall panels in the room, in which four female personifications are depicted, including Justitia and Felicitas Publica (De Angelis 1998, p. 41). They alternate with decoratively framed tondi flanked by sphinxes, in which the monogram of the name of the man behind the renovations—Pius VI Braschi—can be seen (De Angelis 1998, p. 42). The reveals of the window and of a niche, on the other hand, were furnished with new decorative panels measuring 12 *palmi romani* by 3; according to the description in the invoice these contained "ornati con emblemi delle belle arti," as well as illusionistic reliefs and large figures in color. The whole decoration was executed in the *buon fresco* technique and was based—as the document records—on studies and *bozzetti*.

Presumably the four tall rectangular panels in Worcester should be regarded as the models on which the final paintings were based. However this can now be verified only in the case of the two panels with the allegories of Painting and Sculpture, which to a large extent match the pictures still in existence today. Only a few details in the pedestal area were altered in these (Felicetti 1998, pp. 176–77).

The grisaille pictures on the other two panels relate to Poetry and Geometry. Poetry is personified by two busts of classical poets (one of them being Homer), in front of whom a putto leaning over a sheet of paper and a putto making music are sitting. The grisaille picture on the fourth panel is of a different type. In the square picture compartment two figures can be recognized: a seated woman with a globe and a standing man who is measuring the globe with a compass. In an upright oval compartment above stands the personification of Geometry holding a disproportionately large ruler. The crowning feature of the composition is a female winged figure balancing a globe above her head as the symbol of Geometria. Because the Atrio del Torso—as the room was now called—underwent several alterations in rapid succession, the original site of the paintings is not completely clear. On the basis of the documented interventions there are two possibilities. The decorations could have been on either side of the new door made in the reign of Pius VI to link the Atrio del Torso with the new Vestibolo Rotondo, in connection with the new route around the museum. This door was inserted in the place of a wall fountain that until 1771 had been topped by the famous statue of Ariadne–Cleopatra (a popular motif in Batoni's portraits of English travelers). For the same ren-

ovations, the old door that had previously linked the Atrio del Torso to the Cortile delle Statue was now walled up. In 1776 Unterperger adapted it as a niche with a landscape view. The fact that this niche had *ornati*, or decorative painting, in the reveals is indicated in connection with a later alteration to the decoration of the room. When the sarcophagus of Lucius Cornelius Scipio Barbatus (109″ by 43¼″) from the Tomba degli Scipioni (see Wolfgang Helbig, *Führer durch die öffentlichen Sammlungen klassischer Altertümer in Rom*, edited by Hermine Speier [Tübingen, Germany: Ernst Wasmuth, 1963], vol. 1, p. 213) was placed in this niche, in 1787, necessitating its widening, Unterperger was paid (Felicetti 1998, p. 276, document 97) to adapt the landscape view—which is no longer in existence—to the widened niche. At the same time he also repaired the *ornati* on the reveals which had been damaged by the alterations. Therefore this at least confirms that compartments painted with ornaments were in existence there. Accordingly it is possible that the two panels in Worcester referred to these pictures, which may have been executed in monochrome in accordance with the *bozzetti*—also likely because they would have been framing the landscape view in the niche.

The composition of each panel is arranged symmetrically and constructed from familiar components of the Renaissance grotesque repertory, such as can be seen in Raphael's Logge at the Vatican, for example. As in the fifteenth- and sixteenth-century examples, the artist has avoided boring repetition of the same motifs. Unterperger devoted special care to the representation of the muscular male caryatids (*ignudi*) on whose shoulders the painted relief compartments are resting. Their accentuated modeling demonstrates not only his supreme mastery of the nude study but also the Baroque orientation of his style, which was modeled on the Farnese Gallery, by Annibale Carracci. The luxuriant leaf and flower decoration of the upper zone is supplemented by more classical motifs and elements, such as vases, tripods, grotesque masks, medallions, and garlands in the Louis XVI style.

The subject matter of Unterperger's decorative paintings is directly related to the function of the room, for the *Torso del Belvedere*, its featured attraction, is depicted on one of the two painted bas-reliefs. Because the *Torso* could be viewed equally well from any angle, it had been regarded since the Renaissance as the supreme achievement of antique sculpture. In Unterperger's picture, however, the torso is featured on the panel devoted not to sculpture but to painting. The

putti assembled here represent the different stages of imitation that the artist has to master. On the left side one putto is drawing the face of another—this is intended to signify life drawing—and on the right the torso is being drawn—a reference to the study of antiquity. In the middle, a putto is holding a mask in his raised hand—perhaps an allusion to the study of plaster casts. While the elements in this picture are thus generally understood as the foundations of working as an artist, sculpture is shown only in terms of the craftsmanship involved, namely working with the chisel and modeling with clay. It looks as if painting is being accorded the higher status, in line with traditional attitudes, including that of Unterperger himself and of Mengs and Winckelmann (Herrmann Fiore 1998, p. 93). It was only through Canova's success that this view of the relationship of the two arts to one another, which was traditional for Rome, was again reversed. The fact that c. 1780 painters still claimed greater creative ability is also evident in Unterperger's own work. For example, the design for Vincenzo Pacetti's Cavalli Marini Fountain, at the Villa Borghese (1790–91), emanated from Unterperger—not from the sculptor who actually made it.

The new painted decoration of the Atrio del Torso was connected with the new function of the room within the Museo Pio-Clementino; this room, lying behind the stairs, now served as an introduction to the museum. During the final years of the existence of the Papal States the new papal museum of antiquities became one of the greatest attractions for eminent foreign visitors to Rome. It was shaped in several stages in which the older premises, which formed the major part, were repeatedly adapted. The successive enlargements of the Museo Pio-Clementino went hand in hand with the painted decoration of the rooms affected, and several painters were employed in this work, including Tommaso Maria Conca (Sala delle Muse, 1782–87) and Domenico de Angelis (Gabinetto delle Maschere), as well as Unterperger and his ten or so assistants. The guiding spirit behind the new museum, along with Pius VI, was the successful young archaeologist Ennio Quirino Visconti. As well as taking care of the exhibits and their presentation, Visconti was also partly responsible for devising the pictorial programs for the individual rooms (Sala delle Muse). Many of the areas in what had been the villa of Pope Innocent VIII had fifteenth- and sixteenth-century painted decorations, some of which were retained and integrated into the new decorative scheme (Galleria delle Statue). A ver-

satile, experienced, but not outstanding painter such as Unterperger was best equipped to furnish these rooms with appealing paintings that complemented the exhibits and could subsequently be altered, if necessary, to accommodate new acquisitions and structural renovations.

Unterperger had chosen the right time to specialize in the field of decorative painting in the Renaissance style, as it was particularly highly valued in these years. After he had painted the ceiling of the Stanza dei Papiri in the Vatican Library (1773–75) to a design by Anton Raphael Mengs, who had done the frescoes, Unterperger had been the leading exponent in this field in Rome. In contemporary sources he is described as a "pittore ornamentista" (Roettgen 1980, p. 242, document 26). It was only after Bernardino Nocchi had been appointed "pittore figurista" to the pope that Unterperger stopped working for the Museo Pio-Clementino. He was able to make use of the decorative formal repertory of the Renaissance, which he had first assimilated as a restorer of the Raphael Logge, to prepare a copy after that very loggia decoration commissioned by the Catherine the Great (1778–87; Hermitage, St. Petersburg). This work brought Unterperger widespread praise outside Italy (Guerrieri Borsoi, 1998). [SR]

## 299
## Cristoforo Unterperger
### *Apollo Entrusts Asclepius to the Centaur Chiron*

1793
Signed and dated on the stone at bottom right: *C. Unterperger 1793*
Oil on canvas
65″ × 59″ (165 × 150 cm)
PROVENANCE Altieri Family, Palazzo Altieri, Rome
EXHIBITION Cavalese, Jesi, and Rome 1998, cat. nos. 120–21
BIBLIOGRAPHY Rome, Archivio Altieri. Letter of acceptance for commission, Rome, October 4, 1790; Rovereto, Archivio Casa Rosmini. Case 14, letter from the painter Don Antonio Longo to Ambrogio Rosmini, Rome, January 3, 1794; Schiavo 1960, pp. 108, 152, pl. XV; Clark 1961, p. 2, fig. 4; Weingartner 1962, p. 238, n. 35; Rudolph 1983, fig. 699; Mich 1986, pp. 371, 375, 384, fig. 14; Sestieri 1988, p. 66; Barroero 1990, pp. 448, 460, fig. 663; Mich 1990, p. 888; Casale 1991, p. 220, n. 22–23; Sestieri 1994, vol. 1, pp. 180–82; Michel 1996, "Unterberger"; Felicetti 1998, p. 224, cat. nos. 120–21; Roettgen 1998, p. 259
A. B. I., Associazione Bancaria Italiana, Rome

This work of extraordinarily refined classical scholarship demonstrates a mature acceptance of the principles of

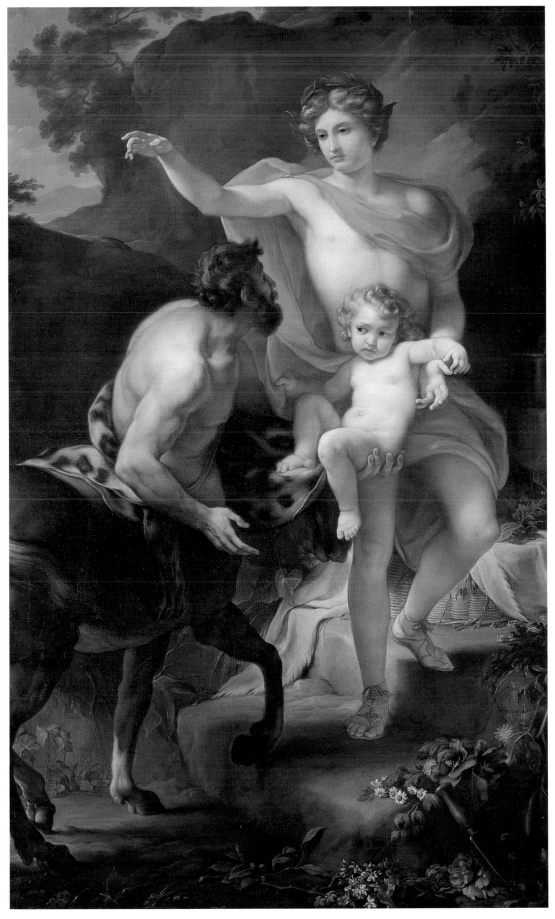

299

Roman Neoclassicism by the artist. The painting was commissioned by the Altieri family to hang in the "gabinetto de novelli sposi," a room destined for the newly married Prince Paluzzo and his bride, Marianna of Saxony, as the painter Don Antonio Longo mentions in a letter to his friend Ambrogio Rosmini dated January 3, 1794. Unterperger accepted the commission, for an agreed fee of 130 *scudi*, in a letter dated October 4, 1790 (Schiavo 1960). The artist has depicted the moment in which Apollo consigns his son Asclepius to the centaur Chiron, to whom he was entrusting the boy's education. The amphora and basket in the bottom right of the background, as well as the plants and flowers in the foreground, are there to suggest the art of medicine, which Chiron taught Asclepius, and exclude the often suggested reference to Achilles. Besides which, the theory was earlier disproved by Casale, on account of Achilles having been handed over to the centaur not by Apollo but by his mother, Thetis.

The overall scheme, as well as the handling rendered in broad, smooth strokes, manifests Unterperger's adherence to the Neoclassical style, which was a feature of his mature work. This is particularly evident in the figure of Apollo, a quotation—as S. Roettgen noted recently (1998)—of the famous statue of *Apollo Belvedere*. The artist had been a meticulous student of ancient sculpture throughout his career, ever since his student days at Vienna's Akademie der Bildenden Künste (1752–54); this interest intensified after 1772, when he was commissioned by Pope Pius VI to decorate the Museo Pio-Clementino. But it was only in the 1780s (as can be seen from his numerous drawings of nudes) that he introduced the theme into his paintings in an overtly Neoclassical style—for example, in *Apollo and the Pythoness* (sketch for the decoration of the since-destroyed Casino del Muro Torto, now in the Brinsley Ford Collection in London) and the *Labors of Hercules* for Sala X of the Villa Borghese. The painter arrived at the composition only after studying various options, as is evident from the preparatory sketch now in the Museo Pinacoteca della Magnifica Comunità di Fiemme (inv. no. 59/A), which shows how, having first decided to place the child Asclepius on the ground, then lying in the arms of Chiron, the artist eventually placed him seated on the centaur's hand—on the same axis as Apollo's leg. By so doing he abandoned the horizontally oriented, more intimate plan in favor of a vertical one, giving an effect of rigidity, solitude, and monumentality; the key characteristics of Neoclassicism.

Besides the choice of a dark background, which accentuates the gesture and statuesque pose of Apollo in accordance with Winckelmann's requirements of "noble simplicity and calm grandeur", the Neoclassical treatment is enhanced by the balanced contrast between areas of color, light, and shade (Johann Joachhim Winckelmann, "Pensieri sull'imitazione dell'arte greca nella pittura e nella scultura (1755)," in *Il bello nell'arte: scritti sull'arte antica*, edited by Federico Pfister [Turin, Italy: Giulio Einaudi, 1973], p. 29). The artist decided not to include the whole of the centaur, but to place him in a subordinate position, cutting the body off along the right thigh and using light to emphasize the contrast between the rosy luminosity of the sun god Apollo and the centaur's dark skin tones. The timid, apprehensive attitude of the child, as he throws a furtive glance at the centaur, and the simplicity and naturalness of his relaxed limbs, breathe gentle life into the painting without overstepping the bounds of Neoclassical composure, while the use of color to characterize the two divinities neither diminishes their statue-like strength nor reduces their vitality.

In this work Unterperger shows, above all, that he was capable of keeping up to date with the new fashions that were now dominating Roman art, yet without sacrificing his own individuality. This expressed itself in his need to breathe life into his characters, partly because he was mindful of the Baroque ideals current in his youth, but more importantly because of his personal response to new theories that the ideal of beauty could be sought through the imitation of nature and the ancients. Nothing but such an ideal could aspire to universal worth. [CF]

## CLAUDE-JOSEPH VERNET
### AVIGNON 1714–1789 PARIS

Claude-Joseph Vernet became one of the most famous landscape and marine painters of eighteenth-century Europe. His father, a decorative painter, was his first teacher. Thus the young Joseph came into contact with the architects, painters, and sculptors who worked for the local nobility and clergy on a number of decorative schemes in Avignon (which still belonged to the papacy) and the surrounding area. Destined to become a more ambitious painter than his father, Vernet studied with the local history painter Philippe Sauvan. He soon established his own contacts with patrons. For the Marquise de Simiane, he executed in 1731 some landscape paintings as decorative overdoors for her Aix-en-Provence *hôtel*, which may have been

his first independent commission. This background in decorative painting remained an important influence on Vernet's art, not just because he continued to paint *tableaux de place* from time to time—for example, a suite of four marine paintings to decorate the Bibliothèque du Dauphin at Versailles in 1762—but also because his paintings always manifest a sure sense of pictorial design and sheer attractiveness; even the most dramatic subjects are done with good taste.

To study in Rome was the dream of most ambitious young French artists in the eighteenth century. In 1734 the twenty-year-old Vernet was able to make the trip, thanks to the help of several patrons, including the Marquis de Caumont, a cultivated and enlightened nobleman from Aix-en-Provence. In Rome, Vernet could study some of the greatest collections of art formed since the Renaissance, full as they were of famous antiquities and modern masterpieces. Vernet also lost no opportunity in exploring the landscape in and around Rome and south to Naples, classic ground rich in literary, historical, and artistic associations. He found his market niche painting topographical views of Rome and Naples, imaginary italianate landscapes, and, above all, marine scenes, usually showing either a calm harbor at dawn or dusk or a rocky shore beaten by storms and peopled with the distraught victims of shipwreck. Part of Vernet's success lay in the fact that his works were reminiscent of the great landscape masters of the previous century, such as Claude Lorrain and Gaspard Dughet, but were rendered with the lighter palette and sharper sense of observation characteristic of his own time.

In Rome, Vernet studied for a short time with the French painter of marine subjects Adrien Manglard, who had long resided there. Although he was encouraged by Nicolas Vleughels, the sympathetic director of the French Academy at Rome, who introduced him to the French artistic community there, Vernet did not enjoy French royal patronage, and of necessity led an independent existence. He established friendships with other French painters resident in the Eternal City, such as Pierre Subleyras, and he also knew Giovanni Paolo Panini, whose lively style of figure painting he adapted.

Vernet not only studied in Rome, but soon found patrons there and in Naples, especially among the French diplomatic community. The close ecclesiastical connections between Avignon and Rome facilitated Vernet's introduction to Roman prelates and their entourages. Thus in the 1740s he painted four marine paintings (Alte Pinakothek, Munich), and a grand landscape (Mauritshuis, The Hague;

cat. 301) for Cardinal Valenti Gonzaga, a particularly distinguished patron who was one of the greatest collectors of Settecento Rome. He also made an impressive cycle of large decorative landscape and marines for Prince Giacomo Borghese (Palazzo Borghese, Rome). British visitors on the Grand Tour greatly esteemed Vernet's landscape and marine paintings, which also served as handsome souvenirs of dangerous seas crossed, ports safely gained, or the Campagna surveyed with an informed tourist's eye. The fact that Vernet's wife, Virginia Parker (the daughter of a captain in the papal navy), had English as her native tongue no doubt facilitated relations with the British. They remained Vernet's most loyal patrons during his twenty years in Italy, from 1734 to 1753.

It was the visit in 1750 of Mme. de Pompadour's brother the Marquis de Marigny—accompanied by the architect Jean-Germain Soufflot and art critics Charles-Nicolas Cochin and the Abbé Le Blanc—that brought Vernet his first royal commission for a pair of paintings and the intimation that he might be summoned to France. Since 1746 he had been sending landscape and, above all, marine paintings from Rome for exhibition at the Salon in Paris, and this fresh breath of Italian air, this gleam of Italian light on French walls, brought him remarkable critical acclaim. Indeed a great commission was soon devised, that Vernet should paint a series of monumental views of the major commercial and military seaports of France. Thus in 1753 began a long and often onerous tour of duty, from Toulon in the south to Dieppe in the north, that would end only in 1765, with the completion of sixteen works that collectively are perhaps the greatest royal commission of the reign of Louis XV. These large paintings are fascinating documents for the social and economic historian, because they present precisely observed pictures of seaport life in France at the time. Indeed, Vernet was required to include characteristic scenes of port life for the different regions of France, along with representative examples of local shipping. But these paintings are also great works of art, in which the artist assimilated a mass of fascinating particular observations into impressive, and unified compositions with as much authority as any history painter of the time.

On his return to France, Vernet continued to exhibit landscapes and marines at every Salon until his death in 1789. He attracted commissions from all over Europe, becoming indisputably the most famous landscape and marine painter of the second half of the eighteenth century. Among Vernet's admirers was Denis Diderot,

300

301

who gave him some of his finest and most adulatory pages in reviewing of the Salons of 1765 and 1767. However, in time Diderot and other critics began to notice that Vernet was relying more and more on well-tried formulas, that his subjects were becoming repetitive, that his observation of nature was less exact, and that his style was becoming too elegant, and even mannered. Vernet's problem—a perennial one for almost any very successful and popular artist—was that most collectors wanted typical works, recognizably by his hand: he had created a Europe-wide demand for evocative italianate landscapes, calm Mediterranean harbors at dawn or sunset, and rocky coasts with dramatic storms and ship-wrecks. The critics were right: by about 1770 his eye was less sharp, his observations were becoming routine, and the touch of his brush was rather soft and even slick. But Vernet had happily established a successful market and was busy until the day he died, in December 1789, satisfying the demands of eager patrons from Paris to St. Petersburg and from London to Vienna. [PC]

BIBLIOGRAPHY Lagrange 1864; Ingersoll-Smouse 1926; Conisbee 1976; Conisbee 1993

## 300
## Claude-Joseph Vernet
### *An Italian Harbor in Stormy Weather*

c. 1745–50
Oil on canvas
39¾″ × 54⅛″ (101 × 138 cm)
PROVENANCE Cardinal Valenti Gonzaga, by 1763; his sale, Amsterdam, May 18, 1763, lot 49; purchased from the art dealer Pieter Yver in 1764 for Willem V of Orange; seized by Napoleon 1795 for the Musée Napoléon, Paris, where exhibited 1795–1815, inv. no. 292; returned to the House of Orange, 1815
EXHIBITIONS s'Hertogenbosch, Heino, and Haarlem 1984, cat. no. 170; Dijon, Paris, and Rotterdam 1992, cat. no. 43
BIBLIOGRAPHY Robillard-Péronville 1807, n.p.; Ingersoll-Smouse 1926, vol. 1, p. 51, no. 200, fig. 42; Drossaers and Scheurleer 1974–76, vol. 3, no. 169; Fock 1976–77, pp. 116–17; Hoetink 1985, p. 458
Mauritshuis, The Hague

## 301
## Claude-Joseph Vernet
### *The Waterfalls Near Tivoli with the Villa of Maecenas*

c. 1745–50
Oil on canvas
39¾″ × 54⅛″ (101 × 138 cm)
PROVENANCE Cardinal Valenti Gonzaga, by 1763; his sale, Amsterdam, May 18,1763, lot 50; purchased from the art dealer Pieter Yver for Willem V of Orange, 1764; seized by Napoleon 1795 for the Musée Napoléon, Paris, where exhibited 1795–1815, inv. no. 293; returned to the House of Orange, 1815
EXHIBITIONS Paris 1976, cat. no. 44; s'Hertogenbosch, Heino, and Haarlem 1984, cat. no. 147
BIBLIOGRAPHY Robillard-Péronville 1807; Ingersoll-Smouse 1926, vol. 1, no. 199, fig. 41; Drossaers and Scheurleer 1974–76, vol. 3, no. 170; Fock 1976–77; pp. 116–17; Hoetink 1985, p. 458
Mauritshuis, The Hague

Cardinal and secretary of state Silvio Valenti Gonzaga assembled one of the greatest picture collections in mid-eighteenth-century Rome. After his death the collection passed to his nephew and heir Cardinal Luigi Valenti Gonzaga, who dispersed some three hundred of the paintings at auction in Amsterdam in 1763. Through the Amsterdam dealer Pieter Yver, the two masterpieces by Vernet entered the collection of Prince Willem V of Orange. It is not known when *An Italian Harbor in Stormy Weather* and *The Waterfalls near Tivoli with the Villa of Maecenas* were acquired by Gonzaga, but it is quite possible that they were purchased directly from the artist. Although there is no mention of them in Vernet's account books (which in any case are not systematic), the artist did record the commission of another pair of contrasting marine paintings for Cardinal Valenti Gonzaga in June 1746, a *Harbor at Dawn* and a *Harbor on Fire at Night*, both completed in 1748 and now in the Alte Pinakothek, Munich. (For the commission and payment documents, see Lagrange 1864, pp. 326–27, 380; Siefert 1997, nos. 3, 4; these two works were not featured in the 1763 sale of the Valenti Gonzaga collection.)

Neither of the Gonzaga pictures is dated, but the Tivoli landscape can be compared in subject and style with Vernet's *Landscape with a Waterfall* in the collection of the Duke of Buccleuch, or the *Romantic Landscape in the Style of Salvator Rosa* in the Pushkin Museum, Moscow, both of which are dated 1746. The two Gonzaga pictures are typical of Vernet's work in the late 1740s and early 1750s. For example, the Comte de Quinson—a patron from Vernet's native Avignon and one of the sponsors of his trip to Italy in 1734—paid for just such a pair of pictures in the later 1740s: "two pictures on imperial-size canvas, one a water-fall and the other a marine" (Lagrange

1864, p. 359). It is not surprising that the cardinal owned four fine and characteristic examples of Vernet's work. This collector had a predilection for the landscape painters of Settecento Rome and possessed many works by Jan Frans van Bloemen, Andrea Locatelli, and Hendrik van Lint, for example.

In the late 1740s Vernet was at the height of his reputation in Rome as a painter of landscapes and of marines, not only finding patronage from Roman collectors but also enjoying the admiration of visitors from all over Europe—above all, the British on their Grand Tour. He frequently made such pairs of paintings, contrasting coast and countryside, storm and fair weather. They played a part in the mainstream of European sensibility, by anticipating the contrasting aesthetic categories of the "sublime" (inspiring feelings of terror, for example) and the "beautiful" (invoking sensations of repose, for example), as defined by Edmund Burke in 1757, in his influential treatise *Philosophical Inquiry into the Origin of our Ideas of the Sublime and Beautiful*. Vernet's marine paintings draw on a tradition that can be traced back through his teacher in Rome, Adrien Manglard, through the seventeenth-century painters Pietro Tempesta, and Gaspard Dughet. Vernet's italianate landscapes draw on models established by Claude Lorrain, Dughet, and Salvator Rosa in the seventeenth century, and continued in Rome in his own time by Van Bloemen and Locatelli.

At the sale of the Gonzaga collection in 1763, the landscape was described as representing Narni, the waterfalls of which were a popular tourist destination at the time. But Vernet's landscape is modeled on the even more famous falls at Tivoli: it is not a topographical rendering of the site, however, but a typically enchanting evocation of it. The attire of his

302

fishermen and women give the scene a timeless and arcadian air. Vernet's rendition of the different textures of nature—rocks, foaming water, foliage, tree trunks—and his sensitive response to the warm evening light demonstrate his mastery of the sensuous possibilities of oil paint. It was such works from his Italian period that were most sought after by eighteenth-century collectors, as his manner hardened somewhat in the second, French period of his career.

In the so-called *Italian Harbor in Stormy Weather*, the harbor itself is actually rather far off. Although in the Gonzaga sale it was described as representing Livorno, it is in fact an imaginary italianate coast and port which the artist has invented. In 1807 the painting was engraved by Jacques Dequevauviller as *The Storm*, which is perhaps a more satisfactory title. A Dutch vessel is desperately skirting the coast in a storm, trying to avoid the treacherously rocky shore; in the foreground fishermen have managed to beach their boat. Vernet has executed this painting with tremendous verve, the vigor of his handling matching the excitement of the moment. [PC]

## 302
## Claude-Joseph Vernet
### *View of the Palazzo Farnese, Caprarola*

1746
Signed and dated: *Joseph Vernet fecit Romae 1746*
Oil on canvas
52⅛″ × 10′ ½″ (132.4 × 306 cm)
PROVENANCE commissioned for Elisabeth Farnese, Queen of Spain, in 1745; perhaps

to her son, Charles VII, King of Naples; Louis-Auguste de Tonnelier, Baron de Breteuil, French ambassador to Naples 1771–75; his sale, Paris, January 16–25, 1786, lot 50; probably acquired for Charles IV of Spain; between 1808 and 1813, acquired in Madrid by Joseph Bonaparte, King of Spain; his sale (as Comte de Survilliers), Bordentown, New Jersey, September 17–18, 1845, lot 116; purchased by The Pennsylvania Academy of the Fine Arts; acquired by the Philadelphia Museum of Art, 1977
EXHIBITIONS New York 1977, cat. no. 24; Bordeaux, Paris, and Madrid 1979, cat. no. 90
BIBLIOGRAPHY Lagrange 1864, pp. 325, 473; Bertin 1893, p. 418; Ingersoll-Smouse 1926, vol. 1, p. 48, no. 167; Rutledge 1955, p. 238; Benisovich 1956, p. 296; Philadelphia Museum of Art. *Bulletin: Annual Report*, vol. 73 (1977), detail on cover; Zeri and González-Palacios 1978, pp. 59, 61, fig. 10; Conisbee 1979, p. 821; Conisbee 1990, p. 93, fig. 13
Philadelphia Museum of Art, Purchased with the Edith H. Bell Fund

Vernet's considerable reputation in Rome as a topographical painter is amply justified by this grand view. Vernet noted in his account book: "For the Queen of Spain a picture on canvas fourteen palms wide, by six high representing the view of Caprarola ordered in the month of June in the year 1745", and he was duly paid in 1746 (Lagrange 1864, pp. 325, 376). The commission came from Cardinal Troiano Acquaviva d'Aragona, archbishop of Monreale, protector of the Two Sicilies, and minister in Rome of their Catholic majesties. As Spanish ambassador to Rome from 1735 until his death, Acquaviva acted as an agent for Elisabeth Farnese, Queen of Spain, looking for works of art on the market and recruiting artists to work for the court in Madrid.

Vignola's celebrated Palazzo Farnese at Caprarola, about 40 miles north of Rome, had been completed for Cardinal Alessandro Farnese by about 1575. In 1731 the palace became the property of the Bourbons, when it was inherited by Elisabeth Farnese of Parma, queen to Philip V of Spain. Their son Don Carlos was King of Naples and the Two Sicilies and on his father's death in 1746 became Charles III of Spain. It is likely that Vernet's painting went to Naples with Don Carlos, as, according to Juan J. Luna, (*L'Art européen* 1979), it does not appear in any Spanish inventories in the eighteenth century. Another impressive painting by Vernet, *Charles III Shooting Duck on Lake Patria*, also dated 1746, remains in the Palazzo Reale, Caserta. (Zeri and González-Palacios 1978). Such a provenance for the Philadelphia painting would help to explain its appearance in the collection of the Baron de Breteuil, French ambassador to Naples from 1771 to 1775 and a great connoisseur of modern French painting, who may have received it as a diplomatic gift. It seems unlikely that a second version ever existed.

The spectator looks from the southwest up a rocky hillside, the ancient Monte Cimino, and his eye follows the small town of Caprarola as it ascends to the entrance façade of the palace, an imposing, fortress-like structure dominating the hill. A herd of goats (*capra* is Italian for "goat") is scattered among the rocks and grass of the small ravines in the right foreground, watched over by a goatherd and his companion, a woman winding wool. This modest scene of daily life is a familiar trope of eighteenth-century landscape imagery, signifying that all is well in the dependent rural community, under the protective shadow of

the palace (De Grazia and Garberson 1996, pp. 14–18). At the left the artist himself sits on a rock in the shade of a tree, drawing the scene. In the center foreground, a well-dressed crowd is out for an afternoon walk, followed by a retinue including horses and carriages for the return trip. In the Breteuil sale (1786) the party is identified as "Cardinal Aquaviva with his company and his entourage." The cardinal is probably the man in a red skullcap leading the party; the most prominent lady, accompanied by courtiers and clerics, may be Elisabeth Farnese. The relation of palace to town and countryside, of ruler to ruled, even of patron to artist, is clearly but unexceptionally spelled out in this image. What is unusual, in the context of eighteenth-century painting, is the sight of such a socially distinguished party out taking the country air in such an informal manner.

In a contemporary guidebook, published in 1741, it is noted that the area around Caprarola had been cherished since antiquity for "the healthiness of the air" (Sebastiani 1741, p. 1). The same volume records that the queen had restoration work undertaken on the palace and its grounds after she inherited it in 1731 and that she soon put it at the disposal of Acquaviva. The cardinal continued the refurbishments, furnished the palace at his own expense, and then "he made it his country residence, with princes, prelates, and nobility, whom he invited there, or who visited him, and whom he treated in a grand style, making this palace always attractive and admired by all of Italy" (Sebastiani 1741, p. 117). [PC]

303

## 303
## Claude-Joseph Vernet
### *Jousting on the River Tiber at Rome*

1750

Signed and dated *Joseph Vernet. f. Romae.*
*1750*

Oil on canvas

39″ × 53½″ (99 × 136 cm)

PROVENANCE commissioned by the
Marquis de Villette; Villette sale, Paris,
April 8, 1765, lot 34; purchased by John
Trumbull in Paris, 1795; Trumbull sale,
London, February 18, 1797, lot 78;
bequeathed to Lady Simpkinson by her
father; and presented, by her to the
National Gallery, London in 1853

EXHIBITIONS Paris 1850, *Salon de 1850*,
no. 124; Rome 1959, cat. no. 644; London
1976, cat. no. 21; Paris 1976, cat. no. 22;
Manchester 1988, cat. no. 26; London and
Rome 1996, cat. no. 146

BIBLIOGRAPHY Buchanan W. 1824, vol. 1,
pp. 257, 267; Lagrange 1864, pp. 327, 330,
360, 470; Ingersoll-Smouse 1926, vol. 1,
p. 56, no. 255, fig. 59; Davies M. 1957, p. 217,
no. 236

The National Gallery, London

This splendid picture was commis-
sioned by the Marquis de Villette, one
of Vernet's most enthusiastic patrons.
The jousting contest is taking place on
what seems to be a public holiday;
banners are flying from the Castel
S. Angelo in the background. The
foreground is filled with many lively
figure groups; at the left, a reception
takes place on the canopied balcony
of a riverside pavilion, and a fanfare is
sounded across the water. Just visible
is the lace-draped raised arm of a lady
who seems to be commanding the
contest to begin. The event could have
a connection with the papal jubilee
year of 1750, and the liveried jousters
may be representatives of two noble
families. But no one has yet been able
to identify the specific event depicted,
nor are such sporting contests on the
Tiber mentioned by travel writers of
the period.

The banks of the river remained
much as the artist shows them until
the construction of the Lungotevere
embankments and boulevards in the
1890s. The Ponte Vittorio Emanuele
would now obstruct the view
upstream. The masonry in midstream
is all that remained in Vernet's day of
the piers of the ancient Pons
Neronianus. The spectator is sta-
tioned on the west bank of the river,
where it bends sharply, looking across
to the Castel S. Angelo, which is also
on the west bank, while the river
flows out of the picture to the right.

In the foreground to the right, the
artist himself and his wife, Virginia,
advance, introduced by one elegant
gentleman to another, who bows and
doffs his hat; behind the couple, their
three-year-old son Livio is restrained
by a nurse as he tries to pursue a
playful dog. It is tempting to identify
speculatively the right-hand gentleman
as Pierre-Charles de Villette, Conseiller-
Secrétaire du Roi, Trésorier Général
de l'Extraordinaire des Guerres, and
owner of this work, introducing the
artist and Mme. Vernet to his elder
brother, who was Directeur des Postes
at Lyon. According to Vernet's account
books, this latter brother placed his
own first order for paintings with the
artist early in 1750.

With regard to *An Italian Harbor in
Stormy Weather* (cat. 300), Vernet
records payment for "two paintings
imperial canvas, a storm and the other
a view of the Ponte Sant'Angelo" (Lugt
1938–87, vol. 1, no. 1448; Vilette sale,
1765, lot 1448); *Jousting on the River Tiber
at Rome* is described in the catalogue
of the Villette sale in 1765 and is the
modified version of the commission
first made in 1749. [PC]

304

305

## 304
### Claude-Joseph Vernet
### *The Garden of the Villa Pamphili*

1749
Signed and dated: *Joseph Vernet f. Romae 1749*
Oil on canvas
29⅞″ × 39¾″ (76 × 101 cm)
PROVENANCE commissioned by the Marquis de Villette; Villette sale, April 8, 1765, lot 38; acquired by the St. Petersburg Academy between 1765 and 1768; the Hermitage, Petrograd, 1922; The Pushkin Museum of Fine Arts, Moscow, 1930
EXHIBITIONS Bordeaux 1965, cat. no. 37; Paris 1965, cat. no. 36; Paris 1976, cat. no. 21
BIBLIOGRAPHY Lagrange 1864, pp. 326, 327, 360, 470; Ingersoll-Smouse 1926, vol. 1, p. 53, no. 212, fig. 51; Réau 1929, no. 393; Sterling 1957, p. 58; Antonova 1977, no. 71; Kuznetsova and Georgievskaya 1979, no. 61
The State Pushkin Museum of Fine Arts, Moscow

## 305
### Claude-Joseph Vernet
### *The Garden of the Villa Ludovisi*

1749
Signed and dated: *Joseph Vernet f. Romae 1749*
Oil on canvas
29⅜″ × 39¼″ (74.5 × 99.5 cm)
PROVENANCE as for cat. 304 until 1922
BIBLIOGRAPHY Lagrange 1864; Ingersoll-Smouse 1926, vol. 1, p. 53, no. 213, fig. 52; Nemilova 1986, p. 382, no. 290
The State Hermitage Museum, St. Petersburg

This pair of pictures comes from the series of eight works ordered from Vernet by the Marquis de Villette in May and June 1746, and originally scheduled to be completed at a rate of two works per year. In his account book Vernet noted "two [others] in gardens with small figures fashionably dressed"; in due course he recorded Villette's payment for "two garden views" (Lugt 1938–87, vol. 1, no. 3974; Breteuil sale, 1786, lot 3974). The sites in the gardens of the Pamphili and Ludovisi villas in Rome are indicated in the catalogue of the Villette sale and can still be recognized, in spite of the considerable toll taken by time on these once enchanting places.

More precisely, the view in the grounds of the Villa Pamphili shows the Giardino del Teatro, or Theater Garden; the hemicycle on the north side was constructed in the mid-seventeenth century, and is seen here from the east end. Ornamented with vases and sculptures, it was designed as a setting for outdoor theatricals. Already by Vernet's time the plantings of the seventeenth-century formal garden had been considerably modified. The hemicycle still exists, but the garden, in addition to later alterations, has suffered badly from neglect.

There has been an alfresco meal, and in the background dancing has begun in front of the semicircular theater. Servants are clearing away plates and cutlery, or else flirting in the inviting shade of the pergola at the left. In the foreground a cleric presents a lady with a posy, while other figures, which may well be portraits, look on.

At the Villa Ludovisi the view is toward the entrance portico of the Casino dell'Aurora, named for the celebrated fresco executed by Guercino in the 1620s on the ceiling of the main salon of the piano nobile. The concealed garden fountains have suddenly been brought into play, startling the ladies in particular, who "find themselves embarrassed," as the Villette sale catalogue puts it. To the right, Vernet is standing, absorbed in showing a drawing to a companion; the two-year-old Livio Vernet, with a nurse, is amused by a playful dog, while Virginia Vernet looks directly out at the spectator. The site is considerably changed today, as the villa was much altered and enlarged and the park much reduced, during the nineteenth and twentieth centuries.

In these two delightful scenes of aristocratic Roman life in the Settecento, Vernet is an observer of contemporary manners. Such subjects were quite popular in eighteenth-century painting; for example, Gian Paolo Panini painted a pair of fanciful views of Italian gardens with fountains and figures in about 1715, and he also treated the theme of surprise fountains in an italianate garden (Arisi 1986, nos. 65–67).

Pierre-Charles de Villette was typical of many of Vernet's patrons in being a highly placed member of the royal administration. He purchased a pair of pictures from Vernet in 1741 and another pair in 1745; in 1746 another eight were ordered, to be completed at a rate of two per year (Lagrange 1864, pp. 326–27); the 1746 commission was slightly modified in 1749. All the paintings by Vernet exhibited at the salons of 1748 (two works) and 1750 (four works) were from the Villette collection, with another four sent to the Salon of 1753. There were twenty-four paintings by Vernet in the Villette sale of 1765, and even a few others are recorded in this collection. [PC]

## GASPAR VAN WITTEL (GASPARE VANVITTELLI)
### AMERSFOORT 1652/53–1736 ROME

Gaspar Adriaensz. van Wittel, the founder of the Italian school of view painting, was born at Amersfoort, near Utrecht, where he was trained by Matthias Withoos, a painter of landscapes and still lifes who had also made a small number of panoramic views of cities. Paintings such as his immense *Panoramic View of Amersfoort* of 1671 (Amersfoort Town Hall) must have left a lasting impression on his young pupil. Like many Dutch artists of the period, Withoos had completed his training with a visit to Italy (1648–52) and Van Wittel followed in his footsteps, arriving in Rome probably in 1674. There he was welcomed by the northern community, becoming a member of the Schildersbent, the association of Dutch and Flemish artists, by January 3, 1675. He soon found employment with Cornelis Meyer, a Dutch hydraulic engineer who had come to Rome for the jubilee of 1675 and been invited by Pope Clement X to investigate the possibility of extending the navigability of the Tiber from Rome to Perugia. Meyer's report of 1676 has survived, accompanied by fifty drawings identified on the frontispiece as the work of Van Wittel but lacking the quality and individual characteristics of the artist's mature drawings.

Three engravings of views of Rome published in 1683 and 1685 follow drawings of c. 1678 by Vanvitelli, as the artist came to be known, and represent his first known venture into the field of view painting. Here for the first time are displayed some of the qualities that set Van Wittel's work apart from earlier views of the city: his skills as a draftsman, his mastery of the rules of perspective—both areas in which his initial training under Withoos may have been limited—and his feeling for striking compositions (often involving elevated viewpoints). Van Wittel frequently repeated successful compositions many times, restricting variations to details such as the (invariably small) figures. Thus the composition of the engraving of the Piazza del Popolo recurs as that of the artist's earliest dated gouache, of 1680, and was to be reused for more than a dozen gouaches and oils, in the

process entering the iconography of Roman view painting as the standard view of the subject. Although Van Wittel was already working in oils by 1682, gouache was initially his preferred medium, and only six of the twenty-eight dated views of the years 1680–85 are in oil. Only in 1686 do the dated oils outnumber the gouaches, and thereafter oils dominate the painter's production. Both are characterized by a light tonality, a unifying use of light, and a meticulous technique, all of which parallel the coeval views of orthern towns by Jan van der Heyden and Gerrit Berckheyde.

Van Wittel's style shows only limited development, and the deterioration of his eyesight—by as early as 1705 he had become known as Gaspare dagli Occhiali, on account of the thick spectacles he was obliged to wear—seems to have had little effect on his work. By the end of the seventeenth century he had created the repertory of views of Rome that was to support him in his adopted city for the rest of his career. While there are series of variant depictions of the Colosseum and of the Arch of Titus, his preference was for the modern city, with its squares teeming with people (Piazza del Popolo, Piazza Navona, and St. Peter's Square) and the Tiber running through its heart (the subject of more than ten major compositions, notably those showing the river at the Castel S. Angelo and at S. Giovanni dei Fiorentini). More than half of his œuvre consists of views of Rome and its surroundings (notably Tivoli). Many of his compositions were to be adopted by later generations as the standard views of the Eternal City and its satellites, while others show rarely depicted quarters from unexpected and highly original vantage points. Van Wittel's subject matter is not, however, confined to Rome, but was augmented from 1690 by views of other parts of Italy. His practice of working from carefully executed drawings meant that these were often produced at some distance of time and place from their subjects. A visit to Lombardy, including Lake Maggiore and Vaprio d'Adda, probably in 1690–91, and a tour of Florence, Bologna, Verona, and Venice, probably in 1694–95, both provided much new subject matter for paintings. Van Wittel's visits to Naples, begun with a stay of more than two years in 1699–1702, were to bear particularly rich fruit, including no fewer than twenty variant views of the Darsena. It was appropriately in Naples that his son Luigi, the great architect and builder of Caserta, was born in 1700.

Paradoxically, Van Wittel, a Dutchman, achieved academic recognition, being admitted to the Roman Accademia di S. Luca in 1711, and

306

enjoyed the patronage of the Italian nobility in a way that not even the greatest of his Italian successors would. Foremost among his patrons were the Colonna family, who were already buying his work in the 1680s. Filippo II Colonna's inventory of 1714–16 records thirty views, and fifty-six are mentioned in that of Cardinal Girolamo Colonna of 1763; the printed catalogue of the collection published in 1783 mentions no fewer than a hundred. Other avid collectors included the Albani family, who acquired about twenty views, the Marchese Sacchetti and the Principi Caracciolo d'Avellino, each of whom purchased about a dozen, and Cardinal Silvio Valenti Gonzaga, who owned about ten. Van Wittel's greatest foreign patron was the 9th Duke of Medinaceli, viceroy of Naples, who commissioned no fewer than thirty-seven views. The wide availability of the artist's work in Italy must have contributed to its enormous impact. Apart from his establishment of view painting as a genre and his creation of some of its most memorable compositions, the influence of his style pervades Roman view painting beyond the middle of the eighteenth century, from Hendrik Frans van Lint to Panini, and was possibly even more significant for the birth of a school of view painting in Venice, the work of Luca Carlevarijs and Canaletto's maturation in the late 1720s being unimaginable without Van Wittel's example. [CB]

BIBLIOGRAPHY Briganti 1966; González-Palacios 1991, pp. 122–32; Salerno, Luigi. *I pittori di vedute in Italia (1580–1830)*. Rome: Ugo Bozzi, 1991, pp. 68–101; González-Palacios 1991, pp. 122–32; Briganti 1996

## 306
## Gaspar van Wittel (Gaspare Vanvittelli)
### *The Castel S. Angelo and the Ponte S. Angelo from the South*

c. 1700–1710
Oil on canvas
28½" × 49" (72.4 × 125 cm)
PROVENANCE Andrew Hay, London; sale, Cock's, London, April 20–21, 1737, lot 163 (sold together with lot 162, a pendant view of the Piazza del Popolo: 84 guineas to the Duke of Leeds; the sale and its contents are known from the Houlditch manuscript in the National Art Library, London); Thomas Osborne, 4th Duke of Leeds, and by descent to the 10th Duke of Leeds; sale, Christie's, London, June 20, 1930, lot 48 (with the pendant: sold for 130 guineas to Agnew's); with Agnew's, London, 1930–October 27, 1942, when acquired by Lenygon & Morant; Mrs. Evelyn Stainton; sale, Sotheby's, London, November 29, 1950, lot 38 (as "G. Occhiali," the measurements given as 28½" × 79½"); sold for £100 to Agnew's, according to whose stock book this is the same painting they had sold in 1942; with Agnew's, London, by whom sold on November 23, 1951, to S. Bulgari; private collection, New York
BIBLIOGRAPHY Briganti 1940, p. 134, fig. 13; Briganti 1966, p. 200, no. 85; Briganti 1996, pp. 136, 183–84, nos. 14, 141 (the illustrations of nos. 141 and 143 transposed)
Private collection

The Castel S. Angelo, which stands at the pivotal point between the cities of Rome and the Vatican, owes its unusual form to its origins as the mausoleum of Hadrian. Built in AD 130–39, it became a fortress in the fifth century and, much extended and altered through the centuries, served as a papal private residence from the fourteenth century to the sixteenth. The castle owes its name to the statue of

the archangel Michael which surmounts it, recording the vision experienced by Pope Gregory the Great there in 590 of the archangel sheathing his sword to signal the end of the plague. The castle commands the Ponte S. Angelo, long the most important of the city's bridges and the successor of the Pons Aelius, dedicated in AD 134. This is decorated with the famous series of ten marble angels bearing the instruments of the Passion, carved to Bernini's designs for Pope Clement IX in 1667–72 and the most recent addition to the scene represented by Van Wittel. This picture, which is taken from an elevated point above the right bank of the Tiber by the hospital of Spirito Santo, shows in the foreground the remains of the central pier of another classical bridge, the Ponte Neroniano. Near by is one of the floating grain mills that were a feature of the river from classical times until the nineteenth century, while in the distance are the Villa Medici, the dome of S. Carlo and S. Trinità dei Monti.

Earlier depictions of the view are not unknown, but Van Wittel made the subject his own and his satisfaction with the composition is demonstrated by its replication in four other canvases, three of them of similar size and two of them almost identical (Briganti 1996, nos. 142–44, 148). All clearly depend on a large, squared preparatory drawing preserved in the Biblioteca Nazionale, Rome (Briganti 1996, no. D309). Two variants are also known, one including an imaginary terrace in the foreground, the other, much smaller, only showing the central part of the composition (Briganti 1996, nos. 145–56). Although this last is recorded by an inscription on the reverse as having been painted in 1706,

none of the versions is dated (and, indeed, only one is signed); the dating of much of Van Wittel's work is complicated by his limited stylistic development and tendency to repetition. His repetition of compositions must, however, have helped to increase their circulation and, although the artist's views of Castel S. Angelo from the south were to be emulated less frequently than those taken from the opposite direction, related viewpoints were adopted by, among others, Andrea Locatelli, Giovanni Battista Busiri, and Claude-Joseph Vernet (Luigi Salerno, *I pittori di vedute in Italia (1500–1830)* [Rome: Ugo Bozzi, 1991], figs. 34.1, 35.2, 41.10). The exhibited painting was accompanied until 1937 by a pendant *View of the Piazza del Popolo*, now in the Memphis Brooks Museum of Art (Briganti 1996, no. 14), one of fifteen versions of one of the artist's earliest compositions. One of the replicas (Briganti 1996, no. 143) is also half of a similar pairing.

Evidence of English patronage of Van Wittel is scarce, only Thomas Coke, later 1st Earl of Leicester, being known to have acquired at least two of his seven oils and four gouaches directly from the artist while on the Grand Tour. This painting and its pendant are among four known to have been consigned to London auctions by Andrew Hay (the others being Briganti 1996, nos. 12, 278, both acquired by Lord Burlington). Hay was an important dealer who made six journeys to Italy to buy paintings and is recorded in Rome in 1716, 1718 (his third visit), and 1721. Burton Fredericksen has kindly pointed out (in a private communication) that no fewer than fifteen works by Van Wittel are recorded in Hay's London sales between 1724 and 1745, the year of his retirement. The quantity suggests that he had a personal relationship with the artist, and he clearly played a far more significant role in the dissemination of Van Wittel's work in England than has hitherto been realized. This painting is one of three purchased in 1737 and 1739 by the 4th Duke of Leeds, who had made a tour of Italy in 1734 and has never received the recognition he deserves as one of the great collectors of Italian view paintings, including a major group of eleven Venetian views by Canaletto (for which see Constable 1976, vol. 2, under no. 95) and a pair of Roman church interiors by Panini (Arisi 1986, nos. 309–10).

This painting is in an English Palladian ("William Kent") style frame of c. 1740, closely comparable with those on a pair of Canaletto views of Venice, *The Bacino di S. Marco on Ascension Day* and *A Regatta on the Grand Canal* in the National Gallery, London (Constable 1962, nos. 333, 350), which was also owned by the 4th Duke of Leeds. [CB]

## 307
## Gaspar van Wittel (Gaspare Vanvittelli)
### *The Abbey of S. Paolo at Albano with the Visit of Pope Clement XI Albani in 1710*

1710

Signed and dated on the wall lower left: GASPA/ VA/ WITEL 1710; with inventory number 139 at lower left and with the crowned column emblem of the Colonna family at lower right
Oil on canvas
19¼" × 39⅛" (49 × 100 cm)
PROVENANCE presumably painted for Cardinal Pietro Ottoboni; probably acquired by Cardinal Marcantonio Colonna, and by inheritance from the Colonna family, Rome, through the Colonna di Sciarra Barberini Family, Rome, to the Corsini family, Florence (by the marriage of Anna Barberini and Tommaso Corsini c. 1858); from whom purchased by the Italian State
EXHIBITIONS Rome 1959, no. 684; Venice 1967, cat. no. 10; Rome 1990, nos. XI, XII, detail illustrated in color on the cover
BIBLIOGRAPHY Briganti 1966, pp. 118, 219, no. 130; Rudolph 1983, fig. 722; Petrucci F. 1987, pp. 81–83, fig. 1; Chiarini, Marco. *I dipinti olandesi del Seicento e del Settecento*. Rome: Istituto Poligrafico e Zecca dello Stato, 1989, pp. 587–90, no. 89.285; Barroero 1990, pp. 406–7, fig. 574; Coccia 1990, "Van Wittel"; Marinelli, Sergio, ed. *Bernardo Bellotto: Verona e la città europee*. Milan: Electa, 1990, p. 110; Briganti 1996, pp. 13, 208, nos. 211, 251, 269, 322, 368, 430, D241, D455

Galleria Palatina di Palazzo Pitti, Florence

Albano Laziale is an attractive small town with a pleasant climate, picturesquely situated in the Alban Hills between Castel Gandolfo and Ariccia above Lake Albano. On the via Appia, 48 miles southeast of Rome, it was a popular summer retreat for members of prominent Roman families such as the Pamphili, Odescalchi, Altieri, Boncompagni, Rospigliosi, and Costaguti, especially after the purchase of the town by the Camera Apostolica from the Savelli family in 1697. The abbey of S. Paolo, at the northeastern tip of Albano and the focal point of two of its three main streets, was founded by Cardinal Jacopo Savelli (later Pope Honorius IV) in 1282. In the time of Pope Alessandro VI Borgia (1492–1503), a former abbot of S. Paolo, the use of the buildings was divided, the monks retaining the monastery but the abbey being entrusted to a cardinal. Two of the most eminent of these cardinals took a particular interest in the embellishment of the abbey in the late sixteenth and seventeenth centuries, the period of its greatest prosperity: Pietro Ottoboni, who became abbot in 1685, had the church and the residential wing of the abbey decorated, while Marcantonio

307

Colonna, abbot from 1746, undertook such a radical transformation and enlargement of the buildings in the 1760s that only the bell tower and parts of the old cloister remained.

This painting is the only significant record of the appearance of the abbey before its reconstruction in the 1760s. In the center is the church, with its three-arched porch built shortly before the arrival of Ottoboni in 1685. To the right of this is the residential wing of the abbey, separated from the monastery behind by a tower, the only visible remnant of the medieval building. At lower right is the garden, the upkeep of which was paid for by the cardinal, and at lower left a chute of the abbey's celebrated water falls into a tank. Beyond the monastery are the ruins of the Roman amphitheater, the Capuchin friary, and, in the distance on the far side of Lake Albano, the Monte Cavo and Rocca di Papa. The painting commemorates the visit of Pope Clement XI Albani, who is shown at the balcony of the abbey's residential wing, while his cortège waits in the courtyard in the foreground, around a fountain crowned by the three hills of the Albani arms, presumably a temporary fixture. Van Wittel has rendered with loving care the details of the buildings and landscape, all bathed in soft morning sunlight. He must have worked from finely executed preparatory drawings such as that formerly in a Roman private collection (Briganti 1996, pp. 430–31, no. D455). This is seen from a slightly different but similarly elevated viewpoint, demonstrating the lengths to which the artist was willing to go to construct a strong composition, even in a case where it was unlikely to require repetition. Other sketches of the abbey from different viewpoints, one datable before 1685 by the absence of the church porch, testify to a long acquaintance with the place (Briganti 1996, pp. 315 and 368–69, nos. D62, D241). Van Wittel's world is one of tranquility rather than pomp, and this is his only depiction of a specific event. He has, however, captured the quiet excitement of the occasion as much as the

character of the setting. Such is the verisimilitude of the attitudes and grouping of the figures that one never doubts that the artist witnessed the scene himself.

It seems probable that the painting was owned successively by the abbey's two seventeenth-century benefactors. The only known painting of the subject by Van Wittel, it must have been commissioned by Ottoboni, whose posthumous inventory of 1740 includes a Van Wittel view of the abbey of Albano. The cardinal's affection for his benefice is shown by the sums he spent on it and by the not infrequent visits recorded in his correspondence, and he had every reason to feel pride in having received the pope there. It is not known how the painting entered the collection of the Corsini family, whose emblem it bears, or at what date, since it is not identifiable in any Colonna inventories. It seems likely that it was acquired by Marcantonio Colonna, who would have had every reason to acquire a record of the previous appearance of the abbey he had done so much to transform, by an artist whose work was so familiar to his family. [CB]

308

## 308

### Gaspar van Wittel (Gaspare Vanvittelli)

*St. Peter's, the Vatican, and Rome from the Vineyard of S. Spirito*

c. 1713
Oil on canvas
22⅛" × 43¼" (56.8 × 110 cm)
PROVENANCE acquired in Rome in the eighteenth century by a member of the Hearne family of Hearnesbrooke House, Killimor, co. Galway, Ireland; purchased with Hearnesbrooke House by Hon. Aeneas MacKay; Hearnesbrooke House sale, December 6, 1912, lot 188; with Richard Green, London; private collection, London; sale, Christie's, London, December 13, 1996, lot 87
BIBLIOGRAPHY Briganti 1996, p. 174, no. 116
Private collection, U.S.A.

St. Peter's, the most important church of Catholic Christendom, has been one of the principal focal points of Rome since the first basilica to mark the site of the burial of Saint Peter was built by the Emperor Constantine c. 324–37. After many modifications this was demolished in the sixteenth century to make way for a new building, begun by Bramante in 1506. After periods under the supervision of Raphael and of Antonio da Sangallo, the project was given in 1546 to Michelangelo, who completed three arms of a Latin-cross plan and to whom the basic articulation of the exterior and form of the dome are due. The church reached its more

or less definitive form with Carlo Maderno's construction of the nave in 1607–14. The approach to the basilica was transformed by Bernini's brilliantly conceived St. Peter's Square of 1656–67, with its curved colonnades.

It is hardly surprising that St. Peter's should be one of the subjects that "the painter of modern Rome" found himself called upon to depict most frequently. Van Wittel was the originator of the most obvious view of the basilica, that of the visitor approaching the mouth of the square. Thirteen versions in oil are known, and one in tempera (Briganti 1996, pp. 169–73, nos. 100–13), the earliest three dating from 1684 and 1685. This was to become one of the standard views of the city, the composition adopted by Hendrik Frans van Lint, Carlevarijs, Panini, Jacopo Fabris, and Giacomo van Lint in succession.

Far more unexpected is this view of St. Peter's from behind its apse, a sight only seen by the most adventurous tourist. Taken from the vineyard of S. Spirito, the composition is dominated by the basilica's dome and apse. To the left is part of the Vatican Hill, with the tower on the wall which surrounds the gardens. Behind this is seen the Vatican Palace, with the exedra at the end of the Courtyard of the Pine Cone and the flank of the Belvedere Court. Below the apse are the roofs of the church of S. Stefano dei Copti, still extant, and of the church of S. Marta, since demolished. To their right, beyond the small palazzo on the far side of the Piazza di S. Marta, are the façade of the church of S. Stefano degli

Ungheri and the Germano-Hungarian College. Behind the German cemetery, in which a cypress grows, and next to the colonnade of St. Peter's Square is the vast Palazzo del S. Uffizio. On the far right is the Janiculum, beyond which Rome stretches out into the distance.

Two other versions of the composition are known, also in oil on canvas and of roughly similar size. Both in Roman private collections, they are clearly based on the same (lost) preparatory drawing. While the buildings are similar, there are, however, notable variations between the three paintings, giving each a distinct character. The right foreground is completely different in each, the other two versions showing different terraces and only one tree. The larger of the variants (Cesare de Seta, *L'Italia del Grand Tour: da Montaigne a Goethe* [Naples: Electa, 1992], p. 139; Briganti 1996, no. 114) has quite different trees in the gardens and is darker in tone. The smaller one (*Luigi Salerno: i pittori di vedute in Italia, (1500–1830)* [Rome: Ugo Bozzi, 1991], p. 82, no. 24; Briganti 1996, no. 115) resembles the exhibited painting more closely, but remained unfinished, having no figures and no distant view of Rome. Although a number of later painters depicted the church from unusual viewpoints, none seems to have attempted to emulate Van Wittel by adopting this particular one.

The painting was accompanied until 1996 by a Hendrik Frans van Lint *View of Borghetto, near Rome* (cat. 236), of similar size and in an eighteenth-century "Carlo Maratti" frame of iden-

tical pattern. This suggests that they were intended as pendants or to hang *en suite* with other paintings, and it has been presumed that the date of 1713 on the Van Lint applies also to the Van Wittel (see Briganti 1996, where the date of the Van Lint is given incorrectly as 1711). [CB]

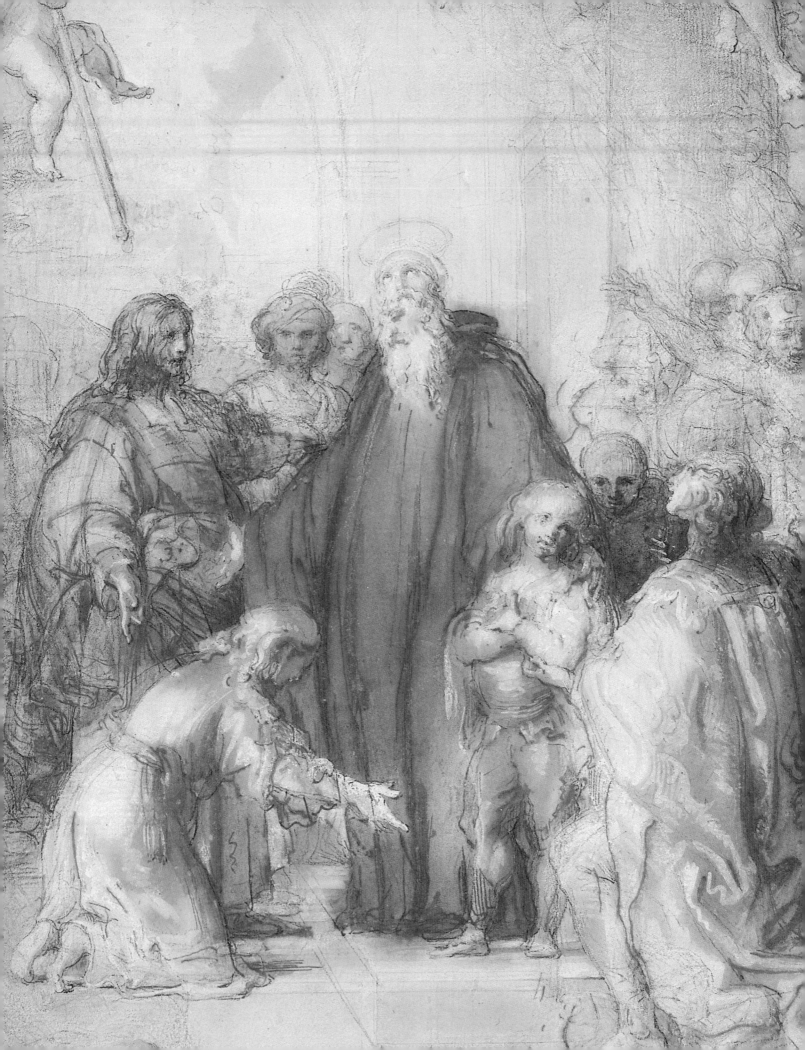

# Drawings and Artistic Production in Eighteenth-Century Rome

## ANN PERCY

Almost a third of the works in this large survey of art in Rome during the eighteenth century are drawings. This is not wholly surprising: studies, designs, and finished compositions on paper in ink and wash and different colors of chalk, in graphite and colored washes (transparent or opaque), and sometimes in pastel pervaded all manner of art production—painting, sculpture, architecture, printmaking, and the decorative arts—in the period. Artists working in all these fields relied on the drawn study—or, more likely, series of studies—as preparatory to creating a work, and for painters, sculptors, and architects in particular, drawing was as fundamental to the process of training as it was to mature professional practice. The drawings themselves were often considered less as ephemera leading to finished products than as beautiful objects to be admired, preserved, and collected, and frequently they were retained to serve as teaching tools in artists' studios. Many drawings were produced as works of art in their own right, and quite a number of artists in the exhibition—Giuseppe Cades, Hubert Robert, Giandomenico Campiglia, and Domenico Corvi, to name only a few—had distinct reputations as draftsmen. With their wide range of types, uses, and functions, drawings have a way of showing artists at work and at play. In matters of pictorial style during the Settecento in Rome they bear witness to the change from the classical High Baroque manner of Carlo Maratti at the beginning of the century to the noble, severe, conceptualized Neoclassicism of Vincenzo Camuccini at its end. And during the last decades of the Settecento several of the most original and avant-garde attitudes and approaches in painting, drawing, and sculpture were fundamentally bound up with the practice of drawing.

The academic system of artists' training in the eighteenth century followed a set program of study that involved constant drawing on the part of the student. In Rome, whether the aspiring painter or sculptor was studying at the French Academy, at the Accademia di S. Luca, or with an individual master, descriptions of a typical course of training indicate that the student would progress from drawing after separate parts of the body from books or prints, to copying figures from paintings or drawings—a practice illustrated in this exhibition by two, albeit more mature, examples, Fragonard's black chalk drawing of some figures from Michelangelo's Sistine ceiling (cat. 347) and Hubert Robert's charming red chalk scene of a young artist copying from a Domenichino fresco in one of the Roman churches (cat. 397)—to copying plaster casts of antique sculpture, and eventually to drawing from the live model. All this was aimed at understanding the human form, its anatomy, its volumetric character, the effects on it of light and shade, and the dynamics of pose and foreshortening, because a thorough mastery of the human body was essential to success in figurative painting or in sculpture.

Rome was not the only city in which an academic training could be obtained, but it was "the academy of Europe" for many reasons: here were to be seen—and drawn or painted, absorbed, and emulated—the venerated remains of ancient Rome, the countryside around the city richly suffused (for the well educated) with erudite associations with classical history and literature, some of the great masterpieces of Renaissance and Baroque art, and famous examples of antique sculpture. Every church was a gallery, and two public museums were founded during the course of the century: in 1734 the Museo Capitolino, which housed about four hundred antique marbles acquired from the Albani collection, and in 1770 the Museo Clementino, the Vatican's collection of antiquities, which became the Museo Pio-Clementino in the early 1780s. And, especially important, there was ample opportunity for artists to draw from the live model.

The practical and theoretical circumstances of academic life drawing in eighteenth-century Rome have been described recently by Edgar Peters Bowron and Stefano Susinno (see also below, cats. 317, 318, 322).[1] The evening classes in the French Academy, located in the Palazzo Capranica until 1724–25 and afterward in the Palazzo Mancini on the Corso, were open to all nationalities, as were the classes in Rome's Accademia di S. Luca, which administered the life drawing exercises that were established in the so-called Accademia del Nudo under Pope Benedict XIV in 1754. The heavily attended

Fig. 116 Charles-Joseph Natoire, *The Interior Court and a Gallery of the Capitoline Museum*, 1759, black chalk brown and gray wash, and white heightening; Musée du Louvre, Paris, Département des Arts Graphiques

Accademia del Nudo classes were held in the Palazzo dei Conservatori until 1804. According to a 1762 account, this facility offered two-hour life classes every day except holidays during its ten-month annual term; these were held early in the morning in the summer and after nightfall in the winter. Moreover, close at hand were the paintings and antiquities of the Museo Capitolino to study (fig. 116). The mix of nationalities at the Accademia del Nudo included French, German, Spanish, Flemish, Swiss, Portuguese, British, Polish, and Russian attendees, as well as Italians, and the supervisors rotated from the Accademia di S. Luca membership, including, over the years, Corvi, Campiglia, and Cades, as well as Pompeo Batoni, Antonio Canova, Anton Raphael Mengs, Stefano Pozzi, Agostino Masucci, Marco Benefial, Giuseppe Bottani, Placido Costanzi, Anton von Maron, and Giovanni Paolo Panini—many of the great names in painting and sculpture of the period. As if this were not enough, some artists found it necessary to form their own life drawing classes, such as some English and Scottish painters and sculptors in 1749—an academy that seems to have lasted until 1758 with various participants—as well as some Swedish artist associates of the sculptor Johan Tobias Sergel around 1772; in the late 1770s two other British painters, Prince Hoare and Ozias Humphry, mention working in other such informal academies.[2]

The dozen or so private teaching academies that existed in Rome by the 1770s offered—again to students of all nationalities, not just

(OPPOSITE) detail of Antonio Cavallucci, *Saint Maurus and Saint Placidus Presenting Themselves to Saint Benedict*, c. 1789 (cat. 333)

Fig. 117  Pompeo Batoni, *Academic Nude (A Reclining River God)*, 1768, black and white chalks; Staatliche Museen zu Berlin, Preussischer Kulturbesitz, Berlin, Kupferstichkabinett

Fig. 118  Francesco Trevisani, *Study of Three Heads and Drapery*, c. 1710–20; red chalk, some stumping, with touches of white chalk; Philadelphia Museum of Art, Bequest of Anthony Morris Clark

the studio assistants of the master—evening classes with supervision in life drawing and perhaps instruction in anatomy, geometry, and perspective. Batoni's and Mengs's were the best-known, but other painters who held such classes in their studios were Corvi, Cades, Benedetto Luti, Pietro Labruzzi, Stefano Tofanelli, and Tommaso Maria Conca. Cades, Camuccini, Gaspare Landi, and Luigi Sabatelli, for example, attended Corvi's academy, and Batoni's students included artists of great note, such as Cades and Canova, as well as numerous totally obscure figures. Batoni seems to have been a committed and popular teacher who encouraged his students to draw after his own paintings and drawings; his splendid black chalk academies, in which every limb and muscle of the model is superlatively observed, were clearly esteemed, were often signed and dated, and probably served as gifts and presentation drawings on occasion (fig. 117). Life drawing was such an ubiquitous feature of artists' training from the seventeenth through the nineteenth centuries that virtually every public collection of European Old Master drawings of any size and age contains numerous examples, usually anonymous, of academic nudes.

Another aspect of the system by which emerging painters, sculptors, and architects established their reputations in Rome was the series of academic student competitions, or *concorsi*, held sporadically (more regularly after the mid-century) by the Accademia di S. Luca throughout the eighteenth century, carrying over a practice that had existed in the previous century. The Concorso Clementino was estab-

lished by Pope Clement XI in 1702. For this competition, which was organized in three classes (with the third class presenting the least difficult exercise and the first class the most complex one), the entries for painters and architects consisted of drawings prepared over a number of months on preassigned themes, as well as extempore drawings done on the spot. Entrants were required to be enrolled as students at the academy.[3]

A large body of prizewinning drawings is still preserved at the Accademia di S. Luca, and included in this exhibition are several examples: the first-prize drawing for the second-class painting competition of the 1704 Concorso Clementino, by the eighteen-year-old Lodovico Mazzanti, the theme being a subject from early Roman history (cat. 375); the first-prize design for a city surrounded by the sea in the architecture competition of the 1732 Concorso Clementino, by the Turinese Bernardo Antonio Vittone, who had arrived in Rome the year before (cat. 39); the first-prize drawing for the second-class painting competition of the 1750 Concorso Clementino, by the twenty-three-year-old Calabrian Nicola Lapiccola, who had arrived in Rome in 1747, the subject being drawn from the Old Testament (cat. 364); and the equal second-prize drawing for the first-class painting competition of the 1783 Concorso, on the subject of Christ driving the money-changers from the temple, by the twenty-five-year-old Felice Giani, who had arrived in Rome from Bologna three years earlier (cat. 357). Also in the exhibition is a version of the Sicilian architect Filippo Juvarra's first-prize entry in the 1705 Concorso Clementino, the program

of which was to design a royal palace as a villa "for the pleasure of three important people"; Juvarra's solution was judged masterful, though he had only been studying in Rome for six months at the time (cat. 10). Winning a prize in one of these first-class competitions— which depended on the entrant's skill in conceiving and executing with high finish and copious detail a complicated set theme, typically working in graphite, ink, wash, chalk, or watercolor, or a combination thereof—often launched a young artist or architect in his professional career, and the custom provides yet another circumstance in which drawing figured importantly in eighteenth-century Roman artistic practice.

The Roman/Bolognese tradition of history or subject painting was based on a process that depended on a sequence of preparatory drawings for a finished work developing, in general, from quick compositional sketches to more elaborate layouts which might be squared for transfer, to individual drawn studies of whole figures or parts of figures—such as heads, hands, or drapery—possibly done from the model to work out poses (figs. 118, 119), to fully finished compositional models (fig. 120). This system, and the large numbers of drawings it produced, was the extension of a long tradition of artistic practice linking the earlier eighteenth-century Roman painters—such as Carlo Maratti, Giuseppe Chiari, Benedetto Luti, and Agostino Masucci—with the great draftsmen of the past—especially Raphael, Annibale Carracci, Domenichino, Guido Reni, and Andrea Sacchi—as well as with those of the mid- and late Settecento, such as Batoni

Fig. 119 Pompeo Batoni, *Studies for "The Holy Family"* *in Pommersfelden*, c. 1747, red chalk, touches of white chalk; Philadelphia Museum of Art, Bequest of Anthony Morris Clark

and Mengs. Thus an unbroken line of descent can be traced from the tradition of drawing in the High Renaissance to the developing European Neoclassicism of the later Settecento, as seen in the work of such painters and draftsmen as Gavin Hamilton, Benjamin West, Allan Runciman, and the young Vincenzo Camuccini.

There are quite a number of preparatory studies for easel paintings and altarpieces in the present exhibition, ranging in date from the first to the last decade of the Settecento. Chiari's black chalk compositional drawing for a painting commissioned in 1708 (cat. 334) harks back in several ways to the Baroque classicism of Carracci, Sacchi, and Nicolas Poussin in the previous century, just as Luti's highly finished composition studies for a print of 1707 (cat. 366) and a painting of 1712 (cat. 367) reveal long attention paid to the earlier Roman classical tradition. A nude female figure by Pierre Subleyras, presumably drawn from the live model (cat. 401), sets the pose of one of the figures in an overdoor painting of 1732, and a splendid squared-for-transfer red chalk study of a muscular, seated young man by Batoni (cat. 315)—also presumably done directly from the model—is for the figure of Hercules choosing between Vice and Virtue in a painting of 1742. Highly finished ink and wash drawings by Corrado Giaquinto and Giovanni Paolo

Panini of 1744–45 and 1747 are elaborate preparatory studies for crowded multifigure compositions, the former (cat. 360) very close to the finished altarpiece, the latter (cat. 383) with figural arrangements for the most part reworked in the final painting. From the end of the century, Jacques-Louis David's study of two female figures (cat. 341) for one of the most famous paintings of the entire century, his *Oath of the Horatii* of 1784–85, and Vincenzo Camuccini's vigorous yet austere wash and chalk drawings of 1796–1800 of scenes from Roman history (cats. 330, 331) articulate the fully blown Neoclassical style. Preparatory studies for large decorative complexes such as ceiling paintings are illustrated by Mengs's compositional designs for the church of S. Eusebio (cat. 377) and for the famous *Parnassus* ceiling of the Villa Albani (cat. 378), both of about 1760, and by Tommaso Maria Conca's careful and precise black chalk overview of all the nine divisions of the ceiling of the Sala delle Muse in the Museo Pio-Clementino of about 1785 (cat. 339).

Few preparatory drawings for three-dimensional objects or sculpture are included in the exhibition, with the exception of a design for sconces by Giovanni Battista Piranesi (cat. 75), two drawings by Luigi Valadier for a Mass card (see cat. 102) and a dressing table service (cat. 77), and John Flaxman's design for a frieze for the monument to the poet William Collins in Chichester Cathedral, done in Rome in 1792 (cat. 346). The complex questions concerning the relationships between designers and executants in sculpture production, either sculptors working from the designs of other artists or making their own drawings for studio assistants to execute, and problems concerning the role of drawings in this process, as opposed to three-dimensional plaster or terracotta models—a number of which are included in the show—are topics to be examined elsewhere.[4] On the other hand, quite a number of drawings provide insight into how architects worked out their ideas for the fountains and altars, chapels and gardens, churches and monuments that were constructed or remodeled in Rome during the Settecento.

Plans, elevations, and perspectives in chalk, ink, and wash, often worked up in color, range from sketchy initial designs to finished presentation drawings for projects in the city and for foreign commissions as well. Andrea Pozzo's red chalk sketch for the S. Luigi Gonzaga altar in the church of S. Ignazio (cat. 29) is a spontaneous, suggestive work indicating an interim stage in the conceptual process of the altar's design, whereas Ferdinando Fuga's project for the portico and benediction loggia for the façade of S. Maria Maggiore (cat. 9) is worked up with great refinement in ink and grey and

Fig. 120 Placido Costanzi, *Innocence Crowned by Justice* *and Peace (Study for a Destroyed Fresco in the Villa* *Alberoni)*, c. 1720–24, red chalk; Istituto Nazionale per la Grafica, Rome

brown washes. Pietro Bracci's elevation and ground plan for a monument to James Stuart, the Old Pretender, in St. Peter's (cat. 4), also highly finished in ink, washes, and white heightening, is one of four presentation drawings offering different solutions to the design, none of which was ever built. Of two other preparatory studies for another monument by Bracci in St. Peter's, a tomb for Pope Benedict XIV of 1764 (cats. 2, 3), one belongs to a group of designs by the architect for a papal monument, some of which are directly related to the Benedict XIV tomb. The two sheets give an idea of the large number of drawings that could be necessary to work out the evolution of a complex construction such as a tomb, composed of both architectural and sculptural elements for each one of which various alternative treatments might need to be considered. In the exhibition are unexecuted proposals for famous monuments, such as those of Ferdinando Fuga in 1723 and Edme Bouchardon in 1730 for the Trevi Fountain (cats. 1, 8), as well as a winning design of 1732 for the fountain as eventually executed by Nicola Salvi (cat. 32). From the same year and by the same architect, a highly finished drawing of an unexecuted project for the façade of the church of St. John Lateran (cat. 31) served as Salvi's donation of a work to the Accademia di S. Luca upon his election to membership in 1733, a gift that was required of each new member. And among the most beautiful and finished architectural designs of the period are Piranesi's magnificent set of presentation drawings with proposals for a

new tribune for St. John Lateran (1764–67), owned by the Avery Architectural Library of Columbia University, two of which are in the exhibition (cats. 21,22).

Architectural drawings could also serve as a testing ground for new and impractical ideas, as in the case of designs for ephemera, such as theater sets, fireworks displays, catafalques, structures for processions or various celebrations, and other temporary constructions that were created with the intention of being destroyed. Examples in the exhibition include Carlo Fontana's design for a triumphal arch for the *possesso* of the newly elected Pope Clement XI in 1700 (cat. 7) and Filippo Juvarra's set design for a play presented in the Teatro Capranica during the carnival of 1714, which takes the form of an unrestrained fantasy version of an eighteenth-century pleasure pavilion (cat. 12).

Another reason that drawings survived in such quantities as to form a key part of the study of eighteenth-century artistic practice is that they tended to be small, highly prized, eagerly collected, little trouble to transport, and convenient to store in cabinets, albums, or portfolios. Foreign artists (such as the British landscape painter Richard Wilson) could come to Rome to perfect their art and over the course of a decade or so create enough sketches and studies of city views, landscapes, antique ruins, and well-known tourist spots that, carried back home, could supply source material for paintings for the remainder of a career. Artists' studios often contained large numbers of drawings—as well as prints, books, casts, and paintings—used as study material for pupils, and a surprising number of period collections have passed down more or less intact until the present day. The best-known of these collections was that of Carlo Maratti, who during all of his working life accumulated paintings, sculpture, *bozzetti*, and drawings by earlier artists such as Raphael, Titian, Correggio, Domenichino, Sacchi, and the Carracci, as well as by his contemporaries. By the end of the seventeenth century this collection was very well known, and Maratti made it available to students and patrons. Most of the drawings were sold to Pope Clement XI in 1703; in the 1760s they were bought for George III of England, where they remain in the royal collection at Windsor Castle.[5] Another eighteenth-century Roman painter who was partial to drawings was Benedetto Luti, an active collector, connoisseur, and dealer who amassed a large holding reputed to be anywhere between three thousand and fifteen thousand drawings—around 1720 he acquired some of Maratti's drawings that had not been bought by the pope—but unfortunately this collection was dispersed after the artist's death

Fig. 121 Benedetto Luti, *Portrait Head of a Man*, c. 1718, pastel; Victoria and Albert Museum, London

by his heirs.[6] The German painter Lambert Krahe, a student of Pierre Subleyras in Rome from 1736, carried back to Düsseldorf on his return there in 1756 a rich collection of drawings that became the basis of the teaching collection of the city's art academy; the original collection is now owned by the Kunstmuseum in Düsseldorf.[7] Several works from that collection are in the present exhibition (cats. 319, 320, 370, 382, 384, 392). By the end of the century the sculptor Bartolomeo Cavaceppi had assembled a huge collection of drawings intended for teaching purposes, comprising more than a hundred volumes which contained works by many of the major figures of the Settecento, such as Maratti, Benefial, Masucci, Corvi, Chiari, Francesco Trevisani, Sebastiano Conca, Giuseppe Passeri, and Pier Leone Ghezzi. Most of these drawings were eventually acquired by the Berlin Kupferstichkabinett, providing yet another example of an eighteenth-century Roman collection that has stayed together to a large degree until the present day.[8]

Artists were not the only collectors of drawings in Settecento Rome. To mention only two other examples, Thomas Coke, 1st Earl of Leicester, embarking on his Grand Tour in 1712 while still in his teens, developed a precocious interest in collecting and acquired all sorts of fine objects while abroad, including manuscripts, books, pictures, drawings, and important antiquities. He patronized as well a number of the major Roman painters of the early Settecento, such as Chiari, Conca, Masucci, Trevisani, Luti, and Gaspar van Wittel.[9] Lord Leicester's seat at Holkham Hall still contains a large collection of eighteenth-century Roman drawings, and a sheet by Luti that presumably

Fig. 122 Girolamo Odam, *Design of an Antique Gem (The Strozzi Medusa)*, c. 1715, brown ink; Philadelphia Museum of Art, Bequest of Anthony Morris Clark

he acquired directly from the artist is included in the exhibition (cat. 366). The eighteenth-century Roman biographer Nicola Pio collected Old Master drawings and assembled a large group of portraits or self-portraits of the artists on whom he wrote, six of which are exhibited here (cats. 338, 350, 373, 374, 393, 402); Pio's drawings passed through the well-known collections of the Frenchman Pierre Crozat and the Swede Carl Gustave Tessin before ending up in the Nationalmuseum in Stockholm.[10]

A number of artists in this exhibition enjoyed high reputations especially as draftsmen or were noted for the quantity and quality of their drawings of various types: Francesco Fernandi, *called* Imperiali, was a prolific draftsman, producing many compositional sketches and studies for individual figures and groups; Benedetto Luti seems to have done a great many academies and colored chalk drawings of heads (fig. 121) but to have left few preparatory studies (two are exhibited here, cats. 367, 366); contemporary accounts tell us that Domenico Corvi's academic nudes were more sought after than his paintings; and the sculptor and ornamental designer Jean-Guillaume Moitte was a brilliant and productive draftsman, lauded in his 1810 obituary for distinguishing himself at the outset of his career "with a plethora of drawings which simultaneously display his own taste and also exude the air of antiquity, of which he revealed himself a disciple."

Fig. 123 Jean-Honoré Fragonard, *Staircase at the Villa d'Este, Tivoli*, 1760, red chalk; Musée des Beaux-Arts, Besançon

Fig. 124 Johan Tobias Sergel, *The Artist in Rome Preparing a "Lingua Salmistrata,"* 1770, ink and wash; Nationalmuseum, Stockholm

There were ready markets for the production of specialized types of drawings in eighteenth-century Rome. Grand Tourists and English dilettanti in particular wanted views of the famous sites of the city and its environs—an example being Lord Dartmouth's well-known commission to Richard Wilson around 1754 for about sixty drawings of Rome and the Campagna (cat. 405)—and they also wanted copies of antiquities. Batoni's earliest reputation in Rome at the end of the 1720s was as a copyist from the antique, and his commission of around 1730 from Richard Topham for drawings after antique sculpture produced some of the most elegant examples of this genre to survive (cats. 310–13). Topham, a retired British public official and graphic arts collector who was attempting to compile a documentation on paper of the principal classical antiquities in Rome, also commissioned Giovan Domenico Campiglia—whose reputation lay especially in his exquisitely refined and accurate black chalk copies of antiquities—to make hundreds of drawings for his compilation, the volumes of which are now owned by Eton College Library. This specialty was Campiglia's primary means of support; he took up the biggest commission of his career in 1734, the drawings for the printed plates to the four-volume publication of the works in the richest collection of antiquities in Rome, the Museo Capitolino, which appeared between 1741 and 1782. Campiglia's drawings, still in their original volume order, are in the Istituto Nazionale per la Grafica in Rome, and an example is included in the show (cat. 329). Ancient engraved gems were yet another type of antiquity that was much admired by scholars and connoisseurs; they were collected and occasionally reproduced in sumptuous publications (fig. 122).[11]

Landscapes and cityscapes—both those taken more or less literally from nature and those transformed into fantasy creations—comprised a large and seductively beautiful portion of Settecento Roman drawings, as witnessed by the fact that almost a fifth of the non-architectural drawings in this exhibition can be classified as views of one sort or another. From 1752, under the directorship of Charles-Joseph Natoire, studying from nature was included in the teaching program of the French Academy in Rome. Natoire encouraged the academy students to make landscape studies after nature in reponse to the incomparably beautiful sites right at hand within the city and in its surroundings, and French artists in Rome—Natoire himself and his student *pensionnaires* Hubert Robert and Jean-Honoré Fragonard—produced in the 1750s and 1760s some of the most atmospheric, evocative, and lyrical views ever done of Rome and its environs (fig. 123; cats. 348, 380, 381, 395, 396). Many landscape painters—Richard Wilson, for instance—wishing to follow the example of their great seventeenth-century predecessors Claude Lorrain and Gaspard Dughet, went into the Roman Campagna to sketch and to draw. The Roman history painter and landscapist Pietro Bianchi, it was said, never set out on a hunting or fishing expedition without his paper and pencil. Gaspar van Wittel, Richard Wilson, Abraham-Louis-Rodolphe Ducros, Philipp Hackert, and Giovanni Battista Lusieri, whose production of landscapes spans the entire course of the Settecento, specialized in a type of view that however much edited, reorganized, formalized, or restructured to reflect the ideal more than the real was essentially an accurate description of the scene in question, whether the latter was created by nature or by

man (cats. 343, 344, 362, 365, 405–7). The views of Giovanni Battista Piranesi, on the other hand, often entered to a greater or lesser degree into the realm of fantasy (cats. 386–88), and so sometimes did those of Giovanni Paolo Panini, Robert Adam, Charles-Louis Clérisseau, and Hubert Robert.

Other specialized areas of drawing production that are encountered less frequently are the portrait, the caricature, the genre scene, and the conversation piece. The very stylish full-length pastel of *Frederick North, Later 5th Earl of Guilford* by Hugh Douglas Hamilton (cat. 363) shows the heights of finish to which the Grand Tourist portrait could be brought on paper. Although Pier Leone Ghezzi more or less cornered the eighteenth-century Roman market on caricature, with his dozens and dozens of amusing drawings of local personalities from all walks of life—nobles and clerics, musicians and scholars, Grand Tourists and artisans—other artists in the city indulged in this diversion, especially the Northerners (fig. 124). Genre scenes per se are few in the show, but Hubert Robert, for one, seems to have been fascinated during his stay in Rome with people at work, from laundresses to shipbuilders, and his drawing of *The Wine Press* is an example of a lively depiction of everyday activities (cat. 394). A classic example of a conversation piece is Giovan Battista dell'Era's elegant ink and wash drawing of a cosmopolitan group of gentlemen, clerics, and a lady enjoying a rustic outing, which depicts an assembly so obviously sophisticated that it has been suggested that the sitters are Goethe and some companions visiting Johann Friedrich Reiffenstein at Frascati, perhaps in the company of Angelika Kauffmann (cat. 342). Occasionally a draftsman will catch some important figure

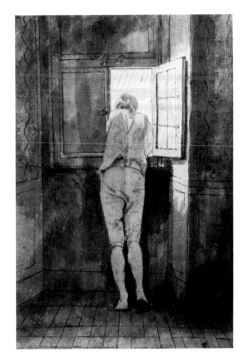

Fig. 125 Johann Heinrich Wilhelm Tischbein, *Goethe at the Window of His Apartment in Rome*, 1786–87, ink and wash; Frankfurter-Goethe-Museum, Frankfurt-am-Main, Freies Deutsches Hochstift

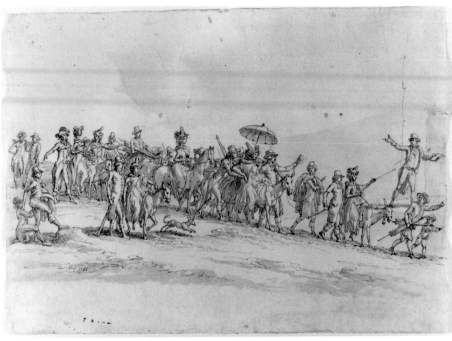

Fig. 126 Giuseppe Cades, *Gavin Hamilton Leading a Party of Grand Tourists to the Archaeological Site at Gabii*, 1793, ink and wash over pencil; National Gallery of Scotland, Edinburgh

of the period in a telling moment, such as Johann Heinrich Wilhelm Tischbein's well-known drawing of his friend Goethe seen from the back, looking out of the window of their rooms on via del Corso (fig. 125), or Giuseppe Cades's delightful *jeu d'esprit* showing Gavin Hamilton conducting a party of tourists on an excursion (fig. 126).

New approaches and new attitudes in painting and drawing emerged during the second half of the Settecento which diverged from the mainstream stylistic continuum of the Roman/Bolognese classical tradition, although leading in the same generally Neoclassical direction, and various functions of drawing were fundamental to many of these currents and eddies. In the summer of 1755 Robert Adam, Charles-Louis Clérisseau, and Giovanni Battista Piranesi began regular expeditions together in and around Rome to study, discuss, and sketch the ancient ruins. Their varying approaches to antiquity produced an interesting mix, from measured academic reconstructions approached with archaeological correctness of detail to fantastic inventions of ancient monuments and romantic evocations of ancient ruins. Clérisseau, in Italy until 1767, went on to produce thousands of drawings and gouaches of ancient buildings and decorative details—real, ideal, and fantastic (cats. 335, 336)—while Adam left Rome in 1757, taking the romantic evocation of ancient Roman

grandeur he had absorbed in the city back north to create his own influential Neoclassical building and decorating style (cat. 309). Meanwhile in Rome, Piranesi, who had been laboring for eight years of intense study and excavation on his monumental four-volume publication *Le antichità romane* (cats. 433–40), which appeared in 1756, was establishing his reputation as the major protagonist of Roman archaeology in Europe and the chief supporter of the Etruscans and Romans over the Greeks as the prior and superior civilization in the origins of the classical style. "In the *Antichità* Piranesi consciously sets out to apply a completely new system of archaeological inquiry to the study of the remains of antiquity," examining and explaining such hitherto neglected aspects of ancient Roman construction as the city's walls, defenses, acqueducts, funerary monuments, bridges, and substructures.[12] Thus study and sketching expeditions among a group of friends to record accurately such sites as the Baths of Caracalla, the Forum, the Palatine, and Hadrian's Villa were part of a process that led to the wide international dissemination of new ideas in Neoclassical art.

A group of painters, sculptors, and draftsmen in Rome in the 1770s that was largely foreign and somewhat marginalized, but in the end crucial to developing Neoclassical and Romantic attitudes in European late eighteenth- and early nineteenth-century art, was the circle

around the Swiss painter Henry Fuseli. Artists associated with this group were the Scottish painter Alexander Runciman and the draftsman John Brown, the Swedish sculptor Johan Tobias Sergel, the English sculptor Thomas Banks, and the Danish painter Nicolai Abraham Abildgaard, among others.[13] Fuseli's intellect and his intense personality made him the central figure of the group. Many of these artists worked primarily as draftsmen, and the combination of living in Rome and their mutual interchanges of ideas led to a burst of original and creative activity, much of it on paper, which for some of the artists—Sergel, Brown, and Runciman in particular—proved to be the most exciting and productive time of their careers. Fuseli, influenced by Michelangelo, the antique, and the Italian Mannerists, achieved a spectacular output of drawings during this period, which with its "innovative themes and highly individual interpretations made him among the most progressive and important artists in Rome in the 1770s" (cats. 349, 350).[14] The members of his circle in Rome shared an interest in horrific, demonic, or extravagant subjects often drawn from English drama and poetry—especially Shakespeare and James Macpherson—Homer, and Dante. Frequently their compositions are characterized by figures with twisted or agitated poses and exaggerated gestures, and by the expression of violent emotions. This was an aesthetic intentionally

opposed to the classical restraint and subdued emotional content advocated by Johann Joachim Winckelmann, Gavin Hamilton, and others. The work of the brilliant and precocious Roman draftsman and painter Giuseppe Cades, who early in his career rebelled against the academic tradition and went on to form his own original, virtuoso, Mannerist-influenced drawing style, a sort of Romantic Neoclassicism, has also been related to the influence of the Fuseli circle in Rome (cat. 324).

Another innovative and extremely influential style created in Rome at the end of the Settecento that was inextricably bound up with the process of drawing—and particularly with an emphasis on pure line and contour—was the outline style of illustration developed by the English sculptor John Flaxman for his illustrations to Homer, Dante, and Aeschylus, drawn in Rome in 1792–94 (cat. 345). Inspired by antique vase painting and sarcophagi, these simple, reductive images, in which all modeling was eschewed in favor of the linear contour, were widely disseminated through the line engravings made by Tommaso Piroli. The *Iliad*, the *Odyssey*, and the *Divine Comedy*, which first appeared in 1793 (followed by the illustrated Aeschylus in 1795), were enormously influential throughout Europe and America for many decades. The deliberate simplification and elemental "purity" of this style was thought to revert back to the primitive world of the Greeks, and through these works Flaxman's contribution to the developing Neoclassical style was profound. At just about the same time another Northern artist in Rome was developing an independent approach based on opposition to academic methods of teaching and on emphasizing the intellectual concept of the work of art at the expense of its technical polish: the drawing *Heroes in the Tent of Achilles* by the Danish painter and graphic artist Asmus Jakob Carstens, a Homeric subject from 1794 with bold, almost crude contours and unmodeled, flat shapes (cat. 332), corresponds to Flaxman's outline drawings in its valuing of the direct and essential over the calculated and highly finished. Carstens executed his intentionally unrefined and unpolished drawings almost on the scale of paintings—indeed, in lieu of highly finished canvases; his principal enterprise between 1794 and his early death in Rome four years later was a series of drawings for engravings for a publication in Rome of *Les Argonautes* (1799), the illustrations to which are in a linear outline style similar to Flaxman's but neither as simplified nor as friezelike.

By the last decades of the century …
there also appeared—to displace somewhat the traditional priority given to careful analytical drawing—a taste for virtuoso performance that was newly expressed in terms of rapid, improvised composition. Cades, Giani, Sabatelli, and Pinelli, all prolific in their graphic output, are among those whose fame initially derived from their spontaneous facility as draftsmen. … No less remarkable was an effort to identify the very act of creative invention as a subject for studied exercise. This was realized through a number of private academies, first introduced by the Accademia de' Pensieri established around 1790 by Felice Giani. … "Pensieri" refer to the first ideas set out by an artist on paper, and it was the aim of Giani's academy to promote free compositional study through regular informal competitions.[15]

As one of the major house and palace decorators in Italy in the late eighteenth century and early nineteenth, Felice Giani traveled peripatetically and left a prodigious number of drawings in an extravagant, exuberant, Mannerist-influenced Neoclassical style. He was known for his ability to extemporize whole compositions from his imagination, from his familiarity with history and mythology, and from his close acquaintance with the "beautiful style of the ancients." The novelty of the Accademia de' Pensieri was that it was not a teaching facility in which a professor provided criticism but a group of colleagues meeting to discuss each other's work on a basis of equal judging equal.

An early manuscript account by a member of the Accademia de' Pensieri, which seems to have been in existence between about 1790 and 1796, reveals how it worked:[16] a group of artists in Rome, some Italian, some from other parts of Europe, met in Giani's house (which at that time was located near the mausoleum of Augustus) once or twice a month; at the end of each meeting a theme was set, of which the members all did drawings, depositing them when finished in Giani's antechamber. At the time of the next meeting, the drawings were put one at a time on an easel and critiqued by the group at large in open discussion. Apparently it was considered highly instructive by the artists to see a single subject depicted by so many different individuals and to hear the various opinions of the compositions, expressed informally and spontaneously, by their peers. At least two drawings in the exhibition may be Accademia de' Pensieri exercises, Giani's *Bacchanal with Dante and Beatrice*, dated 1791 (cat. 358), and Luigi Sabatelli's *The Blind Count Ugolino Groping over the Corpses of His Children* (cat. 399), but this is difficult to know for certain, as the drawings were described as very rare and hard to find, even by the time the above-mentioned contemporary chronicler wrote his account.[17]

It has been noted that Vincenzo Camuccini's mature drawing style, which depends on a quick overall grasp of the essentials of a composition rather than a meticulous working out of its details, may be related to the methods of the Accademia de' Pensieri (cats. 330, 331),[18] which Camuccini frequented along with Sabatelli and Giovan Battista dell'Era, as well as Pietro Benvenuti, Humbert de Superville, and others whose work belongs primarily to the Ottocento and thus outside the scope of this exhibition. Most of Camuccini's career lies in the nineteenth century, but by 1800 he was moving into an austere and noble Neoclassical style that partakes of a new era. Yet part of the training that went into creating that style was essentially no different than the approach of the Roman academic competitions at the beginning of the century, in that an ambitious history painter was judged on his virtuosity as a draftsman, on his ability—upon being given a theme—to invent a composition based on it, and to execute a drawing filled with grace and spirit.

Notes

1  See Bowron 1993, pp. 75–85, and Susinno 1998, pp. 173–89. The best general discussion of draftsmanship in Rome in the Settecento is Rome. Hiesinger and Percy 1980.
2  Bowron 1993, p. 83.
3  For a description of the organization of the Accademia di S. Luca competitions in the late seventeenth century and the eighteenth, see Angela Cipriani's introduction to *Prize winning drawings from the Roman Academy 1682–1754*, in Cipriani 1990. Exhibition held at the Accademia Nazionale di S. Luca, Rome, December 1989–January 1990; Palmer Museum of Art, The Pennsylvania State University, University Park, Pa., February 25–May 20, 1990; National Academy of Design, New York, May 30–September 2, 1990.
4  For a discussion of these issues as they relate to sculpture in seventeenth-century Rome, see Montagu 1989, chapters 4–5.
5  On Maratti's collection, see Westin and Westin 1975, pp. 7–11.
6  On Luti's collection, see Hiesinger 1980, pp. 6, 8, n. 19.
7  On Lambert Krahe and his collection, see Graf 1984.
8  Hiesinger 1980, p. 7.
9  Ingamells 1997, pp. 225–26.
10  On Nicola Pio and his drawings, see Clark 1967, "Portraits"; Bjurström 1995.
11  Mary L. Myers in Hiesinger and Percy 1980, pp. 22–23, 30–32, cat. nos. 11, 19.
12  Wilton-Ely 1994, vol. 1, pp. 327–28.
13  The complicated associations among these artists are discussed by Nancy Pressly in Pressly 1979, pp. v–xii.
14  Pressly 1979, p. 28.
15  Hiesinger 1980, p. 5.
16  See Rudolph 1977.
17  Rudolph 1977, pp. 176, 180.
18  Rudolph 1977, p. 179.

## ROBERT ADAM

KIRKCALDY, SCOTLAND 1728–1792
LONDON

Robert Adam was the second of four sons of William Adam, the foremost architect of his generation in Scotland. He was given a rigorous classical education in the Edinburgh High School and entered Edinburgh University in 1743, but left before taking his degree to join his father and older brother in the family architectural firm. When William Adam died in 1748, the two sons took over the practice, which proved so successful that by 1754 Robert's share of the family fortune amounted to more than £5,000, providing sufficient capital for a lengthy Italian sojourn.

Robert Adam was ambitious. His intentions in making the Grand Tour were not just to expand his horizons and refine his artistic skills, but also to acquire a continental experience that would set him apart from other architects, distinguishing him as a connoisseur and putting him on a more equal intellectual footing with his aristocratic patrons. He left Edinburgh in October 1754, and traveled first through France and then to Italy, arriving in Florence in January 1755. There, he made the decisive encounter of his life when he met the young French architect Charles-Louis Clérisseau, formerly a *pensionnaire* of the French Academy in Rome. Impressed by the freedom of his style and the grandeur of his vision, Adam convinced Clérisseau to return to Rome and become his tutor in drawing and architecture.

On arriving in Rome near the end of February 1755, Adam took rooms near the Spanish Steps, in the heart of the British community in Rome. Soon he settled into a rigorous course of study coordinated by Clérisseau, which included lessons in figure drawing and landscape as well as architectural drafting and composition. Conservative and academic in its emphasis on fundamentals, this program nevertheless introduced Adam to the systematic rigors of a French artistic training and to the most avant-garde architectural ideas current at the French Academy.

A balance to Clérisseau's measured approach came in the person of Piranesi, who was then nearing completion of his monumental archaeological opus the *Antichità romane*. Adam found his curious reconstructions of the ancient temples, baths, and palaces electrifying, and began inventing elaborate plans and fantastic elevations of his own. During the summer of 1755, Piranesi became a regular companion, venturing out with Adam and Clérisseau in the afternoon to study, discuss, and sketch the ancient ruins. As Adam felt his artistic vision

becoming more grand and sure, he began to consider setting up practice in London. He wanted a publication to establish his reputation, and during his last year in Rome worked on a comprehensive survey of the baths of Diocletian and Caracalla. He completed the drawings just before his departure from Rome, but the project never came to publication, and the drawings are now all lost.

Adam left Rome in May 1757, taking Clérisseau and a team of draftsmen to study and record the great imperial palace of Diocletian at Spalato (called Spalatro by Adam, and now Split, Croatia) on the eastern coast of the Adriatic. His intention was to reveal a previously unknown site to architects and archaeologists eager for novelty, but his interest in Diocletian's Palace was also an expression of his conscious search for a less monumental, more intimate and domestic style of ancient architecture, a goal that had motivated his earlier research in Rome at Hadrian's Villa and the Domus Aurea. It was this style, which depended on complex vaulted spaces decorated with painting or stuccowork in shallow relief, that so influenced his later work. Adam's *Ruins of the Palace of the Emperor Diocletian at Spalatro in Dalmatia* was published in 1764.

Adam arrived back in London in January 1758 and established his new home and office there, in Lower Grosvenor Street. Within the first year he won several commissions, designing exterior elevations for Harewood House in Yorkshire and interiors for Hatchlands in Surrey. His most important early project came in 1760, when he took over the plans of Kedleston Hall, Derbyshire, where he redesigned the garden façade with a frontispiece derived from the Arch of Constantine and a low stepped dome modeled on the Pantheon. Inside, he created a scintillating Neoclassical interior, gathered around a central axis formed by a great columned hall succeeded by a circular domed saloon, an arrangement based on his study of Diocletian's Palace. Other commissions followed, so that by 1763, when his younger brother James joined the firm, Robert was already busy with Bowood House, Syon House, Osterley Park, and Kedleston, along with other projects.

The characteristic Adam style that evolved during the 1760s and 1770s involved spatial contrast and variety, with rooms of varied geometric shape, often with vaulted ceilings. Apses and screens of columns recur, used to enliven space and mediate transitions. With time, his ornament became increasingly delicate and frankly superficial. Worked in plaster or stucco in low relief, it employed a limited gamut of antique motifs, including griffins and sphinxes, *paterae*, scrolling acan-

thus foliage, swags of bellflower, panels of classical figures, and friezes of anthemion or palmette. Adam's greatest success came in the realm of domestic architecture. Though he sought public commissions and the recognition they would bring, these projects largely eluded him. Perhaps for this reason, he became involved in speculative town planning schemes. The first and most ambitious was the Adelphi, a complex undertaking begun in 1768 that involved embanking the Thames, creating wharves and vaulted warehouses at water level, and several streets of private houses on the new terrace created above. Other projects followed, including Portland Place and Fitzroy Square in London, and Charlotte Square in Edinburgh.

During the 1760s Adam's brilliant style of Neoclassicism made him the most popular architect in the country. However, the 1770s saw a decline in his fortunes, owing to the financial difficulties of the Adelphi, brought on by a nationwide credit crisis in 1772, and later to the building recession resulting from the American war. Nevertheless, the 1780s saw a late flowering of Adam's career with an increase in work in his native Scotland. Here he won great public commissions. Register House, begun in 1774, was followed in the 1780s and 1790s by the university and the Bridewell, or municipal prison, in Edinburgh, and the Trades House in Glasgow. Perhaps inspired by the austere Scottish scenery, Adam also developed a new castle style, using severe prismatic and cylindrical forms with turrets and battlements on the skyline, but with interiors still rendered in the Neoclassical style. Culzean, Dalquharran, and Seton castles, all Scottish creations of his last years, are among Adam's greatest works.

Robert Adam died on March 3, 1792, and was buried in Westminster Abbey. Close to 9,000 drawings from his studio were purchased by Sir John Soane in 1822 and remain in his museum. Other groups of drawings are at Penicuik House, Lothian, and at the family seat at Blair Adam. Adam's letters from Rome are in the collection of Sir John Clerk of Penicuik, and are on deposit at the Scottish Record Office. [RW]

BIBLIOGRAPHY  Adam 1764; Adam [1773–79] 1980; Bolton 1922; Fleming 1962; Stillman 1966; Stillman 1967; Rowan 1974; King 1991; Brown I. 1992; Tait 1993

## 309
## Robert Adam
### *Reconstruction Based on Roman Baths*

1755–57
Pencil, pen and brown ink, gray and brown washes, and black heightening
11″ × 15¾″ (281 × 399 mm)
BIBLIOGRAPHY  Stillman 1966, pp. 61–62, fig. 8; McCormick 1990, pp. 43, 51, fig. 47; Wilton-Ely 1993, p. 24, fig. 29
By courtesy of the Trustees of Sir John Soane's Museum, London

Adam's depiction of a majestic open hall formed by the domed crossing of two great barrel vaults was undoubtedly inspired by the remains of the great public bathing complexes of imperial Rome, which were the subject of an intensive survey he made during his last year there. Nevertheless, this drawing was not intended as a reconstruction of any particular monument, but should be understood instead as a romantic evocation of the idea of ancient Roman magnificence, and therefore takes its place in the context of other such depictions by Panini, Piranesi, and Clérisseau. Sophisticated in conception and draftsmanship, this image probably dates from near the end of Adam's Grand Tour, and stands therefore as both a summation of what he had learned in Rome, and a point of departure for the long and successful career he would have as one of the most original and influential Neoclassical architects practicing in Britain in the second half of the eighteenth century.

Adam was in Rome for more than two years, from February 1755 to May 1757. Early in his Grand Tour he engaged Clérisseau, whom he had met in Florence, to be his tutor in architecture and drawing. Shortly after his arrival in Rome he also met Piranesi, and by July was writing home of the almost daily excursions the three made to study, sketch, and discuss the ancient ruins. This drawing reflects the lessons learned from direct contact with these two great interpreters of antiquity, each of whom had perfected a style that combined a romantic sensibility overall with archaeological accuracy in the details.

McCormick noted the similarity between Adam's *Reconstruction Based on Roman Baths* and Clérisseau's *Maison antique* in the Hermitage (McCormick 1990, fig. 45). Both images present an oblique view across a space formed by the crossing of barrel vaults, and use an antique ornamental vocabulary of coffered ceilings, screens of columns, aedicular frames, and panels of classical figures. This particular way of depicting the grandeur of ancient Roman architecture was not unique to Clérisseau, however, but had entered

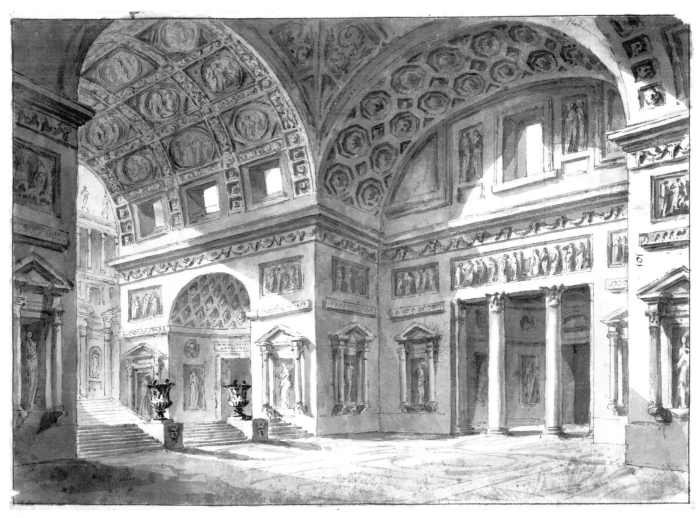

309

the general parlance of artists and architects experimenting with Neoclassical ideas in the 1740s and 1750s. Indeed, in such works as the *Galleria grande di statue* from the *Prima parte di architetture, e prospettive* (Wilton-Ely 1994, vol. 1, no. 4), Piranesi had developed a language of magnificence that depended on vast vaulted spaces elaborated with robust architectural ornament. Even the oblique viewpoint employed by Adam and Clérisseau, which utilizes a perspectival system with two vanishing points to depict architectural spaces oriented at right angles to each other, probably derives from Piranesi, who used this spatial construction incessantly in the *Prima parte* and the 1749 first edition of the *Carceri*. He, in turn, had taken it from the *scena per angolo*, the scene viewed on an angle, perfected by the early eighteenth century by the Galli Bibiena family of stage designers. This was in essence a theatrical device, and in the work of Piranesi its power of suggesting a deep and complex space was underscored by Baroque contrasts of light and dark. The innate drama of the technique, missing in Clérisseau's work of this period, is picked up in

this drawing by Adam, which shows a broad stair much like the one in Piranesi's *Galleria*, punctuated by sculptural elements on piers, backlit for dramatic effect, and leading up toward a distant space bathed in light.

While encompassing the lessons of Rome, Adam's *Reconstruction* also prefigures the work of his mature career. In detail and spirit it is remarkably similar to the grand entrance hall he was to fashion at Syon House just a few years after his return to Britain. Here, for a patron who had asked for interiors in the antique taste, he incorporated many of the elements used in this drawing—a beamed ceiling and patterned stone floor, a coffered apse and a screen of columns, aedicular frames, a clerestory level of lighting, and an elaborate program of antique sculptures and casts, along with classical figure panels set into the walls. Even the drawing's dramatic quality is recalled at Syon in the stair leading from one end of the hall, through the screen of columns, to the ante-room beyond.

However, the hall at Syon is almost a unique instance in which Adam attempted to evoke the magnificence

of ancient Rome by such full-blooded means. In 1773, in the first installment of the *Works in Architecture of Robert and James Adam*, he derided the "massive entablature, the ponderous compartment ceiling, [and] the tabernacle frame" (Adam [1773–79] 1980, p. 1) favored by the English neo-Palladians, arguing for a new grace and lightness in the ornaments and moldings. Though Adam's *Reconstruction Based on Roman Baths* states many of the architectural themes that were to preoccupy him throughout a thirty-year career—complex vaulted spaces, apses, screens of columns, decorative ceilings, ornamental friezes, classical figure panels, and even a picturesque sensibility—missing still is what is most unique and characteristic about the Adam style: its rigid perfection and its brittle, scintillating delicacy of detail. These traits, which set Adam's mature work apart from the Neoclassicism that had developed in Rome by the mid-1750s, remained for him to refine during the 1760s and 1770s on home soil. [RW]

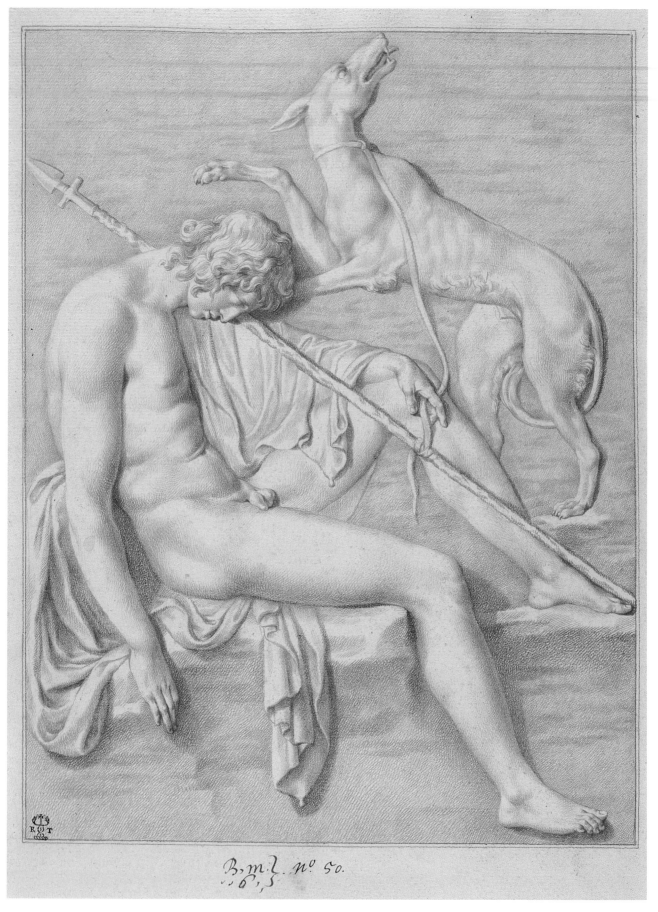

## POMPEO BATONI

LUCCA 1708–1787 ROME
*For biography see Paintings section*

### 310

## Pompeo Batoni
*Endymion Relief, after the Antique*

c. 1730

Inscribed on recto, in ink: *B, m. 6.} . . no. 50*; on verso, by Francesco Imperiali, in ink: *Palazzo Albani con lettera. A*
Red chalk on white paper
18½″ × 14⅛″ (470 × 360 mm)
PROVENANCE  Richard Topham, New Windsor and London; bequeathed by him to Eton College (Bm. 6, no. 50)
BIBLIOGRAPHY  Macandrew 1978, p. 147, pl. 11, no. 20; Clark and Bowron 1985, pp. 48–49, 388, pl. 2, no. D 254
The Provost and Fellows of Eton College

### 311

## Pompeo Batoni
*Circular Base with the Figure of Diana in Relief, after the Antique*

c. 1730

Inscribed on recto, in ink: *B, m. 6.} – no. 52*; on verso, by Francesco Imperiali, in ink: *Palazzo Albani numero. 68*
Red chalk on white paper
19″ × 14″ (481 × 357 mm)
PROVENANCE  as above (Bm. 6, no. 52)
BIBLIOGRAPHY  Macandrew 1978, p. 147, no. 22, pl. 9; Clark and Bowron 1985, pp. 48–49, 388, no. D 256
The Provost and Fellows of Eton College

### 312

## Pompeo Batoni
*Bas-Relief Depicting Sol and a Recumbent Male Figure, after the Antique*

c. 1730

Inscribed on recto, in ink: *B, m. 6.} . no. 62*; on verso, by Francesco Imperiali, in ink: *Palazzo Vitelschi num.o 89*
Red chalk on white paper
18⅜″ × 14⅝″ (474 × 373 mm)
PROVENANCE  as above (Bm. 6, no. 62)
BIBLIOGRAPHY  Macandrew 1978, p. 148, no. 29, pl. 13; Clark and Bowron 1985, pp. 48–49, 388, no. D 263
The Provost and Fellows of Eton College

### 313

## Pompeo Batoni
*Statue of Pan with a Baby Goat, after the Antique*

c. 1730

Inscribed on recto, in ink: *B, n. 3.} . . no. 49*; on verso, by Batoni, in ink: *No 2 Palazzo*

*Salviati fatto da me Batoni*
Red chalk on white paper
16⅞″ × 11⅛″ (428 × 282 mm)
PROVENANCE  as above (Bn. 3, no. 49)
BIBLIOGRAPHY  Macandrew 1978, p. 150, no. 52, pl. 25; Clark and Bowron 1985, pp. 48–49, 388, no. D 285
The Provost and Fellows of Eton College

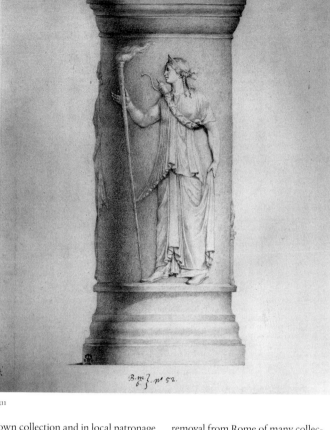

311

Batoni's early biographers all comment upon his success in acquiring a reputation as a copyist of classical statuary shortly after his arrival in Rome in May 1727. For a brief period Batoni joined the ranks of the professional copyists who worked for antiquarians, amateurs, and engravers. His drawings after the antique quickly came to the attention of British antiquarians and collectors in Rome and provided both a source of income and the basis of his earliest local reputation. Francesco Benaglio makes clear in his early account of Batoni's life that it was his copies of the classical sculptures in the Belvedere Courtyard of the Vatican that first attracted his English patrons. He appears to have been provided with an entrée to British collectors in Rome through Francesco Fernandi (*called* Imperiali), who served as an "antiquary" and specialist in guiding British visitors on their excursions round the sights of Rome. Imperiali evidently knew at first hand the Roman collections of antiquities of this period and played the role of agent and entrepreneur for those amateurs who wished to obtain drawings of the classical sculptures they had admired during their visit to the city.

The most important of Imperiali's clients to come to light, owing to the researches of Hugh Macandrew, is Richard Topham, who was sufficiently known in his day for Alexander Pope to mention him in his fourth *Moral Essay* ("He buys for Topham, Drawings and Designs,/ For Pembroke, Statues, dirty Gods, and Coins;/ Rare monkish Manuscripts for Hearne alone,/ And Books for Mead, and Butterflies for Sloane"; cited by Macandrew 1978, p. 142, n. 8). Topham matriculated at Trinity College, Oxford, in 1689 and is recorded as a student of Lincoln's Inn in 1691. He represented New Windsor in the House of Commons from 1698 to 1713, and was keeper of the records of the Tower of London. He retired from public life as MP for Windsor in 1713, a year after his only nephew and heir presumptive died.

Many of Topham's Eton schoolfellows spent time in Italy in the 1690s and there is evidence that he also made the Grand Tour at about this time. Topham withdrew a large sum from his bank in 1692 and there is a break in the pattern of payments till 1695 which may indicate a visit to Italy. A wealthy bachelor, Topham appears to have been increasingly involved in his own collection and in local patronage of the arts after 1720. His collection of drawings remained in Pilgrim Place, Windsor, after his death until 1736. It was Topham's executor, Richard Mead, who selected the newly finished library of Eton College across the Thames as the repository for his collection of books and of prints, his watercolor copies by Francesco Bartoli of antique Roman paintings, and the drawings of classical antiquities in Rome by a variety of Italian artists, some from the sixteenth and seventeenth centuries but the majority from the eighteenth including Giandomenico Campiglia, Stefano Pozzi, Bernardino Ciferri, and the twenty-two-year-old Pompeo Batoni (Louisa M. Connor, "The Topham Collection of Drawings in Eton College Library," *Eutopia* II, vol. 1 [1993], pp. 25–39).

Topham arranged his copies of classical sculpture topographically by location, the greater number in any one of the twenty-three leather-bound folio volumes being identified by the name of the collection stamped on the spine ("Villa Aldobrandini," "Villa Pamphilij," "Villa Borghese," and so forth). The collection as a whole constitutes a major survey of the classical sculptures contained in Roman collections of the period c. 1725–30. It is a unique visual record of the greatest importance, as Hugh Macandrew has observed, and of significant value in view of the sale, dispersal, and removal from Rome of many collections that began shortly after this survey was assembled.

The fifty-three Batoni drawings at Eton College, nine of which are signed, have been praised by Ellis Waterhouse as "the most breathtakingly beautiful professional copies after classical antiquity to survive" (Clark and Bowron 1985, p. 62, n. 131). Macandrew aptly summarized the pictorial qualities of these exquisite drawings—the beauty of the line, the precision of the crosshatching, the careful tonal control, the vividness of the lighting, and the sensitive indications of a shaded background against which the figures are placed. These carefully preserved sheets reveal that as early as 1730 Batoni was an exceptionally polished and mature draftsman. His later drawings may show a loosening of technique and a greater breadth of handling, but the refinement and precision that are the hallmarks of his drawing style remain as much in evidence, if never again so intense and deliberate as in these copies.

The drawings by Batoni were among the latest Topham acquired, by which time he was concentrating almost entirely on modern discoveries and unpublished material. Topham had not annotated all of the sheets, suggesting that these must have reached Windsor after his death, since he was the most meticulous of collectors and particularized each draftsman

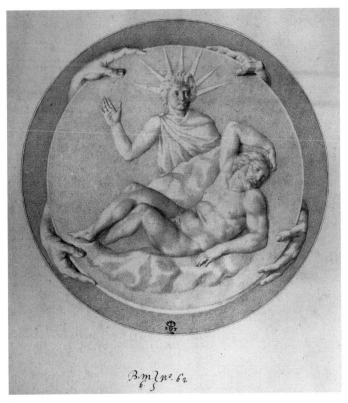

312

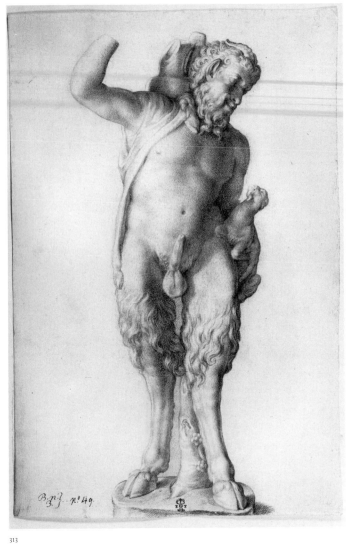

313

as well as each object and the collection in which it was located. Batoni is specifically mentioned as the author of two drawings from Villa Casali in the one surviving letter between Imperiali and Topham, written from Rome on July 24, 1730, in which Imperiali mentioned several bundles of drawings he was assembling for the post (Thomas Ashby, "Drawings of Ancient Paintings in English Collections, Part I: The Eton Drawings," *Papers of the British School at Rome*, vol. 7 [1914], p. 4).

Several of the most celebrated antiquities in the collections of Cardinal Alessandro Albani, the most famous collector of classical statues in eighteenth-century Rome, were drawn by Batoni before Albani was forced to sell a group of antiquities in 1733–34 to Pope Clement XII, who made it the nucleus of a new museum on the Capitol. Among these was the *Endymion Relief* found on the Aventine during the pontificate of Clement XI and later acquired by Cardinal Albani and displayed in his town house, the Palazzo della Quattro Fontane. (The duplicate drawing at Eton by Sempronio Subisati [Bn 6.24] must have been made before Subisati left Italy for Spain in 1721, indicating that the relief was thus already in Albani's hands some time before then [information from Louisa M. Connor, letter of May 25, 1999]). The sculpture, which is generally thought to date from the first century AD, is today in the Capitoline collections, and it is instruc-

tive to compare Batoni's drawing with the engraving taken from Giovan Domenico Campiglia's copy of the same statue, which was published by Giovanni Gaetano Bottari (*Musei Capitolini*, 3 vols. [Rome: Antonii de Rubeis, 1750–55]).

The beautiful *Circular Base with the Figure of Diana in Relief*, which has been dated to the first century AD, also belonged to Cardinal Albani and is today in the Museo Capitolino. The collection in Palazzo Albani della Quattro Fontane is the very last one to be added to the Roman section of Richard Topham's manuscript listing the antique contents of thirty-three Roman palaces and villas, a compilation formed from lists of material available for copying. Although the Albani descriptions are quite vague, Louisa M. Connor (letter of May 25, 1999) has identified the Diana relief with item 68 in the palace: "Tre Vasi tondi, o' siano Urne, ornate due con diversi ornamenti, e l'altra con Basso relievo di piccolo Figure," located in the one big "altra Camerone a pian terreno." Batoni made another drawing of all three figures—Diana, Mercury, and Apollo—which appear on the circular base, depicting them as if they appeared on a rectangular bas-relief (Macandrew 1978, p. 147, no. 18, pl. 8).

Other classical pieces were recorded by Batoni in the Villa Ludovisi, Palazzo Verospi, Palazzo Ruspoli, Collegio Ghisleri, Palazzo Farnese, Palazzo Barberini, Villa Casali, and the house of Count Giuseppe Fede, a collector–

excavator who made important finds at Hadrian's Villa near Tivoli. Topham seems to have been particularly interested in the relief sculpture set into the walls of Roman villas, palaces, casinos, and churches. The *Bas-Relief Depicting Sol and a Recumbent Male Figure* was drawn by Batoni in the palace of Leone Verospi Vitelleschi. The fullest account of the Palazzo Verospi collection was published by Pietro Rossini (*Il Mercurio errante delle grandezze di Roma* [Rome: Zenobj, 1725], pp. 70–71), who noted its high quality while remarking that it was less well known than other Roman collections of classical antiquities. Topham owned a group of eleven drawings by Batoni after works in this collection, none more intriguing than the present relief.

The statue of *Pan with a Baby Goat* was in the eighteenth century in the collection of classical antiquities in Palazzo Salviati on the via della Lungara (now the Collegio Militare di Roma). Batoni's drawn record of it reveals in particular the refinement and fastidiousness of approach praised

by Macandrew. Beauty of line is common to all of Batoni's drawings, but here the figure of Pan is enclosed by a contour that is especially "elegant and purposeful in definition," and the entire sheet is "characterized by a line that in its poise and precision is in the great classicist tradition of Italian draftsmanship which claims Raphael as its progenitor and inspiration" (Macandrew 1978, p. 137).

The significance of the professional copyist in eighteenth-century Rome should not be underestimated. The work of Batoni, Campiglia, and numerous other, often anonymous, draftsmen, in Macandrew's words, "whether directed to producing drawings for the wealthy amateur, or for publication through the work of the engraver, was vital for the dissemination of knowledge of classical antiquity, and contributed substantially to the development of neo-classical taste" (Macandrew 1978, p. 140). Even after the Topham commission of 1730, Batoni continued his activity as a professional copyist. The evidence for this exists in the engravings after

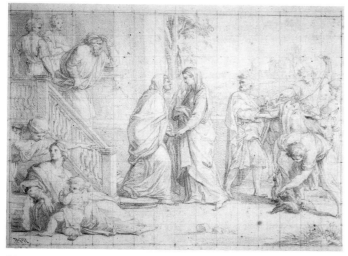

314

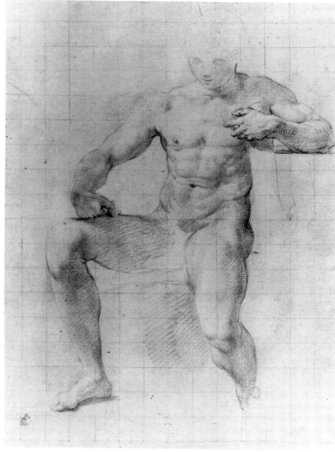

315

Batoni's drawings of two famous sculptures discovered at Hadrian's Villa in 1735 and 1736: the beautiful Albani *Antinous Bas-Relief*, published in Ridolfino Venuti's *Collectanea antiquitatum Romanarum* (Rome, 1736), and one of the two Centaurs that were uncovered during Monsignor Alessandro Furietti's excavations in December 1736 (Haskell and Penny 1981, pp. 144–46, 178–79). The fact that Batoni was engaged at this time in the execution of the altarpiece that Furietti had commissioned for the Roman church of Ss. Celso e Giuliano (Clark and Bowron 1985, no. 15) suggests how intertwined were his relations and services with his patrons in the early stages of his career. The inclusion of the Albani *Antinous* twenty-five years later in a full-length portrait of an unidentified Grand Tourist in Rome (early 1760s; Metropolitan Museum of Art, New York; Clark and Bowron 1985, pl. 213) proves how important this early experience of the antique was to become for the later development of Batoni's art. [EPB]

## 314
## Pompeo Batoni
*Study for "The Visitation"*

1737–38

Inscribed very faintly at the top in pencil: *Pompero*

Red chalk on paper, squared

10⅛″ × 13⅜″ (259 × 348 mm)

PROVENANCE probably acquired by Allan Ramsay in Rome, 1736–37; thence by family descent to Lady Murray of Henderland, by whom presented to the National Gallery in 1860 (D 1940)

EXHIBITIONS Edinburgh 1963, cat. no. 21; London 1982, cat. no. 57

BIBLIOGRAPHY Andrews, Keith. *National Gallery of Scotland: Catalogue of Italian Drawings.* Edinburgh: National Gallery of Scotland, 1968, vol. 1, p. 14, and vol. 2,

fig. 125; Clark and Bowron 1985, pp. 35, 211–12, 380, no. D63, pl. 8

National Galleries of Scotland, Edinburgh

The drawing is a compositional sketch for a painting in the Casino Pallavicini, Rome, that was likely to have been commissioned by one of Batoni's early Roman patrons, Prince Nicolò Maria Pallavicini (Clark and Bowron 1985, no. 6, pl. 10). Although squared as if for transfer on to a large scale, the drawing reveals numerous minor differences from the composition of the finished painting, suggesting that Batoni may have produced it to show his patron an advanced version of his design for the painting. Finished drawings of whole compositions by Batoni are rather rare, since he preferred to submit oil sketches to patrons commissioning works.

Batoni composed his paintings strictly within the Bolognese–Roman academic tradition, and the types of drawings he produced in the course of working out a particular design may be categorized according to method and function. Within a normal preparatory sequence, the first to come are rough compositional sketches on a very small scale. These were usually followed by a compositional layout drawing, almost a *modello* in chalk, highly finished and squared, such as the Edinburgh sheet. The third category of drawing, whole-figure studies from the model to adjust or refine a pose, often provides the most brilliant examples of Batoni's skill as a draftsman. The fourth type—figure, drapery, hand, and head studies— abounds in numerous examples among the artist's surviving drawings.

The Edinburgh drawing establishes the format of the Pallavicini painting down to the number and placement of the figures. The many changes between the two compositions, mostly in the disposition of the figures, however, confirm that Batoni contin-

ued to refine and adjust the poses and gestures of individual figures and their costumes on the canvas itself. In a letter of April 1742 he complained of the unseasonal cold in Rome because it prevented the models from posing nude for extended periods of time. This seriously delayed his progress in finishing commissions on his easel, he explained, as it was his practice "to complete each painting with live models in front of my eyes." In another letter he explained that "a painting that illustrates a story for which all the necessary sketches must be made in advance, and *afterwards must be perfected from reality* [italics added], requires a few months of work" (Clark and Bowron 1985, pp. 35, 61, n. 82–83). This ability to derive sustained inspiration from nature throughout the process of pictorial invention explains both the "meticulous naturalism" admired in his work by contemporary and modern critics and why, at least until the 1780s, his best history paintings remain remarkably convincing.

Clark believed *The Visitation* to have been painted about 1737, and although Batoni's figures in this painting owe a great deal to Marco Benefial and Benedetto Luti, the influence of Imperiali (Francesco Fernando) remains powerful. The Edinburgh

drawing almost certainly belonged to Allan Ramsay, who no doubt obtained it directly from Batoni's studio. As Ramsay had left Rome for Naples in the summer of 1737 and returned on October 1, before departing for home in mid-April of 1738 (Ingamells 1997, p. 796), the drawing, and therefore presumably also the painting, can be dated to 1737–38, on the basis of provenance and of style. [EPB]

## 315
## Pompeo Batoni
*Study of Hercules for "The Choice of Hercules"*

1740–42

Red chalk, squared in red, on beige laid paper, mounted down

11⅛″ × 8⅜″ (284 × 212 mm)

PROVENANCE Veuve Galippe; sale, Amsterdam, De Vries, property of Madame Veuve Galippe, March 27–29, 1923, in lot 515 (as Mengs); Fritz Haussmann, Berlin, 1931; Countess Finckenstein, Zurich, 1950s; Yvonne ffrench, London, 1960; from whom purchased by Anthony Morris Clark, Minneapolis and New York; bequeathed to the Philadelphia Museum of Art in 1978 (1978-70-159)

EXHIBITIONS London, Alpine Club. *Exhibition of Old Master and Early English Drawings, Presented by Yvonne French at the*

Alpine Club Gallery. 1960, cat. no. 24;
Cleveland 1964, cat. no. 8; Minneapolis
1967, cat. no. 6; Minneapolis, The
Minneapolis Institute of Arts. *Eighteenth-
century Italian Paintings, Drawings, Sculpture,
and Decorative Arts.* 1970–71; New York 1978,
Philadephia 1980, cat. no. 33
BIBLIOGRAPHY Emmerling 1932, p. 83;
Clark and Bowron 1985, pp. 228, 385,
no. D165, pl. 61
Philadelphia Museum of Art, Bequest of
Anthony Morris Clark

It is not surprising that Anthony
Clark's collection of eighteenth-centu-
ry drawings was richest in the works
of his favorite Roman artist, Pompeo
Batoni. In the same way that he made
the entire Roman Settecento almost
his own as a field of study, Clark
applied his industry and enthusiasm
to rediscovering the virtues of this
particular Roman painter, whom he
studied for over twenty years. His
drawings by Batoni are of particular
interest for the light they shed on the
artist's methods as a history painter.
He was a superb draftsman, as careful
as he was inventive, for whom the
drawn study performed a crucial
role in the preparation of the final
work. Clark's Batoni drawings, now
in the Philadelphia Museum of Art
(Hiesinger and Percy 1980, nos. 30–43),
range in date over fifty years from the
artist's first public commission to his
last, and illustrate the full scope of his
draftsmanship, with the exception of
Batoni's drawings of antiquities made
for English travelers (for these, see
cats. 310–13).

Batoni's surviving œuvre falls with-
in the traditional categories of seven-
teenth- and eighteenth-century
draftsmanship, including copies of
other artists' works, academies (or
drawings from the nude), and rough
sketches of compositions in the plan-
ning stage; there are many studies for
individual groups and single figures
and rather fewer finished drawings
of whole compositions, since Batoni
preferred to present oil sketches to
patrons commissioning works.
Because his drawings exemplify
the more academic tendencies of
the Roman school in the eighteenth
century, it is not surprising that those
most frequently encountered are
figure and drapery studies in the
tradition of Andrea Sacchi and Carlo
Maratti, a brilliant example of which
is the present drawing.

A letter from Batoni to Marchese
Lodovico Sardini of May 27, 1740,
mentions, without describing the
exact subject, a picture with three fig-
ures ordered by Marchese Carlo Gerini
for 150 scudi. A subsequent letter to
Sardini of December 15, 1742, mentions
that a picture had been recently been
sent to Marchese Andrea Gerini in
Florence, and this painting is almost
certainly the *Choice of Hercules* in the

Galleria d'Arte Moderna, Palazzo
Pitti, Florence, which is signed and
dated 1742 (Clark and Bowron 1985,
pp. 228–29, no. 67). Batoni painted
several other versions of the theme
at different stages of his career (Clark
and Bowron 1985, nos. 123, 173, 188),
each of them derived, to a greater or
lesser degree, from the "canonical"
formulation of the subject, the paint-
ing by Annibale Carracci in the
Pinacoteca Nazionale at Naples
(Donald Posner, *Annibale Carracci*
[London: Phaidon, 1971], vol. 2, pl. 93a).

The moral fable of Hercules at the
Crossroads was invented by the Greek
sophist Prodicus, a friend of Socrates
and Plato, and is described by
Xenophon (*Memorabilia* 2.1: 22ff.) and
other ancient writers. The frequent
occurrence and interpretations of the
theme as an allegory in Renaissance
and Baroque art have been examined
by Erwin Panofsky in a classic study
(*Hercules am Scheidewege*, Leipzig–Berlin,
1930). In the Palazzo Pitti painting,
Hercules is depicted seated under a
tree, divided in choice between the
invitations of two female figures per-
sonifying Virtue and Vice.

Batoni selected a muscular model,
young and beardless, to assume the
exact pose of the seated Hercules in
the painting. The study from life was
presumably made at a relatively late
date in the evolution of the composi-
tion because the pose of the model
corresponds quite closely to that of
Hercules in the painting, and it was
Batoni's practice to finish his paint-
ings with the model before him (see
cat. 314). [EPB]

## 316

### Pompeo Batoni

*Allegory of Physics,
Mathematics, Theology, and
Canon Law Contemplating a
Portrait of Pope Benedict XIV
Borne by Fame*

1745
Red chalk, heightened with white, on beige
paper
14⅛″ × 9¾″ (360 × 249 mm)
PROVENANCE Bartolomeo Cavaceppi,
Rome; Marquis de Lagoy, Château de
Lagoy, near St.-Rémy; sale, London,
Sotheby's, June 19, 1973, lot 229, pl. 3,
bought by Richard Day acting for The
Metropolitan Museum of Art, 1973
EXHIBITIONS New York, The Metropolitan
Museum of Art. *European Drawings Recently
Acquired, 1972–75.* 1975, cat. no. 1; New York
1978, cat. no. 7; New York 1990, cat. no. 6
BIBLIOGRAPHY *Catalogue des dessins qui com-
posent la collection de M. De Lagoy.* Hamburg,
unpublished Ms, p. 33, no. 137; Clark and
Bowron 1985, p. 384, no. D 145; Bean and
Griswold 1990, pp. 28–29, no. 6;
Costamagna 1990, pp. 304–5

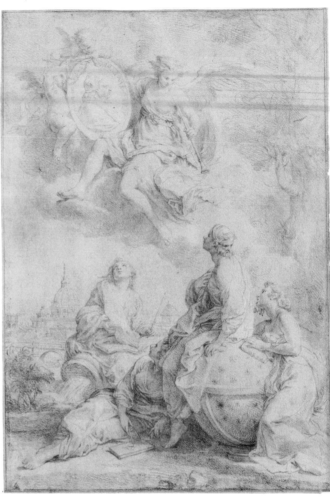

316

The Metropolitan Museum of Art, New
York, Rogers Fund

This exquisite and polished red-chalk
drawing served as the preparatory
*modello* for the engraved frontispiece
by Johann Jakob Frey in a treatise on
Newtonian physics by Cardinal
Marcantonio Colonna. The scion
of a important noble Roman family,
Colonna (whose sister Isabella, a nun
at the monastery of Regina Coeli, sat
to Batoni c. 1768; Clark and Bowron
1985, p. 310, no. 315), enjoyed a distin-
guished ecclesiastical career and along
with cardinals Pietro Aldobrandini
and Pietro Ottoboni was an impor-
tant patron of the abbey of S. Paolo
at Albano (cat. 307).

In 1745 Colonna published the text
of his doctoral thesis, dedicated to the
highly cultivated Pope Benedict XIV
Lambertini, *SS. Domino Nostro Benedicto
decimo quarto pont. opt. max. de suasque
theses ex physico-mathematica, theologia,
et jure canonico, decerptas quas …
propugnandas suscepit Marcus Antoninus
Columna D.D.D.* (Rome: Joannes Maria
Salvioni, 1745). In addition to a number
of technical diagrams intended to
illustrate aspects of the author's dis-
cussion of Sir Isaac Newton's theories

of mathematics, physics, and optics,
the volume contains an exceptional
engraved frontispiece designed by
Batoni representing an allegory of
Physics, Mathematics, Theology, and
Canon Law contemplating a portrait
medallion of the pontiff that is held
aloft by the winged figure of Fame
with a trumpet assisted by two putti.
The most conspicuous of the personi-
fied figures is Theology seated on a
celestial globe. She has two visages—
the younger looking up to heaven,
the older looking down to earth.

The figures are shown before a
backdrop of Rome, indicated by
St. Peter's at the right and at the left
of center the fifteenth-century octag-
onal lantern of the Arcispedale di
S. Spirito in Sassia. Benedict XIV
added a large wing to this ancient
hopital. The addition (pulled down
in the twentieth century), decorated
with frescoes by Gregorio Guglielmi,
was completed in time to figure on
Giambattista Nolli's 1748 plan of
Rome. The façade of Benedict's addi-
tion to the hospital is seen on the
right, just beyond the Ponte S. Angelo
and below the dome of St. Peter's.
The engraved frontispiece by Frey
with the inscriptions *Pomp. Battoni*

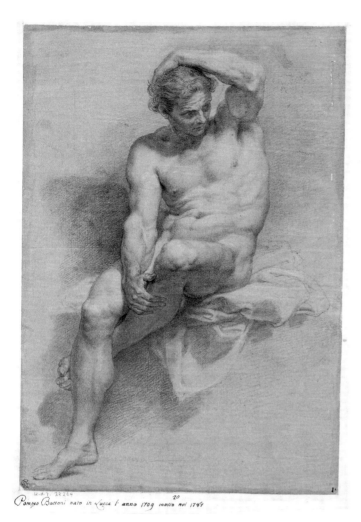

317

318

*inv. et del.* and *I. Frey inc. Romae 1745* (Costamagna 1990, pp. 304, 320, n. 45, fig. 5) deviates significantly from Batoni's design only in the substitution of a church with a rose window for the building with a double order of arcades at the extreme right of the composition.

The Metropolitan Museum drawing is one of the most brilliant examples of Batoni's skill as a draftsman. Highly finished and carefully prepared, the sheet reveals his profound awareness of the engraver's needs in the precise description of forms, lights and darks, and tones that Frey would translate into the black-and-white medium of the engraving. The composition and the treatment of the individual figures anticipate various aspects of Batoni's later allegorical paintings, *Benedict XIV Presenting the Encyclical "Ex Omnibus" to the Count de Choiseul*, 1756 (cat. 168); *Allegory of Religion* (1763), and *Allegory of the Death of Two Children of Ferdinand IV* (1780; Palazzo Reale, Caserta; Clark and Bowron 1985, nos. 262, 427). [EPB]

## 317
# Pompeo Batoni
## *Academic Nude*

c. 1765–70

Inscribed on mount in pen and ink: *Pompeo Battoni nato in Lucca l'anno 1709 morta nel 1787.*

Black chalk, heightened with white chalk, on blue-gray prepared paper

20⅞″ × 14⅛″ (530 × 359 mm)

PROVENANCE Vincenzo Pacetti, Rome; unidentified collector; acquired by the Kaiser Friedrich Museum, Berlin, in 1843, and thence in the Berlin collections to the Kupferstichkabinett

EXHIBITION Berlin 1969, cat. no. 15

BIBLIOGRAPHY Clark and Bowron 1985, p. 379, no. D 23; Valli 1998, p. 195, n.6

Staatliche Museen zu Berlin, Kupferstichkabinett

## 318
# Pompeo Batoni
## *Academic Nude*

1775

Signed and dated in brown ink at lower right: *Pompeo de Batoni 1775*; inscribed in pencil at the lower edge: *Puhlmann*

Black chalk on blue-gray prepared paper

21⅛″ × 15⅛″ (543 × 384 mm)

PROVENANCE probably acquired in Rome through Carlo Bianconi before 1779

BIBLIOGRAPHY Agosti and Ceriana 1997, p. 33; Susinno 1998, pp. 182, 188, n. 45, fig. 11

Accademia di Belle Arti di Brera, Milan, Gabinetto dei Disegni

By the middle of the eighteenth century it had long been an established tradition for artists to travel to Rome to complete their education. The city remained unrivaled as a training ground for young artists, especially as a place where they could improve their ability to draw. Rome remained the "academy of Europe," largely because of opportunities for instruction in life drawing. Artists could study from the model at the two "official" academies, the French Academy at Rome and the Accademia di S. Luca; they could enroll in one of the local evening drawing academies held by Rome's leading masters; and they could—and often did—organize their own independent life drawing classes (for a brief bibliography of eighteenth-century life drawing, see Curzi and Lo Bianco 1998, p. 184, n. 4).

In the 1770s and 1780s artists seeking an *accademia privata del nudo* in Rome could choose from at least a dozen, but the best-known were those of Pompeo Batoni and Anton Raphael Mengs. The letters of a young German assistant and pupil of Batoni, Johann Gottlieb Puhlmann, provide a glimpse into Batoni's private academy. It was usually held one evening a week from November to March or April, although he apparently held no classes between 1768 and 1774 or in the winter of 1781–82. The classes were open to all for a small fee, and the primary purpose was to draw the live model in a variety of poses. Batoni's drawing academy was popular because of the quality both of the models and of his gifts as a teacher. He occasionally presented other formal exercises for the students and encouraged them to draw after his own academy and preparatory drawings, as well as from his paintings and casts after the antique. Following the formal session of instruction he frequently delivered an extemporaneous lecture on the principles of painting and other topics of interest to the young artists.

"The practice of drawing remained central to Batoni's activity as an artist," as Hugh Macandrew has

written (1978, p. 140). "Never was it regarded by him in practical terms only, a necessary but nevertheless subordinate process in the production of a painting. For Batoni drawing remained an act of renewal and regeneration because it was the foundation of his art and the source of its inspiration." Batoni's academy drawings should be appreciated in this context and for the crucial role they play in rounding out our understanding of his activities as a draftsman. Although individual studies of heads, limbs, hands, and drapery dominate Batoni's graphic œuvre, his academy drawings—studies of male nudes drawn from studio models in poses not specifically related to planned compositions—are also important, not least on account of their technical distinction. He made these accomplished studies all his life: in his earliest years in Lucca at the drawing academies of Giovanni Domenico Lombardi and Domenico Brugieri; in Rome, shortly after his arrival in 1727, at Sebastiano Conca's evening life classes; in the drawing sessions held at the Accademia del Nudo, which he supervised in 1756, 1758, and 1759; and during his mature years, when he held private life drawing classes in his own studio. He also drew in the life classes of his contemporaries in Rome, such as those organized by the French painter Laurent Pécheux, and in competition with other Roman painters, such as Mengs (see Clark and Bowron 1985, p. 388, no. D296, for a male academy drawing inscribed *Accademia di Pompeo Batoni che lo fece/ in confronto del Cavaliere Mengs in Campidoglio*).

For reasons that are not clear, Batoni's surviving academy drawings date largely from the 1760s and 1770s (Clark and Bowron 1985, nos. D7, 17–18, 22–26, 81, 91, 93, 110, 124–25, 154–55, 176–77, 208–11, 213, 216, 222–28, 231–34, 295–96). He generally favored black and white chalks and blue prepared paper, but a few redchalk studies survive to confirm that he occasionally employed other media. His drawings of the male nude are characterized by consummate technique and faultless anatomical description. The realism is deliberate and purposeful; rarely does one encounter the aggressive or exaggerated poses characteristic of Roman academy drawings of the first half of the century. The technical finesse and the mastery of the model's heavily muscled anatomy reveal Batoni's extraordinary ability to draw from life as well as his superb knowledge of ancient sculpture, knowledge that he had acquired in the late 1720s and early 1730s, when he supported himself in Rome as a professional copyist of antique statuary (cats. 310–13).

The subtly contoured crosshatching Batoni employed to define the model's musculature was probably achieved by reworking, smoothing, and refining rapid, less precise sketches from life. The extreme detail and polish of these late academy drawings confirm that they are not the common product of a day's work in the studio but are instead demonstration pieces—virtuoso examples of the artist's skill as a draftsman. Batoni obviously regarded his academy drawings with great esteem, for they are generally remarkably well preserved. Most are signed and dated, and he frequently gave them to patrons and others as tokens of appreciation (Clark and Bowron 1985, p. 61, n. 88).

It is evident that Batoni endeavored to create as brilliant an impression as possible through the cold precision of these drawings, investing them with the monumental and severe qualities that characterize his style of history paintings in these years. [EPB]

## MARCO BENEFIAL

ROME 1684–1764 ROME
*For biography see Paintings section*

### 319
Marco Benefial
*Study for "The Transfiguration"*

c. 1720
Black chalk heightened with white lead on gray-green paper
13″ × 10″ (332 × 254 mm)
PROVENANCE Lambert Krahe, Düsseldorf
EXHIBITION Düsseldorf 1969, cat. no. 107
BIBLIOGRAPHY Budde 1930, no. 366; Graf and Schaar 1969, no. 107, fig. 8; Roli and Sestieri 1981, p. 90, no. 148
Kunstmuseum Düsseldorf im Ehrenhof, Graphische Sammlungen

Bought in Rome by Lambert Krahe around the middle of the eighteenth century to add to his collection of graphic art housed at the academy in Düsseldorf, this drawing was originally attributed to Giacinto Calandrucci. It was recognized as the work of Marco Benefial by Eckard Schaar (Graf and Schaar 1969, p. 57, cat. no. 107), who connected it with the *Transfiguration* still on the first altar on the left of the cathedral of Vetralla, a small city near Viterbo. Francesca Raho's "Precisazioni documentarie sul Duomo di Vetralla" (in *Informazioni: Periodico del centro di catalogazione dei beni culturali*, Viterbo, forthcoming) confirms an existing hypothesis, namely that Cardinal Giuseppe Renato Imperiali had the work painted as part of his plans for modernizing the ancient cathedral, the architecture of which was entrusted to Giovan Battista Contini, who began work in 1711 (Prosperi

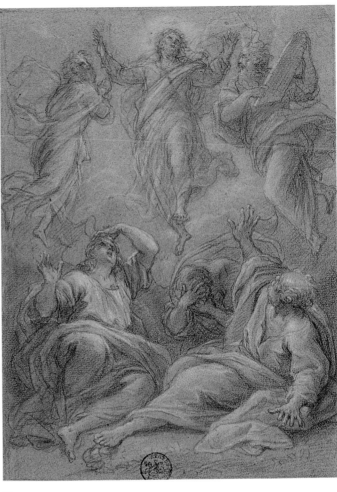

319

Valenti Rodinò 1987). When commissioning paintings for his new altars, the cardinal approached Francesco Fernandi, Giacomo Triga, Domenico Maria Muratori, and Benefial, all artists with whom he had dealt before. Writing to the governor of the town of Viterbo on December 27, 1721, the cardinal informed him that Benefial "finds that he has finished the painting" and had requested that it be removed from his studio and hung above his altar. It was paid for in full the following year (the total fee amounting to 140 *scudi*) and given a carved frame, which still exists.

Although the debt of this painting to Raphael's *Transfiguration* is constantly emphasized, it should be noted that Benefial has treated his illustrious model with his customary lack of inhibition. Not only does he completely dispense with the lower portion of the scene—the figures milling around the possessed boy—concentrating attention on the vision experienced by the apostles Peter, James, and John on Mount Tabor (Matthew 17, 1–8; Mark 9, 2–8; Luke 9, 28–36), but he has taken into account a further two versions of the subject, one by Ludovico Carracci executed for the high altar of S. Pietro Martire in

Bologna between 1595 and 1596 (Pinacoteca Nazionale, Bologna) and the other, just as visionary and original, painted by Mario Balassi around 1630 for the second altar on the right of S. Maria della Concezione in Rome.

The drawing now in Düsseldorf represents a fairly early stage in the gestation of the painting; an even earlier stage exists in the form of a detailed copy made by Benefial of Carracci's *Transfiguration*, a drawing now in the Musées Royaux, Brussels, which, now that it has been convincingly attributed to Benefial by Steffi Roettgen, may be considered a preliminary study for the Vetralla altarpiece. Compared with the copy of Ludovico's work, restricted to sketchy, rapidly drawn outlines, the present drawing is much more detailed and the artist can already be seen striving for the light effects that he needs to bring to life this particular episode of the Gospel story. The apostle James is shown covering his face with his hands, as in the work by Balassi, but in the painting itself not only is this idea relegated to a subordinate position, but other parts of the design are presented in a mirror-image of the drawing. Moses, for example, is on Christ's left and Elias on his right in the drawing, an inver-

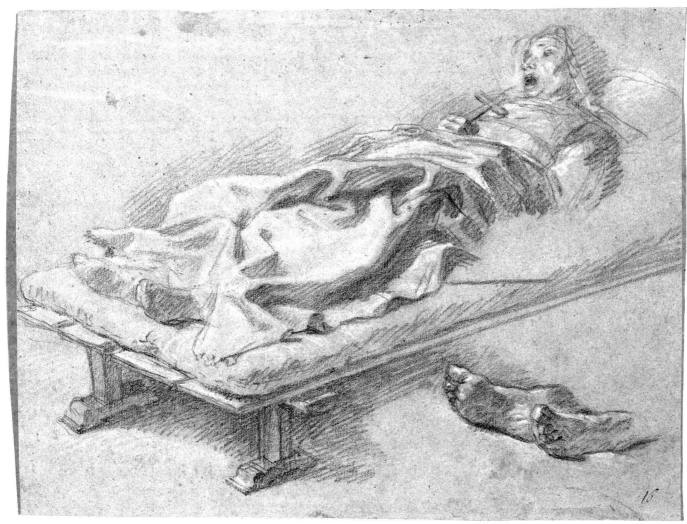

320

sion of the Vetralla canvas. Another similarity with the Balassi is in the figure of the apostle Peter sprawled on the ground with his arms thrown wide open. In both the drawing and the finished work, Benefial shares one fundamental concern with his direct models, which is to accentuate the effect that the light, radiating from Christ and the two prophets, has on the apostles, one of whom—Peter—reacts as if struck by lightning, while of the other two—James and John—one tries to shield his face and the other crouches on the ground as if trying to make himself as small as possible. The drawing is not only an essential step towards the "dramatization" of the Gospel story, but also a vital step forward in the discovery of how to use light which, transferred to canvas and translated into a wealth of contrasts and delicate effects, would influence Domenico Corvi of Viterbo from the very start of his career. A perfectly finished *modello* 25½″ × 19¼″ (650 × 490 mm) for the altarpiece has recently been acquired by the Lemme collection, Rome. [LB]

## 320
## Marco Benefial
### Study for "The Blessed Giacinta Marescotti on Her Deathbed"

1736
Inscribed on verso: *C. Benefial*
Black chalk highlighted with white lead, on gray-green paper
10⅜″ × 13¾″ (264 × 351 mm)
PROVENANCE Lambert Krahe, Düsseldorf
EXHIBITION Düsseldorf 1969, cat. no. 108
BIBLIOGRAPHY Graf and Schaar 1969, pp. 57–58, no. 108; Roli and Sestieri 1981, p. 90, no. 146
Kunstmuseum Düsseldorf im Ehrenhof, Graphische Sammlungen

The drawing is a study for the figure of the Blessed Giacinta Marescotti in the painting above the altar in the Alaleoni Chapel, S. Lorenzo in Lucina, Rome, signed and dated 1736. The *beata* is seen dying in her bare room, assisted by a nun and a gentlewoman while Saint Francis welcomes her with outstretched arms. The daughter of Count Marco Antonio and Ottavia

Orsini, Giacinta (secular name Clarice) Marescotti was forced, much against her will, to enter a convent at the age of twenty. For fifteen years she led a very unmonastic life, but following a serious illness she resolved to live thenceforth in poverty and penitence. Her death, in 1640, was a particularly painful one, and the body Benefial presents for the contemplation of the faithful is wasted by pain and privation. Ponfredi described it as "a truly marvelous expression of the sentence of death which, although it may be passed peacefully upon the just, does not fail to inflict its torments upon humanity in general" (Bottari and Ticozzi 1822–25, vol. 5, p. 23).

The long gestation of the work is documented in a series of drawings for the figure of the saint (her head and hands), that of the weeping nun kneeling beside the bed, and that of Saint Francis, all now in the Kupferstichkabinett in Berlin (Falcidia 1966, figs. 51, 53–54, and Van Dooren 1989, nos. 52–54). As Giorgio Falcidia observed, these studies are a stupendous record of an exceptionally deter-

mined search for reality that went well beyond that established by artists of the Carracci tradition, achieving a naturalism so raw, so unadorned that it is almost "without style." In this he was even more successful than he had been with the painting's immediate predecessor, *The Death of Saint Margaret of Cortona* (Cappella Boccapaduli, Rome; Falcidia 1966, pp. 64, 67, no. 17). His achievement is even more impressive given the probable starting point of his work on the dying saint. As he had previously done with *The Transfiguration*, Benefial made a drawing that was nothing less than a study of an extremely famous work that would appear to be in direct contrast with the intimacy of the eventual painting. This was Gianlorenzo Bernini's sculpture of *The Blessed Ludovica Albertoni* in the church of S. Francesco a Ripa (Van Dooren 1989, no. 190). He seems to have analyzed precise details of his model, such as the thrown-back head, the half-open mouth, and the clenched hands, then used them to produce a totally different result. The face of the saint is pitilessly sunken, the hands

grasp a wooden cross, and the body beneath the heavy cover is obviously skeletal. All the features that would appear in the painting are already present in this drawing, even down to details such as the props supporting the pillow on which the saint's head is resting.

The painting was executed ten years after Giacinta's beatification by Pope Benedict XIII in 1726, and replaced Simon Vouet's *The Stigmata of Saint Francis* (private collection) in a chapel originally dedicated to the saint that the Marescotti had taken over from the Alaleoni family. Two Vouet paintings still hang on the side walls of the chapel. The damaged frescoes in the cupola are also the work of the French painter, while the six remaining canvases present are by Francesco Manno (see Pansecchi 1983–84), who painted them either at the end of the eighteenth century or at the beginning of the nineteenth. Even today, these are sometimes attributed to Benefial, despite the fact that in period and style they are crucially different from the altar painting. [LB]

## 321
## Marco Benefial
### *Reclining Nude*

c. 1730–1735
Signed or inscribed in ink at bottom right: *Benefial*
Red chalk on brownish-gray paper
16″ × 22¼″ (405 × 566 mm)
PROVENANCE purchased in Rome by Giovambattista Romero, 1805
BIBLIOGRAPHY Susinno 1998, pp. 176–77, 187, fig. 4; Susinno 1999
Accademia di Brera, Milan, Gabinetto dei Disegni

In all probability this drawing is one of several purchased in Rome by the engraver Giovambattista Romero, who, on January 26, 1805, wrote to Giuseppe Bossi, then director of the Accademia di Brera, to say that he had acquired twenty-five exceedingly good life drawings of nudes by Corvi. Bossi replied from Milan (February 6, 1805) saying he would like to have them, and the purchase was finalized on February 9 (Valli 1998, p. 196, n. 25). It later transpired that the batch consisted not of twenty-five drawings, all by Corvi, but of thirty-three, some of which were by Corvi while others were by different artists including one by Carlo Maratti, one by Paolo de Matteis, and this one by Benefial. It is possible that they were all originally in a single group and belonged to Corvi himself, so ideologically homogenous does the list—Maratti, De Matteis, Benefial, and Corvi—appear to be. The importance Benefial attached to the study of the nude figure

321

is apparent from events in his own life: he opened a school in Rome that Mengs attended and he was thrown out of the Accademia di S. Luca after criticizing the way the "professors" taught life drawing, according to an account by Giovambattista Ponfredi (Bottari and Ticozzi 1822–25, vol. 5, pp. 31–35); he was never, however, director of the Accademia Capitolina del Nudo, as has been claimed. He also produced a remarkable number of drawings for teaching purposes and as sketches for paintings, such as the nude figure transferred almost unchanged into his *Hercules and Omphale* (Galleria Nazionale d'Arte Antica, Rome [Falcidia 1966, p. 68]). When Stefano Susinno published this life drawing together with the others he had acquired at the same time, he emphasized the debt owed by such a drawing to Maratti and Annibale Carracci via the teaching of Ventura Lamberti, Benefial's teacher, as two of his pupils, Mengs and Ponfredi, recalled (Susinno 1998, p. 176). On the other hand, Maratti and Carracci, the latter in the inexhaustible source of the Galleria Farnese, appear to have urged Benefial towards the direct observation of a real figure caught in a moment of abandon, skilfully foreshortened and the diagonal defined by a firm, continuous line.

Obviously very closely related to this drawing are several masterful studies now in the Berlin Kupferstichkabinett (Van Dooren 1989, cat. no. 138), nearly all inscribed with the painter's name and coming from the extensive collection of drawings assembled by the sculptor Vincenzo Pacetti, who certainly knew Benefial and was in a position to buy directly from him. Pacetti had acquired part of the collection of Bartolomeo Cavaceppi, which was later sold off by his son Michelangelo and is now in the Kupferstichkabinett, Berlin (see Fusconi 1998; Dreyer 1969, pp. 3–16, and Dreyer 1979, p. 19). It is interesting

to note, in this connection, that Pacetti was selected, in 1784, to sculpt a marble bust of Benefial, the first eighteenth-century bust of an Italian painter, destined for the Pantheon (now in the Protomoteca Capitolina). It was commissioned by those of his one-time students who had become members of the very Accademia di S. Luca that had expelled him thirty years previously and that now sought to make tardy amends by describing him in the pages of the *Antologia romana* as "the most perfect painter to have cast luster upon his famous school in recent times" (*Antologia romana*, vol. 10 [1784], pp. 326–27).

The didactic purpose of Benefial's nude drawings is shown by the written "figure" followed by a number that appears on several drawings of the Berlin group, as if they had been sorted into an album for use in a private academy, perhaps the very one that Benefial himself directed. The amazing naturalness and the novelty of the pose makes the Brera drawing stand out not only from the rest of the Berlin group but also from other well-known life drawings, including that recently believed to be a reinterpretation of the Belvedere Torso now at the Albertina in Vienna (Wünsche 1998, p. 199, cat. no. 161). [LB]

## GIUSEPPE BOTTANI
CREMONA 1717–1784 MANTUA
*For biography see Paintings section*

## 322
## Giuseppe Bottani
### *Reclining Male Nude Posed as the Dead Christ*

Red and white chalk on yellowish prepared paper
10 ½″ × 15 ½″ (269 × 397mm)
PROVENANCE collection of the artist's heirs, Rome; Angelo di Castro, Rome, 1969; from whom purchased by Anthony M. Clark, Minneapolis and New York; bequeathed to the Philadelphia Museum of Art, 1978
EXHIBITION Philadelphia 1980, cat. no. 48
Philadelphia Museum of Art, Bequest of Anthony Morris Clark

This life study of a nude comes from a tradition that can be traced back to the Accademia of the Carracci, which had affirmed the intellectual underpinning of such a basic artistic practice. While the drawing of the nude predicated comparison with antique statuary, thereby making the practice a scholarly and antiquarian pursuit, it was also part of the rational scientific study of anatomy. Its closest antecedents were the classicizing tradition of the seventeenth century. Eighteenth-century artists sought their models in the various poses and attitudes offered by the nudes in Carracci's Farnese Gallery (c. 1598–1602) rather than Michelangelo's anthology of poses and daring foreshortenings in the ceiling (1505–11) and *The Last Judgment* of the Sistine Chapel.

There was a renewed interest in the study of the nude in the same years during which, in 1754, the well-run government of Rome under the secretary of state Cardinal Silvio Valenti Gonzaga promoted the institution of the Accademia del Nudo in the extremely prestigious location of the Capitoline (Pietrangeli 1959; Pietrangeli 1962, "Accademia"; Barroero 1998). In competition with this and the official institutions, including the French Academy in the Palazzo Mancini, new private academies sprang up where drawing from the nude found its most rigorous definition in the naturalistic classical tradition; among them were those of Placido Costanzi, Domenico Corvi, Anton Raphael Mengs, and, toward the end of the decade, Laurent Pécheux, who for a long time enjoyed the collaboration and guidance of Batoni (on their troubled relations, see Bollea 1936). A new method of interpreting the nude appeared, distinct from but not rejecting the tradition of the Carracci and Maratti, most recently represented by such masters as Benefial and Subleyras. The new practice was to fix the most exact contours of the figure, almost tracing them as if they were projected in an optical box, and

322

to eliminate any sense of pictorial illusion. In this context an almost Domenichino-like purism distinguishes Bottani in the Roman art world. It found its best expression in the numerous life studies the artist produced with no intention of using them in his own painting. As for other artists, such an output acquired an autonomous value, even if partly didactic, and was also intended for collectors and connoisseurs (Campbell and Carlson 1993, p. 84, no. 3).

Proof of how highly valued these academic studies were is that by 1774, Carlo Bianconi acquired four of Bottani's life drawings for the Sala dei Gessi of the Accademia di Brera in Milan. There, students could compare their own life drawings from nude life models, with casts of the most famous statues of antiquity and with life studies by major contemporary artists of the Roman School such as Batoni, Mengs, Maron, and Corvi, as well as Bottani. These works represent a perfect synthesis of Roman–Bolognese classicism, as represented by Sacchi and Maratti, with the new contributions of Mengs, which were known in Italy through the Italian translation of his theoretical writings. The two Bottani sheets in the Brera, and this one from the Philadelphia Museum of Art, appear to have been executed "with the ultimate Purity" (Mengs 1787, p. 208) that Mengs recommended for restoring to human beauty "the idea of an animal, which has both lightness and strength" (Mengs 1787, p. 17). That Bottani's life studies should be considered at least equal to those of the above cited masters is supported by the high price that the artist's brother put on the drawing after Bottani's death. In the "List of the drawings owned by Gio. Bottani which shall be disposed of by being assigned to the Academy of Mantua for the perpetual use of the school of painting" (Milan, Archivio di Stato, Fondo Studi, parte antica, b. 10; cited in Magni

1984) Giovanni Bottani catalogues ninety-six sheets for 190 *zecchini*, or about four Roman *scudi* per drawing.

Before becoming director of the academy in Mantua, in April 1764, Bottani served as the director of the Scuola del Nudo, in which he had to pose the model. This seemingly easy and banal task in reality was a barometer of the director's own cultural inclinations and ideals. So too is the pose of the Christ in this drawing (Pirotta 1969, p. 330).

The theme of the dead Christ with his arms lying limply by his sides looks back to a canonical model of the *Pietà* by Annibale Carracci then in Palazzo Farnese (now Museo di Capodimonte, Naples), a painting from which Bottani drew inspiration for one of his paintings in 1757. That work, traditionally attributed to Batoni, is now lost, but is known from old photographs (see Susinno 1978, p. 312, no. 13; erroneously as Batoni in Manieri Elia). It is a link between Bottani and two drawings of problematic attribution, representing the dead Christ, now in the Uffizi, that were included in the Batoni exhibition of 1967 with a provisional attribution to him, but a cautious admission that the artist might have been Bottani (Belli Barsalni 1967, p. 169; see also Clark and Bowron 1985, p. 378, no. D7). Nevertheless, those drawings are characterized by a stronger rendering with more emphasis on light and shade, than in this life study, which is already close to Neoclassicism. In the absence of dated examples of life drawings by Bottani— apart from the *ante quem* of 1779 for the two Brera sheets—it is difficult to suggest a chronological frame for his known nude studies, many of which were dispersed in the late 1960s after a sale by his descendants (see the photos in the Bibliotheca Hertziana and Gabinetto Fotografico Nazionale), although they seem to predate the drawings of a marked naturalism that Domenico Corvi, the most admired

draughtsman of nudes in Neoclassical Rome, produced in the 1780s and 1790s. Their high quality, so evident here, is based not only on the refined use of red chalk or pencil on paper often tinted in the most delicate pastel colors, but above all on an impeccable rendering of anatomy seen in light of an idealized model. [ss]

## JOHN BROWN
### EDINBURGH 1749–1787 LEITH

A compelling and enigmatic artist with few surviving works accessible in the literature (over 200 of his drawings were dispersed in a series of auctions early in the nineteenth century), John Brown is a tantalizingly elusive figure whose known œuvre today consists of a mere handful of drawings: landscapes with ancient ruins, portraits, and scenes of Roman street life imbued with strange and sinister overtones. A Scot born in Edinburgh, the son of a watchmaker and goldsmith, Brown studied at the Trustees' Academy in his native city and travelled to Rome shortly after he turned twenty, arriving in the fall of 1769 (Pressly 1979, p. 54). Of the numerous Scottish artists resident in Rome with whom he could have associated—Gavin Hamilton, James Nevay, Colin Morison, David Allan, and Alexander Runciman, to name a few—his principal friend seems to have been Runciman, whom he probably knew earlier in Edinburgh. In any case, the two artists' lifelong association is documented by their portraits of each other: Brown's pencil drawing of Runciman from the early 1780s is now in the National Gallery of Scotland, Edinburgh (Pressly 1979, p. 63, no. 63), and Runciman's late oil painting *Self-portrait with John Brown*, 1784, is on loan to the Scottish National Portrait Gallery, Edinburgh (Macmillan 1986, color pl. 19). Although Runciman left Rome in 1771 to return to Edinburgh, he presumably was the contact through whom Brown met Henry Fuseli. The young Scotsman's Roman drawings are in many ways close to the manner of the fiery and brilliant Swiss painter and draftsman who was the center of a circle of artists in Rome in the 1770s that included, besides Brown and Runciman, the Swedish sculptor Johan Tobias Sergel, the Danish painter Nicolai Abildgaard, the English sculptor Thomas Banks, and the English painter George Romney, among others. Early accounts confirm that Brown and Fuseli were well acquainted (Powell 1962, p. 43).

The members of Fuseli's circle in Rome—a complex subject that was examined in an invaluable exhibition at the Yale Center for British Art in

New Haven in 1979 (Pressly 1979)— shared not so much a common style as a thematic approach emphasizing horrific or extravagant subjects, tragic or dramatic heroic action, the supernatural, and themes drawn from English literature (Milton, Spenser, Shakespeare, James Macpherson, and Thomas Gray), as well as from Homer, Ovid, Dante, and the Bible. Fuseli was extremely influenced by the work of Michelangelo and by the expressive distortions in bodily proportions and poses that he saw in the work of Mannerist painters (and presumably printmakers). Many compositions by the various artists in his circle are characterized by violently agitated and twisted poses, exaggerated gestures, and the expression of strong emotions. The artists of the Fuseli circle embraced an intentionally extravagant aesthestic that was diametrically opposed to the controlled, understated depiction of emotions and the archaeological correctness of detail advocated by more mainstream Neoclassical artists in Rome, such as Anton Raphael Mengs and Gavin Hamilton, and by the scholar and antiquarian Johann Joachim Winckelmann. Nonetheless they shared a common approach as draftsmen, for the most part emphasizing contours over the massing of light and shade, simplifying outlines, and using antique sculpture as a prime source of inspiration.

From April to December of 1772 Brown accompanied as draftsman the soon-to-be famous antiquarian and collector Charles Townley and another English Grand Tourist, William Young of Delaford Park, on a trip to Naples, Sicily, Malta, and other less frequently visited parts of southern Italy. During this trip Brown produced a beautifully refined and delicate pen drawing of *The Cave of Dionysius*, Syracuse, signed and dated July 10, 1772 (The Pierpont Morgan Library, New York; New York 1989, *Piranesi*, and Montreal 1993, pp. 133–34, no. 73), to which he added overtones of romantic melancholy through the inclusion of small brooding or gesticulating figures near the mouth of the cave. The tour exposed Brown to all sorts of new and different ancient sites and objects; in the course of it he also seems to have contracted the malaria that eventually killed him. From sometime after late summer of 1776, he seems to have spent most of his time in Florence, copying works in and guiding foreign visitors around the Uffizi and working further for Townley. He returned to Edinburgh in 1781 and continued to specialize in portraits—especially of leading members of the Society of Antiquaries of Scotland—and miniatures. During a stay in London in 1786, in which Townley again

employed him, this time to draw his famous collection of marbles, Brown fell ill and died in September 1787, just days after returning to his native Scotland and aged only thirty-eight.

Brown, like Fuseli, was obviously an intellectual. He wrote a series of letters on Italian opera that were published posthumously by the recipient, his friend and supporter James Burnett, Lord Monboddo, a remarkable thinker in his own right. Brown had assisted Monboddo in his six-volume essay *The Origin and Progress of Language* (1773–92), in which Monboddo brings humans under the same species as the orang-utang and proposes that they gradually rose from an animal condition to a social state through necessity, developing language as a consequence—ideas far in advance of the time and curiously similar to those of Charles Darwin published eighty-odd years later. It is Monboddo who reveals that Brown considered drawing the most valuable aspect of the visual arts (Irwin and Irwin 1975, p. 113; Macmillan 1986, p. 62), thus casting some light on why the artist seems to have functioned almost exclusively as a draftsman during his relatively short career. [AP]

## 323
## John Brown
## *Woman Standing among Friars*

Verso: *Sketches of Heads* (pencil); *Two Standing Women* (pencil, black ink, black and gray washes)

c. 1770–75

Signed in brown ink on recto at lower right: *Giovanni/RO*; in pencil on verso at center right: *John Brown/Romae*

Pencil, black ink, black and gray washes on two sheets of paper joined vertically down the middle

10¼″ × 14½″ (258 × 369 mm)

PROVENANCE E.V. Thaw and Company, Inc., New York; purchased by The Cleveland Museum of Art, 1969

EXHIBITIONS Paris 1950, cat. no. 92 (possibly, but not certainly, identifiable with the verso of this sheet); Sydney 1979, cat. no. 63

BIBLIOGRAPHY Powell 1952, verso repr., n.p.; Pressly 1979, pp. 57–58, fig. F; Ottani Cavina 1990, pp. 76, 80, fig. 9; Upstone, Robert. *Sketchbooks of the Romantics.* Secaucus, N.J.: The Wellfleet Press, 1991, p. 175; Craske 1997, p. 255–56, fig. 117

The Cleveland Museum of Art, Dudley P. Allen Fund

John Brown worked in several different styles as a draftsman. One, a fine, closely worked pen manner close in effect to etchings, he often used for landscapes (see *The Basilica of Maxentius* [*and Constantine*], National Gallery of Scotland; Pressly 1979, p. 55, no. 55). Another, a pencil technique, distinguishes his portraits and some studies of character heads (see Skinner 1971, p. 394, figs. 2–3 for two portraits of members of the Society of Antiquaries of Scotland, and a sheet at the Yale Center for British Art, New Haven, with two dozen distinctive and mostly threatening male physiognomies lined up in rows, Pressly 1979, p. 56, no. 56). A third style, fairly close to the pen and wash manner of Fuseli, he used for his Roman street life or genre scenes and his depictions of Roman women (see *The Stiletto Merchant*, The Pierpont Morgan Library, New York; *Two Men in Conversation*, Witt Collection, Courtauld Institute of Art, London; and *The Geographers*, Yale Center for British Art, New Haven; Pressly 1979, pp. 57, 60, 62, nos. 57, 59, 61). Fuseli's wildness and extravagance of gesture and emotion are tempered in Brown's drawings toward effects more insidiously bizarre and sinister, which are achieved especially through the careful depiction of facial types, often bearing fierce, threatening, or evil expressions. It is perhaps no coincidence that Brown's friend Fuseli's close compan-

ion from the Swiss artist's early youth in Zurich was the famous physiognomist Johann Kaspar Lavater, nor that Lavater's principal work on this subject (the detection of people's characters from their appearances, especially their faces)—the volumes of his *Physiognomische Fragmente*—were published between 1775 and 1778, the latter years of both Brown's and Fuseli's stays in Italy. Fuseli, at least, had seen the publication by June 1777, when he wrote Lavater a congratulatory letter (Siegfried Frey, "Lavater, Lichtenberg, and the Suggestive Power of the Human Face," in Ellis Shookman, ed., *The Faces of Physiognomy: Interdisciplinary Approaches to Johann Caspar Lavater* [Columbia, S.C.: Camden House, Inc., 1993], p. 85).

One is never sure quite what is happening in Brown's Roman "genre" scenes, only that nothing seems benign or innocent. Who are the "geographers" pondering and gesticulating over a large tome beside a globe? Why is the gaze of one of the *Two Men in Conversation* so demonic? What is the murderous situation that focuses the rapt attention of the group of staring men on the stiletto seller? Even the view of the basilica of Maxentius is backdrop to a murder scene in the foreground. The *Woman Standing among Friars* is as strange and sinister as any of Brown's subject drawings. The men's expressions, each individualized, are startled and grim to the point of caricature; the figures on the right seem a cross between ancient philosophers and friars. (Indeed, it was fashionable in eighteenth-century Rome to wear clerical garb whether or not one was actually a priest or member of a religious order, and many lay figures might be encountered in society in ecclesiastical dress; see Andrieux 1968, pp. 52–53.) The garment the woman wears, revealing both bosom and ankles, may identify her as a courtesan (women in similar bare-breasted dresses in Fuseli's drawings are often so identified; see Schiff 1974, nos. 192–94). Her social position is difficult to determine and, like *The Geographers* and *The Stiletto Merchant*, the scene obviously has a now unknown significance in Roman popular life. Roman women during the Settecento are reported to have been allowed an unusual degree of freedom, with a great deal of license permitted on all levels of society, especially in romantic matters (Andrieux 1968, pp. 108–17).

Brown drew in Rome another strange scene of a woman among a large group of grimacing, cowled, male figures with physiognomies emphasized, entitled *The Congregation* (Powell 1962, n.p.), and he produced there at least four other drawings—one of which appears on the verso of this

sheet—showing women in the same type of costume, wearing light stoles and with very tall headdresses surmounted by transparent bonnets tied behind with ribbons (for illustrations see Paris 1950, no. 91, pl. xxx; Pressly 1979, pp. 60–61, nos. 58, 60). These works seem to have affected some of Fuseli's depictions of women with eccentric hairdos, most of which are dated to the first decade of the nineteenth century (see Schiff 1974, pp. 28, 112, 124, 132–33, nos. 140, 163, 184, 187, 190). Or the influence may have gone the other way, as some critics have suggested: "Fuseli's exaggerations of character types … almost certainly influenced Brown's transformations of Roman genre scenes into something more mysterious and sinister" (Pressly 1979, p. x). Of all the northern artists nourishing their talents and creativity in the Eternal City in the 1770s, John Brown stands out for his evocations of the dark underside of popular life, depicting situations of which we cannot know the real significance but can only imagine. It is ironic that—except for his Roman women and his street-life drawings—the other aspects of Brown's life and art for which there is evidence, such as his antiquarian projects or musical interests, are characterized by the utmost highmindedness and propriety. [AP]

## GIUSEPPE CADES
ROME 1750–1799 ROME
*For biography see Paintings section*

## 324
## Giuseppe Cades
## *Achilles Withdrawing to His Tent with Patroclus, Surprised by Ulysses and Nestor Who Have Come to Summon Him Back to Battle*

1774

Signed and dated at lower left: *G. Cades 1774*

Pen and brown ink, brown wash, heightened with white on sized paper.

The whole torn lower edge has been restored using a thin strip of paper, and the drawing of the foot completed

14¼″ × 20⅛″ (361 × 510 mm)

PROVENANCE collection of Comte Grimod d'Orsay (Lugt 2239); acquired by the museum through seizure of émigré property

EXHIBITION Paris 1983, cat. no. 55

BIBLIOGRAPHY Stein 1913, p. 395; Caracciolo 1978, pp. 75, 81, fig. 6; Caracciolo 1984, pp. 357–58, fig. 5; Caracciolo 1992, p. 184, fig. 16A

Musée du Louvre, Département des Arts Graphiques, Paris

323

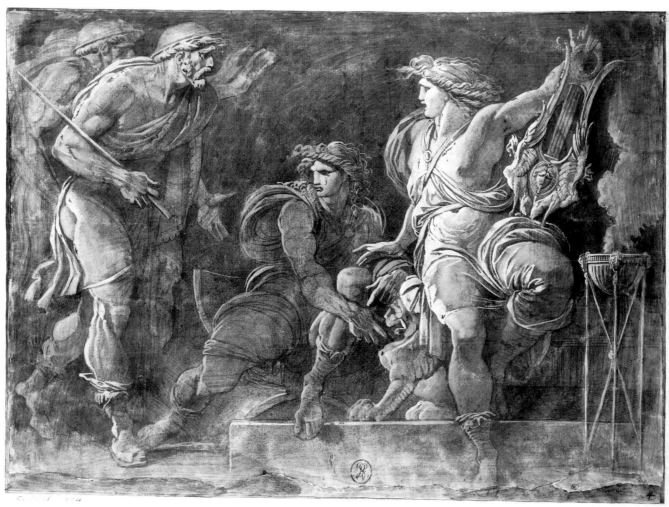

324

This drawing represents the first version of a subject Cades also treated in paint, no doubt later and with some variants; the painting was bought in the 1780s by the Toulouse collector Nicolas-Joseph Marcassus de Puymaurin and remained in the original collection until 1980, when it was acquired by the Louvre. This drawing may have been bought in Rome by the Comte d'Orsay, who lived in the capital between 1775 and 1778. Another *trois crayons* drawing relating to the painting was shown at an exhibition by the Société des Beaux-Arts of Montpellier in 1789. A pen and ink drawing signed and dated 1782 from the collection of the painter Valentin Carderera y Solano, currently held in the Biblioteca Nacional in Madrid, may represent a later return to the subject, possibly even post-dating the painting.

The drawing shown here is an effective illustration of the links Cades maintained with the circle of pre-Romantic northern artists living in Rome in the decade 1770–80, centered on Fuseli and Sergel. That circle was also open to a few French artists operating independently of the French Academy, such as Julien de Parme and

Esprit Antoine Gibelin, with whom Cades had already been able to make spontaneous contact because of his father's French origins. It was among these northern artists, outside the academic climate and even at odds with it, that Cades as a young man seems to have become aware of the possibilities open to him through challenging the classical rules and reverting to the Mannerist form, but in a daring and modern way, where quality and intensity of expression were concerned. The artist sets up his composition like an antique bas-relief, but his reference to antiquity seems to be filtered through a knowledge of sixteenth-century Roman painting. The model Cades had in view seems in this case to be Polidoro da Caravaggio, whose friezes on the façades of some Roman palaces could still be seen. However, it is possible that Cades may also have known Polidoro's characteristic drawings in pen and ink, wash, and watercolor heightened with white gouache. (It is evident from their work that Fuseli and Julien de Parme must have looked at Polidoro with just as much interest as Cades.) The relatively rare subject

depicted in this drawing, taken from Homer's *Iliad* (it is otherwise found only in a painting by Fuseli, currently lost, but known through an engraving by E. Smith), is an opportunity to highlight the hero's painful feelings and the pathos of the situation, which brings him into conflict with his comrades in the Greek army: the conciliatory overtures of Ulysses and Nestor prove to be of no avail, because Achilles' anger over the abduction of Briseis on Agamemnon's orders keeps him away from the battlefield until the death of Patroclus.

This drawing by Cades is typical of a group of works that emerged from the same circle around the same period. These include *Philoctetes* by James Barry (1770; Pinacoteca Nazionale, Bologna) and the same subject by Nicolai Abildgaard (cat. 161) and by Drouais (cat. 214); *The Wrath of Achilles* by Sergel (terracotta, c. 1775; Nationalmuseum, Stockholm); and *The Thinking Man*, also by Sergel after Michelangelo (1777; Nationalmuseum, Stockholm), which paves the way for his amazing, slightly later series, *The Story of a Man in His First Attack of Hypochondria* (Nationalmuseum,

Stockholm), and Fuseli's famous drawing *The Artist Moved by the Grandeur of Ancient Ruins* at the Kunsthaus in Zurich. Homer's hero then appears as the embodiment of melancholy as it was experienced, cultivated, and depicted many times around this time by artists of the northern school, whose troubled souls were confronted with the simultaneously dazzling and overwhelming experience of classicism. [MTC]

## 325
## Giuseppe Cades
### *Unidentified Subject (An Allegory?)*

c. 1780
Inscribed on verso, on a label stuck to the old frame: *Giusepe Cadez*
Black chalk and colored chalks on thick cream paper
12⅛″ × 17¼″ (313 × 440 mm)
PROVENANCE  private collection, England; London sale, Phillips, December 4, 1989, no. 98; W. M. Brady and Co., Inc., New York, 1990 cat. no. 10, (as *Armida Abducting the Sleeping Rinaldo*); purchased by the Philadelphia Museum of Art, 1990

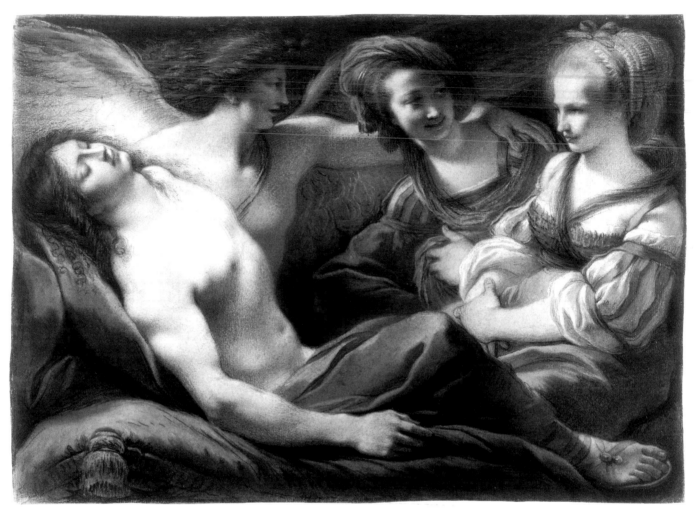

325

EXHIBITIONS New York, W. M. Brady and Co., Inc. *Master Drawings, 1760–1880.* 1990, cat. no. 10; Los Angeles, Philadelphia, and Minneapolis 1993, cat. no. 81
BIBLIOGRAPHY Caracciolo 1992, no. 72, pl. 12; Wintermute 1996, p. 439
Philadelphia Museum of Art, The Henry P. McIlhenny Fund in memory of Frances P. McIlhenny, funds contributed by George Cheston from the sale of deaccessioned works of art

The traditional identification of the subject (among English-language art historians) as an illustration of the episode from Tasso's *Jerusalem Delivered* in which Armida discovers the sleeping Rinaldo and prepares to abduct him on her chariot (Canto XIV, verses 65 ff.) is highly questionable. The iconography of the episode from Tasso had already been well established by famous seventeenth-century paintings (specifically the versions by Poussin, now in Moscow, and by Van Dyck, now in Los Angeles). According to this tradition the episode takes place in a natural setting beside a spring where nymphs are bathing, under the eyes of winged cupids suspended in flight above the hero;

Rinaldo always wears armor and a warrior's clothing. By contrast, the event depicted by Cades seems to take place indoors, or in some unidentifiable setting, and the sleeping young man is naked, apart from the drapery and footwear. Although iconography of this drawing cannot as yet be resolved, therefore, it may be drawn from a work of literature (probably by a sixteenth- or seventeenth-century writer) or else an allegory, in the spirit of Tommaso Minardi's later *Tasso Meditating on the Figure of Beauty*, in which a radiantly beautiful young woman stands before a drowning man (Galleria Nazionale d'Arte Moderna, Rome). In any case, it is most improbable that Cades would have treated a subject taken from Tasso's *Jerusalem Delivered* with such freedom: the tendency in the literary painting of his day, which was already anticipating Romantic history painting, was, rather, to stick faithfully to the text and render its details precisely.

This drawing is also reminiscent of an almost contemporary work by Fuseli: the illustration of an episode from Spenser, *The Fairie Queene Appearing to the Sleeping Prince Arthur,*

itself inspired by the picture Van Dyck's *Armida Gazing at the Sleeping Rinaldo*, referred to above, held in the eighteenth century in the collections of Earl Fitzwilliam at Wentworth Woodhouse (Yorkshire). Fuseli's work was conceived in the context of a project for one hundred paintings intended to form a "gallery" inspired by English poetry, commissioned by the dealer and publisher Macklin in 1787. The idea was for the paintings subsequently to be published as engravings; Fuseli's picture was engraved with aquatint by Tomkins in 1788.

This present work, executed in a subdued, gentle range of colors dominated by gray, enlivened by delicate touches of yellow and blue, demonstrates remarkable technical virtuosity. A. Wintermute has rightly emphasized Cades's dependence on models by Correggio, in line with the taste prevalent in Roman circles in the 1780s. With her rounded, sensual figure, fair coloring, and delicate features, the seated woman on the right, immersed in gazing at the sleeping young man, is one of the most attractive figures encountered in Cades's painting. [MTC]

## 326
## Giuseppe Cades
### *Marriage of Alexander and Roxana*

1793
Signed and dated at lower left: *Cades 1793*
Pen and black ink, gray wash
11½″ × 17½″ (290 × 450 mm)
PROVENANCE acquired in 1915 from Giuseppina Zerboni
EXHIBITIONS Kansas City, Sarasota, and Pittsburgh 1993, cat. no. 85; Rome 1995, cat. no. 85
BIBLIOGRAPHY Caracciolo 1973, p. 4, fig. 14; Clark 1973, p. 76; Caracciolo 1992, pp. 145, 363
Ministero per i Beni e le Attività Culturali, Istituto Nazionale per la Grafica, Rome

In 1973 Anthony Morris Clark suggested that this drawing and the one entitled *The Illness of Alexander* (Lisbon, National Museum of Ancient Art) were preparatory drawings for two paintings by Cades using the encaustic technique and commissioned by Czarina Catherine II of Russia. The hypothesis that Cades had received such a commission, which had first

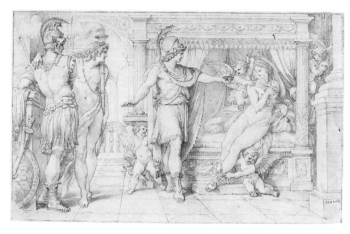

326

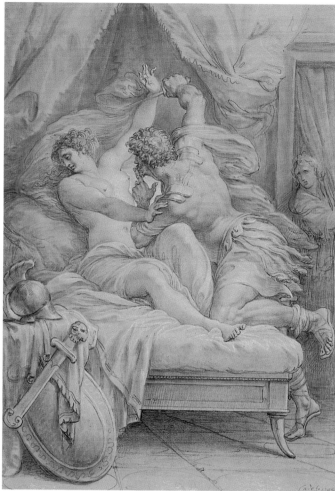

327

been put forward by Friedrich Noack in his article on Cades in Thieme-Becker, turned out to be correct; but neither this composition nor the *Illness of Alexander* are among those he painted using the encaustic technique and sent to Russia: those paintings have in fact recently been rediscovered among the anonymous works from the German and Austrian school in the Hermitage in St. Petersburg and have been presented (but not reproduced) in a Russian publication by I. V. Linnik, curator of the museum (proceedings of the colloquium on Giacomo Quarenghi, St. Petersburg, Hermitage, 1994, in Russian). They are entitled *Alexander Refusing to Drink While His Soldiers Are Suffering from Thirst* and *Alexander in Apelles's Studio*. The paintings have recently been reproduced and studied in the context of Roman painting executed in wax according to the antique method in Rome in the years 1780–90 (Caracciolo 1996, pp. 155–72). They were painted by Cades for the Czarevich Alexander Pavlovich, the czarina's favorite grandson who later became Czar Alexander I, and were initially intended for the imperial residence of Tsarskoe Selo.

It is nonetheless highly probable that the drawing exhibited here, as well as the *Illness of Alexander* in Lisbon, was drawn by Cades in response to a commission from the Empress of Russia. They have real similarities with the Russian pictures in the horizontal format, layout, and style. The *Marriage of Alexander and Roxana* is dated 1793; on August 9, 1794, Czarevich Alexander married Elisabeth Alexeievna, and it is possible the drawing may have been conceived with a view to a painting commemorating this event. The main intermediary between the Russian court and artists in Rome, Councilor Johann Friedrich Reiffenstein (who had become a zealous advocate of wax painting according to the antique

method), died in that city on October 6, 1793. It is possible that his death put an end to commissions to Cades from the Russian court.

In this composition Cades drew inspiration from the Renaissance decoration of the Villa Farnesina in Rome—in particular, Sodoma's fresco in the bedroom of Agostino Chigi "the Magnificent": *The Marriage of Alexander to Roxana*. But the subject was treated for the first time by Raphael, for a fresco for the "Villa Raphael" (later the Casino Olgiati, Doria, and Borghese). This latter fresco was detached in the nineteenth century and is now in the Galleria Borghese, where it is attributed to Siciolante da Sermoneta. It was known in the eighteenth century through drawings which were further disseminated through engraving. One of these, known in French circles, was a red chalk drawing forming part of the Crozat and Mariette collections which was engraved by Cochin (and is now held at the Albertina in Vienna); Cades probably knew the engraved version made by Giovanni Volpato in 1772, which was reproduced as plate 10 in the work *Schola italica picturae* (Rome, 1773).

In 1768, while in Rome, Julien de Parme painted a picture of the same subject which was intended for the court of Parma. That painting closely depended on both the original design by Raphael (which Julien de Parme must have known through Cochin's engraving) and Sodoma's fresco. Cades's composition has surprising similarities with de Parme's painting—similarities that may not be due solely to the common source from which both artists derived their inspiration. Cades and Julien de Parme were close to Fuseli's mysterious "poetical circle" in Rome, and both were friendly with Johan Tobias Sergel. Cades may have remembered Julien's painting when he produced his own composition; but the work of the Roman artist is more richly inventive

and more elegant in its line, as well as showing an ease in appropriating the lessons of the Old Masters that is missing in the work by the French artist.

This drawing is the most finished and detailed version of the composition, which the artist returned to in at least two other drawings (Ecole Nationale Supérieure des Beaux-Arts, Paris, and the art market [New York 1984, Sotheby's sale, January 18, 1984, lot 125]); a pen tracing is also known (Museu Nacional de Arte Antiga). [MTC]

## 327
## Giuseppe Cades
### *Tarquin and Lucretia*

1795
Signed and dated lower right: *Cades 1795*
Black chalk heightened with white on paper prepared with a brown ink wash
16⅛" × 12¼" (411 × 311 mm)

PROVENANCE collection of Bertel Thorvaldsen; bequeathed to the city of Copenhagen with the entire collection with a view to the creation of the Thorvaldsens Museum (1848)

EXHIBITION Rome 1989, *Bertel Thorvaldsen*, cat. no. 113

BIBLIOGRAPHY Müller, L. *Description des tableaux et dessins du Musée Thorvaldsen.* 1847–50, vol. 2, p. 102; Caracciolo 1978, pp. 77, 82; Caracciolo 1992, pp. 147, 366 Thorvaldsens Museum, Copenhagen

Cades painted the story of Lucretia several times; its emotional power and theatricality were very much in tune with the eighteenth-century spirit. In 1779 his painting *Lucretia, a Roman Lady, Dying in the Arms of Her Father and Her Husband While Brutus, Holding the Dagger with which She Has Struck Herself, Swears to Avenge Her Death* (whereabouts unknown) was exhibited at the Société des Beaux-Arts in Montpellier. No doubt Cades was familiar at the time with the famous engraving by Domenico Cunego, after a painting by Gavin Hamilton of the same subject; the innovative role of that painting in the iconography of Brutus has now been proved (see Philippe Bordes, *La Mort de Brutus de Pierre-Narcisse Guérin* [Vizille, France: Musée de la Révolution Française, 1996], p. 15). However, it is likely that the young Cades, with his close associations with Fuseli's circle, also looked at the treatment of the same theme made in Rome by James

Jefferys (now in the Royal Academy, London) and was touched by the powerful, new approach of this English artist—and of other members of the "poetical circle"—to Michelangelo and the great Mannerist artists. Some drawings by Cades, including *Achilles Withdrawing to His Tent* (cat. 324), are indicative of the artist's own similar interests during the 1770s.

When he tackled the theme of Lucretia violated by Tarquin (Sextus Tarquinius, the son of King Tarquin—Tarquinius Superbus), Cades must have been aware of the important ways in which the iconography of the subject had been updated, in Rome specifically by the artists in David's circle. David's *Brutus* (exhibited at the 1789 Salon but already under consideration while David was living in Rome in 1785) broke new ground by focusing on the subject's patriotic and moral connotations and on its virtuous republican hero, the nephew of King Tarquin, who avenged Lucretia by leading a revolt against him. Brutus now became the primary figure in other representations of the subject, including drawings by Desmarais, Wicar, and Réattu. Cades seems deliberately to disregard these contemporary works, leaving Lucretia as the main protagonist: the beautiful naked woman, attacked and violated, occupies the center of the scene, attracting both the viewer's attention and his compassion. Cades's model this time is Titian: he drew inspiration from the painting now held at the Fitzwilliam Museum in Cambridge, which he could have known only through an engraving, as is confirmed by the fact that in Cades's painting the composition is reversed. As in Titian's painting, the background is enlivened by the soft folds of a curtain; Tarquin is resting his knee on the young woman's bed and threatening her with his dagger; she is raising her left arm and stretching out her right arm, while in the background someone is pushing aside a curtain concealing a door and looking on in horror.

There is another known version of this composition by Cades, a pen, ink, and wash drawing currently held at the Art Institute of Chicago. Both drawings have the same finished, carefully executed character, which suggests they were intended for sale. They may have belonged to the category of drawings done "in the manner of a master" (in this case Titian), a genre in which Cades had specialized and which seems to have brought him clients and success. [MTC]

## 328
## Giuseppe Cades
### *Virgin and Child*

Black chalk with areas of stumping, lightly heightened with red chalk
15⅛″ × 9½″ (390 × 240 mm)
PROVENANCE Pithiviers (Paris) sale June 9, 1991, no number; Galerie Moatti, Paris, 1991; purchased by the Philadelphia Museum of Art, 1992
BIBLIOGRAPHY Caracciolo 1992, p. 401, no. 180c
The Metropolitan Museum of Art, New York, Harry G. Sperling Fund

The drawing is one of the versions of a composition Cades treated both individually (also in a drawing that belonged to Bertel Thorvaldsen, now in the Thorvaldsen Museum, Copenhagen) and in the context of a *Flight into Egypt* (present whereabouts unknown, Finarte sale, Milan, March 19, 1991, no. 247). Anthony Morris Clark brought the Copenhagen version to light in 1964, emphasizing the elegance of its style and Cades's individual manner of using the lessons of Raphael and the early Renaissance masters in a "purist" spirit which foreshadowed that of the nineteenth century. The Metropolitan Museum version is a little larger than the Copenhagen drawing; the landscape in the background and the tree trunk depicted on the right make it a more finished work, possibly later than the other. The two drawings could have been preparatory works for a *Flight into Egypt* at present known only through a drawing; but their finished character and careful execution suggest they could also have been intended for sale as private devotional works. [MTC]

## GIOVAN DOMENICO CAMPIGLIA

LUCCA 1692–1775 ROME

The young Giovan Domenico Campiglia worked his first apprenticeship under an uncle who practiced the art of intarsia, inlaying "flowers, animals, and grotesque caprices of various colors" (Marrini 1765–66, vol. 1, p. 45) in wood for Prince Ferdinando de' Medici. From his youth he also practiced drawing, and, in the Florentine tradition, began by copying Renaissance masterpieces in the grand-ducal galleries in Florence under the guidance of Tommaso Redi. According to the Abbot Orazio Marrini, his first biographer, Redi instructed him in the study of anatomy, while from Lorenzo del Moro he learned perspective and the rules of architecture. After further study in Bologna with Giovan Gioseffo dal Sole and a brief stay in Lucca (where he probably did some portraiture),

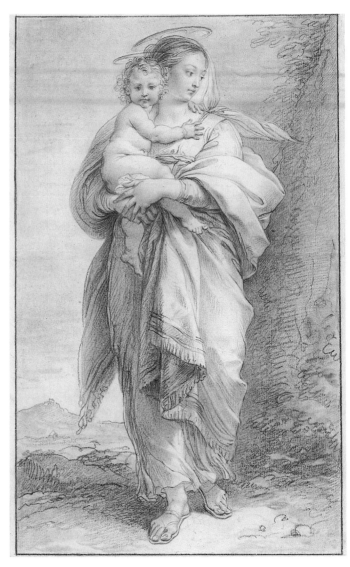

328

Campiglia moved to Rome, where he is known to have been living in 1716 and where he tried his hand at drawing the major collections of ancient art. In the same year the Accademia di S. Luca commissioned from him friezes and drawings for the booklet celebrating the Concorso Clementino competition in which he had carried off first prize in the first painting class (Cipriani and Valeriani 1988–91, vol. 2, p. 161). He was already famous by 1719, when Monsignor Ludovico Sergardi, a canon of St. Peter's, entrusted him with the task of copying the altarpieces by Cigoli, Roncalli, and Domenichino in the basilica, which were deteriorating because of damp. He did the copies between 1719 and 1726.

Although Marrini records that Campiglia worked for churches and courts in Italy and throughout Europe, few of his paintings have survived, except for the altarpiece in S. Giovannino degli Scolopi in Florence (*Saint Nicholas*, commissioned in 1734 by the Marchese Giovan

Domenico Arnaldi), a series of self-portraits in the Uffizi, in the gallery of the Accademia di S. Luca, and in private collections (Quieto 1983), and *The Muse Polyhymnia* (Cortona, Accademia Etrusca). This last was the *divertissement* of a cultured artist; it was presented as an ancient work to the Accademia Etrusca in Cortona by the scholar Marcello Venuti in 1774. A gifted portraitist of cardinals and popes, Campiglia owes his fame mainly to his vast activity as a designer of reproductive prints, which he produced indefatigably throughout his life. He was particularly distinguished for his ability to copy ancient sculptures, establishing himself in Florence and Rome as one of the protagonists of the cultural revival which opened the way to a rediscovery of the antique. These drawings, nearly all executed in black chalk, are notable for their faithfulness to the original, their clarity of line, and their soft rendering of the modeling—all of which characteristics are also found in Pompeo

Batoni's finest drawings, whose pre-Neoclassical purity and concentration Campiglia shared. One of his main clients was the Englishman Richard Topham, who had put together a collection of graphic art documenting the most important sculptures of antiquity; Campiglia did hundreds of drawings for Topham, distinguishing himself among the many others—Sempronio Subissati, Domenico Frezza, Stefano Pozzi, and Giovanni Bigatti—who first found employment in this increasingly popular genre (Connor 1998, pp. 52–54).

After having done the engravings of the *Primatus Hispaniarum vindicatus* in 1729 and while completing those to illustrate Alessandro Specchi's *Nuovo teatro delle fabbriche et edifici fatte fare da Papa Clement XII* (1739), Campiglia devoted himself from 1734 to the largest undertaking of his career: the drawings for the printed plates of the *Museo Capitolino*, the richest collection of Roman antiquity, which was instituted that year by Pope Clement XII. This was actually a real critical catalogue (published by the Calcografia Camerale) edited and commentated by Monsignor Giovanni Gaetano Bottari, the well-known scholar and theoretician, librarian, and adviser to the house of Corsini, who particularly appreciated the artist (Quieto 1984), and of whom Campiglia did a portrait (now in the Biblioteca Corsini). In 1741 there appeared the first volume of this work, comprising busts of philosophers, poets, and orators kept in the museum; in 1750 the second, with those of emperors and empresses; in 1755 the third, with the statues. Finally, in 1782, the fourth volume appeared with the bas-reliefs and a commentary by Nicola Foggini, but by this time both Bottari and Campiglia were dead. All Campiglia's drawings for this enterprise are kept in the Fondo Corsini of Rome's Istituto Nazionale per la Grafica, gathered in four volumes. From these were taken the engravings made by Campiglia himself and by other famous engravers of the time, such as Nicola Billy, Gennaro Gutierrez, Silvestro Pomared, and the best-known, Antonio Pazzi and Carlo Gregori, who both succeeded in capturing the clarity of the originals with extreme fidelity. Campiglia's experience in the field of graphic art had previously procured him, from Cardinal Neri Corsini, first, the prized job in charge of assessing the plates for the Calcografia de' Rossi, and then, in 1738, that of superintendent of the Calcografia Camerale. There, besides doing portraits of newly nominated popes and cardinals, he performed an important teaching role in the training of young engravers. He was eventually succeeded in 1770 by the sculptor Gaspare Sibilia.

At the same time Campiglia was appointed by the Grand Duke of Tuscany to collaborate on the illustration of *Il museo fiorentino*, which reproduced the most noteworthy archaeological, natural, and artistic treasures housed in the Medici collections, edited and with a commentary by the scholar Anton Francesco Gori. For the first part of this work, in four volumes, he did the drawings, now housed in the Uffizi's Gabinetto dei Disegni, for the engravings. The first and second volumes, both dealing with gems, came out in 1731 and 1732; the third, covering statuary, in 1734; and the fourth and fifth, devoted to coins, in 1740 and 1742. The second part of the *Museo fiorentino*, which reproduces the Uffizi's collection of painters' self-portraits, came out in six volumes between 1752 and 1766 and included numerous plates engraved by Campiglia.

Admitted to the Accademia di S. Luca in 1740, when Sebastiano Conca was its Principe, Campiglia donated his canvas *The Genius of Painting* as his reception piece; it is still in the Academy's collection. In April 1757 he was appointed professor at the Scuola del Nudo in Campidoglio (a post that he again held in November 1760).

Campiglia's first marriage, to Paola Dal Pozzo, produced one daughter, Silvia, who entered a convent under the name of Chiara Placidia. His second wife, Francesca Ciccardi, bore him another three daughters, Lucinda, Maria Angela Silvia (whose godmother was the Florentine noblewoman Anna Maria Michelozzi Rucellai), and Cecilia. He died in Rome on September 4, 1775, in his house on the via di Santo Stefano del Cacco, near the Palazzo Altieri. [SPVR]

BIBLIOGRAPHY Prosperi Valenti 1974; Hiesinger and Percy 1980, p. 64; Quieto 1983; Quieto 1984; Coccia 1990, "Campiglia"; Sestieri 1994, vol. 1, p. 42

## 329
## Giovan Domenico Campiglia
### *Copy of the Statue of "The Faun" in Rosso Antico*

c. 1755

Black chalk on white paper
16⅞″ × 11″ (430 × 280 mm)

PROVENANCE Corsini Collection; property of the Accademia Nazionale dei Lincei since 1883

BIBLIOGRAPHY Prosperi Valenti 1974; Quieto 1983; Quieto 1984; Coccia 1990, "Campiglia"; Sestieri 1994, vol. 1, p. 42

Ministero per i Beni e le Attività Culturali, Istituto Nazionale per la Grafica, Rome

This drawing is taken from a volume of ninety drawings, all by Campiglia,

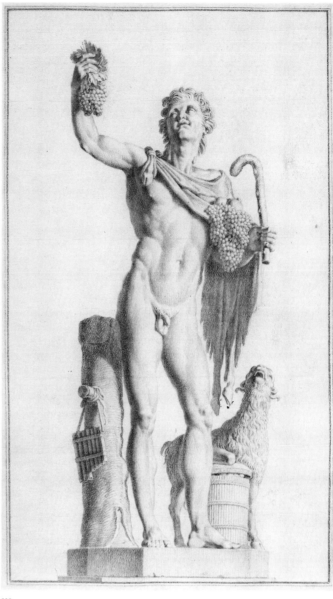

329

devoted to the statues kept in the Museo Capitolino di Scultura Antica. The drawings served as the basis of a collection of engravings forming the third volume in a series of four documenting the treasures contained in this important collection, which had been amassed by the Corsini family. In his introduction to this third volume of engravings, which included the principal full-figure sculptures in the collection, the family's librarian and curator of the work, Monsignor Giovanni Gaetano Bottari, wrote that the engravings "besides being drawn from extremely excellent originals, are designed and cut marvelously and to absolute perfection," thus emphasizing both the draftsman's expertise and his close adherence to the model. The original drawings are pasted on to single sheets, and bound in the order maintained in the engraved version. Remaining in the library of Cardinal

Neri Maria Corsini, they became the property of the Accademia Nazionale dei Lincei when the Italian state acquired the palace in 1883 and was granted the picture collection and the library by the Corsini family.

In this drawing Campiglia has copied with extreme fidelity and fine workmanship the statue of a faun carved in *rosso antico*, a particularly rare and valuable marble found in Greece (for information about this marble and its use in sculptures on Dionysian subjects see Gabriele Borghini, ed., *Marmi antichi* [Rome: De Luca, 1989], p. 288). The statue was discovered at Hadrian's Villa in 1737 and bought directly by Alessandro Gregorio Capponi, president of the recently founded Museo Capitolino, who was compelled by Pope Benedict XIV to donate it to the museum (Haskell and Penny 1981, cat. no. 42). In 1744 Capponi arranged to have the

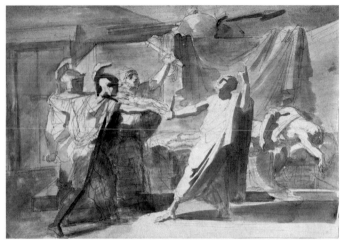

330

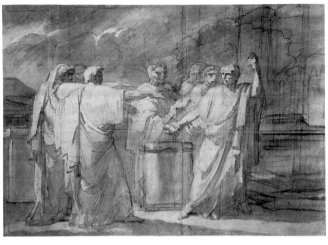

331

sculpture restored, at the expense of the pope, by Clemente Bianchi and Bartolomeo Cavaceppi, who used fragments of another faun found by Monsignor Furietti and donated by him (not entirely spontaneously) to the pope. The inscription that recorded the gift from the marchese was removed in 1746, shortly after he died (see Borsellino 1996, pp. 149–50).

In its total nudity the statue suggests the classical ideal of male beauty, but its fame depends mainly on the rarity of the red marble it is made of; few other examples of sculpture in *rosso antico* were known at that time (they included a *Young Bacchus* in the Pamphili collection, restored by Alessandro Algardi in the mid-seventeenth century). The faun, caught up in the Bacchic frenzy and holding up a bunch of grapes, seems to anticipate the coming taste for less heroic themes than those of classical art. In Campiglia's chalk drawing and the related engraved version (plate XXXIV) of *Il Museo Capitolino*, 1755, the vivid chromatic effect is attenuated: the artist seems almost to have made a deliberate choice to give a clear, abstract version of the statue of the faun, tending more toward the idealized interpretation characteristic of Neoclassicism, which Campiglia seems once again to anticipate as the key to understanding ancient art. To this end he even made use of a camera obscura; in the inventory of his belongings made after his death (Quieto 1980–81) are listed a camera obscura, a magic lantern, and a microscope (Quieto 1984, p. 35), indisputable signs of an almost scientific quest for objectivity. Besides numerous paintings, furnishings, precious ornaments, and jewels— testimony to his professional success—Campiglia's inventory also contains descriptions of various books of ancient history, collections of engravings (evidently material for study and documentation), and, above all, numerous drawings and prints

from antiquity which he himself had made, many of which he had organized into volumes. [SPVR]

## VINCENZO CAMUCCINI

ROME 1771–1844 ROME
*For biography see Paintings section*

### 330
### Vincenzo Camuccini
### *The Oath of Brutus*

1795–1800
Ink and wash on beige paper
16⅞″ × 24⅞″ (430 × 633 mm)
Vincenzo Camuccini, Cantalupo

### 331
### Vincenzo Camuccini
### *The Catilinarian Conspiracy*

Verso: pencil study of a kneeling figure making an offering
1795–1800
Ink and wash on beige cardboard
15¾″ × 22⅛″ (400 × 562 mm)
PROVENANCE artist, Rome; thence by descent
EXHIBITION Rome 1978, cat. nos. 58–59
BIBLIOGRAPHY Pfister 1928; Rudolph 1977; Piantoni de Angelis 1978
Vincenzo Camuccini, Cantalupo

Although drawing was the cornerstone of Vincenzo Camuccini's artistic practice, only two brief studies have assessed his graphic œuvre. Nonetheless, remarkable holdings of over three thousand uncatalogued sheets remain in the hands of the Camuccini family, supplemented by important caches in the Metropolitan Museum of Art, New York, the Albertina, Vienna, and the Gabinetto Nazionale delle Stampe, Rome. The pioneering study by Federico Pfister established three primary categories of Camuccini's drawings: tightly con-

trolled studies after Raphael and Michelangelo, dating largely from the beginning of his career; anatomical and life studies; and studies for painted compositions. The drawings in the latter category reveal Camuccini's painting process, beginning with rapid sketches of the initial conception, followed by more finished studies of the overall design, and then painstaking studies of individual figures.

These two drawings probably date to Camuccini's early maturity but exemplify a style of sketching he would use throughout his life. Beginning with dramatic, quick strokes of wash, Camuccini defines only the most basic forms with dramatic contrasts of color; traces of the artist's hand appear everywhere. He then applies brisk pencil lines over this vigorous composition, heightening the detail, often altering the initial idea, and occasionally working out several alternatives on the same sheet. This experimental drawing technique stands in sharp contrast to Camuccini's paintings, which rely on the primacy of line over color and present sleek, precise, and controlled surfaces that downplay their facture. Camuccini's drawing style marks a crucial conceptual divergence from that of Jacques-Louis David and his circle, a group with which Camuccini has often been connected. As Pfister observed, despite the affinities between the two artists, Camuccini's sketches indicate that his work ought to be seen as *procedurally* distinct from that of the French avant-garde (Pfister 1928, p. 25).

Such energetic sketching of the overall composition stands apart not only from the refined style of draftsmanship promulgated by the Accademia di S. Luca and Domenico Corvi, Camuccini's first teacher, but also the hard-edged precision of Camuccini's earliest drawings. Works such as *Brutus* and *Catilina* instead reveal a rapport with the most vanguard ideas circulating in late eighteenth-century Rome. Artists as diverse as Asmus Jakob Carstens, Pierre-Henri de Valenciennes, and John Flaxman all gave the extemporaneous and essential precedence over the calculated and finished to convey their ideas more purely. But the working methods of the Accademia de' Pensieri contribute most directly to Camuccini's particular style. Gathering informally in Felice Giani's Roman studio, the artists selected a subject, often drawn from classical literature, and each drew quickly executed, spontaneous interpretations (Rudolph 1977, pp. 176–78). Even if the subjects of Camuccini's drawings cannot be linked explicitly to the Accademia de' Pensieri, the fact that Camuccini adopted its techniques for conceptualizing his initial ideas shows its profound impact on the young painter.

Both images depict oaths of the early Roman republic, themes that circulated widely at the end of the century. Gavin Hamilton launched the motif with *The Death of Lucretia* of 1767 and Jacques-Louis David presented it most famously in *The Oath of the Horatii* of 1784. Camuccini surely knew these images through engravings, if not from seeing the paintings in Rome as a youth. However, in contrast to these prototypes, which juxtapose the hard resolution of the oath takers to those who respond sentimentally, Camuccini's *Oath of Brutus* concentrates almost exclusively on the nobility of the pledge and relegates the slumped corpse of Lucretia (which recalls figures by Henry Fuseli) to the background merely as a tool to identify the subject.

Pfister and Piantoni de Angelis have identified the subject of the other drawing as the Catilinarian conspiracy of 63 BC, connecting the work to a more finished version of a similar subject in the Camuccini family collection. As recounted by Cicero, Sallust, and Plutarch, Lucius Sergius

Catilina plotted an overthrow of the senate, intending to seize power from Cicero, an event only averted by Cicero's four remarkable speeches, *In Catilinam*. If the identification of the drawing here is correct, Camuccini shows the moment in which Catiline and his co-conspirators vow their intent to overthrow the state. While the subject is unusual during this period, Camuccini's interest in anti-tyrannical subjects was growing at the end of the century, when stories of rebellion and overthrow pepper his œuvre.

Camuccini is not known to have worked either of these two compositions into finished products, but thematic and visual traces of the compositions remain visible in the group of assassins that foreground the artist's best-known work, *The Death of Caesar* (Capodimonte, Naples). The rapport with this painting, executed from 1793 to 1806, dates the drawings to the last decade of the Settecento, an era in which the artist shifted from his early sentimentalizing work to the vigorous and morally charged subjects that mark his maturity. [JLS]

## ASMUS JAKOB CARSTENS
### ST. JÜRGEN 1754–1798 ROME

When the fifteen-year-old Carstens declined a promising apprenticeship with the noted German painter Johann Heinrich Tischbein rather than assume the required valet duties commensurate with the position, he established the fiercely individualistic and anti-academic stance that marked his career. Born in the rural, then Danish province of Schleswig-Holstein, Carstens began his untraditional career as a cooper in the village of Eckernförde. In this unlikely location, this nonconformist first encountered the vanguard theories that fueled his artistic production: Daniel Webb's *Inquiry into a Theory of Painting*, a text on ideal beauty and the revival of ancient artistic principles derived from the theories of Johann Joachim Winckelmann and Anton Raphael Mengs.

Carstens moved to Copenhagen to join the Danish academy at the relatively late age of twenty-two, and he studied painting briefly (and without success) with Copenhagen's leading painter, Nicolai Abraham Abildgaard. The young artist instantly rebelled against the academy method of first rendering individual body parts and then advancing to copying plaster casts. To Carstens, such education encouraged thoughtless reproduction rather than genius and ignored the integrity of the whole human form. Forging an independent path, he instead studied anatomy and engravings after High Renaissance masters and sat absorbing

the forms of the academy collection of casts, for later recreation from memory at home. Anxious to study in Rome, Carstens left Copenhagen in 1783. Although forced for lack of funds to turn back before achieving his goal, Carstens did get as far as Mantua, where he saw Giulio Romano's frescoes at the Palazzo del Te.

From 1784 to 1788 Carstens taught at Lübeck while working as a portraitist. This period saw the crucial development of his style, characterized by works such as *Morning* (1788, Statens Museum for Kunst, Copenhagen), which feature heavy, muscular forms derived from his study of Michelangelo and Romano as well as a penchant for the most learned subject matter—history and allegory. In 1788 he moved to Berlin and soon assumed a post at the Akademie der Künste (where Carstens characteristically opposed academic policy), constantly simplifying his compositions. Chief among his works in Berlin were ambitious sets of sketches for engravings for two mythologies (*Kürzgefasste Mythologie, oder Lehre von den fabelhaften Göttern und Helden des Altertums*, by Karl Wilhelm Ramter, and *Götterlehre, oder Mythologische Dichtung der Alten*). He also executed two projects for murals, now destroyed, in the homes of Queen Fredericke Luise and Karl Friedrich von Heinitz, the minister of education and Carstens's primary supporter.

A grant from the Prussian government in 1792, engineered by Heinitz, sent Carstens to Rome. Once there, he steadfastly refused to send required progress reports back to Berlin. In a heated exchange of letters with his sponsor, Carstens famously announced: "I belong not to the Berlin Akademie but to mankind … renounce all benefits, preferring poverty, an uncertain future, and perhaps a hopelessly infirm old age … so that I may do my duty to art and fulfill my calling as an artist" (Carstens to Heinitz, February 20, 1795, reprinted in Barth and Oppel 1992, p. 89). With such dramatic words, the rebellious artist launched what Nikolaus Pevsner called the "first comprehensive criticism put forward by an artist against the academic system" (Pevsner 1973, pp. 195–97).

Allying himself with the Roman community of vanguard northern artists and philosophers, Carstens thenceforth worked independently. The insurgent artist now deepened his theoretical leanings, particularly through contact with the ideas of Immanuel Kant and Friedrich von Schiller, which had begun to circulate among the Germanic community in Rome thanks to Carstens's friend and mentor Karl Ludwig Fernow, who lectured publicly on these topics. According to Kant's theory of beauty, perception is rooted in the mind, rather than the senses;

beauty derives from the perceiving intellect rather than the qualities of the object itself. Kant argued that the intellectual generation of the work of art far outweighs the importance of technical skill. Schiller then adapted Kantian ideas to political ends, asserting that works of art best promote the contemplation of true beauty by leading the viewer to a state between intellect and sensation. For Schiller, art leads the viewer to resolve the disjuncture between spirit and form, the fundamental binary of human nature, and the contemplation of a beautiful work of art then leads humans to true political and emotional freedom.

The elevation of the artist's role into moral and intellectual leader as well as the de-emphasis of the art object *qua* object profoundly influenced Carstens. A revolutionary exhibition in Rome in 1795 put these theories into practice. Rather than exhibiting finished canvases, the artist radically presented deliberately unpolished drawings on the scale of paintings. The heavy contour lines and bold, abstracted shapes of such works as *Night with Her Children, Sleep and Death* (Kunstmuseum zu Weimar), and *The Battle of Gods and Giants* (Kunstmuseum, Basel) emphasize form at the expense of color. Furthermore, Carstens deliberately intended the crudity of his work to stand apart from the refined drawing style fostered by the Accademia di S. Luca and above all from the French school, whose work he saw as superficial and mechanical, with "all of the details often rather good, but a terrible main idea" (Carstens to Heinitz, quoted in *Carstens und Koch* 1989, p. 20).

From this point forward, Carstens devoted much of his attention to twenty-four preliminary drawings interpreting the story of Jason and the Argonauts, intended for a portfolio of prints. His close associate Joseph Anton Koch engraved the drawings in 1799, following the draftsman's early death, and the various editions of these prints played a crucial role in disseminating Carstens's ideas. Carstens's bold, reductive visual language, the hypermasculine subject-matter, and above all the conceptual framework (advocated strongly by Fernow) especially influenced subsequent developments, particularly in northern art. This artist's emphasis on innate genius and self-improvement precluded a traditional studio, but his legacy remained not only in his circle of immediate followers—including Bertel Thorvaldsen, Eberhard Wächter, and Koch—but also as a harbinger of the antiacademic movements of the nineteenth century. [JLS]

BIBLIOGRAPHY Müller, Wilhelm, 1869; Heine 1928; Kamphausen 1941; Einem 1958; Pevsner 1973; *Carstens und Koch* 1989; Neuwirth 1989; Barth and Oppel 1992

## 332
## Asmus Jakob Carstens
### *Heroes in the Tent of Achilles*

1794
Signed lower left: *Asmus Cartsens ex Chers. Cimbr. Faciebat Romae 1794*
Watercolor on brown paper
$17\frac{3}{4}'' \times 26''$ (452 × 661 mm)

PROVENANCE artist, Rome; Akademie der Künste, Berlin
EXHIBITIONS Berlin, Akademie der Künste, 1795; Berlin 1989
BIBLIOGRAPHY *Verzeichniß derjenigen Kunstwerke, welche … der König. Preuß. Akademie der Künste … ausgestelt sind Berlin*. Berlin, 1795; Fernow 1797; Müller 1797; Fernow 1806–8; Alten 1866; Schöne 1866; Müller, Wilhelm, 1867; Müller, Wilhelm, 1869; Heine 1928; Kamphausen 1941; Duncan 1981; *Carstens und Koch* 1989; Barth and Oppel 1992
Stiftung Archiv der Akademie der Künste, Berlin, Kunstsammlung

In 1795 Carstens exhibited this drawing in his celebrated one-man show in Rome. He subsequently sent the work to Berlin for exhibition, accompanied by the following description: "Ajax is upset with the uncompromising character of Achilles. The old man Phoenix weeps over the inevitable fate of the Greeks. Ulysses, sitting down, is terribly disappointed because his masterful rhetoric was useless. Even the Heralds are stunned, and Patroclus, deep in thought, looks at his aggrieved friend" (*Carstens und Koch* 1989, p. 95). The image thus interprets the second part of Book 9 of Homer's *Iliad*, which recounts the story of the embassy to Achilles. The hero has withdrawn from the Trojan War, objecting to Agamemnon's seizing of Briseis, a Trojan woman whom Achilles had taken as war booty. As the fortunes of the Greeks declined precipitously in Achilles's absence, Agamemnon sends Ajax, Ulysses, and Phoenix to appeal to Achilles, and they offer an impressive array of gifts, including the return of Briseis. But the overture fails—despite a tearful plea by Phoenix and a brilliant speech by Ulysses—and Achilles firmly announces his intention to leave Troy. Only the subsequent death of Patroclus at the hands of Hector sends a vengeful Achilles charging back into the war.

The reductive simplicity of this drawing characterizes the late production of Carstens. By the mid-1790s he had abandoned the teeming and contorted designs of his earlier work for a more primitive drawing style, increasingly favoring outline over three-dimensional form. While heavily influenced by the whole community of northern artists in Rome, Carstens's late work shows a particular affinity to the work of John Flaxman. Flaxman's drawings after the *Iliad* had been published by Tommaso Piroli the previous

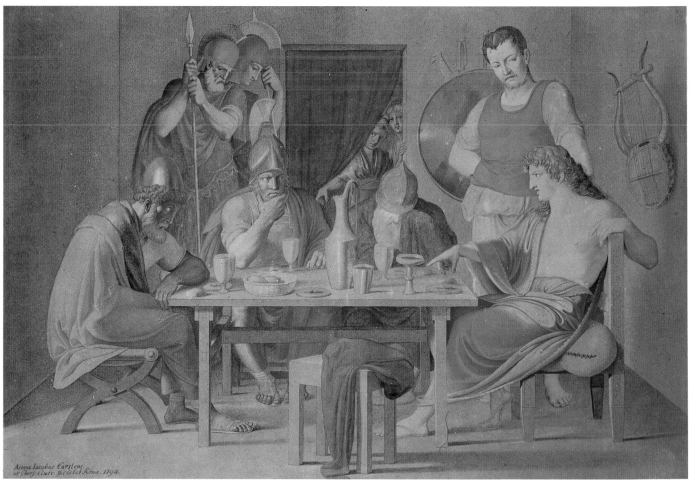

332

year (see cat. 345), including one of the
rare eighteenth-century interpreta-
tions of this subject, which surely
served as a crucial precedent for
Carstens's image. Carstens also
absorbed ancient prototypes exten-
sively in his own work, here adapting
the tightly contained frieze of figures
from the well-known cameo, published
on the titlepage of *Die Geschichte der
Kunst des Altertums*, by Johann Joachim
Winckelmann (*Carstens und Koch* 1989,
p. 34). The image nonetheless retains
traces of Carstens's High Renaissance
and *maniera* models, particularly in the
inflated and monumental bodies that
look back to Michelangelo and Giulio
Romano.

The drawing conveys the over-
whelming power of Achilles. The hero
speaks, actively rejecting the appeal,
and his open and confident pose com-
bines with his hypermasculinized,
bare torso to weigh against the
hunched poses and anxious expres-
sions of the other men at the table.
Moreover, the severe economy of the
composition underscores the tough-
ness of the subject matter. The work is
one of Carstens's most highly finished
productions, but even so, the artist
has colored the composition only
with thin, smooth planes of water-

color; the crude surface of the brown
cardboard mount shows through
everywhere; and the drawing does not
have a high degree of finish, leaving
the figures largely unmodeled, thickly
outlined, and flat.

In the same year Carstens executed
another large-scale drawing from the
*Iliad*—*Priam Appealing to Achilles*
(Kunstsammlungen zu Weimar)—
and he exhibited the works as pen-
dants. Both compositions center on
supplications to Achilles by older men
in a position of weakness. The artist's
writings, stressing his independence
from authority and the destructive
effects of the academy system on
artistic creativity, constantly address
the superiority of youthful genius over
experience and the importance of
overturning moribund power struc-
tures. Carol Duncan has isolated the
theme of "fallen fathers" as a phenom-
enon of late eighteenth-century French
art, which expresses the rejection of
traditional authority. However, the
selection of these two Homeric sub-
jects by Carstens indicates that the
theme of youth ascending over age
in fact occurs far more widely in
European art of this era. Finally, the
work's studied lack of finish deliber-
ately emphasizes the compositional

idea over technical mastery. In this way,
the drawing embodies Carstens's the-
oretical stance, derived from his study
of Kant. The unpolished work of art
stands as an index of the artist's con-
ception, signaling to the viewer that the
object should not be understood as an
end in itself or valued for its facture.
The work of art instead becomes an
instrument through which one con-
templates ideal beauty as filtered
through the genius of the artist.

The Kunstsammlungen zu Weimar
possesses two preliminary drawings,
including an elaborate graphite and
chalk sketch from which Carstens has
made few changes, notably turning
the stool closest to the viewer into a
more dynamic *repoussoir* element and
enlivening the drapery (Barth and
Oppel 1992, p. 157). [JLS]

## ANTONIO CAVALLUCCI

SERMONETA 1752–1795 ROME
*For biography see Paintings section*

### 333
Antonio Cavallucci
*Study for "Saint Maurus and
Saint Placidus Presenting
Themselves to Saint Benedict"*

c. 1789
Inscribed in ink at the bottom: *Antonio
Cavallucci dis*
Pencil, pen, gray and brown washes and
white lead on prepared paper
16¼″ × 11⅛″ (425 × 283 mm)
PROVENANCE acquired by Augusto Rossi,
1914
EXHIBITIONS Kansas City, Sarasota, and
Pittsburgh 1993, cat. no. 86; Rome 1995,
cat. no. 86
BIBLIOGRAPHY De Rossi 1796, p. 30;
Roettgen 1979, p. 3; Catelli Isola, Maria,
Simonetta Prosperi Valenti Rodinò, Elena
Beltrame Quattrocchi, and Giulia Fusconi,
eds. *I grandi disegni italiani del Gabinetto
Nazionale delle Stampe di Roma*. Milan:
Silvana Editoriale d'Arte, 1980, no. 73; Roli
and Sestieri 1981, p. 103, no. 176; Prosperi
Valenti Rodinò 1993, no. 86; Prosperi
Valenti Rodinò 1995, no. 86
Ministero per i Beni e le Attività Culturali,
Istituto Nazionale per la Grafica, Rome

In the eighteenth century the
Benedictine monastery of S. Nicolò
all'Arena in Catania was one of the

most important in Europe, second in size only to that of Mafra in Portugal. It was severely damaged by the 1693 earthquake and rebuilt from 1702; contemporary writers likened it to a royal palace with, apart from its church, hanging gardens and a coffee house (Siracusano 1986, pp. 123–25). The monks all came from the highest echelons of the aristocracy and this was reflected in their mode of life and cultural sophistication, so it was natural that when they decided to refurbish the church, around 1770, they would turn to "continental" artists, those who had trained in Rome. Great paintings by Nicolò Lapiccola, Stefano Tofanelli, Bernardino Nocchi and Mariano Rossi eventually arrived in Sicily, and with them two works by Cavallucci, one of Saint Maurus and Saint Placidus presenting themselves to Saint Benedict and the other of Saint Benedict liberating a slave. The first of these measured over 19 feet in height and about 13 feet wide; the second was slightly smaller.

This drawing relates to the first of Cavallucci's two paintings for Catania. Although no documents regarding the commission—which De Rossi dates as belonging to the last eight years of the artist's life (De Rossi 1796, p. 33)—have yet emerged, the date of its completion is known. The *Diario Ordinario di Roma* of September 19, 1789, no. 1536, records the painting going on public exhibition and also records that, in order to work on a picture of such large dimensions, the artist had to rent a room in the Casa dei Pii Operai near his parish church of the Madonna dei Monti where, once it was finished, such a throng of "amateurs and connoisseurs" gathered to admire it that Cavallucci had to pay for a doorkeeper out of his own pocket (Chracas, *Diario Ordinario di Roma*, September 19, 1789, no. 1536). The chronicler adds that there were also "various princesses, noblewomen and other ladies of different nationalities" who, finding themselves in Rome at the time, asked to see the painting and were given special permission to enter the "holy place" where it was on show.

The drawing depicts Placidus and Maurus, the two young men seeking admission to the monastic order, accompanied by their respective fathers, the Roman senators Eutizius and Tertullius, at the doors of the abbey of Montecassino, where they are being welcomed by Saint Benedict. The saint, dressed in black, is at the center of the composition which, in the final painting, is simplified by the omission of the figures between Saint Benedict and the man on the left (Eutizius) as well as by a reduction in the number of bystanders. Cavallucci would, however, retain the large space in the top half, defined by a corona of

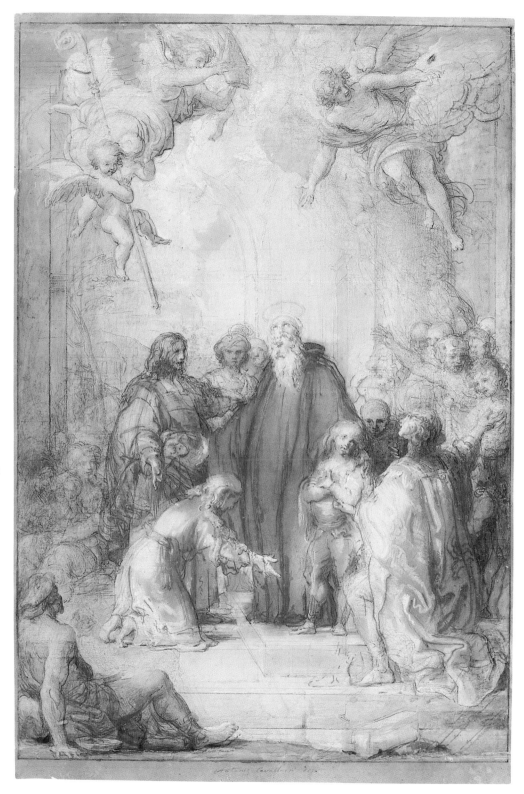

333

flying angels bearing the symbols of the holy abbot—a miter and crozier—and inviting contemplation of the event. The group of figures is more complex in the preparatory drawing than in the finished painting, and while architectural features (such as the columns on the right and the steps) are more sketchy although

clearly present, the rural landscape in the background on the left is more detailed. There are many similarities between this drawing and the preparatory drawings Cavallucci made for *The Investiture of Saint Bona*, which was probably commissioned at the same time or shortly afterwards. Both scenes are framed by a proscenium

arch, with figures forming the "wings" at the sides, and there is a lively interchange in progress between the principal actors and the "extras", splendidly attired in modern dress (the *Diario Ordinario* specifies that the clothes worn by the youths' fathers are those that would be worn by members of the Roman senate). In this very beautiful

drawing Cavallucci has employed a composite technique of extraordinary elaboration to suggest the wealth of brilliant color in the final work.

Cavallucci's graphic work is better known now than ever before thanks largely to the drawings published by Giancarlo Sestieri. These consist of a group of twelve now in the Kupferstichkabinett, Berlin, and others held in public and private collections (Sestieri 1997, pp. 30, 41, figs. 34–35; Sestieri 1998, pp. 478–89). Several of these have the same exquisite finish that makes them the equivalent of *modelli*. In each one, as in Cavallucci's paintings, the artist's study of sixteenth- and seventeenth-century classicism, of Raphael, Correggio, and Domenichino, has evidently influenced his interpretation of Neoclassical culture. This tendency was already apparent in his very first works, which—according to a story that appeared in the *Giornale delle Belle Arti* on June 12, 1784—attracted the admiration of Anton Raphael Mengs who, when examining the students' work entered for a competition at the Accademia di S. Luca, wrote in his own hand under Cavallucci's drawing that this was a student of whom great things could be expected. [LB]

## GIUSEPPE BARTOLOMEO CHIARI

ROME 1654–1727 ROME
*For biography see Paintings section*

### 334
Giuseppe Bartolomeo Chiari
*Study for "Bacchus and Ariadne"*

c. 1708
Black chalk on white paper
11¼″ × 15⅜″ (287 × 390 mm)
PROVENANCE acquired by William Cavendish, 2nd Duke of Devonshire, early eighteenth century
EXHIBITION London 1993, *Master Drawings*, cat. no. 49
BIBLIOGRAPHY Kerber 1968, p. 79, fig. 9; Jaffé 1994, vol. 2, pp. 54–55
Duke of Devonshire and the Chatsworth Settlement Trustees

The Devonshire drawing is a highly finished preparatory study for a painting of the same subject commissioned from Chiari by Cardinal Fabrizio Spada-Veralli in 1708. The painting based on the drawing is still in the Spada Collection in Rome. Probably acquired during the visit of the 2nd Duke of Devonshire to the Eternal City, the subject of the drawing was misidentified as Bacchus and Venus, an error repeated by Kerber (Kerber 1968, fig. 9) and corrected by Jaffé (1994, vol. 2, p. 54). Although unusual, the theme of Bacchus and Venus was painted in 1726 by Noël-Nicholas Coypel (the painting is now in the Musée d'Art et d'Histoire in Geneva) and was a Rococo celebration of the union of love and wine; thus, the mistake in identification in the eighteenth century becomes more understandable.

The figure of Bacchus in the drawing is strongly reminiscent of both Nicolas Poussin and Andrea Sacchi, and Chiari exaggerated the curve of the left leg, crooked the left elbow, and eliminated the thyrsus in the Spada painting. Similarly, the artist elongated the limbs of both the seated Ariadne and her attendants in the painting, dramatically increasing the sense of elegance and languor, which are surprisingly underplayed in the drawing. Ariadne, abandoned on the island of Naxos by the hero Theseus and discovered by her future consort Bacchus, is based on the so-called Vatican *Ariadne*, while the group of the nymph and satyr at right and the tambourine-playing maenad in the middle distance also recall antique sculptural prototypes, mediated by Annibale Carracci's Farnese ceiling. It is perhaps no accident that the spirit of both the drawing and the painting evokes Annibale's ceiling frescoes executed a century earlier. These famous paintings were (and are, when one is able to see them!) among the major tourist attractions of Rome, and the Palazzo Farnese is literally only a stone's throw from the Palazzo Spada. In general, the figures in the drawing have a fresher sense of vigor and brio, while their counterparts in the finished picture conform to a more graceful and sophisticated conception also seen in the other three mythological paintings Chiari executed for Cardinal Spada. [CMSJ]

## CHARLES-LOUIS CLÉRISSEAU

PARIS 1721–1820 AUTEUIL

Charles-Louis Clérisseau, architect, archaeologist, and artist, is an important figure in the genesis and diffusion of the Neoclassical style in architecture and decoration, particularly through his friendship with such key figures as Giovanni Battista Piranesi and Johann Joachim Winckelmann and his tutelage of such pupils as Robert Adam and James Adam, William Chambers, and Friedrich Wilhelm von Erdsmandorff. He also played a role in the invention of the Pompeian decorative style sometimes known as the Louis XVI, Adam, Arabesque, or Cameronian style and its spread from Italy to France, England, Germany, and Russia, although the precise nature of that role is still not completely clear. More than his actual architectural works, it is his thousands of drawings of ancient decorative details, real and imaginary ruins, and ancient-style buildings that became an important part of the Neoclassical style.

Clérisseau first trained as an architect in Paris under Germain Boffrand. After winning the Grand Prix in 1746 he spent the years 1749–54 at the French Academy in Rome. Leaving the academy after the first of many unpleasant scenes that occurred throughout his life, Clérisseau briefly became the teacher of William Chambers and in 1755 he began a long and complex association with Robert Adam, first as teacher or *cicerone* and later as employee in the study of ancient architectural and decorative forms and their adaptation to a new architectural style. Together they visited Diocletian's Palace in Spalato (now Split, Croatia); Adam's book on the palace, with unacknowledged plates by Clérisseau, appeared in 1764. Few of Clérisseau's projects of his Italian years, 1749–67, were executed. The ancient ruin garden for Abate Fracetti at Sala (1767) exists only in a description. Other projects, such as the decoration for the café at the Villa Albani in Rome (1764), which may be one of the first uses of *grotteschi* in the new style, have not survived. The one exception is the painted monastic cell resembling an ancient room, created for Père LeSueur in S. Trinità dei Monti, Rome (c. 1766), a tour de force even today, without its original furniture.

Clérisseau's château for Louis Borély of Marseille (1767) was not executed as planned but reveals the sensitive use of ancient motifs. On his return to France, Clérisseau began a study of the monuments of Roman France, producing in 1778 a volume on the monuments of Nîmes. On returning to Paris, he was admitted to the Academy of Painting and Sculpture in 1769 as a painter of architecture. During the early 1770s, the Adam brothers finally allowed him to come to England to help on their projects (previously they had paid him to stay away). He worked independently in England, but his design for the Lansdowne House library was rejected. He returned to Paris and designed for Catherine the Great of Russia an enormous Roman villa, which she rejected (drawings survive in the Hermitage). The great contretemps that this caused was resolved by Catherine by purchasing more than a thousand drawings, which influenced later Russian architecture. A triumphal arch for the same patron in 1782 was also rejected, but a model and complete drawings survive. Clérisseau decorated two salons in houses for Laurent Grimod de la Reynière in Paris (1775–77, 1780–82), but these were not the first use of *grotteschi* decoration in the Louis XVI style, as has been suggested. Clérisseau's one complete building, the Palais du Gouverneur (now the Palais de Justice), Metz, France (1776–89), is an enormous but somewhat dull structure relieved by classical trophies flanking the entrance. Clérisseau's exact role in the design of Thomas Jefferson's Virginia Capitol, Richmond, Virginia (1785–90), is not clear, aside from his greater architectural and antiquarian expertise and closer knowledge of its prototype, the Maison Carrée. His salon for the Palace at Weimar of 1792 was not executed.

Although Clérisseau's later years were not artistically active, they were filled with honor. In 1804 he published a second edition of his Nîmes book, with text by his son-in-law J. G. Legrand. In 1810 he was made a member of the academy of Rouen and in 1815 a member of the Légion d'honneur. Clérisseau's greatest role was that

334

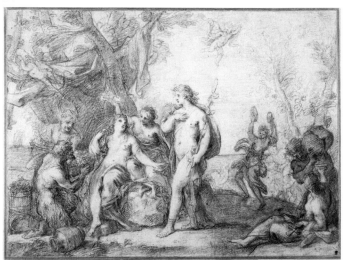

335

of a teacher and an artist-archaeologist who helped diffuse Neoclassicism throughout Europe and the United States. The largest collection of his drawings, including unexecuted designs made for Catherine the Great, is in the Hermitage, St. Petersburg. Additional smaller collections of drawings are in the Fitzwilliam Museum, Cambridge, England; the Soane Museum, London; and the British Museum, London. Panels removed from Ashburnham Place, Sussex, are from the decoration of the second Hôtel Grimod de la Reynière and are in the Victoria and Albert Museum, London. [TJMcC]

BIBLIOGRAPHY McCormick and Fleming 1962; McCormick 1963; McCormick 1964; McCormick 1978; McCormick 1990; McCormick 1994

## 335
## Charles-Louis Clérisseau
### *Portico of the Pantheon, Rome*

c. 1766

Watercolor and gouache on paper
11¼″ × 17½″ (298 × 444 mm)

PROVENANCE Revd J. W. Whittaker

EXHIBITIONS London 1972, cat. no. 1053; London 1974, *Artists*, cat. no. 107; Washington, D.C., National Gallery of Art. *The Eye of Thomas Jefferson*. 1976, cat. no. 137; Cambridge 1977, no number; London 1978, cat. no. 273; London and Rome 1996, cat. no. 231; Lyon 1998, cat. no. 114

BIBLIOGRAPHY McCormick 1963

The Syndics of the Fitzwilliam Museum, Cambridge, England

Although Clérisseau was trained as an architect, he built very little, and made his livelihood primarily from instructing young British gentlemen on the wonders of ancient architecture and art and their possibilities for a new architecture and from guiding them on visits to sites. He produced thousands of detailed drawings of ancient buildings and details, such as this one of the side of the portico of

the Pantheon, one of the best-preserved Roman temples. Throughout his long career he repeated many of his compositions sometimes with slight variations, so it is impossible to date many of his drawings. This view of the Pantheon may have been done during his seventeen-year residence in Italy from 1749 until 1767 or much later. Many—such as this one—are exact views of existing monuments (*vedute esatte*), while others have original variations (*vedute ideate*), or are completely fantastic (*vedute fantastiche*). Clérisseau's production of such views was influenced by his teacher of perspective at the French Academy in Rome, Giovanni Paolo Panini, and by his close friend Giovanni Battista Piranesi. However, Clérisseau's works are less dramatic than Piranesi's drawings and etchings. Panini's views were usually

executed in oil, whereas Clérisseau usually limited himself to brown-gray body color or brighter opaque gouache. Clérisseau's drawings, such as this one, were bought by tourists as souvenirs of their visit as well as source material for architectural projects. There are still great numbers of them in private collections, particularly in England. After Clérisseau's death his collection was sold in December 1820. Professor Michael Jaffé has suggested that the Fitzwilliam drawings in the Whittaker gift may have been in that sale, but this seems unlikely, as the gift was proposed earlier. [TJMcC]

## 336
## Charles-Louis Clérisseau
### *Ruin Room in the Convent of S. Trinità dei Monti, Rome*

c. 1766

Inscribed on verso: *Chambre exécutée pour LeSueur par Clérisseau aux Minimes dans l'infirmerie de la Trinité à Rome*
Gouache, pen and ink over black chalk
14⅜″ × 21″ (365 × 533 mm)

PROVENANCE Rev J. W. Whittaker

EXHIBITION Cambridge 1977, no number

BIBLIOGRAPHY McCormick and Fleming 1962; McCormick 1963, pp. 125–26; Thornton 1984, p. 90; McCormick 1990, pp. 103–12; McCormick 1994

The Syndics of the Fitzwilliam Museum, Cambridge, England

While most of Clérisseau's architectural commissions either were not

executed or no longer exist, his astonishing design for a monastic cell in the monastery of the Minimi painted in imitation of an ancient Roman ruin still survives in what is now the convent of S. Trinità dei Monti in Rome. It was commissioned by the noted mathematician Père Thomas LeSueur and later lived in by his associate Père François Jacquier. This commission was due to Clérisseau's friendship with Winckelmann. The German scholar refers to the mathematicians in letters of 1760 and 1763, but his earliest mention of the room is in a letter of 1767 to Clérisseau. When this letter was published in 1781 the editor noted that "the room, which is one of the curiosities of Rome, represents the interior of an antique temple in which one imagines that a hermit lived" (Johann Joachim Winckelmann, *Lettres familières de M. Winckelmann: avec les œuvres de M. le Chevalier Mengs* [Yverdon, 1784], vol. 2, p. 234). The room is described in detail in the biography of Piranesi compiled by Clérisseau's son-in-law J. G. Legrand.

Clérisseau had just transformed into a picturesque ruin the cell of Père Le Sueur, his friend the celebrated mathematician … On entering you think you are seeing the cella of a temple adorned with ancient fragments that have escaped the ravages of time; the vault and several parts of the wall have fallen apart and are held up by a rotting scaffolding which seems to allow the sun to shine through. These effects

336

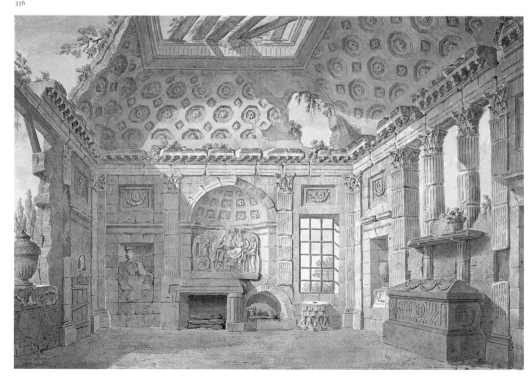

are rendered with skill and truth and create a perfect illusion. This effect is enhanced by the furniture, which is in character. The bed is a richly decorated vessel, the fireplace a mixture of diverse fragments, the desk a damaged antique sarcophagus, the table and the chairs a piece of cornice and inverted capital. Even the dog, faithful guardian of this new style of furniture, is shown lodged in the debris of an arched niche … Piranesi admired the room and intended to make an engraving of it. (Erouart and Mosser 1978, pp. 213–52)

The vast collection of Clérisseau drawings in the Hermitage, St. Petersburg, includes two drawings of the entrance (east wall), no. 2597, and the window wall, no. 3607. The drawing in the Fitzwilliam shown here is a replica of this second drawing. The room itself, which still exists, was executed in brown, gray, and green with highlights of red and orange. The side walls shown in the drawings were reversed in execution, and there are other minor differences. The idea of a ruin room has a long history, going back at least to Giulio Romano's Palazzo del Te of 1531 in Mantua, where one of the interior rooms was painted to look as if it were falling down. And after Clérisseau's example Robert Adam made drawings for a ruin building at Kedleston Hall, Derbyshire, which was not executed. [TJMC]

## SEBASTIANO CONCA
### GAETA 1680–1764 NAPLES

One of the most successful Roman painters of the generation following the death of Carlo Maratti in 1713, Conca was born on January 8, 1680, in the port town of Gaeta in the Kingdom of Naples. There is little evidence to support the traditional claim that he was originally a student of the peripatetic Luca Giordano, and his early style manifests the decided influence of his teacher Francesco Solimena, the most important Neapolitan artist of the early Settecento. Conca's earliest documented activity is work as Solimena's assistant, painting three decorative canvases (1703; destroyed) for the great Benedictine abbey of Montecassino, not far from his native Gaeta, and he moved c. 1707 from Naples to Rome, where he remained until 1752. The last twelve years of his life were spent in Naples, where he executed a series of highly dramatic, theatrical frescoes for the church of S. Chiara, most of which were destroyed in the Allied bombing of 1943. It is likely that he moved back to Naples because of the decreasing

demand in Rome for his suave, effusive, Rococo style in competition with the new, highly classicizing idiom represented by Agostino Masucci and Pompeo Batoni, among others.

One of Conca's first important patrons in Rome was Cardinal Pietro Ottoboni, for whom he painted intimate cabinet pictures of both mythological and religious themes. Probably through Ottoboni, Conca came to the attention of several other important cardinals and Pope Clement XI Albani, who employed him in the new decorations for the restored Paleochristian basilica of S. Clemente. The most significant painting the artist executed for the venerable church was *The Miracle of Saint Clement*, a fresco on the upper wall of the nave arcade. Conca also painted three oil on canvas altarpieces for S. Clemente (c. 1714–15), two of which represent scenes from the life of Saint Dominic commissioned by Cardinal Tommaso Maria Ferrari, the cardinal titular of the church. The painter's success at S. Clemente and his growing reputation in Rome led to Clement XI's commission for *Jeremiah*, one of a series of twelve large paintings of Old Testament Prophets. These oil on canvas pictures, called the Lateran Prophets, were intended to complement the series of twelve colossal marble statues of the Apostles completed during the reign of Clement XI for St. John Lateran, the cathedral of Rome. The Lateran Prophets were placed on the upper nave walls of the basilica high above the marble Apostles. The series forms the single most important papal commission for paintings of the early Settecento.

By the 1720s Conca and Giuseppe Chiari were the most celebrated painters in Rome. Both artists contributed to the cycle of decorative mythological and allegorical paintings executed for the Palazzo de Carolis, and Conca simultaneously painted the most important ceiling fresco of his career, the splendid *Saint Cecilia in Glory* (1721–24), undertaken for the newly restored basilica of S. Cecilia in Trastevere and paid for by the church's cardinal titular, Cardinal Francesco Acquaviva d'Aragona, the Spanish ambassador to the papal court. This elegant fresco, which is rather close to the viewer standing in the nave, is characteristic of Conca's mature style in its rejection of the moody tenebrism of his Neapolitan heritage. The ceiling fresco's pale colors, small, almost mannered figures, complex composition, and an understated, operatic quality are perfectly appropriate to the architectural setting (the interior of the restored basilica has been compared to a Rococo ballroom) and the musical traditions of the basilica and its patron saint. While respecting the

example of Carlo Maratti's fundamentally influential ceiling fresco in the Palazzo Altieri, *The Triumph of Clemency* (1676), Conca nonetheless reinvigorated the Roman tradition with a Rococo elegance that dominated painting in the papal city for the next twenty years.

The third decade of the century also witnessed Conca's rise as an artist of international importance, especially in regard to the Savoyard court at Turin, where he executed decorative paintings for the royal hunting lodge, the Venaria Reale (1721–24), and for the royal palace in the capital. He also provided an altarpiece for Filippo Juvarra's majestic church, La Superga, which towers above the Piedmontese capital. The painter became friends with Juvarra while both were young artists working for Cardinal Ottoboni at the Palazzo della Cancelleria in Rome. Conca also produced a number of highly popular easel pictures for numerous visiting tourists, and he dispatched altarpieces all over Italy. His most important work outside Rome is the magnificent illusionistic fresco *Christ at the Pool of Bethesda* (1731), painted for the hospital chapel of S. Maria della Scala in Siena. Conca's international reputation and connections to important Roman patrons led to his election as Principe of the Accademia di S. Luca, a powerful post in the Roman cultural bureaucracy that he held from 1729 to 1732 and again from 1739 to 1740. His position as Principe led to the execution of his finest altarpiece, the *Assumption of the Virgin with Saint Sebastian* (1740), a work he placed in the academy's church, Ss. Martina e Luca, near the Arch of Septimius Severus. This painting shows the complete subjugation of Conca's florid Neapolitan heritage to the regnant classicizing mode of Maratti and his followers. Also recognizable is considerable Bolognese Baroque influence from the art of Domenichino and Francesco Albani.

Conca's last important Roman works were the frescoes painted for Cardinal Neri Corsini's library in the Palazzo Corsini and the frescoes and altarpiece executed for the Ruffo Chapel in S. Lorenzo in Damaso, Cardinal Pietro Ottoboni's final commission (1742–43). The most important of the Corsini frescoes is *The Allegory of the Sciences* (1747), a work executed with the advice of Corsini's learned librarian, Giovanni Bottari. The *Virgin of the Rosary* in the Ruffo Chapel still reveals the pale, delicate colors preferred by Conca to the more intense, saturated pigments characteristic of the rising generation, above all Batoni. Sebastiano Conca died in Naples on September 1, 1764. One of his most important legacies to Rome was his relative Tommaso, who

became one of the leading Neoclassicizing painters of the second half of the century. [CMSJ]

BIBLIOGRAPHY Pio [1724] 1977, p. 145 and passim; De Dominici 1742–44, vol. 3, pp. 664–66; Voss 1924, pp. 381–83, 619–23; Clark 1967; Sestieri 1969; Sestieri 1970; Michel 1981; Pascoli 1981, pp. 149–75; Sestieri 1981; Rangoni 1990, "Conca"

## 337
## Sebastiano Conca
## *Adoration of the Magi*

c. 1710–20

Pen and brown ink, wash, yellow and white heightening, on brown paper
24⅜" × 16⅞" (619 × 429 mm)

PROVENANCE collection Albert Bourduge; acquired by Duke Albert Casimir August of Saxe-Teschen, from whose estate to the Albertina, Vienna
EXHIBITION Gaeta 1981, fig. 7
BIBLIOGRAPHY Stix and Spitzmüller 1941, p. 59; Birke and Kertész 1992, p. 2054
Graphische Sammlung Albertina, Vienna

Attributed in the nineteenth century to Carlo Cignani, this drawing has now been correctly identified by Giancarlo Sestieri as the work of Sebastiano Conca. The traditional attribution doubtless owes to the old inscription *Roma/Cignani* on the back of the drawing by a hand other than Conca's. The crowded composition, theatrical display of a wide variety of poses, full draperies, and lambent light bear little resemblance to the Bolognese Cignani. Rather, in style this large drawing has close affinities to the early Roman work of Conca, whose Neapolitan training under Francesco Solimena and deep knowledge of the style of the widely influential Luca Giordano (especially in the grace and delicacy of the standing Virgin holding the Child) are very much in evidence. Moreover, the theme was treated in paintings at least three times by Conca in Rome before 1720—a signed and dated work in the Musée des Beaux-Arts at Tours, a picture of almost identical size in the Galleria Nazionale d'Arte Antica in the Palazzo Corsini in Rome, and a larger, Marattesque version in the Roman collection of Principe Girolamo Rospigliosi. The subject was also very popular with Conca's contemporaries Francesco Trevisani and Giuseppe Chiari, among others.

The feigned oval format of the Albertina drawing, which is crowned by a "pediment" of putti leading up to a blazing Star of Bethlehem that illuminates the scene below, after having led the Magi to the Christ Child, is unusual. Indeed, it closely resembles any number of seventeenth-century reliquaries. The drawing's high degree of finish may suggest that it was made

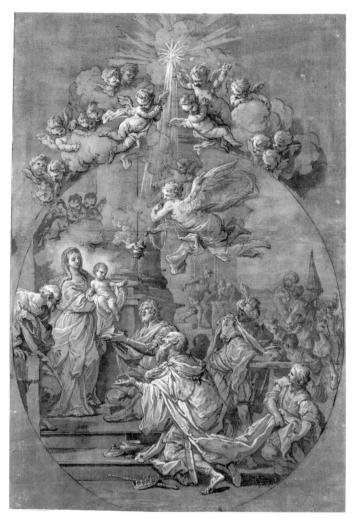

337

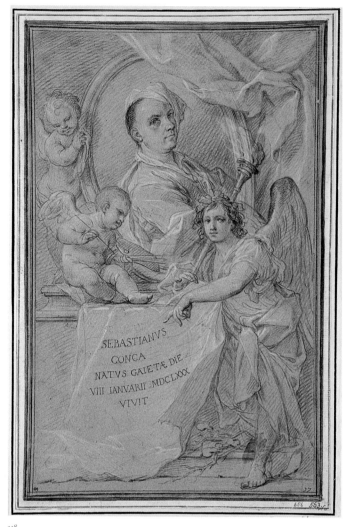

338

for presentation to a patron, although no painting corresponding to the composition has come to light. The three kings on the staircase offer up their gifts in an ascending diagonal from the lower right to the Holy Family at left; above, cherubs resting on clouds and a superb flying angel (which recalls Maratti and Giuseppe Chiari) look approvingly on to the scene. In the middle distance the retinue of the adoring potentates is visible and at least one shepherd strides into the scene. The humble stable at Bethlehem has been transformed by Conca into an imposing palace, and the grand, fluted column on a high base gives a sense of classicizing grandeur to the entire composition. Indeed, the column, which is truncated by the oval "frame," may be a subtle reference to the untimely death of Christ.

The most remarkable feature of the Albertina drawing is the adroit application of white highlights to suggest a lyrical play of light throughout the composition, a technique Conca learned in Naples under Solimena and refined in Rome by studying Carlo Maratti and especially Benedetto Luti.

Stylistically, the work is closely related to another oval drawing in the Albertina by Conca, *Alexander Presenting Campaspe to Apelles*, which also contains the graceful poses, complex composition, and brilliant white highlights present in the *Adoration of the Magi*. Similar features are also seen in Conca's preparatory drawing *Saint Michael Conquering Satan* in Stockholm, a work executed as a finished study for the altarpiece of the same subject in the Roman church of S. Maria in Campitelli. The Stockholm drawing originally came from the celebrated collection of Nicola Pio by way of the even more famous drawings collection of the French financier Pierre Crozat, eloquent testimony to the eighteenth-century reputation of Conca.

The *Adoration of the Magi* was possibly acquired by Duke Albert of Saxe-Teschen and his consort, the Archduchess Maria Christina of Austria, during their trip to Italy from December 1775 through July 1776. The loss of the Saxe-Teschen archive in a fire at the castle of Halbturn shortly after World War II makes such a statement speculative and tragically pre-

vents any authoritative history of the Albertina collection from being written. Given Conca's reputation during the Settecento, it seems unlikely that a discerning a connoisseur as Duke Albert would not have known its author, even if such knowledge was lost after his death in 1822. [CMSJ]

## 338
## Sebastiano Conca
### *Self-portrait*

c. 1720

Inscribed below the portrait: SEBASTIANVS/ CONCA/ NATVS GAIETAE DIE/ VIII IANVARII MDCLXXX/ VIVIT. Numbered at lower right in brown ink: 27 and 563

Black and white chalk on faded blue paper
16¼" × 10⅝" (415 × 270 mm)

PROVENANCE  Nicola Pio, Rome; purchased from him by Pierre Crozat, Paris; his sale, Paris, 1741, where purchased by Carl Gustav Tessin, Stockholm; Royal Library, Stockholm; Royal Museum, Stockholm, which changed its name to Nationalmuseum (NM 656/1863)

BIBLIOGRAPHY  Pio [1724] 1977, p. 145 ("Il di lui ritratto è stato fatto e con gran spirito delineato da se medesimo"); Clark

1967, "Portraits," p. 12, no. 12, pl. 3; *Conca* 1981, p. 35, fig. 1; Bjurström 1995, p. 54, no. 10

Nationalmuseum, Stockholm

The Italian writer and collector Nicola Pio is best known for his biographies of Italian artists from the Renaissance to his own time, *Le vite di pittori scultori et architetti* (MS, 1724; see Pio [1724] 1977, pp. v–vii [a biography of Pio in the introduction]). Between about 1718–19 (or possibly a few years earlier) and 1724 Pio compiled the lives of more than 225 artists, but was unable to find a publisher and lacked the necessary funds to have the manuscript printed. The *Vite* were acquired in 1743 after Pio's death by Marchese Alessandro Gregorio Capponi, a prominent antiquarian, who was appointed by Clement XII as *custode antiquario* at the Museo Capitolino and whose collection of books and manuscripts became part of the Vatican Library. Although the forty or fifty biographies that Pio devoted to Renaissance artists provide nothing new and are derived entirely from earlier authors, as Anthony Clark

(1967, "Portraits," p. 4) observed, the biographies of the artists contemporary to Pio are extremely important to the study of eighteenth-century Roman art; moreover, in many instances, relating to a number of artists and their activities, they are the only source of information from the period that exists. The importance of Pio's biographies was recognized by his contemporaries: Pierre-Jean Mariette used them as a source for a number of entries in his *Abécédario et autres notes inédites de cet amateur sur l'art et les artistes* (unpublished upon his death), and Lione Pascoli also adopted a great deal of material from Pio for his *Vite de' pittori, scultori ed architetti moderni* (2 vols., Rome, 1730–36).

In the early years of the eighteenth century Pio assembled a large and important collection of prints and drawings dating from the fifteenth century up to his own day. Pio was especially proud of his prints, which he assembled in fifty volumes arranged by author, school, and century. Pio sold his collection of prints during his lifetime, and in the 1920s thirty-four of these volumes surfaced in England. These were acquired in 1925–27 by the Italian government on the London art market, and the greater part are now in the Gabinetto Nazionale delle Stampe, Rome (for Pio as collector, see Bjurström 1995, p. 14, n. 16–19, n. 8–9). His collecting activities in fact appears to have stimulated his interest in the lives of the artists whose graphic work he had brought together, and from his annotations and sketchy artists' biographies arose the much more ambitious project of *Le vite di pittori, scultori e architetti*. At some point Pio conceived the idea of accompanying the text of each biography with a portrait that would have been engraved at the time the manuscript was published. Every biography in the manuscript is accompanied by a portrait; fifty, mainly of the leading contemporary artists, are self-portraits; the remainder were produced by artists commissioned by Pio.

The bulk of the portrait drawings in Stockholm were purchased from Pio by the French banker, patron, and collector Pierre Crozat in 1724 or just before, since in his foreward to the *Vite* the author describes the drawings as being "in Francia." The portrait drawings were later part of the famous Crozat sale in Paris in 1741 and listed in the catalogue by Mariette, *Description sommaire des desseins … du feu M. Crozat* ([Paris, 1741]), pp. 33–34, nos. 329–33, sixteen portraits in each). The Swedish nobleman and connoisseur Carl Gustav Tessin bought heavily at the Crozat sale, and his purchases included the Pio drawings (see Bjurström 1995, pp. 27–28, for an account of the numbers involved). From Tessin's

collection, the larger part (a total of 151 out of the original 225 drawings) eventually passed into the collection of the Nationalmuseum in Stockholm. Originally the collection included 224 portraits, of which 149 are in the Nationalmuseum. An additional eleven drawings have been found in other collections and sixty-four are missing or remain to be identified.

The dates of the portrait drawings have never been established with precision. They may have been commissioned as early as 1717 and were still being prepared and gathered until very shortly before, if not in, 1724, according to Clark (1967, "Portraits," pp. 5–6). In certain instances the date of the biography can be ascertained (the life of Locatelli must date to 1723, that of Sani to 1724); in others an approximate date for the portrait drawing can be deduced from external evidence. For example, Pio notes that Andrea Procaccini made his self-portrait before his departure for Spain (by the end of 1720).

The Pio drawings were first thoroughly examined by Clark, who published a catalogue of the entire corpus together with a brief history of the collection and an account of Pio as a collector and connoisseur in an important article in *Master Drawings* in 1967. He described the portraits and self-portraits as "mainly (but not all) of the sort familiar in the *ritratti istoriati* engravings produced without interruption from Vasari through the last gasps of the Baroque during settecento Neoclassicism. The majority of Pio's ornamented portraits are not in the form of tombs or commemorative plaques without reason: they are commemorative work *par excellence*. Fame with her torch, putti with the attributes of the Arts, a landscape background for a *vedutista*, these and various special variations—such as Masucci pointing to the feet in Raphael's *Disputa*, with one of the caryatid decorations below clinching the significance—were thought the proper surroundings of a likeness of a living artist, the scene let into an ornate frame, or the deities themselves supporting an ornately framed likeness within the entire scene, which would then require a simple frame. The example of papal tombs, wall plaques of princelings and clerics, and the actual tombs of Maratti and Salvator Rosa are used" (Clark 1967, "Portraits," p. 10; see also Bjurström 1995, pp. 26–27, for a discussion of the various artists' approaches to the tradition of the so-called *ritratto istoriato*).

The two largest suppliers of portraits were Agostino Masucci (thirty-two) and Luigi Garzi (twenty-two), both prolific draftsmen and distinguished artists in their own right, and the

little-known Pietro Zerman (twenty-two), possibly a pupil of Garzi. Other artists contributing more than a single drawing included Giulio Solimena (twenty-one), Filippo Minei (fourteen), Antonio Grecolini (thirteen), Gaetano Sarti (thirteen), Filippo Germisoni (twelve), Domenico Sani (eleven), Giovanni Domenico Piastrini (five), and Sempronio Subisati (three). The seven remaining artists supplying a single likeness produced a portrait of their master or friend, and it appears that Pio managed to persuade nearly every painter and draftsman prominent in Rome of the importance of his project and to elicit from them a portrait drawing. [EPB]

## TOMMASO MARIA CONCA
ROME 1734–1822 ROME

Tommaso Maria Conca was the son of the painter Giovanni Conca and first cousin once removed of Sebastiano Conca. As a child he spent ten years with his father in Turin, before returning to Rome in 1748 to study with his relative Sebastiano before the latter's departure for Naples in 1752. His career advanced quickly, and he was elected to the Accademia Clementina in Bologna in 1765 and to the Accademia di S. Luca in Rome in 1770. After marrying, in Rome in 1775, he maintained a large family (including eight children) in lodgings held at the Villa Farnesina as a tenant of the Neapolitan government. Tommaso assumed a leading role in educating young artists as the supervisor of *pensionati* for both the palatine elector (from 1777) and the Accademia Napoletana in Rome (from 1790 to 1817). Conca was knighted about 1790, and from 1792 to 1795 he served as Principe of the Roman Accademia di S. Luca. Conca spent most of 1795–97 in Città di Castello painting the rebuilt dome of the cathedral, his last major work. The artist's loyalty to the old regime kept him on the sidelines after 1798; as his eulogist Missirini put it, Conca "was always opposed to following the new doctrines of the age, and during the unhappy times for Rome and for the Kingdom of Naples he preferred to share the latter's financial straits than to embrace the new, interloping governments" (*Conca* 1981, p. 393, author's translation). Nonetheless, in 1812 Tommaso was enlisted to help decorate an apartment for the emperor at the Quirinal Palace, contributing a canvas of Cosimo de' Medici protecting exiled Greek scientists. His personal morality apparently matched his conservative politics. As a young man he assumed clerical dress and much later, as Principe of the Accademia di S. Luca, he threatened to resign over an academician's

"indecent" reception piece depicting Cupid and Psyche (Michel and Michel 1982, p. 706).

Despite his traditional training, Tommaso Conca played a key role in the development of Italian Neoclassicism. While his early apprenticeship with his cousin Sebastiano instilled Rococo tendencies that lasted throughout his career, even an early work such as the *Assumption* for S. Caterina da Siena (1769) shows Tommaso searching for greater forcefulness and realism. Like others of his generation, he allied himself with the progressive figures reshaping Roman painting in the 1760s, and he may have collaborated with Mengs at the coffeehouse of the Villa Albani. He formed friendships with papal antiquaries G. B. and E. Q. Visconti and frequented the Accademia dell'Arcadia under the name Demofilo Imerio. Conca's eulogist noted that after an initial adherence to the example of Guido Reni, Conca befriended both "Cavaliere Mengs and his rival Pompeo Batoni, learning to take the beautiful and the good from each of them like the clever bee he was. He was, however, the first to give serious study to anatomy" (*Conca* 1981, p. 392, author's translation).

Like his peers Cristoforo Unterperger and Domenico de Angelis, Conca is primarily remembered today as a decorator. In 1775 he began his collaboration under the direction of Antonio Asprucci on the redecoration of the museum-like Villa Borghese for Prince Marcantonio IV, an influential project that revolutionized the Roman artistic scene. Conca's first work on the vault of the Room of the Dancing Faun (1775–78) combines a sober central panel in oil (*The Sacrifice of Silenus*) with a surrounding tempera frieze of cavorting satyrs which are remarkable for their naturalism and lustful, earthy vitality. This work earned Mengs's admiration. Tommaso's next project in the adjoining Egyptian Room (1778–82) picked up a theme pioneered by Mengs himself at the Vatican Library. Twelve historical panels and mock hieroglyphics on the walls surround a vault in which fictive statues of Egyptian deities separate colorful panels depicting personifications of the planets (including Mercury as dog-headed Anubis). The central scene, again in oil, depicts Cybele blessing Egypt, while surprisingly realistic putti drape the whole scheme with floral garlands. In the adjoining gallery, meanwhile (1778–80), Conca supplied designs for twenty hexagonal reserves to be executed in white marble on blue mosaic grounds, much like Wedgwood cameos, as well as for eight putti in full relief over the lateral doors. A recent study by K. Herrmann Fiore has located Conca's figural sources in prototypes by Raphael and his pupils

at the Farnesina and Annibale Carracci at the Farnese Gallery, as well as in antique sculpture.

Conca's success at the Villa Borghese brought him to the attention of Pope Pius VI, who was promoting his new Vatican sculpture museum in the same years. Tommaso was commissioned to fresco the large vault of the Sala delle Muse in about 1785, the largest such decoration in the entire complex. Here Conca maintained the division into nine fields but made an even stronger use of *quadratura* and foreshortening to suggest a vision of Parnassus; below, four panels in oil add Latin and Italian poets to the gods, muses, and Greek sages pictured above. The Vatican ceiling, however, was Conca's last mythological commission, and the religious works he executed during his stay in Città di Castello mark his drift away from the currents of contemporary taste. The frescoes in the dome (*Divine Wrath Placated by the Virgin and the Redeemer Accompanied by the Patron Saints of the City*) and the transept (*Allegories of the Church and Religion, Scenes from the Lives of Saints Crescenziano and Florido*) seem to prefigure the mystical "purism" of the early nineteenth century. Modern judgment has favored Conca's decorative work over his easel paintings, which some have found "overworked and congested" (Hiesinger and Percy 1980, p. 87), and Conca seems to have been at his best in small-scale grisailles or in illusionistic schemes that combine compositional boldness and vigor with the light touch and delicate naturalism that he learned from his cousin. [JC]

BIBLIOGRAPHY Noack 1912; Arizzoli-Clémentel 1978, pp. 7, 23, document XVI; Cooper-Hewitt Museum 1978, pp. 48–50; Hiesinger and Percy 1980, pp. 87–89; *Conca* 1981, pp. 391–93, document 21; Michel 1981; Michel and Michel 1982; Rudolph 1983; Cera 1987, pp. 288–305; Sestieri 1988, pp. 64, 69, 72; Paul 1989; Barroero 1990; Rangoni 1990 "Conca," p. 676; Costamagna 1992; Herrmann Fiore 1993; Collins 1995, pp. 249–315; Loire 1998, p. 309; Collins 1999

## 339
## Tommaso Maria Conca
### Study for "The Triumph of Apollo" for the Ceiling of the Sala delle Muse, Museo Pio-Clementino

c. 1782

Pen and brown ink, brown and gray washes, black chalk, pencil
16¾" × 16¾" (425 × 427 mm)
Inscribed on verso in a later hand in pencil: *Conca/Ceiling in the room of the Muses in the Vatican/R. G.*[?]

PROVENANCE Giovanni Piancastelli; Mr. and Mrs. Edward D. Brandegee; purchased by the Smithsonian Institution (Cooper-Hewitt Museum), Friends of the Museum Fund, 1938

EXHIBITIONS New York 1978, cat. no. 13; New York 1978, *Crosscurrents*, cat. no. 34

BIBLIOGRAPHY *Giornale delle Belle Arti* (Rome), January 7, 1786, pp. 1–2; *Memorie per le Belle Arti* (Rome), vol. 2 (June 1786), pp. 131–35; Pistolesi 1829, p. 118, pl. 86; Cooper-Hewitt Museum 1978, pp. 48–49; Pietrangeli 1978; Pietrangeli 1987, p. 120; Collins 1995, pp. 249–315; Collins 1999

Cooper-Hewitt National Design Museum, Smithsonian Institution, New York, Museum Purchase through Gift of Mrs. Edward Brandegee

In the early 1780s Pope Pius VI (Braschi) commissioned Tommaso Conca to fresco the vault of the newly constructed Sala delle Muse in the Museo Pio-Clementino, the museum of ancient art at the Vatican. This was one of the largest decorative commissions of the period, and it reflects Conca's rising fortunes in Rome's official art world. Although this sheet represents an early idea for the fresco, the basic elements are in place: Apollo appears with his muses and some dozen Greek orators, philosophers, and poets on steps in front of a temple or colonnade. The iconography thus reflects the sculptures in the room below, following a tradition recently revived at the Villa Borghese, where Conca himself had worked. The Sala delle Muse was built to house an important group of sculptures unearthed at Tivoli in 1774, which were interspersed with herms of important Greek sages and political leaders in a conversational grouping. As in Carracci's gallery in the Palazzo Farnese, the idea was to bring the statues to life in the vault as a commentary on the display below.

The drawing's shape was determined by the innovative architecture of the 80-foot long room, designed by Michelangelo Simonetti on the model of ancient baths and palaces. Conca was to cover the octagonal vault crowning the hall's tall central zone. Following models from Raphael's Loggie, he divided the space into four principal panels separated by steeply foreshortened ribs converging on a ring-like central cornice. Behind this lurks a second layer of architectural illusionist *quadratura* that remains unresolved; the upright columns conflict with the sharply raked pilasters, or *antae*, and it is unclear whether the colonnades depict a continuous interior space or four sides of an outdoor pavilion. Likewise, the small central reserve is left undecorated, although its color suggests that some design was intended. The finished ceiling resolves many of these problems. First, Conca widened the intermediate ribs, adding paired fictive stucco figures and triads of winged putti; sec-

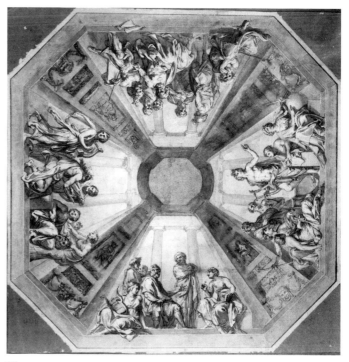

339

ondly, he transformed the plain colonnade into an elaborate circular portico with serlianas and top-lit hemispherical niches like those in the museum's own nearby octagonal courtyard. Third, he introduced numerous flying figures who overlap the fictive architecture and unify the space; finally, he enlarged the central reserve to hold a *quadro riportato* of victorious Apollo flaying defeated Marsyas while his teacher, Olympus, pleads for mercy.

Although Conca's design logically reflects the room's contents, its meaning can be appreciated only in the context of the entire museum. His finished decorations include four supplementary panels in oil below the octagon's short sides, depicting Homer, Virgil, Tasso, and Ariosto, which extend the theme of poetic inspiration from Greece to Rome and modern Italy. Thus both the paintings and the sculptures imply that Pius VI, the new Apollo, has given the muses a permanent home on the Mons Vaticanus, the new Mount Parnassus. This is the theme of papal poet Vincenzo Monti's archaizing "Prosopopea di Pericle," a stilted encomium "spoken" by a bust of Pericles displayed below Conca's vault. Besides acknowledging Mengs's earlier *Parnassus* at the Villa Albani, Conca's ceiling quotes famous precedents by Raphael in the Vatican Palace itself: the *Parnassus* (repeating its topographical allusions and inclusion of selected mortal worthies) and the *School of Athens* (the figures on steps, complete with an illusionistic scroll and a brooding sage reminiscent of Raphael's supposed portrait of

Michelangelo). The Marsyas theme derives from the same source, although here it seems to proclaim the cultural supremacy of Pius VI in the arts. Conca thus presents the Sala delle Muse as a successor both to the Stanza della Segnatura of Julius II (originally a library) and to Julius's original statue court (the new museum's nucleus), which Pius had just redesigned. Conca's historical allusions thus take on specific local significance.

Stylistically, Conca's drawing is more classicizing than the finished ceiling. The figures are larger and more sculptural, only slightly foreshortened, and clustered into tight friezes; other drawings in the Cooper-Hewitt, in Minneapolis, in private collections, and (formerly) in Rome are closer to the finished composition. In execution Tommaso returned to Baroque formulas to animate the vast space, silhouetting figures against puffy clouds, adding dramatic declamatory gestures, and using the steps to lead into the composition. These alterations, like those noted above, revive aspects of his cousin Sebastiano's apse fresco at S. Maria della Scala in Siena in the early 1730s, where the *Pool of Bethesda* presents certain formal parallels with Tommaso's ceiling. Conca was paid for work on the Sala delle Muse from 1782 to 1788, which suggests a date of c. 1782 for this drawing. [JC]

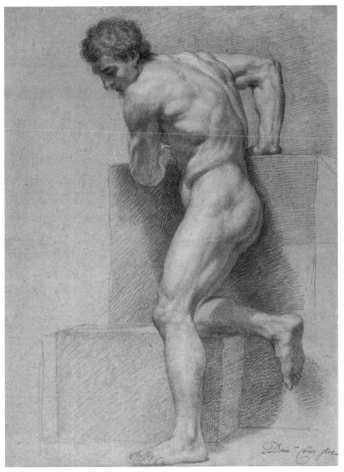

340

341

## DOMENICO CORVI

VITERBO 1721–1802 ROME
*For biography see Paintings section*

### 340
### Domenico Corvi
*Academic Study of a*
*Nude Male Model in Profile,*
*Half-kneeling on a Block*

Signed in black ink on the lower right
corner: *Dom.ᶜᵒ Corvi fece*
Red chalk on white paper
22½″ × 16¾″ (571 × 422 mm)
PROVENANCE Domenico Corvi, Rome,
before 1803; his widow, Angela Maria
Curcia Corvi, 1804–1805, whence pur-
chased by the engraver Giambattista
Romero and sold to the Accademia
Nazionale di Brera, Milan, in 1805
EXHIBITION Viterbo 1998, cat. no. D 28
BIBLIOGRAPHY Susinno 1998, pp. 173–74,
178–83, p. 215, fig. D 28; Valli 1998,
pp. 191–94
Gabinetto dei Disegni dell'Accademia di
Brera, Milan

The study of the anatomy of the
human body, through drawing from
live nude models and copying antique
statues, was the fundamental require-
ment in the training of any aspiring
painter or sculptor and, by the end of
the seventeenth century, had gradually
been instituted in the major academies
as a standard, obligatory practice.
Even though certain masters continued
to hold sessions for their pupils in the
studio, it proved more feasible for the
academy to accommodate a larger
number of students in regular gather-
ings by providing a room or hall, illu-
mination, and heating (essential in the
winter months), as well as the models.
This didactic process culminated, after
generations of development, in the
1754 creation of the Accademia
Capitolina del Nudo in Rome, under
the auspices of the Accademia di
S. Luca, which annually elected one
of its members to serve as director.
Domenico Corvi (who as early as 1752
maintained a private "academy" for
this purpose) was elected director for
the first time in 1757 and repeatedly
again over the next forty-five years; he
was holding the post at the time of his
death in 1802.
 "Corvi was celebrated as a teacher
and for his fine academic studies:
there not having been another school
in Rome more productive of pupils.
He was a truly gifted painter, to be
compared with few in anatomy, per-
spective, and draftsmanship, who
always maintained some idea of

Carracci's style, as learned from his
tutor Mancini. Therefore his academies
are highly esteemed and sought after, I
venture to say, more than his paintings"
(Luigi Lanzi, *Storica pittoresca della Italia
dal risorgimento delle belle arti fin presso al
fine del XVIII secolo* (Bassano, 1789;
edited by Martino Capucci [Florence:
Frangoni, 1968], vol. 1, p. 422).
 Luigi Lanzi's words of praise are
entirely justified by the group of
twenty-eight autograph drawings
of nude models in the Accademia
Nazionale di Brera, Milan, most of
which were purchased in 1805 and
all of which show a similar technique
and large dimensions (for reproduc-
tions of these drawings and discussion
of their purchase and the tradition of
eighteenth-century academic studies
to which they pertain, see Susinno
1998, pp. 175–89, 198–99; Valli 1998,
pp. 190–94). Their provenance from
Corvi's studio indicates that they
themselves had been models available
to his pupils for study (and as such
acquired by Brera for its own students),
whereas the date 1775 on two of the
sheets serves to place them all in the
later phase of his career, around the
time when Giovanni Ludovico
Bianconi had singled him and Pompeo
Batoni out as the only two painters of
the Roman school whom the late
Anton Raphael Mengs really admired
(see Susinno 1998, pp. 173, 198). The
cache of Corvi drawings in the Brera
offers an ample repertory of the by
then established attitudes and torsions
assumed by the models on the master's
direction, as well as the studio props
of blocks and steps that support and
contextualize their poses. Some,
including this example, echo the
stances of famous statues (Myron's
*Diskobolos*); others hold a staff or are

garnished with a swatch of drapery. The
supple outlining of limbs, texturing of
shadow playing over flesh and back-
ground through the crosshatching
of the chalk, and attention to details of
hands, feet, hair, and expressions,
do reveal—as Lanzi pertinently
observed—a lingering graphic tender-
ness imputable to the example of
Corvi's master Francesco Mancini. Yet
the fusion of these stylistic connota-
tions is imprinted by Corvi's own pliant
and at the same time vigorous handling.
The survival of drawings of such uni-
formly superlative quality, attesting
the master's preeminence in the repre-
sentation of anatomy, makes all the
more regrettable the loss of his treatise
"sulle proporzioni del corpo umano e
della figura" which the Accademia di
S. Luca finally granted him permis-
sion to publish on September 5, 1802,
just a few months before his death
(see Ferrara 1974–75, p. 211, n. 12, and
Rudolph 1982, pp. 44–45). The treatise
was never published and the manu-
script has not been found. [SMCR]

## JACQUES-LOUIS DAVID

PARIS 1748–1825 BRUSSELS
*For biography see Paintings section*

### 341
### Jacques-Louis David
*Two Women: Study for*
*"The Oath of the Horatii"*

1786
Pencil, stumping, white highlights, on
beige paper
18¼″ × 20″ (465 × 510 mm)
PROVENANCE David sale, April 17, 1826; no
doubt part of no. 102; initialed by artist's

son, lower right (Lugt 839 and 1437), collection P. J. David d'Angers (1788–1856); gift to the Musée d'Angers in 1846

EXHIBITIONS Paris, Grand Palais. *Le Néoclassicisme français: dessins des Musées de Provence.* 1974–75, cat. no. 16; Copenhagen, Thorvaldsens Museum. *Fransk nyklassicisme: Tekninger fra provinsmuseer, Frankrig.* 1975, cat. no. 10; London, Heim Gallery. *The Finest Drawings from the Museums of Angers.* Traveling exhibition. 1977–78, cat. no. 22; Angers, France, Musée d'Angers. *Cent dessins des Musées d'Angers.* 1978, cat. no. 24

BIBLIOGRAPHY Dauban, M. Jules, ed. *Notice des peintures et sculptures du Musée d'Angers: et description de la Galerie David.* Angers, France: Imprimerie Lachese, Belleuvre et Dolbeau, 1870, p. 237, no. 757 or 758; David, J. *Le Peintre Louis David, 1748–1825.* Paris, 1880, p. 454; *Horace de Corneille: voyage d'une oeuvre.* Le Petit-Couronne, France: Maison des champs de Pierre Corneille, 1987, p. 93 Musées d'Angers

This beautiful drawing of the young woman, who has collapsed in despair, together with her sister and her mother, over the future fate of her three brothers, as they vow to defend Rome, is almost directly transferred to the finished painting, the *Oath of the Horatii* (cat. 213). It is an unusual object in David's working procedure, as he customarily made rougher, more broadly worked sketches in anticipation of individual elements of his large compositions. Perhaps the most refined and detailed elements of the drawing—the complex drapery folds carefully witnessed (and arranged) on the woman's languid arm and the bend of her neck—contain almost the full pathos and sensibility of the same figure in the finished painting. The explanation for this—quite apart from the simple one of the creation of a work of art that can stand quite independently in its own right aside from its intended purpose—may be that David thought of giving this particular figure over to a pupil to be painted and exhibited later (therefore explaining the detail of "instruction" required), a practice that occurred with Drouais in other sections of this work. Alternatively, David may have simply wished to set this complicated passage on paper fully before transferring it to canvas. (It is recorded that he redid the foremost foot of the father fourteen times before it reached his satisfaction.)

This sheet also serves as a good example of the manner in which David's drawing style had changed in the face of what he had seen practiced in Rome upon his arrival some nine years before executing this figure.

Tischbein speaks of David's "second manner" in drawing, with its strong emphasis on the permanence of outline, which set and contained the figure into a flattened space more dramatically than any modeling within the outline could achieve. For many scholars, this way of drawing and the whole attitude it represents about the nature of making art and its place between observation and creation, is one of the major lessons David drew from his Roman experience. Stemming from Winckelmann's theories about the importance of the edge of features as a means of setting their purity and elevation—and the way that an entire generation of artists ranging from Mengs to Flaxman put this theory into practice—the lesson did indeed have a profound effect on the young David, who would transfer it through his activity and teaching to France where, particularly in the work of his last major pupil, Ingres, the notion of "edge" and its manner of containing a figure in space would take on a nearly visionary precision. [JR]

## GIOVAN BATTISTA DELL'ERA

TREVIGLIO 1765–1799 FLORENCE

The personal and artistic details of the life of Giovan Battista Dell'Era have only recently been brought to light, thanks to important new documentary evidence and the growing critical interest in his important graphic work. A gifted and versatile draftsman and sophisticated portraitist, Dell'Era was also skilled as a copyist and specialized in encaustic painting. He was naturally affected by the cultural influences of the time and associated with the leading figures in Roman art life during the last twenty years of the Settecento. In spite of this, as with many other artists who gravitated to Rome during the same period, he did not make his name through undertaking prestigious, major projects, but worked primarily for travelers passing through the capital or foreign clients. Consequently, his paintings, known today by only very few examples, are widely dispersed.

Dell'Era was born on 20 May 1765, the son of Gianmaria, a fairly well-established coppersmith and craftsman. He spent three years studying in Bergamo in the studio of the Venetian painter Francesco Capella, and in 1781 he entered the Accademia di Brera, where he attended the school of decoration, plasterwork, and life drawing. His teachers during this period were Giocondo Albertolli, Giuliano Traballesi, and Giuseppe Franchi. On Franchi's recommendation, in the summer of 1783 Dell'Era went to Bondo di Val Bregaglia in Switzerland as drawing tutor of the children of Pietro de Salis, governor and captain of the Valtellina. The count's favor and economic support allowed Dell'Era to go to Rome for an initial period of study in the spring of 1785, and finally to return there at the end of the same year.

Rome's artistic climate had been revived by the public exhibition of David's *Oath of the Horatii*, and it was against this background that Dell'Era executed his first Roman painting, *Aegeus Recognizing His Son Theseus* (1786; Galleria d'Arte Moderna, Bologna). The following year this work was awarded first prize at the Concorso Curlandese for painting held by the Accademia Clementina di Bologna (Grandi 1980, p. 63). From his arrival in Rome, Dell'Era was able to count on the support of Cardinal Francesco Carrara, who commissioned the artist to paint his portrait (1786; Municipio, Bergamo) and introduced him to the studio of Angelika Kauffmann. The young artist immediately established a friendship and artistic rapport with the celebrated painter. Proof of this was evidenced in the work of Dell'Era's first biographer, friend, and compatriot Giovan Battista Brambilla, who stated: "It was there [in Rome] that Dell'Era made friends with the celebrated Kauffmann; he learned her style easily and often assisted her in the composition of her paintings" (*Dettaglio intorno al pittore Dell'Era*, Treviglio, S. Marfino, Ms., Alzano Maggiore, parish records, 1820). The closeness of the association between the two artists is further demonstrated by the fact that a sketch that Kauffmann presented to Dell'Era later became the property of one of his pupils (Sandner 1998, p. 42, n. 37). Moreover, two letters were found written by Kauffmann in 1795 to the advisor of Catherine II, Friedrich Melchior Grimm, requesting the empress's assistance in the successful achievement of a commission given to Dell'Era to decorate the residence of Tsarskoe Selo (Louis Réau, "Grimm's Correspondence on the Arts with Catherine II," *Archives de l'Art Français*, n.s., vol. 17 (1931–32), pp. 197–198).

Further evidence of Kauffmann's influence on the young artist's development is revealed by some of his drawings in the Museo Civico at Treviglio. They reveal a thematic and stylistic affinity with Kauffmann's graphic art, although Dell'Era's work is distinguished from Kauffmann's by more substantial composition, especially in the construction of the human figure.

In Kauffmann's studio Dell'Era had the opportunity to meet the celebrities that frequented the painter's salon at that time. This was a genuine and distinctive crossroads of Roman cosmopolitan society, and the luminaries who met there included Johann Friedrich Reiffenstein, Thomas Jenkins, Giovanni Volpato, Séroux d'Agincourt, and Goethe. Count Reiffenstein, adviser to the court of Catherine II of Russia and a close friend of Kauffmann, took particular interest in Dell'Era. He admitted him to the team of artists who, under the direction of Cristoforo Unterperger, were completing the prestigious undertaking of the life-size reproduction of Raphael's Vatican Logge, commissioned by Catherine II at the end of 1778 (*Memorie di Belle Arti*, vol. 4 [1788], p. 152). Through this experience Dell'Era became an ardent devotee of the secrets of the ancient technique of encaustic, which was the subject of fierce contemporary debate, in which Reiffenstein himself took a lively interest.

Dell'Era is documented in Florence in early 1789, where he copied a few paintings from the grand-ducal galleries, probably under commission (Fabia Borroni Salvadori, "Artists and Travelers at the Uffizi in the Settecento," *Labyrinthos*, vol. 6, no. 10 [1986], p. 74, and vol. 7, no. 12 [1987], pp. 97, 136, 150). On September 13 he was elected a member of the Accademia di Belle Arti as a "figure painter" (Florence, Archivio di Accademia di Belle Arti, *Atti*, c. 35). On his return to Rome, he maintained contacts with the Accademia di Brera, which from 1789 paid him a grant, approving his status as "supported student" from 1791 to 1795. By this time he was specializing in encaustic and had opened a studio in the Trevi district in via dell'Angelo Custode, where he began to produce an acclaimed series of paintings using the technique. Through Reiffenstein he obtained commissions from Empress Catherine II as well as the architect Giacomo Quarenghi, an enthusiastic collector of Dell'Era's drawings, among other items (Zanella 1988, p. 204, passim). Five of these small paintings were important additions to the imperial residence at Tsarskoe Selo.

During these years of his artistic apprenticeship Dell'Era was therefore immersed in the stimulating and vibrant surroundings of Roman artistic life. This enabled him to keep abreast of innovations developed in graphic art by leading practitioners. He became involved in the vast series of collaborations directed by Séroux d'Agincourt, for whom he executed some copies intended to form part of the illustrations of the *Histoire de l'Art par les Monuments* (Castello Sforzesco, Milan; Museo Civico, Treviglio; Pinacoteca Vaticana, Rome). Along with William Young Ottley, Humbert de Superville, John Flaxman, Giuseppe Bossi, and Felice Giani, Dell'Era took part in the rediscovery of the "primitives" and was among the first to experiment with the expressive potentials of linear transcription (Calbi 1986, pp. 121–26). At the same time he participated in the "competitions" of the Accademia de' Pensieri organized by Felice Giani in his house on via Gregoriana, pitching his draftsmanship against that of the most talented artists of his generation: Luigi Sabatelli, Vincenzo Camuccini, Giuseppe Bossi,

François-Xavier Fabre, Humbert de Superville, and many others (Rudolph 1977, pp. 175–86).

These two contrasting experiences are reflected in Dell'Era's graphic output, which combined the expressive power characteristic of Giani's unorthodox classicism with the distinct and selective lines of "spontaneous" design. Among the original drawings executed with this technique, those that are outstanding for the calligraphic precision of the design include compositions *all'antica* portraying *The Departure* and *The Arrival* from the *Berber Horse Race* (Museo Civico, Treviglio). These are an extraordinary blend of motifs taken from antique sculpture, Raphael, and Michelangelo. Numerous copies are known from the aquatint engravings done by Giovan Battista Romero in 1805 (Istituto Nazionale per la Grafica, Rome). However, a copy of the *Departure* which recently appeared on the antiques market as attributed to Dell'Era, has instead been confirmed as the work of Giuseppe Bossi (Cera 1987, fig. 355).

In spite of the monumental composition, a more conventional work is the grand altarpiece of *Esther before Ahasuerus*, executed in 1795 for the basilica of S. Martino di Alzano Lombardo, near Bergamo. Here the relaxed rhythm, sentimental setting, and delicacy of color again recall Kauffmann's models. The reference to traditional classical models is also evident in the preliminary drawings for scenes from the life of the Virgin, which Dell'Era probably frescoed in the dome of the chapel of the Rosary in the church of the Conforto in Arezzo (Florence, Uffizi Gallery, Gabinetto dei Disegni e Stampe).

This and other commissions were obtained for him by Luigi Siries, director of the workshop for *pietre dure* in Florence. Dell'Era had enjoyed Siries's hospitality after the artist had left Rome in April 1798, owing to the uncertain climate brought about by the invasion of French troops. However, he did not manage to conclude these assignments: after a brief illness, he died on January 7, 1799.

Early sources and biographers also describe Dell'Era as being very busy painting portraits for travelers. The only known example in this field, the portrait of *The Great Crasnacuse of St. Petersburg* (Museo Civico, Treviglio), shows an affinity with the works of Jacques Sablet and Louis Gauffier, with whom the artist had connections either in Rome or Florence (Pinto S. 1977). These connections are also evident in the naturalism of the many portraits and "conversation pieces" among Dell'Era's prints and drawings which until now have been the most important sources of biographical information on him. [EC]

342

BIBLIOGRAPHY Deri 1965; Mencarini 1967; Rodeschini Galati 1988; Frabbi 1989; Buonincontri and Rodeschini Galati 1990; Calbi and Frabbi 1993–97; Nenci 1994; Buonincontri 1996; Buonincontri 1996, "La critica"; Rodeschini Galati 1996

## 342
## Giovan Battista dell'Era
### Group Portrait in a Garden

1787–88?

Inscribed on verso in pencil, in the upper left corner: *Delera*

Pen and brown ink, brown wash, and pencil; heightened with white lead

16⅞″ × 21⅝″ (435 × 550 mm)

PROVENANCE Adriano Cera, Bologna

BIBLIOGRAPHY Cera 1987, fig. 356; Rodeschini Galati 1988, pp. 57, 59; Buonincontri 1996, p. 442

Private collection, Rome

The scene represented in this charming drawing belongs to the typically eighteenth-century genre of the conversation piece. These scenes faithfully portrayed the customs of a cosmopolitan society of artists, aristocrats, and travelers who forged bonds and friendships against the inspiring surroundings of pleasant, fashionable diversions. Here, an outdoor "conversation" is depicted, in which ten male figures are brought together in a garden under the shade of a large oak tree. A surprisingly natural group, they stand next to the only woman in the company. The unusual composition of the group raises interesting questions about the identity of the individual figures, and the place and circumstances in which this moment was captured. In the *Repertorio della pittura neoclassica* (Cera 1987), where the drawing was first published, an intriguing and not unlikely assumption was suggested by the subtitle, *Goethe at Frascati?*

The features of the young man standing near the woman do bear some resemblance to the German poet. The location also calls to mind the restorative beauty of the parks and villas of the Alban Hills, the favorite holiday location of the Roman aristocracy and a popular attraction for artists on excursions from the city. During his second stay in Rome (June 1787–April 1788) Goethe went to Frascati several times. On two occasions he was the guest of Johann Friedrich Reiffenstein, who began to look after his artistic education as well as that of other young artists: "I am very happy here," he wrote in the *Italian Journey*, "all day and far into the night we draw, paint, sketch in inks and practice the arts and crafts very much *ex professo*" (Goethe [1788] 1982, p. 386). In the September *Appunti*, speaking about this same sojourn, Goethe records an event that could be a possible counterpart to the scene portrayed by Dell'Era: "We took delight in a splendid, but not unexpected, view from the windows of the villa of Prince Aldobrandini, who, while on holiday, had courteously invited and entertained us … in the company of his guests, clerics and lay people" (Goethe [1788] 1974, p. 409). Thus, the gentleman shielding himself from the sun with the parasol may be Reiffenstein, in the merry company of his young protégés along with the illustrious guests of Prince Aldobrandini. The prince can be identified as the very elegant and distinguished gentleman at the side of the important-looking figure in cardinal's vestments. The Benedictine monk, who appears to have arrived just recently and is still holding the small offerings box, evokes Frascati and specifically the Camaldolese hermitage, which rises in the distance, near the Villa Conti.

In spite of her unassuming and slightly anonymous appearance, the woman seated at the center, next to Goethe, is traditionally identified as Angelika Kauffmann. This image corresponds perfectly to her role as *femme savante*, through which she enjoyed the privilege of an entirely male company of artists and cultured men. The resemblance is not so much to official portraits of Kauffmann as to the likeness given by the German painter Johann Georg Schütz in his delightful watercolor of the Duchess Anna Amalia di Weimar and her circle of friends in the park of the Villa d'Este in Tivoli (1789; Stiftung Weimarer Klassik Museum, Weimar). There is also good reason to believe that the young Dell'Era himself would be part of this celebrated group. At one time the artist was a regular visitor to Kauffmann's studio and maintained close relations with Reiffenstein, who probably had admitted him to the

group of artists he brought to Frascati. Discreet by nature and somewhat reserved, Dell'Era may feature here in the guise of the young clergyman, absorbed in drawing, who closely resembles the artist as depicted in his numerous self-portraits.

Whether or not this is the case, this work shows how Dell'Era's extraordinary draftsmanship managed to accommodate many of the elements of the cultural environment in which he found himself in the late 1700s. This is illustrated here, where the influence of English portraiture, absorbed in Kauffmann's studio, is expressed in a subtly introspective vision and with "fashionable self-confidence." In this way, events and individuals are described and related in a particularly natural manner, as well as with clarity and precision. The subtle charm of this "conversation piece" is completely free of artifice. Here, art appears to blend with life, discreetly and without undue emphasis or studied observation. This is also seen in the portraits of Jacques Sablet, who—of all Dell'Era's contemporaries—was the most similar in approach. The elegant bearing of the high-ranking guests creates a slight contrast with the spontaneous attitude of the other characters. Despite this, everyone seems to partake equally in the tranquillity of the time and place, which is reflected on the faces in an expression of "absorbed intimacy." The luminous contrasts are modulated by the fluid compositional arrangements of the wash. Against this, the calligraphic precision of the line focuses on even the slightest detail with an extremely sharp precision, investigated with remarkable clarity.

This drawing, which appeared on the art market at the end of the 1980s, is one of the most convincing examples of the artist's graphic talent and his gifts as a sophisticated portrait painter, fully in tune with Roman culture at the end of the Settecento. [EC]

## ABRAHAM-LOUIS-RODOLPHE DUCROS

### MOUDON, PAYS DE VAUD
### 1748–1810 LAUSANNE

Ducros was born and raised in a small town in the west of Switzerland, where the natural beauty of the mountains—a source of inspiration for the culture of the Enlightenment and a regular stop for visitors on the Grand Tour—was copiously illustrated by local artists. In 1769 he went to Geneva to study at a school of painting run privately by Nicolas-Henry-Joseph Fassin, under whose guidance he studied the Flemish and Dutch landscapes in the collection of François

Tronchin, a banker and connoisseur, and traveled through Flanders, the Geneva countryside and Savoy. This was the kind of apprenticeship, based on alternating painting from nature with study of the different styles of seventeenth-century artists, advocated by the Swiss writer and painter Salomon Gessner in his Lettres sur le paysage of 1770 and was widely adopted by northern European artists of the time. In 1776, already an able practitioner of his art but lacking either a personal fortune or financial assistance from public funds, Ducros decided to go to Italy, where he became part of a highly specialized tide of artist-immigrants, predominantly protestants from northern Europe, sharing a common spirit of commercial enterprise and a willingness to respond with the utmost flexibility to the demands of the market.

While accompanying a rich Dutchman, Nicolas Ten Hove, on a visit to the south, Ducros produced drawings and watercolors of fishermen and peasants (Rijksprentenkabinet, Amsterdam). On his return to Rome in 1779, remembering the hand-colored prints from the studio of Johan Ludwig Aberli in Berne, he established a partnership with Giovanni Volpato, the engraver from Bassano famous for his prints of Raphael's Logge and Stanze in the Vatican, and set out to compete with such artists as Jakob Philipp Hackert and Jean-Louis Desprez, who was working with Francesco Piranesi, for the thriving market in prints of views that they had already established in Rome.

Throughout the 1780s Ducros, with Volpato and his students, published a series of hand-colored outline etchings of views of Rome, which show that he had absorbed and advanced the technique developed by Roman artists during the first half of the century for producing topographical prints. Ducros derived his repertory of views of monuments and the topographical accuracy of his images from Giuseppe Vasi and Francesco Panini and, by experimenting with Piranesi's wide-vista techniques, discovered how to give architectural features and ruins a new context in landscapes and vegetation studied from nature and lit by skies reproduced with meteorological exactitude. At the same time he was producing small genre works depicting conventional scenes of city life.

Between 1782 and 1783, as a result of engraving in manière du lavis a series of drawings of local characters executed by his compatriot Jacques Sablet, Ducros enlarged his own range of popular Roman subjects, which were subsequently inserted into his prints, a work frequently carried out by specialized collaborators. These helpers are as yet unidentified, but it is

believed they included Mengs's pupil Giuseppe Mazzola.

Ducros's contribution to the development of landscape prints carried on the work of artists such as Hackert, the Italians Giovanni Battista Lusieri and Giovanni Campovecchio, and, most importantly, the English artists Richard Wilson, Thomas Jones, John Warwick Smith, and John Robert Cozens, all of whom had anticipated and then stimulated the taste for landscapes in the cosmopolitan market of the capital, where interest in the scenic ruins of Giovanni Paolo Panini had been gradually replaced by enthusiasm for scientific themes and detailed accuracy in the depiction of monuments, in natural and atmospheric effects, and picturesque views.

So successful were his landscape prints that in 1782 Ducros set up a business under his own name at his new home in via della Croce. He now devoted himself to painting, widening the range of the locations he chose in and around Rome. Tivoli, Valle della Nera, and Terracina were among his favourite subjects. He completed three oil paintings for a Russian grand duke and duchess who were visiting Rome in 1782 (Grand Duke Paul Visiting the Forum and Grand Duchess Mary at Tivoli, both dated 1782, and Visit of Pius VI to the Pontine Marshes, dated 1783; Pawlovsk Castle, St. Petersburg), and a painting for Pius VI (a version of Visit of Pius VI to the Pontine Marshes, dated 1786; Rome, Museo di Roma).

Around 1785 Ducros was working in watercolor, and exploring the possibility of its competing with oils. He increased the size of pictures by sticking sheets of paper together and worked out a technique of using layers of color combined with the application of viscous solutions and varnishes to produce effects of alternating density and transparency. The success of this technique was confirmed by the appreciation of a large clientele of predominantly English collectors and visitors, including William Constable and the Earl of Bristol. Richard Colt Hoare, a wealthy, cultured English landowner and passionate art collector, commissioned fourteen paintings in all from Ducros when he was in Italy between 1786 and 1791. In subsequent writings he went so far as to express the view that the advances in watercolor technique made possible by Ducros had raised the medium to the same level as oils and paved the way for William Turner (Richard Colt Hoare, The History of Modern Wiltshire [London, 1822], vol. 1, p. 83). Between 1787 and 1795, Ducros—still working with Volpato—published fourteen pictures of the Museo Pio-Clementino in the Vatican (complete series in the Bayerische Staatsbibliothek, Munich) recording in great detail the layout of

the rooms and the position of the works of art.

As a result of the events in France, Ducros, like other foreign artists, was ordered out of Rome in 1793, and after a short stay in Abruzzo went to Naples, where, under the protection of the British ambassador and collector William Hamilton, he devoted his time between 1794 and 1798 exclusively to painting, depicting the natural beauties and the archaeological sites around the city. Between 1794 and 1796 he also painted four large watercolors of the dockyards close to Naples for General Francis Edward Acton, his remit being to show the improvements carried out by the British navy (Coughton Court, Warwickshire).

In contrast to the works of Ducros's Roman period which, despite their lively response to nature, reveal a classical sense of balance in their composition, the Neapolitan landscapes reveal a new interpretation of space in which multiple viewpoints create dynamic effects while the greater intensity of colour and light dramatizes the handling of natural phenomena. This reflects the influence of the contemporary artists Michael Wutki and Pierre Jacques Volaire, interpreters of the new pre-Romantic sensibility prevalent at that time among the British. Paintings typical of this development are Eruption of Vesuvius and Shipwreck and Nocturnal Storm at Cefalù, both dating from 1800 (Musée Cantonal des Beaux-Arts, Lausanne).

After the return of the Bourbons, Ducros was accused of Jacobite sympathies and exiled from Naples. He went to Malta, where in 1801–2 he painted views of the city for General Thomas Graham, who had been sent to the island to recapture it from the French. In works such as View of the Grand Harbor, Valletta (National Museum of Fine Arts, Valletta; copy at Musée Cantonal des Beaux-Arts, Lausanne), Storm Behind the Custom House, Neptune Fountain and Fish Market in Valletta (Musée Cantonal des Beaux-Arts, Lausanne), the vision developed in Naples became more definitive, and the architecture of the city and the depth of the horizon were seen through a more complex handling of perspective.

After another period in Naples (1802–5), Ducros decided to return to his native country and open a drawing school. This he did in 1806, staying briefly in Rome on the way. He settled with his brother in Noyon, close to Geneva. Elected an honorary member of the Société des Arts in 1807, he moved to Lausanne the same year and renewed his application to the government for funding for his school. In 1809, after a very successful exhibition in Berne of all the works he had brought back from Italy, Ducros was

343

appointed professor of painting at the Berne academy, but died suddenly only a few months after taking up the appointment. [RL]

BIBLIOGRAPHY *Memorie per le Belle Arti*. April 1, 1785, pp. LV–LVII; *Memorie Enciclopediche Romane per le Belle Arti*. Vol. 2, pp. 72–74. 1807; Junod 1953; Boissonnas 1954; Woodbridge 1970; Ford 1974; Ford 1974, "Constable"; Chessex 1984; Chessex 1984, "Ducros"; Chessex 1985, *Vedute*; Van de Sandt 1985; Chessex 1986; Chessex 1987; Marini 1988; Chessex 1992; Chessex 1992, "Ducros"; *Voyage en Italie* 1994; Wilton and Bignamini 1996, pp. 22, 24, 129, 174, 228, 233, 288, nos. 58–62, 95–95, 192, 195, 199, 201, 256–59; Zutter 1998–99

## 343
## Abraham-Louis-Rodolphe Ducros
### *Interior of the Villa of Maecenas, Tivoli*

c. 1785
Pen and black ink, watercolor, remains of varnish
21⅛″ × 29⅛″ (538 × 744 mm)

PROVENANCE Ducros studio at Lausanne; acquired through public subscription in 1811, then sold back to the state of Vaud in 1816; from 1841 held in the Musée Arlaud and from 1906 in the Musée cantonal des Beaux-Arts Lausanne

EXHIBITIONS Lausanne 1953, cat. no. 28; London 1985, cat. no. 21 ; Lausanne 1986, cat. no. 51; Rome 1987, cat. no. 44; Lausanne and Quebec 1998, cat. no. 27
BIBLIOGRAPHY Chessex 1984, "Ducros," p. 75; Chessex 1985, p. 56, no. 21; Chessex 1985, *Vedute*, no. 23; Chessex 1986, no. 51; Chessex 1987, p. 94, no. 44; Wilton and Bignamini 1996, p. 306; Zutter 1998–99, pp. 41, 75, no. 27
Musée cantonal des Beaux-Arts, Lausanne

The Temple of Hercules—built in Tivoli toward the end of the republican era, scavenged for building materials and used as stables and storehouses throughout the Middle Ages, then partly occupied by a convent in the fifteenth century—was mistakenly identified in the sixteenth century as the remains of the residence of Maecenas, the emperor Augustus's famous counselor. This had come about due to misinterpretation of some passages in Horace, Seneca, and Suetonius referring to a property in Tivoli owned by Maecenas at which the emperor himself was a frequent guest. It was not until the nineteenth century that the ruins—visited and studied for centuries by such artists and historians as Pirro Ligorio, Michelangelo, Palladio, and Piranesi— were identified by Antonio Nibby (*Analisi antiquaria*, Rome, 1825) as those of a temple dedicated to Hercules (Cairoli Fulvio Giuliani, *Tibur: pars altera* [Rome: De Luca, 1966], pp. 164–72). The fascination exerted for centuries by the grandeur of the remains was heightened in the second half of the eighteenth century by the picturesqueness of the luxuriant vegetation that had sprung up among the ruins and by the waterfalls created by an underground arm of the Aniene river. This taste for the picturesque was reflected in a drawing in red chalk attributed to Jean-Honoré Fragonard in 1760 and a drawing by Louis Chaix of 1775 (Zutter 1998–99, pp. 40–41).

Besides the appeal of the picturesque, ruins acquired an additional focus of interest over the next few decades for the erudite traveler on the trail of historical connections and the moral lessons that could be drawn from them. Tivoli, home of the Sabines in the dawn of Roman history and the chosen playground of emperors, was among the favorite sites of this kind, and its monuments were endowed with complex symbolic values. This is particularly evident in works by Richard Wilson, a favorite artist of the cultured British contingent imbued with the contemporary English philosophical ideas about the inevitable collapse of the great civilizations (Solkin 1982).

A subterranean view of the Villa of Maecenas was one of the watercolors acquired after 1786 by Richard Colt Hoare for his residence in Stourhead (Chessex 1985, pp. 85–86, no. 69). The watercolor in the Musée cantonal at Lausanne may be a small-scale preparatory draft for other paintings or engravings of the subject.

In contrast to many of Ducros's Tivoli paintings (*Washerwomen in the Roman Campagna; Temple of the Sibyl, Tivoli; View of Tivoli with the Sibyl's Temple*, Chessex 1987, pp. 91–93, nos. 38, 40, 42), peopled by ordinary folk and peasants and emphasizing the serenity of rural life, here the artist was experimenting with a mythological landscape, inserting some female figures, swathed in voluminous light-colored clothes at the side of the cascade, whose elongated and transparent forms seem to conjure up the cave-dwelling nymphs described by Salomon Gessner in his *Idilli*. The

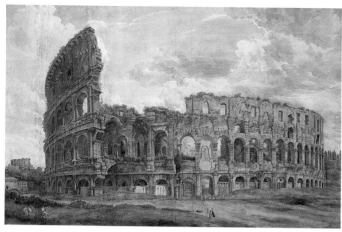

344

same work by the Swiss poet probably also inspired the print that Ducros presented to King Gustav III of Sweden when the king visited his studio in 1784 (Chessex 1987, p. 15). The inclusion of such patently modern objects as the two closed umbrellas beside a classical amphora, however, would seem to indicate that the picture is also working on another level, possibly recalling a scholarly excursion, or suggesting a tableau of a lost golden age.

As in all Ducros's work, the natural scenery is a protagonist. Although the influence of Piranesi is perceptible in the diagonal perspective and the contrasts of light and shade, there is no unnatural enlarging of the ancient ruins for pedagogic ends but rather an interpretation of the power and beauty of nature that raises it toward the poetically sublime. Ducros's composition centers on the luminous mass of foaming water struck by the light filtering through the arches and casting blue reflections on the vaults, the earth, and the golden-brown leaves. These effects are achieved by a virtuoso watercolor technique, eschewing the use of white lead and leaving paper unpainted to create areas of white. The artist's ability to render the foam and mist created by the cascading water—a frequent subject for contemporary landscape painters—was singled out for praise in *Memorie per le Belle Arti* (April 1, 1785, pp. LV–LVII), where two pictures painted for Lord Breadalbane, *The Tivoli Cascades* and *The Cascata delle Marmore*, are mentioned. Colt Hoare also admired Ducros's treatment of cascades and bought his *View of Tivoli* in which falling water is the principal element (Wilton and Bignamini 1996, p. 304, no. 256). [RL]

## 344
## Abraham-Louis-Rodolphe Ducros
### View of the Colosseum

c. 1785

Pen and brown ink, watercolor, heightened with gouache, on ruled paper, cut up, joined, and laid down on canvas

31″ × 45½″ (787 × 1167 mm)

PROVENANCE Ducros studio at Lausanne; acquired through public subscription in 1811, then sold back to the state of Vaud in 1816; from 1814 held in the Musée Arlaud, and from 1906 in the Musée cantonal des Beaux-Arts, Lausanne

EXHIBITIONS Lausanne 1953, cat. no. 3; Rome 1954, cat. no. 2; London 1985, cat. no. 3; Lausanne 1986, cat. no. 3; Rome 1987, cat. no. 3; Lausanne and Quebec 1998 cat. no. 3

BIBLIOGRAPHY Chessex 1984, p. 434; Chessex 1985, p. 46, no. 3; Chessex 1985, *Vedute*, p. 46, nos. 2–3; Chessex 1986, no. 3; Chessex 1987, pp. 33, 72, no. 3; Zutter 1998–99, p. 51, n. 3

Musée cantonal des Beaux-Arts, Lausanne

The Colosseum, monumental symbol of the Eternal City, is the subject of several works by Ducros. In one hand-colored etching (Musée cantonal des Beaux-Arts, Lausanne, inv.D 855; Chessex 1987, p. 73, no. 5) Ducros has followed a work by Francesco Panini, engraved by Giovanni Volpato, in which the building has been pushed into the background to allow a detailed depiction of the gardens, vineyards, and surrounding buildings. By increasing the depth and moving the point of view by a fraction from the Caelian to the Palatine Hills, he gave himself room in the foreground to show a papal procession passing through verdant countryside on its way to an archaeological excavation site. Recording the interior of the amphitheater peopled by visitors (Musée cantonal des Beaux-Arts, Lausanne, inv. D865; Chessex 1987, pp. 72–73, no. 4), Ducros depicted the rich growth of bushes and climbing plants that was one of the main attractions of the place and a source of study material for botanists of the period. During the nineteenth century many articles were published identifying the various species of flora that had found a habitat in the Colosseum; some exotic species were traced back to seeds presumably introduced in the feed provided for the beasts that were kept there to take part in the combats at the time of the empire (Roberto Luciani, *Il Colosseo* [Novara, Italy: Istituto Geografico De Agostini, 1993], p. 246).

Using an extraordinary range of color, Ducros arrived at a microscopically precise portrayal of the Colosseum, the different materials used and the exact state of conservation of the arcades. At the front is the masonry infilling in the ground-floor arches of the Colosseum, built to celebrate the jubilee of Pope Clement X in 1675 with the intention of keeping out vandals. The site had been abandoned for centuries, but, following pressure from various religious organizations, the authorities were considering protecting it by consecrating it to the memory of the martyrs who had died in the arena. It is possible that the iron grilles in the masonry were included at the suggestion of Bernini to make the interior visible from outside. Bernini also suggested that the main gates should be of iron, but they were, in fact, eventually made of wood. Constantly repaired and rebuilt over decades, the walls and gates did succeed in part in preventing the site from total dilapidation. The conversion of the pagan edifice into a Christian memorial was not ratified until 1749, when Pope Benedict XIV issued a papal edict dedicating it to the Passion of Christ and the Via Crucis. On this occasion, some of the arcades being strengthened and the niches of the Via Crucis, which had been in the amphitheater since the beginning of the eighteenth century, were restored and a marble plaque installed with a cross and an inscription in memory of the works sanctioned by Clement X and Benedict XIV (P. Colagrossi, *L'anfiteatro Flavio nei suoi venti secoli di storia* [Florence: Libreria Editrice Fiorentina, 1913], pp. 214–22). Even this plaque is clearly visible in Ducros's work. The painting of the Colosseum on its own is similar in treatment to those of the arches, such as *The Arch of Titus* and *The Arch of Constantine* (Musée cantonal des Beaux-Arts, Lausanne, inv. D816 and 817; Chessex 1987, pp. 33, 71–2, nos. 1–2), in which the architectural feature dominates the landscape. This aggrandizement of a structure within the surrounding space is emphasized, in the case of the Colosseum, by the effect of relief on the left side of the building, which has been cut out and glued to the paper in a way that typifies the artist's experimental approach to technique.

Small figures in the foreground are a constant feature of the Roman landscapes of Ducros, because he knew they would appeal to the taste for the picturesque among the travelers on the Grand Tour. Their execution was often left to his assistants, but the artist always retained control over their precise position in the composition with reference to structural and chromatic criteria. In this painting they have been miniaturized, one of the tricks that help to accentuate the grandeur of the edifice and make the whole experience more memorable for the traveler after he had returned home. As Goethe wrote in his diary, "Once one has seen it, everything else seems small. It is so huge that the mind cannot retain its image; one remembers it as smaller than it is, so that every time one returns to it, one is again astounded by its size" (Goethe [1788] 1982, p. 125).

Even in this topographical view the artist's feeling for natural landscape predominates, and the great edifice is suffused with light from a cloudy sky that throws faint gray shadows onto the ocher of masonry and ground. The artist's perception of Italy is an inseparable interweaving of history and nature. [RL]

## JOHN FLAXMAN
YORK 1755–1826 LONDON

John Flaxman was the most famous sculptor of his day in Britain; his works include major national monuments in Westminster Abbey and St. Paul's Cathedral in London, and a great number of small memorials in churches in most towns and villages. His reputation was for figural monuments of a touching piety and simplicity, without the ostentatious show of grief common among the work of his eighteenth-century predecessors. On the continent of Europe, however, he was barely known as a sculptor, but he had an immense reputation based almost entirely upon line-engravings made by Tommaso Piroli from his drawings in illustration of Homer, Aeschylus, and Dante, made in Rome in the years 1792–93. The impact of these illustrations cannot be overstated; those of the *Iliad* and *Odyssey* especially appeared to contemporaries to have belonged in style to the very age of Homer himself, and their "primitive" linearism created a taste for reductive outline and simplified perspective that swept Europe. In his own time and after his death few artists of importance in Europe were unaffected by the outlines: Blake,

Géricault, Goya, and Ingres all studied and borrowed from them. Even those, such as Goethe, who found Flaxman modish (Goethe called him the "Idol of the Dilettanti"), were obliged to admit that art had been decisively changed by them, not least because of their easy reproducibility. It is arguable even that they remained a force well into the twentieth century in Matisse and Picasso's classical works.

Flaxman was the son of a castmaker who supplied the great potter Josiah Wedgwood with ornamental designs. He studied as a sculptor at the Royal Academy, and one of the closest friends of his youth was William Blake, with whom he shared interests in poetry and unorthodox religion. Having failed to win a scholarship to Rome, he practiced mainly in London as a monument sculptor while making designs in a classical manner for items such as chimneypiece ornaments, portrait medallions, reliefs for pots, and chess pieces. These were produced for Wedgwood, who regarded him as an asset (a number of his designs are still in production). His intention was to make enough money to get to Rome, which he was able to do in the fall of 1787. He evidently only expected to stay for two or three years, but in the end he had enough commissions to remain for seven years, before returning to England in 1794. In Rome he embarked on a period of intense study of classical works, filling many sketchbooks and gradually freeing himself from Wedgwood, who had hopes that he would continue to supply him with designs. The turning point in Flaxman's fortunes was an approach from the notorious earl-bishop the Earl of Bristol and Bishop of Derry, who commissioned a full-size group of *The Fury of Athamas* for Ickworth, his country house, where it still remains. Flaxman learned much from Canova in making the group, and he attracted attention from other English émigrés, including the banker Thomas Hope, who commissioned a fanciful reconstruction of the *Torso Belvedere* as *Hercules and Hebe* (University College London; on loan to Petworth House). More significantly for Flaxman's future reputation, he commissioned 111 drawings to Dante's *Divine Comedy*, with the intention of having them engraved for a private edition. This was rapidly followed by similar commissions from Mrs. Hare-Naylor for Homer's *Iliad* and *Odyssey*, and from Countess Spencer for illustrations to Aeschylus. The Homer and Dante series were engraved by the Italian Tommaso Piroli in 1793. The two Homer series were published, but Hope forbade publication of the Dante illustrations, though the designs soon circulated unofficially.

The Aeschylus series appeared in Rome and London in 1795, and from the beginning of the nineteenth century the outlines spread across Europe with remarkable rapidity in the form of reprints and copies, and they have hardly ever been out of print since, even if only in reduced form as illustrations to school textbooks.

Flaxman had been careful in Rome in the years 1787–94 to keep his ambitions as a sculptor fresh in the minds of patrons in England, and even to send designs back home (see cat. 346). On his return to London in 1794 Flaxman rapidly became recognized as the foremost monumental sculptor of the age in England, and produced vast groups of naval heroes such as Nelson, though he was usually more comfortable on a smaller scale. As a devout if unorthodox Christian, he most fully realized himself in small and touching reliefs of one or two figures in mourning, which combined knowledge of classical models with human warmth and pathos. Despite his apparent other-worldliness his studio became more like a factory than a small workshop, and, perhaps remembering Wedgwood's production methods, he multiplied his most popular designs, often at the expense of quality and finish. The surface of his monuments can be bland and mechanically worked, and he is seen at his best in working models in plaster, of which some hundred have survived from his workshop, in the collections of University College London, along with several hundred drawings.

In 1810 Flaxman became Professor of Sculpture at the Royal Academy and in 1829 his *Lectures* were published posthumously. His later sculpture was predominantly monumental, and only with the rise of a younger generation of sculptors such as Francis Chantrey, did his idealism begin to appear a little staid. He made one more series of classical drawings, this time for Hesiod, which were engraved by William Blake in 1817, and designs for silverware for the firm of Bridge and Rundell. Flaxman died highly honored in both Britain and Europe, as sculptor and pioneer of the outline style. For the Victorians he had a third role, as an artist who had succeeded in reconciling his art with the commercial pressures of the industrial revolution. The work for Wedgwood, which he had regarded as minor work, now made him seem a prophet of later attempts to bring artistic qualities to the design of ordinary objects. In the twentieth century the lack of spatial definition, the minimal outline, and the extreme simplification of form in his illustrations especially, have caused many critics to see Flaxman as an important innovator in his own time, and a major forerunner of modernism. [DB]

345

BIBLIOGRAPHY Irwin 1966; Rosenblum 1967; Honour 1968; Bindman 1979; Irwin 1979

## 345
## John Flaxman
### *Hector Chiding Paris*

1792
Pen and ink over pencil
8⅛" × 12⅛" (212 × 309 mm)
PROVENANCE possibly Thomas Hope; acquired by Bowdoin from Scott and Fowles, New York, 1918
Bowdoin College Museum of Art, Brunswick, Maine, Classical Fund

The drawing is a preliminary study for one of the series of illustrations made by Flaxman in 1792 for Mrs. Hare-Naylor in illustration of Homer's *Iliad* and *Odyssey*. The finished drawings were subsequently engraved by Tommaso Piroli and enjoyed enormous success. The scene shows the great Trojan warrior Hector upbraiding Paris for neglecting the martial arts and the defense of Troy in favor of his wife, the legendary beauty Helen. Hector's mission was "to rouse soft Paris to the war; If yet not lost to all the sense of shame" (*Iliad*, VI. 404–5). The scene is described as follows:

> Thus entering, in the glittering rooms he found
> His brother-chief, whose useless arms lay round,
> His eyes delighting with their splendid show,
> Brightening the shield, and polishing the bow.
> Beside him Helen with her virgins stands,
> Guides their rich labours, and instructs their hands.
> (*Iliad*, VI. 457–63)

The upright figure of Hector is contrasted with the relaxed and "feminized" figure of Paris, polishing his weapons rather than using them, though about to be shamed into action by Hector. This drawing shows Helen attended by her two maidservants, but in the final version engraved by Piroli they were eliminated, simplifying the composition further.

The drawing is a fine and characteristic example of the stripped style that made Flaxman's outlines appear so startlingly original in the 1790s. All interior modeling in the figures has been eliminated, and space is barely indicated. Flaxman's aim in carrying simplification to such an extreme was to revive the outline style of Greek vase paintings, which by the 1790s were being reproduced extensively in line engraving. Greek vases were thought then to belong to the age of Homer, so the outline style was an attempt to match the deeds of the primeval world of Homer's Greeks by a kind of "period" style. The deliberate primitivism of Flaxman's outline method, applied also to Dante, almost immediately became associated with an idea of the rebirth of art itself, touching a particular nerve in the aftermath of the European-wide convulsion caused by the French Revolution.

In Piroli's engraved outlines the "purity" of the outline was enhanced by their mechanical consistency; here, however, the lines are varied in density, with a certain nervousness of touch that gives an attractive vibrancy lost in the engraved version. The designs exhibit a gentility and staidness that hardly do justice to the ferocious emotions embedded in Homer's text, a reminder that Flaxman himself was anything but revolutionary in temperament or belief. Flaxman's domestication of Homer helped the outlines to retain their popularity in the Victorian period. [DB]

346

## 346
## John Flaxman
*Design for the Monument to the Poet William Collins in Chichester Cathedral*

1792
Pencil, pen, and wash on paper
9⅛" × 14¼" (232 × 360 mm)
PROVENANCE acquired by the British Museum, London, 1885
EXHIBITIONS London 1972, cat. no. 567; Wilmington 1976, cat. no. 1–11; Hamburg 1979, cat. no. 139c; London 1979, cat. no. 132c
BIBLIOGRAPHY Bindman 1979, pp. 113–15; Hofmann 1979, pp. 135–37; Irwin 1979, pp. 60–63
The British Museum, London

The circumstances behind the commission for the monument to the poet William Collins, eventually erected in Chichester Cathedral, are extremely well documented, and give a good idea of the complications of a sculptor's life in dealing with patrons, particularly when, as in this case, they were in another country. Because Flaxman was in Rome at the time of the negotiations for the design, in July 1792 he sent long illustrated letters and several drawings for the monument to his friend William Hayley, a poet and

wealthy art patron. Hayley acted as intermediary between the sculptor and the citizens who wanted the monument. The aim was to commemorate Collins, who had died in 1759, in his native city of Chichester, and Flaxman was certainly chosen because of his friendship with Hayley, who also supported the artists George Romney and (later) William Blake. Flaxman presented a series of alternative schemes, carefully distinguished by physical shape, imagery, and price, in a sequence of drawings marked from A to F, with further alternatives in other drawings (British Museum, London). Schemes A, B, C, and D are on one sheet, proposing variations on a relief tablet with a dominant circular relief of the poet himself, poring gloomily over a Bible, and with or without a frieze illustrating Collins's poem *The Passions*. In this drawing Flaxman offers a detailed view of the intended frieze and proposes also a design with the frieze as the principal feature, without the circular relief of Collins.

The frieze design illustrates a passage from Collins's poem *The Passions* in which Hope, falling back on the right, had hoped vainly to separate Love, Joy, and Mirth from Revenge, Anger, Fear, and Despair. Revenge is shown seizing "The War-denouncing Trumpet," perhaps a ref-

erence to Collins's deeply disturbed last years. Possibly fearing that the harsh motif might put off the clients, Flaxman also proposed an alternative and more benign relief design, with Hope, who "enchanted smiled & wav'd her golden hair," still in the ascendant (British Museum, London). The clients were thus offered at least nine different designs, all but two of which included a relief illustrating *The Passions*, and ranging from £225 to £60. It hardly needs saying that the memorial committee chose one of the least expensive ones, settling for D at £98, which had the relief figure of Collins in a roundel but no frieze at all, except for two embracing angels, added later to the pediment. Flaxman completed the marble version in 1795, the year after his return from Italy, and there is a full-size plaster model at University College London.

The fullness of the forms of the figures in this drawing gives an excellent idea of the richness and complexity of the intended bas-relief, which would have reflected Flaxman's close study of antique sarcophagus reliefs and Maitani's *Last Judgment* relief at Orvieto. It makes an instructive contrast with the previous drawing (cat. 345), probably made only a few months later. [DB]

## JEAN-HONORE FRAGONARD

GRASSE 1732–1806 PARIS

Fragonard was born in the south of France, the only child of François Fragonard and Françoise Petit. In 1738 the family moved to Paris, probably for business reasons. There Fragonard studied briefly with Jean-Baptiste-Siméon Chardin and then entered the studio of François Boucher, whose reputation was then at its height. In 1752 Fragonard competed for the coveted *prix de Rome*, which he won with his painting *Jeroboam Sacrificing to the Idols* (Ecole Nationale Supérieure des Beaux-Arts, Paris). At this point, like all *prix de Rome* winners, he entered the Ecole Royale des Elèves Protégés, where he studied for three years to perfect the skills that would make his trip to Italy more rewarding. Fragonard arrived in Rome in December, 1756. Almost nothing is known about his earliest work in Italy, but he must have followed the customary routine of French Academy students of drawing and painting after live models. Students at the academy, then housed in the Palazzo Mancini, also copied paintings to be found in the churches and palaces in Rome. In the lengthy correspondence between Charles-Joseph Natoire, then director of the academy,

and his superior in Paris, the Marquis de Marigny, Italian painters such as Pietro da Cortona, Guido Reni, and Domenichino, and, of course, Michelangelo and Raphael are often mentioned as models assigned to the students. This exchange of letters also notes Fragonard's mercurial temperament and the corresponding changes in his work. At times his paintings and drawings were full of vigor and enthusiasm, but on occasion he rapidly lost confidence in his abilities and his work became overly cautious and plodding.

Among Fragonard's greatest achievements as a student in Italy are his magnificent landscape drawings, made in Rome and the surrounding countryside, which are some of the finest works he ever executed. A number of these drawings were made at the Villa d'Este at Tivoli, where Fragonard spent the summer of 1760 in the company of his friend and supporter Jean Claude Richard, the abbé de Saint-Non, who had rented the villa. Among the friendships Fragonard made in Rome, one of the most important was with Hubert Robert, a compatriot and fellow student at the academy. At times the two students must have worked alongside one another, and each had an influence on the other's work at this time. In 1761 Fragonard and Saint-Non visited Naples; shortly after his return to Rome the two Frenchmen left the city and traveled northward through Italy on their way back to Paris. Numerous Fragonard drawings record their itinerary with stops at Florence, Bologna, Venice, and Genoa.

In Paris, Fragonard set about creating his reception piece for the Académie Royale, on the basis of which he would be approved by the academy. On March 30, 1765, Fragonard submitted to this group his enormous mythological canvas *Coresus and Callirhoë* (Musée du Louvre). The work was greeted with enthusiasm and was purchased for the crown. At this point it seemed that Fragonard would restore the highly esteemed genre of history painting to its former eminent status, and the artist could easily have followed the customary path which would have led to full membership in the academy. However, Fragonard never sought to attain this status. The reasons for this change of direction in his career are unclear, but at the time it was commented that Fragonard preferred to paint decorative subjects for private clients, rather than working for the crown, because he was paid more quickly. The artist's reputation among private patrons was at its height when in 1771–72 he painted on commission for Mme du Barry *The Progress of Love* (Frick Collection, New York), the greatest decorative ensemble produced in eighteenth-century France.

The paintings were ordered for Mme du Barry's new pavilion at Louveciennes, but for some reason she rejected them in favor of another series on the same subject by Joseph-Marie Vien (two are in the Louvre and two in the Préfecture, Chambéry). Vien's Neoclassical style may have been considered more in harmony with the building's architecture. At any event, the loss of this commission is both an important episode in the history of early Neoclassical taste and the beginning of a long, gradual decline in Fragonard's private patronage.

The artist returned to Italy in 1773–74, when he traveled to Rome with a patron, the financier Jacques-Onésyme Bergeret de Grancourt, who was Saint-Non's brother-in-law. The party went on to Naples in the spring of 1774, and returned to France later that year, traveling through Vienna, Prague, and southern Germany. During the voyage Fragonard made a number of drawings, which Bergeret thought should become his property in recompense for the expense of the trip. The artist was not of this opinion, and the dispute led to a rupture (and perhaps a lawsuit) between artist and patron. Fragonard continued to paint major large-scale works, some of which must have been commissions, such as *The Fête at Saint-Cloud* (1775–80; Banque de France, Paris).

During the 1780s Fragonard continued to paint and draw, often treating sentimental Neoclassical subjects or scenes of family life, which he must have hoped would have wide appeal. At the end of 1789 the artist and his family left Paris and returned to Grasse. After 1792, when they came back to Paris, Fragonard's time was occupied not as an artist but as a museum administrator. He was appointed to the various commissions that oversaw the establishment of the Musée du Louvre. In the aftermath of the 1789 revolution many works of art confiscated from churches and private collections were nationalized and incorporated into the collections of public museums. Fragonard had an important role in this process but also attended to many mundane administrative tasks. In 1797 Fragonard was relieved of his post. At the artist's death in 1806 his reputation had lapsed into obscurity. [vc]

BIBLIOGRAPHY Montaiglon 1887–1912; Portalis 1889; Wildenstein 1960; Ananoff 1961–70; Williams E. 1978; Cuzin 1988; Rosenberg 1988; Boulet, Cuzin, and Rosenberg 1990

347

## 347
### Jean-Honoré Fragonard
### *God the Father and the Prophet Joel*

c. 1760–61

Inscribed in pencil, center right, by the abbé de Saint-Non: *Michelange, Chappella Sistine*

Black chalk on white paper
$11\frac{5}{8}$" × $8\frac{1}{8}$" (295 × 205 mm)

PROVENANCE René Gimpel, Paris; gift to the Fogg Art Museum, Harvard University, Cambridge, Massachusetts, 1928

EXHIBITIONS Washington, D.C., Cambridge, and New York 1978, cat. no. 10; Paris and New York 1987, cat. no. 41

BIBLIOGRAPHY Mongan and Sachs 1940, cat. no. 606; Ananoff 1961–70, vol. 2, cat. no. 1085, fig. 293; Rosenberg and Brejon de Lavergnée 1986, p. 349, cat. no. 59

The Fogg Art Museum, Harvard University Art Museums, Cambridge, Massachusetts, Gift of René Gimpel

"I was in awe of Michelangelo's energy. I felt things that I could not express. When I saw the beauty of the Raphaels, I was moved to tears, and I could scarcely hold my pencil. For several months I remained in a state of apathy that I was unable to overcome, until I resolved to study the painters whom I felt I had a chance of rivaling; and so I turned my attention to Barocci, Pietro da Cortona, Solimena, and Tiepolo" (Alexandre Marie Lenoir, "Fragonard," in *Biographie universelle: ancien et moderne* [Paris: Michaud, 1816], vol. 15, pp. 419–21).

These words of discouragement are one of the few records we have of Fragonard's reaction to the masterpieces of Italian art that he encountered as a student at the French Academy, as recorded by Alexandre Marie Lenoir, a contemporary who wrote one of the earliest biographies of the painter. Supposedly François Boucher advised Fragonard, just before the young man left for Italy, that if he took too seriously the work of Raphael and Michelangelo his innate talents would be compromised. This family anecdote was reported by Fragonard's grandson Théophile in conversation with Edmond and Jules Goncourt (Edmond Goncourt and Jules Goncourt, *L'Art du dix-huitième siècle* [Paris: Flammarion, 1927], vol. 3, p. 220, n. 1). In fact, Fragonard himself left no record of his years in Italy, but the letters from the director of the French Academy, Charles-Joseph

Natoire, to his superior in Paris, Abel-François Poisson, the Marquis de Marigny, make it clear that Fragonard was disconcerted by the masterpieces he saw for the first time and suffered a bout of discouragement (for a summary of this aspect of Fragonard's study: Rosenberg 1988, pp. 61–63). In time the crisis was overcome, and Fragonard executed a large number of drawings after Italian works of art that he saw in Rome and Naples, as well as in Florence, Bologna, Venice, Parma, and Genoa. (Many of Fragonard's drawings after works of art that he saw in Rome are reproduced in Rosenberg and Brejon de Lavergnée 1986, pp. 345–64, cat. nos. 40–118).

A number of Fragonard's drawings after Italian works of art, as well as some of his studies of architecture and landscape, were later reproduced in prints by Jean Claude Richard, abbé de Saint-Non. The abbé was a friend of both Fragonard and Hubert Robert, from whom he commissioned numerous drawings which later were the basis for prints used to illustrate his lavishly produced books (a useful summary of Saint-Non's publications is in Rosenberg and Brejon de Lavergnée 1986, pp. 327–33). Such was the case with these two studies after Michelangelo's figures on the ceiling of the Sistine Chapel, so identified in Saint-Non's inscription, which he repeated in an etching and aquatint (Cayeux 1963, pp. 297–372, cat. no. 157; Rosenberg 1988, p. 123, fig. 1). Fragonard's drawings are academically competent records of Michelangelo's figures that convincingly record the master's sculpturesque modeling but which, it must be admitted, fail to convey their physical energy and spiritual drama. [VC]

## 348
## Jean-Honoré Fragonard
### *Avenue of Cypresses at the Villa d'Este*

c. 1760–65

Inscribed, in a later hand, on mount, lower right verso in pen and brown ink: *Pres Tivoli. Vue du Palais et jardin de la/ villa d'Este prise du côté/ de l'entrée dans la parterre/ Bâtie vers l'an 1540./ Fragonard no. 199.*

Pen and brown ink with brown wash and pen and gray ink with gray wash over red chalk counterproof on laid paper
18″ × 13½″ (456 × 342 mm)

PROVENANCE Private collection (sale, Paris, Hôtel Drouot, November 29, 1985, lot 61); purchased by Ian Woodner, New York; Woodner Collections, on deposit at the National Gallery of Art, Washington, D.C., since 1990

EXHIBITIONS Madrid 1986, cat. no. 100; Vienna and Munich 1986, cat. no. XIII; London 1987, cat. no. 100; New York 1989, *Piranesi* (no catalogue); New York 1990, cat. no. 104; Washington, D.C. 1995,

348

cat. no. 88

BIBLIOGRAPHY Roland Michel 1987, p. 32, fig. 23; Rosenberg 1988, fig. 2; Boulet, Cuzin, and Rosenberg 1990, p. 115
The Woodner Collections on deposit at the National Gallery of Art, Washington, D.C.

Fragonard spent the summer months of 1760 at the Villa d'Este at Tivoli as the guest of his friend and patron Jean Claude Richard, the abbé de Saint-Non. While there, he drew many views of the celebrated gardens and the surrounding countryside. These landscape drawings were immediately recognized as major achievements, and they are still considered to be among the finest examples of the artist's draftsmanship. The landscapes Fragonard drew at Tivoli are best known from the ten views executed in red chalk now in the Musée des Beaux-Arts, Besançon (Rosenberg 1988, cat. nos. 24, 25, 27–35, pp. 97–114). For this view of the villa's gardens the artist took a position near the end of the central pathway leading toward the façade of the villa, framed by stately cypress trees which are the actual subject of this monumental composition. When Fragonard finished a chalk drawing, he would normally place a damp sheet of paper over the drawing to remove excess chalk so that his work would not be

smeared—a common practice at the time. This technique also gave the artist a second version of his drawing, although the composition was in reverse to the original study (five counterproofs survive that were made from the ten drawings at Besançon; Rosenberg 1988, cat. no. 27, p. 103, fig. 1; cat. no. 30, p. 107, fig. 2; cat. no. 32, p. 109, fig. 2; cat. no. 33, p. 110, fig. 2; cat. no. 35, p. 114, fig. 1). The Woodner drawing is one of these counterproofs, which Fragonard reworked with pen, brush, and ink to create another version of his view of the cypresses. The radiant, sun-filled atmosphere of the red chalk version is here muted, the dense shadows created by Fragonard's ink washes suggesting another time of day or atmospheric condition when the light was less intense. Another brush and wash version of this composition is known, a repetition in the same direction as the original red chalk Besançon drawing (Albertina, Vienna, inv. no. 12, 755; all three related drawings are illustrated in Roland Michel 1987, pp. 32–33, pls. 22–24).

Tivoli had long been regarded by artists as one of the most picturesque sites in the Roman Campagna, and it is not surprising to learn that Charles-Joseph Natoire, director of the French

Academy, had already spent time there (cat. 380, dated 1765, and a letter to the Marquis de Marigny, dated July 4, 1759; Montaiglon 1887–1912, vol. 11, p. 282). Natoire also returned to the Villa d'Este the next year, when he made the celebrated watercolor view of the gardens dated April 1760 in the Metropolitan Museum of Art, New York (Jacob Bean and Lawrence Turčić, *15th–18th Century French Drawings in the Metropolitan Museum of Art* [New York: The Metropolitan Museum of Art, 1986], p. 189, cat. no. 208). There is no way to know whether Natoire advised Saint-Non to stay at the villa, but these associations do underscore the essential role Natoire played in encouraging the study of landscape among his students. In the eighteenth century the villa was owned by the Duke of Modena, Francesco III d'Este, who had let the property fall into disarray. For Fragonard this only enhanced the picturesque aspects of the site. The artist's drawings of Tivoli and the Villa d'Este are among the most moving evocations of the Italian landscape ever drawn by a French artist.

"There is nothing gratuitous here for every line is the result of a fervent observation of the marvelous Italian scenery. Everything is taut and ordered in the deep breathing of the elements of nature, in the movement of the wind, in the glare of the sun and in the restfulness of the shade. These are among the most truly lyrical drawings that a landscape has ever inspired" (Cuzin 1988, p. 60). [VC]

## HENRY FUSELI
ZURICH 1741–1825 LONDON

Henry Fuseli RA was born Johann Heinrich Füssli, on February 6, 1741, although he later regularly misstated his true birthdate. He was the second of the three sons and two daughters of Johann Caspar Füssli, portrait painter, writer on art, and collector of Renaissance and Swiss Old Master drawings and prints, and his wife, Anna Elisabeth Waser. Johann Caspar liked to refer to his household and five artistically talented children as "the home of the Fuselis, where the art of painting is cultivated," and published in their honor (1771) a series of six engraved portraits bearing this title. Johann Caspar was opposed to his son's becoming an artist (he had destined him for the clergy), but allowed Henry to ghostwrite the *History of the Best Painters in Switzerland* (1755) and other works published under Johann Caspar's name. From the age of ten Henry had surreptitiously developed his drawing skills (using his left hand), copying/imitating the works of the Swiss Mannerists in his father's collection (listed in Boerlin-Brodbeck 1978, pp. 162–71).

At the Caroline College in Zurich, Henry became a student of Johann Jakob Bodmer, whose *Critical Reflections on the Poetic Paintings of the Poets* (1741) prepared the ground for the "Storm and Stress" movement. Bodmer instilled in Henry a love of Homer, the Bible, the *Nibelungenlied*, Dante, Shakespeare, and Milton, which served him throughout his career as inexhaustible sources of artistic subject matter.

In 1761 Fuseli was ordained a Zwinglian minister, although he served only briefly in this capacity. When he, Johann Caspar Lavater, and Felix Hess were forced to leave Switzerland in early 1763 after exposing a corrupt magistrate, Bodmer arranged for them to accompany Johann Georg Sulzer, the Swiss art theorist, to Prussia. The friends spent several months at Barth in Pomerania visiting Johann Joachim Spalding, the theologian and moral philosopher. In October 1763 Fuseli returned to Berlin to assist Sulzer with his *General Theory of the Fine Arts* (1772), to which he contributed important essays on "Allegory," the "Sublime," and related topics. Everywhere he went, Fuseli's erudition, originality, and imaginative daring opened doors for him and he was singled out by the Bodmer circle to visit England as mediator between German and English literature. Sir Andrew Mitchell, the English chargé d'affaires in Berlin, took Fuseli to London in 1764, introducing him to the banker Thomas Coutts, the bookseller Joseph Johnson, and others who became life-long friends and supporters.

Among Fuseli's publications at this time were his translation of Winckelmann's *Reflections on the Painting and Sculpture of the Greeks* (1765) and his *Remarks on Rousseau* (1767), notable for his statements on the separation of art and morality (for Fuseli's early magazine articles and own review of the *Remarks*, see Mason 1951, pp. 134–36, 354–55). In 1768, after meeting Sir Joshua Reynolds, Fuseli finally made his choice of art over literature and decided to study in Italy. His journey was made possible through the generosity of Thomas Coutts, who established credits for him at Rome (Muschg 1942, p. 149).

Fuseli's first oil painting was *Joseph Interpreting the Dreams of the Baker and the Butler* (1768; see Knowles [1831] 1982, vol. 1, pp. 43–44; Schiff and Viotto 1977, no. 1). Because many paintings between 1768 and 1778 remain untraced, Fuseli's skill as a painter at this stage, and the number commissioned by Coutts before and during his stay abroad, have been greatly underestimated (Muschg 1942, pp. 153–54; unpublished letters). There were additional paintings executed for Lavater's *Physiognomy* (see Österre-

ichisches Nationalbibliothek, Vienna, *Das Kunstkabinett des Johann Caspar Lavater*, 1999, cat. no. 55; Susan Wise and Malcolm Warner, *French and British Paintings from 1600 to 1800 in the Art Institute of Chicago* [Chicago: Art Institute of Chicago in association with Princeton University Press, 1996], pp. 227–28; Vienna 1999, no. 55), and Thomas Banks's (probably overblown) estimate to Joseph Nollekens of another £1,300 worth of commissions for "Pictures" Fuseli received in the 1772–73 "season" (Weinglass 1982, p. 14). These bespeak Fuseli's growing experience in his craft and strengthen the broad conclusions of a recent study on him as a painter (Vogel 1996, pp. 77–104). Vogel concedes the precarious physical condition of many surviving paintings owing to Fuseli's handling of his raw materials (Vogel 1996, p. 80), but praises his "painterly intelligence" (p. 84), and judges that Fuseli's "painting technique generally kept pace with his artistic intention" (p. 83).

Fuseli set out by ship for Italy in mid-April 1770, accompanied by the physician–poet John Armstrong, and reached Rome by the end of May (Muschg 1942, pp. 150–51; Ingamells 1997, p. 385), where he adopted the Italianate form and pronunciation of his name (Mason 1951, p. 14, n. 1; Weinglass 1994, p. xi, n. 6). His eight-year stay in Italy, during which he fell under the spell of the Sistine Chapel and Michelangelo's "sublimity of conception, grandeur of form, and breadth of manner" (Knowles [1831] 1982, vol. 2, p. 84), was the most formative event in his artistic development. He even conceived the idea of the Sistine ceiling peopled with characters from Shakespeare. Other stylistic influences upon Fuseli were the Mannerists Parmigianino, Rosso, and Bandinelli. Rome itself with its proliferating antiquities and historical associations was "a trigger to the imagination" (Stainton 1974, p. viii). Pompeii, which Fuseli visited in 1775, could stir the imagination in similar fashion, as is reflected in his drawings *Satyr and Boy* and *The Selling of Cupids* (Schiff 1973, nos. 653, 655). But he did not spend time in formal studies, although he may have attended the Roman schools of anatomy and even performed partial dissections (Knowles [1831] 1982, vol. 1, p. 48).

Fuseli's name became a byword for tempestuous genius. He was "everything in extremes—always an original" (Muschg 1942, p. 168). He became the leading spirit of an international group of artists (Schiff suggests: "virtually leader of a school of painting") that included the painters Alexander Runciman, Nicolai Abraham Abildgaard, James Northcote, and John Brown, and the sculptors Thomas

Banks and Johan Tobias Sergel, whose style was characterized, like Fuseli's, by its emotionally expressive approach, dramatically simplified forms and, in their drawings, the suggestive use of wash (Pressly 1979, p. ix). In 1774 Fuseli sent for exhibition at the Royal Academy a drawing of *The Death of Cardinal Beaufort*, and in 1777 showed a painting of *A Scene from Macbeth* (now identified as *Macbeth and the Armed Head*), which he wanted kept out of sight until exhibited so that it would "produce a greater effect by coming unexpectedly upon the public" (Ozias Humphry to unknown addressee, perhaps Coutts, Royal Academy, HU/2/93).

On his way back to England, Fuseli returned to Switzerland for the last time, spending six months in Zurich (October 1778–April 1779), where he painted *The Oath on the Rütli* and *The Artist in Conversation with J.J. Bodmer*, although he had to complete these in London. Painted after his return to London, *The Nightmare* (1781, exh.1782), inspired by his frustrated passion for Anna Landolt, a niece of Lavater, made Fuseli infamous overnight; the image was disseminated throughout Britain and Europe in the form of engravings. Fuseli contributed eight large paintings and one small one to John and Josiah Boydell's Shakespeare Gallery (Winifred Friedman, *Boydell's Shakespeare Gallery* [New York: Garland, 1976], pp. 204–10, and passim). He also supervised the English edition of Lavater's *Essays on Physiognomy* (1789–98). From 1791 he worked against great odds to complete his Milton Gallery, a cycle of paintings of almost unprecedented artistic scope (cf. Michelangelo's "imitations" of Dante), illustrating John Milton's life and works. The first exhibition in 1799, containing forty paintings, was a financial failure, as was a second, enlarged, exhibition in 1800 (Schiff 1973, nos. 888–922, 1019–31; Weinglass 1982 [letter to William Roscoe, 1790–July 1800]; Staatsgalerie Stuttgart, Stuttgart, Germany, *Johann Heinrich Füssli: Das Verlorene Paradies*, 1987).

In 1788, shortly after his election as an associate of the Royal Academy, Fuseli married the beautiful, fashion-smitten Sophia Rawlins, of whom, over the next twenty years, he executed a remarkable gallery of almost 150 fantasized, mainly pen-and-ink-and-wash, "portraits." He was elected RA in 1790 and professor of painting in 1799 (his *Lectures on Painting* were published in 1801). In 1804 he also became keeper of the Royal Academy. In 1805 he published a new, substantially reworked, edition of Mathew Pilkington's *Dictionary of Painters*. The same year he made the acquaintance of John Knowles, his future executor and biographer. In 1818 Knowles

helped him to get his "Aphorisms on Art" into final shape (he had worked on them intermittently since 1788), and made a clean copy for the press (published in Knowles [1831] 1982, vol. 3). Fuseli died on April 16, 1825, at the home of the Countess of Guilford, Coutts's daughter, at Putney Hill. On April 25 he was buried in St. Paul's Cathedral. [DHW]

BIBLIOGRAPHY Knowles [1831] 1982, vol. 1, pp. 5–12; Muschg 1942; Mason 1951; Schiff 1963; Stainton 1974; Boerlin-Brodbeck 1978; Weinglass 1982; Vogel 1996; Ingamells 1997, pp. 385–86

## 349
## Henry Fuseli
## *Edgar, Feigning Madness, Approaches King Lear, Supported by Kent and the Fool, on the Heath*

1772

Pen and ink and brown and gray washes, heightened with white, over traces of pencil

24⅝" × 37⅘" (625 × 960 mm)

PROVENANCE Edward Croft-Murray; Hobart & MacLean, London, from whence purchased by the Birmingham Museums

EXHIBITIONS London 1997, cat. no. 24; Mamiano di Traversetolo 1997, cat. no. 43

BIBLIOGRAPHY Schiff 1973, vol. 1, p. 108, no. 464; Schiff and Viotto 1977, no. D14; Weinglass 1994, no. 300; Essick, Robert N. "Blake in the Marketplace, 1995: Including a Survey of Blakes in Private Ownership." *Blake: An Illustrated Quarterly*, vol. 29 (1996), 123, pl. 8

Birmingham Museums & Art Gallery, purchased with the assistance of the National Art Collections Fund, the Museums and Galleries Commission/Victoria and Albert Museum Purchase Grant Fund, supported by the Heritage Lottery Fund, the Rowlands Trust, the Public Picture Gallery Fund, John Kenrick and Pinsent Curtis

Fuseli considered Shakespeare "the supreme master of passions and the ruler of our hearts" (Knowles [1831] 1982, vol. 2, p. 145). Fuseli was an avid theater-goer yet he drew inspiration for his 250-plus illustrations of Shakespeare's work almost exclusively from the theater of his mind rather than actual stage performances. Indeed, some of the plays he illustrated were never part of the eighteenth-century Shakespearean repertoire: *King Lear*, for example, was played for over 150 years only in Nahum Tate's adaptation (1681), which omitted the Fool and ended happily with Lear restored to the throne.

In terms of its size and sublimity, this drawing, the largest Fuseli ever executed, represents an important milestone on his road to becoming a full-fledged history painter. Fuseli has chosen the climactic moment in the

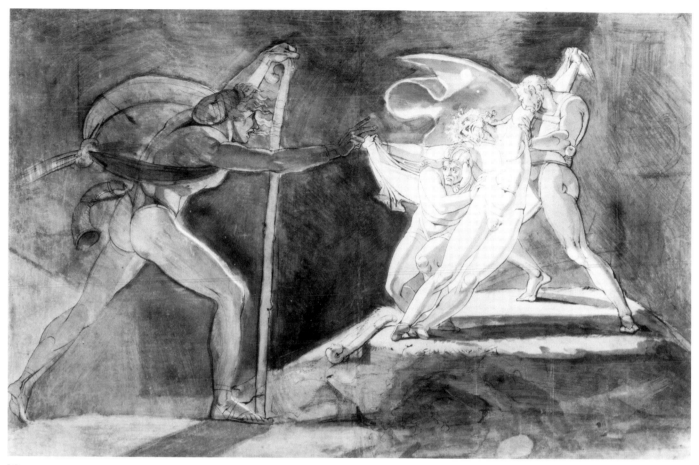

349

play (III. iv) when Lear, driven out by his unnatural daughters, is propelled into madness and an apparent catatonic trance by the sudden apparition of Edgar striding out of the storm toward him. Lear is shown with outflung arms, nude but for the cloak billowing behind him, supported by Kent and the Fool. By the mid-eighteenth century the metaphorical correspondence between the "tempest" within Lear's mind and the "pelting storm" without was widely accepted as the hallmark of Shakespeare's sublimity. But Fuseli created a new criterion for sublimity, determined not by traditional classes of subject matter but by the expressive effect of the work of art on the viewer (Knowles [1831] 1982, vol. 2, pp. 156–57). This is typically achieved through his exploitation of the human figure as his fundamental vehicle of expression in combination with exceptional compositional concentration. Fuseli's dramatic contrast of light and dark and his dynamic opposition of the lunging Edgar and the cowering figures of Lear's group reinforce the emotional impact of the scene. Among Fuseli's representations of Lear, this one stands out as a depiction of madness rather than anguish or grief. Lear's lolling head with its wild nimbus of white hair, eyes rolled back,

slack mouth, and expression of vacancy are characteristics of the introverted/withdrawn type of lunatic. In comparison, Edgar's assumed madness is of the energetic and manic type found in *The Escapee* (Schiff 1973, nos. 515, 956).

The drawing also exemplifies Fuseli's remarkable skill in finding appropriate figures and attitudes from "the great old masters" to transpose into his own compositions. Deliberately arranged like Christ on the cross during the deposition, Lear's attitude is perhaps modeled on a source in Michelangelo (for example, his *Resurrection of Christ*) and constitutes a universal and apposite correlative for suffering Lear, stretched "upon the rack of this tough world." (Compare the similar pose, based on the *Dying Bacchante*, of the fainting Saul in *The Witch of Endor*; Schiff 1973, nos. 372–73, 774, 957). The gigantic figure of Edgar that dominates the left-hand half of the sheet is reminiscent of Moses in Rosso's *Daughters of Jethro* (1523), from whom Fuseli had previously borrowed a figure for a scene showing Lear and Cordelia.

Fuseli's criticism seventeen years later of Joseph Wright of Derby's storm scene in the *Tempest* in his painting *Prospero's Cell*, with its emphasis on "expletives [minor details] of land-

scape and climate" at the expense of the figures (*Analytical Review*, vol. 4 [1789], p. 109), pinpoints the energizing elements of his own emotionally charged depiction of Lear in the storm. The indications of the outdoor setting have been reduced to a barely suggested wall and the door-opening of the hovel, and the curious stone slab atop the grassy mound on which the brightly illuminated group around Lear "contends with the fretful elements" (*King Lear*, act 3, scene 1, line 4). In a reworked version in pencil and black chalk executed in 1815, this group is on an elevation overlooking what might be construed as storm-tossed waves. The fury of the storm is suggested by the cloaks inflated by the wind and Edgar's windwhipped hair (here blown *forward*), a motif used by Fuseli "for human figures involved in a tragic retributive chain or witnessing terrible retribution" (Dotson 1973, p. 415). Fuseli's evocation of the turbulence of the storm is achieved through his subtle and expressive variation in depth of color around the main group by means of overlays of brown wash applied over already dry gray wash and underlying pencil work, and a milky white wash of thin chinese white laid over the wash surrounding the figure of Edgar: "Whatever connects the individual with the elements,

whether by abrupt or imperceptible means, is an instrument of sublimity" (Knowles [1831] 1982, vol. 2, p. 225).

The present drawing may be a study for the lost painting, perhaps from the late 1770s (Schiff 1973, no. 1734), with a squarer format, more compressed composition, and less dramatic lighting, known only from a photograph. The advantage of a finished sketch on paper, akin in size and effect to a painting, would have been practical as well as aesthetic. The crease down the middle of the sheet suggests it might have been folded and sent by post to a patron in England, such as Thomas Coutts, for preliminary approval. [DHW]

## 350
## Henry Fuseli
### *The Punishment of the Thieves*

1772

Inscribed and dated in brown ink at lower left: *Roma März 72/ Bolgia de' Serpenti*
Pen and ink, wash, pencil, heightened with white
18⅛" × 24⅛" (460 × 612 mm)
PROVENANCE Susan, Countess of Guilford, Putney; Paul Ganz, Basel
EXHIBITIONS Zurich 1926, cat. no. 105; Zurich 1941, cat. no. 230; Rome 1969, cat. no. 218; Zurich 1969, cat. no. 137;

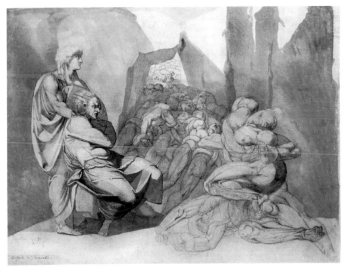

350

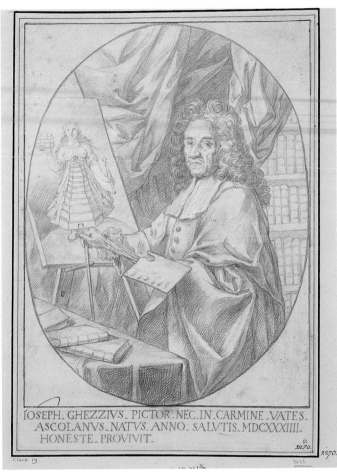

351

Hamburg, London, and Paris 1974, cat. no. 21; Milan 1977, cat. no. 2; Geneva 1978, cat. no. 19; New Haven 1979, cat. no. 32; Torre de' Passeri 1985, cat. no. 3; Copenhagen 1988, cat. no. 16; Stockholm 1990, *Füssli*, cat. no. 44

BIBLIOGRAPHY  Bell, Charles. *Essays on the Anatomy of Expression in Painting*. London: Longmans, 1806, pp. 142–57; Cunningham 1829–33, vol. 2, pp. 223, 269; Knowles [1831] 1982, vol. 1, p. 358, and vol. 2, pp. 164–66; Federmann 1927, pl. 33; Antal 1956, pp. 51, 56, n. 9; Schiff 1964, p. 128, pl. 80; Hartmann 1969, pp. 24–30, 259, 309, no. 1; Tomory 1972, p. 83; Schiff 1973, vol. 1, pp. 87, 101, no. 424; Schiff and Viotto 1977, no. D18; Lyle 1984, pp. 87–90; Russo 1993; Radrizzani 1995; Pinelli O. 1997

Kunsthaus Zürich, Graphische Sammlung

Fuseli's art was firmly grounded in literature. The great works of imagination, including *The Divine Comedy*, the *Nibelungenlied*, Shakespeare's tragedies, and John Milton's *Paradise Lost*, that became the staples of his art had been instilled in him by his teacher Johann Jakob Bodmer. The profound impression that Dante's imagery left on his mind was matched only by Fuseli's discovery of Michelangelo's pervasive "imitations" of Dante in the *Last Judgment* (Knowles [1831] 1982, vol. 2, pp. 164–66). It was this evidence of Michelangelo's and Dante's compatibility, Schiff suggests, that inspired Fuseli to illustrate the poet in the spirit of Michelangelo (Schiff 1973, vol. 1, p. 100). Eight of the ten Dante illustrations (with their various replicas) that Fuseli executed at Rome were drawn from the *Inferno*. These owe their strong emotional impact to their focus on moments of terror, horror, and despair, where Dante uses extreme, and often loathsome, physical torments as a metaphor of moral decay. For Fuseli, repulsive subject matter and such grand-guignol elements as "the axe, the wheel … the blood-stained sheet" (Aphorism 91; Knowles [1831] 1982, vol. 3, p. 91) are not "legitimate substitutes of terror" or effective engines of expression, for they prevent the work of art from "fully pronouncing its own meaning" (Knowles [1831] 1982, vol. 2, p. 190). Yet, although never "a genuine adherent of the Gothic Revival in its literal sense," Fuseli was not immune to the "irrational-gothicising tendency" of Mannerism evinced here (Antal 1956, p. 32). Apart from *Ugolino* and *Paolo and Francesca*, he never revisited any of these early themes.

The theory and practice of expression, defined as "the vivid image of the passion that affects the mind" (Knowles [1831] 1982, vol. 2, p. 255), was one of Fuseli's enduring artistic preoccupations. In *The Punishment of the Thieves*, Fuseli's first Roman representation of Dantean torment in Michelangelo's vein, it is the emphatic expressive attitudes of Fuseli's figures and his striking compositional patterns, particularly the interconnection resulting from the significant juxtaposition of his figures, that create drama and engage the viewer ("We become partners of the scene", Knowles [1831] 1982, vol. 2, p. 246). The exhibited drawing, one of the six largest of the approximately 350 drawings in all subjects that he executed in the 1770s, was conceived on a scale calculated to communicate "the true terrors of Dante" (Knowles [1831] 1982, vol. 2, p. 164). Despite his conflation of the narrative, the drawing displays Fuseli's typical fidelity to the text.

Dante and Virgil are depicted at the head of the seventh *bolgia* (gorge) of the Malebolge ("Evil Pouches") in the eighth circle of Hell, observing the agonies of the thieves as they are attacked and assimilated by the serpents (*Inferno* xxiv–xxv). In contrast to Virgil's contemplative stance, Dante's horror and aversion are reflected in his contorted features, his hair standing on end, and the violence with which he recoils from the sight of God's harsh vengeance. As Charles Bell asserts, "Horror is full of energy" (Bell, p. 148 see above). Dante and Virgil are more solidly drawn than the thieves, suggesting that the separation of the two groups is both physical and moral; Dante thus becomes a touchstone for the viewer's own response. To avoid "clogging" his conception and diluting its immediacy, Fuseli captures Dante's detailed descriptions of the rugged setting by the broad use of wash to suggest cliff walls and jutting crags.

Following his own tenet that "the judicious adoption of figures in art" does not impair originality (Knowles [1831] 1982, vol. 2, p. 81), Fuseli has appropriated the compositional design of the *Brazen Serpent*, with its reminiscences of the *Laocoön*, from one of the spandrels of the Sistine Chapel. By creating a more explicit resemblance between the antique *Laocoön* and the figure of the thief, Vanni Fucci, in the group at the right, as he is metamorphosed into a serpent, Fuseli provides a powerful, generalized, and immediately apprehensible image of anguish "too big for utterance" (Knowles [1831] 1982, vol. 2, p. 259; and Aphorism no. 89, Knowles [1831] 1982, vol. 3, p. 90, where Fucci's "transfusion" is linked to "the metamorphoses of ancient mythology"). Hereafter, until c. 1790, the motif of the thief's thrown-back head is regularly associated in Fuseli's work with Dante's Damned Souls (for bibliographical details, see Radrizzani 1995, p. 365), but reappears, c. 1803, in his illustrations of Homer to convey grief (Schiff 1973, nos. 1192, 1249; Butlin 1992, lot 38; Weinglass 1994, no. 235). The fallen thief, shown in the throes of transformation from reptile back to man, is based on the figure of God the Father in *The Separation of Light from Darkness*. The horror and shock inspired by these partially flayed (écorché) bodies is intensified by the repetition of the entwined and agonized forms of the damned stretching away in an increasingly abstract pattern into the depths of the gorge.

Pressly speculates that Fuseli may have contemplated sending a version of this subject to the Royal Academy before settling on *The Death of Cardinal Beaufort*, also dated 1772. [DHW]

## GIUSEPPE GHEZZI

COMUNANZA 1634–1721 ROME
*For biography see Paintings section*

### 351
## Giuseppe Ghezzi
### *Self-portrait*

c. 1720

Inscribed: *IOSEPH. GHEZZIVS. PICTOR. NE .
IN. CARMINE. VATES./ ASCOLANVS. NATVS.
ANNO. SALVTIS. MDCXXXIIII./ HONESTE.
PROVIVIT.* Numbered at lower right in pen
and brown ink: *2270*
Red chalk
16½″ × 11⅛″ (420 × 290 mm)
PROVENANCE as for cat. 338
BIBLIOGRAPHY Pio [1724] 1977, p. 108;
Clark 1967, "Portraits," p. 13, no. 19;
Bjurström 1995, p. 95, no. 51; De Marchi
1999, "Ghezzi," p. 21, fig. 1.4
Nationalmuseum, Stockholm
*For commentary see cat. 338.*

## PIER LEONE GHEZZI

ROME 1674–1755 ROME
*For biography see Paintings section*

### 352
## Pier Leone Ghezzi
### *Caricature of Farinelli*

1724

Inscribed lower left, in the artist's hand:
*Farinello Napolitano/ famoso cantore di Soprano
che/ cantò nel Teatro d'Aliberti nell'anno 1724/
fatto da me Cav. re Ghezzi di Marzo 1724*
Pen and brown ink
12″ × 8¼″ (305 × 211 mm)
PROVENANCE Edward Goddard, London;
Dr. Max A. Goldstein, St. Louis
EXHIBITIONS Hamburg, Germany,
Hamburger Kunsthalle. *Italienische
Meisterzeichnungen vom 14. bis zum 18.
Jahrhundert aus amerikanischen Besitz: Die
Sammlung Janos Scholz.* 1963, cat. no. 68;
Washington, D.C. 1966, cat. no. 26;
London, Arts Council Gallery. *Italian
Drawings from the Collection of Janos Scholz.*
1968, cat. no. 42; New York 1971
BIBLIOGRAPHY Kirkpatrick 1953, no. 30;
Hamburger Kunsthalle, Hamburg,
Germany. *Italienische Meisterzeichnungen vom
14. bis zum 18. Jahrhundert aus americanischem
Besitz: Die Sammlung Janos Scholz.* Hamburg,
Germany: H. Christians, 1963, no. 68;
Wunder 1966, no. 26; Arts Council of Great
Britain, London. *Italian Drawings from the
Collection of Janos Scholz.* London: Arts
Council of Great Britain, 1968, no. 42;
Petrobelli 1985
The Pierpont Morgan Library, New York

This caricature portrays the famous
singer Carlo Broschi, who was born in
Andria in 1705 and died in Bologna in
1782, known by the name of Farinelli
or Farinello. He was the brother of the
composer Riccardo Broschi and was
the most famous castrato singer of all
time. When still very young he was
invited to Porpora's school in Naples,

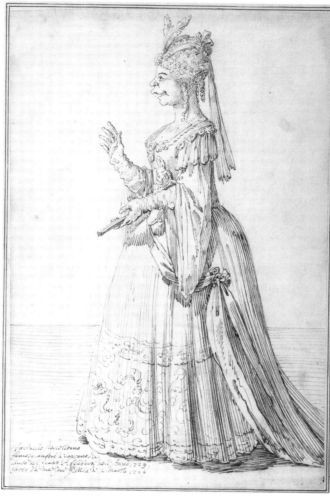

352

where he made his début at the age of
fifteen in the serenade *Angelica and
Medoro*, with music by Porpora and
libretto by Metastasio.

From the very first he enjoyed
prodigious success. He sang in many
Italian theaters and received extraor-
dinary acclaim in the European
courts. From 1731 to 1734 he was
engaged for *The Opera of Nobility* at the
King's Theatre, London, where his
success, along with that of Senesino,
another singer in vogue at the time,
was decisive for the fortune of Italian
opera. Farinelli, who from 1725
onwards appeared many times on
stage in Venice, was portrayed in cari-
cature also by Marco Ricci and Anton
Maria Zanetti.

The portrait by Ghezzi shows him
at age nineteen, just four years into his
long career, which began in Naples in
1720. In Rome he probably sang in
Porpora's *Eumene* at the Teatro d'Aliberti
in 1721; he certainly performed in the
same composer's *Flavio Anicio Olibrio*
in 1724, as this drawing proves. Ghezzi's
caricatures of the musical world are
extremely numerous, and depict com-
posers, librettists, and orchestral con-
ductors, as well as singers such as
Farinelli, whom he drew twice more

(Vatican City, Biblioteca Apostolica
Vaticana, Codice Ottoboniano Latino
3115, fol. 139, and 3116, fol. 146). Other
famous singers of the time immortal-
ized by Ghezzi include the castrato
Porporino (Ott. Lat. 3117, fol. 17) and
Farfallino (Ott. Lat. 3114, fol. 113) (see
Petrobelli 1985).

The artist concentrates mainly on
depicting the richly fashionable gar-
ments, showing every precious detail
of fringes, bows, and laces, and on the
complicated headdress with the
feather. He thus accentuates the sense
of feminine transvestitism and at the
same time indulges one of his own
tastes, for the world of fashion. The
drawing calls to mind the celebrated
portrait of Farinelli painted by Corrado
Giaquinto (Civico Museo Bibliografico,
Bologna). In contrast to Ghezzi's cari-
catures, the singer is depicted there in
male dress, of great and sumptuous
elegance, which turns the example into
a real gala portrait, a celebration of his
fame and prestige. Another portrait
by Giaquinto is a small drawing in the
Spadavecchia collection at Molfetta in
red chalk on paper, showing only the
face and shoulders, a work of great
psychological intensity (*Giaquinto*
1993, pp. 190–91). [ALB]

### 353
## Pier Leone Ghezzi
### *Caricature of Dr. James Hay as
Bear-leader*

c. 1725

Inscribed lower: *Dr. Hay Cav. Ghezzi*; on
verso, in a different hand, is written *A
Caricature of Dr. Hay, an old Scotch travelling
Gouverneur/ Engraved by Pond*
Pen and brown ink
14½″ × 9½″ (363 × 243 mm)
PROVENANCE John Thane; Sir Thomas
Lawrence; sold by Samuel Woodburn, June
4, 1860, to John Bayley; Sir Thomas
Phillipps; by descent to T. FitzRoy Fenwick;
acquired by The British Museum in 1964
through Colnaghi
EXHIBITIONS London 1960, cat. no. 645;
London 1974, cat. no. 238; London and
Rome 1996, cat. no. 54
BIBLIOGRAPHY Popham, A. E. *Catalogue of
Drawings in the Collection Formed by Sir
Thomas Phillipps at Thirlestone House,
Cheltenham.* London: Privately printed for T.
FitzRoy Fenwick, 1935, p. 145; *Italian Art and
Britain 1960*, p. 238; *Portrait Drawings 1974*,
no. 238; Wilton and Bignamini 1996
The British Museum, London

This rare and curious illustration
shows James Hay leading a tame bear.
This alludes to the Englishman's activ-
ity as a companion to travelers making
the Grand Tour in Italy, an occupation
that he often pursued between 1704
and 1729, when he guided at least eight
of his compatriots through their
Italian journeys. As Besley commented
in 1996, the term "bear-leader" became
universally adopted. Bear-leaders were
responsible for the safety and the
financial control of their charges and
their specialist knowledge was supple-
mented by *ciceroni*, who had knowledge
of specific sites. In Rome the best
known *ciceroni* were James Russel and
James Byres.

Ghezzi was in particular touch with
the expatriate community in Rome,
principally with the French, through
the French Academy, which he fre-
quented and about which he left testi-
monies in the form of numerous
caricatures and paintings, including
the famous portrait of the sculptor
Edme Bouchardon (Uffizi, Florence).
The English colony too had connec-
tions with the painter, as is revealed
by some caricatures kept in Rome's
Istituto Nazionale per la Grafica
(volume 2606), recently published by
Antonella Pampalone. These include
*Lord Bruce* (F.N. 4736), *Lord Calon* (F.N.
4737), *Monsignor Martin, Milord English
Visiting Rome in the Year of Our Lord 1750*
(F.N. 4676), and others.

The drawing from the British
Museum appears particularly precise
and masterly in its fine, meticulous
strokes defining the two characters:
the bear dressed up to the nines with
a plumed hat and a dress sword
(showing Ghezzi's qualities as a

353

*Cavaliere Inglese dilettante delle Antichità*

354

draftsman very clearly in the felicitous speed of hand), and Dr. Hay likewise very elegantly dressed in the fashion of the times. His hand resting on his stick stresses the Englishman's job as a guide, having to clear his way on the path to accompany his client. But what is most striking is the man's expression, not only grotesque in his features, according to the contemporary taste for exaggerated defects, but with a look of grim determination that accentuates the role he is playing. In fact the hardness of his features reflects perfectly the demands of Hay's profession, having to defend those he accompanies and probably direct their choices.

The scene takes place in the open air, almost certainly somewhere around Rome, the obvious destination for pleasant and instructive outings. The castle in the background can very probably be identified as that of Bracciano, which is similarly placed and has the same broad turrets.

Belsey dates the caricature to around 1725, based on Hay's time in Italy. This dating is corroborated by the drawing's rich and refined inventiveness, typical of Ghezzi's early maturity. His subsequent output became repetitive, often preferring head-and-shoulders portraits, seen in profile. [ALB]

## 354
## Pier Leone Ghezzi
### *Caricature of Joseph Henry*

1750

Inscribed at lower left, by the artist: *S.r Gioseppe Henrij Inglese Huomo assai erudito nelle Antichità e in Letteratura huomo assai.* Inscribed outside border, in a different hand: *Cavaliere Inglese dilettante delle Antichità* Pen and brown ink over traces of black chalk 12¼″ × 8½″ (312 × 213 mm)

PROVENANCE collection of the 7th Duke of Wellington, Stratfield Saye House, Berkshire; acquired by The Metropolitan Museum of Art, New York, 1973

EXHIBITIONS New York 1978, cat. no. 12; New Haven, London, and Ottawa 1984, cat. no. 8

BIBLIOGRAPHY The Metropolitan Museum of Art, New York. *Annual Report*, 1972–73, p. 34; *Artists in Rome* 1978, no. 12; Hiesinger and Percy 1980, p. 24; *English Caricature* 1984, no. 8; Clark and Bowron 1985, p. 250; Bean and Griswold 1990, p. 87

The Metropolitan Museum of Art, New York, Rogers Fund

Anthony Clark identified the figure as Joseph Henry of Straffan, son of an Irish banker, who went to Italy in 1750 (Hiesinger and Percy 1980, p. 24). Like many British, he went to Italy to study ancient remains and the classical culture. The drawing is emblematic. The young man, dressed with refined elegance but not ostentatiously, is surrounded by the symbols of the ancient world that so enthused him: an ancient column, the remains of capitals and sarcophagi in the foreground, a stele further back and even an oil lamp, bottom left, similar in every detail to those drawn many times by Ghezzi.

The artist depicted James Henry on two further occasions. The first time was with three other persons who shared his interest in archaeology, namely John Martin, Lord Bruce, and Lord Middleton, in a drawing housed in the Philadelphia Museum of Art (Hiesinger and Percy 1980, no. 13). The second instance is a drawing in volume 2606 (folio 204) of the Istituto Nazionale per la Grafica, recently published by Antonella Pampalone, in which Henry is depicted only head and shoulders (Pampalone 1997, p.83). This version is practically identical in the facial expression, pose, and clothing, even though it is limited solely to the bust. The inscription underneath is similar too: *S.r. Giuseppe Henrij inglese uomo assai erudito nelle antichità 9bre 1750/ parti da Roma p. Venezia li 12 Maggio 1751.* In Ghezzi there is a constant attention to everyday events such as the departures and arrivals of foreign visitors, dinners, holidays, visits, weather conditions, and also to families, weddings, friendships, characters, human and professional qualities, and public positions. The artist meticulously notes a collection of observations and events in the captions to his caricatures, suggesting an analogy with the dawn of journalism.

This caricature, datable therefore to Henry's stay in Rome in 1750, appears typical of Ghezzi's style. There is a systematic, almost serial, approach, and a graphic precision, partly owing to his habit at this time of hatching in many of his works. A famous portrait of Henry painted by Pompeo Batoni,

355

now housed in the Walter Art Gallery in Baltimore, also highlights the subject's passion for the ancient world and classical culture (Clark and Bowron 1985, p. 250). [ALB]

## 355

### Pier Leone Ghezzi

*Caricature of the Marquis de Vandières, Jean-Bernard Le Blanc, the Architect Germain Soufflot, and the Engraver Charles Nicholas Cochin*

1750 or 1751

Inscribed by the artist: *1 Monsieur de Vandier Direttore delle Fabbriche del Re di/ Francia 2 L'Abbé Bianco 3 Mons.r Sufflò 4 Mons.r Coscian*
Pen and brown ink over traces of black chalk on paper
12″ × 8¼″ (303 × 211 mm)

PROVENANCE  collection of the 7th Duke of Wellington, Stratfield Saye House, Berkshire; acquired by The Metropolitan Museum of Art, New York, 1972
EXHIBITIONS  New York 1978, p. 11; Paris, Caisse Nationale des Monuments Historiques et des Sites. *Soufflot et son temps, 1780–1980.* 1980–81, cat. no. 76
BIBLIOGRAPHY  The Metropolitan Museum of Art, New York. *Annual Report.* 1971–72, p. 46; *Artists in Rome* 1978, p. 11; Caisse Nationale des Monuments Historiques et des Sites, Paris. *Soufflot et son temps, 1780–1980.* Paris: C.N.M.H.S., 1980, no. 76; Bean and Griswold 1990, p. 86
The Metropolitan Museum of Art, New York, Rogers Fund

The group features Abel Poisson, Marquis de Vandières and the last Marquis de Marigny (labeled no. 1), brother of Mme. Pompadour, who was in Italy from December 1749 to undertake a journey of discovery of the country's artistic and archaeological treasures. Since he had just recently been appointed Surintendant des Bâtiments du Roi, a prestigious and onerous job for a man of only twenty-three, the study tour in Italy seemed an opportunity to learn and prepare for his elevated duty. Under these circumstances he obtained the companionship of the personalities around him in the drawing. These are the abbot Jean Bernard Le Blanc (labeled no. 2), the architect Jacques Germain Soufflot (3), and the engraver Charles Nicholas Cochin (4) who wrote the report of the journey, published under the title *Voyage d'Italie ou Recueil de notes sur les ouvrages de peinture et de sculpture qu'on voit dans les principales villes d'Italie.* At the head of the little expedition, the Marquis de Vandières visited numerous Italian towns and on March 17, 1750, reached Rome, where he was welcomed to the French Academy by the director, Jean-François de Troy (see *I francesi a Roma* [Rome, 1961], p. 240). He stayed a year in the city, absenting himself for a few trips to Naples, and left to return to Paris on March 3, 1751. During his time in Rome he must have got to know Ghezzi well and certainly admired his output of caricatures. It is known in fact that when the artist died the marquis tried to acquire the volumes of his drawings by writing to Charles Natoire, who had become director of the French Academy, asking him to approach the widow, Caterina Peroni. But Poisson failed to acquire them, owing to their very high price (Benisovich 1967).

Ghezzi drew the persons in the group several times. The complete series of portraits is kept in codex 2606 of the Istituto Nazionale per la Grafica (Pampalone 1997, p. 112).

As was his custom, Ghezzi accentuated the facial defects of his various subjects, who are shown in profile to reveal more clearly and easily the anomalies in their features. The most important individual, the Marquis de Vandières, is holding an architectural design, which is unfortunately not identifiable. The others are all richly dressed in the fashion of the time, drawn in minute detail. But the element of great novelty in Ghezzi's repertoire is its documentary value. In fact nearly all the caricatures are accompanied by a caption written by the artist, with detailed information about the person depicted, complete with the date when it was done; they thus constitute a useful source for reconstructing the important fabric of eighteenth-century social history and comprise an archive of eighteenth-century culture that scholars of all disciplines have drawn on.

In their 1990 catalogue Bean and Griswold note an identical copy of the drawing in the Metropolitan Museum of Art, which is housed in the Département des Arts Graphiques (inv. no. 3277) at the Musée du Louvre. [ALB]

## 356

### Pier Leone Ghezzi
*Caricature of Sebastiano Conca*

1750–52

Inscribed at lower left, by the artist:
*Il Sigre. Bastian Conca Pittore napoletano bravissimo il quale sta in atto di dipingere*; inscribed on mount, in a different hand: *Sig.re Gio. Battista Conca Pittore Napolitano*
Pen and brown ink on paper
12½″ × 8½″ (316 × 215 mm)

PROVENANCE  the folio comes from three volumes of caricatures executed for Charles V, King of Naples from 1734 to 1755; it then passed into the collections of Giuseppe Bonaparte (1808–13); the Duke of Wellington; and Robert Light, Santa Barbara; acquired by the National Gallery of Art, 1975
National Gallery of Art, Washington D.C., Ailsa Mellon Bruce Fund

The drawing bears two separate, contradictory inscriptions, indicating that it portrays two different persons: the first, in Ghezzi's own hand, indicates that the subject is Sebastiano Conca, while the second, written later on the edge of the mount, names Giovan Battista Conca. The first is obviously the more reliable because it was written by the artist himself. Nevertheless its identification of Sebastiano Conca is not definitively proved when comparison is made with other portraits of the famous painter. The closest parallel among these is the caricature done by the artist, kept in the Codici Ottoboniani Latini of the Vatican Library (vol. 3117, fol. 115), dated July 15, 1741. The painter was born in Gaeta in 1680, so in the caricature he was sixty-one, younger than in the drawing in Washington. The general system of the composition is similar, but the face is different. Nevertheless there are broad similarities in the physiognomy, which is also similar to that in Conca's *Self-portrait* in the Uffizi, dating from 1731 (inv. no. 1753). All three reveal the same deep-set eyes, wide forehead, and prominent nose.

The painter is depicted inside his studio amid the tools of his trade, with canvases leaning against the walls, unfinished or just completed, and one still on the easel, unfortunately not identifiable except as a scene set in a landscape. The figure with the basket, the only one visible in the canvas he is painting, suggests a narrative subject, admittedly unusual in Conca's repertory.

As for the possibility that this is really Giovan Battista Conca—the son of Giacomo and cousin of Sebastiano, although he was thought of as Sebastiano's brother because of their deep friendship and working relationship (Michel and Michel 1982)—this is impossible to prove either way, since no other images are known of him, from which a comparison with the Washington drawing could be made.

It is safer therefore to assume that Sebastiano is the person depicted, and the differences between the caricature of 1741 and the Washington drawing allow the latter to be dated to around 1750–52, making the Neapolitan painter around seventy at the time it was executed.

With the years Ghezzi's style became so similar in terms of setting,

Sig.re Gio. Battista Conca Pittore Napoletano.

356

choice of pose, and small details that it risked becoming repetitive. This was to some extent an inevitable consequence of the increase in demand for his work, and his growing commercial success. His touch became fastidious and repetitive, but also gained refinement and character, clear reasons for the increasing diffusion of his drawings. [ALB]

## FELICE GIANI

### SAN SEBASTIANO CURONE, ALESSANDRIA 1758–1823 ROME

At the time of his birth there in 1758, the province of Alessandria was the imperial fiefdom of Prince Andrea Doria Pamphili, and it was the prince who later became the artist's patron in Rome. Giani served his apprenticeship in Pavia with the painter Carlo Antonio Bianchi and the architect Antonio Galli Bibiena and is known to have been working in Bologna in 1778 as a pupil of Domenico Pedrini and Ubaldo Gandolfi. The following year he won an award from the Accademia Clementina in Bologna for his *Baptism*

of Christ (Accademia di Belle Arti, Bologna), which pays homage to the sunlit Venetian vision of Gaetano and Ubaldo Gandolfi. Giani then moved to Rome in 1780, having already encountered in Bologna the tenebrist style of the Irish artist James Barry, whose monumental *Philoctetes* (Pinacoteca Nazionale, Bologna) had been painted in that city in the fall of 1770.

The years between 1780, when he arrived in the capital, and 1786, when he was first called to Faenza, were the crucial period of Giani's education. In 1783 he won joint second prize with Giuseppe Cameron di Valenza in a painting competition organized by the Accademia di S. Luca. Giani's large drawing in pen and ink heightened with white lead shows *Christ Driving the Money-changers from the Temple* (cat. 357). Like Giuseppe Cades, Giani emphasized the use of sixteenth- and seventeenth-century sources, creating an imaginative and theatrical Neoclassicism close to that of French contemporaries such as Vien, Peyron, and Perrin. In 1784 he won second prize in a competition at the Accademia di Parma for his *Samson*

*and Delilah* (Pinacoteca Nazionale, Parma). This work is something of a composite, with none of the rigor of Jacques-Louis David's *Oath of the Horatii*, which was painted the same year. Perhaps the most innovative element is the group of onlookers on the left, but the right-hand side is overloaded with quotations from artists ranging from Pellegrino Tibaldi and Giulio Romano to Polidoro da Caravaggio and the Vatican Logge.

This forms a surprising contrast with Giani's graphic art during this period, in which he created figures already Neoclassical in style and touched with Parma grace (*The Genius of the Fine Arts*, 1784; private collection). With this composition Giani took up a precise position. Clearly signed and dated on the lower left-hand edge, the allegory could be read as a manifesto for his dramatic conversion to Rome. From this time onward, he systematically studied the antique, from the Domus Aurea to Hadrian's Villa, and made the inevitable pilgrimage to Naples and Pompeii in 1792. However, the Vatican Logge, and sixteenth-century grandeur in general, remained the central theme of Giani's notebooks, where he recorded all the paintings, architecture, and excavations he saw and made countless detailed impromptu notes. Pompeo Batoni, Cristoforo Unterperger, and the architect Giovanni Antonio Antolini became his acknowledged masters, while for the study of the nude one source was Domenico Corvi (Gasparoni 1863, p. 10).

In fact, though, the works that can be dated to the 1780s show a complex network of artistic sources, ranging from the northern European painters to the circle of Angelika Kauffmann. Giani had joined forces with the decorative artist Liborio Coccetti in order to gain work, and under the direction of Cristoforo Unterperger had been involved in the large encaustic paintings, derived from Raphael's Logge, which were sent to St. Petersburg in 1788 to satisfy the mania of Catherine II for antiquities and to decorate the Winter Palace.

From this period on, Giani's style of interior decoration was dominated by this experience, and he sought to achieve a wholly new version of Raphael's grotesques. He began to specialize in interior decoration, an area in which he was extraordinarily successful, but had yet to set up his own studio. In 1786 he went to work for the *quadratura* painter Serafino Barozzi in Faenza, where he painted first the Galleria dei Cento Pacifici and then the gallery of the Palazzo Conti. Although he adopted a more modern Roman style following the precedent of his teachers in Bologna, Pedrini

and Gandolfi, the architectural framework created by Barozzi, a specialist in illusionist decoration, remained a major influence. The composition, with its large figures projected into the immensity of the sky, remained indebted to the Venetian school, whose style Giani had learned of through the Gandolfi brothers. At this stage in Giani's career the figure painter was undoubtedly subordinate to the *quadratura* specialist.

Giani was elected to the Accademia Clementina in Bologna in 1787; his drawing of *The Miracle of the Loaves and Fishes* was sent as a gesture of thanks two years later. He then returned to Rome, where between 1789 and 1793 he produced a masterpiece: the decoration of the Palazzo Altieri, which marked a turning point in his interior decorative painting. From now on he concentrated almost exclusively on this genre. He was peripherally involved in work on the Villa Borghese and the Palazzo Chigi in Rome, and then worked independently on the decoration of the gallery of the Palazzo Laderchi in Faenza, where he painted the fable of *Cupid and Psyche* in 1794. Giani subsequently went on to set up his own workshop, with whose members he established a close and disorderly relationship. He took on four paid individuals, whom he whimsically referred to as his "studio" (Gasparoni 1863, p. 11). They comprised a decorative artist, Gaetano Bertolani; a stuccoist from Rimini, Antonio Trentanove (replaced in the early nineteenth century by the Ballanti Graziani brothers and later by Pietro and Marcantonio Trefogli); and a few other assistants. The studio worked in accordance with precise instructions by Giani, to which hundreds of autograph drawings bear witness. It was Giani who designed the ornamentation, stuccos, furniture, and fittings, and he also carried out much of the painting himself. "He would always obtain agreement from his patrons that he and all his assistants should be provided with food," records Tommaso Minardi (De Sanctis 1900, p. 22). Provisions and cases of wine feature prominently on the lists of payments received; from April to December (no murals were painted during the cold of winter) the workers lived a riotous communal existence.

The sequence of Giani's work, and thus the development of his art, can be traced with a reasonable degree of clarity. An autograph notebook consisting of sixty-six unnumbered pages records the chronology of his work from 1802 onwards. It indicates when and how payments were received, and how they were divided up between the workers, depending on the work they had done. There is no reference to easel paintings, of which there were

very few. Projects included a number of large cycles in Faenza (Palazzo Naldi, 1802; Milzetti, 1802–5; Gessi, 1813; Cavina, 1816), Bologna (Palazzo Aldini, 1805; Marescalchi, 1810; Lambertini Ranuzzi, 1822; Baciocchi, 1822), and Rome (Palazzo di Spagna, 1806; Palazzo del Quirinale, 1811). He also carried out many decorative projects elsewhere, including Forlì, Ferrara, Ravenna, and Venice. Some of these cannot be traced, including those carried out in Genoa in 1799 and his French commissions. However, his work in the villa of the minister Antonio Aldini in Montmorency, near Paris (1812–13), is very well documented (it is unlikely that Giani carried out the more prestigious projects in which he was later reputed to have been involved, such as the decoration of the Malmaison and the Tuileries). Giani had previously been in Paris to execute the drawings from pictures in the Louvre used in the engravings in the *Musée Français* (1803–9) by Robillard-Péronville and Laurent. Given his insatiable curiosity, he may also have visited England; his brother Giovanni lived in London.

Giani's private life was errant and bohemian. He moved in the highest circles in Rome, Milan, Paris, and Venice, and his letters (Acquaviva and Vitali 1979) show that he was mixing with such major figures as Appiani, Canova, Antonio d'Este, Quarenghi, Giacomo Bianconi, Giovan Battista Borsato, and Ennio Quirino Visconti, whom Giani went to meet in Paris. But official recognition was slow to come. It was not until 1811, at the age of fifty-three, that he was admitted along with Andrea Appiani to the Accademia di S. Luca (Rome, Archivio dell'Accademia di S. Luca, MS. 56). He was proposed for membership by the painters Gaspare Landi, Francesco Manno, and Jean-Baptiste Wicar. In 1819, when he was sixty-one, he joined the Congregazione dei Virtuosi al Pantheon. He continued working at a phenomenal rate until the end of his life. His last commission for Prince Felice Baciocchi in Bologna, the decoration of six rooms which he carried out in 1822 at the age of sixty-four, took only three months. It was executed at the same time as his work on the Palazzo Lambertini Ranuzzi. "Seeking to complete this important enterprise before returning to his beloved Rome, he delayed his return for a time; usually he returned in October. As he was leaving Bologna," Michael Köck recounts, Giani "had the misfortune to fall on his left hand" (Rome, Archivio dell'Accademia di S. Luca, vol. 73, no. 110). The resulting fractures, combined with the cold weather and the lack of treatment, caused gangrene, and he died on January 10, 1823. He was buried in

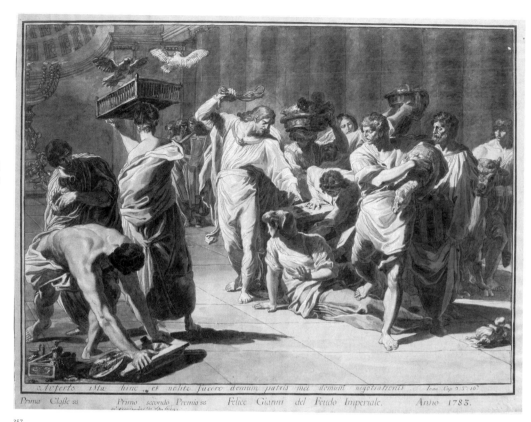

357

S. Andrea delle Fratte, with no tombstone. The *Liber mortuorum* of S. Andrea states that he was buried "in sacello patris Francisci de Paola" on January 11, 1823 (p. 38, no. 79). However there is no trace of his burial in the church. Giani left his house in the via Gregoriana to Michael Köck, together with "all the pictures and books in the said house and in my studio" (see the will and other documents found in June 1997 in the private archive of Dr Riccardo Giani, Alessandria, San Sebastiano Curone). [AOC]

BIBLIOGRAPHY Gasparoni 1863, pp. 10–12; De Sanctis 1900, p. 22; Acquaviva and Vitali 1979, pp. 25–122; Ottani Cavina 1999

## 357
## Felice Giani
### Christ Driving the Money-changers from the Temple

1783

Inscribed on lower edge: *Auferte ista hinc, et nolite facere domum patris mei domum negotiationis. Ioan: Cap:2.V.16/ Prima Classe-Primo secondo Premio—Felice Gianni del Feudo Imperiale. Anno 1783/ Noi Accademico di San Luca*
Pen and brown ink, heightened with white lead; on ivory-colored paper
23¼″ × 31⅛″ (605 × 790 mm)
PROVENANCE Concorso Clementino, Accademia di San Luca, Rome, first class painting, first/second prize, 1783
BIBLIOGRAPHY Salerno 1974, "Collezione," pp. 355, 362, fig. 40; Ottani Cavina et al.

1979, p. 10, no. 6, fig. 7; Ottani Cavina 1999, p. 19, fig. 12

Accademia Nazionale di San Luca, Rome

For the Concorso Clementino of 1783, two subjects were given, as always. The first, announced in advance, was taken from the Gospel of John: "The drawing must show Christ casting out the money-changers from the temple" (Rome, Accademia di S. Luca, *Verbali delle Congregazioni*, vol. 54, cc. 37). The second, "Jesus Christ appears to two of his disciples on the road to Emmaus" (*Verbali delle Congregazioni*, vol. 54, cc. 38), was set for the *extempore* test, and had to be executed without preparation. Giani's submission for the latter test is lost, but for *Christ Driving the Money-changers from the Temple* he was placed equal second with Giuseppe Cameron of Valencia. The winner was Giuseppe Grech from Malta, while a Frenchman, Laurent Blanchard, was placed third.

When he won the Marsili competition in Bologna in 1779, Giani's name was given as "Felice Giani Pavese," referring to his early studies in Pavia with the painter Carlo Antonio Bianchi. Here, he is specified as "del Feudo Imperiale," indicating that he was originally from the city of San Sebastiano Curone in the province of Alessandria. The feudal lord of the city was Prince Andrea Doria Pamphili, who offered Giani hospitality in his Roman palace in via del Corso when the artist arrived in Rome c. 1780.

Sources indicate that while in Rome Giani associated with Pompeo Batoni and then Liborio Coccetti, but the most obvious influence was that of Giuseppe Cades. All Cades's works, from the decoration of the Sala Nova for Senator Don Abbondio Rezzonico in the Capitol (1779) to sketches for some (unexecuted) paintings for St. Petersburg (*The Fall of the Rebellious Angels*, 1798–99), reveal that in decorative projects and graphic works his life and Giani's were running parallel. Both showed a readiness to turn to certain specific models, from Michelangelo to Pellegrino Tibaldi, and they also shared a tendency toward an elaborate and dramatic interpretation of Neoclassicism.

As far as seventeenth-century sources are concerned, however, besides the influence of the Baroque, Poussin, and the Carracci (in the figure in the left foreground), it is obvious that Cecco del Caravaggio's treatment of the same subject, so theatrically set among the columns of the temple, is an almost explicit reference point. Caravaggio's painting was then housed in the Galleria Giustiniani in Rome, but was transferred to Paris in the early nineteenth century and then acquired by the Alte Nationalgalerie, Berlin (1815). [AOC]

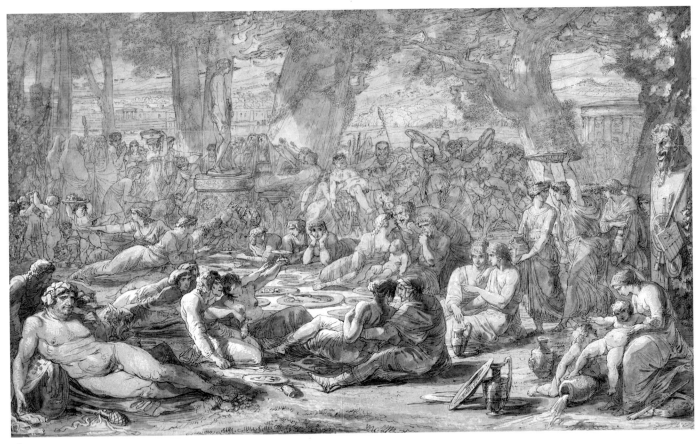

358

## 358
## Felice Giani
### *Bacchanal with Dante and Beatrice*

1791
Signed and dated on the vase in the fore-
ground: *Giani 1791*
Pen and brown ink, heightened with white
lead
20½″ × 32⅞″ (522 × 835 mm)
PROVENANCE  Pico Cellini, Rome
EXHIBITION  Bologna 1998, cat. no. 77
BIBLIOGRAPHY  Dionisotti 1966; *Bella mano*
1997, pp. 160–63; Ottani Cavina 1999,
pp. 83, 86, figs. 141–42
The Roberto and Titti Franchi Collection,
Bologna

Giani produced a series of pages
inspired by themes from the *Divine
Comedy*, nearly all of them dating from
the early years of the nineteenth
century. They are linked to the strong
impulse from Romanticism to promote
a modern view of Dante as a poet, and
not simply as a great citizen, exile, and
prophet of Italy, as he was understood
and loved by writers such as Parini,
Foscolo, and Alfieri. Much of this had
to do with the extraordinary popular-
ity of the poems of Ossian which, like
the culture of Arcadia, paved the way
for a new understanding of the *Divine
Comedy*, and particularly the extreme
emotions exemplified by the *Inferno*.

The emphasis on all that was primi-
tive, barbaric, and passionate placed
Dante at the center of European inter-
est. His poem became one of the
absolute values of literature, in con-
trast to the ecumenism of the age of
Enlightenment. This epic of medieval
Christianity was the expression of a
historical age and its civilization, and
satisfied the expectations of the
Romantic theorists. Dante rapidly
became the center of a veritable cult
following what Dionisotti describes as
"the first impetus of the revolution
which swept Italy in 1796–97, when
literature acquired a whole new
national and civic role" (Dionisotti
1966, p. 553).

In the figurative arts this movement
was triggered by Tommaso Piroli's
engraved illustrations for the *Divine
Comedy*, based on the drawings pre-
pared in Italy by John Flaxman in 1793.
Few episodes had been illustrated
before this date; the best-known
examples are Count Ugolino and
Paolo and Francesca. However, Giani
refused to follow the cult of Dante,
which bordered on idolatry, and this
drawing shows the poet and his muse,
Beatrice, in an extraordinary *déjeuner
sur l'herbe*.

Dante was admired because Italians
saw him as the embodiment of their
nation, and even identified his literary
redemption with the national libera-
tion movement of the Risorgimento.

In Giani's composition, the poet is
shown at the center of a bacchanal,
surrounded by satyrs, thyrsi, women,
a silenus, and a statue of Ganymede.
Crowned with laurel and depicted
with an aquiline nose (in accordance
with the traditional iconographic
cliché), Dante is not the only target of
Giani's irreverence. On the right, sur-
rounded by overturned wineskins, is
a very clear and blasphemous varia-
tion on the iconography of the Virgin
and the infant Saint John, emphasized
in the background by a self-portrait of
the artist, which this curious *divertisse-
ment* has dated to 1791. The temptation
is to read this drawing as a bravura
piece entered for one of the informal
competitions that Giani and his friends
held in the evenings at his house in
Rome. They called themselves the
Accademia de' Pensieri because
"thoughts are what one calls the first
ideas that painters throw on to paper"
(quoted in Rudolph 1977, p. 181).

The theme, the size of the drawing,
and the date mean that the piece could
be one of these experiments which are
known to have taken place around
1790. The artists tried their hands at
improvised interpretations of a partic-
ular subject, and then submitted these
to their colleagues for judgment. This
was a fairly widespread practice, and
there were at least ten private acade-
mies of established artists in Rome.
[AOC]

## 359
## Felice Giani
### *The Infant Moses Throwing Pharoah's Crown to the Ground*

1790s
Pen and brown ink, wash, heightened with
white lead
21″ × 28″ (535 × 710 mm)
BIBLIOGRAPHY  Ottani Cavina et al. 1979,
p. 14, no. 11, fig. 11; Ottani Cavina 1999,
p. 25, fig. 25
Private collection

The subject is taken from the narra-
tive recorded by Flavius Josephus (*De
antiquitatibus judaicis*, vol. 2, 9) .
Thermut, the Pharoah's daughter who
brought up the young Moses after
finding him on the banks of the Nile,
decides to enter him in the succession
to the throne. She takes him to her
father, who, to humor her, places the
crown of Egypt on the boy's head. But
Moses suddenly throws it to the
ground and stamps on it. It is no sur-
prise that after so irreverent a gesture,
so dark an omen, the scribe claims he
should be killed. It is exactly this vivid
romantic quality that Giani heightens
in the slightly ingenuous realism of
his exotic *tableau vivant*.

The drawing is conceived as an
engaging illustration: sentimental
hyperbole, theatrical gestures, exag-
geration of the roles in a far-off, leg-

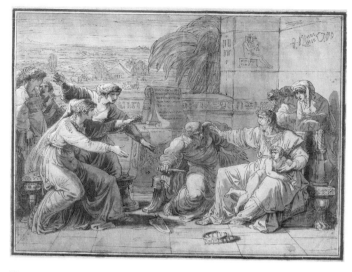

359

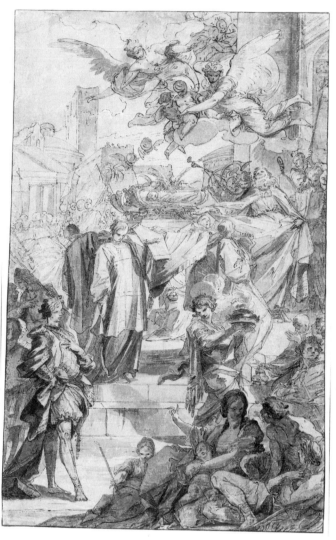

360

endary atmosphere, where Egypt is more than a real Egypt, it is the sum all its *topoi*. Giani, inventing a setting for this episode, is not aiming at historical accuracy. In a playful way he associates the improbable elephants in the Egyptian desert with the graffito silhouette of the god who is holding his *ankh* turned upside down, and a series of obviously illegible hieroglyphs. The correct deciphering of these hieroglyphs, by Jean François Champollion, did not appear until 1824. This drawing, however, dates from the 1790s; at this time Giani attributed an important role to the figures, following the Bolognese tradition of Ubaldo and Gaetano Gandolfi.

A drawing like this, imaginative and in large format, derives from the "academies," those evening competitions between artists associated with Giani's life in Rome, Bologna, and Faenza. It is a fleeting but absolutely central element for knowing his objectives, evaluating his talent as an improviser and the preoccupation with teaching that he had to the end of his life: his will is almost entirely devoted to the institution of "two schools of education for the male youths and the maids," to whom he bequeathed his property so that the young people could continue their studies. (Ottani Cavina 1999, vol. 2, p. 962).

The first of these "academies" was held in Rome around 1790 (a second one named Accademia della Pace was later held in Bologna): "To Giani alone will always remain the honor of having been the first to promote an instructive competition between the artists, aimed at the art of good composition. This was called 'The Academy of the Thoughts' because thoughts are what one calls the first ideas that painters throw on to paper … The gatherings were held in his house. At the end of each session the

theme was given for the next one, a fortnight or even a month later" (A. Migliarini, quoted in Rudolph 1977, p. 181). All the invited artists (Camuccini, Benvenuti, Sabatelli, Dell'Era, Fabre, Humbert de Superville, and others) used to improvise on the same given theme and were then subjected to a collective appraisal.

It is hard to ascertain what the themes and the drawings produced in those splendid evening competitions were. One can imagine that the subject capable of stimulating the imagination and the given dimensions cannot have been very different from the drawing exhibited here. The painter Antonio Basoli saved the record of the "academies" Giani held in Bologna by having tracings made of those drawings and composing a volume of them (Bologna, Italy, Accademia di Belle Arti, *Vita artistica di Basoli Antonio, Catalogo delle opere eseguite e suoi prezzi*, fondo Basoli, MS. F IV 28). This volume has been identified, and consists of a series of compositions very similar in both style and format to the one exhibited here (see Accademia di Belle Arti, Bologna, Italy, Antonio Bagoli, comp., *Studio generale di tutte le Antichità Greche-Romane*, no. 100, carte 311). [AOC]

## CORRADO GIAQUINTO

MOLFETTA 1703–1766 NAPLES
*For biography see Paintings section*

## 360
## Corrado Giaquinto
*Study for "The Translation of the Relics of Saint Acutius and Saint Eutyches from Pozzuoli to Naples"*

C. 1744–45
Pen and black ink, black chalk, gray wash, white heightening over black chalk on pinkish-gray prepared paper
17⅜" × 11¼" (442 × 287 mm)
PROVENANCE  Nathan Chaikin, New York, 1965; David Daniels Collection; sold Sothebys, London, April 25, 1978, lot 41
EXHIBITIONS  Washington, D.C. 1966, cat. no. 33; Minneapolis and Cambridge 1968, cat. no. 18; Storrs 1973, cat. no. 69
BIBLIOGRAPHY  D'Orsi 1958, p. 67; Broeder 1973, p. 78, no. 69; Cioffi 1993; *Giaquinto* 1993, p. 156, no. 20
Private collection, U.S.A.

This drawing is an excellent example of Giaquinto's graphic style and provides important insights into the artist's working methods. It is a preliminary

design for a large-scale painting for the left-hand tribune wall in the cathedral of S. Gennaro in Naples. Both the study and the large-scale painting depict the ceremonial transportation of the relics of the two fourth-century martyred saints to Naples from nearby Pozzuoli. The painting, which was executed in Rome, was commissioned just as Giaquinto completed his work in S. Croce in Gerusalemme. His patron was Cardinal Spinelli, and the project was probably meant to celebrate the prelate's recent appointment to the see of Naples.

Making the most of the subject's dramatic potential, Giaquinto portrays the translation of the relics as a glorious and highly theatrical event. Held within one of the large, elaborately shaped reliquaries for which the Neapolitans were famous, the saints' remains are carried aloft in procession on the shoulders of elegantly garbed priests through a grand architectural setting reminiscent of a Baroque stage. At the lower left of the picture a splendid nobleman in a languid pose observes

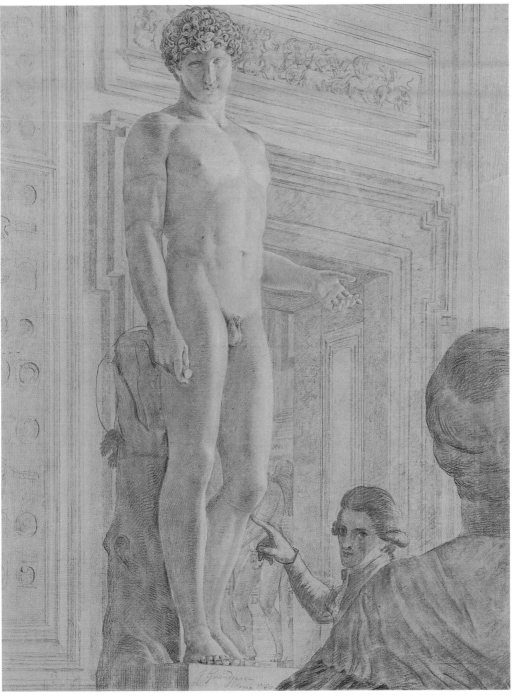

361

which would then have been worked into a larger-scale oil *bozzetto*, and finally into a fully refined *modello* similar to the ones he created for S. Croce and S. Nicola dei Lorenesi. Although the large oil in Palermo (Galleria Regionale delle Sicilia, Palazzo Abatellis) previously has been identified as a *bozzetto* for the Naples picture (*Giaquinto* 1993, p. 156, no. 20), its inferior quality indicates that it is a copy by a close follower rather than an autograph painting by Giaquinto himself (Cioffi 1993). [IC]

## JEAN GRANDJEAN
AMSTERDAM 1755–1781 ROME

Born in Amsterdam into a Huguenot family of French origin, Jean Grandjean was the pupil of Jakob Verstegen and of Jurriaan Andriessen in Amsterdam. His early successes with Dutch art patrons prompted him to pursue his training abroad. He went first to Düsseldorf, and then from there to Italy. He arrived in July 1779 in Rome, where his closeness to German artists such as Tischbein and Füger, and his participation in the "academy" of the sculptor Alexander Trippel, triggered his admission into the circle of Cardinal Albani. Grandjean died shortly after his arrival in Rome. He is buried in the Protestant cemetery, near the pyramid of Cestius. None of Grandjean's paintings seems to have survived. Some of his landscapes with figures were engraved by Raphael Moghen (known above all for his work on the publication of the antiquities of Herculaneum for the King of Naples). His drawings and watercolors, in museums in Amsterdam, Haarlem, and Vienna, show a promising artist, often close to Hackert. It is still to be hoped that additional information on the brief life of this relatively obscure figure from the Goethe circle in Italy will be found. [JPM]

### 361
### Jean Grandjean
*Monsieur Hviid Pointing to the Restoration of the Albani Antinous in the Museo Capitolino*

1780
Inscribed: *J. Grandjean Roma 1780* and *Portrait de monsr. Hviid*
Black and white chalk on paper
21″ × 15⅞″ (535 × 405 mm)
EXHIBITIONS 's-Hertogenbosch, Heino, and Haarlem 1984, cat. no. 111; London and Rome 1996, cat. no. 208
BIBLIOGRAPHY *Ontmoetingen* 1971, p. 19, no. 114
Rijksprentenkabinet, Rijksmuseum, Amsterdam

the proceedings. At the lower right, a seated woman in the pose of Caritas holds her child and points upward to an agile youth carrying a brazier billowing with fire and smoke. Directly above, a cherub heralds the arrival of the relics with the blare of a trumpet while a chorus of lovely angels hovers above. Despite all this excitement, the drawing's monumental composition, along with the poised demeanor and reflective expressions of the principal figures, creates a sense of grandeur and repose that is also evident in the finished painting. These characteristics are also indicative of the classicizing trend in Giaquinto's mature Roman style, epitomized in the *Baptism of Christ* of 1750 (cat. 227).

Typically Giaquinto worked up his compositions with speed and dazzling technical agility. He was not known for the highly detailed and didactic drawing typical of more academic painters such as Anton Raphael Mengs (who criticized the ease and facility of Giaquinto's work when he arrived in Madrid in 1762 to work alongside him at the Bourbon court). Though swiftly rendered in quick strokes of the pen and broadly brushed ink wash, the drawing is highly finished. Indeed, its overall compositional framework, elegant figural poses, complex lighting effects, and dramatic subject matter all closely anticipate the sophisticated polish of the final version in oil. In its vitality of light and shade, precision of line, and lively depiction of the subject Giaquinto's drawing rivals those of Giovanni Battista Tiepolo, whose work in the same expressive medium has long been appreciated by connoisseurs and collectors alike.

While it is possible that this drawing may have been shown to the patron as an initial idea, it is more likely to have been created as a preliminary design,

362

Andreas Christian Hviid, a Dutch orientalist and theologian, who was a tourist in Rome from 1779 to 1780, is shown here in a room of the Museo Capitolino pointing at the restoration on the leg of a celebrated sculpture, the Albani or Capitoline *Antinous*. The sculpture had been discovered on the site of Hadrian's Villa at Tivoli and had been repaired by Pietro Bracci. It achieved popularity with connoisseurs, although comparison with the more famous Belvedere *Antinous* led most critics to favor the latter (see Haskell and Penny 1981, pp. 143–44). Winckelmann for instance did not find much merit in it except for the head. Nonetheless the sculpture was much copied in various media. A notable copy was a marble version made for the King of France—the work of two sculptors, a certain Marchand and the more famous Jacques Saly—and much admired by the painter and director of the French Academy in Rome, Jean-François de Troy. Numerous bronze reproductions of it by Righetti and Zoffoli were sold to tourists in Rome in the eighteenth century.

This drawing—Grandjean's most famous work—illustrates the interest and debate about restoration of

antiques that was of much concern to antiquaries in eighteenth-century Rome. The gesture of the scholar pointing at the restored leg is also part of the visual language of the Grand Tour. It can be compared to the gesturing of many of Batoni's sitters toward antiques, indicating ownership, artistic preference, intellectual affinity, or connoisseurship. The origin of the pointing gesture can even be traced back to that of the shepherd in Poussin's *Arcadian Shepherds*, pointing to the inscription on the stele: ET IN ARCADIA EGO.

Grandjean's composition recalls also one of the most famous and early images of the Grand Tour, Goltzius's engraving of the Farnese *Hercules* (c. 1592; see Ger Luijten et al., *Dawn of the Golden Age: Northern Netherlandish Art, 1589–1620* [Zwolle, Netherlands: Waanders Uitgevers, 1994], p. 261, no. 204), in which the massive sculpture dwarfs the two gazing figures, one being possibly the artist himself. [JPM]

## JAKOB PHILIPP HACKERT
PRESZLAU 1737–1807 SAN PIETRO DI CARPEGGI
*For biography see Paintings section*

### 362
Jakob Philipp Hackert
*View of Rome*

c. 1780
Watercolor on paper
19¼″ × 28⅝″ (490 × 728 mm)
BIBLIOGRAPHY   *La pittura* 1990, p. 532
Staatliche Museen zu Berlin, Kupferstichkabinett

This undated view of Rome seen from the south is among the most remarkable and winning of all Hackert's landscapes, so much so that it is easy to forget how nearly unique it is in his prolific (and sometimes formulaic) output. His pleasure in panoramic views is usually reserved for the open lands of the Campagna, or the park of Caserta, or the sea. The familiar references to Claude Lorrain's heroic dreams seem secondary to his equal (and equally intelligent) devotion to Jan Both and his skills depicting the

dawn light. The single figure looking into the city prefigures Tischbein's portrait of Goethe and, in ways better than that celebrated image, evokes the effect that Rome had particularly on northern artists from the seventeenth century well into the nineteenth. [JR]

## HUGH DOUGLAS HAMILTON
DUBLIN 1740–1808 DUBLIN

Hamilton was an Irish portraitist and subject painter who lived in Italy from c. 1782 to 1792. The son of a Dublin wigmaker, Hamilton entered the Dublin Society School of Drawing about 1750 and studied under Robert West and James Mannin. He was a pupil there for some eight years, winning three premiums for the best drawings of 1756. In that same year he was a fellow student of the future dramatist John O'Keeffe, who later wrote that Hamilton "was remarkable for choosing, when drawing the human figure, the most foreshortened view, consequently the most difficult" (O'Keeffe 1826, vol. 1, p. 12). Hamilton probably left West's academy in the late 1750s and soon set up a flourish-

ing business as a portraitist in pastels. By the early 1760s Hamilton had moved to London and in 1764 was awarded a premium by the Society of Arts for a now lost oil of *Priam and Hercules Lamenting over the Corpse of Hector.*

Portraits continued to be his main activity and he exhibited them at the Society of Artists throughout the 1770s. In the early 1780s economic security allowed him to move to Italy with his wife, Mary, and daughter Harriott. He stayed there for about ten years, living mainly in Rome but also spending time in Florence (1783–85), Venice (1784), and Naples (1788). He painted an extensive number of pastel portraits, in both oval and rectangular frames, of British and Irish Grand Tourists, including resident émigrés such as Prince Charles Edward Stuart (the Young Pretender) and his family (1785–88; examples in the National Portrait Gallery, London, and the Scottish National Portrait Gallery, Edinburgh) and long-term residents such as Frederick Hervey, 4th Earl of Bristol and Bishop of Derry (c. 1786; Ickworth House, Suffolk, National Trust). While in Rome, Hamilton developed a close friendship with fellow artists such as John Flaxman and especially Antonio Canova, solidifying his relationship with the latter by including him in a superb large-scale pastel (1788–89; Victoria and Albert Museum, London) where he stands with another artist, the Irishman Henry Tresham, next to an early model of Canova's celebrated *Cupid and Psyche* now in the Musée du Louvre.

A few years earlier, in 1783, Hamilton made one of his first known attempts at a large-scale subject picture in oils, *Diana and Endymion* (1783; private collection). Strongly influenced by the then current Neoclassical style, this painting has much in common with the derivative antiquity that permeates Roman painting of the 1780s. At the same time Hamilton was purchasing a representative collection of Old Master prints and pictures. Part of this collection was sold by Christie's in 1811. One item in the collection, the first volumes of *L'antichità d'Ercolano*, a lavish collection of fine engravings illustrating the discoveries made during the excavations around Naples earlier in the century, greatly influenced Hamilton's few attempts at historical oil paintings during these years. These influences found their most considered exposure in the oil painting *Cupid and Psyche in the Nuptial Bower* (1792–93; National Gallery of Ireland, Dublin). During his thirteen years in Italy, Hamilton was successful and sociable, yet he stayed clear of factions and his fellow Irishman the sculptor Christopher Hewetson affirmed in a letter of 1792, "[he] belongs to no party yet [has his] share of business"

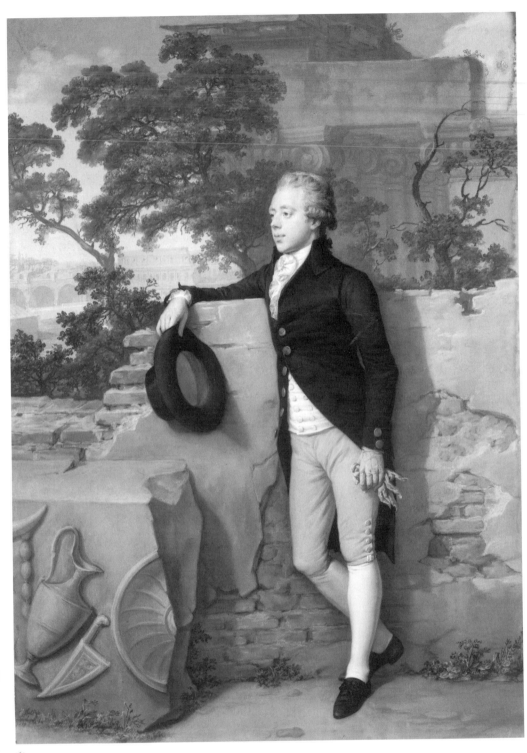

363

(Cumberland Papers, London, British Library, Ms. 36496, fol. 333). Hamilton also penetrated the Italian establishment by being elected to the Accademia del Disegno in Florence in 1784 and painting a pastel self-portrait for Maria Louisa Bourbon, who in 1805 bequeathed it to the Galleria degli Uffizi, where it now hangs in the Corridoio Vasariano.

Hamilton returned to Ireland in 1792. While in Italy he had received commissions from a number of Irish Grand Tourists, and he now renewed his acquaintance with such prominent families as the wealthy bankers La Touche. Hamilton produced a series of pastels portraits for their various homes in Wicklow and Dublin. Similar commissions followed for the Duke of Leinster, Ireland's premier peer, at Carton, co. Kildare. Hamilton had been reluctant to leave Italy, but political events made it a sensible decision. His regret on leaving Rome and his many friends is articulated in a number of letters written to Canova between 1794 and 1802, which document the artist's activities and the artistic stagnation and unenlightened patronage to be found in Dublin at the turn of the eighteenth century.

Yet Hamilton was never short of work. He complained to Canova of the large number of portraits that he had to complete, most of which were now in the more time-consuming medium of oils. He was by far the finest portraitist in Dublin in the 1790s

and he received the best commissions. In 1797 William Drennan, a radical as well as a poet and physician, visited Hamilton's studio and commented on the range of portraits being produced: a large canvas of a reactionary charity preacher, various portraits of a liberal peer, and portraits of such revolutionaries as Lord Edward FitzGerald and Arthur O'Connor.

Between 1800 and 1804 Hamilton exhibited in Dublin to great success at the Society of Artists of Ireland exhibitions. He painted little during the last four years of his life, concentrating his time on a newly developed interest in science. His daughter Harriott finished some of his late portraits. Hamilton died in his home on Lower Mount Street, Dublin. [FC]

BIBLIOGRAPHY O'Keeffe 1826, vol. 1, pp. 12–16; Strickland 1913, vol. 1, pp. 427–45; Crookshank et al. 1978, pp. 91–94; Cullen 1982; Cullen 1984; Cullen 1997, pp. 18–19, 104–15; Ingamells 1997, pp. 451–52

## 363
### Hugh Douglas Hamilton
*The Honorable Frederick North, Later 5th Earl of Guilford, in Rome*

1790
Pastel
37⅜" × 26¼" (950 × 680 mm)
PROVENANCE the sitter; his sister, Anne North Sheffield?; by descent to Henry North Holroyd, 3rd Earl of Sheffield (sale, London, Christie's, December 11, 1909, lot 3); Gooden and Fox, London, 1909; Hazlitt, Gooden and Fox, London, 1990, lot 38.
BIBLIOGRAPHY Crookshank et al. 1994, pp. 69, 71; Crookshank et al. 1997; Ingamells 1997, p. 712
National Gallery of Art, Washington, D.C., Gift of the 50th Anniversary Gift Committee

This pastel is an example of the many fine full-length portraits produced by Hamilton when he was in Italy in the 1780s. These Italian pastels show an artist extending the possibilities of a fragile medium and placing it firmly within the context of a robust Neoclassical taste. Frederick North is placed against a backdrop of the Roman forum. On the left are the Colosseum and the three coffered barrel vaults of the Basilica of Constantine and Maxentius, while directly behind the sitter are the Ionic capitals of the Temple of Saturn. It can be deduced that North is leaning against a wall within the confines of the Temple of Vespasian, owing to the presence in the lower left of the pastel of a broken marble relief with representations of bucrania, a well-known feature of the temple's entablature.

The frieze shows sacrificial instruments and apparatus with, from left to right, a horn from the skull of an ox and a dangling garland, a jug, a dagger, and part of a shield. Surrounded by remnants of antiquity and shown carrying his hat and gloves, this elegant young man is drawn as if pausing during his pleasurable explorations of the forum. His relaxed pose and determined gaze indicate someone at ease with the past, a feature echoed in his choice of surroundings, in particular the frieze with its arcane symbols of ancient rituals.

Hamilton's expert use of the medium of pastel in this portrait demands that it be compared with the great double portrait of *Canova and Tresham* (1788–89) now in the Victoria and Albert Museum, London. Hamilton's control of his ostensibly fragile medium in the North portrait is clear in the contrast of the intense blue of the coat and its shiny metal buttons with the crumpled leather of the unused glove. A similar capacity to convey texture and contrast is wonderfully displayed in the Canova pastel by the way that Hamilton wittily juxtaposes the sculptor's dust-covered velvet jacket with the smooth perfection of his marble Psyche. Inspired by his enthusiasm for Rome and a newly acquired, classically controlled use of line, Hamilton produced an exceptional series of portraits, of which the North pastel is one of the most accomplished.

North's relaxed pose amidst the buildings and sculpture of the forum is entirely appropriate, given that in later life he became a noted philhellene. The Honorable Frederick North was the third and youngest son of Lord North, 2nd Earl of Guilford, who was prime minister of Great Britain during the time of the American Revolution. North eventually succeeded as 5th Earl in 1817. He is known to have been in Spain in 1788 and is recorded to have been in Venice in December 1790 and in Corfu in January 1791, where he converted to the Greek Orthodox Church. He was back in Rome in 1792. It is possible to date the pastel to late 1790, when North is known to have been in Italy and may have visited Rome. Hamilton himself left Italy in or shortly after May 1791 and was thus not there when North returned a year later. If Hamilton's pastel dates from late 1790, the sitter would have been about twenty-four years old, which seems about right for the appearance of this young man in the pastel. North went on to hold various colonial positions in Corsica and Ceylon before eventually finding his true mission in assisting in the foundation of the Ionian University on the island of Corfu. [FC]

## NICOLA LAPICCOLA
### CROTONE 1727–1790 ROME

This "obscure but excellent" artist, as Anthony Clark described him (1960), left his native Calabria in the extreme south of Italy at the age of seventeen and went to Naples to learn to paint. After a brief return home and another period in Naples, he settled definitively in Rome in 1747. Among the various workshops then in business he chose that of Francesco Mancini—one of the favourite painters of Benedict XIV—and diligently followed the *cursus honorum* that led him, from the 1760s on, to the top of his profession as painter to the aristocracy and the pope as well as a recognized master. Two of the most important of the "new" artists who had emerged in Rome during the reign of Pius VI entered his studio: Bernardino Nocchi—who had been rejected by his compatriot Pompeo Batoni—and, a few years later, Stefano Tofanelli (see Rudolph 1985).

Little is known about his early years in Rome. Judging from the first of his known works, *Joseph in Prison Interprets the Dreams of Pharaoh's Servants*, the drawing with which he won first prize in class two of the competition at the Accademia di S. Luca in 1750 (cat. 364), he was undoubtedly stimulated by the work of Corvi and Piranesi, two of the most original artists of the mid-eighteenth century. The first known public work by Lapiccola is the painting in S. Lorenzo in Panisperna of *Saint Francis Receiving the Stigmata* (1757), a subject controlled by a clearly defined iconographical tradition, which left little room for a display of *invenzione*, by which an artist was primarily judged. Nevertheless, the painter introduced, in essence, the features that later became his unmistakable trademark: the search for an essential and severe form, very different from the sometimes attenuated grace of his teacher, Mancini, and rather closer to the austerity of Mengs. Over the following years, while Mengs and Batoni were competing for supremacy, Lapiccola carved out a successful career for himself in the field of fresco painting, a medium totally neglected by Batoni and where Mengs and his school were becoming predominant. From 1766 he was a member of the Accademia di S. Luca (although never truly involved in the life of the school because of continuing dissension). He produced the occasional altarpiece (*Saint Gregory Barbarigo*, 1762, Bergamo Cathedral; *The Return of the Boy Jesus from the Temple*, 1767, Crotone Cathedral; *Ecstasy of Saint Joseph of Copertino*, 1768, executed for the church of the Ss. Apostoli, Rome, but never installed) and an increasing number of wall paintings in fresco and gouache. His first major

work of this kind (c. 1760) was the decoration of rooms in Villa Albani (grisailles in the Galleria del Canopo; vault of the ground-floor chapel; *Wedding of Bacchus and Ariadne* in the Galleria del Canopo; *Perseus Freeing Andromeda*) for which, under the scholarly guide of Winckelmann, he drew inspiration from the paintings in the Domus Aurea (the "Baths of Titus"), which had only recently been rediscovered. These decorations, in which the standard exemplars of Raphael's Logge and Roman wall painting are given a new interpretation that was to achieve its maximum development in the decorations of the Villa Borghese, became Lapiccola's most rewarding type of work. To celebrate Sigismondo Chigi's marriage to Flaminia Odescalchi (1763), he was called in to assist with the refurbishment of the "Salone d'oro," and, a few years later, to decorate the Stanza dell'Ariosto in Villa Chigi in Ariccia. All that now remains of Lapiccola's work in this room is the upper level; the lower was overpainted in tempera by Giuseppe Cades.

In 1768, on the death of Stefano Pozzi, Lapiccola was appointed painter to the pope (Pittore dei Sacri Palazzi), and was employed on the restoration of paintings in the sixteenth-century Villa Giulia (now the Museo Etrusco), together with a team of helpers that included Bernardino Nocchi, Stefano Tofanelli, and Marcello Leopardi. These were the same artists who, with Lapiccola himself, Mariano Rossi, and Antonio Cavallucci, would provide the great canvases for the Benedictine church of S. Nicolò all'Arena in Catania (where Lapiccola's large painting for the high altar had pride of place). He was involved with the decoration of Palazzo Borghese (Sala di Proserpina, 1772–73) and with the *Vision of the Blessed Bernardo Tolomei* (1774–76) and in that of the church of S. Caterina da Siena in via Giulia, of which Cardinal Scipione Borghese was patron. During the same period he was working in Palazzo Stoppani (now Palazzo Vidoni) and in the episcopal residence in Ostia. This last commission, like that for the altarpiece of the *Vision of Saint Bonaventure and the Blessed Andrea Conti* (1775; see Borghini 1984, p. 208) for the church of the Ss. Apostoli, came about through the recommendation of Cardinal Giovan Francesco Albani, a great admirer of Lapiccola.

Together with Ermengildo Costantini, Marcello Leopardi, Giuseppe Cades, Tommaso Maria Conca, and many others among the more successful fresco painters, Lapiccola tendered for the contract to decorate the unfinished pulpit of the cathedral of Città di Castello, near Perugia, whose walls Benefial had painted with a cycle of unprecedented

pictorial power (see Casale 1990, "La pittura," pp. 361–64). Lapiccola failed to win the contract because his fee was thought to be too high. However, the circumstances provided the opportunity for a document in which an unknown cleric listed the painter's previous works and also the criticisms leveled against him from various quarters (see Guerrieri Borsoi 1993, p. 166). Although many believed that he was incomparably superior to all the other applicants ("there are only three in Rome who could do better than him," wrote the cleric, who named the other three as Tommaso Maria Conca, Domenico Corvi, and Pietro Labruzzi), he was censured for a lack of "the naturalism that is normally required in paintings," as well as being "a man of little imagination, who has no grand ideas." The extreme control exercised by the artist was evidently not to everyone's taste, and yet it gave rise to solutions that—through the work of Nocchi and Tofanelli—remained valid until the first years of the following century. The same document records that Lapiccola was Custodian and Antiquarian for the Capitol. His interest in antiquity was put to practical use in his involvement with excavations, and some of his finds are still preserved in the Vatican. [LB]

BIBLIOGRAPHY Rudolph 1983; Rudolph 1985; Coccia 1990; Guerrieri Borsoi 1993; Sestieri 1994, vol. 1, pp. 100–101

## 364
## Nicola Lapiccola
### Joseph in Prison Interprets the Dreams of Pharaoh's Servants

1750
Inscribed on the lower edge: 1750. Seconda Classe Primo Premio Nicola Lapiccola da Cotrone [sic]
Pencil and red chalk on beige paper
23⅝″ × 32″ (600 × 815 mm)
PROVENANCE Concorso Clementino, Accademia di S. Luca, Rome, second class of painting, first prize, 1750
EXHIBITIONS Rome, University Park, and New York 1989, cat. no. 67
BIBLIOGRAPHY Salerno 1974, "La Collezione," p. 352, fig. 35; Cipriani and Valeriani 1988–91, vol. 2, pp. 209, 215; Cipriani 1990, pp. 152–55, no. 67; Guerrieri Borsoi 1993, p. 152, fig. 1
Accademia Nazionale di San Luca, Rome

This drawing relates to the competitions held at the Accademia di S. Luca, by means of which young artists could make their first official appearance upon the art scene in Rome (see Cipriani 1990, pp. 9–12). After the reforms initiated by Clement XI at the beginning of the century, the competitions were divided into three classes. The third class required the student to copy a work, old or modern, while for

the second and first classes they had to submit a composition on a biblical or historical theme with several figures of varying grades of complexity, whose subject was given by the academicians several weeks in advance. The young artists could therefore profit from the advice—if not help—of their teachers or more experienced colleagues: consequently they were also required to produce a work extempore, at the academy itself, without preparation (see Cipriani 1990, p. 152).

The drawing shown here gained Lapiccola first prize in class two. On the same occasion Domenico Corvi was awarded first prize in class one for a drawing, unfortunately now lost, of Joseph Recognized by His Brothers. This was an enviable achievement, carrying with it acceptance as a mature artist, and indeed those who won were never allowed to compete again. The subject given to the class two entrants was the episode in which Joseph foretells the fate of Pharaoh's butler and his baker, with whom he was imprisoned, by interpreting their dreams. In Lapiccola's drawing the butler, to whom Joseph has revealed that he is to be freed, raises his head and thanks God with a gesture of eloquent gratitude; the baker, whose imminent death has been predicted, bows his head in prayer while Death, in the shape of a skeleton, hovers above him. Two more fellow-prisoners, together with Joseph and Pharaoh's servants, form an effective

group whose theatricality is enhanced by the steps and the fetters in the foreground. The whole scene appears to rotate around Joseph's raised arm, while the cloth hanging behind his shoulders separates two jailers and a dog warming themselves by a fire, who form another group set apart from all that is happening before their eyes.

At the time of the competition Lapiccola had only just left Francesco Mancini's studio, where Domenico Corvi (six years older than him) had also studied and where the two promising young men had undoubtedly met. The visionary concept of Lapiccola's drawing, almost comparable to that of Piranesi (Cipriani 1990, pp. 152–55)—whose daring use of perspective in the Carceri must certainly have impressed the twenty-three-year-old painter—with its assured foreshortening di sotto in sù, and the reflection of torches lightening the darkness, reveals that he was completely in harmony with Corvi's ideas at the time, at least to judge from the frescoes in the church of the Gonfalone in Viterbo and some paintings now in Vedana. The fact that Mancini was Principe of the academy in the year of the competition (reinstated to celebrate the jubilee after an interval of eleven years) probably tipped the scales marginally in favor of his own students when such an eagerly contested prize was at stake, but at the same time both Lapiccola and Corvi were destined for success

on their own merits. Lapiccola, despite his extreme youth, appears to have had command already of that solemnity and innovative strength shown in the works produced by Corrado Giaquinto the same year, such as The Baptism of Christ in S. Maria dell'Orto and The Trinity and the Ransomed Slaves above the high altar of SS. Trinità dei Spagnoli. But also notable are the noble and unusual sculptural models which the artist has derived from late seventeenth-century examples: the skeleton leaning over the baker intimating the closeness of death is an almost direct quotation of a group sculpted by Filippo Carcani (after 1675) for the tomb of Cesare Rasponi in St. John Lateran.

Nothing is known about Lapiccola's work after his success in the competition (his name does not appear even among the prizewinners at the Scuola del Nudo) until his Stigmata of Saint Francis of 1757 in S. Lorenzo in Panisperna, Rome. Corvi was equally unlucky, although he was older and the recipient of a more prestigious award. In a letter to the Pesaro-born painter Giovanni Andrea Lazzarini he asked to be subcontracted for some work because it was becoming ever harder for him to find work in Rome (Curzi and Lo Bianco 1998, p. 218). [LB]

1750. Seconda Classe Primo Premio Nicola Lapiccola da Cotrone

364

## GIOVANNI BATTISTA LUSIERI

ROME? 1755–1821 ATHENS

"Sig.re Giambattista Lusier, a Roman, usually called D. [Don] Titta, who made tinted Drawings, which were deservedly admired for their correctness and strict attention to Nature, and many of them purchased by Our English Cavaliers." This is how Thomas Jones describes Giovanni Battista Lusieri in his autobiography, in which he tells of his meetings with artists in Naples in 1782 (Oppé 1951, p. 122). At the time Lusieri—the most interesting of late eighteenth-century Italian landscape painters—was twenty-six, if he was born in 1755, as is now believed. Very little is known about Lusieri's early career; in fact, he has only recently been "rediscovered," as interest in him began to emerge at the same time as an auction sale of twenty of his beautiful watercolors from Lord Elgin's collection in London in 1986 at Sotheby's.

Thomas Jones, one of few artists to go on sketching expeditions with Lusieri in the Naples area, was a close friend, and categorically states that Lusieri was Roman. This is confirmed by A. H. Smith, a historian who had access to reliable sources (Smith 1916, p. 188), and by documents discovered recently in the state archive of Naples by Fara Fusco (as reported in Castel Sant' Elmo, Naples, *All'ombra del Vesuvio: Napoli nella veduta europea dal Quattrocento all'Ottocento* [Naples: Electa, 1990], pp. 442–43). Further evidence of his early life in Rome before moving to Naples in the summer of 1782 can be seen in several views of Roman ruins sketched by Lusieri from nature. One particular work, exhibited here, *The Baths of Caracalla from the Villa Mattei* (Providence Museum of Art), dated 1781, can be considered a point of departure for a reconstruction of Lusieri's early life, even though this view and other contemporary works reveal a degree of artistic maturity far superior to the skills of an artist at the beginning of his career.

Though there are no records to speak of, the stylistic features of his early production suggest that Lusieri was inspired by artists working in Rome at the time, such as Philipp Hackert, Abraham-Louis-Rodolphe Ducros, and Simone Pomardi, who were all topographical artists painting with great precision and attention to detail. It was probably due to this influence that Lusieri cultivated a passion for precise detail and objective realistic views, which became standard features of his landscapes. Even where the inspirations for his painting were the vestiges of ancient Rome, Lusieri's interpretation was detached and remote, and he was never a

visionary like Piranesi. Another characteristic feature of his style was to emerge during his years in Naples, probably owing to the influence of Thomas Jones, John Robert Cozens, and John "Warwick" Smith. Not only was Lusieri an accurate topographer, but he was also able to inject strong emotion into his work: even the clarity of his vision was sensitive and vibrant.

Lusieri's technique is also noteworthy. He only used watercolor, an unusual choice in that Italian artists traditionally painted in oils and believed this to be the most noble medium. Nevertheless, he never used the rapid, "fugitive" sketching technique so typical of his English counterparts. On the contrary, he worked slowly and laboriously, in a manner similar in many ways to Ducros. He detested rough sketches (as he mentions in a letter to Sir William Hamilton in 1819), and preferred to work on a large scale with several pieces of paper joined together, on which he would draw and paint his views with great precision: "Having completed the outline, Lusieri would block in areas of pale, flat colour, again without shading, and would then build upon that with the final, heavier colours and shading, working in fact rather like a painter in oils though he never used body-colour" (Williams 1982, p. 595). He began by drawing an outline, then slowly filling in the color. He only worked from life and because he was so meticulous many works were never finished.

A great deal more is known about Lusieri after his arrival in Naples. In 1782 he was living at the house of the artist Don Luigi Michili, who introduced him to Thomas Jones, the chief source of information on Lusieri. He was introduced into the circle of wealthy patrons of the arts, including English travellers on the Grand Tour and German and Russian diplomats, and in 1783 he began to work for the Bourbons at the court of Naples. He painted views for Queen Maria Carolina for the collection of the governor of Flanders and asked permission to make engravings of these views (1786; *All'ombra del Vesuvio*, pp. 406, 442–43, see above). It was at this time that some of his most important works were painted, now in private collections: in Turin (*View of the Temples at Paestum*, 1783; *On the Slopes of Vesuvius from Portici*, 1784), in Naples (*Eruption of Vesuvius by Night*, 1793), and in England. The *View of Naples from Pizzofalcone* of 1791 (J. Paul Getty Museum, Los Angeles) is a watercolor almost 10 feet wide and consists of six sheets joined together, painted with great accuracy and objectivity.

Lusieri was clearly a successful artist by 1799, for Sir William Hamilton recommended him to Lord

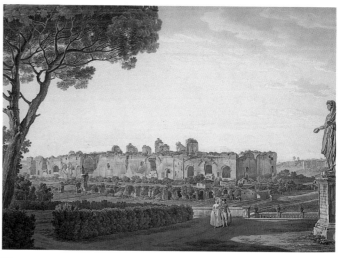

365

Elgin, while staying in Palermo, as a "reporter" for the journey that Elgin was about to take to Constantinople. Moreover Byron mentioned him in his *Childe Harold* (canto 2, stanza XII) in glowing terms as "an Italian painter of the first eminence," though he added "his works as far as they go are most beautiful; but they are almost all unfinished." On October 18, 1799, Lusieri signed a contract with Lord Elgin in Messina, having arrived in Sicily to paint landscapes, and set off with Elgin for Athens, where he was to remain for twenty-two years until his death in 1821. A clause in the contract stated that Lusieri was obliged to hand over all the works painted from the date of entering Lord Elgin's service in exchange for £200 a year. Soon afterwards, he made Lusieri his agent for negotiating the purchase of the marbles by Phidias from the Parthenon.

Research by William St Clair and correspondence between Lord Elgin and Lusieri (in the Elgin collection at Broomhall in Scotland) reveals details of the lengthy and difficult negotiations carried forward by Lusieri with the Turkish government for the purchase of the marbles and their shipment to London in 1807 (see St. Clair 1967). The difficulties faced by the artist emerge all too clearly from his letters, as he was obliged to wait for many months for a reply from his employer (Lord Elgin was the British ambassdor in Constantinople) and was obviously burdened by financial, political, and family concerns.

However, Lusieri's career, during which he continued to produce large-scale views in watercolor, while also supplementing his earnings by working as a guide in Athens for English visitors, was destined to end dramatically. He fell ill with rheumatic fever and died in his lodgings at the foot of the Acropolis on March 21, 1821. Lord Elgin ordered that all his works be sent to England, but the ship carry-

ing the paintings was wrecked, thus destroying years of work and a significant part of the artist's life. There is only one watercolor in Lord Elgin's collection at Broomhall that was painted in Greece—*The Philopappas Monument*. However, the collection contains a number of paintings that can be dated to the Roman and Neapolitan periods, before Lusieri met his patron. As a generous gesture, Lord Elgin bought all the works left behind by Lusieri from the artist's family, so that they could be salvaged and brought back to England. [AOC]

BIBLIOGRAPHY Smith 1916; Oppé 1951; St. Clair 1967; Williams 1982; Sotheby's 1986; Williams 1987; Castel Sant' Elmo, Naples. *All'ombra del Vesuvio: Napoli nella veduta europea dal Quattrocento all'Ottocento*. Naples: Electa, 1990

## 365
## Giovanni Battista Lusieri
### *The Baths of Caracalla from the Villa Mattei*

1781

Signed and dated at lower left on original mount: *Titta Lusier 1781*; verso of mount inscribed by the artist: *Veduta delle terme di Caracalla prese dalla Villa Mattei/Monte Celio*
Watercolor on off-white paper
18⅛" × 25⅛" (460 × 638 mm)

EXHIBITIONS Providence 1957, cat. no. 97; Cleveland 1967, cat. no. 163; New York 1980, cat. no. 26

BIBLIOGRAPHY Clark, Anthony M. *The Age of Canova*. Providence: Rhode Island School of Design, 1957, pp. 15, 24, no. 97; Hawley, Henry. *Neo-classicism: Style and Motif.* Cleveland, Ohio: The Cleveland Museum of Art, 1964, no. 163; Olson, Roberta J. M. *Italian Drawings, 1780–1890.* Bloomington: Indiana University Press; New York: American Federation of Arts 1980, pp. 86–87, no. 26

Museum of Art, Rhode Island School of Design, Providence, Anonymous Gift

This painting is of particular interest because it is an early work and bears an autograph inscription on the verso, in which the artist states that the work was painted in Rome, from nature. It is therefore one of the few paintings that certainly date from Lusieri's early Roman period, of which relatively little is known, and in the absence of any documentation (such as censuses) from several Roman parishes where artists were known to work, including S. Andrea delle Fratte, S. Lorenzo in Lucina, and S. Maria Maggiore, is a valuable source of biographical information.

The exact topographical details of Lusieri's view enable the viewpoint chosen by the artist to be precisely identified: he would have set his stool and easel at the front of the villa. On the right of the painting can be seen one of the statues on high plinths that stood in front of the building, while in the middle ground the baluster of the terrace is visible closing off the south-facing side of the vista. Moving left—before the large cluster of pine trees (counterbalancing the statue) closes and frames the view, as in a traditional composition—other features of the famous garden of the Villa Mattei can be seen, such as the box hedges, the maze, and fountains.

This elaborate and detailed watercolor, with small, elegant figures walking in the park, was probably a commission, no doubt preceded by a series of preparatory studies inspired by the Baths of Caracalla and done from nature. This inference is based on the catalogue of the sale at Sotheby's in London in 1986, where three large watercolors (lots 118, 119, 120) appear, incorrectly titled *Roman Ruins Probably on the Lago d'Averno* (sale catalogue, Sotheby's, London, 1986, lots 118–20). The dimensions of these paintings are 22½ by 36⅞ inches (570 × 936 mm), 19⅝ by 25½ inches (499 × 648 mm), and 19¼ by 25⅛ inches (490 × 639 mm) respectively, and they actually depict interior views of the baths. This subject was particularly significant at the time of painting because of excavations carried out by the engraver Giovanni Volpato after 1779. As a record of this work, Volpato engraved two etchings (with the help of the Swiss artist Louis Ducros), one of which bears evident similarities with the watercolor by Lusieri, showing the tepidarium of the baths (sale catalogue, Sotheby's, London, 1986, lot 19). This similarity suggests an affinity between the work of Lusieri and Ducros, as regards technique (both preferred large-scale watercolors) and also style, during Lusieri's "Roman period." These features also suggest that he came under the influence of artists such as Hackert, who aimed to produce clean,

bright images executed with an almost topographical precision. However, the clear-cut views of Lusieri, though never picturesque, are more romantic and sentimental, owing to their luminosity and the transparency of the colors, which he applied straight on to untreated white paper. This technique was made possible by what was then the new medium of watercolor, which Lusieri used exclusively. [AOC]

## BENEDETTO LUTI
FLORENCE 1666–1724 ROME
*For biography see Paintings section*

### 366
#### Benedetto Luti
#### *Saint Bridget of Sweden*

c. 1707
Pen and brown ink, brown wash, and white heightening on buff paper
14⅝″ × 17″ (372 × 433 mm)
PROVENANCE  presumably acquired in Rome directly from the artist by Thomas Coke, 1st Earl of Leicester
EXHIBITIONS  London, Arts Council of Great Britain. *Old Master Drawings from the Collection of the Earl of Leicester, Holkham Hall.* 1948, cat. no. 20; London, Thos. Agnew and Sons Ltd. *Old Master Drawings from Holkham.* 1977, cat. no. 81
BIBLIOGRAPHY  Dowley 1962, p. 226, n. 47; Bowron 1979, pp. 120–22, fig. 56; Popham, A. E. *Old Master Drawings at Holkham Hall.* Prepared for publication, with an introduction by Christopher Lloyd. Chicago: University of Chicago Press, 1986, p. 74. no. 162 (described as a "Virgin Blessing a Church")
Lord Leicester and the Trustees of the Holkham Estate

The Roman paintings and drawings acquired by Thomas Coke, 1st Earl of Leicester, illustrate perfectly the taste of his time. He embarked on his Grand Tour in 1712 at the age of fifteen and within two years could write from Rome that he had become "a perfect virtuoso, and a great lover of pictures" (Ingamells 1997, p. 225). Coke patronized a number of Roman Settecento painters, including Giuseppe and Tommaso Chiari, Sebastiano Conca (from whom he commissioned a huge *Vision of Aeneas in the Elysian Fields* in which he appears as Virgil with a lyre), Luigi Garzi, Agostino Masucci, Pietro di Pietris, Andrea Procaccini, Francesco Trevisani (to whom he sat for a portrait now at Holkham), and Gaspar van Wittel (from whom he acquired seven Italian views). Coke had especially close dealings with Luti, who may have played a formative role in his collection of drawings. His dedication of two pastel heads of his daughters to "Conte Coke" (as he generously called the young Englishman) is a fas-

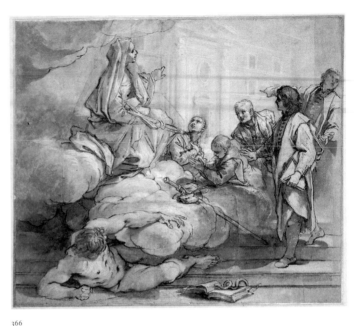

366

cinating document in the history of the collection for it shows Thomas Coke had already started the "nobilissima raccolta" that Luti refers to in an inscription on one of them (see Popham [above], pp. 74–76, nos. 163–66). On September 11, 1717, just before Coke left Rome, he paid for silver bowls to be presented to Van Wittel and Luti (Ingamells 1997, p. 226).

The Holkham drawing of Saint Bridget is important both for understanding the chronology of Luti's development as a draftsman in the first decade of the century and for its function as a preparatory compositional sketch. The largest category of surviving drawings from Luti's hand is represented by academy drawings followed by colored chalk drawings of heads and busts of Apostles, saints, angels, and children. The absence of preparatory drawings by Luti for individual works is puzzling, and the sheets that would normally have been employed by a typical Roman eighteenth-century painter in the course of preparing his work—compositional drafts, studies of heads and limbs, drapery studies, chalk *modelli*—are found to exist in relatively few instances. One explanation is that Luti assiduously kept this preparatory material intact, conserved for subsequent reference, and that the entire mass of drawings was lost in the dispersal of his collection by his heirs. Another is that, like many Roman painters in the first half of the century, he depended upon oil sketches in the preparation of his paintings, preferring to translate his designs from idea to image in paint rather than in the traditional materials of the draftsman.

The Holkham drawing is a carefully finished study that served as the basis for an engraving (possibly for a book

illustration) by Benedict Farjat, dated 1707 and entitled *Saint Bridget of Sweden*. The care taken with the composition by Luti is indicated by the indented outlines and the corrections on fresh pieces of paper, principally to the saint and the figure standing on the steps to the right. The sheet depicts the fourteenth-century foundress of the order of the Holy Saviour, seated on a cloud before a group of five young men, perhaps Swedish pilgrims, and identified by her usual attributes—the pilgrim's staff, wallet, and an open book. She is clearly shown in triumph above a naked man, a personification of Heresy, and points to her church in the Piazza di Campo dei Fiori in the distance. The saint's cult was stimulated in Rome when Cardinal Francesco Albani (before he became Pope Clement XI in 1700) undertook the restoration of the church of S. Brigida and commissioned Biagio Puccini to decorate the interior with frescoes and canvases depicting scenes from the life of the saint. The iconography of Luti's drawing is unusual, however, in that it does not represent Saint Bridget giving her rule and writings to the order, nor does it appear to conform to the scenes traditionally selected by the Brigittine order to represent the episodes of her life (Bowron 1979, vol. 1, p. 121, n. 34).

*Saint Bridget of Sweden* confirms Luti's continuing effort to develop a style suitable for the exposition of religious and mythological subjects. His earlier predilection for crowded compositions and large patterned areas of light and dark has given way to a narrative style eminently more readable. The depth of diagonals is controlled by the steps that run parallel to the picture plane and that serve as a dais upon which the figures are disposed

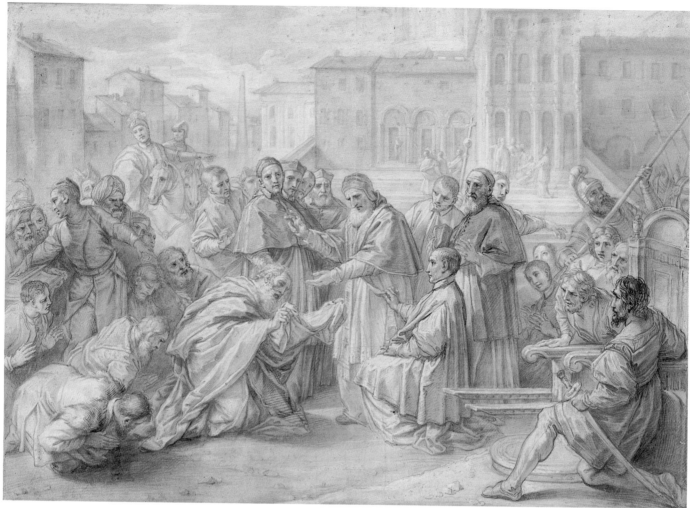

367

clearly in the foreground. The specta-
tor reads the lightly indicated outlines
of the church merely as a backdrop
before which the protagonists enact
the drama. Although compactly
grouped, the individual figures are
now more effectively related to each
other by patterns of attitudes and ges-
tures; each is precisely delineated and
easily distinguished, and each makes
an effective contribution toward clari-
fying the narrative or allegorical
content of the composition.

In its treatment of form and com-
position, the Holkham drawing
reveals that Luti had acquired the
ability to draw in the accepted Roman
style. His articulation of musculature,
modulation of light and shade, and
construction of drapery represent the
fruits of his study of the grand models
of Roman *disegno* from Raphael to
Annibale Carracci to Carlo Maratti.
[EPB]

## 367
## Benedetto Luti
## *Study for "Pius V and the Ambassador of the King of Poland"*

1712

Inscribed in brown ink on old mount:
*Benedetto Luti*

Black, red, and some blue chalk, brown
wash, heightened with white
15⅛″ × 21¼″ (392 × 552 mm)

PROVENANCE  Thomas Brand Hollis;
Mr. Disney and his descendants; sale,
Christie's, London, July 1, 1969, lot 128;
purchased by Hans Calmann, London;
acquired in 1969 in London by The
Metropolitan Museum of Art, New York

EXHIBITIONS  New York 1971, cat. no. 12;
New York, the Metropolitan Museum of
Art. *Drawings Recently Acquired, 1969–1971.*
1972, cat. no. 29; New York 1978

BIBLIOGRAPHY  Sestieri 1973, pp. 244, 246,
fig. 4; Bowron 1979, pp. 152–54, fig. 86;
Bean, Jacob. *17th Century Italian Drawings in
the Metropolitan Museum of Art*, New York:
The Metropolitan Museum of Art, 1979,
pp. 200–201, no. 267; Cipriani 1990,
pp. 104–5; Johns 1993, pp. 46–47, 222–23,
n. 23, fig. 13

The Metropolitan Museum of Art, New
York, Rogers Fund

Pope Clement XI's only canonizations
were pronounced on May 22, 1712,
when he sanctified the Blessed Andrea
Avellino, Catherine of Bologna, and
the Dominican friar, bishop, and pope
Pius V. The general of the Dominican
Order, Antonin Cloche, had con-
ducted a vigorous advocacy for
Michele Ghislieri, Pope Pius V, one
of the most important popes of the
Counter-Reformation and a protector
of the Dominicans. As an expression
of gratitude, Cloche commissioned as
a gift for the pontiff a painting from
Luti depicting *Pius V and the Ambassador
of the King of Poland*. The painting was
exhibited in St. Peter's during the can-
onization ceremonies along with other
depictions of events from the life of
Pius V and later hung in the Palazzo
Albani alle Quattro Fontane, where
it was praised by Lione Pascoli as
"per verità superbissima" (Pascoli
1992, p. 318). Lost for many years until
it appeared on the Italian art market
in the 1980s (reproduced Sestieri 1994,
vol. 3, fig. 644), the canvas is today in
a private collection.

Anthony Clark was the first to
connect the Metropolitan Museum
drawing with the painting commis-
sioned in 1712 as a gift for the Albani
pope. Executed in the technique of
*trois crayons*, the drawing represents
Pope Pius V blessing a sample of the
soil of Rome, which was taken as a
relic to the King of Poland by his
ambassador. The pope is depicted in
the act of blessing the soil, collected
in a piece of linen by the kneeling
ambassador, who accepts the relic in
the name of his sovereign. The subject
is rare in art; another depiction by
Giuseppe Laudati is in S. Domenico,
Perugia (*Bibliotheca Sanctorum* [Rome:
Istituto Giovanni, 1968], vol. 10, p. 887).

In response to the requirements of
this important commission, Luti paid
scrupulous attention to the details of
the subject and attempted a histori-
cally accurate representation of an
event that had taken place a century
and a half earlier. The portrait of Pope
Pius V corresponds to traditional like-
nesses; the façade and square of
St. Peter's are represented as they
appear in the 1560s, and at the right
of upper center may be discerned part
of the dome of the basilica, unfinished
at Michelangelo's death in 1564. Luti, a
conscientious academic artist, proba-
bly consulted for this archaeological

reconstruction a source such as
Antoine Lafréry's 1575 engraving in
the *Speculum romanae magnificentiae*,
an album of plans and views of Rome,
executed between 1545 and 1577.
Indeed, the "archaeological" exacti-
tude of Luti's presentation of the event
reminds us that learning, as careful in
technique as in specific contents, typi-
cally held pride of place in Roman
eighteenth-century painting (see
further the observations of Johns
1993, p. 47). In this sense Luti belongs
to a tradition that extends back to
Raphael and forward to Pompeo
Batoni and Anton Raphael Mengs.

This elaborately finished and
colored drawing, one of the artist's
finest, has been traditionally consid-
ered a drawn *modello* for the painting
commissioned by the General of the
Dominicans. In fact, the sheet almost
certainly served as a *ricordo*, or record,
of the painted composition, to which
it corresponds nearly exactly. [EPB]

## 368
### Benedetto Luti
*Head of a Bearded Man*

1715
Signed in brown ink on the verso of the
original mount: *Roma 1715/ Il Cavalier
Benedetto Luti fece*
Pastels on paper, mounted on cardboard
12⅝″ × 10⅜″ (320 × 264 mm)
PROVENANCE  Mr. and Mrs. S. van Berg,
New York; Julius S. and Ingrid Held, New
York; from whom acquired by the National
Gallery of Art
EXHIBITIONS  New York 1971, cat. no. 13;
Williamstown, Mass., The Sterling and
Francine Clark Art Institute. *Master
Drawings from the Collection of Ingrid and Julius
S. Held*. 1979, cat. no. 22
BIBLIOGRAPHY  Bowron 1979, p. 245,
fig. 178; Bowron 1980, pp. 445–46, fig. 12
National Gallery of Art, Washington D.C.,
Julius S. Held Collection, Ailsa Mellon
Bruce Fund

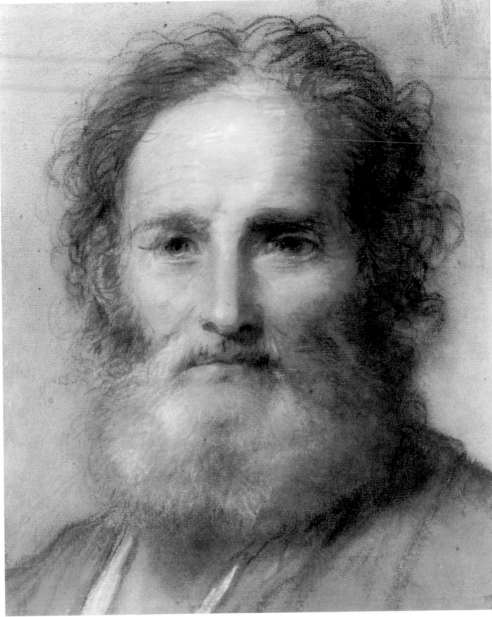

368

Benedetto Luti's contemporary biog-
raphers expressed their admiration for
his pastel and colored chalk drawings,
which, for their relatively early date in
the Settecento, are characterized by
unexpected freshness and brilliance.
In Pascoli's words, "Lavorava eccellen-
temente di pastelli di tanta forza, e di
tanta bellezza, che pajon dipinti"
(Pascoli 1992, p. 318). The genre of
these studies of single heads and bust-
lengths became immensely popular,
so much so that depictions of winsome
youths and pretty girls found a place
in the œuvres of many contemporary
draftsmen. Yet, in spite of the moder-
nity of Luti's pictorial inventions in
this medium, his achievement has not
always been appreciated. Luigi Lanzi
even "regretted that he attached
himself so much to crayons, with
which he is said to have inundated

all Europe" (Lanzi [1809] 1847, vol. 1,
p. 499), although, in fact, Luti's pro-
duction of pastels, like every other
aspect of his art, was limited.

Luti's interest and training in the
use of colored chalks and pastels orig-
inated in his native city of Florence,
where in the 1680s there was consid-
erable appreciation for these media at
the court of Cosimo III de' Medici,
Grand Duke of Tuscany. In Rome,
Luti's position was equivalent to that
of official painter to the grand duke.
He resided in Palazzo Firenze, near
Campo Marzio, and maintained a
studio and exhibited his paintings in
the Villa Medici on the Pincio. Owing
to the patronage and support of
Cosimo III in Rome, Luti received
countless opportunities to meet visit-
ing collectors and the agents of foreign
nobility. With a reputation as one of

the best connoisseurs in the city, he
rapidly emerged as one of the princi-
pal dealers on the Roman art market.
He took advantage of his role as artist
and *marchand amateur* and produced
intermittently throughout his career
highly finished drawings and pastels
for the art trade.

These fresh and luminous studies
of heads and bust-length figures are
historically significant as among the
first of their kind to be created and
appreciated strictly as independent
works of art rather than as preparatory
studies for a canvas or fresco. Much
sought after in Luti's own time, his
pastels and drawings were so fre-
quently imitated and copied that the
problem of attribution often becomes
a delicate issue of connoisseurship.
These drawings made ideal gifts both
for Luti's clients and for his benefac-

tors, who responded to their novelty,
liveliness of handling, color, and
effects of lighting and *sfumato*.

Luti employed stock types for these
drawings and repeated them with little
variation to meet the demand for such
works. His repertory included bust-
lengths of young children, angels and
cherubim, saints and apostles, and old
men. The Washington *Head of a Bearded
Man* is a fine example of the genre and
achieves all of the subtlety inherent in
this fragile medium. Luti's technique
is characterized by use of the stump
to fuse color and tone and to create an
even, luminous pictorial surface. He
then strengthened the image with crisp
strokes of black, brown, and white
chalk. The prominence given these final
undisturbed touches distinguishes his
handling from other contemporary
pastellists.

The Washington head may be associated with several figures in one of the artist's most ambitious undertakings, the monumental *Investiture of Saint Ranieri*, painted in 1712 for Pisa Cathedral. The head is not an actual preparatory study for any single figure in the finished painting, but it clearly relates to several of the idealized male types among the onlookers to the central scene and was evolved from the same type of model. In spite of its vivid impression of directness and immediacy, the drawing represents an idealized character study rather than a specific portrait, the bearded physiognomy of the model recalling types traditionally associated with philosophers and religious personages. Luti's practice of repeating such figures in his canvases suggests that he routinely collected drawings of this kind in albums and utilized them as needed in the transition to actual execution on canvas. [EPB]

## CARLO MARATTI

CAMERANO 1625–1713 ROME

By the time of the death of Pietro da Cortona in 1669, Carlo Maratti had become the most famous painter in Rome, and he retained that position for almost half a century by dint of his extraordinary talent, application, and the instinct with which he cannily developed the High Baroque style in its various forms, presaging both the academic classicism and the Rococo element in Roman art of the eighteenth century.

The authoritative Giovan Pietro Bellori (his friend, mentor, and biographer) described the master's formative years and meteoric career path from success to success as archetypal: after all, Maratti's credentials were impeccable from the start, having entered at the tender age of twelve the studio of Andrea Sacchi, whose artistic lineage went straight back to Annibale Carracci through his own training under Francesco Albani (Bellori [1672] 1976; Mezzetti 1955). Sacchi's rigorous discipline, based on copying the choicest models from antiquity through to Raphael and Domenichino, nurtured his pupil's innate ability as a draftsman while orienting his taste to the measured Baroque style of the exquisitely neo-Correggesque 1650 *Adoration of the Shepherds* altarpiece with which he made his public début in Rome in the small church of S. Giuseppe dei Falegnami (Stella Rudolph, "La prima opera pubblica del Maratti," *Paragone*, vol. 28, no. 329 [1977], pp. 46–58).

From that point on, Maratti's career soared. He rapidly transformed his manner, passing from an austere interpretation of Sacchi's figural

repertory in the canvases and frescoes of the Alaleona Chapel in S. Isidoro Agricola (1652–54) and the more dynamic syntax of the *Augustus Closing the Temple of Janus* for the gallery in the Paris residence of La Vrillière (c. 1654–56; Musée des Beaux-Arts, Lille) to draw inspiration from the narrative potency of Lanfranco (canvases and frescoes in the Ludovisi Chapel, S. Isidoro Agricola, 1655–57), the vibrant intensity of Bernini (*Saint Augustine and the Child*, 1656–57; S. Maria dei Sette Dolori, Rome), and Reni's chromatic suavity (the oval *Immaculate Conception* altarpiece of 1662, mounted in a frame designed by Bernini in the Da Sylva Chapel in S. Isidoro Agricola). In the meantime his crowded, theatrically luminescent *Adoration of the Shepherds* frescoed in the Gallery of Alexander VII (1657; Palazzo del Quirinale, Rome) had catapulted him into the vanguard of the rising generation of painters in a decorative ensemble planned by Pietro da Cortona, and in 1661–64 he painted the lateral canvases (*Visitation* and *Flight into Egypt*) for Bernini's Cappella del Voto, commissioned by Alexander VII for Siena Cathedral. Indeed, by 1664 Maratti had synthesized these diverse sources into a grand Baroque manner perfectly attuned to Bellori's theoretical "Idea" (*Scelta delle bellezze naturali superiore alla natura*), as expounded by the writer in a discourse read that year at the Accademia di S. Luca during Maratti's first term as Principe of that venerable institution.

Maratti's reputation as a portraitist was assured after such penetrating likenesses as that of *Cardinal Alderano Cybo*, surrounded by objects that highlight the sitter's interests as a collector and his rank as a noble prelate (1656–57; Musée des Beaux-Arts, Marseille), those of the "Milords" Spencer and Dillon inaugurating the Grand Tourist portrait genre (1661–64; Lord Spencer Collection, Althorp), and his *Clement IX Rospigliosi* (1669; Pinacoteca Vaticana, Rome), reminiscent of Velazquez's celebrated Doria-Pamphili *Portrait of Innocent X Pamphili* (Stella Rudolph, "An Instance of Time Thwarted by Love: Carlo Maratti's Portrait of an Unusual Lady," *Labyrinthos*, vol. 11–12, no. 22–24 [1992–93], pp. 191–213). He furthermore established the practice, followed in the eighteenth century by Costanzi and Batoni, of collaborating as a figure painter with specialists in landscape (Gaspard Dughet, Jan Frans van Bloemen) and still life (Mario Nuzzi "de' Fiori," Abraham Breughel, Jan Frans Werner von Tamm, and others; see Stella Rudolph, "Carlo Maratti figurista per pittori di natura morte," *Antichità Viva*, vol. 18 [1979], pp. 12–20). And, during the papacy of Clement X Altieri (1670–76), he pro-

vided the late Baroque sequel to Pietro da Cortona's *Allegory of Divine Wisdom* (frescoed on the vault of the *salone* in the Palazzo Barberini a generation earlier) with his *Allegory of Divine Clemency* fresco on the vault of the *salone* of the Palazzo Altieri; its stately figures delimited by a frame in an imagery that in every sense contrasts with the atmospheric illusionism of Baciccio's contemporary decoration of the nave vault in the Gesù church opposite (Stella Rudolph, "Il progetto di Carlo Maratti per la Galeria Falconieri e altri quesiti sulle decorazioni private," *Labyrinthos*, vol. 5, no. 9 [1986], pp. 112–37). Needless to say, these achievements were accompanied by an impressive series of altarpieces for churches in Rome and in such towns as Ancona, Ascoli Piceno, Palma de Mallorca, and Vienna.

Bernini's death in 1680 had left Maratti the uncontested leader of the Roman school; his inventions spread abroad by countless engravings and his clientele comprising not only the papacy and ecclesiastical hierarchy, the aristocracy and foreign dignitaries, but also the new wealth represented by discriminating bankers such as Francesco Montioni and the Marchese Niccolò Maria Pallavicini (Rudolph 1995, passim). If his *Apollo and Daphne* (1679–81) commissioned by the minister Colbert for Louis XIV (Musées Royaux des Beaux-Arts, Brussels) offers a pictorial equivalent of the classicizing bent in poetry that culminated in the creation of the Accademia dell'Arcadia in 1690, Maratti's incursions in other areas in this last period—projects for interior decorations, cartoons for mosaics in St. Peter's, designs for book illustrations and for the statues in the nave of St. John Lateran—also left their mark on Roman art for generations to come.

After having erected an imposing funerary monument to himself in S. Maria degli Angeli, Maratti was proclaimed Principe Perpetuo of the Accademia di S. Luca in 1699, was decorated by Clement XI Albani with the cross of Cavaliere di Cristo in a solemn academic ceremony, and was elected to the Accademia dell'Arcadia in 1704 (Rudolph 1979). These honors attest to his dominant position, even stranglehold (according to his detractors), in Roman art at the outset of the eighteenth century, when a pervading nostalgia for the city's recently lost hegemony elevated him and his famous school to the position of custodians of a precious heritage. Although, as in the case of Raphael, Maratti (now frail and ageing) delegated the execution of his ideas to a host of gifted pupils (such as Calandrucci, Chiari, Passeri, Procaccini, and Masucci), it was those ideas that effectively prolonged his influence and

example, just as Bellori had hoped, up to the advent of Pompeo Batoni. Decades later, Anton Raphael Mengs averred in a period of Neoclassical effervescence that Maratti had in effect "sustained painting in Rome so that it did not decline, as elsewhere" during the Baroque age (Giuseppe Niccola d'Azara, *Opere di Antonio Raffaello Mengs primo pittore della maestà di Carlo III Re di Spagna* [Parma, 1780], vol. 2, p. 124). [SMCR]

BIBLIOGRAPHY Bellori [1672] 1976, pp. 572–654; Mezzetti 1955; Harris and Schaar 1967; Baldinucci 1975, pp. 286–313; Mena Marqués, Manuela B. "Sobre dibujos de Carlo Maratta en colecciones madrileñas." *Mitteilungen des Kunsthistorischen Institutes in Florenz*, vol. 20 (1976), pp. 225–62; Rudolph, Stella. "La prima opera pubblica del Maratti." *Paragone*, vol. 28, no. 329 (1977), pp. 46–58; Rudolph, Stella. "Il progetto di Carlo Maratti per la Galleria Falconieri e altri quesiti sulle decoraziuone private." *Labyrinthos*, vol. 5, no. 9 (1986), pp. 112–37; Rudolph 1994; Rudolph 1995

## 369

Carlo Maratti

*Study for "Saint John the Evangelist Expounding the Doctrine of the Immaculate Conception to Saints Gregory, Augustine, and John Chrysostom" in the Cybo Chapel, S. Maria del Popolo, Rome*

1682
Pen and brown ink, red chalk and red wash on white paper, the scene contoured in ink with an arched top
17¾" × 10¼" (453 × 260 mm)

PROVENANCE William Mayor, London; C. R. Rudolf by 1936, whence purchased by The Metropolitan Museum of Art, New York, in 1963

EXHIBITIONS Leicester, England, Leicester Museums & Art Gallery. *Old Master Drawings*. 1952, cat. no. 40; London, Arts Council Gallery; Birmingham, England, City Museum Art Gallery; Leeds, England, Leeds City Art Gallery. *Old Master Drawings from the Collection of Mr. C. R. Rudolf*. 1962, cat. no. 36; University Park 1975, cat. no. 30

BIBLIOGRAPHY Parker 1935; Mezzetti 1955, p. 337, no. 40; Dowley 1957, pp. 171–74, fig 9; Bean, Jacob. *One Hundred European Drawings in the Metropolitan Museum of Art*. New York: The Metropolitan Museum of Art, 1964, no. 37; Harris and Schaar 1967, p. 126; Stampfle, Felice, and Jacob Bean. *Drawings from New York Collections II: The Seventeenth Century in Italy*. New York: The Metropolitan Museum of Art, and The Pierpont Morgan Library, 1967, no. 117; Westin and Westin 1975, nos. 30, 56–57, fig. 33

The Metropolitan Museum of Art, New York, Rogers Fund

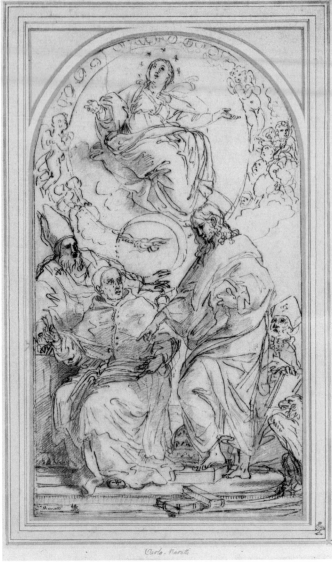

369

In 1682–86 Cardinal Alderano Cybo had the fifteenth-century family chapel in S. Maria del Popolo entirely rebuilt by Carlo Fontana and decorated with paintings by Carlo Maratti (altarpiece), Luigi Garzi (frescoed cupola), and Daniel Seiter (lateral canvases in the atrium), as well as monuments to his ancestor Lorenzo and himself comprising portrait busts sculpted by Francesco Cavallini (Hager 1974, pp. 47–60). Consecrated on August 8, 1687, the chapel is a masterpiece of late Baroque taste and design, its focal point—Maratti's altarpiece—framed by a majestic perspective of columns and colored marble facing on the walls. Cybo's aspirations, at the height of an impressive ecclesiastical career, were fully expressed in the creation of this chapel as an up-to-date pendant, no expense spared, to Raphael's celebrated Chigi Chapel in the left nave opposite. The ensemble not only marks him out as a distinguished patron of the arts and underscores his lineage

from the dukes of Massa, but also proclaims his adherence to the doctrine of the Immaculate Conception in the subject he chose for the altarpiece (Rudolph 1994, "Premessa").

Maratti's scene illustrates the patristic elaboration of the future dogma on two registers: above, the apparition of the Virgin Mary surrounded by Cherubim on clouds, with the moon alluding to her immaculate conception; and below, the early Church fathers who contributed to the definition of the doctrine stemming from passages in the Revelations of Saint John. Since Saint John was perforce the most significant figure in this visual explication of an anachronistic theological debate, recalling *The Dispute upon the Sacrament*, frescoed by Raphael in the Vatican Stanza della Segnatura, Maratti produced an unusual quantity of preparatory drawings for the composition. In these he moved John about and rearranged the other saints, so as to

achieve the clearest possible depiction of their various roles in substantiating the doctrine promulgated by Alexander VII's papal bull dated December 8, 1661 (see Harris and Schaar 1967, p. 126–28, nos. 342–46; Westin and Westin 1975, pp. 53–59, nos. 29–32). In the present sketch the double-tiered composition has already been delineated by modifications to a previous, more fluid one also in the Metropolitan Museum. Only after yet further experiments did the artist reach the definitive solution (a sheet in the Pierpont Morgan Library, New York), which he then painted in oils, not on canvas but directly on the wall above the altar, in 1684–86 (by this method he intended to obviate the inevitable darkening of tones on a canvas placed in the perennially colorful setting of the marble interior devised by Fontana). The placement of John as an isolated figure to the left embodies precisely, through his gestures, the essential link between the vision he described and its later interpreters.

The group of beautiful drawings relating to the Cybo Altarpiece can be dated around 1682, when Maratti presumably received the commission. It offers a valuable glimpse of both his work in progress and the care he took to elucidate a Catholic axiom that at that time required its canonical definition in imagery. In fact, the master's thoughtful, painstaking approach to the task set him by Cardinal Alderano produced a painting that was immediately perceived as a model of the academic standards that would be perpetuated in Rome, by generations of Maratti's followers and imitators, up to the advent of Anton Raphael Mengs. [SMCR]

## 370
## Carlo Maratti
*Studies for Apollo and Other Details in the Allegorical Portrait of the Marchese Niccolò Maria Pallavicini and Carlo Maratti*

c. 1692–95

Inscribed in pen and brown ink, on the lower left corner, by a later hand: *C. Maratti*
Black chalk, heightened with white, on gray-green paper
15¾" × 10⅝" (402 × 270 mm)

PROVENANCE Carlo Maratti; his daughter Faustina Maratti Zappi after 1713; Lambert Krahe by 1756, whence purchased for the Düsseldorf Academy in 1777

EXHIBITION London and Edinburgh 1973, no. 100

BIBLIOGRAPHY Harris and Schaar 1967, p. 143, pl. 103, no. 407; Graf 1973, no. 100
Kunstmuseum Düsseldorf im Ehrenhof, Graphische Sammlungen

Maratti's spectacular portrait of the Marchese Niccolò Maria Pallavicini, a Genoese banker who had become one of the foremost art patrons in Rome by the end of the seventeenth century, was acquired from Pallavicini's heirs in 1758 by the English banker Henry Hoare II for his country house at Stourhead (Wiltshire), now a National Trust property (Rudolph 1995, pp. 2–3, 75–81, 180–83, fig. 42). Replete with a cast of mythological figures in a landscape setting, the large picture epitomizes the relationship between a virtuoso and his favorite painter in the late Baroque conceit of Pallavicini's stately progress toward the "Temple of Virtue" on the heights, by which both patron and artist sought to immortalize themselves, conjoined in effigy. Bewigged and toga-clad *all'antica*, Niccolò Maria is escorted on his journey by Apollo. In the distance Fame flies above bearing a crown of laurels, and History writes his name on the shield of Pallas-Minerva (a punning reference to Pallavicini's surname). In the foreground Maratti has portrayed himself in academic garb, seated and drawing his apotheosis on the canvas he holds, while the Three Graces (so essential to his profession) assist the performance.

Since Maratti sports a chain bearing the cross of Cavaliere di Criso that he received from Pope Clement XI in 1704, the date of 1705 inscribed on the back of the canvas on which he is working has been customarily applied to the execution of the Stourhead picture. Nevertheless, the painting was already described as hanging in Pallavicini's Roman palace prior to 1700, and recent investigation has shown that it is a palimpsest of various repaintings by the master, ranging from its conception around 1692–95 to the 1706 addition of the cross, together with other modifications in the drapery and a realistic updating of the likenesses of the two ageing protagonists (Rudolph 1995, pp. 393, 399–404, fig. 11). Apollo, the presiding deity upon whom the elaborate scenario centers, appears in profile dashing to the right in the earliest sketch for a different composition related to the picture (British Museum, London; see Amalia Mezzetti, "Carlo Maratti, altri contributi," *Arte antica e moderna*, vol. 4 [1961], p. 377, pl. 182a; Rudolph 1995, p. 77, fig. 45), whereas the Düsseldorf study exhibited here presents the figure according to his stance in the picture: frontally posed, statuesquely immobile, and making the gestures necessary to unite all the components in a cogent narrative.

Maratti had evidently reached the final stage of preparation and was now concentrating his attention on studies of extraordinary refinement, in which he translated the classical

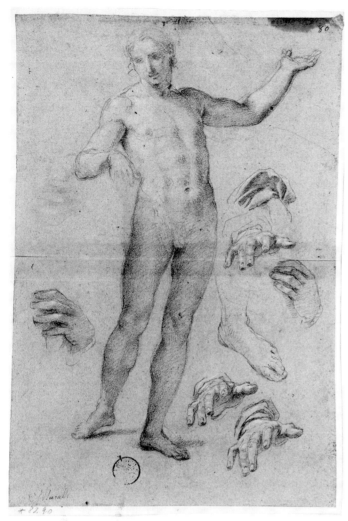

370

371

archetype of the Belvedere *Apollo* (Vatican Museums, Rome; see Blunt and Cooke 1960, p. 62, no. 374) into Pallavicini's tutelary genius through the medium of this life drawing of a nude model, surrounded by several details of the hands, a foot, and a cuff (pertaining to the figures of Apollo and Pallavicini). The sheet is yet another example, among the scores of similar ones he made from the outset of his career onward, of the exacting creative method by which Maratti increasingly frequently produced paintings of the first order, including masterpieces on the level of the Stourhead portrait. [SMCR]

## 371
## Carlo Maratti
## *Mercury Delivering the Infant Bacchus to the Nymphs*

c. 1704–5

Pen and brown ink with brown wash over red chalk on white paper (the female figure immediately to the left of Bacchus drawn by the artist on a separate piece of paper pasted on to the original sheet)
8¾″ × 11⅝″ (222 × 296 mm)

PROVENANCE Yvonne Tan Bunzl, New York, 1971, whence purchased by the Fondation Custodia

EXHIBITION London, Faerber and Maison, Ltd. *Old Master Drawings Presented by Yvonne Tan Bunzl.* 1971, cat. no. 31

BIBLIOGRAPHY Faerber and Maison, Ltd, London. *Old Master Drawings Presented by Yvonne Tan Bunzl.* London, 1971, no. 31, pl. vii; Rudolph 1978, "Torribio," p. 203, no. 46; Byam Shaw 1983, vol. 1, pp. 169–70, no. 167, and vol. 3, pl. 192

Collection Frits Lugt, Institut Néerlandais, Paris

Legend has it that the Greek god Dionysus (Bacchus in the Roman pantheon) was the son of Zeus and Semele, daughter of King Cadmus of Thebes. To protect the infant from his vindictive wife, Hera, Zeus commanded Mercury to entrust him to the nymphs Ino and Athamas at Orchomenus, who reared the child, taking the added precaution of disguising him as a girl (Ovid, *Metamorphoses*, vol. 3, 314–15).

The narrative potential of this story seems to have fascinated Maratti toward the end of his long career, for he made several drawings of the scene and had even begun work on a canvas of the subject, described as an autograph "tela disegnata" in the 1712 inventory of his collection (Galli 1927–28, pp. 69–70, no. 292). An engraving of the same composition by his pupil Andrea Procaccini, inscribed as after a drawing by the "virtuosissimo Cav. Maratti" and dedicated to the master's foremost patron at that time, the Marchese Niccolò Maria Pallavicini, can be dated between 1704 and 1711 (Charles Le Blanc, *Manuel de l'amateur d'estampes* [Paris: Vieweg, 1854–65], vol. 3, p. 256, no. 10; Rudolph 1978, p. 203, no. 46). The graphic mannerisms of Maratti's preparatory drawings likewise place them around 1704–5, whereas their sequence illustrates the various phases in the elaboration of a given subject that he maintained beyond the age of eighty.

It is the Fondation Custodia sketch that reveals his earliest idea for the composition in the extemporaneous jabbing and blotted penstrokes that capture the invention, swiftly corrected there and then with a scrap of paper pasted on to the sheet, redefining the nymph to the left of Bacchus. At the center of a lightly sketched landscape setting, the pivotal figure of Mercury alights from flight to be met by a group of nymphs pressing toward him to receive the infant Bacchus he cradles in his arms. Evidently satisfied with the layout, the master proceeded to refine the left group in another drawing of the scene in the British Museum (Turner 1999, vol. 1, no. 175, and vol. 2, pl. 175) and succinctly finalized the composition in the one now in the Kupferstichkabinett in Berlin (Dreyer 1969, "Maratti," pl. 57, no. 114). Together these studies, with Procaccini's engraving based on them, document the elderly master's development from a composition based on

a static arrangement of figures in the comparable episode of *A Shepherd Consigning the Infants Romulus and Remus to Laurentia* (Rudolph 1995, pp. 38–41, fig. 15), painted for Niccolò Maria Pallavicini in 1680–92, to a more fluid and dynamic representation of a subject well suited to the Arcadian propensities of "Solindo Elafio" Pallavicini, a member of the Accademia dell'Arcadia (Rudolph 1995, passim). [SMCR]

## 372
## Carlo Maratti
## *Allegory of the Old and New Dispensations*

1708

Pen and brown ink over black and red chalk, heightened with white, on beige paper
11⅞″ × 8″ (302 × 211 mm)

PROVENANCE London art market, 1967

BIBLIOGRAPHY Dreyer 1969, "Maratti," pl. 12; Blunt, Anthony. "Supplements to the Catalogues of Italian and French Drawings." In Edmond Schilling, *The German Drawings in the Collection of Her Majesty the Queen at Windsor Castle.* London and New York: Phaidon, 1971, p. 96, under no. 290; Bean, Jacob. *17th Century Italian Drawings in the Metropolitan Museum of Art.* New York: The Metropolitan Museum of Art, 1979, p. 214, no. 280

The Metropolitan Museum of Art, New York, Rogers Fund

Peter Dreyer identified the sheet as preparatory for Giovanni Girolamo Frezza's 1708 engraving in reverse, of similar dimensions and contoured by a frame beneath which the inscriptions clarify the authorship *Eques Carolus Maratti Inu. Et del.* and *Ion. Hieronymus Frezza Scul. Romae sup. Lic. An. 1708* (Dreyer 1969, "Maratti," pp. 24–25, pl. 12). In that same year Maratti had reached the age of eighty-three and,

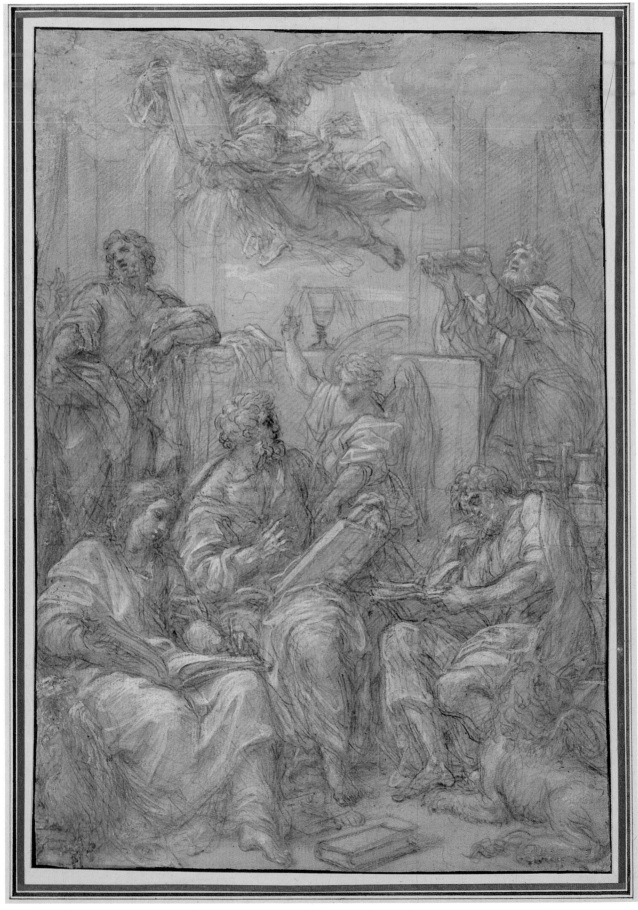

372

373

374

according to the biographer Lione Pascoli, began to suffer from a trembling of the hand that would increasingly limit his artistic production to sketches for compositions destined to be painted or engraved by a number of collaborators (Pascoli 1992, p. 207). If the shaky execution of this autograph drawing corroborates Pascoli's account, the softness of touch in the handling of the chalks is nevertheless so effective as to have left its mark on the graphic style of his most gifted followers, Luti and Passeri. Moreover, this visualization of a rather complex theological allegory shows that the creative talent of this senior Roman artist retained its vigor even at such a late date.

The scene represents a visionary synthesis of the Old and New Testaments, based on the sacramental communion of the Eucharist. Behind the altar, upon which is set the cup of wine, the king-priest Melchizedek offers up the shewbread, while above a flying angel bears the Pentateuch (the "five books of Moses"), or possibly the Tablets of the Law. In the foreground the Evangelists Mark, Matthew, and Luke write their Gospels, and John leans on the altar. As in the case of the Cybo Altarpiece (cat. 369), in which the figure of John connects the

vision of the Immaculate Conception to the Church Fathers who later interpreted it, so here too his positioning isolates him in parallel to the king. They are singled out on either side of the central altar as symbols of the two Testaments comprising the Holy Bible.

Maratti's drawing and the Frezza engraving of it were prepared for the frontispiece of the 1714 edition (Propaganda Fide, Rome) of the most splendid seventeenth-century missal, first published in 1662 for Pope Alexander VII and illustrated with numerous engravings designed by the major painters of the time. The subject of this new frontispiece, replacing Pietro da Cortona's *Allegory of Heresy Vanquished* (engraved by F. Spierre), would seem to reflect a significant shift of interest, during the papacy of Clement XI, from the celebration of a triumphant Catholic Church to the exegesis of its history and rites. [SMCR]

## AGOSTINO MASUCCI
ROME 1691–1768 ROME
*For biography see Paintings section*

### 373
## Agostino Masucci
*Self-portrait*

c. 1720

Inscribed: *AVGVSTINVS MASSVCCIVS ROMANVS PICTOR/ NATVS DIE XXVIII AVGVSTI MDCXCII*; numbered at lower right in brown ink: 15 (cancelled) and 2307
Red chalk
14⅛″ × 10½″ (360 × 268 mm)
PROVENANCE as for cat. 338
BIBLIOGRAPHY Pio [1724] 1977, p. 146; Mariette 1851–60, vol. 3, p. 238; Clark 1967, "Masucci," p. 259, fig. 1; Clark 1967, "Portraits," p. 13, no. 27; Bjurström 1995, p. 104, no. 60
Nationalmuseum, Stockholm

*For commentary see cat. 338.*

### 374
## Agostino Masucci and Alessio de Marchis
*Portrait of Alessio de Marchis*

c. 1720

Inscribed: *ALEXIVS DE MARCHIS PICTOR NEAPOLITANVS/ NATVS ANNO MDCLXXXIV SALVTIS NOSTRAE/ ET IN PRAESENTIA VIVIT ET FLORESCIT ROMAE*; numbered at lower right in pen and brown ink: 185 (cancelled) and 2305
Brush, brown ink, and black chalk on white paper
18⅛″ × 12⅛″ (460 × 310 mm)
PROVENANCE as for cat. 338
BIBLIOGRAPHY Pio [1724] 1977, p. 143 ("*Il di lui ritratto è stato fatto e delineato da Agostino Masucci entro un masso antico il quale, con tutto il resto di quel foglio, è disegnato da lui medesimo*"); Mariette 1851–60, vol. 3, p. 261; Clark 1967, "Portraits," p. 15, no. 59, pl. 10; Bjurström 1995, p. 112, no. 68
Nationalmuseum, Stockholm

*For commentary see cat. 338.*

375

## LUDOVICO MAZZANTI

ROME 1686–1775 ORVIETO
*For biography see Paintings section*

### 375
Ludovico Mazzanti
*Romulus and Remus Pursue
and Kill the Thieves*

1704
Inscribed on the lower edge: *1704. Pittura
Seconda Classe—Ludovico Mazzante Romano
Primo Premio—Romolo, e Remolo fatti Adulti
perseguitano, e uccidono il Ladroni. B. 59*
Red chalk on paper
19¼" × 30¼" (490 × 770 mm)
PROVENANCE Concorso Clementino,
Accademia di S. Luca, Rome, second class
of painting, first prize, 1704
EXHIBITION Rome, University Park, New
York 1989, cat. no. 21
BIBLIOGRAPHY Santucci 1981, pp. 133–34;
Cipriani and Valeriani 1988–91, vol. 2,
pp. 41, 51
Accademia Nazionale di San Luca, Rome

Student drawing competitions had
been a feature of Rome's privately run
drawing academies in the seventeenth
century and were held sporadically at
the Accademia di S. Luca under the
leadership of Pietro da Cortona and
Carlo Maratti. In the eighteenth
century these competitions assumed

a much grander and institutionalized
form, the Concorso Clementino, estab-
lished in 1702 through funds provided
by Pope Clement XI. Marked by solemn
prize ceremonies and orations in the
Palazzo dei Conservatori in the pres-
ence of cardinals and the nobility of
Rome, the academy's drawing compe-
titions quickly emerged as the institu-
tion's most famous and visible activity.

Entries for painters in these compe-
titions were restricted to drawings—
finished compositions prepared on a
*soggetto*, or theme, chosen from a
repertory of mythological and histori-
cal subject matter and episodes from
the Old and New Testaments. (In the
first decade of the eighteenth century
there was a preponderance of themes
relating to the early history of Rome,
from Plutarch's *Lives* and Livy's *History
of Rome*.) The themes were assigned in
advance, and the young artists devel-
oped their drawings over long periods
of time (from three to nine months) in
their own studios and in the work-
shops of their masters, who probably
offered advice and assisted with the
projects. The young artists who par-
ticipated in these competitions had
to be enrolled as students at the
academy, attend its weekly classes,
and select a master from among the
academicians to whom their work
would be submitted.

The third class, reserved for the
youngest painting students, required
a copying exercise that was intended
to confirm that the student possessed
the basic talent necessary for a career
in the visual arts. Students in the second
class were given the task of illustrating
an assigned subject, but one that would
not require excessive anatomical
articulation or crowding with figures.
The *prima classe* was held for the most
advanced students. The drawings pre-
sented on the occasion of the compe-
tition tended to be closer to paintings,
highly finished and technically
sophisticated, executed on uniform
large sheets of paper ("foglio di carta
papale aperto," or "sheet of open papal
paper"). Once the entries had been
collected, the young contestants were
required to prepare an *extempore*
drawing, developing a theme given on
the spot and carried out under super-
vision within a set time. The *concorsi*
often provided the first measure of
local fame for young artists and the
successful entrants often quickly
gained an advantage over their peers
in the struggle for recognition and
commissions for paintings. (For a
brief introduction to the Clementino
Concorso, see Cipriani 1990, pp. 9–12,
from which this synopsis is derived.)

While still a pupil of Giovanni
Battista Gaulli, Mazzanti took part in

the Clementine competitions of 1703,
1704, 1705, and 1708. In each of the
drawings submitted for the *concorsi*,
the influence of his master is readily
apparent. In the assignment given to
the third class in 1703, copying the
ancient relief with *The Emperor Marcus
Aurelius Receiving the Vanquished* (Palazzo
dei Conservatori, Rome), the drawing
he produced was rich in the overtones
of Gaulli's manner. In *The Rape of the
Sabine Women*, which Mazzanti sub-
mitted in 1705 for the first class of
painting (and received second prize),
he remained completely immersed in
the art of Gaulli, quoting motifs and
images from his paintings and the
engravings made after them. Even
in the 1708 competition drawing
(for which he was awarded *primo
premio* in the first class), in which the
tentative expressions of a personal
style emerge, Mazzanti continued to
quote extensively from his master
(Cipriani 1990, p. 58).

The subject assigned to the second
class of painting was to illustrate the
following from the legend of Romulus
and Remus: "Romolo e Remo fatti
adulti e valorosi distrussero i ladri di
quella regione. Si figuri ad arbitrio tre
or quattro ladroni in fuga con le
rubate prede d'animali o altro e i due
fratelli alle spalle in atto chi di aver
raggiunto e chi di ferire e di uccidere.

Si leggano gl'accennati autori" (Cipriani and Valeriani 1988–91, vol. 2, pp. 42–43). In the drawing submitted to the judges—in this instance, Carlo Maratti, Giovanni Maria Morandi, Luigi Garzi, Giuseppe Chiari, Francesco Monnaville, and Benedetto Luti—Mazzanti, in Dieter Graf's words, "held himself tightly to the artistic dictates of his master Gaulli with regard to composition, stroke, typology of the figures, and drapery style. The figure of one of the animal thieves lying on the ground is simply a paraphrase of one of the Damned painted by Gaulli on the ceiling of the church of the Gesù. And the figure of Remus on the extreme left of the drawing, is similar to that of the boy with the ram in Gaulli's painting, *The Thanksgiving of Noah* (High Museum of Art, Atlanta). The figure of Romulus, the central character of the composition, betrays the same errors committed by Gaulli in the drawing of the figure's legs in profile: the observer is not able to distinguish which of the legs is nearest to him. And as occurred frequently in the compositions of Gaulli, the intermediate figures (in Mazzanti's drawing, the man with the sheep on the left between the tents, and the other man in the center leading the herd of cows) appear considerably shrunken. Given the numerous borrowings and citations from Gaulli's formal repertoire, the direct involvement of Gaulli himself in the forming of the idea of the drawing seems probable" (Cipriani 1990, p. 54). [EPB]

## ANTON RAPHAEL MENGS

AUSSIG 1728–1779 ROME
*For biography see Paintings section*

## 376
## Anton Raphael Mengs
*Personification of Truth*

1753–55
Pastel on paper, mounted on canvas
24″ × 19½″ (610 × 497 mm)
BIBLIOGRAPHY  Ripa, Cesare. *Iconologia*. Rome: Lepido Facij, 1603, pp. 499–501; Prange 1786, vol. 1, p. 119; Clark and Bowron 1985, pp. 216–17; Roettgen 1999, pp. 185–86, cat. no. 124
The Museum of Fine Arts, Houston, Purchased with funds provided by "One Great Night in November 1998"

This pastel—of which there is a variant in oil (Roettgen 1999, cat. no. 123)—must have been produced in Rome between 1753 and 1755, as there are close stylistic links with a group of other half-length single figures that Mengs painted in these years. Apart from the famous pastel of *Amor* in the Dresden Gemäldegalerie, these include most notably the pastels for

376

Graf Holbach in Paris and the Marquis de Croixmare, now missing. In this work nothing peripheral distracts the gaze from the close-up figure presented full face. This compositional self-sufficiency and the centering of the head on the picture surface are crucial to the picture's impact. Form and iconography complement one another. The iconographic arrangement is strongly influenced by Cesare Ripa, who produced several variants of the personification of Truth. According to Ripa, the peach in the girl's right hand is an old symbol for the heart, and the leaf on its stem symbolizes the tongue. Thus, what the tongue says should correspond to the heart, and hence to truth. The aureole around the head is the glow

emanating from truth, while the veil partly covering one shoulder is intended as an allusion to unveiled truth. Batoni's ceiling painting of Truth being unveiled by Time (1737–39) at the Palazzo Colonna in Rome (Clark and Bowron 1985, fig. 26) is among the possible sources of iconographic and formal inspiration for this picture. But here, dramatic action is replaced by symbolic intensification, appropriate to a half-length figure—a pictorial type also borrowed by Mengs from Batoni. Allegorical or mythological female half-length figures of an idealized nature had been part of Batoni's repertory since the end of the 1730s (Clark and Bowron 1985, figs. 27, 44, 157–58).

The picture is probably identical to a pastel of Truth that, according to

documentary sources, was in Dresden in the eighteenth century, though its present whereabouts are not known. It is unlikely that this missing portrait was in the royal collections, which included several works by Mengs, as in that case it would have been mentioned in the inventories. In any case, Christian Friedrich Prange, who published a three-volume edition of material written by and about Mengs in 1786, must have seen that painting with his own eyes—he accords it the highest praise—as he describes and characterizes it in detail: "A pastel, in an oval format, depicting Truth, a half-length, full-size figure, with both hands visible; in the right one she holds a peach. The lofty simplicity, the elegance of the draftsmanship, and the

truthful coloring make it one of the most excellent of its kind. Only Mengs himself knew and loved truth so, and this combined with the wholly Greek sensibility with which the picture is executed make it safe to attribute it to that artist" (Prange 1786, vol. 1, p. 119). In analogy to a frequent theme of Baroque iconography—Bernini's marble figure of *Truth* in the Galleria Borghese comes to mind—Prange accordingly interprets the subject as the artist's self-confession, not only in the moral but also in the artistic sense. What he sees as "Greek" style would accordingly be part of the programmatic intention. Prange's association of Greek style with a picture such as this, which to modern eyes appears much more Rococo and mannered, makes it clear how much the association was inferred from superficial aspects, such as the hairstyle and the robes, in a way hard to conceive of today. [SR]

## 377
## Anton Raphael Mengs
### *Study for the "Glory of Saint Eusebius"*

1757–59
Pen and brown and gray ink, heightened with white on tinted paper, squared
14½" × 6⅛" (369 × 163 mm)
PROVENANCE Marquis de Lagoy; auction, Paris, April 17, 1834, H. & S. Baderou collection
BIBLIOGRAPHY Chracas, *Diario Ordinario di Roma*, November 29, 1760; Prange 1786, vol. 1, pp. 38–39; Buchowiecki 1967, pp. 690–91; Roettgen 1993, p. 88, no. 20; Roettgen 1999, pp. 390–97, cat. nos. 301–3
Musée des Beaux-Arts, Rouen

In the course of the renovation of the Early Christian church of S. Eusebio, instigated and financed by its titular cardinal, Henrico Henriquez, Mengs was commissioned in 1757 to paint the church's vaulting. The abbot and general of the Celestine order, the mathematician Federico del Giudice, who lived in the monastery of S. Eusebio (now destroyed), was entrusted with supervising the renovation, which was carried out by Carlo Murena. The initiative for the commission to Mengs seems also to have come from Giudice. The ingenious iconographic details in the ceiling picture, which lie outside the normal repertory, suggest this. Because the Roman priest Eusebius was a declared opponent of Arianism, which was widespread in the fourth century, even within the Curia, he was imprisoned in his house on the Esquiline Hill where he died shortly afterward. In Mengs's painting, the Greek inscription appended to an angel refers to this. It

is the formula of faith (meaning "of one substance with the Father") adopted by the Council of Nicaea (325) to counter Arianism.

The painter received 200 *scudi* for his work, along with free board and lodging in the adjoining monastery. As emerges from various records (Roettgen 1999, p. 389, cat. no. 302), Mengs was very busy with this commission between the summer of 1757 and the summer of 1759, though he seems already to have completed most of the work in 1757. According to Prange, he was assisted by Anton von Maron, supposedly because, unlike Mengs, Maron already had practical experience of fresco painting; the Scottish architect James Byres is supposed also to have lent him a hand. The consecration of the renovated church took place on November 29, 1760. In reporting the event, the Roman weekly newspaper *Diario ordinario* included a mention of Mengs's ceiling picture. The critics reserved special praise for the fact that the picture—although executed using the fresco technique—looked like an oil painting. However, when the ceiling was restored in 1968, it turned out that this effect, unfortunately no longer present, could have been due to the fact that large parts of it were executed in tempera (a *secco* technique).

The reaction of the Roman public to the ceiling appears to have been mainly positive. Just how important critical recognition was to Mengs in this case is revealed by a letter (August 19, 1759) in which he evinces satisfaction that even his enemies could find nothing to carp at. One thing that was emphasized and praised was that Mengs had based his work on the tradition of Roman ceiling painting, which must have been an important concern for him at the time. Mengs's particular interest in this commission may be attributable to a wish to demonstrate how much better he had mastered the rules and composition of Roman ceiling painting than had the director of the French Academy, Charles-Joseph Natoire. Mengs had pronounced a withering judgment on Natoire's recently completed ceiling painting in the French national church of S. Luigi dei Francesi, basing his criticism primarily on Natoire's inadequate mastery of oblique perspective and the hard, irregular coloring (letter dated September 1, 1756). These additional circumstances explain why Mengs drew so directly on the more recent tradition of ceiling painting. He based his own work mainly on Carlo Maratti's *Triumph of Clemency* in the Palazzo Altieri in Rome (1674–77) and Giuseppe Chiari's *Glory of Saint Clement* in S. Clemente (1717). It also drew strongly on Correggio, whose paintings of the Evangelists borne by angels

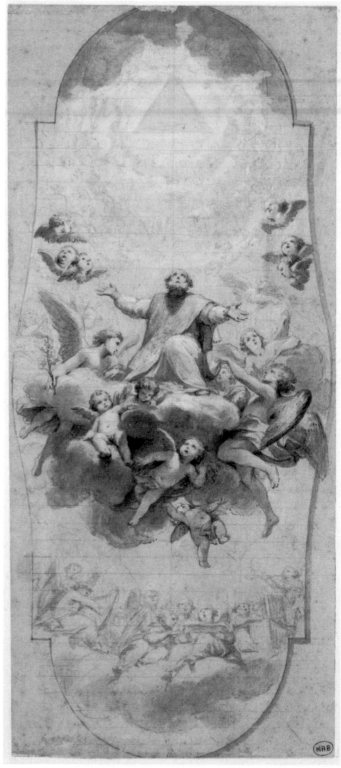

377

in the pendentives of the dome of Parma Cathedral served as a model for the oblique view in Mengs's ceiling. It was apparently the ceiling of S. Eusebio that prompted Cardinal Albani to commission Mengs to carry out the painted decoration of the art gallery at his villa (cat. 378).

The squared drawing in Rouen shows a stage of the composition that

corresponds to the *bozzetto* at the City Art Gallery in Manchester (Roettgen 1993, no. 20). Even though the iconographic attributes are still missing and the positions of the musician angels in the lower area are reversed, the present drawing must be seen as a relevant component of the design process. Compared with the fresco, the central group at this stage still

contains a smaller number of figures. As a result of the way it is bracketed within the picture edges, and because of its powerful modeling, the almost circular central group seems considerably more compact and isolated than it does in the final painting. [SR]

## 378
## Anton Raphael Mengs
*Study for "Parnassus" of the Gallery in the Villa Albani, Rome, with Apollo and the Nine Muses*

Before 1760
Pen and brown ink over hatching in gray chalk, framing in black added later
16″ × 27″ (430 × 685 mm)
EXHIBITIONS Bregenz and Vienna 1968, cat. no. 345; London 1972, cat. no. 694; Rome 1998, cat. no. 180
BIBLIOGRAPHY Mengs 1787, pp. 333–34; Winckelmann 1825, p. 57; Winckelmann 1952–57, vol. 2, p. 130; Casanova 1960–62, vol. 4, p. 186; Roettgen 1977; Schröter 1982; Roettgen 1999, pp. 397–403, cat. nos. 304–6
Graphische Sammlung Albertina, Vienna

In June 1760, shortly after Mengs had returned from a longish stay in Naples, he devoted himself to painting the three ceiling panels in the gallery of the Villa Albani (now Torlonia) on the via Salaria, which he completed in spring 1761. The large central picture, known as *Parnassus*, depicts Apollo Musagetes, surrounded by the nine muses accompanied by their mother, Mnemosyne, the goddess of memory. The two tondi on either side contain allegorical scenes that refer to Alessandro Albani as the client commissioning the building and to the villa itself (Gloria et Premium, Amor Virtutis et Genius Bonarum Artium). The other pictorial fields in the vaulted ceiling are grisaille paintings with subjects taken from Greek mythology which were painted at the same time by Nicola Lapiccola.

The ceiling pictures in the gallery form the climax of an ingenious iconological program which also extends to the ceiling pictures and painted decoration of the other rooms on the main floor of the house and of the villa as a whole. Apollo and the realm of the muses and memory are here related to Rome in a special way (Schröter 1982). The preservation of *Roma antica* and its reinterpretation in a Christian context was an important theme of Roman art in those very years, for example in Panini's paintings or Nolli's 1748 plan of Rome (cat. 18). In the Villa Albani not only did the antique works of art receive a commensurate, splendid presentation in terms of form and content; they were also part of an all-embracing picture

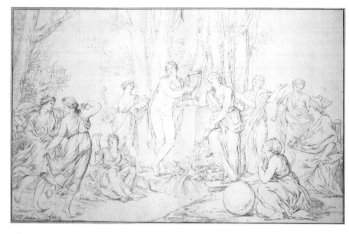

378

program that, while following the Roman Baroque tradition, also anticipated the interest in collecting and decoration that would be taken up and perfected a few years later in the Museo Pio-Clementino at the Vatican and at the Villa Borghese.

Although the drawing in the Albertina is executed carefully and in detail, it represents a fairly early stage of the design. The side groups are shown in a frontal view, indicating that at this stage of the work the perspective of the ceiling picture has not yet been taken into consideration. This is also apparent in the ground area; in the final painting a considerably more pronounced view from above was chosen, with the result that the figures now appear to be pushed so far into the foreground that they virtually "fall" out of the picture. Thalia, standing on the left beside Apollo, and Clio, sitting on the ground turned frontally toward the viewer, were completely altered in the course of the execution. In contrast to the final painting, the landscape background and the horizon line are still missing in the drawing. These differences suggest that the drawing must have been executed considerably earlier than the ceiling. The period in question would have been before Mengs's departure for Naples, where he stayed from October 1759 to May 1760. A later intermediate stage is recorded in a copy by Joseph Schöpf (Roettgen 1977, fig. 9), which was presumably based on the cartoon (until c. 1900 in the Academy of Fine Arts in St. Petersburg), which remained for some years in Mengs's Rome studio, where it was copied by several artists, including Heinrich Friedrich Füger.

In the Vienna drawing the edge of a large block of stone, on which Apollo and the muse Calliope are leaning, forms the central axis of the composition. A dense clump of trees frames and emphasizes this center group. The model for Apollo's pose is an antique statue of *Apollo Kitharoedes* in the

Museo Nazionale in Naples (Roettgen 1977, fig. 6). The figures of the muses (from left to right: Terpsichore, Erato, Clio, Thalia, Calliope, Polyhymnia, Urania, Euterpe, Melpomene) refer to depictions on antique sarcophagi and to the wall paintings from Herculaneum (Roettgen 1977, pp. 16–22, fig. 8). This direct recourse to antiquity reflects Albani's main interest, the collection of antiquities, but is also connected with the fact that Mengs was then in close contact with Winckelmann, who advised him on the iconography for the ceiling. The final painting included two important figures missing from the drawing: Mnemosyne, the mother of the muses, and Tiberinus, god of the source of the Tiber—two figures that have a considerable impact on the message of the picture. The idea of Mnemosyne presumably came from Winckelmann and illustrates his innovative concept of allegory. His purpose was "to give old pictures new meaning and use familiar allegories understood in a new and particular way." In Winckelmann's view, the person who ascribes these new meanings to the pictures is also the intellectual owner of these "new pictures"—a concept well in tune with late-twentieth-century thinking (Johann Joachim Winckelmann, *Versuch einer Allegorie* [Dresden: Waltherischen hof-buchhandlung, 1766], p. 57).

Dependence on antiquity was also a deliberate formal concern, as can be inferred from the fact that in Mengs's view antiquity had not known any "composizioni macchinose" ("Lettera a un amico" in Mengs 1787, pp. 333–34). In fact, the central picture in the Albani gallery which was admired by Winckelmann and the many visitors to the villa caused a sensation in its radical departure from the thematic and formal spectrum of Roman ceiling painting of the time. The unusual composition, with the figures linked only loosely, as in a frieze, was the main factor in this. A

loose group formation, strongly oriented on the conspicuously naked, statue-like figure of Apollo, is achieved only by means of the geometric division of the picture surface. In the vertical perspective of the central picture, however, Mengs did connect up with the Roman tradition of gallery decoration, which since Annibale Carracci's decoration of the Galleria Farnese (1599–1601) had repeatedly used illusionistic *quadro riportato*.

Winckelmann was unreservedly enthusiastic about *Parnassus* and made this known both publicly and privately in every conceivable way. In one of his letters to Germany he declared: "No more beautiful work has appeared in modern times. Even Raphael would bow his head" (Winckelmann 1952–57, vol. 2, p. 130). He felt that in this picture "Greek taste" and the beauty of antiquity had been resurrected. Later generations of critics tended to be more sceptical, objecting to the statue-like appearance of the figures. In a rather biased and historically questionable way, the *Parnassus* came to be considered responsible for the break with the tradition of perspective ceiling painting. What cannot be disputed, however, is that Mengs's picture meant a break with the *ut pictura poesis* tradition that had typified Roman Baroque painting. Rhetorically expressive gestures and motifs are replaced here by an objectivity and stillness that quite literally imply the physical and mental presence of the assembled muses in the villa. Giacomo Casanova, who had the opportunity to view the ceiling picture while it was being painted, was even of the opinion that Mengs had wanted with this picture to "replace" an unobtainable antique painting (Casanova 1960–62, vol. 4, p. 186). [SR]

## 379
## Anton Raphael Mengs
*Seated Male Nude as a Cyclops with Right Leg Raised*

1771–73?
Signed lower left: *Cav.re Antonio Raffaele Mengs*
Black chalk with traces of charcoal, heightened with white
17½″ × 15⅝″ (450 × 397 mm)
BIBLIOGRAPHY Susinno 1998, p. 179, fig. 7; Valli 1998; Roettgen 1999, pp. 278, 428, 449
Accademia di Brera, Milan, Gabinetto dei Disegni

The drawing is one of a fairly large group of nude studies made in Rome by various masters that was purchased in Rome on behalf of the Milan academy on November 2, 1780 (Valli 1998, p. 190). The intermediary for the sale was Abbate Marcabruni, the

Habsburg ambassador in Rome, whose personal relationship with Mengs is documented through several records. The four drawings by Mengs that used to be in this collection presumably came from Marcabruni's estate, which was then being dispersed in Rome. Two of these drawings (Susinno 1998, figs. 5–6) are preliminary studies for the ceiling of the private theater in the royal palace of Aranjuez, Mengs's final Spanish commission, which was left uncompleted in 1777. The fourth of these drawings has not been preserved but can be identified on the basis of an 1805 copy, still in Milan (Valli 1998, fig. 11), which matches a drawing in the Martin von Wagner Museum at the University of Würzburg (Roettgen 1999, p. 469, Z 130). The four drawings were obviously used as study material at the Milan academy over a fairly long period, as is demonstrated by the fact that copies after them have been preserved in its collection. Besides the 1805 copy already mentioned, a copy of the drawing exhibited here, dated 1802, has also been preserved (Valli 1998, p. 192).

Although the present drawing bears no date, it was probably executed some time between 1771 and 1773. It closely resembles a series of eight drawings now in Karlsruhe (Staatliche Kunsthalle, Graphische Sammlung) which were done c. 1772; these had apparently been assembled by Mengs for the purpose of demonstrating the different approaches to the male nude of Michelangelo and Raphael (Roettgen 1999, pp. 439–41, Z 57). In addition, he endowed these nude studies with different thematic meanings, differentiating between a Herculean and a Bacchic type, and between an Apollonian, an Adonic, and an Antinous-like type. The head and the pose also correspond to the body type in question, and in some cases they are even complemented by matching attributes and a quasi-scenic setting. Annibale Carracci's *Polyphemus*, in the Farnese Gallery, could have provided the inspiration for the idea of portraying a rather wild and barbaric-looking man as a Cyclops (with a third eye in his forehead).

The status of his nude studies as models is indicated by the fact that Mengs repeated some of his drawings. Another signed version of the one shown here, now in Darmstadt (Roettgen 1999, p. 428, Z 28), is better preserved. Many of these technically brilliant drawings have a pictorial effect which is derived from the emphasis on the musculature and the intensive play of light and shade on the surface. The intentional nature of this effect is demonstrated by the fact that Mengs also prepared nude studies in colored pastels—although so far

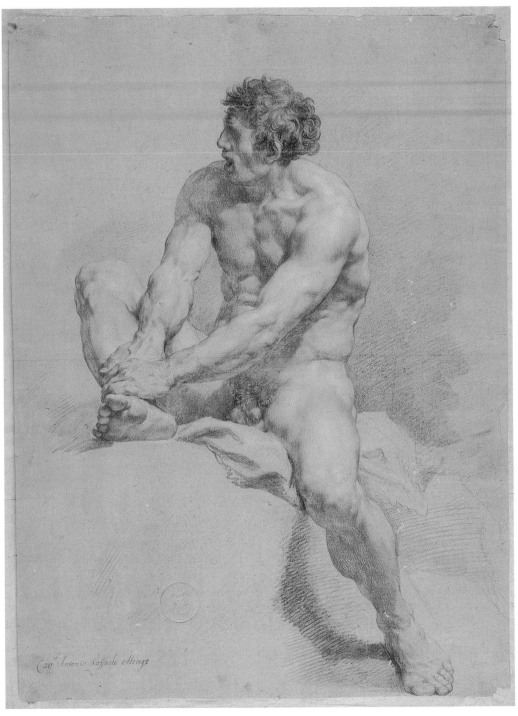

379

not a single example has been identified. It is known that he sent two nude studies in pastel to the engraver Georg Wille, an artist of German origin living in Paris, and that Wille reportedly valued these drawings highly, and presumably also showed them to his illustrious circle of acquaintances. The high esteem in which Mengs's nude studies were held by his contemporaries can be inferred from the fact that they were widely copied.

A striking characteristic of Mengs's life studies is the abandonment of the repertory of violent movements and

rhetorical gestures typical of earlier nude studies. This becomes apparent only if his nude studies are compared with the works of his contemporaries. Both Domenico Corvi (Susinno 1998) and Christoforo Unterperger (Felicetti 1998) were still much more strongly guided by the traditional academic canon of poses. In Mengs's work such poses are replaced by measured movement and the appropriate facial expression in each case. However, the greater naturalness does not mean that he relinquished "ideal" expression. In the long run it was possible to

give painting a new vocabulary only by establishing a new and reduced repertory of poses, a new approach to the human figure linked to a calmer compositional structure. Hence it is a yardstick for more far-reaching stylistic breaks. This explains why Mengs accorded the study of the nude a crucial role in artistic training. During his period of office as Principe of the Accademia di S. Luca (1771–72) he made intensive efforts to improve instruction in life drawing. [SR]

## CHARLES-JOSEPH NATOIRE
### NÎMES 1700–1777 CASTEL GANDOLFO

The only artist mentioned by Casanova in his memoirs, Charles-Joseph Natoire, remains underestimated. Yet his achievements place him on the same level as his contemporaries—and sometimes rivals—François Boucher and Carle van Loo. His graceful mythological compositions are imbued with the same soft eroticism that characterizes Boucher's, or display a masterful and eloquent sense of rhetoric similar to Van Loo's. Natoire's later watercolors—views of Rome or of the Roman Campagna—prefigure in many ways both Fragonard's and Hubert Robert's fascination with similar subjects.

Charles-Joseph Natoire was born in the south of France in March 1700. A contemporary of Boucher and of Pierre Subleyras (a painter also from the south of France), Natoire belongs fully to that generation of artists often evoked in Pierre Rosenberg's writings, which came to maturity around 1725. First apprenticed to his father, a sculptor and, according to his son, architect, Natoire went to Paris in 1717. He studied there with both Louis Galloche and, more significantly, with François Lemoyne. A winner of the *prix de Rome* in 1721, Natoire left for Rome in 1723 along with other students, including the sculptors Bouchardon and Lambert-Sigisbert Adam. During his stay in Rome, Natoire worked under the supervision of two directors, Charles-François Poërson and Nicolas Vleughels. Like all *pensionnaires*, Natoire executed copies after the antique, and also of Renaissance and Baroque masters (Veronese, Pietro da Cortona), and did landscapes (with the encouragement of Vleughels). In 1725 he received the first prize for painting from the Accademia di S. Luca, and in 1727 executed his first commission, *Christ Chasing the Moneylenders from the Temple*, for Cardinal de Polignac (church of St.-Médard, Paris). Little is known about his return to France, with the exception of a mention of his presence in Venice. In 1730 Natoire was in Paris and was *agréé* at the academy. This marked the beginning of a successful career as one of the prime painters of decorative ensembles in Paris. Particularly notable are his commissions for the château at La Chapelle-Godefroy, for Philippe Orry, and for the hôtel of the Duc d'Antin in Paris. In 1734, before being received as an academician that year, he obtained his first commission for the crown, *Youth and Virtue Presenting Two Princesses to France* (Château de Versailles). The next year Natoire began the cartoons for his celebrated suite of tapestries illustrating scenes from Cervantes's *Don Quixote*,

commissioned by Pierre Grimod du Fort and executed at the Beauvais manufactory (cartoons at Château de Compiègne; tapestries at Musée des Tapisseries, Aix-en-Provence). It was, however, in the decoration of Parisian residences that Natoire excelled (overdoors for the Hôtel de Mazarin, along with Boucher), his masterpiece being the series of paintings for the Oval Room of the Hôtel de Soubise, illustrating the story of Psyche (1737–39; *in situ*). These panels, inserted in Germain Boffrand's *boiseries*, contribute to make this room one of the finest examples of eighteenth-century French decoration. Natoire painted extensively for the crown, at Versailles and also at the royal residences at Marly and Fontainebleau (see Patrice Marandel, "Natoire aux appartements du Louis XV à Fontainebleau," *Antologia di Belle Arti*, n.s., no. 39–42 [1992], pp. 129–34). He also executed important commissions for the Church. His most ambitious religious ensemble, the decoration of the chapel of the Enfants-Trouvés (1746–50), also designed by Germain Boffrand and adorned with trompe-l'œil by Gaetano and Paolo Antonio Brunetti, was unfortunately destroyed during the nineteenth century and is only known through the engravings of Etienne Fessard. The much admired decoration of the chapel was well known throughout Europe and contributed to confirm Natoire's position as one of the leading artists in Paris. Shortly after the completion of the ensemble, he was made director of the French Academy at Rome, replacing Jean-François de Troy.

Natoire's second and ultimate Roman period shows a decline in his activity as painter of large decorations. His ceiling for S. Luigi dei Francesi—*The Apotheosis of Saint Louis*, unveiled in 1756—fails to display the spatial complexity or even the brilliant execution of his Parisian decorations (Natoire executed several studies for the whole composition; a particularly important oil sketch is in the Musée des Beaux-Arts, Brest). Instead, it follows a type of academic ceiling decoration much developed in Rome. The artist's deliberate homage to Roman painting was poorly received by the younger painters active in Rome. Anton Raphael Mengs in particular harshly criticized the conventionality of the ceiling. The distance from Paris and his functions as director of the French Academy also contributed to slow down Natoire's production. Yet his correspondence mentions enough paintings done for specific collectors, or sent to be shown at the Salon (Natoire last exhibited in 1757), to belie the image of a retiring figure. More importantly, Natoire executed during his later years his most seductive works, the watercolor views of Rome and of the Campagna. His

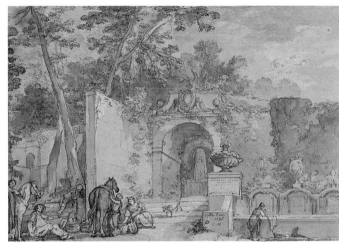

380

tenure at the French Academy was marred by unpleasant incidents—such as a lawsuit instigated by the *pensionnaire* Mouton for being expelled from the academy—and general accusations of mismanagement. Natoire left his position in 1775 and Noël Hallé was named interim director. Having left the Palazzo Mancini, where decorations he had executed as a young *pensionnaire* were still in place, Natoire retired to Castel Gandolfo, where he died in August 1777. [JPM]

BIBLIOGRAPHY  *Natoire 1977*

## 380
## Charles-Joseph Natoire
### *Villa d'Este*

1765
Inscribed, signed, and dated on front of ramp: *Villa Deste/1765/C.N.*
Pen, brown and black ink, black chalk, heightened with white, watercolor on paper
11″ × 16⅜″ (280 × 416 mm)
BIBLIOGRAPHY  Boyer, Ferdinand. "Catalogue raisonné de l'oeuvre de Charles Natoire." *Archives de l'Art Français*, n.s., vol. 21 (1949), p. 79, no. 660 (incorrectly dated 1755)
Staatliche Museen zu Berlin, Kupferstichkabinett

In his correspondence with the Marquis de Marigny, the Surintendant des Bâtiments, which provides a detailed documentation of his daily activities as director of the French Academy, Natoire offers little information about himself. In a letter dated September 18, 1765, however, he informs the marquis of his intention to present him with a landscape "after a drawing that I did some time ago in the garden of M. le Sénateur" (Montaiglon 1887–1912, vol. 12, p. 92). This remark, along with other brief notations in his correspondence, indicates both that Natoire executed landscapes (incorporating classical figures, in the tradition of Claude and Poussin) and that he drew

from nature. His enthusiasm for the Roman landscape, the beauty of the sites, the pleasure he derived from his walks and journeys through the Campagna are mentioned in his letters, as is his satisfaction at executing these views. It is also well known that he encouraged the *pensionnaires* to follow his example, and expressed the idea—well ahead of its time—that landscape painting could offer a welcome alternative to those students not entirely fit to tackle history painting (Duclaux 1991, p. 9). Hubert Robert and Jean-Honoré Fragonard, more than any other *pensionnaires*, profited from Natoire's advice to paint from nature. In fact, their own views of the Villa d'Este precede this particular one. The Abbé de Saint-Non obtained the permission in July 1760 to live at the Villa d'Este. He was joined first by Fragonard and, soon after, by Hubert Robert (see Guimbaud 1928). The Berlin sheet—one of the artist's most accomplished watercolors—presents all the characteristics of a work executed on the spot. The view is an accurate rendition of the gate leading from the Lane of the Hundred Fountains to the upper terraces of the villa (see Coffin 1960, in particular, fig. 29, for a reproduction of Venturini's engraving of the same location, seen from the left). The washes of brown and sepia ink, contrasting subtly with the light blue of the sky, contribute to evoke an early fall day. Natoire shared an interest in the Villa d'Este, which he represented on several occasions, with many other Frenchmen. The date of this drawing coincides with the date of a visit to the villa by a famous French traveler through Italy, J. J. L. F. de Lalande. Lalande wrote in the recollections of his travels one of the most extensive descriptions of the Villa d'Este (*Voyage d'un françois en Italie, fait dans les années 1765 & 1766*, 8 vols. [Venice: Desaint, 1769]). Natoire, whose interest in Roman antiquity was well known (he owned casts of the reliefs of the

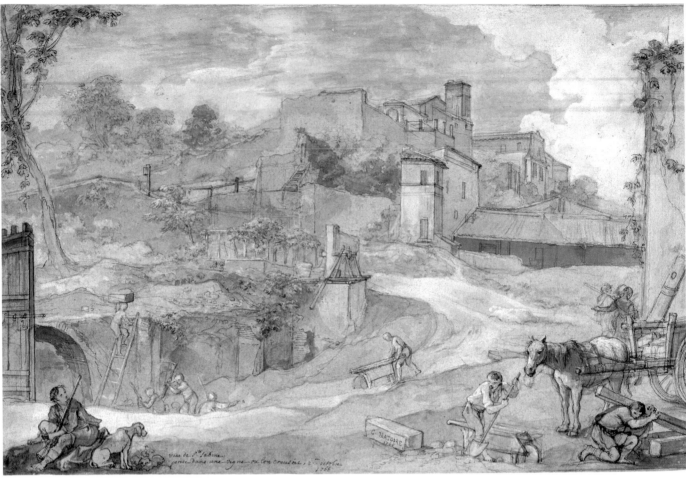

381

Column of Trajan in his country house, which was located on the Palatine, and was open to antiquarians), often preferred to represent the monuments of a more recent past. He may have intended originally to use classical figures in this landscape, as indicated by the lightly sketched group with a figure blowing a trumpet, to the right of the decorative urn. Ultimately, the artist settled for gracious genre figures, a washerwoman, a resting cavalier, better suited to animate the Renaissance and Baroque architecture in the background. [JPM]

## 381
## Charles-Joseph Natoire
### *View of S. Sabina*

1766

Signed and dated on stone, lower center: *C. Natoire 1766*; inscribed, lower center left: *Vue de Ste. Sabina/prise dans une vigne où l'on creusait. 2 octobre 1766*

Pen, brown ink, black chalk, and watercolor on paper, heightened with white

12″ × 18⅛″ (305 × 462 mm)

PROVENANCE Beckerath collection; Kupferstichkabinett, Staatliche Museen zu Berlin

BIBLIOGRAPHY Boyer, Ferdinand. "Catalogue raisonné de l'oeuvre de Charles Natoire." *Archives de l'Art Français*, n.s., vol. 21 (1949), p. 78, no. 643

Staatliche Museen zu Berlin, Kupferstichkabinett

A day before executing this watercolor, Natoire was writing to the Marquis de Marigny about the status of the French Academy's *pensionnaires*, some of whom were returning to France, while others were progressing in their studies in Rome (Montaiglon 1887–1912, vol. 12, pp. 128–29). He also mentions in the same letter the preoccupying lack of wheat in the city. However, neither his administrative duties nor the impending dearth of food seems to have preoccupied him when, the next day, he executed this enticing image of daily life in eighteenth-century Rome.

The church in the background is the Early Christian church of S. Sabina on the Aventine, founded in the fifth century on the site of a Roman house. The area was close to Natoire's house on the Palatine and was rich in works of art, both antique and modern. In the adjacent church of S. Alessio, Natoire could have seen Jean-François de Troy's altarpiece of *Saint Jerome Emiliani Presenting the Orphans to the*

*Virgin Mary* (1749). Continuing his walk along the river, Natoire could have admired Piranesi's façade and decoration of S. Maria del Priorato, completed in 1765, a few months before he executed this watercolor.

Natoire represented the church from the southeast, an area just west of the Circus Maximus and evidently rich in antiquities. The vineyard where he paused to draw was being excavated at the time. The site corresponds almost exactly to that of the temple dedicated to the Syrian god Baal (known as Jupiter Dolichenus), which was scientifically excavated in 1935 (see Ernest Nash, *Pictorial Dictionary of Ancient Rome*, 2d ed. [New York and Washington: Praeger, 1961], vol. 1, p. 521). [JPM]

## GIOVANNI ODAZZI
ROME 1663–1731 ROME

Information about the life and work of Giovanni Odazzi comes from Nicola Pio and—in more detail—from Lione Pascoli, who was a friend of Odazzi's. The artist's appearance is known from his imposing self-portrait, which he drew c. 1720–24 for the publication on the lives of artists planned by Nicola

Pio (Bjurström 1995, p. 137, no. 93), in which he proudly identifies himself as *Ioannes odatius pictor romanus*. According to Nicola Pio and Lione Pascoli, Odazzi was apprenticed by his father at a young age to Cornelis Bloemaert, then working in Rome as an engraver. From there he transferred to the studio of the Roman painter Ciro Ferri, where he remained until Ferri's death in 1689. After that, Odazzi became a pupil and assistant of Giovanni Battista Gaulli, who had become the leading painter in Rome, alongside Carlo Maratti, with the painting of the decoration of the church of Il Gesù (1672–85). As Ferri's assistant, Odazzi is not known to have produced any works of his own. Whatever his style of painting at that time, his later work strongly reflects the influence of Gaulli. Admittedly there tend to be more clearly recognizable echoes of Ferri's style in the squat figures of Odazzi's earliest known works, the *Adoration of the Kings* and the *Flight into Egypt* in S. Maria in Aracoeli; the architecture in the background of the *Flight into Egypt* is also indebted to Ciro Ferri's formal repertory. But the motifs conveying movement, the treatment of the drapery, and the figure types are unequivocally influenced by Gaulli's painting. This is

even more comprehensively true of his fresco of *Joseph's Dream* (c. 1695) in the church of S. Maria della Scala in Rome, where Odazzi has incorporated some figures from Gaulli's paintings almost unchanged.

Odazzi's next important commission, the altarpiece of *The Virgin Appearing to Saint Bruno* in S. Maria degli Angeli in Rome, in 1699–1700, as a fresco measuring 26 feet by 16 feet 6 inches, shows the influence of Maratti. Odazzi's painting now developed in the field of tension between the two great masters Gaulli and Maratti. The two altarpieces created c. 1705 in S. Bernardo alle Terme, *Christ Crucified Embracing Saint Bernard* and *The Virgin Appearing to Saint Robert and Other Saints*, are among Odazzi's masterpieces. Both show the link to Gaulli in their composition, but in the figural types they are also related to Maratti. Thanks to their extraordinary coloring, in pure almost porcelain-like colors, reminiscent of Gaulli's, the two pictures are exceptionally beautiful. It may be no accident that it was in 1706, shortly after completing these superb paintings, that Odazzi was accepted as a member of the Accademia di S. Luca.

In view of the exceptional quality of his paintings for S. Bernardo, it is especially regrettable that Odazzi was not able to paint the altarpiece for the high altar of Ss. Apostoli, Rome, for which he did the design shown in this exhibition (cat. 382). It was not possible to start the paintings until 1714, because up until that date the church was undergoing major reconstruction; the painting actually used as the altarpiece was executed by Domenico Maria Muratori after his own designs, painting directly on the wall in oils. However, the competition for the altarpiece may well have been held years before. In any case, the composition of Odazzi's rival design can be linked with his similarly composed altarpiece of *The Martyrdom of Saint Agapitus*, painted for Toledo Cathedral as a commission from the Cardinal Fernandez Portocarrero, but the Ss. Apostoli design is superior to the Toledo picture in its spacious composition and the large number of figures.

In the painted decoration of the Cappella d'Elci in the church of S. Sabina in Rome (c. 1714), Odazzi created a masterpiece. For the arrangement of the groups of saints resting on clouds in the fresco in the dome, he again drew on a work by Gaulli, namely the *modello* for the fresco in the dome of the church of S. Agnese, also in Rome, but he did not adopt the ecstatic animation of Gaulli's figures or the luminous coloring of Gaulli's *bozzetto*. Odazzi's figures are calm in their movements, the robes are draped in long folds, the coloring of the frescoes is subdued. The same classical tenden-

cies can also be found in the altarpieces Odazzi created c. 1716, such as the *Mystic Marriage of Saint Catherine* (S. Maria in via Lata, Rome) or the very large-format altarpiece for the church of S. Benedetto in Perugia (Galleria Nazionale dell' Umbria).

Odazzi was also engaged by Pope Clement XI Albani to work on two of his most important artistic projects: in the course of the thoroughgoing restoration of the venerable Roman church of S. Clemente, the central nave was decorated with a cycle of frescoes starting in 1716; and in 1717 the pope commissioned twelve pictures of prophets for the nave of St. John Lateran. The most important painters in Rome were involved, including Odazzi. At S. Clemente he painted the *Translation of the Body of Saint Clement*, and for St. John Lateran, the prophet Hosea.

Commissions for other altarpieces and frescoes for churches in Rome, as well as in other places in Latium and in Umbria and Liguria, followed until the beginning of the 1730s. But many of the pictures mentioned by Pascoli

and Titi have now disappeared. The large fresco in the nave of Velletri Cathedral, completed in 1725, was destroyed in World War II. In Rome Odazzi decorated the ceilings of several rooms in the Palazzo Albani del Drago and the Palazzo Poli with allegorical and mythological scenes. In addition he painted a large number of pictures on canvas with biblical and mythological scenes, some of which were recently identified by Erich Schleier, as well as numerous portraits. Odazzi was also an important graphic artist. The majority of his drawings are in the Musée du Louvre and in the Kunstmuseum in Düsseldorf. [DG]

BIBLIOGRAPHY Pio, Nicola. *Le vite de' pittori, scultori ed architetti*. Rome, Biblioteca Apostolica Vaticana, Ms. Capponi 257, 1724; Pio [1724] 1977, pp. 151–52; Pascoli 1730–36, vol. 2, pp. 386–96; Schleier 1978; Trimarchi 1979; Rudolph 1983, p. 792; *Il costume e l'immagine pittorica nel Seicento Umbro*. Florence: Centro Di, 1984, p. 145; Graf 1990, "Odazzis"; Pascoli 1992, pp. 824–35; Schleier 1993, figs. 10–24; Sestieri 1994, vol. 1, pp. 137–39, and vol. 3, figs. 826–36; Bjurström 1995, p. 137, no. 93

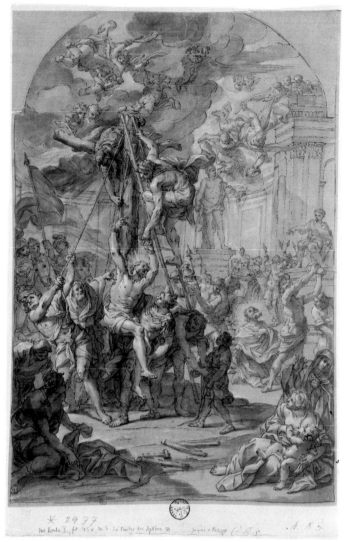

382

## 382

## Giovanni Odazzi

*Study for "The Martyrdom of the Apostles Philip and James the Less"*

1714
Stamp: *Status Montium* (Lugt 2309)
Pen and brown ink, brown and gray wash, heightened with white, on brown paper
The gussets on the top two corners have been glued on
20¾" × 14¼" (526 × 362 mm)
PROVENANCE unidentified collector's mark *Status Montium* (Lugt 2039); Lambert Krahe, Düsseldorf
EXHIBITIONS Düsseldorf 1969, cat. no. 89
BIBLIOGRAPHY Krahe, Lambert. "Le Martyr des Apôtres Sts. Jacques & Philippe, 20 x 14 Pouces." *Inventory II* (Manuscript), 1779, fol. 45, recto no. 3; Budde 1930, no. 469; Graf and Schaar 1969, no. 89; Fernandez 1977, p. 287; Trimarchi 1979, no. 15; Guerrieri Borsoi 1982–83
Kunstmuseum Düsseldorf im Ehrenhof, Graphische Sammlungen

This large-format drawing can be recognized as a design for an altarpiece by the rounded top of the composition. Lambert Krahe, from whose collection the drawing originated, had already entered it in his inventory as being by Giovanni Odazzi and correctly described the subject as "Le Martyr des Apôtres Sts Jacques & Philippe." The two apostles suffered their martyrdom at different places and times. According to the *Legenda aurea*, by the thirteenth-century writer Jacobus de Voragine, the apostle Philip was crucified at Hierapolis. James, on the other hand, was condemned to death by stoning by the Sanhedrin in Jerusalem at the feast of the Passover in AD 62. Odazzi has depicted the two events in a single pictorial space. In the middle of a square that is enclosed at the back by the architectural setting of an exedra, Saint Philip is being raised on to the cross on ropes. On the right, a little farther in the background, the stoning of the apostle James is taking place. Between a pagan divinity on a high pedestal and the figure of the ruler enthroned in high state, he is kneeling on the ground between his executioners. Repoussoir figures are stationed in the foreground: on the right, two women with a child, and on the left, two men, with the one in front holding Philip's robe. Angels are descending from the sky above both saints, bringing crowns and palms to the martyrs.

Through a dramatic use of light Odazzi succeeds in giving each of the scenes of martyrdom its own weight. Dark clouds are gathering above the crucifixion scene—as the Gospels report happened at the Crucifixion of Christ. On the left, a standard is fluttering violently in the wind above a

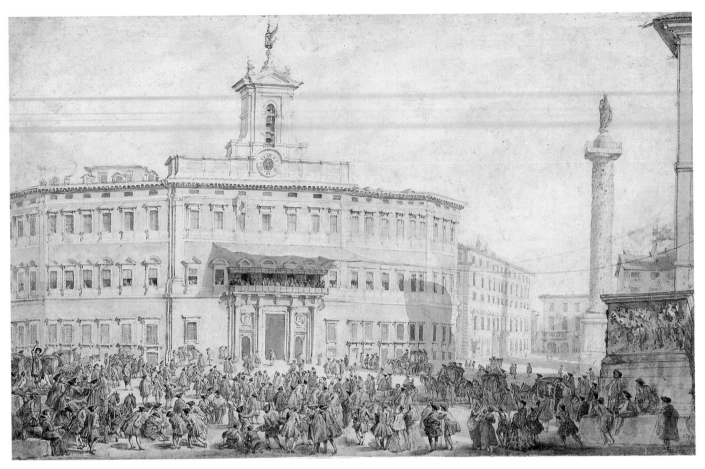

383

group of soldiers on horseback. The figures of Philip and some of his tormentors are sharply lit. Other figures remain in the shadow, but each one is rendered with an almost sculptural plasticity. The scene depicting the stoning of James is bathed in a blinding transcendental light which pours down from the sky over the kneeling apostle. He is looking up to Heaven, his attitude and gestures illustrating the account in the *Legenda aurea*, according to which the saint repeated Christ's words "Father, forgive them, for they know not what they do."

Eckhard Schaar (Graf and Schaar 1969, no. 89), no doubt correctly, associates this many-figured design which Odazzi had developed as a model with the planning of the painting for the high altar for the church of Ss. Apostoli in Rome. The church, in whose crypt relics of the two apostles Philip and James are preserved, had been undergoing a thorough restoration since 1702. Odazzi had presumably already been involved in the execution of Gaulli's ceiling picture in the nave of the church (1707), where Philip and James are again prominently featured, and he painted the apse fresco of Ss. Apostoli with *The Fall of the Rebel Angels* between 1714 and 1716; as this design proves, he obviously also applied to paint the main altarpiece.

But the commission went not to Odazzi but to Domenico Maria Muratori, two years his senior. The subject matter and proportions of Odazzi's design and Muratori's altarpiece coincide, so it is only reasonable to accept Schaar's suggestion that Odazzi's drawing should be seen as a rival design for the altarpiece by Muratori. Yet Jesus Urrea Fernandez (Fernandez 1977, p. 287) saw the Düsseldorf drawing as a design for a completely different picture by the artist, namely the *Martyrdom of Saint Agapitus*, which Odazzi painted c. 1708 for Toledo Cathedral as a commission from the Spanish cardinal Fernandez Portocarrero, archbishop of Palestrina.

In fact, some figures and groups of figures in the Toledo painting have been adopted almost unchanged from the Düsseldorf design for Ss. Apostoli (Fernandez 1977, pp. LXXXII, 2)—for example, the repoussoir figures, the figure of the priest, the large angel flying down, and the executioner's assistant, who is raising the saint with a rope.

Trimarchi (Trimarchi 1979, p. 33) has pointed out that Odazzi used the figure of Scipio from Gaulli's late painting *The Continence of Scipio* (Palazzo Doria, Genoa; Enggass 1964, fig. 132) as a model for the figure of the

enthroned ruler in the Düsseldorf design. The group of women on the right in the foreground of the Düsseldorf drawing has also been taken from Gaulli's picture. On the other hand, the figure of the bearded priest who is pointing at the apostle Philip in Odazzi's drawing comes from Poussin's *Martyrdom of Saint Erasmus* (Pinacoteca Vaticana). In addition Odazzi, as a "pittore romano," studied Daniele da Volterra's *Deposition from the Cross* in the church of SS. Trinità dei Monti and Mattia Preti's frescoes of the martyrdom of Saint Andrew in the choir of S. Andrea della Valle for his composition. But the picture that seems to have impressed him most is Francesco Trevisani's *Saint Andrew Placed on the Cross*, painted c. 1695–97 in the choir of the church of S. Andrea delle Fratte; he borrowed several figures from this, modified them with creative license, then inserted them into his own composition. [DG]

GIOVANNI PAOLO PANINI
PIACENZA 1691–1765 ROME
*For biography see Paintings section*

## 383
## Giovanni Paolo Panini
### Study for "The Lottery in Piazza di Montecitorio, Rome"

c. 1747

Inscribed in brown ink at lower right: *1743*; inscribed in brown ink on fragment of old mount: *Bozzetto Originale del' Caval'. Giō Paulo Panini del Quadro dell'Estrazione del Lotto di Roma, da esso eseguito per L. Emo Cardinale Domenico Orsini*

Pen and black ink, watercolor, over graphite on paper; framing lines in pen and black ink at left, right, and upper margins
13⅜" × 21⅛" (340 × 545 mm)

PROVENANCE illegible, unidentified collector's mark at lower right corner of old mount; Gilberto Zabert, Turin; Agnew's, London, from whom purchased by The Metropolitan Museum of Art in 1968

EXHIBITIONS New York 1971, cat. no. 55; New York, The Metropolitan Museum of Art. *Notable Acquisitions, 1965–1975.* 1975; New York 1978; New York 1990, cat. no. 150

BIBLIOGRAPHY Arisi 1961, p. 176, no. 173; Draper 1969; Arisi 1986, p. 404, under no. 346; Pinto 1986, pp. 173–74, fig. 127; Bean and Griswold 1990, pp. 159, 160–61, no. 150

The Metropolitan Museum of Art, New York, Rogers Fund

This exceptional drawing served as a preliminary design for one of Panini's most brilliant paintings, signed and dated 1747, in a private collection in London (Draper 1969, figs. 1–3), representing the drawing of the papal lottery on the balcony of the Palazzo di Montecitorio in the presence of a vast crowd of excited spectators. An old inscription, affixed to the mount of the drawing, states that the picture was painted for Cardinal Domenico Orsini, an active patron of Roman artists including Pompeo Batoni (cat. 168). The inscription itself, though in an eighteenth-century hand, cannot predate October 1749, when Panini was granted the title Cavaliere dello Sperone d'Oro.

The lottery in Rome was sanctioned by Clement XII in 1731 at a moment when papal finances were in great disorder. Pope Clement's rules for the lottery required nine drawings per year (a number that increased at least threefold over the years), with five winning numbers being drawn at each. The names of ninety poor widows who were to benefit by the profits were published in advance of each draw. The rest of the proceeds were spent at the discretion of the pope, for pious works apparently centered around the archconfraternity of S. Girolamo della Carità. The form and ceremony of the drawing of the lottery were maintained until the abolition of the Papal States in 1870.

The balcony of the Palazzo di Montecitorio, today the seat of the Chamber of Deputies and a familiar monument in Rome, was the official site of the lottery from February 1743. Begun in 1650 by Gianlorenzo Bernini, the palace was completed by Carlo Fontana in 1694 for Innocent XII as the seat of the papal law courts (Curia Innocenzia). Bernini's unusual façade, which is broken into three parts, of which the two side wings angle back slightly, remains today as it is recorded in the drawing, although the view of the Column of Marcus Aurelius from the Piazza di Montecitorio has been blocked since the 1830s by the construction of the Palazzo Wedekind. (It is improbable, however, that the column could have been seen from this particular point of view.) Immediately behind the Palazzo di Montecitorio, on the right, is the sixteenth-century Palazzo Chigi; the building behind and slightly to the left of the column is Palazzo Piombino, replaced in the late nineteenth century by the Galleria Colonna. The pedestal in the extreme right foreground of Panini's drawing is the granite base of the Column of Antoninus Pius, excavated near the Palazzo di Montecitorio in 1703 and erected in the square under the direction of Carlo Fontana, where it remained until 1764. It is now

in the Cortile della Pigna of the Vatican. The obelisk seen today in the center of the piazza was erected there between 1788 and 1792.

In his thorough study of this sheet, James Draper has suggested that Panini made this *bozzetto originale* on the spot in the square, probably on the occasion of an actual drawing of a lottery. The windows on the right wing of the façade of the palace, for example, are drawn too closely together and the lines of the buildings and their relationship to one another have an improvisatory quality, looking as if they were drawn without the use of a straightedge or other mechanical aids. Panini was nonetheless careful to capture the fall of light on to the square, record accurately the rosy buff façade of the Palazzo di Montecitorio, and grasp the energy and excitement of the enormous crowd of spectators, all turned toward the drawing of the names. The draftsmanship of these figures is extremely confident and rapid, swiftly capturing the details of posture, gesture, and dress, such as the tricorn hats worn by the majority of the men.

The preliminary nature of the Metropolitan Museum's drawing is confirmed by comparison with the finished painting. Panini radically changed the foreground of the painting by establishing two basic planes of figures in such a way that three central groups stand out against the throng of the populace. These ladies and gentlemen, better dressed than the lower classes playing with dogs in the foreground, the poor tradesmen reaching in from atop the masonry at the extreme left, or the humbly seated woman with child at the far right of the painting, ignore the drawing of the lottery and instead engage one another in flirtatious conversation and, in Draper's phrase, develop small *commedie* among themselves. Practically all the figures were restudied for the painting, which reveals that Panini again turned to what must have been an enormous stock of figure drawings kept at his disposal, such as those contained in a sketchbook in the British Museum and in a group of drawings formerly in the collection of the Roman sculptor Vincenzo Pacetti and now in the Kupferstichkabinett, Berlin (Draper 1969, pp. 29–33). [EPB]

## GIUSEPPE PASSERI
ROME 1654–1714 ROME

Information about Giuseppe Passeri's life, work, and clients comes from Nicola Pio (1724) and Lione Pascoli (1730). On the paternal side his family came from Siena, but they had already settled in Rome by the 1630s. As Pio and Pascoli report, Passeri was first trained by his uncle, the painter and

artists' biographer Giovanni Battista Passeri, and at an unknown stage transferred from his uncle's studio to that of Carlo Maratti, the most famous painter in Rome. Again according to Pio and Pascoli, he and Giacinto Calandrucci were Maratti's favorite pupils, and Maratti instructed Passeri with special devotion. It would be in keeping with Maratti's intellectual independence and artistic stature if, as his biographers relate, he got Passeri to copy Giovanni Lanfranco's cupola decorations in Rome at his expense. Maratti also directed Passeri specifically to the works of Michelangelo, Annibale Carracci, Guido Reni, Domenichino, and Poussin as models in respect of composition and the expressiveness of the figures. For beauty of coloring he advised his pupil to study Titian and Correggio. Above all, Maratti recommended the young Passeri to make a profound study of Raphael, whom he himself venerated highly. A great many oil sketches by Passeri after works by Lanfranco, Paolo Veronese, and Pietro da Cortona, and more than three hundred drawings confirm Passeri's diligence in copying Old Masters. Pascoli further comments that when Passeri had no work to do for other people, he made copies and oil sketches of the most famous paintings in Rome to decorate his own house. According to the same source, Passeri copied other masters not only during his apprenticeship with Maratti but also as an independent painter. He produced a large number of drawings after paintings, as well as after drawings, for his friend Sebastiano Resta, the collector and connoisseur.

Passeri's comprehensive studies and his own talent allowed him to emerge from the shadow of Maratti and develop a relatively independent style. In his painting he differs both from Maratti himself and from the master's other pupils, such as Nicolò Berrettoni, Giacinto Calandrucci, Giuseppe Chiari, and Agostino Masucci; like Passeri, they played an important role in the artistic life of Rome, especially as they multiplied the impact of Maratti's art, and the youngest of Maratti's pupils perpetuated his style well into the eighteenth century. By contrast, Passeri's painting is characterized by an increasingly free brushwork, extraordinarily finely differentiated coloring, and a new sense of movement in the composition. Even his late large-format pictures for the Roman churches of St. Peter's (*Peter Baptizing Saint Processus and Saint Martinianus*, 1709–11) and S. Sebastiano fuori le Mura (*Pope Fabian Baptizing Philip the Arab*, 1712) and the two pictures with scenes from the life of Saint Francis of Paola in S. Giacomo degli Incurabili (1713–14) contrast clearly

with the severe, monumental pomp that distinguishes similar pictures by Maratti. These are characteristics of a personal style that links the art of Passeri to the incipient Rococo style of painting.

Passeri became a member of the Congregazione dei Virtuosi in 1701 and of the Accademia di S. Luca in 1707, and he was appointed Pittore della Camera Apostolica by Pope Clement XI Albani. He was also widely employed by the Roman nobility. His earliest works, created in 1678, are two ceiling paintings in the Palazzo Barberini in Rome: *Jason Returning from Colchis with the Golden Fleece* and *Bellerophon Overcoming the Chimera*. He executed a large number of wall and ceiling paintings in Roman churches, palaces, and villas, most of which have been destroyed. But the ceiling paintings he executed for the Patrizi family at their country seat in Castel Giuliano (1680–85) and the Palazzo Patrizi in Rome (1712–13) have been preserved.

Of the works that have been preserved, the painted decoration of the choir of Viterbo Cathedral (c. 1690), which includes not only figure paintings in the apse and choir vaulting but also the decoration of the walls with illusionist architecture, must be regarded as his most important decoration of an ecclesiastical space. Other works by Passeri that have been well preserved are his frescoes in the nave of S. Maria in Aracoeli, Rome (1686), and the Cappella Altieri in S. Maria in Campitelli, Rome (1707), whereas the frescoes in the Cappella Papi in S. Francesco a Ripa, Rome (c. 1700), and the cupola of S. Spirito dei Napoletani, Rome (1707–8), are in a poor state of preservation. The most extensive fresco decorations by Passeri disappeared with the demolition of the Roman churches of S. Nicolò in Arcione and S. Anna dei Funari.

Passeri's earliest altarpiece, *Doubting Thomas* (before 1686), is in S. Croce in Gerusalemme, Rome. The two paintings *Moses Breaking the Tablets of the Law* and *The Delivery of the Keys to Peter* in the nave of S. Maria in Vallicella and a picture painted for the monastery of Citeaux, *The Reception of Saint Bernard of Clairvaux into the Monastery of Citeaux* (Musée des Beaux-Arts, Dijon), date from around 1700. Passeri painted two altarpieces, *The Virgin of the Rosary* and *The Three Archangels*, for the church of S. Caterina in Magnanapoli, Rome (c. 1703). Wall and ceiling frescoes that, according to Pascoli, were executed by Passeri in such buildings as the Casino of the Villa Corsini and in other Roman palazzi and villas have disappeared as a result of the alteration or destruction of these buildings.

Passeri also produced a fair number of easel paintings with religious and

mythological themes, and not only for his Roman clients. Pascoli reports that Passeri also sent pictures to Perugia and Spoleto, Naples and Sicily, and England and Scotland. Some of these paintings have been preserved (see Sestieri 1994). Of the many portraits painted by Passeri, his self-portrait (Uffizi, Florence), the portrait of Livinus Poli (Kunsthalle, Bremen), that of Cardinal Lorenzo Corsini (Palazzo Corsini, Florence), and a portrait of a nun (Kunstmuseum, Düsseldorf) are particularly notable. Some of his many portraits of cardinals were also engraved. Passeri was a superb draftsman, and more than 1700 drawings by him are known. Designs for paintings and engravings are to be found in all major graphic collections, of which by far the largest is in the Kunstmuseum, Düsseldorf. [DG]

BIBLIOGRAPHY  Pio, Nicola. *Le vite de' pittori, scultori ed architetti.* Rome, Biblioteca Apostolica Vaticana, Ms. Capponi 257, 1724; Pio [1724] 1977, pp. 104–5; Pascoli 1730–36, vol. 1, pp. 217–23; Montagu 1971; Martin von Wagner Museum 1976, no. 25; Waterhouse 1976, pp. 101–3; Romano S. 1977; Sestieri 1977; Bowron and Graf 1978; Graf 1979; Rudolph 1983, pp. 793–94; Cannatà 1985; Guerrieri Borsoi 1988; Graf 1990; Graf 1990, "Odazzis"; Graf 1991; Pascoli 1992, pp. 301–10; Sestieri 1994, vol. 1, pp. 143–45, and vol. 3, figs. 860–79; Baumgärtel 1995, pp. 27–28; Graf 1995; Graf 1996

## 384
### Giuseppe Passeri
### *The Papal Tiara Offered to Cardinal Gian Francesco Albani*

1700–1701

Pen and brown ink, brown wash, heightened with white over black and red chalk on a paper with a brownish ground; assembled from several sheets and glued onto cardboard

23¾″ × 21⅝″ (603 × 548 mm)

PROVENANCE  unidentified collector's mark *Status Montium* (Lugt 2309); Lambert Krahe, Düsseldorf

EXHIBITIONS  Düsseldorf 1964, cat. no. 117; Düsseldorf 1995, cat. no. 363

BIBLIOGRAPHY  Krahe, Lambert. "Le Cardinal Albani entouré de plusieurs Allégories pour une thèse, 23 x 21 Pouces." Inventory II (Manuscript), 1779, fol. 41, recto no. 194; Budde 1930, no. 112, pl. 36; Schaar 1964, no. 117, fig. 32; Graf 1991, pp. 236–46, fig. 3; Baumgärtel 1995, pp. 27–28; Graf 1995, no. 363, fig. 711 Kunstmuseum Düsseldorf im Ehrenhof, Graphische Sammlungen

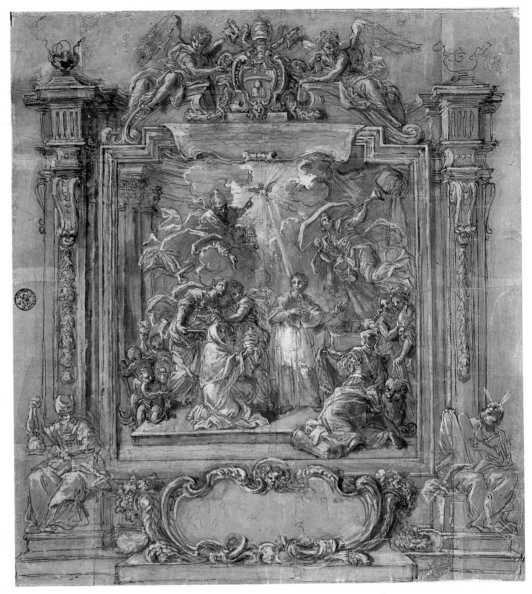

384

On November 23, 1700, the art-loving Cardinal Gian Francesco Albani was elected pope. He called himself Clement XI after the martyr Pope Clement I. Giuseppe Passeri's important design for a large engraving on the subject of the offering of the papal tiara to Cardinal Albani represents a tribute to the newly elected pope, who appointed Passeri to the post of Pittore della Camera Apostolica.

Lambert Krahe had already recognized this work as a design for a broadside, and in his 1779 inventory described it as "Cardinal Albani accompanied by various allegories for a thesis." Early in the twentieth century, Illa Budde mistakenly described it as *Roman Peace through the Subjection of the Sabines*. Eckhard Schaar, who followed Krahe in naming the subject correctly, saw it as a design for a broadside, but would not exclude completely that the artist intended the drawing as a design for a wall decoration. The scene, set in an ornate architectural frame, shows Cardinal Albani with a kneeling female figure offering him the tiara. Behind are two other female figures bringing items from the papal regalia to deck the newly elected pope. As is indicated by the attendant putti bearing their attributes of the chalice and

Host, a burning heart, and an anchor, the three female figures are the Christian cardinal virtues of Faith, Hope, and Love (or Charity) which relate to the pope's spiritual office. On the right is a second group of female figures, embodying the temporal cardinal virtues of Fortitude, Justice, and Prudence, referring to the pope's status as a temporal ruler. In the clouds on the left is the figure of Pope Clement I pointing to the dove of the Holy Ghost. This appears in an aureole of heavenly light, the rays of which touch the head of the elected pope. On the right, above the cardinal, hovers Fame holding a scroll.

The interpretation of this scene as referring to the election of Cardinal Albani as pope is confirmed by the pope's coat of arms; held by two angels supported on a gable that has burst asunder, it forms the crowning feature of the architectural frame. The figures of Moses and Aaron are seated on tall

pedestals in front of the architectural frame. They allude respectively to the pope's duties as lawgiver and high priest. Cartouches under the coat of arms and between Aaron and Moses were intended to receive inscriptions.

The Düsseldorf drawing, executed in the mixed technique characteristic of Giuseppe Passeri, which gives his developed designs something of the quality of a painting, is a presentation drawing. This would have been followed by further studies for the preparation of the final design, which was binding on the engraver. A drawing by Passeri in the Witt Collection (Courtauld Institute, London, inv. no. 21.73), which was subsequent to the Düsseldorf drawing, includes only the main scene, which Passeri has widened a little so that there is more room to develop the figures in the space. In the Courtauld drawing Passeri has substituted the allegorical figure of Ecclesia (the Church) for the

figure of Pope Clement I supported on clouds in the Düsseldorf design. There is a third version of the main scene in the Martin von Wagner Museum in Würzburg (inv. no. HZ 7884). It reproduces the scene in reverse, compared with the drawings in Düsseldorf and London, presumably to make things easier for the engraver. In the designs in Düsseldorf and London the cardinal was initially depicted as an anonymous figure identifiable only through his coat of arms, whereas in the Würzburg drawing Passeri has produced a recognizable portrait of the tall, heavy figure of the cardinal. More unequivocally than in the Düsseldorf and London versions, the cardinal in the Würzburg drawing seems to be repudiating the papal insignia being brought to him—a reminder that he initially did not wish to accept his election as pope, as he did not feel worthy of this high honor. Albani sought the advice of four renowned theologians as to whether he might refuse his unanimous election. Their opinion—that refusing the papacy would be tantamount to acting against the will of God, which had manifested itself in the election—finally persuaded the cardinal to accept it. He reached this decision on the feast day of Pope Clement I, the martyr, which may be the reason why he adopted the name Clement as pope.

Giuseppe Passeri not only made several designs for the main scene of the drawing, but also worked up further details in individual studies. Several of these are in the Martin von Wagner Museum; they include a very detailed drawing of the crowning gable with the two angels positioned beside the pope's coat of arms (HZ 9189), which was already associated with the project by Erich Hubala (Martin von Wagner Museum 1976, no. 25), and also impressive chalk studies for the seated figures of Moses and Aaron (HZ 8213 and HZ 8214) which Lawrence Turčić discovered in Würzburg among the anonymous drawings. Studies for these two figures have been preserved in a drawing in the Düsseldorf Kunstmuseum (inv. no. KK (FP) 12915/13513).

The fact that Passeri had already drawn the Würzburg version of this drawing in reverse for the engraver makes it clear that he considered the planning of this work to be completed. However, as no copy of the engraving has yet been discovered, it must remain an open question whether the engraving was actually produced. [DG]

## LAURENT PECHEUX
LYON 1729–1821 TURIN

In Rome from January 1753 for a three-year stay financed by his family, Laurent Pécheux remained in that city for twenty-five years during a period that was crucial to the role of the pontifical capital as the center for artistic training in Europe. Born on July 17, 1729, Pécheux was the son of a well-off tailor called Martin (the principal source for Pécheux's life and career is his *Memorie*, transcribed by Bollea 1936). He made his first study trip to Paris in 1745. On his return to his native Lyon he produced some life drawings that were admired by Gabriel-François Doyen and Augustin Pajou, both of whom had trained in Rome. In Marseille in 1752, on his way to Italy, Pécheux met Joseph Vernet, an artist whose experience of Rome had proved fundamental. Armed with letters of recommendation to Natoire, the director of the French Academy, Jean-Louis Clérisseau, and Nicolas Guibal, who soon introduced him to his studio, the young Pécheux found himself immediately included in the capital's most advanced circles. Despite Mengs's prejudice against the French, he agreed to instruct Pécheux in studying from the antique, and ordered him to copy a cast of the Borghese *Gladiator* under an overhead light in his studio to teach him the difference between his own rigorous apprenticeship and that of Pécheux's previous instructors. Pécheux met Batoni while he was studying and the twenty-five-year-old Pécheux and his older colleague became firm friends, visiting churches and palaces together on holidays. Even if one cannot say Batoni influenced Pécheux at a deep, theoretical level, he did nonetheless show him the proper taste in artistic matters, expressed more with the eloquence of his instinctive reactions than through an ordered system of aesthetic principles. After a stay in via della Purificazione, Pécheux settled at Trinità dei Monti, near the Arco della Regina, and there, in cooperation with other young artists, he organized an academy for nude drawing that Batoni himself regularly attended as a sort of informal teacher; however, their friendship cooled in 1764 when Batoni wanted to set up a similar school in his own studio.

In his early years in Rome Pécheux's commissions came mainly from France: for the church of Dôle in Franche-Comté he executed a cycle of eight large paintings on Christological themes, and his memoirs record how he sent them off on large rollers, a vivid glimpse of the complex organizational aspects of Rome's artistic industry. (His wife, Clementina Gonzales, was the daughter of a Spanish official at the Vatican who was in charge of overseeing shipments; Bollea 1936, pp. 110, 142.) *The Fountain of Youth*, a subject drawn from Ariosto (also a play on the name of the Lyonnais patron M. de Jouvencel), and *Aurora Abducting Cephalus* and *Diana and Endymion* also were sent to Lyon; the *modello* of the latter served as Pécheux's *pièce de réception* for his election to membership in the Accademia di S. Luca in March 1762, for which he was proposed by Filippo della Valle.

The friendship with Batoni was renewed in 1764 after Pécheux's return from a trip through the Marches to Venice, Padua, and Bologna (where he was welcomed into the Accademia Clementina), and it afforded him an opportunity to compete in two joint commissions with perhaps the most celebrated artist of his age. For Bailly de Breteuil Pécheux painted *Hercules Entrusting Deianeira to the Centaur Nessus* (1762), while Batoni produced *Polyphemus Hurling a Rock at Acis and Galatea* (paintings now respectively in the Galleria Sabauda, Turin, and the Nationalmuseum, Stockholm; see Yavcihtz-Koehler 1987 on the collection). Monsieur de Lyvry ordered from the two artists a *Death of Cleopatra* (Pécheux) and a *Death of Anthony* (Batoni). In his *Note de tableaux*, compiled in 1803, Pécheux listed nineteen paintings executed between his arrival in Rome and the journey of 1764; in these his subjects ranged from the Old and New Testaments to classical mythology, Roman history, and already mentioned themes from Ariosto. He also painted an *Interior of St. Peter's* for Breteuil, in which he placed the most important modern sculptures of Rome, as well as the figures of Breteuil, Father Jacquier, the Abbé Spannocchi, and himself; a similar work but with antique statues and a portrait of Monsieur de Viry, Uditore di Rota, was sent to Paris (1772).

An international impetus to Pécheux's career was provided by Breteuil, who gave him an introduction to the court of Parma, recommending him for the portrait of Maria Luisa, sister of the Duke of Parma and later wife of the King of Spain, and sending the minister Guillaume du Tillot a sketch of his own head and of the head of abbot Jacquier as proof of the artist's ability. In Parma Pécheux became a friend of Gastone della Torre Rezzonico, to whom he gave his self-portrait, and though still continuing to declare himself a "history painter," he produced twelve portraits of the family of the Duke of Parma, thus establishing his fame as a portrait painter as far away as Naples. Those he did in Rome of Charles Stuart, who in March 1773 named him as his personal painter, and the reigning Pope Clement XIV (1744; sent to Catherine of Russia) have not been found, but well known is that of the Marchesa Margherita Gentili Boccapaduli (1777; private collection, Rome), which shows a cultured gentlewoman in her cabinet of natural curiosities, surrounded by furniture by Piranesi and archaeological finds. The portrait of Marchesa Boccapaduli (a member of the Accademia dell'Arcadia as Semira Epicense) is emblematic of the refined intellectual life of Rome in the 1770s.

In these years Pécheux also obtained important commissions from the Borghese family: in 1773 for Cardinal Scipione he frescoed the apse of S. Caterina da Siena in via Giulia with the scene of *Saint Catherine Accompanying Pope Gregory XI on His Return to Rome from Avignon* (later Giovanni Gherardo de Rossi would express a negative judgment on the piece and claim to prefer the work beneath it, by Gaetano Lapis [*Memorie per le Belle Arti*, January 1787, p. 6]), and he decorated a ceiling in the ground-floor rooms of the Palazzo Borghese with *The Wedding of Cupid and Psyche* (c. 1775). In 1782 his *Council of the Gods* for the ceiling of the Sala del Gladiatore in the Villa Borghese was sent to Rome from Turin as part of the redecoration undertaken by Prince Marcantonio. Pécheux also painted a ceiling for Palazzo Barberini, *God the Father Separating the Elements*, the *modello* for which is still in the palace as part of the collections of the Galleria Nazionale d'Arte Antica.

Similarly to his colleague Bottani, the second part of Pécheux's life and career took him away from Rome, where, during the pontificate of Pius VI—from whom he received a gold medal in recompense for painting *The Virgin Lamenting near the Sepulchre* for the church of S. Andrea at Subiaco in 1776—he could have aspired early to inheriting the mantle of Batoni and to challenging the primacy of his contemporary Domenico Corvi. But the prestige of Pécheux's association with Mengs and the courtly manner he had acquired through contact with leading circles in Rome and Parma made him the ideal candidate to become chief painter, head, and master of the school of painting and drawing, and director of the Scuola del Nudo of the refounded academy in Turin. Vittorio Amedeo III, heedless of any local dissatisfaction, proceeded with the nomination, and the new professor moved to Turin in 1777 to spread the prestige of the Roman school and especially of its methods, importing there plaster casts of the most famous works of ancient and modern sculpture (these, according to Pécheux himself, included a relief by Duquesnoy, the head of Moses by Michelangelo, and the anatomy of a horse; for the study of the nude, the academy only had an old

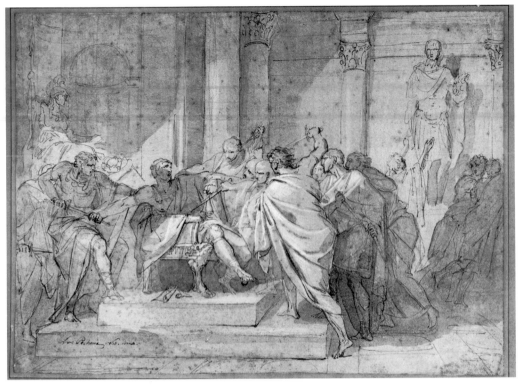

385

soldier to serve as model; for more on Pécheux's activities as director of the academy, see Castelnuovo and Rosci 1980, vol. 1, pp. 11–21). His own production at this time included *Pietro Moricone Baptizing Lamberto, Son of the King of the Balearic Islands*, for the cathedral of Pisa, a commission obtained while he was still in Rome, but only sent to Pisa in 1784, as well as altarpieces, history paintings, and portraits for the churches of the city and the residences of the court. For Vittorio Amedeo III he painted, among other things, a *Clelia* (1787), a *Diana* (1788), *Alexander and the Family of Darius* (1791), and landscapes and portraits (see Castelnuovo and Rosci, 1980, vol. 1, pp. 11–21). His easel paintings, besides scenes from ancient history in the tradition of Poussin, included allegorical subjects more contemporary in feeling, such as *Pygmalion* (1785), an allegory of the superiority of sculpture painted for the Russian ambassador Yussupov (a collector of modern works), and *Nature in the Guise of Venus* and *Reason in the Guise of Minerva* (1793), given by the government to General Joubert. The decoration of the library ceiling of the archives of the royal palace with mythological subjects, done between 1778 and 1781, was an event of crucial importance in bringing Roman Neoclassicism to Piedmont (Pécheux explains the program of this work in his autobiography). The typical *ancien régime* relationship between a court painter and a sovereign found formal expression in the assumption of a spiritual kinship on the part of

members of the royal family on the occasions of the births of the artist's children, from the first-born Vittoria Ferdinanda held at baptism by the royal couple (even if by substitutes chosen from the ladies and gentlemen of the court) whose names she was given.

The political upheavals of the Napoleonic era did not substantially affect Pécheux, and *Napoleon Promoting Education* (now known only from Boucheron's engraving) reflects his transference of allegiance. At a certain point he nonetheless found himself trying to sell all the material in his studio to the academy, and from the lists drawn up on that occasion (1803) we see the solid fundamentals of his academic profession, from 224 drawings (including several foreign academic nudes that he paid three *zecchini* apiece for in Rome) to two life-size mannequins, male and female, brought from Rome. [ss]

BIBLIOGRAPHY Bollea 1936; Maxon and Rishel 1970, pp. 38–39; Hiesinger and Percy 1980, pp. 73–74, no. 60; Baldin 1983; Ghisotti 1990; Romano 1993; Sestieri 1994, vol. 1, p. 145

## 385
## Laurent Pécheux
### *The Assassination of Julius Caesar*

1760
Signed and dated at lower left in black ink: *Lau. Pecheux 1760. romae.*
Pen and black ink, brush and gray wash,

heightened with white on tan paper
10 ⅝″ × 14″ (270 × 368 mm)

PROVENANCE sale, Hôtel Drouot, Paris, Dec 19, 1973, lot 63; Colnaghi, New York, 1982; from whence purchased by the Philadelphia Museum of Art, 1982

EXHIBITIONS New York, Colnaghi, in association with F. A. den Broeder. *Aspects of Neoclassicism: Drawings and Watercolors, 1760–1840.* 1982, cat. no. 38; Los Angeles, Philadelphia, and Minneapolis 1993, cat. no. 19

Philadelphia Museum of Art, Print Revolving Fund

Although not associated with any of the paintings that Pécheux lists in his memoirs among those he did during his long stay in Rome from 1753 to 1777 (Bollea 1936, passim), this drawing has the characteristics of a finished compositional study, in which the nervous and choppy draftsmanship (perhaps recollections of Pécheux's youthful studies after the etchings of Pietro Testa) and the rapid execution are accompanied by an exact definition of the various roles of the characters, the architectural setting, and the contrasts of light and shade. The painting, if ever executed, by virtue of its subject from Roman history would be grouped with those painted by the artist at the request of James Adam (in Rome between 1761 and 1763; see Ingamells 1997, pp. 4–5), namely *The Meeting of Coriolanus with His Mother* and *Attilius Regulus*. But while these were recognized examples of heroism and patriotism, which had acquired a particular contemporary significance

as anticipating the Neoclassical *exemplum virtutis*, the theme of the death of Caesar is evidence that in eighteenth-century classicist Rome attention continued to be focused on the city's ancient history. Patrons could identify themselves either with the Arcadian milieu (Metastasio's drama *Attilio Regolo* dates from 1740, and soon after the election of Benedict XIV that same year the Accademia di Storia Romana began its activity under the pope's patronage), or else with the cultured English gentlemen gathered in the Società degli Antiquari, who had created a sort of pre-Enlightenment mythology about Rome, its monuments, and its history (an example of this type of patronage is that of Count Carlo di Firmian, who commissioned a *Death of Socrates* and a *Death of Cato* from Giambettino Cignaroli at the end of the 1760s; see Palazzo Reale, Milan, *Settecento Lombardo* [Milan: Electa, 1991], p. 222). In this case the episode of the bloody killing of Caesar by a group of conspirators in the senate right under the statue of Pompey (Plutarch 34, 66) presents a tragic subject that, through lack of any precise ethical values to uphold, is closer to the many versions of the deaths of Cleopatra or Dido (in the same vein as the vogue for Roman subjects treated contemporaneously by Batoni, Bottani, Mengs, and Maron) or to rare depictions of the more savage events of Roman history, such as *Caracalla Killing His Young Brother Geta in the Arms of Their Mother, Julia* (1775), by Julien de Parme, which, following the example of Metastasio's melodramas, offered artists points of departure for the "sublime" *mise en scène* loaded with inherent theatricality. In 1724 Giacomo Zoboli completed one of his versions of the death of Caesar theme destined to be considered (Clark 1967; Faldi 1977) a veritable incunabulum of Rome's "proto-Neoclassical" tendencies (as Federica Pirani observes in Paolo Moreno, ed., *Lisippo: L'arte e la fortuna* [Milan: Fabbri, 1995], cat. no. 7.3, p. 434, the painting is actually an almost exact copy after a fresco by Giovanni Ghisolfi in Palazzo Galli, Piacenza, of 1675). He returned to the same subject on several occasions, associating the death of Caesar with that of Pompey, who was treacherously murdered by Ptolemy (the earliest version of this subject is dated 1731), while later versions of the two deaths, which marked the end of the Roman republic, date from 1748–49 and others are cited in the 1767 inventory of Zoboli's belongings (see Maria Barbara Guerrieri Borsoi, *Disegni di Giacomo Zoboli* [Rome: De Luca, 1984], pp. 19–20, 25–26). Pécheux's drawing, dated 1760, can therefore be linked to this thematic series, which, at least as regards the more "sublime" and hor-

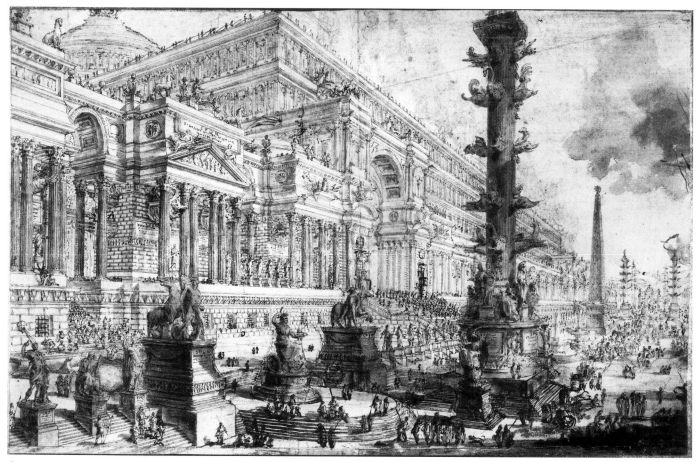

386

rific aspect of those tragic events, was to work its way out ten years later in the "Roman" painting by John Hamilton Mortimer (who, incidentally, never went to Rome [Pressly 1979, p. 75]) of *Sextus the Son of Pompey Applying to Ericthto to Know the Fate of the Battle of Pharsalia*, exhibited at the Society of Artists in London in 1771. In Rome the series appears to end with the *Death of Caesar* by Vincenzo Camuccini (1798; commissioned by the Bishop Count of Bristol; see Ingamells 1997, p. 129), which had some influence on Jean-Léon Gerôme's theatrical canvas of 1867 (Walters Art Gallery, Baltimore).

In the spatial layout of Pécheux's composition the setting consists of a single plane derived from Poussinesque models such as *The Death of Germanicus*, then in the Palazzo Barberini, and the series of The Seven Sacraments, which Pécheux could easily have seen in the Boccapaduli house. The didactic value of the latter series was further emphasized by the *Memorie per le Belle Arti* after the paintings had been fraudulently exported as the works of Gavin Hamilton, another artist well versed in Roman history, whose *Death of Lucretia* (1769; see cat. 231) ratified the movement toward a more deliberate adherence to the values of republican Rome. [SS]

## GIOVANNI BATTISTA PIRANESI

MOGLIANO DI MESTRE 1720–1778 ROME
*For biography see Prints section*

### 386
### Giovanni Battista Piranesi
#### *Architectural Fantasy*

1742–43
Pen, brown ink with brown wash, some graphite and red chalk on paper
10⅝″ × 16⅞″ (270 × 428 mm)
PROVENANCE: purchased from P. & D. Colnaghi, London, 1966
EXHIBITIONS London, Colnaghi. *Exhibition of Old Master Drawings*. 1966, cat. no. 21; London 1978, cat. no. 41; New York 1989, *Piranesi*, no catalogue; Montreal 1993, cat. no. 26
BIBLIOGRAPHY Ryskamp, Charles, ed. *Sixteenth Report to the Fellows of the Pierpont Morgan Library, 1969–71*. New York: The Pierpont Morgan Library, 1973, p. 119; Stampfle 1978, p. xxxii, no. A–1
The Pierpont Morgan Library, New York, Purchased as the Gift of Miss Alice Tully

This splendid rendering provides an example of the kind of preparatory drawing that Piranesi created in the production of his imaginary architectural views of ancient Rome in his

*Prima parte di architetture*, published in 1743. Although this architectural vista is not in the publication, one of the plates in this collection is similar in overall composition. Also, individual motifs, such as the statues of the Dioscuri restraining their horses, the obelisk, and rostral column, appear in other prints in this publication (Wilton-Ely 1994, vol. 1, nos. 4, 10). Sections of the lower margin of the sheet have been cut out and replaced with pasted-in sections. The Dea Roma statue on the circular dais between the two Dioscuri may replace an earlier figure in this section of the sheet. When he added this patched revision with the Dea Roma, Piranesi redrew his red chalk perspective line across the patch; apparently he still needed it for the architectural perspective. This line is one of a triad of lightly sketched perspective lines, one of which establishes the viewer's eye level. These lines converge beyond the left margin of the sheet. The perspective follows the *scena per angolo* model, but cavalierly; the perspective lines along the right margin converge toward but not to a precise vanishing point. Here Piranesi manipulates the three-point perspective system for his own expressive purposes.

Passages of chiaroscuro, achieved by a wash, on some of the foreground

elements, adumbrate Piranesi's evolving darker style, but most of the sketch, in spite of its classicizing content, has been executed in a sketchy, near Rococo style. [MC]

### 387
### Giovanni Battista Piranesi
#### *Grottesco with the Tomb of Nero*

Verso: sketch of the Temple of Saturn in the Roman Forum (black chalk)
1744/45–47
Pen and brush with gray-brown ink and gray wash over red chalk on paper
19⅜″ × 15¼″ (492 × 388 mm)
PROVENANCE Hans Calmann, London; art market, New York, late 1930s; Philip Hofer, Boston; Charles B. Hoyt, Boston; Rowland Burden-Miller, Switzerland; Philip Hofer, Boston; acquired by the National Gallery of Art in 1979
EXHIBITIONS Washington, D.C., National Gallery of Art. *Building a Collection*. 1997–98, cat. no. 57
BIBLIOGRAPHY Robison, Andrew. "Preliminary Drawings for Piranesi's Early Architectural Fantasies." *Master Drawings*, vol. 15 (1977), pp. 387–88, figs. 1–2; Robison 1986, pp. 29–30, fig. 32
National Gallery of Art, Washington, D.C., Gift of Philip Hofer in memory of his mother, Mrs. Jane Arms Hofer, 1979

387

This fantasy drawing, an early preparatory study for the *grottesco* generally known as the *Tomb of Nero* (Wilton-Ely 1994, vol. 1, no. 23), is the only such preparatory located for this series of four untitled prints, of which one, the so-called *Skeletons* is in this exhibition (cat. 411). The actual suite of etchings is horizontal in format, whereas this drawing illustrates an assemblage of antique fragments in a vertical composition, a variation that suggests that it represents an early stage in the project. The tomb in this drawing, a free rendering of the one popularly known as the Tomb of Nero, is now in the Vatican. In Piranesi's time it was still *in situ* on via Cassia, as he later recorded in his *Le antichità romane* (Giovanni Battista Piranesi, *Le antichità romane* [Rome: A. Rotilj, 1756], vol. 1, pl. xiv), where his title clearly states that he knew this sarcophagus was not actually Nero's tomb.

In addition to the so-called Tomb of Nero, the open sarcophagus in the foreground of this drawing with its relief sculpture depicting a battle scene is retained virtually verbatim in the etching. The imperial Roman eagle relief was suppressed; it reappeared, years later, on the title page of the second volume of Piranesi's *Vasi, candelabri, cippi, sarcofagi*, published in 1778, where its actual location, the portico of the church of Ss. Apostoli, is indicated.

Stylistically this sketch displays extraordinary spontaneity. The linear precision typically associated with architectural rendering is emphatically eschewed in favor of a rendering that approaches a freely associative technique in which Piranesi seems to "recall" rather than precisely represent the monuments depicted. Spatial relations are blurred and the application of wash tends to fuse objects rather than define them. These effects, together with transgressions of scale, permit the vigorously but abstractly sketched human figures in the foreground to coalesce eerily with the relief figures on the—comparatively —enormous adjacent sarcophagus. These spatial and proportional disjunctures exceed any recorded in the final suite of etchings. [MC]

## 388
## Giovanni Battista Piranesi
### *An Ancient Port*

1749–50
Red and black chalk with brown and reddish washes on paper; squared in black chalk
15⅛″ × 20¾″ (385 × 528 mm) .
PROVENANCE  private collection, Geneva; art market, Paris; acquired by the J. Paul Getty Museum in 1988
EXHIBITIONS  New York, The Metropolitan Museum of Art. *Drawings from the J. Paul Getty Museum: Checklist.* 1993, pl. 5
BIBLIOGRAPHY  Goldner, George R., and Lee Hendrix, with the assistance of Kelly Pask. *European Drawings 2: Catalogue of the Collections.* Malibu, Cal.: The J. Paul Getty Musuem, 1992, pp. 92–93, no. 34
The J. Paul Getty Museum, Los Angeles

Before the appearance of this drawing, Andrew Robison (Robison 1986, pp. 34–37, figs. 40–41) had identified two drawings related to the evolution of the composition of the print, *Parte di ampio magnifico porto* (cat. 412). One of these drawings, in the Staatliche Kunstsammlungen, Dresden, was quite different in composition but contained architectural elements used in the print. In the other drawing, now in the Statens Museum for Kunst, Copenhagen, the final composition—with just a few modifications—was achieved. This drawing, which is larger than the print, displays an ample foreground area of turbulent water and some architectural elements not retained in the print. Robison surmised that Piranesi created a reduced mirror reversal of this very large drawing that conformed to the size of plate he was then using, and that this reduction caused him to narrow the section of water represented, to eliminate some elements along the right margin, and to compress others.

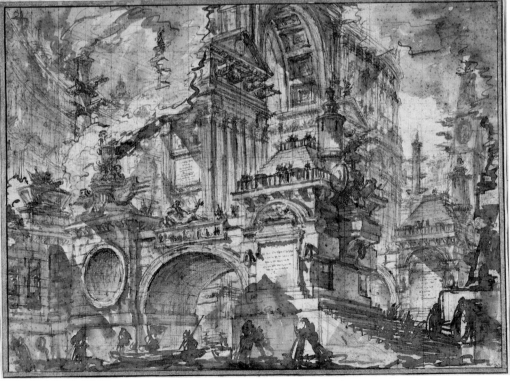

388

389

390

This drawing documents a step between the Copenhagen drawing and the final design but in ways that point to a complex design process, one in which both drawings played a continuous interactive role. This drawing is surely to be considered the surviving master drawing. It conforms to the size of the plate, accurately records the overall composition, and is squared for reverse transcription to a final working drawing or, given Piranesi's facility as an etcher, perhaps for a reverse redrawing on the plate. In the print a number of features present only in the Copenhagen drawing reappear. These include the stairway beneath the foreground archway and the oval niche and one of the two niches with urns to the left of this archway, as well as the stairway topped by a small entrance with a spear-bearing sentinel at the far left. These and some minor details in the Copenhagen drawing appear in the final print, but, significantly, their proportions have been altered to conform to the proportions of this drawing. The tall pilings and massive ropes in the print (the latter lightly sketched in the Copenhagen drawing) are elements probably created directly on the plate. [MC]

## 389
## Giovanni Battista Piranesi
### *Fantasy on a Monumental Wall Tomb*

1766–69

Inscribed on recto at center left in brown ink: *Piranesi f.*; at lower right in brown ink: *Bought of Piranesi in Rome/March 1770 by Joseph Rose*

Pen and brown ink with brown and gray washes over black chalk on paper

23⅜″ × 18⅝″ (606 × 473 mm)

PROVENANCE  Christopher Sykes (1749–1801) and by descent; sale, Christie's, London, July 4, 1989, lot 104; Agnew's, London, and David Tunick, New York; purchased by the National Gallery of Art in 1996

EXHIBITION  Washington, D.C., National Gallery of Art. *Building a Collection.* 1997–98, cat. no. 61

National Gallery of Art, Washington, D.C., Patrons' Permanent Fund

In connection with his heated debate with the French critic Pierre-Jean Mariette over the merits of Greek and Roman art, Piranesi produced his *Parere su l'architettura* and at some point after 1768 augmented his argument with five new plates, including one for which this eloquently powerful drawing is a preparatory. The drawing is larger than the actual print (20⅞″ × 15⅛″ [530 × 385 mm]). The ink lines appear to have been swiftly executed, and the inked washes create a powerful chiaroscuro affect, but one that is quite different from that of the print, in which the light falls from the upper right, thus reversing the cast shadows where recorded. The upper and lower sections of this strange accumulation of antique-inspired objects reflect the recombination of conventional forms. In contrast, the large, overlapping profile heads and shepherds' pipes that form a curious ensemble of high-relief elements mark an emerging dimension in Piranesi's art, one that played an important role in his 1769 *Diverse maniere d'adornare i cammini.* The inscription—not yet written out—at the top of this strange monument will come from Ovid's *Metamorphoses*, Book XV, and attests to Piranesi's combativeness, but also to a reconciliation with his new interests as a practicing architect: *RERVMQVE NOVATRIX EX ALIIS ALIAS REDDIT NATVRA FIGVRAS* ("Nature renews herself constantly; to create the new out of the old is therefore also proper to man"). [MC]

## 390
## Giovanni Battista Piranesi
### *Prisoners in the Barracks of the Gladiators at Pompeii*

1770s

Inscribed on recto: 1/ 2/ 2/ 3/ 2/ 2/ 4; inscribed on verso: *tav. 39/ Veduta del Carcere/ situato nel Castro/ Part. 2. a/ Tav. 37/ Veduta da ingrandirsi*

Pen and brush and blackish-brown ink on paper; squared in red chalk

16⅞″ × 22″ (430 × 560 mm)

PROVENANCE  Ludwig Hermann Philippi, Hamburg (Lugt 1335); Hollstein & Puppel, Berlin; acquired by the Staatliche Museen in 1934

BIBLIOGRAPHY  Allroggen-Bedel 1983, p. 283, fig. 12

Staatliche Museen zu Berlin, Kupferstichkabinett

Piranesi's second visit to Naples in 1770 would have coincided with his work at the museum at Portici and his extended examination of the excavations at Pompeii. The portion of the city then available for exploration was the zone around the harbor where excavations were in progress and also the via Consolare and the via dei Sepolcri, which extended outside of the city, both of which he recorded in sketches that were later published by his son Francesco in the volumes *Antichità della Magna Grecia.*

Several of his drawings were never etched, including this stark and powerful pen and ink drawing of four men imprisoned in stocks. There are, however, numerical indications on the drawing that suggest that he intended to reproduce it as a print. On the verso is written, apparently in another hand, *veduta del carcere situato nel Castro,* a reference to a room identified in the eighteenth century as a room in the barracks of the gladiators. In this area in December 1766 a set of stocks capable of holding ten people was found with the skeletal remains of four prisoners still *in situ,* four bronze helmets attached to a wall, and several leg pieces (*gambieri*), and sword belts (*baltei*; see Allroggen-Bedel 1983). Piranesi has taken pains to reconstruct the scene in this room just prior to the disastrous Vesuvian eruption of A.D. 79 By the time of his visit to Pompeii the room had been cleared, and the gladiatorial arms and the stocks had been removed and, in 1770, installed in the museum at Portici. The powerfully effective pen and ink technique used in this sketch typifies his late style of draftsmanship. [MC]

391

## 391
### Giovanni Battista Piranesi
*The "Canopus" of Hadrian's Villa at Tivoli*

c. 1775

Inscribed at upper right in red chalk:
*musaico/la volta/Calce/musaico*
Red chalk over black chalk on heavy laid paper
16⅛" × 9½" (416 × 242 mm)

PROVENANCE Dr. C. Jessen (Lugt suppl. 1398a); Archduke Franz Ferdinand of Austria, on deposit at the Albertina, Vienna, until c. 1918; Kunsthandlung Gustav Nebehay, Vienna, by 1925; Duc de Talleyrand, Saint-Brice-sous-Forêt; British Rail Pension Fund, London; Hazlitt, Gooden & Fox, London, 1991; private collection, Washington, D.C.; partial gift to the National Gallery of Art, 1994

EXHIBITIONS Norwich, England, Castle Museum. *Old Master Drawings from Venice.* 1984–85, cat. no. 11; Washington, D.C., National Gallery of Art. *Building a Collection.* 1998, cat. no. 60

BIBLIOGRAPHY Morassi, Antonio. *Dessins vénetiens du dix-huitième siècle de la collection du Duc de Talleyrand.* Milan: D. Guarnati, 1958, p. 59; MacDonald and Pinto 1995, p. 259, fig. 342
National Gallery of Art, Washington, D.C., Anonymous (Partial and Promised) Gift, 1994

The drawing, typical of Piranesi's drawings made *in situ* at Hadrian's Villa, is executed in red chalk over a sketchy underdrawing in black chalk. A few drafted lines serve to establish recessionals leading to a vanishing point centered in the fountain located in the niche at the end of the corridor. These recessionals must have helped Piranesi to organize the perspective, but they are not arbitrary; they also relate precisely to changes in the brickwork. In addition, a few drafted vertical lines serve to indicate corners and define niches. Here and there hasty notations appear indicating *mosaico* (mosaic) in the semi-dome of

the niche at the far right and above, *calcio*, where there is plaster with decorative painted bands and, finally, above this area, the hasty notation *mosaici*. The vaulting in the corridor, as Piranesi explained in the finished print, was discontinuous: open, as indicated in the section of the corridor in the foreground, covered over the bridge (where two lightly sketched figures stand over an archway), and open at the end of the corridor adjacent to the terminal fountain. In his notations on the print Piranesi explained that the archway at floor level marks the structure of a bridge. Evidently the floor, like the vaulting, was discontinuous, thus allowing visitors to view the water emitted from the fountain at the end of the corridor passing beneath them. On the print Piranesi noted that this bridge was covered up in excavations made in 1771. This notation is somewhat ambiguous; was Piranesi recalling the obscured bridge from one of his earlier visits or did he make the sketch when it was still visible, producing the etching five years later? In any event, the drawing served as an *aide memoire* for a larger version as the contrasting dimensions of drawing and larger print (17¾" × 22¾"; 450 × 580 mm) indicate. [MC]

### STEFANO POZZI
ROME 1699–1768 ROME
*For biography see Paintings section*

## 392
### Stefano Pozzi
*Study for "Saint Joachim and the Young Virgin"*

1736

Black pencil and white lead on gray-blue paper
16⅛" × 9½" (416 × 242 mm)

PROVENANCE Lambert Krahe, Düsseldorf

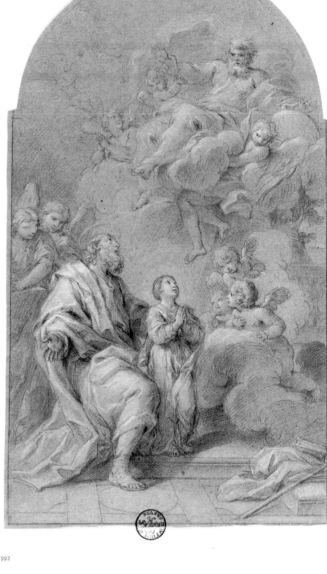

392

BIBLIOGRAPHY Budde 1930, p. 72; Pacia and Susinno 1996, p. 136
Kunstmuseum Düsseldorf im Ehrenhof, Graphische Sammlungen

This drawing belongs to the important group of choice drawings by Stefano Pozzi owned by the painter Lambert Krahe, who was originally from the Palatinate but trained in Rome from 1736 at the school of Pierre Subleyras. In 1756 he returned as curator of the Elector Karl Theodor's gallery, and founded a private academy in Düsseldorf, which in 1766 was granted recognition as a public institution (Graf 1973). Krahe's extensive graphics collection, sold to the elector in 1778, was fundamental to the new institute's teaching resources. Among the thousands of drawings that Krahe took with him to Germany, the thirty-two by Pozzi constitute a particularly remarkable group in that they are the

finest examples of his graphic work (inv. 3380–3412). Spread over the period of twenty years coinciding with Krahe's stay in Rome, they illustrate the artist's various fields of activity, from history painting and religious, allegorical, mythological, and literary subjects (Barroero 1998, "Pozzi") to decoration and the production of compositions probably intended for engraving. But they also appear to document one of his independent graphic activities, represented by a number of finished drawings for which no pictorial versions are known, therefore presumably done for collectors. They constitute the essential point of departure for the reconstruction of Pozzi's activity as a draftsman (Hiesinger and Percy 1980, pp. 57–59), a field in which he distinguished himself with extremely elegant results, sometimes as close to the Rococo vivacity of the French masters of

the French Academy such as Natoire, Vien, Boucher, and Fragonard (whom Pozzi may have looked at, or perhaps he absorbed their influence through Panini), but always remaining unmistakably "Roman" in his declared allegiance to the tradition of Maratti.

The first documented links between Stefano Pozzi and Krahe go back to the time when the Scuola del Nudo was established on the Capitoline Hill by Pope Benedict XIV in November 1754, although it may be supposed that they had met well before then. On behalf of the Cardinal Camerlengo, Krahe had arranged the election from among the "resident" academicians of S. Luca—the ten professors, painters, and sculptors who were to teach in turn in the new school (Michel, G. 1996, "Stefano Pozzi," p. 28)—and Stefano Pozzi became the first director.

This drawing documents the final preparatory stage of an important commission of 1736: the large altar-piece (178½" × 104½"; 453 × 265 cm) for the third chapel on the right in the church of S. Ignazio, which is still in place. This work was the artist's first real chance to establish himself on the Roman scene with a particularly demanding painting for a prestigious destination: one of the most important modern churches in the center of Rome and in a chapel next to that of S. Giuseppe, which for about twenty years had housed Trevisani's altar-piece *The Death of Saint Joseph* (the seminal precedent for Pozzi's painting of the same subject at the SS. Nome di Maria, c. 1755).

Pozzi's universally praised painting replaced a picture of the same subject by the seventeenth-century Jesuit Pietro de Lattre. Its subject is unusual in contemporary iconography, which usually required both parents in the depiction of the education of the Virgin (in comparison with works in Roman churches by Giovanni Battista Calandrucci formerly in S. Lorenzo in Piscibus, Girolamo Pesci in S. Giuseppe alla Lungotevere, Agostino Masucci in SS. Nome di Maria, and Giuseppe Bottani in S. Andrea delle Fratte) and is a touching interpretation of the actors in the sacred history. It can be seen as celebrating the work of the Jesuit Fathers of the adjacent Collegio Romano, the order's greatest institution for the moral and religious training of the Catholic ruling class, and so was a parallel to Saint Joachim's education of the youthful Virgin.

The task of working out the composition was particularly complex, as can be seen from the surviving preparatory drawings. The first of these (Gilmore collection, Baltimore Museum of Art) presents the greatest variants in the arrangement of the various elements in the pyramidal scheme, which includes a kneeling

figure opposite Saint Joachim (probably a Jesuit representing the entire order), who was destined to disappear in successive versions while the composition is topped by a floating Eternal Father of Raphaelesque derivation. A drawing in the Albertina, Vienna, indicates a later stage where the scene is arranged in an ascending diagonal from Mary as a child, bottom left, to the Eternal Father on a throne of clouds at the top right; while the Düsseldorf drawing almost reaches the definitive solution (the many differences—as in the figures of the angels or the cherubim, or in the book on the bottom right, closed in the drawing and accompanied by a wayfarer's staff, but open in the painting where the staff also vanishes—all disprove the theory that this is a drawing after the painting). This drawing is clearer and better balanced than the earlier ones, and its compositional schemes retain the lively mood of the composition while still pursuing two objectives: a greater discernment of the delicate currents of feeling and devotion that run between the protagonists, but also the noble monumentality of the whole.

The work had immediate success as an engraving of 1736 by the artist's brother Rocco Pozzi who added a base and a frame of scrolls and festoons, basing his work on a drawing by Stefano, who sometimes made drawings for the reproduction of his own compositions. Two devotional images of lesser quality were engraved by his brother-in-law Girolamo Frezza and by Pietro Campana. Over twenty years later, an echo of this well-known creation of Pozzi's can be found in *Saint Joachim with the Virgin*, designed and engraved by Giuseppe Bottani (*Mantova nel Settecento* 1983, p. 181). [SS]

## ANDREA PROCACCINI
ROME 1671–1734 LA GRANJA, SPAIN

Andrea Procaccini's life and work are particularly well documented; both the painter's biographers—Nicola Pio, who wrote in 1724, and Lione Pascoli, who wrote in 1736—knew him personally and continued to receive first-hand information about him even after he moved to the Spanish court, where he spent the last fifteen years of his life and met his wife, Rosalie O'Moore from Dublin, whom he married in 1727 (Fernandez 1977, p. 178; see also the accurate edition of Pascoli's biography by Laura Possanzini). His surname suggests that his family came from Lombardy or Bologna, although there is no known link with the painters Camillo and Giulio Cesare Procaccini. Both his parents were well off (Pascoli noted that his mother's dowry was considerable), so much so that his father exercised no profession

but lived off his income—unusual among artists' families. Pascoli, always careful to record the economic conditions of his artists' backgrounds and their eventual changes of status, emphasized that this affluence never diminished. He lived first in strada della Purificazione (1698–1712), then in Piazza Barberini (1714–18), and his clientele consisted mainly of aristocrats and foreigners, including probably William, 1st Marquess of Annandale, whose portrait by Procaccini (1718) hangs in Hopetoun House, Linlithgow (Rudolph 1983, no. 585).

Procaccini was a pupil of Carlo Maratti and worked with him from the beginning of the restoration of Raphael's Stanze in the Vatican (1702; Cicerchia and De Stroebel 1986, p. 116, n. 21) and executed a canvas for the chapel of the baptismal font in St. Peter's, for which Maratti had supplied his great *Baptism of Christ* (1695–98; now S. Maria degli Angeli). In 1710 Procaccini painted *Saint Peter Baptizing the Centurion Cornelius* (DiFederico 1968). At the same time Procaccini had frescoed the vault of the chapel of St. Bruno in S. Maria degli Angeli (*Evangelists* and other figures) and executed *The Meeting of Saint Joachim and Saint Anne at the Golden Gate* and the *Pentecost*, in two tondi supported by stucco angels by Pierre Legros, in the transept of S. Maria dell'Orto (1704–6). From about 1700 onward he produced canvases for the Marchese Niccolò Maria Pallavicini, one of the major collectors of modern art and a friend of Maratti; an inventory of the marchese's belongings lists paintings by Procaccini, including one depicting Pallavicini distributing prizes to the "Virtuosi," and two with figures by Procaccini and still lifes by Alessandro de' Pesci (Rudolph 1995, pp. 80, 97). An *Agony in the Garden* (Burghley House, Lincolnshire) recently reattributed to the artist was very probably painted for the private chapel of Pallavicini (Rudolph 1995, p. 113, pl. 88).

Procaccini was made an academician of S. Luca in 1711, and his *pièce de réception*, *Mercury and Argus*, of 1716 is still in the academy's collection. He also belonged to the Congregazione dei Virtuosi al Pantheon and, according to Pascoli, enjoyed the particular trust of Pope Clement XI. He had a school of his own, and the best-known of his many pupils is Stefano Pozzi, while Sempronio Subissati, who probably accompanied Procaccini to Spain, was the main intermediary between him and Rome.

Procaccini, who was described by Maratti in his will as his "favorite disciple," was one of the most faithful interpreters of his style, and Maratti bequeathed a *Saint John* by Domenichino, and a bas-relief with

cupids by Duquesnoy to his pupil. He also entrusted to Procaccini the distribution of the plaster figures from the workshop among his pupils. Procaccini was one of the witnesses to the inventory of Maratti's possessions, which included a *Mary Magdalen* of his own.

Procaccini probably also owed his position as general superintendent and designer of papal tapestries of S. Michele to his friendship with Maratti (De Strobel 1989, pp. 53, 54, 57). In 1716–18 he painted the *Prophet Daniel* for the main aisle of St. John Lateran. Directly afterward he was commissioned by the Marchese Livio de Carolis to contribute to the decoration of his new palace by Alessandro Specchi on via del Corso, and he produced a delicate *Aurora*, in collaboration with Pietro Paolo Cennini, who executed the floral inserts.

In April 1720 Procaccini left for Spain, where Philip V had invited him as court painter. Before embarking he stayed for a while in Genoa, where he painted some mythological and allegorical frescoes in Palazzo Durazzo (now Giustiniani Adorno).

He then settled in Madrid as the king's chief private painter, although his job involved some traveling. He was a leading exponent of Maratti's classicism in Spain, which paved the way for the acceptance, fifty years later, of Mengs's style. His activity was not limited exclusively to painting, of which there are examples in Aranjuez, Riofrio, Seville, and La Granja; among his portraits is the *Cardinal Borja* (Prado, Madrid). He produced designs for tapestries (Fernandez 1977), but above all he contributed to the development of art in Spain. In 1722 he sent for part of the collection that Faustina Maratti had received from her father, and acted as intermediary for the purchase by the Spanish crown of some antique sculptures from the collection of Queen Christina of Sweden (now in the Prado). When Procaccini died his rich collection of graphic art was presented by his wife to Madrid's Academia de S. Fernando, where it is still one of the most valuable possessions (Fernandez 1977, p. 80). [LB]

BIBLIOGRAPHY Pio [1724] 1977, pp. 16–17; Pascoli 1992, pp. 836–45; Negro 1993; Sestieri 1994, vol. 1, pp. 153–54; Rudolph 1995; Michel G. 1996; Pacia 1996; Pacia and Susinno 1996; Loire 1998, pp. 263–65

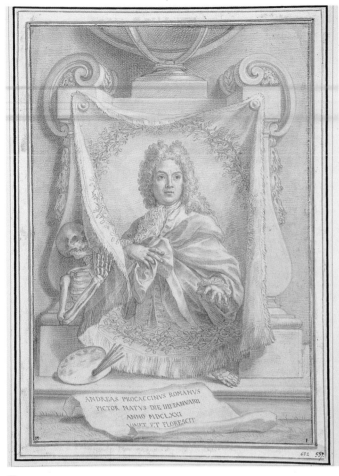

393

394

## 393
## Andrea Procaccini
### *Self-portrait*

c. 1720

Inscribed: *ANDREAS PROCACCINVS ROMAN-*
*VS/ PICTOR NATVS DIE IIII IANVARII/ ANNO*
*MDCLXXI/ VIVIT ET FLORESCIT*. Numbered at
lower right in pen and brown ink: *1* and *559*
Red chalk on paper
17¼″ × 12⅛″ (440 × 310 mm)
PROVENANCE as for cat. 338
BIBLIOGRAPHY Pio [1724] 1977, p. 17;
Mariette 1851–60, vol. 4, p. 221; Clark 1967,
"Masucci," p. 259, fig. 2; Clark 1967,
"Portraits," p. 14, no. 37; Bjurström 1995,
p. 143, no. 99
Nationalmuseum, Stockholm

*For commentary see cat. 338.*

## HUBERT ROBERT
PARIS 1733–1808 PARIS
*For biography see Paintings section*

## 394
## Hubert Robert
### *The Wine Press*

c. 1759

Red chalk on off-white laid paper
11⅛″ × 14⅛″ (289 × 366 mm)
PROVENANCE François Renault, Paris (Lugt
1042 and suppl.); E.V. Thaw and Co., New
York; purchased by the Art Institute of
Chicago in 1963
EXHIBITION Washington, D.C. 1978,
cat. no. 4
BIBLIOGRAPHY "Accessions" 1964, p. 218
The Art Institute of Chicago, Prints and
Drawings Purchase Fund

Robert is best known for his views of
the monuments and architecture of
ancient and modern Rome, but he also
was fascinated by everyday life as
people went about their mundane
tasks of providing for their necessities.
In general, Robert's scenes of laun-
dresses or cooks at work emphasize
the picturesque aspects of these activi-
ties: steaming cauldrons of water for
washing clothes or the cozy warmth
of a fireplace with a meal cooking on
the hearth (Boulet, Cuzin, and
Rosenberg 1990, cat. nos. 15, 55, 57–58,
82). But occasionally he drew detailed
records of the implements or machines
constructed in this pre-industrial age
to manufacture products. The Chicago
drawing is one of Robert's most care-
fully detailed records of the various
implements used to make basic food-
stuffs, such as olive oil or wine (a
similar press is found in an illustration
titled "Economie Rustique: Pressoirs"
in Denis Diderot and Jean le Rond
d'Alembert's *Encylopédie*. (Denis
Diderot, *Diderot Encyclopedia: The
Complete Illustrations, 1762–1777* [New
York: Abrams, 1978], vol. 1, pl. 41).
Another red chalk drawing, *Interior of
a Saltpeter Factory*, dated 1759, is at Musée
des Beaux-Arts, Valenciennes (Boulet,
Cuzin, and Rosenberg 1990,
cat. no. 25, p. 74), which suggests a
similar date for this drawing.

These drawings of crafts and trades
evidently were made during the latter
part of Robert's stay in Rome, from
about 1759 to 1765. A watercolor of the
interior of shipyards at Civitavecchia,
the port of Rome, probably executed
c. 1761, was recently on the London art
market (sale catalogue, Christie's,
London, July 2, 1996, lot 256). Another
sketch, showing men struggling to
raise a beam or mast, was apparently
drawn after life at a dockyard and was
once part of an album or sketchbook
used by the artist c. 1762/63–65 (fol. 81,
formerly in a private collection, Paris;
sold Sotheby's, Monaco, Dec. 1, 1989,
lot 67; for a description of the album,
see Carlson 1978, cat. no. 24, p. 74).
Also from this album is a study of a
piledriver, which served as a prepara-
tory drawing for an etching dated 1764;
this piece of machinery fascinated
Robert because he included it in his
1765 watercolor of men working at
Fiumicino, where Rome's airport is
now located (the black chalk sketch
was fol. 33, formerly in a private col-
lection, Paris; sold Sotheby's, Monaco,
Dec. 1, 1889, lot 30, ill.; the related
watercolor is in London, British
Museum; Denys Sutton, *France in the
Eighteenth Century* [London: Royal
Academy of Arts, 1968], cat. no. 687,
fig. 270). Evidently these drawings of
everyday life were never used by
Robert as the basis for paintings.
Rather, he used such bucolic or
picturesque images of Italian life—
shepherds tending their flocks or
laundresses or cooks at work—as
anecdotal details to animate his
painted landscapes. [VC]

## 395
## Hubert Robert
### *Villa Madama, with
### Washerwomen*

1760

Signed, dated, and inscribed at upper left:
*Villam Madama Delineavit Romae, H. Roberti
1760*
Pen and ink, brush and watercolor over
a black chalk underdrawing, on off-white
laid paper
13⅜″ × 17⅞″ (345 × 455 mm)
PROVENANCE Pierre-Jean Mariette, Paris
(Lugt 1852), his sale Paris, 1775, part of lot
1347; Duke Albert of Saxe-Teschen, estate
inventory, 1822, p. 882 (Lugt 174); Albertina
EXHIBITIONS London 1932, cat. no. 1019;
Paris 1933, cat. no. 117; Paris 1967,
cat. no. 265; Washington, D.C., and New
York 1984, cat. no. 74; Rome 1990, *Fragonard*,
cat. no. 52
BIBLIOGRAPHY Leclère 1913, p. 100;
Hempel 1924, p. 9; Burda 1967, pp. 76, 161;
Bacou 1976, pp. 85–86, pl. 28; Roland
Michel 1978, p. 488, fig. 26; Cayeux 1985,
p. 151, fig. 40; Cayeux 1987, pp. 33–34, fig. 19;
Roland Michel 1987, pp. 107–8, fig. 105
Graphische Sammlung Albertina, Vienna

395

This watercolor has long been recognized as one of the outstanding works executed in Rome by Hubert Robert. For the composition the artist chose a view of the gardens of the Villa Madama showing the aqueduct, which brings water to a pool where laundresses are at work. Above the aqueduct is a terrace, which leads to the portico of the garden loggia. The artist took some liberties in his representation of the architecture; most notably, water from the aqueduct actually flows into a rectangular basin, not the pond seen in this drawing. There are also minor changes in details of the architecture of this celebrated villa, which is just outside Rome on the Monte Mario. Under Cardinal Giulio de' Medici work began on the villa c. 1518. Raphael designed the general plan for the construction, which was finished by Antonio da Sangallo (for Giuseppi Vasi's 1761 engraving of this view, see Belli Barsali 1983, p. 151).

Robert's composition is dominated by the intersecting diagonals of the loggia's roof and the terrace, a device that creates a stable, balanced composition. However, the art critic Denis Diderot thought that this exercise in perspective detracted from the poetic charm of the view, when he saw it in the 1767 Salon a painting based on this composition (The Hermitage State Museum, St. Petersburg; for Diderot's review: Denis Diderot, *Salons*, edited by Jean Seznec and Jean Adhémar

[Oxford: Clarendon Press, 1957–67], vol. 3, pp. 233–34). Notwithstanding Diderot's reservations, this view of the Villa Madama is one of the most popular subjects created by Robert in Rome, and it pleased the connoisseur Pierre-Jean Mariette, who commissioned this drawing from the artist and who kept it until his death (a small sketch of this watercolor was drawn by Gabriel de Saint-Aubin in the margins of the auction catalogue of Mariette's collection, *Catalogue raisonné des différents objets* [Paris: Basan, 1775], part of lot 1347; the catalogue with Saint-Aubin's drawings after works from Mariette's collection remains unpublished in the Museum of Fine Arts, Boston [inv. no. 37.1713]). This view of the villa, together with its pendant, a view of a fountain at the Villa Sacchetti (also in the Albertina, Cayeux 1987, p. 35, fig. 21), may well be the two drawings sent to Mariette in Paris, where they were also seen by the Marquis de Marigny, who greatly admired them (letter from Marigny to Natoire, Nov. 20, 1760 in: Montaiglon 1887–1912, vol. 11, pp. 364–65). After Mariette's sale these watercolors were engraved in color by Jean-François Janinet in 1778 (Marcel Roux, *Inventaire du fonds français: graveurs du dix-huitième siècle* [Paris: M. Le Garrec, 1973], vol. 12, p. 74, cat. nos. 173–74).

In addition, Robert based the composition of two paintings on this watercolor; neither oil is dated, but one was shown at the 1767 Salon (both

are in the Hermitage, St. Petersburg; Boulet, Cuzin, and Rosenberg 1990, cat. no. 53, p. 104). Each work differs from this watercolor in minor details, as does a second version of the watercolor, undated but probably executed about the same time (The State Hermitage Museum, St. Petersburg, inv. no. 14307; *L'Ermitage: le dessin d'Europe occidentale* [Leningrad: Editions d'art Aurore, 1981], pl. 89, cat. no. 89). Apparently these four works were preceded by a red chalk drawing that Robert probably drew in the gardens (Besançon, Bibliothèque Municipale, no date; ill. Loukomski and Nolhac 1930, pl. 66).

Under the directorship of Charles-Joseph Natoire students at the French Academy were encouraged to make landscape studies after nature because, in his words: "Around Rome are the most beautiful sites for landscape that one can imagine … ." He received permission from Paris to incorporate the study of landscape into the academy's teaching program (letters dated June 5 and July 10, 1752; Montaiglon 1887–1912, vol. 10, pp. 396–97). The academy's most talented students were still expected to develop their mastery of the human figure, in order that they might paint the historical and mythological compositions that would bring glory and esteem to French art. But the sketching trips Natoire organized with his pupils created a nurturing climate for artists such as Hubert Robert who were instinctively attracted to this subject. [VC]

## 396
## Hubert Robert
### *The Fountain in the Piazza del Campidoglio*

1762
Dated in red chalk, lower center margin: 1762; inscribed on old mount of drawing: *Vue du Capitole à Rome*
Red chalk on white laid paper
13⅛″ × 17⅞″ (335 × 455 mm)
PROVENANCE Julien-Victor Veyrenc (1755–1837); Musée des Beaux-Arts de Valence, France
EXHIBITIONS Paris 1969, cat. no. 21; Washington, D.C. 1978, cat. no. 12
BIBLIOGRAPHY Loukomski and Nolhac 1930, pl. 21; Pietrangeli 1962; Beau 1968, cat. no. 21, fig. 21a; Cayeux 1970, fig. 2; Cayeux 1985, cat. no. 25, p. 137; Cayeux 1989, pl. 4
Musée des Beaux-Arts de Valence, France

The façade of the Palazzo Senatorio, with its fountain and double staircase, dominates the east side of the

396

397

Capitoline Hill, a site occupied since the Middle Ages by the senate. Today it is officially the city hall of Rome. This venerable center of civic life was given its present form about 1536, when Pope Paul III awarded Michelangelo the task of creating an impressive civic complex—a project continued after the artist's death. Michelangelo designed the double-ramp staircase seen here, but the façade of the Palazzo Senatorio was completed after his death by Giacomo della Porta. At the left of the Palazzo Senatorio is the Palazzo dei Conservatori (today a museum of antique art and also a picture gallery), while on the opposite side of the square is the Palazzo Nuovo, which houses the Museo Capitolino, with another collection of antiquities. At the center of the Piazza del Campidoglio is the ancient equestrian statue of the Roman emperor Marcus Aurelius, which reinforces the role of this urban complex as a symbol of the enduring power and majesty of the city.

The present drawing is one of at least eighteen studies known today that Robert made of various aspects of the Piazza del Campidoglio. They permit one, in effect, to move through the square with the artist as he records its buildings and monuments (for references to other views, see Carlson 1978, p. 50; Cayeux 1985, pp. 128–49). Because many of these other drawings are also dated 1762, it appears likely that Robert decided to embark on a plan to record noteworthy views of this celebrated site, just as a year later he spent much time and effort drawing various aspects of the piazza and basilica of St. Peter. These drawings are executed with remarkable assurance and are generally accurate representations of the sites. This view of the façade of the Palazzo Senatorio is a faithful representation of the building; the only liberty Robert took was to

omit the building that stands behind the portico with three arches to the right of this view. A separate study of the portico, dated 1762, shows the higher building in place (Cayeux 1985, cat. no. 26, p. 139). Most of the 1762–63 views were executed using red chalk and a ruler to set down a diagram of the principal elements of the composition. Here Robert first established the diagonals of the staircase and the roofline and the vertical elements of the building's façade. Only after these basic structural relationships were determined did the artist concern himself with creating a more detailed record of his subject, which he did partially through accurate description and partially by the skillful manipulation of light and shade over architecture and sculpture. Robert's careful placement of accents creates a marvelous evocation of the dappled play of light over these buildings, and in this respect the artist's red chalk drawings are studies, not by a topographical draftsman, but by a painter. [vc]

### 397
### Hubert Robert
### *Draftsman in an Italian Church*

1763
Dated in lower-left corner: 1763
Red chalk on white laid paper
13″ × 17⅝″ (329 × 448 mm)
PROVENANCE M. le Vicomte Beuret (his sale, Galerie Georges Petit, Paris, November 25, 1924, lot 19); Charles Ferault (Lugt 2793a); Mrs. W. H. Crocker; Frank Pearls Gallery, Beverly Hills, California; Mr. and Mrs. Eugene Victor Thaw; acquired by The Pierpont Morgan Library, 1981
EXHIBITIONS New York, Cleveland, Chicago, and Ottawa 1975, cat. no. 37; Washington, D.C. 1978, cat. no. 13; New York 1984, cat. no. 74; New York 1989, *Piranesi* (no catalogue); Rome 1990, *Fragonard*, cat. no. 117; Montreal 1993, cat. no. 94

BIBLIOGRAPHY *Le Gaulois Artistique*, May 12, 1928, p. 189; The Pierpont Morgan Library, New York. *Report to the Fellows of the Pierpont Morgan Library*, vol. 20, (1986), p. 294; Roland Michel 1987, p. 77, fig. 65
The Pierpont Morgan Library, New York

Robert's study of a young artist at work, his drawing board casually balanced on the back of a chair, is set in the Roman church of S. Gregorio al Celio, where the student is working from Domenichino's fresco *The Flagellation of St Andrew* in the oratory named after that saint. Another Robert drawing shows three artists at work in the oratory and includes an almost complete view of Domenichino's composition (present location unknown; red chalk, 14⅛″ × 19¾″ [360 × 500 mm], ex-coll. Paul Bureau; Boulet, Cuzin, and Rosenberg 1990, p. 174) Both drawings were probably executed about the same time, since details such as the easel propped against the holy water font and the kneeling bench are found in each work. Both Fragonard and Robert made copies after the paintings and sculptures to be found in the public spaces of Rome.

This drawing is a vivid illustration of one of the most significant aspects of the French Academy's teaching program, which was the copying of celebrated works of art to be found in Rome. During the eleven years Robert was in Italy the names of Raphael, Michelangelo, Reni, Cortona, and Domenichino are frequently cited in the correspondence of the academy's director as models the French pupils should study (Montaiglon 1887–1912, vol. 11, pp. 45, 125, 199, 243, 380). In the article on the French Academy in the *Encylopédie* of Diderot and d'Alembert, the authors comment on the advantages of prolonged exposure to the works of art to be found only in Rome:

The young Frenchmen who intended to study the fine arts had to go to Rome and remain there for a fairly long time. This is where the works of artists like Michelangelo, Vignola, Domenichino, Raphael, and those of the ancient Greeks give silent lessons much superior to those which could be given by our greatest modern masters … For artists, Italy is truly a classical world. Everything there attracts the painter's eye, everything teaches him, everything arouses his attention. Aside from modern statues, what a great number of ancient ones are contained within the walls of magnificent Rome, these ancient statues that, by the exact proportion and the elegant variety of their forms, served as models for

the artists of the recent periods, and must serve as models for all those of all centuries!" (Diderot and d'Alembert 1777–79)

They go on to add: "In Italy, each church is, as it were, a gallery; monasteries, public and private palaces are adorned with paintings" (Diderot and d'Alembert 1777–79).

Robert's drawing illustrates this philosophy of art education as it was put into practice. [vc]

### 398
### Hubert Robert
### *View of the Vaulting in St. Peter's, Taken from an Upper Cornice*

c. 1763
Inscribed in red chalk along the base of the cupola: *ORUM + TV ES PETRUS ET SUPER HANC PE*
Red chalk on off-white laid paper
13⅛″ × 17½″ (335 × 450 mm)
PROVENANCE sold at Sotheby's, New York, January 18, 1984, lot 81; bought at this sale by the Art Gallery of Ontario
EXHIBITION Rome 1990, *Fragonard*, cat. no. 131
BIBLIOGRAPHY "La Chronique des arts" 1985, p. 22, no. 121; Cayeux 1985, p. 172
Collection, Art Gallery of Ontario, Toronto, Purchase

When Robert drew this view of the interior of St. Peter's he positioned himself vertiginously on the wide cornice that runs around the massive vaults that support the huge dome (one of the greatest achievements of Renaissance architecture) looking across the transept and upward toward the cupola. The dome was originally designed by Michelangelo but was subsequently modified during the course of its construction, which continued after Michelangelo's death. It is supported by arches, one of which frames the foreground of this drawing. From the dim recess of this arch Robert's view opens on to the light-flooded void of the transept. Farther in the distance the shadowy recess of the distant arch at the left leads back to the brightly lit apse, where the tip of Bernini's throne of St. Peter is just barely indicated by a few lines. Robert made a separate drawing of Bernini's throne (probably also in 1763); this is one of his few drawings that can be compared to the present work for its highly detailed description of one of the celebrated monuments of Roman art (Musée Marmottan, Paris, inv. no. 4007; red chalk, 15⅜″ × 13⅜″ [390 × 340 mm]; Boulet, Cuzin, and Rosenberg 1990, p. 187, fig. 131b). About this time Robert drew a number of interior and exterior views of

St. Peter's , several of which are dated 1763: *The Colonnade of the Piazza of St. Peter's* (inv. D. 83), *The Peristyle of St. Peter's* (inv. D. 82), and *St. Peter's, Seen from the Peristyle* (inv. D. 84), all in the collection of the Musée des Beaux-Arts, Valence (Cayeux 1985, cat. no. 34, p. 165; cat. no. 36, p. 169; cat. no. 37, p. 171); a view drawn from the floor of the transept, looking upward at the base of the cupola, also dated 1763, is in a private collection in London (Cayeux 1985, p. 172). A large, very highly finished watercolor of pilgrims in St. Peter's is also dated 1763 (Albertina, Vienna, inv. no. 15330; Boulet, Cuzin, and Rosenberg 1990, pp. 187–88). In addition to these dated works there are many other red chalk views of parts of the basilica that, although undated, appear on the basis of their stylistic similarity to have been executed at about this period (several are illustrated in Cayeux 1989, cat. nos. 35, 38, figs. 48, 50).

In this drawing Robert devotes an unusual amount of attention to describing the ornate interior of the basilica: its deeply coffered vaults and lavishly carved cornices and pilasters, as well as the mosaic decoration of the spandrels. However, the most striking aspect of the work is its complex spatial organization, carried out with a daring and assurance rarely found in Robert's work. The drawing is a faithful record of the basilica's architecture, in which the artist has used the progression from dimly lit to light-flooded spaces to suggest the vastness of the interior. In this respect the drawing bears comparison with some of Piranesi's *Vedute di Roma*, such as his *View of the Interior of the Tomb of Santa Costanza* (Wilton-Ely 1994, vol. 1, no. 158), or the *Interior View of the Basilica of St. Peter in the Vatican* (Wilton-Ely 1994, vol. 1, no. 235). Robert could easily have visited Piranesi's workshop, for it was located on the Corso, opposite the French Academy, which at this time was housed in the Palazzo Mancini. The two artists surely must have encountered one another frequently, but only a few contemporary documents record points of contact between them (for a résumé see Carlson 1978, pp. 20–21, and Cayeux 1989, pp. 72–74). Nonetheless it is tempting to speculate that the example of Piranesi's manipulation of light and shadow to suggest the magnificence of Rome's architectural legacy was relevant to Robert when he drew this audacious view of the interior of Rome's best-known building. [VC]

398

## LUIGI SABATELLI

### FLORENCE 1772–1850 MILAN

As in the case of many of his fellow artists, Luigi Sabatelli's career drew impetus from the widespread eighteenth-and nineteenth-century tendency for members of the lower classes to rise in social rank toward the middle class through the profession of art. Sabatelli's father was a small landowner who in an unexpected twist of fortune found employment in Florence with Marchese Pier Roberto Capponi in the palace in Lungarno Guicciardini where Luigi was born. The cultivated and aristocratic marchese launched Sabatelli's career, arranging for him to study at the academy in Florence under the guidance of an artist whose style was formed in Rome, Pietro Pedroni, and sending him to complete his training, first in Rome between 1789 and 1794, and then in Venice between 1795 and 1797. In 1795 Sabatelli presented the marchese with his first original canvas painted in Rome, *The Fight Between Rodomont and the Mad Orlando*, a subject drawn from Ariosto for which he received twenty-five *zecchini* (Paolozzi Strozzi 1978, p. 35, no. 18); the Capponi coat of arms also appears in the dedication of his early masterpiece *The Plague in Florence*, a large engraving of 1801 on a subject taken from Boccaccio. Many of Sabatelli's large pen and ink drawings representing the most famous battles of antiquity (Olson 1997) were in the collection at the

Capponi villa at Varramista, near Pisa, and were probably known to the political and literary figures who gathered around Pier Roberto's son, Gino Capponi, a leading figure in the Italian Risorgimento. In 1830 Sabatelli painted for the younger Capponi *Pier Capponi Tearing up the Iniquitous Statutes of Charles VIII*, a historical subject involving Florentine opposition to French domination in 1498 that would have appealed to contemporary civic pride.

In his autobiography Sabatelli recounted how, in Rome, "he rendered himself very famous among the young students with his compositions in pen and ink," of Greek, Roman, and Hebrew subjects as well as others drawn from Homer, Dante, and Florentine history, so many that he himself could not remember all of them (*Luigi Sabatelli* 1900, p. 26). He also recalled that their sale usefully swelled the pension assigned him by his Florentine benefactor, gaining him around 100 *zecchini* in four years. He attended the private academy of Domenico Corvi (Malamani 1888, vol. 1, p. 32), where he met the young Camuccini, Benvenuti, and Bossi when they shared life-drawing classes (Pietro Ercole Visconti, *Notizie intorno la vita e le opere del barone Vincenzo Camuccini* [Rome, 1845], p. 7; cited in Paolozzi Strozzi 1978, p. 24 ). Corvi helped form some of the masters most representative of Italian art of the early Ottocento, giving his pupils not only a thorough knowledge of anatomy and perspective but also a sense of the

ethical and civic obligations required of true artists. Sabatelli owned some of his master's drawings (from Tommaso Puccini's collection, Gabinetto dei Disegni e Stampe degli Uffizi, 92493, 92495, 92497), which were later misattributed to Sabatelli himself (Paolozzi Stozzi 1978, pp. 23–24, nos. 1–3).

Among the earliest results of Sabatelli's Roman friendships was the commission for *David and Abigail* (1806) procured for him by Benvenuti (in Rome between 1792 and 1804), a pendant to his *Judith* in Arezzo Cathedral. Another of the young artists' meeting places was the Accademia dei Pensieri, later called the Accademia della Pace, centering around Felice Giani and held in the house that artist shared with Michele Köck. This organization acted as a counterbalance to Corvi's academic teaching, encouraging as it did compositional improvisation and an approach to subject matter open to a more modern and European-wide sensibility (Rudolph 1977)—horizons, figuratively speaking, also explored by the Accademia dell'Arcadia under Pizzi and Godard (Dionisotti 1998).

Corvi was a committed Arcadian by 1777, and soon afterward some of his major pupils became members, such as Cicognara (*alias* Teofilo Meliteo) and Bossi (Alcindo Edipeo); others shared the aesthetic ideology of the Arcadians. Also belonging to this same cultural ambience during his sojourn in Rome was the Pistoiese

intellectual and lover of the fine arts Tommaso Puccini, a member of the Arcadians from 1776 as Egone Menalide. Named director of the Uffizi, he returned to Florence the same year as his protégé. On his return to Florence, Sabatelli was commissioned by Puccini to produce a number of exacting pen and ink drawings on classical and modern subjects (Cecilia Mazzi and Carlo Sisi, eds., *Disegni di Luigi Sabatelli della collezione di Tommaso Puccini* [Pistoia, Italy, 1977]). It was Puccini also who encouraged the exploration of themes on the sublime, suggesting to Sabatelli subjects from classical Greek literature tinged with an atmosphere of mystery and gloom that was already fully Romantic, such as *Antenodorus and the Ghost*. Puccini may also have encouraged him toward an appreciation of Drouais's heroic severity, although Sabatelli seems to have paid more attention to Bénigne Gagneraux's revival of Mannerism (Gagneraux's engraving *The Fight of a Raging Bull* was published in the year that Sabatelli arrived in Rome and may have impressed him with its severe and incisive style). Sabatelli shared with Gagneraux an interest in seventeenth-century Bolognese classicism, particularly in the drawings of Guercino.

Between 1801 and 1803 Puccini fled to Palermo, taking with him many pictures from the Florentine galleries in the hope of saving them from the French. Sabatelli continued to maintain contact, and one of his letters concerns the delivery of a picture executed during his stay in Venice, *Rhadamistus and Zenobia* (Museo Civico, Pistoia). This depicts a subject from the past but taken from modern literature (Prosper Jolyot de Crébillon, partly derived from the *Mithridate* of Jean Racine), and in it the artist drew on his knowledge of Rome's monumental statuary—the group of *Paetus and Arria* (now known as the Ludovisi *Gaul and His Wife*)—as well as the lessons of Corvi, as can be seen in the romantic theatricality of the languishing Zenobia, such as in Corvi's *Lucretia* in the still unpublished *Brutus's Oath before Lucretia's Corpse* (known only through a photograph at Naples, Soprintendenza alle Gallerie, catalogued as an anonymous Neoclassical painter). Sabatelli's skilled use of a Venetian–Flemish palette indicates a familiarity with Titian's work and that of Van Dyck.

In Rome during the last decade of the Settecento, the young Sabatelli's fame as an imaginative draftsman with a precocious talent for improvisation (see Hiesinger and Percy 1980, p. 106, no. 95) was disseminated through the publication of the *Pensieri diversi*, engraved after his drawings by Damiano Pernati in 1795. This consisted of twenty-two engravings on various subjects, one after Dante and at least six devoted to the labors of Hercules, including *Hercules Hurling Lichas into the Sea* (a theme also treated by Canova at the same time in a colossal sculpture). The title *Pensieri* was given also to a collection of subjects from Ariosto, but this probably never progressed beyond the project stage, although Sabatelli created numerous compositions based on the most romantic of the Italian national poems, including the *Death of Zerbino*, engraved in Rome by Giovanbattista Romero after a design sent him from Venice in 1796.

On his return to Florence in 1797 Sabatelli began to work in fresco, decorating the Palazzo Gerini with mythological subjects. A series of pen and ink portraits also dates from this period (Uffizi, Florence, and Galleria Nazionale d'Arte Moderna, Rome); in them Sabatelli depicted himself, his wife, artistic and literary friends, and the leading figures of Florentine culture at the turn of the century; one of them is Luigi Lanzi, the author of the *Storia pittorica*, whom he probably met through Tommaso Puccini.

In 1808 Sabatelli became professor of painting at the Accademia di Brera in Milan, where he completed some extraordinary etchings on the theme of the Apocalypse, taking up again with renewed energy the fusion that he had developed in Rome of a measured figural classicism with a thematic *terribilità* and an unbridled pictorial fantasy. He returned to Florence to execute such important commissions as the decoration of the Sala dell'Iliade in Palazzo Pitti (1820–25) and the Tribuna di Galileo (1841), but by this time his career, impelled into the new century, was developing into a different scenario with respect to the poetics and the protagonists of full Romanticism. [SS]

399

## 399
## Luigi Sabatelli
### *The Blind Count Ugolino Groping over the Corpses of His Children*

Verso: various studies of antique fragments
c. 1793
Signed in ink at lower right: *Sabbatelli*
Ink and lead white with traces of pencil on heavy gray paper
11 ¾" × 19" (299 × 481 mm)
Private collection, Rome

An anonymous article in the Florentine *Antologia* of 1827 recorded of Sabatelli that his "mastery of composition and spirited draftsmanship caused him to be regarded as the most Homeric and Dantesque of all modern painters" and that his "first attempts tossed on to paper with a skillful pen are already jealously guarded in the portfolios of art lovers, and ensured his fame right from his earliest youth" (Cecilia Mazzi and Carlo Sisi, eds., *Disegni di Luigi Sabatelli della collezione di Tommaso Puccini* [Pistoia, Italy, 1977], p. 38). This unusually pictorial composition is similar to that in reverse of the etching of the same subject among the *Pensieri diversi*, printed in Rome in 1795 by Damiano Pernati after drawings by Sabatelli then owned by the engraver Giovambattista Romero. A more precise chronological reference—endorsed by the presence on the reverse of studies from the antique evidently done during Sabatelli's stay in Rome (1789–94)—can be given because the little etching, unlike all the others in the collection, which are of larger format, appears to have been done by Sabatelli himself as early as 1793.

The passage from Dante from which the image is drawn reads "Ond'io mi diedi, già cieco a brancolar sovra ciascuno" ("Where I began, already blind, to grope over each one" [*Inferno*, canto 33, pp. 72–73]). In June 1288 Ugolino della Gherardesca, accused of having betrayed Pisa in the struggle between the Guelph and Ghibelline factions, had been imprisoned in the dungeons of the Gualandi tower on the order of the archbishop of Pisa, Ruggieri degli Ubaldini, as were his sons Uguccione and Gaddo and his grandsons Anselmo and Ugolino (Nino); in May 1289 they were all condemned to die of starvation. Ugolino is depicted on the fifth day without food, when he has already seen his family die around him and is now near to death himself. In 1807 Tommaso Puccini wrote the statement basing himself on ideas found in Gravina's *Ragion poetica*, that in order to exercise the most complete effect on the mind of the spectator it is important to distinguish the various steps in a dramatic narrative: "We feel sorry for Ugolino … we weep at the fatal pronouncement … the tears and the pain increase when we hear the children offering themselves as food to their father … but when he is seen now blind, groping over their bodies, when for three days he calls out their names, indignation and revulsion markedly exacerbate the pain, which is now unbounded, immeasurable. In a single picture all [the] episodes unite: if one overshadows the other … [the mind] will be less moved by the sight of the picture than by the graduated expression of the poem" (Tommaso Puccini, "Esame critico dell'opera sulla pittura di Daniele Webb tradotta dall'inglese e commentata da Francesco Pizzetti professore dell'Università di Parma," *Giornale pisano di letteratura, scienze ed arti*, vol. 6 [1807], pp. 182–83). This rule, clearly of Arcadian origin, appears to have been followed by Sabatelli in his very first composition on a subject from Dante, when, around this very theme of Ugolino, he dwelled on different moments of the unfolding drama. In fact he devoted three separate compositions to these moments, from Dante's meeting with the spirit of Ugolino caught in the act of biting the head of Archbishop Ruggieri to the evocation of Gaddo's death, and the touching crisis expressed here.

Interest in the *Divine Comedy* was already widespread in Rome among the more advanced literary circles in the late eighteenth century, and for nationalistic Italian artists the classical poems of Italian literature and their authors (Dante, Boccaccio, Ariosto, and Tasso) were seen as champions of the nation's cultural identity, as could finally be seen in the celebration of Italy's great poets in the Nazarenes' frescoes commissioned by the Marchese Camillo Massimo (1819–27). Gherardo de Rossi wrote about the *Divine Comedy* in 1788, commenting on a painting by Gaspare Landi that was inspired by the story of Paolo and Francesca (*Memorie per le Belle Arti*, August 1788, p. 197), and a second

important moment occurred in 1791 with the publication of the *Divina Commedia … nuovamente corretta spiegata e difesa* by the Conventual Franciscan Baldassarre Lombardi, which was the first modern Roman edition of Dante's poem, up until then officially condemned by the Catholic Church through the Congregazione dell'Indice (Palazzolo 1991). The patrimony of Dante and of the *Divine Comedy*, together with interest in the "primitive" subjects of Homer, Aeschylus, and even Ossian, entered the ambit of the themes favored by a literary and artistic culture inspired by the sublime and generically defined as proto-Romantic. This is the root of an illustrative tradition that runs through to the height of the Romantic era, and two main threads can be distinguished in the iconography of Ugolino: one, more passionate and dramatic, represents Ugolino's desperation, howled out or silent, as he feels the approach of his harsh destiny; the other, to which this work belongs, stresses the tragedy and horror.

For the young Sabatelli, seeking powerfully expressive effects, an encounter with English culture must have been decisive, starting with Fuseli's drawings on a theme from Dante, *Ugolino in the Tower*, dated between 1774 and 1778. Fuseli was the first to adopt the powerful style of Michelangelo as the only one capable of representing the heroic dimension of Dante's language (Pressly 1979, pp. 32–34, nos. 32–33). In addition, Tommaso Puccini had owned a copy of Burke's famous treatise *On the Sublime* since 1774, and Reynolds's *Ugolino* presented at the Royal Academy in 1773 was well known in Rome through numerous engravings (Yates 1951), studied, among others, by Antoine-Jean Gros in his sketchbooks from his 1793–96 stay in Italy. In this drawing Sabatelli quoted Flaxman's outline composition on the same subject (published in Rome in 1793), drawing from it not only the relationship of the figures to the narrow space of their prison, but also the arrangement of the group and, literally, Gaddo's corpse stiff in death, a very modern evocation of elements of early Italian painting which were known in Seroux d'Agincourt's reproductions. The 109 illustrations by Flaxman to the *Divine Comedy* commissioned by Thomas Hope in 1792 appeared in Rome in July 1793 in a limited edition published by the engraver Tommaso Piroli, with a meaningful dedication to the important arts patron and collector Lord Bristol (Irwin 1979, p. 94). The edition was intended as gifts for Hope's friends and thus had a limited circulation, but evidently the twenty-one-year-old Sabatelli made use of a copy. Sabatelli moderated the union

of form and line of Flaxman's graphic style with other sources more specifically Roman and from the seventeenth century, such as pen drawings by Guercino (see the *Raccolta di alcuni disegni del Barberi* [sic] *da Cento detto il Guercino*, etched by Piranesi and Bartolozzi among others, published in Rome in 1764, and dedicated to Thomas Jenkins [Ingamells 1997, p. 554]). In the rendering of Ugolino's face—for example, the deep wrinkles or furrows etched by time and suffering on the forehead and around the vacant eyes of this modern Laocoön—Sabatelli drew on the teaching of his master Domenico Corvi.

Demonstrating the influence of Flaxman's composition are the successive reprises of it in Rome, from Bartolomeo Pinelli's version in 1825 (Mazzocca 1981, fig. 464) to the "purist" example by Tommaso Minardi at a distance of almost forty years: the most admired Italian draftsman of the restoration in 1831 made use of it in a work with qualities both draftsmanly and painterly destined for the Accademia di S. Luca, in which echoes of the examples by both Flaxman and Sabatelli are evident (see *Minardi 1982*, p. 258, no. 130). [SS]

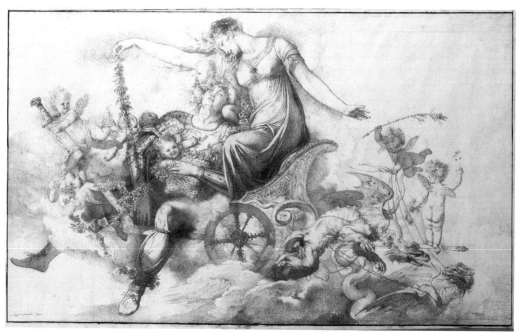

400

## 400
## Luigi Sabatelli
### *Rinaldo and Armida in a Chariot Drawn by Dragons*

c. 1794

Signed in brown ink at lower left: *Luigi Sabatelli fece*

Pen and brown ink, over traces of underdrawing in pencil, on buff paper

19″ × 29⅞″ (482 × 758 mm)

EXHIBITION London, Colnaghi. *Colnaghi: An Exhibition of Master Drawings*. 1999, cat. no. 37

BIBLIOGRAPHY Ongpin, Stephen. *Colnaghi: An Exhibition of Master Drawings*. London: Colnaghi, 1999, no. 37

Private collection, Courtesy Colnaghi, London

The sorceress Armida, after having put to sleep the young Rinaldo with her song, is struck by his beauty and abandons her desire for vengeance: "And, from enemy, she became lover" (Torquato Tasso, *Gerusalemme liberata*, canto 14, stanza 67). She abducts Rinaldo, binds him with a magic garland of woodbines, lilies, and roses ("lente ma tenacissime catene"), places him in her chariot, and carries him off through the heavens to the Fortunate Island (stanza 68), where she attempts to imprison him in her enchanted castle. Although Tasso's poem was a frequent source of inspiration for paintings, this particular episode was rarely depicted, with the notable exception of a work by Guercino (see Andrea Buzzoni, ed., *Torquato Tasso: tra letteratura, musica, teatro e arti figurative* [Bologna, Italy: Nuova Alfa 1985], pp. 272–73). In Guercino's version, painted in 1621 for the ceiling of the

Palazzo Patrizi-Costaguti in Rome, the artist freely interprets the scene in which Rinaldo is lying in the chariot drawn by a pair of dragons, these horrific creatures serving to emphasize the fact that Armida is a sorceress (see Rennsaeler W. Lee, "Ut Pictura Poesis: The Humanistic Theory of Painting," *The Art Bulletin*, vol. 22, [1940], pp. 197–269). In the drawing shown here the young Sabatelli subscribes to a contemporary reawakening of interest in Guercino's work among Roman artists, as is particularly evident in the publication of a group of prints after Guercino's drawings (*Raccolta di alcuni disegni del Barberi* [sic] *da Cento detto il Guercino*, Rome, 1764, with a dedication to Thomas Jenkins; see Ingamells 1997, p. 554) and also in the print of 1776 by Domenico Cunego after the Palazzo Patrizi-Costaguti ceiling, which depicts *The Sleeping Rinaldo Abducted by Armida* (see G. L. Kannes, "Sabatelli, Luigi," in DBI, vol. 31, p. 356). In any case, the most significant source of inspiration for this great pen-and-ink drawing by Sabatelli was surely the print of 1792 by Bénigne Gagneraux of the same subject, in which he reverses the direction of Guercino's composition, as does Sabatelli in his drawing (Laveissière et al. 1983, pp. 147–48, no. 69). Here Rinaldo appears in the same classical pose of a sleeping Endymion, and the vigorous gestures of Guercino's Armida are replaced by a Purist quotation of Guido Reni's Pallavicini *Aurora*, with the sorceress spurring on her monstrous steeds and brandishing her whip like Apollo urging on the horses of the chariot of the sun.

The style and subject matter of this large undated drawing suggest that it was probably executed around 1794 at

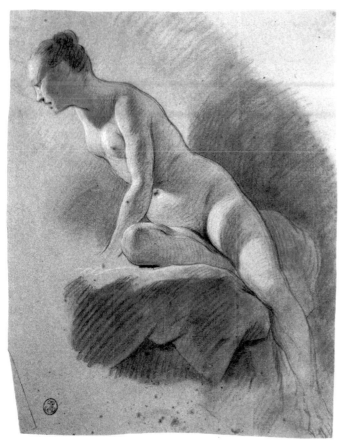

401

the end of Sabatelli's stay in Rome (Ongpin, see above). There is evidence here of Sabatelli's apprenticeship with Domenico Corvi in the foreshortening of Rinaldo's face and in the delicate profile of Armida, whose type of feminine beauty is derived from Corvi, as are the sweet faces and lively gestures of the cherubs that sport around the principal figures in the scene. This same female type would be soon reused by Sabatelli in his *Rhadamistus and Zenobia* (1795; Museo Civico, Pistoia), the first historical subject the artist painted for Tommaso Puccini. However, while Gagneraux looked back to a seventeenth-century precedent in order to arrive at a correct Neoclassical composition in which the figures are organized as if in a bas-relief, Sabatelli illustrates more the sentimental atmosphere of Tasso's poetry, emphasizing Rinaldo's deep sleep, his limbs sprawling, and Armida's passionate emotions, as she holds out her shapely arms ready to clasp them around the object of her desire; the fearful and horrendous dragons, meanwhile, already belong to the vocabulary of Romantic illustration.

This drawing is one of a group of four large works in pen and ink executed by Sabatelli (to which a fifth smaller drawing depicting a battle scene can be added). This group of

drawings can be connected to a sheet illustrating an episode in the *Divine Comedy*, the meeting of Dante with Farinata degli Uberti (*Inferno*, canto 10, 21–123), which has the same dimensions as the drawing discussed here and which was recorded at the beginning of the twentieth century as being at the Villa Capponi at Varramista, near Pisa (Paolozzi Strozzi 1978, p. 32, no. 16). The other drawings, such as this one or *The Abandonment of Armida* (who watches from the Fortunate Island as the ship departs, carrying away Rinaldo and his companions Carlo and Ubaldo, who have been sent by Goffredo di Buglione to bring him home; *Gerusalemme liberata*, canto 16, stanza 59; now in a private collection), illustrate either Tasso's poem or Ariosto's *Orlando furioso*, one significant example being *The Madness of Orlando* (from *Orlando furioso*, canto 23, stanza 134) recently purchased by the Philadelphia Museum of Art. In all probability, the subject of the abovementioned drawing of a battle scene (also in a private collection) will be identified as one of many conflicts described in these two great classic Italian sixteenth-century poems—possibly the fight between Brandimart and Rodomont in *Orlando furioso* (canto 29, stanza 64).

The growing interest of Italians in their great poets—such as Dante (for

example, see also in this exhibition *The Blind Count Ugolino Groping over the Corpses of His Children*; cat. 399), Ariosto, and Tasso—continued to develop apace with the literary culture of the Arcadian academy, in the ambience of which appeared the 1785 *Vita di Torquato Tasso* by Pier Antonio Serassi (who had the Arcadian *alias* Desippo Focense). Published in two volumes by the Stamperia Pagliarini, this was the first biography of the poet to be written in modern historiographical form. The popularity at the time of Ariosto's poem is evident from the painted decoration by Giuseppe Cades in the Palazzo Chigi at Ariccia (see Caracciolo 1977; Caracciolo 1992, pp. 310–14, no. 104), commissioned by Sigismondo Chigi (*alias* Astridio Dafnitico) for a didactic decorative context reflecting the up-to-date literary tastes of the prince, who was one of the major figures in Arcadian circles in late eighteenth-century Rome. [SS]

## PIERRE SUBLEYRAS
SAINT-GILLES-DU-GARD
1699–1749 ROME
*For biography see Paintings section*

### 401
Pierre Subleyras
*Study of a Young Woman Kneeling on a Bed for "Cupid and Psyche"*

1732
Charcoal and stumping, with white highlights, on blue paper
18½" × 14⅞" (470 × 376 mm) (irregular)
PROVENANCE collection of the Comte d'Orsay (1748–1809; his stamp Lugt 2239, below left); entered the Louvre in 1793
EXHIBITIONS Paris 1983, cat. no. 86; Paris and Rome 1987, cat. no. 6
BIBLIOGRAPHY Michel and Rosenberg 1987, pp. 12, 69, 152–53
Musée du Louvre, Paris, Département des Arts Graphiques

Correspondence with the director of the French Academy at Rome, the painter Nicolas Vleughels, to the Duc d'Antin, Surintendant des Bâtiments du Roi, reveals that on March 5, 1732, Subleyras had just "completed an overdoor panel" which was intended for the decoration of one of the "chambers" of the academy. The *Memorie per le Belle Arti* notes also that the subject of the panel was *Cupid and Psyche* ("Vita di Pietro Subleyras," *Memorie per le Belle Arti*, February 1786, p. 25).

The Palazzo Mancini, situated on the Corso (now the Banco di Sicilia), was sacked in 1793, during anti-French and anti-revolutionary riots. By some miracle Subleyras's painting survived. It was rediscovered in 1975 and shown

in 1986 in Brussels (Galerie d'Arenberg, *Peintures et sculptures de maîtres anciens*, cat. no. 8). Today it is in a private collection in Brussels—a small-scale copy (14⅞" × 18⅞" [380 × 480 mm]), with a pendant of *Venus and Cupid* was put up for sale by auction in Lyon, March 18, 1995 (no. 113 in the catalogue, as "Venetian School, 18th century") and in Limoges on June 18 of the same year (as "French school, 18th century"). The drawing in the Louvre is the study for the figure of Psyche, which appears, little changed, on the right of the painted composition, watching the sleeping Cupid with a rapt expression.

By 1732 Subleyras had been in Rome for four years. He was considered one of the academy's most promising students. With the rediscovery of this *Cupid and Psyche* it became possible not only to attribute the drawing in the Louvre (hitherto by an unknown hand) to Subleyras, but also to form a precise idea of the artist's graphic style at that time. He defines the outline of the model's body and indicates areas of shade by skillful use of chalk and stump. It is interesting to note that Subleyras draws directly from the female nude, a practice outlawed in Rome during this period, but one that he refused to give up: indeed, one of his finest works is the glorious *Female Nude Seen from Behind* (Michel and Rosenberg 1987, no. 59, pl. VII) now in the Palazzo Barberini. [PR]

## FRANCESCO TREVISANI
CAPODISTRIA 1656–1746 ROME
*For biography see Paintings section*

### 402
Francesco Trevisani
*Self-portrait*

c. 1720
Inscribed: *FRANCISCVS TREVISANVS PICTOR NATVS TREVIGI/ ANNO SALVTIS MDCLVI./ HONESTE VIVIT ET FLORESCIT*; numbered at lower right in pen and brown ink: 67 and 2282
Black and white chalk on tan prepared paper
14⅜" × 10¼" (365 × 260 mm)
PROVENANCE as for cat. 338
BIBLIOGRAPHY Pio [1724] 1977, p. 38; Mariette 1851–60, vol. 5, p. 348; Clark 1967, "Portraits," p. 14, no. 44, pl. 9; DiFederico 1977, pp. 29, 72, no. 3; Bjurström 1995, p. 188, no. 144
Nationalmuseum, Stockholm

*For commentary see cat. 338.*

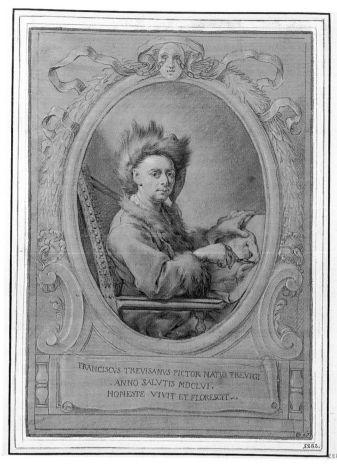

FRANCISCVS TREVISANVS PICTOR NATVS TREVIGI
ANNO SALVTIS MDCLVI,
HONESTE VIVIT ET FLORESCIT

402

## PIERRE-HENRI DE VALENCIENNES

### TOULOUSE 1750–1819 PARIS

Until recently the biography of Pierre-Henri de Valenciennes was poorly established. In spite of Robert Mesuret's attempts to reconstruct the life of the painter, facts about his life were often marred by fiction (Mesuret 1956). In the catalogue of the most recent exhibition devoted to the artist, Geneviève Lacambre has written the definitive biography of Valenciennes (Mantura and Lacambre 1996).

Pierre-Henri de Valenciennes was born on December 6, 1750. His father was a wigmaker who had moved from Paris and married in Toulouse the daughter of a local confectioner. Little is known of Pierre-Henri's early training at the Académie Royale de Peinture de Toulouse, where Jean-Baptiste Despax, a history painter, and Guillaume-Gabriel Bouton, a miniaturist, were teaching at the time. Better known is the fact that in 1769 his young sponsor and future collector, Mathias Marie Armand Pierre Dubourg, took him to Italy. Upon his return, Valenciennes spent some time in the Loire valley, where he had relatives and where he may have met Hubert Robert in the entourage of the Duc de Choiseul at Chanteloup. On Choiseul's

recommendation Valenciennes began apprenticing in 1771 to the history painter Gabriel François Doyen in Paris. On the basis of several inscribed drawings, it can also be suggested that the artist traveled in the south of France and in Brittany, but the date of these drawings is somewhat uncertain (*French Painting* 1974, p. 627).

Six years later, in 1777, Valenciennes left Paris for Italy, arriving in Rome on October 10. With the exception of a visit to France in 1781 (documented in a sketchbook, Musée du Louvre, Département des arts graphiques, RF 12970), Valenciennes remained in Italy until 1784–85. The importance of those seven years in the formation of his style were crucial and justify the inclusion of the artist in this exhibition, even though his own within the Roman milieu seems to have remained marginal (in contrast with artists such as Jacques Sablet, who became part of the cultural fabric of Rome at the time). In Rome, Valenciennes studied perspective thoroughly under the guidance of a mathematician, and obviously learned as well from such painters of architecture as Panini. The most original part of his œuvre at the time may be the hundreds of oil sketches painted out of doors that were rediscovered in the 1930s, when the Princess Louise de Croÿ gave them

to the Musée du Louvre. Hailed, because of their freshness and spontaneous execution, as prefiguring the achievements of the Impressionist artists, they exemplify nonetheless a very different aesthetic, in which the sketch is conceived purely as a step toward a highly finished painting.

While Valenciennes began exhibiting his work in France—particularly in Toulouse during his stay in Rome—there is no evidence of exhibitions of his paintings in Rome at the same time. In Rome, like many foreign artists since the seventeenth century, Valenciennes lived first on via del Babuino, and later near the Pantheon. Some of the artist's travels in Italy are documented: south of Rome, to Naples and Sicily in 1779, where he visited Messina and Palermo among other places, and possibly also some areas north of Rome. During his formative years and shortly after his return to France, Valenciennes was encouraged by such artists as the landscape painter Joseph Vernet whom he had met during his visit to Paris in 1781, and to whom he acknowledged his debt for having perfected, in one lesson, his understanding of perspective, and Pierre-Antoine de Machy, known essentially for his architectural fantasies in the style of Panini. The fusion of these influences defines to a great extent the style of Valenciennes, whose fresh and naturalistic observations, drawn or sketched out of doors, are later reworked and orchestrated in majestic compositions in which painted architectures play an important role. Although fairly brief in comparison with other French artists, Valenciennes's Roman experience was crucial to the rest of his career and, by extension, to the development of French landscape painting in the nineteenth century (see Peter Galassi, *Corot in Italy: Open-Air Painting and the Classical-Landscape Tradition* [New Haven and London: Yale University Press, 1991], chapter 1).

On his return to France, and his acceptance to the Académie Royale de Peinture et de Sculpture, Valenciennes led a successful career. The critics hailed him as the restorer of the grand landscape style of the seventeenth century, the *paysage historique*, exemplified by both Poussin and Claude. He received a studio and lodging at the Louvre in 1787, the year he was made an honorary associate of the Académie Royale de Peinture de Toulouse. His submissions to the Salons were numerous, even during the revolution, which he spent mostly away from Paris, and were well received (Heim, Béraud, and Heim 1989). His love for Italy manifested itself in 1798, when he signed a petition to protest the spoliation of the Roman churches and palaces to the profit of the Paris

museum. Valenciennes's importance as a theoretician took place also at the end of the revolutionary period, with the publication of his *Elémens de perspective pratique à l'usage des artistes, suivis de réflexions et conseils à un élève sur la peinture* (1800), written in collaboration with Simon Céléstin Croze-Magnan. The second part of the book is an eloquent, and almost polemic, defense of landscape painting—more precisely of idealized historical landscape, a genre to be considered on a par with history painting. In 1816 Valenciennes's lifelong desire to see landscape painting recognized officially was fulfilled by the establishment of a *prix de Rome* for landscape painting. Valenciennes's most notable pupils were Jean-Victor Bertin and Achille-Etna Michallon, the winner of the first *prix de Rome* for landscape, but the list of his students should also include Pierre Prevost, Pierre-Athanase Chauvin, and Jean-Baptiste Desperthes. That many of his pupils are known today mostly for their spirited sketches is owing to Valenciennes's original teaching, which gave oil sketches a crucial and innovative role in academic training. In the context of this exhibition, Valenciennes's work exemplifies the achievements of a supremely gifted artist whose contribution to the European painting tradition would not have been possible without the freedom inspired by his formative years in Rome. [JPM]

BIBLIOGRAPHY Mesuret 1956; Mantura and Lacambre 1996

## 403

## Pierre-Henri de Valenciennes

### *Rocca di Papa in the Mist*

1782–85

Oil on paper, mounted on cardboard
5⅝″ × 11⅝″ (144 × 297 mm)

PROVENANCE Princesse Louise de Croÿ; Musée du Louvre, Paris

EXHIBITION Washington, D.C., National Gallery of Art; Brooklyn, Brooklyn Museum; St. Louis, Mo., St. Louis Art Museum. *In the Light of Italy: Corot and Early Open-Air Painting.* 1996–97, cat. no. 21

BIBLIOGRAPHY Mantura and Lacambre 1996, pp. 87, 108

Musée du Louvre, Paris, Département des Peintures

For the modern viewer this rapid sketch capturing the mist over Monte Cavo, one of the Alban Hills, overlooking the ancient village of Rocca di Papa (about fifteen miles from Rome), has the striking appearance of abstract painting. Executed before Constable's cloud studies and Turner's misty landscapes, it justifies the surprise felt by the rediscovery in 1930 of

403

Valenciennes's oil sketches at the time of their acquisition by the Louvre. Yet the sketch—one of two executed within minutes from one another (Philip Conisbee et al., *In the Light of Italy: Corot and Open-air Painting* [Washington, D.C.: National Gallery of Art; New Haven and London: Yale University Press, 1996], no. 22)—should be considered in its own right.

Valenciennes often painted the site of Monte Cavo under different skies. Other studies at the Louvre show the mount bathed in a gold, afternoon light (RF 2989; see Mantura and Lacambre 1996, no. 41), or again under a cloudy sky (RF 3025; see Mantura and Lacambre 1996 , no. 42). Most of these studies concentrate essentially on the sky and clouds either above the mountain or shrouding it. As noted by Jeremy Strick in the Washington catalogue: "The clouds in these paintings do not appear simply as a mask, covering over the solid form of the mountain, but rather as entities possessed of density and gravity" (Philip Conisbee et al., p. 133, see above). It is astonishing to realize that such accomplished painting was not intended for public viewing, and was merely a study or sketch. How it found its use and development in more ambitious paintings can be seen for instance in Valenciennes's *Landscape with Dido and Aeneas Seeking Refuge in a Cave During a Storm* (1792; Musée des Beaux-Arts, Poitiers; see Mantura and Lacambre 1996, no. 63, p. 108), in which the stormy sky is painted with realistic density more terrifying and infinitely more realistic than the stormiest skies of Valenciennes's model, Joseph Vernet. [JPM]

## 404
## Pierre-Henri de Valenciennes
### *View of the Colosseum*

1782–85
Oil on paper, mounted on cardboard
10⅛″ × 15″ (255 × 381 mm)
PROVENANCE Princesse Louise de Croÿ; Musée du Louvre, Paris
EXHIBITION Washington, D.C., National Gallery of Art; Brooklyn, Brooklyn Museum; St. Louis, Mo., St. Louis Art Museum. *In the Light of Italy: Corot and Early Open-Air Painting.* 1996–97, cat. no. 14 Musée du Louvre, Paris, Département des Peintures

The view, taken from the Palatine, shows the Sabine Hills in the distance. The ingenious cropping of the composition, the fresh execution, and above all the vast expanse devoted to the sky—in fact half of the composition—as well as the bold, dark triangle to the foreground, contribute to the original rendition of one of the most represented Roman ruins. As in all of his oil sketches, Valenciennes relinquishes here his concern for precise rendering of architecture—one of his main areas of study in Rome—in order to achieve a more spirited work. The attention to the depiction of the fine morning light makes particularly vivid the delicate contrasts between dark and light areas. Valenciennes's originality in this small sketch can be fully grasped by comparing it with the traditional representations of the Colosseum, both by his predecessors and followers. The artist occasionally wrote on the nostalgic effect a ruin can trigger in the viewer.

Here, however, by representing a ruin in a manner that is neither topographical nor woeful, Valenciennes avoids any sentimentality in its depiction: as a result the sketch achieves a truly exceptional immediacy. [JPM]

## RICHARD WILSON
PENEGOES, WALES 1713?–1782
COLOMENDY, WALES

Of the many British painters who traveled to Rome in the mid-eighteenth century to further their education—including Alexander Cozens, Jonathan Skelton, Thomas Patch, Joshua Reynolds, and Allan Ramsay—Richard Wilson may well be the one whose career was most profoundly affected by the trip. In the course of his 1750 to 1756/57 stay in Italy, during which he lived primarily in Rome, Wilson decided to change from specializing in portraiture to landscape painting. Although he ended his life in poverty and obscurity, modern critical assessment of his œuvre ranks him as the most important British landscape painter of the eighteenth century (Solkin 1978, vol. 1, p. 2); as the first native-born British painter of historical landscapes (Bruce Robertson, "In at the Birth of British Historical Landscape Painting," *Turner Studies*, vol. 4, no. 1 [1984], p. 44); and as the artist who, with Gainsborough, "took Landscape out of the hands of dreary topographers and invested it with poetry" (*British Painting in the Eighteenth Century* [London: British Council, 1957], p. 22). That Wilson "painted Italy as no Italian artist ever painted her is owing to a fusion of the primitive Celtic melancholy with a

profound sympathy for the classical spirit" (Bury 1947, p. 58).

Richard Wilson was born probably in 1713 (Bury 1947, p. 13, n. 1; Constable 1953, p. 15), the son of a rector. His family was well connected, and he received a good classical education. At about age sixteen he was apprenticed to a little-known portrait painter named Thomas Wright in London, and by the 1740s he had established himself there as a portraitist and had also produced some landscapes. When he was thirty-seven he left England for Italy; by fall of 1750 he had arrived in Venice, where he stayed for about a year, and where he found an esteemed patron in the well-known British consul and collector Joseph Smith (Bury 1947, p. 17). During this time the Italian landscape painter Francesco Zuccarelli may have encouraged Wilson to concentrate on that genre (in later years, after Wilson's return to England, his style was compared unfavorably to Zuccarelli's and judged to be less to the English taste than the "lighter" manner of the Italian).

By January 13, 1752, Wilson was resident in Rome (Ford 1951, p. 158), having traveled from Venice in the company of a young connoisseur and future collector, William Lock, and the soon-to-be notorious Thomas Jenkins, a painter, dealer, antiquary, and cicerone, who during his long residence in the city (until just before his death in 1798) became one of the most powerful figures in Roman art and antiquarian circles. Wilson shared lodgings in the Piazza di Spagna with Jenkins in 1752–53 (Ingamells 1997, p. 553). He quickly became acquainted with important members of the Roman art world—such as Anton

404

405

Raphael Mengs and Cardinal Albani—and was commissioned by English or Irish patrons (including Joseph Henry; see cat. 354) to paint the type of picture for which he subsequently became famous: views of Rome and landscapes with subjects from classical history or literature.

Every writer on Wilson emphasizes how profoundly the artist was affected by the works of his great seventeenth-century French predecessors in the classical landscape tradition, Claude Lorrain and Gaspard Dughet, whose paintings were enthusiastically collected in England throughout the eighteenth century (John Hayes, "British Patrons and Landscape Painting," *Apollo*, n.s., vol. 82 [1965], pp. 38–45; vol. 83 [1966], pp. 188–97, and pp. 444–51; vol. 85 [1967], pp. 254–59; vol. 86 [1967], pp. 358–65). Wilson drew on these sources both in structuring his compositions and in creating effects of light and space (his remark about his preferences in this respect is often quoted: "Why, sir, Claude for air and Gaspar for composition and sentiment; you may walk in Claude's pictures and count the miles"; see Sutton 1968, p. 14). Like Claude and Dughet, Wilson went out to draw in the Roman Campagna, and his studies of famous sites in the countryside around Rome—Tivoli, Genzano, Castel Gandolfo, Ariccia, Lake Nemi, and Lake Albano, places often laden with associations with classical antiquity—provided him with material for paintings for the rest of his career.

Back in London by summer or fall of 1757 (Constable 1953, pp. 37–38; Solkin 1978, vol. 1, p. 24, n. 33; Ingamells 1997, p. 1008), Wilson enjoyed considerable success during the 1760s for his Italian views, his historical landscapes, and his depictions of country seats in England and Wales. His pupils (he had also had several in Rome) included the accomplished landscapist Thomas Jones. He was a founding member of the Incorporated Society of Artists in 1759 and of the Royal

Academy in 1768. By the early 1770s, however, both his career and his health seem to have precipitously declined, and in 1776 he was offered a sinecure as librarian to the Royal Academy. He apparently was painting very little, and in 1781 he returned to Wales to live with relatives. He died at Colomendy, Denbighshire, in 1782 (Bury 1947, p. 34; Constable 1953, p. 60).

Although he did not end his career as a successful or influential artist, Wilson did play a profound role in the development of British landscape painting: "By quoting from those classical masters whom Englishmen had come to identify with the antique world, he succeeded in enhancing the symbolic value of his chosen subjects, in elevating them through a comparison with the meaningful landscape of Italy. Earlier painters had made similar efforts to marry British places with Italian designs; Wilson, however, was the first to give this synthesis convincing artistic power and marked intellectual force" (Solkin 1978, vol. 1, p. 194). When he was at his best painting his beautiful native Welsh landscape, according to one critic, "nothing in English [*sic*] landscape painting in the eighteenth century was tougher or more original" (Richard Dorment, *British Painting in the Philadelphia Museum of Art: From the Seventeenth through the Nineteenth Century* [Philadelphia: Philadelphia Museum of Art, 1986], p. 417). [AP]

## 405
## Richard Wilson
### *The Circus of Flora, Rome, with an Artist Sketching in the Foreground*

1754
Signed and dated in black lead at lower left of original mount: *R. W. f. Romae 1754*; numbered in black lead at lower right of original mount: *No. 8*; inscribed in brown ink on label superimposed at lower center on original mount: *Circus/ of/ Flora*; numbered in black lead on verso of original mount: *51*
Pencil, black chalk with some stumping, heightened with white chalk on gray paper
11″ × 16⅝″ (280 × 424 mm)
PROVENANCE  William Legge, 2nd Earl of Dartmouth; by descent to the 7th Earl of Dartmouth; P. & D. Colnaghi & Co. Ltd., 1973; purchased by the Norfolk Museums Service, 1974
EXHIBITIONS  Birmingham 1948, cat. no. 77; London 1949, cat. no. 76; London, P. & D. Colnaghi & Co. Ltd. *Exhibition of English Drawings, Watercolours, and Paintings*. 1973, cat. no. 84; London 1974, cat. no. 23; Louisville, Kentucky, J. B. Speed Art Museum. *British Watercolours: A Golden Age, 1750–1850*. 1977, cat. no. 4; Munich, Haus der Kunst München. *Zwei Jahrhunderte englische Malerei: Britische Kunst und Europa 1680 bis 1880*. 1979–80, cat. no. 93 (as the Circus Maximus); London 1982, *Wilson*, cat. no. 45
BIBLIOGRAPHY  Ford 1948, p. 345, no. 8; Ford 1951, p. 59, no. 54; Brown 1983, p. 290
Norfolk Museums Service (Norwich Castle Museum)

This broad and serene view of a little-known ancient Roman circus is part of Richard Wilson's most important series of drawings, a group of approximately sixty-eight Italian landscapes (most of which are lost today) that were commissioned in Rome—probably in 1752 and very likely through the agency of Thomas Jenkins—by William Legge, 2nd Earl of Dartmouth. The drawings were mentioned as early as June 1, 1754,

in a letter from Jenkins to Lord Dartmouth, and were seen and admired several times in the Dartmouth collection at Blackheath during the first decade of the nineteenth century; subsequently, they disappeared from sight until 1948, when twenty-five of them were rediscovered in a cupboard at Patshull House by Lady Dartmouth (Ford 1948, pp. 337–38, 341). Nineteen of the twenty-five—views of Rome—probably belong to the group of twenty works referred to by Jenkins in his June 1754 letter as being in progress. Most of them bear the date 1754.

These beautifully composed and highly finished drawings include a number of famous sites in and around Rome, such as the Baths of Diocletian, the Temple of Minerva Medica, the Villa Borghese, the Vatican, the via Nomentana, the Capuchin convent at Genzano, and Castel Gandolfo. They are drawn in black chalk with stumping on grayish paper and are heightened with white; this technique, which plays off the lighter and darker chalks against the middle tone of the paper, was a new one for Wilson, which he may have learned from French artists in Rome (such as Louis-Gabriel Blanchet), and was intended to produce a wider range of tonal gradations than he had achieved previously using red or black chalk on white paper. Scholars disagree as to whether these views were drawn entirely in the studio or were sketched on site and completed indoors (Ford 1948, p. 342; Solkin 1978, "Wilson," pp. 404–6; Brown 1983, p. 291); whatever the process, they have an amplitude, a serenity, and a degree of finish that has led them to be regarded almost as highly as the artist's paintings, and they are certainly the best-known of his works on paper.

Draftsmanship was not an essential element of Wilson's artistic makeup, and he did not produce many drawings except during his Italian years. Italy

seems to have been the catalyst that induced him to set down on paper numerous studies of temples, trees, ruins, plants, still lifes, people, fragments of antique architecture, pieces of ancient sculpture, and landscapes, both fictive and real. These would serve him as the basis for many of his paintings for the rest of his career. He left two sketchbooks—dated 1752 and 1754—from his busy and productive years in Rome, one now in the Victoria and Albert Museum in London, and the other at the Yale Center for British Art in New Haven (see Solkin 1982, nos. 21, 39; Sutton 1968).

This view, which may have been labeled "Circus of Flora" by the artist himself, continues to be thus identified, although when it was shown in Munich in 1979–80 it was called the Circus Maximus. Solkin describes the no longer extant Circus of Flora as located near the Porta Salaria at the northeast corner of the old city of Rome, with Wilson's view having been taken looking past the now destroyed Villa Cesi toward St. Peter's in the distance (Solkin 1982, p. 169). [AP]

406

## GASPAR VAN WITTEL (GASPARE VANVITELLI)

AMERSFOORT 1652/53–1736 ROME
*For biography see Paintings section*

## 406
## Gaspar van Wittel (Gaspare Vanvitelli)
### View of Marino

Verso: sketch of a palace and houses (black chalk, pen and ink)
1690–1710
Pen and ink, gray wash heightened with white, on blue paper
11¾″ × 16½″ (298 × 418 mm)
PROVENANCE  Abate Angelo Masseangeli: gift to the Museo Nazionale di San Martino, Naples, 1873
EXHIBITIONS  Ottawa 1977, cat. no. 42; Gaeta 1980, cat. no. 42; Rome 1990, cat. no. VI
BIBLIOGRAPHY  Briganti 1966, p. 303, no. 122; Briganti 1972, p. 15, fig. 4; Calabrese 1980, p. 294, no. 32; Briganti 1996, no. D255
Museo Nazionale di San Martino, Naples

Nearly a third of the elder Van Wittel's graphic production consisted of ideal italianate views in the landscape tradition of the previous century, yet it is unquestionably his topographical drawings of cities—Rome, Naples, Venice—and of smaller Italian towns that today hold the greatest appeal. His representations of hill towns in the Roman Campagna are, as often as not, widespread profile views situating them in a larger panorama surrounded with distant mountains or plains extending toward the sea. In fact, this concentrated study of Marino, typically seen from an unconventional vantage point and carefully respecting rules of perspective, served for a much wider painted composition showing the town, situated on the north shore of Lake Albano, as seen from the terrace of the recently constructed Villa Belpoggio, higher up the slope to the left. The painting and its pendant of Genazanno (Briganti 1996, nos. 215, 227), recorded in the Colonna collection since the inventory drawn up at the death of the Connestabile Filippo II in 1714, are unique views and presumably were commissions meant to depict Colonna strongholds in the area surrounding Rome from the time the Colonna pope, Martin V, was elected in 1417.

During the early sixteenth century Marino suffered damage in the conflict between papal and imperial troops and was ravaged by the plague some years later; after which Colonna vassals from the Abruzzi region were imported to increase the population. Already under Marcantonio II Colonna, hero of the Battle of Lepanto, plans by Antonio Sangallo the Younger to rebuild and transform the former Orsini castle into a palace were carried out. It is possible that the pen sketch on the verso of this sheet represents one of the façades of the palace (the one to the west, with its bell tower forming the axis of via Nuova, has similar articulation but would appear to have three windows to the left of the central bay, and the double stair leading up to the door is lacking: see *Marino* 1981, figs. 9, 12). In the drawing on the recto it is the north façade that is visible beyond the basilica of S. Barnaba. Between the bell tower and octagonal drum of this church, erected 1640–43, the square medieval tower situated behind the palace in Piazza Maggiore can be glimpsed.

Another view of Marino, originally from the Colonna collection, bears the date 1719 and is today in the Uffizi (Briganti 1996, no. 213, with an undated replica still in the Colonna collection, no. 214). Taken from the lower vantage point of the Villa Colonna Bevilacqua (destroyed in World War II), it looks back up at the town with the façades of S. Barnaba and Palazzo Colonna at the far end, and with Monte Cavo in the distance. A preparatory drawing for that second view is somewhat larger and more comprehensive except in the foreground detail and makes more liberal use of wash to indicate the park between the town and the villa that must have existed at the time (Briganti 1996, no. D329), whereas in this dense delineation of buildings the artist essentially limits himself to pen and ink, with diluted wash used only sparingly to indicate shadow on the church roof and eastern façades of the houses and to modulate the plain stretching toward the Mediterranean, while a stronger wash is applied to the olive trees in the foreground. [CJ]

## 407
## Gaspar van Wittel (Gaspare Vanvitelli)
### View of Tivoli

Verso: sketches in red chalk on paper
1690–1710
Inscribed in ink by the artist: *komt roock uyt vande Wa:wal; paese di Tivoli* and *Muro bianco* ("smoke [vapour] rises from the waterfall")
Red chalk, pen and ink with gray wash on paper
11½″ × 17⅜″ (290 × 442 mm)
PROVENANCE  Abate Angelo Masseangeli: gift to the Museo Nazionale di S. Martino, Naples, 1873
EXHIBITIONS  Rome 1969, cat. no. 39; Ottawa 1977, cat. no. 45; Gaeta 1980, cat. no. 45
BIBLIOGRAPHY  Lorenzetti 1934, pp. 27, 43, no. 9, fig. 6; Briganti 1966, p. 302, no. 109d; Chiarini 1972, p. 67, no. 124; Briganti 1996, no. D242
Museo Nazionale di San Martino, Naples

Since the late republican era, Tivoli, with its shady valleys, refreshing breezes, and monumental waterfalls, has been a favorite retreat from the heat of Rome. It was especially valued by the literary circle of Horace, Virgil, and Catullus, who gathered there around their patron, Maecenas. In the mid-sixteenth century, Cardinal Ippolito d'Este revived interest in Tivoli, fashioning a sumptuous villa out of an old Benedictine convent and creating formal gardens with cascading fountains fed by the River Aniene. In the seventeenth century an artist of the classical landscape tradition,

407

Claude Lorrain, made drawings of its environs and even incorporated motifs from Tivoli in some of his paintings. With the development of plein air painting over the next two centuries and a growing interest in the "sublime," the Temple of Vesta (or of the Sybil, as it was known then) became possibly the most represented ruin of Roman antiquity. The attraction for Van Wittel was also strong, inspiring him to make no fewer than eight different views of Tivoli, and their popularity was such that of one of these views twelve autograph versions are known. It would appear also that Van Wittel chose as his reception piece, on being admitted to the Accademia di S. Luca in 1711, a pair of pictures including a view of the Aniene river above the the falls at Tivoli (Briganti 1996, no. 265).

The drawing relates to a unique panoramic view only recently come to light, which has no historic provenance but, stylistically, belongs fairly late in the artist's career (Briganti 1996, no. 248). Seen from the opposite bank of the Aniene, it shows the Grande Cascata, or large waterfall, with the town to the right and Monte Catillo rising at the left. Two other studies made on the spot, originally in the large collection of Van Wittel drawings that belonged to the sculptor Bartolomeo Cavaceppi (now in London and Washington; Briganti 1996, nos. D171, D129), display the same rich combination of media and appear to be related to a similar and exceptionally large view, also recently discovered (Briganti 1996, no. 247), where the vantage point is both lower and farther to the right than in the wider panorama; the eye is thus directed at the spur of land between the two bridges and at the upper falls which occur between it and the Temple of Vesta, silhouetted at the upper right. Here, instead, with a raised viewpoint from farther to the left, the upper falls are hidden and the temple no longer appears to be on the edge of a precipice.

Another drawing of Tivoli in the Museo di S. Martino looking westward toward the smaller waterfalls, has recently been related to a painting formerly in the Colonna collection (Briganti 1996, p. 267, no. D257), but exceeds it in size, suggesting that a larger version of the painting once existed. While most of the drawings of Tivoli are clearly preparatory studies, a large sheet at Chatsworth, Derbyshire, which includes the so-called villa of Maecenas, seen broadside from the opposite bank, and based on a less finished drawing of similar dimensions, is of a refinement and degree of finish, with two artists placed in the foreground right, to suggest that it was made as an end in itself. [CJ]

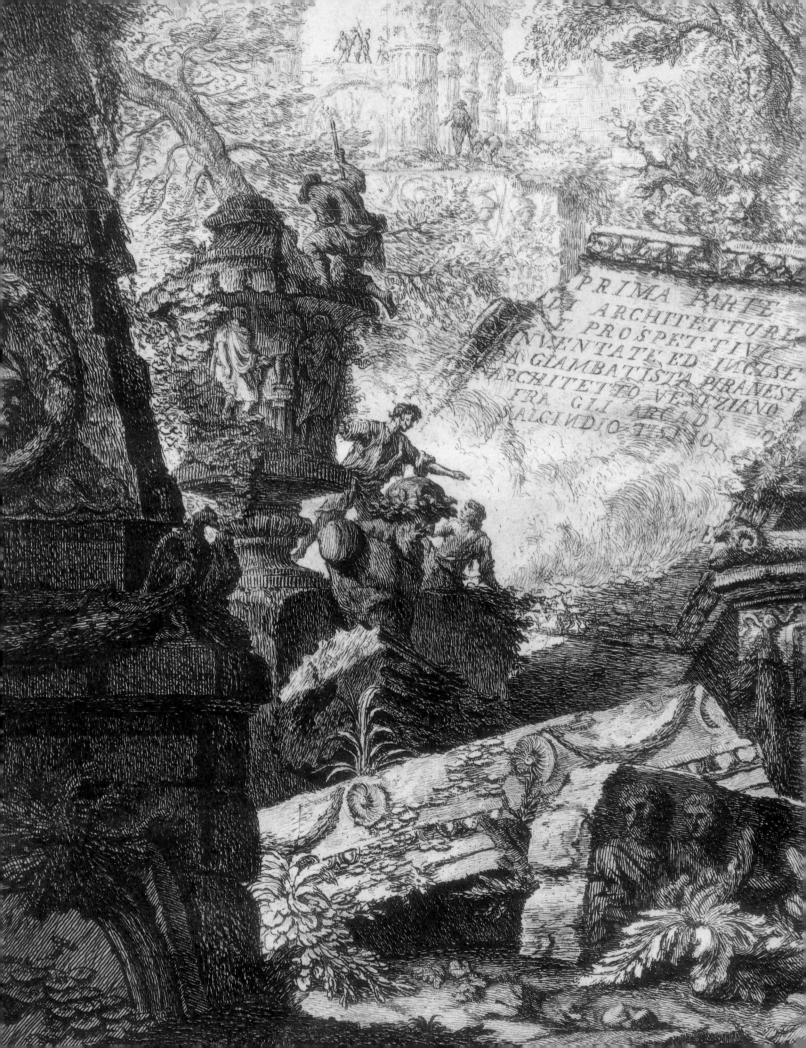

PRIMA PARTE
DI ARCHITETTURE
E PROSPETTIVE
INVENTATE ED INCISE
DA GIAMBATISTA PIRANESI
ARCHITETTO VENEZIANO
FRA GLI ARCADI
SALCINDIO TISEIO

# Piranesi and Innovation in Eighteenth-Century Roman Printmaking

## MALCOLM CAMPBELL

In art, as in politics and philosophy, it is generally acknowledged that the eighteenth century, and especially the late eighteenth century, was a period marked by profound breaches with the past. In a modest but decisive way the art of printmaking in Rome participated in and reflected the changes effected in the grander domains of the arts of painting, sculpture, and architecture. The artist most responsible for changing the practice of printmaking in Rome from a process for producing multiple copies of an image to a truly fine art was the Venetian Giovanni Battista Piranesi.[1] Whereas the vast majority of printmakers in Rome were essentially technicians whose primary task was the transfer of a drawing, usually prepared by someone else, on to a copper plate, a medium that would permit the printing of multiple reproductions, Piranesi controlled the entire process from initial design to execution of the prints. He created the preparatory and composition drawings (which in his case tended to be sketches rather than highly finished works) and transferred these compositions to the copper plate on which he continued, often extensively, to refine his compositions. The fact that the etching process, the stage that most Roman printmakers regarded as essentially mechanical, was not only integral to the artistic process for Piranesi but also a central, critical phase, sets him apart from almost all of his contemporaries in Settecento Rome.

Like most of Rome's printmakers, Piranesi came to the city from another geographical area and, consequently, with a particular cultural and educational experience. In contrast to most of his fellow printmakers who came from northern Europe, where they had learned the techniques of printmaking and such related skills as ornamental metal engraving and the die casting techniques used in producing coinage and medallic art (many were employed in the papal mint), Piranesi, a native of Venice, was trained first and foremost as an architect–engineer. When he became an independent printmaker in Rome, he almost always inscribed *Architetto Veneziano* after his name. Interested in the history, theory, and

practice of architecture, he had been exposed through relatives to the latest debates over archaeological issues. In addition, and of great significance for his artistic and intellectual formation, before his first trip to Rome he had encountered major Venetian painters who were also printmakers: Marco Ricci, Canaletto, and the Tiepolo family. Although Venice, like Rome, had a cadre of artisan printmakers, the presence of some of the greatest artists of the century engaged in making their own etchings gave this medium the status of a fine art.

While growing up in Venice, Piranesi was schooled in perspective theory and may have worked with the Valeriani family on stage design. When, after his first sojourn in Rome, he returned to Venice briefly c. 1744–45, he would certainly have studied Canaletto's etchings of actual and imaginary views, *Vedute prese dai luoghi, altre inventate* (1744), which adumbrated his own work in composition and technique when he returned to Rome. The visit to Venice would also have afforded immediate access to Giovanni Battista Tiepolo's *Capricci* etchings, which had been just published, and perhaps also his *Scherzi di fantasia*, although the precise date of the *Scherzi* is less certain. Both collections of etchings were of central importance for Piranesi's *Grotteschi* (1750) and *Carceri* series (first published 1749 or 1750). For the young architect Piranesi, arriving in Rome in 1740 as a draftsman attached to the entourage of the new Venetian ambassador to Pope Benedict XIV, and finding himself in a city that had enjoyed exceptional activity in the field of architecture during the ten-year reign of Pope Clement XII Corsini but was virtually devoid of new architectural commissions, it must have seemed eminently logical to exploit the economic opportunities available to him as a printmaker. As has already been noted, for Piranesi, coming from Venice, it would have been natural to identify the etched plate as the expressive locus of high art, rather than simply the means of producing printed reproductions. The fact that Piranesi had enjoyed personal contact with contemporary Venetian painters who drew no strict distinction in terms of artistic status or social class between painting and the printmaker's art, together with his status as an architect, emboldened him to interact socially and artistically with Rome's foremost *vedute* painter, Giovanni

Paolo Panini (1691/2–1765) and to consider the important legacy of the painter Gaspar Van Wittel (1652–1736) a part of his own "Roman" heritage. That Piranesi would learn from their art seems, in retrospect, virtually inevitable, for both artists had prints made from their paintings, and thus they infused the conventional *vedute* prints of Rome with fresh compositional devices that were eminently compatible with Piranesi's own artistic vision. Both Van Wittel and Panini were interested in panoramic views and in new compositional viewpoints. Like Piranesi, they absorbed concepts derived from theater design, notably the *scena per angolo* perspective in which multiple vanishing points were employed beyond as well as within the depicted scene, and they also took up the portrayal of architectural monuments, viewed from casual perspectives that eschewed formality for intimacy and gave the sense, even, of the accidental and the momentary, glimpsed view. Aware of these new approaches and their potential from his Venetian experience, Piranesi was quick to respond to their presence in the work of Roman painters, whose use of such devices provided him with credible precedence for their application to his etched views.

Piranesi's Venetian experience and the innovations of the *vedute* painters in Rome were essential elements in his artistic formation. Important as well were a number of Roman artists who were engaged in the production of prints, whether as preparators of drawings for prints or executants of engraved or etched plates. Of these, the most influential in the artistic formation of Piranesi were the architect–printmaker Alessandro Specchi and his immediate predecessor—and future rival—Giuseppe Vasi.

Piranesi and his generation of printmakers would have been drawn to Specchi by the quality and scale of his prints and, in Piranesi's case, by the fact that Specchi was an architect. The compositions of many of Specchi's prints would have been of interest to Piranesi, especially Specchi's masterpiece, his *veduta* of the now destroyed Ripetta (cat. 33), once the northern Roman harbor for inland river traffic on the Tiber, which Pope Clement XII had commissioned Specchi to design in 1704.[2] Composed of three plates and measuring 25½ inches by 52⅜ (650 × 1330 mm) overall, Specchi's print achieves dimensions that must

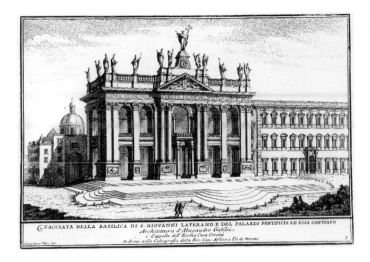

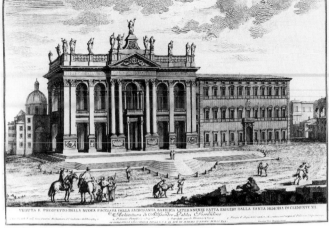

Fig. 127  Giuseppe Vasi, *Basilica of St. John Lateran*, 1739, etching

Fig. 128  Giuseppe Vasi, *View of the Lateran Basilica*, 1741, etching

have inspired later eighteenth-century print-makers to produce large single and multiple plate prints. Other innovative elements of particular interest to the young Piranesi would have been the composite views Specchi employed to document the Ripetta in a single print. Across the top of the print the viewer is treated to a sweeping panorama of the harbor, in which the curved steps that stabilized the river bank and allowed for harbor operations in spite of the seasonal rise and fall of the river are seen against the background of surrounding architecture and enlivened with shipping and ceremonial activity. Below, at the center of the print is a detailed plan of the site, which includes a key and, in dotted lines, an explanation of the geometry for generating the half-oval plan of its central plaza, which was based on a geometric construction known in the eighteenth century as an *ovato tondo*.[3] Beneath the plan a scroll has been introduced providing title and dedication; the titular scroll will be a ubiquitous element in Piranesi's prints, especially after the initiation of his *Vedute di Roma* series c. 1746.

Specchi employed the use of subsidiary vignettes both to document the condition of the Ripetta before the introduction of his innovative design (left) and to provide a view (right) from Specchi's central plaza looking westward across the river at the rolling countryside of the then ex-urban Prati. This vignette also gave Specchi the opportunity to show in more intimate detail the two columns used to record the high water levels of the river at flood time and the double-sided display with a conventional coat of arms of Clement XI Albani on the river side, which on the land side metamorphosed into an activated version consisting of mountains with running water, two dragons spouting water, and, high above, the verso of the Albani sun. Also of interest to Piranesi,

Specchi has even varied the time of day in his series of views so that each scene enjoys maximum clarity, yet retains dramatic effect. The large panorama and the smaller riverside vignette record the Ripetta in morning light, when his curvilinear harbor stairs and the enframing façades were in full sun, but for the view of the river and the area known as the Prati from his oval plaza he chose late afternoon, when the panorama across the river was in full sun but when the church of S. Giralomo degli Schiavone and the surrounding urban infrastructure cast long shadows across via Ripetta and the oval piazza.

Piranesi's first *veduta* of the Porto di Ripetta, published by Bouchard in 1748 as part of a combination volume entitled *Varie vedute di Roma antica e moderna*, was a modest homage to Specchi's spectacular panorama. Measuring just 4⅜ inches by 7⅞ (110 × 195 mm), it is taken from a slightly more elevated viewpoint and, not surprisingly given the dimensions, is cropped.[4] When, c. 1750, he produced a view of the Ripetta for his *Vedute di Roma*, Piranesi produced a dazzling *scena per angolo*, transforming the port, teeming with activity, into a sweeping downstream view. In Piranesi's *veduta* the viewer is introduced to the scene through the river traffic, and the curvilinear shapes of the harbor suggest the flow of the river and complement the sweeping curves of the high prows and sterns of the river boats. Vehicular traffic depicted on via Ripetta reminds the viewer that one of Rome's major streets traverses the harbor, and the angled view makes the viewer conscious that the Tiber is also a thoroughfare, a fact of which Piranesi, raised in a city of canals, would have been acutely aware and pleased to illustrate.

If Specchi can be considered something of a kindred spirit, someone Piranesi and other eighteenth-century printmakers could regard

with respect as a predecessor, Giuseppe Vasi had to be confronted as both a senior print-maker and very much a rival. Vasi was born in Corleone, Sicily, and arrived in Rome c. 1736. Both his education in fine art at the Collegio Carolino in Palermo and the fact that he was about twenty-six years of age when he arrived in Rome suggest that, like Piranesi, he was already professionally trained. Further confirmation of Vasi's professional status is provided by his extensive printmaking in Palermo, which included participation in a sumptuous 1736 publication commemorating the coronation of Charles IV Bourbon, King of the Two Sicilies. This work could well be considered Vasi's diploma piece; he appears to have journeyed to Rome in the year of its publication, and it gave ample proof of his skills as a master of the etched view or *veduta* for which there was high demand in Rome, especially among the visitors that were arriving in ever increasing numbers in the eighteenth century.

Evidence of Piranesi's immediate success in Rome is provided by the fact that when in 1737 the Calcografia Camerale, the papal publishing house, issued a volume celebrating the architecture commissioned by Pope Clement XIII, Vasi produced fifteen of the thirty plates, four of which were based on the designs of Francesco Nicoletti; the remainder were Piranesi's in design and execution.

In his five decades of printmaking in Rome, Vasi executed plates addressing practically the entire gamut of Roman eighteenth-century subject matter; however, apparently he did not participate in print reproduction of paintings or provide illustrations for literary texts, work that was largely in the hands of specialists.

Like other Roman printmakers, Vasi produced images of the marvelously ornate temporary structures that were consumed in fireworks as part of the Chinea ceremony, as

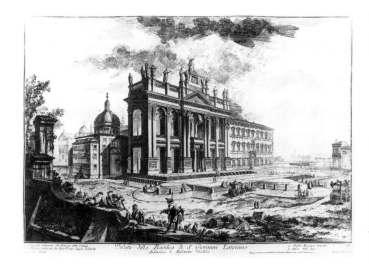

Fig. 129  Giovanni Battista Piranesi, *View of the Basilica of St. John Lateran* c. 1746–48, etching

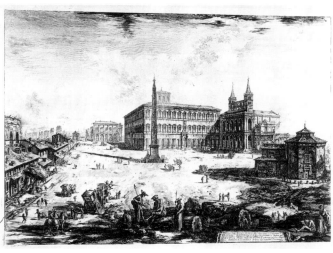

Fig. 131  Giovanni Battista Piranesi, *View of the Piazza and Basilica of St. John Lateran*, c. 1775, etching

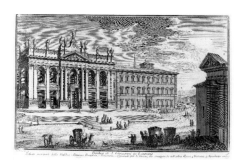

Fig. 130  Giuseppe Vasi, *Basilica of St. John Lateran*, 1752

well as other temporary structures including catafalques and scenic constructions for occasions such as the canonization of saints. Although he took little interest in making prints of genre scenes, a staple product of many printmakers, he enlivened his *vedute* of Rome with vignettes of human activity and interaction, recording individuals of all ages and walks of life. These infusions of genre elements are often repetitious or nearly so, leading one to suspect that Vasi had manipulable mannequins and a model coach with two rearing horses in his studio.

Vasi's greatest contribution to the history of printmaking was his innumerable *vedute* of the city. Averaging approximately 7⅞ inches by 11 (200 × 300 mm) and thus eminently portable and adaptable to insertion in bound volumes and guidebooks, these etched views provide extraordinary documentation of the built environment of Settecento Rome. His masterpiece in this genre is his 1765 panorama of Rome seen from the Janiculum Hill (cat. 38), composed of twelve separate plates and measuring an enormous 39⅜ inches by 100¼ (1000 × 2560 mm).[5]

In many ways Vasi is a continuer of the *vedute* practices of seventeenth-century printmakers, especially Giuseppe Falda as well as Alessandro Specchi, who, as we have noted, continued these traditions into the early eighteenth century. In most of Vasi's *vedute* the viewpoint is either at ground level—with the hypothetical observer standing in the street or piazza—or raised to imply that the scene is viewed as from the piano nobile of an adjacent palazzo. Typically, in Vasi's *vedute* there is little or no spatial exaggeration, little or no pictorial manipulation of monuments or their settings. Indeed, his views could be virtually fitted to a map of the eighteenth-century city drawn to the same scale. Accurate pictorial transcripts of the city, his *vedute* are enlivened by his inclusion of quotidian activity and vehicular traffic. In Vasi's prints the modulation of light and shadow—the technique of chiaroscuro—adds subtle gradations in depth, enlivens architectural surfaces, and now and again reduces a strolling figure to a pure silhouette.

The technical achievements of Giuseppe Vasi as much as the opportunity of employment drew the young Piranesi to enter into an apprenticeship with the Sicilian printmaker when he arrived in Rome. Apparently Piranesi wanted to study Vasi's technique and in particular to acquire the formula for the acids Vasi used in biting his etched lines into his plates. Their association was brief, their parting acrimonious, and from 1741 onwards they were to be lifelong rivals.

There is every reason to believe that Piranesi came to Rome in 1740 with ambitions to succeed as an architect but that, when opportunities in that profession failed to materialize, he directed his energies toward succeeding as a printmaker, grudgingly

accepting the role of architect manqué. It is not surprising, then, that Piranesi would seek out Vasi as the best in Rome, that they would quarrel, or that Vasi would thereafter serve more as a goad than a model, the artist to be surpassed.

The printmaking activities of the two artists give eloquent testimony to their intense competition. In multiple depictions of certain monuments, their competitive production of plates resembles a military exchange. Thus, when in 1739 Vasi produced a simple, descriptive rendering of the piazza and façade of St. John Lateran and the adjacent palace (fig. 127),[6] Piranesi countered in 1741 with a much smaller but sensitively shaded version of the same scene;[7] in the same year, Vasi etched an enormous (18¼″ × 26½″; 463 × 673 mm), more spacious version of his 1739 print.[8] Not to be outdone, Piranesi, c. 1746–48, produced a print nearly as large as Vasi's (15⅜″ × 21½″; 390 × 545 mm) and, following his example, incorporated additional structures on the periphery of the piazza, added more figures and, in the foreground, a dark mass of antique *spolia* (fig. 128).[9] In 1753 Vasi etched a *veduta* of the church that was essentially a repetition of Piranesi's 1741 depiction but nearly doubled in size (fig. 130).[10] And, for the first time, he provided as well a *veduta* of the Piazza di S. Giovanni, located immediately adjacent to the eastern transept of the church.[11] In the process of completing his monumental *Vedute di Roma* publication, Piranesi responded to Vasi's last contribution to their exchange with his c. 1775 views of the two sites (cat. 20 and fig. 131) in enormous etchings (c. 19″ × 25½″; 480 × 700 mm),[12] including an entirely new point of view for his *veduta* of the church façade.

Fig. 132 Francesco Piranesi, *Frontispiece* of *Raccolta de' tempi antichi*, 1776, etching

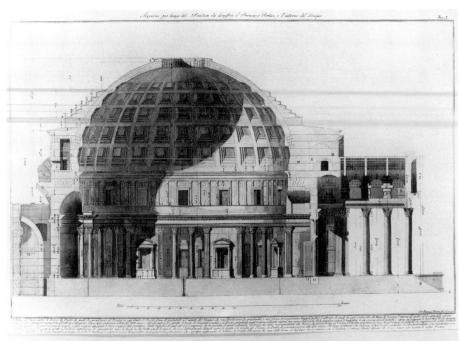

Fig. 133 Francesco Piranesi, *Sectional View of the Pantheon*, c. 1787, etching

The competition between the two print-makers was especially intense at St. John Lateran, but this pattern of back-and-forth occurred frequently in their *vedute* publications. It was, of course, the result of an intensively competitive print market, one in which large-size etchings were increasingly in demand, not as illustrations for guidebooks but as mementos to be collected, bound in volumes, or framed for display. In the second half of the eighteenth century the print had become an object of considerable prestige. Working against each other, both Piranesi and Vasi responded to and encouraged the new consumer demand. Especially in the case of Piranesi, the prints gained new visual force; the play of light and shadow—exemplified by the changes between the earlier c. 1749 *Carceri* and the later edition of 1761—and their increased size invested his prints with enhanced visibility when mounted for display in the print rooms of European and North American collectors.

If Piranesi learned from Vasi, it is also true that Vasi profited from their exchanges. A glance at Vasi's early work in Palermo reveals a preponderance of buildings represented as perpendicular to the viewer and parallel to the picture plane. With few exceptions his scenes take place beneath a virtually uninflected sky. Only in his *Vedute di Roma*, initiated in the 1740s and thus close in time or perhaps coincident with the brief period of the Vasi–Piranesi collaboration, did Vasi consistently include cloud-strewn skies of the kind that are a hallmark of Piranesi's etched *vedute*.[13] In contrast, even in Piranesi's earliest etchings there is at least a hesitant interest in recording touches of atmospheric phenomena. Like his Venetian counterparts, Piranesi infused his etchings with transient, meteorological effects and delighted in the sketch as opposed to the precisely drafted line; through its use he sought to achieve the luminosity of color in his modulation of lights and darks. This *colore* quality, so effective for describing the momentary

aspects of sky, sunlight, and shade, was an integral part of Piranesi's art in Rome. Even in his late maturity, when his chiaroscuro shading grew steadily denser and darker, his skies, often strewn with storm clouds, still retain patches of brilliant sunlight.

The general trend toward increased size, even at the cost of portability, was not limited to the printmakers of *vedute*; it affected the publication of maps as well. Here, too, Piranesi had a role, albeit a limited one. In point of fact, the maps of Rome had begun to expand in size in the seventeenth century, when in 1661–62 Antonio Tempesta incised a map ($41\frac{1}{3}'' \times 94''$; 1050 × 2390 mm) that favored display over portability. Later, Giovanni Battista Falda solved the problem of portability versus display by creating two maps in 1676, a small portable one ($26\frac{7}{8}'' \times 34\frac{5}{8}''$; 682 × 880 mm) and a grander version of nearly double the dimensions ($61\frac{3}{8}'' \times 60\frac{1}{4}''$; 1560 × 1530 mm). The potential of Falda's solution was brilliantly exploited by Giovanni Battista Nolli, when in 1748 he published a set of maps of Rome (cat. 18) which included an eminently portable small map of Rome ($18\frac{1}{2}'' \times 27''$; 470 × 685 mm) and a large map of exceptional scale ($69\frac{1}{4}'' \times 82''$; 1760 × 2085 mm). Both maps recorded the contemporary city. The larger map set new standards in the history of topographic survey. A true planometric map, it was drawn as accurately as any city plan until the advent of aerial photometry. In one respect Nolli's map exceeded even the visual reach of aerial reconnaissance: his plan included the interior ground-floor

plans of the principal palaces and churches of Rome as well as its streets and piazzas. Nolli's accomplishment was an enduring one; for modern architects and city planners, his name has entered the professional vernacular as a verb: "to Nolli a plan" is to illustrate the interior space of a structure and its exterior surroundings in a single plan.

Piranesi, who four years earlier had collaborated with Nolli and his team by providing vignettes for his *Pianta del corso del Tevere*, a detailed mapping of the Tiber river, participated in Nolli's monumental 1748 publication, providing vignette *vedute* embellishments for the portable version of Nolli's Rome map.[14] Later, Piranesi utilized Nolli's maps in the production of a series of mapmaking projects that were part of his ever-expanding publication activities. After eight years of study and excavation, Piranesi produced, in 1756, his multivolume *Antichità romane* in which Nolli's small map served as an unacknowledged template for the plan of ancient Rome,[15] and in 1774 he published a combined depiction of the modern city and the ancient Campus Martius in which he again used the Nolli plan and, in the map of modern Rome, the Nolli system of including the floor plans of major architectural monuments.[16] Although both mapmakers had a keen interest in the fragmentary remains of the great marble map of ancient Rome that Nolli was responsible for reassembling in the Museo Capitolino, Nolli's overriding interest was the documentation of the plan of contemporary Rome, whereas Piranesi was

ultimately more concerned with recording and reconstructing ancient Rome, an interest that became an especially important feature of his career in the 1750s and remained his dominant concern for the rest of his long life.[17] The publication of the *Trofei di Ottaviano Augusto* in 1753, followed in 1756 by the monumental four-volume *Le antichità romane*, marked the initiation of this intensive period in Piranesi's career, one that reflected general changes in printmaking in Rome. Before examining this development in detail, however, the activities of contemporaries who contributed to the ongoing production of *vedute* deserve attention.

This group of *vedutisti* includes two of Piranesi's numerous children, as well as Francesco Panini, the son of eighteenth-century Rome's greatest *vedute* painter, and Jean Barbault, an artist who was both one of Piranesi's closest collaborators and a serious competitor. The Piranesi children of particular concern are Laura and Francesco, born in 1755 and 1758 respectively. Very little is known about Laura beyond the fact that she etched reduced versions of some of her father's *Vedute di Roma*, for which she presumably made the preparatory drawings. Light evanescent creations, her etchings transformed her father's large prints into delicate vignettes, which deserve more scholarly attention than they have received to date.

Of all of Giovanni Battista's children, however, it was Francesco who played the most important role in the family printmaking business. He assisted his father for many years as a silent partner, executing the etched version of many of the last works of Piranesi senior. After his father's death he added two plates, interior views of the Pantheon and the Colosseum, to "complete" his father's *Vedute di Roma* publication. These two prints, datable 1786 and 1788 and signed by Francesco, as was his practice after his father's death, demonstrate his heavier, more labored style. In 1780 he published *Raccolta de' tempi antichi*, a two-volume work dedicated to Pope Pius VI Braschi, whom he honored with a frontispiece featuring a papal profile portrait and medals celebrating papal achievements: the enlargement of the Museo Pio-Clementino at the Vatican, the initiation of excavations in via Appia, and the elimination of papal customs taxes, which are depicted surrounded by antique *spolia* (fig. 132). In the background appears the Pantheon, the subject of the second volume, together with the ancient Roman Curia in its unrestored state and the temple of Vesta at Tivoli. In the frontispiece, as in the prints he added to his father's *Vedute di Roma*, there is a heaviness to Francesco's etching that suggests, improbably, that he did not have access to the senior Piranesi's secret

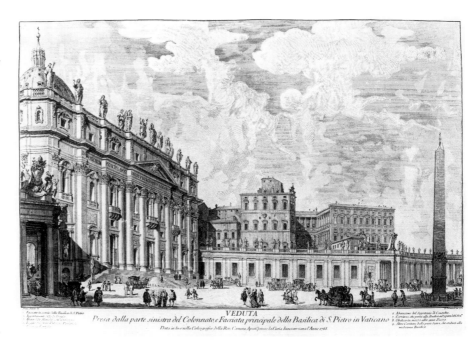

Fig. 134 Francesco Panini, *View of the Left Part of the Colonnade of St. Peter's*, 1764, etching by Francesco Polanzani

slow-acting acids. In surprising contrast, his detailed renderings of elevations and sectional views of the ancient monuments are delineated with remarkable elegance and precision (fig. 133). In 1781 Francesco issued his father's plan of Hadrian's Villa (cat. 26), an enormous work composed of six separate plates and measuring 27¾″ × 122⅝″ (705 × 3114 mm).[18] The print is at least in part the work of the younger Piranesi. Between 1804 and 1807 he completed and published in Paris his father's final work, *Différentes vues de quelques restes … de l'ancienne ville de Pesto*, largely carried out in late 1777 or early 1778, when father and son visited Paestum to record the Greek temples in a suite of twenty-one plates. Allocation of hands in these prints remains problematic, and the fact that eighteen plates are signed by Giovanni Battista and three, including the frontispiece, by Francesco does not appear to establish precisely the contributions of father and son.[19] There is, however, general scholarly agreement that the compositions of all the plates are based on preliminary drawings by Giovanni Battista but that Francesco had a hand in the execution of all the plates including those bearing his father's name. The fact that Francesco had a special interest in material culture makes it likely that the pronounced emphasis on agricultural and animal husbandry evinced throughout this series was encouraged and often introduced by the young Piranesi, who may have added figures to his father's compositions when transferring them to copper plates.[20]

The career of Francesco Panini bears comparison with that of Francesco Piranesi. Both were sons of illustrious fathers, both pursued careers related to that of their fathers, and both came from families in which several siblings appear to have been at least peripherally involved in printmaking. In all probability Francesco Panini was the author of some of the numerous paintings associated with his father but of a quality that has left them categorized as "school," "shop," or "in the circle of." In sum, Francesco's talents were those of a draftsman. He produced watercolor as well as pen and ink *vedute* of Rome and its environs, some of which appear to have been sold as finished works of art. His principal activity, however, was that of a draftsman who prepared drawings to be utilized by professional printmakers for producing etched versions of his compositions, which were derived from his father's painted *vedute* and also sketched *ex novo*. The printmakers who made plates from Francesco's drawings were among the best in Rome and included Vasi, Antonini, Barbazza, Cigni, Montagu, Polanzani, and Volpato. Francesco Panini's *vedute* are generally predictable in composition, and in viewing point similar to those of Giovanni Battista Piranesi. There are, however, interesting exceptions to this rule: refreshingly original views such as the angled view of the façade of St. Peter's, etched by Francesco Polanzani (fig. 134).

Like the younger Panini, Jean Barbault, who arrived at the French Academy in Rome in 1749, produced drawings for professional

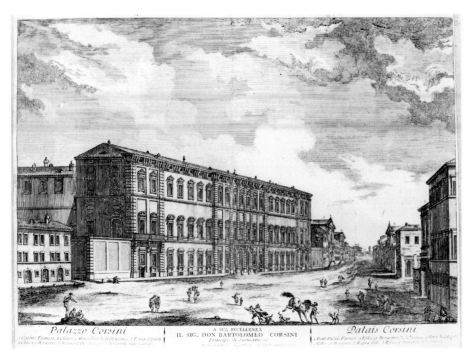

Fig. 135 Jean Barbault, *View of the Palazzo Corsini*, c. 1763, etching by Domenico Montagu

printmakers, most of whom—Montagu, Freicenet, Giraud—were French nationals who worked for the Bouchard and Gravier publishing house with whom Piranesi also had close ties for many years. To a degree both obvious and even obsessive, he repeated the *vedute* compositions of Piranesi and Vasi, but his street and piazzas seem amorphous, his buildings distanced, and his figures not merely small but diminutive and often seemingly aimless in their actions (fig. 135). Now and again he added antique *spolia* to the foreground of his scenes in timid response to Piranesi's bold use of this device, but these elements, powerful visual devices in the hands of the Venetian, are insufficient to overcome Barbault's curious tendency to crop away the foreground margins of his prints which impedes the viewer's entry into the scene. Left at some uncertain locus in space, the spectator hovers above the depicted scene. For the twenty-first century viewer many of Barbault's prints seem adumbrations of the existential visions of early Giorgio de Chirico. Barbault knew his market; practically every print he produced is dedicated to an important contemporary, and his descriptive captions are written in both French and Italian. In 1753 Barbault left the French Academy at Rome, presumably with the intention of returning to France. Apparently the journey was never undertaken; he died in Rome in 1762, one year before Bouchard and Gravier published a set of seventy-three prints of his *vedute* of Rome.

One aspect of Barbault's career deserves special attention. For although his *vedute* seem to bear witness to a fundamental limitation in the rendition of architectural space that cannot be wholly blamed on the limited competence of his designated etcher's skills, it is nevertheless a surprise to turn from his *vedute* to his acknowledged contributions to Piranesi's plates for *Le antichità romane* issued in 1756 by Bouchard and Gravier. Their collaboration apparently began around 1750, when Piranesi issued a modest, undated eleven-plate work entitled *Camere sepolcrali degli antichi romani*. This work grew into the massive four-volume *Le antichità romane*, for which Barbault collaborated extensively on volumes 2 and 3, producing the figural elements in many of the prints.[21] On these collaborative prints Piranesi's name appears as *Piranesi Archit[etto] dis[egno] ed inc[ise]*, indicating that Piranesi, architect, was the designer and etcher. Barbault is inscribed as *Barbault scolpi le Fig[ur]e*, implying, rather surprisingly, that he was not only the designer of the figural elements but, in fact, their executant in the plate. The figural elements in question reveal Barbault to have been a considerably more able artist than his *vedute* suggest. Barbault's name does not appear in the fourth and last volume of the *Antichità romane*. Admittedly, this volume as executed contained few opportunities for his figural talents, but nevertheless the completion of this final volume may perhaps have coincided with his mysteriously precipitous disappearance from the Roman printmaking scene.

The *Antichità romane* provides a unique glimpse into an aspect of the artistic talents of Barbault that would otherwise be lost; it is also Piranesi's greatest single contribution to the study and appreciation of the art and architecture of ancient Rome. Although less well known than his *Vedute di Roma*, this four-volume work is actually much larger in scope, consisting of nearly twice the number of prints in the *Vedute*. The product of over eight years of intensive study, which included personally conducted archaeological excavations, it was this work that first won Piranesi international acclaim as the chief publicist of Roman archaeology and a major protagonist in the contemporary debate over whether the origins of the classical style were Greek or Roman. Piranesi was the most outspoken proponent for the primacy of the Etruscan–Roman contribution. In support of his argument he produced in this multi-volume work an extraordinary body of visual documentation: views of major monuments *in situ*, reconstructions, plans, elevations, depictions of sculpture, painting, and minor arts, inscriptions and proposals for antique construction methods. In the early 1750s, during the gestation period of this enormous corpus, the artist's immediate circle of foreign friends shifted from his associates at the French Academy to a succession of visitors to Rome from the British Isles, including William Chambers, Robert Mylne, and Robert Adam. Contemporaneous with these important associations, and of fateful significance for his career, was Piranesi's encounter with the young Irish peer, James Caulfield, 1st Earl of Charlemont. In 1753 Piranesi secured Charlemont's patronage of the massive *Antichità romane*. In the event, the earl's support was niggardly in sum and begrudgingly bestowed. Piranesi retaliated; only the first forty copies of the first volume carried a dedicatory frontispiece honoring Charlemont's financial support. In subsequent printings Piranesi replaced the original frontispiece with one in which the dedication—presented as though carved on a marble tablet—appears defaced as if by hammer and chisel. He also deleted references to his putative patron in all of the volumes. Still dissatisfied, Piranesi again turned his printmaker's talents against Charlemont, issuing, in 1757, his *Lettere di giustificazione a milord Charlemont* to publicize and justify his execratory actions.

The Charlemont affair initiated additional polemical treatises including Piranesi's *Della magnificenza ed architettura de' Romani* (1761), in which he defended the primacy of Etrusco-Roman architecture over that of Greece. And when, in 1764, P. J. Mariette critiqued *Della magnificenza* in an article in the *Gazette littéraire de l'Europe*, Piranesi counterattacked with a

three-part rejoinder in the following year, entitled *Osservazioni … sopra la lettre de M. Mariette, parere su l'architettura* and *Trattato … del progresso delle belle arti in Europa ne' tempi antichi*. These publications constituted a propaganda broadside aimed at his critics. In contrast, his four-volume *Antichità romane* stands as a truly monumental archaeological achievement.

In addition to his polemical publications, Piranesi followed the *Antichità romane* with a succession of volumes devoted to the ancient city of Rome and its environs, followed by major posthumous publications issued by his son Francesco. Although Piranesi remained an unrepentant advocate of the historic primacy and artistic superiority of ancient Rome over Greece, a shift, even a rapprochement to ancient Greece, can be noted in several of his publications. The change in his attitude toward Greek art and architecture seems to have occurred in close chronological proximity to his active participation in the practice of architecture, after his long, involuntary separation from it. The initiation of his renewed involvement with architectural practice was less than auspicious; in 1763 he received what was to be an unrealized papal commission to design a new high altar and tribune for the church of St. John Lateran, the cathedral church of Rome. This failed project was, however, immediately followed, in 1764, by a commission from the grand prior of the Knights of Malta, Giambattista Rezzonico, for the renovation and architectural enrichment of S. Maria del Priorato, located on the Aventine. This relatively modest but highly visible commission, proffered by the papal cardinal-nephew, may have been given in part as compensation for the devastating loss of the magistral opportunity at St. John Lateran. In any event, Piranesi seized the lesser offer and produced a masterpiece that propelled him into the forefront of Rome's admittedly diminished field of architecture.

Further, even in the midst of his incendiary response to Mariette's critique of his *Della magnificenza dei Romani*, Piranesi added, after 1768, several plates in which Greek as well as Egyptian motifs commingle with Etruscan and Roman ones. The most striking evidence of Piranesi's new, conciliatory position is provided by his publication, in 1769, of the *Diverse maniere d'adornare i cammini ed ogni altra parte degli edifizi*, in which he approves of ornament derived from "Egypt, Etruria, and Greece" via an argument that subsumes Roman art into Etruscan (cats. 441–44). This publication marks a truly new phase in Piranesi's intellectual and artistic life. He is now interested in the common origins of all design in nature and devotes himself to etched diagrams in which he proposes that the forms of Etruscan vase profiles derive from marine shells. True,

he continues his polemical defense of Etruscan art (by which he here means Etrusco-Roman). However, as noted by John Wilton-Ely, the scholarly issues discussed in *Della magnificenza* have retreated into the background and the main argument concerns the need to establish a modern system of design, which will grow from a study of nature as well as all that is excellent from the past, regardless of whether it is Greek or Roman, Etruscan or Egyptian.[22]

A remarkable collection of fireplace designs appeared in the pages of *Diverse maniere*, together with assorted designs for candlesticks, chairs, clocks, commodes, sedan chairs, and coaches. To a striking degree this acceptance of all antiquity as a valuable resource for contemporary design is echoed in his last publication, *Vasi, candelabri, cippi … ed ornamenti antichi*, published in Rome in 1778, the year of his death. In addition, however, the objects portrayed in these pages were in many cases in Piranesi's own collection and for sale. Other objects—many having passed through his shop—were already in private collections, for the most part English, Scottish, or in public or private Italian ones.

The arc of Piranesi's career, and ultimately that of the other printmakers of eighteenth-century Rome, followed the diverse artistic and aesthetic concerns of their contemporaries: tourists, antiquarians, collectors, and, of course, artists and architects. They came to Rome first to see the modern city and the remains of the ancient one; over time they became increasingly eager to acquire visual portrayals of many Romes, the one they found on arrival, the one they imagined once existed, and, last but not least, a Rome from which they could derive inspiration for their own time.

## Notes

1 Scott, Jonathan, 1975 and Wilton-Ely 1978 are fundamental studies. For a complete bibliography, see Wilton-Ely 1994, pp. 1209–18.
2 For details, see Ashby and Welsh 1927, pp. 237–48 and Marder 1980, pp. 28–56.
3 The term *ovato tondo* appears in Ferdinando Bibiena, *Architectura civile* (Parma, 1711); see Kitao 1974, especially p. 31 and n. 117–19.
4 Wilton-Ely 1994, vol. 1, no. 99.
5 Scalabroni 1981, cat. no. 313.
6 Scalabroni 1981, cat. no. 12.
7 Wilton-Ely 1994, vol. 1, no. 69. This Vasi–Piranesi exchange has received some attention (see Wilton-Ely 1978, p. 27, and Ficacci 1996, pp. 59–86).
8 Scalabroni 1981, cat. no. 405.
9 Wilton-Ely 1994, vol. 1, no. 139.
10 Scalabroni 1981, cat. no. 119.
11 Scalabroni 1981, cat. no. 105.
12 Wilton-Ely 1994, vol. 1, nos. 255 and 250 respectively.
13 Millon 1978, pp. 345–62.
14 Wilton-Ely 1994, vol. 2, nos. 1006 and 1007.
15 Wilton-Ely 1994, vol. 1, no. 288.
16 Wilton-Ely 1994, vol. 2, no. 1008.
17 Ceen 1990, pp. 17–22, provides a detailed consideration of the Piranesi–Nolli relationship.
18 Wilton-Ely 1994, vol. 2, no. 1009.
19 Wilton-Ely 1994, vol. 2, pp. 777–78.
20 Pucci 1979, pp. 67–73.
21 Wilton-Ely 1994, vol. 1, nos. 369–72, 377, 390, 392, 402–3, 442–44, 461, and 463.
22 Wilton-Ely 1994, vol. 2, pp. 886–87.

# GIOVANNI BATTISTA PIRANESI

## MOGLIANO DI MESTRE 1720–1778 ROME

Giovanni Battista Piranesi was born near Mestre on the Venetian mainland. An uncle of his, Matteo Lucchesi, who was an engineer in the Venetian water department and an architect with a strong interest in the work of Palladio, provided Piranesi's initial training in architecture. Through his uncle he would have been in contact with leading Venetian neo-Palladian architects and with the most influential Venetian architectural theoretician, Carlo Lodoli, proponent of vigorously rational, functional, architectural design. Venice also provided resources for Piranesi's future work as a printmaker. These included a training period with Carlo Zucchi, etcher and author of a treatise on perspective, and—if his early biographers are correct—contact with the leading scenographic designers of northern Italy, the Bibiena family and the Valeriani brothers. When the etchings of an extraordinary group of older Venetian painter–printmakers, Giovanni Battista Tiepolo, Giovanni Antonio Canal, called Canaletto, and Francesco Guardi, are added to this rich artistic matrix, it is clear that Piranesi's formative years in Venice had a profound impact on the young artist, who—although his primary profession was printmaking—was to refer to himself as "architetto veneziano" throughout his life.

Piranesi first visited Rome in 1740, when he traveled there as a draftsman in the entourage of Marco Foscarini, the Venetian ambassador to Pope Benedict XIV; this association suggests, at the very least, that his exceptional talents had not gone unnoticed. Through Foscarini the young Piranesi was introduced to some of Rome's leading antiquarians who were to spearhead the initiation of Neoclassicism as a countervailent to late Baroque and Rococo stylistic values. In this early period he worked, albeit briefly, for the printmaker Giuseppe Vasi, who in the 1740s was the foremost producer of *vedute* in Rome. Their relationship was brief and stormy. Within a year's time Piranesi was working freelance as a printmaker with a group of young artists from the French Academy at Rome, making small etched views of the city first published in 1741 as the *Varie Vedute di Roma*. Two years later the *Prima parte di architetture e prospettive*, Piranesi's first independent work, appeared.

Apparently, financial duress precipitated a return to Venice in 1744. The timing was propitious; in Venice, Canaletto's spectacular *vedute*, etched by Visentini, had just been reissued. Tiepolo's *Scherzi di fantasia* was available, and shortly thereafter, his *Capricci*. When Giuseppe Wagner, a Venetian print dealer, offered to set him up as his agent in Rome, Piranesi returned to that city and to a shop on via del Corso, across from the Palazzo Mancini, residence of the French Academy.

Once again in Rome, Piranesi commenced in rapid succession a series of important projects, issuing his *Grotteschi* (1747–49), which reflected his immediate response to Tiepolo's macabre *Scherzi* and *Capricci*, followed by the first edition of his prison series, the *Carceri*, in 1749–50. Around 1746–48 he started work on his monumental *Vedute di Roma*, the 135 plates of which he would be producing for the rest of his life. With these new publications, and especially the *Vedute di Roma*, Piranesi moved emphatically to plates of a larger scale; typically the *Varie Vedute* plates had measured 4⅜″ by 7¼″ (112 × 184 mm), whereas the *Vedute di Roma* were generally 17⅞″ by 27½″ (450 × 700 mm). The sheer scale of his new prints overwhelmed the modest efforts of his competitors. Concomitant with the vast *Vedute di Roma* project Piranesi issued numerous publications addressing aspects of the art and architecture of ancient Rome, intending to respond to the growing conviction among antiquarians, historians, and archaeologists that Greek art and architecture enjoyed historic precedent and superior aesthetic value to that of Rome as the origin of classical art.

In 1756 Piranesi issued his monumental *Le antichità romane*, a four-volume work of 250 plates, with which the artist intended to overwhelm the grecophiles. This publication had started as a modest single-volume work for which Piranesi had—or thought he had—the financial support of an Irish dilettante, James Caufield, Earl of Charlemont. When Charlemont reneged on his promised support after the first few copies had been printed, Piranesi turned on his erstwhile benefactor and in an act of execration published the defaced dedication plates in subsequent volumes, declaring on the reinscribed, mutilated plates that the volumes were issued "for his own age, posterity and the public good."

In 1761 Piranesi issued a revised and amplified *Carceri* series with an intensified emphasis on incarceration and torture. In these a profoundly darker chiaroscuro system obtains. Form and content thus combine to urge a far more pessimistic interpretation than the earlier edition. The mood of this edition of the *Carceri* would seem to echo the emotions of its embattled author.

With *Della magnificenza ed architettura de' romani* (1761) and a number of subsequent publications, Piranesi continued his ardent defense of Roman precedence and originality in the formation of classical art. Although Piranesi's publications continued to promote the chronological and aesthetic preeminence of the art of Rome, his approach now became more celebrational, and, ultimately, increasingly conciliatory. And when, in 1765, he responded to P. J. Mariette's criticism of his Rome-biased theories as expressed in *Della magnificenza*, he included a section entitled *Parere su l'architettura*, in which he advocated creative license over what he perceived to be the narrowly circumscribed functionalism of idealized Greek austerity slavishly endorsed by Laugier and Winckelmann. For his part, Piranesi had moved to a more creative and artistically aggressive position, one in which he declared contemporary artists free to borrow from all past styles, albeit favoring the Egyptian and Tuscan.

A number of factors contributed to Piranesi's philosophical and aesthetic reassessments. Of central significance was the election in 1758 of a Venetian to the Holy See. Pope Clement XIII Rezzonico was to enjoy a lengthy reign of eleven years, and during those years Piranesi received the patronage of both the pope and his family. Papal patronage supported costly publications, including *Della magnificenza ed architettura de' romani* and a number of other publications: the *Acqua Giulia*, *Lapides Capitolini*, *Emissario del Lago Albano*, and the *Antichità di Albano*.

Also through Rezzonico patronage Piranesi became—for the first time in his career—a practicing architect with two significant commissions. One of these projects was the installation of a new high altar and the remodeling of the apse of St. John Lateran. This was never carried out; however, when a nephew of the pope was created grand prior of the Knights of Malta, Piranesi was invited to transform the modest church and priory into a remarkable monument. The same papal nephew sponsored the publication of *Diverse maniere* (1769), which extended Piranesi's interests to contemporary fireplaces, clocks, wall decorations, home furnishings, sedan chairs, and coaches, and offered decorative motifs "taken from Egyptian, Etruscan, and Greek architecture." Work as an architect tempered his vision, and although he still preferred the Egyptian and Etruscan styles, he now accepted the role of Greek elements and their application to contemporary architectural practice. A new unity of theory and practice are here articulated, one that prevailed in the publications of his closing years and in the posthumous publications issued by his son Francesco, including his great map of the Villa of Hadrian at Tivoli and, most notably for the old and contentious Rome versus Greece debate, the publication in 1804–7 of the Greek temples at Paestum in *Les antiquités de la grande Grèce*. [MC]

BIBLIOGRAPHY Focillon 1918; Hind 1922; Petrucci C. 1953; Parks 1961; Calvesi 1968; Bacou 1975; Scott, Jonathan, 1975; Bertelli et al. 1976; Brunel 1978; Penny 1978; Stampfle 1978; Wilton-Ely 1978; Wilton-Ely 1978, *Piranesi*; Bettagno 1983; Istituto Storia dell'arte 1983; Robison 1986; Campbell 1988; *Piranesi e la veduta* 1989; Wilton-Ely 1992; Wilton-Ely 1994]

## 408

## Giovanni Battista Piranesi
### *Church of S. Paolo fuori delle Mura*

c. 1744
Etching, in bound volume
From *Roma moderna distinta per rione* (Rome, [1740s])
Signed below image, lower right
5⅜″ × 7⅜″ (136 × 187 mm)

BIBLIOGRAPHY Focillon 1918, no. 109; Bertelli and Pietrangeli 1985, no. XLVI; Robison 1986, pp. 10, 54, n. 15; Wilton-Ely 1994, vol. 1, no. 74

Robison Collection

This small plate is one of six Piranesi prepared for *Roma moderna distinta per rione*, published in 1741 by G. L. Barbielli. After initial publication, these etchings became part of a group of plates, many prepared by students at the French Academy at Rome, which were used to illustrate guidebooks published in the 1740s and 1750s, including Fausto Amadei's *Varie vedute di Roma antica e moderna* of c. 1745. No publisher was more ambitious than Giovanni Bouchard, who included a selection of these Piranesi prints in his *Varie vedute di Roma* in 1748 and later, in 1752, issued the full set of ninety-three prints, of which forty-eight were signed by Piranesi. It is reflective of Piranesi's rising star as a printmaker that, although just over half of these plates bore his signature, Bouchard entitled this publication *Raccolta di varie vedute di Roma si antica che moderna intagliate in maggiore parte dal celebre Giambattista Piranesi*, clearly placing Piranesi above the other contributors in importance and using the artist's name to attract purchasers.

This early etching of S. Paolo fuori delle Mura provides clear evidence of the precocious talent of the young Venetian. Pictorial devices destined to be used on a grand scale in his *Vedute di Roma* are already present: the church has been positioned for an angled view—the *scena per angolo* of contemporary theater design—to dramatize the structure. Thus the church façade recedes toward a vanishing

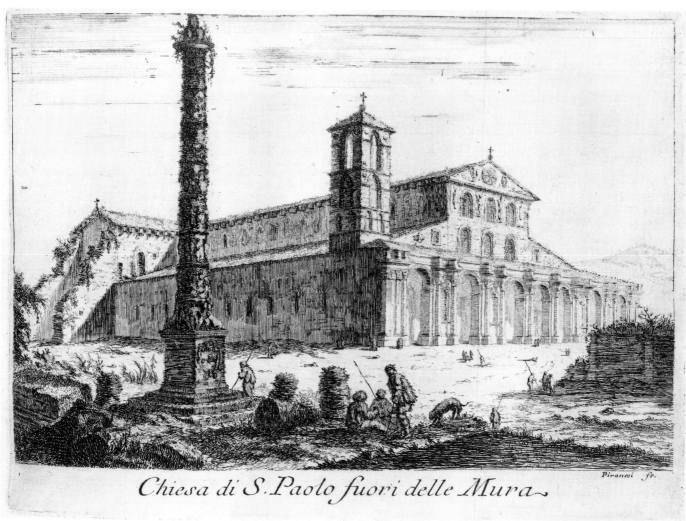

*Chiesa di S. Paolo fuori delle Mura*

Piranesi fc.

408

point at the far right beyond the edge of the plate, a process repeated on the left side of the print in the depiction of the nave. The play of light and shadow serves to establish the time of day. The façade is bathed in the afternoon light of a sun in the western sky, a time of day chosen to emphasize the façade, the most impressive feature of the church exterior. Typical of his later work, Piranesi has eschewed the customary printmaker's technique of crosshatching to create shadow and instead uses a system of parallel lines of variable density, creating an enlivened system of shading. In a gesture of technical hubris, which will appear on occasion in his later work, he defines the linear architectural elements of the scene with a ragged, vermiculated line.

The church is viewed across a foreground of barriers composed of *spolia* in the form of large fragments of ancient architecture. Another compositional device—a commemorative column—truncated at the top by the framing line of the print, serves to subdivide the view into two unequal spatial segments, privileging the one

containing the façade and bell tower and also heightening the sense that the viewer looks into the scene as if through a window. The top of the column also serves to mark a virtual line that descends to the crosses atop the bell tower and the church and to a vanishing point just beyond the right frame of the scene. The compositional role of this column is rendered particularly calculated in view of the fact that it is apparently the artist's invention; except for this print, it is unrecorded. The diminutive figures in the foreground serve to underscore the viewer's distance from the foreground, a sense of separation that is heightened by the markedly underscaled figures in the middle distance.

These manipulations of scale are modest, however, compared to Piranesi's reconfiguration of the actual site. In the map of Rome prepared by Stefano DuPérac and Antonio Lafréry in 1577, the façade of the church is preceded by a forecourt defined by a high wall. This wall appears as a fragment at the far right edge of Piranesi's print. However, in his *Vedute di Roma* series the church is

depicted in a c. 1758 print as viewed from the south, and this wall, articulated by the same series of pilasters and pierced by an elaborate gate, is intact and abuts the façade arcade of the church. Thus there can be little doubt that the walled atrium described in the DuPérac map of 1577 was still present when Piranesi made his etchings and that he arbitrarily "demolished" part of its northern range to obtain this c. 1744 print and then "demolished" part of the southern wall for his c. 1758 view. In 1725 a collapsed portion of the atrium portico was rebuilt on the designs of Antonio Canevari and Matteo Sassi along the church façade by Pope Benedict XIII Orsini.

Comparison of this print with the later one of the church in the *Vedute di Roma* series reveals a surprising, albeit calculated, distortion: in each depiction Piranesi "stretched" the seven bays of the portico in the direction of the adjacent vanishing point. This perspectival distortion draws attention to the portico, the most salient element in the view. Piranesi has taken pains to emphasize this new portico, the most

architecturally significant element of the restoration campaign at the church. [MC]

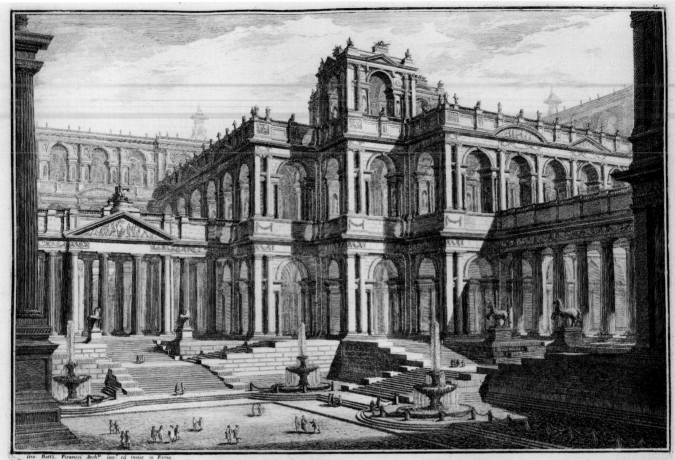

Gio. Battª. Piranesi Archⁱ⁰ invⁿ ed incise in Roma.

*Foro antico Romano circondato da portici, con logge, alcune delle quali si uniscono al Palazzo Imperiale ed altre alle Carceri.*
*Questo Foro dappertutto e attorniato di magnifiche scale presso alle quali ui stano Cavalli, e Fontane che servono di ornamento alle medesime.*

409

## 409

### Giovanni Battista Piranesi
### *Ancient Roman Forum*
### *Surrounded by Porticos*

1742–43

Etching, in bound volume

From *Prima parte di architetture, e prospettive…* (second edition, first issue, Rome, 1751)
Signed below image, lower left

INSCRIPTION *Foro antico Romano circondato da portici, con logge, alcune delle quali si uniscono al Palazzo Imperiale ed altre alle Carceri./ Questo foro dappertutto e attorniato di magnifiche scale presso alle quali vi stano cavalli, e Fontane che servono di ornamento alle mede./ T. VIII.T. 338b*

10⅛″ × 14¼″ (263 × 361 mm), with caption plate

BIBLIOGRAPHY  Focillon 1918, no. 13; Robison 1986, no. 12 iii/vii; Wilton-Ely 1994, vol. 1, no. 14

Robison Collection

As noted in the inscription, this "ancient Roman forum is surrounded by porticos with loggias, some connecting to the imperial palace and others to the prisons. Furthermore this forum is everywhere surrounded by magnificent stairways, near which are horses, and, in the middle, ornamental fountains" Typical of many of the prints in the *Prima parte*, this imaginary reconstruction is dramatized by a version of the *scena per angolo* perspective system, which creates dramatic angled views by stressing the lateral vanishing points. Scale has been profoundly manipulated for dramatic effect; the human figures gathered in the forum are dwarfed by the architecture and sculpture. [MC]

## 410

### Giovanni Battista Piranesi
### *Title Page*

1743–49

Etching, in bound volume

From *Prima parte di architetture, e prospettive…* (bound with *Opere varie*, third edition, Rome, 1780s)

INSCRIPTION  *PRIMA PARTE/DI ARCHITETTURE/E PROSPETTIVE/INVENTATE, ED INCISE/DA GIAMBATISTA PIRANESE/ARCHITETTURE VENEZIANO/FRAGLI ARCADI/SALCINDIO TISEIO*

14¼″ × 10⅛″ (362 × 257 mm)

BIBLIOGRAPHY  Focillon 1918, no. 2; Robison 1986, no. 1 iv/v; Wilton-Ely 1994, vol. 1, no. 2

Philadelphia Museum of Art, Purchased with the Special Print Fund
1931-27-5

The first edition of the *Prima parte* was dedicated to Piranesi's Venetian friend the builder Nicola Giobbe, and consisted of a suite of twelve plates, plus title page. It was issued as a separate work in 1743–49 but, as the title suggests, additional volumes must have been planned. In 1750 Piranesi first developed a combination volume of the type here exhibited. In the fourth state, shown here, the title was indicated in lettering of a more Roman style and Giobbe's name omitted. The plate was burnished and redrawn in a more sophisticated style and the human figures added. Nevertheless, the general composition records the same dramatic setting, the antique architectural fragments, the urn, and the relief sculpture that appeared on the original title plate. The revisions and additions are extensive, but the persistence of the "e" of "Giobbe" from the initial dedication near the lower right margin of the dedication plaque (adjacent to the ram's head) attests to the swiftness with which Piranesi must have reworked the plate.

This later title page deserves attention in its own right. The removal of the dedication to Giobbe does not appear to have resulted from a falling out with the sometimes temperamental artist (as was once assumed). Rather, the change was occasioned by the expansion of the original suite of plates into a combination volume. In any event, the reference to the Arcadians reflects Piranesi's obvious pride in his admission, c. 1743–44, to this famous Roman literary society, which met in a woodland garden, the Bosco Parrasio, on the Janiculum. Members of this society adopted special names for their meetings, at which Piranesi's "persona" was Salcindio Tiseio. The use of "bucolic" pseudonyms was intended to create the aura—if not the actuality—of anonymity. Given the mix of social status and the range of political, national, and religious differences among the members, the artificial social construct of the society was not entirely frivolous. The Bosco Parrasio, a theater located in a woodland, com-

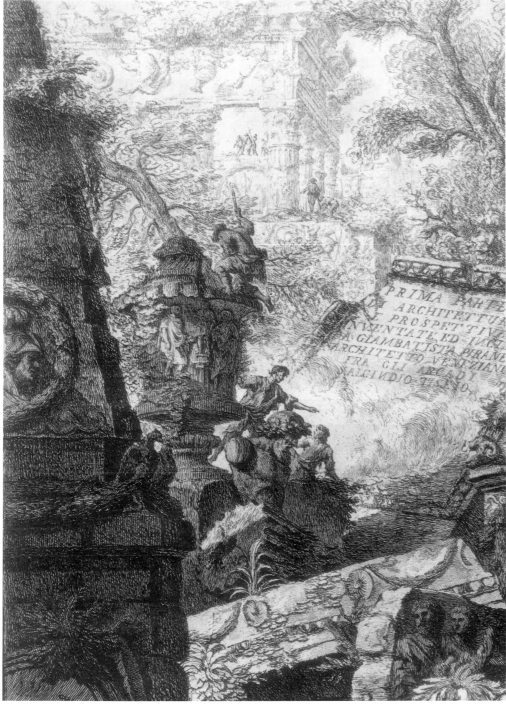

410

## 411
## Giovanni Battista Piranesi
### *The Skeletons*

1747–49
Etching
From the *Grotteschi* (first edition, Rome, 1747–49)
Signed in image, lower right
15¼″ × 21½″ (389 × 546 mm)
BIBLIOGRAPHY Focillon 1918, no. 20; Robison 1986, no. 21 ii/v; Wilton-Ely 1994, vol. 1, no. 21
National Gallery of Art, Washington, D.C., Andrew W. Mellon Fund
1978.49.1

The *Grotteschi* series consisted of four horizontal plates first issued as an independent work c. 1745. Later, in 1750, they were added to a combination volume, the *Opere varie*, which also included Piranesi's revised *Prima parte*. The *Opere varie*, like the original issue of the *Grotteschi*, was published by Piranesi's friend Bouchard.

The *Skeletons* is one of the most animated—and grisly—prints in the series. As frequently noted, Piranesi had just returned from a visit to Venice when he embarked on the project, and the style of the series is profoundly indebted to the work of his Venetian contemporaries, including the etchings of Francesco Guardi and particularly those of Giovanni Battista Tiepolo, who had recently completed his famous *Capricci*. In addition, as Andrew Robison has observed, there are artistic debts to seventeenth-century artists, especially Giovanni Benedetto Castiglione, Salvator Rosa, and the more macabre prints of Stefano della Bella.

Borrowings in the skilled hands of Piranesi, however, amount to motifs completely absorbed into his own visual vocabulary. Sources for the composition of this and other of the *Grotteschi* can also be found among the earlier plates of the *Prima parte di architettura*, first published in 1743. But in none of these earlier examples is there the sense of a veritable wavelike spewing forth of a mass of detritus, vegetal matter, fragments of ancient architecture, sculpture, ornamental urns, and particularly horrifying human skeletons festooned with decaying flesh intermixed with vegetation. This mass of fragmented and decaying forms rises to a crest capped by a monumental shattered urn from which emerges an animatedly gesticulating skeleton, creating a dominant central element of seemingly unstable forms at the center of the composition. A steamy lower central area, along with water spewing from an overturned vase and from the drum of a hollow fluted column without indication of run-off, all contribute to a sense of precariousness, flux, and decay.

bined with the pseudonyms of its members to provide a fantasy setting for serious discourse unfettered by the strictures of eighteenth-century society. The venue of the Arcadians with its mix of frivolity and fantasy as a context for serious discourse may well have encouraged, if not inspired, Piranesi in constructing the mixture of fantasy and archaeological exactitude that characterizes so much of his œuvre. While it seems highly likely that association with the Arcadians affected the content of Piranesi's art, it is even more certain that its member-

ship aided his cultivation of patrons throughout his career.

The frontispiece of the *Opere varie* and other plates in the original issue, including the *Camera oscura*, the *Rovine d'antichi edifici*, and the *Mausoleo antico*, adumbrate the next phase of the artist's career, in which prints of truly extraordinary quality and originality are produced. Among the masterpieces of this phase are the *Grotteschi* (1747), the *Carceri* (1749), and single plates such as the *Ampio porto* (1750). These plates, first published in series or singly, became part of the

expanded contents of the *Opere varie* as a combination volume. The history of the later editions of the *Opere varie* as a combination volume is one of extraordinary longevity, extending into the twentieth century (Robison 1986, pp. 212–14), by which time the impressions bear little witness to their author's genius. [MC]

411

On the left appear two sculptural elements that undisputably identify this frightful landscape apparition as Roman; for Piranesi has depicted the famous Farnese *Hercules* and the sculpture fragment of a draped male torso. As Andrew Robison has indicated, these two images are not derived directly from their readily available sources, but instead copied from two prints in Jan de Bisshop's *Paradigmata graphica*, published in 1671. In transferring these figures to his plate, Piranesi transformed de Bisshop's highly descriptive delineations into the sketched style that now becomes increasingly his signature style. He chose not to—or neglected to—transpose these borrowings before committing them to his copper plate. Consequently, both figures are reversed in the print, and Hercules grasps the golden apples of the Hesperides in his right hand instead of the canonical left. Some vegetation has encroached on Hercules, and more encrusts the satyr term figure who appears immediately in front of and so close to him that the two statues appear engaged in conversation. "Speaking sculptures" is an old Renaissance trope; does Piranesi mean to imply that with his etcher's skills he has given voices to these antique stones?

In the upper right corner, partially obscured by vegetation, clouds, and what may be a large rock ledge, a segment of the zodiac band appears. On the band, reading from left to right, Sagittarius (November) and Scorpio (October) are clearly discernible. Curiously, Sagittarius faces Scorpio, who faces away from Sagittarius, which reverses their customary relationship. Did Piranesi mean to imply a counterclockwise movement to this zodiac, a reversal of the annual sequence of the months and, consequently, of time? Given Piranesi's customary perfect control of the problem of figure reversal in the printmaking process, it is difficult to believe this reversal of the zodiac was unintentional. However, attempts to reduce the *Grotteschi*, collectively or individually, to a specific, hermetic philosophical system have met with little success, beyond their obvious embodiment of a sense of pessimism, of the swift flight of time and the consequent transitory nature of humankind and its achievements. [MC]

## 412
## Giovanni Battista Piranesi
### *Part of a Spacious Magnificent Harbor*

1750
Etching
15¾" × 21½" (400 × 545 mm), without caption plate
BIBLIOGRAPHY Focillon 1918, no. 122; Robison 1986, no. 26 ii/viii (without caption plate); Wilton-Ely 1994, vol. 1, no. 45
The Metropolitan Museum of Art, New York, Harris Brisbane Dick Fund, 1937
37.45.3(41)

This print appears to have been produced as a single print; then, like the *Grotteschi* suite and the *Pianta di ampio magnifico collegio*, it was added, along with a number of prints from his *Prima parte*, to the combination volume entitled *Opere varie di architettura, prospettive, grotteschi, antichità*. This spectacular print is the culmination of a number of sketches of fantastic ports, of which the two most relevant are in the Statens Museum for Kunst, Copenhagen, and at the J. Paul Getty Museum (cat. 388). It also represents a brilliant, conclusive artistic statement to the architectural formulations developed in a series of plates in the original issue of the *Prima parte*, especially the earlier *Ancient Mausoleum, Ancient Roman Forum*, and *Imaginary Ancient Temple* (Wilton-Ely 1994, vol. 1, nos. 7, 10, 17). Piranesi has marshaled a vast array of real and imagined ancient Roman architecture and combined them in a visually rich, even bewildering representation. Thus, for example, the recumbent river god placed above an archway at the center of the composition reproduces an ancient Roman work in the Vatican Museum; in contrast, the obelisk at the far right with striated surfaces, composed of a block of relief sculpture with bristling ships' prows and terminating in a spiral frieze, is entirely a creation of the artist's imagination. In the caption plate later added to the print, Piranesi claims to have created an "ample harbor typical of the ancient Romans," but in fact the maritime activity is confined to the lower border of the print, where a few fragile vessels—reminiscent of gondolas—ride choppy surf and ply their way among enormous pilings. Flights of stairs rise out of the turbulent waters, providing access to a vast segmental oval of multistoried architecture composed of triumphal arch motifs and bristling with galley prows. The façade of this strange edifice is visible in the upper right section of the print, and what appears to be the elevation of its inner wall is described in the upper left section. These façades are inconsistent in architectural detailing and in their expression of elevations. Finally, the section of inner façade visible through the great central arch of the "forum" provides a glimpse of an elevation that resembles neither architectural system. As noted by Robison, these

412

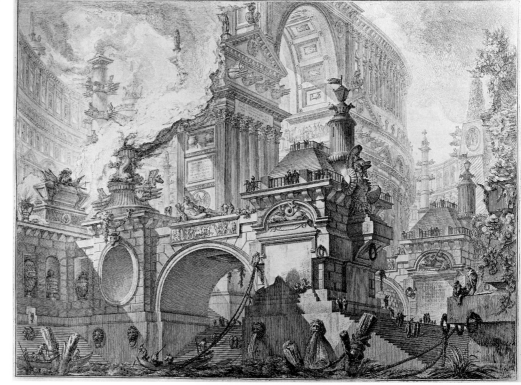

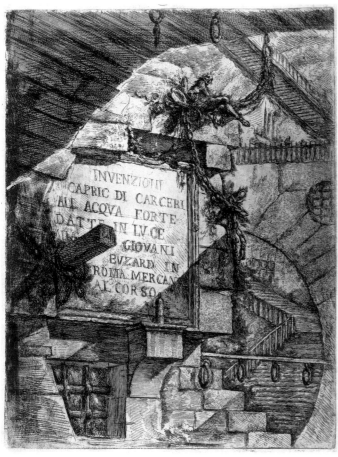

413

inconsistencies were already evident in the Copenhagen drawing, and it can now be added that no attempt appears to have been made to correct them in the Getty sketch—or in the final print (Robison 1986, p. 37). Piranesi describes the space within the great segmented oval structure as "a commercial piazza proudly decorated with rostral columns that denote the most distinguished naval victories." He also commends to the viewer's attention the altar, dedicated to Neptune, which "constantly spews forth perfume."

The billowing, perfumed smoke rising from this altar obscures the base of the great rostral column at the center of the piazza. This swirling smoke is very similar to that found in the *Skeletons* (cat. 411), even to the way that it seems to dessicate the nearer support of the great central arch. The sarcophagi and funerary urns that are a ubiquitous presence "contain the ashes of distinguished naval captains who perished in naval battles, situated at the best locations," Piranesi assures his audience, "to provoke glorious emulation." Mindful of the environment, Piranesi calls attention to the lion-head *mascheroni* that spew forth the sewerage generated in this harbor complex.

The plaques on twin piers at the head of the stairway descending

toward the right margin of the print appear to have been considered for inscriptions; although canceled, two opposed faces are discernible on one of the plaques on the pier on the near side of the stairs, and although the lightly sketched inscription on the plaque on the far right is virtually illegible, the letters MARC ANTON[IUS] can be made out. There are unexpected variations in the details of these two piers. The paired dolphins on the nearer one are symmetrically disposed within an arched frame; one of the dolphins on the further pier has twisted out of his confines. The casual introduction of elements of asymmetry within larger systems of apparent symmetry will emerge as an important conceit in many of Piranesi's later works, most notably in his *Diverse maniere d'adornare i cammini*, published in 1769.

The dramatic effect of this harbor fantasy is enhanced by the play of light and shadow across this vast field of varied architectural and sculptural forms. As in his earlier prints, Piranesi eschewed hatched surfaces and achieved his shaded values through infinitely varied parallel lines of different lengths and thicknesses. Most of these lines adhere to consistently vertical patterns, but occasionally they conform to their architectural surfaces:

for example, the shading on the interior surface on the vault over the stairway in the lower center of the print.

When the Getty drawing is added to the visual documentation provided by the Copenhagen preparatory study, it is evident that the evolution of the final composition has become more, rather than less, complex. A final observation may serve as a case in point. As noted by Robison, even in the more amply scaled Copenhagen drawing, the lower terminus of the stairway in the right section of the drawing appears crowded by the architecture along the right margin of the composition. This problem is left unresolved in the Getty "master drawing" but was masked, as Robison noted, in the print by a "cleverly placed plant" (Robison 1986, p. 37). One now wonders if this vegetal screen was added only at the last moment, directly in the plate. [MC]

## 413
## Giovanni Battista Piranesi
### Title Page

1749–50
Etching
From the *Carceri* (first edition, first issue, Rome, 1749–50)
INSCRIPTION INVENZIONI/CAPRIC DI CARCERI/ALL'ACQUA FORTE/DATTE IN LUCE/DA GIOVANI/BUZARD IN/ROMA MERCANTE/AL CORSO
21″ × 16¼″ (535 × 412 mm)
BIBLIOGRAPHY Focillon 1918, no. 24; Hind 1922, "The Prisons," no. 1; Robison 1986, no. 29 i/ix; Wilton-Ely 1994, vol. 1, no. 26
Philadelphia Museum of Art, The Muriel and Philip Berman Gift, acquired from the John S. Phillips bequest of 1876 to the Pennsylvania Academy of the Fine Arts, with funds contributed by Muriel and Philip Berman, gifts (by exchange) of Lisa Norris Elkins, Bryant W. Langston, Samuel S. White 3rd and Vera White, with additional funds contributed by John Howard McFadden, Jr., Thomas Skelton Harrison, and the Philip H. and A.S.W. Rosenbach Foundation
1985-52-1300

This title page is from the rare first edition of the *Carceri*, which consisted of fourteen unnumbered plates executed in a light, sketchy style. As the title indicates these prints are "capricious inventions," which in style and content should be considered fanciful inventions of prisons. They derive from Piranesi's earlier exploration of the prison motif in a 1743 plate in his *Prima parte di architetture e prospettive*, which itself was derived from the theater designs of Ferdinando Bibiena. In the *Carceri* series Piranesi moves away from this theater venue toward a more fanciful presentation of the subject, one in keeping with the sketchy, *non finito* style that lends

an airy quality to the prison theme. The tenor of this early edition of the *Carceri* is set by the earliest title page on which the very colloquial form *capric* appears instead of *capricciosi*, and the last name of the publisher, Jean (or Giovanni) Bouchard is misspelled as Buzard. A French-born publisher and bookseller in Rome whom Piranesi knew well, Bouchard was one of three friends who gave a formal deposition at Piranesi's marriage and continued to serve as the artist's publisher until 1760. Traditionally, the mistaken spelling has been attributed to the artist's ignorance of French, but, given Piranesi's extensive connections with the French Academy at Rome and his numerous French friends, including Bouchard, there is a more convincing explanation, one that underscores the capriciousness of the earlier version of the *Carceri*. The misspelling is a dirty joke—a *burla*—in which Piranesi has deliberately transformed Bouchard into Buzard, which in Venetian dialect means "bugger." For cultural context, comparison can be made with his Venetian contemporary Giorgio Baffo, whose poems are peppered with references to both hetero- and homosexual sodomy and directed at well-known Venetian contemporaries (Campbell 1990, pp. 90–101, especially pp. 91–92).

Given the ribald crudity of Piranesi's initial title page, it is not surprising that it was issued in limited numbers (hence its rarity) and replaced in scarcely a year's time with a title page in which Bouchard's name was correctly spelled. Significantly, this revised version of the first edition title page of the *Carceri* was used in the second and third issues, enjoying an extended printing from 1750 to 1760. [MC]

## 414
## Giovanni Battista Piranesi
### The Giant Wheel

1749–50
Etching
From the *Carceri* (first edition, first issue, Rome, 1749–50)
Signed in image, lower left
21″ × 15¼″ (535 × 412 mm)
BIBLIOGRAPHY Focillon 1918, no. 32; Hind 1922, "The Prisons," no. 9; Robison 1986, no. 35 ii/viii; Wilton-Ely 1994, vol. 1, no. 34
Philadelphia Museum of Art, The Muriel and Philip Berman Gift, acquired from the John S. Phillips bequest of 1876 to the Pennsylvania Academy of the Fine Arts, with funds contributed by Muriel and Philip Berman, gifts (by exchange) of Lisa Norris Elkins, Bryant W. Langston, Samuel S. White 3rd and Vera White, with additional funds contributed by John Howard McFadden, Jr., Thomas Skelton Harrison, and the Philip H. and A.S.W. Rosenbach Foundation
1985-52-1306

414

415

## 415
## Giovanni Battista Piranesi
### *The Gothic Arch*

1749–50
Etching
From the *Carceri* (first edition, first issue,
Rome, 1749–50)
16¼″ × 21¼″ (411 × 538 mm)
BIBLIOGRAPHY Focillon 1918, no. 37; Hind
1922, "The Prisons," no. 14; Robison 1986,
no. 40 i/vi; Wilton-Ely 1994, vol. 1, no. 39
Philadelphia Museum of Art, The Muriel
and Philip Berman Gift, acquired from the
John S. Phillips bequest of 1876 to the
Pennsylvania Academy of the Fine Arts,
with funds contributed by Muriel and
Philip Berman, gifts (by exchange) of Lisa
Norris Elkins, Bryant W. Langston, Samuel
S. White 3rd and Vera White, with addition-
al funds contributed by John Howard
McFadden, Jr., Thomas Skelton Harrison,
and the Philip H. and A.S.W. Rosenbach
Foundation
1985-52-1312

This print is probably the most abstract and architecturally irrationally structured scene in the *Carceri* series. It is also unique in that it passes through all the revised states of the series with relatively little alteration. Its generic title derives from the nearest of two wheel-like downward curving forms that dominate the upper three-fifths of the scene. It is unlikely that Piranesi intended these forms to represent a wheel, as they lack both hub and spokes. In fact, this "giant wheel" is more like an enormous, truncated circular frame, a sort of freestanding oculus displaced to a vertical position where it ambiguously hovers in space. Within this segmented form is glimpsed a precariously suspended timbered scaffolding partially obscured by smoke or steam. In the lower central section of the print, two masonry arches abut a massive post and lintel masonry door frame.

In the left foreground are three figures, one seated, one standing, and one kneeling. The standing figure presses down on the head of the kneeling one with his right arm. Another triad of figures appears in the lower right corner, and in the background a solitary figure stands atop a sketchily indicated stairway. More figures, lost in a web of

scratched lines, lean over a balustrade in the background. Above the central doorway there is a cylindrical platform to which is affixed a spiked pillar. A crouching figure is pinioned to the left of the pillar, and, to the right, a standing figure turns toward an eerily indeterminate shape, which seems to crouch on the curve of the "giant wheel." Nearby a recumbent figure dangles over the edge of the "giant wheel," and next to this figure are two more who struggle to support a cross-like wooden form.

Of all the etchings in the *Carceri* series, this one most fully retains the immediacy and spontaneity of a pen and ink sketch. The sense of drawing, the evanescent quality of the sketch, and the suggestion of form imprecisely defined—of the *non finito* so greatly appreciated by connoisseurs of the period—permeate the work. Indeed, it is hard to believe that the intervention of the printer's art took place, that this is not actually a swiftly executed drawing in pen and ink. [MC]

Typical of many of the early prints of the *Carceri* series, the so-called *Gothic Arch* is depicted as a vast, labyrinthine structure with no indication of incarceration beyond the presence of barred interior windows and grated arches. Whether the original stone structure is unfinished or in ruin is unclear. In any case, the timber truss system appears to be a late addition, inserted into preexisting stonework. These ambiguities of construction, however, pale before the astonishing spatial and structural manipulations in this print. Similar distortions occur in other prints in the early Bouchard editions of the *Carceri*, but in this print the *scena per angolo* perspective system that Piranesi had employed in many of his compositions is deliberately subverted. This is apparent from a close scrutiny of the three massive piers arranged across the foreground of the print. These piers, their heavily shaded short ends projecting toward

the spectator, create what in the lower section of the print can be read as a consistent right-to-left diagonal recession in a single plane, a recession that permits a flight of stairs to pass between the two left-most piers of this series. However, when the viewer examines the upper left section of the print, it is apparent that the massive receding wall, punctuated by the pointed "gothic" arch and a lower, flattened relieving arch, is carried on these same two piers. The wall containing this idiosyncratic arch can only be read as a single, continuous plane receding toward a vanishing point somewhere outside of the right margin of the print. This planar recession absolutely subverts the placement of the stairway that, as we have noted, passes between these two piers in the lower area of the print.

When Piranesi revised the *Carceri* series in 1761, he augmented the counterrational perspective effects in this print and played similar perspectival tricks in many of the other prints in this series. But his *Gothic Arch* provides one of the fullest—and perhaps the initial—subversion of the supremely rationalized three-point perspective system that he had thoroughly mastered and used with such extraordinary brilliance in contemporaneous plates for his *Prima parte di architetture e prospettive*. [MC]

416

## 416
## Giovanni Battista Piranesi
### The Pier with Chains

1749–50

Etching

From the *Carceri* (first edition, first issue, Rome, 1749–50)

15⅞″ × 21¼″ (405 × 542 mm)

BIBLIOGRAPHY  Focillon 1918, no. 39; Hind 1922, "The Prisons," no. 16; Robison 1986, no. 42 i/vi; Wilton-Ely 1994, vol. 1, no. 41

Philadelphia Museum of Art, The Muriel and Philip Berman Gift, acquired from the John S. Phillips bequest of 1876 to the Pennsylvania Academy of the Fine Arts, with funds contributed by Muriel and Philip Berman, gifts (by exchange) of Lisa Norris Elkins, Bryant W. Langston, Samuel S. White 3rd and Vera White, with additional funds contributed by John Howard McFadden, Jr., Thomas Skelton Harrison, and the Philip H. and A.S.W. Rosenbach Foundation

1985-52-1314

In its first state this print is perhaps the most benign image in the *Carceri* series. Only a few chains dangling from the massive bolstered column at the right, a barred doorway, and several grilled windows lend credibility to the prison theme. In general effect this print conforms to the conventions of the stage set designs that were familiar to Piranesi from his early study in Venice. The architectural enframements of the scene echo the role of the proscenium arch in stage design, and the perspective system, despite the complexities of its piers, arches, and stairs, is essentially a rendition of the *scena per angolo* common to eighteenth-century stagecraft. [MC]

## 417
## Giovanni Battista Piranesi
### Title Page

1749–61

Etching

From the *Carceri* (second edition, first issue, Rome, 1761)

Signed below image, lower left

INSCRIPTION  *CARCERI/D'INVENZIONE/DI G. BATTISTA/PIRANESI/ARCHIT[ETTO]/VENE[ZIANO]*

21½″ × 16⅛″ (546 × 416 mm)

BIBLIOGRAPHY  Focillon 1918, no. 24; Hind 1922, "The Prisons," no. 1; Robison 1986, no. 29 v/ix; Wilton-Ely 1994, vol. 1, no. 26

National Gallery of Art, Washington, D.C., Mark J. Millard Architectural Collection, acquired with assistance from The Morris and Gwendolyn Cafritz Foundation

1983.118.2

The reworking of the *Carceri* title page a dozen years after the first edition sets the stage for the revision—stylistically and thematically—of the entire cycle. Although elements of the original composition are retained, much has changed in this new edition, not least the title, which is now formulated in the version used, somewhat inappropriately, to describe and catalogue both editions. The first edition was *capriccioso* in mood, the prints by turns mysterious, horrific, macabre, and entertaining, and the title page flirted, as has already been seen, with the humorously obscene at the expense of its patron and publisher in the first issue. In the new edition the title, now unframed, is erratically composed, but the lettering is more formal, more "Roman," and *Piranesi, Architetto Veneziano* is identified as creator and publisher. The chiaroscuro effect is greatly heightened throughout the print. Whereas the first edition *Carceri* prints manifest a similarity to pen-and-ink sketches, such that it is tempting to suggest that

417

the artist deliberately sought to counterfeit this technique in his plates, the second edition prints are unassuaged products of the printer's art. Virtually all the new elements and many of the revisions of the print are executed in the dark, *scuro* mode that now enjoys such an unenhanced—even dominating—role in Piranesi's technique. Although the *Carceri* are still fantastic, bearing little resemblance to prisons of Piranesi's own time, and demonstrably none to those of ancient Rome, this revised edition, augmented by two entirely new prints, addresses issues of incarceration far more consistently. The elements added to the title page support this argument.

In the lower foreground of the print a grisly spiked wheel, presumably intended for the impalement of victims, has been introduced. This great wheel carves a space out of the formerly flattened foreground, a spaciousness that is enhanced by a catwalk supported by the console that originally provided a base for a small bollard and its new twin at the far right. The great beam wrapped in cordage that disrupted the first edition title is now submerged in shadow and becomes part of a spiked scaffold.

The changes in the title page are both stylistic and iconographic, and the new ensemble of prints constitute

a series that is profoundly altered and revised. In addition to containing two new prints, and beginning with the second issue of this edition, the sequence of plates was fixed by the addition of Roman numerals, thus assuring, for the first time, a viewing sequence, even if the prints were sold unbound. This numerical sequence follows a chronology, one that implies a reversal of conventional historical time. As in the successive time periods revealed in his archaeological excavations, Piranesi's etchings extend from the despotism and brutality of Neronian imperial Rome back in time to the severe but adjudicated justice of the Roman republic. Both of the two plates added to the set address this issue; however, one of them—untitled, but generally known as *The Man on the Rack* (cat. 418)—served as the first plate in the numerically ordered revised series, and it is the so-called *Pier with Chains*, now number XVI (cat. 420), the final print, that in its revised state most fully articulates Piranesi's thesis of moral, ahistorical progress from the Neronian era to the republican. The emergence of this distinctly Roman theme in the later edition of the *Carceri* is accompanied by an increased emphasis on torture and incarceration, not primarily through its enact-

ment—the *Man on the Rack* is an exception—but through the depiction of its infernal machinery, shackles, chains, spiked fences, and gratings.

This title page epitomizes the accentuation of this more repressive incarceration theme. As noted, the assemblage of spiked beams and wheel makes its appearance in the second edition, where its presence seems to give specific cause for the anguish of the enchained human located directly above. Here, on the title page and throughout the series, the elements of incarceration, barred windows, chains, rings, pulleys, spiked beams, and wheels appear absurdly large in scale for the present inhabitants who are, nevertheless, in proportion with the wooden stairs and catwalks they traverse (see Campbell 1988, pp. 20–23). As in the title page, so too in almost all of the revised *Carceri* series, the number of these wooden insertions increases, heightening the contrast in scale and permanence between them and the massive, enduring stonework they penetrate. The disparity of scale between the depicted inhabitants—the occupants of these fragile wooden constructions—and the architecture may well reflect, in exaggerated form, the emotions experienced by Piranesi and his eighteenth-century contem-

poraries when they confronted such grandiose monuments of ancient Rome as the Colosseum, the Mausoleum of Augustus, or Hadrian's Villa. Certainly the disparity of scale between Piranesi's portrayal of these ancient edifices and his rendering of human scale in his *vedute*, especially after publication of the second edition *Carceri*, lends credibility to this thesis. [MC]

## 418
### Giovanni Battista Piranesi
*The Man on the Rack*

1749–61
Etching
From the *Carceri* (second edition, second issue, Rome, mid-1760s)
Signed below image, lower right
INSCRIPTION *Presso l'Autore a Strada Felice vicino alla Trinità de' Monti. Fogli sedici, al prezzo di paoli venti*
22⅛″ × 16½″ (564 × 418 mm)
BIBLIOGRAPHY Focillon 1918, no. 25; Hind 1922, "The Prisons," no. 2; Robison 1986, no. 43 ii/vi; Wilton-Ely 1994, vol. 1, no. 27
National Gallery of Art, Washington, D.C., Mark J. Millard Architectural Collection, acquired with assistance from The Morris and Gwendolyn Cafritz Foundation 1983.118.3

418

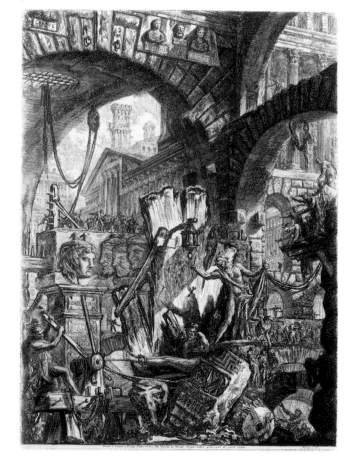

This print was one of two added to the *Carceri* suite when the second edition was printed in 1761. Early in the 1760s the prints were numbered, and this one was designated with a Roman numeral II as the first print following the title page. In this location it opens the cycle with a particularly—in fact most overtly—gruesome scene, for although bondage and apparent torture occur in other *Carceri* prints, this is one in which such an act is made the central theme of a print and unequivocally displayed in the foreground of the scene.

The general composition, in which the scene is viewed as if from near ground level, looking up into an architectural complex of intersecting arcades, is typical of many of the earlier *Carceri* prints. The fact that the observer's eye is led upwards into an outdoor area, to a view of a distant piazza bounded by architecture, including one distant colonnaded façade with unorthodox classical forms, is reminiscent of the fantastic architectural plates added to Piranesi's *Parere su l'architettura* after 1768. It is difficult to know how to interpret the scene. As Andrew Robison has observed, both this print and the other one added to the series include multitudes of diminutive figures in eighteenth-century costumes. Dressed as Piranesi's contemporaries, they behave much like the shepherds and tourists among the architectural ruins in the artist's contemporaneous *vedute* prints. Gesticulating enthusiastically, they appear to have just discovered the torture scene in the foreground to which the viewer also bears witness.

What is the significance of this grisly scene, in which a man is being stretched on a rack? Robison has offered an interpretation:

The three figures involved in the torture are part of the foreground mélange of ancient architectural carvings. Judged by their classical nudity, modeling, drapery, and especially their huge size relative to other figures in the image, these three are not treated as live human beings at all but as antique statues, like the antique bas-reliefs at bottom right and the colossal, antique bas-relief portrait busts behind and above them. (Robison 1986, p. 49 and n. 81)

There is certainly a relationship implied between the torture scene and the antique materials gathered around it, including the inscriptions. These inscriptions offer important clues to Piranesi's intentions. Through the pioneering efforts of Silvia Gavuzzo Stewart (Gavuzzo Stewart 1971) and

subsequently several other scholars, it is now possible to identify the individuals cited in the inscriptions. They are Roman citizens mentioned by the Roman historian Tacitus as having been unjustly executed by the Emperor Nero either because they had offended him or because he coveted their property. Furthermore, Tacitus reports that a freedman of one of these Roman aristocrats was tortured on the rack by Nero's henchman Tigellus. This coincidence seems almost too good to be true, but it is beyond credibility that the Romans would have elected to create a monumental sculpture group of a freedman enduring torture—or that Piranesi would have believed such a thing possible. Given the artist's extensive knowledge of antique sculpture and the archaeological accuracy that generally characterizes his depictions of it, the most natural conclusion is that:

The message conveyed by this group seems to be correctly interpreted by Robison, but it is difficult to consider them as a sculpture group, even a fantastic one. Neither the figural composition nor the rack, a jerry-built machine of crude beams, nor the tree trunk slab affixed with an illegible cartouche and a bizarrely positioned lantern seem reconcilable with antique sculptural compositions. They seem more nearly an apparition, a monumental *tableau vivant* of the imagination intended by Piranesi to shock his contemporaries—and now us (Campbell 1988, p. 34). [MC]

## 419
### Giovanni Battista Piranesi
*The Gothic Arch*

1749–61
Etching
From the *Carceri* (second edition, second issue, Rome, mid-1760s)
Signed in image, lower left
16¼″ × 21⅝″ (415 × 549 mm)
BIBLIOGRAPHY Focillon 1918, no. 37; Hind 1922, "The Prisons," no. 14; Robison 1986, no. 40 iii/vi; Wilton-Ely 1994, vol. 1, no. 39
National Gallery of Art, Washington, D.C., Mark J. Millard Architectural Collection, acquired with assistance from The Morris and Gwendolyn Cafritz Foundation 1983.118.15

In overall composition this print appears to have undergone little modification in the decade that separates the first and third states of the plate other than an intensification of shading to define and darken objects

and structures. Closer examination, however, does in fact reveal changes. Some of these alterations render the content of this print more compatible with the new title and intention of the entire series of *Carceri* prints. Thus spikes have been added to wooden posts in the lower right corner, rings now protrude from several piers, and a cage used to suspend prisoners in solitary confinement hangs from a beam. The last device appeared in an earlier print in the *Prima parte di architetture*, where it is identified as an "*antenna* for the punishment of criminals" (Wilton-Ely 1994, vol. 1, no. 5). At another level, elements have been added that serve to mask many of the spatial dichotomies that were imbedded in the plate from its first state. Thus, the series of beams that stretches from the left margin of the print to the first pier on the left, the cordage that traverses the same space and terminates in a ring in the next pier, and an enormous beam with vertical extensions that passes across the truss beams in the upper section of the print, all serve, like the introduction of a second, pointed arch, to emphasize a continuous receding plane in the upper section of the print, thus mitigating the visual immediacy of the Escher-like spatial ambiguity in the first state of the print (cat. 415). Certainly the dark-inked chiaroscuro of this edition also helps to obscure the calculated spatial aberrations. What is intriguing, however, is that although Piranesi chose to downplay these visual games, he chose not to eliminate them. Instead he actually widened the run of stairs that splits the planar continuity of the left-hand and mid-scene piers, thus heightening the effect of the spatial discontinuities when the observer finally "discovers" them. [MC]

## 420
## Giovanni Battista Piranesi
### *The Pier with Chains*

1749–61
Etching
From the *Carceri* (second edition, first through second issues, Rome, 1761–mid 1760s)
Signed in image, lower right
16⅜″ × 21⅝″ (416 × 549 mm)
BIBLIOGRAPHY Focillon 1918, no. 39; Hind 1922, "The Prisons," no. 16; Robison 1986, no. 42 ii/vi; Wilton-Ely 1994, vol. 1, no. 41
National Gallery of Art, Washington, D.C., Mark J. Millard Architectural Collection, acquired with assistance from The Morris and Gwendolyn Cafritz Foundation
1983.118.17

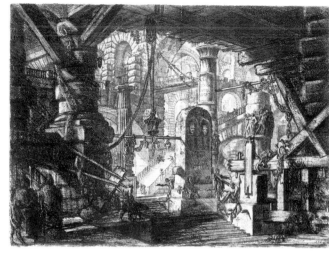

420

This plate as recorded in its first state (cat. 416) was the most neutral of all the scenes in the *Carceri* series. In its revised state the central middle-ground area has been drastically revised, and the scene has been invested with heavy shading around its periphery. A typical repertory of chains, manacles, and spiked timbers is now present, but the condition of these objects suggests that they are in a state of disuse. Chains appear broken, and many of the rings are fragmentary. No figure is unequivocally identifiable as a prisoner; instead the inhabitants of the scene appear to be visitors.

In its revised state the central middle-ground area of this plate has been burnished out and recut with the introduction of four new monuments. These include: a weathered Doric column with chipped, ill-fitting drums; a column with a lotus leaf capital composed of separate drums, one carved in relief and one bearing an inscribed tablet; a short pillar with inscription and a frieze; and in the center foreground, a memorial containing two recessed portrait heads and an inscription. Interpretation of

these objects and their inscriptions has gone on apace for nearly four decades, and, although these interpretations have varied, the essential themes are clear (Robison 1986, pp. 49–50 and especially n. 81 provide a review of the literature). Despite its mildly horrific visual qualities, this revised print is an emphatic counterstatement to the two prints added to the series, especially to the first plate in the revised series, the newly created *Man on the Rack* (cat. 418). Now numbered XVI, *Pier with Chains* constitutes the end of the series, a series that in revised form began with a scene of Neronian despotism and here concludes, as first adduced by Silvia Gavuzzo Stewart (Gavuzzo Stewart 1971), with a scene embodying Roman republican values—moral, political, and aesthetic.

In this revised print Piranesi seeks to separate Roman accomplishments, architectural and civic, from foreign influence. In this context the Doric order, depicted as a non-functional, chipped, and ill-assembled object, seems to be rejected as Greek and hence foreign (for an alternative interpretation, see Robison 1986, p. 50). The tall columns with palm leaf capital would seem to reflect the architecture of the near east, most probably Egypt. Piranesi generally praised Egyptian architecture and allied it with that of the Etruscans, considering both as precedent to that of Greece; however, the inscription on this column suggests negative appraisal of this "foreign" achievement. It bears an inscription from Livy's *History of Rome* (I. 33. viii), AD/ TERROREM/ INCRESCEN[TIS]/ AVDACIAE ("to terrify the growing audacity"), a reference to the decision of the early Roman king Ancus Martius to build Rome's first prison to control the republic's increasingly socially diverse and restless population. The relief sculpture on the column appears

crowded with people. On the adjacent pillar there is another band of relief sculpture featuring a mass of people engaged in an indeterminate action. The unframed inscription above is a fragment of a continuous inscribed band. The top line reads: INFAME SCEISVSS [SCELVS?] ("infamous wickedness") and below [ARBO]RI INFELICI SVSPE[NDE] (Livy I. 26. v). Efforts to find an exact literary source for the first part of this inscription have been unsuccessful; it is known that *scelus* was a word frequently used by Livy to describe severely immoral acts. The misspelling suggests that Piranesi was improvising without his advisers and that he intended this inscripted fragment to modify (rather crudely) the second fragmentary phrase, which alludes to the severe laws of the duumvirs, who in early Rome judged cases of treason. These laws could have been applied to the trial of the patriotic member of the Horatii who survived the fateful duel with the Curatii and murdered his sister when he found her weeping for one of the dead enemy. The fragmentary inscription is a variant on Livy's commentary (I. 26. v): *Caput obnube liberatoris urbis huius; arbori infelici suspende* ("Blindfold the eyes of the liberator of our city; hang him on a barren tree"). In the sentencing, however, this dread punishment was not applied, and the prisoner suffered only a ritual of passing his neck beneath a beam erected for this purpose, the Sororium Tigillum, perhaps represented by the wooden structure added to this print and present as well in several others (Calvesi 1968, p. 17). Piranesi certainly wanted his viewers to reflect on the Horatian trial, but in juxtaposing the two inscriptions he created two fragmentary inscriptions that taken together combined two highly repressive motifs: the apparent need to terrify Rome's unruly populace and the means for effecting such repression,

419

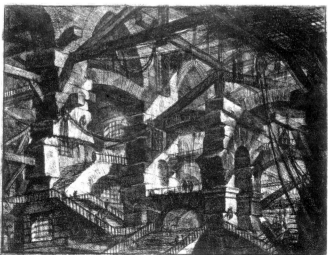

421

## Giovanni Battista Piranesi
### *Frontispiece: Fantasy of Ruins with a Statue of Minerva in the Center Foreground*

1746?–48?
Etching
From *Vedute di Roma* (Rome, before 1778)
Signed below image, lower right
19⅞″ × 25¼″ (505 × 641 mm)
BIBLIOGRAPHY Focillon 1918, no. 786; Hind 1922, "The Views of Rome," no. 2 iii or iv/vii; Campbell 1990, *Piranesi*, no. 2; Wilton-Ely 1994, vol. 1, no. 135
National Gallery of Art, Washington, D.C., Mark J. Millard Architectural Collection, acquired with assistance from The Morris and Gwendolyn Cafritz Foundation
1985.61.2

The frontispiece of the *Vedute di Roma*, a collection of views spanning the architectural history of the city from ancient to contemporary time, is, surprisingly, devoted solely to a collection of real and imaginary ancient monuments, a situation that suggests that this print may initially have been intended for a different print series. In style and content it has much in common with the contemporaneous *Grotteschi*; however, its enormous size precludes inclusion in that series.

At the center of the antique *spolia* is a seated, fragmentary, reversed version of a statue known as the *Dea Roma*. This well-known statue, constructed out of an antique *Minerva* in the Renaissance, is now, as in Piranesi's time, in front of the Palazzo dei Senatori on the Capitoline Hill. Piranesi depicts the figure as if made entirely of marble, although her body is actually porphyry; he has also removed her raised arm (a Renaissance restoration). On the far left appears a reduced version of the right foot of the fragmentary colossal statue of Constantine, also on the Capitol. The nearby keystone with a standing, armed figure is from the so-called Arch of Marcus Aurelius (popularly called the Arco di Portogallo), which stood in via del Corso until it was demolished in 1662, at which time its relief sculpture was placed in the Museo Capitolino and this keystone transferred to the University of Rome, where it was studied by such artists as Peter Paul Rubens and Nicolas Poussin. On the far right appear the effigies of a Roman couple atop an elaborate sarcophagus in the form of a labrum which, on its short side, bears a plaque inscribed: PIRANESI/ INV[.] INCI. Steam or smoke bellows out from urns on this sarcophagus, rising up behind *Dea Roma*, a motif that also appears in the *Capricci* etchings and the *Opere varie*.

Many of the antique remains in the print bear inscriptions, several of

---

the threat of the hangman's noose (for variant, but related, interpretations, see Rykwert 1980, pp. 376–78, and Robison 1986, pp. 49–50).

The inscriptions discussed thus far are open to several different or even multiple interpretations. In contrast, the central monument and its inscription are unambiguously clear. The inscription reads: IMPIE/ TATI/ ET/ MALIS/ ARTIBVS ("through treason and misconduct"). Although the inscription is not to be found in Livy, Robison has convincingly identified these portraits as representations of the decapitated heads of the treacherous sons of Lucius Brutus, who had liberated Rome from the despot Tarquinius Superbus only to have his two sons drawn into a plot to restore the Tarquins to power (Robison 1986, p. 49). The plot uncovered, Livy vividly describes how Brutus as first consul had to preside over the torture and beheading of his sons.

If the two columns are interpreted as foreign importations and contrasted with the massive structure of this Roman prison, they serve as an architectural parallel to Piranesi's thesis on the history of Roman law, one that opened with a vision of imperial abrogation of the ancient laws of Rome, by then corrupted by foreign importations. In contrast, in this concluding image of the series we witness the celebration of the severity but austere probity of Roman republican jurisprudence. [MC]

## 421

## Giovanni Battista Piranesi
### *Title Page*

1746?–48?
Etching
From *Vedute di Roma* (Rome, before 1778)
Signed below image, lower right
INSCRIPTION *VEDUTE DI ROMA/DISEGNATE ED INCISE/DA GIAMBATTISTA PIRANESI/ARCHITETTO VE[NE]ZIANO*
15¼″ × 21¼″ (400 × 540 mm)
BIBLIOGRAPHY Focillon 1918, no. 719; Hind 1922, "The Views of Rome," no. 1 iii/v; Campbell 1990, *Piranesi*, no. 1; Wilton-Ely 1994, vol. 1, no. 134
National Gallery of Art, Washington, D.C., Gift of David Keppel
1943.10.1

The title appears as if inscribed on a sloping architectural fragment. In several instances the letters in the inscription have been arbitrarily composed so that they remain legible in spite of the objects gathered in the foreground of the print. Thus, an improbably wide space separates the initial "P" in *Piranesi* and the next letter in his name, and *Veneziano* is stretched so that the first "e" is partially visible, and the "z," although reduced to a mere fragment, can be read because it is a reversed "z," allowing a fragment of the lower angle of the letter to be seen. In this instance the reformulation of letters serves at least a marginal purpose; when he revised the title page of his *Prima parte* in 1750, Piranesi reversed the "n" in *incise* and *Salcindio* for no apparent reason (cat. 410).

The objects heaped in the foreground are accentuated by heavy inking. Here, among scattered pieces of masonry, a column base, and a Corinthian capital, two remarkable objects appear: an oval, deeply gored, covered vase, capped by weeds and spewing water, and a particularly arresting urn. Capped by an ornamental pine cone, it displays the pitcher, *patera*, and bucrania that Piranesi probably derived from the reliefs on the entablature of the temple of Vespasian in the forum which he, like his contemporaries, mistook for the temple of Jupiter Tonans (see Campbell 1990, cat. no. 37). The urn rests on a circular base carved with figures in relief, three of which are visible. The bearded male in this group is accompanied by an eagle, assuring that this figure is Jupiter; presumably the adjacent seated female is Juno. A male figure located behind the couple wears a cap of the type worn by Mercury. The relief does not appear to have a known antique source. The vase and its elaborate base seem a greatly enriched version of the title page of the *Prima parte*; they are similar to, but even more elaborate than, the vases and bases in his 1778 publication, *Vasi, candelabri …* [MC]

422

which are legible. At the apex of the antique pyramid of *spolia* in the left section of the print are the words: *SABINIS POPVLIS/ QVIS RESISTET/ S.P.Q.R.* This is not an ancient inscription and seems to be a jest. In the dative case, it reads, literally, "To the Sabine peoples. Who will withstand [them]? *S.P.Q.R.*." The lengthy inscription immediately below this spurious inscription is recorded on a broken and cracked tablet, but, contrary to appearance, it is intact and transcribes a slightly modified version of an inscription recorded by Pliny the Elder (*Natural History*, vol. 7, p. 97):

*CN. POMPEIVS CN. F MAGNVS/ IMP[ERATOR]/ BELLO XXX ANNORVM CONFECTO/ FVSIS FVGATIS OCCISIS IN DEDITIONEM/ ACCEPTIS HOMINVM CENTIE[N]S VICIE[N]S/ SEMEL CENTENIS LXXXIII DEPRESSIS AVT CAPT [IS] NAVIBVS DCCCXLVI/ OPPIDIS CASTELIS MDXXXVIII/ IN FIDEM RECEPTIS/ TERRIS A MAEOTIS AD RVBRVM/ MARE SVBACTIS/ VOTVM MERITO MINERVAE.* ("Gnaeus Pompeius, son of Pompeius, Magnus, Commander in Chief, having completed a thirty years' war, routed, scattered, slain, or received the surrender of 12,183,000 people, sunk or taken 846 ships, received the capitulation of 1,538 towns and forts, subdued the lands from the Maeotians to the Red Sea, duly dedicates his offering vowed to Minerva.")

The immensity of Pompey's conquests and the ruinous condition in which Piranesi chooses to show this imaginary version of the dedication powerfully suggest the ephemeral nature of human achievements and the impermanence of the monuments raised to celebrate them.

Below and in front of the Pompey inscription there is another that has attracted the attention of two diminutive humans who appear dwarfed by the colossal fragments of antiquity. This inscription is indistinct and scattered across an enormous *tabula ansata* with curved handles completely out of scale with the humans present. Although fragmentary in appearance, the inscription, like the preceding, is intact and reads: *ROMAE ET AVGVSTO/ CAESARI DIV F[ILIO] PAT[RI] PATRIAE* ("To Rome and Augustus Caesar, Son of the Deified One and Father of the Fatherland"). The text is not from Rome, where Augustus never received the cult; it is taken, in fact, from the drill holes that once held bronze letters on the architrave of a building, still *in situ* at Pola on the Istrian coast. Given his interest in ancient architecture, it is surprising that Piranesi elected to transfer the inscription to a *tabula*. He may have appreciated the fact that it was written in the dative case and was thus a dedication suitable for a frontispiece. More important, however, is surely the locus of the ancient monument bearing the inscription, for Pola is in the area where the Piranesi family originated, and thus the inscription combines references to ancient Rome in its golden age with personal, geographic ones. Furthermore, Piranesi was personally familiar with Pola; in his 1748 publication *Antichità romane* (later retitled *Alcune vedute di archi trionfali*) he devoted three of the original twenty-eight plates to monuments located in that city. At some distance from these inscriptions and their eager readers looms the Farnese *Hercules*. Here, as in the *Skeletons* (cat. 411) in his *Grotteschi* series, Piranesi has printed the statue in mirror reversal.

In the upper section of the print, partially obscured in haze, an oak tree and palm tree emerge, symbolic perhaps of fortitude and renewal. Further back an imaginary, partially ruined, temple can be made out. Its entablature is supported by a highly unorthodox Corinthian order, its columns decorated with spiraling narrative reliefs in the manner of the Antonine Column and Trajan's Column. [MC]

423

Giovanni Battista Piranesi
*View of St. Peter's Basilica and St. Peter's Square in the Vatican*

1746?–48?
Etching
From *Vedute di Roma* (Rome, before 1778)
Signed below image, lower right

INSCRIPTION *Veduta della Basilica, e Piazza di S. Pietro in Vaticano /1. Palazzo Pontificio fabricate da Sisto V/2. Loggie di Giulio II architettura di Bramante Lazzari, e/dipinte da Rafaelle d'Urbino/ 3. Guglia eretta da Sisto V/4. Vasca tutta di un pezzo di granito Orientale*

15¾″ × 21¼″ (402 × 541 mm)

BIBLIOGRAPHY Focillon 1918, no. 787; Hind 1922, "The Views of Rome," no. 3 iv/vii; Campbell 1990, *Piranesi*, no. 3; Wilton-Ely 1994, vol. 1, no. 136
National Gallery of Art, Washington, D.C., Mark J. Millard Architectural Collection, acquired with assistance from The Morris and Gwendolyn Cafritz Foundation 1985.61.3

This print is the first of three in the *Vedute* series devoted to the basilica of St. Peter's, the principal monument of Christian Rome. The viewpoint employed in this print echoes the one most frequently selected by earlier Roman *vedutisti*, but Piranesi has produced a version that is far larger and visually more spectacular than those of his predecessors. In the first *veduta* in the series Piranesi clearly sought to produce a spectacle, one in which the architecture is both a powerful component and a frame for the space it defines and the human activity that enlivens the space. The combination

of church, colonnade, and obelisk provoked what in Piranesi's œuvre is unusual: a perfectly frontal disposition of depicted architecture instead of his more typical *scena per angolo* composition. The symmetry is, however, more suggested than actual, and Piranesi has skillfully countered the asymmetrical massing of the Vatican Palace on the right with the inclusion of a tall structure at the left margin and a marvelous distraction in the form of an extraordinary coach in the left foreground. The architectural vista is important to Piranesi; his labels call attention to the additions made by Sixtus V to the pontifical palace on the designs of Domenico Fontana (no. 1), to Pope Julius II's loggia designed by Bramante and embellished with Raphael's frescoes (no. 2), and also to the watering trough in the foreground, made, as Piranesi indicates, of oriental granite (no. 4).

Although the print provides factual description, it is also highly charged with fantasy. Thus, the relative scale of the architecture is consistent with reality; however, the monumentality of the architectural complex is exaggerated by the diminutive scale of the people who traverse the great piazza on foot or in carriages. And the spatial relationship and scale of these figures to those in the immediate foreground is irrational. There is no transitional space, no true middle ground in the composition to account for the sudden change in scale between the watering trough, coaches, aristocrats, and commoners in the immediate foreground and the panorama that

opens beyond them. The granite watering trough has in fact been displaced from its actual location at roughly the viewing point for this *veduta* and on axis with the obelisk and entrance to St. Peter's. Moved to the right section of the print, it acts as a counterweight to the coaches on the left. As his label indicated, the watering trough was important to Piranesi because of its material and carving from a single stone; it was a *maraviglia* of nature and the stonecutter's craft. Together with the ornamented coaches, it presents the viewer with two examples of virtuoso technique in extreme forms: the Rococo brilliance of the woodcarver's art serves as a pendant to the technical skill of the stonemason.

But there are issues of social strata as well as elements of compositional balance and natural and technical *maraviglia* here. The elaborate coaches, their occupants, and the liveried footman epitomize the privileged classes of Roman society; those gathered about the fountain (really a watering trough for animals) represent another. Observed by some of the aristocratic party on the left, these folk attend to mundane matters, watering a horse, breaking up an encounter between two dogs, chatting, and answering bodily necessities.

The elaborate coach deserves special attention; its ornamentation is extraordinary even by Settecento Roman standards. In addition to simulated vines and vegetation, its extravagant decoration includes winged shields, shell forms, a nymph, paired

dolphins, and shields. It is very much a virtuoso invention of Piranesi, based on a drawing he made in Venice in 1744 or 1745 for a gondola (Robison 1973, pp. 389–92). It seems altogether fitting that Piranesi should commemorate his transfer from Venice to Rome by grafting the design of a ceremonial gondola, a glorified version of the principal mode of canal travel on the watery "streets" of Venice, to an analogous Roman vehicle. [MC]

424

Giovanni Battista Piranesi
*View of the Façade of the Basilica of S. Croce in Gerusalemme*

1757–58?
Etching
From *Vedute di Roma* (Rome, before 1778)
Signed below image, lower right

INSCRIPTION *Veduta della Facciata della Basilica di S. Croce in Gerusalemme/ 1. Monastero de'Monaci Cisterciensi 2. Muro moderno fabbricato sulle rovine dell'Anfiteatro Castrense 3. Avanzi del Tempio della Speranza Vecchia/Presso d'Autore a Strada Felice nel Palazzo Tomati vicino alla Trinità de' monti. A paoli due e mezzo*

16″ × 24⅛″ (406 × 620 mm)

BIBLIOGRAPHY Focillon 1918, no. 729; Hind 1922, "The Views of Rome," no. 11 ii or iii/vi; Campbell 1990, *Piranesi*, no. 47; Wilton-Ely 1994, vol. 1, no. 173
National Gallery of Art, Washington, D.C., Mark J. Millard Architectural Collection, acquired with assistance from The Morris and Gwendolyn Cafritz Foundation 1985.61.11

According to tradition, the church of S. Croce in Gerusalemme was founded by the Emperor Constantine the Great c. 320 as a repository for the relics of the True Cross and Christ's Crown of Thorns, believed to have been obtained in Jerusalem by Constantine's mother, the future Saint Helena. It was renovated in 1144 by Pope Lucius II; of this restoration the bell tower, depicted by Piranesi but diminished in scale, survives. Additional restorations followed the discovery in 1482 of the presumed superscription from the cross, including the interior restoration and transformation of the façade in 1741–44 by Pietro Passalacqua and Domenico Gregorini for Pope Benedict XIV Lambertini, who provided the funds to enhance his former titular church.

Piranesi has positioned the church in space and manipulated scale so as to heighten and dramatize the new additions to the church façade. Employing a *scena per angolo* perspective with vanishing point beyond the left margin of his plate, he has disposed the church façade along a sharply receding diagonal, which

424

accentuates the façade and maximizes its curvilinear forms. The reduced scale of the human figures near the monument emphasizes its height, an effect further enhanced by the towering scale of the statues crowning the façade. A tumultuous, cloud-strewn "Venetian" sky has produced the scattered light and shadow that accentuates the richly articulated Passalacqua–Gregorini façade, visually separating it from the older Cistercian monastery that enframes it. It is the embrace of this monastic structure that appears to account for the stacked giant pilasters and convex center section of the church façade (which actually responds to an oval vestibule).

At the right margin Piranesi's composition is closed by a crude modern structure built on the remains of the Castrense amphitheater and, at the far left, by a fragmented ruin Piranesi identifies as the temple of Ancient Hope (*Tempio della Speranza Vecchia*). These structures, together with the rugate foliage that borders the margins of the plate, offer textural extremes to his crisp delineation of the church façade. The figures who populate the print run the gamut of social status from Piranesi's favorite vagabonds and layabouts to clergy and milords with tricorne hats and swords at their sides. As is often the case, Piranesi's etching seems to threaten the integrity of its frame. Foliage and clouds press against its boundaries; the Romanesque bell tower is visually nicked by this demarcating line. Characteristically, the foreground edge of the scene is enshadowed and heaped with ancient architectural fragments that accentuate this frontal margin through which we visually enter the scene. Here, with eye-arresting caprice, Piranesi violates the boundary between view and frame by thrusting an architectural fragment beyond the space of the scene so that it breaks through the picture plane and casts a shadow

across the title board, interrupting the title but also accentuating the reference to the *facciata* of the basilica located immediately above in the etched scene. [MC]

## 425
## Giovanni Battista Piranesi
*View along the Via del Corso of the Palazzo dell'Accademia Established by Louis XIV, King of France, for French Students of Painting, Sculpture and Architecture*

1757–58?
Etching
From *Vedute di Roma* (Rome, before 1778)
Signed below inscription, lower right
INSCRIPTION VEDUTA, nella Via del Corso, del

425

PALAZZO DELL'ACCADEMIA istituita da LUIGI XIV, RE DI FRANCIA per i Nazionali Francesi studiosi della Pittura, Scultura, e Architettura; colla liberal permissione al Pubblico di eser-/citarvisi in tali arti per il comodo della esposizione quotidiana del Nudo, e dei Modelli delle più rare Statue ed altri segni della Romana Magnificenza, si antichi, che moderni/ 1. Stanze ove sono esposti i modelli della Colonna Trajana, Statue Eque-/stri e Pedestri, Busti, e Bassirilievi 2. Stanze per l'esposizione del Nudo 3. Appartamento Regio ornato parimente di Modelli 4. Appartamento del Signor Direttore 5. Palazzo Panfili 6. Via del Corso 7. Porta del Popolo/ Presso L'Autore a Strada Felice nel Palazzo Tomati vicino alla Trinità de' monti. A paoli due e mezzo
16″ × 24½″ (406 × 623 mm)
BIBLIOGRAPHY Focillon 1918, no. 739; Hind 1922, "The Views of Rome," no. 24 ii/v; Campbell 1990, Piranesi, no. 49; Wilton-Ely 1994, vol. 1, no. 177
National Gallery of Art, Washington, D.C., Mark J. Millard Architectural Collection, acquired with assistance from The Morris and Gwendolyn Cafritz Foundation 1985.61.24

This print, with its detailed description in the plate, depicts the eighteenth-century seat of the French Academy. Once the property of the Salviati family, the palace had belonged since the sixteenth century to the Mancini family, on whose behalf Cardinal Mazarin had commissioned the architect Carlo Rainaldi to modify the structure significantly in the 1660s. In 1725 the palace was bought by the Duc d'Antin, on behalf of Louis XV, for the French Academy, which maintained its seat here until after the Napoleonic Wars, when it moved to the Villa Medici.

Piranesi enjoyed a close relationship with the French Academy and its *pensionnaires*. His first print shop was

across the street from the academy. By the time he started the *Vedute di Roma* series he had moved to the Palazzo Tomati in strada Felice, near SS. Trinità dei Monti, but he retained his association with the academy.

In the legend for this plate Piranesi proclaims his intimate knowledge of the academy, noting the room containing casts of the Column of Trajan, equestrian statues, busts, and bas reliefs (no. 1), rooms for drawing from the nude (no. 2), the Royal Apartment (no. 3), and the director's apartment (no. 4). Piranesi has also indicated the Palazzo Pamphili (no. 5), via del Corso (no. 6)—Rome's equivalent of Venice's Grand Canal—and, just visible in the distance, the Porta del Popolo (no. 7).

The composition follows the long-standing *vedute* model of a street seen as a modified *scena per angolo* receding toward a single vanishing point. Typical of Piranesi, the relative scale of the architecture is enhanced by the diminutive scaling of the human figures. But the human quotidian activity should not be undervalued. Everywhere there is lively action; street vendors line the sidewalk; in center foreground a group of laborers haul what appears to be an antique statue toward the academy. The entire length of the Corso is alive with human activity, and from academy windows and balconies figures have come out to witness the lively scene.

Comparison of this print with an earlier one (Wilton-Ely 1994, vol. 1, no. 72) of the same palace made c. 1748 for the *Varie vedute* volume is profoundly revealing of Piranesi's enormous technical advances. [MC]

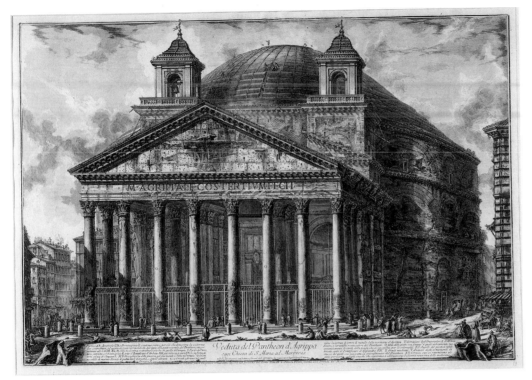

426

i/v; Campbell 1990, *Piranesi*, no. 60;
Wilton-Ely 1994, vol. 1, no. 193
National Gallery of Art, Washington, D.C.,
Mark J. Millard Architectural Collection,
acquired with assistance from The Morris
and Gwendolyn Cafritz Foundation
1985.61.61

In contrast to his first depiction of the
Pantheon in the *Vedute* series (Wilton-
Ely 1994, vol. 1, no. 144), in which this
monument was presented as a defin-
ing presence at one margin of the
piazza, Piranesi has here elected to
focus exclusively on the Pantheon,
placing it stage center so that it domi-
nates the print. The inclusion of a
combined title and legend on a scroll
within the print is a device that makes
an appearance in the *Vedute* around
1760. As in the earlier *Antichità romane*,
in which the Pantheon was also
treated to multiple prints, Piranesi
now uses an alphabetical identifica-
tion system in his labels for ancient
monuments in the *Vedute* series. In this
presentation Piranesi provides both
an extended account of the structure
and a highly detailed rendering. He
includes intrepid visitors who have
ascended to the perimeter of the
oculus and also such everyday details
as the ragged fragments of posters
and proclamations that have been
affixed to the columns.

This view of the Pantheon surpasses
its predecessor in the 1756 *Antichità
romane* (Wilton-Ely 1994, vol. 1, no. 305)
in its stable monumentality and
wealth of archaeological detail and
descriptive commentary. Here, in the
*Vedute* series, Piranesi seems more

adaptable to representing Roman
antiquities in the context of the con-
temporary city. In electing an appar-
ent frontal presentation of the
Pantheon, he has in fact manipulated
this image, collapsing two viewpoints
into one. Thus the view presented of
the portico is virtually frontal: the sty-
lobate, front row of columns, archi-
trave, and pediment read in parallel
and are almost perfectly parallel to the
picture plane. But the receding right
side of the portico and the promi-
nence of the right flank of the great
rotunda imply a viewpoint that is
shifted to the right. The title on the
scroll, which is centered but posi-
tioned beneath the right-hand portico
columns, and the heavy right-hand
shading and concentration of human
activity in this section of the print
emphasize this viewpoint. Although
it is not immediately obvious, the
viewer is simultaneously looking at
the monument from two diverse
points. Finally, the print permits
much more of the low saucer dome
to be seen than would be visible to a
spectator standing as close to the
Pantheon as this print implies. Here,
as in other plates in the *Vedute* series,
these manipulations are to a purpose:
they permit Piranesi to maximize his
recording of the monument as a total
experience, to compile its salient fea-
tures in a single image. [MC]

## Giovanni Battista Piranesi
### Interior View of the Pronaos of the Pantheon

c. 1769
Etching
From *Vedute di Roma* (Rome, before 1778)
Signed below image, lower right
INSCRIPTION *Veduta interna del Pronao del
Panteon/ Sostenuto da sedici colonne di granito
ogn'una di esse di un sol pezzo grosse di diametro
palmi 6.6 alte plmi 63.8. A Pilastri, architravi, e
stipiti della porta composti di gran macigni di
marmo greco. B Lacunarj di legname, antica-
mente di/bronzo tolti via di Urbano VIII. e fatti
rifondere per formare la confessione di S. Pietro in
Vaticano. C Nicchioni dove erano collocate le
statue di Augusto e di Agrippa, quali erano
incrostati di marmo egizio. D Parieti da dove
furono levate le lastre di grani-/ to al tempo di
Benedetto XIV. l'anno 1757 per adornare il
Museo Sagro nel Vaticano. E Memorie di Urbano
VIII. F Porta di bronzo trasportata da altro edi-
fizio antico, ed in parte nuovamente restaurata nel
dett'anno 1757. G Interno del Tempio*
$15\frac{1}{4}'' \times 20\frac{7}{8}''$ (387 × 531 mm)
BIBLIOGRAPHY Focillon 1918, no. 762;
Hind 1922, "The Views of Rome," no. 82
i/iii; Campbell 1990, *Piranesi*, no. 89;
Wilton-Ely 1994, vol. 1, no. 215
National Gallery of Art, Washington, D.C.,
Mark J. Millard Architectural Collection,
acquired with assistance from The Morris
and Gwendolyn Cafritz Foundation
1985.61.85

No print in the *Vedute* series more elo-
quently reflects the transformation of
style evident in the second edition of
the *Carceri* of 1761 than this dramatically
powerful image of the interior of the
portico of the Pantheon. Comparison
with the almost identical view in the
1756 *Antichità romane* (Wilton-Ely 1994,
vol. 1, no. 306) reveals the extraordi-
nary change in rendering and compo-
sition. In the earlier view, even though
it also focuses on the interior of the
pronaos, the spectator remains
outside the space of the pronaos to
glimpse the portico façade and enough
of the cityscape to feel in a larger
urban context. In the *Antichità romane*
view Piranesi eliminated the four
columns that form the left flank and
corner of the portico, obliterating the
sense that the spectator stands within
the portico. In the later version
Piranesi moves the viewing point left-
ward; the portico façade is no longer
visible. Again he arbitrarily eliminates
four columns, three from those that
support the architrave and one from
the left side of the portico. But now
the effect is completely changed; with
the rearmost left side column
retained, the spectator has the illusion
of standing within the portico, of
being encased within its vast struc-
ture. The portico has become the total
visual environment.

The collapse and rebuilding under
popes Urban VIII and Alexander VII

426

## Giovanni Battista Piranesi
### View of the Pantheon of Agrippa, Today the Church of S. Maria ad Martyres

1761
Etching
From *Vedute di Roma* (Rome, before 1778)
Signed in image below text, lower left
INSCRIPTION *Veduta del Pantheon
d'Agrippa/oggi Chiesa di S. Maria ad Martyre/
Pietre del tempano con bozze, e forami delle
spraghe, che reggevano i bassirilievi di bronzo./
Portico AB, Arcoteria CD, e Frontespizio E con-
temporanei, per ciò che dimostra la interna/lor
costruttura, ed aggiunti posteriormente da
Agrippa alla parte rotonda del Pantheon, come
si/ravvisa alle lett. DF, BG, H, dalla medesima
costruttura sciolta da quella del tempio, I Parte
dell'arco-/terio interotto col frontespizio K sotto il
Pontificato d'Urbano VIII per ridurre le parti CE,
L, in forma di/torri ad uso di Campanile, MN
Circonferenza della fenestra, per cui scende il lume
nel tempio. O Colon-/ne uso solide di marmo
sienite di palmi 6.6 di diametro, e di 63.8 d'altez-
za, 2 e 3 Canali e forami ne'quali/erano incastrate
le lettere di metallo della inscrizione d'Agrippa. P
Inscrizione degl'Imperadori L. Settimo/Severo, e
Caracalla restauratori del Pantheon. Q Una delle
pietre con forami a'quali anticamente rac-/coman-
daransi le corde della tenda che si spiegava per la
solennità. RS Angolo del portico rifab-/bricato
sotto il Pontificato d'Alessandro VII. T Gradi mod-
erni. V Avanzi degli ornamenti di/stucco de'quali
era rivestita la circonferenza del Pantheon. XY
Cornici ove si ravvisano al-/cune porzioni degli
stucchi che coprivano e adornavano l'odierna
rozzessa delle medesime./ Si vendono paoli tre pres-
so il medesimo autore nel palazzo del Conte Tomati
a Strada Felice, vicino alla Trinità de'Monti*
$18\frac{7}{8}'' \times 27\frac{1}{2}''$ (478 × 699 mm)
BIBLIOGRAPHY Focillon 1918, no. 761;
Hind 1922, "The Views of Rome," no. 60

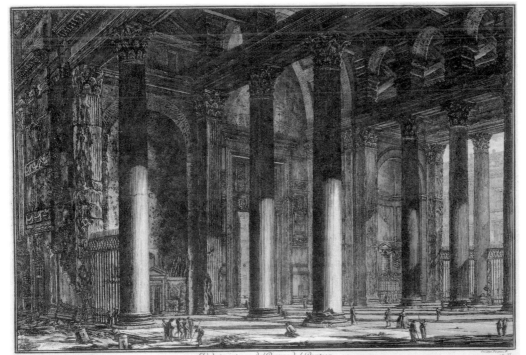

*Veduta interna del Pronao del Panteon*

Sostenuto da sedici colonne di granito ogn'una di afee di un sol pezzo, grosse di diametro palmi 6 6 alti palmi 63 8. A Pilastri archierauv. e segui della porta composta di gran macigna di marmo greco. B Lacunari di legname, anticamente di bronze tolti via da Urbano VIII e fatti refondere per formare la confezione di S.Pietro in Vaticano. C Niechioni due ornau cillium bi eraiu di Augusto e di Agripa quali iraiu incrostati di marmojecho D'Pariari da loro fiorauu levate le lastre di granite al tempo di Benedetto XIV. l'anno 1750 per adornare il Museo Sagro nel Vaticano. E Memorie di Urbano VIII V.Porta di bronzo insaporitati da altro edifizio antico, e in parte nuovamente restaurata nel dett'anno 1757. G Interno del Tempio.

427

of the trabeated system on the left flank of the portico is not noted here, although Piranesi records the deep cracks in the leftmost monolithic granite column. The legend for the plate refers to recent changes and additions: there is a memorial to

Urban VIII (E), who is also identified as the pope who removed the bronze ceiling coffers to construct the baldachin in St. Peter's (B), and the appropriations of Pope Benedict XIV, who in 1757 removed granite revetment for the Vatican Museo Sacro (D), are also

noted. Piranesi claims that the bronze double doors were transferred from another building by Pope Benedict XIV (F); however, these doors, restored in part by Pio IV, may in fact be original. [MC]

428

*Veduta interna della Villa di Mecenate*

428

## Giovanni Battista Piranesi

### Interior View of the Villa of Maecenas

c. 1764

Etching

From *Vedute di Roma* (Rome, before 1778)

Signed below image, lower left

INSCRIPTION *Veduta interna della Villa di/ Mecenate Dall'iscriz.e l. octavius. L.F. VITULUS/C. RUSTICIUS C.F. FLAVOS INTER IIII VIR D S S VIAM/INTEGENDAM CURAVERE; che leggesi affissa ab antico/nella finestra perpendicolare A, e dal vedersi che la/volta, la quale copre la via fa con la villa un sol corpo/di fabbrica, siam persuasi, che tutto l'edifizio non/fosse una villa, ma un'opera fatta per uso del Co-/mune di Tivoli, e per raffrenare la decrescenza/della pendice, come vedesi dall' Iscrizione, che/per mantener la via, ne fu ordinato il coperto/e la volta da quel Senato. In fatti le forni-/ci/sotto la volta segnata col B, non avendo se-/gno che fussero chiuse con veruna imposta,/mostrano d'essere state tante taverne pubbliche.*

18¾″ × 24⅝″ (477 × 626 mm)

BIBLIOGRAPHY Focillon 1918, no. 769; Hind 1922, "The Views of Rome," no. 73 ii/iv; Campbell 1990, *Piranesi*, no. 72; Wilton-Ely 1994, vol. 1, no. 206

National Gallery of Art, Washington, D.C., Mark J. Millard Architectural Collection, acquired with assistance from The Morris and Gwendolyn Cafritz Foundation

1985.61.76

This print is one of three *vedute* Piranesi made of what he and his contemporaries thought to have been the ruins of a villa of Maecenas but which, in fact, were the remains of the sanctuary of Hercules Victor. (The legend is presented on a placard placed behind a small hillock on which two men—one standing and one seated—are conversing.) His deductions based on the transcribed inscriptions, however, are quite correct. This vaulted corridor is a section of the ancient via Tiburtina, which became a vaulted roadway (a *via tecta*) when the sanctuary was constructed above it. Piranesi seems to have been somewhat unconvinced by the traditional "villa" designation. Alluding to the inscriptions, he suggests that part of the structure was "made for the use of the *comune* of Tivoli in order to reduce the incline of the slope and it was vaulted for purposes of maintenance." He further suggests that the subsidiary areas under the vault (designated B) were ungated and served as wine shops.

Compositionally, this *veduta* is essentially a simple exercise in one-point perspective that has been transformed, however, by a richly evocative system of light and shade that permeates the deeply shadowed space from the right and above. The resultant print is a complex, highly charged chiaroscuro scene. To an extraordinary degree Piranesi brings to this print the visual drama of the late edition of the *Carceri*. [MC]

429

430

431

## 429
## Giovanni Battista Piranesi
### *View of the Arch of Titus*

c. 1770

Etching

From *Vedute di Roma* (Rome, before 1778)

Signed below image, lower left

INSCRIPTION *Veduta dell'Arco di Tito/ 1. Villa Farnese 2. Avanzi del Tempio detto di/Giove Statore 3. Monte Capitolino 4. Ruine/del Tempio detto della Pace*

18⅜″ × 28″ (475 × 710)

BIBLIOGRAPHY Focillon 1918, no. 755; Hind 1922, "The Views of Rome," no. 98 i/iv; Campbell 1990, *Piranesi*, no. 98; Wilton-Ely 1994, vol. 1, no. 231

National Gallery of Art, Washington, D.C., Mark J. Millard Architectural Collection, acquired with assistance from The Morris and Gwendolyn Cafritz Foundation 1985.61.101

This print is, in a sense, a pendant to a much earlier *veduta* of the Arch of Titus, in which Piranesi portrayed the eastern façade of the monument as imbedded in a complex of structures including a powder magazine (Wilton-Ely 1994, vol. 1, no. 185). In this *veduta*, in contrast, all of the encumbering structures immediately to the left of the arch have been swept away. Through this enormous embrasure in the built environment the spectator is permitted to look across the Roman forum. In this vast, but from this vantage point unavailable, vista Piranesi has portrayed the battered walls and splendid entry gate of the Villa Farnese, now better known at the Orti Farnesiani (no. 1). The gate to the villa, designed by Jacopo Vignola, removed in 1882, has been reconstructed on via S. Gregorio to serve as an entry to the Palatine Hill. Beyond the walls of the Farnese garden can be seen the now destroyed Baroque church of S. Maria Liberatrice. As documented by the 1748 map of Giambattista Nolli, both the church and garden wall were positioned at right angles to the triumphal

arch and at considerably greater remove. So situated, these structures would have been visible only through Titus's monument. In the print Piranesi has moved them southward and repositioned them at an acute angle with the arch.

The fictional vista to the left of the arch yields more monuments identified by Piranesi: the three columns and entablature of the temple of Jupiter Statore, actually the temple of Castor and Pollux (no. 2), and, in the far distance, the Capitoline Hill (no. 3), which Piranesi has reduced in height, apparently in order to maintain a low horizon.

The vista through the Arch of Titus in this print is also problematic. The visibility of the side of the sloping wall that buttresses the arch suggests that the view is positioned just to the left of the title and legend. From this vantage point (in reality, of course, an impossible viewpoint), the view through the archway might necessarily include a corner of the portico of S. Francesca Romana, and in any event the visible remains of the monument that Piranesi—like his contemporaries—identifies as the Tempio della Pace, actually the basilica of Constantine and Maxentius (no. 4), has been rotated at least 45° to the south in order to be included. Seemingly a transparent *veduta*, this print is, in fact, one of the most edited and manipulated vistas in the entire series. This is, in sum, an extreme case of Piranesi's combining a compendium of disparate and successive views into a single image. By visually demolishing the extensive structures located to the left of the arch, Piranesi created an exciting and informative vista on to the Roman forum and also freed the arch from the narrow, high-walled corridor that actually reduced the monument to an ill-lit gateway. [MC]

## 430
## Giovanni Battista Piranesi
### *View of the Arch of Titus*

c. 1770

Copperplate

From *Vedute di Roma* (Rome, before 1778)

18½″ × 28″ (470 × 710 mm)

Ministero per i Beni e le Attività Culturali, Istituto Nazionale per la Grafica, Rome

## 431
## Giovanni Battista Piranesi
### *View of the Arch of Titus*

c. 1770

Etching, proof worked in red-brown chalk

From *Vedute di Roma* (Rome, before 1778)

18⅝″ × 27¾″ (473 × 706 mm)

BIBLIOGRAPHY Focillon 1918, no. 755; Hind 1922, "The Views of Rome," no. 98, unrecorded state pre-i/iv; Campbell 1990, *Piranesi*, no. 98; Wilton-Ely 1994, vol. 1, no. 231

National Gallery of Art, Washington, D.C., Ailsa Mellon Bruce Fund 1980.36.1

This worked proof highlights an important aspect of Piranesi's working method. Not only did he execute the preparatory drawings for his plates, but he also continued the creative process on the actual plate, revising and editing his compositions in the copper plate. Like many printmakers, he burnished, recut, and reinforced the lines in his plates when the plates became worn from multiple printings. But, in contrast to most printmakers, he burnished out passages and then revised sections of his plates, actually changing compositions and content. As this impression demonstrates, he also considered revising his compositions prior to producing an edition of prints. On this proof Piranesi considered the addition of several figures indicated in red chalk. Burnishings on the copper plate indicate that several of these red chalk figures were transferred to the plate, but then excised before Piranesi initiated the published version of the print. [MC]

## 432

### Giovanni Battista Piranesi
### *Ruins of a Sculpture Gallery at Hadrian's Villa at Tivoli*

1770
Etching
From *Vedute di Roma* (Rome, before 1778)
Signed below image, lower left
INSCRIPTION *Rovine d'una Galleria/di Statue nella Villa Adri/ana a Tivoli/ A. Avanzi di pitture a grottesco*
18″ × 22⅞″ (457 × 580 mm)
BIBLIOGRAPHY Focillon 1918, no. 785; Hind 1922, "The Views of Rome," no. 93 i/iii; Campbell 1990, *Piranesi*, no. 93; Wilton-Ely 1994, vol. 1, no. 226
National Gallery of Art, Washington, D.C., Mark J. Millard Architectural Collection, acquired with assistance from The Morris and Gwendolyn Cafritz Foundation
1985.61.96

Piranesi's designation of this room is inaccurate. When his son Francesco published the index for their map of the site, he correctly identified this entire site as the "Imperial Baths" and referred to it as the "Salone mobile di passaggio a diversi Bagni" ("salon providing access to various baths"). This vaulted room—still in a condition little changed from when Piranesi etched it—was perhaps of all such interiors by Piranesi the one most amenable to transfer to the painted mural surfaces of "ruin rooms" that became popular in eighteenth-century northern European villas and palaces.

The succession of spaces and enclosing forms, the interplay of solid arches and shattered vaulting, and the light-filtering effects of foliage and hanging vines serve to create a wonderfully Rococo motif combined with a more austere message, an essay on the transience of the works of mankind. The frescoed grotesques Piranesi indicates as existing at *A* on the vaulting in the upper left corner of his print are no longer extant. [MC]

432

## 433

### Giovanni Battista Piranesi
### *Frontispiece: Ancient Circus of Mars with Neighboring Monuments Viewed at the Via Appia*

c. 1756
Etching
From *Le antichità romane*, vol. 3 (Rome, 1756)
Signed below image, lower left
15¾″ × 23⅞″ (402 × 608 mm)
BIBLIOGRAPHY Focillon 1918, no. 287; Wilton-Ely 1994, vol. 1, no. 422
Philadelphia Museum of Art, Gift of William H. Helfand
1996-131-2

433

In contrast to most of the site-specific prints in *Le antichità romane*, the frontispieces to the second and third volumes are fantastic reconstructions. The circus of Maxentius, which Piranesi chose to represent that of Mars, was completed in AD 309 and, like the adjacent circular temple, was dedicated to his young son Romulus. The site was not systematically excavated until 1825, but the general configuration of the enormous stadium—it measured 1683 feet in length and 295 feet in width—would have been known to Piranesi. By Piranesi's time much material had been removed from the circus, including the obelisk originally brought to Rome by Domitian that Gianlorenzo Bernini made the central feature of his *Four Rivers Fountain* in the Piazza Navona in 1647.

In Piranesi's visionary recreation of the circus, the *spina*, the central island of the racecourse, bristles with obelisks and commemorative columns. In the foreground are strewn sarcophagi, funerary urns, and sculpture fragments. At the far right an extravagant circular monument closes the view. An adjacent relief bears an inscription, which provides the title for the print. The extraordinary architecture, the pyramids—ziggurat-like structures—the innumerable porticos, and the clusters of obelisks that fill the background of the print are expressions of pure fantasy. So, too, is the precipitous drop from the terrace walkway along the left edge of the circus. The cylin-

drical structure in the center foreground of the print, which here bears a dedication to Mars Ultor, originally contained a dedication to James Caulfield, Lord Charlemont, the young Irish peer who had promised but then failed to sponsor publication of *Le antichità romane*. The choice of Mars the Avenger as replacement for his errant benefactor can scarcely have been accidental, especially in light of the fact that Piranesi undoubtedly knew that this cult was inaugurated by Augustus to give thanks for the successful vendetta against the assassins of Julius Caesar. The fact that Piranesi chose to associate the circus with Mars Ultor, rather than with Maxentius, its commissioner, was certainly part of the artist's vendetta against Caulfield. One of Piranesi's most wildly imaginative creations, this frontispiece was certainly an inspiration for later artistic productions, most notably those of the early nineteenth-century artists John Martin and Thomas Cole. [MC]

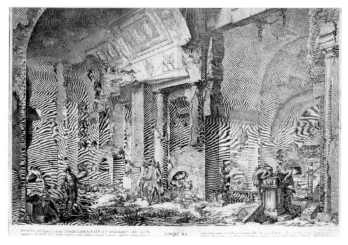

434

## 434

### Giovanni Battista Piranesi
### *View of a Part of the Tomb Chamber of L. Arruntius*

c. 1756

Etching (proof before additions to image and with caption plate for a different print [F.231] included as a trial)

Later included in *Le antichità romane*, vol. 2 (Rome, 1756)

Signed on caption plate above legend

INSCRIPTION VEDUTA *dell'Ingresso della* CAMERA SEPOLCRALE *di* L. ARRUNZIO …

16⅜" × 23½" (423 × 600 mm)

BIBLIOGRAPHY Focillon 1918, nos. 231–32; Wilton-Ely 1994, vol. 1, no. 366 [unrecorded proof state], and 367

Robison Collection

After pulling this print (plate LIII in volume two of *Le antichità romane*), Piranesi, apparently judging it unacceptable for sale, used the verso of this sheet to make a proof of a plate published in volume four (cat. 437).

The tomb, Etruscan in type, is on via Appia near the town of Albano Laziale. Piranesi took considerable interest in this tomb, devoting fourteen plates to it in *Le antichità romane*, including prints recording inscriptions, funerary urns, decorative wall fragments, a floor plan, an elevation and section of a tomb, and two general views, of which this is one. The principal space in this *scena per angolo* view (the left section) can be identified on the floor plan as E (Wilton-Ely 1994, vol. 1, no. 365). This is the largest room in the complex. In the right section of this print some of the contents of room D can be seen on the same plan. Although it was traditionally known as the tomb of the Horatii and Curiatii and also associated with Porsenna, Piranesi identifies the site, on the basis of a dedicatory inscription, as the tomb of the freedmen and household slaves of Lucius Arruntius, third son of Lucius (Wilton-Ely 1994, vol. 1, no. 365).

In his inscribed text Piranesi points out that the tomb has the character of a *columbarium*. He comments that the ruined condition offers the opportunity to study the construction, and he exclaims over the fine stuccowork. He notes in particular the fine stuccos set in areas of plaster treated to resemble *giallo antico* porphyry. He calls attention to the numerous inscriptions, funereal urns, and sarcophagi, and with a morbid curiosity that is very much a part of his personality, he mentions the human remains scattered on the tomb floor, adding that many of the skeletons still have "their medals in their mouths," presumably a reference to the ancient custom of placing coins in the mouths of the deceased to pay Charon, ferryman on the river Acheron, for passage of the deceased into Hades.

Typically, Piranesi has enlivened the scene with figures of his own time. These include a portly guard who holds a lantern in his left hand and ostentatiously grasps his money bag with his right; he clearly seeks a tip for his efforts on behalf of the visitors, presumably especially the well-dressed trio standing at the center of the scene. [MC]

## 435

### Giovanni Battista Piranesi
### *Means by Which the Large Travertine Blocks and Other Marbles Were Lifted in the Construction of the Great Tomb of Caecilia Metella, Today Called Capo di Bove*

c. 1756

Etching

From *Le antichità romane*, vol. 3 (Rome, 1756)

Signed below caption, lower right

INSCRIPTION *Modo, col quale furono alzati i grossi Travertini, e gli altri Marmi nel fabbricare*

*il gran Sepolcro di Cecilia Metella, oggi detto Capo di Bove.*

18¼" × 20¼" (463 × 527 mm)

BIBLIOGRAPHY Focillon 1918, no. 335; Wilton-Ely 1994, vol. 1, no. 468

Robison Collection

Piranesi inscribed a lengthy legend for this plate in a separate plate. The legend is one of the most autobiographically revealing statements in Piranesi's publications and attests to the intensity of his archaeological researches:

Visiting the antique monuments of Rome every day and investigating every minute part, I have discovered in the large stone blocks of which they are constructed well-positioned squared holes, some of which are in the middle of the upper plane [of the block], like A; in others on either the right or left sides, like B.

The squared holes of the A type, Piranesi adduces, are for lifting the blocks with an iron instrument of the type illustrated at C and D, which he claims Vitruvius called *forsice* (and others a *ulivella*). The function of this Vitruvian instrument is illustrated at E.

Piranesi comments on several fragmentary cut stones (F and G), which have a variety of irregular and unaligned protuberances (*bozze*) and indentations, marked on F at H and I. Fragment G is similarly cut and shaped at K and L. There are, he states, related cuts made in sides L, M, and N. Piranesi's discourse on these matters continues at length, finally concluding that these blocks were rejects and never used in the actual construction of the tomb.

Then, promising to be brief, Piranesi proceeds to explain how

indentations and protuberances on the Travertine stones were employed. O provided a cutaway view in which interlinked hooks (*uncini*) are demonstrated at P and shown again lifting stone Q, where the *uncini* are held in place by the rope R secured in turn on the embossment (*bozza*) at I, which helps to hold the linked *uncini* at S in tension as they lift the block at points L and V. (N provides a side view of the indented cut in the left-hand side of stone O.) A variety of different size iron *uncini* are displayed at X, and ropes (*funi* or *cappi*) of varying lengths are presented at Y.

In the third unrolled screen (Z), Piranesi provides a reconstruction of the cranes used to lift the stone blocks into place. Numerical designations and explanations are provided for these machines and, in the case of the nearer one, the resistance-reducing systems of pulleys and windlasses. In the end, Piranesi cannot resist proclaiming his admiration for ancient Roman builders (and expressing his pride in having penetrated their construction methods):

Thus one can deduce that the Ancients studied above everything else the means of lifting enormous blocks of stone so that their structures would conform to their grand ideas and be permanently enduring, leaving their surfaces rough and without ornament. In truth many have come to the conclusion that they are so massive and solid that they seem more made by Nature than by Art. [MC]

435

436

## 436
### Giovanni Battista Piranesi
*Ancient Roman Lifting Devices*

c. 1756

Etching, in bound volume

From *Le antichità romane*, vol. 3 (Rome, 1756)

Signed below text, lower right

INSCRIPTION  *Dopo di aver'esposto nella Tav[ola] passata il Modo con cui sono state alzate le grandi Pietre nel costruire il Magnifico Sepolcro di Cecilia Metella, ec. feci riflessione sopra lo Stromento detto Ulivella, trovato da Brunelesco, et usato oggigiorno, il quale communem[en]te credesi che sia quello, che vienne accennato da Vitr[uvi]o sotto il nome di Forsice o Tanaglia…*

13⅛″ × 23¼″ (335 × 590 mm)

BIBLIOGRAPHY  Focillon 1918, no. 336; Wilton-Ely 1994, vol. 1, no. 469

National Gallery of Art, Washington, D.C., Gift of Mr. and Mrs. Earl H. Look 1979.50.4

With this print Piranesi continues his investigation of ancient Roman construction methods and equipment. From his extensive discourse, several issues emerge as especially important to him. First, he wants the reader to be aware of the originality of his observations: what he is presenting is new and based on personal research and observation. Second, he is at pains to prove that the instrument known as the *ulivella*, which was discovered by Brunelleschi (not rediscovered by him, as often translated), is not the same instrument as that cited by Vitruvius and called *forsice* or *tanaglia*. Brunelleschi's *ulivella* was still in use in Piranesi's time and commonly assumed to be the one described by Vitruvius. Piranesi argues that these are different instruments and proposes that the one used by Vitruvius may have been the more effective. He bases his argument and reconstruction on passages in the writings of Vitruvius and on personal observation of the lifting holes in the stones used in Roman construction. On the basis of these sources and observations, he here presents designs reconstructing the concept (*idea*) of Vitruvius's *tanaglia*, stating that "if they prove useful to the public his efforts will have been well employed."

Piranesi's version of the Vitruvian *tanaglia* is shown at *A* (side view at *K*) and its "footprint" at *B*. Its two sections, labeled *CD* and *EF*, are hinged at *G* by a pin (*perno*). The device is inserted in a square cavity cut in the stone to point *H*, and when a rope or hook *O* is passed through the rings *E* and *C*, the toothed sections at *F* and *D* expand with extraordinary gripping force. For security a *cuneo quadralatero* (four-sided wedge) illustrated at *I* can be inserted at *H* to maintain maximum outward pressure. Figure *M* illustrates a variant type of *tanaglia*, and *N* illustrates the round *cuneo* to be placed in the circular opening below 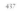 the hinge after the device has been placed in the cut in the stone, thus assuring continuous lateral pressure. Finally, at *P*, Piranesi presents a small example of Brunelleschi's *ulivella*. Then, at *Q*, Piranesi returns to his Vitruvian reconstructions and shows two *M*-type *forsice* in use. The remainder of the discourse references the types of *tanaglie* and *uncini* shown in the preceding plate and the various lifting holes and ridges they require for raising stone blocks. [MC]

## 437
### Giovanni Battista Piranesi
*View of the Bridge and the Mausoleum Built by the Emperor Hadrian*

c. 1756

Etching (proof with artist's corrections, annotations, and drawing in pen and brown ink and in graphite)

Later included in *Le antichità romane*, vol. 4 (Rome, 1756)

15½″ × 25¼″ (396 × 642 mm)

BIBLIOGRAPHY  Focillon 1918, no. 339; Wilton-Ely 1994, vol. 1, no. 472 [unrecorded proof state]

Robison Collection

In many publications in his lifetime Piranesi celebrated the great surviving monuments of ancient Rome: the Colosseum, Pantheon, and Castel S. Angelo. The last of these had a special fascination for the artist. He included a virtually identical, but decidedly picturesque view of the monument in his 1741 *Varie vedute di Roma*, and it is a prominent feature of two plates from the great *Vedute di Roma* series (c. 1748). One of these plates in the *Vedute* (Wilton-Ely 1994, vol. 1, no. 170) may initially have been planned for publication in the *Antichità romane*. Both Wilton-Ely (Wilton-Ely 1978, pp. 35–36) and Robison (Robison 1983, pp. 26–27) note the compositional, calligraphic, and dimensional similarities of the two prints and conclude that this print originally may have been intended for publication in *Le antichità romane*. Conveniently, its inclusion would have provided a view of the opposite elevation presented here. (Further to this discussion see Campbell 1990, cat. no. 30.)

Here in the *Antichità romane* (1756), there are eight plates devoted to the Castel S. Angelo complex (including details of the adjacent bridge, the Pons Aelius, now known as the Ponte S. Angelo). The items listed in Piranesi's alphabetized legend stress climatic, geological, and archaeological considerations. Thus, in the case of the bridge he distinguishes between modern alterations and reconstructions and the original structure, raised in AD 134–38 by Emperor Hadrian. No mention is made, however, of Bernini's monumental statues of angels with symbols of the Passion, commissioned in 1667 by Pope Clement IX, although they appear prominently in the print. In contrast, the construction, alteration, and function of the parts of the bridge are extensively reviewed, as is the seasonal rise and fall of the Tiber river and its effluvial deposits. Distinctions are made between ancient and modern *castello* walls, the great stone mass *N*, nicknamed *il Maschio*, is carefully

437

438

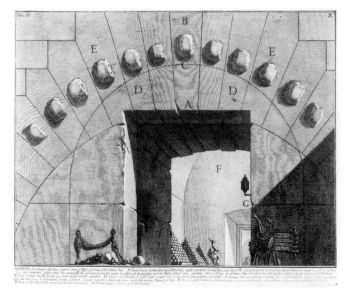

439

## 438

### Giovanni Battista Piranesi
*View of the Subterranean Foundations of the Mausoleum Built by the Emperor Hadrian*

Etching

c. 1756

From *Le antichità romane*, vol. 4 (Rome, 1756)

Signed below text, lower right

INSCRIPTION VEDUTA *del sotterraneo Fondamento del Mausoleo, che fu eretto da Elio Adriano Imp.ᵉ*

27½″ × 18″ (698 × 457 mm)

BIBLIOGRAPHY Focillon 1918, no. 341; Wilton-Ely 1994, vol. 1, no. 474

Robison Collection

This view of a detail of the Castel S. Angelo is one of the most dramatic prints in the *Antichità romane* publication. The huge size of the retaining walls and multiple buttresses is given scale by the lilliputian figures who clamber among the colossal stonework. A richly evocative chiaroscuro play of light and shade, the powerfully repetitive forms of the buttresses, and the fallen pieces of architecture that spill over and cast a heavy shadow across the title (but do not interrupt its text) all contribute to the powerfully effective force of the print. Piranesi's inscription continues:

> *In questa parte, la qual'è opposta alla Facciata, gli Speroni sono tutti co-/struiti di grossi Travertini. A Parte di Riempitura, ovvero sia di Opera incerta a corsi la quale veste d'ogni interno il Fondam[en]ᵗᵒ B Palizzate. C Parte del Mausoleo* ("In this part which is opposite the façade the abutments are all made of massive Travertine. A Part of the infill which is made of courses of *opera incerta* which covers every inner surface of the foundation. B Palisades. C Part of the mausoleum").

Seen in this highly controlled view, Piranesi's reconstruction of the foundations of Castel S. Angelo is convincing; however, before accepting it as archaeologically correct, it would be wise to reflect on the appearance of the foundations drawn in section (cat. 440), where it becomes clear that Piranesi has hypothesized a fantastic foundation system for the mausoleum and the bridge. [MC]

## 439

### Giovanni Battista Piranesi
*View of an Entrance to the Upper Room inside the Mausoleum of the Emperor Hadrian*

Etching

c. 1756

From *Le antichità romane*, vol. 4 (Rome, 1756)

Signed below text, lower right

INSCRIPTION VEDUTA *di un'Ingresso alla Stanza superiore dentro al Masso sepolcrale d'Elio Adriano Imp.ᵉ*…

15½″ × 18¾″ (394 × 477 mm)

BIBLIOGRAPHY Focillon 1918, no. 343; Wilton-Ely 1994, vol. 1, no. 476

Philadelphia Museum of Art, Gift of Mr. and Mrs. Carl Zigrosser

1967-54-2

This room, which Piranesi characterizes as the "upper room inside the mass of the sepulcher," is almost certainly the room now identified as the Sala di Giustizia, which was perhaps used as a courtroom in the sixteenth and seventeenth centuries. In his lengthy description Piranesi is concerned with explaining what he claims are its remarkable structural properties. Although the interior room is accurately depicted, the elaborate system of voussoirs in the entry arch and the barrel-vaulted corridor appear to have been invented by the artist. In Piranesi's version the door jamb (A) is formed by a key stone and voussoirs of Travertine that support the great wall arch (B), which in turn carries the enormous weight of the superstructure above it. Line C marks the curve of the corridor through which the room is approached. Thus only the portions circumscribed by line C—an area Piranesi indicates rather cavalierly with two Ds—are supposedly visible from inside this corridor. This visible section, however, provides what Piranesi describes as an "extraordinary impression of gravity and solidity, one that, it must be said, does not concede a single point to the renowned pyramids of Egypt." The room, accurately depicted with barrel vault and covered with plastered walls, is accessed, according to Piranesi, by an identical entrance way at G. [MC]

noted, as are modern refacings (O). The coat of arms of Pope Alexander VI (P) is indicated, and at R, the "metal angel emplaced at the center of the *Maschio*." The letter S indicates palisades that funnel water to water

wheels not visible in the print. As indicated at V, the Tiber is represented at its lowest state, evidence that Piranesi drew this *veduta* in August. [MC]

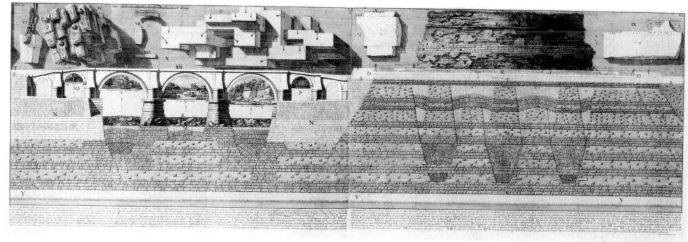

440

## 440
### Giovanni Battista Piranesi
### *Remains of the Mausoleum of the Emperor Hadrian, Today Converted into the Principal Fortress of Rome, Called the Castel S. Angelo*

Etching
c. 1756
From *Le antichità romane*, vol. 4 (Rome, 1756)
Signed below text, lower right
INSCRIPTION  A. Avanzo del Mausoleo del Elio
*Adriano Imp.* ᵉ *oggi ridotto nella principal
Fortezza di Roma, chiamata Castel Sant'Angelo …*
17¼″ × 54⅝″ (451 × 1387 mm)
BIBLIOGRAPHY  Focillon 1918, no. 344;
Wilton-Ely 1994, vol. 1, no. 477
Robison Collection

Piranesi describes the monument in richly encomiastic terms; he notes that it has been celebrated by ancient and modern writers, but that what remains is but a skeleton of the original monument. He laments that it is now much altered. Its marble revetment, both interior and exterior, has been stripped away. In his enthusiasm Piranesi has created an extraordinary substructure, one that is justified—or so he claims—by the incredible visible structure. And he laments the dismantling from the top to its base of both ornaments and marble revetment, which leaves the "mass deformed." Furthermore, upper sections have been reconfigured in brick facing. In addition, Piranesi proposes that by diverting the Tiber Hadrian was able to have an enormous substructure created for his tomb and the bridge. This immense substructure is, of course, entirely conjectural.

The scale of this fantastic creation becomes apparent on examining the tiny scenes glimpsed within the arches of the Ponte S. Angelo. Each archway depicts the level of the Tiber

in a different month, and one, at O, records the extraordinary level obtained in the holy year of 1750. [MC]

## 441
### Giovanni Battista Piranesi
### *Dedicatory Plate*

c. 1769
Etching
From *Diverse maniere d'adornare i cammini …* (Rome, 1769)
Signed below image, lower right
INSCRIPTION  DIVERSE MANIERE/
D'ADORNARE I CAMMINI/ED OGNI ALTRA
PARTE DEGLI EDIFIZJ DESUNTE/
DALL'ARCHITETTURA EGIZIA ETRUSCA
GRECA E ROMANA [cancelled]/
PRESENTATE/A/MONSIG D GIOVAMBATISTA
/REZZONICO/NIPOTE E MAGGIORDUOMO/
DELLA SANTITÀ DI N S/PP CLEMENTE XIII/
E GRAN PRIORE IN ROMA/DELLA SAC
RELIGIONE/GEROSOLIMITANA/DAL CAV
GIOVAMBATISTA PIRANESI/SUO ARCHITETTO
19¼″ × 28¼″ (490 × 717 mm)
BIBLIOGRAPHY  Focillon 1918, no. 854;
Wilton-Ely 1994, vol. 2, no. 815
Philadelphia Museum of Art, Purchased with the Haney Foundation Fund
1965-43-32

This dedicatory plate records a major shift in Piranesi's perception of the historical development of style in antiquity and also records a new emphasis on the relevance of the architecture of the past as a resource for contemporary architectural practice.

The dedication is architecturally divided into two sections, the upper part of which is a partial repetition of the title page stating: DIVERSE
MANIERE/ D'ADORNARE I CAMMINI/ ED
OGNI ALTRA PARTE DEGLI EDIFIZI
DESUNTE/ DALL'ARCHITETTVRA EGIZIA,
ETRVSCA, GRECA. This inscription has always been published as terminating at GRECA and thus translates: "Divers manners of ornamenting chimneys and all other parts of buildings taken from architecture [of] Egypt, Etruria, Greece." However, there is no period

after GRECA, and the inscription actually continues, albeit partially obliterated: E RØ////, and enough remains to permit the reconstruction of E
ROMANA. Thus the inscription is terminated by a crude cancellation, one that, however, leaves no doubt that "and Roman" was originally featured in the title of the dedication. Whereas this deletion appears to have been a hasty afterthought, the two successive lines of inscription have in contrast been meticulously excised in the same manner as the dedications to Lord Charlemont in *Le antichità romane* (cat. 433). These deletions and cancellations have gone unremarked in the literature of art, and while it is unlikely that the content of these last obliterated lines will ever be established, an explanation can be offered for the elimination of Rome from the dedication plate. When the dedication is compared with the title page and text of the publication, it is evident that Piranesi has evolved a new central thesis, namely, that the Etruscan and Roman styles are really synonymous and, indeed, virtually coterminous. Thus the title page conforms to the "edited" version of the dedication, and

the uniquenesses of the Egyptian and Etruscan (also called Tuscan) styles are reiterated (*Diverse maniere d'adornare … edifizi desunte dall'architettura Egizia, Etrusca, e Greca, con un regionamento apologetico in defesa dell'architettura Egizia, e Toscana*). Whereas he was antagonistic toward the Greek style in his earlier publications, Piranesi now perceives it as a third style, alongside the primary styles of Egypt and Etruria, and urges contemporary architects to borrow selectively from all three styles. He tends to perceive the Egyptian style as separate but proposes adaptation of Greek elements to the Etruscan–Roman vocabulary. In his preface he claims that, "This in fact is what the Romans did, for after having used for many centuries Etruscan architecture they then also adopted that of Greece, uniting the one and the other together." The same argument is espoused throughout the text of this volume. This consistency of viewpoint strongly suggests that Piranesi prepared the dedicatory plate at a very early stage of his work on this publication and that in the process of developing the essay and creating the accompanying plates, his anti-Greek

441

442

## Giovanni Battista Piranesi
### *Chimneypiece in the Egyptian Style*

c. 1769
Etching
From *Diverse maniere d'adornare i cammini …* (Rome, 1769)
Signed below image, lower left
10″ × 15¼″ (252 × 388 mm)
BIBLIOGRAPHY Focillon 1918, no. 874; Wilton-Ely 1994, vol. 2, no. 866
Robison Collection

This example articulates Piranesi's bold and unorthodox view of Egyptian art. He perceived Egyptian ornament to be of extraordinary variety and much broader in scope than surviving objects suggest. This thesis has clearly served as a point of departure for this fireplace design.

The fireplace bears no relation to any Egyptian prototype. Supported by two opposed standing male figures, the fireplace lintel, U-shaped and covered with hieroglyphs, supports a variety of reliefs and bands of hieroglyphs. To either side of the fireplace are two identically shaped chairs. The decorative designs on the chairs and on the wall surfaces behind them are a curious mix of symmetrically and asymmetrically disposed ornamental elements and hieroglyphs. What is particularly intriguing is the fact that Piranesi subjects the larger architectural and sculptural elements to a vigorously consistent symmetricality, but within these larger elements, especially at the level of hieroglyphic detail, asymmetry abounds. [MC]

polemics, which had dominated the text and illustrations of his earlier publications, began to subside. When he arrived at the idea that Etruscan and Roman styles were not two distinct phenomena but rather a chronological sequence within a single, unitary style he retroactively canceled out "and Roman" from the dedication title, bringing this plate into conformity with his title page and text. The title also indicates that he has now focused on the application of these architectural styles to contemporary practice.

The dedication is significant in the context of new developments in Piranesi's thinking. The patron is Monsignor Don Giovanni Battista Rezzonico, nephew and maggiordomo of Pope Clement XIII and grand prior in Rome of the order of Jerusalem (the Knights of Malta), and Piranesi identifies himself as "Cav[aliere] Giovambattista Piranesi, his architect." This nomenclature is significant because not only did Pope Clement XIII Rezzonico support his publications, but Giovanni Battista Rezzonico as the chief officer of the Knights of Malta at S. Maria del Priorato was the source of Piranesi's only executed architectural project. The opportunity to engage in architectural design assuredly heightened Piranesi's concern for contemporary practice and the desirability of utilizing the decorative vocabulary of Greek as well as Etrusco-Roman architecture. [MC]

442

## Giovanni Battista Piranesi
### *Chimneypiece in the Etrusco-Roman Style*

c. 1769
Etching (proof), in bound volume
From *Diverse maniere d'adornare i cammini …* (proof set, Rome, 1769)
Signed below image, lower right
9½″ × 15″ (240 × 380 mm)
BIBLIOGRAPHY Focillon 1918, no. 883; Wilton-Ely 1994, vol. 2, no. 838
National Gallery of Art, Washington, D.C., Mark J. Millard Architectural Collection, David K. E. Bruce Fund
1985.61.2628

A particularly ambitious example from the *Diverse maniere*, this plate includes a portion of the proposed setting in which elements of the fireplace design have been extended. The fireplace is composed principally of Roman decorative elements; a bird of indeterminate species flanked by sea monsters appears within a shell at the center of the lintel, and military trophies are displayed in relief panels to either side. Opposed lion-headed terms enframe the vertical elements of the fireplace on which there are paired dolphins, shells, bucrania, and a variety of architectural moldings. It is likely that Piranesi perceived some of these decorative elements as specifically Etruscan. To either side are elaborately curvilinear chairs displaying some of the architectural details and ornamental forms found in the fireplace. The exact shape and dimensions of these chairs is difficult to ascertain. Are they curvilinear, low-slung chairs? Or are the Apollos,

riding in quadrigas and framed by sun bursts, part of the chairs? Did Piranesi arrive at their oddly splayed wheels by copying an antique example? In any event, the cast shadows of these elements suggest that they, together with the relief panels above them, are three-dimensional in form. At the outer edges of the mantel there are two elaborate candelabra. These, like the chairs, present ambiguities: the disks behind them appear to be an integral part of their design. The shadow patterns confirm this relationship, but then who or what are the recumbent figures perched in pairs atop the disks? They seem to be three-dimensional and to rest on the disks, but their outstretched hands grasp the edge of the net design. Perhaps the system of netting is actually executed in relief. Or is the decorative wall system in whole or part a painted illusion? [MC]

443

## 444
## Giovanni Battista Piranesi
### Furniture, Including a Clock Designed for Senator Rezzonico

c. 1769
Etching (proof), in bound volume
From *Diverse maniere d'adornare i cammini …* (proof set, Rome, 1769)
Signed below image, lower left
INSCRIPTION *Quest'orologio A e stato eseguito in metallo/dorato per ordine di Sua Ecc'za il Sig.r/ D. Abondio Rezzonico Senatore di Roma/come ancora alcuni altri ornam'ti che si/vedono sparsi nelle altre tavole di questa/raccolta, quali sono stati messi in opera/nel suo Palazzo sul Campidoglio.*
15⅛" × 10" (390 × 253 mm)
BIBLIOGRAPHY Focillon 1918, no. 924; Wilton-Ely 1994, vol. 2, no. 885
National Gallery of Art, Washington, D.C., Mark J. Millard Architectural Collection, David K. E. Bruce Fund
1985.61.2628

The types of furniture design included in the *Diverse maniere* oscillate between highly Rococo formulations and presentations that are sufficiently freighted with antique elements to be suggestive of the nascent Neoclassical style. Throughout the objects gathered in this plate there is strong adherence to symmetrical composition and near-consistent application of classically derived ornamentation. This is particularly true of the large, centrally placed clock (an inscription indicates that it is *alto palmi cinque* and thus in reality smaller in relation to the table depicted beneath it), which is ornamented with elements that could easily be mistaken for decorative motifs in the Empire style. The trophies atop the clock include, in addition to banners and shields, the prominently displayed barrel of a cannon and an oddly macabre crowning piece consisting of a shell enframing a grisly trophy: the decapitated head of a Turk. The opposed helmets at the base of the clock are, presumably, inspired by antique Roman sources, but they could be easily mistaken for the helmets worn by cuirassiers in the Napoleonic army. Two motifs that ornament the clock are particularly surprising—even curious. One is the prominently displayed winged dragon: this is not one of the Rezzonico symbols (which consist of fortified tower, twin-headed eagle with crown, and Greek cross), but rather one emphatically associated with the Borghese. Piranesi was well aware of the correct Rezzonico devices; he used them extensively in his architectural renovation of S. Maria del Priorato commissioned by the Rezzonico Pope Clement XIII for the Knights of Malta. The absence of Rezzonico *imprese* and the privileged position of the rampant dragon raises

an unanswerable question: could this clock design have been initially projected for a Borghese patron?

The two tabletop clocks are oddities. Curiously folkloristic in character, their decorations suggest pine tree and sunflower themes. And the two smaller objects on the table are totally frivolous. One, a miniature ram's-head rhyton, sports a turtle on its top, an oddly projecting serpent-like creature, and a lion's leg support. Its pendant is even more improbable, consisting of what appears to be a ceramic representation of a piece of fruit, possibly an apple. A stem protrudes from one side; a few leaves and a branch, from the other. Two leaves serve as its seemingly structurally inadequate base.

Wilton-Ely has rightly noted that the more Rococo forms that predominate in Piranesi's other furniture designs "are replaced by a symmetrical arrangement, while the plethora of constituent motifs such as trophies, helmets, shells and tritons are sharply defined" (Wilton-Ely 1978, p. 103). Further, he suggests that "the bizarre pier-table placed under the clock … may also have been designed for the same commission, since it is built up of elements taken exclusively from an antique marble relief in the Capitoline Museum, used by Piranesi as a source for various symbols in the Aventine scheme" (Wilton-Ely 1978, p. 103). That the table was either a commission of the Rezzonico or that Piranesi hoped that it would be commissioned by them is entirely convincing; it seems highly probable that all the objects in the plate were intended at the very least to attract Rezzonico interest. However, the attractive suggestion that the table is composed "of elements taken exclusively from an antique marble relief in the Capitoline Museum" and that this source associates the table with Piranesi's architectural projects on the Aventine is inaccurate and indeed downplays the wildly imaginative conglomeration of motifs from which Piranesi has constructed it. Although similar types of objects are represented in the relief, Piranesi's designs are radically different.

The table here depicted is a side-table; it would have required wall brackets for stabilization. Also side-tables were usually produced in pairs, and this arrangement may have been implicit in Piranesi's scheme. The fact that two tables exist (one in the Minneapolis Institute of Arts, the other in the Rijksmuseum, Amsterdam) that are based on Piranesi's similar design for Cardinal Giovanni Battista Rezzonico (Wilton-Ely 1994, vol. 2, no. 884) supports such a hypothesis or at the very least suggests that Piranesi sought a commission for pendant tables.

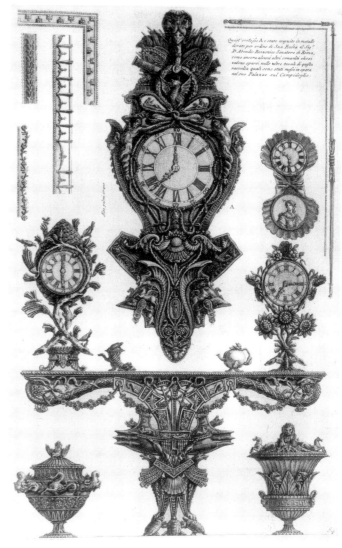

444

What occurs beneath the planar surface of the tabletop is a bizarre eruption of forms: wreaths, ribbons, and floral garlands scroll out to the edges of the table and converge in increasingly weighty forms as they join together to form the central support; this splays into a tripartite set of ever-diminishing supports, which are received by a "foot" consisting, improbably, of three rampant tortoises. [MC]

# List of Sources Cited

ABBREVIATED ENCYCLOPEDIC WORKS

**AKL**
*Allgemeines Künstler-Lexikon: die bildenden Künstler aller Zeiten und Völker.* Munich and Leipzig: K. G. Saur, 1983–.

**DA**
*The Dictionary of Art.* 34 vols. Edited by Jane Turner. London: Macmillan, 1996.

**DBI**
*Dizionario biografico degli Italiani.* Rome: Istituto della Enciclopedia Italiana, 1960–.

**Thieme and Becker**
Thieme, Ulrich, and Felix Becker. *Allgemeines Lexikon der Bildenden Künstler von der Antike bis zur Gegenwart.* 37 vols. Leipzig: E. A. Seemann, 1907–50.

**Acanfora 1996**
Acanfora, Elisa. "Michel-Ange Slodtz: San Bruno." In Rocchi Coopmans de Yoldi 1996, pp. 390–94.

***L'Accademia 1974***
*L'Accademia Nazionale di San Luca.* Rome: De Luca, 1974.

**Accascina 1957**
Accascina, Maria. "La formazione artistica di Filippo Juvara—II: la famiglia, l'ambiente—prime opere a Messina." *Bollettino d'arte,* 4th ser., vol. 42 (1957), pp. 50–62.

**Accascina 1957, "Juvara III"**
Accascina, Maria. "La formazione artistica di Filippo Juvara—II: la famiglia, l'ambiente—prime opere a Messina." *Bollettino d'arte,* 4th ser., vol. 42 (1957), pp. 150–62.

**"Accessions" 1964**
"Accessions of American and Canadian Museums." *The Art Quarterly,* vol. 27 (1964), pp. 203–22.

**Achilles-Syndram 1998**
Achilles-Syndram, Katrin. "Pietro Braccis Büste Benedikt XIV: Ein Meisterwerk aus 'unglücklicher Epoche?'" *Museums Journal,* vol. 12 (1998), pp. 93–96.

**Acquaviva and Vitali 1979**
Acquaviva, Stefano, and Marcella Vitali. *Felice Giani: un maestro nella civiltà figurativa faentina.* Faenza, Italy: Fratelli Lega, 1979.

**Adam 1764**
Adam, Robert. *Ruins of the Palace of the Emperor Diocletian at Spalatro in Dalmatia.* London, 1764.

**Adam [1773–79] 1980**
Adam, Robert. *The Works in Architecture of Robert and James Adam.* 2 vols. 1773–79. Reprint, New York: Dover Publications, 1980.

**Agosti and Ceriana 1997**
Agosti, Giacomo, and Matteo Ceriana, eds. *Le raccolte storiche dell'Accademia di Brera.* Florence: Centro Di, 1997.

**Agostini 1984**
Agostini, Nicoletta. "Gaspare Landi tra neoclassicismo e purismo: interazioni tra iconografie sacre e profane." *Bollettino storico piacentino,* vol. 79 (1984), pp. 38–68.

**Agostini 1985**
Agostini, Nicoletta. "Gaspare Landi tra neoclassicismo e purismo: la schematizzazione espressiva." *Bollettino storico piacentino,* vol. 80 (1985), pp. 25–49.

**Aldega and Gordon 1988**
Aldega, Marcello, and Margot Gordon. *Italian Drawings, 1700–1863.* Rome: De Luca, 1988.

**Aldenhoven 1911**
Aldenhoven, Carl. "A Houdon in Gotha (1887)." In A. Lindner, ed., *Gesammelte Aufsätze,* pp. 139–45. Leipzig, Germany: Klinkhardt & Bierman, 1911.

**Alfieri, Branchetti, and Cornini 1986**
Alfieri, Massimo, Maria-Grazia Branchetti, and Guido Cornini, eds. *Mosaici minuti romani del 700 e dell'800.* Rome: Edizioni del mosaico, 1986.

**Alloisi 1984**
Alloisi, Sivigliano. "Il collezionismo del card. Neri Maria Corsini." In *La Galleria Corsini: a cento anni dalla sua acquisizione allo stato,* pp. 29–36. Rome: Multigrafica, 1984.

**Allroggen-Bedel 1983**
Allroggen-Bedel, Agnes. "Piranesi e l'archeologia nel reame di Napoli." In Istituto Storia dell'Arte 1983, pp. 281–86.

**Alten 1866**
Alten, Friedrich von. *Versuch eines Verzeichnisses der Werke und Entwürfe con Asmus Jakob Carstens.* Olbenburg, 1866.

**Altieri [1873] 1995**
Altieri, Marco Antonio. *Li nuptiali di Marco Antonio Altieri: publicati da Enrico Narducci.* 1873. Reprint, Rome: Roma nel Rinascimento, 1995.

**Amato 1976**
Amato, Pietro. "Corrado Giaquinto: documenti inediti nel Tabularium Vicariatus Urbis." In Michele Paone, ed., *Studi di storia pugliese in onore di Giuseppe Chiarelli.* Vol. 4, pp. 229–50. Galatina, Italy: M. Congedo, 1976.

**Amato 1985**
Amato, Pietro, ed. *Corrado Giaquinto (1703–1766): atti del II Convegno internazionale di studi, Molfetta 19–20, dicembre 1981.* Molfetta, Italy: Mezzina, 1985.

**Ambiveri 1879**
Ambiveri, Luigi. *Gli artisti piacentini: cronaca ragionata.* Piacenza, Italy: Francesco Solari, 1879.

**Ambrosini 1995**
Ambrosini, Alberto. "La pittura dal Cinquecento all'Ottocento." In Adriano Peroni, ed., *Il Duomo di Pisa.* Vol. 1, pp. 313–31. Modena, Italy: F. C. Panini, 1995.

**Ananoff 1961–70**
Ananoff, Alexandre. *L'Oeuvre dessiné de Jean-Honoré Fragonard, 1732–1806.* 4 vols. Paris: F. de Nobele, 1961–70.

***Andrea Pozzo 1996***
*Andrea Pozzo.* Milan: Luni, 1996.

**Andrieux 1968**
Andrieux, Maurice. *Daily Life in Papal Rome in the Eighteenth Century.* Translated by Mary Fitton. London: Allen & Unwin, 1968. Originally published as *La Vie quotidienne dans la Rome pontificale au XVIIIe siècle* (Paris: Hachette, 1962).

**Androsov 1991**
Androsov, Sergej O., ed. *Alle origini di Canova: le terrecotte della collezione Farsetti.* Venice: Marsilio, 1991.

**Androssov 1991, "Maderno"**
Androssov, Sergey O. "Works by Stefano Maderno, Bernini and Rusconi from the Farsetti Collection in the Ca' d'Oro and the Hermitage." *The Burlington Magazine,* vol. 133 (1991), pp. 292–97.

**Androssov and Enggass 1994**
Androssov, Sergey, and Robert Enggass. "Peter the Great on Horseback: A Terracotta by Rusconi." *The Burlington Magazine,* vol. 136 (1994), pp. 816–21.

***Angelika Kauffmann 1979***
*Angelika Kauffmann und ihre Zeit: Graphik und Zeichnungen von 1760–1810.* Düsseldorf: C. G. Boerner, 1979.

**Angelini 1995**
Angelini, Alessandro. "Giuseppe Mazzuoli, la bottega dei fratelli e la committenza della famiglia De'Vecchi." *Prospettiva,* vol. 79 (1995), pp. 78–100.

**Ansaldi 1816**
Ansaldi, Innocenzio Andrea. *Descrizione delle sculture, pitture ed architetture della città, e diocesi di Pescia.* 2d ed., revised and enlarged by Antonio Ansaldi. Pescia, Italy: Anton Giuseppe Natali, 1816.

**Anselmi 1990**
Anselmi, Alessandra. "La decorazione scultorea della facciata di S. Maria Maggiore a Roma: un inedito manoscritto con memoria del programma iconografico Settecentesco." *Ricerche di storia dell'arte,* vol. 40 (1990), pp. 61–80.

**Antal 1956**
Antal, Frederick. *Fuseli Studies.* London: Routledge & Kegan Paul, 1956.

**Antonov 1977**
Antonov, Victor. "Clienti russi del Batoni." *Antologia di Belle Arti,* vol. 1 (1977), pp. 351–53.

**Antonova 1977**
Antonova, Irina Aleksandrovna. *Die Gemäldegalerie des Puschkin-Museums in Moskau.* Leipzig, Germany: E. A. Seemann, 1977.

**Antonsson 1936**
Antonsson, Oscar. "Sergel-Studier: Rön, Omvärderingar och Fynd." *Nationalmusei Årsbok,* n.s., vol. 6 (1936), pp. 66–104.

**Antonsson 1942**
Antonsson, Oscar. *Sergels ungdom och Romtid.* Stockholm: Norstedt, 1942.

**Arcangeli 1985**
Arcangeli, Luciano. "Una 'deliziosa' per gli Albani ed altri progetti di Carlo Marchionni nella Biblioteca Civica di Iesi." In Debenedetti 1985, pp. 129–46.

**Archäologisches Institut 1979**
Archäologisches Institut der Universität Göttingen. *Die Skulpturen der Sammlung Wallmoden: Ausstellung zum Gedenken an Christian Gottlob Heyne, 1729–1812.* Göttingen, Germany: Archäologisches Institut der Universität Göttingen, 1979.

**Arisi 1960**
Arisi, Ferdinando. *Il Museo Civico di Piacenza.* Piacenza, Italy: Edizioni del Museo Civico, 1960.

**Arisi 1961**
Arisi, Ferdinando. *Gian Paolo Panini.* Piacenza, Italy: Cassa di Risparmio, 1961.

**Arisi 1986**
Arisi, Ferdinando. *Gian Paolo Panini e i fasti della Roma del '700.* Rome: Ugo Bozzi, 1986.

**Arisi 1991**
Arisi, Ferdinando. *Gian Paolo Panini.* Soncino, Italy: Edizioni dei Soncino, 1991.

**Arisi 1993**
Arisi, Ferdinando, ed. *Giovanni Paolo Panini, 1691–1765.* Milan: Electa, 1993.

**Arisi, Di Grapello, and Mischi 1981**
Arisi, Ferdinando, Gustavo di Grapello, and Giuseppe Mischi, eds. *Il Gazzola, 1781–1981.* Piacenza, Italy: Istituto Gazzola, 1981.

**Arizzoli-Clémentel 1978**
Arizzoli-Clémentel, Pierre. "Charles Percier e la salle égyptienne de la Villa Borghèse." In Brunel 1978, pp. 1–32.

**Armellini 1942**
Armellini, Mariano. *Le chiese di Roma: dal secolo IV al XIX.* Rev. ed. 2 vols. Rome: R.O.R.E., 1942.

**Arnason 1975**
Arnason, H. Harvard. *The Sculptures of Houdon.* New York: Oxford University Press, 1975.

***L'Art européen 1979***
Galerie des Beaux-Arts, Bordeaux; Grand Palais, Paris; Museo del Prado, Madrid. *L'Art européen à la cour d'Espagne au XVIIIe siècle.* Paris: Réunion des Musées Nationaux, 1979.

**Artemieva et al. 1998**
Artemieva, Irina, et al. *Il mondo di Giacomo Casanova: un veneziano in Europa, 1725–1798.* Venice: Marsilio, 1998.

***Artists in Rome 1978***
The Metropolitan Museum of Art, New York. *Artists in Rome in the 18th Century: Drawings and Prints.* New York: The Metropolitan Museum of Art, 1978.

**Arts Council 1968**
Arts Council of Great Britain, London. *Italian Drawings from the Collection of Janos Scholz.* London: Arts Council of Great Britain, 1968.

**Arts Council 1972**
Arts Council of Great Britain, London. *The Age of Neo-classicism.* London: Arts Council of Great Britain, 1972.

**Ashby and Welsh 1927**
Ashby, Thomas, and Stephen Welsh. "Alessandro Specchi." *The Town Planning Review Quarterly* (Liverpool), vol. 12 (1927), pp. 237–48.

**Associazione Culturale Alma Roma 1997**
Associazione Culturale Alma Roma, Rome. *Chracas: diario ordinario di Roma. Sunto di notizie e indici.* 2 vols. Rome: Associazione Culturale Alma Roma, 1997.

**Augin 1875**
Augin, E. *Exposition Rétrospective de Nancy, Impressions et Souvenirs.* Nancy, France, 1875.

**Avery 1988**
Avery, Charles. *Studies in European Sculpture II.* London: Christies, 1988.

**Ayres de Carvalho 1960–62**
Ayres de Carvalho, Armindo. *D. João V e a arte do seu tempo.* 2 vols. Lisbon: Mafra, 1960–62.

**Babelon 1964**
Babelon, Jean-Pierre. "Les Falconet de la Collection Thiroux d'Épersenne." *Bulletin de la Société de l'Histoire de l'Art Français* (1964), pp. 101–11.

**Bacchi 1994**
Bacchi, Andrea. "L'Andromeda' di Lord Exeter." *Antologia di Belle Arti,* n.s., no. 48–51 (1994), pp. 64–70.

**Bacchi 1996**
Bacchi, Andrea, ed. *Scultura del '600 a Roma.* Milan: Longanesi, 1996.

**Back 1914**
Back, Friedrich, ed. *Verzeichnis der Gemälde.* Darmstadt, Germany: Hessisches Landesmuseum, 1914.

**Bacou 1975**
Bacou, Roseline. *Piranesi: Etchings and Drawings.* Boston: New York Graphic Society, 1975. Originally published as *Piranèse: gravures et dessins* (Paris: Société Nouvelle des Editions du Chêne, 1974).

**Bacou 1976**
Bacou, Roseline. *Le XVIIIe siècle français.* Paris: Editions Princesse, 1976.

**Baetjer and Links 1989**
Baetjer, Katharine, and J. G. Links. *Canaletto.* New York: The Metropolitan Museum of Art, 1989.

**Baker 2000**
Baker, Malcolm. "Public Fame or Private Remembrance? The Portrait Bust as a Mode of Commemoration in Eighteenth-Century England." In A. W. Reinink, ed., *Memory and Oblivion: Twenty-Ninth International Congress of the History of Art, 1996.* Amsterdam: Kluwer, 2000. Forthcoming.

**Baker and Harrison 2000**
Baker, Malcolm, and Colin Harrison. "Bouchardon's British Sitters and Sculptural Portraiture in Rome around 1730." *The Burlington Magazine,* vol. 142 (2000). Forthcoming.

**Baldeschi and Crescimbeni 1723**
Baldeschi, Alessandro, and Giovan Mario Crescimbeni. *Stato della S.S. chiesa papale lateranense nell'anno 1723.* Rome: Stamperia di S. Michele a Ripa Grande, 1723.

**Baldin 1983**
Baldin, Giulia. *Lorenzo Pécheux (1729–1821).* Turin, Italy: Piazza, 1983.

**Baldinucci 1975**
Baldinucci, Francesco Saverio [1625–1696]. *Vite di artisti dei secoli XVII–XVIII.* Edited by Anna Matteoli. Rome: De Luca, 1975.

**Barberini 1993**
Barberini, Maria Giulia. "De lavori ad un fauno di rosso antico." *Bollettino dei musei comunali di Roma,* n.s., vol. 7 (1993), pp. 23–35.

**Barberini 1994**
Barberini, Maria Giulia. "Clemente Bianchi e Bartolomeo Cavaceppi, 1750–1754: restauri conservativi ad alcune statue del Museo Capitolino." *Bollettino dei musei comunali di Roma,* n.s., vol. 8 (1994), pp. 95–121.

**Barberini 1996**
Barberini, Maria Giulia. "Il cratere di Mitridate: un restauro di Francesco Giardoni." *Antologia di Belle Arti,* n.s., no. 52–55 (1996), pp. 132–34.

**Barberini and Gasparri 1994**
Barberini, Maria Giulia, and Carlo Gasparri, eds. *Bartolomeo Cavaceppi, scultore romano (1717–1799).* Rome: Palombi, 1994.

**Bareggi and Pino 1972**
Bareggi, Silvana, and Alessandra Pino. *Cinque secoli di architettura nel disegno—n. 2.* Milan: Stampa della Stanza del Borgo, 1972.

**Baretti 1768**
Baretti, Joseph. *An Account of the Manners and Customs of Italy: with Observations on the Mistakes of Some Travellers, with Regard to that Country.* 2 vols. London: T. Davies, & L. Davies, & C. Rymers, 1768.

**Barghini 1994**
Barghini, Andrea. *Juvarra a Roma: disegni dall'atelier di Carlo Fontana.* Turin, Italy: Rosenberg & Sellier, 1994.

**Barocchi 1998**
Barocchi, Paola. *Dai neoclassici ai puristi, 1780–1861.* Vol. 1 of *Storia moderna dell'arte in Italia: manifesti, polemiche, documenti.* Turin, Italy: Giulio Einaudi, 1998.

**Barnes 1996**
Barnes, Joanna. "An Unknown Bust by Christopher Hewetson." *Antologia di Belli Arti,* n.s., no. 52–55 (1996), pp. 166–69.

**Barroero 1975**
Barroero, Liliana. "Per Gabriele Valvassori." *Bollettino d'arte,* 5th ser., vol. 60, no. 3–4 (1975), pp. 235–38.

**Barroero 1990**
Barroero, Liliana. "La pittura a Roma nel Settecento." In *La pittura 1990.* Vol. 1, pp. 383–463.

**Barroero 1990, "Benefial"**
Barroero, Liliana. "Benefial, Marco." In *La pittura 1990.* Vol. 2, p. 621.

**Barroero 1990, "Batoni"**
Barroero, Liliana. "Batoni, Pompeo Girolamo." In *La pittura 1990.* Vol. 2, p. 616.

**Barroero 1996**
Barroero, Liliana. "Giovanni Gherardo De Rossi biografo, un esempio: la 'vita' di Gaetano Lapis." *Roma moderna e contemporanea,* vol. 4 (1996), pp. 677–90.

**Barroero 1996, "Interventi"**
Barroero, Liliana. "Gli interventi settecenteschi." In Giusi Testa, ed., *La cappella Nova o di San Brizio nel Duomo di Orvieto,* pp. 289–99. Milan: Rizzoli, 1996.

**Barroero 1998**
Barroero, Liliana. "I primi anni della Scuola del Nudo in Campidoglio." In Biagi Maino 1998, pp. 367–84.

**Barroero 1998, "Pozzi"**
Barroero, Liliana. "Disegni di Stefano Pozzi pittore di storia." In Forlani Tempesti and Prosperi Valenti Rodinò 1998, pp. 437–49.

**Barroero 1999**
Barroero, Liliana. "Le pubblicazioni periodiche a Roma nel Settecento: le Memorie per le belle arti e il Giornale delle belle arti." In *La pittura romana dal protoneoclassico al neoclassico e le sue diramazioni nell'area italiana.* Forthcoming.

**Barroero et al. 1980**
Barroero, Liliana, et al. *Pittura del Seicento e del Settecento: ricerche in Umbria, 2.* Treviso, Italy: Canova, 1980.

**Barth and Oppel 1992**
Barth, Renate, and Margarete Oppel. *Asmus Jakob Carstens: Goethes Erwerbungen für Weimar.* Neumünster, Germany: K. Wachholtz, 1992.

**Bassett and Fogelman 1997**
Bassett, Jane, and Peggy Fogelman. *Looking at European Sculpture: A Guide to Technical Terms.* Los Angeles: The J. Paul Getty Museum, 1997.

**Bassi 1959**
Bassi, Elena, ed. *Antonio Canova: i quaderni di viaggio (1779–1780).* Venice and Rome: Istituto per la Collaborazione Culturale, 1959.

**Bassi 1978**
Bassi, Elena, ed. *Venezia nell'età di Canova, 1780–1830.* Venice: Alfieri, 1978.

**Battistelli and Diotallevi 1982**
Battistelli, Franco, and Daniele Diotallevi. *Il Palazzo Malatestiano in Fano: storia e raccolte d'arte.* Fano, Italy: Cassa di Risparmio di Fano, 1982.

**Baudot 1889**
Baudot, Henri. *Eloge historique de Bénigne Gagneraux.* 2nd ed. Dijon, France, 1889.

**Bauer 1962**
Bauer, Hermann. *Rocaille: Zur Herkunft und zum Wesen eines Ornament-Motivs.* Vol. 4 of *Neue Münchner Beiträge zur Kunstgeschichte: Herausgegeben vom Kunsthistorischen Seminar der Universität München.* Berlin: Walter de Gruyter, 1962.

**Bäumel 1986**
Bäumel, Jutta. "Schwert und Hut des sächsischen Kurprinzen Friedrich August." *Jahrbuch der Staatlichen Kunstsammlungen Dresden* (1986), pp. 133–39.

**Bäumel 1990**
Bäumel, Jutta. "Vermißte päpstliches Schwertband wieder in Dresden." *Dresdener Kunstblätter,* vol. 34 (1990), pp. 123–26.

**Baumgärtel 1987**
Baumgärtel, Bettina. "Angelika Kauffmann." In Gisela Breitling, ed., *Das Verborgene Museum: Dokumentation der Kunst von Frauen in Berliner offentlichen Sammlungen,* pp. 108–11. Berlin: Hentrich, 1987.

**Baumgärtel 1990**
Baumgärtel, Bettina. *Angelika Kauffmann (1741–1807): Bedingungen weiblicher Kreativität in der Malerei des 18. Jahrhunderts.* Weinheim, Germany: Beltz, 1990.

**Baumgärtel 1995**
Baumgärtel, Bettina, ed. *Zeichne Passeri Zeichne … und verliere keine Zeit: Giuseppe Passeri, 1654–1714 in seiner Zeit, Zeichnungen und Ölstudien des Barock.* Düsseldorf: Kunstmuseum Düsseldorf, 1995.

**Baumgärtel 1998**
Baumgärtel, Bettina, ed. *Angelika Kauffmann.* Stuttgart, Germany: Hatje, 1998.

**Baumgarten 1936–37**
Baumgarten, Sandor. "Les Oeuvres de Camillo Rusconi a Rome." *Revue de l'art ancien et moderne,* 3rd ser., vol. 40 (1936–37), pp. 233–38.

**Baumstark 1980**
Baumstark, Reinhold. *Masterpieces from the Collection of the Princes of Liechtenstein.* Translated by Robert Erich Wolf. New York: Hudson Hills Press, 1980.

**Bean and Griswold 1990**
Bean, Jacob, and William Griswold. *18th Century Italian Drawings in the Metropolitan Museum of Art.* New York: The Metropolitan Museum of Art, 1990.

**Bean and Stampfle 1971**
Bean, Jacob, and Felice Stampfle. *Drawings from New York Collections III: The Eighteenth Century in Italy.* New York: The Metropolitan Museum of Art, and The Pierpont Morgan Library, 1971.

**Beau 1968**
Beau, Marguerite. *La Collection des dessins d'Hubert Robert au Musée de Valence.* Lyons, France: Audin, 1968.

**Beaulieu 1955**
Beaulieu, Michèle. "La 'Filette aux nattes' de Saly." *Bulletin de la Société de l'Histoire de l'Art Français* (1955), pp. 62–66.

**Becci 1783**
Becci, Antonio. *Catalogo delle pitture che si conservano nelle chiese di Pesaro.* Pesaro, Italy: Gavelli, 1783.

**Bechtoldt and Weiss 1996**
Bechtoldt, Frank-Andreas, and Thomas Weiss, eds. *Weltbild Wörlitz: Entwurf einer Kulturlandschaft.* Stuttgart, Germany: Hatje, 1996.

**Beck 1854**
Beck, August. *Ernst der Zweite, Herzog zu Sachsen-Gotha und Altenburg, als Pfleger und Beschützer der Wissenschaft und Kunst.* Gotha, Germany, 1854.

**Beck and Bol 1982**
Beck, Herbert, and Peter C. Bol, eds. *Forschungen zur Villa Albani: Antike Kunst und die Epoch der Aufklärung.* Berlin: Mann, 1982.

**Beck, Bol, and Bückling 1990**
Beck, Herbert, Peter C. Bol, and M. Bückling, eds. *Polyklet: Der Bildhauer der griechischen Klassik.* Mainz, Germany: Philipp von Zabern, 1990.

**Beck, Bol, and Bückling 1999**
Beck, Herbert, Peter C. Bol, and Maraike Bückling, eds. *Mehr Licht: Europa um 1770. Die bildende Kunst der Aufklärung.* Munich: Klinkhardt & Biermann, 1999.

**Beckford 1805**
Beckford, Peter. *Familiar Letters from Italy, to a Friend in England.* Salisbury, England: J. Easton, 1805.

**Bell 1938**
Bell, Charles F. *Annals of Thomas Banks, Sculptor, Royal Academician, with Some Letters from Sir Thomas Lawrence, P.R.A., to Bank's Daughter.* Cambridge: Cambridge University Press, 1938.

**Bella mano 1997**
Collezioni Comunali d'Arte, Bologna, Italy…. *Di bella mano: disegni antichi dalla raccolta Franchi.* Bologna, Italy: Musei Civici d'Arte Antica di Bologna, 1997.

**Bellenger 1993**
Bellenger, Sylvain. "It Is Not Right for Drawings to Be Nothing but Drawings." In Campbell and Carlson 1993, pp. 87–96.

**Belli Barsali 1964**
Belli Barsali, Isa. "Pompeo Gerolamo Batoni (1708–1787)." *La provincia di Lucca*, vol. 4 (1964), pp. 73–80.

**Belli Barsali 1967**
Belli Barsali, Isa, ed. *Mostra di Pompeo Batoni.* Lucca, Italy: Maria Pacini Fazzi, 1967.

**Belli Barsali 1983**
Belli Barsali, Isa. *Ville di Roma.* 2nd ed. Milan: Rusconi, 1983.

**Bellier de la Chavignerie and Auvray 1885**
Bellier de la Chavignerie, Émile, and Louis Auvray. *Dictionnaire général des artistes de l'école française depuis l'origine des arts du dessin jusqu'à nos jours.* Vol. 2. Paris: Renouard, 1885.

**Bellori [1672] 1976**
Bellori, Giovan Pietro. *Le vite de' pittori, scultori e architetti moderni.* Rome: Moscardi, 1672; Edited by Evelina Borea. Turin, Italy: Giulio Einaudi, 1976.

**Benaglio 1894**
Benaglio, Francesco [1708–59]. "Abbozzo della vita di Pompeo Batoni pittore." In Angelo Marchesan, ed., *Vita e prose scelte di Francesco Benaglio*, pp. 15–66. Treviso, Italy: Turazza, 1894.

**Benedetti 1972**
Benedetti, Sandro. "L'architettura dell'Arcadia: Roma 1730." In *Bernardo Vittone e la disputa fra classicismo e barocco nel Settecento: atti del Convegno internazionale promosso dall'Accademia delle Scienze di Torino nella ricorrenza del secondo centenario della morte di B. Vittone, 21–24 settembre 1970.* Vol. 1, pp. 337–91. Turin, Italy: Accademia delle Scienze, 1972.

**Benedetti 1989**
Benedetti, Sandro. "La sagrestia." In Pietrangeli 1989, pp. 247–57.

**Benisovich 1945**
Benisovich, Michel N. "A Bust of Alexandrine d'Etiolles by Saly." *Gazette des Beaux-Arts*, 6th ser., vol. 28 (1945), pp. 31–42.

**Benisovich 1956**
Benisovich, Michel. "Sales of French Collections of Paintings in the United States during the First Half of the Nineteenth Century." *The Art Quarterly*, vol. 19 (1956), pp. 288–301.

**Benisovich 1967**
Benisovich, Michel N. "Ghezzi and the French Artists in Rome." *Apollo*, n.s., vol. 85 (1967), pp. 340–47.

**Berchtold 1995**
Berchtold, Jacques. "Les Témoignages littéraires du thème de 'Cimon et Miltiade.'" In *Le jardin de l'esprit: textes offerts à Bronislaw Baczko*, pp. 27–47. Paris: Droz, 1995.

**Berliner 1958–59**
Berliner, Rudolf. "Zeichnungen von Carlo und Filippo Marchionni." *Münchner Jahrbuch der Bildenden Kunst*, vol. 9–10 (1958–59), pp. 267–396.

**Bernardini [1774] 1978**
Bernardini, Bernardino. *Descrizione del nuovo ripartimento dei rioni di Roma.* 1774. Reprint, Milan: Insubria, 1978.

**Bernardini M. 1997**
Bernardini, Maria Grazia, ed. *Sei-Settecento a Tivoli: restauri e ricerche.* Rome: Istituto Poligrafico e Zecca dello Stato, Libreria dello Stato, 1997.

**Bernier 1975**
Bernier, Georges. *Anne-Louis Girodet, 1767–1824: Prix de Rome, 1789.* Paris: J. Damase, 1975.

**Bernoulli [1882–94] 1969**
Bernoulli, Johann Jacob. *Römische Ikonographie.* 4 vols. 1882–94. Reprint, Hildesheim, Germany: Georg Olms, 1969.

**Bershad 1976**
Bershad, David L. "Some New Documents on the Statues of Domenico Guidi and Ercole Ferrata in the Elizabeth Chapel in the Cathedral of Breslau (now Wroclaw)." *The Burlington Magazine*, vol. 118 (1976), pp. 700–703.

**Bershad 1984**
Bershad, David L. "Pierre-Étienne Monnot: Newly Discovered Sculpture and Documents." *Antologia di Belle Arti*, n.s., no. 23–24 (1984), pp. 72–75.

**Bershad 1985**
Bershad, David L. "The Newly Discovered Testament and Inventories of Carlo Maratti and His Wife Francesca." *Antologia di Belle Arti*, n.s., no. 25–26 (1985), pp. 65–84.

**Bertelli and Pietrangeli 1985**
Bertelli, Carlo, and Carlo Pietrangeli. *Le piccole vedute di Roma di Giambattista Piranesi.* Milan: Il Polifilo, 1985.

**Bertelli et al. 1976**
Bertelli, Carlo, et al. *Grafica II.* [special Piranesi edition] Rome: Calcografia Nazionale, 1976.

**Bertin 1893**
Bertin, Georges. *Joseph Bonaparte en Amérique.* Paris: Librairie de la Nouvelle Revue, 1893.

**Bertocchi and Dosi-Delfini 1970**
Bertocchi, Luciano, and Gian Carlo Dosi-Delfini, eds. *Lettere di pittori e scultori dei secoli XVII–XVIII.* Pontremoli, Italy, 1970.

**Bertolotti 1875**
Bertolotti, Antonino. "Esportazioni di oggetti di belle arti da Roma nei secoli XVI, XVII, XVIII, XIX." *Archivio storico, artistico, archeologico e letterario della città e provincia di Roma*, vol. 1, year 1 (1875), pp. 173–76.

**Bertolotti 1877**
Bertolotti, Antonino. "Esportazioni di oggetti di belle arti da Roma nei secoli XVI, XVII, XVIII, XIX." *Archivio storico, artistico, archeologico e letterario della città e provincia di Roma*, vol. 2, year 3 (1877), pp. 21–46, 145–69, 209–24.

**Bertolotti 1878**
Bertolotti, Antonino. "Esportazioni di oggetti di belle arti da Roma in Spagna e Portogallo nei secoli XVI, XVII, XVIII, XIX." *Archivio storico, artistico, archeologico e letterario della città e provincia di Roma*, vol. 2, year 4 (1878), pp. 209, 281–301.

**Bertolotti 1879**
Bertolotti, Antonino. "Esportazioni di oggetti di belle arti da Roma in Francia nei secoli XVI, XVII, XVIII, XIX." *Archivio storico, artistico, archeologico e letterario della città e provincia di Roma*, vol. 3, year 5 (1879), pp. 171–80.

**Bertolotti 1880**
Bertolotti, Antonino. "Esportazioni di oggetti di belle arti da Roma per l'Inghilterra." *Archivio storico, artistico, archeologico e letterario della città e provincia di Roma*, vol. 4, year 6 (1880), pp. 74–87.

**Bessone 1993**
Bessone, Silvana. *The National Coach Museum, Lisbon.* Translated by Elisabeth Plaister. Lisbon: Instituto Português de Museus; Paris: Fondation Paribas, 1993.

**Bettagno 1983**
Bettagno, Alessandro, ed. *Piranesi: tra Venezia e l'Europa. Atti del Convegno internazionale di studio promosso dall'Istituto di Storia dell'Arte della fondazione Giorgio Cini per il secondo centenario della morte di Gian Battista Piranesi, Venezia 13–15, ottobre 1978.* Florence: L. S. Olschki, 1983.

**Betti 1830**
Betti, Salvatore. *Elogio funebre del cav. Gaspare Landi pittore piacentino.* Rome: Boulzaler, 1830.

**Bevilacqua 1993**
Bevilacqua, Mario. "Nolli e Piranesi a Villa Albani." In Debenedetti 1993, pp. 71–79.

**Bevilacqua 1998**
Bevilacqua, Mario. *Roma nel secolo dei lumi: architettura erudizione scienza nella pianta di G. B. Nolli "celebre geometra."* Naples: Electa, 1998.

**Biagi Maino 1998**
Biagi Maino, Donatella, ed. *Benedetto XIV e le arti del disegno: Convegno internazionale di studi di storia dell'arte, Bologna 28–30, novembre 1994.* Rome: Quasar, 1998.

**Bianchi 1997**
Bianchi, Eugenia. "Novità per Giuseppe e Giovanni Bottani e un appunto per la formazione di Andrea Appiani." *Paragone*, 3rd ser., vol. 48, no. 14/569 (1997), pp. 64–76.

**Bianchi L. 1955**
Bianchi, Lidia, ed. *Disegni di Ferdinando Fuga e di altri architetti del Settecento.* Rome: Palombi, 1955.

**Bianconi 1779**
Bianconi, Giovanni Lodovico. "Elogio storico del cavaliere Giambattista Piranesi." *Antologia Romana* (Rome), nos. 34–36 (1779), pp. 265–84.

**Bianconi 1780**
Bianconi, Giovanni Lodovico. *Elogio storico del cavaliere Anton Raffaele Mengs: con un catalogo delle opere da esso fatte.* Milan: Imperial Monistero di S. Ambrogio Maggiore, 1780.

**Bianconi 1998**
Bianconi, Giovanni Lodovico [1717–1781]. *Scritti tedeschi.* Edited by Giovanna Perini. Bologna, Italy: Minerva, 1998.

**Biavati 1977**
Biavati, Enrico. "Giovanni Volpato di Bassano." *Faenza*, vol. 63 (1977), pp. 132–40.

**Bindman 1979**
Bindman, David, ed. *John Flaxman.* London: Thames & Hudson, 1979.

**Bindman and Baker 1995**
Bindman, David, and Malcolm Baker. *Roubiliac and the Eighteenth-Century Monument: Sculpture as Theatre.* New Haven and London: Yale University Press, 1995.

**Birke and Kertész 1992**
Birke, Veronika, and Janine Kertész. *Die italienischen Zeichnungen der Albertina.* Vol. 4. Vienna: Böhlau, 1992.

**Bissell 1997**
Bissell, Gerhard. *Pierre Le Gros, 1666–1719.* Reading, England: Si Vede, 1997.

**Bjurström 1976**
Bjurström, Per. *Sergel Tecknar.* Stockholm: LiberFörlag, 1976.

**Bjurström 1993**
Bjurström, Per, ed. *The Genesis of the Art Museum in the Eighteenth Century: Papers Given at a Symposium in Nationalmuseum, Stockholm, June 26, 1992, in Cooperation with the Royal Academy of Letters, History and Antiquities.* Stockholm: Nationalmuseum, 1993.

**Bjurström 1995**
Bjurström, Per. *Nicola Pio as Collector of Drawings.* Stockholm: Svenska Institutet i Roma, 1995.

**Black 1994**
Black, Bernard. *Vassé's 'Bambinelli': The Child Portraits of an 18th-Century French Sculptor.* London and Atlantic Highlands, N.J.: The Athlone Press, 1994.

**Blundell 1803**
Blundell, Henry. *An Account of the Statues, Busts, Bass-Relieves, Cinerary Urns, and Other Ancient Marbles, and Paintings, at Ince.* Liverpool, 1803.

**Blunt 1975**
Blunt, Anthony. *Neapolitan Baroque and Rococo Architecture.* London: A. Zwemmer, 1975.

**Blunt 1980**
Blunt, Anthony. "Roman Baroque Architecture: The Other Side of the Medal." *Art History*, vol. 3 (1980), pp. 61–80.

**Blunt and Cooke 1960**
Blunt, Anthony, and Hereward Lester Cooke. *Roman Drawings of the 17th and 18th Centuries.* Windsor, England: Royal Collection, Windsor Castle, 1960.

**Bodmer 1939**
Bodmer, Heinrich. "Trevisani, Francesco." In Thieme and Becker, vol. 33, pp. 389–91.

**Boehringer 1979**
Boehringer, Christof, ed. *Die Skulpturen der Sammlung Wallmoden: Austellung zum Gedenken an Christian Gottlob Heyne, 1729–1812.* Göttingen, Germany: Archäologisches Institut der Universität Göttingen, 1979.

**Boerlin-Brodbeck 1978**
Boerlin-Brodbeck, Yvonne. "Johann Caspar Füssli und sein Briefwechsel mit Jean-Georges Wille: Marginalien zu Kunstliteratur und Kunstpolitik in der zweiten Hälfte des 18. Jahrhunderts." *Jahrbuch 1974–1977 des Schweizerischen Instituts für Kunstwissenschaft* (1978), pp. 77–178.

**Bogyay 1964**
Bogyay, Thomas von. "Studien zu Jean-Antoine Houdons Werk in Deutschland." *Zeitschrift für Kunstgeschichte*, vol. 27 (1964), pp. 105–32.

**Boime 1987**
Boime, Albert. *Art in an Age of Revolution, 1750–1800.* Vol. 1 of *A Social History of Modern Art.* Chicago and London: The University of Chicago Press, 1987.

**Boissonnas 1954**
Boissonnas, Luc. *Acquarelli di A.L.R.-Du Cros: pittore svizzero, 1748–1810.* Rome: Istituto Svizzero, 1954.

**Bollea 1936**
Bollea, Luigi Cesare. *Lorenzo Pécheux, maestro di pittura nella R. Accademia delle Belle Arti di Torino.* Turin, Italy, 1936.

**Bolton 1919**
Bolton, Arthur T. *English Eighteenth-Century Sculptures in Sir John Soane's Museum.* London: Soane Museum Publications, 1919.

**Bolton 1922**
Bolton, Arthur T. *The Architecture of Robert & James Adam (1758–1794).* 2 vols. London: Country Life, 1922.

**Bona Castellotti 1980**
Bona Castellotti, Marco. "Un dipinto del Batoni a Milano." *Antologia di Belle Arti,* vol. 4 (1980), pp. 41–43.

**Bonaccorso and Manfredi 1998**
Bonaccorso, Giuseppe, and Tommaso Manfredi. *I Virtuosi al Pantheon, 1700–1758.* Rome: Argos, 1998.

**Bonet Correa, Blasco Esquivias, and Cantone 1998**
Bonet Correa, Antonio, Beatriz Blasco Esquivias, and Gaetana Cantone, eds. *Filippo Juvarra e l'architettura europea.* Naples: Electa, 1998.

**Bonfait 1996**
Bonfait, Olivier. "Rome capitale artistique et villages de peintres: un programme informatique pour étudier la population romaine à partir des 'stati delle anime.'" *Roma moderna e contemporanea,* vol. 4 (1996), pp. 217–31.

**Boni 1787**
Boni, Onofrio. *Elogio di Pompeo Girolamo Batoni.* Rome: Stamperia Pagliarini, 1787.

**Bonora 1994**
Bonora, Ettore. "L'Arcadia e l'Europa." *Atti e memorie: Arcadia. Atti del Convegno di studi per il III centenario, Roma 15–18 maggio 1991,* vol. 9 (1994), pp. 3–13.

**Bordes 1974**
Bordes, Philippe. "Girodet et Fabre: camarades d'atelier." *Revue du Louvre,* vol. 24, no. 6 (1974), pp. 393–99.

**Borea 1966**
Borea, Evelina. "Benefial, Marco." In *DBI,* vol. 8, pp. 466–69.

**Borghese 1892**
Borghese, Paolo. *Catalogue des objets d'art et d'ameublement du palais du Prince Borghese à Rome.* Rome: Imprimerie Éditrice Romana, 1892.

**Borghini 1984**
Borghini, Gabriele. "S. Caterina da Siena a Via Giulia (1766–1776): passaggio obbligato per la cultura figurativa del secondo Settecento romano." *Storia dell'arte,* vol. 52 (1984), pp. 205–19.

**Borroni Salvadori 1974**
Borroni Salvadori, Fabia. "Le esposizioni d'arte a Firenze dal 1674 al 1767." *Mitteilungen des Kunsthistorischen Institutes in Florenz,* vol. 18 (1974), pp. 1–166.

**Borsellino 1996**
Borsellino, Enzo. *Musei e collezioni a Roma nel 18. secolo.* Rome: Guidotti, 1996.

**Borsi 1993**
Borsi, Stefano. *Roma di Benedetto XIV: la pianta di Giovan Battista Nolli, 1748.* Rome: Officina, 1993.

**Boscarino 1973**
Boscarino, Salvatore. *Juvarra architetto.* Rome: Officina, 1973.

**Boschetto 1968**
Boschetto, Antonio. "C. L. Ragghianti 'à Baton(i) rompus.'" *Paragone,* n.s., vol. 29, no. 215/35 (1968), pp. 68–70.

**Bösel 1985**
Bösel, Richard. *Jesuitenarchitektur in Italien (1540–1773).* Vol. 1 of *Die Baudenkmäler der römischen und der neapolitanischen Ordensprovinz.* Vienna: Verlag der Österreichischen Akademie der Wissenschaften, 1985.

**Bossi 1805**
Bossi, Giuseppe. *Discorsi letti in occasione della pubblica distribuzione de' premi fatta da S. E. il signor Ministro dell'Interno il giorno 24 di giugno an.1805 nell'Accademia Nazionale di Milano.* Milan: Stamperia e fonderia del genio, 1805.

**Bott 1989**
Bott, Gerhard. "Die Marmorfigur des Apostels Philippus von Giuseppe Mazzuoli für den Würzburger Fürstbischof Johann Philipp von Greiffenclau." *Anzeiger des Germanischen Nationalmuseums* (1989), pp. 231–41.

**Bottari 1772**
Bottari, Giovanni Gaetano. *Dialoghi sopra le tre arti del disegno.* Naples: Presso i Simoni, 1772.

**Bottari and Ticozzi 1822–25**
Bottari, Giovanni Gaetano, and Stefano Ticozzi. *Raccolta di lettere sulla pittura, scultura ed architettura scritte da' piu celebri personaggi dei secoli XV, XVI, e XVII.* 8 vols. Milan: Silvestri, 1822–25.

**Bottari and Ticozzi [1822–25] 1976**
Bottari, Giovanni Gaetano, and Stefano Ticozzi, eds. *Raccolta di lettere sulla pittura, scultura ed architettura scritte da' piu celebri personaggi dei secoli XV, XVI e XVII.* 1822–25. Reprint, Hildesheim, Germany, and New York: Georg Olms, 1976.

**Botto 1909**
Botto, J. M. Pereira. *Promptuário analytico dos carros nobres da Casa Real Portuguêsa e das carruagens de gala.* Vol. 1. Lisbon: Nacional, 1909.

**Bouchardon 1962**
Musée Municipal, Chaumont, France. *Edme Bouchardon, sculpteur du roi, 1698–1762: exposition du bi-centenaire.* Chaumont, France, 1962.

**Boucher 1998**
Boucher, Bruce. *Italian Baroque Sculpture.* London: Thames & Hudson, 1998.

**Boulet, Cuzin, and Rosenberg 1990**
Boulet, Catherine, Jean-Pierre Cuzin, and Pierre Rosenberg. *J. H. Fragonard e H. Robert a Roma.* Rome: Palombi and Carte Segrete, 1990.

**Bowron 1979**
Bowron, Edgar Peters. "The Paintings of Benedetto Luti (1666–1724)." 2 vols. Ph.D. diss., New York: New York University, Institute of Fine Arts, 1979.

**Bowron 1980**
Bowron, Edgar Peters. "Benedetto Luti's Pastels and Coloured Chalk Drawings." *Apollo,* n.s., vol. 111 (1980), pp. 440–47.

**Bowron 1981**
Bowron, Edgar Peters. "A 'View of the Piazza del Popolo, Rome,' by Giovanni Paolo Panini." *The Nelson Gallery and Atkins Museum Bulletin,* vol. 5 (January 1981), pp. 37–55.

**Bowron 1982**
Bowron, Edgar Peters. *Pompeo Batoni (1708–87) and His British Patrons.* London: Greater London Council, 1982.

**Bowron 1982, *Batoni***
Bowron, Edgar Peters. *Pompeo Batoni (1708–1787): A Loan Exhibition of Paintings.* New York: Colnaghi, 1982.

**Bowron 1985**
Bowron, Edgar Peters. "Le 'Portrait de Charles John Crowle' par Pompeo Batoni (1708–1787): les 'dilettanti' e le 'Grand Tour.'" *Revue du Louvre,* vol. 35, no. 1 (1985), pp. 25–31.

**Bowron 1987**
Bowron, Edgar Peters. "A Little-Known Settecento Collector in Rome: Count Cesare Merenda." In Matthiesen 1987, pp. 18–20.

**Bowron 1991**
Bowron, Edgar Peters. "'The Most Wonderful Sight in Nature': Volaire's 'Eruption of Vesuvius,' commissioned by Henry Blundell." *North Carolina Museum of Art Bulletin,* vol. 15 (1991), pp. 1–12.

**Bowron 1993**
Bowron, Edgar Peters. "Academic Life Drawing in Rome, 1750–1790." In Campbell and Carlson 1993, pp. 75–85.

**Bowron 1996**
Bowron, Edgar Peters. "Luti, Benedetto." In *DA,* vol. 19, pp. 816–17.

**Bowron and Graf 1978**
Bowron, Edgar Peters, and Dieter Graf. "Giuseppe Passeri's 'The Cleansing of the Temple' and a Group of Preparatory Drawings in Düsseldorf." *The Journal of the Walters Art Gallery,* vol. 37 (1978), pp. 37–49.

**Braham and Hager 1977**
Braham, Allan, and Hellmut Hager. *Carlo Fontana: The Drawings at Windsor Castle.* London: A. Zwemmer, 1977.

**Brancati 1978**
Brancati, Antonio. "Contributo ad una ipotesi di J. Montagu: su un busto 'pesarese' di Camillo Rusconi." *Notizie da Palazzo Albani,* vol. 7 (1978), pp. 84–89.

**Branchetti 1982**
Branchetti, Maria Grazia. "Cocchi, Filippo." In *DBI,* vol. 26, pp. 446–49.

**Bratti 1917**
Bratti, Ricciotti. "Antonio Canova nella sua vita artistica privata (da un carteggio inedito)." *Nuovo archivio veneto,* n.s., vol. 33 (1917), pp. 281–350.

**Brault-Lerch and Bottineau 1959**
Brault-Lerch, Solange, and Yves Bottineau. *L'Orfèvrerie française du XVIIIe siècle.* Paris: Presses universitaires de France, 1959.

**Breck 1913**
Breck, Joseph. "A Bronze Bust of Pope Benedict XIV." *Art in America,* vol. 1 (1913), pp. 275–76.

**Brejon de Lavergnée 1987**
Brejon de Lavergnée, Arnauld. "Un Ensemble de tableaux romains peints pour les églises de Franche-Comté." In *"Il se rendit en Italie": Etudes offertes à André Chastel,* pp. 537–49. Rome: Elefante; Paris: Flammarion, 1987.

**Bremer-David et al.1993**
Bremer-David, Charissa, et al. *Decorative Arts: An Illustrated Summary Catalogue of the Collections of the J. Paul Getty Museum.* Malibu, Calif.: The J. Paul Getty Museum, 1993.

**Brière 1930**
Brière, Gaston. "DeTroy, 1679 à 1752." In Louis Dimier, ed., *Les Peintres français du XVIIIe siècle: histoire des vies et catalogue des oeuvres,* pp. 1–48. Paris and Brussels: G. van Oest, 1930.

**Briganti 1940**
Briganti, Giuliano. "Chiarimenti su Vanvitelli." *Critica d'arte,* vol. 6, no. 24 (1940), pp. 129–34.

**Briganti 1966**
Briganti, Giuliano. *Gaspar van Wittel e l'origine della veduta Settecentesca.* Rome: Ugo Bozzi, 1966.

**Briganti 1970**
Briganti, Giuliano. *The View Painters of Europe.* Translated by Pamela Waley. London: Phaidon, 1970.

**Briganti 1972**
Briganti, Giuliano. "Dessins de Vanvitelli." *L'Oeil,* no. 205 (1972), pp. 12–17.

**Briganti 1996**
Briganti, Giuliano. *Gaspar van Wittel.* New edition. Edited by Laura Laureati and Ludovica Trezzani. Milan: Electa, 1996.

**Brigstocke 1983**
Brigstocke, Hugh. "Classical Painting in Rome in the Age of the Baroque." *Apollo,* n.s., vol. 117 (1983), pp. 56–63.

**Brinckmann 1923–25**
Brinckmann, Albert Erich. *Barock-Bozzetti.* 4 vols. Frankfurt: Frankfurter Verlags-Anstalt, 1923–25.

**Brising 1914**
Brising, Harald. *Sergels konst.* Stockholm: Norstedt, 1914.

**Brockwell 1915**
Brockwell, Maurice Walter. *Catalogue of the Pictures and Other Works of Art in the Collection of Lord St. Oswald at Nostell Priory.* London: Constable, 1915.

**Broeder 1967**
Broeder, Frederick den. "The Lateran Apostles: The Major Sculpture Commission in Eighteenth-Century Rome." *Apollo,* n.s., vol. 85 (1967), pp. 360–65.

**Broeder 1973**
Broeder, Frederick den. *The Academy of Europe: Rome in the Eighteenth Century.* Storrs, Conn.: The University of Connecticut Foundation, 1973.

**Brown 1983**
Brown, David. Review of *Richard Wilson: The Landscape of Reaction,* by David H. Solkin. *Master Drawings,* vol. 21 (1983), pp. 289–92.

**Brown I. 1992**
Brown, Iain Gordon. *Monumental Reputation: Robert Adam and the Emperor's Palace.* Edinburgh: National Library of Scotland, 1992.

**Bruhns 1940**
Bruhns, Leo. "Das Motiv der ewigen Anbetung in der römischen Grabplastik des 16., 17. und 18. Jahrhunderts." *Römisches Jahrbuch für Kunstgeschichte,* vol. 4 (1940), pp. 253–426.

**Brunel 1978**
Brunel, Georges, ed. *Piranèse et les français: colloque tenu à la Villa Médicis 12–14, Mai 1976.* Rome: Elefante, 1978.

**Brunel 1978, "Recherches"**
Brunel, Georges. "Recherches sur les débuts de Piranèse à Rome: les frères Pagliarini et Nicola Giobbe." In Brunel 1978, pp. 77–146.

**Bryan 1994**
Bryan, Melissa Loring. "Placido Costanzi and the Art World of Settecento Rome." Ph.D. diss., Athens, Georgia: University of Georgia, 1994.

**Bryant 1983**
Bryant, Julius. "'Mourning Achilles': A Missing Sculpture by Thomas Banks." *The Burlington Magazine,* vol. 125 (1983), pp. 742–45.

**Bryant 1985**
Bryant, Julius. "The Church Memorials of Thomas Banks." *Church Monuments,* vol. 1 (1985), pp. 49–64.

**Bryant 1996**
Bryant, Julius. "Thomas Banks." In *DA,* vol. 3, pp. 183–85.

**Buberl 1994**
Buberl, Brigitte, ed. *Roma Antica: Römische Ruinen in der italienischen Kunst des 18. Jahrhunderts.* Munich: Hirmer, 1994.

**Buchanan 1970**
Buchanan, George. *Catalogue of Italian Paintings.* Glasgow: Glasgow Art Gallery and Museum, 1970.

**Buchanan W. 1824**
Buchanan, William. *Memoirs of Painting with a Chronological History of the Importation of Pictures by the Great Masters into England since the French Revolution.* 2 vols. London: R. Ackermann, Strand, 1824.

**Buchowiecki 1967**
Buchowiecki, Walter. *Handbuch der Kirchen Roms: Der römische Sakralbau in Geschichte und Kunst von der altchristlichen Zeit bis zur Gegenwart.* Vol. 1. Vienna: Hollinek, 1967.

**Budde 1930**
Budde, Illa. *Beschreibender Katalog der Handzeichnungen in der Staatlichen Kunstakademie Düsseldorf.* Düsseldorf: L. Schwann, 1930.

**Bulgari 1958–74**
Bulgari, Costantino G. *Argentieri, gemmari e orafi d'Italia.* 4 vols. Rome: L. del Turco, 1958–74.

**Buonincontri 1996**
Buonincontri, Francesca. "Giovan Battista Dell'Era: la vita." In *Pittori bergamaschi* 1996, pp. 439–59.

**Buonincontri 1996, "La critica"**
Buonincontri, Francesca. "Giovan Battista Dell'Era: la critica." In *Pittori bergamaschi* 1996, pp. 460–75.

**Buonincontri and Rodeschini Galati 1990**
Buonincontri, Francesca, and Maria Cristina Rodeschini Galati. "Dell'Era, Giovan Battista." In DBI, vol. 38, pp. 50–55.

**Burda 1967**
Burda, Hubert. *Die Ruine in den Bildern Hubert Roberts.* Munich: W. Fink, 1967.

**Burk 1998**
Burk, J. L. "Pierre Étienne Monnot und die Entstehung des Kasseler Marmorbades: Neue Archivfunde." *Marburger Jahrbuch für Kunstwissenschaft,* vol. 25 (1998), pp. 105–31.

**Burney [1771] 1974**
Burney, Charles. *Music, Men and Manners in France and Italy, 1770.* London, 1771; Edited by H. Edmund Poole. London: Eulenberg Books, 1974.

**Bury 1947**
Bury, Adrian. *Richard Wilson R.A.: The Grand Classic.* Leigh-on-Sea, England: F. Lewis Publishers, 1947.

**Busch 1998**
Busch, Werner. "Das Einfigurenhistorienbild und der Sensibilitätskult des 18. Jahrhunderts." In Baumgärtel 1998, pp. 40–46.

**Busiri Vici 1966**
Busiri Vici, Andrea. *Giovanni Battista Busiri: vedutista romano del '700.* Rome: Ugo Bozzi, 1966.

**Busiri Vici 1968**
Busiri Vici, Andrea. "Ritratti di Sebastiano Ceccarini pittore fanese a Roma." *Palatino,* vol. 12 (1968), pp. 263–73.

**Busiri Vici 1968, "Bloemen"**
Busiri Vici, Andrea. "Bloemen, Jans Frans van." In DBI, vol. 10, pp. 793–95.

**Busiri Vici 1970**
Busiri Vici, Andrea. "Opere romane di Jean de Troy." *Antichità viva,* vol. 9, no. 2 (1970), pp. 3–20.

**Busiri Vici 1972**
Busiri Vici, Andrea. "Busiri, Giovanni Battista." In DBI, vol. 15, pp. 537–38.

**Busiri Vici 1972, *Poniatowski***
Busiri Vici, Andrea. *I Poniatowski e Roma.* Florence: Edam, 1972.

**Busiri Vici 1974**
Busiri Vici, Andrea. *Jan Frans van Bloemen: Orizzonte e l'origine del paesaggio romano Settecentesco.* Rome: Ugo Bozzi, 1974.

**Busiri Vici 1976**
Busiri Vici, Andrea. *Andrea Locatelli e il paesaggio romano del Settecento.* Translated by Stella Rudolph under the title *Andrea Locatelli and Roman Landscape Painting of the Eighteenth Century.* Rome: Ugo Bozzi, 1976.

**Busiri Vici 1976, *Paesistico***
Busiri Vici, Andrea. *Trittico paesistico romano del '700: Paolo Anesi, Paolo Monaldi, Alessio de Marchis.* Rome: Ugo Bozzi, 1976.

**Busiri Vici 1987**
Busiri Vici, Andrea. *Peter, Hendrik e Giacomo van Lint: tre pittori di Anversa del '600 e '700 lavorano a Roma.* Rome: Ugo Bozzi, 1987.

**Butlin 1992**
Butlin, Martin. *Drawings by Henry Fuseli, R. A. Sale catalogue,* Christies, London, April 14, 1992.

**Butzek 1988**
Butzek, Monika. "Die Modellsammlung der Mazzuoli in Siena." *Pantheon,* vol. 46 (1988), pp. 75–102.

**Butzek 1991**
Butzek, Monika. "Giuseppe Mazzuoli e le statue degli Apostoli del Duomo di Siena." *Prospettiva,* vol. 61 (1991), pp. 75–89.

**Butzek 1993**
Butzek, Monika. "Conversio Sancti Galgani: Zu zwei neu entdeckten Reliefs von Giuseppe Mazzuoli." In *Begegnungen: Festschrift für Peter Anselm Riedl zum 60. Geburtstag,* pp. 137–43. Worms, Germany: Wernersche, 1993.

**Byam Shaw 1983**
Byam Shaw, James. *The Italian Drawings of the Frits Lugt Collection.* Paris: Institut Néerlandais, 1983.

**Cadogan 1991**
Cadogan, Jean K., ed. *Wadsworth Atheneum Paintings II: Italy and Spain.* Hartford, Conn.: Wadsworth Atheneum, 1991.

**Caffiero 1992**
Caffiero, Marina. "Tradizione o innovazione? Ideologie e comportamenti della nobiltà romana in tempo di crisi." In Maria Antonietta Visceglia, ed., *Signori, patrizi, cavalieri in Italia centro-meridionale nell'età moderna,* pp. 369–89. Rome and Bari: Laterza, 1992.

**Cagli 1985**
Cagli, Bruno, ed. *Le muse galanti: la musica a Roma nel Settecento.* Rome: Istituto della Enciclopedia Italiana, 1985.

**Cailleux 1975**
Cailleux, Jean, ed. "L'Art du dix-huitième siècle: Hubert Robert's Submissions to the Salon of 1769." *The Burlington Magazine,* vol. 117 (1975), pp. i–xvi.

**Caira Lumetti 1990**
Caira Lumetti, Rossana. *La cultura dei lumi tra Italia e Svezia: il ruolo di Francesco Piranesi.* Rome: Bonacci, 1990.

**Calabrese 1980**
Calabrese, Fernando. "Marino: città, spazi verdi e assetto del territorio." In Almamaria Tantillo Mignosi, ed., *Villa e paese: dimore nobili del Tuscolo e di Marino,* pp. 275–308. Rome: De Luca, 1980.

**Calbi 1978**
Calbi, Emilia. "Un Benefial in Romagna." *Paragone,* vol. 29, no. 343 (1978), pp. 51–60.

**Calbi 1986**
Calbi, Emilia. "A proposito di alcuni disegni per la 'storia dell'arte' di Séroux d'Agincourt." *Paragone,* vol. 37, no. 431–433 (1986), pp. 121–26.

**Calbi 1994**
Calbi, Emilia. "Benefial, Marco." In AKL, vol. 9, pp. 32–34.

**Calbi and Frabbi 1993–97**
Calbi, Emilia, and Nadia Frabbi, eds. *I disegni di Giovan Battista Dell'Era nel Museo Civico di Treviglio.* 3 vols. Casalecchio di Reno, Bologna, Italy: Grafis, 1993–97.

**Calmet [1751] 1971**
Calmet, Dom. *Bibliothèque Lorraine ou histoire des hommes illustres.* 1751. Reprint, Geneva: Slatkine, 1971.

**Calosso 1922**
Calosso, Achille Bertini. "Il San Giovanni Battista di Giovanni Antonio Houdon." *Dedalo,* vol. 3, no. 5 (1922), pp. 289–307.

**Calvano 1996**
Calvano, Teresa. *Viaggio nel pittoresco: il giardino inglese tra arte e natura.* Rome: Donzelli, 1996.

**Calvesi 1968**
Calvesi, Maurizio, ed. *Giovanni Battista e Francesco Piranesi.* Rome: De Luca, 1968.

**Calvet de Magalhães, Garret Pinho, and Bessone 1996**
Calvet de Magalhães, José, Elsa Garret Pinho, and Silvana Bessone. *Embassy of the Marquis of Fontes to Pope Clement XI.* Translated by Elisabeth Plaister. Lisbon: Museu Nacional dos Coches, and Instituto Português de Museus, 1996.

**Calzini 1896**
Calzini, E. "La Galleria Merenda in Forlì e le pitture del Batoni in essa contenute." *Arte e Storia,* vol. 15 (1896), pp. 129–30, 138–39.

**Campbell 1988**
Campbell, Malcolm, ed. *Piranesi: The Dark Prisons.* New York: The Arthur Ross Foundation and The Italian Cultural Institute, 1988.

**Campbell 1990**
Campbell, Malcolm. "Chiaroscuro and 'Non-Finito' in Piranesi's 'Prisons.'" In David Murray, ed., *VIA 11, Architecture and Shadow: Journal of the Graduate School of Fine Arts, University of Pennsylvania,* pp. 90–101. New York: Rizzoli, 1990.

**Campbell 1990, *Piranesi***
Campbell, Malcolm, ed. *Piranesi: Rome Recorded.* 2d ed., rev. New York: The Arthur Ross Foundation, 1990.

**Campbell R. 1982**
Campbell, Richard J. "Jean-Guillaume Moitte: The Sculpture and Graphic Art, 1785–1799." Ph.D. diss., Providence: Brown University, 1982.

**Campbell and Carlson 1993**
Campbell, Richard J., and Victor Carlson, eds. *Visions of Antiquity: Neoclassical Figure Drawings.* Los Angeles: Los Angeles County Museum of Art; Minneapolis: The Minneapolis Institute of Arts, 1993.

**Cancellieri 1802**
Cancellieri, Francesco. *Storia de' solenni possessi de' sommi pontefici: detti anticamente processi o processioni, dopo la loro coronazione dalla Basilica Vaticana alla Lateranense.* Rome: L. Lazzarini, 1802.

**Canestro Chiovenda 1972**
Canestro Chiovenda, Beatrice. "Nuovi documenti su G. B. Gaulli." *Commentari,* n.s., vol. 23 (1972), pp. 174–80.

**Cannatà 1985**
Cannatà, Roberto. "Tre dipinti di Giuseppe Passeri in S. Salome a Veroli." *Storia dell'arte,* vol. 53 (1985), pp. 103–7.

**Cannon-Brookes 1976**
Cannon-Brookes, Peter. "The Paintings and Drawings of Agostino Cornacchini." In *Kunst des Barock in der Toskana: Studien zur Kunst unter den letzten Medici,* pp. 118–25. Vol. 9 of *Italienische Forschungen.* Munich: F. Bruckmannise, 1976.

**Canova all'Ermitage 1991**
Rome, Palazzo Ruspoli. *Canova all'Ermitage: le sculture del Museo di San Pietroburgo.* Venice: Marsilio, 1991.

**Cantarel-Besson 1992**
Cantarel-Besson, Yveline, ed. *Musée du Louvre, janvier 1797–juin 1798: procès-verbaux du Conseil d'administration du "Musée Central des Arts."* Paris: Réunion des Musées Nationaux, 1992.

**Cappelletti 1996**
Cappelletti, Francesca. "La decorazione dell'Appartamento di Rappresentanza." In *Nuova guida alla Galleria Doria Pamphilj,* pp. 29–44. Rome: Àrgos, 1996.

**Caracciolo 1973**
Caracciolo, Maria Teresa. "Per Giuseppe Cades." *Arte illustrata,* vol. 6, no. 52 (1973), pp. 2–14.

**Caracciolo 1977**
Caracciolo, Maria Teresa. "L'ispirazione letteraria di Giuseppe Cades." *Antologia di Belle Arti,* vol. 1 (1977), pp. 246–65.

**Caracciolo 1978**
Caracciolo, Maria Teresa. "Storia antica e mitologia nell'arte di Giuseppe Cades." In *Quaderni sul Neoclassico.* Vol. 1, pp. 73–95. Rome: Bulzoni, 1978.

**Caracciolo 1978, "Cades"**
Caracciolo Arizzoli, Maria Teresa. "Un album di Giuseppe Cades: appunti di viaggio e disegni." In *Meddelelser fra Thorvaldsens Museum,* 1978, pp. 7–48. Copenhagen: Thorvaldsens Museum, 1978.

**Caracciolo 1984**
Caracciolo, Maria Teresa. "Giuseppe Cades (1750–1799): l'expérience française d'un peintre romain." *Revue du Louvre,* vol. 34, no. 5–6 (1984), pp. 353–58.

**Caracciolo 1988**
Caracciolo, Maria Teresa. "Francesi e svedesi a Roma: episodi di storia ed arte Settecentesca." *Antologia di Belle Arti,* n.s., no. 33–34 (1988), pp. 42–51.

**Caracciolo 1988, "Cades"**
Caracciolo, Maria Teresa. "Giuseppe Cades tra Bergamo e la Russia." *Osservatorio delle Arti,* vol. 1 (1988), pp. 68–73.

**Caracciolo 1991–92**
Caracciolo, Maria Teresa. "La malinconia Settecentesca." *Antologia di Belle Arti,* n.s., no. 39–42 (1991–92), pp. 5–16.

**Caracciolo 1992**
Caracciolo, Maria Teresa. *Giuseppe Cades, 1750–1799, et la Rome de son temps.* Paris: Arthena, 1992.

**Caracciolo 1994**
Caracciolo, Maria Teresa. "Lectures de l'Arioste au XVIIIe siècle: du livre illustré au cycle peint." *Gazette des Beaux-Arts*, 6th ser., vol. 136 (1994), pp. 123–46.

**Caracciolo 1996**
Caracciolo, Maria Teresa. "Deux toiles de Cades retrouvées en Russie: théories et pratique de la peinture à l'encaustique à Rome, vers 1780." *Gazette des Beaux-Arts*, 6th ser., vol. 138 (1996), pp. 155–72.

**Caracciolo 1996, "Cades"**
Caracciolo, Maria Teresa. "Cades, Giuseppe." In *DA*, vol. 5, pp. 365–67.

**Caracciolo 1997**
Caracciolo, Maria Teresa. "Cades, Giuseppe." In *AKL*, vol. 15, pp. 484–85.

**Caracciolo 1999**
Caracciolo, Maria Teresa. 'Un patrono delle arti nella Roma del Settecento: Sigismondo Chigi (1736–1793) fra Arcadia e scienza antiquaria." In *La pittura romana dal protoneoclassico al neoclassico e le sue diramazioni nell'area italiana*. Forthcoming.

**Caracciolo A. 1982**
Caracciolo, Alberto. "Clemente XII." In *DBI*, vol. 26, pp. 320–28.

**Caraffa 1974**
Caraffa, Filippo, ed. "La cappella Corsini nella Basilica Lateranense (1731–1799)." *Carmelus*, vol. 21 (1974), pp. 281–338.

**Carboneri 1979**
Carboneri, Nino. *La reale Chiesa di Superga di Filippo Juvarra, 1715–1735*. Turin, Italy: Ages Arti Grafiche, 1979.

**Carboneri and Viale 1967**
Carboneri, Nino, and Vittorio Viale, eds. *Bernardo Vittone architetto*. Turin, Italy: Pozzo-Salvati- Gros-Monti, 1967.

**Cardarelli and Ercolani 1954**
Cardarelli, C., and E. Ercolani, eds. *La civica pinacoteca di Ascoli Piceno*. Ascoli Piceno, Italy: Tipolitografica, 1954.

**Carli 1974**
Carli, Enzo. *Il Museo di Pisa*. Pisa: Pacini, 1974.

**Carlsen and Mejer 1982**
Carlsen, Hanne, and Jørgen Mejer. "Benedetto Luti: Atalante and Hippomenes and other Mythological Paintings." *Analecta Romana Istituti Danici*, vol. 10 (1982), pp. 33–40.

**Carlson 1978**
Carlson, Victor. *Hubert Robert: Drawings and Watercolors*. Washington, D.C.: National Gallery of Art, 1978.

**Carr 1993**
Carr, G. L. "David, Boydell and 'Socrates': A Mixture of Anglophilia, Self-Promotion and the Press." *Apollo*, n.s., vol. 137 (1993), pp. 307–15.

**Carreras 1977**
Carreras, Pietro. *Studi su Luigi Vanvitelli*. Florence: La nuova Italia, 1977.

**Carstens und Koch 1989**
Staatliche Museen zu Berlin Nationalgalerie, Berlin. *Asmus Jakob Carstens und Joseph Anton Koch: Zwei Zeitgenossen der Französischen Revolution*. Berlin: Staatliche Museen zu Berlin, 1989.

**Carta and Menichella 1996**
Carta, Marina, and Anna Menichella. "Il successo editoriale del Trattato." In De Feo and Martinelli 1996, pp. 230–33.

**Casadei 1928**
Casadei, Ettore. *La città di Forlì e i suoi dintori*. Forlì, Italy: Società tipografica forlivese, 1928.

**Casale 1984**
Casale, Vittorio. "Diaspore e ricomposizioni: Gherardi, Cerruti, Grecolini, Garzi, Masucci ai SS. Venanzio ed Ansuino in Roma." In *Scritti di storia dell'arte in onore di Federico Zeri*. Vol. 2, pp. 736–54. Milan: Electa, 1984.

**Casale 1990**
Casale, Vittorio. "Quadri di canonizzazione." In *La pittura 1990*. Vol. 2, pp. 553–76.

**Casale 1990, "La pittura"**
Casale, Vittorio. "La pittura del Settecento in Umbria." In *La pittura 1990*. Vol. 1, pp. 351–70.

**Casale 1996**
Casale, Vittorio. "Il fascino sottile di un pittore in Arcadia: Pietro Bianchi." *Bollettino dei musei comunali di Roma*, n.s., vol. 10 (1996), pp. 102–11.

**Casale 1996, "Baciccio"**
Casale, Vittorio. "Un modello di Baciccio e la freschezza delle sue 'prime idee.'" In Vittorio Casale, ed., *Scritti di archeologia e storia dell'arte in onore di Carlo Pietrangeli*, pp. 33–36. Rome: Quasar, 1996.

**Casale 1997**
Casale, Vittorio. "Gloria ai beati e ai santi: le feste di beatificazione e di canonizzazione." In Fagiolo 1997. Vol. 1, pp. 124–41.

**Casale 1997, "Addobbi"**
Casale, Vittorio. "Addobbi per beatificazioni e canonizzazioni: la rappresentazione della santità." In Fagiolo 1997. Vol. 2, pp. 56–65.

**Casale 1998**
Casale, Vittorio. "Benedetto XIV e le canonizzazioni." In Biagi Maino 1998, pp. 15–27.

**Casale et al. 1976**
Casale, Vittorio, et al. *Pittura del Seicento e del Settecento: ricerche in Umbria, 1*. Treviso, Italy: Canova, 1976.

**Casale G. 1991**
Casale, Gerardo. "From Baroque to Neoclassicism." In Armando Schiavo, *The Altieri Palace*, pp. 211–60. Translated by John Drummond. Rome: Editalia, 1991. Orginally published as *Palazzo Altieri* (Rome: Associazione Bancaria Italiana).

**Casamorata 1925**
Casamorata, Cesare. "Il panorama di Roma, inciso da Giuseppe Vasi." *L'universo*, vol. 6 (March 1925), pp. 173–78.

**Casanova 1960–62**
Casanova, Giacomo [1725–1798]. *Histoire de ma vie*. 12 vols. Wiesbaden, Germany: F. A. Brockhaus, 1960–62.

**Casanova 1997**
Casanova, Giacomo [1725–1798]. *History of My Life*. Translated by Willard Trask. 12 vols. Baltimore and London: The Johns Hopkins University Press, 1997.

**Cash 1985–86**
Cash, Arthur H. *Laurence Sterne: The Early and Middle Years*. 2 vols. London: Methuen, 1985–86.

**Cassanelli 1985**
Cassanelli, Luciana. "Note per una storia del giardino di Villa Albani." In Debenedetti 1985, pp. 167–210.

**Castelnuovo and Rosci 1980**
Castelnuovo, Enrico, and Marco Rosci, eds. *Cultura figurativa e architettonica negli stati del Re di Sardegna, 1773–1861*. 3 vols. Turin, Italy: Stamperia artistica nazionale, 1980.

**Catalogo delle pitture 1740**
*Catalogo delle pitture di uomini eccellenti che si vedono in diverse chiese di Fano*. Fano, Italy: Andrea Donati, 1740.

**Cavaceppi 1768–72**
Cavaceppi, Bartolomeo. *Raccolta d'antiche statue: busti bassirilievi ed altre sculture, restaurate da Bartolomeo Cavaceppi scultore romano*. 3 vols. Rome, 1768–72.

**Cayeux 1963**
Cayeux, Jean de. "Introduction au catalogue critique des 'Griffonis' de Saint-Non." *Bulletin de la Société de l'Histoire de l'Art Français* (1963), pp. 297–372.

**Cayeux 1970**
Cayeux, Jean de. "Dessins d'Hubert Robert." *Revue de l'art*, no. 7 (1970), pp. 100–103.

**Cayeux 1985**
Cayeux, Jean de. *Hubert Robert de la Collection Veyrenc au Musée de Valence*. Valence, France: Musée des Beaux-Arts et d'histoire naturelle, 1985.

**Cayeux 1987**
Cayeux, Jean de. *Hubert Robert et les jardins*. Paris: Herscher, 1987.

**Cayeux 1989**
Cayeux, Jean de. *Hubert Robert*. Paris: Fayard, 1989.

**Caylus 1762**
Caylus, Anne Claude Philippe. *Vie d'Edme Bouchardon, sculpteur de roi*. 2 vols. Paris, 1762.

**Cederlöf and Olausson 1990**
Cederlöf, Ulf, and Magnus Olausson, eds. *Sergel*. Stockholm: Nationalmuseum, 1990.

**Ceen 1984**
Ceen, Allan. Introduction to *Rome 1748: La Pianta Grande di Roma of Giambattista Nolli*. Highmount, N.Y.: J. H. Aronson, 1984.

**Ceen 1990**
Ceen, Allan. "Piranesi and Nolli: Imago Urbis Romae." In Campbell 1990, *Piranesi*, pp. 17–22.

**Celebrazioni tiepolesche 1972**
*Celebrazioni tiepolesche: atti del Congresso internazionale di studi sul Tiepolo, con un'appendice sulla mostra*. Milan: Electa, 1972.

**Cera 1987**
Cera, Adriano, ed. *La pittura neoclassica italiana*. Milan: Longanesi, 1987.

**Cera 1994**
Cera, Adriano. *La pittura bolognese del '700*. Milan: Longanesi, 1994.

**Ceracchi 1989**
Palazzo dei Conservatori, Rome. *Giuseppe Ceracchi: scultore giacobino, 1751–1801*. Rome: Artemide, 1989.

**Ceschi Lavagetto 1983**
Ceschi Lavagetto, Paola, ed. *Un esempio di neoclassicismo romano a Piacenza: restauro della Soprintendenza per i Beni Artistici e Storici di Parma e Piacenza*. Parma, Italy: Artegrafica Silva, 1983.

**Ceschi Lavagetto 1990**
Ceschi Lavagetto, Paola. "La pittura del Settecento a Parma e a Piacenza." In *La pittura 1990*. Vol. 1, pp. 237–51.

**Chadwick 1981**
Chadwick, Owen. *The Popes and European Revolution*. Oxford: Clarendon Press; New York: Oxford University Press, 1981.

**Chaney 1998**
Chaney, Edward. *The Evolution of the Grand Tour: Anglo-Italian Cultural Relations since the Renaissance*. London and Portland: Frank Cass, 1998.

**Chastel and Brunel 1976**
Chastel, André, and Georges Brunel, eds. *Piranèse et les français, 1740–1790*. Rome: Elefante, 1976.

**Chessex 1984**
Chessex, Pierre. "A Swiss Painter in Rome: A.L.R. Ducros." *Apollo*, n.s., vol. 119 (1984), pp. 430–37.

**Chessex 1984, "Ducros"**
Chessex, Pierre. "Ducros' Italian Landscapes: The Perception of Landscape by a Swiss Painter at the End of the 18th Century." *Daidalos* (June 15, 1984), pp. 70–78.

**Chessex 1985**
Chessex, Pierre, ed. *Images of the Grand Tour: Louis Ducros, 1748–1810*. London: Kenwood, The Iveagh Bequest, 1985.

**Chessex 1985, *Vedute***
Chessex, Pierre, ed. *Roma romantica: vedute di Roma e dei suoi dintorni di A.L.R. Ducros, 1748–1810*. Milan: Franco Maria Ricci, 1985.

**Chessex 1986**
Chessex, Pierre, ed. *A.L.R. Ducros, 1748–1810: paysages d'Italie à l'époque de Goethe*. Geneva: Tricorne, 1986.

**Chessex 1987**
Chessex, Pierre, ed. *Ducros, 1748–1810: paesaggi d'Italia all'epoca di Goethe*. Rome: De Luca, 1987.

**Chessex 1992**
Chessex, Pierre. "L'Emigration artistique à la fin de l'ancien régime: quelques points de repère." *Nos monuments d'arts et de histoire*, no. 4 (1992), pp. 491–501.

**Chessex 1992, "Ducros"**
Chessex, Pierre. "Tradition et innovations dans la peinture de paysage à l'époque de la revolution francaise: l'exemple de Louis Ducros (1748–1810)." In *L'Art et les révolutions: XXVIIe congrès international d'histoire de l'art, Strasbourg 1–7 septembre 1989*, pp. 143–56. Strasbourg, France: Société Alsacienne pour le Développement de l'Histoire de l'Art, 1992.

**Chiarini 1967**
Chiarini, Marco. "Alessio de Marchis as a Draughtsman." *Master Drawings*, vol. 5 (1967), pp. 289–91.

**Chiarini 1972**
Chiarini, Marco. *I disegni italiani di paesaggio dal 1600 al 1750*. Treviso, Italy: Canova, 1972.

**Choiseul 1771**
Choiseul, Etienne-François. *Recueil d'estampes gravées d'après les tableaux du cabinet de Monseigneur le Duc de Choiseul*. Paris, 1771.

**Chracas 1716**
Chracas. *Distinto raguaglio del sontuoso treno delle carrozze*. Rome: Giovanni Francesco Chracas, 1716.

**Christie, Manson, and Woods 1930**
Christie, Manson, and Woods. *Catalogue of the Celebrated Collection of Ancient Marbles: The Property of the Most Honourable, The Marquess of Lansdowne*. London: Christie, Manson, and Woods, 1930.

**"La Chronique des arts" 1985**
"La Chronique des arts: principales acquisitions des musées en 1984." *Gazette des Beaux-Arts*, 6th ser., vol. 127 (1985), pp. 1–84.

**Ciardi 1991**
Ciardi, Roberto Paolo. *Da Cosimo III a Pietro Leopoldo: la pittura a Pisa nel Settecento*. Pisa: Pacini, 1991.

**Ciardi, Pinelli, and Sicca 1993**
Ciardi, Roberto Paolo, Antonio Pinelli, and Cinzia Maria Sicca, eds. *Pittura toscana e pittura europea nel secolo dei lumi: atti del convegno, Pisa, Domus galilaeana 3–4 dicembre 1990*. Florence: S.P.E.S., 1993.

**Cicerchia and De Stroebel 1986**
Cicerchia, Edith, and Anna Maria De Stroebel. "Documenti inediti dell'Archivio Segreto Vaticano nei restauri delle stanza di Raffaello e della cappella Sistina nel Settecento." *Bollettino dei monumenti musei e gallerie pontificie*, vol. 6 (1986), pp. 105–82.

**Cicognara 1823–24**
Cicognara, Leopoldo. *Storia della scultura dal suo risorgimento in Italia fino al secolo di Canova*. 2nd ed., rev. 7 vols. Prato, Italy: Fratelli Giachetti, 1823–24.

**Ciofetta 1991**
Ciofetta, Simona. "Lo 'Studio d'Architettura Civile' edito da Domenico De Rossi (1702, 1711, 1721)." In Contardi and Curcio 1991, pp. 214–28.

**Cioffi 1992**
Cioffi, Irene. "Corrado Giaquinto at the Spanish Court, 1753–1762: The Fresco Cycles at the New Royal Palace in Madrid." 3 vols. Ph.D. diss., New York: New York University, Institute of Fine Arts, 1992.

**Cioffi 1993**
Cioffi, Irene. Review of *Giaquinto: capolavori dalle corti in Europa*. *The Burlington Magazine*, vol. 135 (1993), pp. 588–89.

**Cioffi 1996**
Cioffi, Irene. "Giaquinto, Corrado." In DA, vol. 12, pp. 586–90.

**Cioffi 1997**
Cioffi, Irene. "Corrado Giaquinto and the Dissemination of the Italian Style at the Bourbon Court in Madrid." In Ronda Kasl and Suzanne L. Stratton, eds., *Painting in Spain in the Age of Enlightenment: Goya and His Contemporaries*, pp. 27–38. Indianapolis: Indianapolis Museum of Art; New York: The Spanish Institute, 1997.

**Cipriani 1990**
Cipriani, Angela, ed. *Prize Winning Drawings from the Roman Academy, 1682–1754*. Translated by Julia Triolo. Rome: Quasar, 1990.

**Cipriani and De Marchi 1992**
Cipriani, Angela, and Giulia de Marchi. "Appunti per la storia dell'Accademia di San Luca: la collezione dei dipinti nei secoli XVII e XVIII." In Millon and Munshower 1992. Vol. 2, pp. 692–719.

**Cipriani and Valeriani 1988–91**
Cipriani, Angela, and Enrico Valeriani, eds. *I disegni di figura nell'archivio storico dell'Accademia di San Luca*. 3 vols. Rome: Quasar, 1988–91.

**Cipriani et al. 1995**
Cipriani, Angela, et al. *Scritti scelti di Carlo Pietrangeli*. Rome: Quasar, 1995.

**Cipriani M. 1999**
Cipriani, Marina, ed. "Cronologia." In Lo Bianco 1999, pp. 190–92.

**Ciucci 1974**
Ciucci, Giorgio. *La Piazza del Popolo: storia architettura urbanistica*. Rome: Officina, 1974.

**Civai 1990**
Civai, Alessandra. *Dipinti e sculture in casa Martelli: storia di una collezione patrizia fiorentina dal Quattrocento all'Ottocento*. Florence: Opus Libri, 1990.

**Civiltà del '700 1979–80**
Museo e Gallerie Nazionali di Capodimente, Naples. *Civiltà del '700 a Napoli, 1734–1799*. 2 vols. Florence: Centro Di, 1979–80.

**Clark 1961**
Clark, Anthony M. "Four Decorative Panels by Unterberger." *Worcester Art Museum Annual*, vol. 9 (1961), pp. 1–11.

**Clark 1961, "Figures"**
Clark, Anthony M. "A Supply of Ideal Figures." *Paragone*, n.s., vol. 12, no. 139 (1961), pp. 50–58.

**Clark 1961, "Gilmor"**
Clark, Anthony M. "Roman Eighteenth-Century Drawings in the Gilmor Collection." *The Baltimore Museum of Art News*, vol. 24, no. 3 (1961), pp. 8–10.

**Clark 1963**
Clark, Anthony M. "Pierleone Ghezzi's Portraits." *Paragone*, n.s., vol. 14, no. 165 (1963), pp. 11–21.

**Clark 1963, "Neo-Classicism"**
Clark, Anthony M. "Neo-Classicism and the Roman Eighteenth-Century Portrait." *Apollo*, n.s., vol. 78 (1963), pp. 352–59.

**Clark 1964**
Clark, Anthony M. "An Introduction to the Drawings of Giuseppe Cades." *Master Drawings*, vol. 2 (1964), pp. 18–26.

**Clark 1964, "Bianchi"**
Clark, Anthony M. "Introduction to Pietro Bianchi." *Paragone*, n.s., vol. 15, no. 169 (1964), pp. 42–47.

**Clark 1964, "Imperiali"**
Clark, Anthony M. "Imperiali." *The Burlington Magazine*, vol. 106 (1964), pp. 226–33.

**Clark 1964–65**
Clark, Anthony M. "Three Roman Eighteenth-Century Portraits." *The Journal of the Walters Art Gallery*, vol. 27–28 (1964–65), pp. 49–56.

**Clark 1965**
Clark, Anthony M. "Brief Biography of Cardinal Giovanni Battista Rezzonico." *The Minneapolis Institute of Arts Bulletin*, vol. 54 (1965), pp. 30–31.

**Clark 1966**
Clark, Anthony M. "Manners and Methods of Benefial." *Paragone*, n.s., vol. 17, no. 199 (1966), pp. 21–33.

**Clark 1967**
Clark, Anthony M. "Sebastiano Conca and the Roman Rococo." *Apollo*, n.s., vol. 85 (1967), pp. 328–35.

**Clark 1967, "Masucci"**
Clark, Anthony M. "Agostino Masucci: A Conclusion and a Reformation of the Roman Baroque." In Fraser, Hibbard, and Lewine 1967, pp. 259–64.

**Clark 1967, "Portraits"**
Clark, Anthony M. "The Portraits of Artists Drawn for Nicola Pio." *Master Drawings*, vol. 5 (1967), pp. 3–23.

**Clark 1968**
Clark, Anthony M. "Roma mi e sempre in pensiero." In Vorarlberger Landesmuseum 1968, pp. 5–17.

**Clark 1968, "Costanzi"**
Clark, Anthony M. "An Introduction to Placido Costanzi." *Paragone*, n.s., vol. 19, no. 219/39 (1968), pp. 39–54.

**Clark 1970**
Clark, Anthony M. "Rome and the Papal States." In Maxon and Rishel 1970, pp. 163–215.

**Clark 1971–73**
Clark, Anthony M. "Three Ghezzi's." *The Minneapolis Institute of Arts Bulletin*, vol. 60 (1971–73), pp. 62–67.

**Clark 1973**
Clark, Anthony M. "Cades, Giuseppe." In DBI, vol. 16, pp. 72–78.

**Clark 1975**
Clark, Anthony M. "State of Studies: Roman Eighteenth-Century Art." *Eighteenth-Century Studies*, vol. 9 (1975), pp. 102–7.

**Clark 1981**
Clark, Anthony M. "The Wallraf-Richartz Portrait of Hewetson." In Clark and Bowron 1981, pp. 139–41.

**Clark and Bowron 1981**
Clark, Anthony M. *Studies in Roman Eighteenth-Century Painting*. Edited by Edgar Peters Bowron. Washington, D.C.: Decatur House Press, 1981.

**Clark and Bowron 1985**
Clark, Anthony M. *Pompeo Batoni: A Complete Catalogue of His Works*. Edited by Edgar Peters Bowron. New York: New York University Press, 1985.

**Cleri 1992**
Cleri, Bonita. *Sebastiano Ceccarini*. Milan: Silvana, 1992.

**Clifford 1993**
Clifford, Timothy. "Imperiali and His Scottish Patrons." In Ciardi, Pinelli, and Sicca 1993, pp. 41–59.

**Coccia 1990**
Coccia, Marina. "Lapiccola, Nicola." In La pittura 1990. Vol. 2, p. 759.

**Coccia 1990, "Campiglia"**
Coccia, Marina. "Campiglia, Giovanni Domenico." In La pittura 1990. Vol. 2, p. 647.

**Coccia 1990, "Luti"**
Coccia, Marina. "Luti, Benedetto." In La pittura 1990. Vol. 2, pp. 773–74.

**Coccia 1990, "Van Wittel"**
Coccia, Marina. "Van Wittel, Gaspar." In La pittura 1990. Vol. 2, p. 894.

**Coekelberghs 1976**
Coekelberghs, Denis. *Les Peintres belges à Rome de 1700 à 1830*. Vol. 3 of *Études d'histoire de l'art*. Brussels and Rome: L'Institut Historique Belge de Rome, 1976.

**Coen 1996**
Coen, Paolo. *Le magnificenze di Roma nelle incisioni di Giuseppe Vasi: un affascinante viaggio Settecentesco dalle Mura Aureliane fino alle maestose ville patrizie, attraverso le antiche rovine, le basiliche e le più belle piazze della Città Eterna*. Rome: Newton and Compton, 1996.

**Coffin 1960**
Coffin, David R. *The Villa d'Este at Tivoli*. Princeton, N.J.: Princeton University Press, 1960.

**Collins 1995**
Collins, Jeffrey L. "Arsenals of Art: The Patronage of Pope Pius VI and the End of the Ancien Régime." Ph.D. diss., New Haven: Yale University, 1995.

**Collins 1997**
Collins, Jeffrey L. "'Non Tenuis Gloria': The Quirinal Obelisk from Theory to Practice." *Memoirs of the American Academy in Rome*, vol. 42 (1997), pp. 187–245.

**Collins 1999**
Collins, Jeffrey L. "The God's Abode: Pius VI and the Invention of the Vatican Museum." In Hornsby 1999 (in press).

**Colombo 1966**
Colombo, Giulio. "Lo scultore Giambattista Maino." *Rassegna gallaratese di storia e d'arte*, vol. 25 (1966), pp. 29–45.

**Colombo 1967**
Colombo, G. "Domenico Scaramucci, scultore, e la statua di S. Giovanni Battista nella Chiesa di S. Giulio di Cassano Magnano." *Rassegna gallaratese di storia dell'arte*, vol. 26 (1967), pp. 116–31.

**Colombo 1968**
Colombo, Giulio. "Sulle tracce di G. B. Maino." *Rassegna gallaratese di storia e d'arte*, vol. 27 (1968), pp. 25–34.

**Colucci 1998**
Colucci, Isabella. "Antonio Canova, la marchesa Margherita Boccapaduli e Alessandro Verri: lettere e altre testimonianze inedite." *Paragone*, 3rd ser., vol. 49, no. 19 (1998), pp. 64–74.

**Commemorative Catalogue 1933**
*Commemorative Catalogue of the Exhibition of French Art, 1200–1900*. London: Oxford University Press, 1933.

**Comoli Mandracci and Griseri 1995**
Comoli Mandracci, Vera, and Andreina Griseri, eds. *Filippo Juvarra: architetto delle capitali da Torino a Madrid, 1714–1736*. Milan: Fabbri, 1995.

**Comstock 1940**
Comstock, Helen. "French Sculpture of Three Centuries." *The Connoisseur*, vol. 105 (1940), p. 75.

**Conca 1981**
Palazzo de Vio, Gaeta, Italy. *Sebastiano Conca (1680–1764)*. Gaeta, Italy: Centro Storico Culturale "Gaeta," 1981.

**Conforti 1977**
Conforti, Michael. "The Lateran Apostles." Ph.D. diss., Cambridge: Harvard University, 1977.

**Conforti 1980**
Conforti, Michael. "Planning the Lateran Apostles." In Millon 1980, pp. 243–60.

**Conisbee 1976**
Conisbee, Philip. *Claude-Joseph Vernet, 1714–1789: France's Most Famous Landscape and Marine Painter of the Eighteenth Century*. London: Greater London Council, 1976.

**Conisbee 1979**
Conisbee, Philip. "Paris: Art from Spain at the Grand Palais." *The Burlington Magazine*, vol. 121 (1979), pp. 821–22.

**Conisbee 1987**
Conisbee, Philip. "Exhibition Reviews: Paris, Musée du Luxembourg, 'Subleyras, 1699–1749.'" *The Burlington Magazine*, vol. 129 (1987), pp. 414–17.

**Conisbee 1990**
Conisbee, Philip. "The Eighteenth Century: Watteau to Valenciennes." In Alan Wintermute, ed., *Claude to Corot: The Development of Landscape Painting in France*, pp. 85–97. New York: Colnaghi in association with The University of Washington Press, 1990.

**Conisbee 1993**
Conisbee, Philip. "Vernet in Italy." In Ciardi, Pinelli, and Sicca 1993, pp. 129–40.

**Connor 1998**
Connor, Luisa. "Richard Topham et les artistes du cercle d'Imperiali." In *La Fascination de l'antique 1700–1770: Rome découverte, Rome inventée*. Lyon, France: Somogy, 1998.

**Connors 1989**
Connors, Joseph. "Alliance and Enmity in Roman Baroque Urbanism." *Römisches Jahrbuch der Bibliotheca Hertziana*, vol. 25 (1989), pp. 207–94.

**Connors 1991**
Connors, Joseph. "Sebastiano Giannini: 'Opus Architectonicum.'" In Contardi and Curcio 1991, pp. 204–13.

**Consoli 1996**
Consoli, Gian Paolo. *Il Museo Pio-Clementino: la scena dell'antico in Vaticano.* Modena, Italy: F. C. Panini, 1996.

**Constable 1953**
Constable, W. G. *Richard Wilson.* Cambridge: Harvard University Press, 1953.

**Constable 1954**
Constable, W. G. "Richard Wilson: Some Pentimenti." *The Burlington Magazine,* vol. 96 (1954), pp. 139–47.

**Constable 1962**
Constable, W. G. *Canaletto: Giovanni Antonio Canal, 1697–1768.* Oxford: Clarendon Press, 1962.

**Contardi 1991**
Contardi, Bruno. "Il modello di Andrea Pozzo per l'altare del Beato Luigi Gonzaga in Sant'Ignazio." In Contardi and Curcio 1991, pp. 23–39.

**Contardi 1996**
Contardi, Bruno. "L'altare di San Luigi Gonzaga in Sant'Ignazio." In *Andrea Pozzo* 1996, pp. 97–120.

**Contardi and Curcio 1991**
Contardi, Bruno, and Giovanna Curcio, eds. *In urbe architectus: modelli, disegni, misure, la professione dell'architetto Roma, 1680–1750.* Rome: Argos, 1991.

**Convegno Vanvitelliano 1975**
*L'attività architettonica di Luigi Vanvitelli nelle Marche e i suoi epigoni: Convegno Vanvitelliano, Ancona 27–28, aprile 1974.* Ancona, Italy: Deputazione di storia patria per le Marche, 1975.

**Cooper-Hewitt Museum 1978**
Cooper-Hewitt Museum, New York. *Crosscurrents: French and Italian Neoclassical Drawings and Prints from the Cooper-Hewitt Museum.* Washington, D.C.: Smithsonian Institution Press, 1978.

**Corbo 1976**
Corbo, Anna Maria. "Le opere di Agostino Cornacchini per la fabbrica di San Pietro." *Commentari,* n.s., vol. 27 (1976), pp. 311–15.

**Cordaro 1984**
Cordaro, Michele. "Costanzi, Placido." In *DBI,* vol. 30, pp. 385–87.

**Cordaro 1987**
Cordaro, Michele. "Sul testamento di Placido Costanzi con alcune precisazioni sulla sua vita e attività." In Debenedetti 1987, pp. 95–98.

**Cormio 1986**
Cormio, Stefania. "Il cardinale Silvio Valenti Gonzaga promotore e protettore delle scienze e delle belle arti." *Bollettino d'arte,* 6th ser., vol. 71, no. 35–36 (1986), pp. 49–66.

**Corradini 1990**
Corradini, Sandro, ed. "Testamento e quadreria di Caterina Peroni Ghezzi, consorte di Pier Leone Ghezzi." In Martinelli 1990, pp. 111–31.

**Corradini 1990, "Testimonianze"**
Corradini, Sandro. "Testimonianze d'archivio per la vita e le opere dei Ghezzi a San Salvatore in Lauro." In Martinelli 1990, pp. 45–56.

**Costamagna 1975**
Costamagna, Alba. "Agesia Beleminio (G. G. Bottari) e l'Accademia dell'Arcadia nel Settecento." *Quaderni sul neoclassico,* vol. 3 (1975), pp. 43–63.

**Costamagna 1990**
Costmagna, Alba. "L'abbazia di S. Paolo ad Albano e la quadreria del cardinale Marcantonio Colonna: un episodio di mecenatismo settecentesco." In *Papi e principi* 1990.

**Costamagna 1992**
Costamagna, Alba. "Inediti dal territorio: 'La Madonna di Loreto' dello pseudo-Bramantino, 'Il Cristo Benedicente' del Cavalier d'Arpino ed altro dal convento della Beata Maria Colomba a Moricone." *Bollettino d'arte,* 6th ser., vol. 77, no. 76 (1992), pp. 121–32.

**Costanzi [1729] 1987**
Costanzi, Giovanni Battista. *Carlo Magno: festa teatrale in occasione della nascita del Delfino.* 1729. Reprint, Rome: Elefante, 1987.

**Costanzi, Massa, and Montevecchi 1999**
Costanzi, Costanza, Marina Massa, and Benedetta Montevecchi, eds. *I Ghezzi nelle marche: guida alle opere.* Venice: Marsilio, 1999.

**Coudenhove-Erthal 1930**
Coudenhove-Erthal, Eduard. *Carlo Fontana und die Architektur des römischen Spätbarocks.* Vienna: A. Schroll, 1930.

**Coupin 1829**
Coupin, P. A. *Oeuvres posthumes de Girodet-Trioson, peintre d'histoire.* 2 vols. Paris: J. Renouard, 1829.

**Cousins 1981**
Cousins, Windsor F. "Concorso Clementino of 1728: First Class of Architecture, Design for a Piazza Connected with a Harbor Celebration, December 9, 1728." In Hager 1981, pp. 96–99.

**Craske 1997**
Craske, Matthew. *Art in Europe, 1700–1830: A History of the Visual Arts in an Era of Unprecedented Urban Economic Growth.* Oxford and New York: Oxford University Press, 1997.

**Crescimbeni 1712**
Crescimbeni, Giovanni Mario. *Storia dell'Accademia degli Arcadi Istituita in Roma l'anno 1690 per la coltivazione delle scienze, delle lettere umane e della poesia.* Rome, 1712.

**Crespi 1769**
Crespi, Luigi. *Vite de' pittori bolognesi non descritte nella Felsina pittrice.* Rome: Carlo Emanuele III, 1769.

**Croce 1949**
Croce, Benedetto. *La letteratura italiana del Settecento: note critiche.* Bari, Italy: Laterza, 1949.

**Crollalanza [1886–90] 1965**
Crollalanza, Giovanni Battista. *Dizionario storico-blasonico delle famiglie nobili e notabili italiane estinte e fiorenti.* 3 vols. 1886–90. Reprint, Bologna, Italy: A. Forni, 1965.

**Crookshank et al. 1978**
Crookshank, Anne, et al. *The Painters of Ireland, c. 1660–1920.* London: Barrie & Jenkins, 1978.

**Crookshank et al. 1994**
Crookshank, Anne, et al. *The Watercolours of Ireland: Works on Paper in Pencil, Pastel and Paint, c. 1600–1914.* London: Barrie & Jenkins, 1994.

**Crookshank et al. 1997**
Crookshank, Anne, et al. "Some Italian Pastels by Hugh Douglas Hamilton." *Irish Arts Review Yearbook,* vol. 13 (1997), pp. 62–69.

**Crow 1985**
Crow, Thomas E. *Painters and Public Life in Eighteenth-Century Paris.* New Haven and London: Yale University Press, 1985.

**Crow 1989**
Crow, Thomas. "Une Manière de Travailler: In the Studio of David." *Parachute,* vol. 56 (1989), pp. 48–50.

**Croze-Magnan 1807**
Croze-Magnan, S. C. *Le Musée français: recueil complet des tableaux, statues et bas-reliefs, qui composent la collection nationale.* Vol. 3. Paris: L. E. Herhan, 1807.

**Cullen 1982**
Cullen, Fintan. "Hugh Douglas Hamilton in Rome, 1779–92." *Apollo,* n.s., vol. 115 (1982), pp. 86–91.

**Cullen 1984**
Cullen, Fintan. "The Oil Paintings of Hugh Douglas Hamilton." *Walpole Society,* vol. 50 (1984), pp. 165–208.

**Cullen 1997**
Cullen, Fintan. *Visual Politics: The Representation of Ireland, 1750–1930.* Cork, Ireland: Cork University Press, 1997.

**Cunningham 1829–33**
Cunningham, Allan. *The Lives of the Most Eminent British Painters, Sculptors and Architects.* 6 vols. London: John Murray, 1829–33.

**Cunningham 1831**
Cunningham, Allan. *The Lives of the Most Eminent British Painters and Sculptors.* 3 vols. New York: J. & J. Harper, 1831.

**Cunningham P. 1863**
Cunningham, Peter. "New Materials for the Life of Thomas Banks, R.A.." *The Builder,* vol. 3 (1863), pp. 3–5.

**Curcio 1989**
Curcio, Giovanna. "'Casamenti per persone oneste': un intervento di risanamento urbano di Nicola Michetti." *Quaderni dell'Istituto di Storia dell'Architettura,* n.s., vol. 13 (1989), pp. 65–80.

**Curcio 1991**
Curcio, Giovanna. "Michetti, Nicola." In Contardi and Curcio 1991, pp. 401–3.

**Curzi 1990**
Curzi, Valter. "Alcuni inediti di Domenico Corvi a Senigallia." *Bollettino d'arte,* vol. 74, no. 61 (1990), pp. 113–20.

**Curzi 1998**
Curzi, Valter. "Committenti, intermediari e collezionisti: fortuna di Domenico Corvi e sistemi di diffusione delle sue opere fuori Roma." In Curzi and Lo Bianco 1998, pp. 35–49.

**Curzi and Lo Bianco 1998**
Curzi, Valter, and Anna Lo Bianco, eds. *Domenico Corvi.* Rome: Viviani arte, 1998.

**Cuzin 1988**
Cuzin, Jean-Pierre. *Jean-Honoré Fragonard: Life and Work.* New York: Abrams, 1988.

**Czére 1988**
Czére, Andrea. "Five New Chalk Drawings by Aureliano Milani." *Master Drawings,* vol. 26 (1988), pp. 133–37.

**D'Achiardi 1914**
D'Achiardi, P. *La nuova Pinacoteca Vaticana nei quadri provenienti dalla vecchia Pinacoteca Vaticana, dalla Pinacoteca del Laterano, dagli appartamenti privati e dai magazzini dei Palazzi apostolici.* Bergamo, Italy: Istituto Italiano d'Arti Grafiche, 1914.

**Dallaway 1800**
Dallaway, James. *Anecdotes of the Arts in England.* London: T. Cadell & W. Davies, 1800.

**David 1981**
Accademia di Francia, Rome. *David e Roma.* Rome: Accademia di Francia, 1981.

**David 1989**
Musée du Louvre, Paris; Musée National du Château, Versailles. *Jacques-Louis David, 1748–1825.* Paris: Réunion des Musées Nationaux, 1989.

**Davies 1991**
Davies, Glenys. "The Albacini Cast Collection: Character and Significance." *Journal of the History of Collections,* vol. 3 (1991), pp. 145–65.

**Davies M. 1957**
Davies, Martin. *National Gallery Catalogues: French School.* 2nd ed., rev. London: The National Gallery, 1957.

**De Angelis 1998**
De Angelis, Maria Antonietta. "Per una lettura iconografica della decorazione pittorica nel Museo Pio Clementino." In Felicetti 1998, pp. 37–47.

**Debenedetti 1979**
Debenedetti, Elisa, ed. *Valadier: diario architettonico.* Rome: Bulzoni, 1979.

**Debenedetti 1985**
Debenedetti, Elisa, ed. *Committenze della famiglia Albani: note sulla Villa Albani Torlonia.* Vol. 1–2 of *Studi sul Settecento romano.* Rome: Multigrafica, 1985.

**Debenedetti 1985, Valadier**
Debenedetti, Elisa, ed. *Valadier: segno e architettura.* Rome: Mulitgrafica, 1985.

**Debenedetti 1987**
Debenedetti, Elisa, ed. *Ville e palazzi: illusione scenica e miti archeologici.* Vol. 3 of *Studi sul Settecento romano.* Rome: Multigrafica, 1987.

**Debenedetti 1988**
Debenedetti, Elisa, ed. *Carlo Marchionni: architettura, decorazione e scenografia contemporanea.* Vol. 4 of *Studi sul Settecento romano.* Rome: Multigrafica, 1988.

**Debenedetti 1989**
Debenedetti, Elisa, ed., *L'architettura da Clemente XI a Benedetto XIV: pluralità di tendenze.* Vol. 5 of *Studi sul Settecento romano.* Rome: Multigrafica, 1989.

**Debenedetti 1990**
Debenedetti, Elisa, ed. *Temi di decorazione: dalla cultura dell'artificio alla poetica della natura.* Vol. 6 of *Studi sul Settecento romano.* Rome: Multigrafica, 1990.

**Debenedetti 1991**
Debenedetti, Elisa, ed. *Collezionismo e ideologia: mecenati, artisti e teorici dal classico al neoclassico.* Vol. 7 of *Studi sul Settecento romano.* Rome: Mutligrafica, 1991.

**Debenedetti 1992**
Debenedetti, Elisa, ed. *Architettura città territorio: realizzazioni e teorie tra illuminismo e romanticismo.* Vol. 8 of *Studi sul Settecento romano.* Rome: Bonsignori, 1992.

**Debenedetti 1993**
Debenedetti, Elisa, ed. *Alessandro Albani patrono delle arti: architettura, pittura e collezionismo nella Roma del '700.* Vol. 9 of *Studi sul Settecento romano.* Rome: Bonsignori, 1993.

**Debenedetti 1994**
Debenedetti, Elisa, ed. *Roma borghese: case e palazzetti d'affitto, I.* Vol. 10 of *Studi sul Settecento romano.* Rome: Bonsignori, 1994.

**Debenedetti 1995**
Debenedetti, Elisa, ed. *Roma borghese: case e palazzetti d'affitto, II.* Vol. 11 of *Studi sul Settecento romano.* Rome: Bonsignori, 1995.

**Debenedetti 1996**
Debenedetti, Elisa, ed. *Artisti e mecenati: dipinti, disegni, sculture e carteggi nella Roma curiale.* Vol. 12 of *Studi sul Settecento romano.* Rome: Bonsignori, 1996.

**Debenedetti 1997**
Debenedetti, Elisa, ed. *'700 disegnatore: incisioni, progetti, caricature.* Vol. 13 of *Studi sul Settecento romano.* Rome: Bonsignori, 1997.

**Debenedetti 1997, "Giuseppe Barberi"**
Debenedetti, Elisa. "Giuseppe Barberi, un diario visivo idealmente dedicato alla famiglia Altieri." In Debenedetti 1997, pp. 183–228.

**Debenedetti 1998**
Debenedetti, Elisa. "Carlo Spiridione Mariotti: i controsensi di un ribelle in ambiente franco-romano." In Biagi Maino 1998, pp. 59–86.

**De Breffny 1985**
De Breffny, Brian, "Christopher Hewetson: Biographical Notice and Preliminary Catalogue Raisonné." *Irish Arts Review,* vol. 3, no. 3 (1985) pp. 52–75.

**De Brosses 1858**
De Brosses, Charles [1709–1777]. *Lettres familières écrites d'Italie.* 2 vols. Paris, 1858.

**De Brosses 1931**
De Brosses, Charles [1709–1777]. *Lettres familières sur l'Italie.* 2 vols. Paris: Firmon-Didot, 1931.

**De Brosses 1977**
De Brosses, Charles [1709–1777]. *Lettres familières écrites d'Italie.* 2 vols. Paris: Editions D'Aujourd'hui, 1977.

**De Caro 1966**
De Caro, Gaspare. "Benedetto XIII." In DBI, vol. 8, pp. 384–93.

**De Dominici 1742–44**
De Dominici, Bernardo. *Vite de' pittori, scultori, ed architetti napoletani.* 3 vols. Naples: Stamperia del Ricciardi, 1742–44.

**De Felice 1982**
De Felice, Mauro. *Miti ed allegorie egizie in Campidoglio.* Bologna, Italy: Patron, 1982.

**De Feo 1988**
De Feo, Vittorio. *Andrea Pozzo: architettura e illusione.* Rome: Officina, 1988.

**De Feo and Martinelli 1996**
De Feo, Vittorio, and Vittorio Martinelli, eds. *Andrea Pozzo.* Milan: Electa, 1996.

**De Fine Licht 1968**
De Fine Licht, Kjeld. *The Rotunda in Rome: A Study of Hadrian's Pantheon.* Copenhagen: Gyldendal, 1968.

**De Franciscis 1946**
De Franciscis, Alfonso. "Restauri di Carlo Albacini a statue del Museo Nazionale de Napoli." *Samnium,* vol. 19 (1946), pp. 96–110.

**De Fusco 1973**
De Fusco, Renato, ed. *Luigi Vanvitelli.* Naples: Edizioni Scientifiche Italiane, 1973.

**De Grazia and Garberson 1996**
De Grazia, Diane, and Eric Garberson. *Italian Paintings of the Seventeenth and Eighteenth Centuries.* Washington, D.C.: National Gallery of Art, 1996.

**De Juliis 1981**
De Juliis, Giuseppe. "Appunti su una quadreria fiorentina: la collezione dei Marchesi Riccardi." *Paragone,* vol. 32, no. 375 (1981), pp. 57–92.

**De Lalande 1769**
De Lalande, Joseph Jérôme Le Français. *Voyage d'un François en Italie, fait dans les années 1765 & 1766.* 8 vols. Paris, 1769.

**De Marchi 1987**
De Marchi, Giulia. "Mostre di quadri a San Salvatore in Lauro (1682–1725): stime di collezioni romane." *Miscellanea della Società romana di storia patria,* vol. 28 (1987).

**De Marchi 1999**
De Marchi, Giulia, ed. *Sebastiano e Giuseppe Ghezzi: protagonisti del barocco.* Venice: Marsilio, 1999.

**De Marchi 1999, "Ghezzi"**
De Marchi, Giulia. "Giuseppe Ghezzi." In De Marchi 1999, pp. 21–105.

**Demerville 1801**
Demerville, Dominique. *Procès instruit par le tribunal criminel du Département de la Seine, contre Demerville, Céracchi, Aréna et autres, prévenus de conspiration contre la personne du premier consul Bonaparte.* Paris: Impr. de la République, 1801.

**Denison, Rosenfeld, and Wiles 1993**
Denison, Cara D., Myra Nan Rosenfeld, and Stephanie Wiles. *Exploring Rome: Piranesi and His Contemporaries.* New York: The Pierpont Morgan Library; Montreal: Centre Canadien d'Architecture / Canadian Centre for Architecture, 1993.

**Deri 1965**
Deri, Gino. "Ricostruzione biografica per un grafico italiano del Settecento: Giovanni Battista Dell'Era." *Gutenberg Jahrbuch* (1965), pp. 288–92.

**De Rossi 1792**
De Rossi, Giovanni Gherardo. *Vita del cavaliere Giovanni Pikler intagliatore in gemme ed in pietre dure.* Rome: Stamperia Pagliarini, 1792.

**De Rossi 1796**
De Rossi, Giovanni Gherardo. *Vita di Antonio Cavallucci da Sermoneta, pittore.* Venice: Carlo Palese, 1796.

**De Rossi 1804**
De Rossi, Giovanni Gherardo. *Al Sig. cavaliere Onofrio Boni Direttore delle Fabbriche di S. M. il Re d'Etruria, il cavaliere Giovanni Gherardo De Rossi Direttore della R. Accademia di Portogallo in Roma.* Rome, 1804.

**De Rossi 1804, Lettera**
De Rossi, Giovanni Gherardo. *Lettera sopra due quadri dipinti dal signor Gaspare Landi.* Piacenza, Italy: Stamperia Ghiglioni, 1804.

**De Rossi 1805**
De Rossi, Giovanni Gherardo. *Lettera del cav. Gio. Gherardo De Rossi contenente la descrizione di una pittura del sig. cav. Gaspare Landi. Estratta dal magazzino di letteratura, scienze, arti, economia politica e commercio. Opera periodica di Accademici italiani al chiarissimo sig. canonico Giacomo Sacchetti, segretario dell'Accademia Italiana.* Florence: Stamperia Reale, 1805.

**De Rossi [1811] 1970**
De Rossi, Giovanni Gherardo. *Vita di Angelica Kauffmann pittrice.* 1811. Reprint, London: Cornmarket Press, 1970.

**De Sanctis 1900**
De Sanctis, Guglielmo. *Tommaso Minardi e il suo tempo.* Rome: Forzani, 1900.

**Descriptive Catalogue 1834**
*Descriptive Catalogue of the Four Magnificent Paintings of the Most Interesting Monuments of Ancient and Modern Rome, Being the Original Pictures Painted for the Duke of Choiseul, a Minister of Louis XV, by the Cavalier Giovanni Paolo Panini.* Boston: W. W. Clapp, 1834.

**De Seta 1978**
De Seta, Cesare. "Luigi Vanvitelli: l'antico ed il neoclassico." *Prospettiva,* vol. 15 (1978), pp. 40–46.

**Desportes 1963**
Desportes, Ulysse. "Giuseppe Ceracchi in America and His Busts of George Washington." *The Art Quarterly,* vol. 26 (1963), pp. 141–79.

**Desportes 1964**
Desportes, Ulysse. "Ceracchi's Design for a Monument." *The Art Quarterly,* vol. 27 (1964), pp. 475–89.

**D'Este 1864**
D'Este, Antonio. *Memorie di Antonio Canova.* Edited by Alessandro D'Este. Florence: Felice Le Monnier, 1864.

**De Strobel 1989**
De Strobel, Anna Maria. *Le arazzerie romane dal XVII al XIX secolo.* Rome: Istituto Nazionale di Studi Romani, 1989.

**Dezallier d'Argenville 1752**
Dezallier d'Argenville, Antoine-Joseph. *Supplément à l'abrégé de la vie des plus fameux peintres.* Vol. 2. 1752.

**Di Castro 1996**
Di Castro, Daniela. "Il Principe Chigi, Visconti e Volpato." *Gazzetta antiquaria,* n.s., no. 5 (1996), pp. 42–51.

**Diderot and d'Alembert 1777–79**
Diderot, Denis, and Jean Le Rond d'Alembert. *Encyclopédie.* 36 vols. Geneva: Pellet, 1777–79.

**Dierks 1887**
Dierks, Hermann. *Houdons Leben und Werke: Eine kunsthistorische Studie.* Gotha, Germany: E. F. Thienemann, 1887.

**DiFederico 1968**
DiFederico, Frank R. "Documentation for the Paintings and Mosaics of the Baptismal Chapel in Saint Peter's." *The Art Bulletin,* vol. 50 (1968), pp. 194–97.

**DiFederico 1977**
DiFederico, Frank R. *Francesco Trevisani, Eighteenth-Century Painter in Rome: A Catalogue Raisonné.* Washington, D.C.: Decatur House Press, 1977.

**DiFederico 1983**
DiFederico, Frank. *The Mosaics of Saint Peter's: Decorating the New Basilica.* University Park, Pa., and London: The Pennsylvania State University Press, 1983.

**Di Gioia 1990**
Di Gioia, Elena Bianca, ed. *Museo di Roma: le collezioni di scultura del Seicento e Settecento.* Rome: Palombi, 1990.

**Di Macco 1973–74**
Di Macco, Michela. "Graecia Vetus: Italia nova." *Annuario dell'Istituto di Storia dell'Arte,* vol. 1 (1973–74), pp. 345–65.

**Dingé 1814**
Dingé, A. *Notice sur M. Clodion.* Paris, 1814.

**Dionisotti 1966**
Dionisotti, Carlo. "Varia fortuna di Dante." *Rivista storica italiana,* vol. 78 (1966), pp. 544–83.

**Dionisotti 1998**
Dionisotti, Carlo. *Ricordi della scuola italiana.* Rome: Edizioni di storia e letteratura, 1998.

**"Doell" 1913**
"Doell, Friedrich Wilhelm Eugen." In Thieme and Becker, vol. 9, pp. 364–65.

**Domarus 1915**
Domarus, Kurt von. *Pietro Bracci: Beiträge zur römischen Kunstgeschichte des XVIII. Jahrhunderts.* Strasbourg, France: J. H. Heitz, 1915.

**Donati 1942**
Donati, Ugo. *Artisti ticinesi a Roma.* Bellinzona, Switzerland: Istituto Editoriale Ticinese, 1942.

**Donato 1996**
Donato, Maria Pia. "Forme e dinamiche dell'organizzazione intellettuale: le accademie a Roma nel Settecento." Ph.D. diss., Bari, Italy: Università degli Studi di Bari, 1996.

**D'Onofrio 1965**
D'Onofrio, Cesare. *Gli obelischi di Roma.* Rome: Cassa di Risparmio, 1965.

**Don Quichotte 1977**
Musée National du Château de Compiègne, Compiègne, France; Musée des Tapisseries d'Aix-en-Provence, Aix-en-Provence, France. *Don Quichotte vu par un peintre du XVIIIe siècle: Natoire.* Paris: Réunion des Musées Nationaux, 1977.

**D'Orsi 1958**
D'Orsi, Mario. *Corrado Giaquinto.* Rome: Arte della stampa, 1958.

**Dotson 1973**
Dotson, Esther Gordon. "Shakespeare Illustrated, 1770–1820." Ph.D. diss., New York: New York University, Institute of Fine Arts, 1973.

**Dowley 1957**
Dowley, Francis. "Some Maratti Drawings at Düsseldorf." *The Art Quarterly,* vol. 20 (1957), pp. 163–79.

**Dowley 1962**
Dowley, Francis H. "Some Drawings by Benedetto Luti." *The Art Bulletin,* vol. 44 (1962), pp. 219–36.

**Draper 1969**
Draper, James David. "The Lottery in Piazza di Montecitorio." *Master Drawings,* vol. 7 (1969), pp. 27–34.

**Draper 1994**
Draper, James David. "Some Mazzuoli Angels." *Antologia di Belle Arti,* n.s., no. 48–51 (1994), pp. 59–63.

**Dreyer 1969**
Dreyer, Peter. *Römische Barockzeichnungen aus dem Berliner Kupferstichkabinett.* Berlin: Staatliche Museen Kupferstichkabinett, 1969.

**Dreyer 1969, "Maratti"**
Dreyer, Peter. "Notes on a Maratti Drawing in New York." *Master Drawings,* vol. 7 (1969), pp. 24–25.

**Dreyer 1971**
Dreyer, Peter. "Notizen zum malerischen und zeichnerischen Oeuvre der Maratta-Schule: Giuseppe Chiari - Pietro de' Pietri - Agostino Masucci." *Zeitschrift für Kunstgeschichte,* vol. 34 (1971), pp. 184–207.

**Dreyer 1979**
Dreyer, Peter. *I grandi disegni italiani del Kupferstichkabinett di Berlino.* Milan: Silvana, 1979.

**Drossaers and Scheurleer 1974–76**
Drossaers, Sophie Wilhelmina Albertine, and Theodoor Herman Lunsingh Scheurleer, eds. *Inventarissen van de inboedels in de verblijven van de Oranjes en daarmede gelijk te stellen stukken, 1567–1795.* 3 vols. The Hague: Nijhoff, 1974–76.

**Duclaux 1991**
Duclaux, Lise. *Charles Natoire, 1700–1777.* Paris: Galerie de Bayser, 1991.

**Duncan 1981**
Duncan, Carol. "Fallen Fathers: Images of Authority in Pre-Revolutionary French Art." *Art History,* vol. 4 (1981), pp. 186–202.

**Dunn 1982**
Dunn, Marilyn. "Father Sebastiano Resta and the Final Phase of the Decoration of S. Maria in Vallicella." *The Art Bulletin*, vol. 64 (1982), pp. 601–22.

**Duppa 1799**
Duppa, Richard. *A Journal of the Most Remarkable Occurences that Took Place in Rome Upon the Subversion of the Ecclesiastical Government, in 1798.* London: G. G. & J. Robinson, 1799.

**Eckardt 1985**
Eckardt, Götz, ed. *Das italienische Reisetagebuch des Prinzen August von Sachsen-Gotha-Altenburg, des Freundes von Herder, Wieland und Goethe.* Stendal, Germany: Winckelmann- Gesellschaft, 1985.

**Eguillor, Hager, and Hornedo 1991**
Eguillor, José Ramón, Hellmut Hager, and Rafael Maria de Hornedo. *Loyola: historia y arquitectura.* Donostia - San Sebastian, Spain: ETOR, 1991.

**Ehrle 1932**
Ehrle, Francesco. Introduction to *Roma al tempo di Benedetto XIV: la Pianta di Roma di Giambattista Nolli del 1748.* Vatican City: Biblioteca Apostolica Vaticana, 1932.

**Einem 1958**
Einem, Herbert von. *Asmus Jacob Carstens: Die Nacht mit ihren Kindern.* Cologne: Westdeutscher Verlag, 1958.

**Eleuteri 1996**
Eleuteri, Francesco. "Villa Corsini fuori Porta S. Pancrazio a Roma." *Palladio*, n.s., vol. 9, no. 18 (1996), pp. 109–24.

**Elkan 1924**
Elkan, Anne-Lise. "Camillo Rusconi, 1658–1728: Ein Beitrag zur römischen Skulptur des Spätbarocks." Ph.D. diss., Cologne: University of Cologne, 1924.

**Emmerling 1932**
Emmerling, Ernst. *Pompeo Batoni: Sein Leben und Werk.* Darmstadt, Germany: Hobhann, 1932.

**Enggass 1964**
Enggass, Robert. *The Painting of Baciccio: Giovanni Battista Gaulli, 1639–1709.* University Park, Pa.: The Pennsylvania State University Press, 1964.

**Enggass 1968**
Enggass, Robert. "Bernardino Ludovisi - I: The Early Work." *The Burlington Magazine*, vol. 110 (1968), pp. 438–44.

**Enggass 1968, "Ludovisi II"**
Enggass, Robert. "Bernardino Ludovisi - II: The Later Work." *The Burlington Magazine*, vol. 110 (1968), pp. 494–500.

**Enggass 1968, "Portugal"**
Enggass, Robert. "Bernardino Ludovisi - III: His Work in Portugal." *The Burlington Magazine*, vol. 110 (1968), pp. 613–19.

**Enggass 1972**
Enggass, Robert. "Tiepolo and the Concept of the Barocchetto." In *Celebrazioni tiepolesche 1972*, pp. 81–86.

**Enggass 1974**
Enggass, Robert. "Rusconi and Raggi in Sant' Ignazio." *The Burlington Magazine*, vol. 116 (1974), pp. 258–62.

**Enggass 1976**
Enggass, Robert. *Early Eighteenth-Century Sculpture in Rome: An Illustrated Catalogue Raisonné.* 2 vols. University Park, Pa., and London: The Pennsylvania State University Press, 1976.

**Enggass 1978**
Enggass, Robert. "Bernardino Ludovisi: A New Attribution." *The Burlington Magazine*, vol. 120 (1978), pp. 229–30.

**Enggass 1983**
Enggass, Robert. "Cornacchini, Agostino." In DBI, vol. 29, pp. 100–104.

**Enggass 1993**
Enggass, Robert. "Ludovisi's Tomb for a Colonna Prince." *The Burlington Magazine*, vol. 135 (1993), pp. 822–24.

**Enggass 1995**
Enggass, Robert. "Lo stato della scultura in Roma nella prima metà del Settecento." In Vasco Rocca and Borghini 1995, pp. 423–38.

***English Caricature* 1984**
Yale Center for British Art, New Haven; Victoria and Albert Museum, London; The National Gallery of Canada, Ottawa. *English Caricature, 1620 to the Present: Caricaturists and Satirists, Their Art, Their Purpose and Influence.* London: Victoria and Albert Museum, 1984.

**Erffa 1963**
Erffa, Hans Martin Freiherr von. "Die Ehrenpforten für den Possess der Päpste im 17. und 18. Jahrhundert." In *Festschrift für Harald Keller zum sechzigsten Geburtstag dargebracht von seinen Schülern*, pp. 335–70. Darmstadt, Germany: Eduard Roether, 1963.

**Ergmann 1987**
Ergmann, Raoul. "Subleyras, enfin." *Connaissance des Arts*, no. 421 (March 1987), pp. 34–43.

**Eriksen 1961**
Eriksen, Svend. "Lalive de Jully's Furniture 'à la grecque.'" *The Burlington Magazine*, vol. 103 (1961), pp. 340–47.

**Eriksen 1963**
Eriksen, Svend. "Om Salon pas Åkerö og dens Kunster Louis-Joseph Le Lorrain." *Sartryck ur Konsthistorisk Tidskrift*, vol. 32 (1963), pp. 94–120.

**Erouart 1976**
Erouart, Gilbert. "Louis-Joseph Le Lorrain." In Chastel and Brunel 1976, pp. 201–15.

**Erouart and Mosser 1978**
Erouart, Gilbert, and Monique Mosser. "A Propos de la 'Notice historique sur la vie et les ouvrages de J. -B. Piranesi': origine et fortune d'une biographie." In Brunel 1978, pp. 213–56.

**Escobar 1964**
Escobar, Mario. *Le dimore romane dei santi.* Bologna, Italy: Cappelli, 1964.

**Esdaile 1947**
Esdaile, K. A. "Christopher Hewetson and His Monument to Dr. Baldwin in Trinity College, Dublin." *The Journal of the Royal Society of Antiquaries of Ireland*, vol. 77 (1947), pp. 134–35.

***Exposition Hubert Robert* 1933**
Musée de l'Orangerie, Paris. *Exposition Hubert Robert, à l'occasion du deuxième centenaire de sa naissance.* Paris: Musée de l'Orangerie, 1933.

**Faccioli 1966**
Faccioli, Clemente. "Gio. Battista Nolli (1701–1756) e la sua gran 'Pianta di Roma' del 1748." *Studi romani*, vol. 14 (1966), pp. 415–42.

**Faccioli 1968**
Faccioli, Clemente. "Di Agostino Cornacchini da Pescia scultore a Roma (n. 1686 – m. dopo il 1754)." *Studi romani*, vol. 16 (1968), pp. 431–45.

**Fagiolo 1997**
Fagiolo, Marcello, ed. *La festa a Roma: dal Rinascimento al 1870.* 2 vols. Turin, Italy: Umberto Allemandi; Rome: J. Sands, 1997.

**Fagiolo M. 1957**
Fagiolo, Mario. *Pasquino e le Pasquinate.* Milan: Aldo Martello, 1957.

**Fagiolo dell'Arco and Pantanella 1996**
Fagiolo dell'Arco, Maurizio, and Rossella Pantanella, eds. *Museo Baciccio in margine a quattro inventari inediti.* Rome: Antonio Pettini, 1996.

**Fagiolo dell'Arco and Petrucci 1998**
Fagiolo dell'Arco, Maurizio, and Francesco Petrucci, eds. *L'Ariccia del Bernini.* Rome: De Luca, 1998.

**Falcidia 1963**
Falcidia, Giorgio. "Marco Benefial ad Arsoli." *Bollettino d'arte*, 4th ser., vol. 48 (1963), pp. 111–22.

**Falcidia 1964**
Falcidia, Giorgio. "Per un ritratto di Marco Benefial." *Bollettino dei musei comunali di Roma*, vol. 11 (1964), pp. 19–33.

**Falcidia 1966**
Falcidia, Giorgio. "Nuove proposte per Marco Benefial ritrattista." *Paragone*, n.s., vol. 17, no. 195 (1966), pp. 60–68.

**Falcidia 1978**
Falcidia, Giorgio. "Per una definizione del 'caso' Benefial." *Paragone*, vol. 29, no. 343 (1978), pp. 24–51.

**Falcidia 1983–84**
Falcidia, Giorgio. "Di Benefial, di Stefano Parrocel, e d'altro." *Prospettiva*, 33–36 (1983–84), pp. 287–95.

**Faldi 1971**
Faldi, Italo. Review of *Painting in Italy in the Eighteenth Century: Rococo to Romanticism* by John Maxon and Joseph J. Rishel. *The Burlington Magazine*, vol. 113 (1971), pp. 563–71.

**Faldi 1972**
Faldi, Italo. "La serie dipinti celebrativi Chigi Zondadari." In Italo Faldi and Eduard A. Safarik, *Acquisti 1970–1972: XV settimana dei musei italiani*, pp. 70–85. Rome: Galleria Nazionale d'arte antica, 1972.

**Faldi 1977**
Faldi, Italo. "Gli inizi del neoclassicismo in pittura nella prima metà del Settecento." In *Convegno internazionale nuove idee e nuova arte nel '700 italiano, Rome 19–23, maggio 1975*, pp. 495–523. Vol. 26 of *Atti dei Convegni Lincei*. Rome: Accademia Nazionale dei Lincei, 1977.

**Federmann 1927**
Federmann, Arnold. *Johann Heinrich Füssli: Dichter und Maler.* Zurich and Leipzig: Orell-Füssli, 1927.

**Fejfer 1991**
Fejfer, Jane. "The Roman Portraits from the Ince Blundell Collection and Their Eighteenth-Century Context." *Journal of the History of Collections*, vol. 3 (1991), pp. 235–54.

**Fejfer and Southworth 1991**
Fejfer, Jane, and Edmund Southworth. *The Ince Blundell Collection of Classical Sculpture.* Vol. 1. London: HMSO, 1991.

**Felicetti 1998**
Felicetti, Chiara, ed. *Cristoforo Unterperger: un pittore fiemmese nell'Europa del Settecento.* Rome: De Luca, 1998.

**Fenici 1990**
Fenici, Innocenzo. "Rieti, Palazzo Vecchiarelli, le fasi del cantiere e gli interventi successivi al Maderno." *Il Territorio*, vol. 2–3 (1990), pp. 112–39.

**Fermi 1906**
Fermi, Stefano, ed. "Alcune lettere inedite di Gaspare Landi." *Bollettino storico piacentino*, vol. 1 (1906), pp. 193–204.

**Fernandez 1977**
Fernandez, Jesus Urrea. *La pintura italiana del siglo XVIII en España.* Valladolid, Mexico: Departamento de Historia del Arte, 1977.

**Fernow 1797**
Fernow, Carl Ludwig. "Uber einige neue Kunstwerk des Hrn. Prof. Carstens, Rom. den 2 Mai 1795." *Der Neue Teutsche Merkur*, vol. 3 (1797).

**Fernow 1806–8**
Fernow, Carl Ludwig. *Römische Studien.* 3 vols. Zurich, 1806–8.

**Fernow 1867**
Fernow, Carl Ludwig. *Carstens: Leben und Werke.* Edited by Herman Riegel. Hannover, Germany: C. Rümpler, 1867.

**Ferrara 1954**
Ferrara, Luciana. "La stanza di Elena e Paride nella Galleria Borghese." *Rivista dell'Istituto Nazionale d'Archeologia e Storia dell'Arte*, n.s., vol. 3 (1954), pp. 242–56.

**Ferrara 1968**
Ferrara, Luciana. "Pompeo Savini: Venceslao Peter e il mobile neoclassico romano." *Palatino*, vol. 12 (1968), pp. 256–62.

**Ferrara 1974–75**
Ferrara, Luciana. "Domenico Corvi nella Galleria Borghese." *Rivista dell'Istituto Nazionale d' Archeologia e Storia dell'Arte*, n.s., vol. 21–22 (1974–75), pp. 169–217.

**Ferrara Grassi 1987**
Ferrara Grassi, Luciana. "Il casino di Villa Borghese: i camini, note e documenti per l'arredo degli interni, la collaborazione di Agostino Penna e Vincenzo Pacetti." In Debenedetti 1987, pp. 241–94.

**Ferraris 1995**
Ferraris, Paola. "Il Bosco Parrasio dell'Arcadia (1721–1726)." In Vasco Rocca and Borghini 1995, pp. 137–48.

**Ferraris 1995, "Canevari"**
Ferraris, Paola. "Antonio Canevari a Lisbona (1727–1732)." In Vasco Rocca and Borghini 1995, pp. 57–66.

**Ficacci 1996**
Ficacci, Luigi. "L'immaginazione al servizio della verità: considerazioni sulla rappresentazione della Roma moderna." In Elisa Debenedetti, ed., *Giovanni Battista Piranesi: la raccolta di stampe della Biblioteca Fardelliana*, pp. 59–86. Trapani, Italy: Corrao, 1996.

**Fichera 1937**
Fichera, Francesco. *Luigi Vanvitelli.* Rome: Reale Accademia d'Italia, 1937.

**Ficoroni 1744**
Ficoroni, Francesco. *Le vestigia e rarità di Roma antica.* 2 vols. Rome: Stamperia di G. Mainardi, 1744.

**Ficoroni 1757**
Ficoroni, Francesco. *Gemmae antiquae litteratae, aliaequae rariores.* Rome: Sumptibus Venantii Monaldini, 1757.

**Finaldi and Kitson 1997**
Finaldi, Gabriele, and Michael Kitson, eds. *Discovering the Italian Baroque: The Denis Mahon Collection.* London: The National Gallery Publications, 1997.

**Fiorani 1970**
Fiorani, Luigi. "Il secolo XVIII." In Luigi Fiorani et al., *Riti, cerimonie, feste, e vita di popolo nella Roma dei papi*, pp. 219–57. Bologna, Italy: Cappelli, 1970.

**Fiori 1977**
Fiori, Giorgio. "Vicende biografiche ed artistiche di Gaspare Landi." *Bollettino storico piacentino*, vol. 72 (1977), pp. 25–86.

**Fischer 1976**
Fischer, Erik. "Abildgaards Filoktet og Lessings Laokoon." *Kunstmuseets årsskrift*, vol. 62 (1976), pp. 77–102.

**Fischer 1992**
Fischer, Erik. "Abildgaards kongebilleder i Christiansborgs Riddersal." *Kunstmuseets årsskrift* (1992), pp. 4–39.

**Flaxman 1838**
Flaxman, John [1755–1826]. *Lectures on Sculpture*. 2nd ed. London: Henry G. Bohn, 1838.

**Fleming 1962**
Fleming, John. *Robert Adam and His Circle in Edinburgh and Rome*. London: John Murray, 1962.

**Fleming and Honour 1967**
Fleming, John, and Hugh Honour. "Giovanni Battista Maini." In Fraser, Hibbard, and Lewine 1967, pp. 255–58.

**Fleming and Honour 1968**
Fleming, John, and Hugh Honour. "Francis Harwood: An English Sculptor in XVIII Century Florence." In Antje Kosegarten and Peter Tigler, eds., *Festschrift Ulrich Middeldorf*, pp. 510–16. Berlin: Walter de Gruyter, 1968.

**Focillon 1918**
Focillon, Henri. *Giovanni-Battista Piranesi: Essai de catalogue raisonné de son oeuvre*. Paris: Librairie Renouard, 1918.

**Fock 1976–77**
Fock, C. Willemijn. "De schilderijengalerij van Prins Willem V op het Buitenhof te Den Haag." *Antiek*, vol. 2 (1976–77), pp. 113–37.

**Fondazione Lungarotti 1988**
Fondazione Lungarotti, Torgiano, Italy. *Bozzetti, modelli e grisailles dal XVI al XVIII secolo*. Perugia, Italy: Electa Editori Umbri Associati, 1988.

**Fontana 1694**
Fontana, Carlo. *Templum Vaticanum et ipsius origo, cum aedificiis maximè conspicuis antiquitùs, & recèns ibidem constitutis*. Rome: Francisci Buagni, 1694.

**Ford 1948**
Ford, Brinsley. "The Dartmouth Collection of Drawings by Richard Wilson." *The Burlington Magazine*, vol. 90 (1948), pp. 337–48.

**Ford 1951**
Ford, Brinsley. *The Drawings of Richard Wilson*. London: Faber & Faber, 1951.

**Ford 1951, "Wilson"**
Ford, Brinsley. "Richard Wilson in Rome, I–The Wicklow Wilsons." *The Burlington Magazine*, vol. 93 (1951), pp. 157–66.

**Ford 1974**
Ford, Brinsley. "James Byres: Principal Antiquarian for the English Visitors to Rome." *Apollo*, n.s., vol. 99 (1974), pp. 446–61.

**Ford 1974, "Constable"**
Ford, Brinsley. "William Constable: An Enlightened Yorkshire Patron." *Apollo*, n.s., vol. 99 (1974), pp. 408–15.

**Ford 1974, "The Earl-Bishop"**
Ford, Brinsley. "The Earl-Bishop: An Eccentric and Capricious Patron of the Arts." *Apollo*, n.s., vol. 99 (1974), pp. 426–34.

**Ford 1974, "Jenkins"**
Ford, Brinsley. "Thomas Jenkins: Banker, Dealer, and Unofficial English Agent." *Apollo*, n.s., vol. 99 (1974), pp. 416–25.

**Ford 1974, "Williams-Wynn"**
Ford, Brinsley. "Sir Watkin Williams-Wynn: A Welsh Maecenas." *Apollo*, n.s., vol. 99 (1974), pp. 435–39.

**Forlani Tempesti and Prosperi Valenti Rodinò 1998**
Forlani Tempesti, Anna, and Simonetta Prosperi Valenti Rodinò, eds. *Per Luigi Grassi: disegno e disegni*. Rimini, Italy: Galleria Editrice, 1998.

**Foscolo 1978**
Foscolo, Ugo [1778–1827]. *Scritti vari di critica storica e letteraria (1817–1827)*. Edited by Uberto Limentani in collaboration with J.M.A. Lindon. Florence: Felice Le Monnier, 1978.

**Fothergill 1974**
Fothergill, Brian. *The Mitred Earl: An Eighteenth-Century Eccentric*. London: Faber & Faber, 1974.

**Frabbi 1989**
Frabbi, Nadia. "Un gruppo di disegni di Giovanni Battista Dell'Era nella Biblioteca Civica di Treviglio." *Paragone*, n.s., vol. 40, no. 475 (1989), pp. 96–104.

**Franceschini 1993**
Franceschini, M. "La nascita del Museo Capitolino nel diario di Alessandro Gregorio Capponi." *Roma moderna e contemporanea*, vol. 1 (1993), pp. 73–80.

**Frank 1987**
Frank, Louis. "Pierre Subleyras: redécouverte d'un peintre." *L'Estampille* (April 1987), pp. 32–39.

**Franz-Duhme 1984**
Franz Duhme, Helga Nora. "Un rilievo poco noto e un disegno di Angelo de'Rossi." *Antologia di Belle Arti*, n.s., no. 23–24 (1984), pp. 80–83.

**Franz-Duhme 1986**
Franz-Duhme, Helga Nora. *Angelo de Rossi: Ein Bildhauer um 1700 in Rom*. Berlin: Ernst Wasmuth, 1986.

**Fraser, Hibbard, and Lewine 1967**
Fraser, Douglas, Howard Hibbard, and Milton J. Lewine, eds. *Essays in the History of Architecture Presented to Rudolf Wittkower*. London: Phaidon, 1967.

**Freire 1923**
Freire, Luciano. *Catalogo descritivo e ilustrado*. Lisbon: Museu Nacional dos Coches, 1923.

**French Art 1932**
Royal Academy of Arts, London. *French Art, 1200–1900*. London: Royal Academy of Arts, 1932.

**French Painting 1974**
Grand Palais, Paris; Detroit, The Detroit Institute of Arts; New York, The Metropolitan Museum of Art. *French Painting, 1774–1830: The Age of Revolution*. Translated from the French. Paris: Réunion des Musées Nationaux, 1974.

**Freytag 1976**
Freytag, Claudia. "Neuentdeckte Werke des François du Quesnoy." *Pantheon*, vol. 34 (1976), pp. 199–211.

**Frimmel 1908**
Frimmel, Theodor von. "Das Pantheonbild des Hubert Robert in der Darmstädter Galerie." *Blätter für Gemäldekunde*, vol. 4 (1908), pp. 180–82.

**Frutaz 1962**
Frutaz, Amato Pietro, ed. *Le Piante di Roma*. 3 vols. Rome: Istituto di Studi Romani, 1962.

**Fucili Bartolucci 1986**
Fucili Bartolucci, Anna. "Pittura devozionale e patetismo metastasiano: Mancini, Lazzarini, Ceccarini, Lapis." In Franco Battistelli, ed., *Arte e cultura nella provincia di Pesaro e Urbino dalle origini ad oggi*, pp. 449–64. Venice: Marsilio, 1986.

**Fumagalli 1994**
Fumagalli, Elena. *Palazzo Borghese: committenza e decorazione privata*. Rome: De Luca, 1994.

**Fumaroli 1997**
Fumaroli, Marc. *Rome dans la mémoire et l'imagination de l'Europe: celebrazioni sul Campidoglio del cinquantesimo anniversario della fondazione dell'Unione*. Rome: Unione Internazionale degli Istituti di Archeologia Storia e Storia dell'Arte in Roma, 1997.

**Fusco 1975**
Fusco, Peter. "Lambert-Sigisbert Adam's 'Bust of Neptune.'" *Los Angeles County Museum of Art Bulletin*, vol. 21 (1975), pp. 12–25.

**Fusco 1978**
Fusco, Peter. "L.-S. Adam's Adieu to Rome." *Antologia di Belle Arti*, vol. 2 (1978), pp. 225–32.

**Fusco 1988**
Fusco, Peter. "Pierre-Etienne Monnot's Inventory after Death." *Antologia di Belle Arti*, n.s., no. 33–34 (1988), pp. 70–77.

**Fusco 1997**
Fusco, Peter. *Summary Catalogue of European Sculpture in the J. Paul Getty Museum*. Los Angeles: The J. Paul Getty Museum, 1997.

**Fusconi 1984**
Fusconi, Giulia. *I paesaggi di Nicolas-Didier Boguet e i luoghi tibulliani: dalle collezioni del Gabinetto Nazionale delle stampe*. Rome: De Luca, 1984.

**Fusconi 1998**
Fusconi, Giulia. "Frammenti della collezione di disegni Cavaceppi-Pacetti." In Forlani Tempesti and Prosperi Valenti Rodinò 1998, pp. 415–35.

**Gabillot 1895**
Gabillot, Claude. *Hubert Robert et son temps*. Paris: Librairie de l'art, 1895.

**Galleria Ascoli Piceno 1919**
*Guida della Galleria comunale di Ascoli Piceno*. Ascoli Piceno, Italy: Cesari, 1919.

**Galli 1927–28**
Galli, Romeo. "I tesori d'arte d'un pittore del Seicento, Carlo Maratti." *L'Archiginnasio*, vol. 22–23 (1927–28), pp. 59–78, 217–38.

**Gambardella 1979**
Gambardella, Alfonso. *Architettura e committenza nello Stato pontificio tra barocco e rococò: un amministratore illuminato, Giuseppe Renato Imperiali*. Naples: Società Editrice Napoletana, 1979.

**Gardner 1948**
Gardner, Albert ten Eyck. "Fragment of a Lost Monument." *The Metropolitan Museum of Art Bulletin*, vol. 6 (1948), pp. 189–97.

**Garlick, Macintyre, and Cave 1978–84**
Garlick, Kenneth, Angus Macintyre, and Kathryn Cave, eds. *The Diary of Joseph Farington*. [1793–1821]. 16 vols. New Haven and London: Yale University Press, 1978–84.

**Garms 1972**
Garms, Jörg, ed. *Artisti austriaci a Roma dal barocco alla secessione*. Rome: Studio tipografico, 1972.

**Garms 1973**
Garms, Jörg, ed. *Disegni di Luigi Vanvitelli nelle collezioni pubbliche di Napoli e di Caserta*. Naples: Attività Grafiche Editoriali Affini, 1973.

**Garms 1974**
Garms, Jörg. "Beiträge zu Vanvitellis Leben, Werk und Milieu." *Römische Historische Mitteilungen*, vol. 16 (1974), pp. 107–90.

**Garms 1984**
Garms, Jörg. "Der Bilderzyklus des 18. Jahrhunderts im Dom von Pisa." *Römische Historische Mitteilungen*, vol. 26 (1984), pp. 430–52.

**Garms 1992**
Garms, Jörg. "Due parrocchiali nelle Marche ed altre chiese di Carlo Marchionni." In Debenedetti 1992, pp. 131–47.

**Garms 1993**
Garms, Jörg. "Zwei unbekannte Zeichnungen Vanvitellis in österreichischem Privatbesitz." In Martin Kubelik and Mario Schwarz, eds., *Von der Bauforschung zur Denkmalpflege: Festschrift für Alois Machatschek zum 65. Geburtstag*, pp. 65–77. Vienna: Phoibos, 1993.

**Garms 1993, "Annunziata"**
Garms, Jörg. "The Church of the Annunziata in Naples." In Jeanne Chenault Porter and Susan Scott Munshower, eds., *Parthenope's Splendor: Art of the Golden Age in Naples*, pp. 396–429. Vol. 7 of *Papers in Art History from The Pennsylvania State University*. University Park, Pa.: The Pennsylvania State University, 1993.

**Garms 1995**
Garms, Jörg. "La cappella di S. Giovanni Battista nella Chiesa di S. Rocco a Lisbona." In Vasco Rocca and Borghini 1995, pp. 113–23.

**Garms and Garms 1998**
Garms, Elisabeth, and Jörg Garms. "Benedetto XIV, arte e politica: contributo alla discussione." In Biagi Maino 1998, pp. 395–99.

**Garuti 1992**
Garuti, Alfonso. "Immagini per una visita alla chiesa di San Nicolò." In Alfonso Garuti, Romano Pelloni, and Dante Colli, eds., *San Nicolò in Carpi: un modello del classicismo emiliano*, pp. 86–145. Modena, Italy: Artoli, 1992.

**Gasparini 1950**
Gasparini, Lina. "Francesco Trevisani." *Pagine istriane*, vol. 4 (1950), pp. 103–6.

**Gasparoni 1863**
Gasparoni, Francesco. "Cenni biografici del pittore da decorazione Felice Gianni." In vol. 1 of *Arti e lettere*, pp. 10–12. Rome: Tipografia Menicanti, 1863.

**Gasparri 1985**
Gasparri, Carlo. "Piranesi a Villa Albani." In Debenedetti 1985, pp. 211–24.

**Gasparri 1993**
Gasparri, Carlo. "L'eredità Cavaceppi e le sculture Torlonia." *Rivista dell'Istituto Nazionale d'Archeologia e Storia dell'Arte*, n.s., vol. 16 (1993), pp. 1–56.

**Gasparri 1996**
Gasparri, Carlo. "Una fortuna ritrovata ancora su Piranesi a Villa Albani." In Debenedetti 1996, pp. 193–206.

**Gasparri and Ghiandoni 1993**
Gasparri, Carlo, and Olivia Ghiandoni. *Lo studio Cavaceppi e le collezioni Torlonia*. Vol. 16 of *Rivista dell'Istituto Nazionale D'Archeologia e Storia dell'Arte*. Rome: Istituto Nazionale D'Archeologia e Storia dell'Arte, 1993.

**Gaus 1967**
Gaus, Joachim. *Carlo Marchionni: Ein Beitrag zur römischen Architektur des Settecento*. Cologne: Böhlau, 1967.

**Gavuzzo Stewart 1971**
Gavuzzo Stewart, Silvia. "Nota sulle carceri piranesiane." *L'arte*, vol. 15–16 (1971), pp. 57–74.

**Gay 1996**
Gay, Sophie Anne. "Marchis, Alessio de." In DA, vol. 20, pp. 394–95.

**Gentilini and Sisi 1989**
Gentilini, Giancarlo, and Carlo Sisi, eds. *La scultura: bozzetti in terracotta, piccoli marmi e altre sculture dal 14. al 20 secolo*. Florence: S.P.E.S., 1989.

**Gerard 1892**
Gerard, Frances A. *Angelica Kauffmann: A Biography*. London: Ward & Downey, 1892.

**Gérard H. 1886**
Gérard, Henri, ed. *Lettres adressées au baron François Gérard, peintre d'histoire*. 2nd ed. Paris: A. Quantin, 1886.

**Germanò Siracusa 1996**
Germanò Siracusa, Donatella. "Pacetti (1–2)." In DA, vol. 23, p. 701.

**Ghezzi 1696**
Ghezzi, Giuseppe. *Il centesimo dell'anno 1695: celebrato in Roma dall'Accademia del Disegno, essendo principe il Signor Cavalier Carlo Fontana, architetto*. Rome: Gio. Francesco Buagni, 1696.

**Ghezzi 1705**
Ghezzi, Giuseppe. *Il premio tra gli applausi del Campidoglio per l'Accademia del Disegno celebrata il di 7. maggio 1705*. Rome: Gaetano degli Zenobi, 1705.

**Ghezzi 1706**
Ghezzi, Giuseppe. *Le belle arti in lega con la poesia per l'Accademia del Disegno celebrata in Campidoglio il di 6. maggio 1706*. Rome: Gaetano degli Zenobi, 1706.

**"Ghezzi" 1920**
"Ghezzi, Pier Leone." In Thieme and Becker, vol. 13, pp. 539–40.

**"Ghezzi" 1974**
"Ghezzi, Giuseppe." In DEB, vol. 5, pp. 363–66.

**"Ghezzi" 1980**
"Staatsgalerie Stuttgart, Neuerwerbungen: Pier Leone Ghezzi (1674–1755), 'Bildnis des Carlo Albani.'" *Jahrbuch der Staatlichen Kunstsammlungen in Baden-Württemberg*, vol. 17 (1980), pp. 287–88.

**Ghiandoni 1993**
Ghiandoni, Olivia. "La decorazione scultorea della villa Torlonia sulla Via Nomentana." *Rivista dell'Istituto Nazionale d'Archeologia e Storia dell'Arte*, n.s., vol. 16 (1993), pp. 57–218.

**Ghisotti 1990**
Ghisotti, Silvia. "Pécheux, Laurent." In *La pittura in Italia* 1990. Vol. 2, pp. 822–23.

**Giacometti 1929**
Giacometti, Georges. *La Vie et l'oeuvre de Houdon*. 2 vols. Paris: A. Camion, 1929.

**Giaquinto 1993**
Castello Svevo, Bari, Italy. *Giaquinto: capolavori dalle corti in Europa*. Milan: Charta, 1993.

**Gibelli 1888**
Gibelli, Alberto, ed. *Memorie storiche ed artistiche dell'antichissima chiesa abbaziale dei SS. Andrea e Gregorio al Clivo di Scauro sul Monte Celio*. Rome: Monastero di S. Gregorio, 1888.

**Gillies 1972**
Gillies, Linda. "An Eighteenth-Century Roman View: Panini's 'Scalinata della Trinità dei Monti.'" *The Metropolitan Museum of Art Bulletin*, vol. 30 (1972), pp. 172–84.

**Gilmartin 1974**
Gilmartin, John. "The Paintings Commissioned by Pope Clement XI for the Basilica of San Clemente in Rome." *The Burlington Magazine*, vol. 116 (1974), pp. 305–10.

**Giordani 1859**
Giordani, Pietro. "Sopra un dipinto del cav. Landi e uno del cav. Camuccini." In Antonio Gussalli, ed., *Opere*. Vol. 9, pp. 122–39. Milan: Borroni & Scotti, 1859.

**Giorgetti Vichi 1977**
Giorgetti Vichi, Anna Maria, ed. *Gli Arcadi dal 1690 al 1800*. Rome: Tipografica Editrice Romana, 1977.

**Giovannelli 1985**
Giovannelli, Roberto. "Nuovi contributi per Bernardino Nocchi." *Labyrinthos*, vol. 4, no. 7–8 (1985), pp. 119–99.

**Giovannelli 1992–93**
Giovannelli, Roberto. "Per Stefano Tofanelli." *Labyrinthos*, vol. 11–12, no. 21–24 (1992–93), pp. 393–430.

**Girodet 1967**
Musée de Montargis, Montargis, France. *Girodet, 1767–1824*. Paris: L. Philippe, 1967.

**Giuggioli 1980**
Giuggioli, Alfredo. *Il Palazzo de Carolis in Roma*. Rome: Banco di Roma, 1980.

**Giuntella 1958**
Giuntella, Vittorio E. "Studi sul Settecento romano: il pontificato di Benedetto XIV." *Studi romani*, vol. 6 (1958), pp. 184–88.

**Giuntella 1960**
Giuntella, Vittorio E. "Ricerche per una storia religiosa di Roma nel Settecento." *Studi romani*, vol. 8 (1960), pp. 302–13.

**Giuntella 1971**
Giuntella, Vittorio E. *Roma nel Settecento*. Bologna, Italy: Cappelli, 1971.

**Giustini 1997**
Giustini, Laura. *Fornaci e laterizi a Roma dal XV al XIX secolo*. Rome: Edizioni Kappa, 1997.

**Gnoli 1971**
Gnoli, Raniero. *Marmora romana*. Rome: Elefante, 1971.

**Goethe [1788] 1974**
Goethe, Johann Wolfgang von. *Italienische Reise*. 1788; Edited by Erich Trunz and Herbert von Einem. Vol. 11 of *Goethes Werke*. Munich: C. H. Beck, 1974.

**Goethe [1788] 1982**
Goethe, Johann Wolfgang von. *Italian Journey, 1786–1788*. 1788; Translated by W. H. Auden and Elizabeth Mayer. San Francisco: North Point Press, 1982.

**Goethe 1805**
Goethe, Johann Wolfgang von. *Winkelmann und sein Jahrhundert*. Tübingen, Germany: J. G. Cotta, 1805.

**Goethe 1816**
Goethe, Johann Wolfgang von. *Aus meinem Leben, von Goethe: Zweyter abtheilung*. Vol. 1. Stuttgart, Germany: J. G. Cotta, 1816.

**Goethe 1991**
Goethe, Johann Wolfang von [1749–1832]. *Viaggio in Italia*. Milan: Mondadori, 1991.

**Golden Age 1981**
The Detroit Institute of Arts, Detroit; The Art Institute of Chicago, Chicago. *The Golden Age of Naples: Art and Civilization under the Bourbons, 1734–1805*. 2 vols. Detroit: The Detroit Institute of Arts, 1981.

**Golzio 1933**
Golzio, Vincenzo. *Le terrecotte della R. Accademia di San Luca*. Rome: Castaldi, 1933.

**Golzio 1938**
Golzio, Vincenzo. "Artisti romani all'estero: Antonio Canevari e Vicenzo Mazzoneschi." *Roma*, vol. 16 (1938), pp. 464–68.

**Golzio 1939**
Golzio, Vincenzo. *La galleria e le collezioni della R. Accademia di San Luca in Roma*. Rome: a Libreria dello Stato, 1939.

**Golzio 1964**
Golzio, Vincenzo. *La galleria e le collezioni dell'Accademia di San Luca in Roma*. 2nd ed., rev. Rome: Istituto Poligrafico dello Stato, 1964.

**González-Palacios 1976**
González-Palacios, Alvar. "I mani del Piranesi (i Righetti, Boschi, Boschetti, Rafaelli)." *Paragone*, vol. 27, no. 315 (1976), pp. 33–48.

**González-Palacios 1984**
González-Palacios, Alvar. *Il tempio del gusto: Roma e il regno delle Due Sicilie*. 2 vols. Milan: Longanesi, 1984.

**González-Palacios 1986**
González-Palacios, Alvar. *Il tempio del gusto: il granducato di Toscana e gli stati settentrionali*. 2 vols. Milan: Longanesi, 1986.

**González-Palacios 1991**
González-Palacios, Alvar, ed. *Fasto romano: dipinti, sculture, arredi dai palazzi di Roma*. Rome: Leonardo–De Luca, 1991.

**González-Palacios 1993**
González-Palacios, Alvar. *Il gusto dei principi: arte di corte del XVII e del XVIII secolo*. 2 vols. Milan: Longanesi, 1993.

**González-Palacios 1993, "Valadier"**
González-Palacios, Alvar. "Luigi Valadier a Palazzo Borghese." *Antologia di Belle Arti*, n.s. no. 43–47 (1993), pp. 34–51.

**González-Palacios 1994**
González-Palacios, Alvar. "Cornici di Pio VI." In Elisa Acanfora et al., *Studi di storia dell'arte in onore di Mina Gregori*, pp. 348–54. Milan: Silvana, 1994.

**González-Palacios 1995**
González-Palacios, Alvar. "Giovanni Giardini: New Works and New Documents." *The Burlington Magazine*, vol. 137 (1995), pp. 367–76.

**González-Palacios 1997**
González-Palacios, Alvar. "La storia della Stanza di Apollo e Dafne." In Kristina Herrmann Fiore, ed., *Apollo e Dafne del Bernini nella Galleria Borghese*, pp. 15–39. Milan: Silvana, 1997.

**González-Palacios 1997, Valadier**
González-Palacios, Alvar, ed. *L'oro di Valadier: un genio nella Roma del Settecento*. Rome: Palombi, 1997.

**González-Palacios 1998**
González-Palacios, Alvar. "Il deposito di Maria Flaminia Odescalchi Chigi." *Antologia di Belle Arti*, n.s., no. 55–58 (1998), pp. 155–62.

**Goodison 1993**
Goodison, Nicholas. "Minerva and Pupils." *Furniture History*, vol. 29 (1993), pp. 143–46.

**Göthe 1898**
Göthe, Georg. *Johan Tobias Sergel, hans lefnad och verksamhet*. Stockholm: Wahlström & Widstrand, 1898.

**Göthe 1921**
Göthe, Georg. *Johan Tobias Sergels skulpturverk*. Stockholm: Norstedt & Söners, 1921.

**Grabar' 1909**
Grabar', Igor' Emmanuilovich. *Istoriia russkago iskusstva*. Vol. 3. Moscow: I. Knebel', 1909.

**Gradara Pesci 1920**
Gradara Pesci, Costanza. *Pietro Bracci: scultore romano, 1700–1773*. Milan: Alfieri & Lacroix, 1920.

**Gradarini 1821**
Gradarini, Terenzio. *Breve e succinta relazione storica sulla fondazione e pregi di Pesaro, suoi uomini illustri nelle scienze, in santità ed altro*. Foligno, Italy, 1821.

**Graf 1973**
Graf, Dieter. *Master Drawings of the Roman Baroque from the Kunstmuseum Düsseldorf: A Selection from the Lambert Krahe Collection*. London: Victoria and Albert Museum; Edinburgh: Scottish Arts Council, 1973.

**Graf 1976**
Graf, Dieter. *Handzeichnungen von Guglielmo Cortese und Giovanni Battista Gaulli*. 2 vols. Düsseldorf: Kunstmuseum der Stadt Düsseldorf, 1976.

**Graf 1979**
Graf, Dieter. "Der römische Maler Giuseppe Passeri als Zeichner." *Münchner Jahrbuch der bildenden Kunst*, vol. 30 (1979), pp. 131–58.

**Graf 1984**
Graf, Dieter. *Master Drawings of the Roman Baroque from the Kunstmuseum Düsseldorf: A Selection from the Lambert Krahe Collection*. New York: Alpine Fine Arts Collection, Ltd., 1984.

**Graf 1989**
Graf, Dieter. "Gaulli, Giovanni Battista." In *La pittura in Italia: Il Seicento*. Vol. 2, p. 755. Milan: Electa, 1989.

**Graf 1990**
Graf, Dieter. "Giuseppe Passeris Zeichnungen und Ölskizzen: Zu Fresken in römischen Kirchen." *Münchner Jahrbuch der Bildenden Kunst*, vol. 41 (1990), pp. 61–122.

**Graf 1990, "Odazzis"**
Graf, Dieter. "Giovanni Odazzis Studien für die Ausmalung der Cappella Elci in S. Sabina in Rom." In Stefan Kummer and Georg Satzinger, eds., *Studien zur Künstlerzeichnung: Klaus Schwager zum 65. Geburtstag*, pp. 206–23. Stuttgart, Germany: Hatje, 1990.

**Graf 1991**
Graf, Dieter. "Drawings by Giuseppe Passeri in Homage to Clement XI." *Master Drawings*, vol. 29 (1991), pp. 235–54.

**Graf 1995**
Graf, Dieter, ed. *Die Handzeichnungen des Giuseppe Passeri*. 2 vols. Düsseldorf: Kunstmuseum Düsseldorf, 1995.

**Graf 1995, "Passeri"**
Graf, Dieter. "Giuseppe Passeri Zeichnungen und Entwürfe für die Ausmalung römischer Paläste und Villen." *Römisches Jahrbuch der Bibliotheca Hertziana*, vol. 30 (1995), pp. 315–71.

**Graf 1996**
Graf, Dieter. "Giuseppe Passeri als Kopist." In Victoria V. Flemming and Sebastian Schütze, eds., *Ars naturam adiuvans: Festschrift für Matthias Winner*, pp. 529–47. Mainz, Germany: Philipp von Zabern, 1996.

**Graf and Schaar 1969**
Graf, Dieter, and Eckhard Schaar. *Meisterzeichnungen der Sammlung Lambert Krahe*. Düsseldorf: Kunstmuseum der Stadt Düsseldorf, 1969.

**Gramaccini 1993**
Gramaccini, Gisela. *Jean-Guillaume Moitte (1746–1810): Leben und Werk*. 2 vols. Berlin: Akademi, 1993.

**Gramaccini 1996**
Gramaccini, Norberto. "Jacques-Louis Davids 'Schwur der Horatier': Die Révolution des arts und das römische Seicento." In Victoria von Flemming and Sebastian Schütze, eds., *Ars naturam adiuvans: Festschrift für Mathias Winner*, pp. 557–71. Mainz, Germany: Philipp von Zabern, 1996.

**Grandi 1980**
Grandi, Renzo, ed. *I Concorsi Curlandesi: Bologna, Accademia di Belle Arti, 1785–1870*. Bologna, Italy: Galleria comunale d'arte moderna di Bologna, 1980.

**Grassinger 1994**
Grassinger, Dagmar. *Antike Marmorskulpturen auf Schloss Broadlands (Hampshire)*. Edited by Eva Hoffmann. Mainz, Germany: Philipp von Zabern, 1994.

**Gravina 1973**
Gravina, Giovanni Vincenzo [1664–1718]. *Scritti critici e teorici*. Edited by Amedeo Quondam. Rome and Bari: Laterza, 1973.

**Graziosi and Tellini Santoni 1991**
Acquaro Graziosi, Maria Teresa, and Barbara Tellini Santoni. *Tre secoli di storia dell'Arcadia*. Rome: Biblioteca Vallicelliana and La Meridiana, 1991.

**Grigioni 1963**
Grigioni, Carlo. *Giovanni Giardini da Forlì: argentiere e fonditore in Roma*. San Casciano, Italy: Cappelli, 1963.

**Grigsby 1995**
Grigsby, Darcy. "Classicism, Nationalism and History: The Prix Décennaux of 1810 and the Politics of Art Under Post-Revolutionary Empire." 2 vols. Ph.D. diss., Ann Arbor, Mich.: The University of Michigan, 1995.

**Griseri 1962**
Griseri, Andreina. "Francesco Trevisani in Arcadia." *Paragone*, n.s., vol. 13, no. 153 (1962), pp. 28–37.

**Griseri 1982**
Griseri, Andreina. "Arcadia: crisi e trasformazione fra Sei e Settecento. In *Il Cinquecento, il Seicento e il Settecento: dal neoclassicismo al futurismo*. Vol. 3 of *Storia dell'arte italiana*, pp. 527–95. 2nd ed., rev. Florence: Sansoni, 1982.

**Gritella 1992**
Gritella, Gianfranco. *Juvarra: l'architettura*. 2 vols. Modena, Italy: F. C. Panini, 1992.

**Grohn 1960**
Grohn, Hans Werner. "Die Selbstbildnisse des Anton von Maron." *Alte und moderne Kunst*, vol. 5, no. 6–7 (1960), pp. 17–19.

**Gross 1990**
Gross, Hanns. *Rome in the Age of Enlightenment: The Post-Tridentine Syndrome and the Ancien Régime*. Cambridge: Cambridge University Press, 1990.

**Guarnacci 1751**
Guarnacci, Mario. *Vitae, et res gestae pontificum romanorum et S.R.E. cardinalium a Clemente X. usque ad Clementem XII*. 2 vols. Rome: Sumptibus Venantii Monaldini, 1751.

**Guerrieri Borsoi 1982–83**
Guerrieri Borsoi, Maria Barbara. "Per la conoscenza di Domenico Maria Muratori." *Annuario dell'Istituto di Storia dell'Arte*, n.s., no. 2 (1982–83), pp. 32–45.

**Guerrieri Borsoi 1988**
Guerrieri Borsoi, Maria Barbara. "Alcune opere di Giuseppe Passeri per i Marchesi Patrizi." In Debenedetti 1988, pp. 381–403.

**Guerrieri Borsoi 1989**
Guerrieri Borsoi, Maria Barbara. "Un dipinto di Giuseppe Bartolomeo Chiari a Frascati." *Studi romani*, vol. 37 (1989), pp. 324–28.

**Guerrieri Borsoi 1991**
Guerrieri Borsoi, Maria Barbara. "La collezione di dipinti di Fabio e Pietro Paolo Cristofori." In Debenedetti 1991, pp. 111–42.

**Guerrieri Borsoi 1991, "Pozzi"**
Guerrieri Borsoi, Maria Barbara. "L'attività di Stefano e Giuseppe Pozzi nella Basilica di San Pietro." *Studi romani*, vol. 39 (1991), pp. 252–66.

**Guerrieri Borsoi 1993**
Guerrieri Borsoi, Maria Barbara. "Un protagonista della transizione tra tardo barocco e neoclassicismo romano: La piccola." In Debenedetti 1993, pp 141–84.

**Guerrierri Borsoi 1998**
Guerrierri Borsoi, Maria Barbara. "La copia delle Logge di Raffaello di Cristoforo Unterperger." In Felicetti 1998, pp. 77–82.

**Guiffrey 1892**
Guiffrey, Jules-Joseph. "Le Sculpteur Claude Michel, dit Clodion." *Gazette des Beaux-Arts*, 3rd ser., vol. 8 (1892), pp. 478–95.

**Guiffrey 1893**
Guiffrey, Jules-Joseph. "Le Sculpteur Claude Michel, dit Clodion (1738–1814)." *Gazette des Beaux-Arts*, 3rd ser., vol. 9 (1893), pp. 164–76.

**Guiffrey 1893, "Clodion"**
Guiffrey, Jules-Joseph. "Le Sculpteur Claude Michel, dit Clodion (1738–1814)." *Gazette des Beaux-Arts*, 3rd ser., vol. 9 (1893), pp. 392–417.

**Guiffrey 1912**
Guiffrey, Jules-Joseph. "Inventaire après décès de Clodion." *Archives de l'Art Français*, n.s., vol. 6 (1912), pp. 210–44.

**Guimbaud 1928**
Guimbaud, Louis. *Saint-Non et Fragonard*. Paris: Le Goupy, 1928.

**Güthlein 1979**
Güthlein, Klaus. "Quellen aus dem Familienarchiv Spada zum römischen Barock." *Römisches Jahrbuch für Kunstgeschichte*, vol. 18 (1979), pp. 173–246.

**Hackert 1994**
Palazzo delle Esposizioni, Rome. *Il paesaggio secondo natura: Jacob Philipp Hackert et la sua cerchia*. Rome: Artemide, 1994.

**Hager 1964**
Hager, Hellmut. *S. Maria dell'Orazione e Morte*. Rome: Marietti, 1964.

**Hager 1967–68**
Hager, Hellmut. "Zur Planungs- und Baugeschichte der Zwillingskirchen auf der Piazza del Popolo: S. Maria di Monte Santo und S. Maria dei Miracoli in Rom." *Römisches Jahrbuch für Kunstgeschichte*, vol. 11 (1967–68), pp. 189–312.

**Hager 1968**
Hager, Hellmut. "Progetti del tardo barocco romano per il terzo braccio del Colonnato della Piazza S. Pietro." *Commentari*, n.s., vol. 19 (1968), pp. 299–314.

**Hager 1970**
Hager, Hellmut. *Filippo Juvarra e il concorso di modelli del 1715 bandito da Clemente XI per la nuova sacrestia di S. Pietro*. Translated by Carlo Picchio. Rome: De Luca, 1970.

**Hager 1973**
Hager, Hellmut. "La facciata di San Marcello al Corso: contributo alla storia della costruzione." *Commentari*, n.s., vol. 24 (1973), pp. 58–74.

**Hager 1973, "Carlo Fontana"**
Hager, Hellmut. "Carlo Fontana's Project for a Church in Honour of the 'Ecclesia Triumphans' in the Colosseum, Rome." *Journal of the Warburg and Courtauld Institutes*, vol. 36 (1973), pp. 319–37.

**Hager 1974**
Hager, Hellmut. "La cappella del Cardinale Alderano Cybo in Santa Maria del Popolo." *Commentari*, n.s., vol. 25 (1974), pp. 47–61.

**Hager 1975**
Hager, Hellmut. "Carlo Fontana e l'ingrandimento dell'Ospizio di S. Michele: contributo allo sviluppo architettonico di un'istituzione caritativa del tardo barocco romano." *Commentari*, n.s., vol. 26 (1975), pp. 344–59.

**Hager 1981**
Hager, Hellmut. *Architectural Fantasy and Reality: Drawings from the Accademia Nazionale di San Luca, Concorsi Clementini, 1700–1750*. Edited by Susan S. Munshower. University Park, Pa.: Museum of Art, The Pennsylvania State University, 1981.

**Hager 1982**
Hager, Hellmut. "Gian Lorenzo Bernini e la ripresa dell'alto barocco nell'architettura del Settecento romano." In Marcello Fagiolo and Gianfranco Spagnesi, eds., *Immagini del barocco: Bernini e la cultura del Seicento*. Vol. 2, pp. 469–96. Rome: Istituto della Enciclopedia Italiana, 1982.

**Hager 1991**
Hager, Hellmut. "Le opere letterarie di Carlo Fontana come autorappresentazione." In Contardi and Curcio 1991, pp. 155–203.

**Hager 1992**
Hager, Hellmut. "Osservazioni su Carlo Fontana e sulla sua opera del 'tempio Vaticano' (1694)." In Marcello Fagiolo and Maria Luisa Madonna, eds., *Il barocco romano e l'Europa*, pp. 85–149. Rome: Istituto Poligrafico e Zecca dello Stato, Libreria dello Stato, 1992.

**Hager 1993**
Hager, Hellmut. "Carlo Fontana: Pupil, Partner, Principal, Preceptor." *Studies in the History of Art*, vol. 38 (1993), pp. 123–55.

**Hager 1995–97**
Hager, Hellmut. "Bernini, Carlo Fontana e la fortuna del 'Terzo Braccio' del colonnato di Piazza San Pietro in Vaticano." *Quaderni dell'Istituto di Storia dell'Architettura*, vol. 25–30 (1995–97), pp. 337–60.

**Hager and Munshower 1984**
Hager, Hellmut, and Susan Scott Munshower, eds. *Projects and Monuments in the Period of the Roman Baroque*. Vol. 1 of *Papers in Art History from The Pennsylvania State University*. University Park, Pa.: The Pennsylvania State University, 1984.

**Hager and Munshower 1987**
Hager, Hellmut, and Susan Scott Munshower, eds. *Light on the Eternal City: Observations and Discoveries in the Art and Architecture of Rome*. Vol. 2 of *Papers in Art History from The Pennsylvania State University*. University Park, Pa.: The Pennsylvania State University, 1987.

**Hager W. 1929**
Hager, Werner. *Die Ehrenstatuen der Päpste*. Leipzig: Porschel & Trepte, 1929.

**Halsband 1973**
Halsband, Robert. *Lord Hervey: Eighteenth-Century Courtier*. Oxford: Clarendon Press, 1973.

**Hamilton 1879**
Hamilton, Gavin. *Letters of Gavin Hamilton*. Edited by Lord Edmond Fitzmaurice. Devizes, England: H. Barrass, 1879.

**Harder 1981**
Harder, Hermann. *Le President De Brosses et le voyage en Italie au dix-huitième siècle*. Geneva: Slatkine, 1981.

**Harris 1967**
Harris, John. "Le Geay, Piranesi and International Neo-classicism in Rome, 1740–1750." In Fraser, Hibbard, and Lewine 1967, pp. 189–96.

**Harris and Schaar 1967**
Harris, Ann, and Eckhard Schaar, ed. *Die Handzeichnungen von Andrea Sacchi und Carlo Maratta*. Düsseldorf: Kunstmuseum Düsseldorf, 1967.

**Harrison 1996**
Harrison, Colin, "Bouchardon, Edme (i)." In *DA*, vol. 4, pp. 508–11.

**Hartmann 1969**
Hartmann, Wolfgang. "Die Wiederentdeckung Dantes in der Deutschen Kunst: J. H. Füssli, A. J. Carstens, J. A. Koch." Ph.D. diss., Bonn, Germany: Rheinisches Friedrich-Wilhelms-Universität, 1969.

**Haskell 1971**
Haskell, Francis. *Patrons and Painters: A Study in the Relations between Italian Art and Society in the Age of the Baroque*. New York: Harper & Row, 1971.

**Haskell and Penny 1981**
Haskell, Francis, and Nicholas Penny. *Taste and the Antique: The Lure of Classical Sculpture, 1500–1900*. New Haven and London: Yale University Press, 1981.

**Hassall and Penny 1977**
Hassall, W. O., and Nicholas Penny. "Political Sculpture at Holkham." *The Connoisseur*, vol. 195 (1977), pp. 207–11.

**Hawcroft 1958**
Hawcroft, Francis W. "The Cabinet at Felbrigg." *The Connoisseur*, vol. 141 (1958), pp. 216–19.

**Hawcroft 1959**
Hawcroft, Francis W. "Giovanni Battista Busiri." *Gazette des Beaux-Arts*, 6th ser., vol. 53 (1959), pp. 295–304.

**Hederich [1770] 1996**
Hederich, Benjamin. *Gründliches mythologisches Lexikon.* 1770. Reprint, Darmstadt, Germany: Wissenschaftliche Buchgesellschaft, 1996.

**Heim, Béraud, and Heim 1989**
Heim, Jean-François, Claire Béraud, and Philippe Heim. *Les Salons de peinture de la Révolution française, 1789–1799.* Paris: C.A.C. Sarl, 1989.

**Heim Gallery 1972**
Heim Gallery, London. *Paintings and Sculptures, 1770–1830.* London: Heim Gallery, 1972.

**Heimbürger Ravalli 1977**
Heimbürger Ravalli, Minna. *Architettura, scultura e arti minori nel barocco italiano: ricerche nell'archivio Spada.* Florence: L. S. Olschki, 1977.

**Heine 1928**
Heine, Albrecht-Friedrich. *Asmus Jakob Carstens und die Entwicklung des Figurenbildes.* Strasbourg, France: Heitz, 1928.

**Heinzl 1966**
Heinzl, Brigitte. "The Luti Collection: Toward the Reconstruction of a Seventeenth-Century Roman Collection of Master Drawings." *The Connoisseur,* vol. 161 (1966), pp. 17–22.

**Hekler 1912**
Hekler, Antal, ed. *Die Bildniskunst der Griechen & Römer.* Stuttgart, Germany: J. Hoffmann, 1912.

**Helbig 1963**
Helbig, Wolfgang. *Führer durch die öffentlichen Sammlungen klassischer Altertümer in Rom.* Edited by Hermine Speier. Vol. 1 of *Die Päpstlichen Sammlungen im Vatikan und Lateran.* Tübingen, Germany: Ernst Wasmuth, 1963.

**Helbig 1966**
Helbig, Wolfgang. *Führer durch die öffentlichen Sammlungen klassischer Altertümer in Rom.* Edited by Hermine Speier. Vol. 2. Tübingen, Germany: Ernst Wasmuth, 1966.

**Held and Posner 1971**
Held, Julius S., and Donald Posner. *Seventeenth- and Eighteenth-Century Art: Baroque Painting, Sculpture, Architecture.* New York: Abrams, 1971.

**Hempel 1924**
Hempel, Eberhard. "Fragonard und Robert in ihrer römischen Studienzeit." *Die graphischen Kunste,* vol. 47 (1924), pp. 9–24.

**Hercenberg 1976**
Hercenberg, Bernard. *Nicolas Vleughels: peintre et directeur de l'Académie de France à Rome, 1668–1737.* Paris: Léonce Laget, 1976.

**Herding 1973**
Herding, Klaus. "Französische Kunst sur Zeit der Revolution von 1789: Zur Frage der visuellen Ausprägung gesellschaftlicher Widersprüche im entstehenden bürgerlichen Staat." *Sitzungsberichte der Kunstgeschichtlichen Gesellschaft zu Berlin,* n.s., vol. 21 (June 1973), pp. 28–34.

**Herrmann Fiore 1993**
Herrmann Fiore, Kristina. "Disegni di Tommaso Conca per la Galleria di Villa Borghese." *Antologia di Belle Arti,* n.s., no. 43–47 (1993), pp. 52–66.

**Herrmann Fiore 1998**
Herrmann Fiore, Kristina. "La metamorfosi dell'antico nelle pitture di Cristoforo Unterperger a villa Borghese." In Felicetti 1998, pp. 92–101.

**Hersant 1988**
Hersant, Yves. *Italies: anthologie des voyageurs français aux XVIIIe et XIXe siècles.* Paris: Robert Laffont, 1988.

**Hersey 1983**
Hersey, George L. *Architecture, Poetry, and Number in the Royal Palace at Caserta.* Cambridge: MIT Press, 1983.

**Hertel 1983**
Hertel, Dieter. "Los bustos de emperadores romanos, las estatuas ideales de yeso y los retratos griegos de la Casa del Labrador de Aranjuez." *Reales Sitios,* vol. 78 (1983), pp. 17–36.

**Hiesinger 1978**
Hiesinger, Ulrich W. "The Paintings of Vincenzo Camuccini, 1771–1844." *The Art Bulletin,* vol. 60 (1978), pp. 297–320.

**Hiesinger 1980**
Hiesinger, Ulrich W. "Drawings in Eighteenth-Century Rome." In Hiesinger and Percy 1980, pp. 2–9.

**Hiesinger and Percy 1980**
Hiesinger, Ulrich W., and Ann Percy. *A Scholar Collects: Selections from the Anthony Morris Clark Bequest.* Philadelphia: Philadelphia Museum of Art, 1980.

**Hiller 1970**
Hiller, Stefan. *Bellerophon: Ein griechischer Mythos in der römischen Kunst.* Munich: Wilhelm Fink, 1970.

**Hind 1922**
Hind, Arthur M. *Giovanni Battista Piranesi: A Critical Study with a List of His Published Works and Detailed Catalogues of the Prisons and the Views of Rome.* London: The Cotswold Gallery, 1922.

**Hirt 1785**
Hirt, Aloys Ludwig. "Briefe aus Rom hauptsachlich neue Werke jetz daselbst lebbender Kunstler betreffend." *Der Teutsche Merkur,* (November 1785), pp. 285–86.

**Hodgkinson 1954**
Hodgkinson, Terence. "Christopher Hewetson, an Irish Sculptor in Rome." *Walpole Society,* vol. 34 (1954), pp. 42–54.

**Hoetink 1985**
Hoetink, H. R., ed. *The Royal Picture Gallery Mauritshuis.* Amsterdam: Meulenhoff/Landshoff; New York: Abrams in association with the Mauritshuis, 1985.

**Hoff 1973**
Hoff, Ursula. *European Painting and Sculpture before 1800.* 3rd ed. Melbourne, Australia: National Gallery of Victoria, 1973.

**Hoffmann 1967**
Hoffmann, Paola. *Il monte Pincio e la casina Valadier.* Rome: Edizioni del Mondo, 1967.

**Hoffmann 1989**
Hoffmann, Paola. "Il monumento a Van der Capellen: fortuna e vicende." In Ceracchi 1989, pp. 37–41.

**Hofmann 1979**
Hofmann, Werner, ed. *John Flaxman: Mythologie und Industrie.* Munich: Prestel, 1979.

**Holloway 1980**
Holloway, James. "Batoni's Sacrifice of Iphigenia." *The Burlington Magazine,* vol. 122 (1980), pp. 564–67.

**Holst 1987**
Holst, Christian von. *Johann Heinrich Dannecker.* Vol. 1. Stuttgart, Germany: Cantz, 1987.

**Honour 1958**
Honour, Hugh. "English Patrons and Italian Sculptors in the First Half of the Eighteenth Century." *The Connoisseur,* vol. 141 (1958), pp. 220–26.

**Honour 1959**
Honour, Hugh. "Filippo Della Valle." *The Connoisseur,* vol. 144 (1959), pp. 172–79.

**Honour 1959, "Canova"**
Honour, Hugh. "Antonio Canova and the Anglo-Romans: Part I." *The Connoisseur,* vol. 143 (1959), pp. 241–45.

**Honour 1959, "Magazine"**
Honour, Hugh. "Magazine of Wonders." *The Connoisseur,* vol. 144 (1959), pp. 79–85.

**Honour 1960**
Honour, Hugh. "Antonio Canova and the Anglo-Romans: Part II, the First Years in Rome." *The Connoisseur,* vol. 144 (1960), pp. 225–31.

**Honour 1960, "Pacetti"**
Honour, Hugh. "Vincenzo Pacetti." *The Connoisseur,* vol. 146 (1960), pp. 174–81.

**Honour 1961**
Honour, Hugh. "Bronze Statuettes by Giacomo and Giovanni Zoffoli." *The Connoisseur,* vol. 148 (1961), pp. 198–205.

**Honour 1963**
Honour, Hugh. "After the Antique: Some Italian Bronzes of the Eighteenth Century." *Apollo,* n.s., vol. 77 (1963), pp. 194–200.

**Honour 1963, "Pacetti"**
Honour, Hugh. "The Rome of Vincenzo Pacetti: Leaves from a Sculptor's Diary." *Apollo,* n.s., vol. 78 (1963), pp. 368–76.

**Honour 1967**
Honour, Hugh. "Statuettes after the Antique: Volpato's Roman Porcelain Factory." *Apollo,* n.s., vol. 85 (1967), pp. 371–73.

**Honour 1968**
Honour, Hugh. *Neo-classicism.* Harmondsworth, England: Penguin, 1968.

**Honour 1971**
Honour, Hugh. "Bracci, Pietro." In DBI, vol. 13, pp. 620–23.

**Honour 1971, *Goldsmiths***
Honour, Hugh. *Goldsmiths and Silversmiths.* New York: Putnam, 1971.

**Honour 1992**
Honour, Hugh. "Canova's Sculptural Practice." In Pavanello and Romanelli 1992, *Canova,* pp. 33–43.

**Honour 1994**
Honour, Hugh, ed. *Edizione Nazionale delle opere di Antonio Canova.* Rome: Istituto Poligrafico e Zecca dello Stato, Libreria dello Stato, 1994.

**Honour and Weston-Lewis 1995**
Honour, Hugh, and Aidan Weston-Lewis, eds. *The Three Graces: Antonio Canova.* Edinburgh: National Gallery of Scotland, 1995.

**Hornsby 1999**
Hornsby, Clare, ed. *The Contribution of Italy: Aspects of the Grand Tour, 1600–1845.* Forthcoming.

**Howard 1962**
Howard, Seymour. "Some Eighteenth-Century Restorations of Myron's 'Discobolos.'" *Journal of the Warburg and Courtauld Institutes,* vol. 25 (1962), pp. 330–34. Reprinted with an addendum in Howard 1990, pp. 70–77, 254–55.

**Howard 1964**
Howard, Seymour. "Boy on a Dolphin: Nollekens and Cavaceppi." *The Art Bulletin,* vol. 46 (1964), pp. 177–89. Reprinted with an addendum in Howard 1990, pp. 78–97, 256–62.

**Howard 1967**
Howard, Seymour. "A Model of Early Romantic Necrophilia." In *Akten des 21. Internationalen Kongresses für Kunstgeschichte in Bonn, 1964: Stil und Überlieferung in der Kunst des Abendlandes.* Vol. 1, pp. 217–25. Berlin: Mann, 1967. Reprinted in Howard 1997, pp. 358–69.

**Howard 1970**
Howard, Seymour. "Bartolomeo Cavaceppi and the Origins of Neo-Classic Sculpture." *The Art Quarterly,* vol. 33 (1970), pp. 120–33.

**Howard 1973**
Howard, Seymour. "An Antiquarian Handlist and Beginnings of the Pio-Clementino." *Eighteenth- Century Studies,* vol. 7 (1973), pp. 40–61.

**Howard 1982**
Howard, Seymour. *Bartolomeo Cavaceppi: Eighteenth-Century Restorer.* New York and London: Garland, 1982.

**Howard 1988**
Howard, Seymour. "Bartolomeo Cavaceppi's Saint Norbert." *The Art Bulletin,* vol. 70 (1988), pp. 478–85.

**Howard 1990**
Howard, Seymour. *Antiquity Restored: Essays on the Afterlife of the Antique.* Vienna: IRSA, 1990.

**Howard 1991**
Howard, Seymour. "Ancient Busts and the Cavaceppi and Albacini Casts." *Journal of the History of Collections,* vol. 3 (1991), pp. 199–217.

**Howard 1993**
Howard, Seymour. "Some Eighteenth-Century 'Restored' Boxers." *Journal of the Warburg and Courtauld Institutes,* vol. 56 (1993), pp. 238–55. Reprinted and expanded in Howard 1997, pp. 318–57.

**Howard 1993, "David"**
Howard, Seymour. "Crise et classicisme: David et Rome." In Michel R. 1993, pp. 35–57.

**Howard 1997**
Howard, Seymour. *Art and Imago: Essays on Art as a Species of Autobiography.* London: Pindar Press, 1997.

**Howard D. 1969**
Howard, Deborah. "Some Eighteenth-Century English Followers of Claude." *The Burlington Magazine,* vol. 111 (1969), pp. 726–33.

**Hubert 1964**
Hubert, Gérard. *Les Sculpteurs italiens en France sous la Révolution: l'Empire et la Restauration, 1790–1830.* Paris: E. de Boccard, 1964.

**Hubert 1964, *Sculpture***
Hubert, Gérard. *La Sculpture dans l'Italie napoléonienne.* Paris: E. de Boccard, 1964.

**Hubert 1977**
Hubert, Gérard. "Josephine, A Discerning Collector of Sculpture." *Apollo,* n.s., vol. 106 (1977), pp. 34–43.

**Huth 1967**

Huth, Hans. "Lacquer in Rome." *Apollo*, n.s., vol. 85 (1967), pp. 336–39.

**Incisa della Rocchetta 1976**

Incisa della Rocchetta, Giovanni. *Roma sparita: mostra di disegni e acquerelli dal secolo XVI al XX dalla donazione della contessa Anna Laetitia Pecci Blunt al Museo di Roma*. Rome: Palombi, 1976.

**Incisa della Rocchetta 1979**

Incisa della Rocchetta, Giovanni, ed. *La collezione dei ritratti dell'Accademia di San Luca*. Rome: Accademia Nazionale di San Luca, 1979.

**Ingamells 1996**

Ingamells, John. "Discovering Italy: British Travellers in the Eighteenth Century." In Wilton and Bignamini 1996, pp. 21–30.

**Ingamells 1997**

Ingamells, John. *A Dictionary of British and Irish Travellers in Italy, 1701–1800: Compiled from the Brinsley Ford Archive*. New Haven and London: Yale University Press, 1997.

**Ingersoll 1986**

Ingersoll, Richard. "Imago Urbis: Representing Rome." *Design Book Review*, (Winter 1986), pp. 21–23.

**Ingersoll-Smouse 1926**

Ingersoll-Smouse, Florence. *Joseph Vernet: peintre de marine, 1714–1789*. 2 vols. Paris: Étienne Bignou, 1926.

**IRIARTE 1989**

Palazzo Venezia, Rome. *IRIARTE: antico e moderno nelle collezioni del Gruppo IRI*. Milan: Electa, 1989.

**Irwin 1962**

Irwin, David. "Gavin Hamilton: Archaeologist, Painter, and Dealer." *The Art Bulletin*, vol. 44 (1962), pp. 87–102.

**Irwin 1966**

Irwin, David. *English Neoclassical Art: Studies in Inspiration and Taste*. London: Faber & Faber, 1966.

**Irwin 1979**

Irwin, David. *John Flaxman, 1755–1826: Sculptor, Illustrator, Designer*. New York: Rizzoli, 1979.

**Irwin and Irwin 1975**

Irwin, David, and Francina Irwin. *Scottish Painters at Home and Abroad, 1700–1900*. London: Faber & Faber, 1975.

**Isola et al. 1980**

Isola, Maria Catelli, et al. *I grandi disegni italiani del Gabinetto Nazionale delle Stampe di Roma*. Milan: Silvana, 1980.

**Istituto Storia dell'Arte 1983**

Istituto Storia dell'Arte, Università degli studi di Roma, Rome. *Piranesi e la cultura antiquaria: gli antecedenti e il contesto: atti del Convegno 14–17, Novembre 1979*. Rome: Multigrafica, 1983.

**Italian Art and Britain 1960**

Royal Academy of Arts, London. *Italian Art and Britain: Winter Exhibition*, 1960. 2nd ed. London: Royal Academy of Arts, 1960.

**The Iveagh Bequest 1955**

The Iveagh Bequest, Kenwood, London. *Exhibition of Paintings by Angelica Kauffmann at the Iveagh Bequest, Kenwood*. Introduction by Edward Bayliss. London: London County Council, 1955.

**Izzi 1994**

Izzi, Giuseppe. "L'Arcadia nel giudizio dei primi romantici." *Atti e memorie: Arcadia. Atti del Convegno di studi per il III centenario, Roma 15–18 maggio 1991*, vol. 9 (1994), pp. 439–47.

**Jackson-Stops 1985**

Jackson-Stops, Gervase, ed. *The Treasure Houses of Britain: Five Hundred of Years of Private Patronage and Collecting*. Washington, D.C.: National Gallery of Art; New Haven and London: Yale University Press, 1985.

**Jacob 1972**

Jacob, Sabine. "Die Projekte Bibienas und Doris für die Fassade von S. Giovanni in Laterano." *Zeitschrift für Kunstgeschichte*, vol. 35 (1972), pp. 100–117.

**Jacob 1975**

Jacob, Sabine, ed. *Italienische Zeichnungen der Kunstbibliothek Berlin: Architektur und Dekoration 16. bis 18. Jahrhundert*. Berlin: Staatliche Museen Preussischer Kulturbesitz, 1975.

**Jaffé 1993**

Jaffé, Michael. "Collaborations in Landscape." In Ciardi, Pinelli, and Sicca 1993, pp. 81–89.

**Jaffé 1994**

Jaffé, Michael. *The Devonshire Collection of Italian Drawings*. 4 vols. London: Phaidon, 1994.

**Jatta 1998**

Jatta, Barbara, ed. *Piranesi e l'Aventino*. Milan: Electa, 1998.

**Jestaz 1993**

Jestaz, Bertrand. "Copies d'antiques au Palais Farnèse: les fontes de Guglielmo Della Porta." *Mélanges de l'École Française de Rome*, vol. 105 (1993), pp. 7–48.

**Joanni V Magnifico 1994**

Galeria de pintura do Rei D. Luis, Lisbon. *Joanni V Magnifico: a pintura em Portugal ao tempo de D. Joao V, 1706–1750*. Lisbon: IPPAR, 1994.

**Johns 1988**

Johns, Christopher M. S. "Papal Patronage and Cultural Bureaucracy in Eighteenth-Century Rome: Clement XI and the Accademia di San Luca." *Eighteenth-Century Studies*, vol. 22 (1988), pp. 1–23.

**Johns 1989**

Johns, Christopher M. S. "French Connections to Papal Art Patronage in the Rome of Clement XI." *Storia dell'arte*, vol. 67 (1989), pp. 279–85.

**Johns 1991**

Johns, Christopher M. S. Review of *Rome in the Age of Enlightenment: The Post-Tridentine Syndrome and the Ancien Régime*, by Hanns Gross. *The Burlington Magazine*, vol. 133 (1991), pp. 204–5.

**Johns 1993**

Johns, Christopher M. S. *Papal Art and Cultural Politics: Rome in the Age of Clement XI*. Cambridge: Cambridge University Press, 1993.

**Johns 1998**

Johns, Christopher M. S. *Antonio Canova and the Politics of Patronage in Revolutionary and Napoleonic Europe*. Berkeley and Los Angeles: University of California Press, 1998.

**Johns 1998, "Canova"**

Johns, Christopher M. S. "Ecclesiastical Politics and Papal Tombs: Antonio Canova's Monuments to Clement XIV and Clement XIII." *The Sculpture Journal*, vol. 2 (1998), pp. 58–71.

**Johns 1998, "That Amiable Object"**

Johns, Christopher M. S. "'That Amiable Object of Adoration': Pompeo Batoni and the Sacred Heart." *Gazette des Beaux-Arts*, 6th ser., vol. 132 (1998), pp. 19–28.

**Johnson 1989**

Johnson, Dorothy. "Corporality and Communication: The Gestural Revolution of Diderot, David, and 'The Oath of the Horatii.'" *The Art Bulletin*, vol. 71 (1989), pp. 92–113.

**Johnson 1993**

Johnson, Dorothy. *Jacques-Louis David: Art in Metamorphosis*. Princeton, NJ: Princeton University Press, 1993.

**Johnston 1882**

Johnston, Elizabeth Bryant. *Original Portraits of Washington, Including Statues, Monuments and Medals*. Boston: J. R. Osgood, 1882.

**Jones 1986**

Jones, Douglas Signe Margaret. "The Eighteenth-Century Sculptural Program for the Facade of S. Maria Maggiore, Rome." 2 vols. Ph.D. diss., Los Angeles: University of Southern California, 1986.

**Josephson 1956**

Josephson, Ragnar. *Sergels fantasi*. 2 vols. Stockholm: Natur och kultur, 1956.

**Junod 1953**

Junod, Louis. *Aquarelles de Abraham-Louis-Rodolphe Du Cros, 1748-1810*. Laussane, Switzerland: Musée Cantonal des Beaux Arts, 1953.

**Justi 1923**

Justi, Carl. *Winckelmann und seine Zeitgenossen*. 3 vols. Leipzig, Germany: F.C.W. Vogel, 1923.

**Kalnein and Levey 1972**

Kalnein, Wend Graf, and Michael Levey. *Art and Architecture of the Eighteenth Century in France*. Harmondsworth, England: Penguin, 1972.

**Kamphausen 1941**

Kamphausen, Alfred. *Asmus Jakob Carstens*. Neumünster, Germany: K. Wachholtz, 1941.

**Kauffmann 1998**

Kauffmann, Angelica [1741–1807]. *La "Memoria delle pitture."* Edited by Carlo Knight. Rome: De Luca, 1998.

**Keener and Lorsch 1988**

Keener, Frederick M., and Susan E. Lorsch, eds. *Eighteenth-Century Women and the Arts*. New York: Greenwood Press, 1988.

**Kelly 1980**

Kelly, Cathie C. "Ludovico Rusconi Sassi and Early Eighteenth-Century Architecture in Rome." Ph.D. diss., University Park, Pa.: The Pennsylvania State University, 1980.

**Kelly 1991**

Kelly, Cathie C. "Carlo Rainaldi, Nicola Michetti, and the Patronage of Cardinal Giuseppe Sacripante." *Journal of the Society of Architectural Historians*, vol. 50 (1991), pp. 57–67.

**Kelly 1992**

Kelly, Cathie C. "Paolo Posi, Alessandro Dori, and the Palace for the Papal Family on the Quirinal Hill." In Millon and Munshower 1992. Vol. 2, pp. 816–57.

**Kenworthy-Browne 1979**

Kenworthy-Browne, John. "Establishing a Reputation: Joseph Nollekens, the Years in Rome, I." *Country Life* (June 7, 1979), pp. 1844–48.

**Kenworthy-Browne 1979, "Nollekens"**

Kenworthy-Browne, John. "Genius Recognised: Joseph Nollekens, the Years in Rome, II." *Country Life* (June 14, 1979), pp. 1930–31.

**Kenworthy-Browne 1998**

Kenworthy-Browne, John. "Terracotta Models by Joseph Nollekens, R. A." *The Sculpture Journal*, vol. 2 (1998), pp. 72–84.

**Kerber 1968**

Kerber, Bernhard. "Giuseppe Bartolomeo Chiari." *The Art Bulletin*, vol. 50 (1968), pp. 75–86.

**Kerber 1971**

Kerber, Bernhard. *Andrea Pozzo*. Berlin and New York: Walter de Gruyter, 1971.

**Kerslake 1977**

Kerslake, John. *Early Georgian Portraits*. 2 vols. London: Oxford University Press, 1977.

**Keutner 1957–58**

Keutner, Herbert. "Critical Remarks on the Work of Agostino Cornacchini." *The North Carolina Museum of Art Bulletin*, vol. 1 (1957–58), pp. 13–22.

**Keutner 1958**

Keutner, Herbert, ed. "The Life of Agostino Cornacchini by Francesco Maria Niccolò Gabburri." *The North Carolina Museum of Art Bulletin*, vol. 2 (1958), pp. 37–42.

**Keutner 1969**

Keutner, Herbert. *Sculpture: Renaissance to Rococo*. Translated by John Willett. London: George Rainbird, 1969.

**Kiene 1990**

Kiene, Michael. "Musique, peinture et fête: un fête au théâtre Argentina de Rome à l'occasion du mariage du Dauphin de France en 1747." *Revue de l'art*, no. 88 (1990), pp. 21–30.

**Kiene 1990–91**

Kiene, Michael. "Giovanni Paolo Panninis Expertisen für Marchese Capponi und seine Galeriebild für Kardinal Valenti Gonzaga." *Römisches Jahrbuch der Biblioteca Hertziana*, vol. 26 (1990–91), pp. 257–301.

**Kiene 1992**

Kiene, Michael. *Pannini*. Paris: Réunion des Musées Nationaux, 1992.

**Kieven 1987**

Kieven, Elisabeth. "Rome in 1732: Alessandro Galilei, Nicola Salvi, Ferdinando Fuga." In Hager and Munshower 1987, pp. 255–75.

**Kieven 1988**

Kieven, Elisabeth. *Ferdinando Fuga e l'architettura romana del Settecento: i disegni di architettura dalle collezioni del Gabinetto Nazionale delle Stampe, il Settecento*. Rome: Multigrafica, 1988.

**Kieven 1989**

Kieven, Elisabeth. "Überlegungen zu Architektur und Ausstattung der Cappella Corsini." In Debenedetti 1989, pp. 69–95.

**Kieven 1991**

Kieven, Elisabeth, ed. *Architettura del Settecento a Roma: nei disegni della raccolta grafica comunale*. Rome: Carte Segrete, 1991.

**Kieven 1991, "Il ruolo"**

Kieven, Elisabeth. "Il ruolo del disegno: il concorso per la facciata di S. Giovanni in Laterano." In Contardi and Curcio 1991, pp. 78–123.

**Kieven 1992**

Kieven, Elisabeth. "'Sempre si fantastica per San Pietro': Ein Projekt des jungen Valadier für die Sakristei von St. Peter." In Millon and Munshower 1992. Vol. 2, pp. 910–17.

**Kieven 1993**
Kieven, Elisabeth, ed. *Von Bernini bis Piranesi: Römische Architekturzeichnungen des Barock*. Stuttgart, Germany: Hatje, 1993.

**Kieven 1993, "Roman Architecture"**
Kieven, Elisabeth. "Roman Architecture in the Time of Piranesi, 1740–1776." In Denison, Rosenfeld, and Wiles 1993, pp. xv–xxiv.

**Kieven 1995**
Kieven, Elisabeth. "Schlaun in Rom." In Klauss Bussmann, Florian Matzner, and Ulrich Schulze, eds., *Johann Conrad Schlaun, 1695–1773: Architektur des Spätbarock in Europa*, pp. 135–71. Stuttgart, Germany: Oktagon, 1995.

**Kieven 1996**
Kieven, Elisabeth. "Marchionni, Carlo." In DA, vol. 20, pp. 392–94.

**Kieven and Pinto 2000**
Kieven, Elisabeth, and John Pinto. *Architecture and Sculpture in Eighteenth-Century Rome: Drawings by Pietro and Virginio Bracci in the Canadian Centre and Other Collections*. University Park, Pa.: The Pennsylvania State University Press. Forthcoming.

**King 1991**
King, David N. *The Complete Works of Robert and James Adam*. Boston: Butterworth Architecture, 1991.

**Kirby 1952**
Kirby, Paul Franklin. *The Grand Tour in Italy (1700–1800)*. New York: S. F. Vanni, 1952.

**Kirkpatrick 1953**
Kirkpatrick, Ralph. *Domenico Scarlatti*. Princeton, N.J.: Princeton University Press, 1953.

**Kitao 1974**
Kitao, Timothy K. *Circle and Oval in the Square of Saint Peter's: Bernini's Art of Planning*. New York: New York University Press for the College Art Association, 1974.

**Kleiner 1992**
Kleiner, Diana E. E. *Roman Sculpture*. New Haven and London: Yale University Press, 1992.

**Knight 1905**
Knight, Phillipina [1728–1799]. *Lady Knight's Letters from France and Italy, 1776–1795*. Edited by Elizabeth F. Elliott-Drake. London, 1905.

**Knowles [1831] 1982**
Knowles, John. *The Life and Writings of Henry Fuseli*. 3 vols. 1831. Reprint, with a new introduction by D.H. Weinglass, Millwood, N.Y.: Kraus, 1982.

**Kosareva 1961**
Kosareva, Nina. *Kanova i ego proizvedeniia v Ermitazhe*. Leningrad: Izd-vo Gos., Ermitazha, 1961.

**Kragelund 1983**
Kragelund, Patrick. "The Church, the Revolution and the 'Peintre Philosophe.'" *Hafnia: Copenhagen Papers in the History of Art*, vol. 9 (1983), pp. 25–65.

**Kragelund 1987**
Kragelund, Patrick. "Abildgaard around 1800: His Tragedy and Comedy." *Analecta Romana Instituti Danici*, vol. 16 (1987), pp. 137–85.

**Kragelund 1989**
Kragelund, Patrick. "Abildgaard, Homer and the Dawn of the Millennium." *Analecta Romana Instituti Danici*, vol. 17–18 (1989), pp. 181–224.

**Kragelund 1991**
Kragelund, Patrick. "Abildgaard and Thorvaldsen." In Kragelund and Nykjær 1991, pp. 193–98.

**Kragelund 1999**
Kragelund, Patrick. *Abildgaard*. 2 vols. Copenhagen: Museum Tusculanums Forlag, 1999, pp. 210–24.

**Kragelund and Nykjær 1991**
Kragelund, Patrick, and Mogens Nykjær, eds. *Thorvaldsen: l'ambiente, l'influsso et il mito*. Rome: L'Erma di Bretschneider, 1991.

**Kronbichler 1998**
Kronbichler, Johann. *Meisterwerke europäischer Kunst: 1200 Jahre Erzbistum Salzburg*. Salzburg, Geramny: Dommuseum zu Salzburg, 1998.

**Krönig and Wegner 1994**
Krönig, Wolfgang, and Reinhard Wegner. *Jakob Philipp Hackert: Der Landschaftsmaler der Goethezeit*. Cologne: Böhlau; Vienna: Weimar, 1994.

**Kunze 1997**
Kunze, Matthias. "Cavallucci, Antonio." In AKL, vol. 17, pp. 377–79.

**Kuznetsova and Georgievskaya 1979**
Kuznetsova, Irina, and Evgenia Georgievskaya. *French Painting from the Pushkin Museum: 17th to 20th Century*. New York: Abrams; Leningrad: Aurora Art Publishers, 1979.

**Ladendorf 1935**
Ladendorf, H. "Rusconi, Camillo." In Thieme and Becker, vol. 29, p. 221.

**Lafitau 1752**
Lafitau, Pierre-François. *La Vie de Clement XI*. Padua, Italy: Jacques Manfré, 1752.

**Lagrange 1864**
Lagrange, Léon. *Joseph Vernet et la peinture au XVIIIe siècle*. Paris: Didier, 1864.

**Lamers 1995**
Lamers, Petra. *Il viaggio nel sud dell'Abbé de Saint-Non: il "Voyage pittoresque à Naples et en Sicile," la genesi, i disegni preparatori, le incisioni*. Naples: Electa, 1995.

**Lami 1910**
Lami, Stanislas. *Dictionnaire des sculpteurs de l'Ecole Française au dix-huitième-siècle*. Vol. 1. Paris: Honoré Champion, 1910.

**Lami 1911**
Lami, Stanislas. *Dictionnaire des sculpteurs de l'Ecole Française au dix-huitième-siècle*. Vol. 2. Paris: Honoré Champion, 1911.

**Lankheit 1962**
Lankheit, Klaus. *Florentinische Barockplastik: Die Kunst am Hofe der letzten Medici, 1670–1743*. Munich: F. Bruckmann, 1962.

**Lanzi 1795–96**
Lanzi, Luigi. *Storia pittorica della Italia dal risorgimento delle belle arti fin presso al fine del XVIII secolo*. 2 vols. Bassano, Italy: G. Remondini, 1795–96.

**Lanzi 1809**
Lanzi, Luigi. *Storia pittorica della Italia: dal risorgimento delle belle arti fin presso al fine del XVIII secolo*. 6 vols. Bassano, Italy: G. Remondini, 1809.

**Lanzi [1809] 1847**
Lanzi, Luigi. *The History of Painting in Italy from the period of the Revival of the Fine Arts to the End of the Eighteenth Century*. 6 vols. Bassano, Italy: G. Remondini, 1809; Translated by Thomas Roscoe. 3 vols. London: Henry G. Bohn, 1847.

**Larre 1998**
Larre, Virginie. "Vendu, volé, saisi, pillé: le 'muséum' de Mgr. de Thémines ou le destin d'une grande collection au XVIIIe siècle." *Gazette des Beaux-Arts*, 6th ser., vol. 131 (1998), pp. 53–96.

**Laskin 1968**
Laskin, Myron. "Corrado Giaquinto's 'St. Helena and the Emperor Constantine Presented by the Virgin to the Trinity.'" *Museum Monographs*, vol. 1 (1968), pp. 29–40.

**Laureati and Trezzani 1993**
Laureati, Laura, and Ludovica Trezzani, eds. *Pittura antica: la decorazione murale*. Milan: Electa, 1993.

**Lavagnino 1942**
Lavagnino, Emilio. "Palazzo Colonna e l'architetto romano Niccolò Michetti." *Capitolium*, vol. 17 (1942), pp. 139–47.

**Lavalle 1981**
Lavalle, Denis. "Une Décoration à Rome au milieu du XVIIIe siècle: le choeur de l'église Saint-Louis-des-Français." In *Les Fondations nationales dans la Rome pontificale*, pp. 249–331. Rome: École française de Rome and Académie de France, 1981.

**Laveissière et al. 1983**
Laveissière, Sylvain, et al. *Bénigne Gagneraux (1756–1795): un pittore francese nella Roma di Pio VI*. Rome: De Luca, 1983.

**Lavin 1957**
Lavin, Irving. "Decorazioni barocche in San Silvestro in Capite a Roma." *Bollettino d'arte*, 4th ser., vol. 42 (1957), pp. 44–49.

**Lazzareschi 1930**
Lazzareschi, Emilio. "La Villa Mansi a Segromigno e le pitture di Stefano Tofanelli." *Bollettino storico lucchese*, vol. 2 (1930), pp. 196–219.

**Leander Touati 1998**
Leander Touati, Anne-Marie. *Ancient Sculptures in the Royal Museum: The Eighteenth-Century Collection in Stockholm*. Stockholm: The Swedish National Museums and the Swedish Institute in Rome, 1998.

**Leclère 1913**
Leclère, Tristan. *Hubert Robert et les paysagistes français du XVIIIe siècle*. Paris: H. Laurens, 1913.

**Lecoq 1983**
Lecoq, Anne-Marie. "La Peinture en personne." In Pierre Georgel and Anne-Marie Lecoq, *La peinture dans la peinture*, pp. 2–47. Dijon, France: Musée des Beaux-Arts, 1983.

**Leeuw 1984**
Leeuw, Ronald de. *Herinneringen aan Italië: kunst en toerisme in de 18de eeuw*. Zwolle, Netherlands: Waanders, 1984.

**Lefevre 1973**
Lefevre, Renato. *Palazzo Chigi*. Rome: Editalia, 1973.

**Legrand 1991**
Legrand, Catherine. "Deux artistes romains des XVIIe et XVIIIe siècles, Giuseppe et Pier Leone Ghezzi: de nouvelles propositions." *Revue du Louvre*, vol. 41, no. 3 (1991), pp. 44–60.

**Legrand and d'Ormesson-Peugeot 1990**
Legrand, Catherine, and Domitilla d'Ormesson-Peugeot. *La Rome baroque de Maratti à Piranèse: dessins du Louvre et des collections publiques françaises*. Paris: Réunion des Musées Nationaux, 1990.

**Le Moël and Rosenberg 1969**
Le Moël, Michel, and Pierre Rosenberg. "La Collection de tableaux du Duc de Saint-Aignan e le catalogue de sa vente illustré par Gabriele de Saint-Aubin." *Revue de l'art*, no. 6 (1969), pp. 51–67.

**Lettera 1757**
*Lettera di un amico ad un accademico di S. Luca sopra alcuni decreti di quell'Accademia pubblicati contro al sig. cavalier Marco Benefial*. Livorno, Italy: Anton Santini & Compagni, 1757.

**Levey 1957**
Levey, Michael. "Panini, St. Peter's, and Cardinal de Polignac." *The Burlington Magazine*, vol. 99 (1957), pp. 53–54, 56.

**Levey 1965**
Levey, Michael. "A New Identity for Saly's 'Bust of a Young Girl.'" *The Burlington Magazine*, vol. 107 (1965), pp. 91–92.

**Levey 1966**
Levey, Michael. *Rococo to Revolution: Major Trends in Eighteenth-Century Painting*. New York and Washington, D.C.: Praeger, 1966.

**Levey 1993**
Levey, Michael. *Painting and Sculpture in France, 1700–1789*. New Haven and London: Yale University Press, 1993.

**Levitine 1978**
Levitine, George. *Girodet-Trioson: An Iconographical Study*. New York and London: Garland, 1978.

**Levy 1993**
Levy, Evonne Anita. "A Canonical Work of an Uncanonical Era: Re-reading the Chapel of Saint Ignatius (1695–1699) in the Gesù of Rome." 2 vols. Ph.D. diss., Princeton, N.J.: Princeton University, 1993.

**Lewis 1961**
Lewis, Lesley. *Connoisseurs and Secret Agents in Eighteenth-Century Rome*. London: Chatto & Windus, 1961.

**Licht 1983**
Licht, Fred. *Canova*. New York: Abbeville Press, 1983.

**Lindeman 1942**
Lindeman, C.M.A.A. "Een tweetal onbekende ontwerpen voor den H. Bruno van Houdon." *Maandblad voor Beeldende Kunsten*, vol. 19, no. 10 (1942), pp. 228–35.

**Lipinsky 1971**
Lipinsky, Angelo. "Arte orafa a Roma: Giovanni Giardini da Forlì." *Arte illustrata*, vol. 4, no. 45–46 (1971), pp. 18–34.

**Lizzani 1970**
Lizzani, Goffredo. *Il mobile romano*. Milan: Görlich, 1970.

**Lloyd Williams 1994**
Lloyd Williams, Julia. *Gavin Hamilton, 1723–1798*. Edinburgh: National Galleries of Scotland, 1994.

**Lo Bianco 1985**
Lo Bianco, Anna. *Pier Leone Ghezzi pittore*. Palermo, Italy, and São Paulo, Brazil: Italo-Latino- Americana Palma, 1985.

**Lo Bianco 1985, "Vita"**
Lo Bianco, Anna. "La vita di Clemente XI Albani: venti incisioni dai disegni di Pier Leone Ghezzi." In Debenedetti 1985, pp. 13–41.

**Lo Bianco 1997**
Lo Bianco, Anna. "Il dandy della pittura." *FMR*, vol. 123 (1997), pp. 63–84.

**Lo Bianco 1999**
Lo Bianco, Anna, ed. *Pier Leone Ghezzi: Settecento alla moda*. Venice: Marsilio, 1999.

**In lode delle belle arti 1775**
*In lode delle belle arti. Orazioni e componimenti poetici detti in Campidoglio in occasione della festa del concorso celebrata dall'Insigne Accademia del Disegno di S. Luca, essendo principe di essa il signor Carlo Marchionni l'anno 1775.* Rome: Casaletti, 1775.

**In lode delle belle arti 1786**
*In lode delle belle arti. Orazioni e componimenti poetici. Relazione del concorso e de' premj distribuiti in Campidoglio dall'Insigne Accademia del Disegno in S. Luca nel dì 12 giugno 1786 secondo l'istituzione del nobil uomo Carlo Pio Balestra, essendo principe dell'Accademia il signor Antonio de Maron pittore.* Rome: Casaletti, 1786.

**Lo Gatto 1935**
Lo Gatto, Ettore. *Gli artisti italiani in Russia.* Vol. 2. Rome: La Libreria dello Stato, 1935.

**Loire 1993**
Loire, Stéphane. "Panini e i pittori francesi a Roma (1711–1765)." In Arisi 1993, pp. 53–70.

**Loire 1998**
Loire, Stéphane, ed. *La Collection Lemme: tableaux romains des XVIIe et XVIIIe siècles.* Paris: Réunion des Musées Nationaux, 1998.

**Loisel-Legrand 1995**
Loisel-Legrand, Catherine. "Placido Costanzi a Siena." *Prospettiva,* vol. 80 (1995), pp. 90–94.

**Lorenz 1981**
Lorenz, Hellmut. "Unbekannte Projekte für die Fassade von San Giovanni in Laterano." *Wiener Jahrbuch für Kunstgeschichte,* vol. 34 (1981), pp. 183–87.

**Lorenzetti 1934**
Lorenzetti, Costanza. *Gaspare Vanvitelli.* Milan: Fratelli Treves, 1934.

**Loret 1935**
Loret, Mattia. "Pier Leone Ghezzi." *Capitolium,* vol. 11 (1935), pp. 291–307.

**Lotz 1969**
Lotz, Wolfgang. "Die Spanische Treppe: Architektur als Mittel der Diplomatie." *Römisches Jahrbuch für Kunstgeschichte,* vol. 12 (1969), pp. 39–94.

**Loukomski and Nolhac 1930**
Loukomski, Georges K., and Pierre de Nolhac. *La Rome d'Hubert Robert.* Paris: Vincent, Freal, 1930.

**Lucatelli 1750**
Lucatelli, Giampietro. *Museo Capitolino, o sia, descrizione delle statue, busti, bassirilievi, urne sepolcrali, iscrizioni, ed altre ammirabili, ed erudite antichità.* Rome: Stamperia del Bernabò e Lazzarini, 1750.

**Luchs 1996**
Luchs, Alison. "Righetti, Francesco." In DA, vol. 26, p. 389.

**"Ludovisi" 1929**
"Ludovisi, Bernardino." In Thieme and Becker, vol. 23, p. 442.

**Lugt 1938–87**
Lugt, Frits. *Répertoire des catalogues de ventes publiques.* 4 vols. The Hague: Nijhoff, 1938–87.

**Luigi Sabatelli 1900**
*Luigi Sabatelli sul cav. Prof. Luigi Sabatelli a ricordi scritti da lui medesimo e raccolti dal figlio Gaetano pittore.* Milan, 1900.

**Luigi Vanvitelli 1979**
*Luigi Vanvitelli e il '700 europeo: Congresso internazionale di studi, Napoli-Caserta 5–10, novembre 1973.* 2 vols. Naples: Istituto di Storia dell'Architettura, Università di Napoli, 1979.

**Lutterotti 1985**
Lutterotti, Otto R. Von. *Joseph Anton Koch, 1786–1839: Leben und Werk.* Vienna: Herold, 1985.

**Luzi 1894**
Luzi, Emidio. *Cenno storico critico descrittivo della Cattedrale Basilica di Ascoli Piceno.* Ascoli Piceno, Italy: Cesari, 1894.

**Lyle 1984**
Lyle, Janice. "Dante in British Art: 1770–1830." Ph.D. diss., Santa Barbara, Calif.: University of California, Santa Barbara, 1984.

**Macandrew 1978**
Macandrew, Hugh. "A Group of Batoni Drawings at Eton College, and Some Eighteenth-Century Italian Copyists of Classical Sculpture." *Master Drawings,* vol. 16 (1978), pp. 131–50.

**MacDonald and Pinto 1995**
MacDonald, William L., and John Pinto. *Hadrian's Villa and Its Legacy.* New Haven and London: Yale University Press, 1995.

**Macmillan 1986**
Macmillan, Duncan. *Painting in Scotland: The Golden Age.* Oxford: Phaidon, 1986.

**Macmillan 1994**
Macmillan, Duncan. "Woman as Hero: Gavin Hamilton's Radical Alternative." In Perry and Rossington 1994, pp. 78–98.

**Magnanimi 1980**
Magnanimi, Giuseppina, ed. "Inventari della collezione romana dei principi Corsini." *Bollettino d'arte,* 6th ser., vol. 65, no. 7 (1980), pp. 91–126.

**Magnanimi 1980, "Inventari"**
Magnanimi, Giuseppina, ed. "Inventari della collezione romana dei principi Corsini." *Bollettino d'arte,* 6th ser., vol. 65, no. 8 (1980), pp. 73–114.

**Magni 1984**
Magni, Mariaclotilde. "Documenti per il pittore Giuseppe Bottani." *Arte lombarda,* n.s., vol. 68–69 (1984), pp. 147–50.

**Majo, Jørnaes, and Susinno 1989**
di Majo, Elena, Bjarne Jørnaes, and Stefano Susinno, eds. *Bertel Thorvaldsen, 1770–1844: scultore danese a Roma.* Rome: De Luca, 1989.

**Malamani 1888**
Malamani, Vittorio. *Memorie del Conte Leopoldo Cicognara Tratte dai documenti originali.* 2 vols. Venice: I. Merlo, 1888.

**Malamani 1911**
Malamani, Vittorio. *Canova: la vita—le opere.* Milan: U. Hoepli, 1911.

**Mallory 1974**
Mallory, Nina A. "Notizie sulla scultura a Roma nel XVIII secolo (1719–1760)." *Bollettino d'arte,* 5th ser., vol. 59, no. 3–4 (1974), pp. 164–77.

**Mallory 1976**
Mallory, Nina A. "Notizie sulla pittura a Roma nel XVIII secolo (1718–1760)." *Bollettino d'arte,* 5th ser., vol. 61, no. 1–2 (1976), pp. 102–13.

**Mallory 1977**
Mallory, Nina A. *Roman Rococo Architecture from Clement XI to Benedict XIV (1700–1758).* New York: Garland, 1977.

**Mancini 1968**
Mancini, Claudio M., ed. "Le 'Memorie del cav. Leone Ghezzi scritte da sé medesimo da gennaio 1731 a luglio 1734.'" *Palatino,* vol. 12 (1968), pp. 480–87.

**Mancini 1983**
Mancini, Paolo. "La cappella di S. Bonaventura nella Basilica dei SS. Dodici Apostoli e Michelangelo Simonetti." *Alma Roma,* vol. 24 (1983), pp. 10–16.

**Manfredi 1991**
Manfredi, Tommaso. "Specchi, Alessandro." In Contardi and Curcio 1991, pp. 445–48.

**Manfredi 1995**
Manfredi, Tommaso. "Funzione e rappresentazione nell'insediamento dei Corsini a Roma e Anzio." In Simoncini 1995, pp. 399–411.

**Mangili 1991**
Mangili, Renzo. *Giuseppe Diotti nell'accademia tra neoclassicismo e romanticismo storico.* Milan: Mazzotta, 1991.

**Mankowski 1948**
Mankowski, Tadeusz. *Rzezby zbioru Stanisława Augusta.* Kraków, Poland: Nakladem polskiej akademii umiejetnosci, 1948.

**Mann 1997**
Mann, Judith Walker. *Baroque into Rococo: Seventeenth- and Eighteenth-Century Italian Paintings.* Vol. 22 of Saint Louis Art Museum Winter 1997 Bulletin. St. Louis: St. Louis Art Museum, 1997.

**Manners and Williamson 1924**
Manners, Lady Victoria, and G. C. Williamson. *Angelika Kauffmann, R. A.: Her Life and Her Works.* London: John Lane the Bodley Head Limited, 1924.

**Mansfeld 1955**
Mansfeld, Heinz. "Der Bildhauer Jean Antoine Houdon (1741–1828): Seine Zeit, sein Werk in Deutschland." Ph.D. diss., Greifswald, Germany: Universität Greifswald, 1955.

**Mantova nel Settecento 1983**
Palazzo della Ragione, Mantua. *Mantova nel Settecento: un ducato ai confini dell'impero.* Milan: Electa, 1983.

**Mantura and Lacambre 1996**
Mantura, Bruno, and Geneviève Lacambre, eds. *Pierre-Henri de Valenciennes, 1750–1819.* Naples: Electa, 1996.

**Marangoni 1744**
Marangoni, Giovanni. *Delle cose gentilesche, e profane trasportate ad uso, e adornamento delle chiese.* Rome: Stamperia di Niccolò e Marco Pagliarini, 1744.

**Marchionne Gunter 1997**
Marchionne Gunter, Alfredo. "Una segnalazione berniniana: i 'due angioli di marmo sbozzati' da casa Bernini a Sant'Andrea delle Fratte." *Studi romani,* vol. 45 (1997), pp. 97–101.

**Marconi 1963**
Marconi, Paolo. "Contributi alla conoscenza della vita e dell'opera giovanile di Giuseppe Valadier architetto romano." *Quaderni dell'Istituto di Storia dell'Architettura,* 10th ser., nos. 55–60 (1963), pp. 75–139.

**Marconi 1964**
Marconi, Paolo. *Giuseppe Valadier.* Rome: Officina, 1964.

**Marconi, Cipriani, and Valeriani 1974**
Marconi, Paolo, Angela Cipriani, and Enrico Valeriani. *I disegni di architettura dell'Archivio storico dell'Accademia di San Luca.* 2 vols. Rome: De Luca, 1974.

**Marcucci 1942**
Marcucci, Luisa. "L'arte di Pompeo Batoni." *Bollettino storico lucchese,* vol. 14 (1942), pp. 3–17.

**Marcucci 1944**
Marcucci, Luisa. "Pompeo Batoni a Forlì." *Emporium,* vol. 99 (1944), pp. 95–105.

**Marder 1974**
Marder, Tod A. "Piazza della Rotonda e la Fontana del Pantheon: un rinnovamento urbanistico di Clemente XI." *Arte illustrata,* vol. 7, no. 59 (1974), pp. 310–20.

**Marder 1975**
Marder, Tod A. "The Porto di Ripetta in Rome." Ph.D. diss., New York: Columbia University, 1975.

**Marder 1978**
Marder, Tod A. "The Destruction of the Porto di Ripetta in Rome." *Storia della Città,* no. 9 (1978), pp. 62–70.

**Marder 1980**
Marder, Tod A. "The Porto di Ripetta in Rome." *Journal of the Society of Architectural Historians,* vol. 39 (1980), pp. 28–56.

**Marder 1980, "Specchi"**
Marder, Tod A. "Specchi's High Altar for the Pantheon and the Statues by Cametti and Moderati." *The Burlington Magazine,* vol. 122 (1980), pp. 30–40.

**Marder 1989**
Marder, Tod A. "Bernini and Alexander VII: Criticism and Praise of the Pantheon in the Seventeenth Century." *The Art Bulletin,* vol. 71 (1989), pp. 628–45.

**Margutti 1886**
Margutti, Alfredo. "Escursione artistica per Sinigallia." *Arte e Storia,* vol. 5, no. 25–26 (1886), pp. 186–88.

**Mariette 1851–60**
Mariette, Pierre-Jean. *Abecedario de P. J. Mariette et autres notes inédites de cet amateur sur les arts et les artistes.* Edited by Philippe de Chennevières and Anatole de Montaiglon. 6 vols. Paris: J. B. Dumoulin, 1851–60.

**Marinelli 1993**
Marinelli, Claudio, ed. *L'esercizio del disegno: i Vanvitelli.* Ancona, Italy: Il lavoro, 1993.

**Marini 1988**
Marini, Giorgio, ed. *Giovanni Volpato, 1735–1803.* Bassano del Grappa, Italy: Ghedini & Tassotti, 1988.

**Marini M. 1976**
Marini, Maurizio. "La pala d'altare di Simon Vouet per la cappella Alaleoni in San Lorenzo in Lucina." *Ricerche di storia dell'arte,* vol. 1–2 (1976), pp. 157–63.

**Marino 1981**
Palazzo Colonna, Marino, Italy. *Marino e i Colonna (1500–1800).* Rome: De Luca, 1981.

**Marrini 1765–66**
Marrini, Orazio. *Serie di ritratti di celebri pittori dipinti di propria mano: in seguito a quella già pubblicata nel Museo Fiorentino.* 2 vols. Florence: Stamperia Moückiana, 1765–66.

**Marshall 1997**
Marshall, D. R. "Early Panini Reconsidered: The Esztergom 'Preaching of an Apostle' and the Relationship between Panini and Ghisolfi." *Artibus et Historiae,* vol. 18 (1997), pp. 137–99.

**Martin 1996**
Martin, Frank. "Camillo Rusconi: il fauno di Berlino e una ipotesi." *Antologia di Belle Arti,* n.s., nos. 52–55 (1996), pp. 126–31.

**Martin 1998**
Martin, Frank. "'L'emulazione della romana antica grandezza': Camillo Rusconis Grabmal für Gregor XIII." *Zeitschrift für Kunstgeschichte,* vol. 61 (1998), pp. 77–111.

**Martin S. 1997**
Martin, Susanne Christine. "Busiri, Giovanni Battista." In AKL, vol. 15, pp. 329–30.

**Martineau and Robison 1994**
Martineau, Jane, and Andrew Robison, eds. *The Glory of Venice: Art in the Eighteenth Century*. New Haven and London: Yale University Press, 1994.

**Martin von Wagner Museum 1976**
Martin von Wagner Museum, Würzburg, Germany. *Römische Barockzeichnungen*. Würzburg, Germany: Martin von Wagner Museum, 1976.

**Martinelli 1953**
Martinelli, Valentino. "Due modelli di Camillo Rusconi ritrovati." *Commentari*, vol. 4 (1953), pp. 231–41.

**Martinelli 1959**
Martinelli, Valentino. "Un modello di Angelo de Rossi per la statua di Alessandro VIII Ottoboni in San Pietro." *Studi romani*, vol. 7 (1959), pp. 429–37.

**Martinelli 1969**
Martinelli, Valentino. "Un bozzetto in terracotta di Filippo Della Valle per una statua di Clemente XII Corsini." *Bollettino dei musei comunali di Roma*, vol. 16 (1969), pp. 1–12.

**Martinelli 1990**
Martinelli, Valentino, ed. *Giuseppe e Pier Leone Ghezzi*. Rome: Palombi, 1990.

**Martin-Méry 1965**
Martin-Méry, Gilberte. *Chefs-d'oeuvre de la peinture française dans les musées de l'Ermitage et de Moscou*. Bordeaux, France: Delams, 1965.

**Masini 1841**
Masini, Cesare. *Elogio storico del cavaliere Gaspare Landi, pittore piacentino, recitato all'Accademia Tiberina nel dì 25 maggio 1840 da Cesare Masini bolognese. pittore d'istoria*. Rome: C. Puccinelli, 1841.

**Mason 1951**
Mason, Eudo C. *The Mind of Henry Fuseli: Selections from His Writings*. London: Routledge & Kegan Paul, 1951.

**Matitti 1994**
Matitti, Flavia, ed. *Il Baciccio illustratore*. Rome: Antonio Pettini, 1994.

**Matitti 1994, "Santa Genuinda"**
Mattiti, Flavia. "La 'Santa Genuinda' e il cardinale Pietro Ottoboni." In Mattiti 1994, pp. 34–60.

**Matitti 1995**
Matitti, Flavia. "Il cardinale Pietro Ottoboni mecenate delle arti: cronache e documenti (1689–1740)." *Storia dell'arte*, vol. 84 (1995), pp. 156–243.

**Matthiae 1952**
Matthiae, Guglielmo. *Ferdinando Fuga e la sua opera romana*. Rome: Palombi, 1952.

**Matthiae 1954**
Matthiae, Guglielmo. "Nicola Salvi minore." *Palladio*, n.s., vol. 4 (1954), pp. 161–70.

**Matthiesen 1987**
Matthiesen Fine Art, London. *The Settecento: Italian Rococo and Early Neo-Classical Paintings, 1700–1800*. London: Matthiesen Fine Art, 1987.

**Maue and Brink 1989**
Maue, Hermann, and Sonja Brink. *Die Grafen von Schönborn: Kirchenfürsten, Sammler, Mäzene*. Nuremberg, Germany: Germanisches Nationalmuseum, 1989.

**Mauriès 1987**
Mauriès, Patrick. "Subleyras." *FMR* (French edition), vol. 7 (1987).

**Maxon 1970**
Maxon, John. *The Art Institute of Chicago*. London: Thames & Hudson, 1970.

**Maxon and Rishel 1970**
Maxon, John, and Joseph J. Rishel, eds. *Painting in Italy in the Eighteenth Century: Rococo to Romanticism*. Chicago: The Art Institute of Chicago, 1970.

**Mazzocca 1981**
Mazzocca, Fernando. "L'illustrazione romantica." In vol. 2 of *Storia dell'arte italiana*, pp. 323–415. Turin, Italy: Giulio Einaudi, 1981.

**McCormick 1963**
McCormick, Thomas J. "An Unknown Collection of Drawings by Charles-Louis Clérisseau." *Journal of the Society of Architectural Historians*, vol. 22 (1963), pp. 119–26.

**McCormick 1964**
McCormick, Thomas J. "Virginia's Gallic Godfather." *Arts in Virginia*, vol. 4 (1964), pp. 2–13.

**McCormick 1978**
McCormick, Thomas J. "Piranesi and Clérisseau's Vision of Classical Antiquity." In Brunel 1978, pp. 303–14.

**McCormick 1990**
McCormick, Thomas J. *Charles-Louis Clérisseau and the Genesis of Neo-Classicism*. Cambridge: MIT Press, 1990.

**McCormick 1994**
McCormick, Thomas J. "Monastic Caprices, the Monastery of Trinità dei Monti: The Ruin Room by Charles-Louis Clérisseau." *FMR*, vol. 14, no. 71 (1994), pp. 31–44.

**McCormick and Fleming 1962**
McCormick, Thomas J., and John Fleming. "A Ruin Room by Clérisseau." *The Connoisseur*, vol. 149 (1962), pp. 239–43.

**Meeks 1966**
Meeks, Carroll L. V. *Italian Architecture, 1750–1914*. New Haven and London: Yale University Press, 1966.

**Mehr Licht 1999**
Städelsches Kunstinstitut und Städtische Galerie, Frankfurt. *Mehr Licht: Europa um 1770: Die bildende Kunst der Aufklärung*. Munich: Klinkhardt & Biermann, 1999.

**Mellini 1983**
Mellini, Gian Lorenzo. "L'Antioco e Stratonice di Gaspare Landi e un altro autoritratto." *Labyrinthos*, vol. 2, no. 3–4 (1983), pp. 29–39.

**Mellini 1987**
Mellini, Gian Lorenzo. "Addenda per Giuseppe Cades." *Labyrinthos*, vol. 6, no. 12 (1987), pp. 3–19.

**Mellini 1987, "Landi"**
Mellini, Gian Lorenzo. "Terzo intervento per Gaspare Landi." *Labyrinthos*, vol. 6, no. 12 (1987), pp. 39–53.

**Mellini 1992**
Mellini, Gian Lorenzo. *Notti romane e altre congiunture pittoriche tra Sette e Ottocento*. Florence: Vallecchi, 1992.

**Mena 1996**
Mena, Manuela. "Maratta, Carlo." In DA, vol. 20, pp. 373–79.

**Mencarini 1967**
Mencarini, Giuseppe. "Il soggiorno romano di Giovanni Battista Dell'Era (da documenti inediti)." *Gutenberg Jahrbuch* (1967), pp. 221–24.

**Mengs 1787**
Mengs, Anton Raphael. *Opere di Antonio Raffaello Mengs*. Rome: Stamperia Pagliarini, 1787.

**Menniti Ippolito 1996**
Menniti Ippolito, Antonio. *Fortuna e sfortune di una famiglia veneziana nel Seicento: gli Ottoboni al tempo dell'aggregazione al patriziato*. Vol. 64 of *Memorie: classe di scienze morali, lettere ed arti*. Venice: Istituto Veneto di Scienze, Lettere ed Arti, 1996.

**Merolla 1988**
Merolla, Riccardo. "Lo stato del chiesa." In *L'età moderna*. Vol. 2 of *Letteratura italiana: storia e geografia*, pp. 1019–1109. Turin, Italy: Giulio Einaudi, 1988.

**Mesuret 1956**
Mesuret, Robert. *Pierre-Henri de Valenciennes*. Toulouse, France: Musée Dupuy, 1956.

**Metz and Rave 1957**
Metz, Peter, and P. O. Rave. "Ein neuerworbene Bildnisbuste des Barons Phillip von Stosch von Edme Bourchardon." *Berliner Museen: Berichte aus den Preussischen Kunstsammlungen*, n.s., vol. 7 (1957), pp. 19–26.

**Metzger Habel 1981**
Metzger Habel, Dorothy. "Piazza S. Ignazio, Rome, in the 17th and 18th Centuries." *Architectura*, vol. 11 (1981), pp. 31–65.

**Mezzetti 1955**
Mezzetti, Amalia. "Contributi a Carlo Maratti." *Rivista dell'Istituto Nazionale d'Archeologia e Storia dell'Arte*, n.s., vol. 4 (1955), pp. 253–354.

**Mich 1986**
Mich, Elvio. "Introduzione ai disegni di Cristoforo Unterperger." In *Scritti in onore di Nicolò Rasmo*, pp. 355–95 Bolzano, Italy: Comune di Bolzano, Assessorato alla cultura, 1986.

**Mich 1990**
Mich, Elvio. "Unterperger, Cristoforo." In *La pittura 1990*. Vol. 2, pp. 887–88.

**Michaelis 1882**
Michaelis, Adolf. *Ancient Marbles in Great Britain*. Translated by C.A.M. Fennell. Cambridge: University Press, 1882.

**Michel 1972**
Michel, Olivier. "Peintres autrichiens a Rome au seconde moitié du XVIIIème siècle." *Römische Historische Mitteilungen*, vol. 14 (1972), pp. 175–98.

**Michel 1981**
Michel, Olivier. "Vita, allievi e famiglia di Sebastiano Conca." In Conca 1981, pp. 35–46.

**Michel 1984**
Michel, Olivier. "François-Marie Poncet (1736–1797) et le retour à l'antique." In *Lyon et l'Italie: six études d'histoire de l'art*, pp. 115–80. Paris: C.N.R.S., 1984.

**Michel 1989**
Michel, Olivier. "Fortune et infortune de Mariano Rossi." *Quaderni dell'Istituto di Storia dell'Arte dell'Università di Messina*, vol. 13 (1989), pp. 99–114.

**Michel 1995**
Michel, Olivier. "Blanchet, Louis-Gabriel." In AKL, vol. 11, pp. 396–97.

**Michel 1995, "Libraire"**
Michel, Olivier. "Un libraire devenu mécène." In *Alla signorina: mélanges offerts à Noëlle de la Blanchardière*, pp. 285–302. Rome: École française de Rome, 1995.

**Michel 1996, "Bianchi"**
Michel, Olivier. "Bianchi, Pietro (i)." In DA, vol. 3, p. 920.

**Michel 1996, "Blanchet"**
Michel, Olivier. "Un pittore francese a Roma, Louis-Gabriele Blanchet." *Strenna dei romanisti*, vol. 57 (1996), pp. 467–86.

**Michel 1996, "Locatelli"**
Michel, Olivier. "Locatelli, Andrea." In DA, vol. 19, pp. 524–25.

**Michel 1996, " Nocchi"**
Michel, Olivier. "Nocchi, Bernardino." In DA, vol. 20, p. 173.

**Michel 1996, "Unterberger"**
Michel, Olivier. "Christoph Unterberger." In DA, vol. 31, p. 679.

**Michel 1996, Vivre et peindre**
Michel, Olivier. *Vivre et peindre à Rome au XVIIIe siècle*. Rome: École française de Rome, 1996.

**Michel 1998**
Michel, Olivier. "La Sculpture religieuse à Rome durant le pontificat de Benoît XIV." In Biagi Maino 1998, pp. 43–58.

**Michel C. 1991**
Michel, Christian. *Le Voyage d'Italie de Charles-Nicolas Cochin (1758)*. Rome: École française de Rome, 1991.

**Michel C. 1993**
Michel, Christian. *Charles-Nicolas Cochin et l'art des lumières*. Rome: École française de Rome, 1993.

**Michel G. 1996**
Michel, Geneviève. "I Pozzi, una famiglia d'artisti: da Vercurago a Roma." In *Pittori bergamaschi* 1996, pp. 1–19.

**Michel G. 1996, "Stefano Pozzi"**
Michel, Geneviève. "Stefano Pozzi: la vita." In *Pittori bergamaschi* 1996, pp. 23–58.

**Michel R. 1981**
Michel, Régis, ed. *David e Roma*. Rome: De Luca, 1981.

**Michel R. 1988**
Michel, Régis. *David: l'art et le politique*. Paris: Gallimard, 1988.

**Michel, R. 1993**
Michel, Régis, ed. *David contre David: actes du colloque organisé au Musée du Louvre par le service culturel du 6 au 10 décembre 1989*. Vol. 1. Paris: La Documentation française, 1993.

**Michel and Michel 1977**
Michel, Geneviève, and Olivier Michel. "La Décoration du Palais Ruspoli en 1715 et la redécouverte de 'Monsù Francesco Borgonone.'" *Mélanges de l'Ecole Française de Rome, Moyen-âge, temps modernes*, vol. 89 (1977), pp. 265–340.

**Michel and Michel 1982**
Michel, Olivier, and Geneviève Michel. "Conca, Tommaso." In DBI, vol. 27, pp. 703–6.

**Michel and Rosenberg 1987**
Michel, Olivier, and Pierre Rosenberg, eds. *Subleyras, 1699–1749*. Paris: Réunion des Musées Nationaux, 1987.

**Michelini Tocci 1977**
Michelini Tocci, L. *Legature papali da Eugenio IV a Paolo VI*. Vatican City: Biblioteca Apostolica Vaticana, 1977.

**Milizia 1781**
Milizia, Francesco. *Memorie degli architetti antichi e moderni*. 3rd ed. 2 vols. Parma, Italy: Stamperia Reale, 1781.

**Milizia 1785**
Milizia, Francesco. *Memorie degli architetti antichi e moderni*. 4th ed. 2 vols. Bassano, Italy: G. Remondini, 1785.

**Milizia 1827**
Milizia, Francesco [1725–1798]. *Memorie degli architetti antichi e moderni*. 2 vols. Bologna, Italy: Cardinali & Frulli, 1827.

**Miller 1777**
Miller, Anna Riggs. *Letters from Italy Describing the Manners, Customs, Antiquities, Paintings, &c. of That Country in the Year MDCCLXX and MDCCLXXI to a Friend Residing in France by an English Woman*. London: Edward & Charles Dilly, 1777.

**Miller D. 1974**
Miller, Dwight C. "An 'Israelites Worshipping The Golden Calf' by Aureliano Milani." *The Burlington Magazine*, vol. 116 (1974), pp. 331–32.

**Miller D. 1996**
Miller, Dwight C. "Milani, Aureliano." In DA, vol. 21, pp. 538–40.

**Millon 1978**
Millon, Henry A. "Vasi—Piranesi—Juvarra." In Brunel 1978, pp. 345–62.

**Millon 1980**
Millon, Henry A., ed. *Studies in Italian Art and Architecture Fifteenth through Eighteenth Centuries*. Vol. 35 of *Memoirs of the American Academy in Rome*. Rome: Elefante, 1980.

**Millon 1984**
Millon, Henry A. *Filippo Juvarra: Drawings from the Roman Period, 1704–1714*. Rome: Elefante, 1984.

**Millon 1984, "Filippo Juvarra"**
Millon, Henry A. "Filippo Juvarra and the Accademia di San Luca in Rome in the Early Eighteenth Century." Hager and Munshower 1984, pp. 13–24.

**Millon 1999**
Millon, Henry A., ed. *Triumph of the Baroque: Architecture in Europe, 1600–1750*. New York: Rizzoli, 1999.

**Millon and Munshower 1992**
Millon, Henry A., and Susan Scott Munshower, eds. *An Architectural Progress in the Renaissance and Baroque: Sojourns In and Out of Italy*. 2 vols. Vol. 8 of *Papers in Art History from The Pennsylvania State University*. University Park, Pa.: The Pennsylvania State University, 1992.

**Minardi 1982**
Galleria Nazionale d'arte moderna, Rome. *Disegni di Tommaso Minardi (1787–1871)*. Rome: De Luca, 1982.

**Ministero della Pubblica Istruzione 1878**
Ministero della Pubblica Istruzione, Italy. *Documenti inediti per servire alla storia dei musei d'Italia*. 4 vols. Florence and Rome: Bencini, 1878.

**Minor 1978**
Minor, Vernon Hyde. "Della Valle and G. B. Grossi Revisited." *Antologia di Belle Arti*, vol. 2 (1978), pp. 233–47.

**Minor 1989**
Minor, Vernon Hyde. "Della Valle, Filippo." In DBI, vol. 37, pp. 744–47.

**Minor 1997**
Minor, Vernon Hyde. *Passive Tranquility: The Sculpture of Filippo Della Valle*. Philadelphia: American Philosophical Society, 1997.

**Minor 1997, "Rusconi"**
Minor, Vernon Hyde. "Rusconi, Camillo." In DA, vol. 27, pp. 346–47.

**Missirini 1823**
Missirini, Melchior, comp. *Memorie per servire alla storia della romana Accademia di S. Luca fino alla morte di Antonio Canova*. Rome: Stamperia de Romanis, 1823.

**Missirini 1824**
Missirini, Melchior, comp. *Della vita di Antonio Canova*. Prato, Italy: Fratelli Giachetti, 1824.

**Mochi Onori 1988**
Mochi Onori, Lorenza. *La Galleria Nazionale d'arte antica: breve guida al Settecento*. Rome: Palombi, 1988.

**Molaioli et al. 1960**
Molaioli, Bruno, et al. *La Peinture italienne au XVIIIe siècle*. Paris: Musée du Petit Palais, 1960.

**Molbech 1814–17**
Molbech, Christian. *Breve fra Sverriage i aaret, 1812*. 3 vols. Copenhagen: A. Seidelin, 1814–17.

**Mongan and Sachs 1940**
Mongan, Agnes, and Paul J. Sachs. *Drawings in the Fogg Museum of Art*. 2 vols. Cambridge: Harvard University Press, 1940.

**Montagu 1971**
Montagu, Jennifer. "Exhortatio ad Virtutem: A Series of Paintings in the Barberini Palace." *Journal of the Warburg and Courtauld Institutes*, vol. 34 (1971), pp. 366–72.

**Montagu 1975**
Montagu, Jennifer. "Camillo Rusconis Büste der Giulia Albani degli Abati Olivieri." *Jahrbuch der Kunsthistorischen Sammlungen in Wien*, vol. 71 (1975), pp. 311–29.

**Montagu 1985**
Montagu, Jennifer. *Alessandro Algardi*. New Haven and London: Yale University Press, 1985.

**Montagu 1989**
Montagu, Jennifer. *Roman Baroque Sculpture: The Industry of Art*. New Haven and London: Yale University Press, 1989.

**Montagu 1993**
Montagu, Jennifer. "Giovanni Battista Maini's Role in Two Sculptural Projects: The Evidence of the Drawings." *Master Drawings*, vol. 31 (1993), pp. 454–63.

**Montagu 1995**
Montagu, Jennifer. "Joao V e la scultura italiana." In Vasco Rocca and Borghini 1995, pp. 385–90.

**Montagu 1996**
Montagu, Jennifer. *Gold, Silver and Bronze: Metal Sculpture of the Roman Baroque*. Princeton, N.J.: Princeton University Press, 1996.

**Montagu 1996, "Statue"**
Montagu, Jennifer. "Alcune statue che non furono mai eseguite." In Rocchi Coopmans de Yoldi 1996, pp. 309–13.

**Montaiglon 1887–1912**
Montaiglon, Anatole de, ed. *Correspondance des directeurs de l'Académie de France à Rome avec les surintendants des bâtiments*. 18 vols. Paris: Charavay Frères, 1887–1912.

**Montanari 1841**
Montanari, Giuseppe Ignazio. *Della vita e delle opere di Giuseppe Ceracchi: scultore romano*. Rimini, Italy: Tipi Marsoner & Grandi, 1841.

**Montfaucon 1702**
Montfaucon, Bernard de. *Diarium italicum: sive monumentorum veterum, bibliothecarum, musaeorum, &c*. Paris: J. Anisson, 1702.

**Montini 1957**
Montini, Renzo Uberto. *Le tombe dei Papi*. Rome: Angelo Belardetti, 1957.

**Moon 1898–1909**
Moon, Robert C. *The Morris Family of Philadelphia, Descendants of Anthony Morris, Born 1654–1721 Died*. Vol. 2. Philadelphia: Moon, 1898–1909.

**Moore 1792**
Moore, John. *A View of Society and Manners in Italy: With Anecdotes Relating to Some Eminent Characters*. 4th ed. 3 vols. Dublin: W. Gilbert, 1792.

**Moore A. 1985**
Moore, Andrew W. *Norfolk and the Grand Tour: Eighteenth-Century Travellers Abroad and Their Souvenirs*. Norfolk, England: Norwich Castle Museum, 1985.

**Moore J. 1995**
Moore, John E. "Prints, Salami, and Cheese: Savoring the Roman Festival of the Chinea." *The Art Bulletin*, vol. 77 (1995), pp. 584–608.

**Morandotti 1996**
Morandotti, Alessandro. "Francesco Corneliani (1742–1814): realtà e senso nella tradizione pittorica lombarda." *Nuovi Studi*, vol. 1 (1996), pp. 73–103.

**Morazzoni 1960**
Morazzoni, Giuseppe. *Le porcellane italiane*. Rev. ed. 2 vols. Milan: Görlich, 1960.

**Morelli 1955–84**
Morelli, Emilia, ed. *Le lettere di Benedetto XIV al card. De Tencin*. 3 vols. Rome: Edizioni di storia e letteratura, 1955–84.

**Morganti 1995**
Morganti, Lucia. "La fabbrica nuova dei padri Teatini in via del Monte della Farina." In Debenedetti 1995, pp. 303–12.

**Moroni 1840–61**
Moroni, Gaetano. *Dizionario di erudizione storico-ecclesiastica da S. Pietro sino ai nostri giorni*. 103 vols. Venice: Emiliana, 1840–61.

**Moschini 1923**
Moschini, Vittorio. "Benedetto Luti." *L'arte*, vol. 26 (1923), pp. 89–114.

**Moschini 1924**
Moschini, Vittorio. "Giaquinto artista rappresentativo della pittura barocca tarda a Roma." *L'arte*, vol. 27 (1924), pp. 104–23.

**Moschini 1925**
Moschini, Vittorio. "Filippo Della Valle." *L'arte*, vol. 28 (1925), pp. 177–90.

**Moschini 1929**
Moschini, Vittorio. "La prima opera di Nicola Salvi." *Roma*, vol. 7 (1929), pp. 345–47.

**Mosco 1970**
Mosco, Maria Maddalena. "Les Trois Manières d'Andrea Locatelli." *Revue de l'art*, no. 7 (1970), pp. 19–39.

**Moselius 1934**
Moselius, Carl David. *Louis Masreliez och Carl August Ehrensvärds Brevväxling*. Stockholm: Föreningen för bokhantverk, 1934.

**Mossetti 1987**
Mossetti, Cristina. "La politica artistica di Carlo Emanuele III." In Sandra Pinto, ed., *Arte di corte a Torino da Carlo Emanuele III a Carlo Felice*, pp. 12–64. Turin, Italy: Cassa di Risparmio di Torino, 1987.

**Mostra in Palazzo Pitti 1922**
Palazzo Pitti, Florence. *Mostra della pittura italiana del Sei e Settecento in Palazzo Pitti*. Rome: Bestetti & Tumminelli, 1922.

**Mostra landiana 1922**
*Mostra landiana*. Piacenza, Italy, 1922.

**Moücke 1752–62**
Moücke, Francesco. *Serie di ritratti degli eccellenti pittori dipinti di propria mano che esistono nell'Imperial Galleria di Firenze: colle vite in compendio de'medesimi*. 4 vols. Florence: Stamperia Moückiana, 1752–62.

**Müller 1797**
Müller, Friedrich. "Schreiben Hern Mullers: Mahlers in Rom, uber die Ankundigung des Herrn Fernow von der Ausstellung des Professors Carstens in Rom." *Die Horen*, vol. 3 (1797).

**Müller W. 1940**
Müller, Walter. "Die plastischen Bildnisse Winckelmanns." *Jahrbuch des Deutschen Archäologischen Instituts*, vol. 55 (1940), pp. 265–75.

**Müller, Wilhelm, 1867**
Müller, Wilhelm. *Karl Ludwig Fernow: Leben und Werke*. Hannover, Germany, 1867.

**Müller, Wilhelm, 1869**
Müller, Wilhelm. *Carstens Werke in Ausgewählten Umriss-Stichen*. Edited by Herman Riegel. Vol. 1. Leipzig, Germany: Alphons Dürr, 1869.

**Muschg 1942**
Muschg, Walter, ed. *Heinrich Füssli: Briefe*. Klosterberg: S. Schwage, 1942.

**Musée du Louvre 1967**
Musée du Louvre, Paris. *Le Cabinet d'un grand amateur: P. J. Mariette, 1694–1774: dessins du XV siècle au XVIII siècle*. Paris: Réunion de Musées Nationaux, 1967.

**Musée Jacquemart-André 1969**
Musée Jacquemart-André, Paris. *Hubert Robert: les sanguines du musée de Valence*. Paris: Musée Jacquemart-André, 1969.

**Museo della casa 1788**
*Museo della casa eccellentissima Farsetti in Venezia*. 1788. Reprinted in Androsov 1991, pp. 140–53.

**Musiari 1995**
Musiari, Antonio. "La lunga stagione classica: Giuseppe Franchi, Camillo Pacetti, Pompeo Marchesi." In Istituto di Storia e Teoria dell'Arte e dell'Istituto di Scultura, Accademia di Belle Arti di Brera, *La città di Brera: due secoli di scultura*, pp. 2–31. Milan: Fabbri, 1995.

**Nappi 1997**
Nappi, Maria Rosaria. "Una committente inglese per l'editoria romana: la Duchessa di Devonshire e l'Eneide di Virgilio." In Debenedetti 1997, pp. 279–89.

**Natoire 1977**
Musée des Beaux-Arts, Troyes, France; Musée des Beaux-Arts, Nîmes, France; Villa Médicis, Rome. *Charles-Joseph Natoire: peintures, dessins, estampes et tapisseries des collections publiques françaises*. Nantes, France: Chiffoleau, 1977.

**Natoli and Scarpati 1989**
Natoli, Marina, and Maria Antonietta Scarpati, eds. *Il Palazzo del Quirinale: il mondo artistico a Roma nel periodo napoleonico*. 2 vols. Rome: Istituto Poligrafico e Zecca dello Stato, Libreria dello Stato, 1989.

**Nava Cellini 1982**
Nava Cellini, Antonia. *La scultura del Settecento*. Turin, Italy: Unione Tipografico-Editrice Torinese, 1982.

**Nava Cellini 1988**
Nava Cellini, Antonia. "Memoria dell'antico: note su Vincenzo Pacetti e Rinaldo Rinaldi." *Paragone*, n.s., vol. 39, no. 465 (1988), pp. 59–67.

**Nazareni 1981**
Galleria Nazionale d'arte moderna, Rome. *I Nazareni a Roma*. Rome: De Luca, 1981.

**Neergaard 1804**
Neergaard, T. C. Brun. "Om de bildende Kunster i Stockholm: Andre Brev." *Minerva* (Copenhagen), vol. 3 (1804), pp. 113–23.

**Negro 1987**
Negro, Angela. "Nuovi documenti per Giuseppe Mazzuoli e bottega nella Cappella Pallavicini Rospigliosi a San Francesco a Ripa: con una nota per Giuseppe Chiari ed un dipinto inedito." *Bollettino d'arte*, 6th ser., vol. 72, no. 44–45 (1987), pp. 157–78.

**Negro 1989**
Negro, Angela. "Agostino Masucci: un soffitto in Palazzo Rospigliosi Pallavicini ed alcune aggiunte." In Teresa Calvano and Mauro Cristofani, eds., *Per Carla Guglielmi: scritti di allievi*, pp. 125–35. Rome: Amici del Tasso, 1989.

**Negro 1993**
Negro, Angela. "Conca, Melchiorri, Procaccini: tre nuovi bozzetti per i profeti del Laterano." In Debenedetti 1993, pp. 125–40.

**Negro 1995**
Negro, Angela. "Benedetto XIII e il Cardinal Ottoboni: quadri e devozione filippina fra riti sacri e mondani." In *Regola e la fama* 1995, pp. 278–95.

**Negro 1996**
Negro, Angela. "Quadri di caccia e di paese: 'Monsù Francesco,' 'Monsù Leandro' ed altri nella decorazione del Castello Rospigliosi di Maccarese." In Debenedetti 1996, pp. 13–36.

**Negroni 1986**
Negroni, Franco. "Più leggero 'l'atelier' di Agostino Cornacchini." *Notizie da Palazzo Albani*, vol. 15 (1986), pp. 68–72.

**Nemilova 1986**
Nemilova, Inna S. *French Painting: Eighteenth Century*. Moscow: Iskusstvo Publishers; Florence: Giunti, 1986.

**Nenci 1994**
Nenci, Chiara. "I disegni di Giovanni Battista Dell'Era presso il Gabinetto Disegni e Stampe degli Uffizi." *Ricerche di storia dell'arte*, vol. 54 (1994), pp. 85–101.

**Nessi 1978**
Nessi, Silvestro. "Un monumento ignorato nell'opera di Camillo Rusconi a Montefalco." *Spoletium*, vol. 23 (1978), pp. 46–53.

**Neuwirth 1989**
Neuwirth, Markus. *J. A. Koch – A. J. Carstens, Die Argonauten: Ein Bilderbuch als Dokument einer Künstlerfreundschaft*. Graz, Austria: Akademische Druck, 1989.

**Neverov 1984**
Neverov, O. "The Lyde Browne Collection and the History of Ancient Sculpture in the Hermitage Museum." *American Journal of Archaeology*, vol. 88 (1984), pp. 33–42.

**Nibby 1839–41**
Nibby, Antonio. *Roma nell'anno 1838*. 2 vols. Rome: Tipografia delle belle arti, 1839–41.

**Noack 1911**
Noack, Friedrich. "Cades, Giuseppe." In Thieme and Becker, vol. 5, p. 342.

**Noack 1912**
Noack, Friedrich. "Conca, Tommaso," In Thieme and Becker, vol. 70, pp. 288–89.

**Noè 1980**
Noè, Enrico. "Rezzonicorum Cineres: ricerche sulla collezione Rezzonico." *Rivista dell'Istituto Nazionale d'Archeologia e Storia dell'Arte*, 3rd ser., vol. 3 (1980), pp. 173–306.

**Noè V. 1996**
Noè, Virgilio. *I santi fondatori nella Basilica Vaticana*. Modena, Italy: F. C. Panini, 1996.

**Nolhac 1910**
Nolhac, Pierre de. *Hubert Robert, 1773–1808*. 3 vols. Paris: Goupil, 1910.

**Norci Cagiano de Azevedo 1997**
Norci Cagiano de Azevedo, Letizia. *Napoli: capitale, giardino, museo nell'Europa del primo Settecento*. Florence: Il Ventilabro, 1997.

**Novara 1992**
Novara, Vittorina. "Il ritrovato Archivio Bracci." *Strenna dei romanisti*, vol. 53 (1992), pp. 471–88.

**Nyberg 1972**
Nyberg, Dorothea. *Giovanni Battista Piranesi: Drawings and Etchings at Columbia University*. New York: Columbia University, 1972.

**O'Brien 1982**
O'Brien, Elvy S. "Johan Tobias Sergell (1740–1814) and Neoclassicism: Sculpture of Sergel's Years Abroad, 1767–1779." 2 vols. Ph.D. diss., Iowa City: University of Iowa, 1982.

**Obser 1908**
Obser, Karl, ed. "Lettres sur les Salons de 1773, 1777, 1779: adressées par Du Pont de Nemours à la Margrave Caroline-Louise de Bade." *Archives de l'Art Français*, n.s., vol. 2 (1908), pp. 1–123.

**Oechslin 1967**
Oechslin, Werner. "Un tempio di Mosè: i disegni offerti da B. A. Vittone all'Accademia di San Luca nel 1733." *Bollettino d'arte*, 5th ser., vol. 52, no. 3 (1967), pp. 167–73.

**Oechslin 1972**
Oechslin, Werner. *Bildungsgut und Antikenrezeption im frühen Settecento in Rom: Studien zum römischen Aufenthalt Bernardo Antonio Vittones*. Zurich: Atlantis, 1972.

**Oechslin 1996**
Oechslin, Werner. "Pozzo e il suo trattato." In *Andrea Pozzo* 1996, pp. 189–206.

**Ojetti 1926**
Ojetti, Ugo. "Mostra individuale di Gaspare Landi." In *Catalogo della XV esposizione internazionale d'arte della città di Venezia*, pp. 128–30. Venice: Ferrari, 1926.

**O'Keeffe 1826**
O'Keeffe, John. *Recollections of the Life of John O'Keeffe*. 2 vols. London, 1826.

**Olausson 1990**
Olausson, Magnus. "The Launching of Johan Tobias Sergel in Sweden." *Nationalmuseum Bulletin*, vol. 14 (1990), pp. 76–87.

**Olsen 1971**
Olsen, Harald. "Due bozzetti del Giaquinto." In *Studi su Corrado Giaquinto* 1971, pp. 3–7.

**Olsen 1992**
Olsen, Harald. "A Relief by Camillo Rusconi: 'Venus and Cupid.'" In *Docto Peregrino: Roman Studies in Honour of Torgil Magnuson*, pp. 250–60. Rome: Istituto Svedese di studi classici a Roma, 1992.

**Olson 1997**
Olson, Roberta J. M. "An Early Drawing by Luigi Sabatelli Rediscovered." *Master Drawings*, vol. 35 (1997), pp. 289–92.

**Olszewski 1982**
Olszewski, Edward J. "The Tapestry Collection of Cardinal Pietro Ottoboni." *Apollo*, n.s., vol. 116 (1982), pp. 103–11.

**Olszewski 1986**
Olszewski, Edward J. "Giovanni Martino Frugone, Marble Merchant, and a Contract for the Apostle Statues in the Nave of St. John Lateran." *The Burlington Magazine*, vol. 128 (1986), pp. 659–66.

*Ontmoetingen 1971*
Rijksprentenkabinet Rijksmuseum, Amsterdam; Thorvaldsens Museum, Copenhagen. *Ontmoetingen met Italië: Tekenaars uit Scandinavië, Duitsland, Nederland in Italië, 1770–1840*. Amsterdam: Rijksprentenkabinet Rijksmuseum; Copenhagen: Thorvaldsens Museum, 1971.

**Oppé 1951**
Oppé, A. P. "Memoirs of Thomas Jones: Penkerrig Radnorshire, 1803." *The Walpole Society*, vol. 32 (1951).

**Orsini [1790] 1977**
Orsini, Baldassarre. *Descrizione delle pitture sculture architetture ed altre cose rare della insigne città di Ascoli nella Marca*. 1790. Reprint, Bologna, Italy: A. Forni, 1977.

**Ost 1984**
Ost, Hans. *Falsche Frauen: zur Flora im Berliner und zur Klytia im Britischen Museum*. Cologne: W. König, 1984.

**Österreichische Museum 1929**
Österreichische Museum für Kunst und Industrie, Vienna. *Führer durch das Österreichische Museum für Kunst und Industrie*. Vienna: Österreichischen Museums, 1929.

**Ostrow and Johns 1990**
Ostrow, Steven F., and Christopher M. S. Johns. "Illuminations of S. Maria Maggiore in the Early Settecento." *The Burlington Magazine*, vol. 132 (1990), pp. 528–34.

**Ottani Cavina 1982**
Ottani Cavina, Anna. "Il Settecento e l'antico." In Federico Zeri, ed., *Storia dell'arte italiana*. Vol. 2, part 2, pp. 599–660. Turin, Italy: Giulio Einaudi, 1982.

**Ottani Cavina 1990**
Ottani Cavina, Anna. "Inglesi in Italia nel secolo XVIII: Benjamin West, James Barry, John Brown, John Flaxman." In Joselita Raspi Serra, ed., *Pittori europei in Italia, pittori italiani in Europa: gli scambi culturali tra '400 e '700*, pp. 59–81. Milan: Angelo Guerini, 1990.

**Ottani Cavina 1993**
Ottani Cavina, Anna. "Rome 1780: le thème du paysage dans le cercle de David." In Michel R. 1993, pp. 81–92.

**Ottani Cavina 1998**
Ottani Cavina, Anna. "Michael Köck, nel raggio di Giani i disegni." In Forlani Tempesti and Prosperi Valenti Rodinò 1998, pp. 491–99.

**Ottani Cavina 1999**
Ottani Cavina, Anna. *Felice Giani e la cultura di fine secolo, 1758–1823*. 2 vols. Milan: Electa, 1999.

**Ottani Cavina et al. 1979**
Ottani Cavina, Anna, et al. *L'età neoclassica a Faenza, 1780–1820*. Bologna, Italy: Alfa, 1979.

**Ozzola 1907**
Ozzola, L. "A proposito d'un ritratto del Landi." *Bollettino storico piacentino*, vol. 2 (1907), pp. 68–74.

**Ozzola 1907, "Proposito"**
Ozzola, L. "A proposito di un ritratto del Landi: appendice di documenti." *Bollettino storico piacentino*, vol. 2 (1907), pp. 125–36.

**Pacia 1987**
Pacia, Amalia. "Esotismo, cultura archeologia e paesaggio negli affreschi di Palazzo Colonna." In Debenedetti 1987, pp. 125–79.

**Pacia 1990**
Pacia, Amalia. "Esotismo, decorativo a Roma fra tradizione rococò e gusto neoclassico." In Debenedetti 1990, pp. 91–96.

**Pacia 1992**
Pacia, Amalia. "Stefano Pozzi decoratore a Palazzo Sciarra e Palazzo Colonna." *Bollettino d'arte*, 6th ser., vol. 77, no. 76 (1992), pp. 71–94.

**Pacia 1996**
Pacia, Amalia. "Stefano Pozzi: la critica." In *Pittori bergamaschi* 1996, pp. 59–122.

**Pacia and Susinno 1996**
Pacia, Amalia, and Stefano Susinno. "Stefano Pozzi: le opere." In *Pittori bergamaschi* 1996, pp. 123–233.

*Palazzo Montecitorio 1967*
*Il Palazzo di Montecitorio*. Rome: Editalia, 1967.

**Palazzolo 1991**
Palazzolo, Maria Iolanda. "Arcadi e stampatori: i De Romanis nella Roma dei papi." In Grazioso and Tellini Santoni 1991, pp. 59–74.

**Palazzolo 1996**
Palazzolo, Maria Iolanda. "I libri di un artista nella Roma neoclassica." *Rome moderna e contemporanea*, vol. 4 (1996), pp. 637–60.

**Palma 1992**
Palma, Beatrice, ed. *Le erme tiburtine e gli scavi del Settecento*. 2 vols. Rome: Leonardo-De Luca, 1992.

**Pampalone 1985**
Pampalone, Antonella. "Le omelie di Clemente XI versificate da Alessandro Guidi." In Debenedetti 1985, pp. 43–75.

**Pampalone 1990**
Pampalone, Antonella. "Presenza di Pier Leone Ghezzi tra i marchigiani in Roma." In Martinelli 1990, pp. 65–87.

**Pampalone 1995**
Pampalone, Antonella. "Pietro Bianchi tra Arcadia e neoclassicismo: un quadro inedito e riflessioni sul rapporto pittura-scultura." *Storia dell'arte*, vol. 84 (1995), pp. 244–68.

**Pampalone 1997**
Pampalone, Antonella. "I 'volti' della storia nelle caricature della collezione di Pier Leone Ghezzi." In Debenedetti 1997, pp. 83–140.

**Pane 1956**
Pane, Roberto. *Ferdinando Fuga*. Naples: Edizioni Scientifiche Italiane, 1956.

**Pane 1959**
Pane, Roberto. *Ville vesuviane del Settecento*. Naples: Edizioni Scientifiche Italiane, 1959.

**Pansecchi 1959**
Pansecchi, Fiorella. "Contributi a Giuseppe Mazzuoli." *Commentari*, vol. 10 (1959), pp. 33–43.

**Pansecchi 1962**
Pansecchi, Fiorella. "Il modello della Cappella Pallavicini Rospigliosi in S. Francesco a Ripa." *Bollettino dei musei comunali di Roma*, vol. 9 (1962), pp. 21–31.

**Pansecchi 1983–84**
Pansecchi, Fiorella. "Francesco Manno a San Lorenzo in Lucina." *Prospettiva*, vol. 33–36 (1983–84), pp. 327–34.

**Pansecchi 1984**
Pansecchi, Fiorella. "Giuseppe Ghezzi: tre quadri fuori sede." In Mauro Natale, ed., *Scritti di storia dell'arte in onore di Federico Zeri.* Vol. 2, pp. 724–29. Milan: Electa, 1984.

**Pansecchi 1984, "Ceccarini"**
Pansecchi, Fiorella. "Sebastiano Ceccarini tra Roma e Perugia." *Bollettino d'arte,* 6th ser., vol. 69, no. 28 (1984), pp. 61–70.

**Pansecchi 1986**
Pansecchi, Fiorella. "Ceccarini e Gramiccia a Tor de' Specchi: vicenda di Lorenzo Gramiccia." *Bollettino d'arte,* 6th ser., vol. 71, no. 37–38 (1986), pp. 129–36.

**Pansecchi 1989–90**
Pansecchi, Fiorella. "Domenico Corvi, l'apparato della Basilica Vaticana del 1767 e San Giuseppe Calasanzio." *Prospettiva,* vol. 57–60 (1989–90), pp. 340–45.

**Pantanella 1993**
Pantanella, Rossella, ed. "Il Caffeaus." In Laura Laureati and Ludovica Trezzani, eds., *Pittura antica: la decorazione murale,* pp. 291–308. Milan: Electa, 1993.

**Paolini 1965**
Paolini, Maria Grazia. "Quattro tele del Benefial a Monreale." *Paragone,* n.s., vol. 16, no. 181 (1965), pp. 70–81.

**Paolozzi Strozzi 1978**
Paolozzi Strozzi, Beatrice, ed. *Luigi Sabatelli, 1772–1850: disegni e incisioni.* Florence: L. S. Olschki, 1978.

**Paolozzi Strozzi 1978, "Il Sabatelli"**
Paolozzi Strozzi, Beatrice. "Il Sabatelli e Tommaso Puccini, e i temi sublimi." In Paolozzi Strozzi 1978, pp. 13–20.

**Paolucci 1938**
Paolucci, R. "Il pittore Sebastiano Ceccarini e la sua famiglia." *Studia picena,* vol. 13 (1938), pp. 23–41.

**Paoluzzi 1995**
Paoluzzi, Maria Cristina. "Le proprietà del Gaulli." In Debenedetti 1995, pp. 259–72.

**Papi e principi 1990**
Palazzo Venezia, Rome. *L'arte per i papi e per i principi nella campagna romana: grande pittura del '600 e del '700.* 2 vols. Rome: Quasar, 1990.

**Paponi 1958**
Paponi, Maria Enrica. "Appunti su Marco Benefial a Città di Castello." *Paragone,* vol. 9, no. 97 (1958), pp. 59–63.

**Paratore 1994**
Paratore, Ettore. "Il mondo classico nella genesi dell'Arcadia." *Atti e memorie: Arcadia. Atti del Convegno di studi per il III centenario, Roma 15–18 maggio 1991,* vol. 9 (1994), pp. 15–17.

**Paris—New York 1977**
Wildenstein, New York. *Paris—New York: A Continuing Romance.* New York: Wildenstein, 1977.

**Parker 1935**
Parker, K. T. "Designs for Two Altarpieces." *Old Master Drawings,* vol. 10, no. 39 (1935), pp. 45–46.

**Parks 1961**
Parks, Robert O., ed. *Piranesi.* Northampton, Mass.: Smith College Museum of Art, 1961.

**Parson 1969**
Parson, Marribel. "A Monument of Rome." *The Minneapolis Institute of Arts Bulletin,* vol. 58 (1969), pp. 47–54.

**Pascoli 1730–36**
Pascoli, Lione. *Vite de' pittori, scultori, ed architetti moderni scritte, e dedicate alla Maestà di Vittorio Amadeo Re di Sardegna da Lione Pascoli.* 2 vols. Rome: Antonio de' Rossi, 1730–36.

**Pascoli [1730–36] 1933**
Pascoli, Lione. *Vite de' pittori, scultori, ed architetti moderni scritte, da Lione Pascoli.* 2 vols. 1730–36. Reprint, Rome: E. Calzone, 1933.

**Pascoli [1730–36] 1965**
Pascoli, Lione. *Vite de' pittori, scultori, ed architetti moderni.* 2 vols. 1730–36. Reprint, Amsterdam: Boekhandel & Antiquariaat, 1965.

**Pascoli 1981**
Pascoli, Lione [1674–1744]. *Vite de' pittori, scultori, ed architetti viventi: dai manoscritti 1383 e 1743 della Biblioteca comunale Augusta di Perugia.* Edited by Francesco Federico Mancini and Isa Belli Barsali. Treviso: Canova, 1981. Originally published as *Vite de' pittori, scultori, ed architetti moderni scritte, e dedicate alla Maesta di Vittorio Amadeo Re di Sardegna da Lione Pascoli.* 2 vols. (Rome: Antonio de' Rossi, 1730–36).

**Pascoli 1992**
Pascoli, Lione [1674–1744]. *Vite de' pittori, scultori, ed architetti moderni.* 1730–36; Perugia, Italy: Electa, 1992.

**Pasquali 1980**
Pasquali, Marilena, ed. *Il Lazzaretto di Luigi Vanvitelli: indagine su un'opera.* Ancona, Italy: Galleria Comunale d'arte moderna, 1980.

**Pasquali S. 1996**
Pasquali, Susanna. *Il Pantheon: architettura e antiquaria nel Settecento a Roma.* Modena, Italy: F. C. Panini, 1996.

**Pastor 1938–53**
Pastor, Ludwig von. *The History of the Popes from the Close of the Middle Ages: Drawn from the Secret Archives of the Vatican and Other Original Sources, from the German of Dr. Ludwig Pastor.* 6th ed. 40 vols. London: Kegan Paul, Trench, Trubner; St. Louis, Mo.: B. Herder, 1938–53.

**Paul 1989**
Paul, Carole. "The Redecoration of Villa Borghese and the Patronage of Prince Marcantonio IV." Ph.D. diss., Philadelphia: University of Pennsylvania, 1989.

**Paul 1992**
Paul, Carole. "Mariano Rossi's Camillus Fresco in the Borghese Gallery." *The Art Bulletin,* vol. 74 (1992), pp. 297–326.

**Pavanello 1984**
Pavanello, Giuseppe. "Antonio Canova: i bassorilievi 'Rezzonico.'" *Bollettino del Museo Civico di Padova,* vol. 73 (1984), pp. 145–62.

**Pavanello 1998**
Pavanello, Giuseppe. "I Rezzonico: committenza e collezionismo fra Venezia e Roma." *Arte Veneta,* vol. 52 (1998), pp. 87–111.

**Pavanello and Praz 1976**
Pavanello, Giuseppe, and Mario Praz, eds. *L'opera completa del Canova.* Milan: Rizzoli, 1976.

**Pavanello and Romanelli 1992**
Pavanello, Giuseppe, and Giandomenico Romanelli, eds. *Antonio Canova.* Venice: Marsilio, 1992.

**Pavanello and Romanelli 1992, *Canova***
Pavanello, Giuseppe, and Giandomenico Romanelli, eds. *Antonio Canova.* Translated from the Italian. New York: Marsilio, 1992.

**Penny 1978**
Penny, Nicholas. *Piranesi.* London: Oresko Books, 1978.

**Pepe 1961**
Pepe, Mario. "Angelini, Giuseppe." In DBI, vol. 3, pp. 214–15.

**Pepe 1961, "Albacini"**
Pepe, Mario. " Albacini, Carlo." In DBI, vol. 1, p. 588.

**Pepper 1984**
Pepper, D. Stephen. *Guido Reni. A Complete Catalogue of His Works.* London: Phaidon, 1984.

**Pereira 1987**
Pereira, João Castelo-Branco. *Viaturas de aparato em Portugal: coches, berlindas, carruagens.* Lisbon: Bertrand, 1987.

**Pergola 1962**
della Pergola, Paola. *Villa Borghese.* Translated by M. H. Ballance. Rome: Istituto Poligrafico dello Stato, Libreria dello Stato, 1962.

**Pericoli 1963**
Pericoli, Cecilia. "Bernardino Cametti, scultore romano." *Capitolium,* vol. 38 (1963), pp. 130–37.

**Perina 1961**
Perina, Chiara. "Considerazioni su Giuseppe Bottani." *Arte lombarda,* vol. 6 (1961), pp. 51–59.

**Perina Tellini 1971**
Perina Tellini, Chiara. "Bottani, Giuseppe." In DBI, vol. 13, pp. 405–6.

**Perry and Rossington 1994**
Perry, Gil, and Michael Rossington, eds. *Femininity and Masculinity in Eighteenth-Century Art and Culture.* Manchester and New York: Manchester University Press, 1994.

**Petereit Guicciardi 1983**
Petereit Guicciardi, Susanne. "Das Casino Borghese: Dekoration und Inhalt." 2 vols. Ph.D. diss., Vienna, 1983.

**Petereit Guicciardi 1990**
Petereit Guicciardi, Susanne. "Pietro Angeletti." *Antologia di Belle Arti,* n.s., no. 35–38 (1990), pp. 59–66.

**Petraroia 1980**
Petraroia, Pietro. "Contributi al giovane Benefial." *Storia dell'arte,* vol. 38–40 (1980), pp. 371–79.

**Petrioli Tofani, Prosperi Valenti Rodinò, and Sciolla 1993–94**
Petrioli Tofani, Annamaria, Simonetta Prosperi Valenti Rodinò, and Gianni Carlo Sciolla, eds. *Disegno: le collezioni pubbliche italiane.* 2 vols. Milan: Silvana, 1993–94.

**Petrobelli 1985**
Petrobelli, Pierluigi. "Il mondo del teatro in musica nelle caricature di Pierleone Ghezzi." In Cagli 1985, pp. 109–17.

**Petrucci 1940**
Petrucci, Alfredo. "La giovinezza di Giuseppe Vasi." *L'urbe,* vol. 5, no. 18 (1940), pp. 8–15.

**Petrucci 1941**
Petrucci, Alfredo. "I primi venticinque anni del Vasi a Roma." *L'urbe,* vol. 6, no. 19 (1941), pp. 11–22.

**Petrucci 1946**
Petrucci, Alfredo. *Le magnificenze di Roma di Giuseppe Vasi.* Rome: Palombi, 1946.

**Petrucci C. 1953**
Petrucci, Carlo Alberto. *Catalogo generale delle stampe: tratte dai rami incisi posseduti dalla Calcografia Nazionale.* Rome: La Libreria dello Stato, 1953.

**Petrucci F. 1987**
Petrucci, Francesco. "L'abbazia di S. Paolo ad Albano." *Documenta albana,* 2nd ser., vol. 9 (1987), pp. 77–90.

**Petrucci F. 1995**
Petrucci, Francesco. "I ricomparsi 'finti arazzi' del cardinal Pietro Ottoboni." *Bollettino d'arte,* 6th ser., vol. 80, no. 89–90 (1995), pp. 145–48.

**Petrucci F. 1998**
Petrucci, Francesco. "Documenti artistici sul Settecento nell'archivio Chigi." *Bollettino d'arte,* 6th ser., vol. 83, no. 105–6 (1998).

**Pevsner 1973**
Pevsner, Nikolaus. *Academies of Art Past and Present.* Rev. ed. New York: Da Capo, 1973.

**Pfanner 1983**
Pfanner, Michael. *Der Titusbogen.* Mainz, Germany: Philipp von Zabern, 1983.

**Pfister 1928**
Pfister, Federico. "Disegni di Vincenzo Camuccini." *Bollettino d'arte,* 2nd ser., vol. 8 (1928), pp. 21–30.

**Piacenza del Settecento 1979**
Palazzo Farnese, Piacenza, Italy. *Società e cultura nella Piacenza del Settecento.* Piacenza, Italy: Cassa di Risparmio di Piacenza, 1979.

**Piantoni de Angelis 1978**
Piantoni de Angelis, Gianna, ed. *Vincenzo Camuccini (1771–1844): bozzetti e disegni dallo studio dell'artista.* Rome: De Luca, 1978.

**Piccialuti Caprioli 1994**
Piccialuti Caprioli, Maura. *La carità come metodo di governo: istituzioni caritative a Roma dal pontificato di Innocenzo XII a quello di Benedetto XIV.* Turin, Italy: G. Giappichelli, 1994.

**Picón 1983**
Picón, Carlos A. *Bartolomeo Cavaceppi: Eighteenth-Century Restorations of Ancient Marble Sculpture from English Private Collections.* London: Clarendon Gallery, 1983.

**Pietrangeli 1951**
Pietrangeli, Carlo. "Nuovi lavori nella più antica Pinacoteca di Roma." *Capitolium,* vol. 26 (1951), pp. 59–71.

**Pietrangeli 1958**
Pietrangeli, Carlo. *Scavi e scoperte di antichità sotto il pontificato di Pio VI.* 2nd ed. Rome: Istituto di Studi Romani, 1958.

**Pietrangeli 1959**
Pietrangeli, Carlo. "'L'Accademia del Nudo' in Campidoglio." *Strenna dei romanisti,* vol. 20 (1959), pp. 123–28. Reprinted in Cipriani et al. 1995, pp. 305–7.

**Pietrangeli 1959, "Tofanelli"**
Pietrangeli, Carlo. "Un autoritratto di Stefano Tofanelli nel Museo di Roma." *Bollettino dei musei comunali di Roma,* vol. 6 (1959), pp. 38–40.

**Pietrangeli 1962**
Pietrangeli, Carlo. "La Fontana di Piazza di Campidoglio di Hubert Robert." *Capitolium,* vol. 37 (1962), n.p.

**Pietrangeli 1962, "Accademia"**
Pietrangeli, Carlo. "L'Accademia Capitolina del Nudo." *Capitolium,* vol. 37 (1962), pp. 132–34.

**Pietrangeli 1963**
Pietrangeli, Carlo. "I presidenti del Museo Capitolino." *Capitolium*, vol. 38 (1963), pp. 604–9.

**Pietrangeli 1964**
Pietrangeli, Carlo. "Munificentia Benedicti XIV." *Bollettino dei musei comunali di Roma*, vol. 11 (1964), pp. 49–54.

**Pietrangeli 1969**
Pietrangeli, Carlo. "Un ignorato collezionista romano: Fabio Rosa." *Strenna dei romanisti*, vol. 30 (1969), pp. 322–25.

**Pietrangeli 1978**
Pietrangeli, Carlo. "I Musei Vaticani al tempo di Pio VI." *Bollettino dei monumenti, musei e gallerie pontificie*, vol. 1 (1978), pp. 7–45.

**Pietrangeli 1982**
Pietrangeli, Carlo. "La Pinacoteca Vaticana di Pio VI." *Bollettino dei monumenti, musei e gallerie pontificie*, vol. 3 (1982), pp. 143–200.

**Pietrangeli 1985**
Pietrangeli, Carlo. *I Musei Vaticani: cinque secoli di storia*. Rome: Quasar, 1985.

**Pietrangeli 1987**
Pietrangeli, Carlo. "La provenienza delle sculture dei Musei Vaticani." *Bollettino dei monumenti, musei e gallerie pontificie*, vol. 7 (1987), pp. 115–49.

**Pietrangeli 1988**
Pietrangeli, Carlo, ed. *Santa Maria Maggiore a Roma*. Florence: Nardini, 1988.

**Pietrangeli 1989**
Pietrangeli, Carlo, ed. *La Basilica di San Pietro*. Florence: Nardini, 1989.

**Pigage 1778**
Pigage, Nicolas de. *La Galerie électorale de Düsseldorff, ou, catalogue raisonné et figuré de ses tableaux*. Basel, Switzerland: Chez Chretien de Mechel and Inspecteteurs des Galeries électorale à Düsseldorff et à Mannheim, 1778.

**Pilati 1972–73**
Pilati, E. "Luigi Sabatelli." Ph.D. diss., Florence: Università di Firenze, 1972–73.

**Pindemonte 1795**
Pindemonte, Giovanni. *Sonetto: non biasmo il mondo, che s'armò per lei*. Parma, Italy: Bodoniani, 1795.

**Pinelli 1983**
Pinelli, A. "Albacini, Carlo." In AKL, vol. 1, pp. 758–59.

**Pinelli O. 1997**
Rossi Pinelli, Orietta. *Füssli*. Florence: Giunti, 1997.

**Pinto 1976**
Pinto, John. "Nicola Michetti, circa 1675–1758, and Eighteenth-Century Architecture in Rome and Saint Petersburg." 2 vols. Ph.D. diss., Cambridge: Harvard University, 1976.

**Pinto 1976, "Origins"**
Pinto, John. "Origins and Development of the Ichnographic City Plan." *Journal of the Society of Architectural Historians*, vol. 35 (1976), pp. 35–50.

**Pinto 1977**
Pinto, John. "An Early Project by Nicola Michetti for the Trevi Fountain." *The Burlington Magazine*, vol. 119 (1977), pp. 853–57.

**Pinto 1979**
Pinto, John. "An Early Design by Nicola Michetti: The Sacripante Chapel in the Roman Church of S. Ignazio." *Journal of the Society of Architectural Historians*, vol. 38 (1979), pp. 375–81.

**Pinto 1980**
Pinto, John. "Nicola Michetti and Ephemeral Design in Eighteenth-Century Rome." In Millon 1980, pp. 289–322.

**Pinto 1980, "Juvarra"**
Pinto, John. "Filippo Juvarra's Drawings Depicting the Capitoline Hill." *The Art Bulletin*, vol. 62 (1980), pp. 598–616.

**Pinto 1986**
Pinto, John. *The Trevi Fountain*. New Haven and London: Yale University Press, 1986.

**Pinto 1991**
Pinto, John. "Il modello della cappella Pallavicini Rospigliosi." In Contardi and Curcio 1991, pp. 50–57.

**Pinto 1991, "Sagrestia"**
Pinto, John. "Il modello della Sagrestia Vaticana." In Contardi and Curcio 1991, pp. 58–69.

**Pinto 1992**
Pinto, John. "Nicola Michetti and Eighteenth-Century Architecture in St. Petersburg." In Millon and Munshower 1992. Vol. 2, pp. 526–65.

**Pinto 1993**
Pinto, John. "Giovanni Battista Piranesi's Plan of Hadrian's Villa." *Princeton University Library Chronicle*, vol. 55 (1993), pp. 63–84.

**Pinto 1999**
Pinto, John. *La Fontana di Trevi*. Rome: Elio de Rosa, 1999.

**Pinto 1999, "Architettura"**
Pinto, John. "Architettura da esportare." In Giovanna Curcio and Elisabeth Kieven, eds., *Storia dell'architettura italiana: il Settecento*. Milan: Electa, 1999. Forthcoming.

**Pinto 1999, "Michetti"**
Pinto, John. "Nicola Michetti: Model for the Lighthouse at Kronstadt, Russia." In Henry A. Millon, ed., *Triumph of the Baroque: Architecture in Europe 1600-1750*. Milan: RCS Libri, 1999.

**Pinto S. 1972**
Pinto, Sandra. *Sfortuna dell'Accademia: cultura neoclassica e romantica nella Toscana granducale, collezioni lorenesi, acquisizioni posteriori, depositi*. Florence: Centro Di, 1972.

**Pinto S. 1977**
Pinto, Sandra. "Gruppo di famiglia in un interno." In *Scritti di storia dell'arte in onore di Ugo Procacci*. Vol. 1, pp. 614–19. Milan: Electa, 1977.

**Pinto S. 1991**
Pinto, Sandra. "La corte russa e l'Europa: simboli condivisi dell'assolutismo e oggetti di scambio diplomatico." In Bruno Alfieri, ed., *San Pietroburgo, 1703–1825: arte di corte dal Museo dell'Ermitage*, pp. 347–60. Milan: Berenice, 1991.

**Pinto and Kieven 1983**
Pinto, John, and Elisabeth Kieven. "An Early Project by Ferdinando Fuga for the Trevi Fountain in Rome." *The Burlington Magazine*, vol. 125 (1983), pp. 746–49.

**Pio [1724] 1977**
Pio, Nicolo. *Le vite di pittori scultori et architetti*. 1724; Edited by Catherine Enggass and Robert Enggass. Vatican City: Biblioteca Apostolica Vaticana, 1977.

**Piranesi 1975**
Avery Architectural Library, New York. *Piranesi, The Arthur M. Sackler Collection: Drawings and Etchings at the Avery Architectural Library, Columbia University, New York*. New York: The Arthur M. Sackler Foundation, 1975.

**Piranesi e la veduta 1989**
Palazzo Braschi, Rome; Villa la Marignana-Benetton, Mogliano Veneto, Italy. *Piranesi e la veduta del Settecento a Roma*. Rome: Artemide, 1989.

**Pirotta 1969**
Pirotta, Luigi. "I 'direttori' dell'Accademia del Nudo Campidoglio." *Strenna dei romanisti*, vol. 30 (1969), pp. 326–34.

**Pirzio Biroli Stefanelli 1984**
Pirzio Biroli Stefanelli, Lucia. "Costanzi, Carlo." In DBI, vol. 30, pp. 368–70.

**Pistolesi 1829**
Pistolesi, Erasmo. *Il Vaticano descritto ed illustrato*. Vol. 5. Rome: Società editrice, 1829.

**Pistolesi 1841**
Pistolesi, Erasmo. *Descrizione di Roma e suoi contorni con nuovo metodo breve e facile per vedere la città in otto giorni adorna d'incisioni de' primi bulini*. Rome: Giovanni Gallarini, 1841.

**La pittura 1990**
*La pittura in Italia: Il Settecento*. 2 vols. Milan: Electa, 1990.

**Pittori bergamaschi 1996**
*I pittori bergamaschi dal XIII al XIX secolo: Il Settecento*. Vol. 4. Bergamo, Italy: Bolis, 1996.

**Planiscig 1924**
Planiscig, Leo, ed. *Die Bronzeplastiken: Statuetten, Reliefs, Geräte und Plaketten*. Vienna: A. Schroll, 1924.

**Plummer 1983**
Plummer, Ellen Annette. "The Eighteenth-Century Rebuilding of S. Croce in Gerusalemme, Rome." 2 vols. Ph.D. diss., Ann Arbor, Mich.: The University of Michigan, 1983.

**Polichetti 1975**
Polichetti, M. L. "Il Vanvitelli e i Marchionni: Carlo e Filippo nelle opere architettoniche di Ancona." *Atti e memorie della reale deputazione di storia patria per le Marche*, vol. 8 (1975), pp. 177–94.

**Pomian 1993**
Pomian, Krzysztof. "De la Collection particulière au musée d'art." In Bjurström 1993, pp. 9–27.

**Pommer 1967**
Pommer, Richard. *Eighteenth-Century Architecture in Piedmont: The Open Structures of Juvarra, Alfieri, and Vittone*. New York: New York University Press; London: University of London Press Limited, 1967.

**Popham 1935**
Popham, A. E. *Catalogue of Drawings in the Collection Formed by Sir Thomas Phillipps, bart., F.R.S., now in the possession of His grandson, T. FitzRoy Phillipps Fenwick of Thirlestaine House, Cheltenham*. London: Privately printed for T. FitzRoy Fenwick, 1935.

**Portalis 1889**
Portalis, Roger. *Honoré Fragonard: sa vie et son oeuvre*. Paris: J. Rothschild, 1889.

**Portoghesi 1966**
Portoghesi, Paolo. *Roma barocca: storia di una civiltà architettonica*. Rome: Bestetti, 1966.

**Portoghesi 1966, *Bernardo Vittone***
Portoghesi, Paolo. *Bernardo Vittone: un architetto tra illuminismo e rococò*. Rome: Elefante, 1966.

**Portrait Drawings 1974**
The British Museum, London. *Portrait Drawings: XV–XX Centuries*. London: The British Museum Publications, 1974.

**Portrait en Italie 1982**
Musée du Petit Palais, Paris. *Le Portrait en Italie au siècle de Tiepolo*. Paris: Association Française d'Action Artistique, 1982.

**Poulet 1984**
Poulet, Anne L. *Clodion Terracottas in North American Collections*. New York: The Frick Collection, 1984.

**Poulet 1989**
Poulet, Anne L. "A Neoclassical Vase by Clodion." *The Art Institute of Chicago: Museum Studies*, vol. 15 (1989), pp. 139–53, 177–80.

**Poulet 1991**
Poulet, Anne L. "Clodion's Sculpture of the 'Déluge.'" *Journal of the Museum of Fine Arts, Boston*, vol. 3 (1991), pp. 51–76.

**Poulet and Scherf 1992**
Poulet, Anne L., and Guilhem Scherf. *Clodion, 1738–1814*. Paris: Réunion des Musées Nationaux, 1992.

**Powell 1962**
Powell, Nicolas. "Brown and the Women of Rome." *Signature*, no. 14 (1962), pp. 40–50.

**Pozzo 1693–1700**
Pozzo, Andrea. *Perspectiva pictorum et architectorum Andreae Putei e societate Jesu*. 2 vols. Rome: Joannis Jacobi Komareck, 1693–1700.

**Pozzo 1989**
Pozzo, Andrea [1642–1709]. *Perspective Architecture and Painting: An Unabridged Reprint of the English and Latin Edition of the 1693 Perspectiva Pictorum et Architectorum*. New York: Dover Publications, 1989.

**Prange 1786**
Prange, M.C.F., ed. *Des Ritters Anton Raphael Mengs*. 3 vols. Halle, Germany: J. C. Hendels, 1786.

**Pratesi 1993**
Pratesi, Giovanni, ed. *Repertorio della scultura fiorentina del Seicento e Settecento*. 3 vols. Turin, Italy: Umberto Allemandi, 1993.

**Praz 1940**
Praz, Mario. *Gusto neoclassico*. Florence: Sansoni, 1940.

**Praz 1959**
Praz, Mario. *Gusto neoclassico*. 2nd ed., rev. Naples: Edizione Scientifiche Italiane, 1959.

**Predieri 1990**
Predieri, Daniela. *Bosco Parrasio un giardino per l'Arcadia*. Modena, Italy: Mucchi, 1990.

**Pressly 1979**
Pressly, Nancy L. *The Fuseli Circle in Rome: Early Romantic Art of the 1770s*. New Haven: Yale Center for British Art, 1979.

**Pressly W. 1978**
Pressly, William J. "A Portrait of Joseph Nollekens: Reattributed to John Francis Rigaud." *The Connoisseur*, vol. 197 (1978), pp. 111–15.

**Preussischer Kulturbesitz 1978**
*Catalogue of Paintings, 13th–18th Century: Picture Gallery, Staatliche Museen Preussischer Kulturbesitz, Berlin*. 2nd ed., rev. Berlin: Mann, 1978.

**Pröschel 1977**
Pröschel, Peter, ed. *Europäische Architektur-Zeichnungen, 18. und 19. Jahrhundert: Klassizistische Skulpturen.* Munich: Galerie Carroll, 1977.

**Prosperi Valenti 1974**
Prosperi Valenti, Simonetta. "Campiglia, Giovan Domenico." In DBI, vol. 17, pp. 539–41.

**Prosperi Valenti Rodinò 1987**
Prosperi Valenti Rodinò, Simonetta. "Il cardinale Giuseppe Renato Imperiali committente e collezionista." *Bollettino d'arte,* 6th ser., vol. 72, no. 41 (1987), pp. 17–43.

**Prosperi Valenti Rodinò 1993**
Prosperi Valenti Rodinò, Simonetta. *Three Centuries of Roman Drawings from the Villa Farnesina, Rome.* Alexandria, Va.: Art Services International, 1993.

**Prosperi Valenti Rodinò 1995**
Prosperi Valenti Rodinò, Simonetta, ed. *Disegni romani dal XVI al XVIII secolo.* Rome: De Luca, 1995.

**Prosperi Valenti Rodinò 1996**
Prosperi Valenti Rodinò, Simonetta. "La collezione di grafica del cardinal Silvio Valenti Gonzaga." In Debenedetti 1996, pp. 131–92.

**Prosperi Valenti Rodinò 1996, "Imperiali"**
Prosperi Valenti Rodinò, Simonetta. "Imperiali." In DA, vol. 15, pp. 148–49.

**Prosperi Valenti Rodinò 1999**
Prosperi Valenti Rodinò, Simonetta. "Giuseppe Ghezzi collezionista di disegni." In De Marchi 1999, pp. 107–15.

**Prown 1997**
Prown, Jules David. "A Course of Antiquities at Rome, 1764." *Eighteenth-Century Studies,* vol. 31 (1997), pp. 90–100.

**Pucci 1979**
Pucci, Giuseppe. "L'antiquaria e il suo doppio: a proposito di Francesco Piranesi." *Prospettiva,* vol. 16 (1979), pp. 67–73.

**Puhlmann 1979**
Puhlmann, Johann Gottlieb [1751–1826]. *Ein Potsdamer Maler in Rom: Briefe des Batoni-Schülers Johann Gottlieb Puhlmann aus den Jahren 1774 bis 1787.* Edited by Götz Eckardt. Berlin: Henschelverlag Kunst und Gesellschaft, 1979.

**Quatremère de Quincy 1810**
Quatremère de Quincy, Antoine-Chrysôstome. "Institut de France: funérailles de M. Moitte le 3 mai 1810." *Gazette Nationale on le Moniteur Universel,* vol. 4 (1810), pp. 495–96.

**Quatremère de Quincy M. 1834**
Quatremère de Quincy, M. *Canova et ses ouvrages: ou, mémoires historiques sur la vie et les travaux de célèbre artiste.* Paris: A. Le Clere et cie, 1834.

**Quieto 1980–81**
Quieto, Pierpaolo. "Gian Domenico Campiglia e il suo tempo." Ph.D. diss., Rome: Università di Roma, "La Sapienza," 1980–81.

**Quieto 1983**
Quieto, Pierpaolo. "Gli autoritratti di Giovanni Domenico Campiglia." *Rassegna dell'Accademia Nazionale di San Luca,* vol. 1–2 (1983), pp. 2–8.

**Quieto 1984**
Quieto, Pierpaolo. "Giovanni Domenico Campiglia, Mons. Bottari e la rappresentazione dell'antico." *Labyrinthos,* vol. 3, no. 5–6 (1984), pp. 3–36.

**Quieto 1988**
Quieto, Pierpaolo. *Giovanni V di Portogallo e le sue committenze nella Roma del XVIII secolo: la pittura a Mafra, Evora, Lisbona.* Florence: Pierpaolo Quieto, 1988.

**Quieto 1990**
Quieto, Pierpaolo. *D. João V de Portugal: a sua influênça na arte italiana do séc. XVIII.* Lisbon: ELO, 1990.

**Radrizzani 1995**
Radrizzani, Dominique. "Entre le serpent et la pomme: le Laocoon chez les néoclassiques suisses." *Kunst + Architektur in der Schweiz,* vol. 46 (1995), pp. 356–67.

**Ragghianti 1967**
Ragghianti, Carlo L. "Batoni pittore storico." *Critica d'arte,* n.s., vol. 14 (1967), pp. 42–48.

**Raggio 1991**
Raggio, Olga. "New Galleries for French and Italian Sculpture at the Metropolitan Museum of Art." *Gazette des Beaux-Arts,* 6th ser., vol. 118 (1991), pp. 231–52.

**Raho 1996–97**
Raho, F. "I restauri del Duomo di Vetralla: tra tradizione e innovazione." Ph.D. diss., Rome: Università di Roma, 1996–97.

**Ramade and Fournier 1985**
Ramade, Patrick, and Catherine Fournier. *Jean-Germain Drouais, 1763–1788.* Rennes, France: Musée des Beaux-Arts de Rennes, 1985.

**Rangoni 1990**
Rangoni, Fiorenza. "Cavallucci, Antonio." In *La pittura* 1990. Vol. 2, pp. 659–60.

**Rangoni 1990, "Bianchi"**
Rangoni, Fiorenza. "Bianchi, Pietro." In *La pittura* 1990. Vol. 2, pp. 624–25.

**Rangoni 1990, "Bloemen"**
Rangoni, Fiorenza. "Van Bloemen, Jan Frans, detto Orizzonte." In *La pittura* 1990. Vol. 2, p. 892.

**Rangoni 1990, "Conca"**
Rangoni, Fiorenza. "Conca, Sebastiano." In *La pittura* 1990. Vol. 2, pp. 675–76.

**Rangoni 1990, "Hamilton"**
Rangoni, Fiorenza. "Hamilton, Gavin." In *La pittura* 1990. Vol. 2, pp. 750–51.

**Rangoni 1990, "Imperiali"**
Rangoni, Fiorenza. "Fernandi, Franceso, detto l'Imperiali." In *La pittura* 1990. Vol. 2, pp. 714–15.

**Rangoni 1990, "Locatelli"**
Rangoni, Fiorenza. "Locatelli, Andrea." In *La pittura* 1990. Vol. 2, pp. 767–68.

**Rangoni 1990, "Masucci"**
Rangoni, Fiorenza. "Masucci, Agostino." In *La pittura* 1990. Vol. 2, pp. 788–89.

**Rangoni 1990, "Tommaso"**
Rangoni, Fiorenza. "Conca, Tommaso." In *La pittura* 1990. Vol. 2, p. 676.

**Rangoni 1998**
Rangoni, Fiorenza. "Marco Benefial." In *Seicento e Settecento* 1998, pp. 79–83.

**Ratti 1779**
Ratti, Carlo Giuseppe. *Epilogo della vita del fu cavalier Antonio Raffaello Mengs.* Genoa, Italy: Stamperia del Casamara dalle Cinque Lampade, 1779.

**Ratti 1797**
Ratti, Carlo Giuseppe. *Delle vite de' pittori, scultori, ed architetti genovesi e dei forestieri che in Genova hanno operato dall'anno 1584 a tutto 1765.* Genoa, Italy, 1797.

**Réau 1923**
Réau, Louis A. "Le prémier Salon de Houdon." *Gazette des Beaux-Arts,* 5th ser., vol. 7 (1923), pp. 41–52.

**Réau 1929**
Réau, Louis. *Catalogue de l'art français dans les musées russes.* Paris: Librairie Armand Colin, 1929.

**Réau 1945**
Réau, Louis. *Les Sculpteurs français en Italie.* Paris: Les Editions universelles, 1945.

**Réau 1964**
Réau, Louis. *Houdon sa vie et son oeuvre.* 4 vols. Paris: F. De Nobele, 1964.

**Reboulet 1752**
Reboulet, Simon. *Histoire de Clement XI.* Avignon, France: Claude Delorme & François Girard, 1752.

**Recensir col tratto 1989**
Museo Nazionale di Palazzo Mansi, Lucca, Italy. "*Recensir col tratto*": disegni di Bernardino e Pietro Nocchi. Lucca, Italy: Maria Pacini Fazzi, 1989.

**Regola e la fama 1995**
Palazzo Venezia, Rome. *La regola e la fama: San Filippo Neri e l'arte.* Milan: Electa, 1995.

**Ribeiro 1985**
Ribeiro, Aileen. *Dress in Eighteenth-Century Europe, 1715–1789.* New York: Holmes & Meier, 1985.

**Riccoboni 1942**
Riccoboni, Alberto. *Roma nell'arte: la scultura nell'evo moderno dal Quattrocento ad oggi.* Rome: Mediterranea, 1942.

**Richardson 1942**
Richardson, Edgar P. "Three Masters of the Roman Baroque: Cortona, Duquesnoy, Legros." *The Detroit Institute of Arts Bulletin,* vol. 22 (1942), pp. 10–15.

**Richardson 1948**
Richardson, Edgar P. "Two Roman Views by Pannini." *The Detroit Institute of Arts Bulletin,* vol. 27 (1948), pp. 54–58.

**Richardson J. 1722**
Richardson, Jonathan. *An Account of Some of the Statues, Bas-Reliefs, Drawings and Pictures in Italy.* London: J. Knapton, 1722.

**Ridgway 1970**
Ridgway, Brunilde Sismondo. "Dolphins and Dolphin-Riders." *Archaeology,* vol. 23 (1970), pp. 86–95.

**Riebesell 1989**
Riebesell, Christina. *Die Sammlung des Kardinal Alessandro Farnese: Ein 'Studio' für Künstler und Gelehrte.* Weinheim, Germany: Acta Humaniora, 1989.

**Righetti 1940**
Righetti, Romolo. "Fonditori in bronzo romani del Settecento e dell'Ottocento: i Valadier e i Righetti." *L'urbe,* vol. 5, no. 11 (1940), pp. 2–19.

**Righetti 1941**
Righetti, Romolo. "Fonditori in bronzo romani del Settecento e dell'Ottocento: i Valadier e i Righetti." *L'Urbe,* vol. 6, no. 1 (1941), pp. 2–8.

**Rinaldi 1990**
Rinaldi, Alessandro. "Viaggio al Bosco Parrasio: l'Arcadia attraverso i giardini romani." In *Gli orti Farnesiani sul palatino,* pp. 485–504. Rome: École française de Rome and Soprintendenza Archeologica di Roma, 1990.

**Riis 1974**
Riis, Poul Jørgen. "Abildgaard's Athens." *Hafnia: Copenhagen Papers in the History of Art,* vol. 3 (1974), pp. 9–27.

**Robillard-Péronville 1807**
Robillard-Péronville. *Musée français: recueil des plus beaux tableaux, statues, et bas-reliefs qui existaient au Louvre avant 1815.* Vol. 3. Paris: A. & W. Galignani, 1807.

**Robison 1973**
Robison, Andrew. "Piranesi's Ship on Wheels." *Master Drawings,* vol. 11 (1973), pp. 389–92.

**Robison 1983**
Robison, Andrew. "Dating Piranesi's Early 'Vedute di Roma.'" In Bettagno 1983, pp. 11–33.

**Robison 1986**
Robison, Andrew. *Piranesi, Early Architectural Fantasies: A Catalogue Raisonné of the Etchings.* Washington, D.C.: National Gallery of Art; Chicago and London: The University of Chicago Press, 1986.

**Rocchi Coopmans de Yoldi 1996**
Rocchi Coopmans de Yoldi, Giuseppe, ed. *San Pietro: arte e storia nella Basilica Vaticana.* Bergamo, Italy: Bolis, 1996.

**Rocher-Jauneau 1953**
Rocher-Jauneau, Madeleine. "Une oeuvre de Jean-François de Troy au Musée des Beaux-Arts de Lyon." *Bulletin des musées et monuments lyonnais,* vol. 2 (1953), pp. 7–12.

**Rodeschini Galati 1988**
Rodeschini Galati, Maria Cristina. "Un 'giovane molto abile': Giovan Battista Dell'Era." *Osservatorio delle arti,* (1988), pp. 57–59.

**Rodeschini Galati 1996**
Rodeschini Galati, Maria Cristina. "Giovan Battista Dell'Era: le opere." In *Pittori bergamaschi* 1996, pp. 476–517.

**Rodgers 1996**
Rodgers, David. "Hamilton, Gavin." In DA, vol. 14, pp. 108–10.

**Rodrigues 1988**
Madeira Rodrigues, Maria João. *The Chapel of Saint John the Baptist and Its Colections [sic] in São Roque Church, Lisbon.* Translated by Transtex. Lisbon: Inapa, 1988. Originally published as *A Capela de S. João Baptista e as suas Colecções.* (Lisbon: Inapa, 1988).

**Roethlisberger 1983**
Roethlisberger, Marcel. *Im Licht von Claude Lorrain: Landschaftsmalerei aus drei Jahrhunderten.* Munich: Hirmer, 1983.

**Roettgen 1970**
Roettgen, Steffi. "Two Portraits by Mengs in the Art Institute of Chicago." *The Art Institute of Chicago: Museum Studies,* vol. 5 (1970), pp. 65–75.

**Roettgen 1972**
Roettgen, Steffi. "'Antonius de Maron faciebat Romae': zum Werk Anton von Marons in Rom." In *Österreichische Künstler und Rom vom Barock zur Secession.* Vienna: Akademie der Bildenden Künste, 1972.

**Roettgen 1973**
Roettgen, Steffi. Review of *The Age of Neoclassicism. Arte illustrata,* vol. 6, no. 52 (1973), pp. 56–68.

**Roettgen 1976**
Roettgen, Steffi. "Antonio Cavallucci: un pittore romano fra tradizione e innovazione." *Bollettino d'arte,* 5th ser., vol. 61, no. 3–4 (1976), pp. 193–212.

**Roettgen 1977**
Roettgen, Steffi. " Mengs, Alessandro Albani und Winckelmann: Idee und Gestalt des Parnass in der Villa Albani." *Storia dell'arte,* vol. 30–31 (1977), pp. 87–156.

**Roettgen 1979**

Roettgen, Steffi. "Cavallucci, Antonio." In DBI, vol. 23, pp. 1–5.

**Roettgen 1980**

Roettgen, Steffi. "Das Papyruskabinett von Mengs in der Biblioteca Vaticana: Ein Beitrag zur Idee und Geschichte des Museo Pio-Clementino." *Münchner Jahrbuch der Bildenden Kunst*, vol. 31 (1980), pp. 189–246.

**Roettgen 1981**

Roettgen, Steffi. "Zum Antikenbesitz des Anton Raphael Mengs und zur Geschichte und Wirkung seiner Abguss- und Formensammlung." In H. Beck, P. C. Bol, W. Prinz, and H. von Steuben, eds., *Antikensammlungen im 18. Jahrhundert*, pp. 129–48. Vol. 9 of *Frankfurter Forschungen zur Kunst*. Berlin: Mann, 1981.

**Roettgen 1982**

Roettgen, Steffi. "Die Villa Albani und ihre Bauten." In Beck and Bol 1982, pp. 59–184.

**Roettgen 1987**

Roettgen, Steffi. "La Villa Albani e le sue costruzioni." In Elisa Debenedetti, ed., *Contributi su Carlo Marchionni, dal corso della Prof. Elisa Debenedetti, storia dell'arte moderna IV*, pp. 17–83. Rome: Bagatto Libri, 1987.

**Roettgen 1993**

Roettgen, Steffi. *Anton Raphael Mengs, 1728–1779, and His British Patrons.* London: A. Zwemmer and English Heritage, 1993.

**Roettgen 1993, "Mengs"**

Roettgen, Steffi. "Mengs, David et le classicisme romain." In Michel R. 1993, pp. 59–80.

**Roettgen 1994**

Roettgen, Steffi. "Tre pittori romani del Settecento a Siena: Marco Benefial, Placido Costanzi e Giovanni Odazzi a Palazzo Chigi Zondadari." In *Studi di Storia dell'Arte in onore di Mina Gregori*, pp. 341–47. Milan: Silvana, 1994.

**Roettgen 1998**

Roettgen, Steffi. "Begegnung mit Apollo: Zur Rezeptionsgeschichte des Apollo vom Belvedere im 18. Jahrhundert." In Matthias Winner, Bernard Andreae, and Carlo Pietrangeli, eds., *Il Cortile delle Statue: Der Statuenhof des Belvedere im Vatikan. Akten des internationalen Kongresses zu Ehren von Richard Krautheimer, Rom 21.–23. Oktober 1992*, pp. 253–74. Mainz, Germany: Philipp von Zabern, 1998.

**Roettgen 1998, "Mengs"**

Roettgen, Steffi. "Die 'Mengsische Akademie' in Rom: Anton Raphael Mengs, seine Schule und Angelika Kauffmann." In Baumgärtel 1998, pp. 52–59.

**Roettgen 1999**

Roettgen, Steffi. *Anton Raphael Mengs, 1728–1779: Das malerische und zeichnerische Werk.* Vol. 1. Munich: Hirmer, 1999.

**Roettgen 2000**

Roettgen, Steffi. *Anton Raphael Mengs, 1728–1779: Leben und Werk.* Forthcoming.

**Roland Michel 1960**

Roland Michel, Marianne. "Notes on a Painting by Hubert Robert Formerly Attributed to Watteau." *The Burlington Magazine* [supplement], vol. 102 (1960), pp. ii–iii.

**Roland Michel 1978**

Roland Michel, Marianne. "De l'Illusion à 'l'inquiétante étrangeté': quelques remarques sur l'evolution du sentiment et de la représentation de la ruine chez des artistes français à partir de 1730." In Brunel 1978, pp. 475–98.

**Roland Michel 1987**

Roland Michel, Marianne. *Le Dessin français au XVIIIe siècle.* Fribourg, Switzerland: Office du Livre; Paris: Vilo, 1987.

**Roland Michel 1992**

Roland Michel, Marianne. " Mode ou imitation: sculpture et peinture en trompe-l'oeil au XVIIIe siècle." In *Clodion et la sculpture française de la fin du XVIIIe siècle: actes du colloque organisé au Musée du Louvre par le service culturel les 20 et 21 mars 1992*, pp. 355–71. Paris: La Documentation française, 1993.

**Roli 1964**

Roli, Renato. "Per l'attività romana di Aureliano Milani." *Arte antica e moderna*, vol. 27 (1964), pp. 341–48.

**Roli and Sestieri 1981**

Roli, Renato, and Giancarlo Sestieri. *I disegni italiani nel Settecento: scuole piemontese, lombarda, genovese, bolognese, toscana, romana e napoletana.* Treviso, Italy: Canova, 1981.

**Romagnoli 1840**

Romagnoli, Ettore. *Cenni storico-artistici di Siena e suoi suburbii.* Siena, Italy: O. Porri, 1840.

**Romano 1993**

Romano, Giovanni, ed. *Roma, Torino, Parigi, 1770–1830.* Turin, Italy: Umberto Allemandi, 1993.

**Romano S. 1977**

Romano, Serena. "Contributi a Giuseppe Passeri." *Ricerche di storia dell'arte*, vol. 6 (1977), pp. 159–74.

**Romano Cervone 1994**

Romano Cervone, Anna Teresa. "Faustina Maratti Zappi e Petronilla Paolini Massimi: l'universo debole della prima Arcadia romana." *Atti e memorie: Arcadia. Atti del Convegno di studi per il III centenario, Roma 15–18 maggio 1991*, vol. 9 (1994), pp. 169–76.

**Rosa 1999**

Rosa, Mario. *Settecento religioso: politica della ragione e religione del cuore.* Venice: Marsilio, 1999.

**Rosenberg 1988**

Rosenberg, Pierre. *Fragonard.* New York: The Metropolitan Museum of Art, 1988.

**Rosenberg 1996**

Rosenberg, Pierre. "Subleyras: douze ans [sic] après l'exposition de Paris et de Rome." In *Scritti di archeologia e storia dell'arte in onore di Carlo Pietrangeli*, pp. 37–39. Rome: Quasar, 1996.

**Rosenberg 1999**

Rosenberg, Pierre. "Quelques nouveautés concernant Peyron." In *Mélanges Ksenija Rozman.* Ljubljana, Croatia, 1999.

**Rosenberg and Brejon de Lavergnée 1986**

Rosenberg, Pierre, and Barbara Brejon de Lavergnée, eds. *Saint-Non, Fragonard, panopticon italiano: un diario di viaggio ritrovato, 1759–1761.* Rome: Elefante, 1986.

**Rosenberg and Van de Sandt 1983**

Rosenberg, Pierre, and Udolfo Van de Sandt. *Pierre Peyron.* Neuilly-sur-Seine, France: Arthena, 1983.

**Rosenberg, Jansen, and Giltaij 1992**

Rosenberg, Pierre, Guido Jansen, and Jeroen Giltaij. *Chefs-d'oeuvre de la peinture française des musées néerlandais, XVIIe– XVIIIe siècles.* Rotterdam, Netherlands: Museum Boymans-van Beuningen, 1992.

**Rosenblum 1961**

Rosenblum, Robert. "Gavin Hamilton's 'Brutus' and Its Aftermath." *The Burlington Magazine*, vol. 103 (1961), pp. 8–16.

**Rosenblum 1965**

Rosenblum, Robert. "Letters: Jacques-Louis David at Toledo." *The Burlington Magazine*, vol. 107 (1965), pp. 473–75.

**Rosenblum 1967**

Rosenblum, Robert. *Transformations in Late Eighteenth-Century Art.* Princeton, N.J.: Princeton University Press, 1967.

**Rosenthal 1992, "Kauffman"**

Rosenthal, Angela. "Angelica Kauffman Ma(s)king Claims." *Art History*, vol. 15 (1992), pp. 38–59.

**Rosenthal 1996**

Rosenthal, Angela. *Angelika Kauffmann: Bildnismalerei im 18. Jahrhundert.* Berlin: Reimer, 1996.

**Roserot 1908**

Roserot, Alphonse. "La Vie et l'oeuvre d'Edme Bouchardon en Italie." *Gazette des Beaux-Arts*, 3rd ser., vol. 40 (1908), pp. 17–37.

**Roserot 1910**

Roserot, Alphonse. *Edme Bouchardon.* Paris: E. Lévy, 1910.

**Rotili 1982**

Rotili, Mario. *Filippo Raguzzini nel terzo centenario della nascita: precisazioni, aggiunte e prospettive di studio.* Naples: Società Editrice Napoletana, 1982.

**Rovere, Viale, and Brinckmann 1937**

Rovere, Lorenzo, Vittorio Viale, and Albert Erich Brinckmann. *Filippo Juvarra.* Milan: Oberdan Zucchi, 1937.

**Rowan 1974**

Rowan, Alistair J. "After the Adelphi: Forgotten Years in the Adam Brothers' Practice." *Journal of the Royal Society of Arts*, vol. 122 (1974), pp. 639–710.

**Rowlands 1996**

Rowlands, Eliot W. *The Collections of The Nelson-Atkins Museum of Art: Italian Paintings, 1300–1800*, pp. 396–404. Kansas City, Mo.: The Nelson-Atkins Museum of Art in association with the University of Washington Press, 1996.

**Roworth 1984**

Roworth, Wendy Wassyng. "Angelica Kauffman's 'Memorandum of Paintings.'" *The Burlington Magazine*, vol. 126 (1984), pp. 627–28.

**Roworth 1988**

Roworth, Wendy Wassyng. "Biography, Criticism, Art History: Angelica Kauffman in Context." In Keener and Lorsch 1988, pp. 209–23.

**Roworth 1992**

Roworth, Wendy Wassyng. *Angelica Kauffman: A Continental Artist in Georgian England.* London: Reaktion Books, 1992.

**Roworth 1994**

Roworth, Wendy Wassyng. "Anatomy is Destiny: Regarding the Body in the Art of Angelica Kauffman." In Perry and Rossington 1994, pp. 41–62.

**Roworth 1998**

Roworth, Wendy Wassyng. "Angelika Kauffmann e gli artisti inglesi a Roma." In Sandner 1998, pp. XLIX–LVI.

**Rubin 1978**

Rubin, James Henry. "Endymion's Dream as a Myth of Romantic Inspiration." *The Art Quarterly*, vol. 1 (1978), pp. 47–84.

**Rubinstein-Bloch 1930**

Rubinstein-Bloch, Stella. *Paintings, Drawings, Sculptures, XVIIIth Century.* Vol. 5 of *Catalogue of the Collection of George and Florence Blumenthal.* Paris: A. Lévy, 1930.

**Rudolph 1977**

Rudolph, Stella. "Felice Giani: da Accademico 'de' Pensieri' a Madonnero." *Storia dell'arte*, vol. 30–31 (1977), pp. 175–86.

**Rudolph 1978**

Rudolph, Stella. "The 'Gran Sala' in the Cancelleria Apostolica: A Homage to the Artistic Patronage of Clement XI." *The Burlington Magazine*, vol. 120 (1978), pp. 593–601.

**Rudolph 1978, "Torribio"**

Rudolph, Stella. "The Torribio Illustrations and Some Considerations on Engravings after Carlo Maratti." *Antologia di Belle Arti*, vol. 2 (1978), pp. 191–203.

**Rudolph 1979**

Rudolph, Stella. "Camillo Rusconi e la cappellania di Carlo Maratti a Camerano." *Paragone*, vol. 30, no. 347 (1979), pp. 24–33.

**Rudolph 1982**

Rudolph, Stella. "Primato di Domenico Corvi nella Roma del secondo Settecento." *Labyrinthos*, vol. 1, no. 1–2 (1982), pp. 1–45.

**Rudolph 1983**

Rudolph, Stella, ed. *La pittura del '700 a Roma.* Milan: Longanesi, 1983.

**Rudolph 1984**

Rudolph, Stella. "La pittura del '700 a Roma." *Labyrinthos*, vol. 3, no. 5–6 (1984), pp. 315–20.

**Rudolph 1985**

Rudolph, Stella. "Il punto su Bernardino Nocchi." *Labyrinthos*, vol. 4, no. 7–8 (1985), pp. 200–231.

**Rudolph 1988–89**

Rudolph, Stella. "Vincenzo Vittoria fra pitture, poesie e polemiche." *Labyrinthos*, vol. 7–8, no. 13–16 (1988–89), pp. 223–66.

**Rudolph 1994**

Rudolph, Stella. "Una visita alla capanna del pastore Disfilo." *Atti e memorie: Arcadia. Atti del Convegno di studi per il III centenario, Roma 15–18 maggio 1991*, vol. 9 (1994), pp. 387–415.

**Rudolph 1994, "Premessa"**

Rudolph, Stella. "Premessa ad un'indagine sul mecenatismo del cardinale Alderano Cybo, devoto dell'Immacolata nonché parziale a Guercino e a Maratti." *Bollettino dei musei comunali di Roma*, n.s., vol. 8 (1994), pp. 5–31.

**Rudolph 1995**

Rudolph, Stella. *Niccolò Maria Pallavicini: l'ascesa al tempio della virtù attraverso il mecenatismo.* Rome: Ugo Bozzi, 1995.

**Rudolph 1998**

Rudolph, Stella. "L'autoritratto nei 'Sonetti Giocosi' di un pittore sciagurato: la Roma di Benedetto XIV vista e vissuta da Giacomo Diol." In Biagi Maino 1998, pp. 87–121.

**Rudolph 1998, "Corvi"**
Rudolph, Stella. "Le committenze romane di Domenico Corvi." In Curzi and Lo Bianco 1998, pp. 19–33.

**Ruggeri 1996**
Ruggeri, Ugo. "Trevisani, Francesco." In DA, vol. 31, pp. 312–15.

**Russell 1973**
Russell, Francis. "Portraits on the Grand Tour: Batoni's British Sitters." *Country Life* (June 7, 1973), pp. 1608–10; (June 14, 1973), pp. 1754–56.

**Russell 1979**
Russell, Francis. "The British Portraits of Anton Raphael Mengs." *National Trust Studies*, (1979), pp. 9–20.

**Russell 1985**
Russell, Francis. "Dr. Clephane, John Blackwood and Batoni's 'Sacrifice of Iphigenia.'" *The Burlington Magazine*, vol. 127 (1985), pp. 890–93.

**Russell 1988**
Russell, Francis. "Notes on Luti, Batoni and Nathaniel Dance." *The Burlington Magazine*, vol. 130 (1988), pp. 853–55.

**Russo 1993**
Russo, Kathleen. "Henry Fuseli's Interpretations from Dante." *Italian Culture*, vol. 11 (1993), pp. 83–102.

**Rutledge 1955**
Rutledge, Anna Wells, ed. *Cumulative Record of Exhibition Catalogues: The Pennsylvania Academy of the Fine Arts, 1807–1870.* Philadelphia: American Philosophical Society, 1955.

**Rybko 1990**
Rybko, Ana Maria. "Costanzi, Placido." In *La pittura* 1990. Vol. 2, pp. 681–82.

**Rybko 1990, "Bottani"**
Rybko, Ana Maria. "Bottani, Giuseppe." In *La pittura* 1990. Vol. 2, p. 637.

**Rybko 1990, "Mazzanti"**
Rybko, Ana Maria. "Mazzanti, Ludovico." In *La pittura* 1990. Vol. 2, p. 790.

**Rybko 1990, "Milani"**
Rybko, Ana Maria. "Milani, Aureliano." In *La pittura* 1990. Vol. 2, pp. 794–95.

**Rybko 1990, "Panini"**
Rybko, Ana Maria. "Panini, Giovanni Paolo." In *La pittura* 1990. Vol. 2, pp. 818–19.

**Rybko 1996**
Rybko, Ana Maria. "Masucci, Agostino." In DA, vol. 20, pp. 805–6.

**Rybko 1996, "Mazzanti"**
Rybko, Anna Maria. "Mazzanti, Ludovico." In DA, vol. 20, pp. 903–4.

**Rykwert 1977**
Rykwert, Joseph. Introduction to the *Nolli Plan of Rome.* London: Architecture Unit, Polytechnic of Central London, 1977.

**Rykwert 1980**
Rykwert, Joseph. *The First Moderns: The Architects of the Eighteenth Century.* Cambridge: MIT Press, 1980.

**St. Clair 1967**
St. Clair, William. *Lord Elgin and the Marbles.* London and New York: Oxford University Press, 1967.

**Salerno 1974**
Salerno, Luigi. "L'ambiente di Palazzo Carpegna." In *L'Accademia* 1974, pp. 59–77.

**Salerno 1974, "Collezione"**
Salerno, Luigi. "La collezione dei disegni: composizioni, paesaggi, figure." In *L'Accademia* 1974, pp. 323–67.

**Salerno 1974, *Cappella***
Salerno, Luigi. *La cappella del Monte di Pietà di Roma.* Rome: Cassa di Risparmio di Roma, 1974.

**Salmon 1993**
Salmon, Xavier. "Jean-François de Troy et Hyacinthe Collin de Vermont: inspiration réciproque ou culture académique commune?" *Bulletin des musées et monuments lyonnais*, no. 3–4 (1993), pp. 48–61.

**Salviucci Insolera 1996**
Salviucci Insolera, Lydia. "Le prime edizioni del Trattato." In *Andrea Pozzo* 1996, pp. 207–14.

**Sammlung Janos Scholz 1963**
Hamburger Kunsthalle, Hamburg, Germany; Wallraf-Richartz-Museum, Cologne. *Italienische Meisterzeichnungen vom 14. bis zum 18. Jahrhundert aus amerikanischem Besitz: Die Sammlung Janos Scholz, New York.* Hamburg, Germany: H. Christians, 1963.

**Sandner 1998**
Sandner, Oscar, ed. *Angelika Kauffmann e Roma.* Rome: De Luca, 1998.

**Sandström 1981**
Sandström, Birgitta. "Bénigne Gagneraux, 1756–1795: education, inspiration, oeuvre." Ph.D. diss., Stockholm: Stockholms Universitet, 1981.

**Santi 1980–81**
Santi, Bruno, ed. *Zibaldone Baldinucciano.* 2 vols. Florence: Studio Per Edizioni Scelte, 1980–81.

**Santucci 1981**
Santucci, Paola. *Ludovico Mazzanti, 1686–1775.* L'Aquila, Italy: Japadre, 1981.

**Sassoli 1994**
Sassoli, Mario Gori. *Della chinea e di altre "macchine di gioia": apparati architettonici per fuochi d'artificio a Roma nel Settecento.* Milan: Charta, 1994.

**Scalabroni 1981**
Scalabroni, Luisa. *Giuseppe Vasi (1710–1782).* Rome: Multigrafica, 1981.

**Scarabelli 1843**
Scarabelli, Luciano. *Opuscoli artistici, morali, scientifici e letterarii: scritti artistici.* Piacenza, Italy: Antonio del Majus, 1843.

**Scavizzi 1982**
Scavizzi, Giuseppe. "Chiari, Giuseppe Bartolomeo." In DBI, vol. 24, pp. 562–64.

**Schaar 1964**
Schaar, Eckhard. *Italienische Handzeichnungen des Barock: aus den Beständen des Kupferstichkabinetts im Kunstmuseum Düsseldorf.* Düsseldorf: Kunstmuseum Düsseldorf, 1964.

**Schaffran 1931**
Schaffran, Ernst. "Ein unbekanntes Historienbild des Pompeo Batoni." *Belvedere*, vol. 10 (1931), pp. 94–96.

**Scherf 1991**
Scherf, Guilhem. "Autour de Clodion: variations, répétitions, imitations." *Revue de l'art*, no. 91, (1991), pp. 47–59.

**Scherf 1999**
Scherf, Guilhem. "Le Portrait de Madame Vleughels, sculpté en 1732 par Bouchardon, revient en France pour entrer au Louvre." *Revue du Louvre*, vol. 49, no. 2 (1999), pp. 18–21.

**Scheurmann and Bongaerts-Schomer 1997**
Scheurmann, Konrad, and Ursula Bongaerts-Schomer. *"Finalmente in questa capitale del mondo!": Goethe a Roma.* 2 vols. Rome: Artemide, 1997.

**Schiavo 1956**
Schiavo, Armando. *La Fontana di Trevi e le altre opere di Nicola Salvi.* Rome: La Libreria dello Stato, 1956.

**Schiavo 1960**
Schiavo, Armando. *Palazzo Altieri.* Rome: Associazione Bancaria Italiana, 1960.

**Schiavo 1985**
Schiavo, Armando. "La pontificia insigne Accademia artistica dei Virtuosi al Pantheon." *L'Urbe*, n.s., vol. 48 (1985), pp. 9–32.

**Schiavo 1985, "Virtuosi"**
Schiavo, Armando. "Mostra dei Virtuosi al Portico del Pantheon nel 1750." *L'Urbe*, n.s., vol. 48 (1985), pp. 174–81.

**Schiff 1959**
Schiff, Gert. *Zeichnungen von Johann Heinrich Füssli, 1741–1825.* Zurich: Fretz & Wasmuth, 1959.

**Schiff 1963**
Schiff, Gert. *Johann Heinrich Füsslis Milton-Galerie.* Zurich: Fretz & Wasmuth, 1963.

**Schiff 1964**
Schiff, Gert. "Johann Heinrich Füssli und Michelangelo." *Schweizerisches Institut für Kunstwissenschaft Jahresbericht* (1964), pp. 123–34.

**Schiff 1969**
Schiff, Gert. *Johann Heinrich Füssli, 1741–1825: Gemälde und Zeichnungen.* Zurich: Kunsthaus Zürich, 1969.

**Schiff 1973**
Schiff, Gert. *Johann Heinrich Füssli, 1741–1825.* 2 vols. Zurich: Berichthaus; Munich: Prestel, 1973.

**Schiff 1974**
Schiff, Gert. *Henry Fuseli, 1741–1825.* Translated by Sarah Twohig. Munich: Prestel, 1974.

**Schiff and Viotto 1977**
Schiff, Gert, and Paola Viotto, eds. *L'opera completa di Füssli.* Milan: Rizzoli, 1977.

**Schlegel 1963**
Schlegel, Ursula. "Bernardino Cametti, I." *Jahrbuch der Berliner Museen*, vol. 5 (1963), pp. 44–83.

**Schlegel 1963, "Cametti"**
Schlegel, Ursula. Bernardino Cametti, II." *Jahrbuch der Berliner Museen*, vol. 5 (1963), pp. 151–200.

**Schlegel 1967**
Schlegel, Ursula. "Some Statuettes of Giuseppe Mazzuoli." *The Burlington Magazine*, vol. 109 (1967), pp. 388–95.

**Schlegel 1969**
Schlegel, Ursula. "Alcuni disegni di Camillo Rusconi, Carlo Maratta e Angelo de' Rossi." *Antichità viva*, vol. 8 (1969), pp. 28–41.

**Schlegel 1972**
Schlegel, Ursula. "Per Giuseppe e Bartolomeo Mazzuoli: nuovi contributi." *Arte illustrata*, vol. 5, no. 47 (1972), pp. 6–8, 38–49, 105–7.

**Schlegel 1974**
Schlegel, Ursula. "Bozzetti in Terracotta by Pietro Stefano Monnot." *Boston Museum Bulletin*, vol. 72, no. 367 (1974), pp. 56–68.

**Schlegel 1978**
Schlegel, Ursula. *Die italienischen Bildwerke des 17. und 18. Jahrhunderts in Stein, Holz, Ton, Wachs, und Bronze mit Ausnahme der Plaketten und Medaillen.* Berlin: Mann, 1978.

**Schlegel 1988**
Schlegel, Ursula. *Die italienischen Bildwerke des 17. und 18. Jahrhunderts in Stein, Holz, Ton, Wachs, und Bronze mit Ausnahme der Plaketten und Medaillen: Die Erwerbungen von 1978 bis 1988.* Berlin: Mann, 1988.

**Schlegel 1989**
Schlegel, Ursula. *Italienische Skulpturen: Ein Gang durch die Berliner Skulpturengalerie.* Berlin: Mann, 1989.

**Schleier 1971–73**
Schleier, Erich. "'Die Anbetung der Könige' von Giuseppe Chiari: Zur Genese der Komposition." *Jahrbuch der Berliner Museen*, vol. 21–23 (1971–73), pp. 58–67.

**Schleier 1978**
Schleier, Erich. "Un affresco poco noto e due modelli inediti di Giovanni Odazzi." *Paragone*, vol. 29, no. 339 (1978), pp. 63–67.

**Schleier 1993**
Schleier, Erich. "Giovanni Odazzi: inediti e nuove proposte." In Ciardi, Pinelli, and Sicca 1993, pp. 7–17.

**Schlosser 1910**
Schlosser, Julius von. *Werke der Kleinplastik in der Skulpturensammlung des A. H. Kaiserhauses.* 2 vols. Vienna: A. Schroll, 1910.

**Schnapper 1980**
Schnapper, Antoine. *David: témoin de son temps.* Paris: Bibliothèque des Arts, 1980.

**Schneider 1987**
Schneider, S. "Raumgestaltung um 1800: Die ästhetischen Wirkungsmittel bei der Gestaltung profaner Interieure in Wiemar." 2 vols. Ph.D. diss., Halle, Germany: Martin-Luther-Universität Halle-Wittenberg, 1987.

**Schöne 1866**
Schöne, Richard. "Asmus Jakob Carstens." *Archiv für die zeichnenden Künste*, vol. 12 (1866), pp. 121–55.

**Schottmüller 1913**
Schottmüller, Frida, ed. *Die italienischen und spanischen Bildwerke der Renaissance und des Barocks in Marmor, Ton, Holz und Stuck.* Berlin: Georg Reimer, 1913.

**Schottmüller 1933**
Schottmüller, Frida, ed. *Die italienischen und spanischen Bildwerke der Renaissance und des Barock: Die Bildwerke in Stein, Holz, Ton und Wachs.* 2nd ed. Berlin: Walter de Gruyter, 1933.

**Schröter 1982**
Schröter, Elisabeth. "Die Villa Albani als Imago Mundi: Das unbekannte Fresken- und Antikenprogramm im Piano Nobile der Villa Albani zu Rom." In Beck and Bol 1982, pp. 185–299.

**Schulz 1953**
Schulz, Arthur. *Die Bildnisse Johann Joachim Winckelmanns.* Berlin: Akademie, 1953.

**Schulze 1996**
Schulze, Sabine, ed. *Goethe und die Kunst.* Stuttgart, Germany: Hatje, 1996.

**Schulze-Battmann 1939**
Schulze-Battmann, Elfriede. *Giuseppe Valadier: Ein klassizistischer Architekt Roms, 1762–1839.* Dresden, Germany: H. Zetsche, 1939.

**Schuttwolf 1995**
Schuttwolf, Allmuth. *Sammlung der Plastik: Schlossmuseum Gotha.* Gotha, Germany: Gothaer Kultur- und Fremdenverkehrsbetrieb, 1995.

**Schwark 1930**
Schwark, Günther. "Houdon in deutschen Museen." *Belvedere*, vol. 9 (1930), pp. 48–51.

**Scott 1987**
Scott, Barbara. "Letter from Paris: Pierre Subleyras (1699–1749), A Great Artist Rediscovered."*Apollo*, n.s., vol. 125 (1987), pp. 370–72.

**Scott J. 1991**
Scott, John Beldon. *Images of Nepotism: The Painted Ceilings of Palazzo Barberini*. Princeton, N.J.: Princeton University Press, 1991.

**Scott, Jonathan, 1975**
Scott, Jonathan. *Piranesi*. London: Academy Editions; New York: St. Martin's Press, 1975.

**Scott K. 1995**
Scott, Katie. *The Rococo Interior: Decoration and Social Spaces in Early Eighteenth-Century Paris*. New Haven and London: Yale University Press, 1995.

**Scotti 1979**
Scotti, Aurora. *Brera, 1776–1815: nascita e sviluppo di una istituzione culturale milanese*. Vol. 5 of *Quaderni di Brera*. Florence: Centro Di, 1979.

**Scotti 1984**
Scotti, Aurora. *Lo stato e la città: architetture, istituzioni e funzionari nella Lombardia illuminista*. Milan: Franco Angeli, 1984.

**Sebastiani 1741**
Sebastiani, Leopoldo. *Descrizione e relazione istorica del nobilissimo, e real Palazzo di Caprarola: suo principio, situazione, architettura, e pitture*. Rome: Per gl'eredi del Ferri, 1741.

**Seicento e Settecento 1998**
Musée du Louvre, Paris; Palazzo Reale, Milan; Palazzo Barberini, Rome. *Il Seicento e Settecento romano nella collezione Lemme*. Milan: De Luca, 1998.

**Semenza 1999**
Semenza, Giulia. "Sebastiano Ghezzi." In De Marchi 1999, pp. 7–19.

**Sestieri 1969**
Sestieri, Giancarlo. "Contributo a Sebastiano Conca, I." *Commentari*, n.s., vol. 20 (1969), pp. 317–41.

**Sestieri 1970**
Sestieri, Giancarlo. "Contributo a Sebastiano Conca, II." *Commentari*, n.s., vol. 21 (1970), pp. 122–38.

**Sestieri 1973**
Sestieri, Giancarlo. "Il punto su Benedetto Luti."*Arte illustrata*, vol. 6, no. 54 (1973), pp. 232–55.

**Sestieri 1977**
Sestieri, Giancarlo. "Giuseppe Passeri pittore." *Commentari*, n.s., vol. 28 (1977), pp. 114–36.

**Sestieri 1977, "Mancini"**
Sestieri, Giancarlo. "Profilo di Francesco Mancini." *Storia dell'arte*, vol. 29 (1977), pp. 67–79.

**Sestieri 1977, "Trevisani"**
Sestieri, Giancarlo. "Il 'Francesco Trevisani' di Frank Di Ferico (sic)." *Antologia di Belle Arti*, vol. 1 (1977), pp. 372–79.

**Sestieri 1981**
Sestieri, Giancarlo. "La carriera romana di Sebastiano Conca." In *Conca* 1981, pp. 47–66.

**Sestieri 1988**
Sestieri, Giancarlo. *La pittura del Settecento*. Turin, Italy: Unione Tipografico-Editrice Torinese, 1988.

**Sestieri 1991**
Sestieri, Giancarlo. "Aggiunte a Placido Costanzi." *Paragone*, n.s., vol. 42, no. 25/491 (1991), pp. 66–77.

**Sestieri 1994**
Sestieri, Giancarlo. *Repertorio della pittura romana della fine del Seicento e del Settecento*. 3 vols. Turin, Italy: Umberto Allemandi, 1994.

**Sestieri 1995**
Sestieri, Giancarlo. "Bianchi, Pietro." In AKL, vol. 10, pp. 425–26.

**Sestieri 1997**
Sestieri, Giancarlo. "Dallo 'studio' al dipinto: profilo del disegno romano della prima metà del Settecento." In Debenedetti 1997, pp. 13–64.

**Sestieri 1998**
Sestieri, Giancarlo. "Cavallucci disegnatore." In Forlani Tempesti and Prosperi Valenti Rodinò 1998, pp. 479–89.

*Settecento* 1959
Palazzo delle Esposizioni, Rome. *Il Settecento a Roma*. Rome: De Luca, 1959.

*Settecento emiliano* 1979
Palazzo della Pilotta, Parma, Italy. *L'arte del Settecento emiliano: l'arte a Parma dai Farnese ai Borbone*. Bologna, Italy: Alfa, 1979.

**Shawe-Taylor 1987**
Shawe-Taylor, Desmond. *Genial Company: The Theme of the Genius in Eighteenth-Century British Portraiture*. London: White Bros., 1987.

**Sicca 1990**
Sicca, Cinzia Maria. "'Et in Arcadia Pisae': pittori 'eccellenti' e gusto protoneoclassico a Pisa." In Roberto Paolo Ciardi, ed., *Settecento pisano: pittura e scultura a Pisa nel secolo XVIII*, pp. 229–86. Pisa: Pacini, 1990.

**Sicca 1994**
Sicca, Cinzia Maria. "La decorazione del Duomo tra Sette e Ottocento." In Mariagiulia Burresi, ed., *Il modello e la copia: dai quadroni del Duomo di Pisa tra Settecento e Ottocento*, pp. 11–75. Pisa: ETS, 1994.

**Siefert 1997**
Siefert, Helge. *Claude-Joseph Vernet, 1714–1789*. Munich: Bayerische Staatsgemäldessammlungen, 1997.

**Signorini 1981**
Signorini, Italo. *Padrini e compadri: un'analisi antropologica della parentela spirituale*. Turin, Italy: Loescher, 1981.

**Silvagni 1883–85**
Silvagni, David. *La corte e società romana nei secoli XVIII e XIX*. 3 vols. Rome: Forzani, 1883–85.

**Silvagni [1883–85] 1971**
Silvagni, David. *La corte pontificia e la società romana nei secoli XVIII e XIX*. 3 vols. Rome: Forzani, 1883–85; 4 vols. Rome: Biblioteca di Storia Patria, 1971.

**Simoncini 1995**
Simoncini, Giorgio, ed. *L'uso dello spazio privato nell'età dell'illuminismo*. Florence: L. S. Olschki, 1995.

**Siracusano 1983–84**
Siracusano, Citti. "Su alcuni bozzetti catanesi inediti del Settecento." *Quaderni dell'Istituto di Storia dell'Arte medievale e moderna facoltà di lettere e filosofia Università di Messina*, vol. 7–8 (1983–84), pp. 51–55.

**Siracusano 1986**
Siracusano, Citti. *La pittura del Settecento in Sicilia*. Siena, Italy: Monte dei Paschi di Siena, 1986.

**Skinner 1961**
Skinner, Basil. "Hamilton's 'Oath of Brutus.'" *The Burlington Magazine*, vol. 103 (1961), p. 146.

**Skinner 1971**
Skinner, Basil. "John Brown and the Antiquarians." *Country Life* (August 12, 1971), pp. 392–96.

**Skinner 1990**
Skinner, Basil. "Scottish Pupils of Batoni and Mengs." In *Scotland and Italy: Papers Presented at the Fourth Annual Conference of the Scottish Society for Art History, 1989*, pp. 14–27. Edinburgh: Scottish Society for Art History, 1990.

**Smailes 1991**
Smailes, Helen. "A History of the Statue Gallery at the Trustees' Academy in Edinburgh and the Acquisition of the Albacini Casts in 1838." *Journal of the History of Collections*, vol. 3 (1991), pp. 125–43.

**Smith 1889**
Smith, A. H., ed. *A Catalogue of the Ancient Marbles at Lansdowne House, Based upon the Work of Adolf Michaelis*. London, 1889.

**Smith 1916**
Smith, A. H. "Lord Elgin and His Collection." *The Journal of Hellenic Studies*, vol. 36 (1916), pp. 163–372.

**Smith J. [1828] 1920**
Smith, John Thomas. *Nollekens and His Times: Comprehending a Life of That Celebrated Sculptor*. 2 vols. 1828. Reprint, London: John Lane, 1920.

**Smollett 1766**
Smollett, Tobias George. *Travels through France and Italy*. 2nd ed. London: Baldwin, 1766.

**Söldner 1986**
Söldner, Magdalene. *Untersuchungen zu liegenden Eroten in der hellenistischen und römischen Kunst*. 2 vols. Frankfurt and New York: Lang, 1986.

**Solkin 1978**
Solkin, David H. "Richard Wilson and the British Landscape." 2 vols. Ph.D. diss., New Haven: Yale University, 1978.

**Solkin 1978, "Wilson"**
Solkin, David H. "Some New Light on the Drawings of Richard Wilson." *Master Drawings*, vol. 16, (1978), pp. 404–14.

**Solkin 1981**
Solkin, David H. "Richard Wilson's Variations on a Theme by Gaspard Dughet." *The Burlington Magazine*, vol. 123 (1981), pp. 410–14.

**Solkin 1982**
Solkin, David H. *Richard Wilson: The Landscape of Reaction*. London: Tate Gallery, 1982.

**Soprani and Ratti 1768–69**
Soprani, Raffaele, and Carlo Giuseppe Ratti. *Vite de'pittori, scultori, ed architetti genovesi*. 2 vols. Genoa, Italy: Casamara, 1768–69.

**Sotheby's 1986**
Sotheby's, London. *Catalogue of Old Masters Drawings Including a Collection of Watercolours by Giovanni Battista Lusieri*, June 30, 1986.

**Sotheby's 1995**
Sotheby's, London. *Sotheby's Art at Auction: The Art Market Review 1994–95*. London: Conran Octopus, 1995.

**Souchal 1967**
Souchal, François. *Les Slodtz: sculpteurs et décorateurs du Roi (1685–1874)*. Paris: E. de Boccard, 1967.

**Souchal 1973**
Souchal, François. "L'Inventaire après décès du sculpteur Lambert-Sigisbert Adam." *Bulletin de la Société de l'Histoire de l'Art Français* (1973), pp. 181–91.

**Souchal 1993**
Souchal, François. *French Sculptors of the 17th and 18th Centuries: The Reign of Louis XIV*. 4 vols. London and Boston: Faber & Faber, 1993.

**Souchal 1996**
Souchal, François. "Adam (i)." In DA, vol. 1, pp. 132–34.

**Souchal 1996, "Slodtz"**
Souchal, François. "Slodtz." In DA, vol. 28, pp. 845–47.

**Spagnesi 1997**
Spagnesi, Gianfranco. *Alessandro Specchi: alternativa al borrominismo*. Turin, Italy: Testo & immagine, 1997.

**Spagnoli 1987–88**
Spagnoli, Antonella. "Placido Costanzi." Ph.D. diss., Rome: Università degli Studi di Roma, "La Sapienza," 1987–88.

**Speroni 1990**
Speroni, Franco. "Il Gabinetto Nobile: un manifesto estetico in Palazzo Altieri." In Debenedetti 1990, pp. 227–42.

**Spinosa 1993**
Spinosa, Nicola. *Pittura napoletana del Settecento: dal rococò al classicismo*. Naples: Electa Napoli, 1993.

**Stackelberg 1980**
Stackelberg, Jürgen V. "Frankreich und Europa im 18. Jahrundert." In Walter Hinck, ed., *Europäische Aufklärung*. Vol. 3, pp. 9–24. Frankfurt: Athenaion, 1980.

**Stainton 1974**
Stainton, Lindsay. *British Artists in Rome, 1700–1800*. London: Greater London Council, 1974.

**Stainton 1974, "Banks"**
Stainton, Lindsay. "A Re-Discovered Bas-Relief by Thomas Banks." *The Burlington Magazine*, vol. 116 (1974), pp. 327–31.

**Stampfle 1978**
Stampfle, Felice. *Giovanni Battista Piranesi: Drawings in The Pierpont Morgan Library*. New York: Dover Publications in association with The Pierpont Morgan Library, 1978.

**Steegman 1946**
Steegman, John. "Some English Portraits by Pompeo Batoni." *The Burlington Magazine*, vol. 88 (1946), pp. 55–63.

**Stein 1913**
Stein, Henri. "La Société des Beaux-Arts de Montpellier (1779–1787)." In *Mélanges offerts à M. Henry Lemonnier*, pp. 365–403. Paris: Édouard Champion, 1913.

**Sterling 1957**
Sterling, Charles. *Musée de l'Ermitage: la peinture française de Poussin à nos jours*. Paris: Cercle d'art, 1957.

**Stillman 1966**
Stillman, Damie. *The Decorative Work of Robert Adam*. New York: Transatlantic Arts, 1966.

**Stillman 1967**
Stillman, Damie. "Robert Adam and Piranesi." In Fraser, Hibbard, and Lewine 1967, pp. 197–206.

**Stix and Spitzmüller 1941**
Stix, Alfred, and Anna Spitzmüller, eds. *Die Schulen von Ferrara, Bologna, Parma und Modena, der Lombardei, Genuas, Neapels und Siziliens: Mit einem Nachtrag zu allen italienischen Schulen*. Vol. 6 of *Beschreibender Katalog der Handzeichnungen in der Graphischen Sammlung Albertina*. Vienna: A. Schroll, 1941.

**Stoschek 1998**
Stoschek, Jeannette S. "Il Caffeaus di Benedetto XIV nei giardini del Quirinale." In Biagi Maino 1998, pp. 159–76.

**Strazzullo 1976–77**
Strazzullo, Franco, ed. *Le lettere di Luigi Vanvitelli della Biblioteca Palatina di Caserta.* 3 vols. Galatina, Italy: Congedo, 1976–77.

**Strickland 1913**
Strickland, Walter G. *A Dictionary of Irish Artists.* 2 vols. Dublin and London: Maunsel, 1913.

**Stuart Jones 1912**
Stuart Jones, Henry, ed. *A Catalogue of the Ancient Sculptures Preserved in the Municipal Collections of Rome: The Sculptures of the Museo Capitolino.* 2 vols. Oxford: Clarendon Press, 1912.

**Stuart Jones 1968**
Stuart Jones, Henry, ed. *A Catalogue of the Ancient Sculptures preserved in the Municipal Collections of Rome: The Sculptors of the Palazzo Conservatori.* 2 vols. Rome: L'Erma di Bretschneider, 1968.

**Studi su Corrado Giaquinto 1971**
*Atti Convegno di studi su Corrado Giaquinto, 3–5 Gennaio, 1969.* Molfetta, Italy: Mezzina, 1971.

**Suboff 1928**
Suboff, V. "G. Mazzuoli: Bemerkungen zu einer Neuerwerbung der Eremitage." *Jahrbuch der Preussischen Kunstsammlungen,* vol. 48 (1928), pp. 33–49.

**Susinno 1969–70**
Susinno, Stefano. "Giuseppe Bottani: dipinti e disegni." Ph.D. diss., Rome: Università di Roma, "La Sapienza," 1987.

**Susinno 1971**
Susinno, Stefano. "Aureliano Milani e Sebastiano Conca per la SS. Trinità dei Missionara, Roma." *Bollettino della unione storia e arte,* vol. 1–2 (1971), pp. 1–16.

**Susinno 1974**
Susinno, Stefano. "I ritratti degli accademici." In *L'Accademia 1974,* pp. 201–70.

**Susinno 1976**
Susinno, Stefano. "Per Giuseppe Bottani al Museo di Roma: i disegni per la 'merca' ed un gruppo di famiglia." *Bollettino dei musei comunali di Roma,* vol. 23 (1976), pp. 32–44.

**Susinno 1978**
Susinno, Stefano. "Gli scritti in memoria di Maria Cionini Visani ed un contributo a Giuseppe Bottani, pittore di storia." *Antologia di Belle Arti,* vol. 2 (1978), pp. 308–12.

**Susinno 1998**
Susinno, Stefano. "'Accademie' romane nella collezione braidense: primato di Domenico Corvi nel disegno dal nudo." In Curzi and Lo Bianco 1998, pp. 173–89.

**Susinno 1999**
Susinno, Stefano. "Diffusione del classicismo romano nella formazione artistica dell'Accademia di Brera." In *La pittura romana dal protoneoclassico al neoclassico e le sue diramazioni nell'area italiana.* In press.

**Susinno F. 1960**
Susinno, Francesco [active 1724]. *Le vite de'pittori messinesi.* Edited by Valentino Martinelli. Florence: Felice Le Monnier, 1960.

**Sutton 1968**
Sutton, Denys, ed. *An Italian Sketchbook by Richard Wilson R. A.* 2 vols. London: The Paul Mellon Foundation for British Art, 1968.

**Sutton 1982**
Sutton, Denys. *Souvenirs of the Grand Tour.* London: Wildenstein, 1982.

**Sutton J. 1980**
Sutton, John L. *The King's Honor and the King's Cardinal: The War of the Polish Succession.* Lexington, Ky.: The University Press of Kentucky, 1980.

**Swan 1940**
Swan, Mabel Munson. *The Athenaeum Gallery, 1827–1873.* Boston: Boston Athenaeum, 1940.

**Tadini 1796**
Tadini, Faustino. *Le sculture e le pitture di Antonio Canova.* Venice: Stamperia Palese, 1796.

**Tait 1993**
Tait, Alan A. *Robert Adam: Drawings and Imagination.* Cambridge and New York: Cambridge University Press, 1993.

**Tamborra 1988**
Tamborra, Giandavide. "Camillo Rusconi: scultore ticinese, 1658–1728." *Bollettino storico della Svizzera Italiana,* vol. 100, no. 1 (1988), pp. 5–56.

**Tancioni 1988**
Tancioni, Gianluca. "Oratorio di Traspontina: la commissione del cardinale Sacripante e l'attività di Michetti, Garzi, e Giovanni Conca." In Debenedetti 1988, pp. 153–72.

**Tardy 1967**
Tardy. *La Pendule française des origines à nos jours.* 3rd ed. 3 vols. Paris, 1967.

**Tassi 1969–70**
Tassi, Francesco Maria [1710–82]. *Vite de'pittori, scultori ed architetti bergamaschi.* Edited by Franco Mazzini. 2 vols. Milan: Labor, 1969–70.

**Taste for Angels 1987**
Yale University Art Gallery, New Haven; John and Mable Ringling Museum of Art, Sarasota, Fla.; The Nelson-Atkins Museum of Art, Kansas-City, Mo. *A Taste for Angels: Neapolitan Painting in North America, 1650–1750.* New Haven: Yale University Art Gallery, 1987.

**Tatum 1976**
Tatum, George B. *Philadelphia Georgian: The City House of Samual Powel and Some of Its Eighteenth-Century Neighbors.* Middletown, Conn.: Wesleyan University Press, 1976.

**Taylor 1952**
Taylor, Gerald. "Uno scultore ignoto: Joseph Claus." *Bollettino d'arte,* 4th ser., vol. 37 (1952), pp. 231–33.

**Tellini Perina 1973**
Tellini Perina, Chiara. "Per il Bottani." *Antichità viva,* no. 5 (1973), pp. 12–21.

**Tellini Perina 1990**
Tellini Perina, Chiara. "Bottani, Giovanni." In *La pittura 1990.* Vol. 2, p. 637.

**Ternois 1978**
Ternois, Daniel. "En Marge du 'Jugement de Salomon' de Jean-François de Troy." *Bulletin des musées et monuments lyonnais,* vol. 7 (1978), pp. 9–22.

**Tesori d'arte 1975**
Palazzo delle Esposizioni, Rome. *Tesori d'arte sacra di Roma e del Lazio dal medioevo all'Ottocento.* Rome: Emmekappa, 1975.

**Teza 1987**
Teza, Laura. "Carlo Magini e Sebastiano Ceccarini pittori fanesi di natura morta." *Notizie da Palazzo Albani,* vol. 16 (1987), pp. 84–96.

**Thirion 1885**
Thirion, Henri. *Les Adam et Clodion.* Paris: A. Quantin, 1885.

**Thorlacius-Ussing 1942**
Thorlacius-Ussing, V. *Etudes sur l'activité de Saly avant son voyage en Danemark.* Copenhagen: Ny Carlsberg Glyptotek, 1942.

**Thornton 1984**
Thornton, Peter. *Authentic Decor: The Domestic Interior, 1620–1920.* London: Weidenfeld & Nicolson, 1984.

**Three Generations 1991**
David Carritt Limited, London. *Valadier, Three Generations of Roman Goldsmiths: An Exhibition of Drawings and Works of Art.* London: Artemis Group, 1991.

**Thurman 1975**
Thurman, Christa Mayer. *Raiment for the Lord's Service: A Thousand Years of Western Vestments.* Chicago: The Art Institute of Chicago, 1975.

**Tischbein 1993**
Tischbein, Johann Heinrich Wilhelm [1751–1829]. *Dalla mia vita: viaggi e soggiorno a Napoli.* Naples: Edizioni Scientifiche Italiane, 1993.

**Titi 1763**
Titi, Filippo. *Descrizione delle pitture, sculture e architetture esposte al pubblico in Roma.* Rome: Stamperia di Marco Pagliarini, 1763.

**Titi 1987**
Titi, Filippo [1640–1720]. *Studio di pittura, scoltura, et architettura, nelle chiese di Roma (1674–1763).* Edited by Bruno Contardi and Serena Romano. 2 vols. Florence: Centro Di, 1987.

**Tittoni Monti 1983**
Tittoni Monti, Elisa. "Volpato e Roma." In Istituto Storia dell'Arte 1983, pp. 405–19.

**Tolomei 1821**
Tolomei, Francesco. *Guida di Pistoia per gli amanti delle belli arti con notizie degli architetti, scultori, e pittori pistoiesi.* Pistoia, Italy: Bracali, 1821.

**Tomory 1972**
Tomory, Peter. *The Life and Art of Henry Fuseli.* London: Thames & Hudson, 1972.

**Tomory 1978**
Tomory, Peter. "Three Oaths for Gavin Hamilton." *Australian Journal of Art,* vol. 1 (1978), pp. 59–64.

**Tosi 1986**
Tosi, Alessandro. "Aspetti della pittura lucchese durante il principato." In Vito Tirelli, ed., *Il principato napoleonico dei Baciocchi (1805–1814): riforma dello stato e società,* pp. 302–23. Lucca, Italy: Maria Pacini Fazzi, 1986.

**Townley Gallery 1836**
*The British Museum: The Townley Gallery.* 2 vols. London: Charles Knight, 1836.

**Townsend 1994**
Townsend, Richard P. *Botticelli to Tiepolo: Three Centuries of Italian Painting from Bob Jones University.* Tulsa, Okla.: The Philbrook Museum of Art, 1994.

**Trevelyan 1908**
Trevelyan, George Macaulay. *Garibaldi's Defence of the Roman Republic.* London: Longmans, Green, 1908.

**Trimarchi 1979**
Trimarchi, Michele. *Giovanni Odazzi: pittore romano (1663–1731).* Rome, 1979.

**Il trionfo 1767**
*Il trionfo delle bell'arti.* Florence: Stamperia Gio. Batista Stecchi e Anton Giuseppe Pagnani, 1767.

**Tscherny 1977–78**
Tscherny, Nadia. "Domenico Corvi's 'Allegory of Painting': An Image of Love." *Marsyas,* vol. 19 (1977–78), pp. 23–27.

**Tubello 1989**
Tubello, Luciano. "Il restauro dell'altare di Sant'Ignazio al Gesù." *L'Urbe,* n.s., vol. 52, no. 5–6 (1989), pp. 5–10.

**Turner 1976**
Turner, Nicholas. "An Attack on the Accademia di S. Luca: Ludovico David's 'L'Amore dell'Arte.'" In *The British Museum Yearbook, 1: The Classical Tradition,* pp. 157–86. London: The British Museum Publications, 1976.

**Turner 1999**
Turner, Nicholas. *Roman Baroque Drawings, c. 1620 to c. 1700.* 2 vols. London: The British Museum Press, 1999.

**Tutey 1910**
Tutey, Alexandre. "Notices sur les artistes à la classe des Beaux-Arts, 23 Fructidor An VIII." *Archives de l'Art Français,* 4th ser., vol. 4 (1910), p. 258.

**Tutsch 1995**
Tutsch, Claudia. "Man muß mit ihnen, wie mit seinem Freund, bekannt geworden seyn…": Zum Bildnis Johann Joachim Winckelmanns von Anton von Maron. Mainz, Germany: Philipp von Zabern, 1995.

**Valadier 1807**
Valadier, Giuseppe. *Progetti architettonici per ogni specie di fabriche in stili ed usi diversi.* Rome: V. Feoli, 1807.

**Valadier 1828–39**
Valadier, Giuseppe. *L'architettura practica dettata nella scuola e cattedra dell'insigne Accademia di San Luca.* Rome: La Società Tipografica, 1828–39.

**Valadier 1833**
Valadier, Giuseppe. *Opere di architettura e di ornamento.* Rome, 1833.

**Valadier 1991**
Palazzo Strozzi, Florence; Trinity Fine Art, London. *Valadier: sacro e profano.* London: Trinity Fine Art, 1991.

**Valadier au Louvre 1994**
Musée du Louvre, Paris. *Luigi Valadier au Louvre: ou l'antiquité exaltée.* Paris: Réunion des Musées Nationaux, 1994.

**Valazzi 1990**
Valazzi, Maria Rosaria. "La pittura del Settecento nelle Marche." In *La pittura 1990.* Vol. 1, pp. 371–82.

**Valenciennes 1956**
Musée Paul-Dupuy, Toulouse, France. *Pierre-Henri de Valenciennes.* Toulouse, France: Musée Paul-Dupuy, 1956.

**Valeriani 1993**
Valeriani, Roberto. "L'inventario del 1836 di Giacomo Raffaelli." *Antologia di Belle Arti,* n.s., no. 43–47 (1993), pp. 71–87.

**Valesio [1770] 1977–79**
Valesio, Francesco. *Diario di Roma.* Rome, 1770; Edited by Gaetana Scano in collaboration with Giuseppe Graglia. 6 vols. Milan: Longanesi, 1977–79.

**Valli 1998**
Valli, Francesca. "Modelli romani all'Accademia di Brera." In Curzi and Lo Bianco 1998, pp. 190–97.

**Van de Sandt 1985**
Van de Sandt, Anne. *Les Frères Sablet (1775–1815): peintures, dessins, gravures.* Rome: Carte Segrete, 1985.

**Van Dooren 1989**
Van Dooren, Kees. "De Tekeningen van Marco Benefial (1684–1764)." Ph.D. diss., Nijmegen, Netherlands: Catholieke Universiteit Nijmegen, 1989.

**Vanvitelli 1756**
Vanvitelli, Luigi. *Dichiarazione dei disegni del reale Palazzo di Caserta.* Naples: Regia Stamperia, 1756.

**Vanvitelli 1975**
Vanvitelli, Luigi, the Younger [1700–73]. *Vita di Luigi Vanvitelli.* Edited by Mario Rotili. Naples: Società Editrice Napoletana, 1975.

**Varagnoli 1995**
Varagnoli, Claudio. *S. Croce in Gerusalemme: la basilica restaurata e l'architettura del Settecento romano.* Vol. 3 of *I saggi di Opus.* Rome: Bonsignori, 1995.

**Varenne 1913**
Varenne, Gaston. "Clodion à Nancy: ses années d'enfance, sa maison et son atelier de 1793 à 1798." *Revue lorraine illustrée,* no. 2 (1913), pp. 33–64.

**Vasale 1992**
Vasale, Giuseppe. "Sulle tracce di cinque quadri di Hackert: il paesaggista amico di Goethe." *Paragone,* 3rd ser., no. 11/509 (1992), pp. 85–89.

**Vasco Rocca 1985**
Vasco Rocca, Sandra. "Corrado Giaquinto nella basilica di Santa Croce in Gerusalemme." In Amato 1985, pp. 97–111.

**Vasco Rocca and Borghini 1995**
Vasco Rocca, Sandra, and Gabriele Borghini, eds. *Giovanni V di Portogallo (1707–1750) e la cultura romana del suo tempo.* Rome: Àrgos, 1995.

**Vasco Rocca and Caffiero 1979**
Vasco Rocca, Sandra, and Marina Caffiero. "Ceracchi, Giuseppe." In DBI, vol. 23, pp. 645–50.

**Vasco Rocca, Borghini, and Ferraris 1990**
Vasco Rocca, Sandra, Gabriele Borghini, and Paola Ferraris. *Roma lusitana, Lisbona romana.* Rome: Àrgos, 1990.

**Vasi 1747–61**
Vasi, Giuseppe. *Delle magnificenze di Roma antica e moderna.* 10 vols. Rome: Stamperia del Chracas, 1747–61.

**Vasi M. 1970**
Vasi, Mariano. *Roma del Settecento: itinerario istruttivo di Roma.* Edited by Guglielmo Matthiae. Rome: Golem, 1970.

**Vaughan 1991**
Vaughan, Gerard. "Albacini and His English Patrons." *Journal of the History of Collections,* vol. 3 (1991), pp. 183–97.

**Vaughan 1992**
Vaughan, Gerard. "The Restoration of Classical Sculpture in the Eighteenth Century and the Problem of Authenticity." In Mark Jones, ed., *Why Fakes Matter: Essays on Problems of Authenticity,* pp. 41–50. London: The British Museum Press, 1992.

**Vedute italiane 1987**
Museo Diocesano d'Arte Sacra, Venice. *Vedute italiane del '700 in collezioni private italiane.* Milan: Electa, 1987.

**Venditti 1973**
Venditti, Arnaldo. "Note su Antonio Canevari architetto." *Studi romani,* vol. 21 (1973), pp. 358–65.

**Venuti 1766**
Venuti, Ridolfino. *Accurata, e succinta descrizione topografica e istorica di Roma moderna.* Rome: Carlo Barbiellini, 1766.

**Vetter 1962**
Vetter, Ewald M. "Edme Bouchardon in Rom und seine Büsten Papst' Clemens XII." *Heidelberger Jahrbücher,* vol. 6 (1962), pp. 51–72.

**Viale 1966**
Viale, Vittorio, ed. *Mostra di Filippo Juvarra: architetto e scenografo.* Messina, Italy: Università degli studi di Messina, Istituto di Disegni, 1966.

**Viale Ferrero 1968**
Viale Ferrero, Mercedes. "Disegni di Filippo Juvarra per il teatro Capranica a Roma." *Antichità viva,* vol. 7 (1968), pp. 11–20.

**Viale Ferrero 1970**
Viale Ferrero, Mercedes. *Filippo Juvarra: scenografo e architetto teatrale.* Turin, Italy: Pozzo, 1970.

**Videtta 1962**
Videtta, Antonio. "Disegni di Corrado Giaquinto nel Museo di San Martino." *Napoli nobilissima,* vol. 2, no. 1 (1962), pp. 13–28.

**Videtta 1965**
Videtta, Antonio. "Disegni di Corrado Giaquinto nel Museo di S. Martino (II)." *Napoli nobilissima,* vol. 4, no. 5–6 (1965), pp. 174–84.

**Videtta 1966**
Videtta, Antonio. "Disegni di Corrado Giaquinto nel Museo di S. Martino (III)." *Napoli nobilissima,* vol. 5, no. 1 (1966), pp. 3–18.

**Videtta 1967**
Videtta, Antonio. "Disegni di Corrado Giaquinto nel Museo di San Martino (IV)." *Napoli nobilissima,* vol. 6, no. 3–4 (1967), pp. 135–39.

**Villata 1996**
Villata, E. "La cena in casa di Simone di Pierre Subleyras: appunti per una ricorrenza." *Il Platano,* vol. 21 (1996), pp. 154–61.

**Vinci 1795**
Vinci, Giambattista. *Elogio storico del celebre pittore Antonio Cavallucci di Sermoneta.* Rome: Presso Antonio Fulgoni, 1795.

**Vinella 1979**
Vinella, Lucia. "Ceccarini, Giuseppe." In DBI, vol. 23, p. 212.

**Visconti 1796**
Visconti, Ennio Quirino. *Sculture del Palazzo della Villa Borghese detta Pinciana brevemente descritte.* 2 vols. Rome: Stamperia Pagliarini, 1796.

**Visconti 1841**
Visconti, Ennio Quirino [1751–1818]. *Due discorsi inediti di Ennio Quirino Visconti, con alcune sue lettere e con altre a lui scritte, che ora per la prima volta vengono pubblicate.* Milan: G. Resnati, 1841.

**Viterbo and D'Almeida 1997**
Viterbo, Sousa, and R. Vicente D'Almeida. *A Capella de S. João Baptista.* Lisbon: Livros Horizonte, 1997.

**Vittone 1760–66**
Vittone, Bernardo Antonio. *Istruzioni elementari per indirizzo de' giovani allo studio dell'architettura civile.* 4 vols. Lugano, Switzerland: Agnelli Stampatori, 1760–66.

**Vittone 1766**
Vittone, Bernardo Antonio. *Istruzioni diverse concernenti l'officio dell'architetto civile.* Lugano, Switzerland: Agnelli Stampatori, 1766.

**Vittone Convegno 1972**
*Bernardo Vittone e la disputa fra classicismo e barocco nel Settecento: atti del Convegno internazionale promosso dall'Accademia delle Scienze di Torino nella ricorrenza del secondo centenario della morte di B. Vittone, 21–24 settembre 1970.* 2 vols. Turin, Italy: Accademia delle Scienze, 1972.

**Vitzthum 1966**
Vitzthum, Walter, ed. *Disegni napoletani del Sei e del Settecento nel Museo di Capodimonte.* Naples: L'arte tipografica Napoli, 1966.

**Vitzthum 1971**
Vitzthum, Walter. Review of *Drawings from New York Collections III: The Eighteenth Century in Italy,* by Jacob Bean and Felice Stampfle. *Arte illustrata,* vol. 4, no. 39–40 (1971), pp. 74–75.

**Vitzthum 1977**
Vitzthum, Walter. *Drawings by Gaspar van Wittel (1652/53–1736) from Neapolitan Collections.* Translated and edited by Catherine Johnston. Ottawa: The National Gallery of Canada, 1977.

**Vitzthum 1980**
Vitzthum, Walter, ed. *Gaspar van Wittel (1652/53–1736): disegni dalle collezioni napoletane.* Gaeta, Italy: Centro storico culturale Gaeta, 1980.

**Vodret 1994**
Vodret, Rossella. "Primi studi sulla collezione di dipinti Torlonia." *Storia dell'arte,* vol. 82 (1994), pp. 348–424.

**Vogel 1996**
Vogel, Matthias. "Johann Heinrich Füssli als Maler: Gedanken zu seiner Ausdrucksqualität." In Paul Pfister, ed., *Von Claude Lorrain bis Giovanni Segantini: Gemäldeoberfläche und Bildwirkung,* pp. 77–104. Zurich: Kunsthaus Zürich, 1996.

**Vorarlberger Landesmuseum 1968**
Vorarlberger Landesmuseum, Bregenz, Austria. *Angelika Kauffmann und ihre Zeitgenossen.* Bregenz, Austria: Rutz, 1968.

**Voronikhina 1972**
Voronikhina, Anna Nikolaevna. *Peterburg i ego okrestnosti v chertezhakh i risunkakh arkhitektorov pervoi treti XVIII veka.* St. Petersburg: Aurora, 1972.

**Voronikhina 1981**
Voronikhina, Anna Nikolaevna, ed. *Arkhitekturnaia grafika Rossii: pervaia polovina XVIII veka.* Leningrad: Iskusstvo Leningradskoe otd-nie, 1981.

**Voss 1910**
Voss, Hermann. "Berninis Fontänen." *Jahrbuch der Königlich Preuszischen Kunstsammlungen,* vol. 31 (1910), pp. 99–129.

**Voss 1924**
Voss, Hermann. *Die Malerei des Barock in Rom.* Berlin: Propyläen, 1924.

**Voss 1954**
Voss, Hermann. "Die Guido Reni Ausstellung in Bologna." *Kunstchronik,* vol. 7 (1954), pp. 333–38.

**Voyage en Italie 1994**
*Voyage en Italie, en Sicile et à Malte 1787: journaux, lettres et dessins par quatre voyageurs hollandais.* 2 vols. Brussels: Martial, 1994.

**Waga 1968**
Waga, Halina. "Vita nota e ignota dei Virtuosi al Pantheon." *L'Urbe,* n.s., vol. 31, no. 5 (1968), pp. 1–11.

**Walch 1968**
Walch, Peter. "Angelica Kauffman." Ph.D. diss., Princeton, N.J.: Princeton University, 1968.

**Walker 1998**
Walker, Dean. "Surveying the History of Collecting Italian Sculptural Models." In Wardropper 1998, pp. 14–29.

**Walker S. 1995**
Walker, Stefanie. "The Sculptor Pietro Stefano Monnot in Rome, 1695–1713." 2 vols. Ph.D. diss., New York: New York University, Institute of Fine Arts, 1995.

**Walker and Hammond 1999**
Walker, Stefanie, and Frederick Hammond, eds., *Life and the Arts in the Baroque Palaces of Rome.* New Haven and London: Yale University Press, 1999.

**Walpole 1937–74**
Walpole, Horace. *The Yale Edition of Horace Walpole's 'Correspondence.'* Edited by W. S. Lewis et al. 38 vols. New Haven and London: Yale University Press, 1937–74.

**Wardropper 1998**
Wardropper, Ian, ed. *From the Sculptor's Hand: Italian Baroque Terracottas from the State Hermitage Museum.* Chicago: The Art Institute of Chicago, 1998.

**Waterhouse 1937**
Waterhouse, Ellis K. *Baroque Painting in Rome: The Seventeenth Century.* London: Macmillan, 1937.

**Waterhouse 1953**
Waterhouse, Ellis. *Painting in Britain, 1530 to 1790.* Harmondsworth, England: Penguin, 1953.

**Waterhouse 1953, "Bowes"**
Waterhouse, Ellis K. "Some Old Masters Other than Spanish at the Bowes Museum." *The Burlington Magazine,* vol. 95 (1953), pp. 120–23.

**Waterhouse 1954**
Waterhouse, Ellis K. "The British Contribution to the Neo-Classical Style in Painting." *Proceedings of the British Academy,* vol. 40 (1954), pp. 57–74.

**Waterhouse 1958**
Waterhouse, Ellis K. "Francesco Fernandi detto l'Imperiali." *Arte lombarda,* vol. 3 (1958), pp. 101–6.

**Waterhouse 1971**
Waterhouse, Ellis K. "Painting in Rome in the Eighteenth Century." *The Art Institute of Chicago: Museum Studies,* vol. 6 (1971), pp. 7–21.

**Waterhouse 1976**
Waterhouse, Ellis K. *Roman Baroque Painting: A List of the Principal Painters and Their Works in and around Rome.* Oxford: Phaidon, 1976.

**Webb 1956**
Webb, M. I. "A Rusconi Relief of 'Leda and the Swan.'" *The Burlington Magazine,* vol. 98 (1956), p. 207.

**Weber 1969**
Weber, Gerold. "Dessins et maquettes d'Edme Bouchardon." *Revue de l'art,* no. 6 (1969), pp. 39–50.

**Weidner 1998**
Weidner, Thomas. *Jacob Philipp Hackert.* Berlin: Deutscher Verlag für Kunstwissenschaft, 1998.

**Weingartner 1961–62**
Weingartner, Magdalena. "Porträts aus der Mengs-Schule." *Römische Historische Mitteilungen,* vol. 5 (1961–62).

**Weinglass 1982**
Weinglass, D. H., ed. *The Collected English Letters of Henry Fuseli.* Millwood, N.Y.: Kraus International, 1982.

**Weinglass 1994**
Weinglass, D. H. *Prints and Engraved Illustrations By and After Henry Fuseli: A Catalogue Raisonné.* Aldershot, England, and Brookfield, Vt.: Scolar Press, 1994.

**Weinglass 1995**
Weinglass, D. H. "Edgar, Feigning Madness, Approaches King Lear." In *Drawings from Britain and the Continent*, lot 300. Sale Catalogue, Sotheby's, London, July 10, 1995.

**Weinglass, Licht, and Tosini Pizzetti 1997**
Weinglass, D. H., Fred Licht, and Simona Tosini Pizzetti. *Füssli pittore di Shakespeare: pittura e teatro, 1775–1825*. Milan: Electa, 1997.

**Weiss 1999**
Weiss, Thomas, ed. *Vor der Schönheit weissen Marmors: Zum 200. Todestag Bartolomeo Cavaceppis*. Mainz, Germany: Philipp von Zabern, 1999.

**Westin and Westin 1974**
Westin, Robert, and Jean Westin. "Contributions to the Late Chronology of Giuseppe Mazzuoli." *The Burlington Magazine*, vol. 116 (1974), pp. 36–40.

**Westin and Westin 1975**
Westin, Jean K., and Robert H. Westin. *Carlo Maratti and His Contemporaries: Figurative Drawings from the Roman Baroque*. University Park, Pa.: Museum of Art, The Pennsylvania State University, 1975.

**Whinney 1971**
Whinney, Margaret. *English Sculpture 1720-1830*. London: Her Majesty's Stationery Office, 1971.

**Whinney 1988**
Whinney, Margaret D. *Sculpture in Britain, 1530 to 1830*. 2nd ed., rev. London: Penguin, 1988.

**Whitfield 1978**
Whitfield, Clovis. *Pictures from the Grand Tour*. London: Colnaghi, 1978.

**Whitley 1930**
Whitley, William T. *Art in England, 1821–1837*. Cambridge: Cambridge University Press, 1930.

**Wiggers 1971**
Wiggers, Heinz Bernhard. *Caracalla, Geta, Plautilla*. Berlin: Mann, 1971.

**Wildenstein 1960**
Wildenstein, Georges. *The Paintings of Fragonard*. London: Phaidon, 1960.

**Wildenstein and Wildenstein 1973**
Wildenstein, Daniel, and Guy Wildenstein. *Documents complémentaires au catalogue de l'oeuvre de Louis David*. Paris: Fondation Wildenstein, 1973.

**Wildenstein and Wildenstein 1973, David**
Wildenstein, Daniel, and Guy Wildenstein. *Louis David: receuil du document*. Paris: Fondation Wildenstein, 1973.

**Williams 1982**
Williams, C.I.M. "Lusieri's Surviving Works." *The Burlington Magazine*, vol. 124 (1982), pp. 492–96.

**Williams 1987**
Williams, C.I.M. "Lusieri's Masterpiece?" *The Burlington Magazine*, vol. 129 (1987), pp. 457–59.

**Williams E. 1978**
Williams, Eunice. *Drawings by Fragonard in North American Collections*. Washington, D.C.: National Gallery of Art, 1978.

**Williams J. 1994**
Williams, Julia Lloyd. *Gavin Hamilton 1723-1798*. Edinburgh: National Galleries of Scotland, 1994.

**Wilton and Bignamini 1996**
Wilton, Andrew, and Ilaria Bignamini, eds. *Grand Tour: The Lure of Italy in the Eighteenth Century*. London: Tate Gallery Publishing, 1996.

**Wilton-Ely 1972**
Wilton-Ely, John, ed. *Giovanni Battista Piranesi: The Polemical Works*. Farnborough, England: Gregg, 1972.

**Wilton-Ely 1976**
Wilton-Ely, John. "Piranesian Symbols on the Aventine." *Apollo*, n.s., vol. 103 (1976), pp. 214–27.

**Wilton-Ely 1976, "Nollekens"**
Wilton-Ely, John. "A Bust of Piranesi by Nollekens." *The Burlington Magazine*, vol. 118 (1976), pp. 593–95.

**Wilton-Ely 1978**
Wilton-Ely, John. *The Mind and Art of Giovanni Battista Piranesi*. London: Thames & Hudson, 1978.

**Wilton-Ely 1978, Piranesi**
Wilton-Ely, John. *Piranesi*. London: Arts Council of Great Britain, 1978.

**Wilton-Ely 1983**
Wilton-Ely, John. "Piranesi and the Role of Archaeological Illustration." In Istituto Storia dell'Arte 1983, pp. 317–37.

**Wilton-Ely 1992**
Wilton-Ely, John. *Piranesi Architetto*. Rome: Elefante, 1992.

**Wilton-Ely 1993**
Wilton-Ely, John. *Piranesi as Architect and Designer*. New York: The Pierpont Morgan Library; New Haven and London: Yale University Press, 1993.

**Wilton-Ely 1994**
Wilton-Ely, John. *Giovanni Battista Piranesi: The Complete Etchings*. 2 vols. San Francisco: Alan Wofsy Fine Arts, 1994.

**Winckelmann 1783–84**
Winckelmann, Johann Joachim [1717–1768]. *Storia delle arti del disegno presso gli antichi*. 3 vols. Edited by Carlo Fea. Rome: Stamperia Pagliarini, 1783–84.

**Winckelmann 1825**
Winckelmann, Johann Joachim [1717–1768]. *Versuch einer Allegorie, besonders für die Kunst*. Vol. 9 of *Johann Winckelmanns sämtliche Werke*. Donauöschingen, Germany: Classiker, 1825.

**Winckelmann 1952–57**
Winckelmann, Johann Joachim [1717–1768]. *Briefe*. Edited by Walther Rehm and Hans Diepolder. 4 vols. Berlin: Walter de Gruyter, 1952–57.

**Wind 1986**
Wind, Edgar. *Hume and the Heroic Portrait: Studies in Eighteenth-Century Imagery*. Edited by Jaynie Anderson. Oxford: Clarendon Press, 1986.

**Winkelmann 1975–76**
Winkelmann, Jürgen. "Pierleone Ghezzi: un ritratto inedito a Bologna." *Musei ferraresi bollettino annuale*, vol. 5–6 (1975–76), pp. 57–71.

**Winter 1991**
Winter, John. "Further Drawings from Valadier's Workshop: The Silver Designs of Giovanni Bettati." *Apollo*, n.s., vol. 133 (1991), pp. 320–22.

**Winter 1991–92**
Winter, John. "Luigi Valadier and Monreale." *Antologia di Belle Arti*, n.s., no. 39–42 (1991–92), pp. 89–96.

**Wintermute 1996**
Wintermute, Alan. Review of *Visions of Antiquity: Neoclassical Figure Drawings* by Richard J. Campbell and Victor Carlson. *Master Drawings*, vol. 34 (1996), pp. 438–40.

**Wittkower 1926–27**
Wittkower, Rudolf. "Die vier Apostelstatuen des Camillo Rusconi im Mittelschiff von S. Giovanni in Laterno in Rom: Stilkritische Beiträge zur römischen Plastik des Spätbarock." *Zeitschrift für Bildende Kunst*, vol. 60 (1926–27), pp. 9–49.

**Wittkower 1938–39**
Wittkower, Rudolf. "Piranesi's 'Parere su l'architettura.'" *Journal of the Warburg and Courtauld Institutes*, vol. 2 (1938–39), pp. 147–58.

**Wittkower 1967**
Wittkower, Rudolf. "Vittone's Drawings in the Musée des Arts Décoratifs." In *Studies in Renaissance and Baroque Art Presented to Anthony Blunt on His 60th Birthday*, pp. 165–72. London: Phaidon, 1967.

**Wittkower 1973**
Wittkower, Rudolf. *Art and Architecture in Italy, 1600–1750*. 3rd ed., rev. Harmondsworth, England: Penguin, 1973.

**Wittkower 1982**
Wittkower, Rudolf. *Art and Architecture in Italy 1600 to 1750*. Rev. ed. Harmondsworth, England: Penguin, 1982.

**Woodbridge 1970**
Woodbridge, Kenneth. *Landscape and Antiquity: Aspects of the English Culture at Stourhead 1718. to 1838*. Oxford: Clarendon Press, 1970.

**Wright 1824**
Wright, Thomas. *Some Account of the Life of Richard Wilson, Esq., R. A. with Testimonies to His Genius and Memory, and Remarks on His Landscapes*. London: Longman, Hurst, Rees, Orme, Brown, & Green, 1824.

**Wunder 1954**
Wunder, Richard P. "Two Roman Vedute by Panini in the Walters Art Gallery." *Journal of the Walters Art Gallery*, vol. 17 (1954), pp. 9–18.

**Wunder 1966**
Wunder, Richard P., ed. *17th and 18th Century European Drawings*. New York: American Federation of Arts, 1966.

**Wünsche 1998**
Wünsche, Raimund. *Il torso del Belvedere: da Aiace a Rodin*. Vatican City: Musei Vaticani, 1998.

**Yates 1951**
Yates, Frances A. "Transformations of Dante's Ugolino." *Journal of the Warburg and Courtauld Institutes*, vol. 14 (1951), pp. 92–117.

**Yavchitz-Koehler 1987**
Yavchitz-Koehler, Sylvie. "Un Dessin de Hubert Robert: le salon du bailli de Breteuil à Rome au Musée du Louvre." *Revue du Louvre*, vol. 37, no. 5–6 (1987), pp. 369–78.

**Zahlen 1966**
Zahlen, Erik. "A Roman Mosaic." In *Opuscula in honorem C.Hernmarck*, pp. 277–80. Stockholm: Nationalmuseum, 1966.

**Zamboni 1964**
Zamboni, Silla. "Pietro Bracci: il modello per il monumento di Benedetto XIV." *Arte antica e moderna*, vol. 26 (1964), pp. 211–18.

**Zampetti 1990**
Zampetti, Pietro, ed. *Carlo Magini*. Milan: Federico Mottal, 1990.

**Zampetti 1991**
Zampetti, Pietro. *Pittura nelle Marche: dal barocco all'età moderna*. Vol. 4. Florence: Nardini, 1991.

**Zanella 1988**
Zanella, Vanni, ed. *Giacomo Quarenghi, architetto a Pietroburgo: lettere e altri scritti*. Venice: Albrizzi, 1988.

**Zänker 1973**
Zänker, Jürgen. "Die 'nuova Pianta di Roma' von Giovanni Battista Nolli (1748)." *Wallraf- Richardtz-Jahrbuch*, vol. 35 (1973), pp. 309–42.

**Zanotta 1739**
Zanotta, Giampietro. *Storia dell'Accademia Clementina di Bologna aggregata all'Instituto delle Scienze e dell'Arti*. 2 vols. Bologna, Italy: L. dalla Volpe, 1739.

**Zazzarini 1937**
Zazzarini, Nello. *Sinigaglia e il suo circondario*. Senigallia, Italy: Tipografia Marchigiana, 1937.

**Zeller and Steinmann 1956**
Zeller, Hans, and Ulrich Steinmann. "Zur Entstehung der Winckelmann-Büsten von Friedrich Wilhelm Doell." In *Winckelmann-Gesellschaft Stendal, Jahresgabe 1954/55*, pp. 18–56. Berlin: Akademie, 1956.

**Zeri 1985**
Zeri, Federico. "Appunti su Tommaso Righi." *Antologia di Belle Arti*, n.s., no. 25–26 (1985), pp. 56–64.

**Zeri and González-Palacios 1978**
Zeri, Federico, and Alvar González-Palacios. "Un appunto su Vernet e Napoli." *Antologia di Belle Arti*, vol. 2 (1978), pp. 59–61.

**Zinzi 1994**
Zinzi, Matilde. "Casa Barazzi al vicolo detto dell'Olmo secco." In Debenedetti 1994, pp. 217–26.

**Zocca 1959**
Zocca, Emma. *La basilica dei S.S. Apostoli in Roma*. Rome: F. Canella, 1959.

**Zutter 1998-99**
Zutter, Jorg, ed. *Abraham-Louis-Rodolphe Ducros: un peintre suisse en Italie*. Lausanne, Switzerland: Musée cantonal des Beaux Arts; Milan: Skira, 1998–99.

**Zwollo 1973**
Zwollo, An. *Hollandse en Vlaamse veduteschilders te Rome, 1675–1725*. Assen, Netherlands: Koninklijke Van Gorcum, 1973.

# List of Exhibitions Cited

**Aix-en-Provence 1991**
Aix-en-Provence, France, Musée Granet. *La Passion selon Don Juan.* 1991.

**Ancona 1980**
Ancona, Italy, Palazzo Bosdari. *Il Lazzaretto di Luigi Vanvitelli: indagine su un'opera.* 1980. Catalogue edited by Marilena Pasquali.

**Ancona 1993**
Ancona, Italy, Mole Vanvitelliana. *L'esercizio del disegno: i Vanvitelli.* 1993. Catalogue edited by Claudio Marinelli.

**Antwerp 1972**
Antwerp, Belgium, International Cultureel Center. *Neoklassike schilderkunst in Frankrijk.* 1972–73.

**Ascoli Piceno 1999**
Ascoli Piceno, Italy, Palazzo dei Capitani. *Pier Leone Ghezzi: Settecento alla moda.* 1999. Catalogue edited by Anna Lo Bianco.

**Athens and New York 1979**
Athens, National Pinakothiki, and the Alexander Soutzos Museum; New York, The Metropolitan Museum of Art. *Treasures from The Metropolitan Museum of Art: Memories and Revivals of the Classical Spirit.* 1979.

**Bari 1993**
Bari, Italy, Castello Svevo. *Giaquinto: capolavori dalle corti in Europa.* 1993.

**Berlin 1955**
Berlin, Deutsche Akademie der Künste. *Jean Antoine Houdon: Sein Werk in Deutschland.* 1955.

**Berlin 1969**
Berlin, Staatliche Museen Kupferstichkabinett. *Römische Barockzeichnungen aus dem Berliner Kupferstichkabinett.* 1969. Catalogue by Peter Dreyer.

**Berlin 1989**
Berlin, Staatliche Museen zu Berlin Nationalgalerie. *Asmus Jakob Carstens und Joseph Anton Koch: Zwei Zeitgenossen der Französischen Revolution.* 1989–90.

**Birmingham 1948**
Birmingham, England, City Museum and Art Gallery. *Catalogue of Pictures by Richard Wilson and His Circle.* 1948–49.

**Bologna 1980**
Bologna, Italy, Galleria d'arte moderna, and the Museo Civico. *I Concorsi Curlandesi: Bologna, Accademia di Belle Arti, 1785–1870.* 1980. Catalogue edited by Renzo Grandi.

**Bologna 1998**
Bologna, Italy, Collezioni Comunali d'Arte. *… Di bella mano: disegni antichi dalla raccolta Franchi.* 1998.

**Bordeaux 1960**
Bordeaux, France, Musée des Beaux-Arts. *L'Europe et la découverte du monde.* 1960.

**Bordeaux 1965**
Bordeaux, France, Musée des Beaux-Arts. *Chefs-d'oeuvre de la peinture française dans les Musées de l'Ermitage et de Moscou.* 1965. Catalogue by Gilberte Martin-Méry.

**Bordeaux, Paris, and Madrid 1979**
Bordeaux, France, Galerie des Beaux-Arts; Paris, Grand Palais; Madrid, Museo del Prado. *L'Art européen à la Cour d'Espagne au XVIIIᵉ siècle.* 1979–80.

**Bregenz and Vienna 1968**
Bregenz, Austria, Vorarlberger Landesmuseum; Vienna, Österreichisches Museum für Angewandte Kunst. *Angelika Kauffmann und ihre Zeitgenossen.* 1968–69.

**Brussels 1991**
Brussels, Palais des Beaux Arts. *Triomphe du baroque.* 1991.

**Cambridge 1977**
Cambridge, The Fitzwilliam Museum. *The Triumph of the Classical: Cambridge Architecture, 1804–1834.* 1977.

**Cavalese, Jesi, and Rome 1998**
Cavalese, Italy, Palazzo della Magnifica Comunità di Fiemme; Jesi, Italy, Pinacoteca comunale; Rome, Palazzo Barberini. *Cristoforo Unterperger: un pittore fiemmese nell'Europa del Settecento.* 1998–99. Catalogue edited by Chiara Felicetti.

**Chaumont 1962**
Chaumont, France, Musée Municipale. *Edme Bouchardon, sculpteur du roi, 1698–1762: Exposition du bi-centenaire.* 1962.

**Chicago 1978**
Chicago, The David and Alfred Smart Gallery, The University of Chicago. *German and Austrian Painting of the Eighteenth Century.* 1978.

**Chicago, Minneapolis, and Toledo 1970**
Chicago, The Art Institute of Chicago; Minneapolis, The Minneapolis Institute of Arts; Toledo, Ohio, The Toledo Museum of Art. *Painting in Italy in the Eighteenth Century: Rococo to Romanticism.* 1970–71. Catalogue edited by John Maxon and Joseph J. Rishel.

**Cleveland 1964**
Cleveland, The Cleveland Museum of Art. *Neo-classicism: Style and Motif.* 1964.

**Copenhagen 1778**
Copenhagen, Kongelige Danske Kunstakademi. *Forklaring over det Arbeide udi Maler- Billedhugger- Bygnings-Kobberstikker- og Medailleur-Konsten, som … til offentlig Skue udsettes paa Charlottenborg.* 1778.

**Copenhagen 1809**
Copenhagen, Kongelige Danske Kunstakademi. *Fortegnelse over endeel Esquisser og Malerier i Olie-Farve … malet af Justitsraad Nicolai Abildgaard.* 1809.

**Copenhagen 1978**
Copenhagen, Kobberstiksamlingen, Statens Museum for Kunst. *N. A. Abildgaard: Tegninger.* 1978.

**Copenhagen 1988**
Copenhagen, Statens Museum for Kunst. *Johann Heinrich Füssli: Tegninger.* 1988–89.

**Copenhagen 1990**
Copenhagen, Statens Museum for Kunst. *Mellum guder og helte: historiemaleriet i Rom, Paris og København, 1770–1820.* 1990. Catalogue by Kasper Monrad and Peter Nørgaard Larsen.

**Detroit 1965**
Detroit, The Detroit Institute of Arts. *Art in Italy, 1600–1700.* 1965.

**Detroit and Chicago 1981**
Detroit, The Detroit Institute of Arts; Chicago, The Art Institute of Chicago. *The Golden Age of Naples: Art and Civilization under the Bourbons, 1734–1805.* 1981–82.

**Detroit and Florence 1974**
Detroit, The Detroit Institute of Arts; Florence, Palazzo Pitti. *The Twilight of the Medici: Late Baroque Art in Florence, 1670–1743.* 1974.

**Dijon, Paris, and Rotterdam 1992**
Dijon, France, Musée des Beaux-Arts; Paris, Institut Néerlandais; Rotterdam, Netherlands, Museum Boymans-van Beuningen. *Chefs-d'oeuvre de la peinture française des musées néerlandais, XVIIe–XVIIIe siècles.* 1992–93. Catalogue by Pierre Rosenberg, Guido Jansen, and Jeroen Giltaij.

**Dortmund 1994**
Dortmund, Germany, Museum für Kunst und Kulturgeschichte der Stadt Dortmund. *Roma Antica: Römische Ruinen in der italienischen Kunst des 18. Jahrhunderts.* 1994. Catalogue edited by Brigitte Buberl.

**Duisburg and Gotha 1987**
Duisburg, Germany, Wilhelm-Lehmbruck-Museum der Stadt Duisburg; Gotha, Germany, Museen der Stadt. *Von der Kunstkammer zum Museum: Plastik aus dem Schlossmuseum Gotha.* 1987. Catalogue edited by Michel Hebecker and Wolfgang Steguweit.

**Düsseldorf 1964**
Düsseldorf, Kunstmuseum Düsseldorf. *Italienische Handzeichnungen des Barock: Aus den Beständen des Kupferstichkabinetts im Kunstmuseum Düsseldorf.* 1964. Catalogue by Eckhard Schaar.

**Düsseldorf 1969**
Düsseldorf, Kunstmuseum Düsseldorf. *Meisterzeichnungen der Sammlung Lambert Krahe.* 1969–70. Catalogue by Dieter Graf and Eckhard Schaar.

**Düsseldorf 1995**
Düsseldorf, Kunstmuseum Düsseldorf. *Die Handzeichnungen des Giuseppe Passeri.* 1995. Catalogue edited by Dieter Graf.

**Düsseldorf, Munich, and Chur 1998**
Düsseldorf, Kunstmuseum Düsseldorf; Munich, Haus der Kunst München; Chur, Switzerland, Bünder Kunstmuseum Chur. *Angelika Kauffmann.* 1998–99. Catalogue edited by Bettina Baumgärtel.

**Edinburgh 1883**
Edinburgh, Board of Manufactures. *Loan Exhibition of Works of Old Masters and Scottish National Portraits.* 1883.

**Edinburgh 1950**
Edinburgh, Georgian House. *An Exhibition of Rare Scottish Antiquities.* 1950.

**Edinburgh 1963**
Edinburgh, National Gallery of Scotland. *Allan Ramsay: His Masters and Rivals.* 1963.

**Edinburgh 1966**
Edinburgh, National Portrait Gallery. *Scots in Italy in the 18th Century.* 1966.

**Edinburgh 1995**
Edinburgh, National Gallery of Scotland. *The Three Graces: Antonio Canova.* 1995. Catalogue edited by Hugh Honour and Aidan Weston-Lewis.

**Faenza 1979**
Faenza, Italy, Palazzo Milzetti. *L'età neoclassica a Faenza, 1780–1820.* 1979. Catalogue by Anna Ottani Cavina et al.

**Florence 1911**
Florence, Palazzo Vecchio. *Mostra del ritratto italiano: dalla fine del sec. XVI all'anno 1861.* 1911.

**Florence 1922**
Florence, Palazzo Pitti. *Mostra della pittura italiana del Sei e Settecento in Palazzo Pitti.* 1922.

**Florence and London 1991**
Florence, Palazzo Strozzi; London, Trinity Fine Art. *Valadier: sacro e profano.* 1991.

**Frankfurt 1991**
Frankfurt, Schirn Kunsthalle Frankfurt. *Von Lucas Cranach bis Caspar-David Friedrich: Deutsche Malerei aus der Ermitage.* 1991.

**Frankfurt 1999**
Frankfurt, Städelsches Kunstinstitut und Städtische Galerie. *The Art of Enlightenment around 1770.* 1999.

**Frankfurt 1999, *Mehr Licht***
Frankfurt, Städelsches Kunstinstitut und Städtische Galerie. *Mehr Licht: Europa um 1770. Die bildende Kunst der Aufklärung.* 1999–2000. Catalogue edited by Herbert Beck, Peter C. Bol, and Maraike Bückling.

**Frankfurt, Bologna, Los Angeles, and Forth Worth 1988**
Frankfurt, Schirn Kunsthalle Frankfurt; Bologna, Italy, Pinacoteca Nazionale; Los Angeles, Los Angeles County Museum of Art; Forth Worth, Kimbell Art Museum. *Guido Reni, 1575–1642.* 1988–89.

**Gaeta 1980**
Gaeta, Italy, Palazzo de Vio. *Gaspar van Wittel (1652/53–1736): disegni dalle collezioni napoletane.* 1980. Catalogue edited by Walter Vitzthum.

**Gaeta 1981**
Gaeta, Italy, Palazzo de Vio. *Sebastiano Conca (1680–1764).* 1981.

**Geneva 1978**
Geneva, Musée Rath. *Johann Heinrich Füssli, 1741–1825.* 1978.

**Hamburg 1979**
Hamburg, Germany, Hamburger Kunsthalle. *John Flaxman: Mythologie und Industrie.* 1979. Catalogue edited by Werner Hofmann.

**Hamburg 1989**
Hamburg, Germany, Hamburger Kunsthalle. *Europa 1789.* 1989.

**Hamburg and Cologne 1963**
Hamburg, Germany, Hamburger Kunsthalle; Cologne, Germany, Wallraf-Richartz-Museum. *Italienische Meisterzeichnungen vom 14. bis zum 18. Jahrhundert aus amerikanischem Besitz: Die Sammlung Janos Scholz, New York.* 1963.

**Hamburg, London, and Paris 1974**
Hamburg, Germany, Hamburger Kunsthalle; London, Tate Gallery; Paris, Musée du Petit Palais. *Henry Fuseli, 1741–1825.* 1974–75. Catalogue by Gert Schiff.

**'s-Hertogenbosch, Heino, and Haarlem 1984**
's-Hertogenbosch, Netherlands, Noordbrabants Museum; Heino, Netherlands, Kasteel Het Nijenhuis; Haarlem, Netherlands, Frans Halsmuseum. *Herinneringen aan Italië: kunst en toerisme in de 18de eeuw.* 1984. Catalogue by Ronald de Leeuw.

**Indianapolis and New York 1997**
Indianapolis, Indianapolis Museum of Art; New York, The Spanish Institute. *Painting in Spain in the Age of Enlightenment: Goya and His Contemporaries.* 1997.

**Kansas City, Sarasota, and Pittsburgh 1993**
Kansas City, Mo., The Nelson-Atkins Museum of Art; Sarasota, Fla., John and Mable Ringling Museum of Art; Pittsburgh, Frick Art Museum. *Three Centuries of Roman Drawings from the Villa Farnesina, Rome.* 1993. Catalogue by Simonetta Prosperi Valenti Rodinò.

**Kōbe and Yokohama 1993**
Kōbe, Japan, Kobe Shiritsu Hakubutsukan; Yokohama, Japan, Yokohama Bijutsukan. *Exposition du bicentenaire du Musée du Louvre.* 1993.

**Lausanne 1953**
Lausanne, Musée Cantonal des Beaux Arts. *Aquarelles de Abraham-Louis-Rodolphe Du Cros, 1748-1810.* 1953. Catalogue by Louis Junod.

**Lausanne 1986**
Lausanne, Museé Cantonal des Beaux Arts. *A.L.R. Ducros, 1748–1810: paysages d'Italie à l'époque de Goethe.* 1986. Catalogue edited by Pierre Chessex.

**Lausanne and Quebec 1998**
Lausanne, Museé Cantonal des Beaux Arts; Quebec, Musée du Québec. *Abraham-Louis-Rodolphe Ducros: un peintre suisse en Italie.* 1998–99. Catalogue edited by Jorg Zutter.

**Lisbon 1993**
Lisbon, Centro Cultural de Belém. *Triunfo do barroco.* 1993.

**Lisbon 1994**
Lisbon, Galeria de pintura do Rei D. Luis. *Joanni V Magnifico: a pintura em Portugal ao tempo de D. Joao V, 1706-1750.* 1994.

**Liverpool 1960**
Liverpool, England, Walker Art Gallery. *Pictures from Ince Blundell Hall.* 1960.

**London 1862**
London, South Kensington Museum. *The International Exhibition of 1862.* 1862.

**London 1889**
London, The New Gallery. *Exhibition of the Royal House of Stuart.* 1889.

**London 1930**
London, Lansdowne House. *Catalogue of the Celebrated Collection of Ancient Marbles: The Property of the Most Honourable, The Marquess of Lansdowne.* 1930.

**London 1932**
London, Royal Academy of Arts. *French Art, 1200–1900.* 1932.

**London 1949**
London, Tate Gallery. *Catalogue of an Exhibition of Pictures by Richard Wilson and His Circle.* 1949.

**London 1951**
London, Royal Academy of Arts. *The First Hundred Years of the Royal Academy, 1769–1868.* 1951–52.

**London 1954**
London, Royal Academy of Arts. *European Masters of the Eighteenth Century.* 1954–55.

**London 1955**
London, Kenwood, The Iveagh Bequest. *Exhibition of Paintings by Angelica Kauffman at the Iveagh Bequest.* 1955.

**London 1959**
London, Tate Gallery. *The Romantic Movement.* 1959.

**London 1960**
London, Royal Academy of Arts. *Italian Art and Britain: Winter Exhibition, 1960.* 1960.

**London 1963**
London, Thos. Agnew and Sons Ltd.. *Horace Buttery, 1902–1962.* 1963.

**London 1968**
London, Royal Academy of Arts. *France in the Eighteenth Century: Winter Exhibition.* 1968.

**London 1972**
London, Royal Academy of Arts, and the Victoria and Albert Museum. *The Age of Neo-classicism.* 1972. Catalogue by the Arts Council of Great Britain.

**London 1972, *Paintings***
London, Heim Gallery. *Paintings and Sculptures, 1770–1830.* 1972.

**London 1974**
London, British Museum. *Portrait Drawings: XV–XX Centuries.* 1974.

**London 1974, *Artists***
London, Kenwood, The Iveagh Bequest. *British Artists in Rome, 1700–1800.* 1974. Catalogue by Lindsay Stainton.

**London 1976**
London, Kenwood, The Iveagh Bequest. *Claude-Joseph Vernet, 1714–1789: France's Most Famous Landscape and Marine Painter of the Eighteenth Century.* 1976. Catalogue by Philip Conisbee.

**London 1978**
London, Hayward Gallery. *Piranesi.* 1978. Catalogue by John Wilton-Ely.

**London 1978, *Grand Tour***
London, Colnaghi. *Pictures from the Grand Tour.* 1978.

**London 1979**
London, Royal Academy of Arts. *John Flaxman.* 1979. Catalogue edited by David Bindman.

**London 1981**
London, Heim Gallery. *Art as Decoration.* 1981.

**London 1981, *Collecting***
London, Chaucer Fine Arts. *Collecting the 18th Century: Paintings and Drawings, Works of Art.* 1981.

**London 1982**
London, Kenwood, The Iveagh Bequest. *Pompeo Batoni (1708–87) and His British Patrons.* 1982. Catalogue by Edgar Peters Bowron.

**London 1982, *Kings***
London, The Queens Gallery, Buckingham Palace. *Kings and Queens.* 1982–83.

**London 1982, *Wilson***
London, Tate Gallery. *Richard Wilson: The Landscape of Reaction.* 1982–83. Catalogue by David. H. Solkin.

**London 1983**
London, Clarendon Gallery. *Bartolomeo Cavaceppi: Eighteenth-Century Restorations of Ancient Marble Sculpture from English Private Collections.* 1983. Catalogue by Carlos A. Picón.

**London 1985**
London, Kenwood, The Iveagh Bequest. *Images of the Grand Tour, Louis Ducros, 1748–1810.* 1985. Catalogue edited by Pierre Chessex.

**London 1987**
London, Royal Academy of Arts. *Master Drawings: The Woodner Collection.* 1987.

**London 1988**
London, Walpole Gallery. *Treasure of Italian Art.* 1988.

**London 1990**
London, Hobart and Maclean. *Paintings, Watercolours, Drawings and Prints.* 1990.

**London 1991**
London, David Carritt Ltd. *Valadier, Three Generations of Roman Goldsmiths: An Exhibition of Drawings and Works of Art.* 1991.

**London 1991, *Portrait***
London, National Portrait Gallery. *The Portrait in British Art.* 1991–92.

**London 1993**
London, Kenwood, The Iveagh Bequest. *Anton Raphael Mengs, 1728–1779, and His British Patrons.* 1993. Catalogue by Steffi Roettgen.

**London 1993, *Master Drawings***
London, British Museum. *Old Master Drawings from Chatsworth.* 1993.

**London 1994**
London, Royal Academy of Arts. *The Glory of Venice: Art in the Eighteenth Century.* 1994. Catalogue edited by Jane Martineau and Andrew Robison.

**London 1995**
London, Trinity Fine Art. *An Exhibition of Old Master Drawings and European Works of Art.* 1995.

**London 1997**
London, The National Gallery. *Discovering the Italian Baroque: The Denis Mahon Collection.* 1997. Catalogue edited by Gabriele Finaldi and Michael Kitson.

**London 1998**
London, Tate Gallery. *In Celebration: The Art of the Country House.* 1998–99.

**London and Edinburgh 1973**
London, Victoria and Albert Museum; Edinburgh, Talbot Rice Arts Centre. *Master Drawings of the Roman Baroque from the Kunstmuseum Düsseldorf: A Selection from the Lambert Krahe Collection.* 1973. Catalogue by Dieter Graf.

**London and Rome 1996**
London, Tate Gallery; Rome, Palazzo delle Esposizioni. *Grand Tour: The Lure of Italy in the Eighteenth Century.* 1996–97. Catalogue edited by Andrew Wilton and Ilaria Bignamini.

**London, Liverpool, and Edinburgh 1968**
London, Arts Council Gallery; Liverpool, England, Walker Gallery; Edinburgh, National Gallery of Scotland. *Italian Drawings from the Collection Janos Scholz.* 1968.

**Los Angeles and New York 1993**
Los Angeles, Los Angeles County Museum of Art; New York, The Metropolitan Museum of Art. *The Golden Age of Danish Painting.* 1993–94.

**Los Angeles, Philadelphia, and Minneapolis 1993**
Los Angeles, Los Angeles County Museum of Art; Philadelphia, Philadelphia Museum of Art; Minneapolis, The Minneapolis Institute of Arts. *Visions of Antiquity: Neoclassical Figure Drawings.* 1993–94. Catalogue edited by Richard J. Campbell and Victor Carlson.

**Los Angeles, Austin, Pittsburgh, and Brooklyn 1976**
Los Angeles, Los Angeles County Museum of Art; Austin, The University of Texas at Austin; Pittsburgh, Museum of Art, Carnegie Institute; Brooklyn, The Brooklyn Museum. *Women Artists, 1550–1950.* 1976–77.

**Lucca 1967**
Lucca, Italy, Palazzo Ducale. *Mostra di Pompeo Batoni.* 1967. Catalogue edited by Isa Belli Barsali.

**Lyon 1998**
Lyon, France, Musée de la Civilisation Gallo-Romaine. *La Fascination de l'antique, 1700–1770: Rome découverte, Rome inventée.* 1998.

**Madrid 1986**
Madrid, Museo del Prado. *Dibujos de los siglos XIV al XX; Colección Woodner.* 1986–87.

**Madrid and Turin 1994**
Madrid, Palacio Real; Turin, Italy, Palazzo Reale. *Filippo Juvarra: architetto delle capitali da Torino a Madrid, 1714–1736.* 1994–95. Catalogue edited by Vera Comoli Mandracci and Andreina Griseri.

**Mamiano di Traversetolo 1997**
Mamiano di Traversetolo (Parma), Italy, Fondazione Magnani Rocca. *Füssli pittore di Shakespeare: pittura e teatro, 1775–1825.* 1997. Catalogue by D. H. Weinglass, Fred Licht, and Simona Tosini Pizzetti.

**Manchester 1988**
Manchester, England, Whitworth Art Gallery. *Travels in Italy, 1776–1783.* 1988.

**Mantua 1983**
Mantua, Italy, Palazzo della Ragione. *Mantova nel Settecento: un ducato ai confini dell'impero.* 1983.

**Marino 1981**
Marino, Italy, Palazzo Colonna. *Marino e i Colonna.* 1981.

**Messina 1966**
Messina, Italy, Palazzo dell'Università. *Mostra di Filippo Juvarra: architetto e scenografo.* 1966. Catalogue edited by Vittorio Viale.

**Milan 1977**
Milan, Museo Poldi-Pezzoli. *Johann Heinrich Füssli: disegni e dipinti.* 1977–1978.

**Milan 1992**
Milan, Palazzo Reale. *Il primo '800 italiano: la pittura tra passato e futuro.* 1992.

**Minneapolis 1967**
Minneapolis, The Minneapolis Institute of Arts. *Roman Eighteenth-Century Drawings from a Private Collection.* 1967.

**Minneapolis and Cambridge 1968**
Minneapolis, The Minneapolis Institute of Arts; Cambridge, Mass., Fogg Art Museum. *Selections from the Drawing Collection of David Daniels.* 1968.

**Montreal 1993**
Montreal, Centre Canadien d'Architecture / Canadian Centre for Architecture. *Exploring Rome: Piranesi and His Contemporaries.* 1993–94. Catalogue by Cara D. Denison, Myra Nan Rosenfeld, and Stephanie Wiles.

**Munich 1977**
Munich, Galerie Carroll. *Europäische Architektur-Zeichnungen, 18. und 19. Jahrhundert: Klassizistische Skulpturen.* 1977. Catalogue edited by Peter Pröschel.

**Munich 1983**
Munich, Haus der Kunst München. *Im Licht von Claude Lorrain: Landschaftsmalerei aus drei Jahrhunderten.* 1983.

**Munich 1992**
Munich, Kunsthalle der Hypo-Kulturstiftung. *Friedrich der Grosse: Sammler und Mäzen.* 1992–93.

**Munich and Vatican City 1998**
Munich, Glyptothek München; Vatican City, Musei Vaticani. *Il torso del Belvedere: da Aiace a Rodin.* 1998–99. Catalogue by Raimund Wünsche.

**Münster 1995**
Münster, Germany, Westfälisches Landesmuseum für Kunst und Kulturgeschichte. *Johann Conrad Schlaun, 1695–1773: Architektur des Spätbarock in Europa.* 1995.

**Naples 1966**
Naples, Napoli Museo di Capodimonte. *Disegni napoletani del Sei e del Settecento nel Museo di Capodimonte.* 1966–67. Catalogue edited by Walter Vitzthum.

**Naples 1974**
Naples, Palazzo Reale. *Disegni di Luigi Vanvitelli nelle collezioni pubbliche di Napoli e di Caserta.* 1974. Catalogue edited by Jörg Garms.

**Naples 1980**
Naples, Museo e Gallerie Nazionali di Capodimonte. *Civiltà del '700 a Napoli.* 1980.

**Naples 1990**
Naples, Castel Sant'Elmo. *All'ombra del Vesuvio: Napoli nella veduta europea dal Quattrocento all'Ottocento.* 1990. Catalogue by Silvia Cassani.

**Naples 1998**
Naples, Palazzo Reale. *Filippo Juvarra e l'architettura europea.* 1998. Catalogue edited by Antonio Bonet Correa, Beatriz Blasco Esquivias, and Gaetana Cantone.

**New Haven 1979**
New Haven, Yale Center for British Art. *The Fuseli Circle in Rome: Early Romantic Art of the 1770s.* 1979. Catalogue by Nancy L. Pressly.

**New Haven, London, and Ottawa 1984**
New Haven, Yale Center for British Art; London, Victoria and Albert Museum; Ottawa, The National Gallery of Canada. *English Caricature 1620 to the Present: Caricaturists and Satirists, Their Art, Their Purpose and Influence.* 1984.

**New Haven, Sarasota, and Kansas City 1987**
New Haven, Yale University Art Gallery; Sarasota, Fla., John and Mable Ringling Museum of Art; Kansas City, Mo., The Nelson-Atkins Museum of Art. *A Taste for Angels: Neapolitan Painting in North America, 1650–1750.* 1987–88.

**New York 1831**
New York, National Academy of Design. *Mrs. Richard W. Meade's Collection of Paintings.* 1831.

**New York 1853**
New York, American Art Union Gallery. *The Washington Exhibition.* 1853.

**New York 1889**
New York, Metropolitan Opera House Assembly Rooms. *The Centennial Celebration of the Inauguration of George Washington as First President of the United States.* 1889.

**New York 1932**
New York, The Metropolitan Museum of Art. *Exhibition of Portraits of George Washington.* 1932.

**New York 1935**
New York, The Metropolitan Museum of Art. *French Painting and Sculpture of the XVIIIth Century.* 1935–36.

**New York 1942**
New York. *Portraits of American Heroes.* 1942.

**New York 1966**
New York, American Federation of Arts. *17th and 18th Century European Drawings.* Traveling exhibition, 1966–67. Catalogue edited by Richard P. Wunder.

**New York 1967**
New York, M. Knoedler and Company. *Masters of the Loaded Brush: Oil Sketches from Rubens to Tiepolo.* 1967.

**New York 1971**
New York, The Metropolitan Museum of Art. *Drawings from New York Collections III: The Eighteenth Century in Italy.* 1971. Catalogue by Jacob Bean and Felice Stampfle.

**New York 1972**
New York, Low Memorial Library, Columbia University. *Giovanni Battista Piranesi: Drawings and Etchings at Columbia University.* 1972. Catalogue by Dorothea Nyberg.

**New York 1975**
New York, Avery Architectural Library, Columbia University. *Piranesi, The Arthur M. Sackler Collection: Drawings and Etchings at the Avery Architectural Library, Columbia University, New York.* 1975–78.

**New York 1976**
New York, The Metropolitan Museum of Art. *Roman Artists of the 17th Century: Drawings and Prints.* 1976–77.

**New York 1977**
New York, Wildenstein. *Paris—New York: A Continuing Romance.* 1977.

**New York 1978**
New York, The Metropolitan Museum of Art. *Artists in Rome in the 18th Century: Drawings and Prints.* 1978.

**New York 1978, *Crosscurrents***
New York, Cooper-Hewitt Museum. *Crosscurrents: French and Italian Neoclassical Drawings and Prints from the Cooper-Hewitt Museum.* 1978.

**New York 1980**
New York, American Federation of Arts. *Italian Drawings, 1780–1890.* 1980. Traveling exhibition, 1980–81.

**New York 1982**
New York, Colnaghi. *Pompeo Batoni (1708–1787): A Loan Exhibition of Paintings.* 1982. Catalogue by Edgar Peters Bowron.

**New York 1984**
New York, The Pierpont Morgan Library. *French Drawings, 1550–1825.* 1984.

**New York 1984, *Clodion***
New York, The Frick Collection. *Clodion Terracottas in North American Collections.* 1984. Catalogue by Anne L. Poulet.

**New York 1985**
New York, The Metropolitan Museum of Art. *Liechtenstein: The Princely Collections.* 1985–86.

**New York 1989**
New York, The Metropolitan Museum of Art. *Canaletto.* 1989–90. Catalogue by Katharine Baetjer and J. G. Links.

**New York 1989, *Piranesi***
New York, The Pierpont Morgan Library. *Exploring Rome: Piranesi and His Contemporaries.* 1989.

**New York 1990**
New York, The Metropolitan Museum of Art. *Master Drawings from the Woodner Collection.* 1990.

**New York 1990, *Claude***
New York, Colnaghi. *Claude to Corot: The Development of Landscape Painting in France.* 1990.

**New York 1990, *Drawings***
New York, The Metropolitan Museum of Art. *18th Century Italian Drawings in The Metropolitan Museum of Art.* 1990. Catalogue by Jacob Bean and William Griswold.

**New York 1995**
New York, Newhouse Galleries. *An Exhibition of Old Master Drawings and European Works of Art.* 1995.

**New York 1996**
New York, Colnaghi. *The French Portrait, 1550–1850.* 1996.

**New York and Philadelphia 1988**
New York, The Italian Cultural Institute; Philadelphia, University of Pennsylvania. *Piranesi: The Dark Prisons.* 1988–89. Catalogue edited by Malcolm Campbell.

**New York and Rome 1989**
New York, Margot Gordon Gallery; Rome, Galleria Marcello Aldega. *Italian Drawings, 1700–1863.* 1989. Catalogue by Marcello Aldega and Margot Gordon.

**New York and Rome 1990**
New York, Italian Consulate for the American Academy in Rome; Rome, American Academy in Rome. *Piranesi: Rome Recorded.* 1990. Catalogue edited by Malcolm Campbell.

**New York, Cleveland, Chicago, and Ottawa 1975**
New York, The Pierpont Morgan Library; Cleveland, The Cleveland Museum of Art; Chicago, The Art Institute of Chicago; Ottawa, The National Gallery of Canada. *Drawings from the Collection of Mr. and Mrs. Eugene V. Thaw.* 1975–76.

**Northampton 1961**
Northampton, Mass., Smith College Museum of Art. *Piranesi.* 1961. Catalogue edited by Robert O. Parks.

**Northampton 1980**
Northampton, Mass., Smith College Museum of Art. *Promoted to Glory: The Apotheosis of George Washington.* 1980.

**Nottingham 1987**
Nottingham, England, University Art Gallery. *Genial Company: The Theme of Genius in Eighteenth Century British Portraiture.* 1987. Catalogue by Desmond Shawe-Taylor.

**Nuremberg 1989**
Nuremberg, Germany, Germanisches Nationalmuseum. *Die Grafen von Schönborn: Kirchenfürsten, Sammler, Mäzene.* 1989. Catalogue by Hermann Maue and Sonja Brink.

**Ottawa 1977**
Ottawa, The National Gallery of Canada. *Drawings by Gaspar van Wittel (1652/53–1736) from Neapolitan Collections.* 1977. Catalogue by Walter Vitzthum.

**Paris 1913**
Paris, Musée du Petit Palais. *Exposition David et ses élèves.* 1913.

**Paris 1933**
Paris, Musée de l'Orangerie. *Exposition Hubert Robert, à l'occasion du deuxième centenaire de sa naissance.* 1933.

**Paris 1950**
Paris, Musée Carnavalet. *Chefs-d'oeuvre des collections parisiennes.* 1950.

**Paris 1960**
Paris, Musée du Petit Palais. *La Peinture italienne au XVIIIᵉ siècle.* 1960. Catalogue by Bruno Molaioli et al.

**Paris 1961**
Paris, Hôtel de Rohan. *Les Français à Rome: résidents et voyageurs dans la Ville Éternelle de la Renaissance aux débuts du romantisme.* 1961.

**Paris 1965**
Paris, Musée du Louvre. *Chefs-d'oeuvre de la peinture française dans les musées de Leningrad et de Moscou.* 1965–66.

**Paris 1967**
Paris, Musée du Louvre. *Le Cabinet d'un grand amateur P. J. Mariette, 1694–1774: dessins du XV siècle au XVIII siècle.* 1967.

**Paris 1969**
Paris, Musée Jacquemart-André. *Hubert Robert: les sanguines du Musée de Valence.* 1969.

**Paris 1976**
Paris, Musée de la Marine. *Claude-Joseph Vernet.* 1976–77.

**Paris 1982**
Paris, Musée du Petit Palais. *Le Portrait en Italie au siècle de Tiepolo.* 1982.

**Paris 1983**
Paris, Musée du Louvre. *Les Collections du comte d'Orsay: Dessins du Musée du Louvre.* 1983.

**Paris 1987**
Paris, Musée du Louvre. *Nouvelles acquisitions du Département des Peintures (1983–1986).* 1987.

**Paris 1989**
Paris, Grand Palais. *La Révolution française et l'Europe, 1789–1799.* 1989.

**Paris 1989, *David***
Paris, Musée du Louvre; Versailles, Musée National du Château. *Jacques-Louis David, 1748–1825.* 1989–90.

**Paris 1990**
Paris, Musée du Louvre. *La Rome baroque de Maratti à Piranèse: dessins du Louvre et des collections publiques françaises.* 1990–91. Catalogue by Catherine Legrand and Domitilla d'Ormesson-Peugeot.

**Paris 1992**
Paris, Musée du Louvre. *Clodion, 1738–1814.* 1992.

**Paris 1994**
Paris, Musée du Louvre. *Luigi Valadier au Louvre: ou l'antiquité exaltée.* 1994–95.

**Paris 1995**
Paris, Thierry Mercier - Hubert Duchemin - Frédérick Chanoit. *Tableaux et dessins des dix-huitième et dix-neuvième siècles.* 1995.

**Paris 1998**
Paris, Musée du Louvre. *La Collection Lemme: Tableaux romains des XVIIe et XVIIIe siècles.* 1998. Catalogue edited by Stéphane Loire.

**Paris and New York 1987**
Paris, Grand Palais; New York, The Metropolitan Museum of Art. *Fragonard.* 1987–88. Catalogue by Pierre Rosenberg.

**Paris and Rome 1987**
Paris, Musée du Luxembourg; Rome, Académie de France, Villa Médicis. *Subleyras, 1699–1749.* 1987. Catalogue edited by Olivier Michel and Pierre Rosenberg.

**Paris, Detroit, and New York 1974**
Paris, Grand Palais; Detroit, The Detroit Institute of Arts; New York, The Metropolitan Museum of Art. *French Painting, 1774–1830: The Age of Revolution.* 1974–75.

**Paris, Milan, and Rome 1998**
Paris, Musée du Louvre; Milan, Palazzo Reale; Rome, Palazzo Barberini. *Il Seicento e Settecento romano nella collezione Lemme.* 1998–99.

**Paris, Piacenza, and Brunswick 1992–93**
Paris, Musée du Louvre; Piacenza, Italy, Museo Civico; Brunswick, Germany, Herzog Anton Ulrich Museum. *Pannini.* 1992–93. Catalogue by Michael Kiene.

**Philadelphia 1960**
Philadelphia, University of Pennsylvania. *The Ruins of Rome.* 1960–61.

**Philadelphia 1976**
Philadelphia, Philadelphia Museum of Art. *Philadelphia, Three Centuries of American Art: Bicentennial Exhibition.* 1976.

**Philadelphia 1980**
Philadelphia, Philadelphia Museum of Art. *A Scholar Collects: Selections from the Anthony Morris Clark Bequest.* 1980–81. Catalogue by Ulrich W. Hiesinger and Ann Percy.

**Phoenix, Kansas City, and The Hague 1998**
Phoenix, Phoenix Art Museum; Kansas City, Mo., The Nelson-Atkins Museum of Art; The Hague, Koninklijk Kabinet van Schilderijen. *Copper as Canvas: Two Centuries of Masterpiece Paintings on Copper, 1575–1775.* 1998–99.

**Piacenza 1922**
Piacenza, Italy. *Mostra landiana.* 1922.

**Piacenza 1979**
Piacenza, Italy, Palazzo Farnese. *Società e cultura nella Piacenza del Settecento.* 1979.

**Piacenza 1993**
Piacenza, Italy, Palazzo Gotico. *Giovanni Paolo Panini, 1691–1765.* 1993. Catalogue edited by Ferdinando Arisi.

**Pisa 1991**
Pisa, Palazzo Reale-Chiesa di San Matteo. *Da Cosimo III a Pietro Leopoldo: la pittura a Pisa nel Settecento.* 1991. Catalogue by Roberto Paolo Ciardi.

**Pisa 1993**
Pisa, Museo dell'Opera del Duomo. *Il modello e la copia: dai quadroni del Duomo di Pisa tra Settecento e Ottocento.* 1993–96. Catalogue edited by Mariagiulia Burresi.

**Princeton 1980**
Princeton, N.J., The Art Museum, Princeton University. *Italian Baroque Paintings from New York Private Collections.* 1980.

**Providence 1957**
Providence, Rhode Island School of Design. *The Age of Canova.* 1957.

**Rome 1954**
Rome, Istituto Svizzero. *Acquarelli di A.L.R.-Du Cros: pittore svizzero, 1748–1810.* 1954. Catalogue by Luc Boissonnas.

**Rome 1955**
Rome, Istituto nazionale per la grafica, Gabinetto disegni e stampe. *Disegni di Ferdinando Fuga e di altri architetti del Settecento.* 1955. Catalogue edited by Lidia Bianchi.

**Rome 1959**
Rome, Palazzo delle Esposizioni. *Il Settecento a Roma.* 1959.

**Rome 1969**
Rome, Palazzo Barberini. *Disegni napoletani del Sei e del Settecento.* 1969–70.

**Rome 1970**
Rome, Palazzo Carpegna. *Mostra di ritratti di accademici del Settecento e dell'Ottocento.* 1970.

**Rome 1972**
Rome, Palazzo Braschi. *Artisti austriaci a Roma dal barocco alla secessione.* 1972. Catalogue edited by Jörg Garms.

**Rome 1972, *Acquisti***
Rome, Palazzo Barberini. *Acquisti 1970–1972: XV settimana dei musei italiani.* 1972.

**Rome 1973**
Rome, Palazzo Braschi. *Roma giacobina.* 1973–74.

**Rome 1976**
Rome, Palazzo Braschi. *Roma sparita: mostra di disegni e acquerelli dal secolo XVI al XX dalla donazione della contessa Anna Laetitia Pecci Blunt al Museo di Roma.* 1976.

**Rome 1978**
Rome, Galleria nazionale d'arte moderna. *Vincenzo Camuccini (1771–1844): bozzetti e disegni dallo studio dell'artista.* 1978. Catalogue edited by Gianna Piantoni de Angelis.

**Rome 1979**
Rome, Palazzo delle Esposizioni. *Tesori d'arte dai musei di Stato di Berlino, Repubblica Democratica Tedesca.* 1979.

**Rome 1981**
Rome, Accademia di Francia. *David e Roma.* 1981–82.

**Rome 1983**
Rome, Galleria Borghese. *Bénigne Gagneraux (1756–1795): un pittore francese nella Roma di Pio VI.* 1983. Catalogue by Sylvain Laveissière et al.

**Rome 1984**
Rome, Villa Farnesina. *I paesaggi di Nicolas-Didier Boguet e i luoghi tibulliani: dalle collezioni del Gabinetto Nazionale delle stampe.* 1984. Catalogue by Giulia Fusconi.

**Rome 1984, *Galleria Corsini***
Rome, Galleria Corsini. *La galleria Corsini: a cento anni dalla sua acquisizione allo stato.* 1984.

**Rome 1984, *Roma***
Rome, Palazzo Venezia. *Roma, 1300–1875: l'arte degli anni santi.* 1984–85.

**Rome 1987**
Rome, Palazzo Braschi. *Ducros, 1748–1810: paesaggi d'Italia all'epoca di Goethe.* 1987. Catalogue edited by Pierre Chessex.

**Rome 1988**
Rome, Istituto Nazionale per la Grafica. *Ferdinando Fuga e l'architettura romana del Settecento: i disegni di architettura dalle collezioni del Gabinetto Nazionale delle stampe, il Settecento.* 1988. Catalogue by Elisabeth Kieven.

**Rome 1988, *Artisti***
Rome, Galleria Gasparrini. *Artisti in Roma nel Sei e Settecento.* 1988.

**Rome 1989**
Rome, Palazzo dei Conservatori. *Giuseppe Ceracchi: scultore giacobino, 1751–1801.* 1989.

**Rome 1989, *Bertel Thorvaldsen***
Rome, Galleria Nazionale d'arte Moderna. *Bertel Thorvaldsen, 1770–1844: scultore danese a Roma.* 1989–90. Catalogue edited by Elena di Majo, Bjarne Jørnaes, and Stefano Susinno.

**Rome 1989, *IRIARTE***
Rome, Palazzo Venezia. *IRIARTE: antico e moderno nelle collezioni del Gruppo IRI.* 1989.

**Rome 1990**
Rome, Palazzo Venezia. *L'arte per i papi e per i principi nella campagna romana: grande pittura del '600 e del '700.* 1990.

**Rome 1990, *Fragonard***
Rome, Villa Medici. *J. H. Fragonard e H. Robert a Roma.* 1990–91. Catalogue by Catherine Boulet, Jean-Pierre Cuzin, and Pierre Rosenberg.

**Rome 1990, *Lusitana***
Rome, Ospizio di San Michele. *Roma lusitana—Lisbona romana.* 1990–91. Catalogue by Sandra Vasco Rocca, Gabriele Borghini, and Paola Ferraris.

**Rome 1991**
Rome, Palazzo Braschi. *Architettura del Settecento a Roma: nei disegni della raccolta grafica comunale.* 1991. Catalogue edited by Elisabeth Kieven.

**Rome 1991, *Canova***
Rome, Palazzo Ruspoli. *Canova all'Ermitage: le sculture del museo di San Pietroburgo.* 1991–92.

**Rome 1991, *Fasto romano***
Rome, Palazzo Sacchetti. *Fasto romano: dipinti, sculture, arredi dai palazzi di Roma.* 1991. Catalogue edited by Alvar González-Palacios.

**Rome 1992**
Rome, American Academy in Rome. *Piranesi Architetto.* 1992. Catalogue by John Wilton-Ely.

**Rome 1993**
Rome, Palazzo Venezia. *Quadri dal silenzio: dipinti da conventi e istituti religiosi romani.* 1993–94.

**Rome 1994**
Rome, Villa Farnesina. *Della chinea e di altre "macchine di gioia": apparati architettonici per fuochi d'artificio a Roma nel Settecento.* 1994. Catalogue by Mario Gori Sassoli.

**Rome 1994, *Cavaceppi***
Rome, Palazzo Venezia. *Bartolomeo Cavaceppi, scultore romano (1717–1799).* 1994. Catalogue edited by Maria Giulia Barberini and Carlo Gasparri.

**Rome 1995**
Rome, Istituto nazionale per la grafica, Gabinetto delle stampe. *Disegni romani dal XVI al XVIII secolo.* 1995. Catalogue edited by Simonetta Prosperi Valenti Rodinò.

**Rome 1995, *Regola***
Rome, Palazzo Venezia. *La regola e la fama: San Filippo Neri e l'arte.* 1995.

**Rome 1997**
Rome, Palazzo Venezia. *La festa a Roma: dal Rinascimento al 1870.* 1997. Catalogue edited by Marcello Fagiolo.

**Rome 1997, *Goethe a Roma***
Rome, Casa di Goethe. *"Finalmente in questa capitale del mondo!": Goethe a Roma.* 1997. Catalogue by Konrad Scheurmann and Ursula Bongaerts-Schomer.

**Rome 1997, *Valadier***
Rome, Villa Medici. *L'oro di Valadier: un genio nella Roma del Settecento.* 1997. Catalogue edited by Alvar González-Palacios.

**Rome 1998**
Rome, Accademia Nazionale di San Luca, Istituto Nazionale per la Grafica. *Angelika Kauffmann e Roma.* 1998. Catalogue edited by Oscar Sandner.

**Rome 1999**
Rome, Palazzo Venezia. *Gian Lorenzo Bernini: regista del Barocco.* 1999.

**Rome and Mogliano Veneto 1989**
Rome, Palazzo Braschi; Mogliano Veneto, Italy, Villa La Marignana-Benetton. *Piranesi e la veduta del Settecento a Roma.* 1989.

**Rome and Venice 1991**
Rome, Palazzo Ruspoli; Venice, Galleria Giorgio Franchetti alla Ca' d'Oro. *Alle origini di Canova: le terrecotte della collezione Farsetti.* Catalogue edited by Sergei O. Androsov. 1991–92.

**Rome, Dijon, and Paris 1976**
Rome, Villa Medici; Dijon, France, Palais del États de Bourgogne; Paris, Hôtel de Sully. *Piranèse et les français, 1740–1790.* 1976. Catalogue edited by André Chastel and Georges Brunel.

**Rome, University Park, and New York 1989**
Rome, Accademia Nazionale di San Luca; University Park, Pa., Palmer Museum of Art; New York, National Academy of Design. *Prize Winning Drawings from the Roman Academy, 1682–1754.* 1989–90. Catalogue edited by Angela Cipriani.

**St. Petersburg 1981**
St. Petersburg, The Hermitage State Museum. *Anton Rafaél Mengs.* 1981.

**St. Petersburg 1989**
St. Petersburg, The Hermitage State Museum. *Ital'ianskaia terrakotta XVII–XVIII vekov: Eskizy i modeli masterov barokko iz sobraniya Ermitazha.* 1989.

**Salzburg 1998**
Salzburg, Dommuseum. *Meisterwerke europäischer Kunst: 1200 Jahre Erzbistum Salzburg.* 1998. Catalogue by Johann Kronbichler.

**Schleswig-Holsteinisches 1992**
Schleswig-Holsteinisches, Germany, Schleswig-Holsteinisches Landesmuseum. *Asmus Jakob Carstens: Goethes Erwerbungen für Weimar.* 1992. Catalogue by Renate Barth and Margarete Oppel.

**Spoleto 1996**
Spoleto, Italy, Palazzo Racani Arroni. *Pierre-Henri de Valenciennes, 1750–1819.* 1996. Catalogue edited by Bruno Mantura and Geneviève Lacambre.

**Stockholm 1982**
Stockholm, Nationalmuseum. *På Klassik Mark: Målare i Rom på 1780-talet.* 1982.

**Stockholm 1990**
Stockholm, Nationalmuseum. *Sergel.* 1990–91. Catalogue edited by Ulf Cederlöf and Magnus Olausson.

**Stockholm 1990, *Füssli***
Stockholm, Nationalmuseum. *Füssli.* 1990–91.

**Storrs 1973**
Storrs, Conn., The William Benton Museum of Art, The University of Connecticut. *The Academy of Europe: Rome in the Eighteenth Century.* 1973. Catalogue by Frederick den Broeder.

**Stuttgart 1993**
Stuttgart, Germany, Graphische Sammlung, Staatsgalerie Stuttgart. *Von Bernini bis Piranesi: Römische Architekturzeichnungen des Barock.* 1993. Catalogue edited by Elisabeth Kieven.

**Sydney 1979**
Sydney, Australia, Art Gallery of New South Wales. *The Poetical Circle: Fuseli and the British.* 1979.

**Torre de Passeri 1985**
Torre de' Passeri, Italy, Casa di Dante. *Füssli e Dante.* 1985.

**Toulouse 1956**
Toulouse, France, Musée Dupuy. *Pierre-Henri de Valenciennes.* 1956. Catalogue by Robert Mesuret.

**Trapani 1996**
Trapani, Italy, Palazzo Milo. *Giovanni Battista Piranesi: la raccolta di stampe della Biblioteca Fardelliana.* 1996.

**Trieste 1950**
Trieste, Italy, Civici Musei di storia ed arte di Trieste. *Mostra storica dei pittori istriani.* 1950.

**Troyes, Nîmes, and Rome 1977**
Troyes, France, Musée des Beaux-Arts; Nîmes, France, Musée des Beaux-Arts; Rome, Villa Médicis. *Charles Joseph Natoire: peintures, dessins, estampes et tapisseries des collections publiques françaises.* 1977.

**Tulsa 1994**
Tulsa, Okla., The Philbrook Museum of Art. *Botticelli to Tiepolo: Three Centuries of Italian Painting from Bob Jones University.* Traveling exhibition. 1994–95. Catalogue by Richard P. Townsend.

**Turin 1996**
Turin, Italy, Palazzina di caccia di Stupinigi. *Il tesoro della città: opere d'arte e oggetti preziosi di Palazzo Madama.* 1996.

**University Park 1975**
University Park, Pa., Museum of Art, The Pennsylvania State University. *Carlo Maratti and His Contemporaries: Figurative Drawings from the Roman Baroque.* 1975. Catalogue by Jean K. Westin and Robert H. Westin.

**University Park and New York 1981**
University Park, Pa., Museum of Art, The Pennsylvania State University; New York, Cooper-Hewitt Museum. *Architectural Fantasy and Reality: Drawings from the Accademia Nazionale di San Luca, Concorsi Clementini, 1700–1750.* 1981–82. Catalogue by Hellmut Hager.

**Urbino 1973**
Urbino, Italy, Palazzo Ducale. *Restauri nelle Marche: testimonianze acquisti e recuperi.* 1973.

**Vaduz and Milan 1992**
Vaduz, Liechtenstein, Liechtensteinische Staatliche Kunstsammlung Vaduz; Milan, Palazzo della Permanente. *Hommage an Angelika Kauffmann.* 1992–93.

**Venice 1929**
Venice, Palazzo della Biennale. *Il Settecento italiano.* 1929.

**Venice 1967**
Venice, Palazzo Ducale. *I vedutisti veneziani del Settecento.* 1967.

**Venice 1978**
Venice, Museo Correr. *Venezia nell'età di Canova, 1780–1830.* 1978. Catalogue edited by Elena Bassi.

**Venice and Possagno 1992**
Venice, Museo Correr; Possagno, Italy, Gipsoteca. *Antonio Canova.* 1992. Catalogue edited by Giuseppe Pavanello and Giandomenico Romanelli.

**Vercelli 1967**
Vercelli, Italy, Santa Chiara di Vercelli. *Bernardo Vittone architetto.* 1967. Catalogue edited by Nino Carboneri and Vittorio Viale.

**Vienna 1930**
Vienna, Schloss Schönbrunn. *Maria Theresa.* 1930.

**Vienna and Munich 1986**
Vienna, The Albertina; Munich, Haus der Kunst. *Meisterzeichnungen aus sechs Jahrhunderten: Die Sammlung Ian Woodner.* 1986.

**Viterbo 1998**
Viterbo, Italy, Museo della Rocca Albornoz. *Domenico Corvi.* 1998–99. Catalogue edited by Valter Curzi and Anna Lo Bianco.

**Washington, D.C. 1966**
Washington, D.C., National Gallery of Art. *Seventeenth- and Eighteenth-Century European Drawings.* 1966.

**Washington, D.C. 1978**
Washington, D.C., National Gallery of Art. *Hubert Robert: Drawings and Watercolors.* 1978. Catalogue by Victor Carlson.

**Washington, D.C. 1985**
Washington, D.C., National Gallery of Art. *The Treasure Houses of Britain: Five Hundred Years of Private Patronage and Art Collecting.* 1985–86.

**Washington, D.C. 1995**
Washington, D.C., National Gallery of Art. *The Touch of the Artist: Master Drawings from the Woodner Collections.* 1995–96.

**Washington, D.C., and New York 1984**
Washington, D.C., National Gallery of Art; New York, The Pierpont Morgan Library. *Old Master Drawings from The Albertina.* 1984–85.

**Washington, D.C., Cambridge, and New York 1978**
Washington, D.C., National Gallery of Art: Cambridge, Mass., Fogg Art Museum; New York, The Frick Collection. *Drawings by Fragonard in North American Collections.* 1978–79. Catalogue by Eunice Williams.

**Wilmington 1976**
Wilmington, Del., Delaware Art Museum. *The Pre-Raphaelite Era, 1848–1914.* 1976.

**Wörlitz and Stendal 1998**
Wörlitz, Germany, Kulturstiftung Dessau; Stendal, Germany, Winckelmann-Museum. *Römische Antikensammlungen im 18. Jahrhundert.* 1998.

**Zurich 1926**
Zurich, Kunsthaus Zürich. *Johann Heinrich Füssli (Henry Fuseli), 1741–1825.* 1926.

**Zurich 1941**
Zurich, Kunsthaus Zürich. *Johann Heinrich Füssli, 1741–1825: Zur Zweihundertjahrfeier und Gedächtnisausstellung.* 1941.

**Zurich 1959**
Zurich, Haus zum Rechberg. *Zeichnungen von Johann Heinrich Füssli, 1741–1825.* 1959. Catalogue by Gert Schiff.

**Zurich 1969**
Zurich, Kunsthaus Zürich. *Johann Heinrich Füssli, 1741–1825: Gemälde und Zeichnungen.* 1969. Catalogue by Gert Schiff.

# Index

# Acknowledgments

Our thanks to those who have contributed to the making of this project can be found in the preface, the editors' foreword, the compendium of lenders, and the list of contributing authors. However, many others have contributed equally in the way of providing information, ideas, loan advice, and generally sorting out the mechanics of the exhibition, and the accompanying catalogue.

Irene Taurins, Senior Registrar at the Philadelphia Museum of Art has been in charge of all packaging and shipping. She would like to thank Elie-Anne Chevrier and Sara Detweiler Loughman; Katy Spurrell of Propileo has arranged all the loans from Italy. Houston's registrar Charles Carroll would like to thank his staff as well, including Kathleen Crain. Jack Schlechter, assisted by Andy Slavinskas, designed the beautiful installation at Philadelphia; Jack Eby was responsible in Texas. The production of this book has been a shared project between the Philadelphia Museum of Art and Merrell Publishers, London. In England the massive task of editing and translation has been directed by Matthew Taylor; the equally demanding coordination at the Philadelphia end, including the creation of the bibliography, has been handled by Jne Boyd, Vanessa Silberman and Nicole Amoroso, assisted by Susan Cheng, Robert Huber, Jessica Murphy, and Amanda Crystal.

Many others have been good friends of the exhibition and we list them here alphabetically without protocol:

Abita, Salvatore
Alcouffe, Daniel
Aldobrandini, Prince Camillo
Alexander, Kirk
Algranti, Giacomo
Alloisi, Silvigliano
Aluffi Pentini, Stefano
Androsov, Sergej
Antonova, Irina
Arcangeli, Luciano
Ash, Nancy
Attura, Donatella
Bailey, Colin
Baker, Malcolm
Barberini, Maria Giulia
Baroni, Jean Luc
Baumel, Jütta
Beddington, Charles
Bella, Carlo
Benedetti, Sergio
Benini, Maria Grazia
Bentini, Jadranka
Berger, Daniel
Bernheimer, Konrad
Bessone, Silvana
Birke, Veronica
Bizot, Irène
Bobone, Maria Ana
Boggs, Jean S.
Bolla, Roberto
Bonifati, Orsolo
Boorsch, Suzanne
Borea, Evelina
Bossis, Catherine
Bösel, Richard
Brady, Mark
Brook, Col. Richard

Buonanno, Vincent
Buranelli, Francesco
Calderai, Fausto
Carlson, Victor
Casadei, Giovanna
Cassandro, Michele
Castel-Branco, João
Cavalli-Björkman, Görel
Chen, Josephine
Chiarini, Marco
Chong, Alan
Cipriani, Angela
Ciucci, Giorgio
Clark, Alvin L. Jr.
Clifford, Timothy
Conran, Elizabeth
Costamagna, Alba
Creazzo, Ileana
Crichton-Stuart, Anthony
Culverhouse, John
Cuzin, Jean-Pierre
Daprà, Brigitte
Darr, Alan P.
Davidson, Gail S.
Davis, Rhonda
Delaforce, Angela V.
della Porta, Roberto
DeMuzio, David
Den Broeder, Frederick A.
Denison, Cara
di Mayo, Elena
Draper, James David
Dube, Wolf-Dieter
Ebert-Schifferer, Sybille
Enggass, Robert
Evers, Bernd
Faldi, Italo

Feldmann, Dorothee
Fielden, Kate
Filieri, Maria Teresa
Fiorenti, Marina
Foglietta, Thomas
Forlenza, Auberdan
Foster, Carter
Francisci Osti, Ornella
Fusco, Peter
Gallagher, Holly
Gallagher, Rita
Ganz, Kate
Gargari, Tommaso
Giral, Angela
Givaudan, Axelle
Goldner, George R.
Goldstein, Barbara
Grace, Priscilla T.
Grasselli, Margaret Morgan
Griswold, William S.
Gross, Hans
Gubernatis, Helena
Guidici, Corinna
Guarino, Sergio
Guarnieri, Giorgio
Gutman, Nica
Hall, Nicholas
Hardacre, Tim
Harnoncourt, Elise
Hearn, Karen
Henriques da Silva, Raquel
Hiatt, Gary
Hobart, Tim
Hoier, Elisabeth
Howard, Seymour
Huber, Robert
Hungerford, Constance Cain
Ittmann, John
Izzi, Giuseppe
Jackson, Sarah
Jecmen, Gregory
Jodice, Angela
Jodice, Mimmo
Katz, Daniel
Kaye, Susan
Kelch, Jan
Kenworthy-Browne, John
Knight, Richard
Krahn, Volker
Krückmann, Peter O.
Kugel, Alexis
Laing, Alastair
Landis, Jane
Lavalle, Maria Grazia
Lee, Katherine
Leithe-Jasper, Manfred
Leone, Francesco
Levenson, Jay A.
Levkoff, Mary
Lewine, Carole
Lignelli, Teresa
Lo Bianco, Anna
Lopes, Hélder
Loughman, Sara Detweiler
Luly Lemme, Fiammetta
McCormick, Thomas
Maccotta, Luigi
MacFeat, Michael
MacGregor, Neal
Maek-Gérard, Michael

Malenka, Sally
Mann, Judith
Marandel, J. Patrice
Marx, Harald
Masiello, Martha
Masini, Patrizia
Matveev, Vladimir
Mazzocca, Fernando
Meighan, Melissa
Melandri, Giovanna
Meredith, Michael
Mignani, Don Luigi
Millon, Henry A.
Mirti, Paolo
Mittelstaedt, Lilah
Moatti, Alain
Mochi Onori, Lorenza
Monkhouse, Christopher
Monrad, Kasper
Montagu, Jennifer
Mooney, Lee
Morna, Teresa
Munger, Jeffrey
Munro, Jane
Myers, Mary
Nash, David
Nesselrath, Arnold
Noon, Patrick
O'Brien, John
Ongpin, Stephen
Ottani Cavina, Anna
Palamenghi Crispi, Guido
Palazzolo, Maria Iolanda
Papaldo, Serenita
Pasquier, Alain
Pastorelli, Rita
Pavanello, Giuseppe
Pedicini, Luciano (and colleagues)
Peretti, Ferdinando
Perry, Marilyn
Phipps, Hugh
Picón, Carlos A.
Pierucci, Ugo
Piotrovsky, Mikhail
Pixley, Mary
Powel, Betsy
Powel, Robert
Pradelli, Felicita
Price, John
Prohaska, Wolfgang
Prosperi Valenti Rodinò, Simonetta
Raggio, Olga
Rave, August
Razumovsky, Count Andreas
Reed, Sue Welsh
Reiter, Sara
Renieri, Alessandro
Riccio, Bianca
Robinson, Betsey
Robison, Andrew
Roettgen, Steffi
Rolfi, Serenella
Romanelli, Giandomenico
Romano, Francesco
Rosenthal, Angela
Rosenthal, Lynn
Roure, Anne-Sophie
Roworth, Wendy Wassyng
Rudolph, William

Sainte Fare Garnot, Nicolas
Salatino, Kevin
Schaefer, Scott
Schleier, Erich
Schmidt, Gudrun
Schulze-Altcappenberg, Hein.-Th.
Scrase, David
Sell, Stacey
Sella, Mario
Selz, Jean-Pierre
Setta, Maurizio
Shackelford, George
Simari, M. Mathilde
Simpson, Michael
Smith, Lisa
Speri, Angelo
Spinosa, Nicola
Spurrell, Katy
Stock, Julian
Stone, Michael
Strinati, Claudio
Stuffmann, Margret
Symmes, Marilyn
Syre, Cornelia
Tepper, Dana Mossman
Thesiger, Roderic
Thompson, Rob
Thompson, Wendy
Tittoni, Maria Elisa
Toscano, Bruno
Tucker, Mark
Valeriani, Roberto
Valli, Francesca
Vanderwall, Trine
Vassalo e Silva, Nunno
Vial, Marie-Paul
Viatte, Françoise
Viljoen, Madeleine
Virgilio, Carlo
Vodret, Rossella
Vogtherr, Christoph Martin
Volk, Peter
Walker, Stefanie
Ward, Roger
Wardropper, Ian
Warner, Malcolm
Welu, James
Williams, Scott
Williamson, Paul
Wilson, Elizabeth
Winn, Robert
Winter, John
Woltersdorf, Robert
Zafran, Eric
Zieske, Faith
Zütter, Jorg

# Photographic Credits